THE ULTIMATE
PICASSO

THE ULTIMATE
PICASSO

BRIGITTE LÉAL
CHRISTINE PIOT
MARIE-LAURE BERNADAC

Preface by Jean Leymarie

HARRY N. ABRAMS, INC.
Publishers

Part-title illustrations:
Page 6: Picasso in his studio at the villa Voiliers, 1940
(Photo Sir Roland Penrose – R.M.N.)
Page 18: Picasso in his apartment on the boulevard de Clichy, 1910 (Photo R.M.N.)
Page 182: Picasso in his studio on the rue des Grands-Augustins, 1938 (Photo R.M.N.)
Page 394: Picasso and *El Bobo,* after Murillo, at Vauvenargues, April 14–15, 1959
(Photo courtesy David Douglas Duncan)
Page 480: Picasso at Vallauris (Photo André Villiers)

Editor, English-language edition: Barbara Burn
Design Coordinator, English-language edition: Arlene Lee
Translated from the French by Molly Stevens and Marjolijn de Jager
Designed by Jordi Herrero

Library of Congress Cataloging-in-Publication Data
Léal, Brigitte.
[Picasso. English]
The Ultimate Picasso / Brigitte Léal, Christine Piot, Marie-Laure
Bernadac; preface by Jean Leymarie.
p. cm.
Translated from the French original.
Includes bibliographical references and index.
ISBN 0-8109-9114-4 (pbk.)
1. Picasso, Pablo, 1881-1973. 2. Artists--France--Biography. I.
Piot, Christine. II. Bernadac, Marie-Laure. III. Title.

N6853.P5L3613 2003
709'.2--dc21

2003007773

First published in 2000 in a larger, hardcover format

Color separations by Format Digital, Barcelona
Printed and bound in Spain by
Mateu Cromo, Madrid
Dep. legal: B. 25.980-2003

10 9 8 7 6 5 4 3 2 1

Harry N. Abrams, Inc.
100 Fifth Avenue
New York, N.Y. 10011
www.abramsbooks.com

Abrams is a subsidiary of
LA MARTINIÈRE
GROUPE

CONTENTS

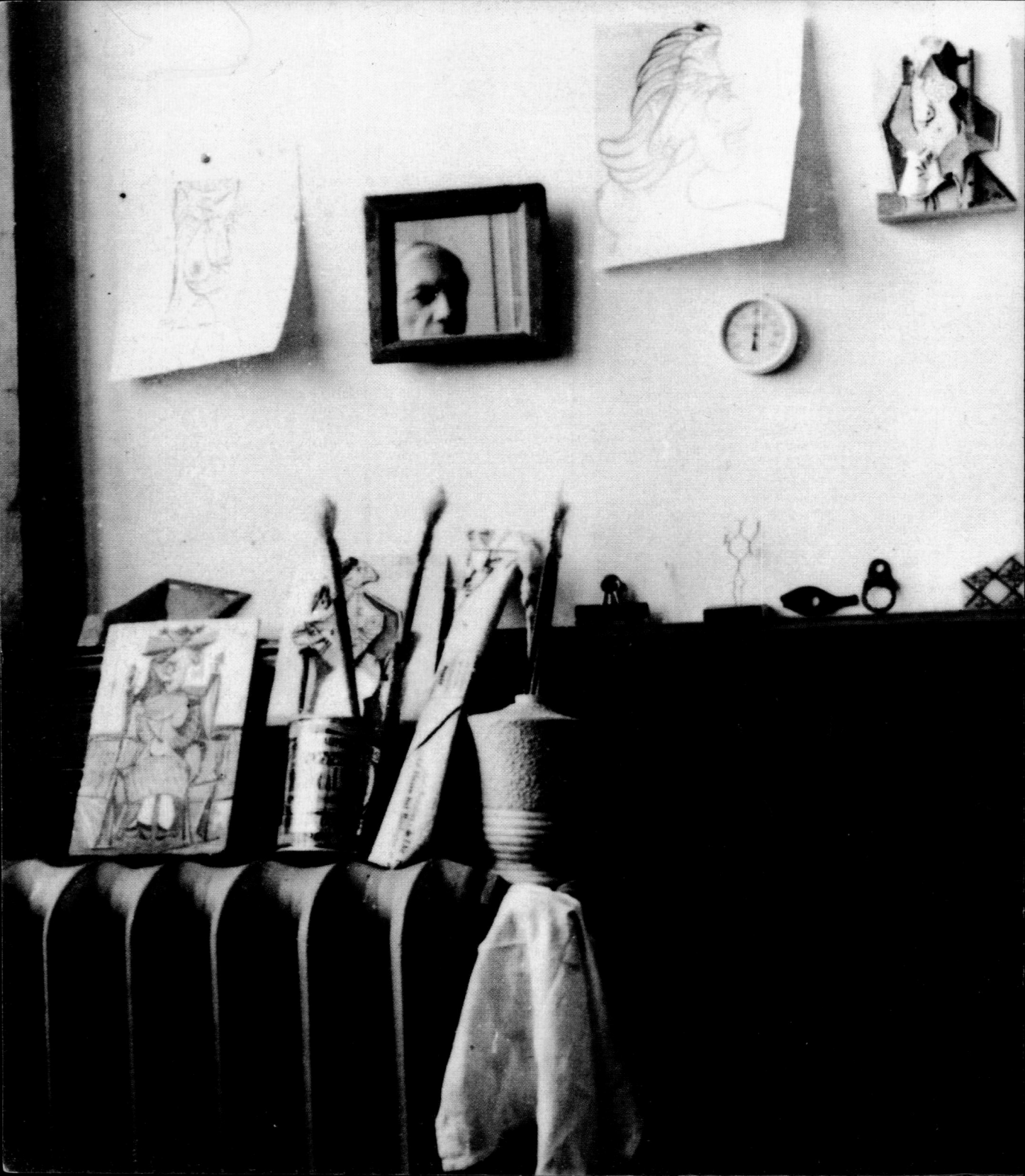

PREFACE

Picasso's supremacy in his century cannot be contested, although one may, depending on one's taste, prefer other painters. Of the awe-inspiring group of artists of the twentieth century, Picasso was the only one whom the demanding poet Pierre Reverdy recognized and hailed as having genius, the power of a demiurge. Thanks to Picasso's long life, and to the scope and variety of his work, he is unquestionably one of the most prolific inventors of the history of forms. He once told me that a book would have to be written on him every day to keep up with his rhythm and his surges of creativity. This book, which has much to teach, offers a relatively large selection of works, which are reproduced with care and attentively explained, thus tracing his vast career, with all its diverse aspects and means of expression.

When Brassaï photographed Picasso's studios and homes, he had the opportunity to note the artist's reactions and record his comments. On December 6, 1943, Brassaï's invaluable records show that Picasso told him: "It will be an amusing picture, but it won't be a 'document.' . . . Do you know why? It's because you've moved my slippers. . . . I never put them away like this. . . . That is how you would do it, not I. Yet the way an artist arranges objects around him is as telling as his works. I like your photographs precisely because they are truthful. . . . The ones you took on rue La Boétie were like a blood sample; we can analyze and diagnose what I was at those moments. . . . Why do you think I date everything I do? It's because it isn't enough to know an artist's work. You also have to know when he made them, why, how, and under what circumstances. There will undoubtedly be a science one day—maybe they'll call it 'the science of man'—that will seek to understand man through the man-creator. . . . I often think about this science, and I intend to leave as much information as possible for posterity."

The extent of this documentation surfaced at Picasso's death. The core of his incredible estate, which took several years to inventory, fills the Picasso Museum in Paris, which also contains his immense archives, manuscripts, photographs, and letters. In the days when art and society were not antagonistic, the old masters did not hesitate to destroy preliminary studies, saving only finished compositions. Picasso belonged to a period of crisis and experimentation, and he took art to its extreme level. Art became its own exercise in which *process* meant as much as realization. "The movement of my thought," he said, "interests me more than the thought itself." He was especially eager to retain all traces of his many activities, all sketches and variations of his major works as they were developed,

in sequence. Through a series of fifteen sketchbooks, as well as drawings and oil studies, we have been able to reconstitute the formidable genesis of *Demoiselles d'Avignon* without shattering the mystery of such a monument of exorcism. "How can a spectator," Picasso asked, "experience a painting as I experienced it? How can you grasp my dreams, my instincts, my desires, my thoughts, which took a long time to develop and come to life, and especially how can you comprehend what I have expressed, perhaps despite my will?"

It was only late in his life—and with a select group of close friends—that Picasso shared the decisive episode of his adolescence, an experience that points to his Spanish soul and dismisses any suspicion of disinterest, of which he has often been accused. In January 1895, while Picasso was living with his family in La Coruña, in Galicia, his youngest sister, Conchita, whom he adored, died of diphtheria. He was thirteen years old. His exceptional talent and his eventual vocation had already become evident, astounding everyone around him. Yet when his sister was sick, he swore that if she were cured, he would give up painting. In other words, he put his entire raison d'être at stake. Destiny did not grant his wish but sealed, with the drama of death, the absolute pact that united him with his destiny, with the unavoidable forces that filled him. From the very beginning, in order to maintain his health and his capacity to work, which completely absorbed him, he subjected himself to severe discipline. Max Jacob said admiringly: "His magnificent stoicism is reflected in his entire life, as well as in a character and spirit that I have never seen elsewhere."

Another pivotal moment in the formation of Picasso as a man occurred in September 1895, when he and his family moved to Barcelona, where he progressed effortlessly along an academic path. When he was sixteen, in the fall of 1897, his parents sent him to Madrid to complete his training. He thoroughly explored the Prado, that sanctuary of Spanish painting, the home of one of the finest collections of Western painting, some of which had been chosen by Velázquez himself. Weakened by hardship and the harsh Castillian winter and afflicted by scarlet fever, Picasso returned to Barcelona in the spring of 1898. His slightly older classmate, Manuel Pallarès, with whom he would retain a lasting friendship, took him to an isolated mountain village, Horta, near Aragon, to regain his health. The young urbanite discovered a rural environment with unaffected customs, and his energy was rekindled. For eight months, he led the simple life of his hosts, who were tied to their land. He took part in their work and their rural celebrations, observed the age-old secrets of artisans, and sharpened his own manual abilities. He would keep a knife he had acquired in Horta for the rest of his life. "All that I know," he confessed, "I learned at Pallarès's village." Having known a rather similar rural atmosphere in my own childhood, I had something in common with Picasso. Many times I ate a frugal meal with him at night as we exchanged our memories of the country. "We are like Cézanne's *Card Players*," he would say. Man's simplicity, at such moments, arises from time immemorial.

Picasso's enormous output has given rise to perpetual exhibitions based on period, theme, style, technique, and place of execution, and each new approach

delights his interpreters. Major museums in several countries have devoted entire rooms to Picasso, and his heirs still own rich collections. In addition to the new museum in Málaga, which consists of family gifts, there are three other museums in splendid buildings devoted exclusively to Picasso: the one in Barcelona unites his early work and the Méninas series; the one in Antibes houses the Dionysus series completed on site in the summer of 1946; and the Paris museum, which traces the intimate course of his career, contains almost all of his sculpture and engravings, the two areas in which the sorcerer's magic comes through most effectively. *Guernica* can be found in Madrid, surrounded by intense drawings, but its presentation should also include, as it never has, the funereal chorus of the Weeping Women. In Vallauris one can see the chapel of *War* and *Peace*, and, in the UNESCO hallway, *The Fall of Icarus*. When Picasso urged me to write an essay on this mythological piece—his only official commission—he asked that the publishing house reproduce all the preliminary drawings, made in various techniques, in their actual sizes and indicating accurate textures. He wanted to reveal his approach in all its fits and starts.

Contemporary with what Malraux called the "museum without walls," Picasso participated in the discovery, or resurrection, of arts from around the world, and this had a resounding effect on his work. He was spellbound by tribal art, especially the cult objects of Africa and the South Pacific islands, which brought together what he loved most: magical power and structural rigor. In spite of its excellence, he was not much influenced by Far Eastern art, which fascinated Matisse, Picasso's chief rival and primary competitor for fifty years. Picasso would prove to be fundamentally Mediterranean in origin and temperament, in his places of residence, in his fascination with myth, and in his imperious syntax. Because of his ties to realism and the mastery of form, he did not participate in two major artistic movements of his time: abstraction, a mostly northern European movement that Picasso felt resided in emptiness, and Expressionism, in which he felt form was too much controlled by the psychological and the social.

Picasso's native Málaga, an acropolis of light located between the sea and the hills, was endowed with Mediterranean attributes at every level: it was a Roman municipality with a Phoenician fortress; it was a Moorish and Christian capital that accepted Jews; a gypsy refuge; and a renowned bullfighting center. The smells and the wind from nearby Africa would sometimes reach Málaga's narrow, ancient streets, where one could hear Arab chants and the poignant accent of the *cante jondo*. Picasso said that the residents had such a strong sense of rhythm that streetcar conductors would drive to the cadence of the songs they sang. Whenever he showed his new paintings—which he jokingly called his new-laid eggs—he would often imitate indigenous accents accompanied by dance steps or humming. Islam, which has had such a strong influence on southern Spain, was an integral part of the Mediterranean composition. Apollinaire said that Picasso was more Latin in spirit, more Arab in rhythm. Beside his libertarian inclinations and his sexual machismo, which Picasso's biographer John Richardson has noted as typically Andalusian, he had *la mirada fuerte*, a piercing gaze, visual predation.

Picasso went to Paris for the first time in October 1900. "Here you are at the door of the century," wrote Vicente Huidobro. "You have the key to the door in your hand." The door opened into a new world, which Picasso would conquer and reveal. He returned to Paris in May 1901, after a short stay in Madrid, and again in October 1902, before settling there in the spring of 1904. During his years of travel and excitement, he fought fiercely to explore his artistic and human powers, to surmount his material difficulties, and to clear a path for himself. He was aware of his genius, of his uniqueness, of his marginality. His self-portrait paintings and drawings reflect his anxieties, his tensions, and his challenges, as well as his penchant for caricature and masquerade. The specter of poverty and the fatality of destiny haunted Picasso's Blue Period; wandering acrobats and their animals filled his Rose Period. "One cannot confuse his performers with minstrels," warned Apollinaire. "Spectators have to be pious, for they are celebrating silent rituals with difficult agility." This religious, or rather sacred, content, which we too often ignore, permeates all of Picasso's work, which is nevertheless Faustian.

Soon his ways changed and strengthened. He returned from a month-long trip to Holland in the summer of 1905 with one of his most carnal nudes. In the fall, he met Gertrude Stein, who made her mark through her physical and mental stature, and he began to paint her portrait in a series of sittings. She introduced him to Matisse the following spring, and the two competing giants were brought together both at social gatherings and on her wall. Picasso consecutively saw Ingres's *Turkish Bath*, Cézanne's *Bathers*, and Matisse's *Joie de Vivre*—all masterpieces that he had to confront. At the Louvre he visited Sumer and Egypt, archaic Greece, the Etruscan room, and the Iberian reliefs recently excavated in his native region. These affected him deeply, and he borrowed their geometric simplicity, as well as certain physiognomic features. He broke away from Symbolism and moved toward what would become the essence of his plastic world.

Picasso underwent a transformation in the summer of 1906, in Gósol, a mountain village on the outskirts of Andorra, which like Horta was accessible only by mule. He celebrated the lush form of his companion Fernande Olivier and captured the ocher and gray tones of the land, as well as of the local people. He abandoned linear and sentimental elongation, favoring instead objective and compact volumes. Heads frozen with the timeless stupor of masks topped immobile body masses. Ancient Iberian masks and a Romanesque sculpture of the Virgin and Child in the church at Gósol, for example, represented for him the reality of the face, the essential or primitive form, the truth of the body in its purely physical density. In his Gósol notebook, Picasso recorded the proud affirmation that all of his future work would justify, characterizing himself as "a tenor who reaches a note higher than any in the score." Upon his return to Paris, he immediately finished the imperial portrait of Gertrude Stein from memory, affixing a mask onto the erased portrait, and he also painted two self-portraits. He kept the more striking of the two pictures, with its otherworldly stare and athletic body, as the icon of his clairvoyance and the symbol of his breakthrough. In 1907,

after reading the impassioned and subversive writings of Rimbaud and while competing with Matisse and Derain's barbarous nudes and discovering African art, Picasso was inspired to create the anatomical thunder of the *Demoiselles d'Avignon* and related primitive work.

Between 1908 and 1914, Picasso's daily conversations with Braque, who was his junior by six months, resulted in Cubism, the new figurative language, which replaced traditional perspective. This historical turning point represented the purely communal creation of two superior partners that for ten years united their opposing and complementary talents, an incomparable phenomenon. One was captivated by form and visual tension, the other by space and its pictorial unity. The real was no longer a given but was in the truest sense a poetic fact. Scholarly texts have long shed light on the chronology, iconography, and understanding of Cubism in its three-level progression—Cézannian, analytic, synthetic—but it was the accounts of the poets who accompanied the painters that succeeded in restoring the legend of Cubism and its epic quality. The most resounding break-throughs occurred in Mediterranean areas, such as Horta and Cadaqués, in Céret in the Roussillon region, and in Sorgues, near Avignon, in the south of France. In 1912, a crucial year, Picasso invented collage and Braque the *papier collé,* the two most characteristic techniques of our time, as simple in means as they are infinite in effect. Without breaking from Cubist order and its crystallization, Picasso was able to obtain a likeness in portraits, to create grand hieratic figures, and to express his love for Eva, his companion. He also sculpted two revolutionary pieces that had an immediate impact: *Head of Fernande*, of 1909, with its broken contours, and *Guitar,* of 1912, a structure constructed through assemblage, another decisive technique that opens and liberates volume.

In February 1917, going against Cubist prescriptions, Picasso traveled to Italy for two months. There he met up with the Ballets Russes and enhanced their performances with his set designs, which have been shown in several exhibitions. He married one of the dancers, Olga, who became the mother of his son Paul and an Olympian model for flawless portraits. His visits to archaeological sites in Rome, Naples, and Pompeii, as well as to sanctuaries in Florence, shaped his grandiose neoclassical period, which is considered Ingresque for its pure line and classical for its majestic form. The period reflected contemporary taste and outclassed it, and it also coincided with the development of synthetic Cubism. In the summer of 1921, Picasso completed two versions each of two compositions of outstanding harmony: the naturalistic *Three Women at the Fountain* and the Cubist *Three Musicians*. There was no obvious dichotomy, but the works moved in different yet parallel directions; even the more traditional piece in each pair contained bold innovations. A master of many subjects, Picasso assumed the right to choose the appropriate mode according to the nature of the subject and the impulse of the moment. "Every time that I have had something to say, I have said it in the way that I felt was right. Different motifs require different methods. This implies neither evolution nor progress, but harmony between the idea one wants to express and the ways of expressing it." The principle that governs Picasso's creations, which are perpetually in motion and carry through to the

present (as he said, "art that is not in the present will never be") is not the principle of evolution, but of metamorphosis.

The neoclassical style, which also influenced Picasso's graphic work, disappeared from his painting in 1925, when two contorted pieces suddenly emerged: *The Dance* and *The Kiss*. Picasso himself said that to paint is to keep a journal. It was at this time that he entered into the complex period of his mature life, a period that was rich in formal explorations, in passionate vicissitudes, and in autobiographical references. Marriage problems were harrowing. Soon he would be swept away by his secret love for Marie-Thérèse, a young blonde beauty with a firm Greek profile and intoxicating charm. The freedom with which he transformed the human body, without changing the total number of parts, allowed him to represent the physical postures of the entire range of relationships between the sexes, between the wonders and terrors conveyed by a woman's naked body, between the monsters in nightmares and sleepers in rapture. Picasso was like Rembrandt in that he granted women a central role, giving his most personal reactions a universal value.

Picasso kept his sculptures near him as if they were people, friends, and he refused to separate from them for a long time. I finally convinced him to lend some pieces to a vast retrospective that I organized in Paris in the fall of 1966. The combination of painting and sculpture, linked through drawing, connected him to Michelangelo, with whom he also shared longevity, solitude, and glory. Picasso's sculptures multiplied between 1928 and 1934, relating directly to groups of paintings, drawings, and engravings. Two contrasting forms followed each other: first he completed metal and openwork sculpture with the help of an expert, Julio González; then he executed sculpture in the round and modeled plasters at the Château de Boisgeloup, which he purchased in 1930. In the interim, he painted the strange and wild *Crucifixion*, the embodiment of his fears, and carved tall figures in fir reminiscent of Etruscan silhouettes and foreshadowing Giacometti. In the giant *Head* from Boisgeloup, one will note the equivalence or permutation of facial elements and genitalia, which was common in Oceanic and Neolithic art. Miró also drew inspiration from these sources at this time. With its phallic nose and vaginal mouth, *Head* is a metaphor for sexual union. Sexuality, which hardly exists in Braque, who exalted objects as a poet of material, and which is immediately transformed in Matisse, was for Picasso, as it was for Rodin, the essential reference. Once, when I had to give a talk on art and sexuality, I asked Picasso for his opinion. He immediately answered: "They are the same thing."

During his youth, Picasso identified himself with the Harlequin figure. Harlequin, who had hidden powers under his gaudy suit, represented the artist's exile from modern society. From 1928 to 1937, the Minotaur replaced Harlequin as the painter's twin, especially in Picasso's graphic work. After his travels to Spain in 1933 and 1934, Picasso went back to painting the bullfights, the offspring of Crete rituals and Mithraism. Through the many transformations and ambivalent nature of the Minotaur, Picasso revealed his unconscious Eros and his contradictory impulses. The horse and the bull became the protagonists of *Guernica*,

the apocalyptic vision presented as a Greek pediment. Between 1936 and 1944, without forsaking Marie-Thérèse and his daughter Maya, whom he brought together and painted from time to time, he painted with deep passion the ardent and serious face of Dora Maar, distorting her face into the cries of anguish and sorrow of those dramatic years. In 1943, at the darkest hour, he built a pillar of endurance and hope against barbarism, *Man with a Sheep*, which depicts the rugged and solemn shepherd of life and is the ultimate piece of sculpture. Immediately following the massacres, he paid homage to victims in two poignant and silent paintings, *The Charnel House* and the *Homage to the Spaniards Who Died for France.*

In 1945 Picasso took his new partner, his sunshine Françoise Gilot, to the Mediterranean coast, which, for him, was filled with both torment and delight. In 1946 his *Bacchanale* triumphed on the walls of the Château d'Antibes, where classical fable mixed with the daily life of the port. The following year he moved to Vallauris, the old pottery center, and revived the art. Present on all continents because of its artistic and utilitarian value, pottery is the stamp of the Mediterranean civilization that Picasso adopted in reaction to Matisse's oriental empire. Picasso's contribution to this popular field was far from small and can be appreciated in terms of both the range of his repertoire and his technical innovations. Having space to work in, Picasso once more devoted himself to sculpture, creating hieratic female figures and a familiar bestiary. Assemblage, or montage, also reached its peak at this time. In it he disregarded the fantastic, which was foreign to his realist art, and highlighted, through transmutation and not without humor, the truth of forms. Elytis, the Greek poet, went to Vallauris to discover the primordial sculptures of 1950 shortly after they were completed. Upon seeing *The Pregnant Woman*, the timeless goddess of fertility, and *Goat*, the typically Mediterranean animal, also pregnant with a heavy belly inside its wicker basket, he wrote: "I felt jealous that the major symbols of the south of France, those archetypes that date back to time immemorial, were not completed on one of the Aegean Islands." It was in Vallauris that Picasso's children Claude and Paloma were born, his daughter having been given the name of his historic dove of peace. Just as he had done with Paul and Maya, Picasso created tender, cheerful images that made him such a marvelous interpreter of the world for children.

Françoise left with the children in the fall of 1953, an upheaval that shook Picasso's masculine pride and forced him to question everything again. Even in shock, he produced an astonishing series of drawings, which denounced in burlesque episodes the irreparable disgrace of age before youth and beauty, the fatal mockery of art before the miracle of life. In his circle of potters, he met his final and perfect partner, Jacqueline Roque, whom he married in 1961. She was classically brunette, a relentless source of inspiration, and an attentive support for twenty years. Two months after Derain's death, in November 1954, Matisse died, leaving Picasso, as he put it, his odalisques. The unsettling likeness between Jacqueline and one of the *Women of Algiers* immediately gave rise to fifteen variations on Delacroix's masterpiece. Picasso reorganized the space and rebuilt the figures according to Cubist principles, exaggerating the erotic languor of the

harem used both in painting and in nature. The oriental mirage continued. In the summer of 1955, he moved to the hills of Cannes into a spacious 1900 villa, which had a somewhat Moorish ambiance and where Jacqueline liked to wear Turkish dress. In the exotic garden, he tied a living goat, Esmeralda, to his sculpted goat to test their relationship. The ground level, with its openwork windows, was the radiant place where paintings of the studio proliferated—high, wide, with or without figures, bare and lavish. In August 1957, Picasso went to the attic, where he stayed for four months, to cast his voracious, transforming eye onto Velázquez's famous painting *Las Meninas,* which had captivated him since adolescence. The painting precisely depicted the fanciful world of the studio in the play of mirrors. By intrepidly appropriating old-master painting, Picasso intended to revive its internal alchemy at a time when non-figuration and non-painting were triumphant. In 1958 he purchased the austere and noble Château de Vauvenargues, located beside Sainte-Victoire, Cézanne's mountain, where he painted a few pictures with a Spanish resonance in harmonious reds and greens.

In June 1961, Picasso moved into a farmhouse at Notre-Dame-de-Vie, in Mougins. In October, for his eightieth birthday, I gave him an Afghan hound named Kaboul, whose thin muzzle would sometimes be found right next to Jacqueline's pure face. After the official ceremonies, there was a private party for his Spanish friends. The pigeons, as if instructed, beat on the windows of the suddenly enchanted country inn, where a fine gypsy dancer and a frenzied singer extemporized before dumbfounded bullfighters in an extraordinary flamenco performance. Picasso, in his element, was radiant. He began in Vauvenargues and finished in Mougins his boldest and most crowded composition, based on *Le Déjeuner sur l'Herbe* by Manet, who initiated the modern vision by absorbing and clarifying the past. The scene moves from the interior toward the exterior, toward the open air, where the pastoral nude is depicted in many improvised poses. I had just given Picasso souvenirs of Málaga from my travels in Spain, following in his footsteps, when he showed me his recent versions of *Déjeuner.* After a relaxing visit with his Spanish hairdresser, with whom he exchanged ribald proverbs, Picasso, without a word, showed me reproductions from a large volume of Goya's Black Paintings. Once we closed the book, I told him that Goya had a stronger smell than Manet. The comment made him happy and, with the sense of verve that gave his writings flavor, he evoked for me—in an extraordinary confidence— the smells of the women he loved, of the houses he had lived in, of the bullfighting arenas, of Montmartre with its brick-oven boulangerie, and the savory little streets of Barcelona. When he was done, he declared: "I don't paint, I smell," a confession that seems crucial to an understanding of his work, especially at the end, when it was more direct and concrete.

In 1962, Picasso simultaneously stopped his history paintings, his systematic confrontations with his predecessors, and his ceramics. He even stopped making sculpture, the last examples of which were cut and bent sheets of metal that have an ethereal grace. Henceforth, he abandoned himself completely to furious painting, to a spontaneous outpouring of work. On March 27, 1963, he wrote in one of his notebooks: "Painting is stronger than I am; it makes me do what it

wants." And what it wanted was that Picasso paint ceaselessly. As a result, the motif of the Painter and Model was immediately revived, having become, as Michel Leiris noted, a genre unto itself. And since the model for Picasso was inevitably a lover, the seismograph of his moods, the artistic couple was also the human couple. In August of that same decisive year, Braque, with whom he had retained the tightest of bonds, contrary to repeated claims of the opposite, died. This event threw Picasso into deeper solitude and withdrawal; he left his home in Mougins only to go to bullfights in Fréjus, and he did not attend the many celebrations that were held in his honor. He countered the awareness of his fame— a growing source of contempt—by diving relentlessly into his work. He completed more and more drawings and engravings with absolute technical ease. Happily drawing on his favorite painters, he depicted in narrative series, in the manner of Spanish fairy tales, the universal masquerade and the unleashing of emotion. The voyeurism on many levels that he attributed to Michelangelo or Degas he applied to the two mysteries of creation, the sexual act and the artistic ritual. Theater is the place for looking. For Picasso, writer, actor, and set designer, a great mime and a lover of costumes, everything was theater, game, and comedy, on stage and off, and everything wavered between reality and dream, between being and illusion.

In painting, where narrative disappears and only basic forms emerge, Picasso's late style was no longer about exploration, but about frenzied explosion. He used speed to capture and halt the movement of time, to resist the inevitability of death; he used repetition, in multiple variations, like an extravagant Spanish genius, to access the truth, of which there was not just one but many. To say everything and to say it completely, if sometimes crudely, Picasso combined his elliptical writing, based on essential signs, knots, and spirals, with eruptive subject matter that was both fluid and transparent, rich and vibrating. Relentlessly he painted the Musketeers borrowed from Rembrandt—hence his major fascination with van Gogh. He painted Harlequins again, now with stocky bodies and carrying bats; his nudes, seated or reclined, had a Telluric accent; the isolated close-up of the human head, "as real as a real head," was elevated by the irrepressible breath of vitality; there was the whirlwind of embraces and kisses, the rite of instinct. Thus, his final creation was the climax of his life as a fighter, raising the pulse of his blood, the height of his demiurgic self.

Jean Leymarie

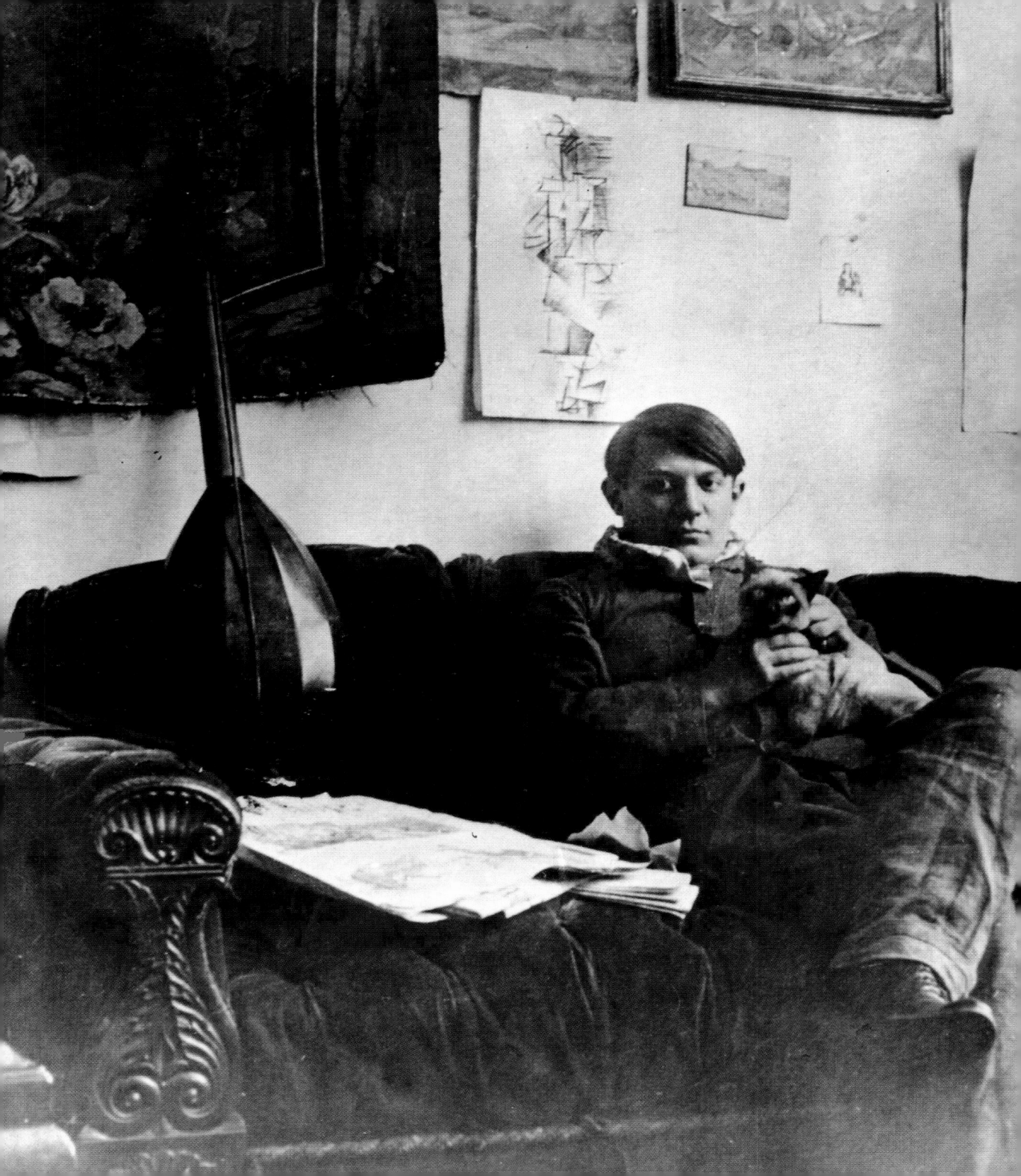

PART I
BY BRIGITTE LÉAL

Chapter 1
1881–1899

Chapter 2
1900–1905

Chapter 3
1906–1909

Chapter 4
1910–1916

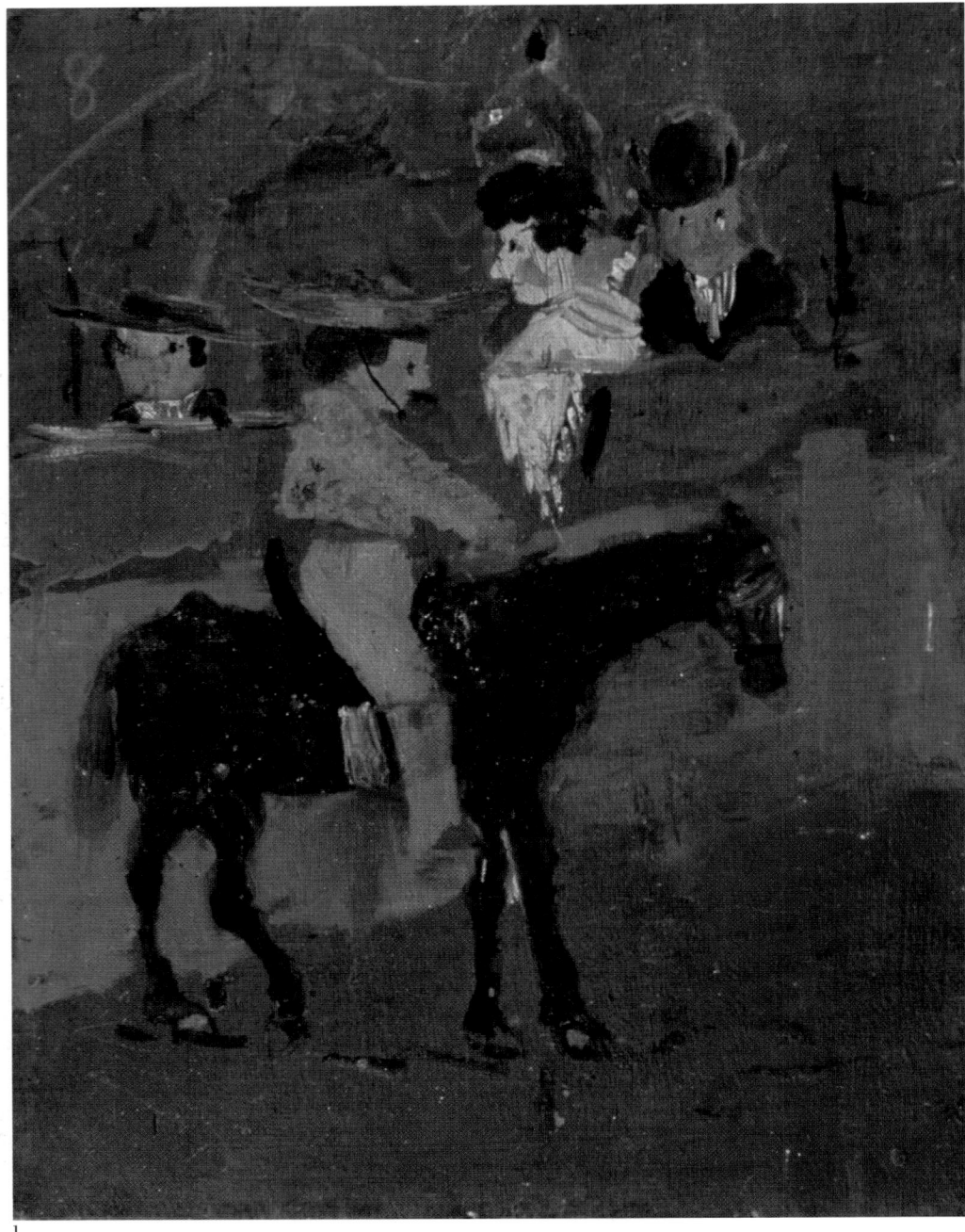

1

1881–1899

The Father as Teacher

Was Pablo Ruiz Picasso—in the eyes of many the greatest artist of our time—a child prodigy like Mozart or Raphael? If we are to believe his biographers and friends, such as Jaime Sabartés and Roland Penrose, or those close to him, such as his mother, who liked to tell the story that her son's first spoken word was "piz, piz" for "lapiz" (pencil), he was most definitely a child endowed with a "terrifying precociousness."[1]

The boy who was born in Málaga, a Mediterranean port in southern Spain, on October 25, 1881, to the painter José Ruiz Blasco and María Picasso López very quickly appropriated the behavior typical of a child prodigy. Completely uninterested in traditional education, he was bored stiff at school and deigned to attend classes only if he could keep some of his father's paintbrushes with him, like a talisman. Once in school, as one might expect, he spent most of his time drawing. But if they did not bear the signature of Pablo Ruiz, his earliest works would arouse hardly any interest, except that their subjects—pigeons and bullfights (figs. 2 and 3)—would always remain a part of his world as Pablo Picasso. Though still awkward, these first sketches reveal the decisive influence that his painter father had on his training, since don José, a quiet man who lacked genius, doggedly pursued one subject only throughout his life, and that was the pigeon, which he painted with maniacal precision. As the creator of what Picasso cruelly called "dining-room paintings," don José recognized his son's gift and allowed him to practice on his own pictures in order to encourage the boy. So it was natural that pigeons would become the first models for Picasso, who made dazzling progress thanks to this daily apprenticeship.

His first painting—an oil on wood that he would keep all his life—was a *Picador* (fig. 1), undoubtedly made after he returned from the Plaza de Toros in Málaga, where don José, himself a great aficionado of bullfighting, must have been happy to take him. Touchingly clumsy, the piece nevertheless reveals the young artist's pride in his skillful brushwork and vivid colors. Clearly, ten-year-old Pablo Ruiz already possessed the tricks of the trade. But he still had to wait a few years before he could register at an art school, where he would be obliged to discipline his considerable exuberance and spontaneity.

In 1891 the whole family settled in La Coruña, a town in northwest Spain on the Atlantic coast, following don José, who had obtained a permanent position as a design teacher at the Instituto da Guarda. Picasso would eventually attend art classes at the local School of Fine Arts, but he was still too young. As he waited, he fought against the rain, his unhappiness, and his boredom in secondary school ("In La Coruña, no Málaga, no bulls, no bullfights, no anything"[2]) by drawing mischievous animals and insolent caricatures all over the pages of his schoolbooks. Later, to amuse himself and his family, he would produce satirical little newspapers—which were simply sheets of paper folded in half—entitled *La Coruña* and *Asul* [sic] *y Blanco* (figs. 4 and 5)—whose sharply observed pictures demonstrate his early talent as a caustic humorist.

The works Picasso created at the School of Fine Arts, to which he was admitted in 1892,

1 *Picador,* c. 1888–90

2

3

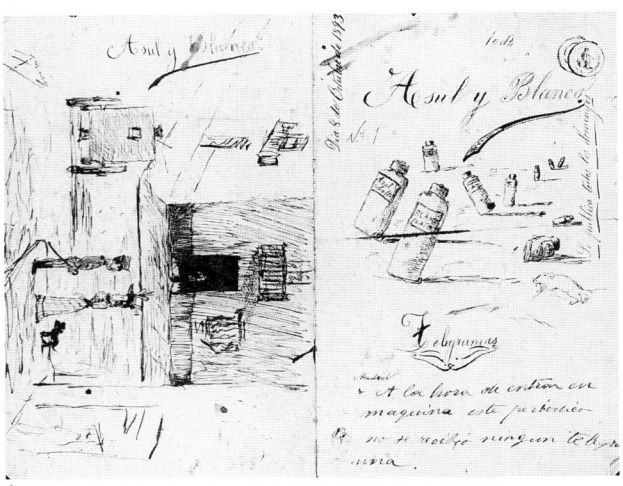

4

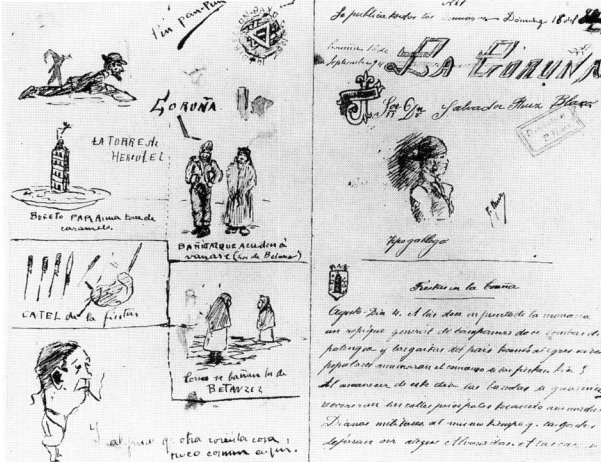

5

are of another caliber. Pure exercises in technical virtuosity, these large sheets of studies after plaster casts in Conté crayon or charcoal (figs. 6–9) reveal something of the extreme intensity of the young student, in spite of their academic nature. The masterpiece of this series of trompe l'oeil drawings, a copy of a plaster of *Moschophor* (fig. 9), the ancient Greek calf-bearer, represents the first appearance in Picasso's work of a subject that he would later choose for its symbolic value during the dark years of World War I.

The sumptuous still lifes of plaster-cast fragments made during the summer of 1925 in Juan-les-Pins may have been parodies of these youthful exercises, but they may also have resulted from what biographer Antonina Vallentin referred to as "a sense of continuity," one of the fundamental aspects of Picasso's character. "One day, this curved hand, this forearm with its clean-cut edges, the inside of the hollowed cast, will be found again in the paintings of Pablo Picasso, the mature man, and will link him to the angel-faced child with remarkably lustrous eyes."[3]

2 *Pigeons,* 1890
3 *Bullfight and Pigeons,* 1890–91
4 *"Asul y Blanco,"* October 8, 1894
5 *"La Coruña,"* September 16, 1894

6

7

8

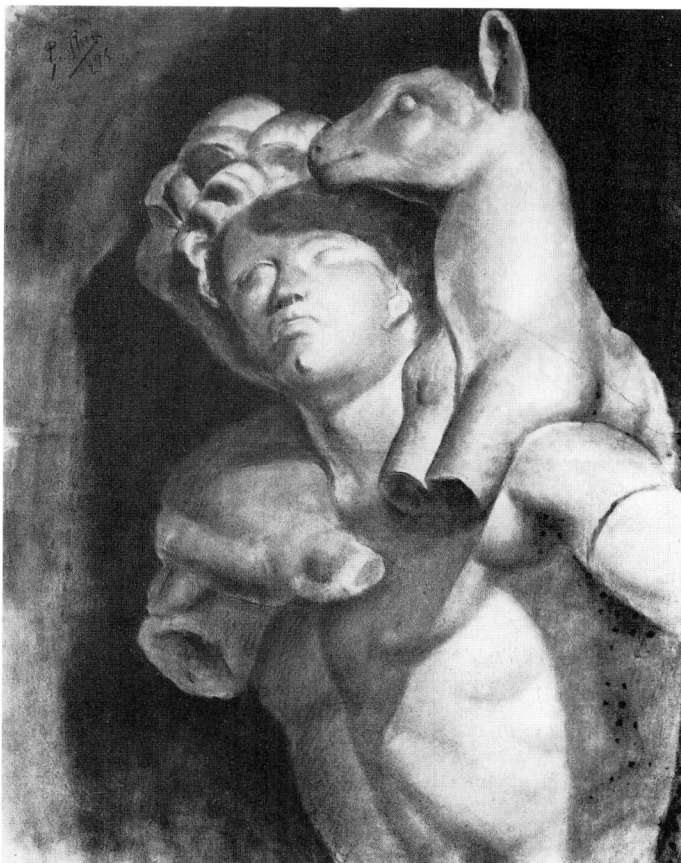

9

It was through an astonishing feat that Picasso put an end to his childhood. In Barcelona, on September 1895, he passed with flying colors the entrance examinations to the prestigious school of fine arts, called La Lonja after the exchange building in which it was housed, where don José had been appointed to teach. Picasso finished the examination drawings in two days and was officially admitted into the second-year level. Looking at these two sheets, on which he drew a model both nude and clothed, one can easily imagine the jury's amazement at the freedom with which the young artist rendered the awkwardness of the figure by disregarding the accepted canons of human proportion.

It was at this point that don José awarded Picasso his stripes as an artist in a highly symbolic gesture resembling the Spanish ceremony known as the *alternativa*, in which the old matador turns over his cloak to his young rival. As Sabartés wrote: "In the end, don José abandons painting definitively. And why not? Pablo has replaced him. 'So he gave me his colors and his brushes and never again did he paint.'"[4]

6 *Academic Study,* 1894
7 *Academic Study of Plaster Cast of a Right Leg,* 1893–94
8 *Nude Torso, Back View,* 1893
9 *Academic Study,* 1895–96

The Father as Model

Between 1895 and 1899, don José was his son's favorite model, while his mother and his sister Lola were portrayed less often, despite his deep affection for them. María Picasso López, with a dark and lively look and gentle, reassuring curves, appears forever bent over her work (fig. 10); the portrait of Lola (fig. 14), who is pictured with a doll on her lap, is remarkable primarily for the Japanese pattern in the background, doubtlessly borrowed from Mariano Fortuny, the Spanish painter who used Japanese motifs in his work.

The painted and drawn portraits of don José reveal the close affection that united father and son, teacher and student, but we may assume from their impressive number that the subject had slowly but surely become a purely formal theme for Picasso, one that would generate endless stylistic variations and emerge in the 1930s as the recurrent theme of the painter and his model. The incurable melancholy, the *desengaño,* of don José, a fine man who was also a failure, are exposed in these portraits with a perceptiveness unusual for a son. A few quick strokes were sufficient to imbue the apathetic figure with a romantic air. Picasso elaborated on his depiction of the weary, resigned expression on the model's face, perpetually resting on a hand (fig. 12), in a long series of expressive portraits in which the physical and the psychological were merged. This poignant picture of a man alone and lost in his life is offered to us in the delicate watercolor warmed with red, whose subject is a frail silhouette wrapped in a blanket (fig. 11).

When, at the age of seventeen or eighteen, Picasso felt mature enough to undertake more ambitious compositions, such as genre paintings, he once again chose don José as a model. One can recognize him as the figure in the center of *First Communion* (fig. 13), an immense canvas with a didactic theme that would seduce the jury of the Exposción de Bellas Artes y Industrias Artisticas in Barcelona in 1896, with its profuse detail, rich palette, and brilliant technique. Don José also posed as the doctor (a personification of Science) who dominates another maudlin, academic set piece, *Science and Charity* (fig. 17).

Brassaï once questioned Picasso about the significance of the bearded figure who haunts his work and was told: "Every time I draw a man, I involuntarily think of my father. . . . For me, man is 'don José' and so it will be for the rest of my life. . . . I see every man I draw more or less with his features."[5]

10

10 *Portrait of the Artist's Mother,* 1896
11 *Picasso's Father Wrapped in a Blanket,* 1895
12 *The Artist's Father,* 1896

11

12

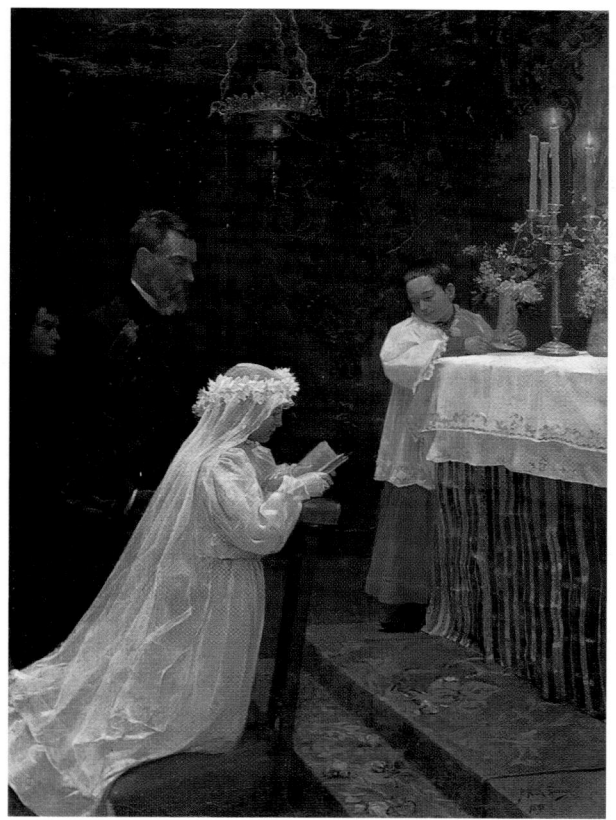

13

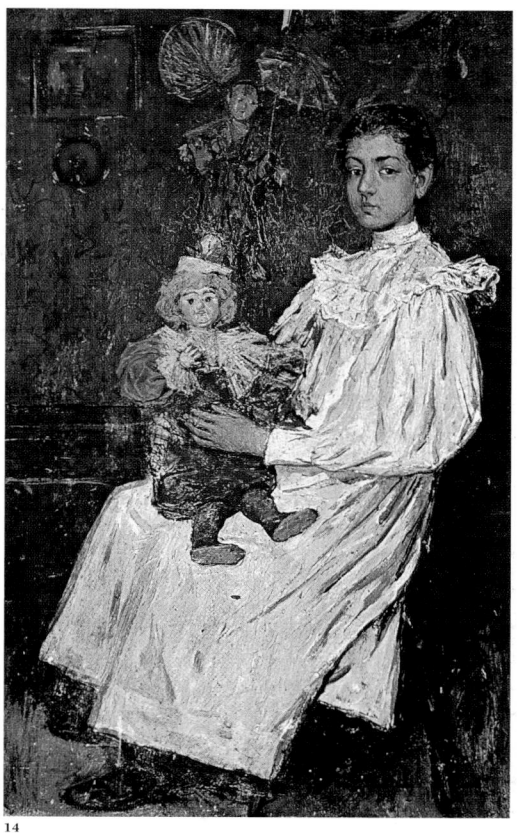

14

15

13 *First Communion,* 1896
14 *Lola with a Doll,* 1896
15 *Theater Scene,* 1896

16 *Sketch for "Science and Charity,"* 1897
17 *Science and Charity,* 1897

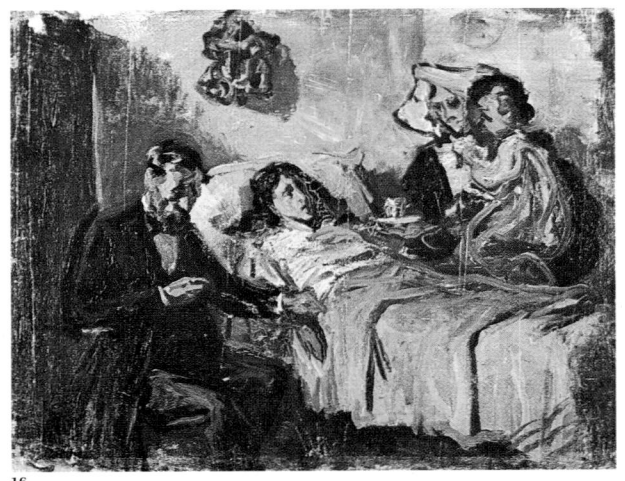

16

17

18

19

First Portraits and Self-Portraits

Above all else, Picasso was a portrait painter: of models, close friends, painters, and himself. The wide range of his first efforts, which concentrate on the individual face and the study of facial expression, reflects the multiple and even contradictory influences that affected him throughout his life. Ever childlike, Picasso had a whimsical imagination that moved him naturally in the direction of caricature. At first, when he was merely reacting to boredom in the classroom, he would draw portrait sketches of his friends that were more witty than malicious. When he found himself depicting the comical aspect of a face or a certain behavior, his drawing would not miss a single ironic nuance. These grotesque images also reveal his blunt honesty and his expressive use of distortion.

In the course of his academic career, Picasso had plenty of time to learn by drawing the studio's models. When he tackled subjects as unappealing as the *The Old Couple* (fig. 19) warming themselves by the hearth or *The Young Girl with Bare Feet* (fig. 20), he was driven by a concern for the truth that was not devoid of emotion. Yet he studied without sentiment the poor girl whose limbs have been misshapen by wretchedness and famine; disdaining the canons of academic beauty, he lingered pitilessly on her swollen hands and feet and on the squint that disfigures her face. Even the dingy red of her dress and the brightly colored rag she wears instead of a scarf cannot enhance this bleak image.

The series of portraits he painted of members of his family during the years 1895–96 derives from a more traditional approach. They are all depicted as busts from the chest up, at a three-quarter angle, with carefully modeled and starkly lighted features emerging from a dark background. The most impressive portrait is that of his elderly aunt from Málaga (fig. 18), the crude realism of which evokes the alienated faces of Géricault. Sabartés wrote: "If, when he was fourteen, he could paint the *Portrait of Aunt Pepa*, it is because he was all eyes to see what was before him."[6]

Those eyes knew they had to look at the old masters before anything else. In 1897, while living briefly in Madrid, Picasso took daily walks to the Prado with his sketchbooks in his pocket, and this saved him from the profound boredom he experienced in his classes at the San Fernando Academy. The sketchbooks preserve his thumbnail sketches, some of which he would then carefully rework in oil in the quiet of his studio: a man's head after El Greco, very dark and elongated (fig. 24), or a portrait of Philip IV based on Velázquez (fig. 25). In a colorful letter to Joaquim Bas, a former classmate at La Lonja who had remained in Barcelona, he confided: "Velázquez first class; some magnificent heads by El Greco; as for Murillo, to my mind, not all his pictures carry conviction. There is a very fine *Mater Dolorosa* by Titian; Vandyk [sic] has some portraits and a really terrific *Adoration of Christ*. Rubens has a painting (*The Fiery Serpent*) that is a prodigy; and then there are some very good little paintings of drunkards by Teniers."[7]

The portraits Picasso made in Barcelona were the most personal works from this period in his student days, which he hated, according to his dealer Daniel-Henri Kahnweiler. From 1899 on, he documented Barcelona's artistic life in a series of paintings of the artist's studio—a common theme in the nineteenth century—in which he recorded the features of his student friends Sabartés, Manuel Pallarès, Ángel Fernández de Soto, and Josep Cardona (fig. 26) as they were engrossed in their work. The rich, solid technique lends both coherence and naturalism to compositions in which the faces emerge from a chiaroscuro that romanticizes them.

The famous double portrait by Raphael in the Louvre, *Portrait of Two Men* (or *Raphael and the Fencing Master*) undoubtedly inspired the composition of one of Picasso's first self-portraits, in which he—with round and beardless cheeks, a shaved skull, and a tense look in his eyes—hides behind another person (fig. 21). Barely a year later, he showed himself in a very different light, that of the romantic artist suffering the rigors of loneliness and

18 *Portrait of Aunt Pepa,* 1896
19 *The Old Couple,* 1894

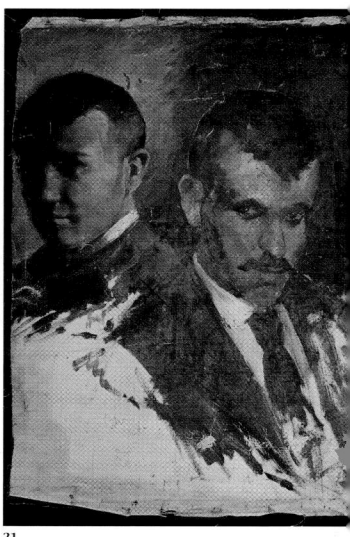

21

20 *The Young Girl with Bare Feet*, 1895
21 *Self-Portrait with a Member of the Artist's Family*, 1895

20

22

23

24

25

26 *Portrait of Josep Cardona,* 1899
27 *A Wise Man,* 1899–1900

26

27

28

29

30

28 *Lola, Picasso's Sister,* 1899
29 *Silhouette of José Ruiz by the Sea,* 1899
30 *Reading the Letter,* 1899–1900

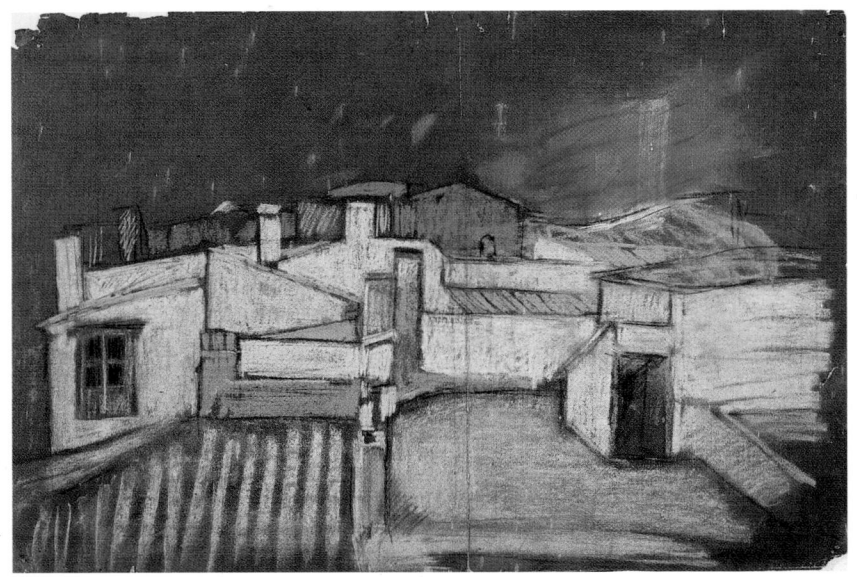

31

32

hunger. The solemn eyes, the hardened and aged features, strangely made up beneath a wig and dressed in old-fashioned clothes, were sketched in powerful brushstrokes, in the style of Frans Hals (fig. 23).

Picasso's lifelong impulse to portray himself testifies to his existential torment, as with Rembrandt or Gauguin, rather than to a naïve narcissism. Picasso never gave up this impassioned search for self in compositions that became increasingly symbolic and complex, glorifying both his character as a painter and the art of painting.

Farewell to the Picador

Picasso boasted—was this a quip or a profound truth?—that he had learned "all that I know" in Horta de Ebro, the village of his friend Pallarès. He spent some time there in the summer of 1898, in the foothills of the Catalan mountains, and this brought him in contact with a rugged peasant population. Perhaps it was there that, in addition to acquiring a taste for manual labor, Picasso recognized the extent of the effort he still had to make to become himself, to free himself from his provincial roots in order to measure up to the best.

At the end of the nineteenth century in Barcelona, Picasso's paintbrush still wandered off into conventional Spanish pieces, which were sometimes weighed down by an

31 *Terraces from the Studio on Riera de Sant Joan,* 1900
32 *The Angel of Death,* 1900
33 *The Left Hander,* 1899
34 *Entry into the Arena of Barceloneta,* 1900
35 *The Andalusian Couple (Tambourine),* 1899

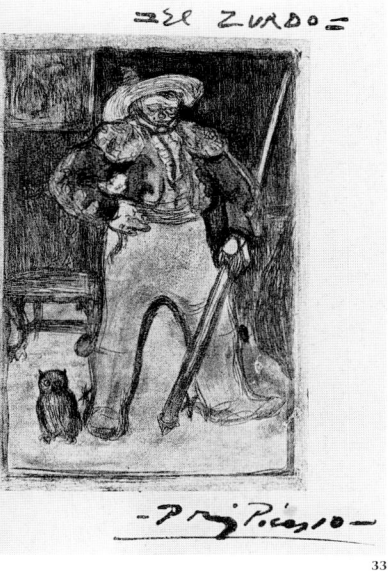

33

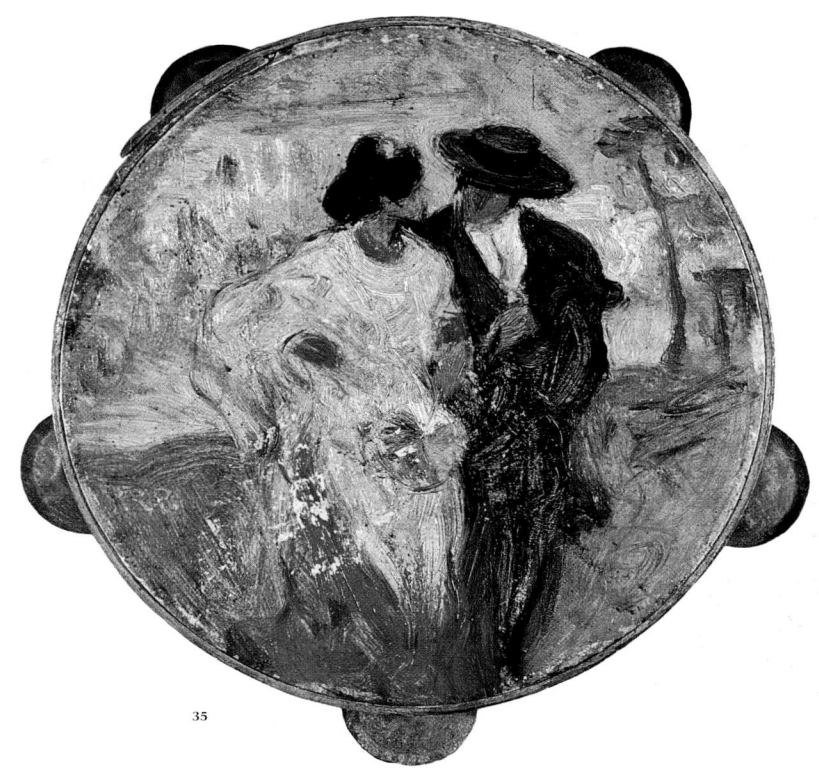

35

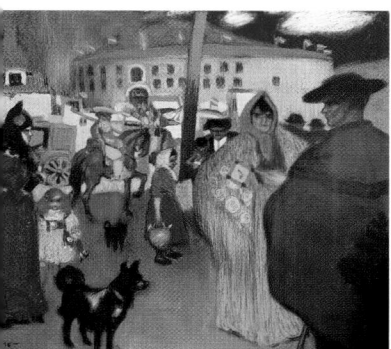

34

excess of technical virtuosity (fig. 34) or else saved by the strength of his humor, which inspired him to select as a framing device for a lively street scene a tambourine with jingling disks (fig. 35).

Infrequent landscapes or panoramic views, however, such as the small pastel of the rooftops of Barcelona seen from his studio in the Riera de San Juan (fig. 31), show that Picasso was already concerned with eliminating the picturesque in favor of the essential: in this case, the pure geometry of volume, enhanced by a tightly knit composition contained by the sky.

In 1899 Picasso obtained a copper plate and, on the advice of Ricard Canals, made his first print, an etching, which enabled him to revisit the familiar subject of his childhood, his beloved picador. The first Picasso owl hops around the figure's feet, the ancestor of a fertile line of picturesque descendants. The artist who would become the greatest engraver of his time was still so ignorant of the medium, however, that he was totally surprised to see his little figure reversed in the printing. No matter. The print was immediately renamed *The Left Hander* (fig. 33), and that was the end of the story!

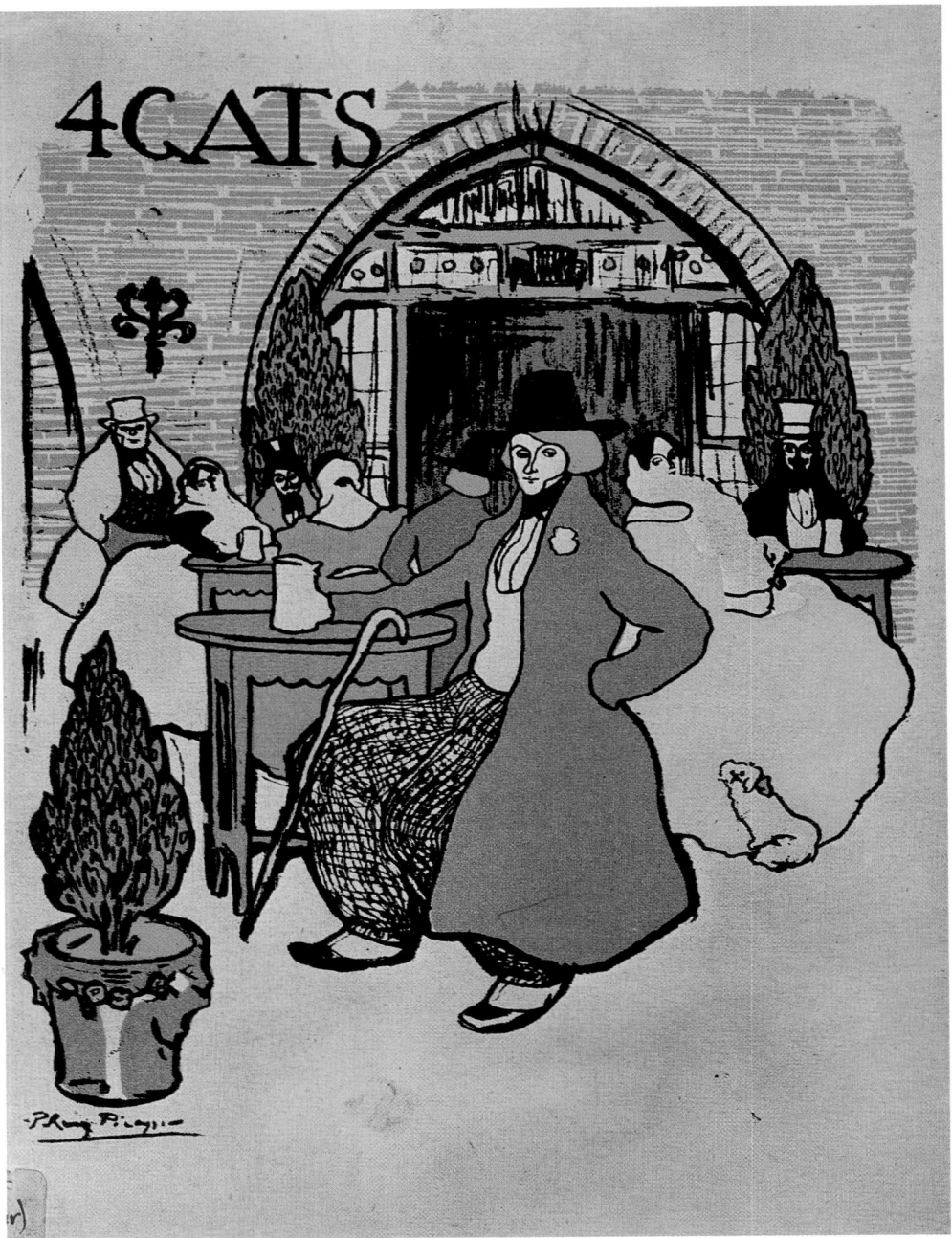

1900-1905

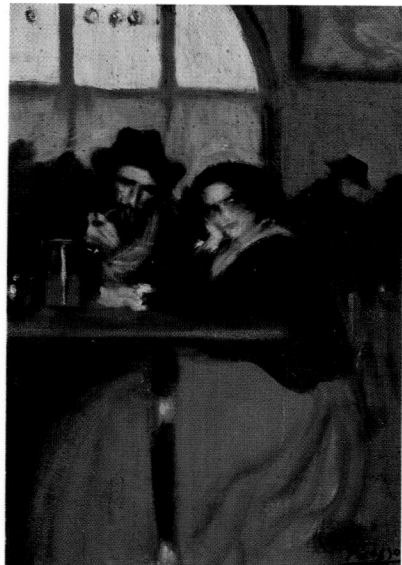

37

Modernismo

It was now 1900, and Picasso, citizen of Barcelona, could no longer feign indifference to the various manifestations of the avant-garde that were crossing swords in the European heavens. Barcelona, the most active city on the Iberian Peninsula, boasted an enterprising middle class, which clung to a blind faith in the destiny of the Catalan nation—the Renaixença—and eagerly embraced the strong feelings cultivated by Antoni Gaudí and Puig i Cadafalch, who built for them palaces and cathedrals whose decorative excesses were a measure of the madness that incites anarchist movements. The old country, sapped by the Cuban war, was ready for any extravagance. Joan Maragall, the intellectual leader of Modernismo, the Catalan version of Art Nouveau, presented himself as the disciple of Novalis and Nietzsche, and his colleague Santiago Rusiñol[1] as the apostle of Munch and Ibsen. Others preferred the sweet pleasures of the Pre-Raphaelites to Nordic morbidity, or the decadent aesthetic of French Symbolists such as Gustave Moreau. New magazines, inspired by Munich (*Joventut*) or Paris (*Pèl I Ploma*), fueled the debates and contributed to the dissemination of European Art Nouveau.

Faced with this intermingling of ideas, Picasso pretended to hold on to his independence, all the while admitting to a weakness for German Symbolism. He confessed to his friend Joaquim Bas that if he had a son who wanted to be a painter, he would not let him study in Spain, but rather "in Munich . . . because it is a city where one can study painting seriously, without being dazzled by anything such as Pointillism and all the others. . . . I am against following any established school."[2]

Nevertheless, the atmosphere of Els Quatre Gats, a tavern that Picasso frequented, was clearly francophile. This was the meeting place for all of *modernista* Barcelona (fig. 37), created in 1897, after the Parisian model of Aristide Bruant's Le Chat Noir, by Pere Romeu, a colorful figure and fervent promoter of Art Nouveau (and of bicycles). Under the tavern's Neo-Gothic vaults, designed by Puig i Cadafalch and decorated by the painter Ramon Casas,[3] Picasso began to rub shoulders with French art, thanks to such regulars of the establishment as Ricard Canals and Isidre Nonell, who divided their time between Barcelona and Paris, where they had already been honored with an exhibition in the company of Toulouse-Lautrec and Gauguin at Le Barc de Bouteville, a gallery on the rue Laffitte. Other habitués included Ramon Casas, a disciple of Carolus-Duran, who himself swore only by Manet, and Santiago Rusiñol, a friend of Erik Satie (of whom he made several portraits) and a former student of Puvis de Chavannes and Eugène Carrière. But these Catalan artists still preferred Steinlen and Toulouse-Lautrec, not to mention the illustrations in satirical Parisian publications, such as *Gil Blas Illustré* and *Assiette au Beurre*, in which they took great delight.

The commission to design menus and posters for Els Quatre Gats, with their large, flat planes of color arranged in tight arabesques, came at just the right moment to confirm Picasso's conversion to Art Nouveau and his definitive break with salon art (fig. 36). The serpentine line of Modernismo was too decorative for his taste, however, and would quickly be abandoned in favor of a dynamic stroke, whose expressive possibilities were

36 *Menu from Els Quatre Gats,* 1900
37 *Interior of Els Quatre Gats,* 1900

38

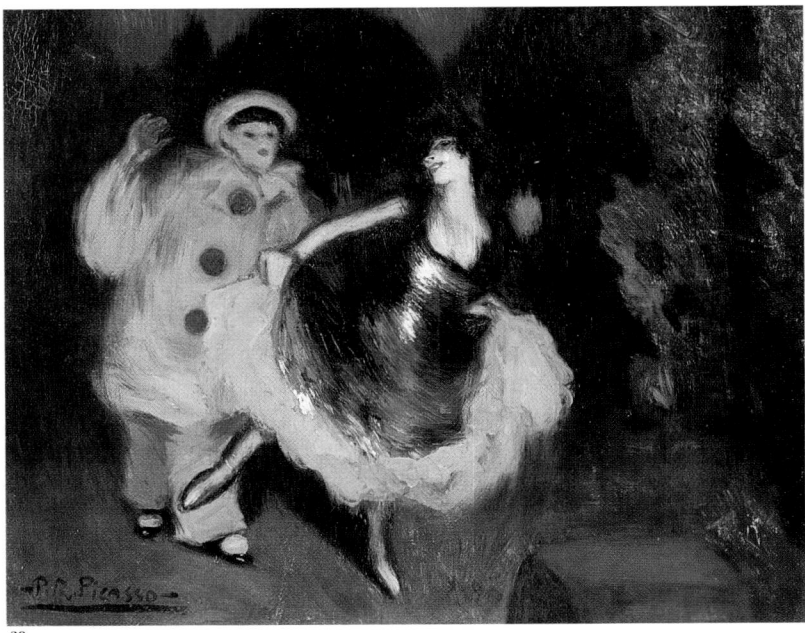

39

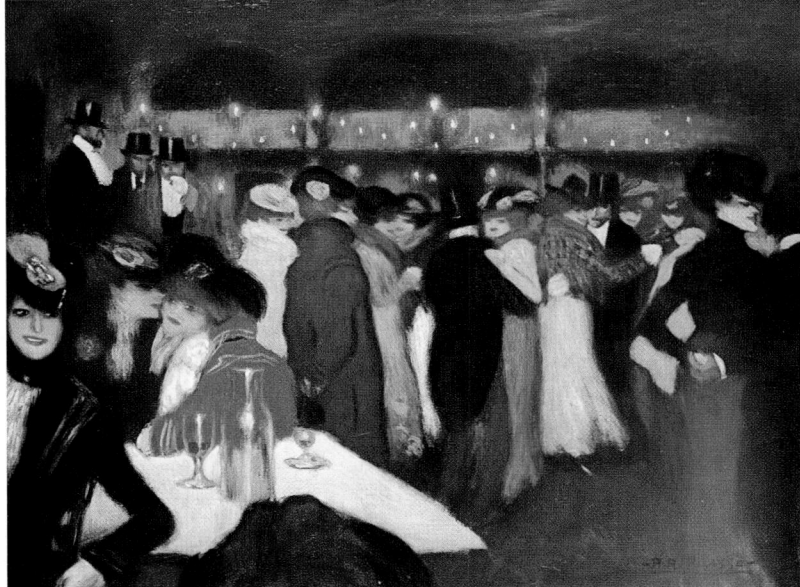

40

38 *Design for a Carnival Poster,* 1900,
39 *Pierrot and Columbine,* Autumn 1900
40 *The Moulin de la Galette,* Autumn 1900

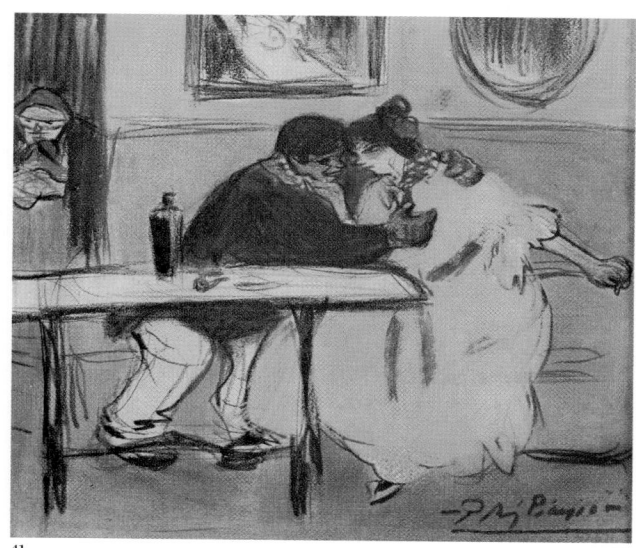

41

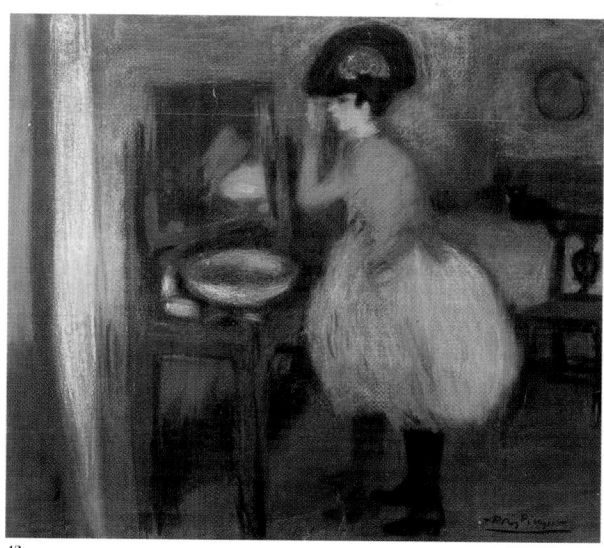

42

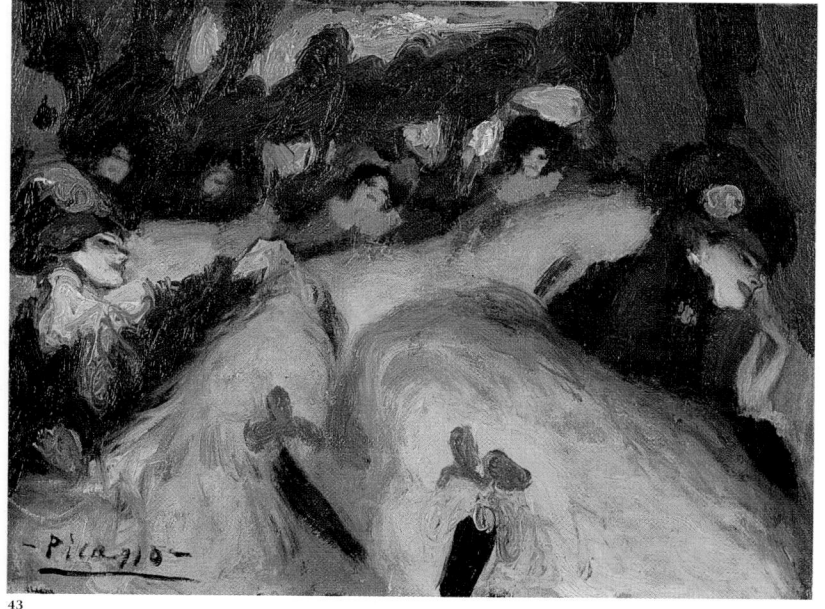

43

41 *The Couch,* 1899
42 *Girl at Her Dressing Table,* 1900
43 *French Cancan,* Autumn 1900

44

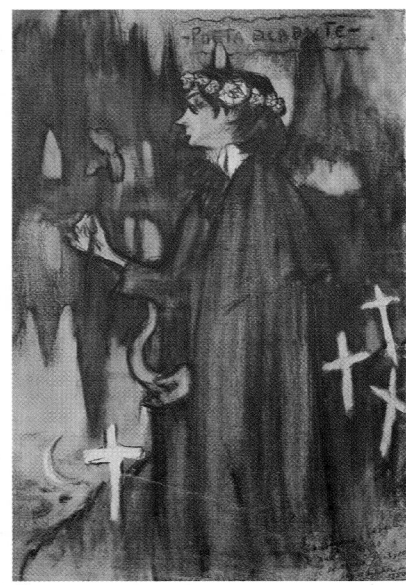

45

46

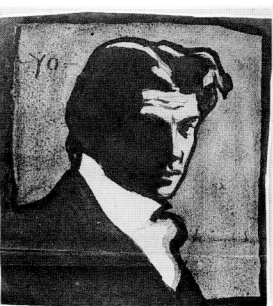

47

better adapted to a wide variety of subjects. For example, Picasso's quick, repetitive pencil stroke beautifully conveys the feverish quality of Carnival for a poster design in which a magisterial Pierrot stands nearly the height of the poster, his pose emphasized by the asymmetrical composition (fig. 38). Elsewhere, it suited Picasso—so astonishing was his skill as a draftsman—to draw portraits as perceptive as they are as vigorous (*Jaime Sabartés Seated,* fig. 44, and *Self-Portrait,* fig. 48), or to blur anonymous shapes with lines that mysteriously disappear off the edge of the sheet in the manner of Steinlen.

In February 1900 Picasso's first exhibition was a truly remarkable accomplishment; eager to respond to the challenge of the memorable display of portraits by Ramon Casas at the Sala Pares gallery, Picasso showed no fewer than 150 images of his friends (a veritable index of the Catalan *modernistas*), which he had just finished. The subjects appear to us fixed for all eternity in their young artists' finery, with bushy beards, wide-brimmed hats, pipes, and floppy neckties; some of the faces are stylized in black-and-white shapes that owe something to Japanese prints (figs. 46 and 47), and some of the figures stand in affected poses (figs. 44 and 49). The most affectionate sheets, and the wittiest as well, were reserved for the poet Jaime Sabartés, who was well on his way to replacing don José in the role of favorite model. In one drawing he looks like a teacher with his wing collar and lorgnette (fig. 44); in another he poses as a decadent poet, planted in a field of crosses with an iris in his fingers and his forehead encircled with lilies—a clever parody of Symbolist works of the fin-de-siècle (fig. 45).

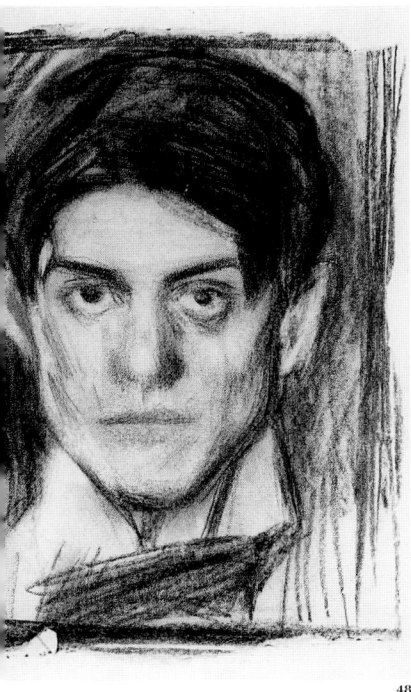

48

49

50

51

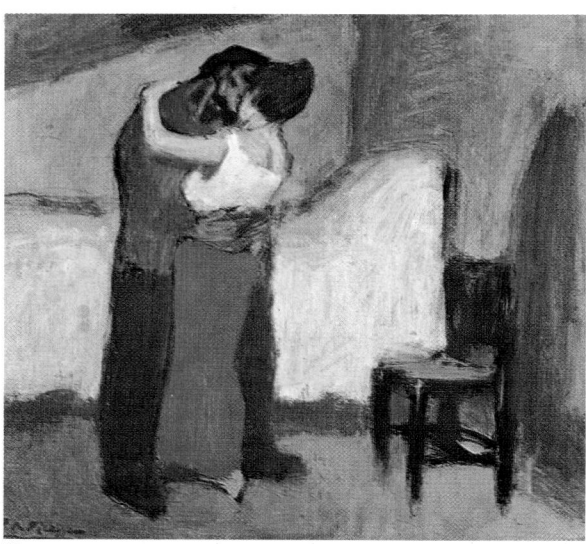

52

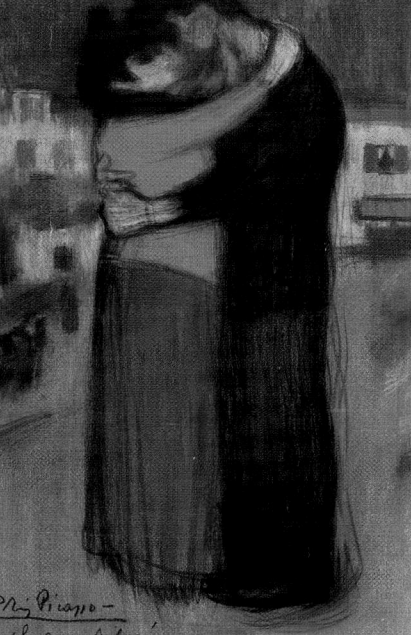

53

54

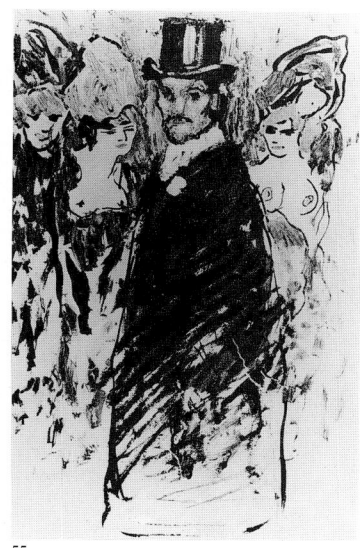

55

Paris 1900

At this time, all of Barcelona was reverberating with the echoes of the 1900 Exposition Universelle, which had been organized in Paris to open the door to the twentieth century. "Art was on the other side of the Pyrenees," Sabartés recalled. Picasso was forever trying to cross the mountains, using the presence of his canvas *The Last Moments* (painted over in 1903 with *La Vie*) in the Exposition's painting section as a pretext for the trip.

Even at the end of his life, Picasso still remembered with wonder everything he discovered during his first brief stay in Paris in the autumn of 1900. One can imagine him running from one end of the capital to the other, striding through every exhibition in town, as well as through the Louvre, exploring the galleries in the rue Laffitte (Ambroise Vollard's Cézannes, what a miracle!), flushing out works by van Gogh, Degas, and the Nabis painters at Le Barc de Bouteville. Paco Durrio, a friend living in Montmartre, even unveiled his collection of Gauguins for his compatriot Picasso, who "saw everything there was to see."

The little sketchbooks Picasso carried with him everywhere were used to express his enchantment with Parisian life: the quiet joy of nice little girls playing in the public parks, sketched in soft watercolors à la Vuillard, and the incredible hats and pinched faces of middle-class women strolling along the boulevards. He was astonished to see lovers kissing openly in the street—an unusual sight for a Spaniard—and this gave birth to an entire series of oils and pastels of couples embracing in the streets against a background of Montmartre or wretched little garrets. Here one can see the silhouettes of lovers melting into one another to form a single figure that twists and turns like a flame, sometimes with all the detail rubbed out by strokes of charcoal (figs. 52 and 53). Soon the dives and the dance halls of Montmartre held no more secrets for him. The sordid reality of the brothels was unmasked by intimate pastels (*Girl at Her Dressing Table,* fig. 42) in which Picasso happily devoted himself to the frilly dresses, kicking feet, and grimacing profiles of cancan dancers caricatured on sheets worthy of Toulouse-Lautrec (figs. 50 and 51), or he captured their dancing figures in whirlwinds of color enhanced by artificial light (fig. 43). A clever revival of all the graphic tricks of Toulouse-Lautrec and Renoir, Picasso's *Moulin de la Galette* (fig. 40), the first painting he made in Paris, turned into a stylistic exercise. The asymmetrical composition sweeps up a series of faces and profiles distorted by make-up and electric lights until they collide in the dark shadows with angular silhouettes painted in single strokes. Finally, Paris confirmed for him an awareness of his own worth, since two dealers, Berthe Weill and Pere Mañach,[4] competed for his pastels of bullfights, which appealed to a clientele hungry for exoticism.

"A painter, a painter absolutely"

In the spring of 1901, during Picasso's second stay in Madrid, Velázquez's example again imposed itself on his oil paintings and pastels (figs. 62 and 63). The excessively wide skirts pay homage to *Las Meninas* but without its freshness or grace. Phoebe Pool has suggested that *Dwarf Dancer* (fig. 61) also came from *Las Meninas*[5]; illuminated by the footlights, the dancer seems to be standing in a shower of little spots of pure, brilliant colors applied in thick layers with a palette knife. This picture and the color harmonies and bold foreshortening of his paintings of bullfights (figs. 56–58) mark the beginning of a "veritable Pre-Fauvism," as his biographer Pierre Daix put it, and show the effects of Picasso's trip to Paris. This technique, borrowed from Pointillism, is used also in *The Prostitute* (fig. 66) to create a background of thickly applied broad strokes, which look like mosaic tesserae, to describe a woman with dark-ringed eyes who has wrapped her arms around herself like snakes (Vollard later renamed this picture *The Morphine Addict*).

56

57

58

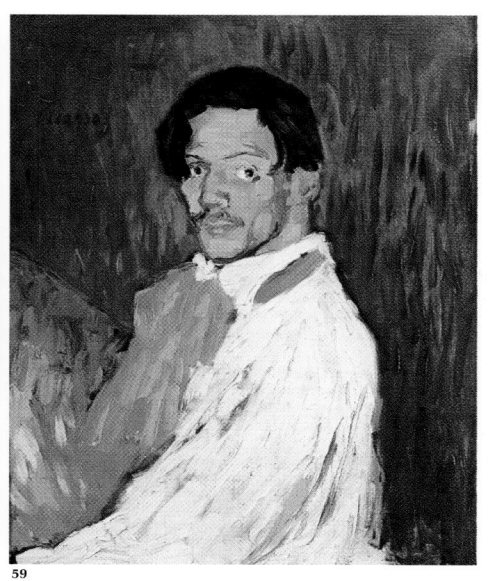

59　　　　　　　　　　　　**60**

An important solo exhibition in 1901 mounted by Pere Mañach in Vollard's prestigious gallery[6] justified Picasso's next visit to Paris. This review of his work from the previous two years consisted of portraits of courtesans and disheveled nudes, bouquets of flowers, elegant women at the races, and holiday celebrations (fig. 60) depicted in pure colors, which reveal the influence of Impressionism brought to life through the lessons Picasso had learned from van Gogh. Although Félicien Fagus, critic of *La Revue Blanche*, deplored Picasso's eclecticism and his "facile virtuosity," he was generally enthusiastic: "He is a painter, a painter absolutely, and beautifully so. . . . He adores color for its own sake. . . . And he is enamored of every subject, and everything is a subject for him."[7]

Abandoning Symbolism was only a question of time. The painter who turns his fierce, determined gaze on us and snaps his orange scarf like a banner in *Yo, Picasso!* (fig. 59) was about to devote himself to a single subject—the celebration and apotheosis of his friend Carles Casagemas.

Casagemas

Manolo remembered Casagemas as "worried, full of nobility . . . with a pale, romantic face." In 1900, hand in hand with Picasso, he had launched an assault on Paris, but a year later he ended his life with a bullet in his head in a café in Clichy, because of his love for a fickle woman, Laure Gargallo, who was known as Germaine. Casagemas's memory haunted Picasso and may even have been one source for his enduring fear of and contempt for women. The female portraits that emerged from Picasso's studio at this time feature only one type of woman: the prostitute. The famous *Courtesan with a Jeweled Necklace* (fig. 67),

62

63

61

64

65

66

45

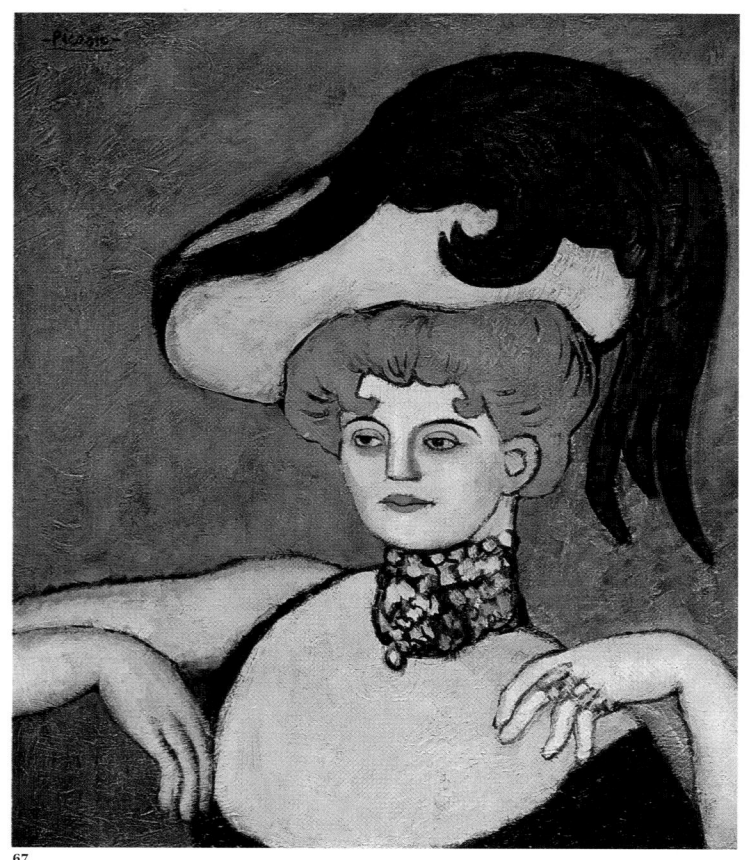

67

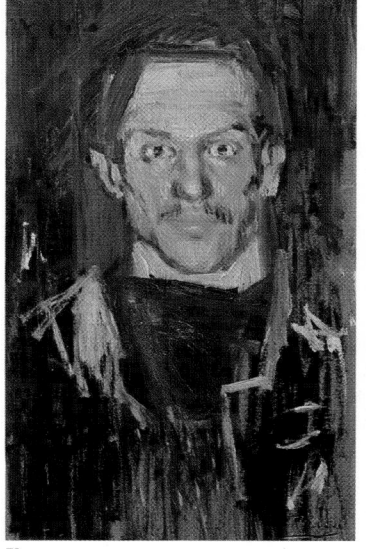

70

68

69

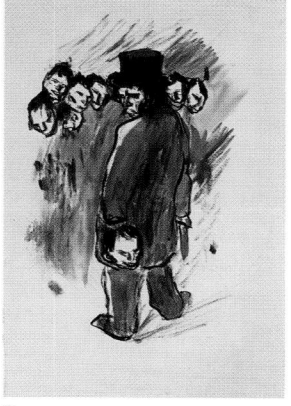

71

46

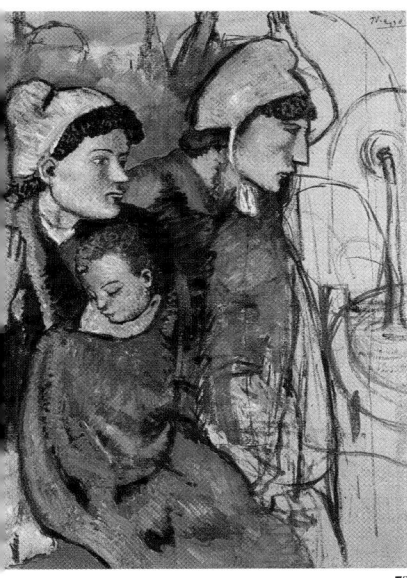

72

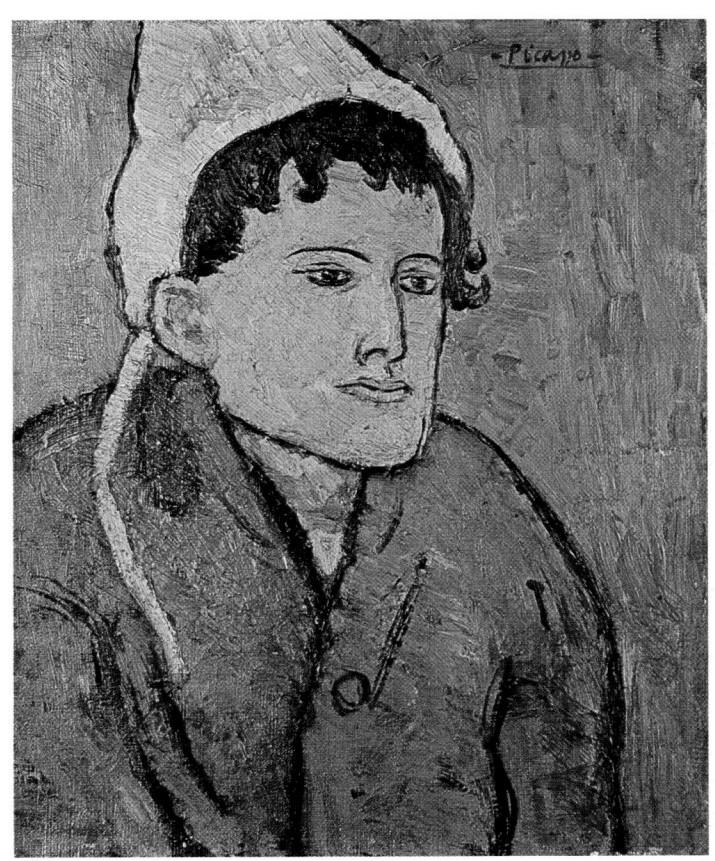

73

exhibited at Berthe Weill's in 1902 and compared to "an idol" by Adrien Farge in the catalogue for the exhibition,[8] was in fact a caricature that ridiculed the prostitute's ostentatious finery and her stupid, avaricious expression. In fact, she is a true monster.

Picasso also exposed the other side of decay, when illness triumphed over vice and these poor girls were locked up in the Saint-Lazare prison (figs. 72 and 73), turning in their fancy feathers for cotton caps. There are no longer traces of makeup on their emaciated faces, which Picasso will paint blue, the color of the death struggle. "It was while thinking of Casagemas as dead that I began to paint in blue," Picasso would later admit, shedding light on a mystery that had long intrigued art historians, who tried to explain why this intense color affected all his figures for a period of some four years. It was the writer Alberto Moravia who best understood that the blue monochrome was for Picasso one way of confirming his personal vision of the world and of making the break with naturalism that was a precondition for Cubism. "The monochrome means simplification, stylization, unification. The monochrome is made to denote a strictly formal idea of the world: a colorful idea. . . . The moment the painter uses this color blue it no longer signifies wretchedness

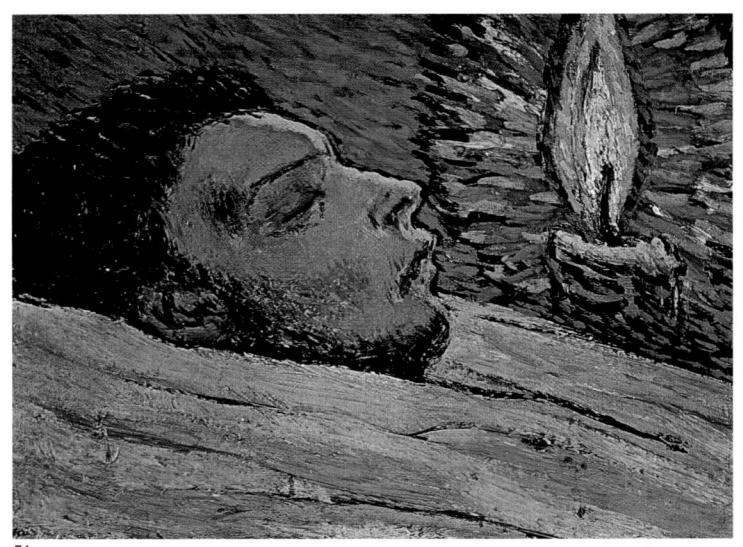

74

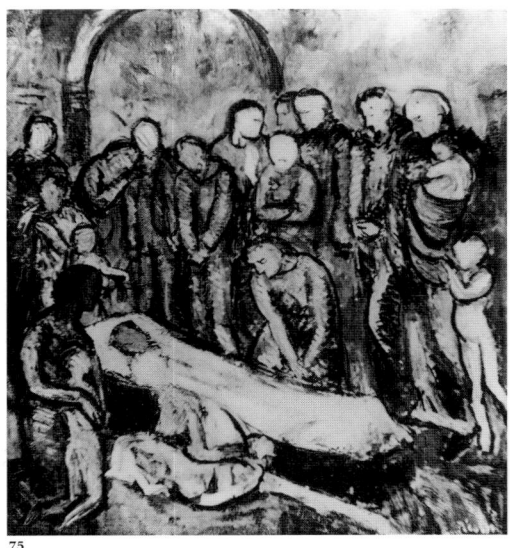

75

76

77

78

79

80

81

82

84

85

83

83 *Self-Portrait,* late 1901
84 *Portrait of Jaime Sabartés,* 1901
85 *Portrait of Mateu F. de Soto,* 1901
86 *The Glass of Beer (Sabartés),* 1901
87 *The Aperitif,* 1901
88 *Woman with Crossed Arms,* 1901

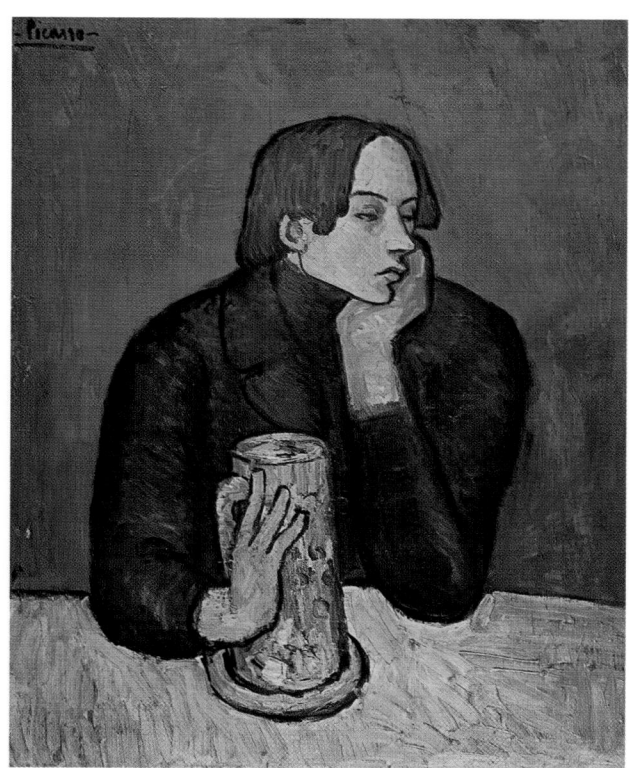

86

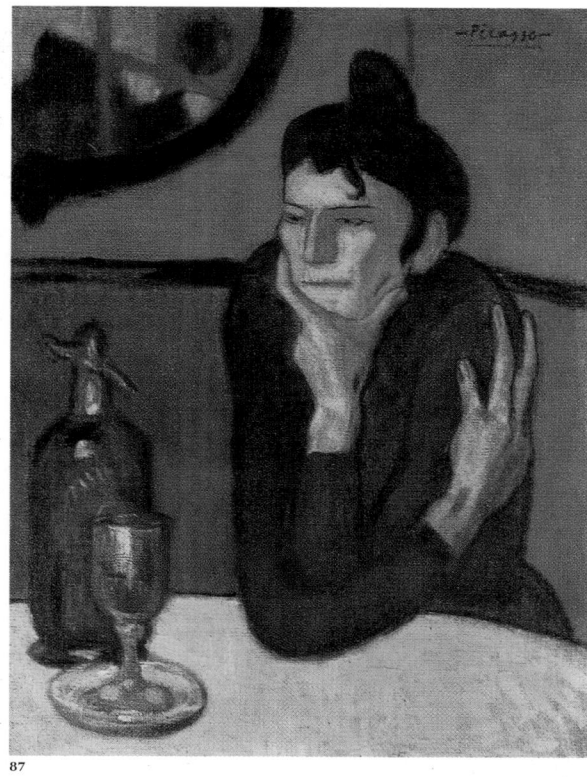

87

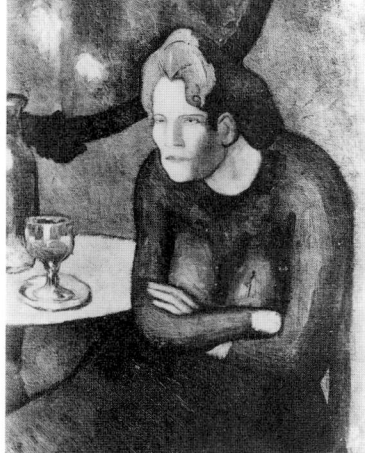

88

or hunger. It confirms Picasso's wish to put himself forward or rather to put his own generic vitality forward, without any judgment, without any moral choice, by using an all-embracing color, a demiurge."[9] Inspired by the accounts of Manuel Pallarès and Manolo, who had witnessed the tragedy of Casagemas's suicide, Picasso began a series of portraits and commemorative pictures, which culminated in two monumental works: *Evocation (The Burial of Casagemas)* of 1901 (fig. 82) and, two years later, *La Vie* (fig. 133). First he painted two small compositions, one entirely in blue, and the other in red and gold, in which only the profile of the dead man shows "the color of wax and with a romantic look" (Manolo), tinted with gold by the candle that flickers over him, a symbol of eternal life (fig. 74). This was the first occurrence in Picasso's work of light as a symbol of Hope, which appears later in *La Minotauromachie* and *Guernica*. The brilliant colors, applied in long and thick strokes and the morbid symbolism are reminiscent of van Gogh, whose great Parisian retrospective Picasso had just visited.

The seven other sketches that preceded *The Burial of Casagemas* (figs. 75–81) have been compared alternately to El Greco's *Burial of Count Orgaz*, because of the circle of hired mourners around the shroud, and to Zurbarán's *Saint Bonaventure on His Bier*,[10] in which the deceased is also placed on the diagonal. Theodore Reff chose to see in Picasso's sketches the lamentation over the body of the dead Christ.[11] Did the presence in one of the studies (fig. 81) of a nude female body rising above the corpse symbolize

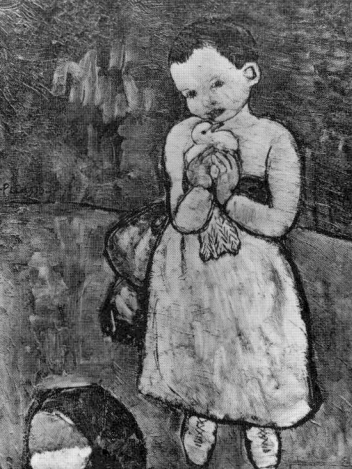

90

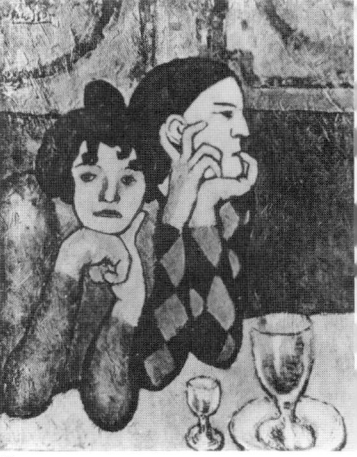

91

89

89 *Harlequin,* 1901
90 *Child with a Pigeon,* 1901
91 *Harlequin and His Companion,* 1901
92 *The Sleepy Drinker,* 1902
93 *Crouching Woman Meditating,* 1902
94 *Crouching Woman with Child,* 1901
95 *Crouching Woman in a Hood,* 1902
96 *Seated Woman,* 1902

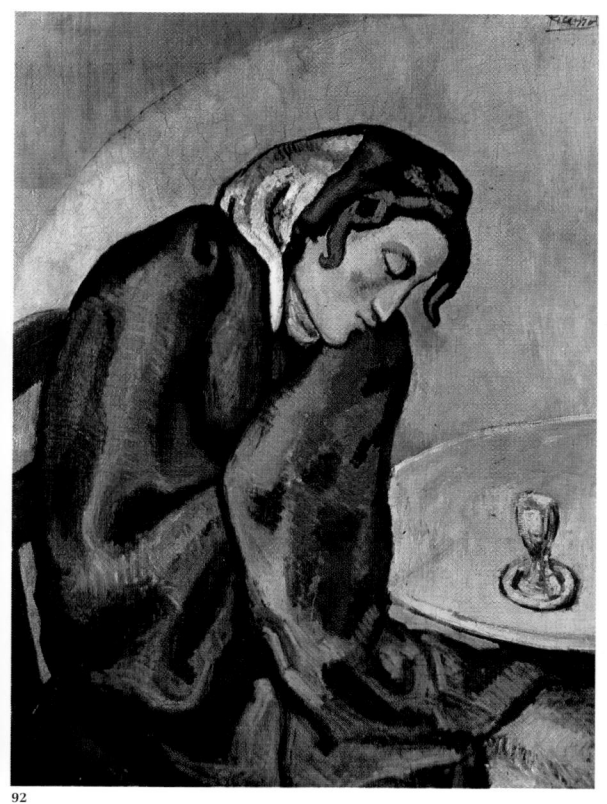

92

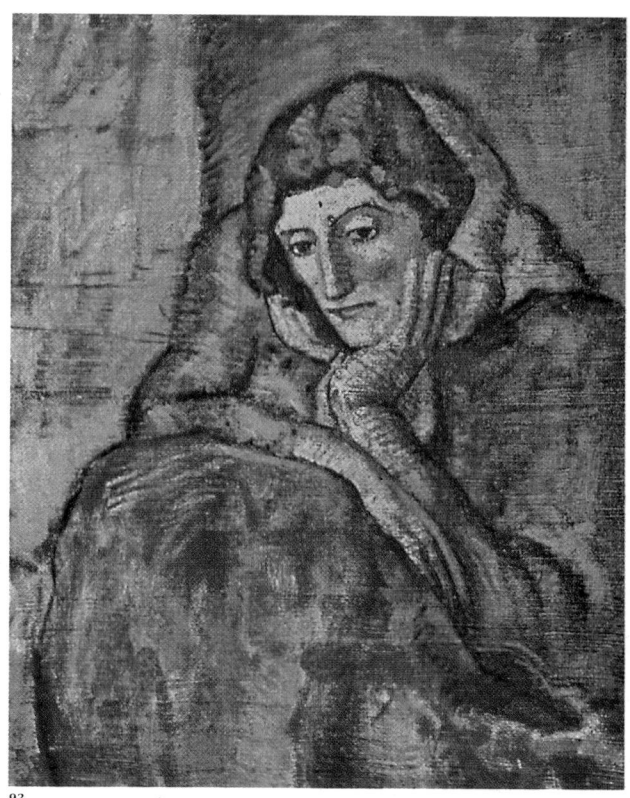

93

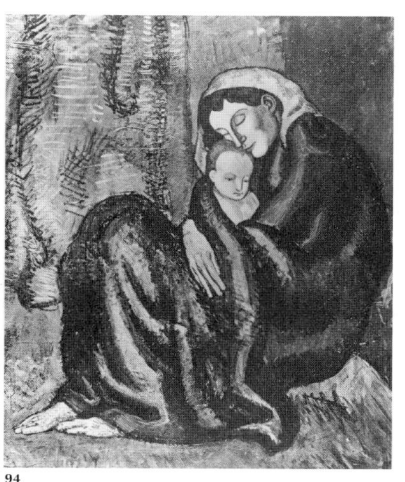

94

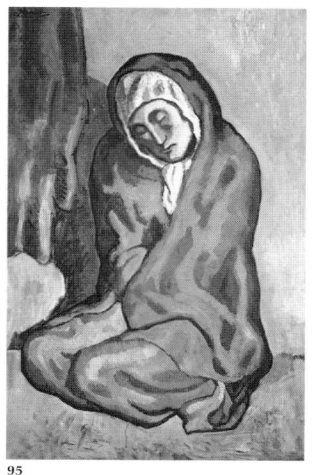

95

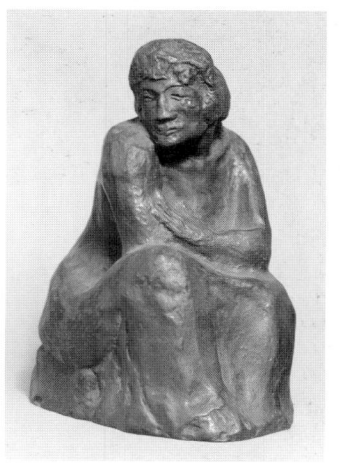

96

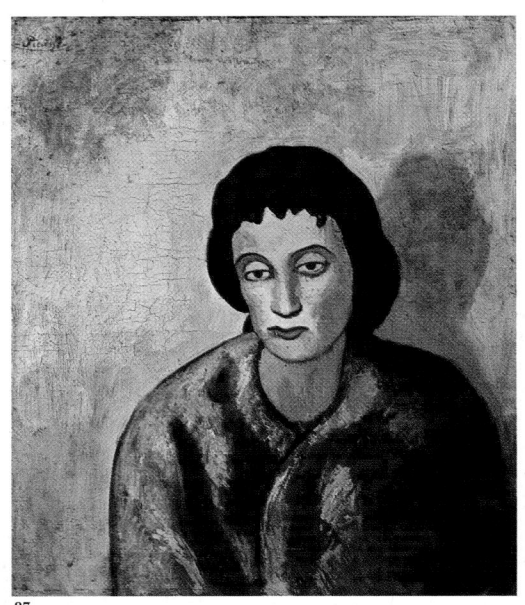

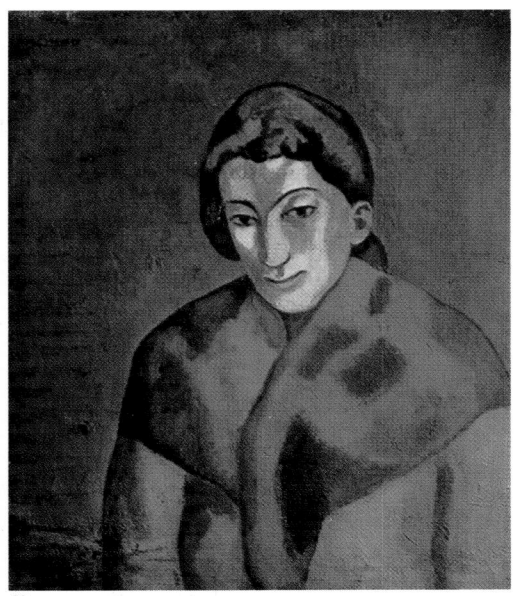

97

98

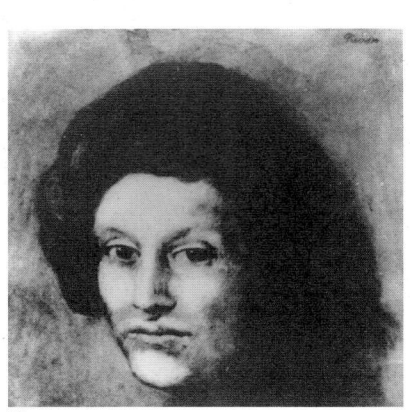

99

97 *Woman with Fringed Hair,* 1902
98 *The Woman with a Shawl,* 1902
99 *Head of a Woman,* late 1902
100 *Seated Nude, Back View,* 1902
101 *Prostitutes at a Bar,* 1902

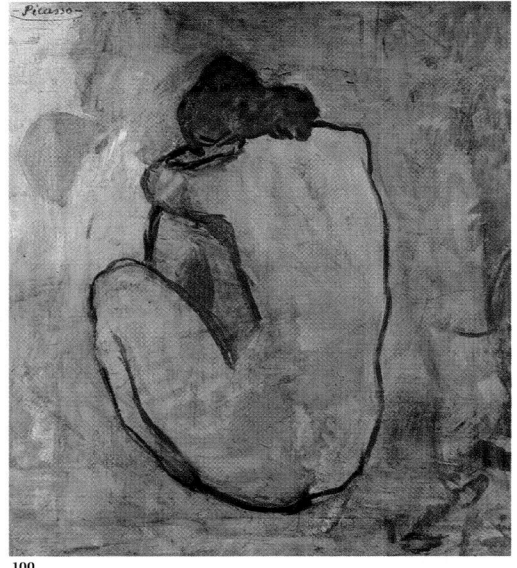

100

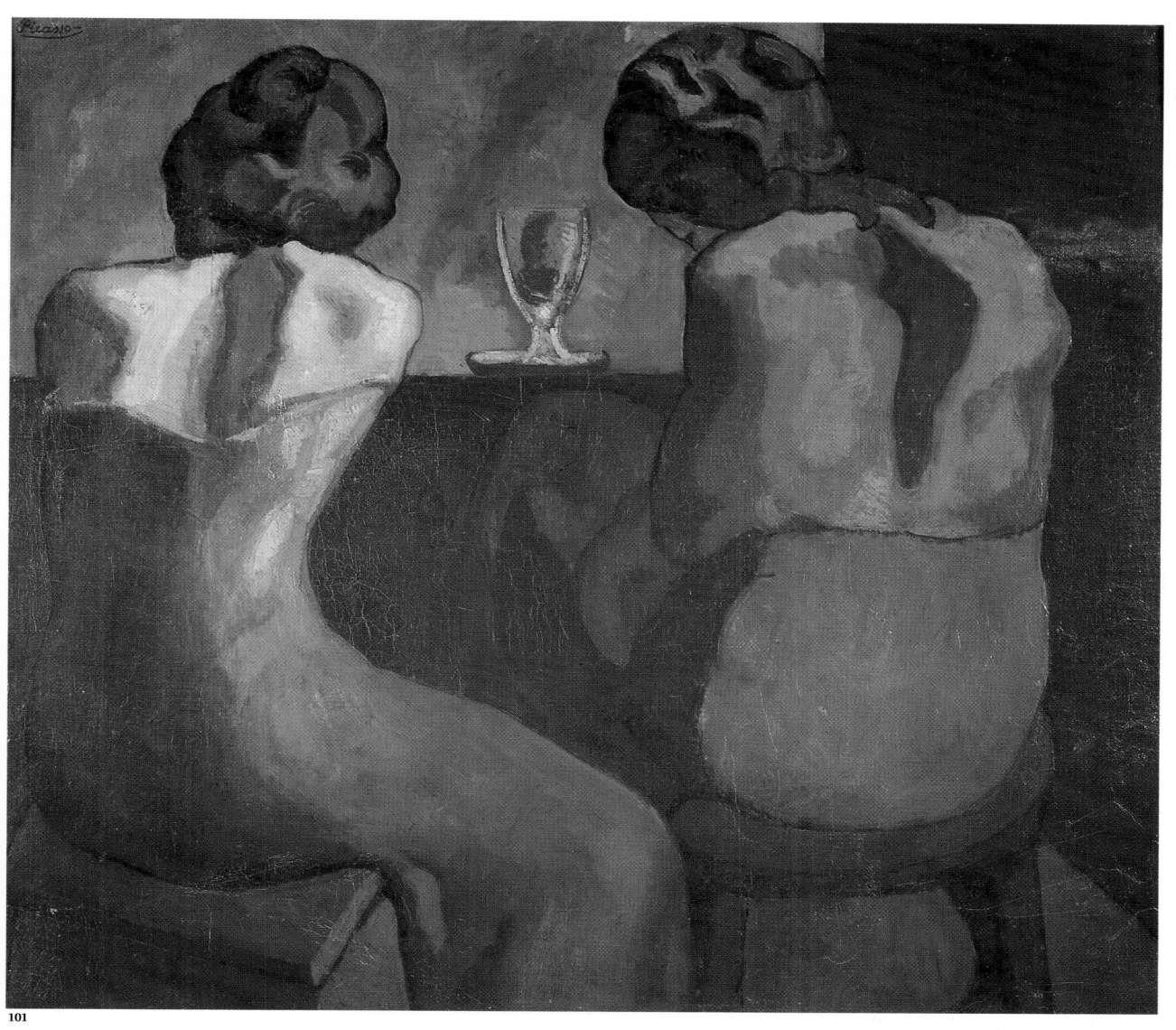

101

Germaine's role in the tragedy or the—presumably feminine—soul of poor Casagemas? With its layered and unsystematic composition, its awkward and naive figures, and the intimate fusion of the human and the miraculous, Picasso's finished allegory (fig. 82) comes closer to certain primitive altarpieces than it does to elaborate Venetian variations on the theme of sacred and profane love.

The symbolic content of *La Vie* (fig. 133)—the masterpiece of the Blue Period—is even more mysterious. Casagemas is once again recognizable, firmly planted on his feet this time and enfolded in his nude lover's arms. But what is the significance of the old woman holding a newborn infant in the folds of her penitent's robe? Are we supposed to recognize her as Casagemas's mother, who had died immediately after hearing the tragic news? With a hardened look, she openly assesses the couple as they emerge from *The Embrace*[12] with a guilty and repentant look (as in Leonardo's *Saint John the Baptist*); Casagemas is lifting his index finger to heaven in order to indicate the inevitable. By using the classic device of the painting within a painting, Picasso has placed two images of melancholy, one inspired by Gauguin and the other by van Gogh, as mediators between the figures as they confront one another.

The allegory in which sacred love triumphs over the profane would be obvious if in the preceding studies (figs. 130–132) Picasso had not substituted his own portrait for that of Casagemas. He even represented himself in Harlequin's clothing next to Germaine (although his back is turned) within the setting of the Montmartre cabaret Le Lapin Agile, where Picasso's group used to congregate in happier days (fig. 160). With this image of dreadful, irredeemable human loneliness, the Casagemas cycle was closed.

102

Paris and Barcelona Blues

By the time he painted his self-portrait in late 1901 (fig. 83), Picasso—that child of "terrifying precociousness"—had just celebrated his twentieth birthday, and he depicted himself as he saw himself, without makeup. His features are emaciated with hunger and cold, his gaze—normally so alive and bright—is clouded and sorrowful, his demoralized look poignant. "In the space of one year, Picasso actually lived that painting, blue as the bottom of the abyss and very pathetic," Apollinaire wrote.[13] Most of his future portraits would be painted in the same vein, as he grew to prefer painting physical and moral distress. In Barcelona the portraits of his friends Jaime Sabartés (fig. 84) and Mateu F. de Soto (fig. 85) were highly formal as well. Their severe images, cast in intense black, stand out against a plain background whose brilliant blue is worthy of Jean Clouet. Lost in his dreams, the poet Sabartés is witnessed in the café, seated behind a glass of beer (fig. 86): "I see myself. I look at myself set on the canvas and I understand what had inspired my friend. It is the specter of my solitude, seen from the outside. . . . Regarding myself for the first time in that marvelous blue mirror makes a great impression on me . . . like a vast lake whose waters contain something of myself, since I see my reflection there."[14] The strong line of his body and the exaggerated proportions of his hand mirror the figures of drinking women (figs. 87 and 88), whose stylized deformities also express loneliness and waiting. These have been compared to works of the same subject matter, such as the absinthe drinkers of Degas and Toulouse-Lautrec, because they were not portraits of specific models but rather studies of anonymous types straight out of Zola's *L'Assommoir*. Picasso's unrelenting repetition (figs. 92, 93, etc.) of these figures with interchangeable features reflects his lifelong obsession with creating variations on a theme.

The theme that underlies this series of seated women turned in upon themselves with their heads in their hands is the ancient and time-honored personification of Melancholy, which was revived by the Symbolists. For the first time, Picasso even used

103

102 *Profile of Suffering Woman,* 1902
103 *Rustic Scene,* 1902

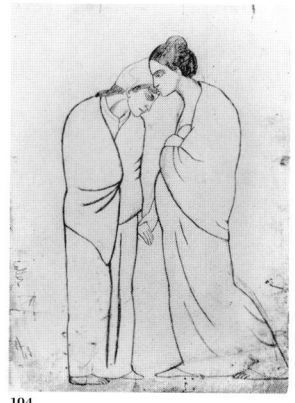

104

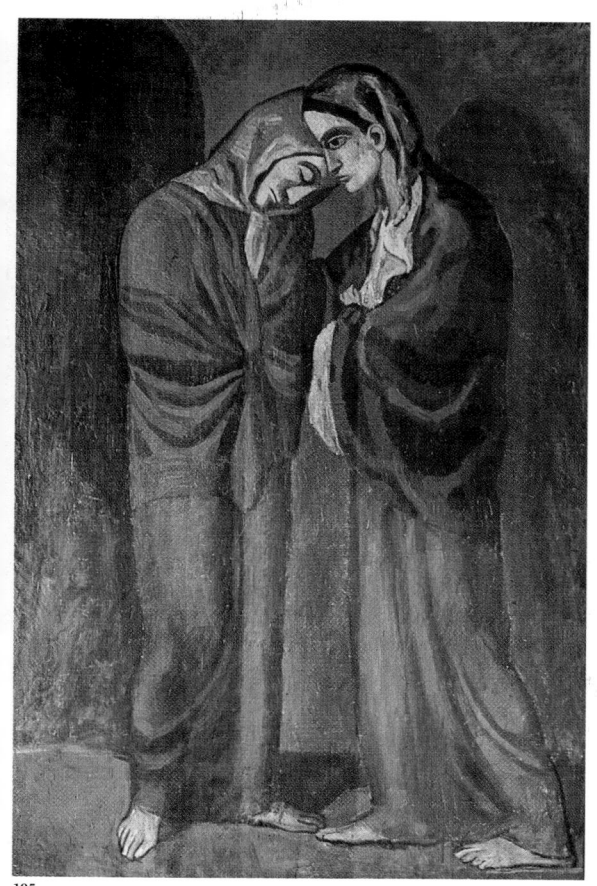

105

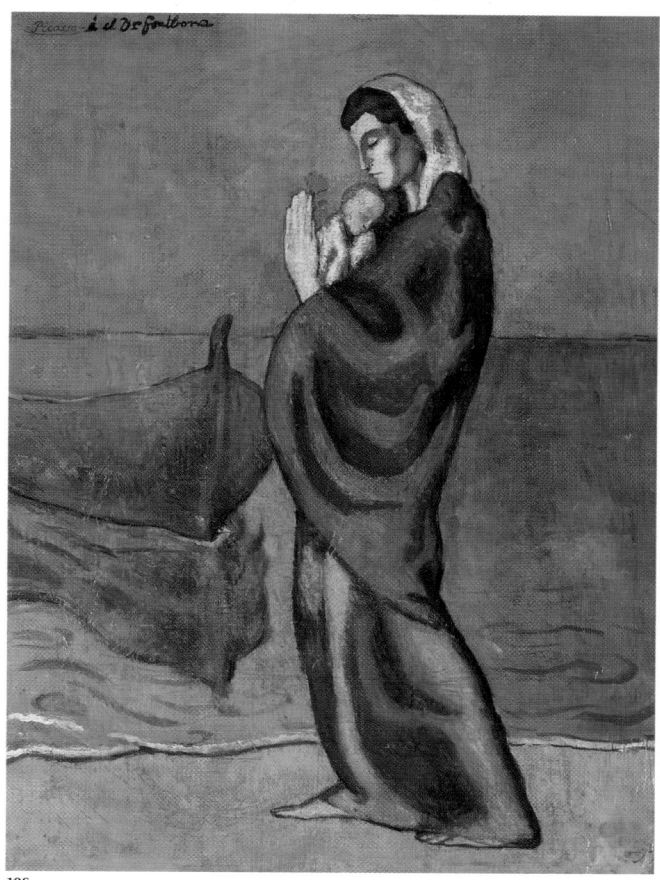

106

57

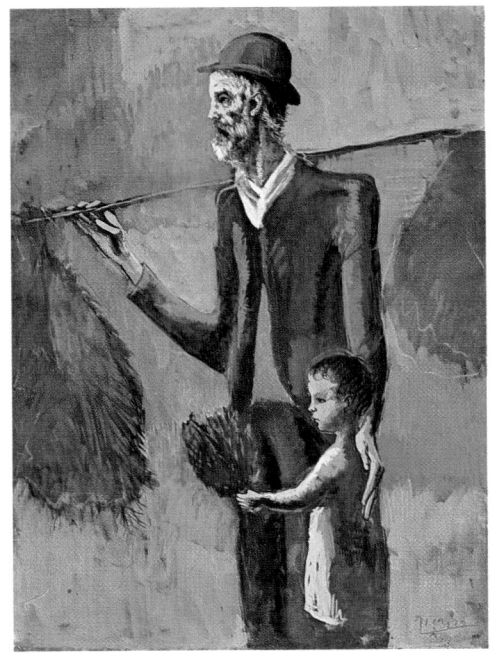

107

109

108

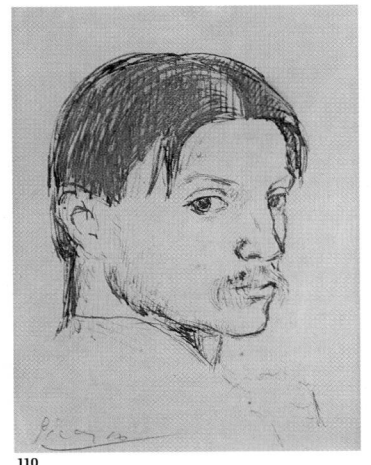

110

111

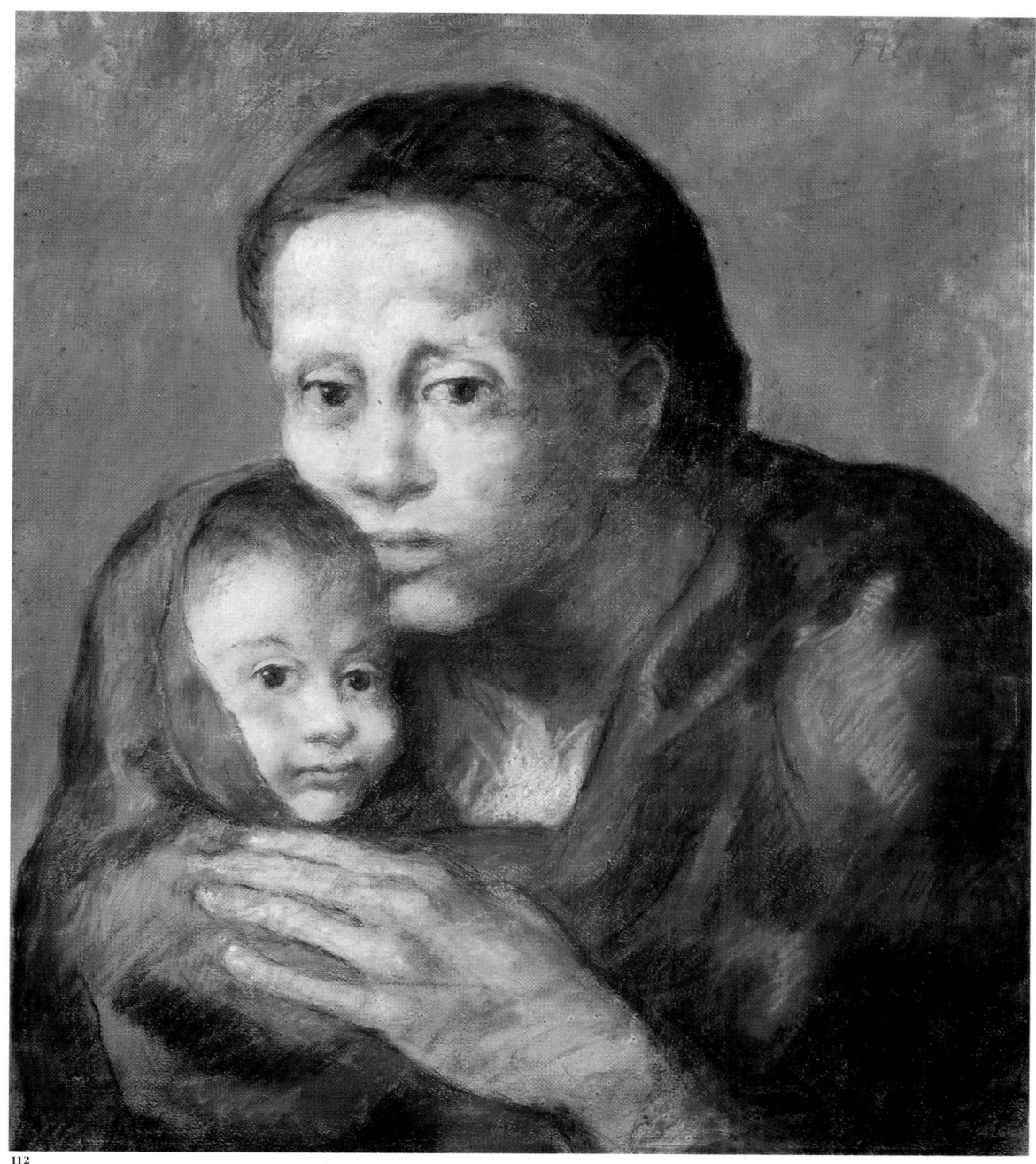

112

the medium of sculpture to express the theme, modeling a terra-cotta figure that he fired in Paco Durrio's kiln (fig. 96). In these studies Picasso pursued to the point of exhaustion the pattern of an arabesque closing in upon itself or hollowing itself out to accommodate the ellipse of a table, a glass (fig. 101), or the weight of a child's body (fig. 94). Despite the precious nature of the materials he used—turquoise alloys rubbed with metallic gray (fig. 92) or with gold-marbled sapphire (fig. 101), whose surface appears either granular or melted into a glaze—all these portraits, drawn with a heavy jagged brushstroke, have a repellent quality, which is, happily, redeemed by a more sensitive painting, *The Two Sisters* (fig. 105). According to Picasso himself, this meeting "between a Saint Lazare whore and a mother," this profane Visitation constructed according to a rigorous and majestic symmetry of forms ("as if supported by the fluted folds of their dresses, the bodies of the two women rise in a parallel movement to join again . . . head down against forehead, like an arch resting on two columns"[15]), is connected to the allegorical and moralizing spirit of *The Burial of Casagemas*. More moving still is the gripping close-up of a dead woman (fig. 108), which summons up the portrait of *Camille on Her Deathbed* painted by Monet in an identical range of blues cut through with white. Was this portrait a female counterpart of the painting of Casagemas on his bier? In any event, it bears witness to Picasso's continuing dread of misfortune and death. As Sabartés wrote, "Picasso believes that sorrow is the foundation of life."[16]

The Jew, the Blind Man, and the Celestina

Despite the critical acclaim for his exhibition in the Berthe Weill gallery and the friendly support of the Symbolist poet Charles Morice, who saluted "the uncorrupted sadness that weighs upon his work,"[17] Picasso's third stay in Paris (October 1901–January 1903) took place once more under the sign of misery and hunger. Although he told biographers that he had sacrificed large numbers of drawings to heat the wretched attic room he shared with the poet Max Jacob, this story is probably apocryphal. However, it is likely that he sold the pastel *Mother and Child by the Sea* (fig. 123) in order to purchase a train ticket to Barcelona, where an old acquaintance from Els Quatre Gats, Àngel F. de Soto (fig. 120), gave Picasso a place to stay in January 1903.

The canvas *Tragedy* (fig. 126) developed the theme Picasso had initiated in Paris with similar images of mothers by the sea. Against a plain background of sea, sand, and sky stand three silhouettes, columnlike statues modeled in dark blue slightly warmed with ocher, every detail articulated in heavy black line. Draped in classical style, their heads tucked between their shoulders as if weighed down by burdens, these silent figures could have descended from Millet's *Angelus*, as Wilhelm Boeck has suggested.

Caught in the "bluish fog that . . . blurs what is concrete and puts it to sleep like a gauze veil . . . [and that] . . . releases a narcotic effect,"[18] *The Old Jew* (fig. 115), *The Blind Man's Meal* (fig. 116), *The Old Guitarist* (fig. 114), and *La Celestina* (fig. 122) are characters from the picaresque world of Cervantes or Quevedo, those who might come across Lazarillo de Tormes or Pablos de Segovia in their travels. The moving figure of the Jew, pariah among pariahs, is the embodiment of decline. His tense silhouette, emphasized by a nervous line, is shaped by a play of light that makes each vein and bone stand out beneath his skin. The sorrow of *The Old Guitarist* is expressed through the broken lines of his emaciated body; El Greco's influence is tangible in his mannered pose and slender fingers and even in the point of the beard that sharpens his profile. The dramatic strength of the *Blind Man's Meal* derives from the huge groping hand "similar to the living branch of a dry tree."[19] This liturgical gesture comes close to the religious compositions of Spain's Golden Age in the seventeenth century, such as Velázquez's *Christ in the House of Martha and Mary*. For a man

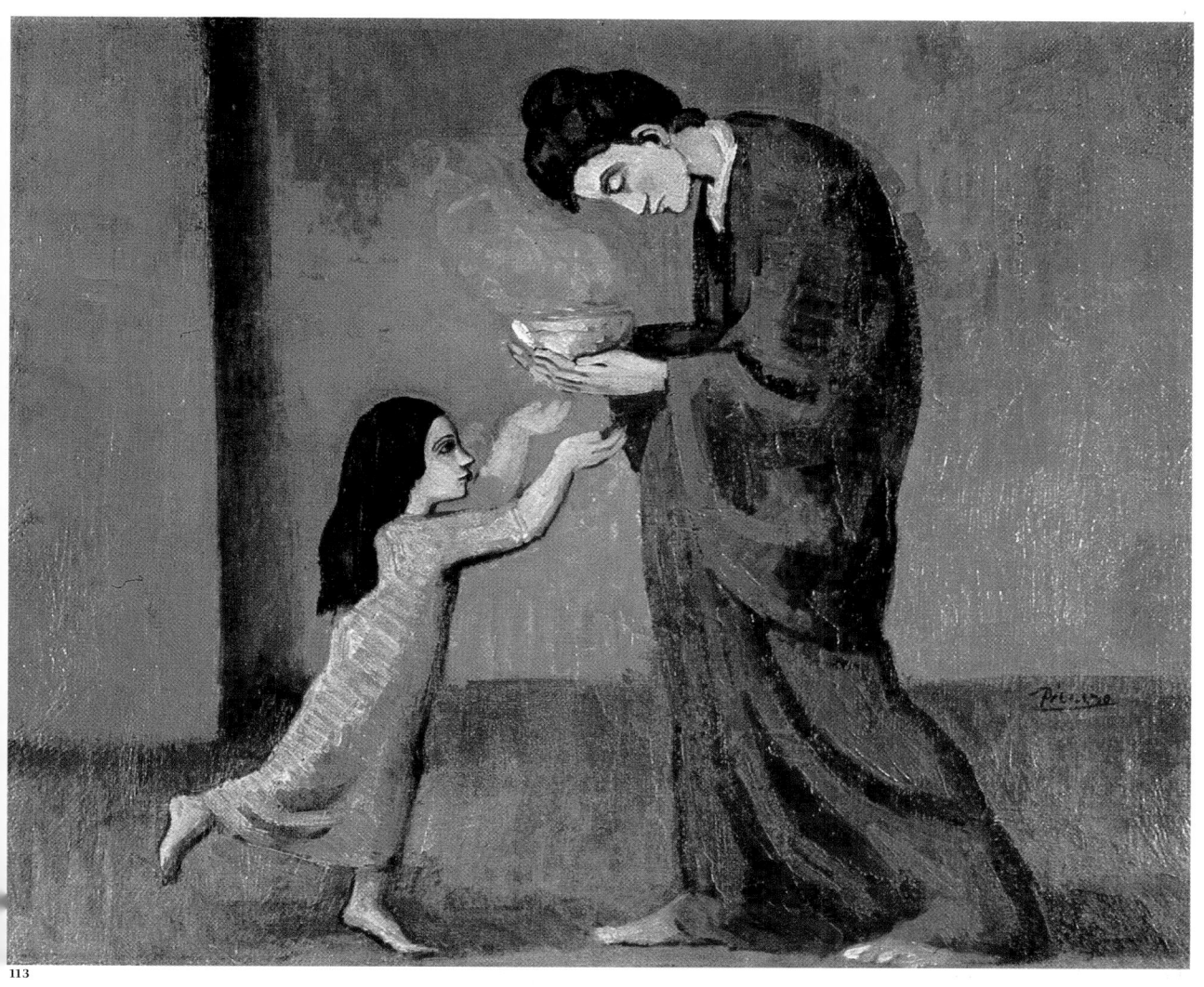

113

113 *The Soup,* 1903

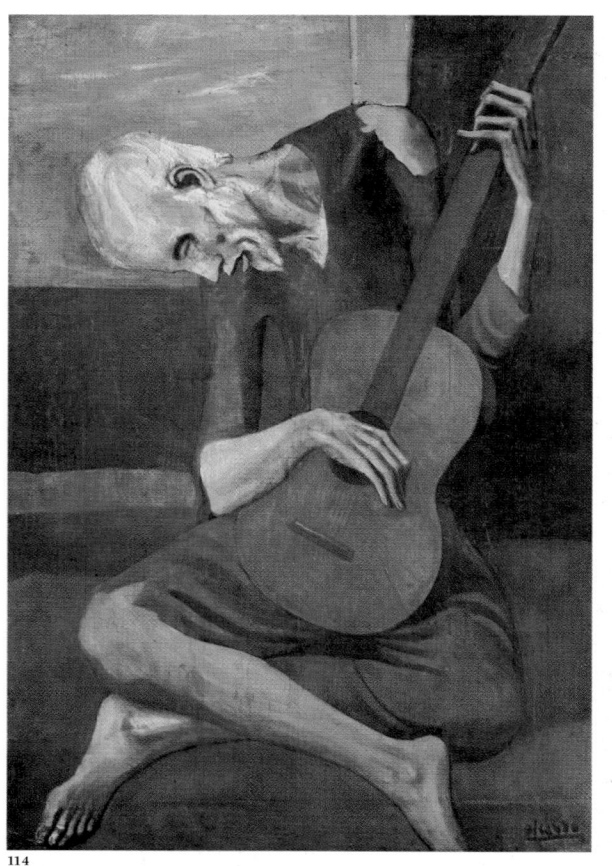

114

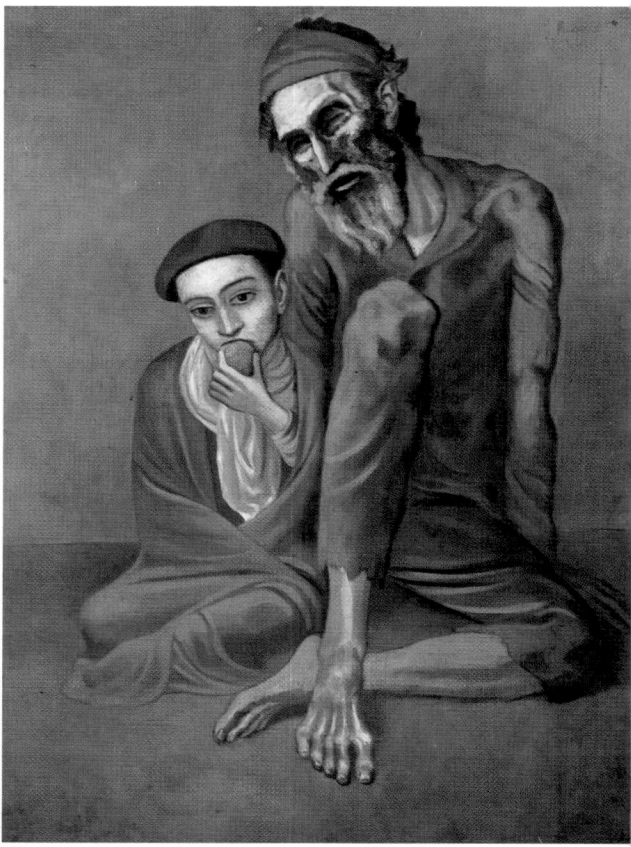

115

114 *The Old Guitarist,* 1903
115 *The Old Jew,* 1903
116 *The Blind Man's Meal,* 1903

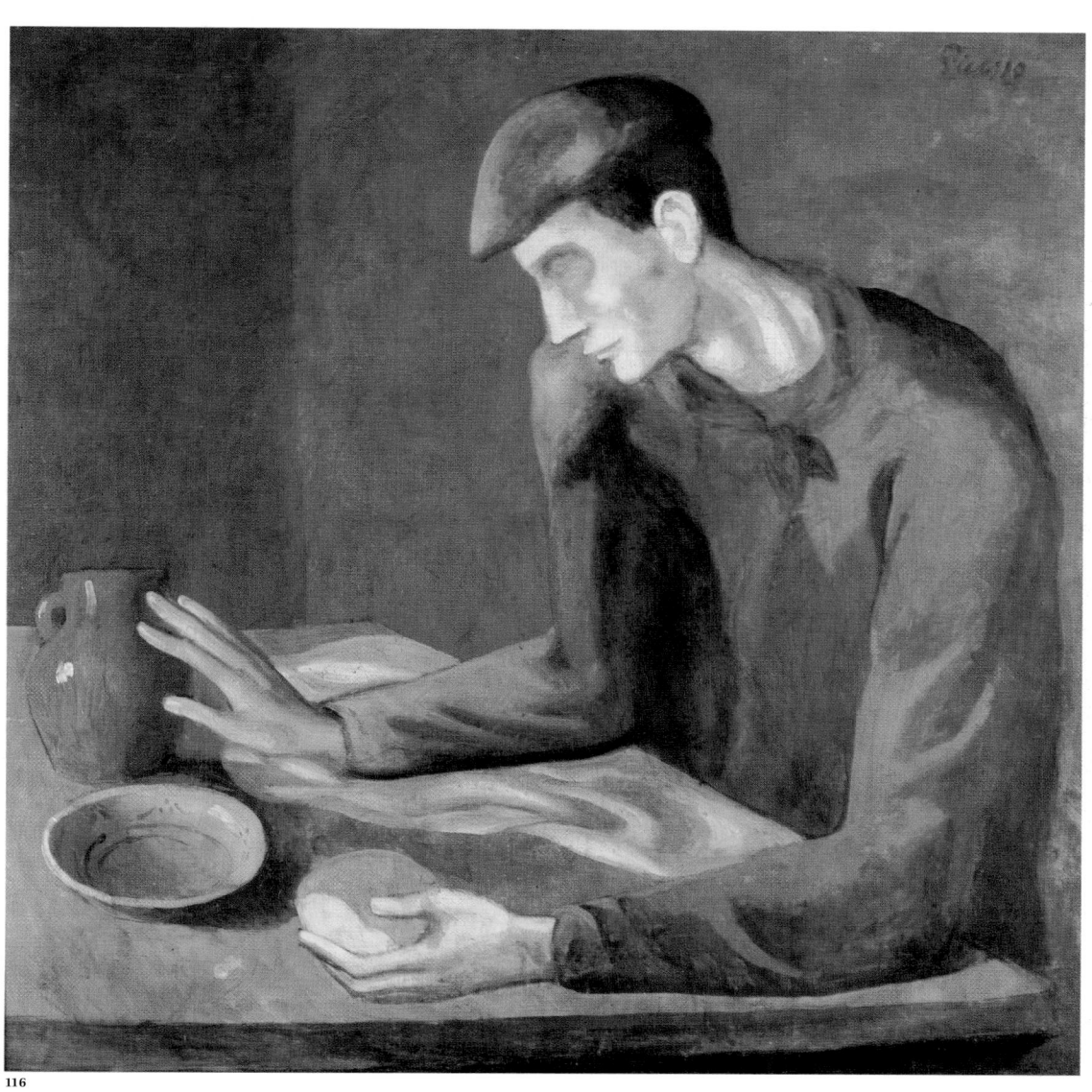

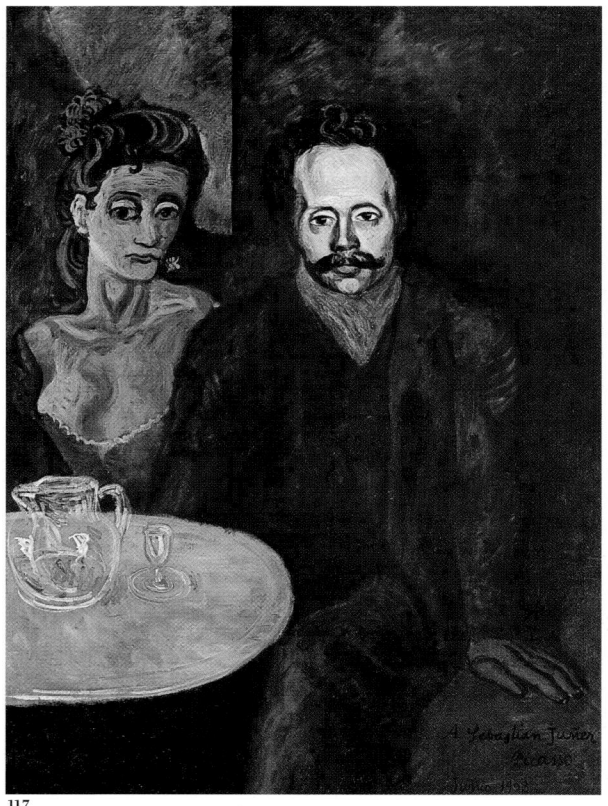

117

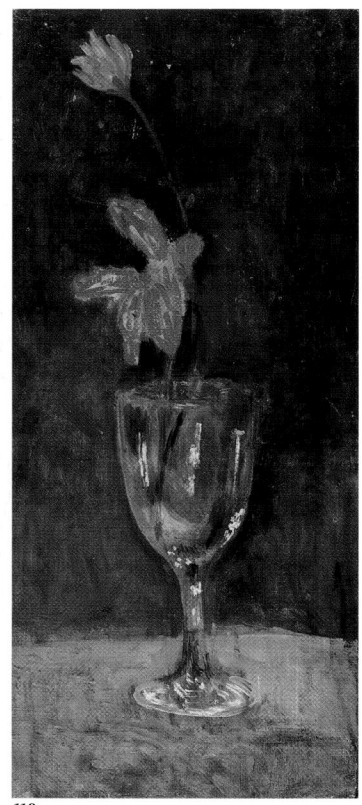

118

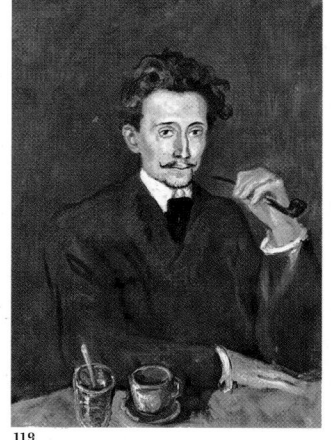

119

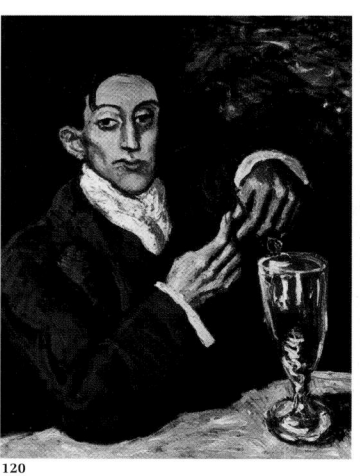

120

121

117 *Sebastià Junyer Vidal with a Woman,* June 1903

118 *The Blue Glass,* 1903

119 *Portrait of Benet Soler,* 1903

120 *Blue Portrait of Àngel F. de Soto,* 1903

121 *Picasso Painting "La Celestina,"* 1904

122 *La Celestina,* March 1904

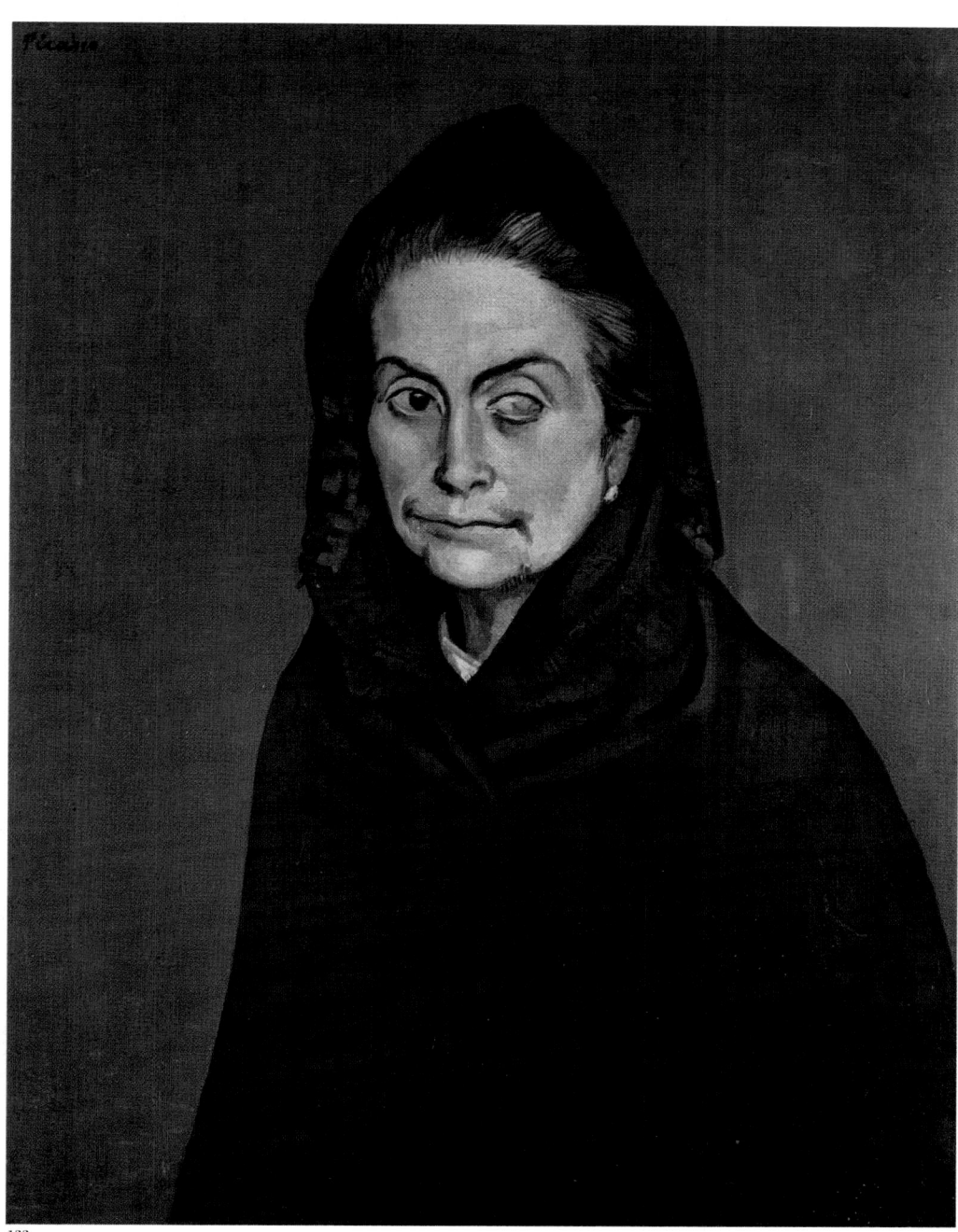

122

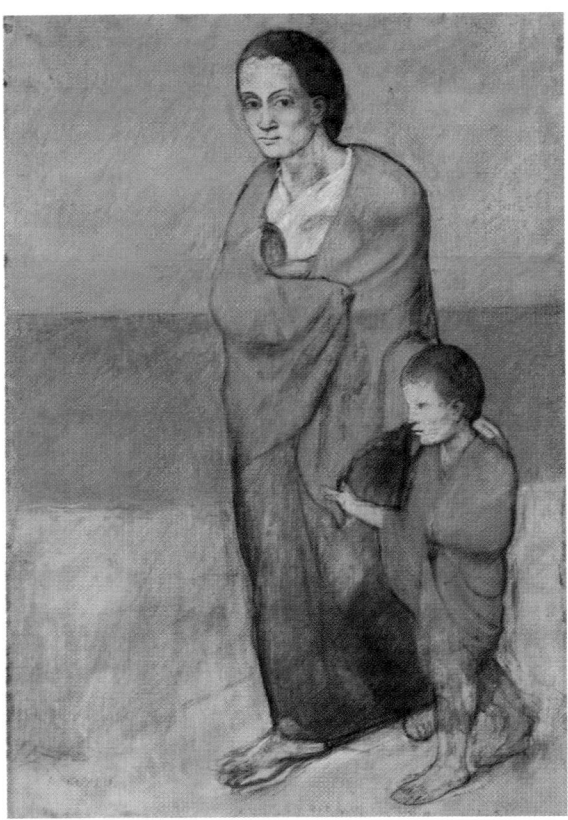

123

124

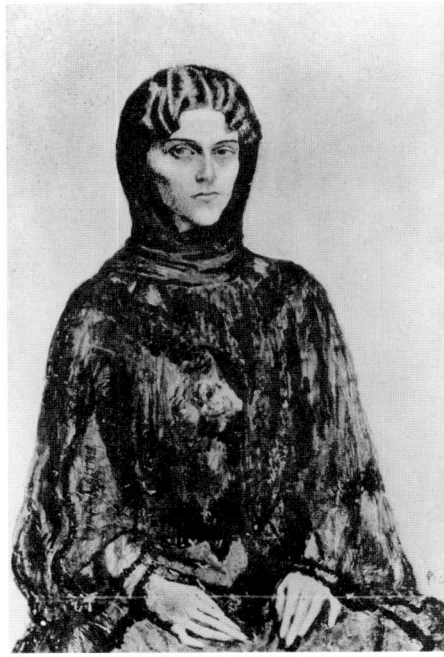

125

123 *Mother and Children by the Sea,* 1902
124 *The Madonna with a Garland,* 1904
125 *Portrait of Gaby,* 1904
126 *The Tragedy,* 1903

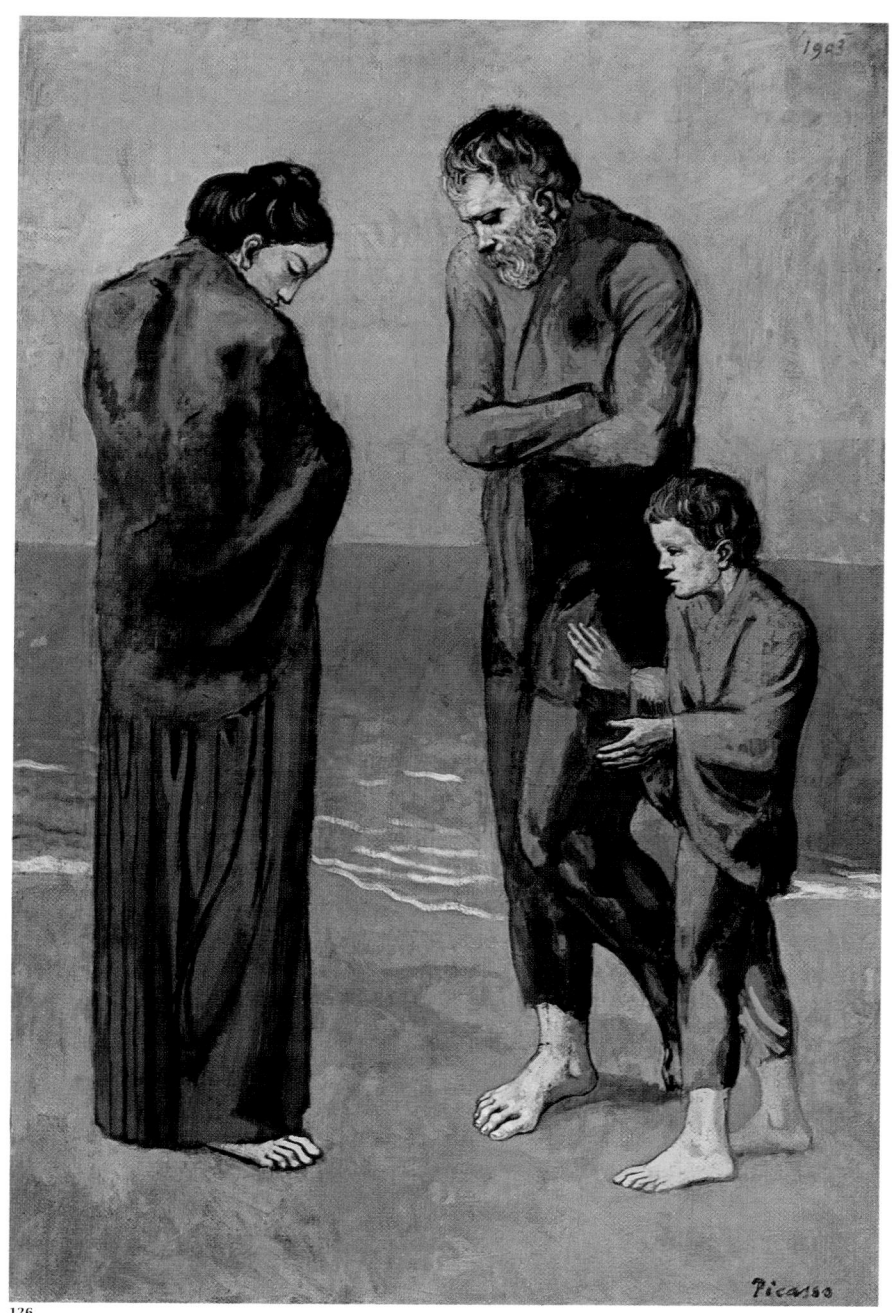

126

127 The Embrace, 1903

128

129

68

130 131

132 133

134

136

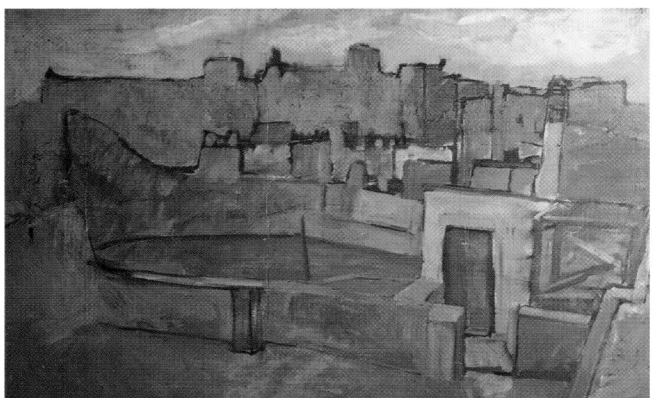

135

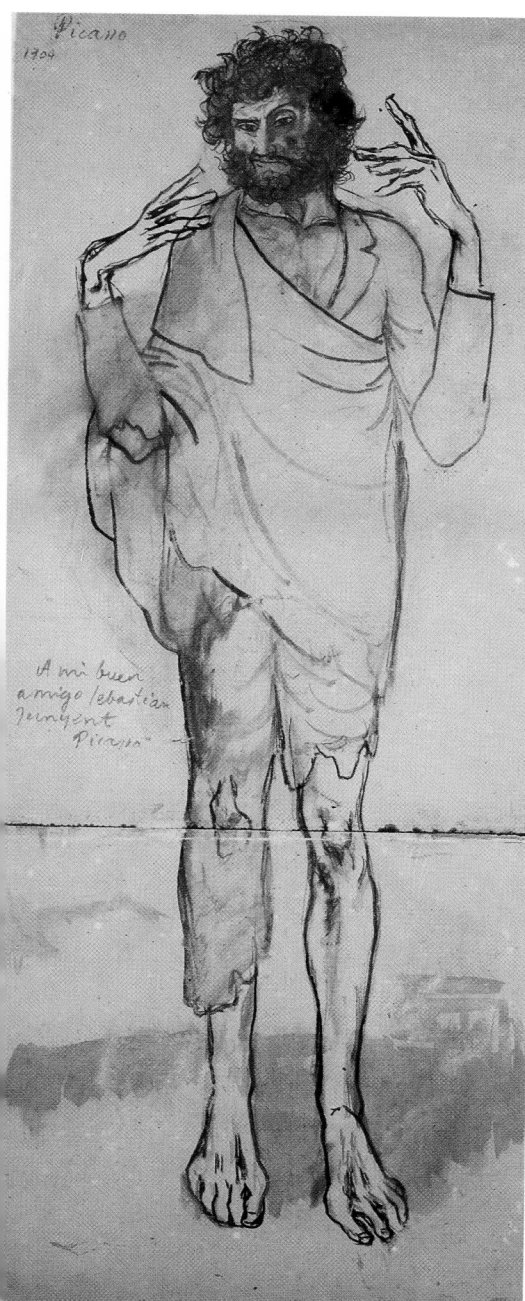

137

138

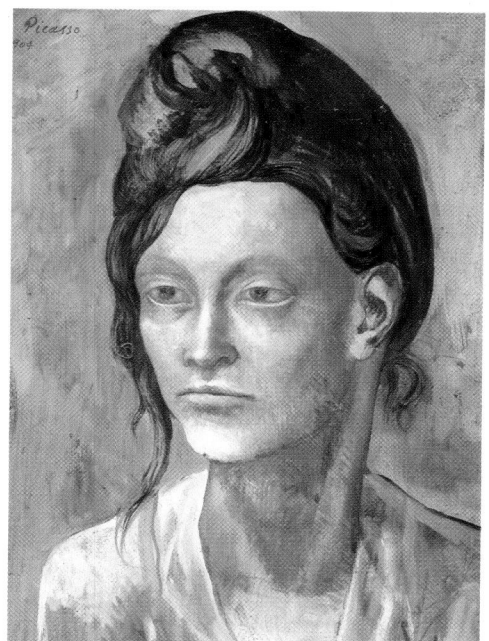

139

like Picasso, who lived through his eyes, blindness must have seemed the most tragic of all afflictions. He studied the facial deformities caused by this impairment in a series of drawings and in one sculpture, *The Old Blind Man*, with a plastic force and a dramatic tension that culminated in *La Celestina* (fig. 122). The one-eyed procuress is, of course, one of the most famous villainesses in Spanish theater, created by Fernando de Rojas for his *Tragicomedia de Caliesto y Malibea*. But it is also, as Picasso indicated on the other side of the canvas, the portrait of the Lady "Carlota Valdivia, calle Conde Asalto, 12/4.º/1.ª escalera interior," a bordello owner by trade. If the early portraits of prostitutes (figs. 97 and 98) were conspicuous because of the radical depersonalization of their faces, which look like anonymous masks, then the image of Celestina fascinates us because of its powerful realism, which hides nothing of her physical misfortune (the opaque eye) and her moral decadence (the avarice in her gaze). The composition against a plain background and the neutral technique disappear behind the brutality of the subject.

At the Bateau-Lavoir

Picasso returned to Paris in April 1904, accompanied by Sebastià Junyer Vidal (fig. 117). In the heart of Montmartre, Picasso took one of the studios in the house at 13, rue Ravignan, known as the Bateau-Lavoir. His neighbor, Fernande Olivier, who would be his lover and companion until 1912, remembered "a mattress on four legs in one corner. A little iron stove, covered in rust; on top a yellow earthenware bowl for washing. . . . A cane chair, easels, canvases of every size and tubes of paint scattered all over the floor with brushes, oil cans, and a bowl for etching fluid. . . . At the time, Picasso was working on an etching, which has since become famous, of a man and a woman sitting at a table in a wine shop. There is the most intense feeling of poverty, alcoholism, and a startling realism in the figures of this wretched, starving couple."[20] The etching was the *The Frugal Repast* (fig. 143), dedicated to "My good friend Sebastiàn Junyent," and it set the tone for his new style, which adopted a mannerist technique emphasized by means of a sharp, rather nervous line.

One of Picasso's models at this time was Marguerite Luc, called Margot, the stepdaughter of Frédé Gerard, who owned Le Lapin Agile, where the Montmartre bohemians hung out (figs. 140 and 141). Against a background of hard blue like that in medieval miniatures, Margot's pale face is chiseled like a Flemish primitive; her weightless body is like a cloud that envelopes the slender fingers of her hand as she caresses a crow in "a mysterious atmosphere evoking the stories of Edgar Allan Poe."[21] Margot, who would marry Pierre MacOrlan, also posed for Picasso's women in chemises (fig. 153), in which he reverted to the use of chiaroscuro as background. Margot is also the subject of *Woman with Helmet of Hair* (fig. 139) with "the provocative boldness of a Marianne,"[22] whose hardened expression is bathed in an arctic light. If Degas's women at the ironing board have lush, colorful forms, the woman painted by Picasso (fig. 142)—which Violet Endicott Barnett called that "secular *imago pietatis*" with ash-colored flesh and a skeletal body, broken by the weight of her daily labor—is the very essence of suffering.

Nevertheless, Picasso spent some happy days at the Bateau-Lavoir, surrounded by the affection of his compatriots, as well as Max Jacob's friends, of whom Picasso drew intense, expressive portraits. Among them were Gaby, the future wife of the actor Harry Baur, with her prettily waved hair (fig. 125), and the beautiful Roman girl Benedetta Canals (fig. 157), who wears a mantilla that heightens the nobility of her bearing and the severe purity of her features. The passionate love that bound Picasso to Fernande Olivier, whose sensual profile appeared for the first time in a preliminary sketch for *The Actor* (fig. 151), gave rise to a large number of erotic or intimate drawings (fig. 145) in which the theme of the painter and his model (fig. 146) is already apparent.

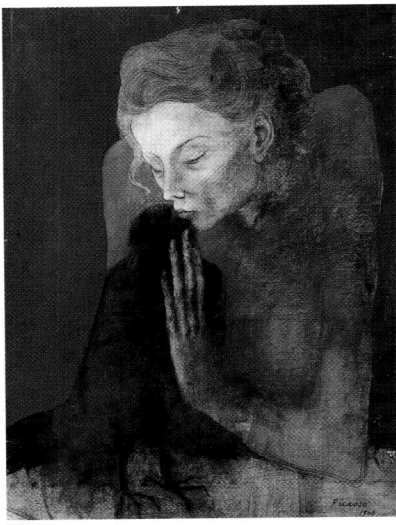

140

140 *Woman with a Crow,* 1904
141 *Woman with a Crow,* 1904

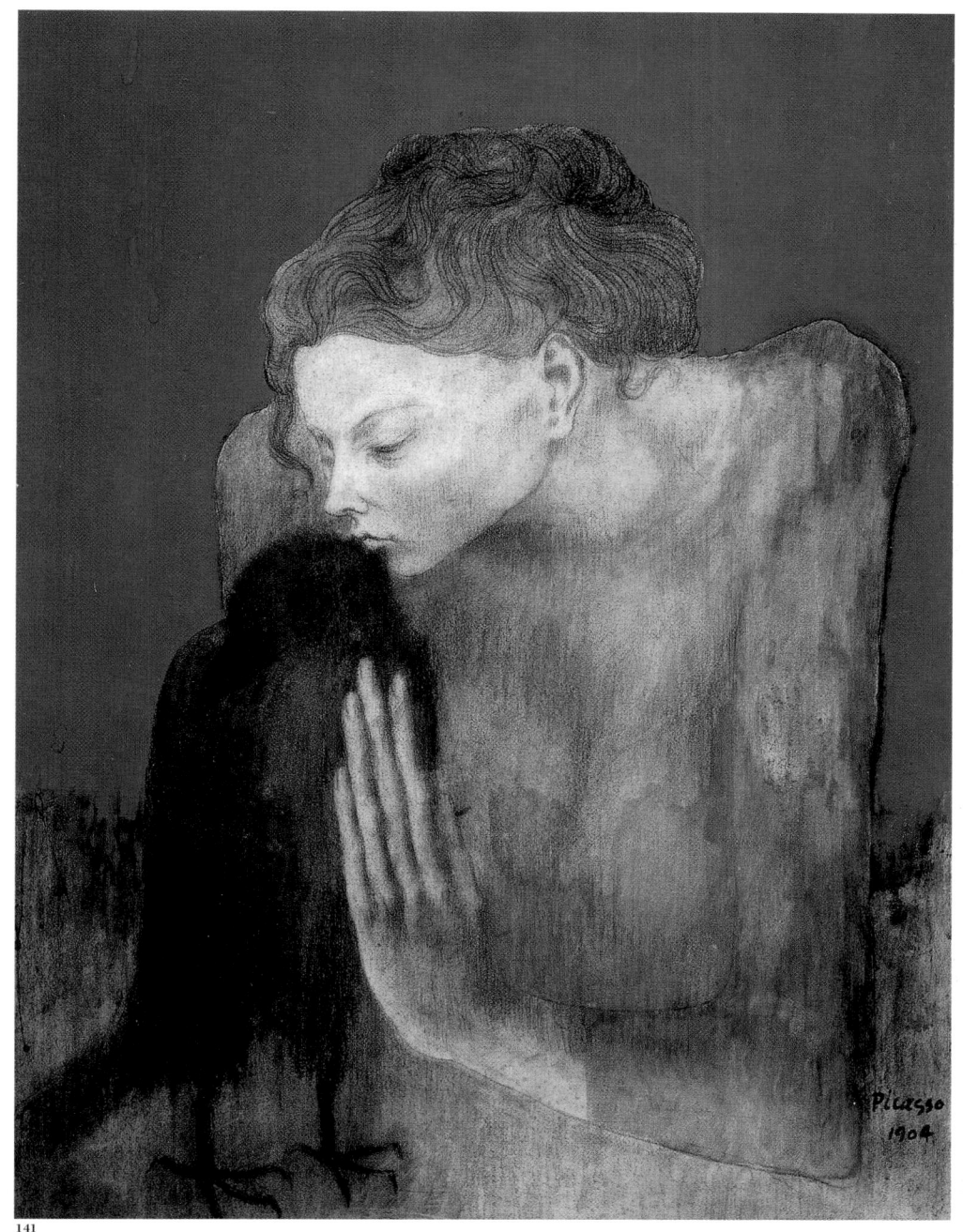

141

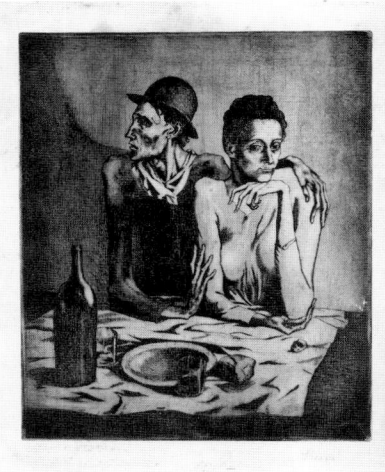

143

144

142

74

145

146

147

148

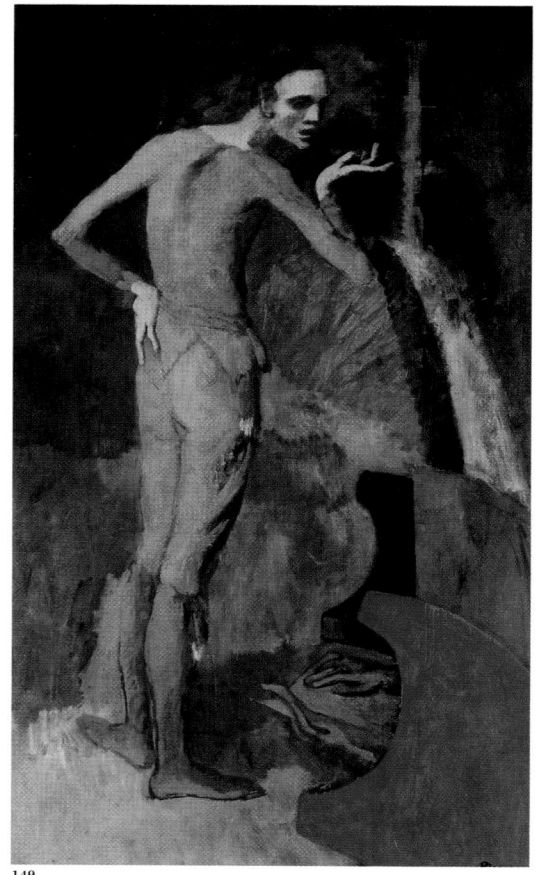

149

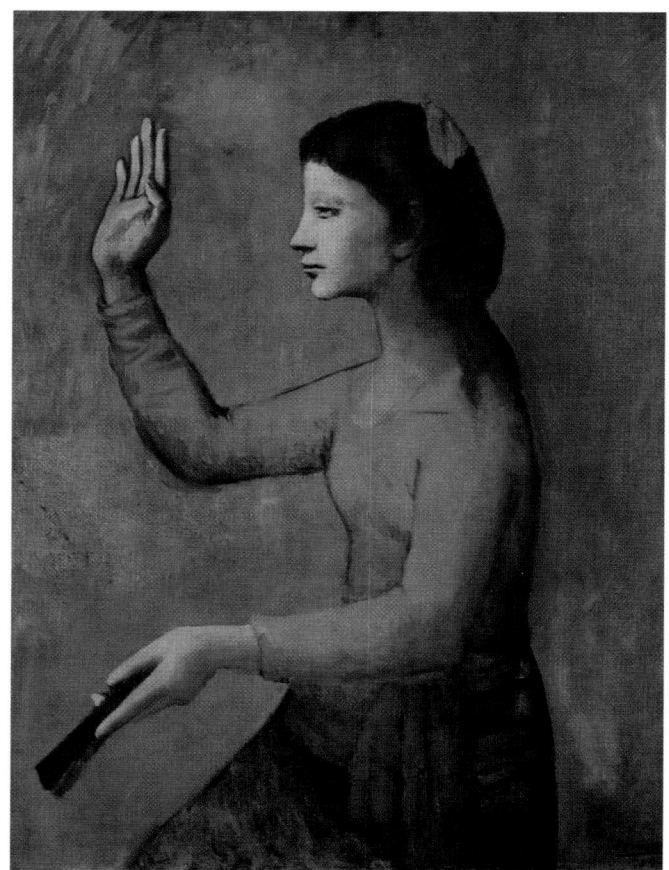

150

151

152

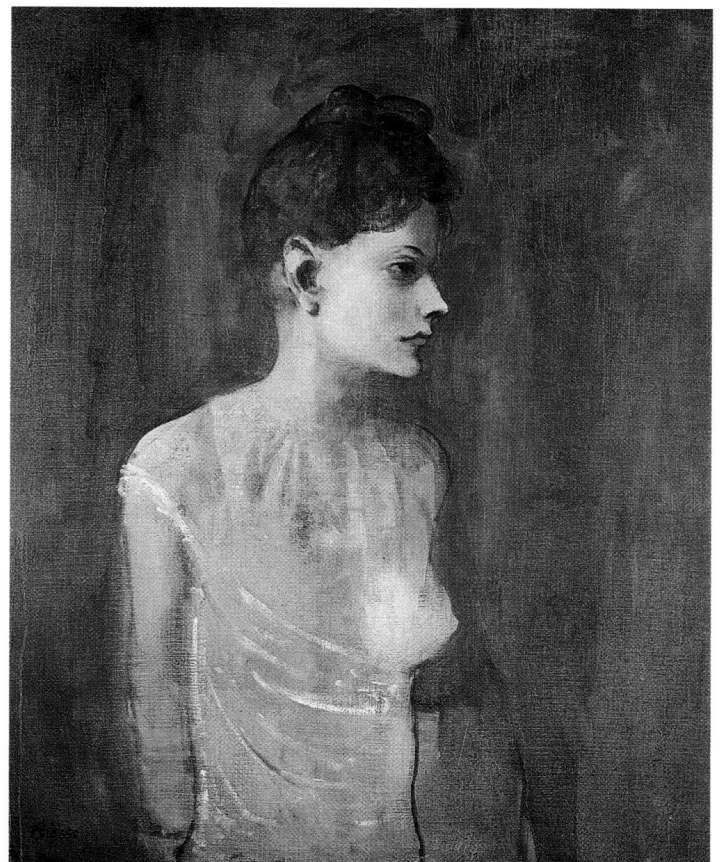

153

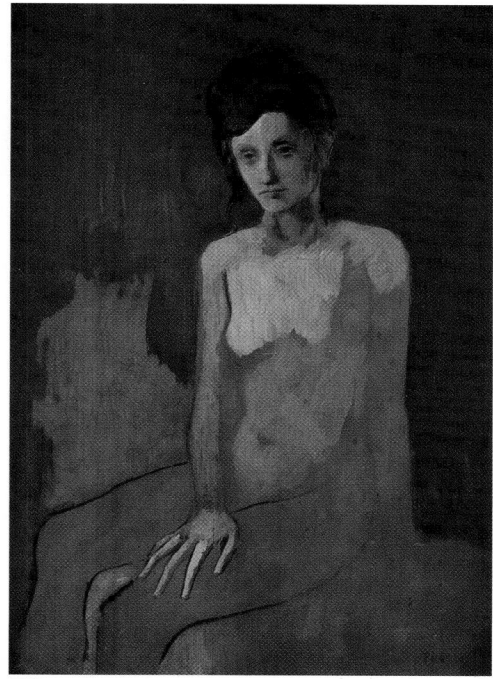

156

154

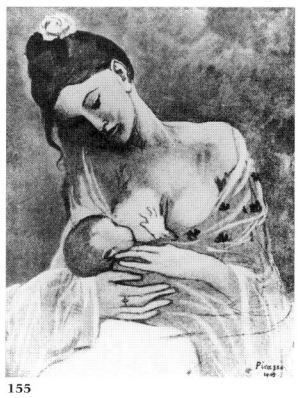

155

149 *The Actor,* late 1904

150 *The Woman with a Fan,* 1905

151 *Study for "The Actor,"* late 1904

152 *Studies for "The Woman with a Fan,"* 1905

153 *Woman in a Chemise,* 1904

154 *Nude with Crossed Legs,* 1904

155 *Mother Nursing Her Child,* early 1905

156 *Seated Nude,* 1905

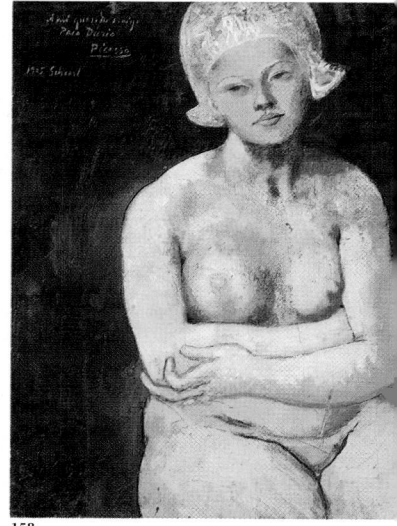

157

158

157 *Portrait of Benedetta Canals,* 1905
158 *The Beautiful Dutch Girl,* 1905
159 *Three Dutch Girls,* Summer 1905

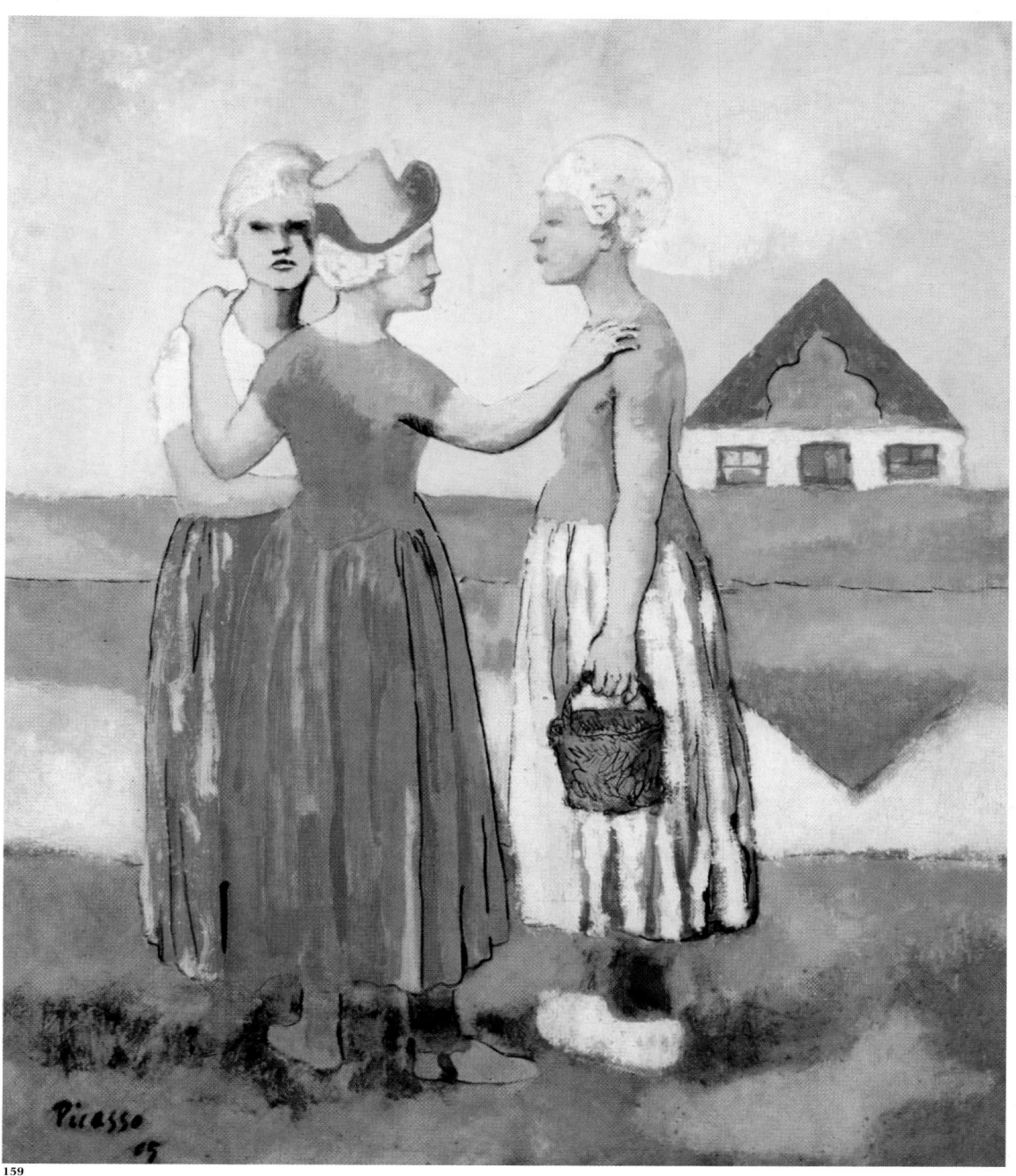

159

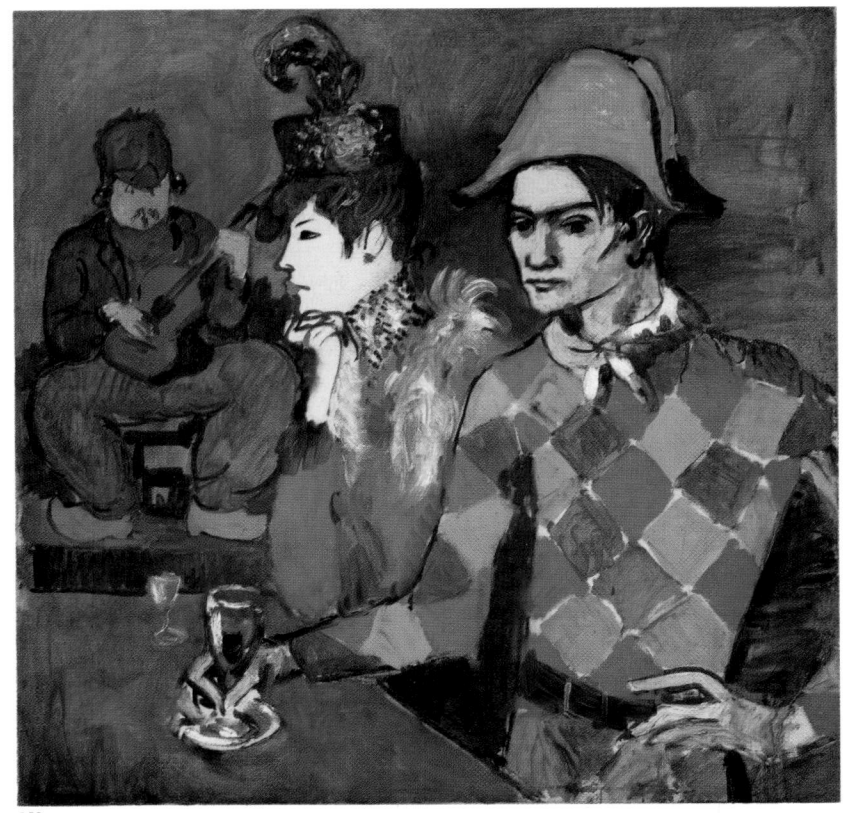

160

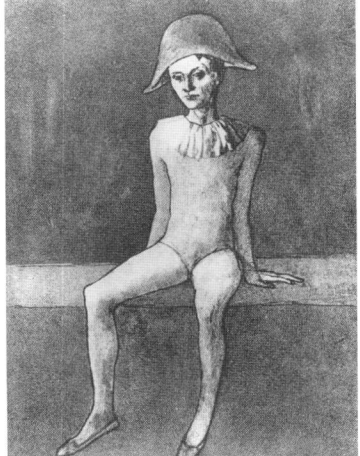

161

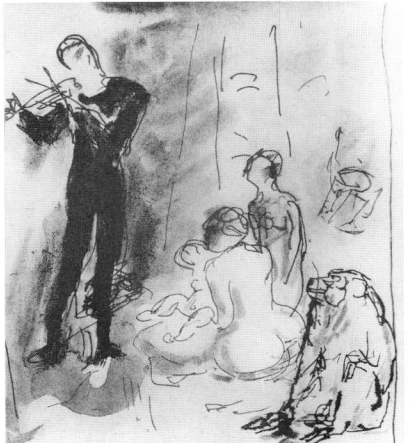

162

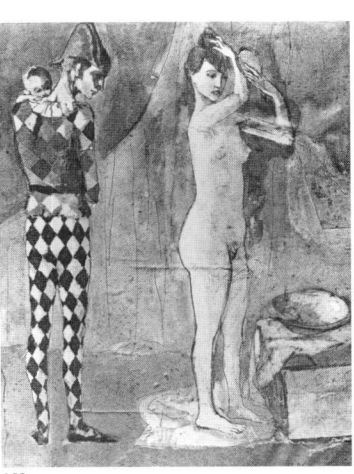

163

160 *Au Lapin Agile*, 1904–5
161 *Seated Harlequin*, 1905
162 *The Violinist (The Family with a Monkey)*, 1905
163 *Harlequin's Family*, 1905
164 *Family of Acrobats with a Monkey*, 1905

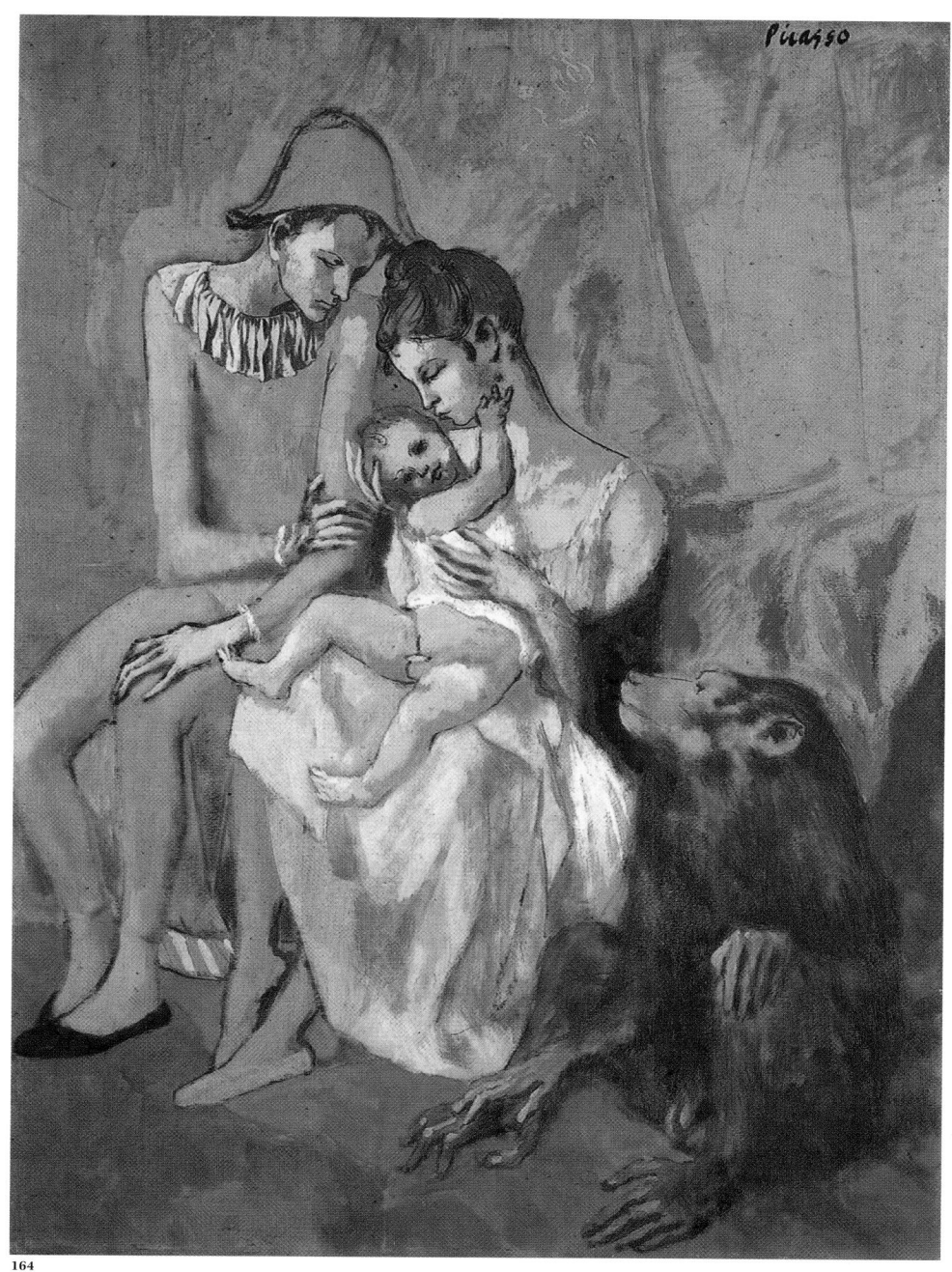

164

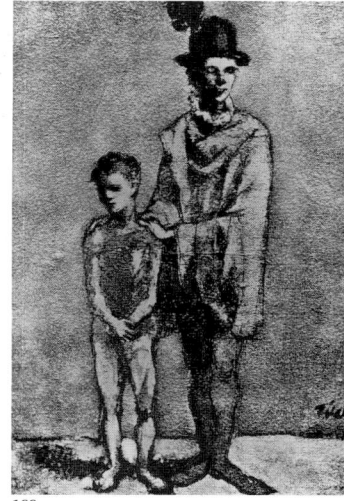

165

166

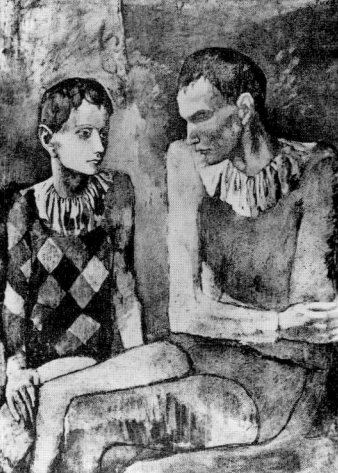

167

165 *Unhappy Mother and Child,* early 1905
166 *The Two Comedians,* 1905
167 *Acrobat and Young Harlequin,* 1905

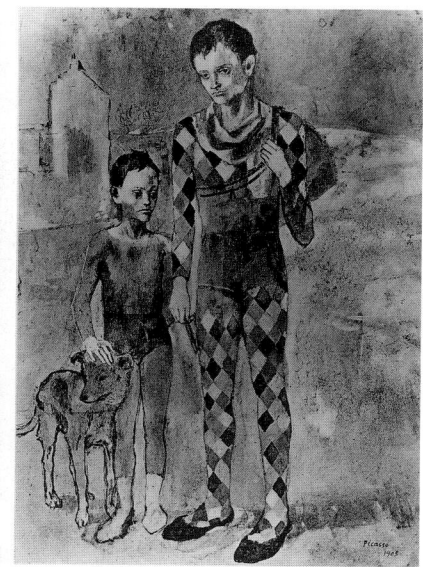

168

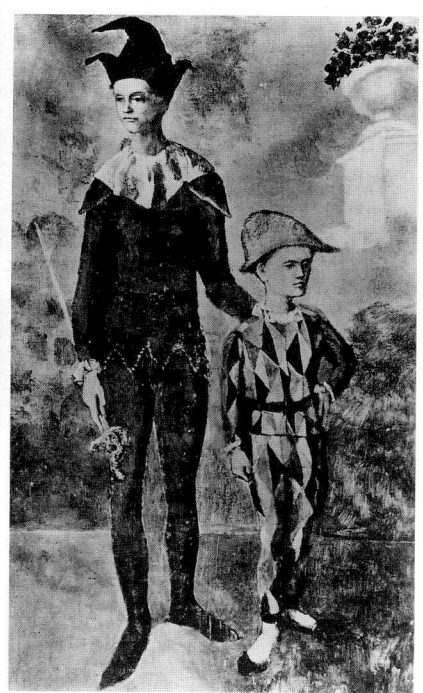

169

170

168 *Saltimbanques with a Dog,* 1905
169 *Comedians,* 1905
170 *The Organ Grinder,* 1905

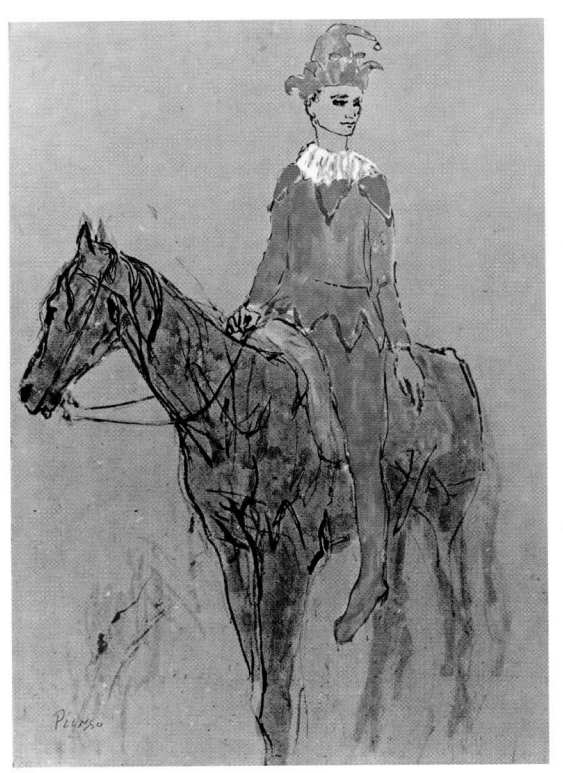

171

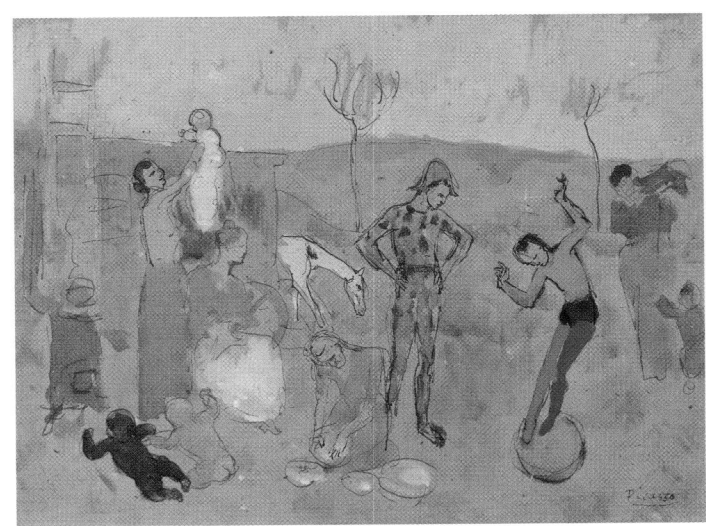

172

173

174

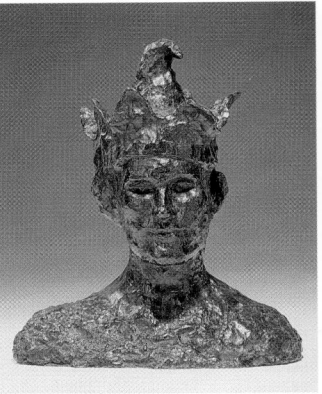

175

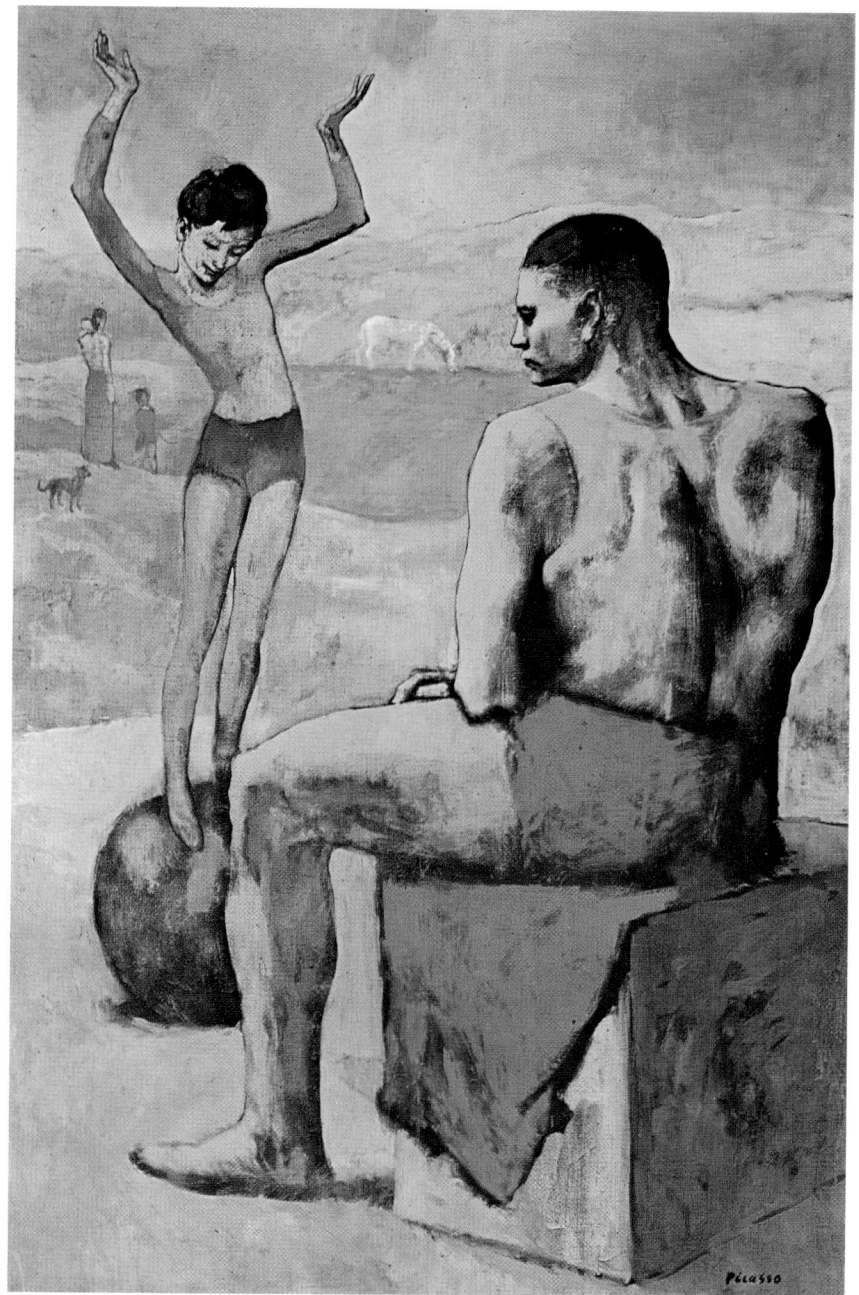

176

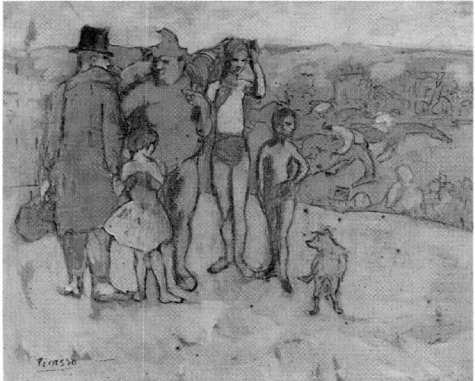

178

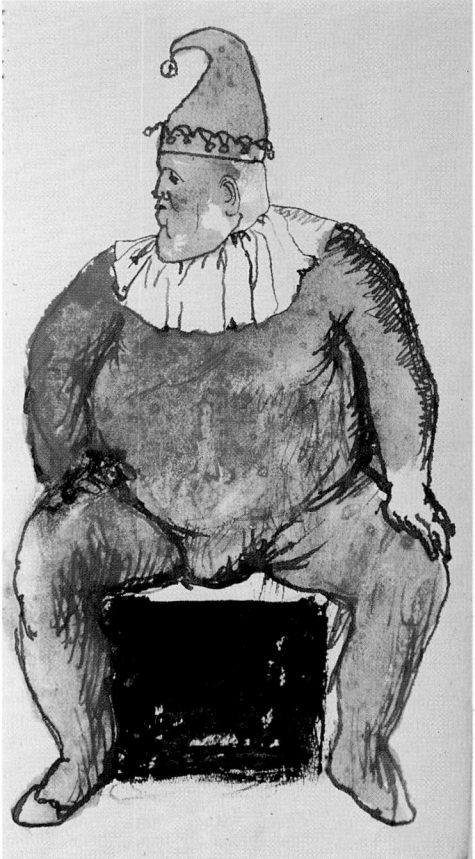

177

179

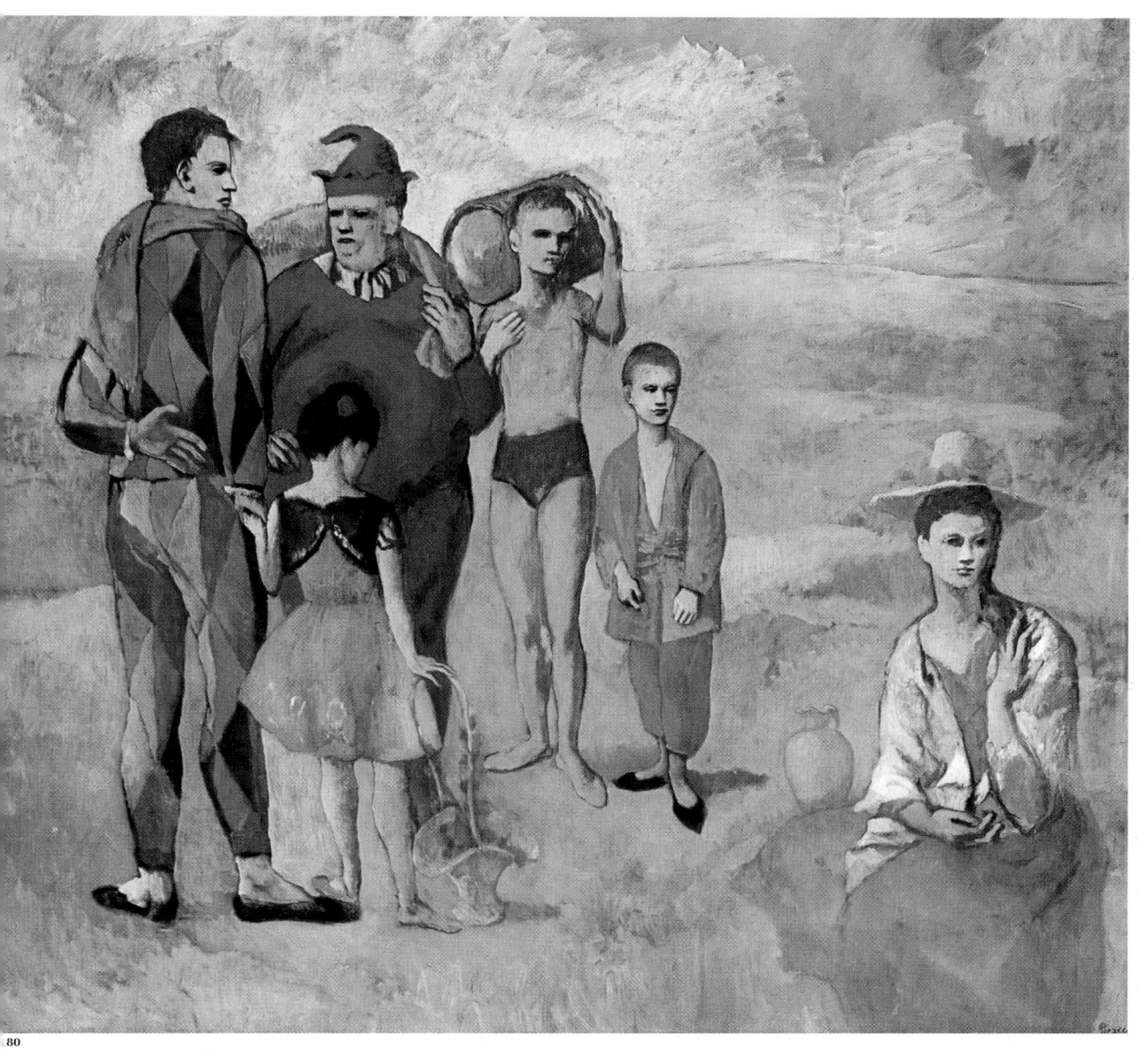

180

177 *Girl with a Basket of Flowers (Flower of the Streets)*, 1905
178 *Family of Acrobats*, 1905
179 *Fat Clown Seated*, 1905
180 *The Saltimbanques*, 1905

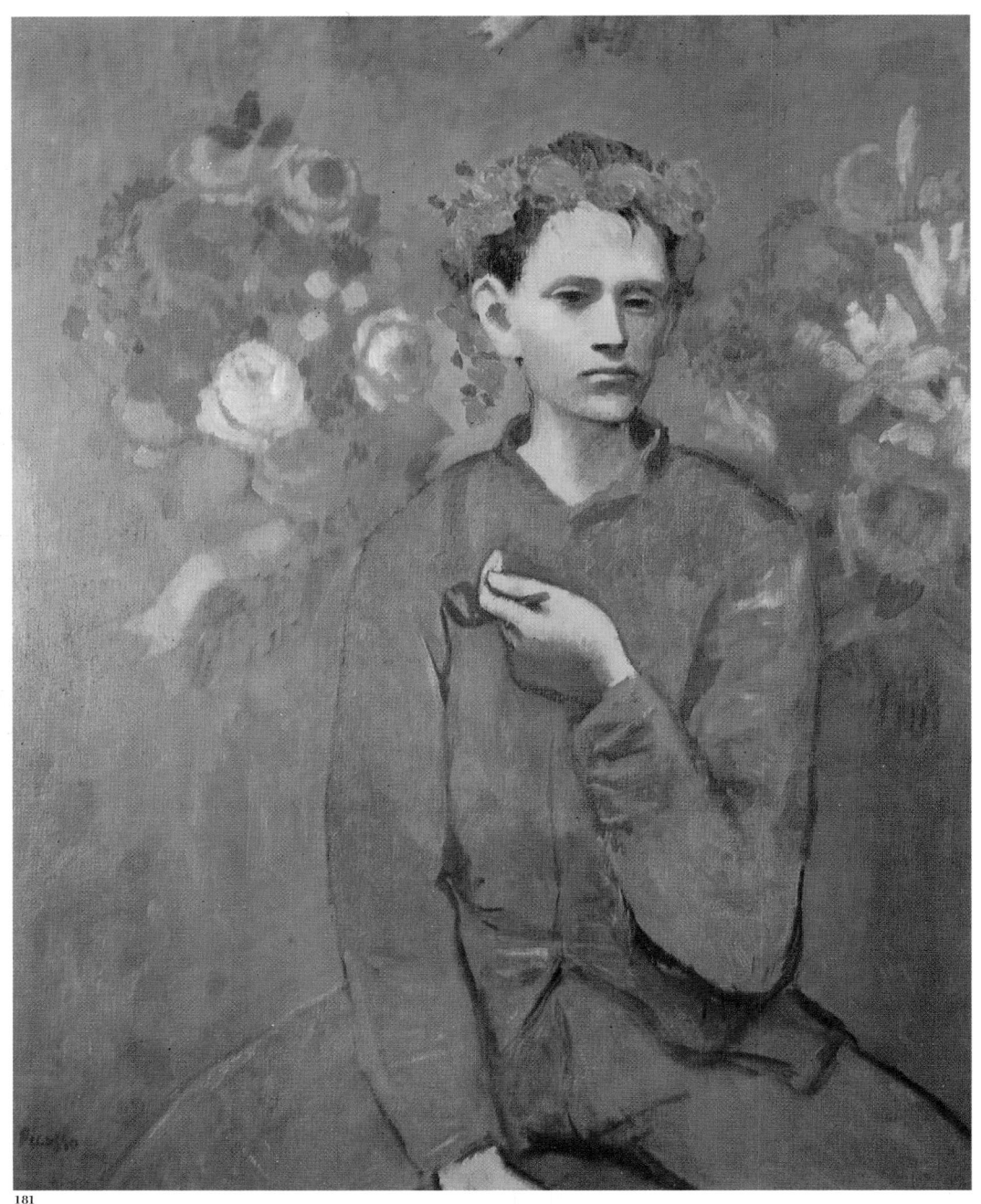

181

88

182

"Who are these wanderers?"

Sugar-candy pink pinned onto the mantilla of *Benedetta Canals* or the brick pink of the tights worn by *The Actor* (fig. 149); the pink that moves toward red on the dress of the *Woman with a Fan* (fig. 150) and blossoms into a flowered crown for *Boy with a Pipe* (fig. 181)—gradually, the icy blue made place for a warmer, more resonant palette, and the sordid themes disappeared in favor of portraits whose meaning remains a mystery. The earnest beauty of the *Woman with a Fan* and of the *Boy with a Pipe*, their calm solemnity sustained by the balanced composition, delivers a message that is at once pictorial and sensitive.

Picasso loved to attend the Médrano Circus with his friends Max Jacob, Guillaume Apollinaire, André Salmon, and Paul Fort,[23] but not for the colorful, noisy spectacle so much as for the actors—Harlequin, Pierrot, Columbine, and the acrobats and musicians flanked by their favorite animals. Seen from the wings, the world of acrobats (*saltimbanques*) had nothing spectacular to offer, but in a few paintings of acrobats practicing Picasso captured their skill and sense of balance (figs. 174 and 176). He observed them at intermission time, alone and absorbed in their thoughts (figs. 161 and 179), or with their families in the privacy of their dressing rooms (figs. 164 and 165). Color found its place again on his palette and gave voice to the vibrant harmonies of their costumes in either brilliant oil (fig. 180) or pale wash drawings (fig. 184). Abandoned in desolate landscapes, the *saltimbanques* came in pairs—the older acrobat in charge of the young one (figs. 166–168), the proven athlete in charge of the novice (fig. 176)—or they gathered together in compositions where they all played a role—the acrobat balancing on his ball, the mother rocking her child, a white horse passing by in the distance (figs. 172 and 176). These contrived scenes hide a certain mystery: "But tell me, who *are* these wanderers / even more transient than we ourselves,"[24] Rainer Maria Rilke asked himself in front of Picasso's great masterpiece *The Saltimbanques* (fig. 180). Might it be, as Reff has suggested, a symbolic portrait gallery in which Picasso himself, in Harlequin costume, holds a little ballerina by the hand, perhaps the child adopted by Fernande Olivier? Is she, the beloved, being kept away from the group by the men? The adolescent with the drum and his younger companion could well be André Salmon and Max Jacob. Guillaume Apollinaire, that disciple of body-building, is here betrayed by his enormous purple belly and jester's cap. These sad strolling minstrels are none other than Picasso's circle of friends.

181 *Boy with a Pipe,* 1905
182 *Tumbler with a Still Life,* 1905

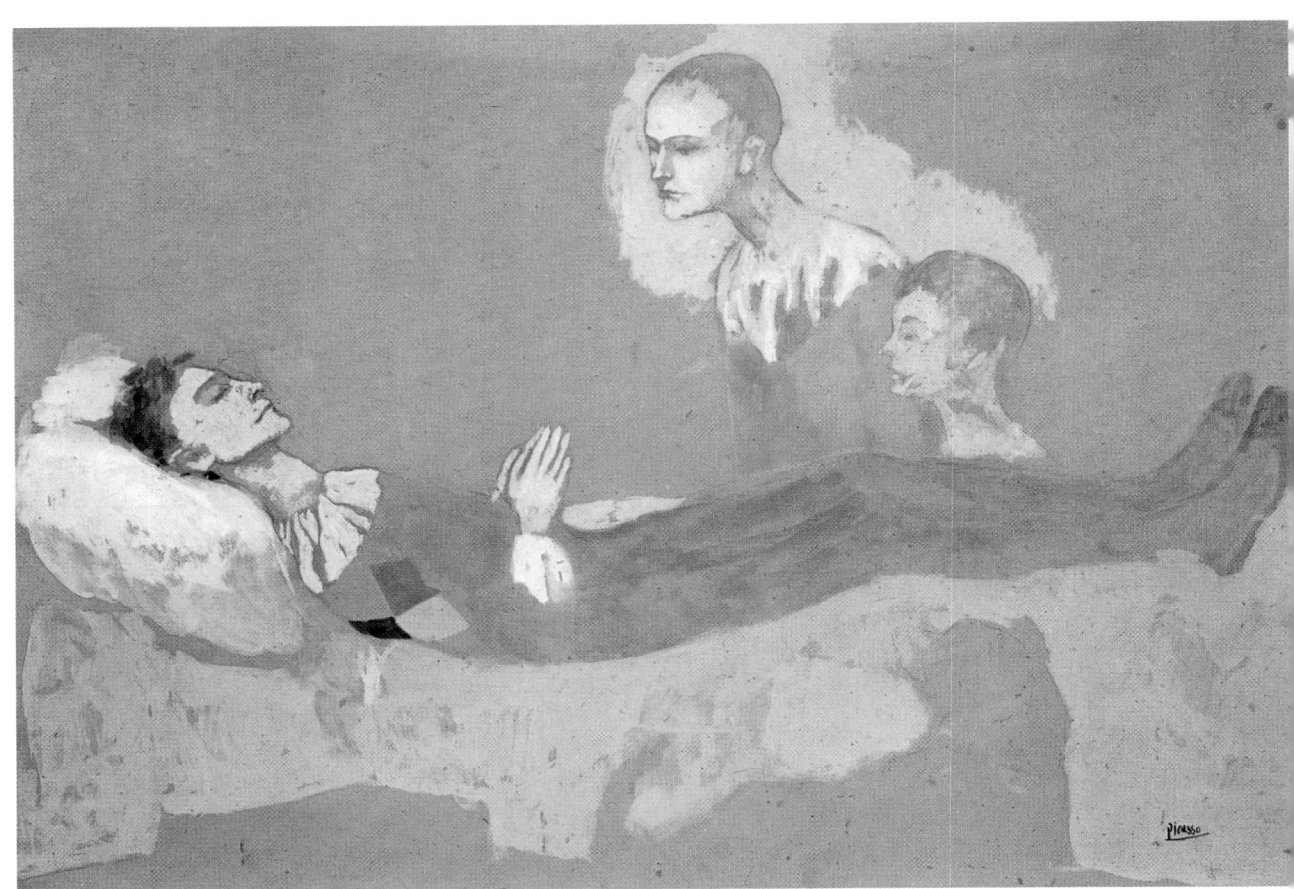

1906–1909

A Different Classicism

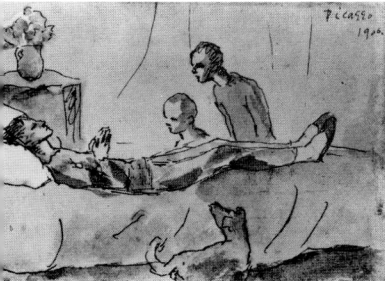

184

An intensely dramatic feeling, enhanced by a remarkably balanced composition, emanates from *The Death of Harlequin* (fig. 183), Picasso's 1905 gouache that brought the cycle of saltimbanque pictures to a close. The figures of the two slender boys bent over the bier would, however, be transplanted to Gósol, a mountain village near Andorra where Picasso settled for the summer of 1906, accompanied by Fernande Olivier. There, solidly planted on sturdy legs with hard, closed faces, nude bodies, and a classical stance, the boys have become Greek kouroi. The drum still binds them to the circus world (fig. 185), but in later pictures it disappears in a monochromatic emptiness that emphasizes the stylized, sculptural mass of the figures; the light pink that colored the acrobats has solidified in a smooth, matte application reflecting the ocher and gray tones of the soil of Gósol (fig. 187).

A brief Dutch escapade during the summer of the previous year had reconciled Picasso to the nude. The fleshy, sculptural shapes of the women of the Netherlands— Fernande liked to refer to their "armored waists"[1]—had inspired Picasso to paint one of the most beautiful nudes of his career (fig. 158). Here he has captured the fullness of the woman's physical presence in richly modeled forms, although at the expense of psychological expression. And in his painting of *Three Dutch Girls* (fig. 159), the young women seem to have met on the banks of a canal for no other purpose than to revive a classical theme, that of the Three Graces.

Upon his return to Paris from Holland in the fall of 1905, Picasso discovered the Salle des Fauves in the Salon d'Automne, as well as several exhibitions that would make a lasting impression on him, including retrospectives of the works of Manet and Ingres. Picasso was especially taken with Ingres's *Turkish Bath* (1862–63, Louvre),[2] and two works he started over the winter of 1905–6 and finished after he returned to Paris from Gósol in August 1906 reveal the great extent of his fascination with Ingres. In fact, the pose of Gertrude Stein (fig. 217) may have been modeled on the portrait of Monsieur Bertin (1802, Louvre), while Picasso's *La Coiffure* (fig. 200) owes everything to a pair of odalisques in *The Turkish Bath*.

The combined influences of Manet, Ingres, Gauguin, and Cézanne were to divert Picasso's attention for a time, as he sought a classical if nonconformist style based on solid forms and harmonious rhythms. Echoing *Riders on the Beach*,[3] painted by Gauguin in 1902, the drawings, watercolors, and oils Picasso had produced in the winter of 1905–6 were stepping stones in the development of *The Watering Place*, which was never finished. Remembering the warning of Ingres ("One must model in the round and without any interior detail"), Picasso captured the young Adonises and the bareback riders with a simple line that puts in relief their slow, deliberate movements, their air of unhurried repose. The central figure in the gouache of *The Watering Place (Arcadia)* (fig. 190) and the watercolor *Study for "The Watering Place"* (fig. 192) was used alone in a larger oil painting, *Boy Leading a Horse* (fig. 193). Because of the vacant look in the boy's eyes and the double line that delineates his muscular body, this figure has been compared by William Rubin to Cézanne's *Large Bather* (Museum of Modern Art, New York), but one may also regard the

183 *The Death of Harlequin,* 1906
184 *The Death of Harlequin,* 1906

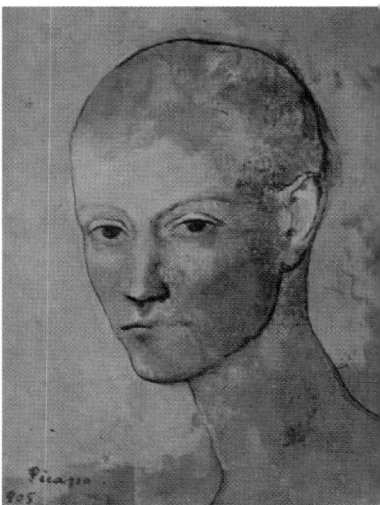

186

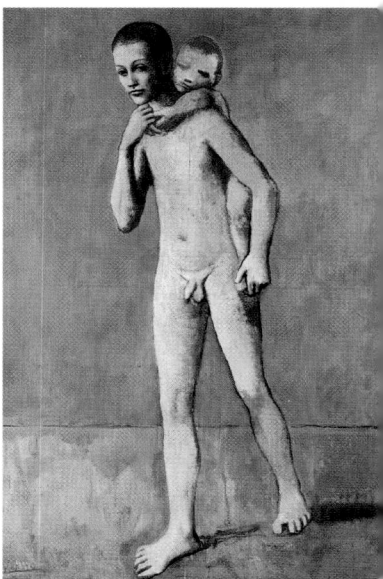

187

185

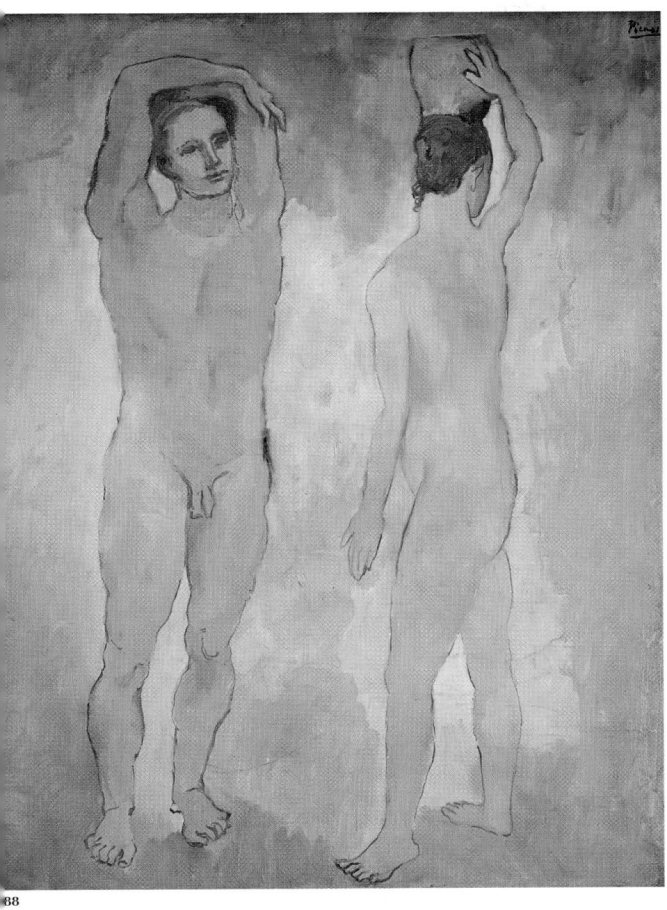

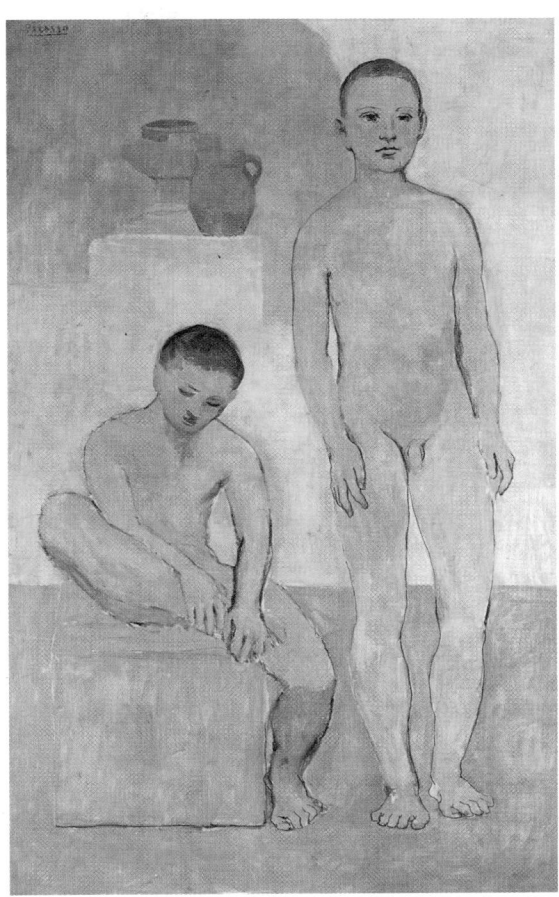

185 *The Two Brothers*, Spring 1906
186 *Head of a Young Man*, 1906
187 *The Two Brothers*, Spring–Summer 1906
188 *Two Youths*, Spring–Summer 1906
189 *Two Youths*, Spring–Summer 1906

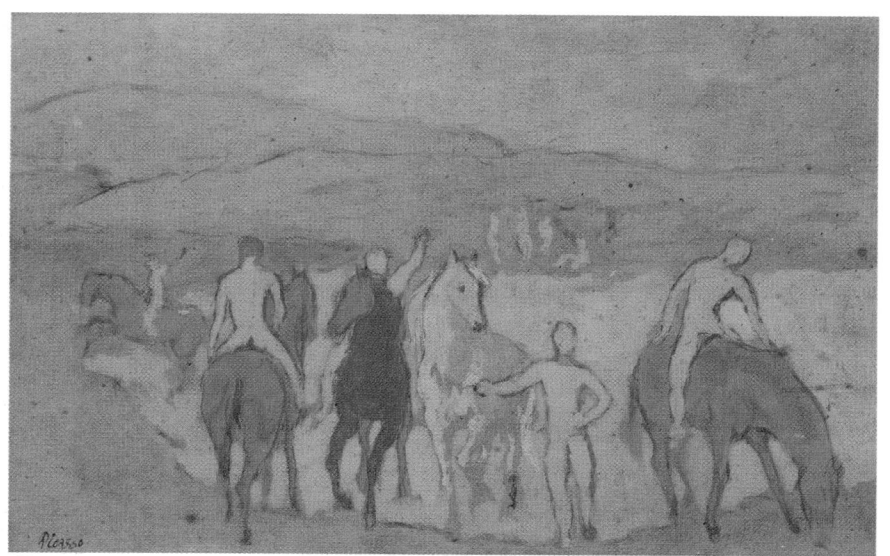

190

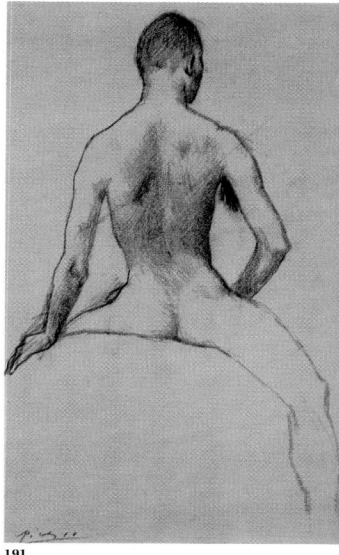

191

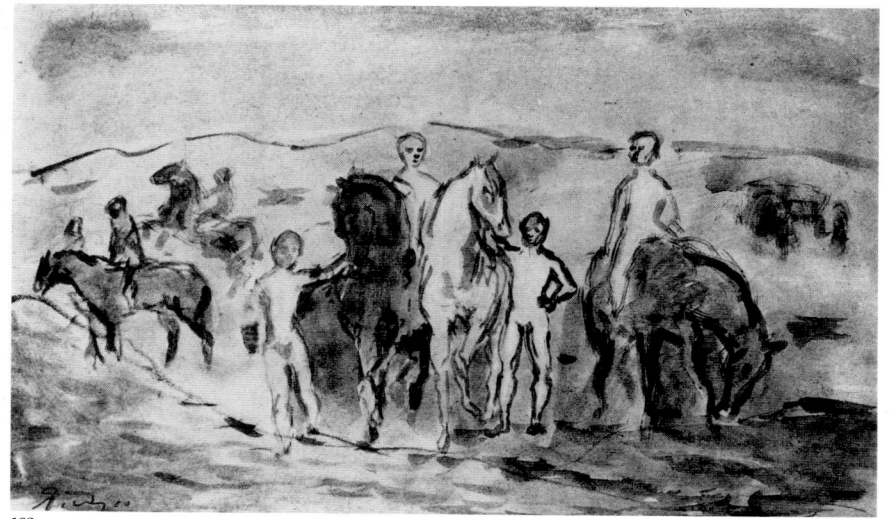

192

190 *The Watering Place (Arcadia),* Spring 1906

191 *Rider from the Back,* 1906

192 *Study for "The Watering Place,"* Spring 1906

193 *Boy Leading a Horse,* 1906

194 *Self-Portrait,* Spring 1906

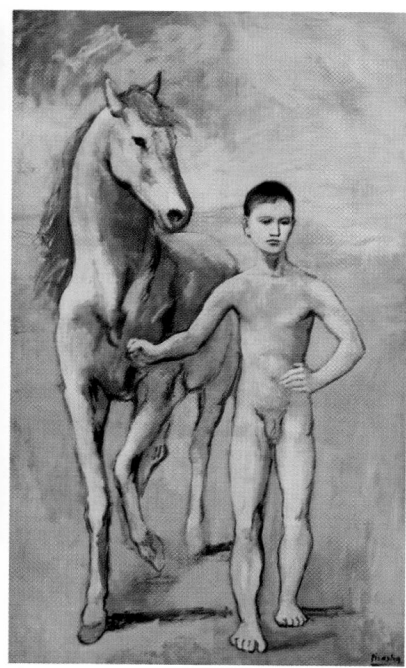

193

figure as a variation on the figures of Castor and Pollux holding the rearing horses in front of the Quirinal Palace in Rome. Following the example of Coustou and Géricault, other brilliant interpreters of the theme of a man leading a horse, Picasso has offered a version stripped of all mythological and allegorical references and all meaningful gestures in order to express his desire for calm and serenity.

The pictures Picasso painted in the solitude of Gósol in 1906 exemplify the absolute simplicity he achieved by removing all narrative, and they confirm the formal nature of his investigations. Unlike the paintings on Greek vases, these austere compositions have no subject; their only purpose is the unremitting study of the human body—standing upright in a contrapuntal pose, facing a double in a disconcerting game of mirrors. Picasso repeated indefinitely the same stocky form, "eyes filled with dark shadows and gazing nowhere,"[4] thereby warding off any psychological or emotional pitfalls. The nude was studied from every angle: standing with one foot forward and ready to advance; seated, in a variation of another classical model, the Spinario (a figure removing a spine from his foot; fig. 189); or with hands crossed above the head, like the odalisques of Ingres, or turning their back on us in a twisting pose that defies the laws of anatomy (fig. 188). Picasso's search, like Matisse's, for the quintessential line was a decisive step in the development of Cubism.

Based on a dialectical game of opposites, symbolized by a mirror, *La Toilette* (fig. 202) comes as a surprise in the middle of this monastic group, thanks to the directness of its color harmonies, which include bright red against turquoise blue. The mirror that appears in *La Coiffure* (fig. 200) has in *La Toilette* been passed into the hands of a servant whose sharp features resemble those of Fernande Olivier. Her statuelike pose contrasts with the relatively natural movement of the nude woman as she bends over to look at her reflection. Her attitude breathes a bit of life into her own luminous, sensuous body and into Picasso's composition of the two figures. There is an unusual charm in these Gósol works, which combine the observation of nature with the classical ideal. "This unpretentious and natural nobility of order and movement," which made Ingres and Puvis seem "vulgar and pale" to Alfred Barr,[5] is what completely transforms the haughty *Woman with Loaves* (fig. 195) into a noble caryatid and confers upon a peasant innkeeper (fig. 198), whose features are furrowed by toil and time, the proud bearing of an imperial Roman bust.

As if they were merely pretexts to provide rhythmic variations, the unconnected bodies caught in the intimate routine of bathing in *The Harem* (fig. 206) have been mounted like cinematic images and placed together end to end without any real coherence. Combining these figures had no real purpose other than the exploration of piled-up forms, as in Ingres's *Turkish Bath*. The shriveled hag at the back of the room, the colossus sitting as shamelessly as the fat odalisque to the right in Ingres's tondo, and the peasant meal, "an insult to the delicacy of the tea served on the low table of the *Bain Turc*" (Pierre Daix), remind us that this work, which leads the way to *Les Demoiselles d'Avignon,* is also a savage parody of Ingres's masterpiece.

Archaic Austerity

During the fall and winter of 1906–7, the works that would be later viewed as precursors of *Les Demoiselles d'Avignon* (fig. 253) were born. Earlier in 1906, Picasso had discovered in the halls of the Louvre Iberian sculptures that had recently been exhumed at the sites of Osuna and Cerro de los Santos, and through Gertrude Stein he saw a great deal of the Fauve painters Derain and Matisse, who greatly admired African masks. In October Picasso also visited an exhibition in the Salon d'Automne of ten paintings by Cézanne, who had just died. All of these experiences would radically change Picasso's art.

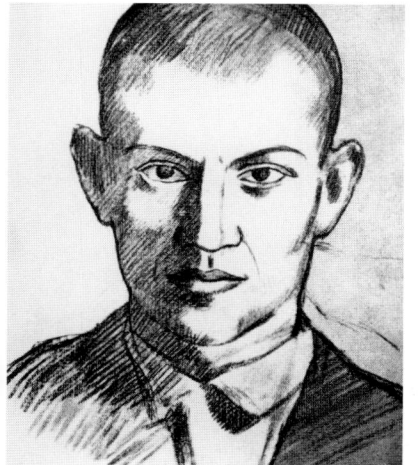

194

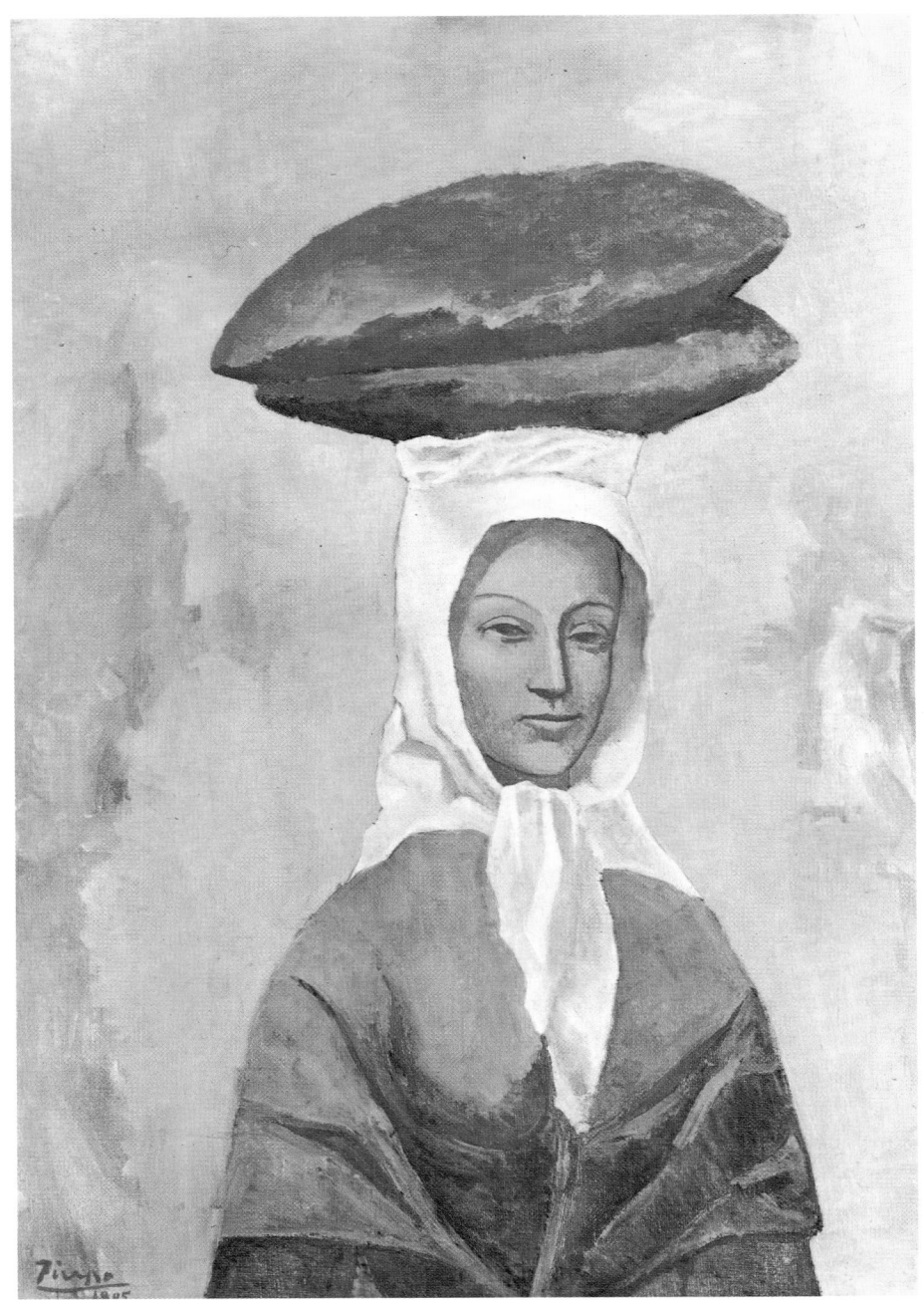

195

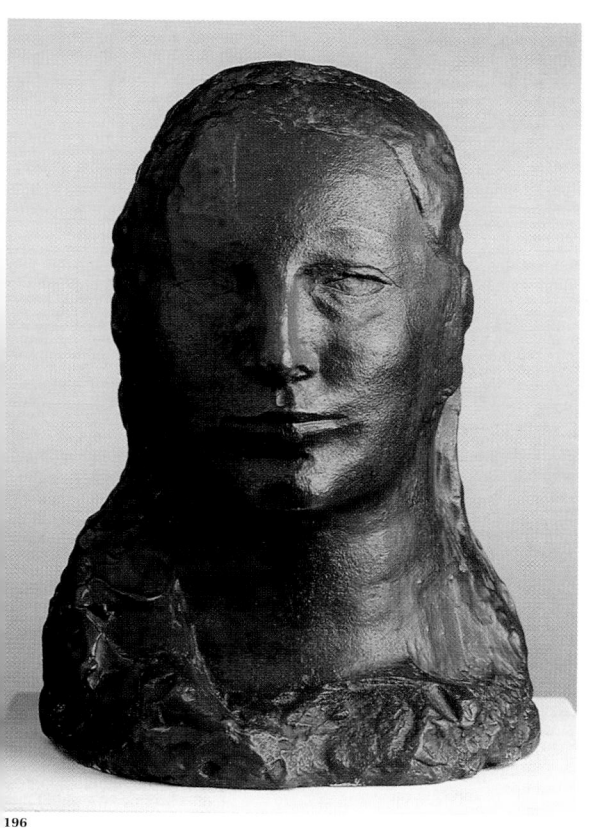

196

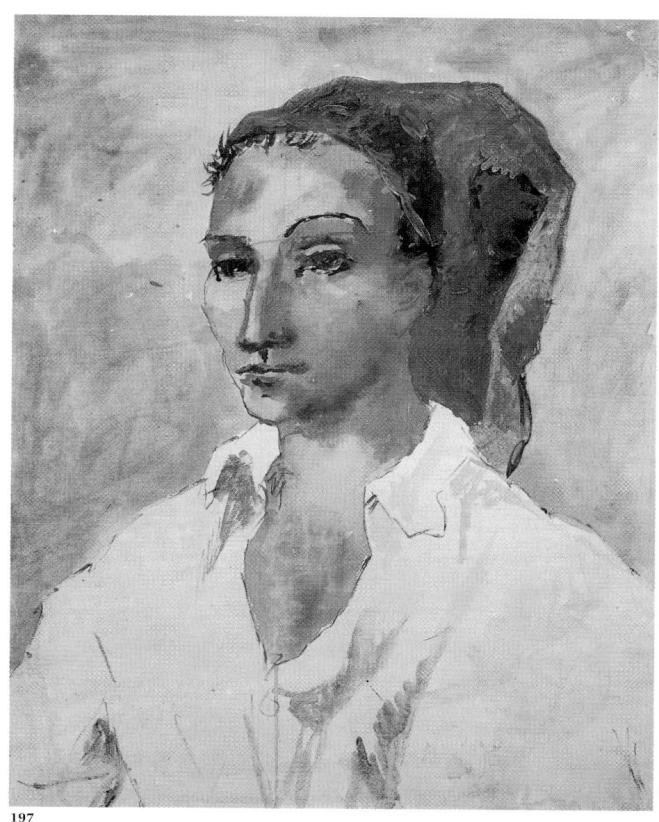

197

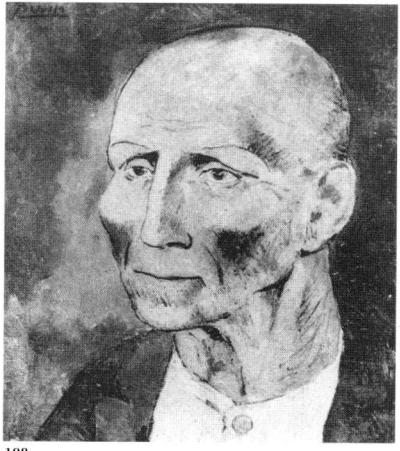

198

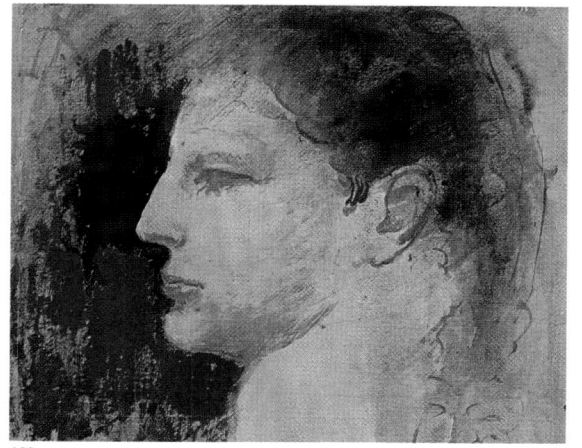

199

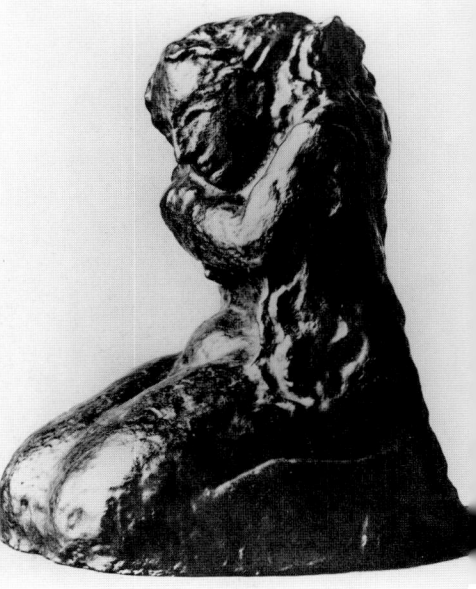

200

201

98

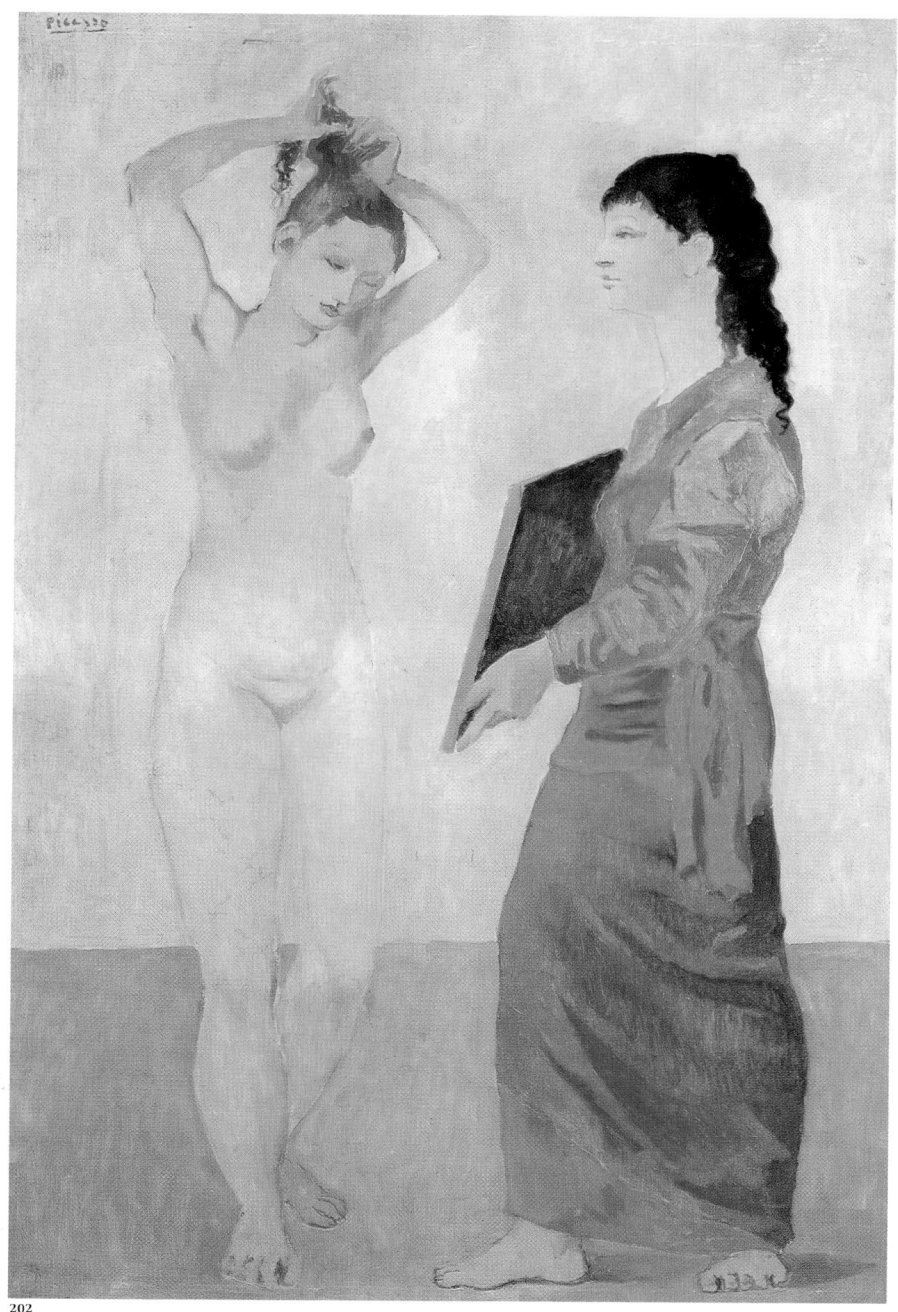

202

203

204

205

203 *Woman Washing Herself (Study for "The Harem"),* Spring–Summer 1906

204 *Woman Doing Her Hair,* Summer–Autumn 1906

205 *Kneeling Woman Doing Her Hair,* 1906

206 *The Harem,* Spring–Summer 1906

100

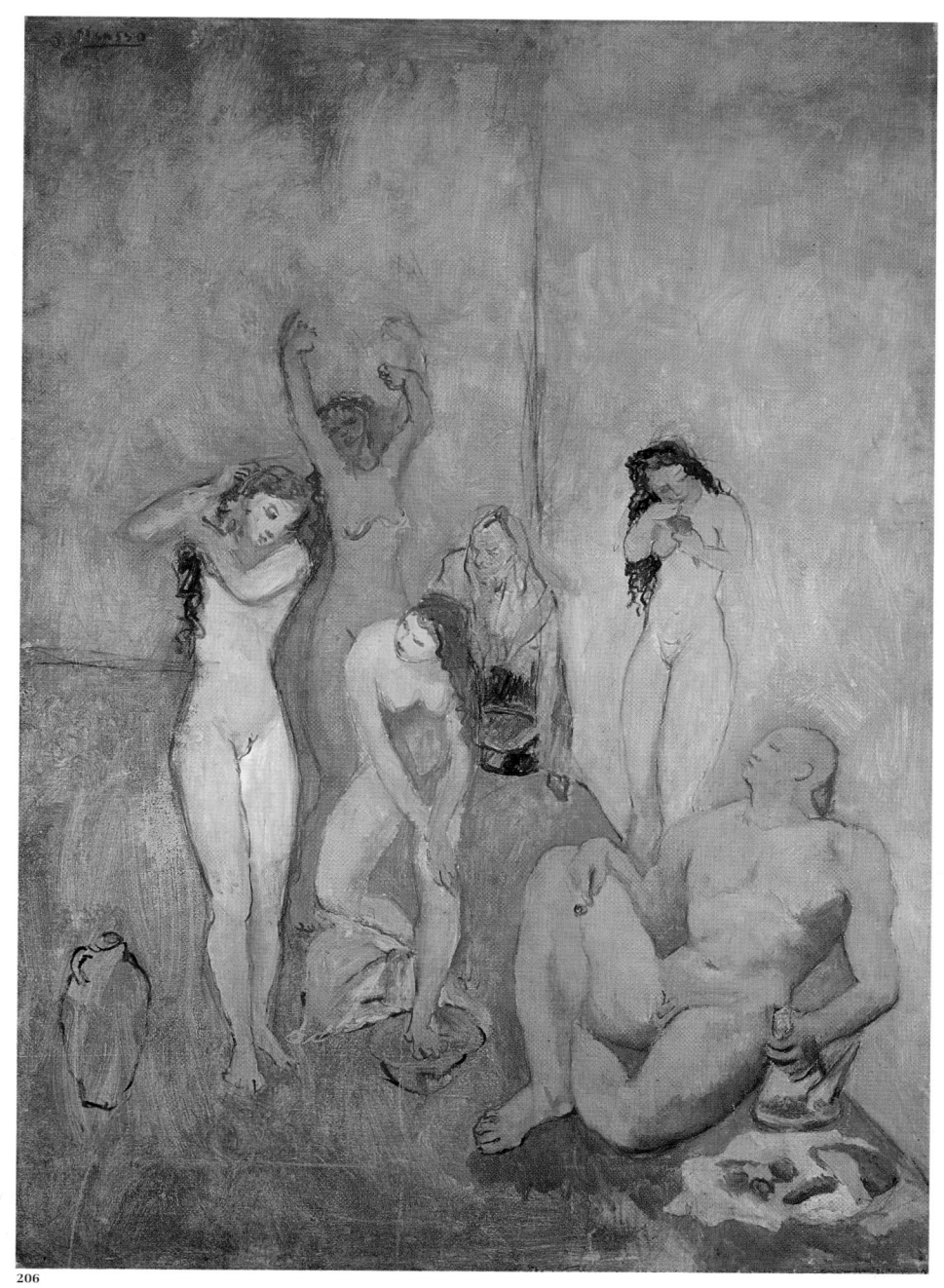

206

208

209

207

102

210

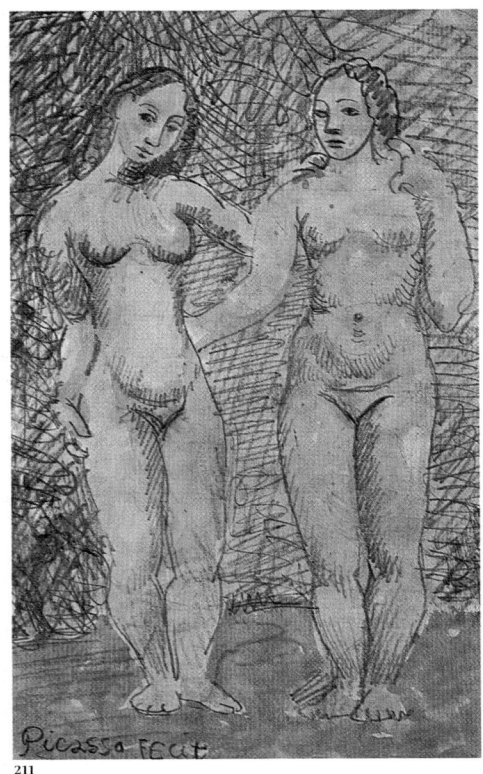

211

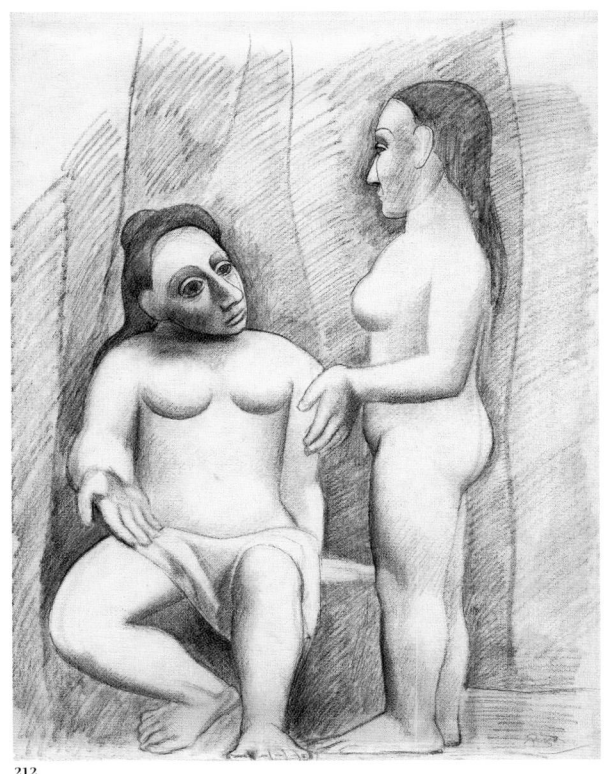

212

211 *Study for "Two Women Holding Each Other by the Waist,"* Summer–Autumn 1906

212 *Woman Seated and Woman Standing,* Autumn–Winter 1906

213 *Study for "Two Nudes,"* Autumn–Winter 1906

214 *Two Women Holding Each Other by the Waist,* Summer–Autumn 1906

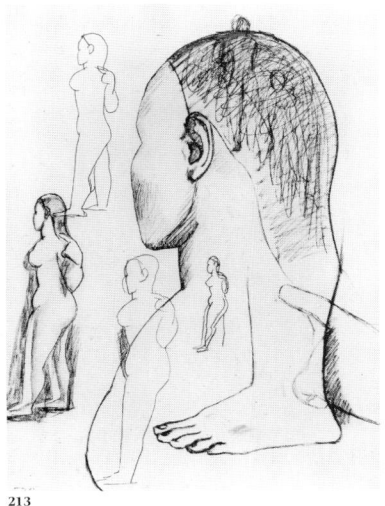

213

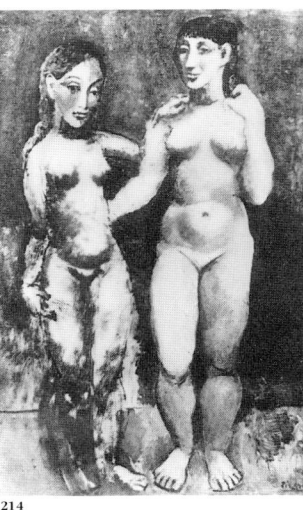

214

104

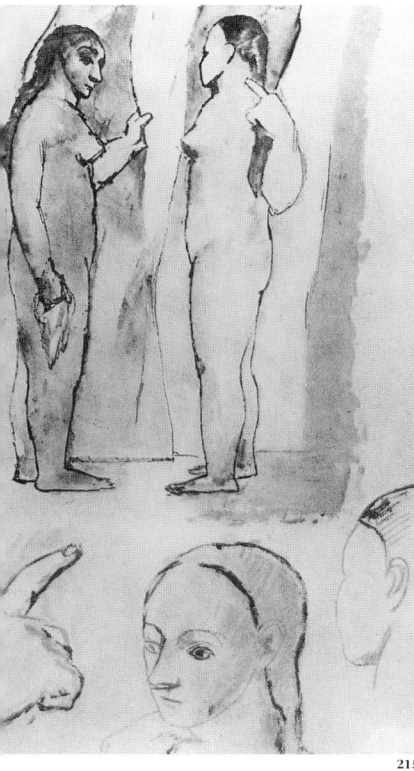

215

216

215 *Study for "Two Nudes,"* Autumn–Winter 1906
216 *Two Nudes,* Autumn–Winter 1906

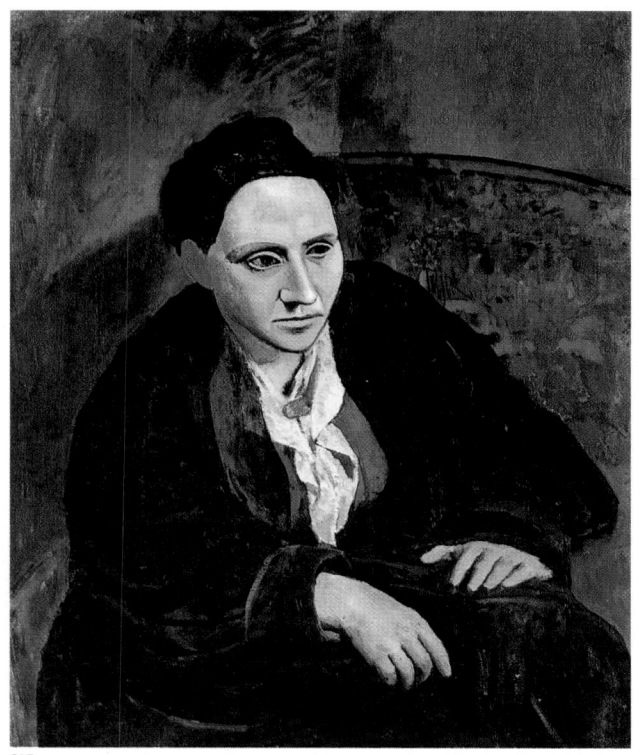

217

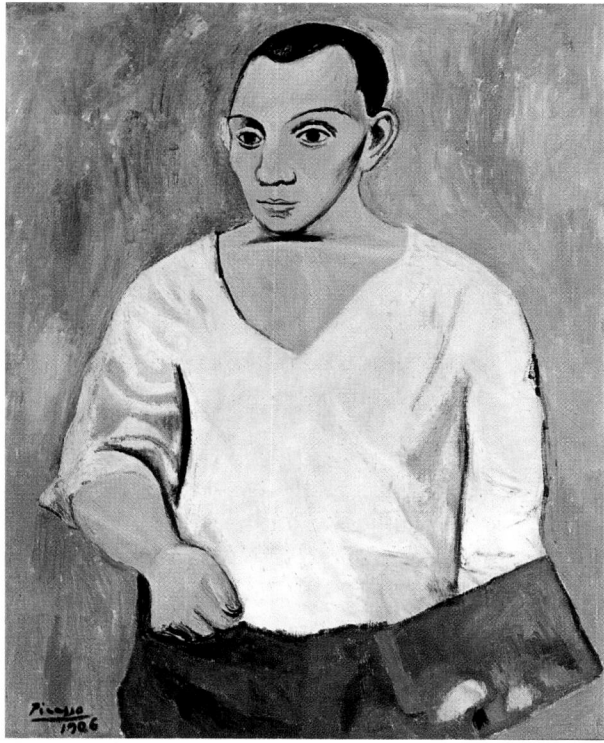

218

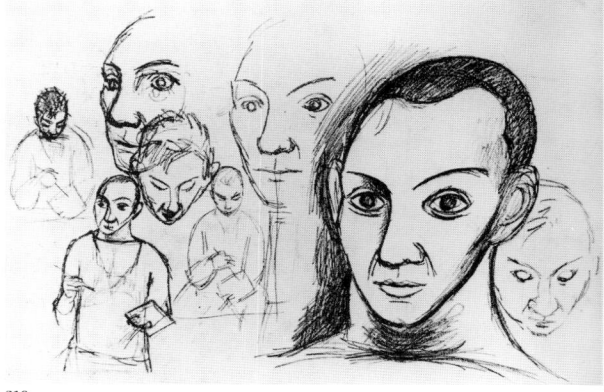

219

217 *Portrait of Gertrude Stein,* Spring–Summer 1906
218 *Self-Portrait with Palette,* Spring–Summer 1906
219 *Studies for Self-Portraits,* Summer 1906

He performed a great coup when he repainted the head in the portrait of Gertrude Stein[6] (fig. 217) on his return from Gósol, for its unfinished state had never ceased to torment him: "I no longer see you when I look at you," he had admitted at the time of her last sitting. Away from museums and from Stein, he practiced simplifying forms in the faces of the Gósol women in order to attain their essence. Paradoxically, the clean, nearly geometric version Picasso made in his final rendition of Stein's face expresses the authoritarian, masculine, and intellectual character of the woman-master of modern art far more accurately than the relatively realistic portrayal it replaced.

Fernande's fine features, which Picasso had cast in bronze for the first time in 1906 (fig. 196), were to undergo the same treatment. Wishing to explore the use of archaic stylization, he found inspiration in the stone face of the *Man Attacked by a Lion* from Osuna. He flattened the oval of Fernande's face and replaced her lively, almond-shaped eyes with heavy lids devoid of expression. The sullen mouth, prominent cheekbones, protuberant ears, and even the complicated twisting gesture that pushes her chin into the hollow of her elbow and presses her body into itself all refer to the Iberian model (figs. 203–5). The use of this gesture in an image of monumental, solid form constitutes a tour de force that marks his definitive break with the naturalism he had brought to the same subject only weeks earlier (fig. 199).

As was his habit, Picasso would try out his new vocabulary on his own features. In this respect, it is useful to compare the blue self-portrait of 1901 (fig. 83) with the pink one of 1906 (fig. 220). The effects of pathos and fine technique, which weigh down the earlier picture, have become an austere image deprived of personality, since the painter has given himself the features of his Iberian ancestors: the rimmed eyes of the mask are emphasized by the immense arch of the eyebrows, the bony nose, and oversized ears. The head fits onto a cylindrical neck, which is lengthened by a solidly constructed torso. One can understand why Picasso never wanted to sell this portrait. What more beautiful symbol of his second artistic birth than this virginal image in which he represented himself as naked as a newborn child!

Responding as well to Cézanne, who advocated the virtue of a formal geometry, Picasso used this new approach, far removed from reality, to depict men, women, and children alike (figs. 219, 221, and 222), and he did not back away from deformity. Viewing his superb *Self-Portrait with Palette* (fig. 218), one is struck by the harsh simplification of the face swallowed up by immense eyes (which perhaps owe something to Romanesque Catalan painting) and attached to a body reconstructed with a distorted, foreshortened perspective. This is surely the pinnacle of Picasso's "purely conceptual way of working" (as William Rubin put it), clearly indebted to his innate mastery of the art of caricature.

Les Demoiselles d'Avignon

Poking fun at himself in 1941, Picasso remembered, through the words of Gros Pied, one of the characters in his six-act play *Desire Caught by its Tail*,[7] that "the *Demoiselles d'Avignon* had already earned thirty-three years of private income." Was he doubtful about their permanence? To tell the truth, after more than ninety years these old ladies have still not lost any of their charm. Even an exhaustive study[8] of the astonishing mass of preliminary studies (at least a thousand in number) failed to diminish the mystery surrounding this work and the fascination it continues to hold.

To begin with, we have the notebooks. In the fall of 1906, in his studio at Bateau-Lavoir, Picasso began to fill the pages of a thick notebook with quick sketches of robust female nudes in motion seen alternately from the front, the back, and in profile, their faces with vacant Iberian eyes carefully worked. During the winter, a second notebook,

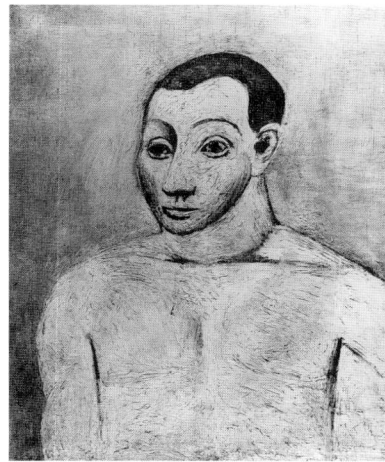

221

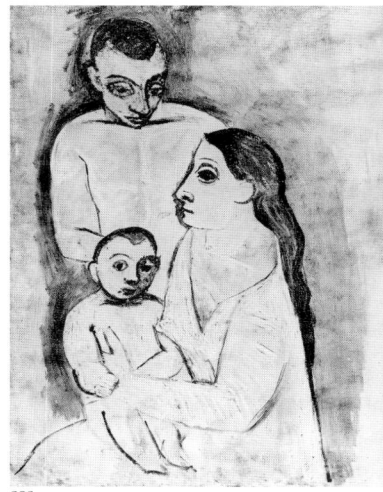

222

220

220 *Self-Portrait as a Boy,* Summer 1906
221 *Self-Portrait,* Autumn 1906
222 *Man, Woman, and Child,* Autumn 1906
223 *Nude Boy,* Autumn 1906

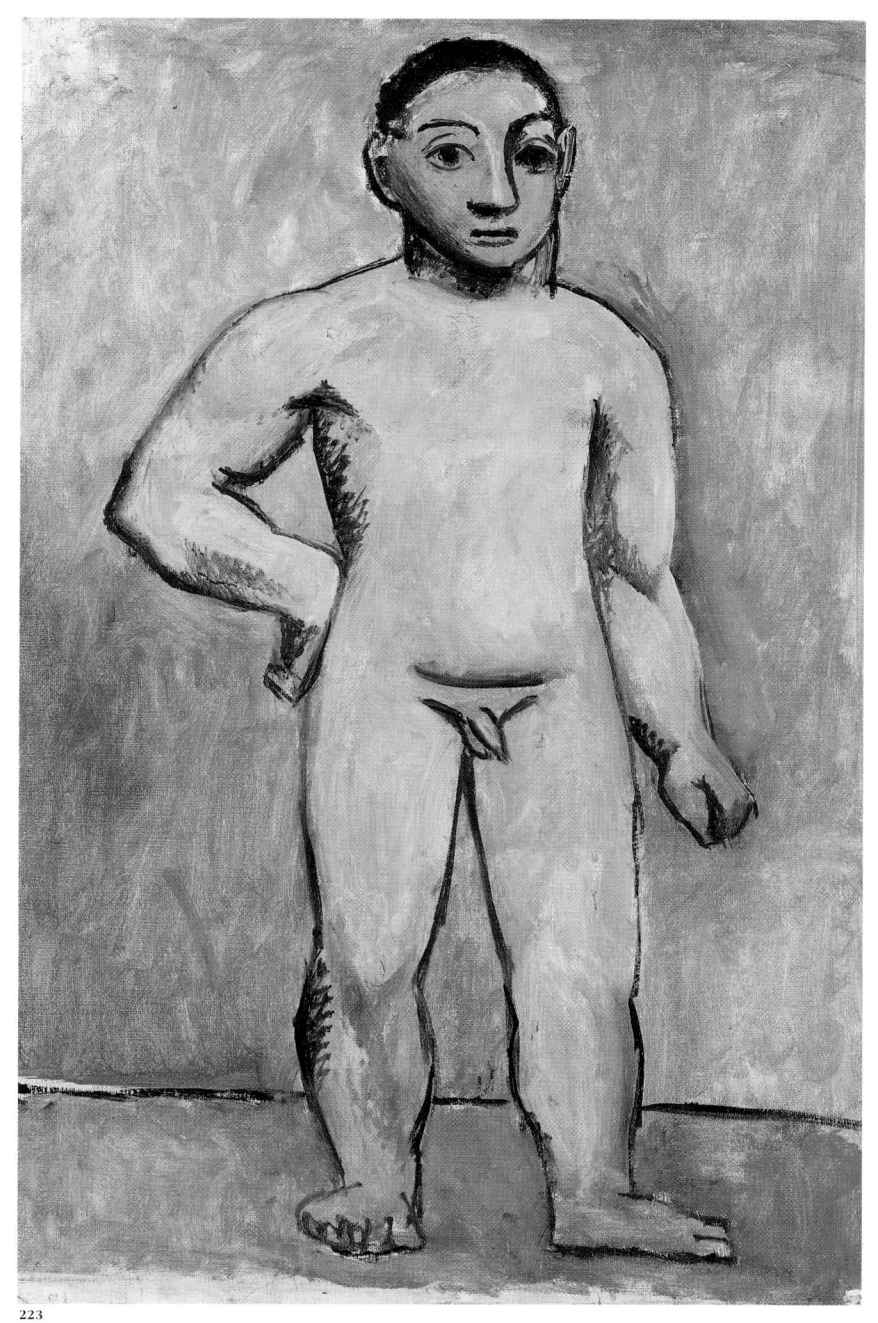

223

relatively small and handsomely bound in red cloth, succeeded the first one. This time, using pencil and red ink, Picasso focused on a strange pair of figures—a seated woman, posed with one leg high across the knee of the other, facing her twin sister, who with her back to us and her legs spread wide, possesses the same stocky Iberian-African form and face. This rather masculine pair in different poses (echoing the imposing mass and imperious expression of Gertrude Stein) was the subject of a series of drawings (figs. 212 and 215) that led to two painted versions; one (fig. 216) depicts the two women separated by a draped cloth, a device Picasso would often use again, and the other (fig. 231) isolates the seated woman, emphasizing her athletic musculature. By this time, Picasso already had the bordello in mind as a subject, since in the center of this notebook appears the first group composition (fig. 240), in which, in spite of the nervous line, one can make out seven figures packed tightly together in a space closed off by drapery. Over the next few months—the first painted version is dated June 1907—he would perfect each figure with meticulous care on the pages of some fifteen notebooks, as well as on loose sheets and oil sketches on canvas or cardboard.

A third notebook contains simpler compositions, which shed even more light; on several pages five nude women are gathered around a seated man, to whom they pay no attention, although they seem to be welcoming a man who enters from the left (fig. 240). The man in the middle of some drawings is clearly a sailor, next to whom is a plate of sliced watermelon; the young man over whom they fuss raises the drapery with one hand and clutches his books (or occasionally a skull) in the other. Toward the end of his life, Picasso identified this enigmatic character as a medical student, thereby destroying the allegorical aura that surrounded the significance of the skull for many years. The prosaic nature of the scene is balanced by the meticulousness with which Picasso tackled the anatomy in this series of sketches—at first buxom (fig. 251) and then slender and geometric—with a pen that censured every detail and streamlined every form with parallel or perpendicular strokes (figs. 242–249). In the spring of 1907, he decided to eliminate one female figure, the one who formerly stood at the left leaning on the chair of the seated woman, and he changed the sex of the medical student; all it took was for a shoulder to become a breast and for hair to come flowing down his back and there he was, now a woman! The composition, still dominated by the caryatid with her arms above her head, was tightened into a square, somewhat higher than wide, which presages the format of the final painting. In June Picasso decided to do away with the last surviving male figure, and so the sailor disappeared, leaving the women to themselves, frozen within the dense folds of the drapery that had become one with their bodies. Their fully exposed flesh and intense eyes, ostensibly turned toward the spectator-voyeur, no longer leave any doubt as to their identity (fig. 252). These certainly are whores, probably drawn from the artist's memory of a brothel on the rue d'Avignon in Barcelona. A slightly shocked Wilhelm Uhde would find an "Assyrian look" in these figures, as well as Iberian stylization. The flat shapes of the deformed bodies are merely suggested by the spaces between the lines—while their faces, reduced to masks, are dominated by noses shown in profile, schematically drawn ears, and bulging eyes.

What impulse led Picasso to decide one month later to touch up the faces of the two girls on the right, thereby transforming them into African masks? Was it his discovery of the collections of so-called primitive art in the Ethnographical Museum at the Trocadéro? Years later he would confirm in a statement to André Malraux that this was the original source of this influence: "All alone in that awful museum with masks, dolls made by redskins, dusty manikins. *Les Demoiselles d'Avignon* must have come to me that very day, but not at all because of the forms; because it was my first exorcism painting, yes absolutely!"[9] Picasso thus retained the essence of the lesson of African art, namely the importance of ritual, with which the *Demoiselles* is saturated.

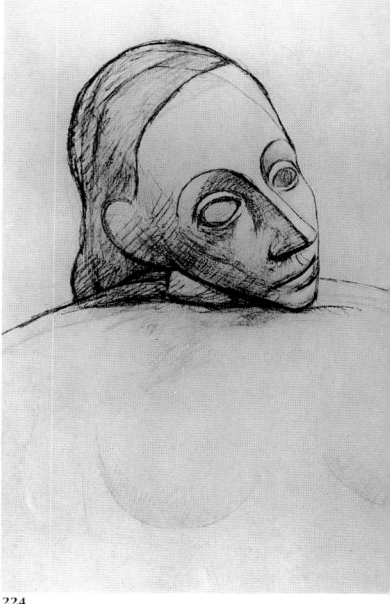

224

224 *Woman with Inclined Head,* Winter 1906–7
225 *Portrait of Max Jacob,* Winter 1907
226 *Bust,* Spring 1907
227 *Bust of a Man,* Spring 1907
228 *Self-Portrait,* Spring 1907
229 *Head of a Woman or a Sailor,* Spring 1907
230 *Head of a Woman,* Spring–Summer 1907

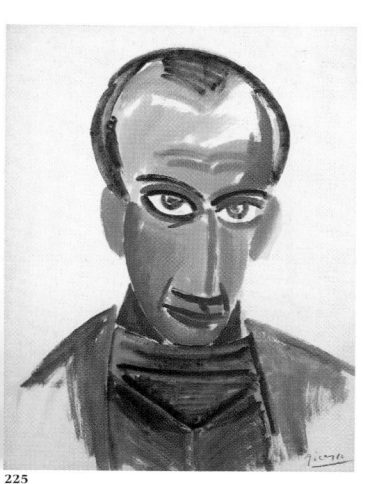

225

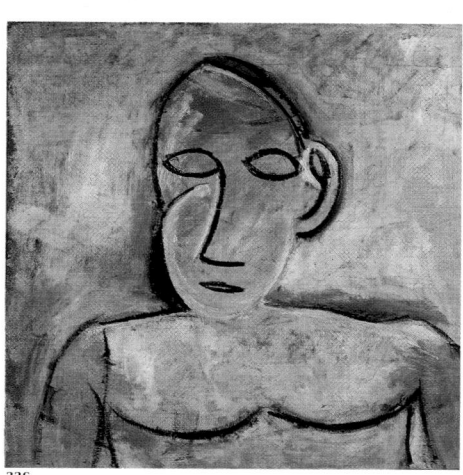

226

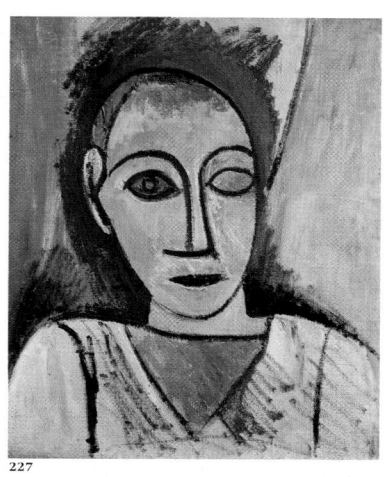

227

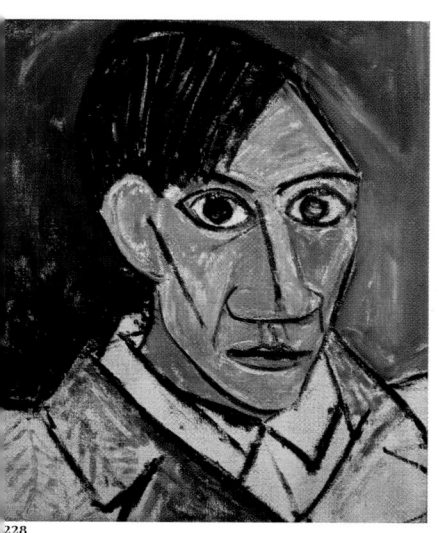

228

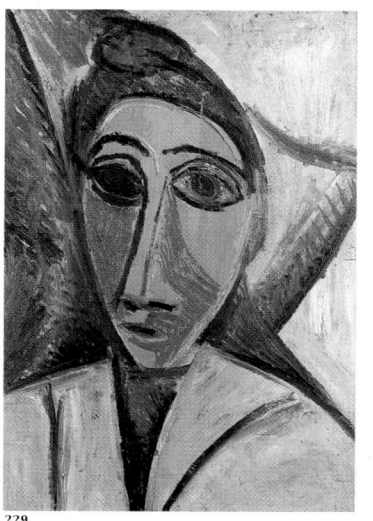

229

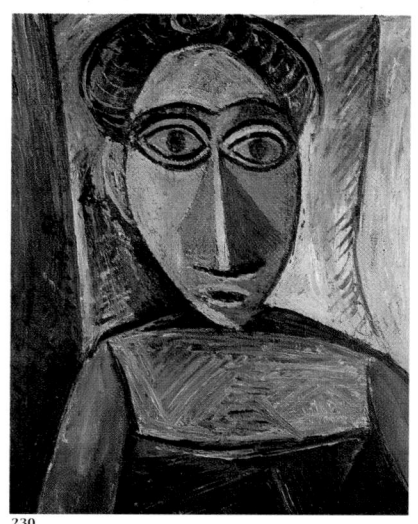

230

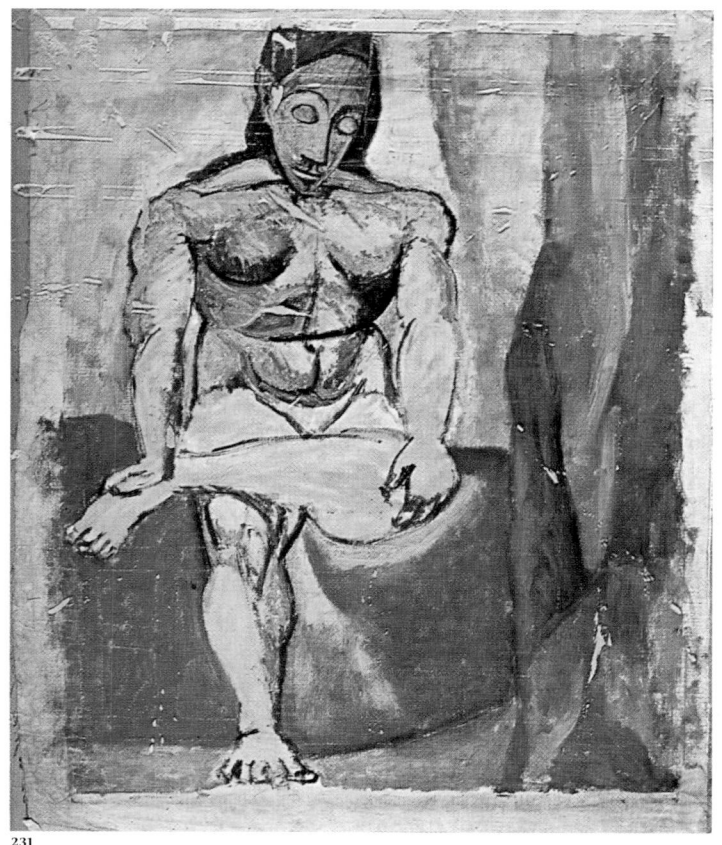

231

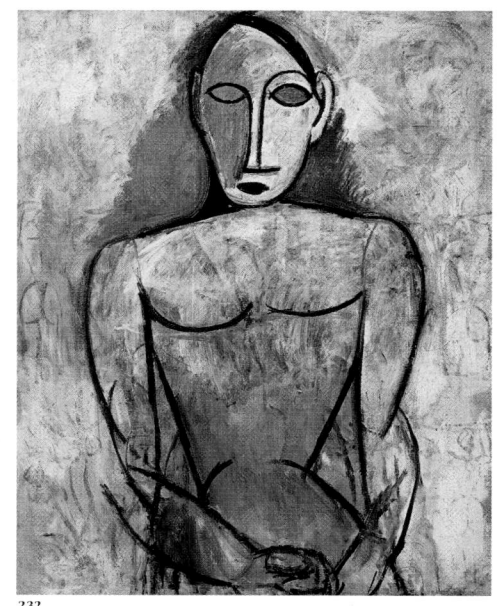

232

231 *Seated Woman Holding Her Foot,*
Spring 1907

232 *Bust of a Woman with Clasped Hands,*
Spring 1907

233 *Small Nude with Raised Arms, Back View*
(Study for "Les Demoiselles d'Avignon"),
Spring 1907

234 *Nude with Raised Arms, Front View*
(Study for "Les Demoiselles d'Avignon"),
Spring 1907

235 *Nude with Raised Arms, Back View*
(Study for "Les Demoiselles d'Avignon"),
Spring 1907

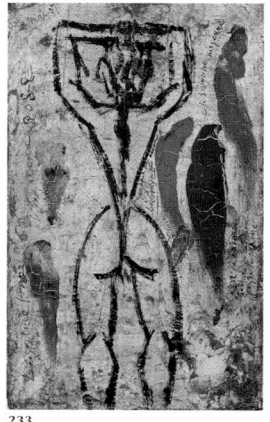

233

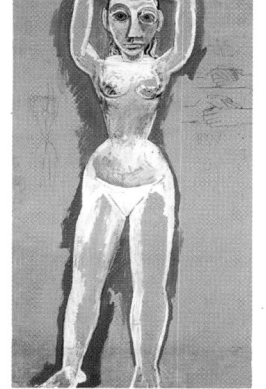

234

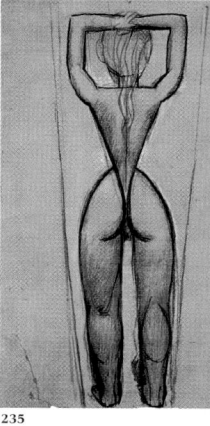

235

112

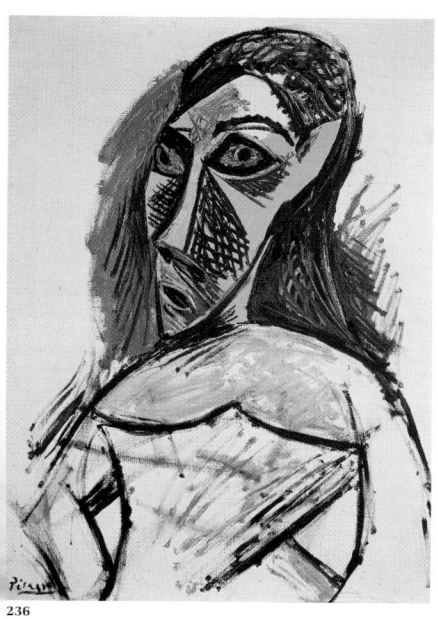

236

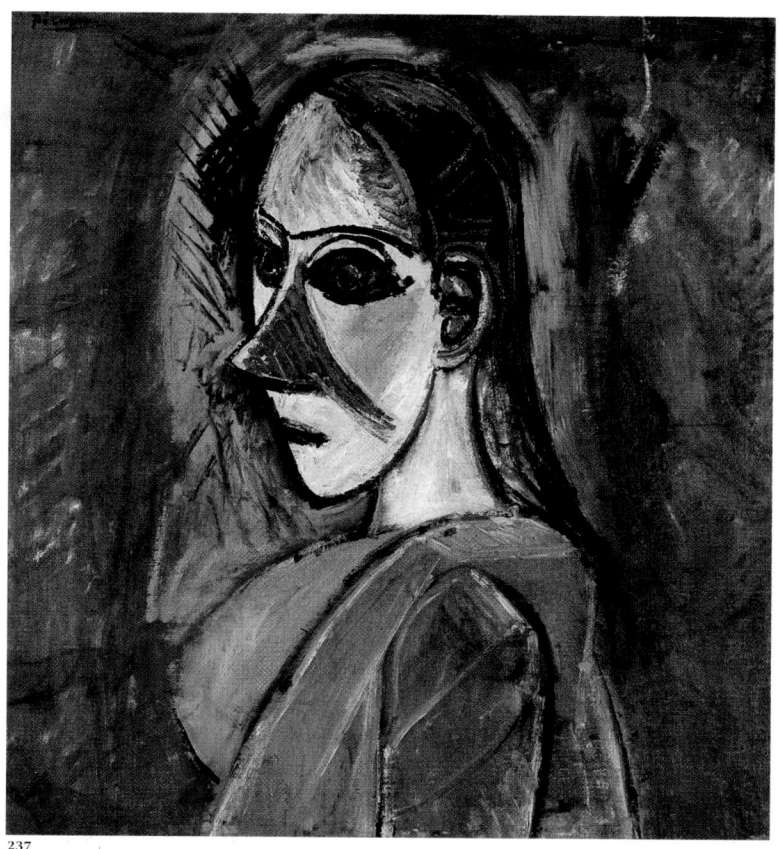

237

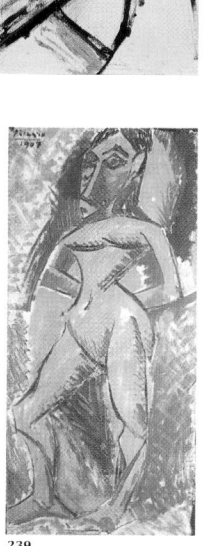

238238

239

236 *Bust of Woman (Study for "Les Demoiselles d'Avignon"),* Spring–Summer 1907
237 *Bust of a "Demoiselle d'Avignon,"* Summer 1907
238 *Moving Face,* Summer 1907
239 *Standing Nude,* Spring 1907

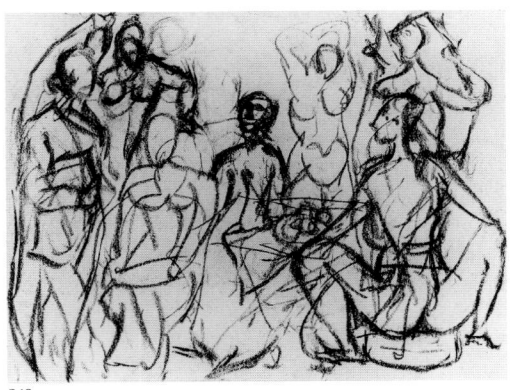

240

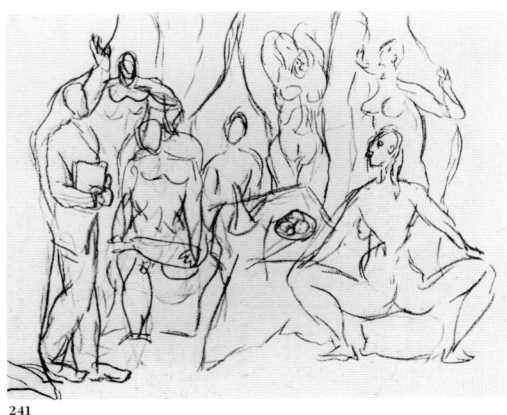

241

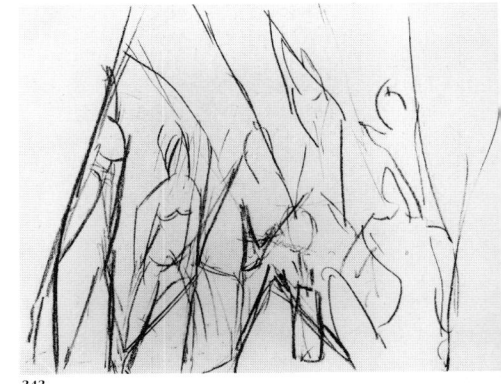

242

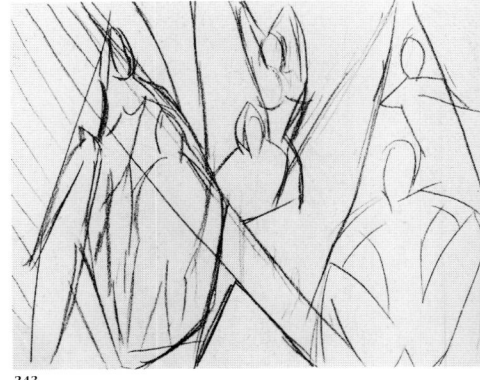

243

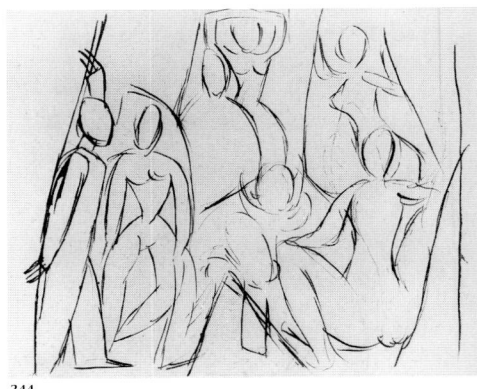

244

240 *Study for "Les Demoiselles d'Avignon,"* Winter 1906–7
241 *Study for "Les Demoiselles d'Avignon,"* March 1907
242 *Study for "Les Demoiselles d'Avignon,"* March 1907
243 *Study for "Les Demoiselles d'Avignon,"* March 1907
244 *Study for "Les Demoiselles d'Avignon,"* March 1907
245 *Study for "Les Demoiselles d'Avignon,"* May 1907
246 *Study for "Les Demoiselles d'Avignon,"* May 1907
247 *Study for "Les Demoiselles d'Avignon,"* May 1907
248 *Study for "Les Demoiselles d'Avignon,"* May 1907
249 *Study for "Les Demoiselles d'Avignon,"* May 1907
250 *Study for "Les Demoiselles d'Avignon,"* May 1907

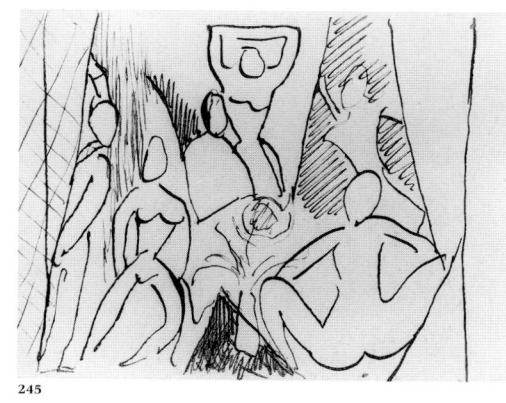

245

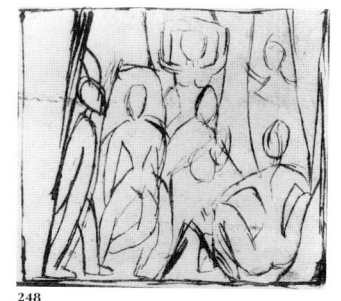

248

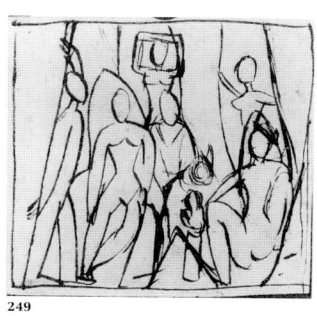

249

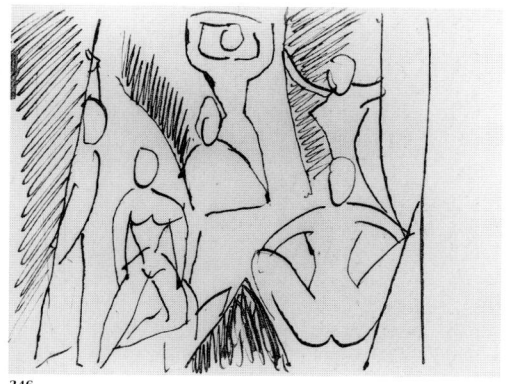

246

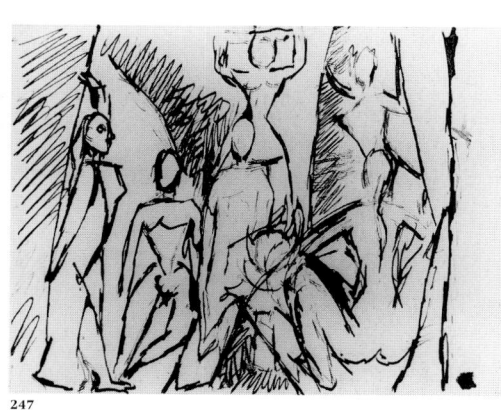

247

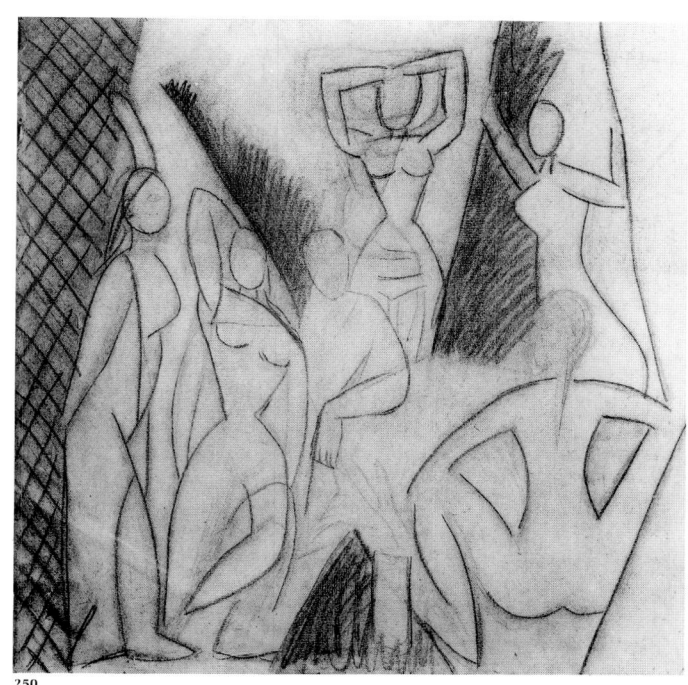

250

115

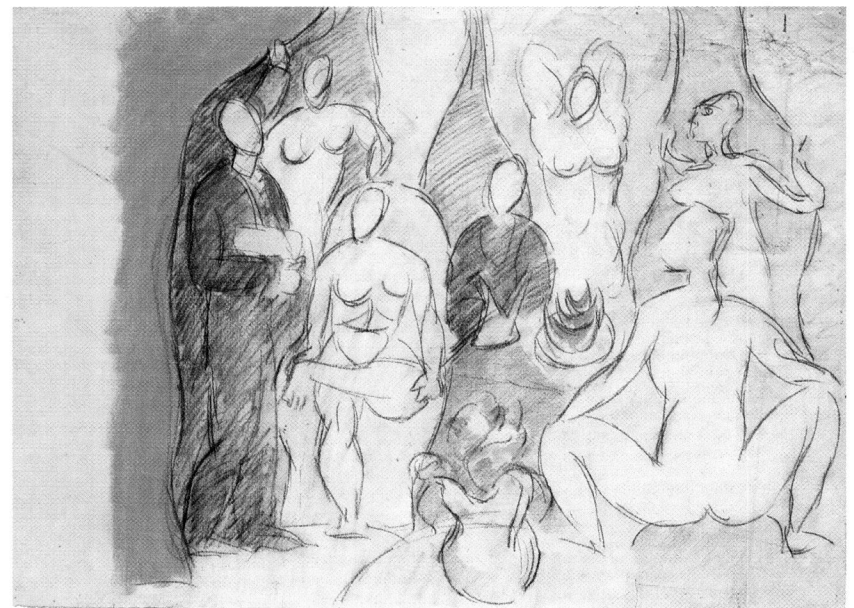

251

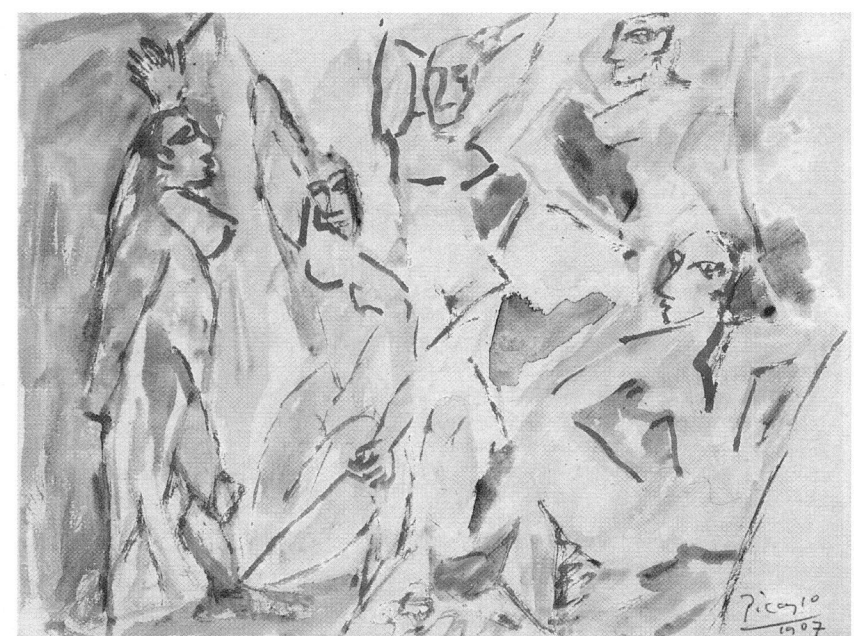

251 *Study for "Les Demoiselles d'Avignon,"* March–April 1907

252 *Study for "Les Demoiselles d'Avignon,"* June 1907

253 *Les Demoiselles d'Avignon,* June–July 1907

252

116

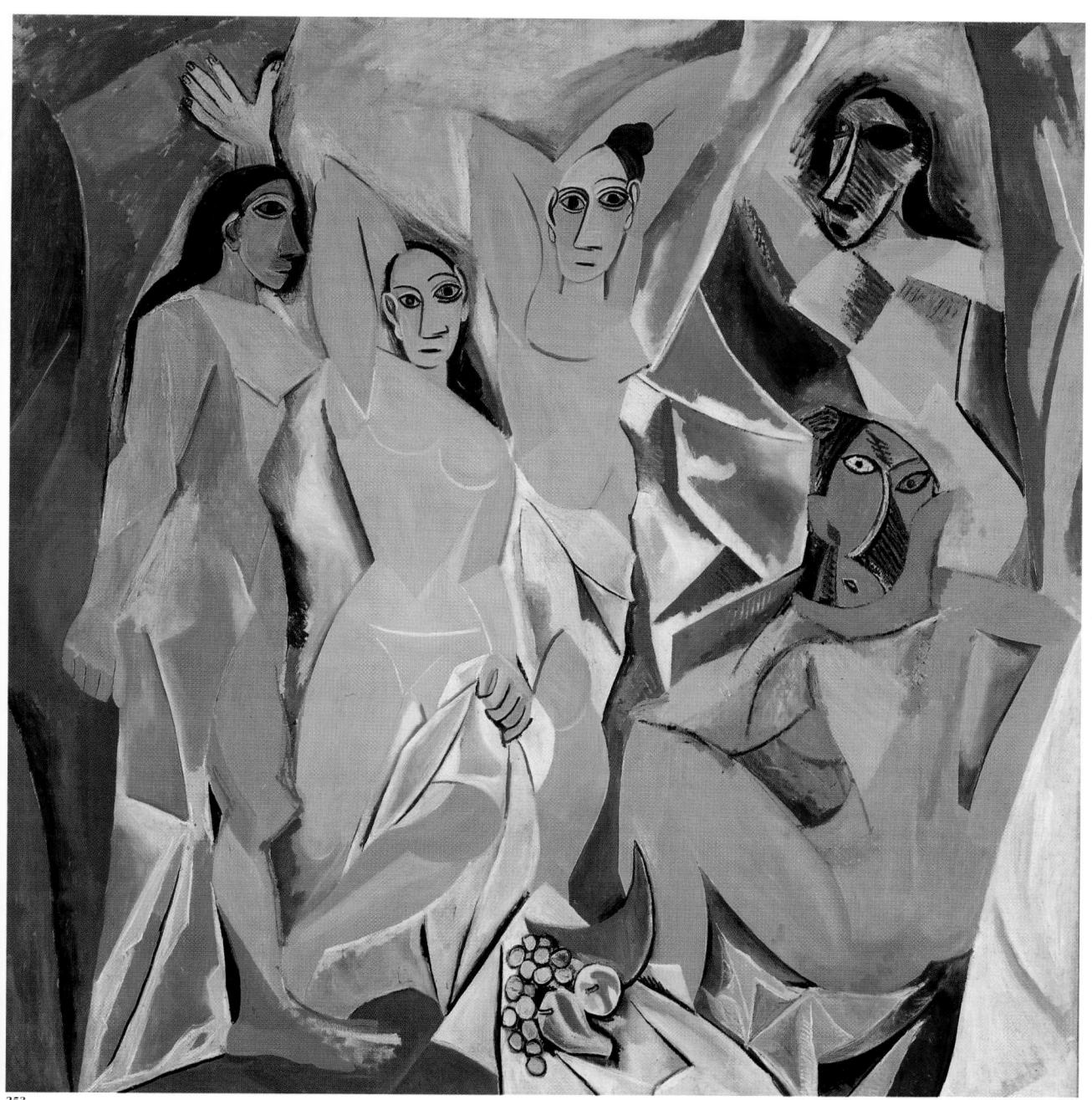

254

255

256

What is it, other than the misfortune of being women, or worse, whores in Barcelona's port, that these bodies convey to us, in their incredible contortions, their faces scarified by vivid colors and pierced by black eyes? In spite of the figure with the death's head, a virtuous reminder of the vanity of earthly pleasures, which for a long time gave priority to the interpretation of the *memento mori,* Leo Steinberg's thesis[10] that this work is a sexual metaphor hits the mark. An "exorcism painting, yes absolutely!" in the face of the inherent anguish over love and death.

The Affirmation of Primitivism

Georges Braque said in regard to the *Demoiselles* that to paint like this was like "drinking petroleum or eating hemp," and Derain predicted that one day Picasso would be found "hanged behind his great canvas"; even Matisse did not let up in front of "the abominable shapeless mess"[11] so deplored by Leo Stein, Gertrude's brother.

A young man, recently arrived from his native Germany, was one of the rare people who greeted the quality and the importance of Picasso's painting with enthusiasm, an intuition that would establish Daniel-Henri Kahnweiler[12] forever—or nearly so—as his new dealer and friend. At the same time, Picasso remained indifferent to all the sarcastic remarks and may even have been stimulated by his friends' lack of understanding; in any event, he persevered in following the difficult road that was to lead him to Cubism. Picasso turned everything that was in the air at this time to his advantage—

254 *Standing Nude,* Spring 1907
255 *Standing Nude,* 1907
256 *Verso of fig. 255,* 1907
257 *Figure,* 1907
258 *Small Seated Nude,* Summer 1907
259 *Mother and Child,* Summer 1907
260 *Face,* Autumn 1907
261 *Head,* Autumn 1907

118

257

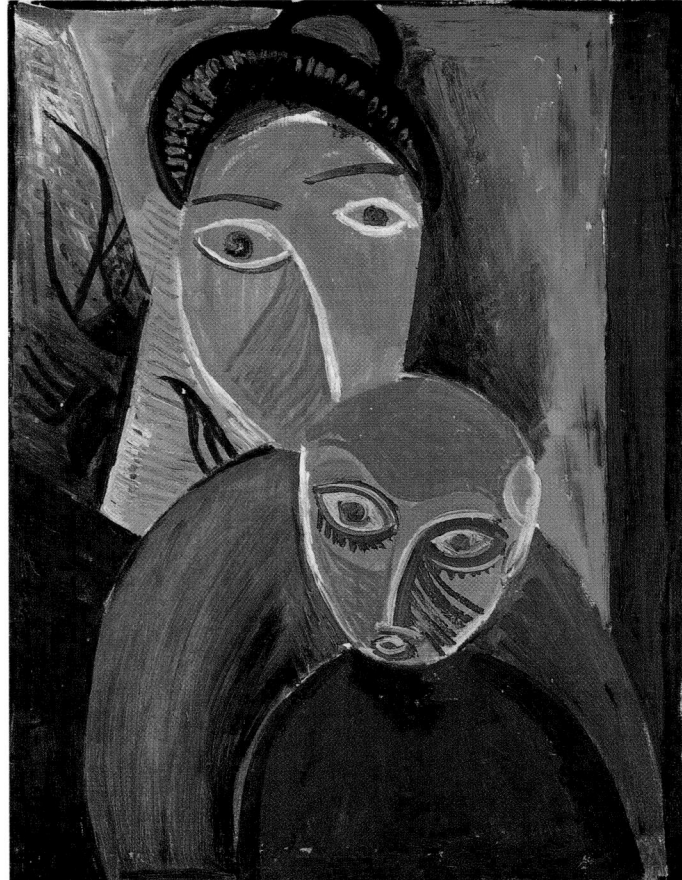

259

258

260

261

119

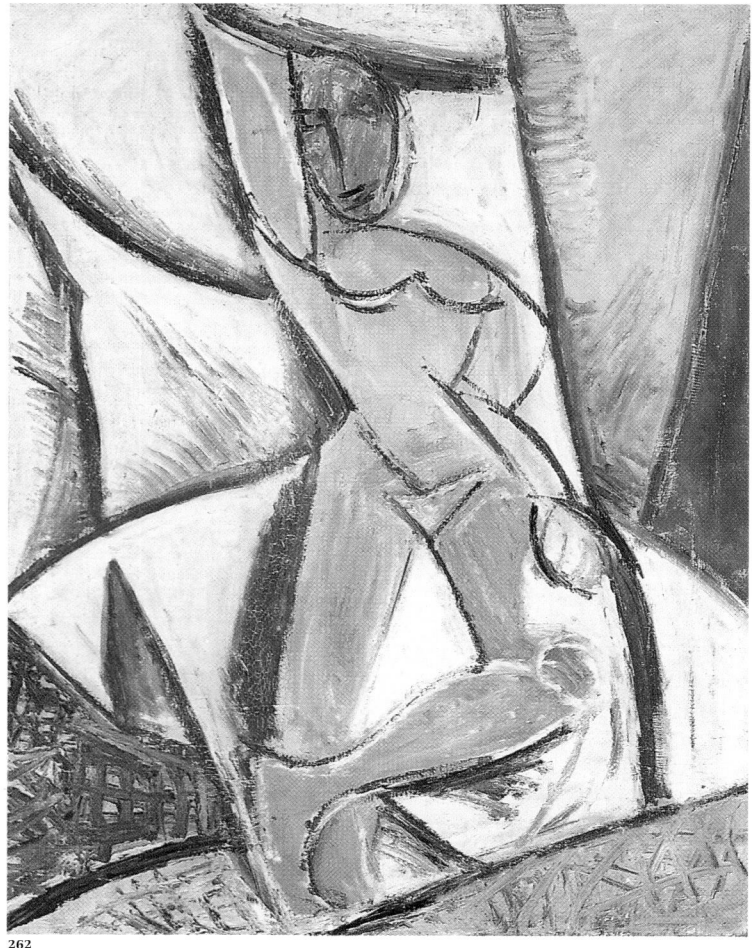

262

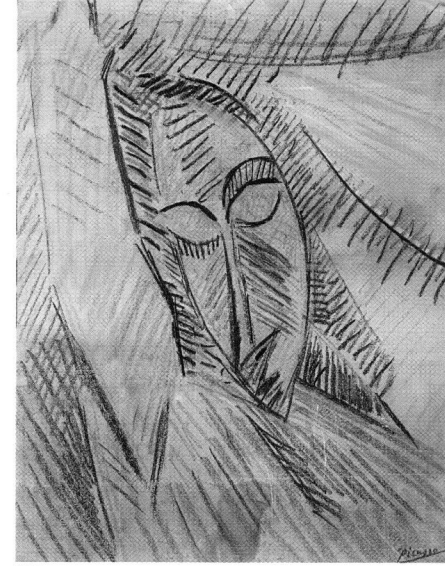

263

264

262 *Study for "Nude with Drapery,"* Spring–Summer 1907
263 *Study for "Nude with Drapery,"* Summer 1907
264 *Study for "Nude with Drapery,"* Summer 1907
265 *Face Mask,* August 1907
266 *Nude with Raised Arms,* Spring–Summer 1907
267 *Nude with Drapery,* Summer–Autumn 1907

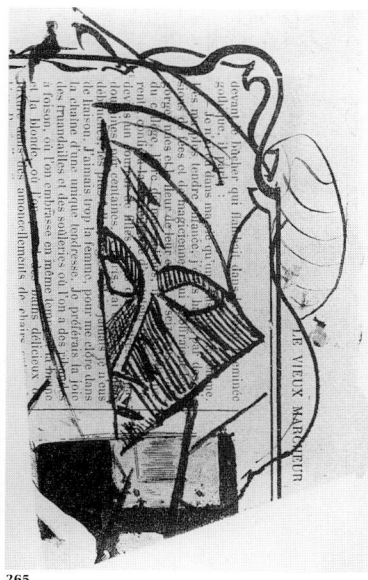

265

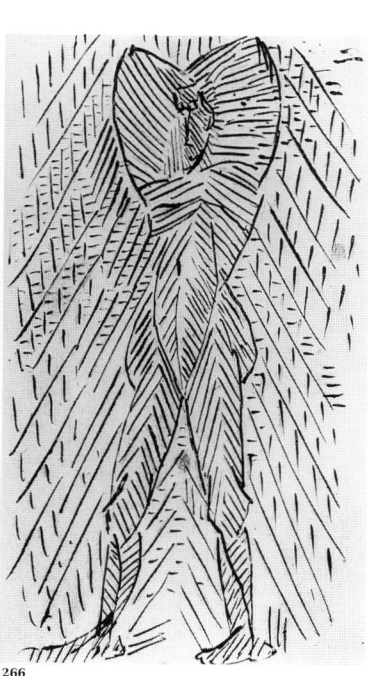

266

267

121

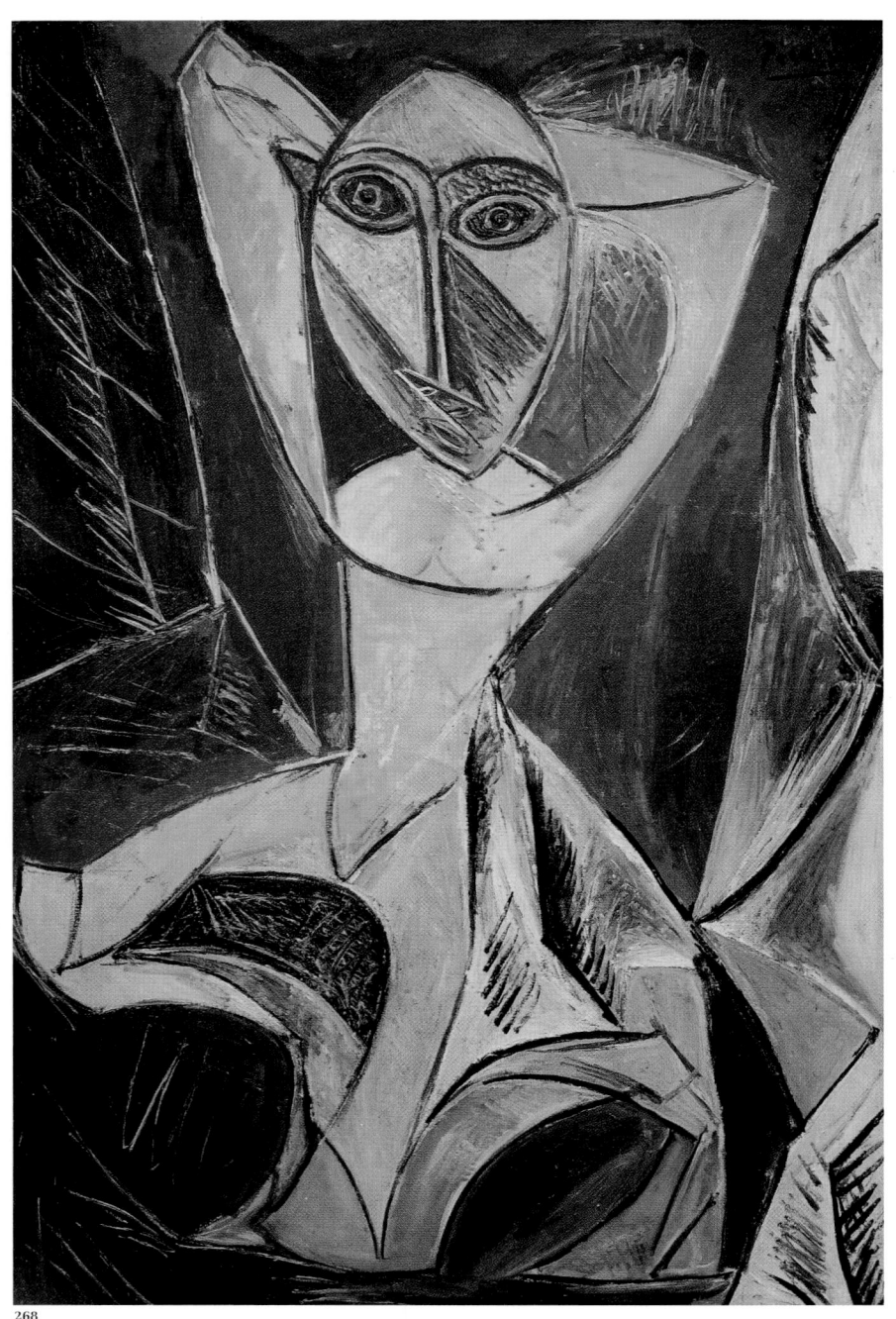

268

268 *Nude with Raised Arms,* Autumn 1907
269 *Nude with Raised Arms,* Autumn 1907
270 *The Tree,* Summer 1907

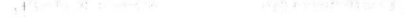

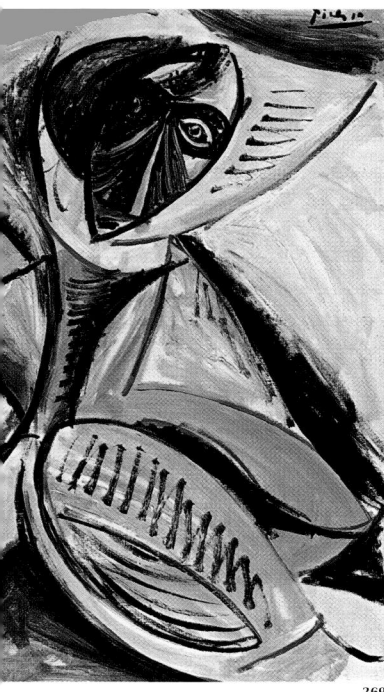

269

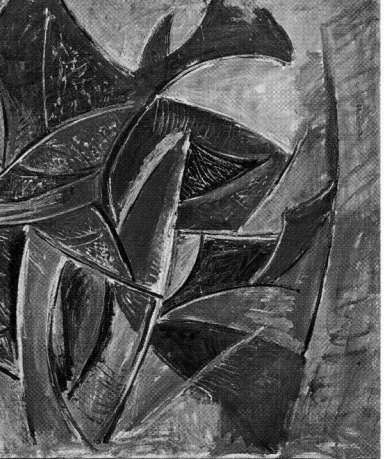

270

Gauguin, Cézanne, and more recently African and Polynesian sculpture. He imposed new norms upon the human figure without considering the secular references, thereby completing the break with the classical tradition that he had begun with his *Demoiselles*.

The nude was the major focus of the young painters of this period who were moved by Ingres's *Turkish Bath* and Cézanne's *Bathers* and were eager to synthesize them with African art. The *Bathers* by Derain, the *Blue Nude, Memory of Biskra* by Matisse, and the *Standing Nude* by Braque[13]—all are contemporaries of the *Demoiselles* and all are vital to the evolution of Cubism.

Spurred on by his peers, Picasso grappled with a figure in the *Demoiselles* style for months on end—the nude with raised arms emerging from the draperies—of which the great *Nude with Drapery* (fig. 267) was the masterful culmination. Merging with the verticality of the painting, the sculptural anatomy has been made radically geometric through a schematic style that emphasizes every protrusion, every bulge of the body, and sharpens arms and thighs like posts or prunes a fist into the shape of a stump. The volumes are created by areas of vividly colored hatching, the tight fabric of which extends into the background, melting figure and space into a unified whole.

Related figure studies greeted the return of color to Picasso's palette as he continued his exploration of form. Indeed, Picasso handled the raucous palette borrowed from the Fauves with unprecedented freedom and arbitrary meaning. These colors, arranged in alternating bands of bright red and green, create simultaneous contrasts when lengthened into symmetrical striations and evoke African scarifications, which confer a primitive quality on the ovoid faces. In contrast, the use of hatching on the faces and in part of the background in *Mother and Child* (fig. 259) accentuates the asymmetry and the distorted proportions of the image, whose brutality is sustained by a formal simplification and aggressive Matissian hues and violates the familiar Western image of motherhood.

Following the example of Matisse, who modeled a *Reclining Nude* after painting his *Blue Nude*, Picasso liked to corroborate his two-dimensional accomplishments in wood or plaster. His astonishing wood figures from the summer of 1907 (figs. 255 and 257) undoubtedly owe their unsophisticated craftsmanship to the ultra-primitive Tahitian idols shown in the Gauguin exhibition at the Salon d'Automne of 1906. The massive figure crudely hewn from a block of oak (fig. 257) specifically evokes a tiki from the Marquesas Islands that Picasso had just acquired.[14] Its heavy forms, furrowed with deep gashes, barely emerge from the block; a few strokes of red paint cause a crudely hewn face to grimace, which accentuates the sullen character of the figure.

The influence of African art on Picasso grew stronger during the winter of 1908 and gave birth to a series of nudes of a savagery that offered a new image of humankind, obeying only formal pictorial laws, with no concerns of a psychological nature. Direct descendants of the central caryatid of the *Demoiselles*, these kneeling nudes have sharp masks for faces, disfigured by hatching and by the asymmetry of their bulging eyes, tacked onto distorted bodies outlined by bold strokes that make them stand out from the background (figs. 268 and 269). The *Nude with a Towel* (fig. 271) and the embracing figures in *Friendship* (fig. 274) have an even more violent appearance, thanks to their apelike faces, which look as if they have been slashed with an axe; their vacant eyes and rectangular mouths derive from African Grebo masks. The two bathers are delineated by hatched shadows and colored outlines to the point where they form a single tangle of bricklike flesh, a compact and solid mass whose conceptual character goes hand in hand with Picasso's vision of woman since *Les Demoiselles d'Avignon*.

One can see the representation of the body evolve through variations on the theme of *Three Women* (in whom nothing remains of the sweet charms of the Three Graces), as they embody the link between Picasso's primitivist phase and his adoption of Cézanne's form of Cubism. The treatment of the faces in *Three Figures Under a Tree* (fig. 275) reminds

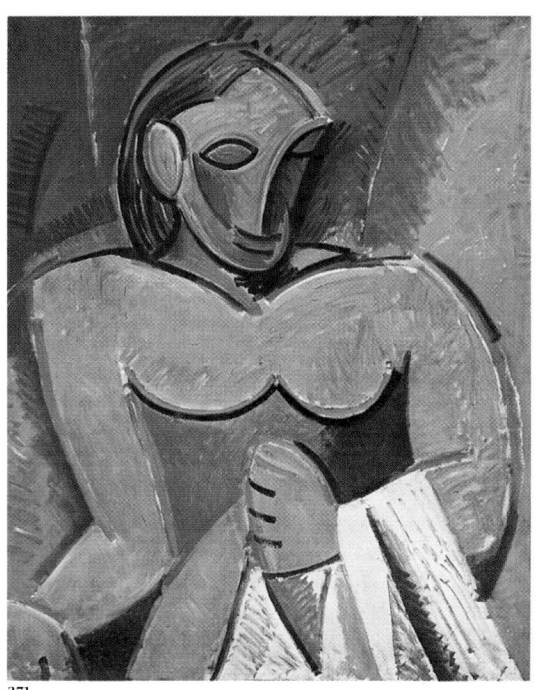

271

272

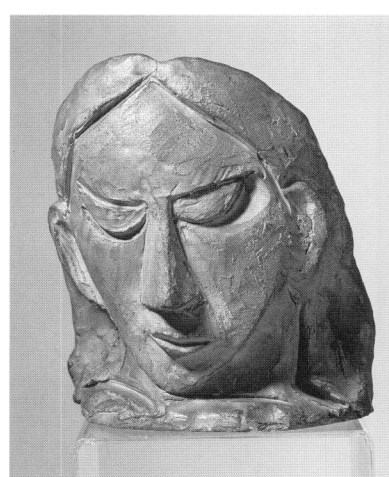

273

271 *Nude with a Towel,* Winter 1907–8
272 *Head of Woman, Three-Quarter View,* Winter 1907–8
273 *Mask of a Woman,* 1908
274 *Friendship,* Winter 1907–8

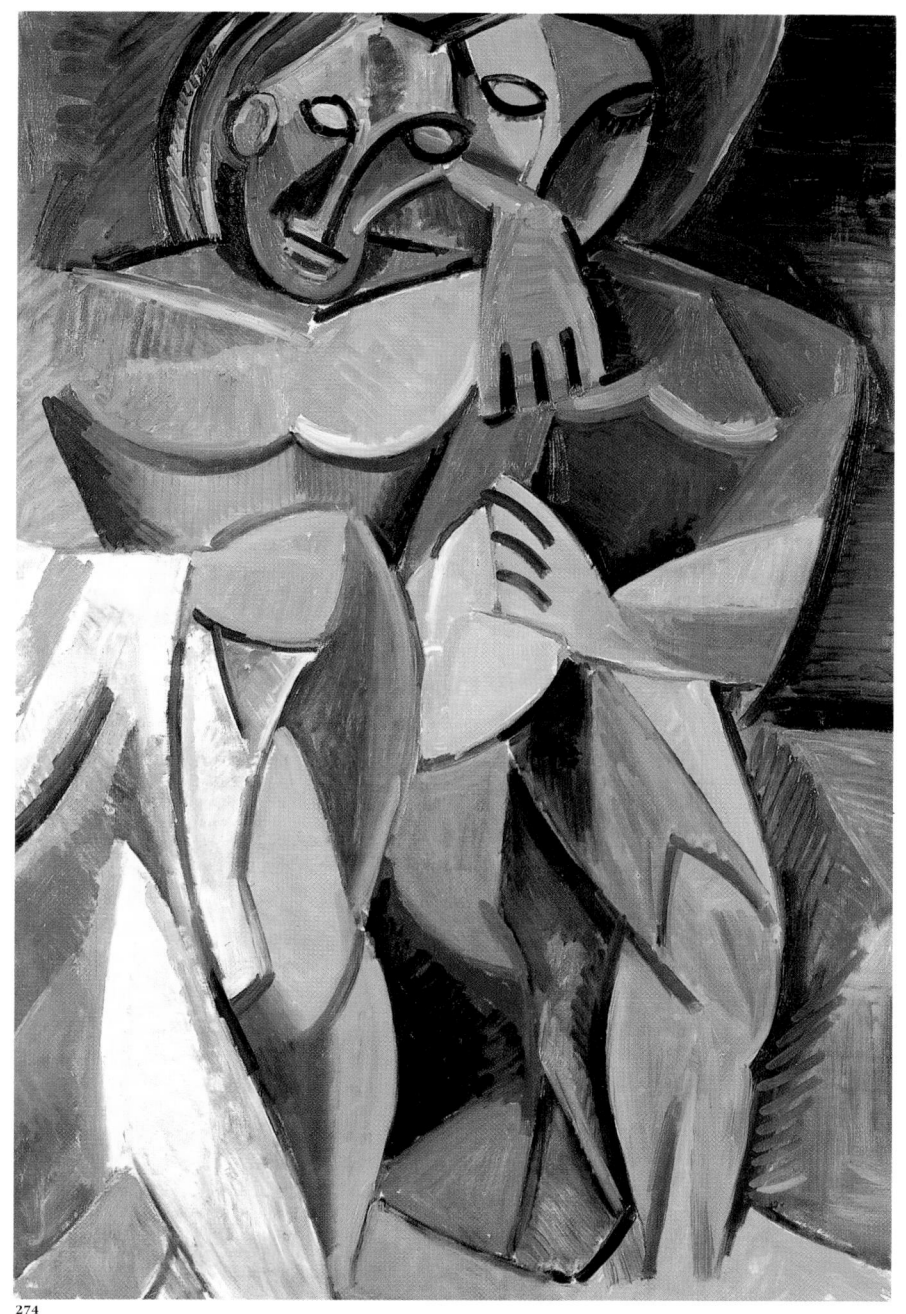

274

us of the simplifications borrowed from Iberian or African art (vacant eyes, protruding ears, and a nose seen from the side in a frontal face). The restrained color is applied in hatchings that accentuate the volumes across the entire surface, which brings unity to the painting.

With singular boldness, Picasso took on the hallowed theme of Dürer's *Melancholia* to create the monumental block of the *Seated Woman* (fig. 286), who squeezes her solid form with some difficulty into the space of the canvas. The warm burst of colors applied in nervous, thick stripes contrasts with the vigorously outlined masses of this figure, so poetic, despite its inhuman scale, that William Rubin could compare it to Michelangelo's figure of *Night* carved for the Medici Chapel.

Even more imposing is *Woman with a Fan* (fig. 288), a veritable "travesty of sculpture in the round" (Rubin), which seems hewn out of a rock. The torso, closely joined to the rectangle of the armchair, is a geometric diagram traced with compass and ruler. The completely expressionless face is made up of three triangles next to the nose, spread open to imitate the folds of the fan, a beautiful example of Picasso's search for plastic unity. The fact that the white of the unpainted canvas appears as a plane makes one think of certain portraits of Madame Cézanne, whose severe and distant beauty is reincarnated here. Looking at these standing nudes painted on wooden panels (figs. 279 and 280), one cannot forget Cézanne's example, despite the primitivist deformations of the features. The well-constructed masses, the direction of the curves, and the harmonious colors are the same as in the late Cézanne nudes. One can understand why Picasso was so attached to one gouache study (fig. 281) that it hung on the wall of the living room in the rue La Boétie thirty years later, as we can see in a photograph by Brassaï.

No more astonishing contrast could be imagined than this population of massive and sad idols than the deeply moving *Composition with Death's Head* (fig. 298), which he produced in memory of one of the inhabitants of Bateau-Lavoir, the German painter Karl-Heinz Wiegels, who committed suicide in June of 1908. Overturning tradition, which called for a somber tone and funereal colors, Picasso lost himself in an expressionist exuberance and dared to use the most vibrant reds and orange-tinted pinks, which clash with the springtime green and the blue turning to purple. Even the presence of a skull cannot manage to cast a shadow over the atmosphere of jumbled odds and ends littering the studio, where books, pipes, brushes, paintings, bowls, and draperies are piled up everywhere, from now on deprived of the painter's presence.

"Cézanne, father of us all"

The analysis of volume, the deconstruction of unified space, the deliberately unfinished state of the painting, the movement of the brush—the work of Cézanne led the way into the twentieth century, and Matisse was not mistaken when, on the evening of Cézanne's death in 1906, he saluted him as the great ancestor, the "father of us all." In 1907 the publication of Cézanne's "Letters to Émile Bernard" in the *Mercure de France* set forth his principles ("treat nature through the cylinder, the sphere, and the cone, all of it put into perspective") and, along with the two Cézanne retrospectives at the Salon d'Automne of 1904 and 1906, encouraged Braque and Picasso in their search. Sometimes entitled *Le Cronstadt*, after the name of Cézanne's favorite headgear, *Still Life with a Hat* (fig. 294), painted by Picasso in the winter of 1908–9, marvelously sums up those two years, which were devoted to the articulation of a new language traditionally known as "Cézannian Cubism."

Everything was played out during that summer. Braque left to work in l'Estaque, near Cézanne's Aix, and he came back with landscapes, which he showed in November at Kahnweiler's gallery. The critic Louis Vauxcelles was shocked by their formal audacity

275 *Three Figures Under a Tree*, Fall 1908
276 *Three Women*, Spring 1908
277 *Three Women*, Autumn 1908
278 *Study for "Three Women,"* Autumn 1908

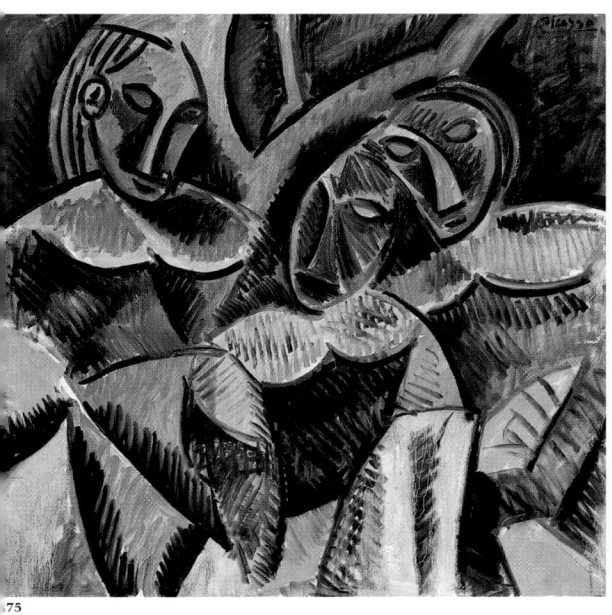

275

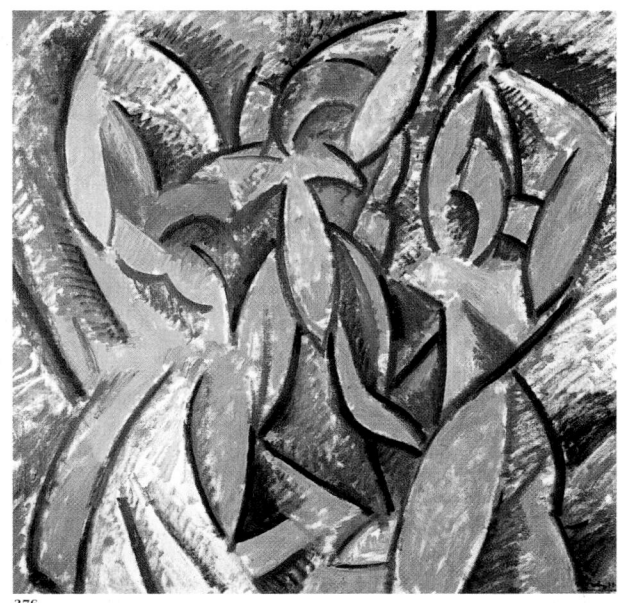

276

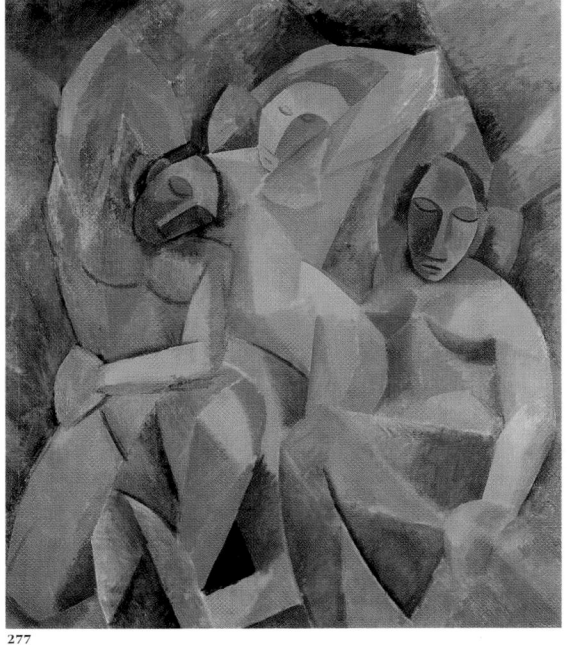

277

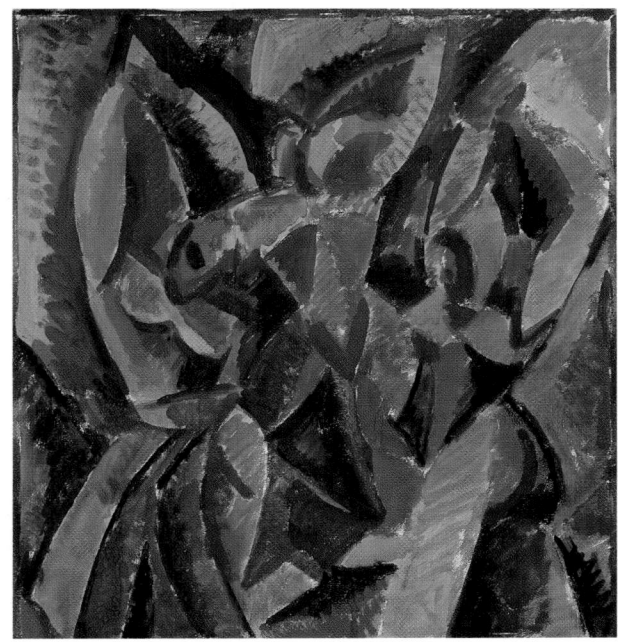

278

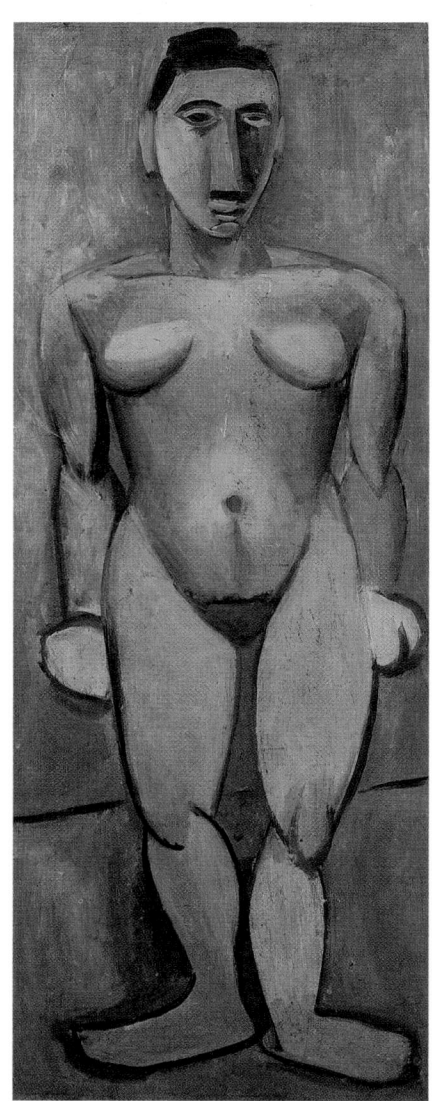

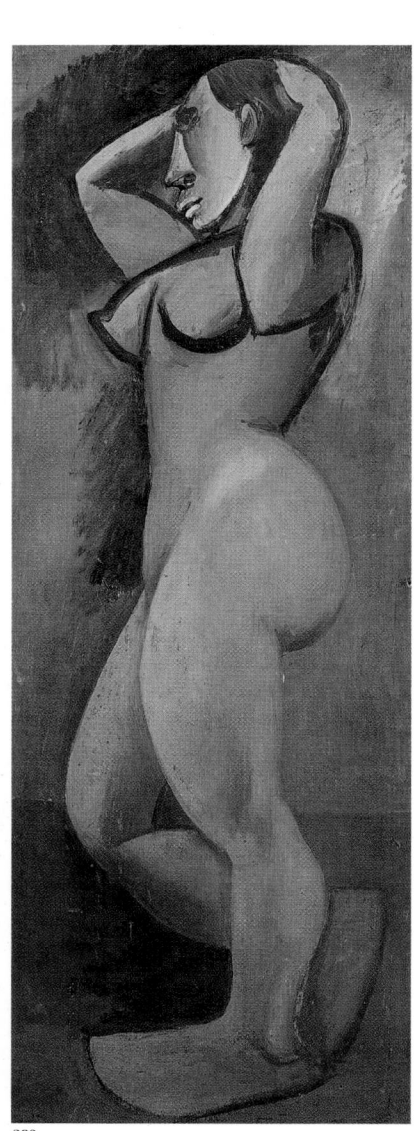

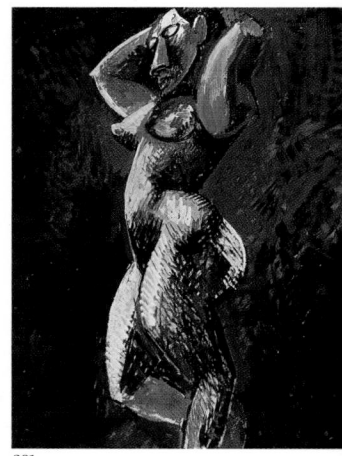

281

279

280

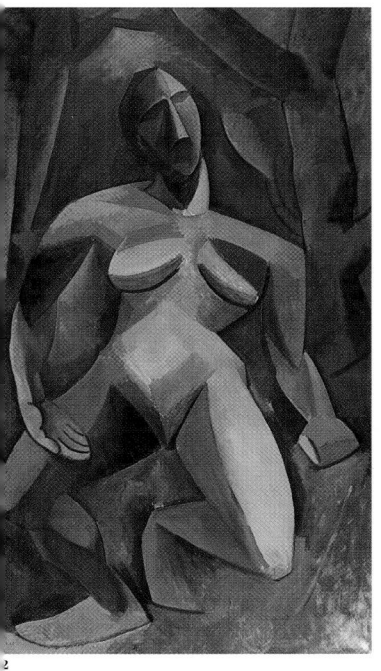

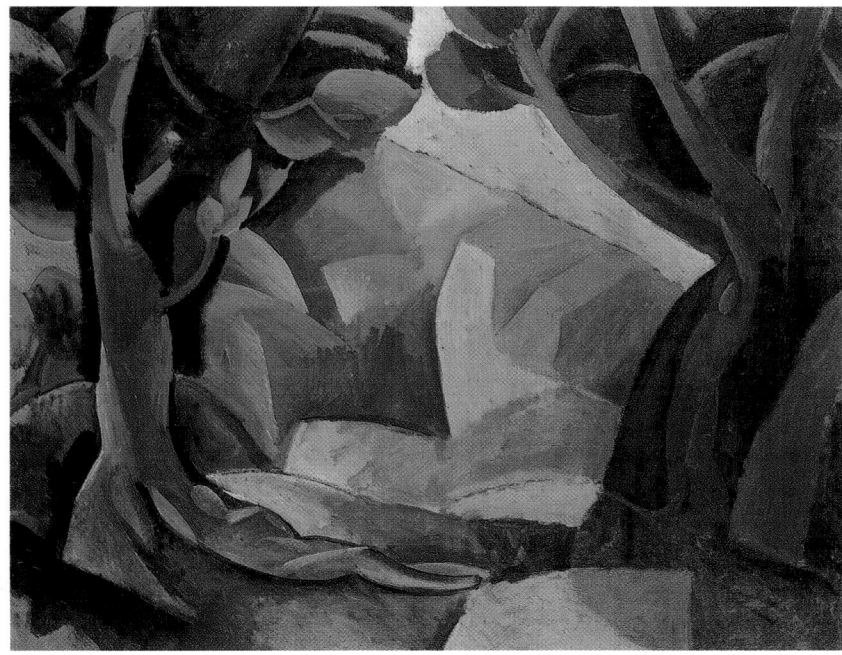

283

284

285

and wrote a review that would make history: "He disdains form, reduces everything, sites, figures, and houses, to geometric diagrams, to cubes."[15] Picasso, on the other hand, contented himself for the duration of the summer in a village on Île de France, in the rue des Bois, where he set up a studio in a room that "smelled like a stable," along with his usual menagerie and his companion, Fernande. Working on an abstract pattern was a new exercise for this painter of the human body, a man more accustomed to pounding the city pavement than rambling in the countryside, a Mediterranean who was going to catch "indigestion from all that green," as he put it, referring to the damp undergrowth of the Halatte forest. Nevertheless, for a few days he would attempt to capture the essential character of that wooded spot, following the example of Cézanne in the pine forests of Château-Noir. The delicate *Landscape with Two Figures* (fig. 283), in which one can barely see two nudes hiding beneath the foliage and under the piles of geometric volumes, illustrates all by itself his decisive breakthrough toward Cubism—to which he committed himself that summer.

Back in Montmartre, concerned with mastering Cézanne's techniques, Picasso made one painting after another. Nudes, still lifes, and portraits were subjected to the test as he pushed himself to revise the large painting he had abandoned for months in his studio, the *Three Women* that Gertrude Stein had found "rather frightening." The impressive number of preliminary studies (figs. 276 and 278)—pure exercises in formal and chromatic rhythms, driven by a circular movement—admit to the painful genesis of this picture. Gradually, the volumetric power of the figures that occupy the entire canvas became integrated and lost in a series of unified planes by means of "passages" (a technique of Cézanne's that erased the distance between surface and depth), while the orange-red reinforces the unity of the composition (fig. 277). "A dynamic sign at one with the forest that it lights up and animates with its clipped rhythm," wrote Georges Boudaille. In an architectonic space appears the large figure of a dryad, whose sculptural mass is buttressed by enormous thighs and whose hands accentuate her menacing character.

The *Large Nude by the Sea* (fig. 304) was the fruit of the same intellectual speculations that produced Braque's *Large Nude*, exhibited in the Salon des Indépendants of 1908. Picasso's voluptuous Venus is constructed of three-dimensional forms that show the results of his efforts at modeling (see fig. 296). All parts of the body, round and muscular, protrude, even those that logic might want to have hidden, such as the back and the buttocks, which are pulled around toward the front. The intense, expressive plasticity of the composition suggests a simultaneous vision of every aspect of the nude without putting its human identity in danger; a tour de force that Christian Zervos saluted as "an event of such a nature that it will be one of the most important aesthetic revolutions ever known."

These formal explorations were pursued on simple shapes—bowls, glasses, apples, and pears—worked in oil or tempera on small pieces of wood and brought together in compact compositions. Picasso conferred a remarkable dimension on these objects by accentuating their geometric nature, as if they were turned in wood, painted in neutral, conventional colors, and showed close-up without any effect of depth (figs. 295 and 296). These still lifes confirm that Cubism is very much a form of realism, a true realism, which, instead of camouflaging the truth of things beneath colors as academic painters did, points it out in all its abundance. Bowls filled with fruit in dancing shapes, as if nourishing sap were passing through them, give full testimony to the gift Picasso had inherited from Cézanne, namely the ability to transform inanimate things into living, lyrical objects (figs. 292–302). The most remarkable of these, *Bread and Fruit Bowl on a Table* (fig. 299) had been conceived at first as a Supper at Emmaus, despite its profane title of *Carnaval au Bistro*. A metaphoric illustration of the legendary banquet offered to the Douanier Rousseau by Picasso's group in November 1908, the project at first picked up the spiritual thread of the *Saltimbanques* of 1905 by presenting the main characters of the farce hidden beneath the masks of Italian actors, the Cronstadt hat of Cézanne, and the round hat of the Douanier.

286

286 *Seated Woman,* Summer 1908

287 *Torso of Sleeping Woman (Repose),* Spring–Summer 1908

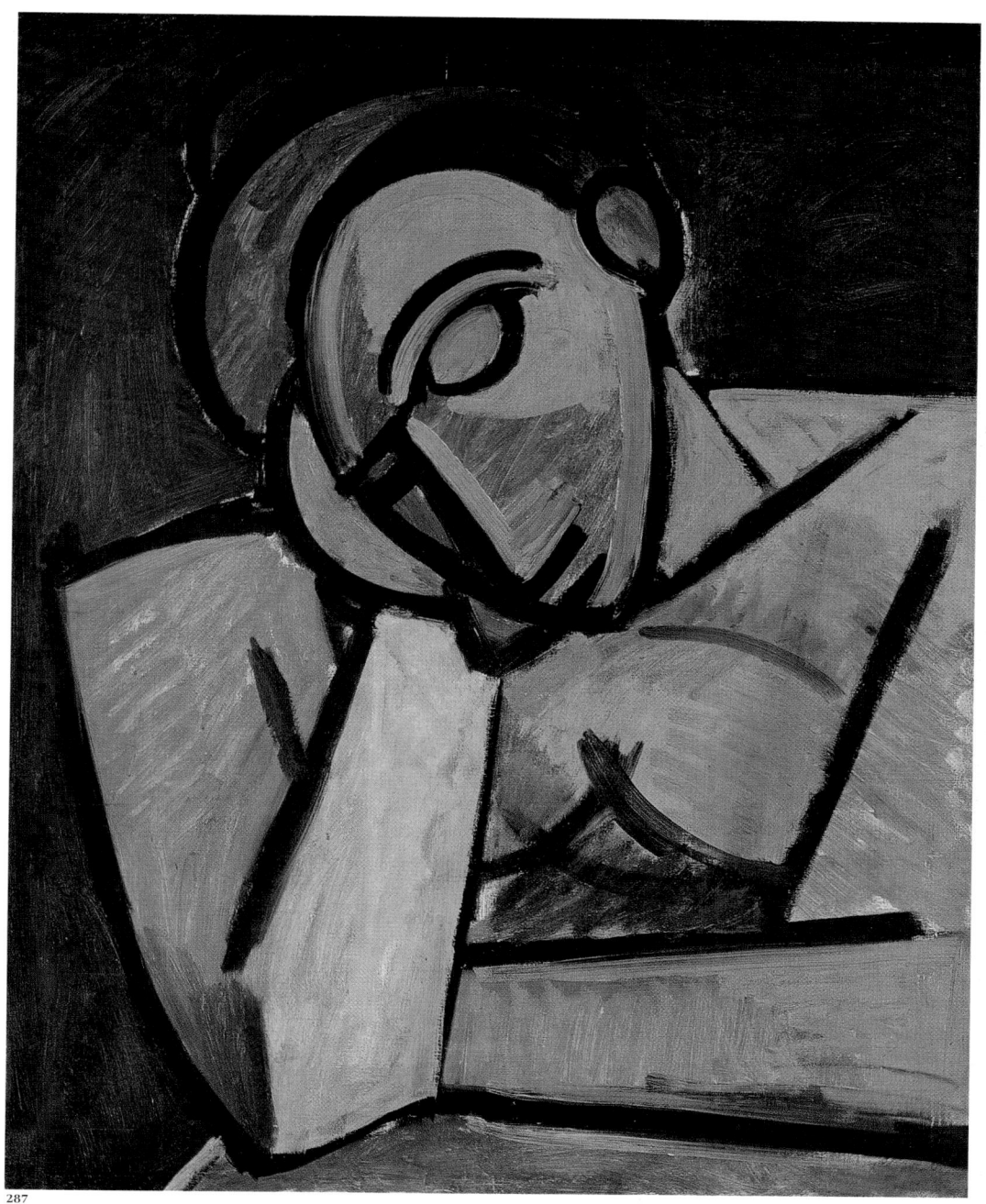

287

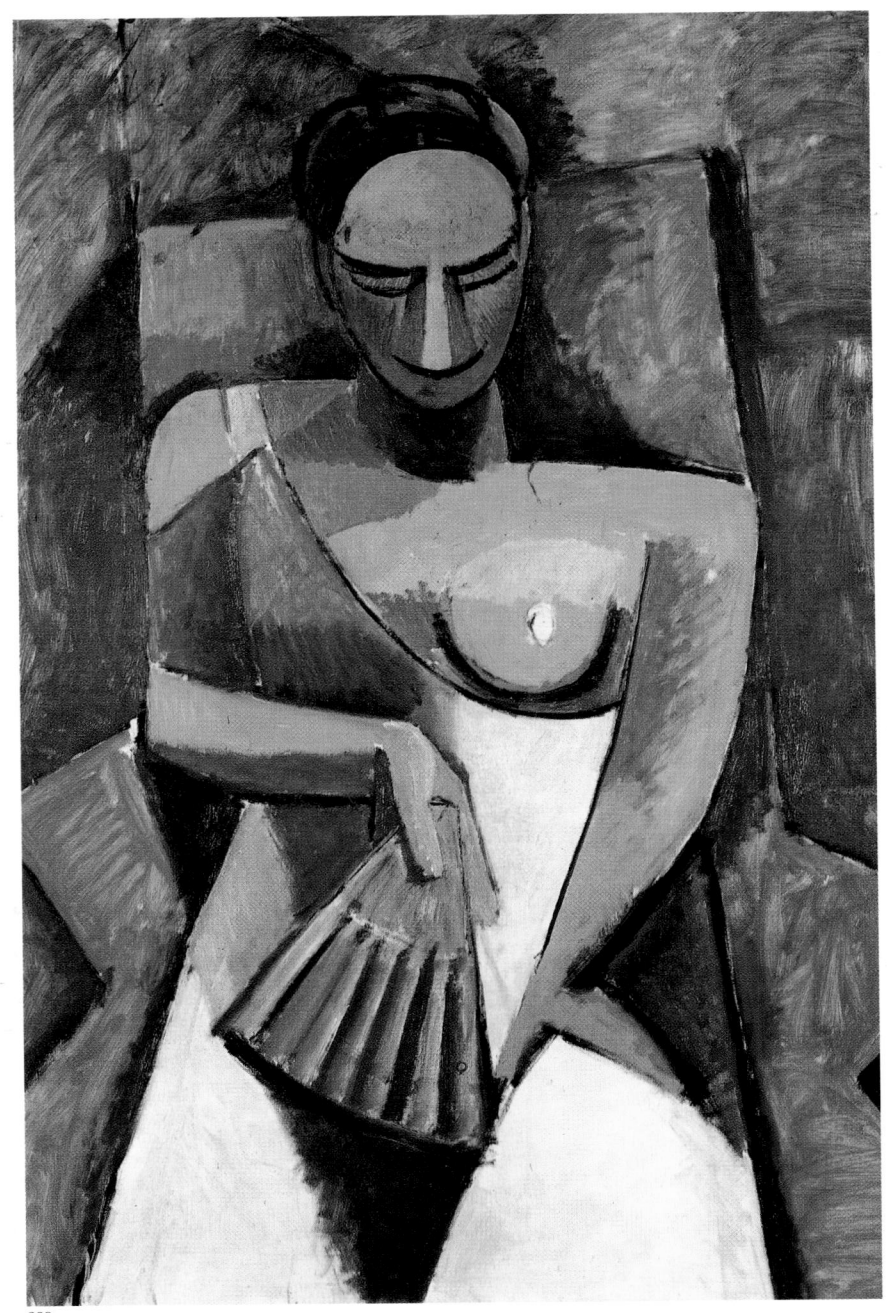

288

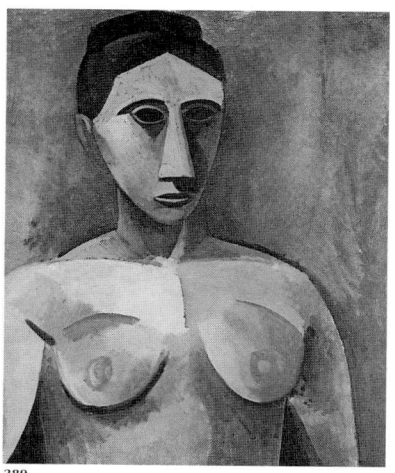

289

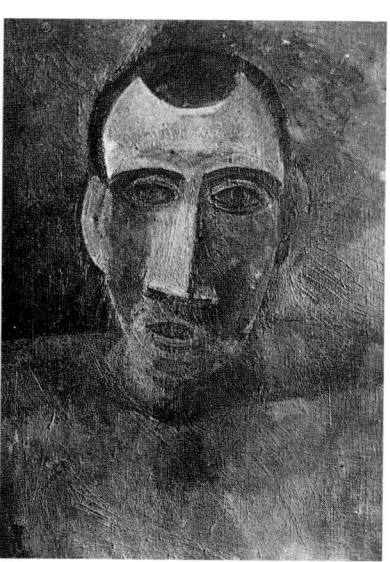

290

291

288 *Woman with a Fan,* late Spring 1908
289 *Torso of a Woman, Three-Quarter View,*
Spring–Summer 1908
290 *Bust of a Man,* Autumn 1908
291 *Seated Male Nude,* Winter 1908–9

133

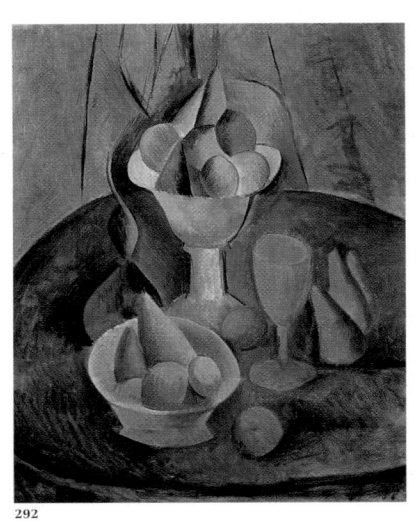

292

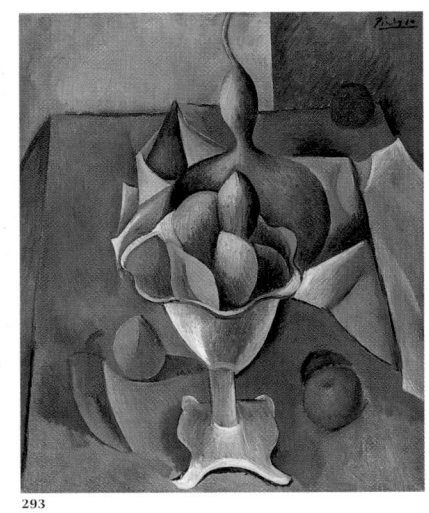

293

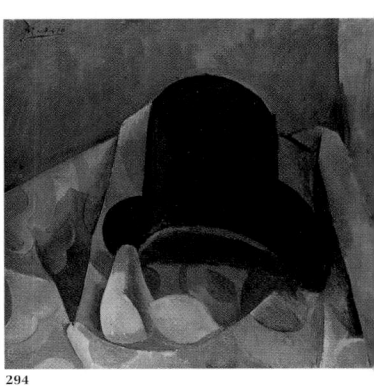

294

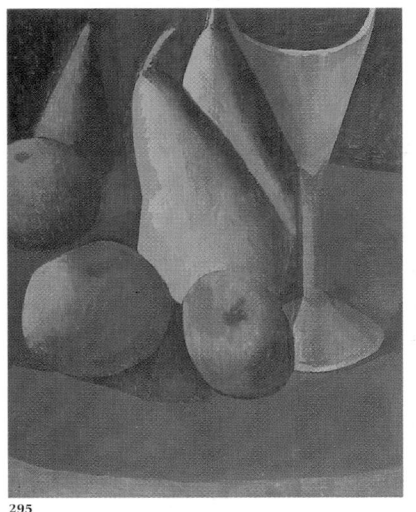

295

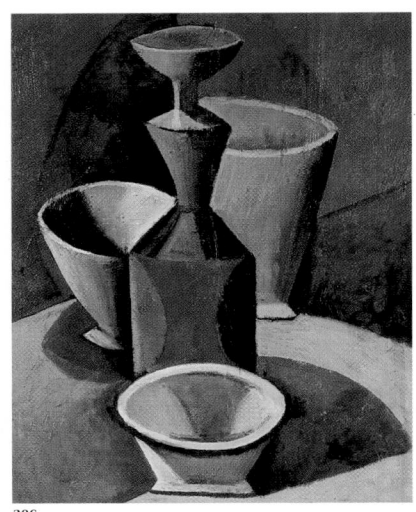

296

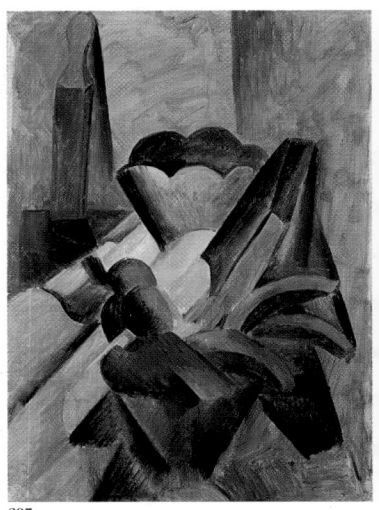

297

134

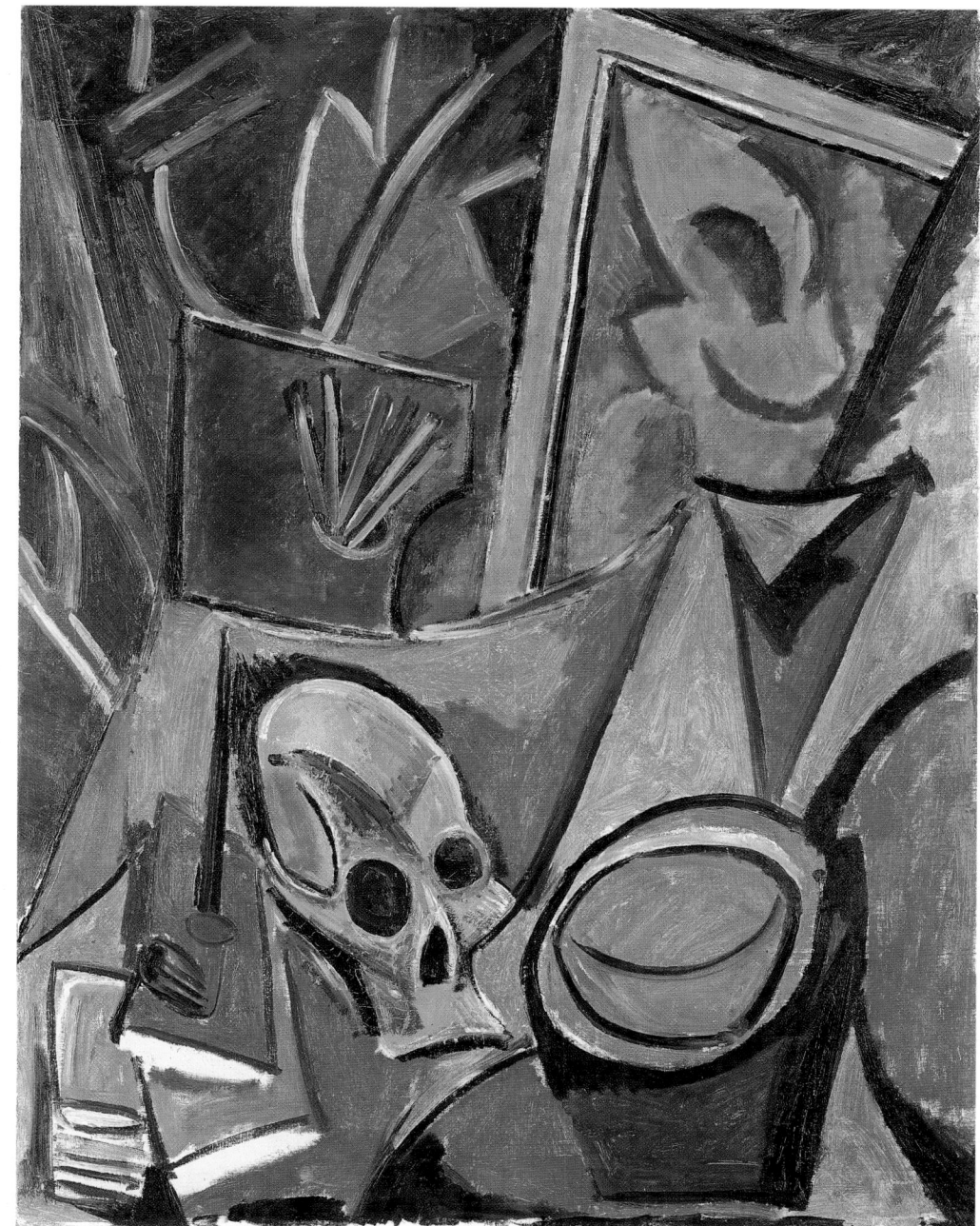

298

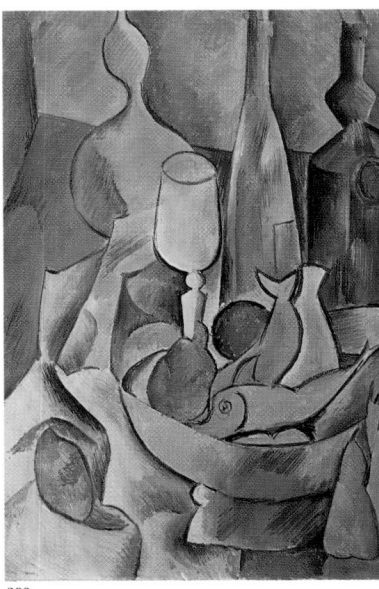

299

300

299 *Bread and Fruit Bowl on a Table,* Winter 1909
300 *Still Life with Fish,* Winter 1908–9

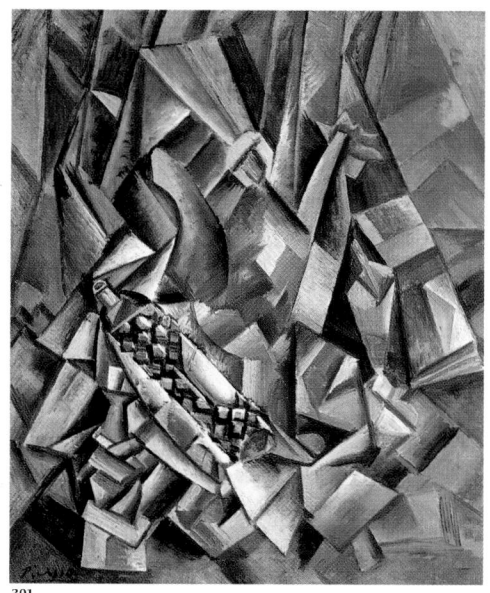

301

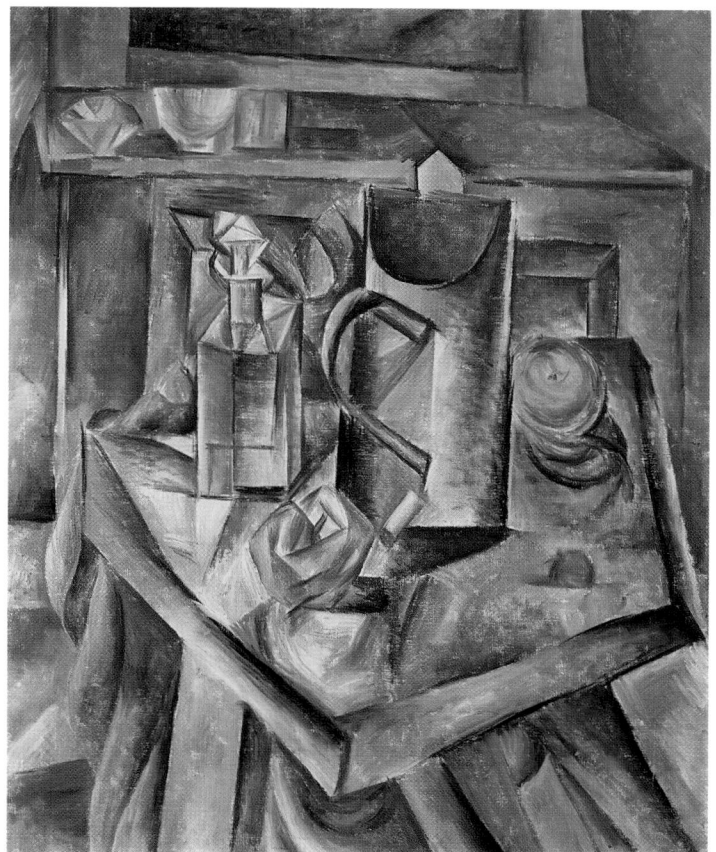

302

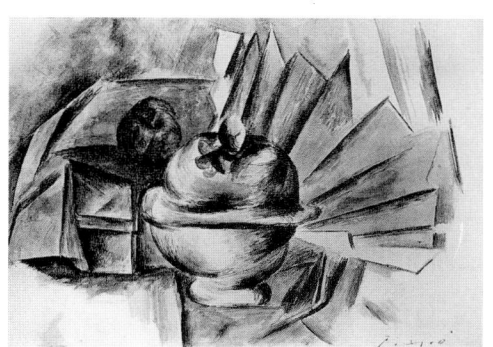

303

301 *Still Life with Liqueur Bottle,* Summer 1909
302 *Beer,* Winter 1909–10
303 *Jewelry Box, Apple, Sugar Bowl, and Fan,*
Autumn 1909

137

Although nothing seems to remain of their passage across the canvas, their blood still flows in the veins of the unstable legs of the table, and the imprint of the Douanier is implicit in the picture's disturbing naïveté, the overworked drawing of the bowl filled with fruit, which cuts into the unfinished section on the right. This banquet of phallic forms—phantoms of an occult presence—embodies the culmination of a move from "the narrative to the iconic," according to William Rubin's time-honored formula.

Picasso's early portraits of 1909 of the dealer Clovis Sagot (fig. 308) and the painter Manuel Pallarès (fig. 309) owe much to the last portraits painted by Cézanne, such as *Self-Portrait with Beret* and *Man with Crossed Arms*, in terms of pose, pictorial treatment, and the absence of psychological intention. Sagot's face is described with great precision, which emphasizes his astounding physical presence. The rift is wide between the first blue portraits of Pallarès and the 1909 portrait, which makes no room at all for the sitter's character (Cézanne to Gasquet: "One doesn't paint souls, one paints bodies"), but in both the artist has focused on the material that covers the body, face, and part of the background, a fabric of frayed colors and hatched stripes. What we see before we notice the pattern is the painter's gesture.

In *Woman with a Fan* (fig. 305), perhaps a portrait of Gertrude Stein's friend Etta Cone, Picasso returned to the theme he had treated the year before and handled it in an even more sculptural fashion, like a still life. The balance of the composition is organized around the fan motif, whose spatial rhythms it closely follows. Curves and planes shape the volumes suggested by the opposition of the muffled light and dark hues; as in the case of the *Woman with a Mandolin* (fig. 307), Picasso does not respect the real color of the objects in order to limit superfluous subjectivity. Here he has reached the ultimate point on his Cézannian path. The real becomes geometric without having achieved the continuity of form. But how was one to go beyond the concrete, the identifiable?

Horta, at the Dawn of Cubism

Picasso would later say about his second stay in Horta de Ebro, Pallarès's little village, during the summer of 1909: "Everything departed from there. . . . It is there that I understood how far I could go." Indeed, the thirty or so pieces—landscapes, still lifes, and portraits of Fernande—produced in the course of these summer months reveal a noticeable transformation of his technique.

Strengthened by the example of Cézanne's Mont Sainte-Victoire paintings, Picasso tackled the harsh landscape that surrounded the small Catalan village, the Santa Bárbara Mountain, near which a factory and a reservoir lay nestled and of which he took photographs for Gertrude Stein. In acquiring two landscapes, Stein was struck by the correspondence between the geometric structure and the color harmony of the Spanish village and Cubism, and she was to conclude that Cubism was "a natural product of Spain."[16]

The process of using geometric shapes in facets, which Picasso had investigated in Paris on the human body (figs. 306 and 307), was finally becoming refined. *The Reservoir* (fig. 311) and *The Factory* (fig. 310) were analyzed and methodically reconstructed, and the three-dimensional volumes were deconstructed into facets that merged and penetrated each other. Spatial perspective has made way for simultaneous and diverging points of view, which stress the reciprocal relationships of the patterns and their plastic unity. (The palm trees of *The Factory*, for example, did not exist in reality, but their presence on the canvas allowed the cubic block of the village and the forms, cut like crystal, of the sky to merge into a coherent whole.) The density of three-dimensional form emphasized by no light source whatsoever is suggested by the opposition of lights and darks—muffled grays and dull ocher browns. Thus interpreted, stylized, and frozen beneath an eternal light,

304 *Large Nude by the Sea,* Spring 1909
305 *Woman with a Fan,* Spring 1909
306 *Seated Nude,* Spring 1909
307 *Woman with a Mandolin,* Spring 1909

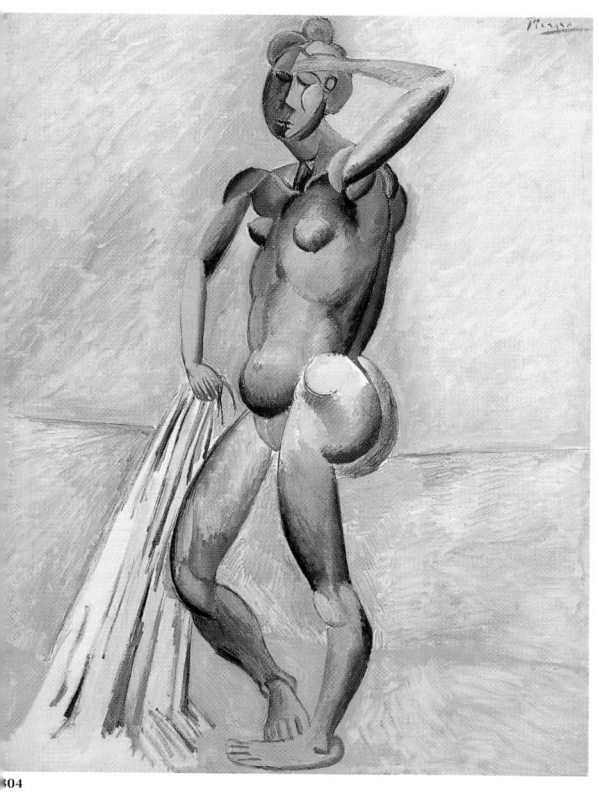

304

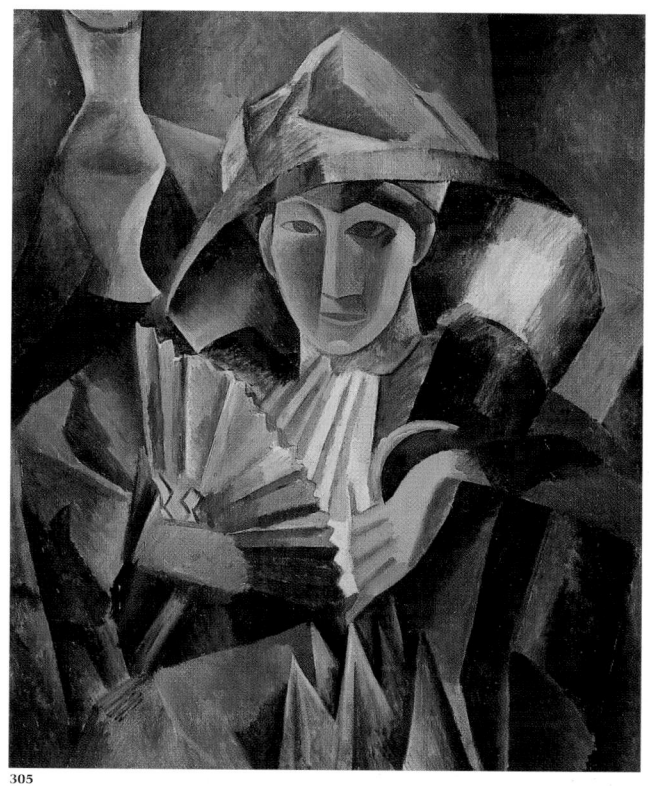

305

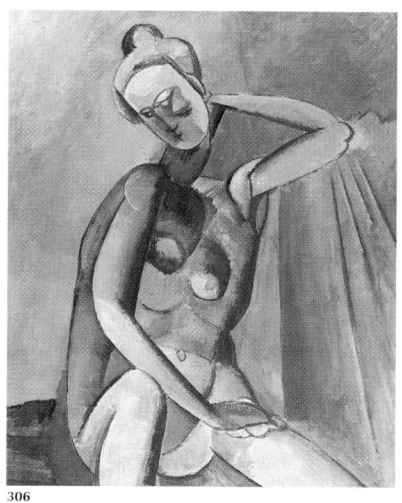

306

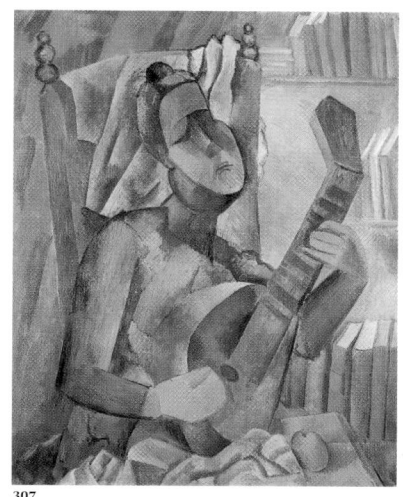

307

139

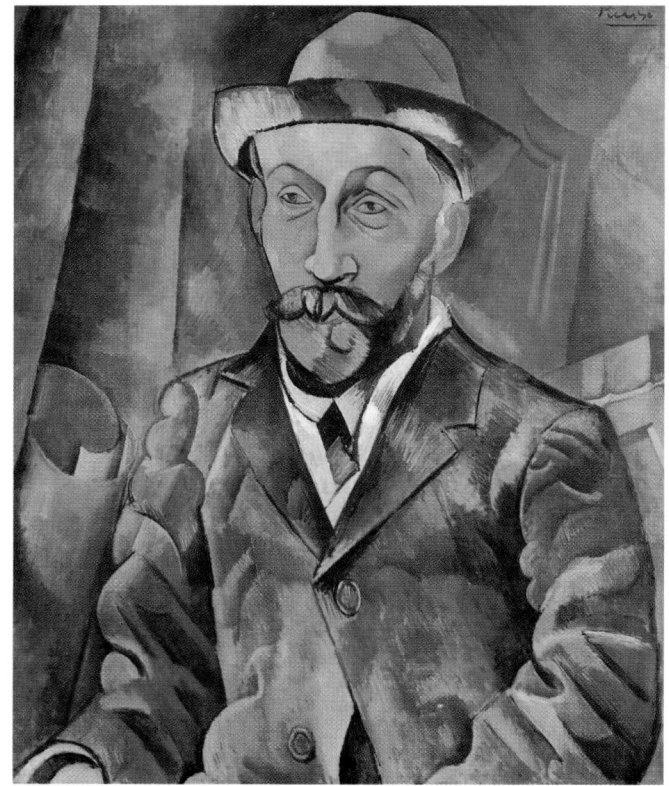

308

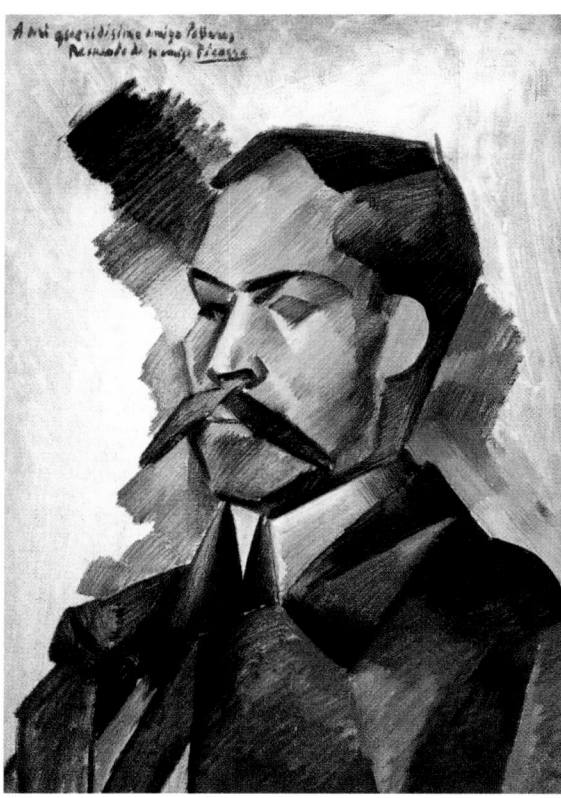

309

these Catalan landscapes resemble those that Braque was painting at the same time, hundreds of kilometers away, beneath the pale gray light of La Roche-Guyon.

Still Life with Liqueur Bottle (fig. 301) is the first example of Picasso's application of analytical deconstruction to a still life. The surface is split up into rhythmical facets, which define a relatively shallow space closed off by draperies. The analysis of the pattern is so abstract that it is very difficult to read. Without the earlier drawing, we cannot know how to recognize the crest of the ceramic rooster (the traditional Spanish *botijo*) in the center of the canvas, surrounded by assorted objects—newspaper, glasses, and bottles, one of which is a liqueur bottle—all of them similarly split into prisms in the same green color made warmer with a few ocher accents.

Fernande Olivier's face was also the point of departure for a series of remarkable heads (figs. 313 and 317), and amazingly Picasso succeeded in preserving the intensity and majesty of human expression in a completely deconstructed form divided into a thousand facets. In the sculpture he made upon his return to Paris (fig. 314), he applied the same principle of volumetric analysis, pushed to the point where the form explodes. Shaped by a play of alternately hollow and filled volumes that catch the light, the head is

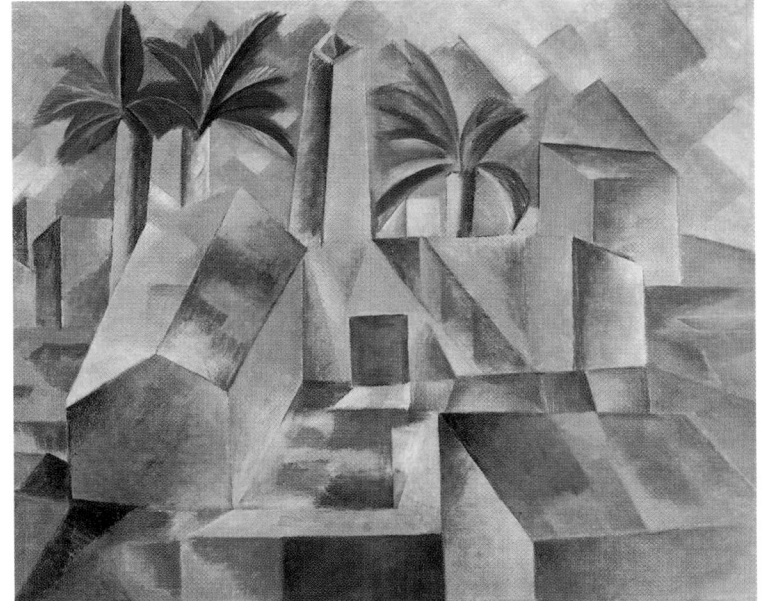

310

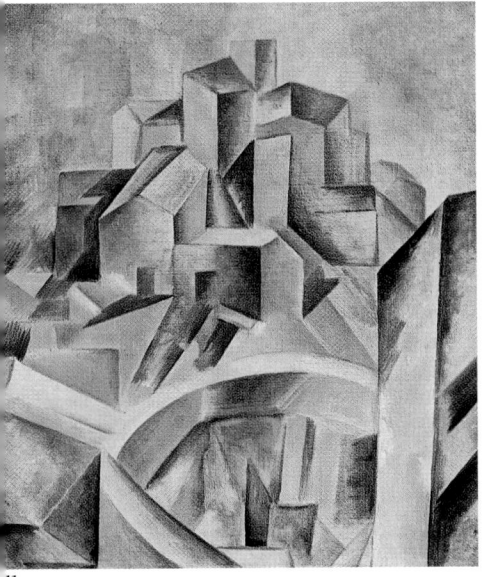

11

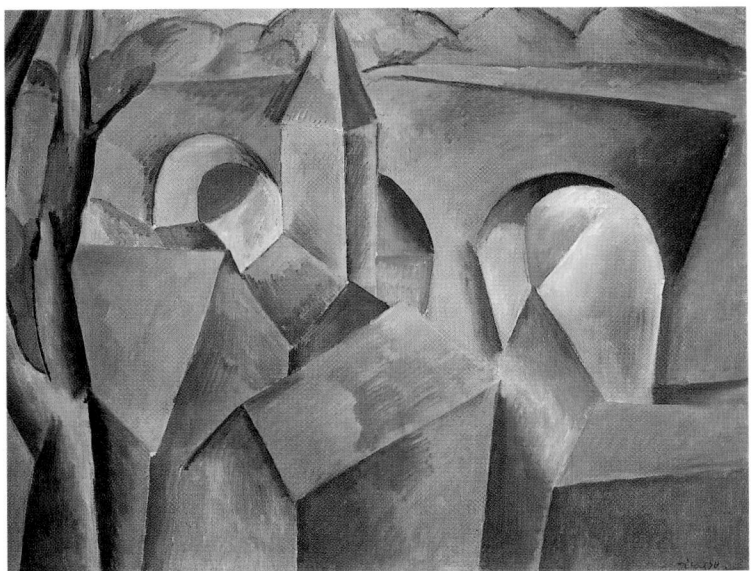

312

313

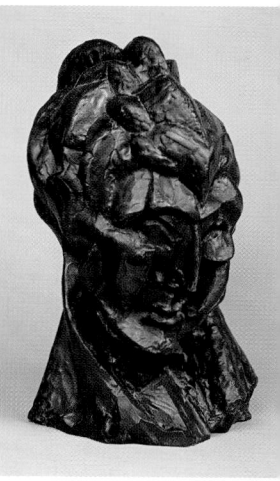

314

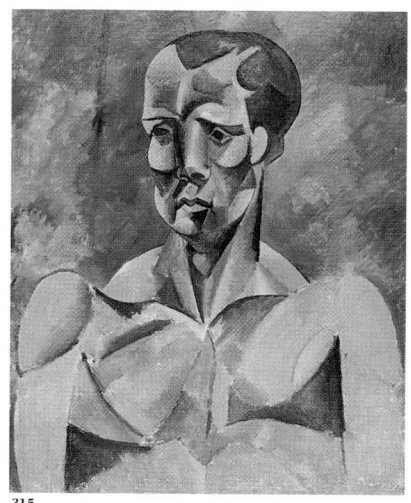

315

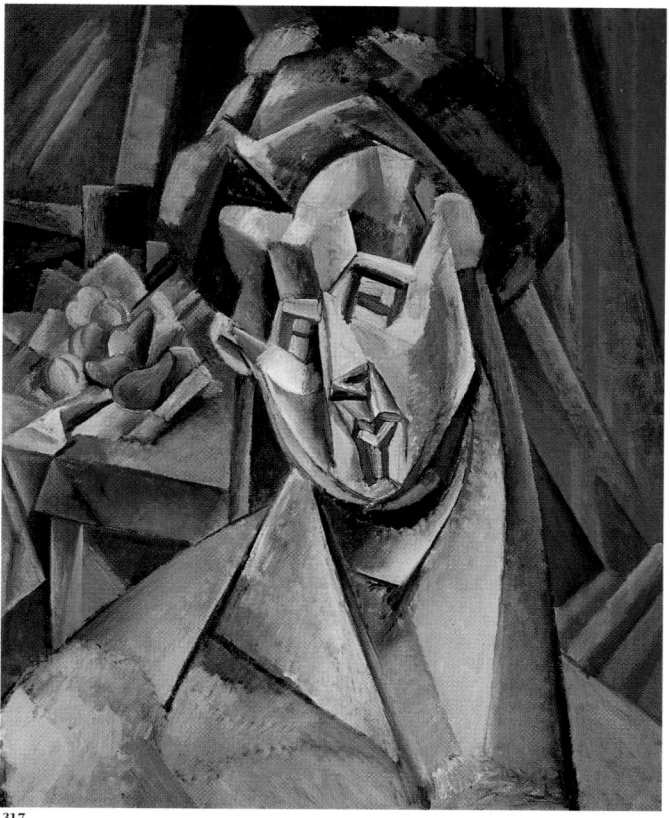

317

316

animated by the movement of the twisting neck, but the lips, nose, and eyes remain recognizable. In spite of its discontinuity of volume, the sculpture has a monolithic effect. A work as significant as *Les Demoiselles d'Avignon*, the *Woman's Head (Fernande)* opened the way for all sculpture of the twentieth century founded on the open form, for it "brought to sculpture a freedom such as no one had been able to approach until then, even through the most audacious pursuit of exploding forms in the style of Rodin or through a radical limitation of the plastic symbols in the style of Maillol."[17]

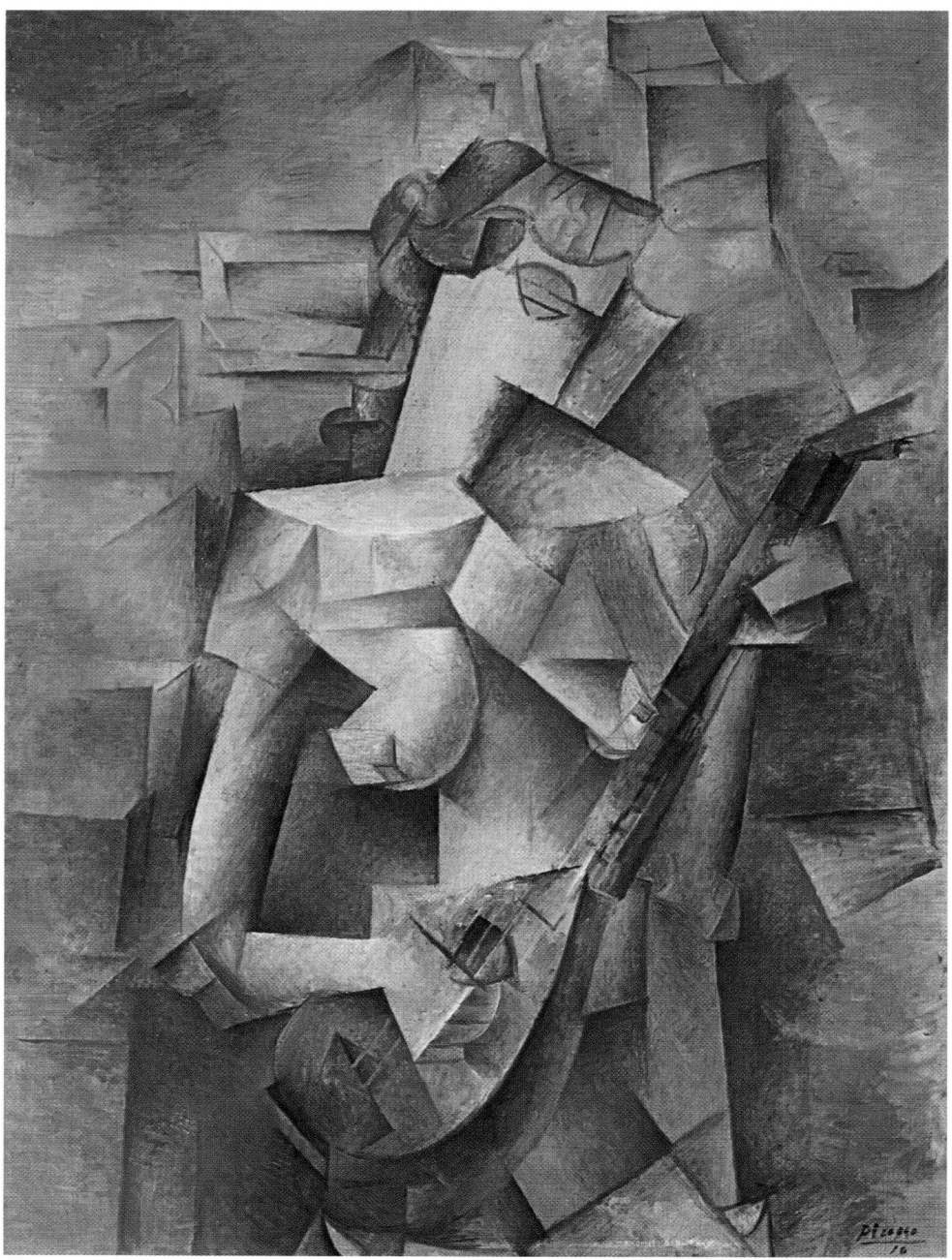

CHAPTER FOUR

1910 – 1916

Between Paris and Cadaqués

In September 1909 Picasso left the Bateau-Lavoir for a more respectable bourgeois apartment at 11, boulevard de Clichy in Pigalle. He painted the view from his windows of the Sacré-Coeur (fig. 319) as shattered facets tinted silver by the Parisian fog. He spent the winter applying Cubist principles to various subjects, such as still lifes (figs. 302 and 303) and heads, and his dissection of forms became increasingly rigorous. The shattering of formal structure, as it became more refined, created a growing separation from the model; thus it was with *Woman in a Black Hat* (fig. 320), which reveals primitivist distortions yet is still treated as a compact and unified mass. Using the motif of a woman seated in an armchair, which he inherited from Cézanne, Picasso quickly placed the single plastic form in a position of prominence. The portrait in the Tate Gallery (fig. 323) and its Parisian counterpart (fig. 321), which is larger but less finished, mark the culmination of his fragmentation of volume into facets before he finally exploded the unified form. Despite the reduction of the body into assemblages of geometric solids, and despite the abandonment of individual expression, the subject remains coherent and clear.

It is not belittling the portraits of Ambroise Vollard (fig. 324) and Wilhelm Uhde (fig. 325) to remember Picasso's fondness for caricature and his impertinent observations of his friends. Even though Vollard's face is dissected into intersecting planes, one can easily recognize the wily, grumpy expression of the dealer, the promoter of Picasso's first Parisian exhibition in 1901. The color values (the flecked white of his hair and the rosy ocher of his skin) and a few distinctive features manage to extract Vollard's face from the oppressive spatial dross, articulated by wide crystalline ridges. Everything—the distillation of colors toned down to shades of brown-gray broken up by white, the delicate touches with the tip of the brush—was used to make this dizzying play of mirrors a masterpiece. The image of Uhde, a refined aesthete who was among the first collectors of Picasso's work, is poured into a thin, pale paste of subtle harmonies. The bold composition, which lacks neither psychology nor humor (the wing collar falls into place with the same Prussian rigidity evident in the sitter's expression), is based on an overall découpage of facets that merge with one another through the use of passages that flatten the volumes with their dissolving outlines. Picasso's study of volumes gradually gave way to the study of planes. *Girl with a Mandolin* (fig. 318), a portrait of Fanny Tellier, marks a decisive turning point in this direction. From here on, the sustaining motif is no longer *destruction* but *construction* broken down into internal elements. Thus the color fades into a monochrome, while technique becomes matter, reacting to the luminous vibration of space with tiny dappled touches.

It is possible that the penchant for portraits of musicians shared by Braque and Picasso can be traced back to the Corot exhibition at the Salon d'Automne of 1909. There is little doubt that Picasso had a special interest in this painter, whose portraits he would collect later in his life. In any case, if *Woman with Toque* was the source of *Girl with a Mandolin*, it was surely a model of flesh and blood who posed in the rue de Pigalle studio;

318 *Girl with a Mandolin (Fanny Tellier),* Spring 1910

from now on, the physical presence of the model was inevitable no matter what the strength of the concept may have been (simultaneity of viewpoints, profile reduced to a straight line, and so on). Fanny Tellier exists right before our eyes, restored to all her grace and femininity, even down to the charming little bun at the back of her neck.

Early in July 1910, Kahnweiler received a postcard from Picasso mailed from Cadaqués, a lovely fishing village just outside Barcelona, where Ramon Pichot lived. Picasso established himself there for the summer, accompanied by Fernande and later joined by André Derain and his wife. According to Kahnweiler's testimony, Picasso "came back to Paris in the fall dissatisfied after weeks of agonizing struggle . . . bringing some unfinished works. But a great step forward had been accomplished. . . . He had shattered the enclosed form." These "unfinished" works consisted of ten canvases and four etchings that were intended to illustrate Max Jacob's book *Saint Matorel*.[1] It is possible that the dissatisfaction attributed to the artist was caused by his awareness of the risk he ran with his painting, such as the loss of any link with reality and the lack of clarity. Indeed, the hermeticism for which this phase of Cubism was blamed is borne out by Picasso's studies for *Saint Matorel* (figs. 331 and 333), which sacrifice the object's unity to its truthfulness. The violation of the enclosed form takes place through the shattering of the volume into open planes that slide into one another, completely free of perspective. *Mademoiselle Léonie* (fig. 331) looks look like a marionette, suspended as she is from cords with points and lines sliding down their length, an apparatus that suggests a transparent, aerial—and unrecognizable—armature.

Even more mysterious is the *Nude* (fig. 328), which has disintegrated into layers of arbitrarily intersecting planes. The color, applied in smears and confined to gray monochrome, does not make it any easier to read the painting. Sometimes, however, as in the case of *The Guitarist* (fig. 329), an exceptionally dense and powerful work, the geometric structure closely follows the body's rhythms. The refraction of the planes, noticeable at the level of the musician's arms, may indicate the echo of the musical vibrations, which issue forth from the three small strings hidden in the hollows of the color.

Picasso was not partial to harbor views like the Fauves and Braque, a man of the Channel, but he did not leave Cadaqués without having caught rowers and boats on the waves. He did not, however, yield to the picturesque in his painting of the harbor (fig. 326), a true postcard subject. Traditional lovers of seascapes would be disappointed by his depiction of this scene, which is completely bereft of flattering detail; only lines of force remain: shimmering planes of water, the edges of piers or boats, and the tall masts. The drawing of an anchor at the lower right and the reflections of the bluish-white rooftops on the horizon are the only spatial reference points in this quasi-abstract composition.

Kahnweiler (fig. 327) was one of the first victims of the so-called hermetic Cubism and the last, and most gripping, of Picasso's series of dealers that had begun in 1909 with the portrait of Clovis Sagot and included the portraits of Uhde and Vollard. Picasso had begun his portrait of Kahnweiler before he went to Cadaqués but finished it upon his return to Paris. The composition is an eloquent one. The resemblance of the Uhde and Vollard portraits to their models is undeniable, but this one must be treated with caution. It would be indecipherable if Picasso had not taken care to scatter markers here and there inside the pyramid-shaped structure of planes, markers that serve less to orient us than to broaden our understanding. The eyes, nose, properly crossed hands, and impeccably parted hair seem incongruous in the midst of this intellectual architecture, but they verbalize the real as well as the realistic details of the primitive sculpture hanging on the wall behind Kahnweiler, a mask from Gabon that was actually in Picasso's studio during the many long sittings that were needed for this incisive and fascinating portrait.

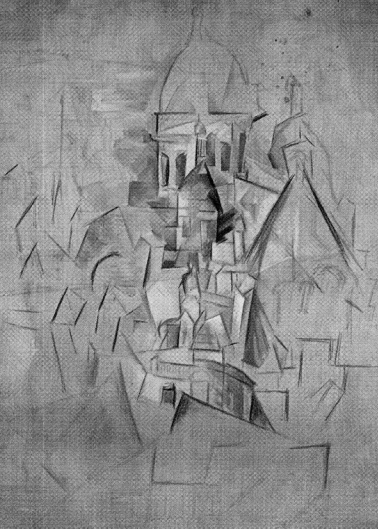

319

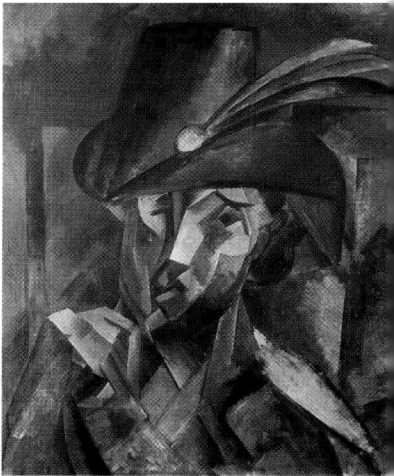

320

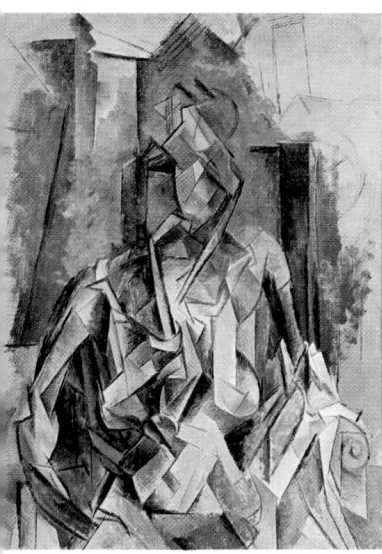

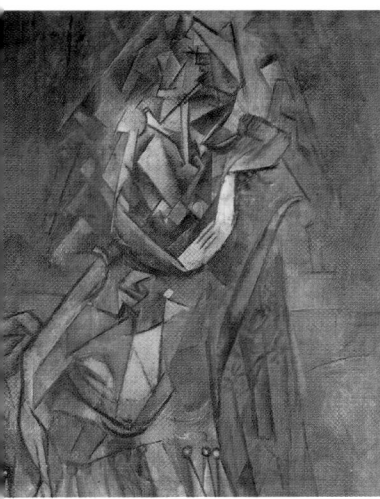

323

319 *The Sacré-Coeur,* Winter 1910
320 *Woman in a Black Hat,* Autumn–Winter 1909–10
321 *Woman Seated in an Armchair,* Winter 1909–10
322 *Woman in an Armchair,* Spring 1910
323 *Seated Nude,* Winter 1909–10

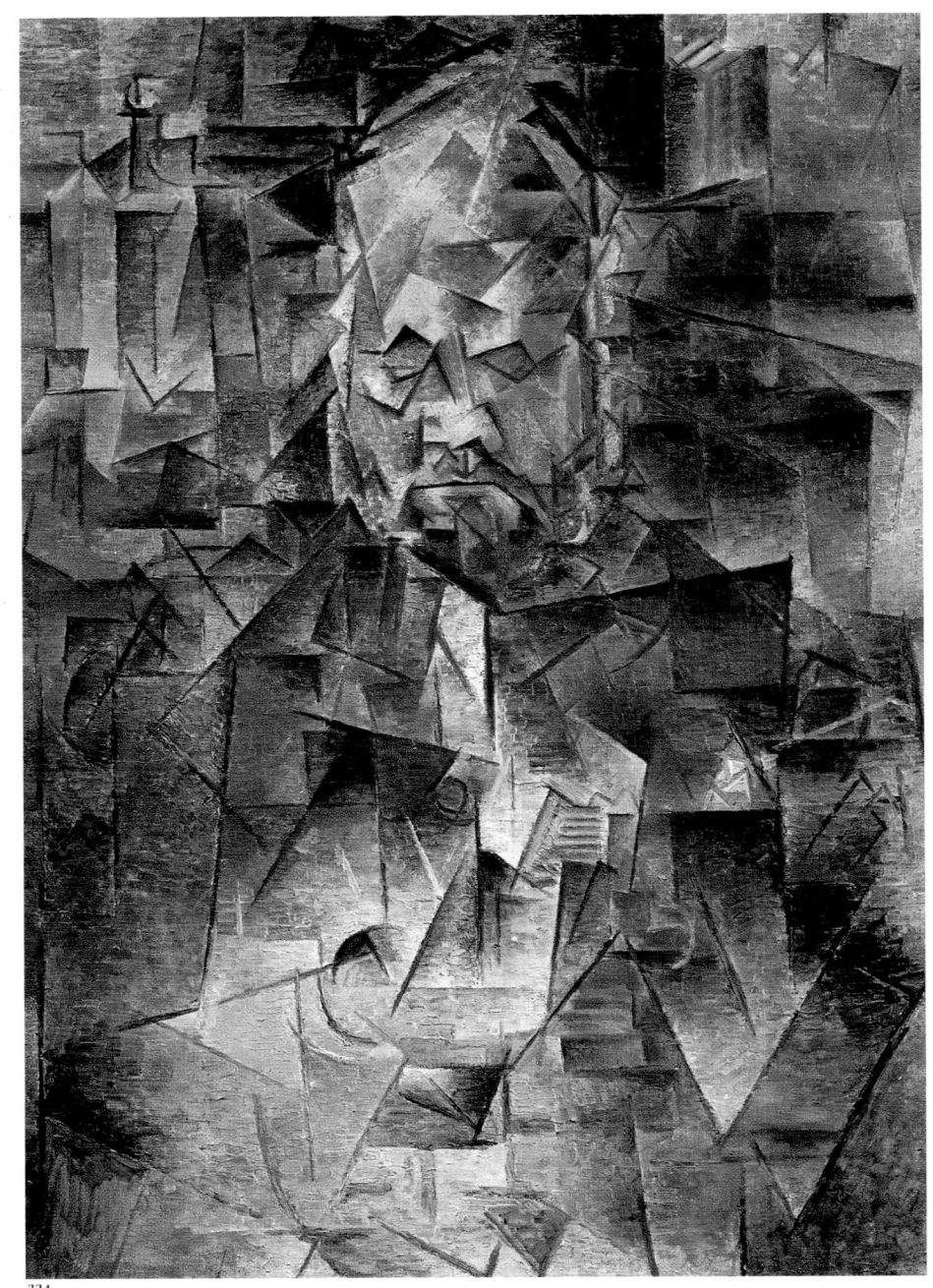

324

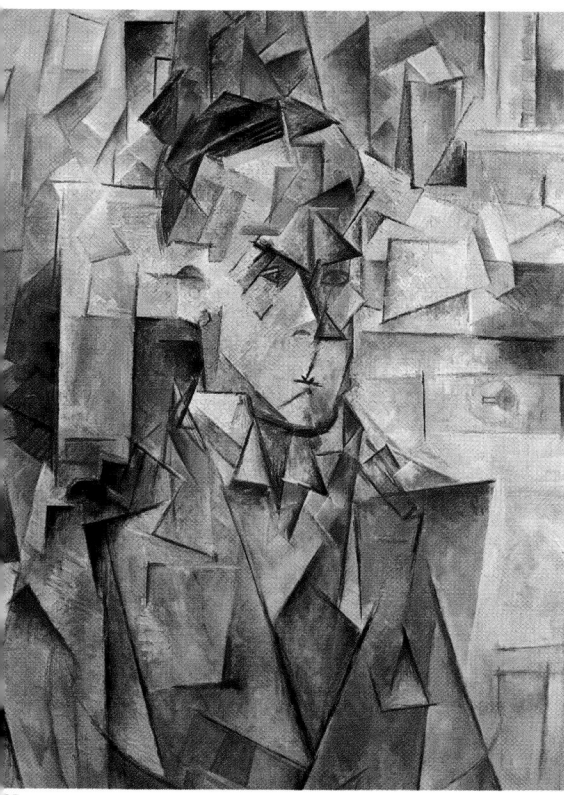

325

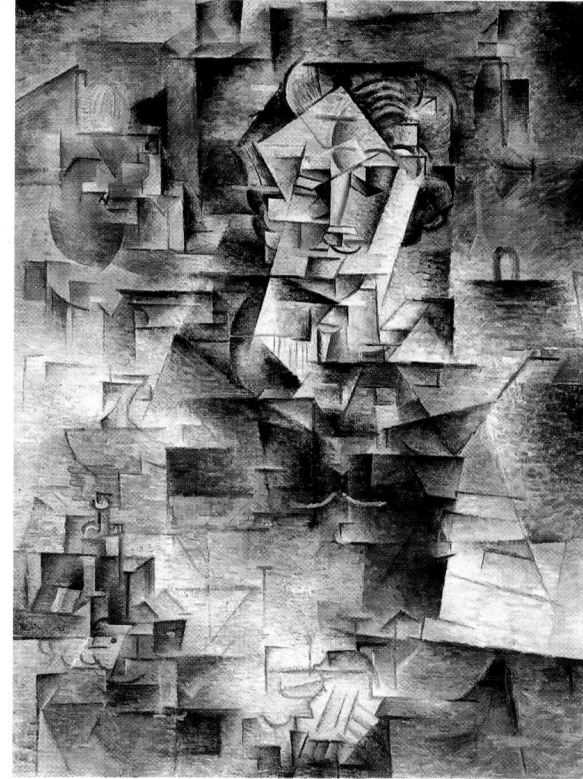

327

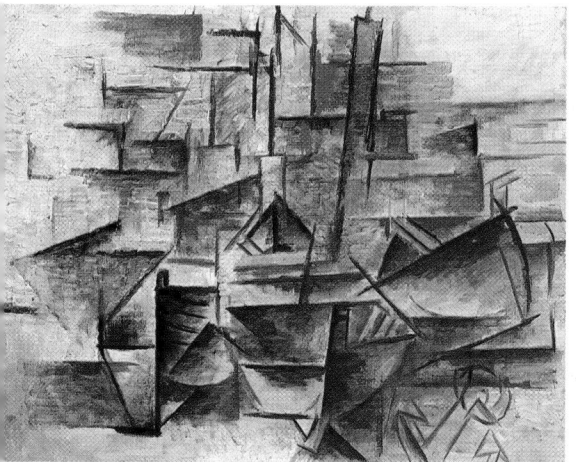

326

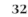

324 *Portrait of Ambroise Vollard,* Spring 1910
325 *Portrait of Wilhelm Uhde,* Spring 1910
326 *The Port of Cadaqués,* Summer 1910
327 *Portrait of Daniel-Henry Kahnweiler,*
Autumn–Winter 1910

149

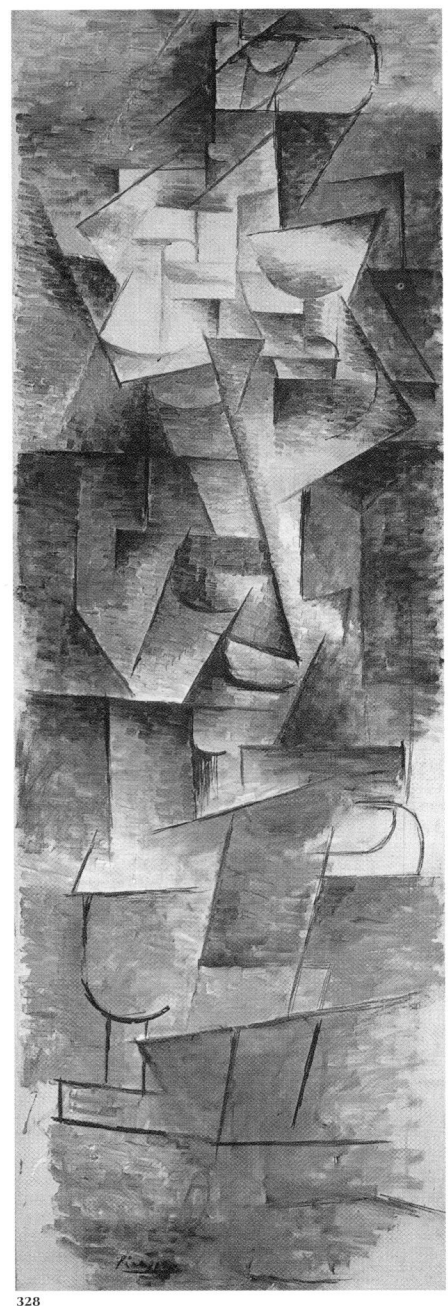

328

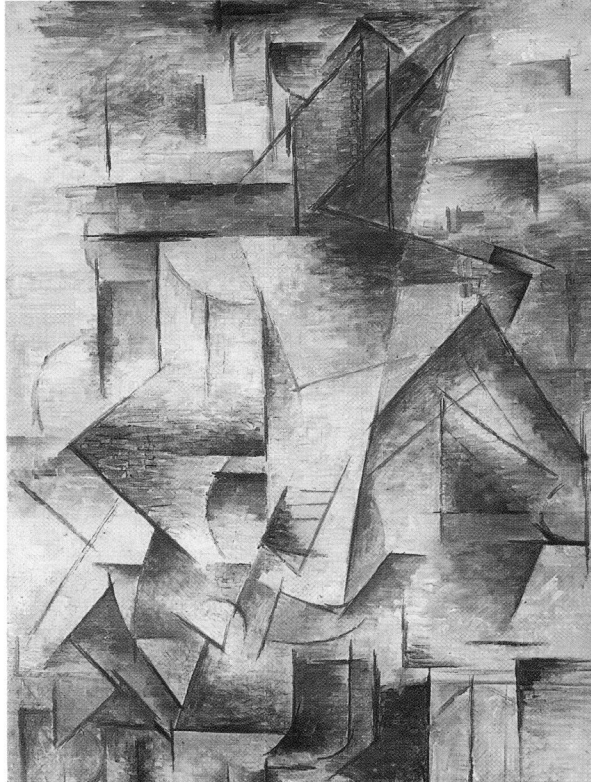

329

328 *Nude,* Summer 1910
329 *The Guitarist,* Summer 1910

330

333

331

332

330 *Head of a Spanish Woman*, 1910–11
331 *Mademoiselle Léonie*, Summer 1910
332 *Standing Nude*, 1910
333 *Standing Nude*, Summer 1912

151

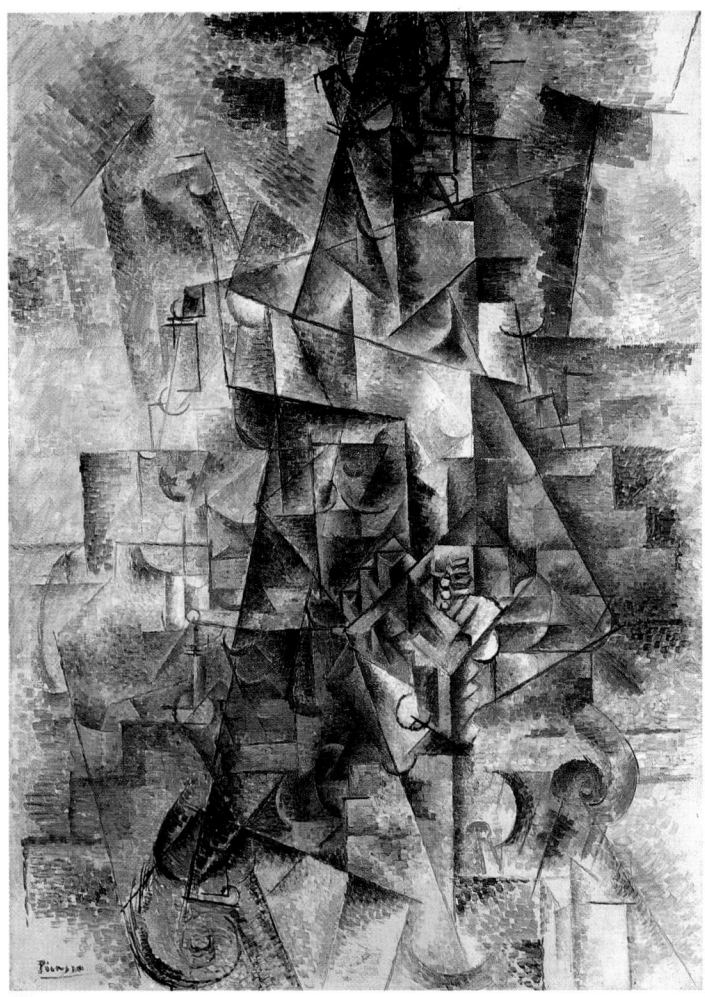

334

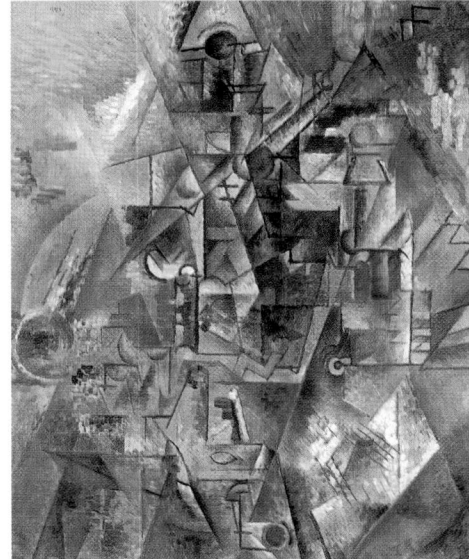

335

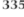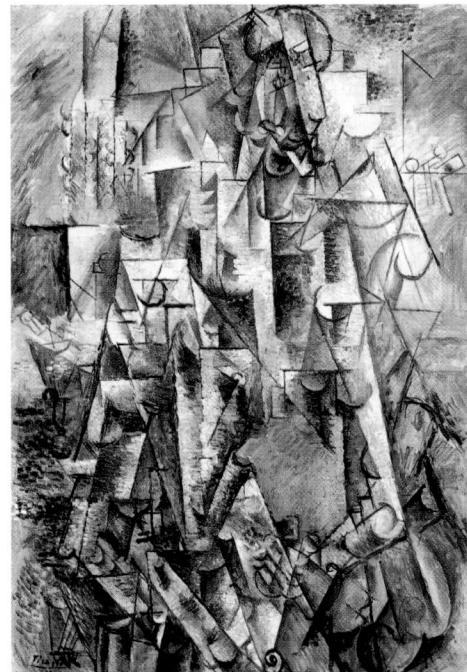

336

334 *The Accordionist,* Summer 1911
335 *The Clarinet,* Summer 1911
336 *The Poet,* Summer 1911

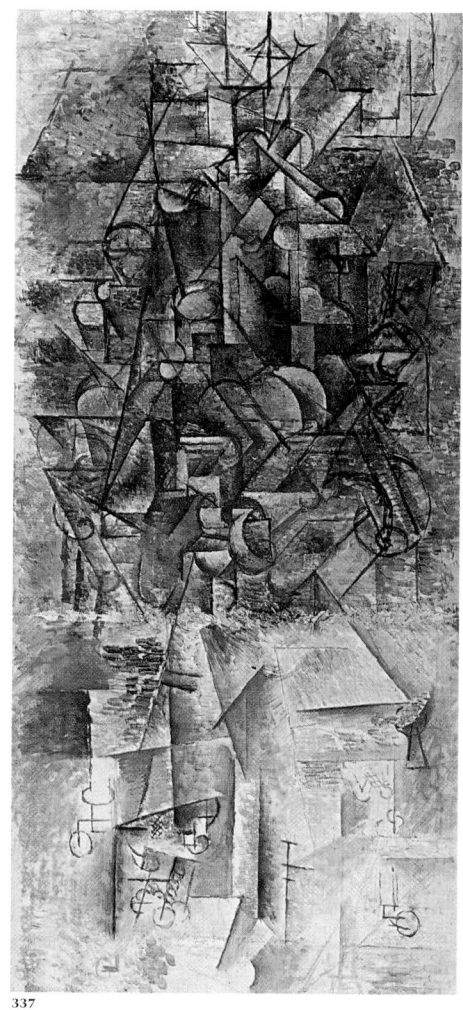

337

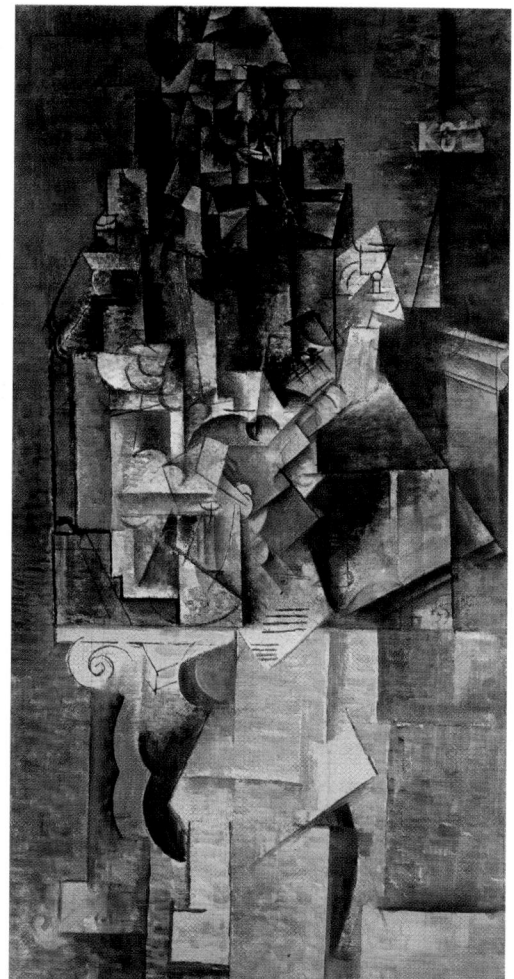

338

337 *Man with a Mandolin,* Autumn 1911
338 *Man with a Guitar,* Autumn 1911 and Spring 1912

153

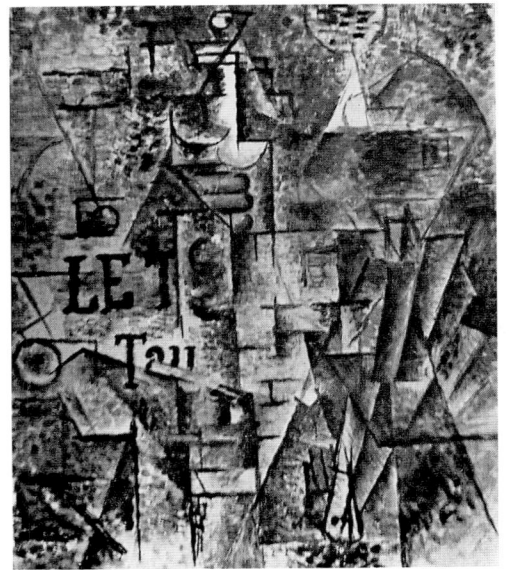

339

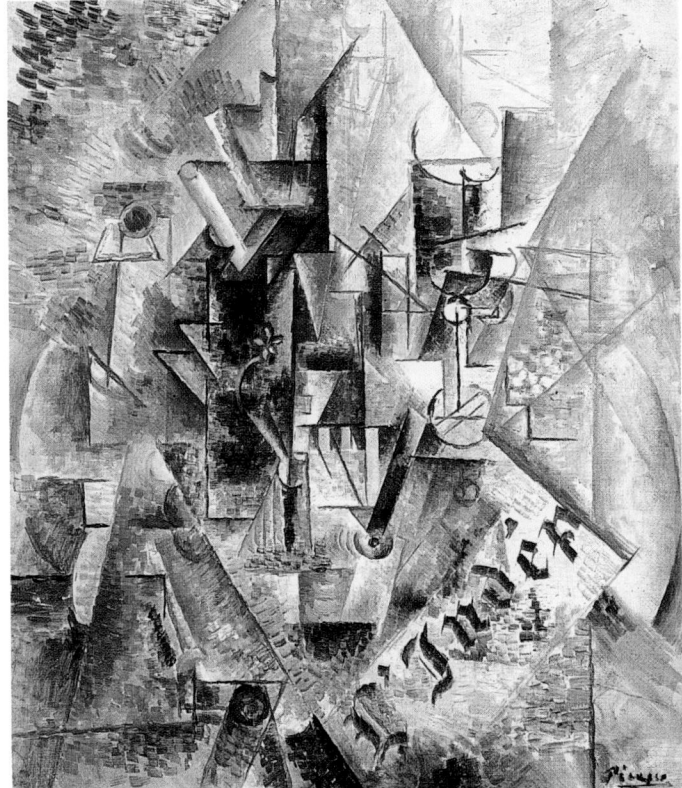

340

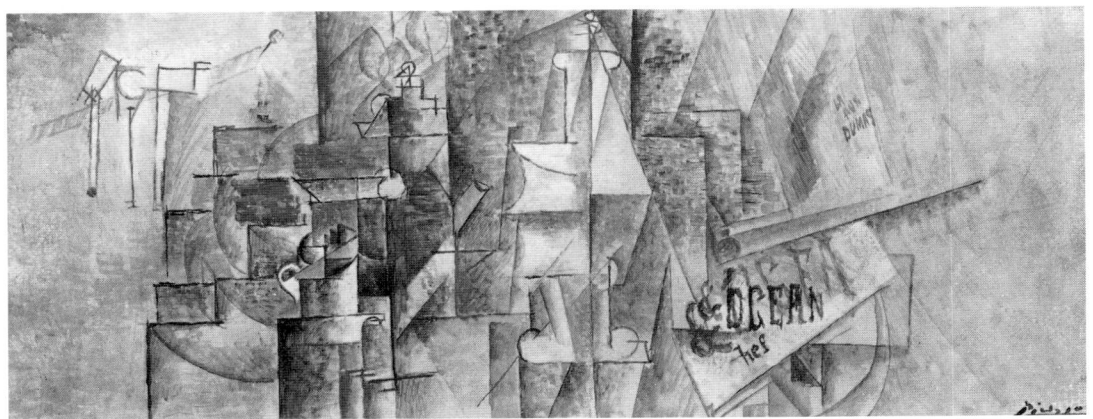

341

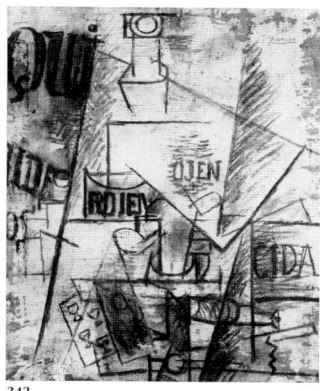

342

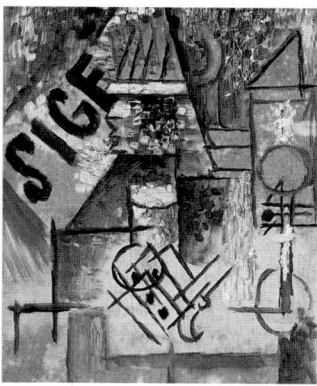

343

339 *Still Life (Le Torero),* Summer 1911

340 *The Fan (L'Indépendant),* Summer 1911

341 *Pipes, Cup, Coffee Pot, and Small Carafe,*
Winter 1911–12

342 *Still Life (QUI),* Spring 1912

343 *Newspaper, Matchbox, Pipe, and Glass,*
Autumn 1911

344 *Woman with a Guitar (Ma Jolie),*
Winter 1911–12

344

Céret 1911: Picasso and Braque

Picasso and Braque spent the summer of 1911 together in Céret, a small village in the foothills of the French Pyrenees, which would become one of the centers of modern art after its discovery by the sculptor Manolo. Invited there by the American collector Frank Burty Haviland, Picasso settled in the Hôtel du Canigou, and Fernande and Braque joined him in August. Since the end of 1909, Picasso and Braque had been working very closely together, "like roped mountain climbers," as Braque put it. "Despite our very different temperaments, we were guided by a common idea. . . . Picasso and I said things to each other during those years that nobody would know how to say any more, that nobody would be able to understand any more . . . things that would be incomprehensible and that gave us so much pleasure . . . and that will end with us. . . . Above all else, we were very focused."[2] Partners and rivals at the same time, the two artists dealt briskly with their research in "new space," attempting to preserve Cubism's primitive rigor without tipping over into abstraction. Each took up the other's gauntlet, and were it not for the signatures, one would have a hard time naming the creator of the *Le Portugais* or *Man with a Guitar* (Braque) and of *The Poet* (fig. 336) and *The Accordionist* (fig. 334) (Picasso). In all these paintings, the figures are made up of flattened volumes reduced to a geometry of acute angles and curvilinear accents and have been screened off within pyramid-shaped armatures raised high and shot through with horizontal strokes that reinforce the unity of the surface.

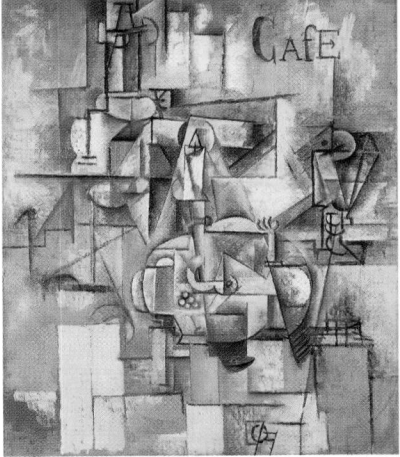

345

The analysis of the form is so subtle and complex that it requires an effort in interpretation, for the objects escape from us just at the moment we think we recognize them. The space in which they have been brought together and dismembered is of such density that the eye gets lost inside it, searching in a labyrinth of shapes for meager reference points that are mischievously blurred, truncated, and laden with ambiguity. The shadow of a mustache (*The Poet*, fig. 336), the folded bellows of the accordion (*The Accordionist*, fig. 334) or of the fan (*The Clarinet*, fig. 335) consolidate the tactile quality of space and soften the dizziness we feel in front of these canvases. According to Roger Fry, "their enduring fascination stems precisely from an almost untenable tension the observer must bear. The latter is delighted by the intellectual and voluptuous appeal of a pictorial structure consistent inside, yet he is equally seduced by the inevitable challenge to interpret this structure according to the known visual universe."[3]

If the methods of composition remained fundamentally the same from Cadaqués on (for Picasso) and from l'Estaque on (for Braque), new solutions that would turn secular notions upside down were put in place in Céret. Braque opened the way by introducing trompe l'oeil elements into his compositions (*Le Portugais*), such as stenciled letters or nails that emphasize the character of the plane and the material of the canvas as the subject of a picture, a prelude to the use of collage. Picasso fell in behind Braque by using the same strategies. Typographic marks—letters or numbers—were not chosen arbitrarily but to draw attention to something specific, such as the name of a newspaper. For example, the capital letters LE/TAU scattered inside the linear grid indicate the presence of the bullfighting paper *Le Taurero* (fig. 339) on a table in the café, and this summons up the world of the *corrida* so dear to Picasso's heart. A series of his canvases celebrated the pedestal table in an extravagant way, a theme also favored by Braque. In *The Fan* (fig. 340), as well as in *Pipes, Cup, Coffee Pot, and Small Carafe* (fig. 341), realistic signs attached to stenciled or drawn letters overlap in the pyramid-shaped structure made up of an oval space inscribed within a rectangle. Although truncated, the name of the Céret newspaper *L'Indépendant* is recognizable in the former, while the latter picture hides a great Romantic masterpiece beneath a deceptive worldliness, since the quivering letters on the right (LA/AUX/DUMAS) may invoke (as John Richardson believes) the lady of the camellias, cradled on a few musical notes by the lovely "OCEAN," while in the opposite corner hangs Braque's pipe rack. With Picasso, humor never lost its rightful place.

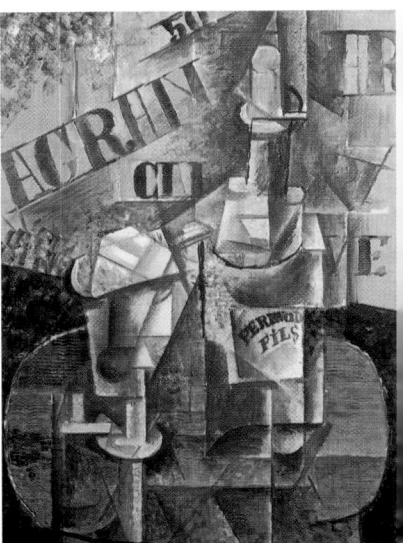

346

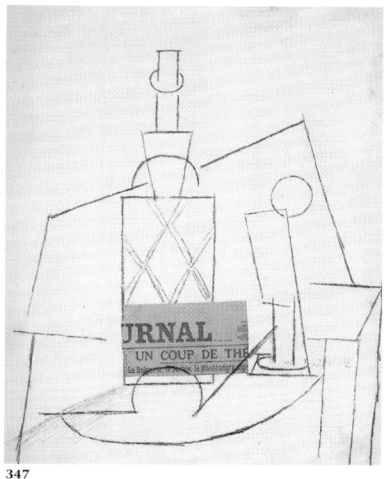

347

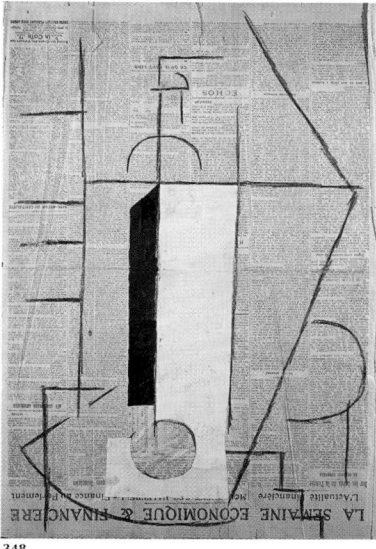

348

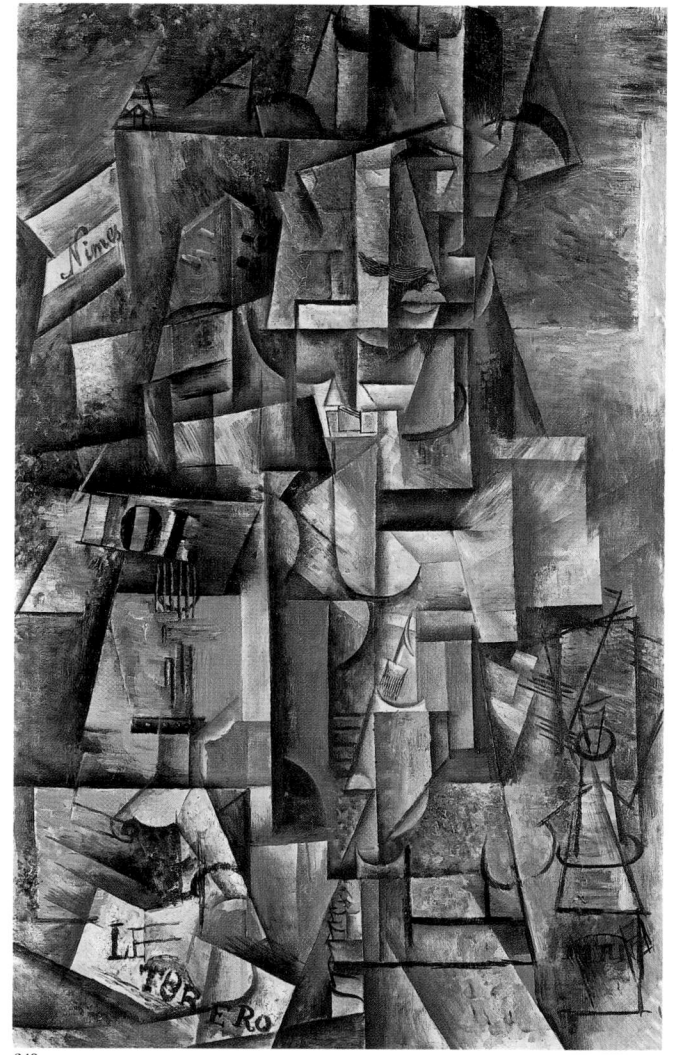

349

"Ma jolie"

It was probably in the fall of 1911 that a new companion entered Picasso's life: Marcelle Humbert, the mistress of the painter Lodowicz Markus Marcoussis. Picasso called her Eva (the Spanish version of her baptismal name Eve), perhaps to signify that she was the first woman who really counted in his heart. "I love her very much and I will write this in my paintings," he later declared to Kahnweiler. Indeed, the inscription "J'aime Eva" appears in several pictures, one of a guitar (fig. 359), whose roundness undoubtedly evoked her beloved body and was used to hide a gingerbread heart, which has, unfortunately, disappeared.

This woman, of whom we know little other than a photograph in which she looks frail in a Japanese kimono, will endure in history as "ma jolie" (my pretty one), words from a popular tune Picasso must have picked up at the Médrano Circus. The words "O Manon, ma jolie, mon coeur te dit bonjour" are stenciled in *Woman with a Guitar* (fig. 344), as if to record Picasso's love for this woman, whom he had met at one of Gertrude Stein's dinners. Words from the song appear on the table in *The Architect's Table* (Museum of Modern Art, New York), close to Stein's visiting card, and reappear in the center of the oval of *Violin, Glass, Pipe, and Anchor* (fig. 351), mixed in with other evocative inscriptions, such as a memento of a trip he took with Braque between Le Havre and Honfleur (HAVRE/FLEUR); a mysterious number 75, which may refer to the address of a favorite brothel, and part of the title of Apollinaire's serious magazine devoted to Cubism, *Les Soirées de Paris* (SOIR/DE/PAR).

Indifferent to the furor caused by the Cubist room at the Salon d'Automne of 1911, where all the Neo-Cubists were shown—with the exception of Braque and Picasso, of course—Picasso spent the winter of 1911–12 patiently spinning together what he had learned in Céret, favoring the motifs of the musician in an armchair (figs. 337 and 338) and the pedestal table (figs. 342 and 343). In *Pigeon with Peas* (fig. 345) one can see the geometric grid evolving toward greater clarity and simplicity, strengthened by inscriptions (CAFE, in this case) and other readily understandable references.

Color began to return noticeably to Picasso's paintings, perhaps a reflection of personal happiness. Was it for its bright tricolor cover or for its poetic title ("Our future is in the air") that Picasso chose a brochure promoting the development of military aviation as the basis for three versions of a still life? It hardly matters, since its presence was enough to transform ordinary little bistro tables where one has just dined on Coquilles Saint-Jacques into a marvelous place for reverie (fig. 353).

Still Life with Chair Caning (fig. 352) represents another sort of revolution. At first glance, the composition resembles any number of other Cubist still lifes of 1912. A pipe, a newspaper (indicated by the letters JOU), a glass, a knife, scallop shells, and a lemon (painted a naturalistic yellow)—all broken into gray or ocher facets—are arranged on what appears to be either a chair or a tabletop. Here, however, for the first time, the painter did not make use of his traditional tools to depict an object. In the place of a painted support, he used a piece of oilcloth printed to imitate chair caning. This, the first Cubist collage, is surrounded by a real piece of rope, which both functions as a frame and suggests the trimmed edge of a tablecloth. This process would be a decisive one for the art of the twentieth century, and Apollinaire soon announced to everyone: "One may paint with whatever one likes, with pipes, postage stamps, postcards or playing cards, candelabra, pieces of oilcloth, detachable collars, wallpaper, newspapers."[4]

Between Céret and Sorgues

Another turning point was reached in the spring of 1912. Braque, a great lover of materials, was the leader in the most extreme experiments carried out by the two painters. He

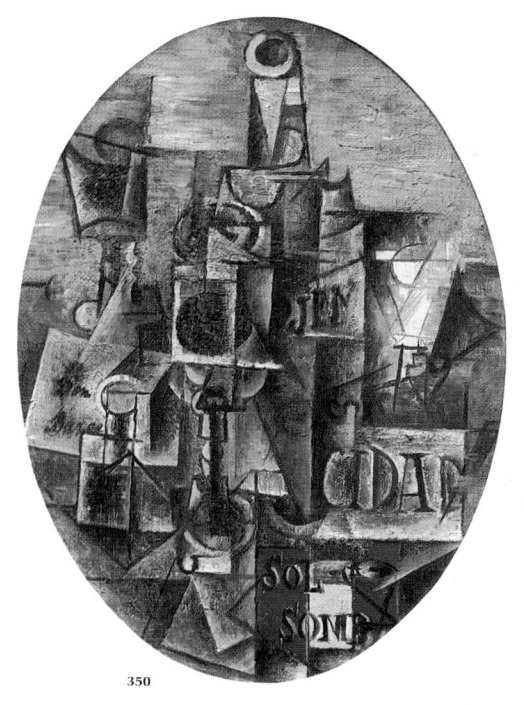

350

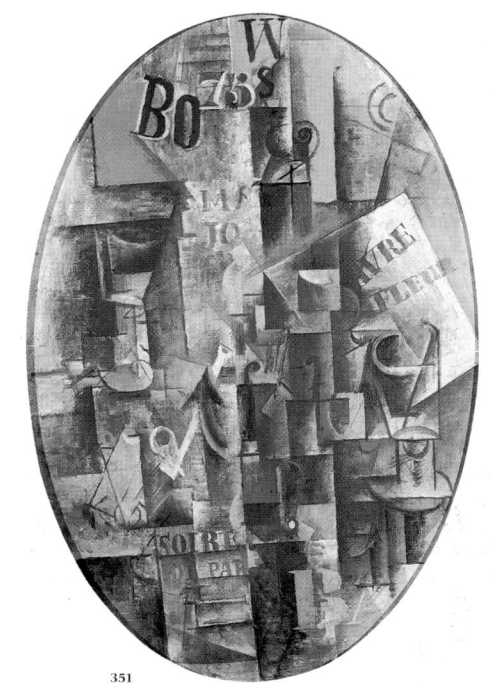

351

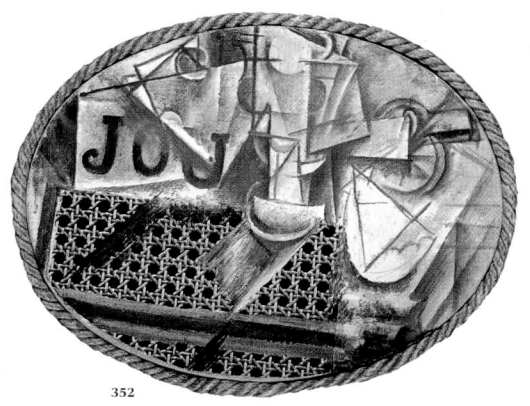

352

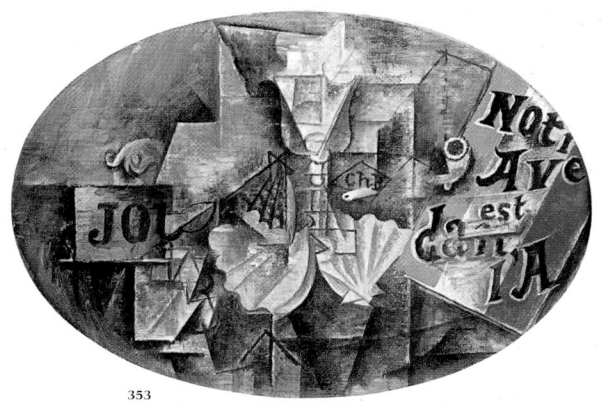

353

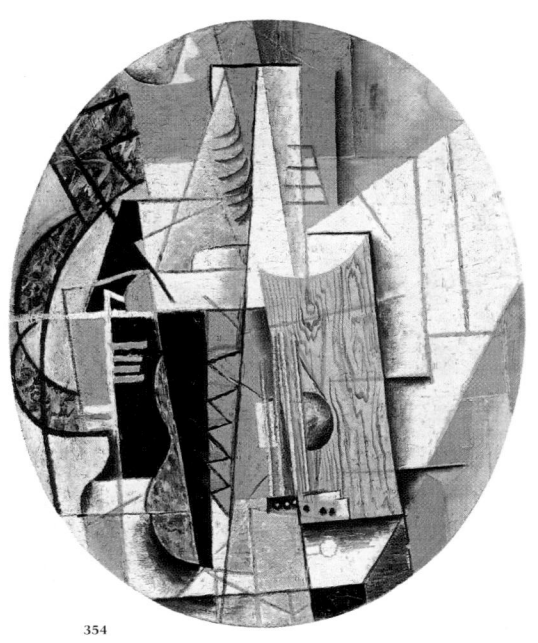

354

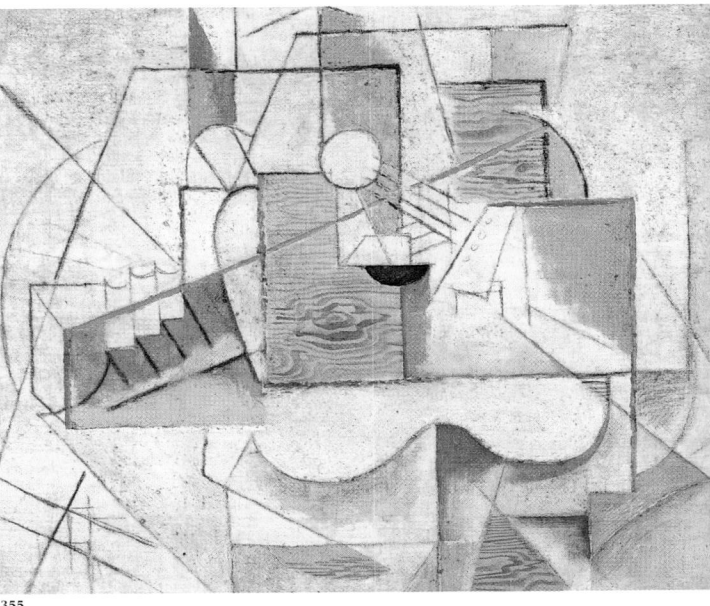

355

came up with the idea of using combs and varnish to imitate the veins of *faux-bois*, as well as other trompe l'oeil effects, and Picasso immediately seized on the possibilities offered by the technique, using a steel comb to trace lines in the hair and mustache of his *Céret Poet* (fig. 361). This treatment introduces an effect of undeniable realism and gives the figure an exceptional, sculptural quality. His guitar paintings from Sorgues (figs. 354 and 359), in which the forms of the instrument separated and refracted over several planes, made the most of this method. Dropping their monkish habits, Picasso and Braque adopted pastel hues—such as candy pink, sky blue, and pistachio green, painted in flat planes and outlined in black—which contrast dramatically with the deep relief of the surfaces covered by the *faux-bois*.

Every new approach helped them liberate painting from its illusionist, imitative role. The two painters spent the summer in the south of France, first in Céret and then in Sorgues, relentlessly pursuing elements or information that offered new optical effects. Captivated by its brilliance and density, Picasso had begun to use Ripolin, an enamel house paint that enabled him to reproduce the brightness and shine of the cards, posters, and packages and to break definitively with Impressionism. "[Ripolin] is the basis of good health for colors," Picasso told Gertrude Stein, "la santé des couleurs." In his *Spanish Still Life* (fig. 350) Picasso's use of Ripolin lends to the arena entrance ticket (SOL Y SOMBRA!) the quality of a collage, and the bright scarlet and pink background remind one of blood spilled by the bull.

The village of Sorgues is located in the area of Avignon, and Picasso and Eva moved into the Villa des Clochettes there on June 25, 1912, followed soon by the Braques, who stayed at the Villa Bel Air. Sorgues would soon become the center of a momentous change in the history of modern art. During the first two weeks of September, Braque bought in a store in Avignon a roll of wallpaper painted in *faux-bois* to imitate oak paneling. On a

354 *Guitar,* Summer 1912
355 *Guitar on a Table,* Autumn 1912
356 *Guitar,* December 1912
357 *Guitar,* Winter 1912–13
358 *Violin and Sheet of Music,* Autumn 1912
359 *Guitar (J'Aime Eva),* Summer 1912
360 *Violin and Grapes,* Spring–Summer 1912

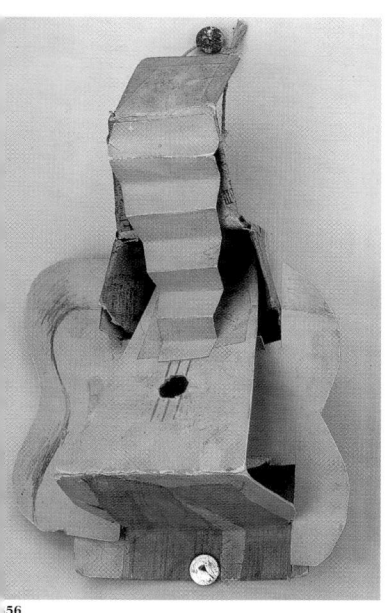

356

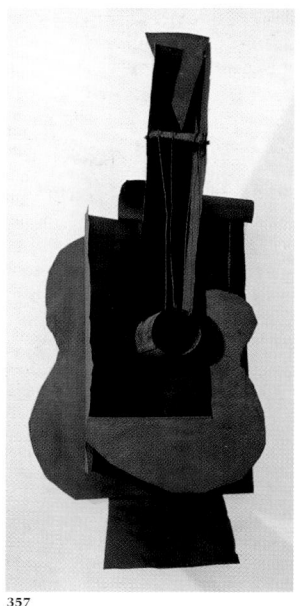

357

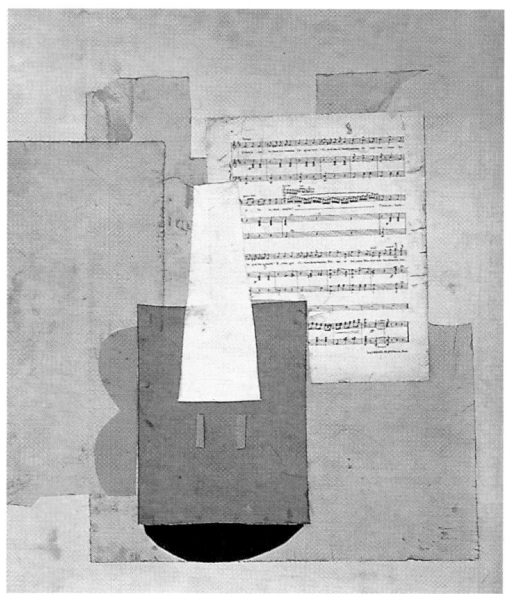

358

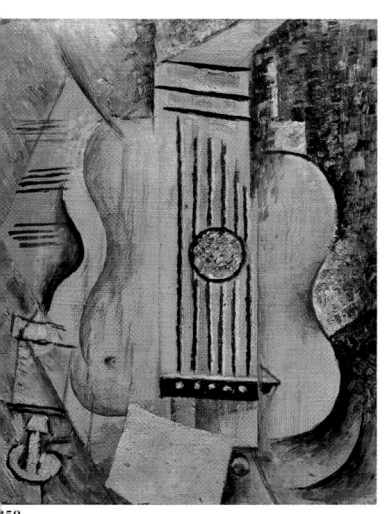

359

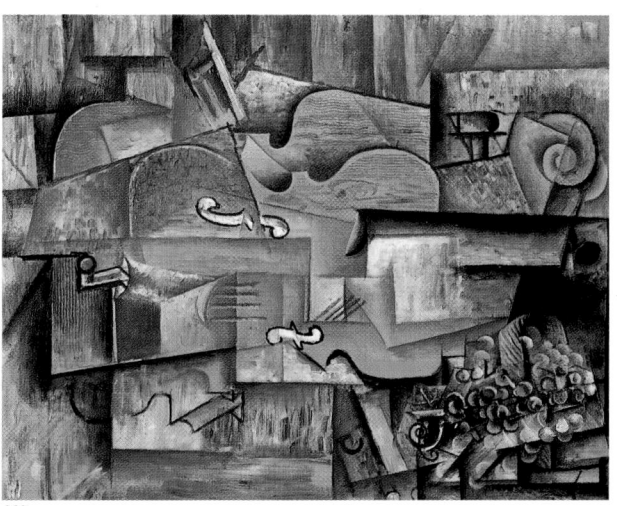

360

sheet of paper he glued bands of this paper to accompany a charcoal drawing. Thus was born the first *papier collé, Fruit Bowl and Glass*. In the same vein, he tackled other experiments with space and color by adding sand to the colored pigments in a portrait of a woman. Picasso could not believe his eyes. His "Wilbur Braque," as Picasso affectionately nicknamed his friend (alluding to the inventions of Wilbur Wright), was in the process of reinventing painting! After returning to Paris and setting up his new studio on the boulevard Raspail, Picasso reacted quickly, to such a point that he wrote Braque on October 9: "My dear friend Braque, I've been using your latest papery and dusty methods. I'm in the process of imagining a guitar, and I'm using a bit of earth on our dreadful canvas."[5] It was now Picasso's turn to explore the *papier collé*, and the photographs he took in the fall of 1912 in the boulevard Raspail studio, where the *papiers collés* were tacked on the wall, bear witness to his infatuation with the medium. Between Paris, Céret, and Avignon and into the year 1914, Picasso produced more than one hundred of them, classified by Daix into "three generations."[6] They would turn the secular notions of support and surface upside down forever.

The Papier Collé *Revolution*

For all that, painting was not abandoned. On the contrary, during the last months of 1912, their exploration of textures, materials, and color to suggest a new reality and space brought about a continuous interchange between painting and *papier collé*, which were constantly compared to each other. If the collages influenced painting (as in the return to color), then the latter was nourished by the experience of collage. In fact, it was through an oil on canvas enhanced with sand, *Fruit Bowl*, that Braque confirmed the validity of his first *papier collé, Fruit Bowl and Glass*.

Picasso too went straight ahead with both approaches. *Guitars on a Table* began as an oil on cardboard and continued as a *papier collé,* ending up as an oil on canvas (fig. 355), in which the subject is drawn in charcoal and finished with sand-covered surfaces or transcribed in *faux-bois*. Clearly, the spatial intent of the collage was identical to that of the sand-covered painting. For the Cubists the interest in collage lay in its anonymity, its "ready-made" aspect, which was not dependent on the painter's hand. One wonders whether the act of putting one's brushes aside might prevent the painter from "devoting himself to narcissism," as Louis Aragon suggested, or whether, as Kahnweiler suspected in Picasso's case, collage might "make the firm hand of the master felt" by demonstrating that there were no "noble techniques," by proving that the painter's emotion could be expressed through bits of paper or cardboard—and later on a shirt tacked on to a wooden board—just as well as through oil or gouache.

Some of all this is present in the series devoted to the *Violin and Sheet Music* (fig. 358), which combines both the impersonal and the sensitive. The form no longer depends on a drawn or painted structure; *papier collé* has taken its place. Cutouts and assemblages alone define the spatial composition. Here color "working simultaneously with form," as Braque put it, takes priority, disrupts the two-dimensionality of space. The score of "Trilles et baisers" (Trills and Kisses)—a real sheet of printed music—enriches the formal content of the painting by giving it additional poetic resonance, and it also marks the transition to a *papier collé*, in which glued cutouts not only deny the painter's hand but also fully confirm their own specificity. The guitars were followed by a series devoted to violins (fig. 374), which were sometimes pictured in association with other objects, such as glasses or fruit bowls.

The use of newspapers as an element of collage (Braque would not begin to use these until much later and in a spirit very different from Picasso) introduced color effects, relief,

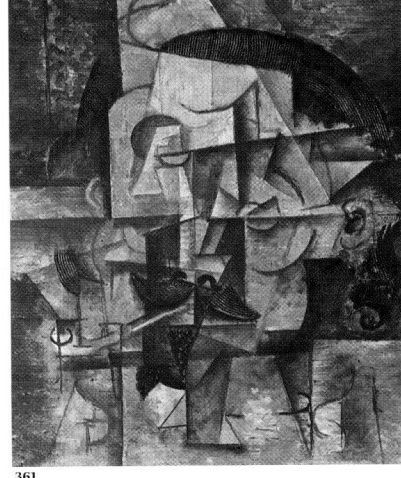

361

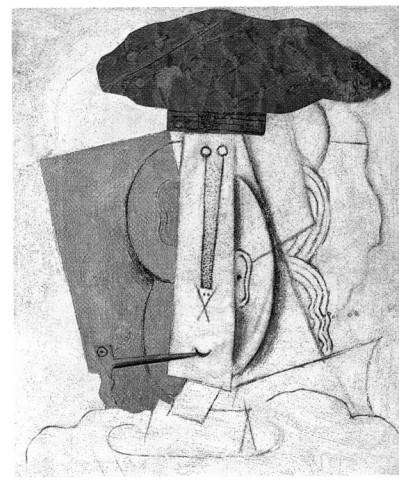

362

361 *The Poet,* Summer 1912
362 *Student with a Pipe,* Winter 1913–14
363 *Student with a Newspaper,* Winter 1913–14

162

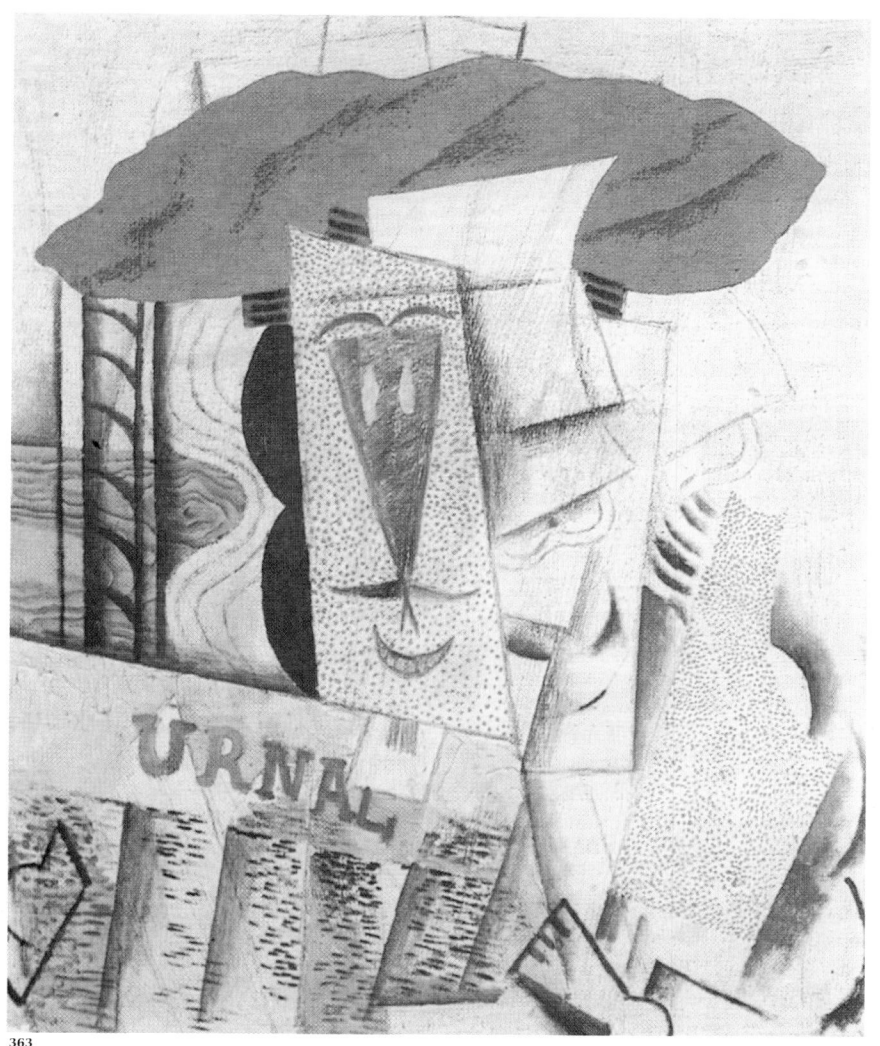

363

163

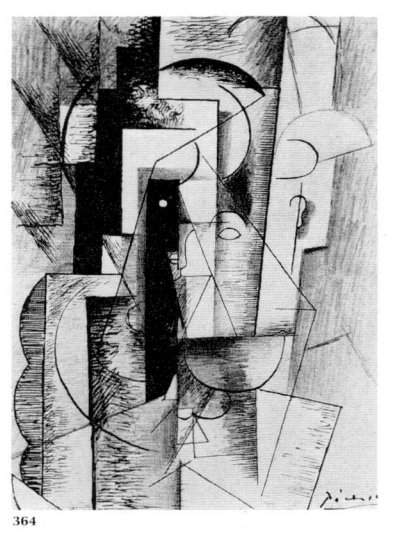

364

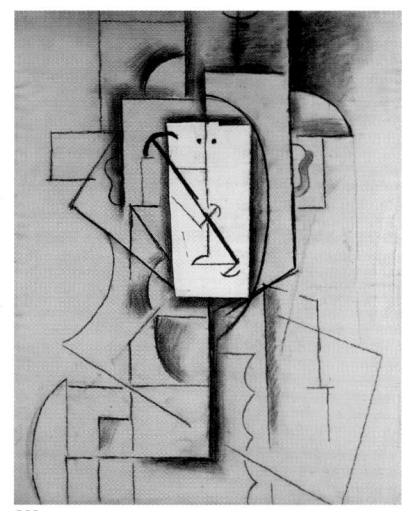

365

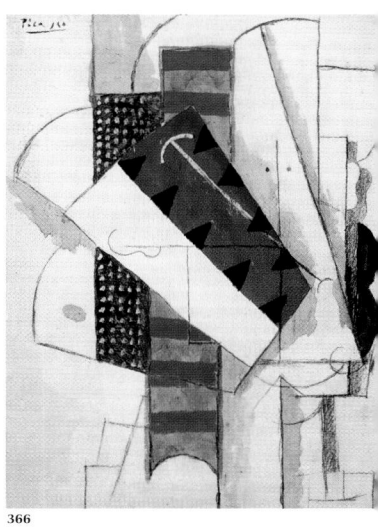

366

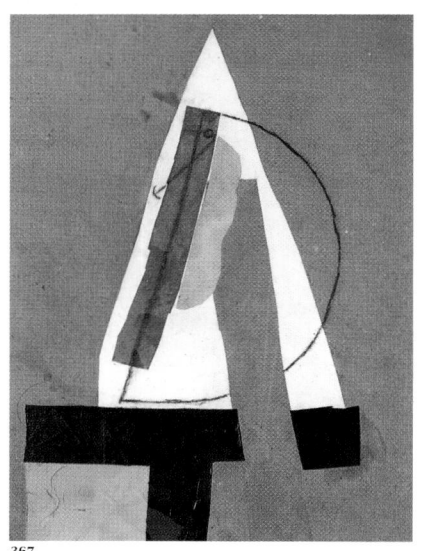

367

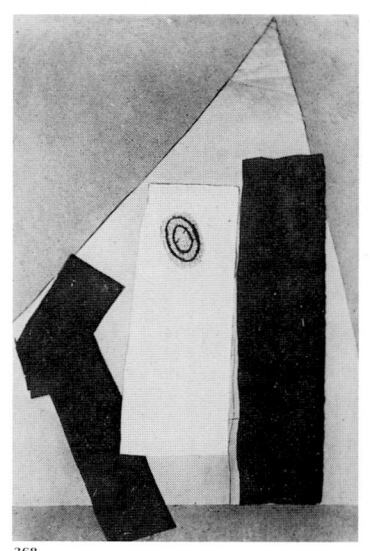

368

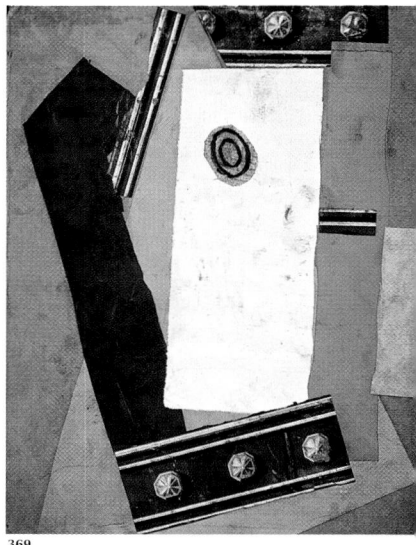

369

and a completely new texture. The finely printed lines resemble the imprinted veins of *fauxbois* like a simple metaphor for the structure of the musical instrument drawn in negative. Acting as both background and form, the newsprint undermines the values of opacity and transparency, of depth and relief. These formal and spatial paradoxes move this collage into the domain of "machines à voir" (looking machines) much praised by Jean Paulhan.[7]

One of the innumerable variations on the theme of the bottle, produced in the fall and winter of 1912, *Bottle, Newspaper, and Glass on a Table* (fig. 347), recognizable in one of the photographs of the boulevard Raspail, is a perfect response to the famous definition of Tristan Tzara: "A shape cut from a newspaper and integrated into a drawing or a painting incorporates the commonplace, a piece of prevailing daily reality, in comparison to another reality, constructed by the spirit."[8] Indeed, the collage here directs one to a play of images and information that anchors the painting to the real, even while the graphic structure supporting it tends toward the emblematic, the emblem of a newspaper and of space, as opposed to signs of objects represented as containers, volumes emptied of their substance, immaterial and transparent. *Bottle on a Table* (fig. 348) is the only example in the series of a collage in which the newspaper, usually presented in the shape of a subtle clipping, takes the place of both support and background at the same time. If the newspaper collage adopts the shape of the bottle, it creates a contradiction by refusing it any transparency. A more synthetic representation was evolving. During the month of August 1912, Kahnweiler had received a letter written by Braque from Sorgues in which he made it known that together with Picasso he was doing "things one cannot do in Paris, sculpture on paper among other things, which has brought me much pleasure." Nothing remains of these construction games for two, nor is there anything left of the work in relief on paper that Braque made later in the Hotel Roman on the rue Caulaincourt. On the other hand, the two small *Guitars* (fig. 356) made of dirty cardboard and strung with cords, which were thrown together by Picasso in December 1912, have resisted time in spite of the fragility of their materials. Put together from a single piece of cardboard that was folded, cut out, and assembled in superimposed planes that suggest relief, these are open forms that break with the closed volume of traditional sculpture-in-the-round.

The first construction in metal was also a *Guitar* (fig. 357) cut out of sheet metal, whose inverted volumes could have been suggested, according to Kahnweiler, by a Nigerian Wobe mask that Picasso had found in Marseilles in August 1912 (the projection reads like a hollow, while the hollow suggests a relief). The reduction of the object to its formal structure by means of geometric planes would serve as a model for synthetic Cubism. Picasso's cardboard prototype—today destroyed but known through a photograph—showed it joined to two pieces of paper tacked to the wall, one of which represents a bottle reduced to a flat, latticed emblem.

Synthetic Cubism

In the early days of 1913, Picasso produced a Cubist portrait of Apollinaire (fig. 364) as the frontispiece for the first edition of *Alcools*. In March he left with Eva for Céret, where they were joined in April by the poet Max Jacob. Even Jacob's legendary impudence could not distract Picasso from the anguish caused by the terminal illness of his father, José Ruiz, who died on May 2 in Barcelona. It was a bleak spring and summer, during which Eva fell ill and his beloved dog Frika died; Picasso himself suffered an attack of what he believed to be typhoid fever. Shattered by the death of the man who had been his first mentor, Picasso threw himself headlong into his work. In mid-August, he brought with him from Céret some ten paintings and drawings and about thirty collages, all of them today grouped under the label "second-generation Cubism."

364 *Portrait of Guillaume Apollinaire,* early 1913
365 *Head of Harlequin,* 1913
366 *Head of a Man,* Spring 1913
367 *Head,* May–June 1913
368 *Guitar,* Spring 1913
369 *Guitar,* Spring 1913

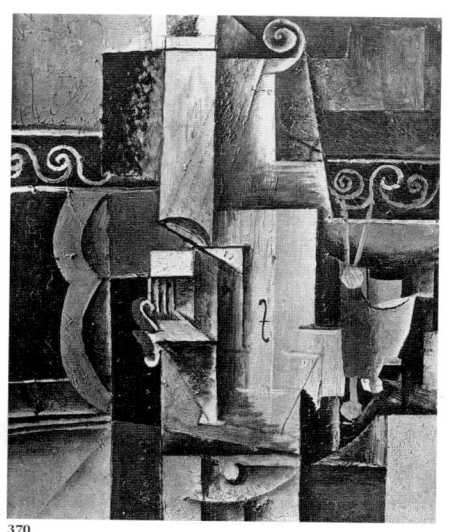

370

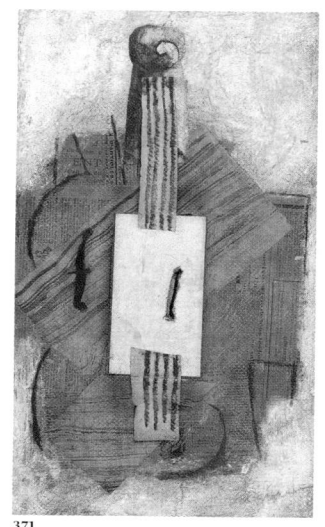

371

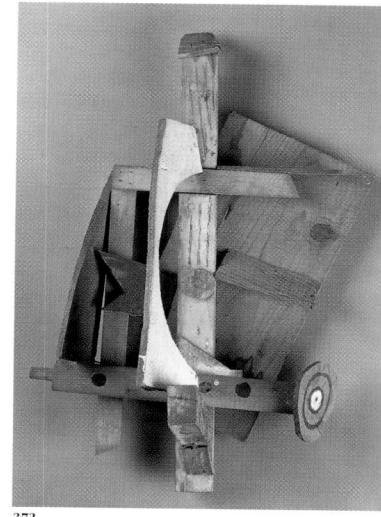

372

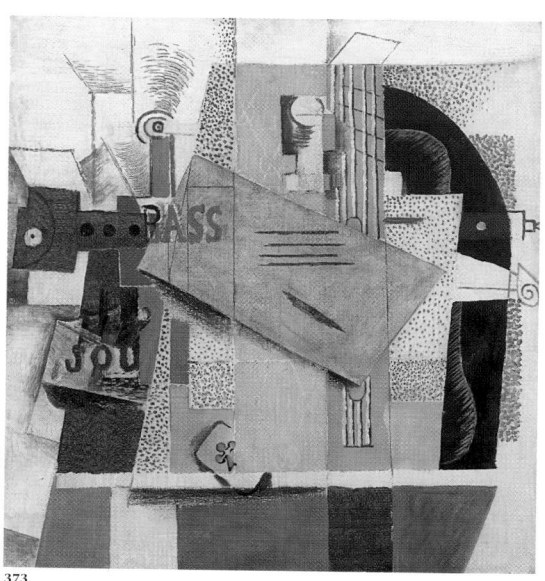

373

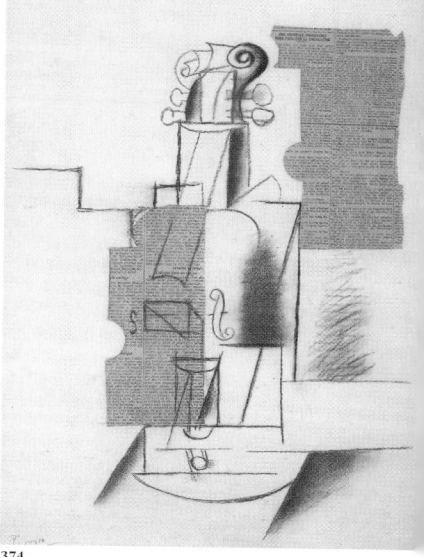

374

370 *Violin and Glasses on a Table,* early 1913

371 *Violin,* end 1913

372 *Mandolin and Clarinet,* Autumn 1913

373 *Still Life with a Violin and a Glass of Bass,* 1913–14

374 *Violin,* Winter 1912

166

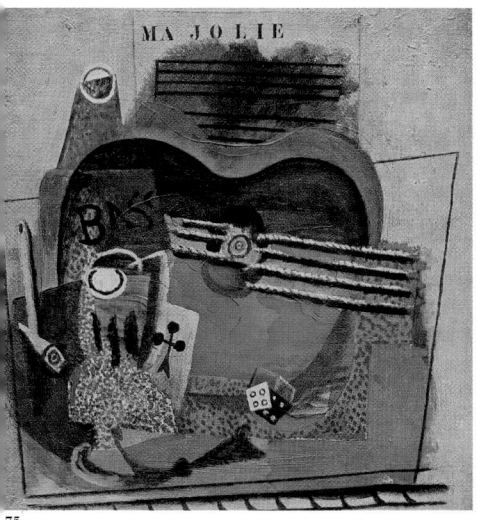

75

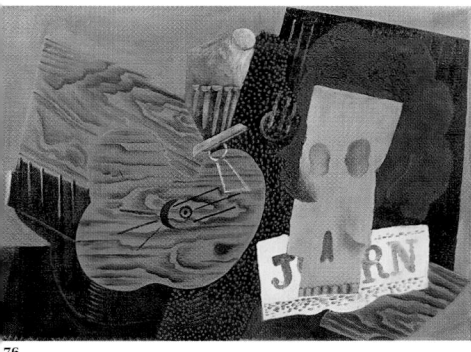

76

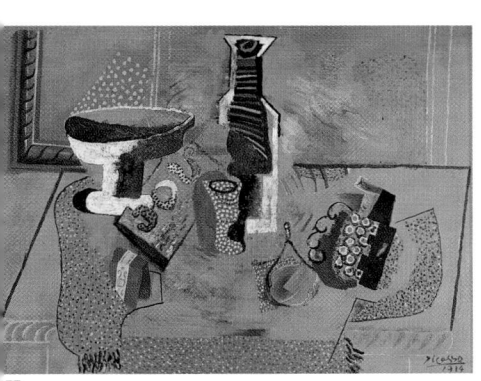

77

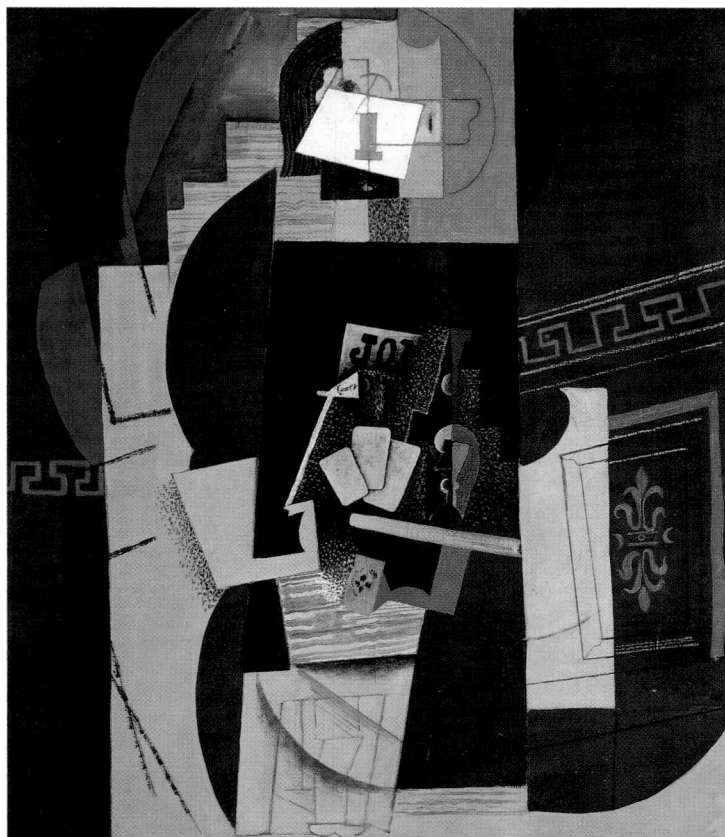

378

375 *Ma Jolie,* Spring 1914

376 *Guitar, Skull, and Newspaper,*
Winter 1913–14

377 *Green Still Life,* Summer 1914

378 *Card Player,* Winter 1913–14

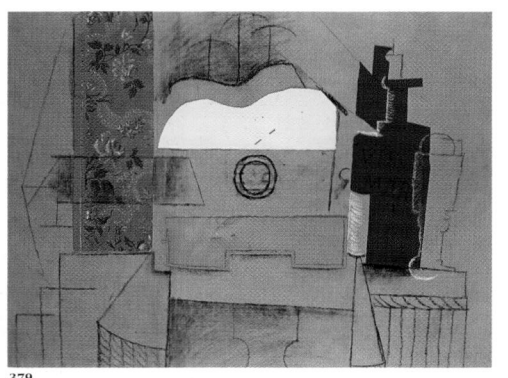

379

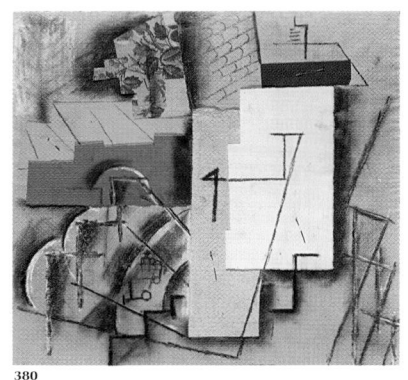

380

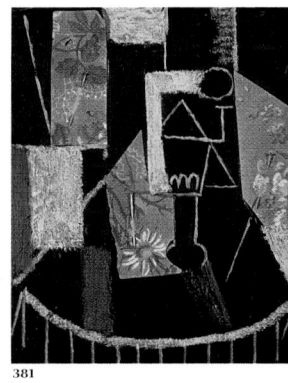

381

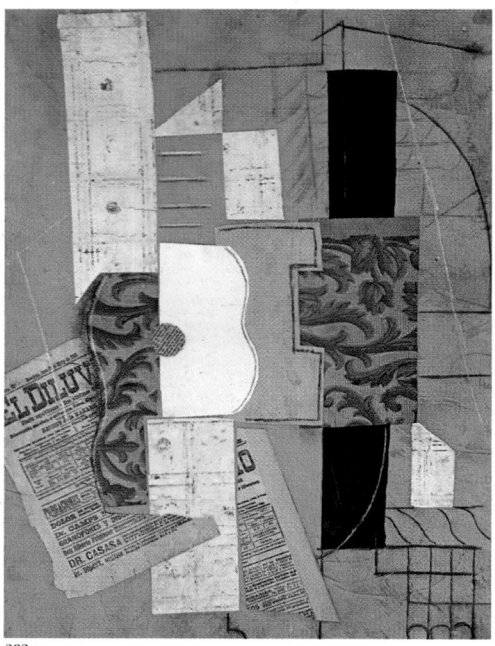

382

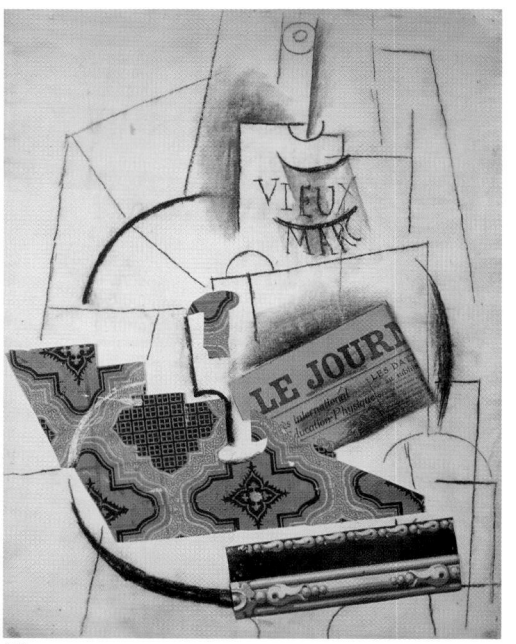

383

384

379 *Guitar, Glass, Bottle of Vieux Marc,*
 Spring 1913

380 *Céret Landscape,* Spring 1913

381 *Glass on a Pedestal Table,* 1913

382 *Guitar (El Diluvio),* after March 31, 1913

383 *Bottle of Vieux Marc,* after March 15, 1913

384 *Still Life (Au Bon Marché),* early 1913

385 *Woman in a Chemise in an Armchair,*
 Autumn 1913

385

Driven by intellectual curiosity, Picasso progressed to the painting of emblems in the summer of 1913. He became interested in capturing the essential attributes of the object compressed into a single image, its pictorial essence. This new method of working elements of the composition into a synthetic form led him at first to a minimalist simplification, which was very rapidly refuted by a series of works that were carried away by a delightful exuberance. In fact, were it not for the presence of a few reference points necessary to understand them (lottery balls for eyes in one picture, a soundboard in another), nothing in these first collages from Céret, which seem completely abstract, would enable one to distinguish between a *Head* (fig. 367) and a *Guitar* (fig. 368). The painter is playing with the ambiguous nature of the clues: the same triangular bases for both, the same bands of black or blue glued paper to stabilize the forms without mimicking the subjects, and the use of the double curve that usually evokes the guitar to form the head.

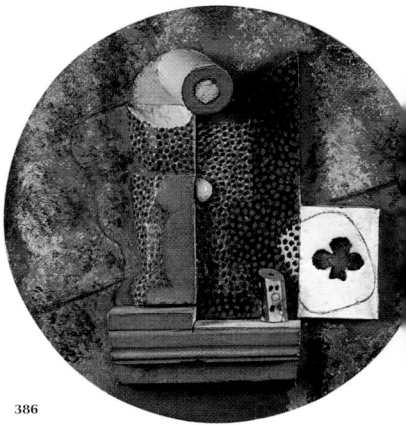

386

Picasso has reduced the realistic clues to the status of ideograms, such as the charcoal line crossed by an arrow, the simple ellipse that gives a human face to an assemblage of planes (fig. 366), and the two circles traced on circular pieces of newspaper to indicate the soundboard of the guitar (figs. 368 and 369). Although the accuracy of the drawing is minimal, the rigorous geometry of the planes is balanced by the presence of color in the form of paper and is thus independent of the object. One can understand the unique character of this limited series—rapidly executed but carefully thought out—and of this conceptual approach, which in the oil version of the guitar collage (Picasso Museum, Paris) comes close to abstraction by dint of purification. It is the same quality of ascetic clarity that one finds again in the series of men's heads so well liked by Tristan Tzara, an insightful commentator and admirer of *papiers collés*, which he called "proverbs in painting." Despite the shattering of volumes into superimposed geometric planes and the elimination of detail, the *Head of Harlequin* (fig. 365)—possibly inspired by a circus passing through Céret, which Max Jacob described colorfully in his letters—is constructed on a single central axis and resembles a face, whereas a comparable collage by Braque, the *Harlequin* of 1912, relies on a less readable side view.

387

One of the main characteristics of the still-life collages of this "second generation" was the growing diversity of the materials, which gave rise to an increasingly complex space based on superimposed colored planes. Without becoming much more articulate, the composition became more dense, enriched by new textures and motifs; by combining samples of commercial wallpaper (strips of trompe l'oeil, imitation paving, and garish flowers chosen for their kitschy quality) with newspaper clippings, the painter could let imagination run free.

Thanks to Robert Rosenblum, who found the actual date of the newspaper glued to the *Bottle of Vieux Marc* (fig. 383)—March 15, 1913—this collage, for a long time thought to date from 1912, has again found its rightful place.[9] A line of charcoal and a strip of wallpaper make up the table's edge. The bottle is summed up in synthetic signs: a circle for the neck, a rectangle and two arcs for the body, and an inscription for its contents. The shapes of the glass and the table have been cut out of the same piece of tapestry and pinned in a way that creates an effect of visible relief. On the pedestal table with its fringes made of cord (hereafter omnipresent; see fig. 381), the bands of paper in one color, either pinned or tacked on, break up the empty space and increase in volume, as a result of the shadows they generate.

With great virtuosity the painter played with and mixed every technique—oil, glued papers, and white chalk on canvas—in order to achieve the *Glass on a Pedestal Table* (fig. 381); its modest dimensions and the crystalline purity of its design, incised negative on a black background, give it the quality of a precious object. On the other hand, the most striking element of the guitar in fig. 382 is unquestionably the page of the newspaper *El Diluvio*, dated "Barcelona, Lunes 31 de Marzo de 1913," whose two torn fragments

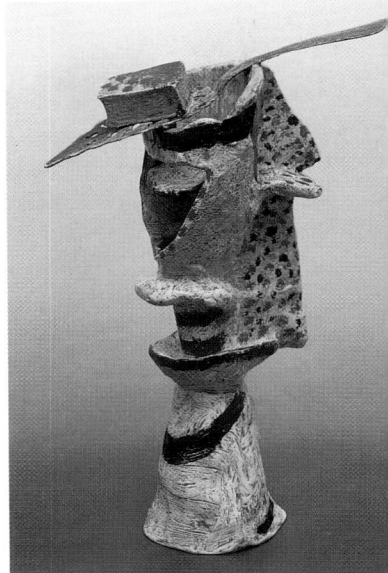

388

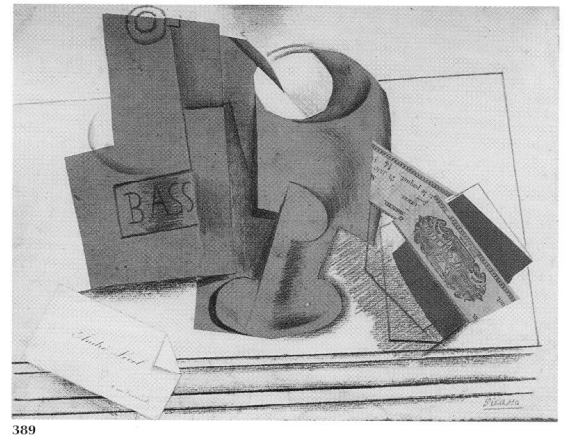

389

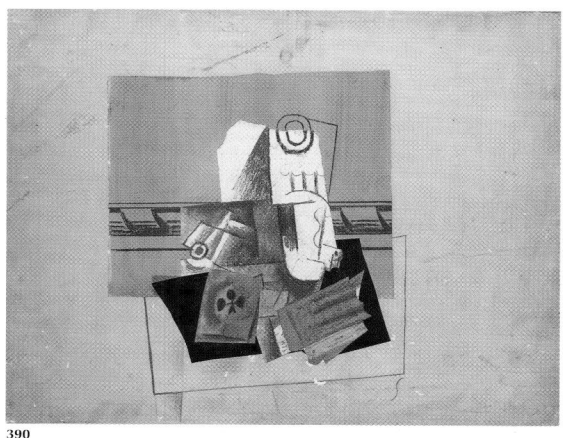

390

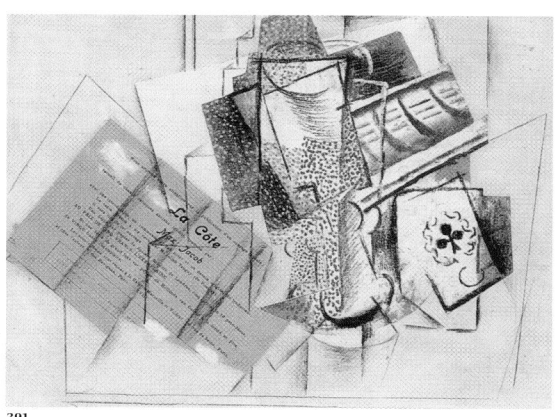

391

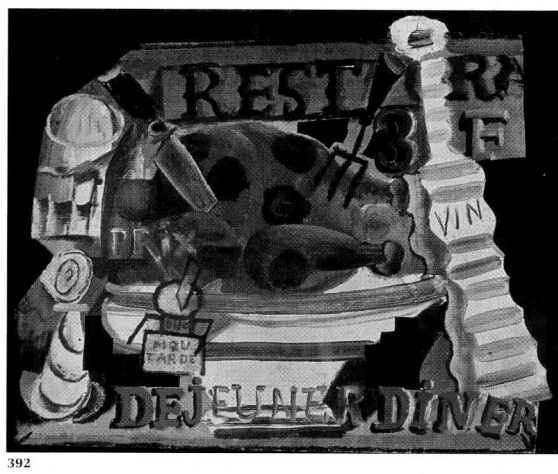

392

386 *Glass, Pipe, Ace of Clubs, and Die,* Summer 1914

387 *Glass and Pipe, Numbers and Letters,* Autumn 1914

388 *The Glass of Absinthe,* Spring 1914

389 *Bottle of Bass and Calling Card,* Spring 1914

390 *Glass, Ace of Clubs, Pack of Cigarettes,* Spring 1914

391 *Still Life with Glass and Card Game
(Homage to Max Jacob),* 1914

392 *The Restaurant,* Spring 1914

393 *Glass and Bottle of Bass,* Spring 1914

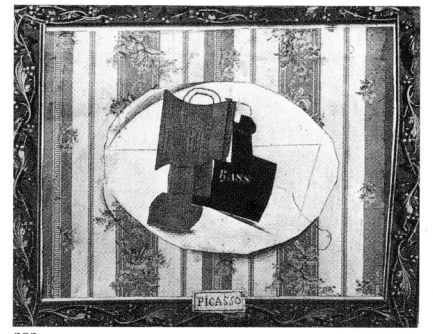

393

create a powerful visual sequence compared to the other elements of the composition (bands of damask tapestry and monochrome paper enhanced with ink, chalk, and charcoal), which merely play with the contrasts of light and dark for spatial purposes. One wonders whether Picasso planned the impact that the text of *El Diluvio* has on this masterfully executed composition, for the fragments consist of nothing but advertisements promoting purgative and gynecological ointments and professors specializing in venereal and eye diseases! As a friend, Jean Paulhan, commented: "The *papier collé* has . . . a sensual and sacred quality in Braque and his disciples, it is spiritual and playful in Picasso and his followers."

It was with Juan Gris—a new companion on the Cubist road—that Picasso produced two small landscapes of Céret (fig. 380), which introduce a decorative element in which virtuosity counts less than concern for craft. He has given priority to color and composition, essential elsewhere but here used only to punctuate the arrangement of the cut-out forms. As Matisse would do later on, Picasso cut relatively realistic forms directly from the colored paper, often with sinuous outlines, in order that the severity not become sterile.

Here then, at the end of the Céret period, one can see how Picasso's search for new ideas is the logical result of his continuous quest for reality. The inert reality of the paper, cut and shaped, comes alive in the very life of the painting. For example, the physical power of the velvet beret made of crumpled paper in *Student with a Pipe* (fig. 362) is such that a commonplace object becomes devastatingly poetic. The student's physiognomy, borrowed from Wobe masks and softened by reference points that are both sensual (the curls in his hair, the ridged earlobes) and picturesque (the pipe and the pin on his beret indicating his field of study), is a good example of Picasso's concern with reality. The painted version of this work (fig. 363), probably done in Paris that August, is invested with pleasant, seductive materials: flecked fabrics, finely lined, shimmering, and richly textured, with inscriptions and motifs painted in trompe l'oeil. Here painting has returned with renewed vigor using its own methods, more masterful than ever, nurtured by the innovations introduced by the *papiers collés*.

Constructions and Relief-Paintings

With the exception of a few paintings—one of which is among his finest masterpieces—and the elaboration of a third generation of *papiers collés*, Picasso would devote a period of eight months—from the fall of 1913 to the spring of 1914 coinciding with his move to a new studio in Montparnasse, at 5-bis, rue Schoelcher—to the development of a completely new group of objects, constructions, and paintings in relief.

The gentle Eva may have been the model for *Woman in a Chemise in an Armchair* (fig. 385), whose assertive eroticism—embodied by the projectile-shaped breasts—seduced the Surrealists to such an extent that they included it in their London exhibition of 1927. Roger Vitrac referred to the picture as "the perfect sign of these times," and Paul Éluard could not get over "the enormous and sculptural mass, . . . the head as large as that of the Sphinx, the breasts like studs on the chest, which contrast wonderfully—something neither the Egyptians nor the Greeks nor any artist before Picasso had managed to create—with the face and its delicate features, the wavy hairdo, the delicious armpit, the ribs that jut out, the diaphanous shirt, the soft and comfortable chair, the daily newspaper."[10] A real visual shock, she is seen simultaneously from the front and in profile, completely spiked with protuberances and angles as sharp as daggers. Yet her geometry is tempered by details of delectable realism: the reddish reflections in her hairdo, the pink strips of padding, the impeccable fringes of the trim, and the crumpled embroidery around a perfect navel all compose a boudoir scene spiced with a pinch of grotesque humor.

The idea of the *Card Player* (fig. 378), a subject inherited from Cézanne, may reflect the

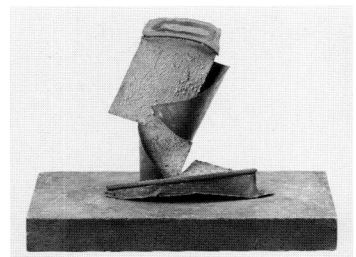
394

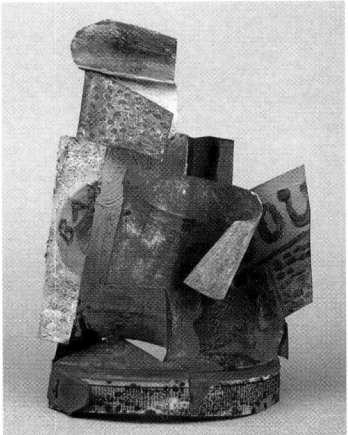
395

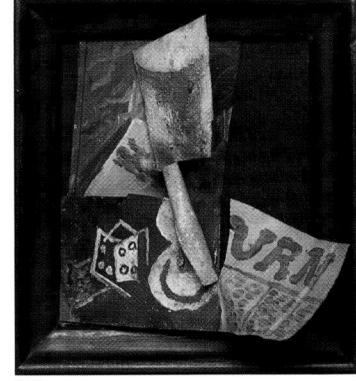
396

394 *Glass*, Spring 1914
395 *Bottle of Bass, Glass, and Newspaper*, Spring
396 *Glass, Die, and Newspaper*, Spring 1914

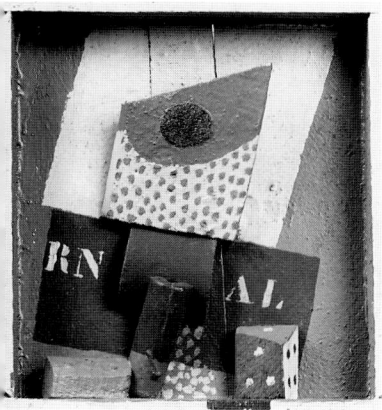

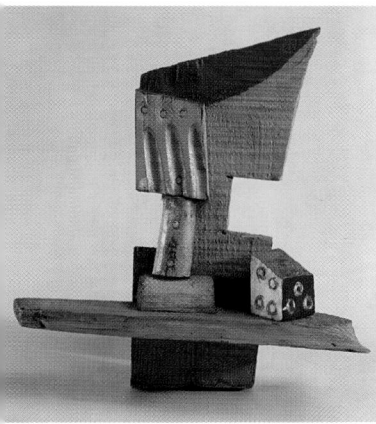

397 *Glass, Newspaper, and Die,* Summer 1914
398 *Glass and Die,* Spring 1914
399 *Still Life (The Snack),* beginning of 1914

influence of Juan Gris (which he himself summed up in his famous remark: "Cézanne makes a cylinder out of a bottle, I . . . make a bottle out of a cylinder"). Here, as in the works of his compatriot, the success of Picasso's composition lies in the perfect balance between the ornamental and the pictorial architecture—the balance of curvilinear and rectilinear forms, the harmony of warm and cool colors, the richness of textures and trompe l'oeil.

These examples of three-way influence (Braque, Gris, Picasso) resulted from their attraction to the same objects, the very ones that obsessed them in their daily lives, such as the wrapping on a package of tobacco printed with "Manufactures de l'État," whose old-fashioned acrony amusing in the context of the austere *Bottle of Bass and Calling Card* (fig. 389), reappeared later on, slipped into many *papiers collés* by Braque and Gris. Picasso's example comes under the category of compositions dedicated to his most ardent defenders. Here, uneasily resting on the table's edge is the dog-eared business card of the merchant André Level, a distinguished interpreter of Picasso's work. Elsewhere, it is the card of "Miss Stein, Miss Toklas, 27 rue de Fleurus" that will follow the same path: real object, found object, painted object.

Homage to Max Jacob (fig. 391) investigates the picturesque and bizarre mind of the poet. The subscription form for *La Côte,* a "collection of unpublished old Celtic songs" (in fact, a farcical pastiche of poetry from Brittany, where Jacob came from), reflects their long friendship. This friendship was sealed on June 24, 1901, in Monsieur Vollard's shop, at the moment Picasso's first Parisian exhibition was opening, and it gave rise to two of this century's most remarkable collections of poetry, *Saint Matorel* (1911) and *Le Siège de Jérusalem* (1914), which were published by Kahnweiler.

One can also see Gris's contribution in Picasso's treatment of the glass, which is deconstructed into several projections that are spread out like a fan and distinguished from each other by shape and color. The design is permeated with lightweight, refined textures that make way for a new motif destined for good luck—the playing card, which has visually replaced the letters. If Braque had a penchant for the ace of hearts, Picasso avowed a special attachment to the ace of clubs. Painted in trompe l'oeil, like the molding that fills the background, the card in *Glass, Ace of Clubs, Pack of Cigarettes* (fig. 390) is placed right next to cigarette pack, which is very real as well, in the heart of a composition closed in upon itself to allow the blank space of the support to radiate out.

This was truly a productive period for Picasso, in terms of quantity (he made some forty *papiers collés* and drawings before he left for Avignon) and virtuosity: the Cubist language here found a second wind, as it moved toward an expression that was both more cerebral and more lyrical. As he tracked down the object, Picasso operated like an entomologist dissecting an insect in order to broaden his knowledge. His points of departure were a few consistent motifs, such as the glass, bottle, pipe, card, and newspaper (the figure was omitted entirely from the *papiers collés* of the third generation), and their forms were endlessly analyzed. Repetition does not always lead to monotony in these works, however, since pieces of increasing subtlety emerged from his hands, thanks to an extensive range of materials combined with his consummate mastery of intrepid formal and spatial contradictions.

No better example exists of this self-reflection in painting than the admirable *Glass and Bottle of Bass* (fig. 393), which functions like a picture within a picture. A tondo of paper is anchored on a background of striped wallpaper, where the *papier collé* has a fine time playing at being a "great" painting, a museum painting suitably displayed (with a strip of paper imitating a gilded frame) and labeled (by a charming unpretentious placard bearing the artist's signature). What a fine conjuring trick, worthy of the earlier acrobats!

Picasso's constructions would arise from this series of *papiers collés*, for it was in these apparently humble, monastic compositions that Picasso worked out a reversal of the respective roles of design and color by using the paper edge to establish the form and

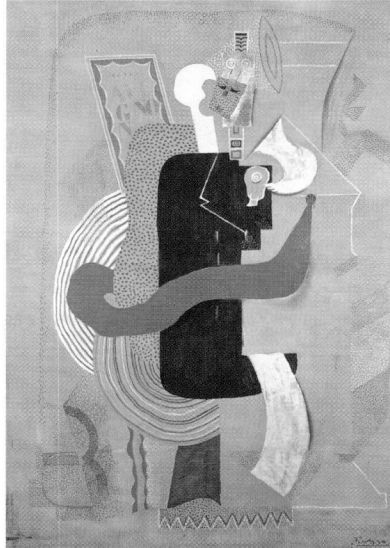
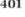
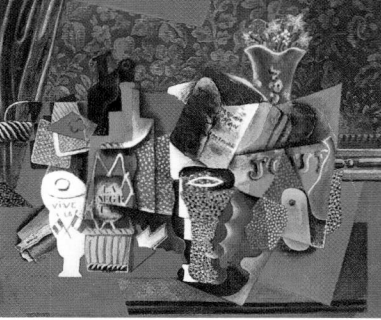

400

401

402

400 *Portrait of a Girl,* Summer 1914
401 *Seated Man with a Glass,* Summer 1914
402 *Playing Cards, Wineglasses,
and Bottle of Rum,* 1914–15

174

transparency of the glass or bottle, so that they "impose themselves by their absence" as John Golding put it. This breach of the consistent space, even when imperceptible, as in the case of the cutout circle in the paper glass of *Bottle of Bass . . .* (fig. 389), was the beginning of the open, broken-up sculptures.

With the exception of the *Violin* (fig. 371), *Mandolin and Clarinet* (fig. 372), and *Guitar and Bottle of Bass*, the constructions and relief-paintings of 1913 did not survive ("the stunning guitars made of inferior pieces of wood, true bridges of fortune thrown at the song, could not withstand the singer's amazing run," André Breton sadly wrote.[11] Fortunately, the "Kahnweiler prints" published by Apollinaire—to the great displeasure of his readers—in the November 1918 issue of *Les Soirées de Paris* immortalized the memory of a torn-up violin on a papered wall and of a bottle perched on the corner of a table together with an abstract structure—called a guitar—that is openly phallic. Not to mention the *Guitar Player* whose newspaper hands, glued onto the drawing, are strumming a very real guitar, which hangs from cords in the 1913 photograph of the Raspail studio reproduced in *Cahiers d'Art,* where one can see the still life *Au Bon Marché* (fig. 384).[12] These three-dimensional objects, called constructions or relief-paintings (when they were hung on the wall like paintings), would play a decisive role in twentieth-century sculpture, as the bridge between painting and sculpture, synthesizing the lessons of African sculpture and the experience with *papiers collés.*

For the construction of *Mandolin and Clarinet* (fig. 372), a few pieces of rough wood were enough: a small board of bent pine creates a background that leans against the wall like an African mask; bits of nailed and painted wood define the shape, which by being hollowed out (Kahnweiler would have said "punched out") is in no way continuous. Paradoxical laws govern the architectonic structure, which is composed of intertwining planes in which volume is suggested in the negative (the body of the mandolin is indicated by a hollow cut in a wooden board) and concave forms are in relief (the bell of the clarinet juts out from the neck). Lines of pencil and paint are the only reference points that enable one to identify the instruments. This sort of open-work construction that exposes the innards of objects delighted the Russian Constructivists, who were captivated by their conceptual power after Tatlin saw them in 1914 in the rue Schoelcher.[13]

The humble appearance of the little *Violin* (fig. 371), which is meticulously put together, is deceptive, because it contains hidden treasures of invention. The addition of a cardboard box as a soundboard transforms the *papier collé* into a relief, or to be more precise into a relief-painting, since it has been painted and hung on the wall. Paradoxically, this explosion of the form into isolated fragments is what contributes to the enhancement of their visual and tactile qualities. As in the *Bottle on a Table* (fig. 348), the newspaper is stretched across the background to provide texture and color, and the pieces of *faux-bois* paper, clearly playing a metaphorical role, reinforce the depth of the space as their dull finish contrasts with the luminosity of the white gouache. The head is painted in an illusionistic way on cut paper, and the strings are indicated with bands of paper striped with chalk. These games of optical illusion create a synthetic image that, despite the crude nature of the materials used, preserves the musical and poetic dimensions of the instrument.

All of the wooden or metal constructions made during the spring of 1914 are about single objects made of glass. The shattered form of a glass or a bottle is cut out of a tin box mounted on a stand (figs. 394 and 395) or placed against a background inside a frame (fig. 396) or carved into a piece of wood (fig. 397) or nailed in a box that serves as a compartment. In this last case, the full form, defined from multiple points of view, is respected. Color plays a key role in these works as it complements the forms produced by the cutouts. Picasso once said to the sculptor Julio González: "With these paintings one needs only to cut them out—since when all is said and done, the colors are no more than indications of different perspectives, planes sloping this way or that—and then to assemble them according to color to find ourselves in the presence of a "sculpture."[14]

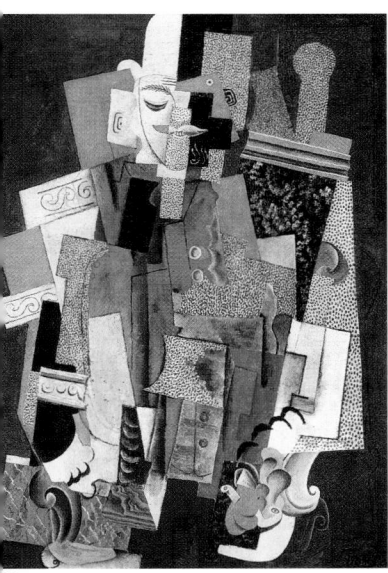

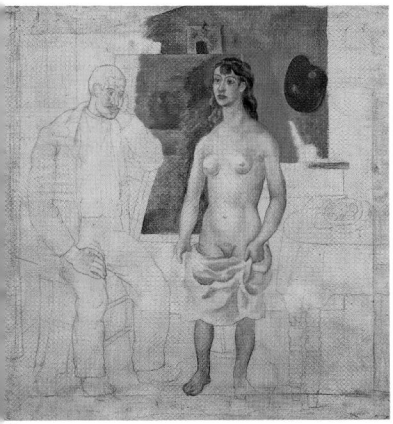

03 *Man in a Bowler Hat,* Summer 1915
04 *The Painter and His Model,* Summer 1914

The most surprising of these constructions is surely the still life subtitled *The Snack* (fig. 399), in which the only element treated in Cubist fashion—the glass—is confronted with objects painted in trompe l'oeil (a knife that splits space with its wooden blade, a perfectly replicated sandwich) and with the prosaic reality of the pompom trim around the edge of the table, the shadow of which dances on the wall that supports the assemblage. Because of its boyish humor and its ready-made quality, this piece holds the seeds of the experiments of Pop Art.

While each of these patiently assembled objects is unique, the *Glass of Absinthe* (fig. 388) was first modeled in wax from which six bronze casts were made (Picasso had kept the first one, which was sand-cast). The glass is topped with a real silver-plated spoon on which lies an imitation sugar cube. The inner surface of the glass is visible, thanks to an opening in its side, and the outer surface of one of the casts is dusted with sand, which is painted white to resemble sugar. Despite the inclusion of a real object—the spoon—the piece is not a readymade in the sense that Duchamp understood the term, but very much a sculpture in the round dealing with three elements of perception: reality (spoon), representation (glass), imitation (sugar). "The relationship between the spoon and the modeled glass interested me . . . the way in which they react to each other," Picasso later said. By means of this simple glass of absinthe, which came straight out of the Impressionist cafés, Picasso turned sculpture radically upside down.

The Colors of Avignon

On June 23, 1914, Gertrude Stein received a letter from Eva: "So now we are in Avignon. This morning Pablo found a somewhat Spanish house in the city proper. . . . It's about time that we found a place where we can feel a little at home; this bohemian-style hotel life does us no good."[15] It was summer vacation: the Braques were staying not far from them in Sorgues and the Derains had found a place in Montfavet. Picasso and Derain had a fine time together painting a panel that assembled four still lifes in which their favorite subjects appear again: glasses, playing cards, and fruit bowls laden with fruit. The glass was still the central figure of the *papiers collés* and relief-paintings (fig. 396), which Picasso continued to make in Avignon, but its contours were now rounded and unusually elongated within the Cubist reduction. The relief-painting *Glass, Pipe, Ace of Clubs, and Die* (fig. 386) has an impressive round format that gives it the feeling of a Renaissance tondo. These constructions are made of perfectly ordinary objects, such as the lid or base of a mirror, which serve as the background to the composition (here one clearly recognizes Picasso's penchant for discarded objects reused for some other purpose) or as a tabletop, where familiar objects are secured to a wooden molding in the center of the space. These objects are closely integrated by being reduced on a flat surface or in relief, by being divided in two or superimposed so that the images are as complete as possible. The glass, for instance, is seen in all of its states: as a simple outline cut into the marble background, as a curved volume whose profile is repeated in blue on the bas-relief, and as stippled geometric forms. All the visual and conceptual tricks of Cubism are necessary here: the pipe flexed with the cylindrical bowl toward the foreground (the limit in a Cubist painting!), where it dissolves, thanks to its small colored dots; the pivoting playing card seems to be behind the speckled framework, while its base (a painted metal lid) is hollowed out to make a place for the club, which is the same faux-marble green as the background. The fundamental problem of Cubism is how to represent three-dimensional objects on a two-dimensional surface without having recourse to illusionistic procedures, and once again it has been resolved here with astounding brilliance.

In the total production from Avignon, devoted almost entirely to still life, Picasso all

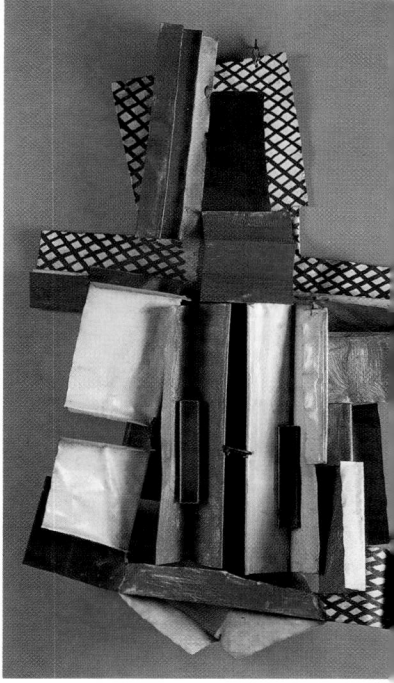

405

405 *Violin,* 1915
406 *Woman in an Armchair,* early 1916
407 *Violin and Bottle on a Table,* Autumn 1915
408 *Liqueur Bottle and Fruit Bowl with Bunch of Grapes,* Autumn 1915
409 *Seated Man with a Guitar,* 1916
410 *Guitarist,* 1916
411 *Man by the Hearth,* 1916

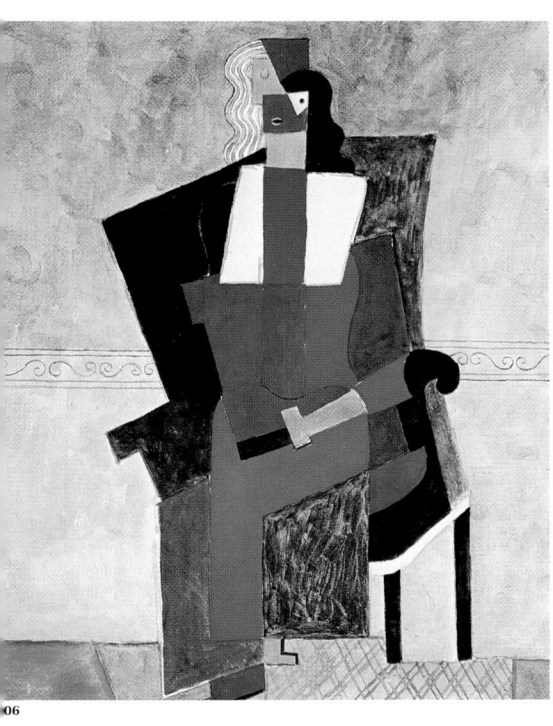

406

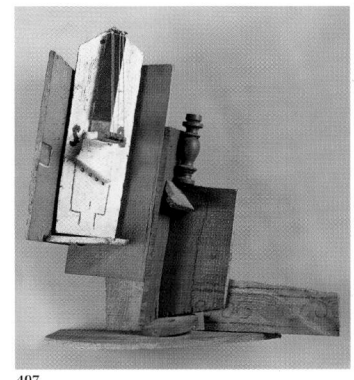

407

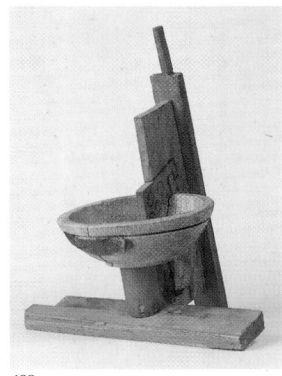

408

09

410

411

177

but abandoned the face, painting no more than five portraits, of which the most appealing is the *Portrait of a Girl* (fig. 400), which was acquired by Eugenia Errazúriz.[16] For lack of a classic face, it will never be known who was hidden beneath the big flowered hat, but no matter, for the question raised here concerns Cubism much more than portraiture. In the profusion of motifs, one may recognize the fruit bowl with grapes from Cadaqués, the pieces of tapestry and trimming from Céret, and many other textures and images so frequently touched by his brushes over the years. Painting or *papier collé?* The illusionistic production is of such perfection that one will be deceived, all the more so because studies done in paper cutouts exist for details such as the feathers of a boa, colored lightbulbs, or hands (Picasso Museum, Paris). Picasso may have intended to glue them onto the painted background, but chances are that they served as models for compositional arrangements (which would mark the beginning of his work for the theater), as Matisse was to do with his last gouache cutouts. Thus, what seems to be a disorganized mass of decorative details actually conceals a rigorous perfecting of technique. How can one not be touched—despite the acidity of the green beach—by this smart young woman beneath her ribbons and her delicate dress? With the pieces of trompe l'oeil painting that circle around her water-marked armchair, Picasso seems to be paying final homage to the endless reinvention of Cubism.

For the enemy is already present. In the very heart of this portrait, an arm—swollen and elongated like a chicken thigh—and other natural forms were uninhibitedly mixed with the Cubist syntax. What is evident here is not the abandonment of Cubism but a new interest in organic distortion with an element of caricature added. The war, which was declared on August 2, may have derailed the course of Cubism (Picasso, both distraught and cruel, said: "I drove Braque and Derain to the Avignon station. I never saw them again"), or it may have been the explosion of Dada that had something to do with this stylistic turnaround, even disavowal. Certainly, the war's heavy burden made itself felt beginning in the summer of 1914, but only in a relatively anecdotal form; without prejudging Picasso's distress (which was to have a very different impact in the 1940s), one may suspect that the tricolor pennants and the triumphant inscriptions ("Vive la France!") strewn about in the still lifes appealed to him more for their visual qualities than for their patriotic meaning.

The most important still life, *Playing Card, Glasses, and Bottle of Rum* (fig. 402) is a veritable feast for the eyes. The Cubist vein, contemptuously called "rococo," which was already germinating in "baroque" pieces like *The Restaurant* (fig. 392), here releases all of its exuberance and freedom of plastic imagination: against a background of flowered tapestry, the jumble of traditional Cubism lies piled up—playing cards, glasses, bottles, newspaper—over which prevails a vase of flowers modeled in Rousseauvian stylization. The forms slide into each other as they spread the folds and double folds of their sumptuous colors, which are finely grained or rendered as dots. In the foreground, two plump glasses push upward from the neck to confirm loud and clear that from here on the soft and the supple have taken over from the geometric.

Still, such astounding pieces as *Seated Man with Glass* (fig. 401) remain unprecedented. What is it about? The white napkin and the glass on a tray enable us to identify, in this assemblage of undulating forms, a waiter crosscut by a strange mollusk. Angry about the lot that awaits him, the man rolls his bulging eyes, which perch on his tubular nose spiked with a fanglike mustache. The formalist severity of analytical Cubism is here, but it is buried in a laconic playfulness that borders on Surrealist biomorphism. Picasso said: "Painting is stronger than I; it makes me do what it wants."

Was *The Painter and His Model* (fig. 404) the last Avignon painting? Was it left intentionally unfinished? So many questions are posed by this mysterious painting, a mystery that Picasso kept until his death, undoubtedly because it was the only portrait of Eva, who would die the following year. The first appearance of this basic theme—the painter and

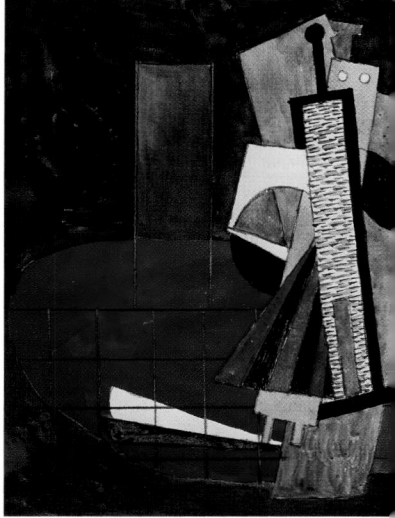

412

412 *Couple Dancing on a Dance Floor,* Winter 1915–16

413 *Seated Harlequin Playing the Guitar,* Autumn 1916

414 *Harlequin,* Autumn 1915

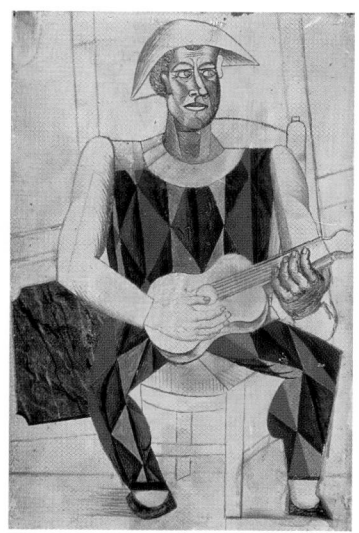

413

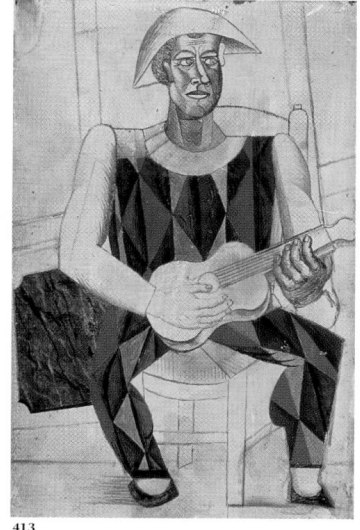

414

his model—it foreshadowed his classical style mixed with Cézanne-inspired inflections that would reach its peak in the 1920s. The delicate canvas of a kitchen cloth, over which a pencil and a few colors have passed, was sufficient to retrace the appearance of the beloved unveiling her frail and awkward beauty for the pensive and affected painter whose heavy-set, distorted silhouette and fat peasant's hand belong to Cézanne's *Card Players*. By means of this elegiac allusion, branded with melancholy, the painter gave his notice to Cubism: the palette remains fixed to the wall and the canvas on the easel remains desperately blank. One wonders which road he will now take.

The Return of the Acrobat

The road that led from Cubism to the "return to order" was a gradual one, strewn with pitfalls and interruptions. Until 1917 Picasso was balancing constantly a pseudo-naturalist vein and a Cubism of colored planes, hoping, as Douglas Cooper suggested, to "the connection between Cubist reality, visible reality, and the accepted pictorial reality of the naturalistic illusion."[17] Thus it was that Picasso tackled new subjects while remaining faithful to the Cubist canon: their severed and flattened volumes are constructed in space with the help of assembled elements, preferably discarded objects that he recovered and used here and there; a turned wooden table leg that looks like a bottle nailed onto small pine boards strung with cords representing a violin (fig. 407) or a bowl of rough wood to which cling rectilinear planes set off with charcoal (*Liqueur Bottle and Fruit Bowl with Bunch of Grapes,* fig. 408) would do.

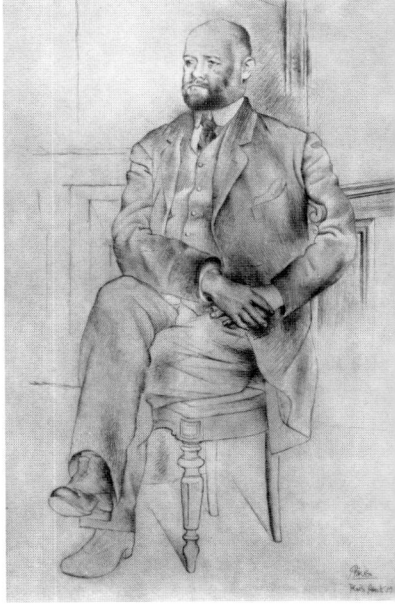

415

The *Violin* (fig. 405) made out of sheet metal differs from its original model, the famous tin *Guitar* of 1912 (fig. 357) in its bold polychromy typical of synthetic Cubism. This was the moment when the decorative language of rococo Cubism was marking time in favor of a more geometric style seen in such paintings as *Woman in an Armchair* (fig. 406) or *Man by the Hearth* (fig. 411). Made from a single sheet of metal, cut in and folded like cardboard, the *Violin* opens wide its shapes transposed into an illogical architecture, with hollows suggesting emptiness and filled areas suggesting relief. Two brown rectangles hidden in its folds identify the instrument, which is otherwise nearly abstract, unlike the tin *Guitar* of 1924 (fig. 533), whose four small steel strings fend off the danger of abstraction.

At this date, Kahnweiler alone would be let in on the secret of the changes that were slowly maturing in Picasso. In the early days of 1915, the artist showed him "two drawings that were not Cubist drawings but Classicist, two drawings of a seated man. He said to me: 'Still, it's better than before, right?' which certainly proves that this idea must have been sprouting in him at that time."[18] He is probably referring to the pencil portraits of *Max Jacob* (fig. 416) and *Ambroise Vollard* (fig. 415). Undoubtedly created on the basis of photographs, these drawings combine a marked frontality and distortions with a lively meticulous line. The portrait of Max Jacob comes closest to the technique of Ingres, which combines carefully worked details with unfinished areas. Pleased with the work of his sponsor in Catholicism (Max Jacob was baptized on February 18 of the following year with Picasso as his godfather), the poet decided that the portrait "resembles at one and the same time that of his grandfather, of a Catalan peasant, and of my mother."

Without even taking a breath, Picasso went on making interminable variations in gouache or watercolor of men and women seated in armchairs, flattened or folded like accordions (to be seen again in the constructions of *Parade* in 1917) or blown up like balloons and studded with tubes. Ubu-like figures settling down on the canvas where realistic parts coexist with Cubist constructions, as in *The Man in a Bowler Hat* (fig. 403). If

416

417

painting shows its very best side here—brilliant variations on the dot in specks, in fine grain, in marks, and in trompe l'oeil, either marbled or twisted—what is one to make of this image with its grotesque characteristics of a middle-class man in a bowler hat, corseted in a tightly buttoned jacket, with a self-satisfied smile?

Picasso's caustic humor would come to a sudden end with the ordeal of war that struck all his friends. On May 11, 1915, Braque was seriously wounded but safe. Apollinaire, who had posed for Picasso during a leave (fig. 417), was less lucky and would not recover from his wounds. At the same time, Eva, who had been ill for a long time, was dying. Distraught, Picasso confided to his longtime ally, Gertrude Stein: "My life is not very much fun. . . . I hardly work any more . . . and yet I have made a painting of an acrobat that, in my opinion and that of several other people, is the best work I've done."[19] *Harlequin* (fig. 414), Picasso's alter ego, veiled in black, grins painfully against a deep brown background. Braced against a moving floor, the great rectangle of Harlequin's body joins the form of the table in an attempt to preserve a precarious balance against the seesaw movement of the split planes, whose matte colors and lack of shadow recall the *papiers collés*. The angular rigidity of the forms, animated by a secret mechanism, would remove all humanity from this sinister puppet, were it not for the deeply moving presence in the foreground of a blank canvas turned toward us as if calling for help.

This combination of rigor and lyricism was continued in the works of 1916 (figs. 409 and 410), which have been frequently accused of lapsing into a morass of proven formulas. In spite of their brilliant colors, the pictures appear at first sight to be colder, more stereotypical. What they lack—in spite of faultless technique—is the addition of the "soul" that would lend greatness to the *Three Musicians* of 1921. "Have pity on us," Apollinaire cried out the night before his death, "we who lived that long struggle between order and adventure." An adventurer in love with order would know how to take things in hand: "What concerns me is Picasso, the set designer. I led him there. . . . We were alive, we were breathing. Picasso was laughing as he saw the face of our painters get smaller and smaller behind the train. . . ."[19] From that moment on, it was Jean Cocteau's turn to speak.

15 *Portrait of Ambroise Vollard,* August 1915
16 *Portrait of Max Jacob,* January 1915
17 *Portrait of Guillaume Apollinaire,* 1916

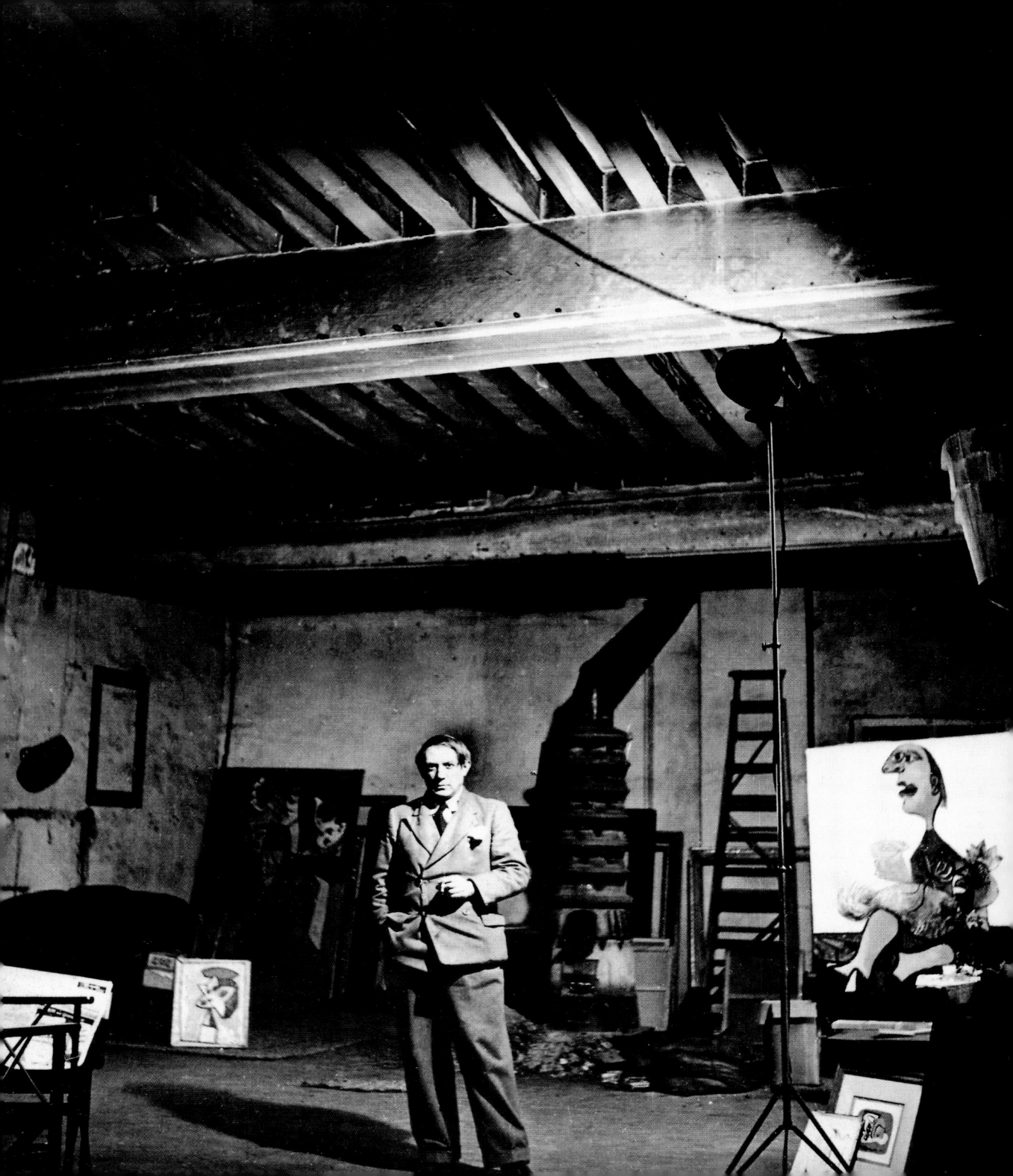

PART II
BY CHRISTINE PIOT

Chapter 5
1917 – 1924

Chapter 6
1925 – 1930

Chapter 7
1931 – 1936

Chapter 8
1937 – 1944

Chapter 9
1945 – 1952

1 9 1 7 – 1 9 2 4

The years between 1917 and 1924, which were filled with amazing contrasts, constituted a period of profound change in Picasso's life and in his work, which seriously disconcerted his contemporaries. Although some paintings, several of them significant ones, inherited the lessons of Cubism, others recalled the figurative tradition foreshadowed by *The Painter and His Model*, painted during the summer of 1914 (fig. 404). For that reason, this period in Picasso's career has been variously termed "classical," "neoclassical," "classicist," or "Ingresque." In 1921 the confrontation between the two major styles of Cubism and neoclassicism would culminate in *Three Musicians* and *Three Women at the Well*, with the 1923 *Pan-Pipes* representing the peak of Picasso's neoclassicism. Balanced, colorful compositions emerged from Picasso's experiences with Cubism, but he strayed from the formulas he had tested in previous years and turned to a more distant past to reconsider and review the tradition of French painting and the legacy of Italy and ancient Greece.

It was during this time that Picasso began to distance himself from the bohemian world of Montparnasse. He left the rue Schoelcher for Montrouge in the spring of 1918, married Olga Khokhlova in July, and in November moved into an apartment with a studio above in the bourgeois neighborhood at 23, rue La Boétie. For a while, Picasso frequented Parisian high society, and he also traveled abroad, to Italy (and Spain) in 1917 and to London in 1919. During the summers, the painter enjoyed exploring the charm of French beaches along the Atlantic and the Mediterranean. His work with Serge Diaghilev's Ballets Russes between 1917 and 1924 is a series of landmarks along a complex, productive journey.

Parade *(1917)*

In April 1916, the young poet Jean Cocteau, cleverly disguised as Harlequin, asked Picasso to create the set, drop curtain, and costumes for *Parade*, a "realist" ballet set to the music of Érik Satie. Cocteau had been sent to Picasso by Serge Diaghilev, director of the Ballets Russes, which had already successfully presented several ballets in Paris. To everyone's surprise, Picasso was intrigued and captivated, and in August he accepted the commission. As Cocteau explained: "I led him there. His entourage wouldn't believe that he would follow me. A dictatorship ruled over Montmartre and Montparnasse. We were living in the austere period of Cubism. . . . Painting a set, especially for the Ballets Russes (this devout youth did not know of Stravinsky), was a crime."[1]

In February 1917, Picasso and Cocteau went to Rome to "meet with [the choreographer] Léonide Massine to marry set, costume, and choreography." The ballet takes place in front of a fairground stall, where circus artists perform to attract people to the show. Cocteau explained: "I will never forget the Rome studio. A small box contained the model for *Parade*, its building, trees, and stall. On a table, in front of the Medici villa, Picasso painted the Chinese, the Managers, the American girl, the horse (about which Madame de Noailles wrote that one might think it a laughing tree), and the blue Acrobats, whom Marcel Proust

418 Design for Drop Curtain for "Parade,"
1916–17

419

420

423

421

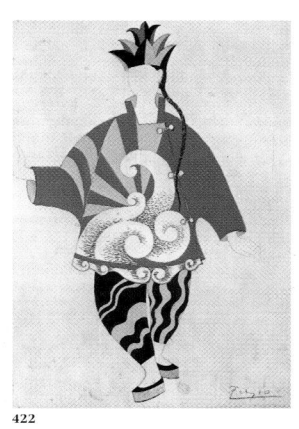

422

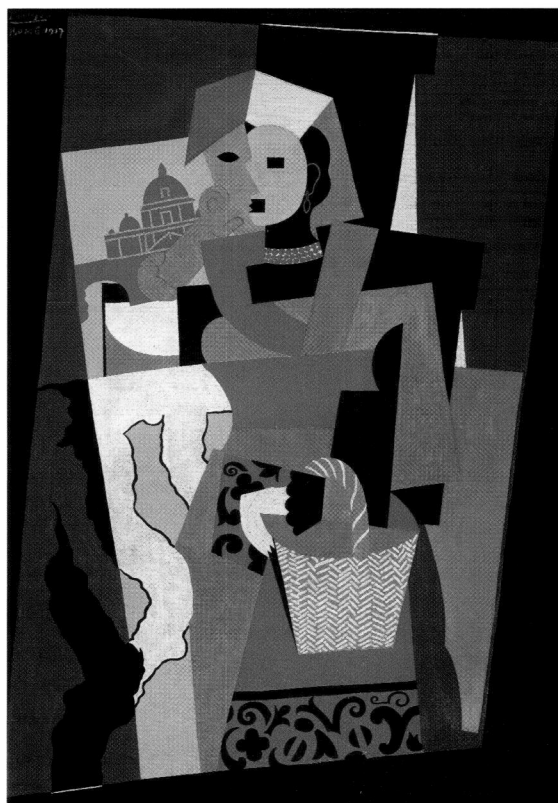

424

419 *Studies for the Managers on Horseback for "Parade,"* 1917

420 *Study for Manager for "Parade,"* 1917

421 *Sketch for Costume of an Acrobat for "Parade,"* 1917

422 *Model for Costume of the Chinese Magician for "Parade,"* 1917

423 *The Villa Medici in Rome,* 1917

424 *The Italian Woman,* Spring 1917

425 *Harlequin and Woman with Necklace,* 1917

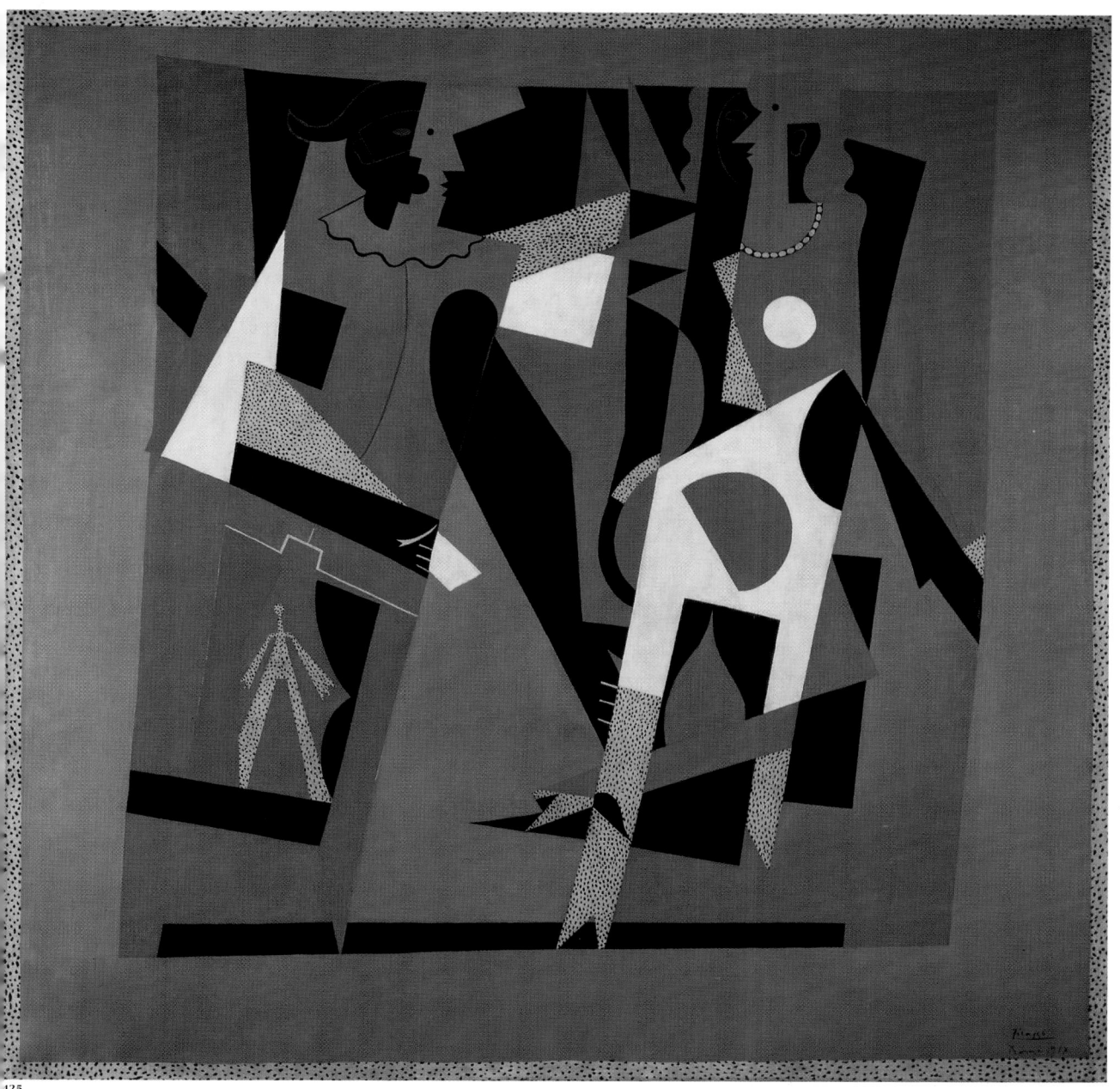

425

compared to Dioscuros." Picasso became involved with his favorite characters—performers and acrobats—and did not hesitate to jumble disparate elements together. The Managers, which are more than six and a half feet high, are Cubist constructions, while the drop curtain, a painting measuring about fifty-five by thirty-three feet (fig. 418), was partly inspired by a nineteenth-century Italian engraving, *Taverna*, by Achille Vianelli.[2] Called a "theater poem" by Apollinaire and a "Cubist ballet" by Leon Bakst, *Parade* caused quite a stir. Apollinaire had predicted as much in the program: "In *Parade* there is a kind of sur-realism that I imagine could be the starting point for a series of presentations in this new spirit, which will alter the arts completely." Cocteau also considered the performance as the beginning of a series of new experiences: "*Parade* united the [itinerant] company and Picasso in such a way that, shortly afterwards, we—Apollinaire, Max Jacob, and I—were witnesses to his marriage in the Russian church on rue Daru, and he created the set and costumes for *Tricorne, Pulcinella,* and *Cuadro Flamenco.*"

In Italy Picasso took walks with Cocteau "in the moonlight with the dancers" and visited Naples and Pompeii, Florence and the museums. He sketched his colleagues on site—Diaghilev, Bakst, and ballerinas in the company—and he continued to paint. *The Italian Woman*, depicted in front of Saint Peter's in Rome, is reminiscent of a postcard view of an Italian woman transformed into a Cubist composition (fig. 424).

The square painting *Harlequin and Woman with Necklace* (fig. 425), which fairly bursts with dynamism, is a major work of 1917. Segmented planes and pointillist motifs alternate to form a clever composition that is so full of vitality one wonders if it is the painted couple or the painting itself that seems to break into dance. One dancer in particular attracted the painter's attention: Olga Khokhlova. The daughter of a colonel in the Russian army, she had just secured her first leading role. The following year, Picasso would confide in a letter to Gertrude Stein, that Olga was a "real young lady."

After a turbulent reception in Paris at the Théâtre du Châtelet on May 18, 1917 ("Foreigners! To Berlin!" shouted the outraged audience), *Parade* traveled to Madrid, where King Alphonse XIII attended a performance, and then to Barcelona. Upon his return to the Catalan capital, Picasso was celebrated by his friends at a banquet, whose guests included Manuel Pallarès, Doctor Reventós, Francisco Iturrino, and others. In the Ranzini boarding house on Paseo de Colón, where artists stayed, Picasso painted a view of the port (fig. 426). The statue of Christopher Columbus, pointing his finger toward the horizon from the top of his column, seems to create a new space in the painting, but Picasso always intended to go to an extreme and then push even beyond that. During the summer of 1917 in Barcelona, he returned to the bullfights and felt Spain's pulse once again. He drew a bleeding horse with splayed legs (fig. 427), twenty years before the one that would appear in *Guernica*. Rage was already in his heart.

At this time and for a few years to come, there was a dichotomy in Picasso's approach to painting. Traces of the Rose Period from 1905 seeped into a neoclassical portrait of *Harlequin* holding his bicorne hat in hand and casting a melancholy glance at the performance from the corner of his eye (fig. 430). And the lessons of Cubism resurfaced in *Figure and Fruit Bowl* (fig. 428), in which the figure, composed of layered planes, holds a knife and fork ready to be dipped into a bowl. This bowl, painted in fresh colors, appeared again in another small painting of 1917 (fig. 429). Although most of his work was devoted to figures, the painter still returned occasionally to still lifes and landscapes.

Picasso essentially drew information from three sources, the traditions of France, Italy, and Spain, and he combined them as he liked. He took from each what he needed, what he could use for his own purposes. Aware that the painter could bring together varied styles almost like an alchemist, Cocteau noted: "So here was a Spaniard, equipped with the oldest French formulas (Chardin, Poussin, Le Nain, Corot), who had a charm." Picasso had already parodied Manet's *Olympia* in a 1901 drawing; as early as 1950 and

426

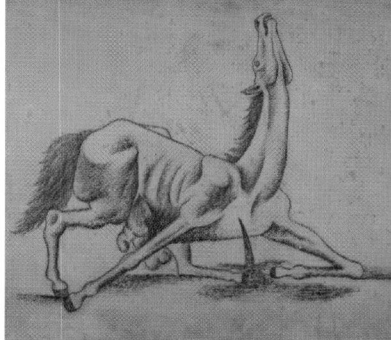

427

426 *View of the Monument to Columbus,* 1917

427 *Disemboweled Horse,* 1917

428 *Figure and Fruit Bowl,* 1917

429 *Fruit Bowl,* 1917

430 *Harlequin,* 1917

428

429

430

431

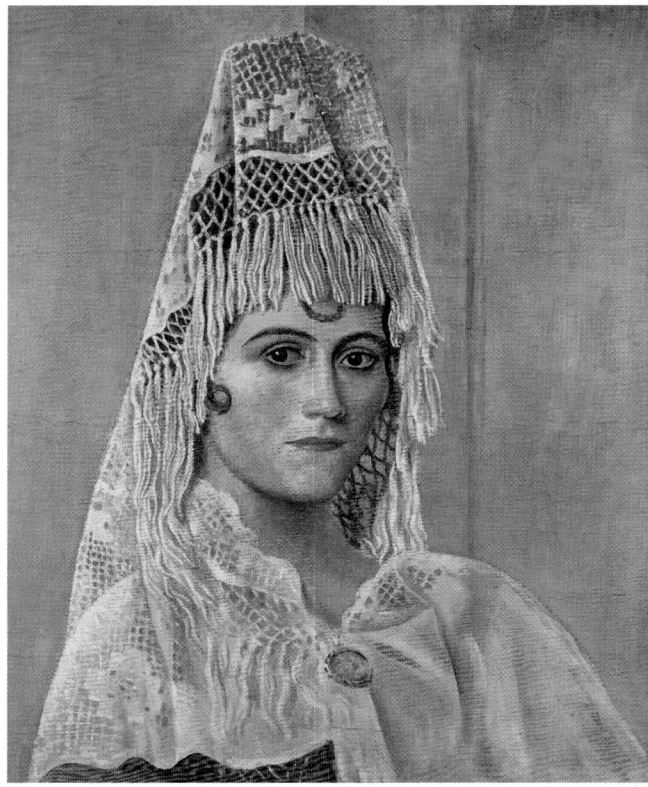

432

until 1963, he would produce several variations on themes by Courbet, El Greco, Delacroix, Velázquez, Manet, David, and Poussin. Picasso had in his personal collection two works by masters of the seventeenth century, one attributed to Louis Le Nain and the other to the Master of the Cortège du Bélier, a follower of the Le Nain brothers. In painting *The Return from the Baptism*, an interpretation of a work by Louis Le Nain, Picasso achieved a delicate metamorphosis (fig. 431). On the one hand, he retained the figures and their placement—the father at the center, glass in hand; the young boy and the old woman to the left; the child and the young woman to the right—as well as the direct stare of the two men and the sideways glance of the two women. But he has transposed the scene to an abstract space, without depth, diminished by a sharp use of pointillism. What was once a realist painting has become a dream, an apparition, a mere memory of Le Nain's painting, which was cheerful but autumnal in color, brown and muted. Picasso added sun to the scene and brought springtime to the painting. The picture impressed Apollinaire, who mentioned it in a letter to Picasso dated August 22, 1918: "I

433

434

435

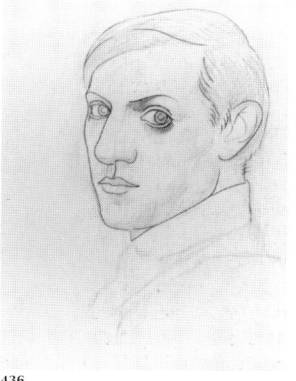

436

191

would like to see you do major works like Poussin, something lyrical like your Le Nain copy."

Pointillism, which is a reference to Seurat (Picasso owned some Seurat drawings), can be found in Picasso's paintings of 1901[3] and is an important element in *La Salchichona* (fig. 433), which was painted in Barcelona, where Picasso was inspired by a model nicknamed La Salchicona (the Sausage), the French mistress of a Spanish painter named Rafael Martínez Padilla. Also known as *Woman in a Mantilla,* this picture recalls the 1905 portrait of Madame Canals (fig. 157). Here the painter has used traditional Spanish costume, complete with comb and mantilla, to emphasize the female face and the position of the head. The drawing is punctuated by vibrating spots of color but left unembellished at the bottom of the unfinished canvas. The model resembles portraits of Olga enthroned, clearly an homage to his lover.

Olga had decided to stay in Barcelona with Picasso, while the Ballets Russes continued its tour of South America. Picasso painted classical portraits of her as a seated woman, his favorite subject. *Olga in a Mantilla* (fig. 432), which was painted during the summer or autumn of 1917, borrows some details from *La Salchichona*, such as the curled hair and the fine lace mantilla closely framing the face. By adding a Spanish dimension, Picasso made the young Russian ballerina his own and, at the same time, an expression of his native country. *Portrait of Olga in an Armchair* (fig. 434), painted in Montrouge in the fall of 1917 from a photograph, depicts her in the French tradition: the fan and the center part in her hair bear a remarkable resemblance to the portrait of Madame Duvauçay by Ingres (Condé Museum, Chantilly). The touches of color on the fan, the transparent flowers sketched on the black dress, and the bunches of flowers and fruit on the chair fabric stand out against the background, which has been left unfinished. The pure lines and soft expression result in a rather idealized version of the photographic image of the model.

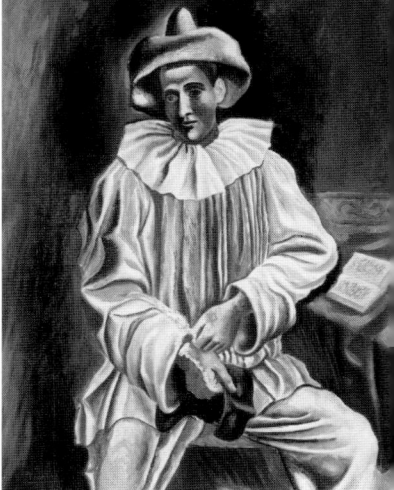

437

"Ingres, the revolutionary par excellence . . . Ingres, the hand," Cocteau would write in his book *Le Coq et l'Arlequin*, published in 1918. Picasso drew his self-portrait in a three-quarter pose (fig. 436) with a confident line that is both incisive and supple, similar to that of Ingres. In Montrouge he also completed a portrait of his old friend Max Jacob (fig. 435), using the same assured line that was the basis of Picasso's portraits from 1919 and 1920.

The year 1918 began with a Matisse-Picasso exhibition held at Paul Guillaume from January 23 to February 15. Picasso was still close to the Ballets Russes; on May 18, he went to the dinner given in honor of Stravinsky's *Renard*, which was also attended by James Joyce and Marcel Proust.

Although Cocteau pretended not to like Harlequin—"Vive le Coq! Down with Harlequin," he wrote in a letter to Georges Auric on March 19, 1918—Picasso did not follow suit; in fact, Pierrot and Harlequin, both characters from the popular Italian repertory, played a major role throughout his work. The Harlequin character appeared sporadically between 1905 and 1970 (see figs. 160 and 1117). In 1918 Pierrot's cream-white costume was adorned with colored reflections (fig. 437), and he returned in 1961 as a corrugated metal sculpture painted white. This moonlike character also alludes to *Gilles* by Watteau, Picasso's elder by some two centuries. In Picasso's work, Pierrot and Harlequin are not so much actors in a mischievous farce as they are melancholy witnesses to the human comedy (figs. 437 and 438). Each holding an eye mask in hand, the two characters foreshadow the mask theme that Picasso would touch on in a series of drawings in 1953–54, published in *Verve*.

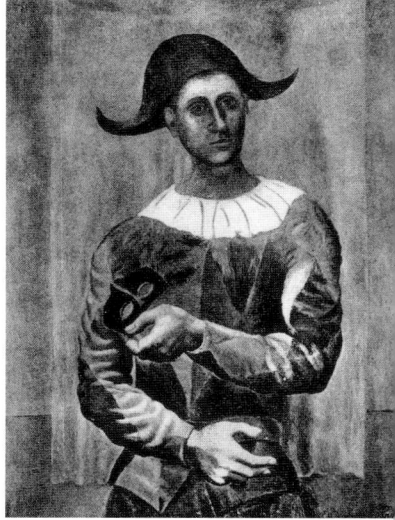

438

Picasso's Pierrot and Harlequin were also musicians: they spoke through music, playing the mandolin and the violin (fig. 439). Picasso was said to like only flamenco music but musical instruments always played a role in his work, as if he wanted to give sound, as well as color, to his painting. Once again, the painter deals with a single subject in two different ways: in an Italian vein, by placing Harlequin before a red curtain, with a classical column and a landscape behind it (fig. 440), and in a Cubist vein, by playing with

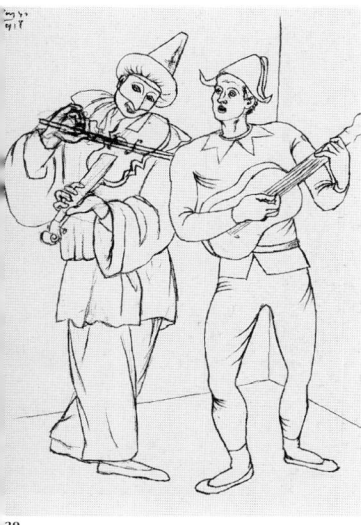

39

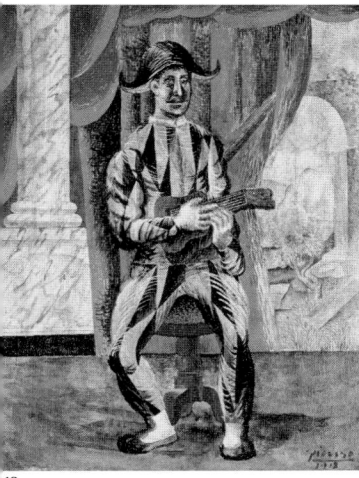

40

441

437 *Pierrot,* 1918

438 *Harlequin,* 1918

439 *Pierrot and Harlequin,* 1918

440 *Harlequin with a Guitar,* 1918

441 *Harlequin with a Violin (If You Like),* 1918

the lozenges on the suit and face of the *Harlequin with a Violin* (fig. 441). "If you wish" reads the sheet of music, like an invitation to freedom, desire, and adventure. When the composer Ernest Ansermet, who joined the Ballets Russes, expressed surprise one day at seeing Picasso "go from a drawing in a natural style to a Cubist drawing," Picasso responded: "But don't you see that the result is the same?"[4]

On July 12, 1918, Picasso married Olga Khokhlova at the Russian Orthodox church in the rue Daru, with Max Jacob, Guillaume Apollinaire, and Jean Cocteau as witnesses. From the end of July to September 1918, Pablo and Olga vacationed in Biarritz, having been invited to the villa of a wealthy Chilean friend, Eugenia Errazúriz. In a bittersweet mood, Picasso wrote to Apollinaire: "I am seeing high-society people. I have decorated a room here where I have put your verses. I am not very unhappy here and I am working, as I told you, but write me long letters." The lines of a quatrain from Apollinaire's poem "Les Saisons" danced on the walls of Picasso's room: "It was a blessed time we were on the beaches / Go early in the morn, feet and head bare / And as quick as the toad's tongue / Love wounded the hearts of madmen and wisemen alike."

In addition to enjoying high society, Picasso also took renewed pleasure in the beach and the outdoors. Indeed, in *The Bathers* in languid poses (fig. 445), we are once again reminded of Ingres, whose *Turkish Bath* Picasso had had the opportunity to admire as early as 1906. In Picasso's picture, however, the nude figures frolic in the open air, and the rhythm of the silhouettes, the mannerist extension of limbs, and the bright burst of colors reflect a past that came back to life. The standing bather will appear again, standing in profile with raised arms, in *Two Women Running on the Beach*, a gouache painted four years later, in 1922 (see fig. 512). Again in the style of Ingres, Picasso used a sharp tip to draw with an engraver's precision an undulating line for *Bathers* (fig. 442) and a nervous, more sophisticated line for a picture of a fisherman carrying a plate of fish on his head and a Christ on the cross (figs. 443 and 444).

On November 9, 1918, Guillaume Apollinaire died of influenza. The poet had wanted to reconcile classicism and modernity, as he wrote in a letter to Picasso dated September 11: "I am trying to renew the poetic tone, but in a classic rhythm. Yet I don't want to take a step back and create a pastiche." Picasso shared the same ambition for his art. In 1919, he studied from up close—with a magnifying glass—the attitudes and poses of the dancers. He made numerous sketches of rehearsals and also drew from photographs (fig. 446), sometimes exaggerating gestures and effects to an extreme (fig. 447). Douglas Cooper and André Fermigier interpreted this distortion as Picasso's mocking or "deriding the grace of classical ballet,"[5] but this was certainly not his only intention. Excessive caricature may have been a way of presenting the impossible challenge of classical dance, in which the body, in spite of its actual weight, must evoke the incorporeal soul of a sylph through a miracle of lightness. If the resulting image was unsuccessful, Picasso would certainly have been aware of the ridiculousness of the situation. On the other hand, the *Portrait of Léonide Massine* (fig. 448), a subject both robust and delicate, is presented as an homage to the dancer and choreographer.

The art of dance was not Picasso's only opportunity to exaggerate line. The work of earlier periods, specifically Italian art and classical antiquity, also provided him with models on which to practice. The detailed drawing of *Italian Peasants* (fig. 449), for example, seems to have been inspired by a nineteenth-century sculpture by Bartolomeo Pinelli.[6] The face of *The Italian Woman* (fig. 450), smooth and perfect like a statue, foreshadows the "femmes en chemise" that populate Picasso's paintings in 1920–21. Corot, van Gogh, Manet, Cézanne—each in turn acted as a starting point either to inspire or to haunt him. And the *Sleeping Peasants* (fig. 451) is an interpretation of van Gogh's *Siesta (La Méridienne)*, painted in 1899–1900 from an engraving of a drawing by Millet.

From Manet's 1877 *Nana*, in which a man in evening attire seated on a couch watches

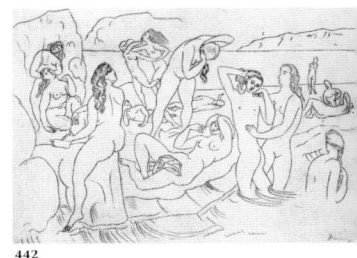

442

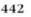

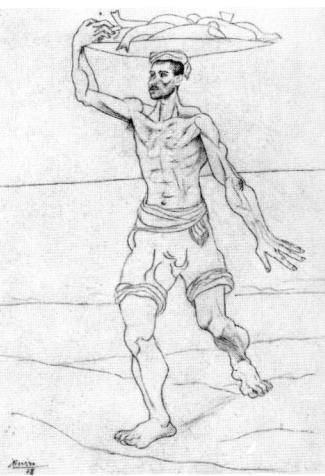

443

444

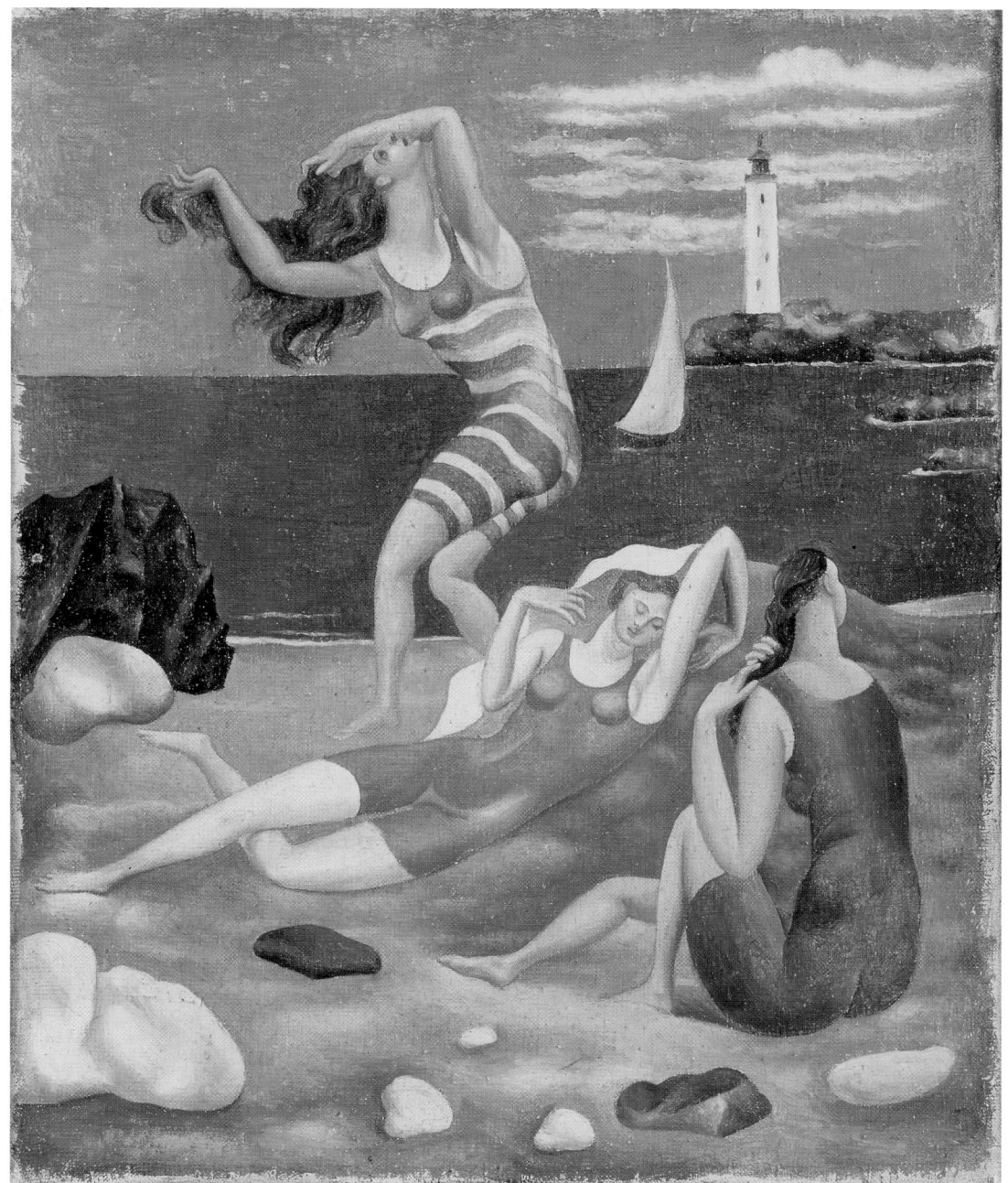

445

446

448

447

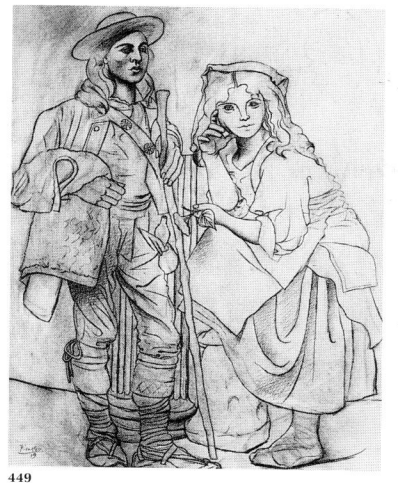

449

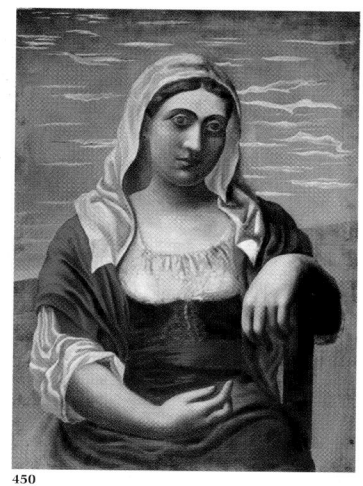

450

451

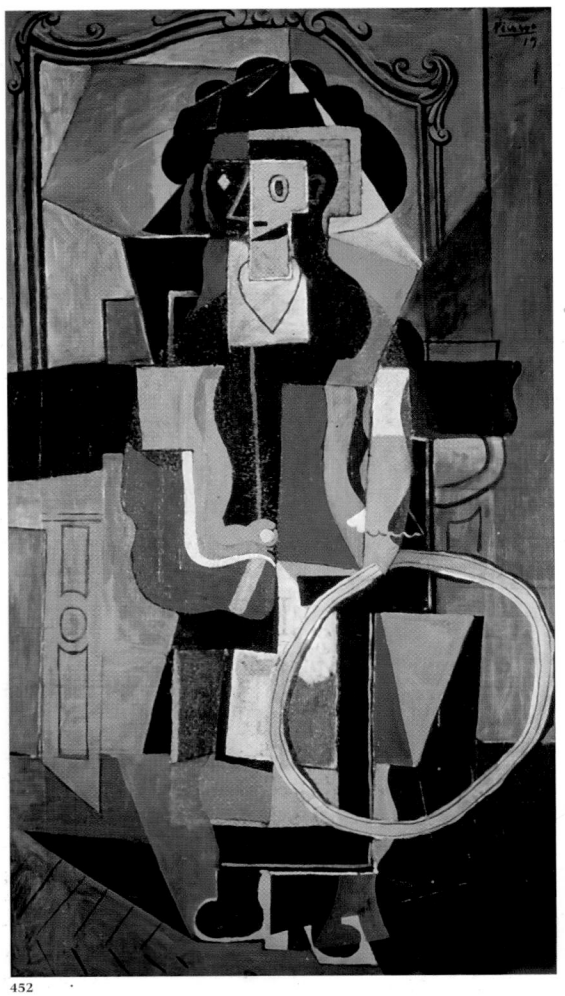

452

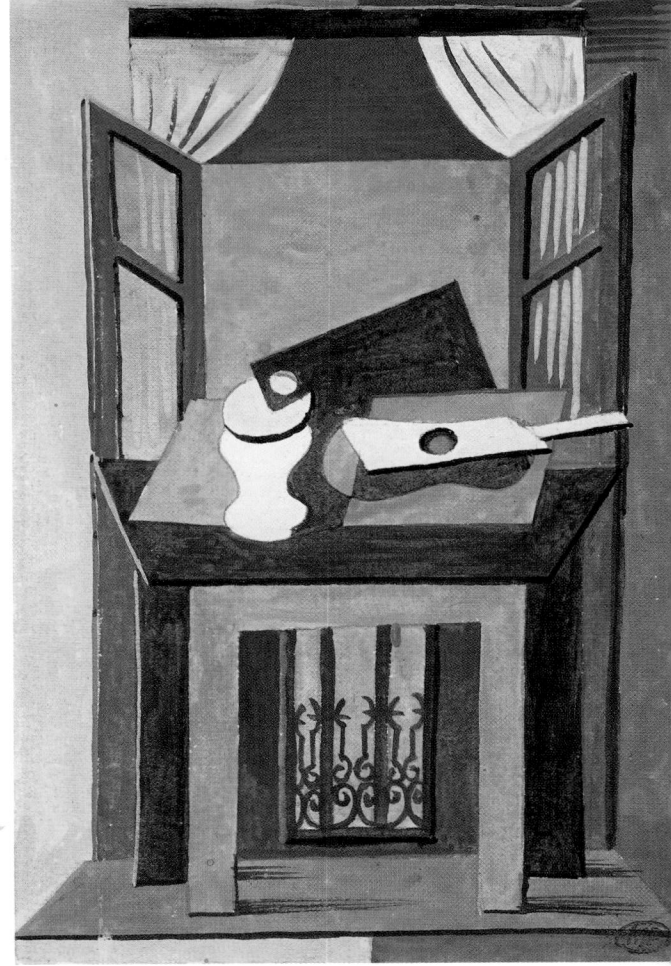

453

452 *Little Girl with a Hoop,* 1919

453 *Still Life on a Table in Front of an Open Window,* October 26, 1919

454 *The Lovers,* 1919

455 *Still Life with Pitcher and Apples,* 1919

198

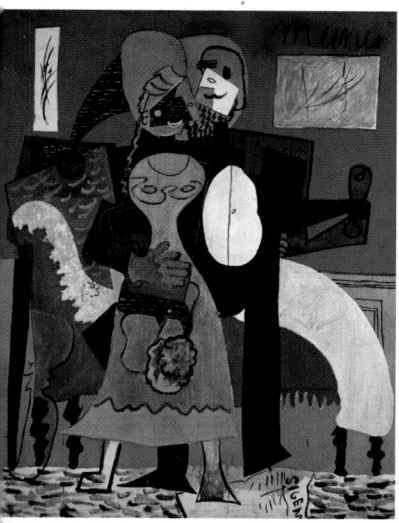

a woman applying makeup in the mirror, Picasso produced *The Lovers,* signing "Manet" at the top right (fig. 454). But in *The Intransigent* (1919), Picasso's space and figures and the crumpled newspaper on the ground reflect a Cubist approach, and similarly, the layered planes in *Little Girl with a Hoop* overlap as in a mirror, like the one that stands in the background on a mantelpiece (fig. 452). Fantastical details and a few touches of red lend a mischievous air to these two compositions. *The Lovers* was reproduced as a plate in Number 5 of *La Révolution Surréaliste,* October 15, 1925.

Although the subject of *Still Life with Pitcher and Apples* alludes discreetly to Cézanne, this dark oil painting of gray and black can also be seen as a kind of trompe l'oeil (fig. 455): the two apples placed on the rim of the pitcher stand out like two dappled breasts, and the body of the vase is rounded like a woman's stomach. Here Picasso seems to anticipate the tour de force of his 1931 *Large Still Life on a Pedestal Table,* whose form is reminiscent of a woman's body (see fig. 630). Along with this apparently classical still life of 1919, Picasso created a series of Cubist still lifes in which objects are arranged on a pedestal before a window (fig. 453). Framing the picture is the same view of the Barcelona port he painted in 1917, with the wrought-iron balcony guardrail (see fig. 426), but the window now opens onto the sea of Saint-Raphaël, where the artist had just spent the late summer of 1919. A series of these still lifes would appear in a drawing and watercolor exhibition that fall—from October 20 to November 15—at the Galerie Paul Rosenberg. Aragon would write about one of them: "Picasso gave me this pedestal table in front of a shutter window in 1919 for the frontispiece of *Feu de Joie*: in fact, and by this very fact, it became the source of everything I wrote from this first book to the present day."[7]

Tricorne

In London during May and June of 1919, at Diaghilev's invitation, Picasso designed the set and costumes for *Tricorne,* a Spanish ballet based on *El Sombrero de Tres Picos,* a nineteenth-century tale by Pedro Antonio de Alarcón. The ballet, choreographed by Massine to the music of Manuel de Falla, is a picaresque romantic farce set in eighteenth-century Andalusia, and it provided Picasso with the opportunity to paint popular and familiar figures: the bullfighter, the Sevillian woman, the picador, and so on (figs. 458–464). He created several sketches for the costumes and set, which takes place on the arch of a bridge (fig. 457). The curtain in the background depicted *el arrastre,* the removal of the dead bull from the arena, from the perspective of a box seat. According to Douglas Cooper, the result was an "astoundingly brilliant, rich, witty, and exciting spectacle."[8] And, according to Roland Penrose, all of London high society was able to make peace with modern Parisian painting.[9]

After staying for some time in the Hotel Lutetia in Paris, Picasso settled with Olga at 23, rue La Boétie, in November 1918. A year later, he made a drawing of the living room of their very tidy apartment, in which Olga, Jean Cocteau, Érik Satie, and the English art critic Clive Bell all posed: only the geometric pattern of the floorboards would bring this somewhat static scene to life (fig. 471). A drawing from June 1920 presents Picasso's studio on the floor above (fig. 472), in which canvases rest on easels, chairs, or the floor; on the wall hangs the mask from *Pulcinella.* This happy mess is far more characteristic of the artist. It is at this time that Picasso, influenced by Ingres, made a series of large portraits of painters, musicians, and figures from the art and literary worlds: Derain and Renoir, Diaghilev and Seligsberg (figs. 465–467). De Falla, Stravinsky, and Satie would all sit in the same chair (figs. 469–470), in a three-quarter pose, each using the space in his own way. Picasso's portrait lithograph of Paul Valéry, made in 1920, illustrated Valéry's edition of *La Jeune Parque,* published the following year; Raymond Radiguet's portrait, also from 1920, would be used as the cover to his first collection of poems, *Les Joues en Feu*, in 1925.

456

459

460

457

456 *Study for the Drop Curtain, for the ballet "Tricorne,"* 1919

457 *Design for a Set, for the ballet "Tricorne,"* 1919

458 *Design for Bullfighter Costume, for the ballet "Tricorne,"* 1919

459 *Design for Woman's Costume, for the ballet "Tricorne,"* 1919

460 *Design for Costume for the Partner of the Woman from Seville, for the ballet "Tricorne,"* 1919

461 *Design for Costume for a Picador, for the ballet "Tricorne,"* 1919

462 *Design for Costume for Old Man with Crutches, for the ballet "Tricorne,"* 1919

463 *Design for Costume for the Miller, for the ballet "Tricorne,"* 1919

464 *Design for Man's Costume, for the ballet "Tricorne,"* 1919

461

462

458

463

464

465

466

471

467

468

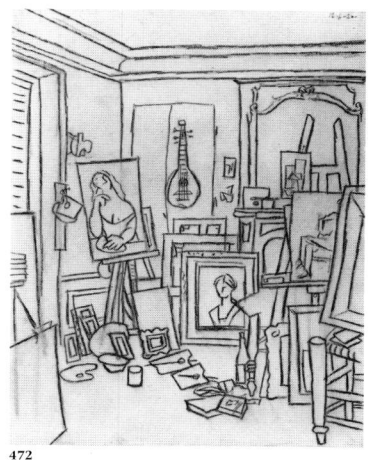

472

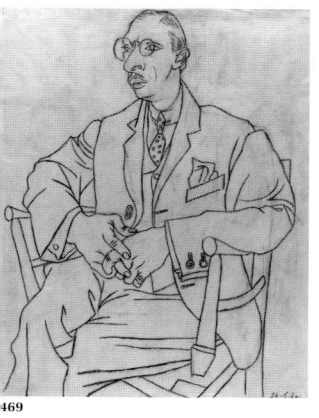

469

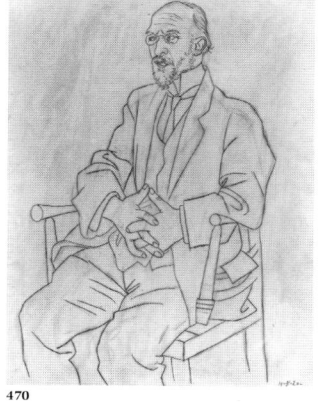

470

465 *Portrait of André Derain,* 1919

466 *Portrait of Auguste Renoir,* 1919–20

467 *Portrait of Serge Diaghilev and Alfred Seligsberg?,* early 1919

468 *Portrait of Manuel de Falla,* June 9, 1920

469 *Portrait of Igor Stravinsky,* May 24, 1920

470 *Portrait of Érik Satie,* May 19, 1920

471 *The Artist's Sitting Room in the rue La Boétie,* November 21, 1919

472 *The Artist's Studio, rue La Boétie,* June 12, 1920

Pulcinella

In the spring of 1920, the Commedia dell'Arte character Pulcinella (Polichinelle) appeared in a ballet by that name. Igor Stravinsky, for whom Picassso had illustrated the score for *Ragtime* in 1919, composed the music for *Pulcinella* after Pergolesi; Léonide Massine was the choreographer, and Picasso created the set and costumes. According to Douglas Cooper, *Pulcinella* was Picasso's favorite ballet, because of its origins in the Commedia dell'Arte. It opened successfully on May 15 in Paris at the Théâtre de l'Opéra, after Picasso and Diaghilev were able to overcome their differences over the concept of the performance.

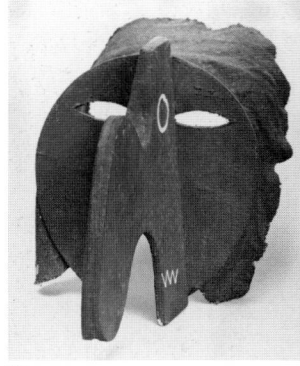

473

A curtain design for *Pulcinella* presents three of Picasso's familiar characters in a circus ring (fig. 476): Harlequin and a woman dancer, both masked, are flanked by a rider in a jester's hat. Dressed in red and mounted on a black horse, the figure waves a stick of ribbons that has an almost diabolic appearance. There has been much speculation about the significance of Harlequin in Picasso's paintings; he has sometimes been considered a double of the painter himself. Although the lozenge suit makes Harlequin a decorative figure, this superficial aspect does not explain his sporadic presence in the artist's work. Harlequin is an ambiguous, complex character; as old as the ages, he is part of the world of buffoons, of tarot and magic. Harlequin was originally an object of scorn because of his naïveté and his role as the eternal loser, but eventually he became mischievous, clever, and crafty in playing the unlucky cards dealt to him by life. Picasso dressed Harlequin in a traditional costume to give the figure contemporary significance. Picasso was less interested in the theatrical character than he was in what it represented symbolically: an agile body and spirit, the sense of playfulness, a taste for disguise, and in the end, a perspective on the human comedy. As Jean Starobinski wrote in *Portrait de l'Artiste en Saltimbanque*: "One indeed realizes that the choice of clown image is not only a pictorial or poetic choice of motif, but a roundabout way to parody and ask the question of art."[10]

Beyond the Italian theater tradition, Picasso drew inspiration from Mediterranean culture in general, notably classical mythology, borrowing subject and style from what he called "the virile realism of Rome."[11] He rediscovered the antique statuary idealized by Michelangelo and explored an exaggerated classicism that yielded fantastic or monstrous creatures, such as centaurs, giants, and mother goddesses. The centaur, that mythological combination of man and horse, appeared in Picasso's work as early as 1920 and as late as 1946, in *Joie de Vivre* (see fig. 903). In his depictions of the centaur Nessus seizing Deianeira, the wife of Hercules, Picasso expressed a violent war of the sexes (figs. 477, 478). A tempera on wood, *The Abduction* (fig. 479) foreshadowed future variations on *The Abduction of the Sabine Women* by Poussin and David, which Picasso developed forty years later, in 1962–63.

474

The women whom Picasso painted in Juan-les-Pins during the summer of 1920 had extremely elongated bodies, even more exaggerated than the Ingres-like bathers he painted in Biarritz in 1918. In *Three Bathers* (fig. 480), the women fly toward an allegorical horizon, as in a theater set. And in *Bathers Watching an Airplane* (fig. 481), they ridicule illusionist perspective by focusing on an airplane the size of a fly. These nudes on the beach would experience even more radical deformities in 1927 and 1928.

Before taking the classical ideal to an extreme, Picasso explored the plastic possibilities of sculpture to the utmost, sometimes achieving the monumental. Olga became pregnant in the summer of 1920, and in Picasso's work forms blossomed and flesh took on the massive quality of stone. A pensive *Seated Woman,* soberly composed of dark gray and ocher tones and with strong hands and square feet like column bases, is both solid and harmonious in construction (fig. 482). The figures in both *Two Women* and *Two Bathers* (figs. 484, 486) appear to be blocks of worked clay in compositions that are as sculptural as they are pictorial, boldly deformed and cleverly arranged. The amazing pastel of *Two Bathers* was reproduced in *La Révolution Surréaliste,* of October 15, 1925. In *Two Bathers with*

475

476

203

477

478

479

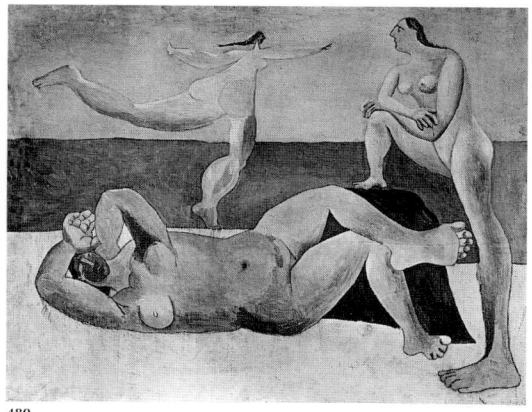

480

481

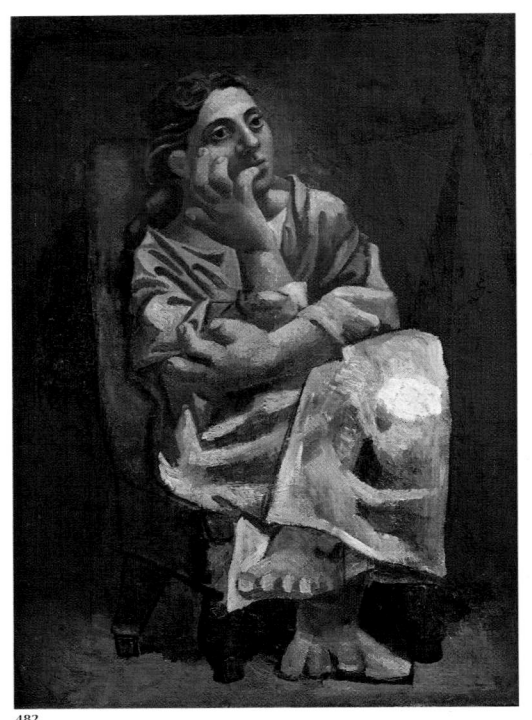

482

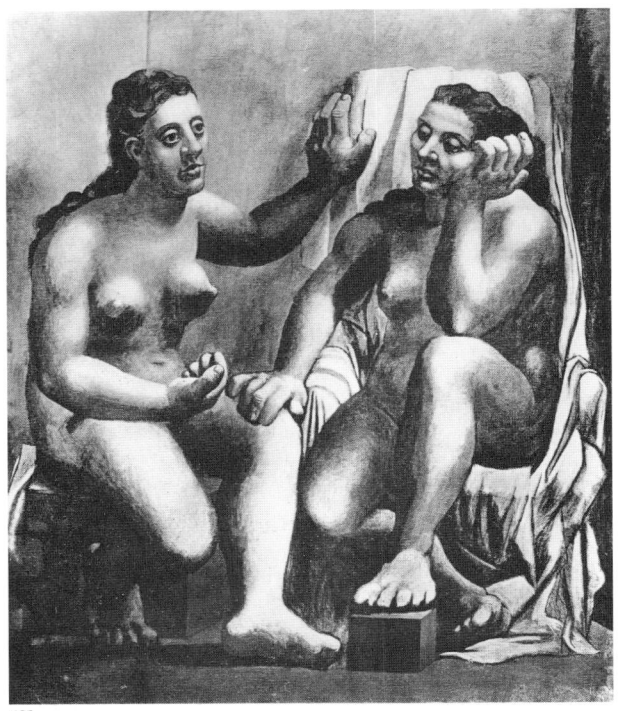

483

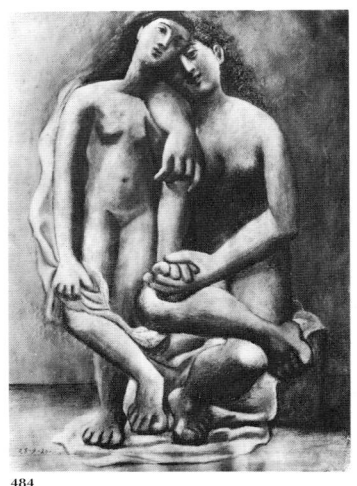

484

485

486

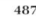

487

488

Towel (fig. 483), a woman rests her foot on a small cube in the foreground, and another sits on a larger cube. This perfect geometric form had already appeared opposite a sphere in the foreground of *Acrobat with Ball* in 1905 and in *Seated Nude with Crossed Legs* (see figs. 176 and 208). The cube would emerge again in 1921 in *Seated Bather Drying Her Feet* (fig. 495).

Unique in its genre, one painting incorporates a group of studies that reflect the many styles that coexisted in Picasso's art at the beginning of the 1920s (fig. 485): Cubist still lifes with glasses, classic themes (profile, hands), and even a couple of dancers, which relate to *The Village Dance* of 1922 (fig. 505). In 1935 Picasso would tell Christian Zervos: "I put everything I love in my paintings. Too bad for the things; they'll just have to work it out among themselves."

On February 4, 1921, Olga gave birth to Pablo's first child, a son they named Paul and often called Paulo. His godmother was Misia Sert, wife of the painter José María Sert. Paul became a model for his father, who made several portraits of him. As early as May–June 1921, sales of the Uhde and Kahnweiler collections, consisting of liquidated property seized from "enemy aliens" (as German residents were called) put early Cubist works on the market for the first time, and at a low price. (After returning to France, Kahnweiler opened a new gallery at 29 bis, rue d'Astrog.) The first book devoted to Picasso was published in Munich that year by Maurice Raynal (a French edition was published in Paris the following year).

Cuadro Flamenco *(1921)*

After approaching Juan Gris, Diaghilev in mid-April again asked Picasso to collaborate on an Andalusian performance, *Cuadro Flamenco,* and he immediately reworked the set designs that had been rejected for *Pulcinella* (see fig. 475). The show, a series of Andalusian dances performed by a troop of musicians, dancers, and gypsy singers, opened at the Théâtre de la Gaîté Lyrique in Paris on May 17, 1921. Representing the painter's salute to Renoir's *La Loge,* Picasso's set presented a stage framed with theater boxes (figs. 487 and 488).

Picasso spent the summer of 1921 with Olga and Paulo at Fontainebleau, where he created large-scale compositions, some Cubist and some classical. He included Pierrot and Harlequin in a trio of *Three Musicians,* which he painted in two slightly different versions (fig. 489 and 490), which Maurice Raynal treated as results of Picasso's Cubist experience. The trio is cheerfully composed of overlapping planes—red and yellow lozenges for Harlequin, white shapes for Pierrot—which stand out against the brown background. In the second painting, Pierrot and Harlequin have changed places, with the monk remaining to their right. According to Theodore Reff's interpretation, the monk represents Max Jacob, who retreated to a presbytery in Saint-Benoît-sur-Loire in the spring of 1921; Pierrot evokes the spirit of Apollinaire and Harlequin, more than ever, represents Picasso's double.[12]

As with *Three Musicians,* Picasso completed several versions of *Three Women at the Well,* as oil paintings (figs. 491 and 493) and in sanguine drawings (fig. 492). The classical reference is obvious here. Picasso has created faces with straight noses and tunics with distinctive parallel folds reminiscent of the grooves in classical columns. Only the roundness of the hands bring life to these static characters, who seem to have emerged from a Parthenon frieze. The voluptuous goddesses stand around a water-filled jug, the symbol of life, which appears here just as it did in *La Source* (fig. 500), itself inspired by a painting of *The Nymph of Fontainebleau.*[13]

Whether the subject is musicians or women, these paintings share the solidity of flawless construction. Each trio is soldered together, with each figure fitting into the others to form a balanced composition, an intelligent arrangement of flat surfaces and volumes. While Matisse was above all a colorist, Picasso proved to be the major architect and

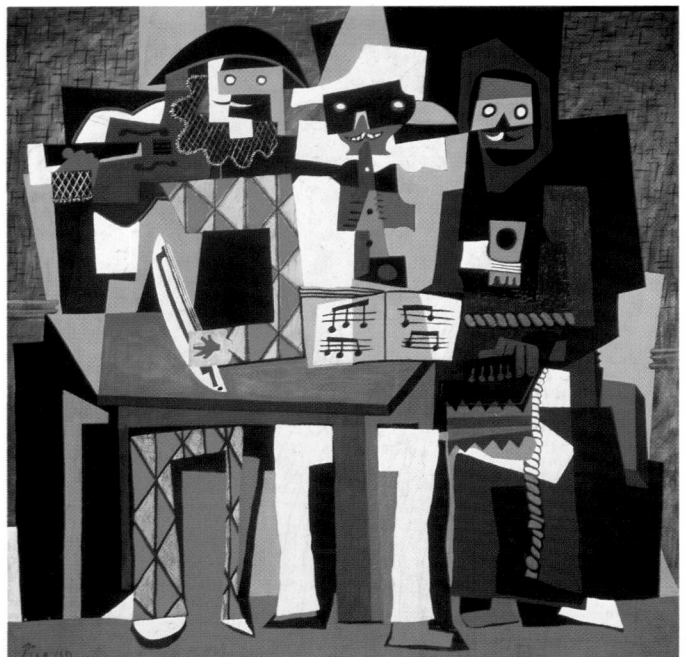

489

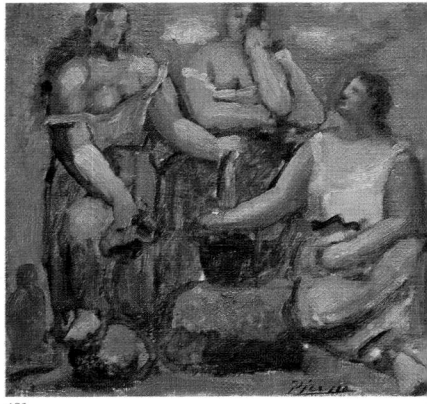

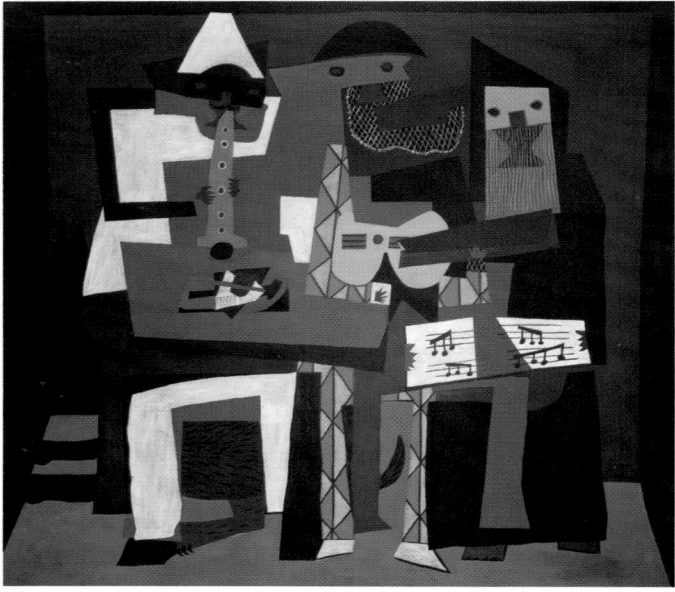

490

492

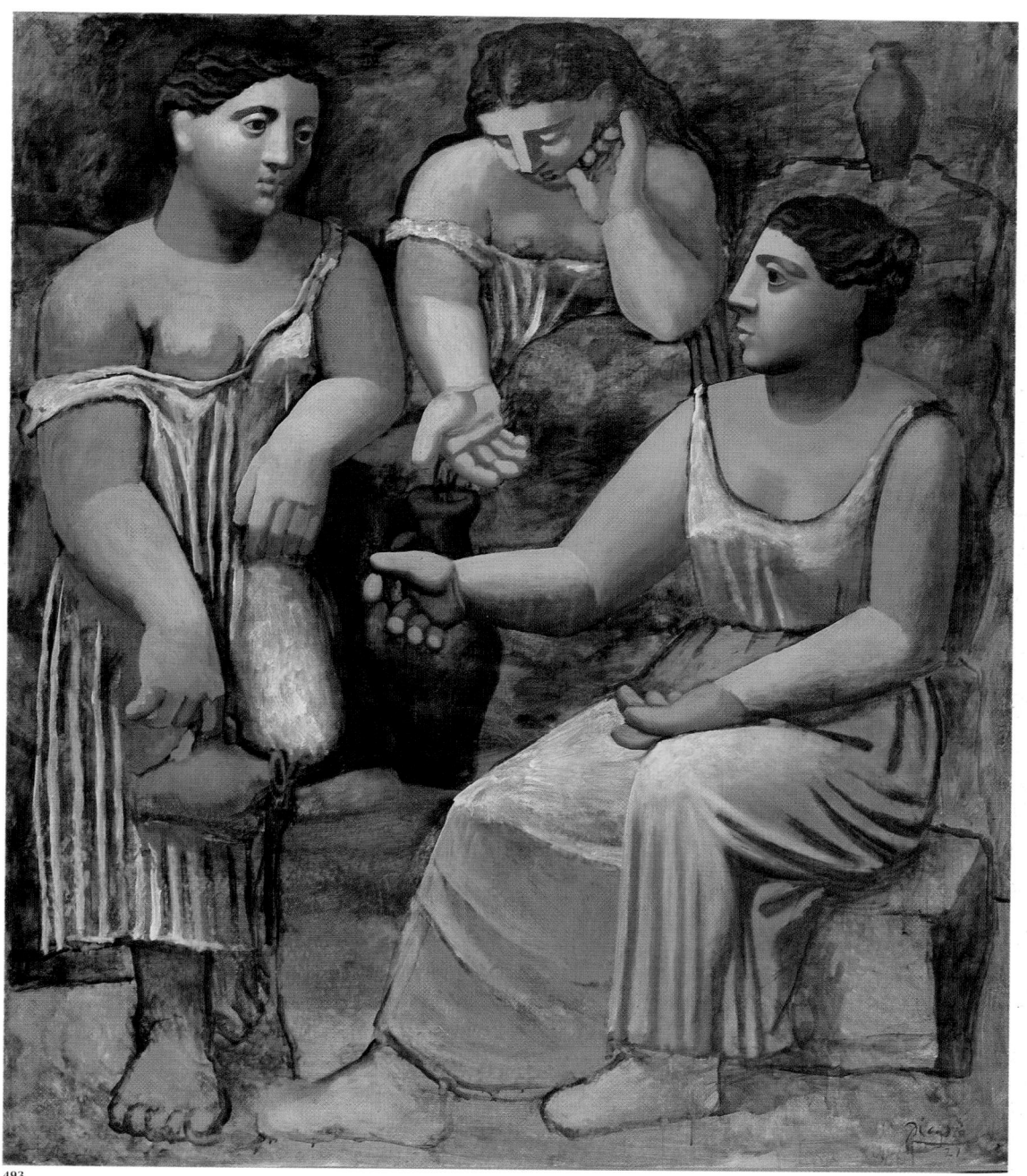

493

494

495

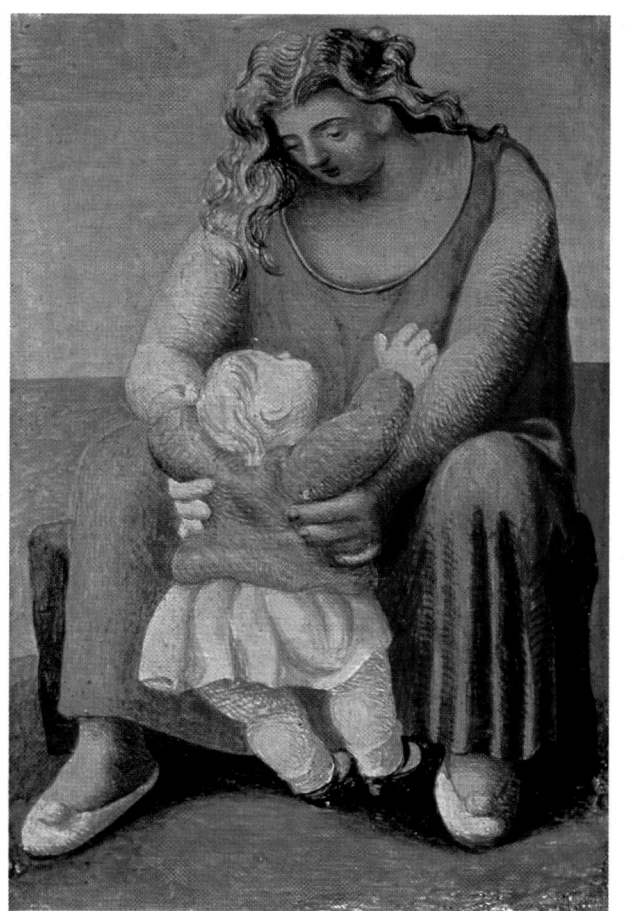

496

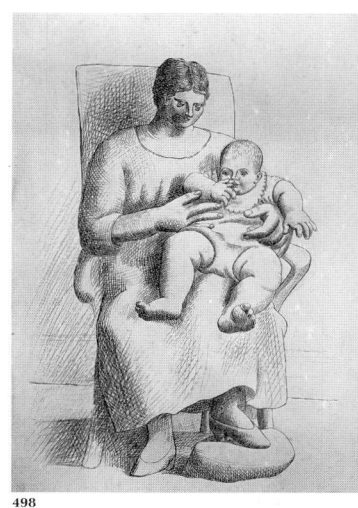

497

498

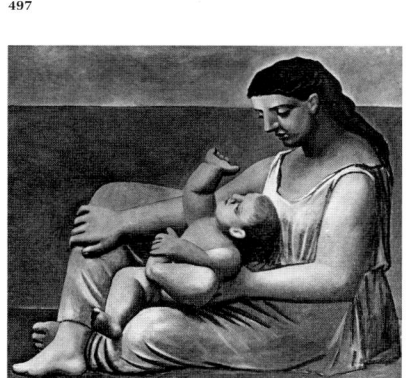

499

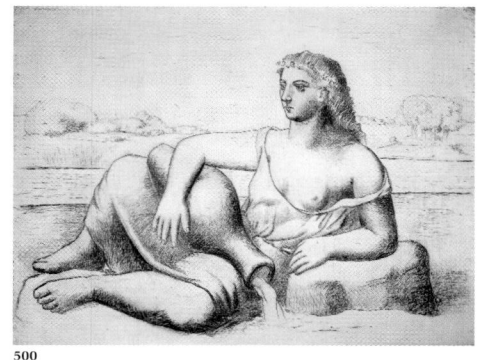

500

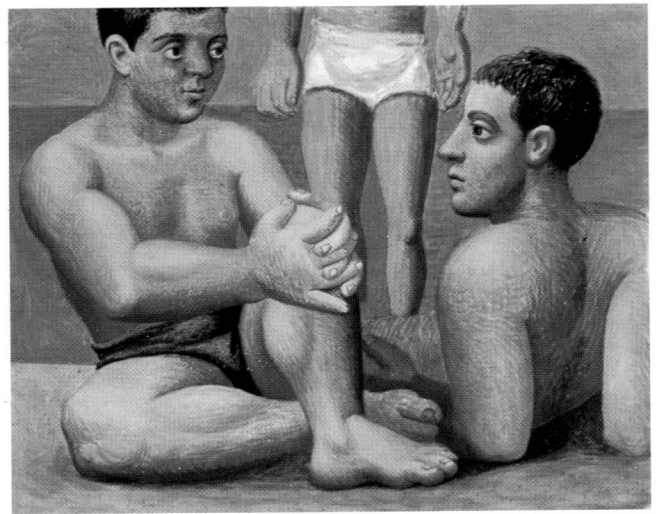

501

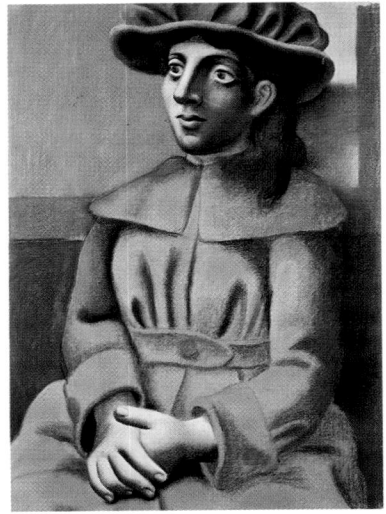

502

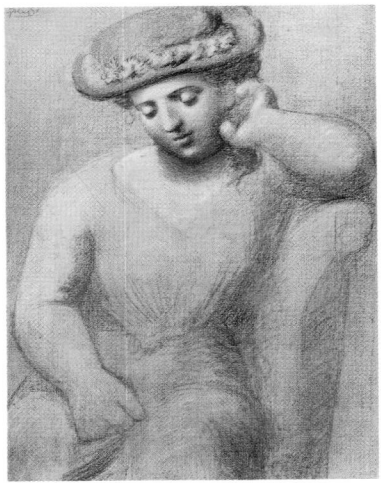

503

construction manager of twentieth-century painting. This type of giantess is found again in the velvety pink nude of *Large Bather* (fig. 494) and in the *Seated Bather Drying Her Feet* (fig. 495), which may have been inspired by one of Renoir's seated Bathers.[14] In his book on Picasso (1923), Cocteau would discuss these "colossal-women, 'Junos with cow eyes' holding a stone cloth in their big, cracked hands."

The familiar image of a woman in a chemise (fig. 496), an allusion to the earth goddess, naturally evolved into rich images of mothers and children (figs. 497 and 499). Although this subject was a common one in 1921, the year Paulo was born, the maternity theme had existed for a long time in Picasso's work—in 1901, 1903, and 1907 (see figs. 94, 112, and 259).

Figures clustered in groups of two or three seem to signify that in this world one is never alone. Whether the subject is two men, two women, a mother and child, or a couple of dancers, one figure invariably appears as a double of the other, worried about or loving his or her counterpart. What is the identity of the formally dressed young men in *Reading the Letter* (fig. 504), which must be some kind of mysterious allegory of friendship? Dominique Bozo sees them as Picasso and Braque or Picasso and Apollinaire, because of the book and the Cronstadt hat on the ground.[14] This a rather recent hypothesis since the painting was not discovered until after the artist's death. In *Bathers by the Sea* (fig. 501), the two young people look alike and share a silent partnership. In March 1921, Picasso drew a self-portrait in profile, like the bather at the right in this painting; he would turn forty years old on October 25.

A figure pictured alone often evoked a nostalgic reference, as in the two pastel drawings of the *Girl in a Hat with Her Hands Crossed* from 1920–21; the subject seems to be waiting for someone, wishing for him with a look or dreaming of him with lowered eyes (figs. 502 and 503). The pastel *Village Dance* (fig. 505) can be read as a melancholy reminiscence of *Country Dance.* The mother-and-child twosome became a family of three, a theme that was present in Picasso's work as early as 1906 and as late as 1970 (see figs. 222, 1143). The mother and child constitute a timeless couple, infinitely interpretable, and the subject yielded several works of harmonious proportion (figs. 508 and 509). In *Family by the Sea* (fig. 510) arms and legs are linked in a continuous line as if they were the bonds uniting man, woman, and child.

501 *Bathers by the Sea,* 1921

502 *Girl in a Hat with Her Hands Crossed,* 1920–21

503 *Seated Woman in a Hat,* 1923

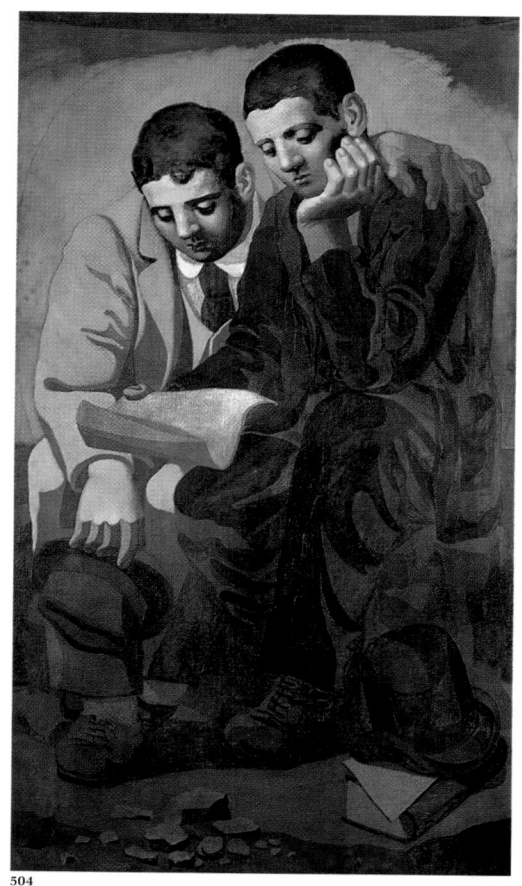

504

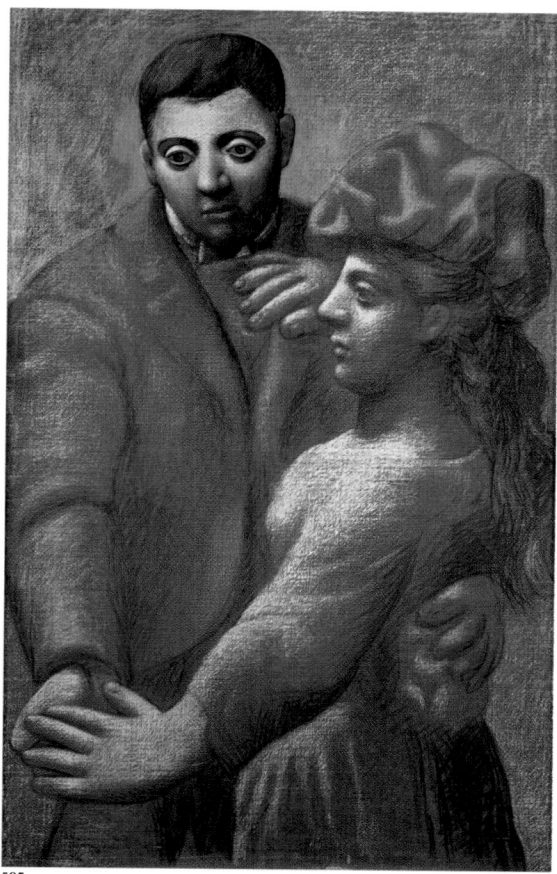

505

506

507

504 *Reading the Letter,* 1921
505 *The Village Dance,* 1922
506 *Study for Three Hands,* 1921
507 *Self-Portrait,* 1921

Large figures return in *Two Women Running on the Beach* (fig. 512), and now they are filled with a new appetite for life. Although this gouache was painted in Dinard during the summer of 1922, the figures are bathed in a Mediterranean light; in 1924, the composition would be enlarged for a drop curtain for *Le Train Bleu*, a dance operetta based on a scenario by Jean Cocteau and put to music by Darius Milhaud, with sets by Henri Laurens and costumes by Coco Chanel. (It was on this occasion that Picasso met Serge Lifar, and both would find each other again years later, in 1959.)

In 1922 Picasso completed the drop curtain for the *Prélude à l'Après-midi d'un Faune* by Claude Debussy. But Diaghilev thought it too simple and was not pleased with it. He told the painter: "I wanted Egypt and you gave me Dieppe." For Cocteau's *Antigone*, based on Sophocles, Picasso created sets for the tragedy as interpreted by Charles Dullin at the Théâtre de l'Atelier in Montmartre, with costumes by Chanel. Cocteau was full of admiration: "He began by rubbing a stick of sanguine on the board, which, because of the unevenness of the wood, became marble. Then he took a bottle of ink and drew motifs, creating brilliant effects. All of a sudden, he blackened some of the holes and three columns appeared. These columns appeared so suddenly and so unexpectedly that we applauded."

The summer of 1922 in Dinard produced intimate scenes, such as those with women and children on a balcony surrounded by theatrical hangings (figs. 513 and 514). The themes of coiffure and the mirror again recur in Picasso's work: the 1922 painting of two women and a child (fig. 514) is an echo of the same trio from the 1906 painting *La Coiffure* (see fig. 200). The small gouache of the *Traveling Circus* (fig. 517) contains several elements that are charged with references to past and future work; in addition to the coiffure theme, the woman with a fisherman's net will reappear in a gouache dated May 6, 1936 (see fig. 744); the ladder from the curtain of *Parade* will reappear in *Crucifixion* (1930) and in *Minotauromachy* (1935; see figs. 418, 608, and 711); and the wheel can be seen in several engravings from 1968.[16]

In his book *Picasso Theater*, Douglas Cooper pointed out the theatrical character of both the circus ring and the bullfight arena. For a 1922 *Bullfight* (fig. 515), the pastel tones, which Picasso rarely used for such a subject, do not mitigate the violence of the scene: here the bull's portrait forms a tragic trio, half-animal, half-human. On the other hand, a yellow-on-blue *Young Man as Pierrot* (fig. 516) is both a tender image of young Paulo—whom Picasso would paint as Harlequin and Pierrot in 1925–25 (see figs. 541 and 543)—and the timeless image of the eternally young man, who reappeared in August 1944 (see fig. 875).

In 1923 Picasso created two portraits of the Catalan painter Jacinto Salvado, who posed in a Harlequin suit given to him by Cocteau when he visited Picasso in 1916. In one portrait (fig. 518), the artist only began to paint in the lozenges on the right shoulder and the work is left unfinished, but the face is drawn in subtle, precise lines. In the other (fig. 519), the pastel-colored lozenges form a patchwork that is blended with superb mastery. Pensive, staring outside the frame, Harlequin, here portrayed as a handsome figure, may be searching for his double. The mirror is no longer the exclusive attribute of women but now attracts the attention of Harlequin, who adjusts his two-cornered hat (fig. 520), as well the glance of a *Seated Woman* (fig. 521). The figures seem to be asking their reflections: "Who am I?" The mirror reflects the face of the woman as she turns her head away, a device that separates the frontal view and the profile, thus showing a woman coming face to face with herself.

The year 1923, when Picasso was beginning to explore this kind of image, would also mark the peak of his classical period. A couple of *Lovers, Seated Saltimbanque with Crossed Legs, Seated Woman in a Chemise,* and *Seated Young Man with a Pipe* (fig. 522–526) are all testimony to his perfectly mastered classicism. Picasso would be in Antibes that summer with the American painter Gerald Murphy and his wife, Sara, and according to Pierre Daix, the women that Picasso painted and drew at that time were directly inspired by the beautiful Sara with her pearl necklace.

508

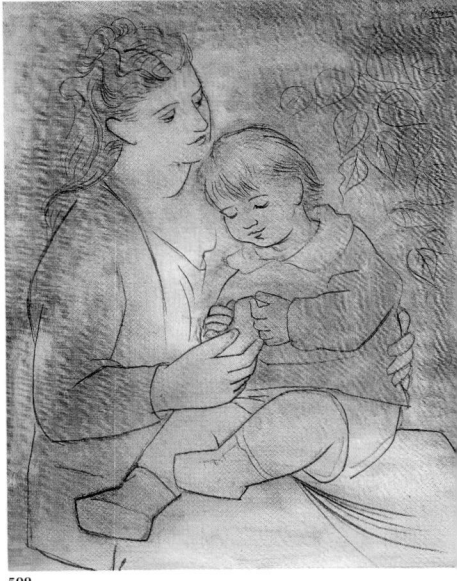

509

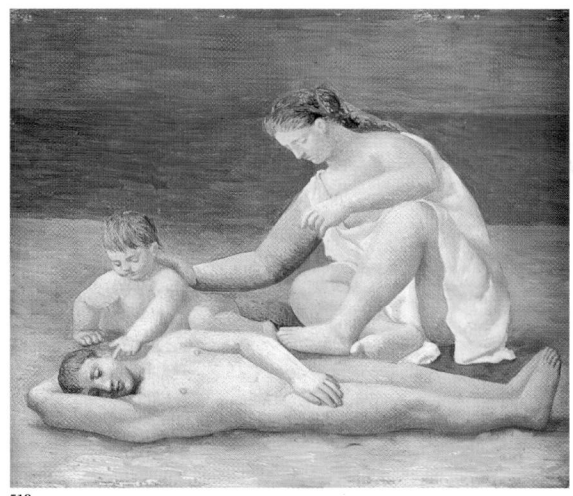

510

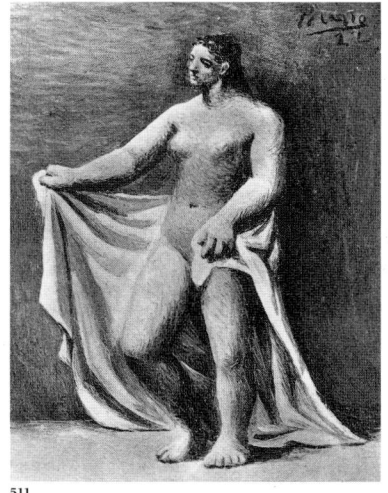

511

512

215

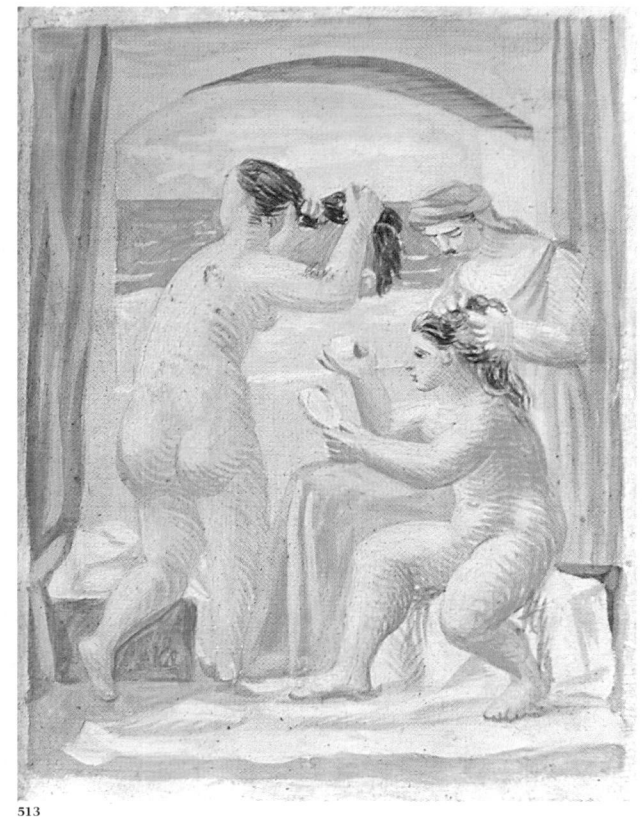

513

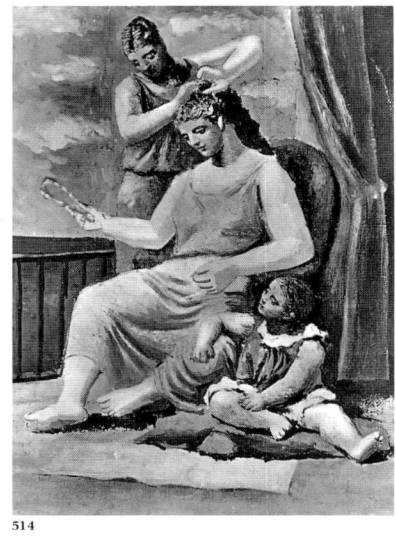

514

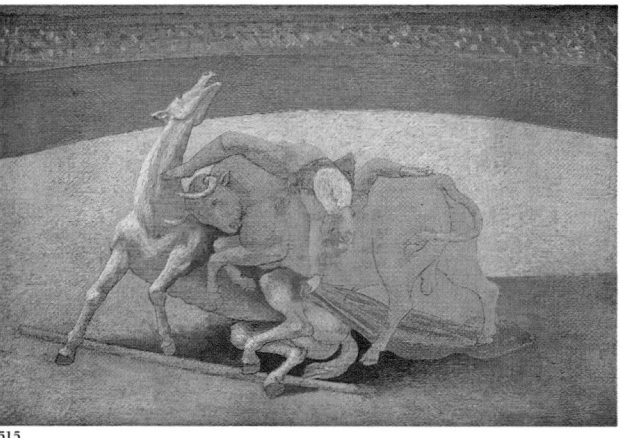

515

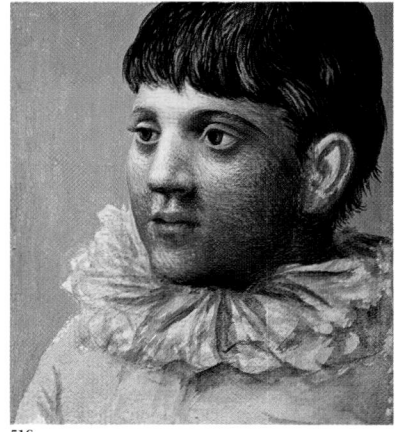

516

216

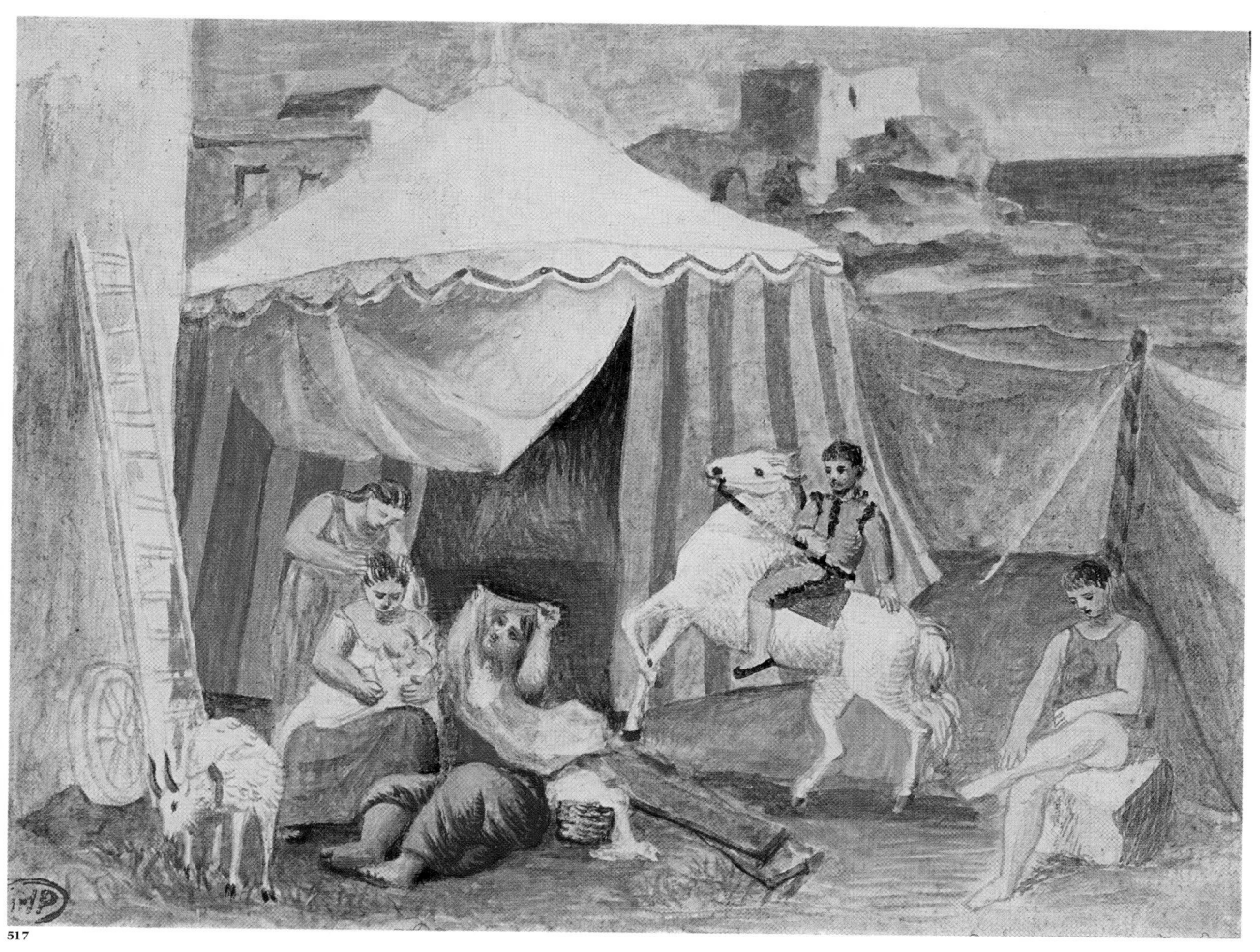

517

217

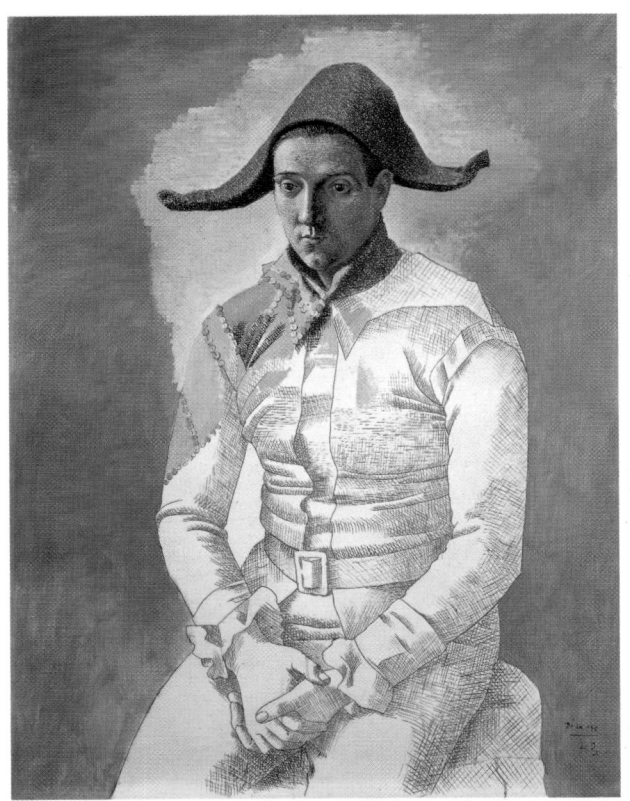

518

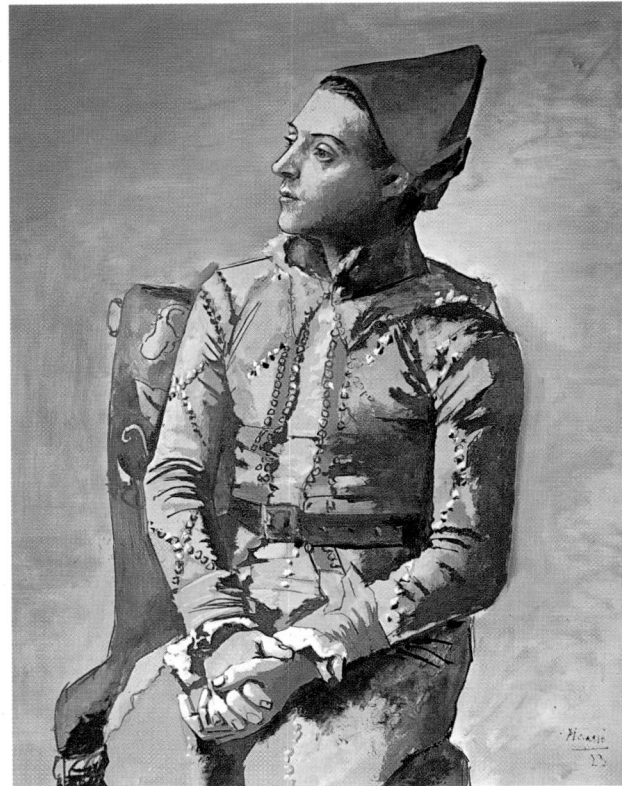

519

518 *Seated Harlequin (Portrait of the Painter Jacint Salvadó)*, 1923

519 *Harlequin (Portrait of the Painter Jacint Salvadó)*, 1923

520 *Harlequin with Mirror*, 1923

521 *Seated Woman*, Winter 1922–23

218

The Pan-Pipes is Picasso's masterpiece of this period (fig. 527). Two young people are pictured against the sky, framed by screens. One plays the flute as the other listens, and we can almost hear the pure sound of Apollo and Marsyas. In addition to the influence of antique art, one can also perceive the teachings of Cézanne: André Fermigier would find this to be "the most Cézannian work that Picasso ever completed." The extremely accomplished painting marks the high point of a neoclassical genre that Picasso would never surpass.

The objects in Picasso's work at this time seem to be very orderly—too much so. The portrait of the young Paulo perched on a donkey (fig. 528), which was based on a photograph, makes childhood charming, comforting, and somewhat conventional; the animal's coat and the blades of grass are rendered with an almost obsessive precision. In two pastel drawings (figs. 529 and 530), Olga's face has become pensive and preoccupied. The last portraits of her date from this year: soon she would disappear altogether from Picasso's paintings. Little by little the couple was growing apart, and she was becoming increasingly irascible.

The serious facial expressions in Picasso's work would give way to violence, suppressed but ready to erupt at any moment. In his neoclassical period, Picasso focused on enhancing the forms and glorifying the flesh, even the skin, of his female nudes. But what was stirring within the painter and his work would disturb the apparent harmony of this attractive style, as in the Cubist *Head of Harlequin* (fig. 531), whose asymmetrical eyes twinkle with curiosity and look in different directions, foreshadowing a new direction for the artist. Harlequin refuses to be a prisoner like the caged bird in the corner of the still life with a pedestal table (fig. 532), a picture that is otherwise cheerfully composed of segmented planes and bursts of color.

It is precisely at this period that Picasso grew closer to André Breton, whom he met on the eve of Apollinaire's death, in November 1918.[17] The painter engraved Breton's portrait, which was to illustrate a collection of his poems, *Clair de Terre* (printed on November 15, 1923). Breton had played an important role for Picasso, since he had advised the couturier Jacques Doucet to acquire *Les Demoiselles d'Avignon* in December 1921.[18]

In 1924 the horizon opened up onto new perspectives, leaving classicism behind. During the summer in Juan-les-Pins, Picasso filled two sketchbooks with a series of studies in which he worked out webs of points and lines based on a guitar shape (figs. 534 and 535). Number 2 of *La Révolution Surréaliste*, dated January 15, 1925, published a spread of these drawings, which would be used to illustrate, with engravings, the publication of Balzac's *Chef-d'Oeuvre Inconnu* in 1931. A large guitar of corrugated painted metal would be published on December 1, 1924, in the first issue of *La Révolution Surréaliste.* In the spring of 1924, Picasso collaborated for the last time with Diaghilev's Ballets Russes, creating the curtain for *Train Bleu*, an enlarged version of *Two Women Running on the Beach*, a gouache from 1922 (see fig. 512). The performance opened on June 20 at the Théâtre des Champs-Elysées, two days after the premiere of *Mercure*.

Mercure *(1924)*

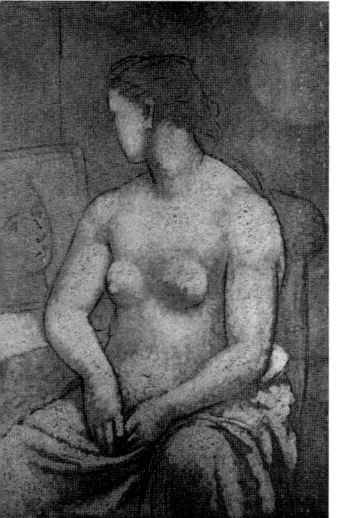

At the request of Léonide Massine, Picasso designed the drop curtain, set, and costumes for the ballet *Mercure*, which was set to music by Erik Satie, as part of the Soirées de Paris series organized by Count Étienne de Beaumont (figs. 536–538). The performance, presented at the Théâtre de Cigale on June 18, caused a stir, but the Surrealists published an "Homage to Picasso" in the June 20 *Paris-Journal*, in which they expressed their profound and complete admiration for the painter in the following terms: "Picasso, *well beyond all those around him*, appears today to be the eternal personification of youth and the uncontested master of the situation."

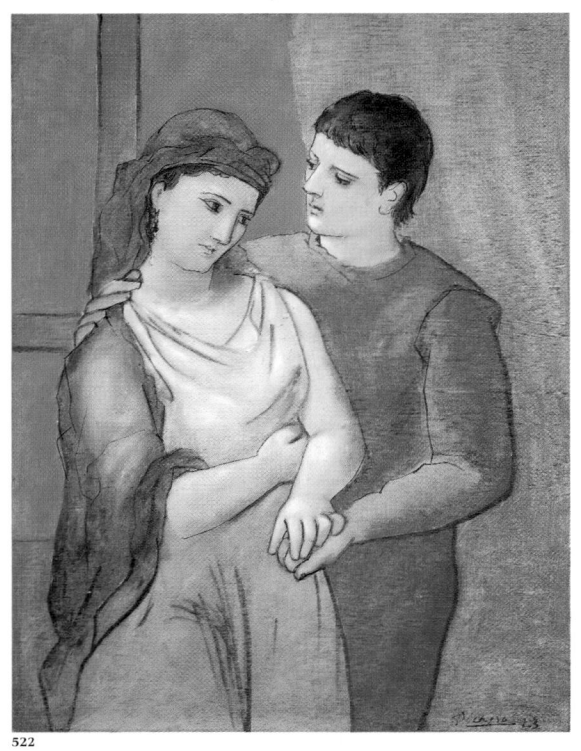

522

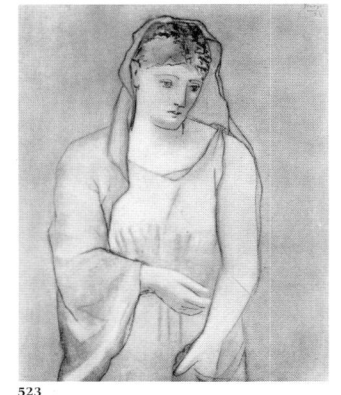

523

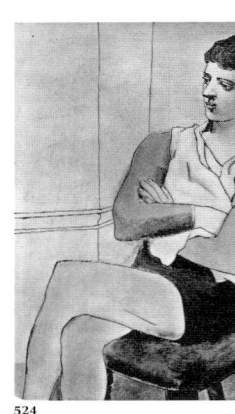

524

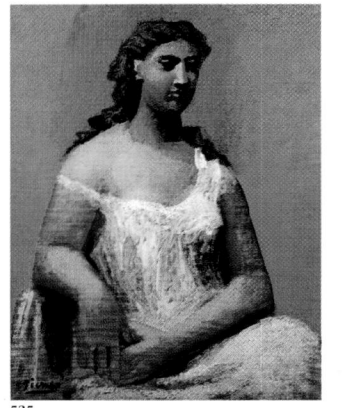

525

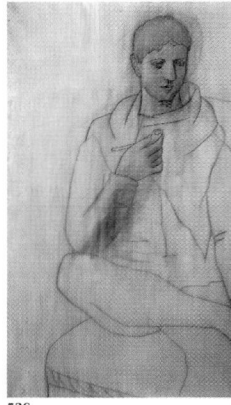

526

522 *The Lovers,* 1923

523 *Woman in a Blue Veil,* 1923

524 *Saltimbanque Seated with Crossed Legs,* 1923

525 *Seated Woman in a Chemise,* 1923

526 *Seated Young Man with a Pipe,* 1923

527 *The Pan-Pipes,* Summer 1923

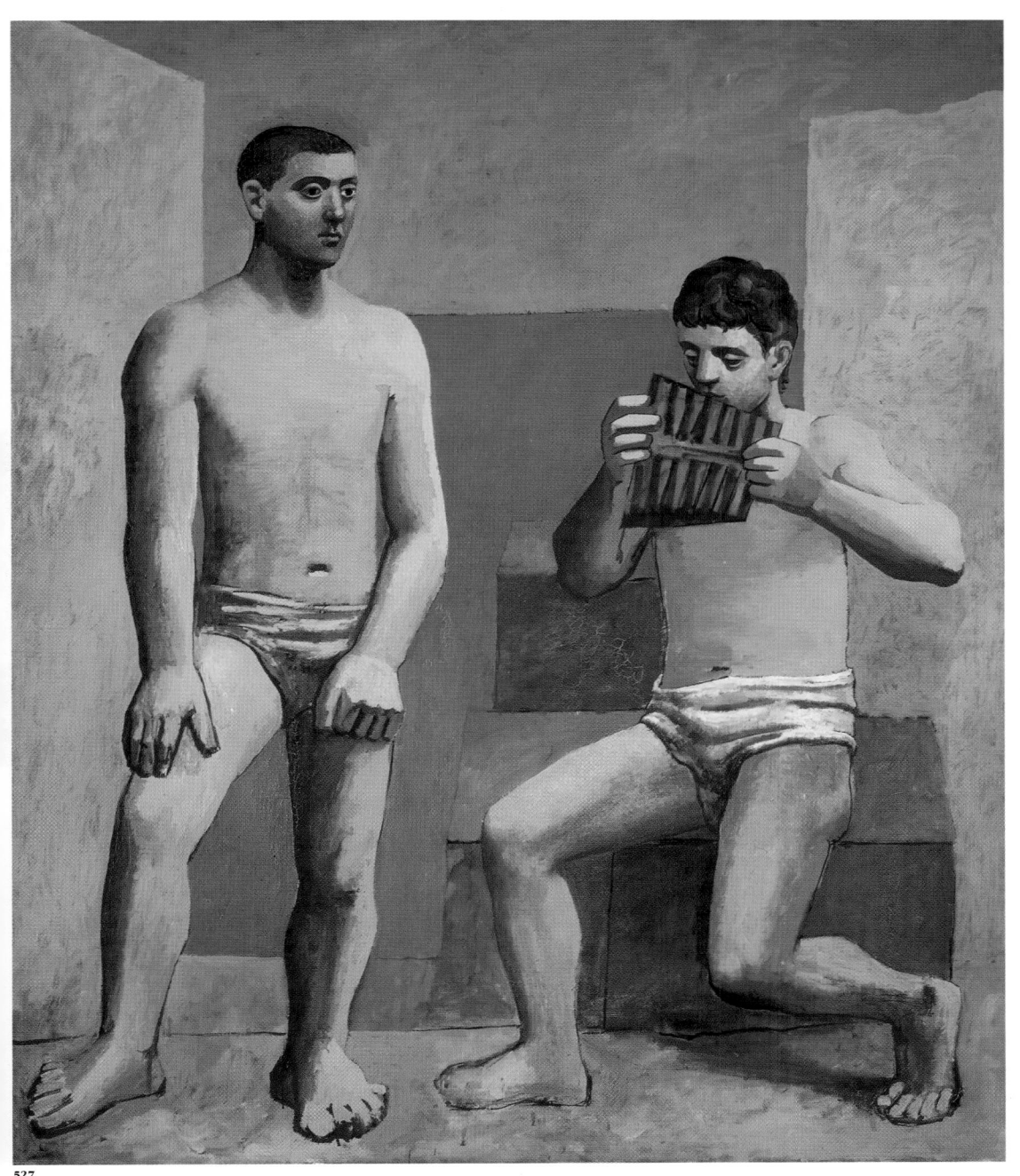

527

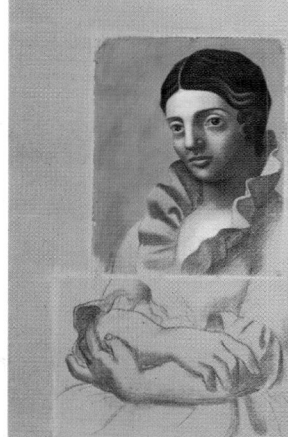

529

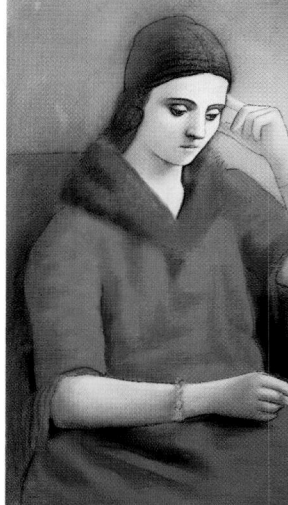

530

528

528 *Paulo, the Artist's Son, at Age Two,* 1923
529 *Portrait of Olga,* 1921
530 *Olga in a Pensive Mood,* 1923

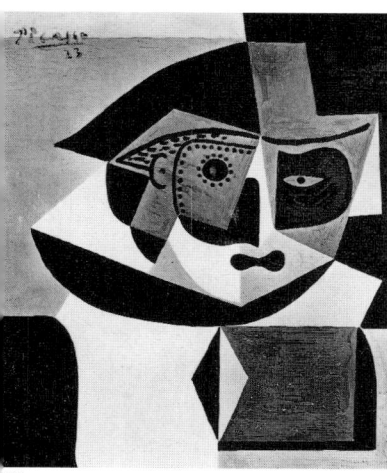

531

531 *Head of Harlequin,* 1923
532 *The Birdcage,* 1923

534

535

533

533 *Guitar,* 1924

534 *Violin and Its Notes,* Summer 1924

535 *Guitars and Guitar Notes,* Summer 1924

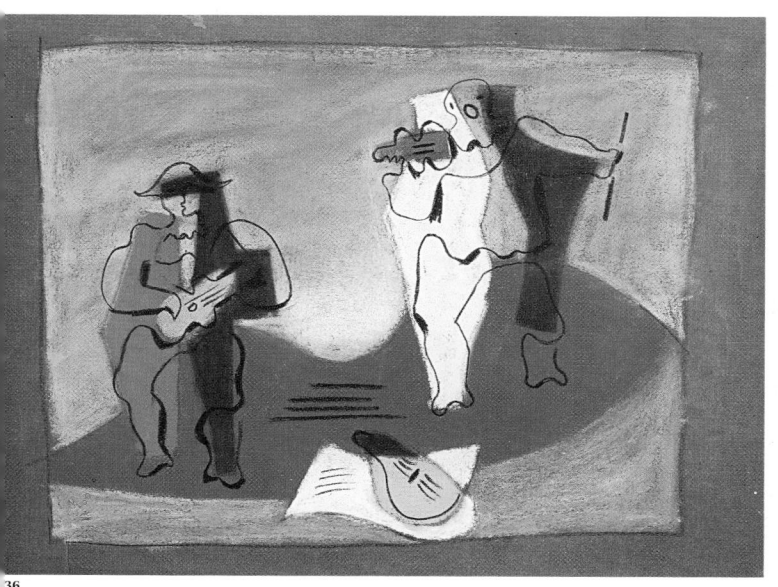

536

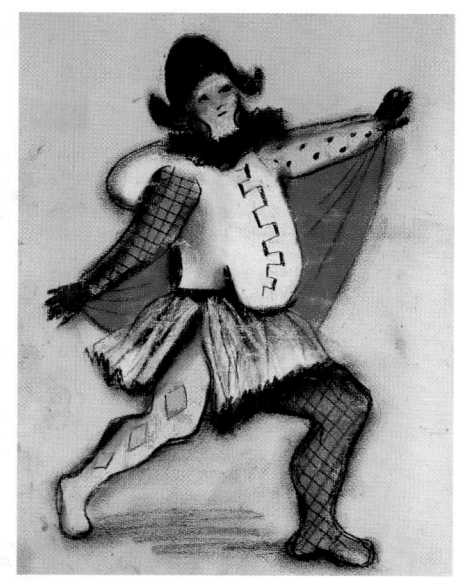

537

538

536 *Design for a Drop Curtain: Harlequin Playing the Guitar and Pierrot Playing the Violin, for the ballet "Mercure,"* 1924

537 *Drawing for Costume for Pulchinella, for the ballet "Mercure,"* 1924

538 *Three Studies, for the ballet "Mercure,"* 1924

225

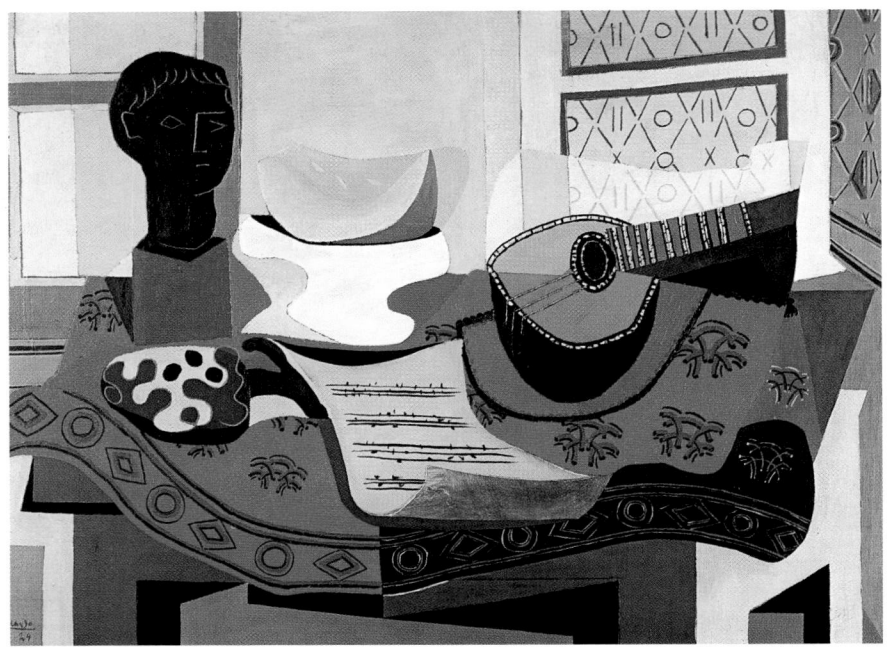

539

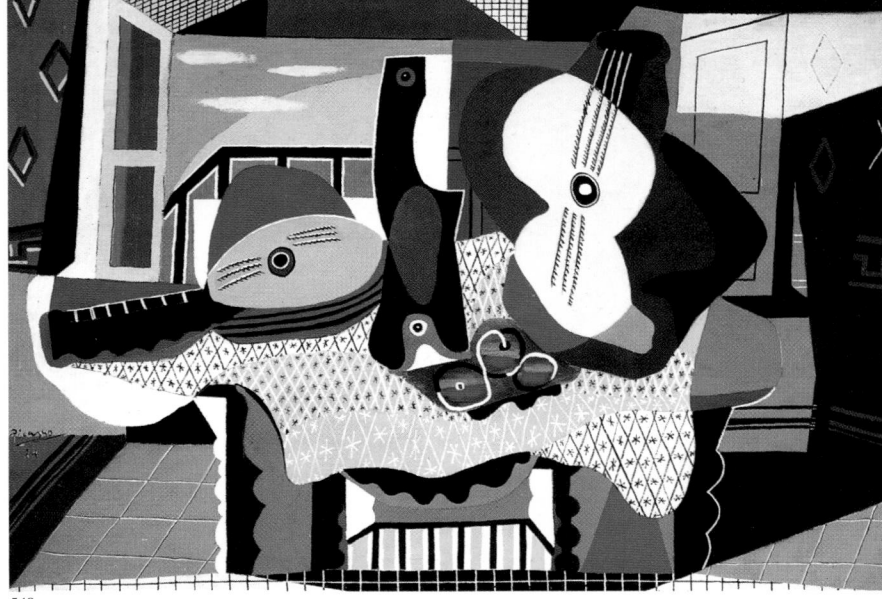

540

539 *The Red Carpet,* 1924
540 *Mandolin and Guitar,* Summer 192

226

In certain Cubist still lifes from 1924, the presence of a plaster bust, sometimes a black one, is another reference to antiquity. These large, strongly colored compositions set in front of an open window, bring together objects, such as a guitar or mandolin, a musical score, a bottle, and a fruit bowl on a tablecloth (figs. 539 and 540). Decorative motifs, including crosses and diamonds, add life to the colored planes with a renewed imaginativeness that would increase in years to come. Through the open window, a puff of fresh air once again fills Picasso's painting.

The Picasso of 1924 who befriended Breton was hardly the same man who had worked with Cocteau in 1917. In the interim, there were the Ballets Russes, Olga, classicism, and abundant mature work. At this point, Picasso was ready to hear Breton order, as he did in *Les Pas Perdus*, published in 1924: "Let go of everything!"

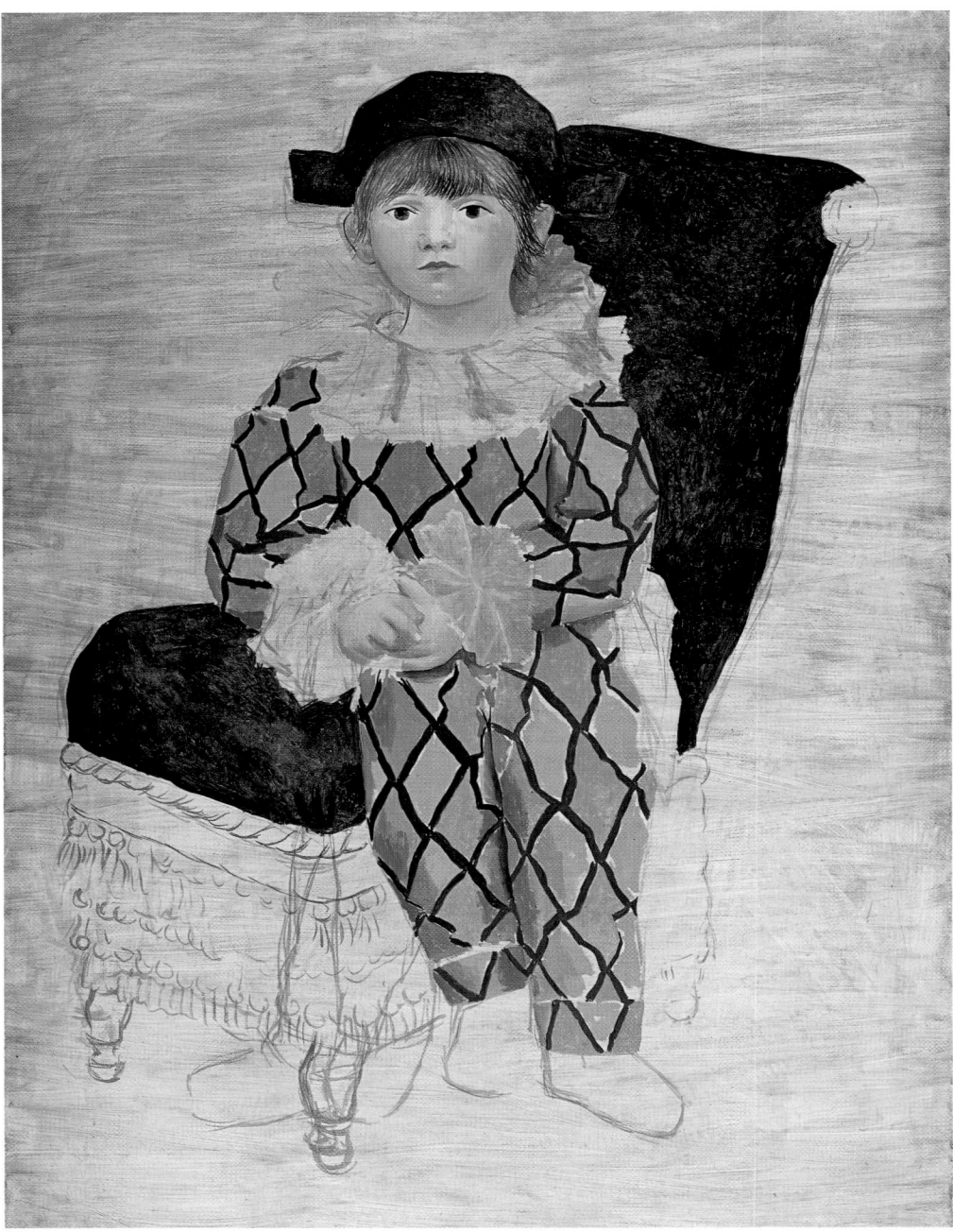

541

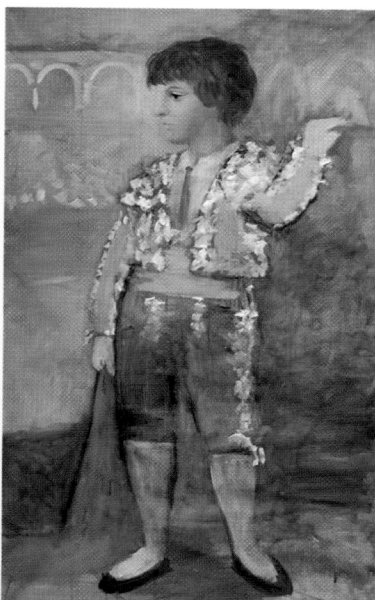
542

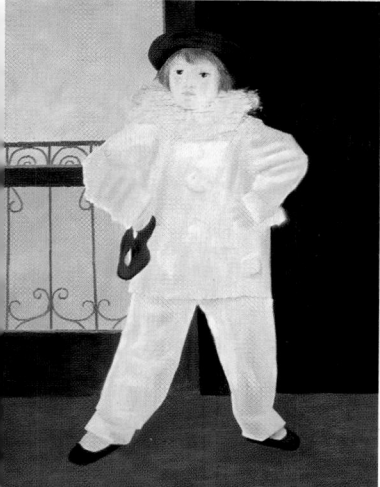
543

541 *Paulo as Harlequin*, 1925
542 *Paulo, the Artist's Son, at Age Four*, 1925
543 *Paulo as Pierrot*, February 28, 1925

1925 – 1930

During the second half of the decade of the 1920s, Picasso again found a unified style characterized by great freedom of expression and innovation. The seemingly innocent beach games of 1927–28 are imbued with growing dramatic tension, starting with *The Dance* in 1925 and culminating in *The Crucifixion* in 1930. In 1927 a major event occurred in the painter's life, one that he would keep secret until the 1930s: he met Marie-Thérèse Walter.

The Sound of Jazz

As in preceding years, Picasso's son, Paulo, modeled frequently for his father, who gave him alternating roles as Harlequin, Pierrot, and a bullfighter (figs. 541–543). The cautious, slightly conventional composition of these still-classical paintings is tempered in the 1924 painting *Paulo as Harlequin* (fig. 541) by the fact that the feet are unfinished and the background is indicated with wash. A bit of melancholy punctuates the child's abstracted air as he poses like a fragile doll, outside of space and time. With this image, Harlequin slipped away for many years.

The still lifes of 1925 derive from those of 1924 and are either barer or more lush. In them we find a plaster bust, a mandolin, and an open book (fig. 544), or a simple bowl of fruit and a glass placed on a fishing net that serves as a tablecloth (fig. 545). The more complex *Studio with Plaster Bust* (fig. 546) presents a table holding a miscellaneous assortment of objects, including the head of a bearded man painted in three views (profile, three-quarter, and frontally), a plaster foot and a forearm holding a staff, an open book, a T-square, an orange, and a leafy branch. The group is complemented by the model of a theater, which, according to Roland Penrose, is "reminiscent of the scenery for *Pulcinella,* which had its origin in a toy theatre he had made to amuse his son."[1]

In *The Statue* (fig. 547), the plaster bust from the still life is set on a stand supported by a young woman whose head is seen both frontally and in profile; this is the first encounter in Picasso's work between sculpture and the live model, a motif that he would often use later. In the background, through the open window, one can see the decorative motif of the balcony's wrought-iron guardrail, similar to the one in *Paulo as Pierrot* (fig. 543). In a play of shadows, the window knob, curiously, fits into the top of the young woman's forehead.

Women more than ever have become by this time Picasso's subject of choice. The mother he celebrated in the early 1920s was supplanted by the lover and the muse. *Woman with a Tambourine* (fig. 548) offers a contemporary image, a modern version of the female model freed of any allusion to the classical tradition or antiquity, which has been replaced by the imagination, as in the details of the red beret, the three-colored skirt, the three pieces of fruit in the foreground, and the strong yellows and blacks, boldly applied. Picasso's art now followed the route of unrestrained figuration, which was sometimes brazen and provocative.

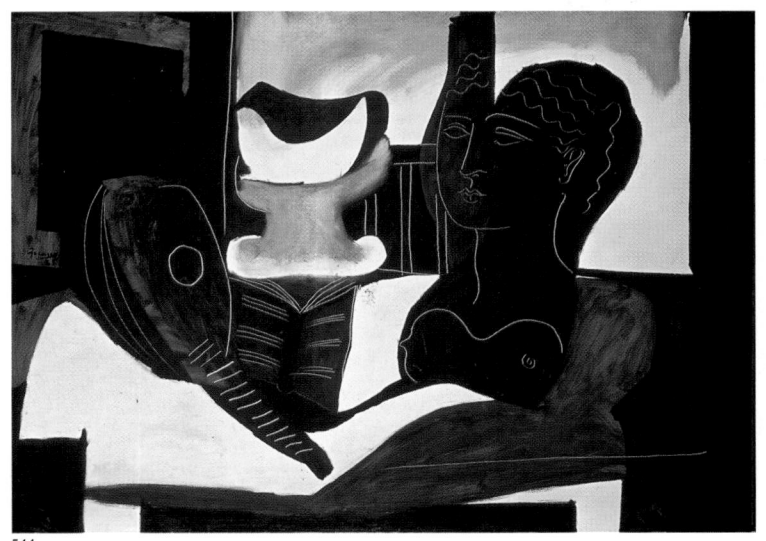

544

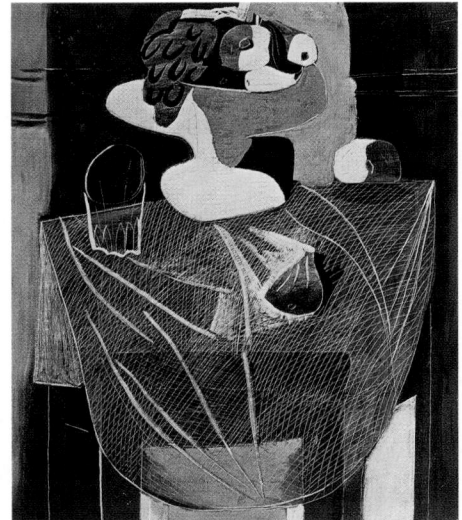

545

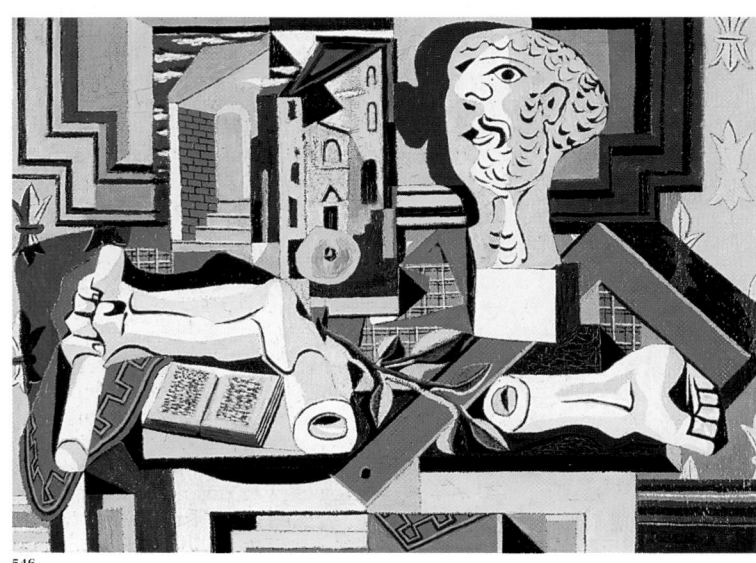

546

230

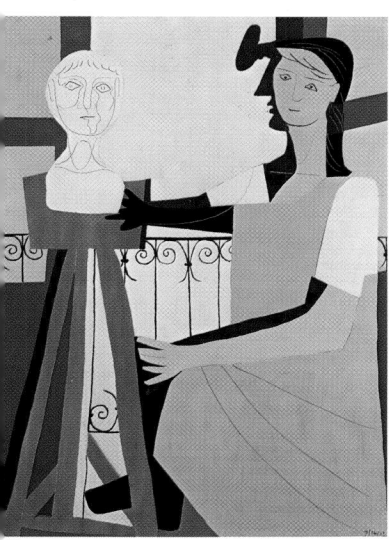

547

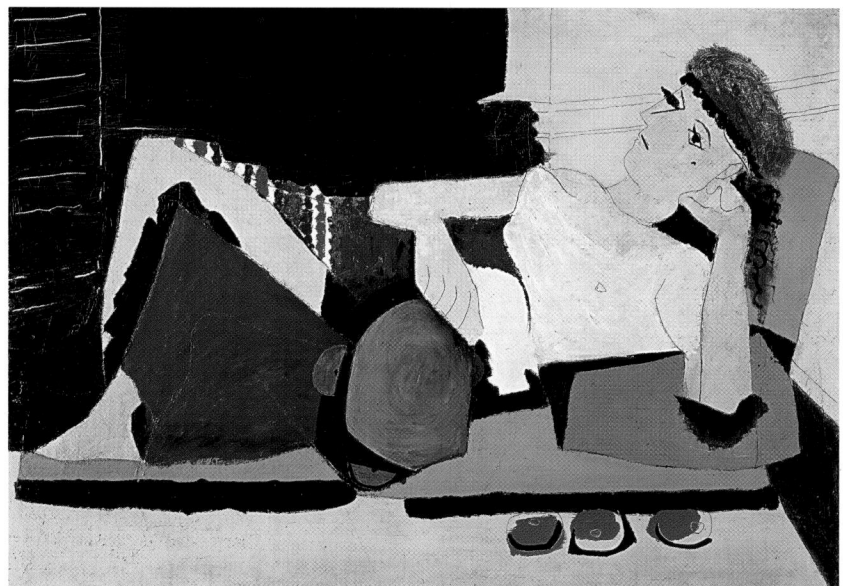

548

The Kiss and The Dance (figs. 549 and 550), each part of a series, seem to unravel to the sound of frenetic jazz. The scenes contradict one another in their movements: the kiss seems turned in on itself, whereas the dance bursts into movement in the form of a crucifixion. Intertwined in an embrace, rather than just a kiss, the bodies are nearly indistinguishable in the jumble of strident colors, in which limbs and sexual organs occasionally appear. "Art is never chaste," Picasso told Antonina Vallentin,[2] at a time when Freud was explaining that libido governed the world. Of all the kisses in Picasso's oeuvre, this is one of the most developed and least restrained.

With its violent, dramatic tension, and a hellish round of frenzied jubilation, The Dance seems to exorcize a combination of pleasure and pain. A nude figure rises in the center, torn between a disturbed maenad on the left and the gloomy silhouette of a man on the right. Picasso confided in Penrose that the execution of this painting was darkened by the news of the death, in Paris, of his childhood friend Ramon Pichot. The painting was reproduced in Number 4 of the La Révolution Surréaliste on July 15, 1925, a few pages after Les Demoiselles d'Avignon. Although Pierre Nabille had proclaimed in Number 3 "that there is no surrealist painting," André Breton began in Number 4 to serialize "Le Surréalisme et la Peinture" (published in book form in 1928), in which he defined the concept of an "interior model." Although Breton promoted young, still unknown artists—the German Max Ernst, the Catalan Joan Miró, the Frenchman André Masson—he considered Picasso a forerunner. Recognizing the painter's "immense responsibility," he did not hesitate to say, "It was due to a lack of will on the part of this man that the direction in which we are involved was postponed, if not lost." And also: "Surrealism, if it intends to define a line of

action, simply has to go where Picasso has gone, and where he will return." Picasso could not have ignored the 1924 *Surrealist Manifesto,* and the last sentence of *Nadja,* published in 1928, seems to match a painting like *The Dance* perfectly: "Beauty will be CONVULSIVE or will not be." It therefore comes as no surprise that Picasso was part of the "La Peinture Surréaliste" exhibition at the Galerie Pierre from December 14 to 25, 1925, even if, as Brassaï put it, "he did not know about it—his paintings having been loaned by collectors."[3]

The powers of life and death would continually come face to face in Picasso's paintings from the 1920s and 1930s, foreshadowing their emergence in the real world during World War II. In the 1926 *Dress Designer's Workshop* (fig. 551), a strange scene is brewing. Darks and lights alternate in this partially dreamed version of a real scene, which Picasso could see from his studio window on rue La Boétie, in a subtle and changing balance of chiaroscuro tones, in which the daylight colors recede. At the right, the profile of a man coming through the door has the same disturbing shadow quality as the man's silhouette against the window in *The Dance.*

In 1926 Picasso was commissioned by Ambroise Vollard to do a series of engravings illustrating Balzac's "imaginary tale," *Le Chef-d'Oeuvre Inconnu.* The story, which takes place in the seventeenth century, is about Frenhofer, an old painter who is full of talent. Over the course of ten years, Frenhofer worked so hard on the masterpiece of his career—a portrait of a woman—that the painting became an indescribable chaos of bizarre lines and colors, similar, wrote Balzac, to "a wall of paint." The only recognizable detail was "a delicious foot, a living foot." When Frenhofer's two friends Porbus and Poussin fail to understand the picture, he ends up committing suicide and destroying his painting.

In the center of Picasso's *Painter and His Model* (fig. 558) is a close-up, exaggerated view of a female model's foot. A huge arabesque at the left presents the woman lying on her back, with her arms crossed beneath her pinlike head; at the right, the painter is seated, holding his palette in hand. Near the center, one can make out a row of nails holding the canvas to the stretcher. (The drawing appears independently of the gray and white vertical strips.) At the far right the painting has been left unfinished, like a drawing. A fabric of curving, undulating lines runs through another still life, *Musical Instruments on a Table* (fig. 553), this time awash in a deep red. The guitar theme, which has always been a favorite, has now given way to a series of entirely new creations, revealing Picasso's talents as jack-of-all-trades.

After the large *Guitar* in painted metal of 1924 (see fig. 533), Picasso made relief-paintings using the same motif (figs. 559–563). This work outside the realm of painting would bring him closer to the Surrealists, who, with Breton, appreciated the fact that the painter or sculptor was not prejudiced by the medium but sought "the perishable and the ephemeral." Breton would write: "What I like so much, although certain of Picasso's paintings are looked at with solemnity in all the museums of the world, is that he has made an object in the most generous of ways that must never be admired for its value as a commission or as speculation other than intellectual."[4] With this ludicrous piece of makeshift construction, which combines tulle, braids, and buttons with the most modest materials (rag, dishcloth, string, cord, nails), Picasso took pleasure in violating the laws of painting. As Aragon would write in 1930, in "La Peinture au Défi": "It happened that Picasso did a very serious thing. He took a dirty shirt and attached it to a canvas with a needle and thread." Thus Picasso introduced raw reality into art in sometimes disturbing, if not hostile, forms, as in the two large *Guitars* from the spring of 1926 (figs. 554 and 555). The first would be reproduced in Number 7 of *La Révolution Surréaliste* on June 15, 1926. According to Roland Penrose, Picasso even considered for the second *Guitar,* which was spiked with nails pointing toward the viewer, "embedding razor blades in the edges of the picture so that whoever went to lift it would cut their hands."[5]

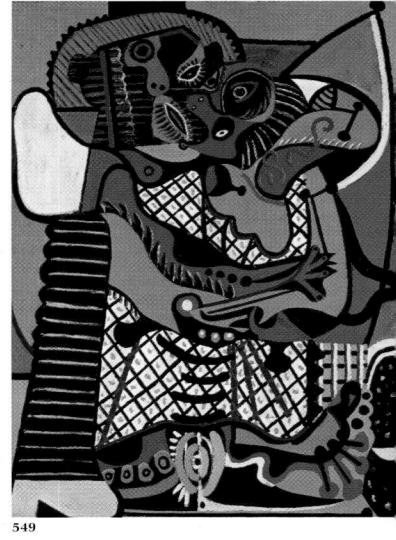

549

549 *The Kiss,* Summer 1925
550 *The Dance,* June 1925

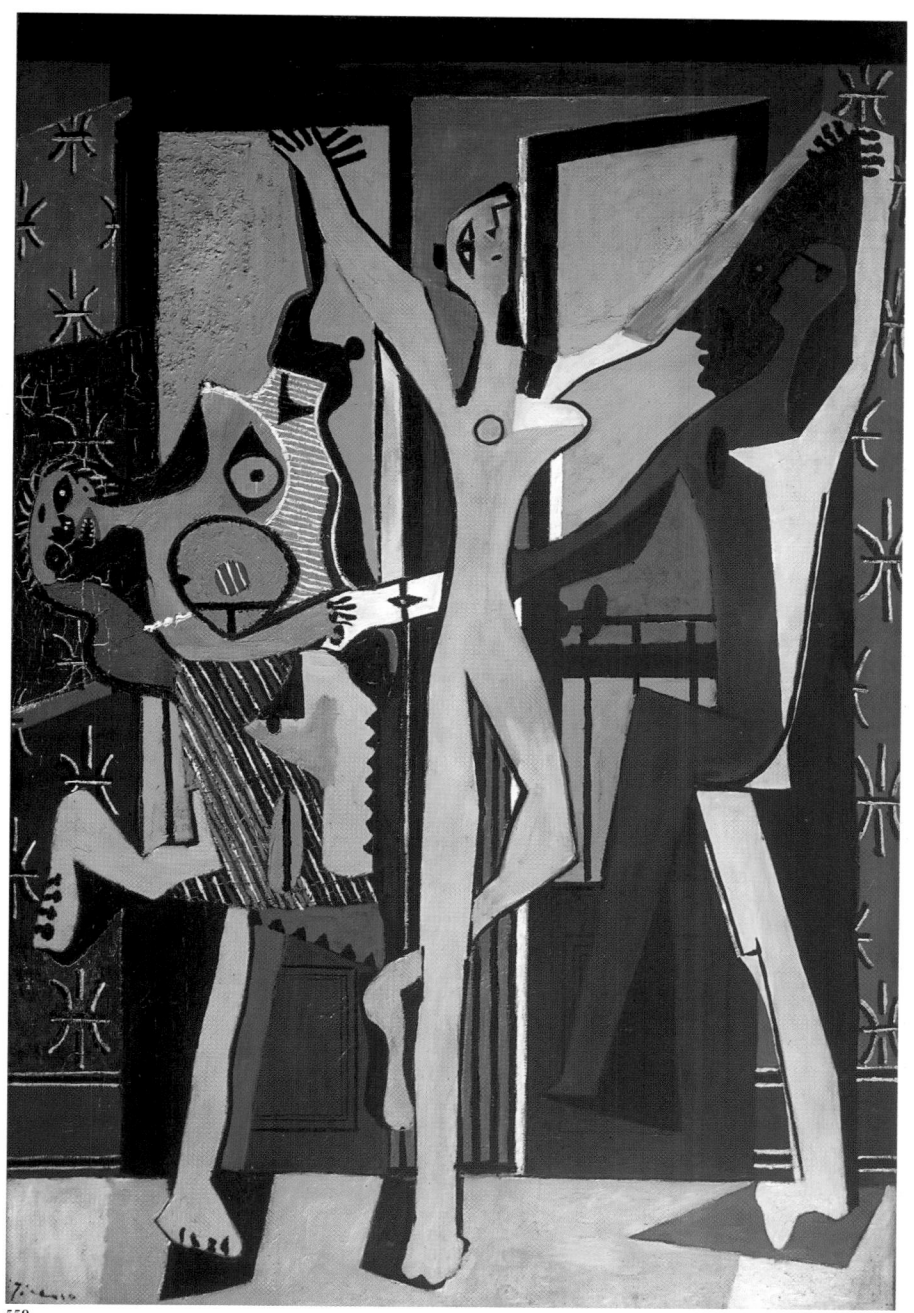

550

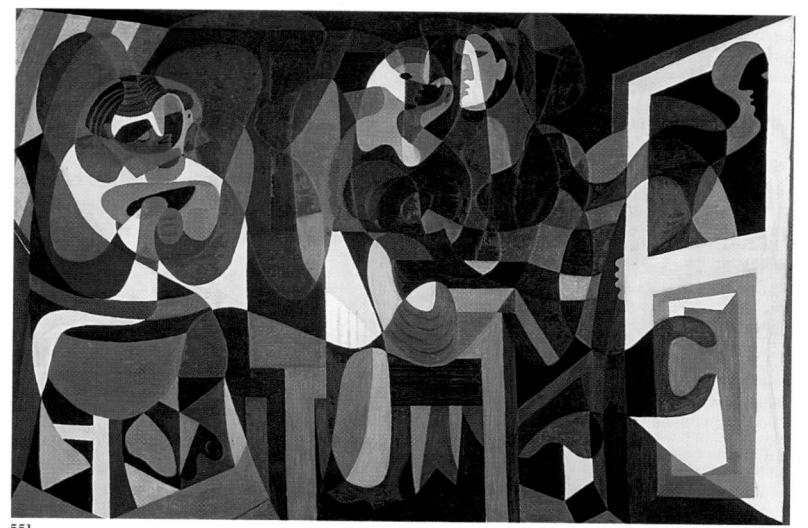

551

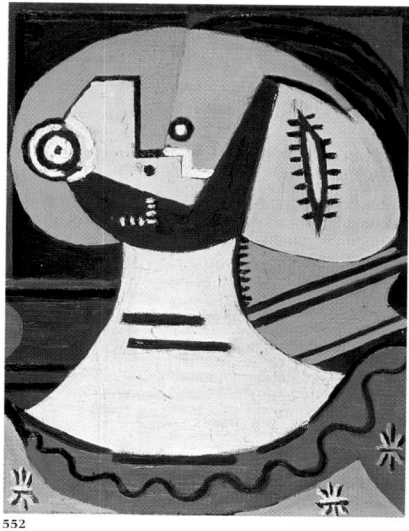

552

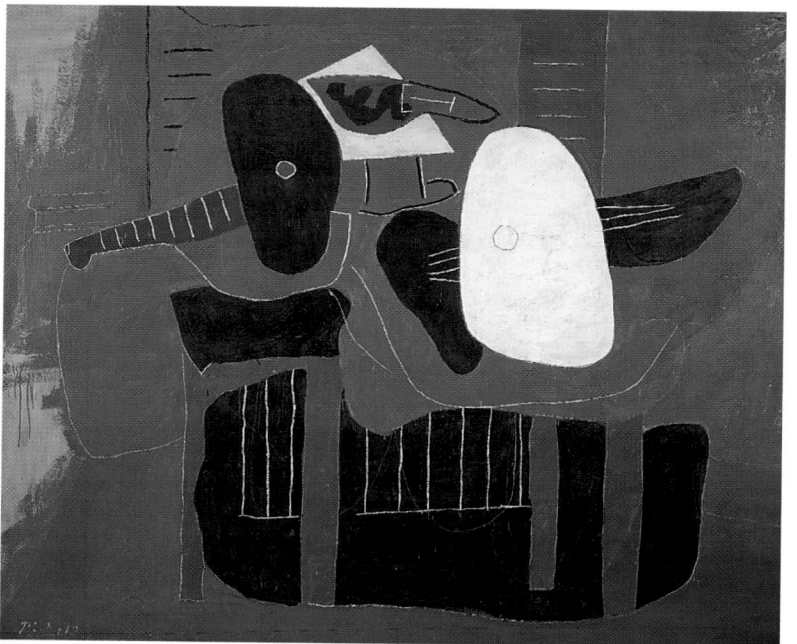

553

554

555

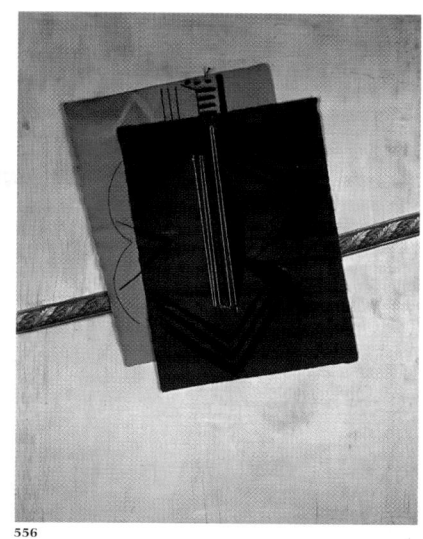

556

57

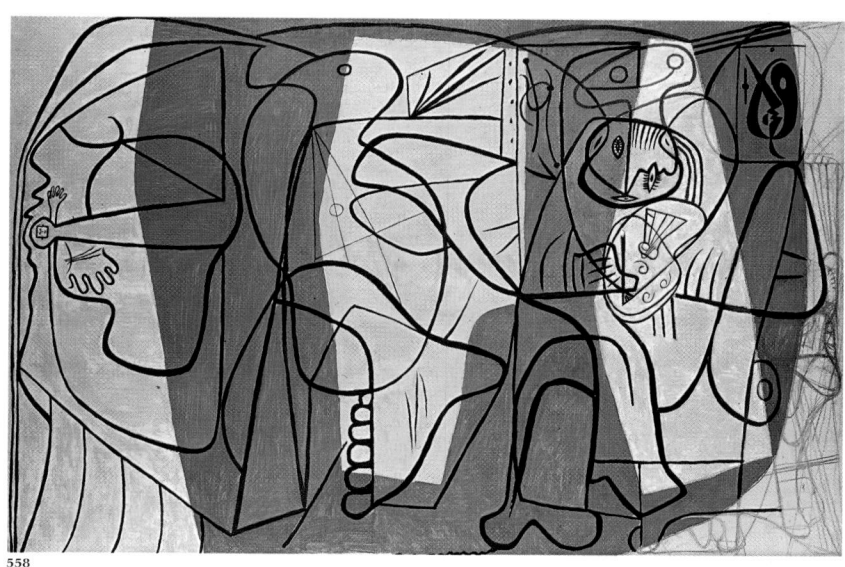

558

235

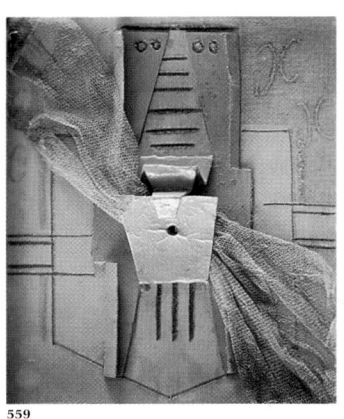

559

560

561

562

563

564

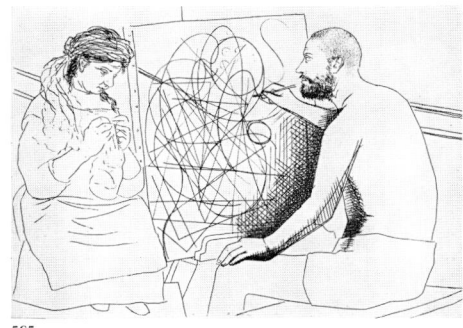

565

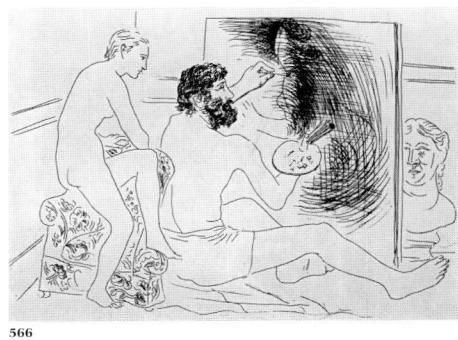

566

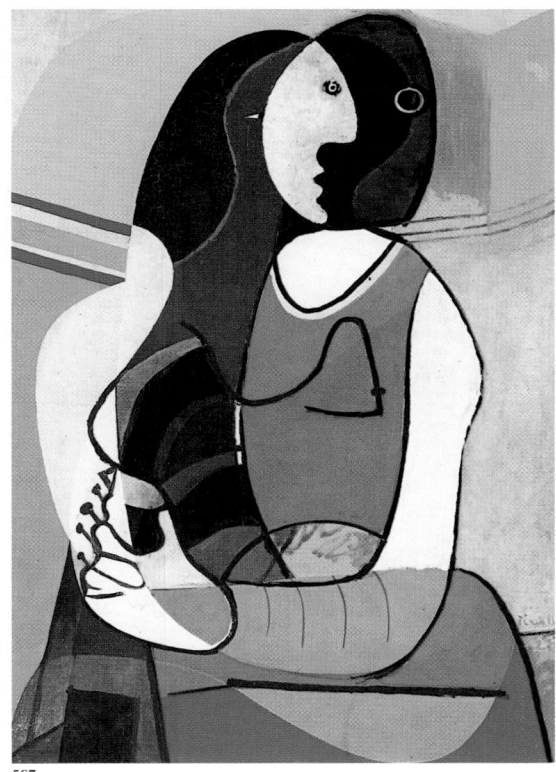

567

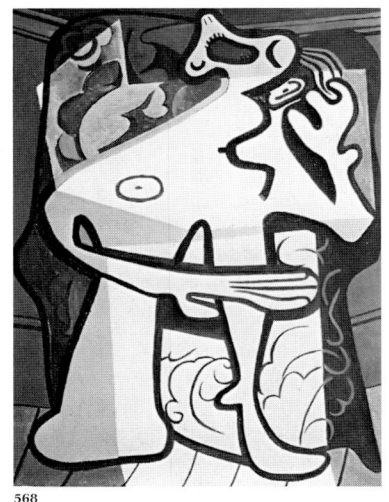

568

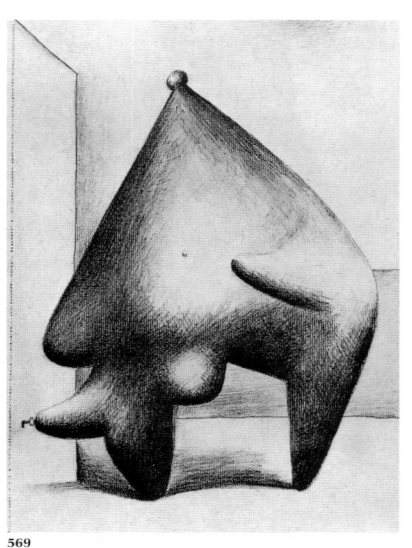

569

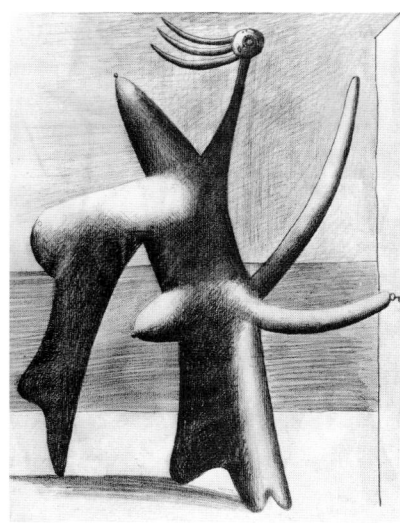

570

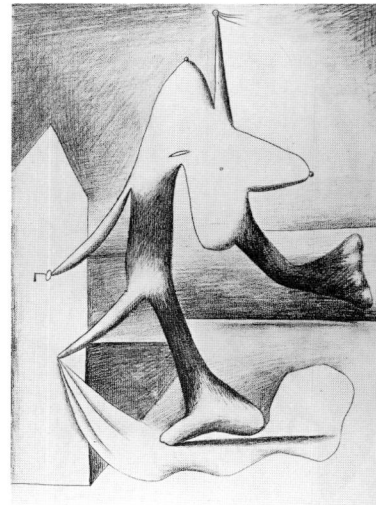

571

Bathers

In January 1927, Picasso met Marie-Thérèse Walter, a robust and athletic young woman with whom he would have a steady relationship until the 1940s. Let Marie-Thérèse tell us about this encounter: "I was seventeen years old, and I was going to do my errands on the boulevards. . . . He looked at me. . . . He smiled at me nicely. Then he approached me and said, "Mademoiselle, you have an interesting face. I would like to do your portrait.' He added, 'I feel that we will do big things together.'"[6]

Soon after, Picasso would mysteriously add the monogram MT to several 1927 compositions with guitars (fig. 564). Because of Olga, Picasso's affair with Marie-Thérèse was secret and would remain so, despite the intensity of their relationship and the birth of Maya in September 1935. However, Marie-Thérèse would become the painter's favorite model, his inspiration, his muse, for more than ten years. During this entire period, she would solidify Picasso's thoughts on the theme of Painter and His Model, which lay precisely at the heart of the illustrations for Balzac's *Chef-d'Oeuvre Inconnu*, which would finally be published in 1931 (figs. 565 and 566). One of these etchings (fig. 565) is, at least in the graphic freedom the painter-draftsman displays on his canvas, reminiscent of automatic writing, a technique greatly valued by the Surrealists at that time and already practiced by André Masson.

What emerged at this point in the career of a painter in search of the avant-garde was the dismantling of illusionism inherent in the imitation of appearances. As Picasso rejected automatism and uncertainty, he imposed and superimposed on visible reality the "interior model" he himself had created. This is most certainly the case with the women he painted in 1927, as it is with the *Large Nude in a Red Armchair* from 1929 (fig. 604). The ectoplasm-like form of the 1927 *Woman in an Armchair* (fig. 568) splashes across a decorative background, her mouth open, stretched wide in a deformed yawn. Another *Woman*

569 *Bather (Design for a Monument),* Summer 1927

570 *Bather (Design for a Monument),* Summer 1927

571 *Bather (Design for a Monument),* Summer 1927

238

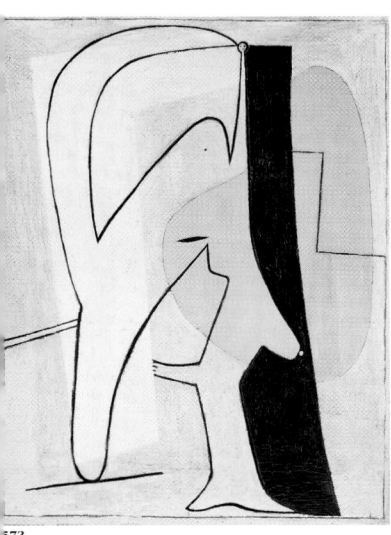

572

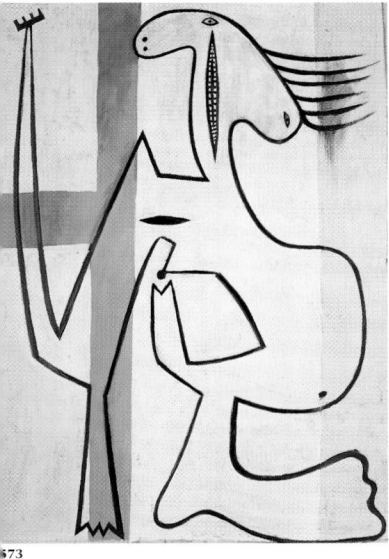

573

574

572 *Figure,* 1927
573 *Nude Against a White Background,* 1927
574 *Woman in an Armchair,* Summer 1927

239

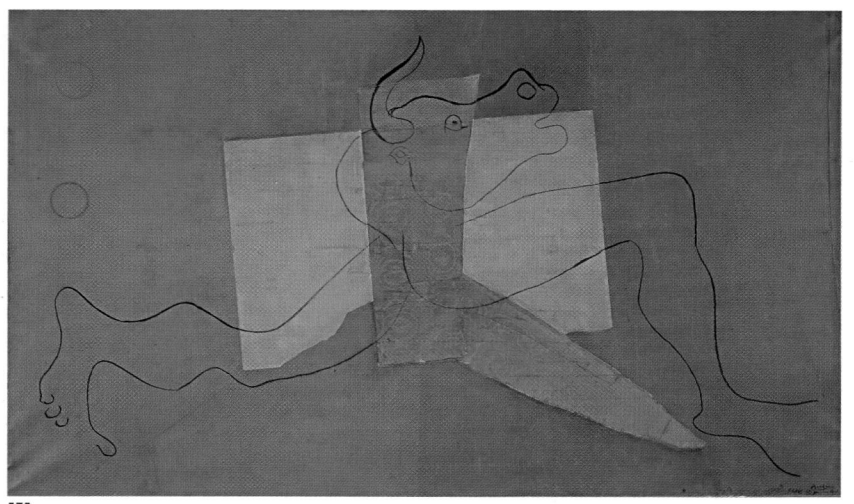

575

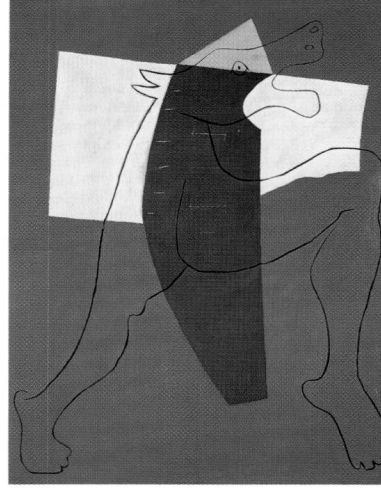

576

in an Armchair from the summer of 1927 (fig. 574) is also a schematic figure, enhanced by bright colors. Similarly, a *Seated Woman* (fig. 567), drawn with sinuous lines, presents a moonlike face and aggressively studded fingers, which transform her hands into claws.

The years 1927 and 1928 would bring a new series of bathers at the beach, ten years after those he painted in Biarritz. Picasso spent the summer of 1927 in Cannes with Olga and Paulo. The bathers in his sketchbooks have become monumental figures, obsessively opening (or are they closing?) their beach huts. This repeated movement may have been inspired by the reproduction of the "hallways of locks" that illustrates the first page of *La Révolution Surréaliste*, Number 8, from December 1926. In any case, the image would reappear in 1928 and 1929. Françoise Gilot later said that these fantastic bodies were rooted in the haunting memory of a childhood dream that Picasso had once told her about: "When I was a child, I often had a dream that used to frighten me greatly. I dreamed that my legs and arms grew to an enormous size and then shrank back just as much in the other direction. And all around me, in my dream, I saw other people going through the same transformations, getting huge or very tiny. I felt terribly anguished every time I dreamed about that." And Françoise added: "When he told me that, I understood the origin of those many paintings and drawings he did in the early 1920s, which show women with huge hands and legs, and sometimes very small heads."[7]

In *Nude Against a White Background* (fig. 573), the only element remaining of the coiffure theme from 1922 is a pitiful little comb with four teeth, waved by a long, skinny arm. The tip of a breast at the center of the painting points upward, and the vertical mouth forms a vulva. These feminine figures, manhandled in every possible way, convey a pathetic quality.

On January 1, 1928, Picasso took a giant step toward inventing an equally fantastic creature: the *Minotaur* (fig. 575), which would be omnipresent throughout the 1930s. The figure appeared again in April but with another profile, this time more centaur than minotaur (fig. 576). The latter picture, an oil on canvas, imitates the process of collage used in the earlier work, which would be made into a tapestry for Marie Cuttoli in 1935.

575 *Minotaur,* January 1, 1928
576 *Running Minotaur,* April 1928
577 *Painter with a Palette and Easel,* 1928
578 *The Studio,* Winter 1927–28
579 *Head,* October 1928
580 *Painter and Model,* 1928

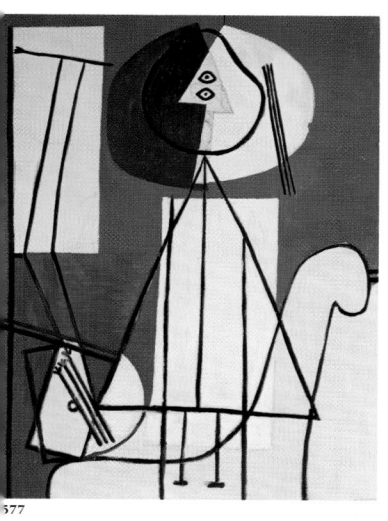

577

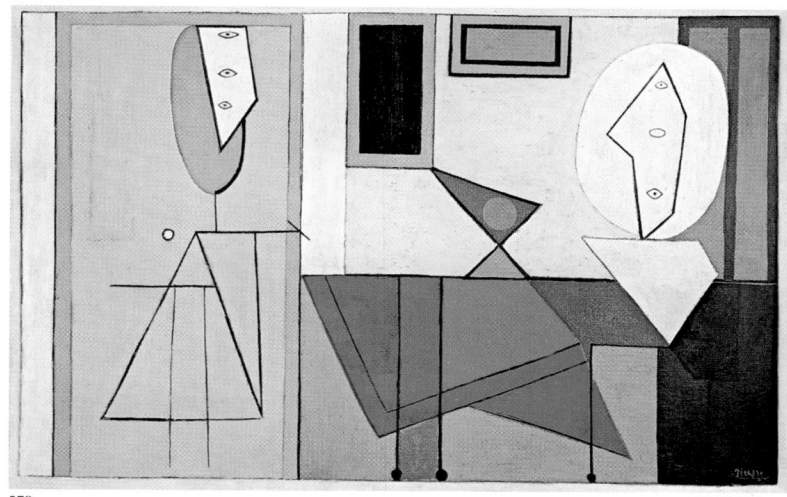

578

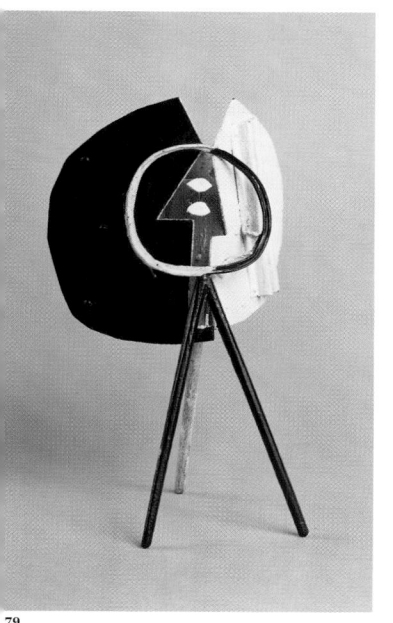

579

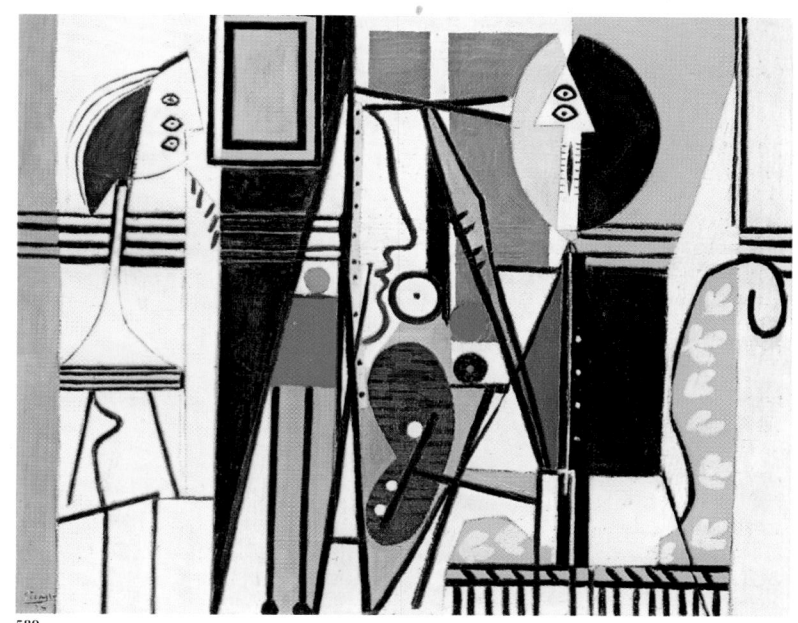

580

241

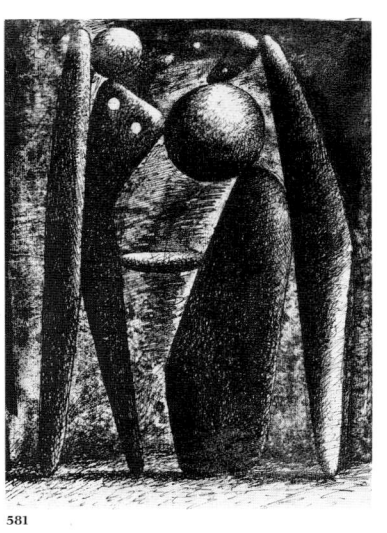

581

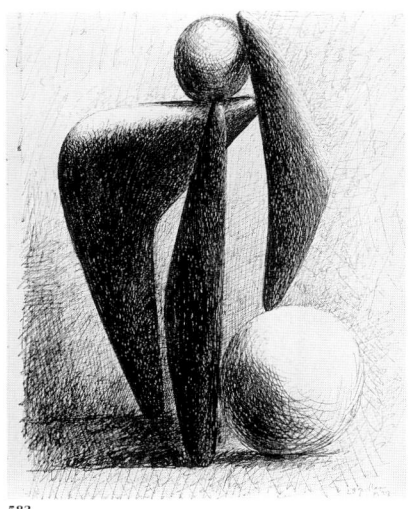

582

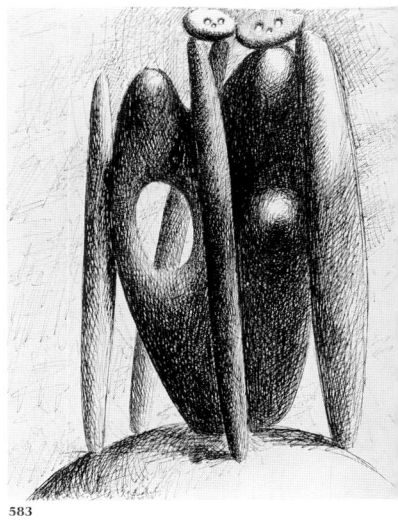

583

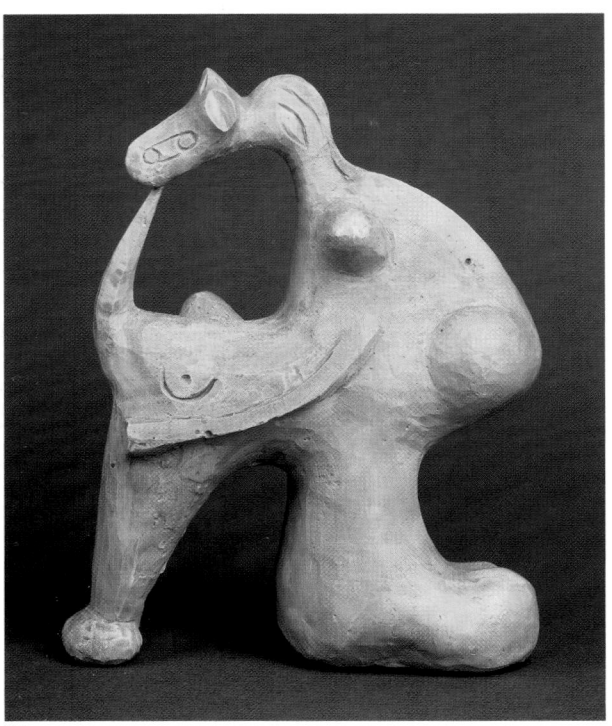

584

581 *Bathers (Design for a Monument),* July 8, 1928

582 *Sketchbook Page,* July 28, 1928

583 *Bathers (Design for a Monument),* July 29, 1928

584 *Metamorphosis II,* 1928

585 *Figure,* Autumn 1928

586 *Figure,* Autumn 1928

587 *Sheet of Studies,* August 3, 1928

242

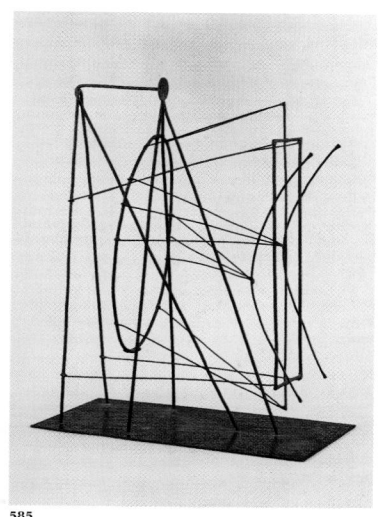

585

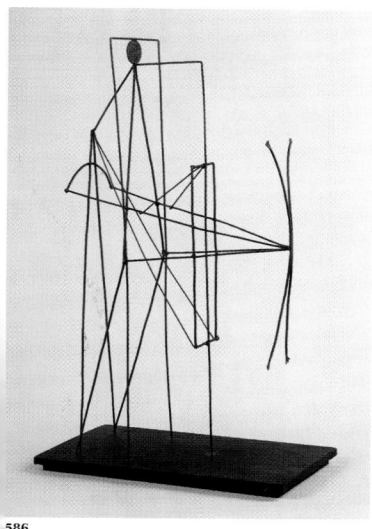

586

587

243

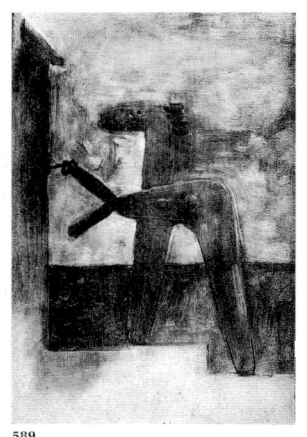

588

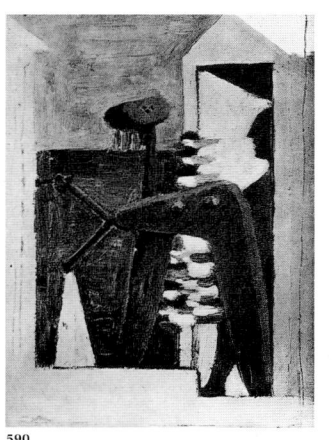

589

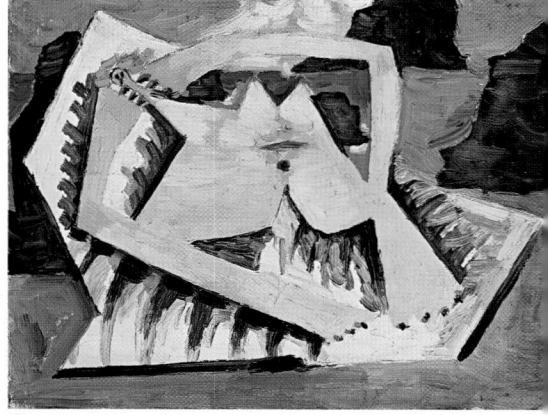

590

591

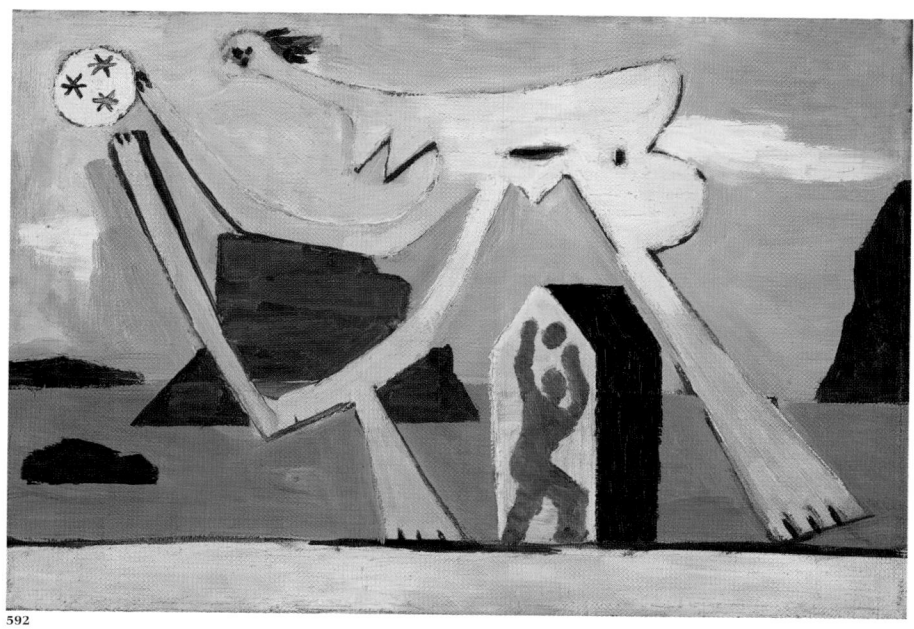

592

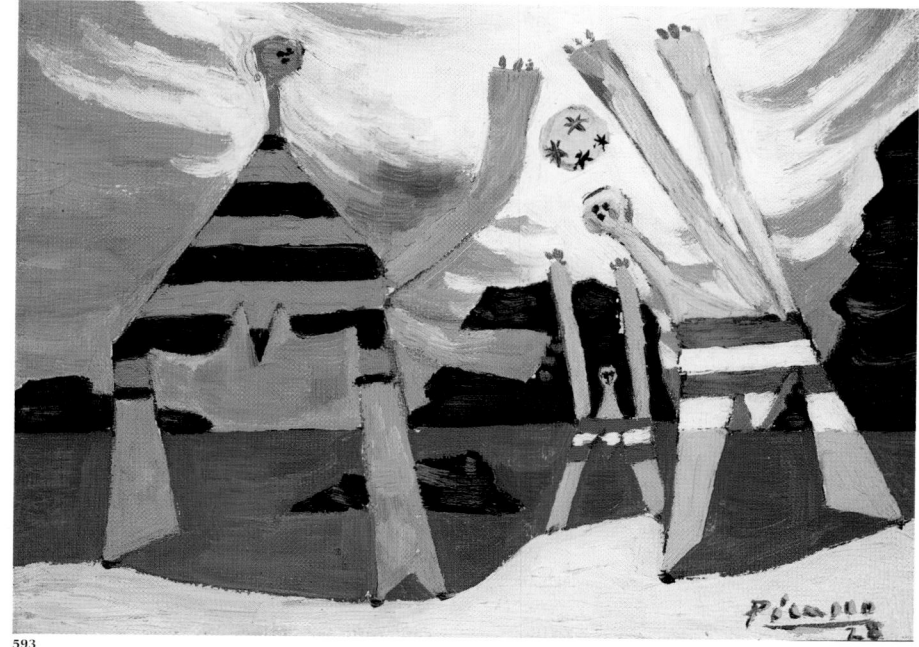

593

Picasso continuously reused theatrical elements in his eternal triangle of painter, model, and object (figs. 577, 578, and 580). The small 1928 *Head* of painted brass and iron (fig. 579) is a three-dimensional rendering of the head depicted in paintings of the same year (figs. 577 and 580). Exploring both the nature of reality and the power of representation, Picasso brought together in *The Studio* and *Painter and Model* (figs. 578 and 580) the perspective of the painter, the model, the work of art, and the mirror hanging on a wall: Who is reflecting what? Picasso's schematic forms and pure colors—yellow, red, white, and black—serve to define a complex composition in which each element relates to all of the others.

In Dinard during the summer of 1928, Picasso used a sketchbook to explore the monumentality of his female nudes without any narrative content (figs. 577–579) and with poses more hieratic than those of the bathers he had drawn in Cannes the preceding summer. In the same spirit, he gave three-dimensional shape and volume to one of these creatures in *Metamorphosis* (fig. 584), of which he made two slightly different plasters that were later cast in bronze.

Using the point-and-line drawings he made in August as a starting point (fig. 587), in the fall of 1928 Picasso gave dimension to his sketches in constructions of wire and sheet-metal (figs. 585 and 586), with the help and in the studio of his friend Julio González, an ironworker who would later become a sculptor himself. Picasso offered these wiry figures in his proposals for a monument to Guillaume Apollinaire to mark the tenth anniversary of his death. Picasso's monument would indeed be "the profound statue made of nothing, like poetry and glory" that the "oiseau de Bénin" (Picasso) imagines at the end of *Poète Assassiné*, published by Apollinaire in 1916. The project was rejected, but a bronze *Head of a Woman* of 1941 would finally be erected in 1959 in the poet's memory in the garden of the church at Saint-Germain-des-Prés. In 1972 a monumental enlargement of one of these figures (fig. 585) would be acquired by the Museum of Modern Art, New York, and in 1985 a larger version of another figure (fig. 586) would be installed in the garden of the Picasso Museum, Paris.

During the summer of 1928, Picasso stayed in Dinard with Olga and Paulo at the Hôtel des Terrasses and at the Villa Les Roches. Marie-Thérèse was not far away, in a summer camp, which led to alleged or imagined secret meetings—a game of closing and opening doors, again with key in hand (figs. 589 and 590). Later, Picasso would confide in Antonina Vallentin: "I adore keys. It seems important to me to have one. It is true that keys have often haunted me. In the series of men and women bathers, there is always a door that they try to open with a large key."[8] Against a background of sea and sky, nudes unabashedly indulge in strange comings and goings, their hair blowing in the wind. Curiously, these pyramidlike creatures contain an element of mobility and spirit; a twinge of humor has crept into these theatrical scenes, giving life to figures sculpted freely in space. Sometimes, however, a disturbing element enters the painting. The painter's profile or a silhouette is inserted into the rectangle of the beach hut, a series of small Pandora's boxes almost as funereal as a procession of standing caskets (figs. 590 and 592). One wonders what the relationship is between the shadow and the bather. The woman seems to be going about her business and pretending not to see her reflection, which is following and perhaps watching her.

Without regard for censure, the nudes undress without modesty, exposing the smallest details of their bodies (fig. 591), or they happily put on two-color striped bathing suits (fig. 593). But in spite of the beach games with star-decorated balls (figs. 592 and 593) and the holiday spirit, there is an element of anxiety in these elongated bodies: "No pleasure without the taste of ashes," Picasso said to Françoise Gilot.[9] The carefree nature of these trivial pleasures no longer completely matches the painter's innermost feelings. There seems to be a subtle gap, a bottomless effect, between the subject and the way it is represented.

594

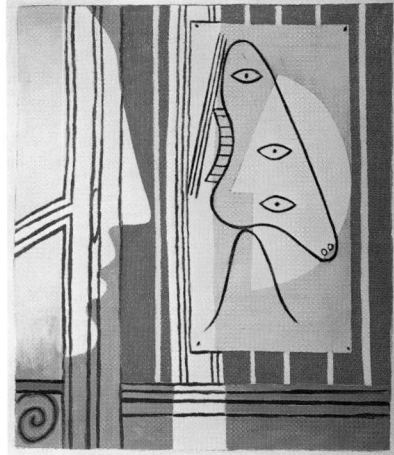

595

594 *Figure and Profile,* 1927–28
595 *Figure and Profile,* 1928
596 *The Studio,* 1928–29

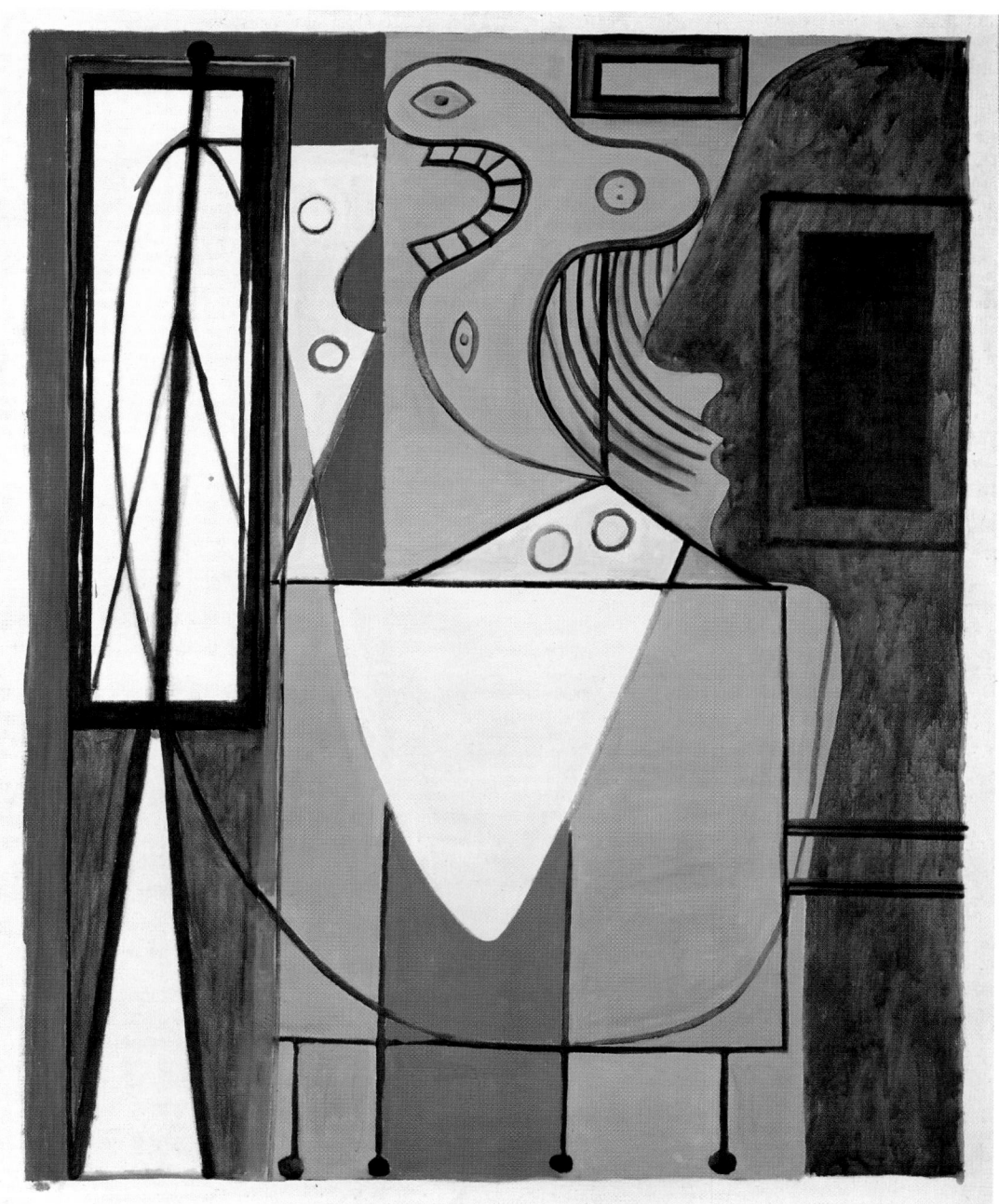

596

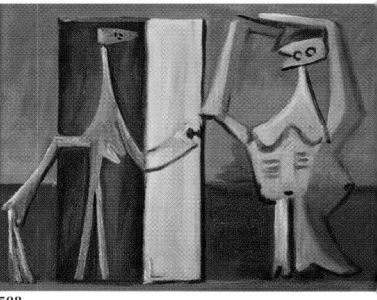

598

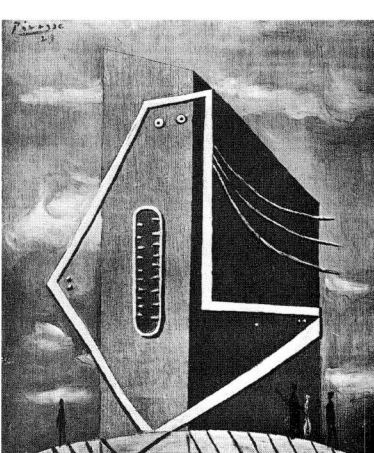

599

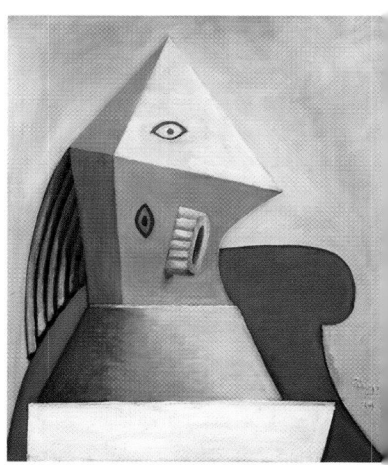

600

597

The painter's profile appears again superimposed on several paintings in which he confronts a work of two or three dimensions (figs. 594–596). Situated on the right or left side of the painting, the impassive artist seems obsessed with the monstrous open-mouthed profile of his creation, which seems to be more intensely alive, animated, and present than its creator. The dehumanized face, baring its teeth as it cries out, could be both the victim and the executioner of its creator, who has been transformed into a kind of sorcerer's apprentice. *The Studio* from 1928–29 (fig. 596) reintroduces in a vertical format the three elements of the *Painter and Model* (see fig. 580), but the tall, lanky silhouette at the left is reminiscent of one of the wire figures that Picasso drew and rendered in space (see figs. 585–587).

All of these paintings are marked with the violence and uncertainty that was agitating Picasso and his contemporaries at this time. In Number 2 of the magazine *Documents*, published in 1930, Michel Leiris would argue that Picasso's approach can be compared to that of the Surrealists: "However, among the blatant but pernicious errors that, over the course of these last years, were propagated by Picasso, the one that comes to the forefront is the one that tended to confuse him with the Surrealists, turning him, when all is said and done, into a kind of man in revolt against, or rather escaping from reality."

Picasso's relationship to Surrealism was not simple. He was not the kind of man to ask for support from a school or a leader; neither was he a loner. For example, on June 6, 1929, he attended the screening of Luis Buñuel's film *Un Chien Andalou* with some of the Surrealists.[10] Since the beginning, and especially since the Bateau-Lavoir period, Picasso had lived and worked in groups that had the greatest poets of his generation as spokesmen. Although in 1917 everything revolved around the Ballets Russes, ten years later the Surrealists were the focus. Picasso's evolution matched the changing times, with Apollinaire having acted as the link between the two generations, even if he himself would never really belong to the Surrealist group.

In fact, Picasso was a Surrealist before Surrealism developed, and he had not waited for the enrollment of his youngest friends, those who were ten years younger than himself. The *papier collé* of 1913 and some of the "astounding" guitars of the same period are genuine anticipations, as Breton would refer to them in "Picasso dans son élément" in 1933. However, if the Surrealists rallied around Picasso for their own purposes, Picasso knew how to take advantage of their company. This friendly exchange served both parties in the end, even if it depended on their differences. Breton defined the issue in 1961 in the following terms: "What always formed an obstacle in the path of complete unification between his views and ours was his unshakable attachment to the outside world (of the 'object') and to the blindness that this tendency causes with regard to dreams and imagination."[11]

Indeed, the liberties that Picasso took so far as physical appearance was concerned and that led him into the realm of fantasy nevertheless respected the particulars of reality. In other words, reality was a starting point, and he always returned to it. In 1943 he told his friend André Warnod, "I am always trying to observe nature. Likeness is important to me, a deeper likeness, more real than reality, to the point of being surreal. This is how I imagined surrealism, but the word was used in an entirely different way." Brassaï confirmed this by reporting that "Picasso also spoke to me of similar things."[12]

Toward a Crucifixion

During the summer of 1929, Picasso returned to Dinard, this time staying at the Hôtel Gallic with Olga and Paulo. Marie-Thérèse was in the area, as she had been the preceding summer. This would be the third season of *Bathers and Beach Hut* (fig. 598), but the women were now animal or mineral, in any case not human. The *Large Bather* of May 1929 (fig. 597), a kind of archaic totem or idol, seems to be wearing a heavy black veil that

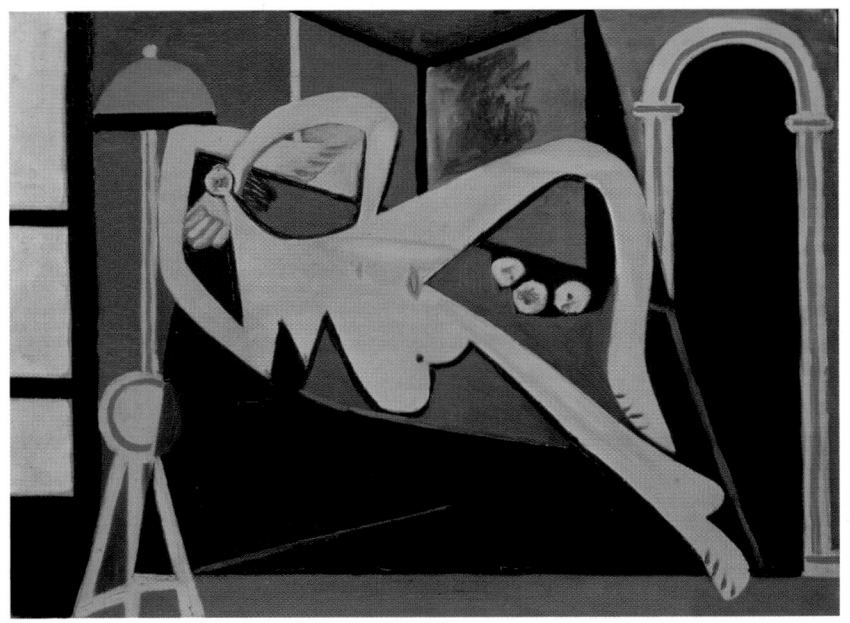

601

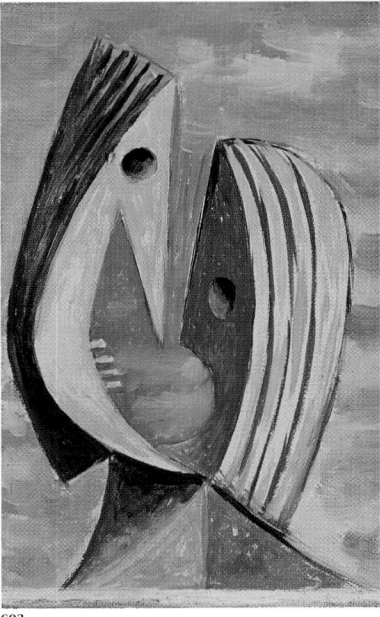

602

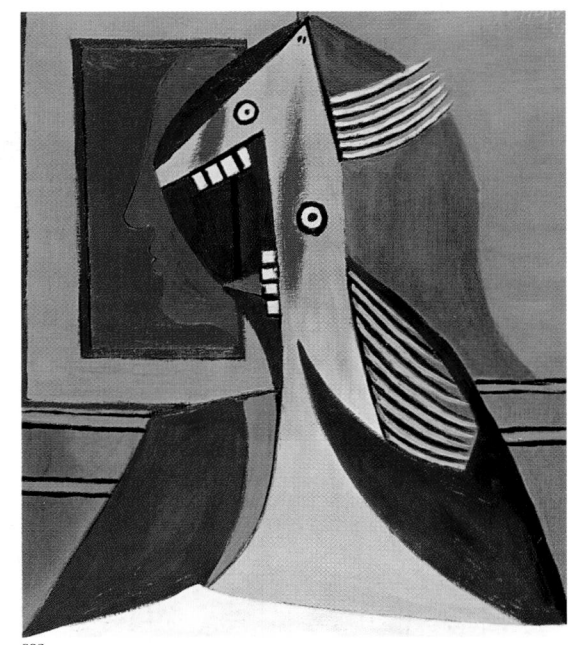

603

601 *Reclining Woman,* April 1929
602 *The Kiss,* August 25, 1929
603 *Head of a Woman with a Self-Portrait,* February 1929
604 *Large Nude in a Red Armchair,* May 5, 192

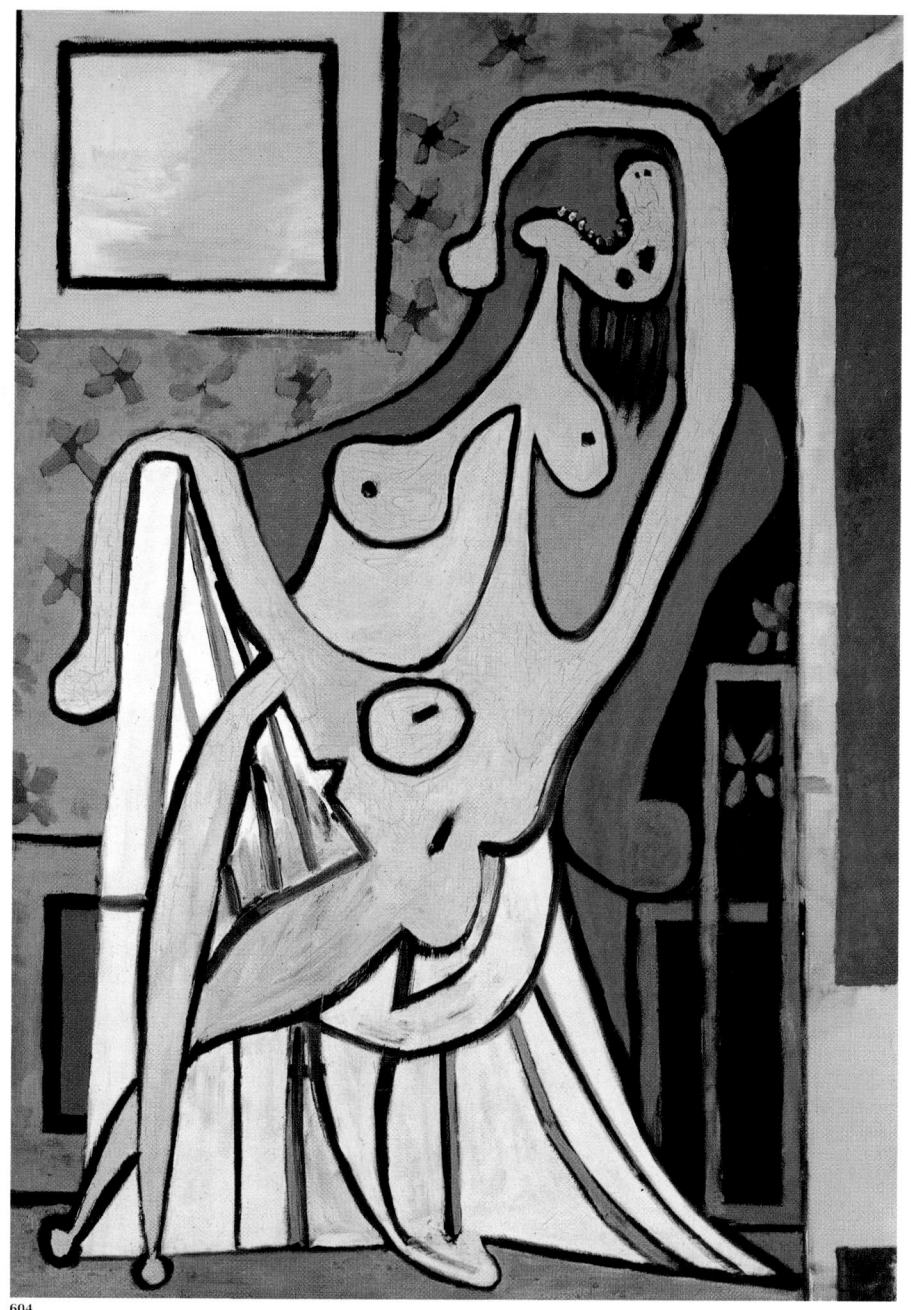

604

hangs down her back, foreshadowing death and mourning long before *Guernica*. In both paintings, one can see the same basic lines forming the breasts and protruding ribs. As if it were tarnished, the beige-pink skin has lost all its joy, and the colors have darkened in the twilight glow. Night has fallen on Picasso's bathers.

Two heads with vertical mouths and sparse hair (figs. 599 and 600) assume a monumental dimension. The pyramidal head of the *Woman in Red Armchair* (fig. 600) is smooth and neat; despite her asymmetrical eyes and robotic appearance, she exists in her own right, strong and with some element of humanity. The other head, constructed like a skyscraper, presents a few Lilliputian-like black figures at the base, silhouetted against the horizon (fig. 599). More than four decades later, similar dark figures, like ghostly fireflies, will be introduced in a painting dated November 14–15, 1971 (see fig. 1161), fluttering around a large *Reclining Nude* wearing a straw hat. Although Picasso has reduced eyes, mouths, and genitalia to simple symbols and schematized the human head or body, he has nonetheless endowed these figures with credibility, and they seem to exist in their own world. Or have our eyes simply grown accustomed to seeing them as familiar creatures?

Following the spirited *Kiss* of the summer of 1925, that of August 25, 1929 (fig. 602), painted in Dinard, plays to advantage the ambiguity of the "one inside the other": the two profiles facing each other are like two halves of a single face. One can easily distinguish the hair, eyes, nose, and teeth, which hint at the voracity of the kiss. Symbolically, this image represents both the unity and the duality of the human being. The kiss expresses the desire for union—to bring two beings together into one—but the being itself is a dual one, divided between its masculine and feminine parts. This *Kiss* of 1929 presents two faces in one.

In February 1929 *Head of a Woman with a Self-Portrait* (fig. 603), borrowing the *Faces and Profiles* from 1928, includes the painter's profile in the mirror and a threatening female profile, whose tongue, painted in loud tones, shoots out. No one would deny that the woman seems to be dangerous to the man, a trap, a hideous and grotesque monster. The same impression of horror can be found in *Large Nude in a Red Armchair*, with its ghoulish jaw and flaccid forms (fig. 604). Here the bath sheet hangs from the chair, the kind that bathers from the early 1920s modestly draped around themselves, though it hides nothing of the body, which appears to be deformed by grief. Harsh black lines mark the folds in the fabric, and the flat areas of color are surrounded by black lines that strangle and imprison. We are far from the blossoming, placid goddesses of the classical period. With this *Nude*, the painting too has begun to cry out, but out of despair and anguish rather than pleasure. Critics often agree that this image of paroxysm is an acknowledgment of the imminent divorce of Pablo and Olga.

Picasso also used the same dominating colors of red, yellow, and green to depict a cheerful *Reclining Woman* (fig. 601) on a divan, harmoniously composed like an odalisque by Matisse. The lines of the body soar in voluptuous arabesques, and details of the setting are expressed in curves, as in the alcove entrance, the lampshade, and even the three yellow pieces of fruit placed mischievously between the figure's long legs.

At peace with itself, the nude would once more exhibit its flexibility and capacity in Picasso's work. *The Swimmer* of November 1929 and the *Acrobat* of January 1930 (figs. 606 and 605), have been given the elasticity of rubber people: weightlessly, they move like fetuses or cosmonauts ahead of their time in history. Although Picasso sometimes presents humans in unbelievable, yogalike positions, these bodies are never completely disorganized or fragmented. The acrobat's pose does not lack balance; rather it exhibits feats of balance. The figure holds its own in the painting, laughing at all the constraints the painter has imposed on him. Even as early as 1905, *The Athlete* and *Acrobat with a Ball* (see figs. 174 and 176) already expressed the conquest and mastery of space in painting.

The Swimmer (fig. 606) stretches her body in the water in all directions, as if she were soaring in flight. Her arms, legs, and head have become practically interchangeable, all

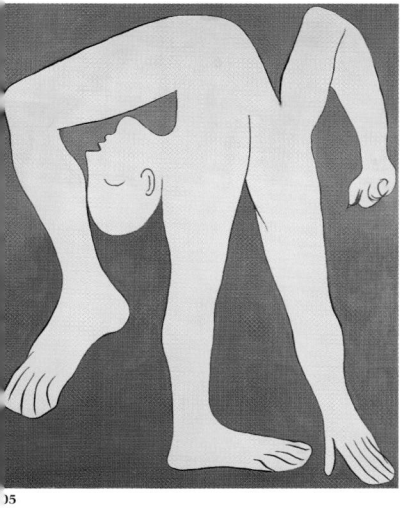

605

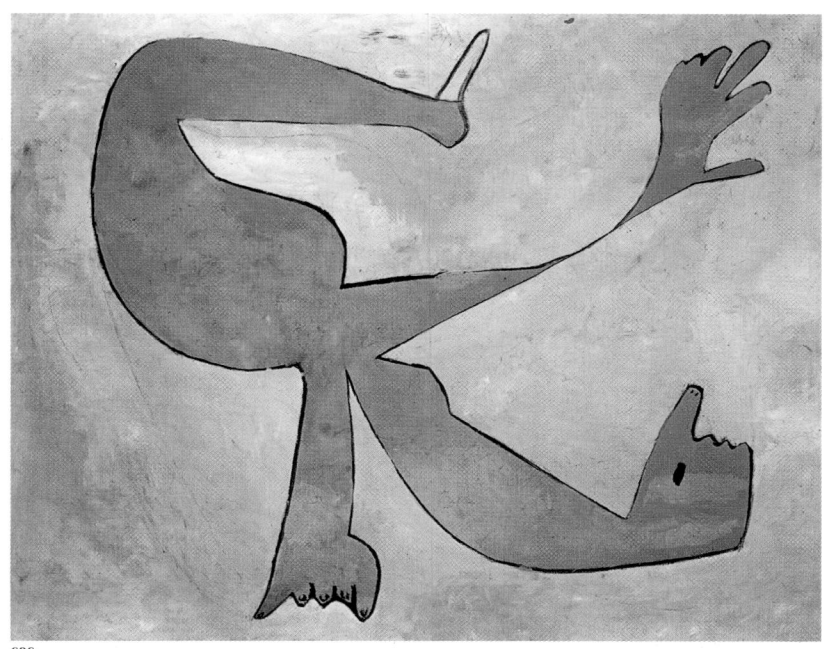

606

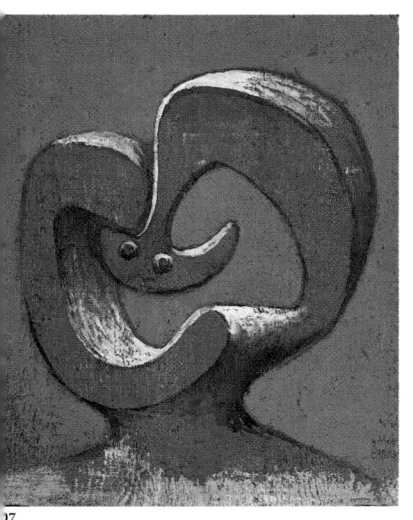

607

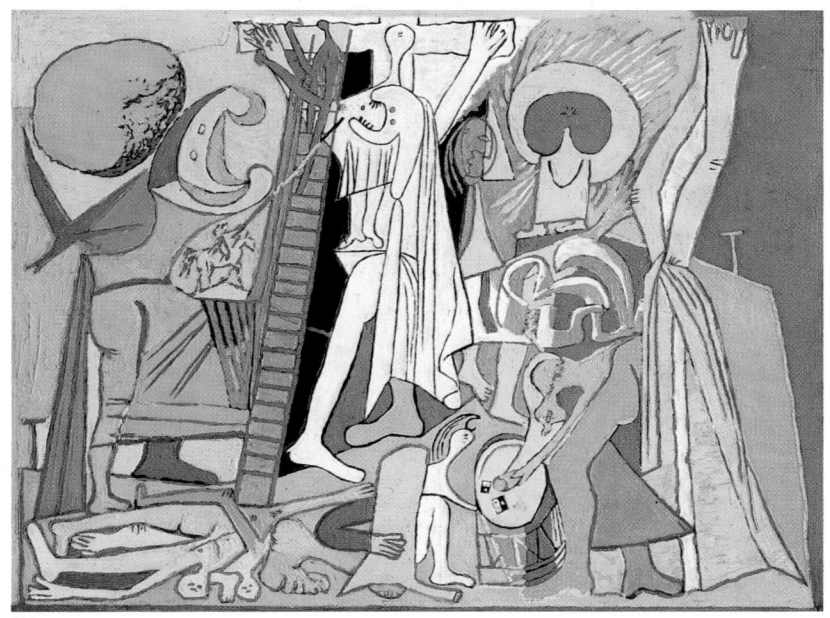

608

253

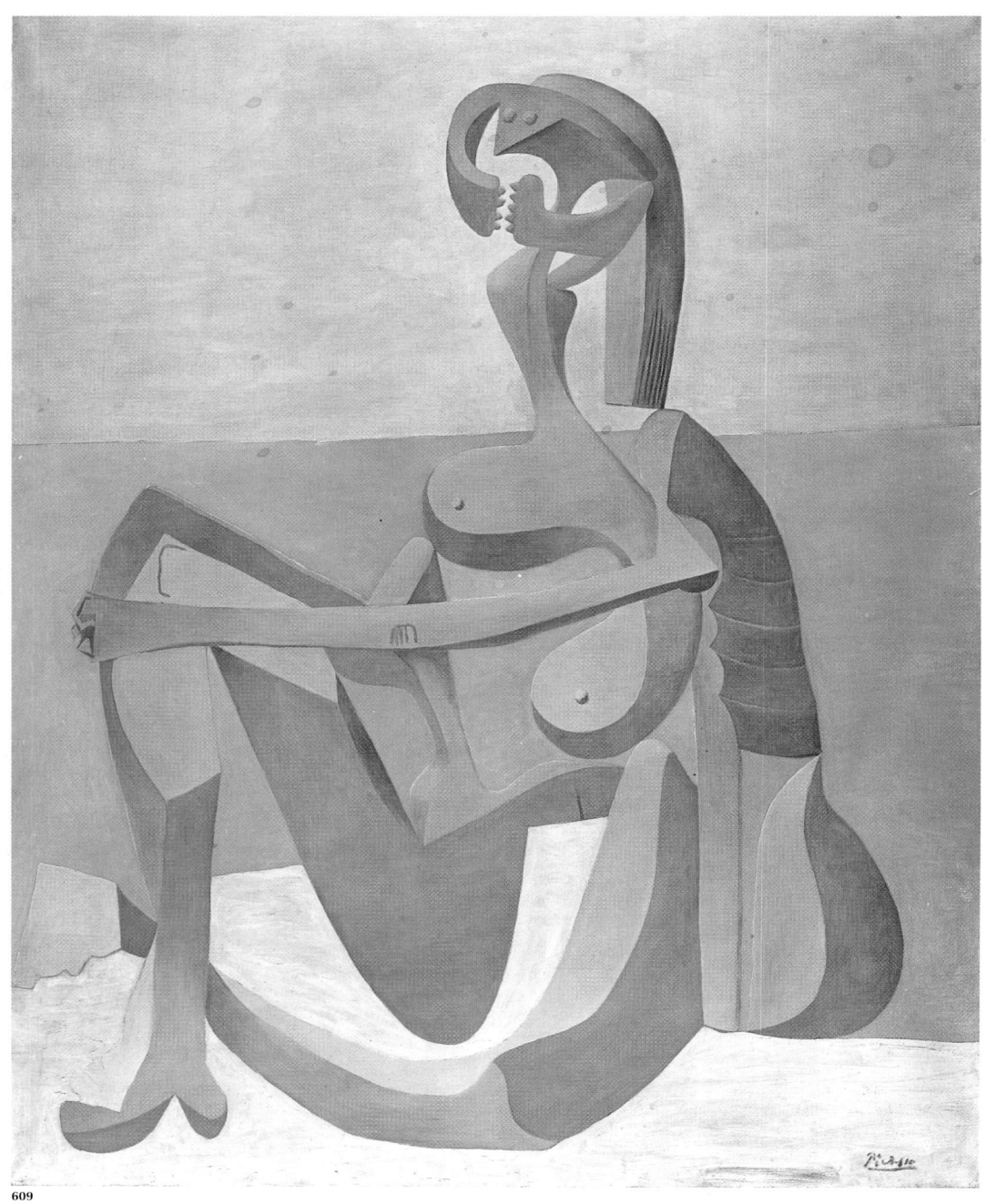

609

09 *Seated Bather by the Sea,* early 1930

10 *Object with Palm Leaf,* August 27, 1930

11 *Composition with Glove,* August 22, 1930

12 *Profile and Woman's Head,* 1931

stemming from a center where the lines of force intersect. The still-visible traces of several layers of paint indicate that Picasso sought to achieve balance in this figure, that he was not satisfied to express free movement for its own sake. The *Acrobat* (fig. 605) stands on one foot and one hand with his head upside down; he is half on the ground, half in the air. He fills the entire surface of the canvas, touching the edges and the corners, exploring the limits of the frame. One wonders if he feels cramped, as if he were wedged in a box. In both of these two-color compositions, the human body looks helical in shape, a spiral whirling around a mysterious center of gravity.

The year 1930 would be marked primarily by *The Crucifixion* (fig. 608), a painting on a small piece of plywood. Picasso made a drawing of Christ on the cross in 1918 (see fig. 444, and the same theme would reappear in 1932 and again during the 1950s. In February 1930, the choice of subject may have been inspired by the manuscript of the eleventh-century *Apocalypse de Saint Sever,* which had been described and commented on by Georges Bataille in *Documents* in 1929. For the most part, however, the work brings together a number of themes specific to Picasso, combining, in very different proportions, women's profiles, religious allusions, and even bullfighting (with a rider who resembles a picador carrying a lance). The scene is painted in great detail and in bright colors that can be found in the most expressive paintings of those years: the red and yellow dominate in sulphurous tones, which are broken up with areas of green and blue. In the middle, the figures of Christ on the cross and a veiled woman are highlighted in white against a black background. At their feet lie the two thieves who have been removed from their crosses, and to the right two centurions throw dice on a drum for Christ's tunic. An enormous yellow-and-red head with its hair standing on end is at the side of Marie-Thérèse's transparent profile, while to the left a massive character climbs the steps to the cross with difficulty, his mouth open. This nightmarelike vision seems to have filled Picasso with both fascination and repulsion. Expressing the same violence, a solitary *Head* stands out against a red background that is both bloody and fiery (fig. 607). Hollowed in the center, defined only by a pair of eyes and an outline like a Moebius strip on a neck, this head has the elementary power of an impossible non-face.

The colorless tong-shaped head with a giant mandible in *The Crucifixion* is curiously similar to the head in the *Seated Bather by the Sea* (fig. 609). This large nude, defined like a skeleton, seems to exorcize the terrifying and terrorizing woman that Olga may have seemed at that time to Picasso. There is no longer any suggestion here of beach games! The dried-out, bony woman with bulging breasts has become a kind of man-eater. The horizon line divides an empty sea and the sky, which seem doomed to an inescapable fate. Picasso's portraits of Olga painted during the 1920s both glorified and massacred the female model. In 1921 woman was a serene full-figured goddess-mother, but gradually she became deformed and then destroyed, emptied of meaning, and by 1927 and 1929, she no longer had flesh. Before the final silence would engulf her, the figure of this woman cries out in grief in several paintings, wailing in vain at the top of her lungs.

In Juan-les-Pins, however, Picasso, not entirely seriously, invented new dream and imagination exercises. He had already used sand in his Cubist pieces from 1912 to 1914, and he also sanded some paintings in Cap d'Antibes in 1923.[13] In August 1930, he created mysterious scenes on the back of some small stretched canvases, where he would glue or sew various elements, covering them with sand and sometimes coloring them in areas (figs. 610 and 611). In one (fig. 611), a distended, gloved hand brushes a face cut out of cardboard: one wonders if the open palm is relaxed or stretched out in tension. In the other (fig. 610), an unidentifiable flying object (perhaps a shameful fantasy) may have escaped a birdcage without being noticed by the little woman quietly seated on her bench. This collage-relief is reminiscent of an oil painting on a panel by Max Ernst, composed in 1924 of wooden elements and entitled *Two Children Threatened by a Nightingale.*[14]

613

The tumult of 1930 disappeared when Picasso portrayed Marie-Thérèse. Calm succeeded anxiety, and curved lines succeeded angular ones. "All of his paintings began to undulate," Brassaï reported,[15] and Picasso's drawings and sculptures would do the same. The large pastel of the *Woman with Pigeons* (fig. 613) expresses an innocent and downy softness, as warm as a nest. This image would later be made into a tapestry by Marie Cuttoli. The ladder on which the young woman is perched symbolizes a rite of passage: she plays the role of one who has the power to let Picasso go from one world to the next, the one who has given him back a taste for life and for the pleasure of painting. As for the pigeons, a mascot for Picasso, we know that he always painted them, as his father had done, later going so far as to transform them magically into doves. The atmosphere in this rural scene is bathed in classical antiquity, even if it is only evident in decorative braid on the young woman's tunic.

Also charged with classical culture are the thirty etchings of an unnamed Marie-Thérèse that Picasso completed in the fall of 1930 to illustrate Ovid's *Metamorphoses* (fig. 612), the first book published by Albert Skira, in 1931. Marie-Thérèse would move into 44, rue La Boétie in the fall of 1930, and become his favorite model at that time, fully blossoming in his art before the great upheaval of *Guernica*.

3 *Woman with Pigeons,* 1930

1931 – 1936

The 1930s before the Spanish Civil War was a time of relentless work for Picasso, who turned fifty years old in 1931. His work revealed an increased maturity in every area to which he applied his talents, including painting, drawing, engraving, and sculpture. After the simplified nudes of the 1920s, Picasso reworked his drawing style, achieving a highly developed, even opulent, means of expression. Woman was now less a screeching monster ready to scratch or bite than a nude voluptuously offered to the painter's eye— Marie-Thérèse, depicted sleeping or dreaming. His fantastic Anatomies of 1933, worthy of an Archimboldo, seem to come from an intensely baroque spirit. In the prime of his life, Picasso identified with the powerful, though vulnerable figure of the Minotaur. In 1933 and 1934, he returned to Spain for the last time, and once again the bullfights were the setting for his personal theater. During this period, a troubled one on many levels, Picasso started writing texts in which he allowed his thoughts to flow freely, and he stopped painting for several months. In 1935 he and Olga separated, and Marie-Thérèse gave birth to Picasso's daughter, Maya. That same year he would meet Dora Maar, with whom he would set out on a new, more tragic adventure.

The Sculptor's Studio

Picasso learned the basic techniques of metalwork from Julio González and, at this point, was able to give free rein to his imagination. Following the wire-and-metal *Figures* of 1928, Picasso developed two sculptures with openwork design forms, which were larger in size: *Head of a Woman* and *Woman in the Garden*, from 1929 and 1930, respectively. They share certain similarities: their hair blows in the wind, and they are made of assembled and welded pieces combined with objects and forged elements. Picasso painted these miscellaneous constructions white in order to unify them. He used the principle of assembled objects again in 1950–53, in sculptures that were cast in bronze and then painted. The *Head of a Woman* (fig. 615) is made of iron and metal, painted sieves, and springs. As to *Woman in the Garden* (fig. 614), Picasso imagined it as a monument memorializing Apollinaire; the original piece would later be enlarged in bronze and installed at the Château de Boisgeloup with its feet in the grass, as one can see in a Brassaï photograph illustrating Breton's text "Picasso Dans son Élément," published in the first number of *Minotaure*.

Picasso had bought the Château de Boisgeloup, near Gisors, in June 1930. In one of the adjoining outbuildings, he set up the largest sculpture studio he had worked in up to that point. Boisgeloup would be his refuge from Olga's moods. Marie-Thérèse's full, agile shape inspired several plaster sculptures: *Seated Woman*, a bust, and heads (figs. 616–624). It was as if the bathers of the preceding years, with their small heads, were given body and flesh and rendered three-dimensional. *The Reclining Bather* (fig. 619), posed with one arm over her head, is like a more limber version of Matisse's *Nu Couché* from 1907 (Picasso saw Matisse's sculpture and painting exhibitions in Paris in 1930 and 1931). As to heads sculpted in the round, *Head of a Woman in Profile* (fig. 624) renders

14 *Woman in the Garden,* 1929–30
15 *Head of a Woman,* 1929–30

259

616

617

618

619

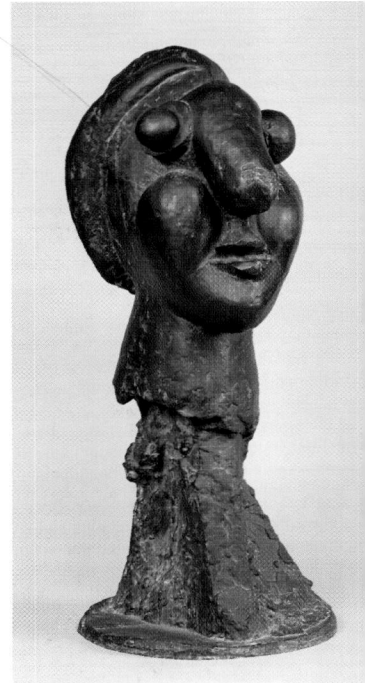

620

616 *Bather,* 1931
617 *Seated Woman,* 1931
618 *Bust of a Woman,* 1931
619 *Reclining Bather,* 1931
620 *Head of a Woman,* 1931

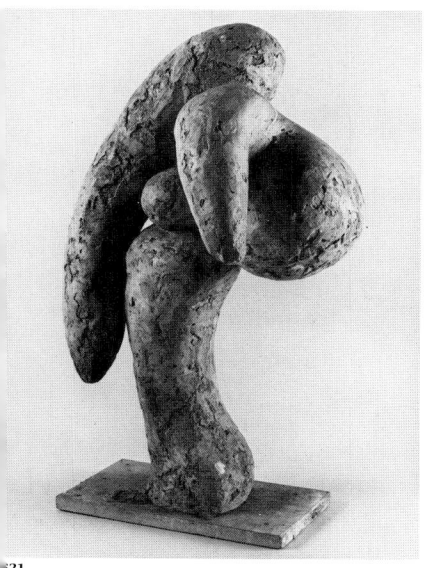

621

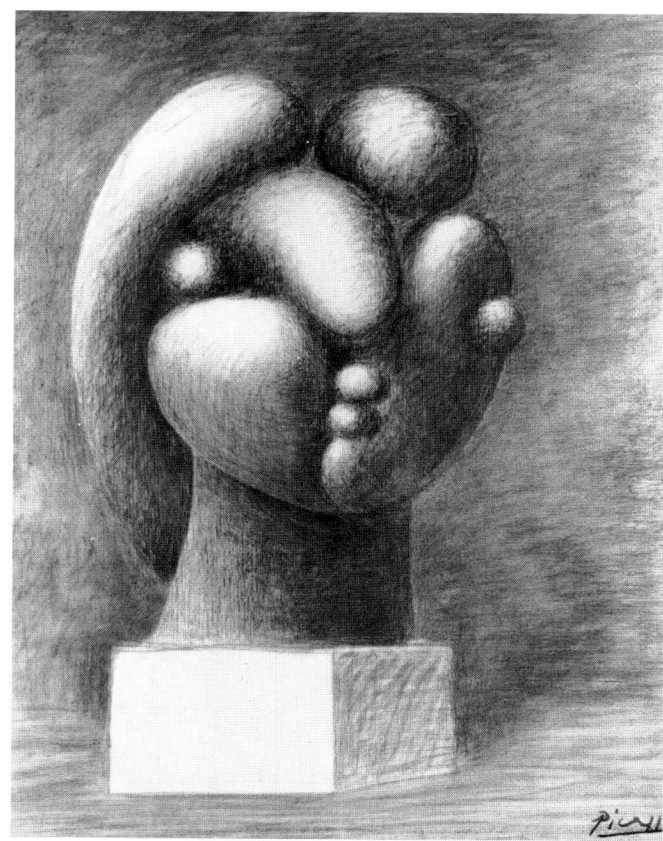

623

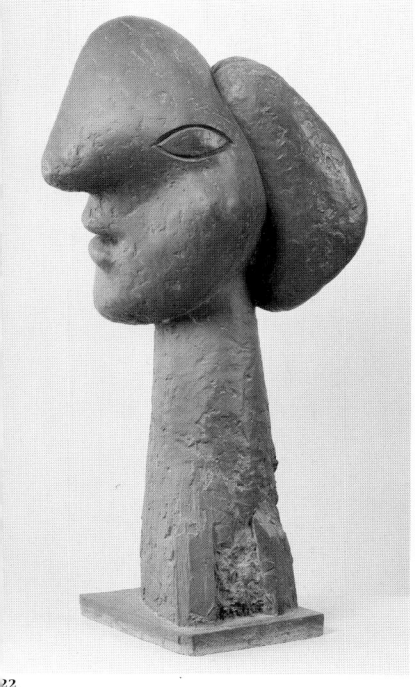

22

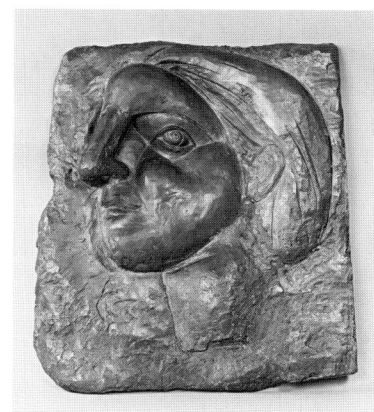

624

621 *Head of a Woman,* 1931
622 *Head of a Woman,* 1931
623 *Sculptural Head,* 1932
624 *Head of a Woman in Profile
(Marie-Thérèse),* 1931

Marie-Thérèse's face in high relief and deep hollows. The drawings of sculptures from 1932 (fig. 623), as well as the engravings from February 1933 (figs. 668–671), present unabashed sexual symbolism, dominated by a protruding nose, which is at this point more phallic than Greek.

There was no electricity in Picasso's sculpture studio: he liked to work at night, and he often had to do so by the glow of an oil lamp. He later explained to Roland Penrose that certain forms came from projecting on the wall shadows that he wanted to capture: "Talking to me one day, Picasso said he was sorry that in working on these heads he once spoilt his original intention. Working at night in the studio at Boisgeloup he had first built up a very complicated construction of wire which looked quite incomprehensible except when a light projected its shadow on the wall. At that moment the shadow became a lifelike profile of Marie-Thérèse. He was delighted at this projection from an otherwise indecipherable mass. But he said, 'I went on, added plaster and gave it its present form.' The secret image was lost. . . ."[1] Concerned about saving the works, Picasso cast most of his plaster sculptures in bronze, yet he confessed to Brassaï: "They were much more beautiful in plaster."[2]

The sculpture studio was often represented in Picasso's paintings and drawings, which were sometimes as finely worked as his engravings. The *Bust with a Lamp* (fig. 628) is situated in the doorway of the Boisgeloup studio, which is lit by a gas lamp. The man's ghostly white bust is surrounded by philodendron leaves, like those adorning the sculpture in the *Woman in the Garden*. The lamp's yellow light and the black background lend a rather frightening nocturnal appearance to this still life.

625

In paintings and drawings of the studio, Picasso returned to themes touched on between 1926 and 1928: the painter or sculptor, the model, and the work. It was as if Picasso had finally substituted the family trio (father, mother, and child, or Picasso, Olga, and Paulo), with another trio that concerned him more deeply: the creator, his muse, and art, or Picasso, Marie-Thérèse, and the work. Playing an essential role, Marie-Thérèse was thus fully connected to the work of the artist, as Jacqueline would be in the last twenty years of Picasso's life.

Two ink drawings made exactly four months apart (figs. 625 and 626) depict the sculptor—one at work, the other contemplating—while the model is both inspiration and witness to the piece. Here the black-and-white contrasts lend a chiaroscuro effect, which encourages one to meditate or reflect on the paradox of a representation that depicts the very act of representing. The same subject is touched upon in a large painting of December 7, 1931, entitled *The Sculptor* (fig. 627). A man with Greek profile, chin in hand, studies a woman's bust, which looks so alive that it is hard to tell if she is a model or a sculpture. One wonders if the bust or the woman seated on a pedestal is the model for the other. All three figures recline on stands, the painter on a faux-marble rectangle. Is this Marie-Thérèse's real face? Is that silhouette spilling over its base at the back of the studio a woman? Which is more "real"? In any case, one can identify Picasso's two realities in the 1930s: his love of sculpture and his love of Marie-Thérèse.

626

From December 19 to 25, 1931, the bittersweet, springlike softness of *The Sculptor* gave way to the murder scene of *Woman with a Dagger* (fig. 629). The screaming monster with a mouth full of teeth painted on May 5, 1929 (see fig. 604), reappears here, piercing the heart of the man in his bath against the background of a red-white-and-blue flag; this is Charlotte Corday murdering Marat. In 1934 the scene would be reinterpreted with equal fury (see fig. 701). Although the subject had been inspired by Jacques-Louis David's 1793 painting, it may have also been influenced by Abel Gance's 1926 film *Napoléon,* in which Antonin Artaud played the part of Marat.

The same oscillation continued between kindness and cruelty, harmony and violence, as if Picasso were constantly wavering between two contradictory impulses. The *Kiss* of January 12, 1931 (fig. 633), in which teeth clank together inside lips that are ready to bite,

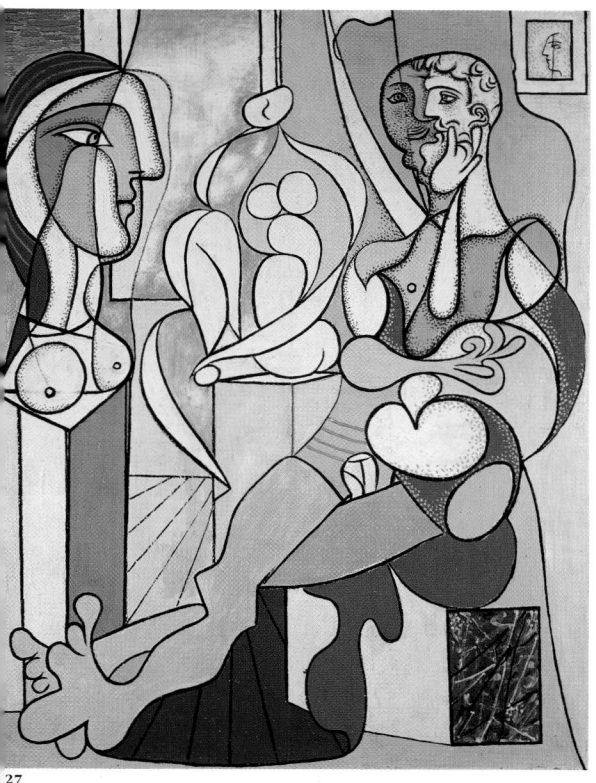

27

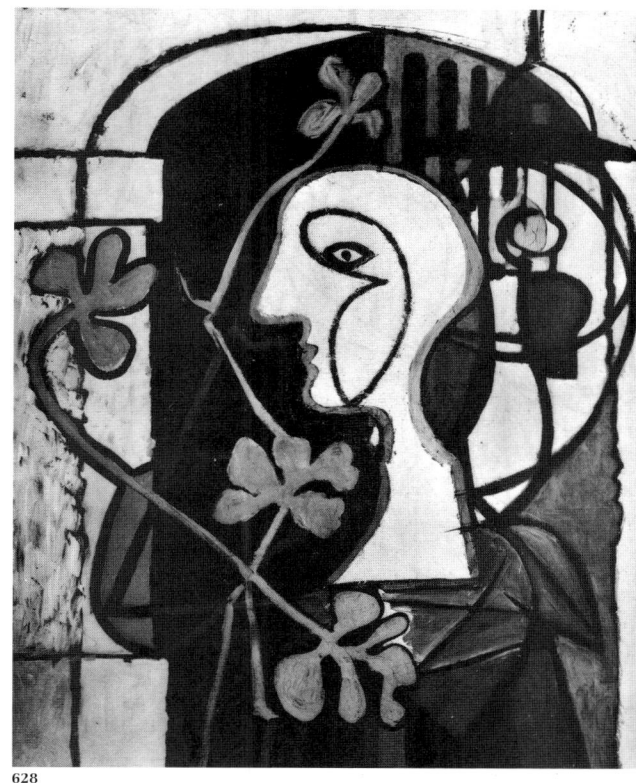

628

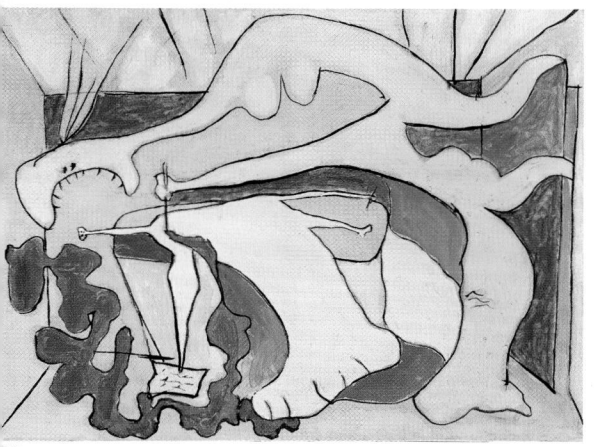

29

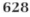

625 *The Sculptor and His Model,* August 4, 1931
626 *The Sculptor's Studio,* December 4, 1931
627 *The Sculptor,* December 7, 1931
628 *Bust with a Lamp,* June 1931
629 *Woman with a Dagger,* December 19–25, 1931

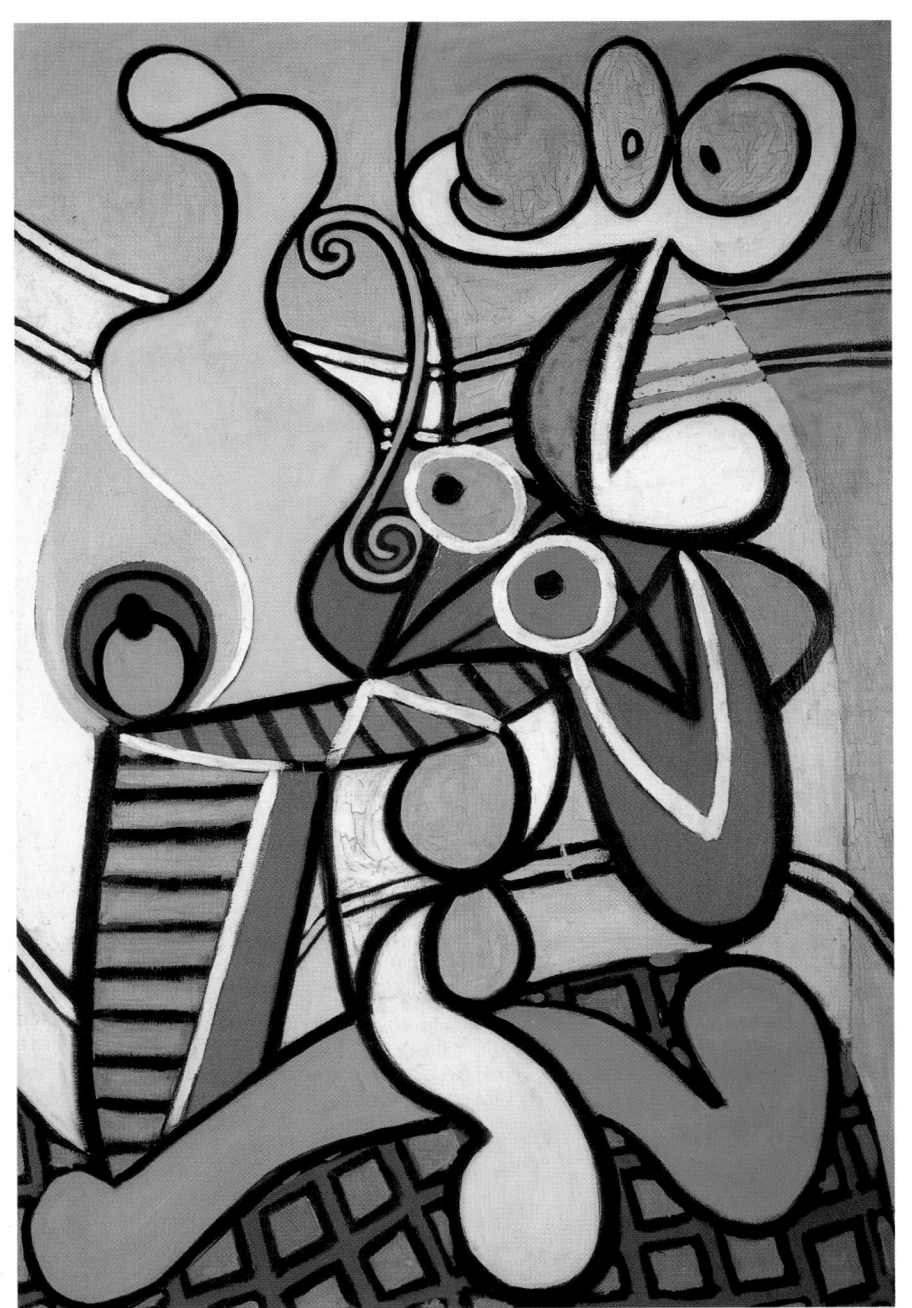

630

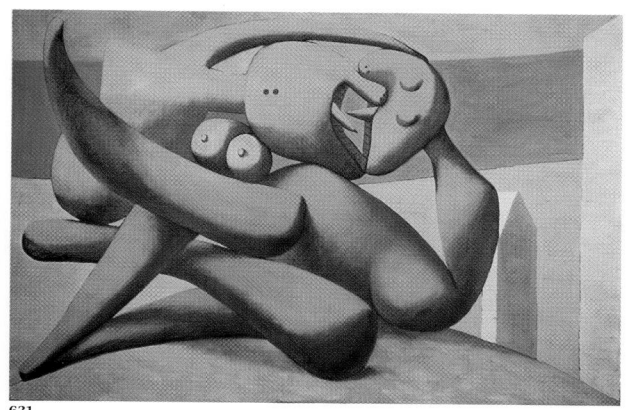

631

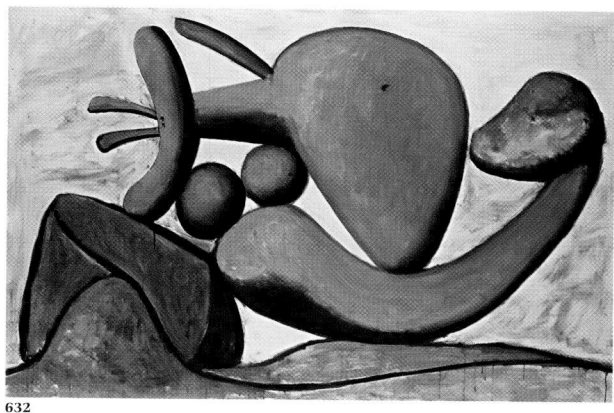

632

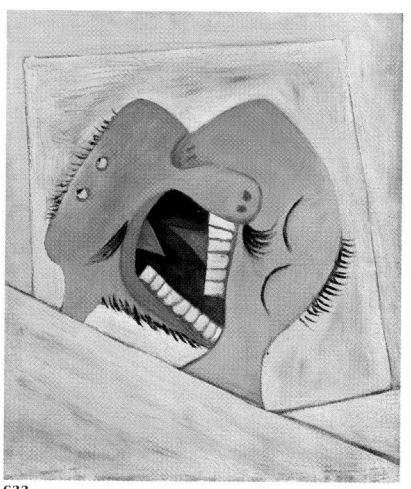

633

reintroduces the toothy kiss of August 25, 1929 (see fig. 602), but in a more realist, grotesque way. A still life from March 11, created entirely of open scrolls, was a hidden allusion to Marie-Thérèse's undulating shape (fig. 630). "This is a still life!" Picasso would acknowledge many years later.[3] It is rather unusual to see a yellow pitcher with fruit and a bowl seated on a pedestal like a woman's body. The complexity of the composition is rooted in the naturally connected surfaces of candid colors encircled by a black line which creates a dynamic but cheerful effect.

In *Figures by the Sea* (fig. 631), painted the same day as *The Kiss,* the tongues are spears and the man's nose a kind of sex organ. The woman leans back against a beach hut, as if against a pillow. It is a strange match, an expression of hostility, in which painting appears to draw inspiration from sculpture. On March 8, the same sculptural monumentality appears in *Woman Throwing a Stone* (fig. 632), in which the woman is herself an assemblage of stone blocks stacked against a boulder. This picture may reveal Picasso's obsession with the giant woman or archaic divinity, or an obscure desire to survive through the woman, to exist in a hard material, and to acquire eternal life from the depths of time. Picasso would tell Christian Zervos in 1935: "A painting comes to me from a far way off, who knows from how far." And the painter raised another question: "How can one penetrate my dreams, my instincts, my desires, my thoughts, which have taken a long time to develop and come to light, especially in order to understand what I have posited, maybe, despite my will?"

Marie-Thérèse

In 1932 sculpture still proved to be an influence on Picasso's painting, and this is especially evident in two pictures in which a Stone Age woman is seated in a red armchair against a black background that is as deep as night (figs. 634 and 635). The structure of spherical and oval forms make her look like a kind of primitive fetish. The female model has become an enigma in stone, re-created from fragments, elusively odd.

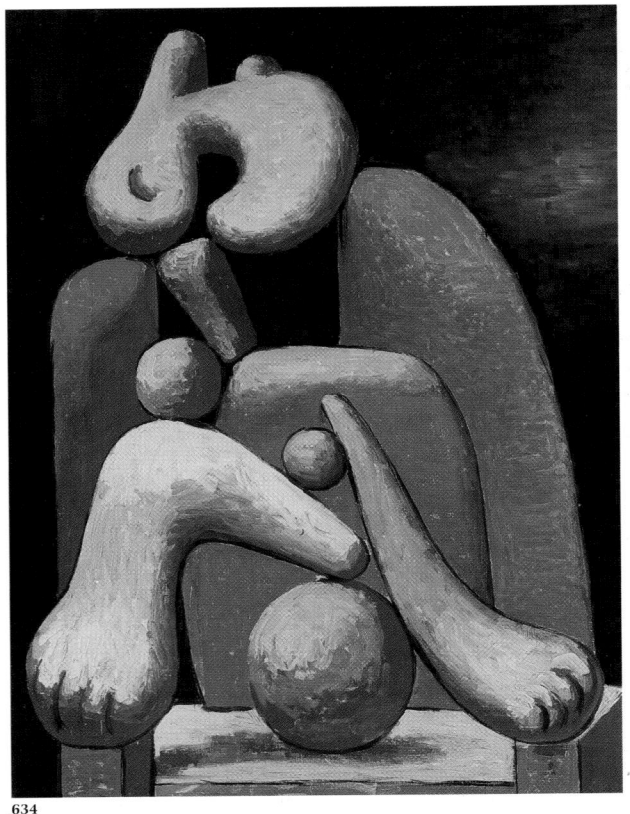

634

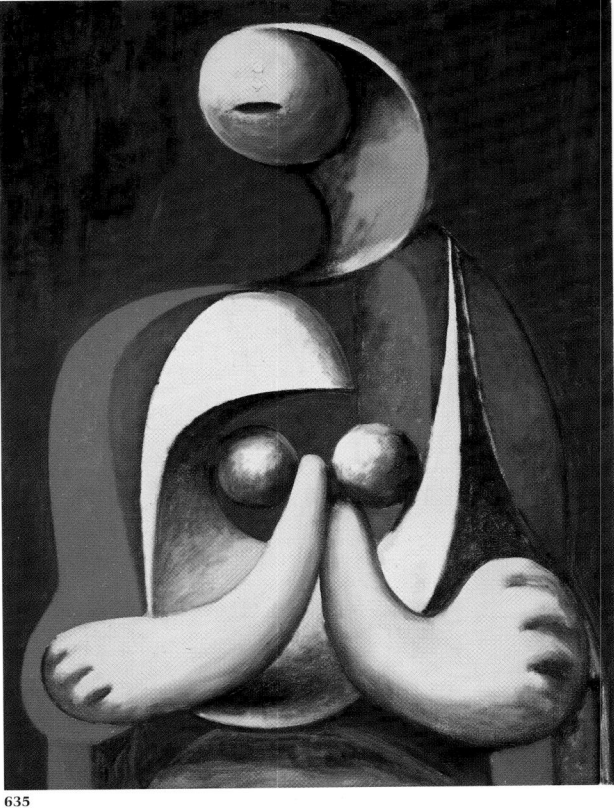

635

636

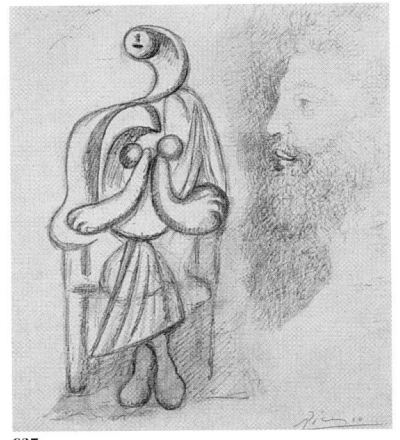

637

634 *Woman in a Red Armchair,* January 27, 1932

635 *Woman Seated in a Red Armchair,* 1932

636 *Composition with Butterfly,* September 15, 1932

637 *Seated Woman and Man's Head,* 1932

638 *Bather with a Ball,* August 30, 1932

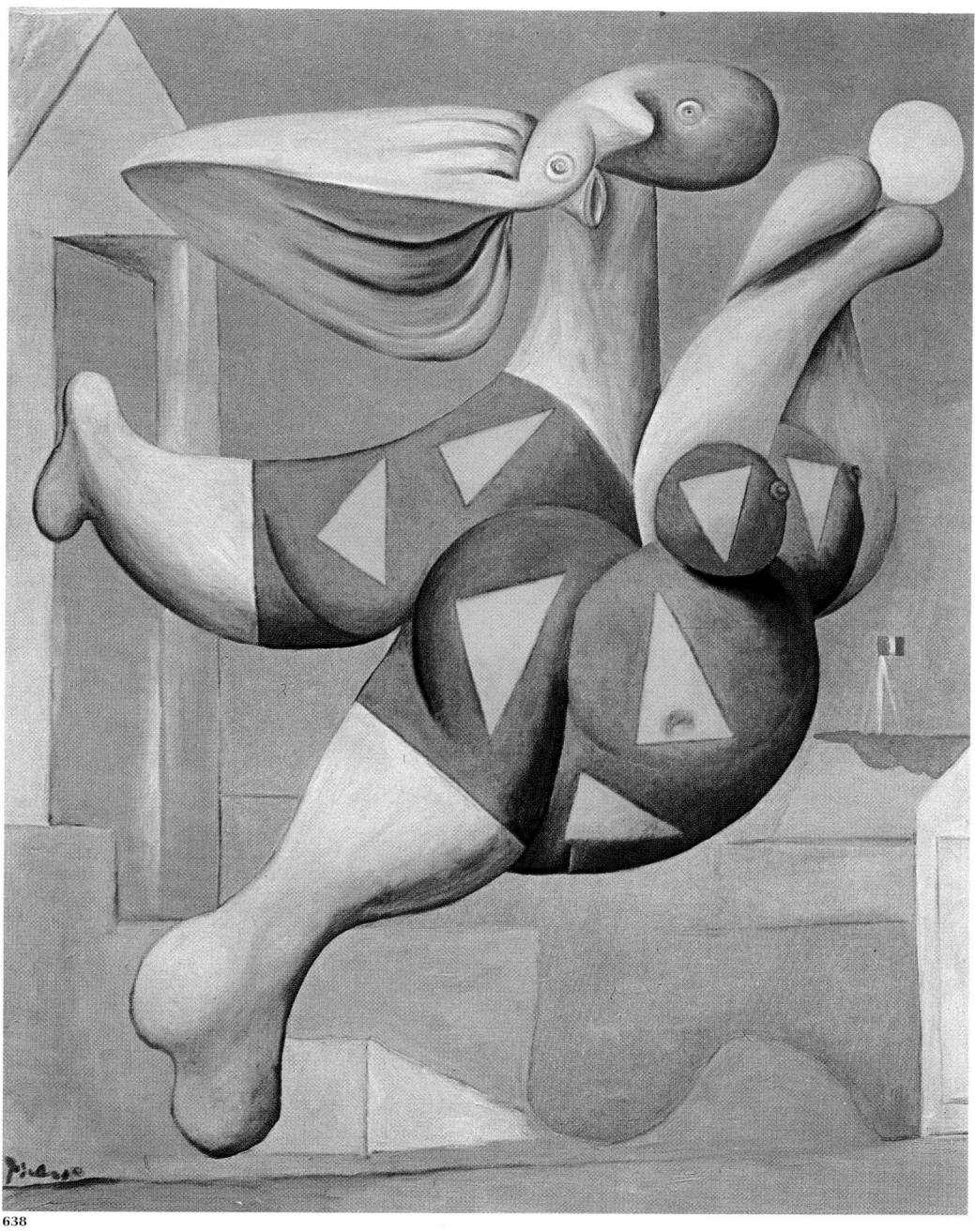

638

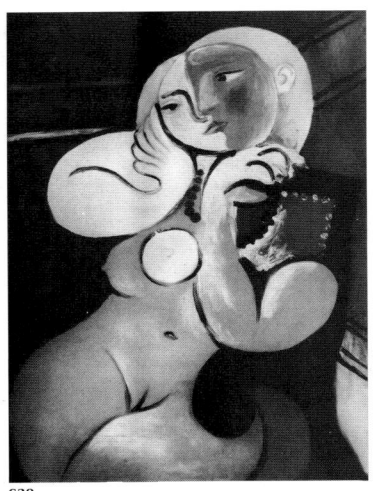

639

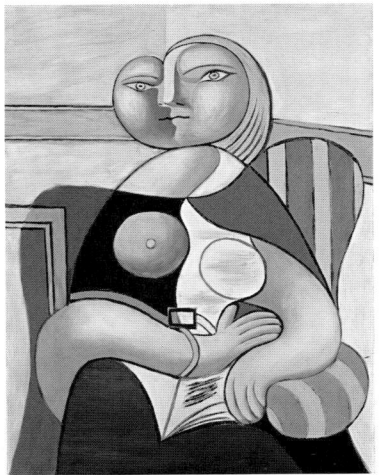

640

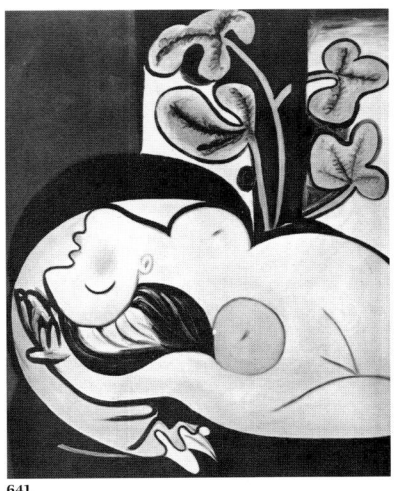

641

At the other end of the incarnation, *Composition with Butterfly* of September 15, 1932 (fig. 636), evokes the unbearable lightness of being. Two small figures made of twisted strands of thread, matches, and fabric, along with a beech-tree leaf and a butterfly, are forever stranded in the plaster. From this "everyday butterfly forever immobilized near a dry leaf," Breton drew "that unique emotion, which, once it takes hold of us, proves without possible error, that we have just been the object of a revelation."[4] With a leap, the *Bather with a Ball* of August 30, 1932 (fig. 638), flies off like the ball she is catching; even her heavy hair has become light for the occasion, and she is suspended in the air above the ground. Art can make the heavy light; it has a magical power, almost like alchemy, to relieve itself of all weight and to transform a person made of stone into a kind of helium-filled balloon.

The year 1932 blended the triumph of love's pleasures and the pleasures of painting. Forms were loosened and lines were transformed into twisted curves (figs. 639 and 640). Three-dimensionality from Picasso's sculpture in the round moved into his painting. Nudes made of supple lines bore Marie-Thérèse's distinctive features: her straight nose extended from her forehead, her mouth was slightly split, her cheeks round, her breasts high. In the Reclining Nudes from March and April (figs. 641 and 642), the woman, far from being feared, embodies the sensuality and happiness of existence. Abandoned to sleep, she returns to the realm of plants and animals, a still life that is full of life, swollen with sap and flavor, like the leaf offered by Marie-Thérèse. On April 4 (fig. 642), radiant with the sunlight that caresses her through the window panes, she is adorned with colors that warm her two-toned body, which has been drawn in black and white.

Although Picasso did not draw dreamlike images, as Salvador Dalí and Yves Tanguy did, he portrayed the sleeping woman several times and, by extension, the phenomenon of sleep. For example, in a painting entitled *The Dream* (fig. 643), a sensual and peaceful dream causes the woman—wearing a necklace, her breasts partly uncovered, her head

639 *Nude in a Red Armchair,* July 27, 1932
640 *Reading,* January 2, 1932
641 *Nude in a Black Armchair,* March 9, 1932
642 *Reclining Nude,* April 4, 1932

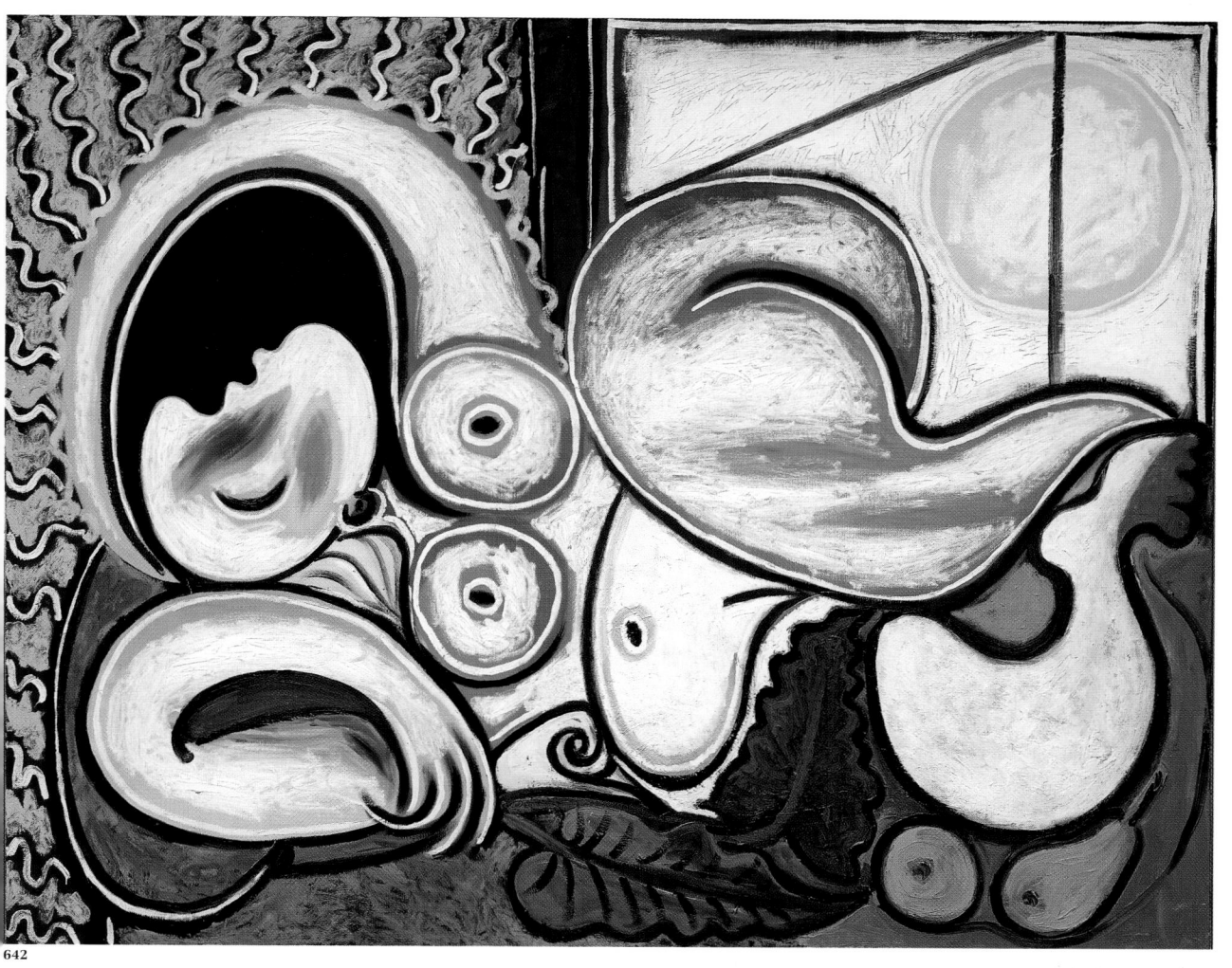

642

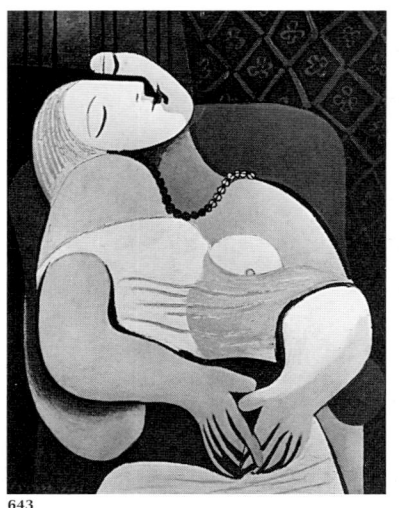

643

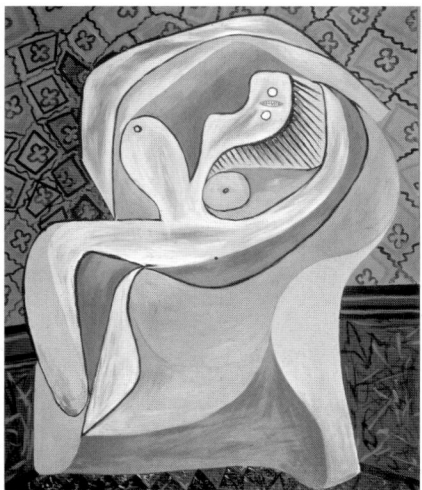

644

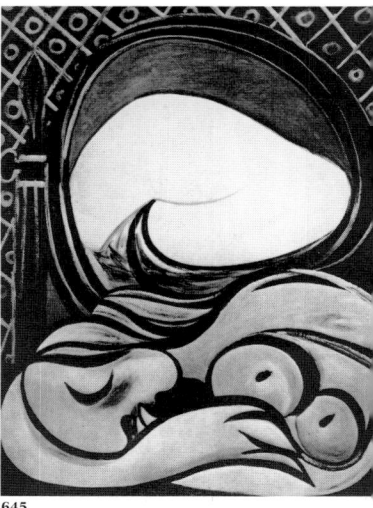

645

gently leaning on her shoulder—to shimmer. On the other hand is a nightmare against the same partitioned background, in the bristling hair of the *Woman in an Armchair* (fig. 644). It is tempting to continue comparing the lawful, dreaded wife, Olga, with the adored mistress, Marie-Thérèse. However, beyond the artist's personal references, these portraits, one soft, the other forbidding, reveal even more clearly the two extreme feelings Picasso had toward women, attraction and repulsion.

A decorative background with diamonds reappears in *The Mirror* and *Woman at the Mirror* (figs. 645 and 646). In the earlier picture, painted on March 12, 1932, by placing the model's back against the mirror, Picasso has devised a way to show two aspects of the same subject in disjointed fashion. The model in the second, painted two days later, faces the mirror, displaying the curves of the *Large Still Life on a Pedestal Table*, dated March 11, 1931 (see fig. 630). The space now is completely partitioned, however, with the colors enclosed and outlined in black. With her arms stretched out, the woman, irrevocably connected to her twin, seems to be on the brink of kissing her own image.

An air of relaxation and amusement emanates from the September 1932 drawings of bathers playing with balls on the beach, stripped of all heaviness (figs. 647 and 648). The transparent silhouettes, their hair blowing in the wind, frolic freely, dappled with spots of bright colors. In the drawing Picasso completed at Boisgeloup on October 4 (fig. 649), two women are together again; the one playing a Greek pipe injects a pastoral atmosphere, tinged with mythology. A more modest version of the 1923 *Pan-Pipes*, the figures may have been inspired at the time by Marie-Thérèse and her sister Jeanne, all the while recalling the *Two Women* and the *Two Bathers* of 1920 (see figs. 484–486).

However, for Picasso, drama lay beneath all pictorial expression, so these games played by the sea give way to rescue scenes in which one woman saves another, very similar to the shipwreck image of the reflection in the mirror. This theme would be touched on again in April–May 1936 (see figs. 728 and 731). In *The Rescue* of December 1932 (fig. 650),

643 *The Dream,* January 24, 1932

644 *Woman in an Armchair (Repose),* January 22, 1932

645 *The Mirror,* March 12, 1932

646 *Woman at the Mirror,* March 14, 1932

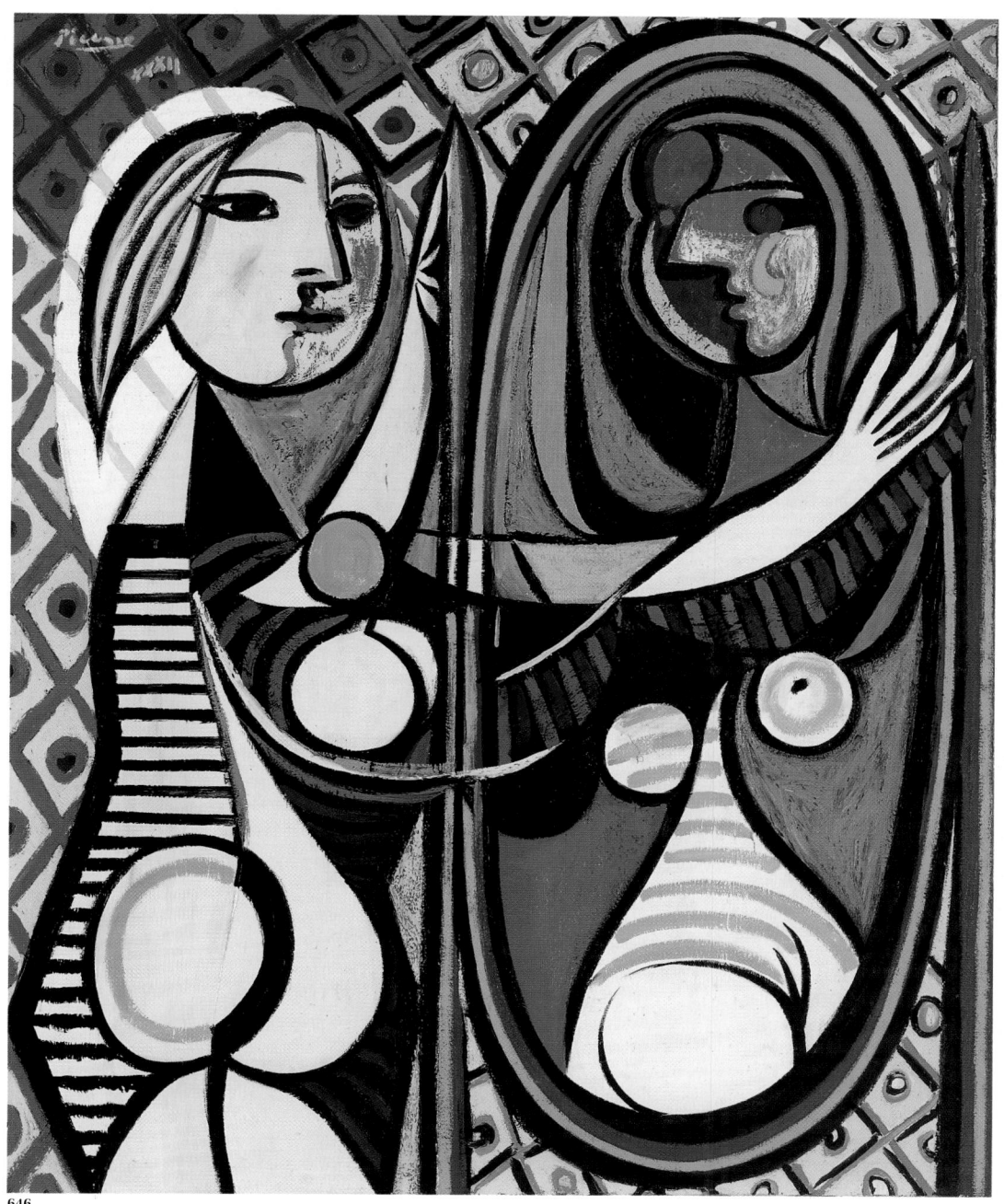

646

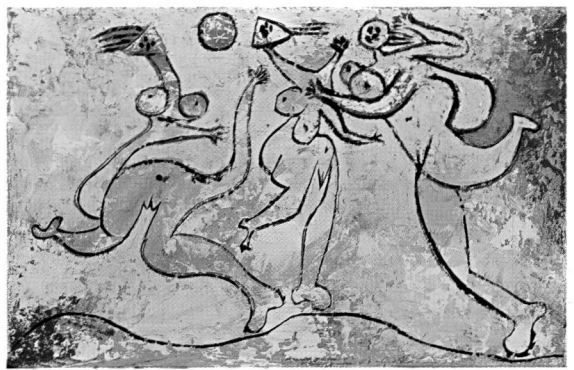

647

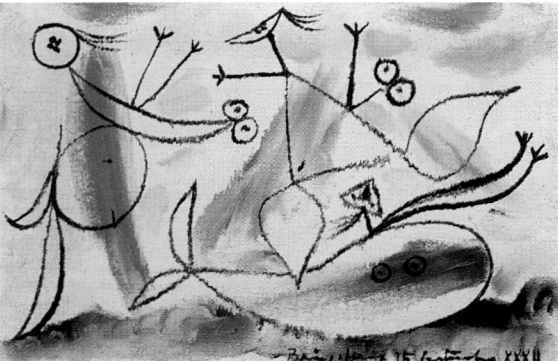

648

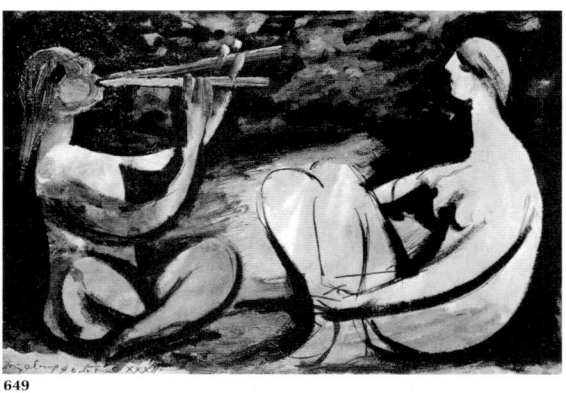

649

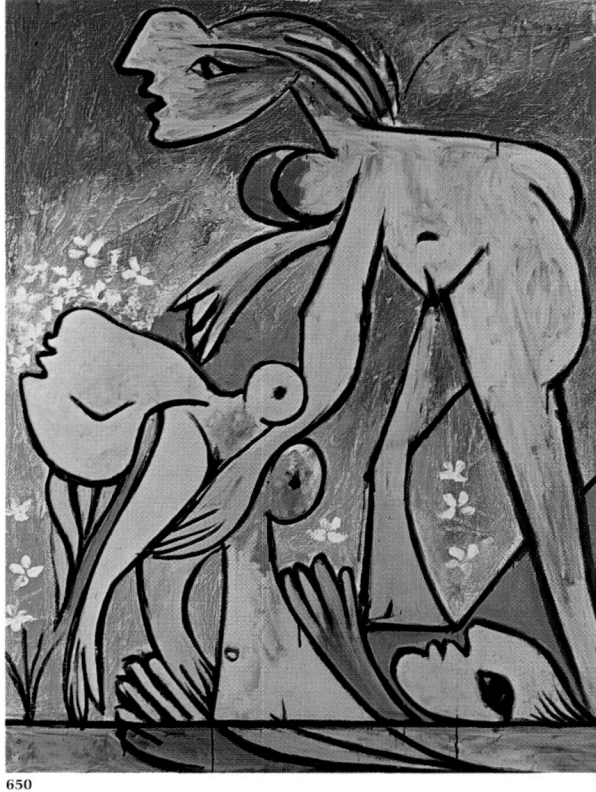

650

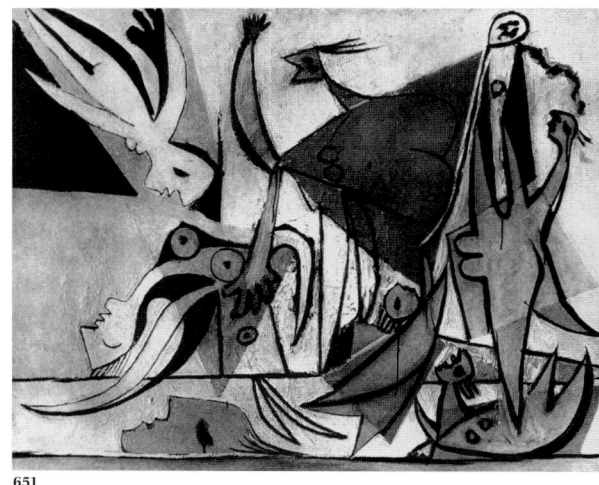

651

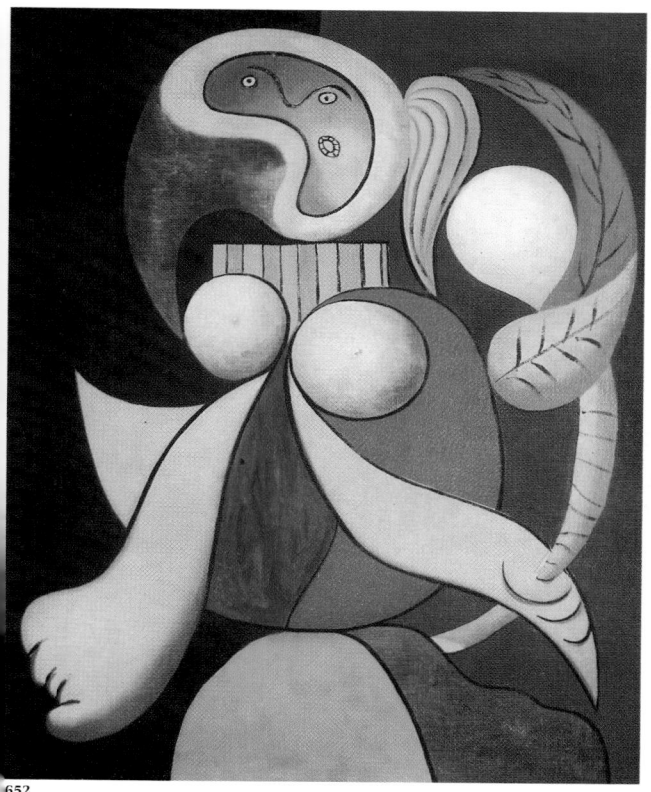

652

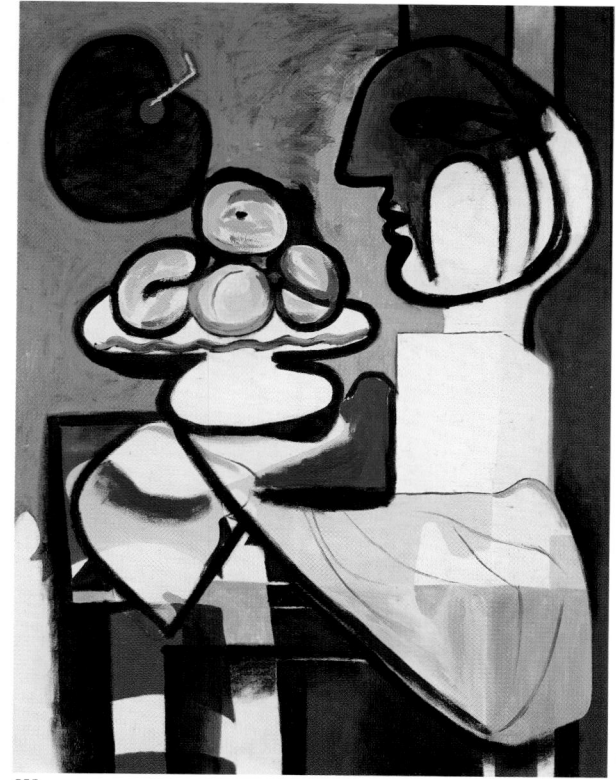

653

273

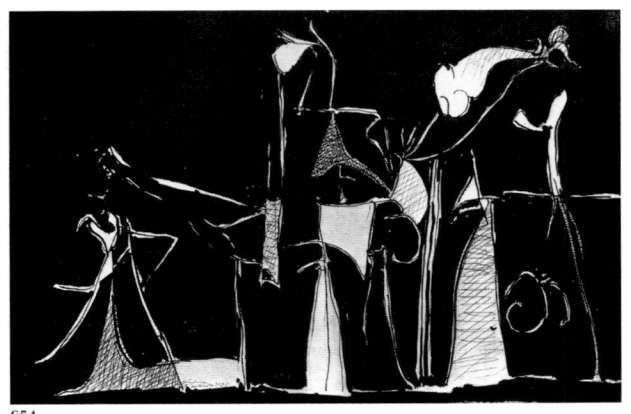

654

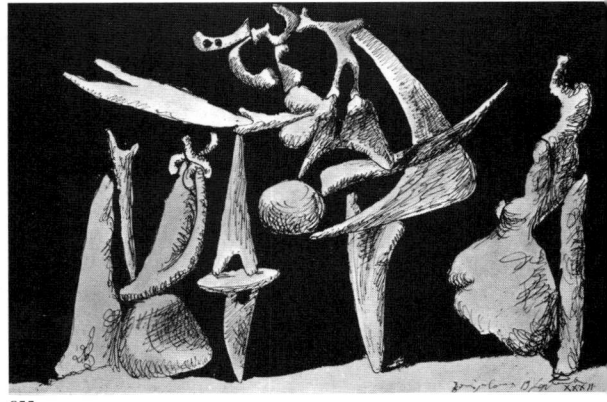

655

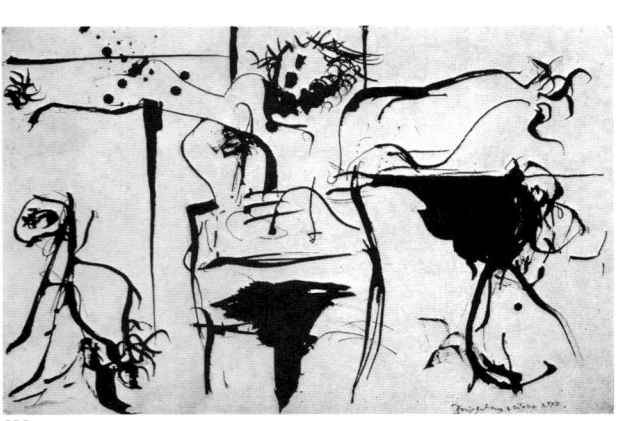

656

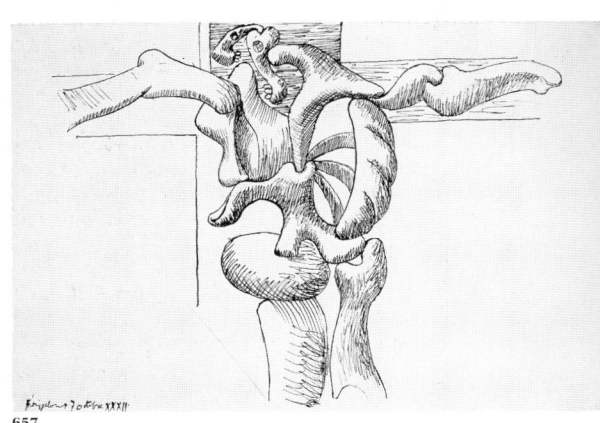

657

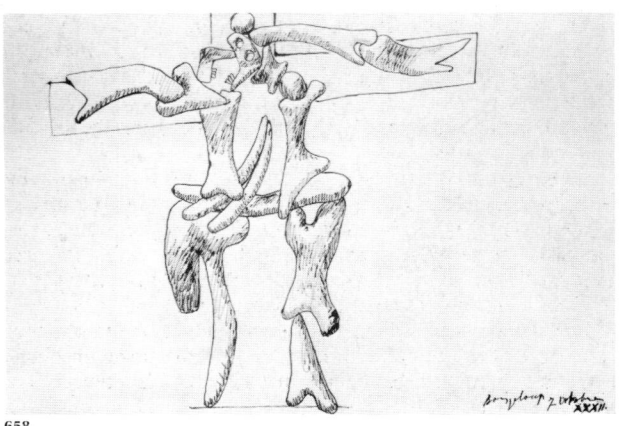

658

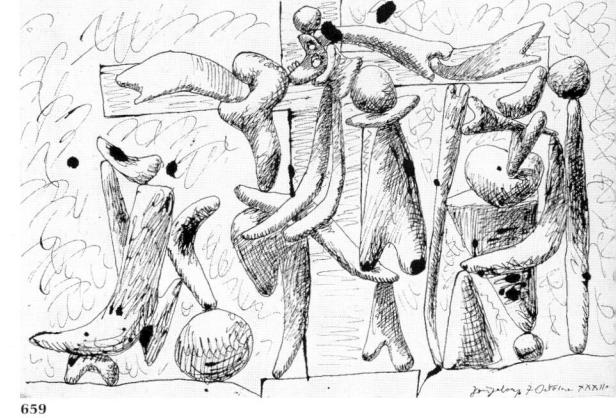

659

274

the three female profiles are also those of Marie-Thérèse: the standing woman with a prominent nose is clearly reminiscent of a *Head of a Woman* sculpted the preceding year (see fig. 622). In another rescue scene (fig. 651), the number of figures has increased, and as a result, the situation has become rather muddled. In the top left corner, one sees a woman diving headfirst. Conjuring up a fallen angel or deity, Picasso has touched on the theme of *The Fall of Icarus*, the title he would give to a fresco he made for UNESCO in 1958.

In June–July 1932, the first major retrospective of Picasso's work took place in Paris, at the Galerie Georges Petit. The catalogue, printed in an edition of 236 copies, published a collection of paintings, gouaches, *papiers collés*, sculptures, and illustrated books. Picasso himself selected and supervised the hanging of his work. In a high-society setting, not so appropriate for the avant-garde, this show was a revelation, hailed as the event of the Paris season, in spite of some disagreement from the critics. Georges Charensol would even write of "the most important art event of the last thirty years."[5] The exhibition went to the Kunsthaus in Zurich in September–October, at which time, C. G. Jung published, in Number 13 of *Neue Zürcher Zeitung*, "a long article on the psychology of Picasso's art," as Christian Zervos put it, with much reservation. Zervos reproduced extracts of Jung's text, translated into French, in Numbers 8–10 of *Cahiers d'Art* in 1932.

In his brightly colored paintings from the spring and summer of 1932, Picasso praised Marie-Thérèse's smooth forms, generally comparing them with flowers and fruit (figs. 652 and 653). In September–October, a tragic tone would resurface in the ink drawings of *The Crucifixion* (figs. 654–659), which were inspired by a reproduction of the Isenheim Altarpiece of Matthias Grünewald. The scene, set at night in the first drawings, was gradually reduced to figurative elements in which the crucified body becomes a skeleton surrounded by figures that are also made of bones. Picasso would tell Brassaï of his "genuine passion for bones," which, "with their convex and concave forms . . . fit into each other."[6]

From Bullfight to Minotaur

The drama of such themes as the shipwreck and the Crucifixion would become more pronounced in representations of bullfighting and its most violent aspects, as well as in the impressive appearance of the Minotaur, in the flood of drawings from 1933 and the Vollard Suite of engravings completed between 1930 and 1937. The September 6 *Death of the Woman Bullfighter* (fig. 662), her chest bare, depicts the bull attacking a horse. Picasso had already painted this scene in 1922 using the same technique—oil and pencil on wood—and the same pastel tones, whose softness contrasts with the violence of the image (see fig. 515). The September 19 version of *Bullfight* (fig. 661), also painted in Boisgeloup, but in bright tones, undoubtedly recalls Picasso's trip to Barcelona with Olga and Paulo in August. An ink drawing from September 24 (fig. 663) depicts the horse gored by the bull, which has left it disemboweled and dead.

In 1967 Claude Esteban wrote about Picasso: "This painter who came from Spain is the least Spanish of the painters. He seems to know nothing of his homeland, neither the millennial angst nor the sleep of reason."[7] This opinion did not take into account the duality of a man divided between his concurrent fascination with both life and death. It is true that Eros prevails here over Thanatos and that Picasso is not Goya, but it is not true that, as Esteban wrote, "this bull fanatic only retained the brilliant aspect of the *corrida* and none of its mystery." Picasso did not glorify violence and blood, but he did not make from them a ballet of decorative figures. In the battle of death, it was the tragic encounter between bull and horse, or between bull and bullfighter, that attracted his attention, and he offered us a close-up view.

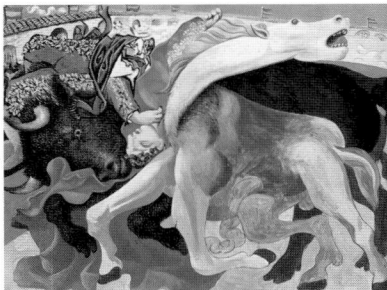
661

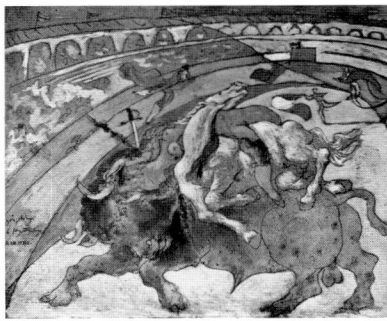
662

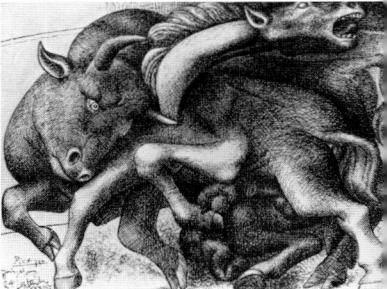
663

660

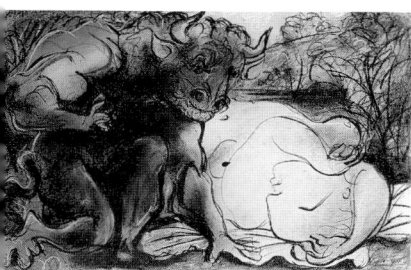

64

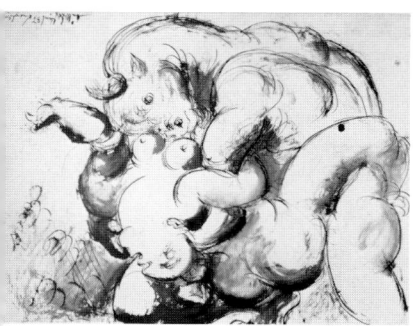

65

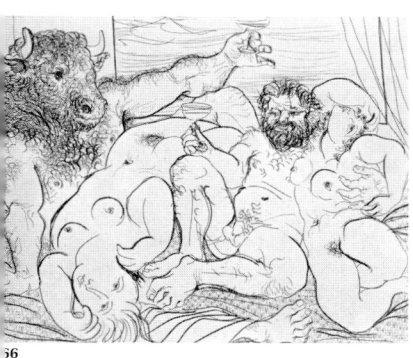

66

667

The Minotaur, half-man and half-animal, was also split between Shadow and Sun, and it was not by chance that Picasso made him a mascot. Kahnweiler would write, "Picasso's *Minotaure*, who feasts, loves, and fights, is Picasso himself. It is he that Picasso wishes to show completely naked, in what he sees as a complete communion."[8] The first issue of *Minotaure*, "the magazine with a beast's head," appeared in May 1933. Thirteen issues would be printed until 1939 with Albert Skira as editor and André Breton influencing the editorial committee. One magazine ousted another: May 1933 also saw the sixth and final issue of *Surréalisme au Service de la Révolution*, which itself replaced *La Révolution Surréaliste*. Picasso created the layout and cover for the first issue of *Minotaure* (fig. 667); the monster, with a nearly human face, stands against a composite background of paper doily, tinfoil, corrugated cardboard, plywood, ribbons, and even artificial leaves "from an out-of-date and neglected hat belonging to Olga,"[9] all of which were assembled with thumbtacks. The man with a bull's head, a cross between classical antiquity and Spain, between mythology and bullfighting, waves a double-edged phallic dagger like a royal scepter. He is both vitality and cruelty, night and day, like Picasso himself, who is an ogre and sultan with women, and a creator and destroyer of forms with his art.

668

In action, the Minotaur is able to overwhelm the young woman he covets. In a gouache drawing (fig, 664), he gazes at her, apparently moved by the innocence of her sleep: we are reminded of the Beauty and the Beast theme. But he can also dominate her—by raping her?—in a grip that tightly intertwines the two bodies. Here the victim seems to be consenting (fig. 665). And in an engraving from the Vollard Suite of May 18, 1933 (fig. 666), two naked women, the Minotaur, and a bearded man with a cut on his hand pay homage to Bacchus and the pleasures of love.

In this year, 1933, Marie-Thérèse would continue to inspire Picasso in everything. Paintings, drawings, and engravings (fig. 668–676) all echo her plastic and sculptural beauty. This dialogue between various mediums used to express the same subject would occur again in the years 1950 to 1952, more specifically between painting and sculpture. The gap between model and the object would start to disappear. The painting of a *Seated Nude* (fig. 676), round in form—who may be sitting in the shade of a beach hut—is reminiscent of a bather from Picasso's other work. But in a pencil drawing of February 22, 1933 (fig. 675), the same figure is also a plaster sculpture placed on a table. There seems to be hardly any difference between the painted nude, living model, and plaster nude. This is indeed the same woman, who appears in different forms. There is rapport and kinship between the sculpted nude on the table (fig. 678) and the woman seated on a chair (fig. 674): this kind of body, this kind of mutant being, falls halfway between subject and object.

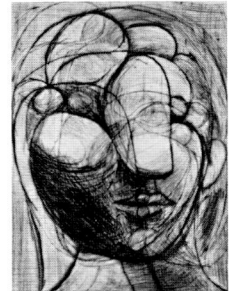

669

Subject and object would indeed be blurred in Picasso's drawings of a body dated February 25 through March 1, 1933, published in the first issue of *Minotaure* (figs. 677 and 678). A "Surrealist figure," seated in a chair, would appear in an ink drawing of March 10, 1933, inscribed for Tristan Tzara (fig. 679). In 1955 Picasso would acknowledge the influence of Surrealism in his 1933 drawings.[10]

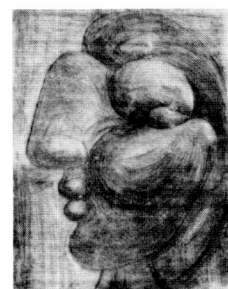

670

Several drawings depict figures along the seashore, or along a horizon, or at a beach indicated with a single line. The giant head of a toothless bather appears, on November 19, like a monstrous *Figure by the Sea*, her hair disheveled (fig. 681). The drawings completed in Cannes in July alternate between or combine Surrealist bodies and mythological references (figs. 680–684). The July 6 *Silenus Dancing* (fig. 680) leads bearded men, women, and youth waving fish and tackle in a frantic sarabande. In Greek mythology, Silenus was Pan's brother; a jovial, stout old man, often too drunk to walk straight, appearing often with Bacchus. As always, Picasso drew inspiration from a legend and freely adapted it in his own way, here with joyful vivacity.

Blending genres, a drawing of July 15 (fig. 682) presents two Surrealist figures in a classical setting, on either side of a profile of Marie-Thérèse, which is perhaps a reflection in

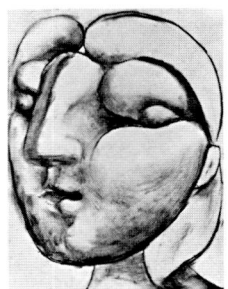

671

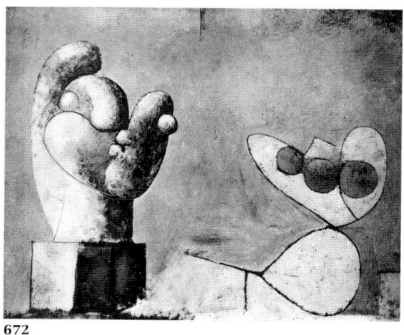

672

673

674

675

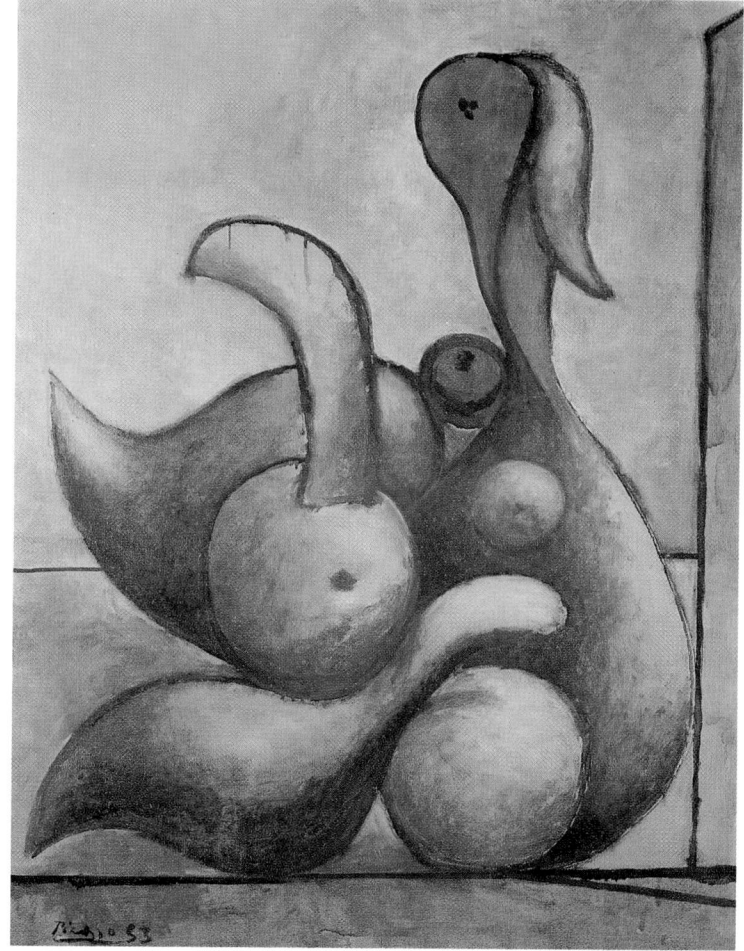

676

668 *Head of a Woman V,* February 16, 1933
669 *Head of a Woman,* February 1933
670 *Head of a Woman,* February 16, 1933
671 *Head of a Woman VI,* February 16, 1933
672 *Still Life,* January 29, 1933
673 *Two Figures,* April 12, 1933
674 *Anatomical Study: Seated Woman,* February 28, 1933
675 *The Studio,* February 22, 1933
676 *Seated Nude,* February 1933

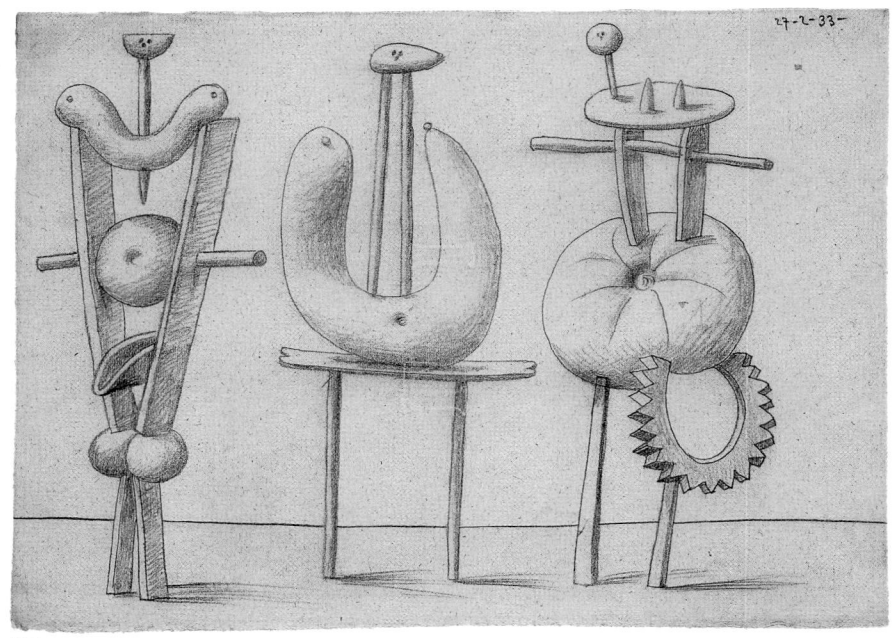

677

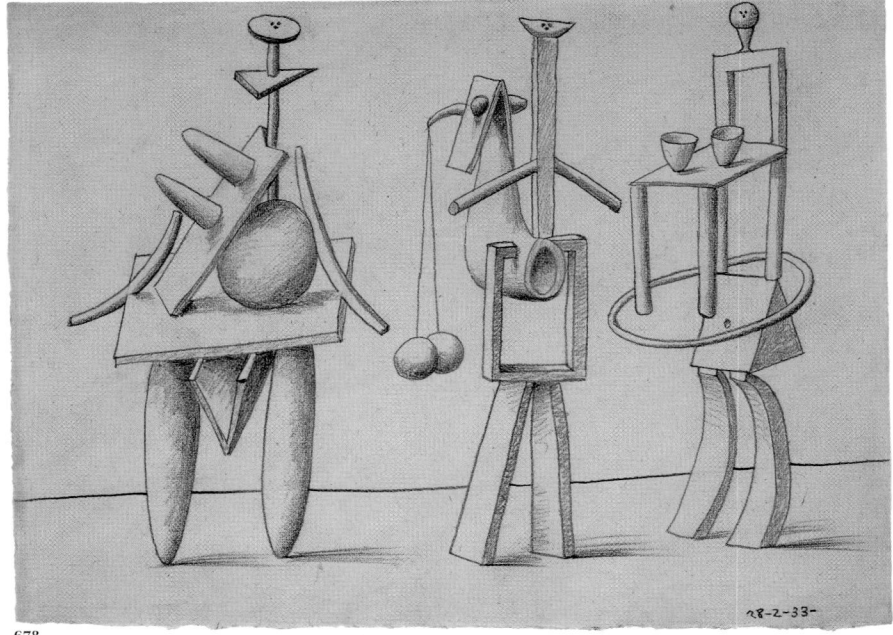

678

280

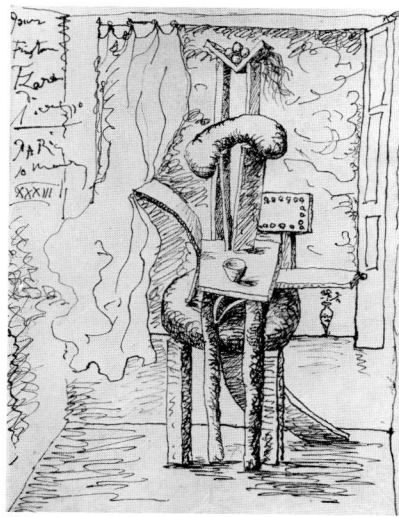

679

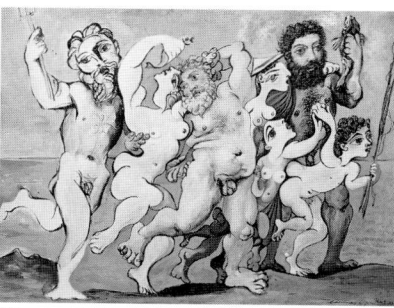

680

681

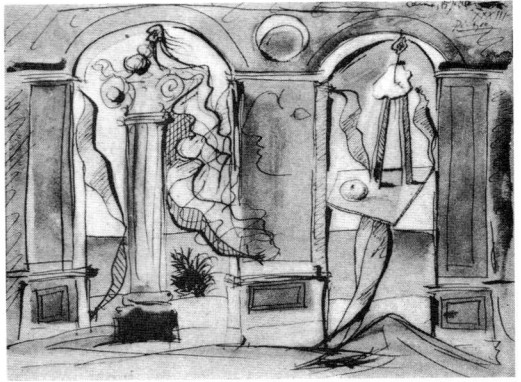

682

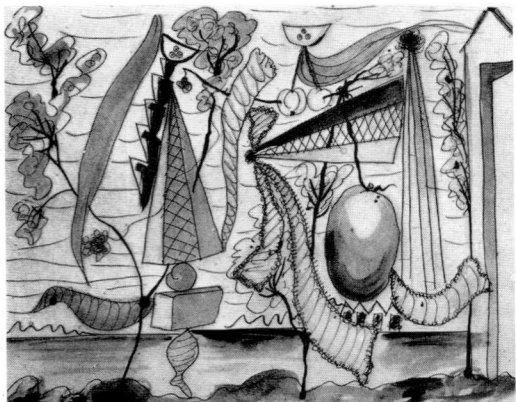

683

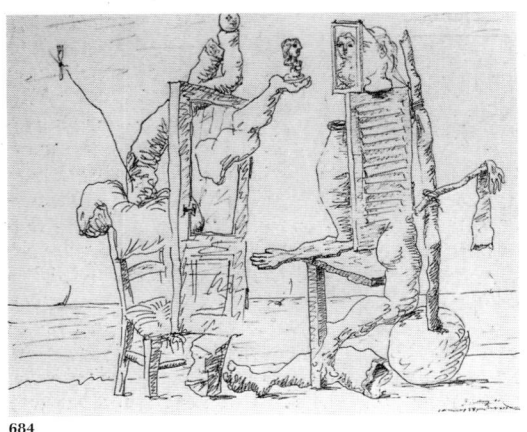

684

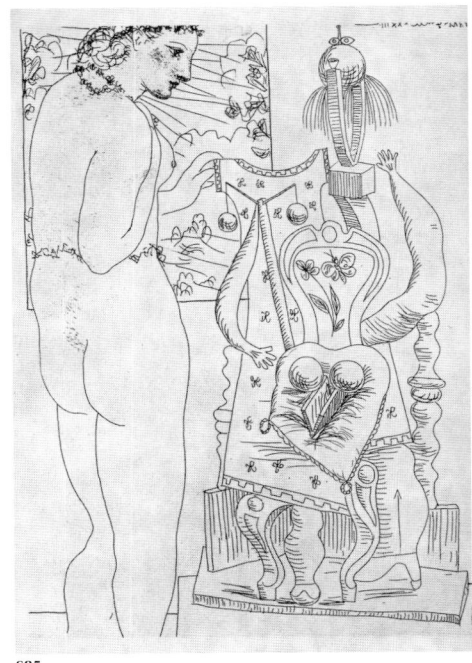

685

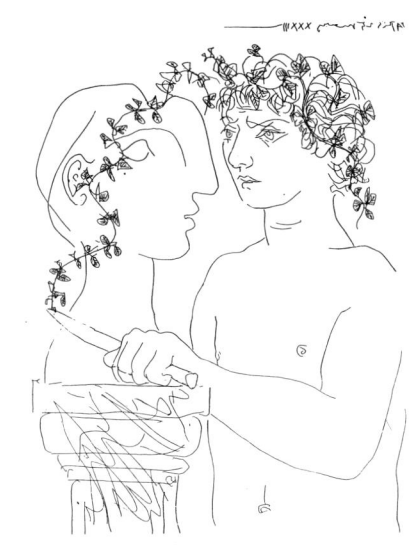

686

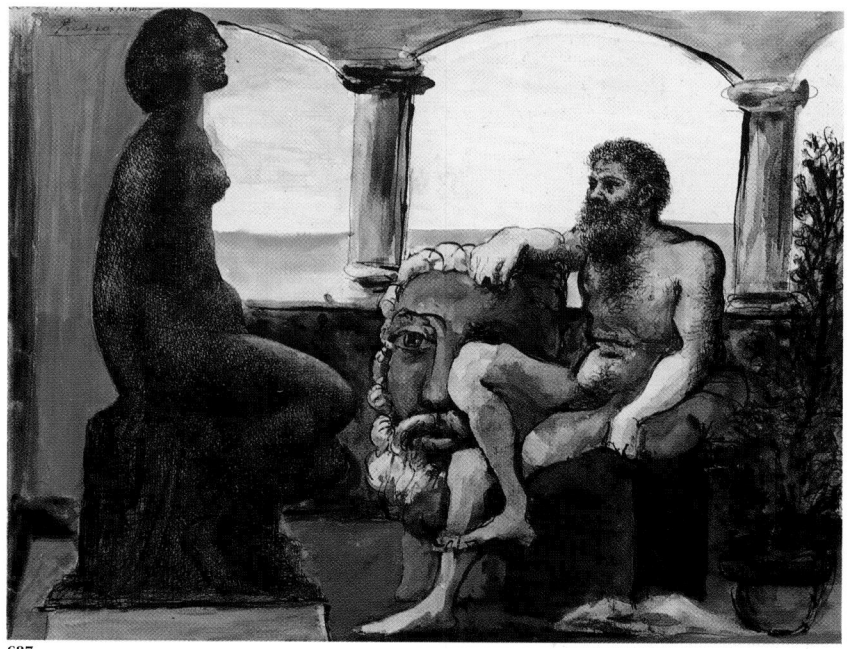

687

a mirror. In two drawings from July 28, Picasso has replaced the figures on the beach—in the first case, with a beach hut (fig. 683). Here two bathers rush toward each other, the one on the right carrying a towel. The second drawing (fig. 684), which is more static, again presents two bodies composed of assorted objects, like door and chair, jar and shutter placed on a table, with plaster arms and legs, a glove, a head, and a bust reflected in a mirror. The same combinations, clearly Surrealist, would reappear in an engraving by both Picasso and Dalí, who published in the first issue of *Minotaure* "the paranoid-critical interpretation of Millet's haunting *Angelus*."[11]

In these fantastic compositions, Picasso continued to explore the relationship between model and work, between reality and fiction, with which he was still obsessed. In a drawing dated July 20, 1933 (fig. 687), the seated sculptor, leaning his elbows on a monumental bearded head, contemplates his still model: black statue or flesh-and-blood woman? Once again this question is raised and the answer is still not forthcoming. Similarly, in an engraving from March 25, 1933 (fig. 686), the young artist at work carves a head wearing a garland, but the knife in his hand seems ready to sacrifice it, to slice its neck in a fit of ill temper. On May 4 the model undresses before a Surrealist sculpture (fig. 685): she seems torn between prudent reserve, with her right hand on her chest, and seduction, with an inviting left hand.

In December 1933, an offer to illustrate Aristophanes's *Lysistrata* once again provided Picasso with the opportunity, as did Ovid's *Metamorphoses*, to express himself in the vein of classical mythology (fig. 688). In January 1934, he completed a portrait of Man Ray (fig. 691), darkening his drawing with black ink, and he did the same in a study for

682 *Surrealist Composition,* July 15, 1933
683 *On the Beach,* July 28, 1933
684 *Two Figures on the Beach,* July 28, 1933
685 *Model and Surrealist Sculpture,* May 4, 1933
686 *Young Sculptor at Work,* March 25, 1933
687 *The Sculptor and the Statue,* July 20, 1933

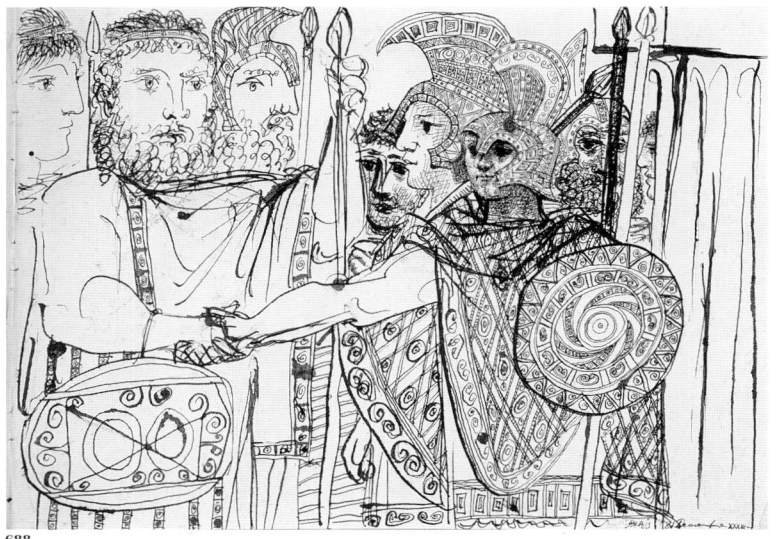

688

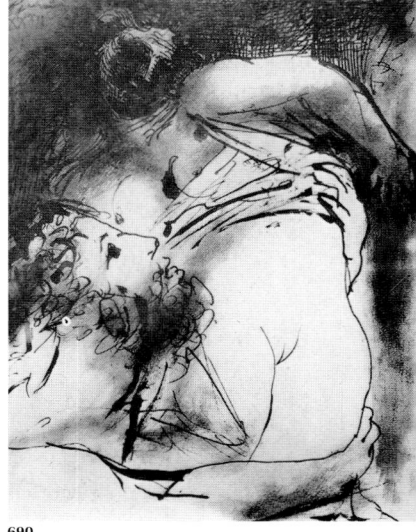

690

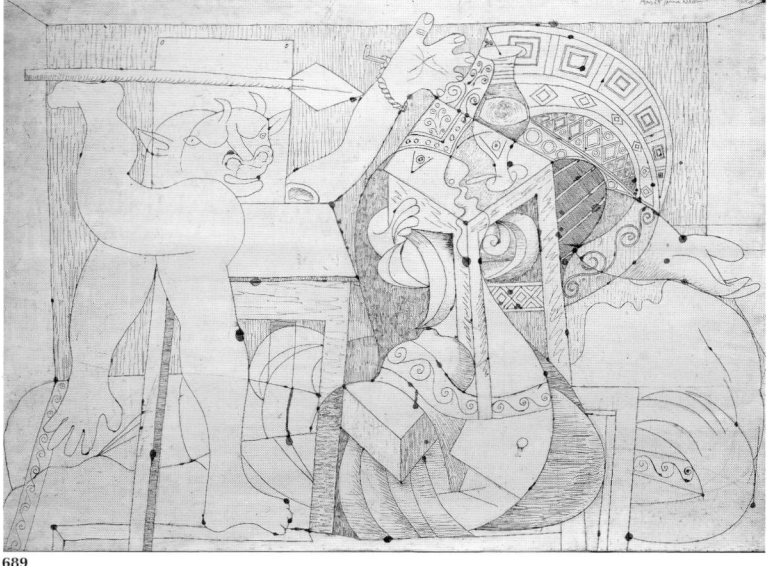

689

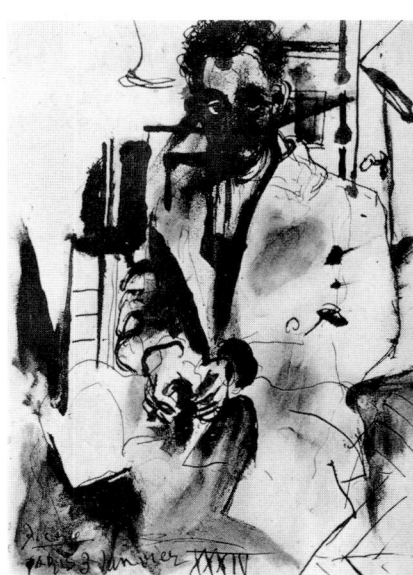

691

688 *Study for "Lysistrata" by Aristophanes,* December 31, 1933
689 *Minotaur with a Javelin,* January 25, 1934
690 *Myrrina and Sinecias, from "Lysistrata," by Aristophanes,* January 18, 1934
691 *Portrait of Man Ray,* January 3, 1934

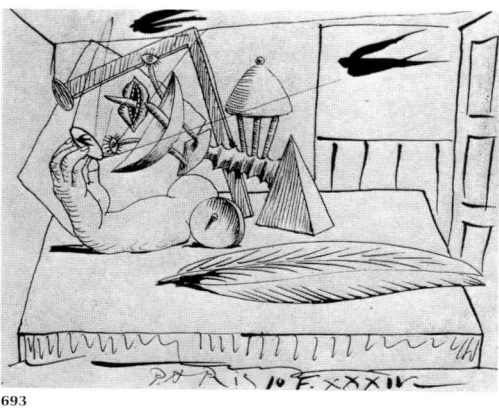

692

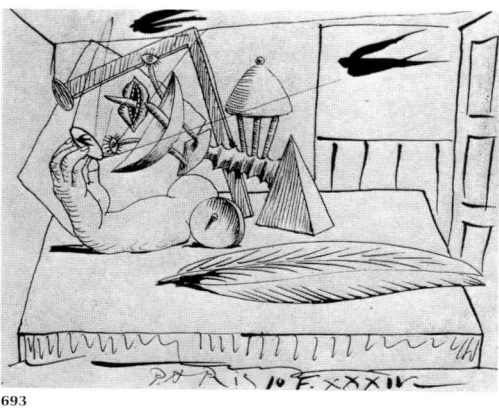
693

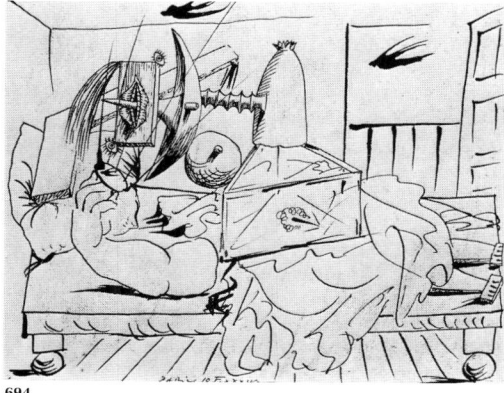
694

692 *Nude Reclining in Front of the Window,* February 7, 1934

693 *Interior with Swallows II,* February 10, 1934

694 *Interior with Swallows I,* February 10, 1934

Lysistrata (fig. 690). Picasso would appear that year in the photomontage of Man Ray's Surrealist chessboard, reproduced in Georges Hugnet's *Petite Anthologie du Surréalisme*, which Picasso illustrated. And in February 1934, Picasso once again made a few drawings inspired by Surrealist figures, posed as a reclining nude in front of a window visited by swallows (figs. 692–694).

As in the Bateau-Lavoir period, Picasso returned to the Médrano Circus with his son Paulo and his friend Brassaï. This circumstance triggered again acrobatic themes in his painting, but in transposed form: they became unfettered bodies, floating in an environment of air and water, like ectoplasm or algae (fig. 695). The Woman in the Mirror also continued to be a theme in Picasso's world and in his paintings, drawings, and engravings. In a drawing of April 1934 (fig. 696), a nude woman is watched by a bearded man, who appears in the upper-right corner. Only the body is lighted; the reflection of the kneeling woman who watches herself in the mirror cannot be seen. The mirror is dark.

Sometimes the women are partners, sometimes enemies. They are the former in an engraving from the Vollard Suite dated March 10, 1934 (fig, 697), in which four nude women stand beneath the gaze of a sculpted head that seems to be that of the sculptor, who has found this way to spy on them. The women in *Confidences* (fig. 699), again partners, are inscrutable to both painter and viewer. This tapestry cartoon from 1934, now in the Musée d'Art Moderne de Paris, was woven in 1935, thanks to Marie Cuttoli. But friendship turns to murder in a July 7, 1934, drawing (fig. 701), in which a woman in a bathtub—no longer Marat—collapses under the glint of a knife blade brandished by another woman. We are reminded of the *Woman with a Dagger* from December 1931 (see fig. 629). This drawing is contemporaneous with the July 21 engraving *The Death of Marat* that would illustrate the collection of poems by Benjamin Péret, *De derrière les fagots*, published in August 1934.

Marie-Thérèse, however, was still the sensual nude, associated with plants and sleep, as seen in *Nude in a Garden* and *Nude with Bouquet of Irises and Mirror* (figs. 698 and 702). In the small statue of the *Woman with Leaves* (fig. 700), a head shaped like a matchbox uses imprints of leaves and corrugated cardboard, all that is needed to magically create a hieratic and mysterious priestess. This sensual softness contrasts the cruelty of the bullfighting scenes depicted in several paintings and drawings from July 1934 (figs. 703–707), in which the horse is disemboweled, and the bull, before being killed himself, feeds on the innards. The only respite from the explosion of violence is a tender little girl who has come to help the blind Minotaur (figs. 708 and 710): everything happens this way, in the eyes of Picasso, with the Minotaur and Oedipus ending as one. The winged bull, with the head of a sphinx (fig. 708), which seems to have come from Jorge Luis Borges's *Manual of Fantastic Zoology*, piques the curiosity of children, despite their fear; and the little girl with the dove and the bouquet of flowers guides the *Blind Minotaur* under the watchful eye of the fishermen (figs. 709 and 710).

A theme that took shape at the end of 1934 would result in the famous engraving of *Minotauromachy*, dated March 23, 1935, in which the little girl, holding a lighted candle and a bouquet, lights the steady-eyed Minotaur; the gored horse reappears here, as well as the bare-breasted woman bullfighter, the two girls in the balcony, and, at the left, a bearded man escaping on a ladder reminiscent of the 1930 *Crucifixion*. All of the painter's personal mythology comes together here, in this David and Goliath–like dual between childhood and beast, innocence and evil, peace and violence. But on April 24, another animal from the fantastic bestiary, with a horse's head and a rat's body, would be set loose again (fig. 714). In the drawings of April 15 and 17, the Minotaur is back in the ring again, blind and helpless or pretending to strut before the frightened horse (fig. 712 and 713). Again, it is the horse that carries the bare-breasted woman bullfighter on its back (fig. 715). In a drawing completed on April 27 in Boisgeloup, the bullfight becomes nocturnal, high in color,

695 *Circus Scene,* 1934

696 *Woman at the Mirror,* April 1934

697 *Four Nudes and Sculpted Head,* March 10, 1934

695

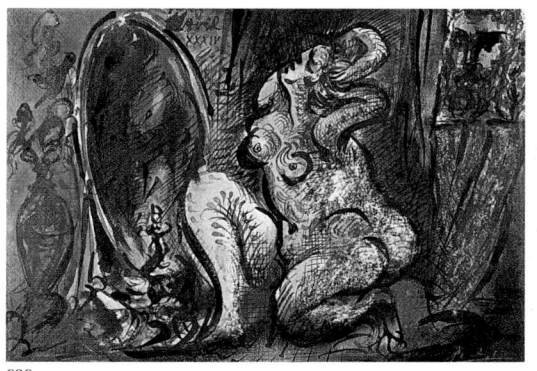

696

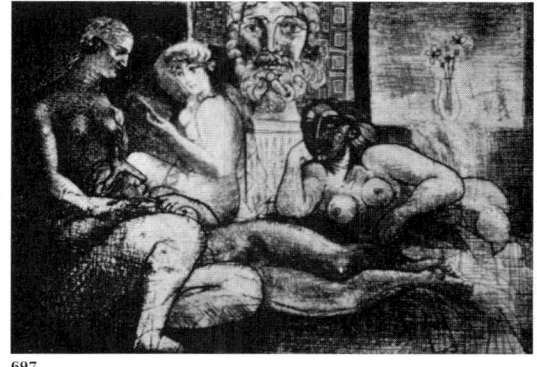

697

287

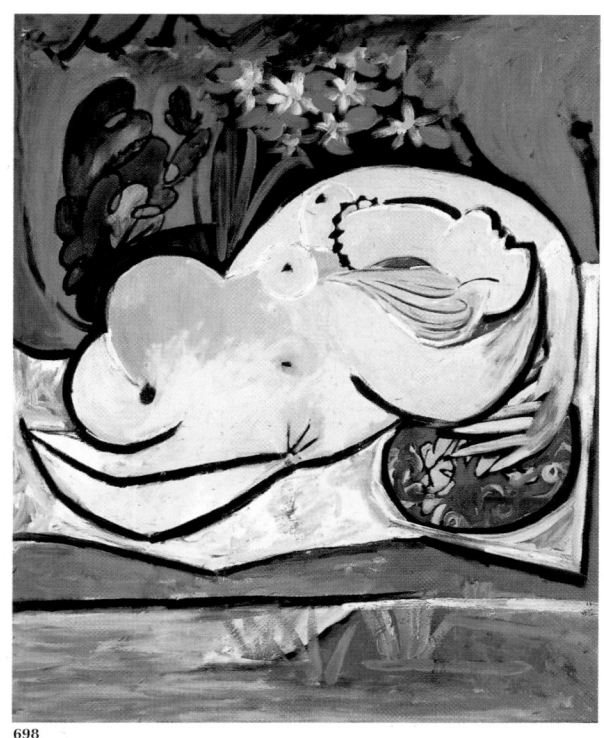

698

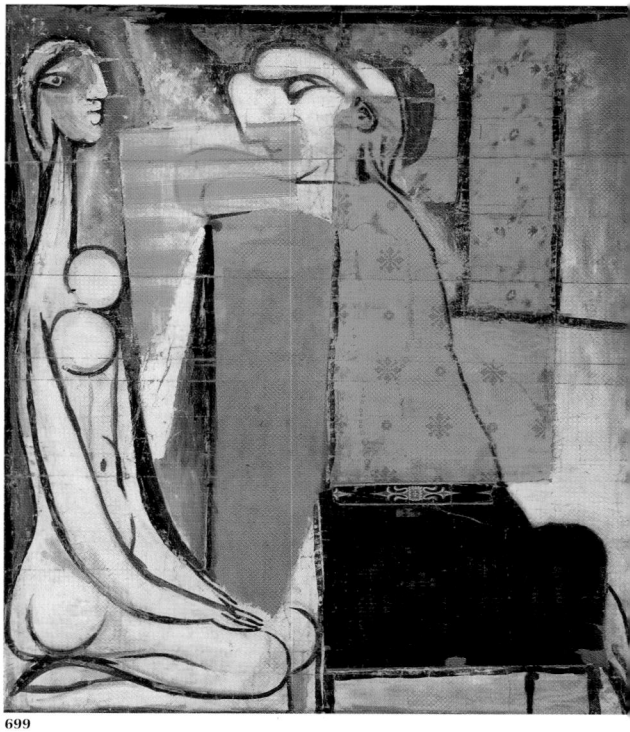

699

700

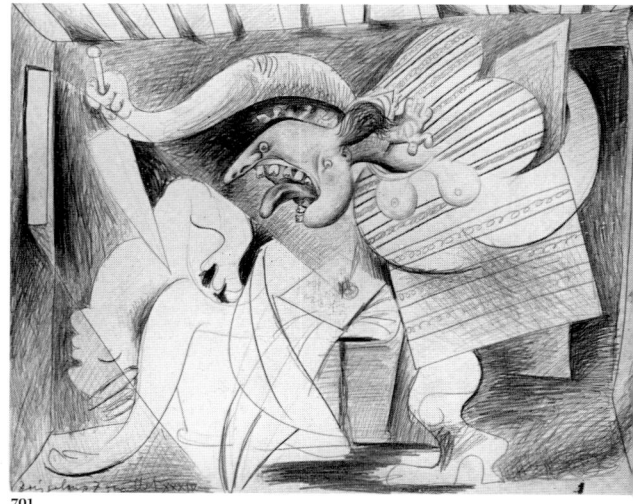

701

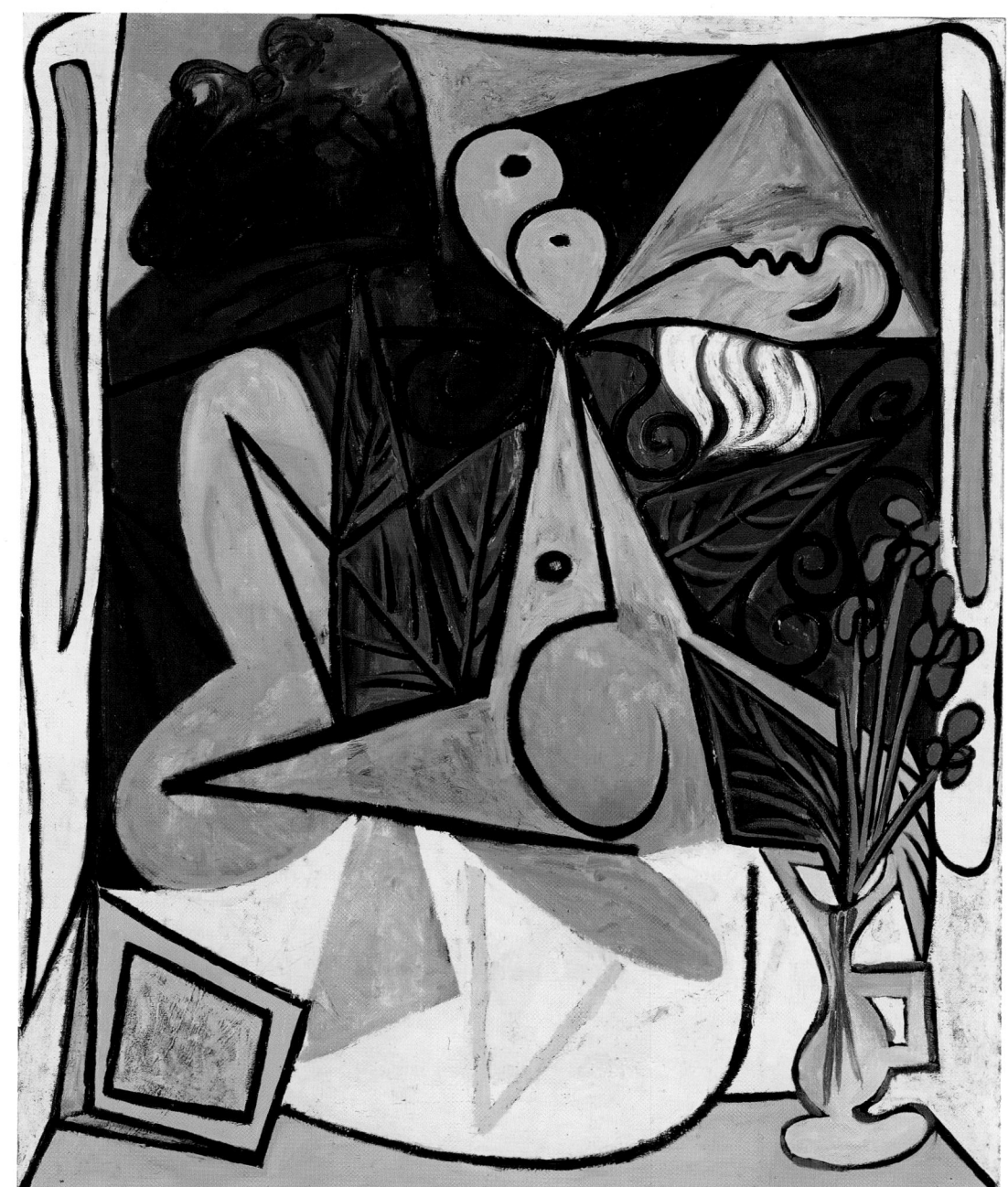

702

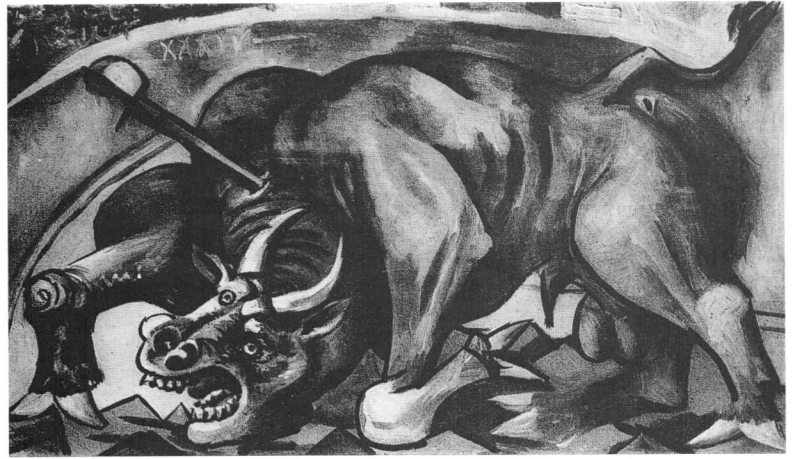

703

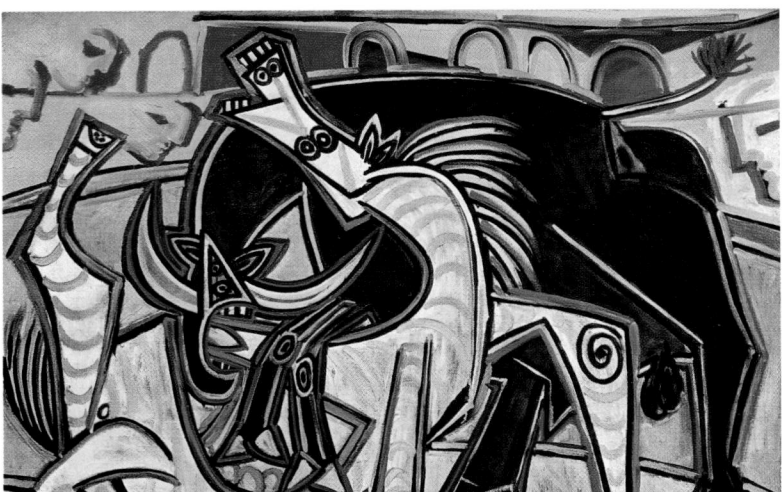

704

705

706

707

703 *Bullfight,* July 16, 1934

704 *Bullfight,* July 2, 1934

705 *Bull and Horse,* July 24, 1934

706 *Bullfight,* 1934

707 *Woman with a Candle, Combat Between the Bull and the Horse,* July 24, 1934

708 *Winged Bull Watched by Four Children,* December 1934

709 *Blind Minotaur Guided by a Little Girl at Night,* November 1934

710 *Blind Minotaur Led by a Girl,* September 22, 1934

708

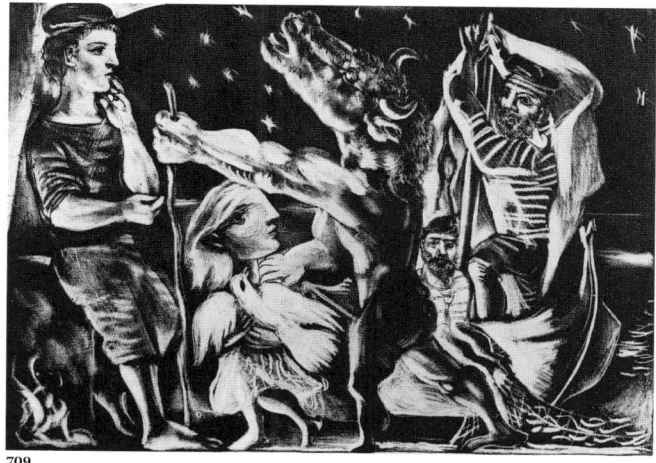

709

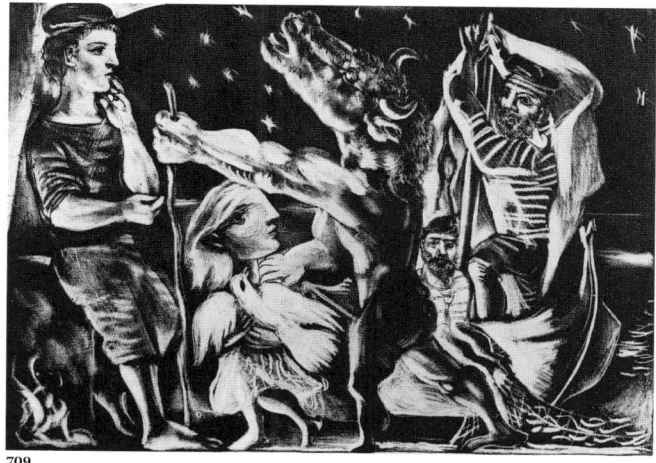

710

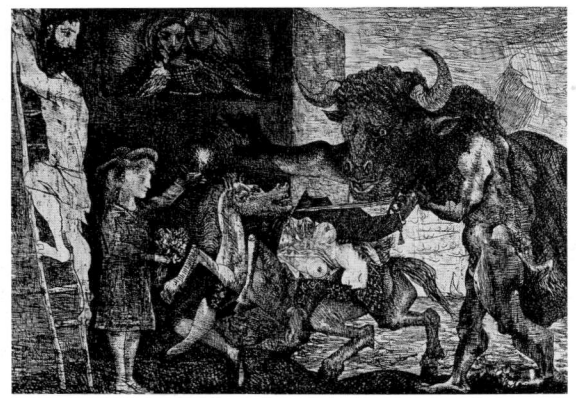

711

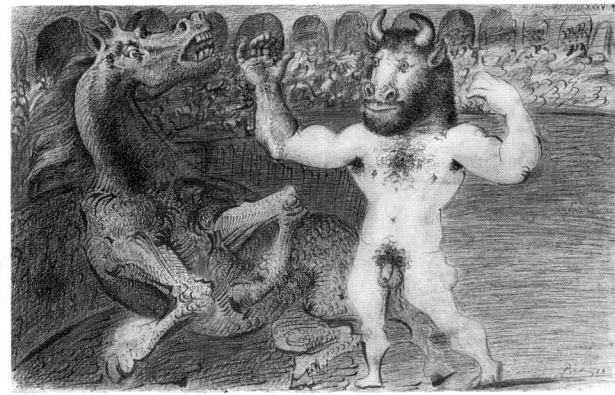

712

713

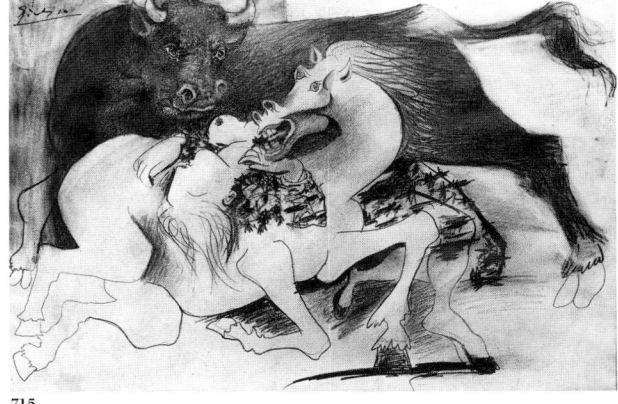

714

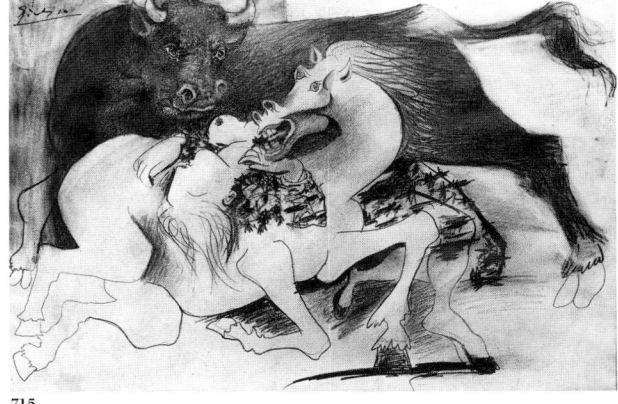

715

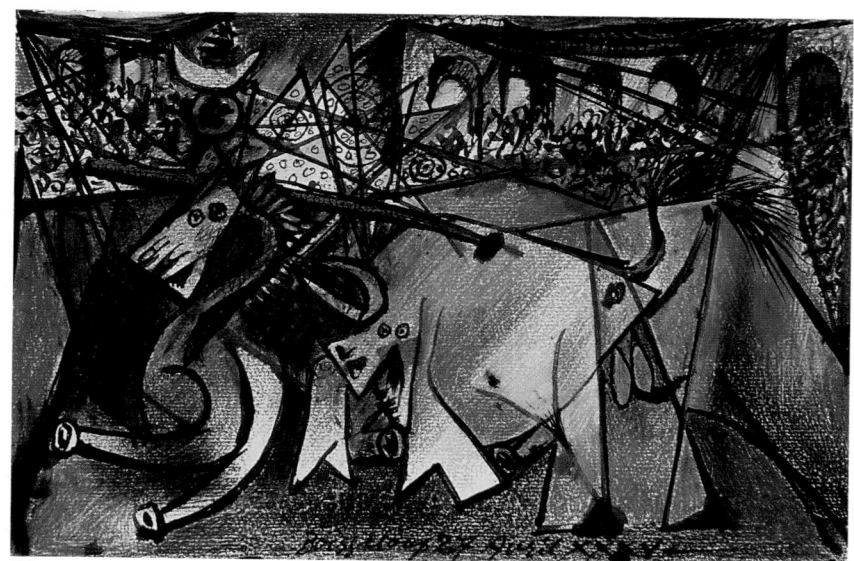

716

striped with black lines. A facsimile would be published in *Cahiers d'Art* at the beginning of 1936 (fig. 716). This issue of *Cahiers d'Art*, which was devoted to Picasso, presented several works from the years 1930 to 1935: paintings, including *The Muse* and *Two Women in an Interior* (figs. 717 and 718), study drawings, and photographs of plaster sculptures. In 1935 drawings once again conjured up the Woman in the Mirror theme, in the act of writing or drawing (figs. 720 and 722). Although the *Woman Reading* of January 9, 1935 (fig. 723), is undoubtedly Marie-Thérèse, as suggested by the initials written on the background window, the forms appear to be more geometric, more rigid than before. The hand shaped like a knife blade serves as an example.

But this issue of *Cahiers d'Art* also contained a surprise, since, for the first time, it published Picasso's texts (from November 28 and December 5, 6, and 24, 1934), accompanied by, among other things, an article by André Breton entitled "Picasso Poète." At this time, Picasso was particularly close to the Surrealists. In February–March 1935, an exhibition of his *papiers collés* from 1912–14 took place at the Galerie Pierre, for which Tristan Tzara was inspired to write an introductory text. After April 18, 1935, in Boisgeloup, Picasso would begin to write texts inspired by the principle of automatic writing, as it had been practiced by the Surrealists since 1919. Some writings were poems; some were presented in calligraphy or with illustrations (fig. 714). Picasso continued to write during the months that followed and did not paint again until February 1936. His difficult private life was no stranger to change. In June Olga left to live with Paulo in the Hôtel California, on the rue Berri. Marie-Thérèse was expecting a child, and on September 5, 1935, a little girl was born. She was named Maria de la Concepción and called Maya, in memory of Pablo's younger sister, who died from diphtheria in 1895 at the age of seven. On July 13, Picasso was at loose ends, hopeless. He sent a call for help to his friend Jaime Sabartés and asked him to come to Paris. Sabartés arrived in Paris on November 12.

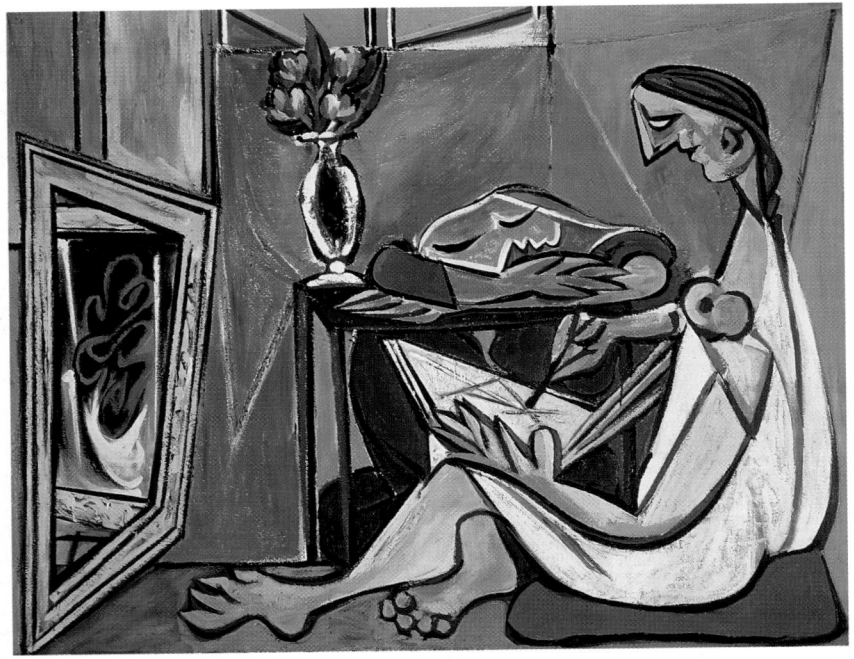

717

719

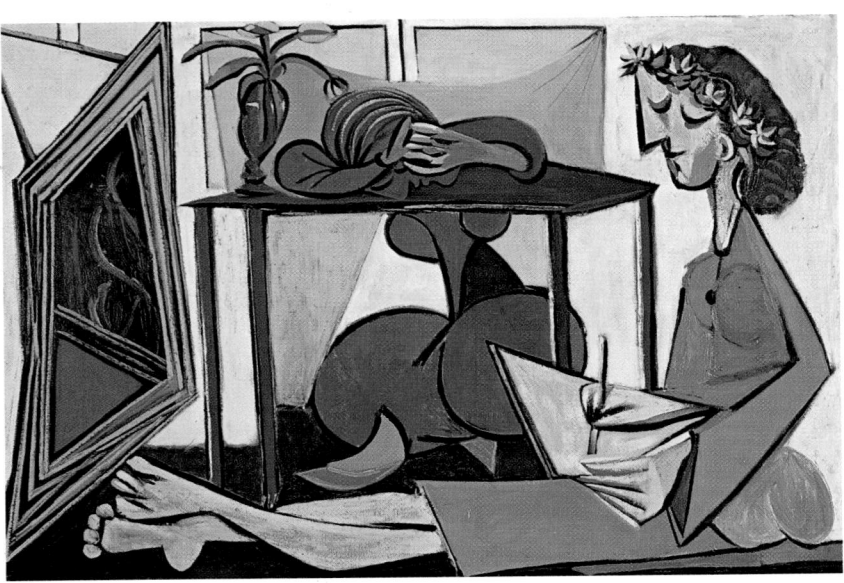

718

720

717 *The Muse,* 1935

718 *Two Women in an Interior,*
February 12, 1935

719 *French Poem ("Sur le dos de l'immense
tranche de melon ardente"),*
December 14, 1935

720 *Girl Drawing in an Interior,*
February 17, 1935

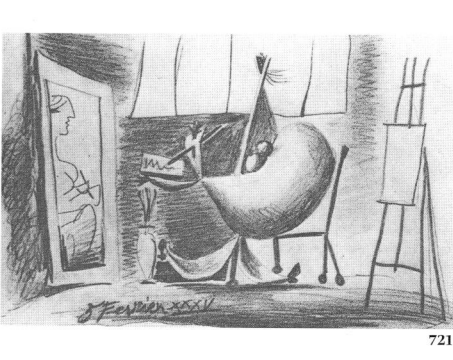

721

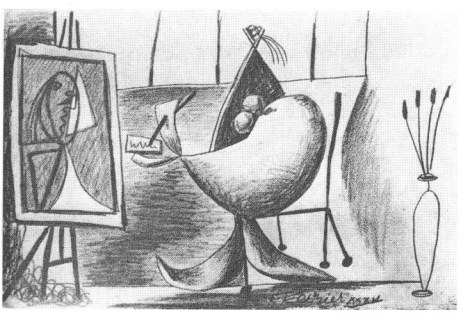

722

723

721 *Girl Drawing in an Interior,* February 5, 1935
722 *Girl Drawing in an Interior,* February 5, 1935
723 *Woman Reading,* January 9, 1935

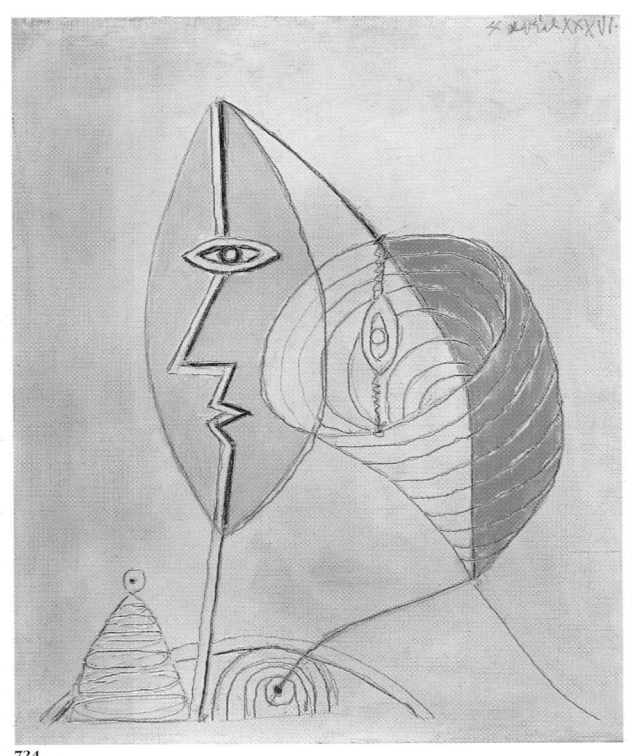

724

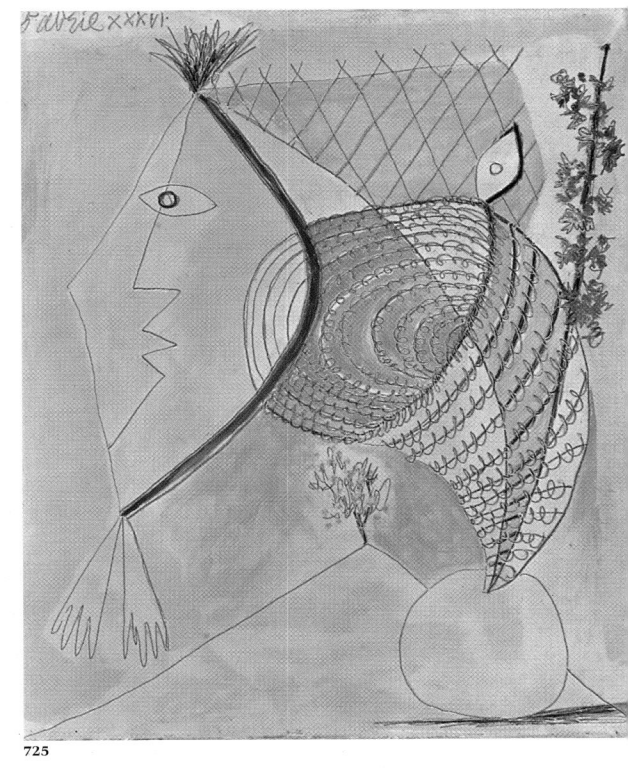

725

724 *Portrait of a Girl,* April 4, 1936
725 *Head of a Woman,* April 5, 1936
726 *Portrait of a Girl,* April 4, 1936
727 *Portrait of a Girl on an Old Food Box
and a French Poem on this Theme,* April 4, 1936

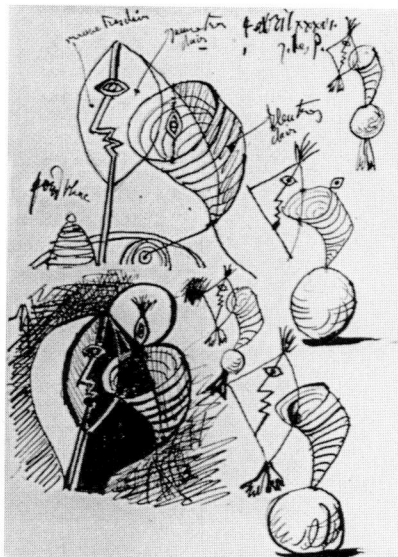

726

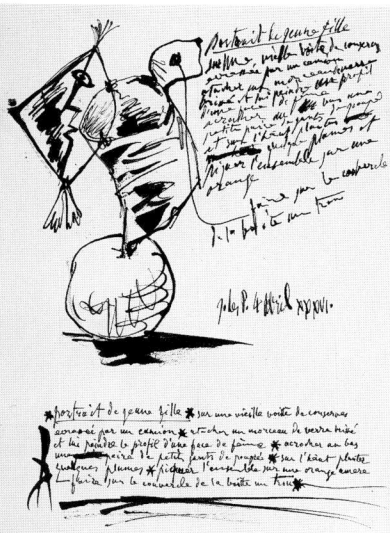

727

One and the Other

Just as the dialogue between painting, drawing, engraving, and sculpture was initiated at the beginning of the 1930s, so it would continue in 1936 between writing, drawing, and painting. Thus, on April 4, in Juan-les-Pins, Picasso drew and wrote a *Portrait of a Girl* (figs. 726 and 727) with India ink on a single sheet of Arches paper. That day and the following one, he would extract from it two slightly different paintings (figs. 724 and 725), which were very similar to the original sketches. The drawing gave way to writing and painting. In April 1936, Picasso often brought together writing and drawing on several pieces of Arches paper folded in half; he would draw in ink on the first page and write on the third.

The shipwreck theme, which had already been touched upon in paintings from 1932 (see figs. 650 and 651), reappeared in both a painting and a drawing in April and May 1936. On April 29, awash in blue, two naked women, each with Marie-Thérèse's profile and a very similar body hold each other (fig. 728), their pose suggesting an embrace as much as a rescue. The May 4 drawing presents a group of three intertwined bathers with a beach hut to the right, a typical attribute of the seaside. The multiple ink lines are like the accents of a pen used both for writing and drawing (fig. 731).

Until this point, the rescue theme had been exclusively female. However, in the drawings of May 6 and 28, one will note that the Minotaur is in a comparable situation, whether he carries a mare in his arms (fig. 744), or is himself carried wearing a Harlequin suit, by an eagle-headed figure (fig. 746). The Minotaur was indeed in distress in that spring of 1936: he has loaded some paintings, a mare, and a ladder into a wheelbarrow that he has to haul himself (figs. 729 and 730), as if he were moving. Years later Picasso would itemize this jumble for the photographer David Douglas Duncan[12]: "a framed painting that the Minotaur does not want to leave behind," a mare that has just given birth, a newborn with a small head and little red legs—an obvious allusion to Picasso, Marie-Thérèse, and Maya.

In March 1936, in an exhibition at the Galerie Paul Rosenberg, Picasso showed twenty-eight paintings made in 1934–35. The selection presented both his new and recent work. Marie-Thérèse was still the woman of choice, the woman whom Picasso would observe constantly, even in sleep. In an engraving from the Vollard Suite, dated June 12, 1936 (fig. 732), *Faun Unveiling a Woman*, the male seems to be unveiling her out of respect and adoration rather than lust. On April 25, in a painting completed at Juan-les-Pins (fig. 735), Marie-Thérèse sleeps in the shade of shutters painted in soft blue and green tones, and her sleep appears to be altogether confident.

However, the underlying violence that always animated Picasso's work would emerge in some paintings at this time to betray a growing inner tension. An amazing portrait of a woman, completed in Juan-les-Pins on May 1 (fig. 733), presents a wide-eyed face sticking out from an enormous neck; a straw hat with blue leaves accentuates the tragic-comic distortion of forms. And the large, contorted nude under a starry sky, painted between August and October 1936 (fig. 734), has the air of a hellish nightmare.

Nevertheless, drawings and paintings produced in the month of April at Juan-les-Pins attested to a tranquil happiness. Two ink drawings depict Picasso's new family (figs. 736 and 737). On April 7 a young woman appears, wearing a necklace; she resembles Marie-Thérèse, seated peacefully, her elbow resting familiarly on the shoulder of a bearded man wearing a hat; he holds a fishing net, like a wise old man carelessly holding the stitches of time. On April 23, the bearded man is leaning against a balcony balustrade; he has put down his Minotaur mask, which he holds in his hand like an accessory that has become useless. The young woman, who like him wears a laurel crown, holds the child (Maya) in her arms. The setting, the tunics, and the figures with laurels on their heads give this scene a classical serenity.

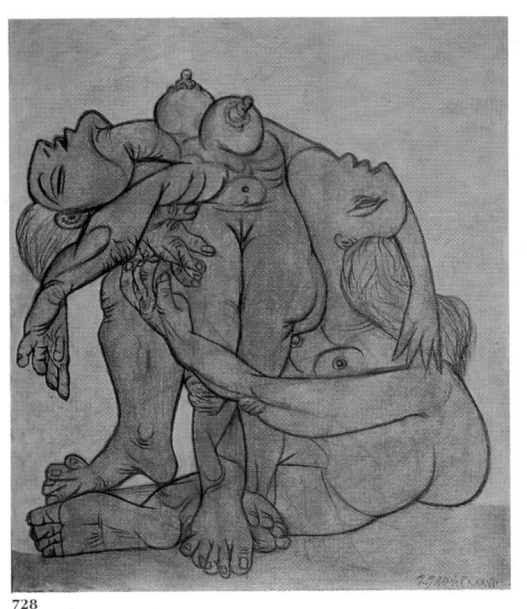

728

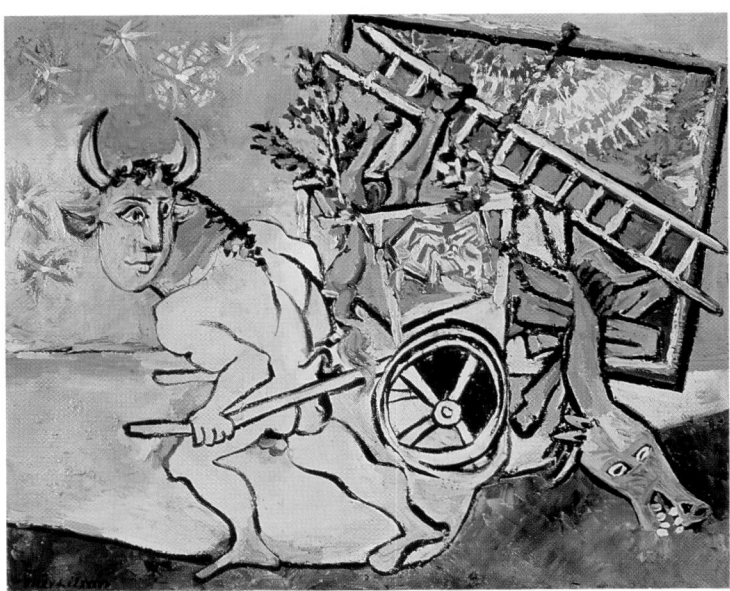

729

730

731

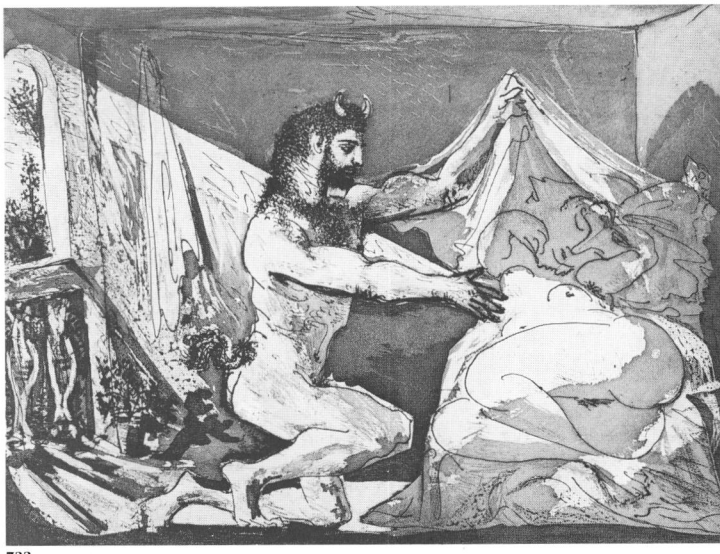

732

298

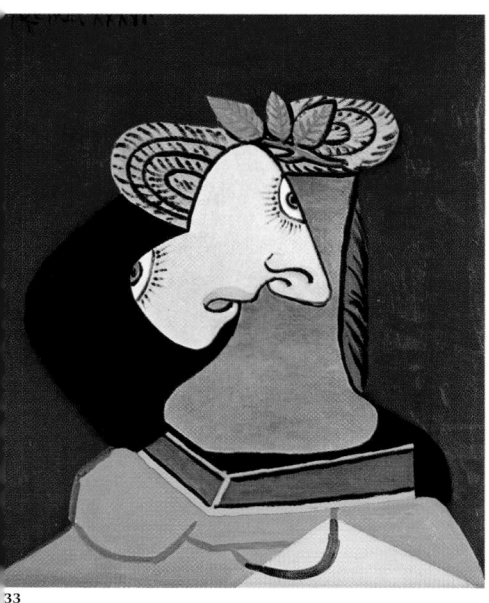

33

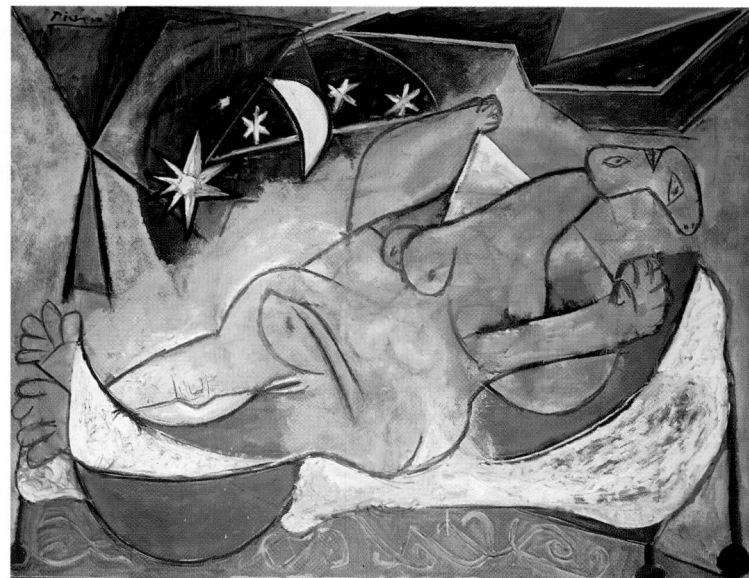

734

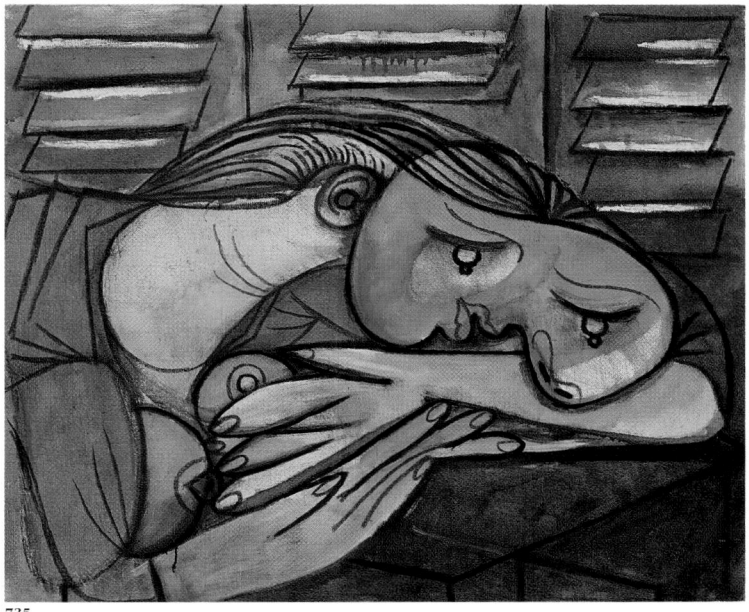

735

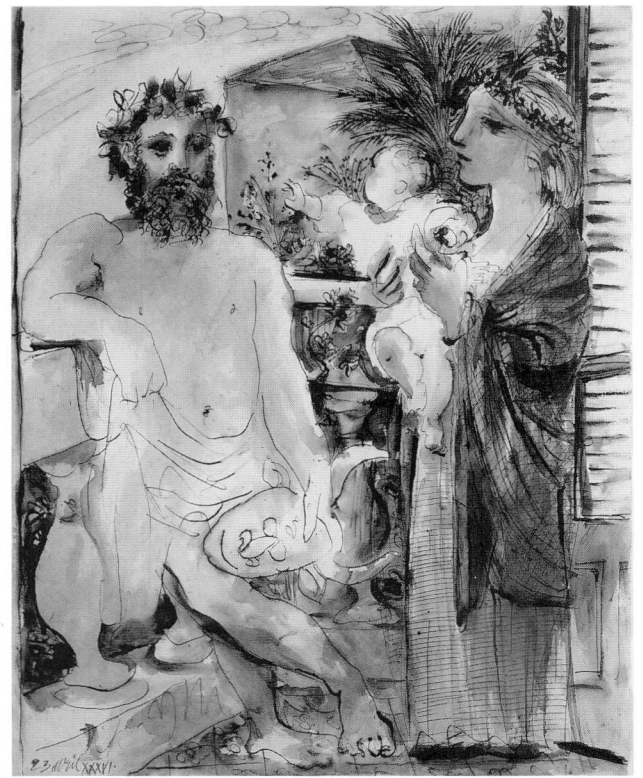

736

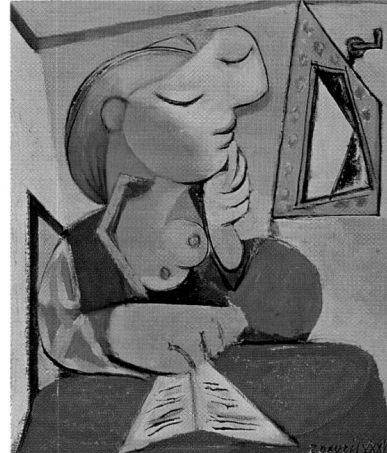

738

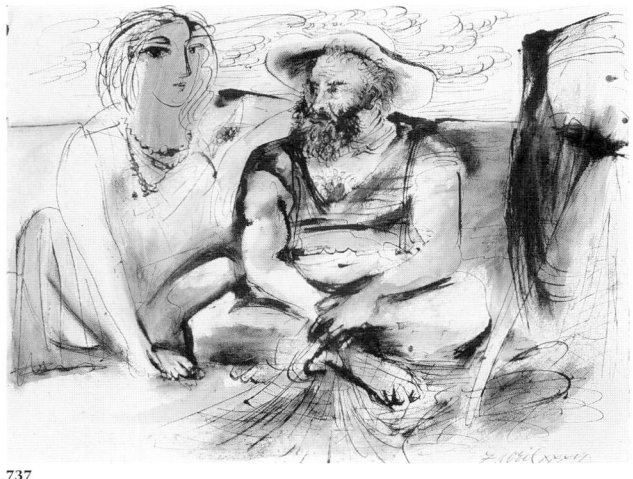

737

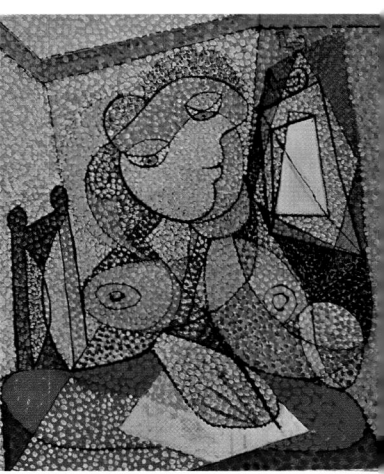

739

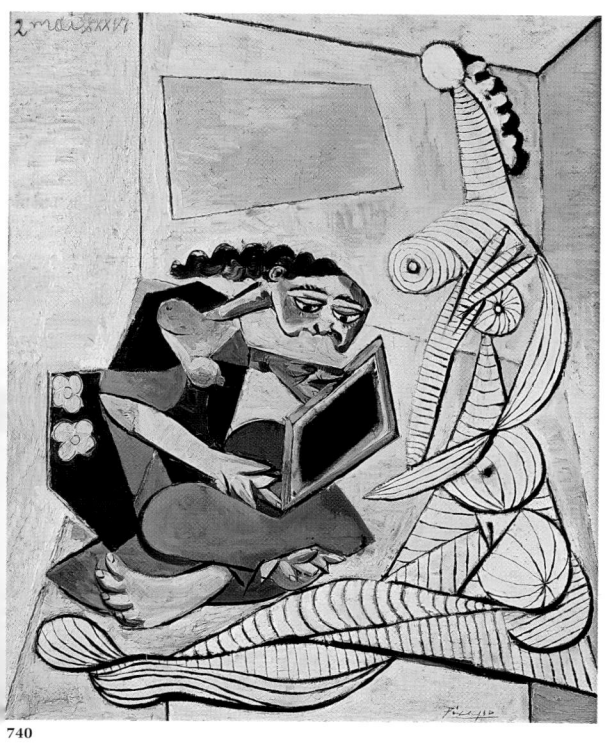

740

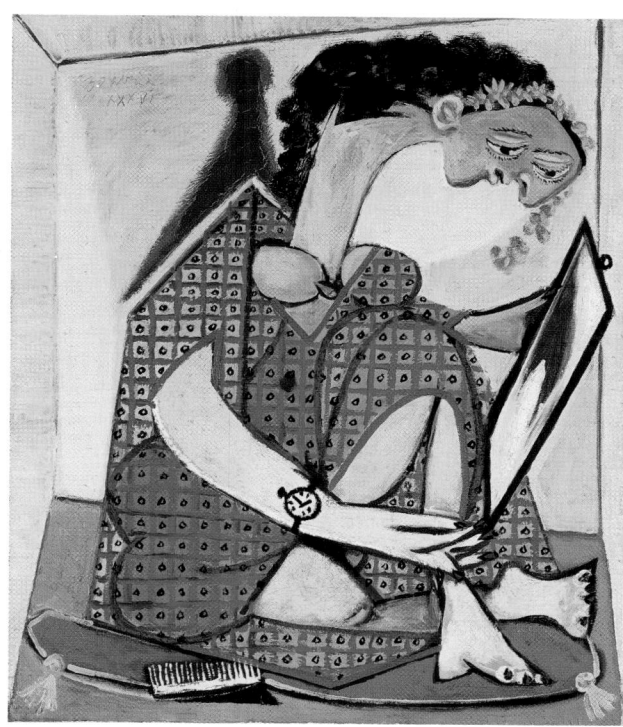

741

736 *Man with a Mask, Woman with Child in Her Arms,* April 23, 1936
737 *Couple,* April 7, 1936
738 *Portrait of a Woman,* April 20, 1936
739 *Portrait of a Woman,* April 22, 1936
740 *Women in an Interior,* May 2, 1936
741 *Woman with a Watch,* April 30, 1936

301

In two paintings from April 20 and 22 (figs. 738 and 739), Marie-Thérèse, her breast bare, appears reading or writing at a table covered with a red cloth. The fresh color and the Pointillism add to the charm of these intimate portraits. In the upper right corner, the mirror is merely a decorative element. However, in two other paintings, a brunette, not the blond Marie-Thérèse, leans anxiously toward her mirror; one wonders if she is trying to read the future, asking questions that at first seem uneasy and then anguished (figs. 740 and 741). In the latter, painted on April 30, a garland falls from her brow and a comb rests on a cushion, distant references to the coiffure theme: here the mirror reflects only a black-and-white shadow. There is an unusual watch on her arm, to remind us that time is passing. The few bold orange lines on the blue-and-green dress are not enough to enliven the figure. Picasso later said to David Douglas Duncan about this painting (fig. 741): "This was the worst period of my life."[13] On May 2, the sense of fear seems to have increased. The brunette, now without garland, comb, or watch, looks in vain for her image in the mirror, which has turned completely black: hunched over, absorbed in her search, she does not seem to notice an anonymous twin, wrapped in cloth strips, standing near the mirror right before her, like a giant mummy. The large colored drawings from May 1936 also present us with tormented scenes that have menacing overtones. These are as much images of the Minotaur's adventures as they are a disparate series, masked in fantasy, echoing the painter's interior life.

On May 6 (fig. 744), the Minotaur and the mare reappeared, as they had a month earlier in the April 5 drawing (fig. 730). With a cave, an archaic version of the beach hut, Picasso reintroduces the idea of inside and outside. Marie-Thérèse, crowned in a garland of flowers, watches the scene (or is she hiding from it?) from behind a veil. The Minotaur's hand seems to prevent her (or protect her) from seeing the scene; she adds her open palm to the two hands emerging from the cavern. This gesture has at least one precedent in Picasso's painting, which dates back to the Rose Period, where we see two strange hands coming out of a fumarole in *The Actor*, painted in the winter of 1904–5 (see fig. 149).

In the drawings of May 8 and 9 (figs. 742 and 745), the Minotaur has been wounded in an enclosure—a kind of corral—along the seashore. A comparison of the two drawings enables us to trace the evolution of the image. In both, a woman on a horse holds a lance pointing toward the sky, while a woman wearing laurels appears behind the sail of a small boat. On May 10 (fig. 743), the wounded Minotaur seems to be dying. The horse is in flames, and the young woman leans over a wall, watching the scene. A young boy (who was standing in the boat the day before) has distanced himself here and is now merely a silhouette on the horizon.

In two later drawings, from May 28 and August 5, a square tower reappears at the right. On May 28 (fig. 746), two couples meet in the distance: in the foreground, an eagle-headed man holds the Minotaur hide, dressed here in a Harlequin costume. Behind them, a bearded man with horselike hair carries on his shoulders a young man crowned with a garland. Both raise their arms and stretch out their hands, one closed, holding a stone, and the other open. This drawing would later be enlarged as the drop curtain for Romain Rolland's *14 Juillet* that same year, an event that deserves a brief explanation. After the victory of the Front Populaire in the 1936 elections, Jean Zay, Minister of National Education; his adviser, the poet Jean Cassou; and Léon Moussinac and Louis Aragon, heads of the Maison de la Culture, wanted to commemorate Bastille Day in 1936 with an original show.[14] In 1936 Rolland's play, which had been written in 1901 and produced the following year, was set to music by composers who, according to the program, included "some of the greatest representatives of contemporary music: Georges Auric, Arthur Honegger, Jacques Ibert, Charles Koechlin, Daniel Lazarus, Darius Milhaud, Albert Roussel." Picasso's gouache was faithfully transposed by his friend the painter Luis Fernández and made into a curtain measuring about thirty-three feet high and fifty-five

742

743

742 *Wounded Minotaur, Rider, and Figures,* May 8, 1936

743 *Wounded Minotaur, Horse, and Figures,* May 10, 1936

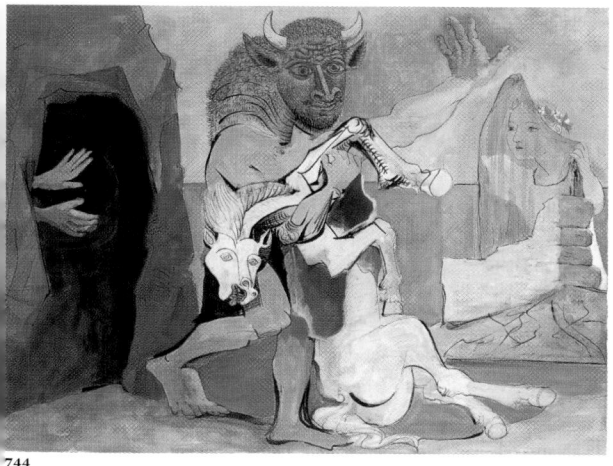

744

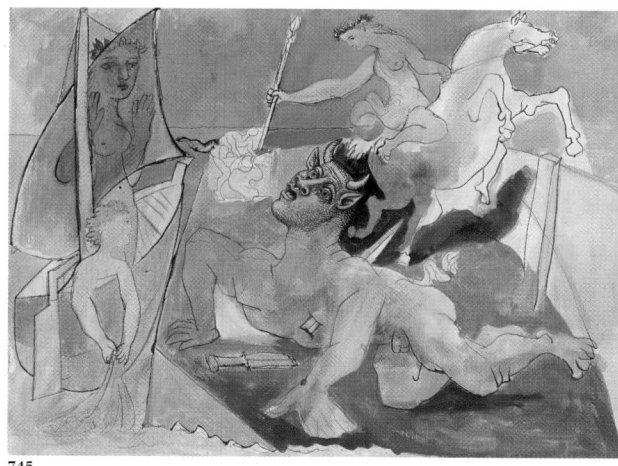

745

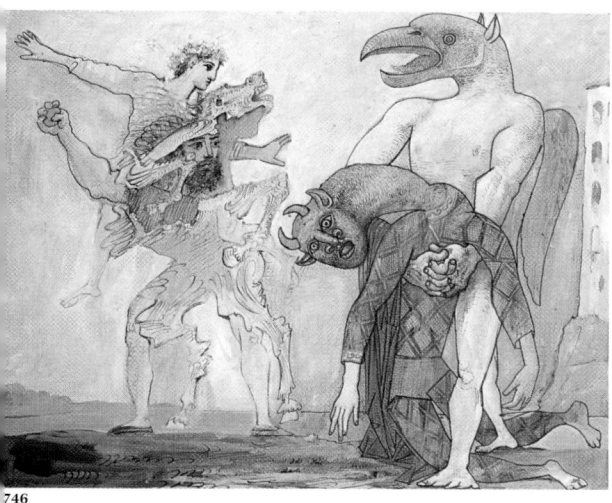

746

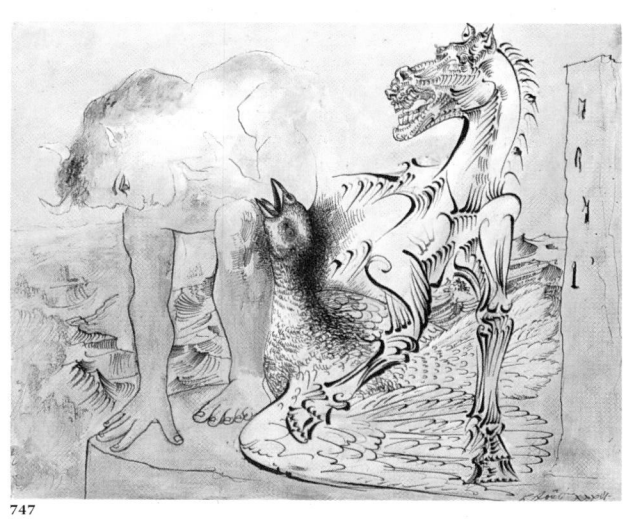

747

744 *Minotaur and Dead Mare Before a Cave Facing a Girl in a Veil,* May 6, 1936

745 *Composition with Minotaur,* May 9, 1936

746 *The Body of the Minotaur in a Harlequin Costume,* May 28, 1936

747 *Faun, Horse, and Bird,* August 5, 1936

748

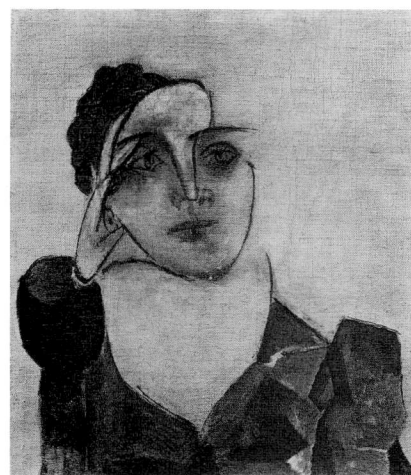

749

748 *Portrait of Woman (Marie-Thérèse),* July 28, 1936
749 *Portrait of Dora Maar,* November 19, 1936
750 *Still Life with a Lamp,* December 29, 1936

750

feet in length. As a finale to this drawing series, there appeared on August 5 three beings enclosed in one three-headed character—a faun, a horse, and a bird (fig. 747). As in the May 4 drawing (fig. 731), the horse is composed here of black lines (which also form the bird's feathers) that are reminiscent of punctuation, such as accents, commas, hyphens, and even question marks.

Producing one figure after another, Picasso never stopped dividing up the unified image and developing its many facets. He also worked in the opposite direction: if the image were multiple, he unified its multiple parts. One figure seems to dominate the others; a new inspiration has clearly made her way into his painting. Picasso had met Dora Maar in 1935[15]; she went with him to Mougins in the month of August, 1936. A friend of the Surrealists and a photographer (fig. 749), she was born in 1907, three years before Marie-Thérèse (fig. 748). In contrast to Marie-Thérèse's kindness, Dora would embody the torment of the violent years that had just started with the civil war breaking out in Spain on July 18. By the disastrous end of the year 1936, like the December 29 painting *Still Life with a Lamp* (fig. 750), Picasso, the ambivalent one, found himself again torn between two mistresses: after Olga and Marie-Thérèse came Marie-Thérèse and Dora.

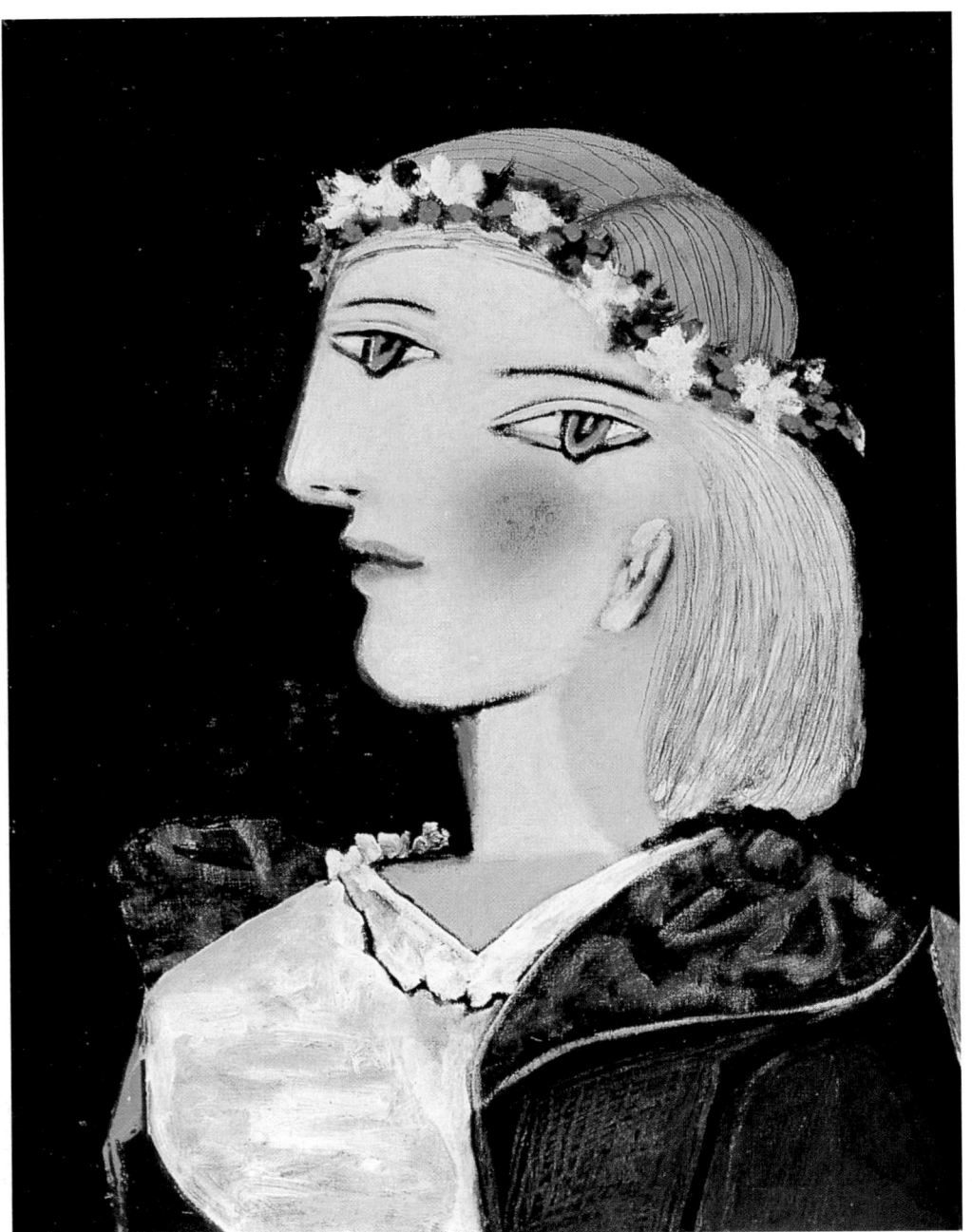

751

1937–1944

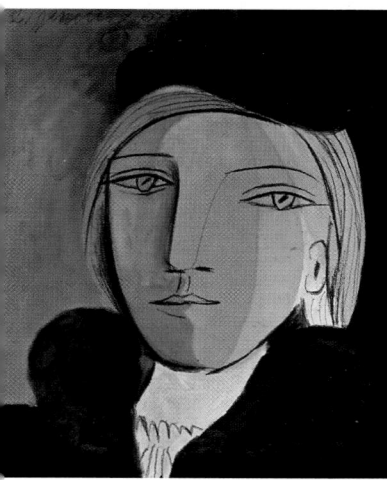

52

During the war years, first the Spanish Civil War and then World War II, Picasso continued to paint and sculpt with a ferocious and determined will. His work was productive, and it yielded major pieces: the universally known masterpiece *Guernica* in 1937, *Night Fishing in Antibes* in 1939, *Large Nude Doing Her Hair* in 1940, *L'Aubade* in 1942, as well as the sculpture of *Man Carrying a Sheep* in 1943.

Moreover, this heroic period would turn an artist superstar into the century's public idol. Picasso was already a famous painter among others, such as Matisse or Chagall. *Guernica* would transform this well-known artist into a popular symbol of freedom, an emblem of intellectual and moral resistance against the forces of oppression. What was at play in between 1937 and 1944 is less conclusive for his painting than for the painter himself. After the Liberation of Paris, Picasso would no longer be merely a figure in the art world; he would become a universal legend.

The reason for this phenomenon is that Picasso's plastic art, until then a simple means of autobiographical expression, began to resonate with the century, to become the expression of an era. The convulsions of his individual imagination coincided with those of historical reality. Picasso's painting no longer reflected nature. It reflected history.

This transition to the epic eluded his Spanish colleagues, who left their studios only to paint nature and for whom painting remained painting. Picasso did not paint nature, but the suffering of the men and women of his time, creating from it beauty and truth. "How is it possible to lose interest in other men and remove yourself to an ivory tower from a life that brings you so much? No," he would tell Simone Téry in 1945, "painting is not made to decorate apartments. It is an offensive and defensive instrument of war for use against the enemy."[1]

Picasso, an individualist hungry for solitude, equipped with an anarchistic, capricious sense of humor, was not inclined to be politically involved. The war of 1914–18 affected him mostly in that he lost several friends who had been sent to the front. "Picasso was the most apolitical man I knew," Kahnweiler told an interviewer. "I remember that in the past, a long time ago, when I asked him who he was in terms of politics, he answered. 'I am a royalist.' In Spain, there is a king, 'I am a royalist.'"[2]

It was Franco's uprising against the Republic and the Popular Front on July 18, 1936, that would bring Picasso out of his "aesthetic narcissism," for which several progressive intellectuals had criticized him. At this time in the Soviet Union, according to Christian Zervos, it was agreed that Picasso's work was one of the last manifestations of "bourgeois art."[3] In a book that she dedicated to Picasso a year later, Gertrude Stein, who liked to stress the Hispanic nature of her friend, commented on his sudden political involvement in 1937: "It was not the events themselves that were happening in Spain which awoke Picasso, but the fact that they were happening in Spain, he had lost Spain, and here was Spain not lost. . . ."[4] He traveled to his native country in 1933 and 1934, but when critics in Madrid called him a representative of the foreign avant-garde, the Director of Fine Arts of the Spanish Republic asked the embassy in Paris to investigate whether Picasso had or

51 *Marie-Thérèse with a Garland,* February 6, 1937

52 *Portrait of Marie-Thérèse,* January 21, 1937

had not kept his Spanish nationality. This question did not stop a new Director of Fine Arts from naming Picasso director of the Prado Museum in September 1936.

About Guernica

At the end of 1936, Dora Maar, who was living on the rue de Savoie, found a new studio for Picasso nearby at 7 rue des Grands-Augustins. Coincidentally—and this must have greatly appealed to the painter—this seventeenth-century building was the very one in which Balzac had set the story of *Chef-d'Oeuvre Inconnu,* and Picasso moved in at the beginning of 1937. He had met Dora Maar through Paul Éluard, with whom he had a special bond, which came about at André Breton's expense. Éluard had just violated the Surrealist taboo of "poetry of circumstance" by publishing, on December 17 in *L'Humanité,* a political poem entitled "Novembre 1936." In January 1937, Picasso was commissioned by the Spanish government, through Luis Araquistain, the Spanish ambassador in Paris, to create a large painting for the future Spanish pavilion at the Exposition Internationale des Arts et Techniques, which had been in preparation since 1934. José Bergamín would write in *Cahiers d'Art* in 1937: "Our current war for Spanish independence will give Picasso a full awareness of his pictorial, poetic, and creative genius, just as the other one had given Goya."[5] For the time being, on January 8 and 9 Picasso was happy to engrave two plates that recounted misadventures of the Spanish dictator as part of a grotesque world, similar to a comic book. These plates were originally intended to be published as postcards to raise funds for the Spanish Republic. They were finished on June 7 (see figs. 766 and 767) and were used to illustrate the text of *The Dream and Lie of Franco,* which Picasso wrote between June 15 and 18.

In the fall of 1936, Marie-Thérèse and Maya moved to Tremblay-sur-Mauldre, into a studio offered to Picasso by Ambroise Vollard. The painter, who was forced to give up Boisgeloup to Olga, met them there every weekend, when he could work there in peace. On February 16, he completed a portrait of Marie-Thérèse seated cross-legged, radiating serenity (fig. 754). The usual elements: the mirror, here resting on the floor, and the open window with a wrought-iron guardrail. In the spirit of his relief-paintings, Picasso playfully created a still life made up of objects attached to the canvas and then covered with paint (fig. 755). A photograph of the piece by Dora Maar was published in the *Dictionnaire Abrégé du Surréalisme* in 1938.

Despite his new relationship with Dora Maar, the painter continued to be moved and fascinated by Marie-Thérèse's face, which he had first encountered ten years earlier. He painted portraits of her using delicate or bright colors, wearing either a beret (fig. 752) or a garland of flowers, viewed in profile and frontally at the same time (fig. 751). In a drawing of December 17 (fig. 753), using the same principle and combining the two eyes with the nose, he depicted two heads, a woman and a man, that were suggestive of Marie-Thérèse and Picasso.

In 1937 the painter alternated between his two muses. Marie-Thérèse, the blonde, is rendered in soft, light, graceful strokes of colors that match her fluid, round shape (figs. 756 and 757). By comparison, Dora Maar, the brunette, is presented in violent, contrasting colors, such as red and black, in forms that meet at sharp angles (fig. 758). The pose in two of these Women in Armchairs (figs. 757 and 758) is the same, although inverted along the right and left side: an arm resting on the arm of the couch, a hand raised to the face.

At the end of July, it was with Dora Maar that Picasso went to Mougins, a small village above Cannes whose charm he would render in certain sun-drenched paintings (fig. 761). They stayed in the Hôtel Vaste-Horizon, where they were joined by Roland Penrose, his wife the photographer Lee Miller, and Paul and Nusch Éluard. Picasso finally completed

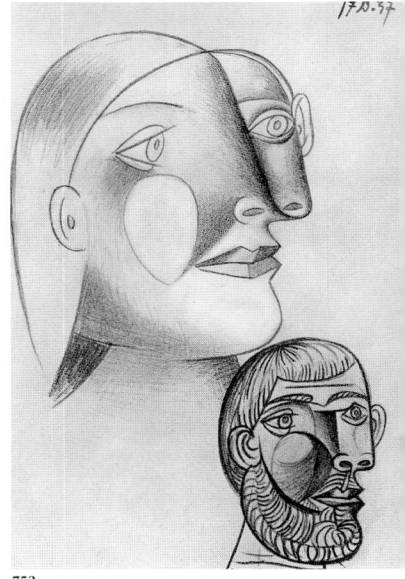

753

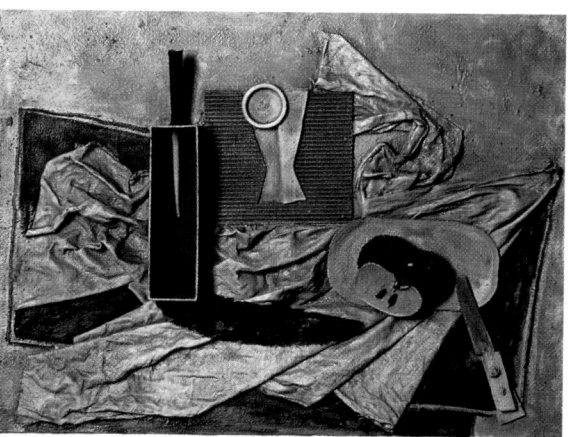

754

755

753 *Female and Male Profiles,* December 17, 1937
754 *Woman at the Mirror,* February 16, 1937
755 *Still Life with an Apple,* February 1937

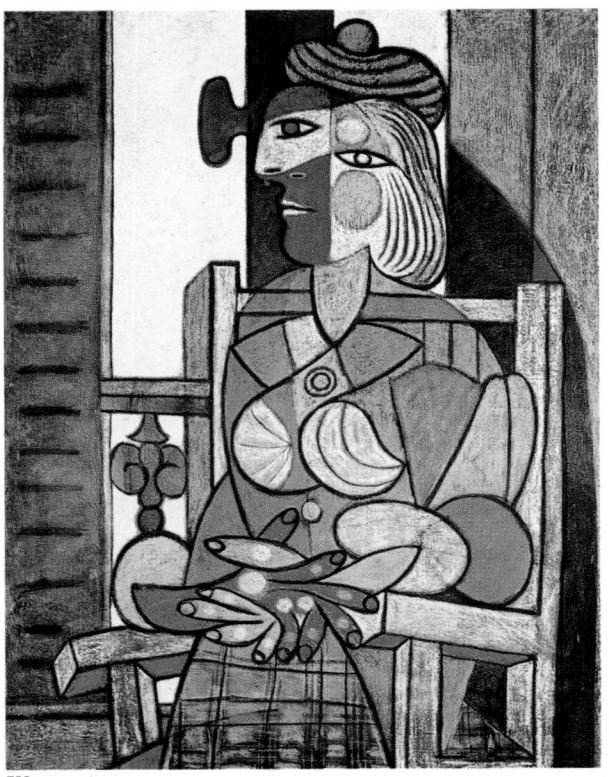

756

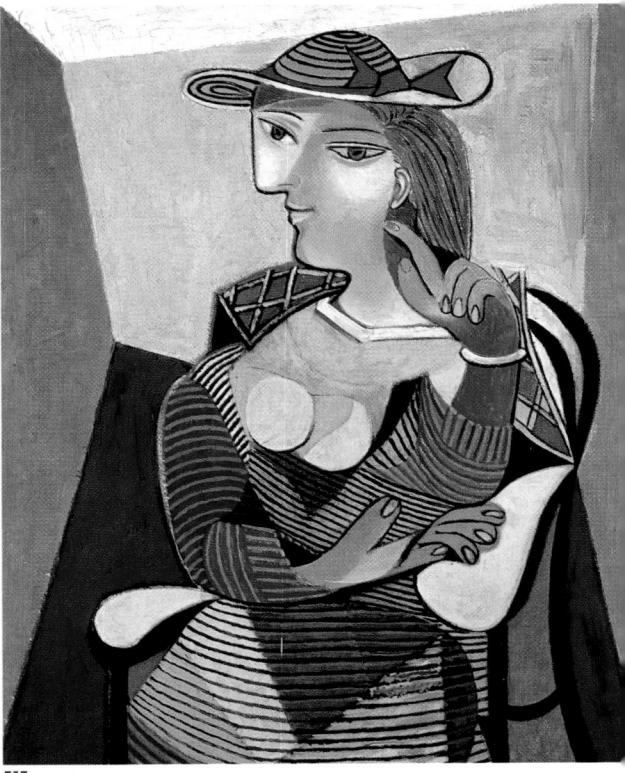

757

756 *Woman Seated Before the Window,*
March 11, 1937

757 *Portrait of Marie-Thérèse,* January 6, 1937

758 *Portrait of Dora Maar,* 1937

759 *Portrait of Nusch Éluard,* 1937

760 *Portrait of a Woman,* December 8, 1937

761 *Houses and Trees,* September 4, 1937

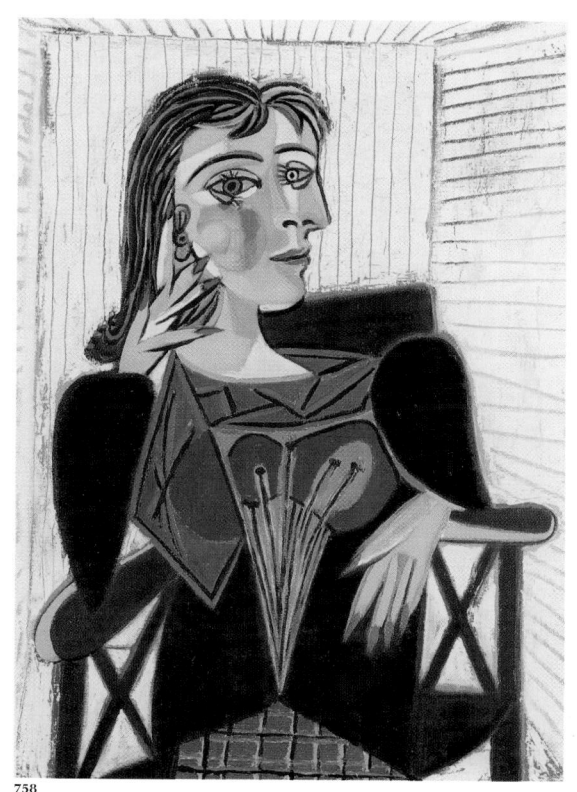

758

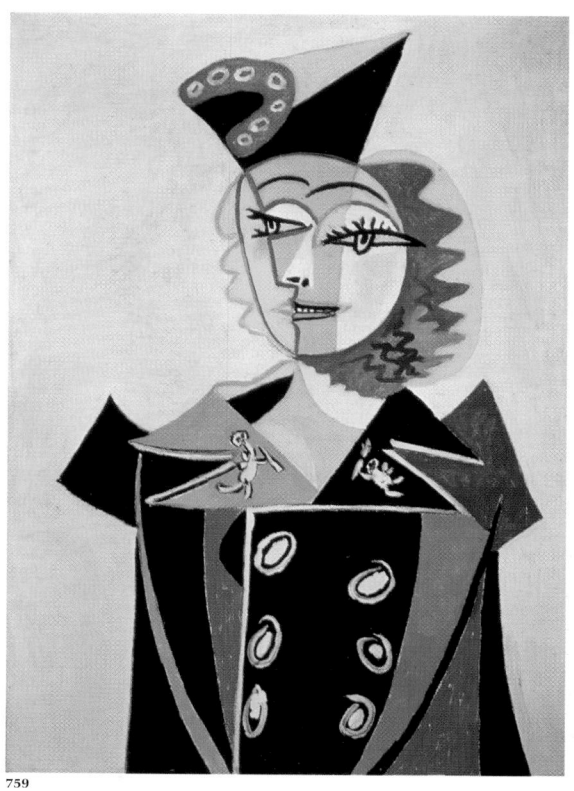

759

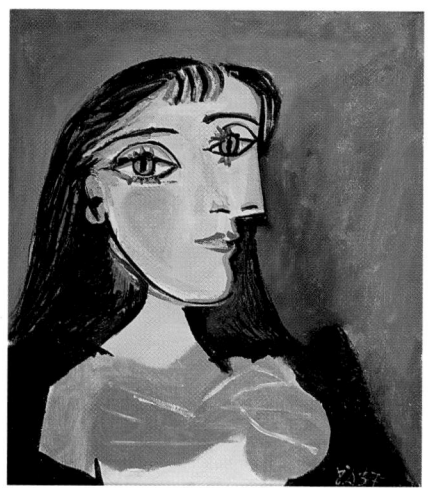

760

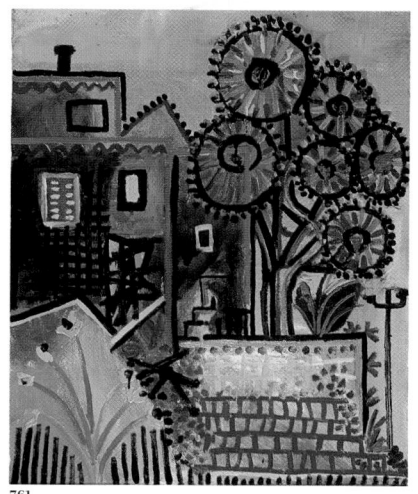

761

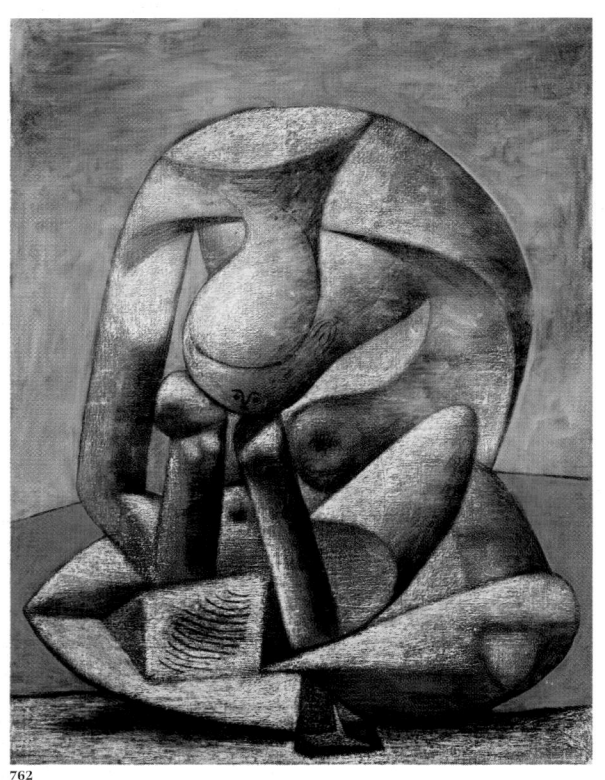

762

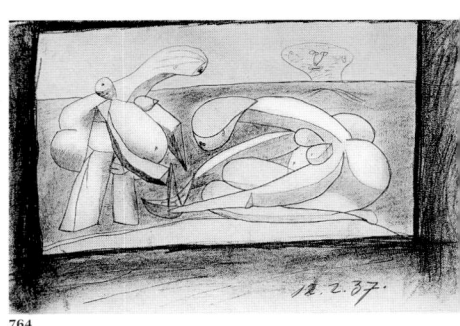

764

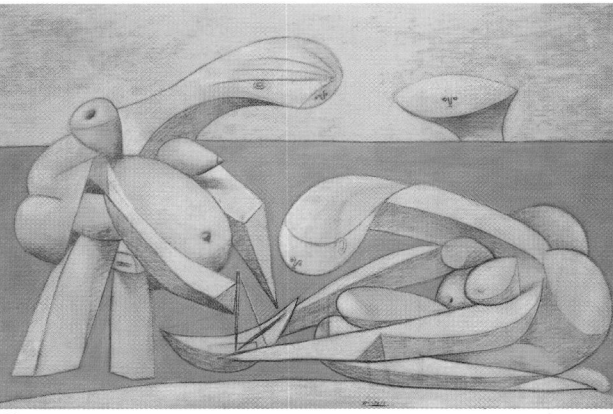

765

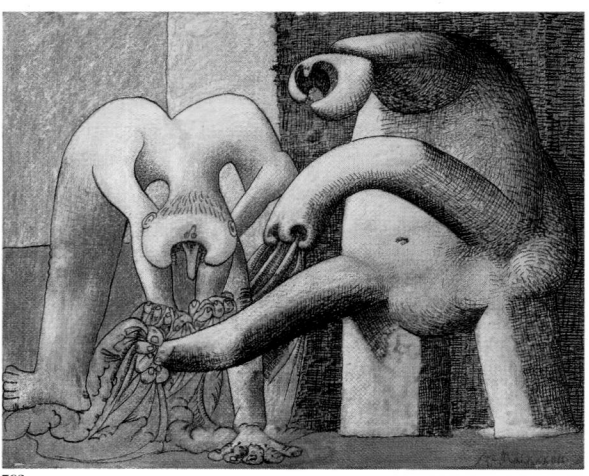

763

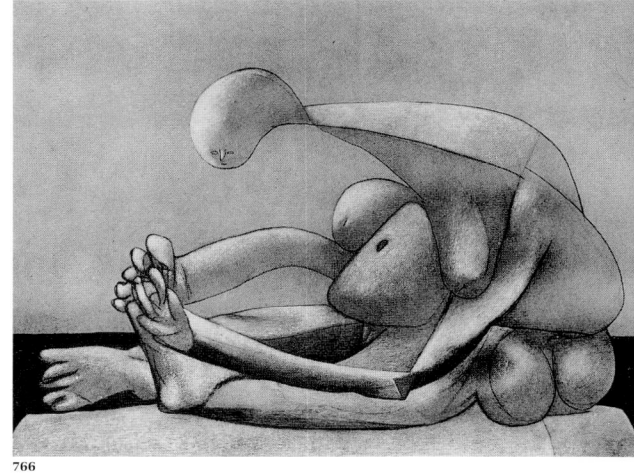

766

a masterly portrait of Nusch wearing a toque, her face crowned in yellow gold; she elegantly sports a garment with large black, green, and blue lapels (fig. 759). In 1939, in numbers 5–10 of *Cahiers d'Art*, Picasso's painting would illustrate a poem that Éluard had dedicated to her: "I want for her to be queen!"

The bathers at the seashore reappeared in a few works during 1937. They are in the same family as the 1933 *Seated Nude* (see fig. 676) and the 1931 beach nudes: monumental stone figures with cleverly arranged forms. The *Large Bather with a Book* of February 18 (fig. 762) is also painted in chalky tones, beige highlighted with white against a background of blue sea and sky, but the pose is different: here the figure is coiled inward, contained entirely within an oval form.

Instead of playing with a ball or jumping in the air, the bathers bend and fold in on themselves, their faces against the ground, overwhelmed. The *Two Nudes on the Beach* of May 1 (fig. 763) no longer embrace each other in a voracious kiss, as in 1931, but revel in a sticky substance, vaguely reminiscent of a towel that has been lifted by the handful. The open mouths and outstretched tongues seem ready to gulp this shapeless manna, as if the monsters were ravished with hunger. Their gluttony suggests the bull devouring the innards of the gored horse in the bullfight pictures of 1934.

The female body folded into an oval shape is no longer vertical, as in the *Large Bather;* in *Woman Seated on the Beach* (fig. 766), it is stretched horizontally. Here again, the spherical head approaches the feet, as if the woman were rounding her back: her neck, arms, and legs stretch out, while the curving forms of her torso are totally feminine. The figure at the right takes the same pose in *Bathing,* this time holding a small boat (fig. 765). Compared to the reduced dimensions of the toy, the size of the figures, which take over the canvas, is even more impressive. Furthermore, the head of a sea monster watching the game appears on the horizon with a sense of both humor and menace.

Another head reappears on the horizon in a shipwreck scene (fig. 767) that draws inspiration from the same theme touched upon in the years 1932–36. In this drawing of March 1937 (fig. 762), the Minotaur carrying a woman's body (Marie-Thérèse?) in his arms also suggests the image of the Minotaur carrying the mare in the May 6, 1936, drawing (see fig. 744). But several female heads emerge from the water (including one at the left who is taller than the rest and reminiscent of Dora Maar) to watch the scene. To the right, a raised arm again seems to call for help.

In a pastel drawing of February 19, the Minotaur, who has placed one foot in the small boat, seems rather threatening (fig. 769). At the left, a woman with a winged brow is carrying in her arms a woman with Marie-Thérèse's profile. In the background, a third female figure, whose hands are tied to the mast of the boat, appears to be the Minotaur's ill-fated prisoner. One wonders if these represent Dora Maar (whom Picasso would depict several times as a bird), Marie-Thérèse with her very recognizable profile, and Olga, the monster figure.

The dramatic tension that burst forth in *Guernica* (fig. 782), which was painted during May and June of 1937, would endure long after the summer of that year. In two drawings dated October 23, a vigilant horse is stricken with extreme fear. In one (fig. 768) the horse stands in a state of alert in the foreground, its eyes steady, its nostrils flared and palpitating. The size of the horse is out of proportion with the mountainous horizon and the tree planted at the left, which gives the animal an incredible presence. In the other drawing from the same day (fig. 770), the scene takes places in the arena: the horse stands still under the command of the man in red, who holds a whip in his right hand. With his head turned toward the spectators, the man seems to be waiting for a verdict of cruelty or clemency. His profile is framed by two female heads: to the right, a woman cries out, deformed with hate; in the left corner is Marie-Thérèse's serene face, which the man searches desperately with his eyes.

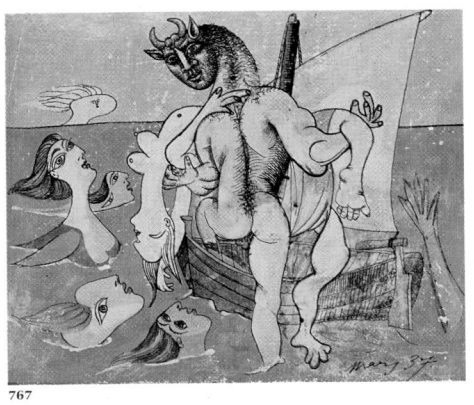

767

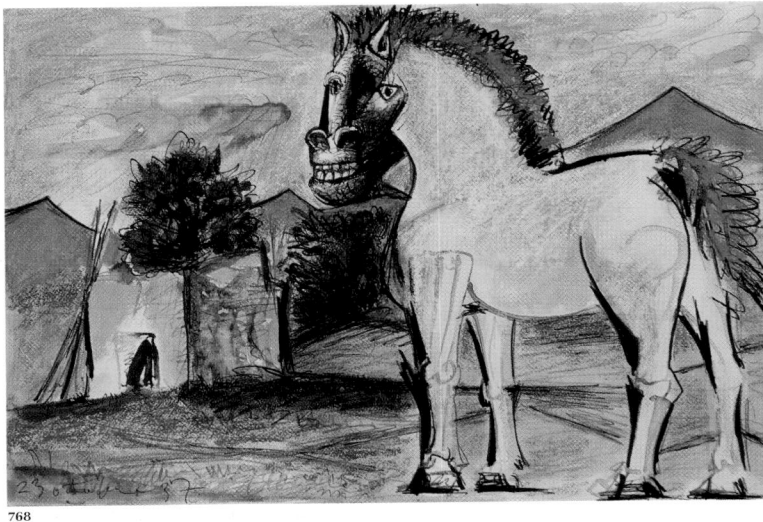

768

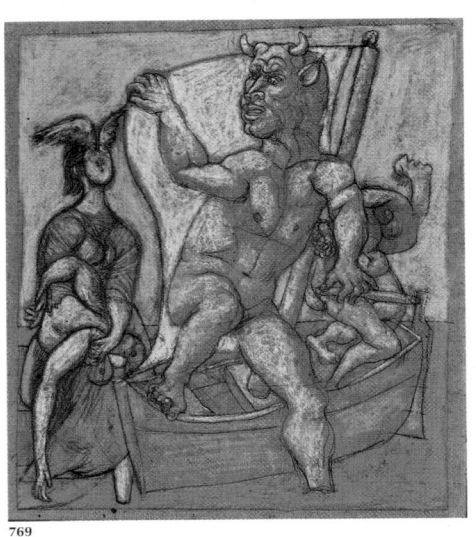

769

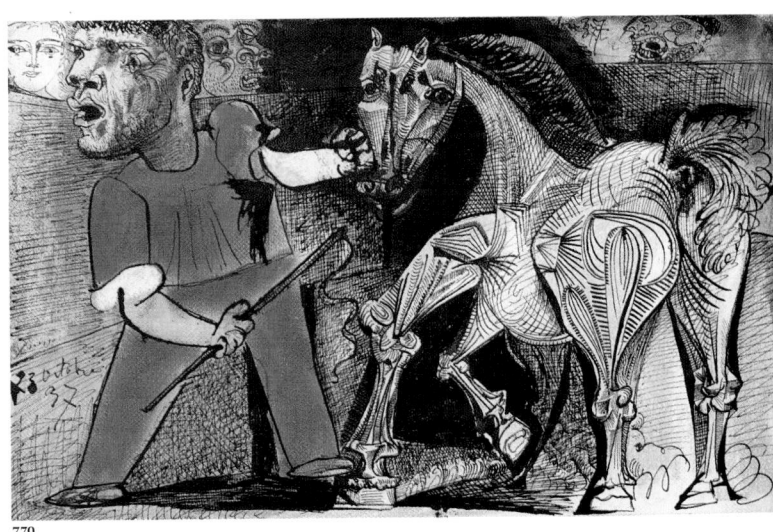

770

767 *Bathers, Mermaids, Nude, and Minotaur,* March 1937
768 *Horse Before a Landscape,* October 23, 1937
769 *Minotaur in a Boat,* February 19, 1937
770 *Man Holding a Horse,* October 23, 1937

Poised between Dora and Marie-Thérèse, Picasso still had to think about the commission from the Spanish Republic for the Exposition Internationale, and current events would provide a tragic pretext. Monday, April 26, was a market day in Guernica, when many peasants from the area came to this city of ten thousand, the historical capital of the Basque country. About twenty miles away, General Mola's fifty thousand men were marching forward. On March 30, he had declared: "I have decided to end the war in the north quickly. Those who are not guilty of murder will have their lives spared, and their property will be maintained. But if submission is not immediate, I will completely destroy the Biscay." In the afternoon of that day, waves of planes from the Condor Legion, Heinkel 51s and Junker 52s piloted by Germans, trailed each other over Guernica. By nightfall Guernica was an inferno. In the days that followed, about 1,660 corpses and 890 wounded were found in the rubble. Eyewitnesses recounted the horror to foreign journalists, and in Paris Picasso read on the front page of *Ce Soir*, dated May 1, an article entitled "Visions de Guernica en Flammes [Images of Guernica in Flames]," illustrated with black-and-white photographs. Picasso had found his subject.

From May 1 to June 4, he made no fewer than forty-five drawings on blue or black paper. The principle elements of the final painting were present as early as the first studies (figs. 775–777): the bull, the horse, classic bullfighting figures, and the lantern stand from the 1935 *Minotauromachy*.

After sketches for the overall composition came the detail studies: the heads of the horse and the bull and then the weeping women (figs. 773, 774, 778, and 779). He worked obsessively on this last motif between July and October in several paintings, drawings, and engravings (figs. 783–787). The weeping woman was inspired by Dora Maar, about whom Picasso would tell André Malraux: "Dora, for me, has always been a woman who weeps."[6] Dora watched the large fresco gradually evolve in the Grands-Augustins studio from May to June: starting on May 11, she photographed the major stages (figs. 780–782). The huge canvas, with its severe black-and-white composition, was ultimately installed in the Spanish Republic pavilion for the Exposition Internationale, which opened in July.

Picasso did not renounce his pictorial vocabulary when he put painting at the service of history but he dealt with history using his own weapons. *Guernica* does not describe the event as a history painting would. It does not represent a regional scene with planes and bombs. Neither narrative nor figurative, this painting, as it turned its back on reality, shocked supporters of social realism and propaganda art in France and Spain at that time. They were expecting a call to arms, and, as Michel Leiris wrote in *Faire-Part* in 1937, they received a letter of condolence: "In a black-and-white rectangle, the kind in which classical tragedy comes to us, Picasso has sent us our bereavement letter: everything that we love is going to die. And that is why it was necessary at this point that everything we love be embodied in something unforgettably beautiful, like the emotion of a final farewell."[7] It was time that made *Guernica's* austere beauty apparent, a perspective beyond the historical event that triggered the image. Although critics applauded, the general public remained perplexed. Jean-Paul Sartre himself spoke of a *moral* painting, "a handsome classical and mythological painting that reminds of events, but says nothing of them," since it "transforms horror into abstract figures."[8]

This powerful imagery, which so quickly became a classic, the most popular of the modern classics, came from the encounter of an interior vision and outside spectacle, between a wild subconscious and a wild reality. The entire array of the painter's fantasies is here, coinciding with the objective violence of history. The simplicity of opposites—black/white, masculine/feminine, war/peace, creation/destruction, Eros/Thanatos—which crystallizes everything before our eyes in a format as large as a billboard, makes *Guernica* readable, tangible, and intelligible throughout the four corners of the world. It is not the atrocity itself, which is hardly shown, but the radical pictorial vocabulary that

771

772

771 *The Dream and Lie of Franco,*
 January 8, June 7, 1937

772 *The Dream and Lie of Franco,*
 January 9, June 7, 1937

773 *Studies for "Guernica": Hooves and
 Heads of a Horse,* May 10, 1937

774 *Study for "Guernica": Horse's Head,*
 May 2, 1937

775 *Study for Composition of "Guernica,"*
 May 1, 1937

776 *Study for Composition of "Guernica":
 Horse and Mother with a Dead Child,*
 May 8, 1937

777 *Study for Composition of "Guernica,"*
 May 9, 1937

773

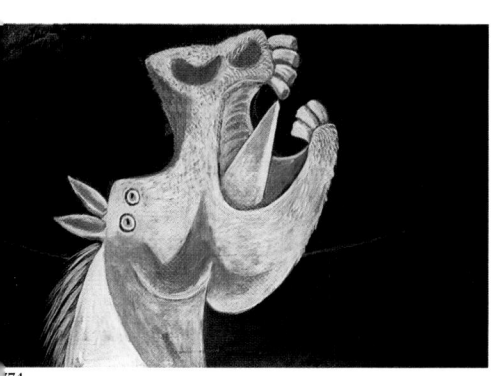

774

775

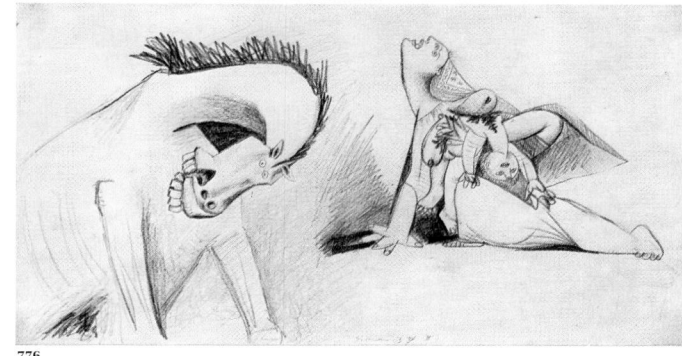

776

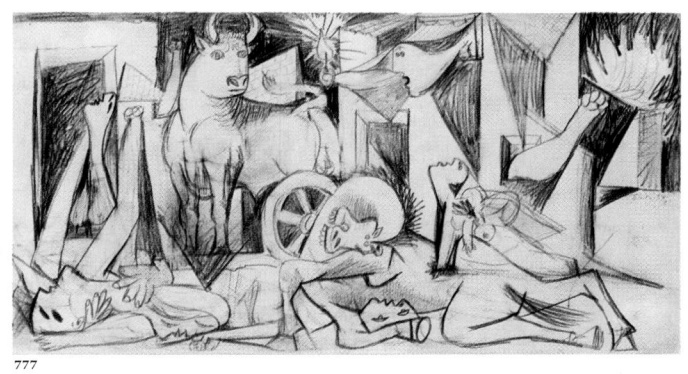

777

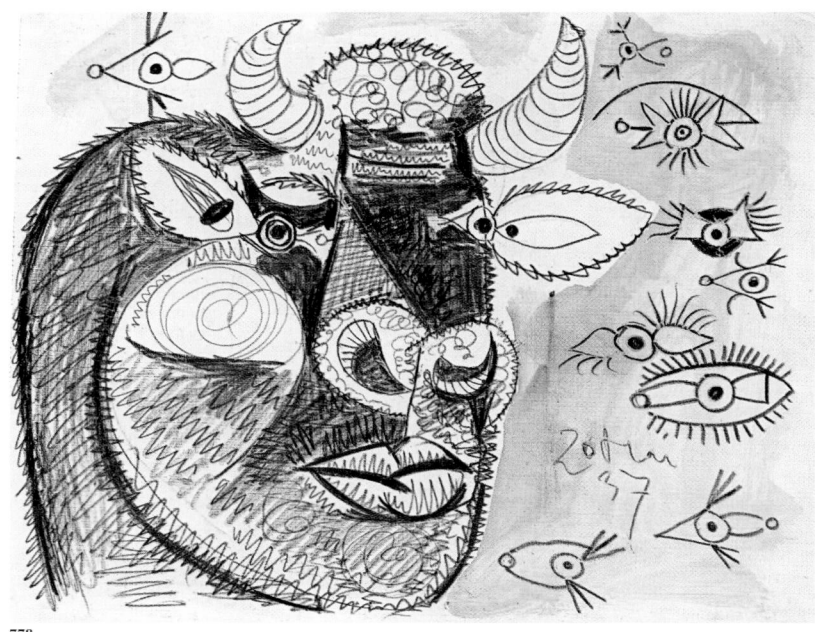

778

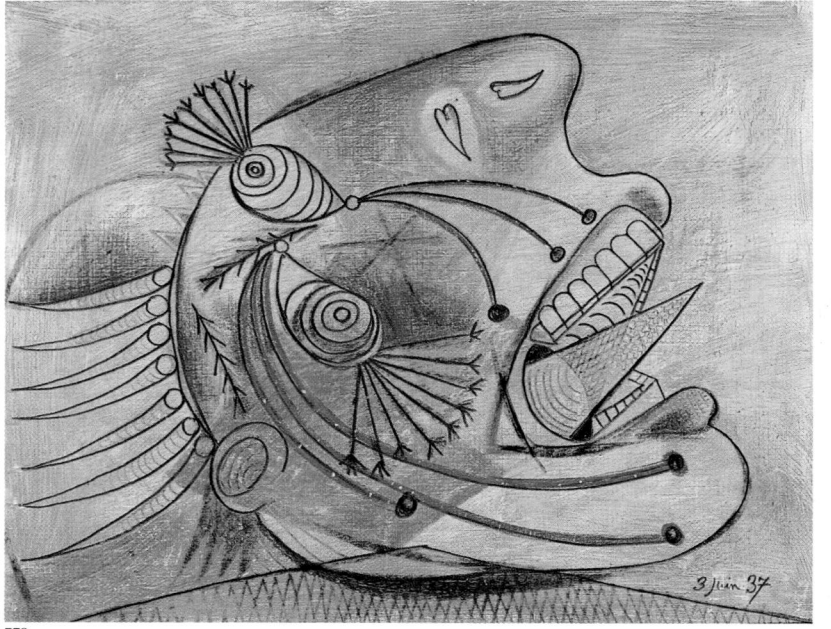

779

778 *Study for "Guernica": Head of Man-Bull and Studies of Eyes,* May 20, 1937

779 *Study for "Guernica": Head of Woman in Tears,* June 3, 1937

780 *Guernica, state 1,* photographed by Dora Maar

781 *Guernica, state 3,* photographed by Dora Maar

318

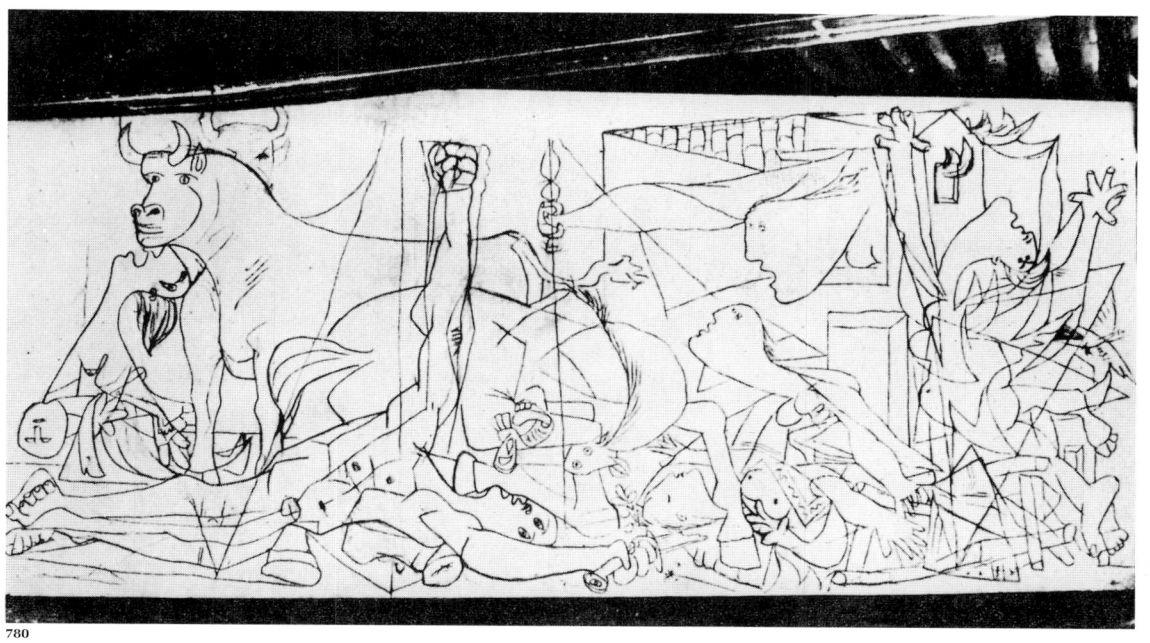

780

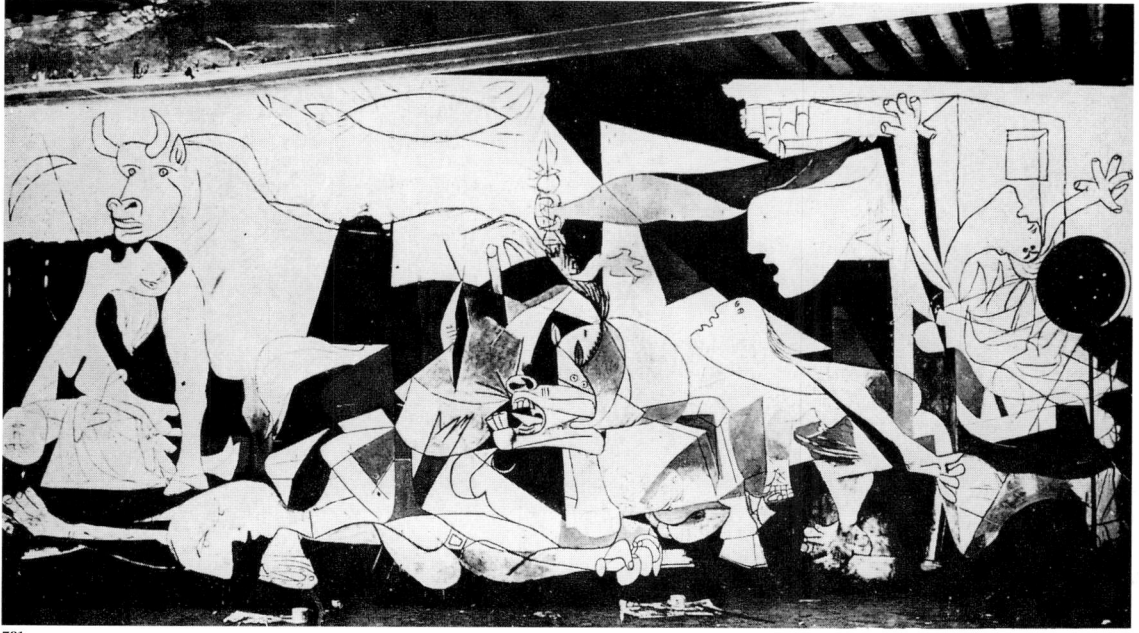

781

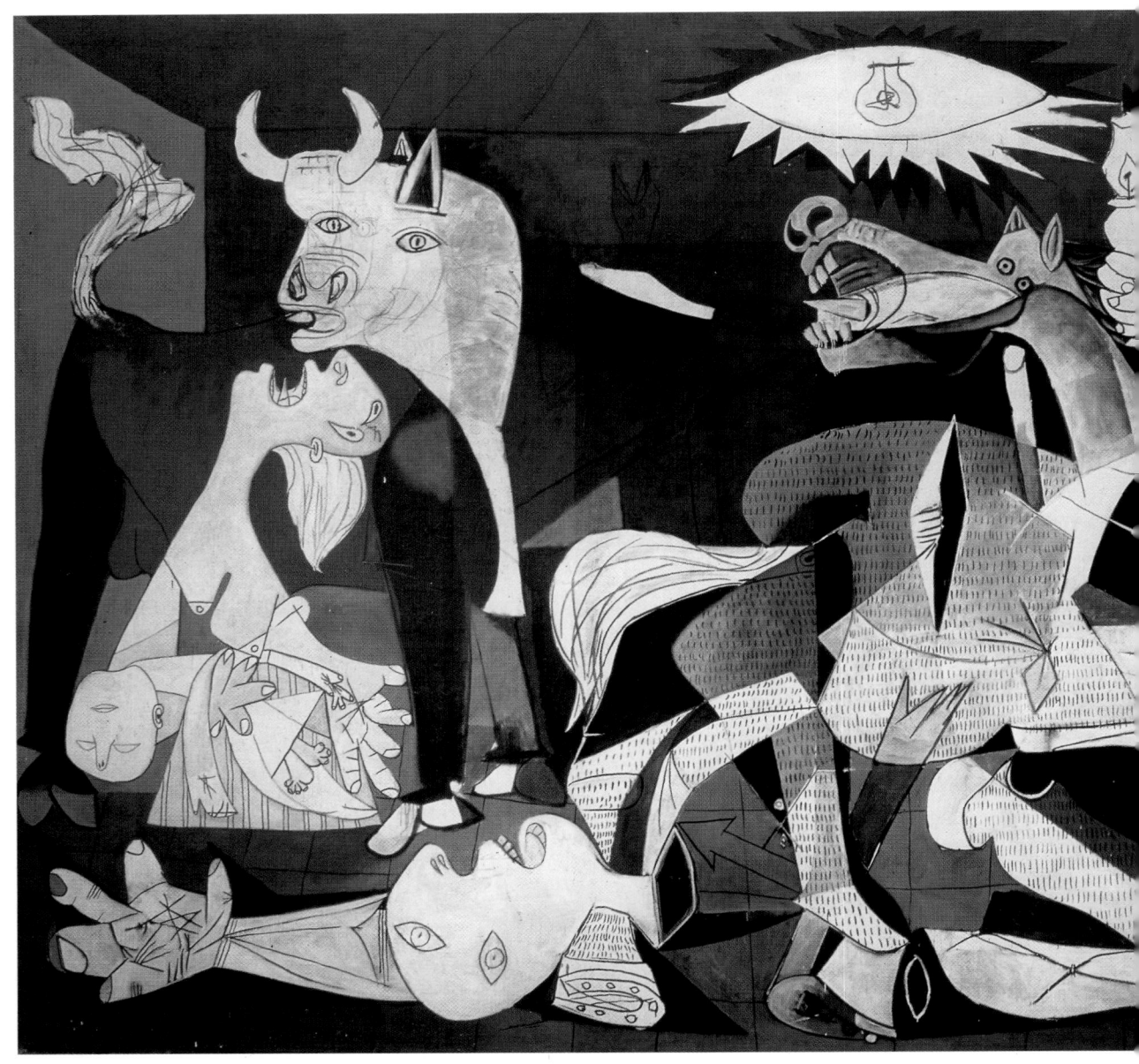

782 *Guernica* May 1–June 4, 1937

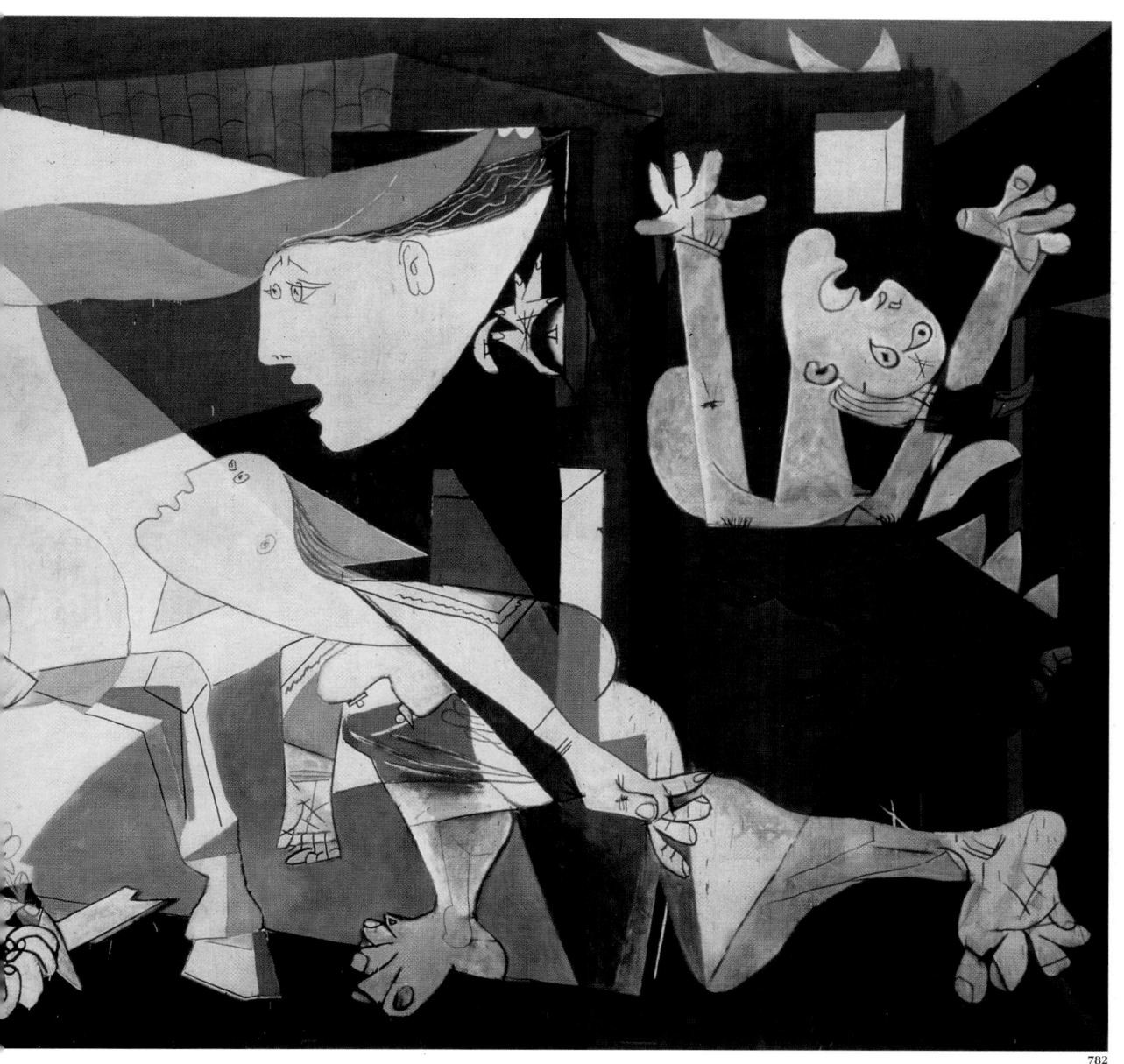

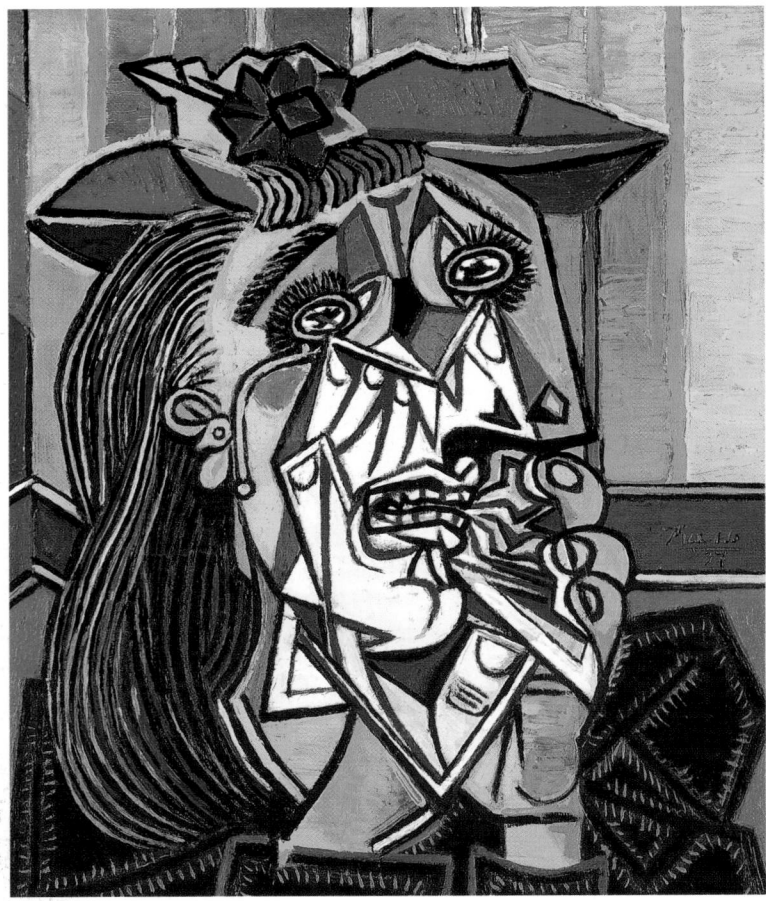

783

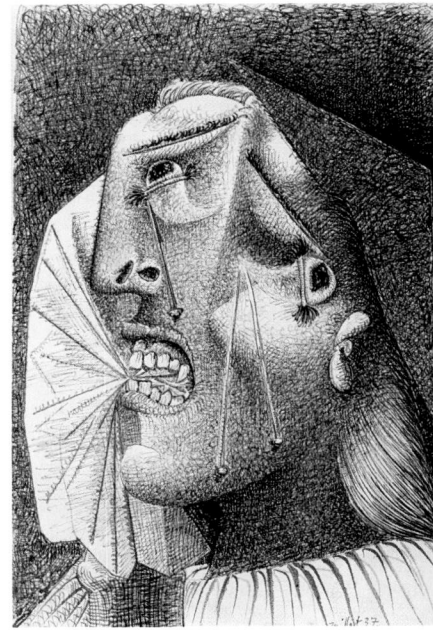

784

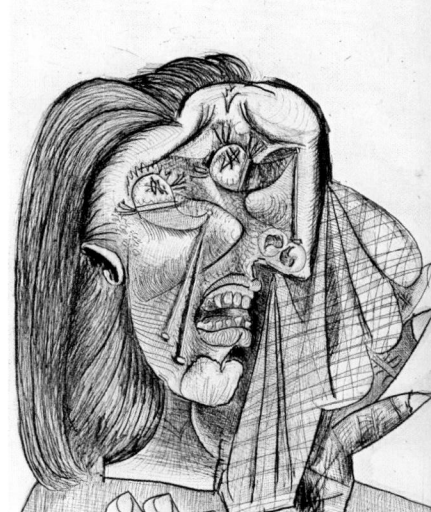

785

783 *Woman in Tears,* October 26, 1937
784 *Woman in Tears I,* July 4, 1937
785 *Woman in Tears II,* July 2, 1937

322

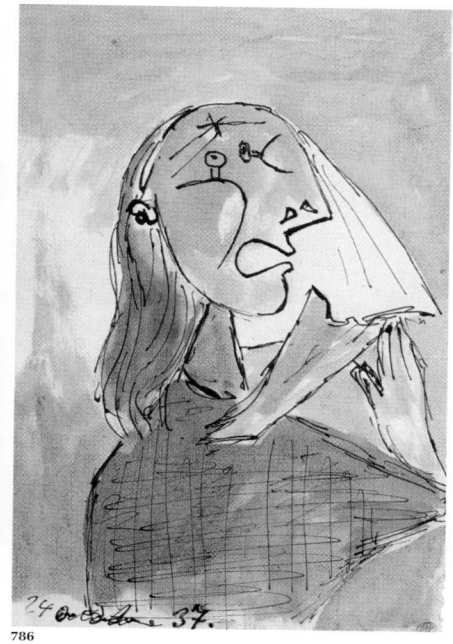

786

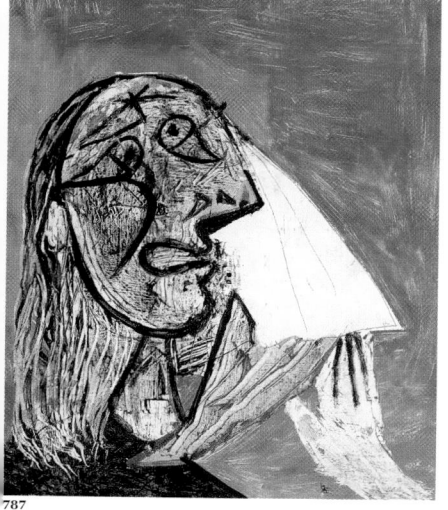

787

788

789

786 *The Weeping Woman,* October 24, 1937
787 *The Weeping Woman,* October 18, 1937
788 *The Supplicant,* December 18, 1937
789 *Weeping Woman,* 1937

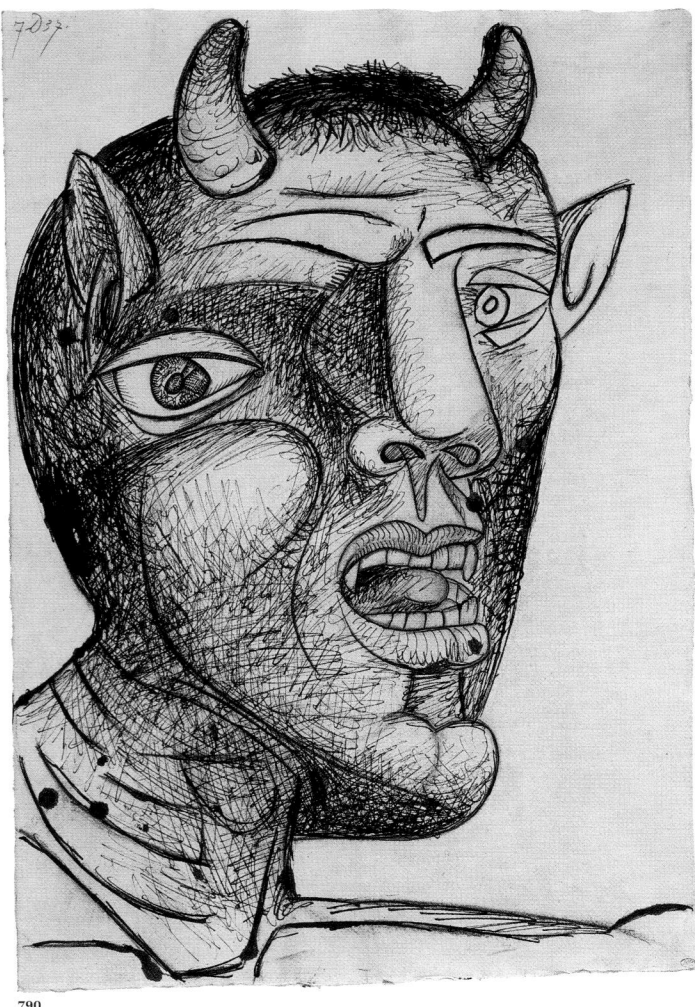

790

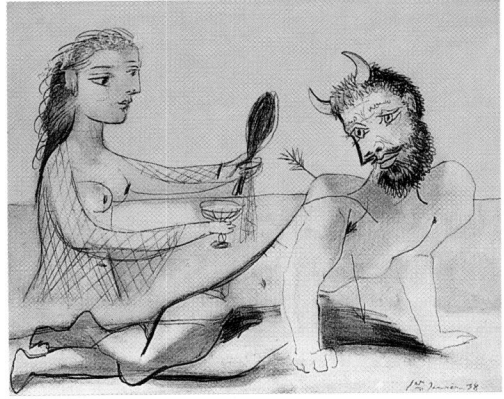

791

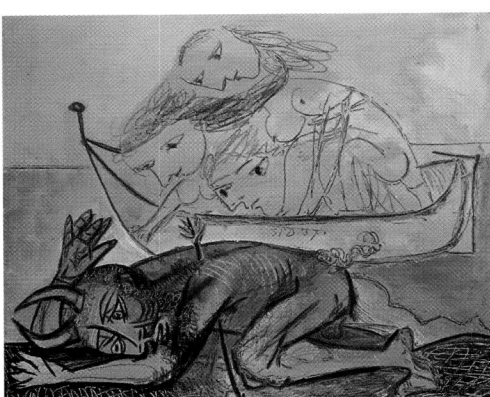

792

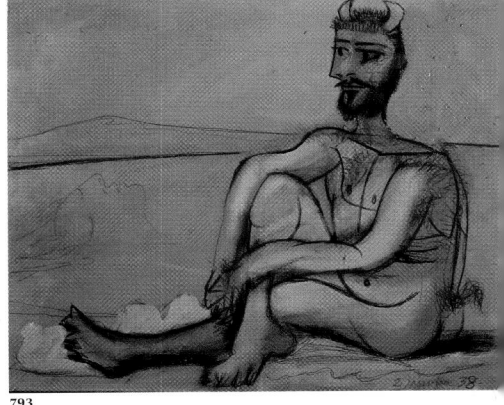

793

324

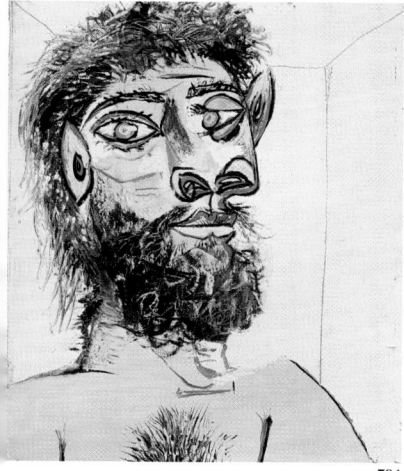

794

hurled this painting into the universal realm. It is not the subject but the painting that has value here, that cries out; and beyond the emotional impact, the cry makes sense, both in history and deep within ourselves.

Women with Hats, Seated in Armchairs

In December 1937 and January 1938, the Minotaur was replaced by a faunlike figure, more human but no less anguished (fig. 790); he sometimes had the head of a bearded man, with protruding ears and bright colors on his face, almost like Lucifer (fig. 794). Like a mutant Minotaur, the faun has lost its arrogance and experienced a few more misfortunes on the beach (figs. 791–793). The usual figures are brought together again. In one picture (fig. 792), three nymphs in a boat seem to want to help a wounded faun who has fallen on the beach, pierced by an arrow (the date is marked at the center of the painting, on the edge of the boat). The following day (fig. 791), one of the nymphs, crowned in a garland like Marie-Thérèse, brings the faun back to life and gives it a cup and a mirror. On January 2 (fig. 793), the faun seems healed, seated quietly on the shore, while the lone face of the woman floats in the water, like Ophelia. The three paintings are painted in blue tones, darkened with gray and black and lightened with white. This was to be the end of the faun-Minotaur adventures. The faun would not reappear until 1946, in *La Joie de Vivre*, this time more cheerfully. Picasso set mythology aside and returned to humans: children, men with hats, women seated in armchairs.

As he did with his Paulo, Picasso used his daughter, Maya, as a model and in several paintings from the beginning of 1938 depicted a little girl with a toy. The toy was sometimes a doll, a small horse, or a tiny boat (fig. 796), reminiscent of the one carried by the bathers in 1937 (see fig. 765). On April 2, a young boy in a sailor suit and a butterfly net displays a frightened and worrisome expression (fig. 797); Picasso mischievously signed his name on the child's cap. Several paintings from 1938, with seemingly insignificant subjects, reflected a growing discomfort and fear. In the world, international tension was growing, and on March 11 Germany annexed Austria.

The *Women at Their Toilette*, a huge painting on paper measuring about ten feet in height and fifteen feet in width, was a tapestry cartoon that would eventually be realized in 1967 by the Manufactures Nationales des Gobelins, thanks to André Malraux (fig. 795). The scene takes up again the theme of the coiffure, with three women, one of whom is seated cross-legged and patiently allowing herself to be coiffed, as another hands her a mirror. The woman who holds the comb wears a dress made of painted paper maps and turns her face away. The figures, their mouths agape, seem to be on alert, preparing themselves to hear bad news.

On March 22, 1938, Picasso painted a woman with a comb (fig. 798) who resembled Dora, and he completed a charcoal drawing of *The Artist Before His Painting* (fig. 801): the two figures resemble each other, with the same profile and stare. On April 14, Dora's pathetic face is once again depicted against a black background (fig. 799). Later, her excessively developed nose (fig. 800) would end up looking like the muzzle of Kazbek, Picasso's pet Afghan hound.

In 1938, as in the preceding year, Picasso would make portraits of both Dora Maar (figs. 802, 805, and 806) and Marie-Thérèse (figs. 803 and 804): each wears a hat that highlights her face. The hat on Dora Maar can also be seen in a drawing on cardboard (fig. 806) and in a painting with a red background in *Woman in a Hairnet* (fig. 802). The drawing in pastel and ink dated February 2 foreshadows a style that would characterize several drawings and paintings in 1938—streaks and parallel or crossed lines that form a tight hatching. Like the hat, the armchair would offer the seated woman a framework within the painting's frame, a device that would continue to play a role during the 1940s.

790 *Minotaur,* December 7, 1937

791 *Wounded Faun and Woman,* January 1, 1938

792 *Wounded Faun,* December 31, 1937

793 *Seated Faun,* January 2, 1938

794 *Head of a Bearded Man,* 1938

795

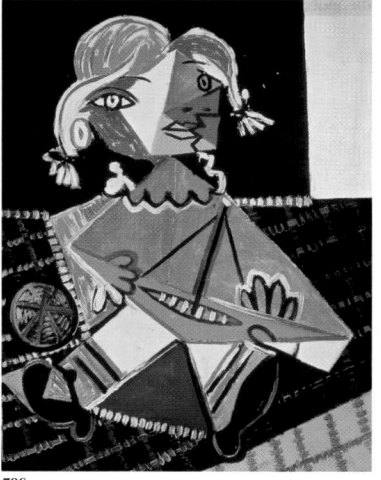

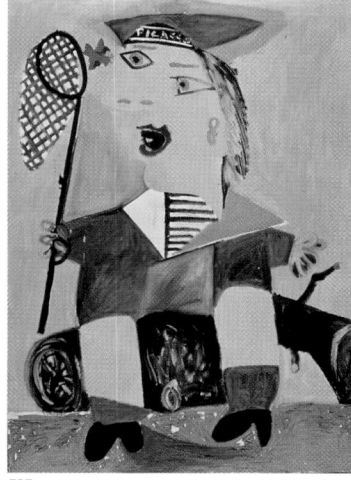

795 *Women at Their Toilette,* 1938
796 *Little Girl with a Boat (Maya),*
January 30, 1938
797 *The Butterfly Chaser,* 1938

796

797

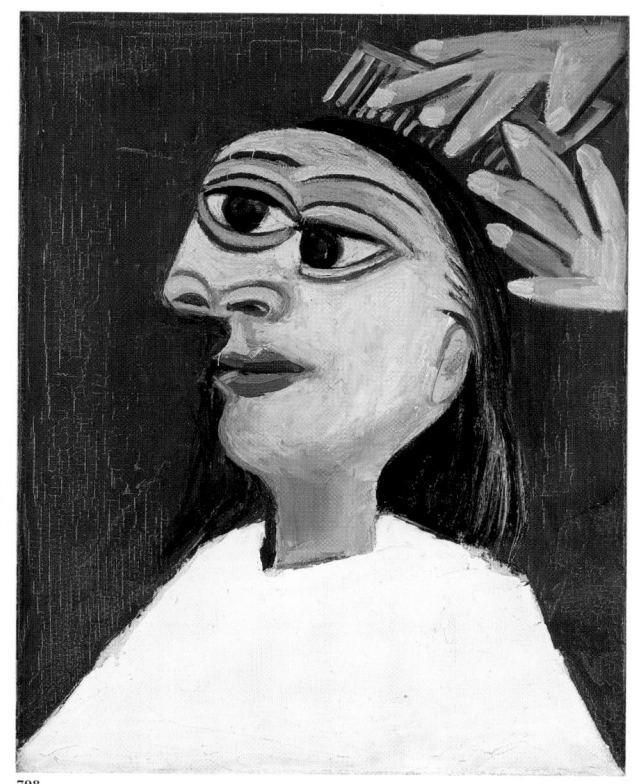

798

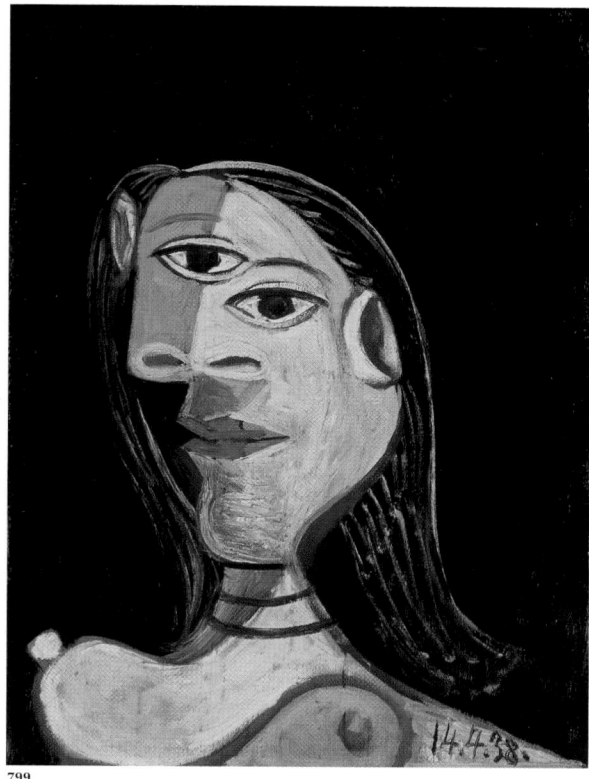

799

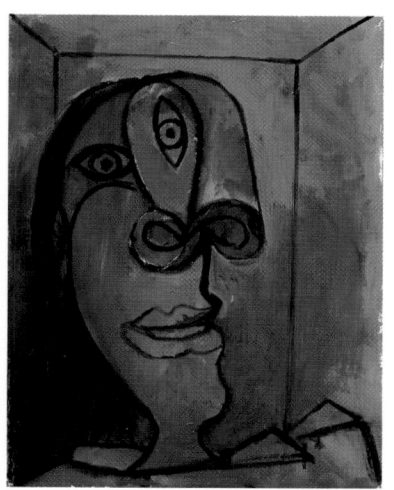

800

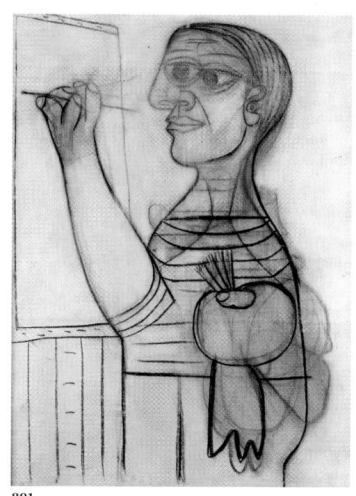

801

798 *The Coiffure,* March 22, 1938
799 *Bust of a Woman,* April 14, 1938
800 *Head of a Woman,* August 14, 1938
801 *The Artist Before His Canvas,* March 22, 1938

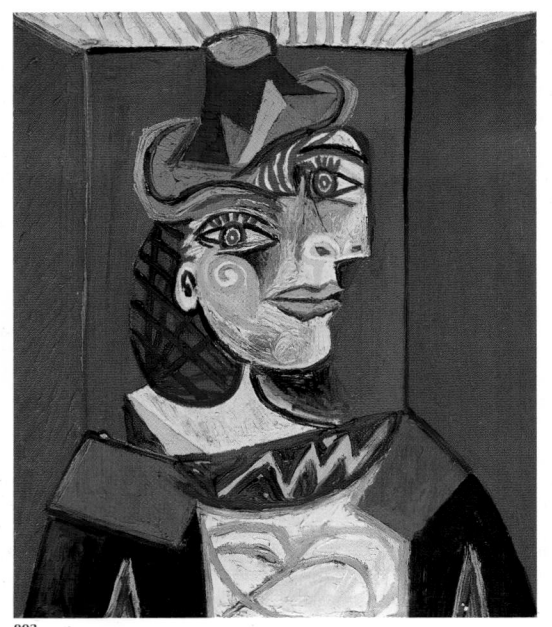

802

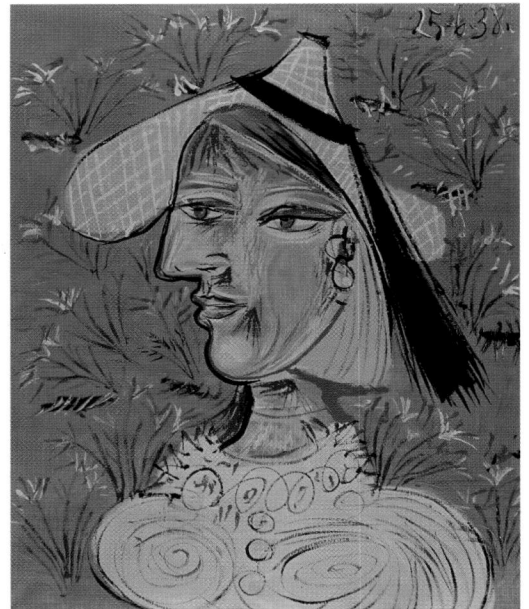

803

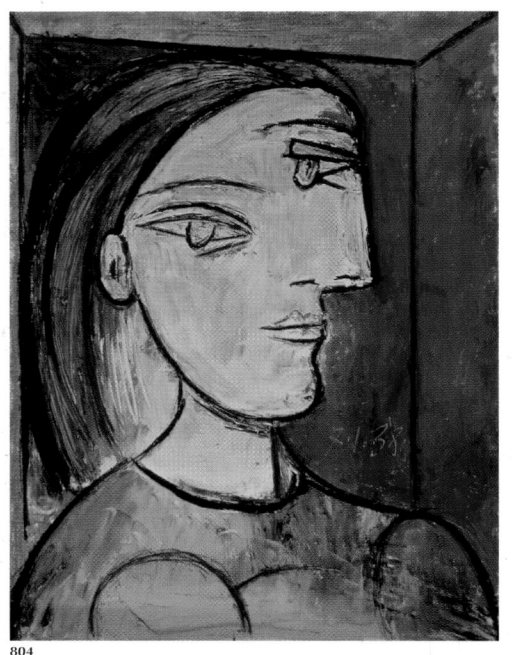

804

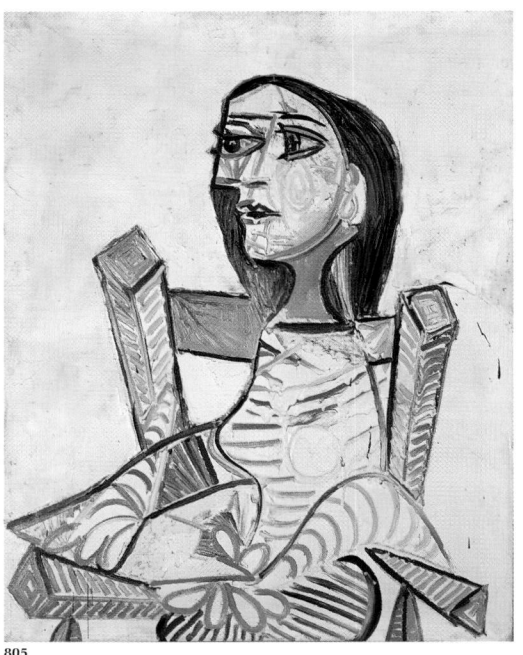

805

328

The portraits of Marie-Thérèse, like those of Dora Maar, present the face both in profile and head on, so that the two eyes and the bridge of the nose can be seen at the same time. However, Picasso uses pastels or bright colors to represent Marie-Thérèse, like the pink background with floral motif in *Woman in a Straw Hat* (fig. 803)—preserving the sweetness and tenderness that belong only to her and to which the painter continues to respond.

During the summer of 1938 in Mougins, the men too wear large straw hats on their heads (figs. 807–809). One of them, featuring a sailor-striped bathing suit (fig. 807), like the charcoal drawing on canvas from March 22 (fig. 801), introduces a bold arrangement of colors: a green-and-blue forehead, green lips, an eyelid and chin highlighted in red. The nose with its nostrils shaped like an eight is reminiscent of the Dora Maar portraits. *The Fisherman's Family* (fig. 813), a distant echo of the acrobat family from the Rose Period, includes a fisherman sleeping in a boat with his head down and his feet up, a plump baby, and two women. The mother and child in the middle, however, are caught between the sleeping man and a visitor with a butterfly net, who ignore them completely. The mother stands alone behind a fishing net or a sail, in a gesture that suggests one of the young woman in the drawing of *Minotaur and Dead Mare* from May 6, 1936 (see fig. 744).

Ice-cream cones seem to have been in fashion that summer. Picasso seized on this detail and twisted it in a lascivious, frightening way in several paintings from August 1938. On August 6, the rays of the sun shine on a man wearing a hat; every line of his face is highlighted and its craggy surface accentuated, almost fragmented, and from his mouth shoots an obscene tongue (fig. 808). On August 30, the image turns celestial against a black nighttime backdrop: a man with a blue face and yellow eyes and teeth seems to shoot out prickles like a sea urchin; from his stiff beard and toothless mouth comes a green tongue licking an ice-cream cone with a provocative eagerness. Even his hat bristles with thorns, like barbed wire (fig. 809). The man is terrifying, perhaps because he is terrified. Inasmuch as drama intertwines with world history, Picasso's figures gradually begin to resemble inextricable bundles of knots.

From April to December 1938, the painted or sketched motifs come closer together, usually in complex hatching. A tangle of parallel lines that create boxed and striped spaces resemble spiderwebs that imprison the subject like a fly; shapes coil inward, like basketry that does not let air pass through. An ink drawing of June 13 (fig. 812) was inspired by the theme of the weeping woman; even the hairstyle is Dora Maar's. The left eye bulges out so far that it looks as if there is a dagger in the pupil.

On July 10, the drawing of the *Bathers with a Crab* (fig. 810) returns to the familiar seashore: as they did more than ten years earlier, women appear with keys near a beach hut, here for the last time. Sharp silhouettes in space, they have lost their stone monumentality and seem to be caught in a web of graphic constraints. At the bottom to the left, only the crab scampers off, like a spider that may have spun the whole scene. As a creature with claws and a shell, the crab is part of the marine life that Picasso loved, like the sea urchins in the works of 1946, the langoustes and lobsters in the paintings of 1941 and 1962 (see figs. 842 and 1070). In a drawing dated October 10 (fig. 811), two women with hats are seated in armchairs, beneath a beaming sun, with an umbrella stuck in the ground on either side. The allusion to a spiderweb is clearly indicated behind the woman at the left. Some of the open areas are filled with ink, which darkens the drawing, but it is a fear of emptiness, of rupture, that seems to have darkened the whole composition.

This intricate use of line appeared earlier in two large colored drawings of the same size, dated April 27 and 29 (figs. 817 and 816). With this subject—a woman wearing a hat, seated in an armchair—Picasso produced a series of pictorial variations that merge imagination with perfect technical mastery. The large painting of the *Woman Seated in a Garden,* from December 10 (fig. 818), was the culmination of the series; in the upper right, one notes a lozenge-shaped sun.

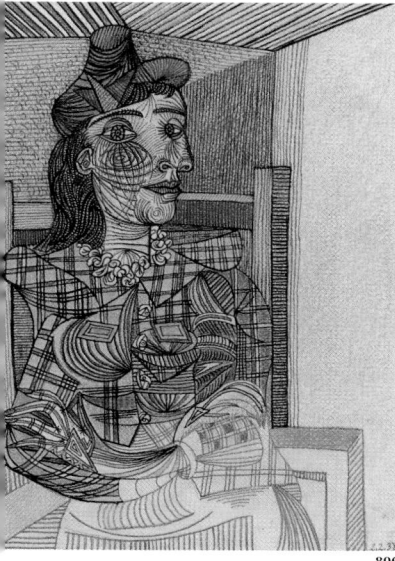

806

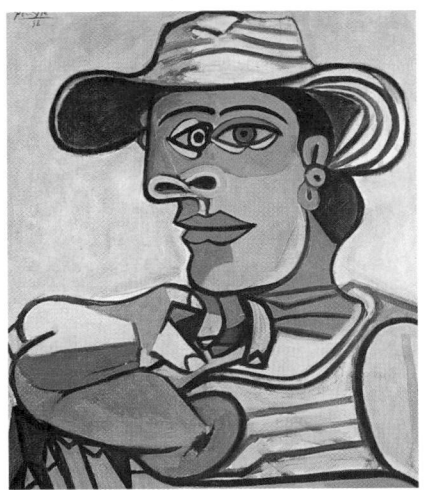

807

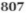

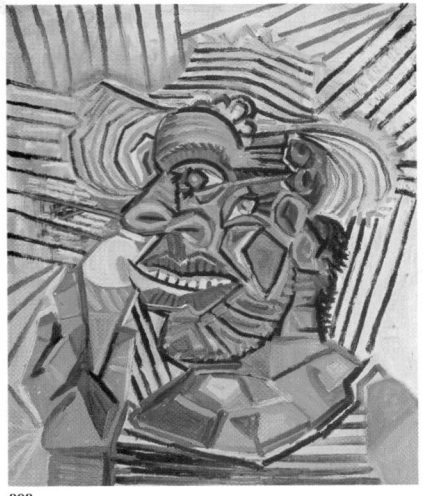

808

809

807 *Sailor,* July 31, 1938

808 *Man with Ice-Cream Cone,* August 6, 1938

809 *Man in a Straw Hat with Ice-Cream Cone,*
August 30, 1938

10

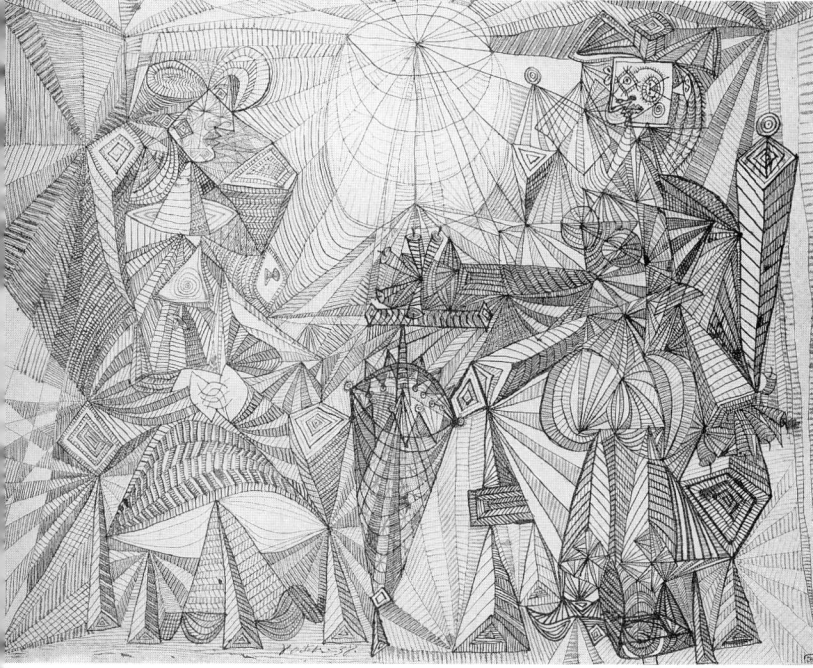

11

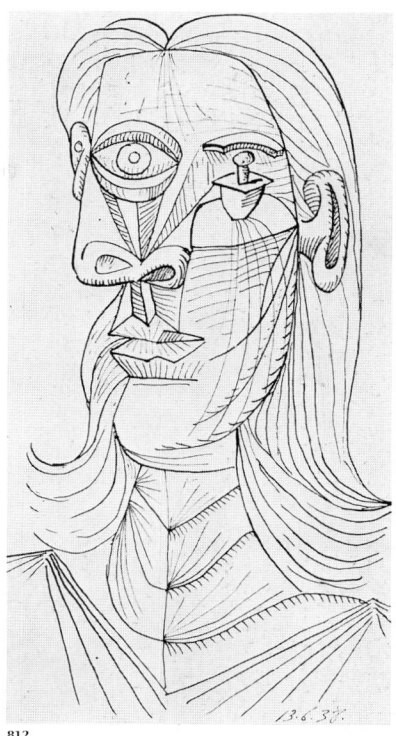

812

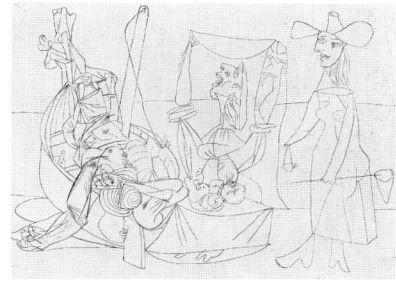

813

810 *Bathers with a Crab,* July 10, 1938

811 *Two Women with an Umbrella,*
October 8, 1938

812 *Head of a Woman,* June 13, 1938

813 *The Fisherman's Family,* 1938

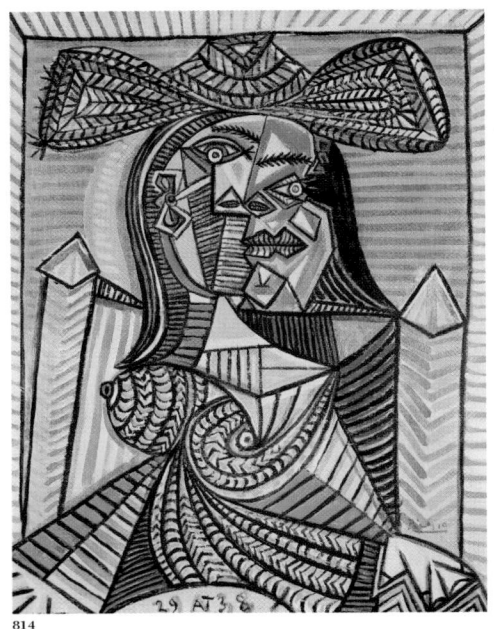

814

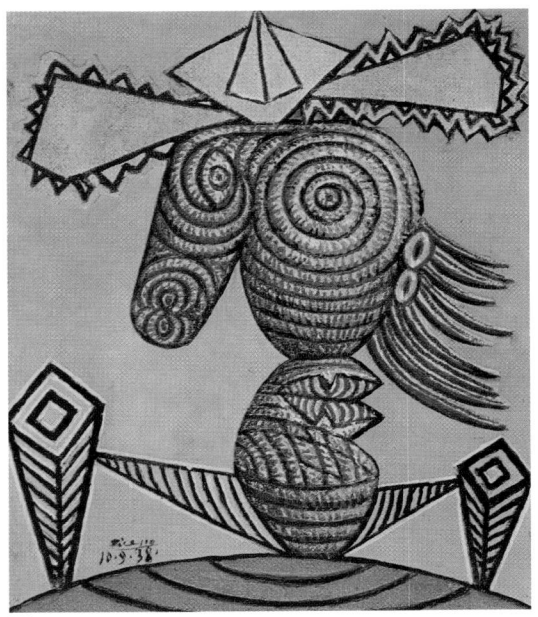

815

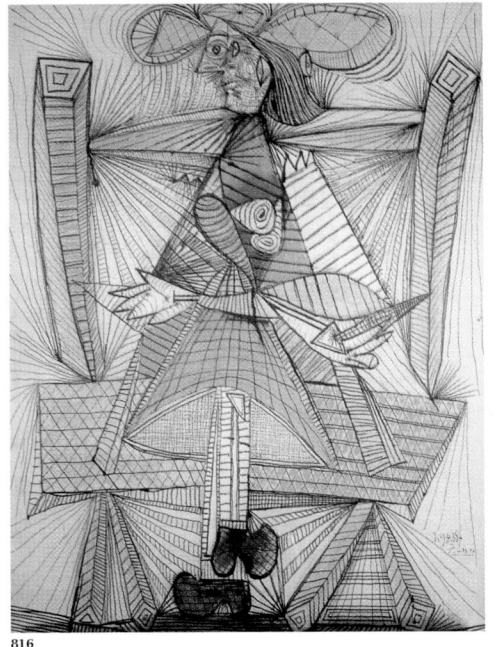

816

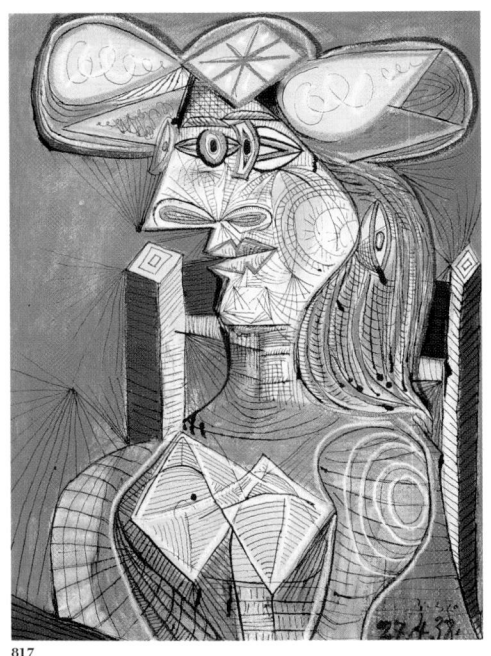

817

814 *Seated Woman,*
August 29, 1938

815 *Seated Woman in a H*
September 10, 1938

816 *Seated Woman,*
April 29, 1938

817 *Seated Woman,*
April 27, 1938

818 *Seated Woman in a*
Garden, December 10
1938

332

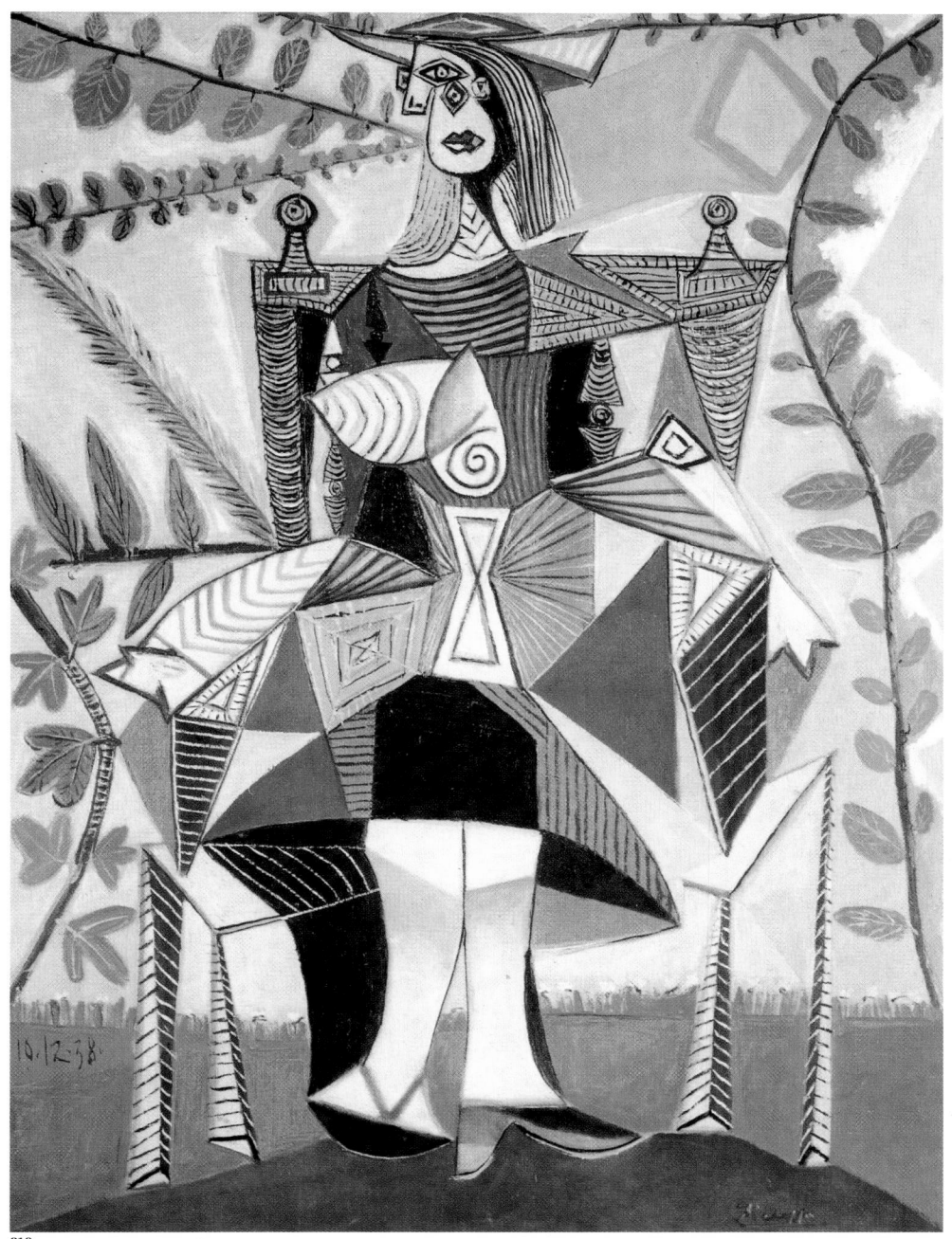

818

A variation on the spiderweb motif and the basketry patterns, perhaps inspired by the straw hat, occurs in two paintings from August and September 1938 and is achieved in a tight network of line in which all transparency is eliminated. In the painting of August 29 (fig. 814), the soft colors of pink and blue lighten the hard, uneven, black lines that constrain the forms of the torso and the thorny lines of the eyebrows and hat rim. On September 10, the painting mixed with sand on a wood board (fig. 815), on the other hand, reveals a head rolled around an incredible gaze, under a funny hat.

Picasso allowed his poorly disguised anguish to emerge through these seemingly innocent subjects. Animals, even before people, seemed to be aware of the historical catastrophe that was rumbling and would erupt the following year. On March 23, 1938, a rooster, the Gallic symbol of France, would cry out in alarm but in vain (fig. 819). On February 15, the shadow of death had already shown itself, cold and naked: the knife on the kitchen tile floor leaves no doubt as to the rooster's fate; the bowl is already ready to collect the blood of the sacrifice (fig. 820). The animal's twisted neck and the priest evoke a situation of intolerable suffocation.

Between Paris and Royan

Picasso's mother died on January 13, 1939, in Barcelona. On March 15, Hitler's troops invaded Czechoslovakia and in the final days of March Franco took over Madrid, signifying the end of the civil war, but at what price? In 1939 and 1940, Picasso's paintings reflected more than ever a climate of oppression, violence, and mourning. In the beginning of September, on the eve of declared war, he took refuge in Royan, where he settled, but he returned to Paris several times until the end of August 1940. It was in Royan, on October 17, 1939, that he painted the three *Heads of Sheep*, piled up and almost laughing nervously (fig. 821), a piece of macabre humor inspired by the skinned sheep heads Picasso bought to feed his dog, Kazbek.

In April 1939, cruelty rippled across two paintings depicting a *Cat Catching a Bird.* In the April 22 version (fig. 822), sand is mixed into the oil paint, giving body to the clawed cat who catches a flying bird in its teeth. In the other version (fig. 824), the cat has become wilder, arching its back with its eyes bulging and its teeth tearing the bird to pieces. Looking at these images, one cannot but feel, as Jean Leymarie wrote, "that man is also the cruelest of all animals."[9]

Marie-Thérèse and Dora Maar continued to coexist in the painter's mind. On the same day, January 21, 1939, Picasso represented each woman reclining beneath a window (figs. 825 and 826). Marie-Thérèse is lost in her book, her round body both welcoming and soft, while Dora Maar, on the alert, sits up, her figure cut at sharp angles, with broken lines and triangular forms.

In July Picasso went with Dora Maar to an apartment in Antibes lent to them by Man Ray. In the month of August, Picasso completed *Night Fishing at Antibes*, an interpretation of his noctural walks, a large painting whose darkness is punctuated by splashes of color (fig. 827). The scene was inspired by Mediterranean lamplight fishing: a fisherman spears a fish from a boat, while another examines the sea floor. Two women on the pier, undoubtedly suggested by the presence of Dora Maar and Jacqueline Lamba-Breton, are watching the catch, one of them holding a bicycle and a double-dip ice-cream cone. The moon, the stars, and the lanterns cast a blurry light onto this hunting scene, creating dark green and purple highlights.

Especially during this period of uncertainty, Picasso continued to depict the woman with a hat, sometimes seated in an armchair, stationed there like a symbol of permanence. With only slight variations, the depiction of this subject evolved in rhythm with

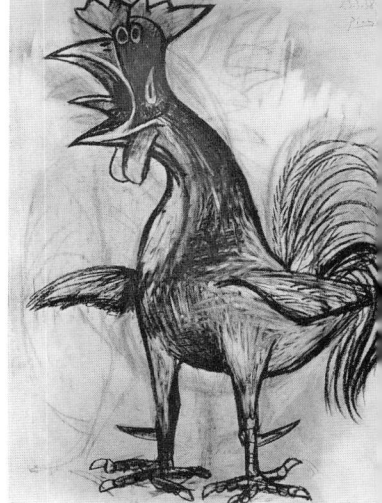

819

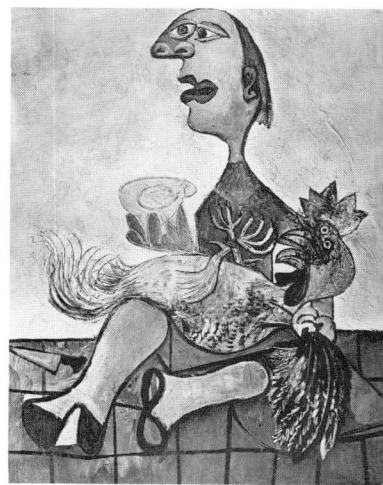

820

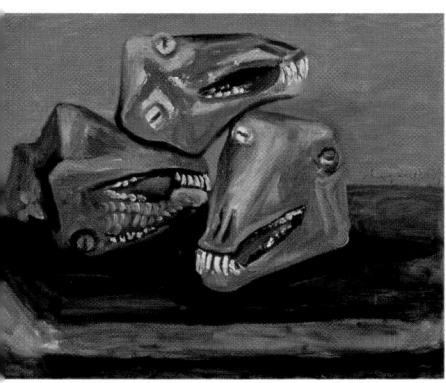

821

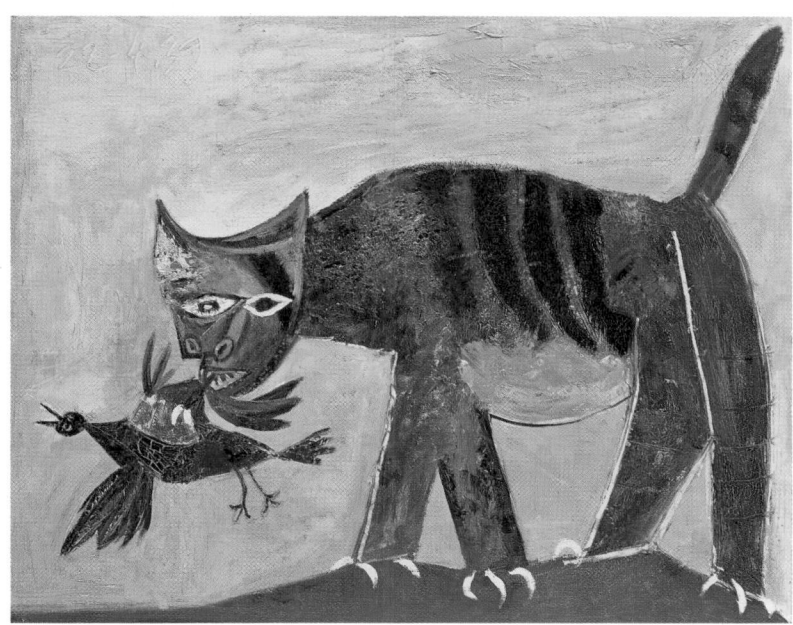

822

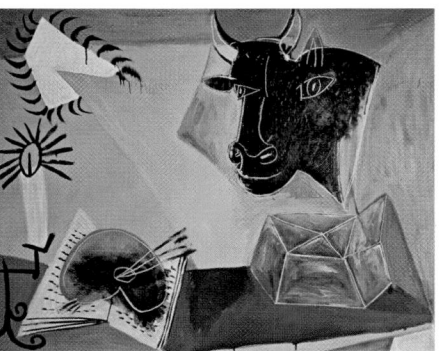

823

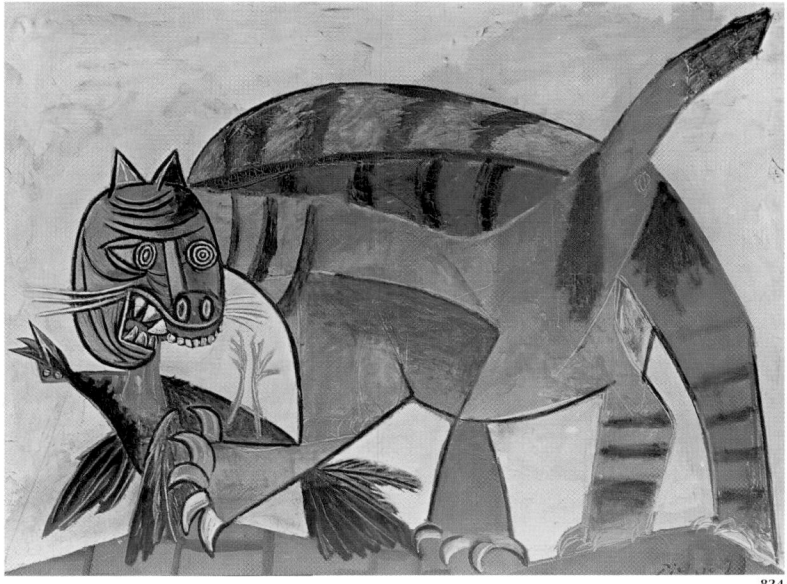

824

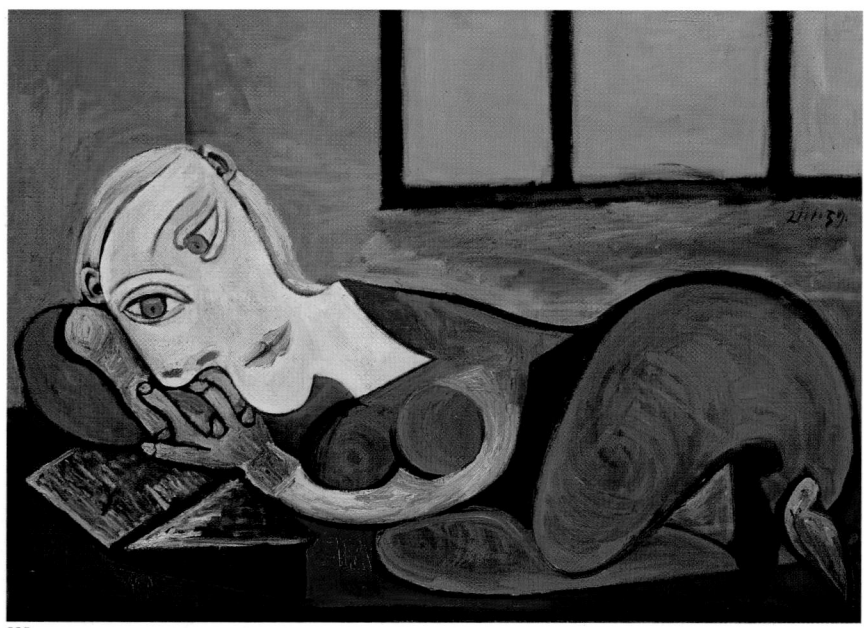

825

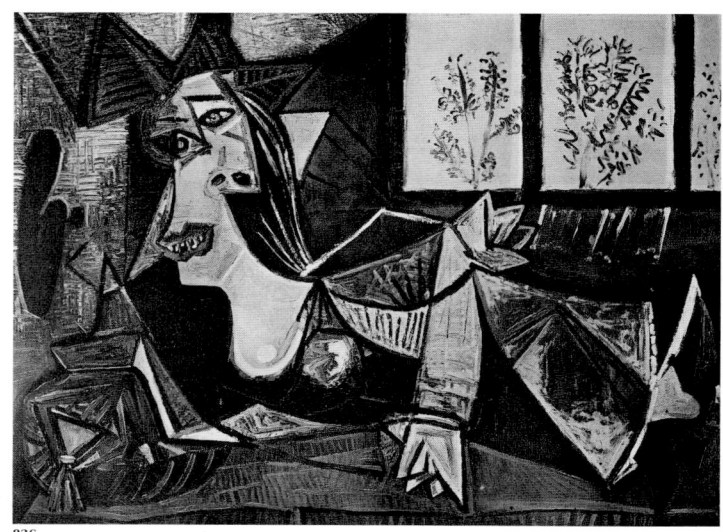

826

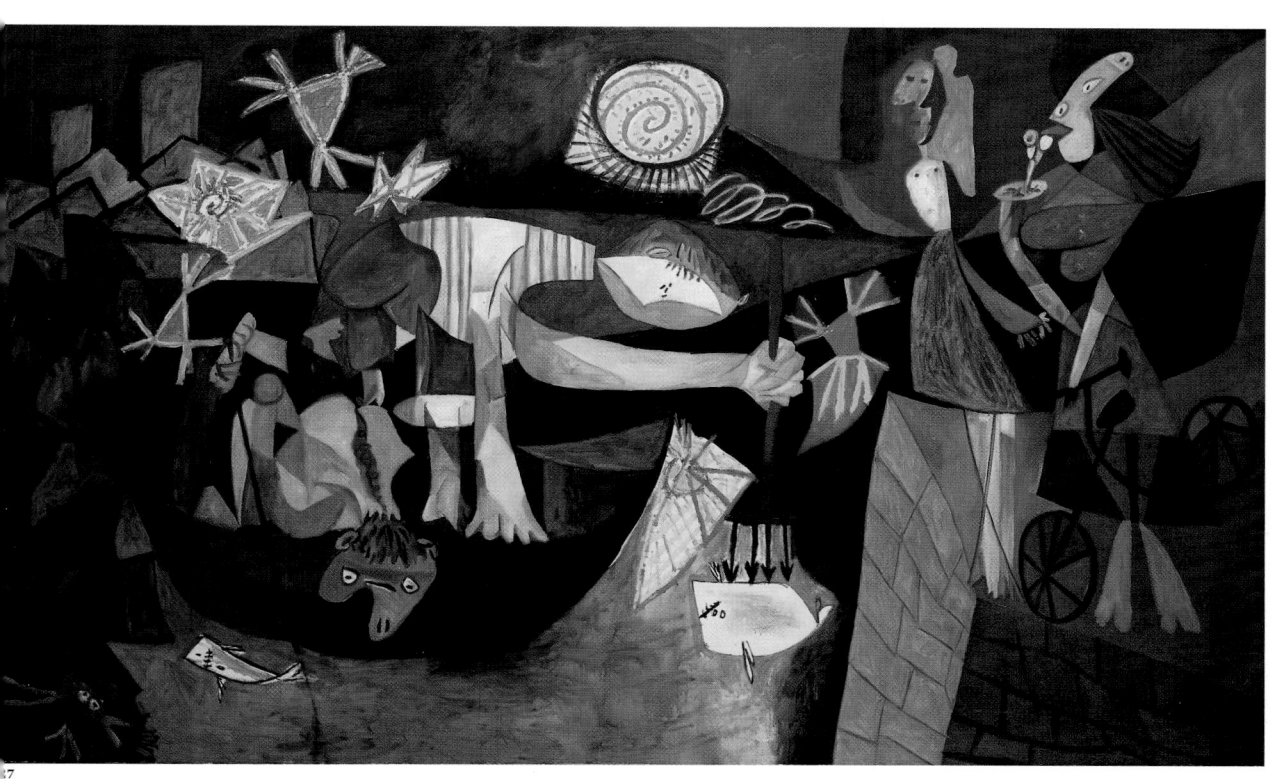

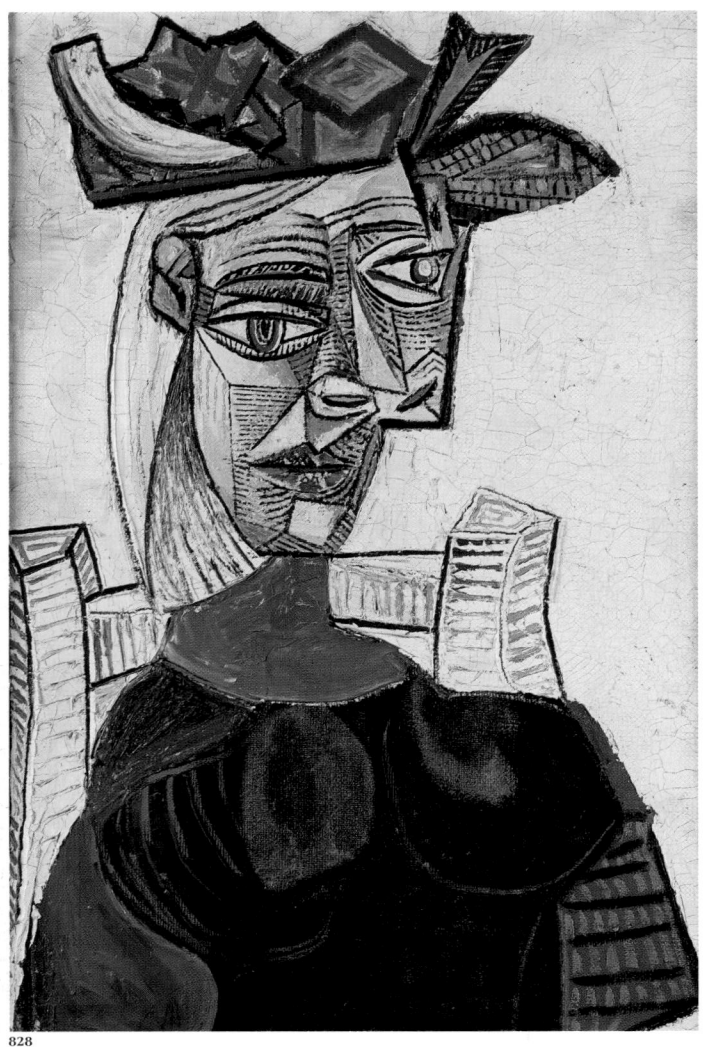

828

829

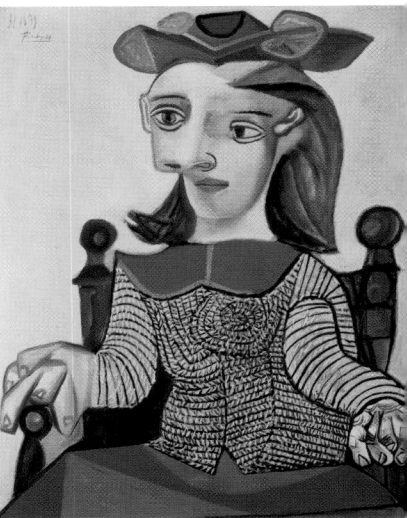

830

828 *Seated Woman in a Hat,* May 27, 1939
829 *Three Heads of Women,* March 11, 1939
830 *The Yellow Sweater,* October 31, 1939

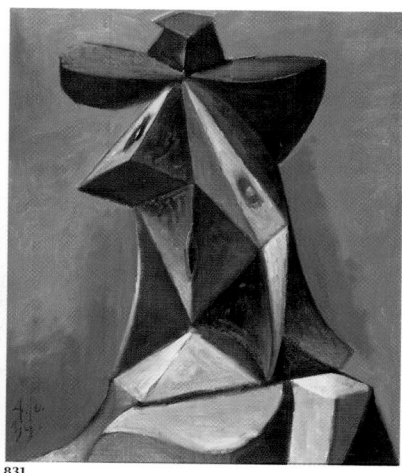

831

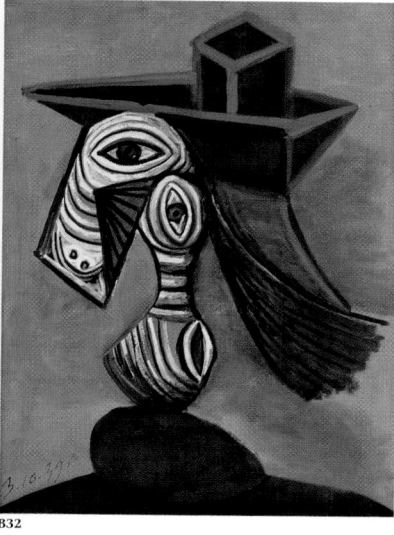

832

833

831 *Head of a Woman,* October 4, 1939
832 *Woman in a Blue Hat,* October 3, 1939
833 *Bust of a Woman in a Striped Hat,* June 3, 1939

339

the mystery of time. Some paintings would again adopt parallel lines, the bands and stripes of 1938, but in a more selective manner. Such is the case with the May *Seated Woman in a Hat* (fig. 828) and *Bust of a Woman in a Striped Hat* from June 3 (fig. 833), in which the date is painted in the center of the hat. Similarly, *The Yellow Sweater* from October 31 (fig. 830) alludes again to basketry or knitting; it should be noted that a knitting woman also appeared in an engraving from 1927 (see fig. 565).

Two paintings from October 3 and 4 mark Picasso's growing tendency during these barbarous years to dehumanize the human figure. On October 3 (fig. 832), the emaciated face is again marked with stripes, like those that had streaked the drawings and paintings of the preceding year. Yet the following day (fig. 831), in a pathetic *Head of a Woman* wearing a hat, the face has been reduced to an assemblage of muted colored triangles, an animal with Kazbek's muzzle. Although the *Cat Catching a Bird* suggests man's cruelty, here the human figure is contaminated with a bestial quality that lowers man to the level of animals. With their wrinkled skin, dark eyes, and menacing gaze, these portraits seem to be losing their beauty and their life before our eyes, succumbing to the weight of complex, often ridiculous hats that were in style at the time (fig. 829).

Hurriedly leaving Antibes for Paris at the end of August, Picasso was immediately forced to take refuge in Royan when war was declared on September 3, 1939. Marie-Thérèse and Maya had been in Royan since the summer and were staying at the Gerbier-de-Joncs villa, while Picasso was at the Hôtel du Tigre, along with Dora Maar and Jaime Sabartés. In Royan Picasso filled numerous sketchbook pages with drawings; in one book he alternated between sketches and text, writing a long passage in Spanish between July 3 and August 19, 1940, which he would later entitle "Bullfighting" or "Bullfighting in Mourning."[10]

On September 11, 1939, a large ink drawing depicted a man holding the reins of two horses in each hand (fig. 835). Even if Picasso was at first impressed by the procession of horses requisitioned by the military, the horse at the left seems as conciliatory as Marie Thérèse and the one at the right as recalcitrant as Dora Maar. The theme of two women reappeared in a gouache dated September 22 (fig. 834). Like those of 1920 (see figs. 483 and 484), they are nearly the same size. The woman at the right is seated, the other standing, but here the first is dressed and the second is nude. In the first few days of February 1940, Picasso composed four small relief-paintings that borrowed the classical theme of a woman in an armchair. As in the 1926 guitar series made with thread and cardboard, he sewed together pieces of cut-out cardboard painted in bright colors (fig. 838).

Between Dora and Marie-Thérèse, Picasso still considered his loyal companion to be Sabartés, whom he represented with his glasses and wearing a feathered hat and a large ruff, like a Spanish grandee (fig. 837). The distortion of the face here does not take away from the portrait's likeness and truth. Ill at ease with Dora Maar, Sabartés, who was always very discreet where Picasso's mistresses were concerned, tried to keep an affectionate, watchful eye on Marie-Thérèse and Maya.

Less than ten days before leaving Royan for good, Picasso painted the Café des Bains, which he could see from his window. He even wrote a suggestion of the name of the café in orange letters on the awning in the middle of the painting (fig. 836). Soon only ruins would remain of this cheerfully colored image, for the city was bombarded at the end of the war. Landscapes, even urban ones, were rather rare in Picasso's work, but they always served to retain the memory of a place to which he was emotionally attached, which he wanted to preserve.

On December 30, 1939, and January 11, 1940, Dora Maar inspired Picasso to complete two gouaches of the same size that placed the parallel lines and striated forms of the 1938 figures against a fiery red background (figs. 840 and 841). The December picture would serve as one of the illustrations for Paul Éluard's *À Pablo Picasso*, which was published in 1944.

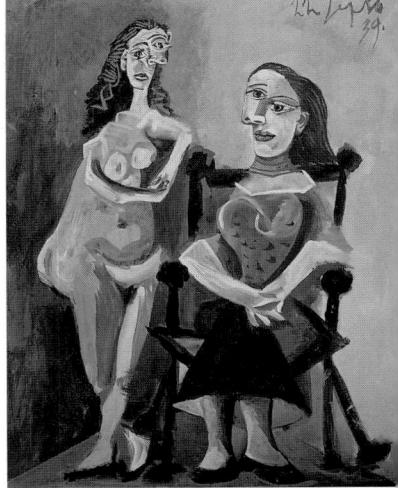

834

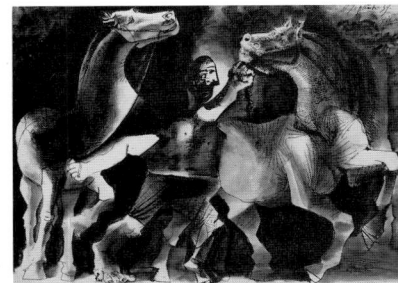

835

834 *Standing Nude and Seated Woman,* September 22, 1939

835 *Man with Horses,* September 11, 1939

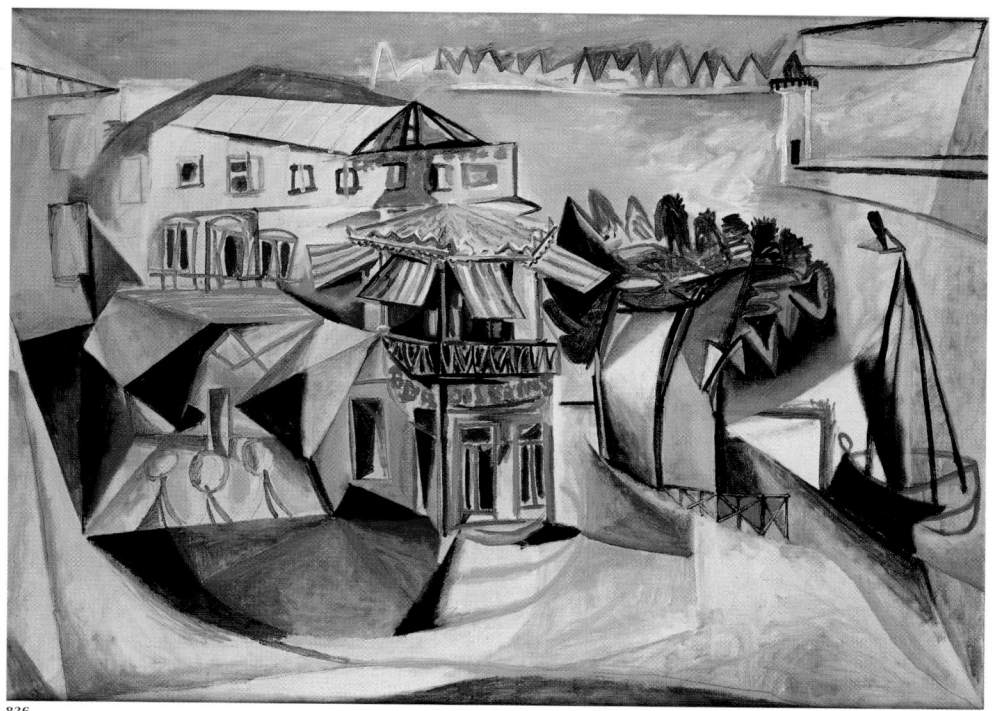

836

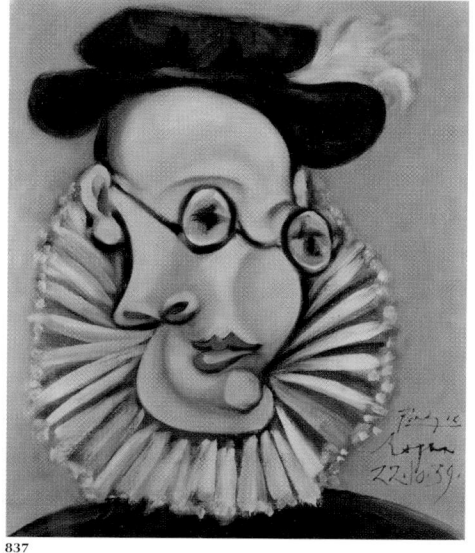

837

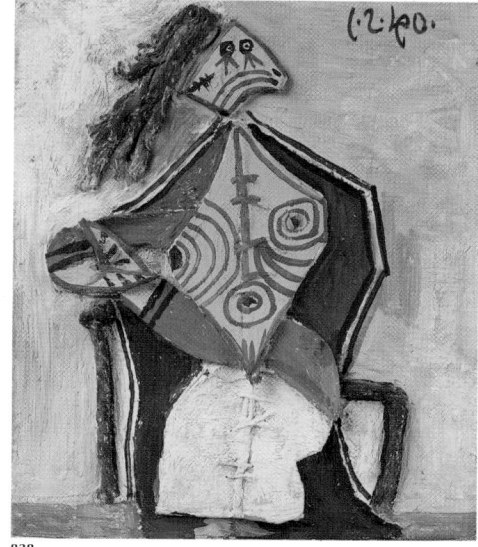

838

836 *Café in Royan,* August 15, 1940

837 *Jaime Sabartés,* October 22, 1939

838 *Woman Seated in an Armchair,* February 1, 1940

341

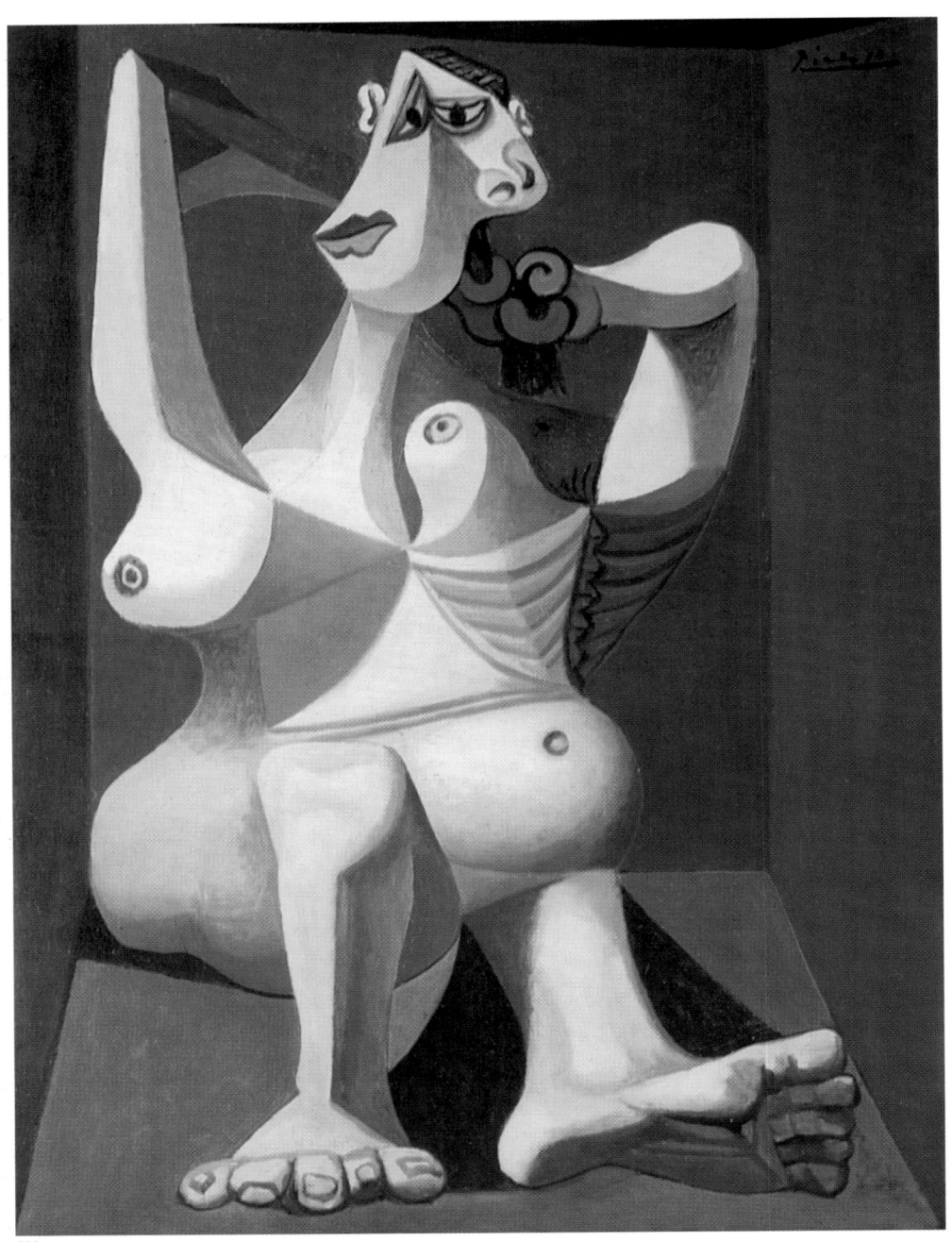

839

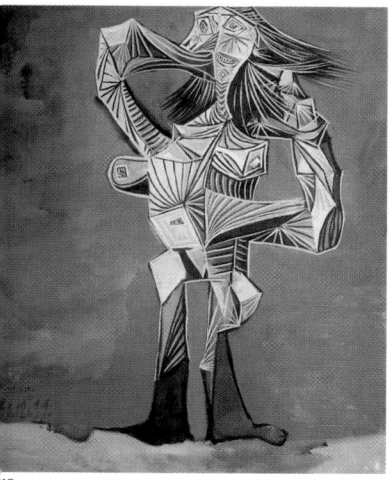

40

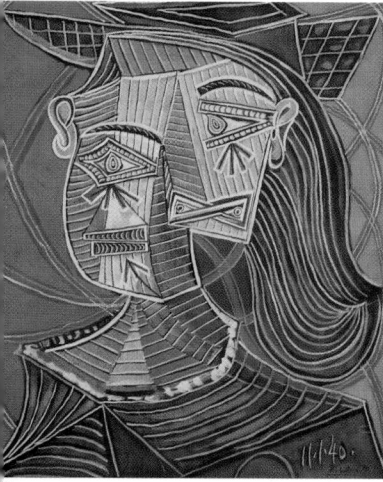

41

But the most impressive painting from this period continues to be the *Large Nude Doing Her Hair*, painted in Royan in June 1940 (fig. 839). The familiar coiffure theme here takes on a rather anguished air. The nude with her raised arms and protruding ribs stands against a green-and-purple background and is practically tearing out her hair; her deformed face with intensely red lips and eyes like circumflex accents, her prominent breasts and stomach, and her enormous feet are more tragic than intimate.

Resisting with Art

After returning from Royan at the end of August 1940, Picasso left his apartment on the rue La Boétie to live in the studio on the avenue Grands-Augustins. In the spring of 1941, Marie-Thérèse and Maya would settle in Paris, on the boulevard Henri IV. Picasso was invited to go abroad to the United States and Mexico, as other painters, writers, and poets were doing at the time, but Picasso chose to stay in the occupied French capital, even though he was refused the right to exhibit his work there. At the beginning of 1941, between January 14 and 17, Picasso drafted his first play, which was written in six acts of automatic writing. (Louise and Michel Leiris hosted a reading of *Le Désir Attrapé par la Queue* [Desire Caught by the Tail] in 1944.) In the fall of 1941, Picasso turned his bathroom at Grands-Augustins into a sculpture studio, and it was here that he created the plaster version of the monumental head of Dora Maar. The bronze statue would eventually finally be installed in memory of Apollinaire in the churchyard of Saint-Germain-des-Prés in 1959.

Despite all opposition, Picasso continued to draw, paint, and sculpt as if his creative work was his way to resist the enemy. Although he did not depict war as a subject, his painting indirectly reflected it: "I did not paint the war," Picasso said after Liberation, "because I am not the kind of painter who searches for a subject, like a photographer. But there is no doubt that war exists in the paintings that I did at that time."[11] The climate was clearly hostile to Picasso, a perfect representative of "degenerate art," which was held in contempt by the Nazis and was the focus of an exhibition in Munich in 1937. The academic painters did not support Picasso either. Vlaminck would write in the magazine *Comoedia* on June 6, 1942: "Pablo Picasso is guilty of having led French painting to the most deadly impasse, into indescribable confusion."

Sorrow and distress were omnipresent in his paintings of this period, with their stone colors, somber, gray, and muted. The portrait of Nusch Éluard with a blue ribbon is a tender, delicate exception (fig. 843). The *Young Boy with a Crayfish* (fig. 842) flashes a threatening crustacean and his exposed penis, a modern version of a Murillo. A woman seated in an armchair holds in her right hand an artichoke bristling with prickly leaves, brandishing it as if it were her only weapon, or her only household possession (fig. 845). Another woman in an armchair cheerfully dons a hat with flowers (fig. 844). Picasso's emphasis on these few minor features echoes the scarcity of the times.

The June 9, 1941, woman wearing a hat, her hand with its red nails tensely gripping the arm of the seat, is clearly Dora Maar (fig. 847). Her face, distorted at the right and left and depicted both frontally and in profile, is framed by a full head of brown hair. It is anything but pleasant: the painter has shown no tenderness toward his subject, whom he has painted in cold green and blue tones. Yet the model's body in a gouache-and-ink drawing of November 28 (fig. 848) is rendered with touching fullness, while the disheveled hair reflects a somber air.

In a 1942 drawing, the profile of a woman wearing a hat shaped like a fish (fig. 849) echoes the burlesque style of a March 11, 1939, drawing (see fig. 829), but the lemon, knife, and fork also indirectly evoke the hunger and the preoccupation with sustenance that haunted these years in which food was scarce. Apart from this baroque detail, the

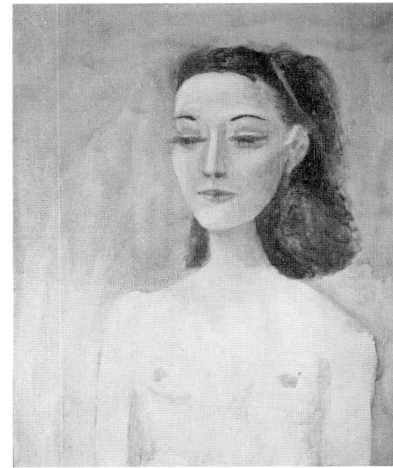

843

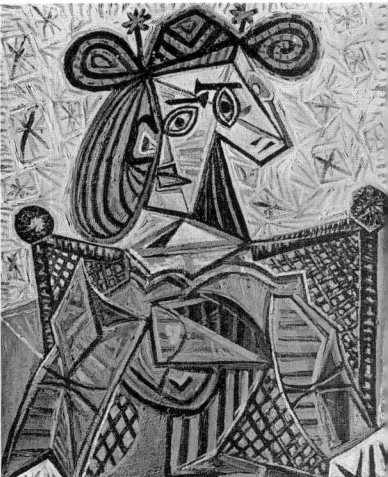

844

842

842 *Young Boy with a Crayfish,* June 21, 1941
843 *Portrait of Nusch Éluard,* 1941
844 *Woman Seated in an Armchair,* October 12, 1941
845 *Woman with an Artichoke,* Summer 1941

344

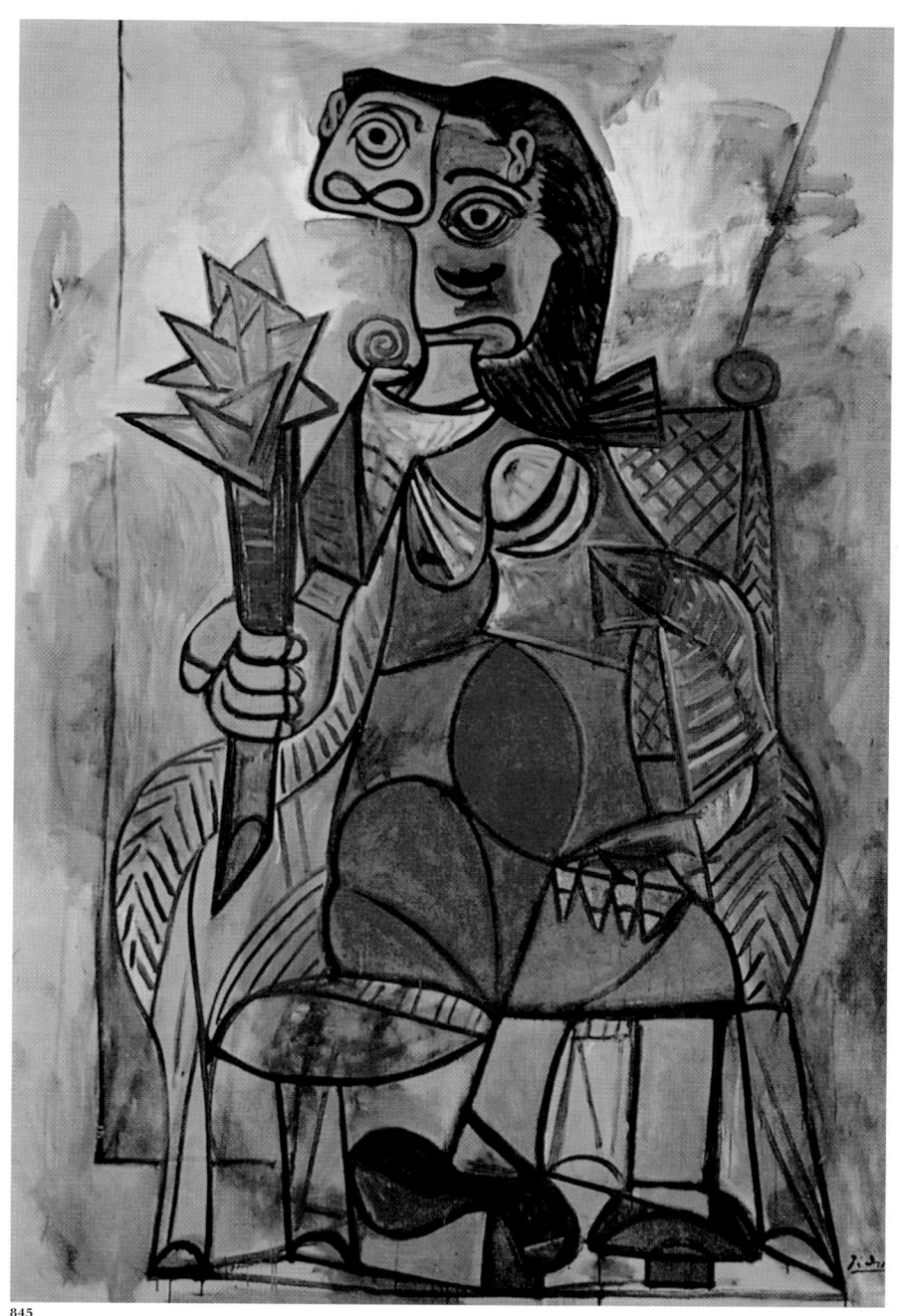

845

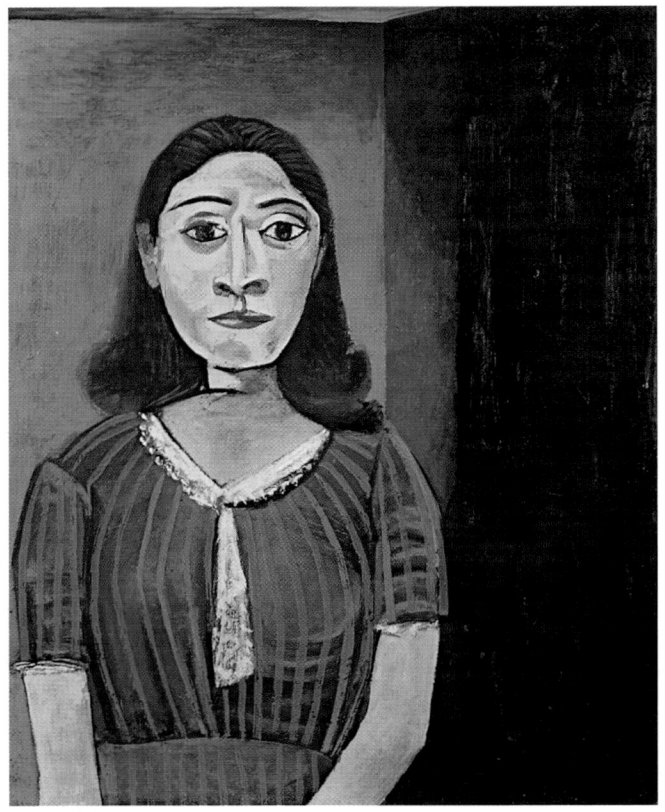

846

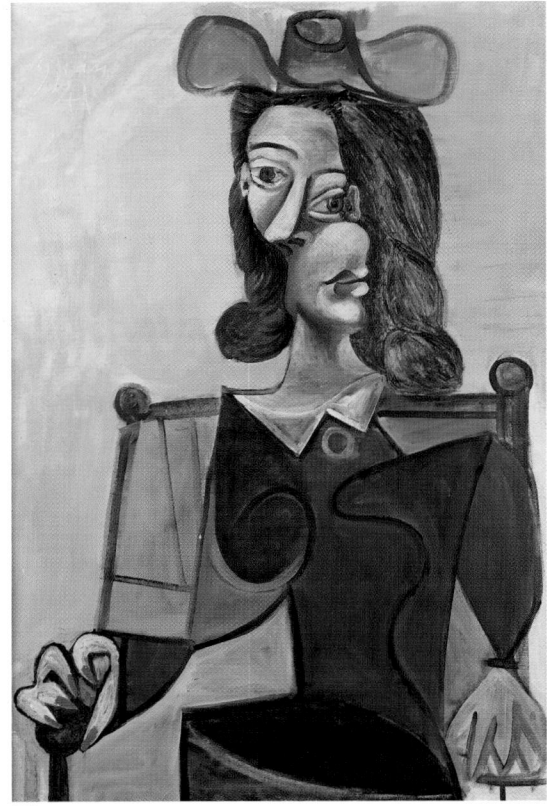

847

846 *Portrait of Dora Maar,*
October 9, 1942

847 *Bust of Woman in a Hat,*
June 9, 1941

848 *Seated Woman (Dora Maar),*
November 28, 1941

849 *Seated Woman in a Hat
Shaped Like a Fish,*
April 19, 1942

850 *Still Life with an Ox Skull,*
April 5, 1942

851 *Head of a Bull,* Spring 1942

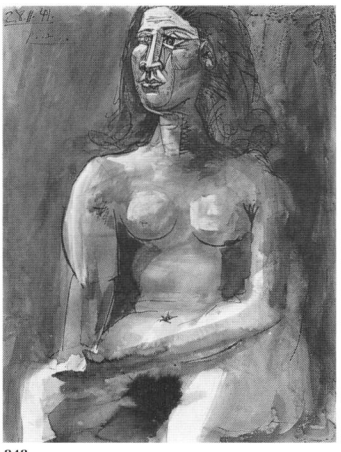

848

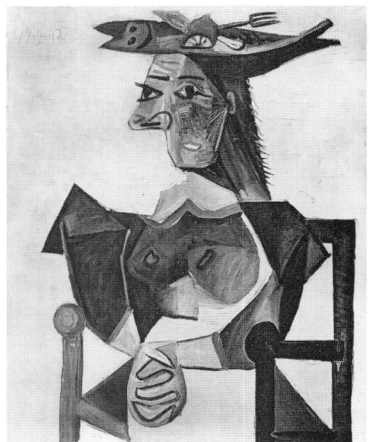

849

composition is relatively stark, with no other embellishments. No painting expresses this period of oppression and deprivation more touchingly than the deeply moving *Portrait of Dora Maar*, which Picasso finished on October 9, 1942 (fig. 846). Dora's face is not deformed here but marked with solemnity and restrained nostalgia. Her simple pose, the intensity of her puzzled stare, and the barrenness of the dark setting all capture the devastation of this period.

A series of graphite and ink drawings, completed between May 1941 and 1942, explore the subject of a reclining nude, sometimes depicted with another woman either seated or standing.[12] These studies resulted in the painting titled *L'Aubade* of May 4, 1942 (fig. 853). The objects in this dark enclosure, such as the silent musical instrument or the two-way mirror neglected in the corner, have lost all meaning. The seated woman watches over the reclining nude; both appear to be suffering, waiting for some news or an event. In the deadly stiffness of these forms, Picasso has expressed a sense of horror. In 1947 he donated this large, thought-provoking painting to the Musée National d'Art Moderne in Paris.

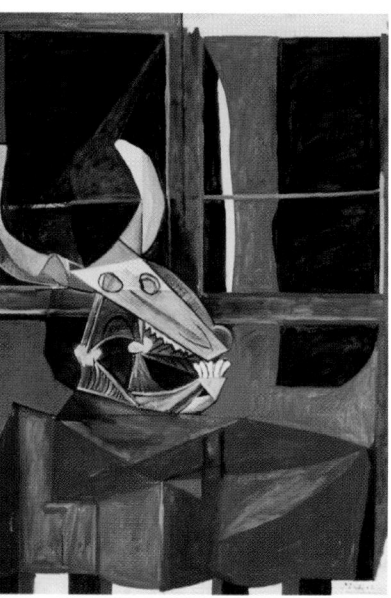

850

Two figures are presented in a similar fashion—but in a more peaceful, more intimate situation—in a series of ink drawings completed between August 1942 and January 1943, in which a seated woman, still at the right, watches a man sleeping (figs. 855 and 857). Picasso had already used this theme in 1901 and 1904 (see figs. 109 and 146), as well as in 1931, but with the roles reversed: the woman slept as the man watched.[13] Perhaps now the warrior is at rest. Picasso turned sixty-one in the fall of 1942.

During 1942 Picasso depicted beings and objects as deeply asleep, plunged into night in a state of hibernation. Julio González, who had introduced Picasso to metalwork at the end of the 1920s, died on March 27. On April 5, Picasso painted a *Still Life with an Ox Skull* (fig. 850), a pale blot set on a table in front of a closed window draped with black and purple funeral hangings. With this macabre subject, Picasso offered a contemporary version of the vanitás tradition in Spanish painting.

Although his imagination was as lively as ever, Picasso created the famous *Head of a Bull* with similar starkness. This unique assemblage of a leather bicycle saddle and an old handlebar would later be cast in bronze (fig. 851). A photograph of the object by Raoul Ubac appeared on the cover of the April 1942 issue of *La Conquête du Monde par l'Image*, a magazine published by Editions de la Main à Plume in Paris, to which Hans Arp, Oscar Domínguez, Paul Delvaux, Paul Éluard, Georges Hugnet, and René Magritte all contributed. Strikingly real, this *Head of a Bull* proved that the Surrealist sorceror could still breathe life into the most trifling found objects.

Returning to what was already a familiar theme in two works from 1942—the sculpting and painting studio—Picasso again depicted the artist with a beard (fig. 854 and 856). In a painted wood panel from November 1942 (fig. 856), he embodied *The Three Ages of Man* in a single image of three naked men of different generations. Looking toward the future through a picture window, a young boy cheerfully plays with a kind of flute, perhaps an echo of *The Pan-Pipes* from 1923. Behind him stands a bearded man, holding the mask of a faun—as in the drawing from April 23, 1936 (see fig. 736). In the foreground, a middle-aged man with the build of the man in Picasso's drawings from 1953–54 sleeps stretched out on the floor. A statuette on a stand at the right resembles the one in a drawing of August 4, 1931 (see fig. 625), but the unfinished canvas on the easel alludes to nothing in the past.

Hope can also be found again in works of this period, symbolized in the spring of 1943 by *Man with a Sheep* (fig. 865). Several studies for the piece were completed between July 1942 and March 1943.[14] A small bronze sculpture, *Standing Man,* cast in the cire-perdue process (fig. 859), foreshadowed the larger piece, which may be interpreted as a universal guarantee of man's faith.

851

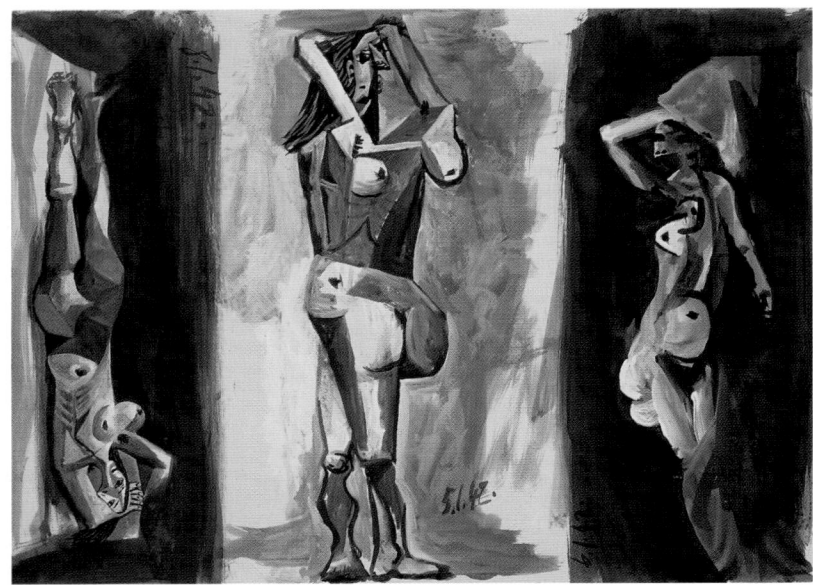

852

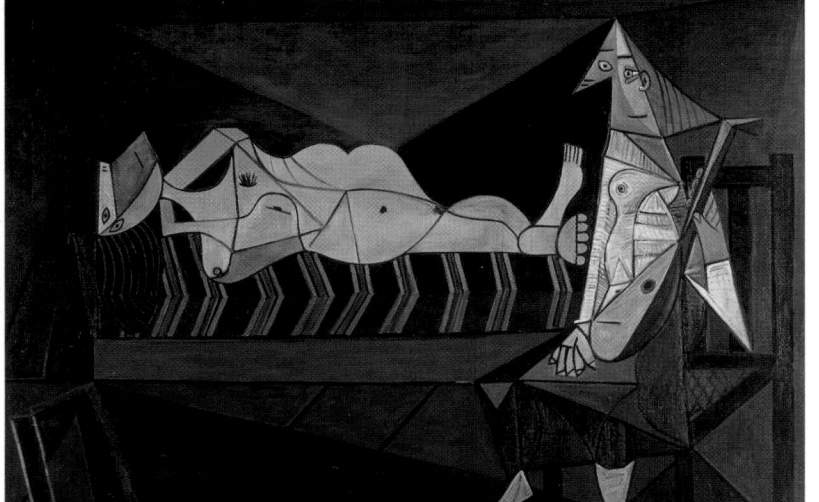

853

852 *Study for "L'Aubade": Three Nudes,* January 5, 6, and 8, 1942

853 *L'Aubade,* May 4, 1942

854 *Figure of a Man,* February 13, 1942

855 *Reclining Man and Seated Woman,* 1942

856 *The Three Ages of Man,* November 1942

857 *Reclining Man and Seated Woman,* December 13, 1942

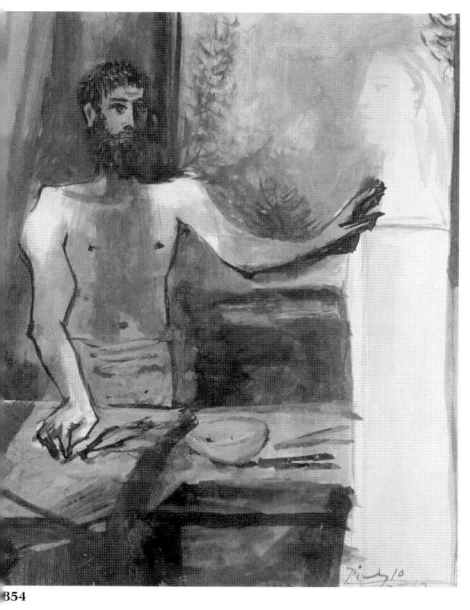

854

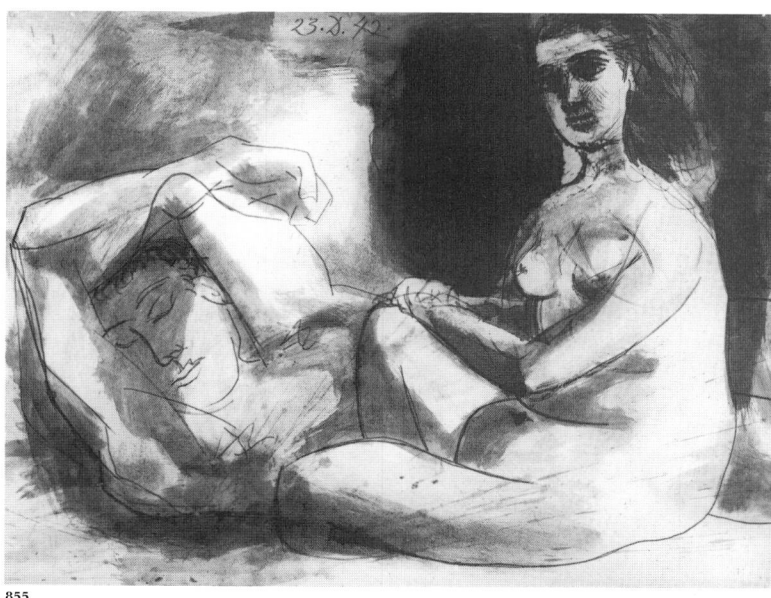

855

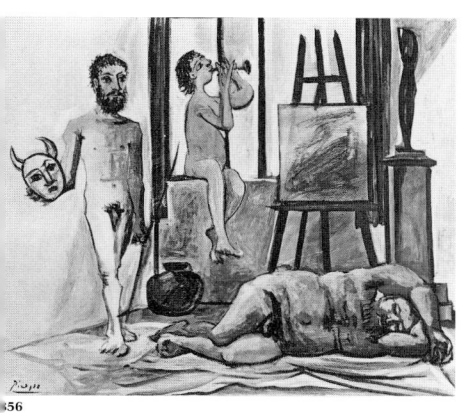

856

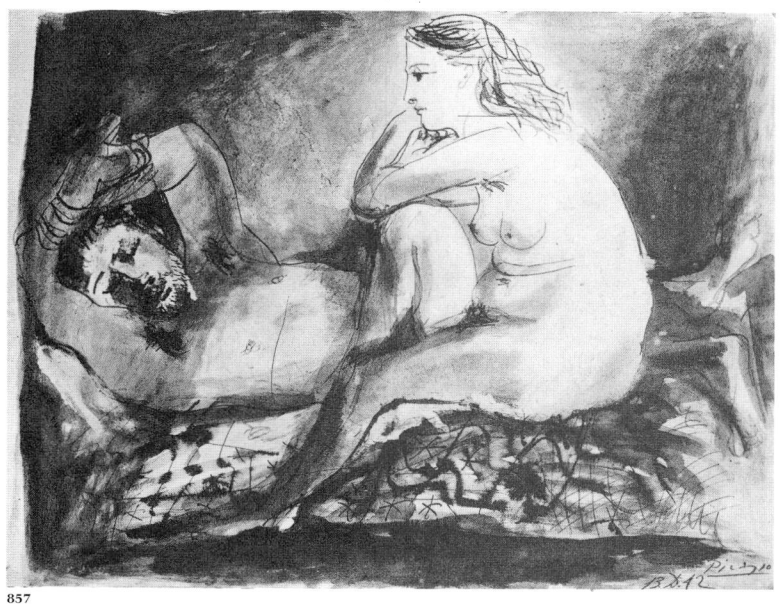

857

349

Hope of Liberation

Picasso denied that he had symbolic intentions when he created *Man with a Sheep* and thus left the viewer responsible for the interpretation. He declared: "The man could be carrying a pig instead of a sheep! There is no symbolism in it. It is simply beautiful. Symbolism is made by the viewer. It is the public that creates it. In *L'Homme au Mouton*, I expressed a human emotion, an emotion that exists today as it has always existed. The *Moschophor*—the man carrying a calf from the Acropolis Museum—the man with the sheep, and, if you like, the man with a pig, why not?—are all human."[15]

Nevertheless, the figure evolved gradually through successive studies. From being simply pastoral at the beginning, the image takes on a biblical aspect: the shepherd becomes prophet; here again, a gesture from the beginning of time is cast deep into a boundless future. The sheep lifts its beseeching head toward the sky, and the man gathers up and holds the helpless animal to save it. The manner is reminiscent of shipwreck scenes from 1932 and 1936, but the man, no longer part of a seaside scene, inspires confidence and gives an impression of strength, of conviction and determination.

In a drawing of October 6, 1942 (fig. 858), the young man holding the animal seems to emerge from a dark cavern, like the Minotaur holding the mare in the drawing of May 6, 1936 (see fig. 744). And on February 13, 1943 (fig. 864), the head of a bearded man is crowned with a garland, as in the mythological drawings of the 1930s. On February 19 (fig. 860), against a black nighttime background, the face of the man has become that of Christ, or the Good Shepherd. But on March 30 (fig. 861), Picasso returned to a less symbolic, more classical figuration. As time went on, he removed the mythological and biblical references that had surfaced in his drawings, retained only the essential gesture and character of the forms, restoring a contemporary expression.

Following this long gestation, the sculpture of *Man with a Sheep* was modeled in clay quickly, in a single afternoon. Because of its height, the original work was very fragile, and an intermediary cast had to be made so that the statue could be cast in bronze (fig. 865). One of three copies was installed in the market square at Vallauris, donated by the artist in 1950. The power of this emblem of life and peace must have enabled Picasso to counter the climate of death that lurked in 1943, reflected in two small but intense sculptures of that year, *The Reaper* and *Death's Head* (figs. 862 and 863).

In *La Tête d'Obsidienne*, André Malraux evoked *The Reaper*, a statue "whose single eye, in the middle of its head, is actually the imprint of a sand-castle mold; a split branch forms the torso of the body and legs, and a plant stump casts a scythe into the ground like the figure of Death."[16] According to Malraux, Picasso wanted to turn the sculpture into a "monument to the *Fleurs du Mal* at the tip of the Île Saint-Louis."

The *Death's Head*, a massive block of plaster that was later cast in bronze, is itself a universal symbol transcending time and civilizations. The eye sockets, the nose, and the jaw are now merely holes in a solid mass, polished like a stone, but they convey a strikingly real appearance. The forces of life and death emerge in Picasso's sculptures even more than in his paintings, perhaps because the bronze provides a weight and density that could stand the test of time.

At the beginning of May 1943, Picasso met a young woman named Françoise Gilot at the Catalan, a restaurant in the rue des Grands-Augustins; she was passionate about painting and visited him often in his studio until the summer. During that difficult year, this young woman was like a ray of sun, bringing joy to Picasso's life. All around him, more and more of his friends were being arrested. In November, a collection entitled *Picasso: Seize Peintures (1939–1942)* was published, with a preface by the poet Robert Desnos, who was arrested by the Gestapo on February 22, 1944. He never returned from the concentration camp at Terezin, where he died on June 8, 1945. Max Jacob was also arrested; he died of pneumonia at the Drancy camp on March 5.

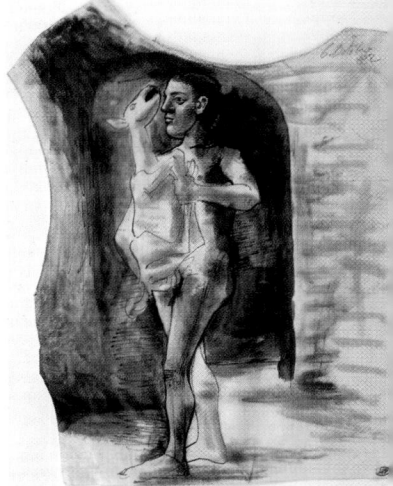

858

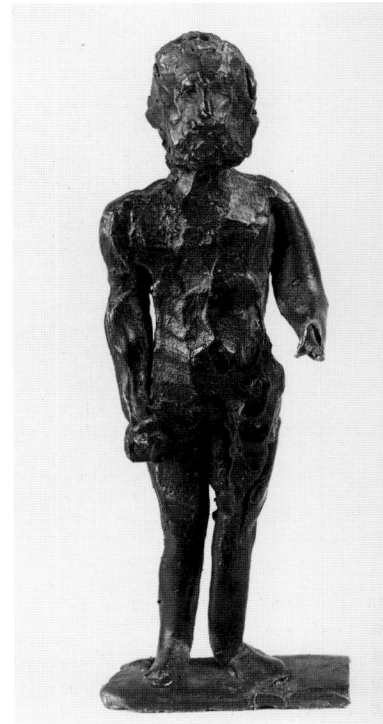

859

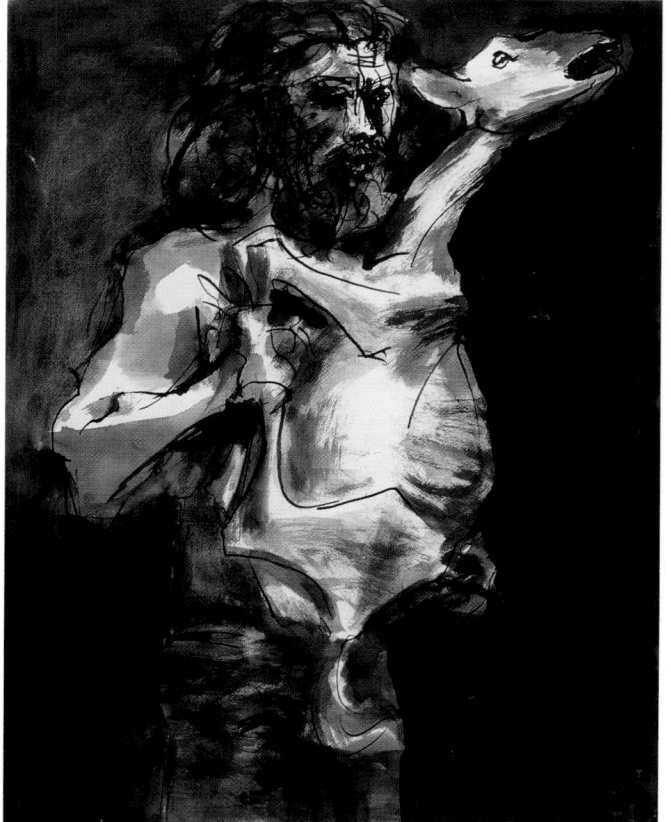

860

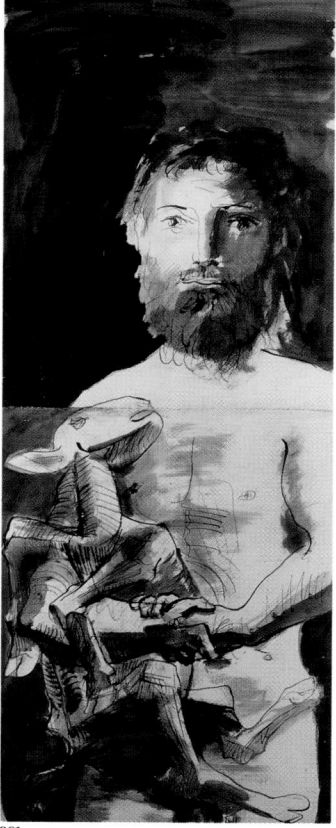

861

862

863

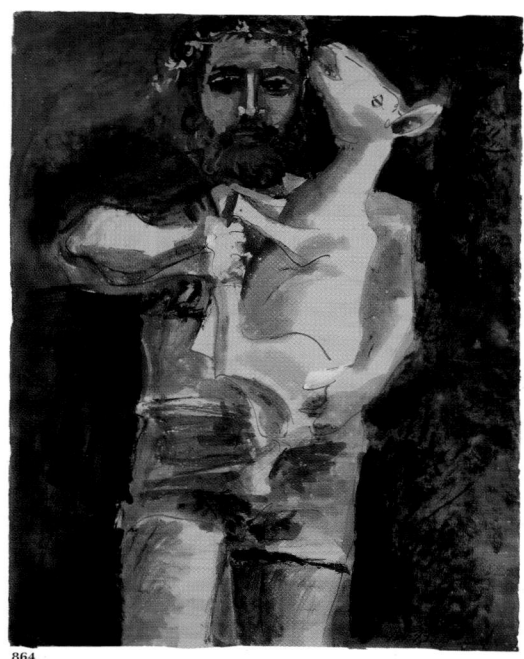

864

865

864 *Study for "Man with a Sheep,"* February 13, 1943
865 *Man with a Sheep,* February or March 1943

The *Child with Doves* (fig. 866) was inspired by the son of Inès, who had looked after Picasso's studio at Grands-Augustins since 1938. The dark, enclosed interior could be a dungeon, but a lighted area and two white doves offer a glimmer of hope. The chubby youngster seated next to a chair whose shadow is cast on the wall was nicknamed Churchill, because, as Picasso laughingly put it, "we thought he looked like him."[17] As always, Picasso combined personal references and historical context. The doves, which are reminiscent of *Woman with Pigeons* from 1930 (see fig. 613), would reappear a few years later as "the doves of peace."

A variation on the woman in a straight-back armchair, the woman here moves in a rocking chair (fig. 867), but the black curves of the chair do not soften her geometric angles as she poses stiffly on the cold, pink terra-cotta tiles. The rocking chair would reappear in a more serene environment more than ten years later, in a portrait of Jacqueline from October 1954 (see fig. 991).

All of Paris was waiting for Liberation. On June 25, 1943, Picasso painted the Square du Vert-Galant surrounded by the Seine (fig. 868), "with trapezoid trunks and sea urchin foliage"[18] and an equestrian statue of Henri IV amid a profusion of summer green. The statue seems to be watching the retreat of the Germans, an event that would not take place for a long time.

On June 28, using the same triangular rhythms, Picasso depicted a *Large Reclining Nude* in an enclosed space (fig. 869) with no hint of the terrible suffering in the world outside the studio. Clearly, he felt that it was better to paint something than to do nothing at all. His friend Pierre Daix later reported: "One day, when we were talking about this dark period, Picasso said to me, 'As for me, I began a painting when a painting came to me. I said to myself, even if it goes nowhere, you will have made a little something.'"[19]

Picasso returned one again to the motif of the woman in an armchair. One version (fig. 871), with a wicker chair, adopts the basketry effect from 1938 and the stripe motifs from *Yellow Sweater*, dated October 31, 1939 (see fig. 830). On March 7, 1944, a woman wearing a hat (fig. 870), painted intense blue, is holding an orange in her hand, as in the 1934 sculpture of a *Woman with an Orange,* and the January 25, 1951, painting of a mother and child (see fig. 962). Perhaps this is an allusion to the omnipotence of woman holding the world in her hand or to Eve holding the apple. In any case, the woman is solidly posed, with restrained contortions adding a dynamic quality to the rhythm of the lines. The facial features are less tormented than in earlier versions, with two well-defined eyes, a nose turned down to the side, visible nostrils, and a thin mouth.

The April 1944 *Woman in Blue* (fig. 872) is more schematically rendered. The blue surfaces are outlined in black; the angular face is taken from *L'Aubade* and the *Large Reclining Nude* of June 28, 1943 (fig. 869). Despite a relatively unattractive treatment of the female form, these women seated in armchairs affirm by their very presence their need to exist; even during this period of waiting, they are undergoing a test of endurance. Even Picasso was ambiguous about the meaning of the armchair in his paintings, as he told Malraux: "When I paint a woman in an armchair, the armchair is old age and death, no? Too bad for her. Or else, it's to protect her."[20]

During the occupation of Paris, Louise and Michel Leiris hosted a reading on March 19 of *Désir Attrapé par la Queue*, the play Picasso wrote in 1941, a burlesque farce that evokes the cold and the hunger endured during the war years. Among the actors were Louise and Michel Leiris, Simone de Beauvoir, Jean-Paul Sartre, Dora Maar, and Raymond Queneau; the performance was directed by Albert Camus. A famous Brassaï photograph taken in Picasso's studio immortalized the principal actors, along with Pierre Reverdy, Cécile Éluard, Valentine Hugo, Dr. Lacan, and Kazbek, the dog. On June 6, the Allies landed in Normandy.

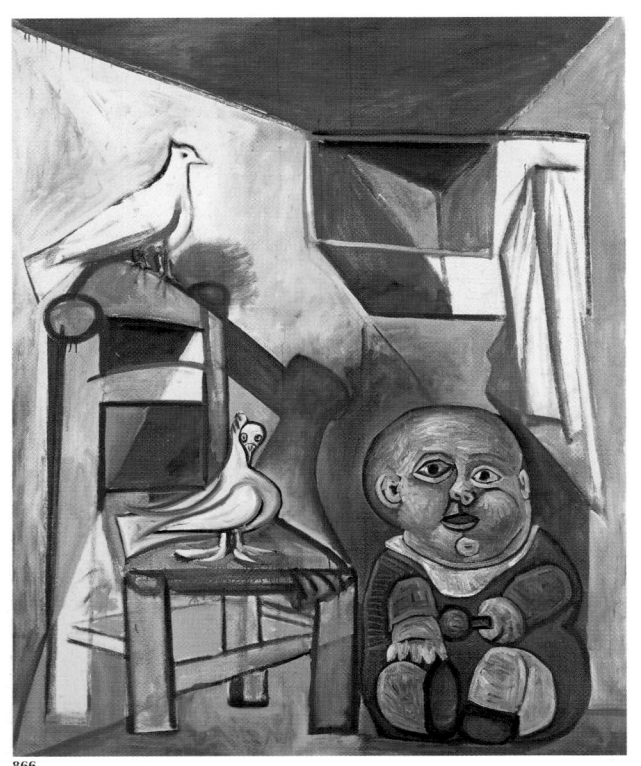

866

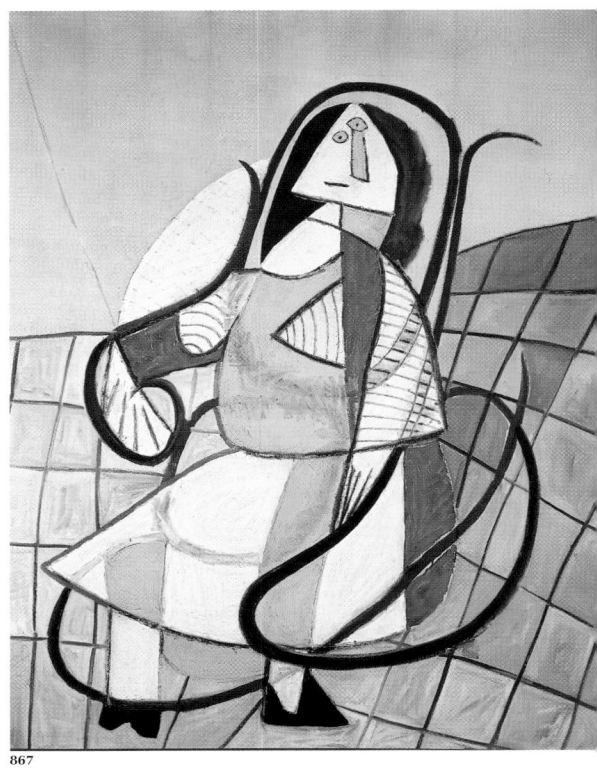

867

868

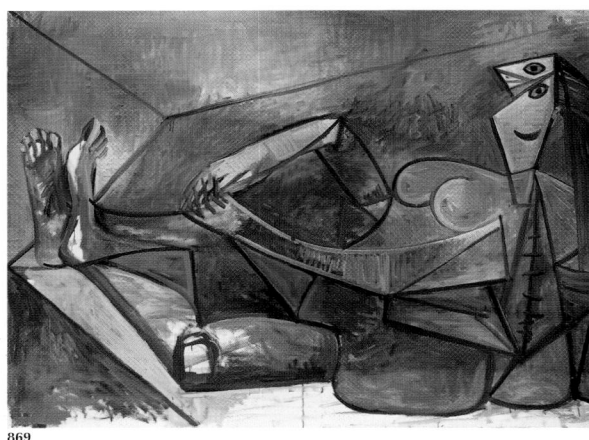

869

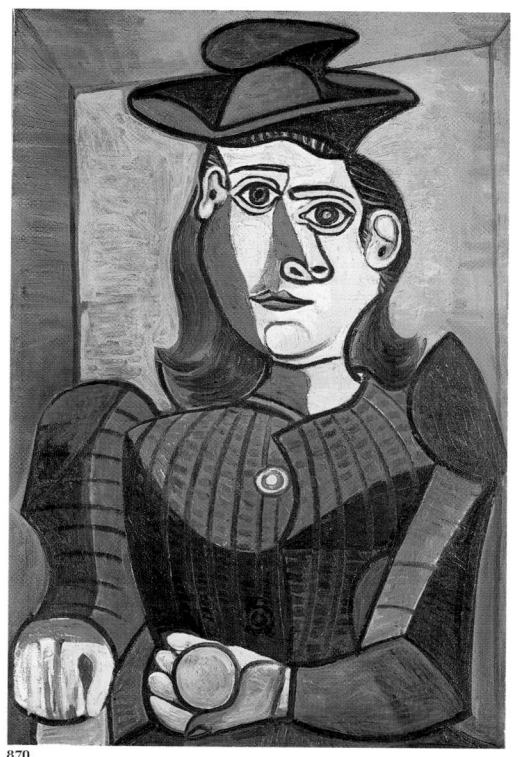

870

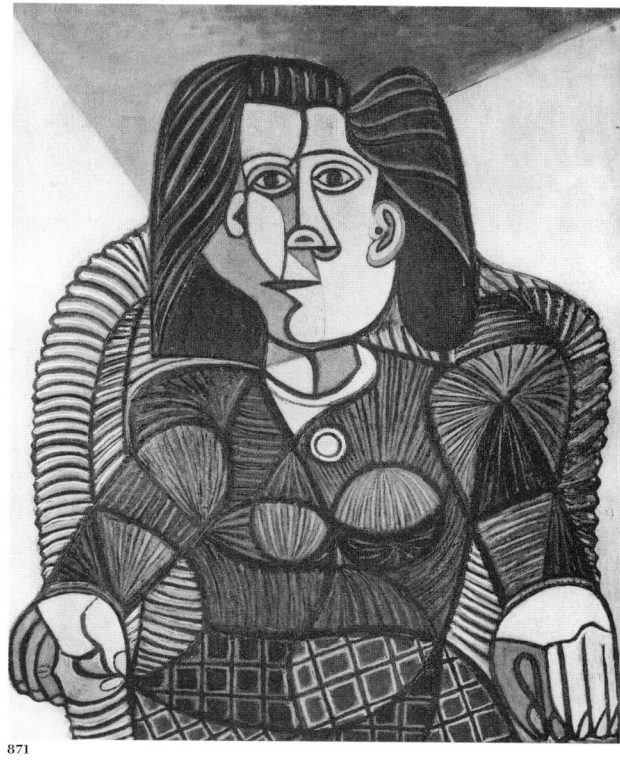

871

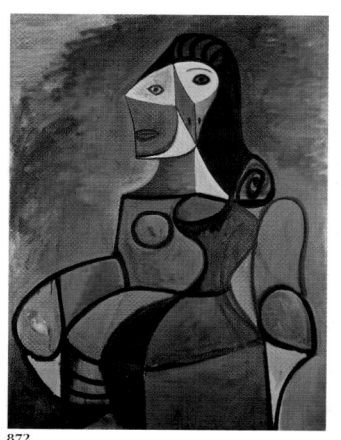

872

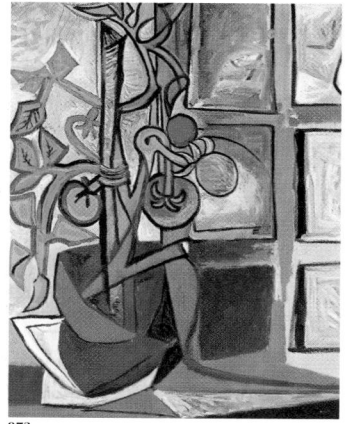

873

866 *Child with Doves,* August 24, 1943
867 *Woman in a Rocking Chair,* August 9, 1943
868 *Le Vert-Galant,* June 25, 1943
869 *Large Reclining Nude,* June 28, 1943
870 *Woman in a Blue Hat,* March 7, 1944
871 *Seated Woman,* 1944
872 *Woman in Blue,* April 1944
873 *The Tomato Plant,* August 10, 1944

355

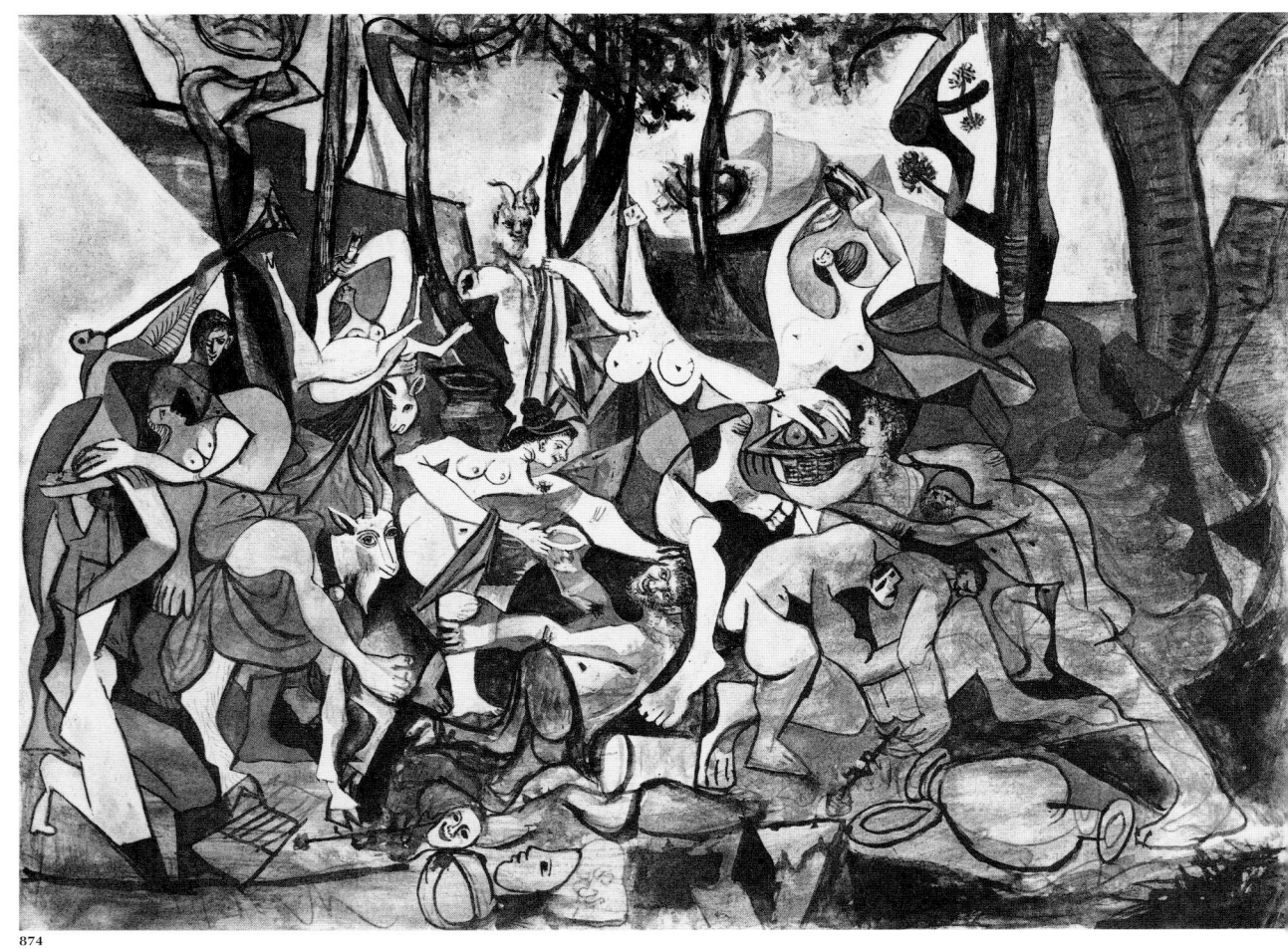

874

874 *Bacchanale, after Poussin,* August 24–29, 1944
875 *Young Man, Left Profile,* August 13, 1944

875

Picasso left his Grands-Augustins studio for the month of August to live with Marie-Thérèse and Maya on the boulevard Henri IV. There he painted *The Tomato Plant,* depicting a plant that was sometimes cultivated in homes during these times of scarcity (fig. 873). From August 24 to 29, to the noise of gunfire, Picasso drew inspiration from a Poussin bacchanal to express the collective joy that accompanied victory (fig. 874). Goats, satyrs, and maenads come together in a dance of panic and joy; one can spot Françoise Gilot's profile in the center of the composition, in the silhouette of a dancing nymph. The years of distress were coming to an end, and another cycle would soon begin, resulting in the 1949 painting *Joie de Vivre.* Even on August 13, 1944, the profile of a young boy (fig. 875) was already staring confidently into the future.

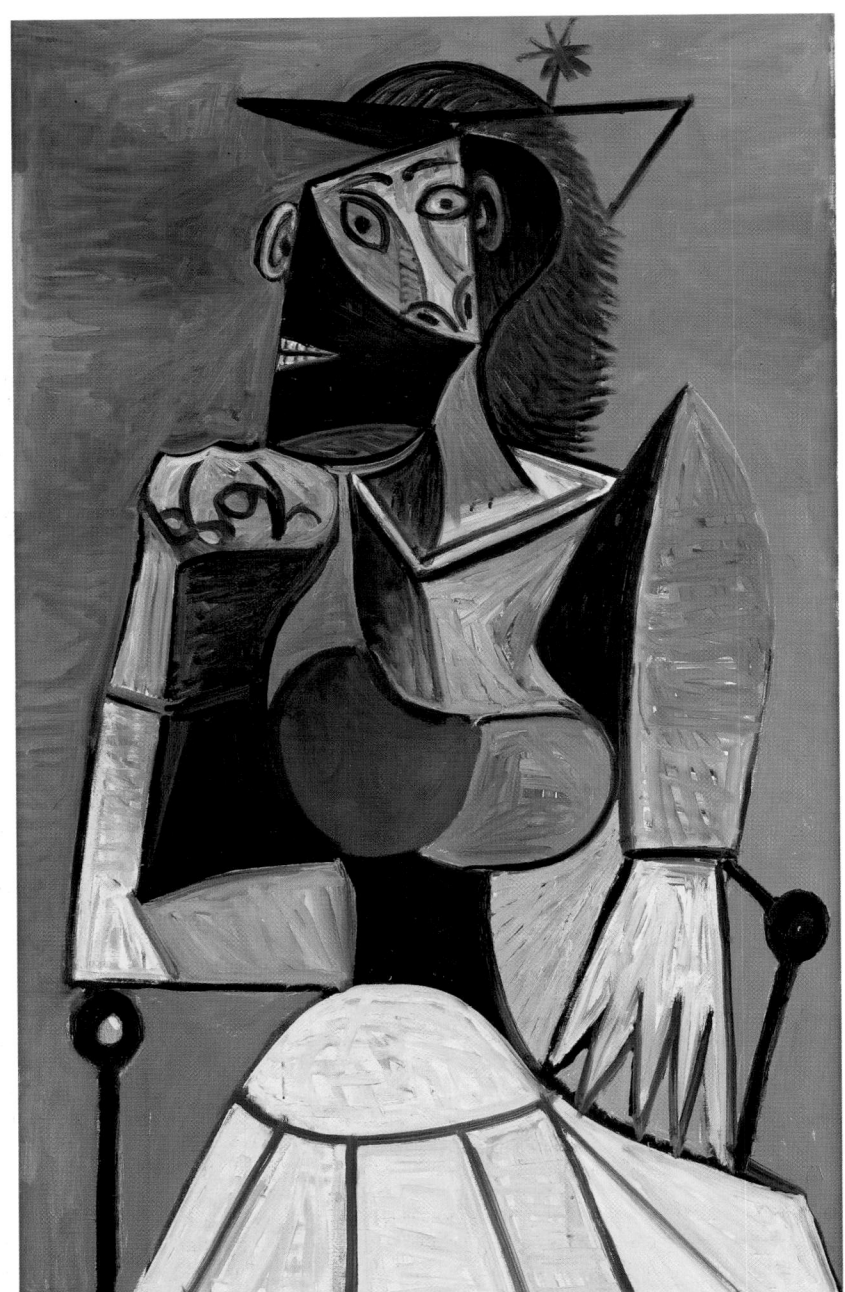

876

1945 – 1952

877

In the days following the end of the war, Picasso was reunited with the Mediterranean. He had left Antibes hurriedly in August 1939, and six years later, in July 1945, he returned to Cap d'Antibes. Over a period of several weeks, he filled the Musée d'Antibes with a population of fauns and nymphs, virtually transforming it into a Picasso museum. This new appetite for life was inspired by the presence of Françoise Gilot, who shared her life with him from 1946 to 1953. Together they had two children, Claude in 1947 and Paloma in 1949. Picasso widened his sphere of activity by exploring new forms of expression. In Paris, at the Mourlot printing studio, he pursued lithography, which he had experimented with in the 1920s, and in the south of France, at Vallauris, he threw himself passionately into ceramics at the Madoura pottery studio, where he created hundreds of original pieces. At the beginning of the 1950s, Picasso amused himself by treating a single subject, such as a still life, in both painting and sculpture, even going so far as to paint the sculpture. He joined the Communist Party in 1944 and produced works with an ideological content, although he did not succumb to social realism: *The Charnel House* in 1945, *Homage to the Spaniards Who Died for France* in 1946–47, *The Dove* in 1949, *Massacres in Korea* in 1951, *War* and *Peace* in 1952.

Françoise and La Joie de Vivre

Immediately after the Liberation of Paris, Picasso's studio was invaded by visitors, especially Americans, Ernest Hemingway among them. Picasso was the "Man of the Hour," as Françoise Gilot wrote: "For weeks after the Liberation, you couldn't walk ten feet inside his atelier without falling over the recumbent body of some young G.I. . . . In the beginning they were mostly young writers, artists, and intellectuals. After a while they were simply tourists, and at the head of their list, apparently, along with the Eiffel Tower, was Picasso's studio."[1]

At this time, Picasso favored a style that relied on rigor and revolved around only what was essential: "A more disciplined art, a less out-of-control freedom, this is the defense and the concern of the artist in times like ours," he would explain to the English poet John Pudney, "It is probably the moment for a poet to write sonnets."[2]

On October 5, 1944, *L'Humanité* announced that Picasso had joined the French Communist Party, with Aragon and Éluard as his sponsors. He explained his reasons in an interview published in the American magazine *The New Masses*, reprinted in the October 29–30 edition of *L'Humanité*: "These years of terrible oppression showed me that I had to fight not only through my art, but also through my person. I was so anxious to find my homeland again! I have always been in exile. This is no longer the case now . . . I am once again among my brothers."[3] Although Picasso found a family in the Communists, he would tell Claude Roy a few years later: "I wanted a family and I got one. The Party is like a family: the son wants to be a poet, the parents want him to be a lawyer."[4]

6 *Seated Woman,* March 5, 1945
7 *Notre-Dame,* July 14, 1945

Picasso's Communist affiliation was announced on the eve of the Salon d'Automne, in which he held a place of honor, represented by seventy-four paintings and five sculptures. But a certain segment of the public reacted violently against the exhibition, which had been organized by Jean Cassou. They disliked not only the evolution of Picasso's work, but also his political commitment. Once this uproar had passed, Picasso went back to work and returned to his favorite themes with a discipline punctuated by humor. The painting of March 3, 1945, in which a seated woman (fig. 876) wears a hat with a flower, fits into a series of variations dating from October 1941 and April 1944 (see figs. 844 and 872). And on July 14, 1945, the painter portrayed the joy of the people in a view of the quais of Paris decked out in tricolor flags (fig. 877), a subject not entirely new, for in 1901 Picasso had already painted a *July 14* in Montmartre.[5]

878

The painter was not quick to forget the past. He wanted to leave a work that spoke of the effects of death left by the war years. From February to July 1945, he painted *The Charnel House* in black and white, inspired by the photograph of a Spanish family massacred in their kitchen (fig. 881). As with *Guernica*, photographs taken by Christian Zervos document the successive stages of the composition (figs. 878–880). The bodies of a woman, a man, and a child lie heaped on the floor at the foot of a table. When Picasso was criticized for leaving the top of the canvas as a drawing, unfinished, he roared: "What is this unfinished, incomplete? Finished? Only death finishes something."[6] Picasso painted this tragic scene before the mass graves in the Nazi concentration camps were made public, as if he had anticipated their discovery. Nevertheless, it was this awful reality that the painting expressed after the fact, from the first moment it was installed in the "Art et Résistance" exhibition in February–March 1946.

879

The still lifes from 1945–46 allowed the painter to contrast themes of life and death as they confronted each other in his work. Regarding the bright blue *Enamel Saucepan* (fig. 883), one of the paintings he gave to the Musée National d'Art Moderne in 1947, Picasso said to Pierre Daix: "You see, a saucepan can also cry out! Everything can cry out! A simple bottle. And Cézanne's apples!"[7]

The glow of a candle (or a gas lamp) symbolizes the flame of life, the same flame that attemped to warm the face of dead Casagemas in 1901 (see fig. 74), and a skull, with its two rows of teeth represents death (figs. 882–886). Grouped to the right and the left, the symbols of life and death seem balanced, weighing the same on an imaginary scale, just as the objects and colors are used to balance the macabre elements. Two still lifes with a skull are painted with bright colors, which lends them an ambiguous gaiety. In the version of March 16, 1945 (fig. 882), the skull is matter-of-factly placed next to a bunch of leeks against a colorful background. The vegetables and the pitcher seem to signify food and drink, restorers of life. The still life of March 1, 1946, features yellow and blue with black and white (fig. 885); the skull sits on an open book, staring at the viewer. A still life of November 27, 1946 (fig. 886), is darker in tone, the oil lamp appears to be turned off, and only the sea urchins on the white plate suggest the "piquancy" of life.

880

At the end of 1945, Picasso met the printer Fernand Mourlot through Georges Braque and made a point of visiting his studio regularly. With great enthusiasm, Picasso rediscovered lithography, which he had practiced sporadically between 1919 and 1930. From December 5, 1945, to January 17, 1946, he made eleven successive stages of a bull profile (figs. 887–897) that truly illustrate the artist's discipline. The series reveals that Picasso liked to add, combine, and stick things together just as much as he like to strip, undo, prune, and purify: "The supreme art is to summarize," André Masson would write, referring to the long evolution of image into symbol from naturalism (fig. 887) and then into quasi-abstraction (fig. 897) whose graphic quality adopts the simple rhythm of a prehistoric figure.

In the paintings and drawings of 1946, Françoise can be recognized by the roundness

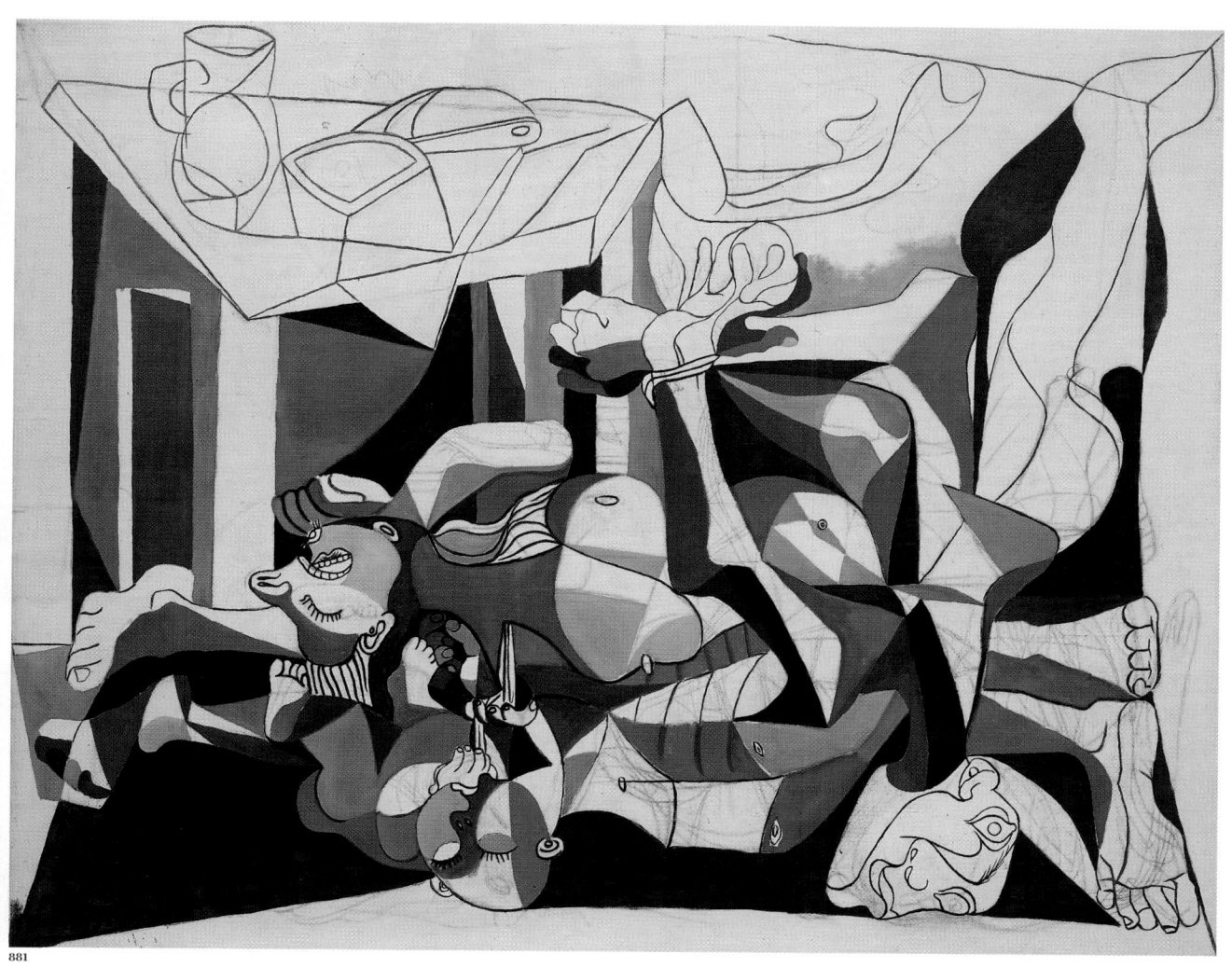

881

878–880 Progressive photographs
of *The Charnel House,*
taken by Christian Zervos,
February–May 1945

881 *The Charnel House,* 1945

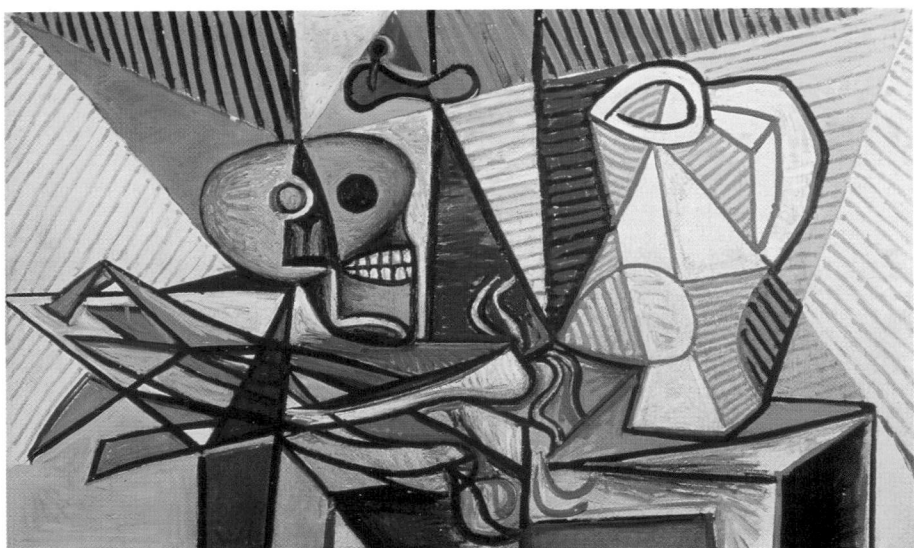

882

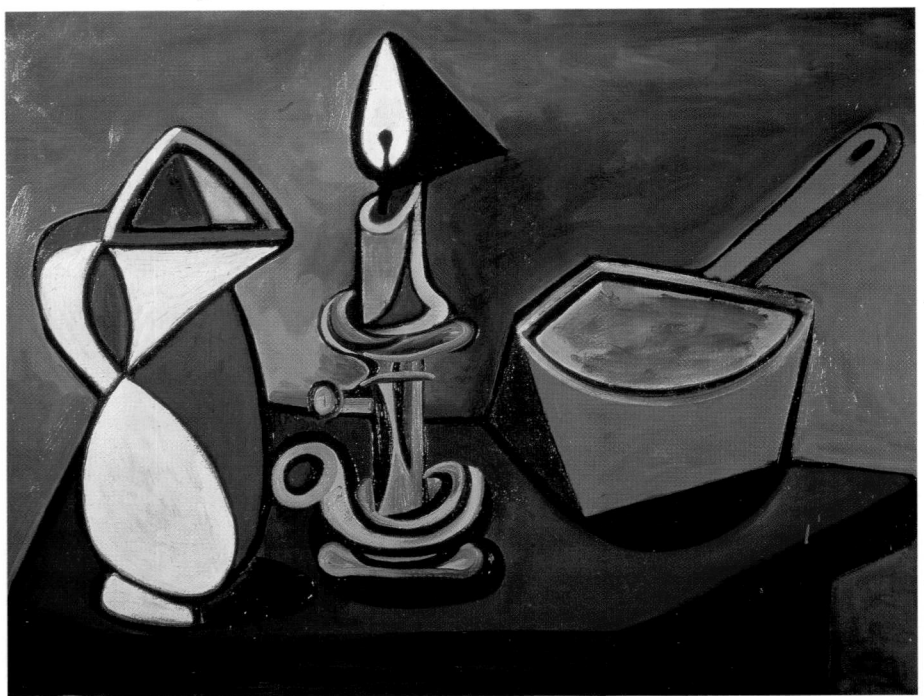

883

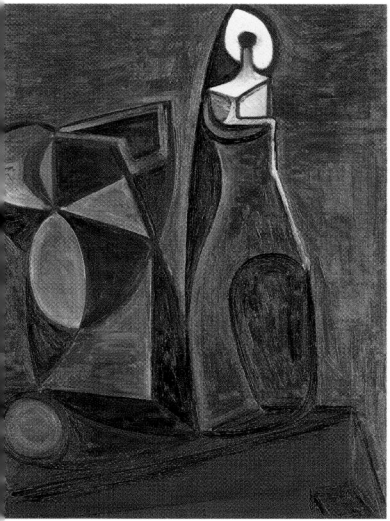

884

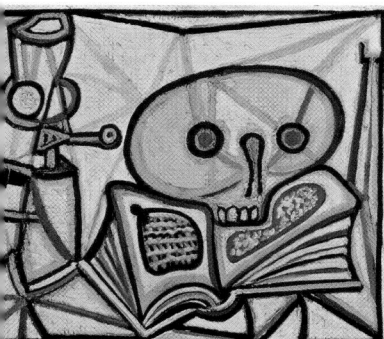

885

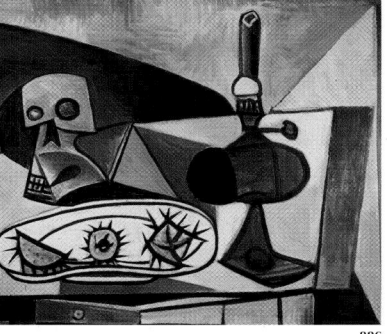

886

and pronounced volume of her breasts. For *The Rape of Europa* (fig. 898), the reappearance of the bull with crescent-moon horns—which Europa grasps in one hand, as legend has it—marks the resurgence of mythological influences in Picasso's work. At this point, the violence in his prewar work, such as the 1920 painting of *Nessus Seizing Deianeira* (see figs. 477–479), has disappeared.

On June 28, Picasso, in love with Françoise, was inspired to create a series of colored-pencil drawings, all dated the same day (fig. 899) and all characterized by pure lines and enormously seductive appeal.[8] Françoise did not come into Picasso's life overnight; during 1945 they had seen each other only infrequently. In July Picasso traveled with Dora Maar to the south of France, and together they visited Marie Cuttoli in Cap d'Antibes. In exchange for a still life, the painter bought a house in Ménerbes in the Vaucluse region, which he would offer to Dora. This gesture was to be a farewell present, however. Picasso rented a room in Golfe-Juan for Françoise from the engraver Louis Fort, but she prudently decided to stay in Brittany for her vacation. In the fall, she did not immediately return to the rue des Grands-Augustins, but at the end of November, she went again to see Picasso, who introduced her to the Mourlot printing studio.

In March 1946, Picasso joined Françoise at Louis Fort's residence in Golfe-Juan. He took her to Vence to see Matisse, who did not hesitate to say: "If I made a portrait of Françoise, I would make her hair green."[9] This remark only piqued Picasso's possessive instinct. In May Françoise agreed to live with Picasso on the rue des Grands-Augustins. Claude, their son, was born on May 15, 1947, and Paloma on April 19, 1949, the day the Peace Congress opened in Paris.

The paintings that depict Françoise, who was forty years younger than Picasso, glorify the young woman's svelte, slim figure. Three paintings completed between May and June 1946 present the contrasts that his model offered him: her abundant hair and long neck, her full breasts and slender waist. The July 3 *Woman in an Armchair* (fig. 901) reintroduces light and lively tones—yellow, pink, blue, and white—which had disappeared from Picasso's paintings of the same subject during the war years. In the portrait of May 31 (fig. 902), Françoise's round face and upright neck are framed with abundant hair; the right eyebrow is drawn like a circumflex accent, a graphic symbol that characterized the young woman's physiognomy.

But the emblematic portrait of Françoise will always be *La Femme Fleur* of May 5, 1946 (fig. 900). In her book *Life with Picasso*, Françoise describes how the portrait was developed from cut paper.[10] Picasso presented his model standing because Françoise was not the "passive type," as he put it. He took Matisse's suggestion to give her green hair, thus rendering the portrait a "symbolic floral pattern." Françoise remarked that Picasso painted her "right hand holding a circular form cut by a horizontal line." We are certainly reminded of the *Woman with Blue Hat* from March 7, 1944 (see fig. 870), who holds an orange in her hand. At the time, Picasso told Françoise: "That hand holds the earth, half-land, half-water, in the tradition of classical paintings in which the subject is holding or handling a globe," and "You see now, a woman holds the whole world—heaven and earth—in her hand."

During the summer of 1946, Picasso and Françoise left for the south of France, where they would stay for several months. In July he took her to Dora's house at Ménerbes, which Picasso's new mistress did not much appreciate. Afterward, they went to see Marie Cuttoli in Cap d'Antibes and Louis Fort in Golfe-Juan. However, it was in Antibes, from the end of August to November, that Picasso was able to engage fully in painting and drawing.

Romuald Dor de la Souchère was the curator at the Musée d'Antibes. Thanks to him, in 1928 the Château Grimaldi had become the city's Musée d'Art, d'Histoire et d'Archéologie. When the château was put up for sale at that time, Picasso wanted to buy it; fate would have it that he would possess it less than twenty years later. In August 1946, Dor de la Souchère, through the photographer Michel Sima, asked Picasso to come and

887 FIRST STATE

888 SECOND STATE

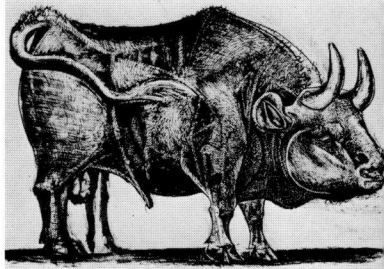

889 THIRD STATE

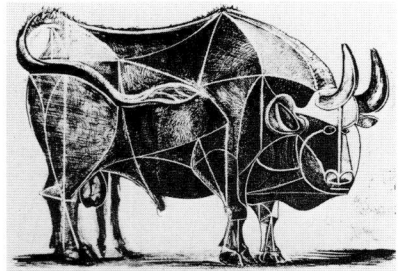

890 FOURTH STATE

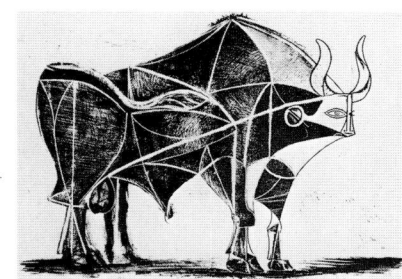

891 FIFTH STATE

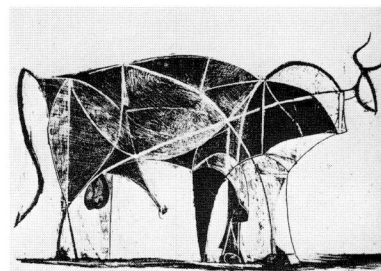

892 SIXTH STATE

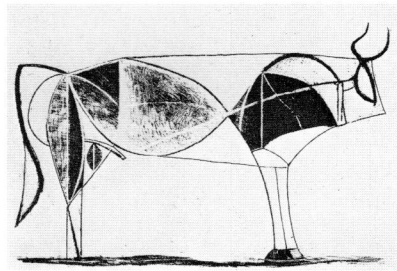

893 SEVENTH STATE

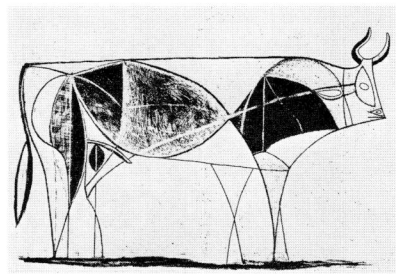

894 EIGHTH STATE

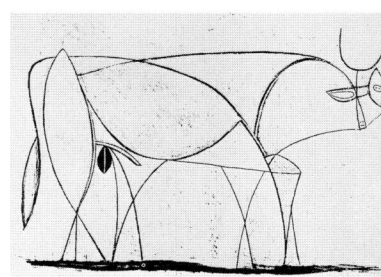

895 NINTH STATE

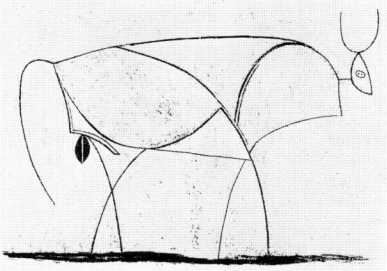

896 TENTH STATE

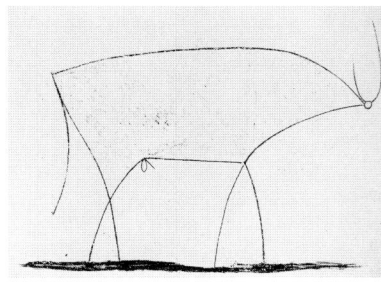

897 ELEVENTH STATE

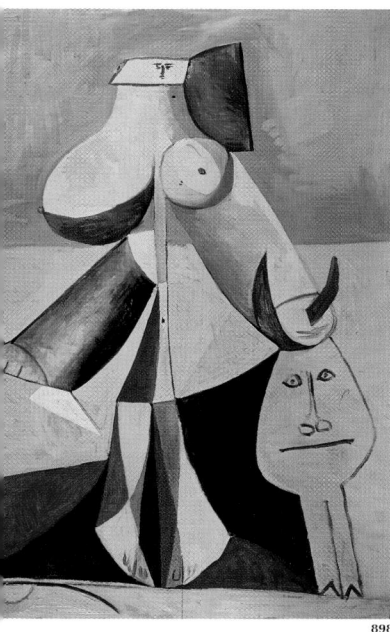

898

899

365

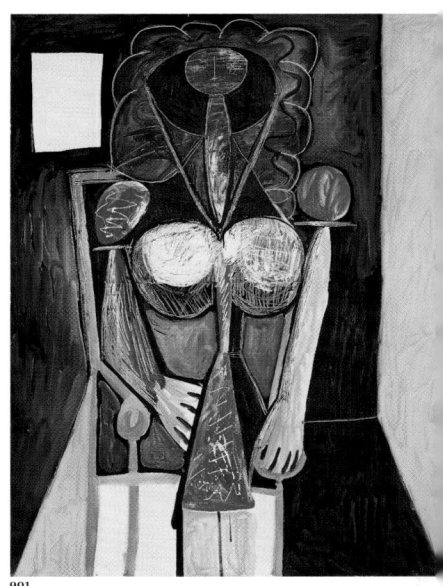

901

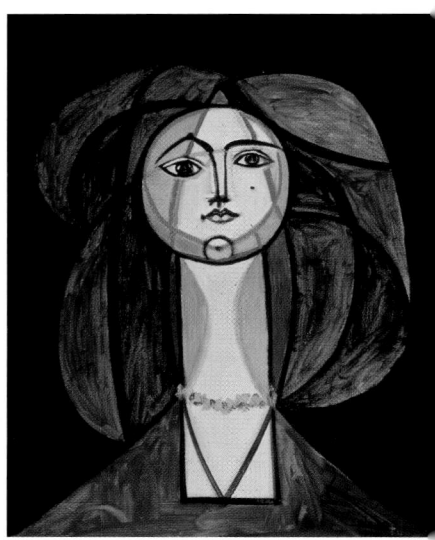

902

900

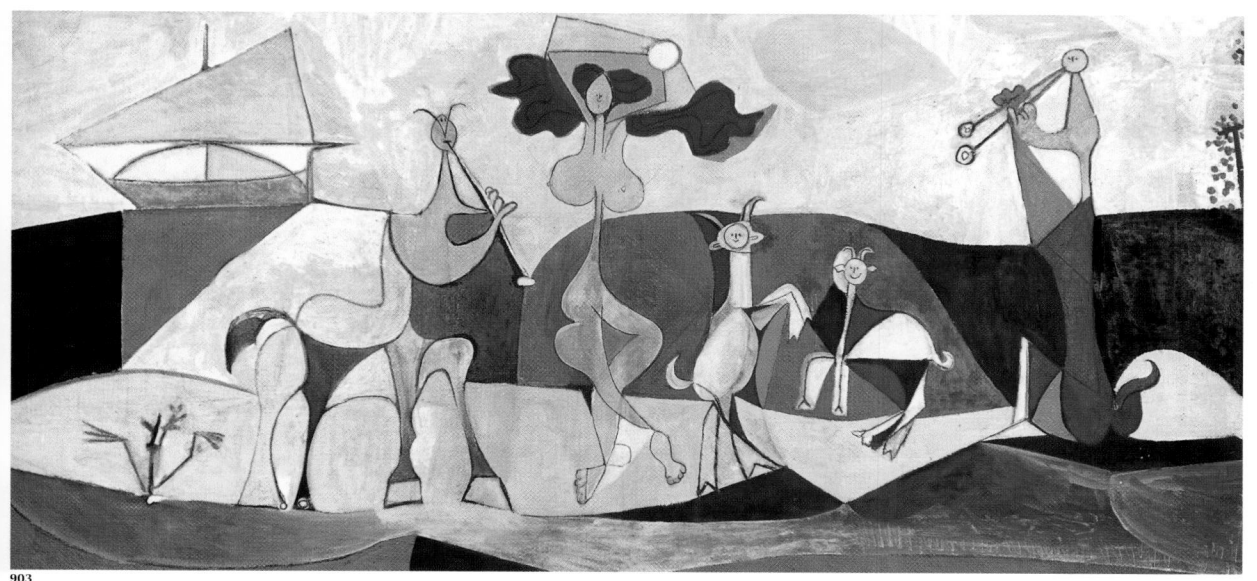

903

904

905

906

900 *La Femme Fleur,*
 May 5, 1946

901 *Woman in an
 Armchair,*
 July 3, 1946

902 *Portrait of Françoise,*
 May 31, 1946

903 *La Joie de Vivre
 (Antipolis), 1946*

904–906 *Satyr, Faun, and
 Centaur with Trident,*
 October 1946

paint in the museum's empty rooms. The painter, who did not have a studio, accepted enthusiastically and even offered to decorate an entire floor. In this postwar period, with no materials at hand, Picasso used boat paint, plywood, and Sheetrock as his materials. This experiment yielded twenty-five paintings and a series of forty-four drawings, which would remain in the gallery space, thus creating the first Picasso museum. Ceramics, lithographs, tapestry, and sculpture were added later.

For the most part, these works contained mythological allusions and images of Mediterranean fauna. Picasso acknowledged to Dor de la Souchère: "Every time I come to Antibes . . . I am taken in again by this Antiquity. . . . Works are born in accordance with the moment, place, circumstance. Everything is a starting point."[11] He painted and drew nudes inspired by Françoise, as well as still lifes with sea urchins and saltwater fish, fishermen wearing striped bathing suits, and pastoral scenes, such as the triptych entitled *Satyr, Faun, and Centaur with Trident* (fig. 904–906).

The painting *Joie de Vivre* (fig. 903) captures the happiness of that time, peace restored: the joy of painting and of being with Françoise, whose silhouette appears with a tambourine at the center of the composition, surrounded by fauns, centaurs, and musicians playing Greek double flutes. The yellow and blue tones suggest sand, sun, and sea. A sailboat floats along the horizon, and there are no clouds in the sky. The whole scene is bathed in light and rediscovered harmony.

Several paintings and drawings from this period were definitely influenced by Matisse. The two graceful drawings of a ewer from September 14 and 15, 1946 (figs. 907 and 907b), also suggest a female figure with Françoise's long neck and slender waist.[12] Nevertheless, the beauty of the Mediterranean would fade. Tragic events followed Picasso's return to Paris in the end of November, starting with the outbreak of war in Indochina. And on November 28, Nusch Éluard suddenly passed away, the victim of a stroke. Her unexpected death was a dark omen for the years to come.

Ceramics and Lithographs

Between 1947 and 1949, Picasso divided his time between Paris and the south of France, working intensively with ceramics and lithography, in addition to his painting. At the end of 1945 or the beginning of 1946, he had begun *Homage to the Spaniards Who Died for France*, which he would rework throughout 1946, finally dating it January 31, 1947 (fig. 909). The work touches on themes emblematic of life and death and grants a special place to the bugle, which Françoise referred to in this way: "In the studio in the Rue des Grands-Augustins, he kept an old French Army bugle, from which hung a red, white, and blue cord. He never let a day pass without picking it up and letting out a few good blasts, as loud as he dared."[13] Between February 14 and March 15, 1946, the painting would be shown, along with *The Charnel House* in the "Art et Résistance" exhibition at the Musée National d'Art Moderne.

Not all violence disappeared from Picasso's painting: a rooster, with its legs tied and its head hanging, lies on a table beside a knife resting on a bowl and is clearly reminiscent of the *Woman with Rooster* from February 15, 1938 (see fig. 820). This time the sacrifice has been completed, proving that the prewar context is not a sufficient explanation for this choice of subject.

More than ten years earlier, in 1936, Picasso had discovered the village of Vallauris with Paul Éluard, who, at the time, in his poem "À Pablo Picasso," predicted what was to become a new form of expression for Picasso. Éluard wrote: "Show me that man forever so soft / Who said that fingers are what raise the earth." During the summer of 1946, Picasso and Françoise visited the Madoura pottery studio in Vallauris, which was managed

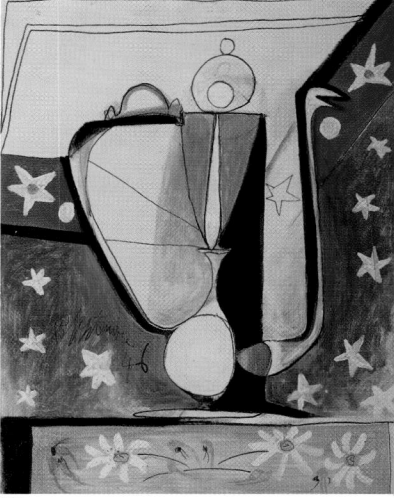

907

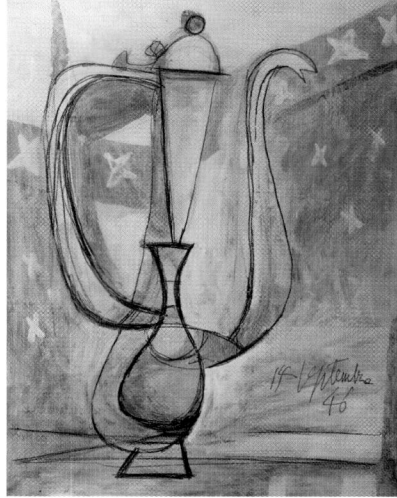

907b

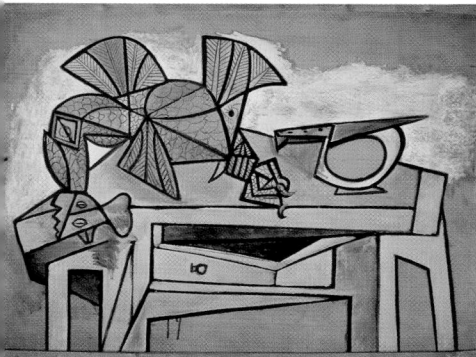

908

909

369

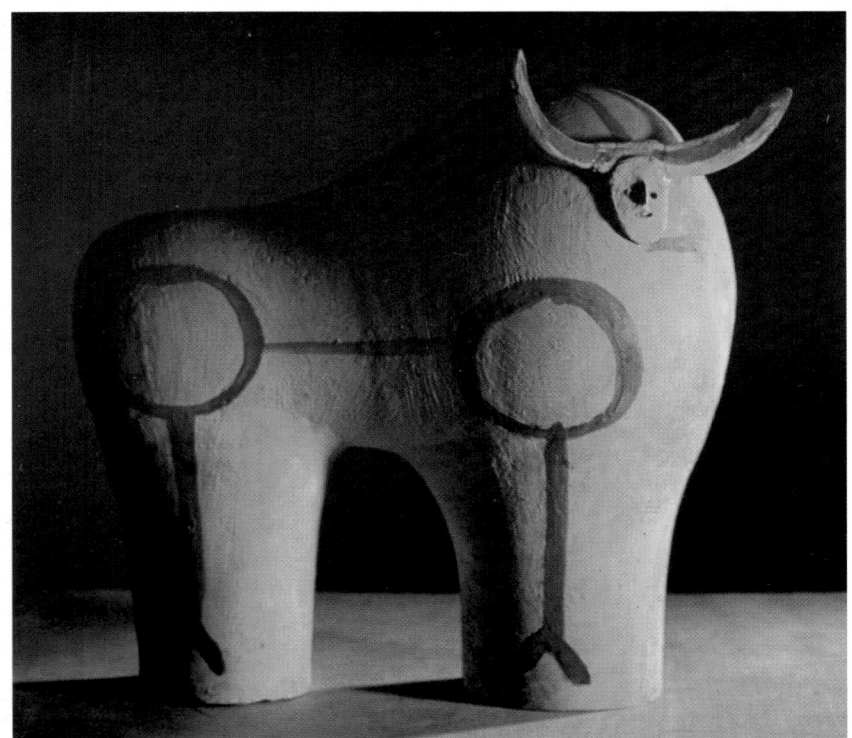

910

911

912

by Georges and Suzanne Ramié. Before long, Picasso was exploring the medium and had decorated "two or three plates made of red clay that had already been fired—what is called biscuit—with a few drawings of fish, eels and sea urchins."[14] A year later, he returned to see the results, and just as he had filled the Antibes museum, he took over the Madoura pottery studio. His presence would reinvigorate this art form, whose popularity was then dormant. For a couple of years, the most famous Vallauris potter explored the possibilities of an art that, until then, had been considered secondary, somewhere between craft and industry. It was only in January 1953 that an electric kiln was installed in the Madoura studio to replace the old Roman stove heated with Aleppo pine, in which Picasso often fired his own pieces.

Picasso invented freely in ceramics, either by decorating industrial pieces or by modeling and shaping forms when the clay was moist and still malleable. In 1947 and 1948, he decorated several oval or rectangular dishes by slitting the clay and enameling it with either matte or brilliant tones. Thus he found a new medium for his favorite subjects, including heads and still lifes (figs. 918–920). Sometimes he would also decorate the backs of the dishes and add the date. Other pieces looked like sculptures made of clay: using his fingers, he would model a clay vase and transform it into a woman, granting her the charm of a tanager (fig. 911). In 1947 an enormous bull appeared (fig. 910) made of ocher clay and highlighted with calligraphy that foreshadowed the lines of *The Kitchen* (see fig. 925) and *Chant des Morts* by Pierre Reverdy, which Picasso illustrated in an edition published the following year. As for the owls (fig. 911), these were among Picasso's favorite animals, and they also appeared in several paintings and drawings from those years.

The ceramic artist used everything that fell into his hands. He wanted to try it all: "An apprentice who worked like Picasso would not find work," joked Georges and Suzanne Ramié. Picasso even decorated pieces of industrial material, painting a man and woman (Picasso and Françoise) on large tiles used to put ceramic pieces into the kiln, known in French as "gazelles" (fig. 913 and 914). He combined coloring agents (metallic oxides, slips, enamel, and glazes) to achieve unexpected results; a ceramic artist's colors are different from those of a painter in that they reveal themselves only during firing. Picasso was still after the surprise effect. Bulbous pitchers were adorned with birds, which were sometimes caged (fig. 915). Simple vessels were decorated with mythological ornamentation, black on an ocher background (figs. 916 and 917). Platters were colored with enamel still lifes (fig. 919); sometimes the clay itself would undulate, like the fish on the imprint of a newspaper page. He also used the concave surface of a large Spanish dish to enhance the shape of a bull (fig. 923). Picasso continued to work with ceramics merging form and decoration until the beginning of the 1960s.

Ceramic art is the art of fire, born of an age-old technique rooted in the Mediterranean area. The most advanced ancient civilizations, such as Crete and especially Greece, to which Picasso often made reference, are not preserved in stone, which crumbles and erodes, nor in cast metal, which oxidizes and pulverizes. They are preserved in clay. In shaping clay, Picasso drew new energy from mother earth. The popular aspect of this earthbound art and his peasantlike simplicity—Léon Moussinac called Picasso a "workman of earth and fire"[15]—suited Picasso, the new Communist, just as it did a generation of traditional artisans working in stained glass, tapestry, and so on. In November 1948, 149 of Picasso's ceramic pieces were exhibited at the Maison de la Pensée Française. Like lithography, which enables one to make reproductions at a low cost, the large number of Picasso's ceramic pieces helped him disseminate his themes to a wide audience through limited editions sold at reasonable prices. In fact, at the Madoura studio, certain original works were reproduced and put on the market with a stamp that read "édition Picasso . . . empreinte originale."

It was also in the south of France that Picasso wrote his second play, *Les Quatre Petites*

910 *Bull,* 1947
911 *Owl,* December 30, 1949
912 *Vase: Woman in a Mantilla,* 1949

913

914

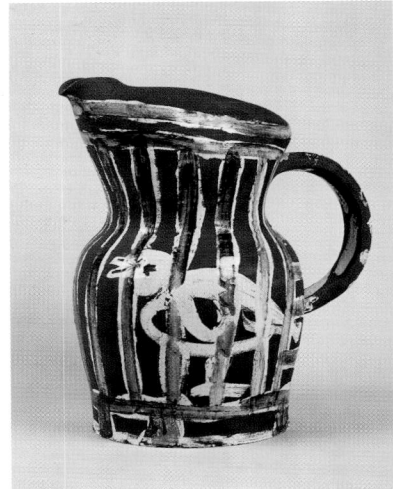

915

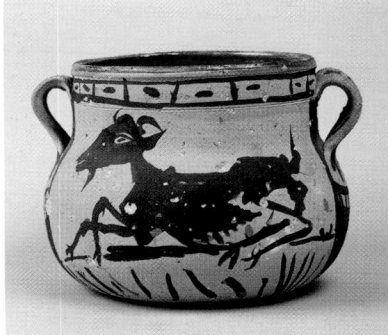

916

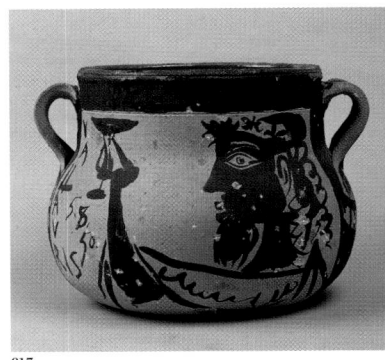

917

913 *Oven Gazelle Decorated with a Nude,*
September 18, 1950

914 *Oven Gazelle Decorated with Bust of a Man
in a Striped Sweater,* September 23, 1950

915 *Gothic Pitcher Decorated with
Two Caged Birds,* February 4, 1948

916–917 *Vessels Decorated with a Goat and a Bust
of a Man Holding a Cup,* August 5, 1950

918 *Rectangular Plate Decorated with a Bunch
of Grapes and Scissors,* 1948

919 *Still Life,* August 5, 1948

920 *Rectangular Plate Decorated with the Head
of a Bearded Faun,* January 21, 1948

921 *Rectangular Plate Decorated with the Head
of a Faun,* 1947

922 *Rectangular Plate Decorated with the Head
of a Faun,* October 20, 1947

923 *Spanish Plate Decorated with a Bull,*
March 30, 1957

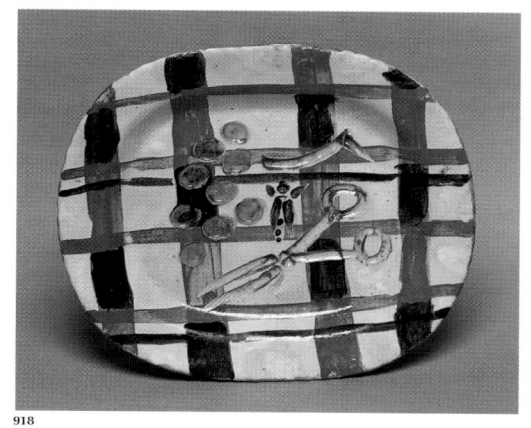

918

919

920

921

922

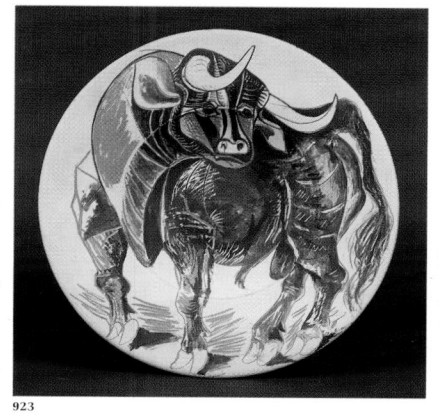

923

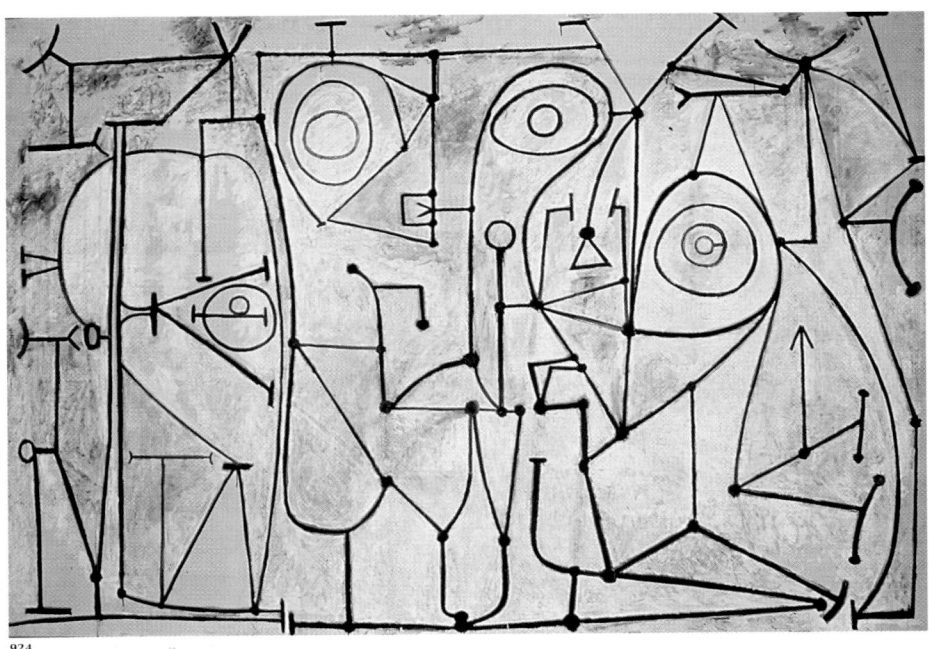

924

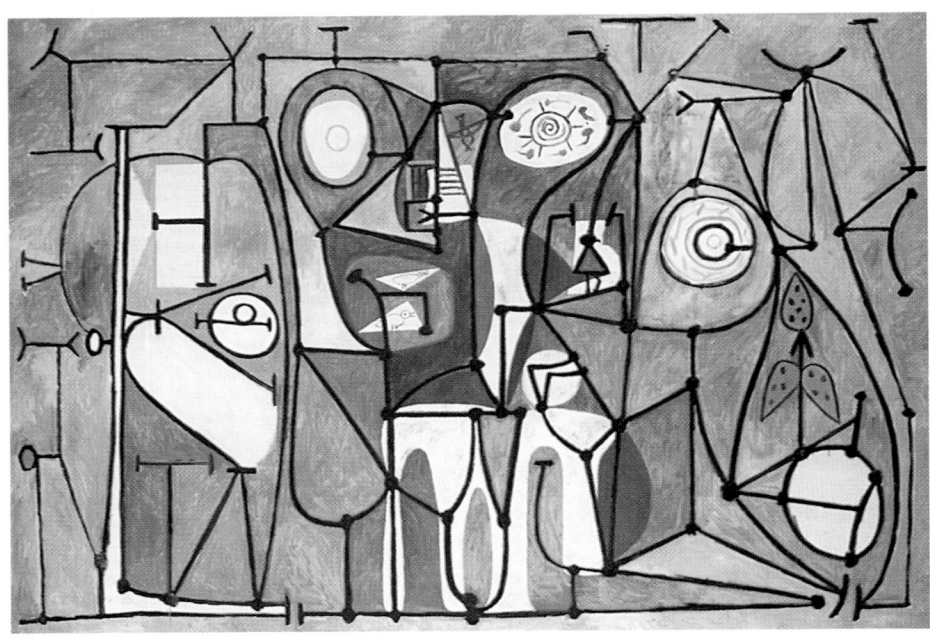

925

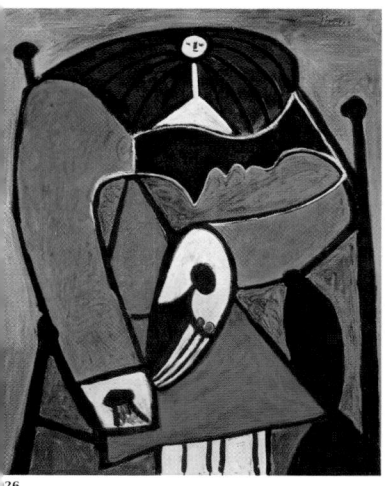

926

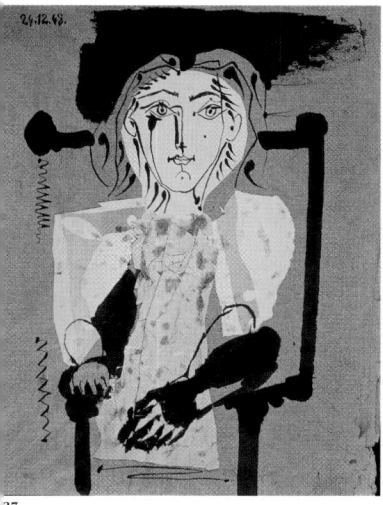

927

928

924 *The Kitchen,* November 9, 1948
925 *The Kitchen,* November 1948
926 *Seated Woman,* 1948
927 *Seated Woman from the Front: Françoise,*
December 24, 1948
928 *Woman Seated in an Armchair,* February 1947

375

Filles (Four Little Girls), which opened in Golfe-Juan on November 24, 1947, and ended its run in Vallauris, on August 13, 1948. The play was written in six acts, and its writing style was as free as it was in *Le Désir Attrapé par la Queue*. Picasso wrote the manuscript using red and blue crayons in a nervous calligraphy that suggests the tragicomic nature of the play.

In November 1948, Picasso said to Françoise about the kitchen at Grands-Augustins: "I'm going to make a canvas out of that—that is, out of nothing."[16] The kitchen was a white painted room, decorated with only three Spanish plates hanging on the wall, each depicting caged birds. Using this as a starting point, the painter developed a web of lines across the painting. He made two versions (figs. 924 and 925), one of which—monochromatic in gray, black, and white—echoes the *Milliner's Workshop* from 1926 (see fig. 551). In this abstract balance of black forms and lines, one can recognize the three circular Spanish plates, the birds, and, to the left, the white vertical line of a door frame and the oval of the door knob. These paintings perfectly illustrate Picasso's intentions: "Painting is poetry and is always written in verse with plastic rhymes, never in prose. . . . Plastic rhymes are forms that rhyme with each other or supply assonances either with other forms or with the space that surrounds them."[17]

During 1948 two books illustrated by Picasso were published: *Vingt Poèmes* by Gongora and *Le Chant des Morts* by Pierre Reverdy. Picasso said of Reverdy's writing, "It's almost a drawing in itself."[18] The motif of black points and lines, either straight or curved, that can be seen in *The Kitchen*, reappear in red in the illustrations for *Le Chant des Morts*; they can also be found in the structure of the large woman in an armchair from the same year (fig. 926). These linear compositions again echo certain drawings of 1924, and even the drawings of 1928 (see figs. 534, 535, and 587). The 1948 *Woman Seated in an Armchair* is monumental in stature, constructed with planes outlined in green, blue, and red. The small round head, the elongated neck, and the abundance of hair indicate that Françoise was the inspiration. However, the giant hand seems to suggest the monsters from the 1920s, in particular, the joined hands of the 1927 *Seated Woman* (see fig. 567). This detail aside, this familiar subject of a woman in an armchair is completely reinvented here. Picasso would begin to reuse the same subject in paintings, drawings, and lithographs.

During the summer of 1948, Picasso and Françoise moved to a villa, La Galloise, in the hills of Vallauris. In August the painter, who rarely traveled abroad, accepted an invitation to go to Wrocław in Poland with Paul Éluard, to attend the Congress of Intellectuals for Peace, where he heard diatribes delivered by Soviet delegates who opposed the decadent formalism of bourgeois art. Furthermore, he came to the defense of his friend Pablo Neruda, who was then being persecuted in Chile. In 1950, the poet hailed the painter's gesture with these words: "Picasso's dove flies over the world. . . . It has set out to go around the world and not a single criminal bird-catcher would now know how to stop its flight."[19]

Echoing Matisse's 1940 *Romanian Blouse*, Picasso's *Woman Seated in an Armchair* of February 1947 is depicted in both a color lithograph, on February 16, and in a painting of February 18 (fig. 928). This reference to Matisse foreshadowed Picasso's variations on a Polish coat, which appears in several lithographs of *Woman in an Armchair*, printed in black and white and in color. These prints were completed the following year, between November 1948 and April 1949 (figs. 929–932). The inspiration for this image was an embroidered coat that Picasso brought back from Poland for Françoise. Another *Woman in an Armchair* is a drawing on gray paper that consists of a crumpled collage, which forms the body; accents and ink lines highlight the face and arms, and the eyebrows are circumflex accents, thus indicating Françoise (fig. 927).

Between November 1945 and May 1949, Fernand Mourlot printed close to two hundred original lithographs, not including different stages. These prints were both black and white and color, and several were large in size.[20] Their subjects were drawn from Picasso's typical repertoire: women's heads (Françoise), nude female figures, bulls and bullfighting,

929 *Woman in an Armchair I*, December 17, 1948

930 *Woman in an Armchair I*, 1949

931 *Woman in an Armchair I*, January 16, 1949

932 *Woman in an Armchair I (The Polish Coat)*, 1949

929

930

931

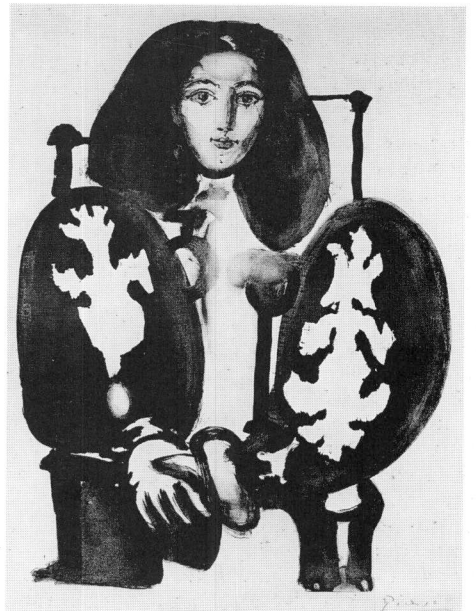

932

377

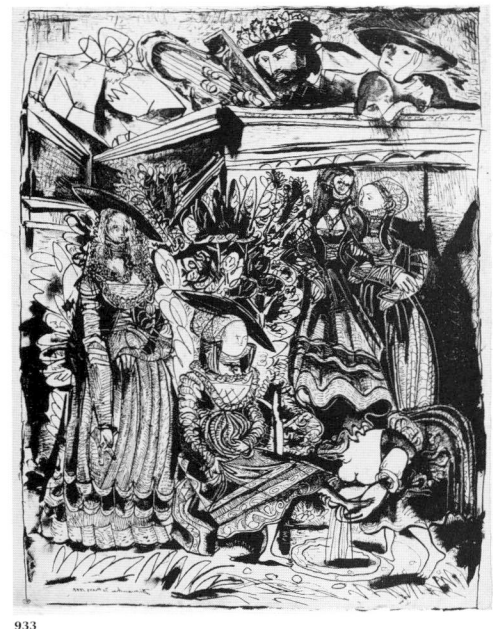

933

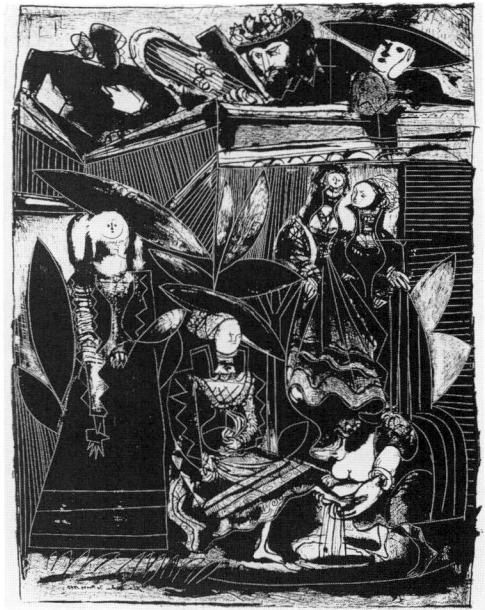

934

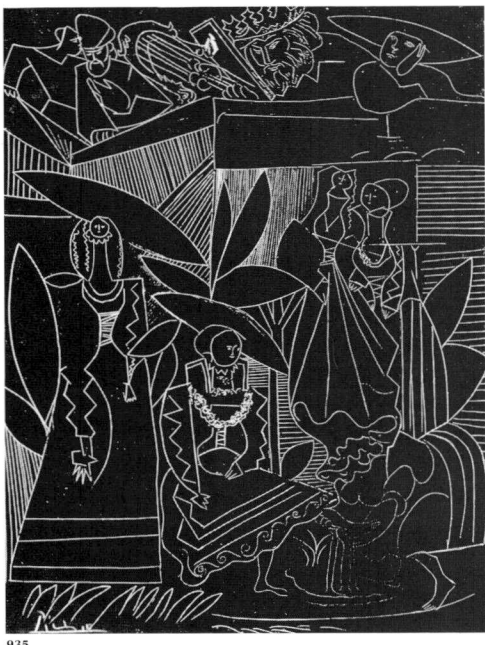

935

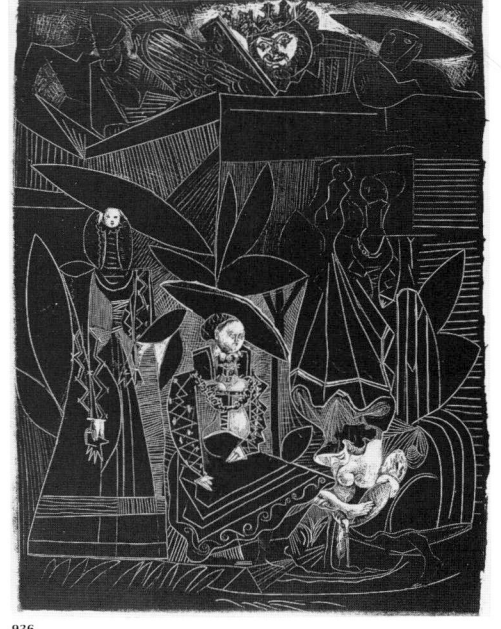

936

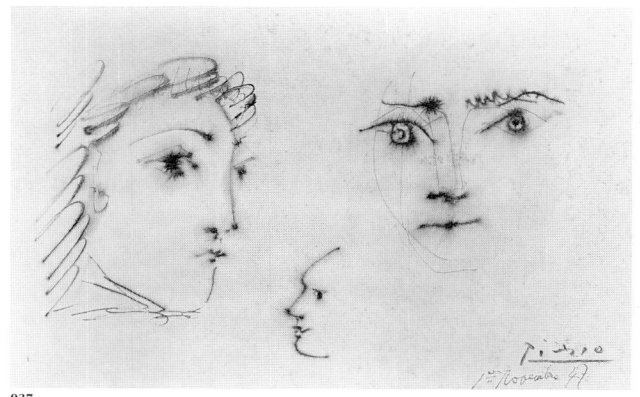

937

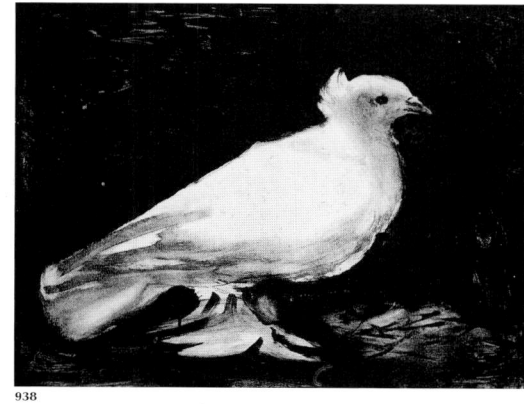

938

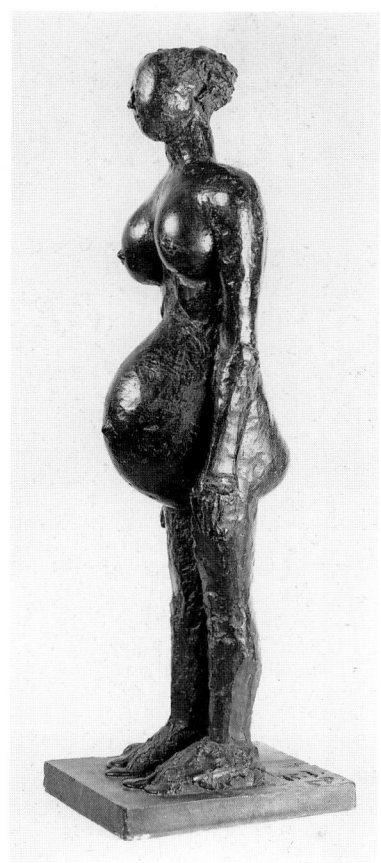

939

940

still lifes, owls, fauns, and centaurs, doves, women in armchairs, and so on. One of these lithographs was a version of Lucas Cranach's *David and Bathsheba* (March 30–April 17, 1949), an intelligent composition that played on contrasts in black and white (figs. 933–936). The theme is borrowed from the Old Testament: from a high terrace, King David watches Bathsheba having her feet washed by a servant and later has her husband, Uriah, assassinated, so that he can marry her. In May 1949, Picasso completed a lithograph based on another Cranach subject, *Venus and Cupid.*

It was in 1949 that Picasso created a series of lithographs to illustrate his 1941 *Poèmes et Lithographies*, which was published by the Galerie Louise Leiris in 1954. The best known of these illustrations is *The Dove*, a downy-white figure highlighted against a black background (fig. 938). In February, Picasso was asked to prepare a poster for the Peace Congress, which was to take place in April in Paris. He permitted Aragon to rummage through his studio and choose what he thought would be a suitable image. Aragon unearthed *The Dove* and soon afterward it would be pinned up on walls all over the world. Picasso noted that the dove was a particularly warlike bird, but the symbol was a great success, and variations on the image were created for the Second World Congress of Partisans for Peace in London in 1950 and for the Congress of Peoples for Peace in Vienna in 1952.[21]

The Dialogue between Paintings and Sculptures

In 1949 Picasso set up painting and sculpture studios at Fournas in Vallauris. The following year, he executed several large-scale sculptures: the *Pregnant Woman*, the *Woman with a Stroller*, *Little Girl Skipping Rope*, and *The Goat*, plaster casts, all of which would be cast in bronze. The small statue of *Woman with Crossed Arms* is a three-dimensional rendition of Françoise's slender silhouette (fig. 940). Picasso's memory of the pregnant Françoise took shape in a more monumental piece with three ceramic pitchers expressing the roundness of her breasts and belly (fig. 939). Picasso reworked the breasts and feet nine years later, in 1959. Standing very erect, this expectant mother is in some ways the female counterpart of *Man with a Sheep.*

Like Paulo and Maya, Claude and Paloma became models for the painter and beginning in 1950 appear in paintings in which they can be seen playing on the tiles of La Galloise (figs. 941 and 942). The *Woman with a Stroller*, a sculpture that is more than six and a half feet high, was also an homage to motherhood (fig. 943). Picasso constructed it using ceramic elements and miscellaneous objects: stroller, kiln shovel, cooking pans, and cake tins. André Malraux saw the piece, with its "eyes of studded cabochons" and outstretched arms, as a kind of fetish, "separated from the baby carriage that it pushes like Anubis leading the dead."[22]

The *Goat* (fig. 945), its belly fat with promise, is another homage to pregnancy. One can only admire Picasso's ingenuity in depicting every anatomical detail by imbedding the most disparate objects into the plaster: a palm leaf, a wicker basket, pieces of wood, cardboard, scrap iron, and ceramic pots, which form the animal's spine, stomach, legs, tail, ears, udders, penis, and anus. On horizontal plywood, Picasso painted a goat in a style that was both realist and baroque (fig. 946), thus rendering the subject in two and three dimensions, with equal virtuosity in both.

The *Little Girl Skipping Rope* (fig. 947) undoubtedly expresses one of Picasso's ambitions: to remove weight from all matter. One recalls the dancers and acrobats in the painting of the *Bather with a Ball* from August 30, 1932, in which an enormous figure seems to fly away as she leaps from the ground (see fig. 638). Here it is the jump rope, a twisted iron rod, that bears the little girl's weight, keeping her in the air. As with past sculptures, the most ordinary objects are used to form the child: a pair of mismatched shoes, a wicker

941

942

943

941 *Claude and Paloma,* 1950
942 *Claude and Paloma,* January 20, 1950
943 *Woman with a Stroller,* 1950

381

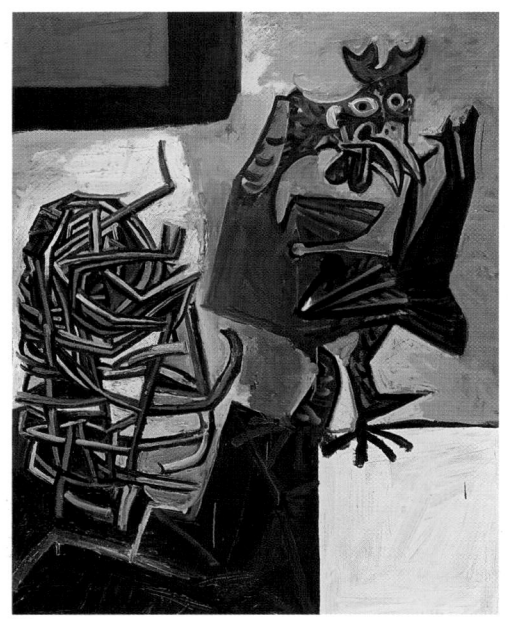

944

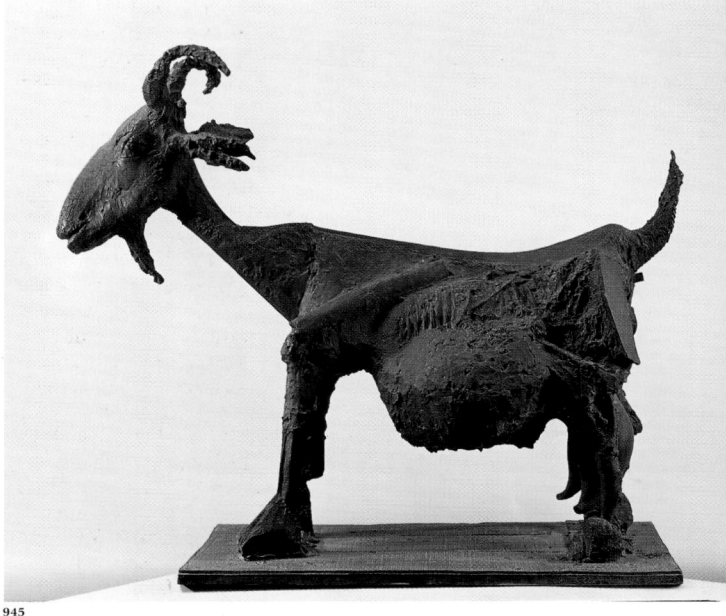

945

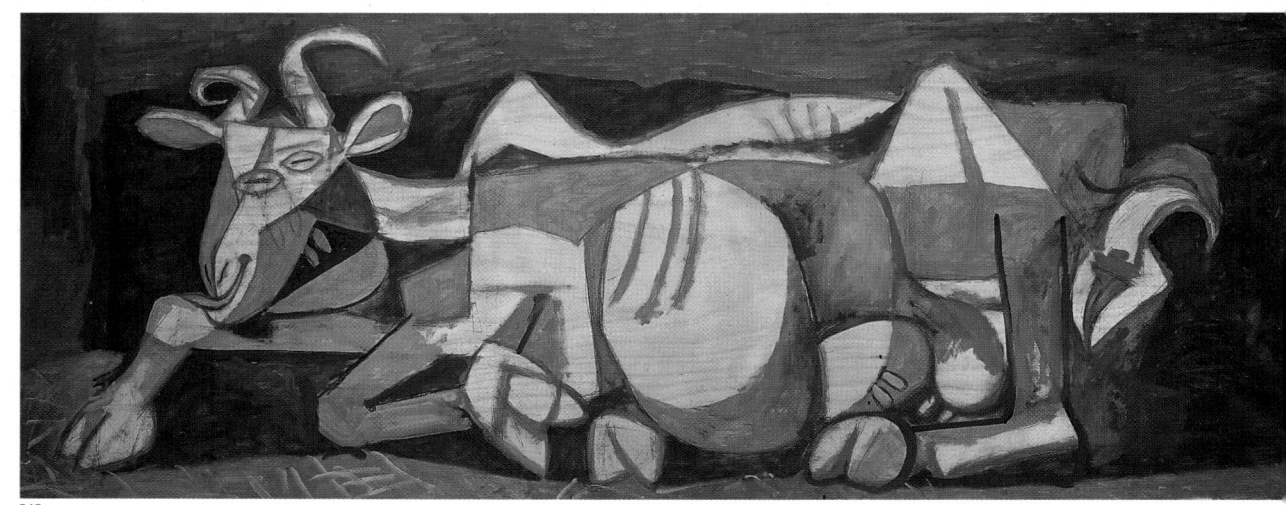

946

382

basket, and elements of ceramic, wood, and scrap iron. The cake tins and stove burner that form a flower beside a snake, remind us that this little girl could very well be one of the *Four Little Girls* in Picasso's play. The action takes place in a garden, and at the beginning of the sixth act, a snake that "bites flowers" appears.

In 1947, thanks to Georges Salles, Picasso donated ten paintings dating from 1926 to 1945 to the Musée National d'Art Moderne. One Tuesday, when the museum was closed to the public, Picasso would have the privilege of seeing his paintings hung next to masterpieces from the Louvre. He wanted to see his own work next to Zurbarán's *Saint Bonaventure on His Bier* and paintings by Delacroix and Courbet. It must have made an impression on him for in 1950, Picasso began interpreting paintings of the old masters, from El Greco to Courbet. His *Portrait of a Painter* of February 22, 1950 (fig. 949), painted on plywood, adopts the exact pose of El Greco's model, in tones of brown and white. With brush in hand, the painter seems to be announcing that he plans to devote himself to several variations on old masters. With *Young Women on the Banks of the Seine*, after Courbet (fig. 948), Picasso has divided up the surface by color and segmented the planes, which are outlined in black and white lines to create a baroque composition. In an ink-and-gouache drawing on a lithograph stone, Picasso returned once again to the theme of a Woman and Mirror (fig. 950).

In January 1951, Picasso painted two pieces that attested to his political involvement. *Smoke in Vallauris* from January 12 (fig. 952) is a part-urban, part-industrial landscape, in which the black smoke emerges from the pottery kilns. This solidly constructed painting expressed Picasso's demands that "when I paint smoke, I want you to be able to drive a nail into it."[23] *Massacres in Korea* of January 18 (fig. 951) denounces American intervention in Korea. In January, at Bernheim Jeune, there was an exhibition, "Au Pays des Mines," of works by André Fougeron, who was greatly supported by *l'Humanité* and known as the "anti-Picasso." Picasso's *Massacres in Korea* was exhibited at the Salon de Mai, but without success. Pierre Daix wrote about this picture: "He has endeavored to treat a subject. It is not his painting that speaks. Whether intentional or not, it was a political act."[24] But Picasso defended his painting, telling Édouard Pignon: "Even if no one likes it, it's still something, no?"

These figures of armored men, like those in *Massacres in Korea*, which allude to medieval times, engaged Picasso's attention during the first months of 1951, appearing in ceramics, paintings, and drawings. He decorated white clay dishes with detailed drawings of cavaliers and caparisoned horses (figs. 955–957), and he treated the same subject in a February 24 painting, adding the figures of medieval pages (fig. 954). In an ink drawing finished between March 31 and April 7, Picasso returned to a mythological scene with *The Judgment of Paris* (fig. 953). To the left are three nudes: the goddesses Aphrodite, Hera, and Pallas Athena. To the right is Paris, the shepherd, here dressed in armor with his two hands leaning on his sword; the small figure of a page stands at his side. We are familiar with the story: Paris gave the golden apple to Aphrodite, who promised him the most beautiful woman in the world, which would become the cause of the Trojan War. Picasso filled this large drawing with a wealth of ink lines shaped like nails and stars; some areas are reminiscent of the spiderweb compositions of 1938.

These references to the Middle Ages and classical mythology may have seemed archaic or too cultural in 1951, and Picasso was criticized, in particular by John Berger, for not being more in step with his times and more in tune with current events. Nevertheless, Picasso was close to everyday life and his circle. At seventy years of age, he was still concerned with themes of motherhood and family. The sculpture of *The Female Monkey and Her Baby* is a moving example (fig. 959). The monkey had held a special place in Picasso's work during different periods, both in 1905, with the *Family of Acrobats with a Monkey*, and in 1954, with the drawing of the monkey and the apple (see figs. 164 and 983). As in previous sculptures, *The Female Monkey and Her Baby* is made up of miscellaneous objects

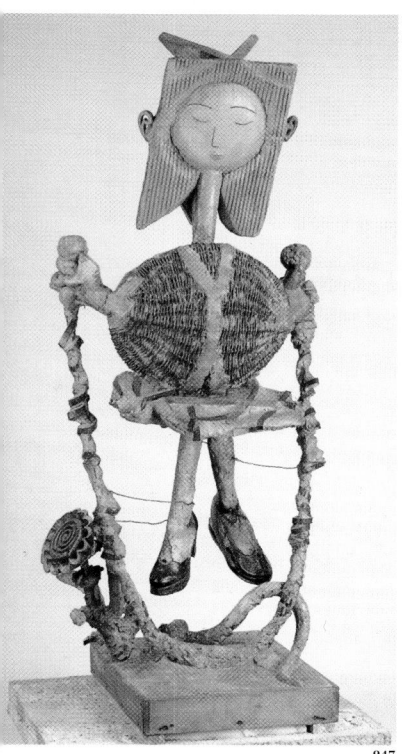

947

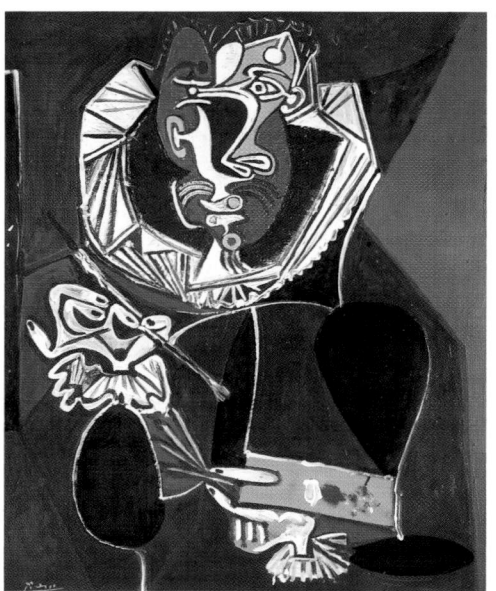

948

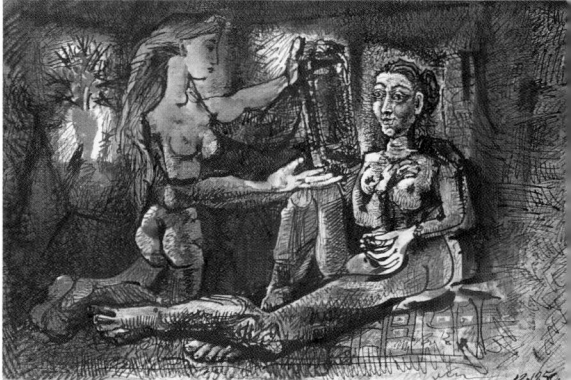

950

949

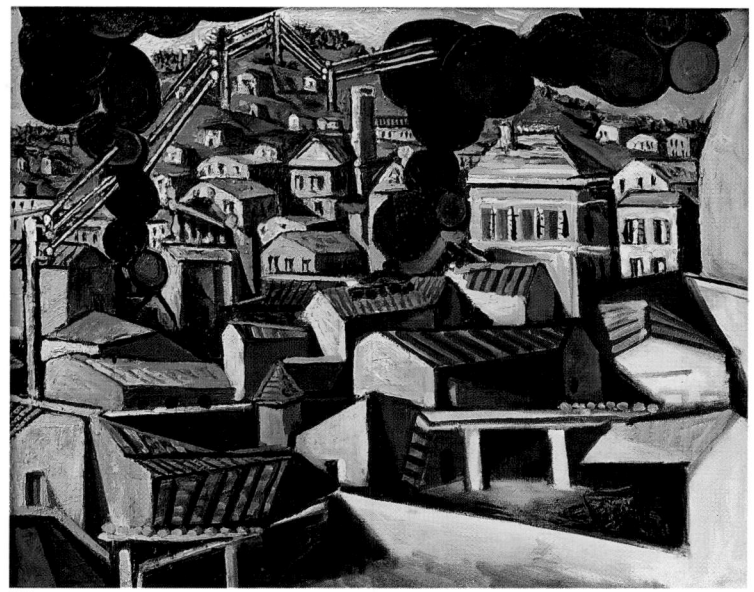

51

952

385

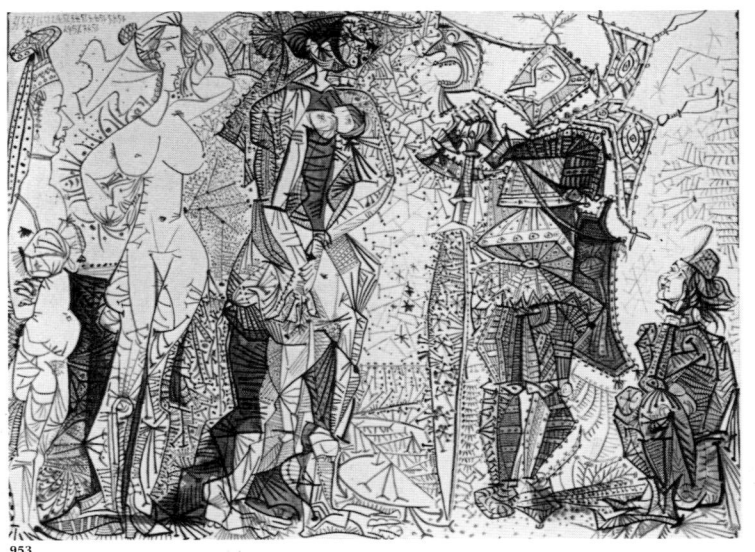

953

955

956

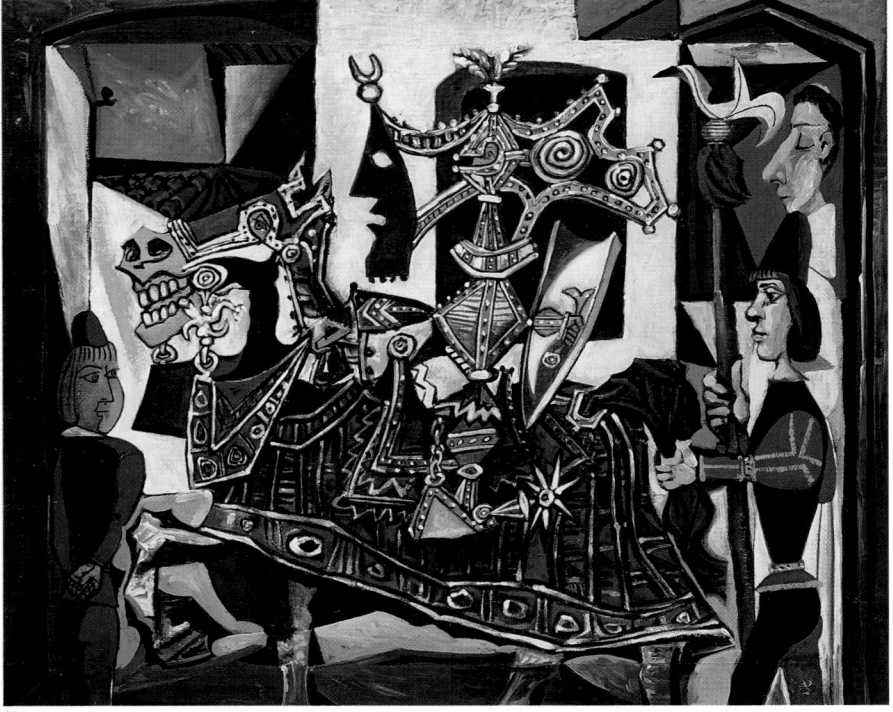

954

957

386

958

959

960

387

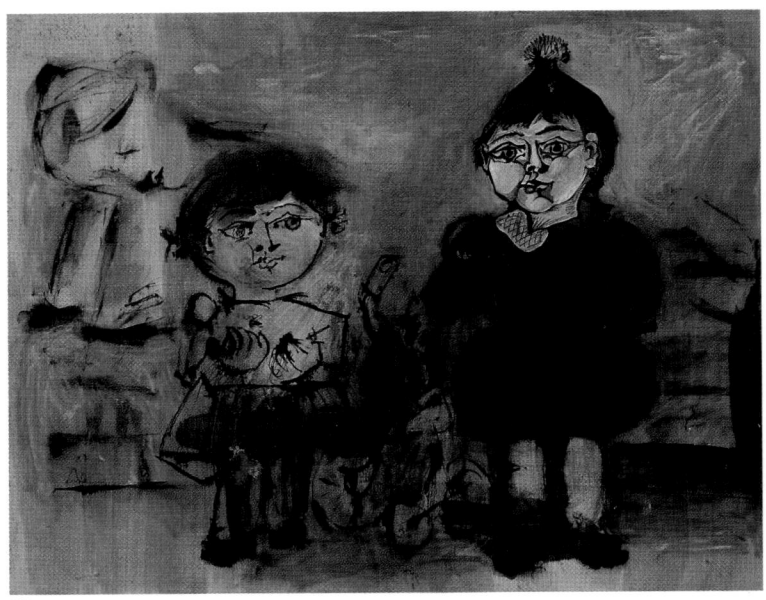

961

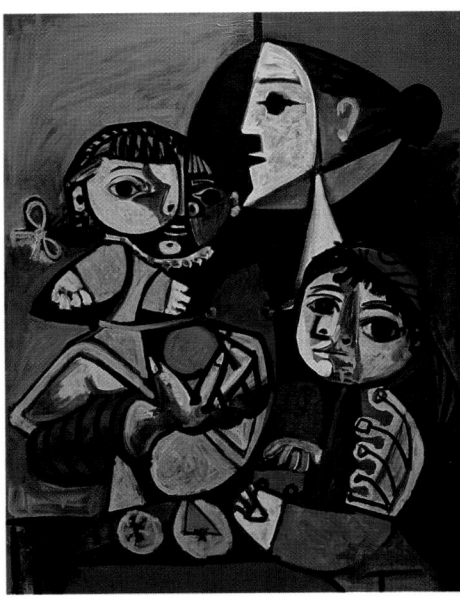

962

held together with plaster; two toy cars belonging to his son Claude form the head of the monkey; pitcher handles, jars, kiln shovels, and bent iron slabs become the animal's ears, belly, legs, and tail. It was while walking to his Fournas studio that Picasso would sift through garbage dumps, collecting secondhand objects that could be recycled for his plaster sculptures, which would eventually be cast in bronze.[25] *The Crane* follows the same principle of assorted assemblages, using a shovel, forks, a faucet, a wicker blade, and metallic objects, all of which are magically held together with plaster (fig. 958). The four bronze versions would all be painted slightly differently.

Another painted statue, *Woman Reading*, revives a theme that was often depicted in Picasso's paintings, but it does so in an unexpected way. The plaster original (fig. 960) included wood, screws, nails, and metal objects, and the three bronzes would be painted in almost the same way. The pose of a reclining woman with her head leaning against her hand reappears in a wash drawing on plywood depicting Françoise, Claude, and Paloma (fig. 961); the same trio, tightly unified, would also surface in a painting from January 25 (fig. 962), in which the mother holds an orange in her right hand.

Between 1951 and 1952, Picasso continued to try subjects in two different forms of expression, as in *Goat's Skull, Bottle, and Candle*. One may recall the still lifes with skulls or oil lamps or candles that were painted in 1945–46 (see figs. 882–886). Picasso now proposed a new encounter between life and death, light and dark. The nails in a painted sculpture, driven into the neck of the bottle, represent the candle's radiance (fig. 964). Two paintings from 1952 depict the same subject with the same arrangement of objects (figs. 963 and 965).

In his paintings, Picasso tended to divide the surfaces with lines that branch out, multiplying and interlacing to create a luxuriance that the severe postwar compositions did not have. Was Picasso's work and situation becoming complex again? A pensive profile of

961 *Reclining Woman*, 1951

962 *Maternity with an Orange*, January 25, 19

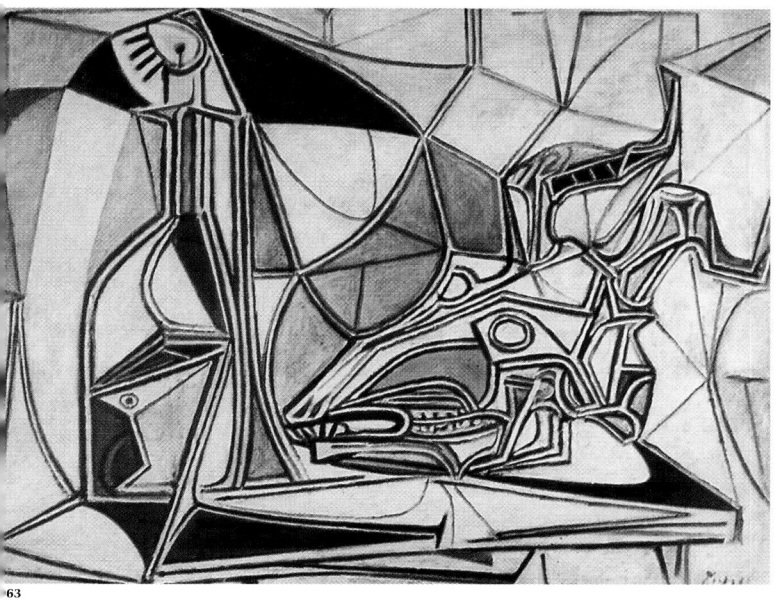

963

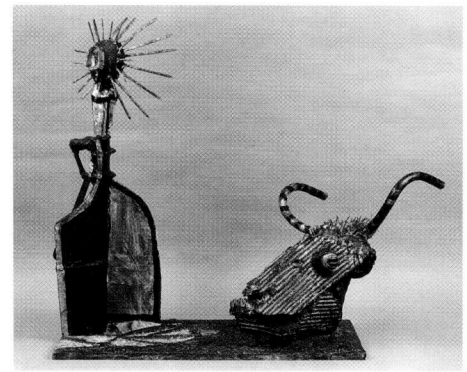

964

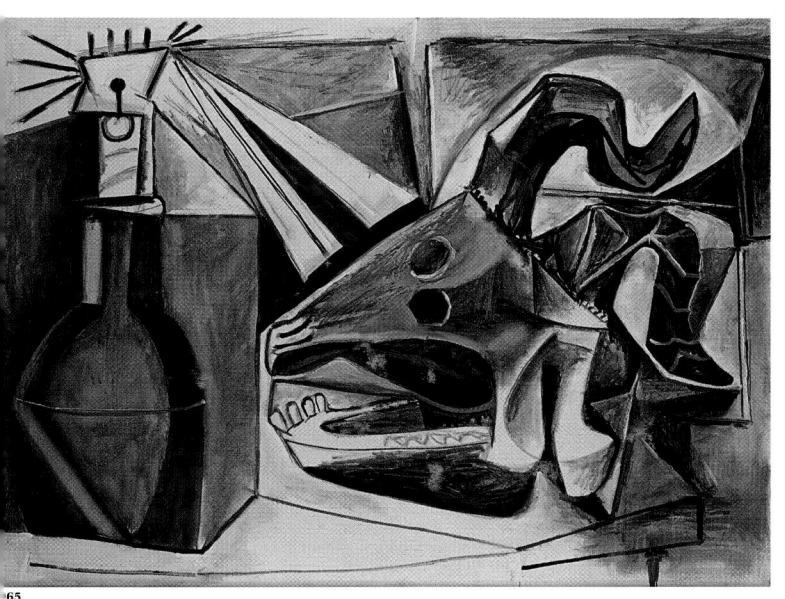

965

963 *Goat's Skull, Bottle, and Candle,*
April 16, 1952
964 *Goat's Skull, Bottle, and Candle,* 1951–53
965 *Goat's Skull, Bottle, and Candle,*
March 25, 1952

Françoise shows her hair imprisoned in green and blue interlacing (fig. 966). In contrast, the portrait of Hélène Parmelin (fig. 967) portrays abundant red-blond hair falling around her face, dangling freely over her shoulder. Hélène Parmelin and Édouard Pignon were at that time among Picasso's closest friends within the French Communist Party.

According to Françoise herself, the situation between Picasso and herself deteriorated during the summer of 1951.[26] They were still together for Paul and Dominique Éluard's wedding in Saint-Tropez on June 14, 1951, but a week later, Picasso was with another young woman, Geneviève Laporte, with whom he would spend part of the summer. Still a high-school student in 1944, at the time of the Liberation, Laporte had visited Picasso to interview him on his political involvement. Their sporadic affair at the beginning of the 1950s eventually came to a sudden end.[27]

Matisse's chapel at Vence opened on June 25, 1951. Picasso and Françoise went to see Matisse from time to time, and they visited the chapel. In April 1952, Picasso accepted a commission to decorate a chapel himself, one in Vallauris that was not in use; he wanted to work in the secular spirit of a "temple of peace." It is not surprising that Picasso, who liked to deal with the confrontation between life and death, used two antithetical panels, *War* (fig. 968) and *Peace* (fig. 969), in the chapel's decoration. There were specific technical obstacles to the realization of this design, since the walls of the vault required a flexible surface, like plywood. In a book devoted to this piece, Claude Roy presented numerous preliminary drawings chronicling the work on *War* and *Peace* between April and September 1952.[28] As to the pieces, which were completed in the beginning of December, he quoted Picasso's intentions: "Never has one of my paintings been painted so quickly in terms of the covered surface. . . . I filled entire books with sketches, with details, but there was not a single drawing of the whole composition. I started with *War*. The first thing that impressed itself upon me was the meandering, bumpy journey of those provincial pitiful and squeaking hearses that one can see passing through the streets of small towns. I started with the right side, and it is around this image that the rest of the composition is built. I could not proceed with each part of the painting as I had done for those built around similar parts, for example the series of horsemen from the Middle Ages in which I developed variations on the mounted figure and the war horse, caparisoned, armored, and harnessed. For months, for years, I was, like everyone else, obsessed with the threat of war; I was haunted by this fear and by the desire to fight against fear. *Massacres in Korea* came out of this. The painting was disturbing, but it was not appealing. Now I have begun to see it for what it is, and I know why it was received with bewilderment: I did not redo *Guernica*—and that is what was expected of me. Nor did I paint the *Charnel House* or *Massacres*."

With *War* and *Peace,* the entire postwar period truly seems to have drawn to a close for Picasso. Paul Éluard, his loyal friend since 1936, died suddenly on November 18, 1952, six years after Nusch. Picasso had just turned seventy-one years old. The following year, the separation with Françoise Gilot would become final. But, like the blind Minotaur from 1935, the painter would meet another young woman, Jacqueline, the companion who would light up the last twenty years of his life.

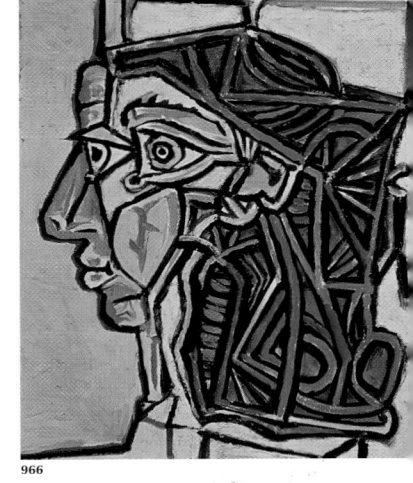

966

966 *Head of a Woman,* May 16, 1952
967 *Portrait of Madame P.*
(*Hélène Parmelin*), 1952

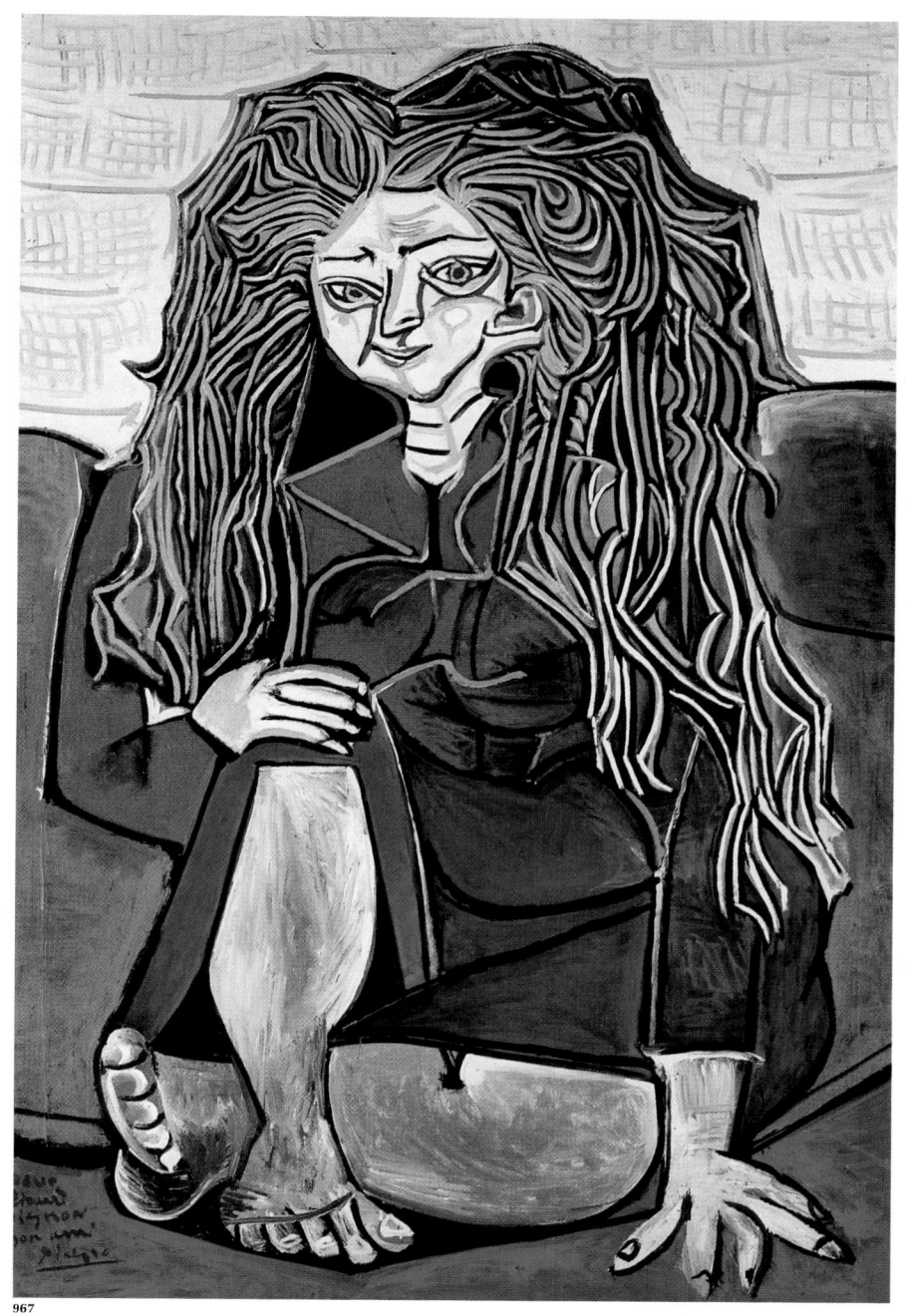

967

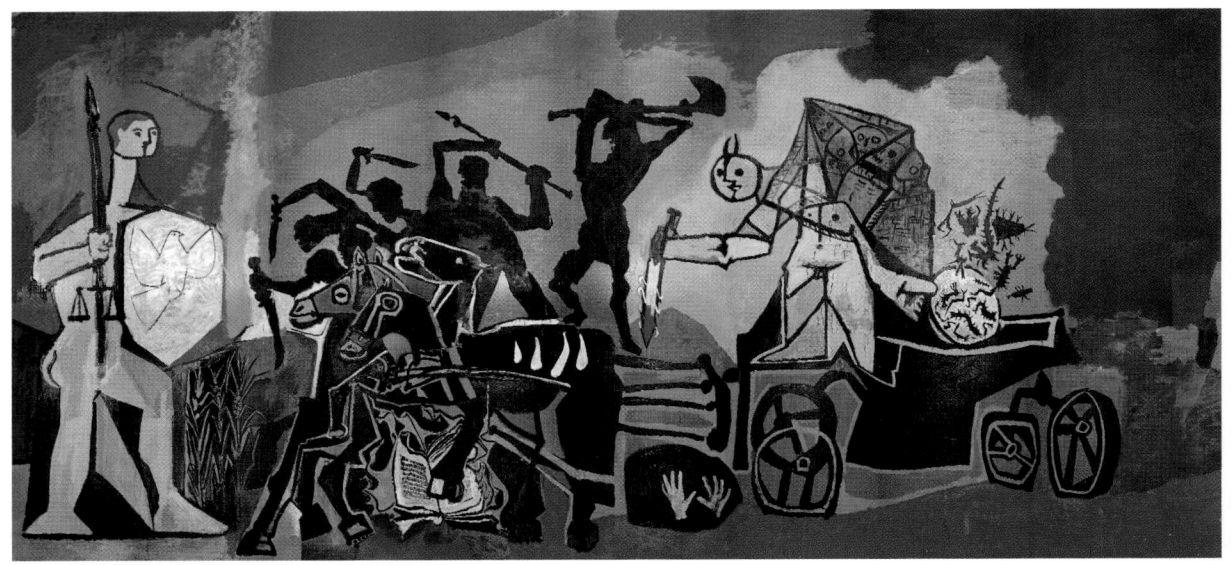

968

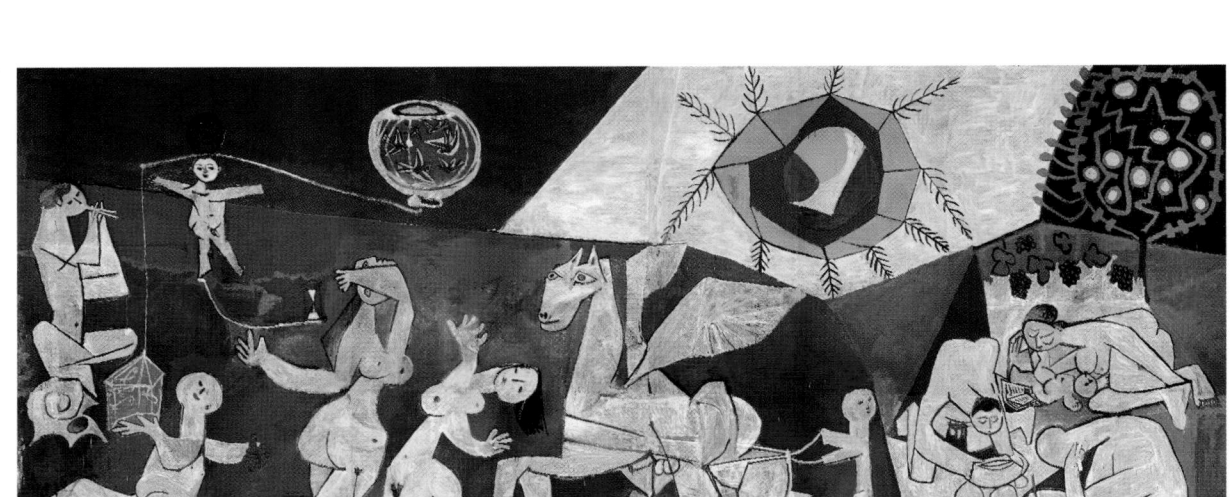

969

970

971

968 *War,* 1954
969 *Peace,* 1954
970 *Paloma,* December 23, 1952
971 *Child Playing with a Toy Truck,*
December 27, 1953

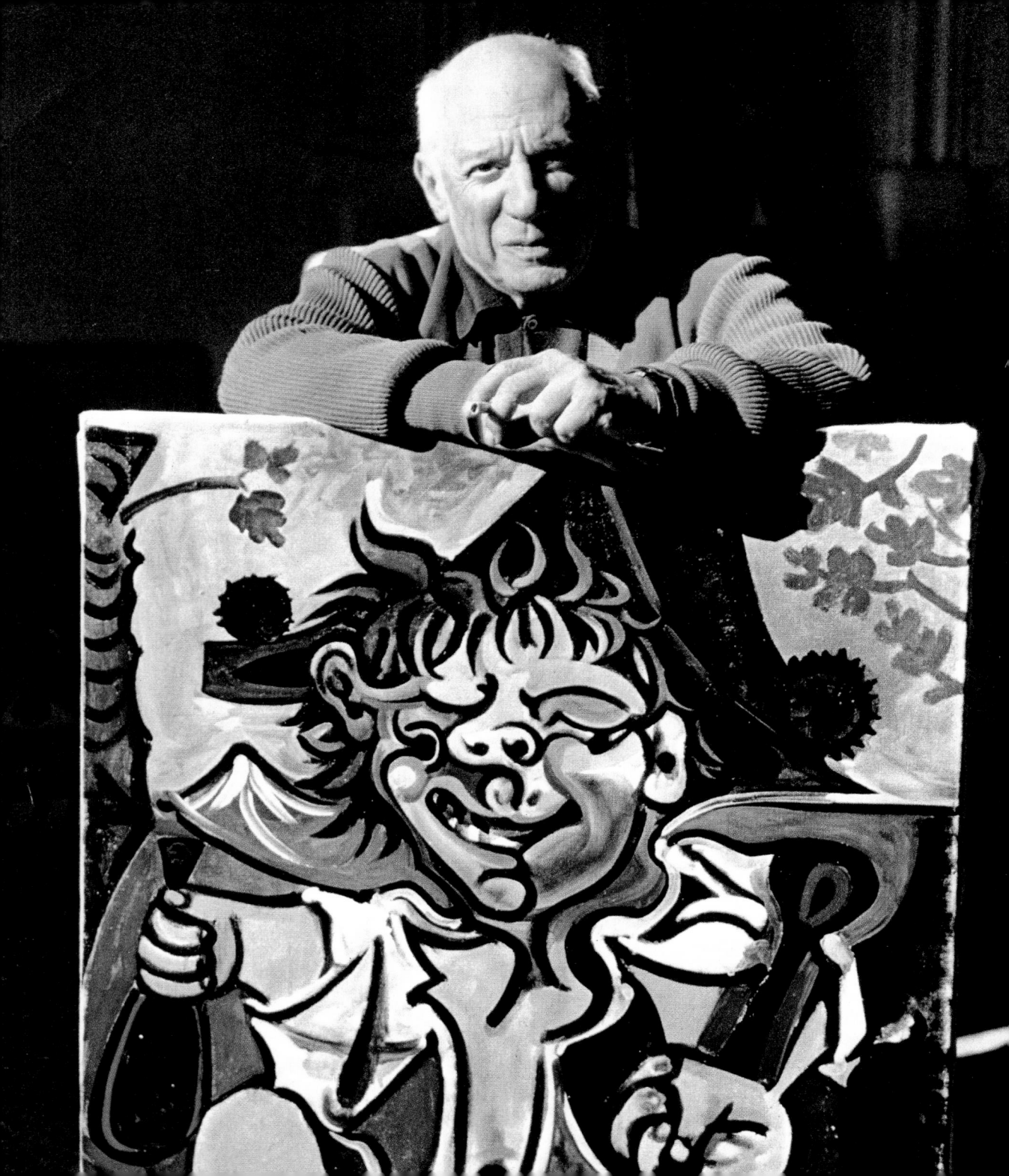

PART III

BY MARIE-LAURE BERNADAC

Chapter 10
1953–1963

Chapter 11
1963–1968

Chapter 12
1969–1973

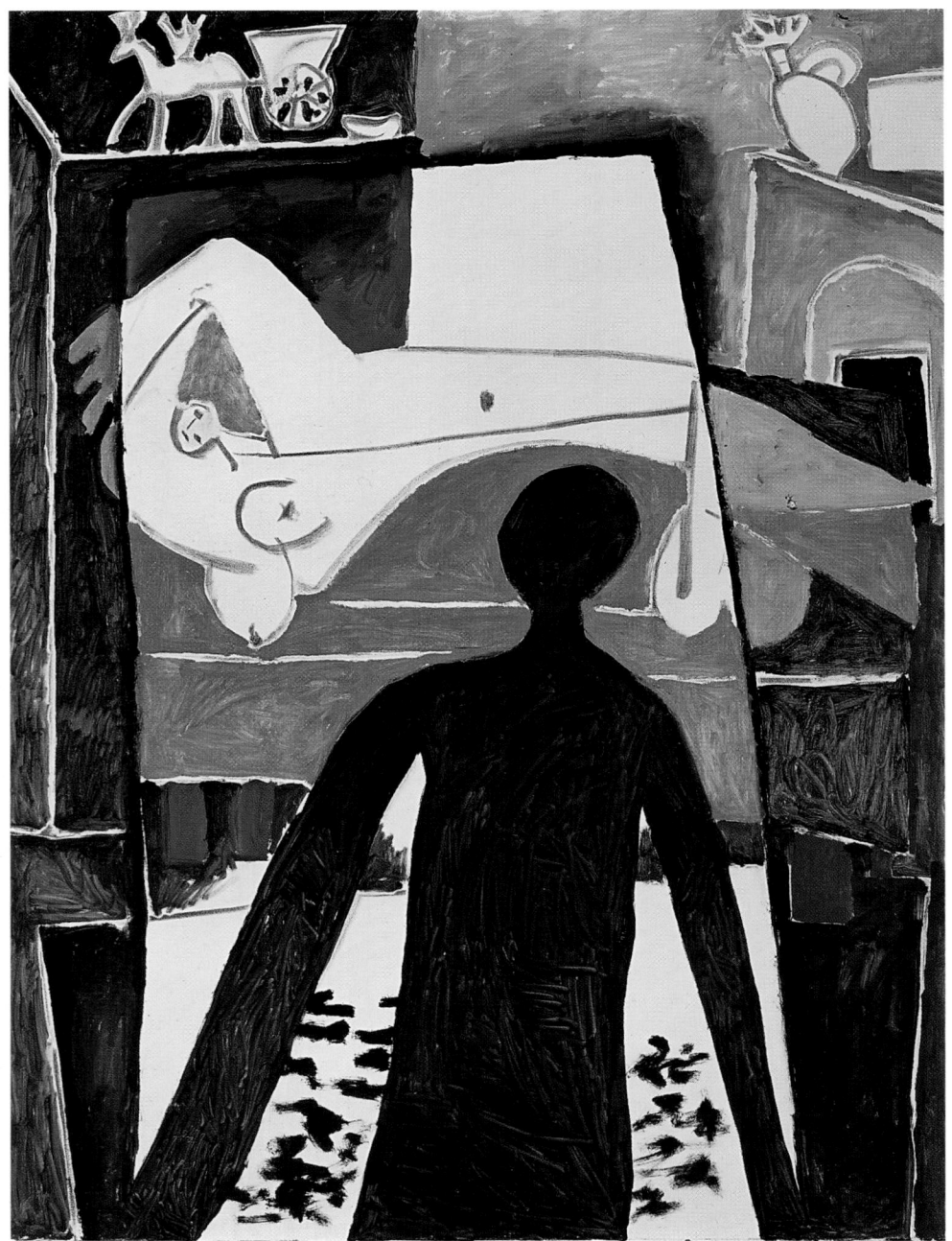

1 9 5 3 – 1 9 6 3

The Verve *Drawings*

The year 1953 marked a turning point in both Picasso's work and his life. It was a year of personal ruptures, first with Geneviève Laporte and then with Françoise Gilot, and of his ideological crisis with the Communist Party following the affair of the *Portrait of Stalin* published in *Les Lettres Françaises* on March 12–16, 1953. At Aragon's request and on the occasion of Stalin's death, Picasso drew a portrait of the young Stalin based on a photograph from 1903, and this shocked many of the party leaders, who expected an image of the mature man. Their disapproval, which had existed for a long time in terms of aesthetics, now became political and exploded in a statement published a week later. Thereafter, Picasso kept his distance with regard to the Communist Party and focused solely on his creative work. His relationship with Françoise had become increasingly difficult. At the end of March, she left for Paris with the children but then came back to spend the summer in Vallauris, which would result in a series of busts and heads. When school opened in September, however, she left Picasso for good and went to live in the rue Gay-Lussac in Paris. Picasso was now alone at La Galloise. Whatever their misunderstandings and reasons for this separation may have been, the fact was that a young and beautiful woman, and the mother of two of his children, had left him, abandoning him to his loneliness, his burdensome fame, his advancing age. This turning point in his personal life with all the upheavals that it entailed would unleash a profound aesthetic crisis (as had occurred at the time of his separation from Olga in 1935), which would lead to a general reassessment.[1] Between November 28, 1953, and February 3, 1954, Picasso locked himself away in the deserted house and frenetically produced 180 drawings, whose central theme was the Painter and his Model (figs. 973–981). Some of them incorporated other themes summoned up from the past—the circus, clowns, acrobats, and monkeys—while others anticipated what was to come: masks, old age, eroticism, and scorn for the painter's profession and the art world. Colored pencils, India ink, watercolor, pencil—every technique was called upon to illustrate this record of "an abhorrent season in hell."[2] In a bitter, cruel, ironic, and merciless way, the series summarized the absurd drama of creation, of the insolvable duality between art and life, between art and love: woman should be painted but she must also be loved, and no matter how great his genius, the artist is no less a man because of it, being subject to aging, illness, and death. This series, beyond its unsurpassed graphic quality and unprecedented freedom, was of vital importance in the painter's career. Michel Leiris has beautifully revealed its profound meaning, comparing it to Goya's *Caprichos*, to burlesque comedy that links satire to intimate diary, tragedy to comedy. Vacillating between the *Old Acrobat* of Baudelaire and Charlie Chaplin, between the *commedia dell'arte* and the picaresque novel, Picasso in his own way exposed the myth of the spurned and ridiculed artist, the mockery of art, and his lunatic pretensions to equal real life and true carnal beauty. Every type of painter is present—romantic, academic, naïve, arrogant, characterized even in caricature,

972 *The Shadow,* December 29, 1953

973 *In the Studio (Drawing for* Verve*)*, February 3, 1954
974 *Clown with a Mirror and a Nude (Drawing for* Verve*)*, January 6, 1954
975 *The Saltimbanques (Drawing for* Verve*)*, January 7, 1954
976 *Sheet of Studies (Drawing for* Verve*)*, January 21, 1954
977 *Nymph and Faun (Drawing for* Verve*)*, January 7, 1954
978 *In the Studio (Drawing for* Verve*)*, January 10, 1954

982 *Interior (Woman Painter and Nude in the Studio),* January 21, 1954
983 *Seated Man, Girl with Monkey and Apple,* January 26, 1954

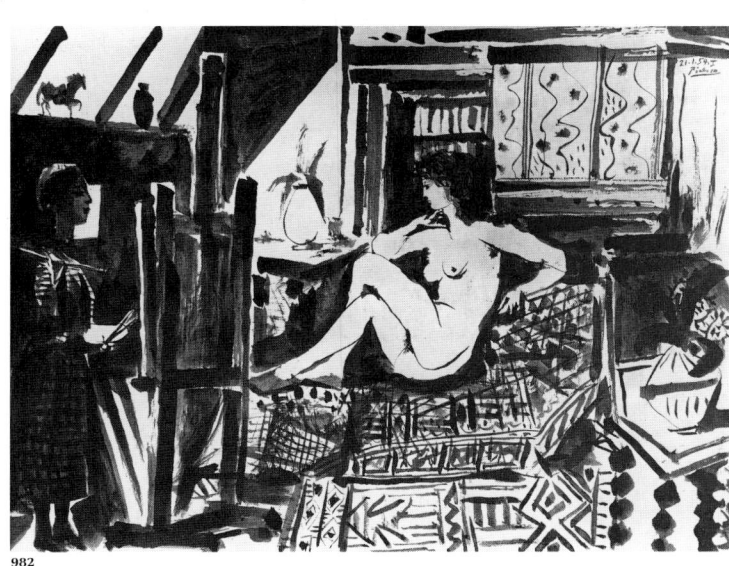

982

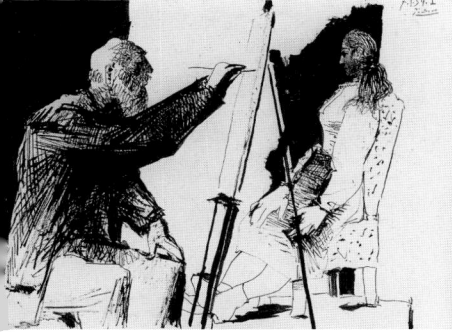

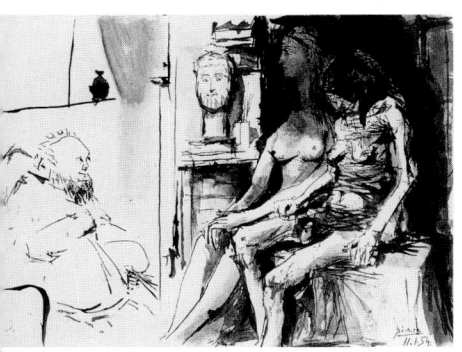

979 *The Masks (Drawing for* Verve*),* January 25, 1954
980 *In the Studio (Drawing for* Verve*),* January 7, 1954
981 *Models Posing (Drawing for* Verve*),* January 11, 1954

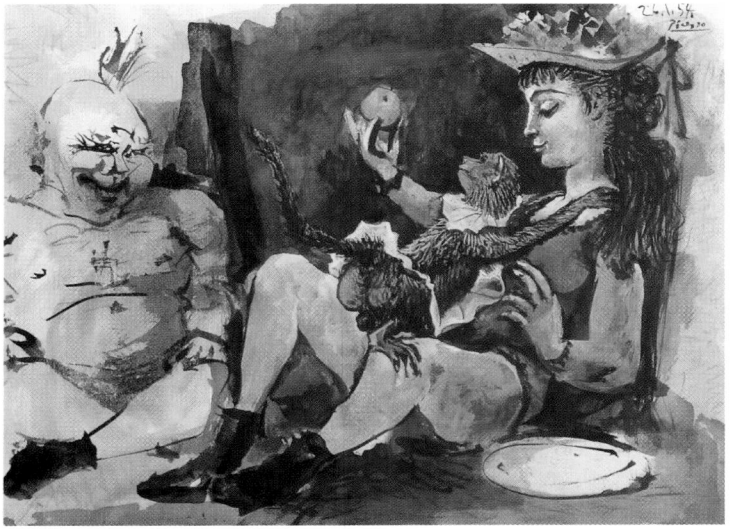

983

399

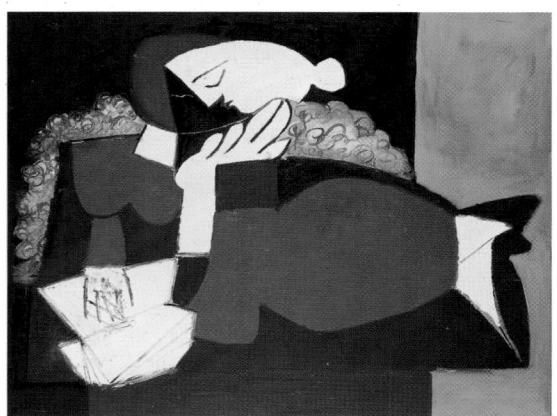

984

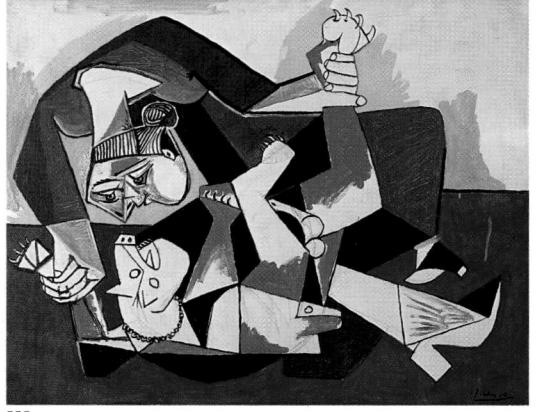

985

986

while woman remains the model, ideal and timeless. In their diversity and their unity, the *Verve* drawings in some sense constituted the overture to the opera that was yet to come. All of his future themes are, in fact, foreshadowed here, and the tragicomic tone of the whole was set from the very beginning. Picasso introduced the process of the series and its variations, the narrative style, the mixture or the alternation of genres, going from a nervous, incisive, and elliptical stroke to a pure and classical line, or else to a geometric oversimplification. In the circus and carnival scenes, the connection between art and theater is clear, the inversion of roles—young to old, man to woman—that illustrates the lie of art and appearance. The persistent presence of the model and the studio reveals Picasso's obsession with creation, his anguish over his inability to create and to love that went hand in hand with the revelation of female eroticism.

This very personal series takes the form of a descent into the chasms of the unconscious: the Blue Period of his youth came back to the surface, and with terrifying lucidity Picasso bared his condition as an artist and as a man. Every path he was to explore afterward was already implicit in these 180 drawings. After having delved thus into these frightening images, where and how was he to find a new momentum?

The two paintings that introduce and are symptomatic of this period, paralleling the *Verve* drawings, are *The Shadow* (fig. 972) and the *Nude in the Studio* (fig. 984), dated November 29 and 30, 1953. The former is a view of the bedroom at La Galloise with a nude woman lying on the bed and the shadow of a man watching her, his figure a cutout within a rectangle of light, the silhouette of a phantomlike painter, who is nevertheless present, facing his model, Françoise, who is nevertheless absent. In another version of this painting,[3] the shadow merges with the background motifs so that the man's body is made of the very substance of the painting. When David Douglas Duncan asked Picasso about the meaning of this enigmatic canvas, the artist responded: "That was our bedroom. Do you see my shadow? I had just come away from the window; so now do you see my shadow and the light of the sun falling on the bed and the floor? Do you see the toy, shaped like a cart, on the dresser and the little vase on the mantelpiece? They come from Sicily and are still in the house."[4] The next day Picasso changed the location of the scene, going from the intimacy of a bedroom to the bright openness of the studio (fig. 984). Favoring the aesthetic point of view as compared to that of his private life, Picasso placed the model in a luxurious setting in which different spaces, windows and doors, canvases and easel, are interlinked with an opulence of color never before seen in his work. The complex structure of the space and its depth, regulated by the elements of the furniture, presages the series of Studios of his villa, La Californie, while the decorative checkered patterns, the mosaic of tapestries, and the warmth of the colors foretells the *Women of Algiers*. In its composition, this crucial painting is close to a later drawing, dated January 21, 1954 (fig. 982), in which a female painter stands next to the easel, brush in hand, and the nude model sits encased in her environment. The image no longer has the soaring curves or the morphology of the nudes inspired by Françoise; in the drawing numbered "IV" of the same date, the profile with the long neck of Jacqueline Roque (fig. 976) appears for the first time.

Interlude

In 1953 the violence of Picasso's emotional relationship with Françoise was still evident, as the strange painting of the *Woman with a Dog* (fig. 986) shows. A woman with her hair in a bun and with features that remind us of Françoise is shown in an ambiguous, amorous pose bearing down with her full weight on a dog that lies crushed on the floor. This scene, which Picasso would transform into a fight between a cat and a rooster the following December,[5] reveals the power relationship, the cat-and-dog arrangement that

existed between the couple at that time. Picasso also turned to using flat patches of bright color and cutout and folded shapes, as in *Woman Reading* (fig. 985) of January 1953. The pensive and contemplative attitude of the reading woman, Marie-Thérèse's favorite theme, has its equivalent in sculpture with the *Woman Reading* of 1951 (fig. 960), a marvel of imagination and realism made from pieces of wood, screws, and bolts.

The early months of 1954 constituted a kind of interlude before the reign of Jacqueline. Picasso did a graceful painting, *The Coiffure* (fig. 989), unique for its hues of pink and soft green and for its theme, which recalls *The Harem* of 1906. The twisting of the nude that shows the front, back, and profile all at the same time foreshadowed his work on *Women of Algiers*. With simplified forms, the hieratic young man who faces the nude model is undoubtedly an evocation of youth, of a bygone adolescence. The freedom of the brushwork and the use of impasto also make this painting a precursor of Picasso's later style. Then, for sentimental reasons, he painted his children Claude and Paloma, who had come to visit him at Easter, drawing or playing, with and without their mother (fig. 990), in a decorative Matissian style. Finally, he selected a neutral model with whom he had no personal relationship, a twenty-year-old girl named Sylvette David, whose face and famous ponytail he studied and deconstructed into rectangular overlapping planes, which allow her to be seen simultaneously from the front and in profile. Proceeding from a graceful, meticulous realism to a strict geometry, this series of portraits anticipated Picasso's sculptures of cutout sheet metal and prefigured his triumphant entrance into the painting of Madame Z., "the modern sphinx," of whom he did two well-known portraits (figs. 993 and 994) in June 1954.

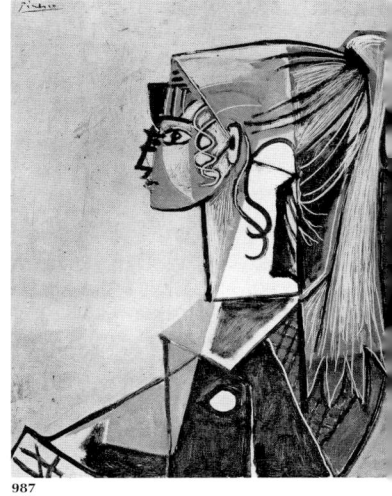

987

Jacqueline

Picasso met Jacqueline Roque in the summer of 1952 at the Madoura pottery, where she was working with the Ramiés. This young divorcée lived with her daughter, Catherine, in the Villa Ziquer, hence the name Madame Z. In the course of the next two years, Picasso would see her more and more frequently, but he did not really let her become part of his work until June 1954. The first two portraits he did of her are not great likenesses. There are still traces of the morphology of Sylvette and Geneviève Laporte, the young girl he had met in 1945 and then found again in 1951 at the time of his conflicts with Françoise. Still, the slouched position, half-odalisque, half-sphinx, is characteristic of Jacqueline. Her resolute look and haughty demeanor leave no doubt as to the place she was to occupy from here on in the painter's life. These two paintings were exhibited in July 1954 at the Maison de la Pensée Française. After a summer's stay in Perpignan at the house of the Lazermes, Picasso left for Vallauris with Jacqueline, then took her to Paris to the studio in the rue des Grands-Augustins. Two other portraits from this time depict Jacqueline more accurately: *Jacqueline in a Rocking Chair* (fig. 991) and *Jacqueline with a Black Shawl* (fig. 992). The model is facing the viewer, and her distinctive features are recognizable. In the former, she is seated hieratically in an armchair; in the latter, she is slouched, a pose she preferred and one that would make her into the odalisque of the *Women of Algiers*. In fact, when Picasso first met Jacqueline, he was struck by her resemblance to the woman with a hookah in Delacroix's painting.

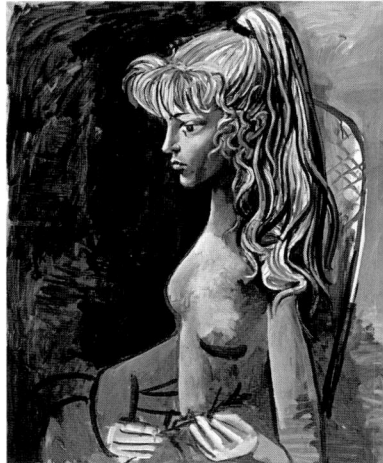

988

Her Mediterranean type, with large almond-shaped eyes and a nose that descends in a straight line from the forehead, made her a worthy heiress to the peasant women of Gósol, an effect emphasized by the black shawl. Her luminous gaze, her calm beauty, and her frailty are fully visible. She would be the ideal companion for the painter during his last twenty years—attentive, omnipresent in his art, and playing every role: wife, model, secretary, photographer, cook, chauffeur. Every woman in Picasso's oeuvre of those years is directly or indirectly "a Jacqueline."

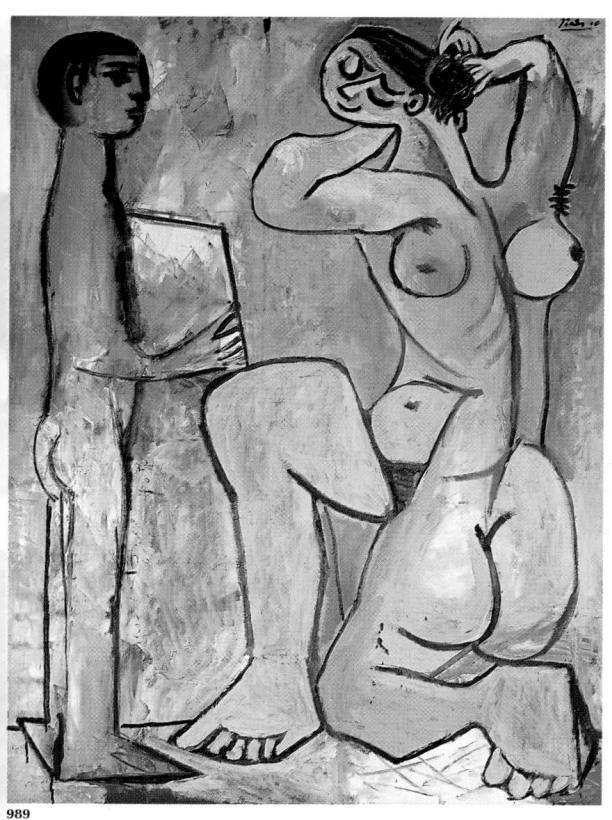

989

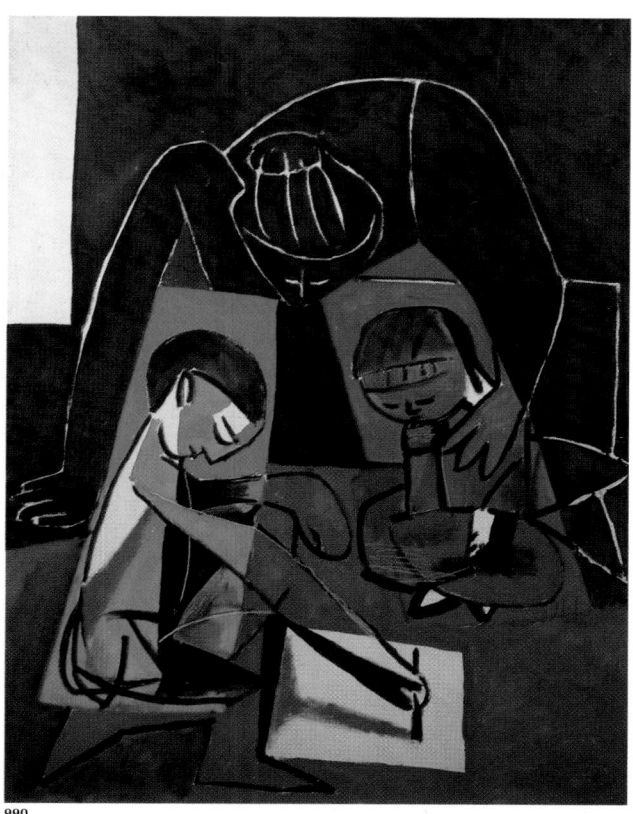

990

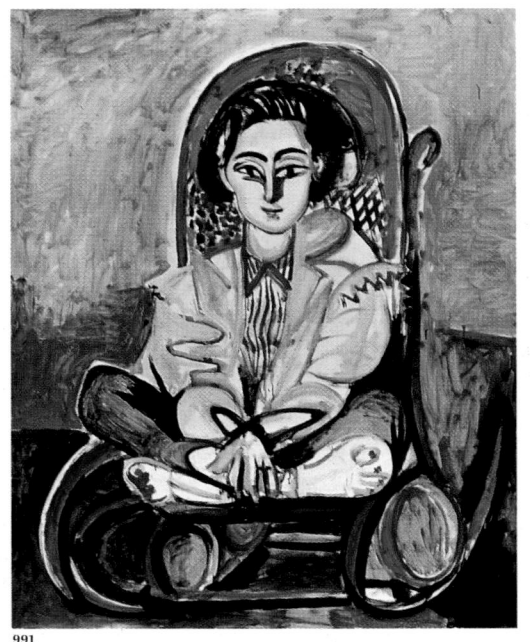

991

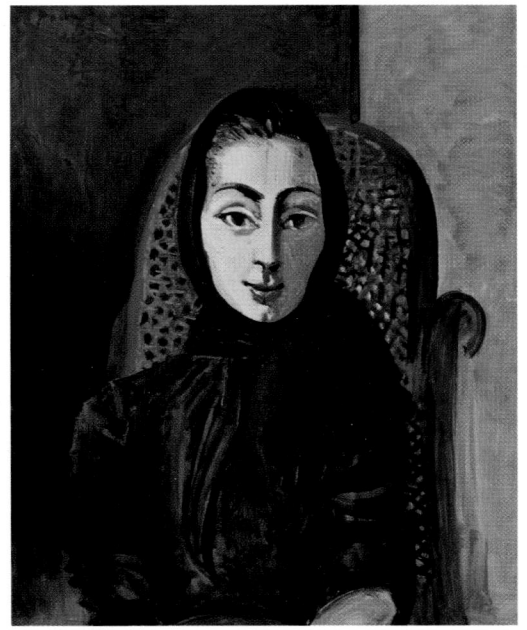

992

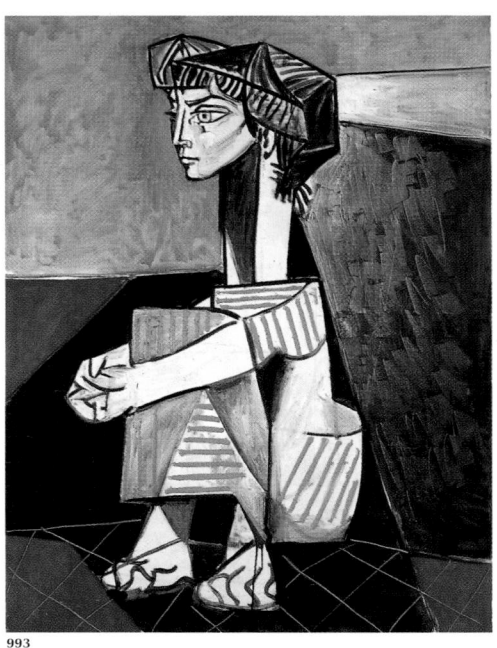

993

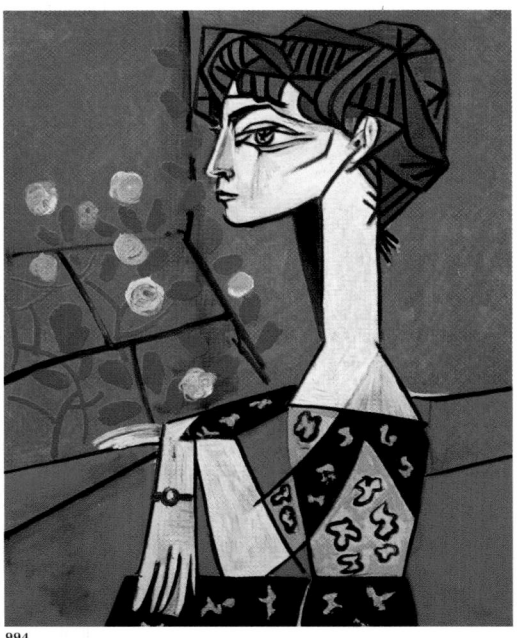

994

Women of Algiers

The period from 1954 to 1963 was completely characterized by the painting of the past, by the inventory of Picasso's pictorial resources, as well as those of his contemporaries Matisse and Braque. Picasso endlessly analyzed, deconstructed, and reconstructed the masterpieces of the others, digesting them to make them his own. This pictorial cannibalism is unprecedented in the history of art. In every period, of course, painters—and Picasso most of all—have had recourse to the images of the past, have drawn motifs from them, have borrowed shapes from the dictionary of world art: pastiches, copies, paraphrases, or direct quotes. But Picasso's undertaking was of an entirely different scale with its great cycles exploring the work of Delacroix, Velázquez, and Manet. In his fever Picasso would make a hundred canvases from one example, exhausting every possibility it offered him, seeking to verify his own voice, to test the power of his painting on a given subject. One wonders why, at this stage in his artistic development, he felt the need to return to the masters, to tradition. There are multiple reasons: a chance resemblance, the suggestion of a place, but above all the need to confront "great painting," a challenge to history, and finally the awareness that he had a task to accomplish, a heritage to shoulder and to exceed in order to send painting in new directions. These were the personal motivations. Historic context was a factor as well, such as the high point of abstract art, which Picasso had been resisting all along, having partly fomented it himself, and above all the death of Matisse, his friend and rival with whom he had carried on an uninterrupted and fruitful dialogue since the beginning of the century. Henceforth Picasso was to find himself alone responsible for the future of painting, which had emerged from the Renaissance, been revolutionary at the dawn of the twentieth century, and then become obstinately figurative.

He began with Delacroix's *Women of Algiers*. Picasso had in fact been thinking about this picture for a long time. Françoise Gilot has said that he would often take her to the Louvre to look at it, and in a notebook of 1940 from Royan he drew the first sketches of his own version, its composition, the characters in their respective poses, and the color palette.[6] In June 1954, there was another sign, a drawing after Delacroix's *Self-Portrait* in a notebook that also contains his rough sketches of Manet's *Déjeuner sur l'herbe*.[7] In December 1954, another seven drawings appeared in a notebook.[8] The ground, therefore, was very well prepared. Then Picasso met Jacqueline, the perfect odalisque in body, who bore a strange resemblance to one of the women in the Delacroix, and in temperament, with her calm and her sensuality. After the stormy times, Picasso once again found a flourishing serenity with her, one that gave him renewed enthusiasm and lust for life, for love and for painting.

Still more decisive than the personal emotions was the shock brought on by the death of Matisse in November 1954. "At his death," Picasso said, "he bequeathed me his odalisques."[9] "Sometimes I tell myself that this is perhaps the heritage of Matisse," he confided again to Daniel-Henri Kahnweiler in speaking of the *Women of Algiers*. "When all is said and done, why shouldn't we inherit from our friends?"[10] Matisse's odalisques did not merely represent the myth of the Orient, of the harem, of sensual and colorful voluptuousness, but they also solved the pictorial problem of the integration of one figure into an ornamental background. Thus Picasso picked up again on the work that Matisse had begun in the twenties, and he developed the idea initiated by Delacroix of two different versions of the same painting (the one in the Louvre and the other in the Montpellier Museum). And so Picasso locked himself up in his studio in the Grands-Augustins for three months and immediately painted two variations of the same view.

This work provided him with an opportunity to improve the Cubist language, to develop the simultaneous views of the body, which he was forced to present lying on the back and on the belly at the same time, all the while respecting its anatomical unity without dislocating it into successive planes as he had done earlier. Innumerable preparatory

995 *Study for "The Women of Algiers," after Delacroix,* December 29, 1954

996 *Study for "The Women of Algiers," after Delacroix,* December 21, 1954

997 *Study for "The Women of Algiers," after Delacroix,* December 27, 1954

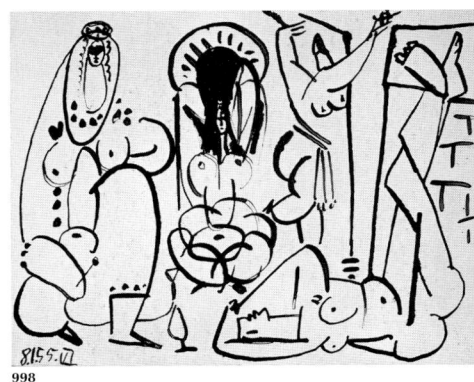

998 *Study for "The Women of Algiers," after Delacroix,* January 8, 1955

999 *Study for "The Women of Algiers," after Delacroix,* January 23, 1955

1000 *Study for "The Women of Algiers," after Delacroix,* February 3, 1955

1001 *The Women of Algiers, after Delacroix,* December 13, 1954

1002 *The Women of Algiers, after Delacroix,* December 28, 1954

1003 *The Women of Algiers, after Delacroix,* January 1, 1955

1004 *The Women of Algiers, after Delacroix,* February 11, 1955

1005 *The Women of Algiers, after Delacroix,* January 24, 1955

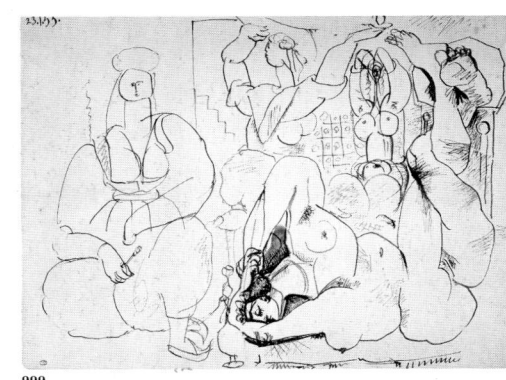

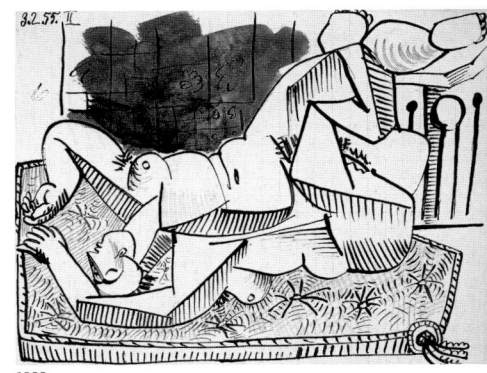

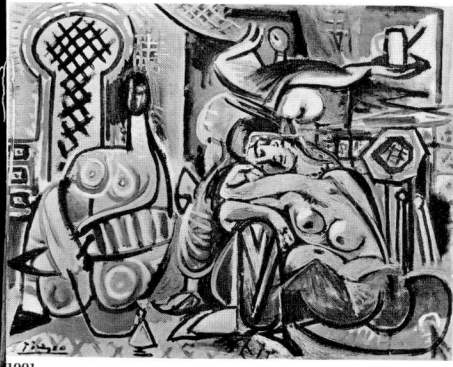

1001

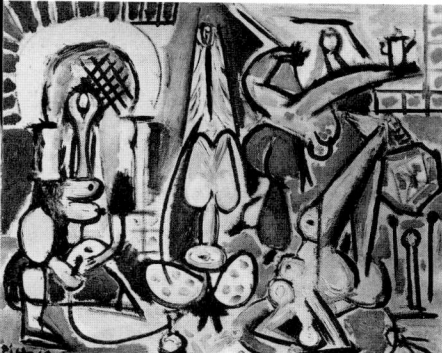

1002

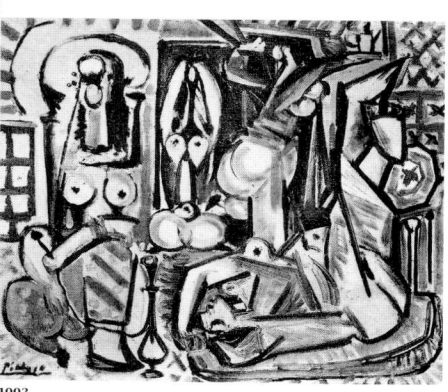

1003

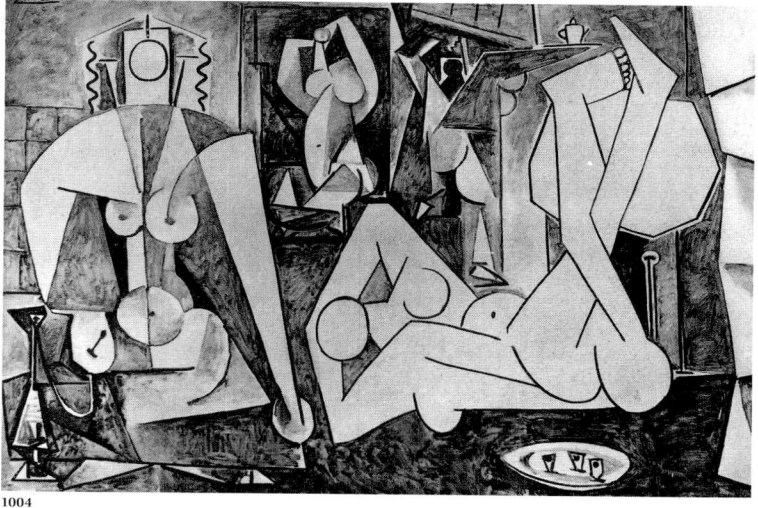

1004

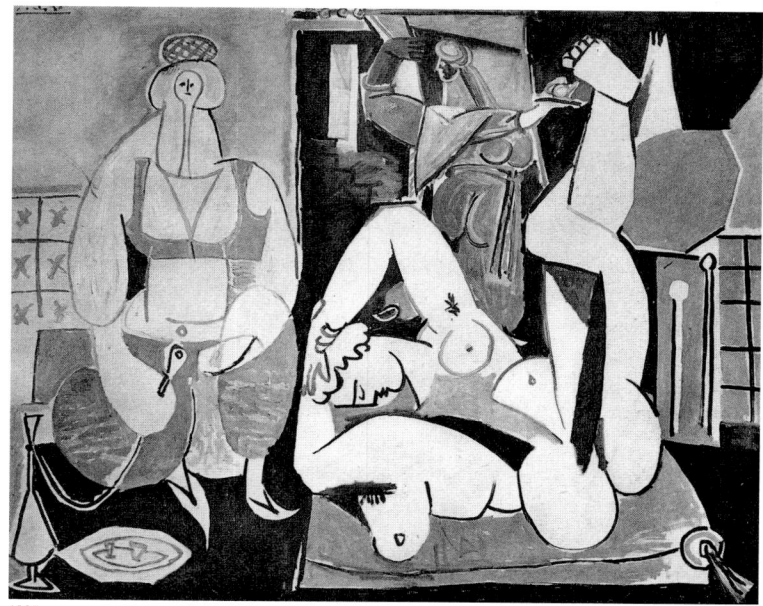

1005

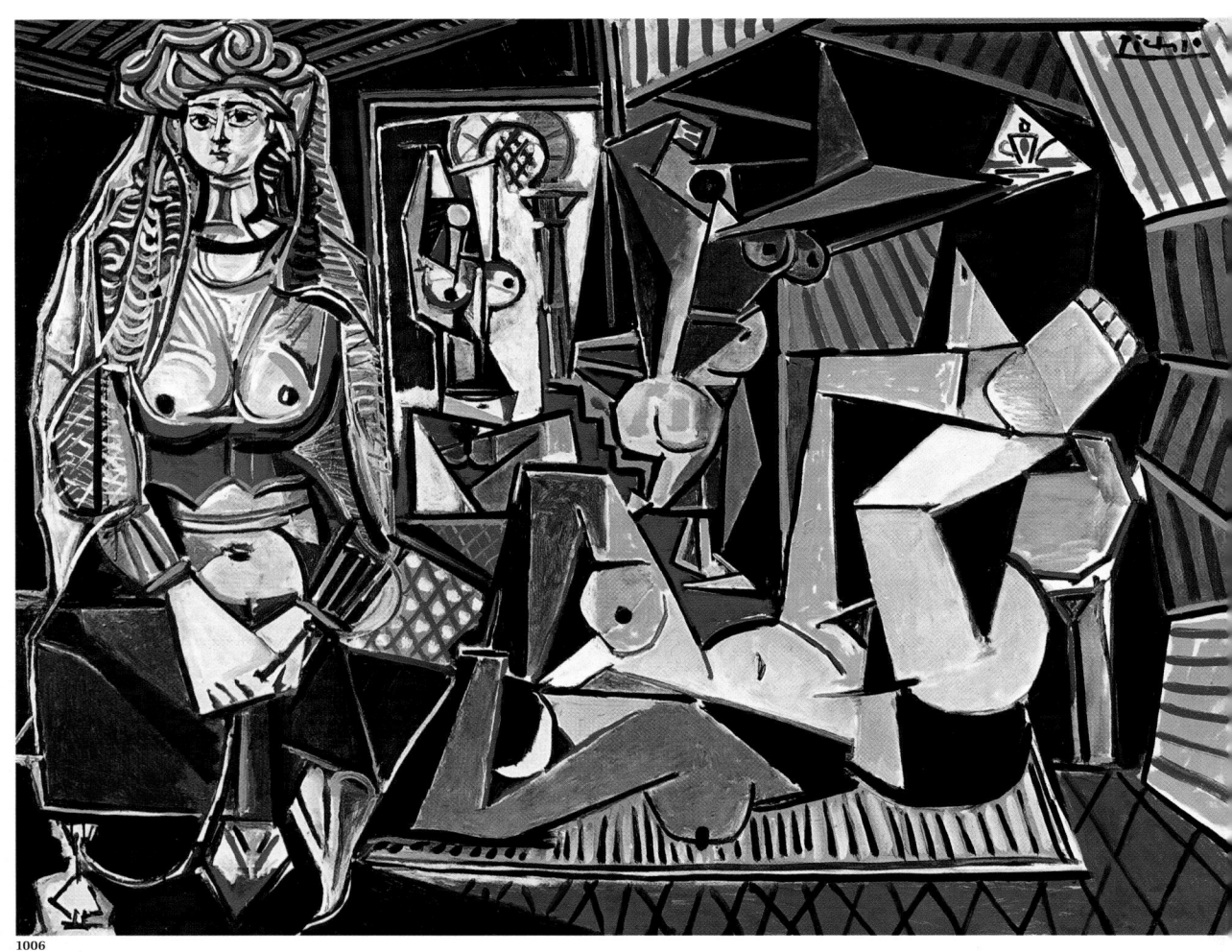

1006 *The Women of Algiers, after Delacroix,*
February 14, 1955

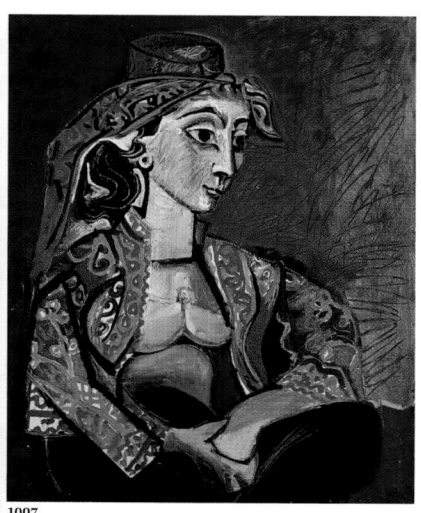

1007

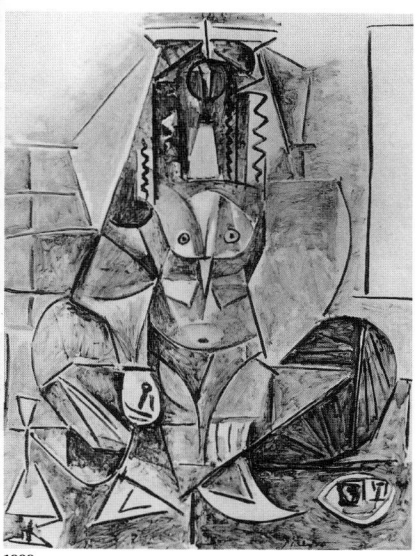

1008

1009

1007 *Woman in a Turkish Jacket,* November 20, 1955

1008 *The Women of Algiers, after Delacroix,*
February 9, 1955

1009 *Nude in a Turkish Hat,* December 1, 1955

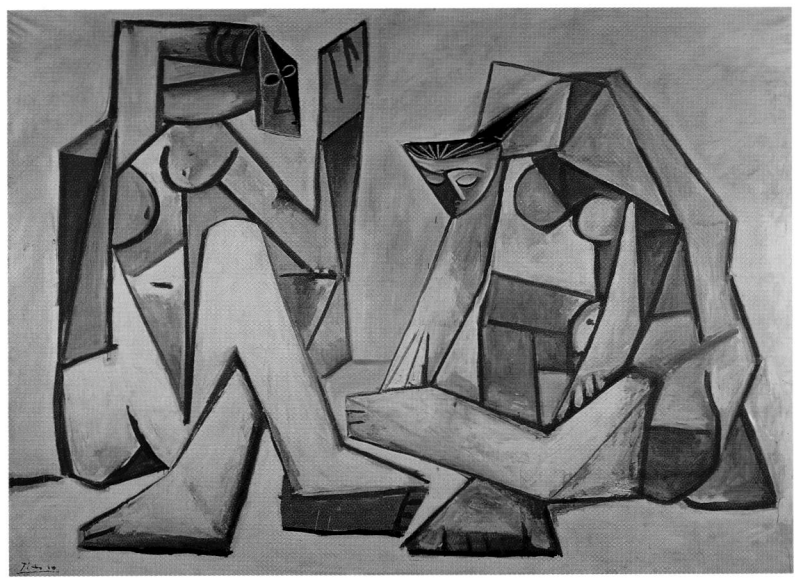

1010

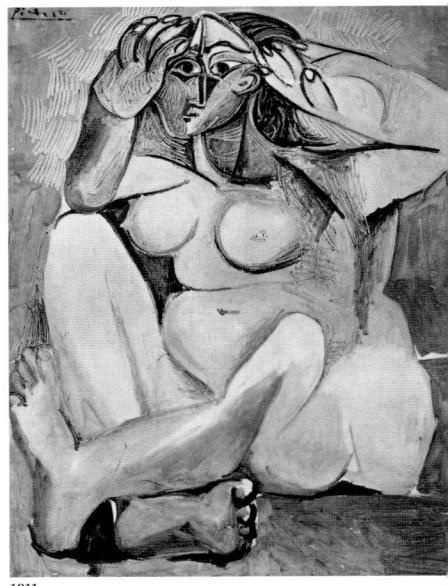

1011

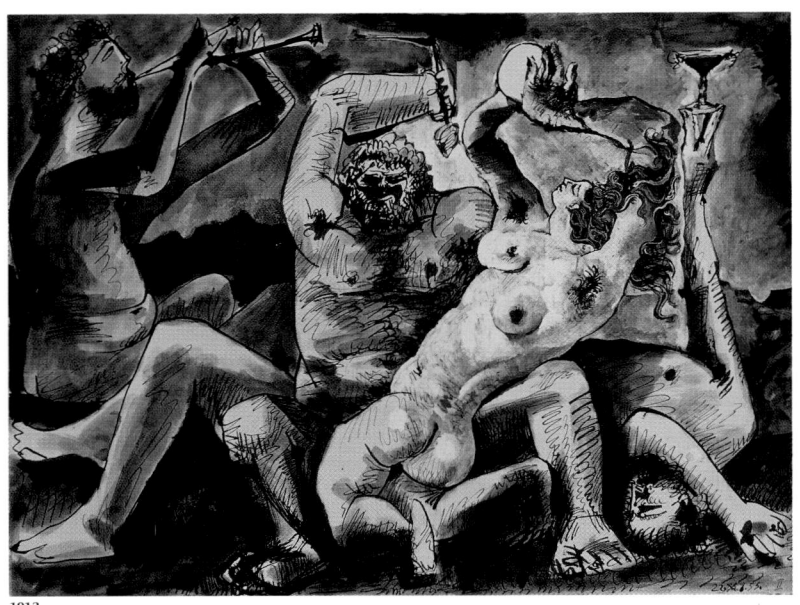

1012

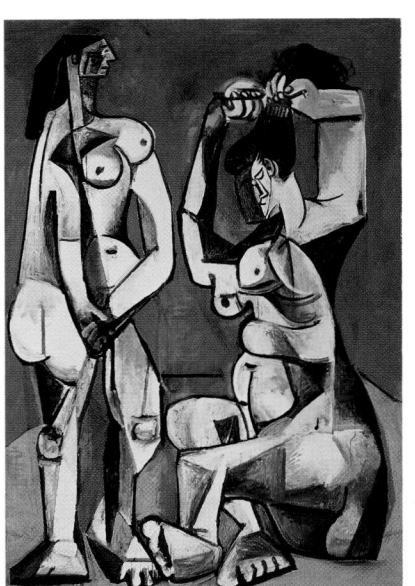

1013

410

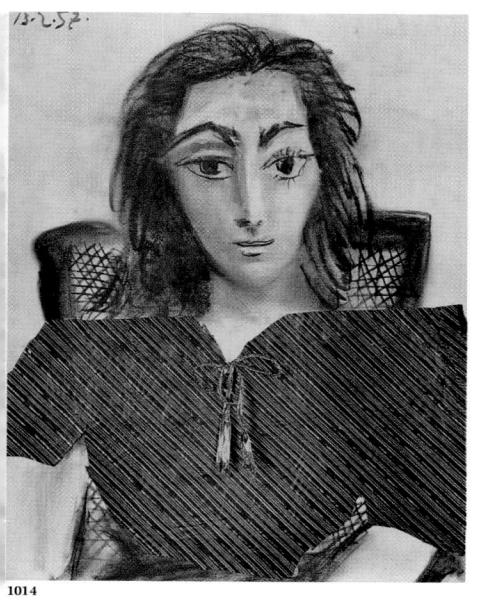

1014

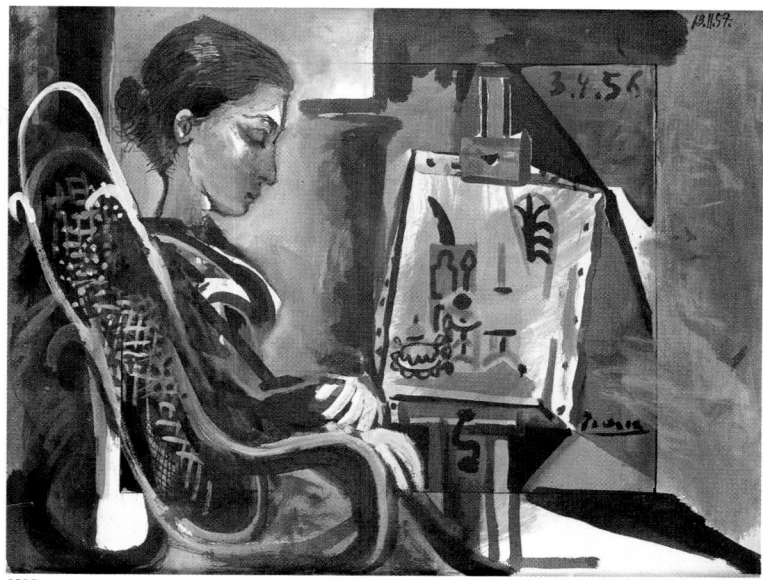

1015

1010 *Two Women on the Beach,*
February 6–March 26, 1956

1011 *Crouching Nude,* January 3, 1956

1012 *Bacchanale,* September 22–23, 1955

1013 *Women at Their Toilette,* January 4, 1956

1014 *Portrait of Jacqueline,* February 13, 1956

1015 *Jacqueline in the Studio,* November 13, 1957

1016 *Man with a Golden Helmet, after Rembrandt,*
January 14, 1956

1017 *Jacqueline on Horseback, after Velázquez,*
March 10, 1959

1016

1017

1018

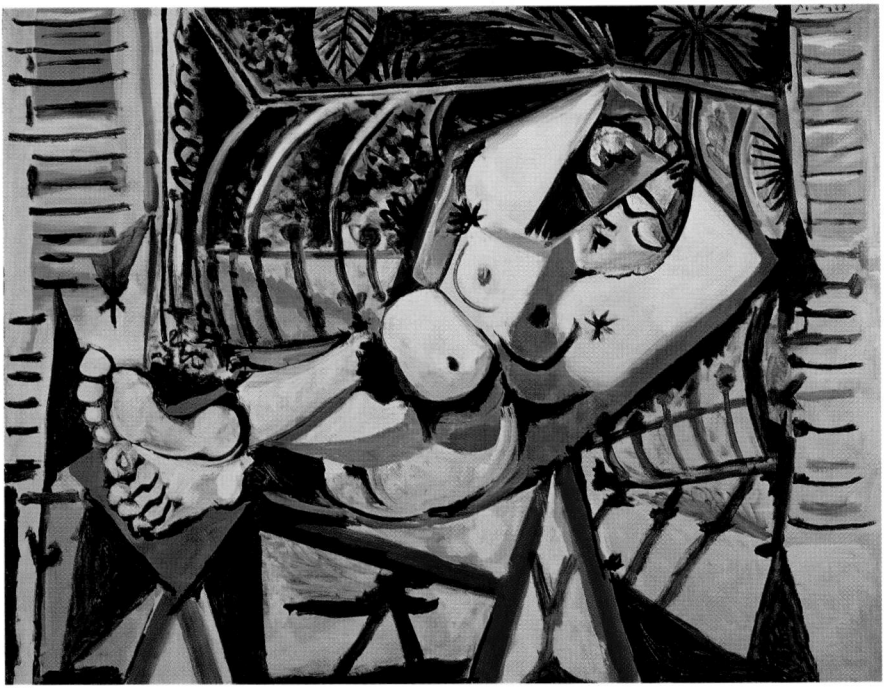

1019

412

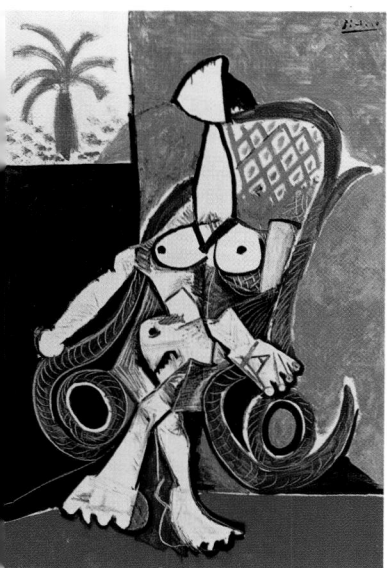

1020

drawings analyzed different postures of women, superimposing and overlapping them in a decorative checkerboard. Picasso threw himself into this work heart and soul, allowing an aggressive and joyous eroticism to emerge, a far cry from the hushed sensuality of the harem. He kneads the ample flesh, folding it with a lithe and nimble brush, indulging in twists and arabesques, then breaking them up, constricting them in a rigorous geometry of sharp angles and faceted volumes straight out of Cubism. Slowly but surely he changed the composition, transforming it into his favored themes, of the Old Age Seated and the Reclining Woman Asleep. He concluded the process with two contrasting pieces, one canvas sumptuously colored and decorative (fig. 1006), the other one stripped and monochromatic (fig. 1004), one painted, the other a drawing. Picasso's work on the *Women of Algiers* allowed him to draw from—and exhaust—his pictorial resources without having to focus on subject matter and allowed him to conceive of his work as a whole, a totality, and not as a succession of unique paintings. What interested him was what happened from one version to the next, the modifications, the metamorphoses, the comings and goings, the immutabilities. "You see," he said to Kahnweiler, "it is not time rediscovered but time to be discovered."[11] Indeed, the *Women of Algiers* are only an iconographic homage to Matisse, for in their pictorial vocabulary they are completely Picasso. The pictorial homage would take place in connection with Matisse's quintessential theme, the artist's studio.

Although Picasso made numerous variations or paraphrases of old masters, he sometimes copied certain masterpieces, especially in drawings, which explains how drawings appeared in a 1957 notebook of Rembrandt's *Man with a Golden Helmet* (fig. 1016) and a portrait of *Jacqueline on Horseback* (fig. 1017) inspired by Velázquez. These drawings, whose detailed lines approach those of engraving, show the virtuosity of Picasso the classicist. It is well known that Picasso admired Rembrandt immensely, especially the old Rembrandt. Picasso made numerous portraits of the aged artist and increasingly identified with him toward the end of his life.

The classical impulse in Picasso the draftsman appears also in the drawing *Bacchanale* (fig. 1012). Picasso was returning to themes of antiquity: flute players, frenzied maenads, and a triumphant Bacchus. The originality of this drawing lies in the upside-down face of the reclining man who is balancing his glass. But there are other drawings in which Picasso went back to the processes of assemblage and collage, inherited from Cubism, as in the *Portrait of Jacqueline,* whose bodice is made with wrapping paper from a box of chocolate (fig. 1014).

The influence of Matisse, which is very evident in the Studio series, can already be felt in the *Nude in a Rocking Chair* (fig. 1020); the brightly colored flat areas, the decorative caning, and the presence of a little palm tree are all signs of Matisse. The joy of living appears in all of Picasso's pieces from these years, as seen by the remarkable canvas of the *Springtime* (fig. 1018), in which one sees a young man stretched out beneath a tree at which a goat is browsing away. This pastoral, idyllic theme is a very unusual one in the painter's oeuvre. The canvas that best summarizes this period is without a doubt the *Reclining Nude Before a Window* (fig. 1019), which links the heritage of Matisse—the motifs of the Venetian blinds and the window—to a language and a silver-gray light that are typical of Picasso.

The Studio

1018 *Springtime,* March 20, 1956
1019 *Reclining Nude Before a Window,* August 29–31, 1956
1020 *Nude in a Rocking Armchair,* March 26, 1956

The move into the Villa La Californie was an enormous event. It was Picasso's first move into a house big enough for him to store all his earlier canvases from Paris, thus accumulating traces and memories of his past in calculated disorder. Shortly after he arrived, Picasso took possession of the space and occupied the entire ground floor of this large 1900 building, which was surrounded by a lavish garden, and here began a new stage of his life with Jacqueline. He very quickly responded to the lure of the place with a series he was to

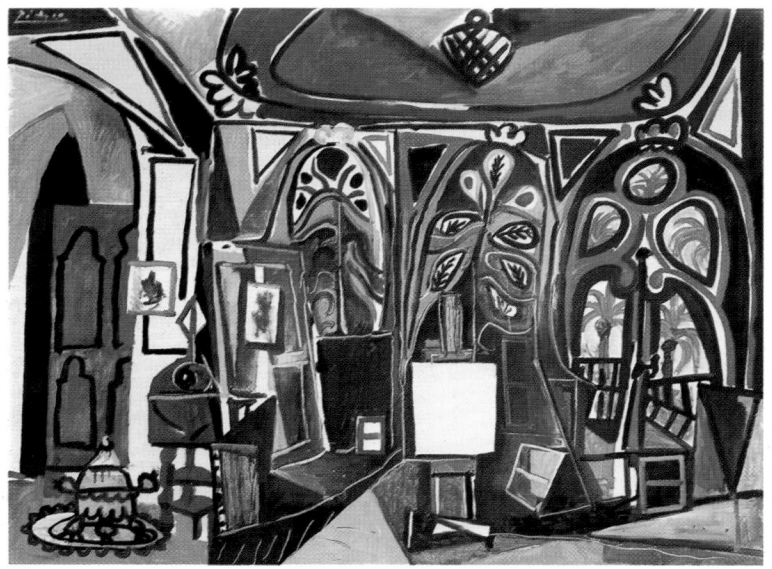

1021

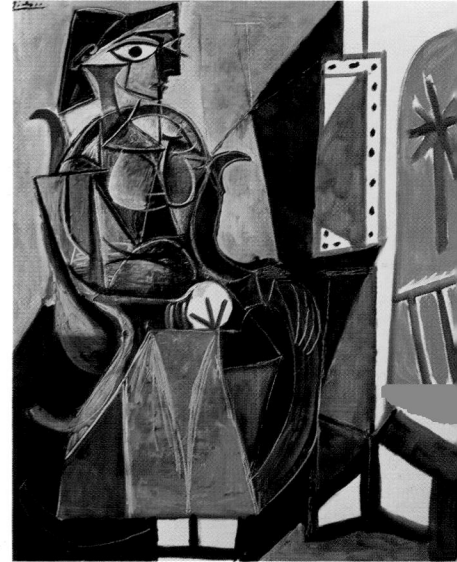

1022

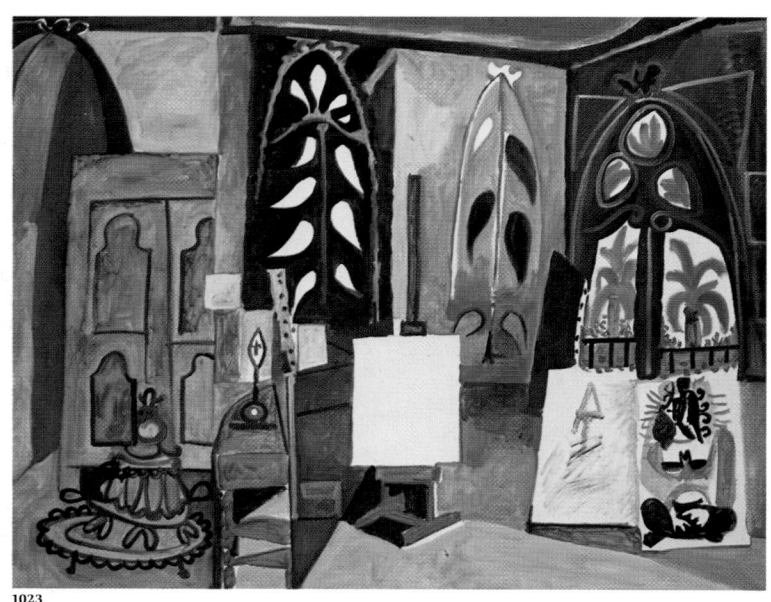

1023

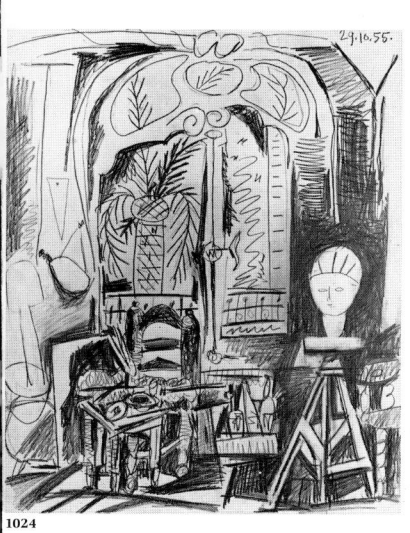

1024

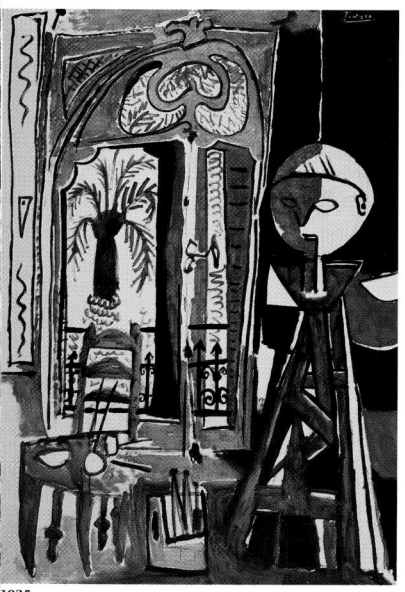

1025

call "interior landscapes." For Picasso the studio was like a self-portrait. Sensitive to its rituals, to its private poetry, he marked the environment and its objects with his presence and transformed the terrain into a "second skin." The work was done very quickly. In the first phase, from October 23 to November 12, 1955, he favored a vertical format, light paint, and transparent space bathed in glowing light. His approach was supple and illustrative: the tracery of the window motifs is mixed with a jumble of vegetation, thus unifying the interior and exterior within the same space (fig. 1024). Then Picasso's vision began to grow more dense. He reduced the depth to flat, colored, and unified surfaces. Within a compact articulation of an overloaded and baroque space, one may see the invariable elements of the furniture interwoven with the setting: the palette stand, the turntable with a clay head, the low table with three shelves. The second phase began in March 1956, but between these two came the postscript to the *Women of Algiers*: the series of Jacqueline Seated in Turkish Costume (figs. 1007 and 1008), which expanded the sensual, erotic atmosphere of Delacroix. Translated into plastic ideograms or, in a more classical style approaching that of Matisse, Jacqueline enabled Picasso to explore various pictorial voices. "Jacqueline has the gift of becoming a painting to an unimaginable degree,"[12] he used to say. Two large transitional canvases, *Women at Their Toilette* (fig. 1013) and *Two Women on the Beach* (fig. 1010), summarize Picasso's study of the body's formal beauty begun with the *Women of Algiers*. His first efforts were twisted, dark, and dramatic and recalled the distorted bathers of the 1920s, which themselves foreshadowed his later period in the freedom of their pictorial treatment. The second efforts were monumental, transfixed within a limpid, transparent light, and they confirmed the solidity of Cubist volumes. At that stage, Picasso was not able to go any further along this road, so he came back to the Studio and painted his most Matissian canvas (fig. 1021). Hereafter, the format was horizontal, the visual angle turned toward the room's interior, the surface punctuated by the three high-paneled doors, the cupboard, the Moroccan dish, the easel in the middle—as in the painting that served as his example (*The Studio* by Courbet)—and a few canvases on the floor. With the opposition of white and black, positive-negative forms, flat areas of light paint, use of unpainted areas, and the importance of decorative elements, Picasso devoted himself to the "verification of the language of Matisse . . . to an inventory of his plastic signs."[13] Then his colors changed to brown-black, ocher, and gray. The mood became Spanish: "Mozarabic chapel," as Antonina Vallentin put it,[14] or "Velázquez," as Picasso said to Alfred Barr.[15] After Picasso had removed the space and tested different ways of suggesting it, he could not help but put the model back in the studio, Jacqueline seated in an armchair facing the easel. The design was simplified and became more geometric; the colors were once again happy and dazzling. The confrontation between the seated model and the easel ended with the large, majestic, and classical painting of Jacqueline seated (fig. 1022). This work, which took a year to complete, allowed Picasso to explore pictorial space, to verify certain Cubist solutions regarding depth and to combine them with the space in the studios of Matisse and Braque, to practice a stripped language made up of linear brushstrokes, and at the same time to speak a language as clear as that of a child. One year after Delacroix, one year before Velázquez, having made his analysis, Picasso could make his triumphant return to painting.

Las Meninas

This was not about just any painter, since it concerned his compatriot Velázquez, whom Picasso had admired all his life: "Velázquez first class," he had written in 1897 to a Spanish friend after visiting the Prado. This was not just about any painting either, since he tackled the absolute masterpiece, the most disturbing painting in the history of art, a veritable "pictorial theology" that unveils the secret of its foundations: *Las Meninas*. A mirror-painting, an

ambush painting, a game of reflections and role reversals, of the watched and the watching, this canvas could not help but fascinate the painting's painter. In making his own *Meninas,* Picasso did in fact fall in line with the last reflection of the game of mirrors set in place by Velázquez. He made a painting of the painting that represented a painting emptied of those who had been painted (the king and queen) and filled it with those who stand on the other side of the canvas (the painter and the courtiers). It was an ambiguity of exterior reality and pictorial truth, the coexistence of two worlds, art and life. In his work, Picasso would interpret this double play in his own way by integrating exterior views into his series, the windows with pigeons, the sea, landscapes, and elements of daily life, such as his basset hound Lump, who replaced the noble Spanish dog and, in the end, Jacqueline. From August 17 until December 30, locked away in empty rooms that had been specifically converted into a studio on the second floor of La Californie, Picasso produced fifty-eight paintings, including forty-four *Meninas,* nine *Pigeons,* one *Piano,* three landscapes, and one portrait of Jacqueline.

The first version (fig. 1026), in contrast to the *Women of Algiers,* is the most faithful and the most finished. Immediately he posed the problem, then afterward entered into explanations of details, advancing by association or digression. Besides the format, which had changed from vertical to horizontal in order to enlarge the space, and the choice of grisaille, all elements of the original painting are present. The painter at the left, huge, blended into his easel, is treated with the same tight graphic style as the *Portrait of a Painter* after El Greco (fig. 949) or the *Young Women on the Banks of the Seine* after Courbet (fig. 948). The more one moves to the right of the painting, the more the characters become schematic and lose their substance, until they are no more than a roughly sketched white silhouette. On the same canvas, Picasso had combined various pictorial voices that he would develop one at a time, in the end preferring the simple and stripped-down approach made of color screens and big geometric strokes, an extrapolation of synthetic Cubism. The choice of black and white allowed him to structure the space and to study the placement of the figures. Colors would not come until later; they were to be vivid, dazzling, with a base of bright red, green, and yellow, sometimes against a black background and sometimes against red. Very quickly Picasso focused on the Infanta, whom he made into the main character. Alone, as a bust or at full length, or accompanied by the courtiers, she is alternately treated in simplified forms and flat areas or with nervous, thick, and superimposed strokes. The pictorial language is sometimes hurried, indirect: a few spots of color onto which the forms are incised. Picasso pushed the variety of styles even further, going from overlapping multicolored facets to a Matissian stripping down, to a construction of the space with unified colored planes. From this enigmatic scene, Picasso kept the spirit of pictorial experimentation. Of Velázquez's lavish production, he preserved the depiction of flesh and silk, the subtle light on the dress of the Infanta, which he replicated through spots of white and yellow against a green background, as in the last, small painting of the Infanta curtseying that ended the series on December 30 (fig. 1032). This laboratory work, this autopsy, during the course of which Picasso analyzed, dissected, and recomposed, brought him an extraordinary freedom of brush and an insatiable enthusiasm, and it allowed him to manipulate his characters at will. Humor and irony were not absent, as one can see in the crazy canvas of the *Piano,* which shows up suddenly because the position of the raised hands of the little page at the right requires the presence of the instrument.

Las Meninas represented Picasso's first return to Spain, an experience that would intensify during the Vauvenargues period (1958–59) and culminate in the Musketeers of 1967. Liberated from having to choose a subject, Picasso now let the painting itself speak. Once again, as with *Women of Algiers,* this was a composition with several figures, a genre he rarely tackled, although in this case he quickly reduced the number of protagonists as he sought a way to verify Cubist space and depth, expanding on what he had begun with the Studio series. As he inventoried and invented new pictorial means and settled

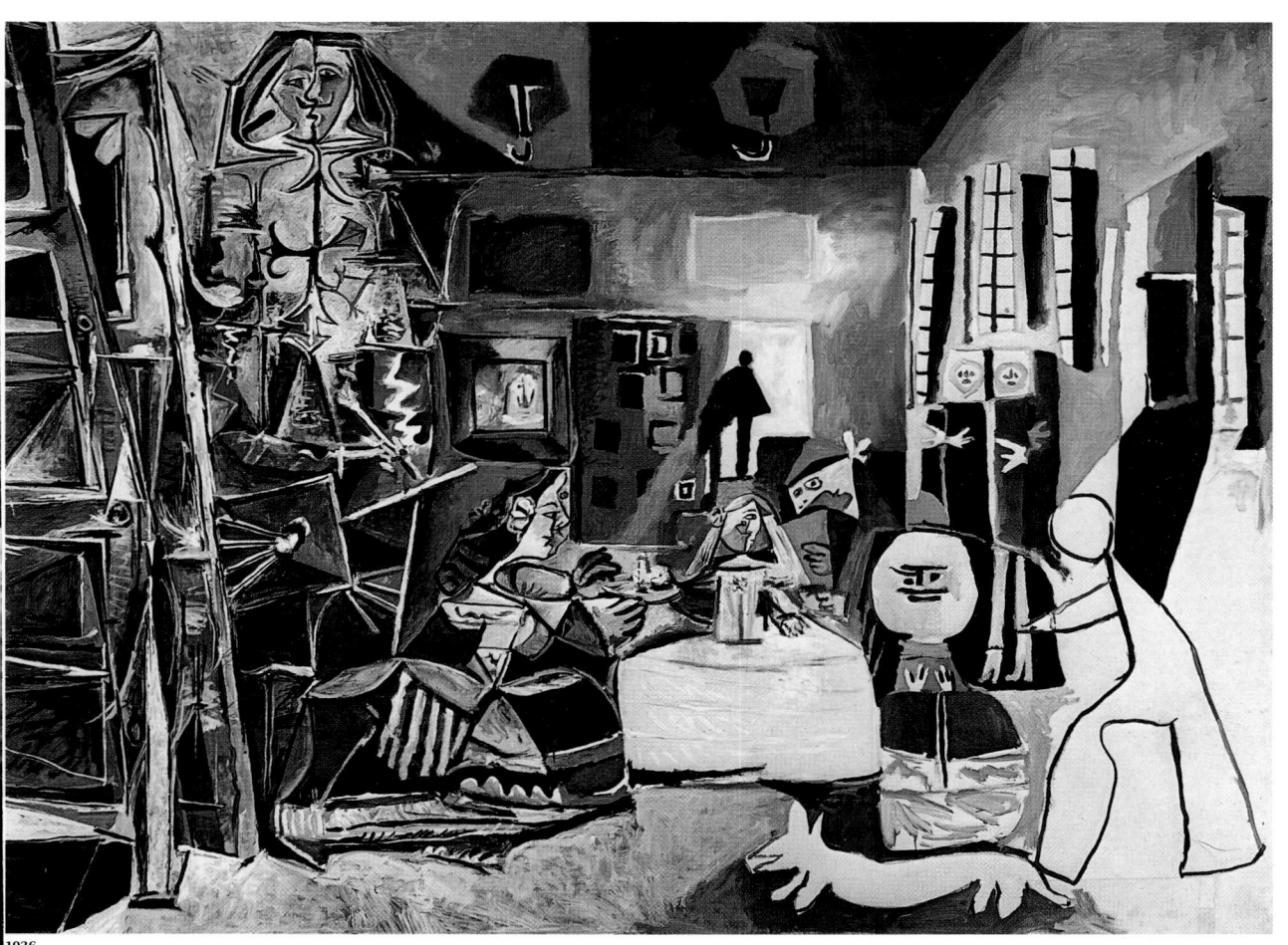

1026

1026 *Las Meninas,* August 17, 1957

417

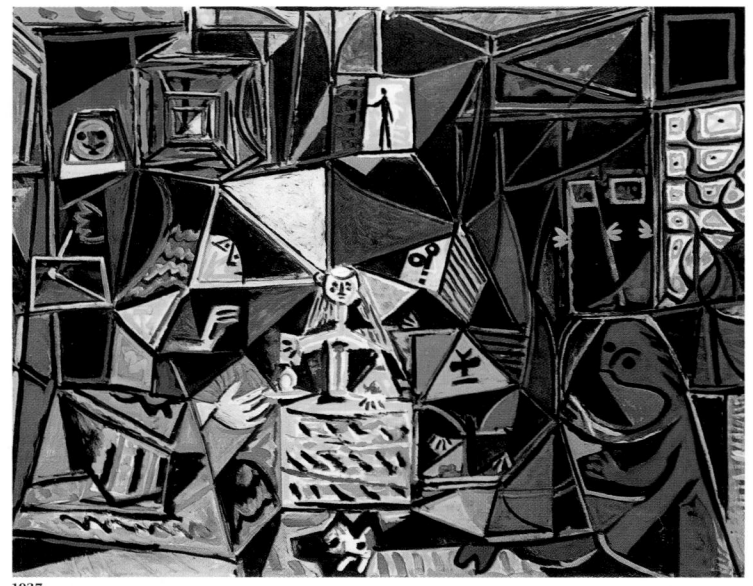

1027

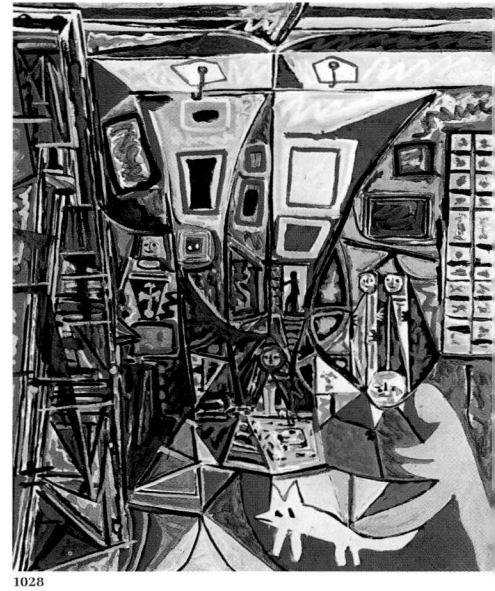

1028

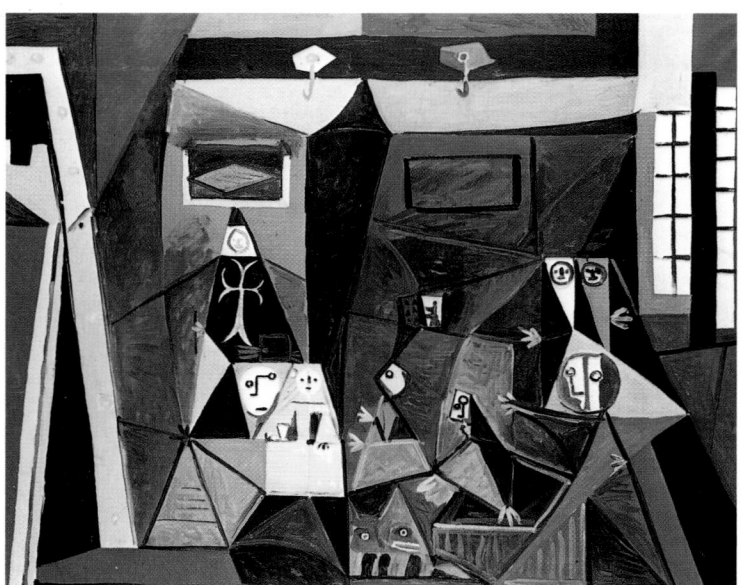

1029

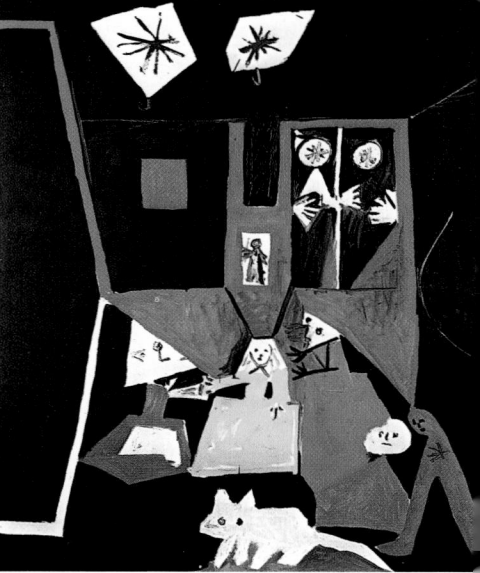

1030

418

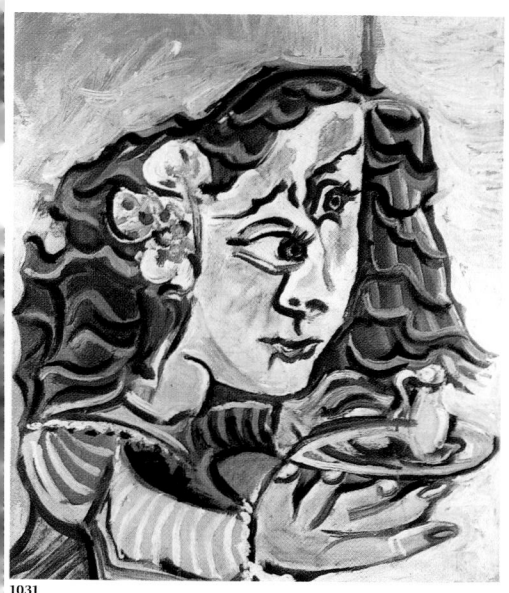

1031

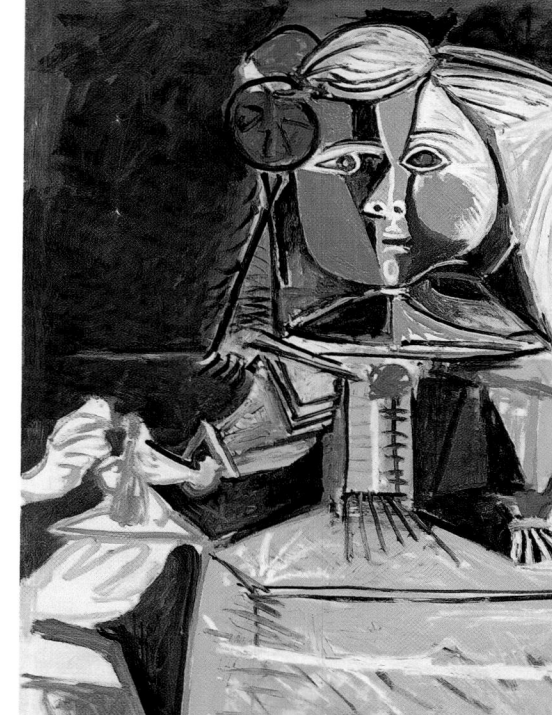

1033

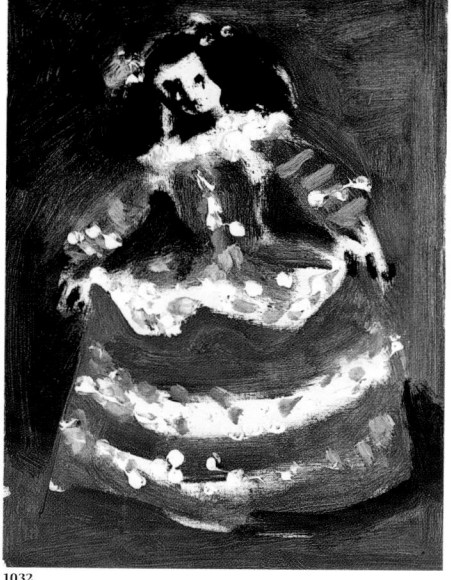

1032

accounts with his great predecessor, Picasso went on his own way with one foot in the past and the other in the future. At this stage, he would need a springboard, and it would be offered to him accidentally by *The Fall of Icarus*.

The Fall of Icarus

Picasso's preparatory work for the huge panel at the Palais de l'UNESCO allowed him to recapitulate the problems that had haunted him, and thus it constituted a turning point in his career, an interlude before the last phase. Between December 1957 (corresponding to the completion of the *Meninas* series) and January 1958, Picasso accumulated preparatory drawings and sketches, which he recorded in two notebooks (figs. 1035–1038).[16] An immense surface to be covered, an unattractive architectural space, a humanitarian project, and an official commission, these were the many obstacles Picasso had to confront in this, his third completed project of monumental decoration after *Guernica* and *War and Peace*. His point of departure, the genesis of the work, was once again, as it had been for *Guernica*,[17] the "primitive scene," that is to say the studio, the painter, and the model. But right away he added a new element, sculpture (in the form of painted Bathers), that would be the catalyst of this huge composition. As he did so often throughout the course of his evolution, Picasso came back to sculpture. In the continuous dialogue between the two-dimensional and the three-dimensional, which characterizes his entire oeuvre, sculpture represents a distance, another point of view, a means of verification and an enrichment for the painting. The first sketch of December 6, 1957, shows the studio; a nude model, who seems to be coming out of a canvas placed on an easel; a large painting representing *The Bathers*, which functions as an open window (perhaps sculptures or the painting of sculptures); and finally the tall, ghostlike silhouette of the painter. Little by little, as the complex progression moved through the drawings—a series of jumps or abrupt changes described perfectly by Gaëtan Picon in *La Chute d'Icare*[18]—Picasso integrated and summarized the knowledge he had acquired over the past five years. Taking up again the theme of the studio sent him back to two paintings of 1953, the *Reclining Nude* and *The Shadow*, which are seen together in two drawings of January 7, 1958 (*III* and *IV*)[19]; he even evoked the bedroom at Vallauris with the presence of a little Sicilian horse on a shelf[20]; "from time to time," he said, "one also needs a bit of sculpture."[21] The studies of reclining nudes from the *Women of Algiers* reemerged, with distortions resulting from either a great plastic flexibility or the folding of rigid cutout forms.[22] In other drawings he studied the geometry of the studio, and its restructured space recalls the studio at La Californie or that of *Las Meninas*. Furthermore, there is a striking resemblance between *The Bathers* and the first version of *Las Meninas*, with the same arrangement of characters—a large figure with a small head at the left, a small figure with a huge head in the middle, the same view from the front, and so forth. Above all, however, these different studies reflect Picasso's transposition of the problem posed by Velázquez about the ambiguity of pictorial space and its interference with reality. Indeed, Picasso multiplies the double readings: the painting of a sculpture or a painted sculpture, window or canvas, real model or model painted on the canvas. The apex of these ambiguities is the silhouette of the painter who becomes the subject of a canvas. This is yet another sign of fusion, of the identification of the painter with his subject. The painter within the painting, the painting within the painting, the play of double backgrounds, all continue to be emphasized. Curiously, after having accumulated all these games of illusion, in the central canvas Picasso comes straight to the point and selects as his main motif that of *The Bathers*, specifically the diver on the diving board with his arms spread wide.[23] With *The Bathers*, Picasso returned to a theme that was dear to his heart and that he had been treating since 1928, first in Dinard and then in Boisgeloup.

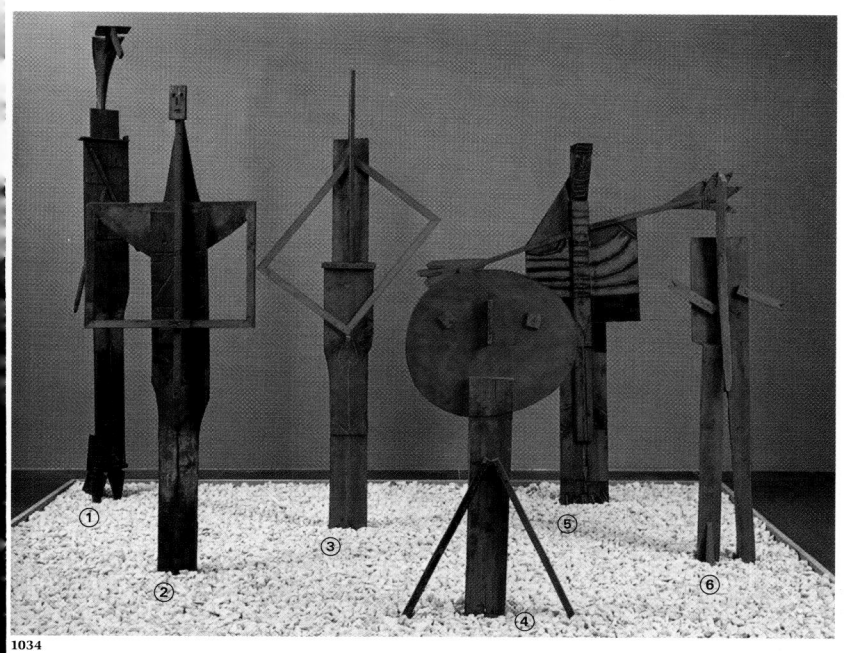

1034

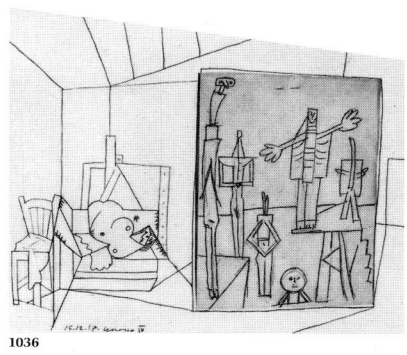

1036

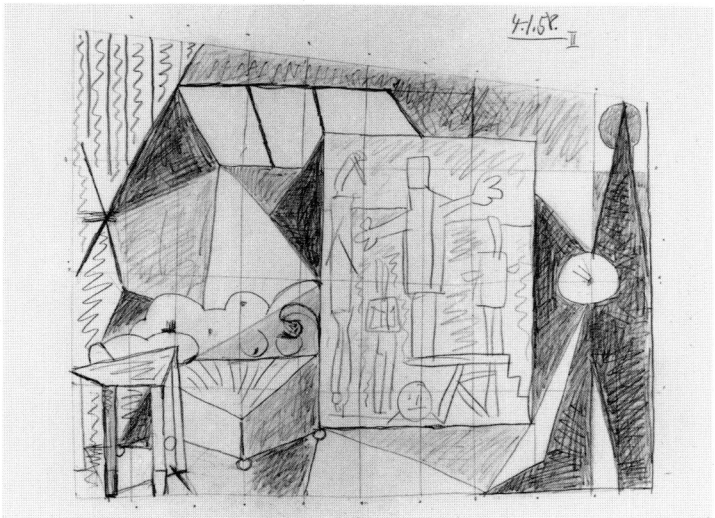

1035

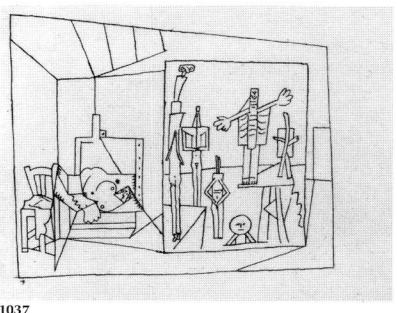

1037

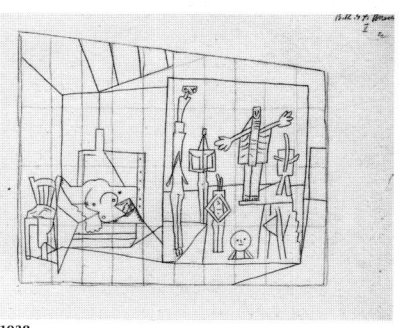

1038

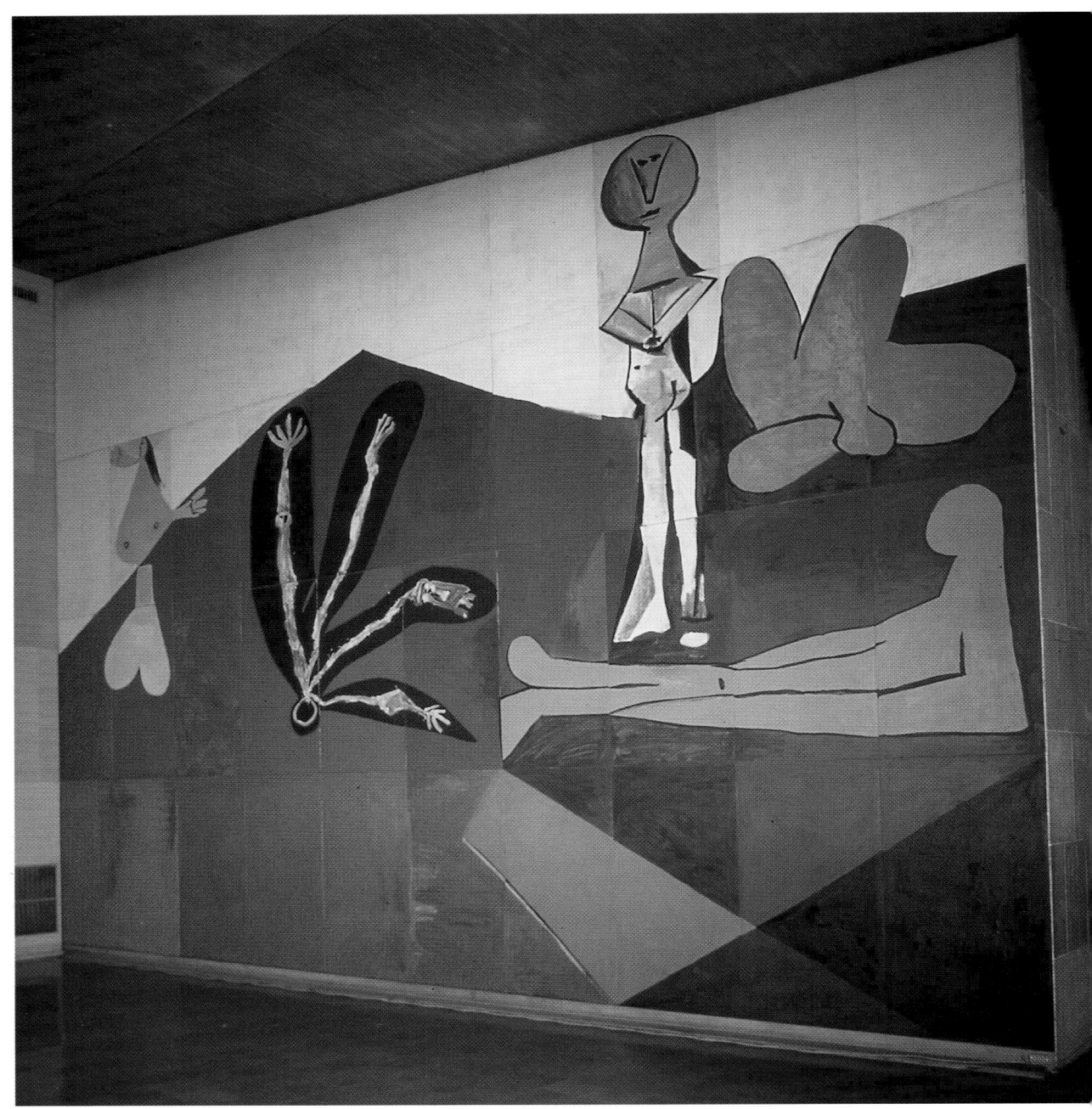

1039

1040

This was also the picture in Clouzot's film *La Plage de la Garoupe* and the scene of daily life that he observed on the beach. *The Bathers* (fig. 1034), an assemblage of wood, including frames and boards, is a monumental sculpture, a fountain project, and the first sculpted group of his career. The piece would engender a few descendants[24] and in particular would open the way for flat sculpture, which he would cut out of sheet metal in the 1960s. Most of these figures are "painting-bodies, painting-easels,"[25] because their shapes evoke a frame and the original material of which they are made. In 1957 Picasso produced three heads composed of profiles that intersect at ninety degrees on a vertical axis (fig. 1063). Sculptures in cardboard or tin grew out of his work on the portraits of Sylvette, which allowed him to reunite painting and sculpture. Picasso himself confided to Pierre Daix: "In the studio at La Californie I used to light these cut-out heads very brightly, and then I would try to catch them through my painting. I did the same with *Les Baigneurs*. First I painted them, then I sculpted them, and then I painted the sculptures once more on a canvas. Painting and sculpture truly talked together."[26] As Pierre Daix remarked, these new sculptures would become the springboard for painting. "That's legitimate since they were born from painting and since they materialized it in three dimensions." After all was said and done, Picasso would keep for his final composition of the Bathers theme only one standing figure—the diver—and the immense blue sea. The other characters are lying down or sitting, one woman bather taking on the swollen forms of the Dinard Bathers. He pushed simplification and abstraction to their maximum, evaded his initial subject, and at the last moment added the enigmatic figure of a bird-man falling from the sky into the sea. The theme of the springboard and the diver was not an accident. As Pierre Daix and Gaëtan Picon emphasize, this attitude of risk-taking, of diving, leaping into the unknown, corresponded quite well to Picasso's state of mind at the time. "The painting, the springboard. It is between these two elements that everything is played out. . . . Is the diver not like the painter, facing the risk and the void of his element."[27]

The myth of Icarus, an idea suggested by Georges Salles and superimposed on the project from the start, certainly exists in Picasso's oeuvre, even if the work's official title was *The Forces of Life and the Spirit Triumph over Evil*. The lesson of the father was not passed on, Picasso concluded, after his experiments with the masters of the past. At this stage of his career, after becoming disillusioned with ideology, Picasso found himself alone with himself, with creation alone. This painting, often misunderstood, often disparaged, marked the stage of a "reconquest of self," as Pierre Daix wrote.

Vauvenargues

In 1958, Picasso painted two characteristic and isolated canvases: *The Bay of Cannes* (fig. 1041) and the *Still Life with a Bull's Head* (fig. 1043), views from the window of his studio on the second floor of La Californie. After having painted pigeons on his balcony, a series of images he integrated into *Las Meninas*, Picasso looked farther afield and painted the Bay of Cannes with its big buildings, sailboats, the Lerins Islands, the sea, and the Mediterranean light. Few landscapes are to be found in his work, and almost all of these are urban landscapes, in which the architecture of the houses plays a fundamental role that leaves little space for nature. In this canvas, the towering buildings do not merely play a role in the structure of the composition, but they also allude to the devastation caused by the massive construction that was running wild on the Côte d'Azur and of which Picasso was to be a victim. Threatened by these huge buildings, which invaded his privacy and blocked his view, he left La Californie in September. He would later draw these very same buildings with great humor in a sketchbook of May 1958.[28] His pictorial language characteristic of this period is extremely tight, precise, and quasi-graphic; every detail has been drawn, and certain motifs,

1039 *The Fall of Icarus,* 1958

1040 *The Studio: Reclining Woman and the Picture (Study for UNESCO),* December 6, 1957

1041

1042

1043

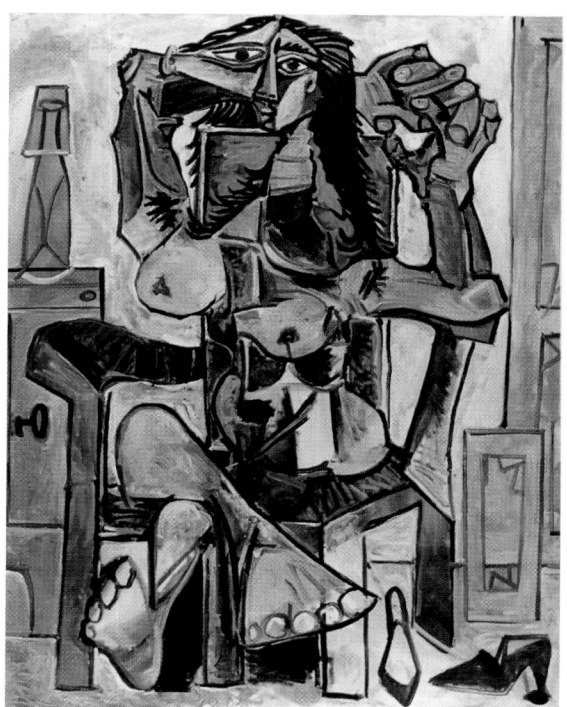

1044

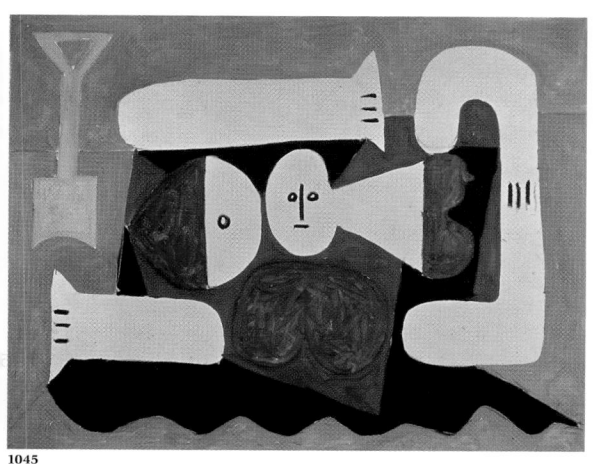

1045

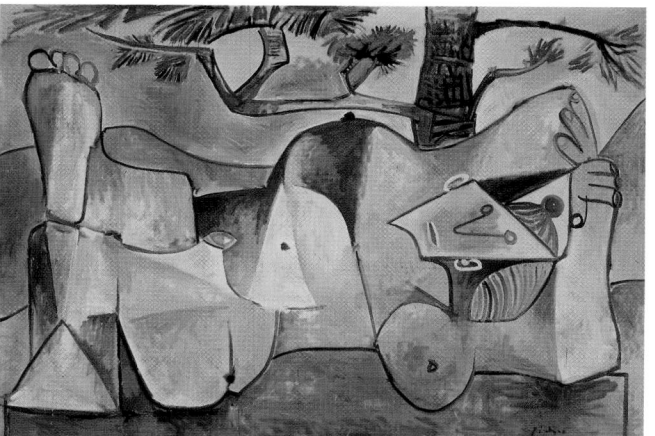

1046

![1047]

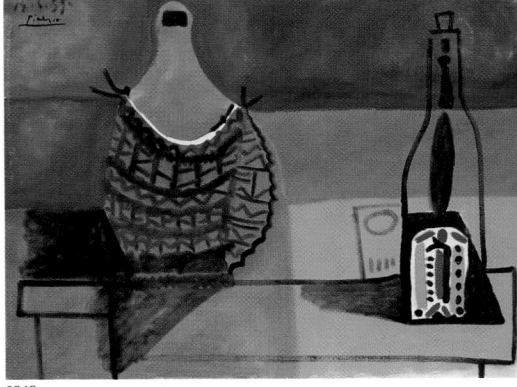

1048

1047 *The Vauvenargues Sideboard ,*
 March 23, 1959–January 23, 1960
1048 *Still Life with a Demijohn,* June 14, 1959
1049 *Bust of a Seated Woman,* April 2–May 10, 1960

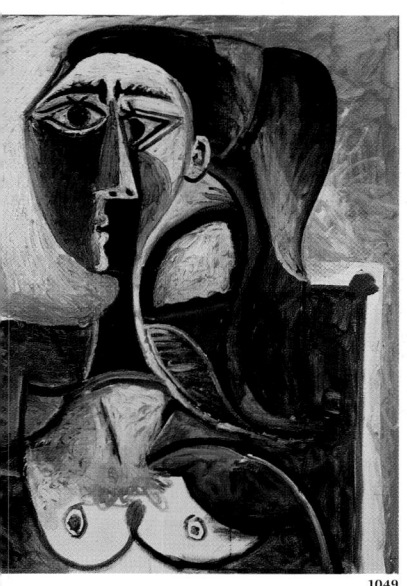

1049

such as the rolling of the hills and the waves of the sea, are emphasized and insistently repeated. The colorful beaches are outlined in black, thereby reminding the viewer of the technique of stained glass that can also be seen in the linoleum cuts Picasso was making during the same period. He confided to Pierre Daix: "It is not the subject, it is the white that interests me."[29] The canvas came into being between April 19 and June 6, 1958. The one-month interruption, in May, corresponded to the political crisis that followed the events in Algeria, and to the creation of *Still Life with a Bull's Head*. The dates inscribed on the back of this painting, May 28–30, June 7–9, are those when Charles de Gaulle took power, and they prompted Pierre Daix to correlate the climate of concern and violence that reigned at the time with the return of the motif of the dead bull. In relation to this memento-mori theme, one should note the still life of 1942 (see fig. 850), painted when González died. The contrast between death and life in this image is striking and tragic, like "a thunder clap in a blue sky." The unusual presence of the decapitated head, the eye sockets, and the jaw have a morbid connotation whereas the bouquet of flowers, the star motifs, the bright hues, and the sun are ablaze with light and life.

The year 1958 was characterized by Picasso's adoption of a new pictorial technique, rich in all the possibilities of the oil medium in which he explored the contrasts between areas saturated with color and those diluted to the extreme. He gave free rein to the medium and to the effects of texture: tensions, splashes, and trickles. He allowed the paint to go its own way and asked "the pictorial material for its material truth" (Pierre Daix). These impastos, the play of transparency in layers, the integration of thick and hardened pieces of paint into the surface foreshadowed certain works from his last period.

The decisive event of the year 1959 was Picasso's move to Vauvenargues, the land of Cézanne. "I have bought the Sainte-Victoire mountain," he told Kahnweiler, "the real one." A new place, august and austere, and a new way of painting, with a strong Spanish resonance dominated by dark red, deep green, and ocher. Picasso painted *Still Life with a Demijohn* (fig. 1048) and the famous *Vauvenargues Sideboard* (fig. 1047), which depicts a monumental Rococo piece in the style of Henri II that he had just bought to furnish his new home.

In 1959 a brilliant canvas paying homage to Cubism expressed Picasso's classical mastery and the maturity of his style in the late 1950s: *Nude Beneath a Pine Tree* (fig. 1046), in which the massive and monumental forms of the bathing women of the 1920s slip into rigid, geometric volumes inherited from Cubism and the stretched-out body of this ample woman evokes a landscape of hills. In Vauvenargues, surrounded by nature, Picasso began working with green, the dominant color of this brief period. He developed a kind of decorative all-over composition that can also be found in *Woman with a Dog* (fig. 1042), a portrait of Jacqueline painted in Mougins with their Afghan Kabul. Humor was never absent in the canvases of this period, as shown in the *Seated Nude* (fig. 1044), which depicts a monstrous female with a twisted and distorted body, a stupefied expression, along with such aggressive details as underarm hair, a tousled hairdo, and stiletto heels.

In August 1959 in Vauvenargues, Picasso began the cycle of the *Déjeuner sur l'Herbe*, whose last variation was finished in July 1962 at Mougins, after twenty-seven paintings, one hundred and forty drawings, five linoleum cuts, and innumerable cardboard models, which he later produced in concrete.

Le Déjeuner sur l'Herbe

Why Manet? The reasons are many and quite obvious[30]: Manet represented a certain aspect of Spanish art, but he was also a painter of citation, the leader of a pictorial revolution, and the incontestable father of modernity. In fact, Manet had been haunting Picasso for a very

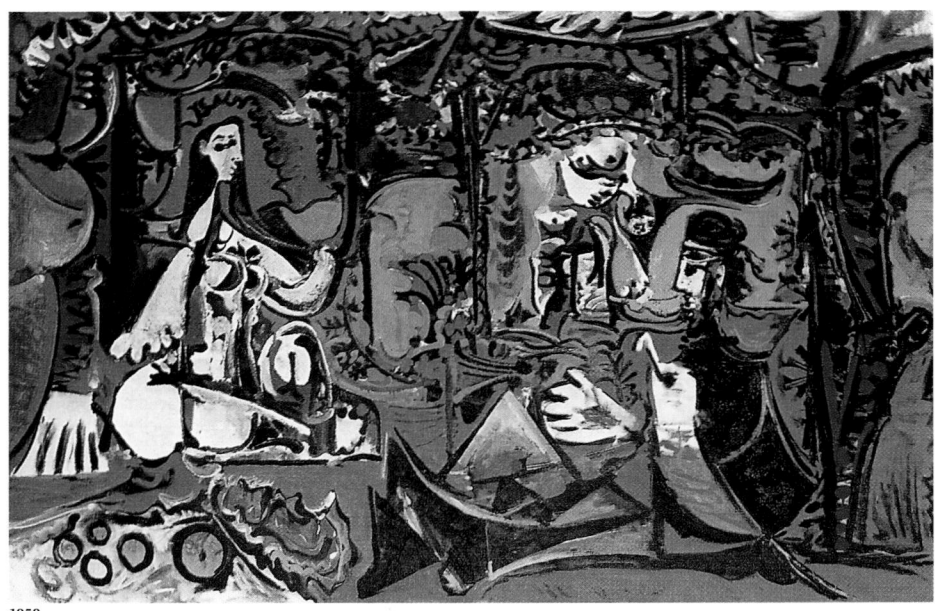

1050

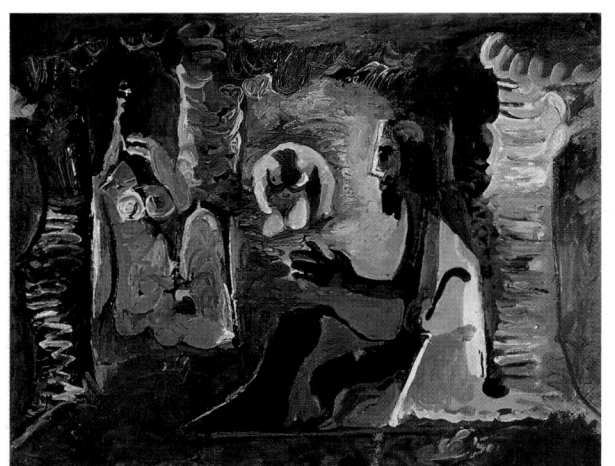

1051

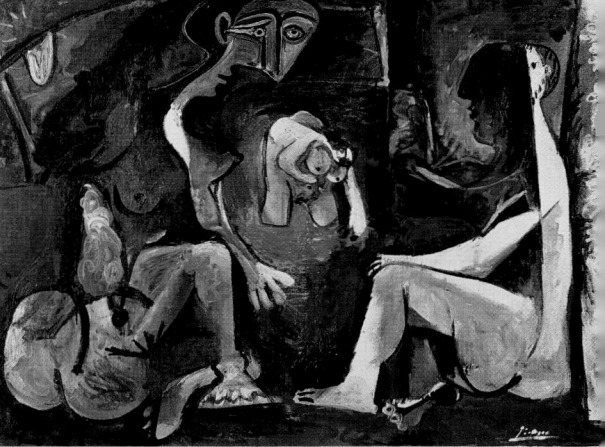

1052

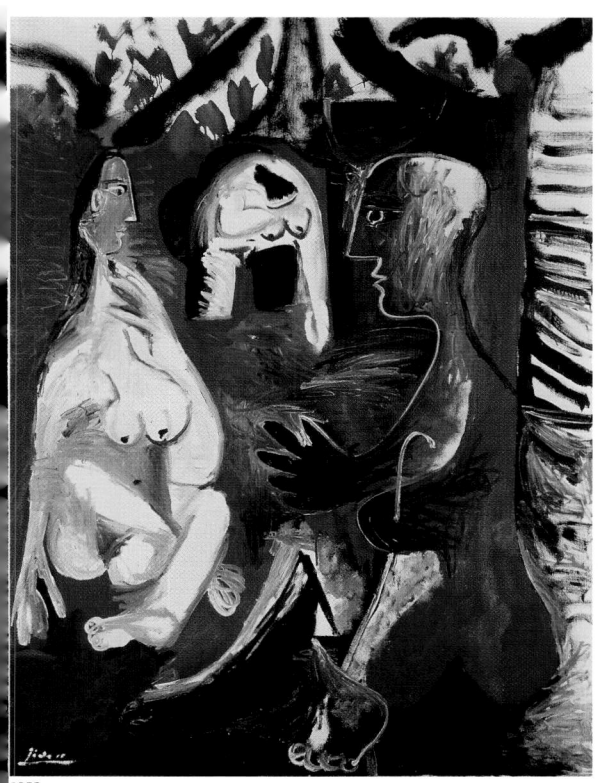

1053

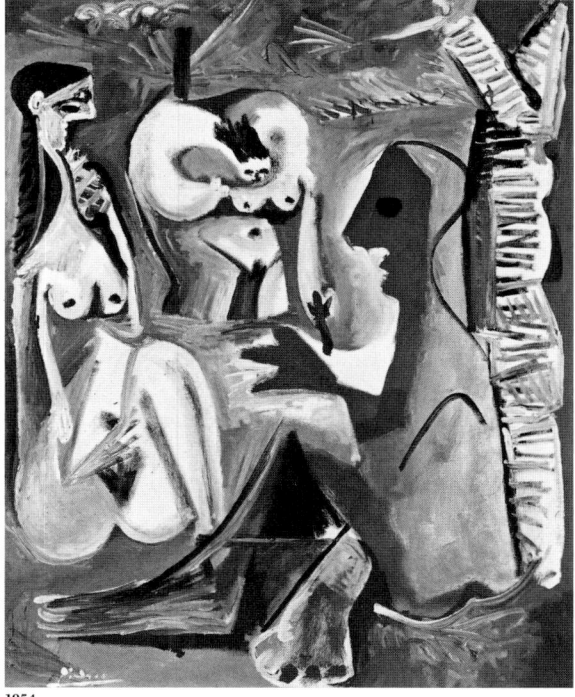

1054

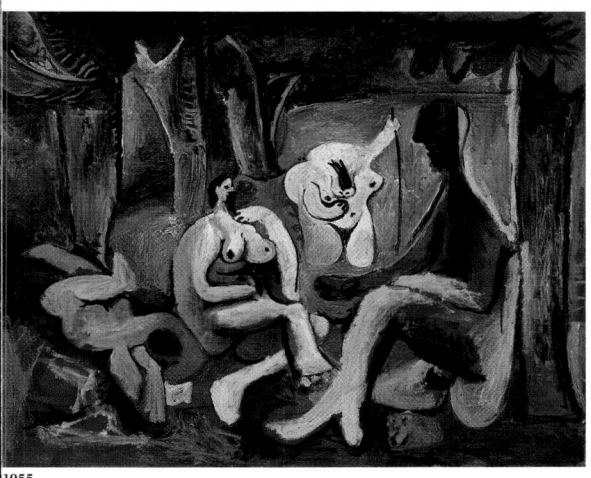

1055

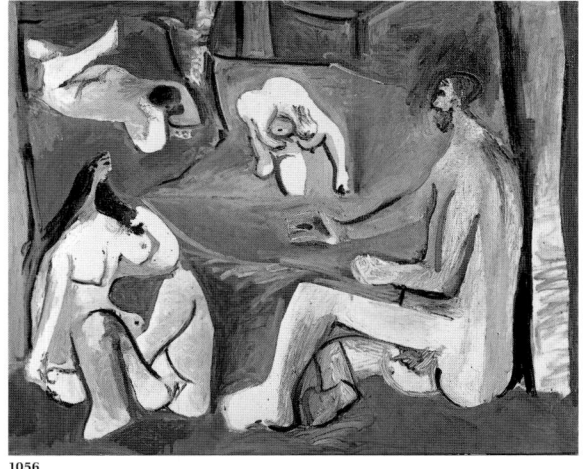

1056

long time. In 1907 Picasso parodied the *Olympia*, in 1919 *The Lovers*—an allusion to *Nana*. The *Massacres in Korea* (1950) is a pastiche of the *The Execution of Emperor Maximilian*, itself a pastiche of Goya's *Third of May*. The warning signs had been building up throughout Picasso's life. In 1932, on the back of an envelope, he wrote this ominous sentence heavy with meaning: "When I see Manet's *Déjeuner sur l'Herbe*, I tell myself: grief for later."[31] As with the *Women of Algiers*, the *Déjeuner* had been anticipated ever since 1954 in a sketchbook in which he recorded the characters' heads and worked out the composition.[32] In 1955 he drew Jacqueline as *Lola de Valence*,[33] following the same preparatory steps as always before tackling a painting from the past. Picasso seemed obsessed with this canvas, on which he worked assiduously at various periods, each time in a completely different way.

Le Déjeuner sur l'Herbe (figs. 1050–1057) gave Picasso the opportunity to work on an outdoor scene after having done so many interiors (the harem, the studio). It was also an indirect homage to Cézanne's *Grandes Baigneuses* and to the *Joie de Vivre* by Matisse, as he preserved Cézanne's attempt to integrate the body with the landscape, its architectural solidity, and he retained Matisse's idyllic, pastoral atmosphere. The picture also provided a chance for him to study the female nude. The pose of Victorine Meurent that led Manet to flatten her joints and superimpose her arms and legs, as well as those of the woman bending forward, found new life in Picasso's innumerable drawings of nudes that are part of this *Déjeuner* cycle. Picasso drew these two figures in every possible posture, manipulating them as he saw fit. The full, schematic, and "punched out" forms (Delacroix's term) of Manet's characters were translated by Picasso into a kind of rounded tube. As he worked on the *Déjeuner*, Picasso thus managed to invent a new morphology. They are these same curved shapes that will be seen again cut out of sheet metal in the *Soccer Players* (1961). As always, Picasso digressed in the initial theme toward his personal preoccupations. The woman bending over in the background brought him back to a pose in which the body turns in upon itself, a pose that he had been studying since 1944. Above all, the two central characters—the seated nude female and the man conversing with her—are involved in a dialogue that subtly becomes that of the painter with his model.

It is a strange paradox that the flat and silent painting of Manet violated by Picasso should give birth to the latter's voluble, voluminous painting.[34] Sometimes he transforms this forest scene into a bathing place that enables him to summon forth the light of the underbrush, the deep and dark green of the glade. This is an exceptional setting in his oeuvre, which recalls the *Nudes in the Forest* and the *Landscapes* of the rue des Bois (1908). In each picture Picasso changed voices. Beginning with flat areas, he progressed from a very elaborate decorative style to a whirlwind expression of nervous brushstrokes. The *Déjeuners* differ from the preceding series in that they allow Picasso not only to test various compositions and different pictorial voices, but also to remove himself from the subject to do work that was entirely his own. This passage was facilitated by the fact that this theme once again met up with characters and poses he had favored for a long time (woman reclining, seated, bending forward and nude, and so forth). Every phase of his thought process is visible in the countless drawings that accompany the series and form what Douglas Cooper called the "laboratory of the image." There are, in fact, many more drawings, very free interpretations of the theme, than there are paintings. This cycle is also more important than the others because of the length of time he took and the different nature of its structure. Picasso came back to it on several occasions, as if he could not separate himself from a subject so essential, as if he were aware of the importance of this series, of its significance in his creative process. Indeed, Picasso surpassed Manet and gave birth to a new expression. The bet Picasso had made with himself was one he could handle, since he would go even farther than Manet had gone with Giorgione: "Picasso embraced the totality of nineteenth-century painting, and his great triumph is to have gone beyond that pictorial tradition and to have established his own independence and supremacy."[35] For Manet it was a question of the

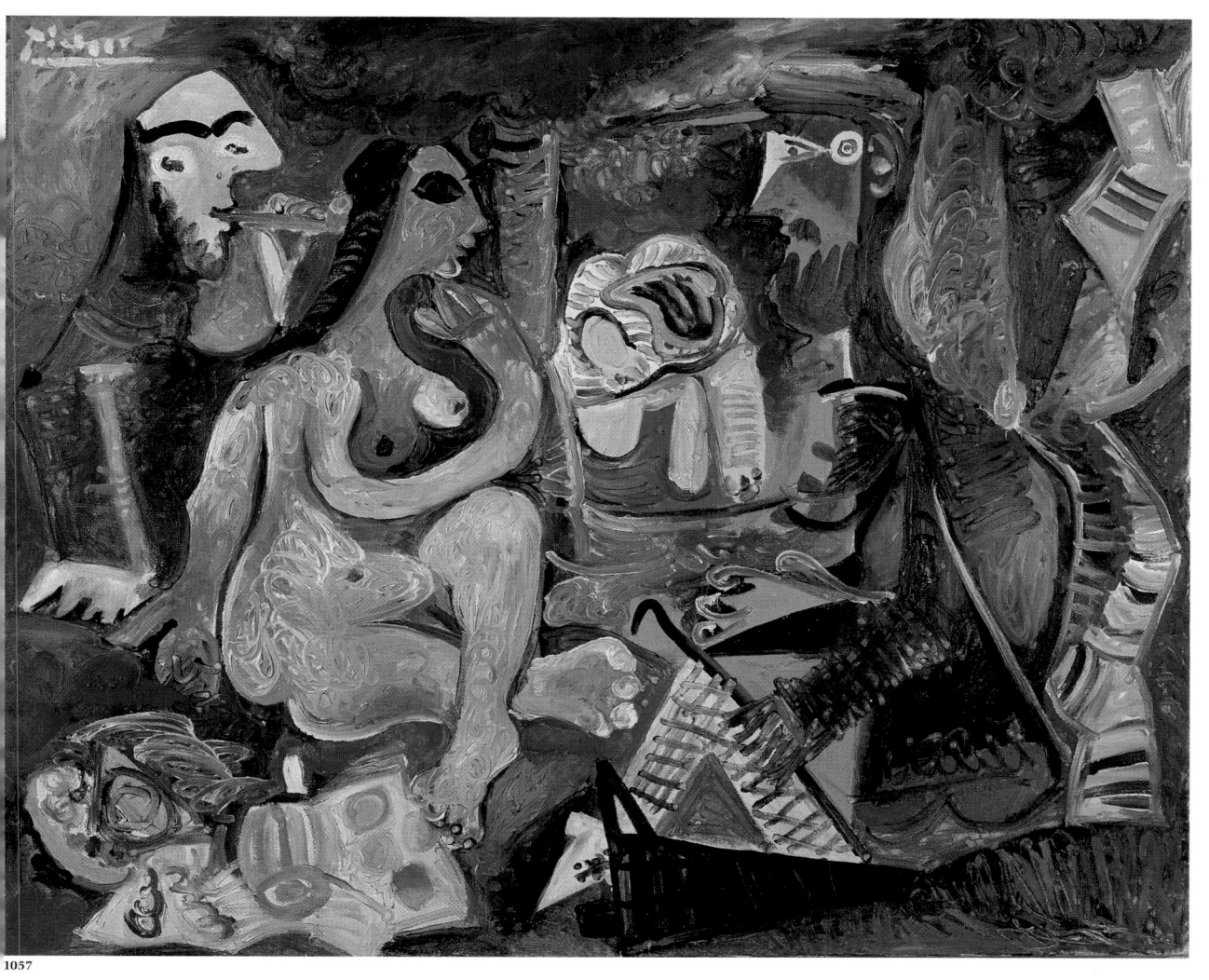

1057

1057 *Le Déjeuner sur l'Herbe, after Manet,*
June 17, 1961

1058

1059

1060

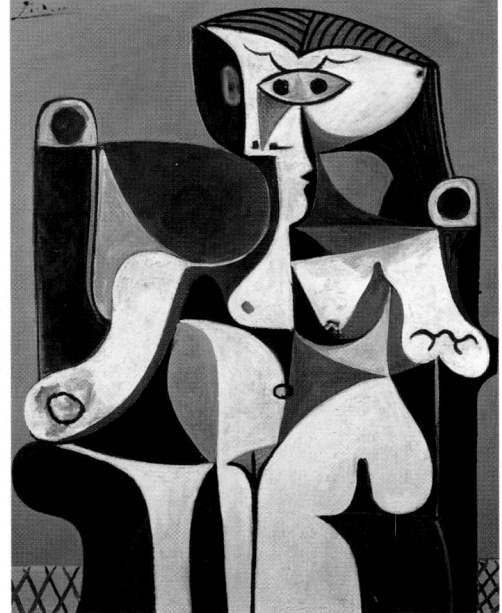

1061

432

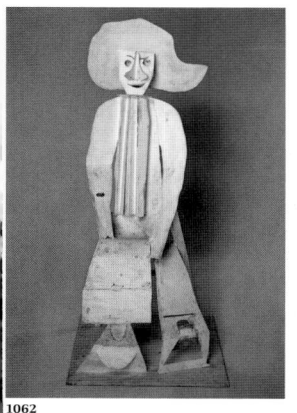

1062

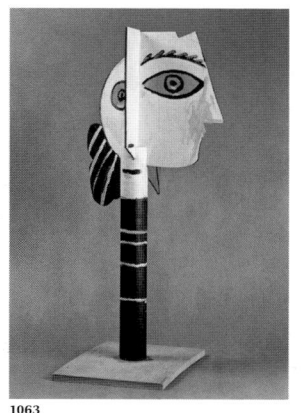

1063

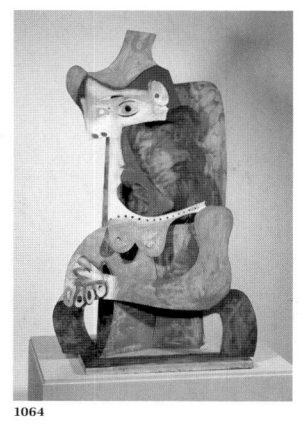

1064

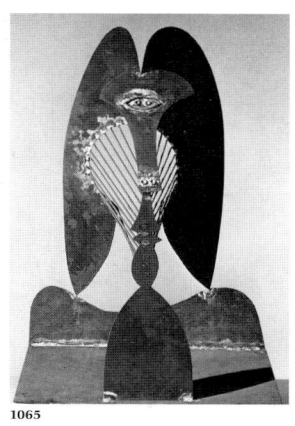

1065

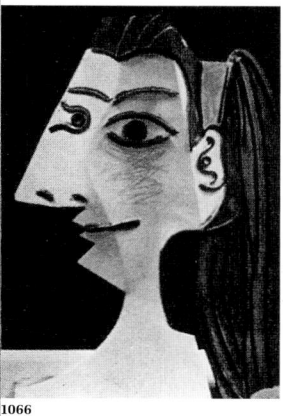

1066

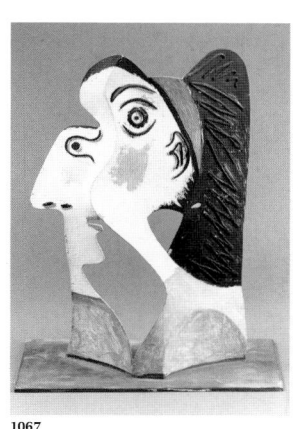

1067

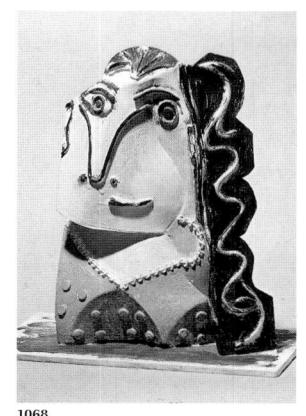

1068

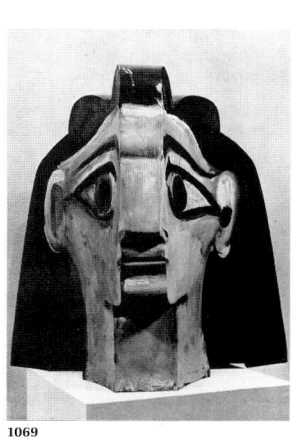

1069

1058 *Seated Woman in a Yellow and Green Hat,* January 2, 1962

1059 *Seated Woman in a Hat,*
January 27, 1961

1060 *Bust of a Woman in a Yellow Hat,*
December 19–25, 1961 to January 10–20, 1962

1061 *Seated Woman,* May 13–June 16, 1962

1062 *Pierrot Seated,* Spring 1961

1063 *Head of Woman (Design for a Monument),* 1957

1064 *Bust of Woman in a Hat,* 1961

1065 *Head of a Woman,* 1962–64

1066 *Head of a Woman (Jacqueline with a Green Ribbon),* 1962

1067 *Head of a Woman,* late 1962

1068 *Bust of a Woman,* 1962

1069 *Head of a Woman,* 1962

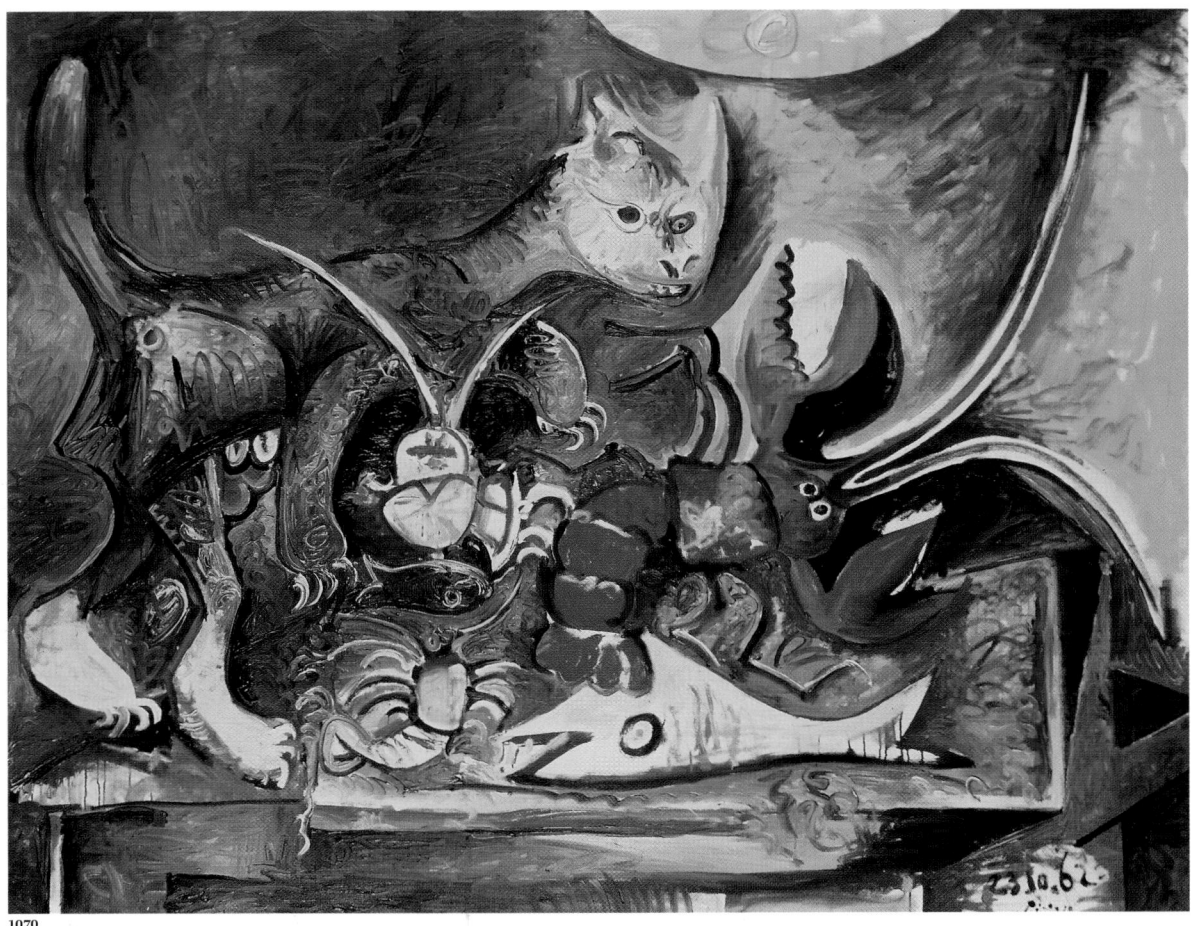

1070

relationship between painting and painting, for Picasso between painter and painter. It is not merely his pictorial power that is at play here, but also his power as a creator—the power of the metamorphosis of real objects that are also museum paintings. Manet liberated him from the past and gave him a new creative impetus. It was the last variation, but the richest and the most productive one.

Flat Sculpture

Picasso's work on the characters in the *Déjeuner sur l'Herbe* led him toward sculpture once again. In 1961–62 he inaugurated a new technique and a new material—sheet metal— which allowed him to reconcile painting and sculpture, as it had during his Cubist period.

434

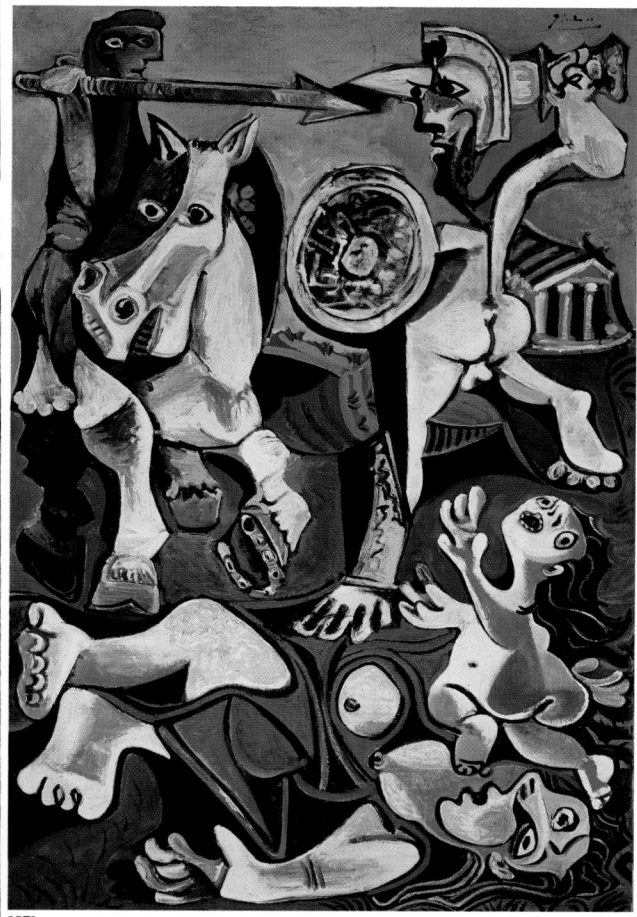

1071

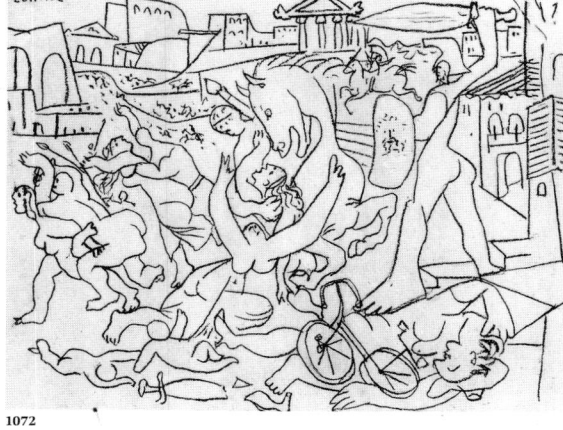

1072

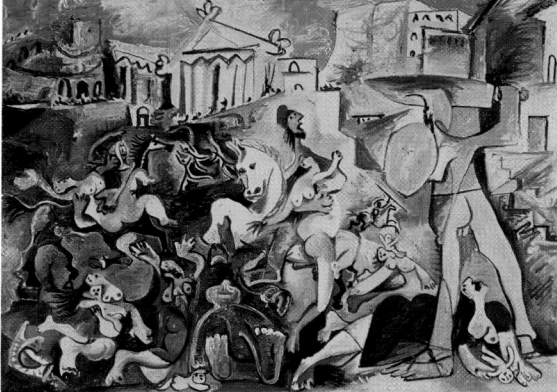

1073

1070 *Still Life with a Cat,*
October 23–November 1, 1962

1071 *The Abduction of the Sabine Women,*
January 9–February 7, 1963

1072 *Study for "The Abduction of the Sabine Women,"*
October 26, 1962

1073 *The Abduction of the Sabine Women,*
November 4 and 8, 1962

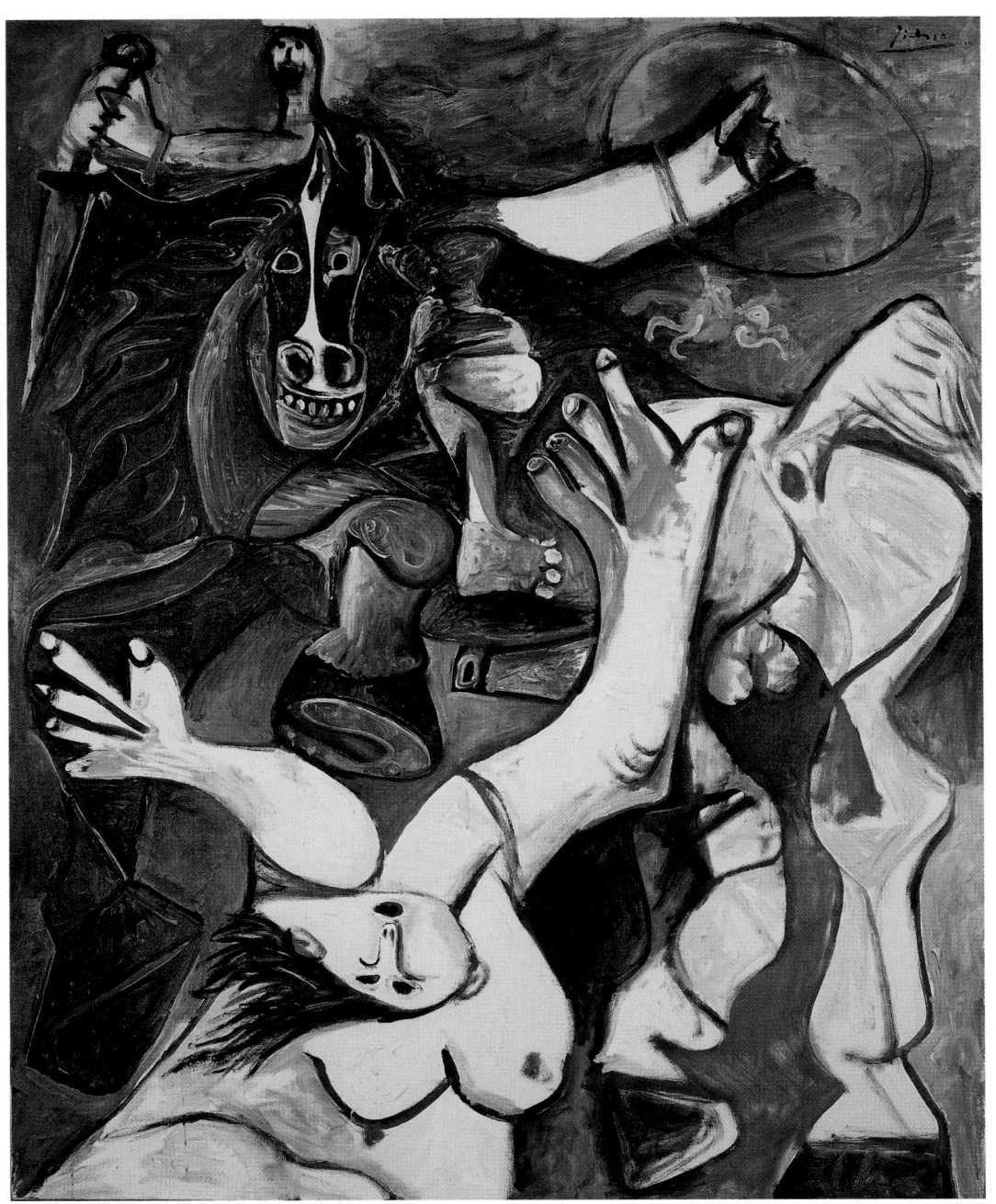

1074

Starting with paper or cardboard models that he cut out and folded, Picasso then increased the size of these figures in sheet metal and painted them either in white, which would recall their original material and confer on them an apparent fragility, or in different colors. Sometimes he even left the rough, rusty surface of the metal. The play of folds, hollow spaces, and polychromatic tones provided a means of suggesting relief. This flat sculpture originated in the Bathers, and then in 1957 Picasso created various Heads made of intersecting planes (fig. 1063), some of which would be enlarged into monumental sculptures. This series of sheet-metal cutouts was the last contribution Picasso would make to twentieth-century sculpture. He renewed the dialogue between two dimensions and three, between volume and color. Some pieces such as *Bust of a Woman in a Hat* (fig. 1064), of which there are four different versions, have their equivalent in paintings (fig. 1059). This holds true as well for the 1962 *Head of a Woman* (fig. 1067), which juxtaposes two face-to-face profiles in a single image (see the painting *Bust of a Woman in a Yellow Hat*, fig. 1060). Picasso explored every point of view, and the viewer should move completely around these small heads in order to see them in all of their subtlety. Some of them (figs. 1066 and 1066) are portraits of Jacqueline; others are based more on imagination, but all of them, despite their small size, have an astonishing presence and expressivity. The largest metal project he produced was the *Head* of 1964 (fig. 1065) in the Art Institute of Chicago, whose flat shapes are held together by metal strips, and which recalls the constructivist works of Pevsner and Gabo. Folding and cutting allowed Picasso to superimpose different points of view while retaining the frontal view. Depth was suggested by the contrast between filled and empty spaces or, in painting, between bright and dark beaches as in *Seated Woman* (fig. 1061).

The Abduction of the Sabine Women

The example of the *Sabine Women* was of a different order, neither a question of variations nor of a series based on a given painting. Picasso mixed several canvases, that of the *Massacre of the Innocents* by Poussin and *The Abduction of the Sabine Women* by both Poussin and David. It was Picasso's last historical painting, undoubtedly inspired by the threatening events in Cuba, which brought back to him subjects of warfare and innocent victims. The violence of the movement pushed him toward simplification and anatomical distortion that was full of expression (fig. 1073). In the final version (fig. 1071), the presence of the horse and the woman with a child, who is treated like the *Young Women on the Banks of the Seine,* after Courbet, makes indirect reference to *Guernica.*

The *Sabine Women* are followed by the helmeted *Warriors* and then by the portraits of *Jacqueline in an Armchair.* In 1963, after having used paintings as his model for ten years, having analyzed and deconstructed the works of others, having in one leap promoted flat sculpture, exhausted every subject of general interest, and made compositions with several characters, Picasso returned to his point of departure, the scene of the crime, the crucial battlefield—the painter face to face with his model—which was the decisive turning point of this period.

In 1962, still within the threatening context of the Cold War and as an echo of the *Sabine Women,* Picasso painted an aggressive still life (fig. 1070). The presence of the cruel and savage cat recalls the *Cat Catching a Bird* (see fig. 822) of 1939. The claws, the teeth, the pincers, the pointed antennae of the animals, as well as their hard shells, speak of violence and bestiality. The gray and pallid light, which contrasts with the bright yellows and reds and the whirls of paint, give an expressive force to this unique canvas, which marks a milestone in the conquest of a greater pictorial freedom.

1074 *The Abduction of the Sabine Women,* November 2 and 4, 1962

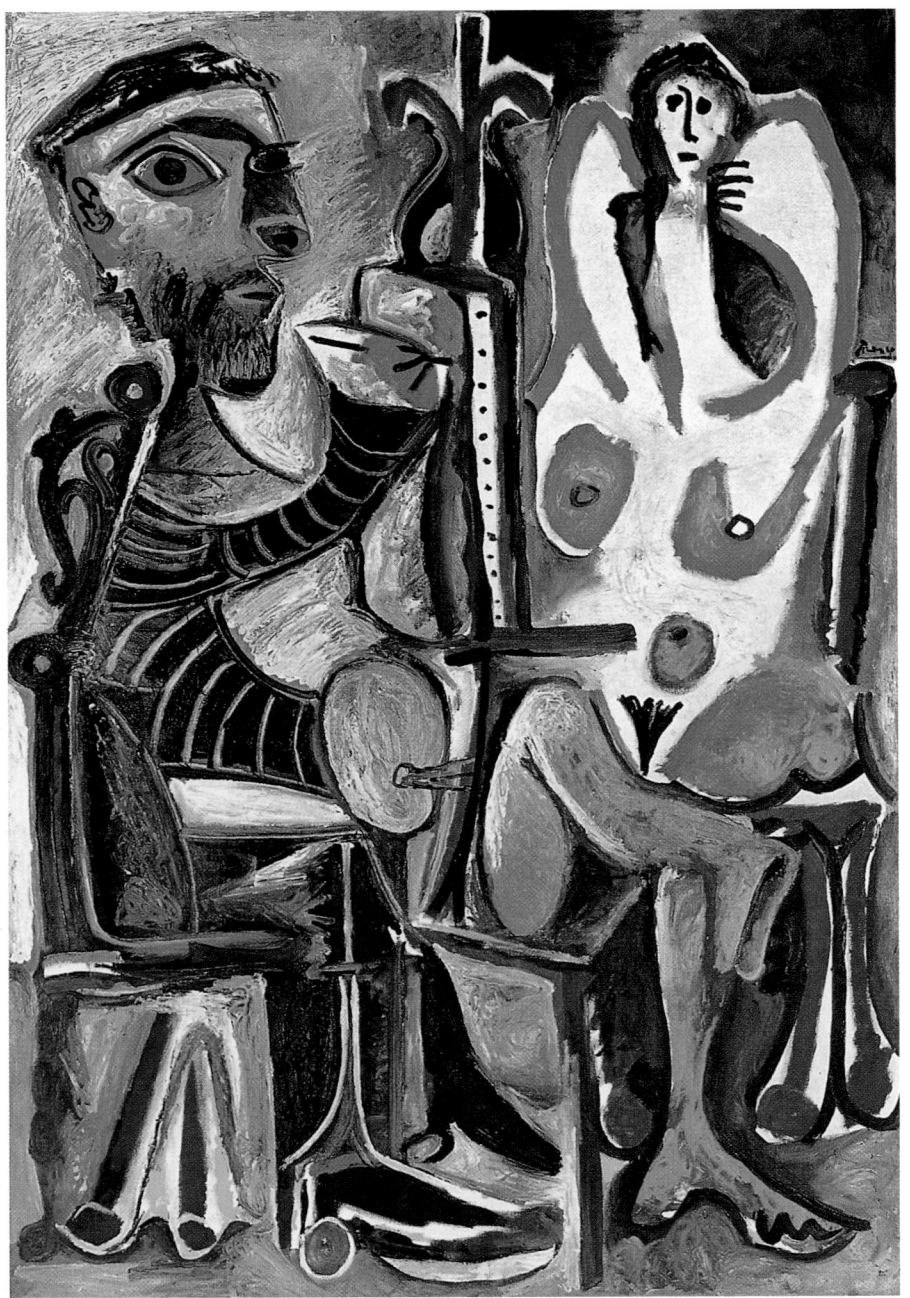

1075

1963 – 1968

The Painter and His Model

Picasso had painted, drawn, and etched so many images of the theme of the Painter and His Model from every possible angle throughout the course of his career that they had become, as Michel Leiris wrote,[1] almost a genre in and of itself, like landscape or still life. In 1963 and 1964 Picasso painted almost nothing else. The painter equipped with his attributes—palette and brushes, canvas on the easel—is seen most often in profile, and the nude model seated or crouching in a studio that bears all the characteristics of an artist's studio: such as the glass wall, the sculpture on a turntable, screen, lamp, sofa, and so on. Many of these studios did not in fact correspond to Picasso's own situation, for he painted directly onto canvases that lay flat without using a palette or an easel. Clearly it was more a question of representing the profession than of invoking his own work as a painter. "In February of 1963," Hélène Parmelin recounted, "Picasso was unleashed. He painted *The Painter and his Model,* and from that moment on he painted like a madman. Perhaps he had never worked in such a frenzy before."[2] From February to May of 1963, then again in January, October, November, and December of 1964 and in March 1965, one canvas followed another with just a few variations: either the model is absent, leaving the painter alone with his canvas, or the scene has been moved from the studio to a landscape reminiscent of the *Déjeuner sur l'Herbe.* The painter is again seen alone, in profile and close up, with a worried and searching look.[3] Although for the most part the format is horizontal in order to distribute the protagonists across the canvas, it sometimes changes and becomes vertical. The figures are lying down, coming closer to each other. The woman melts into the easel. "It is only one step from a look of inquiry to the look of desire."[4] The sudden passage from model to lover heralded a series of etchings on the theme of Ingres's *Raphael et la Fornarina,* which would appear in the "347" series in 1968. In October 1964, Picasso's artist paints directly on the model's body by penetrating the canvas with his brush (fig. 1082). The theme of the Painter and the Model and the practice of art, a corollary of that of the studio, was not a new subject for Picasso. It can be traced throughout his oeuvre beginning with a 1914 canvas (see fig. 404) that announced a return to the Classical style. In 1926, having received a commission from Vollard to illustrate Balzac's *Chef-d'Oeuvre Inconnu,* Picasso produced, along with preparatory drawings, a large canvas in grisaille that unites the faces of model and painter (fig. 558) in a jumble of brushstrokes. From this network of tracery emerges an enormous foot as if Picasso had insisted on invoking the famous painting by Frenhofer. An etching of 1926 (fig. 565) shows the painter opposite the seated model, who is busy knitting, as he paints a filigree of lines on his canvas. The myth of the absolute masterpiece; the suicidal attitude of the painter Frenhofer, who by wanting perfection rendered his painting invisible; the opposition between the real model and its abstract pictorial transcription; and the choice to be made between art and love, between creature and creation—all of these themes that form the fabric of Balzac's book would hereafter haunt Picasso to the point of obsession.

1075 *The Painter and His Model,* June 10 and 12, 1963

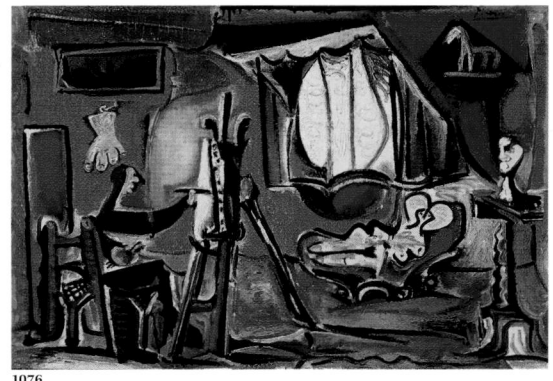

1076

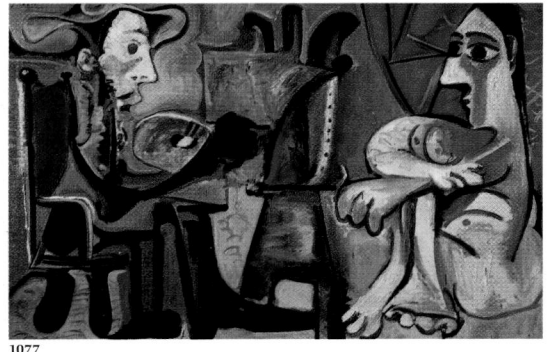

1077

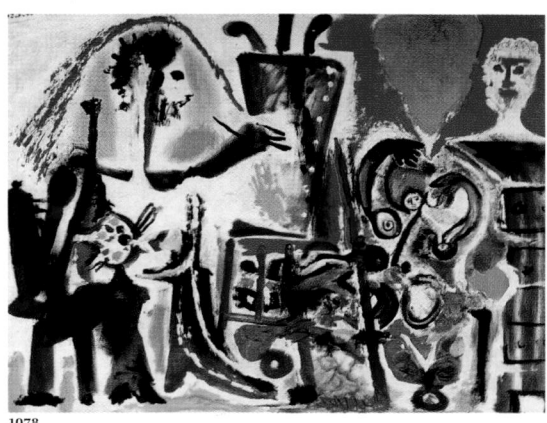

1078

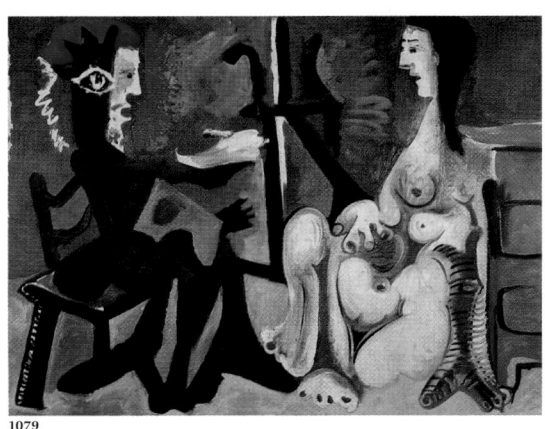

1079

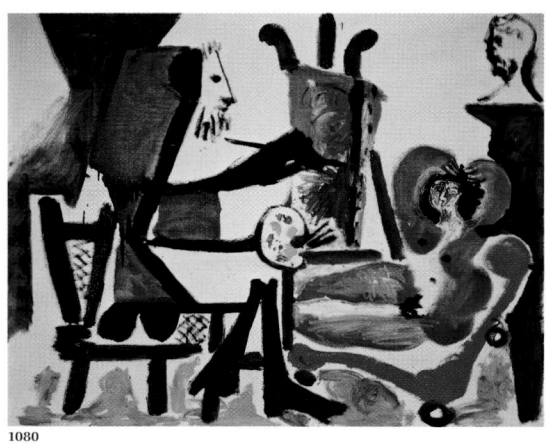

1080

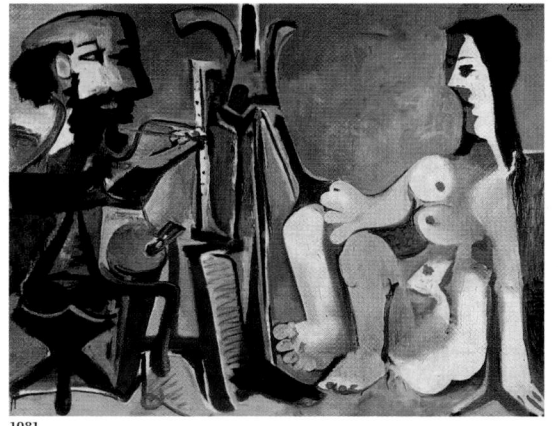

1081

440

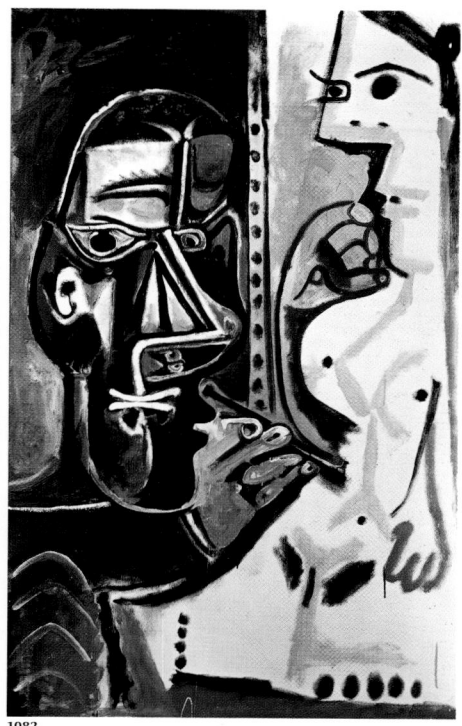

1082

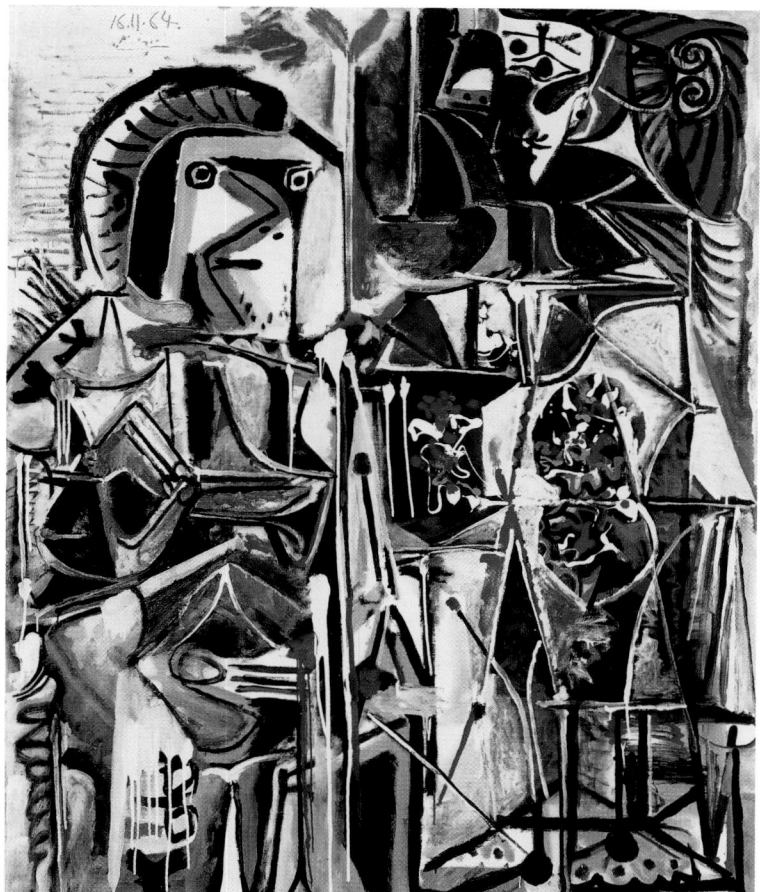

1084

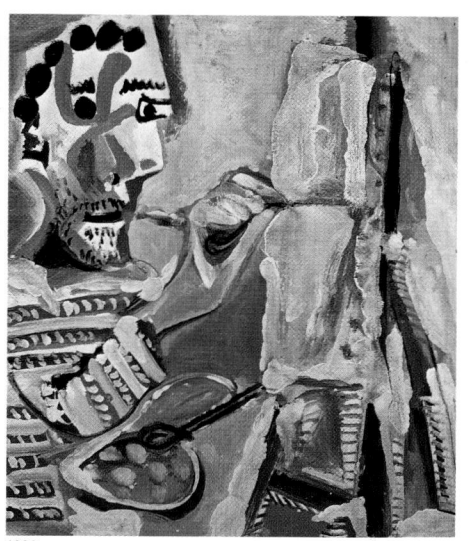

1083

1076 *The Painter and His Model,* April 9, 1963

1077 *The Painter and His Model,* April 3 and 8, 1963

1078 *The Painter and His Model,* March 5 and September 20, 1963

1079 *The Painter and His Model,* March 30, 1963

1080 *The Painter and His Model,* March 4 and 5, 1963

1081 *The Painter and His Model,* March 29 and April 1, 1963

1082 *The Painter and His Model,* October 26 and November 3, 1964

1083 *Painter at Work,* March 31, 1964

1084 *The Painter and His Model,* November 16 and December 9, 1964

441

Throughout his life, Picasso returned to this basic myth of creation, which defines the artist as an equal of God, capable of giving life, or rather the illusion of life, to inanimate material. But Picasso is not Frenhofer, his art is not devoted to destruction, and his figures are alive because they are also paintings. In 1933 the theme changed with the series of *The Sculptor's Studio* (fig. 687) of the Vollard Suite, which presented the sculptor confronting both his model and his sculpted version. The stylistic permutation between the work and the model is always there, but the breach between the real woman and the painted image is replaced by direct, manual, physical contact with the work and its logical result, the (loving) relationship between the sculptor and his model. Twenty years later with the *Verve* series, Picasso continued his exploration of this essential theme. But we have seen that the bearded, timeless artist was replaced by a painter so highly individualized that he verges on caricature. Well aware of the frailty of the painter's profession, Picasso passed from idealism to the prosaic to ironic ridicule: "The poor painter!" he used to say. *The Painter and His Model* engendered a series of male portraits illustrating the prototype of the painter[5] decked out in various hats—the black one of the artist's apprentice, or the straw hat of van Gogh—bearded, dressed in a striped sweater (like Picasso himself), and sometimes holding a cigarette in his mouth. It was a true character of flesh and blood that Picasso sought to create—"the good-natured painter," he used to say.

1085

The arduous, relentless painter, the "everlasting subordinate of the easel . . . with its instruments of torture," Picasso would treat his own double, the painter-artist, with familiarity and gentle mockery.[6] "Ah, if only I were a painter-artist!" he said to Brassaï, regretting that he did not have the naïveté of the Impressionists or even of the Sunday painter. "He really thinks he's going to be able to cope, poor guy."[7] In analyzing the deeper meaning of the Painter and His Model theme, Michel Leiris saw two underlying elements: that of the gaze, of voyeurism, the staging of the act of watching, creation's point of departure—"the eye, the hand"—and that of his irony about the profession, the staging of the act of painting. Across these multiple scenes, Picasso always asked himself the question: What is a painter? A handler of brushes, a dauber, an unrecognized genius, or a demiurge creator who sees himself as God? In each new reworking of this scenario, he attempted to grasp the impossible, the secret alchemy that operates between the real model, the vision and feeling of the artist, and the pictorial reality. Which of these elements would prevail and how would he preserve the authenticity of each of them? "There is no painter without a model," he stated, once again signaling what André Breton used to call his "unfailing attachment to the exterior world." "The subject has never frightened me," Picasso said. "It is foolishness to suppress the subject, it is impossible. It is as if you were to say: Pretend that I am not there. . . . Even if the canvas is green, well then, the subject is green."[8] By painting this theme, Picasso pushed the relationship between painter and model to its ultimate conclusion: the painter embraces his model, thereby abolishing the distance, the obstacle of the canvas, and transforming the painter-and-model relationship into the man-and-woman relationship. "Painting is an act of love," Gert Schiff wrote,[9] and John Richardson said: "Sex a metaphor for art, art a metaphor for sex."[10] In March 1965 Picasso produced yet another series, in a style that became increasingly indirect, and then he was done with the theme. It seemed that this motif was only a pretext, hence the more literal than pictorial, even anecdotal, nature of the series. In telling the story of painting, Picasso spoke more than he painted; he was not able to paint the act of painting, which is why he preferred the shorthand style, the writing-painting in signs and ideograms. From 1964 on, "painting was stronger than he was." He allowed it to flow, to act, to move out of the canvas. After this hand-to-hand struggle with painting, he moved on to painting the body, then to the body of painting, "thus raising the material procedure of painting to the matter of painting itself."[11]

1086

1085 *Reclining Woman Playing with a Cat,* May 10 and 11, 1965

1086 *Reclining Nude with Crossed Legs,* January 21–23, 1965

1087 *Large Nude,* February 20–22 and March 5, 1964

1088 *Reclining Nude,* January 9, 18, 1964

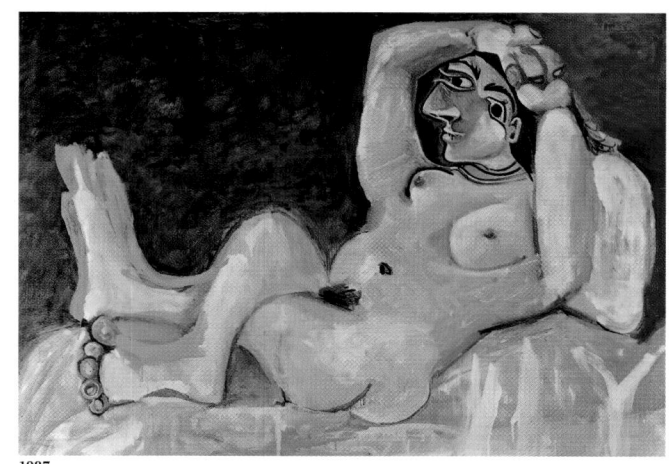

1087

1088

443

The Nude, the Woman: Painting the Body

After 1963 the bountiful and varied iconography whose source was in images of the past became secondary to pictorial form, and he continued to tell the tale in etchings. No longer did he make direct reference to the old themes, nor were there any more compositions with multiple characters. Picasso began to favor isolated figures and archetypes, and he focused on the essential: the nude, the couple, man disguised or stripped, the means by which he could speak of woman, love, and the human comedy.

After having isolated the painter in a series of portraits, it was logical that Picasso would also paint the model alone, that is to say, the female nude reclining on a sofa, open to the painter's gaze, to man's desire. One of Picasso's characteristics, compared to Matisse and to many other twentieth-century painters, was that he used his own wife as model and muse. He rarely used a professional; it was the woman he loved, with whom he shared his daily life, who was his model. What he painted, then, was not a "model" woman but the woman-as-model. This difference had consequences in both the emotional and the pictorial realm, for the beloved woman is the painting and the painted female is the beloved woman; thus, no distance is possible. Picasso never painted from life, however; Jacqueline did not pose for him, but she was there, everywhere, always present. Every woman of those years was Jacqueline, and at that time, they were rarely portraits. The image of the woman he loved was a model inscribed deep inside himself, one that emerged every time that he painted a woman, in the same way that when he painted a man he was thinking of don José.

In the series of great nudes of 1964 (figs. 1085–1088), the artistic references were indirect: "Venus, Maja, Olympia,"[12] as Christian Geelhaar correctly wrote. The pose of the woman with raised arms, showing her armpits, is a reminder of Goya's *Naked Maja*, while the little black cat comes from Manet's *Olympia*. This black cat was not an erotic attribute, but a real cat that Picasso and Jacqueline had found and picked up in Mougins. The first nudes, massive and voluminous, are seen in profile lying on a bed, showing every part of themselves to the viewer—two legs with enormous feet, two buttocks, two breasts—a pose that forces the body to twist, to fold itself in order to fill the entire surface of the canvas. Picasso remained faithful to the simultaneity that came from Cubism, to the desire to seize reality from every angle at once.

The reclining nudes that appeared to be either seated or standing, such as the *Reclining Nude* (fig. 1098) present dislocated, disheveled bodies in which all parts have neither an up nor a down, yet remain intact. This study of the female body goes hand in hand with Picasso's evocation of the manipulations and distortions of the Bathers from Dinard. At that time, the bodies were seen in profile, their simplified limbs assembled like puzzle pieces, or else they were blown up like balloons; in any case, they were seen more as sexual machines than as nudes. Now Picasso was looking to retain the body's unity, its cohesion, and indeed everything is here, whatever its implications. "I am looking to paint the nude as it is," he said. "If I do a nude, people have to think: There's a nude, not there's Madame so-and-so in the nude."[13] There were several factors at work in his obsession with the nude—a desire to translate the physical and carnal reality of the body, to make the canvas so real and natural that the difference could no longer be seen. He said: "With Braque, when we would look at paintings, we would say: Is that a woman or a painting? . . . Can you smell her underarms?"[14] Then there was his fascination with the feminine myth, which turned into dread at the end of his life. The painted women of those last years remain young and attractive; they are arrogant, sometimes comical; they have massive and ample shapes, colossal proportions. But in the last drawings and in the etchings, old age and disintegration sometimes affect these women in cruel and tragic ways. This vision of a body split into parts, exploded, and yet unified in spite of its diffusion, corresponds to a

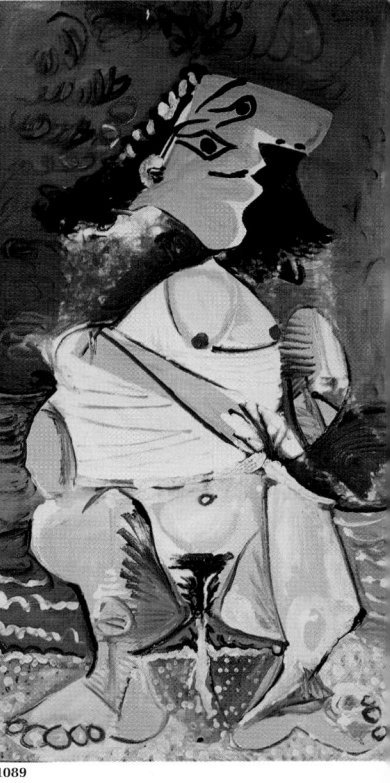

1089

1089 *Woman Pissing*, April 16, 1965
1090 *Nude Reclining Against a Green Background*, January 24, 1965
1091 *The Two Friends*, January 20–26, 1965
1092 *The Sleepers*, April 13, 1965

444

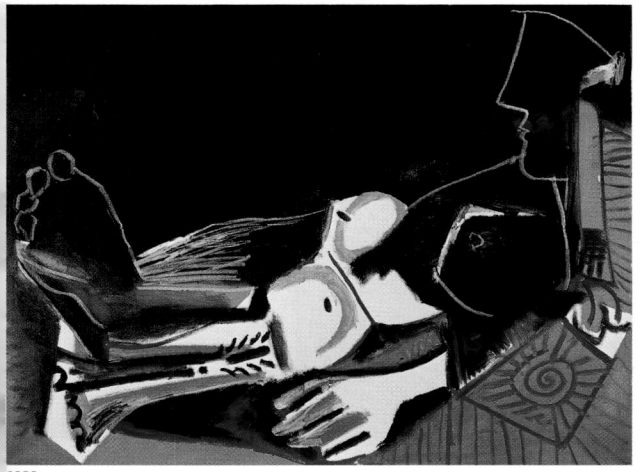

1090

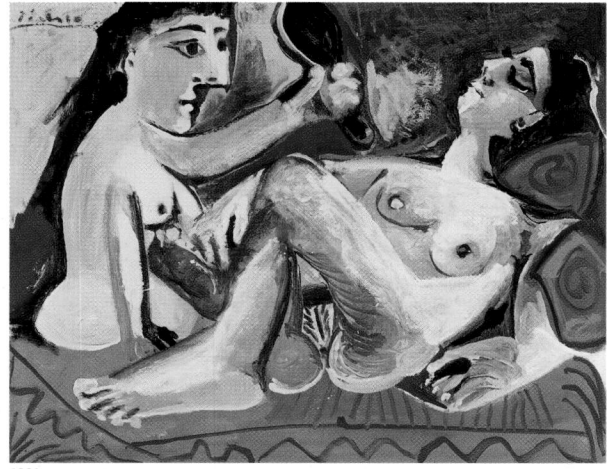

1091

1092

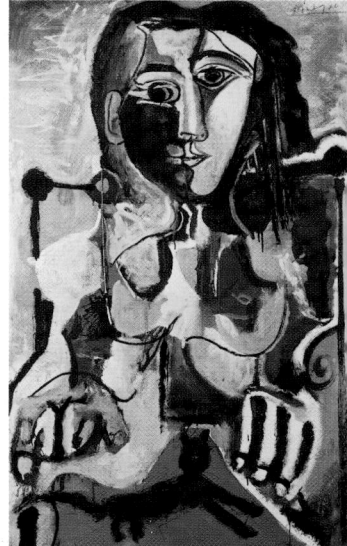

1094

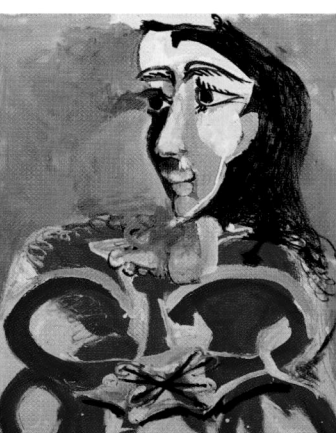

1095

1093 *Jacqueline Seated with Her Black Cat,*
February 26–March 3, 1964

1094 *Seated Woman with a Cat,*
May 4 and 15, 1964

1095 *Portrait of Jacqueline,*
April 4 and 5, 1965

1093

446

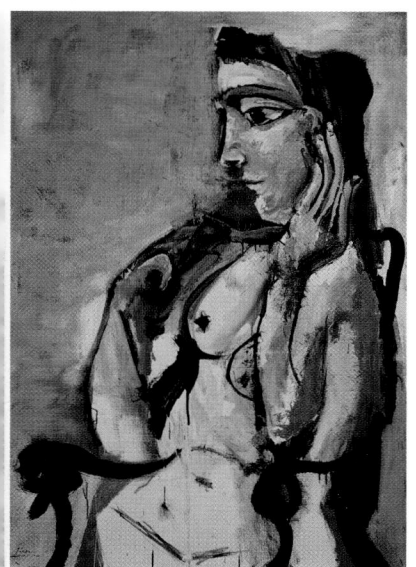

1096

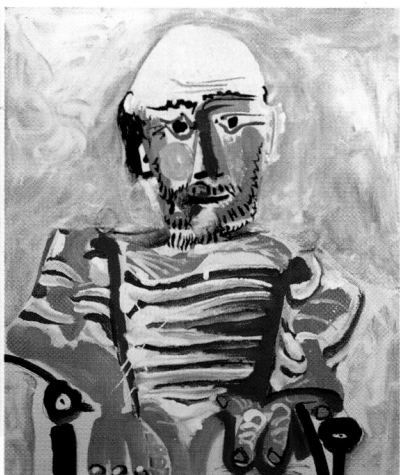

1097

1096 *Jacqueline Nude in an Armchair,*
May 2–June 7, 1964
1097 *Seated Man (Self-Portrait),* April 3, 1965

certain state of feminine eroticism and to Picasso's wish to maintain control over her, her body, the object of desire and the eternal subject of painting. Picasso was indeed the painter of women, ancient goddess, alma mater, man eater, swollen balloon, weeping woman, hysterical female, her body coiled like an egg or abandoned to sleep, a pile of exposed flesh, woman happily pissing, fertile mother, or courtesan. No painter has gone this far in unveiling the female universe, in unraveling the complexity of its reality and its fantasies. The body of woman was the obstacle on which he projected his male desire and his creative flight. The rift between art and reality, the irremediable difference between man and woman, allowed him to retain the tension, and that is why the obsession with the painter and his model, transformed into an erotic relationship, gave rise to a production of extraordinary fertility, the emergence of a new kind of painting.

Woman Pissing and Women Sleeping

Picasso's nudes are not all of the same formal or erotic style. His exploration of the female body sometimes pushed him to make striking simplifications, as in the *Nude Reclining Against a Green Background* (fig. 1090), in which a single stroke, cut into the color, suggests the body's outlines. This elliptical language will be developed later on and will become one of the characteristics of his later style. In *The Two Friends* (fig. 1091), on the other hand, the forms are full and rounded, treated in a more naturalistic way, in spite of the disproportionate feet and hands. This theme of two women, the mirror, the ornamental linear motifs, the warm and lively colors remind one of Matisse, but Picasso's sensuality is never without irony, an irony masterfully translated in *Woman Pissing* (fig. 1089). A healthy and alert dark-haired young woman raises her dress, crouches down, and happily pisses on the beach, mixing her fluids with those of the sea. The provocative subject, considered trivial and vulgar in fine art, and the appearance of a new pictorial vocabulary consisting of decorative dots, stripes, and impasto, this exceptional painting clearly expresses Picasso's profound sense of the comical, revealing the mixture of humor and tenderness always present in his work. The morphology of the woman's face with her big triangular nose, her heavy features, her clearly drawn and converging eyes is characteristic of the female type that Picasso painted during this period. The earthy Rabelaisian theme, treated here with a sensual, mother-of-pearl tonality, is not unique in the history of art. Rembrandt had already tackled it in an etching called *Woman Pissing* (Rijksmuseum, Amsterdam).

At this time, Picasso also expressed his taste for the commonplace and the everyday in his bucolic scene *The Sleepers* (fig. 1092), which depicts a middle-class man in his Sunday best slumped over napping next to a nude woman, a kind of postscript to the *Déjeuner sur l'Herbe* but treated in the same naïve, simplified language as the *Woman Pissing*. After the curves and flexibility of the great nudes of 1964, a more angular style has now appeared, pushing the dislocations of limbs to an extreme and entangling the bodies within each other.

Autobiography is always present. Side by side with the great nudes of 1964, Picasso also painted several great portraits of Jacqueline seated, with and without the little black cat (figs. 1093 and 1094). The theme of a woman seated in an armchair was also one of Picasso's favorites, as we have seen, and can be found again and again throughout his oeuvre. The composition of the woman, who contrasts with the severity of the chair's frame, originated in the majestic classical portraits. The importance Picasso has given to the appearance and the immensity of the figure, whether full length or partial, recalls the Fayum portraits or Byzantine images of the Empress Theodora, as Dominique Bozo has emphasized.[15]

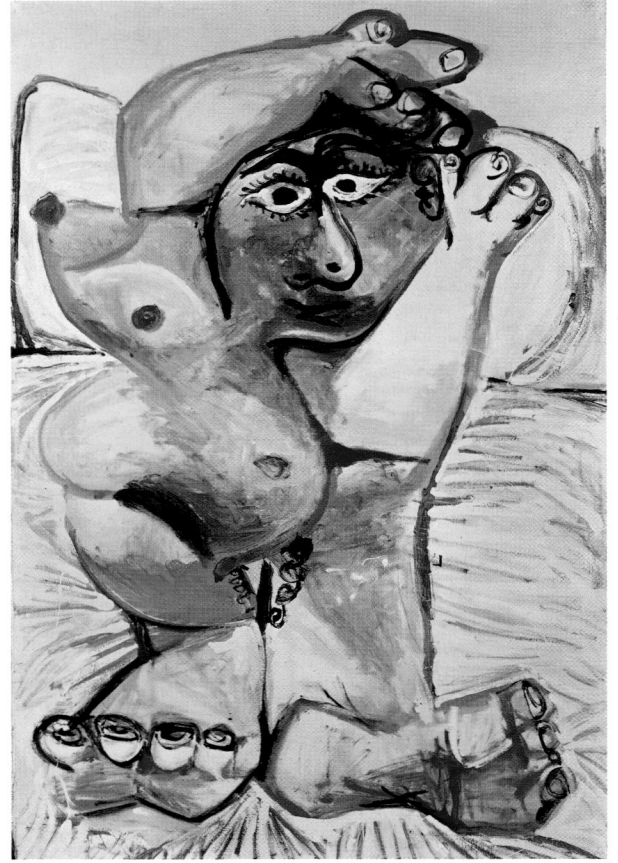

1098

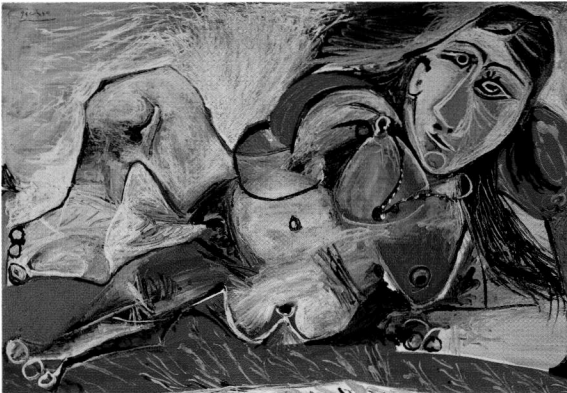

1099

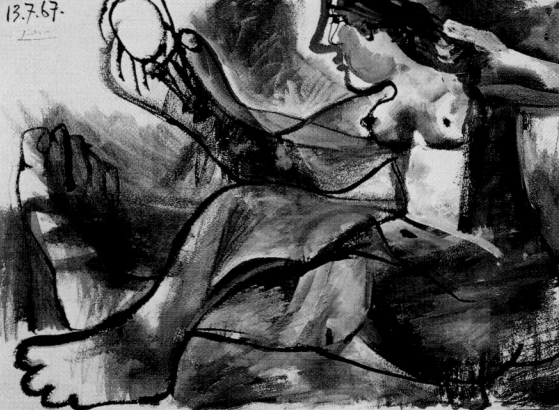

1100

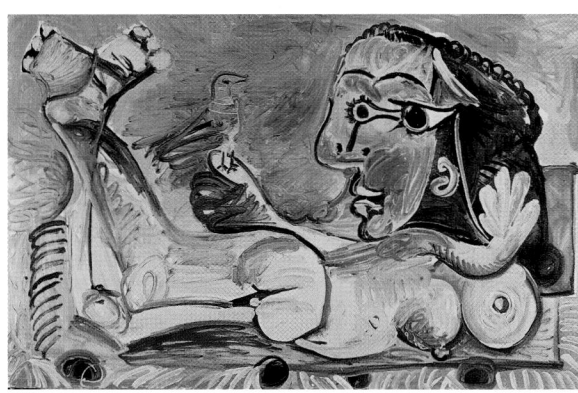

1101

1098 *Reclining Nude,* June 14, 1967
1099 *Reclining Nude with a Necklace,* October 8, 1968
1100 *Seated Nude with a Mirror,* July 13, 1967
1101 *Reclining Nude with a Bird,* January 17, 1968

In the February–March painting that depicts her (fig. 1093), the model would never have been so idealized. Her petite body is contained in a rectangle of overlapping planes that integrate her into the armchair; from this mass there emerges Jacqueline's large, noble profile and brown mane. The little cat underlines the mystery of this sphinxlike portrait. In another painting, completed in May–June (fig. 1096), the model is seen in profile, with her head tilted. With her elongated hand against her cheek, her pose is filled with melancholy and thoughtfulness, the mood accentuated by the color blue. The few delicate brushstrokes playing off the untouched white of the canvas skillfully capture the model's figure and demonstrate Picasso's mastery and confidence.

On April 3–5, 1965, Picasso painted a diptych consisting of a self-portrait and a portrait of Jacqueline (figs. 1097 and 1095). Both are painted in soft and creamy tones of white and gray, and both figures have astonishingly expressive gazes. Picasso is viewed frontally, seated in an armchair and wearing his blue sailor sweater. His two hands lie flat and his large fingers are spread, just as in Doisneau's famous photographs with bread rolls. As in all of his portraits, Picasso's gaze is steady and scrutinizing; his shaggy beard likens him to the painters in his Painter and His Model series. The simplified linear treatment of the face, with a red bar for the nose, is typical of the pictorial, ideogrammatic language that interested Picasso in 1965. Jacqueline, who looks ravishing in her red dress with puffed sleeves, is turned to the side. Her stare suggests concern.

In 1967 and 1968, Picasso continued his series of large reclining nudes, relentlessly seeking to renew his style, to test various pictorial languages. The *Reclining Nude with Necklace* (fig. 1099) is covered with frenetic hatching that looks like graffiti. The colors are garish and the woman's features are rather unrefined, if not vulgar, an effect that is accentuated by the necklace. The woman's costume jewelry gives her the aggressive air of a courtesan. Her breasts and buttocks are provocatively exhibited on the same plane. In *Reclining Nude with a Bird* (fig. 1101), the brushwork is broad and free as it depicts multiple swirls. Parallel to these achievements and pictorial experiments, Picasso continued to explore a Classical vein in this nude, which is painted entirely in black and white, in a grisaille palette that Picasso rarely used. The woman's pose, her arms raised as she reclines on a lace pillow, is derived from Goya's *Naked Maja*; her powerful facial expression results from the almost natural integration of the profile into the face. This theme of the reclining nude had already been touched upon in 1967 but in a more comic way (fig. 1098). The monumental structure of the woman's body facing forward shows how much, for Picasso, the woman's body *is* painting. The dynamism of the brushwork and the never-ending search for new ways of painting clearly point to the vitality and vigor of Picasso's painting in these late years.

In 1967 a figure from the past reemerged. Ten years after his 1957 drawing of the *Man With a Golden Helmet,* Picasso returned to Rembrandt, specifically to study a painting that depicted themes mirroring his own concerns. In a painting dated June 10, 1967 (fig. 1102), Picasso painted a version of Rembrandt's *Self-Portrait with Saskia* (Gemäldegalerie Alte Meister, Dresden). The man, dressed in seventeenth-century fashion with hat and sword and long pipe, would become the prototype for Picasso's later Musketeers. The large-nosed profile of this woman with a bun, posed facing the painter, also appears in *Venus and Cupid* (fig. 1103), after Cranach, and Picasso has painted her using soft tones and tender colors.

It was also in 1967 that Picasso completed a series of drawings that allowed him to demonstrate all of his skills and to test a variety of techniques in ink, gouache, watercolor, pencil, and so on. The mysterious scene in *The Circus Rider* (fig. 1104) anticipated the first etching of the "347" series. The woman's face is composed of a series of multiple overlapping profiles, which represents a new way of rendering the many faces of human expression and physiognomy. Picasso juxtaposes different styles in the same drawing: he

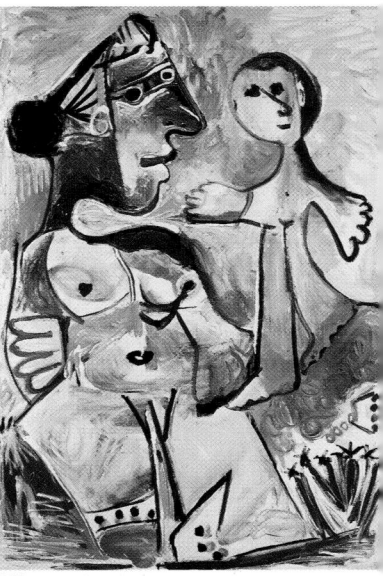

1102

1103

1102 *The Couple,* June 10, 1967
1103 *Venus and Cupid,* June 9, 1967
1104 *The Circus Rider,* July 27, 1967

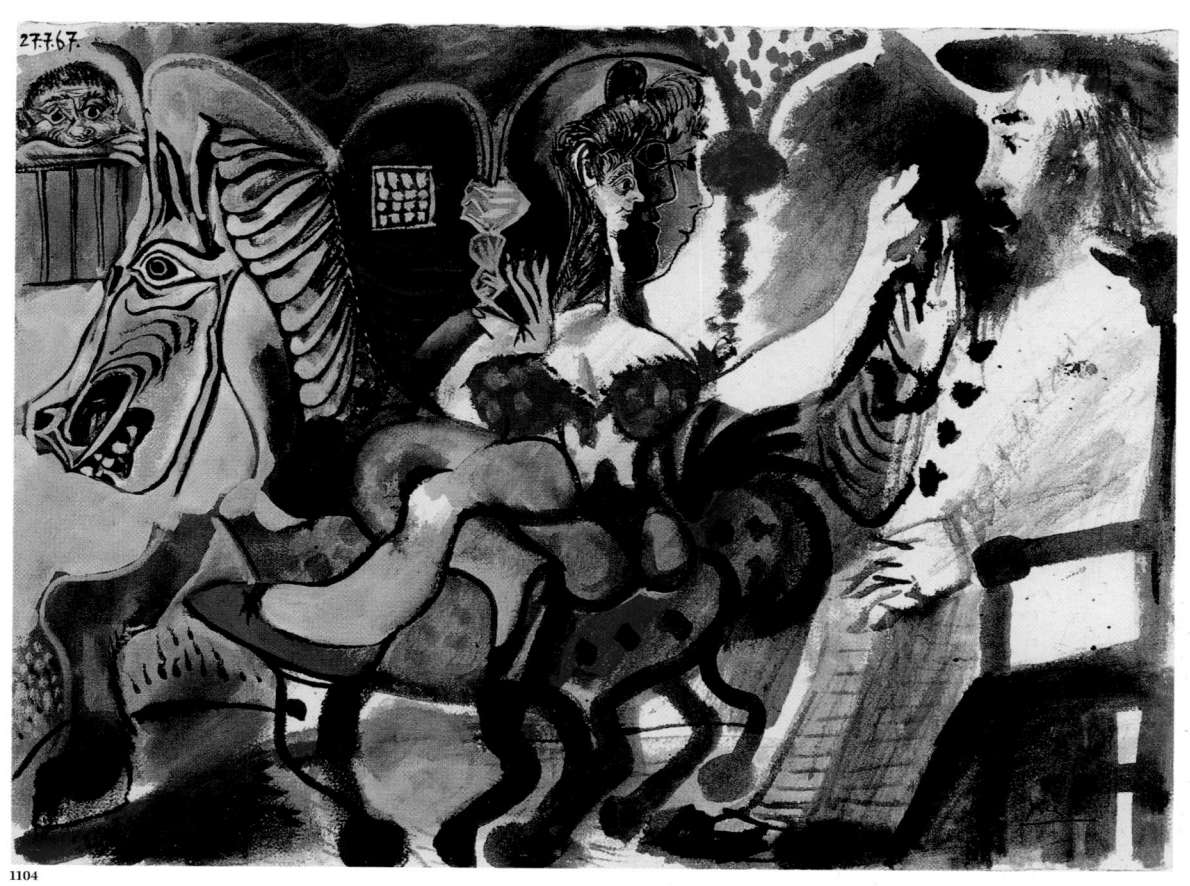

1104

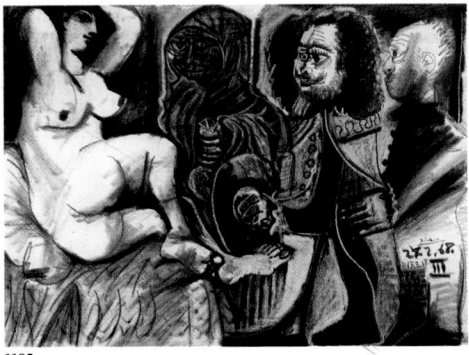

1105

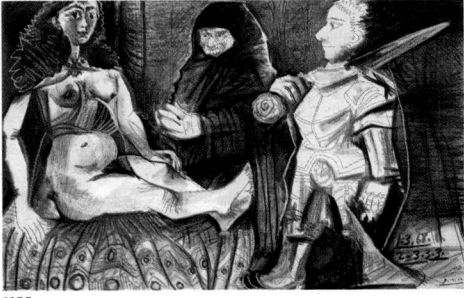

1106

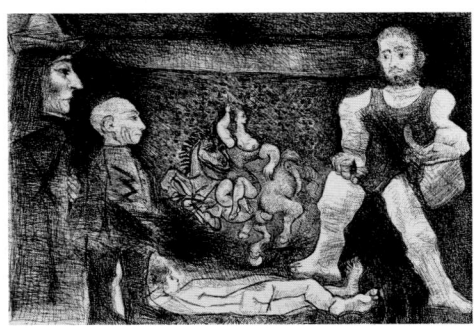

1107

1105 *Interior with Figures,* February 28,
March 17–19, 1968

1106 *Courtesan and Warrior,*
March 1–3, 1968

1107 *347 Suite,* March 16–22, 1968

1108 *347 Suite,* August 29, 1968

1109 *347 Suite,* September 2, 1968

1110 *347 Suite,* September 3, 1968

1108

1109

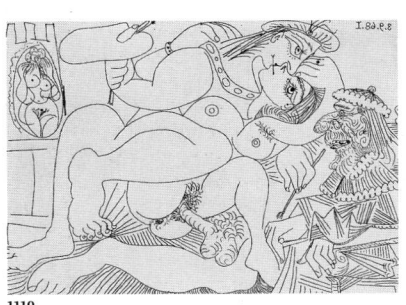

1110

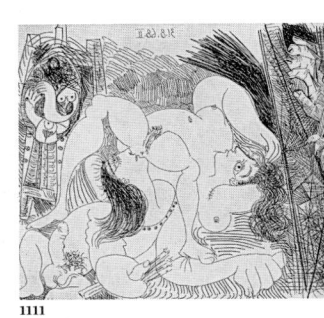

1111

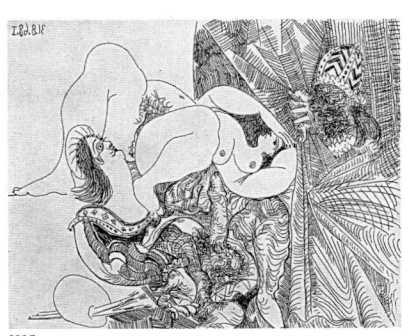

1112

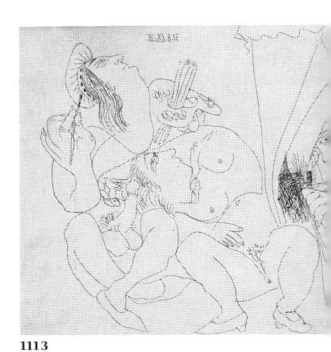

1113

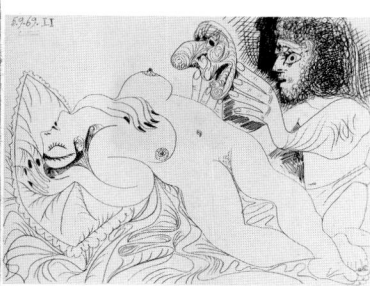

1114

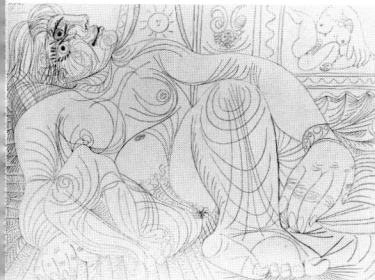

1115

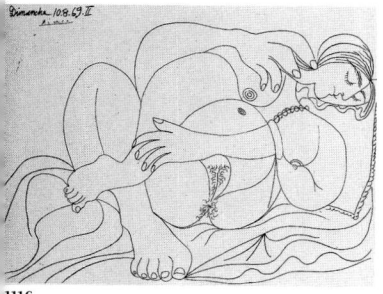

1116

uses a specific and tight language for the horse's head; free, sinuous lines for the rider's body and the horse's hindquarters; and a few delicate strokes for the seated figure. This combination of styles would also appear in Picasso's etchings, and this type of free drawing would be characteristic of his late style.

The "347" Suite

In 1966, after ulcer surgery in November 1965 and during his recovery, Picasso returned to etching and completed a series of plates that included some depictions of phalluses turning somersaults. In 1963 he had met the Crommelynck brothers, Aldo and Piero, who worked for the printer Lacourière, and at the end of his life, Picasso worked exclusively with them, developing a brilliant technique that would yield the series of "347 etchings" from 1968 and the "156 etchings" from 1971–72.

Between May and September 1968, possessed by incredible creative fervor, Picasso etched 347 plates that were to be shown together in the Galerie Louise Leiris. This idea was inspired by the illustrations in Fernando de Rojas's famous book *La Célestine* (figs. 1105 and 1106) on a typically Spanish theme of a procuress struggling with some adventurers who are wooing and kidnapping one of her girls. These scenes of gallantry—a return to the Golden Age of Spain—and their brazen, chivalrous, and courtly aspects provided fertile material for him to draw upon. Sugar-lift aquatints allowed Picasso to obtain the effects of engraving and subtle gray variations. Other themes emerged in the Célestine series: the Turkish bath after Ingres, circus and theater scenes, and especially the series after Ingres's *Raphaël et la Fornarina* (figs. 1107–1113).

The first etching (fig. 1107) depicts Jacqueline as a rider in a circus attended by many spectators. To the left, Picasso has portrayed himself as an old man dressed as a clown. Behind him is a mysterious figure, a kind of magician wearing a pointed hat. One can see a bearded acrobat in front, in the foreground a man lying down. Is he dreaming this mysterious scene? Picasso has let his unconscious loose in this etching. He has combined all the images from his own past and that of the painting, and he has dramatized his life and his figures by telling stories.

Etching was Picasso's preferred medium of expression during his last years. It was more demanding than painting, but it was lighter and more flexible. He could etch at any time and anywhere. This particular technique, in which an artist must draw in reverse and in which the image will only appear during printing, particularly suited him. Etching does indeed test the truth. In these final years, Picasso depicted Raphaël and La Fornarina, his lover and model, but the studio scene has been transformed into an erotic scene with additional miscellaneous characters, including the pope and Michelangelo hidden under the bed in one of the floorboards. Painting is an act of physical love, and the painter seizes the model while still holding his palette and brush, even in the most acrobatic poses.

In 1969 Picasso rendered a few line drawings of reclining nudes, which once again point to his technical mastery. With a single line, he is able to capture the contours and the contortions of the body. In a drawing of September 5, 1969 (fig. 1114), a man is seen removing his old person's mask—clown and monster—in order to look at the sleeping beauty lying on a cushion. Her supple hand with its long nails and her distorted forms express the languor and abandon of being asleep. The play of masks and the two faces of being had already appeared in Picasso's 1953 *Verve* drawings. By the end of his life Picasso had become obsessed by this theme of dual personality and by the notion of disguise. These are expressed in painting by his series of Musketeers.

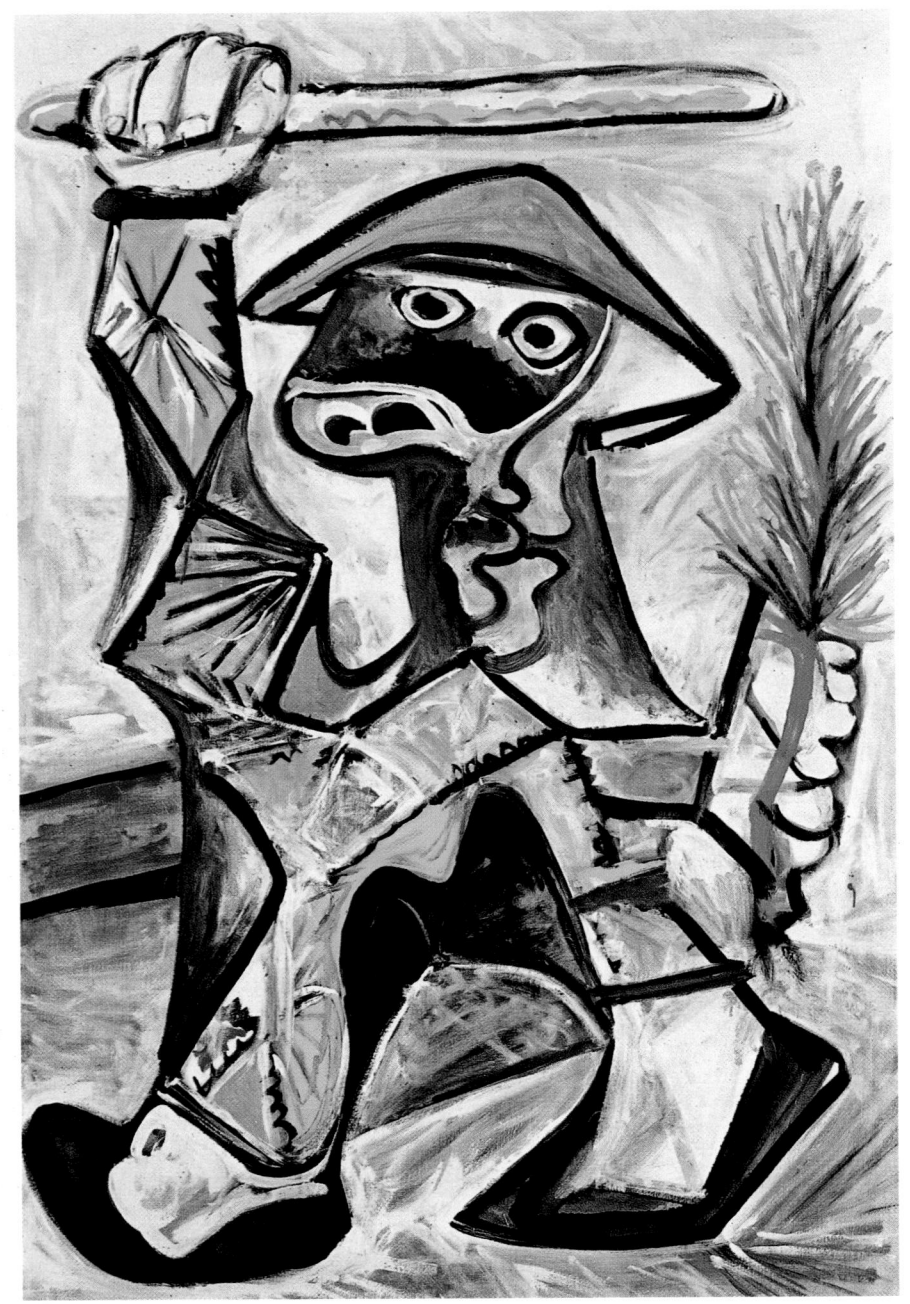

1117

1969 – 1973

The Musketeers

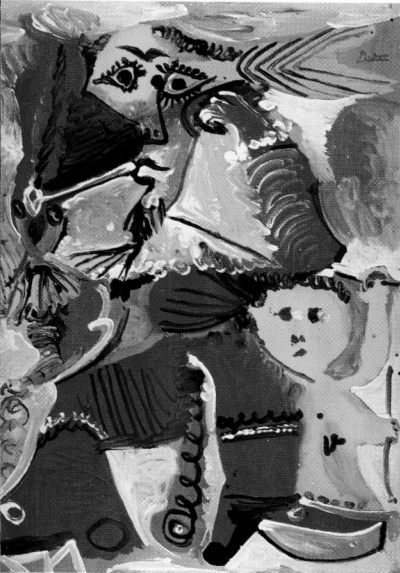

I f woman was depicted in all her aspects in Picasso's art, man always appeared in disguise or in a specific role, the painter at work or the musketeer-matador holding the implements of his virility—the long pipe, the dagger, or the sword. In 1966, a new and final character emerged in Picasso's iconography and dominated his last period to the point of becoming its emblem. This was the Golden Age gentleman, a half-Spanish, half-Dutch musketeer dressed in richly adorned clothing complete with ruffs, a cape, boots, and a big plumed hat. "It began when Picasso started to study Rembrandt," Jacqueline told Malraux.[1] Other sources have also been mentioned, but whether they derive from Rembrandt, Velázquez, Shakespeare, Piero Crommelynck, or even Picasso's father, all of these musketeers are men in disguise, romantic gentlemen, virile and arrogant soldiers, vainglorious and ridiculous despite their haughtiness. Dressed, armed, and helmeted, this man is always seen in action; sometimes the musketeer even takes up a brush and becomes the painter. With this series at the end of his life, Picasso went back to his first loves, following the acrobats and circus people of his youth—marginal wanderers, frail and androgynous— with characters in masquerade—burlesque gentlemen of the picaresque novel, Baroque heroes of the Golden Age, chivalrous adventurers. Pierrot and Harlequin made their last appearance, as the slender silhouette of the mercurial Harlequin moved aside for a stocky, masked character aggressively brandishing his stick (fig. 1117). Picasso's fondness for the past, which caused him to look for his themes in classical antiquity and then in the Middle Ages and the seventeenth century, and his persistent refusal of what was fashionable, stimulated him to revive the painters of an earlier time or the knights in their rich finery. As he felt his virility abandon him, Picasso drew a renewed youthfulness from the gallant escapades of his musketeers who emerged just after his ulcer surgery in 1965. Matisse had also reread *The Three Musketeers* after his illness. Daydreaming and nostalgic, these characters are frequently associated with young Cupid, armed with his deadly arrow, a memory of the sting of desire (figs. 1118 and 1119). One of the most beautiful paintings on this theme is undoubtedly *The Rembrandtian Figure and Cupid*. The magnificence of the Spanish colors; the red, yellow, and pink of the bullfight; the exuberant technique with its whirls, hatchings, and repeated images that animate the painting and indicate its directions; the lavish and rich pigment; the interlocking shapes, such as the little Cupid; or the musketeer's profile with the pipe smoke—all are evidence of the composition's boldness and the continuing pictorial invention of the later Picasso.

The Pipe Smokers (figs. 1119–1121)—a favorite theme of Picasso's that goes back to Cubism—afforded him one way of assuaging his frustration. "Age has forced us to abandon [smoking]," he said to Brassaï, "but the desire remains. It's the same with love."[2] For Picasso man was no longer a godlike sculptor at the height of his maturity, nor was he the monstrous Minotaur, symbol of duality; he was a fictitious character, a carnival puppet whose identity and truth lay in masks and signs. Malraux accurately compared these figures to

1117 *Harlequin,* December 12, 1969
1118 *Rembrandtian Figure and Cupid,*
February 19, 1969

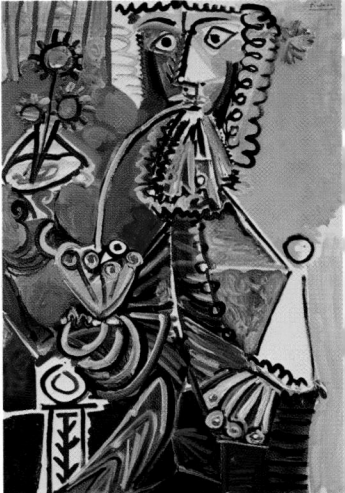

1120

1119



1119 *Man with a Pipe,* March 14, 1969

1120 *The Gentleman with a Pipe,* November 5, 1969

1121 *Smoker with a Sword (The Matador),* October 4, 1970

1122 *Seated Man with a Sword and a Flower,* September 27, 1969

1123 *Matador,* May 4, 1970

456

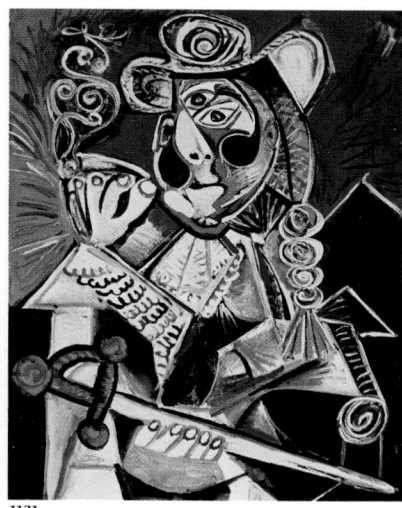

1121

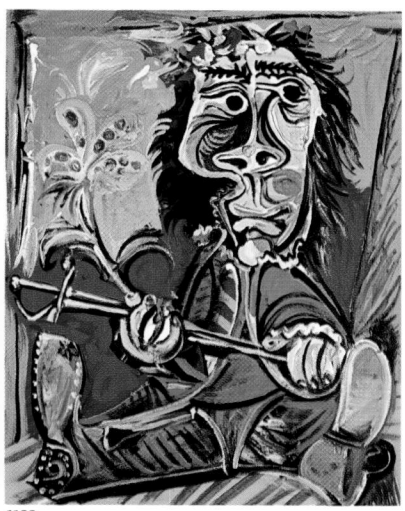

1122

1123

457

the flat and emblematic personages of the tarot. It was not without humor that Picasso created these characters, whose amorous adventures he chronicled in his etchings. Imagine painting musketeers in 1970! They were ornamental figures whose clothes were a pretext both for the blaze of blood red and golden yellow and for the resurgence of a newly found Spanishness. Another of Picasso's sword carriers, a relative of the Musketeers, was the *Matador* (figs. 1121 and 1123), who is recognizable by his hairdo. Here, however, is a character whose tragedy was real. A last memory of his passion for the bullfight, he represented for Picasso the true hero, the one who runs risks, confronts them and kills.

The Kiss, the Embrace, the Couple

Man and woman, the infernal couple in all of their postures: "Basically there is only love," he used to say, and the ardent embraces, the raw realism of his Kisses clearly speak of the place that physical passion held in his life. In these Kisses (figs. 1128 and 1129) the two profiles meld into a single line in a cinematic close-up; the noses crash, folding into the shape of an eight, the bulging eyes go up toward the highest point of the forehead as it bends backward, and the mouths are devouring each other. Picasso made a single being out of two, expressing the carnal fusion brought forth by the act of kissing. Never had erotic power been suggested with such realism. He bared sexuality in a completely explicit way in the Embraces (figs. 1124, 1125, and 1127): "Art is never chaste," the painter said waving his brush in order to paint every detail of the phallus and of copulation, as in graffiti. Paintings of the other couples emerged—the serenade, the flute player, the watermelon eaters—in which objects became erotic substitutes. In 1969 Picasso painted a series of still lifes that were more living than still, bouquets of flowers and voracious plants (figs. 1130 and 1131), yet another way of expressing the organic vision he had of sexuality. This series constituted the old man's last homage to carnal pleasures. Indeed, from 1971 on the Couples showed an impotent old man supported by a woman holding him like a child, underneath his arms (fig. 1150 and 1154). After the virile arrogance of the Musketeers, these poignant images of old age and its physical losses clearly show to what extent Picasso was haunted by the impotence that was the subtext of these final years, a haunting that was all the stronger because for Picasso sexual power and creative power shared the same impulse.

Man

Alongside these baroque figures, Picasso painted a gallery of portraits of men "in majesty." With faces long and bearded, enormous questioning eyes, long hair with or without a hat, depicted in the act of writing or smoking, these Heads (figs. 1151 and 1152) were the painter's last concession to human frailty. In contrast to the Musketeers, who all have the same face, these are true portraits, strongly characterized and individualized. One resembles a hippie, the other a prophet or an evangelist. Picasso had a good time with his friends Édouard Pignon and Hélène Parmelin identifying them, conjuring up their peculiarities, their expressions, and their personalities. "The painting-characters are taking over the painting."[3] This confrontation with the human face, which is what makes Picasso the great portraitist of the twentieth century, brought him back to the confrontation with himself, with the painter, young or old. With the Heads he made a concession to human expression and an homage to life, with *Maternity* (fig. 1145) and *Flutist and Child* (fig. 1144) it was an homage to childhood. Mother and child, old man and child, father, mother, and child (fig. 1134), a Holy Family that recalls the themes of the Blue and the Rose Periods. The more Picasso aged, the closer he drew to his childhood. In his drawings and etchings,

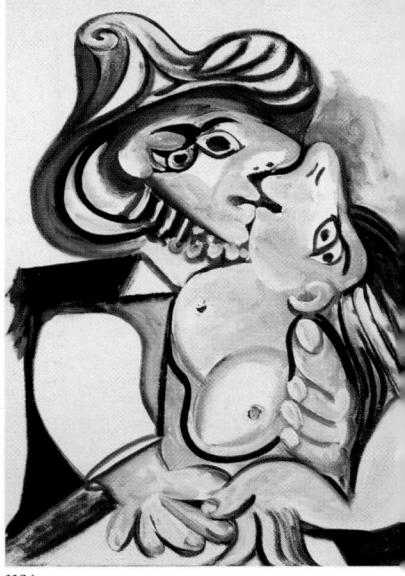

1124

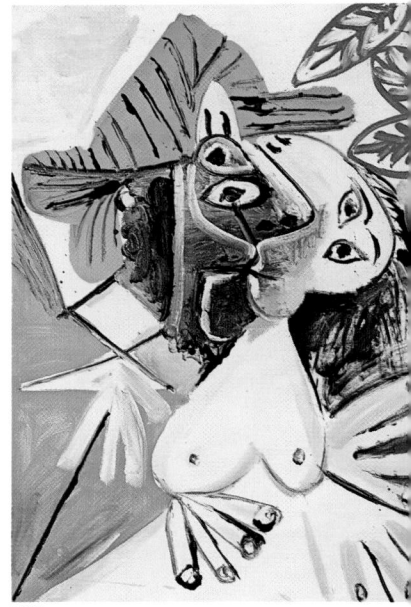

1125

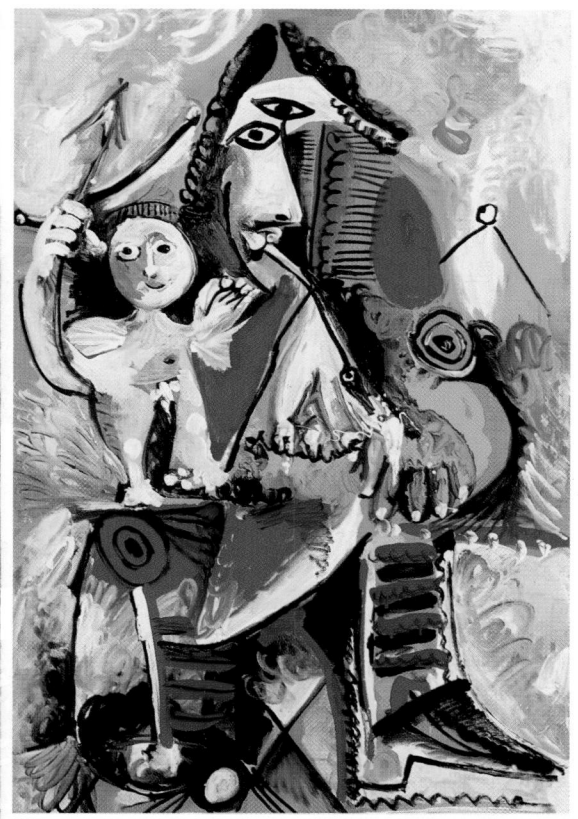

1126

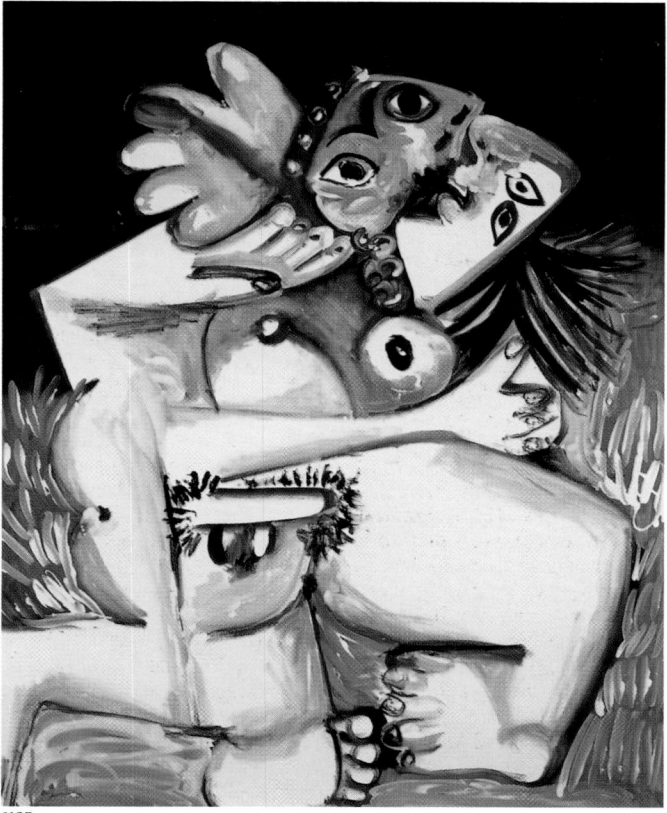

1127

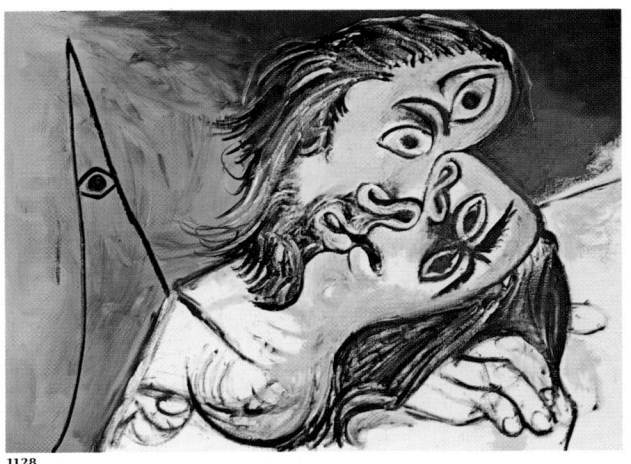

1128

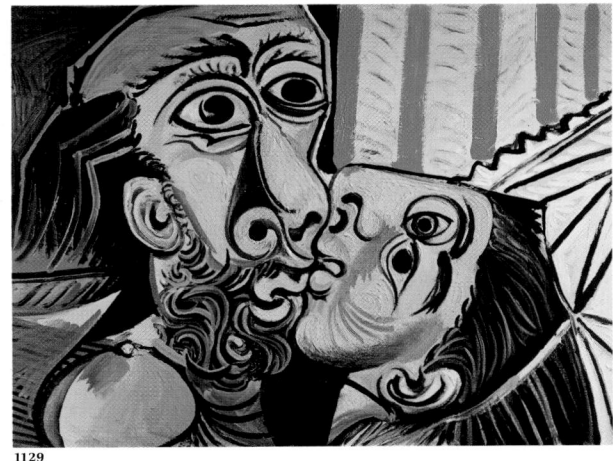

1129

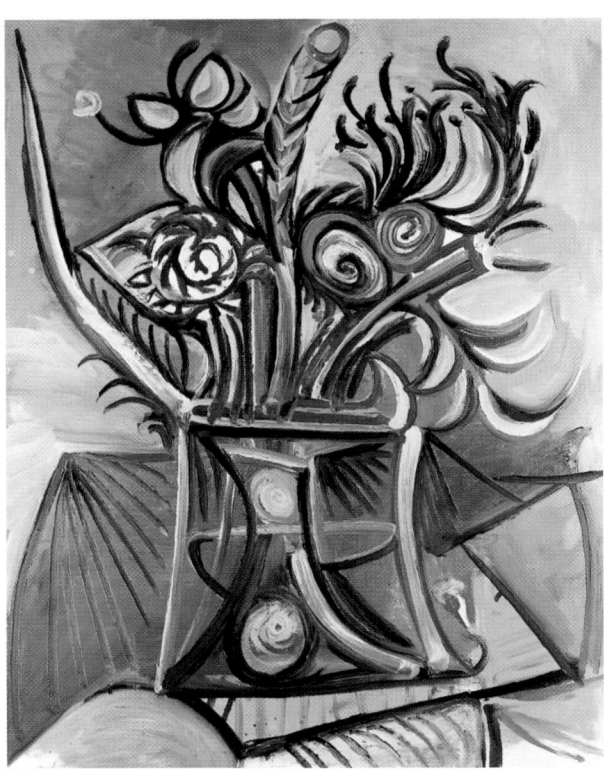

1130

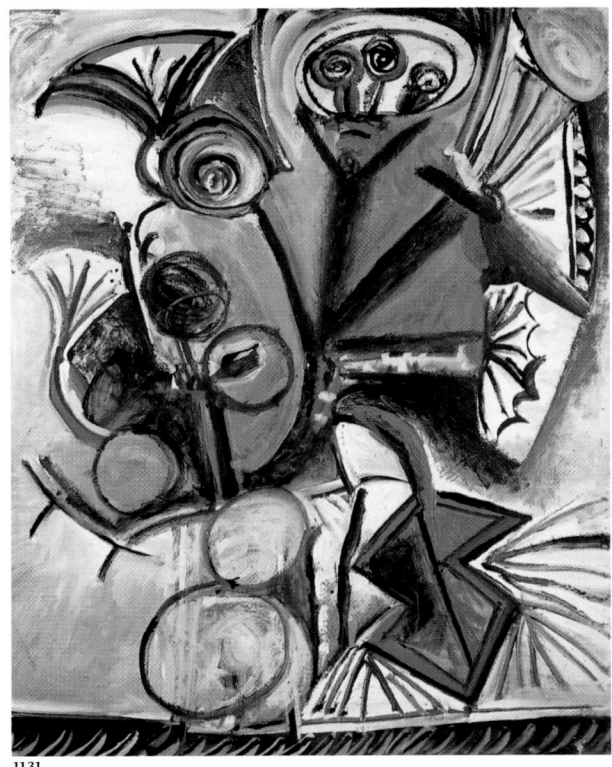

1131

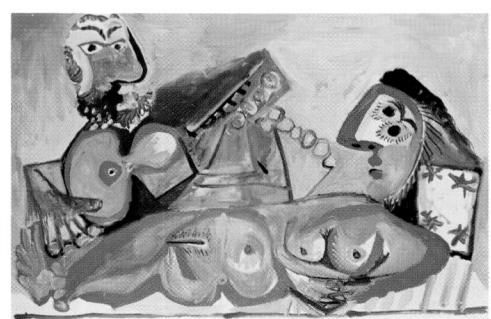

1132

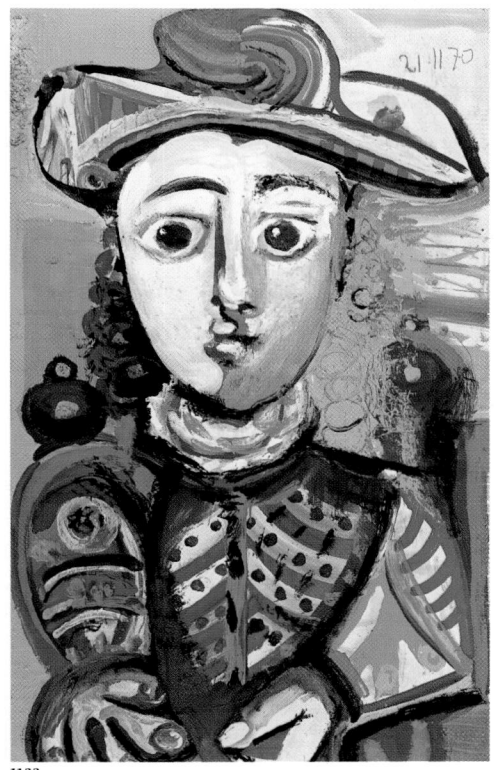

1133

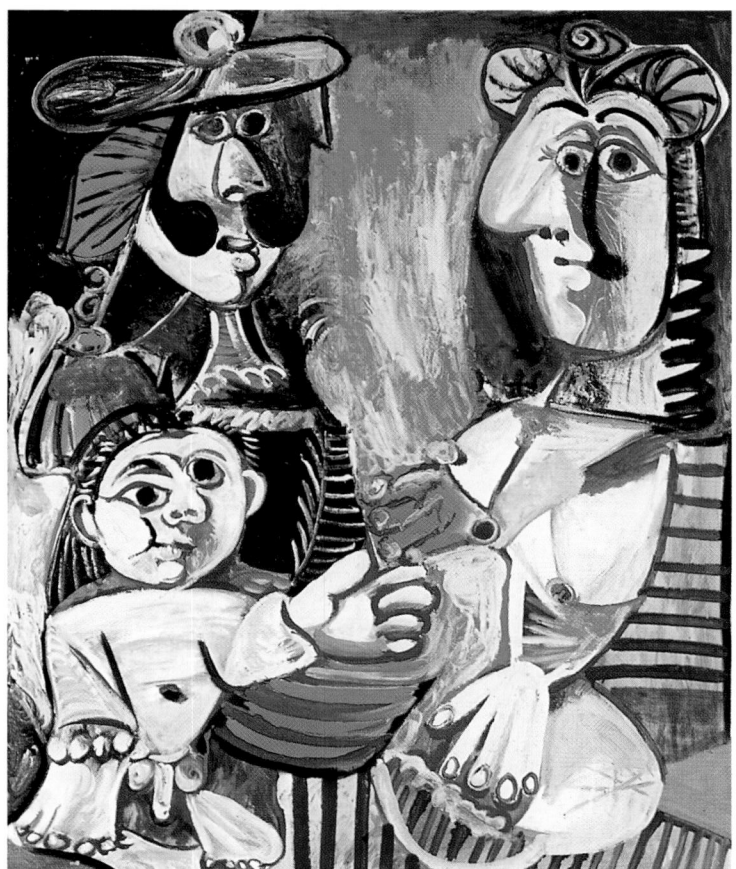

1134

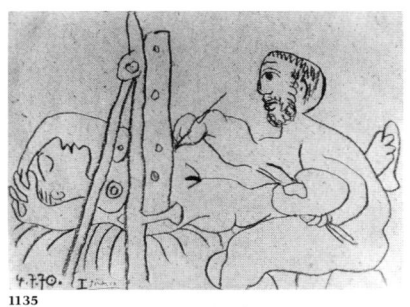

1135

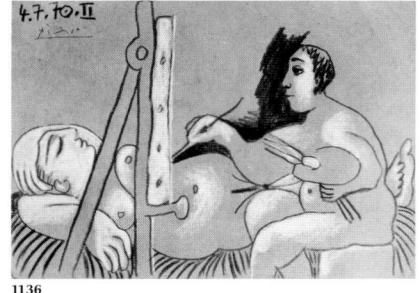

1136

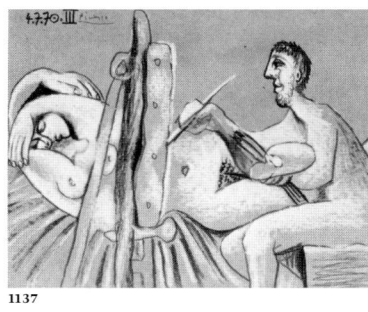

1137

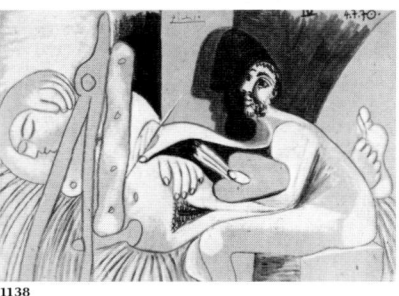

1138

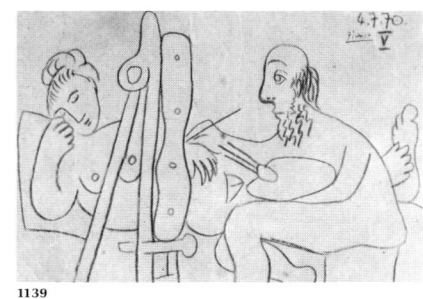

1139

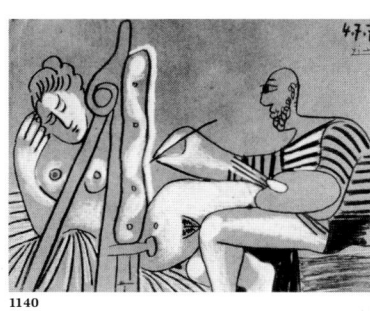

1140

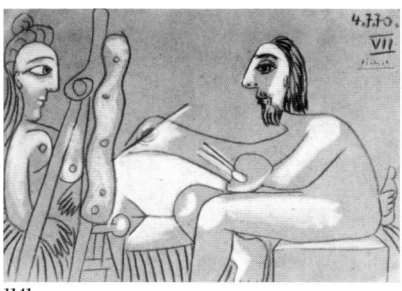

1141

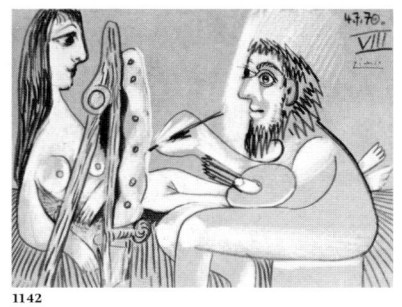

1142

1135 *The Painter and His Model I,* July 4, 1970
1136 *The Painter and His Model II,* July 4, 1970
1137 *The Painter and His Model III,* July 4, 1970
1138 *The Painter and His Model IV,* July 4, 1970

1139 *The Painter and His Model V,* July 4, 1970
1140 *The Painter and His Model VI,* July 4, 1970
1141 *The Painter and His Model VII,* July 4, 1970
1142 *The Painter and His Model VIII,* July 4, 1970

1143 *Child with a Shovel,* July 7–November 14, 1971
1144 *Flutist and Child,* August 29, 1971
1145 *Maternity,* August 30, 1971
1146 *The Card Player,* December 30, 1971

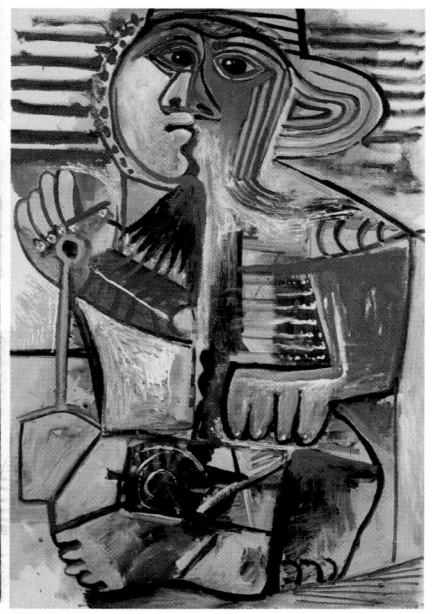

1143

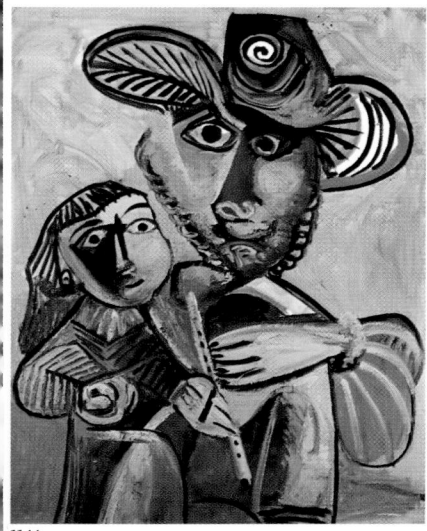

1144

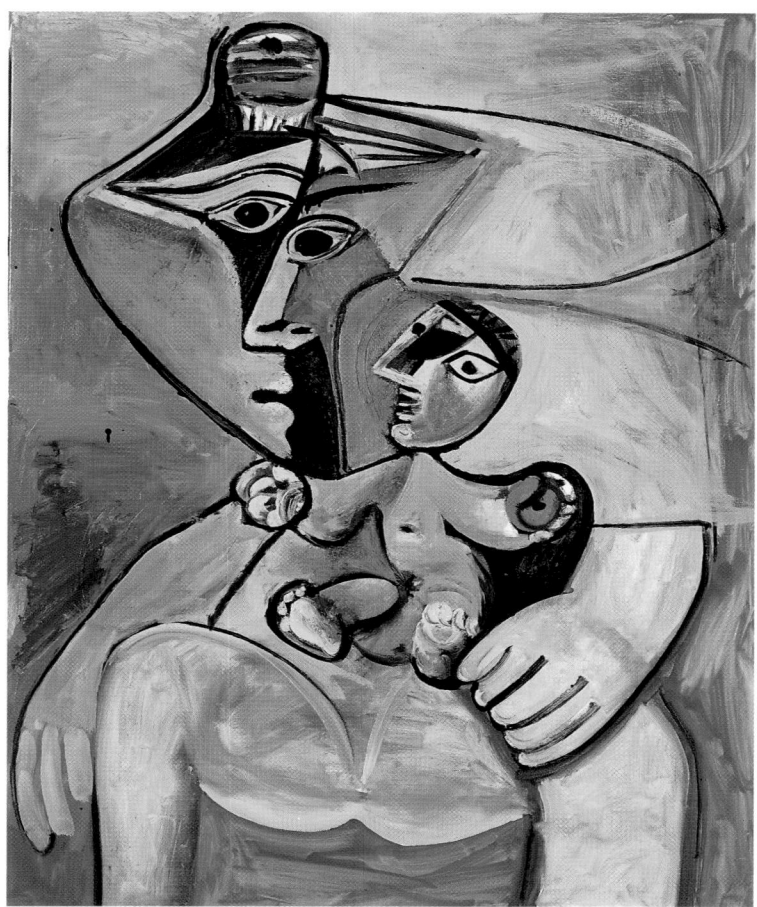

1145

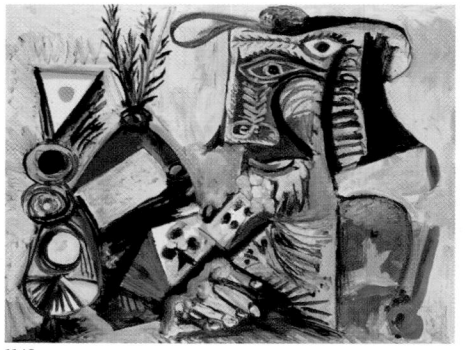

1146

463

the innocent adolescent as opposed to the old man (the ages of life) appears many times, and one of the last paintings is that of the *Young Painter* (fig. 1174). On the threshold of his death, Picasso projected himself, with a few brushstrokes on a blank canvas, onto this hazy vision of a shy and astonished young painter, holding his brush and wearing his eternal hat. Its slightly earlier counterpart was *Seated Old Man* (fig. 1153). This fateful portrait of the "old" painter, a resplendent painting in which several pictorial and symbolic references are compressed into a single image, represents the most moving and the most tragic of Picasso's self-portraits. It is the portrait of an old painter at the end of his life, but it also portrays Matisse of *The Romanian Blouse*, van Gogh of the hat, Renoir of the truncated hand, and Cézanne of the gardener Vallier. All of them are reunited here to recount the drama of the painter on the threshold of death, the devastation of knowledge, the weight of existence, the loneliness and nostalgia of one who has seen it all and at the final moment remembers the essential images, culminating in the wild passion for painting to which one sacrificed his ear and the other his hands. But Picasso remained Picasso until the very end, and the great impetus that animated him transformed his old age into an apotheosis, expressed in the vehemence of the brush, the whirls of wild colors, the manipulation of the material.

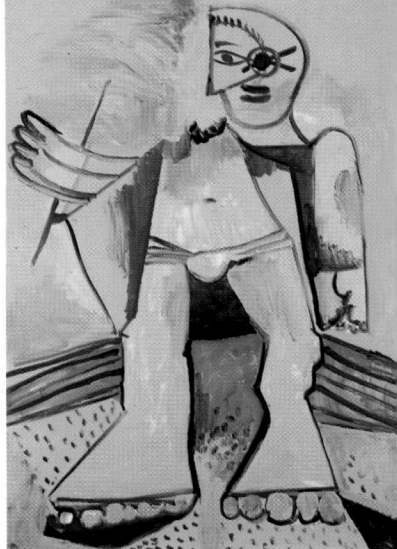

1147

The Card Player of December 30, 1971 (fig. 1146) brings Picasso's symbolic iconography together in a single image. The man in the hat is at one and the same time the old painter, a musketeer, and a matador with his black headdress. He is linked to a still life with vase and glass and especially the ace of clubs, an heirloom from Cubism.

The Late Style, a Language of Urgency

Vitality is the most striking feature of Picasso's late period, reflected in the enormous quantity and speed of his production and the fervor of its execution. Here are a few figures, extraordinary numbers for a man whose productivity at the age of eighty-eight remains exceptional in the history of painting: 347 etchings between March and October of 1968, 167 paintings between January 1969 and January 1970, 194 drawings between December 1969 and January 1971, 156 etchings between January 1970 and March 1972, 201 paintings between September 1970 and June 1972. No fewer than thirteen of the thirty-three volumes of the catalogue by Christian Zervos are devoted to his last twenty years of work. One of the reasons for the quantity (the other being the principle of repetition), Picasso's rapid rate of production betokens his sense of urgency at this stage of his life. Accumulation and speed were the only means of defense he had left in his merciless struggle against time. Every piece he created is a part of himself, a fragment of his life, one more point won against death. "I have less and less time," he said, "and more and more to say." What allowed him to gain time, to go faster, was the fact that he resorted to convention, to formal abbreviation, to the archetypal figure that consolidated the essence of his discourse.

The late style, appearing in the course of 1968, is characterized by the juxtaposition of two pictorial languages: an elliptical shorthand style made of ideograms or codified signs, and a technique of thick and fluid painting, hastily brushed with drips, impasto, visible brushstrokes. Thus Picasso associated a painting-language with a painting-painting, a kind of literal image-making that bared all and allowed the material to act. The elaboration of the simplistic drawing style was used in the Studios and *Las Meninas* and then perfected in the series of the Painter and His Model of 1964, in which the painter's face is suggested by a kind of X, which links the eyes, the nose, and the mouth, and the model has been reduced to her basic outlines. "A dot for the breast, a line for the painter, five spots of color for the foot, a few strokes of pink and green. . . . That's enough, isn't it? What else do I need to do? What can I add to that? It has all been said."[4] This oversimplification,

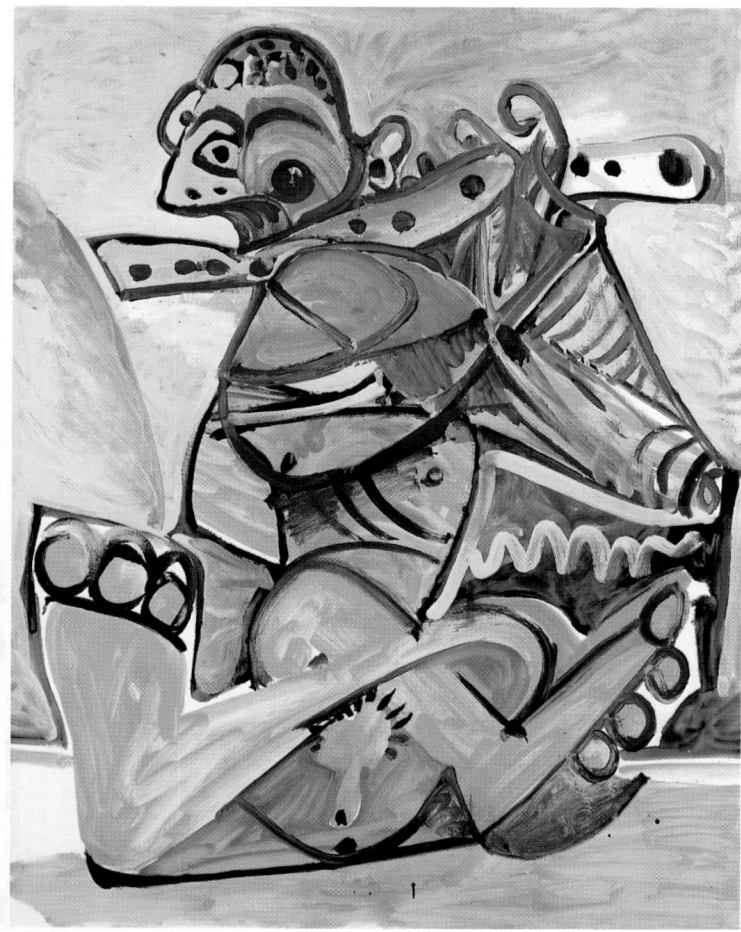

1148

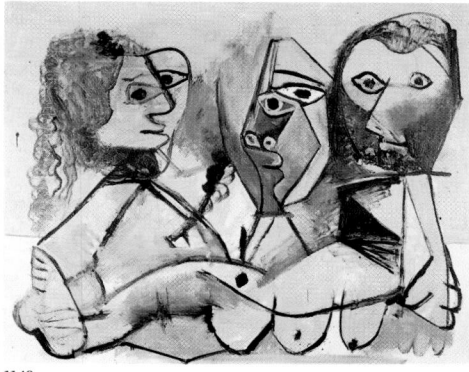

1149

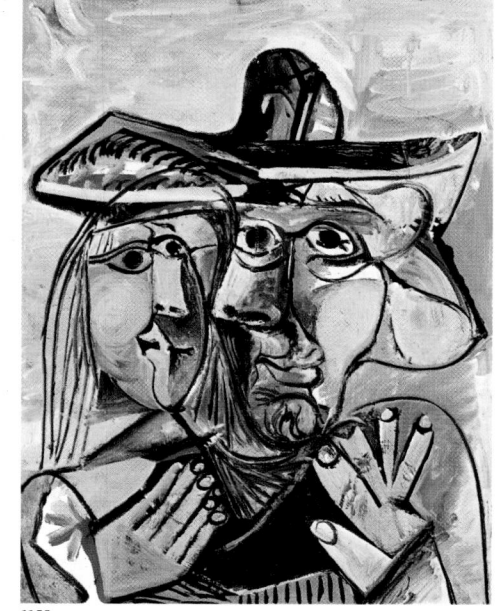

1150

these shortcuts, corresponded to his need to paint and draw at the same time: "When one is looking, the design and the color should be the same thing in the end."[5] He wanted simplification: "At this time I put less and less on my canvases"[6]; less and less paint as well, resulting in very thin, light layers and the importance of the blank canvas. For Picasso to paint is to speak, thus his remark: "What is necessary is to *name* things. . . . I want to *speak* the nude; I don't want to just make a nude as a nude; I want only to *speak* breast, *speak* foot, *speak* hands, belly. . . . Find the means to *speak* and that is enough."[7] That is why, as Picasso proceeded with his research, he adopted codified signs that summarize and signify each part of the body and when regrouped express the nude. "A single word is sufficient when one speaks about it."[8] Picasso's recourse to writing is, in fact, one way to do away with distance between the thing to be said and the means to represent it so that the image *is* the object. This need to go to the very essence, to simplify, is undoubtedly one of the characteristics of the later work. Just as Matisse managed to draw directly in color at the end of his life, so Picasso managed to paint while drawing. But he was not content with this somewhat dry language and the loose, thickened action painting that appeared in *Women of Algiers*, and some of the *Déjeuners* took over in some of the canvases from 1965 on. This unrestricted painting, which obeys no rule, has no outlines, shows itself in whirls, arabesques, flames, deletions, and squirts is the expression of the enormous energy that still drove the aged Picasso.

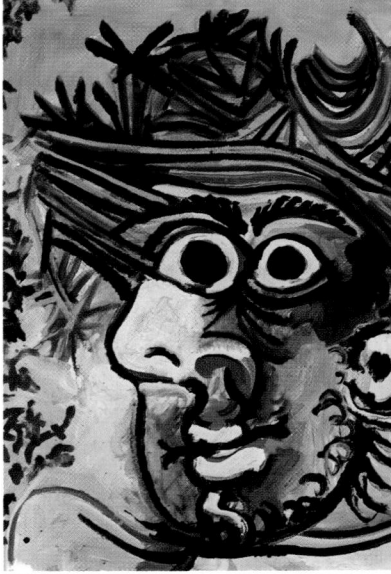

After 1965, the two styles melded to such an extent that one cannot distinguish between drawing or form or color or composition. The thick strokes and dynamic lines that suggest tension are caught in the superimposition of the layers to create subtle ranges of tone through the play of transparency. The figure seems to emerge from this jumble in which painting and drawing have united to become the body of the painting, its flesh and its infrastructure. In fact, Picasso distorts more than he shapes. If one were to compare these canvases to those of 1939–42 where the same decorative patchwork made up of stripes, stars, checkering, and thick strokes can be found, as well as the same poses, one would see that up to the last period Picasso outlined his shapes, invented them, traced them, and imposed his vision onto the material, but afterward it was the material, the painting itself that dictated the form. It almost seems as if the shaping came more from the will of the figure itself than from a formal decision of the artist.

Among the characteristic signs of the Avignon period are the eyes shaped like a hairpin; the sex shaped like fishbones; enormous fan-shaped feet and hands with circles for the fingers and toes; horizontal eights for the nose, spirals for the ears, whirls for the hair; hats shaped like double ellipses with a bobble; and certain recurring decorative motifs such as scratches, squares, stars, arrows, fishbones, and shapeless, nervous scribbles. His use of these simplified signs, which are reminiscent of a child's drawing ("it took me a lifetime to learn to draw like them,"[9] he said), linked to repeated ornamental models, created a sort of "pattern-painting." Some elements, such as the arrow, the fishbone, the dot, and the line, have a symbolic resonance that is clearly of a sexual order. The painting is the result of penetration, of the fusion of male and female elements. This new way of painting, which some at the time saw as nothing other than "incoherent scribbles produced by a frenzied old man in the anteroom of death"[10]—contradicted by the virtuosity and the accuracy of the execution of the drawings and etchings—was thus absolutely deliberate, the result of a lifelong determination to make the painting "speak," to submit himself to its laws. One has to get rid of art, Picasso would say; "the less art there is, the more painting there is."[11] This desire to lose control, to make fewer decisions—"I no longer choose," he also said—is another characteristic of the late style, as proven by the words of Matisse, who declared at the end of his life that he wanted to "yield to instinct" and who regretted that he had been "held back by his will, had lived with his belt fastened."[12] Great age, in fact, offers the possibility of resurrection, of a second wind. Liberated from the past—and Picasso had settled his account brilliantly—the old painter could now permit himself everything, could break laws

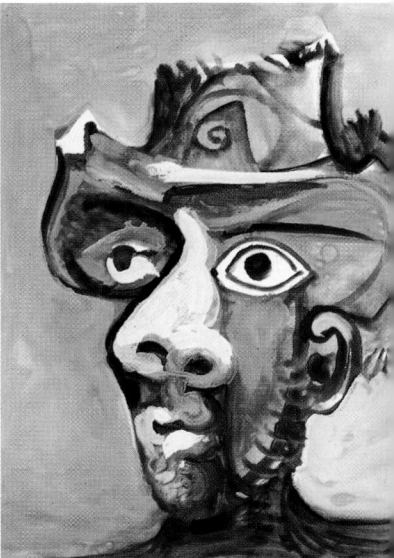

1151

1152

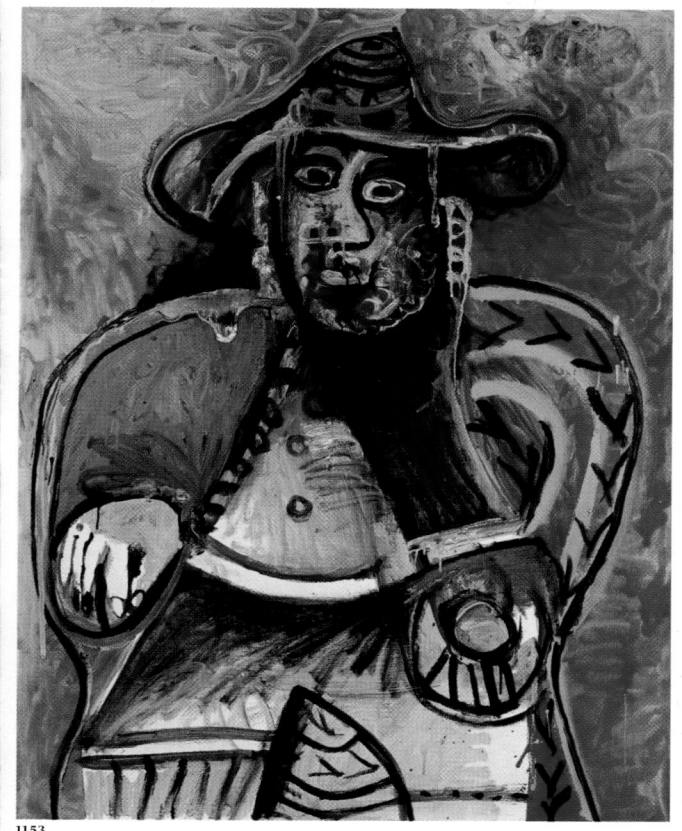

1153

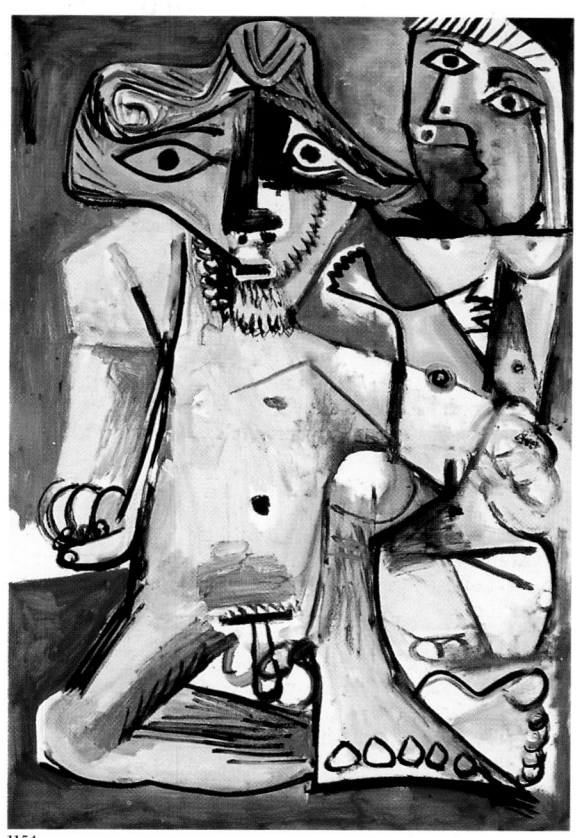

1154

1151 *Head of a Man in a Straw Hat,* July 26, 1971

1152 *Head of a Man in a Hat,* July 25, 1971

1153 *Seated Old Man,* September 26,
1970–November 14, 1971

1154 *Nude Man and Woman,* August 18, 1971

467

1155

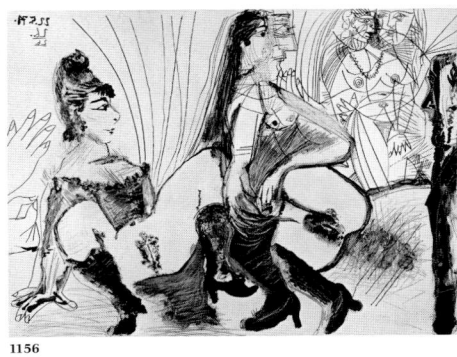

1156

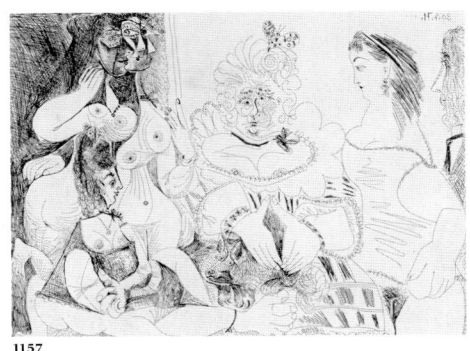

1157

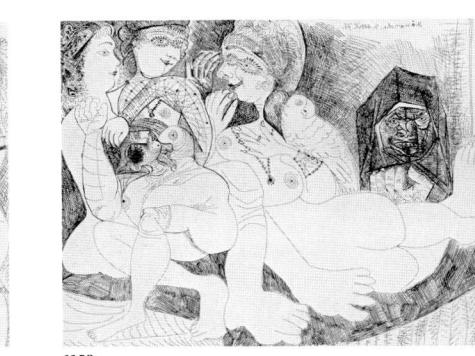

1158

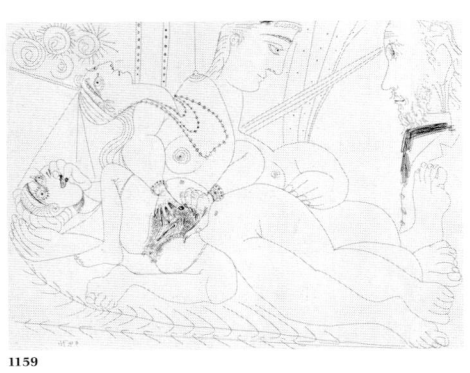

1159

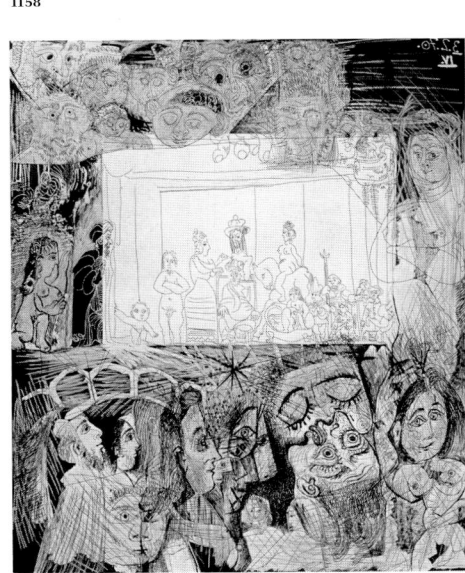

1160

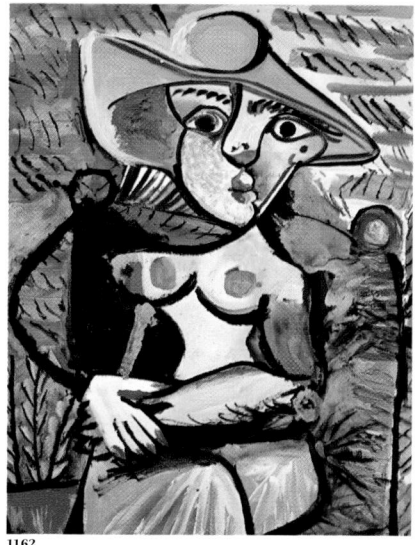

1161

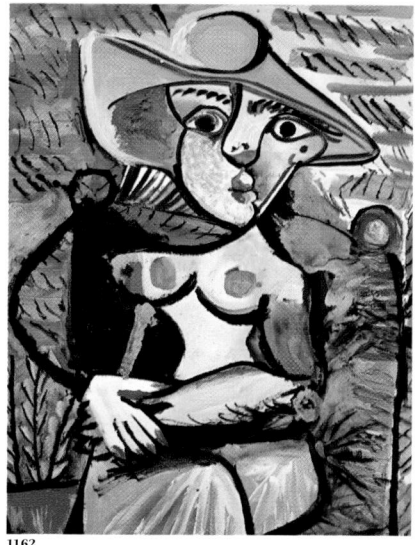

1162

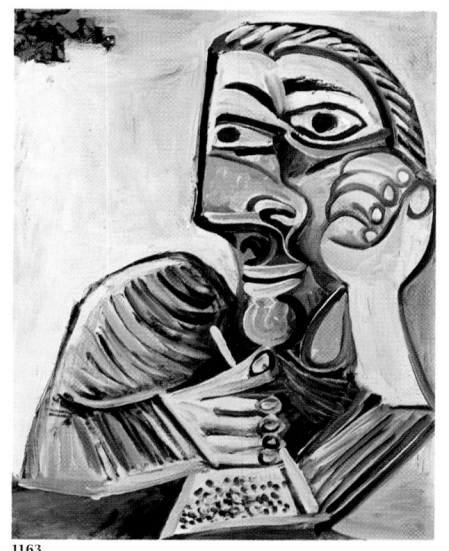

1163

and offend the profession, since nothing was denied him. One thing that demonstrated how new this style was could be found in the perceptual blockage on the part of the viewers. The distortions and probably also the subjects did not trouble them (Picasso had gone farther than this between 1939 and 1943), but rather the manner of painting, that which appeared to be the "unfinished" quality, the sketchiness, the rough scribble, the "bad-painting" aspect, which only those painters who know how to paint can permit themselves. "One has to know how to be vulgar, how to paint with swear words,"[13] Picasso used to say, and "every day I make it worse."[14] It was translated through a dirty, muddy kind of paint with crushed impasto, violent contrasts of pure color, and the creation of crossbred monsters in which the human is fused with the crudest animality (fig. 1145). Paradoxically, this slapdash style sometimes gave rise to a smooth, fluid, and refined painting, worthy of the Spanish masters with subtle ranges of pale and tender pinks, blues, and grays, the colors of childhood. This "slang of art" of which David Sylvester spoke,[15] this refusal to conform or to be locked into a style or elegance, was the final demonstration of Picasso's irreducible anarchism. After having learned everything, one has to forget everything. "Painting still has to be made," he would say, as if it were only just in its primary stage, as if the late style were the shaping of chaos, the painting of the origins that offers the fundamental images of the unformulated.

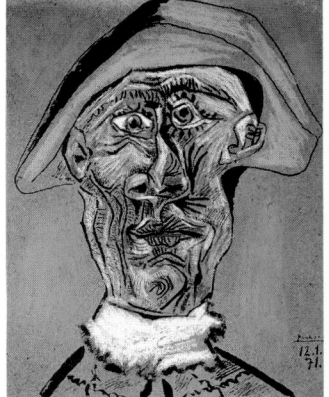

1164

The Last Paintings

Some isolated paintings on a variety of themes summarize the pictorial and personal preoccupations of the artist on the threshold of death. They are exceptional paintings both in their style and in their complex iconography. The *Three Figures* of September 1971 (fig. 1149) shows a reclining female body surmounted by three heads in harmonies of beige and gray—a rare monochrome in that period of flaming colors. The head at the left, its double face derived from the black and white portraits of 1926, appears to be the portrait of an old woman or a witch with bushy hair. The one in the middle, which is geometric, angular, and more sculptural, is beyond description. The head at the right is reminiscent of the 1906 *Self-Portrait*, especially in the hair. A juxtaposition of the three ages of life, a fusion of the sexes, these emblematic figures that preside over Picasso's drawing could be the Three Fates ready to cut his life's cord. In November 1971 Picasso painted another surprising picture, *Reclining Nude* (fig. 1161) that also went beyond the usual characteristics of his final period. The woman's body stretched out on the beach is subjected to a kind of implosion; her scattered limbs explode in every direction, emphasized by the red arrows at the end of the arms. But at the same time this blow-out is locked into an organic form that is clearly the body of a bathing woman, even if it is permeated by sand and water. The sex is central with its brown flames from which small, black ghostlike figures emerge, little devils dancing morbidly around the figure. The white sun and the murky colors add to the overall impression of a waking nightmare. The sand has been rendered by spots of paint in relief, a new technical discovery of Picasso's that accentuates the reality of the painting. This vision of the great final leap, the artist's obsession with the female body as the matrix of the cosmos, this expression of madness achieves what few of Picasso's paintings do.

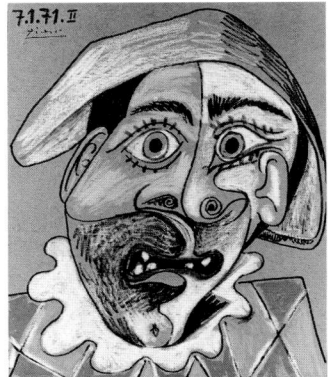

1165

The oppressive atmosphere of these final paintings also appears in the magnificent *Landscape* of March 1972 (fig. 1167). Here again is the lavish use of thick paint, carefully worked in subtle ranges of green and gray. Nature is organic, run through with energy, subjected to ascending and descending forces, which are expressed here with black arrows. Picasso painted few landscapes, but this one summarizes the dramatic vision he had of nature. The presence of the palm trees is the only detail that enables the viewer to recognize the south of France.

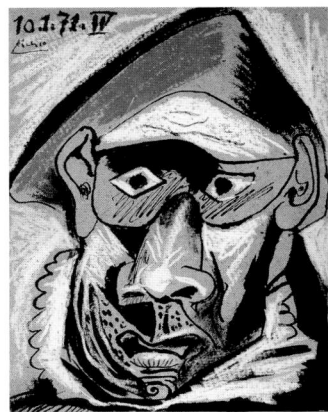

1166

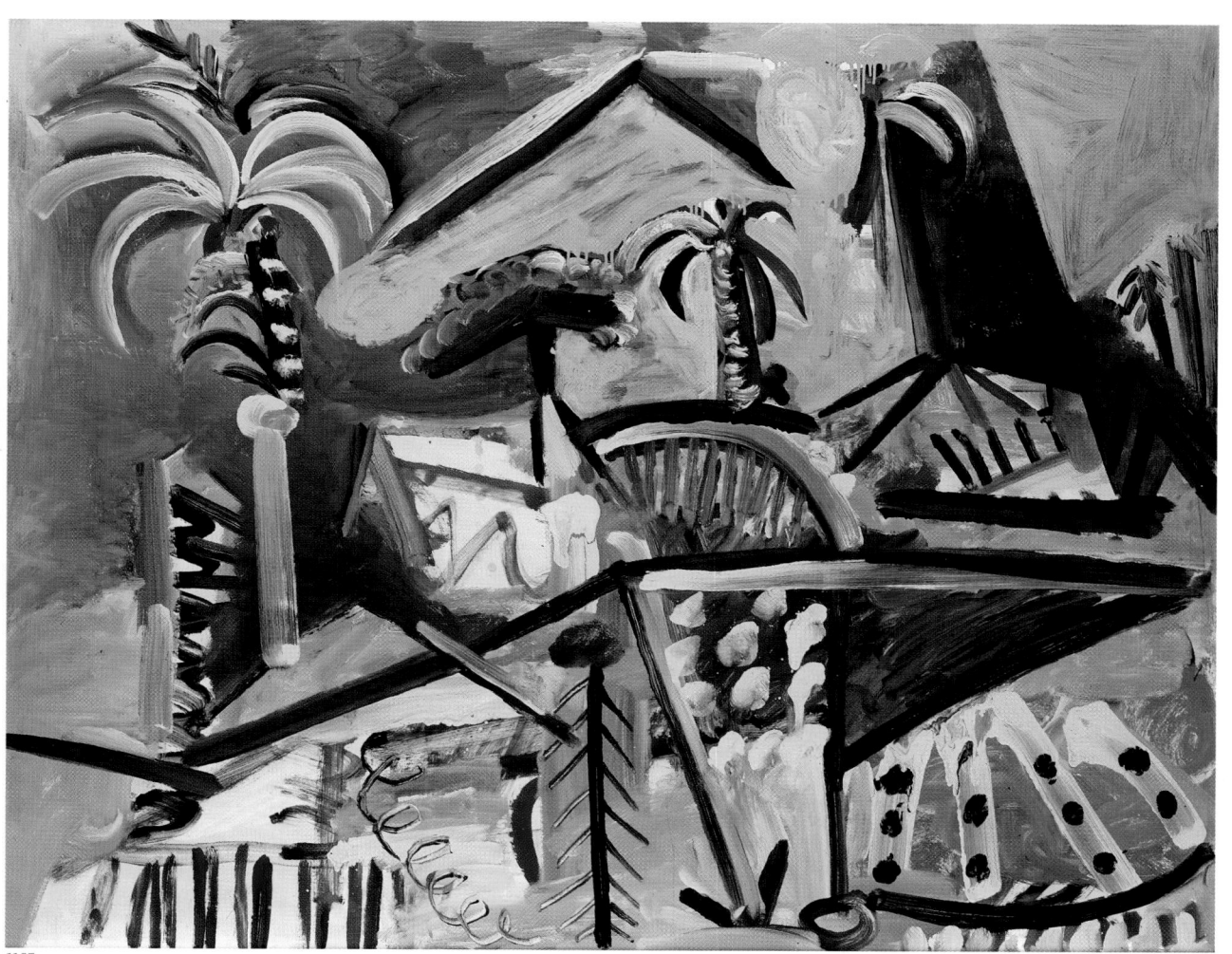

1167

1164 *Head of Harlequin,* January 12, 1971
1165 *Head of Harlequin,* January 7, 1971
1166 *Masked Head of Harlequin,* January 10, 1971
1167 *Landscape,* March 31, 1972

1168

1169

1170

1168 *Musician,* May 26, 1972
1169 *Figure,* January 19, 1972
1170 *Man with a Sword,* January 28, 1972
1171 *Figure with a Bird,* January 13, 1972

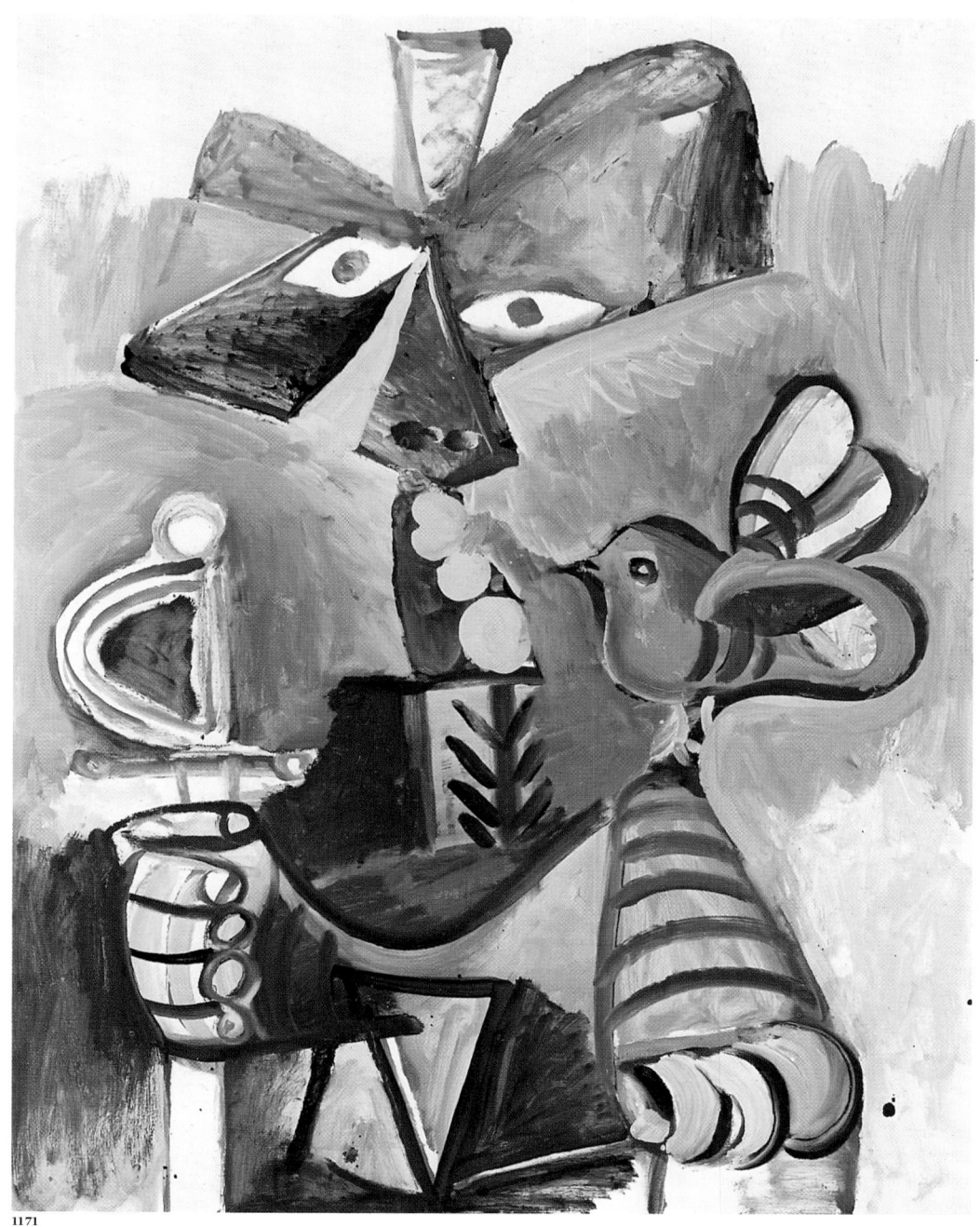

1171

The Musketeers made one final appearance in 1972, as Picasso returned to his archetype to test a variety of approaches. One version (fig. 1169) is painted in broad, firm, and decisive strokes with a great deal of color; the other (fig. 1170) is made of multiple dots that liquefy the figure. A contrast between two approaches, the force and the simplifying energy of the brushstroke or the confused mist of the painting. The *Musician* of May 1972 (fig. 1168) brought Picasso back to the Spanish harmonies of black and gray, to which a spot of orange-red adds a musical note. The strange sign of the fishbone-arrow appears again, as it did in the landscape. *Figure with a Bird* (fig. 1171) of January 1972 is thought to be one of Picasso's last paintings. This ghostlike Don Quixote holding his sword is brought to life by the presence of the bird, a favorite animal that can be found in numerous paintings of this period, but the face has disappeared to make place for a kind of hat with the sails of a windmill. Another mysterious work, *Reclining Nude and Head* of May 1972 (fig. 1171b), is supposed to have been one of the last pieces Picasso painted. The original figure was apparently covered over with white and left this way by the painter. A head with the horns of a bull is recognizable, reminiscent of the *Bull's Head* of 1942, and a woman's sex is in the middle ground, with a rectangular recumbent form, which John Richardson interprets as a coffin.[16] Whatever the underlying theme may be, this strange painting carries the signature of death, the end, and the silence of painting.

1171b

Last Etchings

Between January 1970 and June 1972, Picasso engraved "156" plates, which form the last series of etchings and are an echo of the "347" suite of 1968. Here again we have a cycle devoted to the old masters. Picasso borrowed from the monotypes of Degas, of which he owned several copies, to illustrate *La Maison Tellier* by Guy de Maupassant. These are scenes of a brothel with its madam and her girls, subjected to the gaze of a discreet but omnipresent man seen in profile or in the process of drawing, who is none other than Degas (figs. 1155–1159). In this way Picasso introduced the theme of voyeurism. Having worked through the act of love with the "347" suite, he now took the vantage of the onlooker. The painter's eye—Degas or Picasso, who thus identifies himself to his predecessor— exposes, reveals, and gives life to the scenes he draws. Picasso alternated among various etching techniques for this series, but all of them show the constant renewal of the quest, the pleasure he took in etching. The Celestina reappeared in certain prints (fig. 1158). Among the most impressive work is an etching that represents the theater of the world (fig. 1160), gathering on the stage all of Picasso's favorite figures and his favorite themes. This composition was inspired by Rembrandt's famous etching *Ecce Homo*.

1172

Last Drawings

Picasso was a painter, etcher, and draftsman. Until the end of his life, he tackled everything head-on, demanding of every technique its unique characteristics. The themes of his drawings are frequently the same as those of the paintings, but they are pushed to an extreme, reduced to the essential design. Carnival characters can be found again in the series of masked Heads (figs. 1164–1166), one of which resembles his friend the writer Michel Leiris (fig. 1164). But the central character in these last drawings is once again a woman (fig. 1181). Her body has been completely broken up and folded to accommodate the composition. Picasso pushed the disfigurement so far that the nude became a scrawny spider with half-masculine, half-feminine limbs; he exposed its gaping sex and she seems to be crawling back into her own breasts in a fusion of male and female elements. Toward

1173

1171b *Reclining Nude and Head,* May 25, 1972
1172 *Nude with a Mirror and Seated Figure,*
 July 19, 1972
1173 *Winged Horse Led by a Child,*
 July 26–29, 1972
1174 *The Young Painter,* April 14, 1972

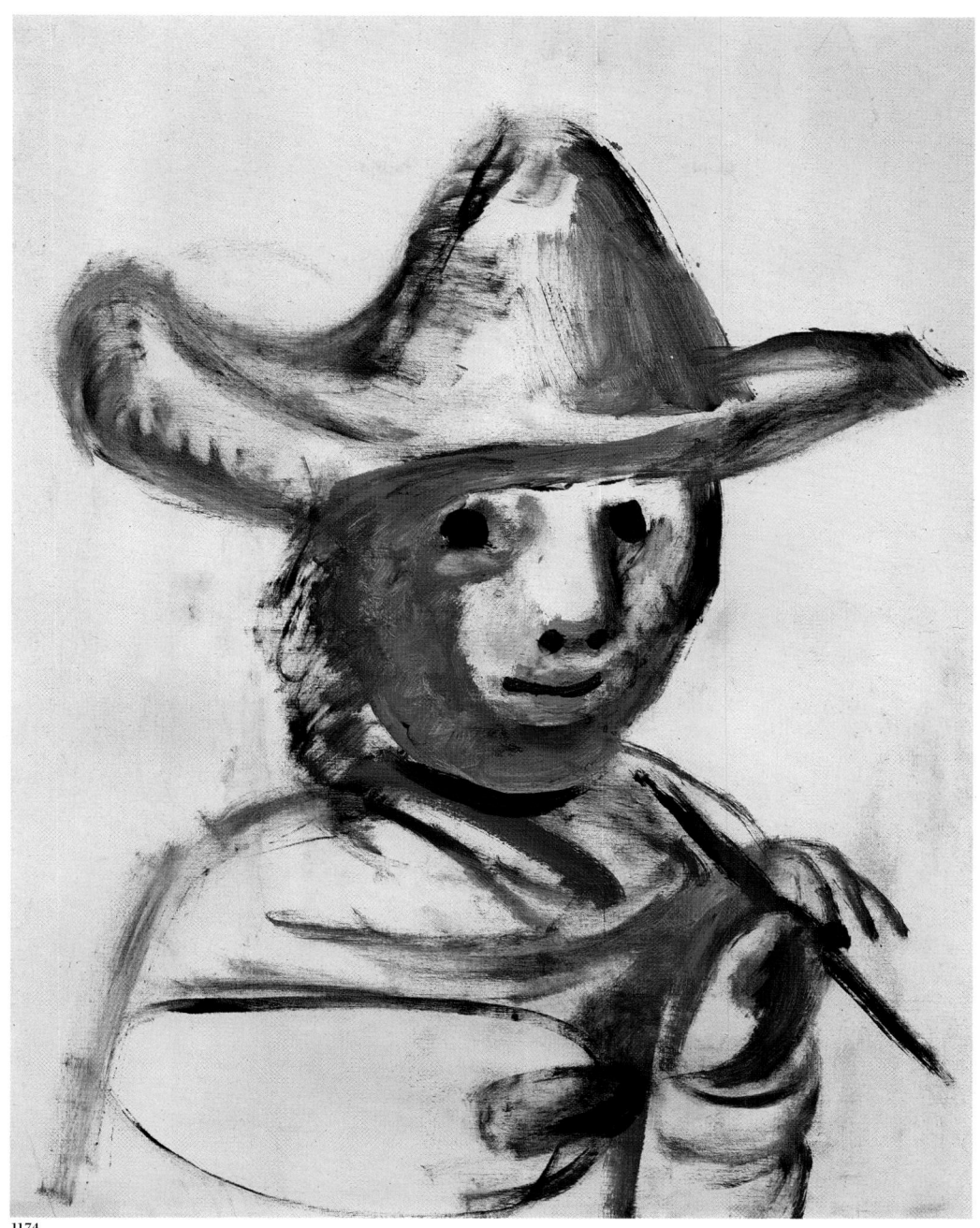

1174

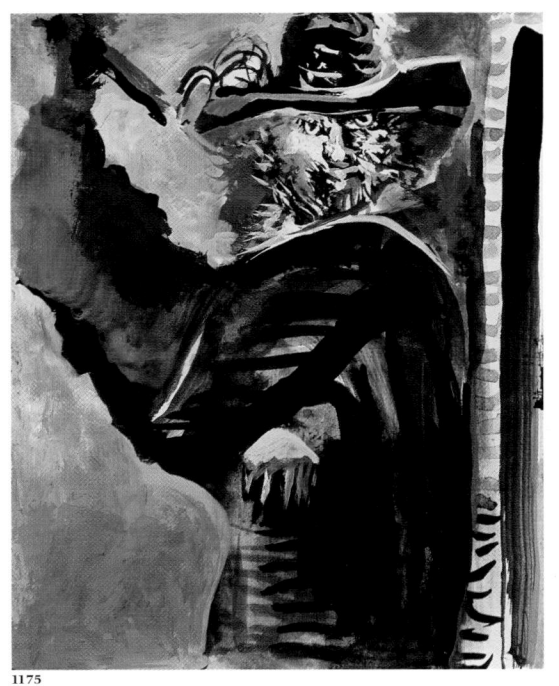

1175

1176

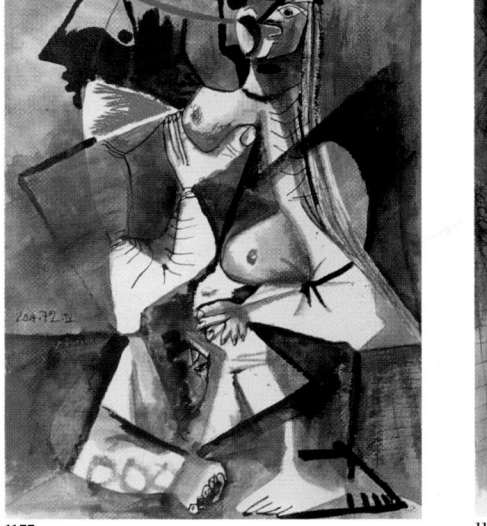

1177

1178

1175 *Musketeer with a Sword,*
 October 8, 1972

1176 *Head,* October 8, 1972

1177 *Nude and Head,* April 20, 1972

1178 *Nude,* May 1 and 3, 1972

1179

1180

1181

1179 *Nude,* October 5, 1972
1180 *Reclining Nude,* April 20, 1972
1181 *Nude in an Armchair,*
October 3, 1972

the end of his life, Picasso allowed his bisexuality—the impulse of creation—greater and greater expression. There is only one more face to be confronted, that of Death, and in order to do so, Picasso gave it his own face and the multiplicity of his styles.

Four drawings of 1972, in which Picasso linked either his features or those of previous figures to a death's head, summarize a variety of pictorial languages from the past. One of them evokes Cubism and the skull of *Les Demoiselles d'Avignon* (fig. 1183); the second is a drawing of a stone head (fig. 1184) whose profile resembles that of Marie-Thérèse and recalls the Bathers from Dinard; the third (fig. 1182), the head of a woman (Dora Maar) or a man with long hair once more takes up the twisting of the two parts of the face as he did in the 1940s. The last and most realistic drawing (fig. 1185) is reminiscent of the 1907 *Self-Portrait* in its distinctive features, the nose, and the wide-open eyes). Blue arrows surround the face; the closed mouth is indicated by three bars, and the colors—green and mauve—are those of the 1942 *Still Life*, done, as Pierre Daix pointed out, after the death of Gonzáles. Picasso was looking death straight in the eye (see fig. 850), no longer hiding anything. He has said it all and achieved the mask's truth. When the two faces, that of reality and that of art, were superimposed, it meant that the end was near. "Yesterday I made a drawing, I believe I touched something. . . . It looks like nothing else ever done before." Pierre Daix recounted that Picasso "held the drawing next to his face to show clearly that the fear expressed in it was merely an invention."[17]

1182

Avignon: The Last Judgment

Avignon was definitely a magic name for Picasso, from the brothel in *Les Demoiselles d'Avignon* to the exhibition that opened in Avignon's Palace of the Popes in May 1973, featuring his last works, which he himself chose. Unnoticed by a formalist generation, savagely criticized by some, and praised by only a few absolute admirers, the works in that exhibition hold up today in all their opulence, newness, and boldness, in comparison to the contemporary artistic context. Picasso in Avignon was "the pope of modern art in exile."[18] The *Last Judgment* of the old Picasso is made up of a clash of paintings without any frames, an exuberant and colorful masquerade of swordsmen, couples, nude women, and serious portraits, parading in tight rows on the bare walls of the chapel like sacrilegious ex-votos. Paintings "full of sound and fury," in which everything moves and resounds, sending the viewer back and forth from one canvas to the next. The rattling of sabers, the panache of feathers, the twisting of bodies, the hallucinations of gazes, the stridency of color, the frenzy of touch, here Picasso hands us his artistic testament. This ultimate stage is, in essence, the source of new pictorial possibilities that lead toward a renewal of figurative language, a plea in favor of the lyrical power found again in the painted image. It seems that the late Picasso played the role of a beacon in the development of the 1980s, a referent comparable to the role of Matisse's paper cutouts in the development of the 1970s. A rediscovery encouraged by distance, "one has to forget him in order to rediscover him"[19] (and Picasso had been to Purgatory). Within the contemporary artistic context, that of the return to painting, to the figure, to Neo-Expressionism, to subjectivity, all of which make the perception of these canvases possible and enable us to comprehend what is at stake.

Finally, the last message he delivers to us in this final apotheosis is quite simply that of enthusiasm, a commodity that has become rare in these times of aesthetic demoralization. Picasso lived to the fullest, loved to the fullest, created to the fullest, setting the example of having achieved art's return to childhood, to that moment when everything is ready to begin.

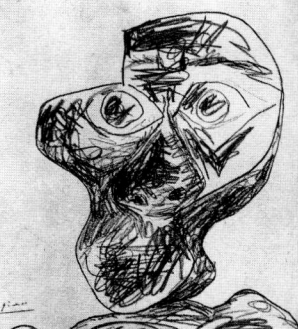

1183

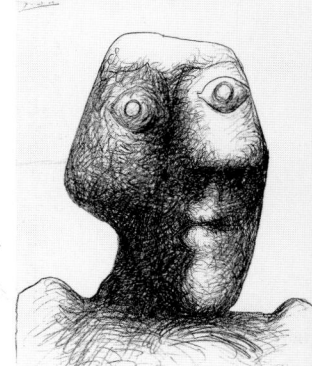

1184

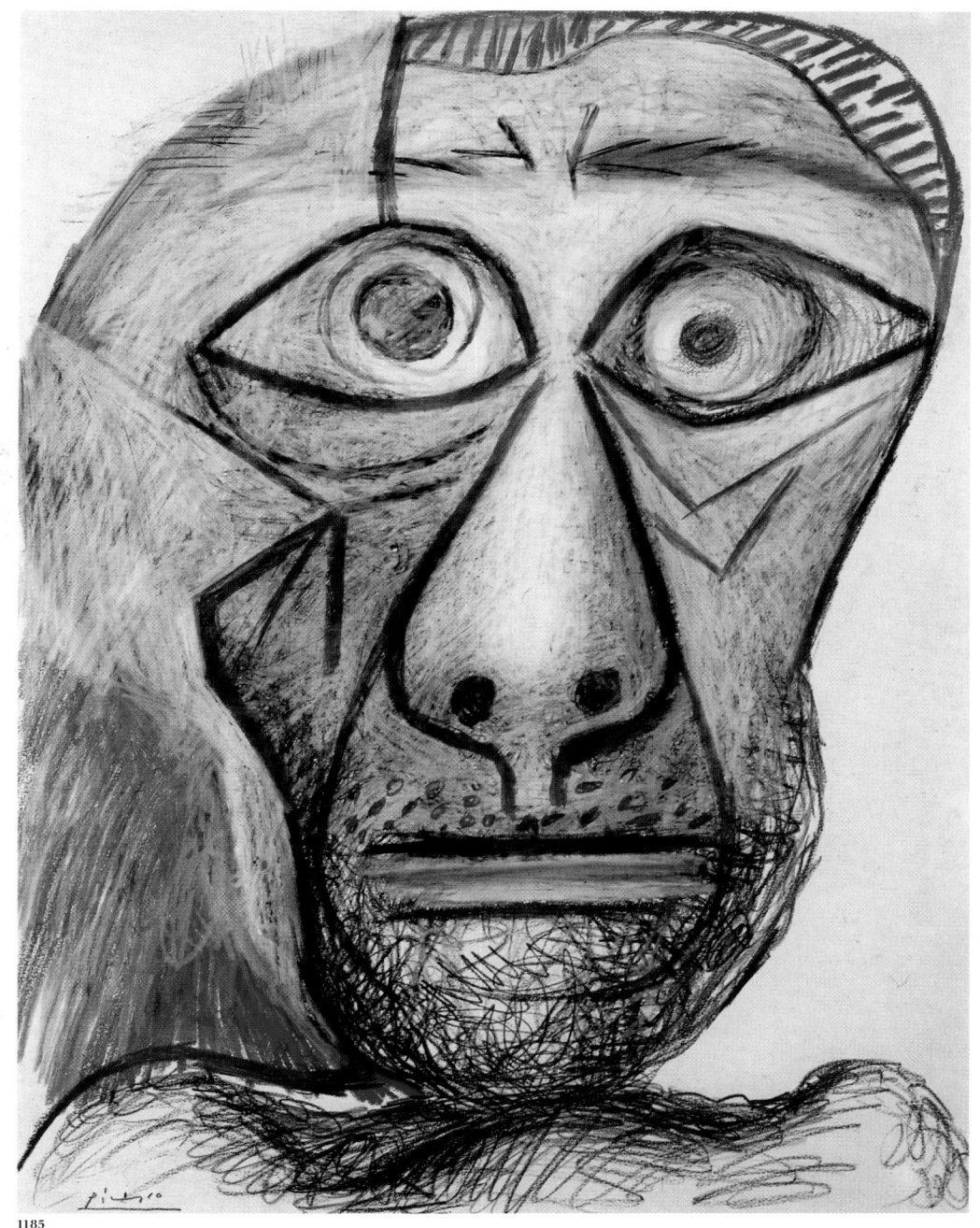

1182 *Head,* June 29, 1972
1183 *Head,* July 2, 1972
1184 *Head,* July 3, 1972
1185 *Self-Portrait,*
June 30, 1972

1185

479

NOTES
CHRONOLOGY
LIST OF ILLUSTRATIONS
BIBLIOGRAPHY
INDEX

NOTES

Chapter 1

1. Charles Morice, Review of exhibition "Peintures, pastels et dessins de MM. Girieud, Launay, Picasso et Pichot" at the Galerie Berthe Weill, Paris. *Mercure de France* (Dec. 15, 1902).
2. Jaime Sabartés, *Picasso: Portraits et souvenirs.* P. M. Grand and A. Chastel, trans. (Paris: Louis Carré and Maximilien Vox, 1946), p. 17. Published in English as *Picasso: An Intimate Portrait* (New York: Prentice-Hall, 1948).
3. Antonina Vallentin, *Picasso* (Paris: Éditions Albin Michel, 1957), p. 15.
4. Jaime Sabartés, *Picasso: Documents iconographiques,* F. Leal and A. Rosset, trans. (Geneva: Pierre Cailler, 1954), p. 39.
5. Brassaï, *Conversations avec Picasso* (Paris: Gallimard, 1944), p. 71. Published in English as *Conversations with Picasso* (Chicago: University of Chicago Press, 1999).
6. Jaime Sabartés, "Thoughts about Picasso," in Wilhelm Boeck, *Picasso* (New York: Harry N. Abrams, 1955), p. 16.
7. Quoted by Josep Palau i Fabre in *Picasso, The Early Years, 1881–1907.* K. Lyons, trans. (New York: Rizzoli, 1981), p. 135.

Chapter 2

1. Santiago Rusiñol (1861–1931). Painter, novelist, chronicler, and with Ramón Casas one of the principal practitioners of Catalan Modernismo. In Paris, where Rusiñol lived from 1887 to 1894, he was one of the regulars in the Symbolist literary and artistic circles. His collection, rich in works by Picasso, Zuloaga, and others, has been reunited in Le Cau Ferrat de Sitges, Barcelona, a museum-studio created by Rusiñol in 1894.
2. Quoted by Palau i Fabre in *Picasso, The Early Years,* p. 135.
3. Ramón Casas (1866–1932). Painter of Parisian life (he lived in Montmartre from 1882 to 1894), who became one of the movers of Els Quatre Gats and of Catalan Modernismo. His portrait work (which was exhibited in the Sala Parés in 1890 in Barcelona) greatly influenced the young Picasso.
4. In 1900 in Paris, the young Catalan dealer Pere Mañach offered Picasso 150 francs a month in exchange for a few pieces of his work and introduced him to Berthe Weill who bought three bullfight pastels from him. Picasso's first exhibition was held April 1–15, 1901, at the Galerie Berthe Weill in Paris, followed by a second one in November–December.
5. Phoebe Pool, "Sources and Background for Picasso's Art 1900–1906," *Burlington Magazine* 101 (1959), pp. 176–92.

6. Ambroise Vollard (1868–1939). The dealer of Cézanne, Gauguin, and Bonnard, who held the first large exhibition of Picasso's work in his famous boutique in the rue Laffitte in Paris.
7. Félicien Fagus, "L'Invasion espagnole: Picasso," *La Revue blanche* (July 15, 1901).
8. Adrien Farge, Preface in the catalogue of the Galerie Berthe Weill exhibition "Tableaux et pastels de Louis-Bernard Lemaire et de Picasso" (Paris, April 1–15, 1902).
9. Alberto Moravia, Paolo Lecaldano, and Pierre Daix, *Tout l'oeuvre peint de Picasso, périodes bleue et rose* (Paris: Flammarion, 1980).
10. El Greco, *The Burial of Comte d'Orgaz,* 1578. Santo Tomé Church, Toledo. Francisco de Zurbarán, *Saint Bonaventure on His Bier,* 1629. Musée du Louvre, Paris.
11. Theodore Reff, "Love and Death in Picasso's Early Work," *Artforum* (May 1973), pp. 64–73.
12. Jean Leymarie, *Picasso: Métamorphoses et unité,* revised ed. (Geneva: Skira, 1971). First edition published in English as *Picasso: Artist of the Century* (New York: Viking, 1962), p. 7.
13. Guillaume Apollinaire, "Les Jeunes: Picasso peintre," *La Plume* 372 (May 15, 1905).
14. Sabartés, *Picasso: Portraits,* p. 72.
15. Vallentin, *Picasso,* p. 76.
16. Sabartés, *Picasso: Portraits,* p. 73.
17. Morice, Review.
18. Werner Spies, *Picasso: Pastelle, Zeichnungen, Aquarelle* (Stuttgart: Hatje, 1986), pp. 18–19.
19. Vallentin, *Picasso,* p. 88.
20. Fernande Olivier, *Picasso et ses amis* (Paris: Stock, 1933), p. 26. Published in English as *Picasso and His Friends* (London: Heinemann, 1964).
21. Pierre Daix, Georges Boudaille, and Joan Rosselet, *Picasso 1900–1906, catalogue raisonné de l'oeuvre peint* (Neuchâtel: Ides et Calendes, 1966), p. 66. Published in English as *Picasso, The Blue and Rose Periods: A Catalogue of the Paintings, 1900–06,* P. Pool, trans. (Greenwich, Conn.: New York Graphic Society, 1967).
22. Ibid.
23. The writer André Salmon, of whom Picasso made some famous caricatures, wrote in *Souvenirs sans fin* (Paris: Gallimard, 1955–56) of the trials and tribulations of Picasso's group, which also included the poets Max Jacob (1876–1944) and Apollinaire (1880–1918) of whom Picasso made numerous portraits.
24. Rainer Maria Rilke, *Duino Elegies* (Frankfurt: Insel Verlag, 1929).

Chapter 3

1. Olivier, *Picasso et ses amis*, p. 43.
2. J. A. D. Ingres, *The Turkish Bath*, 1862. Musée du Louvre, Paris.
3. Paul Gauguin, *Riders on the Beach*, 1902. Private collection.
4. Vallentin, *Picasso*, p. 128.
5. Alfred H. Barr, Jr. *Picasso: Fifty Years of His Art* (New York: Museum of Modern Art, 1966), p. 42.
6. Gertrude Stein (1874–1946). American writer and collector who settled in Paris in 1903. She played a major role, together with her brothers, Leo and Michael, in the lives of the avant-garde painters (Picasso, Matisse, Derain) by purchasing some of their finest works and displaying them in the Stein apartment at 27, rue de Fleurus, Paris.
7. *Le Désir Attrapé par la Queue*, a play in six acts by Picasso, was read at the home of Louise and Michel Leiris on March 19, 1944, with the participation of the Leirises, Simone de Beauvoir, Jean-Paul Sartre, Albert Camus, Dora Maar, and others.
8. Hélène Seckel, ed., *Les Demoiselles d'Avignon*, exh. cat., 2 vols. (Paris: Réunion des Musées Nationaux, and Barcelona: Polígrafa, 1988).
9. André Malraux, *La Tête d'Obsidienne* (Paris: Gallimard, 1974), pp. 18–19.
10. Leo Steinberg, "The Philosophical Brothel," *Art News* (Sept. 1972), pp. 20–29; (Oct. 1972), pp. 38, 40.
11. Seckel, *Les Demoiselles d'Avignon*, II, p. 551.
12. Daniel-Henry Kahnweiler (1884–1979). Passionate about art, this young German dealer opened a gallery in Paris early in 1907 at 28, rue Vignon. At first he was primarily interested in the Fauves, but the *Demoiselles d'Avignon* led him toward Picasso's work, and he remained Picasso's primary dealer until his death in 1979.
13. Henri Matisse, *Blue Nude, Souvenir of Biskra*, 1907. Baltimore Museum of Art, Cone Collection. André Derain, *Bathers*, 1907. The Museum of Modern Art, New York. Georges Braque, *Standing Nude*, 1907. Private collection.
14. Apollinaire can be seen sitting next to this tiki in a photograph taken in Picasso's studio on the boulevard de Clichy in 1910–11.
15. Louis Vauxcelles, *Gil Blas* (Nov. 14, 1908).
16. Gertrude Stein, *Picasso* (Paris: Floury, 1938), pp. 71–72, n. 1.
17. Werner Spies, *Sculptures by Picasso* (New York: Harry N. Abrams, 1971), p. 27.

Chapter 4

1. The book was published by Daniel-Henry Kahnweiler in 1910.
2. Braque's words collected by Dora Vallier in "Braque, la peinture et nous," *Cahiers d'Art* 1 (Oct. 1, 1954).
3. Quoted by N. Pouillon and I. Monod-Fontaine in *Oeuvres de Georges Braque (1882–1953) [dans les] collections du Musée national d'Art moderne* (Paris: Centre Georges Pompidou, Musée National d'Art Moderne, 1982), p. 39.
4. Guillaume Apollinaire, "Pablo Picasso," *Montjoie!* (March 8, 1913). Reprinted in *Chroniques d'Art 1902–1918* (Paris: Gallimard, 1960), p. 367. Published in English as *Apollinaire on Art: Essays and Reviews, 1902–1918*, Leroy C. Breunig, ed., S. Suleiman, trans. (New York: Viking, 1972).

5. Letter sent by Picasso to Braque on October 9, 1912, published by I. Monod-Fontaine, *Georges Braque, les papiers collés* (Paris: Centre Georges Pompidou, Musée National d'Art Moderne, 1982), p. 41.
6. Pierre Daix and Joan Rosselet, *Le Cubisme de Picasso, catalogue raisonné de l'oeuvre peint 1907–1916*. (Neuchâtel: Ides et Calendes 1979). Published in English as *The Cubist Years, 1907–1916. A Catalogue Raisonné of the Paintings and Related Works* (Boston: New York Graphic Society, 1979).
7. Jean Paulhan, "L'Espace cubiste ou de papier collé," *L'Arc* 10 (1960) pp. 9–12.
8. Tristan Tzara, "Le Papier collé ou le proverbe en peinture," *Cahiers d'Art* 2 (1931), pp. 61–74.
9. Robert Rosenblum, "Picasso and the Coronation of Alexander III: A Note on the Dating of Some *Papiers Collés*," *Burlington Magazine* 113 no. 823 (Oct. 1971), pp. 602, 604–7.
10. Paul Éluard, *À Pablo Picasso* (Geneva and Paris: Trois Collines, 1944), p. 36.
11. André Breton, "Picasso dans son élément," *Minotaure* 1 (June 1933) p. 14.
12. "Construction au joueur de guitare, 1913," *Cahiers d'Art* II (1950) p. 281, and Daix and Rosselet, *Le Cubisme*, p. 299, no. 578.
13. Vladimir Tatlin (1885–1953). Russian constructivist artist. At Picasso's house Tatlin probably saw *The Guitar* in sheet metal, as well as other assemblages. After returning to Moscow, he displayed his first picture-reliefs in his studio.
14. Quoted by Julio González in "Picasso sculpteur," *Cahiers d'Art* XI, nos. 6–7 (1986), p. 189.
15. Quoted by Pierre Daix in *La Vie de peintre de Pablo Picasso* (Paris: Seuil, 1977), p. 142, no. 30.
16. According to Douglas Cooper (*Pablo Picasso, pour Eugénie*. Paris: Berggruen, 1976), Picasso met E. Errazúriz, a wealthy Chilean who was attached to the Ballets Russes, in June 1917 in Madrid. After their marriage, Picasso and Olga settled in Biarritz in the summer of 1918.
17. Douglas Cooper, *Picasso Theatre* (New York: Harry N. Abrams 1987), p. 29.
18. Quoted by Pierre Daix in *La Vie*, p. 139.
19. Ibid., p. 148.
20. Jean Cocteau, *Picasso* (Paris: Stock, 1923), p. 20.

Chapter 5

1. Jean Cocteau, *Entre Picasso et Radiguet* (Paris: Hermann, 1967), p. 122. Quotations have been taken from pp. 65, 123–25.
2. See the essay by Werner Spies on *Parade* in *Mélanges André Chastel* (Paris: Flammarion, 1987).
3. See Palau i Fabre, *Picasso, The Early Years*, nos. 561, 598, and 602.
4. See Pierre Daix, *Picasso créateur* (Paris: Seuil, 1987), pp. 163 and 171, for the quotation from Picasso's letter to Apollinaire.
5. André Fermigier, *Picasso* (Paris: Librairie générale française, 1969) pp. 142–43.
6. See Werner Spies's preface to *Picasso, Werke aus der Sammlung Marina Picasso*, exh. cat. (Munich: Prestel, 1981), p. 75.

7. Louis Aragon, *Je n'ai jamais appris à écrire ou les "Incipit"* (Paris: Skira-Flammarion, 1981), p. 39.

8. Douglas Cooper, *Picasso Theatre* (New York: Harry N. Abrams, 1968), p. 42.

9. Roland Penrose, *Picasso: His Life and Work* (New York: Harper & Row, 1958), p. 211.

10. Jean Starobinski, *Portrait de l'artiste en saltimbanque* (Geneva: Skira, 1970), p. 7.

11. Marie-Laure Bernadac, *Picasso e il Mediterraneo*, exh. cat. (Rome: Villa Medici, and Athens: Pinacothèque Nationale, 1983), p. 58.

12. Theodore Reff, "Picasso's Three Musicians, Maskers, Artists, and Friends," *Art in America, Picasso Special Issue* (Oct. 1980).

13. Bernadac, *Picasso e il Mediterraneo*, p. 123, and Ulrich Weisner, *Picassos Klassizismus (1914–1934)*, exh. cat. (Bielefeld: Kunsthalle, 1988), p. 84.

14. *Les Grandes Baigneuses de Picasso*, exh. cat. (Paris: Musée de l'Orangerie, 1988), pp. 10, 52–53.

15. *Picasso: oeuvres reçues en paiement des droits de succession* (Paris: Réunion des Musées Nationaux, 1979), p. 16.

16. *Picasso: 347 gravures*, exh. cat. (Paris: Galerie Louise Leiris, 1989), nos. 53, 54, 81, 82.

17. Roberto Otero, *Recuerdo de Picasso* (interview, Oct. 5, 1966) (Madrid: Ministerio de Cultura, 1984).

18. Seckel, *Les Demoiselles d'Avignon*, II, pp. 583–84.

19. José Pierre, *Tracts surréalistes et déclarations collectives*, I (1922–39) (Paris: Losfeld, 1980), pp. 16–17, 369–70.

Chapter 6

1. Penrose, *Picasso*, p. 226.

2. Vallentin, *Picasso*, p. 273.

3. Brassaï, *Conversations avec Picasso*, p. 39.

4. André Breton, "Picasso dans son élément," pp. 10, 14.

5. Penrose, *Picasso*, p. 232.

6. Pierre Cabanne, "Picasso et les joies de la paternité" (interview with Marie-Thérèse Walter), *L'Oeil* 266 (May 1974), p. 2.

7. Françoise Gilot and Carlton Lake, *Life with Picasso* (New York: McGraw-Hill, 1964; repr. New York: Doubleday, 1989), p. 119.

8. Vallentin, *Picasso*, p. 90.

9. Gilot and Lake, *Life with Picasso*, p. 246.

10. Agustín Sánchez Vidal, *Buñuel, Lorca, Dalí: El enigma sin fin* (Barcelona: Planeta, 1988), p. 218.

11. André Breton, "80 carats . . . mais une ombre," *Le Surréalisme et la peinture* (Paris: Gallimard, 1965), p. 117.

12. Brassaï, *Conversations avec Picasso*, p. 40.

13. Daix and Rosselet, *Le Cubisme*, nos. 514–16, 567, 568, 781, 782, and Christian Zervos, *Pablo Picasso*, V (Paris: Cahiers d'Art, 1923), nos. 2, 188.

14. At the Museum of Modern Art, New York. See *Max Ernst*, exh. cat. (Paris: Galeries Nationales du Grand Palais, 1975), p. 57, no. 109.

15. Brassaï, *Conversations avec Picasso*, p. 28.

Chapter 7

1. Penrose, *Picasso*, p. 244.

2. Brassaï, *Conversations avec Picasso*, p. 65.

3. Vallentin, *Picasso*, p. 293, and Daix, *Picasso créateur*, p. 229.

4. Breton, "Picasso dans son élément," p. 10.

5. Pierre Cabanne, *Le Siècle de Picasso*, II (Paris: Gallimard, 1992), p. 715 ("Folio/Essais," p. 174).

6. Brassaï, *Conversations avec Picasso*, pp. 92–93.

7. Claude Esteban, "L'apothéose de don Juan," *La Nouvelle Revue française* 170 (Feb. 1, 1967), pp. 350, 353.

8. Vallentin, *Picasso*, p. 299.

9. Brassaï, *Conversations avec Picasso*, p. 19.

10. Maurice Jardot, Introduction to *Picasso: Peintures 1900-1955*, exh. cat. (Paris: Musée des Arts Décoratifs, 1955), n.p., text facing no. 40.

11. This print is reproduced in [Didier Pemerle], *La Vie publique de Salvador Dalí*, petit journal of *Salvador Dalí: Retrospective 1920–1980*, exh. cat. (Paris: Centre Georges Pompidou, Musée National d'Art Moderne, 1980), p. 33.

12. David Douglas Duncan, *Picasso's Picassos* (New York: Harper & Row, 1961), p. 87.

13. Duncan, *Picasso's Picassos*, p. 111.

14. Denis Milhau, *Picasso, couleurs d'Espagne, couleurs de France, couleurs de vie*, exh. cat. (Toulouse: Réfectoire des Jacobins, 1983), pp. 15–17.

15. Édouard Jaguer, Preface to *Dora Maar, oeuvres anciennes*, exh. cat. (Paris: Galerie 1900–2000, 1990), p. 3.

Chapter 8

1. Simone Téry, "Picasso n'est pas officier dans l'armée française" (interview), *Les Lettres françaises* (March 24, 1945).

2. Daniel-Henry Kahnweiler, *Mes galeries et mes peintres. Entretiens avec Francis Crémieux.* (Paris: Gallimard, 1982), p. 171. Published in English as *My Galleries and Painters*, H. Weaver, trans. (New York: Viking, 1971).

3. Christian Zervos, "Fait social et vision cosmique," *Cahiers d'Art, Pablo Picasso 1930-1935* (1936), p. 12: "In the U.S.S.R. it was said of his work that it constituted the last stage of the great demonstrations of bourgeois art."

4. Gertrude Stein, *Picasso*, pp. 159–60.

5. José Bergamín, "Tout et rien de la peinture," *Cahiers d'Art* 1–3 (1937), p. 10.

6. Malraux, *La Tête d'Obsidienne*, p. 128.

7. Michel Leiris, "Faire-part," *Cahiers d'Art* 4–5 (1937), p. 128.

8. Jean-Louis Ferrier, *De Picasso à Guernica* (Paris: Denoël, 1985), p. 11.

9. Leymarie, *Picasso: Métamorphoses et unité*, p. 109.

10. Marie-Laure Bernadac and Christine Piot, eds. *Picasso Écrits* (Paris: Réunion des Musées Nationaux/Gallimard, 1989), p. 418 (note on the text of July 3–Aug. 19, 1940).

11. Quoted by Vallentin, *Picasso*, p. 355.

12. Michèle Richet, *Musée Picasso: Catalogue sommaire des collections,* II (Paris: Réunion des Musées Nationaux, 1987), nos. 1172–1182, 1192, 1193, 1201–1206.

13. Leymarie, *Picasso: Métamorphoses et unité,* ill. p. 9: *Sleeping Female Nude and Seated Male Nude,* pencil, 1931. Private collection, Zurich.

14. Richet, *Catalogue,* II, nos. 1172–1210.

15. Quoted by J.-P. Hodin. "Quand les artistes parlent du sacré," *XXe Siècle* 24 (Dec. 1964), n.p.

16. Malraux, *La Tête d'Obsidienne,* p. 34. See also pp. 40–41.

17. Vallentin, *Picasso,* p. 359.

18. Malraux, *La Tête d'Obsidienne,* p. 98.

19. Daix, *Picasso créateur,* p. 281.

20. Malraux, *La Tête d'Obsidienne,* p. 128.

Chapter 9

1. Gilot and Lake, *Life with Picasso,* p. 63.

2. Daix, *Picasso créateur,* p. 290.

3. *L'Humanité* (Oct. 29–30, 1944).

4. Claude Roy, *Nous* (Paris: Gallimard, 1972), p. 369.

5. Palau i Fabre, *Picasso, The Early Years,* no. 649.

6. Daix, *Picasso créateur,* p. 294. Pierre Daix met Picasso in December 1945 and was from then on a privileged witness of his work and a confidant of the artist.

7. Ibid.

8. Richet, *Catalogue,* II, nos. 1241–1251.

9. Gilot and Lake, *Life with Picasso,* p. 99.

10. Ibid., pp. 117–18.

11. Danièle Giraudy, *Guide du Musée Picasso* (Paris: Hazan, 1987), p. 22.

12. See also Danièle Giraudy, *Le Musée Picasso d'Antibes* (Paris: Musées et Monuments de France/Villes d'Antibes and Albin Michel, 1989), p. 38; two other drawings of *The Studded Ewer.*

13. Gilot and Lake, *Life with Picasso,* p. 127.

14. Ibid., pp. 182–83.

15. Moussinac, *Les Lettres françaises,* Dec. 2, 1948, quoted in André Fermigier, *Picasso,* p. 334.

16. Gilot and Lake, *Life with Picasso,* p. 220.

17. Ibid., p. 120.

18. Ibid., p. 193.

19. Quoted by Fermigier, *Picasso,* p. 318.

20. Fernand Mourlot, *Picasso lithographe* (Paris: André Sauret/Editions du Livre, 1970).

21. Ibid., nos. 141, 193, 214.

22. Malraux, *La Tête d'Obsidienne,* pp. 277–78.

23. Gilot and Lake, *Life with Picasso,* p. 73.

24. Daix, *Picasso créateur,* p. 216. Same reference for the following quotation from Picasso to Édouard Pignon.

25. Gilot and Lake, *Life with Picasso,* p. 317.

26. Ibid., pp. 344–45.

27. See Geneviève Laporte, *Si tard le soir . . .* (Paris: Plon, 1973).

28. Claude Roy, *La Guerre et la Paix* (Paris: Cercle d'Art, 1952). The preface, "Picasso, chemin faisant," was reprinted in *L'Amour de la peinture* (Paris: Gallimard, 1987), pp. 235–36.

Chapter 10

1. Michel Leiris, "Picasso et la comédie humaine ou les Avatars de Gros-Pied" (1954) in idem, *Un génie sans piédestal and other writings by Picasso,* Marie-Laure Bernadac, ed. (Paris: Fourbis, 1992), p. 45.

2. Ibid.

3. Zervos, *Catalogue,* XVI, no. 99.

4. Duncan, *Picasso's Picassos,* p. 183.

5. Zervos, *Catalogue,* XVI, nos. 36–55, 58, 59.

6. Musée Picasso, Paris, MP 1879.

7. Musée Picasso, Paris, MP 1882.

8. Musée Picasso, Paris, MP 1883.

9. Penrose, *Picasso,* p. 467.

10. Daniel-Henry Kahnweiler, "Entretiens avec Picasso au sujet des Femmes d'Alger," *Aujourd'hui* 4 (1955).

11. Ibid.

12. Hélène Parmelin, *Picasso dit. . .* (Paris: Gonthier, 1966), p. 80. Published in English as *Picasso Says . . .* (South Brunswick, N.J.: A. S. Barnes, 1969).

13. Pierre Daix, *La Vie,* p. 362.

14. Vallentin, *Picasso,* p. 441.

15. Quoted by William Rubin in *Picasso in the Collection of the Museum of Modern Art* (New York: Museum of Modern Art, 1972), p. 179.

16. Musée Picasso, Paris, MP 1884 and MP 1885.

17. See the drawings of *The Studio* of April 18, 1937 (Musée Picasso, Paris, MP 1179–1191).

18. Gaëtan Picon, *La Chute d'Icare* (Geneva: Skira, 1971).

19. Zervos, *Catalogue,* XVIII, nos. 26, 27.

20. Musée Picasso, Paris, MP 1885.

21. Parmelin, *Picasso dit,* p. 118.

22. Musée Picasso, Paris, MP 1885, or Zervos, *Catalogue,* XVII, nos. 419, 436.

23. Zervos, *Catalogue,* VII, no. 348.

24. Spies, *Picasso: Pastellen . . . ,* nos. 509, 538, 541–544.

25. Picon, *La Chute,* p. 19.

26. Daix, *Picasso créateur,* p. 342.

27. Picon, *La Chute,* p. 18.

28. Zervos *Catalogue,* XVIII, nos. 122–135.

29. Daix, *La Vie.*

30. See Marie-Laure Bernadec, "De Manet à Picasso, l'éternel retour," in *Bonjour, Monsieur Manet* (Paris: Centre Georges Pompidou, Musée National d'Art Moderne, 1983), pp. 33–46.

31. Written on the back of an envelope of the Galerie Simon, dated 1929, in Bernadac, *Picasso, Écrits,* p. 371. (The sentence might be from 1932, the date of the Manet retrospective at the Orangerie.)

32. Musée Picasso, Paris, MP 1882.

33. Zervos, *Catalogue,* XIII, no. 291.

34. As seen in the cement sculptures in the gardens of the Moderna Museet in Stockholm, 1960.

35. Douglas Cooper, *Pablo Picasso, Les Déjeuners* (Paris: Cercle d'Art, 1962).

Chapter 11

1. Michel Leiris, "Le Peintre et son modèle," *Au verso des images* (Montpellier: Fata Morgana, 1980), p. 125.

2. Parmelin, *Picasso, le peintre et son modèle* (Paris: Cercle d'Art, 1965), p. 114. Published in English as *Picasso: The Painter and His Model* (New York: Harry N. Abrams, 1965).

3. Zervos, *Catalogue,* XXIII, nos. 148–166, 177–183, 190–202, 214–243.

4. Leiris, "Le Peintre," p. 118.

5. Zervos, *Catalogue,* XXIV, nos. 148–166, 177–183, 190–202, 214–243.

6. Parmelin, *Picasso dit,* pp. 108–9.

7. Ibid., p. 113.

8. Ibid., pp. 56–57.

9. Gert Schiff, "Suite 347, or Painting as an Act of Love," in *Picasso in Perspective* (Englewood Cliffs, N.J.: Prentice-Hall, Inc., 1976), pp. 163–67.

10. John Richardson, "Les Dernières années de Picasso: Notre Dame de Vie," in *Pablo Picasso, Rencontre à Montréal,* exh. cat. (Montreal: Musée des Beaux-Arts, 1985), p. 91.

11. K. Gallwitz, *Picasso Laureatus, son oeuvre depuis 1945* (Paris: La Bibliothèque des Arts, 1971), p. 70. Published in English as *Picasso at 90: The Late Work.* (New York: Putnam, 1971).

12. Ch. Geelhaar, "Themen 1964–1972," in *Picasso, Das Spätwerk,* exh. cat. (Basel: Kunstmuseum, 1981).

13. André Malraux, *La Tête d'Obsidienne,* p. 110.

14. Hélène Parmelin, *Voyage en Picasso* (Paris: Laffont, 1980), pp. 82–83.

15. Dominique Bozo, Introduction to *Picasso: Oeuvres reçues en paiement des droits de succession,* exh. cat. (Paris: Galeries Nationales du Grand-Palais, 1979–80).

Chapter 12

1. Malraux, *La Tête d'Obsidienne,* p. 11.

2. Brassaï, "The Master at 90: Picasso's Great Age Seems Only to Stir up the Demons Within," *The New York Times Magazine,* Oct. 24, 1971.

3. Parmelin, *Voyage en Picasso,* p. 81.

4. Parmelin, *Picasso dit,* pp. 18–19.

5. Parmelin, *Le Peintre,* p. 40.

6. Ibid., p. 30.

7. Parmelin, *Picasso dit,* p. 111.

8. Ibid.

9. Penrose, *Picasso,* p. 275.

10. Douglas Cooper, Review of exhibition "Pablo Picasso, 1970–1972," *Connaissance des Arts* 257 (July 1973), p. 23.

11. Hélène Parmelin, *Les Dames de Mougins* (Paris, Cercle d'Art, 1964), p. 30. Published in English as *Picasso, Women: Cannes and Mougins, 1954–1963* (New York: Harry N. Abrams, 1967).

12. Pierre Schneider, *Matisse* (Paris: Flammarion, 1986). American edition, *Matisse* (New York: Rizzoli, 1984).

13. Parmelin, *Picasso dit,* p. 40.

14. Penrose: *Picasso,* p. 501.

15. David Sylvester, "Fin de partie," in *Le Dernier Picasso,* exh. cat. (Paris: Centre Georges Pompidou, Musée National d'Art Moderne, 1988).

16. John Richardson, "Les années Jacqueline," in *Le Dernier Picasso.*

17. Daix, *Picasso créateur,* p. 378.

18. K. Levin, "Die Avignon-Bilder," in *Picasso: Das Spatwerk,* p. 68.

19. J. Hélion, "Le courage illimité de Picasso," *L'Arc* 82 (1981), pp. 44–48.

CHRONOLOGY
Compiled by Odile Michel

Youth and Education

1881
Pablo Picasso is born on October 25, the son of José Ruiz Blasco (1838–1912) and María Picasso López (1855–1939).

1884
First sister, Lola (1884–1958), is born.

1887
Picasso's second sister, Concepción (1887–1891), nicknamed Conchita, is born.

1888
Picasso begins to paint bullfights. *Picador* (fig. 1) is his first painting.

1891
Picasso's father is appointed to the Instituto da Guarda in La Coruña. His youngest daughter, Concepción, dies of diphtheria.

1892
Picasso takes ornamental drawing classes with his father.

1893
At age twelve, Picasso founds the magazine *Asul* [*sic*] *y Blanco* (fig. 4). The first issue is dated October 8.

1894
Picasso begins his academic training: plaster copies, figure drawing, paintings, and copies from nature. On September 16 the first issue of Picasso's magazine *La Coruña* (fig. 5) is created.

1895
In July the whole family travels to Málaga for vacation. They pass through Madrid, where Picasso visits the Prado for the first time and is able to admire Velázquez, Zurbarán, and Goya. In the summer he completes a small painting of Cartagena, as well as seascapes in Alicante and Valencia. In September, the Picasso family moves to Barcelona. Picasso attends La Lonja, Barcelona's school of fine arts, where his father is appointed teacher. He is fourteen years old and executes drawings and paintings of family members and landscapes.

1896
In April Picasso shows *First Communion* (fig. 13) in the Exposición de Bellas Artes y Industrias Artísticas in Barcelona. The piece was completed in the winter of 1895–96. He meets Manuel Pallarès, from Horta de Ebro, of whom he would make several portraits.

1897
Picasso is accepted to compete in the admissions process for the Academy of San Fernando in Madrid. At age sixteen, he completes academic paintings, in particular *Science and Charity* (fig. 17), for which he would receive honorary mention in the General Exhibition of Fine Arts of Madrid, and then a gold medal in Málaga. The Picasso family spends the summer again in Málaga. In September, Picasso travels by himself to Madrid and ends up leaving the Academy.

1898
Picasso slowly recovers from scarlet fever in Horta de Ebro, where he remains for seven months.

1899
He returns to Barcelona and moves into a studio at 2 Carrer Escudillers Blancs. He frequents avant-garde circles and the tavern Els Quatre Gats, founded by Pere Romeu. Here, he meets several painters like Sebastià Junyer Vidal, Isidre Nonell, Joaquim Sunyer, Ramon Casas, and Carles Casagemas (1881–1901), as well as the sculptor Manolo Hugué; Jaime Sabartés (1881–1968), the poet who would become his secretary; the writer Ramon Reventós; the critic Eugenio d'Ors; the art historian Miguel Utrillo; and the collector Carles Junyer Vidal.

Doña María Picasso López, the artist's mother

Don José Ruiz Blanco, the artist's father

The home in which Picasso was born: 36 Plaza de la Merced in Málaga

Pablo Picasso at the age of seven with his sister Lola

a

b

c

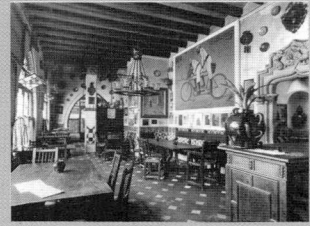

d

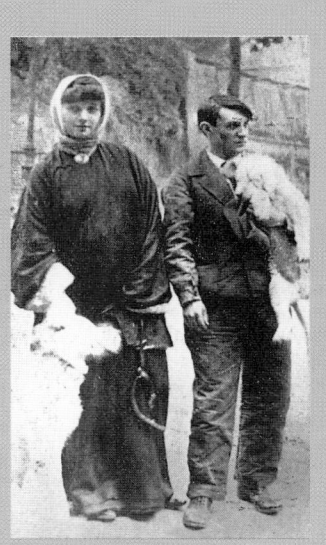

e

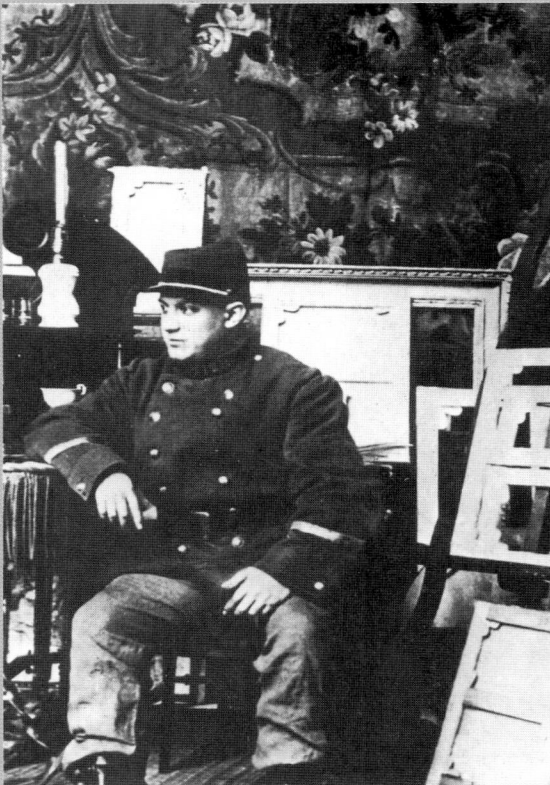

f

a. Pablo Picasso at the age of fifteen in 1896

b. Picasso in Montmartre, about 1904

c. Picasso and Ramon Reventós in Barcelona in 1906

d. Interior of Els Quatre Gats in Barcelona

e. Picasso and Fernande Olivier in Montmartre about 1906

f. Picasso in the uniform of his friend Georges Braque, photographed by Braque in Picasso's studio at 11, boulevard de Clichy, in Paris

1900

On February 1, Picasso exhibits 150 drawings for the first time at Els Quatre Gats. He shares a studio with Casagemas at 17 Riera de San Juan. Some Catalan magazines—*Joventut* and *Catalunya Artística*—publish his drawings. In October he takes his first trip to Paris with his friend Casagemas; he stays in Montmartre at 49, rue Gabrielle and frequents Catalan circles with Ramon Pitxot and Isidre Nonell, in whose studio he is living. He sells a few pieces through his first dealer Pere Mañach, son of a Catalan manufacturer, and is paid a monthly retainer of 150 francs. Picasso specifically refers to this period in *Le Moulin de la Galette* (fig. 40).

Paris-Barcelona: The Blue Period, 1901–1904

1901

Picasso spends Christmas in Málaga and does not return to Barcelona until April. He spends time in Madrid, where he founds the magazine *Arte Joven* with Francisco de Asís Soler. At this time, he learns of the suicide in Paris of his best friend, Casagemas, to whom he would dedicate several works, such as *Evocation (The Death of Casagemas)* (fig. 74). This is the beginning of the Blue Period (1901–4). The circus world appears in Picasso's work with *Harlequin* (fig. 89) or *Harlequin and His Companion* (fig. 91).

June 1901–January 1902

Second trip to Paris. Picasso has a show at Ambroise Vollard (1868–1939) and meets poet Max Jacob (1876–1944). He lives at 130*ter*, boulevard de Clichy.

1902

Picasso goes to Paris for the third time, between October 1902 and January 1903, to prepare an exhibition at the Galerie Berthe Weill. The show opens on November 15.

1903

He returns to Barcelona in the spring. Here he begins working on *La Vie* (fig. 133), which he paints over an academic piece, *The Last Moments*.

From the Rose Period to Les Demoiselles d'Avignon: 1904–1907

1904

In January, Picasso moves to Calle del Comercio in Barcelona. He paints *La Celestina* (fig. 122). On April 12, Picasso travels for the fourth and final time to Paris. He moves to 13, rue Ravignan, in the Bateau-Lavoir. He paints one of his last Blue Period paintings, *Woman Ironing* (fig. 142). The Rose Period then begins (1903–6). Picasso meets Guillaume Apollinaire (1880–1918) and falls in love with Fernande Olivier (1881–1966) in the autumn. They would remain lovers until 1911. He has his last exhibition at the Galerie Berthe Weill.

1905

He completes one of his first bronze sculptures: *The Jester* (fig. 175). In February Picasso exhibits his first Rose Period paintings at the Galerie Serrurier, mostly on the circus theme: *Acrobat on a Ball* (fig. 176), *Family of Acrobats with a Monkey* (fig. 164) or even *Au Lapin Agile* (fig. 160). In the summer of 1905, he takes a short trip to Holland, to Schoorl, returning with *Three Dutch Girls* (fig. 159). In the autumn, he meets Gertrude Stein (1874–1946) and her brother Leo. They would expand their collection, buying from André Salmon and the art dealer Wilhelm Uhde. *The Saltimbanques* (fig. 180) particularly embodies Picasso's concerns in this period.

1906

Picasso meets Matisse (1896–1954), through Gertrude Stein in the spring and is introduced to African art. In the summer, Picasso goes to Gósol in the Spanish Pyrenees with Fernande. Upon his return, he visits the Ethnographic Museum at the Trocadéro in Paris at the suggestion of André Derain.

The Cubist Years: 1907–1914

1907

In April and May, Picasso begins working on *Les Demoiselles d'Avignon* (fig. 253), which depicts a brothel scene in Carrer d'Avinyó in Barcelona. The painting, which he completes in July, represents a departure from his previous work. In the summer he meets the dealer Daniel-Henry Kahnweiler (1884–1979), who would represent both Braque and Picasso. In the autumn Picasso meets Georges Braque (1882–1963) through Apollinaire; they set out on the Cubist adventure, which would last from 1907 to 1914.

1908

Picasso begins to paint still lifes. In August he moves with Fernande to the Oise region to La-Rue-des-Bois. The first Braque-Picasso Cubist exhibition takes place at Daniel-Henry Kahnweiler's gallery.

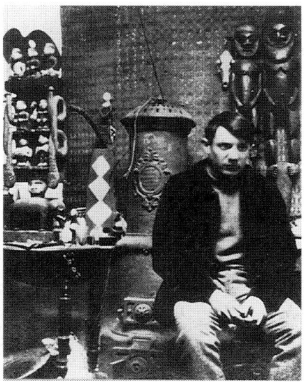

Picasso in his Bateau-Lavoir studio in 1908 (Photo: Gelett Burgess)

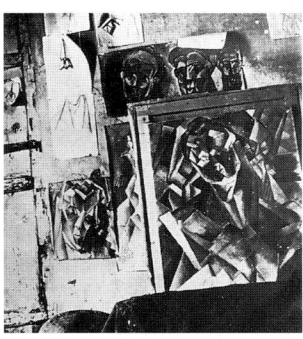

Inside the Horta de Ebro studio, 1909

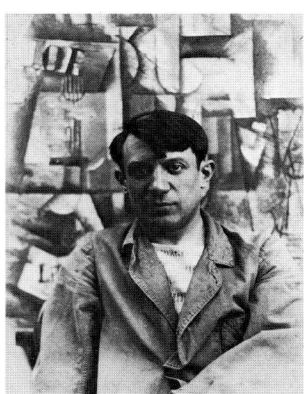

Picasso in front of *L'Aficionado* in Sorgues in the summer or autumn of 1912

Picasso and assistants with the *Parade* curtain in Rome, 1917

Olga, Picasso, and Cocteau in Rome, 1917

1909
Time spent in Spain at Horta de Ebro is devoted to analytic Cubism. In September the painter leaves the Bateau-Lavoir and moves to 11, boulevard de Clichy, from which he can see the Sacré-Coeur.

1910
Cubism becomes synthetic. Picasso paints the portraits of his dealers Ambroise Vollard (fig. 324) and Daniel-Henry Kahnweiler (fig. 327). In April–May, Picasso shows work in Budapest in a group exhibition at the Müvészház gallery. At the end of June, Fernande, the Derain family, and Picasso travel to Cadaqués, Spain. Between July and October, Braque and Picasso are represented in group shows in Düsseldorf and at the Thannhauser gallery in Munich.

1911
Braque and Picasso introduce stenciled numbers and letters into their work. Picasso makes his first trip to Céret with Fernande, the Braque family, and Max Jacob. Picasso is not represented at the Salon des Indépendants in April although works by Robert Delaunay, Marie Laurencin, Picabia, and even Marcel Duchamp are exhibited. The same is true for the Salon d'Automne in October. At the end of June, Picasso illustrates Max Jacob's poetry books with prints, including *Saint Matorel*. Fernande and Picasso separate, and Eva, née Eve Gouel, nicknamed "Ma Jolie" in his works, enters his life.

1912
First collages and assemblages: *Still Life with Chair Caning* (fig. 352). Drawings are exhibited in London and Picasso's first works are shown in Barcelona at the Dalmau gallery as well as in Berlin at the Der Sturm gallery. Again Picasso does not participate in the Salon des Indépendants. In September he moves into a new studio at 242, boulevard Raspail. Here he completes his first *papiers collés* and his first constructions.

1913
One of Picasso's most beautiful Cubist pieces, *Woman in a Chemise in an Armchair* (fig. 385), depicts Eva, with whom he travels to Céret in March. He continues experimenting with *papiers collés*. Picasso's father dies on May 3. During the summer Picasso moves to 5, rue Schoelcher. He continues to be represented in various exhibitions abroad, including those in Vienna, Munich, Berlin, Moscow, and Prague.

1914
The declaration of war on August 2 ends the Cubist enterprise. Picasso spends the summer in Sorgues, near Avignon, and returns to Paris at the end of November. Paul Rosenberg becomes his dealer. During the summer of 1914, he paints *The Painter and His Model* (fig. 404), the premise for his classical period.

1915
During Kahnweiler's absence, Léonce Rosenberg sells Picasso's works. Edgard Varèse, the musician, introduces Cocteau (1889–1963) to Picasso, at rue Schoelcher. Eva dies of tuberculosis in December.

1916
Cocteau proposes to Picasso that he design the sets for the ballet *Parade* (fig. 418), which is set to music by Erik Satie. Picasso moves to Montrouge. *Les Demoiselles d'Avignon* is shown for the first time at the Salon d'Antin in Paris as part of an exhibition organized by André Salmon.

The Classical Period: 1917–1924

1917
In January, Picasso visits his family in Barcelona. On February 17 he travels to Italy (Rome, Naples, Pompeii, and Florence) to work on the ballet *Parade* with the Ballets Russes. In Rome he stays on Via Margutta and he meets the ballerina Olga Khokhlova (1891–1955), returning to Paris at the end of April. *Parade* premieres at the Théâtre du Châtelet on May 18. It runs in Barcelona in November. In June Picasso travels to Madrid. He returns to Paris at the end of November and moves to Montrouge with Olga. He illustrates Max Jacob's new book *Le Cornet à Dés* and also paints a very beautiful *Harlequin* (fig. 430).

1918
Picasso-Matisse exhibit at Paul Guillaume. On July 12 Picasso marries Olga at the Russian church in Paris; Max Jacob, Jean Cocteau, and Guillaume Apollinaire are witnesses. Picasso and Olga make a summer trip to Biarritz. Apollinaire dies of influenza.

1919
Joan Miró visits Picasso's studio. In May Picasso leaves for England in order to work on the ballet *Le Tricorne,* which is presented at the Alhambra Theatre in London on July 22; he makes several drawings of the dancers. In

the summer Picasso and Olga travel to the Côte d'Azur and to Saint-Raphaël. In December Diaghilev asks Picasso to create the sets for *Pulcinella*, a ballet based on the commedia dell'arte.

1920
Picasso's dealer, Kahnweiler, returns to France after his exile. *Pulcinella* premieres at the Paris Opéra on May 15. Picasso and Olga leave for Juan-les-Pins. Mythological themes emerge, as in *Nessus and Deyanira* (fig. 478).

1921
The birth of Picasso's first son, Paulo (d. 1975), on February 4. Motherhood themes appear in his work. On May 22 the ballet *Cuadro Flamenco*, for which the painter designed the sets, premieres at the Théâtre de la Gaîté Lyrique in Paris. Picasso spends the summer in Fontainebleau and completes the *Three Women at the Fountain* (fig. 493), which is classical in style. At the same time, he continues with his Cubist experiments in *Three Musicians* (fig. 490).

1922
The Picasso family spends the summer in Brittany, in Dinard. Picasso paints *Two Women Running on the Beach* (fig. 512). The Thannhauser gallery in Munich once again presents a Picasso exhibition.

1923
The harlequin motif reemerges in Picasso's work in *Portrait of the Painter Jacint Salvadó* (fig. 519), for which the Catalan painter poses in a harlequin costume, and in *Harlequin with Mirror* (fig. 520). In the summer Picasso goes to Cap d'Antibes on the Côte d'Azur. Picasso meets André Breton. Picasso paints the masterpiece of his Classical Period, *The Pipe of Pan* (fig. 527).

1924
Major constructions are completed, such as the *Guitars*, as well as monumental still lifes. On June 18, the ballet *Mercure* premieres at the Théâtre de la Cigale in Paris. Picasso's drop-curtain design baffles the audience. On June 20, *Le Train Bleu* ballet opens at the Théâtre des Champs-Élysées; its curtain adopts motifs from *Two Women Running on the Beach*. The summer is spent in Juan-les-Pins. Paulo, Picasso's son, is depicted in costume: *Paulo as Harlequin* (fig. 541). The Surrealists, led by André Breton, found *La Révolution Surréaliste*, which would publish Picasso's works.

Metamorphoses: 1925–1936

1925
Picasso breaks from motherhood themes with *The Dance* (fig. 550), in which his figures are deformed for the first time. In March–April Picasso goes to Monte Carlo with his wife. Erik Satie dies on July 1. Summer is spent in Juan-les-Pins. Starting on November 14, Picasso participates in the first exhibition of Surrealist painting at the Galerie Pierre.

1926
In January Christian Zervos founds the magazine *Cahiers d'Art*. Picasso works on the Guitar series in the spring. In June Paul Rosenberg's gallery exhibits works of the past twenty years. Waldemar George publishes sixty-four Picasso drawings in *L'Amour de l'Art* in Paris. The family spends the summer in Juan-les-Pins. In October Picasso takes a short trip to Barcelona. At this time, his prints are more classical in style.

1927
In January Picasso meets Marie-Thérèse Walter (1909–1975) in front of Galeries Lafayette in Paris. She is seventeen at the time. Juan Gris dies on May 11. In July Paul Rosenberg once again shows Picasso's work. The Picasso family spends the summer in Cannes. Ambroise Vollard commissions Picasso to illustrate *Le Chef-d'Oeuvre Inconnu* by Balzac, which will be published in 1931. Picasso's works are exhibited in October in Berlin and in December at the Galerie Pierre in Paris.

1928
In January the Minotaur theme emerges (fig. 575). In March Picasso revives his friendship with Julio González, whom he had met in Barcelona in 1902. Picasso works at his studio on the rue de Médéa. He spends his second summer in Brittany, in Dinard. Dalí visits Picasso.

1930
In June Picasso buys the Château de Boisgeloup, which is about forty miles from Paris. In the autumn, he arranges for Marie-Thérèse to move into an apartment near his. During this year, Picasso's works are shown in New York at the Museum of Modern Art and at the Reinhardt Gallery.

1931
In May a sculpture studio is built in Boisgeloup, where Picasso will create the monumental Heads and where the young photographer Brassaï, astonished by the great number of sculptures here, will do a photographic series in

Picasso and his son Paulo in 1922

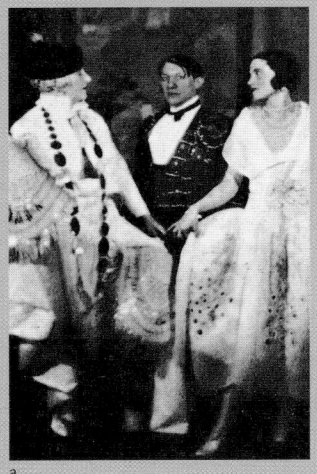

a

b

c

d

e

f

a. Picasso with his wife, Olga, and Madame Errazúriz at a ball hosted by the Count Etienne de Beaumont, Paris, 1924 (Photo: Man Ray)

b. Picasso in 1928

c. Olga in the apartment on rue de la Boétie. Her portrait and drawings for *Le Tricorne* on the wall, 1920

d. Picasso in Juan-les-Pins, photographed by Man Ray in the summer of 1926

e. Marie-Thérèse in Dinard, photographed by Picasso in the summer of 1920

f. Beach play improvised in Garoupe, in Antibes, in 1926. Picasso, wearing a hat, is dressed in "civilian" clothes. The Count and Countess of Beaumont, in costume, are also part of the group.

g. Olga and Picasso in London in the studio where the curtain for *Le Tricorne* was created, 1919

g

1932. Picasso will work in this studio until 1935. He spends the summer again in Juan-les-Pins. The first Surrealist exhibition takes place in the United States, where Picasso, Dalí, de Chirico, and Max Jacob are represented.

1932
In June the first major Picasso retrospective is mounted at the Galerie Georges Petit and at the Kunsthaus in Zurich. Zervos publishes a special edition of *Cahiers d'Art* dedicated to Picasso. In the autumn, Picasso returns to the theme of the Crucifixion.

1933
In June the first issue of the magazine *Minotaure* (fig. 667) appears, with a cover by Picasso. A Surrealist exhibition is held at the Galerie Pierre Colle (including Duchamp, Éluard, Giacometti, Dalí, Magritte, Picasso, Man Ray, and Tanguy). Picasso spends the summer in Cannes with Olga and Paulo. In the autumn, he tries to stop Fernande Olivier's book *Picasso et Ses Amis* from being published, fearing that Olga will react jealously. Bernhard Geiser publishes the first volume of Picasso's prints, *Picasso: Peintre-Graveur 1899–1931*.

1934
Picasso develops studio themes in his prints. At the end of August, Picasso makes his last trip to Spain with Olga and Paulo. Several exhibitions take place abroad and in Paris.

1935
Papiers collés exhibition at the Galerie Pierre. Picasso and Olga separate in June. Olga leaves the apartment on rue de la Boétie. Picasso fails to obtain a divorce. On October 5 Maya, the daughter of Picasso and Marie-Thérèse, is born. Picasso then asks his old friend Jaime Sabartés to help him manage his business. Picasso becomes a close friend of Paul Éluard (1895–1952), whom he has known since the late 1920s.

1936
Picasso's poems are published in *Cahiers d'Art*. He steals away to Juan-les-Pins with Marie-Thérèse and Maya. He returns to Paris at the beginning of May and works with the Lacourière printers in Montmartre on Buffon's *Histoire Naturelle*, which will not be published until 1945. Éluard introduces Picasso to Dora Maar (1907–1997), a painter and photographer with whom Picasso spends the summer in Mougins, in the south of France, with Man Ray, Zervos, and René Char. On July 18, the Spanish Civil War breaks out. Picasso moves to Tremblay-sur-Mauldre with Marie-Thérèse and Maya.

The War Years and After the War

1937
On January 8 and 9, Picasso engraves *The Dream and Lie of Franco* (figs. 771 and 772) and moves into the studio at 7, rue des Grands-Augustins with Dora Maar. On April 26 a German squadron under Franco's command bombs the Basque city of Guernica. On July 12, the Spanish Pavilion at the Exposition Internationale de Paris is inaugurated. *Guernica* is exhibited (fig. 782).

1938
On January 22, Picasso paints his daughter, *Maya with a Doll* (Musée Picasso, Paris). He spends the summer in Mougins with Dora Maar, joining Paul and Nusch Éluard. He executes many portraits of Dora and Nusch during this time.

1939
Picasso's mother dies on January 13; Ambroise Vollard dies on July 22. After the fall of Madrid on March 28, Picasso finishes *Cat Catching a Bird* (fig. 822) on April 22. He again spends the summer in the south of France with Dora and Sabartés, returning to Paris on August 25. He travels frequently between Royan and Paris. On September 3, France and England declare war on Germany. A major retrospective, "Picasso: Forty Years of His Art" is mounted at the Museum of Modern Art in New York from November 15 to January 7, 1940.

1940
During the first year of war, Picasso lives in Royan with Dora Maar, while Marie-Thérèse and Maya live nearby in the Gerbier-de-Joncs villa. In particular, he paints *Café in Royan* (fig. 836).

1941
Picasso writes his first Surrealist play, *Le Désir Attrapé par la Queue*. Marie-Thérèse and Maya move to Paris to boulevard Henri-IV.

1942
His friend Julio González dies on March 27, which inspires *Still Life with an Ox Skull* (fig. 850). Several pieces depict the hardships and limitations of the times, including *The Catalan Buffet* in 1943 (Musée des Beaux-Arts, Lyons).

1943
Following several preliminary studies begun in 1942, the statue of *Man with a Sheep* (fig. 865) is completed; one copy would be installed in Vallauris in 1950. Picasso meets Françoise

The Château de Boisgeloup, in Gisors, which Picasso bought in 1930

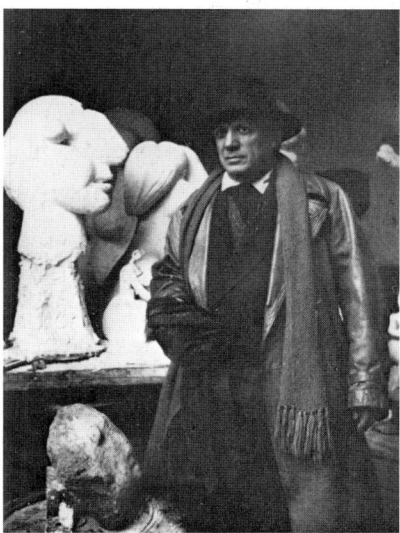

Picasso in his sculpture studio in Boisgeloup, 1931 (Photo: Bernès-Marouteau)

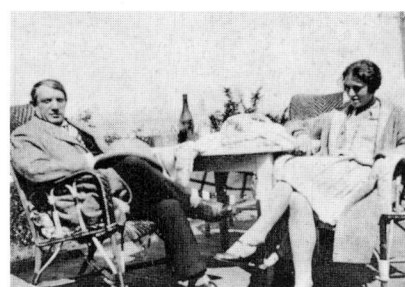

Picasso and Olga in Cannes, 1933

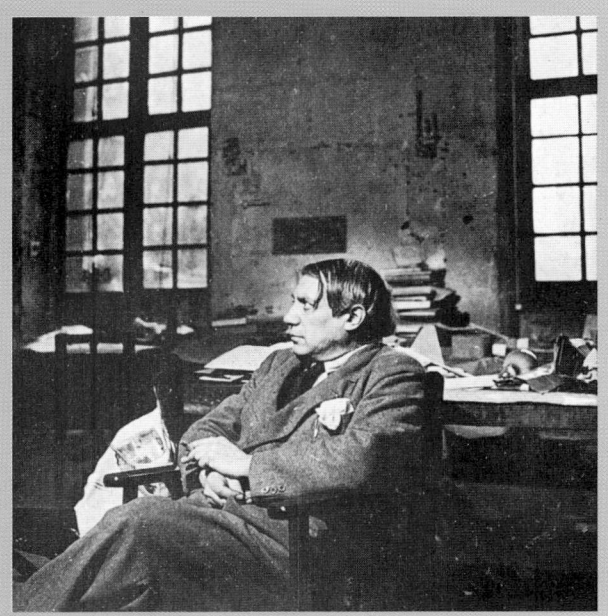

a. Picasso in his studio on the rue des Grands-Augustins

b. Picasso painting *Guernica* in the Grands-Augustins studio, 1937 (Photo: Dora Maar)

c. Picasso and Sabartés in the Royan Studio with *Nude Arranging Her Hair*, 1940

d. Picasso and Dora Maar in Golfe-Juan, 1937 (Photo: Roland Penrose)

e. Number 7, rue des Grands-Augustins

f. Reading of *Désir Attrapé par la Queue* at the home of Louise and Michel Leiris, March 19, 1944 (Photo: Brassaï)

a

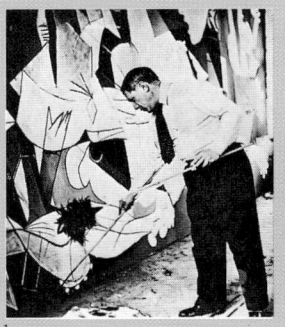

b

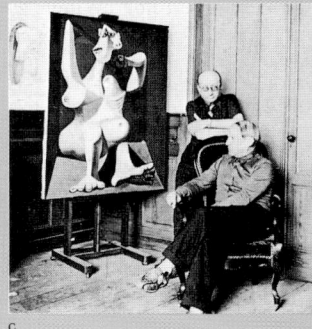

c

d

e

f

Gilot (born in 1921) who becomes his model, the "woman-flower." It is probably during this year that Picasso meets André Malraux. Malraux would describe their relationship in *La Tête d'Obsidienne* (1974).

1944

On March 5, his friend the poet Max Jacob dies in the Drancy camp, a victim of Nazi anti-Semitism. Michel and Louise Leiris sponsor a reading of *Désir Attrapé par la Queue* on March 19. Paris is liberated on August 25, and Picasso returns to his studio on the rue des Grands-Augustins. The Salon d'Automne, this year called the Salon de la Libération, opens with a retrospective of Picasso's work. Picasso joins the French Communist Party on October 5.

1945

June 15, the Théâtre Sarah-Bernhardt presents *Le Rendez-Vous*, a ballet performed by Roland Petit's dancers. Picasso designs the drop curtain. He leaves for Cap d'Antibes in July and buys an old house for Dora Maar in Ménerbes, in the Vaucluse region. His first lithographs are printed in the Mourlot studio. Picasso exhibits work in the Salon d'Automne, and his work is also shown with Matisse's in London and Brussels.

1946

Picasso moves in with Françoise Gilot. In July they leave for Ménerbes, but three weeks later they move to Cap d'Antibes, in order to be farther away from Marie-Thérèse and Dora. Between October and November, Picasso works at the château at Antibes, where Romuald Dor de la Souchère, curator of the Antibes Museum, offers him rooms. Picasso completes *La Joie de Vivre* (fig. 903). He also meets Suzanne and Georges Ramié, who run a ceramics workshop in Vallauris, the Madoura studio. On November 28, his friend Nusch Éluard dies. His secretary and friend Jaime Sabartés publishes *Picasso: Portraits et Souvenirs*.

1947

At Jean Cassou's suggestion, Picasso gives ten paintings to the Musée National d'Art Moderne de Paris. Claude, the son of Françoise Gilot and Picasso, is born on May 15. The family departs for Golfe-Juan. In August Picasso works in the pottery studio of Ramié in Vallauris. Paul Rosenberg, the gallery owner, dies. Picasso writes a new play, *Les Quatre Petites Filles*, between November 24, 1947, and August 13, 1948, using what is known as automatic writing. In December a production of *Oedipus Rex* by Sophocles with sets designed by Picasso is presented at the Théâtre des Champs-Élysées.

1948

During the twenty-fourth Venice Biennale, Picasso's works are shown for the first time in Italy. Françoise and Picasso spend the summer in the La Galloise villa, in the Vallauris hills. On August 25, he goes to the Congress of Intellectuals for Peace in Wrocław, Poland. He returns to Paris in October. La Maison de la Pensée Française in Paris exhibits 149 of his ceramic pieces in November.

1949

Sculptures de Picasso, with an essay by Daniel-Henry Kahnweiler and photographs by Brassaï, is published in January. Picasso's print of *La Colombe* [The Dove] is chosen by Aragon in February for a poster for the Congress of Peace, to take place on April 20 at the Salle Pleyel in Paris. On April 19, Paloma, the second child of Françoise and Picasso, is born.

1950

June 25: the Korean War breaks out. In November, Picasso receives the Lenin Prize for Peace.

1951

The piece *Massacres in Korea* (fig. 951) confirms Picasso's political commitment. Marina, Paulo's daughter and Picasso's first granddaughter, is born. Picasso and Françoise spend the summer in Vallauris and the winter in Paris.

1952

Picasso finishes his play *Les Quatre Petites Filles*, which would be published in 1968. Named an honorary citizen of Vallauris, he decorates the former chapel with *War* and *Peace*. During the summer he meets Jacqueline Roque, a cousin of Suzanne Ramié, in the Madoura pottery studio in Vallauris. His relationship with Gilot falls apart. On November 18, his old friend Paul Éluard dies.

1953

In January the Musée National d'Art Moderne exhibits *Les Demoiselles d'Avignon* for the first time since 1937 in Paris. In March, Françoise returns to Paris with her children and Picasso remains in Vallauris. The French Communist Party disapproves of Picasso's *Portrait of Stalin*. In September, Françoise moves to the rue Gay-Lussac with Claude and Paloma. Solo exhibitions at the Galleria Nazionale d'Arte Moderna in Rome and at the Palazzo Reale in Milan, as well as in Lyons and São Paulo.

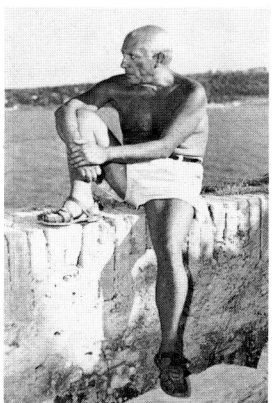

Picasso in Golfe-Juan, 1947

Picasso as a potter, 1948

The *Portrait of Stalin*, published in *Les Lettres Françaises*, March 12–19, 1953

The Final Years

1954

At the beginning of the year, Picasso meets a young woman, Sylvette David, who poses for him. Gilot leaves Picasso, who departs for Vallauris and then to Paris with Jacqueline Roque. Ramié Pablito (d. 1973), Paulo's son and Picasso's first grandson, is born. Picasso paints variations on *Women of Algiers* by Delacroix and, until 1962, explores the works of old masters, particularly those of Manet, Velázquez, and Rembrandt. Several retrospective exhibitions take place around the world (Munich, Brussels, Amsterdam, New York, and Chicago).

1955

On February 11 his wife, Olga, dies. By June Picasso moves permanently with Jacqueline to the villa La Californie in the south of France, at Cannes. An official retrospective, "Picasso: Peintures 1900–1955," is held at the Musée des Arts Décoratifs in Paris. During the summer, the painter works with Henri-Georges Clouzot on the film *Le Mystère Picasso*.

1956

Forever fascinated by bathers, Picasso paints *Two Women on the Beach* (fig. 1010). *Le Mystère Picasso* opens to the public. On October 25, Picasso celebrates his seventy-fifth birthday in Vallauris.

1957

He paints variations of Velázquez's *Las Meninas* starting in August. In the fall, the United Nations asks Picasso to create a piece for its Paris headquarters; he would paint *The Fall of Icarus* (fig. 1039). A traveling show is organized in the United States for Picasso's seventy-fifth birthday. The Musée Reattu in Arles also celebrates the occasion.

1958

La Maison de la Pensée Française exhibits 150 original ceramic pieces. In September Picasso buys the Château de Vauvenargues, at the foot of the Sainte-Victoire mountain that was so dear to Cézanne.

1959

In May–June, the Galerie Louise Leiris presents *Las Meninas* based on Velázquez's painting (figs. 1026–1033). In August Picasso begins to make studies of Manet's *Le Déjeuner sur l'Herbe* (figs. 1050–1057). He then moves to Notre-Dame-de-Vie in Mougins. Bernard, Paulo's second son and Picasso's second grandson, is born.

1961

From July to September, the Tate Gallery in London presents a retrospective from 1895 to 1959 that includes 270 pieces. On March 2, Picasso marries Jacqueline Roque in Vallauris. In June they move to Notre-Dame-de-Vie. Picasso turns eighty. The UCLA Art Gallery in Los Angeles presents an exhibition of 170 works entitled "Happy Birthday, Mr. Picasso."

1962

The Lenin Prize for Peace is awarded to Picasso for the second time. The Museum of Modern Art in New York celebrates Picasso's eightieth birthday with an exhibition. Several prints, including linoleum cuts, are completed.

1963

On March 9 the Picasso Museum in Barcelona opens to the public. In October Picasso begins to work on prints with the Crommelynck brothers. Braque dies on August 31. Cocteau dies on October 11.

1964

A major retrospective, "Picasso and Man," is mounted in Toronto and then in Montreal, including 273 works from 1898 to 1961. In the spring, Françoise Gilot, in collaboration with Carlton Lake, the American art critic, publishes *Life with Picasso*. The following year, Picasso will try to stop it from being published in French. In May and June Picasso's first retrospective in Japan is held at the National Museum of Modern Art of Tokyo and then travels to Kyoto and Nagoya. Brassaï publishes his *Conversations Avec Picasso*.

1965

Exhibition "Picasso et le Théâtre" held at the Musée des Augustins in Toulouse and then travels to La Sala Gaspar in Barcelona in July.

1966

André Malraux, then minister of culture, organizes a large retrospective, "Hommage à Pablo Picasso," at the Grand-Palais and Petit Palais in Paris. The Bibliothèque Nationale also presents 171 prints. André Breton dies on September 28.

1967

Picasso refuses the Legion of Honor and leaves his Grands-Augustins studio. First the Tate Gallery and then the Museum of Modern Art of New York present large retrospectives of his sculptures and ceramic pieces.

a

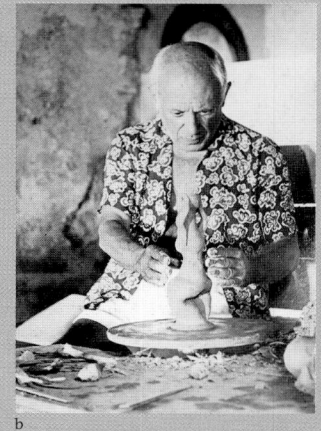

b

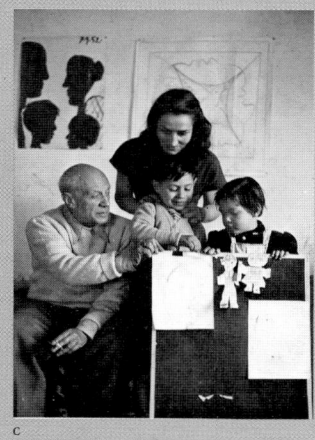

c

d

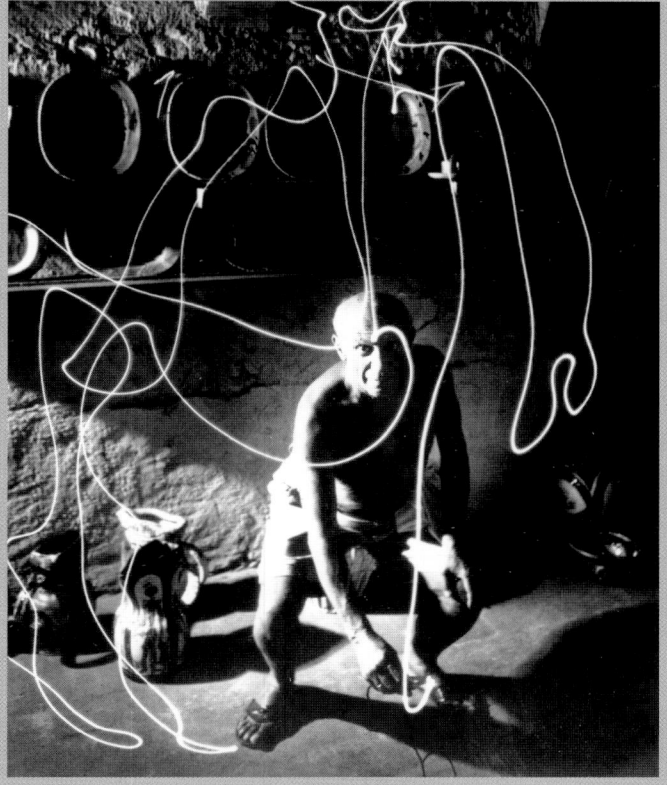

e

a. Picasso at work in his Antibes studio, 1946 (Photo: Michel Sima)

b. Picasso working on a ceramic piece, about 1947 (Photo: P. Manciet)

c. Picasso, Françoise Gilot, Claude, and Paloma in Vallauris, 1952–53 (Photo: E. Quinn)

d. Picasso in Cracow in 1948. To his right is Paul Éluard; in the second row, to the right, are Aimé Césaire and Pierre Daix.

e. Picasso at Madoura, using a light wand, 1949 (Photo: Gjon Mili)

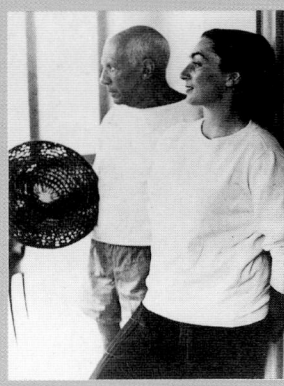

a

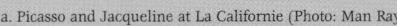

a. Picasso and Jacqueline at La Californie (Photo: Man Ray)

b. Picasso on his eightieth birthday

c. Picasso drawing Daniel-Henry Kahnweiler at Cannes in 1957 (Photo: Jacqueline Picasso)

d. Picasso and one of his *Bathers*, La Californie, 1956

e. The Château de Vauvenargues, from a postcard

f. Picasso, Jacqueline, Michel Leiris, and Paulo at a bullfight, about 1960 (Photo: E. Quinn)

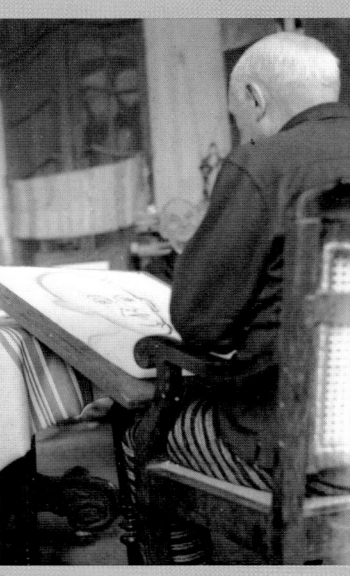

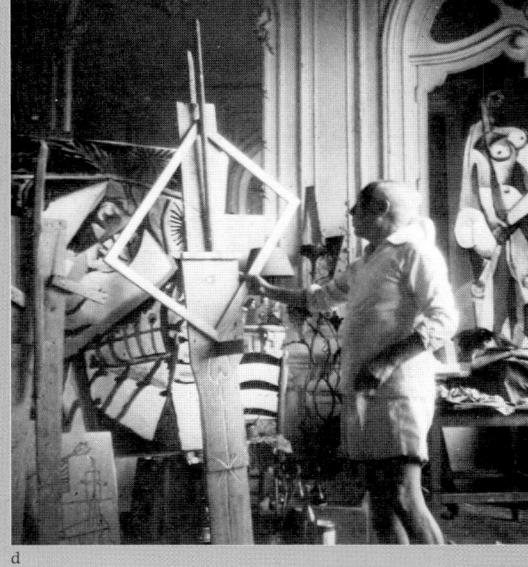

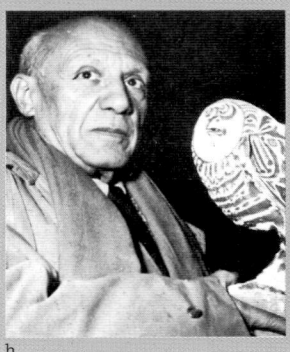

b

c

d

e

f

1968

On February 13 his secretary Sabartés dies. Exhibition of the suite of prints known as *347* at the Galerie Louise Leiris in Paris.

1969

Sixteen prints of *La Celestina* from the *347* suite are published in *El Entierro del Conde de Orgaz* (Gustavo Gili, Barcelona).

1970

The artist's work kept by the painter's family in Spain are donated to the Picasso Museum of Barcelona. Exhibition of recent works at the Palais des Papes in Avignon. On May 12, his first studio in Paris, the Bateau-Lavoir, is destroyed in a fire. Christian Zervos dies on September 12. Several exhibitions are mounted in the United States.

1971

Picasso turns ninety. On this occasion, a selection of works is exhibited in the Grande Galerie at the Musée du Louvre.

1972

Picasso continues to work in Mougins. The Galerie Louise Leiris exhibits 172 drawings executed between November 1971 and August 1972. William Rubin of the Museum of Modern Art in New York presents "Picasso in the Collection of the Museum of Modern Art."

1973

The last Picasso exhibit is held at the Galerie Louise Leiris: 155 prints completed between 1970 and March 1972. Picasso dies on April 9 in Mougins at the age of ninety-two. On May 23, the Palais des Papes in Avignon organizes a major retrospective prepared by Christian Zervos's widow.

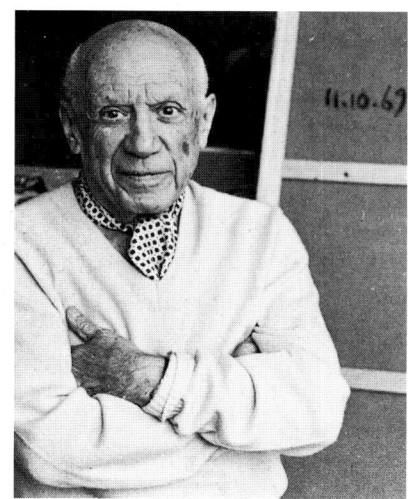

Picasso at eighty-eight

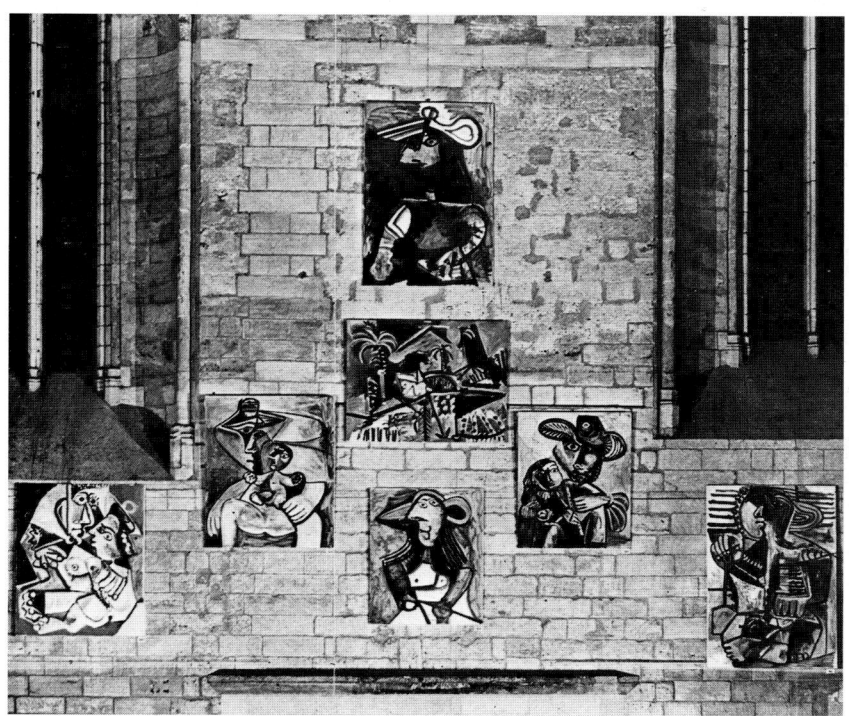

Part of the exhibition at the Palais des Papes in Avignon in 1973

LIST OF ILLUSTRATIONS

The abbreviations used below refer to the following catalogues:
Z. (Zervos), P. i. F. (Palau i Fabre), Sp. (Werner Spies), Bl. (Georges Bloch), Baer (Brigitte Baer), D. R. (Pierre Daix and Joan Rosselet), and G. (Sebastian Goeppart et al.). These publications are marked with an asterisk in the Selected Bibliography, pp. 529–32.

29 *Silhouette of José Ruiz by the Sea*
Barcelona, 1899
Oil on canvas, 46¼ × 5½ in.
(118.5 × 14 cm)
Private collection
Z. XXI, 64;
P. i F. 1881–1907, 311

30 *Reading the Letter*
Barcelona, 1899–1900
Charcoal, black pencil, and
oil on paper, 18¾ × 24⅝ in.
(48 × 63 cm)
Picasso Museum, Paris
Z. VI, 300

31 *Terraces from the Studio on
Riera de Sant Joan*
Barcelona, 1900
Pastel on paper, 19⅞ × 14¾ in.
(50.9 × 37.8 cm)
Private collection
Z. VI, 250;
P. i F. 1881–1907, 382

32 *The Angel of Death*
Barcelona, 1900
Watercolor and Conté crayon
on paper, 17¾ × 11¾ in.
(45.5 × 30 cm)
The Solomon R. Guggenheim
Museum, New York. Justin K.
Thannhauser Foundation
Z. XXI, 79;
P. i F. 1881–1907, 370

33 *The Left-hander*
Barcelona, 1899
Etching on copper embell-
ished with watercolor,
4⅝ × 3¼ in. (11.8 × 8 cm)
Private collection
P. i F. 1881–1907, 314

34 *Entry into the Arena of
La Barceloneta*
Barcelona, 1900
Pastel on cardboard,
20 × 27 in. (51 × 69 cm)
The Museum of Modern Art,
Toyama
Z. XXI, 145;
P. i F. 1881–1907, 454

35 *The Andalusian Couple
(Tambourine)*
Barcelona, 1899
Oil on parchment,
dimensions unknown
Private collection
P. i F. 1881–1907, 303

36 *Menu from Els Quatre Gats*
Barcelona, 1900
Pen and color crayon on paper,
8⅝ × 6¼ in. (22 × 16 cm)
Private collection
Z. VI, 193;
P. i F. 1881–1907, 377

37 *Interior of Els Quatre Gats*
Barcelona, 1900
Oil on canvas, 16 × 11 in.
(41 × 28 cm)
Private collection
Z. I, 21; P. i F. 1881–1907, 375

38 *Design for a Carnival Poster*
Barcelona, 1900
Oil and black pencil,
18⅞ × 12½ in. (48.2 × 32 cm)
Picasso Museum, Paris
Z. XXI, 127;
P. i F. 1881–1907, 371

39 *Pierrot and Columbine*
Paris, Autumn 1900
Oil on panel, 14⅞ × 18 in.
(38 × 46 cm)
Private collection
Z. XXI, 224;
P. i F. 1881–1907, 507

40 *The Moulin de la Galette*
Paris, Autumn 1900
Oil on canvas, 35⅛ × 45⅝ in.
(90.2 × 117 cm)
The Solomon R. Guggenheim
Museum, New York. Justin K.
Thannhauser Foundation
Z. I, 41; P. i F. 1881–1907, 509

41 *The Couch*
Barcelona, 1899
Charcoal, pastel, and colored
crayon on paper, varnished,
10¼ × 11⅝ in. (26.2 × 29.7 cm)
Picasso Museum, Barcelona
Z. I, 23

42 *Girl at Her Dressing Table*
Paris, 1900
Pastel on paper, 18¾ × 20⅝ in.
(48 × 53 cm)
Picasso Museum, Barcelona
Z. I, 38; P. i F. 1881–1907, 490

43 *French Cancan*
Paris, Autumn 1900
Oil on canvas, 18 × 23¾ in.
(46 × 61 cm)
Private collection
Z. XXI, 209;
P. i F. 1881–1907, 508

44 *Jaime Sabartés Seated*
Barcelona, 1900
Charcoal and watercolor on
paper, 19¾ × 12⅞ in.
(50.5 × 33 cm)
Picasso Museum, Barcelona
Z. VI, 247;
P. i F. 1881–1907, 393

45 *Sabartés as a Decadent Poet*
Barcelona, 1900
Charcoal and watercolor on
paper, 18¾ × 12½ in.
(48 × 32 cm)
Picasso Museum, Barcelona
Z. XXI, 159;
P. i F. 1881–1907, 386

46 *Portrait of Hermen Anglada
Camarasa*
Barcelona, 1900
Pen and watercolor on paper,
4¾ × 3⅞ in. (12.1 × 9.8 cm)
The Metropolitan Museum of
Art, New York
Z. XXI, 105;
P. i F. 1881–1907, 430

47 *Modernista Self-Portrait*
Barcelona, 1900
Pen and watercolor on paper,
3¾ × 3⅜ in. (9.5 × 8.6 cm)
The Metropolitan Museum of
Art, New York
Z. XXI, 109;
P. i F. 1881–1907, 427

48 *Self-Portrait*
Barcelona, 1899–1900
Charcoal on paper,
8¾ × 6½ in. (22.5 × 16.5 cm)
Picasso Museum, Barcelona
P. i F. 1881–1907, 357

49 *Man in a Cloak*
1900
Oil on canvas, 31⅝ × 19½ in.
(81 × 50 cm)
Van der Heydt Museum,
Wuppertalm
Z. I, 16

50 *Paris Garden*
(sketch for a poster)
Paris, 1901
Gouache, ink, and watercolor
on paper, 25¼ × 19¼ in.
(64.8 × 49.5 cm)
The Metropolitan Museum of
Art, New York
Z. VI, 367;
P. i F. 1881–1907, 590

51 *Cancan Dancer*
Paris, 1901
Painted sketch with spray-
painted background,
18⅜ × 12¼ in. (47 × 31.3 cm)
Private collection
Z. XXI, 226;
P. i F. 1881–1907, 653

52 *Embrace in an Attic*
Paris, 1900
Oil on cardboard, 20 × 21⅝ in.
(51.2 × 55.3 cm)
Pushkin Museum, Moscow
Z. I, 26; P. i F. 1881–1907, 499

53 *Embrace in the Street*
Paris, 1900
Pastel on paper, 23 × 13⅝ in.
(59 × 35 cm)
Picasso Museum, Barcelona
Z. I, 24; P. i F. 1881–1907, 498

54 *Picasso in Front of the Moulin
Rouge*
Paris, 1900
Ink and colored crayon on
paper, 7 × 4½ in.
(18 × 11.5 cm)
Private collection
Z. XXI, 250;
P. i F. 1881–1907, 664

55 *Self-Portrait in a Top Hat*
Paris, Summer 1901
Oil on paper, 19½ × 12⅞ in.
(50 × 33 cm)
Private collection
Z. XXI, 251;
P. i F. 1881–1907, 608

56 *Bullfighting Scene (The Victims)*
Barcelona, Spring 1901
Oil on cardboard mounted on
wood panel, 19⅜ × 25¼ in.
(49.5 × 64.7 cm)
Private collection
Z. VI, 378;
P. i F. 1881–1907, 559

57 *Bull Pulled by the Tail*
Barcelona, 1900
Pastel on paper,
13⅝ × 15⅜ in. (35 × 39.5 cm)
Private collection
Z. XXI, 146;
P. i F. 1881–1907, 455

58 *Bullfighting Scene*
Barcelona, 1900
Pastel and gouache on paper,
6⅜ × 11⅞ in. (16.2 × 30.5 cm)
Museu del Cau Ferrat, Sitges
(Province of Barcelona)
Z. XXI, 147;
P. i F. 1881–1907, 453

59 *Yo, Picasso!*
Paris, Spring 1901
Oil on canvas, 28⅝ × 23⅜ in.
(73.5 × 60 cm)
Private collection
Z. XXI, 192;
P. i F. 1881–1907, 570

60 *The 14th of July*
Paris, 1901
Oil on cardboard mounted on
a stretcher, 18⅞ × 24⅝ in.
(48.3 × 63.2 cm)
The Solomon R. Guggenheim
Museum, New York. Justin K.
Thannhauser Foundation
Z. VI, 335;
P. i F. 1881–1907, 649

61 *Dwarf Dancer (La Nana)*
Barcelona or Paris, 1901
Oil on cardboard,
39¾ × 23⅜ in. (102 × 60 cm)
Picasso Museum, Barcelona
Z. I, 66; P. i F. 1881–1907, 602

62 *Woman in Blue and White*
Madrid, 1901
Pastel on cardboard,
20⅞ × 14¼ in. (53.5 × 36.5 cm)
Private collection
Z. XXI, 215;
P. i F. 1881–1907, 543

63 *Woman in Blue*
Madrid, 1901
Oil on canvas, 52 × 39⅛ in.
(133.5 × 101 cm)
Museo Nacional Centro de
Arte Reina Sofia, Madrid
Z. XXI, 211;
P. i F. 1881–1907, 539

64 *Still Life (The Sideboard)*
Paris, 1901
Oil on canvas, 23 × 30⅜ in.
(59 × 78 cm)
Picasso Museum, Barcelona
Z. I, 70; P. i F. 1881–1907, 659

65 *The Blue Room*
Paris, 1901
Oil on canvas, 19⅞ × 24⅜ in.
(51 × 62.5 cm)
The Phillips Collection,
Washington, D.C.
Z. I, 103; P. i F. 1881–1907, 694

66 *The Prostitute*
Paris, 1901
Oil on cardboard, 27 × 22¼ in.
(69.5 × 57 cm)
Picasso Museum, Barcelona
Z. I, 63; P. i F. 1881–1907, 598

67 *Courtesan with a Jeweled
Necklace*
Paris, 1901
Oil on canvas, 25½ × 21¼
(65.5 × 54.5 cm)
Los Angeles County Museum
of Art. Mr. and Mrs. George
Gard de Sylva Collection
Z. I, 42; P. i F. 1881–1907, 662

68 *Portrait of Pere Mañach*
Paris, Spring 1901
Oil on canvas, 39¼ × 26⅜ in.
(100.5 × 67.5 cm)
The National Gallery of Art,
Washington, D.C. Chester
Dale Collection
Z. VI, 1459;
P. i F. 1881–1907, 569

69 *Portrait of Gustave Coquio*
Paris, Spring–Summer 1901
Oil on canvas, 39 × 31¼ in.
(100 × 80 cm)
Musée National d'Art Moderne,
Centre Georges Pompidou,
Paris. Gift of Madame
Gustave Coquiot
Z. I, 84; P. i F. 1881–1907, 605

70 *Hallucinated Self-Portrait*
Paris, 1901
Oil on cardboard, 21 × 12⅜ in.
(54 × 31.8 cm)
Private collection
Z. I, 113; P. i F. 1881–1907, 678

71 *The Executioner*
Barcelona, Spring 1901
India ink, wash, and gouache
on paper, 19½ × 12½ in.
(50 × 32 cm)
Picasso Museum, Paris
Z. XXI, 202

72 *Women at the Well*
Paris, 1901
Oil on canvas, 31⅝ × 25⅜ in.
(81 × 65 cm)
Private collection
Z. I, 80; P. i F. 1881–1907, 696

73 *The Woman in a Bonnet*
Paris, 1901
Oil on canvas, 16 × 12⅞ in.
(41.3 × 33 cm)
Picasso Museum, Barcelona
Z. I, 101; P. i F. 1881–1907, 695

74 *The Death of Casagemas*
Paris, Summer 1901
Oil on panel, 10½ × 13⅝ in.
(27 × 35 cm)
Picasso Museum, Paris
Z. XXI, 178;
P. i F. 1881–1907, 676

75 *Death (The Mourners)*
Paris, 1901
Oil on canvas, 39 × 35⅛ in.
(100 × 90.2 cm)
Private collection
Z. I, 52; P. i F. 1881–1907, 682

76 *Study for "Death" or "Evocation"*
Paris, 1901
Ink and pencil on paper,
7⅛ × 8½ in. (18.3 × 21.7 cm)
Private collection
Z. VI, 571;
P. i F. 1881–1907, 686

77 *Study for "Death"*
Paris, 1901
India ink on paper,
15⅝ × 21⅞ in. (40 × 56 cm)
Private collection
Z. VI, 330;
P. i F. 1881–1907, 685

78 *Study for "Death"*
Paris, 1901
Pen on paper, 5 × 6¾ in.
(13 × 17.3 cm)
Picasso Museum, Barcelona
P. i F. 1881–1907, 684

79 *Study for "Death"*
Paris, 1901
Pen on paper, 3.9 × 5⅛ in.
(10 × 13.2 cm)
Picasso Museum, Barcelona
P. i F. 1881–1907, 683

80 *Study for "Evocation"*
Paris, 1901
Black pencil on paper,
9⅜ × 12 in. (24 × 31 cm)
Picasso Museum, Paris
Z. VI, 328;
P. i F. 1881–1907, 687

81 *Study for "Evocation"*
Paris, 1901
Black pencil on the back of a
reproduction of the "Regreso
de la fiesta di Napoli . . .
1885," 16¼ × 11¼ in.
(41.6 × 29 cm)
Picasso Museum, Paris
Z. VI, 356;
P. i F. 1881–1907, 679

82 *Evocation (The Burial of
Casagemas)*
Paris, 1901
Oil on canvas, 58⅝ × 35¼ in.
(150.5 × 90.5 cm)
Musée d'Art Moderne de la
Ville de Paris
Z. I, 55; P. i F. 1881–1907, 688

83 *Self-Portrait*
Paris, late 1901
Oil on canvas, 31⅝ × 23⅜ in.
(81 × 60 cm)
Picasso Museum, Paris
Z. I, 91; P. i F. 1881–1907, 715

84 *Portrait of Jaime Sabartés*
Paris, 1901
Oil on canvas, 18 × 14⅞ in.
(46 × 38 cm)
Picasso Museum, Barcelona
Z. I, 87; P. i F. 1881–1907, 706

85 *Portrait of Mateu F. de Soto*
Paris, 1901
Oil on canvas, 17½ × 14⅜ in.
(45 × 37 cm)
Private collection
Z. I, 86; P. i F. 1881–1907, 708

86 *The Glass of Beer (Portrait of
Sabartés)*
Paris, 1901
Oil on canvas, 32 × 25¼ in.
(82 × 66 cm)
Pushkin Museum, Moscow
Z. I, 97; P. i F. 1881–1907, 665

87 *The Apéritif*
Paris, 1901
Oil on canvas, 28½ × 21 in.
(73 × 54 cm)
The State Hermitage
Museum,
St. Petersburg
Z. I, 98; P. i F. 1881–1907, 675

88 *Woman with Crossed Arms*
Paris, 1901
Oil on canvas, 30 × 23¾ in.
(77 × 61 cm)
Private collection
Z. I, 100; P. i F. 1881–1907, 668

89 *Harlequin*
Paris, 1901
Oil on canvas, 31¼ × 23½ in.
(80 × 60.3 cm)
The Metropolitan Museum of
Art, New York. Gift of Mr. and
Mrs. John L. Loeb
Z. I, 79; P. i F. 1881–1907, 670

90 *Child with a Pigeon*
Paris, 1901
Oil on canvas, 28½ × 21 in.
(73 × 54 cm)
The National Gallery, London
Z. I., 83; P. i F. 1881–1907, 669

91 *Harlequin and His Companion*
Paris, 1901
Oil on canvas, 28½ × 23⅜ in.
(73 × 60 cm)
Pushkin Museum, Moscow
Z. I, 92; P. i F. 1881–1907, 666

92 *The Sleepy Drinker*
Barcelona, 1902
Oil on canvas, 31¼ × 24⅛ in.
(80 × 62 cm)
Kunstmuseum, Berne. Gift of
Othmar Huber
Z. I, 120; P. i F. 1881–1907, 732

93 *Crouching Woman, Meditating*
Barcelona, 1902
Oil on canvas, 24¾ × 19½ in.
(63.5 × 50 cm)
Private collection
Z. I, 160; P. i F. 1881–1907, 731

94 *Crouching Woman and Child*
Paris, 1901
Oil on canvas, 43⅛ × 37⅝ in.
(110.5 × 96.5 cm)
The Fogg Art Museum,
Harvard University,
Cambridge, Massachusetts.
Maurice Wertheim Bequest
Z. I, 105; P. i F. 1881–1907, 705

95 *Crouching Woman in a Hood*
Barcelona, 1902
Oil on canvas, 39½ × 25¾ in.
(101.2 x 66 cm)
The Art Gallery of Ontario,
Toronto. Anonymous gift
Z. I, 121; P. i F. 1881–1907, 726

96 *Seated Woman*
Barcelona, 1902
Terra cotta, 5⅝ × 3¼ × 4½ in.
(14.5 × 8.5 × 11.5 cm)
Picasso Museum, Paris
Bronze cast, 5½ × 3⅛ × 2¾ in.
(14 × 8 × 7 cm)
Picasso Museum, Barcelona
Sp., 1; P. i F. 1881–1907, 751

97 *Woman with Fringed Hair*
Barcelona, 1902
Oil on canvas, 23⅜ × 19⅛ in.
(60 × 49 cm)
The Baltimore Museum of
Art. Cone Collection
Z. I, 118; P. i F. 1881–1907, 760

98 *Woman with a Shawl*
Barcelona, 1902
Oil on canvas, 24⅝ × 20⅜ in.
(63 × 52.4 cm)
Private collection
Z. I, 155; P. i F. 1881–1907, 733

99 *Head of a Woman*
Paris, late 1902
Pastel, dimensions unknown
Private collection
Z. I, 206; P. i F. 1881–1907, 833

100 *Seated Nude, Back View*
Barcelona, 1902
Oil on canvas, 18 × 15⅝ in.
(46 × 40 cm)
Private collection
Z. VI, 449;
P. i F. 1881–1907, 750

101 *Prostitutes at a Bar*
Barcelona, 1902
Oil on canvas, 31¼ × 35⅝ in.
(80 × 91.5 cm)
Hiroshima Museum of Art
Z. I, 132; P. i F. 1881–1907, 754

102 *Profile of Suffering Woman*
Paris, 1902
Conté crayon on paper,
12⅛ × 9½ in. (31.2 × 24.3 cm)
Picasso Museum, Barcelona
Z. XXI, 351;
P. i F. 1881–1907, 814

103 *Rustic Scene*
Paris, 1902
Drawing on paper,
10⅛ × 7⅝ in. (26 × 19.5 cm)
The Cleveland Museum of
Art. Bequest of Leonard C.
Hanna, Jr.
Z. I, 136; P. i F. 1881–1907, 807

104 *Study for "The Two Sisters"*
Barcelona, 1902
Pencil on paper,
17½ × 12½ in. (45 × 32 cm)
Picasso Museum, Paris
Z. XXI, 369;
P. i F. 1881–1907, 737

105 *The Two Sisters (The Meeting)*
Barcelona, 1902
Oil on canvas, 59¼ × 39 in.
(152 × 100 cm)
The State Hermitage
Museum, St. Petersburg
Z. I, 163; P. i F. 1881–1907, 739.

106 *Maternity by the Sea*
Barcelona, 1902
Oil on canvas, 32⅜ × 23⅜ in.
(83 × 60 cm)
Private collection
Z. VI, 478;
P. i F. 1881–1907, 746

107 *The Mistletoe Seller*
Paris, 1902–3
Gouache on paper,
21½ × 14⅞ in. (55 × 38 cm)
Private collection
Z. I, 123; P. i F. 1881–1907, 834

108 *Head of a Dead Woman*
Barcelona, 1902 or 1903
Oil on canvas, 17⅜ × 13¼ in.
(44.5 × 34.1 cm)
Picasso Museum, Barcelona
Z. XXI, 392;
P. i F. 1881–1907, 722

109 *Couple and Flowers*
1902–3
Ink and watercolor on paper,
6⅞ × 9⅛ in. (17.6 × 23.2 cm)
Picasso Museum, Barcelona
Z. XXI, 283

110 *Self-Portrait*
[Barcelona], 1903
India ink on paper,
5½ × 4¼ in. (14 × 11 cm)
Private collection
Z. XXII, 38;
P. i F. 1881–1907, 823

111 *Woman at a Bidet*
1902–3
Ink and watercolor on paper,
7¾ × 5 in. (19.8 × 13 cm)
Picasso Museum, Barcelona

112 *The Disinherited Ones*
Barcelona, 1903
Pastel on paper, 18½ × 16 in.
(47.5 × 41 cm)
Picasso Museum, Barcelona
Z. I, 169; P. i F. 1881–1907, 842

113 *The Soup*
Barcelona, 1903
Oil on canvas, 15 × 18 in.
(38.5 × 46 cm)
The Art Gallery of Ontario,
Toronto. Gift of Margaret
Dunlap Crang
Z. I, 131; P. i F. 1881–1907, 848

114 *The Old Guitarist*
Barcelona, 1903
Oil on panel, 47⅝ × 32⅛ in.
(122.3 × 82.5 cm)
The Art Institute of Chicago
Z. I, 202; P. i F. 1881–1907, 932

115 *The Old Jew*
Barcelona, 1903
Oil on canvas, 48¼ × 35⅞ in.
(125 × 92 cm)
Pushkin Museum, Moscow
Z. I, 175; P. i F. 1881–1907, 936

116 *The Blind Man's Meal*
Barcelona, 1903
Oil on canvas, 37⅛ × 36⅞ in.
(95.3 × 94.6 cm)
The Metropolitan Museum of
Art, New York. Gift of Mr. and
Mrs. Ira Haupt
Z. I, 168; P. i F. 1881–1907, 920

117 *Sebastià Junyer Vidal with a
Woman*
Barcelona, June 1903
Oil on canvas, 49¼ × 36⅝ in.
(126.4 × 94 cm)
Los Angeles County Museum
of Art. Bequest of David E.
Bright
Z. I, 174; P. i F. 1881–1907, 898

118 *The Blue Glass*
Barcelona, 1903
Oil on canvas, 25¼ × 11⅛ in.
(66.1 × 28.5 cm)
Picasso Museum, Barcelona
P. i F. 1881–1907, 899

119 *Portrait of Benet Soler*
Barcelona, 1903
Oil on canvas, 39 × 27¼ in.
(100 × 70 cm)
The State Hermitage Museum,
St. Petersburg
Z. I, 199; P. i F. 1881–1907, 905

120 *Blue Portrait of Angel F. de Soto*
Barcelona, 1903
Oil on canvas, 27⅛ × 21½ in.
(69.7 × 55.2 cm)
Private collection
Z. I, 201; P. i F. 1881–1907, 911

121 *Picasso Painting "La Celestina"*
Barcelona, 1904
Conté crayon and colored
crayons, 10⅜ × 8 in.
(26.7 × 20.6 cm)
Private collection
Z. XXII, 56;
P. i F. 1881–1907, 955

122 *La Celestina*
Barcelona, March 1904
Oil on canvas, 27¼ × 21⅞ in.
(70 × 56 cm)
Picasso Museum, Paris
Z. I, 183; P. i F. 1881–1907, 958

123 *Mother and Children by the Sea*
Barcelona, 1903
Pastel on paper, 18 × 12⅛ in.
(46 × 31 cm)
Private collection
Z. I, 381; P. i F. 1881–1907, 841

124 *The Madonna with a Garland*
Paris, 1904
Gouache on paper,
24½ × 18¾ in. (63 × 48 cm)
Private collection
Z. I, 229; P. i F. 1881–1907, 990

125 *Portrait of Gaby*
Paris, 1904
Gouache on cardboard,
39⅝ × 29½ in. (101.6 × 75.5 cm)
Private collection
Z. I, 215; P. i F. 1881–1907, 980

126 *The Tragedy*
Barcelona, 1903
Oil on panel, $41^{1}/_{8} \times 26^{7}/_{8}$ in.
(105.4 × 69 cm)
The National Gallery of Art,
Washington, D.C. Chester
Dale Collection
Z. I, 208; P. i F. 1881–1907, 864

127 *The Embrace*
Barcelona, 1903
Pastel on paper,
$38^{1}/_{4} \times 22^{1}/_{4}$ in. (98 × 57 cm)
Musée de l'Orangerie, Paris.
Collection of Jean Walter-Paul
Guillaume
Z. I, 161; P. i F. 1881–1907, 856

128 *Studies of Couples Embracing
and Heads*
Barcelona, 1902–3
Ink on paper, $21^{1}/_{2} \times 14^{7}/_{8}$ in.
(55 × 38 cm)
Marina Picasso Collection,
courtesy Galerie Jan Krugier,
Ditesheim & Cie, Geneva
Z. XXI, 386

129 *Couple Embracing with a Bull's
Head in the Background*
Barcelona, 1903
Colored crayons on paper,
$8^{1}/_{8} \times 9^{1}/_{2}$ in. (21 × 24.5 cm)
Private collection
Z. XXII, 42;
P. i F. 1881–1907, 891

130 *Study for "La Vie"*
Barcelona, 1903
Pencil on paper, $6^{5}/_{8} \times 3^{3}/_{4}$ in.
(17.1 × 9.5 cm)
Picasso Museum, Barcelona
P. i F. 1881–1907, 878

131 *Study for "La Vie"*
Barcelona, 1903
Pencil on paper, $5^{5}/_{8} \times 3^{3}/_{4}$ in.
(14.5 × 9.5 cm)
Picasso Museum, Barcelona
P. i F. 1881–1907, 879

132 *Study for "La Vie"*
Barcelona, 1903
Pen and sepia on paper,
$6^{1}/_{4} \times 4^{1}/_{4}$ in. (15.9 × 11 cm)
Picasso Museum, Paris
Z. VI, 534;
P. i F. 1881–1907, 880

133 *La Vie*
Barcelona, May 1903
Oil on canvas, $76^{7}/_{8} \times 49^{5}/_{8}$ in.
(197 × 127.3 cm)
The Cleveland Museum of
Art. Gift of the Hanna
Foundation
Z. I, 179; P. i F. 1881–1907, 882

134 *The Riera de Sant Joan at
Dawn*
Barcelona, 1903
Oil on canvas, $21 \times 17^{3}/_{4}$ in.
(54 × 45.5 cm)
Private collection
Z. XXII, 43;
P. i F. 1881–1907, 840

135 *Roofs of Barcelona*
Barcelona, 1903
Oil on canvas, $27^{1}/_{8} \times 42^{3}/_{4}$ in.
(69.5 × 109.6 cm)
Picasso Museum, Barcelona
Z. I, 207; P. i F. 1881–1907, 900

136 *The Madman*
Barcelona, 1904
Watercolor on paper,
$11^{3}/_{8} \times 8^{1}/_{8}$ in. (29.2 × 21 cm)
The Solomon R. Guggenheim
Museum, New York. Justin K.
Thannhauser Collection
Z. I, 184; P. i F. 1881–1907, 947

137 *The Madman*
Barcelona, 1904
Blue watercolor on wrapping
paper, $33^{1}/_{2} \times 13^{3}/_{4}$ in.
(85 × 35 cm)
Picasso Museum, Barcelona
Z. I, 232; P. i F. 1881–1907, 948

138 *Portrait of Jaime Sabartés*
Barcelona, Spring 1904
Oil on canvas, $19^{1}/_{4} \times 14^{7}/_{8}$ in.
(49.5 × 38 cm)
Kunstnernes Museum, Oslo
Z. VI, 655;
P. i F. 1881–1907, 961

139 *Woman with a Helmet of Hair*
Paris, 1904
Gouache on cardboard,
$16^{3}/_{4} \times 12^{1}/_{8}$ in. (42.9 × 31.2 cm)
The Art Institute of Chicago.
Gift of Kate L. Brewster
Z. I, 233; P. i F. 1881–1907, 977

140 *Woman with a Crow*
Paris, 1904
Gouache and pastel on paper
mounted on cardboard,
$25^{3}/_{8} \times 19^{1}/_{8}$ in. (65 × 49 cm)
The Toledo Museum of Art.
Gift of Edward Drummond
Libley
Z. I, 240; P. i F. 1881–1907, 996

141 *Woman with a Crow*
(first version)
Paris, 1904
Gouache and pastel on paper,
$23^{1}/_{2} \times 17^{3}/_{4}$ in. (60.5 × 45.5 cm)
Private collection
Z. XXII, 75;
P. i F. 1881–1907, 997

142 *Woman Ironing*
Paris, 1904
Oil on canvas, $45^{5}/_{8} \times 28^{1}/_{2}$ in.
(116.2 × 73 cm)
The Solomon R. Guggenheim
Museum, New York. Gift of
Justin K. Thannhauser
Z. I, 247; P. i F. 1881–1907, 982

143 *The Frugal Repast*
Paris, September 1904
Etching on zinc plate,
$19^{7}/_{8} \times 16$ in. (50.9 × 41 cm)
Private collection
G., 2, II a/b; Bl. 1;
P. i F. 1881–1907, 994

144 *Scene of Married Life*
Paris, Autumn 1904
Pen and gouache on card-
board, dimensions unknown
Private collection
Z. XXII, 121;
P. i F. 1881–1907, 1002

145 *The Lovers*
Paris, August 1904
Pen, India ink, pencil, and
watercolor on paper,
$15^{5}/_{8} \times 10^{1}/_{2}$ in. (39.5 × 26.9 cm)
Picasso Museum, Paris
Z. XXII, 104;
P. i F. 1881–1907, 986

146 *Sleeping Woman
(Contemplation)*
Paris, Autumn 1904
Pen and watercolor on paper,
$14^{3}/_{8} \times 10^{1}/_{2}$ in. (36.8 × 27 cm)
Private collection
Z. I, 235; P. i F. 1881–1907, 1004

147 *The Two Friends*
Paris, 1904
Gouache on paper,
$21^{1}/_{2} \times 14^{3}/_{4}$ in. (55 × 38 cm)
Private collection
Z. VI, 652;
P. i F. 1881–1907, 976

148 *The Two Friends*
Paris, Autumn 1904
Crayon and watercolor on
paper, $10^{1}/_{2} \times 14^{1}/_{2}$ in.
(27 × 37 cm)
Private collection
Z. XXII, 63;
P. i F. 1881–1907, 1000

149 *The Actor*
Paris, late 1904
Oil on canvas, $75^{5}/_{8} \times 43^{5}/_{8}$ in.
(194 × 112 cm)
The Metropolitan Museum of
Art, New York. Gift of Thelma
Chrysler Foy
Z. I, 291; P. i F. 1881–1907, 1017

150 *Woman with a Fan*
Paris, 1905
Oil on canvas, $38^{5}/_{8} \times 31^{3}/_{4}$ in.
(99 × 81.3 cm)
The National Gallery of Art,
Washington, D.C. Gift of the
W. Averell Harriman
Foundation, in memory of
Marie N. Harriman
Z. I, 308; P. i F. 1881–1907, 1163

151 *Study for "The Actor"*
Paris, late 1904
Crayon on paper,
$18^{1}/_{2} \times 12^{1}/_{4}$ in. (47 × 31.5 cm)
Private collection
Z. VI, 681;
P. i F. 1881–1907, 1018

152 *Studies for "The Woman with a
Fan"*
Paris, 1905
Pencil on paper, $9^{3}/_{4} \times 12^{1}/_{3}$ in.
(25 × 32 cm)
Private collection
Z. XXII, 276;
P. i F. 1881–1907, 1162

153 *Woman in a Chemise*
Paris, 1905
Oil on canvas, $28^{1}/_{4} \times 23^{3}/_{8}$ in.
(72.5 × 60 cm)
The Tate Gallery, London.
Bequest of C. Frank Stoop
Z. I, 307; P. i F. 1881–1907, 1050

154 *Nude with Crossed Legs*
Paris, 1905
Crayon and charcoal on
canvas, $39 \times 31^{3}/_{4}$ in.
(100 × 81.5 cm)
Picasso Museum, Paris

155 *Mother Nursing Her Child*
Paris, early 1905
Gouache, $25^{5}/_{8} \times 19^{3}/_{4}$ in.
(65 × 50.5 cm)
Private collection
Z. XXII, 141;
P. i F. 1881–1907, 1020

156 *Seated Nude*
Paris, 1905
Oil on cardboard,
$41^{3}/_{8} \times 22^{3}/_{4}$ in. (106 × 76 cm)
Musée National d'Art
Moderne, Centre Georges
Pompidou, Paris
Z. I, 257; P. i F. 1881–1907, 1051

157 *Portrait of Benedetta Canals*
Paris, 1905
Oil on canvas, $34^{5}/_{8} \times 26^{1}/_{2}$ in.
(88 × 68 cm)
Picasso Museum, Barcelona
Z. I, 263; P. i F. 1881–1907, 1152

158 *The Beautiful Dutch Girl*
Schoorldam, 1905
Oil, gouache, and chalk on
cardboard, 70¼ × 26¼ in.
(78 × 67.3 cm)
The Queensland Art Gallery,
Brisbane
Z. I, 260; P. i F. 1881–1907, 1134

159 *Three Dutch Girls*
Schoorldam, Summer 1905
Gouache on paper mounted
on cardboard,
30 × 26⅛ in. (77 × 67 cm)
Musée National d'Art
Moderne, Centre Georges
Pompidou, Paris.
Gift of André Lefèvre
Z. I, 261; P. i F. 1881–1907, 1139

160 *Au Lapin Agile*
Paris, 1904–5
Oil on canvas, 38⅝ × 39⅛ in.
(99 × 100.3 cm)
The Metropolitan Museum of
Art, New York. The Walter H.
and Lenore Annenberg
Collection, Partial Gift of
Walter H. and Lenore
Annenberg
Z. I, 275; P. i F. 1881–1907, 1012

161 *Seated Harlequin*
Paris, 1905
India ink and watercolor
dimensions unknown
Private collection
Z. XXII, 237;
P. i F. 1881–1907, 1044

162 *The Violinist
(The Family with a Monkey)*
Paris, 1905
Pen and watercolor on paper,
6⅜ × 5⅛ in. (16.2 × 14.2 cm)
The Baltimore Museum of
Art. Cone Collection
Z. XXII, 161;
P. i F. 1881–1907, 1059

163 *Harlequin's Family*
Paris, 1905
India ink and gouache on
cardboard, 22⅛ × 17 in.
(58 × 43.5 cm)
Private collection
Z. I, 298; P. i F. 1881–1907, 1039

164 *Family of Acrobats with a
Monkey*
Paris, 1905
India ink, gouache, watercol-
or, and pastel on cardboard,
40½ × 29¼ in. (104 × 75 cm)
Göteborgs Kunstmuseum,
Göteborg
Z. I, 299; P. i F. 1881–1907, 1058

165 *Unhappy Mother and Child*
Paris, early 1905
Gouache on canvas,
34⅜ × 27⅛ in. (88 × 69.5 cm)
Staatsgalerie, Stuttgart
Z. I, 296; P. i F. 1881–1907, 1021

166 *The Two Comedians*
Paris, 1905
Gouache and pastel on gray
paper, 27½ × 20¼ in.
(70.5 × 52 cm)
The National Museum, Osaka
Z. I, 295; P. i F. 1881–1907, 1042

167 *Acrobat and Young Harlequin*
Paris, 1905
Gouache on cardboard,
41 × 29⅝ in. (105 × 76 cm)
Private collection
Z. I, 297; P. i F. 1881–1907, 1040

168 *Saltimbanques with a Dog*
Paris, 1905
Gouache on cardboard,
41⅛ × 29¼ in. (105.5 × 75 cm)
The Museum of Modern Art,
New York. Gift of Mr. and
Mrs. William A. M. Burden
Z. I, 300; P. i F. 1881–1907, 1035

169 *Comedians*
Paris, 1905
Oil on canvas, 74 × 42⅛ in.
(190 × 108 cm)
The Barnes Foundation,
Merion, Pennsylvania
Z. I, 301; P. i F. 1881–1907, 1043

170 *The Organ Grinder*
Paris, 1905
Gouache on cardboard,
39 × 27⅛ in. (100 × 70 cm)
Kunsthaus, Zurich
Z. VI, 798;
P. i F. 1881–1907, 1073

171 *Clown on a Horse*
Paris, 1905
Oil on cardboard, 39 × 27 in.
(100 × 69.2 cm)
Private collection
Z. I, 243; P. i F. 1881–1907, 1065

172 *Family of Saltimbanques*
Paris, 1905
India ink and watercolor on
paper, 9⅜ × 11⅞ in.
(24 × 30.5 cm)
The Baltimore Museum of
Art. Cone Collection
Z. XXII, 159;
P. i F. 1881–1907, 1031

173 *Amazon on a Horse*
Paris, 1905
Gouache on cardboard,
23⅜ × 30¾ in. (60 × 79 cm)
Private collection
Z. XXII, 268;
P. i F. 1881–1907, 1124

174 *The Athlete*
Paris, 1905
Gouache on cardboard,
25⅜ × 21¾ in. (65 × 56 cm)
Private collection
Z. XXII, 244;
P. i F. 1881–1907, 1114

175 *The Jester*
Paris, 1905
Bronze, 16⅛ × 14⅜ × 8⅞ in.
(41.5 × 37 × 22.8 cm)
Picasso Museum, Paris
Z. I, 322;
P. i F. 1881–1907, 1061; Sp., 4

176 *Acrobat on a Ball*
Paris, 1905
Oil on canvas, 57⅜ × 37 in.
(147 × 95 cm)
Pushkin Museum, Moscow
Z. I, 290; P. i F. 1881–1907, 1055

177 *Girl with a Basket of Flowers
(Flower of the Streets)*
Paris, 1905
Oil on canvas, 59¼ × 25⅜ in.
(152 × 65 cm)
Private collection
Z. I, 256; P. i F. 1881–1907, 1155

178 *Family of Acrobats*
Paris, 1905
Gouache on cardboard,
20 × 23⅞ in. (51.2 × 61.2 cm)
Pushkin Museum, Moscow
Z. I, 287; P. i F. 1881–1907, 1126

179 *Fat Clown Seated*
Sketchbook no. 24, Paris, 1905
Sheet no. 35
Ink and watercolor on paper,
5⅝ × 3⅛ in. (14.3 × 7.8 cm)
Marina Picasso Collection,
Galerie Jan Krugier,
Ditesheim & Cie, Geneva
P. i F. 1881–1907, 1107

180 *The Saltimbanques*
Paris, 1905
Oil on canvas, 83 × 89½ in.
(212.8 × 229.6 cm)
The National Gallery of Art,
Washington, D.C. Chester
Dale Collection
Z. I, 285; P. i F. 1881–1907, 1151

181 *Boy with a Pipe*
Paris, 1905
Oil on canvas, 39 × 31⅝ in.
(100 × 81.3 cm)
Mrs. John Hay Whitney
Collection
Z. I, 274; P. i F. 1881–1907, 1166

182 *Tumbler with a Still Life*
Paris, 1905
Gouache on cardboard,
39 × 27¼ in. (100 × 69.9 cm)
The National Gallery of Art,
Washington, D.C. Chester
Dale Collection
Z. I, 294; P. i F. 1881–1907, 1168

183 *The Death of Harlequin*
Paris, 1906
Gouache on cardboard,
25⅜ × 37 in. (65 × 95 cm)
Mellon Collection,
Washington, D.C.
Z. I, 302; P. i F. 1881–1907, 1182

184 *The Death of Harlequin*
Paris, 1906
Pen and watercolor, 4 × 6¾ in.
(10.5 × 17.5 cm)
Mellon Collection,
Washington, D.C.
Z. XXII, 337;
P. i F. 1881–1907, 1179

185 *The Two Brothers*
Gósol, Spring 1906
Gouache on cardboard,
31¼ × 23 in. (80 × 59 cm)
Picasso Museum, Paris
Z. VI, 720;
P. i F. 1881–1907, 1229

186 *Head of a Young Man*
Paris or Gósol, 1906
Gouache on cardboard,
12 × 9⅜ in. (31 × 24 cm)
The Cleveland Museum of
Art. Bequest of Leonard C.
Hanna, Jr.
Z. I, 303; P. i F. 1881–1907, 1231

187 *The Two Brothers*
Gósol, Spring–Summer 1906
Oil on canvas, 55⅛ × 37⅞ in.
(142 × 97 cm)
Kunstmuseum, Basel
Z. I, 304; P. i F. 1881–1907, 1233

188 *Two Youths*
Gósol, Spring–Summer 1906
Oil on canvas, 61¼ × 45⅝ in.
(157 × 117 cm)
Musée de l'Orangerie, Paris.
Jean Walter-Paul Guillaume
Collection
Z. I, 324; P. i F. 1881–1907, 1239

189 *Two Youths*
Gósol, Spring–Summer 1906
Oil on canvas, 59 × 36½ in.
(151.5 × 93.7 cm)
The National Gallery of Art,
Washington, D.C. Chester
Dale Collection
Z. VI, 715;
P. i F. 1881–1907, 1241

190 *The Watering Place (Arcadia)*
Paris, Spring 1906
Gouache on cardboard,
14¾ × 22½ in. (38.1 × 57.8 cm)
The Metropolitan Museum of
Art, New York. Bequest of
Scofield Thayer
Z. I, 265; P. i F. 1881–1907, 1197

191 *Rider from the Back*
Paris, 1906
Charcoal on gray paper,
18⅛ × 11¾ in. (46.6 × 30.4 cm)
Private collection
Z. VI, 682;
P. i F. 1881–1907, 1192

192 *Study for "The Watering Place"*
Paris, Spring 1906
Watercolor on paper,
12 × 19⅛ in. (31 × 49 cm)
Private collection
Z. VI, 682;
P. i F. 1881–1907, 1195

193 *Boy Leading a Horse*
Paris, 1906
Oil on canvas, 86¼ × 50¼ in.
(221 × 130 cm)
The Museum of Modern Art,
New York. William S. Paley
Collection

194 *Self-Portrait*
Gósol, Spring 1906
Charcoal, dimensions
unknown
Private collection
Z. XXII, 450;
P. i F. 1881–1907, 1207

195 *Woman with Loaves*
Gósol, Spring–Summer 1906
Oil on canvas, 39 × 27¼ in.
(100 × 69.8 cm)
The Philadelphia Museum of
Art. Gift of Charles E. Ingersoll
Z. VI, 735;
P. i F. 1881–1907, 1294

196 *Head of Fernande*
Paris, 1906
Bronze, 13⅝ × 9⅜ × 9¼ in.
(35 × 24 × 25 cm)
Picasso Museum, Paris
P. i F. 1881–1907, 1205; Sp., 6

197 *Young Gósolan Wearing a Barretina Hat*
Gósol, Spring–Summer 1906
Gouache and watercolor on
paper,
24 × 18¾ in. (61.5 × 48 cm)
Göteborgs Kunstmuseum,
Göteborg
Z. I, 318; P. i F. 1881–1907, 1322

198 *Portrait of Josep Fontdevila*
Gósol, Spring–Summer 1906
Oil on canvas, 17⅝ × 15¼ in.
(45.1 × 40.3 cm)
The Metropolitan Museum of
Art, New York
Z. VI, 769;
P. i F. 1881–1907, 1313

199 *Profile of Fernande*
Paris, Summer–Autumn 1906
Gouache on paper,
12½ × 15⅝ in. (32 × 40 cm)
Prins Eugens Waldemarsudde
Museum, Stockholm
Z. XXII, 333;
P. i F. 1881–1907, 1348

200 *La Coiffure*
Paris, Spring 1906
Oil on canvas, 68¼ × 38⅞ in.
(175 × 99.7 cm)
The Metropolitan Museum of
Art, New York. Catherine
Lorillard Wolfe Collection
Z. I, 313; P. i F. 1881–1907, 1213

201 *Kneeling Woman Doing Her Hair*
Paris, Autumn 1906
Bronze, 16⅝ × 10⅛ × 12⅜ in.
(42.2 × 26 × 31.8 cm)
Picasso Museum, Paris
Z. I, 329;
P. i F. 1881–1907, 1364; Sp., 7

202 *La Toilette*
Gósol, Spring–Summer 1906
Oil on canvas, 58⅞ × 38⅝ in.
(151 × 99 cm)
Albright-Knox Art Gallery,
Buffalo. Fellows for Life Fund
Z. I, 325; P. i F. 1881–1907, 1248

203 *Woman Washing Herself (Study for "The Harem")*
Gósol, Spring–Summer 1906
Watercolor on paper,
25 × 19⅛ in. (64.1 × 49 cm)
The Cleveland Museum of
Art. Hinman B. Hurlbut
Collection
Z. I, 320; P. i F. 1881–1907, 1265

204 *Woman Doing Her Hair*
Paris, Summer–Autumn 1906
Oil on canvas, 49⅛ × 35⅜ in.
(126 × 90.7 cm)
Private collection
Z. I, 336; P. i F. 1881–1907, 1363

205 *Kneeling Woman Doing Her Hair*
Paris, 1906
Pencil and charcoal on paper,
21⅝ × 15⅝ in. (55.5 × 40 cm)
Robert and Lisa Sainsbury
Collection, University of
East Anglia, Norwich
Z. I, 341; P. i F. 1881–1907, 1361

206 *The Harem*
Gósol, Spring–Summer 1906
Oil on canvas, 60½ × 42⅞ in.
(154.3 × 110 cm)
The Cleveland Museum of
Art. Bequest of Leonard C.
Hanna, Jr.
Z. I, 321; P. i F. 1881–1907, 1266

207 *Large Standing Nude*
Gósol, Spring–Summer 1906
Oil on canvas, 59⅝ × 36⅝ in.
(153 × 94 cm)
The Museum of Modern Art,
New York. William S. Paley
Collection
Z. I, 327; P. i F. 1881–1907, 1287

208 *Seated Nude with Crossed Legs*
Paris, Autumn–Winter 1906
Oil on canvas, 58⅞ × 39 in.
(151 × 100 cm)
Národni Gallery, Prague
Z. I, 373; P. i F. 1881–1907, 1397

209 *Head of a Woman*
Paris, Winter 1906–1907
Gouache and ink on paper,
24½ × 18⅝ in. (63 × 47 cm)
Musée National d'Art
Moderne, Centre Georges
Pompidou, Paris
Z. XXII, 470;
P. i F. 1881–1907, 1421

210 *Female Nude Against a Red Background*
Paris, Summer–Autumn 1906
Oil on canvas, 31⅝ × 21 in.
(81 × 54 cm)
Musée de l'Orangerie, Paris.
Jean Walter-Paul Guillaume
Collection
Z. I, 328; P. i F. 1881–1907, 1359

211 *Study for "Two Women Holding Each Other by the Waist"*
Paris, Summer–Autumn 1906
Watercolor and India ink on
paper, 8¼ × 5¼ in.
(21.2 × 13.5 cm)
Private collection
Z. XXII, 409;
P. i F. 1881–1907, 1350

212 *Woman Seated and Woman Standing*
Paris, Autumn–Winter 1906
Charcoal on paper,
24 × 18⅛ in. (61.5 × 47 cm)
The Philadelphia Museum of
Art. Louise and Walter
Arensberg Collection
Z. I, 368; P. i F. 1881–1907, 1406

213 *Study for "Two Nudes"*
Paris, Autumn–Winter 1906
Conté crayon on paper,
23¾ × 17⅝ in. (61 × 45.1 cm)
The Museum of Fine Arts,
Boston. Arthur Tracy Cabot
Foundation
Z. XXII, 467;
P. i F. 1881–1907, 1407

214 *Two Women Holding Each Other by the Waist*
Paris, Summer–Autumn 1906
Oil on canvas, 58⅞ × 39 in.
(151 × 100 cm)
Private collection
Z. I, 360; P. i F. 1881–1907, 1354

215 *Study for "Two Nudes"*
Paris, Autumn–Winter 1906
Watercolor and India ink on
paper, dimensions unknown
Private collection
Z. I, 364; P. i F. 1881–1907, 1410

216 *Two Nudes*
Paris, Autumn–Winter 1906
Oil on canvas, 59 × 36¼ in.
(151.3 × 93 cm)
The Museum of Modern Art,
New York. Gift of David
Thompson, in honor of Alfred
H. Barr, Jr.
Z. I, 366; P. i F. 1881–1907, 1411

217 *Portrait of Gertrude Stein*
Paris, Spring–Summer 1906
Oil on canvas, 39 × 31¾ in.
(100 × 81.3 cm)
The Metropolitan Museum of
Art, New York. Bequest of
Gertrude Stein
Z. I, 352; P. i F. 1881–1907, 1339

218 *Self-Portrait with Palette*
Paris, Spring–Summer 1906
Oil on canvas, 35⅞ × 28½ in.
(92 × 73 cm)
The Philadelphia Museum of
Art. E. A. Gallatin Collection
Z. I, 375; P. i F. 1881–1907, 1380

219 *Studies for Self-Portraits*
Paris, Summer 1906
Pencil on paper,
12¼ × 18½ in. (31.5 × 47.5 cm)
Picasso Museum, Paris
Z(MG). XXVI, 5;
P. i F. 1881–1907, 1377

220 *Self-Portrait as a Boy*
Paris, Summer 1906
Oil on canvas, 15¼ × 11¾ in.
(39 × 30 cm)
Private collection
Z.II**, 1; 592;
P. i F. 1881–1907, 1375

221 *Self-Portrait*
Paris, Autumn 1906
Oil on canvas, 25⅜ × 21 in.
(65 × 54 cm)
Picasso Museum, Paris
Z. II*, 1; P. i F. 1881–1907, 1376

222 *Man, Woman, and Child*
Paris, Autumn 1906
Oil on canvas, 44⅞ × 34⅜ in.
(115 × 88 cm)
Kunstmuseum, Basel. Picasso
Gift, 1967
Z. II**, 587;
P. i F. 1881–1907, 1381

223 *Nude Boy*
Paris, Autumn 1906
Oil on canvas, 26⅛ × 17⅛ in.
(67 × 44 cm)
Picasso Museum, Paris
P. i F. 1881–1907, 1384

224 *Woman with an Inclined Head*
Paris, Winter 1906–7
Drawing on paper,
24⅜ × 18⅜ in. (62.5 × 47 cm)
Private collection
Z. II**, 597;
P. i F. 1881–1907, 1419

225 *Portrait of Max Jacob*
Paris, Winter 1907
Gouache on paper,
24½ × 18¾ in. (62.7 × 48 cm)
Museum Ludwig, Cologne.
Ludwig Collection
Z. II*, 9; P. i F. 1881–1907,
1412; D. R., 48

226 *Bust*
Paris, Spring 1907
Oil on canvas, 23½ × 23 in.
(60.5 × 59.2 cm)
Picasso Museum, Paris
Z(MG). XXVI, 18; P. i F.
1881–1907, 1440; D. R., 23

227 *Bust of a Man*
Paris, Spring 1907
Oil on canvas, 21¾ × 18⅛ in.
(56 × 46.5 cm)
Picasso Museum, Paris
Z(MG). XXVI, 12; D. R., 22

228 *Self-Portrait*
Paris, Spring 1907
Oil on canvas, 19½ × 18 in.
(50 × 46 cm)
Národni Gallery, Prague
Z. II*, 8; P. i F. 1881–1907, 35;
D. R., 25

229 *Head of a Woman or a Sailor*
Paris, Spring 1907
Oil on cardboard,
20¾ × 14⅛ in. (53.5 × 36.2 cm)
Picasso Museum, Paris
D. R., 28

230 *Head of a Woman*
Paris, Spring–Summer 1907
Oil on canvas, 25¼ × 19½ in.
(64.5 × 50 cm)
Národni Gallery, Prague
Z. II*, 16; P. i F. 1881–1907,
1546; D. R., 33

231 *Seated Woman Holding Her Foot*
Paris, Spring 1907
Oil on canvas, 51½ × 40½ in.
(131 × 104 cm)
Picasso Museum, Paris
Z. II**, 651; P. i F. 1881–1907,
1477; D. R., 15

232 *Bust of a Woman with Clasped
Hands*
Paris, Spring 1907
Oil on canvas, 35⅛ × 27¾ in.
(90 × 71 cm)
Picasso Museum, Paris
Z. II**, 662; P. i F. 1881–1907,
1439; D. R., 26

233 *Small Nude with Raised Arms,
Back View (Study for
"Les Demoiselles d'Avignon")*
Paris, Spring 1907
Oil on panel, 7⅜ × 4½ in.
(19 × 11.5 cm)
Picasso Museum, Paris
D. R., 18

234 *Nude with Raised Arms, Front
View (Study for "Les
Demoiselles d'Avignon")*
Paris, Spring 1907
Gouache, charcoal, and pencil
on paper mounted on canvas,
51⅛ × 31 in. (131 × 79.5 cm)
Picasso Museum, Paris
Z(MG). XXVI, 190; P. i F.
1881–1907, 1460; D. R., 17

235 *Nude with Raised Arms, Back
View (Study for
"Les Demoiselles d'Avignon")*
Paris, Spring 1907
Gouache, charcoal, and pencil
on paper mounted on canvas,
52¼ × 33½ in. (134 × 86 cm)
Picasso Museum, Paris
Z(MG). XXVI, 189; P. i F.
1881–1907, 1459; D. R., 19

236 *Bust of Woman (Study for
"Les Demoiselles d'Avignon")*
Paris, Spring–Summer 1907
Oil on canvas, 31⅝ × 23⅜ in.
(81 × 60 cm)
Berggruen Collection, Berlin
Z. II*, 24; P. i F. 1881–1907,
1550; D. R., 24

237 *Bust of a "Demoiselle d'Avignon"*
Paris, Summer 1907
Oil on canvas, 25⅜ × 23 in.
(65 × 59 cm)
Musée National d'Art
Moderne, Centre Georges
Pompidou, Paris
Z. II*, 23; P. i F. 1881–1907,
1556; D. R., 38

238 *Moving Face*
Paris, Summer 1907
Oil on canvas, partly mount-
ed on new canvas,
37⅜ × 12⅞ in. (96 × 33 cm)
Kunstmuseum, Basel. On loan
from private collection
Z. II*, 22; P. i F. 1881–1907,
1555; D. R., 46

239 *Standing Nude*
Paris, Spring 1907
Oil on canvas, 36¼ × 16¾ in.
(93 × 43 cm)
Private collection
Z. II*, 40; D. R., 40

240 *Study for "Les Demoiselles
d'Avignon"*
Paris, Winter 1906–1907
Sketchbook no. 2, page 32r
Black crayon on paper,
4⅛ × 5¾ in. (10.6 × 14.7 cm)
Picasso Museum, Paris
Z. II**, 643;
P. i F. 1881–1907, 1509

241 *Study for "Les Demoiselles
d'Avignon"*
Paris, March 1907
Sketchbook no. 3, page 29r
Black crayon on paper,
7¾ × 9½ in. (19.9 × 24.2 cm)
Picasso Museum, Paris
Z(MG). XXVI, 59;
P. i F. 1881–1907, 1510

242 *Study for "Les Demoiselles
d'Avignon"*
Paris, March 1907
Sketchbook no. 3, page 19v
Black crayon on paper,
7½ × 9½ in. (19.3 × 24.2 cm)
Picasso Museum, Paris
Z(MG). XXVI, 70;
P. i F. 1881–1907, 1516

243 *Study for "Les Demoiselles
d'Avignon"*
Paris, March 1907
Black crayon on paper,
7½ × 9½ in. (19.3 × 24.2 cm)
Picasso Museum, Paris
Z(MG). XXVI, 97;
P. i F. 1881–1907, 1522

244 *Study for "Les Demoiselles
d'Avignon"*
Paris, March 1907
Sketchbook no. 6, page 2r
Pen and India ink on paper,
4⅛ × 5⅜ in. (10.5 × 13.6 cm)
Picasso Museum, Paris
Z. II**, 633;
P. i F. 1881–1907, 1527

245 *Study for "Les Demoiselles
d'Avignon"*
Paris, May 1907
Sketchbook no. 6, page 6r
Pen and India ink on paper,
4⅛ × 5⅜ in. (10.5 × 13.6 cm)
Picasso Museum, Paris
Z. II**, 637;
P. i F. 1881–1907, 1531

246 *Study for "Les Demoiselles
d'Avignon"*
Paris, May 1907
Sketchbook no. 6, page 7r
Pen and India ink on paper,
4⅛ × 5⅜ in. (10.5 × 13.6 cm)
Picasso Museum, Paris
Z. II**, 638;
P. i F. 1881–1907, 1537

247 *Study for "Les Demoiselles
d'Avignon"*
Paris, May 1907
Sketchbook no. 6, page 18r
Pen and India ink on paper,
4⅛ × 5⅜ in. (10.5 × 13.6 cm)
Picasso Museum, Paris
Z. II**, 642;
P. i F. 1881–1907, 1539

248 *Study for "Les Demoiselles d'Avignon"*
Paris, May 1907
Pen and sepia on paper,
3³/₈ × 3¹/₂ in. (8.7 × 9 cm)
Picasso Museum, Paris
Z. VI, 980;
P. i F. 1881–1907, 1541

249 *Study for "Les Demoiselles d'Avignon"*
Paris, May 1907
Pen and India ink on paper,
3¹/₄ × 3¹/₂ in. (8.2 × 9 cm)
Picasso Museum, Paris
Z. VI, 981;
P. i F. 1881–1907, 1542

250 *Study for "Les Demoiselles d'Avignon"*
Paris, May 1907
Charcoal on paper,
18¹/₂ × 25³/₈ in. (47.6 × 65 cm)
Kunstmuseum, Basel
Z. II**, 644;
P. i F. 1881–1907, 1548

251 *Study for "Les Demoiselles d'Avignon"*
Paris, March–April 1907
Pencil and pastel on paper,
18¹/₂ × 24³/₄ in. (47.7 × 63.5 cm)
Kunstmuseum, Basel
Z. II*, 19; P. i F. 1881–1907,
1511; D. R., 29

252 *Study for "Les Demoiselles d'Avignon"*
Paris, June 1907
Watercolor on paper,
6³/₄ × 8³/₄ in. (17.4 × 22.5 cm)
The Philadelphia Museum of
Art. A. E. Gallatin Collection
Z. II*, 21; P. i F. 1881–1907,
1543; D. R., 31

253 *Les Demoiselles d'Avignon*
Paris, June–July 1907
Oil on canvas, 95¹/₈ × 91¹/₈ in.
(243.9 × 233.7 cm)
The Museum of Modern Art,
New York. Acquired through
the Lillie P. Bliss Bequest
Z. II*, 18; P. i F. 1881–1907,
1557; D. R., 47

254 *Standing Nude*
Paris, Spring 1907
Gouache and pastel on paper,
24³/₈ × 18³/₄ × in. (62.5 × 48 cm)
Picasso Museum, Paris
Z(MG). XXVI, 275; P. i F.
1907–1917, 39; D. R., 72

255 *Standing Nude*
Paris, 1907
Engraved and painted panel,
12³/₈ × 3¹/₈ × 1¹/₈ in.
(31.8 × 8 × 3 cm)
Picasso Museum, Paris
Z. II**, 667;
P. i F. 1907–1917, 103; Sp., 17

256 Verso of fig. 255: birds
engraved and painted in
gouache

257 *Figure*
Paris, 1907
Carved oak with touches of
oil paint, 31³/₈ × 9³/₈ × 8¹/₈ in.
(80.5 × 24 × 20.8 cm)
Picasso Museum, Paris
Z. II**, 607; Sp., 19

258 *Small Seated Nude*
Paris, Summer 1907
Oil on panel, 6⁷/₈ × 5⁷/₈ in.
(17.6 × 15 cm)
Picasso Museum, Paris
Z(MG). XXVI, 262; P. i F.
1907–1917, 94; D. R., 71

259 *Mother and Child*
Paris, Summer 1907
Oil on canvas, 31⁵/₈ × 23³/₈ in.
(81 × 60 cm)
Picasso Museum, Paris
Z. II*, 38; D. R., 52

260 *Face*
Paris, Autumn 1907
Oil on panel, 6⁵/₈ × 5¹/₂ in.
(17.5 × 14 cm)
Private collection
Z(MG). XXVI, 269; P. i F.
1881–1907, 98; D. R., 74

261 *Head*
Paris, Autumn 1907
Oil on canvas, 7 × 6⁵/₈ in.
(18 × 14 cm)
Private collection
Z(MG). XXVI, 270; P. i F.
1907–1917, 97; D. R., 73

262 *Study for "Nude with Drapery"*
Paris, Spring–Summer 1907
Oil on canvas, 25¹/₂ × 19¹/₂ in.
(65.5 × 50 cm)
Private collection
Z(MG). XXVI, 263;
P. i F. 1881–1907, 1493

263 *Study for "Nude with Drapery"*
Paris, Summer 1907
Pastel on gray paper,
23³/₄ × 19¹/₂ in. (61 × 50 cm)
Musée National d'Art
Moderne, Centre Georges
Pompidou, Paris. Bequest of
Georges Salles
D. R., 94

264 *Study for "Nude with Drapery"*
Paris, Summer 1907
Color, crayon, and pastel on
paper, 18³/₄ × 24¹/₄ × in.
(48 × 63.5 cm)
Picasso Museum, Paris
Z(MG). XXVI, 264;
P. i F. 1907–1917, 70; D. R., 76

265 *Face Mask*
Paris, August 1907
Ink on newsprint, 6 × 3¹/₂ in.
(15.5 × 9 cm)
Private collection
Z(MG). XXVI, 259;
P. i F. 1881–1907, 1485

266 *Nude with Raised Arms*
Paris, Spring–Summer 1907
Ink on paper, 8¹/₄ × 5¹/₄ in.
(21.2 × 13.4 cm)
Private collection
Z. VI, 961;
P. i F. 1881–1907, 1505

267 *Nude with Drapery*
Paris, Summer–Autumn 1907
Oil on canvas, 59¹/₄ × 39³/₈ in.
(152 × 101 cm)
The State Hermitage
Museum, St. Petersburg
Z. II*, 47; P. i F. 1907–1917,
74; D. R., 95

268 *Nude with Raised Arms*
Paris, Autumn 1907
Oil on canvas, 58¹/₂ × 39 in.
(150 × 100 cm)
Private collection
Z. II*, 35; P. i F. 1907–1917,
107; D. R., 53

269 *Nude with Raised Arms*
Paris, Autumn 1907
Oil on canvas, 24¹/₂ × 16¹/₄ in.
(63 × 43 cm)
Thyssen-Bornemisza
Collection, Madrid
Z. II*, 36; P. i F. 1907–1917,
106; D. R., 54

270 *The Tree*
Paris, Summer 1907
Oil on canvas, 36⁵/₈ × 36¹/₂ in.
(94 × 93.7 cm)
Picasso Museum, Paris
Z. II**, 47; P. i F. 1907–1917,
114; D. R., 62

271 *Nude with a Towel*
Paris, Winter 1907-8
Oil on canvas, 45¹/₄ × 34³/₄ in.
(116 × 89 cm)
Private collection
Z. II*, 48; P. i F. 1907–1917,
124; D. R., 99

272 *Head of Woman, Three-Quarter View*
Paris, Winter 1907-8
Oil on canvas, 28¹/₂ × 23³/₈ in.
(73 × 60 cm)
Private collection
Z. II*, 52; P. i F. 1907–1917,
123; D. R., 105

273 *Mask of a Woman*
Paris, 1908
Bronze, 7 × 6¹/₄ × 4⁵/₈ in.
(18 × 16 × 12 cm)
Musée National d'Art
Moderne, Centre Georges
Pompidou, Paris
Sp., 22

274 *Friendship*
Paris, Winter 1907-8
Oil on canvas, 59¹/₄ × 39³/₈ in.
(152 × 101 cm)
The State Hermitage
Museum, St. Petersburg
Z. II*, 60; P. i F. 1907–1917,
128; D. R., 104

275 *Three Figures Under a Tree*
Paris, Autumn 1908
Oil on canvas, 38⁵/₈ × 38⁵/₈ in.
(99 × 99 cm)
Picasso Museum, Paris
Z. II*, 53; P. i F. 1907–1917,
122; D. R., 106

276 *Three Women*
Paris, Spring 1908
Oil on canvas, 35¹/₂ × 35¹/₂ in.
(91 × 91 cm)
Sprengel Museum, Hanover
Z. II*, 107; P. i F. 1907–1917,
152; D. R., 123

277 *Three Women*
Paris, Autumn 1907–late 1908
Oil on canvas, 78 × 30³/₈ in.
(200 × 78 cm)
The State Hermitage
Museum, St. Petersburg
Z. II*, 108; P. i F. 1907–1917,
180; D. R., 131

278 *Study for "Three Women"*
Paris, Autumn–Winter 1907
Gouache on paper,
19⁷/₈ × 18³/₄ in. (51 × 48 cm)
Musée National d'Art
Moderne, Centre Georges
Pompidou, Paris. Gift of
Monsieur and Madame André
Lefèvre
Z. II*, 104; P. i F. 1907–1917,
150; D. R., 124

279 *Standing Nude, Front View*
Paris, Spring 1908
Oil on panel, 26¹/₈ × 10³/₈ in.
(67 × 26.7 cm)
Private collection
Z. II**, 694; P. i F. 1907–1917,
204; D. R., 167

280 *Nude with Raised Arms, Profile View*
Paris, Spring 1908
Oil on panel, 26¹/₈ × 10 in.
(67 × 25.5 cm)
Private collection
Z. II*, 693; P. i F. 1907–1917,
205; D. R., 166

281 *Nude with Raised Arms*
Paris, Spring 1908
Gouache on paper,
12¹/₂ × 9³/₄ in. (32 × 25 cm)
Picasso Museum, Paris
Z. II*, 39; P. i F. 1907–1917,
202; D. R., 165

282 *The Dryad*
Paris, Spring–Autumn 1908
Oil on canvas, 72¹/₈ × 42¹/₈ in.
(185 × 108 cm)
The State Hermitage
Museum, St. Petersburg
Z. II*, 113; P. i F. 1907–1917,
273; D. R., 133

283 *Landscape with Two Figures*
Paris, Autumn 1908
Oil on canvas, 23³/₈ × 28¹/₂ in.
(60 × 73 cm)
Picasso Museum, Paris
Z. II*, 79; P. i F. 1907–1917,
242; D. R., 187

284 *Reclining Nude*
Paris, Spring 1908
Oil on panel, 10¹/₂ × 8¹/₄ in.
(27 × 21 cm)
Picasso Museum, Paris
Z(MG). XXVI, 364; P. i F.
1907–1917, 222; D. R., 156

285 *Seated Nude*
Paris, 1908
Bronze, 4³/₈ × 3¹/₂ × 4¹/₈ in.
(11 × 9 × 10.5 cm)
Picasso Museum, Paris
P. i F. 1907–1917, 223; Sp., 23

286 *Seated Woman*
Paris, Summer 1908
Oil on canvas, 58¹/₂ × 38⁵/₈ in.
(150 × 99 cm)
The State Hermitage
Museum, St. Petersburg
Z. II*, 68; P. i F. 1907–1917,
235; D. R., 169

287 *Torso of Sleeping Woman (Repose)*
Paris, Spring–Summer 1908
Oil on canvas, 31³/₄ × 25¹/₂ in.
(81.3 × 65.5 cm)
The Museum of Modern Art,
New York. Acquired through
the Bequest of Katherine S.
Dreier and de Hillman
Periodicals, Philip Johnson,
Miss Janice Loeb, Abby
Aldrich Rockefeller, and Mr.
and Mrs. Norbert Schimmel
Funds
Z(MG). XXVI, 303; P. i F.
1907–1917, 234; D. R., 170

288 *Woman with a Fan*
Paris, late Spring 1908
Oil on canvas, 59¹/₈ × 39³/₈ in.
(152 × 101 cm)
The State Hermitage
Museum, St. Petersburg
Z. II*, 67; P. i F. 1907–1917,
236; D. R., 168

289 *Torso of a Woman, Three-Quarter View*
Paris, Spring–Summer 1908
Oil on canvas, 28¹/₂ × 23³/₈ in.
(73 × 60 cm)
Národni Gallery, Prague
Z. II*, 64; P. i F. 1907–1917,
233; D. R., 134

290 *Bust of a Man*
Paris, Autumn 1908
Oil on canvas, 24¹/₄ × 16 in.
(62 × 43.5 cm)
The Metropolitan Museum of
Art, New York
Z. II*, 76; P. i F. 1907–1917,
276; D. R., 143

291 *Seated Male Nude*
Paris, Winter 1908–9
Oil on canvas, 37¹/₂ × 29⁵/₈ in.
(96 × 76 cm)
Musée d'Art Moderne du
Nord, Villeneuve d'Ascq. Gift
of Geneviève and Jean
Masurel
Z. II*, 117; P. i F. 1907–1917,
298; D. R., 229

292 *Bowls, Fruit, and Glass*
Paris, late 1908
Oil on canvas, 35⁷/₈ × 28¹/₂ in.
(92 × 73 cm)
The State Hermitage
Museum, St. Petersburg
Z. II*, 124; P. i F. 1907–1917,
288; D. R., 209

293 *Fruit Bowl*
Paris, Winter 1908–9
Oil on canvas, 29 × 23³/₄ in.
(74.3 × 61 cm)
The Museum of Modern Art,
New York. Acquired through
the Lillie P. Bliss Bequest
Z. II*, 121

294 *Still Life with a Hat*
Paris, Winter 1908
Oil on canvas, 23⁵/₈ × 28¹/₂ in.
(60 × 73 cm)
Private collection
Z. II*, 84; P. i F. 1907–1917,
344; D. R., 215

295 *Fruit and Glass*
Paris, Autumn 1908
Tempera on panel,
10¹/₂ × 8¹/₄ in. (27 × 21.1 cm)
The Museum of Modern Art,
New York. Estate of John Hay
Whitney
Z. II*, 123; P. i F. 1907–1917,
285; D. R., 203

296 *Small Carafe and Three Bowls*
Paris, Summer 1908
Oil on cardboard,
25³/₄ × 19¹/₂ in. (66 × 50 cm)
The State Hermitage
Museum, St. Petersburg
Z. II*, 90; P. i F. 1907–1917,
206; D. R., 176

297 *Still Life with a Razor Strap*
Paris, 1909
Oil on canvas, 21¹/₂ × 15⁵/₈ in.
(55 × 40.5 cm)
Picasso Museum, Paris.
Verbal Bequest of D.-H.
Kahnweiler.
Z. II*, 135; P. i F. 1907–1917,
296; D. R., 227

298 *Composition with Death's Head*
Paris, Spring 1908
Oil on canvas, 45³/₈ × 34³/₄ in.
(116.3 × 89 cm)
The State Hermitage
Museum, St. Petersburg
Z. II*, 50; P. i F. 1907–1917,
216; D. R., 172

299 *Bread and Fruit Bowl on a Table*
Paris, Winter 1909
Oil on canvas, 64 × 51⁵/₈ in.
(164 × 132.5 cm)
Kunstmuseum, Basel
Z. II*, 134; P. i F. 1907–1917,
329; D. R., 220

300 *Still Life with Fish*
Paris, Winter 1908–9
Oil on canvas, 28⁵/₈ × 23³/₈ in.
(73.5 × 60 cm)
Musée d'Art Moderne du
Nord, Villeneuve d'Ascq. Gift
of Geneviève and Jean
Masurel
Z. II*, 122; P. i F. 1907–1917,
291; D. R., 213

301 *Still Life with Liqueur Bottle*
Horta de Sant Joan,
Summer 1909
Oil on canvas, 31³/₄ × 25¹/₂ in.
(81.6 × 65.4 cm)
The Museum of Modern Art,
New York. Mrs. Simon
Guggenheim Collection
Z. II*, 173; P. i F. 1907–1917,
427; D. R., 299

302 *Beer*
Paris, Winter 1909–10
Oil on canvas, 31⁵/₈ × 25¹/₂ in.
(81 × 65.5 cm)
Musée d'Art Moderne du
Nord, Villeneuve-d'Ascq. Gift
of Geneviève and Jean
Masurel
Z. II*, 192; P. i F. 1907–1917,
451; D. R., 312

303 *Jewelry Box, Apple, Sugar Bowl, and Fan*
Paris, Autumn 1909
Watercolor on paper,
12¹/₈ × 16³/₄ in. (31 × 43 cm)
Private collection
Z(MG). XXVI, 405; D. R., 313

304 *Large Nude by the Sea*
Paris, [Winter–Spring] 1909
Oil on canvas, 50³/₄ × 37³/₄ in.
(130 × 97 cm)
The Metropolitan Museum of
Art, New York
Z. II*, 111; P. i F. 1907–1917,
346; D. R., 239

305 *Woman with a Fan*
Paris, Spring 1909
Oil on canvas, 39 × 31⁵/₈ in.
(100 × 81 cm)
Pushkin Museum, Moscow
Z. II*, 137; P. i F. 1907–1917,
372; D.R., 263

306 *Seated Nude*
Paris, Spring 1909
Oil on canvas, 39 × 31⁵/₈ in.
(100 × 81 cm)
The State Hermitage
Museum, St. Petersburg
Z. II*, 109; P. i F. 1907–1917,
350; D. R., 240

307 *Woman with a Mandolin*
Paris, Spring 1909
Oil on canvas, $35^7/_8 \times 27^3/_4$ in.
(92 × 73 cm)
The State Hermitage
Museum, St. Petersburg
Z. II*, 133; P. i F. 1907–1917,
363; D. R., 236

308 *Portrait of Clovis Sagot*
Paris, Spring 1909
Oil on canvas, 32 × $25^3/_4$ in.
(82 × 66 cm)
Kunsthalle, Hamburg
Z. II*, 129; P. i F. 1907–1917,
365; D. R., 270

309 *Portrait of Manuel Pallarès*
Barcelona, May 1909
Oil on canvas, $26^1/_2 \times 19^3/_8$ in.
(68 × 49.5 cm)
The Detroit Institute of Art.
Gift of Mr. and Mrs. Henry
Ford II
Z(MG). XXVI, 425; P. i F.
1907–1917, 377; D. R., 274

310 *The Factory*
Horta de Sant Joan, Summer
1909
Oil on canvas, $20^5/_8 \times 23^5/_8$ in.
(53 × 60 cm)
The State Hermitage
Museum, St. Petersburg
Z. II*, 158; P. i F. 1907–1917,
411; D. R., 279

311 *The Reservoir*
Horta de Sant Joan, Summer
1909
Oil on canvas, $23^5/_8 \times 19^1/_2$ in.
(60 × 50 cm)
Private collection
Z. II*, 157; P. i F. 1907–1917,
403; D. R., 280

312 *Landscape with a Bridge*
Paris, Spring 1909
Oil on canvas, $31^5/_8 \times 39$ in.
(81 × 100 cm)
Národni Gallery, Prague
Z(MG). XXVI, 426; P. i F.
1907–1917, 376; D. R., 273

313 *Portrait of Fernande*
Horta de Sant Joan, Summer
1909
Oil on canvas, $24^1/_8 \times 16^5/_8$ in.
(61.8 × 42.8 cm)
Kunstsammlung Nordrhein-
Westfalen, Düsseldorf
Z(MG). XXVI, 419; P. i F.
1907–1917, 409; D. R., 288

314 *Head of Fernande*
Paris, Autumn 1909
Bronze, $15^5/_8 \times 9 \times 10^1/_8$ in.
(40.5 × 23 × 26 cm)
Picasso Museum, Paris
Z. II**, 573;
P. i F. 1907–1917, 433; Sp., 24

315 *The Athlete*
Horta de Sant Joan,
Spring–Summer 1909
Oil on canvas, $32^1/_8 \times 28$ in.
(83 × 72 cm)
Museu de Arte, São Paulo
Z. II*, 166; P. i F. 1907–1917,
391; D. R., 297

316 *Seated Peasant Woman ("The
Italian"
by Derain)*
Paris, Winter 1909–10
Oil on canvas, $25^3/_8 \times 20^7/_8$ in.
(65 x 53.5 cm)
Private collection
Z(MG). XXVI, 390; P. i F.
1907–1917, 460; D. R., 323

317 *Bust of a Woman in Front of a
Still Life*
Horta de Sant Joan, Summer
1909
Oil on canvas, $35^7/_8 \times 28^1/_2$ in.
(92 × 73 cm)
Private collection
Z. II*, 170; P. i F. 1907–1917,
417; D. R., 290

318 *Girl with a Mandolin (Fanny
Tellier)*
Paris, Spring 1910
Oil on canvas, $39^1/_8 \times 28^1/_4$ in.
(100.3 × 73.6 cm)
The Museum of Modern Art,
New York. Nelson A
Rockefeller Bequest
Z. II*, 235; P. i F. 1907–1917,
492; D. R., 346

319 *The Sacré-Coeur*
Paris, Winter 1910
Oil on canvas, 36 × $25^3/_8$ in.
(92.5 × 65 cm)
Picasso Museum, Paris
Z. II*, 196; P. i F. 1907–1917,
479; D. R., 339

320 *Woman in a Black Hat*
Paris, Autumn–Winter
1909–10
Oil on canvas, $28^1/_2 \times 23^5/_8$ in.
(73 × 60 cm)
Private collection
Z. II*, 178; P. i F. 1907–1917,
443; D. R., 329

321 *Woman Seated in an Armchair*
Paris, Spring 1910
Oil on canvas, 39 × $28^1/_2$ in.
(100 × 73 cm)
Musée National d'Art
Moderne, Centre Georges
Pompidou, Paris
Z. II*, 200; P. i F. 1907–1917,
467; D. R., 342

322 *Woman in an Armchair*
Paris, Spring 1910
Oil on canvas, $36^5/_8 \times 29^1/_4$ in.
(94 × 75 cm)
Národni Gallery, Prague
Z. II*, 213; P. i F. 1907–1917,
476; D. R., 44

323 *Seated Nude*
Paris, Winter 1909–10
Oil on canvas, $35^7/_8 \times 28^1/_2$ in.
(92 × 73 cm)
The Tate Gallery, London
Z. II*, 201; P. i F. 1907–1917,
466; D. R., 343

324 *Portrait of Ambroise Vollard*
Paris, Spring 1910
Oil on canvas, $35^7/_8 \times 25^5/_8$ in.
(92 × 65 cm)
Pushkin Museum, Moscow
Z. II*, 214; P. i F. 1907–1917,
488; D. R., 337

325 *Portrait of Wilhelm Uhde*
Paris, Spring 1910
Oil on canvas, $31^5/_8 \times 23^5/_8$ in.
(81 × 60 cm)
Private collection
Z. II*, 217; P. i F. 1907–1917,
487; D. R., 338

326 *The Port of Cadaqués*
Cadaqués, Summer 1910
Oil on canvas, $14^7/_8 \times 17^3/_4$ in.
(38 × 45.5 cm)
Národni Gallery, Prague
Z. II*, 230; P. i F. 1907–1917,
507; D. R., 358

327 *Portrait of Daniel-Henry
Kahnweiler*
Paris, Autumn–Winter 1910
Oil on canvas, $39^1/_4 \times 28^1/_2$ in.
(100.6 × 72.8 cm)
The Art Institute of Chicago.
Gift of Mme. Gilbert W.
Chapman, in memory of
Charles R. Goodspeed
Z. II*, 227; P. i F. 1907–1917,
552; D. R., 368

328 *Nude*
Cadaqués, Summer 1910
Oil on canvas, 73 × $23^3/_4$ in.
(187.3 × 61 cm)
The National Gallery of Art,
Washington, D.C. Ailsa
Mellon Bruce Fund
Z. II*, 233; P. i F. 1907–1917,
543; D. R., 363

329 *The Guitarist*
Cadaqués, Summer 1910
Oil on canvas, 39 × $28^1/_2$ in.
(100 × 73 cm)
Musée National d'Art
Moderne, Centre Georges
Pompidou, Paris. Gift of M. et
Mme. André Lefèvre, 1910
Z. II*, 233; P. i F. 1907–1917,
540; D. R., 362

330 *Head of a Spanish Woman*
1910–11
Charcoal with highlights in
black pencil on paper,
25 × $19^1/_8$ in. (64 × 49 cm)
Picasso Museum, Paris
Z. VI, 1126;
P. i F. 1907–1917, 608

331 *Mademoiselle Léonie*
Cadaqués (August) and Paris
(Autumn), 1910
Etching for *Saint Matorel* by
Max Jacob, $7^3/_4 \times 5^1/_2$ in.
(20 × 14 cm)
P. i F. 1907–1917, 511; Bl. 19;
G, 23

332 *Standing Nude*
Cadaqués–Paris, 1910
Charcoal on paper,
$18^7/_8 \times 12^1/_8$ in. (48.3 × 31.2 cm)
The Metropolitan Museum of
Art, New York. Alfred Stieglitz
Collection
Z. II*, 208;
P. i F. 1907–1917, 533

333 *Standing Nude*
Sorgues, Summer 1912
Ink on paper, $12^5/_8 \times 7^3/_8$ in.
(31.8 × 19 cm)
Private collection
Z(MG). XXVIII, 38;
P. i F. 1907–1917, 702

334 *The Accordionist*
Céret, Summer 1911
Oil on canvas, $50^3/_4 \times 34^7/_8$ in.
(130 × 89.5 cm)
The Solomon R. Guggenheim
Museum, New York
Z. II*, 277; P. i F. 1907–1917,
601; D. R., 424

335 *The Clarinet*
Céret, Summer 1911
Oil on canvas, 23¾ × 19½ in.
(61 × 50 cm)
Národni Gallery, Prague
Z. II*, 265; P. i F. 1907–1917,
598; D. R., 415

336 *The Poet*
Céret, Summer 1911
Oil on canvas, 51⅛ × 34⅞ in.
(131.2 × 89.5 cm)
Peggy Guggenheim
Collection, Venice; Solomon
R. Guggenheim Foundation,
New York
Z. II*, 285; P. i F. 1907–1917,
600; D. R., 423

337 *Man with a Mandolin*
Paris, Autumn 1911
Oil on canvas, 63⅛ × 27⅝ in.
(162 × 71 cm)
Picasso Museum, Paris
Z. II*, 290; P. i F. 1907–1917,
655; D. R., 428

338 *Man with a Guitar*
Paris, Autumn 1911 and
Spring 1912
Oil on canvas, 60 × 30¼ in.
(154 × 77.5 cm)
Picasso Museum, Paris
Z(MG). XXVIII, 57; P. i F.
1907–1917, 656; D. R., 427

339 *Still Life (Le Torero)*
Céret, Summer 1911
Oil on canvas, 18 × 14⅞ in.
(46 × 38 cm)
Private collection
Z. II*, 266; P. i F. 1907–1917,
606; D. R., 413

340 *The Fan (L'Indépendant)*
Céret, Summer 1911
Oil on canvas, 23¾ × 19½ in.
(61 × 50 cm)
Private collection
Z. II*, 264; P. i F. 1907–1917,
595; D. R., 412

341 *Pipes, Cup, Coffee Pot, and
Small Carafe*
Paris, Winter 1911–12
Oil on canvas, 19½ × 50 in.
(50 × 128 cm)
Private collection
Z. II**, 726; P. i F. 1907–1917,
629; D. R., 417

342 *Still Life (QUI)*
Paris, Spring 1912
Oil and charcoal on canvas,
18 × 14⅞ in. (46 × 38 cm)
Musée National d'Art
Moderne, Centre Georges
Pompidou, Paris.
Gift of Mme Paul Cuttoli
Z(MG). XXVIII, 53;
P. i F. 1907–1917, 694

343 *Newspaper, Matchbox, Pipe,
and Glass*
Paris, Autumn 1911
Oil on canvas, 10½ × 8½ in.
(26.8 × 21.8 cm)
Picasso Museum, Paris
Z. II**, 729; D. R., 433

344 *Woman with a Guitar (Ma
Jolie)*
Paris, Winter 1911–12
Oil on canvas, 39 × 25½ in.
(100 × 65.4 cm)
The Museum of Modern Art,
New York. Acquired through
the Lillie P. Bliss Bequest
Z. II*; P. i F. 1907–1917, 637;
D. R., 430

345 *Pigeon with Peas*
Paris, Spring 1912
Oil on canvas, 25⅜ × 21 in.
(65 × 54 cm)
Musée d'Art Moderne de la
Ville de Paris, Paris. Maurice
Girardin Bequest
Z. II*, 308; P. i F. 1907–1917,
663; D. R., 453

346 *Bottle of Pernod and Glass*
Paris, Spring 1912
Oil on canvas, 18 × 12⅞ in.
(46 × 33 cm)
The State Hermitage
Museum, St. Petersburg
Z. II*, 307; P. i F. 1907–1917,
682; D. R., 460

347 *Bottle, Newspaper, and Glass
on a Table*
Paris, after December 4, 1912
Papier collé, charcoal, and
gouache on paper,
24⅛ 18¾ × in. (62 × 48 cm)
Musée National d'Art
Moderne, Centre Georges
Pompidou, Paris.
Gift of Henri Laugier
Z. II**, 755; D. R., 542

348 *Bottle on a Table*
Paris, Autumn–Winter 1912
Papiers collés, ink, and char-
coal on newsprint,
24⅛ × 17⅛ in. (62.5 × 44 cm)
Picasso Museum, Paris
Z. II**, 782; P. i F. 1907–1917,
845; D. R., 551

349 *The Aficionado*
Sorgues, Summer 1912
Oil on canvas, 52⅝ × 32 in.
(135 × 82 cm)
Kunstmuseum, Basel. Gift of
Raoul Le Roche, 1952
Z. II**, 362; P. i F. 1907–1917,
765; D. R., 500

350 *Spanish Still Life*
Paris, Spring 1912
Oil and enamel on canvas,
18 × 12⅞ in. (46 × 33 cm)
Musée d'Art Moderne du
Nord, Villeneuve-d'Ascq. Gift
of Geneviève and Jean
Masurel
Z. II*, 301; P. i F. 1907–1917,
695; D. R., 476

351 *Violin, Glasses, Pipe, and
Anchor*
Paris, May 1912
Oil and enamel on canvas,
31⅝ × 21 in. (81 × 54 cm)
Národni Gallery, Prague
Z. II*, 306; P. i F. 1907–1917,
803; D. R., 457

352 *Still Life with Chair Caning*
Paris, Spring 1912
Oil and waxed canvas on
canvas edged with rope,
11⅜ × 14⅜ in. (29 × 37 cm)
Picasso Museum, Paris
Z. II*, 294; P. i F. 1907–1917,
674; D. R., 466

353 *Our Future is in the Air
(Coquilles Saint-Jacques)*
Paris, Spring 1912
Oil and enamel on canvas,
14⅞ × 21⅝ in. (38 × 55.5 cm)
Private collection
Z. II*, 311; P. i F. 1907–1917,
680; D. R., 464

354 *Guitar*
Begun in Sorgues, late
Summer 1912, completed in
Paris, Winter 1912–13
Oil on canvas, 28¼ × 23⅜ in.
(72.5 × 60 cm)
Nasjonalgalleriet, Oslo
Z. II*, 357; P. i F. 1907–1917,
761; D. R., 489

355 *Guitar on a Table*
Paris, Autumn 1912
Oil, sand, and charcoal on
canvas, 20 × 24 in.
(51.1 × 61.6 cm)
Hood Museum of Art,
Dartmouth College, Hanover,
N.H. Gift of Nelson A.
Rockefeller, Class of 1930
Z. II**, 373; P. i F. 1907–1917,
830; D. R., 509

356 *Guitar*
Paris, December 1912
Construction: Cutout card-
board, *papier collé*, canvas,
string, and pencil strokes,
8½ × 5⅝ × 2¾ in.
(22 × 14.5 × 7 cm)
Picasso Museum, Paris
Z. II**, 779; P. i F. 1907–1917,
831; D. R., 556; Sp., 29

357 *Guitar*
Winter, 1912–13
Construction: Iron sheet and
wire, 29½ × 13⅝ × 7½ in.
(75.5 × 35 × 19.3 cm)
The Museum of Modern Art,
New York. Gift of the Artist
Z. II**, 773; P. i F. 1907–1917,
667; D. R., 471

358 *Violin and Sheet of Music*
Paris, Autumn 1912
Gouache, colored paper, and
music score stuck onto card-
board, 30⅜ × 24¼ in.
(78 × 63.5 cm)
Picasso Museum, Paris
Z. II**, 771; P. i F. 1907–1917,
839; D. R., 518

359 *Guitar (J'Aime Eva)*
Sorgues, Summer 1912
Oil on canvas, 13⅝ × 10½ in.
(35 × 27 cm)
Picasso Museum, Paris
Z. II*, 352; P. i F. 1907–1917,
732; D. R., 485

360 *Violin and Grapes*
Céret and Sorgues,
Spring–Summer 1912
Oil on canvas, 19¾ × 23¾ in.
(50.6 × 61 cm)
The Museum of Modern Art,
New York. Bequest of Mrs.
David M. Levy
Z. II*, 350; P. i F. 1907–1917,
783; D. R., 482

361 *The Poet*
Sorgues, Summer 1912
Oil on canvas, 23⅜ × 18¾ in.
(60 × 48 cm)
Kunstmuseum, Basel. Gift of
Maja Sacher-Stehlin
Z. II*, 313; P. i F. 1907–1917,
766; D. R., 499

362 *Student with a Pipe*
Paris, Winter 1913–14
Plaster, sand, *papier collé*, oil,
and charcoal on canvas,
28½ × 22⅞ in. (73 × 58.7 cm)
The Museum of Modern Art,
New York. Nelson A.
Rockefeller Bequest
Z. II**, 444; P. i F. 1907–1917,
1017; D. R., 620

363 *Student with a Newspaper*
Paris, Winter 1913–14
Oil and sand on canvas,
28½ × 23¼ in. (73 × 59.5 cm)
Private collection
Z. II**, 443; P. i F. 1907–1917,
1019; D. R., 621

364 *Portrait of Guillaume
Apollinaire*
Paris, early 1913
Pencil and ink on paper,
8¼ × 5⅞ in. (21 × 15 cm)
Private collection
Z(MG). XXVIII, 214; P. i F.
1907–1917, 895; D. R., 579

365 *Head of Harlequin*
Céret, 1913
Pinned paper, charcoal on
Ingres paper, 24½ × 18⅜ in.
(62.7 × 47 cm)
Picasso Museum, Paris
Z. II**, 425; P. i F. 1907–1917,
938; D. R., 617

366 *Head of a Man*
Paris [and Céret],
Winter[–Spring] 1913
Oil, charcoal, ink, and pencil
on paper, 24 × 18 in.
(61.6 × 46.3 cm)
Private collection
Z. II**, 431; P. i F. 1907–1917,
933; D. R., 615

367 *Head*
[Céret, May–June] 1913
Papier collé, charcoal, and
pencil on cardboard,
17 × 12⅞ in. (43.5 × 33 cm)
Private collection
Z. II**, 414; P. i F. 1907–1917,
927; D. R., 595

368 *Guitar*
Céret, Spring 1913
Papier collé and pinned paper,
26¾ × 18 in. (68.5 × 46 cm)
Private collection
Z. II**, 415; P. i F. 1907–1917,
917; D. R., 596

369 *Guitar*
Céret, Spring 1913
Colored paper, painted paper,
pieces of newspaper, charcoal,
and pencil on cardboard,
17⅛ × 12⅞ in. (44 × 32.7 cm)
Picasso Museum, Paris
Z(MG), XXVIII, 301; P. i F.
1907–1917, 919; D. R., 598

370 *Violin and Glasses on a Table*
Paris, early 1913
Oil on canvas, 25⅜ × 21 in.
(65 × 54 cm)
The State Hermitage
Museum, St. Petersburg
Z. II*, 370; P. i F. 1907–1917,
888; D. R., 572

371 *Violin*
Paris, end 1913
Cardboard box, *papier collé*,
gouache, charcoal, and chalk
on cardboard,
20 × 11¾ × 1½ in.
(51.5 × 30 × 4 cm)
Picasso Museum, Paris
Z. II**, 784; P. i F. 1907–1917,
1061; D. R., 652; Sp., 32

372 *Mandolin and Clarinet*
Paris, Autumn 1913
Construction: pieces of fir
with paint and pencil strokes,
22⅝ × 14 × 9 in.
(58 × 36 × 23 cm)
Picasso Museum, Paris
Z. II**, 784; App. 853;
P. i F. 1907–1917, 963;
D. R., 632; Sp., 54

373 *Still Life with a Violin and a
Glass of Bass*
Paris, [Winter] 1913–14
Oil on canvas, 31⅝ × 29½ in.
(81 × 75 cm)
Musée National d'Art
Moderne, Centre Georges
Pompidou, Paris.
Gift of Raoul La Roche, 1953
Z. II**, 487; P. i F. 1907–1917,
1086; D. R., 624

374 *Violin*
Paris, Winter 1912
Charcoal and *papier collé* on
paper, 24¼ × 18⅛ in.
(62 × 47 cm)
Musée National d'Art
Moderne, Centre Georges
Pompidou, Paris.
Gift of Henri Laugier
Z(MG). XXVIII, 356; P. i F.
1907–1917, 846; D. R., 524

375 *Ma Jolie*
Paris, Spring 1914
Oil on canvas, 17½ × 15⅝ in.
(45 × 40 cm)
Berggruen Collection, Berlin
Z. II**, 525; P. i F. 1907–1917,
1186; D. R., 742

376 *Guitar, Skull, and Newspaper*
Paris, Winter 1913–14
Oil on canvas, 17 × 23¾ in.
(43.5 × 61 cm)
Musée d'Art Moderne du
Nord, Villeneuve-d'Ascq. Gift
of Geneviève and Jean
Masurel
Z. II**, 450; P. i F. 1907–1917,
1034; D. R., 739

377 *Green Still Life*
Avignon, Summer 1914
Oil on canvas, 23¼ × 31 in.
(59.7 × 79.4 cm)
The Museum of Modern Art,
New York. Lillie P. Bliss
Collection
Z. II**, 485; P. i F. 1907–1917,
1190; D. R., 778

378 *Card Player*
Paris, Winter 1913–14
Oil on canvas, 42⅛ × 34⅞ in.
(108 × 89.5 cm)
The Museum of Modern Art,
New York. Acquired through
the Lillie P. Bliss Bequest
Z. II**, 466; P. i F. 1907–1917,
1026; D. R., 650

379 *Guitar, Glass, Bottle of Vieux
Marc*
Céret, Spring 1913
Colored paper, pinned paint-
ed paper, charcoal, and chalk
on blue Ingres paper,
18⅜ × 24⅛ in. (47.2 × 61.8 cm)
Picasso Museum, Paris
Z. II**, 575; P. i F. 1907–1917,
914; D. R., 603

380 *Céret Landscape*
Céret, Spring 1913
Colored paper, pinned paint-
ed paper, charcoal, and chalk
on blue Ingres paper,
14⅞ × 15 in. (38 × 38.5 cm)
Picasso Museum, Paris
Z. II**, 343; P. i F. 1907–1917,
905; D. R., 612

381 *Glass on a Pedestal Table*
Céret, 1913
Oil on canvas, *papier collé*,
pinned down, 8 × 8 in.
(20.5 × 20.5 cm)
Picasso Museum, Paris
Z. II**, 758; P. i F. 1907–1917,
929; D. R., 606

382 *Guitar (El Diluvio)*
Céret, after March 31, 1913
Papier collé, charcoal, ink, and
chalk, 25⅝ × 19⅜ in.
(66.4 × 49.6 cm)
The Museum of Modern Art,
New York. Nelson A.
Rockefeller Bequest
Z. II*, 348; P. i F. 1907–1917,
915; D. R., 608

383 *Bottle of Vieux Marc*
Céret, after March 15, 1913
Charcoal, pinned-down *papier
collé*, 24⅝ × 19⅛ in.
(63 × 49 cm)
Musée National d'Art
Moderne, Centre Georges
Pompidou, Paris.
Gift of Henri Laugier
Z. II*, 334; P. i F. 1907–1917,
904; D. R., 600

384 *Still Life (Au Bon Marché)*
Paris, early 1913
Oil and *papier collé* on
cardboard, 9⅛ × 12⅛ × in.
(23.5 × 31 cm)
Ludwig Museum, Cologne.
Ludwig Collection
Z. II**, 378; P. i F. 1907–1917,
896; D. R., 557

385 *Woman in a Chemise in an
Armchair*
Paris, Autumn 1913
Oil on canvas, 57¾ × 38⅝ in.
(148 × 99 cm)
Private collection
Z. II**, 522; P. i F. 1907–1917,
994; D. R., 642

386 *Glass, Pipe, Ace of Clubs, and Die*
Avignon, Summer 1914
Pieces of painted wood and metal against wood painted in oil, diameter 13¼ in. (34 cm)
Picasso Museum, Paris
Z. II**, 830; P. i F. 1907–1917, 1197; D. R., 788; Sp., 45

387 *Glass and Pipe, Numbers and Letters*
Paris, Autumn 1914
Oil and charcoal on canvas, 5½ × 11¼ in. (14 × 29 cm)
Picasso Museum, Paris
D. R., 721

388 *The Glass of Absinthe*
Paris, Spring 1914
Painted bronze and absinthe grill, 8⅜ × 6⅜ × 3⅜ in.
(21.5 x 16.5 × 8.5 cm)
Berggruen Collection, Berlin
Z. II**, 584; P. i F. 1907–1917, 1130; D. R., 756; Sp., 36 D.

389 *Bottle of Bass and Calling Card*
Paris, early 1914
Papier collé and pencil on paper, 9⅜ × 11⅞ in.
(24 × 30.5 cm)
Musée National d'Art Moderne, Centre Georges Pompidou, Paris. Louise and Michel Leiris Bequest
Z. II**, 456; P. i F. 1907–1917, 1052; D. R., 660

390 *Glass, Ace of Clubs, Pack of Cigarettes*
Paris, Spring 1914
Oil on paper and cigarette packet stuck onto Arches paper, pastel and pencil, 19⅛ × 25 in. (49 × 64 cm)
Picasso Museum, Paris
D. R., 673

391 *Still Life with Glass and Card Game (Homage to Max Jacob)*
1914
Graphite pencil, gouache, and *papier collé* on paper, 13⅝ × 18 in. (35 × 46 cm)
Berggruen Collection, Berlin
P. i F. 1907–1917, 1085; D. R., 696

392 *The Restaurant*
Paris, Spring 1914
Oil on cutout canvas, 14½ × 19⅛ in. (37 × 49 cm)
Private collection
Z. II*, 347; P. i F. 1907–1917, 1146; D. R., 703

393 *Glass and Bottle of Bass*
Paris, Spring 1914
Charcoal and *papier collé* on cardboard, 20¼ × 26⅛ in.
(52 × 67 cm)
Private collection
P. i F. 1907–1917, 1068; D. R., 684

394 *Glass*
Paris, Spring 1914
Construction: tin, cut and painted, nails, and wood, 5⅞ × 9 × 3⅞ in.
(15 × 23 × 10 cm)
Picasso Museum, Paris
Z. II**, 848; P. i F. 1907–1917, 1103; Sp., 52

395 *Bottle of Bass, Glass, and Newspaper*
Paris, Spring 1914
Construction: tin, cut out and painted, sand, iron wire, and paper, 8⅛ × 5½ × 3⅛ in.
(20.7 × 14 × 8.5 cm)
Picasso Museum, Paris
Z. II**, 849; P. i F. 1907–1917, 1104; Sp., 53

396 *Glass, Die, and Newspaper*
Paris, Spring 1914
Tin, cut out and painted, sand, and iron wire, 8 × 7⅜ × 3¾ in.
(20.6 × 19 × 9.5 cm)
Picasso Museum, Paris
Z. II**, 852; P. i F. 1907–1917, 1074; Sp., 51

397 *Glass, Newspaper, and Die*
Avignon, Summer 1914
Pieces of painted wood and sand on wood painted in oils, 6⅞ × 6 × 1⅛ in.
(17.5 × 15.2 × 3 cm)
Picasso Museum, Paris
Z. II**, 847; P. i F. 1907–1917, 1191; Sp., 50

398 *Glass and Die*
Paris, Spring 1914
Construction: pieces of pine wood, painted and assembled, 6⅝ × 6⅜ × 2⅛ in.
(17 × 16.2 × 5.5 cm)
Picasso Museum, Paris
Z. II**, 840; P. i F. 1907–1917, 1100; Sp., 46

399 *Still Life (The Snack)*
Paris, beginning of 1914
Construction: painted wood and braid, 10 × 18 × 3¾ in.
(25.5 × 46 × 9.5 cm)
The Tate Gallery, London
P. i F. 1907–1917, 1110; D. R., 746; Sp., 47

400 *Portrait of a Girl*
Avignon, Summer 1914
Oil on canvas, 50¾ × 37⅞ in.
(130 × 97 cm)
Musée National d'Art Moderne, Centre Georges Pompidou, Paris. Georges Salles Bequest
Z. II**, 528; P. i F. 1907–1917, 1229; D. R., 783

401 *Seated Man with a Glass*
Avignon, Summer 1914
Oil on canvas, 92¾ × 65⅜ in.
(238 × 167.5 cm)
Private collection
Z. II**, 845; P. i F. 1907–1917, 1220; D. R., 783

402 *Playing Cards, Wineglasses, and Bottle of Rum*
Avignon, Autumn 1914–Paris, 1915
Oil and sand on canvas, 21⅛ × 25½ in. (54.2 × 65.4 cm)
Private collection
Z. II**, 523; P. i F. 1907–1917, 1256; D. R., 782

403 *Man in a Bowler Hat*
Paris, Summer 1915
Oil on canvas, 50¾ × 34⅞ in.
(130.2 × 89.5 cm)
The Art Institute of Chicago. Gift of Mrs. Leigh B. Block, in memory of Albert D. Lasker
Z. II**, 564; P. i F. 1907–1917, 1293; D. R., 842

404 *The Painter and His Model*
Avignon, Summer 1914
Oil and crayon on canvas, 22⅝ × 21¼ in. (58 × 55.9 cm)
Picasso Museum, Paris
P. i F. 1907–1917, 1252; D. R., 763

405 *Violin*
Paris, 1915
Construction, metal sheet cut out, folded, and painted, iron wire, 39 × 24⅞ × 7 in.
(100 × 63.7 × 18 cm)
Picasso Museum, Paris
Z. II**, 580; P. i F. 1907–1917, 1385; D. R., 835; Sp., 55

406 *Woman in an Armchair*
Paris, early 1916
Watercolor and gouache on paper, 7¾ × 9 in. (20 × 23 cm)
Private collection
Z(MG). XXIX, 183; P. i F. 1907–1917, 1415; D. R., 863

407 *Violin and Bottle on a Table*
Paris, Autumn 1915
Construction: pieces of fir wood, string, nails, with oil paint and charcoal strokes, 17½ × 16 × 9 in.
(45 × 41 × 23 cm)
Picasso Museum, Paris
Z. II**, 926; P. i F. 1907–1917, 1343; D. R., 833; Sp., 57

408 *Liqueur Bottle and Fruit Bowl with Bunch of Grapes*
Paris, Autumn 1915
Construction: pieces of fir and pine, tin, nails, with charcoal strokes, 13⅞ × 10¾ × 10⅛ in.
(35.5 × 27.5 × 26 cm)
Picasso Museum, Paris
Z. II**, 927; P. i F. 1907–1917, 1337; D. R., 834; Sp., 58

409 *Seated Man with a Guitar*
Paris or Montrouge, second half of 1916
Watercolor and gouache on paper, 12⅛ × 9⅜ in.
(31 × 24 cm)
Private collection
Z. II**, 549; P. i F. 1907–1917, 1446; D. R., 875

410 *Guitarist*
Paris or Montrouge, second half of 1916
Oil and sand on canvas, 50¾ × 37⅞ in. (130 × 97 cm)
Moderna Museet, Stockholm
Z. II**, 551; P. i F. 1907–1917, 1455; D. R., 890

411 *Man by the Hearth*
Paris, 1916
Oil on canvas, 50¾ × 31⅝ in.
(130 × 81 cm)
Picasso Museum, Paris
P. i F. 1907–1917, 1475; D. R., 891

412 *Couple Dancing on a Dance Floor*
Paris, Winter 1915-16
Crayon and gouache on paper, 5⅝ × 5½ in. (14.5 × 12 cm)
Private collection
Z. II**, 556; P. i F. 1907–1917, 1382; D. R., 848

413 *Seated Harlequin Playing the Guitar*
Montrouge, Autumn 1916
Oil on wood, 8⅝ × 5½ in.
(22 × 14 cm)
Berggruen Collection, Berlin
P. i F. 1907–1917, 1482

414 *Harlequin*
Paris, Autumn–Winter 1915
Oil on canvas, 71$\frac{1}{2}$ × 41 in.
(183.5 × 105 cm)
The Museum of Modern Art,
New York. Acquired through
the Bequest of Lillie P. Bliss
Z. II**, 555;
P. i F. 1907–1917, 1384

415 *Portrait of Ambroise Vollard*
Paris, August 1915
Graphite pencil on paper,
18$\frac{1}{4}$ × 12$\frac{1}{2}$ in. (46.7 × 32 cm)
The Metropolitan Museum of
Art, New York. Elisha
Whittelsey Fund
Z. II**, 922;
P. i F. 1907–1917, 1336

416 *Portrait of Max Jacob*
Paris, January 1915
Pencil on paper,
12$\frac{5}{8}$ × 13$\frac{1}{2}$ in. (32.5 × 34.5 cm)
Picasso Museum, Paris
Z. VI, 1284;
P. i F. 1907–1917, 1268

417 *Portrait of Guillaume
Apollinaire*
Paris, 1916
Pencil on paper, 19 × 11$\frac{7}{8}$ in.
(48.8 × 30.5 cm)
Private collection
Z(MG). XXIX, 200

418 *Design for Drop Curtain
(for the ballet "Parade")*
Paris–Rome, 1916–17
Oil on fabric, 34 ft. 6 in. × 56 ft.
(10.6 × 17.25 m)
Musée National d'Art
Moderne, Centre Georges
Pompidou, Paris
Z. II**, 951;
P. i F. 1917–1926, 100

419 *Studies for the Managers on
Horseback (for the ballet
"Parade")*
Rome, 1917
Pencil and watercolor on
paper, 11$\frac{1}{8}$ × 8$\frac{1}{8}$ in.
(28.5 × 20.7 cm)
Picasso Museum, Paris

420 *Study for Manager
(for the ballet "Parade")*
Rome, 1917
Pencil on paper, 10$\frac{7}{8}$ × 8$\frac{7}{8}$ in.
(27.8 × 22.6 cm)
Picasso Museum, Paris
Z. II**, 955;
P. i F. 1917–1926, 26

421 *Sketch for Costume of an
Acrobat (for the ballet "Parade")*
Rome, 1917
Watercolor and pencil on
paper, 10$\frac{7}{8}$ × 8 in.
(28 × 20.5 cm)
Picasso Museum, Paris
Z(MG). XXIX, 160;
P. i F. 1917–1926, 54

422 *Model for Costume of the
Chinese Magician
(for the ballet "Parade")*
Rome, 1917
Watercolor on paper,
10$\frac{7}{8}$ × 7$\frac{3}{8}$ in. (28 × 19 cm)
Private collection
Z(MG). XXIX, 253;
P. i F. 1917–1926, 55

423 *The Villa Medici in Rome*
Rome, 1917
Pencil on paper, 8$\frac{1}{8}$ × 11 in.
(20.9 × 28.1 cm)
Picasso Museum, Paris
Z. III, 9; P. i F. 1917–1926, 3

424 *The Italian Woman*
Rome, Spring 1917
Oil on canvas,
58$\frac{1}{8}$ × 39$\frac{3}{8}$ × in. (149 × 101 cm)
E. G. Bührle Foundation,
Zurich
Z. III, 18; P. i F. 1917–1926, 83

425 *Harlequin and Woman with
Necklace*
Rome, 1917
Oil on canvas, 78 × 78 in.
(200 × 200 cm)
Musée National d'Art
Moderne, Centre Georges
Pompidou, Paris. Gift of
Baronness Napoléon Gourgaud
Z. III, 23; P. i F. 1917–1926, 85

426 *View of the Monument to
Columbus*
Barcelona, 1917
Oil on canvas, 15$\frac{5}{8}$ × 12$\frac{1}{2}$ in.
(40.1 × 32 cm)
Picasso Museum, Barcelona
Z. III, 47; P. i F. 1917–1926, 125

427 *Disemboweled Horse*
Barcelona, 1917
Charcoal on canvas,
31$\frac{1}{4}$ × 40$\frac{1}{4}$ in.
(80.2 × 103.3 cm)
Picasso Museum, Barcelona
Z. III, 70; P. i F. 1917–1926, 153

428 *Figure and Fruit Bowl*
Barcelona, 1917
Oil on canvas, 39 × 27$\frac{7}{8}$ in.
(100 × 70.2 cm)
Picasso Museum, Barcelona
Z. III, 48; P. i F. 1917–1926, 126

429 *Fruit Bowl*
Barcelona, 1917
Oil on canvas, 15$\frac{5}{8}$ × 11 in.
(40 × 28.1 cm)
Picasso Museum, Barcelona
Z. III, 46; P. i F. 1917–1926, 127

430 *Harlequin*
Barcelona, 1917
Oil on canvas, 45$\frac{1}{4}$ × 35$\frac{1}{8}$ in.
(116 × 90 cm)
Picasso Museum, Barcelona
Z. III, 28; P. i F. 1917–1926, 173

431 *The Return from the Baptism,
after Le Nain*
Paris, Autumn 1917
Oil on canvas, 63$\frac{1}{8}$ × 46 in.
(162 × 118 cm)
Picasso Museum, Paris
Z. III, 96; P. i F. 1917–1926, 203

432 *Olga in a Mantilla*
Barcelona, 1917
Oil on canvas, dimensions
unknown
Private collection
Z. III, 40; P. i F. 1917–1926, 163

433 *Woman in a Mantilla (La
Salchichona)*
Barcelona, 1917
Oil on canvas, 45$\frac{1}{4}$ × 34$\frac{3}{4}$ in.
(116 × 89 cm)
Picasso Museum, Barcelona
Z. III, 45; P. i F. 1917–1926, 129

434 *Portrait of Olga, in an
Armchair*
Montrouge, Autumn 1917
Oil on canvas, 50$\frac{3}{4}$ × 34$\frac{5}{8}$ in.
(130 × 88.8 cm)
Picasso Museum, Paris
Z. III, 83; P. i F. 1917–1926, 191

435 *Portrait of Max Jacob*
Montrouge, 1917
Pencil on paper, 12$\frac{3}{4}$ × 9$\frac{7}{8}$ in.
(32.6 × 25.3 cm)
Picasso Museum, Paris
Z. III, 73

436 *Self-Portrait*
1917–1919
Pencil and charcoal on paper,
25 × 19$\frac{1}{4}$ in. (64 × 49.5 cm)
Picasso Museum, Paris
Z(MG). XXIX, 309;
P. i F. 1917–1926, 268

437 *Pierrot*
Paris, 1918
Oil on canvas, 36$\frac{1}{8}$ × 28$\frac{1}{2}$ in.
(92.7 × 73 cm)
The Museum of Modern Art,
New York. Sam A. Lewisohn
Bequest
Z. III, 137;
P. i F. 1917–1926, 226

438 *Harlequin*
Montrouge, 1918
Oil on panel, 45$\frac{1}{4}$ × 34$\frac{3}{4}$ in.
(116 × 89 cm)
Rudolf Staechelinsche
Familiensliftung Collection,
Basel
Z. III, 103;
P. i F. 1917–1926, 261

439 *Pierrot and Harlequin*
Paris, 1918
Pencil on paper, 10$\frac{1}{8}$ × 8$\frac{3}{8}$ in.
(26 × 21.6 cm)
The Art Institute of Chicago.
Gift of Mrs. Gilbert W.
Chapman
Z. III, 135;
P. i F. 1917–1926, 218

440 *Harlequin with a Guitar*
1918
Oil on panel, 13$\frac{5}{8}$ × 10$\frac{1}{2}$ in.
(35 × 27 cm)
Berggruen Collection, Berlin
Z. III, 158;
P. i F. 1917–1926, 331

441 *Harlequin with a Violin (If You
Like)*
Paris, 1918
Oil on canvas, 55$\frac{3}{8}$ × 39$\frac{1}{8}$ in.
(142 × 100.3 cm)
The Cleveland Museum of
Art. Bequest of Leonard C.
Hanna, Jr.
Z. III, 160;
P. i F. 1917–1926, 334

442 *Bathers*
Biarritz, Summer 1918
Pencil on paper, 9 × 12$\frac{3}{8}$ in.
(23 × 31.9 cm)
The Fogg Art Museum,
Harvard University Art
Museum, Cambridge
Z. III, 233;
P. i F. 1917–1926, 287

443 *Fisherman*
Paris, 1918
Pencil on paper, 13$\frac{5}{8}$ × 10 in.
(35 × 25.5 cm)
Private collection
Z. III, 250;
P. i F. 1917–1926, 370

444 *Crucifixion*
1918–19
Pencil on paper, 14 × 10$\frac{3}{8}$ in.
(36 × 26.6 cm)
Picasso Museum, Paris
Z. VI, 1331;
P. i F. 1917–1926, 371

445 *Bathers*
Biarritz, Summer 1918
Oil on canvas, 10¹/₂ × 8⁵/₈ in.
(27 × 22 cm)
Picasso Museum, Paris
Z. III, 237;
P. i F. 1917–1926, 289

446 *Group of Dancers*
(after a photograph)
1919–20. Olga Kokhlova lying
in the foreground.
India ink and watercolor on
paper, 10¹/₈ × 15¹/₈ in.
(26.5 × 39.5 cm)
Private collection
Z. III, 355;
P. i F. 1917–1926, 378

447 *Three Dancers*
1919–20
Pencil on three stuck-down
sheets, 14⁵/₈ × 12¹/₂ in.
(37.5 × 32 cm)
Picasso Museum, Paris
Z(MG). XXIX, 432;
P. i F. 1917–1926, 383

448 *Portrait of Léonide Massine*
London, Summer 1919
Pencil on paper,
14⁷/₈ × 11¹/₄ in. (38 × 29 cm)
The Art Institute of Chicago.
Margaret Day Blake Collection
Z. III, 297;
P. i F. 1917–1926, 386

449 *Italian Peasants*
(after a photograph)
Paris, 1919
Pencil on paper, 23 × 18¹/₈ in.
(59 × 46.5 cm)
The Santa Barbara Museum of
Art, California. Gift of Wright
S. Ludington
Z. III, 431

450 *The Italian Woman*
Paris, 1919
Oil on canvas, 38¹/₈ × 27¹/₂ in.
(98.5 × 70.5 cm)
Private collection
Z. III, 363;
P. i F. 1917–1926, 557

451 *Peasants Sleeping*
Paris, 1919
Tempera, watercolor, and
crayon on paper,
12¹/₈ × 19¹/₄ in. (31.1 × 48.9 cm)
The Museum of Modern Art,
New York. Abby Aldrich
Rockefeller Fund
Z. III, 371;
P. i F. 1917–1926, 497

452 *Little Girl with a Hoop*
Paris, 1919
Oil and sand on canvas,
55³/₈ × 30¹/₄ in. (142 × 79 cm)
Musée National d'Art
Moderne, Centre Georges
Pompidou, Paris
Z. III, 289;
P. i F. 1917–1926, 349

453 *Still Life on a Table in Front of
an Open Window*
Paris, October 26, 1919
Gouache on paper,
6¹/₄ × 4¹/₈ in. (15.9 × 10.5 cm)
Picasso Museum, Paris
P. i F. 1917–1926, 521

454 *The Lovers*
Paris, 1919
Oil on canvas, 72¹/₈ × 54⁵/₈ in.
(185 × 140 cm)
Picasso Museum, Paris
Z. III, 438;
P. i F. 1917–1926, 575

455 *Still Life with Pitcher and Apples*
1919
Oil on canvas, 25³/₈ × 16³/₄ in.
(65 × 43 cm)
Picasso Museum, Paris
P. i F. 1917–1926, 355

456 *Study for the Drop Curtain
(for the ballet "Tricorne")*
London, 1919
Gouache and pencil on paper,
7³/₄ × 10³/₈ in. (20 × 26.5 cm)
Picasso Museum, Paris
P. i F. 1917–1926, 401

457 *Sketch for a Set (for the ballet
"Tricorne")*
London, 1919
Watercolor on paper,
4¹/₈ × 4³/₄ in. (10.5 × 12.3 cm)
Picasso Museum, Paris
Z(MG). XXIX, 407;
P. i F. 1917–1926, 417

458 *Sketch for Bullfighter Costume
(for the ballet "Tricorne")*
London, 1919
Gouache on paper,
10¹/₈ × 7³/₄ in. (26 × 20 cm)
Picasso Museum, Paris
Z(MG). XXIX, 406;
P. i F. 1917–1926, 478

459 *Sketch for Woman's Costume
(for the ballet "Tricorne")*
London, 1919
Pencil and watercolor,
9³/₄ × 6¹/₄ in. (25 × 16 cm)
Picasso Museum, Paris
Z(MG). XXIX, 393;
P. i F. 1917–1926, 472

460 *Sketch for Costume for the
Partner of the Woman from
Seville (for the ballet "Tricorne")*
London, 1919
Gouache and pencil on paper,
10¹/₂ × 7³/₄ in. (27 × 20 cm)
Picasso Museum, Paris
Z. III, 313;
P. i F. 1917–1926, 467

461 *Sketch for Costume for a
Picador (for the ballet "Tricorne")*
London, 1919
Gouache and pencil on paper,
10³/₈ × 7³/₄ in. (26.5 × 19.7 cm)
Picasso Museum, Paris
Z. III, 311;
P. i F. 1917–1926, 453

462 *Sketch for Costume for Old Man
with Crutches
(for the ballet "Tricorne")*
London, 1919
Gouache and pencil on paper,
10³/₈ × 7³/₄ in. (26.5 × 19.7 cm)
Picasso Museum, Paris
Z. III, 317;
P. i F. 1917–1926, 454

463 *Sketch for Costume for the
Miller (for the ballet "Tricorne")*
London, 1919
Gouache and pencil on paper,
10¹/₈ × 7⁵/₈ in. (26 × 19.5 cm)
Picasso Museum, Paris
Z. III, 320;
P. i F. 1917–1926, 451

464 *Sketch for Man's Costume
(for the ballet "Tricorne")*
London, 1919
Gouache and pencil on paper,
10¹/₈ × 7³/₄ in. (26 × 19.8 cm)
Picasso Museum, Paris
Z. III, 335;
P. i F. 1917–1926, 468

465 *Portrait of André Derain*
London, 1919
Pencil on paper, 15⁵/₈ × 12 in.
(39.9 × 30.8 cm)
Picasso Museum, Paris
Z. III, 300;
P. i F. 1917–1926, 482

466 *Portrait of Auguste Renoir*
(after a photograph)
Paris, 1919–20
Pencil and charcoal on paper,
23³/₄ × 19¹/₄ in. (61 × 49.3 cm)
Picasso Museum, Paris
Z. III, 413;
P. i F. 1917–1926, 565

467 *Portrait of Serge Diaghilev and
Alfred Seligsberg?*
(after a photograph)
Early 1919
Charcoal and black pencil on
paper, 25¹/₈ × 19¹/₂ in.
(65 × 50 cm)
Picasso Museum, Paris
Z. III, 301;
P. i F. 1917–1926, 381

468 *Portrait of Manuel de Falla*
Paris, June 9, 1920
Pencil and charcoal on paper,
24⁵/₈ × 18³/₄ in. (63 × 48 cm)
Picasso Museum, Paris
Z. IV, 62; P. i F. 1917–1926, 729

469 *Portrait of Igor Stravinsky*
Paris, May 24,1920
Pencil and charcoal on paper,
24 × 18³/₄ in. (61.5 × 48.2 cm)
Picasso Museum, Paris
Z. IV, 60; P. i F. 1917–1926, 728

470 *Portrait of Érik Satie*
Paris, May 19, 1920
Pencil and charcoal on paper,
24¹/₈ × 18⁵/₈ in. (62 × 47.7 cm)
Picasso Museum, Paris
Z. IV, 59; P. i F. 1917–1926, 727

471 *The Artist's Sitting Room in the
rue La Boétie*
Paris, November 21, 1919
Pencil on paper,
19¹/₈ × 23¹/₄ in. (49 × 61 cm)
Picasso Museum, Paris
Z. III, 427;
P. i F. 1917–1926, 579

472 *The Artist's Studio, rue La
Boétie*
Paris–Saint-Raphaël, June 12,
1920
Pencil and charcoal on gray,
23³/₈ × 18³/₄ in. (62.5 × 48 cm)
Picasso Museum, Paris
Z. IV, 78; P. i F. 1917–1926, 747

473 *Pulcinella Mask*
Paris, early 1920
Wood, paper, and painted
fabric, 6⁵/₈ × 5⁵/₈ × 8³/₈ in.
(17 × 14.5 × 21.5 cm)
Picasso Museum, Paris
P. i F. 1917–1926, 634; Sp., 61 E.

474 *Design for Pulcinella Costume*
Paris, 1920
Gouache and pencil on paper,
13¹/₄ × 9¹/₄ in. (34 × 23.5 cm)
Picasso Museum, Paris
Z. VI, 21; P. i F. 1917–1926, 650

475 *Study for a Set (for the ballet "Pulcinella")*
Paris, 1920
Gouache and India ink on paper, 8⅝ × 9 in. (22 × 23.2 cm)
Picasso Museum, Paris
Z. IV, 24; P. i F. 1917–1926, 669

476 *Design for a Drop Curtain, Harlequin on the Stage with Dancer and Rider (for the ballet "Pulcinella")*
Paris, 1920
Oil on paper, 6¼ × 9¾ in. (16 × 25 cm)
Picasso Museum, Paris
Z(MG). XXIX, 293; P. i F. 1917–1926, 267

477 *The Abduction*
1920
Crayon, gouache, and pastel on paper, 28⅞ × 41 in. (74 × 105 cm)
Private collection
Z. XXX, 104; P. i F. 1917–1926, 842

478 *Nessus Seizing Deyanira*
Juan-les-Pins, September 22, 1920
Silverpoint on prepared paper, 8¼ × 10½ in. (21.3 × 27 cm)
The Art Institute of Chicago. The Clarence Buckingham Collection
Z. VI, 1395; P. i F. 1917–1926, 850

479 *The Abduction*
Juan-les-Pins, 1920
Wood etching, 9¼ × 12¾ in. (23.8 × 32.6 cm)
The Museum of Modern Art, New York. The Philip L. Goodwin Collection
Z. IV, 109; P. i F. 1917–1926, 865

480 *Three Bathers*
Juan-les-Pins, June 1920
Oil on wood, 31⅝ × 39 in. (81 × 100 cm)
Private collection
Z. IV, 169; P. i F. 1917–1926, 829

481 *Bathers Watching an Airplane*
Juan-les-Pins, Summer 1920
Oil on plywood, 28⅝ × 36⅛ in. (73.5 × 92.5 cm)
Picasso Museum, Paris
Z. IV, 163; P. i F. 1917–1926, 827

482 *Seated Woman*
Paris, 1920
Oil on canvas, 35⅞ × 25⅝ in. (92 × 65 cm)
Picasso Museum, Paris
Z. IV, 179; P. i F. 1917–1926, 920

483 *Two Bathers with Towel*
Paris, 1920
Oil on canvas, 76 × 64 in. (195 × 164 cm)
The Chrysler Museum, Norfolk, Virginia
Z. IV, 217; P. i F. 1917–1926, 947

484 *Two Women*
Paris, April 28, 1920
Pastel on paper, 25½ × 18¾ in. (65.5 × 48 cm)
Private collection
Z. IV, 58; P. i F. 1917–1926, 718

485 *Studies*
1920
Oil on canvas, 39 × 31⅝ in. (100 × 81 cm)
Picasso Museum, Paris
Z. IV, 226; P. i F. 1917–1926, 1291

486 *Two Bathers*
Paris, October 24, 1920
Pastel on paper, 42⅜ × 29⅝ in. (108.5 × 75.8 cm)
Picasso Museum, Paris
Z. IV, 202; P. i F. 1917–1926, 879

487 *Sheet of Studies for Set and Spectators in a Loge (for "Cuadro Flamenco")*
Paris, 1921
Pencil on paper, 7¾ × 10⅛ in. (20 × 26 cm)
Picasso Museum, Paris
Z(MG). XXX, 24; P. i F. 1917–1926, 664

488 *Design for Set (for "Cuadro Flamenco")*
Paris, 1921
Gouache and pencil on paper, 9⅛ × 13¼ in. (23.5 × 34 cm)
Z. IV, 245; P. i F. 1917–1926, 1028

489 *Three Musicians*
Fontainebleau, Summer 1921
Oil on canvas, 79⅛ × 73⅜ in. (203 × 188 cm)
The Philadelphia Museum of Art. A. E. Gallatin Collection
Z. IV, 332; P. i F. 1917–1926, 1090

490 *Three Musicians*
Fontainebleau, Summer 1921
Oil on canvas, 78¼ × 86⅞ in. (200.7 × 222.9 cm)
The Museum of Modern Art, New York. Mrs. Simon Guggenheim Collection
Z. IV, 331; P. i F. 1917–1926, 1091

491 *Three Women at the Well*
Fontainebleau, 1921
Oil on canvas, 9 × 9½ × in. (23 × 24.5 cm)
Musée National d'Art Moderne, Centre Georges Pompidou, Paris. Louise and Michel Leiris Donation
P. i F. 1917–1926, 1080

492 *Three Women at the Well*
Fontainebleau, Summer 1921
Red chalk on canvas, 78 × 62¾ in. (200 × 161 cm)
Picasso Museum, Paris
P. i F. 1917–1926, 1082

493 *Three Women at the Well*
Fontainebleau, Summer 1921
Oil on canvas, 79½ × 67⅞ in. (203.9 × 174 cm)
The Museum of Modern Art, New York. Gift of Mr. and Mrs. Allan D. Emil
Z. IV, 322; P. i F. 1917–1926, 1077

494 *Large Bather*
Fontainebleau or Paris, 1921–22
Oil on canvas, 70¼ × 38¼ in. (180 × 98 cm)
Musée de l'Orangerie, Paris. Jean Walter-Paul Guillaume Collection
Z. IV, 329; P. i F. 1917–1926, 1112

495 *Seated Bather Drying Her Feet*
Fontainebleau, Summer 1921
Pastel on paper, 25¼ × 19⅞ in. (66 × 50.8 cm)
Berggruen Collection, Berlin
Z. IV, 330; P. i F. 1917–1926, 1109

496 *Bust of a Woman*
Fontainebleau, Summer 1921
Oil on canvas, 45¼ × 28½ in. (116 × 73 cm)
Z. IV, 328; P. i F. 1917–1926, 1110

497 *Mother and Child in Red*
Paris, Autumn 1921
Oil on panel, 5⅝ × 3¾ in. (14.5 × 9.5 cm)
Private collection
P. i F. 1917–1926, 1153

498 *Woman and Child*
Paris, 1921
Pencil on paper, 25⅛ × 19¼ in. (64.5 × 49.5 cm)
Private collection
Z. IV, 294

499 *Woman and Child by the Sea*
1921
Oil on canvas, 55¾ × 63⅛ in. (143 × 162 cm)
The Art Institute of Chicago
Z. IV, 311; P. i F. 1917–1926, 1155

500 *La Source*
Fontainebleau, Summer 1921
Oil crayon on canvas, 39 × 78 in. (100 × 200 cm)
Picasso Museum, Paris
P. i F. 1917–1926, 1046

501 *Bathers by the Sea*
Paris, 1921
Oil on panel, 6¼ × 7¾ in. (16 × 20 cm)
Private collection
Z. IV, 264; P. i F. 1917–1926, 991

502 *Girl in a Hat with Her Hands Crossed*
1920–21
Pastel and charcoal on paper, 41 × 29¼ in. (105 × 75 cm)
Picasso Museum, Paris
Z(MG). XXX, 262; P. i F. 1917–1926, 1134 b.

503 *Seated Woman in a Hat*
1923
Charcoal and chalk on canvas, dimensions unknown
Private collection
Z. V, 162

504 *Reading the Letter*
Paris, 1921
Oil on canvas, 71¾ × 41 in. (184 × 105 cm)
Picasso Museum, Paris
P. i F. 1917–1926, 1158

505 *The Village Dance*
Paris, 1922
Fixed pastel and oil on canvas, 54⅜ × 33⅜ in. (139.5 × 85.5 cm)
Picasso Museum, Paris
Z(MG). XXX, 270; P. i F. 1917–1926, 1159

506 *Study for Three Hands*
1921
Charcoal and pastel on paper,
19½ × 25⅜ in. (50 × 64.5 cm)
Private collection, courtesy
Galerie Jan Krugier,
Ditesheim & Cie, Geneva
Z. IV, 238;
P. i F. 1917–1926, 1007

507 *Self-Portrait*
Paris, 1921
Pencil on paper, 10½ × 8⅛ in.
(27 × 21 cm)
Private collection
Z(MG). XXX, 149;
P. i F. 1917–1926, 996

508 *Mother and Child*
Dinard, 1922
Pencil on paper,
11⅞ × 16⅜ in. (30.5 × 42 cm)
Sketchbook sheet
Picasso Museum, Paris
Z(MG). XXX, 360;
P. i F. 1917–1926, 1240

509 *Mother and Child*
Dinard, Summer 1922
Oil on canvas, 39 × 31⅝ in.
(100 × 81.3 cm)
The Baltimore Museum of
Art. Cone Collection
Z. IV, 371;
P. i F. 1917–1926, 1195

510 *Family by the Sea*
Dinard, Summer 1922
Oil on panel, 6⅞ × 7⅞ in.
(17.6 × 20.2 cm)
Picasso Museum, Paris
P. i F. 1917–1926, 1216

511 *Draped Nude*
Dinard, Summer 1922
Oil on wood, 7⅜ × 4¾ in.
(18.8 × 12.2 cm)
Wadsworth Atheneum,
Hartford, Connecticut. The
Ella Gallup Summer and Mary
Catlin Summer Collection
Z. IV, 382;
P. i F. 1917–1926, 1220

512 *Two Women Running on the
Beach (The Race)*
Dinard, Summer 1922
Gouache on plywood,
12⅝ × 16 in. (32.5 × 41.1 cm)
Picasso Museum, Paris
Z. IV, 380;
P. i F. 1917–1926, 1260

513 *Women Doing Their Hair*
Paris, Winter 1922–23
Terebinth gouache on panel,
4⅛ × 3⅛ in. (10.5 × 8 cm)
Private collection
P. i F. 1917–1926, 1284

514 *La Coiffure*
Dinard, 1922
Oil on canvas, 8⅝ × 6¼ in.
(22 × 16 cm)
Private collection
Z. IV, 385

515 *Bullfight*
1922
Oil and pencil on panel,
5¼ × 7⅜ in. (13.6 × 19 cm)
Picasso Museum, Paris
P. i F. 1917–1926, 1415

516 *Young Man Dressed as Pierrot*
Paris, December 27, 1922
Gouache and watercolor on
paper, 4⅝ × 4⅛ in.
(11.8 × 10.5 cm)
Picasso Museum, Paris
P. i F. 1917–1926, 1287

517 *Traveling Circus*
Paris, December 1922
Gouache on paper,
4¼ × 5⅝ in. (11 × 14.5 cm)
Picasso Museum, Paris
P. i F. 1917–1926, 1288

518 *Seated Harlequin (Portrait of
the Painter Jacint Salvadó)*
Paris, 1923
Tempera on canvas,
50¾ × 37⅞ in. (130 × 97 cm)
Musée National d'Art
Moderne, Centre Georges
Pompidou, Paris
Z. V, 17; P. i F. 1917–1926, 1334

519 *Harlequin (Portrait of the
Painter Jacint Salvadó)*
Oil on canvas, 50¾ × 37⅞ in.
(130 × 97 cm)
Kunstmuseum, Basel
Z. V, 23; P. i F. 1917–1926, 1335

520 *Harlequin with Mirror*
Paris, Autumn 1923
Oil on canvas, 39 × 31⅝ in.
(100 × 81 cm)
Thyssen-Bornemisza
Collection, Madrid
Z. V, 142;
P. i F. 1917–1926, 1433

521 *Seated Woman*
Paris, Winter 1922–23
Oil on canvas, 50¾ × 37⅞ in.
(130 × 97 cm)
Z. IV, 454;
P. i F. 1917–1926, 1282

522 *The Lovers*
Paris, 1923
Oil on canvas, 50¾ × 37⅞ in.
(130 × 97 cm)
The National Gallery of Art,
Washington, D.C. Chester
Dale Collection
Z. V, 14; P. i F. 1917–1926, 1330

523 *Woman in a Blue Veil*
Paris, 1923
Oil on canvas, 39⅛ × 31¾ in.
(100.3 × 81.3 cm)
Los Angeles County Museum
of Art. Acquisition De Sylva
Fund
Z. V, 16; P. i F. 1917–1926, 1327

524 *Saltimbanque Seated with
Crossed Legs*
1923
Oil on canvas, 50¾ × 37⅞ in.
(130 × 97 cm)
The National Gallery of Art,
Washington, D.C. Chester
Dale Collection
Z. V, 15; P. i F. 1917–1926, 1326

525 *Seated Woman in a Chemise*
1923
Oil on canvas, 35⅞ × 28½ in.
(92 × 73 cm)
The Tate Gallery, London
Z. V, 3; P. i F. 1917–1926, 1302

526 *Seated Young Man with a Pipe*
Paris, 1923
Oil on canvas, 50¾ × 37⅞ in.
(130 × 97 cm)
Private collection
Z. V, 131; P. i F. 1917–1926, 1348

527 *Pan-Pipes*
Antibes, Summer 1923
Oil on canvas, 80 × 67⅞ in.
(205 × 174 cm)
Picasso Museum, Paris
Z. V, 141; P. i F. 1917–1926, 1388

528 *Paulo, the Artist's Son, at Age
Two (after a photograph)*
Paris, 1923
Oil on canvas, 39 × 31⅝ in.
(100 × 81 cm)
Private collection
Z. VI, 1429;
P. i F. 1917–1926, 1308

529 *Portrait of Olga*
1921
Pastel and charcoal on paper
mounted on canvas,
49½ × 37⅝ in. (127 × 96.5 cm)
Picasso Museum, Paris (on
deposit at the Musée de
Peinture et de Sculpture de
Grenoble)
P. i F. 1917–1926, 1137

530 *Olga in a Pensive Mood*
Paris, 1923
Pastel and black pencil on
paper, 40⅝ × 27⅝ in.
(104 × 71 cm)
Picasso Museum, Paris
Z. V, 38; P. i F. 1917–1926, 1303

531 *Head of Harlequin*
1923
Oil on canvas, 18 × 14⅞ in.
(46 × 38 cm)
Private collection
Z. V, 62; P. i F. 1917–1926, 1436

532 *The Birdcage*
Paris, 1923
Oil and charcoal on canvas,
78¼ × 54¼ in.
(200.7 × 140.4 cm)
Private collection
Z. V, 84; P. i F. 1917–1926, 1331

533 *Guitar*
Paris, 1924
Construction: cutout and
folded metal sheet, tin box,
and steel wire, painted,
43¼ × 24¾ × 10⅝ in.
(111 × 63.5 × 26.6 cm)
Picasso Museum, Paris
Z. V, 217;
P. i F. 1917–1926, 1443; Sp. 63

534 *Violin and Its Notes*
Juan-les-Pins, Summer 1924
Pen and ink on paper,
12⅛ × 9⅛ in. (31 × 23.5 cm)
Sketchbook sheet
Picasso Museum, Paris
P. i F. 1917–1926, 1495

535 *Guitars and Guitar Notes*
Juan-les-Pins, Summer 1924
Pen and ink on paper,
12⅛ × 9⅛ in. (31 × 23.5 cm)
Sketchbook sheet
Picasso Museum, Paris
Z. V, 316;
P. i F. 1917–1926, 1498

536 *Design for a Drop Curtain:
Harlequin Playing the Guitar
and Pierrot Playing the Violin
(for the ballet "Mercure")*
Paris, 1924
Pastel on gray paper,
9¾ × 12½ in. (25 × 32 cm)
Picasso Museum, Paris
Z. V, 192;
P. i F. 1917–1926, 1458

537 *Drawing for Costume for Polichinella (for the ballet "Mercure")*
Paris, 1924
Pastel and charcoal on paper, 11³/₄ × 9 in. (30 × 23.1 cm)
Private collection
Z. V, 204

538 *Three Studies (for the ballet "Mercure")*
Paris, 1924
Pastel and pencil on beige paper, 7⁷/₈ × 8⁵/₈ in. (20 × 22.2 cm)
Picasso Museum, Paris
P. i F. 1917–1926, 1460

539 *The Red Carpet*
Paris, 1924
Oil on canvas, 38³/₈ × 51¹/₄ in. (98.5 × 131.5 cm)
Private collection
Z. V, 364; P. i F. 1917–1926, 1541

540 *Mandolin and Guitar*
Juan-les-Pins, Summer 1924
Oil and sand on canvas, 54⁷/₈ × 78¹/₈ in. (140.6 × 200.2 cm)
The Solomon R. Guggenheim Museum, New York
Z. V, 220; P. i F. 1917–1926, 1486

541 *Paulo, as Harlequin*
Paris, 1924
Oil on canvas, 50¹/₄ × 38 in. (130 × 97.5 cm)
Picasso Museum, Paris
Z. V, 178; P. i F. 1917–1926, 1446

542 *Paulo, the Artist's Son, at Age Four*
1925
Oil on canvas, 63¹/₈ × 37⁷/₈ in. (162 × 97 cm)
Private collection
Z. VI, 1452; P. i F. 1917–1926, 1619

543 *Paulo as Pierrot*
Paris, February 28, 1925
Oil on canvas, 50¹/₄ × 37⁷/₈ in. (130 × 97 cm)
Picasso Museum, Paris
Z. V, 374; P. i F. 1917–1926, 1565

544 *Still Life with an Antique Bust*
Juan-les-Pins, Summer 1925
Oil on canvas, 37⁷/₈ × 50³/₄ in. (97 × 130 cm)
Musée National d'Art Moderne, Centre Georges Pompidou, Paris.
Gift of Paul Rosenberg
Z. V, 377; P. i F. 1917–1926, 1551

545 *Still Life with a Fishing Net*
1925
Oil on canvas, 39 × 31⁵/₈ in. (100 × 81 cm)
Private collection
Z. V, 459; P. i F. 1917–1926, 1604

546 *Studio with a Plaster Bust*
Juan-les-Pins, Summer 1925
Oil on canvas, 38¹/₄ × 51¹/₈ in. (98.1 × 131.2 cm)
The Museum of Modern Art, New York
Z. V, 445; P. i F. 1917–1926, 1595

547 *The Sculptress*
Juan-les-Pins, Summer 1925
Oil on canvas, 51⁵/₈ × 37⁷/₈ in. (131 × 97 cm)
Private collection
Z. V, 451; P. i F. 1917–1926, 1583

548 *The Woman with a Tambourine*
1925
Oil on canvas, 37⁷/₈ × 50³/₄ in. (97 × 130 cm)
Musée de l'Orangerie, Paris.
Jean Walter-Paul Guillaume Collection
Z. V, 415; P. i F. 1917–1926, 1585

549 *The Kiss*
Juan-les-Pins, Summer 1925
Oil on canvas, 50⁷/₈ × 38¹/₈ in. (130.5 × 97.7 cm)
Picasso Museum, Paris
Z. V, 460; P. i F. 1917–1926, 1586

550 *The Dance*
Paris, June 1925
Oil on canvas, 83⁷/₈ × 55¹/₈ in. (215 × 142 cm)
The Tate Gallery, London
Z. V, 426; P. i F. 1917–1926, 1580

551 *The Dress Designer's Workshop*
Paris, January 1926
Oil on canvas, 67¹/₈ × 99⁷/₈ in. (172 × 256 cm)
Musée National d'Art Moderne, Centre Georges Pompidou, Paris
Z. VII, 2; P. i F. 1917–1926, 1628

552 *Woman with a Ruffle*
Juan-les-Pins, Summer 1926
Oil on canvas, 13⁵/₈ × 10¹/₂ in. (35 × 27 cm)
Picasso Museum, Paris
P. i F. 1917–1926, 1681

553 *Musical Instruments on a Table*
Juan-les-Pins, Summer 1926
Oil on canvas, 65¹/₂ × 80 in. (168 × 205 cm)
Private collection
Z. VII, 3; P. i F. 1917–1926, 1674

554 *Guitar*
Paris, Spring 1926
Canvas, wood, string, nails, and pegs on a painted panel, 50³/₄ × 37⁵/₈ in. (130 × 96.5 cm)
Picasso Museum, Paris
P. i F. 1917–1926, 1640

555 *Guitar*
Paris, Spring 1926
Ropes, newsprint, floorcloth, and nails on a painted canvas, 50³/₄ × 37⁵/₈ in. (130 × 96.5 cm)
Picasso Museum, Paris
Z. VII, 9; P. i F. 1917–1926, 1638; Sp., 65 H

556 *Guitar Collage*
Paris, Spring 1926
Panel of wood with appliquéd sheets of paper and string, made for a décor, 50³/₄ × 37³/₄ in. (130 × 97 cm)
Private collection
Z. VII, 18; P. i F. 1917–1926, 1641

557 *Study of Three Guitars*
Paris, Spring 1926
Ink on paper, 19¹/₈ × 12⁵/₈ in. (49 × 32.5 cm)
Sketchbook sheet
Private collection
P. i F. 1917–1926, 1639

558 *The Painter and His Model*
Paris, 1926
Oil on canvas, 67¹/₈ × 99⁷/₈ in. (172 × 256 cm)
Picasso Museum, Paris
Z. VII, 30; P. i F. 1917–1926, 1636

559 *Guitar*
Paris, April 29, 1926
Cardboard, tulle, string, and pencil strokes on cardboard, 4⁷/₈ × 4 in. (12.5 × 10.4 cm)
Picasso Museum, Paris
P. i F. 1917–1926, 1645; Sp., 65 A

560 *Guitar*
Paris, May 2, 1926
Cardboard, string, tulle, lead ball, ink, gouache, and pencil marks on cardboard, 9¹/₂ × 7⁵/₈ in. (24.5 × 19.5 cm)
Picasso Museum, Paris
P. i F. 1917–1926, 1648; Sp., 65 D

561 *Guitar*
Paris, May 1926
Tulle, string, button, and pencil strokes on cardboard, 5¹/₂ × 3⁷/₈ in. (14 × 10 cm)
Picasso Museum, Paris
Z. VII, 21; P. i F. 1917–1926, 1650; Sp., 65

562 *Guitar*
Paris, May 1926
String, nails, cardboard painted in ink and oils, button, fabrics, and pencil strokes on cardboard, 9⁵/₈ × 4³/₄ in. (24.7 × 12.3 cm)
Picasso Museum, Paris
P. i F. 1917–1926, 1649; Sp., 65 F

563 *Guitar*
Paris, 1926
Collage: pencil, stuck-on paper, string, and tulle, 16¹/₄ × 14¹/₈ in. (41.8 × 28.7 cm)
Private collection, courtesy Galerie Jan Krugier, Ditesheim & Cie, Geneva
Z. VII, 19; P. i F. 1917–1926, 1642

564 *Guitar*
Paris, April 27, 1927
Oil and charcoal on canvas, 31⁵/₈ × 31⁵/₈ in. (81 × 81 cm)
Picasso Museum, Paris
Z. VII, 56

565 *Painter and Model Knitting*
From *Chef d'Oeuvre Inconnu* by Honoré de Balzac, Paris, 1927. Published by Ambroise Vollard, Paris, 1931
Etching, 7¹/₂ × 10³/₄ in. (19.2 × 27.7 cm)
Bl. 85; G. 126/b

566 *Painter at Work*
1927
From *Chef d'Oeuvre Inconnu* by Honoré de Balzac, 1927. Published by Ambroise Vollard, Paris, 1931
Etching, 7⁵/₈ × 10⁷/₈ in. (19.4 × 27.9 cm)
Bl. 89; G. 130/b

567 *Seated Woman*
Paris, 1927
Oil on panel, 50⅝ × 37⅞ in.
(129.9 × 97.2 cm)
The Museum of Modern Art,
New York. James Thrall Soby
Bequest
Z. VII, 77

568 *Woman in an Armchair*
Paris, January 1927
Oil on canvas, 50⅞ × 37⅞ in.
(130.5 x 97.2 cm)
Private collection
Z. VII, 79

569 *Bather (Design for a
Monument)*
Cannes, Summer 1927
Graphite pencil on paper,
11⅞ × 9 in. (30.3 × 23 cm)
Sketchbook sheet
Picasso Museum, Paris
Z. VII, 98

570 *Bather (Design for a
Monument)*
Cannes, Summer 1927
Graphite pencil on paper,
11⅞ × 9 in. (30.3 × 23 cm)
Sketchbook sheet
Picasso Museum, Paris
Z. VII, 99

571 *Bather (Design for a
Monument)*
Cannes, Summer 1927
Graphite pencil on paper,
11⅞ × 9 in. (30.3 × 23 cm)
Sketchbook sheet
Picasso Museum, Paris
Z. VII, 104

572 *Figure*
1927
Oil on plywood,
50¼ × 37½ in. (129 × 96 cm)
Picasso Museum, Paris
Z. VII, 137

573 *Nude Against a White
Background*
1927
Oil on canvas, 50¾ × 37⅞ in.
(130 × 97 cm)
Picasso Museum, Paris

574 *Woman in an Armchair*
Cannes, Summer 1927
Oil on canvas, 50¾ × 37⅞ in.
(130 × 97 cm)
Picasso Museum, Paris
Z. VII, 68

575 *Minotaur*
Paris, January 1, 1928
Charcoal and paper stuck to
canvas, 54¼ × 89¾ in.
(139 × 230 cm)
Musée National d'Art
Moderne, Centre Georges
Pompidou, Paris
Z. VII, 135

576 *Minotaur*
Paris, April 1928
Oil on canvas, 63⅜ × 50¾ in.
(162.5 × 130 cm)
Picasso Museum, Paris
Z. VII, 423

577 *Painter with a Palette and Easel*
1928
Oil on canvas, 50¾ × 37⅞ in.
(130 × 97 cm)
Picasso Museum, Paris

578 *The Studio*
Paris, Winter 1927–28
Oil on canvas, 58½ × 90⅛ in.
(149.9 × 231.2 cm)
The Museum of Modern Art,
New York. Gift of Walter P.
Chrysler, Jr.
Z. VII, 142

579 *Head*
Paris, October 1928
Painted brass and steel,
7 × 4¼ × 2⅞ in.
(18 × 11 × 7.5 cm)
Picasso Museum, Paris
Sp., 66 A

580 *Painter and Model*
Paris, 1928
Oil on canvas, 50⅝ × 63⅝ in.
(128.8 × 163 cm)
The Museum of Modern Art,
New York. The Sidney and
Harriet Janis Collection
Z. VII, 143

581 *Bathers (Design for a
Monument)*
Dinard, July 8, 1928
India ink on paper,
11¾ × 8⅝ in. (30.2 × 22 cm)
Sketchbook sheet
Picasso Museum, Paris
Z. VII, 199

582 *Sketchbook Page*
Dinard, 28 July 1928
India ink and pencil on paper,
14⅞ × 12⅛ in. (38 × 31 cm)
Marina Picasso Collection,
Galerie Jan Krugier,
Ditesheim & Cie, Geneva
Z. VII, 201

583 *Bathers (Design for a
Monument)*
Dinard, July 29, 1928
India ink and pencil on paper,
14⅞ × 12⅛ in. (38 × 31 cm)
Sketchbook sheet
Marina Picasso Collection,
courtesy Galerie Jan Krugier,
Ditesheim & Cie, Geneva
Z. VII, 203

584 *Metamorphosis II*
Paris, 1928
Original plaster, 9 × 7 × 4¼ in.
(23 × 18 × 11 cm)
Picasso Museum, Paris
Sp., 67 A (I)

585 *Figure*
(Proposed as a plan for a
monument to Guillaume
Apollinaire)
Paris, Autumn 1928
Steel wire and sheet metal,
19⅝ × 7¼ × 15⅞ in.
(50.5 × 18.5 × 40.8 cm)
Picasso Museum, Paris
Sp., 68

586 *Figure*
(Proposed as a plan for a
monument to Guillaume
Apollinaire)
Paris, Autumn 1928
Steel wire and sheet metal,
23⅝ × 5⅞ × 13¼ in.
(60.5 × 15 × 34 cm)
Picasso Museum, Paris
Sp., 69

587 *Sheet of Studies*
Dinard, August 3, 1928
India ink on paper,
14⅞ × 12⅛ in. (38 × 31 cm)
Marina Picasso Collection,
courtesy Galerie Jan Krugier,
Ditesheim & Cie, Geneva

588 *Bathers on the Beach*
Dinard, August 12, 1928
Oil on canvas, 8⅜ × 15¾ in.
(21.5 × 40.4 cm)
Picasso Museum, Paris
Z. VII, 216

589 *Bather Opening a Beach Hut*
Dinard, August 9, 1928
Oil on canvas, 12¾ × 8⅝ in.
(32.8 × 22 cm)
Picasso Museum, Paris
Z. VII, 210

590 *Bather and Beach Hut*
Dinard, August 9, 1928
Oil on canvas, 8⅜ × 6¼ in.
(21.6 × 15.9 cm)
The Museum of Modern Art,
New York. Hillman
Periodicals Fund
Z. VII, 211

591 *Bather Lying on the Sand*
Dinard, August 23, 1928
Oil on canvas, 7⅜ × 9¼ in.
(18.8 × 23.8 cm)
Private collection
Z. VII, 221

592 *Playing Ball on the Beach*
Dinard, August 15, 1928
Oil on canvas, 9⅜ × 13⅝ in.
(24 × 34.9 cm)
Picasso Museum, Paris
Z. VII, 223

593 *Bathers with a Ball*
Dinard, August 21, 1928
Oil on canvas, 6¼ × 8½ in.
(15.9 × 21.9 cm)
Private collection
Z. VII, 226

594 *Figure and Profile*
1927–28
Oil on canvas, 25⅜ × 23⅜ in.
(65 × 54 cm)
Private collection
Z. VII, 144

595 *Figure and Profile*
1928
Oil on canvas, 28½ × 23⅜ in.
(72 × 60 cm)
Picasso Museum, Paris
Z. VII, 129

596 *The Studio*
Paris, 1928–29
Oil on canvas, 63⅛ × 50¾ in.
(162 × 130 cm)
Picasso Museum, Paris

597 *Large Bather*
Paris, May 26, 1929
Oil on canvas, 12⅞ × 50¾ in.
(195 × 130 cm)
Picasso Museum, Paris
Z. VII, 262

598 *Bathers at the Beach Hut*
Paris, May 19, 1929
Oil on canvas, 12⅞ × 16⅛ in.
(33 × 41.5 cm)
Picasso Museum, Paris
Z. VII, 276

599 *Monument: Woman's Head*
1929
Oil on canvas, 25⅜ × 21 in.
(65 × 54 cm)
Z. VII, 290

600 *Woman in a Red Armchair*
Paris, 1929
Oil on canvas, 25^1/$_8$ × 21 in.
(64.5 × 54 cm)
Picasso Museum, Paris
Z. VII, 291

601 *Reclining Woman*
April 1929
Oil on canvas, 15^5/$_8$ × 23^1/$_4$ in.
(40 × 61 cm)
Private collection
Z. VII, 260

602 *The Kiss*
Dinard, August 26, 1929
Oil on canvas, 8^5/$_8$ × 5^1/$_2$ in.
(22 × 14 cm)
Picasso Museum, Paris

603 *Head of a Woman with a Self-Portrait*
Paris, February 1929
Oil on canvas, 27^5/$_8$ × 23^5/$_8$ in.
(71 × 60.5 cm)
Private collection
Z. VII, 248

604 *Large Nude in a Red Armchair*
Paris, May 5, 1929
Oil on canvas, 76 × 59^3/$_8$ in.
(195 × 129 cm)
Picasso Museum, Paris
Z. VII, 263

605 *The Acrobat*
Paris, January 18, 1930
Oil on canvas, 63^1/$_8$ × 50^3/$_4$ in.
(162 × 130 cm)
Picasso Museum, Paris
Z. VII, 310

606 *The Swimmer*
Paris, November 1929
Oil on canvas, 50^3/$_4$ × 63^1/$_8$ in.
(130 × 162 cm)
Picasso Museum, Paris
Z. VII, 419

607 *Head Against a Red Background*
Paris, February 2, 1930
Oil on panel, 10^1/$_8$ × 8^1/$_8$ in.
(26 × 21 cm)
Picasso Museum, Paris
Z. VII, 301

608 *The Crucifixion*
Paris, February 7, 1930
Oil on plywood, 20^1/$_8$ × 26 in.
(51.5 × 66.5 cm)
Picasso Museum, Paris
Z. VII, 287

609 *Seated Bather by the Sea*
Paris, early 1930
Oil on canvas, 63^5/$_8$ × 50^1/$_2$ in.
(163.2 × 129.5 cm)
The Museum of Modern Art,
New York. Mrs. Simon
Guggenheim Collection
Z. VII, 206

610 *Object with Palm Leaf*
Juan-les-Pins, August 27, 1930
Sand, partly colored, on the
reverse of the canvas and
stretcher, plants, cardboard,
nails, objects glued on and
sewn onto canvas,
9^3/$_4$ × 12^7/$_8$ × 1^3/$_4$ in.
(25 × 33 × 4.5 cm)
Picasso Museum, Paris
Sp., 78

611 *Composition with Glove*
Juan-les-Pins, August 22, 1930
Sand, partly colored, on the
reverse of the canvas and
stretcher, glove, cardboard,
plants glued on and sewn
onto canvas,
10^3/$_4$ × 13^3/$_4$ × 3^1/$_8$ in.
(27.5 × 35.5 × 8 cm)
Picasso Museum, Paris
Sp., 75

612 *Profile and Woman's Head*
1931
(Illustration for Ovid's
Metamorphoses)
Etching, 14^7/$_8$ × 11^3/$_8$ in.
(38.1 × 29.9 cm)
Bl. 101; G. 145/5

613 *Woman with Pigeons*
1930
Oil on canvas, 78 × 72^1/$_8$ in.
(200 × 185 cm)
Musée National d'Art
Moderne, Centre Georges
Pompidou, Paris

614 *Woman in a Garden*
Paris, 1929–30
Soldered and painted steel,
80^3/$_4$ × 45^5/$_8$ × 33^1/$_8$ in.
(206 × 117 × 85 cm)
Picasso Museum, Paris
Sp., 71 (I)

615 *Head of a Woman*
Paris, 1929–30
Iron, metal plate, painted
springs, and sieves,
39 × 14^3/$_8$ × 23 in.
(100 × 37 × 59 cm)
Picasso Museum, Paris
Sp., 81

616 *Bather*
Boisgeloup, 1931
Bronze (unique cast),
27^1/$_4$ × 15^5/$_8$ × 12^1/$_4$ in.
(70 × 40.2 × 31.5 cm)
Picasso Museum, Paris
Sp., 108

617 *Seated Woman*
Boisgeloup, 1931
Original plaster,
13^5/$_8$ × 9 × 11^7/$_8$ in.
(35 × 23.2 × 30.5 cm)
Picasso Museum, Paris
Sp., 105 (I)

618 *Bust of a Woman*
Boisgeloup, 1931
Bronze (unique cast),
30^3/$_8$ × 17^3/$_8$ × 21 in.
(78 × 44.5 × 54 cm)
Picasso Museum, Paris
Sp., 131 (II)

619 *Reclining Bather*
Boisgeloup, 1931
Bronze (unique cast),
9 × 28^1/$_8$ × 12^1/$_8$ in.
(23 × 72 × 31 cm)
Picasso Museum, Paris
Sp., 109 (II)

620 *Head of a Woman*
Boisgeloup, 1931
Bronze, 33^1/$_2$ × 12^1/$_2$ × 18^1/$_8$ in.
(86 × 32 × 48.5 cm)
Picasso Museum, Paris
Sp., 132 (II a)

621 *Head of a Woman*
Boisgeloup, 1931
Original plaster,
27^7/$_8$ × 16 × 12^7/$_8$ in.
(71.5 × 41 × 33 cm)
Picasso Museum, Paris
Sp., 110 (I)

622 *Head of a Woman*
Boisgeloup, 1931
Bronze (unique cast),
50^1/$_8$ × 21^1/$_4$ × 24^3/$_8$ in.
(128.5 × 54.5 × 62.5 cm)
Picasso Museum, Paris
Sp., 133 (II)

623 *Sculptural Head*
Boisgeloup, 1932
Charcoal on canvas,
35^7/$_8$ × 28^1/$_2$ in. (92 × 73 cm)
Beyeler Galerie, Basel

624 *Head of a Woman in Profile
(Marie-Thérèse)*
Boisgeloup, 1931
Bronze (unique cast),
26^3/$_4$ × 23 × 3^1/$_8$ in.
(68.5 × 59 × 8 cm)
Picasso Museum, Paris
Sp., 130 (II)

625 *The Sculptor and His Model*
Juan-les-Pins, August 4, 1931
Pen and India ink on paper,
12^5/$_8$ × 10 in. (32.4 × 25.5 cm)
Picasso Museum, Paris
Z. VII, 351

626 *The Sculptor's Studio*
Boisgeloup–Paris,
December 4, 1931
Pen and India ink on paper,
12^7/$_8$ × 10^1/$_8$ in. (33 × 26 cm)
Picasso Museum, Paris
Z. VII, 352

627 *The Sculptor*
Paris, December 7, 1931
Oil on plywood,
50^1/$_8$ × 37^1/$_2$ in. (128.5 × 96 cm)
Picasso Museum, Paris
Z. VII, 346

628 *Bust with a Lamp*
Boisgeloup, June 1931
Oil on canvas, 63^1/$_8$ × 50^3/$_4$ in.
(162 × 130 cm)
Private collection
Z. VII, 347

629 *Woman with a Dagger*
Paris, December 19–26, 1931
Oil on canvas, 18^1/$_8$ × 24 in.
(46.5 × 61.5 cm)
Picasso Museum, Paris

630 *Large Still Life on a Pedestal Table*
Paris, March 11, 1931
Oil on canvas, 76 × 50^7/$_8$ in.
(195 × 130.5 cm)
Picasso Museum, Paris
Z. VII, 317

631 *Figures by the Sea*
Paris, January 12, 1931
Oil on canvas, 50^3/$_4$ × 76 in.
(130 × 195 cm)
Picasso Museum, Paris
Z. VII, 328

632 *Woman Throwing a Stone*
Paris, March 8, 1931
Oil on canvas, 50^7/$_8$ × 76^1/$_4$ in.
(130.5 × 195.5 cm)
Picasso Museum, Paris
Z. VII, 329

633 *The Kiss*
Paris, January 12, 1931
Oil on canvas, 23^3/$_4$ × 19^5/$_8$ in.
(61 × 50.5 cm)
Picasso Museum, Paris
Z. VII, 325

634 *Woman in a Red Armchair*
Boisgeloup, January 27, 1932
Oil on canvas, 50¼ × 37⅞ in.
(130.2 × 97 cm)
Picasso Museum, Paris
Z. VII, 330

635 *Woman Seated in a Red Armchair*
Boisgeloup, 1932
Oil on canvas, 50¼ × 38 in.
(130 × 97.5 cm)
Picasso Museum, Paris

636 *Composition with a Butterfly*
Boisgeloup, September 15, 1932
Fabric, wood, plants, string, drawing-pin, butterfly, oil on canvas, 6¼ × 8⅝ × 1 in.
(16 × 22 × 2.5 cm)
Picasso Museum, Paris
Sp., 116

637 *Seated Woman and Man's Head*
1932
Pencil on paper, 10¾ × 10 in.
(27.5 × 25.5 cm)
Private collection

638 *Bather with a Ball*
Boisgeloup, August 30, 1932
Oil on canvas, 57 × 44⅝ in.
(146.2 × 114.6 cm)
Private collection
Z. VIII, 147

639 *Nude in a Red Armchair*
Boisgeloup, July 27, 1932
Oil on canvas, 50¾ × 37⅞ in.
(130 × 97 cm)
The Tate Gallery, London
Z. VII, 395

640 *Reading*
Boisgeloup, January 2, 1932
Oil on canvas, 50¼ × 38 in.
(130 × 97.5 cm)
Picasso Museum, Paris
Z. VII, 358

641 *Nude in a Black Armchair*
Boisgeloup, March 9, 1932
Oil on canvas, 63⅛ × 50¾ in.
(162 × 130 cm)
Private collection
Z. VII, 377

642 *Reclining Nude*
Boisgeloup, April 4, 1932
Oil on canvas, 50¼ × 63 in.
(130 × 161.7 cm)
Picasso Museum, Paris
Z. VII, 332

643 *The Dream*
Boisgeloup, January 24, 1932
Oil on canvas, 50¼ × 37⅞ in.
(130 × 97 cm)
Private collection
Z. VII, 364

644 *Woman in an Armchair (Repose)*
January 22, 1932
Oil on canvas, 63⅛ × 50¾ in.
(162 × 130 cm)
Private collection
Z. VII, 361

645 *The Mirror*
Boisgeloup, March 12, 1932
Oil on canvas, 51 × 37⅞ in.
(130.7 × 97 cm)
Gustav Stern Foundation, Inc., New York
Z. VII, 378

646 *Woman at the Mirror*
Boisgeloup, March 14, 1932
Oil on canvas, 63¼ × 50¾ in.
(162.3 × 130.2 cm)
The Museum of Modern Art, New York, Gift of Mrs. Simon Guggenheim
Z. VII, 379

647 *Three Women Playing with a Ball*
1932
Oil on canvas, 8⅝ × 12⅞ in.
(22 × 33 cm)
Private collection
Z. VIII, 231

648 *Three Women Playing with a Ball on the Beach*
Boisgeloup, September 15, 1932
Oil on canvas, 16 × 10½ in.
(41 × 27 cm)
Private collection

649 *Two Nudes, One Playing a Double Flute*
Boisgeloup, October 4, 1932
Oil over India ink drawing, 13⅜ × 19⅞ in.
(34.2 × 51.1 cm)
Picasso Museum, Paris
Z. VIII, 43

650 *The Rescue*
1932
Oil on canvas, 50¼ × 37⅞ in.
(130 × 97 cm)
Private collection
Z. VIII, 66

651 *Women and Children by the Sea*
1932
Oil on canvas, 31⅝ × 39 in.
(81 × 100 cm)
Private collection
Z. VIII, 63

652 *Woman with a Flower*
Boisgeloup, April 10, 1932
Oil on canvas, 63⅛ × 50¾ in.
(162 × 130 cm)
Private collection
Z. VII, 381

653 *Still Life with Bust, Bowl, and Palette*
Boisgeloup, March 3, 1932
Oil on canvas, 50⅞ × 38 in.
(130.5 × 97.5 cm)
Picasso Museum, Paris

654 *The Crucifixion*
Boisgeloup, September 17, 1932
India ink on paper, 13¼ × 19⅞ in. (34 × 51 cm)
Picasso Museum, Paris
Z. VIII, 51

655 *The Crucifixion*
Boisgeloup, September 19, 1932
India ink on paper, 13¼ × 19⅞ in. (34 × 51 cm)
Picasso Museum, Paris
Z. VIII, 55

656 *The Crucifixion*
Boisgeloup, October 4, 1932
India ink on paper, 13¼ × 19⅞ in. (34 × 51 cm)
Picasso Museum, Paris
Z. VIII, 50

657 *The Crucifixion*
Boisgeloup, October 7, 1932
Pen and India ink on paper, 13¼ × 19⅞ in. (34 × 51 cm)
Picasso Museum, Paris

658 *The Crucifixion*
Boisgeloup, October 7, 1932
Pen and India ink on paper, 13¼ × 19⅞ in. (34 × 51 cm)
Picasso Museum, Paris
Z. VIII, 53

659 *The Crucifixion*
Boisgeloup, October 7, 1932
Pen and India ink on paper, 13¼ × 19⅞ in. (34 × 51 cm)
Picasso Museum, Paris

660 *Minotaur*
1933
Charcoal on paper, 19⅞ × 13¼ in. (51 × 34 cm)
Picasso Museum, Paris
Z. VIII, 137

661 *Bullfight: Death of the Bullfighter*
Boisgeloup, September 19, 1933
Oil on panel, 12⅛ × 15⅝ in.
(31 × 40 cm)
Picasso Museum, Paris
Z. VIII, 214

662 *Bullfight: Death of the Woman Bullfighter*
Boisgeloup, September 6, 1933
Oil and crayon on panel, 8½ × 10½ in. (21.7 × 27 cm)
Picasso Museum, Paris
Z. VIII, 138

663 *Bull Goring a Horse*
Boisgeloup, September 24, 1933
India ink on paper, 10⅛ × 13⅜ in. (26 × 35 cm)
Private collection

664 *Minotaur*
Paris, November 12, 1933
Gouache, pastel, colored pencil, pen, and India ink on paper, 13¼ × 20 in.
(34 × 51.4 cm)
Musée des Beaux-Arts de Dijon. Granville Gift
Z. VIII, 139

665 *Minotaur Abducting a Woman*
Boisgeloup, June 28, 1933
Pen, India ink, and wash on paper, 18⅜ × 24⅛ in.
(47 × 62 cm)
Picasso Museum, Paris

666 *Bacchanale and Minotaur*
Paris, May 18, 1933
Etching, 11⅝ × 14¼ in.
(29.7 × 36.5 cm)
The Museum of Modern Art, New York
Bl. 192; G. 351/IV

667 *Design for the cover of "Minotaur"*
Paris, May 1933
Collage of pencil on paper, corrugated cardboard, silver foil, ribbons, plywood, artificial leaves, and drawing pens, 18⅞ × 16 in. (48.5 × 41 cm)
The Museum of Modern Art, New York. Gift of Mr. and Mrs. Alexandre P. Rosenberg

668 *Head of a Woman V*
Paris, February 16, 1933
Monotype, 12⅞ × 8⅞ in.
(31.7 × 22.9 cm)
Picasso Museum, Paris
G. 555

669 *Head of a Woman*
Paris, February 1933
Drypoint, $12^3/_8 \times 8^7/_8$ in.
(31.7 × 22.9 cm)
Picasso Museum, Paris
Bl. 250; G. 228/XX

670 *Head of a Woman*
Paris, February 16, 1933
Drypoint, $12^3/_8 \times 8^7/_8$ in.
(31.7 × 22.9 cm)
Picasso Museum, Paris
G. 288/IV

671 *Head of a Woman VI*
Paris, February 16, 1933
Monotype, $12^3/_8 \times 8^7/_8$ in.
(31.7 × 22.9 cm)
Picasso Museum, Paris
G. 556

672 *Still Life*
Paris, January 29, 1933
Oil on canvas, $27^5/_8 \times 35^7/_8$ in.
(70.8 × 92 cm)
The Fogg Art Museum,
Harvard University,
Cambridge, Massachusetts.
Gift of Mr. and Mrs. Joseph
Pulitzer, Jr.
Z. VIII, 84

673 *Two Figures*
Boisgeloup, April 12, 1933
Pencil on paper,
$13^1/_2 \times 18^1/_8$ in. (34.5 × 46.5 cm)
Picasso Museum, Paris
Z. VIII, 95

674 *Anatomical Study: Seated Woman*
Paris, February 28, 1933
Pencil on paper, $7^3/_4 \times 10^1/_2$ in.
(20 × 27 cm)
Picasso Museum, Paris
Z. VIII, 93

675 *The Studio*
Paris–Boisgeloup,
February 22, 1933
Pencil on paper,
$10^1/_4 \times 13^3/_8$ in. (26.2 × 34.3 cm)
Picasso Museum, Paris
Z. VIII, 92

676 *Seated Nude*
Paris, February 1933
Oil on canvas, $50^3/_4 \times 37^7/_8$ in.
(130 × 97 cm)
Kunstsammlung Nordrhein-
Westfalen, Düsseldorf
Z. VIII, 91

677 *Anatomical Study: Three Women*
Paris, February 27, 1933
Pencil on paper, $7^3/_4 \times 10^1/_2$ in.
(20 × 27 cm)
Picasso Museum, Paris

678 *Anatomical Study: Three Women*
Paris, February 28, 1933
Pencil on paper, $7^5/_8 \times 10^1/_2$ in.
(19.7 × 27 cm)
Picasso Museum, Paris

679 *For Tristan Tzara*
Paris, March 10, 1933
India ink on paper,
dimensions unknown
Galerie Louise Leiris, Paris

680 *Silenus Dancing*
Cannes, July 6, 1933
Ink and gouache on paper,
$13^1/_4 \times 17^1/_2$ in. (34 × 45 cm)
Private collection

681 *Figure by the Sea*
Paris, November 19, 1933
Pastel, India ink, and charcoal
on paper, $19^7/_8 \times 13^1/_8$ in.
(51 × 34.2 cm)
Picasso Museum, Paris
Z. VIII, 149

682 *Surrealist Composition*
Cannes, July 15, 1933
India ink and watercolor on
paper, $15^5/_8 \times 19^1/_2$ in.
(40 × 50 cm)
Private collection
Z. VIII, 116

683 *On the Beach*
Cannes, July 28, 1933
India ink and watercolor on
paper, $15^1/_4 \times 19^3/_8$ in.
(39 × 49.8 cm)
Private collection
Z. VIII, 119

684 *Two Figures on the Beach*
Cannes, July 28, 1933
India ink on paper,
$15^5/_8 \times 19^3/_4$ in. (40 × 50.8 cm)
The Museum of Modern Art,
New York
Z. VIII, 124

685 *Model and Surrealist Sculpture*
May 4,1933
Etching, $10^1/_2 \times 7^1/_2$ in.
(26.8 × 19.3 cm)
Picasso Museum, Paris
Bl. 187; G. 346/II

686 *Young Sculptor at Work*
March 25, 1933
Etching, $10^3/_8 \times 7^5/_8$ in.
(26.7 × 19.4 cm)
Picasso Museum, Paris
Bl. 156; G. 309/II

687 *The Sculptor and the Statue*
Cannes, July 20, 1933
Pen, watercolor, and gouache
on paper, $15^1/_4 \times 19^1/_4$ in.
(39 × 49.5 cm)
Private collection
Z. VIII, 120

688 *Study for "Lysistrata" by Aristophanes*
Paris, December 31, 1933
India ink on paper,
14 × $21^1/_2$ in. (36 × 55 cm)
Private collection
Z. VIII, 155

689 *Minotaur with a Javelin*
Paris, 25 January 1934
India ink on plywood,
$37^3/_4 \times 50^3/_4$ in. (97 × 130 cm)
Picasso Museum, Paris
Z. VIII, 167

690 *Myrrina and Sinecias, from "Lysistrata" by Aristophanes*
Paris, January 18, 1934
India ink on paper,
$12^3/_8 \times 9^5/_8$ in. (31.7 × 24.7 cm)
Private collection
Z. VIII, 163

691 *Portrait of Man Ray*
Paris, January 3, 1934
India ink on paper,
$13^1/_2 \times 9^5/_8$ in. (34.7 × 24.8 cm)
Private collection
Z. VIII, 165

692 *Nude Reclining in Front of a Window*
Paris, February 7, 1934
Pen and India ink on paper,
$10^1/_4 \times 12^3/_4$ in. (26.2 × 32.7 cm)
Picasso Museum, Paris
Z. VIII, 179

693 *Interior with Swallows II*
Paris, February 10, 1934
India ink and charcoal on
paper, $10^1/_8 \times 12^3/_4$ in.
(26 × 32.7 cm)
Picasso Museum, Paris
Z. VIII, 173

694 *Interior with Swallows I*
Paris, February 10, 1934
India ink and charcoal on
paper, 10 × $12^5/_8$ in.
(25.7 × 32.5 cm)
Picasso Museum, Paris
Z. VIII, 175

695 *Circus Scene*
Boisgeloup, 1934
Oil on canvas, $31^1/_4 \times 39$ in.
(80 × 100 cm)
Private collection
Z. VIII, 115

696 *Woman at the Mirror*
Paris, April 1934
Ink, watercolor, and colored
crayons on paper,
$17^3/_4 \times 21^3/_4$ in. (45.4 × 55.8 cm)
Los Angeles County Museum
of Art. Mr. and Mrs. William
Preston Harrison Collection

697 *Four Nudes and Sculpted Head*
March 10, 1934
Etching and engraving,
$8^5/_8 \times 12^3/_8$ in. (22.3 × 31.6 cm)
Picasso Museum, Paris
Bl. 219; G. 424/V

698 *Nude in a Garden*
Boisgeloup, August 4, 1934
Oil on canvas, $63^1/_8 \times 50^3/_4$ in.
(162 × 130 cm)
Picasso Museum, Paris

699 *Confidences*
1934
Cartoon for a tapestry
Musée National d'Art Moderne,
Centre Georges Pompidou,
Paris
Z. VIII, 268

700 *Woman with Leaves*
Boisgeloup, 1934
Bronze (unique cast),
$14^3/_4 \times 7^3/_4 \times 10^1/_8$ in.
(37.9 × 20 × 25.9 cm)
Picasso Museum, Paris
Sp., 157 (II)

701 *The Murder*
Boisgeloup, July 7, 1934
Pencil on paper,
$15^1/_2 \times 19^5/_8$ in. (39.8 × 50.4 cm)
Picasso Museum, Paris
Z. VIII, 216

702 *Nude with a Bouquet of Irises and a Mirror*
Boisgeloup, May 22, 1934
Oil on canvas, $63^1/_8 \times 50^3/_4$ in.
(162 × 130 cm)
Picasso Museum, Paris
Z. VIII, 210

703 *Bullfight*
Boisgeloup, July 16, 1934
Oil on canvas, $12^7/_8 \times 21^1/_2$ in.
(33 × 55 cm)
Private collection
Z. VIII, 228

704 *Bullfight*
Boisgeloup, July 2, 1934
Oil on canvas, $37^7/_8 \times 50^3/_4$ in.
(97 × 130 cm)
Private collection
Z. VIII, 229

705 *Bull and Horse*
Boisgeloup, July 24, 1934
Pencil on paper,
10⅛ × 13½ in. (26 × 34.5 cm)
Private collection
Z. VIII, 217

706 *Bullfight*
1934
India ink on paper,
8⅛ × 9⅝ in. (21.5 × 24.8 cm)
Private collection
Z. VIII, 224

707 *Woman with a Candle, Combat Between the Bull and the Horse*
Boisgeloup, July 24, 1934
Pen and India ink, brown crayon on canvas stuck onto plywood, 12¼ × 15¾ in.
(31.5 × 40.5 cm)
Picasso Museum, Paris
Z. VIII, 215

708 *Winged Bull Watched by Four Children*
Paris, December 1934
Etching, 9¼ × 11½ in.
(23.7 × 29.5 cm)
Picasso Museum, Paris
Bl. 229; G. 444/II

709 *Blind Minotaur Guided by a Little Girl at Night*
Paris, November 1934
Aquatint, dry point, and black pigment, 9⅝ × 13½ in.
(24.6 × 34.6 cm)
Picasso Museum, Paris
Bl. 225; G. 437/IV

710 *Blind Minotaur Led by a Girl*
Boisgeloup, September 22, 1934
Oil, India ink, and wash on paper, 13⅝ × 19⅞ in.
(35 × 51 cm)
Hamburger Kunsthalle. Klaus Megewisch Collection

711 *Minotauromachy*
Paris, Spring 1935
Etching and scraper,
19⅜ × 27 in. (49.8 × 69.3 cm)
Picasso Museum, Paris
Bl. 288; G. 573/VII

712 *Minotaur and Wounded Horse*
April 17, 1935
Pen, India ink, and pencil on paper, 13¼ × 21 in.
(33.7 × 53.7 cm)
Private collection

713 *Minotaur and Horse*
Boisgeloup, April 15, 1935
Pencil on paper, 6⅞ × 10 in.
(17.5 × 25.5 cm)
Picasso Museum, Paris
Z. VIII, 244

714 *Monster*
Boisgeloup, April 26, 1935
Pencil and ink on paper,
6⅝ × 10 in. (17 × 25.5 cm)
Private collection

715 *The Victorious Bull*
1935
India ink and watercolor on paper, 13½ × 20 in.
(34.5 × 51.2 cm)
Galerie Louise Leiris, Paris

716 *Bullfight*
Boisgeloup, April 27, 1935
India ink and pastel on paper,
6⅞ × 10 in. (17.5 × 25.5 cm)
Museum Ludwig, Cologne.
Ludwig Collection
Z. VIII, 240

717 *The Muse*
1935
Oil on canvas, 50¼ × 63⅛ in.
(130 × 162 cm)
Musée National d'Art Moderne, Centre Georges Pompidou, Paris
Z. VIII, 256

718 *Two Women in an Interior*
Paris, 12 February 1935
Oil on canvas, 50¾ × 76 in.
(130 × 195 cm)
The Museum of Modern Art, New York. Nelson A. Rockefeller Bequest
Z. VIII, 263

719 *French Poem ("Sur le dos de l'immense tranche de melon ardent")*
Paris, December 14, 1935
India ink and colored crayons on paper, 10 × 6⅝ in.
(25.5 × 17.1 cm)
Picasso Museum, Paris

720 *Girl Drawing in an Interior* (with color annotations)
Paris, February 17, 1935
Pen and India ink over pencil strokes on paper, 6⅝ × 9⅞ in.
(17.1 × 25.3 cm)
Picasso Museum, Paris
Z. VIII, 262

721 *Girl Drawing in an Interior*
Paris, February 5, 1935
Pencil on paper, 6⅞ × 10⅜ in.
(17.5 × 26.5 cm)
Picasso Museum, Paris
Z. VIII, 250

722 *Girl Drawing in an Interior*
Paris, February 5, 1935
Pencil on paper, 6⅝ × 10 in.
(17 × 25.5 cm)
Picasso Museum, Paris
Z. VIII, 252

723 *Woman Reading*
Paris, January 9, 1935
Oil on canvas, 63⅛ × 44⅛ in.
(162 × 113 cm)
Picasso Museum, Paris
Z. VIII, 260

724 *Portrait of a Girl*
April 4, 1936
Oil and crayon on canvas,
18 × 14⅞ in. (46 × 38 cm)
Private collection

725 *Head of a Woman*
April 5, 1936
Oil and crayon on canvas,
18 × 14⅞ in. (46 × 38 cm)
Private collection

726 *Portrait of a Girl* (with color annotations)
Juan-les-Pins, April 4, 1936
India ink on a sheet folded in two, 10⅞ × 6⅝ in. (28 × 17 cm)
Picasso Museum, Paris

727 *Portrait of a Girl on an Old Food Box and a French Poem on this Theme*
Juan-les-Pins, April 4, 1936
India ink on sheet folded in two, 10⅞ × 6⅝ in. (28 × 17 cm)
Picasso Museum, Paris

728 *The Rescue*
April 29, 1936
Pastel and charcoal on canvas,
25⅜ × 21 in. (65 × 54 cm)
Private collection

729 *Minotaur Carrying a Mare and Her Colt in a Cart*
April 6, 1936
Oil on canvas, 18 × 21½ in.
(46 × 55 cm)
Private collection

730 *Minotaur Pulling a Mare and Her Colt in a Cart*
Juan-les-Pins, April 5, 1936
Pen and India ink on paper,
19⅝ × 25¼ in. (50.5 × 66 cm)
Picasso Museum, Paris
Z. VIII, 276

731 *Composition*
Paris, May 4, 1936
Pen and India ink on paper,
13½ × 19⅞ in. (34.5 × 51 cm)
Private collection
Z. VIII, 284

732 *Faun Unveiling a Woman*
Paris, June 12, 1936
Etching and aquatint,
12⅜ × 16¼ in. (31.6 × 41.7 cm)
The Museum of Modern Art, New York
Bl. 230; G. 609/VI

733 *The Straw Hat with Blue Leaves*
Juan-les-Pins, May 1, 1936
Oil on canvas, 23¾ × 19½ in.
(61 × 50 cm)
Picasso Museum, Paris

734 *Reclining Nude with a Starry Sky*
Paris, August 12–October 2, 1936
Oil on canvas, 50¾ × 63⅛ in.
(130 × 162 cm)
Musée National d'Art Moderne, Centre Georges Pompidou, Paris
Z. VIII, 310

735 *Sleeping Woman with Shutters*
Juan-les-Pins, April 25, 1936
Oil and charcoal on canvas,
21¼ × 25⅜ in. (54.4 × 65.2 cm)
Picasso Museum, Paris

736 *Man with a Mask, Woman with Child in Her Arms*
Juan-les-Pins, April 23, 1936
Pen, India ink, and wash on paper, 25⅜ × 19½ in.
(65 × 50 cm)
Picasso Museum, Paris
Z. VIII, 278

737 *Couple*
Juan-les-Pins, April 7, 1936
India ink and wash on paper,
19½ × 25½ in. (50 × 65.5 cm)
Private collection
Z. VIII, 280

738 *Portrait of a Woman*
April 20, 1936
Oil on canvas, 16 × 12⅞ in.
(41 × 33 cm)
Private collection

739 *Portrait of a Woman*
April 22, 1936
Oil on canvas, 18 × 14⅞ in.
(46 × 38 cm)
Private collection

740 *Women in an Interior*
Juan-les-Pins, May 2, 1936
Oil on canvas, 23¾ × 19⅝ in.
(61 × 50.5 cm)
Picasso Museum, Paris

741 *Woman with a Watch*
Juan-les-Pins, April 30, 1936
Oil on canvas, 25⅜ × 21⅛ in.
(65 × 54.2 cm)
Picasso Museum, Paris

742 *Wounded Minotaur, Rider, and Figures*
Juan-les-Pins, May 8, 1936
India ink and gouache on paper, 19½ × 25⅜ in.
(50 × 65 cm)
Picasso Museum, Paris
Z. VIII, 285

743 *Wounded Minotaur, Horse, and Figures*
Juan-les-Pins, May 10, 1936
Gouache, pen, and India ink on paper, 19½ × 25⅜ in.
(50 × 65 cm)
Picasso Museum, Paris
Z. VIII, 288

744 *Minotaur and Dead Mare Before a Cave Facing a Girl in a Veil*
Juan-les-Pins, May 6, 1936
Gouache and India ink on paper, 19½ × 25⅜ in.
(50 × 65 cm)
Picasso Museum, Paris

745 *Composition with Minotaur*
Paris, May 9, 1936
Gouache and India ink on paper, 19½ × 25⅜ in.
(50 × 65 cm)
Private collection
Z. VIII, 286

746 *The Body of the Minotaur in a Harlequin Costume* (drawing used as a design for the drop curtain for a scene in Romain Rolland's "14 Juillet")
Paris, May 28, 1936
Gouache and India ink on paper, 17⅜ × 21¼ in.
(44.5 × 54.5 cm)
Picasso Museum, Paris
Z. VIII, 287

747 *Faun, Horse, and Bird*
Paris, August 5, 1936
Gouache and India ink on paper, 17⅛ × 21 in.
(44 × 54 cm)
Picasso Museum, Paris

748 *Portrait of Woman: Marie-Thérèse*
July 28, 1936
India ink and wash on paper, 19⅞ × 13⅜ in. (51 × 34.3 cm)
Private collection

749 *Portrait of Dora Maar*
Paris, November 19, 1936
Oil on canvas, 25 × 19⅞ in.
(64 × 51 cm)
Private collection
Z. VIII, 302

750 *Still Life with a Lamp*
Le Tremblay-sur-Mauldre, December 29, 1936
Oil on canvas, 37⅞ × 50¾ in.
(97 × 130 cm)
Picasso Museum, Paris

751 *Marie-Thérèse with a Garland*
February 6, 1937
Oil on canvas, 23¾ × 18 in.
(61 × 46 cm)
Private collection
Z. IX, 312

752 *Portrait of Marie-Thérèse*
January 21, 1937
Oil on canvas, 16 × 12⅞ in.
(41 × 33 cm)
Private collection

753 *Female and Male Profiles*
Paris, December 17, 1937
Pencil on paper, 10 × 6⅞ in.
(25.8 × 17.5 cm)
Picasso Museum, Paris
Z. IX, 88

754 *Woman at the Mirror*
February 16, 1937
Oil on canvas, 50¾ × 76 in.
(130 × 195 cm)
Kunstsammlung Nordrhein-Westfalen, Düsseldorf
Z. VIII, 340

755 *Still Life with an Apple*
February 1937
Steel coil, wooden knife, crumpled paper, cardboard, piece of cloth, and oil on canvas, 19½ × 25⅜ in.
(50 × 65 cm)
Private collection
Sp., 170

756 *Woman Seated Before the Window*
Le Tremblay-sur-Mauldre, March 11, 1937
Oil and pastel on canvas, 50¾ × 38 in. (130 × 97.3 cm)
Picasso Museum, Paris

757 *Portrait of Marie-Thérèse*
Paris, January 6, 1937
Oil on canvas, 39 × 31⅝ in.
(100 × 81 cm)
Picasso Museum, Paris
Z. VIII, 324

758 *Portrait of Dora Maar*
Paris, 1937
Oil on canvas, 35⅞ × 25⅜ in.
(92 × 65 cm)
Picasso Museum, Paris
Z. VIII, 331

759 *Portrait of Nusch Éluard*
Paris, 1937
Oil on canvas, 35⅞ × 25⅜ in.
(92 × 65 cm)
Picasso Museum, Paris
Z. VIII, 377

760 *Portrait of a Woman*
December 8, 1937
Oil on canvas, 21½ × 18 in.
(55 × 46 cm)
Private collection

761 *Houses and Trees*
Mougins, September 4, 1937
Oil on canvas, 31⅝ × 25⅜ in.
(81 × 65 cm)
Private collection

762 *Large Bather with a Book*
Paris, February 18, 1937
Oil, pastel, and charcoal on canvas, 50¾ × 38 in.
(130 × 97.5 cm)
Picasso Museum, Paris
Z. VIII, 351

763 *Two Nudes on the Beach*
Paris, May 1, 1937
India ink and gouache on panel, 8⅝ × 10½ in.
(22 × 27 cm)
Picasso Museum, Paris
Z. IX, 217

764 *Study for "Bathing"*
Paris–Le Tremblay-sur-Mauldre, February 12, 1937
Pencil, charcoal, and pastel on paper, 13¼ × 20¼ in.
(34 × 52 cm)
Picasso Museum, Paris
Z. VIII, 342

765 *Bathing*
Le Tremblay-sur-Mauldre
February 12, 1937
Oil, pastel, and charcoal on canvas, 50⅜ × 75⅝ in.
(129.1 × 194 cm)
Peggy Guggenheim Collection, Venice. Solomon R. Guggenheim Foundation, New York
Z. VIII, 344

766 *Woman Seated on the Beach*
February 10, 1937
Oil, charcoal, and chalk on canvas, 50¾ × 63⅛ in.
(130 × 162 cm)
Private collection
Z. VIII, 345

767 *Bathers, Mermaids, Nudes, and Minotaur*
Paris, March 1937
India ink and Ripolin paint on cardboard, 8¾ × 10⅜ in.
(22.4 × 26.5 cm)
Private collection
Z. IX, 97

768 *Horse Before a Landscape*
Paris, October 23, 1937
Pastel, pencil, and India ink on paper, 11⅜ × 16¾ in.
(29 × 43 cm)
Private collection
Z. IX, 82

769 *Minotaur in a Boat*
Paris, February 19, 1937
Pastel and pencil on paper, 8 × 9 in. (23 × 20.5 cm)
Private collection
Z. IX, 96

770 *Man Holding a Horse*
Paris, October 23, 1937
India ink and pastel on paper, 11⅜ × 16¾ in. (29 × 43 cm)
Private collection
Z. IX, 83

771 *The Dream and Lie of Franco I*
January 8, 1937
Etching and aquatint, 14⅞ × 22¼ in. (38 × 57 cm)
Picasso Museum, Paris
Bl. 297; G. 615/II B. C.

772 *The Dream and Lie of Franco II*
January 9 and June 7, 1937
Etching and aquatint, 14⅞ × 22¼ in. (38 × 57 cm)
Picasso Museum, Paris
Bl. 298; G. 616/V B. C.

773 *Studies for "Guernica": Hooves and Heads of a Horse*
May 10, 1937
Pencil on paper, 17$^{3}/_{4}$ × 9$^{1}/_{2}$ in. (45.4 × 24.3 cm)
Museo Nacional Centro de Arte Reina Sofia, Madrid
Z. IX, 21

774 *Studies for "Guernica": Horse's Head*
May 2, 1937
Oil on canvas, 25$^{3}/_{8}$ × 35$^{7}/_{8}$ in. (65 × 92.1 cm)
Museo Nacional Centro de Arte Reina Sofia, Madrid
Z. IX, 11

775 *Study for Composition of "Guernica"*
May 1, 1937
Pencil on blue paper, 8$^{1}/_{8}$ × 10$^{1}/_{2}$ in. (21 × 26.9 cm)
Museo Nacional Centro de Arte Reina Sofia, Madrid
Z. IX, 1

776 *Study for Composition of "Guernica": Horse and Mother with a Dead Child*
May 8, 1937
Pencil on paper, 9$^{3}/_{8}$ × 17$^{3}/_{4}$ in. (24.1 × 45.4 cm)
Museo Nacional Centro de Arte Reina Sofia, Madrid
Z. IX, 12

777 *Study for Composition of "Guernica"*
May 9, 1937
Pencil on paper, 9$^{3}/_{8}$ × 17$^{5}/_{8}$ in. (24 × 45.3 cm)
Museo Nacional Centro de Arte Reina Sofia, Madrid
Z. IX, 18

778 *Study for "Guernica": Head of Man-Bull and Studies of Eyes*
Pencil and gouache on paper, 9 × 11$^{3}/_{8}$ in. (23.2 × 29.2 cm)
Museo Nacional Centro de Arte Reina Sofia, Madrid
Z. IX, 29

779 *Study for "Guernica": Head of Woman in Tears*
June 3, 1937
Pencil, colored crayons, and gouache on paper, 9 × 11$^{1}/_{2}$ in. (23.2 × 29.3 cm)
Museo Nacional Centro de Arte Reina Sofia, Madrid
Z. IX, 44

780 *Guernica, state 1*
Photograph by Dora Maar
Z. IX, 58

781 *Guernica, state 3*
Photograph by Dora Maar
Z. IX, 60

782 *Guernica*
Paris, May 1–June 4, 1937
Oil on canvas, 136$^{1}/_{4}$ × 302$^{7}/_{8}$ in. (349.3 × 776.6 cm)
Museo Nacional Centro de Arte Reina Sofia, Madrid
Z. IX, 65

783 *Woman in Tears*
Paris, October 26, 1937
Oil on canvas, 23$^{1}/_{8}$ × 19$^{1}/_{8}$ in. (60 × 49 cm)
Private collection
Z. IX, 73

784 *Woman in Tears I*
Paris, July 4, 1937
Ink on paper, 9$^{7}/_{8}$ × 6$^{5}/_{8}$ in. (25.3 × 17.1 cm)
Museo Nacional Centro de Arte Reina Sofia, Madrid
Z. IX, 56

785 *Woman in Tears II*
Paris, July 2, 1937
Etching and aquatint, 30$^{1}/_{8}$ × 22 in. (77.2 × 56.4 cm)
Museo Nacional Centro de Arte Reina Sofia, Madrid
Bl. 1333; G. 623/VI b.

786 *The Weeping Woman*
Paris, October 24, 1937
Oil and India ink on paper, 10 × 6$^{3}/_{4}$ in. (25.5 × 17.3 cm)
Picasso Museum, Paris

787 *The Weeping Woman*
Paris, October 18, 1937
Oil on canvas, 21$^{5}/_{8}$ × 18 in. (55.3 × 46.3 cm)
Picasso Museum, Paris

788 *The Supplicant*
Paris, December 18, 1937
Gouache on panel, 9$^{3}/_{8}$ × 7$^{1}/_{4}$ in. (24 × 18.5 cm)
Picasso Museum, Paris

789 *Weeping Woman*
Paris, 1937
Plaster, 3$^{3}/_{4}$ × 3$^{1}/_{8}$ × 1$^{5}/_{8}$ in. (9.5 × 8 × 4 cm)
Picasso Museum, Paris
Sp., 171 A

790 *Minotaur*
Paris, December 7, 1937
Pen, India ink, charcoal, and pencil on paper, 22$^{1}/_{4}$ × 15 in (57 × 38.5 cm)
Picasso Museum, Paris

791 *Wounded Faun and Woman*
January 1, 1938
Oil and charcoal on canvas, 18 × 21$^{1}/_{2}$ in. (46 × 55 cm)
Private collection

792 *Wounded Faun*
December 31, 1937
Oil and charcoal on canvas, 18 × 21$^{1}/_{2}$ in. (46 × 55 cm)
Private collection

793 *Seated Faun*
January 2, 1938
Oil, pencil, and charcoal on canvas, 19$^{1}/_{2}$ × 23$^{3}/_{4}$ in. (50 × 61 cm)
Private collection

794 *Head of a Bearded Man*
1938
Oil and charcoal on canvas, 21$^{1}/_{2}$ × 18 in. (55 × 46 cm)
Picasso Museum, Paris

795 *Women at Their Toilette*
Paris, 1938
Glued-on colored paper and gouache mounted on paper, 11$^{5}/_{8}$ × 17$^{1}/_{2}$ in. (29.9 × 44.8 cm)
Picasso Museum, Paris
Z. IX, 103

796 *Little Girl with a Boat (Maya)*
Paris, January 30, 1938
Oil on canvas, 23$^{3}/_{4}$ × 18 in. (61 × 46 cm)
A. Rosengart Collection, Lucerne

797 *The Butterfly Chaser*
1938
Oil on canvas, 47$^{3}/_{4}$ × 33$^{7}/_{8}$ in. (122.5 × 87 cm)
Private collection
Z. IX, 104

798 *La Coiffure*
Paris, March 22, 1938
Oil on canvas, 22$^{1}/_{4}$ × 17 in. (57 × 43.5 cm)
Picasso Museum, Paris

799 *Bust of a Woman*
April 14, 1938
Oil on canvas, 25$^{1}/_{8}$ × 18$^{3}/_{8}$ in. (64.5 × 47 cm)
Private collection
Z. IX, 127

800 *Head of a Woman*
August 14, 1938
Oil on canvas, 25$^{3}/_{8}$ × 19$^{1}/_{2}$ in. (65 × 50 cm)
Private collection
Z. IX, 216

801 *The Artist before His Canvas*
Paris, March 22, 1938
Charcoal on canvas, 50$^{3}/_{4}$ × 36$^{5}/_{8}$ in. (130 × 94 cm)
Picasso Museum, Paris

802 *Woman in a Hairnet*
January 12, 1938
Oil on canvas, 25$^{3}/_{8}$ × 21$^{1}/_{8}$ in. (65 × 54 cm)
Private collection
Z. IX, 119

803 *Woman in a Straw Hat Against a Flowered Background*
June 25, 1938
Oil on canvas, 28$^{1}/_{2}$ × 23$^{3}/_{8}$ in. (73 × 60 cm)
A. Rosengart Collection, Lucerne

804 *Marie-Thérèse*
January 7, 1938
Oil on canvas, 23$^{1}/_{4}$ × 18 in. (61 × 46 cm)
Private collection

805 *Seated Woman*
Paris, 1938
Oil on canvas
Musée National d'Art Moderne, Centre Georges Pompidou, Paris
Z. IX, 134

806 *Dora Maar, Seated*
Paris, February 2, 1938
Pastel, India ink, and pencil on cardboard, 10$^{1}/_{2}$ × 8$^{1}/_{2}$ in. (27 × 21.9 cm)
Picasso Museum, Paris
Z. IX, 118

807 *Sailor*
Mougins, July 31, 1938
Oil on canvas, 22$^{7}/_{8}$ × 18$^{3}/_{4}$ in. (58.5 × 48 cm)
Private collection
Z. IX, 191

808 *Man with Ice-Cream Cone*
Mougins, August 6, 1938
Oil on canvas, 23$^{3}/_{4}$ × 19$^{1}/_{2}$ in. (61 × 50 cm)
Private collection
Z. IX, 190

809 *Man in a Straw Hat with Ice-Cream Cone*
Mougins, August 30, 1938
Oil on canvas, 23$^{3}/_{4}$ × 18 in. (61 × 46 cm)
Picasso Museum, Paris
Z. IX, 205

810 *Bathers with a Crab*
Mougins, July 10, 1938
India ink, gouache, and petals
nibbed on paper,
14¼ × 19⅝ in. (36.5 × 50.5 cm)
Picasso Museum, Paris
Z. IX, 172

811 *Two Women with an Umbrella*
Mougins–Paris, October 8, 1938
Pen, India ink, and blue ink
on paper, 17⅛ × 21 in.
(44 × 54 cm)
Picasso Museum, Paris
Z. IX, 227

812 *Head of a Woman*
Paris, June 13, 1938
Pen and India ink on paper,
18 × 9½ in. (46 × 24.5 cm)
Picasso Museum, Paris
Z. IX, 156

813 *The Fisherman's Family*
1938
India ink on paper,
27¼ × 33⅛ in. (70 × 85 cm)
Private collection
Z. IX, 185

814 *Seated Woman*
Mougins, August 29, 1938
Oil on canvas, 25⅜ × 19½ in.
(65 × 50 cm)
Private collection
Z. IX, 211

815 *Seated Woman in a Hat*
Mougins, September 10, 1938
Oil and sand on panel,
21¼ × 17⅞ in. (54.6 × 45.7 cm)
Private collection
Z. IX, 228

816 *Seated Woman*
Paris, April 29, 1938
Ink, pastel, and gouache on
paper, 29⅞ × 21½ in.
(76.5 × 55 cm)
Private collection
Z. IX, 132

817 *Seated Woman*
Paris, April 27, 1938
Ink, gouache, and colored
chalk on paper, 29⅞ × 21½ in.
(76.5 × 55 cm)
Galerie Beyeler, Basel
Z. IX, 133

818 *Seated Woman in a Garden*
Paris, December 10, 1938
Oil on canvas, 51⅛ × 37⅞ in.
(131 × 97 cm)
Private collection
Z. IX, 232

819 *The Rooster*
Paris, March 23, 1938
Charcoal on paper,
30 × 22⅛ in. (76.9 × 56. 9 cm)
Private collection
Z. IX, 114

820 *Woman with Rooster*
Paris, February 15, 1938
Oil on canvas, 56½ × 46¾ in.
(145 × 120 cm)
Private collection
Z. IX, 109

821 *Heads of Sheep*
Royan, October 17, 1939
Oil on canvas, 25⅜ × 31⅝ in.
(65 × 81 cm)
Private collection
Z. IX, 349

822 *Cat Catching a Bird*
Paris, April 22, 1939
Oil on canvas, 31⅝ × 39 in.
(81 × 100 cm)
Picasso Museum, Paris
Z. IX, 296

823 *Still Life with a Black Bull,
Book, Palette, and Chandelier*
Paris, November 19, 1938
Oil on canvas, 37⅞ × 50¾ in.
(97 × 130 cm)
Private collection
Z. IX, 240

824 *Cat and Bird*
Le Tremblay-sur-Mauldre,
April 1939
Oil on canvas, 37⅞ × 50¼ in.
(97 × 129 cm)
Private collection
Z. IX, 297

825 *Reclining Woman Reading*
Le Tremblay-sur-Mauldre,
January 21, 1939
Oil on canvas, 37⅝ × 50¾ in.
(96.5 × 130 cm)
Picasso Museum, Paris
Z. IX, 253

826 *Woman Lying on a Sofa
(Dora Maar)*
Le Tremblay-sur-Mauldre,
January 21, 1939
Oil on canvas, 37⅞ × 50¾ in.
(97 × 130 cm)
Private collection
Z. IX, 252

827 *Night Fishing at Antibes*
Antibes, August 1939
Oil on canvas, 80¼ × 134¾ in.
(205.7 × 345.5 cm)
The Museum of Modern Art,
New York. Mrs. Simon
Guggenheim Collection
Z. IX, 316

828 *Seated Woman in a Hat*
Paris, May 27, 1939
Oil on canvas, 31⅝ × 21 in.
(81 × 54 cm)
Picasso Museum, Paris
Z. IX, 301

829 *Three Heads of Women*
March 11, 1939
Crayon on paper,
11⅜ × 16¾ in. (29 × 43 cm)
Private collection
Z. IX, 256

830 *The Yellow Sweater*
31 October 31, 1939
Oil on canvas, 31⅝ × 25⅜ in.
(81 × 65 cm)
Berggruen Collection,
Staatliche Museen zu Berlin
Preussischer
Kulturbesitz, Berlin

831 *Head of a Woman*
Royan, October 4, 1939
Oil on canvas, 25½ × 21¼ in.
(65.5 × 54.5 cm)
Picasso Museum, Paris
Z. IX, 357

832 *Woman in a Blue Hat*
Royan, October 3, 1939
Oil on canvas, 25½ × 19½ in.
(65.5 × 50 cm)
Picasso Museum, Paris
Z. IX, 353

833 *Bust of a Woman in a Striped
Hat*
Paris, June 3, 1939
Oil on canvas, 31⅝ × 21 in.
(81 × 54 cm)
Picasso Museum, Paris

834 *Standing Nude and Seated
Woman*
Royan, September 22, 1939
Gouache on paper,
10½ × 8⅛ in. (26.8 × 21 cm)
Picasso Museum, Paris
Z. IX, 339

835 *Man with Horses*
September 11, 1939
India ink on paper,
18 × 25 in. (46 × 64 cm)
Museum Ludwig, Cologne.
Ludwig Gift

836 *Café in Royan*
Royan, August 15, 1940
Oil on canvas, 37⅞ × 50¼ in.
(97 × 130 cm)
Picasso Museum, Paris
Z. XI, 88

837 *Jaime Sabartés*
Royan, October 22, 1939
Oil on canvas, 17⅞ × 14⅞ in.
(45.7 × 38 cm)
Picasso Museum, Paris
Z. IX, 366

838 *Woman Seated in an Armchair*
Royan, February 1, 1940
String and pieces of painted
cardboard sewn onto
cardboard painted in oil,
6⅝ × 5⅞ × ⅝ in.
(17 × 15 × 1.5 cm)
Picasso Museum, Paris
Sp., 182

839 *Large Nude Doing Her Hair*
Royan, June 1940
Oil on canvas, 50¾ × 37⅞ in.
(130 × 97 cm)
Private collection
Z. X, 302

840 *Portrait of Dora Maar*
Royan, December 30, 1939
Gouache on paper,
18 × 14⅞ in. (46 × 38 cm)
Private collection
Z. IX, 382

841 *Head of a Woman*
Royan, January 11, 1940
Gouache on paper,
18 × 14⅞ in. (46 × 38 cm)
Private collection
Z. X, 198

842 *Young Boy with a Crayfish*
Paris, June 21, 1941
Oil on canvas, 50¾ × 38 in.
(130 × 97.3 cm)
Picasso Museum, Paris
Z. XI, 200

843 *Portrait of Nusch Éluard*
1941
Oil on canvas, 28½ × 23⅛ in.
(73 × 60 cm)
Musée National d'Art Moderne,
Centre Georges Pompidou,
Paris
Z. XI, 274

844 *Woman Seated in an Armchair*
October 12, 1941
Oil on canvas, 31⅝ × 25⅜ in.
(81 × 65 cm)
Private collection
Z. XI, 340

845 *Woman with an Artichoke*
Paris, Summer 1941
Oil on canvas, 76 × 50¼ in.
(195 × 130 cm)
Museum Ludwig, Cologne.
Ludwig Gift
Z. XII, 1

846 *Portrait of Dora Maar*
Paris, October 9, 1942
Oil on canvas, 35⁷/₈ × 28¹/₂ in.
(92 × 73 cm)
Private collection
Z. XII, 154

847 *Bust of Woman in a Hat*
Paris, June 9, 1941
Oil on canvas, 35⁷/₈ × 23³/₈ in.
(92 × 60 cm)
Picasso Museum, Paris
Z. XI, 155

848 *Seated Woman (Dora Maar)*
Paris, November 28, 1941
India ink and gouache on
paper, 15⁷/₈ × 11⁷/₈ in.
(40.7 × 30.5 cm)
A. Rosengart Collection,
Lucerne
Z. XI, 352

849 *Seated Woman in a Hat Shaped
Like a Fish*
Paris, April 19, 1942
Oil on canvas, 39 × 31⁵/₈ in.
(100 × 81 cm)
Private collection
Z. XII, 36

850 *Still Life with an Ox Skull*
Paris, April 5, 1942
Oil on canvas, 50³/₄ × 37⁷/₈ in.
(130 × 97 cm)
Kunstsammlung Nordrhein-
Westfalen, Düsseldorf

851 *Head of a Bull*
Paris, Spring 1942
Original items: Saddle and
handle bars (leather and
metal), 13¹/₈ × 17 × 7³/₈ in.
(33.5 × 43.5 × 19 cm)
Picasso Museum, Paris
Sp., 240 (I)

852 *Study for "L'Aubade": Three
Nudes*
Paris, January 5, 6, and 8,
1942
Gouache on a sketchbook
page of drawings,
11⁷/₈ × 15³/₄ in. (30.3 × 40.5 cm)
Picasso Museum, Paris
Z. XII, 2

853 *L'Aubade*
Paris, May 4, 1942
Oil on canvas, 76 × 103³/₈ in.
(195 × 265 cm)
Musée National d'Art Moderne,
Centre Georges Pompidou,
Paris
Z. XII, 69

854 *Figure of a Man*
February 13, 1942
India ink on paper,
13³/₈ × 9³/₄ in. (35 × 25 cm)
Musée National d'Art Moderne,
Centre Georges Pompidou,
Paris
Z. XII, 14

855 *Reclining Man and Seated
Woman*
1942
India ink on paper,
19⁷/₈ × 25³/₄ in. (51 × 66 cm)
Private collection
Z. XII, 193

856 *The Three Ages of Man*
November 1942
Oil on panel, 21 × 25³/₈ in.
(54 × 65 cm)
Private collection
Z. XII, 155

857 *Reclining Man and Seated
Woman*
December 13, 1942
India ink on paper,
19¹/₂ × 25³/₈ in. (50 × 65 cm)
Private collection
Z. XII, 185

858 *Study for "Man with a Sheep"*
Paris, October 6, 1942
India ink and gouache on
parchment, 11¹/₈ × 8³/₈ in.
(28.4 × 21.5 cm)
Picasso Museum, Paris
Z. XII, 139

859 *Standing Man*
Paris, 1942
Bronze (unique cast),
7¹/₂ × 2³/₄ × 2 in.
(19.3 × 7 × 5 cm)
Picasso Museum, Paris
Sp., 208

860 *Study for "Man with a Sheep"*
Paris, February 19, 1943
India ink and wash on paper,
25³/₄ × 19⁵/₈ in. (66 × 50.2 cm)
Picasso Museum, Paris
Z. XII, 238

861 *Study for "Man with a Sheep"*
Paris, March 30, 1943
India ink and wash on two
attached sheets, 50⁷/₈ × 19³/₄ in.
(130.5 × 50.7 cm)
Picasso Museum, Paris
Z. XII, 241

862 *The Reaper*
Paris, 1943
Bronze (unique cast),
19⁷/₈ × 13¹/₈ × 7⁵/₈ in.
(51 × 33.5 × 19.5 cm)
Picasso Museum, Paris
Sp., 234 (II)

863 *Death's Head*
Paris, 1943
Bronze and copper,
9³/₄ × 8¹/₈ × 12¹/₈ in.
(25 × 21 × 31 cm)
Picasso Museum, Paris
Sp., 219 (II)

864 *Study for "Man with a Sheep"*
Paris, February 13, 1943
India ink and gouache on
paper, 25³/₈ × 19³/₈ in.
(65.2 × 49.6 cm)
Picasso Museum, Paris
Z. XII, 240

865 *Man with a Sheep*
Paris, February or March 1943
Bronze, 86³/₄ × 30³/₈ × 30³/₈ in.
(222.5 × 78 × 78 cm)
Picasso Museum, Paris
Sp., 280 (II)

866 *Child with Doves*
Paris, August 24, 1943
Oil on canvas, 63¹/₈ × 50³/₄ in.
(162 × 130 cm)
Picasso Museum, Paris
Z. XIII, 95

867 *Woman in a Rocking Chair*
August 9, 1943
Oil on canvas, 63¹/₈ × 50³/₄ in.
(162 × 130 cm)
Musée National d'Art Moderne,
Centre Georges Pompidou,
Paris
Z. XIII, 74

868 *Le Vert-Galant*
Paris, June 25, 1943
Oil on canvas, 25¹/₈ × 35⁷/₈ in.
(64.5 × 92 cm)
Picasso Museum, Paris
Z. XIII, 64

869 *Large Reclining Nude*
Paris, June 28, 1943
Oil on canvas, 50³/₄ × 76¹/₄ in.
(130 × 195.5 cm)
Picasso Museum, Paris
Z. XIII, 65

870 *Woman in a Blue Hat*
March 7, 1944
Oil on canvas, 35⁷/₈ × 23¹/₂ in.
(92 × 60.2 cm)
Picasso Museum, Paris
Z. XIII, 302

871 *Seated Woman*
1944
Oil on canvas, 39 × 31⁵/₈ in.
(100 × 81 cm)
Private collection
Z. XIII, 328

872 *Woman in Blue*
April 1944
Oil on canvas, 50³/₄ × 37⁷/₈ in.
(130 × 97 cm)
Musée National d'Art Moderne,
Centre Georges Pompidou,
Paris
Z. XIII, 245

873 *The Tomato Plant*
August 10, 1944
Oil on canvas, 35⁷/₈ × 28¹/₂ in.
(92 × 73 cm)
Private collection
Z. XIV, 26

874 *Bacchanale, after Poussin*
Paris, August 24–29, 1944
Watercolor and gouache on
paper, 12¹/₈ × 16¹/₈ in.
(31 × 41.3 cm)
Private collection
Z. XIV, 35

875 *Young Man, Left Profile*
August 13, 1944
India ink on paper,
26¹/₈ × 20 in. (66 × 51 cm)
Private collection, courtesy
Galerie Jan Krugier,
Ditesheim & Cie, Geneva
Z. XIV, 33

876 *Seated Woman*
Paris, March 5, 1945
Oil on canvas, 51¹/₄ × 31⁵/₈ in.
(131.5 × 81 cm)
Picasso Museum, Paris
Z. XIV, 77

877 *Notre-Dame*
July 14, 1945
Oil on canvas, 3⁷/₈ × 7 in.
(10 × 18 cm)
Private collection

878 First photograph of *The
Charnel House,* taken by
Christian Zervos
February 1945
Z. XIV, 72

879 Second photograph of *The
Charnel House,* taken by
Christian Zervos
April 1945
Z. XIV, 73

880 Third photograph of *The Charnel House*, taken by Christian Zervos
May 1945
Z. XIV, 75

881 *The Charnel House*
Paris, 1945
Oil and charcoal on canvas, 77 7/8 × 97 1/2 in.
(199.8 × 250.1 cm)
The Museum of Modern Art, New York. Mrs. Sam A. Lewisohn Bequest (by exchange) and Mrs. Marja Bernard Fund, in memory of her husband, Dr. Bernard Bernard and anonymous funds
Z. XIV, 76

882 *Still Life with Skull, Leeks, and Pitcher*
Paris, March 16, 1945
Oil on canvas, 28 1/2 × 45 1/4 in.
(73 × 116 cm)
Private collection
Z. XIV, 97

883 *The Enamel Saucepan*
Paris, February 16, 1945
Oil on canvas, 32 × 41 3/8 in.
(82 × 106 cm)
Musée National d'Art Moderne, Centre Georges Pompidou, Paris
Z. XIV, 71

884 *Still Life with Candle*
Paris, February 21, 1945
Oil on canvas, 36 × 28 1/2 in.
(92.2 × 73 cm)
Picasso Museum, Paris
Z. XIV, 69

885 *Vanitas*
March 1, 1946
Oil on plywood panel, 21 × 25 3/8 in. (54 × 65 cm)
Musée des Beaux-Arts, Lyons

886 *Skull, Sea Urchins, and Lamp on a Table*
Antibes–Paris, November 27, 1946
Oil on plywood panel, 31 5/8 × 39 in. (81 × 100 cm)
Picasso Museum, Paris
Z. XIV, 290

887–897 *The Bull*
December 5–January 17, 1946
Lithograph (11 states), 11 1/4 × 16 in. (28.9 × 41 cm)
Picasso Museum, Paris
Bl. 389

898 *The Rape of Europa*
1946
Oil on wood, 50 3/4 × 37 7/8 in.
(130 × 97 cm)
Private collection

899 *Standing Nude*
Paris, June 28, 1946
Colored crayons on paper, 19 7/8 × 12 5/8 in. (51 × 32.5 cm)
Picasso Museum, Paris

900 *La Femme Fleur*
Paris, May 5, 1946
Oil on canvas, 57 × 34 3/4 in.
(146 × 89 cm)
Private collection
Z. XIV, 167

901 *Woman in an Armchair*
Paris, July 3, 1946
Oil and gouache on canvas, 50 3/4 × 37 7/8 in.
(130.2 × 97.1 cm)
Picasso Museum, Paris

902 *Portrait of Françoise*
Paris, May 31, 1946
Oil on canvas, 31 3/4 × 25 1/4 in.
(81.3 × 64.8 cm)
Private collection

903 *La Joie de Vivre (Antipolis)*
Antibes, 1946
Oil on fiberboard, 46 3/4 × 97 1/2 in. (120 × 250 cm)
Picasso Museum, Antibes
Z. XIV, 289

904–906 *Satyr, Faun, and Centaur with Trident* (triptych)
October 1946
Oil and Ripolin paint on fiberboard, 97 1/2 × 140 in.
(250 × 360 cm)
Picasso Museum, Antibes
Z. XIV, 242–244

907 *The Starry Ewer*
Golfe-Juan, September 15, 1946
Oil and pencil on paper, 25 3/4 × 19 5/8 in. (66 × 50.5 cm)
Picasso Museum, Paris

907b *The Starry Ewer*
Golfe-Juan, September 14, 1946
Oil and pencil on paper, 25 3/8 × 19 5/8 in. (65 × 50.5 cm)
Picasso Museum, Paris

908 *Chicken and Knife on a Table*
Paris, March 21, 1947
Oil on canvas, 31 1/4 × 39 in.
(80 × 100 cm)
Private collection
Z. XV, 42

909 *Homage to the Spaniards Who Died for France*
Paris, 1946–47
Oil on canvas, 76 × 50 3/4 in.
(195 × 130 cm)
Museo Nacional Centro de Arte Reina Sofia, Madrid. Gift of the French Government

910 *Bull*
Vallauris, 1947
Ceramic, reddish clay, 14 3/8 × 9 × 14 3/8 in.
(37 × 23 × 37 cm)
Picasso Museum, Antibes

911 *Owl*
December 30, 1949
White clay, thrown piece, decorated with wash and white enamel, incisions, all covered with brushwork, 7 3/8 × 7 × 8 5/8 in.
(19 × 18 × 22 cm)
Picasso Museum, Paris

912 *Vase: Woman in a Mantilla*
1949
White clay, thrown and modeled piece; decorated with wash, 18 3/8 × 4 7/8 × 3 3/4 in.
(47 × 12.5 × 9.5 cm)
Picasso Museum, Paris

913 *Oven Gazelle Decorated with a Nude*
September 18, 1950
Pink clay decorated with black wash, 39 3/4 × 8 5/8 × 3 1/2 in.
(102 × 22.3 × 9 cm)
Picasso Museum, Paris

914 *Oven Gazelle Decorated with the Bust of a Man in a Striped Sweater*
September 23, 1950
Pink clay with black wash decoration, 39 5/8 × 8 7/8 × 3 1/8 in.
(101.5 × 22.7 × 8 cm)
Picasso Museum, Paris

915 *Gothic Pitcher Decorated with Two Caged Birds*
February 4, 1948
White clay, thrown and sculpted piece, decorated with black wash and partially covered with brushwork, incisions, India-ink patina, 14 3/8 × 13 3/8 × 9 3/8 in.
(37 × 35 × 24 cm)
Picasso Museum, Paris

916–917 *Vessels Decorated with a Goat and the Bust of a Man Holding a Cup*
August 5, 1950
Red kitchenware clay; thrown piece decorated with black wash, 7 3/8 × 10 1/2 × 9 1/2 in.
(19.7 × 27 × 24.5 cm)
Picasso Museum, Paris

918 *Rectangular Plate Decorated with a Bunch of Grapes and Scissors*
1948
White clay, stamped form, decorated with blue wash, incised with impressions of fingers, redecorated with wash and white enamel, all covered with brushwork, 12 1/8 × 14 1/2 × 1 1/2 in.
(31 × 37.2 × 4 cm)
Picasso Museum, Paris

919 *Still Life*
August 5, 1948
Sheet of painted red clay, 7 1/8 × 10 1/2 in. (19 × 27 cm)
Musée National d'Art Moderne, Centre Georges Pompidou, Paris

920 *Rectangular Plate Decorated with the Head of a Bearded Faun*
January 21, 1948
White clay; stamped form, decorated with white enamel, irregular brushwork wash patina after firing with highly diluted India ink, 15 × 12 1/2 × 1 5/8 in.
(38.3 × 32 × 4 cm)
Picasso Museum, Paris

921 *Rectangular Plate Decorated with the Head of a Faun*
April 1957
Ceramic, 15 × 12 1/8 × 1 1/2 in.
(38.5 × 31 × 4 cm)
Picasso Museum, Antibes

922 *Rectangular Plate Decorated with the Head of a Faun*
October 20, 1947
White clay; stamped form, decorated with wash, white enamel, and incisions, all coated by dipping in paint, 12 1/2 × 14 7/8 × 1 3/8 in.
(32 × 38.2 × 3.5 cm)
Picasso Museum, Paris

923 *Spanish Plate Decorated with a Bull*
March 30, 1957
Red clay, thrown piece, covered in white wash, decorated with black wash, incisions and scratched surfaces,
diameter 17¹/₂ in. (45 cm)
Picasso Museum, Paris

924 *The Kitchen*
Paris, November 9, 1948
Oil on canvas, 68¹/₄ × 97¹/₂ in. (175 × 250 cm)
The Museum of Modern Art, New York. Acquired through the Nelson A. Rockefeller Bequest
Z. XV, 106

925 *The Kitchen*
Paris, November 1948
Oil on canvas, 68¹/₄ × 98¹/₄ in. (175 × 252 cm)
Picasso Museum, Paris
Z. XV, 107

926 *Seated Woman*
1948
Oil on canvas, 39 × 31⁵/₈ in. (100 × 81 cm)
Private collection
Z. XV, 103

927 *Seated Woman from the Front: Françoise*
December 24, 1948
Papier collé and India ink on paper, 21¹/₂ × 15 in. (55 × 38.5 cm)
Private collection

928 *Woman Seated in an Armchair*
Paris, February 1947
Oil on canvas, dimensions unknown
Private collection

929 *Woman in an Armchair I*
Paris, December 17, 1948
Lithograph, 27 × 19⁷/₈ in. (69.1 × 51.1 cm)
Picasso Museum, Paris

930 *Woman in an Armchair I*
Paris, 1949
Lithograph, 25³/₈ × 19¹/₂ in. (65 × 50 cm)
Picasso Museum, Paris

931 *Woman in an Armchair I*
Paris, January 16, 1949
Lithograph (3rd state), 27¹/₄ × 21¹/₂ in. (70 × 55 cm)
Picasso Museum, Paris

932 *Woman in an Armchair I (The Polish Coat)*
Paris, 1949
Lithograph (final state), 27¹/₄ × 21¹/₂ in. (70 × 55 cm)
Picasso Museum, Paris
Bl. 587

933 *David and Bathsheba*
Paris, March 30, 1947
Lithograph (2nd state), 25⁵/₈ × 19¹/₈ in. (65.7 × 49 cm)
Picasso Museum, Paris
Bl. 440

934 *David and Bathsheba*
Paris, March 30, 1947
Lithograph (3rd state), 25⁵/₈ × 19¹/₈ in. (65.7 × 49 cm)
Picasso Museum, Paris

935 *David and Bathsheba*
Paris, March 30, 1947
Lithograph (4th state), 25⁵/₈ × 19¹/₈ in. (65.7 × 49 cm)
Picasso Museum, Paris
Bl. 441

936 *David and Bathsheba*
Paris, March 30, 1947
Lithograph (6th state), 25⁵/₈ × 19¹/₈ in. (65.7 × 49 cm)
Picasso Museum, Paris

937 *Three Heads*
November 1, 1947
India ink, 12⁷/₈ × 19⁵/₈ in. (33 × 50.5 cm)
Galerie Louise Leiris, Paris

938 *The Dove*
January 9, 1949
Lithograph, 21¹/₄ × 27¹/₄ in. (54.4 × 70 cm)
Picasso Museum, Paris
Bl. 583

939 *The Pregnant Woman (second state)*
Vallauris, 1950–59
Bronze, 42¹/₂ × 11³/₄ × 13¹/₄ in. (109 × 30 × 34 cm)
Picasso Museum, Paris
Sp., 350 (II)

940 *Woman with Crossed Arms*
Vallauris, 1950
Bronze, finished with engraved decoration (unique cast), 13¹/₄ × 3⁷/₈ × 3⁷/₈ in. (34 × 10 × 10 cm)
Private collection
Sp., 351

941 *Claude and Paloma*
Vallauris, 1950
Oil and enamel on plywood, 46 × 56¹/₂ in. (118 × 145 cm)
Private collection
Z. XV, 163

942 *Claude and Paloma*
Vallauris, January 20, 1950
Oil and Ripolin on plywood, 45¹/₄ × 34³/₄ in. (116 × 89 cm)
Private collection, courtesy Galerie Jan Krugier, Ditesheim & Cie, Geneva
Z. XV, 157

943 *Woman with a Stroller*
Vallauris, 1950
Bronze, 79¹/₈ × 56¹/₂ × 23³/₄ in. (203 × 145 × 61 cm)
Picasso Museum, Paris
Sp., 407 (II)

944 *Rooster with a Woven Basket*
Vallauris, January 12, 1950
Oil on panel, 45¹/₄ × 34³/₄ in. (116 × 89 cm)
Marina Picasso Collection, courtesy Galerie Jan Krugier, Ditesheim & Cie, Geneva
Z. XV, 154

945 *The Goat*
Vallauris, 1950
Bronze, 47 × 28¹/₈ × 56¹/₈ in. (120.5 × 72 × 144 cm)
Picasso Museum, Paris
Sp., 409 (II)

946 *The Goat*
Vallauris, 1950
Oil and charcoal on plywood, 36¹/₄ × 90¹/₈ in. (93 × 231 cm)
Picasso Museum, Paris
Z. XV, 153

947 *Little Girl Skipping Rope*
Vallauris, 1950
Original plaster (wicker basket, cake tin, shoes, wood, iron, ceramic, and plaster), 59¹/₄ × 25³/₈ × 25³/₄ in. (152 × 65 × 66 cm)
Picasso Museum, Paris
Sp., 408 (I)

948 *Young Women on the Banks of the Seine, after Courbet*
Vallauris, February 1950
Oil on plywood, 39¹/₈ × 78³/₈ in. (100.5 × 201 cm)
Oeffentliche Kunstsammlung Basel, Kunstmuseum, Basel
Z. XV, 164

949 *Portrait of a Painter, after El Greco*
Vallauris, February 22, 1950
Oil on plywood, 39 × 31⁵/₈ in. (100 × 81 cm)
A. Rosengart Collection, Lucerne
Z. XV, 165

950 *The Women with a Mirror*
Paris, December 12, 1950
India ink and gouache on lithograph, 15 × 21⁷/₈ in. (38.5 × 56 cm)
Picasso Museum, Paris

951 *Massacres in Korea*
Vallauris, January 18, 1951
Oil on plywood, 42⁷/₈ × 81⁷/₈ in. (110 × 210 cm)
Picasso Museum, Paris
Z. XV, 173

952 *Smoke in Vallauris*
January 12, 1951
Oil on canvas, 23¹/₄ × 28⁵/₈ in. (59.5 × 73.5 cm)
Picasso Museum, Paris
Z. XV, 174

953 *The Judgment of Paris*
March 31–April 7, 1951
Pen, India ink, and wash on paper, 19³/₄ × 25⁵/₈ in. (50.6 × 65.6 cm)
Picasso Museum, Paris

954 *Games of Pages*
Vallauris, February 24, 1951
Oil on wood, 21 × 25³/₈ in. (54 × 65 cm)
Picasso Museum, Paris
Z. XV, 184

955 *Plate Decorated with a Tournament Scene: Cavalier in Armor and Page*
January 26, 1951
White clay, thrown piece; decorated with black wash, very lightly scratched, diameter 9¹/₈ in. (23.5 cm)
Picasso Museum, Paris

956 *Plate Decorated with a Tournament Scene: Cavalier in Armor*
January 26–February 1, 1951
White clay; thrown piece; decorated with wash and incisions, diameter 8³/₄ in. (22.5 cm)
Picasso Museum, Paris

957 *Plate Decorated with a Tournament Scene: Cavalier in Armor and Page*
January 30, 1951
White clay; thrown piece, decorated with black wash, diameter 8⅝ in. (22 cm)
Picasso Museum, Paris

958 *The Crane*
Vallauris, 1951
Original plaster (bucket, forks, metal objects, tap, length of wicker, and plaster on a wooden base),
29⅞ × 11¼ × 17 in. (76.5 × 29 × 43.5 cm)
Picasso Museum, Paris
Sp., 461 (I)

959 *The Female Monkey and Her Baby*
Vallauris, October 1951
Original plaster (ceramic, two small cars, metal, and plaster), 21⅞ × 13¼ × 27⅝ in. (56 × 34 × 71 cm)
Picasso Museum, Paris
Sp., 463 (I)

960 *Woman Reading*
Vallauris, 1951
Original plaster (wood, metallic objects, nails, screws, and plaster), 6⅜ × 14 × 5¼ in. (16.4 × 36 × 13.5 cm)
Picasso Museum, Paris
Sp., 462 (I)

961 *Reclining Woman*
1951
Wash on plywood, dimensions unknown
Private collection

962 *Maternity with an Orange*
January 25, 1951
Oil on panel, 44⅞ × 34⅜ in. (115 × 88 cm)
Private collection

963 *Goat's Skull, Bottle, and Candle*
Paris, April 16, 1952
Oil on canvas, 34¾ × 45¼ in. (89 × 116 cm)
The Tate Gallery, London
Z. XV, 198

964 *Goat's Skull, Bottle, and Candle*
Vallauris, 1951–53
Painted bronze, 30¾ × 36¼ × 21 in. (79 × 93 × 54 cm)
Picasso Museum, Paris
Sp., 410 (IIa)

965 *Goat's Skull, Bottle, and Candle*
Paris, March 25, 1952
Oil on canvas, 34¾ × 45¼ in. (89 × 116 cm)
Picasso Museum, Paris
Z. XV, 201

966 *Head of a Woman*
May 16, 1952
Oil on canvas, 18 × 14⅞ in. (46 × 38 cm)
Private collection
Z. XV, 206

967 *Portrait of Madame P. (Hélène Parmelin)*
Vallauris, 1952
Oil on plywood, 56¾ × 37⅝ in. (145.5 × 96.5 cm)
Private collection
Z. XV, 215

968 *War*
Vallauris, 1952
Oil on hardboard, 15 ft. 5 in. × 33 ft. ⅝ in. (4.7 × 10.2 m)
Chapel of the Château, Temple de la Paix, Vallauris
Z. XV, 196

969 *Peace*
Vallauris, 1952
Oil on hardboard, 15 ft. 5 in. × 33 ft. ⅝ in. (4.7 × 10.2 m)
Chapel of the Château, Temple de la Paix, Vallauris
Z. XV, 197

970 *Paloma*
Vallauris, December 23, 1952
India ink on paper, 25¾ × 19⅝ in. (66 × 50.5 cm)
Private collection

971 *Child Playing with a Toy Truck*
Vallauris, December 27, 1953
Oil on canvas, 50¾ × 37⅝ in. (130 × 96.5 cm)
Picasso Museum, Paris
Z. XVI, 98

972 *The Shadow*
Vallauris, December 29, 1953
Oil and charcoal on canvas, 50½ × 37⅝ in. (129.5 × 96.5 cm)
Picasso Museum, Paris
Z. XVI, 100

973 *In the Studio* (Drawing for "Verve")
February 3, 1954
Wash and drawing in colored crayons on paper, 9⅛ × 12½ in. (24 × 32 cm)
Private collection
Z. XVI, 239

974 *Clown with a Mirror and a Nude* (Drawing for "Verve")
January 6, 1954
India ink on paper, 9⅜ × 12½ in. (24 × 32 cm)
Private collection
Z. XVI, 150

975 *The Saltimbanques* (Drawing for "Verve")
January 21, 1954
Wash on paper, 9⅜ × 12½ in. (24 × 32 cm)
Private collection
Z. XVI, 157

976 *Sheet of Studies* (Drawing for "Verve")
January 21, 1954
Wash on paper, 9⅜ × 12½ in. (24 × 32 cm)
Private collection
Z. XVI, 203

977 *Nymph and Faun* (Drawing for "Verve")
January 7, 1954
India ink on paper, 9⅜ × 12½ in. (24 × 32 cm)
Private collection
Z. XVI, 161

978 *In the Studio* (Drawing for "Verve")
January 10, 1954
India ink on paper, 9⅜ × 12½ in. (24 × 32 cm)
Private collection
Z. XVI, 175

979 *The Masks* (Drawing for "Verve")
January 25, 1954
Wash on paper, 9⅜ × 12½ in. (24 × 32 cm)
Private collection
Z. XVI, 224

980 *In the Studio* (Drawing for "Verve")
January 7, 1954
India ink on paper, 9⅜ × 12½ in. (24 × 32 cm)
Private collection
Z. XVI, 158

981 *Models Posing* (Drawing for "Verve")
January 11, 1954
India ink on paper, 9⅜ × 12½ in. (24 × 32 cm)
Private collection
Z. XVI, 178

982 *Interior (Woman Painter and Nude in the Studio)*
January 21, 1954
India ink wash on paper, 9⅛ × 12⅛ in. (23.5 × 31 cm)
Mr. and Mrs. Daniel Saidenberg Collection, New York
Z. XVI, 200

983 *Seated Man, Girl with Monkey and Apple*
Vallauris, January 26, 1954
Watercolor on paper, 9⅜ × 12½ in. (24 × 32 cm)
Private collection
Z. XVI, 229

984 *Nude in the Studio*
Vallauris, December 30, 1953
Oil on canvas, 34¾ × 45⅜ in. (89 × 116.2 cm)
Private collection
Z. XVI, 96

985 *Woman Reading*
Vallauris, January 29, 1953
Oil on plywood, 44½ × 57 in. (114 × 146 cm)
Picasso Museum, Paris
Z. XVI, 237

986 *Woman with a Dog*
Vallauris, March 8, 1953
Oil on plywood, 31⅝ × 39 in. (81 × 100 cm)
Picasso Museum, Lucerne. Rosengart Gift
Z. XV, 246

987 *Portrait of Sylvette*
May 18, 1954
Oil on canvas, 31⅝ × 25⅝ in. (81 × 65 cm)
Private collection
Z. XVI, 308

988 *Portrait of Sylvette*
1954
Oil on canvas, 33⅛ × 25⅝ in. (85 × 65 cm)
Private collection

989 *The Coiffure*
1954
Oil on canvas, 50¾ × 37⅞ in. (130 × 97 cm)
Picasso Museum, Lucerne. Rosengart Gift
Z. XVI, 262

990 *Claude Drawing, Françoise and Paloma*
Vallauris, May 17, 1954
Oil on canvas, 45¼ × 34¾ in. (116 × 89 cm)
Picasso Museum, Paris
Z. XVI, 323

991 *Jacqueline in a Rocking Chair*
October 9, 1954
Oil on canvas, 44⁷/₈ × 56¹/₂ in.
(115 × 145 cm)
Private collection
Z. XVI, 327

992 *Jacqueline with a Black Shawl*
Paris, October 11, 1954
Oil on canvas, 35⁷/₈ × 28¹/₂ in.
(92 × 73 cm)
Private collection
Z. XVI, 331

993 *Jacqueline with Crossed Hands*
June 3, 1954
Oil on canvas, 45¹/₄ × 34¹/₂ in.
(116 × 88.5 cm)
Private collection
Z. XVI, 324

994 *Jacqueline with Flowers*
Vallauris, June 2, 1954
Oil on canvas, 39 × 31⁵/₈ in.
(100 × 81 cm)
Private collection
Z. XVI, 325

995 *Study for "The Women of
Algiers," after Delacroix*
Paris, December 29, 1954
India ink on paper,
13¹/₂ × 17 in. (34.5 × 43.5 cm)
Picasso Museum, Paris

996 *Study for "The Women of
Algiers," after Delacroix*
Paris, December 21, 1954
Pen and India ink on squared
paper, 8¹/₈ × 10¹/₂ in.
(21 × 27 cm)
Picasso Museum, Paris

997 *Study for "The Women of
Algiers," after Delacroix*
Paris, December 26, 1954
Pen and India ink on squared
paper, 8¹/₈ × 10¹/₂ in.
(21 × 27 cm)
Picasso Museum, Paris

998 *Study for "The Women of
Algiers," after Delacroix*
Paris, January 8, 1955
Pen and India ink on the
reverse of an invitation card,
3⁷/₈ × 4⁷/₈ in. (10 × 12.5 cm)
Picasso Museum, Paris

999 *Study for "The Women of
Algiers," after Delacroix*
Paris, January 23, 1955
Pen and India ink on paper,
16³/₈ × 21¹/₂ in. (42.1 × 55 cm)
Picasso Museum, Paris
Z. XVI, 350

1000 *Study for "The Women of
Algiers," after Delacroix*
Paris, February 3, 1955
India ink on squared paper,
8¹/₈ × 10¹/₂ in. (21 × 27 cm)
Picasso Museum, Paris

1001 *The Women of Algiers,
after Delacroix*
Paris, December 13, 1954
Oil on canvas, 23⁵/₈ × 28¹/₂ in.
(60 × 73 cm)
Private collection
Z. XVI, 342

1002 *The Women of Algiers,
after Delacroix*
Paris, December 28, 1954
Oil on canvas, 21 × 25⁵/₈ in.
(54 × 65 cm)
Private collection
Z. XVI, 345

1003 *The Women of Algiers,
after Delacroix*
Paris, January 1, 1955
Oil on canvas, 21 × 25⁵/₈ in.
(54 × 65 cm)
Private collection
Z. XVI, 346

1004 *The Women of Algiers,
after Delacroix*
Paris, February 11, 1955
Oil on canvas, 50³/₄ × 76 in.
(130 × 195 cm)
Private collection
Z. XVI, 357

1005 *The Women of Algiers,
after Delacroix*
Paris, January 24, 1955
Oil on canvas, 50³/₄ × 63¹/₈ in.
(130 × 162 cm)
Private collection
Z. XVI, 356

1006 *The Women of Algiers,
after Delacroix*
Paris, February 14, 1955
Oil on canvas, 44¹/₂ × 57 in.
(114 × 146 cm)
Private collection
Z. XVI, 360

1007 *Woman in a Turkish Jacket*
Cannes, November 20, 1955
Oil on canvas, 31⁵/₈ × 39 in.
(81 × 100 cm)
Private collection

1008 *The Women of Algiers,
after Delacroix*
Paris, February 9, 1955
Oil on canvas, 50³/₄ × 37⁷/₈ in.
(130 × 97 cm)
Private collection
Z. XVI, 352

1009 *Nude in a Turkish Hat*
Cannes, December 1, 1955
Oil on canvas, 45¹/₄ × 34³/₄ in.
(116 × 89 cm)
Musée National d'Art Moderne,
Centre Georges Pompidou,
Paris. Gift of Louise and
Michel Leiris
Z. XVI, 529

1010 *Two Women on the Beach*
February 6–March 26, 1956
Oil on canvas, 76 × 101³/₈ in.
(195 × 260 cm)
Musée National d'Art Moderne,
Centre Georges Pompidou,
Paris. Marie Cuttoli Bequest
Z. XVII, 36

1011 *Crouching Nude*
January 3, 1956
Oil on canvas, 45¹/₄ × 34³/₄ in.
(116 × 89 cm)
Private collection
Z. XVII, 2

1012 *Bacchanale*
September 22–23, 1955
India ink and gouache on
paper, 19³/₄ × 25⁵/₈ in.
(50.7 × 65.8 cm)
Private collection
Z. XVI, 430

1013 *Women at Their Toilette*
Cannes, January 4, 1956
Oil on canvas, 76¹/₄ × 50³/₄ in.
(195.5 × 130 cm)
Picasso Museum, Paris
Z. XVII, 54

1014 *Portrait of Jacqueline*
February 13, 1957
Collage and charcoal on paper,
25 × 19¹/₂ in. (64 × 50 cm)
Private collection

1015 *Jacqueline in the Studio*
Cannes, November 13, 1957
Gouache and India ink on a
Spitzer reproduction transfer
of the painting "The Woman
in the Studio," of April 3,
1956, 24³/₄ × 31¹/₂ in.
(63.5 × 80.8 cm)
Picasso Museum, Paris
Z. XVII, 403

1016 *Man with a Golden Helmet,
after Rembrandt*
Cannes, January 14, 1956
Pen drawing on paper,
16³/₈ × 10¹/₂ in. (42 × 27 cm)
Private collection

1017 *Jacqueline on Horseback,
after Velázquez*
Cannes, March 10, 1959
India ink and colored crayon
on paper, 14³/₈ × 10¹/₂ in.
(37 × 27 cm)
Private collection
Z. XVIII, 367

1018 *Springtime*
March 20, 1956
Oil on canvas, 50³/₄ × 76 in.
(130 × 195 cm)
Musée National d'Art Moderne,
Centre Georges Pompidou,
Paris. Gift of Louise and
Michel Leiris
Z. XVII, 45

1019 *Reclining Nude Before a
Window*
Cannes, August 29–31, 1956
Oil on canvas, 50³/₄ × 53¹/₈ in.
(130 × 162 cm)
Stedelijk Museum, Amsterdam
Z. XVII, 158

1020 *Nude in a Rocking Chair*
Cannes, March 26,1956
Oil on canvas, 76 × 50³/₄ in.
(195 × 130 cm)
The Art Gallery of New South
Wales, Sydney
Z. XVII, 55

1021 *The Studio*
Cannes, April 1, 1956
Oil on canvas, 34³/₄ × 45¹/₄ in.
(89 × 116 cm)
Private collection
Z. XVII, 57

1022 *Woman Seated near the
Window (Jacqueline)*
Cannes, June 11, 1956
Oil on canvas, 63¹/₈ × 50³/₄ in.
(162 × 130 cm)
The Museum of Modern Art,
New York. Mrs. Simon
Guggenheim Collection
Z. XVII, 120

1023 *The Studio at La Californie*
Cannes, March 30, 1956
Oil on canvas, 44¹/₂ × 57 in.
(114 × 146 cm)
Picasso Museum, Paris
Z. XVII, 56

1024 *The Studio at La Californie*
Cannes, October 29, 1955
Pencil on paper,
25³/₈ × 19³/₄ in. (65 × 50.5 cm)
Picasso Museum, Paris
Z. XVI, 475

1025 *The Studio*
Cannes, October 23, 1955
Oil on canvas, 76 × 50³/₄ in.
(195 × 130 cm)
Picasso Museum, Lucerne.
Rosengart Gift
Z. XVI, 486

1026 *Las Meninas* (complete)
Cannes, August 17, 1957
Oil on canvas,
75⁵/₈ × 101³/₈ in. (194 × 260 cm)
Picasso Museum, Barcelona
Z. XVII, 351

1027 *Las Meninas* (complete)
Cannes, September 18, 1957
Oil on canvas, 50³/₈ × 62³/₄ in.
(129 × 161 cm)
Picasso Museum, Barcelona
Z. XVII, 372

1028 *Las Meninas* (complete)
Cannes, October 2, 1957
Oil on canvas, 62³/₄ × 50³/₈ in.
(161 × 129 cm)
Picasso Museum, Barcelona
Z. XVII, 374

1029 *Las Meninas* (complete)
Cannes, October 3, 1957
Oil on canvas, 50³/₈ × 62³/₄ in.
(129 × 161 cm)
Picasso Museum, Barcelona
Z. XVII, 375

1030 *Las Meninas* (complete)
Cannes, September 19, 1957
Oil on canvas, 62³/₄ × 50³/₈ in.
(161 × 129 cm)
Picasso Museum, Barcelona
Z. XVII, 373

1031 *Las Meninas (Mariqa Agustina Sarmiento)*
Cannes, August 20, 1957
Oil on canvas, 18 × 14³/₈ in.
(46 × 37.5 cm)
Picasso Museum, Barcelona
Z. XVII, 352

1032 *Las Meninas (Isabel de Velasco)*
Cannes, December 30, 1957
Oil on canvas, 12⁷/₈ × 9³/₈ in.
(33 × 24 cm)
Picasso Museum, Barcelona

1033 *Las Meninas (Infanta Margarita María)*
Cannes, September 14, 1957
Oil on canvas, 39 × 31⁵/₈ in.
(100 × 81 cm)
Picasso Museum, Barcelona
Z. XVII, 368

1034 *The Bathers*
Cannes, Summer 1956

1 *The Diver*:
Bronze, 103 × 32⁵/₈ × 32⁵/₈ in.
(264 × 83.5 × 83.5 cm)

2 *The Man with Clasped Hands*
Bronze, 83¹/₄ × 28¹/₂ × 14 in.
(213.5 × 73 × 36 cm)

3 *The Fountain Man*:
Bronze, 83¹/₄ × 34³/₈ × 30¹/₄ in.
(228 × 88 × 77.5 cm)

4 *The Child*:
Bronze, 53 × 26¹/₈ × 18 in.
(136 × 67 × 46 cm)

5 *The Woman with Outstretched Arms*:
Bronze, 77¹/₄ × 67⁷/₈ × 18 in.
(198 × 174 × 46 cm)

6 *The Young Man*:
Bronze, 68³/₈ × 25³/₈ × 18 in.
(176 × 65 × 46 cm)
Picasso Museum, Paris
Sp., 503–508

1035 *The Studio: Reclining Woman, the Picture, and the Painter*
Cannes, January 4, 1958
Pencil on paper,
19⁵/₃ × 25¹/₂ in. (50.5 × 65.5 cm)
Picasso Museum, Paris

1036 *The Studio: Reclining Woman and the Picture*
Cannes, December 15, 1957
Pencil on two sheets of paper that have been stapled together, 16⁵/₈ × 19⁵/₈ in.
(42.5 × 50.5 cm)
Picasso Museum, Paris
Z. XVII, 415

1037 *The Studio: Reclining Woman and the Picture*
Cannes, December 1957
India ink over blue pencil strokes on paper,
19⁵/₈ × 25³/₄ in. (50.5 × 66 cm)
Picasso Museum, Paris
Z. XVII, 417

1038 *The Studio: Reclining Woman and the Picture*
Cannes, December 15, 1957
Pencil and blue crayon on paper, 20⁵/₈ × 25⁷/₈ in.
(53 × 66.5 cm)
Picasso Museum, Paris
Z. XVII, 416

1039 *The Fall of Icarus*
1958
Mural composition,
26 ft. × 32 ft. 6 in. (8 × 10 m)
Hall of the Delegates' Lobby,
Maison de l'UNESCO, Paris

1040 *The Studio: Reclining Woman and Picture*
(study for UNESCO)
Cannes, December 6, 1957
Wash, pencil, gray gouache, drawings on blue carbon paper, 19¹/₂ × 25⁵/₈ in.
(50 × 65 cm)
Z. XVII, 409

1041 *The Bay of Cannes*
Cannes, April 19–June 9, 1958
Oil on canvas, 50³/₄ × 76 in.
(130 × 195 cm)
Picasso Museum, Paris
Z. XVIII, 83

1042 *Woman with a Dog*
December 13, 1961
Oil on canvas, 63¹/₈ × 50³/₄ in.
(162 × 130 cm)
Private collection
Z. XX, 160

1043 *Still Life with Bull's Head*
Cannes, May 25–June 9, 1958
Oil on canvas, 63³/₈ × 50¹/₄ in.
(162.5 × 130 cm)
Picasso Museum, Paris
Z. XVIII, 237

1044 *Seated Nude*
[Vauvenargues or Cannes],
1959
Oil on canvas, 57 × 44¹/₂ in.
(146 × 114.2 cm)
Private collection
Z. XVIII, 308

1045 *Bathers with a Spade*
Vauvenargues, April 12, 1960
Oil on canvas, 44¹/₂ × 57 in.
(114 × 146 cm)
Private collection
Z. XIX, 236

1046 *Nude Beneath a Pine Tree*
January 20, 1959
Oil on canvas, 76 × 109¹/₄ in.
(195 × 280 cm)
The Art Institute of Chicago.
Donated by the J. Pick Foundation
Z. XVIII, 323

1047 *The Vauvenargues Sideboard*
March 23, 1959–January 23, 1960
Oil on canvas, 76 × 109¹/₄ in.
(195 × 280 cm)
Picasso Museum, Paris
Z. XVIII, 395

1048 *Still Life with a Demijohn*
June 14, 1959
Oil on canvas, 34³/₄ × 45¹/₄ in.
(89 × 116 cm)
Musée National d'Art Moderne, Centre Georges Pompidou, Paris. Gift of Louise and Michel Leiris
Z. XVIII, 482

1049 *Bust of a Seated Woman*
April 2–May 10, 1960
Oil on canvas, 39 × 31⁵/₈ in.
(100 × 81 cm)
Musée d'Unterlinden, Colmar
Z. XIX, 255

1050 *Le Déjeuner sur l'Herbe, after Manet*
Vauvenargues, March 3–August 20, 1960
Oil on canvas, 50³/₄ × 76 in.
(130 × 195 cm)
Picasso Museum, Paris
Z. XIX, 204

1051 *Le Déjeuner sur l'Herbe, after Manet*
Mougins, July 27, 1961
Oil on canvas, 25⁵/₈ × 31⁵/₈ in.
(65 × 81 cm)
Picasso Museum, Paris
Z. XX, 111

1052 *Le Déjeuner sur l'Herbe, after Manet*
July 16, 1961
Oil on canvas, 34³/₄ × 45¹/₄ in.
(89 × 116 cm)
Picasso Museum, Lucerne.
Rosengart Gift
Z. XX, 91

1053 *Le Déjeuner sur l'Herbe, after Manet*
Mougins, July 30, 1961
Oil on canvas, 50³/₄ × 37⁷/₈ in.
(130 × 97 cm)
Louisiana Museum of Modern Art, Humlebaek, Denmark
Z. XX, 113

1054 *Le Déjeuner sur l'Herbe, after Manet*
August 10, 1961
Oil on canvas, 35⁵/₈ × 28¹/₈ in.
(91.5 × 72 cm)
Private collection
Z. XX, 117

1055 *Le Déjeuner sur l'Herbe, after Manet*
Mougins, July 12, 1961
Oil on canvas, 31⁵/₈ × 38⁷/₈ in.
(81 × 99.8 cm)
Picasso Museum, Paris
Z. XX, 89

1056 *Le Déjeuner sur l'Herbe, after Manet*
Mougins, July 13, 1961
Oil on canvas, 23³/₈ × 28¹/₂ in.
(60 × 73 cm)
Picasso Museum, Paris
Z. XX, 90

1057 *Le Déjeuner sur l'Herbe, after Manet*
June 17, 1961
Oil on canvas, 23³/₈ × 28¹/₂ in.
(60 × 73 cm)
Private collection
Z. XX, 34

1058 *Seated Woman in a Yellow and Green Hat*
January 2, 1962
Oil on canvas, 63¹/₈ × 50³/₄ in.
(162 × 130 cm)
Private collection
Z. XX, 179

1059 *Seated Woman in a Hat*
January 27, 1961
Oil on panel, 45⁵/₈ × 34³/₄ in.
(117 × 89 cm)
A. Rosengart Collection, Lucerne
Z. XIX, 422

1060 *Bust of a Woman in a Yellow Hat*
Mougins, December 19–26, 1961, to January 10–20, 1962
Oil on canvas, 35⁵/₈ × 28¹/₂ in.
(91.5 × 73 cm)
Private collection
Z. XX, 162

1061 *Seated Woman*
Mougins, May 13–June 16, 1962
Oil on canvas, 57 × 44¹/₂ in.
(146 × 114 cm)
Private collection
Z. XX, 227

1062 *Seated Pierrot*
Cannes, Spring 1961
Cutout sheet metal, folded, assembled, and painted,
52¹/₂ × 22¹/₄ × 22¹/₄ in.
(134.5 × 57 × 57 cm)
Picasso Museum, Paris
Sp., 605 (II)

1063 *Head of a Woman*
(Design for a Monument)
Cannes, 1957
Cutout and painted wooden panel, 30³/₈ × 13¹/₄ × 14 in.
(78.5 × 34 × 36 cm)
Picasso Museum, Paris
Sp., 493

1064 *Bust of a Woman in a Hat*
Cannes, 1961
Cutout sheet metal, folded and assembled in 1963 and painted in several colors,
49¹/₈ × 28¹/₂ × 16 in.
(126 × 73 × 41 cm)
Ernst Collection, Basel
Sp., 626 (II)

1065 *Head of a Woman* (Design for a Monument realized at the Civic Center, Chicago)
Mougins, 1962–64
Cutout iron and tin sheet metal, folded and assembled,
40⁷/₈ × 27¹/₄ × 18⁷/₈ in.
(104.7 × 69.9 × 48.3 cm)
The Art Institute of Chicago. Gift of the Artist
Sp., 643

1066 *Head of a Woman (Jacqueline with a Green Ribbon)*
Mougins, 1962
Sheet metal, cut out, folded, and painted (both sides) in several colors,
19³/₄ × 15¹/₄ × 10⁷/₈ in.
(50.7 × 39 × 28 cm)
Private collection
Sp., 629 (II)

1067 *Head of a Woman*
Mougins, late 1962
Cutout sheet metal, folded, and steel wire, polychromed,
12¹/₂ × 9³/₈ × 6¹/₂ in.
(32 × 24 × 16 cm)
Picasso Museum, Paris
Sp., 631 (II)

1068 *Bust of a Woman*
Mougins, 1962
Cutout sheet metal, folded and painted (both sides) in several colors,
9¹/₂ × 9³/₈ × 4⁵/₈ in.
(24.5 × 24.2 × 12 cm)
Private collection
Sp., 635

1069 *Head of a Woman*
Mougins, 1962
Cutout sheet metal, folded and painted on both sides,
19¹/₂ × 19¹/₂ × 11³/₄ in.
(50 × 50 × 30 cm)
Private collection
Sp., 636

1070 *Still Life with a Cat*
Mougins, October 23–November 1, 1962
Oil on canvas, 50³/₄ × 63¹/₈ in.
(130 × 162 cm)
The Hakone Open-Air Museum, Japan
Z. XX, 356

1071 *The Abduction of the Sabine Women*
Mougins, January 9–February 7, 1963
Oil on canvas, 76¹/₃ × 51¹/₈ in.
(195.4 × 131 cm)
The Museum of Fine Arts, Boston. Juliana Cheney Edwards Collection, Tompkins Collection and Fanny P. Mason Fund, in memory of Alice Thevin
Z. XXIII, 121

1072 *Study for "The Abduction of the Sabine Women"*
Mougins, October 26, 1962
Charcoal on paper,
19⁵/₈ × 25¹/₄ in. (50.5 × 66 cm)
Picasso Museum, Paris
Z. XXIII, 33

1073 *The Abduction of the Sabine Women*
Mougins, November 4 and 8, 1962
Oil on canvas, 37⁷/₈ × 50³/₄ in.
(97 × 130 cm)
Musée National d'Art Moderne, Centre Georges Pompidou, Paris
Z. XXIII, 69

1074 *The Abduction of the Sabine Women*
Mougins, November 2 and 4, 1962
Oil on canvas, 63¹/₈ × 50³/₄ in.
(161.8 × 130.2 cm)
Norman Granz Collection, Beverly Hills
Z. XXIII, 71

1075 *The Painter and His Model*
Mougins, June 10 and 12, 1963
Oil on canvas, 76 × 50³/₄ in.
(195 × 130 cm)
Bayerische Staatsgemälde-sammlungen, Staatsgalerie Moderner Kunst. Bayerische Landesbank Collection, Munich
Z. XXIII, 286

1076 *The Painter and His Model*
Mougins, April 9, 1963
Oil on canvas, 25⁵/₈ × 35⁷/₈ in.
(65 × 92 cm)
Musée National d'Art Moderne, Centre Georges Pompidou, Paris. Gift of Louise and Michel Leiris
Z. XXIII, 205

1077 *The Painter and His Model*
Mougins, April 3 and 8, 1963
Oil on canvas, 50³/₄ × 76 in.
(130 × 195 cm)
Museo Nacional Centro de Arte Reina Sofia, Madrid
Z. XXIII, 202

1078 *The Painter and His Model*
Mougins, March 5 and September 20, 1963
Oil on canvas, 34³/₈ × 45¹/₄ in.
(88 × 116 cm)
The Hakone Open-Air Museum, Japan
Z. XXIII, 161

1079 *The Painter and His Model*
Mougins, March 30, 1963
Oil on canvas, 50³/₄ × 63¹/₈ in.
(130 × 162 cm)
Museo Nacional Centro de Arte Reina Sofia, Madrid
Z. XXIII, 197

1080 *The Painter and His Model*
Mougins, March 4 and 5, 1963
Oil on canvas, 31⁵/₈ × 39 in.
(81 × 100 cm)
Private collection
Z. XXIII, 159

1081 *The Painter and His Model*
Mougins, March 29 and April 1, 1963
Oil on canvas, 50³/₄ × 63¹/₈ in.
(130 × 162 cm)
Galerie Beyeler, Basel
Z. XXIII, 195

1082 *The Painter and His Model*
Mougins, October 26 (II) and November 3, 1954
Oil on canvas, 57 × 34³/₄ in.
(146 × 89 cm)
Private collection
Z. XXIV, 246

1083 *The Painter at Work*
March 31, 1965
Oil on canvas, 39 × 31⁵/₈ in.
(100 × 81 cm)
Picasso Museum, Barcelona
Z. XXV, 87

1084 *The Painter and His Model*
November 16 and
December 9, 1964
Oil on canvas, 63⅛ × 50¾ in.
(162 × 130 cm)
Museum Ludwig, Cologne.
Ludwig Collection
Z. XXIV, 312

1085 *Reclining Woman Playing
with a Cat*
Mougins, May 10 and 11, 1964
Oil on canvas, 44½ × 76 in.
(114 × 195 cm)
Galerie Beyeler, Basel
Z. XXIV, 145

1086 *Reclining Nude with
Crossed Legs*
Mougins, January 21–23, 1965
Gouache and India ink on
paper, 19½ × 25 in.
(50 × 64 cm)
Private collection
Z. XXV, 21

1087 *Large Nude*
Mougins, February 20–22 and
March 5, 1964
Oil on canvas, 54⅝ × 76 in.
(140 × 195 cm)
Kunsthaus, Zurich
Z. XXIV, 95

1088 *Reclining Nude*
Mougins, January 9
and 18, 1964
Oil on canvas, 25 × 39 in.
(64 × 100 cm)
A. Rosengart Collection,
Lucerne
Z. XXIV, 25

1089 *Woman Pissing*
Mougins, April 16, 1965
Oil on canvas, 76 × 37⅞ in.
(195 × 97 cm)
Musée National d'Art Moderne,
Centre Georges Pompidou,
Paris. Gift of Louise and
Michel Leiris
Z. XXV, 108

1090 *Reclining Nude Against a
Green Background*
Mougins, January 24, 1965
Oil on canvas, 34¾ × 45¼ in.
(89 × 116 cm)
Private collection
Z. XXV, 20

1091 *The Two Friends*
Mougins, January 20–26, 1965
Oil on canvas, 31⅝ × 39 in.
(81 × 100 cm)
Kunstmuseum, Bern. Gift of
Walter and Gertrud Hadorn
Z. XXV, 18

1092 *The Sleepers*
Mougins, April 13, 1965
Oil on canvas, 44½ × 76 in.
(114 × 195 cm)
Galerie Louise Leiris, Paris
Z. XXV, 106

1093 *Jacqueline Seated with Her
Black Cat*
Mougins,
February 26–March 3, 1964
Oil on canvas, 75⅝ × 50⅛ in.
(194 × 128.5 cm)
Private collection
Z. XXIV, 101

1094 *Seated Woman with a Cat*
Mougins, May 4 and 15, 1964
Oil on canvas, 50¾ × 31⅝ in.
(130 × 81 cm)
Private collection
Z. XXIV, 141

1095 *Portrait of Jacqueline*
April 4 and 5, 1965
Oil on canvas, 39 × 31⅝ in.
(100 × 81 cm)
Private collection
Z. XXV, 97

1096 *Jacqueline Nude in an Armchair*
May 2–June 7, 1964
Oil on canvas, 45¼ × 31¼ in.
(116 × 80 cm)
Private collection
Z. XXIV, 138

1097 *Seated Man (Self-Portrait)*
April 3, 1965
Oil on canvas, 39 × 31⅝ in.
(100 × 81 cm)
Private collection
Z. XXV, 95

1098 *Reclining Nude*
Mougins, June 14, 1967
Oil on canvas, 76 × 50¾ in.
(195 × 130 cm)
Picasso Museum, Paris
Z. XXVII, 35

1099 *Reclining Nude with a Necklace*
Mougins, October 8, 1968
Oil and lacquer paint on
canvas, 44¼ × 63⅛ in.
(113.5 × 161.7 cm)
The Trustees of the Tate
Gallery, London
Z. XXVII, 331

1100 *Seated Nude with a Mirror*
July 13, 1967
India ink and gouache on
paper, 21⅞ × 29¼ in.
56 × 75 cm)
Picasso Museum, Lucerne.
Rosengart Gift
Z. XXVII, 74

1101 *Reclining Nude with a Bird*
Mougins, January 17, 1968
Oil on canvas, 50¾ × 72⅛ in.
(130 × 185 cm)
Museum Ludwig, Cologne.
Ludwig Collection
Z. XXVII, 195

1102 *The Couple*
June 10, 1967
Oil on canvas, 76 × 50¾ in.
(195 × 130 cm)
Kunstmuseum, Basel

1103 *Venus and Cupid*
June 9, 1967
Oil on canvas, 76 × 50¾ in.
(195 × 130 cm)
Kunstmuseum, Basel

1104 *The Circus Rider*
July 27, 1967
India ink and gouache on
paper, 22 × 29¼ in.
(56.5 × 75 cm)
Private collection

1105 *Interior with Figures*
February 28 and
March 17–19, 1968
Drawing in pencil, red chalk,
and chalk on paper,
19¼ × 25⅜ in. (49.5 × 65 cm)
Museum Ludwig, Cologne.
Ludwig Collection
Z. XXVII, 248

1106 *Courtesan and Warrior*
March 1–3, 1968
Drawing in pencil, red chalk,
and colored crayon on paper,
19¼ × 29⅝ in. (49.5 × 76 cm)
Acquavella Galleries, Inc.,
New York
Z. XXVII, 255

1107 *347 Suite* (plate 1)
Mougins, March 16–22, 1968
Etching, 15⅜ × 22 in.
(39.5 × 56.5 cm)
Bibliothèque Nationale de
France, Paris
Bl. 1481

1108 *347 Suite* (plate 297)
August 29, 1968
Etching, 10⅞ × 15¼ in.
(28 × 39 cm)
Bibliothèque Nationale de
France, Paris
Bl. 1777

1109 *347 Suite* (plate 305)
September 2, 1968
Etching, 5⅞ × 8 in.
(15 × 20.5 cm)
Bibliothèque Nationale de
France, Paris

1110 *347 Suite* (plate 308)
September 3, 1968
Etching, 5⅞ × 8 in.
(15 × 20.5 cm)
Bibliothèque Nationale de
France, Paris
Bl. 1788

1111 *347 Suite* (plate 299)
August 31, 1968
Etching, 9⅛ × 13⅛ in.
(23.5 × 33.5 cm)
Bibliothèque Nationale de
France, Paris
Bl. 1779

1112 *347 Suite* (plate 298)
August 31, 1968
Etching, 6⅝ × 8 in.
(17 × 20.5 cm)
Bibliothèque Nationale de
France, Paris
Bl. 1778

1113 *347 Suite* (plate 300)
August 31, 1968
Etching, 16⅛ × 19¼ in.
(41.5 × 49.5 cm)
Bibliothèque Nationale de
France, Paris
Bl. 1780

1114 *Nude and Man with Mask*
Mougins, September 5, 1969
Pencil on paper,
19¾ × 25⅜ in. (50.5 × 65 cm)
Galerie Beyeler, Basel
Z. XXXI, 414

1115 *Reclining Nude*
October 1, 1969
Pencil on paper,
19¾ × 25⅜ in. (50.5 × 65 cm)
Galerie Louise Leiris, Paris
Z. XXXI, 451

1116 *Reclining Nude*
Mougins, August 1, 1969
Pencil on paper,
19¾ × 25⅜ in. (50.5 × 65 cm)
Private collection
Z. XXXI, 357

1117 *Harlequin*
Mougins, December 12, 1969
Oil on canvas, 76 × 50¾ in.
(195 × 130 cm)
Private collection
Z. XXXI, 543

1118 *Rembrandtian Figure and Cupid*
Mougins, February 19, 1969
Oil on canvas, 63⅛ × 50¾ in.
(162 × 130 cm)
Picasso Museum, Lucerne.
Rosengart Gift
Z. XXXI, 73

1119 *Man with a Pipe*
March 14, 1969
Oil on canvas, 76 × 50¾ in.
(195 × 130 cm)
Private collection
Z. XXXI, 101

1120 *The Gentleman with a Pipe*
Mougins, November 5, 1968
Oil on canvas, 56¾ × 37⅞ in.
(145.5 × 97 cm)
A. Rosengart Collection,
Lucerne
Z. XXVII, 364

1121 *Smoker with a Sword (The Matador)*
Mougins, October 4, 1970
Oil on canvas, 57 × 44½ in.
(146 × 114 cm)
Picasso Museum, Paris
Z. XXXII, 273

1122 *Seated Man with a Sword and a Flower*
Mougins, September 27, 1969
Oil on canvas, 57 × 44½ in.
(146 × 114 cm)
Private collection
Z. XXXI, 449

1123 *Matador*
Mougins, October 4, 1970
Oil on canvas, 45¼ × 34¾ in.
(116 × 89 cm)
Private collection
Z. XXXII, 274

1124 *The Kiss*
Mougins, December 1, 1969
Oil on canvas, 57 × 44½ in.
(146 × 114 cm)
Museum Ludwig, Cologne.
Ludwig Collection
Z. XXXI, 535

1125 *The Kiss*
Mougins, November 28, 1969
Oil on canvas, 45¼ × 34¾ in.
(116 × 89 cm)
Private collection
Z. XXXI, 531

1126 *Seated Man with a Pipe and Cupid*
Mougins, February 18, 1969
Oil on canvas, 76 × 50¾ in.
(195 × 130 cm)
Museum Ludwig, Cologne.
Ludwig Collection
Z. XXXI, 67

1127 *Couple*
Mougins, November 19, 1969
Oil on canvas, 63⅛ × 50¾ in.
(162 × 130 cm)
Private collection
Z. XXXI, 507

1128 *The Kiss*
Mougins, October 24, 1969
Oil on canvas, 37⅞ × 50¾ in.
(97 × 130 cm)
Private collection
Z. XXXI, 475

1129 *The Kiss*
Mougins, October 26, 1969
Oil on canvas, 37⅞ × 50¾ in.
(97 × 130 cm)
Picasso Museum, Paris
Z. XXXI, 484

1130 *Vase of Flowers on a Table*
Mougins, October 28, 1969
Oil on canvas, 45¼ × 34¾ in.
(116 × 89 cm)
Galerie Beyeler, Basel
Z. XXXI, 486

1131 *Bouquet of Flowers*
Mougins, November 7, 1969
Oil on canvas, 57 × 44½ in.
(146 × 114 cm)
Private collection, courtesy
Galerie Jan Krugier,
Ditesheim & Cie, Geneva
Z. XXXI, 492

1132 *Reclining Nude and Man Playing the Guitar*
Mougins, October 27, 1970
Oil on canvas, 50¾ × 76 in.
(130 × 195 cm)
Picasso Museum, Paris
Z. XXXII, 293

1133 *Seated Girl*
Mougins, November 21, 1970
Oil on plywood, 50⅞ × 31⅜ in.
(130.3 × 80.3 cm)
Picasso Museum, Paris
Z. XXXII, 307

1134 *The Family*
Mougins, September 30, 1970
Oil on canvas, 63⅛ × 50¾ in.
(162 × 130 cm)
Picasso Museum, Paris
Z. XXXII, 271

1135 *The Painter and His Model I*
Mougins, July 4, 1970
Pencil on cardboard,
10 × 13⅜ in. (25.5 × 34.3 cm)
Musée National d'Art Moderne,
Centre Georges Pompidou,
Paris. Gift of Louise and
Michel Leiris
Z. XXXII, 187

1136 *The Painter and His Model II*
Mougins, July 4, 1970
Colored crayon on cardboard,
8½ × 12⅛ in. (21.7 × 31 cm)
Musée National d'Art Moderne,
Centre Georges Pompidou,
Paris. Gift of Louise and
Michel Leiris
Z. XXXII, 188

1137 *The Painter and His Model III*
Mougins, July 4, 1970
Colored crayon on cardboard,
8¾ × 12¼ in. (22.5 × 31.5 cm)
Musée National d'Art Moderne,
Centre Georges Pompidou,
Paris. Gift of Louise and
Michel Leiris
Z. XXXII, 189

1138 *The Painter and His Model IV*
Mougins, July 4, 1970
Colored crayon on cardboard,
8⅝ × 12⅛ in. (22.1 × 31 cm)
Musée National d'Art Moderne,
Centre Georges Pompidou,
Paris. Gift of Louise and
Michel Leiris
Z. XXXII, 190

1139 *The Painter and His Model V*
Mougins, July 4, 1970
Colored crayon on cardboard,
8⅝ × 12⅛ in. (22.1 × 31.1 cm)
Musée National d'Art Moderne,
Centre Georges Pompidou,
Paris. Gift of Louise and
Michel Leiris
Z. XXXII, 191

1140 *The Painter and His Model VI*
Mougins, July 4, 1970
Colored crayon on cardboard,
8¾ × 12¼ in. (22.5 × 31.3 cm)
Musée National d'Art Moderne,
Centre Georges Pompidou,
Paris. Gift of Louise and
Michel Leiris
Z. XXXII, 192

1141 *The Painter and His Model VII*
Mougins, July 4, 1970
Colored crayon on cardboard,
9¼ × 12¼ in. (23.8 × 31.5 cm)
Musée National d'Art Moderne,
Centre Georges Pompidou,
Paris. Gift of Louise and
Michel Leiris
Z. XXXII, 193

1142 *The Painter and His Model VIII*
Mougins, July 4, 1970
Colored crayon on cardboard,
9¼ × 12¼ in. (23.8 × 31.5 cm)
Musée National d'Art Moderne,
Centre Georges Pompidou,
Paris. Gift of Louise and
Michel Leiris
Z. XXXII, 194

1143 *Child with a Shovel*
Mougins,
July 7–November 14, 1971
Oil on canvas, 76 × 50¾ in.
(195 × 130 cm)
Private collection
Z. XXXIII, 229

1144 *Flutist and Child*
August 29, 1971
Oil on canvas, 57 × 44½ in.
(146 × 114 cm)
Private collection
Z. XXXIII, 167

1145 *Maternity*
Mougins, August 30, 1971
Oil on canvas, 63⅛ × 50¾ in.
(162 × 130 cm)
Picasso Museum, Paris
Z. XXXIII, 168

1146 *The Card Player*
Mougins, December 30, 1971
Oil on canvas, 44½ × 57 in.
(114 × 146 cm)
Louisiana Museum of Modern
Art, Humlebaek, Denmark
Z. XXXIII, 265

1147 *Standing Bather*
Mougins, August 14, 1971
Oil on canvas, 76 × 50¾ in.
(195 × 130 cm)
Private collection
Z. XXXIII, 144

1148 *Flute Player*
Mougins, July 30, 1971
Oil on canvas, 57 × 44½ in.
(146 × 114 cm)
Private collection
Z. XXXIII, 127

1149 *Three Figures*
Mougins, September 6, 1971
Oil on canvas, 50¾ × 63⅛ in.
(130 × 162 cm)
Kunstmuseum, Bern
Z. XXXIII, 169

1150 *Man and Woman*
Mougins, July 12, 1971
Oil on canvas, 45¼ × 34½ in.
(116 × 88.5 cm)
Musée des Beaux-Arts, Nancy
Z. XXXIII, 100

1151 *Head of a Man in a Straw Hat*
Mougins, July 26, 1971
Oil on canvas, $35^3/8 \times 28^1/2$ in.
(91.5 × 73 cm)
Musée d'Unterlinden, Colmar
Z. XXXIII, 117

1152 *Head of a Man in a Hat*
Mougins, July 25, 1971
Oil on canvas, $39 \times 31^5/8$ in.
(100 × 81 cm)
Private collection
Z. XXXIII, 116

1153 *Seated Old Man*
Mougins, September 26,
1970–November 14, 1971
Oil on canvas, $56^3/4 \times 44^1/2$ in.
(145.5 × 114 cm)
Picasso Museum, Paris
Z. XXXII, 265

1154 *Male and Female Nudes*
Mougins, August 18, 1971
Oil on canvas, $76 \times 50^3/4$ in.
(195 × 130 cm)
Private collection
Z. XXXIII, 148

1155 *156 Suite* (plate 117)
Mougins, May 1–4, 1971
Drypoint and scraper,
$14^3/8 \times 19^1/2$ in. (37 × 50 cm)
Picasso Museum, Paris
Bl. 1972

1156 *156 Suite* (plate 133)
Mougins, May 22, 26–June 2,
1971
Aquatint, drypoint, and
scraper, $14^3/8 \times 19^1/2$ in.
(37 × 50 cm)
Picasso Museum, Paris
Bl. 1988

1157 *156 Suite* (plate 116)
Mougins, April 30, 1971
Aquatint, drypoint, and
scraper, $14^3/8 \times 19^1/2$ in.
(37 × 50 cm)
Picasso Museum, Paris
Bl. 1971

1158 *156 Suite* (plate 109)
Mougins, April 4, 1971
Etching, $14^3/8 \times 19^1/2$ in.
(37 × 50 cm)
Picasso Museum, Paris
Bl. 1964

1159 *156 Suite* (plate 111)
Mougins, April 9, 1971
Etching, $14^3/8 \times 19^1/2$ in.
(37 × 50 cm)
Picasso Museum, Paris
Bl. 1966

1160 *156 Suite* (plate 10)
Mougins,
February 3–March 5, 6, 1970
Etching, aquatint, and
scraper, $19^1/2 \times 16^3/8$ in.
(50 × 42 cm)
Picasso Museum, Paris
Bl. 1865

1161 *Reclining Nude*
Mougins, November 14–15,
1971
Oil on canvas, $50^3/4 \times 76$ in.
(130 × 195 cm)
Private collection
Z. XXXIII, 228

1162 *Seated Woman*
Mougins, July 28, 1971
Oil on canvas, $50^3/4 \times 37^7/8$ in.
(130 × 97 cm)
Private collection
Z. XXXIII, 122

1163 *Figure with a Book*
Mougins, August 28, 1971
Oil on canvas, $45^1/4 \times 34^3/4$ in.
(116 × 89 cm)
Private collection
Z. XXXIII, 78

1164 *Head of Harlequin*
Mougins, January 12, 1971
Ink and colored crayon on
cardboard, $14^3/4 \times 11^1/4$ in.
(37.7 × 28.9 cm)
Galerie Louise Leiris, Paris
Z. XXXIII, 27

1165 *Head of Harlequin*
Mougins, January 7, 1971
Ink and colored crayon on
cardboard, $9^7/8 \times 7^7/8$ in.
(25.2 × 20.3 cm)
Galerie Louise Leiris, Paris
Z. XXXIII, 6

1166 *Masked Head of Harlequin*
Mougins, January 10, 1971
Ink and colored crayon on
cardboard, $10^1/2 \times 8$ in.
(26.8 × 20.6 cm)
Galerie Louise Leiris, Paris
Z. XXXIII, 19

1167 *Landscape*
Mougins, March 31, 1972
Oil on canvas, $50^3/4 \times 63^1/8$ in.
(130 × 162 cm)
Picasso Museum, Paris
Z. XXXIII, 331

1168 *Musician*
Mougins, May 26, 1972
Oil on canvas, $75^7/8 \times 50^1/2$ in.
(194.5 × 129.5 cm)
Picasso Museum, Paris
Z. XXXIII, 397

1169 *Figure*
Mougins, January 19, 1972
Oil on canvas, $57 \times 44^1/2$ in.
(146 × 114 cm)
Private collection
Z. XXXIII, 278

1170 *Man with a Sword*
Mougins, January 28, 1972
Oil on canvas, $45^1/4 \times 34^3/4$ in.
(116 × 89 cm)
Private collection
Z. XXXIII, 301

1171 *Figure with a Bird*
Mougins, January 13, 1972
Oil on canvas, $57 \times 44^1/2$ in.
(146 × 114 cm)
Courtesy Thomas Ammann,
Fine Art AG, Zurich
Z. XXXIII, 274

1171b
Reclining Nude and Head
Mougins, May 25, 1972
Oil on canvas, $50^3/4 \times 76$ in.
(130 × 195 cm)
Private collection
Z. XXXIII, 374

1172 *Nude with a Mirror and Seated Figure*
Mougins, July 19, 1972
India ink wash and gouache
on paper, $21^7/8 \times 29^1/8$ in.
(56 × 74.7 cm)
Galerie Louise Leiris, Paris
Z. XXXIII, 472

1173 *Winged Horse Led by a Child*
Mougins, July 26–27, 1972
Gouache and ink on paper,
$12^1/4 \times 17^3/8$ in. (31.5 × 44.5 cm)
Private collection

1174 *The Young Painter*
Mougins, April 14, 1972
Oil on canvas, $35^1/2 \times 28^1/4$ in.
(91 × 72.5 cm)
Picasso Museum, Paris
Z. XXXIII, 350

1175 *Musketeer with a Sword*
Mougins, October 8, 1972
Wash and watercolor on
paper, $9^1/8 \times 7$ in.
(23.5 × 18 cm)
Estate of the Artist
Z. XXXIII, 515

1176 *Head*
Mougins, October 8, 1972
India ink wash and watercolor
on paper, $9^1/8 \times 7$ in.
(23.5 × 18 cm)
Private collection
Z. XXXIII, 517

1177 *Nude and Head*
Mougins, April 20, 1972
Wash, gouache, and colored
crayon on paper,
$29^1/4 \times 21^7/8$ in. (75 × 56 cm)
Museum Ludwig, Cologne.
Ludwig Collection
Z. XXXIII, 359

1178 *Nude*
Mougins, May 1, 1972
Pencil and gouache on paper,
$29 \times 21^3/4$ in. (74.3 × 55.9 cm)
Private collection
Z. XXXIII, 375

1179 *Nude*
Mougins, October 5, 1972
India ink and felt pen on
cardboard, $13^1/4 \times 6^1/4$ in.
(34 × 16 cm)
Picasso Museum, Paris
Z. XXXIII, 514

1180 *Reclining Nude*
Mougins, April 20, 1972
India ink wash, gouache, and
colored crayon on paper,
$22 \times 29^1/4$ in. (56.5 × 75 cm)
Private collection
Z. XXXIII, 358

1181 *Nude in an Armchair*
Mougins, October 3, 1972
Pen and India ink on paper,
$23 \times 29^1/2$ in. (59 × 75.5 cm)
Picasso Museum, Paris
Z. XXXIII, 513

1182 *Head*
Mougins, June 29, 1972
India ink wash and gouache
on paper, $25^5/8 \times 19^5/8$ in.
(65.7 × 50.5 cm)
Private collection
Z. XXXIII, 434

1183 *Head*
Mougins, July 2, 1972
Pencil and chalk on paper,
$25^5/8 \times 19^5/8$ in. (65.7 × 50.5 cm)
Private collection
Z. XXXIII, 436

1184 *Head*
Mougins, July 3, 1972
Pencil on paper,
$25^5/8 \times 19^5/8$ in. (65.7 × 50.5 cm)
Private collection
Z. XXXIII, 437

1185 *Self-Portrait*
Mougins, June 30, 1972
Pencil and colored crayons
on paper, $25^5/8 \times 19^5/8$ in.
(65.7 × 50.5 cm)
Fuji Television Gallery, Tokyo
Z. XXXIII, 435

SELECTED BIBLIOGRAPHY

References below marked with an asterisk are catalogues abbreviated in the *List of Illustrations*, pp. 501–28.

Alberti, Rafael. *Picasso en Avignon: Commentaires à une peinture en mouvement*. G. Franck, trans. Paris: Cercle d'Art, 1971.

———. *Picasso, le rayon ininterrompu*. G. Franck, trans. Paris: Cercle d'Art, 1974.

———. *Los 8 nombres de Picasso y No digo más que lo que no digo (1966–1970). Con dedicatorias de Picasso*. Barcelona: Kairós, 1970 ; 2nd ed., 1970; 3rd ed., 1978.

———. *Lo que canté y dije de Picasso*. Barcelona: Bruguera, 1981.

Apollinaire, Guillaume. *Cubist Painters: Aesthetic Meditations 1912*. New York: Wittenborn, 1944.

———. *Apollinaire on Art: Essays and Reviews, 1902–1918*. L.-C. Breunig, ed., S. Suleiman, trans. New York: Viking, 1972.

———. *Oeuvres en prose,* II. Pierre Caizergues and Michel Décaudin, eds. Paris: Gallimard, 1991.

Aragon, Louis. *Les Collages*. Paris: Hermann, 1965.

———. *Je n'ai jamais appris à écrire ou les "Incipit."* Paris: Skira-Flammarion, 1981.

Arnheim, Rudolf. *The Genesis of a Painting: Picasso's* Guernica. Berkeley, Los Angeles, London: University of California Press, 1962; paperback ed., 1973.

Ashton, Dore. *Picasso on Art: A Selection of Views*. New York: Viking Press, 1972; 2nd ed. New York: Da Capo, 1996.

*Baer, Brigitte, *Picasso, Peintre Graveur: Catalogue raisonné de l'oeuvre gravé et des monotypes, 1935–1972*. 5 vols. and addendum. Bern: Kornfeld and Klipstein, 1986–96.

Barr, Alfred H., Jr. *Cubism and Abstract Art*. New York: Museum of Modern Art, 1936; 2nd ed., 1974.

———. *Picasso: Forty Years of His Art*. New York: Museum of Modern Art, 1939.

———. *Picasso: Fifty Years of His Art*. New York: Museum of Modern Art, 1946 ; 2nd ed., 1966; paperback ed., 1974.

Berger, John. *The Success and Failure of Picasso*. Baltimore: Penguin Books, 1965; reprint ed., New York: Pantheon, 1980.

Bernadac, Marie-Laure. *Picasso e il Mediterraneo*, exh. cat. Rome: Villa Medici, and Athens: Pinacothèque Nationale, 1983.

———. *Musée Picasso: The Masterworks*. Paris: Réunion des Musées Nationaux, 1991.

Bernadac, Marie-Laure, ed. *Un génie sans piédestal and other writings by Picasso*. Paris: Fourbis, 1992.

Bernadac, Marie-Laure, and Paule du Bouchet. *Picasso: Master of the New Idea*. Discoveries. New York: Harry N. Abrams, 1993.

Bernadac, Marie-Laure, and Michèle Richete, and Hélène Seckel. *The Picasso Museum, Paris: Paintings,* Papiers collés, *Picture reliefs, Sculptures, and Ceramics*. New York: Harry N. Abrams, 1985.

Bernadac, Marie-Laure, and Christine Piot, eds. *Picasso Écrits*. Paris: Réunion des Musées Nationaux/Gallimard, 1989.

Bernadac, Marie-Laure, and Androula Michael, eds. *Pablo Picasso: Collected Writings*. C. Volk and A. Bensousse, trans. New York: Abbeville, 1989.

*Bloch, Georges. *Pablo Picasso: Catalogue de l'oeuvre gravé et lithographié*. 4 vols. Bern: Kornfeld and Klipstein, 1968–79.

Blunt, Anthony, and Phoebe Pool. *Picasso, The Formative Years: A Study of His Sources*. London: Studio Books, Greenwich, Conn.: New York Graphic Society, 1962.

Boeck, Wilhelm, and Jaime Sabartés. *Picasso*. New York: Harry N. Abrams, 1955.

Boudaille, Georges. *Picasso: Première époque 1881–1906*. Paris: Musée Personnel, 1964.

Bozo, Dominique. *Picasso: Oeuvres reçues en paiement des droits de succession,* exh. cat. Paris: Galeries Nationales du Grand Palais, 1979–80.

Brassaï. *Conversations with Picasso*. J. Todd, trans. Chicago: University of Chicago Press, 1999.

Breton, André. *Surrealism and Painting,* S. W. Taylor, trans. New York: Harper & Row, 1972.

Cabanne, Pierre. *Picasso: His Life and Work.* H. J. Salemson, trans. New York: William Morrow, 1977.

——. *Le Siècle de Picasso*. 4 vols. Paris: Gallimard, 1992.

Cachin, Françoise, and Fiorella Minervino. *Tout l'œuvre peint de Picasso, 1907–1916.* Paris: Flammarion, 1977.

Carmean, E. A. *Picasso: The Saltimbanques.* Washington, D.C.: National Gallery of Art, 1980.

Cassou, Jean. *Picasso.* Paris: Hypérion, 1940.

——. *Picasso.* Paris: Somogy, 1975.

Chevalier, Denys. *Picasso: The Blue and Rose Periods.* New York: Crown, 1969.

Chipp, Herschel B. *Picasso's* Guernica*: History, Transformations, Meanings.* Berkeley: University of California Press, 1988.

Cocteau, Jean. *Le Rappel à l'ordre.* Paris: Stock, 1926.

——. *Picasso de 1916 à 1961.* Paris: Rocher, 1962.

——. *Entre Picasso et Radiguet.* Paris: Hermann, 1967.

Cooper, Douglas. *Pablo Picasso: Les Déjeuners.* Paris: Cercle d'Art, 1967.

——. *Picasso Theatre.* New York: Harry N. Abrams, 1968.

——. *The Cubist Epoch.* London: Phaidon, 1971.

——. *Pablo Picasso, pour Eugénie.* Paris: Berggruen, 1976.

Czwiklitzer, Christophe. *The Posters of Pablo Picasso.* New York: Random House, 1971.

Daix, Pierre. *Picasso.* New York: Praeger, 1964.

——. *La Vie de peintre de Pablo Picasso.* Paris: Seuil, 1977.

——. *Journal du cubisme.* Geneva: Skira, 1982.

——. *Picasso créateur.* Paris: Seuil, 1987.

——. *Picasso, la Provence et Jacqueline.* Arles: Actes Sud, 1991.

——. *Picasso: Life and Art.* O. Emmet, trans. New York: Harper & Row, 1993.

——. *Dictionnaire Picasso.* Paris: Laffont, 1995.

Daix, Pierre, and Georges Boudaille and Joan Rosselet. *Picasso 1900–1906, catalogue raisonné de l'oeuvre peint.* Neuchâtel: Ides et Calendes, 1966. Published in English as *Picasso, The Blue and Rose Periods: A Catalogue of the Paintings, 1900–06.* P. Pool, trans. Greenwich, Conn.: New York Graphic Society, 1967.

*Daix, Pierre, and Joan Rosselet. *Le Cubisme de Picasso, catalogue raisonné de l'oeuvre peint 1907–1916.* Neuchâtel: Ides et Calendes, 1979. Published in English as *Picasso, The Cubist Years, 1907–1916: A Catalogue Raisonné of the Paintings and Related Works.* Boston: New York Graphic Society, 1979.

Diehl, Gaston. *Picasso.* H. C. Slonim, trans. New York: Crown, 1960.

Duncan, David Douglas. *The Private World of Pablo Picasso.* New York: Harper & Brothers, 1958.

——. *Picasso's Picassos.* New York: Harper & Row, 1961.

——. *Goodbye Picasso.* New York: Grosset and Dunlap, 1974.

——. *Picasso and Jacqueline.* New York: W. W. Norton, 1988.

Elgar, Frank. *Picasso: A Study of the Work.* F. Scarfem, trans. New York: Praeger, 1956.

Éluard, Paul. *À Pablo Picasso.* Geneva and Paris: Trois Collines, 1944.

Fermigier, André. *Picasso.* Paris: Librairie Générale française, 1969; paperback ed., Livres de poche, 1979.

Fernandez Molina, Antonio. *Picasso, escritor*. Madrid: Prensa y Ediciones Iberoamericanas, 1988.

Ferrier, Jean-Louis. *De Picasso à Guernica.* Paris: Denoël, 1977.

Fry, Edward. *Cubism.* New York: McGraw-Hill, 1966.

Galassi, Susan Grace. *Picasso's Variations on the Masters: Confrontations with the Past.* New York: Harry N. Abrams, 1996.

Gallwitz, Klaus. *Picasso at 90: The Late Work.* New York: Putnam, 1971.

Gateau, Jean-Charles. *Éluard, Picasso et la peinture.* Geneva: Droz, 1983.

Gilot, Françoise, and Carlton Lake. *Life with Picasso.* New York: McGraw-Hill, 1964; paperback ed., New York: Anchor Books, 1989.

Giraudy, Danièle. *Guide du Musée Picasso.* Paris: Hazan, 1987.

———. *Le Musée Picasso d'Antibes.* Paris: Musées et Monuments de France/Villes d'Antibes and Albin Michel, 1989.

*Goeppert, Sebastian, et al. *Pablo Picasso. The Illustrated Books: Catalogue raisonné.* G. Mangold-Vine, trans. Geneva: P. Cramer, 1983.

Golding, John. *Cubism: A History and an Analysis, 1907–1914.* New York: Wittenborn, 1959; 2nd ed. London: Faber, 1968; 3rd ed., Cambridge, Mass.: Harvard University Press, 1988.

Huelin y Ruiz Blasco, Ricardo. *Pablo Ruiz Picasso.* Madrid: Ediciones Revista de Occidente, 1975.

Jardot, Maurice. *Pablo Picasso Drawings.* New York: Harry N. Abrams, 1959.

Kahnweiler, Daniel-Henry. *The Sculpture of Picasso.* With photographs by Brassaï. London: R. Phillips, 1949.

———. *My Galleries and Painters.* Interview with Francis Crémieux. H. Weaver, trans. New York: Viking, 1971.

———. *Confessions esthétiques.* Paris: Gallimard, 1963.

Kibbey, Ray Anne. *Picasso, A Comprehensive Bibliography.* New York: Garland, 1977.

Léal, Brigitte. *Catalogue raisonné des Papiers-collés du Musée Picasso.* Paris: Réunion des Musées Nationaux, 1998.

Le Dernier Picasso, exh. cat. Paris: Centre Georges Pompidou, Musée National d'Art Moderne, 1988.

Leiris, Michel. *Un génie sans piédestal et autres écrits sur Picasso.* Marie-Laure Bernadac, ed. Paris: Fourbis, 1992.

Les Grandes Baigneuses *de Picasso,* exh. cat. Paris: Musée de l'Orangerie, 1988.

Level, André. *Picasso.* G. Crès, Paris, 1928.

Leymarie, Jean. *Picasso, Artist of the Century.* New York: Viking, 1962.

McCully, Marilyn. *Els Quatre Gats.* Princeton: Princeton University Press, 1978.

———. *Ceramics by Picasso.* 2 vols. With photographs by Éric Baudoin. Paris: Images Modernes, 1999.

McCully, Marilyn, ed. *A Picasso Anthology: Documents, Criticism, Reminiscences.* Princeton: Princeton University Press, 1981.

Malraux, André. *La Tête d'Obsidienne.* Gallimard, Paris, 1974.

Marin, Juan. *Guernica, ou le rapt des Ménines.* Paris: Lagune, 1994.

Matarasso, Henri. *Bibliographie des livres illustrés par Pablo Picasso. Œuvres graphiques 1905–1945.* Nice: Matarasso, 1956.

Migel, Parmenia. *Pablo Picasso. Dessins pour "Le tricorne."* Paris: Chêne, 1978.

Milhau, Denis. *Picasso, couleurs d'Espagne, couleurs de France, couleurs de vie,* exh. cat. Toulouse: Réfectoire des Jacobins, 1983.

Moravia, Alberto, Paolo Lecaldano, and Pierre Daix. *Tout l'oeuvre peint de Picasso, périodes bleue et rose.* Paris: Flammarion, 1980.

Mourlot, Fernand. *Picasso Lithographs.* 3 vols. Boston: Boston Book and Art Publishers, 1970.

Mújica Gallo, Manuel. *La Minotauromáquia de Picasso.* Madrid: Prensa española, 1971.

Olivier, Fernande. *Picasso and His Friends.* J. Miller, trans. London: Heinemann, 1964.

———. *Souvenirs intimes écrits pour Picasso.* Paris: Calmann-Lévy, 1988.

Otero, Roberto. *Forever Picasso: An Intimate Look on His Last Years.* E. Kerrigan, trans. New York: Harry N. Abrams, 1974.

———. *Recuerdo de Picasso* (interview, Oct. 5, 1966). Madrid: Ministerio de Cultura, 1984.

Pablo Picasso, Rencontre à Montréal, exh. cat. Montreal: Musée des Beaux-Arts, 1985.

Palau i Fabre, Josep. *Doble assaig sobre Picasso.* Barcelona: Selecta, 1964.

———. *Picasso i els seus amics catalans.* Barcelona: Aedos, 1971.

———. *Picasso en Catalogne.* R. Marrast, trans. Paris: Société française du livre, 1979.

*———. *Picasso, The Early Years, 1881–1907.* K. Lyons, trans. New York: Rizzoli, 1981.

———. *El secret de las meninas de Picasso.* Barcelona: Polígrafa, 1981.

———. *Picasso.* New York: Rizzoli, 1985.

*———. *Picasso Cubism (1907–1917).* New York: Rizzoli, 1990.

*———. *Picasso. Des ballets au drame (1917–1926).* R. Marrast, trans. Cologne: Könemann, 1999.

Parmelin, Hélène. *Picasso Plain: An Intimate Portrait*. H. Hare, trans. New York: St. Martin's, 1963.

———. *The Painter and His Model and Other Recent Works*. New York: Harry N. Abrams, 1965.

———. *Notre-Dame-de-Vie*. Paris: Cercle d'Art, 1966.

———. *Picasso, Women: Cannes and Mougin, 1954–1963*. H. Hare, trans. New York: Harry N. Abrams, 1967.

———. *Picasso Says* . . . C. Trollope, trans. South Brunswick, N.J.: A. S. Barnes, 1969.

———. *Voyage en Picasso*. Paris: Laffont, 1980.

Paulhan, Jean. *La Peinture cubiste*. Paris: Denoël/Gonthier, 1971.

Penrose, Roland. *Portrait of Picasso*. New York: Museum of Modern Art, 1957; rev. ed., 1971.

———. *Picasso: His Life and Work*. New York: Harper & Row, 1958; rev. ed. Berkeley: University of California Press, 1981.

Perry, Jacques. *Yo-Picasso*. Paris: J. C. Lattès, 1982.

Picasso, Pablo. *Carnet catalan*. Preface and notes by Douglas Cooper. 2 vols. Paris: Berggruen, 1958.

———. *"Je suis le cahier." The Sketchbooks of Picasso*. Arnold Glimcher et Marc Glimcher, eds. New York: Pace, 1986.

Picasso, Pablo, and Guillaume Apollinaire. *Correspondance*. Pierre Caizergues and Hélène Seckel, eds. Paris: Gallimard/Réunion des Musées Nationaux, 1992.

Picasso: 347 gravures, exh. cat. Paris: Galerie Louise Leiris, 1989.

Picasso: Oeuvres reçues en paiement des droits de succession. Paris: Réunion des Musées Nationaux, 1979.

Picasso: Peintures 1900–1955, exh. cat. Paris: Musée des Arts Décoratifs, 1955.

Picon, Gaëtan. *La Chute d'Icare*. Geneva: Skira, 1971.

Pierre, José. *Tracts surréalistes et déclarations collectives*, I (1922–39). Paris: Losfeld, 1980.

Ramié, Georges, and Suzanne, eds. *Ceramics by Picasso*. Geneva: Skira, 1950.

Raynal, Maurice. *Picasso*. Geneva: Skira, 1953.

Read, Peter. *Picasso et Apollinaire: Les Métamorphoses de la Mémoire 1905–1973*. Paris: J.-M. Place, 1995.

Reverdy, Pierre. *Pablo Picasso*. Paris: Éditions de la Nouvelle Revue Française, 1924.

Richardson, John. *Pablo Picasso, Watercolours and Gouaches*. London: Barrie and Rockliff, 1964.

———. *A Life of Picasso: 1881–1906*. With the collaboration of Marilyn McCully. New York: Random House, 1991.

———. *A Life of Picasso: 1907–1917*. With the collaboration of Marilyn McCully. New York: Random House, 1996.

———. *Picasso, Women: Cannes and Mougins, 1954–1963*. H. Hare, trans. New York: Harry N. Abrams, 1967.

Richet, Michèle. *Musée Picasso: Catalogue sommaire des collections*. 2 vols. Paris: Réunion des Musées Nationaux, 1987.

Rodrigo, Luis Carlos. *Picasso in His Posters*. Barcelona: Arte Ediciones, 1992.

Rodriguez-Aguilera, Cesáreo. *Picasso de Barcelone*. R. Marrast, trans. Paris: Cercle d'Art, 1975.

Rubin, William. *Picasso in the Collections of The Museum of Modern Art*. New York: Museum of Modern Art, 1972; rev. ed. 1980.

———. *Picasso and Braque: Pioneering Cubism*. New York: Museum of Modern Art, 1989.

———. *Picasso and Portraiture: Representation and Transformation*. New York: Museum of Modern Art, 1996

Sabartés, Jaime. *Picasso: An Intimate Portrait*. A. Flores, trans. New York: Prentice-Hall, 1948.

———. *Dans l'atelier de Picasso*. Paris: F. Mourlot, 1947.

———. *Picasso. Documents iconographiques*. F. Leal et A. Rosset, trans. Geneva: Pierre Cailler, 1954.

Salmon, André. *Souvenirs sans fin*. 3 vols. Paris: Gallimard, 1955–61.

Seckel, Hélène. *Musée Picasso: Guide*. Paris: Réunion des Musées Nationaux, 1985.

Seckel, Hélène, ed., *Les Demoiselles d'Avignon*, exh. cat., 2 vols. Paris: Réunion des Musées Nationaux, and Barcelona: Polígrafa, 1988.

Sopeña Ibañez, Federico. *Picasso y la música*. Madrid: Ministerio de Cultura, 1982.

*Spies, Werner. *Sculptures by Picasso, with a Catalogue of the Works*. New York: Harry N. Abrams, 1971.

——. *Das plastische Werk*. Stuttgart: Hatje, 1983.

——. *Picasso: Pastelle, Zeichnungen, Aquarelle*. Stuttgart: Hatje, 1986.

Starobinski, Jean. *Portrait de l'artiste en saltimbanque*. Geneva: Skira, 1970.

Stein, Gertrude. *Autobiography of Alice B. Toklas*. New York: Harcourt Brace, 1933.

——. *Picasso*. New York: Charles Scribner's Sons, 1946; paperback ed., New York: Dover, 1984.

Tzara, Tristan. *Picasso et les chemins de la connaissance*. Geneva: Skira, 1948.

Uhde, Wilhelm. *Picasso and the French Tradition: Notes on Contemporary Painting*. F. M. Loving, trans. New York: Weyhe, 1929.

Vallentin, Antonina. *Picasso*. Paris: Albin Michel, 1957.

Weisner, Ulrich. *Picassos Klassizismus (1914–1934)*, exh. cat. Bielefeld: Kunsthalle, 1988.

Zelevansky, Lynn, ed. *Picasso and Braque: A Symposium*. New York: Museum of Modern Art, 1992.

Zervos, Christian. *Picasso, oeuvres 1920–26*. Paris: Cahiers d'Art, 1926.

——. *Dessins de Picasso, 1892–1948*. Paris: Cahiers d'Art, 1949.

*——. *Catalogue général illustré de l'oeuvre de Picasso*. 33 vols. Paris: Cahiers d'Art, 1932–78.

INDEX

Page numbers in italics refer to illustrations

A

Alarcón, Pedro Antonio de, 199
Alphonse XIII, 188
Anglada Camarasa, Hermen, *38*
Ansermet, Ernest, 194
Apollinaire, Guillaume, 11, 12, 56, 89, 158, *164,* 165, 175, 181, *181,* 188, 190, 192, 194, 207, 212, 219, 246, 249, 259, 343
Aragon, Louis, 162, 199, 232, 302, 359, 380, 397
Araquistain, Luis, 308
Aristophanes, 283, *284*
Arp, Hans, 347
Artaud, Antonin, 262
Auric, Georges, 192, 302

B

Bakst, Leon, 188
Balzac, Honoré de, 219, 232, 238, 308, 439
Barnett, Violet Endicott, 72
Barr, Alfred, 95, 415
Bas, Joaquim, 27, 35
Bataille, Georges, 255
Baudelaire, Charles-Pierre, 397
Baur, Harry, 72
Beaumont, Étienne de, 219
Beauvoir, Simone de, 353
Bell, Clive, 199
Bergamín, José, 308
Berger, John, 383
Bernard, Émile, 126
Boeck, Wilhelm, 60
Borges, Jorge Luis, 286
Boudaille, Georges, 130
Bozo, Dominique, 212, 447
Braque, Georges, 12, 13, 14, 16, 118, 123, 126, 130, 140, 145, 146, 156, 158, 160, 162, 165, 170, 172, 173, 176, 178, 181, 212, 360, 405, 415, 444
Brassaï, 9, 24, 126, 232, 249, 257, 259, 262, 275, 286, 353, 442, 455
Breton, André, 175, 219, 227, 231, 232, 249, 259, 268, 278, 293, 308, 442
Bruant, Aristide, 35
Buñuel, Luis, 249

C

Camarasa, Hermen Anglada, *38*
Camus, Albert, 353
Canals, Benedetta, 72, *78,* 89, 192
Canals, Ricard, 33, 35
Cardona, Josep, 27, *30*
Carolus-Duran, 35
Carrière, Eugène, 35
Casagemas, Carles, 43, 47, *48, 49,* 51, 56, 60, 360
Casas, Ramon, 35, 38
Cassou, Jean, 302, 360
Cervantes, Miguel de, 60
Cézanne, Paul, 10, 12, 13, 16, 41, 91, 95, 107, 123, 126, 130, 138, 145, 172, 173, 180, 194, 199, 219, 360, 427, 430, 464
Chagall, Marc, 307
Chanel, Coco, 214
Chaplin, Charlie, 397
Chardin, Jean, 188
Charensol, Georges, 275
Churchill (son of Inès), 353
Clouet, Jean, 56
Clouzot, 423
Cocteau, Jean, 181, 185, 188, 192, 194, 199, 212, 214, 227
Columbus, Christopher, 188, *188*
Cone, Etta, 138
Cooper, Douglas, 180, 194, 199, 202, 214, 430
Coquiot, Gustav, *46*
Corday, Charlotte, 262, *263, 288*
Corot, Camille, 145, 188, 194
Courbet, Gustave, 190, 383, 415, 416
Coustou, Guillaume, 95
Cranach, Lucas, 380, 449
Crommelynck, Aldo, 453
Crommelynck, Piero, 453, 455
Cuttoli, Marie, 240, 257, 286, 363

D

Daix, Pierre, 41, 95, 162, 214, 353, 360, 383, 423, 427, 478
Dalí, Salvador, 268, 283
David, Jacques-Louis, 190, 202, 262, 437
David, Sylvette, 402, *402,* 423
Debussy, Claude, 214
Degas, Edgar, 17, 41, 56, 72, 474
de Gaulle, Charles, 47

Delacroix, Eugène, 15, 190, 383, 402, 405, 415, 430
Delvaux, Paul, 347
Derain, André, 12, 15, 95, 118, 123, 146, 176, 178, 199, *201*
Desnos, Robert, 350
Diaghilev, Serge, 185, 188, 199, *201,* 202, 207, 214, 219
Dioscuros, 188
Doisneau, Robert, 449
Domínguez, Oscar, 347
Dor de la Souchère, Romuald, 363, 368
Doucet, Jacques, 219
Duchamp, Marcel, 176
Dullin, Charles, 214
Duncan, David Douglas, 297, 302, 401
Dürer, Albrecht, 126
Durrio, Paco, 41, 60
Duvauçay (Madame), 192

E

Éluard, Cécile, 353
Éluard, Dominique, 390
Éluard, Nusch, 308, *311,* 313, 343, *344,* 368, 390
Éluard, Paul, 172, 308, 313, 340, 347, 359, 368, 376, 390
Elytis, Odysseus, 15
Ernst, Max, 231, 255
Errazúriz, Eugenia, 178, 194
Esmeralda (goat), 15
Esteban, Claude, 275
Eva (Marcelle Humbert, also called "Ma Jolie"), 13, *155,* 158, 160, 165, *167,* 172, 176, 178, 181

F

Fagus, Félicien, 43
Falla, Manuel de, 199, *201*
Farge, Adrien, 47
Fermigier, André, 194, 219
Fernández, Luis, 302
Fernández de Soto, Àngel, 27, 60, *64*
Fernández de Soto, Mateu, *50,* 56
Fondevila, Josep, *97*
Fort, Louis, 363
Fort, Paul, 89
Fortuny, Mariano, 24

Fougeron, André, 383
Franco, Francisco, 307, 308, 334
Frenhofer, 232, 439, 442
Freud, Sigmund, 231
Frika (dog), 165
Fry, Roger, 156

G

Gabo, Naum, 437
Gaby, *66,* 72
Gance, Abel, 262
Gargallo, Laure (Germaine), 43, 56
Gasquet, Joachim, 138
Gaudí, Antoni, 35
Gauguin, Paul, 32, 35, 41, 56, 91, 123
Gaulle, Charles de, 47
Geelhaar, Christian, 444
Gerard, Frédé, 72
Géricault, 95
Germaine. *See* Gargallo, Laure (Germaine)
Giacometti, Alberto, 14
Gilot, Françoise, 15, 240, 246, 350, 357, 359,
 360, 363, *366,* 368, *375,* 376, 388, 390, 397,
 401, 402, *403,* 405
Giorgione, 430
Gogh, Vincent van, 17, 41, 43, 51, 56, 194,
 442, 464
Golding, John, 173, 175
Gongora, Luis de, 376
González, Julio, 14, 175, 246, 259, 347, 427,
 478
Goya, Francisco, 16, 275, 308, 397, 430, 444,
 449
Greco, El, 27, 51, 60, 190, 383, 416
Gris, Juan, 172, 173, 207
Grünewald, Matthias, 275
Guillaume, Paul, 192

H

Hals, Frans, 32
Haviland, Frank Burty, 156
Hemingway, Ernest, 359
Hitler, Adolf, 334
Honegger, Arthur, 302
Hugnet, Georges, 286, 347
Hugo, Valentine, 353
Huidobro, Vicente, 11
Humbert, Marcelle. *See* Eva (Marcelle
 Humbert, also called "Ma Jolie")

I

Ibert, Jacques, 302
Ibsen, Henrik, 35
Inès, 353

Ingres, Jean-Auguste-Dominique, 12, 13, 91,
 95, 123, 180, 185, 192, 194, 199, 202, 439,
 453
Iturrino, Francisco, 188

J

Jacob, Max, 10, 60, 72, 89, *111,* 146, 165, 170,
 173, 180, *180,* 188, *191,* 192, 194, 207, 350
Joyce, James, 192
Jung, C. G., 275
Junyer Vidal, Sebastià, *64,* 72

K

Kaboul (dog), 16, 427
Kahnweiler, Daniel-Henry, 27, 118, 126, 146,
 149, 158, 162, 165, 173, 175, 180, 207, 278,
 307, 405, 413, 427
Kazbek (dog), 325, 334, 340, 353
Khokhlova, Olga, 13, 14, 185, 188, *190, 191,*
 192, 194, 199, 202, 207, 219, *222,* 227, 238,
 240, 246, 249, 252, 255, 259, 262, 270, 275,
 278, 293, 305, 308, 313, 397
Koechlin, Charles, 302

L

Lacan (Dr.), Jacques, 353
Lacourière, 453
La Fornarina, 453
Lamba-Breton, Jacqueline, 334
Laporte, Geneviève, 390, 397, 402
La Salchichona, 192
Laurens, Henri, 214
Lazarus, Daniel, 302
Lazerme, 402
Leiris, Louise, 343, 353, 380, 453
Leiris, Michel, 16, 249, 315, 343, 353, 397,
 439, 442, 474
Le Nain, Louis, 188, 190, 192
Leonardo da Vinci, 56
Level, André, 173
Leymarie, Jean, 334
Lifar, Serge, 214
Luc, Marguerite (Margot), 72
Lump (dog), 416

M

Maar, Dora, 14, 259, *304,* 305, 308, *311,* 313,
 315, 325, 329, *329,* 334, *336,* 340, 343, *343,*
 346, 347, 353, 363, 478
MacOrlan, Pierre, 72
Madame Z. *See* Roque, Jacqueline (Madame Z)
Madoura, 359, 368, 371, 402
Magritte, René, 347

Maillol, Aristide, 143
Malraux, André, 11, 110, 315, 325, 350, 353,
 380, 455, 458
Mañach, Pere, 41, 43, *46*
Manet, Édouard, 16, 35, 91, 188, 190, 194,
 199, 405, 427, 430, 434, 444
Manolo, 51, 156
Man Ray, 283, *284,* 286, 334
Maragall, Joan, 35
Marat, Jean-Paul, 262, 286
Marcoussis, Lodowicz Markus, 158
Margot (Marguerite Luc), 72
María, Margarita, *419*
Martinez Padilla, Rafael, 192
Massine, Léonide, 185, 194, *196,* 199, 202, 219
Masson, André, 231, 238, 360
Matisse, Henri, 11, 12, 14, 15, 95, 118, 123,
 126, 172, 178, 207, 252, 259, 307, 363, 368,
 376, 390, 402, 405, 413, 415, 416, 430, 444,
 447, 455, 464, 466, 478
Maupassant, Guy de, 474
Meurent, Victorine, 430
Michelangelo, 14, 17, 126, 202, 453
Milhaud, Darius, 214, 302
Miller, Lee, 308
Millet, Jean-François, 60, 194, 283
Miró, Joan, 14, 231
Mola (General), 315
Monet, Claude, 60
Moravia, Alberto, 47, 51
Moreau, Gustave, 35
Morice, Charles, 60
Mourlot, Fernand, 359, 360, 363, 376
Moussinac, Léon, 302, 371
Mozart, Wolfgang Amadeus, 21
Munch, Edvard, 35
Murillo, Bartolomé, 27, 343
Murphy, Gerald and Sara, 214

N

Nabille, Pierre, 231
Neruda, Pablo, 376
Nietzsche, Friedrich, 35
Noailles, Madame de, 185
Nonell, Isidre, 35
Novalis, 35

O

Olivier, Fernande, 12, 72, 89, 91, 95, *97,* 107,
 130, 138, 140, *142,* 143, 146, 156
Ovid, 257, 283

P

Pallarès, Manuel, 10, 27, 32, 51, 138, *140,* 188
Parmelin, Hélène, 390, *391,* 439, 458

Paulhan, Jean, 165, 172
Penrose, Roland, 21, 199, 229, 231, 232, 262, 308
Pepa, Aunt, 27, *27*
Péret, Benjamin, 286
Pergolesi, Giovanni, 202
Petit, Georges, 275
Pevsner, Antoine, 437
Philip IV, 27, *29*
Picasso, Claude, 15, 359, 363, 380, *381*, 388, 402, *403*
Picasso, Conchita, 10, 293
Picasso, Lola, 24, *25, 31*
Picasso, Maria de la Concepción (Maya), 14, 15, 238, 259, 293, 297, 308, 325, *326*, 340, 343, 357, 380
Picasso, Paloma, 15, 359, 363, 380, *381*, 388, *393*, 402, *403*
Picasso, Paul (Paulo), 13, 15, 207, 212, 214, 219, *222, 228*, 229, *229*, 240, 246, 249, 262, 275, 286, 293, 325, *357*, 380
Picasso López, Maria, 21, 24, *24*, 334
Pichot, Ramon, 146, 231
Picon, Gaëtan, 420, 423
Pignon, Édouard, 383, 390, 458
Pinelli, Bartolomeo, 194
Poe, Edgar Allan, 72
Pool, Phoebe, 41
Porbus, 232
Poussin, Nicolas, 188, 190, 192, 202, 232, 357, 437
Proust, Marcel, 185, 188, 192
Pudney, John, 359
Puig i Cadafalch, Josep, 35
Puvis de Chavannes, 35, 95

Q

Queneau, Raymond, 353
Quevedo, 60

R

Rabelais, François, 447
Radiguet, Raymond, 199
Ramié, Georges and Suzanne, 368, 371, 402
 See also Madoura
Ranzini, 188
Raphael, 21, 27, 35, 453
Raynal, Maurice, 207
Reff, Theodore, 51, 89, 207
Rembrandt, 14, 17, 32, 413, 447, 449, 455, 474
Renoir, Auguste, 41, 199, *201*, 207, 212, 464
Reventós (Doctor), 188
Reverdy, Pierre, 9, 353, 371, 376
Richardson, John, 11, 156, 442, 474
Rilke, Rainer Maria, 89
Rimbaud, Arthur, 12

Rodin, Auguste, 14, 143
Rojas, Fernando de, 72, 453
Rolland, Romain, 302
Romeu, Pere, 35
Roque, Catherine, 402
Roque, Jacqueline (Madame Z), 15, 16, 262, 390, 401, 402, *404*, 405, *411*, 413, *414*, 415, 416, 427, 430, *433*, 437, 444, *446*, 447, *447*, 449, 453, 455
Rosenberg, Paul, 199, 297
Rosenblum, Robert, 170
Rousseau, Henri, le Douanier, 130, 138
Roussel, Albert, 302
Roy, Claude, 359, 390
Rubens, Peter Paul, 27
Rubin, William, 91, 107, 126, 138
Ruiz Blasco, José, 21, 23, 24, *24, 31*, 38, 165, 444, 455
Rusiñol, Santiago, 35

S

Sabartés, Jaime, 21, 23, 27, 38, *38*, 41, *50, 51*, 56, 60, *71*, 293, 340, *341*
Sagot, Clovis, 138, *140*, 146
Salles, Georges, 383, 423
Salmon, André, 89
Salvadó, Jacint, 214, *218*
Sariento, María Agustina, *419*
Sartre, Jean-Paul, 315, 353
Satie, Erik, 35, 185, 199, *201*, 219
Schiff, Gert, 442
Segovia, Pablos de, 60
Seligsberg, Alfred, 199, *201*
Sert, José Maria, 207
Sert, Misia, 207
Seurat, Georges, 192
Shakespeare, William, 455
Sima, Michel, 363
Skira, Albert, 257, 278
Soler, Benet, *64*
Stalin, Joseph, 397
Starobinski, Jean, 202
Stein, Gertrude, 12, 91, 95, *106*, 107, 110, 130, 138, 158, 160, 173, 176, 181, 188, 307
Stein, Leo, 118
Steinberg, Leo, 118
Steinlen, Théophile Alexandre, 35, 38
Stravinsky, Igor, 185, 192, 199, *201*, 202
Sylvester, David, 470

T

Tanguy, Yves, 268
Tatlin, Vladimir, 175
Tellier, Fanny, *144*, 145, 146
Teniers, David, 27
Téry, Simone, 307

Theodora (Empress), 447
Titian, 27
Toklas (Miss) Alice B., 173
Tormes, Lazarillo de, 60
Toulouse-Lautrec, Henri de, 35, 41, 56
Tzara, Tristan, 165, 170, 278, 293

U

Ubac, Raoul, 347
Uhde, Wilhelm, 110, 145, 146, *149*, 207

V

Valdivia, Carlota, *65*, 72
Valéry, Paul, 199
Vallentin, Antonina, 22, 231, 246, 415
Van Dyck, Anthony, 27
van Gogh, Vincent, 17, 41, 43, 51, 56, 194, 442, 464
Vauxcelles, Louis, 126, 130
Velasco, Isabel de, *419*
Velázquez, Diego, 10, 15, 27, 41, 60, 190, 405, 413, 415, 416, 420, 455
Vianelli, Achille, 188
Vidal, Sebastià Junyer, *64*, 72
Vitrac, Roger, 172
Vlaminck, Maurice de, 343
Vollard, Ambroise, 41, 43, 145, 146, *148*, 173, 180, *180*, 232, 275, 278, 286, 297, 308, 439, 442
Vuillard, Édouard, 41

W

Walter, Jeanne, 270
Walter, Marie-Thérèse, 14, 229, 238, 246, 249, 255, 257, 259, *261*, 262, 265, 268, 270, 275, 278, 286, 293, 297, 302, *304*, 305, *306, 307*, 308, *310*, 313, 315, 325, *328*, 329, 334, 340, 343, 357, 402, 478
Warnod, André, 249
Watteau, Antoine, 192
Weill, Berthe, 41, 47, 60
Wiegels, Karl-Heinz, 126
Wright, Wilbur, 162

Z

Zay, Jean, 302
Zervos, Christian, 130, 207, 265, 275, 307, 360, 464
Z (Madame). *See* Roque, Jacqueline (Madame Z)
Zola, Émile, 56
Zurbarán, Francisco de, 51, 383

ETHICS

ETHICS

History, Theory,
and Contemporary Issues

SIXTH EDITION

Edited by

Steven M. Cahn
The City University of New York Graduate Center

Peter Markie
University of Missouri–Columbia

New York Oxford
OXFORD UNIVERSITY PRESS

Oxford University Press is a department of the University of Oxford.
It furthers the University's objective of excellence in research,
scholarship, and education by publishing worldwide.

Oxford New York
Auckland Cape Town Dar es Salaam Hong Kong Karachi
Kuala Lumpur Madrid Melbourne Mexico City Nairobi
New Delhi Shanghai Taipei Toronto

With offices in
Argentina Austria Brazil Chile Czech Republic France Greece
Guatemala Hungary Italy Japan Poland Portugal Singapore
South Korea Switzerland Thailand Turkey Ukraine Vietnam

For titles covered by Section 112 of the U.S. Higher Education
Opportunity Act, please visit www.oup.com/us/he for the
latest information about pricing and alternate formats.

Published by Oxford University Press
198 Madison Avenue, New York, New York 10016
http://www.oup.com

Library of Congress Cataloging-in-Publication Data
Ethics : history, theory, and contemporary issues / edited by Steven M. Cahn, The City University
of New York Graduate Center, Peter Markie, University of Missouri Columbia. -- SIXTH EDITION.
 pages cm
 ISBN: 978-0-19-020980-3
 1. Ethics. I. Cahn, Steven M., editor. II. Markie, Peter J., 1950- editor.
 BJ1012.E8944 2015
 170--dc23

 2015025558

Printing number: 9 8 7 6 5 4 3 2 1

Printed in the United States of America
on acid-free paper

To the memory of James Rachels

CONTENTS

PREFACE

The most comprehensive collection of its kind, *Ethics: History, Theory, and Contemporary Issues,* sixth edition, is essentially three books in one. Its fifty-nine selections offer instructors the opportunity to construct courses in ethics combining, as wished, the history of moral philosophy, modern ethical theory, and contemporary moral problems. The readings are reprinted, wherever possible, without omissions. Historical works presented unabridged are Plato's *Euthyphro*, *Defence of Socrates*, and *Crito*, Kant's *Groundwork for the Metaphysics of Morals*, Mill's *Utilitarianism*, Dewey's *Theory of Valuation*, and Sartre's *Existentialism Is a Humanism.*

NEW TO THIS EDITION

- The complete text of John Dewey's *Theory of Valuation.*
- Articles by J. J. C. Smart on utilitarianism, T. M. Scanlon on contractualism, and Julia Annas on virtue ethics.
- Articles by Walter Sinnott-Armstrong on moral psychology, Mary Midgley on cultural relativism, and James Rachels on egoism.
- A second article on the trolley problem by Judith Jarvis Thomson.
- One-third of the essays in Parts II and III are authored by women.

READINGS ADDED TO THIS EDITION

- John Dewey, *Theory of Valuation*
- J. J. C. Smart, "Extreme and Restricted Utilitarianism"
- Thomas Scanlon, "Contractualism and Utilitarianism"
- Julia Annas, "Being Virtuous and Doing the Right Thing"
- Walter Sinnott-Armstrong, "Moral Intuitionism Meets Empirical Psychology"
- Mary Midgley, "Trying Out One's New Sword"
- James Rachels, "Egoism and Moral Skepticism"
- Judith Jarvis Thomson, "Turning the Trolley"

Essays by Joel Feinberg, James Rachels, Martha Nussbaum, Tom Regan, Carl Cohen, John M. Taurek, and Derek Parfit from the previous edition are omitted.

Note that all the new readings, like all the contemporary essays in the book, are reprinted in their entirety.

RESOURCES FOR STUDENTS AND INSTRUCTORS

A variety of supplemental materials are available to accompany this book. PowerPoint lecture outlines and an Instructor's Manual with summaries and fifteen multiple-choice, ten true/false, four essay, and three essay/discussion questions per reading are available on the book's Ancillary Resource Center (ARC). A Companion Website for students (www.oup .com/us/cahn) contains interactive self-quizzes and essay/discussion questions so that students can check their basic understanding of key points. For more information, please contact your Oxford University Press representative or call 1-800-280-0280.

ACKNOWLEDGMENTS

The idea for such an inclusive volume developed from conversations with Robert Miller, executive editor at Oxford University Press, and we remain grateful for his initial encouragement and continuing support. We also wish to express our thanks to assistant editors Kaitlin Coats and Alyssa Palazzo for their generous help, to senior production editors Marianne Paul and Susan Lee for their conscientiousness, and to other members of the staff at Oxford University Press for valuable assistance throughout production.

Changes to the sixth edition in part reflect recommendations made by our colleagues as well as reviewers chosen by the publisher. These reviewers include: Eric Chwang (University of Colorado at Boulder), Tristin Hassell (Oakland University), Paul Hughes (University of Michigan–Dearborn), Daniel Imparato (City University of New York, College of Staten Island), Ivan Marquez (Texas State University–San Marcos), David McElhoes (Arizona State University), David Murphy (Truman State University), Mike Pelletti (Solano Community College and Sacramento State University), Robert B. Talisse (Vanderbilt University), Jeffrey Watson (Arizona State University), and Ronald Weed (University of New Brunswick–Fredericton). We appreciate their thoughtful advice.

We wish to acknowledge again the contribution of Christa Davis Acampora (City University of New York, Hunter College and the Graduate Center), who provided the abridgment of Nietzsche's *On the Genealogy of Morals*. Finally, we are especially grateful to Andrew Forcehimes for offering valuable suggestions about the contents and structure of the book as well as helping to formulate the study questions and extended introductions that enhance this new edition.

INTRODUCTION

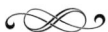

All of us from time to time reflect on the moral dimension of our lives: what sorts of persons we ought to be, which goals are worth pursuing, and how we should relate to others. We may wonder about the answers to these questions that have been provided by the most profound thinkers of past generations; we may speculate whether their conflicting opinions amount to disagreements about the truth or are merely expressions of their differing attitudes; we may consider how their varied theories might help us understand moral issues of our own day.

This book of readings provides the materials to address these matters. In Part I we have collected the most influential ethical theories from nearly 2,500 years of philosophical thought, beginning in ancient Greece with Socrates, Plato, and Aristotle and continuing through medieval and modern times to the twentieth-century French thinkers Camus and Sartre. Part II contains recent articles that explore theoretical issues concerning the nature of moral judgments, the resolution of moral disagreements, and the evaluation of moral theories. Part III offers reflections on contemporary moral problems, including abortion, euthanasia, and global economic inequality. In each case thoughtful arguments for and against are presented for your consideration.

Which philosophical positions are correct? Just as each member of a jury at a trial needs to make a decision and defend a view after considering all the relevant evidence, so each philosophical inquirer needs to make a decision and defend a view after considering all the relevant arguments. This book makes available in convenient form the materials on which to base your thinking. The challenge and excitement of philosophy, however, is that after taking account of the work others have done, the responsibility for reaching conclusions is your own.

Should you wish to learn more about particular moral philosophers or specific moral issues, an excellent source to consult is the *Encyclopedia of Ethics,* 2nd ed. (Routledge, 2001), edited by Lawrence C. Becker and Charlotte B. Becker. It contains detailed entries with bibliographies on every significant topic in the field.

PART I

Historical Sources

INTRODUCTION

Alasdair MacIntyre

Alasdair MacIntyre is Professor Emeritus of Philosophy at the University of Notre Dame.

Moral philosophy is often written as though the history of the subject were only of secondary and incidental importance. This attitude seems to be the outcome of a belief that moral concepts can be examined and understood apart from their history. Some philosophers have even written as if moral concepts were a timeless, limited, unchanging, determinate species of concept, necessarily having the same features throughout their history, so that there is a part of language waiting to be philosophically investigated which deserves the title "*the* language of morals" (with a definite article and a singular noun). In a less sophisticated way, historians of morals are all too apt to allow that moral practices and the content of moral judgments may vary from society to society and from person to person, but at the same time these historians have subtly assimilated different moral concepts—and so they end up by suggesting that although what is held to be right or good is not always the same, roughly the same concepts of right and good are universal.

In fact, of course, moral concepts change as social life changes. I deliberately do not write "because social life changes," for this might suggest that social life is one thing, morality another, and that there is merely an external, contingent causal relationship between them. This is obviously false. Moral concepts are embodied in and are partially constitutive of forms of social life. One key way in which we may identify one form of social life as

From *A Short History of Ethics: A History of Moral Philosophy from the Homeric Age to the Twentieth Century* by Alasdair MacIntyre. Reprinted by permission of the author and the University of Notre Dame Press.

distinct from another is by identifying differences in moral concepts. So it is an elementary commonplace to point out that there is no precise English equivalent for the Greek word δικαιοσύνη [dikaiasune], usually translated *justice*. And this is not a mere linguistic defect, so that what Greek achieves by a single word English needs a periphrasis [longer phrasing] to achieve. It is rather that the occurrence of certain concepts in ancient Greek discourse and of others in modern English marks a difference between two forms of social life. To understand a concept, to grasp the meaning of the words which express it, is always at least to learn what the rules are which govern the use of such words and so to grasp the role of the concept in language and social life. This in itself would suggest strongly that different forms of social life will provide different roles for concepts to play. Or at least for some concepts this seems likely to be the case. There certainly are concepts which are unchanging over long periods, and which must be unchanging for one of two reasons. Either they are highly specialized concepts belonging within stable and continuing disciplines, such as geometry; or else they are highly general concepts necessary to any language of any complexity. I have in mind here the family of concepts expressed by such words as *and, or,* and *if.* But moral concepts do not fall into either of these two classes.

So it would be a fatal mistake to write as if, in the history of moral philosophy, there had been one single task of analyzing the concept of, for example, justice, to the performance of which Plato, Hobbes, and Bentham all set themselves, and for their achievement at which they can be awarded higher or lower marks. It does not of course follow, and it is in fact untrue, that what Plato says about δικαιοσύνη and what Hobbes or Bentham says about *justice* are totally irrelevant to one another. There are continuities as well as breaks in the history of moral concepts. Just here lies the complexity of the history.

The complexity is increased because philosophical inquiry itself plays a part in changing moral concepts. It is not that we have first a straightforward history of moral concepts and then a separate and secondary history of philosophical comment. For to analyze a concept philosophically may often be to assist in its transformation by suggesting that it needs revision, or that it is discredited in some way, or that it has a certain kind of prestige. Philosophy leaves everything as it is—except concepts. And since to possess a concept involves behaving or being able to behave in certain ways in certain circumstances, to alter concepts, whether by modifying existing concepts or by making new concepts available or by destroying old ones, is to alter behavior. So the Athenians who condemned Socrates to death, the English parliament which condemned Hobbes' *Leviathan* in 1666, and the Nazis who burned philosophical books were correct at least in their apprehension that philosophy can be subversive of established ways of behaving. Understanding the world of morality and changing it are far from incompatible tasks. The moral concepts which are objects for analysis to the philosophers of one age may sometimes be what they are partly because of the discussions by philosophers of a previous age. . . .

It is all too easy for philosophical analysis, divorced from historical inquiry, to insulate itself from correction. In ethics it can happen in the following way. A certain unsystematically selected class of moral concepts and judgments is made the subject of attention. From the study of these it is concluded that specifically moral discourse possesses certain characteristics. When counterexamples are adduced to show that this is not always so, these counterexamples are dismissed as irrelevant, because not examples of moral discourse; and they are shown to be nonmoral by exhibiting their lack of the necessary characteristics. From this kind

of circularity we can be saved only by an adequate historical view of the varieties of moral and evaluative discourse. This is why it would be dangerous, and not just pointless, to begin these studies with a definition which would carefully delimit the field of inquiry. We cannot, of course, completely avoid viewing past moralists and past philosophers in terms of present distinctions. . . . But it is important that we should, as far as it is possible, allow the history of philosophy to break down our present-day preconceptions, so that our too narrow views of what can and cannot be thought, said, and done are discarded in face of the record of what has been thought, said, and done.

I

PLATO

Plato (c. 428–347 B.C.E.), the famed Athenian philosopher, wrote a series of dialogues, most of which feature his teacher Socrates (469–399 B.C.E.), who himself wrote nothing but in conversation was able to befuddle the most powerful minds of his day. The *Euthyphro, Defence of Socrates*, and *Crito* are generally considered among Plato's earlier dialogues, offering an account of events immediately preceding, during, and after the trial of Socrates, who, having been found guilty of impiety, was put to death by the Athenian democracy. Common to all three dialogues is the Socratic assumption that possessing a virtue suffices to be able to give an account of it, or, in other words, those who cannot provide an account of a virtue do not possess it. The *Republic*, regarded by most as Plato's greatest work, presents a unified view of central issues in metaphysics, epistemology, philosophy of mind, ethics, political philosophy, philosophy of art, and philosophy of education. Plato's central concern, however, was the relationship between justice and happiness. He maintained that a just life is superior to an unjust life, both intrinsically and instrumentally.

Euthyphro

2a *Euthyphro.* What trouble has arisen, Socrates, to make you leave your haunts in the Lyceum, and spend your time here today at the Porch of the King Archon? Surely you of all people don't have some sort of lawsuit before him, as I do?

Socrates. Well no; Athenians, at any rate, don't call it a lawsuit, Euthyphro—they call it an indictment.

b *Euthyphro.* What's that you say? Somebody must have indicted you, since I can't imagine your doing that to anyone else.

Socrates. No, I haven't.

Euthyphro. But someone else has indicted you?

Socrates. Exactly.

Euthyphro. Who is he?

Socrates. I hardly even know the man myself, Euthyphro; I gather he's young and unknown—but I believe he's named Meletus. He belongs to the Pitthean deme—can you picture a Meletus from that deme, with straight hair, not much of a beard, and a rather aquiline nose?

Euthyphro. No, I can't picture him, Socrates. But tell me, what is this indictment he's brought against you? c

Socrates. The indictment? I think it does him credit. To have made such a major discovery is no mean achievement for one so young: he claims to know how the young people are being corrupted, and who are corrupting them.

He's probably a smart fellow; and noticing that in my ignorance I'm corrupting his contemporaries, he is going to denounce me to the city, as if to his mother.

d Actually, he seems to me to be the only one who's making the right start in politics: it *is* right to make it one's first concern that the young should be as good as possible, just as a good farmer is likely to care first for the young plants, and only later for the others. And so Meletus is no doubt first weeding out those of us who are "ruining the shoots of youth," as he puts it. Next after this, he'll take care of the older people, and will obviously bring many great blessings to the city: at least that would be the natural outcome after such a start.

3a

Euthyphro. So I could wish, Socrates, but I'm afraid the opposite may happen: in trying to injure you, I really think he's making a good start at damaging the city. Tell me, what does he claim you are actually doing to corrupt the young?

b *Socrates.* Absurd things, by the sound of them, my admirable friend: he says that I'm an inventor of gods; and for inventing strange gods, while failing to recognize the gods of old, he's indicted me on their behalf, so he says.

Euthyphro. I see, Socrates; it's because you say that your spiritual sign visits you now and then. So he's brought this indictment against you as a religious innovator, and he's going to court to misrepresent you, knowing that such things are easily misrepresented before the public.

c Why, it's just the same with me: whenever I speak in the Assembly on religious matters and predict the future for them, they laugh at me as if I were crazy; and yet not one of my predictions has failed to come true. Even so, they always envy people like ourselves. We mustn't worry about them, though—we must face up to them.

Socrates. Yes, my dear Euthyphro, being laughed at is probably not important. You know, Athenians don't much care, it seems to me, if they think someone clever, so long as he's not imparting his wisdom to others; but once they

d think he's making other people clever, then they get angry—whether from envy, as you say, or for some other reason.

Euthyphro. In that case I don't much want to test their feelings towards me.

Socrates. Well, they probably think you give sparingly of yourself, and aren't willing to impart your wisdom. But in my case, I fear my benevolence makes them think I give all that I have, by speaking without reserve to every comer; not only do I speak without charge, but I'd gladly be out of pocket if anyone cares to listen to me. So, as I was just saying, if they were only going to laugh at me, as you say they laugh at you, it wouldn't be bad sport if they passed the time joking and laughing in the courtroom. But if they're going to be serious, then there's no knowing how things will turn out—except for you prophets.

e

Euthyphro. Well, I dare say it will come to nothing, Socrates. No doubt you'll handle your case with intelligence, as I think I shall handle mine.

Socrates. And what is this case of yours, Euthyphro? Are you defending or prosecuting?

Euthyphro. Prosecuting.

Socrates. Whom?

Euthyphro. Once again, someone whom I'm thought crazy to be prosecuting.

4a

Socrates. How's that? Are you chasing a bird on the wing?

Euthyphro. The bird is long past flying: in fact, he's now quite elderly.

Socrates. And who is he?

Euthyphro. My father.

Socrates. What? Your own *father!*

Euthyphro. Precisely.

Socrates. But what is the charge? What is the case about?

Euthyphro. It's a case of murder, Socrates.

Socrates. Good heavens above! Well, Euthyphro, most people are obviously ignorant of where the right lies in such a case, since I can't imagine any ordinary person taking that action. It must need someone pretty far advanced in wisdom.

b

Euthyphro. Goodness yes, Socrates. Far advanced indeed!

Socrates. And is your father's victim one of your relatives? Obviously, he must be—you'd hardly be prosecuting him for murder on behalf of a stranger.

Euthyphro. It's ridiculous, Socrates, that you should think it makes any difference whether the victim was a stranger or a relative, and not see that the sole consideration is whether or not the slaying was lawful. If it was, one should leave the slayer alone; but if it wasn't, one should prosecute, even if the slayer shares one's own hearth and board—because the pollution is just the same, if you knowingly associate with such a person, and fail to cleanse yourself and him by taking legal action.

In point of fact, the victim was a day-labourer of mine: when we were farming in Naxos, he was working there on our estate. He had got drunk, flown into a rage with one of our servants, and butchered him. So my father had him bound hand and foot, and flung into a ditch; he then sent a messenger here to find out from the religious authority what should be done. In the mean time, he disregarded his captive, and neglected him as a murderer, thinking it wouldn't much matter even if he died. And that was just what happened: the man died of hunger and cold, and from his bonds, before the messenger got back from the authority.

That's why my father and other relatives are now upset with me, because I'm prosecuting him for murder on a murderer's behalf. According to them, he didn't even kill him. And even if he was definitely a killer, they say that, since the victim was a murderer, I shouldn't be troubled on such a fellow's behalf—because it is unholy for a son to prosecute his father for murder. Little do they know, Socrates, of religious law about what is holy and unholy.

Socrates. But heavens above, Euthyphro, do you think *you* have such exact knowledge of religion, of things holy and unholy? Is it so exact that in the circumstances you describe, you aren't afraid that, by bringing your father to trial, you might prove guilty of unholy conduct yourself?

Euthyphro. Yes it is, Socrates; in fact I'd be good for nothing, and Euthyphro wouldn't differ at all from the common run of men, unless I had exact knowledge of all such matters.

Socrates. Why then, my admirable Euthyphro, my best course is to become your student, and to challenge Meletus on this very point before his indictment is heard. I could say that even in the past I always used to set a high value upon religious knowledge; and that now, because he says I've gone astray by freethinking and religious innovation, I have become your student.

"Meletus," I could say: "If you agree that Euthyphro is an expert on such matters, then you should regard me as orthodox too, and drop the case. But if you don't admit that, then proceed against that teacher of mine, not me, for corrupting the elderly—namely, myself and his own father—myself by his teaching, and his father by admonition and punishment."

Then, if he didn't comply and drop the charge, or indict you in my place, couldn't I repeat in court the very points on which I'd already challenged him?

Euthyphro. By God, Socrates, if he tried indicting me, I fancy I'd soon find his weak spots; and we'd have *him* being discussed in the courtroom long before I was.

Socrates. Why yes, dear friend, I realize that, and that's why I'm eager to become your student. I know that this Meletus, amongst others no doubt, doesn't even seem to notice you; it's me he's detected so keenly and so readily that he can charge me with impiety.

So now, for goodness' sake, tell me what you were just maintaining you knew for sure. What sort of thing would you say that the pious and the impious are, whether in murder or in other matters? Isn't the holy itself the same as

itself in every action? And conversely, isn't the unholy the exact opposite of the holy, in itself similar to itself, or possessed of a single character, in anything at all that is going to be unholy?

Euthyphro. Indeed it is, Socrates.

Socrates. Tell me, then, what do you say that the holy is? And the unholy?

Euthyphro. All right, I'd say that the holy is just what I'm doing now: prosecuting wrongdoers, whether in cases of murder or temple-robbery, or those guilty of any other such offence, be they one's father or mother or anyone else whatever; and failing to prosecute is unholy.

e

See how strong my evidence is, Socrates, that this is the law—evidence I've already given others that my conduct was correct: one must not tolerate an impious man, no matter who he may happen to be. The very people

6a

who recognize Zeus as best and most righteous of the gods admit that he put his father in bonds for wrongfully gobbling up his children; and that that father in turn castrated *his* father for similar misdeeds. And yet they are angry with me, because I'm prosecuting *my* father as a wrongdoer. Thus, they contradict themselves in what they say about the gods and about me.

Socrates. Could this be the reason why I'm facing indictment, Euthyphro? Is it because when people tell such stories of the gods, I somehow find them hard to accept? That, I suppose, is why some will say that, I've gone astray. But now,

b

if these stories convince you—with your great knowledge of such matters—then it seems that the rest of us must accept them as well. What can we possibly say, when by our own admission we know nothing of these matters? But tell me, in the name of friendship, do you really believe that those things happened as described?

Euthyphro. Yes, and even more remarkable things, Socrates, of which most people are ignorant.

Socrates. And do you believe that the gods actually make war upon one another? That they have terrible feuds and fights, and much more of the sort related by our poets, and depicted by our able painters, to adorn our temples—

c

especially the robe which is covered with such adornments, and gets carried up to the Acropolis at the great Panathenaean festival? Are we to say that those stories are true, Euthyphro?

Euthyphro. Not only those, Socrates, but as I was just saying, I'll explain to you many further points about religion, if you'd like, which I'm sure you'll be astonished to hear.

Socrates. I shouldn't be surprised. But explain them to me at leisure some other time. For now, please try to tell me more clearly what I was just asking. You see, my friend, you didn't instruct me properly when I asked my earlier question: I asked what the holy might be, but you told me that the holy was what you are now doing, prosecuting your father for murder.

d

Euthyphro. Yes, and there I was right, Socrates.

Socrates. Maybe. Yet surely, Euthyphro, there are many other things you call holy as well.

Euthyphro. So there are.

Socrates. And do you recall that I wasn't urging you to teach me about one or two of those many things that are holy, but rather about the form itself whereby all holy things are holy? Because you said, I think, that it was by virtue of a single character that unholy things are unholy, and holy things are holy. Don't you remember?

e

Euthyphro. Yes, I do.

Socrates. Then teach me about that character, about what it might be, so that by fixing my eye upon it and using it as a model, I may call holy any action of yours or another's, which conforms to it, and may deny to be holy whatever does not.

Euthyphro. All right, if that's what you want, Socrates, that's what I'll tell you.

Socrates. Yes, that *is* what I want.

Euthyphro. In that case, what is agreeable to the gods is holy, and what is not agreeable to them is unholy.

7a

Socrates. Splendid, Euthyphro!—You've given just the sort of answer I was looking for. Mind you, I don't yet know whether it's correct, but obviously you will go on to show that what you say is true.

Euthyphro. I certainly will.

Socrates. All right then, let's consider what it is we're saying. A thing or a person loved-by-the-gods is holy, whereas something or someone hated-by-the-gods is unholy; and the holy isn't the same as the unholy, but is the direct opposite of it. Isn't that what we're saying?

Euthyphro. Exactly.

Socrates. And does it seem well put?

b *Euthyphro.* I think so, Socrates.

Socrates. And again, Euthyphro, the gods quarrel and have their differences, and there is mutual hostility amongst them. Hasn't that been said as well?

Euthyphro. Yes, it has.

Socrates. Well, on what matters do their differences produce hostility and anger, my good friend? Let's look at it this way. If we differed, you and I, about which of two things was more numerous, would our difference on these questions make us angry and hostile towards one another? Or would we resort to counting in

c such disputes, and soon be rid of them?

Euthyphro. We certainly would.

Socrates. Again, if we differed about which was larger and smaller, we'd soon put an end to our difference by resorting to measurement, wouldn't we?

Euthyphro. That's right.

Socrates. And we would decide a dispute about which was heavier and lighter, presumably, by resorting to weighing.

Euthyphro. Of course.

Socrates. Then what sorts of questions would make us angry and hostile towards one another, if we differed about them and were

d unable to reach a decision? Perhaps you can't say offhand. But consider my suggestion, that they are questions of what is just and unjust, honourable and dishonourable, good and bad. Aren't those the matters on which our disagreement and our inability to reach a satisfactory decision occasionally make enemies of us, of you and me, and of people in general?

Euthyphro. Those are the differences, Socrates, and that's what they're about.

Socrates. And what about the gods, Euthyphro? If they really do differ, mustn't they differ about those same things?

Euthyphro. They certainly must.

Socrates. Then, by your account, noble e Euthyphro, different gods also regard different things as just, or as honourable and dishonourable, good and bad; because unless they differed on those matters, they wouldn't quarrel, would they?

Euthyphro. Correct.

Socrates. And again, the things each of them regards as honourable, good, or just, are also the things they love, while it's the opposites of those things that they hate.

Euthyphro. Indeed.

Socrates. And yet it's the same things, according to you, that some gods consider just, 8a and others unjust, about which their disputes lead them to quarrel and make war upon one another. Isn't that right?

Euthyphro. It is.

Socrates. Then the same things, it appears, are both hated and loved by the gods, and thus the same things would be both hated-by-the-gods and loved-by-the-gods.

Euthyphro. It does appear so.

Socrates. So by this argument, Euthyphro, the same things would be both holy and unholy.

Euthyphro. It looks that way.

Socrates. So then you haven't answered my question, my admirable friend. You see, I wasn't asking what selfsame thing proves to be at once holy and unholy. And yet something which is loved-by-the-gods is apparently also hated-by-the-gods. Hence, as regards your present action b in punishing your father, Euthyphro, it wouldn't be at all surprising if you were thereby doing something agreeable to Zeus but odious to Cronus and Uranus, or pleasing to Hephaestus but odious to Hera; and likewise for any other gods who may differ from one another on the matter.

Euthyphro. Yes Socrates, but I don't think any of the gods do differ from one another on this point, at least: whoever has unjustly killed another should be punished.

Socrates. Really? Well, what about human beings, Euthyphro? Have you never heard any of them arguing that someone who has killed unjustly, or acted unjustly in some other way, should not be punished?

Euthyphro. Why yes, they are constantly arguing that way, in the lawcourts as well as elsewhere: people who act unjustly in all sorts of ways will do or say anything to escape punishment.

Socrates. But do they admit acting unjustly, Euthyphro, yet still say, despite that admission, that they shouldn't be punished?

Euthyphro. No, they don't say that at all.

Socrates. So it isn't just anything that they will say or do. This much, I imagine, they don't dare to say or argue: if they act unjustly, they should not be punished. Rather, I imagine, they deny acting unjustly, don't they?

Euthyphro. True.

Socrates. Then they don't argue that one who acts unjustly should not be punished; but they do argue, maybe, about who it was that acted unjustly, and what he did, and when.

Euthyphro. True.

Socrates. Then doesn't the very same thing also apply to the gods—if they really do quarrel about just and unjust actions, as your account suggests, and if each party says that the other acts unjustly, while the other denies it? Because surely, my admirable friend, no one among gods or men dares to claim that anyone should go unpunished who *has* acted unjustly.

Euthyphro. Yes, what you say is true, Socrates, at least on the whole.

Socrates. Rather, Euthyphro, I think it is the individual act that causes arguments among gods as well as human beings—if gods really do argue: it is with regard to some particular action that they differ, some saying it was done justly, while others say it was unjust. Isn't that so?

Euthyphro. Indeed.

Socrates. Then please, my dear Euthyphro, instruct me too, that I may grow wiser. When a hired man has committed murder, has been put in bonds by the master of his victim, and has died from those bonds before his captor can find out from the authorities what to do about him, what proof have you that all gods regard that man as having met an unjust death? Or that it is right for a son to prosecute his father and press a charge of murder on behalf of such a man? Please try to show me plainly that all gods undoubtedly regard that action in those circumstances as right. If you can show that to my satisfaction, I'll never stop singing the praises of your wisdom.

Euthyphro. Well, that may be no small task, Socrates, though I *could* of course prove it to you quite plainly.

Socrates. I see. You must think me a slower learner than the jury, because obviously you will show them that the acts in question were unjust, and that all the gods hate such things.

Euthyphro. I will show that very clearly, Socrates, provided they listen while I'm talking.

Socrates. They'll listen all right, so long as they approve of what you're saying.

But while you were talking, I reflected and put to myself this question: "Even suppose Euthyphro were to instruct me beyond any doubt that the gods all do regard such a death as unjust, what more have I learnt from him about what the holy and the unholy might be? This particular deed would be hated-by-the-gods, apparently; yet it became evident just now that the holy and unholy were not defined in that way, since what is hated-by-the-gods proved to be loved-by-the-gods as well."

So I'll let you off on that point, Euthyphro; let *all* the gods consider it unjust, if you like, and let *all* of them hate it. Is this the correction we are now making in our account: whatever *all* the gods hate is unholy, and whatever they *all* love is holy; and whatever some gods love but others hate is neither or both? Is that how you would now have us define the holy and the unholy?

Euthyphro. What objection could there be, Socrates?

Socrates. None on my part, Euthyphro. But consider your own view, and see whether, by making that suggestion, you will most easily teach me what you promised.

e *Euthyphro.* Very well, I would say that the holy is whatever all the gods love; and its opposite, whatever all the gods hate, is unholy.

Socrates. Then shall we examine that in turn, Euthyphro, and see whether it is well put? Or shall we let it pass, and accept it from ourselves and others? Are we to agree with a position merely on the strength of someone's say-so, or should we examine what the speaker is saying?

Euthyphro. We should examine it. Even so, for my part I believe that this time our account is well put.

10a *Socrates.* We shall soon be better able to tell, sir. Just consider the following question: is the holy loved by the gods because it is holy? Or is it holy because it is loved?

Euthyphro. I don't know what you mean, Socrates.

Socrates. All right, I'll try to put it more clearly. We speak of a thing's "being carried" or "carrying," of its "being led" or "leading," of its "being seen" or "seeing." And you understand, don't you, that all such things are different from each other, and how they differ?

Euthyphro. Yes, I think I understand.

Socrates. And again, isn't there something that is "being loved," while that which loves is different from it?

Euthyphro. Of course.

b *Socrates.* Then tell me whether something in a state of "being carried" is in that state because someone is carrying it, or for some other reason.

Euthyphro. No, that is the reason.

Socrates. And something in a state of "being led" is so because someone is leading it, and something in a state of "being seen" is so because someone is seeing it?

Euthyphro. Certainly.

Socrates. Then someone does not see a thing because it is in a state of "being seen," but on the contrary, it is in that state because someone is seeing it; nor does someone lead a thing because it is in a state of "being led," but rather it is in that state because someone is leading it; nor does someone carry a thing because it is in a state of "being carried," but it is in that state because someone is carrying it. Is my meaning quite clear, Euthyphro? What I mean is this: if something gets into a certain state or is affected in a certain way, it does not get into that state because it possesses it; rather, it possesses that state because it gets into it; nor is it thus affected because it is in that condition; rather, it is in that condition because it is thus affected. Don't you agree with that? c

Euthyphro. Yes, I do.

Socrates. Again, "being loved" is a case of either being in a certain state or being in a certain condition because of some agent?

Euthyphro. Certainly.

Socrates. Then this case is similar to our previous examples: it is not because it is in a state of 'being loved' that an object is loved by those who love it; rather, it is in that state because it is loved by them. Isn't that right?

Euthyphro. It must be.

Socrates. Now, what are we saying about the holy, Euthyphro? On your account, doesn't it consist in being loved by all the gods? d

Euthyphro. Yes.

Socrates. Is that because it is holy, or for some other reason?

Euthyphro. No, that is the reason.

Socrates. So it is loved because it is holy, not holy because it is loved.

Euthyphro. So it seems.

Socrates. By contrast, what is loved-by-the-gods is in that state—namely, being loved-by-the-gods—because the gods love it.

Euthyphro. Of course.

Socrates. Then what is loved-by-the-gods is not the holy, Euthyphro, nor is the holy what

is loved-by-the-gods, as you say, but they differ from each other.

Euthyphro. How so, Socrates?

Socrates. Because we are agreed, aren't we, that the holy is loved because it is holy, not holy because it is loved?

Euthyphro. Yes.

Socrates. Whereas what is loved-by-the-gods is so because the gods love it. It is loved-by-the-gods by virtue of their loving it; it is not because it is in that state that they love it.

Euthyphro. That's true.

Socrates. But if what is loved-by-the-gods and the holy were the same thing, Euthyphro, then if the holy were loved because it is holy, what is loved-by-the-gods would be loved because it is loved-by-the-gods; and again, if what is loved-by-the-gods were loved-by-the-gods because they love it, then the holy would be holy because they love it. In actual fact, however, you can see that the two of them are related in just the opposite way, as two entirely different things: one of them is lovable because they love it, whereas the other they love for the reason that it is lovable.

And so, Euthyphro, when you are asked what the holy might be, it looks as if you'd prefer not to explain its essence to me, but would rather tell me one of its properties—namely, that the holy has the property of being loved by all the gods; but you still haven't told me what it *is.*

So please don't hide it from me, but start again and tell me what the holy might be— whether it is loved by the gods or possesses any other property, since we won't disagree about that. Out with it now, and tell me what the holy and the unholy are.

Euthyphro. The trouble is, Socrates, that I can't tell you what I have in mind, because whatever we suggest keeps moving around somehow, and refuses to stay put where we established it.

Socrates. My ancestor Daedalus seems to be the author of your words, Euthyphro. Indeed, if they were my own words and suggestions, you might make fun of me, and say that it's because of my kinship with him that my works of art in conversation run away from me too, and won't stay where they're placed. But in fact those suggestions are your own; and so you need a different joke, because you're the one for whom they won't stay put—as you realize yourself.

Euthyphro. No, I think it's much the same joke that is called for by what we said, Socrates: I'm not the one who makes them move around and not stay put. I think you're the Daedalus because, as far as I'm concerned, they would have kept still.

Socrates. It looks then, my friend, as if I've grown this much more accomplished at my craft than Daedalus himself: he made only his own works move around, whereas I do it, apparently, to those of others besides my own. And indeed the really remarkable feature of my craft is that I'm an expert at it without even wanting to be. You see, I'd prefer to have words stay put for me, immovably established, than to acquire the wealth of Tantalus and the skill of Daedalus combined.

But enough of this. Since I think you are being feeble, I'll join you myself in an effort to help you instruct me about the holy. Don't give up too soon, now. Just consider whether you think that everything that is holy must be just.

Euthyphro. Yes, I do.

Socrates. Well then, is everything that is just holy? Or is everything that is holy just, but not everything that is just holy? Is part of it holy, and part of it something else?

Euthyphro. I can't follow what you're saying, Socrates.

Socrates. And yet you are as much my superior in youth as you are in wisdom. But as I say, your wealth of wisdom has enfeebled you. So pull yourself together, my dear sir—it really isn't hard to see what I mean: it's just

the opposite of what the poet meant who composed these verses:

> *"With Zeus, who wrought it and who generated*
> *all these things,*
> *You cannot quarrel, for where there is fear,*
> *there is also shame."*

b

I disagree with that poet. Shall I tell you where?

Euthyphro. By all means.

Socrates. I don't think that "where there is fear, there is also shame"; because many people, I take it, dread illnesses, poverty, and many other such things. Yet although they dread them, they are not ashamed of what they fear. Don't you agree?

Euthyphro. Certainly.

Socrates. On the other hand, where there is shame, there is also fear: doesn't anyone

c who is ashamed and embarrassed by a certain action both fear and dread a reputation for wickedness?

Euthyphro. Indeed he does.

Socrates. Then it isn't right to say that "where there is fear, there is also shame"; nevertheless, where there is shame there is also fear, even though shame is not found everywhere there is fear. Fear is broader than shame, I think, since shame is one kind of fear, just as odd is one kind of number. Thus, it is not true that wherever there is number there is also odd, although it is true that where there is odd, there is also number. You follow me now, presumably?

Euthyphro. Perfectly.

Socrates. Well, that's the sort of thing

d I meant just now: I was asking, "Is it true that wherever a thing is just, it is also holy? Or is a thing just wherever it is holy, but not holy wherever it is just?" In other words, isn't the holy part of what is just? Is that what we're to say, or do you disagree?

Euthyphro. No, let's say that: your point strikes me as correct.

Socrates. Then consider the next point: if the holy is one part of what is just, it would seem that we need to find out which part it might be. Now, if you asked me about one of the things just mentioned, for example, which kind of number is even, and what sort of number it might be, I'd say that it's any number which is not scalene but isosceles. Would you agree?

Euthyphro. I would.

Socrates. Now you try to instruct me, like- e wise, which part of what is just is holy. Then we'll be able to tell Meletus not to treat us unjustly any longer, or indict us for impiety, because I've now had proper tuition from you about what things are pious or holy, and what are not.

Euthyphro. Well then, in my view, the part of what is just that is pious or holy has to do with ministering to the gods, while the rest of it has to do with ministering to human beings.

Socrates. Yes, I think you put that very well, Euthyphro. I am still missing one small 13a detail, however. You see, I don't yet understand this "ministering" of which you speak. You surely don't mean "ministering" to the gods in the same sense as "ministering" to other things. That's how we talk, isn't it? We say, for example, that not everyone understands how to minister to horses, but only the horse-trainer. Isn't that right?

Euthyphro. Certainly.

Socrates. Because, surely, horse-training is ministering to horses.

Euthyphro. Yes.

Socrates. Nor, again, does everyone know how to minister to dogs, but only the dog-trainer.

Euthyphro. Just so.

Socrates. Because, of course, dog-training is ministering to dogs.

Euthyphro. Yes. b

Socrates. And again, cattle-farming is ministering to cattle.

Euthyphro. Certainly.

Socrates. And holiness or piety is ministering to the gods, Euthyphro? Is that what you're saying?

Euthyphro. It is.

Socrates. Well, doesn't all ministering achieve the same thing? I mean something like this: it aims at some good or benefit for its object. Thus, you may see that horses, when they are being ministered to by horse-training, are benefited and improved. Or don't you think they are?

Euthyphro. Yes, I do.

c *Socrates.* And dogs, of course, are benefited by dog-training, and cattle by cattlefarming, and the rest likewise. Or do you suppose that ministering is for harming its objects?

Euthyphro. Goodness, no!

Socrates. So it's for their benefit?

Euthyphro. Of course.

Socrates. Then, if holiness is ministering to the gods, does it benefit the gods and make them better? And would you grant that whenever you do something holy, you're making some god better?

Euthyphro. Heavens, no!

d *Socrates.* No, I didn't think you meant that, Euthyphro—far from it—but that was the reason why I asked what sort of ministering to the gods you did mean. I didn't think you meant that sort.

Euthyphro. Quite right, Socrates: that's not the sort of thing I mean.

Socrates. Very well, but then what sort of ministering to the gods would holiness be?

Euthyphro. The sort which slaves give to their masters, Socrates.

Socrates. I see. Then it would appear to be some sort of service to the gods.

Euthyphro. Exactly.

Socrates. Now could you tell me what result is achieved by service to doctors? It would be health, wouldn't it?

Euthyphro. It would.

e *Socrates.* And what about service to shipwrights? What result is achieved in their service?

Euthyphro. Obviously, Socrates, the construction of ships.

Socrates. And service to builders, of course, achieves the construction of houses.

Euthyphro. Yes.

Socrates. Then tell me, good fellow, what product would be achieved by service to the gods? You obviously know, since you claim religious knowledge superior to any man's.

Euthyphro. Yes, and there I'm right, Socrates.

Socrates. Then tell me, for goodness' sake, just what that splendid task is which the gods accomplish by using our services?

Euthyphro. They achieve many fine things, Socrates.

Socrates. Yes, and so do generals, my friend. 14a Yet you could easily sum up their achievement as the winning of victory in war, couldn't you?

Euthyphro. Of course.

Socrates. And farmers too. They achieve many fine things, I believe. Yet they can be summed up as the production of food from the earth.

Euthyphro. Certainly.

Socrates. And now how about the many fine achievements of the gods? How can their work be summed up?

Euthyphro. I've already told you a little while ago, Socrates, that it's a pretty big job to b learn the exact truth on all these matters. But I will simply tell you this much: if one has expert knowledge of the words and deeds that gratify the gods through prayer and sacrifice, those are the ones that are holy: such practices are the salvation of individual families, along with the common good of cities; whereas practices that are the opposite of gratifying are impious ones, which of course upset and ruin everything.

Socrates. I'm sure you could have given a summary answer to my question far more briefly, Euthyphro, if you'd wanted to. But c you're not eager to teach me—that's clear because you've turned aside just when you were on the very brink of the answer. If you'd

given it, I would have learnt properly from you about holiness by now. But as it is, the questioner must follow wherever the person questioned may lead him. So, once again, what are you saying that the holy or holiness is? Didn't you say it was some sort of expertise in sacrifice and prayer?

Euthyphro. Yes, I did.

Socrates. And sacrifice is giving things to the gods, while prayer is asking things of them?

Euthyphro. Exactly, Socrates.

d *Socrates.* So, by that account, holiness will be expertise in asking from the gods and giving to them.

Euthyphro. You've gathered my meaning beautifully, Socrates.

Socrates. Yes, my friend, that's because I'm greedy for your wisdom, and apply my intelligence to it, so that what you say won't fall wasted to the ground. But tell me, what is this service to the gods? You say it is asking from them, and giving to them?

Euthyphro. I do.

Socrates. Well, would asking rightly be asking for things we need from them?

Euthyphro. Why, what else could it be?

e *Socrates.* And conversely, giving rightly would be giving them in return things that they do, in fact, need from us. Surely it would be inept to give anybody things he didn't need, wouldn't it?

Euthyphro. True, Socrates.

Socrates. So then holiness would be a sort of skill in mutual trading between gods and mankind?

Euthyphro. Trading, yes, if that's what you prefer to call it.

Socrates. I don't prefer anything unless it is actually true. But tell me, what benefit do the gods derive from the gifts they receive from

15a us? What they give, of course, is obvious to anyone—since we possess nothing good which they don't give us. But how are they benefited by what they receive from us? Do we get so much the better bargain in our trade with them

that we receive all the good things from them, while they receive none from us?

Euthyphro. Come, Socrates, do you really suppose that the gods are benefited by what they receive from us?

Socrates. Well if not, Euthyphro, what ever would they be, these gifts of ours to the gods?

Euthyphro. What else do you suppose but honour and reverence, and—as I said just now—what is gratifying to them?

Socrates. So the holy is gratifying, but not b
beneficial or loved by the gods?

Euthyphro. I imagine it is the most loved of all things.

Socrates. Then, once again, it seems that this is what the holy is: what is loved by the gods.

Euthyphro. Absolutely.

Socrates. Well now, if you say that, can you wonder if you find that words won't keep still for you, but walk about? And will you blame me as the Daedalus who makes them walk, when you're far more skilled than Daedalus yourself at making them go round in a circle? Don't you c
notice that our account has come full circle back to the same point? You recall, no doubt, how we found earlier that what is holy and what is loved-by-the-gods were not the same, but different from each other? Don't you remember?

Euthyphro. Yes, I do.

Socrates. Then don't you realize that now you're equating holy with what the gods love? But that makes it identical with loved-by-the-gods, doesn't it?

Euthyphro. Indeed.

Socrates. So either our recent agreement wasn't sound; or else, if it was, our present suggestion is wrong.

Euthyphro. So it appears.

Socrates. Then we must start over again, and consider what the holy is, since I shan't be willing to give up the search till I learn the d
answer. Please don't scorn me, but give the matter your very closest attention and tell me the truth—because you must know it, if any man

does; and like Proteus you mustn't be let go until you tell it.

You see, if you didn't know for sure what is holy and what unholy, there's no way you'd ever have ventured to prosecute your elderly father for murder on behalf of a labourer. Instead, fear of the gods would have saved you from the risk of acting wrongly, and you'd have been embarrassed in front of human beings. But in fact I'm quite sure that you think you have certain knowledge of what is holy and what is not; so tell me what you believe it to be, excellent Euthyphro, and don't conceal it.

e

Euthyphro. Some other time, Socrates: I'm hurrying somewhere just now, and it's time for me to be off.

Socrates. What a way to behave, my friend, going off like this, and dashing the high hopes I held! I was hoping I'd learn from you what acts are holy and what are not, and so escape Meletus' indictment, by showing him that Euthyphro had made me an expert in religion, and that my ignorance no longer made me a free-thinker or innovator on that subject: and also, of course, that I would live better for what remains of my life.

16a

Defence of Socrates

17a I don't know how you, fellow Athenians, have been affected by my accusers, but for my part I felt myself almost transported by them, so persuasively did they speak. And yet hardly a word they have said is true. Among their many falsehoods, one especially astonished me: their warning that you must be careful not to be taken in by me, because I am a clever speaker. It seemed to me the height of impudence on their part not to be embarrassed at being refuted straight away by the facts; once it became apparent that I was not a clever speaker at all—unless indeed they call a "clever" speaker one who speaks the truth. If that is what they mean, then I would admit to being an orator, although not on a par with them.

b

As I said, then, my accusers have said little or nothing true; whereas from me you shall hear the whole truth, though not, I assure you, fellow Athenians, in language adorned with fine words and phrases or dressed up, as theirs was: you shall hear my points made spontaneously in whatever words occur to me—per-

c

suaded as I am that my case is just. None of you should expect anything to be put differently, because it would not, of course, be at all fitting at my age, gentlemen, to come before you with artificial speeches, such as might be composed by a young lad.

One thing, moreover, I would earnestly beg of you, fellow Athenians. If you hear me defending myself with the same arguments I normally use at the bankers' tables in the market-place (where many of you have heard me) and elsewhere, please do not be surprised or protest on that account. You see, here is the reason: this is the first time I have ever appeared before a court of law, although I am over 70; so I am literally a stranger to the diction of this place. And if I really were a foreigner, you would naturally excuse me, were I to speak in the dialect and style in which I had been brought up; so in the present case as well I ask you, in all fairness as I think, to disregard my manner of speaking—it may not be as good, or it may be better—but to consider and attend simply

d

18a

to the question whether or not my case is just; because that is the duty of a judge, as it is an orator's duty to speak the truth.

To begin with, fellow Athenians, it is fair that I should defend myself against the first set of charges falsely brought against me by my first accusers, and then turn to the later charges and the more recent ones. You see, I have been accused before you by many people for a long time now, for many years in fact, by people who spoke not a word of truth. It is those people I fear more than Anytus and his crowd, though they too are dangerous. But those others are more so, gentlemen: they have taken hold of most of you since childhood, and made persuasive accusations against me, yet without an ounce more truth in them. They say that there is one Socrates, a "wise man," who ponders what is above the earth and investigates everything beneath it, and turns the weaker argument into the stronger.

Those accusers who have spread such rumour about me, fellow Athenians, are the dangerous ones, because their audience believes that people who inquire into those matters also fail to acknowledge the gods. Moreover, those accusers are numerous, and have been denouncing me for a long time now, and they also spoke to you at an age at which you would be most likely to believe them, when some of you were children or young lads; and their accusations simply went by default for lack of any defence. But the most absurd thing of all is that one cannot even get to know their names or say who they were—except perhaps one who happens to be a comic playwright. The ones who have persuaded you by malicious slander, and also some who persuade others because they have been persuaded themselves, are all very hard to deal with: one cannot put any of them on the stand here in court, or cross-examine anybody, but one must literally engage in a sort of shadow-boxing to defend oneself, and cross-examine without anyone to answer. You too, then, should allow, as I just said, that I have

two sets of accusers: one set who have accused me recently, and the other of long standing to whom I was just referring. And please grant that I need to defend myself against the latter first, since you too heard them accusing me earlier, and you heard far more from them than from these recent critics here.

Very well, then. I must defend myself, fellow Athenians, and in so short a time must try to dispel the slander which you have had so long to absorb. That is the outcome I would wish for, should it be of any benefit to you and to me, and I should like to succeed in my defence—though I believe the task to be a difficult one, and am well aware of its nature. But let that turn out as God wills: I have to obey the law and present my defence.

Let us examine, from the beginning, the charge that has given rise to the slander against me—which was just what Meletus relied upon when he drew up this indictment. Very well then, what were my slanderers actually saying when they slandered me? Let me read out their deposition, as if they were my legal accusers:

"Socrates is guilty of being a busybody, in that he inquires into what is beneath the earth and in the sky, turns the weaker argument into the stronger, and teaches others to do the same."

The charges would run something like that. Indeed, you can see them for yourselves, enacted in Aristophanes' comedy: in that play, a character called "Socrates" swings around, claims to be walking on air, and talks a lot of other nonsense on subjects of which I have no understanding, great or small.

Not that I mean to belittle knowledge of that sort, if anyone really is learned in such matters—no matter how many of Meletus' lawsuits I might have to defend myself against—but the fact is, fellow Athenians, those subjects are not my concern at all. I call most of you to witness yourselves, and I ask you to make that quite clear to one another, if you have ever

heard me in discussion (as many of you have). Tell one another, then, whether any of you has ever heard me discussing such subjects, either briefly or at length; and as a result you will realize that the other things said about me by the public are equally baseless.

In any event, there is no truth in those charges. Moreover, if you have heard from anyone that I undertake to educate people and charge fees, there is no truth in that either—though for that matter I do think it also a fine thing if anyone *is* able to educate people, as Gorgias of Leontini, Prodicus of Ceos, and Hippias of Elis profess to. Each of them can visit any city, gentlemen, and persuade its young people, who may associate free of charge with any of their own citizens they wish, to leave those associations, and to join with them instead, paying fees and being grateful into the bargain.

On that topic, there is at present another expert here, a gentleman from Paros; I heard of his visit, because I happened to run into a man who has spent more money on sophists than everyone else put together—Callias, the son of Hipponicus. So I questioned him, since he has two sons himself.

"Callias," I said, "if your two sons had been born as colts or calves, we could find and engage a tutor who could make them both excel superbly in the required qualities—and he'd be some sort of expert in horse-rearing or agriculture. But seeing that they are actually human, whom do you intend to engage as their tutor? Who has knowledge of the required human and civic qualities? I ask, because I assume you've given thought to the matter, having sons yourself. Is there such a person," I asked, "or not?"

"Certainly," he replied.

"Who is he?" I said; "Where does he come from, and what does he charge for tuition?"

"His name is Evenus, Socrates," he replied; "He comes from Paros, and he charges 5 minas."

I thought Evenus was to be congratulated, if he really did possess that skill and imparted it for such a modest charge. I, at any rate, would certainly be giving myself fine airs and graces if I possessed that knowledge. But the fact is, fellow Athenians, I do not.

Now perhaps one of you will interject: "Well then, Socrates, what is the difficulty in your case? What is the source of these slanders against you? If you are not engaged in something out of the ordinary, why ever has so much rumour and talk arisen about you? It would surely never have arisen, unless you were up to something different from most people. Tell us what it is, then, so that we don't jump to conclusions about you."

That speaker makes a fair point, I think; and so I will try to show you just what it is that has earned me my reputation and notoriety. Please hear me out. Some of you will perhaps think I am joking, but I assure you that I shall be telling you the whole truth.

You see, fellow Athenians, I have gained this reputation on account of nothing but a certain sort of wisdom. And what sort of wisdom is that? It is a human kind of wisdom, perhaps, since it might just be true that I have wisdom of that sort. Maybe the people I just mentioned possess wisdom of a superhuman kind; otherwise I cannot explain it. For my part, I certainly do not possess that knowledge; and whoever says I do is lying and speaking with a view to slandering me—

Now please do not protest, fellow Athenians, even if I should sound to you rather boastful: I am not myself the source of the story I am about to tell you, but I shall refer you to a trustworthy authority. As evidence of my wisdom, if such it actually be, and of its nature, I shall call to witness before you the god at Delphi.

You remember Chaerephon, of course. He was a friend of mine from youth, and also a comrade in your party, who shared your recent exile and restoration. You recall too what sort

of man Chaerephon was, how impetuous he was in any undertaking. Well, on one occasion he actually went to the Delphic oracle, and had the audacity to put the following question to it—as I said, please do not make a disturbance, gentlemen—he went and asked if there was anyone wiser than myself; to which the Pythia responded that there was no one. His brother here will testify to the court about that story, since Chaerephon himself is deceased.

b Now keep in mind why I have been telling you this: it is because I am going to explain to you the origin of the slander against me. When I heard the story, I thought to myself: "What ever is the god saying? What can his riddle mean? Since I am all too conscious of not being wise in any matter, great or small, what ever can he mean by pronouncing me to be the wisest? Surely he cannot be lying: for him that would be out of the question."

So for a long time I was perplexed about what he could possibly mean. But then, with great reluctance, I proceeded to investigate the matter somewhat as follows. I went to one of the people who had a reputation for wisdom, c thinking there, if anywhere, to disprove the oracle's utterance and declare to it: "Here is someone wiser than I am, and yet you said that I was the wisest."

So I interviewed this person—I need not mention his name, but he was someone in public life; and when I examined him, my experience went something like this, fellow Athenians: in conversing with him, I formed the opinion that, although the man was thought to be wise by many other people, and especially by himself, yet in reality he was not. So I then d tried to show him that he thought himself wise without being so. I thereby earned his dislike, and that of many people present; but still, as I went away, I thought to myself: "I am wiser than that fellow, anyhow. Because neither of us, I dare say, knows anything of great value; but he thinks he knows a thing when he doesn't; whereas I neither know it in fact, nor think that

I do. At any rate, it appears that I am wiser than he in just this one small respect: if I do not know something, I do not think that I do."

Next, I went to someone else, among people thought to be even wiser than the previous man, and I came to the same conclusion again; e and so I was disliked by that man too, as well as by many others.

Well, after that I went on to visit one person after another. I realized, with dismay and alarm, that I was making enemies; but even so, I thought it my duty to attach the highest importance to the god's business; and therefore, in seeking the oracle's meaning, I had to go on to examine all those with any reputation 22a for knowledge. And upon my word, fellow Athenians—because I am obliged to speak the truth before the court—I truly did experience something like this: as I pursued the god's inquiry, I found those held in the highest esteem were practically the most defective, whereas men who were supposed to be their inferiors were much better off in respect of understanding.

Let me, then, outline my wanderings for you, the various "labours" I kept undertaking, only to find that the oracle proved completely irrefutable. After I had done with the politicians, I turned to the poets—including tragedians, dithyrambic poets, and the rest—thinking b that in their company I would be shown up as more ignorant than they were. So I picked up the poems over which I thought they had taken the most trouble, and questioned them about their meaning, so that I might also learn something from them in the process.

Now I'm embarrassed to tell you the truth, gentlemen, but it has to be said. Practically everyone else present could speak better than the poets themselves about their very own compositions. And so, once more, I soon realized this truth about them too: it was not from c wisdom that they composed their works, but from a certain natural aptitude and inspiration, like that of seers and soothsayers—because

those people too utter many fine words, yet know nothing of the matters on which they pronounce. It was obvious to me that the poets were in much the same situation; yet at the same time I realized that because of their compositions they thought themselves the wisest people in other matters as well, when they were not. So I left, believing that I was ahead of them in the same way as I was ahead of the politicians.

d Then, finally, I went to the craftsmen, because I was conscious of knowing almost nothing myself, but felt sure that amongst them, at least, I would find much valuable knowledge. And in that expectation I was not disappointed: they did have knowledge in fields where I had none, and in that respect they were wiser than I. And yet, fellow Athenians, those able craftsmen seemed to me to suffer from the same failing as the poets: because of their excellence at their own trade, each claimed to be a great expert also on matters of the utmost importance; and this arrogance e of theirs seemed to eclipse their wisdom. So I began to ask myself, on the oracle's behalf, whether I should prefer to be as I am, neither wise as they are wise, nor ignorant as they are ignorant, or to possess both their attributes; and in reply, I told myself and the oracle that I was better off as I was.

The effect of this questioning, fellow Athenians, was to earn me much hostility of a very vexing and trying sort, which has given rise to numerous slanders, including this reputation I have for being "wise"—because those present on each occasion imagine me to be wise regarding the matters on which I examine others. But in fact, gentlemen, it would appear that it is only the god who is truly wise; and that he is saying to us, through this oracle, that human wisdom is worth little or nothing. b It seems that when he says "Socrates," he makes use of my name, merely taking me as an example—as if to say, "The wisest amongst you, human beings, is anyone like Socrates

who has recognized that with respect to wisdom he is truly worthless."

That is why, even to this day, I still go about seeking out and searching into anyone I believe to be wise, citizen or foreigner, in obedience to the god. Then, as soon as I find that someone is not wise, I assist the god by proving that he is not. Because of this occupation, I have had no time at all for any activity to speak of, either in public affairs or in my family life; indeed, because of my service to c the god, I live in extreme poverty.

In addition, the young people who follow me around of their own accord, the ones who have plenty of leisure because their parents are wealthiest, enjoy listening to people being cross-examined. Often, too, they copy my example themselves, and so attempt to cross-examine others. And I imagine that they find a great abundance of people who suppose themselves to possess some knowledge, but really know little or nothing. Consequently, the people they question are angry with me, though d not with themselves, and say that there is a nasty pestilence abroad called "Socrates," who is corrupting the young.

Then, when asked just what he is doing or teaching, they have nothing to say, because they have no idea what he does; yet, rather than seem at a loss, they resort to the stock charges against all who pursue intellectual inquiry, trotting out "things in the sky and beneath the earth," "failing to acknowledge the gods," and "turning the weaker argument into the stronger." They would, I imagine, be loath to admit the truth, which is that their pretensions to knowledge have been exposed, and they are e totally ignorant. So because these people have reputations to protect, I suppose, and are also both passionate and numerous, and have been speaking about me in a vigorous and persuasive style, they have long been filling your ears with vicious slander. It is on the strength of all this that Meletus, along with Anytus and Lycon, has proceeded against me: Meletus is

24a aggrieved for the poets, Anytus for the crafts-men and politicians, and Lycon for the ora-tors. And so, as I began by saying, I should be surprised if I could rid your minds of this slander in so short a time, when so much of it has accumulated.

There is the truth for you, fellow Athenians. I have spoken it without concealing anything from you, major or minor, and without glossing over anything. And yet I am virtually certain that it is my very candour that makes enemies for me—which goes to show that I am right: the slander against me is to that effect, and b such is its explanation. And whether you look for one now or later, that is what you will find.

So much for my defence before you against the charges brought by my first group of accus-ers. Next, I shall try to defend myself against Meletus, good patriot that he claims to be, and against my more recent critics. So once again, as if they were a fresh set of accusers, let me in turn review their deposition. It runs something like this:

"Socrates is guilty of corrupting the young, and of failing to acknowledge the gods ack-c nowledged by the city, but introducing new spiritual beings instead."

Such is the charge: let us examine each item within it.

Meletus says, then, that I am guilty of cor-rupting the young. Well I reply, fellow Athe-nians, that Meletus is guilty of trifling in a serious matter, in that he brings people to trial on frivolous grounds, and professes grave concern about matters for which he has never cared at all. I shall now try to prove to you too that that is so.

Step forward, Meletus, and answer me. It is d your chief concern, is it not, that our younger people shall be as good as possible?

—It is.

Very well, will you please tell the judges who influences them for the better—because you must obviously know, seeing that you care? Having discovered me, as you allege, to be the one who is corrupting them, you bring me before the judges here and accuse me. So speak up, and tell the court who has an improv-ing influence.

You see, Meletus, you remain silent, and have no answer. Yet doesn't that strike you as shameful, and as proof in itself of exactly what I say—that you have never cared about these matters at all? Come then, good fellow, tell us who influences them for the better.

—The laws.

Yes, but that is not what I'm asking, excel- e lent fellow. I mean, which *person*, who already knows the laws to begin with?

—These gentlemen, the judges, Socrates.

What are you saying, Meletus? Can these people educate the young, and do they have an improving influence?

—Most certainly.

All of them, or some but not others?

—All of them.

My goodness, what welcome news, and what a generous supply of benefactors you speak of! And how about the audience here in court? Do they too have an improving influ- 25a ence, or not?

—Yes, they do too.

And how about members of the Council?

—Yes, the Councillors too.

But in that case, how about people in the Assembly, its individual members, Meletus? They won't be corrupting their youngers, will they? Won't they all be good influences as well?

—Yes, they will too.

So every person in Athens, it would appear, has an excellent influence on them except for me, whereas I alone am corrupting them. Is that what you're saying?

—That is emphatically what I'm saying.

Then I find myself, if we are to believe you, in a most awkward predicament. Now answer me this. Do you think the same is true b of horses? Is it everybody who improves them,

while a single person spoils them? Or isn't the opposite true: a single person, or at least very few people, namely the horse-trainers, can improve them; while lay people spoil them, don't they, if they have to do with horses and make use of them? Isn't that true of horses as of all other animals, Meletus? Of course it is, whether you and Anytus deny it or not. In fact, I dare say our young people are extremely lucky if only one person is corrupting them, while everyone else is doing them good.

All right, Meletus. Enough has been said to prove that you never were concerned about the young. You betray your irresponsibility plainly, because you have not cared at all about the charges on which you bring me before this court.

Furthermore, Meletus, tell us, in God's name, whether it is better to live among good fellow citizens or bad ones. Come sir, answer: I am not asking a hard question. Bad people have a harmful impact upon their closest companions at any given time, don't they, whereas good people have a good one?

—Yes.

Well, is there anyone who wants to be harmed by his companions rather than benefited?— Be a good fellow and keep on answering, as the law requires you to. Is there anyone who wants to be harmed?

—Of course not.

Now tell me this. In bringing me here, do you claim that I am corrupting and depraving the young intentionally or unintentionally?

—Intentionally, so I maintain.

Really, Meletus? Are you so much smarter at your age than I at mine as to realize that the bad have a harmful impact upon their closest companions at any given time, whereas the good have a beneficial effect? Am I, by contrast, so far gone in my stupidity as not to realize that if I make one of my companions vicious, I risk incurring harm at his hands? And am I, therefore, as you allege, doing so much damage intentionally?

That I cannot accept from you, Meletus, and neither could anyone else, I imagine. Either I am not corrupting them—or if I am, I am doing so unintentionally; so either way your charge is false. But if I am corrupting them unintentionally, the law does not require me to be brought to court for such mistakes, but rather to be taken aside for private instruction and admonition—since I shall obviously stop doing unintentional damage, if I learn better. But you avoided association with me and were unwilling to instruct me. Instead you bring me to court, where the law requires you to bring people who need punishment rather than enlightenment.

Very well, fellow Athenians. That part of my case is now proven: Meletus never cared about these matters, either a lot or a little. Nevertheless, Meletus, please tell us in what way you claim that I am corrupting our younger people. That is quite obvious, isn't it, from the indictment you drew up? It is by teaching them not to acknowledge the gods acknowledged by the city, but to accept new spiritual beings instead? You mean, don't you, that I am corrupting them by teaching them that?

—I most emphatically do.

Then, Meletus, in the name of those very gods we are now discussing, please clarify the matter further for me, and for the jury here. You see, I cannot make out what you mean. Is it that I am teaching people to acknowledge that some gods exist—in which case it follows that I do acknowledge their existence myself as well, and am not a complete atheist, hence am not guilty on that count—and yet that those gods are not the ones acknowledged by the city, but different ones? Is that your charge against me—namely, that they are different? Or are you saying that I acknowledge no gods at all myself, and teach the same to others?

—I am saying the latter: you acknowledge no gods at all.

What ever makes you say that, Meletus, you strange fellow? Do I not even acknowledge,

then, with the rest of mankind, that the sun and the moon are gods?

—By God, he does not, members of the jury, since he claims that the sun is made of rock, and the moon of earth!

My dear Meletus, do you imagine that it is Anaxagoras you are accusing? Do you have such contempt for the jury, and imagine them so illiterate as not to know that books by Anaxagoras of Clazomenae are crammed with such assertions? What's more, are the young e learning those things from me when they can acquire them at the bookstalls, now and then, for a drachma at most, and so ridicule Socrates if he claims those ideas for his own, especially when they are so bizarre? In God's name, do you really think me as crazy as that? Do I acknowledge the existence of no god at all?

—By God no, none whatever.

I can't believe you, Meletus—nor, I think, can you believe yourself. To my mind, fellow Athenians, this fellow is an impudent scoun- 27a drel who has framed this indictment out of sheer wanton impudence and insolence. He seems to have devised a sort of riddle in order to try me out: "Will Socrates the Wise tumble to my nice self-contradiction? Or shall I fool him along with my other listeners?" You see, he seems to me to be contradicting himself in the indictment. It's as if he were saying: "Socrates is guilty of not acknowledging gods, but of acknowledging gods"; and yet that is sheer tomfoolery.

I ask you to examine with me, gentle- men, just how that appears to be his meaning. b Answer for us, Meletus; and the rest of you, please remember my initial request not to protest if I conduct the argument in my usual manner.

Is there anyone in the world, Meletus, who acknowledges that human phenomena exist, yet does not acknowledge human beings?— Require him to answer, gentlemen, and not to raise all kinds of confused objections. Is there anyone who does not acknowledge horses, yet does acknowledge equestrian phenom- ena? Or who does not acknowledge that musi- cians exist, yet does acknowledge musical phenomena?

There is no one, excellent fellow: if you don't wish to answer, I must answer for you, and for the jurors here. But at least answer my c next question yourself. Is there anyone who acknowledges that spiritual phenomena exist, yet does not acknowledge spirits?

—No.

How good of you to answer—albeit reluc- tantly and under compulsion from the jury. Well now, you say that I acknowledge spiritual beings and teach others to do so. Whether they actually be new or old is no matter: I do at any rate, by your account, acknowledge spiritual beings, which you have also mentioned in your sworn deposition. But if I acknowledge spirit- ual beings, then surely it follows quite inevita- bly that I must acknowledge spirits. Is that not so?—Yes, it is so: I assume your agreement, since you don't answer. But we regard spirits, d don't we, as either gods or children of gods? Yes or no?

—Yes.

Then given that I do believe in spirits, as you say, if spirits are gods of some sort, this is precisely what I claim when I say that you are presenting us with a riddle and making fun of us: you are saying that I do not believe in gods, and yet again that I do believe in gods, seeing that I believe in spirits.

On the other hand, if spirits are children of gods, some sort of bastard offspring from nymphs—or from whomever they are tradition- ally said, in each case, to be born—then who in the world could ever believe that there were children of gods, yet no gods? That would be e just as absurd as accepting the existence of chil- dren of horses and asses—namely, mules—yet rejecting the existence of horses or asses!

In short, Meletus, you can only have drafted this either by way of trying us out, or because you were at a loss how to charge me with a

genuine offence. How could you possibly persuade anyone with even the slightest intelligence that someone who accepts spiritual

28a beings does not also accept divine ones, and again that the same person also accepts neither spirits nor gods nor heroes? There is no conceivable way.

But enough, fellow Athenians. It needs no long defence, I think, to show that I am not guilty of the charges in Meletus' indictment; the foregoing will suffice. You may be sure, though, that what I was saying earlier is true: I have earned great hostility among many people. And that is what will convict me, if I am convicted: not Meletus or Anytus, but the slan-

b der and malice of the crowd. They have certainly convicted many other good men as well, and I imagine they will do so again; there is no risk of their stopping with me.

Now someone may perhaps say: "Well then, are you not ashamed, Socrates, to have pursued a way of life which has now put you at risk of death?"

But it may be fair for me to answer him as follows: "You are sadly mistaken, fellow, if you suppose that a man with even a grain of self-respect should reckon up the risks of living or dying, rather than simply con-

c sider, whenever he does something, whether his actions are just or unjust, the deeds of a good man or a bad one." By your principles, presumably, all those demigods who died in the plain of Troy were inferior creatures—yes, even the son of Thetis, who showed so much scorn for danger, when the alternative was to endure dishonour. Thus, when he was eager to slay Hector, his mother, goddess that she was, spoke to him—something like this, I fancy:

"My child, if thou dost avenge the murder of thy
 friend, Patroclus,
And dost slay Hector, then straightway [so runs
 the poem]

Shalt thou die thyself, since doom is prepared
 for thee
Next after Hector's."

But though he heard that, he made light of d
death and danger, since he feared far more to
live as a base man, and to fail to avenge his
dear ones. The poem goes on:

"Then straightway let me die, once I have given
 the wrongdoer
His deserts, lest I remain here by the
 beakprowed ships,
An object of derision, and a burden upon
 the earth."

Can you suppose that he gave any thought
to death or danger?

You see, here is the truth of the matter, fellow Athenians. Wherever a man has taken up a position because he considers it best, or has been posted there by his commander, that is where I believe he should remain, steadfast in danger, taking no account at all of death or of anything else rather than dishonour. I would therefore have been acting absurdly, fellow e
Athenians, if when assigned to a post at Potidaea, Amphipolis, or Delium by the superiors you had elected to command me, I remained where I was posted on those occasions at the risk of death, if ever any man did—whereas now that the god assigns me, as I became completely convinced, to the duty of leading the 29a
philosophical life by examining myself and others, I desert that post from fear of death or anything else. Yes, that would be unthinkable; and then I truly should deserve to be brought to court for failing to acknowledge the gods' existence, in that I was disobedient to the oracle, was afraid of death, and thought I was wise when I was not.

After all, gentlemen, the fear of death amounts simply to thinking one is wise when one is not: it is thinking one knows something one does not know. No one knows, you see,

whether death may not in fact prove the greatest of all blessings for mankind; but people fear it as if they knew it for certain to be the greatest of evils. And yet to think that one knows what one does not know must surely be the kind of folly which is reprehensible.

On this matter especially, gentlemen, that may be the nature of my own advantage over most people. If I really were to claim to be wiser than anyone in any respect, it would consist simply in this: just as I do not possess adequate knowledge of life in Hades, so I also realize that I do not possess it; whereas acting unjustly in disobedience to one's betters, whether god or human being, is something I *know* to be evil and shameful. Hence I shall never fear or flee from something which may indeed be a good for all I know, rather than from things I know to be evils.

Suppose, therefore, that you pay no heed to Anytus, but are prepared to let me go. He said I need never have been brought to court in the first place, but that once I had been, your only option was to put me to death. He declared before you that, if I got away from you this time, your sons would all be utterly corrupted by practising Socrates' teachings. Suppose, in the face of that, you were to say to me:

"Socrates, we will not listen to Anytus this time. We are prepared to let you go—but only on this condition: you are to pursue that quest of yours and practise philosophy no longer; and if you are caught doing it any more, you shall be put to death."

Well, as I just said, if you were prepared to let me go on those terms, I should reply to you as follows:

"I have the greatest fondness and affection for you, fellow Athenians, but I will obey my god rather than you; and so long as I draw breath and am able, I shall never give up practising philosophy, or exhorting and showing the way to any of you whom I ever encounter, by giving my usual sort of message. 'Excellent friend,' I shall say; 'You are an Athenian. Your city is the most important and renowned for its wisdom and power; so are you not ashamed that, while you take care to acquire as much wealth as possible, with honour and glory as well, yet you take no care or thought for understanding or truth, or for the best possible state of your soul?' "

"And should any of you dispute that, and claim that he does take such care, I will not let him go straight away nor leave him, but I will question and examine and put him to the test; and if I do not think he has acquired goodness, though he says he has, I shall say, 'Shame on you, for setting the lowest value upon the most precious things, and for rating inferior ones more highly!' That I shall do for anyone I encounter, young or old, alien or fellow citizen; but all the more for the latter, since your kinship with me is closer."

Those are my orders from my god, I do assure you. Indeed, I believe that no greater good has ever befallen you in our city than my service to my god; because all I do is to go about, persuading you, young and old alike, not to care for your bodies or for your wealth so intensely as for the greatest possible well-being of your souls. "It is not wealth," I tell you, "that produces goodness; rather, it is from goodness that wealth, and all other benefits for human beings, accrue to them in their private and public life."

If, in fact, I am corrupting the young by those assertions, you may call them harmful. But if anyone claims that I say anything different, he is talking nonsense. In the face of that I should like to say: "Fellow Athenians, you may listen to Anytus or not, as you please; and you may let me go or not, as you please, because there is no chance of my acting otherwise, even if I have to die many times over—"

Stop protesting, fellow Athenians! Please abide by my request that you not protest against what I say, but hear me out; in fact, it

will be in your interest, so I believe, to do so. You see, I am going to say some further things to you which may make you shout out— although I beg you not to.

You may be assured that if you put to death the sort of man I just said I was, you will not harm me more than you harm yourselves. Meletus or Anytus would not harm me at all; nor, in fact, could they do so, since I believe it is out of the question for a better man to be harmed by his inferior. The latter may, of course, inflict death or banishment or disenfranchisement; and my accuser here, along with others no doubt, believes those to be great evils. But I do not. Rather, I believe it a far greater evil to try to kill a man unjustly, as he does now.

At this point, therefore, fellow Athenians, so far from pleading on my own behalf, as might be supposed, I am pleading on yours, in case by condemning me you should mistreat the gift which God has bestowed upon you— because if you put me to death, you will not easily find another like me. The fact is, if I may put the point in a somewhat comical way, that I have been literally attached by God to our city, as if to a horse—a large thoroughbred, which is a bit sluggish because of its size, and needs to be aroused by some sort of gadfly. Yes, in me, I believe, God has attached to our city just such a creature—the kind which is constantly alighting everywhere on you, all day long, arousing, cajoling, or reproaching each and every one of you. You will not easily acquire another such gadfly, gentlemen; rather, if you take my advice, you will spare my life. I dare say, though, that you will get angry, like people who are awakened from their doze. Perhaps you will heed Anytus, and give me a swat: you could happily finish me off, and then spend the rest of your life asleep—unless God, in his compassion for you, were to send you someone else.

That I am, in fact, just the sort of gift that God would send to our city, you may recognize from this: it would not seem to be in human nature for me to have neglected all my own affairs, and put up with the neglect of my family for all these years, but constantly minded your interests, by visiting each of you in private like a father or an elder brother, urging you to be concerned about goodness. Of course, if I were gaining anything from that, or were being paid to urge that course upon you, my actions could be explained. But in fact you can see for yourselves that my accusers, who so shamelessly level all those other charges against me, could not muster the impudence to call evidence that I ever once obtained payment, or asked for any. It is I who can call evidence sufficient, I think, to show that I am speaking the truth—namely, my poverty.

Now it may perhaps seem peculiar that, as some say, I give this counsel by going around and dealing with others' concerns in private, yet do not venture to appear before the Assembly, and counsel the city about your business in public. But the reason for that is one you have frequently heard me give in many places: it is a certain divine or spiritual sign which comes to me, the very thing to which Meletus made mocking allusion in his indictment. It has been happening to me ever since childhood: a voice of some sort which comes, and which always—whenever it does come—restrains me from what I am about to do, yet never gives positive direction. That is what opposes my engaging in politics—and its opposition is an excellent thing, to my mind; because you may be quite sure, fellow Athenians, that if I had tried to engage in politics, I should have perished long since, and should have been of no use either to you or to myself.

And please do not get angry if I tell you the truth. The fact is that there is no person on earth whose life will be spared by you or by any other majority, if he is genuinely opposed to many injustices and unlawful acts, and tries to prevent their occurrence in our city. Rather, anyone who truly fights for what is just, if he is

going to survive for even a short time, must act in a private capacity rather than a public one.

I will offer you conclusive evidence of that—not just words, but the sort of evidence that you respect, namely, actions. Just hear me tell my experiences, so that you may know that I would not submit to a single person for fear of death, contrary to what is just; nor would I do so, even if I were to lose my life on the spot. I shall mention things to you which are vulgar commonplaces of the courts; yet they are true.

b Although I have never held any other public office in our city, fellow Athenians, I have served on its Council. My own tribe, Antiochis, happened to be the presiding commission on the occasion when you wanted a collective trial for the ten generals who had failed to rescue the survivors from the naval battle. That was illegal, as you all later recognized. At the time I was the only commissioner opposed to your acting illegally, and I voted against the motion. And though its advocates were prepared to lay information against me and have me arrested, while you c were urging them on by shouting, I believed that I should face danger in siding with law and justice, rather than take your side for fear of imprisonment or death, when your proposals were contrary to justice.

Those events took place while our city was still under democratic rule. But on a subsequent occasion, after the oligarchy had come to power, the Thirty summoned me and four others to the round chamber, with orders to arrest Leon the Salaminian, and fetch him from Salamis for execution; they were constantly issuing such orders, of course, to many others, in their wish to implicate as many as possible in their crimes. On that occasion, however, d I showed, once again not just by words, but by my actions, that I couldn't care less about death—if that would not be putting it rather crudely—but that my one and only care was to avoid doing anything sinful or unjust. Thus, powerful as it was, that regime did not frighten

me into unjust action: when we emerged from the round chamber, the other four went off to Salamis and arrested Leon, whereas I left them and went off home. For that I might easily have been put to death, had the regime not collapsed e shortly afterwards. There are many witnesses who will testify before you about those events.

Do you imagine, then, that I would have survived all these years if I had been regularly active in public life, and had championed what was right in a manner worthy of a brave man, and valued that above all else, as was my duty? Far from it, fellow Athenians. I would not, and nor would any other man. But 33a in any public undertaking, that is the sort of person that I, for my part, shall prove to have been throughout my life; and likewise in my private life, because I have never been guilty of unjust association with anyone, including those whom my slanderers allege to have been my students.

I never, in fact, was anyone's instructor at any time. But if a person wanted to hear me talking, while I was engaging in my own business, I never grudged that to anyone, young or old; nor do I hold conversation only when b I receive payment, and not otherwise. Rather, I offer myself for questioning to wealthy and poor alike, and to anyone who may wish to answer in response to questions from me. Whether any of those people acquires a good character or not, I cannot fairly be held responsible, when I never at any time promised any of them that they would learn anything from me, nor gave them instruction. And if anyone claims that he ever learnt anything from me, or has heard privately something that everyone else did not hear as well, you may be sure that what he says is untrue.

Why then, you may ask, do some people enjoy spending so much time in my company?— c You have already heard, fellow Athenians: I have told you the whole truth—which is that my listeners enjoy the examination of those who think themselves wise but are not, since

the process is not unamusing. But for me, I must tell you, it is a mission which I have been bidden to undertake by the god, through oracles and dreams, and through every means whereby a divine injunction to perform any task has ever been laid upon a human being.

d That is not only true, fellow Athenians, but is easily verified—because if I do corrupt any of our young people, or have corrupted others in the past, then presumably, when they grew older, should any of them have realized that I had at any time given them bad advice in their youth, they ought now to have appeared here themselves to accuse me and obtain redress. Or else, if they were unwilling to come in person, members of their families—fathers, brothers, or other relations—had their relatives suffered any harm at my hands, ought now to put it on record and obtain redress.

e In any case, many of those people are present, whom I can see: first there is Crito, my contemporary and fellow demesman, father of Critobulus here; then Lysanias of Sphettus, father of Aeschines here; next, Epigenes' father, Antiphon from Cephisia, is present; then again, there are others here whose brothers have spent time with me in these studies: Nicostratus, son of Theozotides, brother of Theodotus—Theodotus himself, incidentally, is deceased, so Nico-
34a stratus could not have come at his brother's urging; and Paralius here, son of Demodocus, whose brother was Theages; also present is Ariston's son, Adimantus, whose brother is Plato here; and Aeantodorus, whose brother is Apollodorus here.

There are many others I could mention to you, from whom Meletus should surely have called some testimony during his own speech. However, if he forgot to do so then, let him call it now—I yield the floor to him—and if he has any such evidence, let him produce it. But quite the opposite is true, gentlemen: you will find that they are all prepared to support me, their corruptor, the one who is, according to Meletus and Anytus, doing their relatives b mischief. Support for me from the actual victims of corruption might perhaps be explained; but what of the uncorrupted—older men by now, and relatives of my victims? What reason would they have to support me, apart from the right and proper one, which is that they know very well that Meletus is lying, whereas I am telling the truth?

There it is, then, gentlemen. That, and perhaps more of the same, is about all I have to say in my defence. But perhaps, among your number, there may be someone who will harbour resent- c ment when he recalls a case of his own: he may have faced a less serious trial than this one, yet begged and implored the jury, weeping copiously, and producing his children here, along with many other relatives and loved ones, to gain as much sympathy as possible. By contrast, I shall do none of those things, even though I am running what might be considered the ultimate risk. Perhaps someone with those thoughts will harden his heart against me; and enraged by those same thoughts, he may cast his vote d against me in anger. Well, if any of you are so inclined—not that I expect it of you, but if anyone *should* be—I think it fair to answer him as follows:

"I naturally do have relatives, my excellent friend, because—in Homer's own words— I too was 'not born of oak nor of rock,' but of human parents; and so I do have relatives— including my sons, fellow Athenians. There are three of them: one is now a youth, while two are still children. Nevertheless, I shall not produce any of them here, and then entreat you to vote for my acquittal."

And why, you may ask, will I do no such thing? Not out of contempt or disrespect for e you, fellow Athenians—whether or not I am facing death boldly is a different issue. The point is that with our reputations in mind— yours and our whole city's, as well as my own—I believe that any such behaviour would

be ignominious, at my age and with the reputation I possess; that reputation may or may not, in fact, be deserved, but at least it is believed that Socrates stands out in some way from the run of human beings. Well, if those of you who are believed to be pre-eminent in wisdom, courage, or any other form of goodness, are going to behave like that, it would be demeaning.

35a

I have frequently seen such men when they face judgment: they have significant reputations, yet they put on astonishing performances, apparently in the belief that by dying they will suffer something unheard of—as if they would be immune from death, so long as you did not kill them! They seem to me to put our city to shame: they could give any foreigner the impression that men preeminent among Athenians in goodness, whom they select from their own number to govern and hold other positions, are no better than women. I say this, fellow Athenians, because none of us who has even the slightest reputation should behave like that; nor should you put up with us if we try to do so. Rather, you should make one thing clear: you will be far more inclined to convict one who stages those pathetic charades and makes our city an object of derision, than one who keeps his composure.

b

But leaving reputation aside, gentlemen, I do not think it right to entreat the jury, nor to win acquittal in that way, instead of by informing and persuading them. A juror does not sit to dispense justice as a favour, but to determine where it lies. And he has sworn, not that he will favour whomever he pleases, but that he will try the case according to law. We should not, then, accustom you to transgress your oath, nor should you become accustomed to doing so: neither of us would be showing respect towards the gods. And therefore, fellow Athenians, do not require behaviour from me towards you which I consider neither proper nor right nor pious—more especially now, for God's sake, when I stand charged by Meletus

c

d

here with impiety: because if I tried to persuade and coerce you with entreaties in spite of your oath, I clearly *would* be teaching you not to believe in gods; and I would stand literally self-convicted, by my defence, of failing to acknowledge them. But that is far from the truth: I do acknowledge them, fellow Athenians, as none of my accusers do; and I trust to you, and to God, to judge my case as shall be best for me and for yourselves.

For many reasons fellow Athenians, I am not dismayed by this outcome[1]—your convicting me, I mean—and especially because the outcome has come as no surprise to me. I wonder far more at the number of votes cast on each side, because I did not think the margin would be so narrow. Yet it seems, in fact, that if a mere thirty votes had gone the other way, I should have been acquitted. Or rather, even as things stand, I consider that I have been cleared of Meletus' charges. Not only that, but one thing is obvious to everyone: if Anytus had not come forward with Lycon to accuse me, Meletus would have forfeited 1,000 drachmas, since he would not have gained one-fifth of the votes cast.

e

36a

b

But anyhow, this gentleman demands the death penalty for me. Very well, then: what alternative penalty shall I suggest to you, fellow Athenians? Clearly, it must be one I deserve. So what do I deserve to incur or to pay, for having taken it into my head not to lead an inactive life? Instead, I have neglected the things that concern most people—making money, managing an estate, gaining military or civic honours, or other positions of power, or joining political clubs and parties which have formed in our city. I thought myself, in truth, too honest to survive if I engaged in those things. I did not pursue a course, therefore, in which I would be of no use to you or to myself. Instead, by going to each individual privately, I tried to render a service for you which is—so I maintain—the highest service of all. Therefore that was the course

c

I followed: I tried to persuade each of you not to care for any of his possessions rather than care for himself, striving for the utmost excel-

d lence and understanding; and not to care for our city's possessions rather than for the city itself; and to care about other things in the same way.

So what treatment do I deserve for being such a benefactor? If I am to make a proposal truly in keeping with my deserts, fellow Athenians, it should be some benefit; and moreover, the sort of benefit that would be fitting for me. Well then, what *is* fitting for a poor man who is a benefactor, and who needs time free for exhorting you? Nothing could be more fitting, fellow Athenians, than to give such a man regular free meals in the Prytaneum; indeed, that is far more fitting for him than for any of you who may have won an Olympic race with a pair or a team of horses: that victory brings you only the appearance of success, whereas

e I bring you the reality; besides, he is not in

37a want of sustenance, whereas I am. So if, as justice demands, I am to make a proposal in keeping with my deserts, that is what I suggest: free meals in the Prytaneum.

Now, in proposing this, I may seem to you, as when I talked about appeals for sympathy, to be speaking from sheer effrontery. But actually I have no such motive, fellow Athenians. My point is rather this: I am convinced that I do not treat any human being unjustly, at least intentionally—but I cannot make you share that conviction, because we have conversed together so briefly. I say this, because if it were the law here, as in other jurisdictions, that a capital case must not be tried in a single day, but over several, I think you could have been

b convinced; but as things stand, it is not easy to clear oneself of such grave allegations in a short time.

Since, therefore, I am persuaded, for my part, that I have treated no one unjustly, I have no intention whatever of so treating myself, nor of denouncing myself as deserving ill, or proposing any such treatment for myself.

Why should I do that? For fear of the penalty Meletus demands for me, when I say that I don't know if that is a good thing or a bad one? In preference to that, am I then to choose one of the things I know very well to be bad, and demand that instead? Imprisonment, for instance? Why should I live in prison, in servi-

c tude to the annually appointed prison commissioners? Well then, a fine, with imprisonment until I pay? That would amount to what I just mentioned, since I haven't the means to pay it.

Well then, should I propose banishment? Perhaps that is what you would propose for me. Yet I must surely be obsessed with survival, fellow Athenians, if I am so illogical as that. You, my fellow citizens, were unable to put up with my discourses and arguments, but

d they were so irksome and odious to you that you now seek to be rid of them. Could I not draw the inference, in that case, that others will hardly take kindly to them? Far from it, fellow Athenians. A fine life it would be for a person of my age to go into exile, and spend his days continually exchanging one city for another, and being repeatedly expelled— because I know very well that wherever I go, the young will come to hear me speaking, as they do here. And if I repel them, they will

e expel me themselves, by persuading their elders; while if I do not repel them, their fathers and relatives will expel me on their account.

Now, perhaps someone may say: "Socrates, could you not be so kind as to keep quiet and remain inactive, while living in exile?" This is the hardest point of all of which to convince some of you. Why? Because, if I tell you that that would mean disobeying my god,

38a and that is why I cannot remain inactive, you will disbelieve me and think that I am practising a sly evasion. Again, if I said that it really is the greatest benefit for a person to converse every day about goodness, and about the other subjects you have heard me discussing when examining myself and others—and

that an unexamined life is no life for a human being to live—then you would believe me still less when I made those assertions. But the facts, gentlemen, are just as I claim them to be, though it is not easy to convince you of them. At the same time, I am not accustomed to think of myself as deserving anything bad. If I had money, I would have proposed a fine of as much as I could afford: that would have done me no harm at all. But the fact is that I have none—unless you wish to fix the penalty at a sum I could pay. I could afford to pay you 1 mina, I suppose, so I suggest a fine of that amount—

One moment, fellow Athenians. Plato here, along with Crito, Critobulus, and Apollodorus, is urging me to propose 30 minas, and they are saying they will stand surety for that sum. So I propose a fine of that amount, and these people shall be your sufficient guarantors of its payment.

For the sake of a slight gain in time, fellow Athenians, you will incur infamy and blame from those who would denigrate our city, for putting Socrates to death[2]—a "wise man"—because those who wish to malign you will say I am wise, even if I am not; in any case, had you waited only a short time, you would have obtained that outcome automatically. You can see, of course, that I am now well advanced in life, and death is not far off. I address that not to all of you, but to those who condemned me to death; and to those same people I would add something further.

Perhaps you imagine, gentlemen, that I have been convicted for lack of arguments of the sort I could have used to convince you, had I believed that I should do or say anything to gain acquittal. But that is far from true. I have been convicted, not for lack of arguments, but for lack of brazen impudence and willingness to address you in such terms as you would most like to be addressed in—that is to say, by weeping and wailing, and doing and

saying much else that I claim to be unworthy of me—the sorts of thing that you are so used to hearing from others. But just as I did not think during my defence that I should do anything unworthy of a free man because I was in danger, so now I have no regrets about defending myself as I did; I should far rather present such a defence and die, than live by defending myself in that other fashion.

In court, as in warfare, neither I nor anyone else should contrive to escape death at any cost. On the battlefield too, it often becomes obvious that one could avoid death by throwing down one's arms and flinging oneself upon the mercy of one's pursuers. And in every sort of danger there are many other means of escaping death, if one is shameless enough to do or to say anything. I suggest that it is not death that is hard to avoid, gentlemen, but wickedness is far harder, since it is fleeter of foot than death. Thus, slow and elderly as I am, I have now been overtaken by the slower runner; while my accusers, adroit and quick-witted as they are, have been overtaken by the faster, which is wickedness. And so I take my leave, condemned to death by your judgment, whereas they stand for ever condemned to depravity and injustice as judged by Truth. And just as I accept my penalty, so must they. Things were bound to turn out this way, I suppose, and I imagine it is for the best.

In the next place, to those of you who voted against me, I wish to utter a prophecy. Indeed, I have now reached a point at which people are most given to prophesying—that is, when they are on the point of death. I warn you, my executioners, that as soon as I am dead retribution will come upon you—far more severe, I swear, than the sentence you have passed upon me. You have tried to kill me for now, in the belief that you will be relieved from giving an account of your lives. But in fact, I can tell you, you will face just the opposite outcome. There will be more critics to call you to account, people whom I have restrained for the time being

though you were unaware of my doing so. They will be all the harder on you since they are younger, and you will rue it all the more—because if you imagine that by putting people to death you will prevent anyone from reviling you for not living rightly, you are badly mistaken. That way of escape is neither feasible nor honourable. Rather, the most honourable and easiest way is not the silencing of others, but striving to make oneself as good a person as possible. So with that prophecy to those of you who voted against me, I take my leave.

e As for those who voted for my acquittal, I should like to discuss the outcome of this case while the officials are occupied, and I am not yet on the way to the place where I must die. Please bear with me, gentlemen, just for this short time: there is no reason why we should not have a word with one another while that is still permitted.

40a Since I regard you as my friends, I am willing to show you the significance of what has just befallen me. You see, gentlemen of the jury—and in applying that term to you, I probably use it correctly—something wonderful has just happened to me. Hitherto, the usual prophetic voice from my spiritual sign was continually active, and frequently opposed me even on trivial matters, if I was about to do anything amiss. But now something has befallen me, as you can see for yourselves, which one

b certainly might consider—and is generally held—to be the very worst of evils. Yet the sign from God did not oppose me, either when I left home this morning, or when I appeared here in court, or at any point when I was about to say anything during my speech; and yet in other discussions it has very often stopped me in mid-sentence. This time, though, it has not opposed me at any moment in anything I said or did in this whole business.

Now, what do I take to be the explanation for that? I will tell you: I suspect that what has befallen me is a blessing, and that those of

c us who suppose death to be an evil cannot be

making a correct assumption. I have gained every ground for that suspicion, because my usual sign could not have failed to oppose me, unless I were going to incur some good result.

And let us also reflect upon how good a reason there is to hope that death is a good thing. It is, you see, one or other of two things: either to be dead is to be non-existent, as it were, and a dead person has no awareness whatever of anything at all; or else, as we are told, the soul undergoes some sort of transformation, or exchanging of this present world for another. Now if there is, in fact, no awareness d
in death, but it is like sleep—the kind in which the sleeper does not even dream at all—then death would be a marvellous gain. Why, imagine that someone had to pick the night in which he slept so soundly that he did not even dream, and to compare all the other nights and days of his life with that one; suppose he had to say, upon consideration, how many days or nights in his life he had spent better and more agreeably than that night; in that case, I think he e
would find them easy to count compared with his other days and nights—even if he were the Great King of Persia, let alone an ordinary person. Well, if death is like that, then for my part I call it a gain; because on that assumption the whole of time would seem no longer than a single night.

On the other hand, if death is like taking a trip from here to another place, and if it is true, as we are told, that all of the dead do indeed exist in that other place, why then, gentlemen of the jury, what could be a greater blessing 41a
than that? If upon arriving in Hades, and being rid of these people who profess to be "jurors," one is going to find those who are truly judges, and who are also said to sit in judgment there—Minos, Rhadamanthys, Aeacus, Triptolemus, and all other demigods who were righteous in their own lives—would that be a disappointing journey?

Or again, what would any of you not give to share the company of Orpheus and Musaeus,

of Hesiod and Homer? I say "you," since I personally would be willing to die many times over, if those tales are true. Why? Because my own sojourn there would be wonderful, if I could meet Palamedes, or Ajax, son of Telamon, or anyone else of old who met their death through an unjust verdict. Whenever I met them, I could compare my own experiences with theirs—which would be not unamusing, I fancy—and best of all, I could spend time questioning and probing people there, just as I do here, to find out who among them is truly wise, and who thinks he is without being so.

What would one not give, gentlemen of the jury, to be able to question the leader of the great expedition against Troy, or Odysseus, or Sisyphus, or countless other men and women one could mention? Would it not be unspeakable good fortune to converse with them there, to mingle with them and question them? At least that isn't a reason, presumably, for people in that world to put you to death—because amongst other ways in which people there are more fortunate than those in our world, they have become immune from death for the rest of time, if what we are told is actually true.

Moreover, you too, gentlemen of the jury, should be of good hope in the face of death, and fix your minds upon this single truth: nothing can harm a good man, either in life or in death; nor are his fortunes neglected by the gods. In fact, what has befallen me has come about by no mere accident; rather, it is clear to me that it was better I should die now and be rid of my troubles. That is also the reason why the divine sign at no point turned me back; and for my part, I bear those who condemned me, and my accusers, no ill will at all—though, to be sure, it was not with that intent that they were condemning and accusing me, but with intent to harm me—and they are culpable for that. Still, this much I ask of them. When my sons come of age, gentlemen, punish them: give them the same sort of trouble that I used to give you, if you think they care for money or anything else more than for goodness, and if they think highly of themselves when they are of no value. Reprove them, as I reproved you, for failing to care for the things they should, and for thinking highly of themselves when they are worthless. If you will do that, then I shall have received my own just deserts from you, as will my sons.

But enough. It is now time to leave—for me to die, and for you to live—though which of us has the better destiny is unclear to everyone, save only to God.

Notes

1. The verdict was "Guilty." Socrates here begins his second speech, proposing an alternative to the death penalty demanded by the prosecution.
2. The jury has now voted for the death penalty, and Socrates begins his final speech.

Crito

43a *Socrates.* Why have you come at this hour, Crito? It's still very early, isn't it?
 Crito. Yes, very.
 Socrates. About what time?
 Crito. Just before daybreak.

Socrates. I'm surprised the prisonwarder was willing to answer the door.
 Crito. He knows me by now, Socrates, because I come and go here so often; and besides, I've done him a small favour.

b *Socrates.* Have you just arrived, or have you been here for a while?

Crito. For quite a while.

Socrates. Then why didn't you wake me up right away instead of sitting by me in silence?

Crito. Well *of course* I didn't wake you, Socrates! I only wish I weren't so sleepless and wretched myself. I've been marvelling all this time as I saw how peacefully you were sleeping, and I deliberately kept from waking you, so that you could pass the time as peacefully as possible. I've often admired your disposition in the past, in fact all your life; but more than ever in your present plight, you bear it so easily and patiently.

c *Socrates.* Well, Crito, it really would be tiresome for a man of my age to get upset if the time has come when he must end his life.

Crito. And yet others of your age, Socrates, are over-taken by similar troubles, but their age brings them no relief from being upset at the fate which faces them.

Socrates. That's true. But tell me, why *have* you come so early?

Crito. I bring painful news, Socrates—not painful for you, I suppose, but painful and hard for me and all your friends—and hardest of all
d for me to bear, I think.

Socrates. What news is that? Is it that the ship has come back from Delos, the one on whose return I must die?

Crito. Well no, it hasn't arrived yet, but I think it will get here today, judging from reports of people who've come from Sunium, where they disembarked. That makes it obvious that it will get here today; and so tomorrow, Socrates, you will have to end your life.

Socrates. Well, may that be for the best,
44a Crito. If it so please the gods, so be it. All the same, I don't think it will get here today.

Crito. What makes you think that?

Socrates. I'll tell you. You see, I am to die on the day after the ship arrives, am I not?

Crito. At least that's what the authorities say.

Socrates. Then I don't think it will get here on the day that is just dawning, but on the next one. I infer that from a certain dream I had in the night—a short time ago, so it may be just as well that you didn't wake me.

Crito. And what was your dream?

Socrates. I dreamt that a lovely, handsome woman approached me, robed in white. She b
called me and said: "Socrates,

*Thou shalt reach fertile Phthia upon the
 third day."*

Crito. What a curious dream, Socrates.

Socrates. Yet its meaning is clear, I think, Crito.

Crito. All too clear, it would seem. But please, Socrates, my dear friend, there is still time to take my advice, and make your escape—because if you die, I shall suffer more than one misfortune: not only shall I lose such a friend as I'll never find again, but it will look to many people, who hardly know you or me, as if I'd abandoned you—since I could have rescued c
you if I'd been willing to put up the money. And yet what could be more shameful than a reputation for valuing money more highly than friends? Most people won't believe that it was you who refused to leave this place yourself, despite our urging you to do so.

Socrates. But why should we care so much, my good Crito, about what most people believe? All the most capable people, whom we should take more seriously, will think the matter has been handled exactly as it has been.

Crito. Yet surely, Socrates, you can see d
that one must heed popular opinion too. Your present plight shows by itself that the populace can inflict not the least of evils, but just about the worst, if someone has been slandered in their presence.

Socrates. Ah Crito, if only the populace *could* inflict the worst of evils! Then they would also be capable of providing the greatest of goods, and a fine thing that would be.

But the fact is that they can do neither: they are unable to give anyone understanding or lack of it, no matter what they do.

Crito. Well, if you say so. But tell me this, Socrates: can it be that you are worried for me and your other friends, in case the blackmailers give us trouble, if you escape, for having smuggled you out of here? Are you worried that we might be forced to forfeit all our property as well, or pay heavy fines, or even incur some further penalty? If you're afraid of anything like that, put it out of your mind. In rescuing you we are surely justified in taking that risk, or even worse if need be. Come on, listen to me and do as I say.

Socrates. Yes, those risks do worry me, Crito—amongst many others.

Crito. Then put those fears aside—because no great sum is needed to pay people who are willing to rescue you and get you out of here. Besides, you can surely see that those blackmailers are cheap, and it wouldn't take much to buy them off. My own means are available to you and would be ample, I'm sure. Then again, even if—out of concern on my behalf—you think you shouldn't be spending my money, there are visitors here who are ready to spend theirs. One of them, Simmias from Thebes, has actually brought enough money for this very purpose, while Cebes and quite a number of others are also prepared to contribute. So, as I say, you shouldn't hesitate to save yourself on account of those fears.

And don't let it trouble you, as you were saying in court, that you wouldn't know what to do with yourself if you went into exile. There will be people to welcome you anywhere else you may go: if you want to go to Thessaly, I have friends there who will make much of you and give you safe refuge, so that no one from anywhere in Thessaly will trouble you.

Next, Socrates, I don't think that what you propose—giving yourself up, when you could be rescued—is even just. You are actually hastening to bring upon yourself just the sorts of thing which your enemies would hasten to bring upon you—indeed, they have done so—in their wish to destroy you.

What's more, I think you're betraying those sons of yours. You will be deserting them, if you go off when you could be raising and educating them: as far as you're concerned, they will fare as best they may. In all likelihood, they'll meet the sort of fate which usually befalls orphans once they've lost their parents. Surely, one should either not have children at all, or else see the toil and trouble of their upbringing and education through to the end; yet you seem to me to prefer the easiest path. One should rather choose the path that a good and resolute man would choose, particularly if one professes to cultivate goodness all one's life. Frankly, I'm ashamed for you and for us, your friends: it may appear that this whole predicament of yours has been handled with a certain feebleness on our part. What with the bringing of your case to court when that could have been avoided, the actual conduct of the trial, and now, to crown it all, this absurd outcome of the business, it may seem that the problem has eluded us through some fault or feebleness on our part—in that we failed to save you, and you failed to save yourself, when that was quite possible and feasible, if we had been any use at all.

Make sure, Socrates, that all this doesn't turn out badly, and a disgrace to you as well as us. Come now, form a plan—or rather, don't even plan, because the time for that is past, and only a single plan remains. Everything needs to be carried out during the coming night; and if we go on waiting around, it won't be possible or feasible any longer. Come on, Socrates, do all you can to take my advice, and do exactly what I say.

Socrates. My dear Crito, your zeal will be invaluable if it should have right on its side; but otherwise, the greater it is, the harder it makes matters. We must therefore consider whether or not the course you urge should

be followed—because it is in my nature, not just now for the first time but always, to follow nothing within me but the principle which appears to me, upon reflection, to be best.

I cannot now reject the very principles that I previously adopted, just because this fate has overtaken me; rather, they appear to me much the same as ever, and I respect and honour the same ones that I did before. If we cannot find better ones to maintain in the present situation, you can be sure that I won't agree with you—not even if the power of the populace threatens us, like children, with more bogeymen than it does now, by visiting us with imprisonment, execution, or confiscation of property.

What, then, is the most reasonable way to consider the matter? Suppose we first take up the point you make about what people will think. Was it always an acceptable principle that one should pay heed to some opinions but not to others, or was it not? Or was it acceptable before I had to die, while now it is exposed as an idle assertion made for the sake of talk, when it is really childish nonsense? For my part, Crito, I'm eager to look into this together with you, to see whether the principle is to be viewed any differently, or in the same way, now that I'm in this position, and whether we should disregard or follow it.

As I recall, the following principle always used to be affirmed by people who thought they were talking sense: the principle, as I was just saying, that one should have a high regard for some opinions held by human beings, but not for others. Come now, Crito: don't you think that was a good principle? I ask because you are not, in all foreseeable likelihood, going to die tomorrow, and my present trouble shouldn't impair your judgment. Consider, then: don't you think it a good principle, that one shouldn't respect all human opinions, but only some and not others; or, again, that one shouldn't respect everyone's opinions, but those of some people, and not those of others? What do you say? Isn't that a good principle?

Crito. It is.

Socrates. And one should respect the good ones, but not the bad ones?

Crito. Yes.

Socrates. And good ones are those of people with understanding, whereas bad ones are those of people without it?

Crito. Of course.

Socrates. Now then, once again, how were such points established? When a man is in training, and concentrating upon that, does he pay heed to the praise or censure or opinion of each and every man, or only to those of the individual who happens to be his doctor or trainer?

Crito. Only to that individual's.

Socrates. Then he should fear the censures, and welcome the praises of that individual, but not those of most people.

Crito. Obviously.

Socrates. So he must base his actions and exercises, his eating and drinking, upon the opinion of the individual, the expert supervisor, rather than upon everyone else's.

Crito. True.

Socrates. Very well. If he disobeys that individual and disregards his opinion and his praises, but respects those of most people, who are ignorant, he'll suffer harm, won't he?

Crito. Of course.

Socrates. And what is that harm? What does it affect? What element within the disobedient man?

Crito. Obviously, it affects his body, because that's what it spoils.

Socrates. A good answer. And in other fields too, Crito—we needn't go through them all, but they surely include matters of just and unjust, honourable and dishonourable, good and bad, the subjects of our present deliberation—is it the opinion of most people that we should follow and fear, or is it that of the individual authority—assuming that some expert exists who should be respected and feared above all others? If we don't follow that

person, won't we corrupt and impair the element which (as we agreed) is made better by what is just, but is spoilt by what is unjust? Or is there nothing in all that?

Crito. I accept it myself, Socrates.

Socrates. Well now, if we spoil the part of us that is improved by what is healthy but corrupted by what is unhealthy, because it is not expert opinion that we are following, are our lives worth living once it has been corrupted? The part in question is, of course, the body, isn't it?

Crito. Yes.

Socrates. And are our lives worth living with a poor or corrupted body?

Crito. Definitely not.

Socrates. Well then, are they worth living if the element which is impaired by what is unjust and benefited by what is just has been corrupted? Or do we consider the element to which justice or injustice belongs, whichever part of us it is, to be of less value than the body?

Crito. By no means.

Socrates. On the contrary, it is more precious?

Crito. Far more.

Socrates. Then, my good friend, we shouldn't care all that much about what the populace will say of us, but about what the expert on matters of justice and injustice will say, the individual authority, or Truth. In the first place, then, your proposal that we should care about popular opinion regarding just, honourable, or good actions, and their opposites, is mistaken.

"Even so," someone might say, "the populace has the power to put us to death."

Crito. That's certainly clear enough; one might say that, Socrates.

Socrates. You're right. But the principle we've rehearsed, my dear friend, still remains as true as it was before—for me at any rate. And now consider this further one, to see whether or not it still holds good for us. We

should attach the highest value, shouldn't we, not to living, but to living well?

Crito. Why yes, that still holds.

Socrates. And living well is the same as living honourably or justly? Does that still hold or not?

Crito. Yes, it does.

Socrates. Then in the light of those admissions, we must ask the following question: is it just, or is it not, for me to try to get out of here, when Athenian authorities are unwilling to release me? Then, if it does seem just, let us attempt it; but if it doesn't, let us abandon the idea.

As for the questions you raise about expenses and reputation and bringing up children, I suspect they are the concerns of those who cheerfully put people to death, and would bring them back to life if they could, without any intelligence, namely, the populace. For us, however, because our principle so demands, there is no other question to ask except the one we just raised: shall we be acting justly— we who are rescued as well as the rescuers themselves—if we pay money and do favours to those who would get me out of here? Or shall we in truth be acting unjustly if we do all those things? And if it is clear that we shall be acting unjustly in taking that course, then the question whether we shall have to die through standing firm and holding our peace, or suffer in any other way, ought not to weigh with us in comparison with acting unjustly.

Crito. I think that's finely *said,* Socrates; but do please consider what we should *do.*

Socrates. Let's examine that question together, dear friend; and if you have objections to anything I say, please raise them, and I'll listen to you—otherwise, good fellow, it's time to stop telling me, again and again, that I should leave here against the will of Athens. You see, I set great store upon persuading you as to my course of action, and not acting against your will. Come now, just consider whether you find the starting-point of

49a our inquiry acceptable, and try to answer my questions according to your real beliefs.

Crito. All right, I'll try.

Socrates. Do we maintain that people should on no account whatever do injustice willingly? Or may it be done in some circumstances but not in others? Is acting unjustly in no way good or honourable, as we frequently agreed in the past? Or have all those former agreements been jettisoned during these last few days? Can it be, Crito, that men of our age have long failed to notice, as we earnestly con-

b versed with each other, that we ourselves were no better than children? Or is what we then used to say true above all else? Whether most people say so or not, and whether we must be treated more harshly or more leniently than at present, isn't it a fact, all the same, that acting unjustly is utterly bad and shameful for the agent? Yes or no?

Crito. Yes.

Socrates. So one must not act unjustly at all.

Crito. Absolutely not.

Socrates. Then, even if one is unjustly treated, one should not return injustice, as most people believe—given that one should act not unjustly at all.

c *Crito.* Apparently not.

Socrates. Well now, Crito, should one ever ill-treat anybody or not?

Crito. Surely not, Socrates.

Socrates. And again, when one suffers illtreatment, is it just to return it, as most people maintain, or isn't it?

Crito. It is not just at all.

Socrates. Because there's no difference, I take it, between ill-treating people and treating them unjustly.

Crito. Correct.

Socrates. Then one shouldn't return injustice or ill-treatment to any human being, no

d matter how one may be treated by that person. And in making those admissions, Crito, watch out that you're not agreeing to anything

contrary to your real beliefs. I say that, because I realize that the belief is held by few people, and always will be. Those who hold it share no common counsel with those who don't; but each group is bound to regard the other with contempt when they observe one another's decisions. You too, therefore, should consider very carefully whether you share that belief with me, and whether we may begin our deliberations from the following premiss: neither doing nor returning injustice is ever right, nor should one who is ill-treated defend himself by retaliation. Do you agree? Or do you dis- e sent and not share my belief in that premiss? I've long been of that opinion myself, and I still am now; but if you've formed any different view, say so, and explain it. If you stand by our former view, however, then listen to my next point.

Crito. Well, I do stand by it and share that view, so go ahead.

Socrates. All right, I'll make my next point—or rather, ask a question. Should the things one agrees with someone else be done, provided they are just, or should one cheat?

Crito. They should be done.

Socrates. Then consider what follows. If we leave this place without having persuaded 50a our city, are we or are we not ill-treating certain people, indeed people whom we ought least of all to be ill-treating? And would we be abiding by the things we agreed, those things being just, or not?

Crito. I can't answer your question, Socrates, because I don't understand it.

Socrates. Well, look at it this way. Suppose we were on the point of running away from here, or whatever else one should call it. Then the Laws, or the State of Athens, might come and confront us, and they might speak as follows:

"Please tell us, Socrates, what do you have in mind? With this action you are attempting, b do you intend anything short of destroying us, the Laws and the city as a whole, to the best of

your ability? Do you think that a city can still exist without being overturned, if the legal judgments rendered within it possess no force, but are nullified or invalidated by individuals?"

What shall we say, Crito, in answer to that and other such questions? Because somebody, particularly a legal advocate, might say a great deal on behalf of the law that is being invali-

c dated here, the one requiring that judgments, once rendered, shall have authority. Shall we tell them: "Yes, that is our intention, because the city was treating us unjustly, by not judging our case correctly?" Is that to be our answer, or what?

Crito. Indeed it is, Socrates.

Socrates. And what if the Laws say: "And was that also part of the agreement between you and us, Socrates? Or did you agree to abide by whatever judgments the city rendered?"

Then, if we were surprised by their words, perhaps they might say: "Don't be surprised at what we are saying, Socrates, but answer us, seeing that you like to use question-and-

d answer. What complaint, pray, do you have against the city and ourselves, that you should now attempt to destroy us? In the first place, was it not we who gave you birth? Did your father not marry your mother and beget you under our auspices? So will you inform those of us here who regulate marriages whether you have any criticism of them as poorly framed?"

"No, I have none," I should say.

"Well then, what of the laws dealing with children's upbringing and education, under which you were educated yourself? Did those of us Laws who are in charge of that area not

e give proper direction, when they required your father to educate you in the arts and physical training?"

"They did," I should say.

"Very good. In view of your birth, upbringing, and education, can you deny, first, that you belong to us as our offspring and slave, as your forebears also did? And if so, do you imagine that you are on equal terms with us in

regard to what is just, and that whatever treatment we may accord to you, it is just for you to do the same thing back to us? You weren't on equal terms with your father, or your master (assuming you had one), making it just for you to return the treatment you received— 51a answering back when you were scolded, or striking back when you were struck, or doing many other things of the same sort. Will you then have licence against your fatherland and its Laws, if we try to destroy you, in the belief that that is just? Will you try to destroy us in return, to the best of your ability? And will you claim that in doing so you are acting justly, you who are genuinely exercised about goodness? Or are you, in your wisdom, unaware that, in comparison with your mother and father and all your other forebears, your b fatherland is more precious and venerable, more sacred and held in higher esteem among gods, as well as among human beings who have any sense; and that you should revere your fatherland, deferring to it and appeasing it when it is angry, more than your own father? You must either persuade it, or else do whatever it commands; and if it ordains that you must submit to certain treatment, then you must hold your peace and submit to it: whether that means being beaten or put in bonds, or whether it leads you into war to be wounded or killed, you must act accordingly, and that is what is just; you must neither give way nor retreat, nor leave your position; rather, in warfare, in court, and everywhere else, you must do whatever your city or fatherland commands, or else persuade it c as to what is truly just; and if it is sinful to use violence against your mother or father, it is far more so to use it against your fatherland."

What shall we say to that, Crito? That the Laws are right or not?

Crito. I think they are.

Socrates. "Consider then, Socrates," the Laws might go on, "whether the following is also true: in your present undertaking you are

d not proposing to treat us justly. We gave you birth, upbringing, and education, and a share in all the benefits we could provide for you along with all your fellow citizens. Nevertheless, we proclaim, by the formal granting of permission, that any Athenian who wishes, once he has been admitted to adult status, and has observed the conduct of city business and ourselves, the Laws, may—if he is dissatisfied with us—go wherever he pleases and take his property. Not one of us Laws hinders or forbids that: whether any of you wishes to emigrate to a colony, or

e to go and live as an alien elsewhere, he may go wherever he pleases and keep his property, if we and the city fail to satisfy him.

"We do say, however, that if any of you remains here after he has observed the system by which we dispense justice and otherwise manage our city, then he has agreed with us by his conduct to obey whatever orders we give him. And thus we claim that anyone who fails to obey is guilty on three counts: he disobeys us as his parents; he disobeys those who nurtured him; and after agreeing to obey us he

52a neither obeys nor persuades us if we are doing anything amiss, even though we offer him a choice, and do not harshly insist that he must do whatever we command. Instead, we give him two options: he must either persuade us or else do as we say; yet he does neither. Those are the charges, Socrates, to which we say you too will be liable if you carry out your intention; and among Athenians, you will be not the least liable, but one of the most."

And if I were to say, "How so?" perhaps they could fairly reproach me, observing that I am actually among those Athenians who have made that agreement with them most emphatically.

b "Socrates," they would say, "we have every indication that you were content with us, as well as with our city, because you would never have stayed home here, more than is normal for all other Athenians, unless you were abnormally content. You never left our city

for a festival—except once to go to the Isthmus—nor did you go elsewhere for other purposes, apart from military service. You never travelled abroad, as other people do; nor were c you eager for acquaintance with a different city or different laws: we and our city sufficed for you. Thus, you emphatically opted for us, and agreed to be a citizen on our terms. In particular, you fathered children in our city, which would suggest that you were content with it.

"Moreover, during your actual trial it was open to you, had you wished, to propose exile as your penalty; thus, what you are now attempting to do without the city's consent, you could then have done with it. On that occasion, you kept priding yourself that it would not trouble you if you had to die: you would choose death ahead of exile, so you said. Yet now you dishonour those words, and show no regard for us, the Laws, in your effort to destroy us. You are d acting as the meanest slave would act, by trying to run away in spite of those compacts and agreements you made with us, whereby you agreed to be a citizen on our terms.

"First, then, answer us this question: are we right in claiming that you agreed, by your conduct if not verbally, that you would be a citizen on our terms? Or is that untrue?"

What shall we say in reply to that, Crito? Mustn't we agree?

Crito. We must, Socrates.

Socrates. "Then what does your action amount to," they would say, "except breaking e the compacts and agreements you made with us? By your own admission, you were not coerced or tricked into making them, or forced to reach a decision in a short time: you had seventy years in which it was open to you to leave if you were not happy with us, or if you thought those agreements unfair. Yet you preferred neither Lacedaemon nor Crete—places you often 53a say are well governed—nor any other Greek or foreign city: in fact, you went abroad less often than the lame and the blind or other cripples. Obviously, then, amongst Athenians you

were exceptionally content with our city and with us, its Laws—because who would care for a city apart from its laws? Won't you, then, abide by your agreements now? Yes you will, if you listen to us, Socrates; and then at least you won't make yourself an object of derision by leaving the city.

b "Just consider: if you break those agreements, and commit any of those offences, what good will you do yourself or those friends of yours? Your friends, pretty obviously, will risk being exiled themselves, as well as being disenfranchised or losing their property. As for you, first of all, if you go to one of the nearest cities, Thebes or Megara—they are both well governed—you will arrive as an enemy of their political systems, Socrates: all who are concerned for their own cities will look askance at you, regarding you as a subverter of laws. You will also confirm your jurors in their judgc ment, making them think they decided your case correctly: any subverter of laws, presumably, might well be thought to be a corrupter of young, unthinking people.

"Will you, then, avoid the best-governed cities and the most respectable of men? And if so, will your life be worth living? Or will you associate with those people, and be shameless enough to converse with them? And what will you say to them, Socrates? The things you used to say here, that goodness and justice are most precious to mankind, along with institutions and laws? Don't you think that the pred dicament of Socrates will cut an ugly figure? Surely you must.

"Or will you take leave of those spots, and go to stay with those friends of Crito's up in Thessaly? That, of course, is a region of the utmost disorder and licence; so perhaps they would enjoy hearing from you about your comical escape from gaol, when you dressed up in some outfit, wore a leather jerkin or some other runaway's garb, and altered your appearance. Will no one observe that you, an e old man with probably only a short time left

to live, had the nerve to cling so greedily to life by violating the most important laws? Perhaps not, so long as you don't trouble anyone. Otherwise, Socrates, you will hear a great deal to your own discredit. You will live as every person's toady and lackey; and what will you be doing—apart from living it up in Thessaly, as if you had travelled all the way to Thessaly to have dinner? As for those principles of yours 54a about justice and goodness in general—tell us, where will they be then?

"Well then, is it for your children's sake that you wish to live, in order to bring them up and give them an education? How so? Will you bring them up and educate them by taking them off to Thessaly and making foreigners of them, so that they may gain that advantage too? Or if, instead of that, they are brought up here, will they be better brought up and educated just because you are alive, if you are not with them? Yes, you may say, because those friends of yours will take care of them. Then will they take care of them if you travel to Thessaly, but not take care of them if you travel to Hades? Surely if those professing to be your b friends are of any use at all, you must believe that they will.

"No, Socrates, listen to us, your own nurturers: do not place a higher value upon children, upon life, or upon anything else, than upon what is just, so that when you leave for Hades, this may be your whole defence before the authorities there: to take that course seems neither better nor more just or holy, for you or for any of your friends here in this world. Nor will it be better for you when you reach the next. As things stand, you will leave this world (if c you do) as one who has been treated unjustly not by us Laws, but by human beings; whereas if you go into exile, thereby shamefully returning injustice for injustice and ill-treatment for ill-treatment, breaking the agreements and compacts you made with us, and inflicting harm upon the people you should least harm— yourself, your friends, your fatherland, and

ourselves—then we shall be angry with you in your lifetime; and our brother Laws in Hades will not receive you kindly there, knowing that
d you tried, to the best of your ability, to destroy us too. Come then, do not let Crito persuade you to take his advice rather than ours."

That, Crito, my dear comrade, is what I seem to hear them saying, I do assure you. I am like the Corybantic revellers who think they are still hearing the music of pipes: the sound of those arguments is ringing loudly in my head, and makes me unable to hear the others. As far as these present thoughts of mine go, then, you may be sure that if you object to them, you will plead in vain. None the less, if you think you will do any good, speak up.

Crito. No, Socrates, I've nothing to say.

Socrates. Then let it be, Crito, and let us e act accordingly, because that is the direction in which God is guiding us.

Phaedo

115b When he'd spoken, Crito said: "Very well, Socrates: what instructions have you for these others or for me, about your children or about anything else? What could we do, that would be of most service to you?"

"What I'm always telling you, Crito," said he, "and nothing very new: if you take care for yourselves, your actions will be of service to me and mine, and to yourselves too, whatever they may be, even if you make no promises now; but if you take no care for yourselves, and are unwilling to pursue your lives along the tracks, as it were, marked by our present
c and earlier discussions, then even if you make many firm promises at this time, you'll do no good at all."

"Then we'll strive to do as you say," he said; "but in what fashion are we to bury you?"

"However you wish," said he; "provided you catch me, that is, and I don't get away from you." And with this he laughed quietly, looked towards us and said: "Friends, I can't persuade Crito that I am Socrates here, the one who is now conversing and arranging each of the things being discussed; but he imagines
d I'm that dead body he'll see in a little while, so he goes and asks how he's to bury me! But as for the great case I've been arguing all this time, that when I drink the poison, I shall no longer remain with you, but shall go off and depart for some happy state of the blessed, this, I think, I'm putting to him in vain, while comforting you and myself alike. So please stand surety for me with Crito, the opposite surety to that which he stood for me with the judges: his guarantee was that I *would* stay behind, whereas you must guarantee that, when I die, I shall *not* stay behind, but shall e go off and depart; then Crito will bear it more easily, and when he sees the burning or interment of my body, he won't be distressed for me, as if I were suffering dreadful things, and won't say at the funeral that it is Socrates they are laying out or bearing to the grave or interring. Because you can be sure, my dear Crito, that misuse of words is not only troublesome in itself, but actually has a bad effect on the soul. Rather, you should have confidence, and say you are burying my body; and bury it however you please, and think most proper." 116

After saying this, he rose and went into a room to take a bath, and Crito followed him

but told us to wait. So we waited, talking among ourselves about what had been said and reviewing it, and then again dwelling on how great a misfortune had befallen us, literally thinking of it as if we were deprived of a father and would lead the rest of our life as orphans.

b After he'd bathed and his children had been brought to him—he had two little sons and one big one—and those women of his household had come, he talked with them in Crito's presence, and gave certain directions as to his wishes; he then told the women and children to leave, and himself returned to us.

By now it was close to sunset, as he'd spent a long time inside. So he came and sat down, fresh from his bath, and there wasn't much talk after that. Then the prison official came in,

c stepped up to him and said: "Socrates, I shan't reproach you as I reproach others for being angry with me and cursing, whenever by order of the rulers I direct them to drink the poison. In your time here I've known you for the most generous and gentlest and best of men who have ever come to this place; and now especially, I feel sure it isn't with me that you're angry, but with others, because you know who are responsible. Well now, you know the mes-

d sage I've come to bring: good-bye, then, and try to bear the inevitable as easily as you can." And with this he turned away in tears, and went off.

Socrates looked up at him and said: "Good-bye to you too, and we'll do as you say." And to us he added: "What a civil man he is! Throughout my time here he's been to see me, and sometimes talked with me, and been the best of fellows; and now how generous of him to weep for me! But come on, Crito, let's obey him: let someone bring in the poison, if it has been prepared; if not, let the man prepare it."

e Crito said: "But Socrates, I think the sun is still on the mountains and hasn't yet gone down. And besides, I know of others who've taken the draught long after the order had been given them, and after dining well and drinking plenty, and even in some cases enjoying themselves with those they fancied. Be in no hurry, then: there's still time left."

Socrates said: "It's reasonable for those you speak of to do those things—because they think they gain by doing them; for myself, it's reasonable not to do them; because I think I'll gain nothing by taking the draught a little later: 117 I'll only earn my own ridicule by clinging to life, and being sparing when there's nothing more left. Go on now; do as I ask, and nothing else."

Hearing this, Crito nodded to the boy who was standing nearby. The boy went out, and after spending a long time away he returned, bringing the man who was going to administer the poison, and was carrying it ready-pounded in a cup. When he saw the man, Socrates said: "Well, my friend, you're an expert in these things: what must one do?"

"Simply drink it," he said, "and walk about till a heaviness comes over your legs; then lie b down, and it will act of itself." And with this he held out the cup to Socrates.

He took it perfectly calmly, Echecrates, without a tremor, or any change of colour or countenance; but looking up at the man, and fixing him with his customary stare, he said: "What do you say to pouring someone a libation from this drink? Is it allowed or not?"

"We only prepare as much as we judge the proper dose, Socrates," he said.

"I understand," he said: "but at least one c may pray to the gods, and so one should, that the removal from this world to the next will be a happy one; that is my own prayer: so may it be." With these words he pressed the cup to his lips, and drank it off with good humour and without the least distaste.

Till then most of us had been fairly well able to restrain our tears; but when we saw he was drinking, that he'd actually drunk it, we could do so no longer. In my own case, the tears came pouring out in spite of myself, so that I covered my face and wept for myself—not for him, no,

but for my own misfortune in being deprived of such a man for a companion. Even before me, Crito had moved away, when he was unable to restrain his tears. And Apollodorus, who even earlier had been continuously in tears, now burst forth into such a storm of weeping and grieving, that he made everyone present break down except Socrates himself.

But Socrates said: "What a way to behave, my strange friends! Why, it was mainly for this reason that I sent the women away, so that they shouldn't make this sort of trouble; in fact, I've heard one should die in silence. Come now, calm yourselves and have strength."

When we heard this, we were ashamed and checked our tears. He walked about, and when he said that his legs felt heavy he lay down on his back—as the man told him—and then the man, this one who'd given him the poison, felt him, and after an interval examined his feet and legs; he then pinched his foot hard and asked if he could feel it, and Socrates said not.

After that he felt his shins once more; and moving upwards in this way, he showed us that he was becoming cold and numb. He went on feeling him, and said that when the coldness reached his heart, he would be gone.

By this time the coldness was somewhere in the region of his abdomen, when he uncovered his face—it had been covered over—and spoke; and this was in fact his last utterance: "Crito," he said, "we owe a cock to Asclepius: please pay the debt, and don't neglect it."

"It shall be done," said Crito; "have you anything else to say?"

To this question he made no answer, but after a short interval he stirred, and when the man uncovered him his eyes were fixed; when he saw this, Crito closed his mouth and his eyes.

And that, Echecrates, was the end of our companion, a man who, among those of his time we knew, was—so we should say—the best, the wisest too, and the most just.

Republic

BOOK I

I went down yesterday to the Piraeus with Glaucon, the son of Ariston, to offer up prayer to the goddess, and also I wanted to see how the festival, then to be held for the first time, would be celebrated. I was very much pleased with the native Athenian procession; though that of the Thracians appeared to be no less brilliant. We had finished our prayers, and satisfied our curiosity, and were returning to the city, when Polemarchus, the son of Cephalus, caught sight of us at a distance, as we were on our way towards home, and told his servant to run and order us to wait for him. The servant came behind me, took hold of my cloak, and said, "Polemarchus asks you to wait." I turned round and asked him where his master was. "There he is," he replied, "coming from behind. Wait for him." "We will wait," answered Glaucon. Soon afterwards Polemarchus came up, with Adeimantus the brother of Glaucon, and Niceratus the son of Nicias, and a few other persons, apparently coming away from the procession.

Polemarchus then said: Socrates, it looks to me as if you are rushing to leave for town.

You are not wrong in your surmise, I replied.

From Plato, *The Republic,* translation by John Llewelyn Davies and David James Vaughan, revised by Andrea Tschemplik (Lanham, MD: Rowman & Littlefield Publishers, 2005). Reprinted by permission of the publisher.

Well, do you see how many we are?

Certainly I do.

Then either prove yourselves the stronger party, or else stay where you are.

No, I replied, there is still an alternative: suppose we persuade you that you ought to let us go.

Could you possibly persuade us, if we refused to listen?

Certainly not, replied Glaucon.

Get it through your head that we will not listen.

328 Then Adeimantus interposed and said, Are you not aware that towards evening there will be a torch-race on horseback in honor of the goddess?

On horseback! I exclaimed: that is a novelty. Will they carry torches, and pass them on to one another, while the horses are racing? or how do you mean?

As you say, replied Polemarchus: besides, there will be a night-festival, which will be worth looking at. After dinner we will go out to see this festival, and there we will meet with many of our young men, with whom we can b converse. Therefore stay, and do not refuse us.

Upon this Glaucon said, It seems we shall have to stay.

Well, said I, if you like, let us do so.

We went therefore home with Polemarchus, and found there his brothers Lysias and Euthydemus, and, along with them, Thrasymachus of Chalcedon, and Charmantides the Paeanian, and Cleitophon the son of Aristonymus. Polemarchus's father, Cephalus, was also in the house. He looked much older to me: for it was c long since I had seen him. He was sitting on a cushioned chair, with a garland upon his head, as he happened to have been sacrificing in the court. We found seats placed round him; so we sat down there by his side. The moment Cephalus saw me, he greeted me, and said, It is seldom indeed, Socrates, that you pay us a visit at the Piraeus; you ought to come more often. If I were still strong enough to walk with ease to the city, there would be no occasion for your coming here, because we should go to you. But as it is, you ought to come here more frequently. For d I assure you that I find the decay of the mere bodily pleasures accompanied by a proportionate growth in my appetite for philosophical conversation and in the pleasure I derive from it. Therefore do not refuse my request, but let these young men have the benefit of your company, and come often to see us as though you were visiting friends and relatives.

To tell you the truth, Cephalus, I replied, I delight in conversing with very old persons. e For as they have gone before us on the road over which perhaps we also shall have to travel, I think we ought to try to learn from them what the nature of that road is—whether it be rough and difficult, or smooth and easy. And now that you have arrived at that period of life, which poets call "the threshold of Age," there is no one whose opinion I would more gladly ask. Is life painful at that age, or what report do you make of it?

I will certainly tell you, Socrates, what my 329 own experience of it is. I and a few other people of my own age are in the habit of frequently meeting together, true to the old proverb. On these occasions, most of us give way to lamentations, and regret the pleasures of youth, and call up the memory of sex and drinking parties and banquets and similar proceedings. They are grievously discontent at the loss of what they consider great privileges, and describe themselves as living well in those days, whereas now, by their own account, they cannot be said b to live at all. Some also complain of the manner in which their relations insult their infirmities, and make this a ground for reproaching old age with the many miseries it brings upon them. But in my opinion, Socrates, these persons miss the true cause of their unhappiness. For if old age were the cause, the same discomforts would have been also felt by me, as an old man, and by every other person that has reached that period of life. But, as it is, I have before

now met with several old men who expressed
themselves in a quite different manner; and in
particular I may mention Sophocles the poet,
who was once asked in my presence, "How do
you feel about love, Sophocles? are you still
capable of it?" to which he replied, "Hush! if
you please: to my great delight I have escaped
from it, and feel as if I had escaped from a frantic
and savage master." I thought then, as I do now,
that he spoke wisely. For unquestionably old age
brings us profound repose and freedom from
this and other passions. When the appetites have
abated, and their force is diminished, the descrip-
tion of Sophocles is perfectly realized. It is like
being delivered from a multitude of furious mas-
ters. But the complaints on this score, as well as
the troubles with relatives, may all be referred to
one cause, and that is, not the age, Socrates, but
the character of the men. If they possess well-
regulated souls and easy tempers, old age itself
is no intolerable burden: if they are differently
constituted, why in that case, Socrates, they find
even youth as irksome to them as old age.

I admired these remarks of Cephalus, and
wishing him to go on talking, I endeavored to
draw him out by saying: I think, Cephalus, that
people do not generally welcome these views
of yours, because they think that it is not your
character, but your great wealth that enables
you to bear with old age. For the rich, it is said,
have many consolations.

True, he said, they will not believe me;
and they are partly right, though not so right
as they suppose. There is great truth in the
reply of Themistocles to the Seriphian who
tauntingly told him, that his reputation
was due not to himself, but to his country:
"*I* should not have become famous if I had
been a native of Seriphus; neither would you,
if you had been an Athenian." And to those
who, not being rich, are impatient with old
age, it may be said with equal justice, that
while on the one hand, a good man cannot be
altogether cheerful with old age and poverty

combined, so on the other, no wealth can ever
make a bad man at peace with himself.

But has your property, Cephalus, been
chiefly inherited or acquired?

You want to know how I have acquired it,
Socrates? Why, in the conduct of money mat-
ters, I stand midway between my grandfather
and my father. My grandfather, whose name
I bear, inherited nearly as much property
as I now possess, and increased it until it was
many times as large; while my father Lysanias
brought it down even below what it now is. For
my part, I shall be content to leave it to these
my sons not less, but if anything rather larger,
than it was when it came into my hands.

I asked the question, I said, because you
seemed to me to be not very fond of money—
which is generally the case with those who
have not made it themselves; whereas those
who have made it, are attached to it twice as
much as other people. For just as poets love
their own works, and fathers their own chil-
dren, in the same way those who have created
a fortune value their money, not merely for its
uses, like other persons, but because it is their
own production. This makes them moreover
disagreeable companions, because they will
praise nothing but riches.

It is true, he replied.

Indeed it is, said I. But let me ask you one
more question. What do you think is the great-
est advantage that you have derived from being
wealthy?

If I mention it, he replied, I shall perhaps
get few persons to agree with me. Be assured,
Socrates, that when a man is nearly persuaded
that he is going to die, he feels alarmed and
concerned about things which never affected
him before. Until then he has laughed at the
stories concerning those in Hades, which tell us
that he who has done wrong here must suffer
for it there; but now his mind is tormented with
a fear that these stories may possibly be true.
And either owing to the infirmity of old age,

or because he is now nearer to what happens there, he has a clearer insight into those mysteries. However that may be, he becomes full of misgiving and apprehension, and sets himself to the task of calculating and reflecting whether he has done any wrong to any one. Hereupon, 331 if he finds his life full of unjust deeds, he is apt to awaken from sleep in terror, as children do, and he lives haunted by gloomy anticipations. But for the man who is conscious of no unjust deeds sweet hope is always present, that "kind nurse of old age," as Pindar calls it. For indeed, Socrates, those are beautiful words of his, in which he says of the man who has lived a just and holy life,

> "Sweet Hope is his companion, cheering his heart,
> the nurse of age; Hope, which, more than anything else,
> steers the capricious will of mortal men."

b There is really a wonderful truth in this description. And it is this consideration, I think, that makes riches chiefly valuable, not for everybody, but for the decent and orderly person. Not to have cheated or lied to anyone against one's will, not to leave for the other world in fear, owing sacrifices to a god or money to a man, to this wealth contributes a great deal. There are many other uses as well. But after weighing them all separately, Socrates, I am inclined to consider this service as anything but the least important which riches can render to a sensible man.

c You have spoken admirably, Cephalus. But are we to say that justice is this thing, namely to speak the truth and to give back what one has taken from another? Or is it possible for actions of this very nature to be sometimes just and sometimes unjust? For example, every one, I suppose, would admit, that, if a man, while in the possession of his senses, were to place dangerous weapons in the hands of a friend, and

afterwards in a fit of madness to demand them back, such a deposit ought not to be restored, and that his friend would not be a just man if he either returned the weapons, or consented to tell the whole truth to someone in such a condition.

You are right, he replied. d

Then it is no true definition of justice to say that it consists in speaking the truth and restoring what one has received.

But it is indeed, Socrates, said Polemarchus, interrupting, at least if we are at all to believe Simonides.

Very well, said Cephalus, I will just leave the discussion to you. It is time for me to attend to the sacrifices.

Then Polemarchus inherits your share in it, does he not? I asked.

Certainly, he replied, with a smile; and immediately withdrew to the sacrifices.

Answer me then, I proceeded, you that are e the heir to the discussion: What do you maintain to be the correct account of justice, as given by Simonides?

That to restore to each man what is his due, is just. To me it seems that Simonides is right in giving this account of the matter.

Well, certainly it is not an easy matter to disbelieve Simonides: for he is a wise and inspired man. But what he means by his words, you, Polemarchus, may perhaps understand, though I do not. It is clear that he does not mean what we were saying just now, namely, that property given by one person in trust to another, is to be returned to the donor, if he asks for it in a state of insanity. And yet I conclude that property given in trust is due to the truster. Is it not?

Yes, it is. 332

But, when the person who asks for it is not in his senses, it must not be returned on any account, must it?

True, it must not.

Then it would seem that Simonides means something different from this, when he says that it is just to restore what is due.

Most certainly he does, he replied: for he declares that the debt of friend to friend is to do good to one another, and not harm.

b I understand: the person who returns money to a depositor does not restore what is due, if the repayment on the one side, and the receipt on the other, prove to be injurious, and if the two parties are friends. Is not this, according to you, the meaning of Simonides?

Certainly it is.

Well, must we restore to our enemies whatever happens to be due to them?

Yes, no doubt, what is due to them; and the debt of an enemy to an enemy is, I suppose, harm—because harm is what is fitting.

c So then it would seem that Simonides, after the manner of poets, employed a riddle to describe the nature of justice: for apparently he thought that justice consisted in rendering to each man that which is appropriate to him, which he called his due. What do you think? Suppose that subsequently someone had asked him the following question: "That being the case, Simonides, what due and appropriate thing is rendered by the art called medicine, and what are the recipients?" What do you think he would have answered us?

Obviously he would have said that bodies are the recipients, and drugs, meats, and drinks, the things rendered.

And what due and appropriate thing is rendered by the art called cookery, and what are d the recipients?

Seasoning is the thing rendered; dishes are the recipients.

Good; then what is the thing rendered by the art that we are to call justice, and who are the recipients?

If we are to be at all guided by our previous statements, Socrates, assistance and harm are the things rendered, friends and enemies the recipients.

Then, by justice, Simonides means doing good to our friends and harm to our enemies, does he?

I think so.

Now, in cases of illness, who is best able to do good to friends and harm to enemies, with reference to health and disease?

A physician.

And, on a voyage, who is best able to do good to friends and harm to enemies, with reference to the perils of the sea? e

A pilot.

Well, in what transaction, and with reference to what object, is the just man best able to help his friends and injure his enemies?

In the transactions of war, I imagine, as the ally of the former, and the antagonist of the latter.

Good. You will grant, my dear Polemarchus, that a physician is useless to persons in sound health.

Certainly.

And a pilot to persons on shore.

Yes.

Is the just man, also, useless to those who are not at war?

I do not quite think that. 333

Then justice is useful in time of peace too, is it?

It is.

And so is farming, is it not?

Yes.

That is to say, as a means of acquiring the fruits of the earth.

Yes.

And further, the shoemaker's art is also useful, is it not?

Yes.

As a means of acquiring shoes, I suppose you will say.

Certainly.

Well then, of what does justice, according to you, promote the use or acquisition in time of peace?

Of contracts, Socrates.

And by contracts do you understand partnerships, or something different?

Partnerships, certainly.

b Then is it the just man, or the skillful checkers-player, that makes a good and useful partner in playing checkers?

The checkers-player.

Well, in bricklaying and stone masonry is the just man a more useful and a better partner than the regular builder?

By no means.

Well then, in what partnership is the just man superior to the harp-player, in the sense in which the harp-player is a better partner than the just man in playing music?

In a money-partnership, I think.

Excepting perhaps, Polemarchus, when the object is to lay out money—as when a horse is

c to be bought or sold by the partners—in which case, I imagine, the horse-dealer is better. Is he not?

Apparently he is.

And again, when a ship is to be bought or sold, the ship-builder or pilot is better.

It would seem so.

That being the case, when does the opportunity arrive for that joint use of silver or gold, in which the just man is more useful than any one else?

When you want to place your money in trust and have it safe, Socrates.

That is to say, when it is to be deposited, and not to be put to any use?

Just so.

d So that justice can only be usefully applied to money when the money is useless?

It looks like it.

In the same way, when you want to keep a pruning-hook, justice is useful whether you be in partnership or not; but when you want to use it, justice gives place to the art of the vine dresser?

Apparently.

Do you also maintain that, when you want to keep a shield or a lyre without using them, justice is useful; but when you want to use them, you require the art of the soldier or of the musician?

I must.

And so of everything else: justice is useless when a thing is in use, but useful when it is out of use?

So it would seem.

Then, my friend, justice cannot be a very e valuable thing if it is only useful as applied to things useless. But let us continue the inquiry thus. Is not the man who is most expert in dealing blows in an encounter, whether in boxing or otherwise, also most expert in parrying blows?

Certainly.

Is it not also true that whoever is expert in repelling a disease, and evading its attack, is also extremely expert in producing it in others?

I think so. 334

And undoubtedly a man is well able to guard an army, when he has also a talent for stealing the enemy's plans and all his other operations.

Certainly.

That is to say, a man can guard expertly whatever he can thieve expertly.

So it would seem.

Hence, if the just man is expert in guarding money, he is also expert in stealing it.

I confess the argument points that way.

Then, to all appearance, it turns out that the just man is a kind of thief—something which b you have probably learnt from Homer, with whom Autolycus, the maternal grandfather of Odysseus, is a favorite, because, as the poet says, he outdid all men in thievishness and perjury. Justice therefore, according to you, Homer, and Simonides, appears to be a kind of art of stealing, whose object, however, is to help one's friends and injure one's enemies. Was not this your meaning?

Most certainly it was not, he replied; but I no longer know what I did mean. However, it is still my opinion that it is justice to help one's friends, and hurt one's enemies. c

Should you describe a man's friends as those who *seem* to him to be, or those who

really are, honest men, though they may not seem so? And do you define a man's enemies on the same principle?

I should certainly expect a man to love all whom he thinks honest, and hate all whom he thinks wicked.

But do not people make mistakes in this matter, and imagine many persons to be honest who are not really honest, and many wicked who are not really wicked?

They do.

Then to such persons the good are enemies, and the bad are friends, are they not?

d Certainly they are.

And, notwithstanding this, it is just for such persons at such times to help the wicked, and to injure the good.

Apparently it is.

Yet surely the good are just, and injustice is foreign to their nature.

True.

Then, according to your argument, it is just to do harm to those who commit no injustice.

Heaven forbid, Socrates: for that looks like a wicked speech.

Then it is just, said I, to injure the unjust and to assist the just.

e That is evidently better than the former.

In that case, Polemarchus, the result will be that, in those numerous instances in which people have thoroughly mistaken their men, it is just for these mistaken persons to injure their friends, because in their eyes they are wicked; and to help their enemies, because they are good. And thus our statement will be in direct opposition to the meaning which we assigned to Simonides.

That consequence certainly follows, he replied. But let us change our positions: for very probably our definition of friend and enemy was incorrect.

What was our definition, Polemarchus?

That a friend is one who seems to be an honest man.

And what is to be our new definition?

That a friend is one who not only seems to 335 be, but really is, an honest man; whereas the man who seems to be, but is not honest, is not really a friend, but only seems one. And I define an enemy on the same principle.

Then, by this way of speaking, the good man will, in all likelihood, be a friend, and the wicked an enemy.

Yes.

Then you would have us attach to the idea of justice more than we at first included in it, when we called it just to do good to our friend and bad to our enemy. We are now, if I understand you, to make an addition to this, and render it thus: It is just to do good to our friend if he is a good man, and to hurt our enemy if he is b a bad man. Precisely so, he replied; I think that this would be a right statement.

Now is it the act of a just man, I asked, to hurt anybody?

Certainly it is, he replied; that is to say, it is his duty to hurt those who are both wicked, and enemies of his.

Are horses made better, or worse, by being hurt?

Worse.

Worse with reference to the excellence of dogs, or that of horses?

That of horses.

Are dogs in the same way made worse by being hurt, with reference to the excellence of dogs, and not of horses?

Unquestionably they are. c

And must we not, on the same principle, assert, my friend, that men, by being hurt, are lowered in the scale of virtue or human excellence?

Indeed we must.

But is not justice a virtue?

Undoubtedly it is.

And therefore, my friend, those men who are hurt necessarily become more unjust.

So it would seem.

Can musicians, by the art of music, make men unmusical?

They cannot.

Can riding-masters, by the art of riding, make men bad riders?

No.

d But if so, can the just by justice make men unjust? In short, can the good by goodness make men bad?

No, it is impossible.

True; for, if I am not mistaken, it is the work, not of warmth, but of its opposite, to make things cold.

Yes.

And it is the work not of drought, but of its opposite, to make things wet.

Certainly.

Then it is the work not of good, but of its opposite, to hurt.

Apparently it is.

Well, is the just man good?

Certainly he is.

Then, Polemarchus, it is the work, not of the just man, but of his opposite, the unjust man, to hurt either friend or any other creature.

You seem to me to be perfectly right, e Socrates.

Hence if any one asserts that it is just to render to every man his due, and if he understands by this, that what is due on the part of the just man is injury to his enemies, and assistance to his friends, the assertion is that of an unwise man. For what was said is untrue: because we have discovered that, in no instance, is it just to injure anybody.

I grant you are right.

Then you and I will make common cause against any one who shall attribute this to Simonides, or Bias, or Pittacus, or any other wise and highly favored man.

Very good, said he; I, for one, am quite 336 ready to take my share of the fighting.

Do you know who I think is the author of this saying, that it is just to help our friends, and hurt our enemies?

To whom?

I attribute it to Periander, or Perdiccas, or Xerxes, or Ismenias the Theban, or some other rich man who thought himself very powerful.

You are perfectly right.

Well, but as we have again failed to discover the true definition of justice and the just, what other definition can one propose?

b

While we were still in the middle of our discussion, Thrasymachus was, more than once, bent on interrupting the conversation with objections; but he was checked on each occasion by those who sat by, who wished to hear the argument out. However, when I had made this last remark and we had come to a pause, he could restrain himself no longer, but, gathering himself up like a wild beast, he sprang upon us, as if he would tear us in pieces. I and Polemarchus were terrified and startled; while Thrasymachus, raising his voice to the company, said, What nonsense has possessed you and Pole- c marchus all this time, Socrates? And why do you play the fool together, submitting to one another? No, if you really wish to understand what justice is, do not confine yourself to asking questions, and making a display of refuting the answers that are returned—for you are aware that it is easier to ask questions than to answer them; but give us an answer also yourself, and tell us what you assert justice to be, and do not answer me by defining it as the d obligatory, or the advantageous, or the profitable, or the lucrative, or the expedient; but whatever your definition may be, let it be clear and precise: for I will not accept your answer, if you talk such trash as that.

When I heard this speech, I was astounded, and gazed at the speaker in terror; and I think if I had not set eyes on him before he eyed me, I should have been struck dumb. But, as it was, when he began to be exasperated by the conversation, I had looked him in the face first— so that I was enabled to reply to him, and said e with a slight tremble: Thrasymachus, do not be hard upon us. If I and Polemarchus are making mistakes in our examination of the subject, be assured that the error is involuntary. You do not suppose that, if we were looking for a piece of gold, we would ever willingly give way to one another in the search as to spoil the chance

of finding it; and therefore, do not suppose that, in seeking for justice, which is a thing more precious than many pieces of gold, we should give way to one another so weakly as you describe, instead of doing our very best to bring it to light. You, my friend, may think so, if you choose; but my belief is that the subject is beyond our powers. Surely then we might very reasonably expect to be pitied, not harshly treated, by such clever men as you.

When he had heard my reply, he burst out laughing very scornfully, and said: O Hercules! here is an instance of that irony which Socrates affects. I knew how it would be, and warned the company that you would refuse to answer, and would be ironic, and do anything rather than reply, if any one asked you a question.

Yes, you are a wise man, Thrasymachus, I replied; and therefore you were well aware that, if you asked a person what factors make the number 12, and at the same time warned him thus: "Please do not tell me that 12 is twice 6, or 3 times 4, or 6 times 2, or 4 times 3: for I will not take such nonsense from you;" you were well aware, I dare say, that no one would give an answer to such an inquirer. But suppose the person replied to you thus: "Thrasymachus, explain yourself; am I to be precluded from all these answers which you have denounced? What, my good sir! even if one of these is the real answer, am I still to be precluded from giving it, and am I to make a statement that is at variance with the truth? or what is your meaning?" What reply should you make to this inquiry?

Oh, indeed! he exclaimed; as if the two cases were alike!

There is nothing to prevent their being so, I replied. However, suppose they are not alike; still if one of these answers seems the right one to the person questioned, do you think that our forbidding it, or not, will affect his determination to give the answer which he believes to be the correct one?

Do you not mean that this is what you are going to do? You will give one of the answers on which I have put a veto?

It would not surprise me if I did; supposing I thought right to do so, after examination.

Then, what if I produce another answer on the subject of justice, unlike those I denounced, and superior to them all? What punishment do you think you merit?

Simply the punishment which it is proper for the non-knower to submit to; and that is, I suppose, to be instructed by those who know. This, then, is the punishment which I, among others, deserve to suffer.

Really you are a pleasant person, he replied. But, besides being instructed, you must make me a payment.

I will, when I have any money, I replied.

But you have, said Glaucon. So, as far as money is a consideration, speak on, Thrasymachus. We will all contribute for Socrates.

Oh, to be sure! said he; in order that Socrates, I suppose, may pursue his usual plan of refusing to answer himself, while he criticizes and refutes the answers given by other people.

My excellent friend, said I, how can an answer be given by a person who, in the first place, does not, and confesses he does not, know what to answer; and who, in the next place, if he has any thoughts upon the subject, has been forbidden by a man who is not thoughtless to say what he believes? No, it is more fitting that you should be the speaker; because you profess to know the subject, and to have something to say. Therefore do not decline; but gratify me by answering, and do not grudge to instruct Glaucon and the rest of the company as well.

When I had said this, Glaucon and the others begged him to comply. Now it was evident that Thrasymachus was eager to speak, in order that he might gain glory, because he thought himself in possession of a very fine answer. But he affected to contend for my being the

b respondent. At last he gave in, and then said: This here then is the wisdom of Socrates! He will not give instruction himself, but he goes about and learns from others, without even showing gratitude for their lessons.

As for my learning from others, Thrasymachus, I replied, there you speak truth; but it is false of you to say that I pay no gratitude in return. I *do* pay all I can; and, as I have no money, I can only give praise. How readily I do this, if in my judgment a person speaks well, you will very soon find, when you make your answer: for I expect *you* to speak well.

c Then listen, said he. I say that justice is simply the interest of the stronger. Well, why do you not praise me? No, you refuse.

Not so, I replied; I am only waiting to understand your meaning, which at present I do not see. You say that the interest of the stronger is just. What in the world do you mean by this, Thrasymachus? You do not, I presume, mean anything like this, that, if Polydamas, the athlete, is stronger than we are, and it is for his

d interest to eat beef in order to strengthen his body, such food is for the interest of us weaker men, and therefore is just.

You are disgusting, Socrates; you take up my speech in such a way as to damage it most easily.

No, no, my excellent friend; but state your meaning more clearly.

So you are not aware, he continued, that some cities are ruled by a tyrant, and others by a democracy, and others by an aristocracy?

Of course I am.

In every city does not superior strength reside in the ruling body?

Certainly it does.

e And further, each regime has its laws framed to suit its own interests: a democracy making democratic laws, a tyrant tyrannical laws, and so on. Now by this procedure these regimes have pronounced that what is for the interest of themselves is just for their subjects; and whoever deviates from this, is chastised by them as

guilty of illegality and injustice. Therefore, my good sir, my meaning is, that in all cities the same thing, namely, the interest of the established regime, is just. And superior strength, I presume, is to be found on the side of regime. So that the conclusion of right reasoning is that the same thing, namely, the interest of the stronger, is everywhere just. 339

Now I understand your meaning, and I will endeavor to make out whether it is true or not. So then, Thrasymachus, you yourself in your answer have defined justice as interest, though you forbade my giving any such reply. To be sure, you have made an addition, and describe it as the interest of the stronger.

Yes, quite a trifling addition, perhaps. b

It remains to be seen, whether it is an important one. We need to examine whether you spoke truly. For we both admit that justice is in harmony with interest; but you lengthen this into the assertion that justice is the interest of the stronger—and I do not know about that. Therefore we must certainly examine it.

Please do so.

It shall be done. Be so good as to answer this question. You no doubt also maintain that it is just to obey the rulers?

I do.

Are the rulers infallible in every city, or are they liable to make a few mistakes? c

No doubt they are liable to make mistakes.

And therefore, when they undertake to frame laws, is their work sometimes rightly, and sometimes wrongly done?

I should suppose so.

Do "rightly" and "wrongly" mean, respectively, legislating for, and against, their own interests? Or how do you state it?

Just as you do.

And do you maintain that whatever has been enacted by the rulers must be obeyed by their subjects, and that this is justice?

Unquestionably I do. d

Then, according to your argument, it is not only just to do what makes for the interest of

the stronger, but also to do what runs counter to his interest, in other words, the opposite of the former.

What are you saying?

What *you* say, I believe. But let us examine the point more thoroughly. Has it not been admitted that, when the rulers enjoin certain acts upon their subjects, they are sometimes thoroughly mistaken as to what is best for themselves; and that, whatever is enjoined by them, it is just for their subjects to obey? Has not this been admitted?

Yes, I think so, he replied.

e Then let me tell you, that you have also admitted the justice of doing what runs counter to the interest of the ruling and stronger body on every occasion when this body unintentionally enjoins what is injurious to itself, so long as you maintain that it is just for the subjects to obey, in every instance, the injunctions of their rulers. In that case, O most wise Thrasymachus, must it not follow of course, that it is just to act in direct opposition to what you said? For, obviously, it is enjoined upon the weaker to do what is disadvantageous to the stronger.

340 Yes, indeed, Socrates, said Polemarchus; that is perfectly clear.

No doubt, retorted Cleitophon, if you appear as a witness in Socrates' behalf.

What do we want witnesses for? said Polemarchus. Thrasymachus himself admits that the rulers sometimes enjoin what is bad for themselves; and that it is just for their subjects to obey such injunctions.

No, Polemarchus; Thrasymachus laid it down that to do what the rulers command is just.

Yes, Cleitophon; and he also laid it down
b that the interest of the stronger is just. And having laid down these two positions, he further admitted that the stronger party sometimes orders its weaker subjects to do what is disadvantageous to its own interests. And the consequence of these admissions is, that what is for the interest of the stronger will be not a bit more just than what is not for his interest.

But, said Cleitophon, by the interest of the stronger he meant, what the stronger conceived to be for his own interest. His position was, that this must be done by the weaker, and that this is the notion of justice.

That was not what he said, replied Polemarchus.

It does not matter, Polemarchus, said I; if c
Thrasymachus chooses to speak this way now, let us make no objection to his doing so.

Tell me then, Thrasymachus, was this the definition you meant to give of justice, that it is what seems to the stronger to be the interest of the stronger, whether it be really for his interest or not? Shall we take that as your account of it?

Certainly not, he replied; do you think I should call a man who is mistaken, at the time of his mistake, the stronger?

Why I thought that you said as much, when you admitted that rulers are not infallible, but do really commit some mistakes.

You are a quibbler, Socrates; do you call, d
now, that man a physician who is in error about the treatment of the sick, with strict reference to his error? Or do you call another an accountant, who makes a mistake in a calculation, at the time of his mistake, and with reference to that mistake? We say, to be sure, in so many words that the physician was in error, and e
the accountant or the writer was in error; but in fact each of these, I imagine, in so far as he is what we call him, never falls into error. So that, to speak with precise accuracy, since you require such preciseness of language, no craftsman errs. For it is through a failure of knowledge that a man errs, and to that extent he is no craftsman; so that whether as craftsman, or wise man, or ruler, no one errs while he actually is what he professes to be; although everyone would say that such a physician was in error, or such a ruler was in error. In this sense I would have you to understand my own 341

recent answer. But the statement, if expressed with perfect accuracy, would be that a ruler, in so far as he is a ruler, never errs, and so long as this is the case, he enacts what is best for himself, and that this is what the subject has to do. Therefore, as I began with saying, I call it just to do what is for the interest of the stronger.

Very good, Thrasymachus; you think me a quibbler, do you?

Yes, a thorough quibbler.

Do you think that I put you those questions with a mischievous intent to damage your position in the argument?

b I am quite sure of it. However you shall gain nothing by it; for you shall neither injure me by taking me unawares, nor will you be able to overpower me by open argument.

I should not think of attempting it, my excellent friend! But that nothing of this kind may occur again, tell me whether you employ the words "ruler" and "stronger" in the popular sense of them, or with the precise meaning of which you were speaking just now, when you say that it is just for the weaker to do what is for the interest of the ruler as being the stronger.

I mean a ruler in the strictest sense of the word. So now try your powers of quibbling and mischief; I ask for no mercy. But your attempts will be ineffectual.

c Why, do you suppose I should be so mad as to attempt to shave a lion, or play off quibbles on a Thrasymachus?

At any rate you tried it just now, though you failed utterly.

Enough of this banter, I replied. Tell me this: is the physician of whom you spoke as being strictly a physician, a maker of money, or a healer of the sick? Take care you speak of the *real* physician.

A healer of the sick.

And what of a pilot? Is the true pilot a sailor or a commander of sailors?

A commander of sailors.

d There is no need, I imagine, to take into account his being on board the ship, nor should he be called a sailor: for it is not in virtue of his being on board that he has the name of pilot, but in virtue of his art and of his rule over the sailors.

True.

Has not each of these persons an interest of his own?

Certainly.

And is it not the proper end of their art to seek and procure what is for the interest of each of them?

It is.

Have the arts severally any other interest to pursue than their own highest perfection?

What does your question mean?

Why, if you were to ask me whether it is e sufficient for a man's body to be a body, or whether it stands in need of something additional, I should say, Certainly it does. To this fact the discovery of the healing art is due, because the body is defective, and it is not enough for it to be a body. Therefore the art of medicine has been devised to provide the body with advantageous things. Should I be right, do you think, in so expressing myself, or not?

You would be right.

Well then, is the art of medicine itself defec- 342 tive, or does any art whatever require a certain additional virtue: as eyes require sight, and ears hearing, so that these organs need a certain art which shall investigate and provide what is conducive to these ends. Is there, I ask, any defectiveness in an art as such, so that every art should require another art to consider its interests, and this other provisional art a third, with a similar function, and so on, without limit? b Or will it investigate its own interest? Or is it unnecessary either for itself, or for any other art, to inquire into the appropriate remedy for its own defects because there are no defects or faults in any art, and because it is not the duty of an art to seek the interests of anything save that to which, as an art, it belongs, being itself free from hurt and blemish as a true art, so long as it continues strictly and in its integrity

what it is? View the question according to the strict meaning of terms, as we agreed. Is it so or otherwise?

Apparently it is so, he replied.

c Then the art of healing does not consider the interest of the art of healing, but the interest of the body.

Yes.

Nor horsemanship what is good for horsemanship, but for horses: nor does any other art seek its own interest—for it has no wants—but the good of that to which as an art it belongs.

Apparently it is so.

Well, but you will grant, Thrasymachus, that an art rules and is stronger than that of which it is the art.

He assented, with great reluctance, to this proposition.

Then no science or knowledge investigates or orders the interest of the stronger, but the interest of the weaker, its subject.

d To this also he at last assented, though he attempted to show fight about it. After gaining his admission, I proceeded: Then is it not also true, that no physician, in so far as he is a physician, considers or orders what is for the physician's interest, but that all seek the good of their patients? For we have agreed that a physician strictly so called, is a ruler of bodies, and not a maker of money, have we not?

He allowed that we had.

And that a pilot strictly so called is a commander of sailors, and not a sailor?

e We have.

Then this kind of pilot and commander will not seek and order the pilot's interest, but that of the sailor and the subordinate.

He reluctantly gave his assent.

And thus, Thrasymachus, all who are in any place of ruling, in so far as they are rulers, neither consider nor order their own interest, but that of the subjects for whom they exercise their craft; and in all that they do or say, they act with an exclusive view to *them,* and to what is good and proper for *them.*

When we had arrived at this stage of the 343 discussion, and it had become evident to all that the explanation of justice was completely reversed, Thrasymachus, instead of making any answer, said,

Tell me, Socrates, do you have a wet-nurse?

Why? I rejoined; had you not better answer my questions than make inquiries of that sort?

Why because she leaves you to drivel, and omits to wipe your nose when you require it, so that in consequence of her neglect you cannot even distinguish between sheep and shepherd.

For what particular reason do you think so?

Because you think that shepherds and herds- b men regard the good of their sheep and of their oxen, and fatten them and take care of them with other views than to benefit their masters and themselves; and you actually imagine that the rulers in cities, those I mean who are really rulers, are otherwise minded towards their subjects than as one would feel towards sheep, or that they think of anything else by night and by day than how they may secure their own advantage. And you are so far wrong in your c notions respecting justice and injustice, the just and the unjust, that you do not know that the former is really the good of another, that is to say the interest of the stronger and of the ruler, but your own loss, where you are the subordinate and the servant; whereas injustice is the reverse, ruling those that are really simple-minded and just, so that they, as subjects, do what is for the interest of the unjust man who is stronger than they, and promote his happiness by their services, but not their own in the least d degree. You may see by the following considerations, my most simple Socrates, that a just man everywhere has the worst of it, compared with an unjust man.

In the first place, in their mutual dealings, wherever a just man enters into partnership with an unjust man, you will find that at the dissolution of the partnership the just man never has more than the unjust man, but always less. Then again in their dealings with the city,

when there is a property-tax to pay, the just man will pay more and the unjust less, on the same amount of property; and when there is any-e thing to receive, the one gets nothing, while the other makes great gains. And whenever either of them holds any ruling office, if the just man suffers no other loss, at least his private affairs fall into disorder through want of attention to them, while his principles forbid his deriving any benefit from the public money; and besides this, it is his fate to offend his friends and acquaintances every time that he refuses to serve them at the expense of justice. But with the unjust man every thing is reversed. I am speaking of the case I mentioned just now, of an 344 unjust man who has the power to over-reach. To him you must direct your attention, if you wish to judge how much more profitable it is to a man's own self to be unjust than to be just. And you will learn this truth with the greatest ease, if you turn your attention to the most consummate form of injustice, which, while it makes the wrong-doer most happy, makes those who are wronged, and will not retaliate, most miserable. This form is a tyranny, which proceeds not by small degrees, but by wholesale, in its open or fraudulent appropriation of the property of others, whether it be sacred or profane, public b or private; perpetrating offenses, if a person commits a part of the offense and is found out, he becomes liable to a penalty and incurs deep disgrace: for partial offenders in this class of crimes are called sacrilegious, kidnappers, burglars, thieves, and robbers. But when a man not only seizes the property of his fellow-citizens but captures and enslaves their persons also, c instead of those dishonorable titles he is called happy and highly favored, not only by the men of his own city, but also by all others who hear of the comprehensive injustice which he has wrought. For when people abuse injustice, they do so because they are afraid, not of committing it, but of suffering it. Thus it is, Socrates, that injustice, realized on an adequate scale, is a stronger, a freer, and a more lordly thing than

justice; and as I said in the beginning, justice is the interest of the stronger; injustice, a thing profitable and advantageous to oneself.

When he had made this speech, Thrasyma- d chus had a mind to take his departure, after deluging our ears like a bath-man with this copious and unbroken flood of words. Our companions however would not let him go, but obliged him to stay and answer for his arguments. I myself also was especially urgent in my entreaties, exclaiming, Really, my good Thrasymachus, after flinging at us such a speech as this, do you have it in mind to take your leave, before you have satisfactorily taught us, or learnt yourself, whether your argument is right or wrong? Do you think you are undertaking to settle some insignificant question, and not the principles e on which each of us must conduct his life in order to lead the most profitable existence?

What else am I supposed to think? said Thrasymachus.

So it seems, I said, or else that you are quite indifferent about us, and feel no concern whether we shall live the better or the worse for our ignorance of what you profess to know. But please, my good sir, try to impart your 345 knowledge to us also—any benefit you confer on such a large party as we are will surely be no bad investment. For I tell you plainly for my own part that I am not convinced, and that I do not believe that injustice is more profitable than justice, even if it be let alone and suffered to work its will unchecked. On the contrary, my good sir, let there be an unjust man, and let him have full power to practice injustice, either by evading detection or by overpowering opposition, still I am not convinced that such a course is more profitable than justice. This, b perhaps, is the feeling of some others amongst us, as well as mine. Then do convince us satisfactorily, my highly-gifted friend, that we are not well advised in valuing justice above injustice.

But how, said he, can I persuade you? If you are not convinced by my recent statements,

what more can I do for you? must I take the speech and thrust it into your soul?

You should not do that; but in the first place, abide by what you say, or if you change your ground, change it openly without deceiving us. As it is, Thrasymachus—for we must not yet take leave of our former investigations— you see that having first defined the meaning of the true physician, you did not think it necessary afterwards to adhere strictly to the true shepherd. On the contrary, you suppose him to feed his sheep, in so far as he is a shepherd, not with an eye to what is best for the flock, but, like a guest about to be feasted, with an eye to the feasting, or else to their sale, like a money-maker, and not like a shepherd. Whereas the only concern of the shepherd's art is, I presume, how it shall procure what is best for *that,* of which it is the appointed guardian: since as far as concerns its own perfection, sufficient provision is made, I suppose, for that, so long as it is all that is implied in its title; and so I confess I thought we were obliged just now to admit that every regime, in so far as it is a regime, looks solely to the advantage of that which is ruled and tended by it, whether that regime be of a public or a private nature. But what is your opinion? do you think that the rulers in cities, who really rule, do so willingly?

No, I do not *think* it, I am sure of it.

But, Thrasymachus, what about other kinds of regime, do you not observe that no one is willing to rule, if he can help it, but that they all ask to be paid on the assumption that the advantages of their regime will not accrue to themselves, but to the governed? For answer me this question: Do we not say without hesitation, that every art is distinguished from other arts by having a distinctive capacity? Be so good, my dear sir, as not to answer contrary to your opinion, or we shall make no progress.

Yes, that is what distinguishes it.

And does not each of them provide us with some special and peculiar benefit? the art of healing, for example, giving us health, that of piloting safety at sea, and so on?

Certainly.

Then is there not an art of wages which provides us with wages, this being its proper faculty? Or do you call the art of healing and that of piloting identical? Or, if you choose to employ strict definitions as you engaged to do, the fact of a man's regaining his health while acting as a pilot, through the beneficial effects of the sea-voyage, would not make you call the art of the pilot a healing art, would it?

Certainly not.

Nor would you so describe the art of wages, I think, supposing a person to keep his health while in the receipt of wages.

No.

Well then, would you call the physician's art a mercenary art, if fees be taken for medical attendance?

No.

Did we not allow that the benefit of each art was peculiar to itself?

Be it so.

Then whatever benefit accrues in common to all craftsmen is clearly derived from a common use of some one and the same thing.

So it would seem.

And we further maintain, that if these craftsmen are benefited by earning wages, they owe it to their use of the wage-earning craft.

He reluctantly assented.

Then this advantage, the receipt of pay, does not come to each from his own art, but, strictly considered, the art of healing produces health, and the art of wages produces pay; the art of house-building produces a house, while the art of wages follows it and produces pay; and so of all the rest: each works its own work, and benefits that which is its appointed object. If, however, an art be practiced without pay, does the craftsman derive any benefit from his art?

Apparently not.

e Does he also confer no benefit, when he works for nothing?

I suppose he does confer benefit.

So far then, Thrasymachus, we see clearly, that an art or a regime never provides that which is profitable for itself, but as we said some time ago, it provides and orders what is profitable for the subject, looking to his interest who is the weaker, and not to the interest of the stronger. It was for these reasons that I said just now, my dear Thrasymachus, that no one will voluntarily take office, or assume the duty
347 of correcting the disorders of others, but that all ask wages for the work, because one who is to prosper in his art never practices or prescribes what is best for himself, but only what is best for the subject, so long as he acts within the limits of his art; and on these grounds, apparently, wages must be given to make men willing to hold office, in the shape of money or honor, or of punishment, in case of refusal.

What do you mean, Socrates? asked Glaucon. I understand two out of the three kinds of wages; but, what the punishment is, and how you could describe it as playing the part of wages, I do not comprehend.

Then you do not comprehend, I said, the wages of the best men, which induce the most
b virtuous to hold office, when they consent to do so. Do you not know that to be honor-loving and money-loving is considered a disgrace, and really is a disgrace?

I do.

For this reason, then, good men will not consent to rule, either for the sake of money or for that of honor: for they neither wish to get the name of hirelings by openly exacting hire for their duties, nor of thieves by using their power to obtain it secretly; nor yet will they
c take office for the sake of honor, for they are not honor-loving. Therefore compulsion and the fear of a penalty must be brought to bear upon them, to make them consent to hold office— which is probably the reason why it is thought shameful to accept power willingly without waiting to be compelled. Now the heaviest of all penalties is to be ruled by a worse man, in case of one's own refusal to rule; and it is the fear of this, I believe, which induces virtuous men to take the posts of regime and when they do so, they enter upon their rulership, not with any idea of coming into a good thing, but as an d unavoidable necessity, not expecting to enjoy themselves in it, but because they cannot find any person better or no worse than themselves, to whom they can commit it. For the probability is, that if there were a city composed of none but good men, it would be an object of competition to avoid the possession of power, just as now it is to obtain it; and then it would become clearly evident that it is not the nature of the genuine ruler to look to his own interest, but to that of the subject—so that every judicious man would choose to be the recipient of benefits, rather than to have the trouble of conferring them upon others. Therefore I will on no account concede to Thrasymachus e that justice is the interest of the stronger. However we will resume this inquiry hereafter, for Thrasymachus now affirms that the life of the unjust man is better than the life of the just man; and this assertion seems to me of much greater importance than the other. Which side do you take, Glaucon? and which do you think the truer statement?

I for my part hold, he replied, that the life of the just man is the more advantageous.

Did you hear, I asked, what a long list of 348 attractions Thrasymachus just now attributed to the life of the unjust man?

I did, but I am not convinced.

Should you then like us to convince him, if we can find any means of doing so, that what he says is not true?

Undoubtedly I should.

If then we adopt the plan of matching argument against argument, we enumerating all the advantages of being just, and Thrasymachus replying, and we again putting in a rejoinder: it will be necessary to count and measure the b

advantages which are claimed on both sides. And eventually we shall want a jury to give a verdict between us; but if we proceed in our inquiries, as we lately did, by the method of mutual agreement, we ourselves shall be both judges and advocates.

Precisely so.

Which plan, then, do you prefer?

The latter, he said.

Come then, Thrasymachus, said I, let us start from the beginning, and oblige us by answering: Do you assert that a perfect injustice is more profitable than an equally perfect justice?

c Most decidedly I do; and I have said why.

Well then, how do you describe them under another aspect? Probably you call one of them a virtue, and the other a vice?

Undoubtedly.

That is, justice a virtue, and injustice a vice?

A likely thing, my facetious friend, when I assert that injustice is profitable, and justice the reverse.

Then what do you say?

Just the contrary.

Do you call justice a vice?

No, but I call it very egregious good nature.

d Then do you call injustice ill nature?

No, I call it good judgment.

Do you think, Thrasymachus, that the unjust are positively prudent and good?

Yes, those who are able to practice injustice on the complete scale, having the power to reduce whole cities and nations of men to subjection. You, perhaps, imagine that I am speaking of petty criminals, and I certainly allow that even deeds like theirs are profitable if they escape detection; but they are not worthy to be considered in comparison with those I have just mentioned.

e I quite understand what you mean; but I did wonder at your ranking injustice under the heads of virtue and wisdom, and justice under the opposite.

Well, I do so rank them, without hesitation.

You have now taken up a more stubborn position, my friend, and it is no longer easy to know what to say. If after laying down the position that injustice is profitable, you had still admitted it to be a vice and a baseness, as some others do, we should have had an answer to give, speaking according to generally received 349 notions; but now it is plain enough that you will maintain it to be beautiful, and strong, and will ascribe to it all the qualities which we have been in the habit of ascribing to justice, seeing that you have actually ventured to rank it as a portion of virtue and of wisdom.

You divine most correctly, he said.

Nevertheless, I must not shrink from pursuing the inquiry and the argument, so long as I suppose that you are saying what you think: for if I am not mistaken, Thrasymachus, you are really not bantering now, but saying what you think to be the truth.

What difference does it make to you whether I think it true or not? Can you not assail the argument?

It makes none. But will you endeavor to b answer me one more question? Do you think that a just man would wish to outdo another just man in anything?

Certainly not, for then he would not be so charmingly simple as he is.

Would a just man go beyond a just line of conduct?

No, not beyond that either.

But would he go beyond an unjust man without scruple, and think it just to do so, or would he not think it just?

He would think it just, and would not scruple to do it, but he would not be able.

That was not my question, but whether a just man both resolves and desires to outdo an c unjust man, but not beyond a just man?

Well, it is so.

But how is it with the unjust man? Would he take upon himself to outdo a just man and a just line of conduct?

Undoubtedly, when he takes upon himself to outdo all and in every thing.

Then will not the unjust man also outdo another unjust man and an unjust action, and smuggle that he may himself obtain more than any one else?

He will.

Then let us put it in this form: The just man goes not beyond his like, but his unlike; the unjust man goes beyond both his like and his unlike?

Very well said.

And further, the unjust man is prudent and good, the just man is neither.

Well spoken again.

Does not the unjust man further resemble the wise and the good, whereas the just man does not resemble them?

Why, of course, a man of a certain character must resemble others of that character; whereas one who is of a different character will not resemble them.

Very good; then the character of each is identical with that of those whom he resembles.

Why, what else would you have?

Very well, Thrasymachus; do you call one man musical, and another unmusical?

I do.

Which of them do you call sensible, and which foolish?

The musical man, of course, I call wise, and the unmusical, foolish.

Do you also say that wherein a man is sensible, in that he is good, and wherein foolish, bad?

Yes.

Do you speak in the same manner of a medical man?

I do.

Do you think then, my excellent friend, that a musician, when he is tuning a lyre, would wish to outdo a musician in the tightening or loosening of the strings, or would claim to get the better of him?

I do not.

Would he wish to get the better of an unmusical person?

Unquestionably he would.

How would a medical man act? would he wish to go beyond a medical man or medical practice in a question of diet?

Certainly not.

But beyond an unprofessional man he would?

Yes.

Consider now, looking at every kind of knowledge and ignorance, whether you think that any knowledgeable man whatever would, by his own consent, choose to do or say more than another knowledgeable man, and not the same that one like himself would do in the same matter.

Well, perhaps the latter view is necessarily the true one.

But what do you say to the ignorant person? would he not go beyond the knowledgeable and the unknowledgeable alike?

Perhaps.

And the knowledgeable person is wise?

Yes.

And the wise man is good.

Yes.

Then a good and a wise man will not wish to go beyond his like, but his unlike and opposite?

So it would seem.

But a bad and an ignorant man will go beyond both his like and his opposite.

Apparently.

Well then, Thrasymachus, does not our unjust man go beyond both his like and his unlike? was not that your statement?

It was.

But the just man will not go beyond his like, but only beyond his unlike?

Yes.

Consequently the just man resembles the wise and the good, whereas the unjust man resembles the bad and the ignorant.

So it would seem.

But we agreed, you know, that the character of each of them is identical with the character of those whom he resembles.

We did.

Consequently we have made the discovery, that the just man is wise and good, and the unjust man ignorant and bad.

d Thrasymachus had made all these admissions, not in the easy manner in which I now relate them, but reluctantly and after much resistance, in the course of which he perspired profusely, as it was hot weather to boot: on that occasion also I saw what I had never seen before—Thrasymachus blushing. But when we had thus mutually agreed that justice was a part of virtue and of wisdom, and injustice of vice and ignorance, I proceeded thus: Very good, we will consider this point settled; but we said, you know, that injustice was also strong. Do you not remember it, Thrasymachus?

I do, he replied; but for my part I am not satisfied with your last conclusions, and I know what I could say on the subject. But if I were to express my thoughts, I am sure you would say e that I was haranguing the people like a demagogue. Take your choice then; either allow me to say as much as I please, or if you prefer asking questions, do so; and I will do with you as we do with old women when they tell us stories: I will say "Good," and nod my head or shake it, as the occasion requires.

If so, do no violence to your own opinions.

Anything to please you, he said, as you will not allow me to speak. What else do you want?

Nothing, I assure you; but if you will do this, do so; and I will ask questions.

Proceed then.

Well then, I will repeat the question which I put to you just now, that our inquiry may be 351 carried out continuously; namely, what sort of a thing justice is compared with injustice. It was said, I think, that injustice is more powerful and stronger than justice; but now, seeing that justice is both wisdom and virtue, and injustice is ignorance, it may easily be shown, I imagine, that justice is likewise stronger than injustice. No one can now fail to see this. But I do not wish to settle the question in such a

simple way, Thrasymachus, but I would investigate it in the following manner: Should you b admit that a city may be unjust, and that it may unjustly attempt to enslave other cities, and so succeed in so doing, and hold many in such slavery to itself?

Undoubtedly I should; and this will be more frequently done by the best city, that is, the one that is most completely unjust, than by any other.

I understand, I said, that this is your position. But the question which I wish to consider is, whether the city that becomes the mistress of another city, will have this power without the aid of justice, or whether justice will be indispensable to it.

If, as you said just now, justice is wisdom, c justice must lend her aid; but if it is as I said, injustice must lend hers.

I am quite delighted to find, Thrasymachus, that you are not content merely to nod and shake your head, but give exceedingly good answers.

I do it to indulge you.

You are very good; but indulge me so far as to say, whether you think that either a city, or an army, or a band of thieves or robbers, or any other body of men, pursuing certain unjust ends in common, could succeed in any enterprise if they were to deal unjustly with one another?

Certainly not. d

If they refrain from such conduct towards one another, will they not be more likely to succeed?

Yes, certainly.

Because, I presume, Thrasymachus, injustice breeds divisions and animosities and broils between man and man, while justice creates unanimity and friendship; does it not?

Be it so, he said, that I may not quarrel with you.

Truly I am very much obliged to you, my excellent friend; but tell me this: if the working of injustice is to implant hatred wherever

it exists, will not the presence of it, whether among freemen or slaves, cause them to hate one another, and to form parties, and disable

e them from anything together?

Certainly.

Well, and if it exists in two persons, will they not quarrel and hate one another, and be enemies each to the other, and both to the just?

They will.

And supposing, my admirable friend, that injustice has taken up its residence in a single individual, will it lose its proper power, or retain it just the same?

We will say it retains it.

And does not its power appear to be of such a nature, as to make any subject in which it resides, whether it be city, or family, or army, or anything else whatsoever, unable to act unit-

352 edly, because of the divisions and quarrels it excites; and moreover hostile both to itself and to everything that opposes it, and to the just? Is it not so?

Certainly it is.

Then, if it appears in an individual also, it will produce all these its natural results: in the first place it will make him unable to act because of inward strife and division; in the next place, it will make him an enemy to himself and to the just, will it not?

It will.

And the gods, my friend, are just?

We will suppose they are.

b Then to the gods also will the unjust man be an enemy, and the just a friend.

Feast on your argument, said he, to your heart's content: I will not oppose you, or I shall give offense to the company.

Be so good, said I, as to make my entertainment complete by continuing to answer as you have now been doing. I am aware, indeed, that the just are shown to be wiser, and better, and more able to act than the unjust, who are indeed, incapable of any combined action. We do not speak with entire accuracy when we say that any party of unjust men ever

acted vigorously in concert together: for, had they been thoroughly unjust, they could not c have kept their hands off each other. But it is obvious that there was some justice at work in them, which made them refrain at any rate from injuring, at one and the same moment, both their comrades and the objects of their attacks, and which enabled them to achieve what they did achieve; and that their injustice partly disabled them, even in the pursuit of their unjust ends, since those who are complete villains, and thoroughly unjust, are also thoroughly unable to act. I understand that all this is true, and that what you at first set down d is not true. But whether the just also live a better life, and are happier than the unjust, is a question which we proposed to consider next, and which we now have to investigate. Now, I for my part, think it is already apparent, from what we have said, that they do; nevertheless, we must examine the point still more carefully. For we are debating no trivial question, but the manner in which a man ought to live.

Please consider it.

I will. Tell me, do you think there is such a thing as a horse's work.

I do. e

Would you, then, describe the work of a horse, or of anything else whatever, as that work, for the accomplishment of which it is either the sole or the best instrument?

I do not understand.

Look at it this way. Can you see with anything besides eyes?

Certainly not.

Can you hear with anything besides ears?

No.

Then should we not justly say that seeing and hearing are the functions of these organs?

Yes, certainly.

Again, you might cut off a vine-shoot with 353 a carving knife, or chisel, or many other tools?

Undoubtedly.

But with no tool, I imagine, so well as with the pruning knife made for the purpose.

True.

Then shall we not define pruning to be the function of the pruning knife?

By all means.

Now then, I think, you will better understand what I wished to learn from you just now, when I asked whether the function of a thing is not that work for the accomplishment of which it is either the sole or the best instrument?

b I do understand, and I believe that this is in every case the function of a thing.

Very well, do you not also think that everything which has an appointed function has also a proper virtue? Let us go back to the same instances—we say that the eyes have a function?

They have.

Then have the eyes a virtue also?

They have.

And the ears—did we assign them a function?

Yes.

Then have they a virtue also?

They have.

And is it the same with all other things?

The same.

c Attend then: Do you suppose that the eyes could accomplish their work well if they had not their own proper virtue, that virtue being replaced by a vice?

How could they? You mean, probably, if sight is replaced by blindness.

I mean, whatever their virtue be: for I am not come to that question yet. At present I am asking whether it is through their own peculiar virtue that things perform their proper functions well, and through their own peculiar vice that they perform them ill?

You cannot be wrong in that.

Then if the ears lose their own virtue, will they execute their functions ill?

Certainly.

d May we include all other things in the same argument?

I think we may.

Come, then, consider this point next. Has the soul any function which could not be executed by means of anything else whatsoever? For example, could we in justice assign managing and ruling, deliberation and the like, to anything but the soul, or should we pronounce them to be peculiar to it?

We could ascribe them to nothing else.

Again, shall we declare life to be a function of the soul?

Decidedly.

Do we not also maintain that the soul has a virtue?

We do.

e Then can it ever so happen, Thrasymachus, that the soul will perform its functions well when destitute of its own peculiar virtue, or is that impossible?

Impossible.

Then a bad soul necessarily manages and rules badly, and a good soul must do all these things well.

Unquestionably.

Now did we not grant that justice was a virtue of the soul, and injustice a vice?

We did.

Consequently the just soul and the just man will live well, and the unjust man ill?

354 Apparently, according to your argument.

And you will allow that he who lives well is blessed and happy, and that he who lives otherwise is the reverse.

Unquestionably.

Consequently the just man is happy, and the unjust man miserable.

Let us suppose them to be so.

But surely it is not misery, but happiness, that is advantageous.

Undoubtedly.

Never then, my excellent Thrasymachus, is injustice more advantageous than justice.

Well, Socrates, let this be your entertainment for the feast of Bendis.

I have to thank *you* for it, Thrasymachus, because you recovered your temper, and left off being angry with me. Nevertheless, I have b

not been well entertained; but that was my own fault, and not yours: for as your gluttons seize upon every new dish as it goes round, and taste its contents before they have had a reasonable enjoyment of its predecessor, so I seem to myself to have left the question which we were at first examining, concerning the real nature of justice, before we had found out the answer to it, in order to rush to the inquiry whether this unknown thing is a vice and an ignorance, or a virtue and a wisdom; and again, when a new theory, that injustice is more profitable than justice, was subsequently started, I could not refrain from passing from the other to this, so that at present the result of our conversation is that I know nothing: for while I do not know what justice is, I am little likely to know whether it is in fact a virtue or not, or whether its owner is happy or unhappy.

BOOK II

357 When I had made these remarks I thought I was to be freed from the discussion; whereas it seems it was only a prelude. For Glaucon, with that eminent courage which he displays on all occasions, would not accept the retreat of Thrasymachus, and began thus: Socrates, do you wish really to convince us that it is on every account better to be just than to be unjust, or only to seem to have convinced us?

If it were in my power, I replied, I should prefer convincing you really.

Then, he proceeded, you are not doing what you wish. Let me ask you: Is there, in your opinion, a class of good things of such a kind that we are glad to possess them, not because we desire their consequences, but simply welcoming them for their own sake? Take, for example, the feelings of enjoyment and all those pleasures that are harmless, and that are followed by no consequences, beyond simple enjoyment in their possession.

Yes, I certainly think there is a class of this description.

Well, is there another class, do you think, of those which we value, both for their own sake and for their results? Such as intelligence, and sight, and health—all of which we surely welcome on both accounts.

Yes.

And do you further recognize a third class of good things, which would include gymnastic training, and submission to medical treatment in illness, as well as the practice of medicine, and all other means of making money? Things like these we should describe as irksome, and yet beneficial to us; and while we should reject them viewed simply in themselves, we accept them for the sake of the rewards, and of the other consequences which result from them.

Yes, undoubtedly there is such a third class also; but what then?

In which of these classes do you place justice?

I should say in the highest—that is, among the good things which will be valued by one who is in the pursuit of true happiness, alike for their own sake and for their consequences.

Then your opinion is not that of the many, by whom justice is ranked in the irksome class, as a thing which in itself, and for its own sake, is disagreeable and repulsive, but which it is well to practice for the advantages to be had from it, with an eye to rewards and to a good name.

I know it is so; and under this idea Thrasymachus has been for a long time disparaging justice and praising injustice. But apparently I am a slow learner.

Listen to my proposal then, and tell me whether you agree to it. Thrasymachus appears to me to have yielded like a snake to your fascination sooner than he need have done; but for my part I am not satisfied as yet with the exposition that has been given of justice and injustice; for I long to be told what they respectively are, and what force they exert, taken simply by themselves, when residing in the soul, dismissing the consideration of their

c rewards and other consequences. This shall be my plan then, if you do not object: I will revive Thrasymachus's argument, and will first state the common view respecting what kind of thing justice is and how it came to be; in the second place, I will maintain that all who practice it do so against their will, because it is indispensable, not because it is a good thing; and thirdly, that they act reasonably in so doing, because the life of the unjust man is, as men say, far better than that of the just. Not that I think so myself, Socrates; only my ears are ringing so with what I hear from Thrasymachus and a thousand others, that I am puzzled. Now I have never heard the argument for

d the superiority of justice over injustice maintained to my satisfaction: for I should like to hear it praised, considered simply in itself; and from you if from any one, I should expect such a treatment of the subject. Therefore I will speak as forcibly as I can in praise of an unjust life, and I shall thus give you a specimen of the manner in which I wish to hear you afterwards censure injustice and commend justice. See whether you approve of my plan.

Indeed I do, for on what other subject could a sensible man like better to talk and to hear others talk, again and again?

e Admirably spoken! So now listen to me while I speak on my first theme, what kind of thing justice is and how it came to be.

To commit injustice is, they say, in its nature, a good thing, and to suffer it a bad thing; but the bad of the latter exceeds the

359 good of the former; and so, after the two-fold experience of both doing and suffering injustice, those who cannot avoid the latter and choose the former find it expedient to make a contract of mutual abstinence from injustice. Hence arose legislation and contracts between man and man, and hence it became the custom to call that which the law enjoined just, as well as lawful. Such, they tell us, is justice, and so it came into being; and it stands midway between that which is best, to com-

mit injustice with impunity, and that which is worst, to suffer injustice without any power of retaliating. And being a mean between these two extremes, the principle of justice is regarded with satisfaction, not as a positive good, but because the inability to commit injustice has rendered it valuable: for they say that one who had it in his power to be unjust, b and who deserved the name of a man, would never be so weak as to contract with any one that both the parties should abstain from injustice. Such is the current account, Socrates, of the nature of justice, and of the circumstances in which it originated.

Even those men who practice justice do so unwillingly, because they lack the power to violate it, will be most readily perceived, if we used the following reasoning. Let us give c full liberty to the just man and to the unjust alike, to do whatever they please, and then let us follow them, and see whither the inclination of each will lead him. In that case we shall surprise the just man in the act of traveling in the same direction as the unjust, owing to that desire to gain more, the gratification of which every creature naturally pursues as a good, only that it is forced out of its path by law, and constrained to respect the principle of equality. That full liberty of action would, perhaps, be most effectively realized if they were invested with a power which they say was in old time d possessed by the ancestor of Gyges the Lydian. He was a shepherd, so the story runs, in the service of the reigning sovereign of Lydia, when one day a violent storm of rain fell, the ground was rent asunder by an earthquake, and a yawning gulf appeared on the spot where he was feeding his flocks. Seeing what had happened, and wondering at it, he went down into the gulf, and among other marvelous objects he saw, as the legend relates, a hollow brazen horse, with windows in its sides, through which he looked, and beheld in the interior a corpse, apparently of superhuman size; from which he e took the only thing remaining, a golden ring

on the hand, and therewith made his way out. Now when the usual meeting of the shepherds occurred, for the purpose of sending to the king their monthly report of the state of his flocks, this shepherd came with the rest, wearing the ring. And, as he was seated with the company, he happened to turn the hoop of the ring round towards himself, until it came to the inside of 360 his hand. Whereupon he became invisible to his neighbors, who fell to talking about him as if he were gone away. While he was marveling at this, he again began playing with the ring, and turned the hoop to the outside, upon which he became once more visible. Having noticed this effect, he made experiments with the ring, to see whether it possessed this virtue; and so it was, that when he turned the hoop inwards he became invisible, and when he turned it outwards he was again visible. After this discovery, he immediately contrived to be appointed one of the messengers to carry the report to b the king; and upon his arrival he seduced the queen, and conspiring with her, slew the king, and took possession of the throne.

If then there were two such rings in existence, and if the just and the unjust man were each to put on one, it is to be thought that no one would be so steeled against temptation as to abide in the practice of justice, and resolutely to abstain from touching the property of his neighbors, when he had it in his power to help himself without fear to any thing he pleased in the market, or to go into private houses and have intercourse with whom he would, or to c kill and release from prison according to his own pleasure, and in every thing else to act among men with the power of a god. And in thus following out his desires the just man will be doing precisely what the unjust man would do; and so they would both be pursuing the same path. Surely this will be allowed to be strong evidence that none are just willingly, but only by compulsion, because to be just is not a good to the individual; for all violate justice whenever they imagine that there is nothing

to hinder them. And they do so because every one thinks that, in the individual case, injustice is much more profitable than justice; and they are right in so thinking, as the speaker of this d speech will maintain. For if any one having this licence within his grasp were to refuse to do any injustice, or to touch the property of others, all who were aware of it would think him a most pitiful and irrational creature, though they would praise him before each other's faces, deceiving one another, through their fear of suffering injustice. And so much for this topic.

But in actually deciding between the lives e of the two persons in question, we shall be enabled to arrive at a correct conclusion, by contrasting together the thoroughly just and the thoroughly unjust man, and only by so doing. Well then, how are we to contrast them? In this way. Let us take anything away either from the injustice of the unjust, or from the justice of the just, but let us suppose each to be perfect in his own line of conduct. First of all then, the unjust man must act as skillful craftsmen do. For a first-rate pilot or physician perceives the difference between what is doable and what is undoable in his art; and while he attempts the 361 former, he leaves the latter alone; and moreover, should he happen to make a false step, he is able to recover himself. In the same way, if we are to form a conception of a consummately unjust man, we must suppose that he makes no mistake in the prosecution of his unjust enterprises, and that he escapes detection; but if he be found out, we must look upon him as a bungler: for it is the perfection of injustice to seem just without really being so. We must therefore grant to the perfectly unjust man, without taking anything away, the most perfect injustice; and we must concede to him, that while committing the grossest acts of injustice he has won himself the highest reputation for b justice; and that should he make a false step, he is able to recover himself, partly by a talent for speaking with effect in case he be called in question for any of his misdeeds, and partly

because his courage and strength, and his command of friends and money, enable him to employ force with success, whenever force is required. Such being our unjust man, let us, in speech, place the just man by his side, a man of true simplicity and nobleness, resolved, as Aeschylus says, not to seem, but to be, good. We must certainly take away the seeming: for if he be thought to be a just man, he will have honors and gifts on the strength of this reputation, so that it will be uncertain whether it is for justice's sake, or for the sake of the gifts and honors, that he is what he is. Yes, we must strip him bare of everything but justice, and make his whole case the reverse of the former. Without being guilty of one unjust act, let him have the worst reputation for injustice, so that his justice may be thoroughly tested, and shown to be proof against infamy and all its consequences; and let him go on until the day of his death, steadfast in his justice, but with a lifelong reputation for injustice, in order that, having brought both the men to the utmost limits of justice and of injustice respectively, we may then give judgment as to which of the two is the happier.

Good heavens! my dear Glaucon, said I, how vigorously you work, scouring the two characters clean for our judgment, like a pair of statues.

I do it as well as I can, he said. And after describing the men as we have done, there will be no further difficulty, I imagine, in proceeding to sketch the kind of life which awaits them respectively. Let me therefore describe it. And if the description be somewhat coarse, do not regard it as mine, Socrates, but as coming from those who commend injustice above justice. They will say that in such a situation the just man will be scourged, racked, fettered, will have his eyes burnt out, and at last, after suffering every kind of torture, will be crucified; and thus learn that it is best to resolve, not to be, but to seem, just. Indeed those words of Aeschylus are far more applicable to the

unjust man than to the just. For it is in fact the unjust man, they will maintain, inasmuch as he devotes himself to a course which is allied to reality, and does not live with an eye to appearances, who "is resolved not to seem, but to be," unjust,

> "Reaping a harvest of wise purposes,
> Sown in the fruitful furrows of his mind";

being enabled first of all to rule in the city through his reputation for justice, and in the next place to choose a wife wherever he will, and marry his children into whatever family he pleases, to enter into contracts and join in partnership with any one he likes, and besides all this, to enrich himself by large profits, because he is not too nice to commit a fraud. Therefore, whenever he engages in a contest, whether public or private, he defeats and overreaches his enemies, and by so doing grows rich, and is enabled to benefit his friends and injure his enemies, and to offer sacrifices and dedicate gifts to the gods in magnificent abundance; and thus having greatly the advantage of the just man to do service to the gods, as well as to such men as he chooses, he is also more likely than the just man, to be dearer to the gods. And therefore they affirm, Socrates, that a better provision is made both by gods and men for the life of the unjust, than for the life of the just.

When Glaucon had said this, before I could make the reply I had in mind, his brother Adeimantus exclaimed, You surely do not suppose, Socrates, that the doctrine has been satisfactorily expounded.

Why not? said I.

The very point which it was most important to urge has been omitted.

Well then, according to the proverb, "May a brother be present to help one," it is for you to supply his deficiencies, if there are any, by your assistance. But indeed, for my part, what Glaucon has said is enough to prostrate me,

and put it out of my power to come up to the rescue of justice.

e You are not in earnest, he said: listen to the following argument also; for we must now go through those representations which, reversing the declarations of Glaucon, commend justice and disparage injustice, in order to bring out more clearly what I take to be his meaning. Now, surely, fathers tell their sons and those in whom they feel an interest, that one must be just, 363 and impress it upon their children or those in whom they feel an interest, they do not praise justice in itself, but only the respectability which it gives—their object being that a reputation for justice may be gained, and that this reputation may bring the offices, marriages, and the other good things which Glaucon has just told us are secured to the just man by his high character. And these persons carry the advantages of a good name still further; for, by introducing the good opinion of the gods, they are enabled to describe innumerable blessings which the gods, they say, grant to the pious, as the excellent Hesiod tells us, and Homer too—the former saying, that the gods cause the oak-trees of the just

b *"On their tops to bear acorns, and swarms of bees in the middle;*
 Also their wool-laden sheep sink under the weight of their fleeces"

with many other good things of the same sort; while the latter, in a similar passage, speaks of one,

 "Like to a blameless king, who, godlike in virtue and wisdom,
c *Justice ever maintains; whose rich land fruitfully yields him*
 Harvests of barley and wheat, and his orchards are heavy with fruit;
 Strong are the young of his flocks; and the sea gives him fish in abundance."

But the blessings which Musaeus and his son Eurnolpus represent the gods as bestowing upon

the just, are still more delectable than these; for they bring them to the abode of Hades, and describe them as reclining on couches at a banquet of the pious, and with garlands on their heads spending all time in winebibbing, the fairest reward of virtue being, in their esti- d mation, an everlasting carousal. Others, again, do not stop even here in their enumeration of the rewards bestowed by the gods; for they tell us that the man who is pious and true to his oath leaves children's children and a posterity to follow him. Such, among others, are the commendations which they lavish upon justice. The ungodly, on the other hand, and the unjust, they plunge into a swamp in Hades, and condemn them to carry water in a sieve; and while they are still alive, they bring them into ill repute, and inflict upon the unjust precisely e those punishments which Glaucon enumerated as the lot of the just who are reputed to be unjust; more they cannot. Such is their method of praising the one character and condemning the other.

Once more, Socrates, take into consideration another and a different mode of speaking with regard to justice and injustice, which 364 we meet with both in common life and in the poets. All as with one mouth proclaim, that to be temperate and just is an admirable thing certainly, but at the same time a hard and an irksome one; while intemperance and injustice are pleasant things and of easy acquisition, and only rendered base by law and public opinion. But they say that justice is in general less profitable than injustice, and they do not hesitate to call wicked men happy, and to honor them both in public and in private, when they are rich or possess other sources of power, and on the other hand to treat with dishonor and disdain those who are in any way feeble b or poor, even while they admit that the latter are better men than the former. But of all their statements the most wonderful are those which relate to the gods and to virtue; according to which even the gods allot to many good men

a calamitous and bad life, and to men of the opposite character an opposite portion. And there are quacks and soothsayers who flock to the rich man's doors, and try to persuade him that they have a power procured from the gods, which enables them, by sacrifices and incantations performed amid feasting and indulgence,

c to make amends for any crime committed either by the individual himself or by his ancestors; and that, should he desire to do a mischief to any one, it may be done at a trifling expense, whether the object of his hostility be a just or an unjust man: for they profess that by certain invocations and spells they can prevail upon the gods to do their bidding. And in support of all these assertions they produce the evidence of poets—some, to exhibit the facilities of vice, quoting the words

d
 "Whoso wickedness seeks, may even in masses
 obtain it
 Easily. Smooth is the way, and short, for nigh is
 her dwelling.
 Virtue, Heav'n has ordained, shall be reached
 by the sweat of the forehead,"

and by a long and up-hill road; while others, to prove that the gods may be turned from their purpose by men, adduce the testimony of Homer, who has said:

e
 "Yea, even the gods do yield to entreaty;
 Therefore to them men offer both victims and
 meek supplications,
 Incense and melting fat, and turn them from
 anger to mercy;
 Sending up sorrowful prayers, when trespass
 and sin is committed."

And they produce a host of books written by Musaeus and Orpheus, children, as they say, of Selene and of the Muses, which form their

365 ritual, persuading not individuals merely, but whole cities also, that men may be absolved and purified from crimes, both while they are still alive and even after their death, by means of certain sacrifices and pleasurable amusements which they call Mysteries—which deliver us from the torments of the other world, while the neglect of them is punished by an awful doom.

When views like these, he continued, my dear Socrates, are proclaimed and repeated with so much variety, concerning the honors in which virtue and vice are respectively held by gods and men, what can we suppose is the effect produced on the minds of all those good-natured young men, who are able, after skimming like birds, as it were, over all that they hear, to draw conclusions from it, respecting the character which a man must possess, and

b the path in which he must walk, in order to live the best possible life? In all probability a young man would say to himself in the words of Pindar, "Shall I by justice or by crooked wiles climb to a loftier stronghold, and, having thus fenced myself in, live my life?" For common opinion declares that to be just without being also thought just, is no advantage to me, but only entails manifest trouble and loss; whereas if I am unjust and get myself a name for justice, an unspeakably happy life is promised

c me. Very well then, since the appearance, as the wise inform me, overpowers the truth, and is the sovereign dispenser of felicity, to this I must of course wholly devote myself; I must draw round about me a picture of virtue to serve as an exterior front, but behind me I must keep the fox with its cunning and shiftiness— of which that most clever Archilochus tells us. Yes, but it will be objected, it is not an easy matter always to conceal one's wickedness.

d No, we shall reply, nor yet is anything else easy that is great; nevertheless, if happiness is to be our goal, this must be our path, as the steps of the argument indicate. To assist in keeping up the deception, we will form secret societies and clubs. There are, moreover, teachers of persuasion, who impart skill in popular and forensic oratory; and so by fair means or by foul, we shall gain our ends, and carry on our dishonest

proceedings with impunity. But, it is urged, neither evasion nor violence can succeed with the gods. Well, but if they either do not exist, or do not concern themselves with the affairs of men, why need *we* concern ourselves to evade their observation? But if they do exist, and do pay attention to us, we know nothing and have heard nothing of them from any other quarter than the current traditions and the genealogies of poets; and these very authorities state that the gods are beings who may be wrought upon and diverted from their purpose by sacrifices and meek supplications and votive offerings. Therefore we must believe them in both statements or in neither. If we are to believe them, we will act unjustly, and offer sacrifices from the proceeds of our crimes. For if we are just, we shall, it is true, escape punishment at the hands of the gods, but we renounce the profits which accrue from injustice; but if we are unjust, we shall not only make these gains, but also by putting up prayers when we overstep and make mistakes, we shall prevail upon the gods to let us go unscathed. But then, it is again objected, in Hades we shall pay the just penalty for the crimes committed here, either in our own persons or in those of our children's children. But my friend, the champion of the argument will continue, the mystic rites, again, are very powerful, and the absolving divinities, as we are told by the mightiest cities, and by the sons of the gods who have appeared as poets and inspired prophets, who inform us that these things are so.

What consideration, therefore, remains which should induce us to prefer justice to the greatest injustice? Since if we combine injustice with a spurious decorum, we shall fare to our liking with the gods and with men, in this life and the next, according to the most numerous and the highest authorities. Considering all that has been said, by what device, Socrates, can a man who has any advantages, either of high talent, or wealth, or personal appearance, or birth, bring himself to honor justice, instead

of smiling when he hears it praised? Indeed, if there is any one who is able to show the falsity of what we have said, and who is fully convinced that justice is best, far from being angry with the unjust, he doubtless makes great allowance for them, knowing that, with the exception of those who may possibly refrain from injustice through the disgust of a godlike nature or from the acquisition of knowledge, there is certainly no one else who is willingly just; but it is from cowardice, or age, or some other infirmity, that men condemn injustice, simply because they lack the power to commit it. And the truth of this is proved by the fact, that the first of these people who comes to power is the first to commit injustice, to the extent of his ability.

And the cause of all this is simply that fact, which my brother and I both stated at the very commencement of this address to you, Socrates, saying: With all due respect, to you who profess to be admirers of justice—beginning with the heroes of old, of whom accounts have descended to the present generation—have every one of you, without exception, made the praise of justice and condemnation of injustice turn solely upon the reputation and honor and gifts resulting from them; but what each is in itself, by its own peculiar force as it resides in the soul of its possessor, unseen either by gods or men, has never, in poetry or in prose been adequately discussed, so as to show that injustice is the greatest bane that a soul can receive into itself, and justice the greatest blessing. Had this been the language used by all of you from the start, and had you tried to persuade us of this from our childhood, we should not be on the watch to check one another in the commission of injustice, because every one would be his own watchman, fearful lest by committing injustice he might attach to himself the greatest of evils.

All this, Socrates, and perhaps still more than this, would be put forward respecting justice and injustice, by Thrasymachus, and

I dare say by others also; thus vulgarly, in my opinion, turning around the power of each. For my own part, I confess—for I do not want to hide anything from you—that I have a great desire to hear you defend the opposite view, and therefore I have exerted myself to speak as forcefully as I can. So do not limit your argument to the proposition that justice is stronger than injustice, but show us what is that influence exerted by each of them on its possessor, whereby the one is in itself a blessing, and the other a curse; and take away the estimation in which the two are held, as Glaucon urged you to do. For if you omit to withdraw from each quality its true reputation and to add the false, we shall declare that you are praising, not the reality, but the semblance of justice, and blaming, not the reality, but the semblance of injustice; that your advice, in fact, is to be unjust without being found out, and that you hold with Thrasymachus, that justice is another man's good, being for the interest of the stronger; injustice a man's own interest and advantage, but against the interest of the weaker. Since then you have allowed that justice belongs to the highest class of good things, the possession of which is valuable, both for the sake of their results, and also in a higher degree for their own sake, such as sight, hearing, understanding, health, and everything else which is genuinely good in its own nature and not merely reputed to be good. Select for commendation this particular feature of justice, I mean the benefit which in itself it confers on its possessor, in contrast with the harm which injustice inflicts. The rewards and reputations leave to others to praise; because in others I can tolerate this mode of praising justice and condemning injustice, which consists in eulogizing or reviling the reputations and the rewards which are connected with them; but in you I cannot, unless you require it, because you have spent your whole life in investigating such questions, and such only. Therefore do not content yourself with proving to us that justice is better than injustice; but show us what is that influence exerted by each

on its possessor, by which, whether gods and men see it or not, the one is in itself a good, and the other a detriment.

Much as I had always admired the nature of both Glaucon and Adeimantus, I confess that on this occasion I was quite charmed with what I had heard; so I said: Aptly indeed did Glaucon's admirer address you, sons of the man there named, in the first line of his elegiac poem, after you had distinguished yourselves in the battle of Megara, saying:

> *"Race of a famous man, ye godlike sons of Ariston."*

There seems to me to be great truth in this epithet, my friends: for there is something truly god-like in the state of your minds, if you are not convinced that injustice is better than justice, when you can plead its cause so well. I do believe that you really are not convinced of it. But I infer it from your general character; for judging merely from your statements I should have distrusted you: but the more I place confidence in you, the more I am perplexed how to deal with the case; for though I do not know how I am to render assistance, having learnt how unequal I am to the task from your rejection of my answer to Thrasymachus, wherein I imagined that I had demonstrated that justice is better than injustice; yet, on the other hand, I dare not refuse my assistance: because I am afraid that it might be positively wrong in me, when I hear justice disparaged in my presence, to lose heart and desert her, so long as breath and utterance are left in me. My best plan, therefore, is to succor her in such fashion as I can.

Thereupon Glaucon, and all the rest with him, requested me by all means to give my assistance, and not to let the conversation drop, but thoroughly to investigate the real nature of justice and injustice, and the truth with regard to their respective advantages. So I said what seemed to me to be the case. The inquiry we are undertaking is no trivial one, but demands a keen sight, according to my notion of it. Therefore,

d since I am not a clever person, I think we had better adopt a mode of inquiry which may be thus illustrated. Suppose we had been ordered to read small writing at a distance, not having very good eye-sight, and that one of us discovered that the same writing was to be found somewhere else in larger letters, and upon a larger space, we should have looked upon it as a piece of luck, I imagine, that we could read the latter first, and then examine the smaller, and observe whether the two were alike.

e Undoubtedly we should, said Adeimantus; but what parallel can you see to this, Socrates, in our inquiry after justice?

I will tell you, I replied. We speak of justice as residing in an individual man, and also as residing in an entire city, do we not?

Certainly we do, he said.

Well, a city is larger than one man.

It is.

369 Perhaps, then, justice may exist in larger proportions the greater subject, and thus be easier to discover; so, if you please, let us first investigate its character in cities; afterwards let us apply the same inquiry to the individual, looking for the counterpart of the greater as it exists in the form of the less.

Indeed, he said, I think your plan is a good one.

If then we were to trace in thought the gradual formation of a city, should we also see the growth of its justice or of its injustice?

Perhaps we should.

Then, if this were done, might we not hope b to see more easily the object of our search?

Yes, much more easily.

Is it your advice, then, that we should attempt to carry out our plan? It is no trifling task, I imagine; therefore consider it well.

We have considered it, said Adeimantus; yes, do so by all means.

Well then, I proceeded, the formation of a city is due, as I imagine, to this fact, that we are not individually independent, but have many wants. Or would you assign any other principle for the founding of cities?

No I agree with you, he replied.

Thus it is, then, that owing to our many c wants, and because each seeks the aid of others to supply his various requirements, we gather many associates and helpers into one dwelling-place, and give to this joint dwelling the name of city. Is it so?

Undoubtedly.

And every one who gives or takes in exchange, whatever it be that he exchanges, does so from a belief that he is consulting his own interest.

Certainly.

Now then, let us construe our imaginary city from the beginning. It will owe its construction, it appears, to our needs.

Unquestionably.

Well, but the first and most pressing of all d wants is that of sustenance to enable us to exist as living creatures.

Most decidedly.

Our second want would be that of a house, and our third that of clothing and the like.

True.

Then let us know what will render our city adequate to the supply of so many things. Must we not begin with a farmer for one, and a house-builder, and besides these a weaver? Will these suffice, or shall we add to them a shoemaker, and perhaps one or two more of the class of people who minister to our bodily wants?

By all means.

Then the smallest possible city will consist of four or five men.

So we see.

To proceed then: ought each of these to e place his own work at the disposal of the community, so that the single farmer, for example, shall provide food for four, spending four times the amount of time and labor upon the preparation of food, and sharing it with others; or must he be regardless of them, and produce 370 for his own consumption alone the fourth part of this quantity of food, in a fourth part of the time, spending the other three parts, one in

making his house, another in procuring himself clothes, and the third in providing himself with shoes, saving himself the trouble of sharing with others, and doing his own business by himself, and for himself?

To this Adeimantus replied, Well, Socrates, perhaps the former plan is the easier of the two.

Really, I said, it is not improbable; for I recollect myself, after your answer, that, in the first place, no two persons are born exactly alike, but each differs in his nature, one being suited for one occupation, and another for another. Do you not think so?

I do.

Well, when is a man likely to succeed best? When he divides his exertions among many trades, or when he devotes himself exclusively to one?

When he devotes himself to one.

Again, it is also clear, I imagine, that if a person lets the right moment for any work go by, it never returns.

It is quite clear.

For the thing to be done does not choose, I imagine, to await the leisure of the doer, but the doer must be at the call of the thing to be done, and not treat it as a secondary affair.

He must.

From these considerations it follows that all things will be produced in superior quantity and quality, and with greater ease, when each man works at a single occupation, in accordance with his nature, and at the right moment, without meddling with anything else.

Unquestionably.

More than four citizens, then, Adeimantus, are needed to provide the requisites which we named. For the farmer, it appears, will not make his own plough, if it is to be a good one, nor his hoe, nor any of the other tools employed in agriculture. No more will the builder make the numerous tools which he also requires; and so of the weaver and the shoemaker.

True.

Then we shall have carpenters and smiths, and many other artisans of the kind, who will become members of our little city, and create a population.

Certainly.

Still it will not yet be very large, supposing we add to them cowherds and shepherds, and the rest of that class, in order that the farmers may have oxen for ploughing, and the housebuilders, as well as the farmers, beasts of burden for hauling, and the weavers and shoemakers wool and leather.

It will not be a small city, either, if it contains all these.

Moreover, it is scarcely possible to plant the actual city in a place where it will have no need of imports.

No, it is impossible.

Then it will further require a new class of persons to bring from other cities all that it requires.

It will.

Well, but if the agent goes empty-handed, carrying with him none of the commodities in demand among those people from whom our city is to procure what it requires, he will also come empty-handed away, will he not?

I think so.

Then it must produce at home not only enough for itself, but also articles of the right kind and quantity to accommodate those whose services it needs.

It must.

Then our city requires larger numbers both of farmers and other craftsmen.

Yes, it does.

And among the rest it will need more of those agents also, who are to export and import the several commodities; and these are merchants, are they not?

Yes.

Then we shall require merchants also.

Certainly.

And if the commerce is carried on by sea, there will be a further demand for a considerable number of other persons, who are skilled in the practice of navigation.

A considerable number, undoubtedly.

But now tell me: in the city itself how are they to exchange their several productions? For it was to promote this exchange, you know, that we formed the community, and so founded our city.

Clearly, by buying and selling.

Then this will give rise to a market and a currency, for the sake of exchange.

Undoubtedly.

c Suppose then that the farmer, or one of the other craftsmen, should come with some of his produce into the market, at a time when none of those who wish to make an exchange with him are there, is he to leave his occupation and sit idle in the market-place?

By no means, there are persons who, with an eye to this contingency, undertake the service required; and these in well-regulated cities are, generally speaking, persons of excessive physical weakness, who are of no use in other kinds of labor. Their business is to remain on d the spot in the market, and give money for goods to those who want to sell, and goods for money to those who want to buy.

This demand, then, causes a class of tradesmen to spring up in our city. For do we not give the name of retail dealers to those who station themselves in the market, to minister to buying and selling, applying the term merchants to those who go about from city to city?

Exactly so.

e In addition to these, I imagine, there is also another class of servants, consisting of those whose reasoning capacities do not recommend them as associates, but whose bodily strength is equal to hard labor, these, selling the use of their strength and calling the price of it hire, are thus named, I believe, hired laborers. Is it not so?

Precisely.

Then hired laborers also form, as it seems, a complementary portion of a city.

I think so.

Shall we say then, Adeimantus, that our city has at length grown to its full stature?

Perhaps so.

Where then, I wonder, shall we find justice and injustice in it? With which of these elements that we have contemplated, has it simultaneously made its entrance?

I have no notion, Socrates, unless perhaps it 372 be discoverable somewhere in the mutual relations of these same persons.

Well, perhaps you are right. We must investigate the matter, and not flinch from the task.

Let us consider then, in the first place, what kind of life will be led by persons thus provided. I presume they will produce bread and wine, and clothes and shoes, and build themselves houses; and in summer, no doubt, they will generally work naked and without shoes, while in winter they will be suitably clothed and shod. And they will live, I suppose, on bar- b ley and wheat, baking cakes of the meal, and kneading loaves of the flour. And spreading these excellent cakes and loaves upon mats of straw or on clean leaves, and themselves reclining on rude beds of yew or myrtleboughs, they will make merry, themselves and their children, drinking their wine, wearing garlands, and singing the praises of the gods, enjoying one another's society, and not begetting chil- c dren beyond their means, through a prudent fear of poverty or war.

Glaucon here interrupted me, remarking, Apparently you describe your men as feasting without any seasonings.

True, I said, I had forgotten. Of course they will have something to season their food—salt, no doubt, and olives and cheese, together with the country fare of boiled onions and cabbage. We shall also set before them a dessert, I imagine, of figs and chickpeas and beans; and they may roast myrtle-berries and beech-nuts at the fire, taking wine with their fruit in moderation. d And thus passing their days in tranquillity and sound health, they will, in all probability, live to an advanced age, and dying, bequeath to their children a life in which their own will be reproduced.

Upon this Glaucon exclaimed, Why Socrates, if you were founding a community of

swine, this is just the style in which you would fatten them up!

How then, said I, would you have them live, Glaucon?

In a civilized manner, he replied. They ought to recline on couches, I should think, if they are not to have a hard life of it, and dine off tables, and have the usual dishes and dessert of a modern dinner.

Very good. I understand. Apparently we are considering the growth not of a city merely, but of a luxurious city. I dare say it is not a bad plan: for by this extension of our inquiry we shall perhaps discover how it is that justice and injustice take root in cities. Now it appears to me that the city which we have described is the genuine and, so to 373 speak, healthy city. But if you wish us to contemplate a city that is suffering from inflammation, there is nothing to hinder us. Some people will not be satisfied, it seems, with the fare or the mode of life which we have described, but must have, in addition, couches and tables and every other article of furniture, as well as seasonings and fragrant oils, and perfumes, and courtesans, and confectionery; and all these in plentiful variety. Moreover, we must not limit ourselves now to essentials in those articles which we specified at first, I mean houses and clothes and shoes, but we must set painting and embroidery to work, and acquire gold and ivory, and all similar valuables, must we not?

b Yes.

Then we shall also have to enlarge our city, for our first or healthy city will not now be of sufficient size, but requires to be increased in bulk, and needs to be filled with a multitude of callings, which do not exist in cities to satisfy any natural want: for example, the whole class of hunters, and all who practice the art of imitation, including many who use forms and colors, and many who use music; and poets also—and their helpers, the rhapsodes, actors, dancers, contractors; and lastly, the craftsmen

of all sorts of articles, and among others those who make parts of women's dresses. We shall similarly require more personal servants, shall c we not? that is to say, teachers, wet-nurses, dry-nurses, beauticians, barbers, and cooks moreover, and butchers? Swineherds again are among the additions we shall require, a class of persons not to be found, because not wanted, in our former city, but needed among the rest in this. We shall also need great quantities of all kinds of cattle, for those who may wish to eat them, shall we not?

Of course we shall.

Then shall we not experience the need of d medical men also, to a much greater extent under this than under the former regime?

Yes, indeed.

The country too, I presume, which was formerly adequate to the support of its then inhabitants will be now too small, and adequate no longer. Shall we say so?

Certainly.

Then must we not cut ourselves a slice of our neighbor's territory, if we are to have land enough both for pasture and tillage, while they will do the same to ours, if they, like us, permit themselves to overstep the limit of necessities, and plunge into the unbounded acquisition of wealth?

It must inevitably be so, Socrates. e

Will our next step be to go to war, Glaucon, or how will it be?

As you say.

At this stage of our inquiry let us avoid asserting either that war does good or that it does harm, confining ourselves to this statement, that we have further traced the origin of war to causes which are the most fruitful sources of whatever ills befall a city, either in its public capacity, or in its individual members.

Exactly so.

Once more then, my friend, our city must be larger and not just by a small extent, I mean that of a whole army, which must go forth and 374 do battle with all invaders in defense of its

entire property, and of the persons whom we were just now describing.

How? he asked; are not those persons sufficient ŏf themselves?

They are not, if you and all the rest of us were right in the admissions which we made, when we were modeling our city. We admitted, I think, if you remember, that it was impossible for one man to work well at many professions.

True.

b Well then, is not the business of war looked upon as a profession in itself?

Undoubtedly.

And have we not as much reason to concern ourselves about the trade of war as about the trade of shoemaking?

Quite as much.

But we cautioned the shoemaker, you know, against attempting to be a farmer or a weaver or a builder besides, with a view to our shoemaking work being well done; and to every other artisan we assigned in like manner one occupation, namely, that for which he was naturally fitted, and in which, if he let other things alone, and worked at it all his time

c without neglecting his opportunities, he was likely to prove a successful workman. Now is it not of the greatest moment that the work of war should be well done? Or is it so easy, that any one can succeed in it and be at the same time a farmer or a shoemaker or a laborer at any other trade whatever, although there is no one in the world who could become a good checkers-player or dice-player by merely taking up the game at unoccupied moments, instead of pursuing it as his special study from his childhood? And will it be enough for

d a man merely to handle a shield or the other arms and implements of war? Will that make him competent to play his part well on that very day in an engagement of heavy troops or in any other military service—although the mere handling of any other instrument will never make any one a true craftsman or athlete, nor will such instrument be even useful

to one who has neither learnt its capabilities nor exercised himself sufficiently in its practical applications?

If it were so, these implements of war would be very valuable.

In proportion, then, to the importance of the work which these guardians have to do, it will require more leisure than most, as well as extraordinary skill and attention.

I quite think so. e

Will it not also require natural endowments suited to this particular occupation?

Undoubtedly.

Then, apparently, it will be up to us to choose, if we can, the kind of nature which qualifies its possessors for the guardianship of a city.

Certainly; it belongs to us.

Then, I assure you, we have taken upon ourselves no trifling task: nevertheless, there must be no flinching, so long as our strength holds out.

No, there must not.

Do you think then, I asked, that there is any 375 difference, in the qualities required for keeping guard, between a well-bred dog and a gallant young man?

I do not quite understand you.

Why, I suppose, for instance, they ought both of them to be quick to discover an enemy, and swift to overtake him when discovered, and strong also, in case they have to fight when they have come up with him.

Certainly, all these qualities are required.

Moreover, they must be brave if they are to fight well.

Undoubtedly.

But will either a horse, or a dog, or any other animal, be likely to be brave if it is not spirited? or have you failed to observe what an irresistible and unconquerable thing the spirit is, so that under its influence every creature will be fearless and unconquerable in the face b of any danger?

I have observed it.

We know then what bodily qualities are required in our guardian.

We do.

And also what qualities of the mind, namely, that he must be spirited.

Yes.

How then, Glaucon, if such be their natural disposition, are they to be kept from behaving fiercely to one another, and to the rest of the citizens?

It will not be easy.

c Nevertheless, they certainly ought to be gentle to their friends, and dangerous only to their enemies—else they will not wait for others to destroy them, but will be the first to do it for themselves.

True.

What then shall we do? Where shall we find a character at once gentle and high-spirited? For I suppose a gentle nature is the opposite of a spirited one?

Apparently it is.

Nevertheless a man who is devoid of either gentleness or spirit cannot possibly make a good guardian. And as they seem to be incom-
d patible, the result is, that a good guardian is an impossibility.

It looks like it, he said.

Here then I was perplexed, but having reconsidered our conversation, I said, We deserve, my friend, to be puzzled: for we have deserted the illustration which we set before us.

How so?

It never struck us, that after all there are natures, though we fancied there were none, which combine these opposite qualities.

And where is such a combination to be found?

You may see it in several animals, but par-
e ticularly in the one which we ourselves compared to our guardian. For I suppose you know that it is the natural disposition of well-bred dogs to be perfectly gentle to their friends and acquaintance, but the reverse to strangers.

Certainly I do.

Therefore the thing is possible; and we are not contradicting nature in our endeavor to give such a character to our guardian.

So it would seem.

Then is it your opinion, that in one who is to make a good guardian it is further required that his character should be philosophical as well as high-spirited?

How so? I do not understand you. 376

You will notice in dogs this other trait, which is really marvelous in the creature.

What is that?

Whenever they see a stranger they are irritated before they have been provoked by any ill-usage; but when they see an acquaintance they welcome him, though they may never have experienced any kindness at his hands. Has this never excited your wonder?

I never applied my mind to it hitherto; but no doubt they do behave so.

Well, but this affection is a very clever thing b
in the dog, and truly philosophical.

How so?

Why, because the only mark by which he distinguishes between the appearance of a friend and that of an enemy is, that he knows the former and is ignorant of the latter. How, I ask, can the creature be other than fond of learning when it makes knowledge and ignorance the criteria of the familiar and the strange?

Beyond a question, it must be fond of learning.

Well, is not the love of learning identical with a philosophical disposition?

It is.

Shall we not then assert with confidence in the case of a man also, that if he is to show c
a gentle disposition towards his relatives and acquaintances, he must have a turn for learning and philosophy?

Be it so.

Then in our judgment the man who is a fine and good guardian of the city will be in his nature philosophical, high-spirited, swift-footed, and strong.

Undoubtedly he will. . . .

BOOK III

412 . . . Very good; then what will be the next point for us to settle? is it not this, which of the persons so educated are to be the rulers, and which the ruled?

c Unquestionably it is.

There can be no doubt that the rulers must be the elderly men, and the subjects would be the younger.

True.

And also that the rulers must be the best men among them.

True again.

Are not the best farmers those who are most farmer-like?

Yes.

In the present case, as we require the best guardians, shall we not find them in those who are most capable of guarding a city?

Yes.

Then for this purpose must they not be intelligent and powerful, and, moreover, careful of the city?

d They must.

And a man will be most careful of that which he loves?

Of course.

And assuredly he will love that most whose interests he regards as identical with his own, and in whose prosperity or adversity he believes his own fortunes to be involved.

Just so.

Then we must select from the whole body of guardians those individuals who appear to us, after due observation, to be remarkable above others for the zeal with which, through their whole life, they have done what they have

e thought advantageous to the city, and inflexibly refused to do what they thought the reverse.

Yes, these are the suitable persons, he said.

Then I think we must watch them at every stage of their life, to see if they are tenacious guardians of this conviction, and never bewitched or forced into a forgetful banishment

of the belief that they ought to do what is best for the city.

What is this banishment you speak of?

I will tell you. Opinion appears to depart from our reasoning, either by a voluntary or 413 involuntary act; a false opinion by a voluntary act, when the holder learns his error; but a true opinion invariably by an involuntary act.

I understand the notion of a voluntary abandonment, but I have yet to learn the meaning of the involuntary.

Well, then, do you not agree with me, that men are deprived of good things against their will, of bad things with their will? And is it not a bad thing to be the victim of a lie, and a good thing to possess the truth? And do you not think that a man is in possession of the truth when his opinions represent things as they are?

Yes, you are right; and I believe that men are deprived of a true opinion against their will.

Then, when this happens, must it not be b owing either to theft, or witchcraft, or violence?

I still do not understand.

I am afraid I use language as obscure as tragedy. By those who have a theft practiced on them, I mean such as are argued out of, or forget, their opinions, because, argument in the one case and time in the other robs them of their opinion unawares. Now, I suppose you understand?

Yes.

By those who have violence done to them I mean all whose opinions are changed by pain or grief.

That too I understand, and I think you are right.

And those who are bewitched, you would c yourself, I believe, assert to be those who change their opinion either through the seductions of pleasure or under the pressure of fear.

Yes, everything that deceives may be said to bewitch.

Then, as I said just now, we must inquire who are the best guardians of this inward

conviction, that they must always do that which they think best for the city. We must watch them, I say, from their earliest childhood, giving them actions to perform in which people would be most likely to forget, or be beguiled of, such a belief, and then we must select those whose memory is tenacious, and who are proof against deceit, and exclude the rest. Must we not?

Yes.

We must also appoint them labors, and vexations, and contests, in which we must watch for the same symptoms of character.

Rightly so.

And, as a third kind of test, we must try them with witchcraft, and observe their behavior; and, just as young horses are taken into the presence of noise and tumult, to see whether they are timid, so must we bring our men, while still young, into the midst of objects of terror, and presently transfer them to scenes of pleasure, trying them much more thoroughly than gold is tried in the fire, to find whether they show themselves under all circumstances inaccessible to witchcraft, and proper in their bearing, good guardians of themselves and of the music which they have been taught, proving themselves on every occasion true to the laws of rhythm and harmony, and acting in such a way as would render them most useful to themselves and the city. And whoever, from time to time, after being put to the proof, as a child, as a youth, and as a man, comes forth uninjured from the trial, must be appointed a ruler and guardian of the city, and must receive honors in life and in death, and be admitted to the highest privileges, in the way of funeral rites and other tributes to his memory. And all who are the reverse of this character must be rejected. Such appears to me, Glaucon, to be the true method of selecting and appointing our rulers and guardians, described simply in outline, without accuracy in detail.

I am pretty much of your mind.

Is it not then entirely correct to give them the name of thorough-going guardians, as being qualified to take care that their friends at home shall not wish, and their enemies abroad not be able, to do any mischief; and to call the young men, whom up to this time we called "guardians," "auxiliaries" and helpers with the decrees of the rulers?

I think so, he said.

This being the case, I continued, can we contrive any ingenious mode of bringing into play one of those noble lies of which we lately spoke, so that, propounding a single noble lie, we may bring even the rulers themselves, if possible, to believe it, or if not them, the rest of the city?

What kind of a lie?

Nothing new, but a Phoenician story, which has been realized often before now, as the poets tell and mankind believe, but which in our time has not been, nor, so far as I know, is likely to be realized, and for which it would require great powers of persuasion for it to be creditable.

You seem very reluctant to tell it.

You will think my reluctance very natural when I have told it.

Speak out boldly and without fear.

Well I will; and yet I hardly know where I shall find the courage or where the words to express myself. I shall try, I say, to persuade first the rulers themselves and the military class, and after them the rest of the city, that when we were training and instructing them, they only thought, as in dreams, that all this was happening to them and about them, while in reality they were in course of formation and training in the bowels of the earth, where they themselves, their armor, and the rest of their equipments were manufactured, and whence, as soon as they were finished, the earth, their real mother, sent them up to its surface; and, consequently, that they ought now to take thought for the land in which they dwell, as their mother and nurse, and repel all attacks upon it, and to feel towards their fellow citizens as brothers born of the earth.

It was not without reason that you were so long ashamed to tell us your fiction.

415 I dare say; nevertheless, hear the rest of the story. We shall tell our people, in mythical language: You are doubtless all brethren, as many as inhabit the city, but the god who created you mixed gold in the composition of such of you as are qualified to rule, which gives them the highest value; while in the auxiliaries he made silver an ingredient, assigning iron and bronze to the cultivators of the soil and the other workmen. Therefore, inasmuch as you are all related to one another, although your children will generally
b resemble their parents, yet sometimes a golden parent will produce a silver child, and a silver parent a golden child, and so on, each producing any. The rulers therefore have received this in charge first and above all from the gods, to observe nothing more closely, in their character of vigilant guardians, than the children that are born, to see which of these metals enters into the composition of their souls; and if a child be born in their class with an alloy of bronze or iron, they are to have no manner of pity upon it, but giving it the value that belongs to its
c nature, they are to thrust it away into the class of artisans or farmers; and if again among these a child be born with any admixture of gold or silver, when they have examined it, they are to raise it either to the class of guardians, or to that of auxiliaries: because there is an oracle which declares that the city shall then perish when it is guarded by iron or bronze. Can you suggest any device by which we can make them believe this fiction?

d None at all by which we could persuade the men with whom we begin our new city: but I think their sons, and the next generation, and all subsequent generations, might be taught to believe it.

Well, I said, even this might have a good effect towards making them care more for the city and for one another; for I think I understand what you mean. However, we will leave this fiction to posterity; but for our part, when we have armed these children of the soil, let us lead them forward under the command of their officers, until they arrive at the city; then let them look around them to discover the most eligible position for their camp, from which they may best coerce the inhabitants, if there be any disposition to refuse obedience to the e
laws, and repel foreigners, if an enemy should come down like a wolf on the fold. And when they have pitched their camp, and offered sacrifices to the proper divinities, let them arrange their sleeping-places. Is all this right?

It is.

And these sleeping-places must be such as will keep out the weather both in winter and summer, must they not?

Certainly; you mean dwelling-houses, if I am not mistaken.

I do; but the dwelling-houses of soldiers, not of moneyed men.

What is the difference which you imply? 416

I will endeavor to explain it to you, I replied. I presume it would be a most monstrous and scandalous proceeding in shepherds to keep for the protection of their flocks such a breed of dogs, or so to treat them, that owing to unruly tempers, or hunger, or any bad propensity whatever, the dogs themselves should begin to worry the sheep, and behave more like wolves than dogs.

It would be monstrous, undoubtedly.

Then must we not take every precaution b
that our auxiliary class, being stronger than the other citizens, may not act towards them in a similar fashion, and so resemble savage despots rather than friendly allies?

We must.

And will they not be furnished with the best of safeguards, if they are really well educated?

But they are *that* already, he exclaimed.

To which I replied, It is not worth while now to insist upon that point, my dear Glaucon; but it is most necessary to maintain what we c
said this minute, that they must have the right education, whatever it may be, if they are to have what will be most effectual in rendering

them gentle to one another, and to those whom they guard.

True.

But besides this education a rational man would say that their dwellings and property generally should be arranged on such a scale as shall neither prevent them from being perfect d thorough-going guardians, nor provoke them to do mischief to the other citizens.

He will say so with truth.

Consider then, I continued, whether the following plan is the right one for their lives and their dwellings, if they are to be of the character I have described. In the first place, no one should possess any private property, except as necessary; secondly, no one should have a dwelling or storehouse into which all who please may not enter; whatever necessaries are required by moderate and courageous men, who are trained to war, they should receive e by regular appointment from their fellow-citizens, as wages for their services, and the amount should be such as to leave neither a surplus on the year's consumption nor a deficit; and they should attend common messes and live together as men do in a camp; as for gold and silver, we must tell them that they are in perpetual possession of a divine species of the precious metals placed in their souls by the gods themselves, and therefore have no 417 need of the earthly ore; that in fact it would be profanation to pollute their spiritual riches by mixing them with the possession of mortal gold, because the world's coinage has been the cause of countless impieties, whereas theirs is undefiled. Therefore to them, as distinguished from the rest of the people, it is forbidden to handle or touch gold and silver, or enter under the same roof with them, or to wear them on their dresses, or to drink out of the precious metals. If they follow these rules, they will be safe themselves and the saviors of the city; b but whenever they come to possess lands, and houses, and money of their own, they will be householders and cultivators instead of guardians, and will become hostile masters

of their fellow-citizens rather than their allies; and so they will spend their whole lives, hating and hated, plotting and plotted against, standing in more frequent and intense alarm of their enemies at home than of their enemies abroad; by which time they and the rest of the city will be running on the very brink of ruin. On all these accounts, I asked, shall we say that the foregoing is the right arrangement of the houses and other concerns of our guardians, and shall we legislate accordingly; or not?

Yes, by all means, answered Glaucon.

BOOK IV

. . . Then the organization of our city is now 427 complete, son of Ariston; and the next thing d for you to do is to examine it, furnishing yourself with the necessary light from any quarter you can, and calling to your aid your brother and Polemarchus and the rest, in order to try if we can see where justice may be found in it, and where injustice, and wherein they differ the one from the other, and which of the two the man who desires to be happy ought to possess, whether all gods and men know it or not.

That will not do! exclaimed Glaucon; it was you that engaged to make the inquiry, on the e ground that it would not be holy for you to refuse to give justice.

I recollect that it was as you say, I replied; and I must do so, but you also must assist me.

We will.

I hope, then, that we may find the object of our search thus. I imagine that our city, being rightly organized, is a perfectly good city.

It must be.

Then obviously it is wise and brave and temperate and just.

Obviously.

Then if we can find some of these qualities in the city, there will be a remainder consisting of the undiscovered qualities.

Undoubtedly. 428

Suppose then that there were any other four things, contained in any subject, and that we were in search of one of them. If we discovered this before the other three, we should be satisfied; but if we recognized the other three first, the thing sought for would by this very fact have been found; for it is plain that it could only be the remainder.

You are right.

Ought we not to adopt this mode of inquiry in the case before us, since the qualities in question are also four in number?

Clearly we ought.

b To begin then, in the first place wisdom seems to be plainly discernible in our subject; and there seems to be something strange about it.

What is that?

The city which we have described is really wise, if I am not mistaken, inasmuch as it is prudent in counsel, is it not?

It is.

And this very quality, prudence in counsel, is evidently a kind of knowledge: for it is not ignorance, I imagine, but knowledge, that makes men deliberate prudently.

Evidently.

But there are many different kinds of knowledge in the city.

Unquestionably there are.

Is it then in virtue of the knowledge of its carpenters that the city is to be described as wise, or prudent in counsel?

c Certainly not; for in virtue of such knowledge it could only be called a city of good carpentry.

Then it is not the knowledge it employs in considering how vessels of wood may best be made, that will justify us in calling our city wise.

Certainly not.

Well, is it the knowledge which has to do with vessels of bronze, or any other of this kind?

No, none whatever.

Neither will a knowledge of the mode of raising produce from the soil give a city the claim to the title of wise, but only to that of a successful agricultural city.

So I think.

Tell me, then, does our newly organized city contain any kind of knowledge, residing in any section of the citizens, which takes measures, d not in behalf of anything in the city, but in behalf of the city as a whole, devising in what manner its internal and foreign relations may best be regulated?

Certainly it does.

What is this knowledge, and in whom does it reside? It is the science of guardianship, and it resides in that ruling part, whom we just now called our perfect guardians.

Then in virtue of this knowledge what do you call the city?

I call it prudent in counsel and truly wise.

Which do you suppose will be the more numerous class in our city, the smiths, or these e genuine guardians?

The smiths will far outnumber the others.

Then will the guardians be the smallest of all the classes possessing this or that branch of knowledge, and bearing this or that name in consequence?

Yes, much the smallest.

Then it is the knowledge residing in its smallest part or section, that is to say, in the predominant and ruling body, which entitles a city, organized agreeably to nature, to be called wise as a whole; and that part whose right and duty it is to partake of the knowl- 429 edge which alone of all kinds of knowledge is properly called wisdom, is naturally, as it appears, the least numerous body in the city.

Most true.

Here then we have made out—I do not know how—in some way or other, one of the four qualities, and the part of the city in which it is seated.

To my mind, said he, it has been made out satisfactorily.

Again, there can assuredly be no great difficulty in discerning courage itself, and the part

in which it resides, and which entitles the city to be called brave.

How so?

b In pronouncing a city to be cowardly or brave, who would look to any but that portion of it which fights in its defense and takes the field in its behalf?

No one would look to anything else.

No; and for this reason, I imagine, that the cowardice or courage of the city itself is not necessarily implied in that of the other parts.

No, it is not.

c Then a city is brave as well as wise, in virtue of a certain portion of itself, because it has in that portion a power which can without intermission keep safe the right opinion concerning things to be feared, which teaches that they are such as the legislator has declared in the prescribed education. Is not this what you call courage?

I did not quite understand what you said; be so good as to repeat it.

I say that courage is a kind of safe keeping.

What kind of safe keeping?

The safe keeping of the opinion created by law through education, which teaches what things and what kind of things are to be feared. And when I spoke of keeping it safe without intermission, I meant that it was to be thoroughly preserved alike in moments of pain and d of pleasure, of desire and of fear, and never to be cast away. And if you like, I will illustrate it by a comparison which seems to me an apt one.

I should like it.

Well then, you know that dyers, when they wish to dye wool so as to give it the true sea-purple, first select from the numerous colors one variety, that of white wool, and then subject it to much careful preparatory dressing, that it may take the color as brilliantly as possible; after which they proceed to dye it. And when the wool has been dyed on this e system, its color is indelible, and no washing either with or without soap can rob it of its brilliancy. But when this course has not been pursued, you know the results, whether this or any other color be dyed without previous preparation.

I know that the dye washes out in a ridiculous way.

You may understand from this what we were laboring, to the best of our ability, to 430 bring about, when we were selecting our soldiers and training them in music and gymnastic. Imagine that we were only contriving how they might be best persuaded to accept, as it were, the color of the laws, in order that their opinion concerning things to be feared, and on all other subjects, might be indelible, owing to their congenial nature and appropriate training, and that their color might not be washed out by such terribly efficacious detergents as pleasure, which works more powerfully than soda or lye, and pain, and fear, and desire, b which are more potent than any other solvent in the world. This power, therefore, to hold fast continually the right and lawful opinion concerning things to be feared and things not to be feared, I define to be courage, and call it by that name, if you do not object.

No, I do not; for when the right opinion on these matters is held without education, as by beasts and slaves, you would not, I think, regard it as altogether legitimate, and you c would give it some other name than courage.

Most true.

Then I accept this account of courage.

Do so, at least as an account of the courage of citizens, and you will be right. On a future occasion, if you like, we will go into this question more fully; at present it is beside our inquiry, the object of which is justice: we have done enough therefore, I imagine, for the investigation of courage.

You are right.

Two things, I proceeded, now remain, that we must look for in the city, temperance, and d that which is the cause of all these investigations, justice.

Exactly so.

Well, not to trouble ourselves any further about temperance, is there any way by which we can discover justice?

For my part, said he, I do not know, nor do I wish justice to be brought to light first, if we are to make no further inquiry after temperance; so, if you wish to gratify me, examine into the latter, before you proceed to the former.

e Indeed, I do wish it, for I am not unjust.

Proceed then with the examination.

I will; and from our present point of view, temperance has more the appearance of a concord or harmony, than the former qualities had.

How so?

Temperance is, I imagine, a kind of order and a mastery, as men say, over certain pleasures and desires. Thus we plainly hear people talking of a man's being master of himself, in some sense or other; and other similar expressions are used, in which we may trace a print of the thing. Is it not so?

Most certainly it is.

431 But is not the expression "master of himself" a ridiculous one? For the man who is master of himself will also, I presume, be the slave of himself, and the slave will be the master. For the subject of all these phrases is the same person.

Undoubtedly.

Well, I continued, it appears to me that the meaning of the expression is, that in the man himself, that is, in his soul, there resides a good principle and a bad, and when the naturally good principle is master of the bad this state of things is described by the term "master of himself": certainly it is a term of praise; but when in consequence of poor training, or the influence of associates, the smaller force of the good principle is overpowered by the superior numbers of the bad, the person so situated is

b described in terms of reproach and condemnation, as a slave of self, and a dissolute person.

Yes, this seems a likely account of it.

Now turn your eyes towards our new city, and you will find one of these conditions realized in it: for you will allow that it may fairly be called "master of itself," if temperance and self-mastery may be predicated of that in which the good principle governs the bad.

I am looking as you direct, and I acknowledge the truth of what you say.

It will further be admitted that those desires, and pleasures, and pains, which are many and various, will be chiefly found in children, and women, and servants; and those who c are called free among the common many.

Precisely so.

On the other hand, those simple and moderate desires, which go hand in hand with mind and right opinion, under the guidance of reasoning, will be found in a small number of men, that is, in those of the best natural endowments, and the best education.

True.

Do you not see that the parallel to this exists in your city—in other words, that the desires d of the vulgar many are there controlled by the desires and the wisdom of the cultivated few?

I do.

If any city then may be described as master of itself, its pleasures and its desires, ours may be so characterized.

Most certainly.

May we not then also call it temperate, on all these accounts?

Surely we may.

And again, if there is any city in which the rulers and the ruled are unanimous on the question who ought to govern, such unanimity will e exist in ours. Do you not think so?

Most assuredly I do.

In which of the two classes of citizens will you say that temperance resides, when they are in this condition? in the rulers or in the ruled?

In both, I suppose.

Do you see, then, that we were not bad prophets when we divined just now that temperance resembled a kind of harmony?

How do you mean?

Because it does not operate like courage and wisdom, which, by residing in particular 432 sections of the city, make it brave and wise respectively; but simply spreads throughout the whole, producing a unison between the weakest and the strongest and the middle part, whether you measure by the standard of prudence, or bodily strength, or numbers, or wealth, or anything else of the kind: so that we shall be fully justified in pronouncing temperance to be that unanimity, which we described as a concord between the naturally better element and the naturally worse, whether in a city or in a single person, as to which of the two has the right to rule.

b I fully agree with you.

Very well, I continued; we have discerned in our city three out of the four principles; at least such is our present impression. Now what will that remaining principle be through which the city will further participate in virtue? for this, we may be sure, is justice.

Evidently it is.

Now then, Glaucon, we must be like hunters surrounding a bush, and must take care that justice nowhere escape us and disappear from c our view: for it is manifest that she is somewhere here; so look for her, and strive to gain a sight of her, for perhaps you may discover her first, and give the alarm to me.

I wish I might, replied he; but you will use me quite well enough, if, instead of that, you will treat me as one who is following your steps, and is able to see what is pointed out to him.

Follow me then, after joining your prayers with mine.

I will do so; just you lead the way.

Truly, said I, the place seems to be shady and inaccessible, dark and hard to traverse; but still we must go on.

d Yes, that we must.

Here I caught a glimpse, and exclaimed, Ho! ho! Glaucon, here is something that looks

like a track, and I believe the game will not altogether escape us.

That is good news.

Upon my word, said I, we are in a most foolish predicament.

How so?

Why, my good sir, it appears that what we were looking for has been rolling before our feet from the beginning, and we never saw it, but did the most ridiculous thing. Just as people at times go about looking for something which they hold in their hands, so we, instead e of fixing our eyes upon the thing itself, kept gazing at some point in the distance, and this was probably the reason why it eluded our search.

What do you mean?

This—that I believe we ourselves were just now saying and hearing it, without understanding that we were in a way describing it ourselves.

Your preface seems long to one who is anxious for the explanation.

Well then, listen, and judge whether I am 433 right or not. What at the beginning we laid down as a universal rule of action, when we were founding our city, this, if I am not mistaken, or some modification of it, is justice. I think we affirmed, if you recollect, and frequently repeated, that every individual ought to have some one occupation in the city, which should be that to which his natural capacity was best adapted.

We did say so.

And again, we have often heard people say, that to mind one's own business, and not be meddlesome, is justice; and we have often said the same thing ourselves.

We have said so. b

Then it would seem, my friend, that to do one's own business, in some shape or other, is justice. Do you know from what I infer this?

No; be so good as to tell me.

I think that the remainder left in the city, after eliminating the things we have already

considered, I mean temperance, and courage, and wisdom, must be that which made their entrance into it possible, and which preserves them there so long as they exist in it. Now we affirmed that the remainder, when three out of the four were found, would be justice.

Yes, unquestionably it would.

If, however, it were required to decide which of these qualities will have most influence in perfecting by its presence the virtue of our city, it would be difficult to determine; whether it will be the harmony of opinion between the rulers and the ruled, or the faithful adherence on the part of the soldiers to the lawful belief concerning the things which are, and the things which are not, to be feared; or the existence of wisdom and watchfulness in the rulers; or whether the virtue of the city may not be chiefly traced to the presence of that fourth principle in every child and woman, in every slave, freeman, and artisan, in the ruler and in the ruled, requiring each to do his own work, and not meddle with many things.

It would be a difficult point to settle, unquestionably.

Thus it appears that, in promoting the virtue of a city, the power that makes each member of it do his own work, may compete with its wisdom, and its temperance, and its courage.

Decidedly it may.

But if there is a principle which rivals these qualities in promoting the virtue of a city, will you not determine it to be justice?

Most assuredly.

Consider the question in another light, and see whether you will come to the same conclusion. Will you assign to the rulers of the city the judging of law-suits?

Certainly.

Will not their judgments be guided, above everything, by the desire that no one may appropriate what belongs to others, nor be deprived of what is his own?

Yes, that will be their main study.

Because that is just?

Yes.

Thus, according to this view also, it will be granted that to have and do what belongs to us and is our own, is justice.

True.

Now observe whether you hold the same opinion that I do. If a carpenter should undertake to execute the work of a shoemaker, or a shoemaker that of a carpenter, either by interchanging their tools and honors, or by the same person undertaking both trades, with all the changes involved in it, do you think it would greatly damage the city?

Not very greatly.

But when one whom nature has made an artisan, or a producer of any other kind, is so elated by wealth, or a large connection, or bodily strength, or any similar advantages, as to intrude himself into the class of the warriors; or when a warrior intrudes himself into the class of the counselors and guardians, of which he is unworthy, and when these interchange their tools and their distinctions, or when one and the same person attempts to discharge all these duties at once, then, I imagine, you will agree with me, that such change and meddling among these will be ruinous to the city.

Most assuredly they will.

Then any intermeddling in the three parts, or change from one to another, would inflict great damage on the city, and may with perfect propriety be described, in the strongest sense, as doing harm.

Quite so.

And will you not admit that the greatest harm towards one's own city is injustice?

Unquestionably.

This then is injustice. On the other hand, let us state that, conversely, adherence to their own business on the part of the merchants, the military, and the guardians, each of these doing its own work in the city, is justice, and will render the city just.

I fully agree, he said.

Let us not state it yet quite positively; but if we find, on applying this form to the individual man, that there too it is recognized as constituting justice, we will then give our assent—for what more can we say?—but if not, in that case we will begin a new inquiry. At present, however, let us complete the investigation which we undertook in the belief that, if we first endeavored to contemplate justice in some larger subject which contains it, we should find it easier to discern its nature in the individual man. Such a subject we recognized in a city, and accordingly we organized the best we could, being sure that justice must reside in a *good* city. The view, therefore, which presented itself to us there, let us now apply to the individual; and if it be admitted, we shall be satisfied; but if we should find something different in the case of the individual, we will again go back to our city, and put our theory to the test. And perhaps by considering the two cases side by side, and rubbing them together, we may cause justice to flash out from the contact, like fire from dry bits of wood, and when it has become visible to us, may settle it firmly in our own minds.

There is method in your proposal, he replied, and so let us do.

I proceeded therefore to ask: When two things, a greater and a less, are called by a common name, are they, in so far as the common name applies, unlike or like?

Like.

Then a just man will not differ from a just city, so far as the form of justice is involved, but the two will be like.

They will.

Well, but we resolved that a city was just, when the three natural kinds present in it were severally occupied in doing their proper work; and that it was temperate, and brave, and wise, in consequence of certain affections and conditions of these same classes.

True.

Then, my friend, we shall make the same claim in the case of the single individual, and, supposing him to have the same forms in his soul, on account of having the same affections as those in the city, we shall judge that he can be deemed worthy of the same names as the city.

It must inevitably be so.

Once more then, my excellent friend, we have stumbled on an easy question concerning the nature of the soul, namely, whether it contains these three forms or not.

Not so very easy a question, I think; but perhaps, Socrates, the common saying is true, that the beautiful is difficult.

It would appear so; and I tell you plainly, Glaucon, that in my opinion we shall never attain to exact truth on this subject, by such methods as we are employing in our present discussion. However, the path that leads to that goal is too long and toilsome; and I dare say we may arrive at the truth by our present methods, in a manner not unworthy of our former arguments and speculations.

Shall we not be content with that? For my part it would satisfy me for the present.

Well, certainly it will be quite enough for me.

Do not give up, then, but proceed with the inquiry.

Then tell me, I continued, can we possibly refuse to admit that there exist in each of us the same forms and characters as are found in the city? For I presume the city has not received them from any other source. It would be ridiculous to imagine that the presence of the spirited element in cities is not to be traced to individuals, wherever this character is imputed to the people, as it is to the natives of Thrace, and Scythia, and generally speaking, of the northern countries; or the love of study, which would be chiefly attributed to our own country; or the love of riches, which people would especially connect with the Phoenicians and the Egyptians.

Certainly.

This then is a fact so far, and one which it is not difficult to apprehend.

No, it is not.

But here begins a difficulty. Are all our actions alike performed by the one faculty, or are there three faculties operating severally in our different actions? Do we learn with one faculty, and become angry with another, and with a third feel desire for all the pleasures connected with eating and drinking, and the propagation of the species; or upon every impulse to action, do we perform these several operations with the whole soul? The difficulty will consist in settling these points in a satisfactory manner.

I think so too.

Let us try therefore the following plan, in order to ascertain whether the faculties engaged are distinct or identical.

What is your plan?

It is manifest that the same thing cannot do two opposite things, or be in two opposite states, in the same part of it, and with reference to the same object; so that where we find these phenomena occurring, we shall know that the subjects of them are not identical, but more than one.

Very well.

Now consider what I say.

Speak on.

Is it possible for the same thing to be at the same time, and in the same part of it, at rest and in motion?

Certainly not.

Let us come to a still more exact understanding, lest we should chance to differ as we proceed. If it were said of a man who is standing still, but moving his hands and his head, that the same individual is at the same time at rest and in motion, we should not, I imagine, allow this to be a correct way of speaking, but should say, that part of the man is at rest, and part in motion; should we not?

We should.

And if the objector should indulge in yet further pleasantries, so far refining as to say, that at any rate a top is wholly at rest and in motion at the same time, when it spins with its peg fixed on a given spot, or that anything else revolving in the same place, is an instance of the same thing, we should reject his illustration, because in such cases the things are not both stationary and in motion in respect of the same parts of them; and we should reply, that they contain an axis and a circumference, and that in respect of the axis they are stationary, inasmuch as they do not lean to any side; but in respect of the circumference they are moving round and round; but if, while the rotatory motion continues, the axis at the same time inclines to the right or to the left, forwards or backwards, then they cannot be said in any sense to be at rest.

That is true.

Then no objection of that kind will alarm us, or tend at all to convince us that it is ever possible for one and the same thing, at the same time, in the same part of it, and relatively to the same object to be acted upon in two opposite ways or to be two opposite things, or to produce two opposite effects.

It will not alarm me, at any rate.

However, that we may not be compelled to spend time in discussing all such objections, and convincing ourselves that they are unsound, let us assume this to be the fact, and proceed forwards, with the understanding that, if ever we take a different view of this matter, all the conclusions founded on this assumption will fall to the ground.

Yes, that will be the best way.

Well then, I continued, would you place assent and dissent, the seeking after an object and the refusal of it, attraction and repulsion, and the like, in the class of mutual opposites? Whether they be active or passive processes will not affect the question.

Yes, I should.

Well, would you not, without exception, include hunger and thirst, and the desires generally, and likewise willing and wishing, somewhere under the earlier forms just mentioned? For instance, would you not say that the soul of a man under the influence of desire always either seeks after the object of desire, or attracts to itself that which it wishes to have; or again, so far as it wills the possession of anything,

it assents inwardly thereto, as though it were asked a question, longing for the accomplishment of its wish?

I should.

Again, shall we not classify disinclination, unwillingness, and not-desiring with the soul's thrusting and driving away from itself, and alongside the opposites of the previously discussed cases?

d Unquestionably.

This being the case, shall we say that desires form a class, the most marked of which are what we call thirst and hunger?

We shall.

The one being a desire of drink, and the other of food?

Yes.

Can thirst then, so far as it is thirst, be a desire of anything more than drink? That is to say, is thirst, as such, a thirst for hot drink or cold, for much or little, or, in one word, for any particular kind of drink? Or, will it not rather

e be true that, if there be heat combined with the thirst, the desire of cold drink will be superadded to it, and if there be cold, of hot drink; and if owing to the presence of "muchness," the thirst be great, the desire of much will be added, and if little, the desire of little; but that thirst in itself cannot be a desire of anything else than its natural object, which is simple drink, or again, hunger, of anything but food?

You are right, he replied; every desire in itself is of its natural object, while the desire for this or that particular is added on.

438 Let not any one, I proceeded, for want of consideration on our part, disturb us by the objection, that no one desires drink simply, but good drink, nor food simply, but good food; because, since all desire good things, if thirst is a desire, it must be a desire of something good, whether that something, which is its object, be drink or anything else; an argument which applies to all the desires.

True, there might seem to be something in the objection.

Recollect, however, that in the case of all essentially correlative terms, when the first member of the relation is qualified, the sec- b ond is also qualified, if I am not mistaken; but individually they are both related to something which is unqualifiedly itself.

I do not understand you.

Do you not understand that "greater" is a relative term, implying another term?

Certainly.

It implies a "less," does it not?

Yes.

And a much greater implies a much less, does it not?

Yes.

Does a once greater also imply a once less, and a future greater a future less?

Inevitably.

Does not the same reasoning apply to the c correlative terms, "more" and "fewer," "double" and "half," and all relations of quantity; also to the terms, "heavier" and "lighter," "quicker" and "slower"; and likewise to "cold" and "hot," and all similar terms?

Certainly it does.

But how is it with the various types of knowledge? Does not the same principle hold? That is, knowledge itself is knowledge simply of the knowable, or of whatever that be called which is the object of knowledge; but a particular science, of a particular kind, has a particular object of a particular kind. To explain my meaning: as soon as a knowledge of the d construction of houses arose, was it not distinguished from other kinds of knowledge, and thus called the science of building?

Undoubtedly.

And is it not because it is of a particular character, which no other science possesses?

Yes.

And is not its particular character derived from the particular character of its object? and may we not say the same of all the other arts and sciences?

We may.

This then you are to regard as having been my meaning before—provided, that is, you now understand that in the case of all correlative terms, of whatever sort the first member is, the second is also of that sort; if the second is qualified, the first is also qualified. I do not mean to say that the qualities of the two are identical, as for instance, that the science of health is healthy, and the science of disease diseased; or that the science of evil things is evil, and of good things good: but as soon as knowledge, instead of limiting itself to those objects to which knowledge is related, became related to a particular kind of object, namely, in the present case, the conditions of health and disease, the result was that the knowledge also came to be qualified in a certain manner, so that it was no longer called simply science, but, by the addition of a qualifying epithet, medical science.

I understand, and I think what you say is true.

To return to the case of thirst, I continued, do you not consider this to be one of the things whose nature it is to have an object correlative with themselves, assuming that there is such a thing as thirst?

I do, and its object is drink.

Then, for any particular kind of drink there is a particular kind of thirst; but thirst itself is neither for much drink, nor for little, neither for good drink nor for bad, nor, in one word, for any kind of drink, but simply and absolutely thirst for drink, is it not?

Most decidedly so.

Then the soul of a thirsty man, in so far as he is thirsty, has no other wish than to drink; but this it desires, and towards this it is impelled.

Clearly so.

Therefore, whenever anything pulls back a soul that is under the influence of thirst, it will be something in the soul distinct from the principle which thirsts, and which drives it like a beast to drink: for we hold it to be impossible that the same thing should, at the same time, with the same part of itself, in reference to the same object, be doing two opposite things.

Certainly it is.

Just as, I imagine, it would not be right to say of the bowman, that his hands are at the same time drawing the bow towards him, and pushing it from him—the fact being, that one of his hands pushes it from him, and the other pulls it to him.

Precisely so.

Now, can we say that people sometimes are thirsty, and yet do not wish to drink?

Yes, certainly; it often happens to many people.

What then can one say of them, except that their soul contains one principle which commands, and another which forbids them to drink, the latter being distinct from and stronger than the former?

That is my opinion.

Whenever the authority which forbids such indulgences grows up in the soul, is it not engendered there by reasoning; while the powers which lead and draw the soul towards them, owe their presence to passive and morbid states?

It would appear so.

Then we shall have reasonable grounds for assuming that these are two principles distinct one from the other, and for giving to that part of the soul with which it reasons the title of the rational principle, and to that part with which it loves and hungers and thirsts, and experiences the flutter of the other desires, the title of the irrational and appetitive principle, the ally of sundry indulgences and pleasures.

Yes, he replied; it will not be unreasonable to think so.

Let us consider it settled, then, that these two specific parts exist in the soul. But now, will spirit, or that by which we feel indignant, constitute a third distinct part? If not, with which of the two former has it a natural affinity?

Perhaps with the appetitive principle.

But I was once told a story, which I can quite believe, to the effect, that Leontius, the son of Aglaion, as he was walking up from the Piraeus, and approaching the northern wall from the outside, observed some dead bodies on the ground, and the executioner standing by them. He immediately felt a desire to look at them, but at the same time loathing the thought 440 he tried to divert himself from it. For some time he struggled with himself, and covered his eyes, until at length, over-mastered by the desire, he opened his eyes wide with his fingers, and running up to the bodies, exclaimed, "There! you wretches! gaze your fill at the beautiful spectacle!"

I have heard this too.

This story, however, indicates that anger sometimes fights against the desires, which implies that they are two distinct principles.

True, it does indicate that.

b And do we not often observe in other cases that when a man is overpowered by the desires against the dictates of his reason, he reviles himself, and resents the violence thus exerted within him, and that, in this struggle of contending parties, the spirit sides with the reason? But that it should make common cause with the desires, when the reason pronounces that they ought not to act against itself, is a thing which I suppose you will not profess to have experienced yourself, nor yet, I imagine, have you ever noticed it in any one else.

No, I am sure I have not.

c Well, and when any one thinks he is in the wrong, is he not, in proportion to the nobleness of his character, so much the less able to be angry at being made to suffer hunger or cold or any similar pain at the hands of him whom he thinks justified in so treating him; his spirit, as I describe it, refusing to be roused against his punisher?

True.

On the other hand, when any one thinks he is wronged, does he not instantly boil and chafe, and enlist himself on the side of what he thinks to be justice; and whatever extremities of hunger and cold and the like he may have to suffer, does he not endure until he conquers, never ceasing from his noble efforts, until d he has either gained his point, or perished in the attempt, or been recalled and calmed by the voice of reason within, as a dog is called off by a shepherd?

Yes, he replied, the case answers very closely to your description; and in fact, in our city we made the auxiliaries, like sheep-dogs, subject to the rulers, who are as it were the shepherds of the city.

You rightly understand my meaning. But try whether you also apprehend my next observation.

What is it? e

That our recent view of the spirited principle is exactly reversed. Then we thought it had something of the appetitive character, but now we say that, far from this being the case, it much more readily takes arms on the side of the rational principle in the party conflict of the soul.

Decidedly it does.

Is it then distinct from this principle also; or is it only a modification of it, thus making two instead of three distinct principles in the soul, namely, the rational and the appetitive? Or ought we to say that, as the city was held 441 together by three great classes, the producing part, the auxiliary, and the deliberative, so also in the soul the spirited principle constitutes a third element, the natural ally of the rational principle, if it be not corrupted by bad training?

It must be a third, he replied.

Yes, I continued; if it shall appear to be distinct, from the rational principle, as we found it different from the appetitive.

That will easily appear. For even in little children any one may see this, that from their very birth they have plenty of spirit, whereas reason is a principle to which most men only b attain after many years, and some, in my opinion, never.

Upon my word, well said. In brute beasts also one may see what you describe exemplified. And besides, that passage in Homer, which we quoted on a former occasion, will support our view:

"Smiting his breast, to his heart thus spake he in accents of chiding."

c For in this line Homer has distinctly made a difference between the two principles, representing that which had considered the good or the bad of the action as rebuking that which was indulging in unreflecting resentment.

You are perfectly right.

Here then, I proceeded, after a hard swim, we have, though with difficulty, reached the land; and we are pretty well satisfied that there are corresponding divisions, equal in number, in a city, and in the soul of every individual.

True.

Then does it not necessarily follow that, as and whereby the city was wise, so and thereby the individual is wise?

Without doubt it does.

d And that as and whereby the individual is brave, so and thereby is the city brave; and that everything conducing to virtue which is possessed by the one, finds its counterpart in the other?

It must be so.

Then we shall also assert, I imagine, Glaucon, that a man is just, in the same way in which we found the city to be just.

This too is a necessary corollary.

But surely we have not allowed ourselves to forget, that what makes the city just, is the fact of each of the three parts therein doing its own work.

No; I think we have not forgotten this.

e We must bear in mind, then, that each of us also, if his inward parts do severally their proper work, will, in virtue of that, be a just man, and a doer of his proper work.

Certainly, it must be borne in mind.

Is it not then essentially the domain of the rational principle to command, inasmuch as it is wise, and has to exercise forethought in behalf of the entire soul, and the domain of the spirited principle to be its subject and ally?

Yes, certainly.

And will not the combination of music and 442 gymnastic bring them, as we said, into unison—elevating and fostering the one with lofty discourses and scientific teachings, and lowering the tone of the other by soothing address, until its wildness has been tamed by harmony and rhythm?

Yes, precisely so.

And so these two, having been thus trained, and having truly learned their parts and having been educated, will exercise control over the appetitive principle, which in every man forms the largest portion of the soul, and is by nature most insatiable. And they will watch it narrowly, that it may not be filled with what are called the pleasures of the body, as to grow large and strong, and forthwith refuse to do its proper b work, and even aspire to subjugate and dominate over that which it has no right to rule by virtue of its class, thus totally upsetting the life of all.

Certainly they will.

And would not these two principles be the best qualified to guard the entire soul and body against enemies from without—the one taking counsel, and the other fighting its battles, in obedience to the ruling power, to whose designs it gives effect by its bravery?

True.

In like manner, I think, we call an indi- c vidual brave, in virtue of the spirited element of his nature, when this part of him holds fast, through pain and pleasure, the instructions of the reason as to what is to be feared, and what is not.

Yes, and rightly.

And we call him wise, in virtue of that small part which reigns within him, and issues these instructions, and which also in its turn contains within itself a true knowledge of what is advantageous for the whole community composed of these three principles, and for each member of it.

Exactly so.

Again, do we not call a man temperate, in virtue of the friendship and harmony of these same principles, that is to say, when the two that are governed agree with that which governs in regarding the rational principle as the rightful sovereign, and set up no opposition to its authority?

Certainly, he replied; temperance is nothing else than this, whether in city or individual.

Lastly, a man will be just, in the way and by the means which we have repeatedly described.

Unquestionably he will.

Tell me then, I proceeded, do we find anything indistinct in our view of justice, which makes us regard it as something different from what we found it to be in the city?

I do not think so.

Because we might thoroughly confirm our opinion, if we have any lingering doubts in our souls, by applying commonplace examples to it.

What kind of examples do you mean?

For example, if in speaking of this city, and of an individual who in nature and training resembles it, we were required to declare whether we think that such an individual would despoil a deposit of gold or silver committed to his charge, do you suppose that any one would think him more likely to do such a deed than other men who are not such as he is?

No one would think so.

And will he not also be clear of suspicion of temple robbery, and of theft, and of being either false to his friends, or a traitor to his country?

He will.

Moreover, he will be wholly incapable of bad faith, in the case of an oath or of any other kind of contract.

Clearly he will.

Again, he is the last person in the world to be guilty of adultery, or neglect of parents, or indifference to the worship of the gods.

Certainly he is.

And is not all this attributable to the fact that each of his inward principles keeps to his own work in regard to the relations of ruler and the ruled?

Yes, it may be entirely attributed to this.

Do you still seek then for any other account of justice than that it is the power which creates such men and such cities?

No, he replied, assuredly I do not.

Then our dream is completely realized, or that suspicion which we expressed, that at the very beginning of the work of constructing our city we were led by some divine intervention, as it would seem, to a kind of rudimentary type of justice.

Yes, it certainly is.

And so there really was, Glaucon, an image of justice—and hence of its utility—in the principle that it is right for a man whom nature intended for a shoemaker to confine himself to shoemaking, and for a man who has a turn for carpentering to do carpenter's work, and so on.

It appears so.

The truth being that justice is indeed, to all appearance, something of the kind, only that, instead of dealing with a man's outward performance of his own work, it has to do with that inward performance of it which truly concerns the man himself, and his own interests: so that the just man will not permit the several principles within him to do any work but their own, nor allow the distinct classes in his soul to interfere with each other, but will really set his house in order; and having gained the mastery over himself, will so regulate his own character as to be on good terms with himself, and to set those three principles in tune together, as if they were verily three chords of a harmony, a higher and a lower and a middle, and whatever may lie between these; and after he has bound all these together, and reduced the many elements of his nature to a real unity, as a temperate and duly harmonized man, he will then at length proceed to do whatever he may have

to do, whether it involve a business transaction, or the care of his body, a political matter or a private contract; in all which he will believe and profess that the just and honorable course is that which preserves and assists in creating the aforesaid condition, and that the genuine knowledge which presides over such conduct is wisdom; while on the other hand, he will 444 hold that an unjust action is one which tends to destroy this habit, and that the mere opinion which presides over unjust conduct, is folly.

What you say is thoroughly true, Socrates.

Very good; if we were to say we have discovered the just man and the just city, and what justice is as found in them, it would not be thought, I imagine, to be an altogether false statement.

No, indeed, it would not.

Shall we say so then?

We will.

Be it so, I continued. In the next place we have to investigate, I imagine, what injustice is.

Evidently we have.

b Must it not then, as the reverse of justice, be a state of strife between the three principles, and the disposition to meddle and interfere, and the insurrection of a part of the soul against the whole, this part aspiring to the supreme power within the soul, to which it has no right, its proper place and destination being, on the contrary, to do service to any member of the rightfully ruling part? Such doings as these, I imagine, and the confusion and bewilderment of the aforesaid principles, will, in our opinion, constitute injustice, and licentiousness, and cowardice, and folly, and, in one word, all vice.

Yes, precisely so.

c And is it not now quite clear to us what it is to act unjustly, and to be unjust, and, on the other hand, what it is to act justly, knowing as we do the nature of justice and injustice?

How so?

Because there happens to be no difference with regard to the health and disease of the body and the soul.

In what way?

The conditions of health, I presume, produce health, and those of disease engender disease.

Yes.

In the same way, does not the practice of justice beget the habit of justice, and the practice of injustice the habit of injustice?

Inevitably.

Now to produce health is so to constitute the bodily forces as that they shall master and be mastered by one another in accordance with nature; and to produce disease is to make them govern and be governed by one another in a way which violates nature.

True.

Similarly, will it not be true that to beget justice is so to constitute the powers of the soul that they shall master and be mastered by one another in accordance with nature, and that to beget injustice is to make them rule and be ruled by one another in a way which violates nature?

Quite so.

Then virtue, it appears, will be a kind of health and beauty, and good habit of the soul; and vice will be a disease, and deformity, and sickness of it.

True.

And may we not add, that all fair practices tend to the acquisition of virtue, and all foul practices to that of vice?

Undoubtedly they do.

What now remains for us, apparently, is to inquire whether it is also profitable to act justly, and to pursue honorable aims, and to be just, whether a man be known to be such or not, or to act unjustly, and to be unjust, if one suffer no punishment, and be not made a better man by chastisement.

To me, Socrates, I confess that the inquiry begins to assume a ludicrous appearance, now that the real nature of justice and injustice has presented itself to us in the light described above. Do people think that when the

constitution of the body is ruined, life is not worth having, though you may command all varieties of food and drink, and possess endless wealth and power; and shall we be told that, when the constitution of that very principle whereby we live is going to rack and ruin, life is still worth having, let a man do what he will, if that is excepted which will enable him to get rid of vice and injustice, and to acquire virtue and justice?

Yes, it is ludicrous, I replied; still, since we have arrived at this point, we must not lose heart, until we have ascertained, in the clearest possible manner, the correctness of our conclusions.

No, indeed; anything rather than lose heart.

Come with me, then, that you may see how many varieties of vice there are, according to my belief, looking only at those which are worth the survey.

I follow you; just tell me.

Well, I can see as it were from a watchtower, now that we have ascended to this lofty stage in the argument, that while there is only one form of virtue, there are infinite varieties of vice, of which four in particular deserve to be noticed.

How do you mean?

It would seem that there are as many characters of soul, as there are distinctive forms of government.

How many are they?

There are five forms of regime and five characters of soul.

Tell me what they are.

I will: one form of government will be that which we have been describing, and it may be called by two different names—should there arise among the governing body one man excelling the rest, it will be called a kingdom; if there be more than one of equal excellence, it will be entitled an aristocracy.

True.

This then I call one form: for whether it belongs to one or many, any law of the city worth mentioning will not change, if their training and education be such as we have described.

So we may justly expect, he replied.

BOOK VI

. . . [T]he inquiry concerning the rulers must be pursued afresh from the beginning. In describing them, we said, if you remember, that they must appear to love the city, that they must be tested by pleasure and by pain, and proved never to have deserted their principles in the midst of toil and danger and every vicissitude of fortune, on pain of forfeiting their position if their powers of endurance fail; and that whoever comes forth from the trial without a flaw, like gold tried in the fire, must be appointed to office, and receive, during life and after death, privileges and rewards. This was pretty nearly the drift of our argument, which, from fear of awakening the question now pending, turned aside and hid its face.

Your account is quite correct, he said; I remember perfectly.

Yes, my friend, I shrank from making assertions which I have since dared, but now let me venture upon this declaration, that we must make philosophers the most precise guardians.

We hear you, he replied.

Now consider what a small supply of these men you will, in all probability, find. For the parts of that nature, which we described as essential to philosophers, will seldom grow together in the same place: in most cases that nature grows disjointed.

What do you mean?

You are aware that persons endowed with a quick grasp, a good memory, sagacity, quickness, and their attendant qualities, do not readily grow up to be at the same time so noble and magnificent as to consent to live a regular, calm, and steady life; on the contrary, such persons are carried away by their quickness

hither and thither, and all steadiness vanishes from their life.

True.

On the other hand, those steady and invariable characters, whose trustiness makes one anxious to employ them, and who in war are slow to take alarm, behave in the same way when pursuing their studies—that is to say, they are torpid and stupid, as if they were benumbed, and are constantly dozing and yawning, whenever they have to toil at anything of the kind.

That is true.

But we declare that, unless a person possesses a pretty fair amount of both qualifications, he must not share in the strictest education, in honor, and in ruling.

We are right.

Then do you not anticipate a scanty supply of such characters?

Most assuredly I do.

Hence we must not be content with testing their behavior in the toils, dangers, and pleasures, which we mentioned before; but we must go on to try them in ways which we then omitted, exercising them in a variety of studies, and observing whether their character will be able to support the greatest studies, or whether it will flinch from the trial, like those who flinch under other circumstances.

No doubt it is proper to examine them in this way. But which do you mean by the greatest studies?

I presume you remember, that, after separating the soul into three specific parts, we deduced the several natures of justice, temperance, courage, and wisdom?

Why, if I did not remember, I should deserve not to hear the rest of the discussion.

Do you also remember the remark which preceded that one?

What was that?

We remarked, I believe, that to obtain the best possible view of the question, we should have to take a different and a longer route, which would bring us to a thorough insight into the subject; still that it would be possible to add proofs on the same level as the previous demonstrations. Thereupon you said that such a demonstration would satisfy you; and then followed those investigations, which, to my own mind, were less than exact; but you can tell me whether they were satisfactory to you?

Well, to speak for myself, I thought them measured; and certainly the rest of the party held the same opinion.

But, my friend, no measure of such a subject, which falls perceptibly short of the truth, can be said to be a measure at all: for nothing imperfect is a measure of anything; though people sometimes suppose that enough has been done, and that there is no call for further investigation.

Yes, he said, that is a very common habit, and it arises from sluggishness.

Yes, but it is a habit remarkably undesirable in the guardian of a city and its laws.

So I should suppose.

That being the case, my friend, such a person must go round by that longer route, and must labor as devotedly in his studies as in his bodily exercises. Otherwise, as we were saying just now, he will never reach the goal of that greatest study, which is most peculiarly his own.

What! he exclaimed, are not these the greatest? Is there still something greater than justice and those other things which we have discussed?

Yes indeed, I replied. And here we must not contemplate a rude outline, as we have been doing; on the contrary, we must be satisfied with nothing short of the most complete elaboration. For would it not be ridiculous to exert oneself on other subjects of small value, taking all imaginable pains to bring them to the most exact and spotless perfection; and at the same time to ignore the claim of the greatest subjects to a corresponding exactitude of the highest order?

The sentiment is a very just one. But do you suppose that any one would let you go without asking what that study is which you call the greatest, and of what it treats?

Certainly not, I replied; so put the question yourself. Assuredly you have heard the answer many a time; but at this moment either you have forgotten it, or else you intend to cause the trouble in turn. I incline to think this; for you have often been told that the idea of the good is the highest study, and it is by relation to it that just acts and other things become useful and advantageous. And at this moment you can scarcely doubt that I am going to assert this, and to assert, besides, that we are not sufficiently acquainted with this. And if so—if, I say, we know everything else perfectly, without knowing this—you are aware that it will profit us nothing; just as it would be equally profitless to possess everything without possessing what is good. Or do you imagine it would be a gain to possess all things that can be possessed, with the single exception of things good; or to apprehend all things, without apprehending what is good, while understanding nothing with regard to the beautiful and the good?

Not I, believe me.

Moreover, you doubtless know besides, that the good is supposed by the multitude to be pleasure, and by the more enlightened prudence?

Of course I know that.

And you are aware, my friend, that the advocates of this latter opinion are unable to explain what they mean by prudence, and are compelled at last to explain it as being about the good.

Yes, they are in a ludicrous difficulty.

They certainly are: since they reproach us with ignorance of that which is good, and then speak to us the next moment as if we knew what it was. For they tell us that the good is prudence about the good, assuming that we understand their meaning, as soon as they have uttered the term "good."

It is perfectly true.

Again, are not those, whose definition identifies pleasure with good, just as much infected with error as the preceding? For they are forced to admit the existence of bad pleasures, are they not?

Certainly they are.

From which it follows, I should suppose, that they must admit the same thing to be both good and bad.

Does it not?

Certainly it does.

Then is it not evident that this is a subject often and severely disputed?

Doubtless it is.

Well then, is it not evident, that though many persons would be ready to do and seem to do, or to possess and seem to possess, what seems just and beautiful, without really being so; yet, when you come to things good, no one is content to acquire what only seems such; on the contrary, everybody seeks the reality, and semblances are here, if nowhere else, treated with universal contempt?

Yes, that is quite evident.

This good, then, which every soul pursues, as the end of all its actions, divining its existence, but perplexed and unable to apprehend satisfactorily its nature, or to enjoy that steady confidence in relation to it, which it does enjoy in relation to other things, and therefore doomed to forfeit any advantage which it might have derived from those same things; are we to maintain that, on a subject of such overwhelming importance, the blindness we have described is a desirable feature in the character of those best members of the city in whose hands everything is to be placed?

Most certainly not.

At any rate, if it be not known in what way just things and beautiful things come to be also good, I imagine that such things will not possess a very valuable guardian in the person of him who is ignorant on this point. And I surmise that none will know the just and the beautiful satisfactorily until he knows the good.

You are right in your surmise.

Then will not the arrangement of our regime be perfect, provided it be overlooked by a guardian who is a knower of these things?

Unquestionably. But tell us, Socrates, do *you* assert the good to be knowledge or pleasure or something different from both?

I saw long ago that you are the kind of man who would certainly not put up with the opinions of other people on these subjects.

Why, Socrates, it appears to me to be positively wrong in one who has devoted so much time to these questions, to be able to state the opinions of others, without being able to state his own.

Well, I said, do you think it is just to speak as if one knows when one in fact does not know about these things?

Certainly not as if one knew, but I think it right to be willing to state one's opinion for what it is worth.

Well, but have you not noticed that opinions divorced from knowledge are all ugly? At the best they are blind. Or do you conceive that those who, unaided by the mind, entertain a correct opinion, are at all superior to blind men, who manage to keep the straight path?

Not at all superior, he replied.

Then is it your desire to contemplate objects that are ugly, blind, and crooked, when it is in your power to learn from other people about bright and beautiful things?

I implore you in the name of Zeus, Socrates, cried Glaucon, not to hang back, as if you had come to the end. We shall be content even if you only discuss the subject of the good in the style in which you discussed justice, temperance, and the rest.

Yes, my friend, and I likewise should be thoroughly content. But I distrust my own powers, and I feel afraid that my awkward zeal will subject me to ridicule. No, I will have to put aside, for the present at any rate, all inquiry into the good itself. For, it seems to me, it is beyond the measure of this effort to find the way to what is, after all, only my present opinion on the subject. But I am willing to talk to you about that which appears to be an off-shoot of the good, and bears the strongest resemblance to it, provided it is also agreeable to you; but if it is not, I will let it alone.

But please tell us about it, he replied. You shall remain in our debt for an account of the parent.

I wish that I could pay, and you receive, the parent sum, instead of having to content ourselves with the interest springing from it. However, here I present you with the interest and the child of the good itself. Only take care that I do not involuntarily impose upon you by handing in a spurious account of this offspring.

We will take all the care we can; only proceed.

I will do so as soon as we have come to a settlement together, and you have been reminded of certain statements made in a previous part of our conversation, and renewed before now again and again.

What statements exactly?

In the course of the discussion we have distinctly maintained the existence of a multiplicity of things that are beautiful, and good, and so on.

True, we have.

And also the existence of beauty itself, and good itself, and so on; reducing all those things which before we regarded as manifold, to a single idea and a single substance in each case, and addressing each as "that which is."

Just so.

And we assert that the former address themselves to the eye, and not to the mind, whereas the ideas address themselves to the mind, and not to the eye.

Certainly.

Now with what part of ourselves do we see that which is visible?

With the eyesight.

In the same way we hear sounds with the hearing, and perceive everything sensible with the other senses, do we not?

Certainly.

Then have you noticed how very lavishly the craftsman of the senses has fashioned the faculty of seeing and being seen?

Not exactly, he replied.

d Well then, look at it in this light. Is there any other kind of thing, which the ear and the voice require, to enable the one to hear, and the other to be heard, in the absence of which third thing the one will not hear, and the other will not be heard?

No, there is not.

And I believe that very few, if any, of the other senses require any such third thing. Can you mention one that does?

No, I cannot.

But do you not perceive that, in the case of vision and visible objects, there is a demand for something additional?

How so?

e Why, granting that vision is seated in the eye, and that the owner of it is attempting to use it, and that color is present in what is to be seen; still, unless there be present a third kind of thing, devoted to this special purpose, you are aware that the eyesight will see nothing, and the colors will be invisible.

And what is the third thing to which you refer?

Of course I refer to what you call light.

You are right.

508 Hence it appears, that of all the pairs aforesaid, the sense of sight, and the power of being seen, are coupled by the more honorable link, whose nature is anything but insignificant, unless light is not an honorable thing.

No, indeed; it is very far from being dishonorable.

To whom, then, of the gods in heaven can you refer as the author and dispenser of this blessing? And whose light is it that enables our sight to see so excellently well, and makes the visible appear?

There can be but one opinion on the subject, he replied: your question evidently alludes to the sun.

Then the relation between eyesight and this deity is of the following nature, is it not?

Describe it.

Neither the sight itself, nor the eye, which is the seat of sight, can be identified with the sun. b

Certainly not.

And yet, of all the organs of sensation, the eye, I think, bears the closest resemblance to the sun.

Yes, quite so.

Further, is not the faculty which the eye possesses dispensed to it from the sun, and held by it as a kind of overflow?

Certainly it is.

Then is it not also true, that the sun, though not identical with sight, is nevertheless the cause of sight, and is moreover seen by its aid?

Yes, quite true.

Well then, I continued, understand that I meant the sun when I spoke of the offspring of the good, begotten by it in a certain resemblance to itself—that is to say, bearing the same relation in the visible world to sight and to the visible, which the good bears in the intelligible world to mind and the knowable. c

How so? Be so good as to explain it to me more at length.

Are you aware that whenever a person makes an end of looking at things, upon which the light of day is shedding color, and looks instead at things colored by the light of the moon and stars, his eyes grow dim and appear almost blind, as if they were not the seat of distinct vision?

I am fully aware of it.

But whenever the same person looks at things on which the sun is shining, these very eyes, I believe, see clearly, and are evidently the seat of distinct vision? d

Unquestionably it is so.

In the same way understand the condition of the soul as follows. Whenever it has fastened upon those things, over which truth and that which is are shining, it seizes it by an act of mind, and knows it, and thus proves itself to be

possessed of reason; but whenever it has fixed upon objects that are blent with darkness, the world of becoming and passing away, it rests in opinion, and its sight grows dim, as its opinions shift backwards and forwards, and it has the appearance of being destitute of mind.

True, it has.

Now, this power, which supplies the knowable with the truth that is in them, and which renders to him who knows them the faculty of knowing them, you must consider to be the idea of the good and you must regard it as the cause of knowledge and of truth, so far as the latter comes within the range of knowledge; and though knowledge and truth are both very beautiful things, you will be right in looking upon good as something distinct from them, and even more beautiful. And just as, in the analogous case, it is right to regard light and vision as resembling the sun, but wrong to identify them with the sun; so, in the case of knowledge and truth, it is right to regard both of them as resembling good, but wrong to identify either of them with good; because, on the contrary, the having of the good is still more honorable.

That implies an inexpressible beauty, if it not only is the source of knowledge and truth, but also surpasses them in beauty; for, I presume, you do not mean by it pleasure.

Hush! I exclaimed, not a word of that. But you had better examine the illustration further, as follows.

Show me how.

I think you will admit that the sun supplies the visible things, not only the faculty of being seen, but also their generation, growth, and nutriment, though it is not itself the same as generation.

Of course it is not.

Then admit that, in like manner, the knowable not only derives from the good the gift of being known, but is further endowed by it with being and essence; so the good, far from being identical with it, is beyond being in dignity and power.

Hereupon Glaucon exclaimed with a very amusing air, By Apollo! what amazing hyperbole!

Well, I said, you are the person to blame, because you compel me to state my opinions on the subject.

Let me entreat you not to stop, until you have at all events gone through the likeness of the sun, if you are leaving anything out.

Well, to tell the truth, I am leaving out a great deal.

Then do not omit even a trifle.

I think I shall leave much unsaid; however, if I can help it under the circumstances, I will not intentionally make any omission.

Please do not.

Now understand that, according to us, there are two powers reigning, one over an intelligible and the other over a visible region and class. If I were to use the term firmament you might think I was playing on the word. Well then, are you in possession of these as two kinds, one visible, the other intelligible?

Yes, I am.

Suppose you take a line divided into two unequal parts—one to represent the visible class of objects, the other the intelligible—and divide each part again into two segments in the same proportion. Then, if you make the lengths of the segments represent degrees of distinctness or indistinctness, one of the two segments of the part which stands for the visible world will represent all images—meaning by images, first of all, shadows; and, in the next place, reflections in water, and in close-grained, smooth, bright substances, and everything of the kind, if you understand me.

Yes, I do understand.

Let the other segment stand for that which corresponds to these images—namely, the animals about us, and everything that grows and the whole class of crafted things.

Would you also consent to say that, with reference to this class, there is, in point of truth and untruthfulness, the same distinction between the copy and the original, that there is

between what is a matter of opinion and what is a matter of knowledge?

b Certainly I should.

Then let us proceed to consider how we must divide that part of the whole line which represents the intelligible world.

How must we do it?

Thus one segment of it will represent what the soul is compelled to investigate by the aid of the segments of the other part, which it employs as images, starting from hypotheses, and traveling not to a first principle, but to a conclusion. The other segment will represent the soul, as it makes its way from a hypothesis to a first principle which is not hypothetical, unaided by those images which the former division employs, and shaping its journey by the sole help of the forms themselves.

I have not understood your description so well as I might wish.

c Then we will try again. You will understand me more easily when I have made some previous observations. I think you know that the students of subjects like geometry and calculation, assume by way of materials, in each investigation, all odd and even numbers, figures, three kinds of angles, and other similar things. These things they assume as known, and having adopted them as hypotheses, they decline to give any account of them, either to themselves or to others, on the assumption that they are self-evident; and, making these their
d starting point, they proceed to travel through the remainder of the subject, and arrive at last, with perfect unanimity, at that which they have proposed as the object of investigation.

I am perfectly aware of the fact, he replied.

Then you also know that they summon to their aid visible forms, and discourse about them, though their thoughts are busy not with these forms, but with their originals, and though they discourse not with a view to the particular square and diameter which they draw, but with a view to the square itself and the diameter
e itself, and so on. For while they employ by way

of images those figures and diagrams aforesaid, which again have their shadows and images in water, they are really endeavoring to behold things themselves, which a person can only see 511 with the eye of reasoning.

True.

This, then, was the class of things which I called intelligible; but I said that the soul is constrained to employ hypotheses while engaged in the investigation of them, not traveling to a first principle, because it is unable to step out of, and mount above, its hypotheses, but using as images the copies presented by things below, which copies, as compared with the originals, are vulgarly esteemed distinct and valued accordingly.

I understand you to be speaking of the sub- b ject matter of the various branches of geometry and the kindred arts.

Again, by the second segment of the intelligible world understand me to mean all that reason itself apprehends by the force of dialectic, when it considers hypotheses not as first principles, but in the truest sense, that is to say, as stepping-stones and impulses, whereby it may force its way up to something that is not hypothetical, and arrive at the first principle of every thing, and seize it in its grasp; which done, it turns round, and takes hold of that which takes hold of this first principle, until at last it comes down to a conclusion, calling in the aid of no sensible object whatever, but c simply employing the self-subsisting forms themselves, and terminating in the same.

I do not understand you so well as I could wish, for I believe you to be describing an arduous task; but at any rate I understand that you wish to declare distinctly, that what is and is intelligible, as contemplated by the knowledge of dialectics, is more clear than the field investigated by what are called the arts, in which hypotheses constitute first principles, which the students are compelled, it is true, to contemplate with the mind and not with the senses; but, at the same time, as they do not come back,

d in the course of inquiry, to a first principle, but push on from hypothetical premises, you think that they do not exercise mind on the questions that engage them, although taken in connection with a first principle these questions come within the domain of reason. And I believe you apply the term reasoning, not understanding, to the habit of such people as geometricians, regarding reasoning as something intermediate between opinion and understanding.

You have taken in my meaning most satisfactorily; and I beg you will accept these four dispositions in the soul, as corresponding to the four segments, namely understanding corresponding to the highest, reasoning to the e second, trust to the third, and imagination to the last; and now arrange them in gradation, and believe them to partake of distinctness in a degree corresponding to the truth of their respective domains.

I understand you, said he. I quite agree with you, and will arrange them as you desire.

BOOK VII *Allegory of the Cave*

514 Now then, I proceeded to say, go on to compare our natural condition, as far as education and ignorance are concerned, to a state of things like the following. Imagine a number of men living in an underground cave-like chamber, with an entrance open to the light, extending along the entire length of the cave, in which they have been confined, from their childhood, with their legs and necks so shackled, that they are obliged to sit still and look straight forwards, because their chains make it b impossible for them to turn their heads round. And imagine a bright fire burning some way off, above and behind them, and a kind of roadway above which passes between the fire and the prisoners, with a low wall built along it, like the screens which puppeteers put up in front of their audience, and above which they exhibit their wonders.

I have it, he replied.

Also picture to yourself a number of persons walking behind this wall, and carrying 515 with them statues of men, and images of other animals, fashioned in wood and stone and all kinds of materials, together with various other articles, which are above the wall; and, as you might expect, let some of the passers-by be talking, and others silent.

You are describing a strange scene, and strange prisoners.

They resemble us, I replied. For let me ask you, in the first place, whether persons so confined could have seen anything of themselves or of each other, beyond the shadows thrown by the fire upon the part of the cave facing them?

Certainly not, if you suppose them to have been compelled all their lifetime to keep their b heads unmoved.

And what about the things carried past them? Is not the same true with regard to them?

Unquestionably it is.

And if they were able to converse with one another, do you not think that they would be in the habit of giving names to the things which they saw before them?

Doubtless they would.

Again, if their prison-house returned an echo from the part facing them, whenever one of the passers-by opened his lips, to what, let me ask you, could they refer the voice, if not to the shadow which was passing?

Unquestionably they would refer it to that.

Then surely such persons would hold the c shadows of those manufactured articles to be the only truth.

Without a doubt they would.

Now consider what would happen if the course of nature brought them a release from their fetters, and a remedy for their foolishness, in the following manner. Let us suppose that one of them has been released, and compelled suddenly to stand up, and turn his neck

round and walk with open eyes towards the light—and let us suppose that he goes through all these actions with pain, and that the dazzling splendor renders him incapable of perceiving those things of which he formerly used to see only the shadows. What answer should

d　you expect him to give, if someone were to tell him that in those days he was watching foolery, but that now he is somewhat nearer to reality, and is turned towards things more real, and sees more correctly? Above all, if he were to point out to him the several objects that are passing by, and question him, and compel him to answer what they are? Should you not expect him to be puzzled, and to regard his old visions as truer than the objects now forced upon his notice?

　　Yes, much truer.

e　　And if he were further compelled to gaze at the light itself, would not his eyes be distressed, do you think, and would he not shrink and turn away to the things which he could see distinctly, and consider them to be really clearer than the things pointed out to him?

　　Just so.

　　And if some one were to drag him violently up the rough and steep ascent from the cave, and refuse to let him go until he had drawn him

516　out into the light of the sun, do you not think that he would be vexed and indignant at such treatment, and on reaching the light, would he not find his eyes so dazzled by the glare as to be incapable of making out so much as one of the objects that are now called true?

　　Yes, he would find it so at first.

　　Hence, I suppose, it will be necessary for him to become accustomed before he is able to perceive the things above. At first he will be most successful in distinguishing shadows, then he will discern the reflections of men and other things in water, and afterwards the things

b　themselves? and after this he will raise his eyes to encounter the light of the moon and stars, finding it less difficult to study the heavenly bodies and the heaven itself by night, than the sun and the sun's light by day?

Doubtless.

Last of all, I imagine, he will be able to observe and contemplate the nature of the sun, not as it *appears* in water or on alien ground, but as it *is* in itself in its own territory.

Of course.

His next step will be to draw the conclusion, that the sun is the provider of the seasons and the years, and the guardian of all things in　c the visible world, and in a manner the cause of all those things which he and his companions used to see.

Obviously, this will be his next step.

What then? When he recalls to mind his first home, and the wisdom of the place, and his old fellow-prisoners, do you not think he will think himself happy on account of the change, and pity them?

Assuredly he will.

And if it was their practice in those days to receive honor and praise one from another, and to give prizes to him who had the keenest eye for the things passing by, and who remembered best all that used to precede　d and follow and accompany it, and from these divined most ably what was going to come next, do you imagine that he will desire these prizes, and envy those who receive honor and exercise authority among them? Do you not rather imagine that he will feel what Homer describes, to "drudge on the lands of a master, serving a man of no great estate," and be ready　e to go through anything, rather than entertain those opinions, and live in that fashion?

For my own part, he replied, I am quite of that opinion. I believe he would consent to go through anything rather than live in that way.

And now consider what would happen if such a man were to descend again and seat himself on his old seat? Coming so suddenly out of the sun, would he not find his eyes blinded with the darkness of the place?

Certainly, he would.

And if he were forced to deliver his opinion again, about those previously mentioned shadows, and to compete earnestly against those　517

who had always been prisoners, while his sight continued dim, and his eyes unsteady, and if he needed quite some time to get adjusted—would he not be made a laughingstock, and would it not be said of him, that he had gone up only to come back again with his eyesight destroyed, and that it was not worth while even to attempt the ascent? And if any one endeavored to set them free and carry them to the light, would they not go so far as to put him to death, if they could only manage to get their hands on him?

Yes, that they would.

b Now this imaginary case, my dear Glaucon, you must apply in all its parts to our former statements, by comparing the region which the eye reveals, to the prison-house, and the light of the fire to the power of the sun; and if, by the upward ascent and the contemplation of the things above, you understand the journeying of the soul into the intelligible region, you will not disappoint my hopes, since you desire to be told what they are; though, indeed, god only knows whether they are true. But, be that as it may, the view which I take of the phenomena is to the following effect. In the world of knowledge, the essential idea of the

c good is the limit of what can be seen, and can barely be perceived; but, when perceived, we cannot help concluding that it is in every case the source of all that is right and beautiful, in the visible world giving birth to light and its master, and in the intelligible world, as master, providing truth and mind—and that whoever would act wisely, either in private or in public, must see it.

To the best of my power, said he, I quite agree with you.

That being the case, I continued, agree with me on another point, and do not be surprised, that those who have climbed so high are unwilling to take part in the affairs of men, because their souls are eager to spend all their

d time in that upper region. For how could it be otherwise, if in turn it follows from the image we've discussed before?

True, it could scarcely be otherwise.

Well, do you think it amazing that a person, who has turned from the contemplation of the divine to the study of human infirmities, should betray awkwardness, and appear very ridiculous, when with his sight still dazed, and before he has become sufficiently accustomed to the surrounding darkness, he finds himself compelled to contend in courts of law, or elsewhere, about the shadows of justice, or images which cast the shadows, and to take up in what way e the lists are to be grasped by those who have never yet had a glimpse of justice itself?

No, it is anything but amazing.

Right, for a sensible man will recollect 518 that the eyes may be confused in two distinct ways and from two distinct causes, that is to say, by sudden transitions either from light to darkness, or from darkness to light. And, believing the same idea holds for the soul, whenever such a person sees a case in which the soul is perplexed and unable to distinguish objects, he will not laugh irrationally, but will rather examine whether it has just come from a brighter life, and has been blinded by the novelty of darkness, or whether it has come from the depths of ignorance into a more brilliant life, and has been dazzled by the unusual b splendor; and not until then will he consider the one happy in its life and condition, or have pity on the other; and if he chooses to laugh, such laughter will be less ridiculous than that which is raised at the expense of the soul that has descended from the light of a higher region.

You are speaking in a sensible manner.

Hence, if this is true, we must consider the following about these matters, that education is not what certain men proclaim. They say, I think, that they can infuse the soul with c knowledge, when it was not in there, just as sight might be instilled in blinded eyes.

True, such are their pretensions.

Whereas, our present argument shows us that there is a faculty residing in the soul of each person, and an instrument enabling each of us to learn; and that, just as we might suppose it to

be impossible to turn the eye round from darkness to light without turning the whole body, so must this faculty, or this instrument, be wheeled round, in company with the entire soul, from the perishing world, until it be enabled to endure the contemplation of the real world and

d the brightest part thereof, which, according to us, is the idea of the good. Am I not right?

You are.

Hence, I continued, there should be an art of this turning around, involving the way that the change will most easily and most effectually be brought about. Its object will not be to produce in the person the power of seeing. On the contrary, it assumes that he possesses it, though he is turned in a wrong direction, and does not look towards the right quarter—and its aim is to remedy this defect.

So it would appear.

Hence, while, on the one hand, the other so-called virtues of the soul seem to resemble those of the body, inasmuch as they really do

e not pre-exist in the soul, but are formed in it in the course of time by habit and exercise; while the virtue of prudence, on the other hand, does, above everything else, appear to come from a more divine substance, which never loses its energy, but by a turn-around becomes useful

519 and serviceable, or else remains useless and injurious. For you must have noticed how keen-sighted are the puny souls of those who have the reputation of being wise but vicious, and how sharply they see through the things to which they are directed, thus proving that their powers of vision are by no means feeble, though they have been compelled to become the servants of wickedness, so that the more sharply they see, the more numerous are the harms which they work.

Yes, indeed it is the case.

But, I proceeded, if from earliest childhood this part of their nature had been shorn and

b stripped of those leaden, earth-born weights, which grow and cling to the pleasures of eating and gluttonous enjoyments of a similar nature,

and keep the eye of the soul turned upon the things below—if, I repeat, they had been released from these snares, and turned round to look at true things, then these very same souls of these very same men would have had as keen an eye for such pursuits as they actually have for those in which they are now engaged.

Yes, probably it would be so.

Once more, is it not also probable, or rather does it not follow our previous remarks, that neither those who are uneducated and ignorant of truth, nor those who spend their time continuously on their education all their life, can ever be competent guardians of the city, the for-

c mer, because they have no single mark in life, which they are to constitute the end and aim of all their conduct both in private and in public? And the latter, because they will not act without compulsion, believing that, while yet alive, they have emigrated to the islands of the blest?

That is true.

It is, therefore, our task as founders of the city, I continued, to constrain the best natures to arrive at that learning which we formerly pronounced the highest, and to set eyes upon

d the good, and to mount that ascent we spoke of; and, when they have mounted and looked long enough, we must take care to refuse to permit them that which is at present allowed.

And what is that?

Staying where they are, and refusing to descend again to those prisoners, or partake of their toils and honors, be they mean or be they exalted.

Then are we to do them a wrong, and make them live a life that is worse than the one within their reach?

You have again forgotten, my friend, that

e law does not ask itself how some one part of a city is to live extraordinarily well. On the contrary, it tries to bring about this result in the entire city—for which purpose it links the citizens together by persuasion and by constraint,

520 makes them share with one another the benefit which each individual can contribute to the

commonwealth, and does actually create men of this exalted character in the city, not with the intention of letting them go each on his own way, but by using them to make a beginning towards binding the city together.

True, he replied, I had forgotten.

Therefore reflect, Glaucon, that far from wronging the future philosophers of our city, we shall only be treating them with strict justice, if we put them under the additional obligation of guarding and caring for the others. We shall say b with good reason that when men of this type come to be in other cities, it is likely that they will not partake in the labor of the city. For they take root in a city spontaneously, against the will of the prevailing regime. And it is but fair that a self-sown plant, which is indebted to no one for support, should have no inclination to pay to anybody wages for attendance. But in your case, it is we that have begotten you for the city as well as for yourselves, to be like leaders and kings of a hive, better and more c perfectly educated than the rest, and more capable of playing a part in both modes of life. You must therefore descend by turns, and associate with the rest of the community, and you must accustom yourselves to the contemplation of these dark things. For, when accustomed, you will see ten thousand times better than the residents, and you will recognize what each image is, and what is its original, because you have seen the truth of which beautiful and just and good things are copies. And in this way, for you and for us, the city is ruled in a waking state and not in a dream like so many of our present cities, which are mostly composed of men who fight among themselves for shadows, and are at feud for the administration of affairs, which d they regard as a great good. Whereas I conceive the truth stands thus: That city in which those who are going to rule are least eager to rule will inevitably be ruled in the best and least factious manner, and a contrary result will ensue if the rulers are of a contrary disposition.

You are perfectly right.

And do you imagine that our pupils, when addressed in this way, will disobey our commands, and refuse to toil with us in the city by turns, while they spend most of their time together in that pure region?

Impossible, he replied, for certainly it is e a just command and those who are to obey it are just men. No, doubtless each of them will undertake ruling as an unavoidable duty—the opposite of what is pursued by the present rulers in each city. . . .

BOOK IX

It only remains for us, I proceeded, to inquire 571 how the democratic man is transformed into the tyrannical, and what kind of person he is, and whether his manner of living is happy or the reverse.

True, this case is still remaining, he said.

Then do you know, I asked, what I am still missing?

What is that?

I think that the number and nature of the appetites has not been satisfactorily defined; and while this deficiency continues, the inquiry upon which we are entering will be wrapped in b obscurity.

It is not too late to make up for that?

Certainly it is not. Observe the peculiarity which I wish to notice in the case before us. It is this. Some of the unnecessary pleasures and appetites, if I am not mistaken, are hazardous to the law, and come to be in all men; though, in the case of some persons, under the correction of the laws and the higher appetites aided by reason, they either wholly disappear, or only a few weak ones remain; while, in the case of others, they continue strong and numerous. c

And what are the appetites to which you refer?

I refer to those appetites which wake up in sleep—when, during the slumbers of that other part of the soul, which is rational and tamed and master of the former, the wild animal part,

sated with meat or drink, becomes rampant, and pushing sleep away, endeavors to set out after the gratification of its own proper character. You know that in such moments there is nothing that it dares not do, released and delivered as it is from any sense of shame and reflection. It does not shrink from attempting, as it thinks,

d unholy intercourse with a mother, or with any man or deity or animal whatever; and it does not hesitate to commit the foulest murder, or to indulge itself in the most defiling meats. In one word, there is no limit either to its folly or to its audacity.

Your description is perfectly true.

But, I imagine, whenever a man relates to himself in a healthy and temperate way, and, when going to sleep, he has stimulated the rational part of him, and feasted it on beautiful discussions and high inquiries, by means of close and inward reflection; while, on the

e other hand, he has neither stinted nor gorged the appetitive part in order that it may sleep

572 instead of troubling with its joys or its griefs that highest part, which may thus be permitted to pursue its studies in purity and independence, and to strain forward to perceive something until then unknown, either past, present, or future; and when, in like manner, he has calmed the spirited element by avoiding every burst of passion, which would send him to sleep with his spirit stirred—when, I say, he proceeds to rest, with two elements out of the three quieted, and the third, wherein wisdom resides, aroused, you are aware that, at such moments, he is best able to apprehend truth,

b and that the visions, which present themselves in his dreams, are then anything but unlawful.

I concur with your opinion.

Well, we have been carried too far out of our way, in order to make these remarks. What we wish to recognize is, that apparently a terrible species of wild and lawless appetites resides in every one of us, even when in some cases we have the appearance of being perfectly self-restrained. And this fact, it seems, becomes evident in sleep. Consider whether

you think I am right, and whether you agree with me.

Yes, I do agree.

Remember then the character which we ascribed to the man of the people. He grew c up from his youth, I believe, reared under the eye of a miserly father, who respected only the money-making appetites, and despised those unnecessary appetites which have for their object amusement and display. Am I not right?

You are.

By intercourse with more fashionable men, replete with those appetites which we just now discussed, he had run, like them, into utter riot, in detestation of his father's miserliness; but, as he possessed a better disposition than his corrupters, he was drawn in two directions, and ended by adopting an intermediate character; and while enjoying every pleasure in d perfect moderation, as he imagined, he lived a life which was neither unfree nor unlawful, and was thus transformed from an oligarchical into a democratic man.

Yes, this was and is our opinion about this person.

Well then, I continued, suppose that this man has grown old in his turn, and that a young son is raised again in his habits.

Very good.

Suppose furthermore, that the same things that happened to his father happen to him— that he is seduced into an utter violation of law, or, to use the language of his seducers, into perfect freedom, and that his father and his other relations bring support to these inter- e mediate appetites, which is met by counter support on the other side; and when these terrible sorcerers and tyrant-makers have despaired of securing the young man by other spells, imagine that they contrive to engender in him some passion, to champion those idle appetites which divide among themselves what comes to hand; and this passion you may describe as a kind of huge, winged drone: for 573 how else can you describe the passion entertained by such men?

I cannot describe it otherwise.

This done, the other appetites, overflowing with incense and perfumes and garlands and wines and the loose pleasures which form part of such get-togethers, begin to buzz around this drone, and exalt and nurse him to the uttermost, until they have engendered in him the sting of desire; and from that moment forward this leader of the soul, with frenzy for his body-guard, is goaded on to madness; and if he deters within himself any opinions or appetites which are regarded as good, and which still feel a sense of shame, he destroys them or thrusts them from his presence, until he has purged out temperance, and filled himself with imported madness.

You exactly describe the generation of a tyrannical man.

Is not this the reason why love has of old been called a tyrant?

Probably it is.

Also, my friend, does not a drunken man possess what may be called a tyrannical spirit?

He does.

And we know that an insane, or deranged person, expects to be able to lord it not only over men, but even over gods, and attempts to do so.

Certainly he does.

So, my excellent friend, a man becomes strictly tyrannical, whenever, by nature, or by habit, or by both together, he has fallen under the dominion of wine, or love, or melancholy.

Yes, precisely so.

Such is his origin, apparently, and such his nature; but how does he live?

As they say in the game, he replied, *you* must tell *me* that.

So be it, I said. Well, if I am not mistaken, from henceforth feasts and revels and banquets and mistresses, and every thing of the kind, become the order of the day with persons whose souls are wholly piloted by an indwelling tyrant passion.

It must be so.

And do not many frightful appetites, needy of many things, shoot up by their side every day and every night?

Yes, many indeed.

So that all existing revenues are soon spent.

Of course they are.

Then follow schemes for raising money, and consequent loss of property.

Undoubtedly.

And when every resource has failed, must not those violent appetites, which have nestled thickly within, lift up their voices? And goaded on, as these people are, by their appetites, and especially by that ruling passion under which all the rest serve as body-guard, must they not, in a frenzy of rage, look out for anyone who has anything, whom they may rob by fraud or violence?

Yes, indeed, they must.

So that if they cannot pillage in every quarter, they are constrained to suffer grievous throes and pangs.

They are.

Now, just as the inward pleasures of later growth bested the original pleasures and took away what belonged to them, in the same way will not the man himself determine to have more than his father and mother, though he is younger than they, and to help himself at their expense out of his father's property, if he has expended his own share?

Undoubtedly he will.

And if his parents oppose his designs, will he not attempt in the first instance to cheat and outwit them?

Assuredly he will.

And whenever that is impossible, will he proceed to robbery and violence?

I think so.

Then if his aged father and mother hold out against him and offer resistance, will he be so scrupulous as to shrink from playing the tyrant?

I am not altogether without my fears for the parents of such a man.

But do you think, Adeimantus, that his attachment to his unnecessary and unconnected mistress is new, while his love for his very own indispensable mother is old, and that his affection for his unnecessary and unconnected friend who is in the bloom of youth, is of recent date compared with that for his very own father, his oldest friend, faded and aged as he is. This being the case, can you believe that he would beat his mother and father for the sake of his mistress and his friend, and that he would make the former the slaves of the latter, if he brought them into the same house?

Upon my word I believe he would, he replied.

Then to all appearance it is a most delightful thing to be the parents of a tyrannical son.

Yes, that it is.

However, when the property of his father and mother begins to fail the son, while at the same time the swarm of pleasures has collected within him, will not his first exploit be to break into a house or strip some traveler of his clothes by night, and will he not afterwards proceed to sweep off the contents of some temple? And in the meantime those old and, in common estimation, just opinions, which he held from childhood on the subject of base and noble actions, will be defeated by those opinions which have been just emancipated from slavery, aided by that ruling passion whose bodyguard they form, opinions which, so long as he was subject to the laws and to his father, and while his inward constitution was democratic, used to be emancipated only in the dreams of sleep. But, now that he is tyrannized by Eros, that character, which used to be his only in dreams, and at rare intervals, has become his constant waking state. There is not a dire murder, a forbidden meat, or an unholy act, from which he will restrain himself; but this passion that lives and reigns within him, in the midst of utter anarchy and lawlessness, will, by virtue of its being sole king, seduce its possessor, as in the case of a city, into

unbounded recklessness, to procure means for the maintenance of itself and its attendant rowdy crowd, which has partly made entrance from without as a result of wicked companionship, and partly been liberated and released from within by the same bad habits. Or am I wrong in my description of the life of such a man?

No, you are right, he replied.

And if, I proceeded, a city contains only a few such characters, the rest of the population being sober-minded, these people leave and enlist in the body-guard of some other tyrant, or else serve as mercenaries in any war that may be going on. But if they live in a time of peace and quiet, they commit many small mischiefs on the spot in the city.

Such as what?

Such as theft, burglary, purse snatching, stealing clothes, sacrilege, kidnaping—and sometimes they turn sycophant, if they have a talent for speaking, and perjure themselves, and take bribes.

True, these are small mischiefs, if the perpetrators are few in number.

Things that are small, I replied, are small comparatively; and assuredly all these mischiefs, in their bearings on the corruption and misery of a city, do not, as the proverb says, nearly come up to the mark of a tyrant. For whenever such persons, and others, their followers, become numerous in a city, and perceive their own numbers, then, assisted by the folly of the people, these men generate the tyrant, who is simply that one of their number whose own soul contains the mightiest and hugest tyrant.

So one might expect, because such a person must have most of the tyrant about him.

Consequently if the citizens obey willingly, all goes smoothly. But if the city cannot be relied on, the tyrant will chastise his fatherland, if he can, just as in the former case he chastised his mother and father; and to do this, he will summon to his assistance youthful

comrades, to whom he enslaves his once-beloved mother-country, as the Cretans call it, or father-land. And this will be the consummation of the appetite of such a person.

Assuredly it will.

e

And do not these persons display the same character in private, even before they become rulers? In the first place, in their intercourse with others, is it not the case either that all their associates are their flatterers and ready to serve them in everything, or that, if they want anything from anybody, they go down on their knees for it, acting as though they belonged to him, whereas when they have gained their point they become distant and estranged?

576

Precisely so.

Thus all their life long they live friendless, and they are always either masters or slaves: for a tyrant nature can never taste true freedom and friendship.

Certainly not.

Then shall we not be right if we call such persons faithless?

Undoubtedly we shall.

And not only faithless, but also supremely unjust, if we were right in our former conclusions as to the nature of justice.

b

And certainly we were right.

Then let us describe summarily the most wicked man. He is one whose waking state is the very counterpart of the dreamlike description which we have given.

Exactly so.

Such is the end of the man, who, with a nature most tyrannical, gains sole rule—and the longer his life of tyranny lasts, the more exactly does he answer to our description.

That is unquestionably true, said Glaucon, taking up the reply.

That being the case, I continued, will not the man, who shall be proved to be most vicious, be thereby proved to be also most miserable? And will it not be apparent that the man, whose tyranny has lasted longest in the intensest form, has really been for the longest time

c

most intensely vicious and miserable, notwithstanding the variety of opinions entertained by the many?

Yes, that much is certain, he replied.

And can we help regarding the tyrannical man as the counterpart and representative of the city which is under the sway of a tyrant, the democratic man of the democratic city, and so on?

Unquestionably we cannot.

d

Hence, as city is to city in point of virtue and happiness, so also is man to man; is it not so?

Undoubtedly it is.

Then, in point of virtue, how does a city under a tyrant stand as compared with a city under such a kingly government, as we at first described?

They are the very opposite of one another, he replied: one is the most virtuous, and the other the most wicked.

I shall not ask you which is which, because that is obvious. But do you decide the question of happiness and misery in the same way, or not? And here let us not be dazzled by looking only at the tyrant, who is just one man, or at a few of his immediate followers; but, as it is our duty to enter and survey the city as a whole, let us, before giving our opinion, creep into every part of it and look about.

e

Well, your proposal is a just one; indeed it is clear to everybody, that a city governed by a tyrant is the most miserable of cities; whereas a city under kingly rule is the happiest of cities.

Then shall I not do right, if, in discussing the corresponding men, I make the same proposal, and recognize only *his* verdict, who can in thought penetrate into a man's character, and look through it, and who does not, like a child, scrutinize the exterior, until he is dazzled by the artificial glitter which the tyrannical man carries on the outside, but on the contrary sees through it all thoroughly? Suppose I give it as my opinion, that we are all bound to listen to the judge, who is not only capable of passing

577

sentence, but has also lived in the same place with the person in question, and has been an eye-witness of his goings on at home, and of his bearing towards the several members of his family, wherein he will be most thoroughly stripped of the theatrical garb, and also of his behavior in public perils; and suppose we bid him take all these particulars into consideration, and then pronounce, how, on the score of happiness and misery, the tyrant stands as compared with the other men?

This proposal, he replied, would be also a most just one.

Then, in order that we may have some person who will reply to our questions, do you want us to pretend to be among those who, besides being competent to deliver judgment, have before now encountered people of this description?

Yes, I should.

Come then, let me beg you to consider the question in the following light. Bearing in mind the similarity that subsists between the city and the man, examine them singly in turn, and tell me the circumstances in which each is placed.

To what circumstances do you refer?

To begin with the city, do you say of one which is under the dominion of a tyrant that it is free or slave?

Consummate slavery.

And yet you see it contains masters and freemen.

True, it does contain a few such persons; but the mass of the inhabitants, I might say, and the best of them are reduced to a dishonorable and miserable servitude.

Now, since the man resembles the city, must not the same order of things exist in him also, and must not his soul be filled with much slavery and servility, those parts of it, which were the best, being enslaved, while a small part, and that the most corrupt and insane, is dominant?

It must be so.

If so, will such a soul, by your account, be slave or free?

I should certainly say the former.

To return, is not the city, which is enslaved to a tyrant, utterly precluded from acting as it likes?

Yes, quite so.

Then the soul also, which is the seat of a tyranny, considered as a whole will be very far from doing whatever it wishes. On the contrary it will always be goaded by a gadfly, and filled with confusion and remorse.

Beyond a doubt.

And must the city which is the seat of a tyranny be rich or poor?

It must be poor.

Then the tyrannical soul also must always be poverty-stricken and craving.

Just so.

Again, must not such a city and such a man be, as a matter of course, full of fear?

Yes, indeed.

Do you expect to find in any other city more weeping and wailing and lamentation and grief?

Certainly not.

And to return to the individual, do you imagine such things to exist in any one so abundantly as in this tyrannical man, who is maddened by appetites and longings?

Why, how could they?

Looking then, I suppose, at all these facts, and others like them, you have decided that the city is the most miserable of cities.

And am I not right?

You are very right. But once more, looking at the same facts, what account do you give of the tyrannical man?

I should say that he is quite the most miserable of all men.

There you are no longer right.

How so?

I believe, that this person is still not the most miserable of all.

Then who is?

You will perhaps think the following person even more miserable.

Describe him.

c I refer to the man who, being tyrannical, is prevented from living a private life, because he is so unfortunate as to have the post of tyrant, by some bad luck, procured for him.

I infer from the previous remarks that you are right.

Yes, I said, but you must not be content with surmises here; on the contrary, you must examine an argument such as this thoroughly; for surely the point under investigation is of the greatest importance, since it is the choice between a good and a bad life.

That is perfectly true.

d Observe, then, whether I am right. It appears to me that, in examining the question, we ought to begin our inquiry with the following considerations.

What are they?

We must begin by considering the individual case of those private members of cities who are wealthy and possess many slaves. For they have this point in common with the tyrant, that they rule over many persons. The difference lies in the greater number of his subjects.

Yes, it does.

And now, are you aware that such persons are confident and do not fear their servants?

Yes. What should make them fear them?

Nothing, but do you understand the reason for it?

Yes. It is because the entire city supports each private person.

e You are right. But if some deity were to lift out of the city a single individual, who has fifty slaves or more, and were to plant him with his wife and children in some desert along with the rest of his substance and his servants, where none of the freemen would be likely to help him, do you not think he would be seized with an indescribable terror lest he and his wife and children should be murdered by his servants?

Yes, with utter terror, I think.

And would he not be compelled from that 579 time forward to fawn on some of his very slaves, and to make many promises and free them without any demand for it? In fact, would he not appear to be an abject flatterer of his servants?

He is doomed to death if he fails to do so.

But what if the god had surrounded him with a multitude of other neighbors, who would not endure that one person should claim the rights of a master over another, but punished with the utmost severity any such person whom they caught?

In that case he would be, I imagine, involved b still further in a greater evil, because he would be hemmed in by a ring of warders, and all of them would be his enemies.

And is not the tyrant a prisoner in a similar prison? For if his nature is such as we have described, he is filled with a multitude of terrors and longings of every kind; and, though he has a greedy and inquisitive soul, is he not the only citizen that is precluded from traveling or setting eyes upon all those objects which every freeman desires to see? Does he not bury himself in his house, and live for the most part the life of a woman, while he c positively envies all other citizens who travel abroad and see anything good?

Yes, assuredly he does.

Such being his sick condition, I continued, a larger harvest of misery is reaped by that person, who, with a sick inward constitution like that of the tyrannical man, whom you just now judged as most wretched, is forced out of private life, and constrained by some accident to assume tyrannical power, thus undertaking to rule others when he cannot govern himself, just like a person who with a diseased and incontinent body is compelled to pass his life, d not in retirement, but in wrestling and contending with other persons.

Undoubtedly, Socrates, the cases are very similar, and your account is very true.

Then, my dear Glaucon, is not the condition of the tyrant utterly wretched, and does he not live a life which is even more intolerable than that of the man who, by your verdict, lives most intolerably?

Unquestionably, he replied.

So, whatever may be thought, a real tyrant is in truth a real slave to the greatest flattery and slavery, and a flatterer of the most vicious; and, far from satisfying his cravings in the smallest degree, he stands in utmost need of numberless things, and is in truth a pauper, in the eyes of one who knows how to contemplate the soul as a whole; and all his life long he is loaded with terrors, and full of convulsions and pangs, if he resembles the disposition of the city over which he rules; and he does resemble it, does he not?

Certainly he does.

Then we shall also, in addition to this, ascribe to the man what we stated before—namely, that he cannot help being, and, in virtue of his power, becoming more and more envious, faithless, unjust, friendless, unhealthy, and the host and nurse of every vice; and, in consequence of all this, he must in the first place be unhappy in himself, and in the next place he must make those who are near him as unhappy as himself.

No sensible man will contradict you.

Then go on, I proceeded, and, like the judge who passes sentence after going through the whole case, declare forthwith who is first, in your opinion, in point of happiness, and who second, and so on, arranging all the five men in order, the kingly, the timocratic, the oligarchic, the democratic, the tyrannical.

Well, he said, the decision is an easy one. I arrange them, like choruses, in the order of their entrance, in point of virtue and vice, happiness and misery.

Shall we, then, hire a herald, or shall I make proclamation in person, that the son of Ariston has given his verdict to the effect that he is the happiest man who is best and most just, that is, who is most kingly, and who rules over himself royally; whereas he is the most wretched man who is worst and most unjust, that is, who is most tyrannical, and who plays the tyrant to the greatest perfection both over himself and over a city?

Let such be your proclamation, he replied.

And am I to add to my proclamation, that it makes no difference whether all men and gods notice their characters, or not?

Do so.

Very well, I proceeded, this will make one demonstration for us. The following must make a second, if it shall be approved.

What is it?

Since the soul of each individual has been divided into three parts corresponding to the three classes in the city, our position will admit, I think, of a second demonstration.

What is it?

It is the following. As there are three parts, so there appear to me to be three pleasures, one appropriate to each part, and similarly three appetites, and governing principles.

Explain yourself.

According to us, one part was that with which a man learns, and another that whereby he shows spirit. The third was so multiform that we were unable to address it by a single appropriate name. So we named it after that which is its most important and strongest characteristic. We called it appetitive, on account of the intensity of the appetites of hunger, thirst, and sex, and all their accompaniments and we called it peculiarly money-loving, because money is the chief agent in the gratification of such appetites.

Yes, we were right.

Then if we were to assert that the pleasure and the love of this third part is of gain, would not this be the best summary of the facts upon which we should be likely to settle by force of argument, so that it is clear to us, whenever

we spoke of this part of the soul. And shall we not be right in calling it money-loving and gain-loving?

I think so, he replied.

Again, do we not maintain that the spirited part is wholly bent on winning power and victory and celebrity?

b Certainly we do.

Then would the title of victory-loving and honor-loving be appropriate to it?

Yes, most appropriate.

Well, but with regard to the part by which we learn, it is obvious to every one that its entire and constant aim is to know the truth as it is, and that this one cares the least about wealth and reputation.

Yes, quite the least.

Then shall we not do well to call it learning-loving and wisdom-loving?

Of course we shall.

Does not this last reign in the souls of some c persons, while in the souls of other people one or other of the two former, according to circumstances, is dominant?

You are right.

And for these reasons may we assert that men may be primarily classed under the three heads of lovers of wisdom, of victory, and of gain?

Yes, certainly.

And that there are three kinds of pleasures, respectively underlying the three classes?

Exactly so.

Now, are you aware, I continued, that if you choose to ask three such men each in his turn, which of these lives is the most pleasant, each will extol his own beyond the oth-d ers? Thus the money-making man will tell you, that compared with the pleasures of gain, the pleasures of being honored or of becoming learned are worthless, except in so far as they can produce money.

True.

But what of the honor-loving man? Does he not look upon the pleasure derived from money

as a vulgar one, while, on the other hand, he regards the pleasure derived from learning as a mere vapor and absurdity, unless honor be the fruit of it?

That is precisely the case.

And must we not suppose that the lover of wisdom regards all the other pleasures as, by comparison, very far inferior to the pleasure of e knowing the truth as it is, and of being constantly occupied with this pursuit of learning; and that he calls those other pleasures strictly necessary, because, if they were not necessary, he would feel no desire for them?

We may be certain that it is so, he replied.

Then whenever a dispute is raised as to the pleasures of each kind and the life itself of each class, not with reference to beauty and ugliness, the worse and the better, but 582 with reference merely to their position in the scale of pleasure and painlessness, how can we know which of the three men speaks most truly?

I am not quite prepared to answer.

Well, look at the question in this light. By what do we judge in order for a judgment to be correct? Must it not be experience, prudence and reasoning? Or can one find better means of judging than these?

Of course we cannot.

Then observe. Of the three men, which is the best acquainted by experience with all the pleasures which we have mentioned? Does the lover of gain study the nature of truth itself as it is, in your opinion, and is he acquainted with the pleasure of knowledge better than the lover of wisdom is acquainted with the pleas- b ure of gain?

There is a great difference, he replied. The lover of wisdom is compelled to taste the pleasures of gain from his childhood; whereas the lover of gain is not compelled to study the nature of the things that are, and thus to taste the sweetness of this pleasure, and become acquainted with it; rather I should say,

it is not easy for him to do this, even if he has the inclination.

Hence, I proceeded, the lover of wisdom is far superior to the lover of gain in having experienced both pleasures.

c He is indeed.

But what of the lover of honor? Is he acquainted with the pleasure of thinking as thoroughly as the lover of wisdom is acquainted with the pleasure of honor?

Honor waits upon them all, he said, if each works out the object of his pursuit. For the rich man is honored by many people, as well as the courageous and the wise—so that all are acquainted with the nature of the pleasure to be derived from the fact of being honored. But the nature of the pleasure to be found in the vision of that which is, none can have tasted, except the lover of wisdom.

d Then, as far as experience goes, the lover of wisdom is the best judge of the three.

Quite so.

Also we know that he alone can lay claim to prudence as well as experience.

Undoubtedly.

Once more, the tool by which judgment is passed is an organ belonging, not to the lover of gain or of honor, but to the lover of wisdom.

What is that tool?

We stated, I believe, that judgment must be passed by means of argument. Did we not?

We did.

And argument is to a special degree, the tool of the lover of wisdom.

Certainly.

Consequently, if wealth and gain were the
e best tools for deciding questions as they arise, the praise and the censure of the lover of gain would necessarily be most true.

Quite so.

And if honor, victory, and courage, were the best tools for the purpose, the sentence of the lover of honor and of victory would be most true, would it not?

Obviously it would.

But since experience, prudence, and argument, are the best instruments, what then?

Why of course, he replied, the praise of the lover of wisdom and of argument is the truest.

Then, if the pleasures are three in number, 583 will the pleasure of this part of the soul, by which we learn, be most pleasant? And will the life of that man amongst us, in whom this part is dominant, be also most pleasant?

Unquestionably it will—at any rate, the man of prudence is fully authorized to praise his own life.

And what life, I asked, does the judge pronounce second, and what pleasure second?

Obviously, the pleasure of the warlike and honor-loving man. For it approaches the first more nearly than the pleasure of the money-making man does.

Then the pleasure of the lover of gain is to be placed last, as it appears.

Undoubtedly, he replied.

Thus the just man will be victorious over b the unjust twice in a row. And now for the third and last time, address yourself, like a contestant in the Olympic games, to Olympian Zeus, the Preserver, and observe that in the pleasure of all but the prudent man there is something which is not entirely true and which is impure, but is rather like shadow-painting as I think I have been told by some wise man. And let me say, that this bout will be the heaviest and most decisive defeat of all.

Quite so, but explain yourself.

I shall find what we want, I replied, if you c will respond while I look.

Ask your questions by all means.

Tell me then, I proceeded, do we not assert that pain is the opposite of pleasure?

Assuredly we do.

And also that there is such a thing which is neither pleasure nor pain?

Certainly there is.

In other words, you admit that there is a point midway between the two at which the soul reposes from both. Is not that your meaning?

It is.

Have you forgotten the speeches of sick people when they are ill?

Give me an example of that.

d They tell us that nothing is more pleasant than health, but that, before they were ill, they had not found out its supreme pleasantness.

I remember.

Do you not also hear persons who are in excessive pain say, that nothing is so pleasant as relief from pain?

I do.

And I think you find that, on many other similar occasions, persons, when they are uneasy, extol as supremely pleasant, not positive joy, but the absence of, and repose from, uneasiness.

True, he replied; and perhaps the reason is, that at such times this relief does become positively pleasant and delightful.

e In the same way we might expect, that when a person's joy has ceased, the repose from pleasure will be painful.

Perhaps so.

Thus the repose, which we described just now as midway between pleasure and pain, must be now one, now the other.

So it would seem.

Can that, which is neither pleasure nor pain, become both?

I think not.

Again, pleasure and pain, when present in the soul are both of them emotions, are they not?

They are.

584 But was not the simultaneous absence of pleasure and of pain shown just now to indicate a state of undoubted repose, midway between the two?

It was.

Then how can it be right to regard the absence of pain as pleasant, or the absence of pleasure as painful?

It cannot be right.

Hence, the repose felt at the times we speak of is not really, but only appears to be, pleasant

by the side of what is painful, and painful by the side of what is pleasant; and these appearances will in no instance stand the test of comparison with true pleasure, because they are only some kind of bewilderment.

I confess that the argument points to that conclusion.

In the next place turn your eyes to pleasures b
which do not grow out of pains, to prevent your supposing, as perhaps at the present moment you might do, that it should naturally come to be that pleasure should be a cessation of pain, and pain a cessation of pleasure.

Where am I to look, and what pleasures do you mean?

Among many others, I replied, you may, if you will, take as the best example for your consideration the pleasures of smell—which, without the existence of any previous uneasiness, spring up suddenly in extraordinary intensity, and when they are over, leave no pain behind.

That is quite true.

Then do not let us be persuaded that pure c
pleasure consists in the release from pain, or that pure pain consists in the release from pleasure.

No.

But it is certain that, speaking roughly, most of the so-called pleasures which reach the soul through the body, and the keenest of them, belong to this species—that is to say, they are a kind of release from pain.

They are.

Does not the same remark apply to those pleasures and pains of anticipation which precede them?

It does.

Now, are you aware what the character of d
these pleasures is, and what they most resemble?

What?

Do you believe that there is by nature an above, and below, and an intermediate?

Yes, I do.

And do you imagine that a person, carried from below to that intermediate position, could

help supposing that he is being carried above? And when he is stationary in that situation, and looks to the place from where he has been carried, do you imagine that he can help supposing his position to be above, if he has not seen the real above?

For my own part, he replied, I assure you I cannot imagine how such a person is to think differently.

e Well, supposing him to be carried to his old place, would he think that he is being carried below, and would he be right in so thinking?

Of course he would.

And will not all this happen to him, because he has not experienced what is truly above, and between, and below?

Obviously it will.

Then can you wonder, that persons inexperienced in the truth, besides holding a multitude of other unsound opinions, stand to pleasure and pain and their intermediate, in such a position, that though when they are carried
585 to what is painful, they form a correct opinion of their condition, and are really in pain; yet, when they are carried from pain to the middle point between pain and pleasure, they obstinately imagine that they have arrived at fulfillment and pleasure, which they have never experienced, and consequently are deceived by contrasting pain with the absence of pain, like persons who, not knowing white, contrast gray with black, and take it for white?

No, indeed, I cannot wonder at it; in fact, I should wonder much more if it were not so.

b Well, consider the question in another light. Are not hunger and thirst, and similar sensations, a kind of emptiness of the bodily condition?

Undoubtedly.

Similarly, are not ignorance and folly an emptiness of the condition of the soul?

Yes, certainly.

Will not the man who eats, and the man who gets understanding, be filled?

Of course.

And is fulness more true if it is in relation to that which is more or that which is less?

Obviously, that which is more.

Then do you think that pure essence participates more in the classes of things like bread and meat and drink, and food generally, c
than that species of things which includes true opinion and science and mind, and in a word, all virtue? In forming your judgment look at the matter thus. In your opinion, which one is more—that which is attached to what is always similar to itself, deathless, and true, and that which is itself and comes to be in such a sort of thing, or its opposite, that is, something which is never like itself, which is mortal, and which is itself the sort of thing that it becomes?

It is that which is connected with what is always like itself.

And as to the essence of that which is always similar to itself, does it participate more in essence than in knowledge?

Certainly not.

Well, what about truth?

No.

That is to say, if truth participates less, essence participates less also?

Necessarily so.

Speaking universally, does not the cultivation of the body in all its branches participate d
in truth and essence less than the cultivation of the soul in all its branches?

Yes, in a much less degree.

And does not the same hold for the body itself as for the soul?

It does.

So, that which is filled with more being and is more real is more truly filled than that which is filled with less.

Undoubtedly it is.

Hence, as it is pleasant to a subject to be filled with the things that are naturally appropriate to it, that subject which is really more filled, and filled with real essences, will in a more real and true sense be productive of true pleasure; e
whereas that subject which participates in things

less real, will be less really and less securely filled, and will participate in a less true and less trustworthy pleasure.

The conclusion is absolutely inevitable, he replied.

586 Those, therefore, who are inexperienced with prudence and virtue, and who spend their time in perpetual banqueting and similar indulgences, are carried down, as it appears, and back again only as far as the midway point on the upward road; and between these limits they roam their life long, without ever overstepping them so as to look up towards, or be carried to, the true above—and they have never been really filled with what is real, or tasted sure and unmingled pleasure; but, like cattle, they are always looking downwards, and hanging their heads to the ground, and poking them into their dining-tables, while they graze and get fat and
b propagate their species; and, to satiate their greedy desire for these enjoyments, they kick and butt with hoofs and horns of iron, till they kill one another under the influence of ravenous appetites—trying to fill their leaky part with things that are not.

Socrates, said Glaucon, you certainly describe like an oracle the life of the majority of people.

And does it not follow that they consort with pleasures mingled with pain which are mere images and shadow-paintings of the true
c pleasure, and which are so colored by being positioned next to pain, that they appear in each case to be extravagantly great, and beget a frantic passion for themselves in the breasts of the foolish people, and are made subjects of contention, like that image of Helen, for which, according to Stesichorus, the combatants at Troy fought, in ignorance of the true Helen?

Such a state of things, he replied, follows as a matter of course.

And now to come to the spirited element. Must not the consequences be the same sort of thing, whenever a man labors for the gratification of this part of his nature, either in the shape of jealousy from motives of honor-loving, or in the shape of violence from victory-loving, or in the shape of anger out of discontent, while he pursues after honor and victory and anger d to his own satisfaction, without calculation and mindfulness?

The consequences in this case also must necessarily be similar.

And what is the inference? May we assert confidently, that of all the appetites with which the gain-loving and honor-loving elements are conversant, those which follow the lead of knowledge and reason, and along with them pursue the pleasures which the prudent part directs, until they find them, will find not only the truest pleasures that they can possibly find, in consequence of their devotion to truth, but also the pleasures appropriate to them, since e what is best for each is also most appropriate?

Yes, no doubt it is most appropriate.

Hence, so long as the whole soul follows the guidance of the wisdom-loving element without any dissension, each part can not only 587 do its own proper work in all respects, or in other words, be just; but, moreover, it can enjoy its own proper pleasures, in the best and to the greatest extent possible.

Yes, precisely so.

On the other hand, whenever either of the two other elements has gained the mastery, it is fated not only to miss the discovery of its own pleasure, but also to constrain the other principles to pursue an alien and untrue pleasure.

Just so.

Well, the further a thing is removed from philosophy and reason, the more likely will it be to produce such bad effects, will it not?

Yes, much more likely.

And that is furthest removed from reason which is furthest removed from law and order, is it not?

Obviously so.

And have not the passionate or tyrannical appetites been proved to be furthest removed b from law and order?

Yes, quite the furthest.

Whereas the kingly and regular appetites stand nearest to law and order, do they not?

They do.

Hence, if I am not mistaken, the tyrant will be furthest from, and the king nearest to, true and specially appropriate pleasure.

It is undeniable.

And therefore the tyrant will live most unpleasantly, and the king most pleasantly.

It is quite undeniable.

And are you aware of the extent to which the discomfort of the tyrant's life exceeds that of the king's?

I wait for you to tell me.

c There are three pleasures, it appears,—one genuine, and two spurious. Now the tyrant has trespassed beyond these last, has fled from law and reason, and lives with a body-guard of slavish pleasures; and the extent of his inferiority is hard indeed to state, unless perhaps it may be stated thus.

How?

Reckoning from the oligarchical man, the tyrant stands third, I believe, in the descending line; for the democratic man stood between them.

Yes.

Then, if our former remarks were true, must not the pleasure with which he consorts, be, so far as truth is concerned, a copy of a copy, the original of which is in the possession of the oligarchic man?

Just so.

d Again, reckoning from the kingly man, the oligarchic in his turn stands third in the descending line, supposing us to identify the aristocratic and the kingly?

True, he does.

Therefore the tyrant is thrice three times removed from true pleasure.

Apparently so.

Then it seems that tyrannical pleasure may be represented geometrically by a square number, 9.

Exactly so.

And by squaring and cubing, it is made quite clear to what a great distance the tyrant is removed.

Yes, to an arithmetician it is.

Conversely, if you wish to state the distance at which the king stands from the tyrant in point of true pleasure, by working out the mul- e tiplication you will find that the former lives 729 times more pleasantly than the latter, or that the latter lives more painfully than the former in the same proportion.

You have brought out an extraordinary result in calculating the difference between the 588 just man and the unjust, on the score of pleasure and pain.

Well, I replied, I am sure that the number is b correct, and applicable to human life, if days and nights and months and years are applicable thereto.

And no doubt they are.

Then if the good and just man so far surpasses the wicked and unjust in point of pleasure, will he not surpass him incalculably more in gracefulness of life, in beauty, and in virtue?

Yes, indeed he will, incalculably.

Well, then, I continued, now that we have arrived at this stage of the argument, let us resume that first discussion which brought us here. It was stated, I believe, that injustice is profitable to the man who is perfectly unjust, while he is reputed to be just. Or am I wrong about the statement?

No, you are right.

This is the moment for arguing with the speaker of this remark, now that we have come to an agreement as to the respective effects of a course of injustice, and of a course of justice.

How must we proceed?

We must fashion in speech an image of the soul, in order that the speaker may perceive what his remark amounts to.

What kind of image is it to be? c

We must imagine, I replied, a creature like one of those which, according to the legend,

existed in old times, such as Chimera, and Scylla, and Cerberus, not to mention a host of other monsters, in the case of which we are told that several generic forms have grown together and coalesced into one.

True, we do hear such stories.

Well, mold in the first place the form of a motley many-headed monster, furnished with a ring of heads of tame and wild animals, which he can produce by turns in every instance out of himself.

d It requires a cunning modeler to do so; nevertheless, since speech is more pliable than wax, consider it done.

Now proceed, secondly, to mold the form of a lion, and, thirdly, the form of a man. But let the first be much the greatest of the three, and the second next to it.

That is easier. It is done.

Now combine the three into one, so as to make them grow together to a certain extent.

I have done so.

Lastly, invest them externally with the form of one, namely, the man, so that the person who cannot see inside, and only notices the outside skin, may think that it is one single animal, to wit, a human being.

e I have molded the form.

And now to the person who asserts that it is profitable for this creature man to be unrighteous, and that it is not for his interest to do justice, let us reply that his assertion amounts to this, that it is profitable for him to feast and strengthen the multifarious monster and the lion and its members, and to starve and enfeeble the man to such an extent as to leave him at the mercy of the guidance of either of the other two, without making any attempt to habituate or reconcile them to one another, but leaving them together to bite and struggle and devour each other.

589

True, he replied, the person who praises injustice will certainly in effect say this.

On the other hand, will not the advocate of the profitableness of justice assert that actions and words ought to be such as will enable the inward man to have the firmest control over the entire man, and, with the lion for his ally, to cultivate, like a farmer, the many-headed beast, nursing and rearing the tame parts of it, and checking the growth of the wild; and thus to pursue his training on the principle of concerning himself for all jointly, and reconciling them to one another and to himself?

b

Yes, these again are precisely the assertions of the person who praises justice.

Then in every way the one who praises justice will speak the truth, while the one who praises injustice will lie. For whether you look at pleasure, at reputation, or at advantage, the one who praises the righteous man speaks truth, whereas all the criticisms of his enemy are unsound and ignorant.

c

I am entirely of that opinion, said he.

Let us therefore persuade him mildly—for his mistake is involuntary—and let us put this question to him: My good friend, may we not assert that the practices which are held by law to be beautiful or ugly are beautiful or ugly according as they either subjugate the brutal parts of our nature to the man—perhaps I should rather say, to the divine part—or make the tame part the servant and slave of the wild? Will he say, yes? Or how will he reply?

d

He will say yes, if he will take my advice.

Then according to this argument, I proceeded, can it be profitable for any one to take gold unjustly, since the consequence is, that, in the moment of taking the gold, he is enslaving the best part of him to the most vile? Or, it being admitted that, had he taken gold to sell a son or a daughter into slavery, and a slavery among wild and wicked masters, it could have done him no good to receive even an immense sum for such a purpose, will it be argued that, if he ruthlessly enslaves the most divine part of himself to the most ungodly and accursed, he is not a miserable man, and is *not* being bribed to a far more awful destruction than Eriphyle, when she took the necklace as the price of her husband's life?

e

590

I will reply in his behalf, said Glaucon: it is indeed much more awful.

And do you not think that intemperance, again, has been blamed for a long time for reasons of that kind, that, during its outbreaks, that great and multiform beast, which is so terrible, receives more liberty than it ought to have?

Obviously, you are right.

And are not the terms, self-will and discontent, used to convey a reproof, whenever the lion-like and serpentine creature is exalted and strengthened unharmoniously?

Exactly so.

Again, are not luxury and softness censured because they relax and unnerve this same creature, by begetting cowardice in him?

Undoubtedly they are.

And are not the reproachful names of flattery and servility bestowed, whenever a person subjugates this same spirited animal to the turbulent monster, and, to gratify the latter's insatiable craving for money, trains the former from the first, by a long course of insult, to become an ape instead of a lion?

Certainly you are right.

And why, let me ask you, are the mechanical and manual arts discredited? May we not assert that these terms imply that the most excellent element in the person, to whom they are attributed, is naturally weak, so that instead of being able to govern the creatures within him, he pays them court, and can only learn how to flatter them?

Apparently so, he replied.

Then, in order that such a person may be governed by an authority similar to that by which the best man is governed, do we not maintain that he ought to be made the servant of that best man, in whom the divine element is supreme? We do not indeed imagine that the servant ought to be governed to his own detriment, which Thrasymachus held to be the lot of the subject; on the contrary, we believe it to be better for every one to be governed by a wise and divine power, which ought,

if possible, to be seated in the man's own heart, the only alternative being to impose it from without; in order that we may be all alike, as far as possible, and all mutual friends, due to the fact that we are steered by the same pilot.

Yes, that is quite right.

And this, I continued, is plainly the intention of law, that common friend of all the members of a city, and also of the supervising of children, which consists in withholding their freedom, until the time when we have formed a constitution in them, as we should in a city, and until, by cultivating the noblest principle of their nature, we have established in their hearts a guardian and a sovereign, the very counterpart of our own—from which time forward we let them go free.

Yes that is plain.

On what principle then, Glaucon, and by what line of argument, can we maintain that it is profitable for a man to be unjust, or intemperate, or to commit any disgraceful act, which will sink him deeper in vice, though he may increase his wealth thereby, or acquire additional power?

We cannot maintain this in any way.

And by what argument can we uphold the advantages of disguising the doing of injustice, and escaping the penalties of it? Am I not right in supposing that the man, who thus escapes detection, grows still more vicious than before; whereas if he is found out and punished, the brute part of him is put to sleep and tamed, and the tame part is liberated, and the whole soul is molded to its best nature, and thus, through the acquisition of temperance and justice combined with wisdom, attains to a condition which is more precious than that attained by a body endowed with strength and beauty and health, in the exact proportion in which the soul is more precious than the body?

Yes, indeed, you are right.

Hence I conclude, the man who has a mind will direct all his energies through life to this one object—his plan being, in the first place,

to honor those studies which will fashion this high character upon his soul, while at the same time he dishonors all others.

Obviously.

And as for his bodily habit and bodily support, in the second place, far from living devoted to the indulgence of brute irrational pleasure, he will show that even health is no object with him, and that he does not attach pre-eminent importance to the acquisition of strength or health or beauty, unless they are likely to make him temperate; because, in keeping the harmony of the body in tune, his constant aim is to preserve the harmonic symphony which resides in the soul.

Yes, no doubt it is, if he in truth cares for music.

Will he not also show how strictly he upholds that syntax and concord which ought to be maintained in the acquisition of wealth? And will he not avoid being dazzled by the congratulations of the crowd into multiplying infinitely the bulk of his wealth, which would bring him endless trouble?

I think he will.

On the contrary, an anxious look to his inward constitution, and guarding that none of its parts be pushed about by having too much or too little—these will be the principles by which, to the best of his ability, he will steer his course in increasing or spending his property.

Precisely so.

And, once more, in reference to honors, with the same standard constantly before his eyes, he will be glad to taste and participate in those which he thinks will make him a better man; whereas he will shun, in private and in public, those which he thinks likely to break up his existing condition.

If that is his chief concern, I suppose he will not consent to interfere with politics.

But surely you are wrong, I replied, for he certainly will—at least in his own city, though perhaps not in his fatherland, unless some divine chance should occur.

I understand, he replied. He will do so, you mean, in the city whose organization we have now completed, and which is confined to the region of speech; for I do not believe it is to be found anywhere on earth.

Well, said I, perhaps in heaven there is laid up a pattern of it for him who wishes to behold it, and, beholding, to organize himself accordingly. And the question of its present or future existence on earth is quite unimportant. For in any case he will adopt the practices of such a city, to the exclusion of those of every other.

Probably he will, he replied.

Study Questions

1. Is murder wrong because God prohibits it, or does God prohibit it because it is wrong?

2. Would Socrates have been wiser to approach the jury in a different manner?

3. Does Socrates accept the fairness of the laws under which he was tried and convicted?

4. Should your happiness depend on how others treat you?

2

ARISTOTLE

Aristotle (384–322 B.C.E.), a student of Plato, made extraordinary contributions in virtually every area of philosophy. The *Nicomachean Ethics*, named after Aristotle's son Nicomachus, is widely regarded as one of the great books of moral philosophy. Aristotle grounded morality in human nature, viewing the good as the fulfillment of the human potential to live well. To live well is to live in accordance with virtue. But how does one acquire virtue? Aristotle's answer depended on his distinction between moral and intellectual virtue. Moral virtue, which we might call "goodness of character," is formed by habit. One becomes good by doing good. Repeated acts of justice and self-control result in a just, self-controlled person who not only performs just, self-controlled actions but does so from a fixed character. Intellectual virtue, on the other hand, which we might refer to as "wisdom," requires sophisticated intelligence and is acquired by teaching. Virtuous activities are those that avoid the two extremes of excess and deficiency. For example, if you fear too much, you become cowardly; if you fear too little, you become rash. The mean is courage. To achieve the mean, you need to make a special effort to avoid that extreme to which you are prone. Thus if you tend to be foolhardy, aim at timidity, and you will achieve the right measure of boldness.

Nicomachean Ethics

BOOK I • THE GOOD FOR MAN

Subject of Our Inquiry

All human activities aim at some good: some goods subordinate to others

1. Every art and every inquiry, and similarly every action and pursuit, is thought to aim at some good; and for this reason the good has rightly been declared to be that at which all things aim. But a certain difference is found among ends; some are activities, others are products apart from the activities that produce them. Where there are ends apart from the actions, it is the nature of the products to be better than the activities. Now, as there are many actions, arts, and sciences, their ends also are many; the end of the medical art is health, that of shipbuilding a vessel, that of strategy victory, that of economics wealth. But where such arts fall under a single capacity—as bridle-making and the other arts concerned with the equipment of horses fall under the art of riding, and this and every military action under

From *Aristotle's Nicomachean Ethics*, translated by W. D. Ross, revised by J. L. Ackrill and J. O. Urmson (1925; 1980). Reprinted by permission of Oxford University Press.

strategy, in the same way other arts fall under yet others—in all of these the ends of the master arts are to be preferred to all the subordinate ends; for it is for the sake of the former that the latter are pursued. It makes no difference whether the activities themselves are the ends of the actions, or something else apart from the activities, as in the case of the sciences just mentioned.

The science of the good for man is politics

2. If, then, there is some end of the things we do, which we desire for its own sake (everything else being desired for the sake of this), and if we do not choose everything for the sake of something else (for at that rate the process would go on to infinity, so that our desire would be empty and vain), clearly this must be the good and the chief good. Will not the knowledge of it, then, have a great influence on life? Shall we not, like archers who have a mark to aim at, be more likely to hit upon what is right? If so, we must try, in outline at least, to determine what it is, and of which of the sciences or capacities it is the object. It would seem to belong to the most authoritative art and that which is most truly the master art. And politics appears to be of this nature; for it is this that ordains which of the sciences should be studied in a state, and which each class of citizens should learn and up to what point they should learn them; and we see even the most highly esteemed of capacities to fall under this, e.g., strategy, economics, rhetoric; now, since politics uses the rest of the sciences, and since, again, it legislates as to what we are to do and what we are to abstain from, the end of this science must include those of the others, so that this end must be the good for man. For even if the end is the same for a single man and for a state, that of the state seems at all events something greater and more complete whether to attain or to preserve; though it is worth while to attain the end merely for one man, it is finer and more godlike to attain it for a nation or for city-states. These, then, are the ends at which our inquiry aims, since it is political science, in one sense of that term.

Nature of the Science

We must not expect more precision than the subject-matter admits of. The student should have reached years of discretion

3. Our discussion will be adequate if it has as much clearness as the subject-matter admits of, for precision is not to be sought for alike in all discussions, any more than in all the products of the crafts. Now fine and just actions, which political science investigates, exhibit much variety and fluctuation, so that they may be thought to exist only by convention, and not by nature. And goods exhibit a similar fluctuation because they bring harm to many people; for before now men have been undone by reason of their wealth, and others by reason of their courage. We must be content, then, in speaking of such subjects and with such premises to indicate the truth roughly and in outline, and in speaking about things which are only for the most part true, and with premises of the same kind, to reach conclusions that are no better. In the same spirit, therefore, should each type of statement be *received;* for it is the mark of an educated man to look for precision in each class of things just so far as the nature of the subject admits; it is evidently equally foolish to accept probable reasoning from a mathematician and to demand from a rhetorician demonstrative proofs.

Now each man judges well the things he knows, and of these he is a good judge. And so the man who has been educated in a subject is a good judge of that subject, and the man who has received an all-round education is a good judge in general. Hence a young man is not a proper hearer of lectures on political science; for he is inexperienced in the actions that occur in life, but its discussions start from these and are about these; and, further, since he tends to follow his passions, his study will be vain and unprofitable, because the end aimed at is not knowledge but action. And it makes no difference whether he is young in years or youthful in character; the defect does not depend on time, but on his living, and pursuing each successive object, as passion directs. For to such

persons, as to the incontinent, knowledge brings no profit; but to those who desire and act in accordance with a rational principle knowledge about such matters will be of great benefit.

These remarks about the student, the sort of treatment to be expected, and the purpose of the inquiry, may be taken as our preface.

What Is the Good for Man?

It is generally agreed to be happiness, but there are various views as to what happiness is. What is required at the start is an unreasoned conviction about the facts, such as is produced by a good upbringing

4. Let us resume our inquiry and state, in view of the fact that all knowledge and every pursuit aims at some good, what it is that we say political science aims at and what is the highest of all goods achievable by action. Verbally there is very general agreement; for both the general run of men and people of superior refinement say that it is happiness, and identify living well and faring well with being happy; but with regard to what happiness is they differ, and the many do not give the same account as the wise. For the former think it is some plain and obvious thing, like pleasure, wealth, or honour; they differ, however, from one another—and often even the same man identifies it with different things, with health when he is ill, with wealth when he is poor; but, conscious of their ignorance, they admire those who proclaim some great thing that is above their comprehension. Now some thought that apart from these many goods there is another which is good in itself and causes the goodness of all these as well. To examine all the opinions that have been held were perhaps somewhat fruitless; enough to examine those that are most prevalent or that seem to be arguable.

Let us not fail to notice, however, that there is a difference between arguments from and those to the first principles. For Plato, too, was right in raising this question and asking, as he used to do, "Are we on the way from or to the first principles?" There is a difference, as there is in a race-course between the course

from the judges to the turning-point and the way back. For, while we must begin with what is evident, things are evident in two ways—some to us, some without qualification. Presumably, then, *we* must begin with things evident to *us*. Hence any one who is to listen intelligently to lectures about what is noble and just and, generally, about the subjects of political science must have been brought up in good habits. For the fact is a starting-point, and if this is sufficiently plain to him, he will not need the reason as well; and the man who has been well brought up has or can easily get starting-points. And as for him who neither has nor can get them, let him hear the words of Hesiod:

Far best is he who knows all things himself;
Good, he that hearkens when men counsel right;
But he who neither knows, nor lays to heart
Another's wisdom, is a useless wight.

Discussion of the popular views that the good is pleasure, honour, wealth; a fourth kind of life, that of contemplation, deferred for future discussion

5. Let us, however, resume our discussion from the point at which we digressed. To judge from the lives that men lead, most men, and the men of the most vulgar type, seem (not without some ground) to identify the good, or happiness, with pleasure; which is the reason why they love the life of enjoyment. For there are, we may say, three prominent types of life—that just mentioned, the political, and thirdly the contemplative life. Now the mass of mankind are evidently quite slavish in their tastes, preferring a life suitable to beasts, but they get some ground for their view from the fact that any of those in high places share the tastes of Sardanapallus. A consideration of the prominent types of life shows that people of superior refinement and of active disposition identify happiness with honour; for this is, roughly speaking, the end of the political life. But it seems too superficial to be what we are looking for, since it is thought to depend on those who bestow honour rather than on him who receives it, but the good we divine to be something of one's own and

not easily taken from one. Further, men seem to pursue honour in order that they may be assured of their merit; at least it is by men of practical wisdom that they seek to be honoured, and among those who know them, and on the ground of their virtue; clearly, then, according to them, at any rate, virtue is better. And perhaps one might even suppose this to be, rather than honour, the end of the political life. But even this appears somewhat incomplete; for possession of virtue seems actually compatible with being asleep, or with lifelong inactivity, and, further, with the greatest sufferings and misfortunes; but a man who was living so no one would call happy, unless he were maintaining a thesis at all costs. But enough of this; for the subject has been sufficiently treated even in the popular discussions. Third comes the contemplative life, which we shall consider later.

The life of money-making is one undertaken under compulsion, and wealth is evidently not the good we are seeking; for it is merely useful and for the sake of something else. And so one might rather take the aforenamed objects to be ends; for they are loved for themselves. But it is evident that not even these are ends; yet many arguments have been wasted on the support of them. Let us leave this subject, then.

Discussion of the philosophical view that there is an Idea of good

6. We had perhaps better consider the universal good and discuss thoroughly what is meant by it, although such an inquiry is made an uphill one by the fact that the Forms have been introduced by friends of our own. Yet it would perhaps be thought to be better, indeed to be our duty, for the sake of maintaining the truth even to destroy what touches us closely, especially as we are philosophers or lovers of wisdom; for, while both are dear, piety requires us to honour truth above our friends.

The men who introduced this doctrine did not posit Ideas of classes within which they recognized priority and posteriority (which is the reason why they did not maintain the existence of an Idea embracing all numbers); but the term "good" is used both in the category of substance and in that of quality and in that of relation, and that which is per se, i.e., substance, is prior in nature to the relative (for the latter is like an offshoot and accident of being); so that there could not be a common Idea set over all these goods. Further, since "good" has as many senses as "being" (for it is predicated both in the category of substance, as of God and of reason, and in quality, i.e., of the virtues, and in quantity, i.e., of that which is moderate, and in relation, i.e. of the useful, and in time, i.e. of the right opportunity, and in place, i.e. of the right locality and the like), clearly it cannot be something universally present in all cases and single; for then it could not have been predicated in all the categories, but in one only. Further, since of the things answering to one Idea there is one science, there would have been one science of all the goods; but as it is there are many sciences even of the things that fall under one category, e.g. of opportunity, for opportunity in war is studied by strategics and in disease by medicine, and the moderate in food is studied by medicine and in exercise by the science of gymnastics. And one might ask the question, what in the world they *mean* by "a thing itself," if (as is the case) in "man himself" and in a particular man the account of man is one and the same. For in so far as they are men, they will in no respect differ; and if this is so, neither will "good itself" and particular goods, in so far as they are good. But again it will not be good any the more for being eternal, since that which lasts long is no whiter than that which perishes in a day. The Pythagoreans seem to give a more plausible account of the good, when they place the One in the column of goods; and it is they that Speusippus seems to have followed.

But let us discuss these matters elsewhere; an objection to what we have said, however, may be discerned in the fact that the Platonists have not been speaking about *all* goods, and that the goods that are pursued and loved for themselves are called good by reference to a single Form, while those which tend to produce or to preserve these somehow or to prevent their contraries are called so by reason of these, and in a different way. Clearly, then, goods must be spoken of in two ways, and some must be

good in themselves, the others by reason of these. Let us separate, then, things good in themselves from things useful, and consider whether the former are called good by reference to a single Idea. What sort of goods would one call good in themselves? Is it those that are pursued even when isolated from others, such as intelligence, sight, and certain pleasures and honours? Certainly, if we pursue these also for the sake of something else, yet one would place them among things good in themselves. Or is nothing other than the Idea of good good in itself? In that case the Form will be empty. But if the things we have named are also things good in themselves, the account of the good will have to appear as something identical in them all, as that of whiteness is identical in snow and in white lead. But of honour, wisdom, and pleasure, just in respect of their goodness, the accounts are distinct and diverse. The good, therefore, is not something common answering to one Idea.

But what then do we mean by the good? It is surely not like the things that only chance to have the same name. Are goods one, then, by being derived from one good or by all contributing to one good, or are they rather one by analogy? Certainly, as sight is in the body, so is reason in the soul, and so on in other cases. But perhaps these subjects had better be dismissed for the present; for perfect precision about them would be more appropriate to another branch of philosophy. And similarly with regard to the Idea; even if there is some one good which is universally predicable of goods, or is capable of separate and independent existence, clearly it could not be achieved or attained by man; but we are now seeking something attainable. Perhaps, however, someone might think it worth while to have knowledge of it with a view to the goods that *are* attainable and achievable; for, having this as a sort of pattern, we shall know better the goods that are good for us, and if we know them shall attain them. This argument has some plausibility, but seems to clash with the procedure of the sciences; for all of these, though they aim at some good and seek to supply the deficiency of it, leave on one side the knowledge of *the* good. Yet that all the exponents of the arts should be ignorant of,

and should not even seek, so great an aid is not probable. It is hard, too, to see how a weaver or a carpenter will be benefited in regard to his own craft by knowing this "good itself," or how the man who has viewed the Idea itself will be a better doctor or general thereby. For a doctor seems not even to study health in this way, but the health of man, or perhaps rather the health of a particular man; it is individuals that he is healing. But enough of these topics.

The good must be something final and self-sufficient. Definition of happiness reached by considering the characteristic function of man

7. Let us again return to the good we are seeking, and ask what it can be. It seems different in different actions and arts; it is different in medicine, in strategy, and in the other arts likewise. What then is the good of each? Surely that for whose sake everything else is done. In medicine this is health, in strategy victory, in architecture a house, in any other sphere something else, and in every action and pursuit the end; for it is for the sake of this that all men do whatever else they do. Therefore, if there is an end for all that we do, this will be the good achievable by action, and if there are more than one, these will be the goods achievable by action.

So the argument has by a different course reached the same point; but we must try to state this even more clearly. Since there are evidently more than one end, and we choose some of these (e.g., wealth, flutes, and in general instruments) for the sake of something else, clearly not all ends are final ends; but the chief good is evidently something final. Therefore, if there is only one final end, this will be what we are seeking, and if there are more than one, the most final of these will be what we are seeking. Now we call that which is in itself worthy of pursuit more final than that which is worthy of pursuit for the sake of something else, and that which is never desirable for the sake of something else more final than the things that are desirable both in themselves and for the sake of that other thing, and therefore we call final without qualification that which is always desirable in itself and never for the sake of something else.

Now such a thing happiness, above all else, is held to be; for this we choose always for itself and never for the sake of something else, but honour, pleasure, reason, and every virtue we choose indeed for themselves (for if nothing resulted from them we should still choose each of them), but we choose them also for the sake of happiness, judging that through them we shall be happy. Happiness, on the other hand, no one chooses for the sake of these, nor, in general, for anything other than itself.

From the point of view of self-sufficiency the same result seems to follow; for the final good is thought to be self-sufficient. Now by self-sufficient we do not mean that which is sufficient for a man by himself, for one who lives a solitary life, but also for parents, children, wife, and in general for his friends and fellow citizens, since man is born for citizenship. But some limit must be set to this; for if we extend our requirement to ancestors and descendants and friends' friends we are in for an infinite series. Let us examine this question, however, on another occasion; the self-sufficient we now define as that which when isolated makes life desirable and lacking in nothing; and such we think happiness to be; and further we think it most desirable of all things, not a thing counted as one good thing among others—if it were so counted it would clearly be made more desirable by the addition of even the least of goods; for that which is added becomes an excess of goods, and of goods the greater is always more desirable. Happiness, then, is something final and self-sufficient, and is the end of action.

Presumably, however, to say that happiness is the chief good seems a platitude, and a clearer account of what is is still desired. This might perhaps be given, if we could first ascertain the function of man. For just as for a flute-player, a sculptor, or any artist, and, in general, for all things that have a function or activity, the good and the "well" is thought to reside in the function, so would it seem to be for man, if he has a function. Have the carpenter, then, and the tanner certain functions or activities, and has man none? Is he born without a function? Or as eye, hand, foot, and in general each of the parts evidently has a function, may one lay it down that man similarly has a function apart from all these? What then can this be? Life seems to belong even to plants, but we are seeking what is peculiar to man. Let us exclude, therefore, the life of nutrition and growth. Next there would be a life of perception, but *it* also seems to be shared even by the horse, the ox, and every animal. There remains then, an active life of the element that has a rational principle; of this, one part has such a principle in the sense of being obedient to one, the other in the sense of possessing one and exercising thought. And, as "life of the rational element" also has two meanings, we must state that life in the sense of activity is what we mean; for this seems to be the more proper sense of the term. Now if the function of man is an activity of soul which follows or implies a rational principle, and if we say "a so-and-so" and "a good so-and-so" have a function which is the same in kind, e.g., a lyre-player and a good lyre-player, and so without qualification in all cases, eminence in respect of goodness being added to the name of the function (for the function of a lyre-player is to play the lyre, and that of a good lyre-player is to do so well): if this is the case [and we state the function of man to be a certain kind of life, and this to be an activity or actions of the soul implying a rational principle, and the function of a good man to be the good and noble performance of these, and if any action is well performed when it is performed in accordance with the appropriate excellence: if this is the case], human good turns out to be activity of soul exhibiting excellence, and if there are more than one excellence, in accordance with the best and most complete.

But we must add "in a complete life." For one swallow does not make a summer, nor does one day; and so too one day, or a short time, does not make a man blessed and happy.

Let this serve as an outline of the good; for we must presumably first sketch it roughly, and then later fill in the details. But it would seem that any one is capable of carrying on and articulating what has once been well outlined, and that time is a good discoverer or partner in such a work; to which facts the advances of the arts are due; for any one can add what is lacking. And we must also remember what has been said before, and not look for precision in all things alike, but in each class of things such precision as accords

with the subject-matter, and so much as is appropriate to the inquiry. For a carpenter and a geometer investigate the right angle in different ways; the former does so in so far as the right angle is useful for his work, while the latter inquires what it is or what sort of thing it is; for he is a spectator of the truth. We must act in the same way, then, in all other matters as well, that our main task may not be subordinated to minor questions. Nor must we demand the cause in all matters alike; it is enough in some cases that the *fact* be well established, as in the case of the first principles; the fact is a primary thing and first principle. Now of first principles we see some by induction, some by perception, some by a certain habituation, and others too in other ways. But each set of principles we must try to investigate in the natural way, and we must take pains to determine them correctly, since they have a great influence on what follows. For the beginning is thought to be more than half of the whole, and many of the questions we ask are cleared up by it.

Our definition is confirmed by current beliefs about happiness

8. But we must consider happiness in the light not only of our conclusion and our premises, but also of what is commonly said about it; for with a true view all the data harmonize, but with a false one the facts soon clash. Now goods have been divided into three classes, and some are described as external, others as relating to soul or to body; we call those that relate to soul most properly and truly goods, and psychical actions and activities we class as relating to soul. Therefore our account must be sound, at least according to this view, which is an old one and agreed on by philosophers. It is correct also in that we identify the end with certain actions and activities; for thus it falls among goods of the soul and not among external goods. Another belief which harmonizes with our account is that the happy man lives well and fares well; for we have practically defined happiness as a sort of living and faring well. The characteristics that are looked for in happiness seem also, all of them, to belong to what we have defined happiness as being. For some identify

happiness with virtue, some with practical wisdom, others with a kind of philosophic wisdom, others with these, or one of these, accompanied by pleasure or not without pleasure; while others include also external prosperity. Now some of these views have been held by many men and men of old, others by a few eminent persons; and it is not probable that either of these should be entirely mistaken, but rather that they should be right in at least some one respect, or even in most respects.

With those who identify happiness with virtue or some one virtue our account is in harmony; for to virtue belongs virtuous activity. But it makes, perhaps, no small difference whether we place the chief good in possession or in use, in state of mind or in activity. For the state of mind may exist without producing any good result, as in a man who is asleep or in some other way quite inactive, but the activity cannot; for one who has the activity will of necessity be acting, and acting well. And as in the Olympic Games it is not the most beautiful and the strongest that are crowned but those who compete (for it is some of these that are victorious), so those who act win, and rightly win, the noble and good things in life.

Their life is also in itself pleasant. For pleasure is a state of *soul,* and to each man that which he is said to be a lover of is pleasant; e.g. not only is a horse pleasant to the lover of horses, and a spectacle to the lover of sights, but also in the same way just acts are pleasant to the lover of justice and in general virtuous acts to the lover of virtue. Now for most men their pleasures are in conflict with one another because these are not by nature pleasant, but the lovers of what is noble find pleasant the things that are by nature pleasant; and virtuous actions are such, so that these are pleasant for such men as well as in their own nature. Their life, therefore, has no further need of pleasure as a sort of adventitious charm, but has its pleasure in itself. For, besides what we have said, the man who does not rejoice in noble actions is not even good; since no one would call a man just who did not enjoy acting justly, nor any man liberal who did not enjoy liberal actions; and similarly in all other cases. If this is so, virtuous actions must be in themselves pleasant. But they are also good and noble, and have

each of these attributes in the highest degree, since the good man judges well about these attributes; his judgment is such as we have described. Happiness then is the best, noblest, and most pleasant thing in the world, and these attributes are not severed as in the inscription at Delos—

> *Most noble is that which is justest, and best is health; But most pleasant it is to win what we love.*

For all these properties belong to the best activities; and these, or one—the best—of these, we identify with happiness.

Yet evidently, as we said, it needs the external goods as well; for it is impossible, or not easy, to do noble acts without the proper equipment. In many actions we use friends and riches and political power as instruments; and there are some things the lack of which takes the lustre from happiness—good birth, goodly children, beauty; for the man who is very ugly in appearance or ill-born or solitary and childless is not very likely to be happy, and perhaps a man would be still less likely if he had thoroughly bad children or friends or had lost good children or friends by death. As we said, then, happiness seems to need this sort of prosperity in addition; for which reason some identify happiness with good fortune, though others identify it with virtue.

> *Is happiness acquired by learning or habituation, or sent by God or by chance?*

9. For this reason also the question is asked, whether happiness is to be acquired by learning or by habituation or some other sort of training, or comes in virtue of some divine providence or again by chance. Now if there is *any* gift of the gods to men, it is reasonable that happiness should be god-given, and most surely god-given of all human things inasmuch as it is the best. But this question would perhaps be more appropriate to another inquiry; happiness seems, however, even if it is not god-sent but comes as a result of virtue and some process of learning or training, to be among the most godlike things; for that which is the prize and end of virtue seems to

be the best thing in the world, and something godlike and blessed.

It will also on this view be very generally shared; for all who are not maimed as regards their potentiality for virtue may win it by a certain kind of study and care. But if it is better to be happy thus than by chance, it is reasonable that the facts should be so, since everything that depends on the action of nature is by nature as good as it can be, and similarly everything that depends on art or any rational cause, and especially if it depends on the best of all causes. To entrust to chance what is greatest and most noble would be a very defective arrangement.

The answer to the question we are asking is plain also from the definition of happiness; for it has been said to be a virtuous activity of soul, of a certain kind. Of the remaining goods, some must necessarily pre-exist as conditions of happiness, and others are naturally co-operative and useful as instruments. And this will be found to agree with what we said at the outset; for we stated the end of political science to be the best end, and political science spends most of its pains on making the citizens to be of a certain character, viz. good and capable of noble acts.

It is natural, then, that we call neither ox nor horse nor any other of the animals happy; for none of them is capable of sharing in such activity. For this reason also a boy is not happy; for he is not yet capable of such acts, owing to his age; and boys who are called happy are being congratulated by reason of the hopes we have for them. For there is required, as we said, not only complete virtue but also a complete life, since many changes occur in life, and all manner of chances, and the most prosperous may fall into great misfortunes in old age, as is told of Priam in the Trojan Cycle; and one who has experienced such chances and has ended wretchedly no one calls happy.

> *Should no man be called happy while he lives?*

10. Must no one at all, then, be called happy while he lives; must we, as Solon says, see the end? Even if we are to lay down this doctrine, is it also the case that a man *is* happy when he is *dead?* Or is not this quite absurd, especially for us who say that

happiness is an activity? But if we do not call the dead man happy, and if Solon does not mean this, but that one can then safely *call* a man blessed, as being at last beyond evils and misfortunes, this also affords matter for discussion; for both evil and good are thought to exist for a dead man, as much as for one who is alive but not aware of them; e.g., honours and dishonours and the good or bad fortunes of children, and in general of descendants. And this also presents a problem; for though a man has lived blessedly until old age and has had a death worthy of his life, many reverses may befall his descendants— some of them may be good and attain the life they deserve, while with others the opposite may be the case; and clearly too the degrees of relationship between them and their ancestors may vary indefinitely. It would be odd, then, if the dead man were to share in these changes and become at one time happy, at another wretched; while it would also be odd if the fortunes of the descendants did not for *some* time have *some* effect on the happiness of their ancestors.

But we must return to our first difficulty; for perhaps by a consideration of it our present problem might be solved. Now if we must see the end and only then call a man blessed, not as being blessed but as having been so before, surely this is a paradox, that when he is happy the attribute that belongs to him is not to be truly predicated of him because we do not wish to call living men happy, on account of the changes that may befall them, and because we have assumed happiness to be something permanent and by no means easily changed, while a single man may suffer many turns of fortune's wheel. For clearly if we were to follow his fortunes, we should often call the same man happy and again wretched, making the happy man out to be "a chameleon, and insecurely based." Or is this following his fortunes quite wrong? Success or failure in life does not depend on these, but human life, as we said, needs these as well, while virtuous activities or their opposites are what determine happiness or the reverse.

The question we have now discussed confirms our definition. For no function of man has so much permanence as virtuous activities (these are thought to be more durable even than knowledge of the sciences), and of these themselves the most valuable are more durable because those who are blessed spend their life most readily and most continuously in these; for this seems to be the reason why we do not forget them. The attribute in question, then, will belong to the happy man, and he will be happy throughout his life; for always, or by preference to everything else, he will do and contemplate what is excellent, and he will bear the chances of life most nobly and altogether decorously, if he is "truly good" and "foursquare beyond reproach."

Now many events happen by chance, and events differing in importance; small pieces of good fortune or of its opposite clearly do not weigh down the scales of life one way or the other, but a multitude of great events if they turn out well will make life more blessed (for not only are they themselves such as to add beauty to life, but the way a man deals with them may be noble and good), while if they turn out ill they crush and maim blessedness; for they both bring pain with them and hinder many activities. Yet even in these nobility shines through, when a man bears with resignation many great misfortunes, not through insensibility to pain but through nobility and greatness of soul.

If activities are, as we said, what determines the character of life, no blessed man can become miserable; for he will never do the acts that are hateful and mean. For the man who is truly good and wise, we think, bears all the chances of life becomingly and always makes the best of circumstances, as a good general makes the best military use of the army at his command, and a good shoemaker makes the best shoes out of the hides that are given him; and so with all other craftsmen. And if this is the case, the happy man can never become miserable—though he will not reach *blessedness,* if he meet with fortunes like those of Priam.

Nor, again, is he many-coloured and changeable; for neither will he be moved from his happy state easily or by any ordinary misadventures; but only by many great ones, nor, if he has had many great misadventures, will he recover his happiness in a short time, but if at all, only in a long and complete one in which he has attained many splendid successes.

Why then should we not say that he is happy who is active in accordance with complete virtue and is sufficiently equipped with external goods, not for some chance period but throughout a complete life? Or must we add "and who is destined to live thus and die as befits his life"? Certainly the future is obscure to us, while happiness, we claim, is an end and something in every way final. If so, we shall call blessed those among living men in whom these conditions are, and are to be, fulfilled—but blessed *men*. So much for these questions.

Kinds of Virtue

Division of the faculties, and resultant division of virtue into intellectual and moral

13. Since happiness is an activity of soul in accordance with perfect virtue, we must consider the nature of virtue; for perhaps we shall thus see better the nature of happiness. The true student of politics, too, is thought to have studied virtue above all things; for he wishes to make his fellow citizens good and obedient to the laws. As an example of this we have the lawgivers of the Cretans and the Spartans, and any others of the kind that there may have been. And if this inquiry belongs to political science, clearly the pursuit of it will be in accordance with our original plan. But clearly the virtue we must study is human virtue; for the good we were seeking was human good and the happiness human happiness. By human virtue we mean not that of the body but that of the soul; and happiness also we call an activity of soul. But if this is so, clearly the student of politics must know somehow the facts about the soul, as the man who is to heal the eyes must know about the whole body also; and all the more since political science is more prized and better than medical; but even among doctors the best educated spend much labour on acquiring knowledge of the body. The student of politics, then, must study the soul, and must study it with these objects in view, and do so just to the extent which is sufficient for the questions we are discussing; for further precision would perhaps involve more labour than our purposes require.

Some things are said about it, adequately enough, even in the discussions outside our school, and we must use these; e.g., that one element in the soul is irrational and one has a rational principle. Whether these are separated as the parts of the body or of anything divisible are, or are distinct by definition but by nature inseparable, like convex and concave in the circumference of a circle, does not affect the present question.

Of the irrational element one division seems to be widely distributed, and vegetative in its nature, I mean that which causes nutrition and growth; for it is this kind of power of the soul that one must assign to all nurslings and to embryos, and this same power to full-grown creatures; this is more reasonable than to assign some different power to them. Now the excellence of this seems to be common to all species and not specifically human; for this part or faculty seems to function most in sleep, while goodness and badness are least manifest in sleep (whence comes the saying that the happy are no better off than the wretched for half their lives; and this happens naturally enough, since sleep is an inactivity of the soul in that respect in which it is called good or bad), unless perhaps to a small extent some of the movements actually penetrate to the soul, and in this respect the dreams of good men are better than those of ordinary people. Enough of this subject, however; let us leave the nutritive faculty alone, since it has by its nature no share in human excellence.

There seems to be also another irrational element in the soul—one which in a sense, however, shares in a rational principle. For we praise the rational principle of the continent man and of the incontinent, and the part of their soul that has such a principle, since it urges them aright and towards the best objects; but there is found in them also another natural element beside the rational principle, which fights against and resists that principle. For exactly as paralysed limbs, when we intend to move them to the right, turn on the contrary to the left, so is it with the soul; the impulses of incontinent people move in contrary directions. But while in the body we see that which moves astray, in the soul we do not. No doubt, however, we must none the less suppose that in the soul too there is something beside the rational principle, resisting and opposing

it. In what sense it is distinct from the other elements does not concern us. Now even this seems to have a share in a rational principle, as we said; at any rate in the continent man it obeys the rational principle—and presumably in the temperate and brave man it is still more obedient; for in him it speaks, on all matters, with the same voice as the rational principle.

Therefore the irrational element also appears to be twofold. For the vegetative element in no way shares in a rational principle, but the appetitive and in general the desiring element in a sense shares in it, in so far as it listens to and obeys it; this is the sense in which we speak of "taking account" of one's father or one's friends, not that in which we speak of "accounting" for a mathematical property. That the irrational element is in some sense persuaded by a rational principle is indicated also by the giving of advice and by all reproof and exhortation. And if this element also must be said to have a rational principle, that which has a rational principle (as well as that which has not) will be twofold, one subdivision having it in the strict sense and in itself, and the other having a tendency to obey as one does one's father.

Virtue too is distinguished into kinds in accordance with this difference; for we say that some of the virtues are intellectual and others moral, philosophic wisdom and understanding and practical wisdom being intellectual, liberality and temperance moral. For in speaking about a man's character we do not say that he is wise or has understanding, but that he is good-tempered or temperate; yet we praise the wise man also with respect to his state of mind; and of states of mind we call those which merit praise virtues.

BOOK II • MORAL VIRTUE

Moral Virtue, How Produced, in What Medium and in What Manner Exhibited

Moral virtue, like the arts, is acquired by repetition of the corresponding acts

1. Virtue, then, being of two kinds, intellectual and moral, intellectual virtue in the main owes both its birth, and its growth to teaching (for which reason it requires experience and time), while moral virtue comes about as a result of habit, whence also its name (ἠθική) is one that is formed by a slight variation from the word ἔθος (habit). From this it is also plain that none of the moral virtues arises in us by nature; for nothing that exists by nature can form a habit contrary to its nature. For instance the stone which by nature moves downwards cannot be habituated to move upwards, not even if one tries to train it by throwing it up ten thousand times; nor can fire be habituated to move downwards, nor can anything else that by nature behaves in one way be trained to behave in another. Neither by nature, then, nor contrary to nature do the virtues arise in us; rather we are adapted by nature to receive them, and are made perfect by habit.

Again, of all the things that come to us by nature we first acquire the potentiality and later exhibit the activity (this is plain in the case of the senses; for it was not by often seeing or often hearing that we got these senses, but on the contrary we had them before we used them, and did not come to have them by using them); but the virtues we get by first exercising them, as also happens in the case of the arts as well. For the things we have to learn before we can do them, we learn by doing them, e.g., men become builders by building and lyre-players by playing the lyre; so too we become just by doing just acts, temperate by doing temperate acts, brave by doing brave acts.

This is confirmed by what happens in states; for legislators make the citizens good by forming habits in them, and this is the wish of every legislator, and those who do not effect it miss their mark, and it is in this that a good constitution differs from a bad one.

Again, it is from the same causes and by the same means that every virtue is both produced and destroyed, and similarly every art; for it is from playing the lyre that both good and bad lyre-players are produced. And the corresponding statement is true of builders and of all the rest; men will be good or bad builders as a result of building well or badly. For if this were not so, there would have been no need of a teacher, but all men would have been born good or bad at their craft. This, then, is the case with the virtues also; by doing the acts that we do in

our transactions with other men we become just or unjust, and by doing the acts that we do in the presence of danger, and by being habituated to feel fear or confidence, we become brave or cowardly. The same is true of appetites and feelings of anger; some men become temperate and good-tempered, others self-indulgent and irascible, by behaving in one way or the other in the appropriate circumstances. Thus, in one word, states of character arise out of like activities. This is why the activities we exhibit must be of a certain kind; it is because the states of character correspond to the differences between these. It makes no small difference, then, whether we form habits of one kind or of another from our very youth; it makes a very great difference, or rather *all* the difference.

These acts cannot be prescribed exactly, but must avoid excess and defect

2. Since, then, the present inquiry does not aim at theoretical knowledge like the others (for we are inquiring not in order to know what virtue is, but in order to become good, since otherwise our inquiry would have been of no use), we must examine the nature of actions, namely how we ought to do them; for these determine also the nature of the states of character that are produced, as we have said. Now, that we must act according to the right rule is a common principle and must be assumed—it will be discussed later, i.e., both what the right rule is, and how it is related to the other virtues. But this must be agreed upon beforehand, that the whole account of matters of conduct must be given in outline and not precisely, as we said at the very beginning that the accounts we demand must be in accordance with the subject-matter; matters concerned with conduct and questions of what is good for us have no fixity, any more than matters of health. The general account being of this nature, the account of particular cases is yet more lacking in exactness; for they do not fall under any art or precept, but the agents themselves must in each case consider what is appropriate to the occasion, as happens also in the art of medicine or of navigation.

But though our present account is of this nature we must give what help we can. First, then, let us consider this, that it is the nature of such things to be destroyed by defect and excess, as we see in the case of strength and of health (for to gain light on things imperceptible we must use the evidence of sensible things); exercise either excessive or defective destroys the strength, and similarly drink or food which is above or below a certain amount destroys the health, while that which is proportionate both produces and increases and preserves it. So too is it, then, in the case of temperance and courage and the other virtues. For the man who flies from and fears everything and does not stand his ground against anything becomes a coward, and the man who fears nothing at all but goes to meet every danger becomes rash; and similarly the man who indulges in every pleasure and abstains from none becomes self-indulgent, while the man who shuns every pleasure, as boors do, becomes in a way insensible; temperance and courage, then, are destroyed by excess and defect, and preserved by the mean.

But not only are the sources and causes of their origination and growth the same as those of their destruction, but also the sphere of their actualization will be the same; for this is also true of the things which are more evident to sense, e.g., of strength; it is produced by taking much food and undergoing much exertion, and it is the strong man that will be most able to do these things. So too is it with the virtues; by abstaining from pleasures we become temperate, and it is when we have become so that we are most able to abstain from them; and similarly too in the case of courage; for by being habituated to despise things that are fearful and to stand our ground against them we become brave, and it is when we have become so that we shall be most able to stand our ground against them.

Pleasure in doing virtuous acts is a sign that the virtuous disposition has been acquired: a variety of considerations show the essential connexion of moral virtue with pleasure and pain

3. We must take as a sign of states of character the pleasure or pain that supervenes upon acts; for the man who abstains from bodily pleasures and delights in this very fact is temperate, while the man who is

annoyed at it is self-indulgent, and he who stands his ground against things that are terrible and delights in this or at least is not pained is brave, while the man who is pained is a coward. For moral excellence is concerned with pleasures and pains; it is on account of the pleasure that we do bad things, and on account of the pain that we abstain from noble ones. Hence we ought to have been brought up in a particular way from our very youth, as Plato says, so as both to delight and to be pained by the things that we ought; this is the right education.

Again, if the virtues are concerned with actions and passions, and every passion and every action is accompanied by pleasure and pain, for this reason also virtue will be concerned with pleasures and pains. This is indicated also by the fact that punishment is inflicted by these means; for it is a kind of cure, and it is the nature of cures to be effected by contraries.

Again, as we said but lately, every state of soul has a nature relative to and concerned with the kind of things by which it tends to be made worse or better; but it is by reason of pleasures and pains that men become bad, by pursuing and avoiding these—either the pleasures and pains they ought not or when they ought not or as they ought not, or by going wrong in one of the other similar ways that may be distinguished. Hence men even define the virtues as certain states of impassivity and rest; not well, however, because they speak absolutely, and do not say "as one ought" and "as one ought not" and "when one ought or ought not," and the other things that may be added. We assume, then, that this kind of excellence tends to do what is best with regard to pleasures and pains, and vice does the contrary.

The following facts also may show us that virtue and vice are concerned with these same things. There being three objects of choice and three of avoidance, the noble, the advantageous, the pleasant, and their contraries, the base, the injurious, the painful, about all of these the good man tends to go right and the bad man to go wrong, and especially about pleasure; for this is common to the animals, and also it accompanies all objects of choice; for even the noble and the advantageous appear pleasant.

Again, it has grown up with us all from our infancy; this is why it is difficult to rub off this passion, engrained as it is in our life. And we measure even our actions, some of us more and others less, by the rule of pleasure and pain. For this reason, then, our whole inquiry must be about these; for to feel delight and pain rightly or wrongly has no small effect on our actions.

Again, it is harder to fight with pleasure than with anger, to use Heraclitus' phrase, but both art and virtue are always concerned with what is harder; for even the good is better when it is harder. Therefore for this reason also the whole concern both of virtue and of political science is with pleasures and pains, for the man who uses these well will be good, he who uses them badly bad.

That virtue, then, is concerned with pleasures and pains, and that by the acts from which it arises it is both increased and, if they are done differently, destroyed, and that the acts from which it arose are those in which it actualizes itself—let this be taken as said.

The actions that produce moral virtue are not good in the same sense as those that flow from it: the latter must fulfil certain conditions not necessary in the case of the arts

4. The question might be asked, what we mean by saying that we must become just by doing just acts, and temperate by doing temperate acts; for if men do just and temperate acts, they are already just and temperate, exactly as, if they do what is in accordance with the laws of grammar and of music, they are grammarians and musicians.

Or is this not true even of the arts? It is possible to do something that is in accordance with the laws of grammar, either by chance or under the guidance of another. A man will be a grammarian, then, only when he has both said something grammatical and said it grammatically; and this means doing it in accordance with the grammatical knowledge in himself.

Again, the case of the arts and that of the virtues are not similar; for the products of the arts have their

goodness in themselves, so that it is enough that they should have a certain character, but if the arts that are in accordance with the virtues have themselves a certain character it does not follow that they are done justly or temperately. The agent also must be in a certain condition when he does them; in the first place he must have knowledge, secondly he must choose the acts, and choose them for their own sakes, and thirdly his action must proceed from a firm and unchangeable character. These are not reckoned in as conditions of the possession of the arts, except the bare knowledge; but as a condition of the possession of the virtues knowledge has little or no weight, while the other conditions count not for a little but for everything, i.e., the very conditions which result from often doing just and temperate acts.

Actions, then, are called just and temperate when they are such as the just or the temperate man would do; but it is not the man who does those that is just and temperate, but the man who also does them as just and temperate men do them. It is well said, then, that it is by doing just acts that the just man is produced, and by doing temperate acts the temperate man; without doing these no one would have even a prospect of becoming good.

But most people do not do these, but take refuge in theory and think they are being philosophers and will become good in this way, behaving somewhat like patients who listen attentively to their doctors, but do none of the things they are ordered to do. As the latter will not be made well in body by such a course of treatment, the former will not be made well in soul by such a course of philosophy.

Definition of Moral Virtue

The genus of moral virtue: it is a state of character, not a passion, nor a faculty

5. Next we must consider what virtue is. Since things that are found in the soul are of three kinds—passions, faculties, states of character—virtue must be one of these. By passions I mean appetite, anger, fear, confidence, envy, joy, friendly feeling, hatred, longing, emulation, pity, and in general the feelings that are accompanied by pleasure or pain; by faculties the things in virtue of which we are said to be capable of feeling these, e.g., of becoming angry or being pained or feeling pity; by states of character the things in virtue of which we stand well or badly with reference to the passions, e.g., with reference to anger we stand badly if we feel it violently or too weakly, and well if we feel it moderately; and similarly with reference to the other passions.

Now neither the virtues nor the vices are *passions,* because we are not called good or bad on the ground of our passions, but are so called on the ground of our virtues and our vices, and because we are neither praised nor blamed for our passions (for the man who feels fear or anger is not praised, nor is the man who simply feels anger blamed, but the man who feels it in a certain way), but for our virtues and our vices we *are* praised or blamed.

Again, we feel anger and fear without choice, but the virtues are modes of choice or involve choice. Further, in respect of the passions we are said to be moved, but in respect of the virtues and the vices we are said not to be moved but to be disposed in a particular way.

For these reasons also they are not *faculties;* for we are neither called good or bad, nor praised or blamed, for the simple capacity of feeling the passions; again, we have the faculties by nature, but we are not made good or bad by nature; we have spoken of this before.

If, then, the virtues are neither passions nor faculties, all that remains is that they should be *states of character.*

Thus we have stated what virtue is in respect of its genus.

The differentia of moral virtue: it is a disposition to choose the mean

6. We must, however, not only describe virtue as a state of character, but also say what sort of state it is. We may remark, then, that every virtue or excellence both brings into good condition the thing of which it is the excellence and makes the work of that thing be done well; e.g., the excellence of the eye makes both

the eye and its work good; for it is by the excellence of the eye that we see well. Similarly the excellence of the horse makes a horse both good in itself and good at running and at carrying its rider and at awaiting the attack of the enemy. Therefore, if this is true in every case, the virtue of man also will be the state of character which makes a man good and which makes him do his own work well.

How this is to happen we have stated already, but it will be made plain also by the following consideration of the specific nature of virtue. In everything that is continuous and divisible it is possible to take more, less, or an equal amount, and that either in terms of the thing itself or relatively to us; and the equal is an intermediate between excess and defect. By the intermediate in the object I mean that which is equidistant from each of the extremes, which is one and the same for all men; by the intermediate relatively to us that which is neither too much nor too little—and this is not one, nor the same for all. For instance, if ten is many and two is few, six is the intermediate, taken in terms of the object; for it exceeds and is exceeded by an equal amount; this is intermediate according to arithmetical proportion. But the intermediate relatively to us is not to be taken so; if ten pounds are too much for a particular person to eat and two too little, it does not follow that the trainer will order six pounds; for this also is perhaps too much for the person who is to take it, or too little—too little for Milo, too much for the beginner in athletic exercises. The same is true of running and wrestling. Thus a master of any art avoids excess and defect, but seeks the intermediate and chooses this—the intermediate not in the object but relatively to us.

If it is thus, then, that every art does its work well—by looking to the intermediate and judging its works by this standard (so that we often say of good works of art that it is not possible either to take away or to add anything, implying that excess and defect destroy the goodness of works of art, while the mean preserves it; and good artists, as we say, look to this in their work), and if, further, virtue is more exact and better than any art, as nature also is, then virtue must have the quality of aiming at the intermediate. I mean moral virtue; for it is this that

is concerned with passions and actions, and in these there is excess, defect, and the intermediate. For instance, both fear and confidence and appetite and anger and pity and in general pleasure and pain may be felt both too much and too little, and in both cases not well; but to feel them at the right times, with reference to the right objects, towards the right people, with the right motive, and in the right way, is what is both intermediate and best, and this is characteristic of virtue. Similarly with regard to actions also there is excess, defect, and the intermediate. Now virtue is concerned with passions and actions, in which excess is a form of failure, and so is defect, while the intermediate is praised and is a form of success; and being praised and being successful are both characteristics of virtue. Therefore virtue is a kind of mean, since, as we have seen, it aims at what is intermediate.

Again, it is possible to fail in many ways (for evil belongs to the class of the unlimited, as the Pythagoreans conjectured, and good to that of the limited), while to succeed is possible only in one way (for which reason also one is easy and the other difficult—to miss the mark easy, to hit it difficult); for these reasons also, then, excess and defect are characteristic of vice, and the mean of virtue;

For men are good in but one way, but bad in many.

Virtue, then, is a state of character concerned with choice, lying in a mean, i.e., the mean relative to us, this being determined by a rational principle, and by that principle by which the man of practical wisdom would determine it. Now it is a mean between two vices, that which depends on excess and that which depends on defect; and again it is a mean because the vices respectively fall short of or exceed what is right in both passions and actions, while virtue both finds and chooses that which is intermediate. Hence in respect of what it is, i.e., the definition which states its essence, virtue is a mean, with regard to what is best and right it is an extreme.

But not every action nor every passion admits of a mean; for some have names that already imply badness, e.g., spite, shamelessness, envy, and in the case of actions adultery, theft, murder; for all of these and suchlike things imply by their names that they are themselves bad, and not the excesses

or deficiencies of them. It is not possible, then, ever to be right with regard to them; one must always be wrong. Nor does goodness or badness with regard to such things depend on committing adultery with the right woman, at the right time, and in the right way, but simply to do any of them is to go wrong. It would be equally absurd, then, to expect that in unjust, cowardly, and voluptuous action there should be a mean, an excess, and a deficiency; for at that rate there would be a mean of excess and of deficiency, an excess of excess, and a deficiency of deficiency. But as there is no excess and deficiency of temperance and courage because what is intermediate is in a sense an extreme, so too of the actions we have mentioned there is no mean nor any excess and deficiency, but however they are done they are wrong; for in general there is neither a mean of excess and deficiency, nor excess and deficiency of a mean.

The above proposition illustrated by reference to particular virtues

7. We must, however, not only make this general statement, but also apply it to the individual facts. For among statements about conduct those which are general apply more widely, but those which are particular are more true, since conduct has to do with individual cases, and our statements must harmonize with the facts in these cases. We may take these cases from our table. With regard to feelings of fear and confidence courage is the mean; of the people who exceed, he who exceeds in fearlessness has no name (many of the states have no name), while the man who exceeds in confidence is rash, and he who exceeds in fear and falls short in confidence is a coward. With regard to pleasures and pains—not all of them, and not so much with regard to the pains— the mean is temperance, the excess self-indulgence. Persons deficient with regard to the pleasures are not often found; hence such persons also have received no name. But let us call them "insensible."

With regard to giving and taking of money the mean is liberality, the excess and the defect prodigality

and meanness. In these actions people exceed and fall short in contrary ways; the prodigal exceeds in spending and falls short in taking, while the mean man exceeds in taking and falls short in spending. (At present we are giving a mere outline or summary, and are satisfied with this; later these states will be more exactly determined.) With regard to money there are also other dispositions—a mean, magnificence (for the magnificent man differs from the liberal man; the former deals with large sums, the latter with small ones), an excess, tastelessness and vulgarity, and a deficiency, niggardliness; these differ from the states opposed to liberality, and the mode of their difference will be stated later.

With regard to honour and dishonour the mean is proper pride, the excess is known as a sort of "empty vanity," and the deficiency is undue humility; and as we said liberality was related to magnificence, differing from it by dealing with small sums, so there is a state similarly related to proper pride, being concerned with small honours while that is concerned with great. For it is possible to desire honour as one ought, and more than one ought, and less, and the man who exceeds in his desires is called ambitious, the man who falls short unambitious, while the intermediate person has no name. The dispositions also are nameless, except that that of the ambitious man is called ambition. Hence the people who are at the extremes lay claim to the middle place; and we ourselves sometimes call the intermediate person ambitious and sometimes unambitious, and sometimes praise the ambitious man and sometimes the unambitious. The reason of our doing this will be stated in what follows; but now let us speak of the remaining states according to the method which has been indicated.

With regard to anger also there is an excess, a deficiency, and a mean. Although they can scarcely be said to have names, yet since we call the intermediate person good-tempered let us call the mean good temper; of the persons at the extremes let the one who exceeds be called irascible, and his vice irascibility, and the man who falls short an unirascible sort of person, and the deficiency unirascibility.

There are also three other means, which have a certain likeness to one another, but differ from one

another: for they are all concerned with intercourse in words and actions, but differ in that one is concerned with truth in this sphere, the other two with pleasantness; and of this one kind is exhibited in giving amusement, the other in all the circumstances of life. We must therefore speak of these too, that we may the better see that in all things the mean is praiseworthy, and the extremes neither praiseworthy nor right, but worthy of blame. Now most of these states also have no names, but we must try, as in the other cases, to invent names ourselves so that we may be clear and easy to follow. With regard to truth, then, the intermediate is a truthful sort of person and the mean may be called truthfulness, while the pretence which exaggerates is boastfulness and the person characterized by it a boaster, and that which understates is mock modesty and the person characterized by it mock-modest. With regard to pleasantness in the giving of amusement the intermediate person is ready-witted and the disposition ready wit, the excess is buffoonery and the person characterized by it a buffoon, while the man who falls short is a sort of boor and his state is boorishness. With regard to the remaining kind of pleasantness, that which is exhibited in life in general, the man who is pleasant in the right way is friendly and the mean is friendliness, while the man who exceeds is an obsequious person if he has no end in view, a flatterer if he is aiming at his own advantage, and the man who falls short and is unpleasant in all circumstances is a quarrel-some and surly sort of person.

There are also means in the passions and concerned with the passions; since shame is not a virtue, and yet praise is extended to the modest man. For even in these matters one man is said to be intermediate, and another to exceed, as for instance the bashful man who is ashamed of everything; while he who falls short or is not ashamed of anything at all is shameless, and the intermediate person is modest. Righteous indignation is a mean between envy and spite, and these states are concerned with the pain and pleasure that are felt at the fortunes of our neighbours; the man who is characterized by righteous indignation is pained at undeserved good fortune, the envious man, going beyond him, is pained at all

good fortune, and the spiteful man falls so far short of being pained that he even rejoices. But these states there will be an opportunity of describing elsewhere; with regard to justice, since it has not one simple meaning, we shall, after describing the other states, distinguish its two kinds and say how each of them is a mean; and similarly we shall treat also of the rational virtues.

BOOK III • MORAL VIRTUE (*cont.*)

Inner Side of Moral Virtue: Conditions of Responsibility for Action

Praise and blame attach to voluntary actions, i.e., actions done (1) not under compulsion, and (2) with knowledge of the circumstances

1. Since virtue is concerned with passions and actions, and on voluntary passions and actions praise and blame are bestowed, on those that are involuntary pardon, and sometimes also pity, to distinguish the voluntary and the involuntary is presumably necessary for those who are studying the nature of virtue, and useful also for legislators with a view to the assigning both of honours and of punishments.

Those things, then, are thought involuntary, which take place by force or owing to ignorance; and that is compulsory of which the moving principle is outside, being a principle in which nothing is contributed by the person who acts—or, rather, is acted upon, e.g., if he were to be carried somewhere by a wind, or by men who had him in their power.

But with regard to the things that are done from fear of greater evils or for some noble object (e.g., if a tyrant were to order one to do something base, having one's parents and children in his power, and if one did the action they were to be saved, but otherwise would be put to death), it may be debated whether such actions are involuntary or voluntary. Something of the sort happens also with regard to the throwing of goods overboard in a storm; for in the abstract no one throws goods away voluntarily, but on condition of its securing the safety of himself and his crew

any sensible man does so. Such actions, then, are mixed, but are more like voluntary actions; for they are worthy of choice at the time when they are done, and the end of an action is relative to the occasion. Both the terms, then, "voluntary" and "involuntary," must be used with reference to the moment of action. Now the man acts voluntarily; for the principle that moves the instrumental parts of the body in such actions is in him, and the things of which the moving principle is in a man himself are in his power to do or not to do. Such actions, therefore, are voluntary, but in the abstract perhaps involuntary; for no one would choose any such act in itself.

For such actions men are sometimes even praised, when they endure something base or painful in return for great and noble objects gained; in the opposite case they are blamed, since to endure the greatest indignities for no noble end or for a trifling end is the mark of an inferior person. On some actions praise indeed is not bestowed, but pardon is, when one does a wrongful act under pressure which overstrains human nature and which no one could withstand. But some acts, perhaps, we cannot be forced to do, but ought rather to face death after the most fearful sufferings; for the things that "forced" Euripides' Alcmaeon to slay his mother seem absurd. It is difficult sometimes to determine what should be chosen at what cost, and what should be endured in return for what gain, and yet more difficult to abide by our decisions; for as a rule what is expected is painful, and what we are forced to do is base, whence praise and blame are bestowed on those who have been forced or have not.

What sort of acts, then, should be called forced? We answer that without qualification actions are so when the cause is in the external circumstances and the agent contributes nothing. But the things that in themselves are involuntary, but now and in return for these gains are worthy of choice, and whose moving principle is in the agent, are in themselves involuntary, but now and in return for these gains voluntary. They are more like voluntary acts; for actions are in the class of particulars, and the particular acts here are voluntary. What sort of things are to be chosen, and in return for what, it is not easy to state; for there are many differences in the particular cases.

But if someone were to say that pleasant and noble objects have a forcing power, forcing us from without, all acts would be for him forced; for it is for these objects that all men do everything they do. And those who act by force and unwillingly act with pain, but those who do acts for their pleasantness or nobility do them with pleasure; it is absurd to make external circumstances responsible, and not oneself, as being easily caught by such attractions, and to make oneself responsible for noble acts but the pleasant objects responsible for base acts. The forced, then, seems to be that whose moving principle is outside, the person forced contributing nothing.

Everything that is done by reason of ignorance is *not* voluntary; it is only what produces pain and regret that is *in*voluntary. For the man who has done something owing to ignorance, and feels not the least vexation at his action, has not acted voluntarily, since he did not know what he was doing, nor yet involuntarily, since he is not pained. Of people, then, who act by reason of ignorance he who regrets is thought an involuntary agent, and the man who does not regret may, since he is different, be called a not voluntary agent; for, since he differs from the other, it is better that he should have a name of his own.

Acting by reason of ignorance seems also to be different from acting *in* ignorance; for the man who is drunk or in a rage is thought to act as a result not of ignorance but of one of the causes mentioned, yet not knowingly but in ignorance.

Now every wicked man is ignorant of what he ought to do and what he ought to abstain from, and error of this kind makes men unjust and in general bad; but the term "involuntary" tends to be used not if a man is ignorant of what is to his advantage— for it is not mistaken purpose that makes an action involuntary (*it* makes men *wicked*), nor ignorance of the universal (for *that* men are *blamed*), but ignorance of particulars, i.e., of the circumstances of the action and the objects with which it is concerned. For it is on these that both pity and pardon depend, since the person who is ignorant of any of these acts involuntarily.

Perhaps it is just as well, therefore, to determine their nature and number. A man may be ignorant, then, of who he is, what he is doing, what or whom he is acting on, and sometimes also what (e.g. what instrument) he is doing it with, and to what end (e.g. he may think his act will conduce to someone's safety), and how he is doing it (e.g. whether gently or violently). Now of all of these no one could be ignorant unless he were mad, and evidently also he could not be ignorant of the agent; for how could he not know himself? But of what he is doing a man might be ignorant, as for instance people say "it slipped out of their mouths as they were speaking," or "they did not know it was a secret," as Aeschylus said of the mysteries, or a man might say he "let it go off when he merely wanted to show its working," as the man did with the catapult. Again, one might think one's son was an enemy, as Merope did, or that a pointed spear had a button on it, or that a stone was pumice-stone; or one might give a man a draught to save him, and really kill him; or one might want to touch a man, as people do in sparring, and really wound him. The ignorance may relate, then, to any of these things, and the man who was ignorant of any of these is thought to have acted involuntarily, and especially if he was ignorant on the most important points; and these are thought to be the circumstances of the action and its end. Further, the doing of an act that is called involuntary in virtue of ignorance of this sort must be painful and involve regret.

Since that which is done by force or by reason of ignorance is involuntary, the voluntary would seem to be that of which the moving principle is in the agent himself, he being aware of the particular circumstances of the action. Presumably acts done by reason of anger or appetite are not rightly called involuntary. For in the first place, on that showing none of the other animals will act voluntarily, nor will children; and secondly, is it meant that we do not do voluntarily *any* of the acts that are due to appetite or anger, or that we do the noble acts voluntarily and the base acts involuntarily? Is not this absurd, when one and the same thing is the cause? But it would surely be odd to describe as involuntary the things one ought to desire; and we ought both to be angry at certain things and to have an appetite for certain things, e.g., for health and for learning. Also what is involuntary is thought to be painful, but what is in accordance with appetite is thought to be pleasant. Again, what is the difference in respect of involuntariness between errors committed upon calculation and those committed in anger? Both are to be avoided, but the irrational passions are thought not less human than reason is, and therefore also the actions which proceed from anger or appetite are the man's actions. It would be odd, then, to treat them as involuntary.

Moral virtue implies that the action is done (3) by choice: the object of choice is the result of previous deliberation

2. Both the voluntary and the involuntary having been delimited, we must next discuss choice; for it is thought to be most closely bound up with virtue, and to discriminate characters better than actions do.

Choice, then, seems to be voluntary, but not the same thing as the voluntary; the latter extends more widely. For both children and the lower animals share in voluntary action, but not in choice, and acts done on the spur of the moment we describe as voluntary, but not as chosen.

Those who say it is appetite or anger or wish or a kind of opinion do not seem to be right. For choice is not common to irrational creatures as well, but appetite and anger are. Again, the incontinent man acts with appetite, but not with choice; while the continent man on the contrary acts with choice, but not with appetite. Again, appetite is contrary to choice, but not appetite to appetite. Again, appetite relates to the pleasant and the painful, choice neither to the painful nor to the pleasant.

Still less is it anger; for acts due to anger are thought to be less than any other objects of choice.

But neither is it wish, though it seems near to it; for choice cannot relate to impossibles, and if any one said he chose them he would be thought silly; but there may be a wish even for impossibles, e.g., for immortality. And wish may relate to things that could in no way be brought about by one's own efforts, e.g., that a particular actor or athlete should win in

a competition; but no one chooses such things, but only the things that he thinks could be brought about by his own efforts. Again, wish relates rather to the end, choice to the means; for instance, we wish to be healthy, but we choose the acts which will make us healthy, and we wish to be happy and say we do, but we cannot well say we choose to be so; for, in general, choice seems to relate to the things that are in our own power.

For this reason, too, it cannot be opinion; for opinion is thought to relate to all kinds of things, no less to eternal things and impossible things than to things in our own power; and it is distinguished by its falsity or truth, not by its badness or goodness, while choice is distinguished rather by these.

Now with opinion in general perhaps no one even says it is identical. But it is not identical even with any kind of opinion; for by choosing what is good or bad we are men of a certain character, which we are not by holding certain opinions. And we choose to get or avoid something good or bad, but we have opinions about what a thing is or whom it is good for or how it is good for him; we can hardly be said to opine to get or avoid anything. And choice is praised for being related to the right object or for being *right*, opinion for being true. And we choose what we best know to be good, but we opine what we do not in the least know to be good; and it is not the same people that are thought to make the best choices and to have the best opinions, but some are thought to have fairly good opinions, but by reason of vice to choose what they should not. If opinion precedes choice or accompanies it, that makes no difference; for it is not this that we are considering, but whether choice is *identical* with some kind of opinion.

What, then, or what kind of thing is it, since it is none of the things we have mentioned? It seems to be voluntary, but not all that is voluntary to be an object of choice. Is it, then, what has been deliberated about before? At any rate choice involves a rational principle and thought. Even the name seems to suggest that it is what is chosen before other things.

The nature of deliberation and its objects: choice is deliberate desire of things in our own power

3. Do we deliberate about everything, and is everything a possible subject of deliberation, or is deliberation impossible about some things? We ought presumably to call not what a fool or a madman would deliberate about, but what a sensible man would deliberate about, a subject of deliberation. Now about eternal things no one deliberates, e.g., about the material universe or the incommensurability of the diagonal and the side of a square. But no more do we deliberate about the things that involve movement but always happen in the same way, whether of necessity or by nature or from any other cause, e.g., the solstices and the risings of the stars; nor about things that happen now in one way, now in another, e.g., droughts and rains; nor about chance events, like the finding of treasure. But we do not deliberate even about all human affairs; for instance, no Spartan deliberates about the best constitution for the Scythians. For none of these things can be brought about by our own efforts.

We deliberate about things that are in our power and can be done; and these are in fact what is left. For nature, necessity, and chance are thought to be causes, and also reason and everything that depends on man. Now every class of men deliberates about the things that can be done by their own efforts. And in the case of exact and self-contained sciences there is no deliberation, e.g., about the letters of the alphabet (for we have no doubt how they should be written); but the things that are brought about by our own efforts, but not always in the same way, are the things about which we deliberate, e.g., questions of medical treatment or of money-making. And we do so more in the case of the art of navigation than in that of gymnastics, inasmuch as it has been less exactly worked out, and again about other things in the same ratio, and more also in the case of the arts than in that of the sciences; for we have more doubt about the former. Deliberation is concerned with things that happen in a certain way for the most part, but in which the event is obscure, and with things in which it is indeterminate. We call in others to aid us in deliberation on important questions, distrusting ourselves as not being equal to deciding.

We deliberate not about ends but about means. For a doctor does not deliberate whether he shall heal, nor an orator whether he shall convince, nor a statesman whether he shall produce law and order, nor does any one else deliberate about his end. Having set the end, they consider how and by what means it is to be attained; and if it seems to be produced by several means they consider by which it is most easily and best produced, while if it is achieved by one only they consider how it will be achieved by this and by what means *this* will be achieved, till they come to the first cause, which in the order of discovery is last. For the person who deliberates seems to inquire and analyse in the way described as though he were analysing a geometrical construction (not all inquiry appears to be deliberation—for instance mathematical inquiries—but all deliberation is inquiry), and what is last in the order of analysis seems to be first in the order of becoming. And if we come on an impossibility, we give up the search, e.g., if we need money and this cannot be got; but if a thing appears possible we try to do it. By "possible" things I mean things that might be brought about by our own efforts; and these in a sense include things that can be brought about by the efforts of our friends, since the moving principle is in ourselves. The subject of investigation is sometimes the instruments, sometimes the use of them; and similarly in the other cases—sometimes the means, sometimes the mode of using it or the means of bringing it about. It seems, then, as has been said, that man is a moving principle of actions; now deliberation is about the things to be done by the agent himself, and actions are for the sake of things other than themselves. For the end cannot be a subject of deliberation, but only the means; nor indeed can the particular facts be a subject of it, e.g., whether this is bread or has been baked as it should; for these are matters of perception. If we are to be always deliberating, we shall have to go on to infinity.

The same thing is deliberated upon and is chosen, except that the object of choice is already determinate, since it is that which has been decided upon as a result of deliberation that is the object of choice. For everyone ceases to inquire how he is to act when he has brought the moving principle back to himself and to the ruling part of himself; for this is what chooses. This is plain also from the ancient constitutions, which Homer represented; for the kings announced their choices to the people. The object of choice being one of the things in our own power which is desired after deliberation, choice will be deliberate desire of things in our own power; for when we have reached a judgement as a result of deliberation, we desire in accordance with our deliberation.

We may take it, then, that we have described choice in outline; we have stated the nature of its objects and the fact that it is concerned with means.

The object of rational wish is the end, i.e., the good or apparent good

4. That *wish* is for the end has already been stated; some think it is for the good, others for the apparent good. Now those who say that the good is the object of wish must admit in consequence that that which the man who does not choose aright wishes for is not an object of wish (for if it is to be so, it must also be good; but it may well have been bad); while those who say that apparent good is the object of wish must admit that there is no natural object of wish, but only what seems good to each man. Now different things appear good to different people, and, if it so happens, even contrary things.

If these consequences are unpleasing, are we to say that absolutely and in truth the good is the object of wish, but for each person the apparent good; that that which is in truth an object of wish is an object of wish to the good man, while any chance thing may be so to the bad man, as in the case of bodies also the things that are in truth wholesome are wholesome for bodies which are in good condition, while for those that are diseased other things are wholesome—or bitter or sweet or hot or heavy, and so on; since the good man judges each class of things rightly, and in each the truth appears to him? For each state of character has its own ideas of the noble and the pleasant, and perhaps the good man differs from others most by seeing the truth in each class of things, being as it were the norm and measure of them. In most things the error seems to be due to pleasure; for this appears

a good when it is not. We therefore choose the pleasant as a good and avoid pain as an evil.

We are responsible for bad as well as for good actions

5. The end, then, being what we wish for, the means what we deliberate about and choose, actions concerning means must be according to choice and voluntary. Now the exercise of the virtues is concerned with means. Therefore virtue also is in our own power, and so too vice. For where it is in our power to act it is also in our power not to act, and *vice versa;* so that, if to act, where this is noble, is in our power, not to act, which will be base, will also be in our power, and if not to act, where this is noble, is in our power, to act, which will be base, will also be in our power. Now if it is in our power to do noble or base acts, and likewise in our power not to do them, and this was what being good or bad meant, then it is in our power to be virtuous or vicious.

The saying that "no one is voluntarily wicked nor involuntarily happy," seems to be partly false and partly true; for no one is involuntarily happy, but wickedness *is* voluntary. Or else we shall have to dispute what has just been said, at any rate, and deny that man is a moving principle or begetter of his actions, as of children. But if these facts are evident and we cannot refer actions to moving principles other than those in ourselves, the acts whose moving principles are in us must themselves also be in our power and voluntary.

Witness seems to be borne to this both by individuals in their private capacity and by legislators themselves; for these punish and take vengeance on those who do wicked acts (unless they have acted under compulsion or as a result of ignorance for which they are not themselves responsible), while they honour those who do noble acts, as though they meant to encourage the latter and deter the former. But no one is encouraged to do the things that are neither in our power nor voluntary; it is assumed that there is no gain in being persuaded not to be hot or in pain or hungry or the like, since we shall experience these feelings none the less. Indeed, we punish a man for his very ignorance, if he is thought responsible for the ignorance, as when penalties are doubled in the case of drunkenness; for the moving principle is in the man himself, since he had the power of not getting drunk and his getting drunk was the cause of his ignorance. And we punish those who are ignorant of anything in the laws that they ought to know and that is not difficult, and so too in the case of anything else that they are thought to be ignorant of through carelessness; we assume that it is in their power not to be ignorant, since they have the power of taking care.

But perhaps a man is the kind of man not to take care. Still they are themselves by their slack lives responsible for becoming men of that kind, and men are themselves responsible for being unjust or self-indulgent, in that they cheat or spend their time in drinking-bouts and the like; for it is activities exercised on particular objects that make the corresponding character. This is plain from the case of people training for any contest or action; they practise the activity the whole time. Now not to know that it is from the exercise of activities on particular objects that states of character are produced is the mark of a thoroughly senseless person. Again, it is irrational to suppose that a man who acts unjustly does not wish to be unjust or a man who acts self-indulgently to be self-indulgent. But if *without* being ignorant a man does the things which will make him unjust, he will be unjust voluntarily. Yet it does not follow that if he wishes he will cease to be unjust and will be just. For neither does the man who is ill become well on those terms. We may suppose a case in which he is ill voluntarily, through living incontinently and disobeying his doctors. In that case it was *then* open to him not to be ill, but not now, when he has thrown away his chance, just as when you have let a stone go it is too late to recover it; but yet it was in your power to throw it, since the moving principle was in you. So, too, to the unjust and to the self-indulgent man it was open at the beginning not to become men of this kind; and so they are unjust and self-indulgent voluntarily; but now that they have become so it is not possible for them not to be so.

But not only are the vices of the soul voluntary, but those of the body also for some men, whom we

accordingly blame; while no one blames those who are ugly by nature, we blame those who are so owing to want of exercise and care. So it is, too, with respect to weakness and infirmity; no one would reproach a man blind from birth or by disease or from a blow, but rather pity him, while every one would blame a man who was blind from drunkenness or some other form of self-indulgence. Of vices of the body, then, those in our own power are blamed, those not in our power are not. And if this be so, in the other cases also the vices that are blamed must be in our own power.

Now someone may say that all men aim at the apparent good, but have no control over the appearance, but the end appears to each man in a form answering to his character. We reply that if each man is somehow responsible for his state of character, he will also be himself somehow responsible for the appearance; but if not, no one is responsible for his own evildoing, but everyone does evil acts through ignorance of the end, thinking that by these he will get what is best, and the aiming at the end is not self-chosen but one must be born with an eye, as it were, by which to judge rightly and choose what is truly good, and he is well endowed by nature who is well endowed with this. For it is what is greatest and most noble, and what we cannot get or learn from another, but must have just such as it was when given us at birth, and to be well and nobly endowed with this will be perfect and true excellence of natural endowment. If this is true, then, how will virtue be more voluntary than vice? To both men alike, the good and the bad, the end appears and is fixed by nature or however it may be, and it is by referring everything else to this that men do whatever they do.

Whether, then, it is not by nature that the end appears to each man such as it does appear, but something also depends on him, or the end is natural but because the good man adopts the means voluntarily virtue is voluntary, vice also will be none the less voluntary; for in the case of the bad man there is equally present that which depends on himself in his actions even if not in his end. If, then, as is asserted, the virtues are voluntary (for we are ourselves somehow part-causes of our states of character, and it is by being persons of a certain kind that we set the end to be so

and so), the vices also will be voluntary; for the same is true of them.

With regard to the virtues *in general* we have stated their genus in outline, viz. that they are means and that they are states of character, and that they tend, and by their own nature, to the doing of the acts by which they are produced, and that they are in our power and voluntary, and act as the right rule prescribes. But actions and states of character are not voluntary in the same way; for we are masters of our actions from the beginning right to the end, if we know the particular facts, but though we control the beginning of our states of character the gradual progress is not obvious, any more than it is in illnesses; because it was in our power, however, to act in this way or not in this way, therefore the states are voluntary.

Courage

Courage concerned with the feelings of fear and confidence—strictly speaking, with the fear of death in battle

6. That it is a mean with regard to feelings of fear and confidence has already been made evident; and plainly the things we fear are fearful things, and these are, to speak without qualification, evils; for which reason people even define fear as expectation of evil. Now, we fear all evils, e.g., disgrace, poverty, disease, friendlessness, death, but the brave man is not thought to be concerned with all; for to fear some things is even right and noble, and it is base not to fear them—e.g., disgrace; he who fears this is good and modest, and he who does not is shameless. He is, however, by some people called brave, by a transference of the word to a new meaning; for he has in him something which is like the brave man, since the brave man also is a fearless person. Poverty and disease we perhaps ought not to fear, nor in general the things that do not proceed from vice and are not due to a man himself. But not even the man who is fearless of these is brave. Yet we apply the word to him also in virtue of a similarity; for some who in the dangers of war are cowards are liberal

and are confident in face of the loss of money. Nor is a man a coward if he fears insult to his wife and children or envy or anything of the kind; nor brave if he is confident when he is about to be flogged. With what sort of fearful things, then, is the brave man concerned? Surely with the greatest; for no one is more likely than he to stand his ground against what is awe-inspiring. Now death is the most fearful of all things; for it is the end, and nothing is thought to be any longer either good or bad for the dead. But the brave man would not seem to be concerned even with death in *all* circumstances, e.g., at sea or in disease. In what circumstances, then? Surely in the noblest. Now such deaths are those in battle; for these take place in the greatest and noblest danger. And these are correspondingly honoured in city-states and at the courts of monarchs. Properly, then, he will be called brave who is fearless in face of a noble death, and of all emergencies that involve death; and the emergencies of war are in the highest degree of this kind. Yet at sea also, and in disease, the brave man is fearless, but not in the same way as the seamen; for he has given up hope of safety, and is disliking the thought of death in this shape, while they are hopeful because of their experience. At the same time, we show courage in situations where there is the opportunity of showing prowess or where death is noble; but in these forms of death neither of these conditions is fulfilled.

The motive of courage is the sense of honour: characteristics of the opposite vices, cowardice and rashness

7. What is fearful is not the same for all men; but we say there are things fearful even beyond human strength. These, then, are fearful to every one—at least to every sensible man; but the fearful things that are *not* beyond human strength differ in magnitude and degree, and so too do the things that inspire confidence. Now the brave man is as dauntless as man may be. Therefore, while he will fear even the things that are not beyond human strength, he will face them as he ought and as the rule directs, for honour's sake; for this is the end of virtue. But it is possible to

fear these more, or less, and again to fear things that are not fearful as if they were. Of the faults that are committed, one consists in fearing what we should not, another in fearing as we should not, another in fearing when we should not, and so on; and so too with respect to the things that inspire confidence. The man, then, who faces and who fears the right things and from the right motive, in the right way and at the right time, and who feels confidence under the corresponding conditions, is brave; for the brave man feels and acts according to the merits of the case and in whatever way the rule directs. Now the end of every activity is conformity to the corresponding state of character. This is true, therefore, of the brave man as well as of others. But courage is noble. Therefore the end also is noble; for each thing is defined by its end. Therefore it is for a noble end that the brave man endures and acts as courage directs.

Of those who go to excess he who exceeds in fearlessness has no name (we have said previously that many states of character have no names), but he would be a sort of madman or insensitive to pain if he feared nothing, neither earthquakes nor the waves, as they say the Celts do not; while the man who exceeds in confidence about what really is fearful is rash. The rash man, however, is also thought to be boastful and only a pretender to courage; at all events, as the brave man *is* with regard to what is fearful, so the rash man wishes to *appear;* and so he imitates him in situations where he can. Hence also most of them are a mixture of rashness and cowardice; for, while in these situations they display confidence, they do not hold their ground against what is really fearful. The man who exceeds in fear is a coward; for he fears both what he ought not and as he ought not, and all the similar characterizations attach to him. He is lacking also in confidence; but he is more conspicuous for his excess of fear in painful situations. The coward, then, is a despairing sort of person; for he fears everything. The brave man, on the other hand, has the opposite disposition; for confidence is the mark of a hopeful disposition. The coward, the rash man, and the brave man, then, are concerned with the same objects but are differently disposed towards them; for the first two exceed and fall short, while the

third holds the middle, which is the right, position; and rash men are precipitate, and wish for dangers beforehand but draw back when they are in them, while brave men are excited in the moment of action, but collected beforehand.

As we have said, then, courage is a mean with respect to things that inspire confidence or fear, in the circumstances that have been stated; and it chooses or endures things because it is noble to do so, or because it is base not to do so. But to die to escape from poverty or love or anything painful is not the mark of a brave man, but rather of a coward; for it is softness to fly from what is troublesome, and such a man endures death not because it is noble but to fly from evil.

BOOK V • MORAL VIRTUE (*cont.*)

Justice: Its Sphere and Outer Nature: In What Sense It Is a Mean

The just as the lawful (universal justice) and the just as the fair and equal (particular justice): the former considered

1. With regard to justice and injustice we must consider (1) what kind of actions they are concerned with, (2) what sort of mean justice is, and (3) between what extremes the just act is intermediate. Our investigation shall follow the same course as the preceding discussions.

We see that all men mean by justice that kind of state of character which makes people disposed to do what is just and makes them act justly and wish for what is just; and similarly by injustice that state which makes them act unjustly and wish for what is unjust. Let us too, then, lay this down as a general basis. For the same is not true of the sciences and the faculties as of states of character. A faculty or a science which is one and the same is held to relate to contrary objects, but a state of character which is one of two contraries does *not* produce the contrary results; e.g., as a result of health we do not do what is the opposite of healthy, but only what is healthy;

for we say a man walks healthily, when he walks as a healthy man would.

Now often one contrary state is recognized from its contrary, and often states are recognized from the subjects that exhibit them; for (A) if good condition is known, bad condition also becomes known, and (B) good condition is known from the things that are in good condition, and they from it. If good condition is firmness of flesh, it is necessary both that bad condition should be flabbiness of flesh and that the wholesome should be that which causes firmness in flesh. And it follows for the most part that if one contrary is ambiguous the other also will be ambiguous; e.g., that if "just" is so, "unjust" will be so too.

Now "justice" and "injustice" seem to be ambiguous, but because their different meanings approach near to one another the ambiguity escapes notice and is not obvious as it is, comparatively, when the meanings are far apart, e.g. (for here the difference in outward form is great) as the ambiguity in the use of *kleis* for the collar-bone of an animal and for that with which we lock a door. Let us take as a starting-point, then, the various meanings of "an unjust man." Both the lawless man and the grasping and unfair man are thought to be unjust, so that evidently both the law-abiding and the fair man will be just. The just, then, is the lawful and the fair, the unjust the unlawful and the unfair.

Since the unjust man is grasping, he must be concerned with goods—not all goods, but those with which prosperity and adversity have to do, which taken absolutely are always good, but for a particular person are not always good. Now men pray for and pursue these things; but they should not, but should pray that the things that are good absolutely may also be good for them, and should choose the things that *are* good for them. The unjust man does not always choose the greater, but also the less—in the case of things bad absolutely; but because the lesser evil is itself thought to be in a sense good, and graspingness is directed at the good, therefore he is thought to be grasping. And he is unfair; for this contains and is common to both.

Since the lawless man was seen to be unjust and the law-abiding man just, evidently all lawful acts are

in a sense just acts; for the acts laid down by the legislative art are lawful, and each of these, we say, is just. Now the laws in their enactments on all subjects aim at the common advantage either of all or of the best or of those who hold power, or something of the sort; so that in one sense we call those acts just that tend to produce and preserve happiness and its components for the political society. And the law bids us do both the acts of a brave man (e.g., not to desert our post nor take to flight nor throw away our arms), and those of a temperate man (e.g., not to commit adultery nor to gratify one's lust), and those of a good-tempered man (e.g., not to strike another nor to speak evil), and similarly with regard to the other virtues and forms of wickedness, commanding some acts and forbidding others; and the rightly-framed law does this rightly, and the hastily conceived one less well.

This form of justice, then, is complete virtue, although not without qualification, but in relation to our neighbour. And therefore justice is often thought to be the greatest of virtues, and "neither evening nor morning star" is so wonderful; and proverbially "in justice is every virtue comprehended." And it is complete virtue in its fullest sense because it is the actual exercise of complete virtue. It is complete because he who possesses it can exercise his virtue not only in himself but towards his neighbour also; for many men can exercise virtue in their own affairs, but not in their relations to their neighbour. This is why the saying of Bias is thought to be true, that "rule will show the man"; for a ruler is necessarily in relation to other men, and a member of a society. For this same reason justice, alone of the virtues, is thought to be "another's good," because it is related to our neighbour; for it does what is advantageous to another, either a ruler or a co-partner. Now the worst man is he who exercises his wickedness both towards himself and towards his friends, and the best man is not he who exercises his virtue towards himself but he who exercises it towards another; for this is a difficult task. Justice in this sense, then, is not part of virtue but virtue entire, nor is the contrary injustice a part of vice but vice entire. What the difference is between virtue and justice in this sense is plain from what we have said; they are the same but their essence is not the same; what, as a relation to one's neighbour, is justice is, as a certain kind of state without qualification, virtue.

The just as the fair and equal: divided into distribution and rectificatory justice

2. But at all events what we are investigating is the justice which is a *part* of virtue; for there is a justice of this kind, as we maintain. Similarly it is with injustice in the particular sense that we are concerned.

That there is such a thing is indicated by the fact that while the man who exhibits in action the other forms of wickedness acts wrongly indeed, but not graspingly (e.g., the man who throws away his shield through cowardice or speaks harshly through bad temper or fails to help a friend with money through meanness), when a man acts graspingly he often exhibits none of these vices—no, nor all together, but certainly wickedness of some kind (for we blame him) and injustice. There is, then, another kind of injustice which is a part of injustice in the wide sense, and a use of the word "unjust" which answers to a part of what is unjust in the wide sense of "contrary to the law." Again, if one man commits adultery for the sake of gain and makes money by it, while another does so at the bidding of appetite though he loses money and is penalized for it, the latter would be held to be self-indulgent rather than grasping, but the former is unjust, but not self-indulgent; evidently, therefore, he is unjust by reason of his making gain by his act. Again, all other unjust acts are ascribed invariably to some particular kind of wickedness, e.g., adultery to self-indulgence, the desertion of a comrade in battle to cowardice, physical violence to anger; but if a man makes gain, his action is ascribed to no form of wickedness but injustice. Evidently, therefore, there is apart from injustice in the wide sense another, "particular," injustice which shares the name and nature of the first, because its definition falls within the same genus; for the significance of both consists in a relation to one's neighbour, but the one is concerned with honour or money or safety—or that which includes all these, if we had a single name for it—and its motive is the pleasure that arises

from gain; while the other is concerned with all the objects with which the good man is concerned.

It is clear, then, that there is more than one kind of justice, and that there is one which is distinct from virtue entire; we must try to grasp its genus and differentia.

The unjust has been divided into the unlawful and the unfair, and the just into the lawful and the fair. To the unlawful answers the aforementioned sense of injustice. But since the unfair and the unlawful are not the same, but are different as a part is from its whole (for all that is unfair is unlawful, but not all that is unlawful is unfair), the unjust and injustice in the sense of the unfair are not the same as but different from the former kind, as part from whole; for injustice in this sense is a part of injustice in the wide sense, and similarly justice in the one sense of justice in the other. Therefore we must speak also about particular justice and particular injustice, and similarly about the just and the unjust. The justice, then, which answers to the whole of virtue, and the corresponding injustice, one being the exercise of virtue as a whole, and the other that of vice as a whole, towards one's neighbour, we may leave on one side. And how the meanings of "just" and "unjust" which answer to these are to be distinguished is evident; for practically the majority of the acts commanded by the law are those which are prescribed from the point of view of virtue taken as a whole; for the law bids us practise every virtue and forbids us to practise any vice. And the things that tend to produce virtue taken as a whole are those of the acts prescribed by the law which have been prescribed with a view to education for the common good. But with regard to the education of the individual as such, which makes him without qualification a good *man*, we must determine later whether this is the function of the political art or of another; for perhaps it is not the same to be a good man and a good citizen of any state taken at random.

Of particular justice and that which is just in the corresponding sense, (A) one kind is that which is manifested in distributions of honour or money or the other things that fall to be divided among those who have a share in the constitution (for in these it is possible for one man to have a share either unequal or equal to that of another), and (B) one is that which plays a rectifying part in transactions between man and man. Of this there are two divisions; of transactions (1) some are voluntary and (2) others involuntary—voluntary such transactions as sale, purchase, loan for consumption, pledging, loan for use, depositing, letting (they are called voluntary because the *origin* of these transactions is voluntary), while of the involuntary (a) some are clandestine, such as theft, adultery, poisoning, procuring, enticement of slaves, assassination, false witness, and (b) others are violent, such as assault, imprisonment, murder, robbery with violence, mutilation, abuse, insult.

Natural and legal justice

7. Of political justice part is natural, part legal,—natural, that which everywhere has the same force and does not exist by people's thinking this or that; legal, that which is originally indifferent, but when it has been laid down is not indifferent, e.g., that a prisoner's ransom shall be a mina, or that a goat and not two sheep shall be sacrificed, and again all the laws that are passed for particular cases, e.g., that sacrifice shall be made in honour of Brasidas, and the provisions of decrees. Now some think that all justice is of this sort, because that which is by nature is unchangeable and has everywhere the same force (as fire burns both here and in Persia), while they see change in the things recognized as just. This, however, is not true in this unqualified way, but is true in a sense; or rather, with the gods it is perhaps not true at all, while with us there is something that is just even by nature, yet all of it is changeable; but still some is by nature, some not by nature. It is evident which sort of thing, among things capable of being otherwise, is by nature; and which is not but is legal and conventional, assuming that both are equally changeable. And in all other things the same distinction will apply; by nature the right hand is stronger, yet it is possible that all men should come to be ambidextrous. The things which are just by virtue of convention and expediency are like measures; for wine and corn measures are not everywhere equal, but larger in wholesale and smaller in retail markets.

Similarly, the things which are just not by nature but by human enactment are not everywhere the same, since constitutions also are not the same, though there is but one which is everywhere by nature the best. . . .

Equity, a corrective of legal justice

10. Our next subject is equity and the equitable, and their respective relations to justice and the just. For on examination they appear to be neither absolutely the same nor generically different; and while we sometimes praise what is equitable and the equitable man (so that we apply the name by way of praise even to instances of the other virtues, instead of "good," meaning by "more equitable" that a thing is better), at other times, when we reason it out, it seems strange if the equitable, being something different from the just, is yet praiseworthy; for either the just or the equitable is not good, if they are different; or, if both are good, they are the same.

These, then, are pretty much the considerations that give rise to the problem about the equitable; they are all in a sense correct and not opposed to one another; for the equitable, though it is better than one kind of justice, yet is just, and it is not as being a different class of thing that it is better than the just. The same thing, then, is just and equitable, and while both are good the equitable is superior. What creates the problem is that the equitable is just, but not the legally just but a correction of legal justice. The reason is that all law is universal but about some things it is not possible to make a universal statement which shall be correct. In those cases, then, in which it is necessary to speak universally, but not possible to do so correctly, the law takes the usual case, though it is not ignorant of the possibility of error. And it is none the less correct; for the error is not in the law nor in the legislator but in the nature of the thing, since the matter of practical affairs is of this kind from the start. When the law speaks universally, then, and a case arises on it which is not covered by the universal statement, then it is right, where the legislator fails us and has erred by over-simplicity, to correct the omission—to say what the legislator himself would

have said had be been present, and would have put into his law if he had known. Hence the equitable is just, and better than one kind of justice—not better than absolute justice, but better than the error that arises from the absoluteness of the statement. And this is the nature of the equitable, a correction of law where it is defective owing to its universality. In fact this is the reason why all things are not determined by law, viz. that about some things it is impossible to lay down a law, so that a decree is needed. For when the thing is indefinite the rule also is indefinite, like the leaden rule used in making the Lesbian moulding; the rule adapts itself to the shape of the stone and is not rigid, and so too the decree is adapted to the facts.

It is plain, then, what the equitable is, and that it is just and is better than one kind of justice. It is evident also from this who the equitable man is; the man who chooses and does such acts, and is no stickler for his rights in a bad sense but tends to take less than his share though he has the law on his side, is equitable, and this state of character is equity, which is a sort of justice and not a different state of character.

BOOK VI • INTELLECTUAL VIRTUE

Introduction

Reasons for studying intellectual virtue: intellect divided into the contemplative and the calculative

1. Since we have previously said that one ought to choose that which is intermediate, not the excess nor the defect, and that the intermediate is determined by the dictates of the right rule, let us discuss the nature of these dictates. In all the states of character we have mentioned, as in all other matters, there is a mark to which the man who has the rule looks, and heightens or relaxes his activity accordingly, and there is a standard which determines the mean states which we say are intermediate between excess and defect, being in accordance with the right rule. But such a statement, though true, is by no means clear; for not only here but in all other pursuits which are objects of knowledge it is indeed true to say that we must not exert ourselves nor relax our efforts too much or too

little, but to an intermediate extent and as the right rule dictates; but if a man had only this knowledge he would be none the wiser—e.g. we should not know what sort of medicines to apply to our body if someone were to say "all those which the medical art prescribes, and which agree with the practice of one who possesses the art." Hence it is necessary with regard to the states of the soul also, not only that this true statement should be made, but also that it should be determined what is the right rule and what is the standard that fixes it.

We divided the virtues of the soul and said that some are virtues of character and others of intellect. Now we have discussed in detail the moral virtues; with regard to the others let us express our view as follows, beginning with some remarks about the soul. We said before that there are two parts of the soul—that which grasps a rule or rational principle, and the irrational; let us now draw a similar distinction within the part which grasps a rational principle. And let it be assumed that there are two parts which grasp a rational principle—one by which we contemplate the kind of things whose originative causes are invariable, and one by which we contemplate variable things; for where objects differ in kind the part of the soul answering to each of the two is different in kind, since it is in virtue of a certain likeness and kinship with their objects that they have the knowledge they have. Let one of these parts be called the scientific and the other the calculative; for to deliberate and to calculate are the same thing, but no one deliberates about the invariable. Therefore the calculative is one part of the faculty which grasps a rational principle. We must, then, learn what is the best state of each of these two parts; for this is the virtue of each.

The proper object of contemplation is truth; that of calculation is truth corresponding with right desire

2. The virtue of a thing is relative to its proper work. Now there are three things in the soul which control action and truth—sensation, reason, desire.

Of these sensation originates no action; this is plain from the fact that the lower animals have sensation but no share in action.

What affirmation and negation are in thinking, pursuit and avoidance are in desire; so that since moral virtue is a state of character concerned with choice, and choice is deliberate desire, therefore both the reasoning must be true and the desire right, if the choice is to be good, and the latter must pursue just what the former asserts. Now this kind of intellect and of truth is practical; of the intellect which is contemplative, not practical nor productive, the good and the bad state are truth and falsity respectively (for this is the work of everything intellectual); while of the part which is practical and intellectual the good state is truth in agreement with right desire.

The origin of action—its efficient, not its final cause—is choice, and that of choice is desire and reasoning with a view to an end. This is why choice cannot exist either without reason and intellect or without a moral state; for good action and its opposite cannot exist without a combination of intellect and character. Intellect itself, however, moves nothing, but only the intellect which aims at an end and is practical; for this rules the productive intellect as well, since everyone who makes makes for an end, and that which is made is not an end in the unqualified sense (but only an end in a particular relation, and the end of a particular operation)—only that which is *done* is that; for good action is an end, and desire aims at this. Hence choice is either desiderative reason or ratiocinative desire, and such an origin of action is a man. (It is to be noted that nothing that is past is an object of choice, e.g. no one chooses to have sacked Troy; for no one *deliberates* about the past, but about what is future and capable of being otherwise, while what is past is not capable of not having taken place; hence Agathon is right in saying:

For this alone is lacking even to God,
To make undone things that have once been done.)

The work of both the intellectual parts, then, is truth. Therefore the states that are most strictly those in respect of which each of these parts will reach truth are the virtues of the two parts.

The Chief Intellectual Virtues

Science—demonstrative knowledge of the necessary and eternal

3. Let us begin, then, from the beginning, and discuss these states once more. Let it be assumed that the states by virtue of which the soul possesses truth by way of affirmation or denial are five in number, i.e. art, scientific knowledge, practical wisdom, philosophic wisdom, intuitive reason; we do not include judgement and opinion because in these we may be mistaken.

Now what *scientific knowledge* is, if we are to speak exactly and not follow mere similarities, is plain from what follows. We all suppose that what we know is not even capable of being otherwise; of things capable of being otherwise we do not know, when they have passed outside our observation, whether they exist or not. Therefore the object of scientific knowledge is of necessity. Therefore it is eternal; for things that are of necessity in the unqualified sense are all eternal; and things that are eternal are ungenerated and imperishable. Again, every science is thought to be capable of being taught, and its object of being learnt. And all teaching starts from what is already known, as we maintain in the *Analytics* also; for it proceeds sometimes through induction and sometimes by syllogism. Now induction is the starting-point which knowledge even of the universal presupposes, while syllogism proceeds *from* universals. There are therefore starting-points from which syllogism proceeds, which are not reached by syllogism; it is therefore by induction that they are acquired. Scientific knowledge is, then, a state of capacity to demonstrate, and has the other limiting characteristics which we specify in the *Analytics;* for it is when a man believes in a certain way and the starting-points are known to him that he has scientific knowledge, since if they are not better known to him than the conclusion, he will have his knowledge only incidentally.

Let this, then, be taken as our account of scientific knowledge.

Practical wisdom—knowledge of how to secure the ends of human life

5. Regarding *practical wisdom* we shall get at the truth by considering who are the persons we credit with it. Now it is thought to be a mark of a man of practical wisdom to be able to deliberate well about what is good and expedient for himself, not in some particular respect, e.g. about what sorts of thing conduce to health or to strength, but about what sorts of thing conduce to the good life in general. This is shown by the fact that we credit men with practical wisdom in some particular respect when they have calculated well with a view to some good end which is one of those that are not the object of any art. It follows that in the general sense also the man who is capable of deliberating has practical wisdom. Now no one deliberates about things that are invariable, or about things that it is impossible for him to do. Therefore, since scientific knowledge involves demonstration, but there is no demonstration of things whose first principles are variable (for all such things might actually be otherwise), and since it is impossible to deliberate about things that are of necessity, practical wisdom cannot be scientific knowledge or art; not science because that which can be done is capable of being otherwise, not art because action and making are different kinds of thing. The remaining alternative, then, is that it is a true and reasoned state of capacity to act with regard to the things that are good or bad for man. For while making has an end other than itself, action cannot; for good action itself is its end. It is for this reason that we think Pericles and men like him have practical wisdom, viz. because they can see what is good for themselves and what is good for men in general; we consider that those can do this who are good at managing households or states. (This is why we call temperance [*sōphrosunē*] by this name; we imply that it preserves one's practical wisdom [*sōzousa tēn phronēsin*]. Now what it preserves is a judgement of the kind we have described. For it is not any and every judgement that pleasant and painful objects destroy and pervert, e.g. the judgement that the triangle has or has not its angles equal to two right angles, but only judgements about what is to be done. For the originating causes of the things that are done consist in the end at which they are aimed; but the man who has been ruined by pleasure or pain

forthwith fails to see any such originating cause—to see that for the sake of this or because of this he ought to choose and do whatever he chooses and does; for vice is destructive of the originating cause of action.)

Practical wisdom, then, must be a reasoned and true state of capacity to act with regard to human goods. But further, while there is such a thing as excellence in art, there is no such thing as excellence in practical wisdom; and in art he who errs willingly is preferable, but in practical wisdom, as in the virtues, he is the reverse. Plainly, then, practical wisdom is a virtue and not an art. There being two parts of the soul that can follow a course of reasoning, it must be a virtue of one of the two, i.e. of that part which forms opinions; for opinion is about the variable and so is practical wisdom. But yet it is not only a reasoned state; this is shown by the fact that a state of that sort may be forgotten but practical wisdom cannot.

Intuitive reason—knowledge of the principles from which science proceeds

6. Scientific knowledge is judgement about things that are universal and necessary; and the conclusions of demonstration, and all scientific knowledge, follow from first principles (for scientific knowledge involves proof). This being so, the first principle from which what is scientifically known follows cannot be an object of scientific knowledge, of art, or of practical wisdom; for that which can be scientifically known can be demonstrated, and art and practical wisdom deal with things that are variable. Nor are these first principles the objects of philosophic wisdom, for it is a mark of the philosopher to have *demonstration* about some things. If, then, the states of mind by which we have truth and are never deceived about things invariable or even variable are scientific knowledge, practical wisdom, philosophic wisdom, and intuitive reason, and it cannot be any of the three (i.e. practical wisdom, scientific knowledge, or philosophic wisdom), the remaining alternative is that it is *intuitive reason* that grasps the first principles.

Philosophic wisdom—the union of intuitive reason and science

7. *Wisdom* (1) in the arts we ascribe to their most finished exponents, e.g. to Phidias as a sculptor and to Polyclitus as a maker of portrait-statues, and here we mean nothing by wisdom except excellence in art; but (2) we think that some people are wise in general, not in some particular field or in any other limited respect, as Homer says in the *Margites,*

> *Him did the gods make neither a digger nor yet a ploughman*
> *Nor wise in anything else.*

Therefore wisdom must plainly be the most finished of the forms of knowledge. It follows that the wise man must not only know what follows from the first principles, but must also possess truth about the first principles. Therefore wisdom must be intuitive reason combined with scientific knowledge—scientific knowledge of the highest objects which has received as it were its proper completion.

Of the highest objects, we say; for it would be strange to think that the art of politics, or practical wisdom, is the best knowledge, since man is not the best thing in the world. Now if what is healthy or good is different for men and for fishes, but what is white or straight is always the same, anyone would say that what is wise is the same but what is practically wise is different; for it is to that which considers well the various matters concerning itself that one ascribes practical wisdom, and it is to this that one will entrust such matters. This is why we say that some even of the lower animals have practical wisdom, viz. those which are found to have a power of foresight with regard to their own life. It is evident also that philosophic wisdom and the art of politics cannot be the same; for if the state of mind concerned with a man's own interests is to be called philosophic wisdom, there will be many philosophic wisdoms; there will not be one concerned with the good of all animals (any more than there is one art of medicine for all existing things), but a different philosophic wisdom about the good of each species.

But if the argument be that man is the best of the animals, this makes no difference; for there are other things much more divine in their nature even than man, e.g., most conspicuously, the bodies of which

the heavens are framed. From what has been said it is plain, then, that philosophic wisdom is scientific knowledge, combined with intuitive reason, of the things that are highest by nature. This is why we say Anaxagoras, Thales, and men like them have philosophic but not practical wisdom, when we see them ignorant of what is to their own advantage, and why we say that they know things that are remarkable, admirable, difficult, and divine, but useless; viz. because it is not human goods that they seek.

Practical wisdom on the other hand is concerned with things human and things about which it is possible to deliberate; for we say this is above all the work of the man of practical wisdom, to deliberate well, but no one deliberates about things invariable, or about things which have not an end which is a good that can be brought about by action. The man who is without qualification good at deliberating is the man who is capable of aiming in accordance with calculation at the best for man of things attainable by action. Nor is practical wisdom concerned with universals only—it must also recognize the particulars; for it is practical, and practice is concerned with particulars. This is why some who do not know, and especially those who have experience, are more practical than others who know; for if a man knew that light meats are digestible and wholesome, but did not know which sorts of meat are light, he would not produce health, but the man who knows that chicken is wholesome is more likely to produce health.

Now practical wisdom is concerned with action; therefore one should have both forms of it, or the latter in preference to the former. But here, too, there must be a controlling kind.

Relations between practical wisdom and political science

8. Political wisdom and practical wisdom are the same state of mind, but their essence is not the same. Of the wisdom concerned with the city, the practical wisdom which plays a controlling part is legislative wisdom, while that which is related to this as particulars to their universal is known by the general name "political wisdom"; this has to do with action and deliberation, for a decree is a thing to be carried out in the form of an individual act. This is why the exponents of this art are alone said to "take part in politics"; for these alone "do things" as manual labourers "do things."

Practical wisdom also is identified especially with that form of it which is concerned with a man himself—with the individual; and this is known by the general name "practical wisdom"; of the other kinds one is called household management, another legislation, the third politics, and of the latter one part is called deliberative and the other judicial. Now knowing what is good for oneself will be one kind of knowledge, but it is very different from the other kinds; and the man who knows and concerns himself with his own interests is thought to have practical wisdom, while politicians are thought to be busybodies; hence the words of Euripides:

> *But how could I be wise, who might at ease,*
> *Numbered among the army's multitude,*
> *Have had an equal share? . . .*
> *For those who aim too high and do too much. . . .*

Those who think thus seek their own good, and consider that one ought to do so. From this opinion, then, has come the view that such men have practical wisdom; yet perhaps one's own good cannot exist without household management, nor without a form of government. Further, how one should order one's own affairs is not clear and needs inquiry.

What has been said is confirmed by the fact that while young men become geometricians and mathematicians and wise in matters like these, it is thought that a young man of practical wisdom cannot be found. The cause is that such wisdom is concerned not only with universals but with particulars, which become familiar from experience, but a young man has no experience, for it is length of time that gives experience; indeed one might ask this question too, why a boy may become a mathematician, but not a philosopher or a physicist. Is it because the objects of mathematics exist by abstraction, while the first principles of these other subjects come from experience, and because young men have no conviction

about the latter but merely use the proper language, while the essence of mathematical objects is plain enough to them?

Further, error in deliberation may be either about the universal or about the particular; we may fail to know either that all water that weighs heavy is bad, or that this particular water weighs heavy.

That practical wisdom is not scientific knowledge is evident; for it is, as has been said, concerned with the ultimate particular fact, since the thing to be done is of this nature. It is opposed, then, to intuitive reason; for intuitive reason is of the limiting premises, for which no reason can be given, while practical wisdom is concerned with the ultimate particular, which is the object not of scientific knowledge but of perception—not the perception of qualities peculiar to one sense but a perception akin to that by which we perceive that the particular figure before us is a triangle; for in that direction as well there will be a limit. But this is rather perception than practical wisdom, though it is another kind of perception than that of the qualities peculiar to each sense.

Relation of Philosophic to Practical Wisdom

What is the use of philosophic and of practical wisdom? Philosophic wisdom is the formal cause of happiness; practical wisdom is what ensures the taking of proper means to the proper ends desired by moral virtue

12. Difficulties might be raised as to the utility of these qualities of mind. For (1) philosophic wisdom will contemplate none of the things that will make a man happy (for it is not concerned with any coming into being), and though practical wisdom has *this* merit, for what purpose do we need it? Practical wisdom is the quality of mind concerned with things just and noble and good for man, but these are the things which it is the mark of a *good* man to do, and we are none the more able to act for *knowing* them if the virtues are states of *character,* just as we are none the better able to act for knowing the things that are healthy and sound, in the sense not of producing but of issuing from the state of health; for we

are none the more able to act for having the art of medicine or of gymnastics. But (2) if we are to say that a man should have practical wisdom not for the sake of knowing moral truths but for the sake of becoming good, practical wisdom will be of no use to those who *are* good; but again it is of no use to those who have *not* virtue; for it will make no difference whether they have practical wisdom themselves or obey others who have it, and it would be enough for us to do what we do in the case of health; though we wish to become healthy, yet we do not learn the art of medicine. (3) Besides this, it would be thought strange if practical wisdom, being inferior to philosophic wisdom, is to be put in authority over it, as seems to be implied by the fact that the art which produces anything rules and issues commands about that thing.

These, then, are the questions we must discuss; so far we have only stated the difficulties.

(1) Now first let us say that in themselves these states must be worthy of choice because they are the virtues of the two parts of the soul respectively, even if neither of them produces anything.

(2) Secondly, they do produce something, not as the art of medicine produces health, however, but as health produces health; so does philosophic wisdom produce happiness; for, being a part of virtue entire, by being possessed and by actualizing itself it makes a man happy.

(3) Again, the work of man is achieved only in accordance with practical wisdom as well as with moral virtue; for virtue makes us aim at the right mark, and practical wisdom makes us take the right means. (Of the fourth part of the soul—the nutritive—there is no such virtue; for there is nothing which it is in its power to do or nor to do.)

(4) With regard to our being none the more able to do because of our practical wisdom what is noble and just, let us begin a little further back, starting with the following principle. As we say that some people who do just acts are not necessarily just, i.e. those who do the acts ordained by the laws either unwillingly or owing to ignorance or for some other reason and not for the sake of the acts themselves (though, to be

sure, they do what they should and all the things that the good man ought), so is it, it seems, that in order to be good one must be in a certain state when one does the several acts, i.e. one must do them as a result of choice and for the sake of the acts themselves. Now virtue makes the choice right, but the question of the things which should naturally be done to carry out our choice belongs not to virtue but to another faculty. We must devote our attention to these matters and give a clearer statement about them. There is a faculty which is called cleverness; and this is such as to be able to do the things that tend towards the mark we have set before ourselves, and to hit it. Now if the mark be noble, the cleverness is laudable, but if the mark be bad, the cleverness is mere smartness; hence we call even men of practical wisdom clever or smart. Practical wisdom is not the faculty, but it does not exist without this faculty. And this eye of the soul acquires its formed state not without the aid of virtue, as has been said and is plain; for the syllogisms which deal with acts to be done are things which involve a starting-point, viz. "since the end, i.e. what is best, is of such and such a nature," whatever it may be (let it for the sake of argument be what we please); and this is not evident except to the good man; for wickedness perverts us and causes us to be deceived about the starting-points of action. Therefore it is evident that it is impossible to be practically wise without being good.

Relation of practical wisdom to natural virtue, moral virtue, and the right rule

13. We must therefore consider virtue also once more; for virtue too is similarly related; as practical wisdom is to cleverness—not the same, but like it—so is natural virtue to virtue in the strict sense. For all men think that each type of character belongs to its possessors in some sense by nature; for from the very moment of birth we are just or fitted for self-control or brave or have the other moral qualities; but yet we seek something else as that which is good in the strict sense—we seek for the presence of such qualities in another way. For both children and brutes have the natural dispositions to these qualities, but without reason these are

evidently hurtful. Only we seem to see this much, that, while one may be led astray by them, as a strong body which moves without sight may stumble badly because of its lack of sight, still, if a man once acquires reason, that makes a difference in action; and his state, while still like what it was, will then be virtue in the strict sense. Therefore, as in the part of us which forms opinions there are two types, cleverness and practical wisdom, so too in the moral part there are two types, natural virtue and virtue in the strict sense, and of these the latter involves practical wisdom. This is why some say that all the virtues are forms of practical wisdom, and why Socrates in one respect was on the right track while in another he went astray; in thinking that all the virtues were forms of practical wisdom he was wrong, but in saying they implied practical wisdom he was right. This is confirmed by the fact that even now all men, when they define virtue, after naming the state of character and its objects add "that (state) which is in accordance with the right rule"; now the right rule is that which is in accordance with practical wisdom. All men, then, seem somehow to divine that this kind of state is virtue, viz. that which is in accordance with practical wisdom. But we must go a little further. For it is not merely the state in accordance with the right rule, but the state that implies the *presence* of the right rule, that is virtue; and practical wisdom is a right rule about such matters. Socrates, then, thought the virtues were rules or rational principles (for he thought they were, all of them, forms of scientific knowledge), while we think they *involve* a rational principle.

It is clear, then, from what has been said, that it is not possible to be good in the strict sense without practical wisdom, or practically wise without moral virtue. But in this way we may also refute the dialectical argument whereby it might be contended that the virtues exist in separation from each other; the same man, it might be said, is not best equipped by nature for all the virtues, so that he will have already acquired one when he has not yet acquired another. This is possible in respect of the natural virtues, but not in respect of those in respect of which a man is called without qualification good; for with the presence of the one quality, practical wisdom, will be given all the virtues. And it is plain that, even if it

were of no practical virtue, we should have needed it because it is the virtue of the part of us in question; plain too that the choice will not be right without practical wisdom any more than without virtue; for the one determines the end and the other makes us do the things that lead to the end.

But again it is not *supreme* over philosophic wisdom, i.e. over the superior part of us, any more than the art of medicine is over health; for it does not use it but provides for its coming into being; it issues orders, then, for its sake, but not to it. Further, to maintain its supremacy would be like saying that the art of politics rules the gods because it issues orders about all the affairs of the state.

BOOK VII • CONTINENCE AND INCONTINENCE: PLEASURE

Continence and Incontinence

Six varieties of character: method of treatment: current opinions

1. Let us now make a fresh beginning and point out that of moral states to be avoided there are three kinds—vice, incontinence, brutishness. The contraries of two of these are evident—one we call virtue, the other continence; to brutishness it would be most fitting to oppose superhuman virtue, a heroic and divine kind of virtue, as Homer has represented Priam saying of Hector that he was very good,

> *For he seemed not, he,*
> *The child of a mortal man, but as one that of God's*
> *seed came.*

Therefore if, as they say, men become gods by excess of virtue, of this kind must evidently be the state opposed to the brutish state: for as a brute has no vice or virtue, so neither has a god; his state is higher than virtue, and that of a brute is a different kind of state from vice.

Now, since it is rarely that a godlike man is found—to use the epithet of the Spartans, who when they admire anyone highly call him a "godlike man"—so too the brutish type is rarely found among men; it is found chiefly among barbarians, but some brutish qualities are also produced by disease or deformity; and we also call by this evil name those who surpass ordinary men in vice. Of this kind of disposition, however, we must later make some mention, while we have discussed vice before; we must now discuss incontinence and softness (or effeminacy), and continence and endurance; for we must treat each of the two neither as identical with virtue or wickedness, nor as a different genus. We must, as in all other cases, set the apparent facts before us and, after first discussing the difficulties, go on to prove, if possible, the truth of all the common opinions about these affections of the mind, or, failing this, of the greater number and the most authoritative; for if we both resolve the difficulties and leave the common opinions undisturbed, we shall have proved the case sufficiently.

Now (1) both continence and endurance are thought to be included among things good and praiseworthy, and both incontinence and softness among things bad and blameworthy; and the same man is thought to be continent and ready to abide by the result of his calculations, or incontinent and ready to abandon them. And (2) the incontinent man, knowing that what he does is bad, does it as a result of passion, while the continent man, knowing that his appetites are bad, refuses on account of his rational principle to follow them. (3) The temperate man all men call continent and disposed to endurance, while the continent man some maintain to be always temperate but others do not; and some call the self-indulgent man incontinent and the incontinent man self-indulgent indiscriminately, while others distinguish them. (4) The man of practical wisdom, they sometimes say, cannot be incontinent, while sometimes they say that some who are practically wise and clever *are* incontinent. Again, (5) men are said to be incontinent even with respect to anger, honour, and gain.—These, then, are the things that are said.

Contradictions involved in the current opinions

2. Now we may ask (1) what kind of right judgement has the man who behaves incontinently?

That he should behave so when he has knowledge, some say is impossible; for it would be strange—so Socrates thought—if when knowledge was in a man something else could master it and drag it about like a slave. For *Socrates* was entirely opposed to the view in question, holding that there is no such thing as incontinence; no one, he said, when he judges acts against what he judges best—people act so only by reason of ignorance. Now this view plainly contradicts the apparent facts, and we must inquire about what happens to such a man; if he acts by reason of ignorance, what is the manner of his ignorance? For that the man who behaves incontinently does not, before he gets into this state, *think* he ought to act so, is evident. But there are *some* who concede certain of Socrates' contentions but not others; that nothing is stronger than knowledge they admit, but not that no one acts contrary to what has seemed to him the better course, and therefore they say that the incontinent man has not knowledge when he is mastered by his pleasures, but opinion. But *if* it is opinion and not knowledge, if it is not a strong conviction that resists but a weak one, as in men who hesitate, we sympathize with their failure to stand by such convictions against strong appetites; but we do not sympathize with wickedness, nor with any of the other blameworthy states. Is it then *practical wisdom* whose resistance is mastered? That is the strongest of all states. But this is absurd; the same man will be at once practically wise and incontinent, but *no one* would say that it is the part of a practically wise man to do willingly the basest acts. Besides, it has been shown before that the man of practical wisdom is one who will *act* (for he is a man concerned with the individual facts) and who has the other virtues.

(2) Further, if continence involves having strong and bad appetites, the temperate man will not be continent nor the continent man temperate; for a temperate man will have neither excessive nor bad appetites. But the continent man *must;* for if the appetites are good, the state of character that restrains us from following them is bad, so that not all continence will be good; while if they are weak and not bad, there is nothing admirable in resisting them, and if they are weak and bad, there is nothing great in resisting these either.

(3) Further, if continence makes a man ready to stand by any and every opinion, it is bad, i.e. if it makes him stand even by a false opinion; and if incontinence makes a man apt to abandon any and every opinion, there will be a good incontinence, of which Sophocles, Neoptolemus in the *Philoctetes* will be an instance; for he is to be praised for not standing by what Odysseus persuaded him to do, because he is pained at telling a lie.

(4) Further, the sophistic argument presents a difficulty; the syllogism arising from men's wish to expose paradoxical results arising from an opponent's view, in order that they may be admired when they succeed, is one that puts us in a difficulty (for thought is bound fast when it will not rest because the conclusion does not satisfy it, and cannot advance because it cannot refute the argument). There is an argument from which it follows that folly coupled with incontinence is virtue; a man does the opposite of what he thinks right, owing to incontinence, but thinks what is good to be evil and something that he should not do, and in consequence he will do what is good and not what is evil.

(5) Further, he who on conviction does and pursues and chooses what is pleasant would be thought to be better than one who does so as a result not of calculation but of incontinence; for he is easier to cure since he may be persuaded to change his mind. But to the incontinent man may be applied the proverb "When water chokes, what is one to wash it down with?" If he had been persuaded of the rightness of what he does, he would have desisted when he was persuaded to change his mind; but now he acts in spite of his being persuaded of something quite different.

(6) Further, if incontinence and continence are concerned with any and every kind of object, who is it that is incontinent in the unqualified sense? No one has all the forms of incontinence, but we say some people are incontinent without qualification.

Solution of the problem, how the incontinent man's knowledge is impaired

3. Of some such kind are the difficulties that arise; some of these points must be refuted and the others left in possession of the field; for the solution of the difficulty is the discovery of the truth. (1) We must consider first, then, whether incontinent people act knowingly or not, and with what sort of knowledge; then (2) with what sorts of object the incontinent and the continent man may be said to be concerned (i.e. whether with any and every pleasure and pain or with certain determinate kinds), and whether the continent man and the man of endurance are the same or different; and similarly with regard to the other matters germane to this inquiry. The starting-point of our investigation is *(a)* the question whether the continent man and the incontinent are differentiated by their objects or by their attitude, i.e. whether the incontinent man is incontinent simply by being concerned with such-and-such objects, or, instead, by his attitude, or, instead of that, by both these things; *(b)* the second question is whether incontinence and continence are concerned with any and every object or not. The man who is incontinent in the unqualified sense neither is concerned with any and every object, but with precisely those with which the self-indulgent man is concerned, nor is he characterized by being simply related to these (for then his state would be the same as self-indulgence), but by being related to them in a certain way. For the one is led on in accordance with his own choice, thinking that he ought always to pursue the present pleasure; while the other does not think so, but yet pursues it.

(1) As for the suggestion that it is true opinion and not knowledge against which we act incontinently, that makes no difference to the argument; for some people when in a state of opinion do not hesitate, but think they know exactly. If, then, the notion is that owing to their weak conviction those who have opinion are more likely to act against their judgement than those who know, we answer that there need be no difference between knowledge and opinion in this respect; for some men are no less convinced of what they think than others of what they know; as is shown by the case of Heraclitus. But *(a)*, since we use the word "know" in two senses (for both the man who has knowledge but is not using it and he who is using it are said to know), it *will* make a difference

whether, when a man does what he should not, he has the knowledge but is not exercising it, or is exercising it; for the latter seems strange, but not the former.

(b) Further, since there are two kinds of premisses, there is nothing to prevent a man's having both premisses and acting against his knowledge, provided that he is using only the universal premiss and not the particular; for it is particular acts that have to be done. And there are also two kinds of universal term; one is predictable of the agent, the other of the object; e.g. "dry food is good for every man," and "I am a man," or "such-and-such food is dry"; but whether "this food is such-and-such," of this the incontinent man either has not or is not exercising the knowledge. There will, then, be, firstly, an enormous difference between these manners of knowing, so that to know in one way when we act incontinently would not seem anything strange, while to know in the other way would be extraordinary.

And further *(c)* the possession of knowledge in another sense than those just named is something that happens to men; for within the case of having knowledge but not using it we see a difference of state, admitting of the possibility of having knowledge in a sense and yet not having it, as in the instance of a man asleep, mad, or drunk. But now this is just the condition of men under the influence of passions; for outbursts of anger and sexual appetites and some other such passions, it is evident, actually alter our bodily condition, and in some men even produce fits of madness. It is plain, then, that incontinent people must be said to be in a similar condition to men asleep, mad, or drunk. The fact that men use the language that flows from knowledge proves nothing; for even men under the influence of these passions utter scientific proofs and verses of Empedocles, and those who have just begun to learn a science can string together its phrases, but do not yet know it; for it has to become part of themselves, and that takes time; so that we must suppose that the use of language by men in an incontinent state means no more than its utterance by actors on the stage.

(d) Again, we may also view the cause as follows in the way a student of nature would. The one opinion is universal, the other is concerned with the particular facts, and here we come to something within

the sphere of perception; when a single opinion results from the two, the soul must in one type of case affirm the conclusion, while in the case of opinions concerned with production it must immediately act (e.g. if "everything sweet ought to be tasted," and "this is sweet," in the sense of being one of the particular sweet things, the man who can act and is not restrained must at the same time actually act accordingly). When, then, the universal opinion is present in us restraining us from tasting, and there is also the opinion that "everything sweet is pleasant," and that "this is sweet" (now this is the opinion that is active), and when appetite happens to be present in us, the one opinion bids us avoid the object, but appetite leads us towards it (for it can move each of our bodily parts); so that it turns out that a man behaves incontinently under the influence (in a sense) of a rule and an opinion, and of one not contrary in itself, but only incidentally—for the appetite is contrary, not the opinion—to the right rule. It also follows that this is the reason why the lower animals are not incontinent, viz. because they have no universal judgement but only imagination and memory of particulars.

The explanation of how the ignorance is dissolved and the incontinent man regains his knowledge, is the same as in the case of the man drunk or asleep and is not peculiar to this condition; we must go to the students of natural science for it. Now, the last premiss being an opinion about a perceptible object, and being also what determines our actions, this a man either has not when he is in the state of passion, or has it in the sense in which having knowledge did not mean knowing but only talking, as a drunken man may mutter the verses of Empedocles. And because the last term is not universal nor equally an object of scientific knowledge with the universal term, the position that Socrates sought to establish actually seems to result; for it is not in the presence of what is thought to be knowledge proper that the passion occurs (nor is it this that is "dragged about" as a result of the passion), but in that of perceptual knowledge.

This must suffice as our answer to the question of whether an incontinent man acts knowingly or not, and with what sort of knowledge it is possible to be incontinent.

BOOK VIII • FRIENDSHIP

Kinds of Friendship

Friendship both necessary and noble: main questions about it

1. After what we have said, a discussion of friendship would naturally follow, since it is a virtue or implies virtue, and is besides most necessary with a view to living. For without friends no one would choose to live, though he had all other goods; even rich men and those in possession of office and of dominating power are thought to need friends most of all; for what is the use of such prosperity without the opportunity of beneficence, which is exercised chiefly and in its most laudable form towards friends? Or how can prosperity be guarded and preserved without friends? The greater it is, the more exposed is it to risk. And in poverty and in other misfortunes men think friends are the only refuge. It helps the young, too, to keep from error; it aids older people by ministering to their needs and supplementing the activities that are failing from weakness; those in the prime of life it stimulates to noble actions—"two going together"—for with friends men are more able both to think and to act. Again, parent seems by nature to feel it for offspring and offspring for parent, not only among men but among birds and among most animals; it is felt mutually by members of the same race, and especially by men, whence we praise lovers of their fellow men. We may see even in our travels how near and dear every man is to every other. Friendship seems too to hold states together, and lawgivers to care more for it than for justice; for concord seems to be something like friendship, and this they aim at most of all, and expel faction as their worst enemy; and when men are friends they have no need of justice, while when they are just they need friendship as well, and the truest form of justice is thought to be a friendly quality.

But it is not only necessary but also noble; for we praise those who love their friends, and it is thought to be a fine thing to have many friends; and again we think it is the same people that are good men and are friends.

Not a few things about friendship are matters of debate. Some define it as a kind of likeness and say like people are friends, whence come the sayings "like to like," "Birds of a feather flock together," and so on; others on the contrary say "Two of a trade never agree." On this very question they inquire for deeper and more physical causes, Euripides saying that "Parched earth loves the rain, and stately heaven when filled with rain loves to fall to earth," and Heraclitus that "It is what opposes that helps" and "From different tones comes the fairest tune" and "all things are produced through strife"; while Empedocles, as well as others, expresses the opposite view that like aims at like. The physical problems we may leave alone (for they do not belong to the present inquiry); let us examine those which are human and involve character and feeling, e.g. whether friendship can arise between any two people or people cannot be friends if they are wicked, and whether there is one species of friendship or more than one. Those who think there is only one because it admits of degrees have relied on an inadequate indication; for even things different in species admit of degree. We have discussed this matter previously.

Three objects of love: implications of friendship

2. The kinds of friendship may perhaps be cleared up if we first come to know the object of love. For not everything seems to be loved but only the lovable, and this is good, pleasant, or useful; but it would seem to be that by which some good or pleasure is produced that is useful, so that it is the good and the pleasant that are lovable as ends. Do men love, then, *the* good, or what is good *for them?* These sometimes clash. So too with regard to the pleasant. Now it is thought that each loves what is good for himself, and that the good is without qualification lovable, and what is good for each man is lovable for him; but each man loves not what is good for him but what seems good. This however will make no difference; we shall just have to say that this is "that which seems lovable." Now there are three grounds on which people love: of the love of lifeless objects we do not use the word "friendship," for it is not mutual love, nor is there a wishing

of good to the other (for it would surely be ridiculous to wish wine well; if one wishes anything for it, it is that it may keep, so that one may have it oneself); but to a friend we say we ought to wish what is good for his sake. But to those who thus wish good we ascribe only goodwill, if the wish is not reciprocated; goodwill when it *is* reciprocal being friendship. Or must we add "when it is recognized"? For many people have goodwill to those whom they have not seen but judge to be good or useful; and one of these might return this feeling. These people seem to bear goodwill to each other; but how could one call them friends when they do not know their mutual feelings? To be friends, then, they must be mutually recognized as bearing goodwill and wishing well to each other for one of the aforesaid reasons.

Three corresponding kinds of friendship: superiority of friendship whose motive is good

3. Now these reasons differ from each other in kind; so, therefore, do the corresponding forms of love and friendship. There are therefore three kinds of friendship, equal in number to the things that are lovable; for with respect to each there is a mutual and recognized love, and those who love each other wish well to each other in that respect in which they love one another. Now those who love each other for their utility do not love each other for themselves but in virtue of some good which they get from each other. So too with those who love for the sake of pleasure; it is not for their character that men love ready-witted people, but because they find them pleasant. Therefore those who love for the sake of utility love for the sake of what is good *for themselves,* and those who love for the sake of pleasure do so for the sake of what is pleasant *to themselves,* and not in so far as the other is the person loved but in so far as he is useful or pleasant. And thus these friendships are only incidental; for it is not as being the man he is that the loved person is loved, but as providing some good or pleasure. Such friendships, then, are easily dissolved, if the parties do not remain like themselves; for if the one party is no longer pleasant or useful the other ceases to love him.

Now the useful is not permanent but is always changing. Thus when the motive of the friendship is done away, the friendship is dissolved, inasmuch as it existed only for the ends in question. This kind of friendship seems to exist chiefly between old people (for at that age people pursue not the pleasant but the useful) and, of those who are in their prime or young, between those who pursue utility. And such people do not live much with each other either; for sometimes they do not even find each other pleasant; therefore they do not need such companionship unless they are useful to each other; for they are pleasant to each other only in so far as they rouse in each other hopes of something good to come. Among such friendships people also class the friendship of host and guest. On the other hand the friendship of young people seems to aim at pleasure; for they live under the guidance of emotion, and pursue above all what is pleasant to themselves and what is immediately before them; but with increasing age their pleasures become different. This is why they quickly become friends and quickly cease to be so; their friendship changes with the object that is found pleasant, and such pleasure alters quickly. Young people are amorous too; for the greater part of the friendship of love depends on emotion and aims at pleasure; this is why they fall in love and quickly fall out of love, changing often within a single day. But these people do wish to spend their days and lives together; for it is thus that they attain the purpose of their friendship.

Perfect friendship is the friendship of men who are good, and alike in virtue; for these wish well alike to each other *qua* good, and they are good in themselves. Now those who wish well to their friends for their sake are most truly friends; for they do this by reason of their own nature and not incidentally; therefore their friendship lasts as long as they are good—and goodness is an enduring thing. And each is good without qualification and to his friend, for the good are both good without qualification and useful to each other. So too they are pleasant; for the good are pleasant both without qualification and to each other, since to each his own activities and others like them are pleasurable, and the actions of the good *are* the same or like. And such a friendship is, as might

be expected, permanent, since there meet in it all the qualities that friends should have. For all friendship is for the sake of good or of pleasure—good or pleasure either in the abstract or such as will be enjoyed by him who has the friendly feeling—and is based on a certain resemblance; and to a friendship of good men all the qualities we have named belong in virtue of the nature of the friends themselves; for in the case of this kind of friendship the other qualities also are alike in both friends, and that which is good without qualification is also without qualification pleasant, and these are the most lovable qualities. Love and friendship therefore are found most and in their best form between such men.

But it is natural that such friendships should be infrequent; for such men are rare. Further, such friendship requires time and familiarity; as the proverb says, men cannot know each other till they have "eaten salt together," nor can they admit each other to friendship or be friends till each has been found lovable and been trusted by each. Those who quickly show the marks of friendship to each other wish to be friends, but are not friends unless they both are lovable and know the fact; for a wish for friendship may arise quickly, but friendship does not.

Relation of Reciprocity in Friendship to That Involved in Other Forms of Community

Parallelism of friendship and justice: the state comprehends all lesser communities

9. Friendship and justice seem, as we have said at the outset of our discussion, to be concerned with the same objects and exhibited between the same persons. For in every community there is thought to be some form of justice, and friendship too; at least men address as friends their fellow voyagers and fellow soldiers, and so too those associated with them in any other kind of community. And the extent of their association is the extent of their friendship, as it is the extent to which justice exists between them. And the proverb "What friends have is common property" expresses the truth; for friendship depends on community. Now brothers and comrades have all things

in common, but the others to whom we have referred have definite things in common—some more things, others fewer; for of friendships, too, some are more and others less truly friendships. And the claims of justice differ too; the duties of parents to children and those of brothers to each other are not the same, nor those of comrades and those of fellow citizens, and so, too, with the other kinds of friendship. There is a difference, therefore, also between the acts that are unjust towards each of these classes of associates, and the injustice increases by being exhibited towards those who are friends in a fuller sense; e.g. it is a more terrible thing to defraud a comrade than a fellow citizen, more terrible not to help a brother than a stranger, and more terrible to wound a father than anyone else. And the demands of justice also seem to increase with the intensity of the friendship, which implies that friendship and justice exist between the same persons and have an equal extension.

Now all forms of community are like parts of the political community; for men journey together with a view to some particular advantage, and to provide something that they need for the purposes of life; and it is for the sake of advantage that the political community too seems both to have come together originally and to endure, for this is what legislators aim at, and they call just that which is to the common advantage. Now the other communities aim at advantage bit by bit, e.g. sailors at what is advantageous on a voyage with a view to making money or something of the kind, fellow soldiers at what is advantageous in war, whether it is wealth or victory or the taking of a city that they seek, and members of tribes and demes act similarly [Some communities seem to arise for the sake of pleasure, viz. religious guilds and social clubs; for these exist respectively for the sake of offering sacrifice and of companionship. But all these seem to fall under the political community; for it aims not at present advantage but at what is advantageous for life as a whole], offering sacrifices and arranging gatherings for the purpose, and assigning honours to the gods, and providing pleasant relaxations for themselves. For the ancient sacrifices and gatherings seem to take place after the harvest as a sort of firstfruits, because it was at these seasons

that people had most leisure. All the communities, then, seem to be parts of the political community; and the particular kinds of friendship will correspond to the particular kinds of community.

BOOK IX • FRIENDSHIP (*cont.*)

Internal Nature of Friendship

Friendship is based on self-love

4. Friendly relations with one's neighbours, and the marks by which friendships are defined, seem to have proceeded from a man's relations to himself. For (1) we define a friend as one who wishes and does what is good, or seems so, for the sake of his friend, or (2) as one who wishes his friend to exist and live, for his sake; which mothers do to their children, and friends do who have come into conflict. And (3) others define him as one who lives with and (4) has the same tastes as another, or (5) one who grieves and rejoices with his friend; and this too is found in mothers most of all. It is by some one of these characteristics that friendship too is defined.

Now each of these is true of the good man's relation to himself (and of all other men in so far as they think themselves good; virtue and the good man seem, as has been said, to be the measure of every class of things). For his opinions are harmonious, and he desires the same things with all his soul; and therefore he wishes for himself what is good and what seems so, and does it (for it is characteristic of the good man to work out the good), and does so for his own sake (for he does it for the sake of the intellectual element in him, which is thought to be the man himself); and he wishes himself to live and be preserved, and especially the element by virtue of which he thinks. For existence is good to the virtuous man, and each man wishes himself what is good, while no one chooses to possess the whole world if he has first to become someone else (for that matter, even now God possesses the good); he wishes for this only on condition of being whatever he is; and the element that thinks would seem to be the individual man, or

to be so more than any other element in him. And such a man wishes to live with himself; for he does so with pleasure, since the memories of his past acts are delightful and his hopes for the future are good, and therefore pleasant. His mind is well stored too with subjects of contemplation. And he grieves and rejoices, more than any other, with himself; for the same thing is always painful, and the same thing always pleasant, and not one thing at one time and another at another; he has, so to speak, nothing to regret.

Therefore, since each of these characteristics belongs to the good man in relation to himself, and he is related to his friend as to himself (for his friend is another self), friendship too is thought to be one of these attributes, and those who have these attributes to be friends. Whether there is or is not friendship between a man and himself is a question we may dismiss for the present; there would seem to be friendship in so far as he is two or more, to judge from the aforementioned attributes of friendship, and from the fact that the extreme of friendship is likened to one's love for oneself.

But the attributes named seem to belong even to the majority of men, poor creatures though they may be. Are we to say then that in so far as they are satisfied with themselves and think they are good, they share in these attributes? Certainly no one who is thoroughly bad and impious has these attributes, or even seems to do so. They hardly belong even to inferior people; for *they* are at variance with themselves, and have appetites for some things and rational desires for others. This is true, for instance, of incontinent people; for they choose, instead of the things they themselves think good, things that are pleasant but hurtful; while others again, through cowardice and laziness, shrink from doing what they think best for themselves. And those who have done many terrible deeds and are hated for their wickedness even shrink from life and destroy themselves. Besides, wicked men seek for people with whom to spend their days, and shun themselves; for they remember many a grievous deed, and anticipate others like them, when they are by themselves, but when they are with others they forget. And having nothing lovable in them they

have no feeling of love to themselves. Therefore also such men do not rejoice or grieve with themselves; for their soul is rent by faction, and one element in it by reason of its wickedness grieves when it abstains from certain acts, while the other part is pleased, and one draws them this way and the other that, as if they were pulling them in pieces. If a man cannot at the same time be pained and pleased, at all events after a short time he is pained *because* he was pleased, and he could have wished that these things had not been pleasant to him; for bad men are full of regrets.

Therefore the bad man does not seem to be amicably disposed even to himself, because there is nothing in him to love; so that if to be thus is the height of wretchedness, we should strain every nerve to avoid wickedness and should endeavour to be good; for so and only so can one be either friendly to oneself or a friend to another.

The pleasure of beneficence

7. Benefactors are thought to love those they have benefited, more than those who have been well treated love those that have treated them well, and this is discussed as though it were paradoxical. Most people think it is because the latter are in the position of debtors and the former of creditors; and therefore as, in the case of loans, debtors wish their creditors did not exist, while creditors actually take care of the safety of their debtors, so it is thought that benefactors wish the objects of their action to exist since they will then get their gratitude, while the beneficiaries take no interest in making this return. Epicharmus would perhaps declare that they say this because they "look at things on their bad side," but it is quite like human nature; for most people are forgetful, and are more anxious to be well treated than to treat others well. But the cause would seem to be more deeply rooted in the nature of things; the case of those who have lent money is not even analogous. For they have no friendly feeling to their debtors, but only a wish that they may be kept safe with a view to what is to be got from them; while those who have done a service to others feel friendship and love for those they have served, even if these

are not of any use to them and never will be. This is what happens with craftsmen too; every man loves his own handiwork better than he would be loved by it if it came alive; and this happens perhaps most of all with poets; for they have an excessive love for their own poems, doting on them as if they were their children. This is what the position of benefactors is like; for that which they have treated well is their handiwork, and therefore they love this more than the handiwork does its maker. The cause of this is that existence is to all men a thing to be chosen and loved, and that we exist by virtue of activity (i.e. by living and acting), and that the handiwork *is,* in a sense, the producer in activity; he loves his handiwork, therefore, because he loves existence. And this is rooted in the nature of things; for what he is in potentiality, his handiwork manifests in activity.

At the same time, to the benefactor that is noble which depends on his action, so that he delights in the object of his action, whereas to the patient there is nothing noble in the agent, but at most something advantageous, and this is less pleasant and lovable. What *is* pleasant is the activity of the present, the hope of the future, the memory of the past; but most pleasant is that which depends on activity, and similarly this is most lovable. Now for a man who has made something his work remains (for the noble is lasting), but for the person acted on the utility passes away. And the memory of noble things is pleasant, but that of useful things is not likely to be pleasant; or is less so; though the reverse seems true of expectation.

Further, love is like activity, being loved like passivity; and loving and its concomitants are attributes of those who are the more active.

Again, all men love more what they have won by labour; e.g. those who have made their money love it more than those who have inherited it; and to be well treated seems to involve no labour, while to treat others well is a laborious task. These are the reasons, too, why mothers are fonder of their children than fathers; bringing them into the world costs them more pains, and they know better that the children are their own. This last point, too, would seem to apply to benefactors.

The nature of true self-love

8. The question is also debated, whether a man should love himself most, or someone else. People criticize those who love themselves most, and call them self-lovers, using this as an epithet of disgrace, and a bad man seems to do everything for his own sake, and the more so the more wicked he is—and so men reproach him, for instance, with doing nothing of his own accord—while the good man acts for honour's sake, and the more so the better he is, and acts for his friend's sake, and sacrifices his own interest.

But the facts clash with these arguments, and this is not surprising. For men say that one ought to love best one's best friend, and a man's best friend is one who wishes well to the object of his wish for his sake, even if no one is to know of it; and these attributes are found most of all in a man's attitude towards himself, and so are all the other attributes by which a friend is defined; for, as we have said, it is from this relation that all the characteristics of friendship have extended to our neighbours. All the proverbs, too, agree with this, e.g. "A single soul," and "What friends have is common property," and "Friendship is equality," and "Charity begins at home"; for all these marks will be found most in a man's relation to himself; he is his own best friend and therefore ought to love himself best. It is therefore a reasonable question, which of the two views we should follow; for both are plausible.

Perhaps we ought to mark off such arguments from each other and determine how far and in what respects each view is right. Now if we grasp the sense in which each school uses the phrase "lover of self," the truth may become evident. Those who use the term as one of reproach ascribe self-love to people who assign to themselves the greater share of wealth, honours, and bodily pleasures; for these are what most people desire, and busy themselves about as though they were the best of all things, which is the reason, too, why they become objects of competition. So those who are grasping with regard to these things gratify their appetites and in general their feelings and the irrational element of the soul; and most men are of this nature (which is the reason why the epithet

has come to be used as it is—it takes its meaning from the prevailing type of self-love, which is a bad one); justly, therefore, are men who are lovers of self in this way reproached for being so. That it is those who give themselves the preference in regard to objects of this sort that most people usually call lovers of self is plain; for if a man were always anxious that he himself, above all things, should act justly, temperately, or in accordance with any other of the virtues, and in general were always to try to secure for himself the honourable course, no one would call such a man a lover of self or blame him.

But such a man would seem more than the other a lover of self; at all events he assigns to himself the things that are noblest and best, and gratifies the most authoritative element in himself and in all things obeys this; and just as a city or any other systematic whole is most properly identified with the most authoritative element in it, so is a man; and therefore the man who loves this and gratifies it is most of all a lover of self. Besides, a man is said to have or not to have self-control according as his reason has or has not the control, on the assumption that this is the man himself; and the things men have done on a rational principle are thought most properly their own acts and voluntary acts. That this is the man himself, then, or is so more than anything else, is plain, and also that the good man loves most this part of him. Whence it follows that he is most truly a lover of self, of another type than that which is a matter of reproach, and as different from that as living according to a rational principle is from living as passion dictates, and desiring what is noble from desiring what seems advantageous. Those, then, who busy themselves in an exceptional degree with noble actions all men approve and praise; and if *all* were to strive towards what is noble and strain every nerve to do the noblest deeds, everything would be as it should be for the common weal, and everyone would secure for himself the goods that are greatest, since virtue is the greatest of goods.

Therefore the good man should be a lover of self (for he will both himself profit by doing noble acts, and will benefit his fellows), but the wicked man should not; for he will hurt both himself and his neighbours, following as he does evil passions. For the wicked man, what he does clashes with what he ought to do, but what the good man ought to do he does; for reason in each of its possessors chooses what is best for itself, and the good man obeys his reason. It is true of the good man too that he does many acts for the sake of his friends and his country, and if necessary dies for them; for he will throw away both wealth and honours and in general the goods that are objects of competition, gaining for himself nobility; since he would prefer a short period of intense pleasure to a long one of mild enjoyment, a twelvemonth of noble life to many years of humdrum existence, and one great and noble action to many trivial ones. Now those who die for others doubtless attain this result; it is therefore a great prize that they choose for themselves. They will throw away wealth too on condition that their friends will gain more; for while a man's friend gains wealth he himself achieves nobility; he is therefore assigning the greater good to himself. The same too is true of honour and office; all these things he will sacrifice to his friend; for this is noble and laudable for himself. Rightly then is he thought to be good, since he chooses nobility before all else. But he may even give up actions to his friend; it may be nobler to become the cause of his friend's acting than to act himself. In all the actions, therefore, that men are praised for, the good man is seen to assign to himself the greater share in what is noble. In this sense, then, as has been said, a man should be a lover of self; but in the sense in which most men are so, he ought not.

The Need of Friendship

Why does the happy man need friends?

9. It is also disputed whether the happy man will need friends or not. It is said that those who are supremely happy and self-sufficient have no need of friends; for they have the things that are good, and therefore being self-sufficient they need nothing further, while a friend, being another self, furnishes what a man cannot provide by his own effort;

whence the saying "When fortune is kind, what need of friends?" But it seems strange, when one assigns all good things to the happy man, not to assign friends, who are thought the greatest of external goods. And if it is more characteristic of a friend to do well by another than to be well done by, and to confer benefits is characteristic of the good man and of virtue, and it is nobler to do well by friends than by strangers, the good man will need people to do well by. This is why the question is asked whether we need friends more in prosperity or in adversity, on the assumption that not only does a man in adversity need people to confer benefits on him, but also those who are prospering need people to do well by. Surely it is strange, too, to make the supremely happy man a solitary; for no one would choose the whole world on condition of being alone, since man is a political creature and one whose nature is to live with others. Therefore even the happy man lives with others; for he has the things that are by nature good. And plainly it is better to spend his days with friends and good men than with strangers or any chance persons. Therefore the happy man needs friends.

What then do holders of the first view mean, and in what respect are they right? Is it that most men identify friends with useful people? Of such friends indeed the supremely happy man will have no need, since he already has the things that are good; nor will he need those whom one makes one's friends because of their pleasantness, or he will need them only to a small extent (for his life, being pleasant, has no need of adventitious pleasure); and because he does not need *such* friends he is thought not to need friends.

But that is surely not true. For we have said at the outset that happiness is an activity; and activity plainly comes into being and is not present at the start like a piece of property. If (1) happiness lies in living and being active, and the good man's activity is virtuous and pleasant in itself, as we have said at the outset, and (2) a thing's being one's own is one of the attributes that make it pleasant, and (3) we can contemplate our neighbours better than ourselves and their actions better than our own, and if the actions of virtuous men who are their friends are pleasant to

good men (since these have both the attributes that are naturally pleasant)—if this be so, the supremely happy man will need friends of this sort, since his purpose is to contemplate worthy actions and actions that are his own, and the actions of a good man who is his friend have both these qualities.

Further, men think that the happy man ought to live pleasantly. Now if he were a solitary, life would be hard for him; for by oneself it is not easy to be continuously active, but with others and towards others it is easier. With others therefore his activity will be more continuous, and it is in itself pleasant, as it ought to be for the man who is supremely happy; for a good man *qua* good delights in virtuous actions and is vexed at vicious ones, as a musical man enjoys beautiful tunes but is pained at bad ones. A certain training in virtue arises also from the company of the good, as Theognis has said before us.

If we look deeper into the nature of things, a virtuous friend seems to be naturally desirable for a virtuous man. For that which is good by nature, we have said, is for the virtuous man good and pleasant in itself. Now life is defined in the case of animals by the power of perception, in that of man by the power of perception or thought; and a power is defined by reference to the corresponding activity, which is the essential thing; therefore life seems to be essentially the act of perceiving or thinking. And life is among the things that are good and pleasant in themselves, since it is determinate and the determinate is of the nature of the good; and that which is good by nature is also good for the virtuous man (which is the reason why life seems pleasant to all men); but we must not apply this to a wicked and corrupt life or to a life spent in pain; for such a life is indeterminate, as are its attributes. The nature of pain will become plainer in what follows. But if life itself is good and pleasant (which it seems to be, from the very fact that all men desire it, and particularly those who are good and supremely happy; for to such men life is most desirable, and their existence is the most supremely happy); and if he who sees perceives that he sees, and he who hears, that he hears, and he who walks, that he walks, and in the case of all other activities similarly there is something which perceives that we

are active, so that if we perceive, we perceive that we perceive, and if we think, that we think; and if to perceive that we perceive or think is to perceive that we exist (for existence was defined as perceiving or thinking); and if perceiving that one lives is in itself one of the things that are pleasant (for life is by nature good, and to perceive what is good present in oneself is pleasant); and if life is desirable, and particularly so for good men, because to them existence is good and pleasant (for they are pleased at the consciousness of the presence in them of what is in itself good); and if as the virtuous man is to himself, he is to his friend also (for his friend is another self)—if all this be true, as his own being is desirable for each man, so, or almost so, is that of his friend. Now his being was seen to be desirable because he perceived his own goodness, and such perception is pleasant in itself. He needs, therefore, to be conscious of the existence of his friend as well, and this will be realized in their living together and sharing in discussion and thought; for this is what living together would seem to mean in the case of man, and not, as in the case of cattle, feeding in the same place.

If, then, being is in itself desirable for the supremely happy man (since it is by its nature good and pleasant), and that of his friend is very much the same, a friend will be one of the things that are desirable. Now that which is desirable for him he must have, or he will be deficient in this respect. The man who is to be happy will therefore need virtuous friends.

The essence of friendship is living together

12. Does it not follow, then, that, as for lovers the sight of the beloved is the thing they love most, and they prefer this sense to the others because on it love depends most for its being and for its origin, so for friends the most desirable thing is living together? For friendship is a partnership, and as a man is to himself, so is he to his friend; now in his own case the consciousness of his being is desirable, and so therefore is the consciousness of his friend's being, and the activity of this consciousness is produced when they live together, so that it is natural that they

aim at this. And whatever existence means for each class of men, whatever it is for whose sake they value life, in *that* they wish to occupy themselves with their friends; and so some drink together, others dice together, others join in athletic exercises and hunting, or in the study of philosophy, each class spending their days together in whatever they love most in life; for since they wish to live with their friends, they do and share in those things which give them the sense of living together. Thus the friendship of bad men turns out an evil thing (for because of their instability they unite in bad pursuits, and besides they become evil by becoming like each other), while the friendship of good men is good, being augmented by their companionship; and they are thought to become better too by their activities and by improving each other; for from each other they take the mould of the characteristics they approve—whence the saying "Noble deeds from noble men."—So much, then, for friendship; our next task must be to discuss pleasure.

PLEASURE, HAPPINESS, ACTIVITY

BOOK X • PLEASURE, HAPPINESS

HAPPINESS NEEDS SELF-SUFFICIENCY

Definition of pleasure

WHAT TYPE OF LIFE LEADS TO MOST HAPPY LIFE

4. What pleasure is, or what kind of thing it is, will become plainer if we take up the question again from the beginning. Seeing seems to be at any moment complete, for it does not lack anything whose coming into being later will complete its form; and pleasure also seems to be of this nature. For it is a whole, and at no time can one find a pleasure whose form will be completed if the pleasure lasts longer. For this reason, too, it is not a movement. For every movement (e.g. that of building) takes time and is for the sake of an end, and is complete when it has made what it aims at. It is complete, therefore, only in the whole time or at that final moment. In their parts and during the time they occupy, all movements are incomplete, and are different in kind from the whole movement and from each other. For the fitting together of the stones is different from the fluting of the column, and these are both different

from the making of the temple; and the making of the temple is complete (for it lacks nothing with a view to the end proposed), but the making of the base or of the triglyph is incomplete; for each is the making of only a part. They differ in kind, then, and it is not possible to find at any and every time a movement complete in form, but if at all, only in the whole time. So, too, in the case of walking and all other movements. For if locomotion is a movement from here to there, it, too, has differences in kind—flying, walking, leaping, and so on. And not only so, but in walking itself there are such differences; for the whence and whither are not the same in the whole race-course and in a part of it, nor in one part and in another, nor is it the same thing to traverse this line and that; for one traverses not only a line but one which is in a place, and this one is in a different place from that. We have discussed movement with precision in another work, but it seems that it is not complete at any and every time, but that the many movements are incomplete and different in kind, since the whence and whither give them their form. But of pleasure the form is complete at any and every time. Plainly, then, pleasure and movement must be different from each other, and pleasure must be one of the things that are whole and complete. This would seem to be the case, too, from the fact that it is not possible to move otherwise than in time, but it *is* possible to be pleased; for that which takes place in a moment is a whole.

From these considerations it is clear, too, that these thinkers are not right in saying there is a movement or a coming into being *of* pleasure. For these cannot be ascribed to all things, but only to those that are divisible and not wholes; there is no coming into being of seeing nor of a point nor of a unit, nor is any of these a movement or coming into being; therefore there is no movement or coming into being of pleasure either, for it is a whole.

Since every sense is active in relation to its object, and a sense which is in good condition acts perfectly in relation to the most beautiful of its objects (for perfect activity seems to be ideally of this nature; whether we say that *it* is active, or the organ in which it resides, may be assumed to be immaterial), it follows that in the case of each sense the best activity is that of the best-conditioned organ in relation to the finest of its objects. And this activity will be the most complete and pleasant. For, while there is pleasure in respect of any sense, and in respect of thought and contemplation no less, the most complete is pleasant, and that of a well-conditioned organ in relation to the worthiest of its objects is the most complete; and the pleasure completes the activity. But the pleasure does not complete it in the same way as the combination of object and sense, both good, just as health and the doctor are not in the same way the cause of man's being healthy. (That pleasure is produced in respect to each sense is plain; for we speak of sights and sounds as pleasant. It is also plain that it arises most of all when both the sense is at its best and it is active in reference to an object which corresponds; when both object and perceiver are of the best there will always be pleasure, since the requisite agent and patient are both present.) Pleasure completes the activity not as the corresponding permanent state does, by its immanence, but as an end which supervenes as the bloom of youth does on those in the flower of their age. So long, then, as both the intelligible or sensible object and the discriminating or contemplative faculty are as they should be, the pleasure will be involved in the activity; for when both the passive and the active factor are unchanged and are related to each other in the same way, the same result naturally follows.

How, then, is it that no one is continuously pleased? Is it that we grow weary? Certainly all human things are incapable of continuous activity. Therefore pleasure also is not continuous; for it accompanies activity. Some things delight us when they are new, but later do so less, for the same reason; for at first the mind is in a state of stimulation and intensely active about them, as people are with respect to their vision when they look hard at a thing, but afterwards our activity is not of this kind, but has grown relaxed; for which reason the pleasure also is dulled.

One might think that all men desire pleasure because they all aim at life; life is an activity, and each man is active about those things and with those faculties that he loves most; e.g. the musician is active with his hearing in reference to tunes, the student

with his mind in reference to theoretical questions, and so on in each case; now pleasure completes the activities, and therefore life, which they desire. It is with good reason, then, that they aim at pleasure too, since for every one it completes life, which is desirable. But whether we choose life for the sake of pleasure or pleasure for the sake of life is a question we may dismiss for the present. For they seem to be bound up together and not to admit of separation, since without activity pleasure does not arise, and every activity is completed by the attendant pleasure.

Pleasures differ with the activities which they accompany and complete: criterion of the value of pleasures

5. For this reason pleasures seem, too, to differ in kind. For things different in kind are, we think, completed by different things (we see this to be true both of natural objects and of things produced by art, e.g. animals, trees, a painting, a sculpture, a house, an implement); and, similarly, we think that activities differing in kind are completed by things differing in kind. Now the activities of thought differ from those of the senses, and both differ among themselves, in kind; so, therefore, do the pleasures that complete them.

This may be seen, too, from the fact that each of the pleasures is bound up with the activity it completes. For an activity is intensified by its proper pleasure, since each class of things is better judged of and brought to precision by those who engage in the activity with pleasure; e.g. it is those who enjoy geometrical thinking that become geometers and grasp the various propositions better, and, similarly, those who are fond of music or of building, and so on, make progress in their proper function by enjoying it; so the pleasures intensify the activities, and what intensifies a thing is proper to it, but things different in kind have properties different in kind.

This will be even more apparent from the fact that activities are hindered by pleasures arising from other sources. For people who are fond of playing the flute are incapable of attending to arguments if they overhear someone playing the flute, since they enjoy flute-playing more than the activity in hand; so the pleasure connected with flute-playing destroys the activity concerned with argument. This happens, similarly, in all other cases, when one is active about two things at once; the more pleasant activity drives out the other, and if it is much more pleasant does so all the more, so that one even ceases from the other. This is why when we enjoy anything very much we do not throw ourselves into anything else, and do one thing only when we are not much pleased by another; e.g. in the theatre the people who eat sweets do so most when the actors are poor. Now since activities are made precise and more enduring and better by their proper pleasure, and injured by alien pleasures, evidently the two kinds of pleasure are far apart. For alien pleasures do pretty much what proper pains do, since activities are destroyed by their proper pains; e.g. if a man finds writing or doing sums unpleasant and painful, he does not write, or does not do sums, because the activity is painful. So an activity suffers contrary effects from its proper pleasures and pains, i.e. from those that supervene on it in virtue of its own nature. And alien pleasures have been stated to do much the same as pain; they destroy the activity, only not to the same degree.

Now since activities differ in respect of goodness and badness, and some are worthy to be chosen, others to be avoided, and others neutral, so, too, are the pleasures; for to each activity there is a proper pleasure. The pleasure proper to a worthy activity is good and that proper to an unworthy activity bad; just as the appetites for noble objects are laudable, those for base objects culpable. But the pleasures involved in activities are more proper to them than the desires; for the latter are separated both in time and in nature, while the former are close to the activities, and so hard to distinguish from them that it admits of dispute whether the activity is not the same as the pleasure. (Still, pleasure does not seem to *be* thought or perception—that would be strange; but because they are not found apart they appear to some people the same.) As activities are different, then, so are the corresponding pleasures. Now sight is superior to touch in purity, and hearing and smell to taste; the pleasures, therefore, are similarly superior, and those of

thought superior to these, and within each of the two kinds some are superior to others.

Each animal is thought to have a proper pleasure, as it has a proper function; viz. that which corresponds to its activity. If we survey then species by species, too, this will be evident; horse, dog, and man have different pleasures, as Heraclitus says "asses would prefer sweepings to gold"; for food is pleasanter than gold to asses. So the pleasures of creatures different in kind differ in kind; and it is plausible to suppose that those of a single species do not differ. But they vary to no small extent, in the case of men at least; the same things delight some people and pain others, and are painful and odious to some, and pleasant to and liked by others. This happens, too, in the case of sweet things; the same things do not seem sweet to a man in a fever and a healthy man—nor hot to a weak man and one in good condition. The same happens in other cases. But in all such matters that which appears to the good man is thought to be really so. If this is correct, as it seems to be, and virtue and the good man as such are the measure of each thing, those also will be pleasures which appear so to him, and those things pleasant which he enjoys. If the things he finds tiresome seem pleasant to someone, that is nothing surprising; for men may be ruined and spoilt in many ways; but the things are not pleasant, but only pleasant to these people and to people in this condition. Those which are admittedly disgraceful plainly should not be said to be pleasures, except to a perverted taste; but of those that are thought to be good what kind of pleasure or what pleasure should be said to be that proper to man? Is it not plain from the corresponding activities? The pleasures follow these. Whether, then, the perfect and supremely happy man has one or more activities, the pleasures that perfect these will be said in the strict sense to be pleasures proper to man, and the rest will be so in a secondary and fractional way, as are the activities.

Happiness is good activity, not amusement

6. Now that we have spoken of the virtues, the forms of friendship, and the varieties of pleasure, what remains is to discuss in outline the nature of happiness, since this is what we state the end of human affairs to be. Our discussion will be the more concise if we first sum up what we have said already. We said, then, that it is not a state; for if it were it might belong to someone who was asleep throughout his life, living the life of a plant, or, again, to someone who was suffering the greatest misfortunes. If these implications are unacceptable, and we must rather class happiness as an activity, as we have said before, and if some activities are necessary, and desirable for the sake of something else, while others are so in themselves, evidently happiness must be placed among those desirable in themselves, not among those desirable for the sake of something else; for happiness does not lack anything, but is self-sufficient. Now those activities are desirable in themselves from which nothing is sought beyond the activity. And of this nature virtuous actions are thought to be; for to do noble and good deeds is a thing desirable for its own sake.

Pleasant amusements also are thought to be of this nature: we choose them not for the sake of other things; for we are injured rather than benefited by them, since we are led to neglect our bodies and our property. But most of the people who are deemed happy take refuge in such pastimes, which is the reason why those who are ready-witted at them are highly esteemed at the courts of tyrants; they make themselves pleasant companions in the tyrants' favourite pursuits, and that is the sort of man they want. Now these things are thought to be of the nature of happiness because people in despotic positions spend their leisure in them, but perhaps such people prove nothing; for virtue and reason, from which good activities flow, do not depend on despotic position; nor, if these people, who have never tasted pure and generous pleasure, take refuge in the bodily pleasures, should these for that reason be thought more desirable; for boys, too, think the things that are valued among themselves are the best. It is to be expected, then, that, as different things seem valuable to boys and to men, so they should to bad men and to good. Now, as we have often maintained, those things are both valuable and pleasant which are such to the good man; and to each man the activity in accordance with his

own state is most desirable, and therefore to the good man that which is in accordance with virtue. Happiness, therefore, does not lie in amusement; it would, indeed, be strange if the end were amusement, and one were to take trouble and suffer hardship all one's life in order to amuse oneself. For, in a word, everything that we choose we choose for the sake of something else—except happiness, which is an end. Now to exert oneself and work for the sake of amusement seems silly and utterly childish. But to amuse oneself in order that one may exert oneself, as Anacharsis puts it, seems right; for amusement is a sort of relaxation, and we need relaxation because we cannot work continuously. Relaxation, then, is not an end; for it is taken for the sake of activity.

The happy life is thought to be virtuous; now a virtuous life requires exertion, and does not consist in amusement. And we say that serious things are better than laughable things and those connected with amusement, and that the activity of the better of any two things—whether it be two elements of our being or two men—is the more serious; but the activity of the better is ipso facto superior and more of the nature of happiness. And any chance person—even a slave—can enjoy the bodily pleasures no less than the best man; but no one assigns to a slave a share in happiness—unless he assigns to him also a share in human life. For happiness does not lie in such occupations, but, as we have said before, in virtuous activities.

Happiness in the highest sense is the contemplative life

7. If happiness is activity in accordance with virtue, it is reasonable that it should be in accordance with the highest virtue; and this will be that of the best thing in us. Whether it be reason or something else that is this element which is thought to be our natural ruler and guide and to take thought of things noble and divine, whether it be itself also divine or only the most divine element in us, the activity of this in accordance with its proper virtue will be perfect happiness. That this activity is contemplative we have already said.

Now this would seem to be in agreement both with what we said before and with the truth. For, firstly, this activity is the best (since not only is reason the best thing in us, but the objects of reason are the best of knowable objects); and, secondly, it is the most continuous, since we can contemplate truth more continuously than we can *do* anything. And we think happiness ought to have pleasure mingled with it, but the activity of philosophic wisdom is admittedly the pleasantest of virtuous activities; at all events the pursuit of it is thought to offer pleasures marvellous for their purity and their enduringness, and it is to be expected that those who know will pass their time more pleasantly than those who inquire. And the self-sufficiency that is spoken of must belong most to the contemplative activity. For while a philosopher, as well as a just man or one possessing any other virtue, needs the necessaries of life, when they are sufficiently equipped with things of that sort the just man needs people towards whom and with whom he shall act justly, and the temperate man, the brave man, and each of the others is in the same case, but the philosopher, even when by himself, can contemplate truth, and the better the wiser he is; he can perhaps do so better if he has fellow workers, but still he is the most self-sufficient. And this activity alone would seem to be loved for its own sake; for nothing arises from it apart from the contemplating, while from practical activities we gain more or less apart from the action. And happiness is thought to depend on leisure; for we are busy that we may have leisure, and make war that we may live in peace. Now the activity of the practical virtues is exhibited in political or military affairs, but the actions concerned with these seem to be unleisurely. Warlike actions are completely so (for no one chooses to be at war, or provokes war, for the sake of being at war; anyone would seem absolutely murderous if he were to make enemies of his friends in order to bring about battle and slaughter); but the action of the statesman also is unleisurely, and aims—beyond the political action itself—at despotic power and honours, or at all events happiness, for him and his fellow citizens—a happiness different from political action, and evidently sought as being

different. So if among virtuous actions political and military actions are distinguished by nobility and greatness, and these are unleisurely and aim at an end and are not desirable for their own sake, but the activity of reason, which is contemplative, seems both to be superior in serious worth and to aim at no end beyond itself, and to have its pleasure proper to itself (and this augments the activity), and the self-sufficiency, leisureliness, unweariedness (so far as this is possible for man), and all the other attributes ascribed to the supremely happy man are evidently those connected with this activity, it follows that this will be the complete happiness of man, if it be allowed a complete term of life (for none of the attributes of happiness is *in*complete).

But such a life would be too high for man; for it is not in so far as he is man that he will live so, but in so far as something divine is present in him; and by so much as this is superior to our composite nature is its activity superior to that which is the exercise of the other kind of virtue. If reason is divine, then, in comparison with man, the life according to it is divine in comparison with human life. But we must not follow those who advise us, being men, to think of human things, and, being mortal, of mortal things, but must, so far as we can, make ourselves immortal, and strain every nerve to live in accordance with the best thing in us; for even if it be small in bulk, much more does it in power and worth surpass everything. And this would seem actually to *be* each man, since it is the authoritative and better part of him. It would be strange, then, if he were to choose not the life of himself but that of something else. And what we said before will apply now: that which is proper to each thing is by nature best and most pleasant for each thing; for man, therefore, the life according to reason is best and pleasantest, since reason more than anything else *is* man. This life therefore is also the happiest.

Superiority of the contemplative life further considered

8. But in a secondary degree the life in accordance with the other kind of virtue is happy; for the activities in accordance with this befit our human estate. Just and brave acts, and other virtuous acts, we do in relation to each other, observing our respective duties with regard to contracts and services and all manner of actions and with regard to passions; and all of these seem to be typically human. Some of them seem even to arise from the body, and virtue of character to be in many ways bound up with the passions. Practical wisdom, too, is linked to virtue of character, and this to practical wisdom, since the principles of practical wisdom are in accordance with the moral virtues and rightness in morals is in accordance with practical wisdom. Being connected with the passions also, the moral virtues must belong to our composite nature; and the virtues of our composite nature are human; so, therefore, are the life and the happiness which correspond to these. The excellence of the reason is a thing apart: we must be content to say this much about it, for to describe it precisely is a task greater than our purpose requires. It would seem, however, also to need external equipment but little, or less than moral virtue does. Grant that both need the necessaries, and do so equally, even if the statesman's work is the more concerned with the body and things of that sort; for there will be little difference there; but in what they need for the exercise of their activities there will be much difference. The liberal man will need money for the doing of his liberal deeds, and the just man too will need it for the returning of services (for wishes are hard to discern, and even people who are not just *pretend* to wish to act justly); and the brave man will need power if he is to accomplish any of the acts that correspond to his virtue, and the temperate man will need opportunity; for how else is either he or any of the others to be recognized? It is debated, too, whether the will or the deed is more essential to virtue, which is assumed to involve both; it is surely clear that its perfection involves both; but for deeds many things are needed, and more, the greater and nobler the deeds are. But the man who is contemplating the truth needs no such thing, at least with a view to the exercise of his activity; indeed they are, one may say, even hindrances, at all events to his contemplation; but in so far as he is a man and lives with a number of people, he chooses to do virtuous acts; he will therefore need such aids to living a human life.

But that perfect happiness is a contemplative activity will appear from the following consideration as well. We assume the gods to be above all other beings blessed and happy; but what sort of actions must we assign to them? Acts of justice? Will not the gods seem absurd if they make contracts and return deposits, and so on? Acts of a brave man, then, confronting dangers and running risks because it is noble to do so? Or liberal acts? To whom will they give? It will be strange if they are really to have money or anything of the kind. And what would their temperate acts be? Is not such praise tasteless, since they have no bad appetites? If we were to run through them all, the circumstances of action would be found trivial and unworthy of gods. Still, everyone supposes that they *live* and therefore that they are active; we cannot suppose them to sleep like Endymion. Now if you take away from a living being action, and still more production, what is left but contemplation? Therefore the activity of God, which surpasses all others in blessedness, must be contemplative; and of human activities, therefore, that which is most akin to this must be most of the nature of happiness.

This is indicated, too, by the fact that the other animals have no share in happiness, being completely deprived of such activity. For while the whole life of the gods is blessed, and that of men too in so far as some likeness of such activity belongs to them, none of the other animals is happy, since they in no way share in contemplation. Happiness extends, then, just so far as contemplation does, and those to whom contemplation more fully belongs are more truly happy, not as a mere concomitant but in virtue of the contemplation; for this is in itself precious: Happiness, therefore, must be some form of contemplation.

But, being a man, one will also need external prosperity; for our nature is not self-sufficient for the purpose of contemplation, but our body also must be healthy and must have food and other attention. Still, we must not think that the man who is to be happy will need many things or great things, merely because he cannot be supremely happy without external goods; for self-sufficiency and action do not involve excess, and we can do noble acts without

ruling earth and sea; for even with moderate advantages one can act virtuously (this is manifest enough; for private persons are thought to do worthy acts no less than despots—indeed even more); and it is enough that we should have so much as that; for the life of the man who is active in accordance with virtue will be happy. Solon, too, was perhaps sketching well the happy man when he described him as moderately furnished with externals but as having done (as Solon thought) the noblest acts, and lived temperately; for one can with but moderate possessions do what one ought. Anaxagoras also seems to have supposed the happy man not to be rich nor a despot, when he said that he would not be surprised if the happy man were to seem to most people a strange person; for they judge by externals, since these are all they perceive. The opinions of the wise seem, then, to harmonize with our arguments. But while even such things carry some conviction, the truth in practical matters is discerned from the facts of life; for these are the decisive factor. We must therefore survey what we have already said, bringing it to the test of the facts of life, and if it harmonizes with the facts we must accept it, but if it clashes with them we must suppose it to be mere theory. Now he who exercises his reason and cultivates it seems to be both in the best state of mind and most dear to the gods. For if the gods have any care for human affairs, as they are thought to have, it would be reasonable both that they should delight in that which was best and most akin to them (i.e. reason) and that they should reward those who love and honour this most, as caring for the things that are dear to them and acting both rightly and nobly. And that all these attributes belong most of all to the philosopher is manifest. He, therefore, is the dearest to the gods. And he who is that will presumably be also the happiest; so that in this way too the philosopher will more than any other be happy.

Legislation is needed if the end is to be attained: transition to the Politics

9. If these matters and the virtues, and also friendship and pleasure, have been dealt with sufficiently in outline, are we to suppose that our programme has

reached its end? Surely, as the saying goes, where there are things to be done the end is not to survey and recognize the various things, but rather to do them; with regard to virtue, then, it is not enough to know, but we must try to have and use it, or try any other way there may be of becoming good. Now if arguments were in themselves enough to make men good, they would justly, as Theognis says, have won very great rewards, and such rewards should have been provided; but as things are, while they seem to have power to encourage and stimulate the generous-minded among our youth, and to make a character which is gently born, and a true lover of what is noble, ready to be possessed by virtue, they are not able to encourage the *many* to nobility and goodness. For these do not by nature obey the sense of shame, but only fear, and do not abstain from bad acts because of their baseness but through fear of punishment; living by passion they pursue their own pleasures and the means to them, and avoid the opposite pains, and have not even a conception of what is noble and truly pleasant, since they have never tasted it. What argument would remould such people? It is hard, if not impossible, to remove by argument the traits that have long since been incorporated in the character; and perhaps we must be content if, when all the influences by which we are thought to become good are present, we get some tincture of virtue.

Now some think that we are good by nature, others by habituation, others by teaching. Nature's part evidently does not depend on us, but as a result of some divine causes is present in those who are truly fortunate; while argument and teaching, we may suspect, are not powerful with all men, but the soul of the student must first have been cultivated by means of habits for noble joy and noble hatred, like earth which is to nourish the seed. For he who lives as passion directs will not hear argument that dissuades him, nor understand it if he does; and how can we persuade one in such a state to change his ways? And in general passion seems to yield not to argument but to force. The character, then, must somehow be there already with a kinship to virtue, loving what is noble and hating what is base.

But it is difficult to get from youth up a right training for virtue if one has not been brought up under right laws; for to live temperately and hardily is not pleasant to most people, especially when they are young. For this reason their nurture and occupations should be fixed by law; for they will not be painful when they have become customary. But it is surely not enough that when they are young they should get the right nurture and attention: since they must, even when they are grown up, practise and be habituated to them, we shall need laws for this as well, and generally speaking to cover the whole of life; for most people obey necessity rather than argument, and punishments rather than the sense of what is noble.

This is why some think that legislators ought to stimulate men to virtue and urge them forward by the motive of the noble, on the assumption that those who have been well advanced by the formation of habits will attend to such influences; and that punishments and penalties should be imposed on those who disobey and are of inferior nature, while the incurably bad should be completely banished. A good man (they think), since he lives with his mind fixed on what is noble, will submit to argument, while a bad man, whose desire is for pleasure, is corrected by pain like a beast of burden. This is, too, why they say the pains inflicted should be those that are most opposed to the pleasures such men love.

However that may be, if (as we have said) the man who is to be good must be well trained and habituated, and go on to spend his time in worthy occupations and neither willingly nor unwillingly do bad actions, and if this can be brought about if men live in accordance with a sort of reason and right order, provided this has force—if this be so, the paternal command indeed has not the required force or compulsive power (nor in general has the command of one man, unless he be a king or something similar), but the law *has* compulsive power, while it is at the same time a rule proceeding from a sort of practical wisdom and reason. And while people hate *men* who oppose their impulses, even if they oppose them rightly, the law in its ordaining of what is good is not burdensome.

In the Spartan state alone, or almost alone, the legislator seems to have paid attention to questions

of nurture and occupation; in most states such matters have been neglected, and each man lives as he pleases, Cyclops-fashion, "to his own wife and children dealing law." Now it is best that there should be a public and proper care for such matters; but if they are neglected by the community it would seem right for each man to help his children and friends towards virtue, and that they should have the power, or at least the will, to do this.

It would seem from what has been said that he can do this better if he makes himself capable of legislating. For public control is plainly effected by laws, and good control by good laws; whether written or unwritten would seem to make no difference, nor whether they are laws providing for the education of individuals or of groups—any more than it does in the case of music or gymnastics and other such pursuits. For as in cities laws and prevailing types of character have force, so in households do the injunctions and the habits of the father, and these have even more because of the tie of blood and the benefits he confers; for the children start with a natural affection and disposition to obey. Further, private education has an advantage over public, as private medical treatment has; for while in general rest and abstinence from food are good for a man in a fever, for a particular man they may not be; and a boxer presumably does not prescribe the same style of fighting to all his pupils. It would seem, then, that the detail is worked out with more precision if the control is private; for each person is more likely to get what suits his case.

But the details can be best looked after, one by one, by a doctor or gymnastic instructor or anyone else who has the general knowledge of what is good for everyone or for people of a certain kind (for the sciences both are said to be, and are, concerned with what is universal); not but what some particular detail may perhaps be well looked after by an unscientific person, if he has studied accurately in the light of experience what happens in each case, just as some people seem to be their own best doctors, though they could give no help to anyone else. None the less, it will perhaps be agreed that if a man does wish to become master of an art or science he must go to the universal, and come to know it as well as

possible; for, as we have said, it is with this that the sciences are concerned.

And surely he who wants to make men, whether many or few, better by his care must try to become capable of legislating, if it is through laws that we can become good. For to get anyone whatever—anyone who is put before us—into the right condition is not for the first chance comer; if anyone can do it, it is the man who knows, just as in medicine and all other matters which give scope for care and prudence.

Must we not, then, next examine whence or how one can learn how to legislate? Is it, as in all other cases, from statesmen? Certainly it was thought to be a part of statesmanship. Or is a difference apparent between statesmanship and the other sciences and arts? In the others the same people are found offering to teach the arts and practising them, e.g. doctors or painters; but while the sophists profess to teach politics, it is practised not by any of them but by the politicians, who would seem to do so by dint of a certain skill and experience rather than of thought; for they are not found either writing or speaking about such matters (though it were a nobler occupation perhaps than composing speeches for the law-courts and the assembly), nor again are they found to have made statesmen of their own sons or any other of their friends. But it was to be expected that they should if they could; for there is nothing better than such a skill that they could have left to their cities, or could prefer to have for themselves, or, therefore, for those dearest to them. Still, experience seems to contribute not a little; else they could not have become politicians by familiarity with politics; and so it seems that those who aim at knowing about the art of politics need experience as well.

But those of the sophists who profess the art seem to be very far from teaching it. For, to put the matter generally, they do not even know what kind of thing it is nor what kinds of things it is about; otherwise they would not have classed it as identical with rhetoric or even inferior to it, nor have thought it easy to legislate by collecting the laws that are thought well of; they say it is possible to select the best laws, as though even the selection did not demand intelligence and as though right judgement were not

the greatest thing, as in matters of music. For while people experienced in any department judge rightly the works produced in it, and understand by what means or how they are achieved, and what harmonizes with what, the inexperienced must be content if they do not fail to see whether the work has been well or ill made—as in the case of painting. Now laws are as it were the "works" of the political art; how then can one learn from them to be a legislator, or judge which are best? Even medical men do not seem to be made by a study of textbooks. Yet people try, at any rate, to state not only the treatments, but also how particular classes of people can be cured and should be treated—distinguishing the various habits of body; but while this seems useful to experienced people, to the inexperienced it is valueless. Surely, then, while collection of laws, and of constitutions also, may be serviceable to those who can study them and judge what is good or bad and what enactments suit what circumstances, those who go through such collections without a practised faculty will not have right judgement (unless it be as a spontaneous gift of nature), though they may perhaps become more intelligent in such matters.

Now our predecessors have left the subject of legislation to us unexamined; it is perhaps best, therefore, that we should ourselves study it, and in general study the question of the constitution, in order to complete to the best of our ability the philosophy of human nature. First, then, if anything has been said well in detail by earlier thinkers, let us try to review it; then in the light of the constitutions we have collected let us study what sorts of influence preserve and destroy states, and what sorts preserve or destroy the particular kinds of constitution, and to what causes it is due that some are well and others ill administered. When these matters have been studied we shall perhaps be more likely to see with a comprehensive view which constitution is best, and how each must be ordered, and what laws and customs it must use, if it is to be at its best. Let us make a beginning of our discussion.

Study Questions

1. If human beings are unique in their ability to laugh, is laughter the highest good for humanity?

2. Explain in your own words Aristotle's distinction between moral and intellectual virtue.

3. Is friendship required for a good life?

4. Do you agree with Aristotle that happiness is found in contemplation?

3

EPICURUS

Epicurus (341–270 B.C.E.) was an influential Greek philosopher who founded a community in Athens called the Garden, in which men and women as well as free persons and slaves participated on equal terms. He was a prolific author, but few of his writings survive. His system of thought, known as Epicureanism, stresses that the gods are detached from this world and that the ultimate aim of philosophy is to provide a guide to living well, maximizing pleasures and minimizing pains. We should accept pains that lead to greater pleasures and reject pleasures that lead to greater pains. Our lives will thus avoid extravagance. The virtues, such as temperance or courage, are prized because they lead to a pleasant life, as do friendships, which are, therefore, to be cultivated. Death is not to be feared, because while we exist, death is not present, and when death is present, we do not exist.

Letter to Menoeceus

Let no one when young delay to study philosophy, nor when he is old grow weary of his study. For no one can come too early or too late to secure the health of his soul. And the man who says that the age for philosophy has either not yet come or has gone by is like the man who says that the age for happiness is not yet come to him, or has passed away. Wherefore both when young and old a man must study philosophy, that as he grows old he may be young in blessings through the grateful recollection of what has been, and that in youth he may be old as well, since he will know no fear of what is to come. We must then meditate on the things that make our happiness, seeing that when that is with us we have all, but when it is absent we do all to win it.

The things which I used unceasingly to commend to you, these do and practice, considering them to be the first principles of the good life. First of all believe that god is a being immortal and blessed, even as the common idea of a god is engraved on men's minds, and do not assign to him anything alien to his immortality or ill-suited to his blessedness: but believe about him everything that can uphold his blessedness and immortality. For gods there are, since the knowledge of them is by clear vision. But they are not such as the many believe them to be: for indeed they do not consistently represent them as they believe them to be. And the impious man is not he who denies the gods of the many, but he who attaches to the gods the beliefs of the many. For the statements of the many about the gods are not conceptions derived from sensation, but false suppositions, according to which the greatest misfortunes befall the wicked and the greatest blessings (the good) by the gift of the gods. For men being accustomed always to their own virtues welcome those like themselves, but regard all that is not of their nature as alien.

From *Epicurus: The Extant Remains,* translated by Cyril Bailey (1926). Reprinted by permission of Oxford University Press.

Become accustomed to the belief that death is nothing to us. For all good and evil consists in sensation, but death is deprivation of sensation. And therefore a right understanding that death is nothing to us makes the mortality of life enjoyable, not because it adds to it an infinite span of time, but because it takes away the craving for immortality. For there is nothing terrible in life for the man who has truly comprehended that there is nothing terrible in not living. So that the man speaks but idly who says that he fears death not because it will be painful when it comes, but because it is painful in anticipation. For that which gives no trouble when it comes, is but an empty pain in anticipation. So death, the most terrifying of ills, is nothing to us, since so long as we exist, death is not with us; but when death comes, then we do not exist. It does not then concern either the living or the dead, since for the former it is not, and the latter are no more.

But the many at one moment shun death as the greatest of evils, at another (yearn for it) as a respite from the (evils) in life. (But the wise man neither seeks to escape life) nor fears the cessation of life, for neither does life offend him nor does the absence of life seem to be any evil. And just as with food he does not seek simply the larger share and nothing else, but rather the most pleasant, so he seeks to enjoy not the longest period of time, but the most pleasant.

And he who counsels the young man to live well, but the old man to make a good end, is foolish, not merely because of the desirability of life, but also because it is the same training which teaches to live well and to die well. Yet much worse still is the man who says it is good not to be born, but

"once born make haste to pass the gates of Death."

For if he says this from conviction why does he not pass away out of life? For it is open to him to do so, if he had firmly made up his mind to this. But if he speaks in jest, his words are idle among men who cannot receive them.

We must then bear in mind that the future is neither ours, nor yet wholly not ours, so that we may not altogether expect it as sure to come, nor abandon hope of it, as if it will certainly not come.

We must consider that of desires some are natural, others vain, and of the natural some are necessary and others merely natural; and of the necessary some are necessary for happiness, others for the repose of the body, and others for very life. The right understanding of these facts enables us to refer all choice and avoidance to the health of the body and (the soul's) freedom from disturbance, since this is the aim of the life of blessedness. For it is to obtain this end that we always act, namely, to avoid pain and fear. And when this is once secured for us, all the tempest of the soul is dispersed, since the living creature has not to wander as though in search of something that is missing, and to look for some other thing by which he can fulfil the good of the soul and the good of the body. For it is then that we have need of pleasure, when we feel pain owing to the absence of pleasure; (but when we do not feel pain), we no longer need pleasure. And for this cause we call pleasure the beginning and end of the blessed life. For we recognize pleasure as the first good innate in us, and from pleasure we begin every act of choice and avoidance, and to pleasure we return again, using the feeling as the standard by which we judge every good.

And since pleasure is the first good and natural to us, for this very reason we do not choose every pleasure, but sometimes we pass over many pleasures, when greater discomfort accrues to us as the result of them: and similarly we think many pains better than pleasures, since a greater pleasure comes to us when we have endured pains for a long time. Every pleasure then because of its natural kinship to us is good, yet not every pleasure is to be chosen: even as every pain also is an evil, yet not all are always of a nature to be avoided. Yet by a scale of comparison and by the consideration of advantages and disadvantages we must form our judgement on all these matters. For the good on certain occasions we treat as bad, and conversely the bad as good.

And again independence of desire we think a great good—not that we may at all times enjoy but a few things, but that, if we do not possess many, we may enjoy the few in the genuine persuasion that those

have the sweetest pleasure in luxury who least need it, and that all that is natural is easy to be obtained, but that which is superfluous is hard. And so plain savours bring us a pleasure equal to a luxurious diet, when all the pain due to want is removed; and bread and water produce the highest pleasure, when one who needs them puts them to his lips. To grow accustomed therefore to simple and not luxurious diet gives us health to the full, and makes a man alert for the needful employments of life, and when after long intervals we approach luxuries disposes us better towards them, and fits us to be fearless of fortune.

When, therefore, we maintain that pleasure is the end, we do not mean the pleasures of profligates and those that consist in sensuality, as is supposed by some who are either ignorant or disagree with us or do not understand, but freedom from pain in the body and from trouble in the mind. For it is not continuous drinkings and revellings, nor the satisfaction of lusts, nor the enjoyment of fish and other luxuries of the wealthy table, which produce a pleasant life, but sober reasoning, searching out the motives for all choice and avoidance, and banishing mere opinions, to which are due the greatest disturbance of the spirit.

Of all this the beginning and the greatest good is prudence. Wherefore prudence is a more precious thing even than philosophy: for from prudence are sprung all the other virtues, and it teaches us that it is not possible to live pleasantly without living prudently and honourably and justly, (nor, again, to live a life of prudence, honour, and justice) without living pleasantly. For the virtues are by nature bound up with the pleasant life, and the pleasant life is inseparable from them. For indeed who, think you, is a better man than he who holds reverent opinions concerning the gods, and is at all times free from fear of death, and has reasoned out the end ordained by nature? He understands that the limit of good things is easy to fulfil and easy to attain, whereas the course of ills is either short in time or slight in pain: he laughs at (destiny), whom some have introduced as the mistress of all things. (He thinks that with us lies the chief power in determining events, some of which happen by necessity) and some by chance, and some are within our control; for while necessity cannot be called to account, he sees that chance is inconstant, but that which is in our control is subject to no master, and to it are naturally attached praise and blame. For, indeed, it were better to follow the myths about the gods than to become a slave to the destiny of the natural philosophers: for the former suggests a hope of placating the gods by worship, whereas the latter involves a necessity which knows no placation. As to chance, he does not regard it as a god as most men do (for in a god's acts there is no disorder), nor as an uncertain cause (of all things): for he does not believe that good and evil are given by chance to man for the framing of a blessed life, but that opportunities for great good and great evil are afforded by it. He therefore thinks it better to be unfortunate in reasonable action than to prosper in unreason. For it is better in a man's actions that what is well chosen (should fail, rather than that what is ill chosen) should be successful owing to chance.

Meditate therefore on these things and things akin to them night and day by yourself, and with a companion like to yourself, and never shall you be disturbed waking or asleep, but you shall live like a god among men. For a man who lives among immortal blessings is not like to a mortal being.

Leading Doctrines

I. The blessed and immortal nature knows no trouble itself nor causes trouble to any other, so that it is never constrained by anger or favour. For all such things exist only in the weak.

II. Death is nothing to us: for that which is dissolved is without sensation; and that which lacks sensation is nothing to us.

From *Epicurus: The Extant Remains*, translated by Cyril Bailey (1926). Reprinted by permission of Oxford University Press.

III. The limit of quantity in pleasures is the removal of all that is painful. Wherever pleasure is present, as long as it is there, there is neither pain of body nor of mind, nor of both at once.

IV. Pain does not last continuously in the flesh, but the acutest pain is there for a very short time, and even that which just exceeds the pleasure in the flesh does not continue for many days at once. But chronic illnesses permit a predominance of pleasure over pain in the flesh.

V. It is not possible to live pleasantly without living prudently and honourably and justly, [nor again to live a life of prudence, honour, and justice] without living pleasantly. And the man who does not possess the pleasant life, is not living prudently and honourably and justly, [and the man who does not possess the virtuous life], cannot possibly live pleasantly.

VI. To secure protection from men anything is a natural good, by which you may be able to attain this end.

VII. Some men wished to become famous and conspicuous, thinking that they would thus win for themselves safety from other men. Wherefore if the life of such men is safe, they have obtained the good which nature craves; but if it is not safe, they do not possess that for which they strove at first by the instinct of nature.

VIII. No pleasure is a bad thing in itself: but the means which produce some pleasures bring with them disturbances many times greater than the pleasures.

IX. If every pleasure could be intensified so that it lasted and influenced the whole organism or the most essential parts of our nature, pleasures would never differ from one another.

X. If the things that produce the pleasures of profligates could dispel the fears of the mind about the phenomena of the sky and death and its pains, and also teach the limits of desires (and of pains), we should never have cause to blame them: for they would be filling themselves full with pleasures from every source and never have pain of body or mind, which is the evil of life.

XI. If we were not troubled by our suspicions of the phenomena of the sky and about death, fearing that it concerns us, and also by our failure to grasp the limits of pains and desires, we should have no need of natural science.

XII. A man cannot dispel his fear about the most important matters if he does not know what is the nature of the universe but suspects the truth of some mythical story. So that without natural science it is not possible to attain our pleasures unalloyed.

XIII. There is no profit in securing protection in relation to men, if things above and things beneath the earth and indeed all in the boundless universe remain matters of suspicion.

XIV. The most unalloyed source of protection from men, which is secured to some extent by a certain force of expulsion, is in fact the immunity which results from a quiet life and the retirement from the world.

XV. The wealth demanded by nature is both limited and easily procured; that demanded by idle imaginings stretches on to infinity.

XVI. In but few things chance hinders a wise man, but the greatest and most important matters reason has ordained and throughout the whole period of life does and will ordain.

XVII. The just man is most free from trouble, the unjust most full of trouble.

XVIII. The pleasure in the flesh is not increased, when once the pain due to want is removed, but is only varied: and the limit as regards pleasure in the mind is begotten by the reasoned understanding of these very pleasures and of the emotions akin to them, which used to cause the greatest fear to the mind.

XIX. Infinite time contains no greater pleasure than limited time, if one measures by reason the limits of pleasure.

XX. The flesh perceives the limits of pleasure as unlimited and unlimited time is required to supply it. But the mind, having attained a reasoned understanding of the ultimate good of the flesh and its limits and having dissipated the fears concerning the time to come, supplies us with the complete life, and we have no further need of infinite time: but neither does the mind shun pleasure, nor, when circumstances begin to bring about the departure from life, does it approach its end as though it fell short in any way of the best life.

XXI. He who has learned the limits of life knows that that which removes the pain due to want and makes the whole of life complete is easy to obtain; so that there is no need of actions which involve competition.

XXII. We must consider both the real purpose and all the evidence of direct perception, to which we always refer the conclusions of opinion; otherwise, all will be full of doubt and confusion.

XXIII. If you fight against all sensations, you will have no standard by which to judge even those of them which you say are false.

XXIV. If you reject any single sensation and fail to distinguish between the conclusion of opinion as to the appearance awaiting confirmation and that which is actually given by the sensation or feeling, or each intuitive apprehension of the mind, you will confound all other sensations as well with the same groundless opinion, so that you will reject every standard of judgement. And if among the mental images created by your opinion you affirm both that which awaits confirmation and that which does not, you will not escape error, since you will have preserved the whole cause of doubt in every judgement between what is right and what is wrong.

XXV. If on each occasion instead of referring your actions to the end of nature, you turn to some other nearer standard when you are making a choice or an avoidance, your actions will not be consistent with your principles.

XXVI. Of desires, all that do not lead to a sense of pain, if they are not satisfied, are not necessary, but involve a craving which is easily dispelled, when the object is hard to procure or they seem likely to produce harm.

XXVII. Of all the things which wisdom acquires to produce the blessedness of the complete life, far the greatest is the possession of friendship.

XXVIII. The same conviction which has given us confidence that there is nothing terrible that lasts for ever or even for long, has also seen the protection of friendship most fully completed in the limited evils of this life.

XXIX. Among desires some are natural (and necessary, some natural) but not necessary, and others neither natural nor necessary, but due to idle imagination.

XXX. Wherever in the case of desires which are physical, but do not lead to a sense of pain, if they are not fulfilled, the effort is intense, such pleasures are due to idle imagination, and it is not owing to their own nature that they fail to be dispelled, but owing to the empty imaginings of the man.

XXXI. The justice which arises from nature is a pledge of mutual advantage to restrain men from harming one another and save them from being harmed.

XXXII. For all living things which have not been able to make compacts not to harm one another or be harmed, nothing ever is either just or unjust; and likewise too for all tribes of men which have been unable or unwilling to make compacts not to harm or be harmed.

XXXIII. Justice never is anything in itself, but in the dealings of men with one another in any place whatever and at any time it is a kind of compact not to harm or be harmed.

XXXIV. Injustice is not an evil in itself, but only in consequence of the fear which attaches to the apprehension of being unable to escape those appointed to punish such actions.

XXXV. It is not possible for one who acts in secret contravention of the terms of the compact not to harm or be harmed, to be confident that he will escape detection, even if at present he escapes a thousand times. For up to the time of death it cannot be certain that he will indeed escape.

XXXVI. In its general aspect justice is the same for all, for it is a kind of mutual advantage in the dealings of men with one another: but with reference to the individual peculiarities of a country or any other circumstances the same thing does not turn out to be just for all.

XXXVII. Among actions which are sanctioned as just by law, that which is proved on examination to be of advantage in the requirements of men's dealings with one another, has the guarantee of justice, whether it is the same for all or not. But if a man makes a law and it does not turn out to lead to advantage in men's dealings with each other, then it no longer has the essential nature of justice. And even if the advantage in the matter of justice shifts from one side to the other, but for a while accords with the general concept, it is none the less just for that period in the eyes of those who do not confound themselves with empty sounds but look to the actual facts.

XXXVIII. Where, provided the circumstances have not been altered, actions which were considered just, have been shown not to accord with the general concept in actual practice, then they are not just. But where, when circumstances have changed, the same actions which were sanctioned as just no longer lead to advantage, there they were just at the time when they were of advantage for the dealings of fellow-citizens with one another; but subsequently they are no longer just, when no longer of advantage.

XXXIX. The man who has best ordered the element of disquiet arising from external circumstances has made those things that he could akin to himself and the rest at least not alien: but with all to which he could not do even this, he has refrained from mixing, and has expelled from his life all which it was of advantage to treat thus.

XL. As many as possess the power to procure complete immunity from their neighbours, these also live most pleasantly with one another, since they have the most certain pledge of security, and after they have enjoyed the fullest intimacy, they do not lament the previous departure of a dead friend, as though he were to be pitied.

Study Questions

1. According to Epicurus, why should you not fear death?
2. Is a good life always a pleasant life?
3. Is a pleasant life always a good life?
4. Is living well more than finding satisfaction?

4

CICERO

Marcus Tullius Cicero (106–43 B.C.E.) was a Roman orator, statesman, and philosopher. He defends natural law, which finds moral order in the structure of the world, but thinks, nevertheless, that what is right or wrong for a person to do depends in part on that individual's personal traits. Furthermore, he contends that while some goods have their source in morality and others stem from expediency, i.e., utility, the honorable and the beneficial are never in conflict. Cicero's work strongly influenced the development of European moral thought.

On Duties

BOOK I • MORAL GOODNESS

I. My dear son Marcus, you have now been studying a full year under Cratippus, and that too in Athens, and you should be fully equipped with the practical precepts and the principles of philosophy; so much at least one might expect from the pre-eminence not only of your teacher but also of the city; the former is able to enrich you with learning, the latter to supply you with models. Nevertheless, just as I for my own improvement have always combined Greek and Latin studies—and I have done this not only in the study

From Cicero, *De Officiis*, translated by Walter Miller, Harvard University Press, 1913.

of philosophy but also in the practice of oratory—so I recommend that you should do the same, so that you may have equal command of both languages. And it is in this very direction that I have, if I mistake not, rendered a great service to our countrymen, so that not only those who are unacquainted with Greek literature but even the cultured consider that they have gained much both in oratorical power and in mental training.

You will, therefore, learn from the foremost of present-day philosophers, and you will go on learning as long as you wish; and your wish ought to continue as long as you are not dissatisfied with the progress you are making. For all that, if you will read my philosophical books, you will be helped; my philosophy is not very different from that of the Peripatetics (for both they and I claim to be followers of Socrates and Plato). As to the conclusions you may reach, I leave that to your own judgment (for I would put no hindrance in your way), but by reading my philosophical writings you will be sure to render your mastery of the Latin language more complete. But I would by no means have you think that this is said boastfully. For there are many to whom I yield precedence in knowledge of philosophy; but if I lay claim to the orator's peculiar ability to speak with propriety, clearness, elegance, I think my claim is in a measure justified, for I have spent my life in that profession....

II. But since I have decided to write you a little now (and a great deal by and by), I wish, if possible, to begin with a matter most suited at once to your years and to my position. Although philosophy offers many problems, both important and useful, that have been fully and carefully discussed by philosophers, those teachings which have been handed down on the subject of moral duties seem to have the widest practical application. For no phase of life, whether public or private, whether in business or in the home, whether one is working on what concerns oneself alone or dealing with another, can be without its moral duty; on the discharge of such duties depends all that is morally right, and on their neglect all that is morally wrong in life.

Moreover, the subject of this inquiry is the common property of all philosophers; for who would

presume to call himself a philosopher, if he did not inculcate any lessons of duty?...

Since, therefore, the whole discussion is to be on the subject of duty, I should like at the outset to define what duty is....For every systematic development of any subject ought to begin with a definition, so that everyone may understand what the discussion is about.

III. Every treatise on duty has two parts: one, dealing with the doctrine of the supreme good; the other, with the practical rules by which daily life in all its bearings may be regulated. The following questions are illustrative of the first part: whether all duties are absolute; whether one duty is more important than another; and so on. But as regards special duties for which positive rules are laid down, though they are affected by the doctrine of the supreme good, still the fact is not so obvious, because they seem rather to look to the regulation of everyday life; and it is these special duties that I propose to treat at length in the following books....

The consideration necessary to determine conduct is...a threefold one: first, people question whether the contemplated act is morally right or morally wrong; and in such deliberation their minds are often led to widely divergent conclusions. And then they examine and consider the question whether the action contemplated is or is not conducive to comfort and happiness in life, to the command of means and wealth, to influence, and to power, by which they may be able to help themselves and their friends; this whole matter turns upon a question of expediency. The third type of question arises when that which seems to be expedient seems to conflict with that which is morally right; for when expediency seems to be pulling one way, while moral right seems to be calling back in the opposite direction, the result is that the mind is distracted in its inquiry and brings to it the irresolution that is born of deliberation....

First, therefore, we must discuss the moral...; secondly...the expedient; and finally, the cases where they must be weighed against each other.

V....[A]ll that is morally right rises from some one of four sources: it is concerned either (1) with the full perception and intelligent development of

the true; or (2) with the conservation of organized society, with rendering to every man his due, and with the faithful discharge of obligations assumed; or (3) with the greatness and strength of a noble and invincible spirit; or (4) with the orderliness and moderation of everything that is said and done, wherein consist temperance and self-control....

VI. Now, of the four divisions which we have made of the essential idea of moral goodness, the first, consisting in the knowledge of truth, touches human nature most closely. For we are all attracted and drawn to a zeal for learning and knowing; and we think it glorious to excel therein, while we count it base and immoral to fall into error, to wander from the truth, to be ignorant, to be led astray. In this pursuit, which is both natural and morally right, two errors are to be avoided: first, we must not treat the unknown as known and too readily accept it; and he who wishes to avoid this error (as all should do) will devote both time and attention to the weighing of evidence. The other error is that some people devote too much industry and too deep study to matters that are obscure and difficult and useless as well....

VII. Of the three remaining divisions, the most extensive in its application is the principle by which society and what we may call its "common bonds" are maintained. Of this again there are two divisions— justice, in which is the crowning glory of the virtues and on the basis of which men are called "good men"; and, close akin to justice, charity, which may also be called kindness or generosity.

The first office of justice is to keep one man from doing harm to another, unless provoked by wrong; and the next is to lead men to use common possessions for the common interests, private property for their own.

There is, however, no such thing as private ownership established by nature, but property becomes private either through long occupancy (as in the case of those who long ago settled in unoccupied territory) or through conquest (as in the case of those who took it in war) or by due process of law, bargain, or purchase, or by allotment....Therefore, inasmuch as in each case some of those things which by nature had been common property became the property of individuals, each one should retain possession of that which has fallen to his lot; and if anyone appropriates to himself anything beyond that, he will be violating the laws of human society.

But since, as Plato has admirably expressed it, we are not born for ourselves alone, but our country claims a share of our being, and our friends a share; and since, as the Stoics hold, everything that the earth produces is created for man's use; and as men, too, are born for the sake of men, that they may be able mutually to help one another; in this direction we ought to follow Nature as our guide, to contribute to the general good by an interchange of acts of kindness, by giving and receiving, and thus by our skill, our industry, and our talents to cement human society more closely together, man to man....

There are, on the other hand, two kinds of injustice—the one, on the part of those who inflict wrong, the other on the part of those who, when they can, do not shield from wrong those upon whom it is being inflicted. For he who, under the influence of anger or some other passion, wrongfully assaults another seems, as it were, to be laying violent hands upon a comrade; but he who does not prevent or oppose wrong, if he can, is just as guilty of wrong as if he deserted his parents or his friends or his country. Then, too, those very wrongs which people try to inflict on purpose to injure are often the result of fear: that is, he who premeditates injuring another is afraid that, if he does not do so, he may himself be made to suffer some hurt. But, for the most part, people are led to wrong-doing in order to secure some personal end; in this vice, avarice is generally the controlling motive....

XIV. Next in order, as outlined above, let us speak of kindness and generosity. Nothing appeals more to the best in human nature than this, but it calls for the exercise of caution in many particulars: we must, in the first place, see to it that our act of kindness shall not prove an injury either to the object of our beneficence or to others; in the second place, that it shall not be beyond our means; and finally, that it shall be proportioned to the worthiness of the recipient; for this is the corner-stone of justice; and by the standard of justice all acts of kindness must be measured.

For those who confer a harmful favour upon someone whom they seemingly wish to help are to be accounted not generous benefactors but dangerous sycophants; and likewise those who injure one man, in order to be generous to another, are guilty of the same injustice as if they diverted to their own accounts the property of their neighbours.

Now, there are many—and especially those who are ambitious for eminence and glory—who rob one to enrich another; and they expect to be thought generous towards their friends, if they put them in the way of getting rich, no matter by what means. Such conduct, however, is so remote from moral duty that nothing can be more completely opposed to duty. We must, therefore, take care to indulge only in such liberality as will help our friends and hurt no one....

The second point for the exercise of caution was that our beneficence should not exceed our means; for those who wish to be more open-handed than their circumstances permit are guilty of two faults: first, they do wrong to their next of kin; for they transfer to strangers property which would more justly be placed at their service or bequeathed to them. And second, such generosity too often engenders a passion for plundering and misappropriating properly, in order to supply the means for making large gifts. We may also observe that a great many people do many things that seem to be inspired more by a spirit of ostentation than by heart-felt kindness; for such people are not really generous but are rather influenced by a sort of ambition to make a show of being open-handed. Such a pose is nearer akin to hypocrisy than to generosity or moral goodness.

The third rule laid down was that in acts of kindness we should weigh with discrimination the worthiness of the object of our benevolence; we should take into consideration his moral character, his attitude toward us, the intimacy of his relations to us, and our common social ties, as well as the services he has hitherto rendered in our interest. It is to be desired that all these considerations should be combined in the same person; if they are not, then the more numerous and the more important considerations must have the greater weight....

XXVII. We have next to discuss the one remaining division of moral rectitude. That is the one in which we find considerateness and self-control, which give, as it were, a sort of polish to life; it embraces also temperance, complete subjection of all the passions, and moderation in all things....Such is its essential nature, that it is inseparable from moral goodness; for what is proper is morally right, and what is morally right is proper. The nature of the difference between morality and propriety can be more easily felt than expressed. For whatever propriety may be, it is manifested only when there is pre-existing moral rectitude. And so, not only in this division of moral rectitude which we have now to discuss but also in the three preceding divisions, it is clearly brought out what propriety is. For to employ reason and speech rationally, to do with careful consideration whatever one does, and in everything to discern the truth and to uphold it—that is proper. To be mistaken, on the other hand, to miss the truth, to fall into error, to be led astray—that is as improper as to be deranged and lose one's mind. And all things just are proper; all things unjust, like all things immoral, are improper.

The relation of propriety to fortitude is similar. What is done in a manly and courageous spirit seems becoming to a man and proper; what is done in a contrary fashion is at once immoral and improper.

This propriety, therefore, of which I am speaking belongs to each division of moral rectitude; and its relation to the cardinal virtues is so close, that it is perfectly self-evident and does not require any abstruse process of reasoning to see it. For there is a certain element of propriety perceptible in every act of moral rectitude; and this can be separated from virtue theoretically better than it can be practically. As comeliness and beauty of person are inseparable from the notion of health, so this propriety of which we are speaking, while in fact completely blended with virtue, is mentally and theoretically distinguishable from it.

The classification of propriety, moreover, is two-fold: (1) we assume a general sort of propriety, which is found in moral goodness as a whole; then (2) there is another propriety, subordinate to this, which belongs to the several divisions of moral goodness. The former

is usually defined somewhat as follows: "Propriety is that which harmonizes with man's superiority in those respects in which his nature differs from that of the rest of the animal creation." And they so define the special type of propriety which is subordinate to the general notion, that they represent it to be that propriety which harmonizes with Nature, in the sense that it manifestly embraces temperance and self-control, together with a certain deportment such as becomes a gentleman.

XXVIII. That this is the common acceptation of propriety we may infer from that propriety which poets aim to secure. Concerning that, I have occasion to say more in another connection. Now, we say that the poets observe propriety, when every word or action is in accord with each individual character. For example, if Aeacus or Minos said:

"Let them hate, if only they fear,"

or:

"The father is himself his children's tomb,"

that would seem improper, because we are told that they were just men. But when Atreus speaks those lines, they call forth applause; for the sentiment is in keeping with the character. But it will rest with the poets to decide, according to the individual characters, what is proper for each; but to us Nature herself has assigned a character of surpassing excellence, far superior to that of all other living creatures, and in accordance with that we shall have to decide what propriety requires.

The poets will observe, therefore, amid a great variety of characters, what is suitable and proper for all—even for the bad. But to us Nature has assigned the roles of steadfastness, temperance, self-control, and considerateness of others; Nature also teaches us not to be careless in our behaviour towards our fellow-men. Hence we may clearly see how wide is the application not only of that propriety which is essential to moral rectitude in general, but also of the special propriety which is displayed in each particular subdivision of virtue. For, as physical beauty with harmonious symmetry of the limbs engages the attention and delights the eye, for the very reason that all the parts combine in harmony and grace, so this propriety, which shines out in our conduct, engages the approbation of our fellow-men by the order, consistency, and self-control it imposes upon every word and deed.

We should, therefore, in our dealings with people show what I may almost call reverence toward all men—not only toward the men who are the best, but toward others as well. For indifference to public opinion implies not merely self-sufficiency, but even total lack of principle. There is, too, a difference between justice and considerateness in one's relations to one's fellow-men. It is the function of justice not to do wrong to one's fellow-men; of considerateness, not to wound their feelings; and in this the essence of propriety is best seen.

With the foregoing exposition, I think it is clear what the nature is of what we term propriety.

Further, as to the duty which has its source in propriety, the first road on which it conducts us leads to harmony with Nature and the faithful observance of her laws. If we follow Nature as our guide, we shall never go astray, but we shall be pursuing that which is in its nature clear-sighted and penetrating (Wisdom), that which is adapted to promote and strengthen society (Justice), and that which is strong and courageous (Fortitude). But the very essence of propriety is found in the division of virtue which is now under discussion (Temperance). For it is only when they agree with Nature's laws that we should give our approval to the movements not only of the body, but still more of the spirit.

Now we find that the essential activity of the spirit is twofold: one force is appetite..., which impels a man this way and that; the other is reason, which teaches and explains what should be done and what should be left undone. The result is that reason commands, appetite obeys.

XXIX. Again, every action ought to be free from undue haste or carelessness; neither ought we to do anything for which we cannot assign a reasonable motive; for in these words we have practically a definition of duty.

The appetites, moreover, must be made to obey the reins of reason and neither allowed to run ahead of it nor from listlessness or indolence to lag behind; but people should enjoy calm of soul and be free from every sort of passion. As a result strength of character and self-control will shine forth in all their lustre. For when appetites overstep their bounds and, galloping away, so to speak, whether in desire or aversion, are not well held in hand by reason, they clearly overleap all bound and measure; for they throw obedience off and leave it behind and refuse to obey the reins of reason, to which they are subject by Nature's laws. And not only minds but bodies as well are disordered by such appetites. We need only to look at the faces of men in a rage or under the influence of some passion or fear or beside themselves with extravagant joy: in every instance their features, voices, motions, attitudes undergo a change....

XXX....We must realize...that we are invested by Nature with two characters, as it were: one of these is universal, arising from the fact of our being all alike endowed with reason and with that superiority which lifts us above the brute. From this all morality and propriety are derived, and upon it depends the rational method of ascertaining our duty. The other character is the one that is assigned to individuals in particular. In the matter of physical endowment there are great differences: some, we see, excel in speed for the race, others in strength for wrestling; so in point of personal appearance, some have stateliness, others comeliness. Diversities of character are greater still. Lucius Crassus and Lucius Philippus had a large fund of wit; Gaius Caesar, Lucius's son, had a still richer fund and employed it with more studied purpose. Contemporary with them, Marcus Scaurus and Marcus Drusus, the younger, were examples of unusual seriousness; Gaius Laelius, of unbounded jollity; while his intimate friend, Scipio, cherished more serious ideals and lived a more austere life. Among the Greeks, history tells us, Socrates was fascinating and witty, a genial conversationalist;...in every conversation, pretending to need information and professing admiration for the wisdom of his companion. Pythagoras and Pericles, on the other hand, reached the heights of influence and power without any seasoning of mirthfulness. We read that Hannibal, among the Carthaginian generals, and Quintus Maximus, among our own, were shrewd and ready at concealing their plans, covering up their tracks, disguising their movements, laying stratagems, forestalling the enemy's designs. In these qualities the Greeks rank Themistocles and Jason of Pherae above all others. Especially crafty and shrewd was the device of Solon, who, to make his own life safer and at the same time to do a considerably larger service for his country, feigned insanity.

Then there are others, quite different from these, straightforward and open, who think that nothing should be done by underhand means or treachery. They are lovers of truth, haters of fraud. There are others still who will stoop to anything, truckle to anybody, if only they may gain their ends. Such, we saw, were Sulla and Marcus Crassus. The most crafty and most persevering man of this type was Lysander of Sparta, we are told; of the opposite type was Callicratidas, who succeeded Lysander as admiral of the fleet. So we find that another, no matter how eminent he may be, will condescend in social intercourse to make himself appear but a very ordinary person. Such graciousness of manner we have seen in the case of Catulus—both father and son—and also of Quintus Mucius Mancia. I have heard from my elders that Publius Scipio Nasiea was another master of this art; but his father, on the other hand—the man who punished Tiberius Gracchus for his nefarious undertakings—had no such gracious manner in social intercourse, and because of that very fact he rose to greatness and fame.

Countless other dissimilarities exist in natures and characters, and they are not in the least to be criticized.

XXXI. Everybody, however, must resolutely hold fast to his own peculiar gifts, in so far as they are peculiar only and not vicious, in order that propriety, which is the object of our inquiry, may the more easily be secured. For we must so act as not to oppose the universal laws of human nature, but, while safeguarding those, to follow the bent of our own particular nature; and even if other careers should be better and nobler, we may still regulate our own pursuits by

the standard of our own nature. For it is of no avail to fight against one's nature or to aim at what is impossible of attainment. From this fact the nature of that propriety defined above comes into still clearer light, inasmuch as nothing is proper that "goes against the grain," as the saying is—that is, if it is in direct opposition to one's natural genius.

If there is any such thing as propriety at all, it can be nothing more than uniform consistency in the course of our life as a whole and all its individual actions. And this uniform consistency one could not maintain by copying the personal traits of others and eliminating one's own. For as we ought to employ our mother-tongue, lest, like certain people who are continually dragging in Greek words, we draw well-deserved ridicule upon ourselves, so we ought not to introduce anything foreign into our actions or our life in general. Indeed, such diversity of character carries with it so great significance that suicide may be for one man a duty, for another [under the same circumstances] a crime. Did Marcus Cato find himself in one predicament, and were the others, who surrendered to Caesar in Africa, in another? And yet, perhaps, they would have been condemned, if they had taken their lives; for their mode of life had been less austere and their characters more pliable. But Cato had been endowed by nature with an austerity beyond belief, and he himself had strengthened it by unswerving consistency and had remained ever true to his purpose and fixed resolve; and it was for him to die rather than to look upon the face of a tyrant.

How much Ulysses endured on those long wanderings, when he submitted to the service even of women (if Circe and Calypso may be called women) and strove in every word to be courteous and complaisant to all! And, arrived at home, he brooked even the insults of his men-servants and maidservants, in order to attain in the end the object of his desire. But Ajax, with the temper he is represented as having, would have chosen to meet death a thousand times rather than suffer such indignities!

If we take this into consideration, we shall see that it is each man's duty to weigh well what are his own peculiar traits of character, to regulate these properly, and not to wish to try how another man's would suit him. For the more peculiarly his own a man's character is, the better it fits him.

Everyone, therefore, should make a proper estimate of his own natural ability and show himself a critical judge of his own merits and defects; in this respect we should not let actors display more practical wisdom than we have. They select, not the best plays, but the ones best suited to their talents....Shall a player have regard to this in choosing his role upon the stage, and a wise man fail to do so in selecting his part in life?

We shall, therefore, work to the best advantage in that role to which we are best adapted. But if at some time stress of circumstances shall thrust us aside into some uncongenial part, we must devote to it all possible thought, practice, and pains, that we may be able to perform it, if not with propriety, at least with as little impropriety as possible; and we need not strive so hard to attain to points of excellence that have not been vouchsafed to us as to correct the faults we have.

XXXII. To the two above-mentioned characters is added a third, which some chance or some circumstance imposes, and a fourth also, which we assume by our own deliberate choice. Regal powers and military commands, nobility of birth and political office, wealth and influence, and their opposites depend upon chance and are, therefore, controlled by circumstances. But what role we ourselves may choose to sustain is decided by our own free choice. And so some turn to philosophy, others to the civil law, and still others to oratory, while in case of the virtues themselves one man prefers to excel in one, another in another.

They, whose fathers or forefathers have achieved distinction in some particular field, often strive to attain eminence in the same department of service: for example, Quintus, the son of Publius Mucius, in the law; Africanus, the son of Paulus, in the army. And to that distinction which they have severally inherited from their fathers some have added lustre of their own; for example, that same Africanus, who crowned his inherited military glory with his own eloquence. Timotheus, Conon's son, did the same: he proved himself not inferior to his father in military

renown and added to that distinction the glory of culture and intellectual power. It happens sometimes, too, that a man declines to follow in the footsteps of his fathers and pursues a vocation of his own. And in such callings those very frequently achieve signal success who, though sprung from humble parentage, have set their aims high.

All these questions, therefore, we ought to bear thoughtfully in mind, when we inquire into the nature of propriety; but above all we must decide who and what manner of men we wish to be and what calling in life we would follow; and this is the most difficult problem in the world. For it is in the years of early youth, when our judgment is most immature, that each of us decides that his calling in life shall be that to which he has taken a special liking. And thus he becomes engaged in some particular calling and career in life, before he is fit to decide intelligently what is best for him.

For we cannot all have the experience of Hercules, as we find it in the words of Prodicus in Xenophon: "When Hercules was just coming into youth's estate (the time which Nature has appointed unto every man for choosing the path of life on which he would enter), he went out into a desert place. And as he saw two paths, the path of Pleasure and the path of Virtue, he sat down and debated long and earnestly which one it were better for him to take." This might, perhaps, happen to a Hercules, "scion of the seed of Jove"; but it cannot well happen to us; for we copy each the model he fancies, and we are constrained to adopt their pursuits and vocations. But usually, we are so imbued with the teachings of our parents, that we fall irresistibly into their manners and customs. Others drift with the current of popular opinion and make especial choice of those callings which the majority find most attractive. Some, however, as the result either of some happy fortune or of natural ability, enter upon the right path of life, without parental guidance.

XXXIII. There is one class of people that is very rarely met with: it is composed of those who are endowed with marked natural ability, or exceptional advantages of education and culture, or both, and who also have time to consider carefully what career in life they prefer to follow; and in this deliberation the decision must turn wholly upon each individual's natural bent. For we try to find out from each one's native disposition, as was said above, just what is proper for him; and this we require not only in case of each individual act but also in ordering the whole course of one's life; and this last is a matter to which still greater care must be given, in order that we may be true to ourselves throughout all our lives and not falter in the discharge of any duty.

But since the most powerful influence in the choice of a career is exerted by Nature, and the next most powerful by Fortune, we must, of course, take account of them both in deciding upon our calling in life; but, of the two, Nature claims the more attention. For Nature is so much more stable and steadfast, that for Fortune to come into conflict with Nature seems like a combat between a mortal and a goddess. If, therefore, anyone has conformed his whole plan of life to the kind of nature that is his (that is, his better nature), let him go on with it consistently—for that is the essence of Propriety—unless, perchance, he should discover that he has made a mistake in choosing his life work. If this should happen (and it can easily happen), he must change his vocation and mode of life. If circumstances favour such change, it will be effected with greater ease and convenience. If not, it must be made gradually, step by step, just as, when friendships become no longer pleasing or desirable, it is more proper (so wise men think) to undo the bond little by little than to sever it at a stroke. And when we have once changed our calling in life, we must take all possible care to make it clear that we have done so with good reason.

But whereas I said a moment ago that we have to follow in the steps of our fathers, let me make the following exceptions: first, we need not imitate their faults; second, we need not imitate certain other things, if our nature does not permit such imitation; for example, the son of the elder Africanus (that Scipio who adopted the younger Africanus, the son of Paulus) could not on account of ill-health be so much like his father as Africanus had been like his. If, then, a man is unable to conduct cases at the bar or to hold the people spell-bound with his

eloquence or to conduct wars, still it will be his duty to practise these other virtues, which are within his reach—justice, good faith, generosity, temperance, self-control—that his deficiencies in other respects may be less conspicuous. The noblest heritage, however, that is handed down from fathers to children, and one more precious than any inherited wealth, is a reputation for virtue and worthy deeds; and to dishonour this must be branded as a sin and a shame.

XXXIV. Since, too, the duties that properly belong to different times of life are not the same, but some belong to the young, others to those more advanced in years, a word must be said on this distinction also.

It is, then, the duty of a young man to show deference to his elders and to attach himself to the best and most approved of them, so as to receive the benefit of their counsel and influence. For the inexperience of youth requires the practical wisdom of age to strengthen and direct it. And this time of life is above all to be protected against sensuality and trained to toil and endurance of both mind and body, so as to be strong for active duty in military and civil service. And even when they wish to relax their minds and give themselves up to enjoyment they should beware of excesses and bear in mind the rules of modesty. And this will be easier, if the young are not unwilling to have their elders join them even in their pleasures.

The old, on the other hand, should, it seems, have their physical labours reduced; their mental activities should be actually increased. They should endeavour, too, by means of their counsel and practical wisdom to be of as much service as possible to their friends and to the young, and above all to the state. But there is nothing against which old age has to be more on its guard than against surrendering to feebleness and idleness, while luxury, a vice in any time of life, is in old age especially scandalous. But if excess in sensual indulgence is added to luxurious living, it is a twofold evil; for old age not only disgraces itself; it also serves to make the excesses of the young more shameless.

At this point it is not at all irrelevant to discuss the duties of magistrates, of private individuals, [of native citizens,] and of foreigners.

It is, then, peculiarly the place of a magistrate to bear in mind that he represents the state and that it is his duty to uphold its honour and its dignity, to enforce the law, to dispense to all their constitutional rights, and to remember that all this has been committed to him as a sacred trust.

The private individual ought first, in private relations, to live on fair and equal terms with his fellow citizens, with a spirit neither servile and grovelling nor yet domineering; and second, in matters pertaining to the state, to labour for her peace and honour; for such a man we are accustomed to esteem and call a good citizen.

As for the foreigner or the resident alien, it is his duty to attend strictly to his own concerns, not to pry into other people's business, and under no condition to meddle in the politics of a country not his own.

In this way I think we shall have a fairly clear view of our duties when the question arises what is proper and what is appropriate to each character, circumstance, and age. But there is nothing so essentially proper as to maintain consistency in the performance of every act and in the conception of every plan.

BOOK II • EXPEDIENCY

I. I believe, Marcus, my son, that I have fully explained in the preceding book how duties are derived from moral rectitude, or rather from each of virtue's four divisions. My next step is to trace out those kinds of duty which have to do with the comforts of life, with the means of acquiring the things that people enjoy, with influence, and with wealth....

III....The principle with which we are now dealing is that one which is called Expediency. The usage of this word has been corrupted and perverted and has gradually come to the point where, separating moral rectitude from expediency, it is accepted that a thing may be morally right without being expedient, and expedient without being morally right. No more pernicious doctrine than this could be introduced into human life.

There are, to be sure, philosophers of the very highest reputation who distinguish theoretically between these three conceptions, although they are indissolubly blended together; and they do this, I assume, on

moral, conscientious principles. [For whatever is just, they hold, is also expedient; and, in like manner, whatever is morally right is also just. It follows, then, that whatever is morally right is also expedient.] Those who fail to comprehend that theory do often, in their admiration for shrewd and clever men, take craftiness for wisdom. But they must be disabused of this error and their way of thinking must be wholly converted to the hope and conviction that it is only by moral character and righteousness, not by dishonesty and craftiness, that they may attain to the objects of their desires.

Of the things, then, that are essential to the sustenance of human life, some are inanimate (gold and silver, for example, the fruits of the earth, and so forth), and some are animate and have their own peculiar instincts and appetites. Of these again some are rational, others irrational. Horses, oxen, and the other cattle, [bees,] whose labour contributes more or less to the service and subsistence of man, are not endowed with reason; of rational beings two divisions are made—gods and men. Worship and purity of character will win the favour of the gods; and next to the gods, and a close second to them, men can be most helpful to men.

The same classification may likewise be made of the things that are injurious and hurtful. But, as people think that the gods bring us no harm, they decide (leaving the gods out of the question) that men are most hurtful to men.

As for mutual helpfulness, those very things which we have called inanimate are for the most part themselves produced by man's labours; we should not have them without the application of manual labour and skill nor could we enjoy them without the intervention of man. And so with many other things: for without man's industry there could have been no provisions for health, no navigation, no agriculture, no ingathering or storing of the fruits of the field or other kinds of produce. Then, too, there would surely be no exportation of our superfluous commodities or importation of those we lack, did not men perform these services. By the same process of reasoning, without the labour of man's hands, the stone needful for our use would not be quarried from the earth, nor would "iron, copper, gold, and silver, hidden far within," be mined.

IV. And how could houses ever have been provided in the first place for the human race, to keep out the rigours of the cold and alleviate the discomforts of the heat; or how could the ravages of furious tempest or of earthquake or of time upon them afterward have been repaired, had not the bonds of social life taught men in such events to look to their fellow-men for help? Think of the aqueducts, canals, irrigation works, breakwaters, artificial harbours; how should we have these without the work of man? From these and many other illustrations it is obvious that we could not in any way, without the work of man's hands, have received the profits and the benefits accruing from inanimate things.

Finally, of what profit or service could animals be, without the co-operation of man? For it was men who were the foremost in discovering what use could be made of each beast; and to-day, if it were not for man's labour, we could neither feed them nor break them in nor take care of them nor yet secure the profits from them in due season. By man, too, noxious beasts are destroyed, and those that can be of use are captured.

Why should I recount the multitude of arts without which life would not be worth living at all? For how would the sick be healed? What pleasure would the hale enjoy? What comforts should we have, if there were not so many arts to minister to our wants? In all these respects the civilized life of man is far removed from the standard of the comforts and wants of the lower animals. And, without the association of men, cities could not have been built or peopled. In consequence of city life, laws and customs were established, and then came the equitable distribution of private rights and a definite social system. Upon these institutions followed a more humane spirit and consideration for others, with the result that life was better supplied with all it requires, and by giving and receiving, by mutual exchange of commodities and conveniences, we succeeded in meeting all our wants....

XI.... Now, in my opinion at least, every walk and vocation in life calls for human co-operation—first

and above all, in order that one may have friends with whom to enjoy social intercourse. And this is not easy, unless one is looked upon as a good man. So, even to a man who shuns society and to one who spends his life in the country a reputation for justice is essential—even more so than to others; for they who do not have it [but are considered unjust] will have no defence to protect them and so will be the victims of many kinds of wrong. So also to buyers and sellers, to employers and employed, and to those who are engaged in commercial dealings generally, justice is indispensable for the conduct of business. Its importance is so great, that not even those who live by wickedness and crime can get on without some small element of justice. For if a robber takes anything by force or by fraud from another member of the gang, he loses his standing even in a band of robbers....

Since, therefore, the efficacy of justice is so great that it strengthens and augments the power even of robbers, how great do we think its power will be in a constitutional government with its laws and courts?...

XV.... I must next in order discuss kindness and generosity. The manner of showing it is twofold: kindness is shown to the needy either by personal service, or by gifts of money. The latter way is the easier, especially for a rich man; but the former is nobler and more dignified and more becoming to a strong and eminent man. For, although both ways alike betray a generous wish to oblige, still in the one case the favour makes a draft upon one's bank account, in the other upon one's personal energy; and the bounty which is drawn from one's material substance tends to exhaust the very fountain of liberality. Liberality is thus forestalled by liberality: for the more people one has helped with gifts of money, the fewer one can help. But if people are generous and kind in the way of personal service—that is, with their ability and personal effort—various advantages arise: first, the more people they assist, the more helpers they will have in works of kindness; and second, by acquiring the habit of kindness they are better prepared and in better training, as it were, for bestowing favours upon many.

That liberality, therefore, which consists in personal service and effort is more honourable, has wider application, and can benefit more people. There can be no doubt about that. Nevertheless, we should sometimes make gifts of money; and this kind of liberality is not to be discouraged altogether. We must often distribute from our purse to the worthy poor, but we must do so with discretion and moderation. For many have squandered their patrimony by indiscriminate giving. But what is worse folly than to do the thing you like in such a way that you can no longer do it at all? Then, too, lavish giving leads to robbery; for when through over-giving men begin to be impoverished, they are constrained to lay their hands on the property of others. And so, when men aim to be kind for the sake of winning good-will, the affection they gain from the objects of their gifts is not so great as the hatred they incur from those whom they despoil.

One's purse, then, should not be closed so tightly that a generous impulse cannot open it, nor yet so loosely held as to be open to everybody. A limit should be observed and that limit should be determined by our means. We ought, in a word, to remember the phrase, which, through being repeated so very often by our countrymen, has come to be a common proverb: "Bounty has no bottom." For indeed what limit can there be, when those who have been accustomed to receive gifts claim what they have been in the habit of getting, and those who have not wish for the same bounty?...

XVIII.... It will, moreover, befit a gentleman to be at the same time liberal in giving and not inconsiderate in exacting his dues, but in every business relation—in buying or selling, in hiring or letting, in relations arising out of adjoining houses and lands—to be fair, reasonable, often freely yielding much of his own right, and keeping out of litigation as far as his interests will permit and perhaps even a little farther. For it is not only generous occasionally to abate a little of one's rightful claims, but it is sometimes even advantageous....

XX. Now in rendering helpful service to people, we usually consider either their character or their circumstances. And so it is an easy remark, and one commonly made, to say that in investing kindnesses

we look not to people's outward circumstances, but to their character. The phrase is admirable! But who is there, pray, that does not in performing a service set the favour of a rich and influential man above the cause of a poor, though most worthy, person? For, as a rule, our will is more inclined to the one from whom we expect a prompter and speedier return. But we should observe more carefully how the matter really stands: the poor man of whom we spoke cannot return a favour in kind, of course, but if he is a good man he can do it at least in thankfulness of heart. As someone has happily said, "A man has not repaid money, if he still has it; if he has repaid it, he has ceased to have it. But a man still has the sense of favour, if he has returned the favour; and if he has the sense of the favour, he has repaid it."

On the other hand, they who consider themselves wealthy, honoured, the favourites of fortune, do not wish even to be put under obligations by our kind services. Why, they actually think that they have conferred a favour by accepting one, however great; and they even suspect that a claim is thereby set up against them or that something is expected in return. Nay more, it is bitter as death to them to have accepted a patron or to be called clients. Your man of slender means, on the other hand, feels that whatever is done for him is done out of regard for himself and not for his outward circumstances. Hence he strives to show himself grateful not only to the one who has obliged him in the past but also to those from whom he expects similar favours in the future—and he needs the help of many; and his own service, if he happens to render any in return, he does not exaggerate, but he actually depreciates it. This fact, furthermore, should not be overlooked—that, if one defends a wealthy favourite of fortune, the favour does not extend further than to the man himself or, possibly, to his children. But, if one defends a man who is poor but honest and upright, all the lowly who are not dishonest—and there is a large proportion of that sort among the people—look upon such an advocate as a tower of defence raised up for them. I think, therefore, that kindness to the good is a better investment than kindness to the favourites of fortune.

We must, of course, put forth every effort to oblige all sorts and conditions of men, if we can. But if it comes to a conflict of duty on this point, we must, I should say, follow the advice of Themistocles: when someone asked his advice whether he should give his daughter in marriage to a man who was poor but honest or to one who was rich but less esteemed, he said: "For my part, I prefer a man without money to money without a man." But the moral sense of to-day is demoralized and depraved by our worship of wealth. Of what concern to any one of us is the size of another man's fortune? It is, perhaps, an advantage to its possessor; but not always even that. But suppose it is; he may, to be sure, have more money to spend; but how is he any the better man for that? Still, if he is a good man, as well as a rich one, let not his riches be a hindrance to his being aided, if only they are not the motive to it; but in conferring favours our decision should depend entirely upon a man's character, not on his wealth.

The supreme rule, then, in the matter of kindnesses to be rendered by personal service is never to take up a case in opposition to the right nor in defence of the wrong. For the foundation of enduring reputation and fame is justice, and without justice there can be nothing worthy of praise....

BOOK III • THE CONFLICT BETWEEN THE RIGHT AND THE EXPEDIENT

IV....Those who measure everything by a standard of profits and personal advantage and refuse to have these outweighed by considerations of moral rectitude are accustomed, in considering any question, to weigh the morally right against what they think the expedient; good men are not....[F]or it is most immoral to think more highly of the apparently expedient than of the morally right, or even to set these over against each other and to hesitate to choose between them.

What, then, is it that may sometimes give room for a doubt and seem to call for consideration? It is, I believe, when a question arises as to the character of an action under consideration. For it often

happens, owing to exceptional circumstances, that what is accustomed under ordinary circumstances to be considered morally wrong is found not to be morally wrong. For the sake of illustration, let us assume some particular case that admits of wider application: what more atrocious crime can there be than to kill a fellow-man, and especially an intimate friend? But if anyone kills a tyrant—be he never so intimate a friend—he has not laden his soul with guilt, has he? The Roman People, at all events, are not of that opinion; for of all glorious deeds they hold such an one to be the most noble. Has expediency, then, prevailed over moral rectitude? Not at all; moral rectitude has gone hand in hand with expediency.

Some general rule, therefore, should be laid down to enable us to decide without error, whenever what we call the expedient seems to clash with what we feel to be morally right; and, if we follow that rule in comparing courses of conduct, we shall never swerve from the path of duty....

V. Well then, for a man to take something from his neighbour and to profit by his neighbour's loss is more contrary to Nature than is death or poverty or pain or anything else that can affect either our person or our property. For, in the first place, injustice is fatal to social life and fellowship between man and man. For, if we are so disposed that each, to gain some personal profit, will defraud or injure his neighbour, then those bonds of human society, which are most in accord with Nature's laws, must of necessity be broken. Suppose, by way of comparison, that each one of our bodily members should conceive this idea and imagine that it could be strong and well if it should draw off to itself the health and strength of its neighbouring member, the whole body would necessarily be enfeebled and die; so, if each one of us should seize upon the property of his neighbours and take from each whatever he could appropriate to his own use, the bonds of human society must inevitably be annihilated. For, without any conflict with Nature's laws, it is granted that everybody may prefer to secure for himself rather than for his neighbour what is essential for the conduct of life; but Nature's laws do forbid us to increase our means, wealth, and resources by despoiling others.

But this principle is established not by Nature's laws alone (that is, by the common rules of equity), but also by the statutes of particular communities, in accordance with which in individual states the public interests are maintained. In all these it is with one accord ordained that no man shall be allowed for the sake of his own advantage to injure his neighbour. For it is to this that the laws have regard; this is their intent, that the bonds of union between citizens should not be impaired; and any attempt to destroy these bonds is repressed by the penalty of death, exile, imprisonment, or fine.

Again, this principle follows much more effectually directly from the Reason which is in Nature, which is the law of gods and men. If anyone will hearken to that voice (and all will hearken to it who wish to live in accord with Nature's laws), he will never be guilty of coveting anything that is his neighbour's or of appropriating to himself what he has taken from his neighbour. Then, too, loftiness and greatness of spirit, and courtesy, justice, and generosity are much more in harmony with Nature than are selfish pleasure, riches, and life itself; but it requires a great and lofty spirit to despise these latter and count them as naught, when one weighs them over against the common weal....

VIII. Now when we meet with expediency in some specious form or other, we cannot help being influenced by it. But if upon closer inspection one sees that there is some immorality connected with what presents the appearance of expediency, then one is not necessarily to sacrifice expediency but to recognize that there can be no expediency where there is immorality. But if there is nothing so repugnant to Nature as immorality (for Nature demands right and harmony and consistency and abhors their opposites), and if nothing is so thoroughly in accord with Nature as expediency, then surely expediency and immorality cannot coexist in one and the same object.

Again: if we are born for moral rectitude and if that is either the only thing worth seeking, as Zeno thought, or at least to be esteemed as infinitely outweighing everything else, as Aristotle holds, then it necessarily follows that the morally right is either

the sole good or the supreme good. Now, that which is good is certainly expedient; consequently, that which is morally right is also expedient.

Thus it is the error of men who are not strictly upright to seize upon something that seems to be expedient and straightway to dissociate that from the question of moral right. To this error the assassin's dagger, the poisoned cup, the forged wills owe their origin; this gives rise to theft, embezzlement of public funds, exploitation and plundering of provincials and citizens; this engenders also the lust for excessive wealth, for despotic power, and finally for making oneself king even in the midst of a free people; and anything more atrocious or repulsive than such a passion cannot be conceived. For with a false perspective they see the material rewards but not the punishment—I do not mean the penalty of the law, which they often escape, but the heaviest penalty of all, their own demoralization.

Away, then, with questioners of this sort (for their whole tribe is wicked and ungodly), who stop to consider whether to pursue the course which they see is morally right or to stain their hands with what they know is crime. For there is guilt in their very deliberation, even though they never reach the performance of the deed itself. Those actions, therefore, should not be considered at all, the mere consideration of which is itself morally wrong.

Furthermore, in any such consideration we must banish any vain hope and thought that our action may be covered up and kept secret. For if we have only made some real progress in the study of philosophy, we ought to be quite convinced that, even though we may escape the eyes of gods and men, we must still do nothing that savours of greed or of injustice, of lust or of intemperance.

IX. By way of illustrating this truth Plato introduces the familiar story of Gyges: Once upon a time the earth opened in consequence of heavy rains; Gyges went down into the chasm and saw, so the story goes, a horse of bronze; in its side was a door. On opening this door he saw the body of a dead man of enormous size with a gold ring upon his finger. He removed this and put it on his own hand and then repaired to an assembly of the shepherds, for he was a shepherd of the king. As often as he turned the bezel of the ring inwards toward the palm of his hand, he became invisible to everyone, while he himself saw everything; but as often as he turned it back to its proper position, he became visible again. And so, with the advantage which the ring gave him, he debauched the queen, and with her assistance he murdered his royal master and removed all those who he thought stood in his way, without anyone's being able to detect him in his crimes. Thus, by virtue of the ring, he shortly rose to be king of Lydia.

Now, suppose a wise man had just such a ring, he would not imagine that he was free to do wrong any more than if he did not have it; for good men aim to secure not secrecy but the right.

And yet on this point certain philosophers, who are not at all vicious but who are not very discerning, declare that the story related by Plato is fictitious and imaginary. As if he affirmed that it was actually true or even possible! But the force of the illustration of the ring is this: if nobody were to know or even to suspect the truth, when you do anything to gain riches or power or sovereignty or sensual gratification—if your act should be hidden for ever from the knowledge of gods and men, would you do it? The condition, they say, is impossible. Of course it is. But my question is, if that were possible which they declare to be impossible, what, pray, would one do? They press their point with right boorish obstinacy: they assert that it is impossible and insist upon it; they refuse to see the meaning of my words, "if possible." For when we ask what they would do, if they could escape detection, we are not asking whether they can escape detection; but we put them as it were upon the rack: should they answer that, if impunity were assured, they would do what was most to their selfish interest, that would be a confession that they are criminally minded; should they say that they would not do so, they would be granting that all things in and of themselves immoral should be avoided.

But let us now return to our theme....

XII. Let it be set down as an established principle, then, that what is morally wrong can never be expedient—not even when one secures by means of it that which one thinks expedient; for the mere act

of thinking a course expedient, when it is morally wrong, is demoralizing. But, as I said above, cases often arise in which expediency may seem to clash with moral rectitude; and so we should examine carefully and see whether their conflict is inevitable or whether they may be reconciled. The following are problems of this sort: suppose, for example, a time of dearth and famine at Rhodes, with provisions at fabulous prices; and suppose that an honest man has imported a large cargo of grain from Alexandria and that to his certain knowledge also several other importers have set sail from Alexandria, and that on the voyage he has sighted their vessels laden with grain and bound for Rhodes; is he to report the fact to the Rhodians or is he to keep his own counsel and sell his own stock at the highest market price? I am assuming the case of a virtuous, upright man, and I am raising the question how a man would think and reason who would not conceal the facts from the Rhodians if he thought that it was immoral to do so, but who might be in doubt whether such silence would really be immoral.

In deciding cases of this kind Diogenes of Babylonia, a great and highly esteemed Stoic, consistently holds one view; his pupil Antipater, a most profound scholar, holds another. According to Antipater all the facts should be disclosed, that the buyer may not be uninformed of any detail that the seller knows; according to Diogenes the seller should declare any defects in his wares, in so far as such a course is prescribed by the common law of the land; but for the rest, since he has goods to sell, he may try to sell them to the best possible advantage, provided he is guilty of no misrepresentation.

"I have imported my stock," Diogenes's merchant will say; "I have offered it for sale; I sell at a price no higher than my competitors—perhaps even lower, when the market is overstocked. Who is wronged?"

"What say you?" comes Antipater's argument on the other side; "it is your duty to consider the interests of your fellow-men and to serve society; you were brought into the world under these conditions and have these inborn principles which you are in duty bound to obey and follow, that your interest shall be the interest of the community and conversely that the interest of the community shall be your interest as well; will you, in view of all these facts, conceal from your fellow-men what relief in plenteous supplies is close at hand for them?"

"It is one thing to conceal," Diogenes will perhaps reply; "not to reveal is quite a different thing. At this present moment I am not concealing from you, even if I am not revealing to you, the nature of the gods or the highest good; and to know these secrets would be of more advantage to you than to know that the price of wheat was down. But I am under no obligation to tell you everything that it may be to your interest to be told."

"Yea," Antipater will say, "but you are, as you must admit, if you will only bethink you of the bonds of fellowship forged by Nature and existing between man and man."

"I do not forget them," the other will reply; "but do you mean to say that those bonds of fellowship are such that there is no such thing as private property? If that is the case, we should not sell anything at all, but freely give everything away."

XIII. In this whole discussion, you see, no one says, "However wrong morally this or that may be, still, since it is expedient, I will do it"; but the one side asserts that a given act is expedient, without being morally wrong, while the other insists that the act should not be done, because it is morally wrong.

Suppose again that an honest man is offering a house for sale on account of certain undesirable features of which he himself is aware but which nobody else knows; suppose it is unsanitary, but has the reputation of being healthful; suppose it is not generally known that vermin are to be found in all the bedrooms; suppose, finally, that it is built of unsound timber and likely to collapse, but that no one knows about it except the owner; if the vendor does not tell the purchaser these facts but sells him the house for far more than he could reasonably have expected to get for it, I ask whether his transaction is unjust or dishonourable.

"Yes," says Antipater, "it is; for to allow a purchaser to be hasty in closing a deal and through mistaken judgment to incur a very serious loss, if this is not refusing 'to set a man right when he has lost his

way' (a crime which at Athens is prohibited on pain of public execration), what is? It is even worse than refusing to set a man on his way: it is deliberately leading a man astray."

"Can you say," answers Diogenes, "that he compelled you to purchase, when he did not even advise it? He advertised for sale what he did not like; you bought what you did like. If people are not considered guilty of swindling when they place upon their placards For Sale: A Fine Villa, Well Built, even when it is neither good nor properly built, still less guilty are they who say nothing in praise of their house. For where the purchaser may exercise his own judgment, what fraud can there be on the part of the vendor? But if, again, not all that is expressly stated has to be made good, do you think a man is bound to make good what has not been said? What, pray, would be more stupid than for a vendor to recount all the faults in the article he is offering for sale? And what would be so absurd as for an auctioneer to cry, at the owner's bidding, 'Here is an unsanitary house for sale'?"

In this way, then, in certain doubtful cases moral rectitude is defended on the one side, while on the other side the case of expediency is so presented as to make it appear not only morally right to do what seems expedient, but even morally wrong not to do it. This is the contradiction that seems often to arise between the expedient and the morally right. But I must give my decision in these two cases; for I did not propound them merely to raise the questions, but to offer a solution. I think, then, that it was the duty of that grain-dealer not to keep back the facts from the Rhodians, and of this vendor of the house to deal in the same way with his purchaser. The fact is that merely holding one's peace about a thing does not constitute concealment, but concealment consists in trying for your own profit to keep others from finding out something that you know, when it is for their interest to know it. And who fails to discern what manner of concealment that is and what sort of person would be guilty of it? At all events he would be no candid or sincere or straightforward or upright or honest man, but rather one who is shifty, sly, artful, shrewd, underhand, cunning, one grown old in fraud

and subtlety. Is it not inexpedient to subject oneself to all these terms of reproach and many more besides?

XIV. If, then, they are to be blamed who suppress the truth, what are we to think of those who actually state what is false? Gaius Canius, a Roman knight, a man of considerable wit and literary culture, once went to Syracuse for a vacation, as he himself used to say, and not for business. He gave out that he had a mind to purchase a little country seat, where he could invite his friends and enjoy himself, uninterrupted by troublesome visitors. When this fact was spread abroad, one Pythius, a banker of Syracuse, informed him that he had such an estate; that it was not for sale, however, but Canius might make himself at home there, if he pleased; and at the same time he invited him to the estate to dinner next day. Canius accepted. Then Pythius, who, as might be expected of a money-lender, could command favours of all classes, called the fishermen together and asked them to do their fishing the next day out in front of his villa, and told them what he wished them to do. Canius came to dinner at the appointed hour; Pythius had a sumptuous banquet prepared; there was a whole fleet of boats before their eyes; each fisherman brought in in turn the catch that he had made; and the fishes were deposited at the feet of Pythius.

"Pray, Pythius," said Canius thereupon, "what does this mean?—all these fish?—all these boats?"

"No wonder," answered Pythius; "this is where all the fish in Syracuse are; here is where the fresh water comes from; the fishermen cannot get along without this estate."

Inflamed with desire for it, Canius insisted upon Pythius's selling it to him. At first he demurred. To make a long story short, Canius gained his point. The man was rich, and, in his desire to own the country seat, he paid for it all that Pythius asked; and he bought the entire equipment, too. Pythius entered the amount upon his ledger and completed the transfer. The next day Canius invited his friends; he came early himself. Not so much as a thole-pin was in sight. He asked his next-door neighbour whether it was a fishermen's holiday, for not a sign of them did he see.

"Not so far as I know," said he; "but none are in the habit of fishing here. And so I could not make out what was the matter yesterday."

Canius was furious; but what could he do? For not yet had my colleague and friend, Gaius Aquilius, introduced the established forms to apply to criminal fraud. When asked what he meant by "criminal fraud," as specified in these forms, he would reply: "Pretending one thing and practising another"—a very felicitous definition, as one might expect from an expert in making them. Pythius, therefore, and all others who do one thing while they pretend another are faithless, dishonest, and unprincipled scoundrels. No act of theirs can be expedient, when what they do is tainted with so many vices.

XV. But if Aquilius's definition is correct, pretence and concealment should be done away with in all departments of our daily life. Then an honest man will not be guilty of either pretence or concealment in order to buy or to sell to better advantage. Besides, your "criminal fraud" had previously been prohibited by the statutes: the penalty in the matter of trusteeships, for example, is fixed by the Twelve Tables; for the defrauding of minors, by the Plaetorian law. The same prohibition is effective, without statutory enactment, in equity cases, in which it is added that the decision shall be "as good faith requires." In all other cases in equity, moreover, the following phrases are most noteworthy: in a case calling for arbitration in the matter of a wife's dowry: what is "the fairer is the better"; in a suit for the restoration of a trust: "honest dealing, as between honest parties." Pray, then, can there be any element of fraud in what is adjusted for the "better and fairer"? Or can anything fraudulent or unprincipled be done, when "honest dealing between honest parties" is stipulated? But "criminal fraud," as Aquilius says, consists in false pretence. We must, therefore, keep misrepresentation entirely out of business transactions: the seller will not engage a bogus bidder to run prices up nor the buyer one to bid low against himself to keep them down; and each, if they come to naming a price, will state once for all what he will give or take. Why, when Quintus Scaevola, the son of Publius Scaevola, asked that the price of a farm that he desired to purchase be definitely named

and the vendor named it, he replied that he considered it worth more, and paid him 100,000 sesterces over and above what he asked. No one could say that this was not the act of an honest man; but people do say that it was not the act of a worldly-wise man, any more than if he had sold for a smaller amount than he could have commanded. Here, then, is that mischievous idea—the world accounting some men upright, others wise; and it is this fact that gives Ennius occasion to say:

"In vain is the wise man wise, who cannot benefit himself."

And Ennius is quite right, if only he and I were agreed upon the meaning of "benefit."

Now I observe that Hecaton of Rhodes, a pupil of Panaetius, says in his books on "Moral Duty" dedicated to Quintus Tubero that "it is a wise man's duty to take care of his private interests, at the same time doing nothing contrary to the civil customs, laws, and institutions. But that depends on our purpose in seeking prosperity; for we do not aim to be rich for ourselves alone but for our children, relatives, friends, and, above all, for our country. For the private fortunes of individuals are the wealth of the state." Hecaton could not for a moment approve of Scaevola's act, which I cited a moment ago; for he openly avows that he will abstain from doing for his own profit only what the law expressly forbids. Such a man deserves no great praise nor gratitude.

Be that as it may, if both pretence and concealment constitute "criminal fraud," there are very few transactions into which "criminal fraud" does not enter; or, if he only is a good man who helps all he can, and harms no one, it will certainly be no easy matter for us to find the good man as thus defined.

To conclude, then, it is never expedient to do wrong, because wrong is always immoral; and it is always expedient to be good, because goodness is always moral.

XVI. In the laws pertaining to the sale of real property it is stipulated in our civil code that when a transfer of any real estate is made, all its defects shall be declared as far as they are known to the vendor.

According to the laws of the Twelve Tables it used to be sufficient that such faults as had been expressly declared should be made good and that for any flaws which the vendor expressly denied, when questioned, he should be assessed double damages. A like penalty for failure to make such declaration also has now been secured by our jurisconsults: they have decided that any defect in a piece of real estate, if known to the vendor but not expressly stated, must be made good by him. For example, the augurs were proposing to take observations from the citadel and they ordered Tiberius Claudius Centumalus, who owned a house upon the Caelian Hill, to pull down such parts of the building as obstructed the augurs' view by reason of their height. Claudius at once advertised his block for sale, and Publius Calpurnius Lanarius bought it. The same notice was served also upon him. And so, when Calpurnius had pulled down those parts of the building and discovered that Claudius had advertised it for sale only after the augurs had ordered them to be pulled down, he summoned the former owner before a court of equity to decide "what indemnity the owner was under obligation 'in good faith' to pay and deliver to him." The verdict was pronounced by Marcus Cato, the father of our Cato (for as other men receive a distinguishing name from their fathers, so he who bestowed upon the world so bright a luminary must have his distinguishing name from his son); he, as I was saying, was presiding judge and pronounced the verdict that "since the augurs' mandate was known to the vendor at the time of making the transfer and since he had not made it known, he was bound to make good the purchaser's loss."

With this verdict he established the principle that it was essential to good faith that any defect known to the vendor must be made known to the purchaser. If his decision was right, our grain-dealer and the vendor of the unsanitary house did not do right to suppress the facts in those cases. But the civil code cannot be made to include all cases where facts are thus suppressed; but those cases which it does include are summarily dealt with. Marcus Marius Gratidianus, a kinsman of ours, sold back to Gaius Sergius Orata the house which he himself had bought a few years before from that same Orata. It was sub-ject to an encumbrance, but Marius had said nothing about this fact in stating the terms of sale. The case was carried to the courts. Crassus was counsel for Orata; Antonius was retained by Gratidianus. Crassus pleaded the letter of the law that "the vendor was bound to make good the defect, for he had not declared it, although he was aware of it"; Antonius laid stress upon the equity of the case, pleading that, "inasmuch as the defect in question had not been unknown to Sergius (for it was the same house that he had sold to Marius), no declaration of it was needed, and in purchasing it back he had not been imposed upon, for he knew to what legal liability his purchase was subject."

What is the purpose of these illustrations? To let you see that our forefathers did not countenance sharp practice....

XVIII. Let us put our principle to the test, if you please, and see if it holds good in those instances in which, perhaps, the world in general finds no wrong; for in this connection we do not need to discuss cut-throats, poisoners, forgers of wills, thieves, and embezzlers of public moneys, who should be repressed not by lectures and discussions of philosophers, but by chains and prison walls; but let us study here the conduct of those who have the reputation of being honest men.

Certain individuals brought from Greece to Rome a forged will, purporting to be that of the wealthy Lucius Minucius Basilus. The more easily to procure validity for it, they made joint-heirs with themselves two of the most influential men of the day, Marcus Crassus and Quintus Hortensius. Although these men suspected that the will was a forgery, still, as they were conscious of no personal guilt in the matter, they did not spurn the miserable boon procured through the crime of others. What shall we say, then? Is this excuse competent to acquit them of guilt? I cannot think so, although I loved the one while he lived, and do not hate the other now that he is dead. Be that as it may, Basilus had in fact desired that his nephew Marcus Satrius should bear his name and inherit his property....

And therefore it was not right that two of the leading citizens of Rome should take the estate and

Satrius succeed to nothing except his uncle's name. For if he does wrong who does not ward off and repel injury when he can,...what is to be thought of the man who not only does not try to prevent wrong, but actually aids and abets it? For my part, I do not believe that even genuine legacies are moral, if they are sought after by designing flatteries and by attentions hypocritical rather than sincere.

And yet in such cases there are times when one course is likely to appear expedient and another morally right. The appearance is deceptive; for our standard is the same for expediency and for moral rectitude. And the man who does not accept the truth of this will be capable of any sort of dishonesty, any sort of crime. For if he reasons, "That is, to be sure, the right course, but this course brings advantage," he will not hesitate in his mistaken judgment to divorce two conceptions that Nature has made one; and that spirit opens the door to all sorts of dishonesty, wrong-doing, and crime.

XIX. Suppose, then, that a good man had such power that at a snap of his fingers his name could steal into rich men's wills, he would not avail himself of that power—no, not even though he could be perfectly sure that no one would ever suspect it. Suppose, on the other hand, that one were to offer a Marcus Crassus the power, by the mere snapping of his fingers, to get himself named as heir, when he was not really an heir, he would, I warrant you, dance in the forum. But the righteous man, the one whom we feel to be a good man, would never rob anyone of anything to enrich himself. If anybody is astonished at this doctrine, let him confess that he does not know what a good man is. If, on the other hand, anyone should desire to unfold the idea of a good man which lies wrapped up in his own mind, he would then at once make it clear to himself that a good man is one who helps all whom he can and harms nobody, unless provoked by wrong. What shall we say, then? Would he not be doing harm who by a kind of magic spell should succeed in displacing the real heirs to an estate and pushing himself into their place? "Well," someone may say, "is he not to do what is expedient, what is advantageous to himself?" Nay, verily; he should rather be brought to realize that nothing that is unjust is either advantageous or expedient; if he

does not learn this lesson, it will never be possible for him to be a "good man."

When I was a boy, I used to hear my father tell that Gaius Fimbria, an ex-consul, was judge in a case of Marcus Lutatius Pinthia, a Roman knight of irreproachable character. On that occasion Pinthia had laid a wager to be forfeited "if he did not prove in court that he was a good man." Fimbria declared that he would never render a decision in such a case, for fear that he might either rob a reputable man of his good name, if he decided against him, or be thought to have pronounced someone a good man, when such a character is, as he said, established by the performance of countless duties and the possession of praiseworthy qualities without number.

To this type of good man, then, known not only to a Socrates but even to a Fimbria, nothing can possibly seem expedient that is not morally right. Such a man, therefore, will never venture to think—to say nothing of doing—anything that he would not dare openly to proclaim. Is it not a shame that philosophers should be in doubt about moral questions on which even peasants have no doubts at all? For it is with peasants that the proverb, already trite with age, originated: when they praise a man's honour and honesty, they say, "He is a man with whom you can safely play at odd and even in the dark." What is the point of the proverb but this—that what is not proper brings no advantage, even if you can gain your end without anyone's being able to convict you of wrong?

Do you not see that in the light of this proverb no excuse is available either for the Gyges of the story or for the man who I assumed a moment ago could with a snap of his fingers sweep together everybody's inheritance at once? For as the morally wrong cannot by any possibility be made morally right, however successfully it may be covered up, so what is not morally right cannot be made expedient, for Nature refuses and resists....

XXIV. The question arises also whether agreements and promises must always be kept, "when," in the language of the praetors' edicts, "they have not been secured through force or criminal fraud."

If one man gives another a remedy for the dropsy, with the stipulation that, if he is cured by it, he shall

never make use of it again; suppose the patient's health is restored by the use of it, but some years later he contracts the same disease once more; and suppose he cannot secure from the man with whom he made the agreement permission to use the remedy again, what should he do? That is the question. Since the man is unfeeling in refusing the request, and since no harm could be done to him by his friend's using the remedy, the sick man is justified in doing what he can for his own life and health.

Again: suppose that a millionaire is making some wise man his heir and leaving him in his will a hundred million sesterces; and suppose that he has asked the wise man, before he enters upon his inheritance, to dance publicly in broad daylight in the forum; and suppose that the wise man has given his promise to do so, because the rich man would not leave him his fortune on any other condition; should he keep his promise or not? I wish he had made no such promise; that, I think, would have been in keeping with his dignity. But, seeing that he has made it, it will be morally better for him, if he believes it morally wrong to dance in the forum, to break his promise and refuse to accept his inheritance rather than to keep his promise and accept it—unless, perhaps, he contributes the money to the state to meet some grave crisis. In that case, to promote thereby the interests of one's country, it would not be morally wrong even to dance, if you please, in the forum.

XXV. No more binding are those promises which are inexpedient for the persons themselves to whom they have been given. To go back to the realm of story, the sungod promised his son Phaëthon to do for him whatever he should wish. His wish was to be allowed to ride in his father's chariot. It was granted. And before he came back to the ground he was consumed by a stroke of lightning. How much better had it been, if in his case the father's promise had not been kept. And what of that promise, the fulfilment of which Theseus required from Neptune? When Neptune offered him three wishes, he wished for the death of his son Hippolytus, because the father was suspicious of the son's relations with his step-mother. And when this wish was granted, Theseus was overwhelmed with grief. And once more; when Agamemnon had vowed to Diana the most beautiful creature born that year within his realm, he was brought to sacrifice Iphigenia; for in that year nothing was born more beautiful than she. He ought to have broken his vow rather than commit so horrible a crime.

Promises are, therefore, sometimes not to be kept; and trusts are not always to be restored. Suppose that a person leaves his sword with you when he is in his right mind, and demands it back in a fit of insanity; it would be criminal to restore it to him; it would be your duty not to do so. Again, suppose that a man who has entrusted money to you proposes to make war upon your common country, should you restore the trust? I believe you should not; for you would be acting against the state, which ought to be the dearest thing in the world to you. Thus there are many things which in and of themselves seem morally right, but which under certain circumstances prove to be not morally right: to keep a promise, to abide by an agreement, to restore a trust may, with a change of expediency, cease to be morally right.

With this I think I have said enough about those actions which masquerade as expedient under the guise of prudence, while they are really contrary to justice.

Study Questions

1. Might a person be reasonable yet immoral?
2. Does your talent at an activity give you a reason to pursue it?
3. If you reside in a country, do you have duties to it?
4. Should the seller of a product reveal its defects to a potential purchaser?

5

EPICTETUS

Epictetus (c. 55–c. 135), a freed Roman slave, was an exponent of Stoicism, an intellectual system founded in Greece soon after the death of Aristotle that offers a unified logical, physical, and moral philosophy. Epictetus is primarily concerned with moral teaching, and like other Stoics believes in living one's life in accord with the natural order, accepting what happens with a tranquility that renders one immune from disappointment and pain. Self-sufficiency is prized, for if you are not dependent on others, their failures cannot harm you. Because happiness can be achieved if events occur as one desires, and one has control over one's desires but not over events, the way to happiness lies in adjusting one's desires so that they are in accord with events. Note that the *Enchiridion* ends with quotations from Plato's *Apology* and *Crito*, emphasizing the equanimity of Socrates in the face of death. Such tranquility in the face of tribulation epitomizes the outlook on life presented by Epictetus, who himself endured without complaint the physical abuse that accompanied his slavery.

Enchiridion

1

Of all existing things some are in our power, and others are not in our power. In our power are thought, impulse, will to get and will to avoid, and, in a word, everything which is our own doing. Things not in our power include the body, property, reputation, office, and, in a word, everything which is not our own doing. Things in our power are by nature free, unhindered, untrammelled; things not in our power are weak, servile, subject to hindrance, dependent on others. Remember then that if you imagine that what is naturally slavish is free, and what is naturally another's is your own, you will be hampered, you will mourn, you will be put to confusion, you will blame gods and men; but if you think that only your own belongs to you, and that what is another's is indeed another's, no one will ever put compulsion or hindrance on you, you will blame none, you will accuse none, you will do nothing against your will, no one will harm you, you will have no enemy, for no harm can touch you.

Aiming then at these high matters, you must remember that to attain them requires more than ordinary effort; you will have to give up some things entirely, and put off others for the moment. And if you would have these also—office and wealth—it may be that you will fail to get them, just because your desire is set on the former, and you will certainly fail to attain those things which alone bring freedom and happiness.

From *Epictetus: The Discourses and Manual,* translated by P. E. Matheson (1917). Reprinted by permission of Oxford University Press.

Make it your study then to confront every harsh impression with the words, "You are but an impression, and not at all what you seem to be." Then test it by those rules that you possess; and first by this—the chief test of all—"Is it concerned with what is in our power or with what is not in our power?" And if it is concerned with what is not in our power, be ready with the answer that it is nothing to you.

2

Remember that the will to get promises attainment of what you will, and the will to avoid promises escape from what you avoid; and he who fails to get what he wills is unfortunate, and he who does not escape what he wills to avoid is miserable. If then you try to avoid only what is unnatural in the region within your control, you will escape from all that you avoid; but if you try to avoid disease or death or poverty you will be miserable.

Therefore let your will to avoid have no concern with what is not in man's power; direct it only to things in man's power that are contrary to nature. But for the moment you must utterly remove the will to get; for if you will to get something not in man's power you are bound to be unfortunate; while none of the things in man's power that you could honourably will to get is yet within your reach. Impulse to act and not to act, these are your concern; yet exercise them gently and without strain, and provisionally.

3

When anything, from the meanest thing upwards, is attractive or serviceable or an object of affection, remember always to say to yourself, "What is its nature?" If you are fond of a jug, say you are fond of a jug; then you will not be disturbed if it be broken. If you kiss your child or your wife, say to yourself that you are kissing a human being, for then if death strikes it you will not be disturbed.

4

When you are about to take something in hand, remind yourself what manner of thing it is. If you are going to bathe put before your mind what happens in the bath—water pouring over some, others being jostled, some reviling, others stealing; and you will set to work more securely if you say to yourself at once: "I want to bathe, and I want to keep my will in harmony with nature," and so in each thing you do; for in this way, if anything turns up to hinder you in your bathing, you will be ready to say, "I did not want only to bathe, but to keep my will in harmony with nature, and I shall not so keep it, if I lose my temper at what happens."

5

What disturbs men's mind is not events but their judgements on events. For instance, death is nothing dreadful, or else Socrates would have thought so. No, the only dreadful thing about it is men's judgement that it is dreadful. And so when we are hindered, or disturbed, or distressed, let us never lay the blame on others, but on ourselves, that is, on our own judgements. To accuse others for one's own misfortunes is a sign of want of education; to accuse oneself shows that one's education has begun; to accuse neither oneself nor others shows that one's education is complete.

6

Be not elated at an excellence which is not your own. If the horse in his pride were to say, "I am handsome," we could bear with it. But when you say with pride, "I have a handsome horse," know that the good horse is the ground of your pride. You ask then what you can call your own. The answer is—the way you deal with your impressions. Therefore when you deal with your impressions in accord with nature, then you may be proud indeed, for your pride will be in a good which is your own.

7

When you are on a voyage, and your ship is at anchorage, and you disembark to get fresh water, you may pick up a small shellfish or a truffle by the way, but you must keep your attention fixed on the ship, and keep looking towards it constantly, to see if the Helmsman calls you; and if he does, you have to leave everything, or be bundled on board with your legs tied like a sheep. So it is in life. If you have a dear wife or child given you, they are like the shellfish or the truffle, they are very well in their way. Only, if the Helmsman call, run back to your ship, leave all else, and do not look behind you. And if you are old, never go far from the ship, so that when you are called you may not fail to appear.

8

Ask not that events should happen as you will, but let your will be that events should happen as they do, and you shall have peace.

9

Sickness is a hindrance to the body, but not to the will, unless the will consent. Lameness is a hindrance to the leg, but not to the will. Say this to yourself at each event that happens, for you shall find that though it hinders something else it will not hinder you.

10

When anything happens to you, always remember to turn to yourself and ask what faculty you have to deal with it. If you see a beautiful boy or a beautiful woman, you will find continence the faculty to exercise there; if trouble is laid on you, you will find endurance; if ribaldry, you will find patience. And if you train yourself in this habit your impressions will not carry you away.

11

Never say of anything, "I lost it," but say, "I gave it back." Has your child died? It was given back. Has your wife died? She was given back. Has your estate been taken from you? Was not this also given back? But you say, "He who took it from me is wicked." What does it matter to you through whom the Giver asked it back? As long as He gives it you, take care of it, but not as your own; treat it as passers-by treat an inn.

12

If you wish to make progress, abandon reasonings of this sort: "If I neglect my affairs I shall have nothing to live on"; "If I do not punish my son, he will be wicked." For it is better to die of hunger, so that you be free from pain and free from fear, than to live in plenty and be troubled in mind. It is better for your son to be wicked than for you to be miserable. Wherefore begin with little things. Is your drop of oil spilt? Is your sup of wine stolen? Say to yourself, "This is the price paid for freedom from passion, this is the price of a quiet mind." Nothing can be had without a price. When you call your slave-boy, reflect that he may not be able to hear you, and if he hears you, he may not be able to do anything you want. But he is not so well off that it rests with him to give you peace of mind.

13

If you wish to make progress, you must be content in external matters to seem a fool and a simpleton; do not wish men to think you know anything, and if any should think you to be somebody, distrust yourself. For know that it is not easy to keep your will in accord with nature and at the same time keep outward things; if you attend to one you must needs neglect the other.

14

It is silly to want your children and your wife and your friends to live for ever, for that means that you want what is not in your control to be in your control, and what is not your own to be yours. In the same way if you want your servant to make no mistakes, you are a fool, for you want vice not to be vice but something different. But if you want not to be disappointed in your will to get, you can attain to that.

Exercise yourself then in what lies in your power. Each man's master is the man who has authority over what he wishes or does not wish, to secure the one or to take away the other. Let him then who wishes to be free not wish for anything or avoid anything that depends on others; or else he is bound to be a slave.

15

Remember that you must behave in life as you would at a banquet. A dish is handed round and comes to you; put out your hand and take it politely. It passes you; do not stop it. It has not reached you; do not be impatient to get it, but wait till your turn comes. Bear yourself thus towards children, wife, office, wealth, and one day you will be worthy to banquet with the gods. But if when they are set before you, you do not take them but despise them, then you shall not only share the gods' banquet, but shall share their rule. For by so doing Diogenes and Heraclitus and men like them were called divine and deserved the name.

16

When you see a man shedding tears in sorrow for a child abroad or dead, or for loss of property, beware that you are not carried away by the impression that it is outward ills that make him miserable. Keep this thought by you: "What distresses him is not the event, for that does not distress another, but his judgement on the event." Therefore do not hesitate to sympathize with him so far as words go, and if it so chance, even to groan with him; but take heed that you do not also groan in your inner being.

17

Remember that you are an actor in a play, and the Playwright chooses the manner of it: if he wants it short, it is short; if long, it is long. If he wants you to act a poor man you must act the part with all your powers; and so if your part be a cripple or a magistrate or a plain man. For your business is to act the character that is given you and act it well; the choice of the cast is Another's.

18

When a raven croaks with evil omen, let not the impression carry you away, but straightway distinguish in your own mind and say, "These portents mean nothing to me; but only to my bit of a body or my bit of property or name, or my children or my wife. But for me all omens are favourable if I will, for, whatever the issue may be, it is in my power to get benefit therefrom."

19

You can be invincible, if you never enter on a contest where victory is not in your power. Beware then that when you see a man raised to honour or great power or high repute you do not let your impression carry you away. For if the reality of good lies in what is in our power, there is no room for envy or jealousy. And you will not wish to be praetor, or prefect or consul, but to be free; and there is but one way to freedom— to despise what is not in our power.

20

Remember that foul words or blows in themselves are no outrage, but your judgement that they are so. So when anyone makes you angry, know that it is your own thought that has angered you. Wherefore make it your first endeavour not to let your impressions carry you away. For if once you gain time and delay, you will find it easier to control yourself.

21

Keep before your eyes from day to day death and exile and all things that seem terrible, but death most of all, and then you will never set your thoughts on what is low and will never desire anything beyond measure.

22

If you set your desire on philosophy you must at once prepare to meet with ridicule and the jeers of many who will say, "Here he is again, turned philosopher. Where has he got these proud looks?" Nay, put on no proud looks, but hold fast to what seems best to you, in confidence that God has set you at this post. And remember that if you abide where you are, those who first laugh at you will one day admire you, and that if you give way to them, you will get doubly laughed at.

23

If it ever happen to you to be diverted to things outside, so that you desire to please another, know that you have lost your life's plan. Be content then always to be a philosopher; if you wish to be regarded as one too, show yourself that you are one and you will be able to achieve it.

24

Let not reflections such as these afflict you: "I shall live without honour, and never be of any account," for if lack of honour is an evil, no one but yourself can involve you in evil any more than in shame. Is it your business to get office or to be invited to an entertainment?

Certainly not.

Where then is the dishonour you talk of? How can you be "of no account anywhere," when you ought to count for something in those matters only which are in your power, where you may achieve the highest worth?

"But my friends," you say, "will lack assistance."

What do you mean by "lack assistance"? They will not have cash from you and you will not make them Roman citizens. Who told you that to do these things is in our power, and not dependent upon others? Who can give to another what is not his to give?

"Get them then," says he, "that we may have them."

If I can get them and keep my self-respect, honour, magnanimity, show the way and I will get them. But if you call on me to lose the good things that are mine, in order that you may win things that are not good, look how unfair and thoughtless you are. And which do you really prefer? Money, or a faithful, modest friend? Therefore help me rather to keep these qualities, and do not expect from me actions which will make me lose them.

"But my country," says he, "will lack assistance, so far as lies in me."

Once more I ask, What assistance do you mean? It will not owe colonnades or baths to you. What of that? It does not owe shoes to the blacksmith or arms to the shoemaker; it is sufficient if each man fulfils his own function. Would you do it no good if you secured to it another faithful and modest citizen?

"Yes."

Well, then, you would not be useless to it.

"What place then shall I have in the city?"

Whatever place you can hold while you keep your character for honour and self-respect. But if you are going to lose these qualities in trying to benefit your city, what benefit, I ask, would you have done her when you attain to the perfection of being lost to shame and honour?

25

Has some one had precedence of you at an entertainment or a levée or been called in before you to give advice? If these things are good you ought to be glad that he got them; if they are evil, do not be angry that you did not get them yourself. Remember that if you want to get what is not in your power, you cannot earn the same reward as others unless you act as they do. How is it possible for one who does not haunt the great man's door to have equal shares with one

who does, or one who does not go in his train equality with one who does; or one who does not praise him with one who does? You will be unjust then and insatiable if you wish to get these privileges for nothing, without paying their price. What is the price of a lettuce? An obol perhaps. If then a man pays his obol and gets his lettuces, and you do not pay and do not get them, do not think you are defrauded. For as he has the lettuces so you have the obol you did not give. The same principle holds good too in conduct. You were not invited to some one's entertainment? Because you did not give the host the price for which he sells his dinner. He sells it for compliments, he sells it for attentions. Pay him the price then, if it is to your profit. But if you wish to get the one and yet not give up the other, nothing can satisfy you in your folly.

What! you say, you have nothing instead of the dinner?

Nay, you have this, you have not praised the man you did not want to praise, you have not had to bear with the insults of his doorstep.

26

It is in our power to discover the will of Nature from those matters on which we have no difference of opinion. For instance, when another man's slave has broken the wine-cup we are very ready to say at once, "Such things must happen." Know then that when your own cup is broken, you ought to behave in the same way as when your neighbour's was broken. Apply the same principle to higher matters. Is another's child or wife dead? Not one of us but would say, "Such is the lot of man," but when one's own dies, straightway one cries, "Alas! miserable am I." But we ought to remember what our feelings are when we hear it of another.

27

As a mark is not set up for men to miss it, so there is nothing intrinsically evil in the world.

28

If any one trusted your body to the first man he met, you would be indignant, but yet you trust your mind to the chance comer, and allow it to be disturbed and confounded if he revile you; are you not ashamed to do so?

29

In everything you do consider what comes first and what follows, and so approach it. Otherwise you will come to it with a good heart at first because you have not reflected on any of the consequences, and afterwards, when difficulties have appeared, you will desist to your shame. Do you wish to win at Olympia? So do I, by the gods, for it is a fine thing. But consider the first steps to it, and the consequences, and so lay your hand to the work. You must submit to discipline, eat to order, touch no sweets, train under compulsion, at a fixed hour, in heat and cold, drink no cold water, nor wine, except by order; you must hand yourself over completely to your trainer as you would to a physician, and then when the contest comes you must risk getting hacked, and sometimes dislocate your hand, twist your ankle, swallow plenty of sand, sometimes get a flogging, and with all this suffer defeat. When you have considered all this well, then enter on the athlete's course, if you still wish it. If you act without thought you will be behaving like children, who one day play at wrestlers, another day at gladiators, now sound the trumpet, and next strut the stage. Like them you will be now an athlete, now a gladiator, then orator, then philosopher, but nothing with all your soul. Like an ape, you imitate every sight you see, and one thing after another takes your fancy. When you undertake a thing you do it casually and half-heartedly, instead of considering it and looking at it all round. In the same way some people, when they see a philosopher and hear a man speaking like Euphrates (and indeed who can speak as he can?), wish to be philosophers themselves.

Man, consider first what it is you are undertaking; then look at your own powers and see if you can bear it. Do you want to compete in the pentathlon or in wrestling? Look to your arms, your thighs, see what your loins are like. For different men are born for different

tasks. Do you suppose that if you do this you can live as you do now—eat and drink as you do now, indulge desire and discontent just as before? Nay, you must sit up late, work hard, abandon your own people, be looked down on by a mere slave, be ridiculed by those who meet you, get the worst of it in everything—in honour, in office, in justice, in every possible thing. This is what you have to consider: whether you are willing to pay this price for peace of mind, freedom, tranquillity. If not, do not come near; do not be, like the children, first a philosopher, then a tax-collector, then an orator, then one of Caesar's procurators. These callings do not agree. You must be one man, good or bad; you must develop either your Governing Principle, or your outward endowments; you must study either your inner man, or outward things—in a word, you must choose between the position of a philosopher and that of a mere outsider.

30

Appropriate acts are in general measured by the relations they are concerned with. "He is your father." This means you are called on to take care of him, give way to him in all things, bear with him if he reviles or strikes you.

"But he is a bad father."

Well, have you any natural claim to a good father? No, only to a father.

"My brother wrongs me."

Be careful then to maintain the relation you hold to him, and do not consider what he does, but what you must do if your purpose is to keep in accord with nature. For no one shall harm you, without your consent; you will only be harmed, when you think you are harmed. You will only discover what is proper to expect from neighbour, citizen, or praetor, if you get into the habit of looking at the relations implied by each.

31

For piety towards the gods know that the most important thing is this: to have right opinions about them— that they exist, and that they govern the universe well

and justly—and to have set yourself to obey them, and to give way to all that happens, following events with a free will, in the belief that they are fulfilled by the highest mind. For thus you will never blame the gods, nor accuse them of neglecting you. But this you cannot achieve, unless you apply your conception of good and evil to those things only which are in our power, and not to those which are out of our power. For if you apply your notion of good or evil to the latter, then, as soon as you fail to get what you will to get or fail to avoid what you will to avoid, you will be bound to blame and hate those you hold responsible. For every living creature has a natural tendency to avoid and shun what seems harmful and all that causes it, and to pursue and admire what is helpful and all that causes it. It is not possible then for one who thinks he is harmed to take pleasure in what he thinks is the author of the harm, any more than to take pleasure in the harm itself. That is why a father is reviled by his son, when he does not give his son a share of what the son regards as good things; thus Polynices and Eteocles were set at enmity with one another by thinking that a king's throne was a good thing. That is why the farmer, and the sailor, and the merchant, and those who lose wife or children revile the gods. For men's religion is bound up with their interest. Therefore he who makes it his concern rightly to direct his will to get and his will to avoid, is thereby making piety his concern. But it is proper on each occasion to make libation and sacrifice and to offer first-fruits according to the custom of our fathers, with purity and not in slovenly or careless fashion, without meannness and without extravagance.

32

When you make use of prophecy remember that while you know not what the issue will be, but are come to learn it from the prophet, you do know before you come what manner of thing it is, if you are really a philosopher. For if the event is not in our control, it cannot be either good or evil. Therefore do not bring with you to the prophet the will to get or the will to avoid, and do not approach him with trembling, but with your mind made up, that the whole issue is indifferent and does not affect you and that, whatever it be,

it will be in your power to make good use of it, and no one shall hinder this. With confidence then approach the gods as counsellors, and further, when the counsel is given you, remember whose counsel it is, and whom you will be disregarding if you disobey. And consult the oracle, as Socrates thought men should, only when the whole question turns upon the issue of events, and neither reason nor any art of man provides opportunities for discovering what lies before you. Therefore, when it is your duty to risk your life with friend or country, do not ask the oracle whether you should risk your life. For if the prophet warns you that the sacrifice is unfavourable, though it is plain that this means death or exile or injury to some part of your body, yet reason requires that even at this cost you must stand by your friend and share your country's danger. Wherefore pay heed to the greater prophet, Pythian Apollo, who cast out of his temple the man who did not help his friend when he was being killed.

<div align="center">

33

</div>

Lay down for yourself from the first a definite stamp and style of conduct, which you will maintain when you are alone and also in the society of men. Be silent for the most part, or, if you speak, say only what is necessary and in a few words. Talk, but rarely, if occasion calls you, but do not talk of ordinary things—of gladiators, or horse-races, or athletes, or of meats or drinks—these are topics that arise everywhere—but above all do not talk about men in blame or compliment or comparison. If you can, turn the conversation of your company by your talk to some fitting subject; but if you should chance to be isolated among strangers, be silent. Do not laugh much, nor at many things, nor without restraint.

Refuse to take oaths, altogether if that be possible, but if not, as far as circumstances allow.

Refuse the entertainments of strangers and the vulgar. But if occasion arise to accept them, then strain every nerve to avoid lapsing into the state of the vulgar. For know that, if your comrade have a stain on him, he that associates with him must needs share the stain, even though he be clean in himself.

For your body take just so much as your bare need requires, such as food, drink, clothing, house, servants, but cut down all that tends to luxury and outward show.

Avoid impurity to the utmost of your power before marriage, and if you indulge your passion, let it be done lawfully. But do not be offensive or censorious to those who indulge it, and do not be always bringing up your own chastity. If some one tells you that so and so speaks ill of you, do not defend yourself against what he says, but answer, "He did not know my other faults, or he would not have mentioned these alone."

It is not necessary for the most part to go to the games; but if you should have occasion to go, show that your first concern is for yourself; that is, wish that only to happen which does happen, and him only to win who does win, for so you will suffer no hindrance. But refrain entirely from applause, or ridicule, or prolonged excitement. And when you go away do not talk much of what happened there, except so far as it tends to your improvement. For to talk about it implies that the spectacle excited your wonder.

Do not go lightly or casually to hear lectures; but if you do go, maintain your gravity and dignity and do not make yourself offensive. When you are going to meet anyone, and particularly some man of reputed eminence, set before your mind the thought, "What would Socrates or Zeno have done?" and you will not fail to make proper use of the occasion.

When you go to visit some great man, prepare your mind by thinking that you will not find him in, that you will be shut out, that the doors will be slammed in your face, that he will pay no heed to you. And if in spite of all this you find it fitting for you to go, go and bear what happens and never say to yourself, "It was not worth all this"; for that shows a vulgar mind and one at odds with outward things.

In your conversation avoid frequent and disproportionate mention of your own doings or adventures; for other people do not take the same pleasure in hearing what has happened to you as you take in recounting your adventures.

Avoid raising men's laughter; for it is a habit that easily slips into vulgarity, and it may well suffice to lessen your neighbour's respect.

It is dangerous too to lapse into foul language; when anything of the kind occurs, rebuke the offender, if the occasion allow, and if not, make it plain to him

by your silence, or a blush or a frown, that you are
angry at his words.

34

When you imagine some pleasure, beware that it does
not carry you away, like other imaginations. Wait a
while, and give yourself pause. Next remember two
things: how long you will enjoy the pleasure, and
also how long you will afterwards repent and revile
yourself. And set on the other side the joy and self-
satisfaction you will feel if you refrain. And if the
moment seems to come to realize it, take heed that you
be not overcome by the winning sweetness and attrac-
tion of it; set in the other scale the thought how much
better is the consciousness of having vanquished it.

35

When you do a thing because you have determined
that it ought to be done, never avoid being seen doing
it, even if the opinion of the multitude is going to
condemn you. For if your action is wrong, then avoid
doing it altogether, but if it is right, why do you fear
those who will rebuke you wrongly?

36

The phrases, "It is day" and "It is night," mean a
great deal if taken separately, but have no meaning
if combined. In the same way, to choose the larger
portion at a banquet may be worth while for your
body, but if you want to maintain social decencies it
is worthless. Therefore, when you are at meat with
another, remember not only to consider the value of
what is set before you for the body, but also to main-
tain your self-respect before your host.

37

If you try to act a part beyond your powers, you not
only disgrace yourself in it, but you neglect the part
which you could have filled with success.

38

As in walking you take care not to tread on a nail
or to twist your foot, so take care that you do not
harm your Governing Principle. And if we guard
this in everything we do, we shall set to work more
securely.

39

Every man's body is a measure for his property, as
the foot is the measure for his shoe. If you stick to
this limit, you will keep the right measure; if you go
beyond it, you are bound to be carried away down a
precipice in the end; just as with the shoe, if you once
go beyond the foot, your shoe puts on gilding, and
soon purple and embroidery. For when once you go
beyond the measure there is no limit.

40

Women from fourteen years upwards are called
"madam" by men. Wherefore, when they see that
the only advantage they have got is to be marriage-
able, they begin to make themselves smart and to set
all their hopes on this. We must take pains then to
make them understand that they are really honoured
for nothing but a modest and decorous life.

41

It is a sign of a dull mind to dwell upon the cares
of the body, to prolong exercise, eating, drinking,
and other bodily functions. These things are to be
done by the way; all your attention must be given
to the mind.

42

When a man speaks evil or does evil to you, remem-
ber that he does or says it because he thinks it is

fitting for him. It is not possible for him to follow what seems good to you, but only what seems good to him, so that, if his opinion is wrong, he suffers, in that he is the victim of deception. In the same way, if a composite judgement which is true is thought to be false, it is not the judgement that suffers, but the man who is deluded about it. If you act on this principle you will be gentle to him who reviles you, saying to yourself on each occasion, "He thought it right."

43

Everything has two handles, one by which you can carry it, the other by which you cannot. If your brother wrongs you, do not take it by that handle, the handle of his wrong, for you cannot carry it by that, but rather by the other handle—that he is a brother, brought up with you, and then you will take it by the handle that you can carry by.

44

It is illogical to reason thus, "I am richer than you, therefore I am superior to you," "I am more eloquent than you, therefore I am superior to you." It is more logical to reason, "I am richer than you, therefore my property is superior to yours," "I am more eloquent than you, therefore my speech is superior to yours." You are something more than property or speech.

45

If a man wash quickly, do not say that he washes badly, but that he washes quickly. If a man drink much wine, do not say that he drinks badly, but that he drinks much. For till you have decided what judgement prompts him, how do you know that he acts badly? If you do as I say, you will assent to your apprehensive impressions and to none other.

46

On no occasion call yourself a philosopher, nor talk at large of your principles among the multitude, but act on your principles. For instance, at a banquet do not say how one ought to eat, but eat as you ought. Remember that Socrates had so completely got rid of the thought of display that when men came and wanted an introduction to philosophers he took them to be introduced; so patient of neglect was he. And if a discussion arise among the multitude on some principle, keep silent for the most part; for you are in great danger of blurting out some undigested thought. And when someone says to you, "You know nothing," and you do not let it provoke you, then know that you are really on the right road. For sheep do not bring grass to their shepherds and show them how much they have eaten, but they digest their fodder and then produce it in the form of wool and milk. Do the same yourself; instead of displaying your principles to the multitude, show them the results of the principles you have digested.

47

When you have adopted the simple life, do not pride yourself upon it, and if you are a water-drinker do not say on every occasion, "I am a water-drinker." And if you ever want to train laboriously, keep it to yourself and do not make a show of it. Do not embrace statues. If you are very thirsty take a good draught of cold water, and rinse your mouth and tell no one.

48

The ignorant man's position and character is this: he never looks to himself for benefit or harm, but to the world outside him. The philosopher's position and character is that he always look to himself for benefit and harm.

The signs of one who is making progress are: he blames none, praises none, complains of none, accuses none, never speaks of himself as if he were somebody, or as if he knew anything. And if anyone compliments him he laughs in himself at his compliment; and if one blames him, he makes no defence. He goes about like a convalescent, careful not to disturb his constitution on its road to recovery, until it has got firm hold. He has got rid of the will to get, and his will to avoid is directed no longer to what is beyond our power but only to what is in our power and contrary to nature. In all things he exercises his will without strain. If men regard him as foolish or ignorant he pays no heed. In one word, he keeps watch and guard on himself as his own enemy, lying in wait for him.

49

When a man prides himself on being able to understand and interpret the books of Chrysippus, say to yourself, "If Chrysippus had not written obscurely this man would have had nothing on which to pride himself."

What is my object? To understand Nature and follow her. I look then for someone who interprets her, and having heard that Chrysippus does I come to him. But I do not understand his writings, so I seek an interpreter. So far there is nothing to be proud of. But when I have found the interpreter it remains for me to act on his precepts; that and that alone is a thing to be proud of. But if I admire the mere power of exposition, it comes to this—that I am turned into a grammarian instead of a philosopher, except that I interpret Chrysippus in place of Homer. Therefore, when someone says to me, "Read me Chrysippus," when I cannot point to actions which are in harmony and correspondence with his teaching, I am rather inclined to blush.

50

Whatever principles you put before you, hold fast to them as laws which it will be impious to transgress.

But pay no heed to what any one says of you; for this is something beyond your own control.

51

How long will you wait to think yourself worthy of the highest and transgress in nothing the clear pronouncement of reason? You have received the precepts which you ought to accept, and you have accepted them. Why then do you still wait for a master, that you may delay the amendment of yourself till he comes? You are a youth no longer, you are now a full-grown man. If now you are careless and indolent and are always putting off, fixing one day after another as the limit when you mean to begin attending to yourself, then, living or dying, you will make no progress but will continue unawares in ignorance. Therefore make up your mind before it is too late to live as one who is mature and proficient, and let all that seems best to you be a law that you cannot transgress. And if you encounter anything troublesome or pleasant or glorious or inglorious, remember that the hour of struggle is come, the Olympic contest is here and you may put off no longer, and that one day and one action determines whether the progress you have achieved is lost or maintained.

This was how Socrates attained perfection, paying heed to nothing but reason, in all that he encountered. And if you are not yet Socrates, yet ought you to live as one who would wish to be a Socrates.

52

The first and most necessary department of philosophy deals with the application of principles; for instance, "not to lie." The second deals with demonstrations; for instance, "How comes it that one ought not to lie?" The third is concerned with establishing and analysing these processes; for instance, "How comes it that this is a demonstration? What is demonstration, what is consequence, what is contradiction, what is true, what is false?" It follows then that the third department is necessary because of the second, and the second because of the first. The first

is the most necessary part, and that in which we must rest. But we reverse the order: we occupy ourselves with the third, and make that our whole concern, and the first we completely neglect. Wherefore we lie, but are ready enough with the demonstration that lying is wrong.

53

On every occasion we must have these thoughts at hand,

"Lead me, O Zeus, and lead me, Destiny,
Whither ordained is by your decree.
I'll follow, doubting not, or if with will
Recreant I falter, I shall follow still.[1]

Study Questions

1. How does Epictetus believe we should deal with loss?
2. Is the desire to live forever misguided?
3. Do we have any control over our desires?

"Who rightly with necessity complies
In things divine we count him skilled and wise,[2]

"Well, Crito, if this be the gods' will, so be it."[3]

"Anytus and Meletus have power to put me to death, but not to harm me."[4]

Notes

1. This quotation is by Cleanthes (c. 331–232 B.C.), who headed the Stoic school following Zeno. His most famous work is the poem *Hymn to Zeus*.
2. These lines are from a fragment by Euripides.
3. The reference is to Plato's *Crito*.
4. The reference is to Plato's *Defence of Socrates*.

4. Would you be able to go through even one day maintaining the outlook on life and death recommended by Epictetus?

6

AUGUSTINE

Augustine (354–430) was born in North Africa and became a leader of the Christian church. He was strongly influenced by Platonism, accepting, for example, that we can never err except through ignorance. This enchiridion (or handbook) explores the nature of good and evil. According to Augustine, God made all things good but not perfectly so, thus allowing corruption, the loss of goodness. Living a good life depends on identifying the causes of evil, and chief among them is intellectual error, accepting what is false as true. Thus Augustine believed that lying is always impermissible.

Enchiridion on Faith, Hope, and Love

X. The supremely good creator made all things good

By the Trinity, thus supremely and equally and unchangeably good, all things were created; and these are not supremely and equally and unchangeably good, but yet they are good, even taken separately. Taken as a whole, however, they are very good, because their *ensemble* constitutes the universe in all its wonderful order and beauty.

XI. What is called evil in the universe is but the absence of good

And in the universe, even that which is called evil, when it is regulated and put in its own place, only enhances our admiration of the good; for we enjoy and value the good more when we compare it with the evil. For the Almighty God, who, as even the heathen acknowledge, has supreme power over all things, being Himself supremely good, would never permit the existence of anything evil among His works, if He were not so omnipotent and good that He can bring good even out of evil. For what is that which we call evil but the absence of good? In the bodies of animals, disease and wounds mean nothing but the absence of health; for when a cure is effected, that does not mean that the evils which were present—namely, the diseases and wounds—go away from the body and dwell elsewhere: they altogether cease to exist; for the wound or disease is not a substance, but a defect in the fleshy substance—the flesh itself being a substance, and therefore something good, of which those evils—that is, privations of the good which we call health—are accidents. Just in the same way, what are called vices in the soul are nothing but privations of natural good. And when they are cured, they are not transferred elsewhere: when they cease to exist in the healthy soul, they cannot exist anywhere else.

XII. All beings were made good, but not being made perfectly good, are liable to corruption

All things that exist, therefore, seeing that the Creator of them all is supremely good, are themselves good. But because they are not, like their Creator, supremely and unchangeably good, their good may be diminished and increased. But for good to be diminished is an evil, although, however much it may be diminished, it is necessary, if the being is to continue, that some good should remain to constitute the being. For however small or of whatever kind the being may be, the good which makes it a being cannot be destroyed without destroying the being itself. An uncorrupted nature is justly held in esteem. But if, still further, it be incorruptible, it is undoubtedly considered of still higher value. When it is corrupted, however, its corruption is an evil, because it is deprived of some sort of good. For if it be deprived of no good, it receives no injury; but it does receive injury, therefore it is deprived of good. Therefore, so long as a being is in process of corruption, there is in it some good of which it is being deprived; and if a part of the being should remain which cannot be corrupted, this will certainly be an incorruptible being, and accordingly the process of corruption will result in the manifestation of this great good. But if it do not cease to be corrupted, neither can it cease to possess good of which corruption may deprive it. But if it should be thoroughly and completely consumed by corruption, there will then be no good left, because there will be no being. Wherefore corruption can consume the good only by consuming the being. Every being, therefore is a good; a great good, if it cannot be corrupted; a little good, if it can: but in any case, only the foolish or ignorant will deny that it is a good. And if it be wholly consumed by corruption, then the corruption itself must cease to exist, as there is no being left in which it can dwell.

XIII. There can be no evil where there is no good; and an evil man is an evil good

Accordingly, there is nothing of what we call evil, if there be nothing good. But a good which is wholly without evil is a perfect good. A good, on the other hand, which contains evil is a faulty or imperfect good; and there can be no evil where there is no good. From

all this we arrive at the curious result: that since every being, so far as it is a being, is good, when we say that a faulty being is an evil being, we just seem to say that what is good is evil, and that nothing but what is good can be evil, seeing that every being is good, and that no evil can exist except in a being. Nothing, then, can be evil except something which is good. And although this, when stated, seems to be a contradiction, yet the strictness of reasoning leaves us no escape from the conclusion. We must, however, beware of incurring the prophetic condemnation: "Woe unto them that call evil good, and good evil: that put darkness for light, and light for darkness: that put bitter for sweet, and sweet for bitter."[1] And yet our Lord says: "An evil man out of the evil treasure of his heart bringeth forth that which is evil."[2] Now, what is an evil man but an evil being? for a man is a being. Now, if a man is a good thing because he is a being, what is an evil man but an evil good? Yet, when we accurately distinguish these two things, we find that it is not because he is a man that he is an evil, or because he is wicked that he is a good; but that he is a good because he is a man, and an evil because he is wicked. Whoever, then, says, "To be a man is an evil," or, "To be wicked is a good," falls under the prophetic denunciation: "Woe unto them that call evil good, and good evil!" For he condemns the work of God, which is the man, and praises the defect of man, which is the wickedness. Therefore every being, even if it be a defective one, in so far as it is a being is good, and in so far as it is defective is evil.

XIV. Good and evil are an exception to the rule that contrary attributes cannot be predicated of the same subject. Evil springs up in what is good, and cannot exist except in what is good

Accordingly, in the case of these contraries which we call good and evil, the rule of the logicians, that two contraries cannot be predicated at the same time of the same thing, does not hold. No weather is at the same time dark and bright: no food or drink is at the same time sweet and bitter: no body is at the same time and in the same place black and white: none is at the same time and in the same place deformed and beautiful. And this rule is found to hold in regard to many, indeed

nearly all, contraries, that they cannot exist at the same time in any one thing. But although no one can doubt that good and evil are contraries, not only can they exist at the same time, but evil cannot exist without good, or in anything that is not good. Good, however, can exist without evil. For a man or an angel can exist without being wicked; but nothing can be wicked except a man or an angel: and so far as he is a man or an angel, he is good; so far as he is wicked, he is an evil. And these two contraries are so far co-existent, that if good did not exist in what is evil, neither could evil exist; because corruption could not have either a place to dwell in, or a source to spring from, if there were nothing that could be corrupted; and nothing can be corrupted except what is good, for corruption is nothing else but the destruction of good. From what is good, then, evils arose, and except in what is good they do not exist; nor was there any other source from which any evil nature could arise. For if there were, then, in so far as this was a being, it was certainly a good: and a being which was incorruptible would be a great good; and even one which was corruptible must be to some extent a good, for only by corrupting what was good in it could corruption do it harm.

XV. The preceding argument is in no wise inconsistent with the saying of our Lord: "A good tree cannot bring forth evil fruit"

But when we say that evil springs out of good, let it not be thought that this contradicts our Lord's saying: "A good tree cannot bring forth evil fruit."[3] For, as the Truth says, you cannot gather grapes of thorns,[4] because grapes do not grow on thorns. But we see that on good soil both vines and thorns may be grown. And in the same way, just as an evil tree cannot bring forth good fruit, so an evil will cannot produce good works. But from the nature of man, which is good, may spring either a good or an evil will. And certainly there was at first no source from which an evil will could spring, except the nature of angel or of man, which was good. And our Lord Himself clearly shows this in the very same place where He speaks about the tree and its fruit. For He says: "Either make the tree good, and his fruit good; or

else make the tree corrupt, and his fruit corrupt"[5]—clearly enough warning us that evil fruits do not grow on a good tree, nor good fruits on an evil tree; but that nevertheless the ground itself, by which He meant those whom He was then addressing, might grow either kind of trees.

XVI. It is not essential to man's happiness that he should know the causes of physical convulsions; but it is, that he should know the causes of good and evil

Now, in view of these considerations, when we are pleased with that line of Maro, "Happy the man who has attained to the knowledge of the causes of things,"[6] we should not suppose that it is necessary to happiness to know the causes of the great physical convulsions, causes which lie hid in the most secret recesses of nature's kingdom, "whence comes the earthquake whose force makes the deep seas to swell and burst their barriers, and again to return upon themselves and settle down."[7] But we ought to know the causes of good and evil as far as man may in this life know them, in order to avoid the mistakes and troubles of which this life is so full. For our aim must always be to reach that state of happiness in which no trouble shall distress us, and no error mislead us. If we must know the causes of physical convulsions, there are none which it concerns us more to know than those which affect our own health. But seeing that, in our ignorance of these, we are fain to resort to physicians, it would seem that we might bear with considerable patience our ignorance of the secrets that lie hid in the earth and heavens.

XVII. The nature of error. All error is not hurtful, though it is man's duty as far as possible to avoid it

For although we ought with the greatest possible care to avoid error, not only in great but even in little things, and although we cannot err except through ignorance, it does not follow that, if a man is ignorant of a thing, he must forthwith fall into error. That is rather the fate of the man who thinks he knows what he does not know. For he accepts what is false as if it were true, and that is the essence of error. But it is a point of very great importance what the subject is in regard to which a man makes a mistake. For on one and the same subject we rightly prefer an instructed man to an ignorant one, and a man who is not in error to one who is. In the case of different subjects, however—that is, when one man knows one thing, and another a different thing, and when what the former knows is useful, and what the latter knows is not so useful, or is actually hurtful—who would not, in regard to the things the latter knows, prefer the ignorance of the former to the knowledge of the latter? For there are points on which ignorance is better than knowledge. And in the same way, it has sometimes been an advantage to depart from the right way—in travelling, however, not in morals. It has happened to myself to take the wrong road where two ways met, so that I did not pass by the place where an armed band of Donatists lay in wait for me. Yet I arrived at the place whither I was bent, though by a roundabout route; and when I heard of the ambush, I congratulated myself on my mistake, and gave thanks to God for it. Now, who would not rather be the traveller who made a mistake like this, than the highwayman who made no mistake? And hence, perhaps, it is that the prince of poets puts these words into the mouth of a lover in misery:[8] "How I am undone, how I have been carried away by an evil error!" for there is an error which is good, as it not merely does not harm, but produces some actual advantage. But when we look more closely into the nature of truth, and consider that to err is just to take the false for the true, and the true for the false, or to hold what is certain as uncertain, and what is uncertain as certain, and that error in the soul is hideous and repulsive just in proportion as it appears fair and plausible when we utter it, or assent to it, saying, "Yea, yea; Nay, nay"—surely this life that we live is wretched indeed, if only on this account, that sometimes, in order to preserve it, it is necessary to fall into error. God forbid that such should be that other life, where truth itself is the life of the soul, where no one deceives, and no one is deceived. But here men deceive and are deceived, and they are more to be pitied when they lead others astray than when they are themselves led astray by putting trust in liars. Yet so much does a rational soul shrink from what is false, and so earnestly does it struggle against error, that even those who love to deceive are

most unwilling to be deceived. For the liar does not think that he errs, but that he leads another who trusts him into error. And certainly he does not err in regard to the matter about which he lies, if he himself knows the truth; but he is deceived in this, that he thinks his lie does him no harm, whereas every sin is more hurtful to the sinner than to the sinned against.

XVIII. It is never allowable to tell a lie; but lies differ very much in guilt, according to the intention and the subject

But here arises a very difficult and very intricate question, about which I once wrote a large book, finding it necessary to give it an answer. The question is this: whether at any time it can become the duty of a good man to tell a lie? For some go so far as to contend that there are occasions on which it is a good and pious work to commit perjury even, and to say what is false about matters that relate to the worship of God, and about the very nature of God Himself. To me, however, it seems certain that every lie is a sin, though it makes a great difference with what intention and on what subject one lies. For the sin of the man who tells a lie to help another is not so heinous as that of the man who tells a lie to injure another; and the man who by his lying puts a traveller on the wrong road, does not do so much harm as the man who by false or misleading representations distorts the whole course of a life. No one, of course, is to be condemned as a liar who says what is false, believing it to be true, because such an one does not consciously deceive, but rather is himself deceived. And, on the same principle, a man is not to be accused of lying, though he may sometimes be open to the charge of rashness, if through carelessness he takes up what is false and holds it as true; but, on the other hand, the man who says what is true, believing it to be false, is, so far as his own consciousness is concerned, a liar. For in saying what he does not believe, he says what to his own conscience is false, even though it should in fact be true; nor is the man in any sense free from lying who with his mouth speaks the truth without knowing it, but in his heart wills to tell a lie. And, therefore, not looking at the matter spoken of, but solely at the intention of the speaker, the man who

unwittingly says what is false, thinking all the time that it is true, is a better man than the one who unwittingly says what is true, but in his conscience intends to deceive. For the former does not think one thing and say another; but the latter, though his statements may be true in fact, has one thought in his heart and another on his lips: and that is the very essence of lying. But when we come to consider truth and falsehood in respect to the subjects spoken of, the point on which one deceives or is deceived becomes a matter of the utmost importance. For although, as far as a man's own conscience is concerned, it is a greater evil to deceive than to be deceived, nevertheless it is a far less evil to tell a lie in regard to matters that do not relate to religion, than to be led into error in regard to matters the knowledge and belief of which are essential to the right worship of God. To illustrate this by example: suppose that one man should say of some one who is dead that he is still alive, knowing this to be untrue, and that another man should, being deceived, believe that Christ shall at the end of some time (make the time as long as you please) die; would it not be incomparably better to lie like the former, than to be deceived like the latter? and would it not be a much less evil to lead some man into the former error, than to be led by any man into the latter?

XIX. Men's errors vary very much in the magnitude of the evils they produce; but yet every error is in itself an evil.

In some things, then, it is a great evil to be deceived; in some it is a small evil; in some no evil at all; and in some it is an actual advantage. It is to his grievous injury that a man is deceived when he does not believe what leads to eternal life, or believes what leads to eternal death. It is a small evil for a man to be deceived, when, by taking falsehood for truth, he brings upon himself temporal annoyances; for the patience of the believer will turn even these to a good use, as when, for example, taking a bad man for a good, he receives injury from him. But one who believes a bad man to be good, and yet suffers no injury, is nothing the worse for being deceived, nor does he fall under the prophetic denunciation: "Woe to those who call evil good!"[9] For we are to understand that this is spoken not about evil

man, but about the things that make men evil. Hence the man who calls adultery good, falls justly under that prophetic denunciation. But the man who calls the adulterer good, thinking him to be chaste, and not knowing him to be an adulterer, falls into no error in regard to the nature of good and evil, but only makes a mistake as to the secrets of human conduct. He calls the man good on the ground of believing him to be what is undoubtedly good; he calls the adulterer evil, and the pure man good; and he calls this man good, not knowing him to be an adulterer, but believing him to be pure. Further, if by making a mistake one escapes death, as I have said above once happened to me, one even derives some advantage from one's mistake. But when I assert that in certain cases a man may be deceived without any injury to himself, or even with some advantage to himself, I do not mean that the mistake in itself is no evil, or is in any sense a good; I refer only to the evil that is avoided, or the advantage that is gained, through making the mistake. For the mistake, considered in itself, is an evil: a great evil if it concern a great matter, a small evil if it concern a small matter, but yet always an evil. For who that is of sound mind can deny that it is an evil to receive what is false as if it were true, and to reject what is true as if it were false, or to hold what is uncertain as certain, and what is certain as uncertain? But it is one thing to think a man good when he is really bad, which is a mistake; it is another thing to suffer no ulterior injury in consequence of the mistake, supposing that the bad man whom we think good inflicts no damage upon us. In the same way, it is one thing to think that we are on the right road when we are not; it is another thing when this mistake of ours, which is an evil, leads to some good, such as saving us from an ambush of wicked men.

XX. Every error is not a sin. An examination of the opinion of the academic philosophers, that to avoid error we should in all cases suspend belief

I am not sure whether mistakes such as the following—when one forms a good opinion of a bad man, not knowing what sort of man he is; or when, instead of the ordinary perceptions through the bodily senses, other appearances of a similar kind present themselves, which we perceive in the spirit, but think we perceive in

the body, or perceive in the body, but think we perceive in the spirit (such a mistake as the Apostle Peter made when the angel suddenly freed him from his chains and imprisonment, and he thought he saw a vision[10]); or when, in the case of sensible objects themselves, we mistake rough for smooth, or bitter for sweet, or think that putrid matter has a good smell; or when we mistake the passing of a carriage for thunder; or mistake one man for another, the two being very much alike, as often happens in the case of twins (hence our great poet calls it "a mistake pleasing to parents"[11])—whether these, and other mistakes of this kind, ought to be called sins. Nor do I now undertake to solve a very knotty question, which perplexed those very acute thinkers, the Academic philosophers: whether a wise man ought to give his assent to anything, seeing that he may fall into error by assenting to falsehood: for all things, as they assert, are either unknown or uncertain. Now I wrote three volumes shortly after my conversion, to remove out of my way the objections which lie, as it were, on the very threshold of faith. And assuredly it was necessary at the very outset to remove this utter despair of reaching truth, which seems to be strengthened by the arguments of these philosophers. Now in their eyes every error is regarded as a sin, and they think that error can only be avoided by entirely suspending belief. For they say that the man who assents to what is uncertain falls into error; and they strive by the most acute, but most audacious arguments, to show that, even though a man's opinion should by chance be true, yet that there is no certainty of its truth, owing to the impossibility of distinguishing truth from falsehood. But with us, "the just shall live by faith."[12] Now, if assent be taken away, faith goes too; for without assent there can be no belief. And there are truths, whether we know them or not, which must be believed if we would attain to a happy life, that is, to eternal life. But I am not sure whether one ought to argue with men who not only do not know that there is an eternal life before them, but do not know whether they are living at the present moment; nay, say that they do not know what it is impossible they can be ignorant of. For it is impossible that any one should be ignorant that he is alive, seeing that if he be not alive it is impossible for him to be ignorant; for not knowledge merely, but ignorance too, can be an attribute only of the living. But, forsooth, they think that by not

acknowledging that they are alive they avoid error, when even their very error proves that they are alive, since one who is not alive cannot err. As, then, it is not only true, but certain, that we are alive, so there are many other things both true and certain; and God forbid that it should ever be called wisdom, and not the height of folly, to refuse assent to these.

XXI. Error, though not always a sin, is always an evil

But as to those matters in regard to which our belief or disbelief, and indeed their truth or supposed truth or falsity, are of no importance whatever, so far as attaining the kingdom of God is concerned: to make a mistake in such matters is not to be looked on as a sin, or at least as a very small and trifling sin. In short, a mistake in matters of this kind, whatever its nature and magnitude, does not relate to the way of approach to God, which is the faith of Christ that "worketh by love."[13] For the "mistake pleasing to parents" in the case of the twin children was no deviation from this way; nor did the Apostle Peter deviate from this way, when, thinking that he saw a vision, he so mistook one thing for another, that, till the angel who delivered him had departed from him, he did not distinguish the real objects among which he was moving from the visionary objects of a dream,[14] nor did the patriarch Jacob deviate from this way, when he believed that his son, who was really alive, had been slain by a beast.[15] In the case of these and other false impressions of the same kind, we are indeed deceived, but our faith in God remains secure. We go astray, but we do not leave the way that leads us to Him. But yet these errors, though they are not sinful, are to be reckoned among the evils of this life, which is so far made subject to vanity, that we receive what is false as if it were true, reject what is true as if it were false, and cling to what is uncertain as if it were certain. And although they do not trench upon that true and certain faith through which we reach eternal blessedness, yet they have much to do with that misery in which we are now living. And assuredly, if we were now in the enjoyment of the true and perfect happiness that lies before us, we should not be subject to any deception through any sense, whether of body or of mind.

XXII. A lie is not allowable, even to save another from injury

But every lie must be called a sin, because not only when a man knows the truth, but even when, as a man may be, he is mistaken and deceived, it is his duty to say what he thinks in his heart, whether it be true, or whether he only think it to be true. But every liar says the opposite of what he thinks in his heart, with purpose to deceive. Now it is evident that speech was given to man, not that men might therewith deceive one another, but that one man might make known his thoughts to another. To use speech, then, for the purpose of deception, and not for its appointed end, is a sin. Nor are we to suppose that there is any lie that is not a sin, because it is sometimes possible, by telling a lie, to do service to another. For it is possible to do this by theft also, as when we steal from a rich man who never feels the loss, to give to a poor man who is sensibly benefited by what he gets. And the same can be said of adultery also, when, for instance, some woman appears likely to die of love unless we consent to her wishes, while if she lived she might purify herself by repentance; but yet no one will assert that on this account such an adultery is not a sin. And if we justly place so high a value upon chastity, what offense have we taken at truth, that, while no prospect of advantage to another will lead us to violate the former by adultery, we should be ready to violate the latter by lying? It cannot be denied that they have attained a very high standard of goodness who never lie except to save a man from injury; but in the case of men who have reached this standard, it is not the deceit, but their good intention, that is justly praised, and sometimes even rewarded. It is quite enough that the deception should be pardoned, without its being made an object of laudation, especially among the heirs of the new covenant, to whom it is said: "Let your communication be, Yea, yea; Nay, nay: for whatsoever is more than these cometh of evil."[16] And it is on account of this evil, which never ceases to creep in while we retain this mortal vesture, that the co-heirs of Christ themselves say, "Forgive us our debts."[17]

XXIII. Summary of the results of the preceding discussion

As it is right that we should know the causes of good and evil, so much of them at least as will suffice for the way that leads us to the kingdom, where there will be life without the shadow of death, truth without any alloy of error, and happiness unbroken by any sorrow, I have discussed these subjects with the brevity which my limited space demanded. And I think there cannot now be any doubt, that the only cause of any good that we enjoy is the goodness of God, and that the only cause of evil is the falling away from the unchangeable good of a being made good but changeable, first in the case of an angel, and afterwards in the case of man.

Notes

1. Isa. v. 20.
2. Luke vi. 45.
3. Matt. vii. 18.
4. Matt. vii. 16.
5. Matt. xii. 33.
6. Virgil, *Georgics,* ii. 490.
7. Ibid.
8. Virgil, *Eclog.* viii. 41.
9. Isa. v. 20.
10. Acts xii. 9.
11. Virgil, *Aen.* x. 392.
12. Rom. i. 17.
13. Gal. v. 6.
14. Acts xii. 9–11.
15. Gen. xxxvii. 33.
16. Matt. v. 37.
17. Matt. vi. 12.

Study Questions

1. If God is all-good and all-powerful, why does evil exist?
2. Can one know what is right but fail to act accordingly?
3. May you lie to prevent a greater evil?
4. Can you mistakenly believe you exist?

7

THOMAS AQUINAS

Thomas Aquinas (1225–1274) was a Dominican monk who taught at the University of Paris. His work synthesizes Aristotelian thought and Christian doctrine. Aquinas argued that each thing's proper operation determines its final end, and in the case of human beings that final

end is happiness (or beatitude). It is achieved by the fulfillment of our capacity for contemplating that which is most perfect, namely, God. Aquinas defended this conclusion against those who would contend that happiness consists in pleasure, power, or the arts.

Summa Contra Gentiles

BOOK THREE

Providence

Chapter II

THAT EVERY AGENT ACTS FOR AN END

Accordingly we must first show that every agent, by its action, intends an end.

For in those things which clearly act for an end, we declare the end to be that towards which the movement of the agent tends; for when this is reached, the end is said to be reached, and to fail in this is to fail in the end intended. This may be seen in the physician who aims at health, and in a man who runs towards an appointed goal. Nor does it matter, as to this, whether that which tends to an end be endowed with knowledge or not; for just as the target is the end of the archer, so is it the end of the arrow's flight. Now the movement of every agent tends to something determinate, since it is not from any force that any action proceeds, but heating proceeds from heat, and cooling from cold; and therefore actions are differentiated by their active principles. Action sometimes terminates in something made, as for instance building terminates in a house, and healing in health; while sometimes it does not so terminate, as for instance, in the case of understanding and sensation. And if action terminates in something made, the movement of the agent tends by that action towards the thing made; while if it does not terminate in something made, the movement of the agent tends to the action itself. It follows therefore that every agent intends an end while acting, which end is sometimes the action itself, sometimes a thing made by the action.

Again. In all things that act for an end, that is said to be the last end beyond which the agent seeks nothing further; and thus the physician's action goes as far as health, and when this is attained, his efforts cease. But in the action of every agent, a point can be reached beyond which the agent does not desire to go; or else actions would tend to infinity, which is impossible, for since *it is not possible to pass through an infinite medium,*[1] the agent would never begin to act, because nothing moves towards what it cannot reach. Therefore every agent acts for an end.

Moreover. If the actions of an agent proceed to infinity, these actions must needs result either in something made, or not. If the result is something made, the being of that thing made will follow after an infinity of actions. But that which presupposes an infinity of things cannot possibly be, since *an infinite medium cannot be passed through.* Now impossibility of being argues impossibility of becoming, and that which cannot become, it is impossible to make. Therefore it is impossible for an agent to begin to make a thing for the making of which an infinity of actions is presupposed.—If, however, the result of such actions be not something made, the order of these actions must be either according to the order of active powers (for instance, if a man feels that he may imagine, and imagines that he may understand, and understands that he may will), or according to the order of objects (for instance, I consider the body that I may consider the soul, which I consider in order to consider a separate substance, which again I consider so that I may consider God). Now it is not possible to proceed to infinity, either in active powers (as neither is this possible in the forms of things, as is proved in *Metaph.* ii,[2] since the form is the principle of activity), or in objects (as neither is this possible in beings, since there is one first being, as we have proved above).[3] Therefore it is not possible for agents to proceed to infinity, and consequently there must be something, upon whose attainment the efforts of the agent cease. Therefore every agent acts for an end.

Further. In things that act for an end, whatsoever comes between the first agent and the last end, is an

end in respect to what precedes, and an active principle in respect of what follows. Hence if the effort of the agent does not tend to something determinate, and if its action, as stated, proceeds to infinity, the active principles must needs proceed to infinity; which is impossible, as we have shown above. Therefore the effort of the agent must of necessity tend to something determinate.

Again. Every agent acts either by nature or by intellect. Now there can be no doubt that those which act by intellect act for an end, since they act *with* an intellectual preconception of what they attain by their action, and they act *through* such a preconception; for this is to act by intellect. Now just as in the preconceiving intellect there exists the entire likeness of the effect that is attained by the action of the intellectual being, so in the natural agent there pre-exists the likeness of the natural effect, by virtue of which the action is determined to the appointed effect; for fire begets fire, and an olive produces an olive. Therefore, even as that which acts by intellect tends by its action to a definite end, so also does that which acts by nature. Therefore every agent acts for an end.

Moreover. Fault is not found save in those things which are for an end, for we do not find fault with one who fails in that to which he is not appointed; and thus we find fault with a physician if he fail to heal, but not with a builder or a grammarian. But we find fault in things done according to art, as when a grammarian fails to speak correctly, and in things that are ruled by nature, as in the case of monstrosities. Therefore every agent, whether according to nature, or according to art, or acting of set purpose, acts for an end.

Again. Were an agent not to act for a definite effect, all effects would be indifferent to it. Now that which is indifferent to many effects does not produce one rather than another. Therefore, from that which is indifferent to either of two effects, no effect results, unless it be determined by something to one of them. Hence it would be impossible for it to act. Therefore every agent tends to some definite effect, which is called its end.

There are, however, certain actions which would seem not to be for an end, such as playful and contemplative actions, and those which are done without attention, such as scratching one's beard, and the like. Whence some might be led to think that there is an agent that acts not for an end.—But we must observe that contemplative actions are not for another end, but are themselves an end. Playful actions are sometimes an end, when one plays for the mere pleasure of play; and sometimes they are for an end, as when we play that afterwards we may study better. Actions done without attention do not proceed from the intellect, but from some sudden act of the imagination, or some natural principle; and thus a disordered humor produces an itching sensation and is the cause of a man scratching his beard, which he does without his intellect attending to it. Such actions do tend to an end, although outside the order of the intellect. Hereby is excluded the error of certain natural philosophers of old, who maintained that all things happen by the necessity of matter, thus utterly banishing the final cause from things.[4]

Chapter III

THAT EVERY AGENT ACTS FOR A GOOD

Hence we must go on to prove that every agent acts for a good.

For that every agent acts for an end clearly follows from the fact that every agent tends to something definite. Now that to which an agent tends definitely must needs be befitting to that agent, since the agent would not tend to it save because of some fittingness thereto. But that which is befitting to a thing is good for it. Therefore every agent acts for a good.

Further. The end is that wherein the appetite of the agent or mover comes to rest, as also the appetite of that which is moved. Now it is the very notion of good to be the term of appetite, since *good is the object of every appetite.*[5] Therefore all action and movement is for a good.

Again. All action and movement would seem to be directed in some way to being, either for the preservation of being in the species or in the individual, or for the acquisition of being. Now this itself, namely, being, is a good; and for this reason all things desire being. Therefore all action and movement is for a good.

Furthermore. All action and movement is for some perfection. For if the action itself be the end, it is clearly a second perfection of the agent. And if the action consist in the transformation of external matter, clearly the mover intends to induce some perfection into the thing moved, towards which perfection the movable also tends, if the movement be natural. Now we say that this is to be good, namely, to be perfect. Therefore every action and movement is for a good.

Also. Every agent acts according as it is actual. Now by acting it tends to something similar to itself. Therefore it tends to an act. But an act has the nature of good, since evil is not found save in a potentiality lacking act. Therefore every action is for a good.

Moreover. The intellectual agent acts for an end, as determining for itself its end; whereas the natural agent, though it acts for an end, as was proved above,[6] does not determine its end for itself, since it knows not the nature of end, but is moved to the end determined for it by another. Now an intellectual agent does not determine the end for itself except under the aspect of good; for the intelligible object does not move except it be considered as a good, which is the object of the will. Therefore the natural agent also is not moved, nor does it act for an end, except in so far as this end is a good, since the end is determined for the natural agent by some appetite. Therefore every agent acts for a good.

Again. To shun evil and to seek good are of the same nature, even as movement from below and upward are of the same nature. Now we observe that all things shun evil, for intellectual agents shun a thing for the reason that they apprehend it as evil, and all natural agents, in proportion to their strength, resist corruption which is the evil of everything. Therefore all things act for a good.

Again. That which results from the agent's action outside his intention, is said to happen by chance or luck. Now we observe in the works of nature that either always or more often that happens which is best: thus in plants the leaves are so placed as to protect the fruit; and the parts of an animal are so disposed as to conduce to the animal's safety. Therefore, if this happens outside the intention of the natural agent, it will be the result of chance or luck. But that is impossible, because things that happen always, or frequently, are not by chance or fortuitous, but those which occur seldom.[7] Therefore the natural agent tends to that which is best; and much more evidently is this so with the intellectual agent. Therefore every agent intends a good in acting.

Moreover. Whatever is moved is brought to the term of movement by the mover and agent. Therefore mover and moved tend to the same term. Now that which is moved, since it is in potentiality, tends to an act, and consequently to perfection and goodness; for by its movement it passes from potentiality to act. Therefore mover and agent by moving and acting always intend a good.

Hence the philosophers in defining the good said: *The good is the object of every appetite;* and Dionysius says that *all things desire the good and the best.*[8]

Chapter XXV

THAT TO KNOW GOD IS THE END OF EVERY INTELLECTUAL SUBSTANCE

Now, seeing that all creatures, even those that are devoid of reason, are directed to God as their last end, and that all reach this end in so far as they have some share of a likeness to Him, the intellectual creature attains to Him in a special way, namely, through its proper operation, by understanding Him. Consequently this must be the end of the intellectual creature, namely, to understand God.

For, as we have shown above,[9] God is the end of each thing, and hence, as far as it is possible to it, each thing intends to be united to God as its last end. Now a thing is more closely united to God by reaching in a way to the very substance of God; which happens when it knows something of the divine substance, rather than when it reaches to a divine likeness. Therefore the intellectual substance tends to the knowledge of God as its last end.

Again. The operation proper to a thing is its end, for it is its second perfection; so that when a thing is well conditioned for its proper operation it is said to be fit and good. Now understanding is the proper

operation of the intellectual substance, and consequently is its end. Therefore, whatever is most perfect in this operation is its last end; and especially in those operations which are not directed to some product, such as understanding and sensation. And since operations of this kind take their species from their objects, by which also they are known, it follows that the more perfect the object of any such operation, the more perfect is the operation. Consequently to understand the most perfect intelligible, namely God, is the most perfect in the genus of the operation which consists in understanding. Therefore to know God by an act of understanding is the last end of every intellectual substance.

Someone, however, might say that the last end of an intellectual substance consists indeed in understanding the best intelligible object, but that what is the best intelligible for this or that intellectual substance is not absolutely the best intelligible; and that the higher the intellectual substance, the higher is its best intelligible. So that possibly the supreme intellectual substance has for its best intelligible object that which is best absolutely, and its happiness will consist in understanding God; whereas the happiness of any lower intellectual substance will consist in understanding some lower intelligible object, which however will be the highest thing understood by that substance. Especially would it seem not to be in the power of the human intellect to understand that which is absolutely the best intelligible, because of its weakness; for it is as much adapted for knowing the supreme intelligible *as the owl's eye for seeing the sun.*[10]

Nevertheless it is evident that the end of any intellectual substance, even the lowest, is to understand God. For it has been shown above that God is the last end towards which all things tend.[11] And the human intellect, although the lowest in the order of intelligent substances, is superior to all that are devoid of understanding. Since then a more noble substance has not a less noble end, God will be the end also of the human intellect. Now every intelligent being attains to its last end by understanding it, as we have proved. Therefore the human intellect attains to God as its end, by understanding Him.

Again. Just as things devoid of intellect tend to God as their end by way of assimilation, so do intellectual substances by way of knowledge, as clearly appears from what has been said. Now, although things devoid of reason tend towards a likeness to their proximate causes, the intention of nature does not rest there, but has for its end a likeness to the highest good, as we have proved,[12] although they are able to attain to this likeness in a most imperfect manner. Therefore, however little be the knowledge of God to which the intellect is able to attain, this will be the intellect's last end, rather than a perfect knowledge of lower intelligibles.

Moreover. Everything desires most of all its last end. Now the human intellect desires, loves and enjoys the knowledge of divine things, although it can grasp but little about them, more than the perfect knowledge which it has of the lowest things. Therefore man's last end is to understand God in some way.

Further. Everything tends to a divine likeness as its own end. Therefore a thing's last end is that whereby it is most of all like God. Now the intellectual creature is especially likened to God in that it is intellectual, since this likeness belongs to it above other creatures, and includes all other likenesses. And in this particular kind of likeness it is more like God in understanding actually than in understanding habitually or potentially, because God is always actually understanding, as we proved in the First Book.[13] Furthermore, in understanding actually, the intellectual creature is especially like God in understanding God; for by understanding Himself God understands all other things, as we proved in the First Book.[14] Therefore the last end of every intellectual substance is to understand God.

Again. That which is lovable only because of another is for the sake of that which is lovable for its own sake alone; because we cannot go on indefinitely in the appetite of nature, since then nature's desire would be in vain, for it is impossible to pass through an infinite number of things. Now all practical sciences, arts and powers are lovable only for the sake of something else, since their end is not knowledge, but work. But speculative sciences are lovable for their

own sake, for their end is knowledge itself. Nor can we find any action in human life that is not directed to some other end, with the exception of speculative consideration. For even playful actions, which seem to be done without any purpose, have some end due to them, namely that the mind may be relaxed, and that thereby we may afterwards become more fit for studious occupations; or otherwise we should always have to be playing, if play were desirable for its own sake, and this is unreasonable. Accordingly, the practical arts are directed to the speculative arts, and again every human operation, to intellectual speculation, as its end. Now, in all sciences and arts that are mutually ordered, the last end seems to belong to the one from which others take their rules and principles. Thus the art of sailing, to which belongs the ship's purpose, namely its use, provides rules and principles to the art of ship-building. And such is the relation of first philosophy to other speculative sciences, for all others depend thereon, since they derive their principles from it, and are directed by it in defending those principles; and moreover first philosophy is wholly directed to the knowledge of God as its last end, and is consequently called the *divine science.*[15] Therefore the knowledge of God is the last end of all human knowledge and activity.

Furthermore. In all mutually ordered agents and movers, the end of the first agent and mover must be the end of all, even as the end of the commander-in-chief is the end of all who are soldiering under him. Now of all the parts of man, the intellect is the highest mover, for it moves the appetite, by proposing its object to it; and the intellective appetite, or will, moves the sensitive appetites, namely the irascible and concupiscible. Hence it is that we do not obey the concupiscence, unless the will command; while the sensitive appetite, when the will has given its consent, moves the body. Therefore the end of the intellect is the end of all human actions. *Now the intellect's end and good are the true,*[16] and its last end is the first truth. Therefore the last end of the whole man, and of all his deeds and desires, is to know the first truth, namely, God.

Moreover. Man has a natural desire to know the causes of whatever he sees; and so through wondering at what they saw, and not knowing its cause, men first began to philosophize, and when they had discovered the cause they were at rest. Nor do they cease inquiring until they come to the first cause; and *then do we deem ourselves to know perfectly when we know the first cause.*[17] Therefore man naturally desires, as his last end, to know the first cause. But God is the first cause of all things. Therefore man's last end is to know God.

Besides. Man naturally desires to know the cause of any known effect. But the human intellect knows universal being. Therefore it naturally desires to know its cause, which is God alone, as we proved in the Second Book.[18] Now one has not attained to one's last end until the natural desire is at rest. Therefore the knowledge of any intelligible object is not enough for man's happiness, which is his last end, unless he know God also, which knowledge terminates his natural desire as his last end. Therefore this very knowledge of God is man's last end.

Further. A body that tends by its natural appetite to its place is moved all the more vehemently and rapidly the nearer it approaches its end. Hence Aristotle proves that a natural straight movement cannot be towards an indefinite point, because it would not be more moved afterwards than before.[19] Hence that which tends more vehemently to a thing afterwards than before is not moved towards an indefinite point but towards something fixed. Now this we find in the desire of knowledge, for the more one knows, the greater one's desire to know. Consequently, man's natural desire in knowledge tends to a definite end. This can be none other than the highest thing knowable, which is God. Therefore the knowledge of God is man's last end.

Now the last end of man and of any intelligent substance is called *happiness* or *beatitude,* for it is this that every intellectual substance desires as its last end, and for its own sake alone. Therefore the last beatitude or happiness of any intellectual substance is to know God.

Hence it is said (*Matt.* v. 8): *Blessed are the clean of heart, for they shall see God; and (Jo. xvii. 3): This is eternal life, that they may know thee, the only true God.* Aristotle himself agrees with this judgment

when he says that man's ultimate happiness is *specu-lative, and this with regard to the highest object of speculation.*[20]

Chapter XXVI

DOES HAPPINESS CONSIST IN AN ACT OF THE WILL?

Since the intellectual substance attains to God by its operation, not only by an act of understanding but also by an act of the will, through desiring and loving Him, and through delighting in Him, someone might think that man's last end and ultimate happiness consists, not in knowing God, but in loving Him, or in some other act of the will towards Him; [1] especially since the object of the will is the good, which has the nature of an end, whereas the true, which is the object of the intellect, has not the nature of an end except in so far as it also is a good. Therefore, seemingly, man does not attain to his last end by an act of his intellect, but rather by an act of his will.

[2] Further. The ultimate perfection of operation is delight, *which perfects operation as beauty perfects youth,* as the Philosopher says,[21] Hence, if the last end be a perfect operation, it would seem that it must consist in an act of the will rather than of the intellect.

[3] Again. Delight apparently is desired for its own sake, so that it is never desired for the sake of something else; for it is silly to ask of anyone why he seeks to be delighted. Now this is a condition of the ultimate end, namely, that it be sought for its own sake. Therefore, seemingly, the last end consists in an act of the will rather than of the intellect.

[4] Moreover. All agree in their desire of the last end, for it is a natural desire. But more people seek delight than knowledge. Therefore delight would seem to be the last end rather than knowledge.

[5] Furthermore. The will is seemingly a higher power than the intellect, for the will moves the intellect to its act; since when a person wills, his intellect considers by an act what he holds by a habit. Therefore, seemingly, the action of the will is more noble than the action of the intellect. Therefore, it would seem that the last end, which is beatitude, consists in an act of the will rather than of the intellect.

But this can be clearly shown to be impossible.

For since happiness is the proper good of the intellectual nature, it must needs become the intellectual nature according to that which is proper thereto. Now appetite is not proper to the intellectual nature, but is in all things, although it is found diversely in diverse things. This diversity, however, arises from the fact that things are diversely related to knowledge. For things wholly devoid of knowledge have only a natural appetite; those that have a sensitive knowledge have also a sensitive appetite, under which the irascible and concupiscible appetites are comprised; and those which have intellectual knowledge have also an appetite proportionate to that knowledge, namely, the will. The will, therefore, in so far as it is an appetite, is not proper to the intellectual nature, but only in so far as it is dependent on the intellect. On the other hand, the intellect is in itself proper to the intellectual nature. Therefore, beatitude or happiness consists principally and essentially in an act of the intellect, rather than in an act of the will.

Again. In all powers that are moved by their objects, the object is naturally prior to the acts of those powers, even as the mover is naturally prior to the movable being moved. Now the will is such a power, for the appetible object moves the appetite. Therefore the will's object is naturally prior to its act, and consequently its first object precedes its every act. Therefore an act of the will cannot be the first thing willed. But this is the last end, which is beatitude. Therefore beatitude or happiness cannot be the very act of the will.

Besides. In all those powers which are able to reflect on their acts, their act must first bear on some other object, and afterwards the power is brought to bear on its own act. For if the intellect understands that it understands, we must suppose first that it understands some particular thing, and that afterwards it understands that it understands; for this very act of understanding, which the intellect understands, must have an object. Hence either we must go on forever, or if we come to some first thing understood, this will not be an act of understanding, but some intelligible thing. In the same way, the first thing willed cannot

be the very act of willing, but must be some other good. Now the first thing willed by an intellectual nature is beatitude or happiness; because it is for its sake that we will whatever we will. Therefore happiness cannot consist in an act of the will.

Further. The truth of a thing's nature is derived from those things which constitute its substance; for a true man differs from a man in a picture by the things which constitute man's substance. Now false happiness does not differ from true in an act of the will; because, whatever be proposed to the will as the supreme good, whether truly or falsely, it makes no difference to the will in its desiring, loving, or enjoying that good: the difference is on the part of the intellect, as to whether the good proposed as supreme be truly so or not. Therefore beatitude or happiness consists essentially in an act of the intellect rather than of the will.

Again. If an act of the will were happiness itself, this act would be an act either of desire, or love, or delight. But desire cannot possibly be the last end. For desire implies that the will is tending to what it has not yet; and this is contrary to the very notion of the last end.—Nor can love be the last end. For a good is loved not only while it is in our possession, but even when it is not, because it is through love that we seek by desire what we have not; and if the love of a thing we possess is more perfect, this arises from the fact that we possess the good we love. It is one thing, therefore, to possess the good which is our end, and another to love it; for love was imperfect before we possessed the end, and perfect after we obtained possession.—Nor again is delight the last end. For it is possession of the good that causes delight, whether we are conscious of possessing it actually, or call to mind our previous possession, or hope to possess it in the future. Therefore delight is not the last end.—Therefore no act of the will can be happiness itself essentially.

Furthermore. If delight were the last end, it would be desirable for its own sake. But this is not true. For the desirability of a delight depends on what gives rise to the delight, since that which arises from good and desirable operations is itself good and desirable, but that which arises from evil operations is itself evil and to be avoided. Therefore its goodness and desirability are from something else, and consequently it is not itself the last end or happiness.

Moreover. The right order of things agrees with the order of nature, for in the natural order things are ordered to their end without any error. Now, in the natural order delight is for the sake of operation, and not conversely. For it is to be observed that nature has joined delight with those animal operations which are clearly ordered to necessary ends: for instance, to the use of food that is ordered to the preservation of the individual, and to sexual matters, that are appointed for the preservation of the species; since were there no pleasure, animals would abstain from the use of these necessary things. Therefore delight cannot be the last end.

Again. Delight, seemingly, is nothing else than the quiescence of the will in some becoming good, just as desire is the inclining of the will towards the attaining of some good. Now just as by his will a man is inclined towards an end, and rests in it, so too natural bodies have a natural inclination to their respective ends, and are at rest when they have once attained their end. Now it is absurd to say that the end of the movement of a heavy body is not to be in its proper place, but that it is the quiescence of the inclination towards that place. For if it were nature's chief intent that this inclination should be quiescent, it would not give such an inclination; but it gives the inclination so that the body may tend towards its proper place, and when it has arrived there, as though it were its end, quiescence of the inclination follows. Hence this quiescence is not the end, but accompanies the end. Neither therefore is delight the ultimate end, but accompanies it. Much less therefore is happiness any act of the will.

Besides. If a thing have something extrinsic for its end, the operation whereby it first obtains that thing will be called its last end. Thus, for those whose end is money possession is said to be their end, but not love or desire. Now the last end of the intellectual substance is God. Hence that operation of man whereby he first obtains God is essentially his happiness or beatitude. And this is understanding, since we cannot will what we do not understand.

Therefore man's ultimate happiness is essentially to know God by the intellect; it is not an act of the will.

From what has been said we can now solve the arguments that were objected in the contrary sense. For it does not necessarily follow that happiness is essentially the very act of the will, from the fact that it is the object of the will, through being the highest good, as the *first argument* reasoned. On the contrary, the fact that it is the first object of the will shows that it is not an act of the will, as appears from what we have said.

Nor does it follow that whatever perfects a thing in any way whatever must be the end of that thing, as the *second objection* argued. For a thing perfects another in two ways: first, it perfects a thing that has its species; secondly, it perfects a thing that it may have its species. Thus the perfection of a house, considered as already having its species, is that to which the species "house" is directed, namely to be a dwelling; for one would not build a house but for that purpose, and consequently we must include this in the definition of a house, if the definition is to be perfect. On the other hand, the perfection that conduces to the species of a house is both that which is directed to the completion of the species, for instance, its substantial principles; and also that which conduces to the preservation of the species, for instance, the buttresses which are made to support the building; as well as those things which make the house more fit for use, for instance, the beauty of the house. Accordingly, that which is the perfection of a thing, considered as already having its species, is its end; as the end of a house is to be a dwelling. Likewise, the operation proper to a thing, its use, as it were, is its end. On the other hand, whatever perfects a thing by conducing to its species is not the end of that thing; in fact, the thing itself is its end, for matter and form are for the sake of the species. For although the form is the end of generation, it is not the end of the thing already generated and having its species, but is required in order that the species be complete. Again, whatever preserves the thing in its species, such as health and the nutritive power, although it perfects the animal, is not the animal's

end, but vice versa. And again, whatever adapts a thing for the perfection of its proper specific operations, and for the easier attainment of its proper end, is not the end of that thing, but vice versa; for instance, a man's comeliness and bodily strength, and the like, of which the Philosopher says that they *conduce to happiness instrumentally.*[22]—Now delight is a perfection of operation, not as though operation were directed thereto in respect of its species, for thus it is directed to other ends (thus, eating, in respect of its species, is directed to the preservation of the individual); but it is like a perfection that is conducive to a thing's species, since for the sake of the delight we perform more attentively and becomingly an operation we delight in. Hence the Philosopher says that *delight perfects operation as beauty perfects youth,*[23] for beauty is for the sake of the one who has youth and not *vice versa.*

Nor is the fact that men seek delight not for the sake of something else but for its own sake a sufficient indication that delight is the last end, as the *third objection* argued. Because delight, though it is not the last end, nevertheless accompanies the last end, since delight arises from the attainment of the end.

Nor do more people seek the pleasure that comes from knowledge than knowledge itself. But more there are who seek sensible delights than intellectual knowledge and the delight consequent thereto; because those things that are outside us are better known to the majority, in that human knowledge takes its beginning from sensible objects.

The suggestion put forward by the *fifth argument,* that the will is a higher power than the intellect, as being the latter's motive power, is clearly untrue. Because the intellect moves the will first and *per se,* for the will, as such, is moved by its object, which is the apprehended good; whereas the will moves the intellect accidentally as it were, in so far, namely, as the act of understanding is itself apprehended as a good, and on that account is desired by the will, with the result that the intellect understands actually. Even in this, the intellect precedes the will, for the will would never desire understanding, did not the intellect first apprehend its understanding as a

good.—And again, the will moves the intellect to actual operation in the same way as an agent is said to move; whereas the intellect moves the will in the same way as the end moves, for the good understood is the end of the will. Now the agent in moving presupposes the end, for the agent does not move except for the sake of the end. It is therefore clear that the intellect is higher than the will absolutely, while the will is higher than the intellect accidentally and in a restricted sense.

Chapter XXVII

THAT HUMAN HAPPINESS DOES NOT CONSIST IN CARNAL PLEASURES

From what has been said it is clearly impossible that human happiness consists in pleasures of the body, the chief of which are pleasures of the table and of sex.

It has been shown that according to nature's order pleasure is for the sake of operation, and not conversely.[24] Therefore, if an operation be not the ultimate end, the consequent pleasure can neither be the ultimate end, nor accompany the ultimate end. Now it is manifest that the operations which are followed by the pleasures mentioned above are not the last end; for they are directed to certain manifest ends: eating, for instance, to the preservation of the body, and carnal intercourse to the begetting of children. Therefore the aforesaid pleasures are not the last end, nor do they accompany the last end. Therefore happiness does not consist in them.

Again. The will is higher than the sensitive appetite, for it moves the sensitive appetite, as was stated above.[25] But happiness does not consist in an act of the will, as we have already proved.[26] Much less therefore does it consist in the aforesaid pleasures which are seated in the sensitive appetite.

Moreover. Happiness is a good proper to man, for it is an abuse of terms to speak of brute animals as being happy. Now these pleasures are common to man and brute. Therefore we must not assign happiness to them.

The last end is the most noble of things belonging to a reality, for it has the nature of that which is best. But the aforementioned pleasures do not befit man according to what is most noble in him, namely, the intellect, but according to the sense. Therefore happiness is not to be located in such pleasures.

Besides. The highest perfection of man cannot consist in his being united to things lower than himself, but consists in his being united to something above him; for the end is better than that which tends to the end. Now the above pleasures consist in man's being united through his senses to things beneath him, namely, certain sensible things. Therefore we must not assign happiness to such pleasures.

Further. That which is not good unless it be moderate is not good in itself, but receives its goodness from its moderator. Now the use of the aforesaid pleasures is not good for man unless it be moderate; for otherwise they would frustrate one another. Therefore these pleasures are not in themselves man's good. But the highest good is good of itself, because that which is good of itself is better than what is good through another. Therefore such pleasures are not man's highest good, which is happiness.

Again. In all *per se* predications, if A be predicated of B absolutely, an increase in A will be predicated of an increase in B. Thus if a hot thing heats, a hotter thing heats more, and the hottest thing will heat most. Accordingly, if the pleasures in question were good in themselves, it would follow that to use them very much would be very good. But this is clearly false, because it is considered sinful to use them too much; besides, it is hurtful to the body, and hinders pleasures of the same kind. Therefore they are not per se man's good, and human happiness does not consist in them.

Again. Acts of virtue are praiseworthy through being ordered to happiness.[27] If therefore human happiness consisted in the aforesaid pleasures, an act of virtue would be more praiseworthy in acceding to them than in abstaining from them. But this is clearly untrue, for the act of temperance is especially praised in abstinence from pleasures; whence that act takes its name. Therefore man's happiness is not in these pleasures.

Furthermore. The last end of everything is God, as was proved above.[28] We must therefore posit as man's last end that by which especially man approaches to

God. Now man is hindered by the aforesaid pleasures from his chief approach to God, which is effected by contemplation, to which these same pleasures are a very great hindrance, since more than anything they plunge man into the midst of sensible things, and consequently withdraw him from intelligible things. Therefore human happiness is not to be placed in bodily pleasures.

Hereby is refuted the error of the Epicureans who ascribed man's happiness to pleasures of this kind. In their person Solomon says (*Eccles.* v. 17): *This therefore hath seemed good to me, that a man should eat and drink, and enjoy the fruit of his labor . . . and this is his portion*; and (*Wis.* ii. 9): *Let us everywhere leave tokens of joy, for this is our portion, and this is our lot.*

The error of the Cerinthians is also refuted. For they *pretended that,* in the state of final happiness, *after the resurrection Christ will reign for a thousand years, and men will indulge in the carnal pleasures of the table. Hence they are called "Chiliastae,"*[29] or believers in the Millennium.

The fables of the Jews and Mohammedans are also refuted, who pretend that the reward of the righteous consists in such pleasures. For happiness is the reward of virtue.

Chapter XXVIII

THAT HAPPINESS DOES NOT CONSIST IN HONORS

From the foregoing it is also clear that neither does man's highest good, or happiness, consist in honors.

For man's ultimate end and happiness is his most perfect operation, as we have shown above.[30] But man's honor does not consist in something done by him, but in something done to him by another who shows him respect.[31] Therefore man's happiness must not be placed in honors.

Again. That which is for the sake of another good and desirable thing is not the last end. Now such is honor, for a man is not rightly honored, except because of some other good in him. For this reason men seek to be honored, as though wishing to have a voucher for some good that is in them; so that they rejoice more in

being honored by the great and the wise. Therefore we must not assign man's happiness to honors.

Besides. Happiness is obtained through virtue. Now virtuous deeds are voluntary, or else they would not be praiseworthy. Therefore happiness must be a good obtainable by man through his will. But it is not in a man's power to secure honor, rather is it in the power of the man who pays honor. Therefore happiness is not to be assigned to honors.

Moreover. Only the good can be worthy of honor, and yet it is possible even for the wicked to be honored. Therefore it is better to become worthy of honor, than to be honored. Therefore honor is not man's supreme good.

Furthermore. The highest good is the perfect good. Now the perfect good is incompatible with any evil. But that which has no evil in it cannot possibly be evil. Therefore that which is in possession of the highest good cannot be evil. Yet it is possible for an evil person to receive honor. Therefore honor is not man's supreme good.

Chapter XXIX

THAT MAN'S HAPPINESS DOES NOT CONSIST IN GLORY

Therefore it is evident also that man's supreme good does not consist in glory, which is the recognition of one's good name.

For glory, according to Cicero, is *the general recognition and praise of a person's good name,*[32] and, in the words of Ambrose, consists in *being well known and praised.*[33] Now men seek praise and distinction through being famous, so that they may be honored by those whom their fame reaches. Therefore glory is sought for the sake of honor, and consequently if honor be not the highest good, much less is glory.

Again. Those goods are worthy of praise, whereby a man shows himself to be ordered to his end. Now he who is directed to his end has not yet reached his last end. Therefore praise is not bestowed on one who has reached his last end; rather does he receive honor, as the Philosopher says.[34] Therefore glory cannot be the highest good, since it consists chiefly in praise.

Besides. It is better to know than to be known, because only the higher realities know, whereas the lowest are known. Therefore man's highest good cannot be glory, which consists in a man's being known.

Further. A man does not seek to be known except in good things; in evil things he seeks to be hidden. Therefore, to be known is good and desirable, because of the good things that are known in a man. Therefore these good things are better still. Consequently glory, which consists in a man's being known, is not his highest good.

Moreover. The highest good must needs be perfect, for it satisfies the appetite. But the knowledge of one's good name, wherein glory consists, is imperfect, for it is beset with much uncertainty and error. Therefore glory of this kind cannot be the supreme good.

Furthermore. Man's highest good must be supremely stable in human things, for it is natural to desire unfailing endurance in one's goods. Now glory, which consists in fame, is most unstable, since nothing is more changeable than human opinion and praise. Therefore such glory is not man's highest good.

Chapter XXX

THAT MAN'S HAPPINESS DOES NOT CONSIST IN WEALTH

Hence it is evident that neither is wealth man's highest good. For wealth is not sought except for the sake of something else, because of itself it brings us no good, but only when we use it, whether for the support of the body or for some similar purpose. Now the highest good is sought for its own, and not for another's sake. Therefore wealth is not man's highest good.

Again. Man's highest good cannot consist in the possession or preservation of things whose chief advantage for man consists in their being spent. Now the chief advantage of wealth is in its being spent, for this is its use. Therefore the possession of wealth cannot be man's highest good.

Moreover. Acts of virtue deserve praise according as they lead to happiness. Now acts of liberality and magnificence, which are concerned with money, are deserving of praise because of money being spent rather than because of its being kept; and it is from this

that these virtues derive their names. Therefore man's happiness does not consist in the possession of wealth.

Besides. Man's highest good must consist in obtaining something better than man. But man is better than wealth, since wealth is something directed to man's use. Therefore man's supreme good does not consist in wealth.

Further. Man's highest good is not subject to fortune.[35] For things that are fortuitous escape the forethought of reason, whereas man has to attain his own end by means of his reason. But fortune occupies the greatest place in the attaining of wealth. Therefore human happiness does not consist in wealth.

Moreover. This is evident from the fact that wealth is lost unwillingly; also because wealth can come into the possession of evil persons, who, of necessity, must lack the highest good. Again because wealth is unstable. Other similar reasons can be gathered from the arguments given above.[36]

Chapter XXXI

THAT HAPPINESS DOES NOT CONSIST IN WORLDLY POWER

In like manner, neither can worldly power be man's highest happiness, since in the achievement thereof chance can effect much. Again, it is unstable, and not subject to man's will; and it is often obtained by evil men. These are incompatible with the highest good, as was already stated.[37]

Again. Man is said to be good especially according as he approaches the highest good. But in respect to his having power, he is not said to be either good or evil, since not everyone who can do good deeds is good, nor is a person evil because he can do evil deeds. Therefore the highest good does not consist in being powerful.

Besides. Every power implies reference to something else. But the highest good is not referred to anything further. Therefore power is not man's highest good.

Moreover. Man's highest good cannot be a thing that one can use both well and ill; for the better things are those that we cannot abuse. But one can use one's power both well and ill, for *rational powers can be*

directed to contrary objects.[38] Therefore human power is not man's good.

Further. If any power be man's highest good, it must be most perfect. Now human power is most imperfect, for it is based on human will and opinion, which are full of inconstancies. Also, the greater a power is reputed to be, the greater number of people does it depend on; which again conduces to its weakness, since what depends on many is in many ways destructible. Therefore man's highest good does not consist in worldly power.

Consequently man's happiness does not consist in any external good, for all external goods, which are known as *fortuitous goods,* are contained under those we have mentioned.[39]

Chapter XXXII

THAT HAPPINESS DOES NOT CONSIST IN GOODS OF THE BODY

Like arguments avail to prove that man's highest good does not consist in goods of the body, such as health, beauty and strength. For they are common to good and evil, they are unstable, and they are not subject to the will.

Besides. The soul is better than the body, which neither lives nor possesses these goods without the soul. Therefore, the soul's good, such as understanding and the like, is better than the body's good. Therefore the body's good is not man's highest good.

Again. These goods are common to man and other animals, whereas happiness is a good proper to man. Therefore man's happiness does not consist in the things mentioned.

Moreover. Many animals surpass man in goods of the body, for some are fleeter than he, some more sturdy, and so on. Accordingly, if man's highest good consisted in these things, man would not excel all animals; which is clearly untrue. Therefore human happiness does not consist in goods of the body.

Chapter XXXIII

THAT HUMAN HAPPINESS IS NOT SEATED IN THE SENSES

By the same arguments it is evident that neither does man's highest good consist in goods of his sensitive nature. For these goods, again, are common to man and other animals.

Again. Intellect is superior to sense. Therefore the intellect's good is better than that of the sense. Consequently man's supreme good is not seated in the senses.

Besides. The greatest sensual pleasures are those of the table and of sex, wherein the supreme good must needs be, if seated in the senses. But it does not consist in them. Therefore man's highest good is not in the senses.

Moreover. The senses are appreciated for their utility and for knowledge. Now the entire utility of the senses is referred to the goods of the body. Again, sensitive knowledge is ordered to intellectual knowledge, and hence animals devoid of intellect take no pleasure in sensation except in reference to some bodily utility, in so far as by sensitive knowledge they obtain food or sexual intercourse. Therefore, man's highest good which is happiness is not seated in the sensitive part of man.

Chapter XXXIV

THAT MAN'S ULTIMATE HAPPINESS DOES NOT CONSIST IN ACTS OF THE MORAL VIRTUES

It is clear that man's ultimate happiness does not consist in moral activities.

For human happiness, if ultimate, cannot be directed to a further end. But all moral activities can be directed to something else. This is clear from a consideration of the principal among them. Because deeds of fortitude in time of war are directed to victory and peace; for it were foolish to go to war merely for its own sake.[40] Again, deeds of justice are directed to keeping peace among men, for each man possesses with contentment what is his own. The same applies to all the other virtues. Therefore man's ultimate happiness is not in moral deeds.

Again. The purpose of the moral virtues is that through them we may observe the mean in the passions within us, and in things outside us. Now it is impossible that the moderation of passions or of external things be the ultimate end of man's life, since both passions and external things can be directed to

something less. Therefore it is not possible that the practice of moral virtue be man's final happiness.

Further. Since man is man through the possession of reason, his proper good, which is happiness, must needs be in accordance with that which is proper to reason. Now that which reason has in itself is more proper to reason than what it effects in something else. Seeing, then, that the good of moral virtue is a good established by reason in something other than itself, it cannot be the greatest good of man which happiness is; rather this good must be a good that is in reason itself.

Moreover. We have already proved that the last end of all things is to become like God.[41] Therefore that in which man chiefly becomes like God will be his happiness. Now this is not in terms of moral actions, since such actions cannot be ascribed to God, except metaphorically; for it is not befitting to God to have passions, or the like, with which moral virtue is concerned. Therefore man's ultimate happiness, which is his last end, does not consist in moral actions.

Furthermore. Happiness is man's proper good. Therefore that good, which of all goods is most proper to man in comparison with other animals, is the one in which we must seek his ultimate happiness. Now this is not the practice of moral virtue, for animals share somewhat either in liberality or in fortitude, whereas no animal has a share in intellectual activity. Therefore man's ultimate happiness does not consist in moral acts.

Chapter XXXV

THAT ULTIMATE HAPPINESS DOES NOT CONSIST IN THE ACT OF PRUDENCE

It is also evident from the foregoing that neither does man's happiness consist in the act of prudence.

For acts of prudence are solely about matters of moral virtue. But human happiness does not consist in the practice of moral virtue.[42] Neither therefore does it consist in the practice of prudence.

Again. Man's ultimate happiness consists in man's most excellent operation. Now man's most excellent operation, in terms of what is proper to man, is in relation to most perfect objects. But the

act of prudence is not concerned with the most perfect objects of intellect or reason; for it is not about necessary things, but about contingent practical matters.[43] Therefore its act is not man's ultimate happiness.

Besides. That which is ordered to another as to its end is not man's ultimate happiness. Now the act of prudence is ordered to another as to its end, both because all practical knowledge, under which prudence is comprised, is ordered to operation, and because prudence disposes a man well in choosing means to an end, as may be gathered from Aristotle.[44] Therefore man's ultimate happiness is not in the practice of prudence.

Furthermore. Irrational animals have no share of happiness, as Aristotle proves.[45] Yet some of them have a certain share of prudence, as may be gathered from the same author.[46] Therefore happiness does not consist in an act of prudence.

Chapter XXXVI

THAT HAPPINESS DOES NOT CONSIST IN THE PRACTICE OF ART

It is also evident that it cannot consist in the practice of art.

For even the knowledge of art is practical, and so is directed to an end, and is not the ultimate end.

Besides. The end of the practice of art is the thing produced by art, and such a thing cannot be the ultimate end of human life, since it is rather we who are the end of those products, for they are all made for man's use. Therefore final happiness cannot consist in the practice of art.

Chapter XXXVII

THAT MAN'S ULTIMATE HAPPINESS CONSISTS IN CONTEMPLATING GOD

Accordingly, if man's ultimate happiness does not consist in external things, which are called goods of fortune; nor in goods of the body; nor in goods of the soul, as regards the sensitive part; nor as regards the intellectual part, in terms of the life of moral virtue; nor in terms of the intellectual virtues which are concerned with action, namely, art and prudence:—it remains for us to conclude that man's

ultimate happiness consists in the contemplation of truth.

For this operation alone is proper to man, and it is in it that none of the other animals communicates.

Again. This is not directed to anything further as to its end, since the contemplation of the truth is sought for its own sake.

Again. By this operation man is united to beings above him, by becoming like them; because of all human actions this alone is both in God and in the separate substances. Also, by this operation man comes into contact with those higher beings, through knowing them in any way whatever.

Besides, man is more self-sufficing for this operation, seeing that he stands in little need of the help of external things in order to perform it.

Further. All other human operations seem to be ordered to this as to their end. For perfect contemplation requires that the body should be disencumbered, and to this effect are directed all the products of art that are necessary for life. Moreover, it requires freedom from the disturbance caused by the passions, which is achieved by means of the moral virtues and of prudence; and freedom from external disturbance, to which the whole governance of the civil life is directed. So that, if we consider the matter rightly, we shall see that all human occupations appear to serve those who contemplate the truth.

Now, it is not possible that man's ultimate happiness consists in contemplation based on the understanding of first principles; for this is most imperfect, as being most universal, containing potentially the knowledge of things. Moreover, it is the beginning and not the end of human inquiry, and comes to us from nature, and not through the pursuit of the truth. Nor does it consist in contemplation based on the sciences that have the lowest things for their object, since happiness must consist in an operation of the intellect in relation to the most noble intelligible objects. It follows then that man's ultimate happiness consists in wisdom, based on the consideration of divine things.

It is therefore evident also by way of induction that man's ultimate happiness consists solely in the contemplation of God, which conclusion was proved above by arguments.[47]

Notes

1. Aristotle, *Post. Anal.,* I, 22 (82b 38).
2. Aristotle, *Metaph.,* I a, 2 (994, 6).
3. *C. G.* I, 42.
4. Cf. Aristotle, *Phys.,* II, 8 (198b 12).
5. Aristotle, *Eth.,* I, 1 (1094a 1).
6. Ch. 2.
7. Cf. Aristotle, *Phys.,* II, 5 (196b 11).
8. *De Div. Nom.,* IV, 4 (PG 3, 699).
9. Ch. 17.
10. Aristotle, *Metaph.,* I a, 1 (993b 9).
11. Ch. 17.
12. Ch. 19.
13. *C. G.,* I, 56.
14. *C. G.,* I, 49.
15. Aristotle, *Metaph.,* I, 2 (983a 6).
16. Aristotle, *Eth.,* VI, 2 (1139a 27).
17. Aristotle, *Metaph.,* I, 3 (983a 25).
18. *C. G.,* II, 15.
19. *De Caelo,* I, 8 (277a 18).
20. *Eth.,* X, 7 (1177a 18).
21. *Eth.,* X, 4 (1174b 31).
22. *Eth.,* I, 8 (1099b 2); 9 (1099b 28).
23. *Op. cit.,* X, 4 (1174b 31).
24. Ch. 26.
25. *Ibid.*
26. *Ibid.*
27. Cf. Aristotle, *Eth.,* I, 12 (1101b 14).
28. Ch. 17
29. St. Augustine, *De Haeres.,* 8 (PL 42, 27).
30. Ch. 25.
31. Cf. Aristotle, *Eth.,* I, 5 (1095b 25).
32. *De Inventione,* II, 55 (p. 150[b]).
33. Cf. St. Augustine, *Contra Maximin.,* II, 13 (PL 42, 770).
34. *Eth.,* I. 12 (1101b 24).
35. *Eth.,* I, 9 (1099b 24).
36. Ch. 28ff.
37. Ch. 28ff.
38. Aristotle, *Metaph.,* IX, 2 (1046b 25).
39. Ch. 28ff.
40. Cf. Aristotle, *Eth.,* X, 7 (1177b 9).
41. Ch. 19.
42. Ch. 34.
43. Cf. Aristotle, *Eth.,* VI, 5 (1104a 35).
44. *Op. cit.,* VI, 13 (1145a 6).
45. *Op cit.,* I, 9 (1099b 33).
46. Aristotle, *Metaph.,* I, 1 (980a 30).
47. Ch. 25.

Study Questions

1. Can you act to achieve an end that you believe is bad?
2. Can the human intellect understand God?
3. Can animals be happy?
4. Does luck play any role in achieving the highest good?

8

THOMAS HOBBES

Thomas Hobbes (1588–1679) was an English philosopher who played a crucial role in the history of social thought. He developed a moral and political theory that viewed justice and other ethical ideals as resting on an implied agreement among individuals. Hobbes argued that reason requires that we should relinquish the right to do whatever we please in exchange for all others limiting their rights in a similar manner, thus achieving security for all. Outside the social order each human life is, in the famous words of Hobbes, "solitary, poor, nasty, brutish, and short."

Leviathan

CHAPTER VI

Of the Interior Beginnings of Voluntary Motions; Commonly Called the Passions; and the Speeches by Which They Are Expressed

There be in animals, two sorts of *motions* peculiar to them: one called *vital;* begun in generation, and continued without interruption through their whole life; such as are the *course* of the *blood,* the *pulse,* the *breathing,* the *concoction, nutrition, excretion,* &c., to which motions there needs no help of imagination: the other is *animal motion,* otherwise called *voluntary motion;* as to *go,* to *speak,* to *move* any of our limbs, in such manner as is first fancied in our minds. That sense is motion in the organs and interior parts of man's body, caused by the action of the things we see, hear, &c.; and that fancy is but the relics of the same motion, remaining after sense, has been already said in the first and second chapters. And because *going, speaking,* and the like voluntary motions, depend always upon a precedent thought of *whither, which way,* and *what;* it is evident, that the imagination is the first internal beginning of all voluntary motion. And although unstudied men do not conceive any motion at all to be there, where the thing moved is invisible; or the space it is moved in is, for the shortness of it, insensible; yet that doth not hinder, but that such motions are. For let a space be never so little, that which is moved over a greater space, whereof that little one is part, must first be moved over that. These small beginnings of motion, within the body of man, before they appear in walking, speaking,

From *Leviathan,* Thomas Hobbes (1660).

striking, and other visible actions, are commonly called ENDEAVOUR.

This endeavour, when it is toward something which causes it, is called APPETITE, or DESIRE; the latter, being the general name; and the other often-times restrained to signify the desire of food, namely *hunger* and *thirst.* And when the endeavour is fromward something, it is generally called AVERSION. These words, *appetite* and *aversion,* we have from the Latins; and they both of them signify the motions, one of approaching, the other of retiring. So also do the Greek words for the same, which are ὁρμὴ and ἀφορμὴ. For nature itself does often press upon men those truths, which afterwards, when they look for somewhat beyond nature, they stumble at. For the Schools find in mere appetite to go, or move, no actual motion at all: but because some motion they must acknowledge, they call it metaphorical motion; which is but an absurd speech: for though words may be called metaphorical; bodies and motions can not.

That which men desire, they are also said to LOVE: and to HATE those things for which they have aversion. So that desire and love are the same thing; save that by desire, we always signify the absence of the object; by love, most commonly the presence of the same. So also by aversion, we signify the absence; and by hate, the presence of the object.

Of appetites and aversions, some are born with men: as appetite of food, appetite of excretion, and exoneration, which may also and more properly be called aversions, from somewhat they feel in their bodies; and some other appetites, not many. The rest, which are appetites of particular things, proceed from experience, and trial of their effects upon themselves or other men. For of things we know not at all, or believe not to be, we can have no further desire, than to taste and try. But aversion we have for things, not only which we know have hurt us, but also that we do not know whether they will hurt us, or not.

Those things which we neither desire, nor hate, we are said to *contemn;* CONTEMPT being nothing else but an immobility, or contumacy of the heart, in resisting the action of certain things; and proceeding from that the heart is already moved otherwise, by other more potent objects; or from want of experience of them.

And because the constitution of a man's body is in continual mutation, it is impossible that all the same things should always cause in him the same appetites, and aversions: much less can all men consent, in the desire of almost any one and the same object.

But whatsoever is the object of any man's appetite or desire, that is it which he for his part calleth *good:* and the object of his hate and aversion, *evil;* and of his contempt, *vile* and *inconsiderable.* For these words of good, evil, and contemptible, are ever used with relation to the person that useth them: there being nothing simply and absolutely so, nor any common rule of good and evil, to be taken from the nature of the objects themselves; but from the person of the man, where there is no commonwealth; or, in a commonwealth, from the person that representeth it; or from an arbitrator or judge, whom men disagreeing shall by consent set up, and make his sentence the rule thereof.

The Latin tongue has two words, whose significations approach to those of good and evil; but are not precisely the same; and those are *pulchrum* and *turpe.* Whereof the former signifies that, which by some apparent signs promiseth good; and the latter, that which promiseth evil. But in our tongue we have not so general names to express them by. But for *pulchrum* we say in some things, *fair;* in others, *beautiful,* or *handsome,* or *gallant,* or *honourable,* or *comely,* or *amiable;* and for *turpe, foul, deformed, ugly, base, nauseous,* and the like, as the subject shall require; all which words, in their proper places, signify nothing else but the mien, or countenance, that promiseth good and evil. So that of good there be three kinds; good in the promise, that is *pulchrum;* good in effect, as the end desired, which is called *jucundum, delightful;* and good as the means, which is called *utile, profitable;* and as many of evil: for evil in promise, is that they call *turpe;* evil in effect, and end, is *molestum, unpleasant, troublesome;* and evil in the means, *inutile, unprofitable, hurtful.*

As, in sense, that which is really within us, is, as I have said before, only motion, caused by the action of external objects, but in appearance; to the sight, light and colour; to the ear, sound; to the nostril, odour, &c.: so, when the action of the same object is continued from

the eyes, ears, and other organs to the heart, the real effect there is nothing but motion, or endeavour; which consisteth in appetite, or aversion, to or from the object moving. But the appearance, or sense of that motion, is that we either call *delight,* or *trouble of mind.*

This motion, which is called appetite, and for the appearance of it *delight,* and *pleasure,* seemeth to be a corroboration of vital motion, and a help thereunto; and therefore such things as caused delight, were not improperly called *jucunda, àjuvando,* from helping or fortifying; and the contrary, *molesta, offensive,* from hindering, and troubling the motion vital.

Pleasure therefore, or *delight,* is the appearance, or sense of good; and *molestation,* or *displeasure,* the appearance, or sense of evil. And consequently all appetite, desire, and love, is accompanied with some delight more or less; and all hatred and aversion, with more or less displeasure and offence.

Of pleasures or delights, some arise from the sense of an object present; and those may be called *pleasures of sense;* the word *sensual,* as it is used by those only that condemn them, having no place till there be laws. Of this kind are all onerations and exonerations of the body; as also all that is pleasant, in the *sight, hearing, smell, taste,* or *touch.* Others arise from the expectation, that proceeds from foresight of the end, or consequence of things; whether those things in the sense please or displease. And these are *pleasures of the mind* of him that draweth those consequences, and are generally called JOY. In the like manner, displeasures are some in the sense, and called pain; others in the expectation of consequences, and are called GRIEF. . . .

CHAPTER XI

Of the Difference of Manners

By manners, I mean not here, decency of behaviour; as how one should salute another, or how a man should wash his mouth, or pick his teeth before company, and such other points of the *small morals;* but those qualities of mankind, that concern their living together in peace, and unity. To which end we are to consider, that the felicity of this life, consisteth not in the repose of a mind satisfied. For there is no such *finis ultimus,* utmost aim, nor *summum bonum,* greatest good, as is spoken of in the books of the old moral philosophers. Nor can a man any more live, whose desires are at an end, than he, whose senses and imaginations are at a stand. Felicity is a continual progress of the desire, from one object to another; the attaining of the former, being still but the way to the latter. The cause whereof is, that the object of man's desire, is not to enjoy once only, and for one instant of time; but to assure for ever, the way of his future desire. And therefore the voluntary actions, and inclinations of all men, tend, not only to the procuring, but also to the assuring of a contented life; and differ only in the way: which ariseth partly from the diversity of passions, in divers men; and partly from the difference of the knowledge, or opinion each one has of the causes, which produce the effect desired.

So that in the first place, I put for a general inclination of all mankind, a perpetual and restless desire of power after power, that ceaseth only in death. And the cause of this, is not always that a man hopes for a more intensive delight, than he has already attained to; or that he cannot be content with a moderate power: but because he cannot assure the power and means to live well, which he hath present, without the acquisition of more. And from hence it is, that kings, whose power is greatest, turn their endeavours to the assuring it at home by laws, or abroad by wars: and when that is done, there succeedeth a new desire; in some, of fame from new conquest; in others, of ease and sensual pleasure; in others, of admiration, or being flattered for excellence in some art, or other ability of the mind.

Competition of riches, honour, command, or other power, inclineth to contention, enmity, and war: because the way of one competitor, to the attaining of his desire, is to kill, subdue, supplant, or repel the other. Particularly, competition of praise, inclineth to a reverence of antiquity. For men contend with the living, not with the dead; to these ascribing more than due, that they may obscure the glory of the other.

Desire of ease, and sensual delight, disposeth men to obey a common power: because by such desires, a man doth abandon the protection that might be hoped for from his own industry, and labour. Fear of

death, and wounds, disposeth to the same; and for the same reason. On the contrary, needy men, and hardy, not contented with their present condition; as also, all men that are ambitious of military command, are inclined to continue the causes of war; and to stir up trouble and sedition: for there is no honour military but by war; not any such hope to mend an ill game, as by causing a new shuffle.

Desire of knowledge, and arts of peace, inclineth men to obey a common power: for such desire, containeth a desire of leisure; and consequently protection from some other power than their own. . . .

CHAPTER XIII

Of the Natural Condition of Mankind as Concerning Their Felicity, and Misery

Nature hath made men so equal, in the faculties of the body, and mind; as that though there be found one man sometimes manifestly stronger in body, or of quicker mind than another; yet when all is reckoned together, the difference between man, and man, is not so considerable, as that one man can thereupon claim to himself any benefit, to which another may not pretend, as well as he. For as to the strength of body, the weakest has strength enough to kill the strongest, either by secret machination, or by confederacy with others, that are in the same danger with himself.

And as to the faculties of the mind, setting aside the arts grounded upon words, and especially that skill of proceeding upon general, and infallible rules, called science; which very few have, and but in few things; as being not a native faculty, born with us; nor attained, as prudence, while we look after somewhat else, I find yet a greater equality amongst men, than that of strength. For prudence, is but experience; which equal time, equally bestows on all men, in those things they equally apply themselves unto. That which may perhaps make such equality incredible, is but a vain conceit of one's own wisdom, which almost all men think they have in a greater degree, than the vulgar; that is, than all men but themselves, and a few others, whom by fame, or for concurring with themselves,

they approve. For such is the nature of men, that howsoever they may acknowledge many others to be more witty, or more eloquent, or more learned; yet they will hardly believe there be many so wise as themselves; for they see their own wit at hand, and other men's at a distance. But this proveth rather that men are in that point equal, than unequal. For there is not ordinarily a greater sign of the equal distribution of any thing, than that every man is contented with his share.

From this equality of ability, ariseth equality of hope in the attaining of our ends. And therefore if any two men desire the same thing, which nevertheless they cannot both enjoy, they become enemies; and in the way to their end, which is principally their own conservation, and sometimes their delectation only, endeavour to destroy, or subdue one another. And from hence it comes to pass, that where an invader hath no more to fear, than another man's single power; if one plant, sow, build, or possess a convenient seat, others may probably be expected to come prepared with forces united, to dispossess, and deprive him, not only of the fruit of his labour, but also of his life, or liberty. And the invader again is in the like danger of another.

And from this diffidence of one another, there is no way for any man to secure himself, so reasonable, as anticipation; that is, by force, or wiles, to master the persons of all men he can, so long, till he see no other power great enough to endanger him: and this is no more than his own conservation requireth, and is generally allowed. Also because there be some, that taking pleasure in contemplating their own power in the acts of conquest, which they pursue farther than their security requires; if others, that otherwise would be glad to be at ease within modest bounds, should not by invasion increase their power, they would not be able, long time, by standing only on their defence, to subsist. And by consequence, such augmentation of dominion over men being necessary to a man's conservation, it ought to be allowed him.

Again, men have no pleasure, but on the contrary a great deal of grief, in keeping company, where there is no power able to over-awe them all. For every man looketh that his companion should value him, at the same rate he sets upon himself: and upon all signs of contempt, or undervaluing, naturally endeavours, as

far as he dares, (which amongst them that have no common power to keep them in quiet, is far enough to make them destroy each other), to extort a greater value from his contemners, by damage; and from others, by the example.

So that in the nature of man, we find three principal causes of quarrel. First, competition; secondly, diffidence; thirdly, glory.

The first, maketh man invade for gain; the second, for safety; and the third, for reputation. The first use violence, to make themselves masters of other men's persons, wives, children, and cattle; the second, to defend them; the third, for trifles, as a word, a smile, a different opinion, and any other sign of undervalue, either direct in their persons, or by reflection in their kindred, their friends, their nation, their profession, or their name.

Hereby it is manifest, that during the time men live without a common power to keep them all in awe, they are in that condition which is called war; and such a WAR, as is of every man, against every man. For war, consisteth not in battle only, or the act of fighting; but in a tract of time, wherein the will to contend by battle is sufficiently known: and therefore the notion of *time,* is to be considered in the nature of war; as it is in the nature of weather. For as the nature of foul weather, lieth not in a shower or two of rain; but in an inclination thereto of many days together: so the nature of war, consisteth not in actual fighting; but in the known disposition thereto, during all the time there is no assurance to the contrary. All other time is PEACE.

Whatsoever therefore is consequent to a time of war, where every man is enemy to every man; the same is consequent to the time, wherein men live without other security, than what their own strength, and their own invention shall furnish them withal. In such condition, there is no place for industry; because the fruit thereof is uncertain: and consequently no culture of the earth; no navigation nor use of the commodities that may be imported by sea; no commodious building; no instruments of moving, and removing, such things as require much force; no knowledge of the face of the earth; no account of time; no arts; no letters; no society; and which is worst of all, continual

fear, and danger of violent death; and the life of man, solitary, poor, nasty, brutish, and short.

It may seem strange to some man, that has not well weighed these things; that nature should thus dissociate, and render men apt to invade, and destroy one another: and he may therefore, not trusting to this inference, made from the passions, desire perhaps to have the same confirmed by experience. Let him therefore consider with himself, when taking a journey, he arms himself, and seeks to go well accompanied; when going to sleep, he locks his doors; when even in his house he locks his chests; and this when he knows there be laws, and public offices, armed, to revenge all injuries shall be done him; what opinion he has of his fellow-subjects, when he rides armed; of his fellow citizens, when he locks his doors; and of his children, and servants, when he locks his chests. Does he not there as much accuse mankind by his actions, as I do by my words? But neither of us accuse man's nature in it. The desires, and other passions of man, are in themselves no sin. No more are the actions, that proceed from those passions, till they know a law that forbids them: which till laws be made they cannot know: nor can any law be made, till they have agreed upon the person that shall make it.

It may peradventure be thought, there was never such a time, nor condition of war as this; and I believe it was never generally so, over all the world: but there are many places, where they live so now. For the savage people in many places of America, except the government of small families, the concord whereof dependeth on natural lust, have no government at all; and live at this day in that brutish manner, as I said before. Howsoever, it may be perceived what manner of life there would be, where there were no common power to fear, by the manner of life, which men that have formerly lived under a peaceful government, use to degenerate into, in a civil war.

But though there had never been any time, wherein particular men were in a condition of war one against another; yet in all times, kings, and persons of sovereign authority, because of their independency, are in continual jealousies, and in the state and posture of gladiators; having their weapons pointing, and their eyes fixed on one another; that is, their forts, garrisons, and guns upon the frontiers

of their kingdoms; and continual spies upon their neighbours; which is a posture of war. But because they uphold thereby, the industry of their subjects; there does not follow from it, that misery, which accompanies the liberty of particular men.

To this war of every man, against every man, this also is consequent; that nothing can be unjust. The notions of right and wrong, justice and injustice have there no place, where there is no common power, there is no law: where no law, no injustice. Force, and fraud, are in war the two cardinal virtues. Justice, and injustice are none of the faculties neither of the body, nor mind. If they were, they might be in a man that were alone in the world, as well as his senses, and passions. They are qualities, that relate to men in society, not in solitude. It is consequent also to the same condition, that there be no propriety, no dominion, no *mine* and *thine* distinct; but only that to be every man's, that he can get: and for so long, as he can keep it. And thus much for the ill condition, which man by mere nature is actually placed in; though with a possibility to come out of it, consisting partly in the passions, partly in his reason.

The passions that incline men to peace, are fear of death; desire of such things as are necessary to commodious living; and a hope by their industry to obtain them. And reason suggesteth convenient articles of peace, upon which men may be drawn to agreement. These articles, are they, which otherwise are called the Laws of Nature: whereof I shall speak more particularly, in the two following chapters.

CHAPTER XIV

Of the First and Second Natural Laws, and of Contracts

The RIGHT OF NATURE, which writers commonly call *jus naturale,* is the liberty each man hath, to use his own power, as he will himself, for the preservation of his own nature; that is to say, of his own life; and consequently, of doing any thing, which in his own judgment, and reason, he shall conceive to be the aptest means thereunto.

By LIBERTY, is understood, according to the proper signification of the word, the absence of external impediments: which impediments, may oft take away part of a man's power to do what he would; but cannot hinder him from using the power left him, according as his judgment, and reason shall dictate to him.

A LAW OF NATURE, *lex naturalis,* is a precept or general rule, found out by reason, by which a man is forbidden to do that, which is destructive of his life, or taketh away the means of preserving the same; and to omit that, by which he thinketh it may be best preserved. For though they that speak of this subject, use to confound *jus,* and *lex, right* and *law:* yet they ought to be distinguished; because right, consisteth in liberty to do, or to forbear: whereas LAW, determineth, and bindeth to one of them: so that law, and right, differ as much, as obligation, and liberty; which in one and the same matter are inconsistent.

And because the condition of man, as hath been declared in the precedent chapter, is a condition of war of every one against every one; in which case every one is governed by his own reason; and there is nothing he can make use of, that may not be a help unto him, in preserving his life against his enemies; it followeth, that in such a condition, every man has a right to every thing; even to one another's body. And therefore, as long as this natural right of every man to every thing endureth, there can be no security to any man, how strong or wise soever he be, of living out the time, which nature ordinarily alloweth men to live. And consequently it is a precept, or general rule of reason, *that every man, ought to endeavour peace, as far as he has hope of obtaining it; and when he cannot obtain it, that he may seek, and use, all helps, and advantages of war.* The first branch of which rule, containeth the first, and fundamental law of nature; which is, to *seek peace, and follow it.* The second, the sum of the right of nature; which is, *by all means we can, to defend ourselves.*

From this fundamental law of nature, by which men are commanded to endeavour peace, is derived this second law; *that a man be willing, when others are so too, as far-forth, as for peace, and defence of himself, he shall think it necessary, to lay down this right to all things; and be contented with so much liberty against other men; as he would allow other men*

against himself. For as long as every man holdeth this right, of doing any thing he liketh; so long are all men in the condition of war. But if other men will not lay down their right, as well as he; then there is no reason for any one, to divest himself of his: for that were to expose himself to prey, which no man is bound to, rather than to dispose himself to peace. This is that law of the Gospel; *whatsoever you require that others should do to you, that do yet to them.* And that law of all men, *quod tibi fieri non vis, alteri ne feceris.*

To *lay down* a man's *right* to any thing, is to *divest* himself of the *liberty,* of hindering another of the benefit of his own right to the same. For he that renounceth, or passeth away his right, giveth not to any other man a right which he had not before; because there is nothing to which every man had not right by nature: but only standeth out of his way, that he may enjoy his own original right, without hindrance from him; not without hindrance from another. So that the effect which redoundeth to one man, by another man's defect of right, is but so much diminution of impediments to the use of his own right original. Right is laid aside, either by simply renouncing it; or by transferring it to another. By *simply* RENOUNCING; when he cares not to whom the benefit thereof redoundeth. By TRANSFERRING; when he intendeth the benefit thereof to some certain person, or persons. And when a man hath in either manner abandoned, or granted away his right; then he is said to be OBLIGED, or BOUND, not to hinder those, to whom such right is granted, or abandoned, from the benefit of it: and that he *ought,* and it is his DUTY, not to make void that voluntary act of his own: and that such hindrance is INJUSTICE, and INJURY, as being *sine jure;* the right being before renounced, or transferred. So that *injury,* or *injustice,* in the controversies of the world, is somewhat like to that, which in the disputations of scholars is called absurdity. For as it is there called an *absurdity,* to contradict what one maintained in the beginning: so in the world, it is called injustice, and injury, voluntarily to undo that, which from the beginning he had voluntarily done. The way by which a man either simply renounceth, or transferreth his right, is a declaration, or signification, by some voluntary and sufficient sign, or signs, that he doth so renounce, or transfer; or hath so renounced,

or transferred the same, to him that accepteth it. And these signs are either words only, or actions only; or, as it happeneth most often, both words, and actions. And the same are the BONDS, by which men are bound, and obliged: bonds, that have their strength, not from their own nature, for nothing is more easily broken than a man's word, but from fear of some evil consequences upon the rupture.

Whensoever, a man transferreth his right, or renounceth it; it is either in consideration of some right reciprocally transferred to himself; or for some other good he hopeth for thereby. For it is a voluntary act: and of the voluntary acts of every man, the object is some *good to himself.* And therefore there be some rights, which no man can be understood by any words, or other signs, to have abandoned, or transferred. As first a man cannot lay down the right of resisting them, that assault him by force, to take away his life; because he cannot be understood to aim thereby, at any good to himself. The same may be said of wounds, and chains, and imprisonment; both because there is no benefit consequent to such patience; as there is to the patience of suffering another to be wounded, or imprisoned: as also because a man cannot tell, when he seeth men proceed against him by violence, whether they intend his death or not. And lastly the motive, and end for which this renouncing, and transferring of right is introduced, is nothing else but the security of a man's person, in his life, and in the means of so preserving life, as not to be weary of it. And therefore if a man by words, or other signs, seem to despoil himself of the end, for which those signs were intended; he is not to be understood as if he meant it, or that it was his will; but that he was ignorant of how such words and actions were to be interpreted.

The mutual transferring of right, is that which men call CONTRACT. . . .

CHAPTER XV

Of Other Laws of Nature

From that law of nature, by which we are obliged to transfer to another, such rights, as being retained,

hinder the peace of mankind, there followeth a third; which is this, *that men perform their covenants made:* without which, covenants are in vain, and but empty words; and the right of all men to all things remaining, we are still in the condition of war.

And in this law of nature, consisteth the fountain and original of JUSTICE. For where no covenant hath preceded, there hath no right been transferred, and every man has right to every thing; and consequently, no action can be unjust. But when a covenant is made, then to break it is *unjust:* and the definition of INJUSTICE, is no other than *the not performance of covenant.* And whatsoever is not unjust, is *just.*

But because covenants of mutual trust, where there is a fear of not performance on either part, as hath been said in the former chapter, are invalid; though the original of justice be the making of covenants; yet injustice actually there can be none, till the cause of such fear be taken away; which while men are in the natural condition of war, cannot be done. Therefore before the names of just, and unjust can have place, there must be some coercive power, to compel men equally to the performance of their covenants, by the terror of some punishment, greater than the benefit they expect by the breach of their covenant; and to make good that propriety, which by mutual contract men acquire, in recompense of the universal right they abandon: and such power there is none before the erection of a commonwealth. And this is also to be gathered out of the ordinary definition of justice in the Schools: for they say, that *justice is the constant will of giving to every man his own.* And therefore where there is no *own,* that is no propriety, there is no injustice; and where there is no coercive power erected, that is, where there is no commonwealth, there is no propriety; all men having right to all things: therefore where there is no commonwealth, there nothing is unjust. So that the nature of justice, consisteth in keeping of valid covenants: but the validity of covenants begins not but with the constitution of a civil power, sufficient to compel men to keep them: and then it is also that propriety begins.

The fool hath said in his heart, there is no such thing as justice; and sometimes also with his tongue; seriously alleging, that every man's conservation, and contentment, being committed to his own care, there could be no reason, why every man might not do what he thought conduced thereunto: and therefore also to make, or not make; keep, or not keep covenants, was not against reason, when it conduced to one's benefit. He does not therein deny, that there be covenants; and that they are sometimes broken, sometimes kept; and that such breach of them may be called injustice, and the observance of them justice: but he questioneth, whether injustice, taking away the fear of God, (for the same fool hath said in his heart there is no God,) may not sometimes stand with that reason, which dictateth to every man his own good; and particularly then, when it conduceth to such a benefit, as shall put a man in a condition, to neglect not only the dispraise, and revilings, but also the power of other men. The kingdom of God is gotten by violence: but what if it could be gotten by unjust violence? were it against reason so to get it, when it is impossible to receive hurt by it? and if it be not against reason, it is not against justice; or else justice is not to be approved for good. From such reasoning as this, successful wickedness hath obtained the name of virtue: and some that in all other things have disallowed the violation of faith; yet have allowed it, when it is for the getting of a kingdom. . . . This specious reasoning is nevertheless false.

For the question is not of promises mutual, where there is no security of performance on either side; as when there is no civil power erected over the parties promising; for such promises are no covenants: but either where one of the parties has performed already; or where there is a power to make him perform; there is the question whether it be against reason, that is, against the benefit of the other to perform, or not. And I say it is not against reason. For the manifestation whereof, we are to consider; first, that when a man doth a thing, which notwithstanding any thing can be foreseen, and reckoned on, tendeth to his own destruction, howsoever some accident which he could not expect, arriving may turn it to his benefit; yet such events do not make it reasonably or wisely done. Secondly, that in a condition of war, wherein every man to every man, for want of a common power to keep them all in awe, is an enemy, there is no man can hope by his own strength, or wit,

to defend himself from destruction, without the help of confederates; where every one expects the same defence by the confederation, that any one else does: and therefore he which declares he thinks it reason to deceive those that help him, can in reason expect no other means of safety, than what can be had from his own single power. He therefore that breaketh his covenant, and consequently declareth that he thinks he may with reason do so, cannot be received into any society, that unite themselves for peace and defence, but by the error of them that receive him; nor when he is received, be retained in it, without seeing the danger of their error; which errors a man cannot reasonably reckon upon as the means of his security: and therefore if he be left, or cast out of society, he perisheth; and if he live in society, it is by the errors of other men, which he could not foresee, nor reckon upon; and consequently against the reason of his preservation; and so, as all men that contribute not to his destruction, forbear him only out of ignorance of what is good for themselves. . . .

As justice dependeth on antecedent covenant; so does GRATITUDE depend on antecedent grace; that is to say, antecedent free gift: and is the fourth law of nature; which may be conceived in this form, *that a man which receiveth benefit from another of mere grace, endeavour that he which giveth it, have no reasonable cause to repent him of his good will.* For no man giveth, but with intention of good to himself; because gift is voluntary; and of all voluntary acts, the object is to every man his own good; of which if men see they shall be frustrated, there will be no beginning of benevolence, or trust; nor consequently of mutual help; nor of reconciliation of one man to another; and therefore they are to remain still in the condition of *war;* which is contrary to the first and fundamental law of nature, which commandeth men to *seek peace.* The breach of this law, is called *ingratitude;* and hath the same relation to grace, that injustice hath to obligation by covenant.

A fifth law of nature, is COMPLAISANCE; that is to say, *that every man strive to accommodate himself to the rest.* For the understanding whereof, we may consider, that there is in men's aptness to society, a diversity of nature, rising from their diversity of affections; not unlike to that we see in stones brought together for building of an edifice. . . . For seeing every man, not only by right, but also by necessity of nature, is supposed to endeavour all he can, to obtain that which is necessary for his conservation; he that shall oppose himself against it, for things superfluous, is guilty of the war that thereupon is to follow; and therefore doth that, which is contrary to the fundamental law of nature, which commandeth *to seek peace.* The observers of this law, may be called SOCIABLE, the Latins call them *commodi;* the contrary, *stubborn, insociable, forward, intractable.*

A sixth law of nature, is this, *that upon caution of the future time, a man ought to pardon the offences past of them that repenting, desire it.* For PARDON, is nothing but granting of peace; which though granted to them that persevere in their hostility, be not peace, but fear; yet not granted to them that give caution of the future time, is sign of an aversion to peace; and therefore contrary to the law of nature.

A seventh is, *that in revenges,* that is, retribution of evil for evil, *men look not at the greatness of the evil past, but the greatness of the good to follow.* Whereby we are forbidden to inflict punishment with any other design, than for correction of the offender, or direction of others. For this law is consequent to the next before it, that commandeth pardon, upon security of the future time. Besides, revenge without respect to the example, and profit to come, is a triumph, or glorying in the hurt of another, tending to no end; for the end is always somewhat to come; and glorying to no end, is vain-glory, and contrary to reason, and to hurt without reason, tendeth to the introduction of war; which is against the law of nature; and is commonly styled by the name of *cruelty.*

And because all signs of hatred, or contempt, provoke to fight; insomuch as most men choose rather to hazard their life, than not to be revenged; we may in the eighth place, for a law of nature, set down this precept, *that no man by deed, word, countenance, or gesture, declare hatred, or contempt of another.* The breach of which law, is commonly called contumely. The question who is the better man, has no place in the condition of mere nature; where, as has been shewn before, all men are equal. The inequality that now

is, has been introduced by the laws civil. I know that Aristotle in the first book of his *Politics,* for a foundation of his doctrine, maketh men by nature, some more worthy to command, meaning the wiser sort, such as he thought himself to be for his philosophy; others to serve, meaning those that had strong bodies, but were not philosophers as he; as if master and servant were not introduced by consent of men, but by difference of wit: which is not only against reason; but also against experience. For there are very few so foolish, that had not rather govern themselves, than be governed by others: nor when the wise in their own conceit, contend by force, with them who distrust their own wisdom, do they always, or often, or almost at any time, get the victory. If nature therefore have made men equal, that equality is to be acknowledged: or if nature have made men unequal; yet because men that think themselves equal, will not enter into conditions of peace, but upon equal terms, such equality must be admitted. And therefore for the ninth law of nature, I put this, *that every man acknowledge another for his equal by nature.* The breach of this precept is *pride.*

On this law, dependeth another, *that at the entrance into conditions of peace, no man require to reserve to himself any right, which he is not content should be reserved to every one of the rest.* As it is necessary for all men that seek peace, to lay down certain rights of nature; that is to say, not to have liberty to do all they list: so is it necessary for man's life, to retain some; as right to govern their own bodies; enjoy air, water, motion, ways to go from place to place; and all things else, without which a man cannot live, or not live well. If in this case, at the making of peace, men require for themselves, that which they would not have to be granted to others, they do contrary to the precedent law, that commandeth the acknowledgment of natural equality, and therefore also against the law of nature. The observers of this law, are those we call *modest,* and the breakers *arrogant* men. The Greeks call the violation of this law πλεονεξία; that is, a desire of more than their share.

Also if *a man be trusted to judge between man and man,* it is a precept of the law of nature, *that he deal equally between them.* For without that, the controversies of men cannot be determined but by war.

He therefore that is partial in judgment, doth what in him lies, to deter men from the use of judges, and arbitrators; and consequently, against the fundamental law of nature, is the cause of war.

The observance of this law, from the equal distribution to each man, of that which in reason belongeth to him, is called EQUITY, and, as I have said before, distributive justice: the violation, acception of persons, προσωποληψία.

And from this followeth another law, *that such things as cannot be divided, be enjoyed in common, if it can be; and if the quantity of the thing permit, without stint; otherwise proportionably to the number of them that have right.* For otherwise the distribution is unequal, and contrary to equity.

But some things there be, that can neither be divided, nor enjoyed in common. Then, the law of nature, which prescribeth equity, requireth, *that the entire right; or else, making the use alternate, the first possession, be determined by lot.* For equal distribution, is of the law of nature; and other means of equal distribution cannot be imagined.

Of lots there be two sorts, *arbitrary,* and *natural.* Arbitrary, is that which is agreed on by the competitors; natural, is either *primogeniture,* which the Greek calls κληρονομία, which signifies, *given by lot;* or *first seizure.*

And therefore those things which cannot be enjoyed in common, nor divided, ought to be adjudged to the first possessor; and in some cases to the first born, as acquired by lot.

It is also a law of nature, *that all men that mediate peace, be allowed safe conduct.* For the law that commandeth peace, as the end, commandeth intercession, as the *means;* and to intercession the means is safe conduct.

And because, though men be never so willing to observe these laws, there may nevertheless arise questions concerning a man's action; first, whether it were done, or not done; secondly, if done, whether against the law, or not against the law; the former whereof, is called a question *of fact;* the latter a question *of right,* therefore unless the parties to the question, covenant mutually to stand to the sentence of another, they are as far from peace as ever. This

other to whose sentence they submit is called an ARBITRATOR. And therefore it is of the law of nature, *that they that are at controversy, submit their right to the judgment of an arbitrator.*

And seeing every man is presumed to do all things in order to his own benefit, no man is a fit arbitrator in his own cause; and if he were never so fit; yet equity allowing to each party equal benefit, if one be admitted to be judge, the other is to be admitted also; and so the controversy, that is, the cause of war, remains, against the law of nature.

For the same reason no man in any cause ought to be received for arbitrator, to whom greater profit, or honour, or pleasure apparently ariseth out of the victory of one party, than of the other: for he hath taken, though an unavoidable bribe, yet a bribe; and no man can be obliged to trust him. And thus also the controversy, and the condition of war remaineth, contrary to the law of nature.

And in a controversy of *fact,* the judge being to give no more credit to one, than to the other, if there be no other arguments, must give credit to a third; or to a third and fourth; or more; for else the question is undecided, and left to force, contrary to the law of nature.

These are the laws of nature, dictating peace, for a means of the conservation of men in multitudes; and which only concern the doctrine of civil society. There be other things tending to the destruction of particular men; as drunkenness, and all other parts of intemperance; which may therefore also be reckoned amongst those things which the law of nature hath forbidden; but are not necessary to be mentioned, nor are pertinent enough to this place.

And though this may seem too subtle a deduction of the laws of nature, to be taken notice of by all men; whereof the most part are too busy in getting food, and the rest too negligent to understand; yet to leave all men inexcusable, they have been contracted into one easy sum, intelligible even to the meanest capacity; and that is, *Do not that to another, which thou wouldest not have done to thyself;* which sheweth him, that he has no more to do in learning the laws of nature, but, when weighing the actions of other men with his own, they seem too heavy, to put

them into the other part of the balance, and his own into their place, that his own passions, and self-love, may add nothing to the weight; and then there is none of these laws of nature that will not appear unto him very reasonable.

The laws of nature oblige *in foro interno;* that is to say, they bind to a desire they should take place: but *in foro externo;* that is, to the putting them in act, not always. For he that should be modest, and tractable, and perform all he promises, in such time, and place, where no man else should do so, should but make himself a prey to others, and procure his own certain ruin, contrary to the ground of all laws of nature, which tend to nature's preservation. And again, he that having sufficient security, that others shall observe the same laws towards him, observes them not himself, seeketh not peace, but war; and consequently the destruction of his nature by violence.

And whatsoever laws bind *in foro interno,* may be broken, not only by a fact contrary to the law, but also by a fact according to it, in case a man think it contrary. For though his action in this case, be according to the law; yet his purpose was against the law; which, where the obligation is *in foro interno,* is a breach.

The laws of nature are immutable and eternal; for injustice, ingratitude, arrogance, pride, iniquity, acception of persons, and the rest, can never be made lawful. For it can never be that war shall preserve life, and peace destroy it.

The same laws, because they oblige only to a desire, and endeavour, I mean an unfeigned and constant endeavour, are easy to be observed. For in that they require nothing but endeavour, he that endeavoureth their performance, fulfilleth them; and he that fulfilleth the law, is just.

And the science of them, is the true and only moral philosophy. For moral philosophy is nothing else but the science of what is *good,* and *evil,* in the conversation, and society of mankind. *Good,* and *evil,* are names that signify our appetites, and aversions; which in different tempers, customs, and doctrines of men, are different: and divers men, differ not only in their judgment, on the senses of what is pleasant, and unpleasant to the taste, smell, hearing, touch, and sight; but also of what is conformable, or disagreeable

to reason, in the actions of common life. Nay, the same man, in divers times, differs from himself; and one time praiseth, that is, calleth good, what another time he dispraiseth, and calleth evil: from whence arise disputes, controversies, and at last war. And therefore so long as a man is in the condition of mere nature, which is a condition of war, as private appetite is the measure of good, and evil: and consequently all men agree on this, that peace is good, and therefore also the way, or means of peace, which, as I have shewed before, are *justice, gratitude, modesty, equity, mercy,* and the rest of the laws of nature, are good; that is to say; *moral virtues;* and their contrary vices, evil. Now the science of virtue and vice, is moral philosophy; and therefore the true doctrine of the laws of nature, is the true moral philosophy. But the writers of moral philosophy,

though they acknowledge the same virtues and vices; yet not seeing wherein consisted their goodness; nor that they come to be praised, as the means of peaceable, sociable, and comfortable living, place them in a mediocrity of passions: as if not the cause, but the degree of daring, made fortitude; or not the cause, but the quantity of a gift, made liberality.

These dictates of reason, men used to call by the name of laws, but improperly: for they are but conclusions, or theorems concerning what conduceth to the conservation and defence of themselves; whereas law, properly, is the word of him, that by right hath command over others. But yet if we consider the same theorems, as delivered in the word of God, that by right commandeth all things; then are they properly called laws.

Study Questions

1. What did Hobbes mean by a "law of nature"?
2. Can a supporter of democracy agree with Hobbes' view of the state of nature?

3. According to Hobbes, what does the "fool" believe?
4. Did Hobbes provide a satisfying response to the fool?

9

JOSEPH BUTLER

Joseph Butler (1692–1752) was a bishop of the Church of England. He maintains that to act morally is to act in accord with human nature. Conscience, our sense of right and wrong, is the supreme feature of that nature. Thus virtue consists of acting in accord with conscience. Doing so is in our own long-term self-interest. Hence morality and self-interest do not conflict, and our benevolence or care for others is not in conflict with our concern for ourselves.

From *Fifteen Sermons*, Joseph Butler (1726).

Fifteen Sermons

SERMON I

Upon Human Nature

For as we have many members in one body, and all members have not the same office: so we, being many, are one body in Christ, and every one members one of another

—Romans XII: 4, 5.

The Epistles in the New Testament have all of them a particular reference to the condition and usages of the Christian world at the time they were written. Therefore, as they cannot be thoroughly understood unless that condition and those usages are known and attended to, so further, though they be known, yet if they be discontinued or changed, exhortations, precepts, and illustrations of things, which refer to such circumstances now ceased or altered, cannot at this time be urged in that manner and with that force which they were to the primitive Christians. Thus the text now before us, in its first intent and design, relates to the decent management of those extraordinary gifts which were then in the church,[1] but which are now totally ceased. And even as to the allusion that "we are one body in Christ," though what the apostle here intends is equally true of Christians in all circumstances— and the consideration of it is plainly still an additional motive, over and above moral considerations, to the discharge of the several duties and offices of a Christian—yet it is manifest this allusion must have appeared with much greater force to those who, by the many difficulties they went through for the sake of their religion, were led to keep always in view the relation they stood in to their Saviour, who had undergone the same; to those who, from the idolatries of all around them and their ill treatment, were taught to consider themselves as not of the world in which they lived, but as a distinct society of themselves, with laws and ends, and principles of life and action, quite contrary to those which the world professed themselves at that time influenced by. Hence the relation of a Christian was by them considered as nearer than that of affinity and blood; and they almost literally esteemed themselves as members one of another.

It cannot indeed possibly be denied that our being God's creatures, and virtue being the natural law we are born under, and the whole constitution of man being plainly adapted to it, are prior obligations to piety and virtue than the consideration that God sent his Son into the world to save it, and the motives which arise from the peculiar relations of Christians, as members one of another under Christ our Head. However, though all this be allowed, as it expressly is by the inspired writers, yet it is manifest that Christians at the time of the revelation, and immediately after, could not but insist mostly upon considerations of this latter kind.

These observations show the original particular reference of the text; and the peculiar force with which the thing intended by the allusion in it, must have been felt by the primitive Christian world. They likewise afford a reason for treating it at this time in a more general way.

The relation which the several parts or members of the natural body have to each other and to the whole body is here compared to the relation which each particular person in society has to other particular persons and to the whole society; and the latter is intended to be illustrated by the former. And if there be a likeness between these two relations, the consequence is obvious: that the latter shows us we were intended to do good to others, as the former shows us that the several members of the natural body were intended to be instruments of good to each other and the whole body. But as there is scarce any ground for a comparison between society and the mere material body, this without the mind being a dead unactive thing, much less can the comparison be carried to any length. And since the apostle speaks of the several members as having distinct offices, which implies the mind, it cannot be thought an unallowable liberty, instead of the *body* and *its members,* to substitute the *whole nature of man* and *all the*

variety of internal principles which belong to it. And then the comparison will be between the nature of man as respecting self and tending to private good, his own preservation and happiness, and the nature of man as having respect to society and tending to promote public good, the happiness of that society. These ends do indeed perfectly coincide; and to aim at public and private good are so far from being inconsistent that they mutually promote each other; yet in the following discourse they must be considered as entirely distinct, otherwise the nature of man as tending to one, or as tending to the other, cannot be compared. There can no comparison be made without considering the things compared as distinct and different.

From this review and comparison of the nature of man as respecting self and as respecting society, it will plainly appear that there are as real and the same kind of indications in human nature that we were made for society and to do good to our fellow creatures, as that we were intended to take care of our own life and health and private good; and that the same objections lie against one of these assertions as against the other. For,

First, there is a natural principle of *benevolence*[2] in man, which is in some degree to *society* what *self-love* is to the *individual.* And if there be in mankind any disposition to friendship; if there be any such thing as compassion, for compassion is momentary love; if there be any such thing as the paternal or filial affections; if there be any affection in human nature the object and end of which is the good of another—this is itself benevolence or the love of another. Be it ever so short, be it in ever so low a degree, or ever so unhappily confined, it proves the assertion and points out what we were designed for, as really as though it were in a higher degree and more extensive. I must however remind you that though benevolence and self-love are different, though the former tends most directly to public good, and the latter to private, yet they are so perfectly coincident that the greatest satisfactions to ourselves depend upon our having benevolence in a due degree, and that self-love is one chief security of our right behavior toward society. It may be added

that their mutual coinciding, so that we can scarce promote one without the other, is equally a proof that we were made for both.

Secondly, this will further appear, from observing that the *several passions and affections,* which are distinct[3] both from benevolence and self-love, do in general contribute and lead us to *public* good as really as to *private.* It might be thought too minute and particular, and would carry us too great a length, to distinguish between and compare together the several passions or appetites distinct from benevolence, whose primary use and intention is the security and good of society; and the passions distinct from self-love, whose primary intention and design is the security and good of the individual.[4] It is enough to the present argument that desire of esteem from others, contempt and esteem of them, love of society as distinct from affection to the good of it, indignation against successful vice— that these are public affections or passions, have an immediate respect to others, naturally lead us to regulate our behavior in such a manner as will be of service to our fellow creatures. If any or all of these may be considered likewise as private affections, as tending to private good, this does not hinder them from being public affections, too, or destroy the good influence of them upon society, and their tendency to public good. It may be added that as persons without any conviction from reason of the desirableness of life would yet of course preserve it merely from the appetite of hunger, so by acting merely from regard (suppose) to reputation, without any consideration of the good of others, men often contribute to public good. In both these instances they are plainly instruments in the hands of another, in the hands of Providence, to carry on ends, the preservation of the individual and good of society, which they themselves have not in their view or intention. The sum is, men have various appetites, passions, and particular affections, quite distinct both from self-love and from benevolence—all of these have a tendency to promote both public and private good, and may be considered as respecting others and ourselves equally and in common; but some of them seem most immediately to respect

others, or tend to public good, others of them most immediately to respect self, or tend to private good; as the former are not benevolence, so the latter are not self-love; neither sort are instances of our love either to ourselves or others, but only instances of our Maker's care and love both of the individual and the species, and proofs that He intended we should be instruments of good to each other, as well as that we should be so to ourselves.

Thirdly, there is a principle of reflection in men by which they distinguish between, approve and disapprove, their own actions. We are plainly constituted such sort of creatures as to reflect upon our own nature. The mind can take a view of what passes within itself, its propensions, aversions, passions, affections, as respecting such objects and in such degrees, and of the several actions consequent thereupon. In this survey it approves of one, disapproves of another, and toward a third is affected in neither of these ways, but is quite indifferent. This principle in man by which he approves or disapproves his heart, temper, and actions, is conscience for this is the strict sense of the word, though sometimes it is used so as to take in more. And that this faculty tends to restrain men from doing mischief to each other, and leads them to do good, is too manifest to need being insisted upon. Thus a parent has the affection of love to his children; this leads him to take care of, to educate, to make due provision for them; the natural affection leads to this, but the reflection that it is his proper business, what belongs to him, that it is right and commendable so to do— this added to the affection becomes a much more settled principle and carries him on through more labor and difficulties for the sake of his children than he would undergo from that affection alone, if he thought it, and the course of action it led to, either indifferent or criminal. This indeed is impossible, to do that which is good and not to approve of it; for which reason they are frequently not considered as distinct, though they really are, for men often approve of the actions of others which they will not imitate, and likewise do that which they approve not. It cannot possibly be denied that there is this principle of reflection or conscience in human nature.

Suppose a man to relieve an innocent person in great distress, suppose the same man afterwards, in the fury of anger, to do the greatest mischief to a person who had given no just cause of offense; to aggravate the injury, add the circumstances of former friendship and obligation from the injured person, let the man who is supposed to have done these two different actions coolly reflect upon them afterwards, without regard to their consequences to himself; to assert that any common man would be affected in the same way toward these different actions, that he would make no distinction between them, but approve or disapprove them equally, is too glaring a falsity to need being confuted. There is therefore this principle of reflection or conscience in mankind. It is needless to compare the respect it has to private good with the respect it has to public, since it plainly tends as much to the latter as to the former, and is commonly thought to tend chiefly to the latter. This faculty is now mentioned merely as another part in the inward frame of man, pointing out to us in some degree what we are intended for, and as what will naturally and of course have some influence. The particular place assigned to it by nature, what authority it has, and how great influence it ought to have, shall be hereafter considered.

From this comparison of benevolence and self-love, of our public and private affections, of the courses of life they lead to, and of the principle of reflection or conscience as respecting each of them, it is as manifest that we were made for society and to promote the happiness of it, as that we were intended to take care of our own life and health and private good.

And from this whole review must be given a different draught of human nature from what we are often presented with. Mankind are by nature so closely united, there is such a correspondence between the inward sensations of one man and those of another that disgrace is as much avoided as bodily pain, and to be the object of esteem and love as much desired as any external goods; and in many particular cases, persons are carried on to do good to others, as the end their affection tends to and rests in, and manifest that they find real satisfaction and enjoyment in this

course of behavior. There is such a natural principle of attraction in man toward man that having trod the same tract of land, having breathed in the same climate, barely having been born in the same artificial district or division, becomes the occasion of contracting acquaintances and familiarities many years after; for anything may serve the purpose. Thus relations merely nominal are sought and invented, not by governors, but by the lowest of the people; which are found sufficient to hold mankind together in little fraternities and copartnerships—weak ties indeed, and what may afford fund enough for ridicule if they are absurdly considered as the real principles of that union; but they are in truth merely the occasions, as anything may be of anything, upon which our nature carries us on according to its own previous bent and bias; which occasions therefore would be nothing at all were there not this prior disposition and bias of nature. Men are so much one body that in a peculiar manner they feel for each other; shame, sudden danger, resentment, honor, prosperity, distress; one or another, or all of these, from the social nature in general, from benevolence, upon the occasion of natural relation, acquaintance, protection, dependence—each of these being distinct cements of society. And therefore to have no restraint from, no regard to, others in our behavior is the speculative absurdity of considering ourselves as single and independent, as having nothing in our nature which has respect to our fellow creatures, reduced to action and practice. And this is the same absurdity as to suppose a hand or any part to have no natural respect to any other or to the whole body.

But allowing all this, it may be asked, "Has not man dispositions and principles within, which lead him to do evil to others as well as to do good? Whence come the many miseries else, which men are the authors and instruments of to each other?" These questions, so far as they relate to the foregoing discourse, may be answered by asking, Has not man also dispositions and principles within, which lead him to do evil to himself as well as good? Whence come the many miseries else, sickness, pain, and death, which men are instruments and authors of to themselves?

It may be thought more easy to answer one of these questions than the other, but the answer to both is really the same—that mankind have ungoverned passions which they will gratify at any rate, as well to the injury of others as in contradiction to known private interest, but that as there is no such thing as self-hatred, so neither is there any such thing as ill-will in one man toward another, emulation and resentment being away, whereas there is plainly benevolence or good-will; there is no such thing as love of injustice, oppression, treachery, ingratitude, but only eager desires after such and such external goods, which, according to a very ancient observation, the most abandoned would choose to obtain by innocent means if they were as easy and as effectual to their end that even emulation and resentment, by any one who will consider what these passions really are in nature,[5] will be found nothing to the purpose of this objection; and that the principles and passions in the mind of man, which are distinct both from self-love and benevolence, primarily and most directly lead to right behavior with regard to others as well as himself, and only secondarily and accidentally to what is evil. Thus, though men, to avoid the shame of one villainy, are sometimes guilty of a greater, yet it is easy to see that the original tendency of shame is to prevent the doing of shameful actions; and its leading men to conceal such actions when done is only in consequence of their being done, that is, of the passion's not having answered its first end.

If it be said that there are persons in the world who are in great measure without the natural affections toward their fellow creatures, there are likewise instances of persons without the common natural affections to themselves; but the nature of man is not to be judged of by either of these, but by what appears in the common world, in the bulk of mankind.

I am afraid it would be thought very strange if to confirm the truth of this account of human nature and make out the justness of the foregoing comparison, it should be added that, from what appears, men in fact as much and as often contradict that *part* of their nature which respects *self* and which leads them to their *own private* good and happiness, as they contradict that *part* of it which respects *society* and tends

to *public* good; that there are as few persons who attain the greatest satisfaction and enjoyment which they might attain in the present world, as who do the greatest good to others which they might do—nay, that there are as few who can be said really and in earnest to aim at one as at the other. Take a survey of mankind: the world in general, the good and bad, almost without exception, equally are agreed that were religion out of the case, the happiness of the present life would consist in a manner wholly in riches, honors, sensual gratifications, insomuch that one scarce hears a reflection made upon prudence, life, conduct, but upon this supposition. Yet on the contrary, that persons in the greatest affluence of fortune are no happier than such as have only a competency; that the cares and disappointments of ambition for the most part far exceed the satisfactions of it; as also the miserable intervals of intemperance and excess, and the many untimely deaths occasioned by a dissolute course of life—these things are all seen, acknowledged, by every one acknowledged, but are thought no objections against, though they expressly contradict this universal principle that the happiness of the present life consists in one or other of them. Whence is all this absurdity and contradiction? Is not the middle way obvious? Can anything be more manifest than that the happiness of life consists in these possessed and enjoyed only to a certain degree, that to pursue them beyond this degree is always attended with more inconvenience than advantage to a man's self, and often with extreme misery and unhappiness? Whence then, I say, is all this absurdity and contradiction? Is it really the result of consideration in mankind how they may become most easy to themselves, most free from care, and enjoy the chief happiness attainable in this world? Or is it not manifestly owing either to this that they have not cool and reasonable concern enough for themselves to consider wherein their chief happiness in the present life consists, or else, if they do consider it, that they will not act conformably to what is the result of that consideration; that is, reasonable concern for themselves, or cool self-love, is prevailed over by passion and appetite. So that, from what appears, there is no ground to assert that those principles in the nature of

man which most directly lead to promote the good of our fellow creatures are more generally or in a greater degree violated than those which most directly lead us to promote our own private good and happiness.

The sum of the whole is plainly this. The nature of man considered in his single capacity, and with respect only to the present world, is adapted and leads him to attain the greatest happiness he can for himself in the present world. The nature of man considered in his public or social capacity leads him to a right behavior in society, to that course of life which we call virtue. Men follow or obey their nature in both these capacities and respects to a certain degree, but not entirely; their actions do not come up to the whole of what their nature leads them to in either of these capacities or respects; and they often violate their nature in both. That is, as they neglect the duties they owe to their fellow creatures, to which their nature leads them, and are injurious, to which their nature is abhorrent, so there is a manifest negligence in men of their real happiness or interest in the present world when that interest is inconsistent with a present gratification, for the sake of which they negligently, nay, even knowingly, are the authors and instruments of their own misery and ruin. Thus they are as often unjust to themselves as to others, and for the most part are equally so to both by the same actions.

SERMON II

Upon the Natural Supremacy of Conscience

For when the Gentiles, which have not the law, do by nature the things contained in the law, these, having not the law, are a law unto themselves.

—*Rom. ii. 14.*

As speculative truth admits of different kinds of proof, so likewise moral obligations may be shewn by different methods. If the real nature of any creature leads him and is adapted to such and such purposes only, or more than to any other; this is a reason to believe the author of that nature intended it for those purposes. Thus there is no doubt the eye

was intended for us to see with. And the more complex any constitution is, and the greater variety of parts there are which thus tend to some one end, the stronger is the proof that such end was designed. However, when the inward fame of man is considered as any guide in morals, the utmost caution must be used that none make peculiarities in their own temper, or any thing which is the effect of particular customs, though observable in several, the standard of what is common to the species; and above all, that the highest principle be not forgot or excluded, that to which belongs the adjustment and correction of all other inward movements and affections: which principle will of course have some influence, but which being in nature supreme, as shall now be shewn, ought to preside over and govern all the rest. The difficulty of rightly observing the two former cautions; the appearance there is of some small diversity amongst mankind with respect to this faculty, with respect to their natural sense of moral good and evil; and the attention necessary to survey with any exactness what passes within, have occasioned that it is not so much agreed what is the standard of the internal nature of man, as of his external form. Neither is this last exactly settled. Yet we understand one another when we speak of the shape of a human body: so likewise we do when we speak of the heart and inward principles, how far soever the standard is from being exact or precisely fixed. There is therefore ground for an attempt of shewing men to themselves, of shewing them what course of life and behaviour their real nature points out and would lead them to. Now obligations of virtue shewn, and motives to the practice of it enforced, from a review of the nature of man, are to be considered as an appeal to each particular person's heart and natural conscience: as the external senses are appealed to for the proof of things cognizable by them. Since then our inward feelings, and the perceptions we receive from our external senses, are equally real; to argue from the former to life and conduct is as little liable to exception, as to argue from the latter to absolute speculative truth. A man can as little doubt whether his eyes were given him to see with, as he can doubt of the truth of the science of *optics,* deduced from ocular experiments.

And allowing the inward feeling, shame; a man can as little doubt whether it was given him to prevent his doing shameful actions, as he can doubt whether his eyes were given him to guide his steps. And as to these inward feelings themselves; that they are real, that man has in his nature passions and affections, can no more be questioned, than that he has external senses. Neither can the former be wholly mistaken; though to a certain degree liable to greater mistakes than the latter.

There can be no doubt but that several propensions or instincts, several principles in the heart of man, carry him to society, and to contribute to the happiness of it, in a sense and a manner in which no inward principle leads him to evil. These principles, propensions, or instincts which lead him to do good, are approved of by a certain faculty within, quite distinct from these propensions themselves. All this hath been fully made out in the foregoing discourse.

But it may be said, "What is all this, though true, to the purpose of virtue and religion? these require, not only that we do good to others when we are led this way, by benevolence or reflection, happening to be stronger than other principles, passions, or appetites; but likewise that the *whole* character be formed upon thought and reflection; that *every* action be directed by some determinate rule, some other rule than the strength and prevalency of any principle or passion. What sign is there in our nature (for the inquiry is only about what is to be collected from thence) that this was intended by its Author? Or how does so various and fickle a temper as that of man appear adapted thereto? It may indeed be absurd and unnatural for men to act without any reflection; nay, without regard to that particular kind of reflection which you call conscience; because this does belong to our nature. For as there never was a man but who approved one place, prospect, building, before another: so it does not appear that there ever was a man who would not have approved an action of humanity rather than of cruelty; interest and passion being quite out of the case. But interest and passion do come in, and are often too strong for and prevail over reflection and conscience. Now as brutes have various instincts, by which they are carried on to the end the Author

of their nature intended them for: is not man in the same condition: with this difference only, that to his instincts (i.e., appetites and passions) is added the principle of reflection or conscience? And as brutes act agreeably to their nature, in following that principle or particular instinct which for the present is strongest in them: does not man likewise act agreeably to his nature, or obey the law of his creation, by following that principle, be it passion or conscience, which for the present happens to be strongest in him? Thus different men are by their particular nature hurried on to pursue honour or riches or pleasure: there are also persons whose temper leads them in an uncommon degree to kindness, compassion, doing good to their fellow-creatures: as there are others who are given to suspend their judgment, to weigh and consider things, and to act upon thought and reflection. Let every one then quietly follow his nature; as passion, reflection, appetite, the several parts of it, happen to be strongest: but let not the man of virtue take upon him to blame the ambitious, the covetous, the dissolute; since these equally with him obey and follow their nature. Thus, as in some cases we follow our nature in doing the works *contained in the law,* so in other cases we follow nature in doing contrary."

Now all this licentious talk entirely goes upon a supposition, that men follow their nature in the same sense, in violating the known rules of justice and honesty for the sake of a present gratification, as they do in following those rules when they have no temptation to the contrary. And if this were true, that could not be so which St. Paul asserts, that men are *by nature a law to themselves.* If by following nature were meant only acting as we please, it would indeed be ridiculous to speak of nature as any guide in morals: nay the very mention of deviating from nature would be absurd; and the mention of following it, when spoken by way of distinction, would absolutely have no meaning. For did ever any one act otherwise than as he pleased? And yet the ancients speak of deviating from nature as vice; and of following nature so much as a distinction, that according to them the perfection of virtue consists therein. So that language itself should teach people another sense to the words *following nature,* than barely acting as

we please. Let it however be observed, that though the words *human nature* are to be explained, yet the real question of this discourse is not concerning the meaning of words, any other than as the explanation of them may be needful to make out and explain the assertion, that *every man is naturally a law to himself,* that *every one may find within himself the rule of right, and obligations to follow it.* This St. Paul affirms in the words of the text, and this the foregoing objection really denies by seeming to allow it. And the objection will be fully answered, and the text before us explained, by observing that *nature* is considered in different views, and the word used in different senses; and by shewing in what view it is considered, and in what sense the word is used, when intended to express and signify that which is the guide of life, that by which men are a law to themselves. I say, the explanation of the term will be sufficient, because from thence it will appear, that in some senses of the word *nature* cannot be, but that in another sense it manifestly is, a law to us.

I. By nature is often meant no more than some principle in man, without regard either to the kind or degree of it. Thus the passion of anger, and the affection of parents to their children, would be called equally *natural.* And as the same person hath often contrary principles, which at the same time draw contrary ways, he may by the same action both follow and contradict his nature in this sense of the word; he may follow one passion and contradict another.

II. *Nature* is frequently spoken of as consisting in those passions which are strongest, and most influence the actions; which being vicious ones, mankind is in this sense naturally vicious, or vicious by nature. Thus St. Paul says of the Gentiles, *who were dead in trespasses and sins, and walked according to the spirit of disobedience, that they were by nature the children of wrath.*[6] They could be no otherwise *children of wrath* by nature, than they were vicious by nature.

Here then are two different senses of the word *nature,* in neither of which men can at all be said to be a law to themselves. They are mentioned only to be excluded; to prevent their being confounded, as

the latter is in the objection, with another sense of it, which is now to be inquired after and explained.

III. The apostle asserts, that the Gentiles *do by NATURE the things contained in the law.* Nature is indeed here put by way of distinction from revelation, but yet it is not a mere negative. He intends to express more than that by which they *did not,* that by which they *did* the works of the law; namely, by *nature.* It is plain the meaning of the word is not the same in this passage as in the former, where it is spoken of as evil; for in this latter it is spoken of as good; as that by which they acted, or might have acted virtuously. What that is in man by which he is *naturally a law to himself,* is explained in the following words: *Which shew the work of the law written in their hearts, their consciences also bearing witness, and their thoughts the mean while accusing or else excusing one another.* If there be a distinction to be made between the *works written in their hearts,* and the *witness of conscience;* by the former must be meant the natural disposition to kindness and compassion, to do what is of good report, to which this apostle often refers: that part of the nature of man, treated of in the foregoing discourse, which with very little reflection and of course leads him to society, and by means of which he naturally acts a just and good part in it, unless other passions or interest lead him astray. Yet since other passions, and regards to private interest, which lead us (though indirectly, yet they lead us) astray, are themselves in a degree equally natural, and often most prevalent; and since we have no method of seeing the particular degrees in which one or the other is placed in us by nature; it is plain the former, considered merely as natural, good and right as they are, can no more be a law to us than the latter. But there is a superior principle of reflection or conscience in every man, which distinguishes between the internal principles of his heart, as well as his external actions: which passes judgment upon himself and them; pronounces determinately some actions to be in themselves just, right, good; others to be in themselves evil, wrong, unjust: which, without being consulted, without being advised with, magisterially exerts itself, and approves or condemns him the doer of them accordingly: and which, if not forcibly stopped, naturally and always of course goes on to anticipate a higher and more effectual sentence, which shall hereafter second and affirm its own. But this part of the office of conscience is beyond my present design explicitly to consider. It is by this faculty, natural to man, that he is a moral agent, that he is a law to himself: but this faculty, I say, not to be considered merely as a principle in his heart, which is to have some influence as well as others; but considered as a faculty in kind and in nature supreme over all others, and which bears its own authority of being so.

This *prerogative,* this *natural supremacy,* of the faculty which surveys, approves or disapproves the several affections of our mind and actions of our lives, being that by which men *are a law to themselves,* their conformity or disobedience to which law of our nature renders their actions, in the highest and most proper sense, natural or unnatural; it is fit it be further explained to you: and I hope it will be so, if you will attend to the following reflections.

Man may act according to that principle or inclination which for the present happens to be strongest, and yet act in a way disproportionate to, and violate his real proper nature. Suppose a brute creature by any bait to be allured into a snare, by which he is destroyed. He plainly followed the bent of his nature, leading him to gratify his appetite: there is an entire correspondence between his whole nature and such an action: such action therefore is natural. But suppose a man, foreseeing the same danger of certain ruin, should rush into it for the sake of a present gratification; he in this instance would follow his strongest desire, as did the brute creature: but there would be as manifest a disproportion, between the nature of a man and such an action, as between the meanest work of art and the skill of the greatest master in that art: which disproportion arises, not from considering the action singly in *itself,* or in its *consequences;* but from *comparison* of it with the nature of the agent. And since such an action is utterly disproportionate to the nature of man, it is in the strictest and most proper sense unnatural; this word expressing that disproportion. Therefore instead of the words *disproportionate to his nature,* the word *unnatural* may now be put; this being more familiar to us: but

let it be observed, that it stands for the same thing precisely.

Now what is it which renders such a rash action unnatural? Is it that he went against the principle of reasonable and cool self-love, considered *merely* as a part of his nature? No: for if he had acted the contrary way, he would equally have gone against a principle, or part of his nature, namely, passion or appetite. But to deny a present appetite, from foresight that the gratification of it would end in immediate ruin or extreme misery, is by no means an unnatural action; whereas to contradict or go against cool self-love for the sake of such gratification, is so in the instance before us. Such an action then being unnatural; and its being so not arising from a man's going against a principle or desire barely, nor in going against that principle or desire which happens for the present to be strongest; it necessarily follows, that there must be some other difference or distinction to be made between these two principles, passion and cool self-love, than what I have yet taken notice of. And this difference, not being a difference in strength or degree, I call a difference in *nature* and in *kind*. And since, in the instance still before us, if passion prevails over self-love, the consequent action is unnatural; but if self-love prevails over passion, the action is natural: it is manifest that self-love is in human nature a superior principle to passion. This may be contradicted without violating that nature; but the former cannot. So that, if we will act conformably to the economy of man's nature, reasonable self-love must govern. Thus, without particular consideration of conscience, we may have a clear conception of the *superior nature* of one inward principle to another; and see that there really is this natural superiority, quite distinct from degrees of strength and prevalency.

Let us now take a view of the nature of man, as consisting partly of various appetites, passions, affections, and partly of the principle of reflection or conscience; leaving quite out all consideration of the different degrees of strength, in which either of them prevail, and it will further appear that there is this natural superiority of one inward principle to another, and that it is even part of the idea of reflection or conscience.

Passion or appetite implies a direct simple tendency towards such and such objects, without distinction of the means by which they are to be obtained. Consequently it will often happen there will be a desire of particular objects, in cases where they cannot be obtained without manifest injury to others. Reflection or conscience comes in, and disapproves the pursuit of them in these circumstances; but the desire remains. Which is to be obeyed, appetite or reflection? Cannot this question be answered, from the economy and constitution of human nature merely, without saying which is strongest? Or need this at all come into consideration? Would not the question be *intelligibly* and fully answered by saying, that the principle of reflection or conscience being compared with the various appetites, passions, and affections in men, the former is manifestly superior and chief, without regard to strength? And how often soever the latter happens to prevail, it is mere *usurpation:* the former remains in nature and in kind its superior; and every instance of such prevalence of the latter is an instance of breaking in upon and violation of the constitution of man.

All this is no more than the distinction, which every body is acquainted with, between *mere power* and *authority:* only instead of being intended to express the difference between what is possible, and what is lawful in civil government; here it has been shewn applicable to the several principles in the mind of man. Thus that principle, by which we survey, and either approve or disapprove our own heart, temper, and actions, is not only to be considered as what is in its turn to have some influence; which may be said of every passion, of the lowest appetites; but likewise as being superior; as from its very nature manifestly claiming superiority over all others: insomuch that you cannot form a notion of this faculty, conscience, without taking in judgment, direction, superintendency. This is a constituent part of the idea, that is, of the faculty itself: and, to preside and govern, from the very economy and constitution of man, belongs to it. Had it strength, as it had right; had it power, as it had manifest authority, it would absolutely govern the world.

This gives us a further view of the nature of man; shews us what course of life we were made for: not

only that our real nature leads us to be influenced in some degree by reflection and conscience; but likewise in what degree we are to be influenced by it, if we will fall in with, and act agreeably to the constitution of our nature: that this faculty was placed within to be our proper governor; to direct and regulate all under principles, passions, and motives of action. This is its right and office: thus sacred is its authority. And how often soever men violate and rebelliously refuse to submit to it, for supposed interest which they cannot otherwise obtain, or for the sake of passion which they cannot otherwise gratify; this makes no alteration as to the *natural right* and *office* of conscience.

Let us now turn this whole matter another way, and suppose there was no such thing at all as this natural supremacy of conscience; that there was no distinction to be made between one inward principle and another, but only that of strength; and see what would be the consequence.

Consider then what is the latitude and compass of the actions of man with regard to himself, his fellow-creatures, and the Supreme Being? What are their bounds, besides that of our natural power? With respect to the two first, they are plainly no other than these: no man seeks misery as such for himself; and no one unprovoked does mischief to another for its own sake. For in every degree within these bounds, mankind knowingly from passion or wantonness bring ruin and misery upon themselves and others. And impiety and profaneness, I mean, what every one would call so who believes the being of God, have absolutely no bounds at all. Men blaspheme the Author of nature, formally and in words renounce their allegiance to their Creator. Put an instance then with respect to any one of these three. Though we should suppose profane swearing, and in general that kind of impiety now mentioned, to mean nothing, yet it implies wanton disregard and irreverence towards an infinite Being, our Creator; and is this as suitable to the nature of man, as reverence and dutiful submission of heart towards that Almighty Being? Or suppose a man guilty of parricide, with all the circumstances of cruelty which such an action can admit of. This action is done in consequence of its principle being for the present strongest; and if there

be no difference between inward principles, but only that of strength; the strength being given, you have the whole nature of the man given, so far as it relates to this matter. The action plainly corresponds to the principle, the principle being in that degree of strength it was; it therefore corresponds to the whole nature of the man. Upon comparing the action and the whole nature, there arises no disproportion, there appears no unsuitableness between them. Thus the *murder of a father* and the *nature of man* correspond to each other, as the same nature and an act of filial duty. If there be no difference between inward principles, but only that of strength; we can make no distinction between these two actions considered as the actions of such a creature; but in our coolest hours must approve or disapprove them equally: than which nothing can be reduced to a greater absurdity.

SERMON III

The natural supremacy of reflection or conscience being thus established; we may from it form a distinct notion of what is meant by *human nature,* when virtue is said to consist in following it, and vice in deviating from it.

As the idea of a civil constitution implies in it united strength, various subordinations, under one direction, that of the supreme authority; the different strength of each particular member of the society not coming into the idea; whereas, if you leave out the subordination, the union, and the one direction, you destroy and lose it: so reason, several appetites, passions, and affections, prevailing in different degrees of strength, is not *that* idea or notion of *human nature;* but *that nature* consists in these several principles considered as having a natural respect to each other, in the several passions being naturally subordinate to the one superior principle of reflection or conscience. Every bias, instinct, propension within, is a natural part of our nature, but not the whole: add to these the superior faculty, whose office it is to adjust, manage, and preside over them, and take in this its natural superiority, and you complete the idea of human nature. And as in civil government

the constitution is broken in upon, and violated by power and strength prevailing over authority; so the constitution of man is broken in upon and violated by the lower faculties or principles within prevailing over that which is in its nature supreme over them all. Thus, when it is said by ancient writers, that tortures and death are not so contrary to human nature as injustice; by this to be sure is not meant, that the aversion to the former in mankind is less strong and prevalent than their aversion to the latter: but that the former is only contrary to our nature considered in a partial view, and which takes in only the lowest part of it, that which we have in common with the brutes; whereas the latter is contrary to our nature, considered in a higher sense, as a system and constitution contrary to the whole economy of man.[7]

And from all these things put together, nothing can be more evident, than that, exclusive of revelation, man cannot be considered as a creature left by his Maker to act at random, and live at large up to the extent of his natural power, as passion, humour, wilfulness, happen to carry him; which is the condition brute creatures are in: but that *from his make, constitution, or nature, he is in the strictest and most proper sense a law to himself.* He hath the rule of right within: what is wanting is only that he honestly attends to it.

The inquiries which have been made by men of leisure after some general rule, the conformity to, or disagreement from which, should denominate our actions good or evil, are in many respects of great service. Yet let any plain honest man, before he engages in any course of action, ask himself, Is this I am going about right, or is it wrong? Is it good, or is it evil? I do not in the least doubt, but that this question would be answered agreeably to truth and virtue, by almost any fair man in almost any circumstance. Neither do there appear any cases which look like exceptions to this; but those of superstition, and of partiality to ourselves. Superstition may perhaps be somewhat of an exception: but partiality to ourselves is not; this being itself dishonesty. For a man to judge that to be the equitable, the moderate, the right part for him to act, which he would see to be hard, unjust, oppressive in another; this is plain vice, and can proceed only from great unfairness of mind.

But allowing that mankind hath the rule of right within himself, yet it may be asked, "What obligations are we under to attend to and follow it?" I answer: it has been proved that man by his nature is a law to himself, without the particular distinct consideration of the positive sanctions of that law; the rewards and punishments which we feel, and those which from the light of reason we have ground to believe, are annexed to it. The question then carries its own answer along with it. Your obligation to obey this law, is its being the law of your nature. That your conscience approves of and attests to such a course of action, is itself alone an obligation. Conscience does not only offer itself to shew us the way we should walk in, but it likewise carries its own authority with it, that it is our natural guide; the guide assigned us by the Author of our nature: it therefore belongs to our condition of being, it is our duty to walk in that path, and follow this guide, without looking about to see whether we may not possibly forsake them with impunity.

However, let us hear what is to be said against obeying this law of our nature. And the sum is no more than this: "Why should we be concerned about any thing out of and beyond ourselves? If we do find within ourselves regards to others, and restraints of we know not how many different kinds; yet these being embarrassments, and hindering us from going the nearest way to our own good, why should we not endeavour to suppress and get over them?"

Thus people go on with words, which, when applied to human nature, and the condition in which it is placed in this world, have really no meaning. For does not all this kind of talk go upon supposition, that our happiness in this world consists in somewhat quite distinct from regard to others; and that it is the privilege of vice to be without restraint or confinement? Whereas, on the contrary, the enjoyments, in a manner all the common enjoyments of life, even the pleasures of vice, depend upon these regards of one kind or another to our fellow-creatures. Throw off all regards to others, and we should be quite indifferent to infamy and to honour; there could be no such thing at all as ambition; and scarce any such thing as covetousness; for we should likewise be equally

indifferent to the disgrace of poverty, the several neglects and kinds of contempt which accompany this state; and to the reputation of riches, the regard and respect they usually procure. Neither is restraint by any means peculiar to one course of life; but our very nature, exclusive of conscience and our condition, lays us under an absolute necessity of it. We cannot gain any end whatever without being confined to the proper means, which is often the most painful and uneasy confinement. And in numberless instances a present appetite cannot be gratified without such apparent and immediate ruin and misery, that the most dissolute man in the world chooses to forego the pleasure, rather than endure the pain.

Is the meaning then, to indulge those regards to our fellow-creatures, and submit to those restraints, which upon the whole are attended with more satisfaction than uneasiness, and get over only those which bring more uneasiness and inconvenience than satisfaction? "Doubtless this was our meaning." You have changed sides then. Keep to this; be consistent with yourselves; and you and the men of virtue are *in general* perfectly agreed. But let us take care and avoid mistakes. Let it not be taken for granted that the temper of envy, rage, resentment, yields greater delight than meekness, forgiveness, compassion, and good-will; especially when it is acknowledged that rage, envy, resentment, are in themselves mere misery; and the satisfaction arising from the indulgence of them is little more than relief from that misery; whereas the temper of compassion and benevolence is itself delightful; and the indulgence of it, by doing good, affords new positive delight and enjoyment. Let it not be taken for granted, that the satisfaction arising from the reputation of riches and power, however obtained, and from the respect paid to them, is greater than the satisfaction arising from the reputation of justice, honesty, charity, and the esteem which is universally acknowledged to be their due. And if it be doubtful which of these satisfactions is the greatest, as there are persons who think neither of them very considerable, yet there can be no doubt concerning ambition and covetousness, virtue and a good mind, considered in themselves, and as leading to different courses of life; there can, I say, be no doubt, which temper and which course is attended with most peace and tranquillity of mind, which with most perplexity, vexation, and inconvenience. And both the virtues and vices which have been now mentioned, do in a manner equally imply in them regards of one kind or another to our fellow-creatures. And with respect to restraint and confinement: whoever will consider the restraints from fear and shame, the dissimulation, mean arts of concealment, servile compliances, one or other of which belong to almost every course of vice, will soon be convinced that the man of virtue is by no means upon a disadvantage in this respect. How many instances are there in which men feel and own and cry aloud under the chains of vice with which they are enthralled, and which yet they will not shake off! How many instances, in which persons manifestly go through more pains and self-denial to gratify a vicious passion, than would have been necessary to the conquest of it! To this is to be added, that when virtue is become habitual, when the temper of it is acquired, what was before confinement ceases to be so, by becoming choice and delight. Whatever restraint and guard upon ourselves may be needful to unlearn any unnatural distortion or odd gesture; yet, in all propriety of speech, natural behaviour must be the most easy and unrestrained. It is manifest that, in the common course of life, there is seldom any inconsistency between our duty and what is *called* interest: it is much seldomer that there is an inconsistency between duty and what is really our present interest; meaning by interest, happiness and satisfaction. Self-love then, though confined to the interest of the present world, does in general perfectly coincide with virtue; and leads us to one and the same course of life. But, whatever exceptions there are to this, which are much fewer than they are commonly thought, all shall be set right at the final distribution of things. It is a manifest absurdity to suppose evil prevailing finally over good, under the conduct and administration of a perfect mind.

The whole argument, which I have been now insisting upon, may be thus summed up, and given you in one view. The nature of man is adapted to some course

of action or other. Upon comparing some actions with this nature, they appear suitable and correspondent to it: from comparison of other actions with the same nature, there arises to our view some unsuitableness or disproportion. The correspondence of actions to the nature of the agent renders them natural: their disproportion to it, unnatural. That an action is correspondent to the nature of the agent, does not arise from its being agreeable to the principle which happens to be the strongest: for it may be so, and yet be quite disproportionate to the nature of the agent. The correspondence therefore, or disproportion, arises from somewhat else. This can be nothing but a difference in nature and kind, altogether distinct from strength, between the inward principles. Some then are in nature and kind superior to others. And the correspondence arises from the action being conformable to the higher principle; and the unsuitableness from its being contrary to it. Reasonable self-love and conscience are the chief or superior principles in the nature of man: because an action may be suitable to this nature, though all other principles be violated; but becomes unsuitable, if either of those are. Conscience and self-love, if we understand our true happiness, always lead us the same way. Duty and interest are perfectly coincident; for the most part in this world, but entirely and in every instance if we take in the future, and the whole; this being implied in the notion of a good and perfect administration of things. Thus they who have been so wise in their generation as to regard only their own supposed interest, at the expense and to the injury of others, shall at last find, that he who has given up all the advantages of the present world, rather than violate his conscience and the relations of life, has infinitely better provided for himself, and secured his own interest and happiness.

SERMON XI

Upon the Love of Our Neighbour

And if there be any other commandment, it is briefly comprehended in this saying, namely, Thou shalt love thy neighbour as thyself.

—*Rom. xiii. 9.*

It is commonly observed, that there is a disposition in men to complain of the viciousness and corruption of the age in which they live, as greater than that of former ones; which is usually followed with this further observation, that mankind has been in that respect much the same in all times. Now, not to determine whether this last be not contradicted by the accounts of history; thus much can scarce be doubted, that vice and folly takes different turns, and some particular kinds of it are more open and avowed in some ages than in others; and, I suppose, it may be spoken of as very much the distinction of the present to profess a contracted spirit, and greater regards to self-interest, than appears to have been done formerly. Upon this account it seems worth while to inquire, whether private interest is likely to be promoted in proportion to the degree in which self-love engrosses us, and prevails over all other principles; *or whether the contracted affection may not possibly be so prevalent as to disappoint itself, and even contradict its own end, private good.*

And since, further, there is generally thought to be some peculiar kind of contrariety between self-love and the love of our neighbour, between the pursuit of public and of private good; insomuch that when you are recommending one of these, you are supposed to be speaking against the other; and from hence arises a secret prejudice against, and frequently open scorn of all talk of public spirit, and real good-will to our fellow-creatures; it will be necessary to *inquire what respect benevolence hath to self-love, and the pursuit of private interest to the pursuit of public:* or whether there be any thing of that peculiar inconsistence and contrariety between them, over and above what there is between self-love and other passions and particular affections, and their respective pursuits.

These inquiries, it is hoped, may be favourably attended to: for there shall be all possible concessions made to the favourite passion, which hath so much allowed to it, and whose cause is so universally pleaded: it shall be treated with the utmost tenderness and concern for its interests.

In order to do this, as well as to determine the forementioned questions, it will be necessary to *consider the nature, the object, and end of that self-love, as*

distinguished from other principles or affections in the mind, and their respective objects.

Every man hath a general desire of his own happiness; and likewise a variety of particular affections, passions, and appetites to particular external objects. The former proceeds from, or is self-love; and seems inseparable from all sensible creatures, who can reflect upon themselves and their own interest or happiness, so as to have that interest an object to their minds: what is to be said of the latter is, that they proceed from, or together make up that particular nature, according to which man is made. The object the former pursues is somewhat internal, our own happiness, enjoyment, satisfaction; whether we have, or have not, a distinct particular perception what it is, or wherein it consists: the objects of the latter are this or that particular external thing, which the affections tend towards, and of which it hath always a particular idea or perception. The principle we call self-love never seeks any thing external for the sake of the thing, but only as a means of happiness or good: particular affections rest in the external things themselves. One belongs to man as a reasonable creature reflecting upon his own interest or happiness. The others, though quite distinct from reason, are as much a part of human nature.

That all particular appetites and passions are towards *external things themselves,* distinct from the *pleasure arising from them,* is manifested from hence; that there could not be this pleasure, were it not for that prior suitableness between the object and the passion: there could be no enjoyment or delight from one thing more than another, from eating food more than from swallowing a stone, if there were not an affection or appetite to one thing more than another.

Every particular affection, even the love of our neighbour, is as really our own affection, as self-love; and the pleasure arising from its gratification is as much my own pleasure, as the pleasure self-love would have, from knowing I myself should be happy some time hence, would be my own pleasure. And if, because every particular affection is a man's own, and the pleasure arising from its gratification his own pleasure, or pleasure to himself, such particular affection must be called self-love; according to this way of speaking, no creature whatever can possibly act but merely from self-love; and every action and every affection whatever is to be resolved up into this one principle. But then this is not the language of mankind: or if it were, we should want words to express the difference, between the principle of an action, proceeding from cool consideration that it will be to my own advantage; and an action, suppose of revenge, or of friendship, by which a man runs upon certain ruin, to do evil or good to another. It is manifest the principles of these actions are totally different, and so want different words to be distinguished by: all that they agree in is, that they both proceed from, and are done to gratify an inclination in a man's self. But the principle or inclination in one case is self-love; in the other, hatred or love of another. There is then a distinction between the cool principle of self-love, or general desire of our own happiness, as one part of our nature, and one principle of action; and the particular affections towards particular external objects, as another part of our nature, and another principle of action. How much soever therefore is to be allowed to self-love, yet it cannot be allowed to be the whole of our inward constitution; because, you see, there are other parts or principles which come into it.

Further, private happiness or good is all which self-love can make us desire, or be concerned about: in having this consists its gratification: it is an affection to ourselves; a regard to our own interest, happiness, and private good: and in the proportion a man hath this, he is interested, or a lover of himself. Let this be kept in mind; because there is commonly, as I shall presently have occasion to observe, another sense put upon these words. On the other hand, particular affections tend towards particular external things: these are their objects: having these is their end: in this consists their gratification: no matter whether it be, or be not, upon the whole, our interest or happiness. An action done from the former of these principles is called an interested action. An action proceeding from any of the latter has its denomination of passionate, ambitious, friendly, revengeful, or any other, from the particular appetite or affection

from which it proceeds. Thus self-love as one part of human nature, and the several particular principles as the other part, are, themselves, their objects and ends, stated and shewn.

From hence it will be easy to see, how far, and in what ways, each of these can contribute and be subservient to the private good of the individual. Happiness does not consist in self-love. The desire of happiness is no more the thing itself, than the desire of riches is the possession or enjoyment of them. People may love themselves with the most entire and unbounded affection, and yet be extremely miserable. Neither can self-love any way help them out, but by setting them on work to get rid of the causes of their misery, to gain or make use of those objects which are by nature adapted to afford satisfaction. Happiness or satisfaction consists only in the enjoyment of those objects, which are by nature suited to our several particular appetites, passions, and affections. So that if self-love wholly engrosses us, and leaves no room for any other principle, there can be absolutely no such thing at all as happiness, or enjoyment of any kind whatever; since happiness consists in the gratification of particular passions, which supposes the having of them. Self-love then does not constitute *this* or *that* to be our interest or good; but, our interest or good being constituted by nature and supposed, self-love only puts us upon obtaining and securing it. Therefore, if it be possible, that self-love may prevail and exert itself in a degree or manner which is not subservient to this end; then it will not follow, that our interest will be promoted in proportion to the degree in which that principle engrosses us, and prevails over others. Nay further, the private and contracted affection, when it is not subservient to this end, private good, may, for any thing that appears, have a direct contrary tendency and effect. And if we will consider the matter, we shall see that it often really has. *Disengagement* is absolutely necessary to enjoyment: and a person may have so steady and fixed an eye upon his own interest, whatever he places it in, as may hinder him from *attending* to many gratifications within his reach, which others have their minds *free* and *open* to. Over-fondness for a child is not generally thought

to be for its advantage: and, if there be any guess to be made from appearances, surely that character we call selfish is not the most promising for happiness. Such a temper may plainly be, and exert itself in a degree and manner which may give unnecessary and useless solicitude and anxiety, in a degree and manner which may prevent obtaining the means and materials of enjoyment, as well as the making use of them. Immoderate self-love does very ill consult its own interest: and, how much soever a paradox it may appear, it is certainly true, that even from self-love we should endeavour to get over all inordinate regard to, and consideration of ourselves. Every one of our passions and affections hath its natural stint and bound, which may easily be exceeded; whereas our enjoyments can possibly be but in a determinate measure and degree. Therefore such excess of the affection, since it cannot procure any enjoyment, must in all cases be useless; but is generally attended with inconveniences, and often is downright pain and misery. This holds as much with regard to self-love as to all other affections. The natural degree of it, so far as it sets us on work to gain and make use of the materials of satisfaction, may be to our real advantage; but beyond or besides this, it is in several respects an inconvenience and disadvantage. Thus it appears, that private interest is so far from being likely to be promoted in proportion to the degree in which self-love engrosses us, and prevails over all other principles; that *the contracted affection may be so prevalent as to disappoint itself, and even contradict its own end, private good.*

"But who, except the most sordidly covetous, ever thought there was any rivalship between the love of greatness, honour, power, or between sensual appetites, and self-love? No, there is a perfect harmony between them. It is by means of these particular appetites and affections that self-love is gratified in enjoyment, happiness, and satisfaction. The competition and rivalship is between self-love and the love of our neighbour: that affection which leads us out of ourselves, makes us regardless of our interest, and substitute that of another in its stead." Whether then there be any peculiar competition and contrariety in this case, shall now be considered.

Self-love and interestedness was stated to consist in or be an affection to ourselves, a regard to our own private good: it is therefore distinct from benevolence, which is an affection to the good of our fellow-creatures. But that benevolence is distinct from, that is, not the same thing with self-love, is no reason for its being looked upon with any peculiar suspicion; because every principle whatever, by means of which self-love is gratified, is distinct from it: and all things which are distinct from each other are equally so. A man has an affection or aversion to another: that one of these tends to, and is gratified by doing good, that the other tends to, and is gratified by doing harm, does not in the least alter the respect which either one or the other of these inward feelings has to self-love. We use the word *property* so as to exclude any other persons having an interest in that of which we say a particular man has the property. And we often use the word *selfish* so as to exclude in the same manner all regards to the good of others. But the cases are not parallel: for though that exclusion is really part of the idea of property; yet such positive exclusion, or bringing this peculiar disregard to the good of others into the idea of self-love, is in reality adding to the idea, or changing it from what it was before stated to consist in, namely, in an affection to ourselves. This being the whole idea of self-love, it can no otherwise exclude good-will or love of others, than merely by not including it, no otherwise, than it excludes love of arts or reputation, or of any thing else. Neither on the other hand does benevolence, any more than love of arts or of reputation, exclude self-love. Love of our neighbour then has just the same respect to, is no more distant from, self-love, than hatred of our neighbour, or than love or hatred of any thing else. Thus the principles, from which men rush upon certain ruin for the destruction of an enemy, and for the preservation of a friend, have the same respect to the private affection, and are equally interested, or equally disinterested: and it is of no avail, whether they are said to be one or the other. Therefore to those who are shocked to hear virtue spoken of as disinterested, it may be allowed that it is indeed absurd to speak thus of it; unless hatred, several particular instances of vice, and all the common affections and aversions in mankind, are acknowledged to be disinterested too. Is there any less inconsistence, between the love of inanimate things, or of creatures merely sensitive, and self-love; than between self-love and the love of our neighbour? Is desire of and delight in the happiness of another any more a diminution of self-love, than desire of and delight in the esteem of another? They are both equally desire of and delight in somewhat external to ourselves: either both or neither are so. The object of self-love is expressed in the term self: and every appetite of sense, and every particular affection of the heart, are equally interested or disinterested, because the objects of them all are equally self or somewhat else. Whatever ridicule therefore the mention of a disinterested principle or action may be supposed to lie open to, must, upon the matter being thus stated, relate to ambition, and every appetite and particular affection, as much as to benevolence. And indeed all the ridicule, and all the grave perplexity, of which this subject hath had its full share, is merely from words. The most intelligible way of speaking of it seems to be this: that self-love and the actions done in consequence of it (for these will presently appear to be the same as to this question) are interested; that particular affections towards external objects, and the actions done in consequence of those affections, are not so. But every one is at liberty to use words as he pleases. All that is here insisted upon is, that ambition, revenge, benevolence, all particular passions whatever, and the actions they produce, are equally interested or disinterested.

Thus it appears that there is no peculiar contrariety between self-love and benevolence; no greater competition between these, than between any other particular affections and self-love. This relates to the affections themselves. Let us now see whether there be any peculiar contrariety between the respective courses of life which these affections lead to; whether there be any greater competition between the pursuit of private and of public good, than between any other particular pursuits and that of private good.

There seems no other reason to suspect that there is any such peculiar contrariety, but only that the course of action which benevolence leads to, has a

more direct tendency to promote the good of others, than that course of action which love of reputation, suppose, or any other particular affection leads to. But that any affection tends to the happiness of another, does not hinder its tending to one's own happiness too. That others enjoy the benefit of the air and the light of the sun, does not hinder but that these are as much one's own private advantage now, as they would be if we had the property of them exclusive of all others. So a pursuit which tends to promote the good of another, yet may have as great tendency to promote private interest, as a pursuit which does not tend to the good of another at all, or which is mischievous to him. All particular affections whatever, resentment, benevolence, love of arts, equally lead to a course of action for their own gratification, i.e., the gratification of ourselves; and the gratification of each gives delight: so far then it is manifest they have all the same respect to private interest. Now take into consideration further, concerning these three pursuits, that the end of the first is the harm, of the second, the good of another, of the last, somewhat indifferent; and is there any necessity, that these additional considerations should alter the respect, which we before saw these three pursuits had to private interest; or render any one of them less conducive to it, than any other? Thus one man's affection is to honour as his end; in order to obtain which he thinks no pains too great. Suppose another, with such a singularity of mind, as to have the same affection to public good as his end, which he endeavours with the same labour to obtain. In case of success, surely the man of benevolence hath as great enjoyment as the man of ambition; they both equally having the end their affections, in the same degree, tended to: but in case of disappointment, the benevolent man has clearly the advantage; since endeavouring to do good considered as a virtuous pursuit, is gratified by its own consciousness, i.e. is in a degree its own reward.

And as to these two, or benevolence and any other particular passions whatever, considered in a further view, as forming a general temper, which more or less disposes us for enjoyment of all the common blessings of life, distinct from their own gratification: is benevolence less the temper of tranquillity and freedom than ambition or covetousness? Does the benevolent man appear less easy with himself, from his love to his neighbour? Does he less relish his being? Is there any peculiar gloom seated on his face? Is his mind less open to entertainment, to any particular gratification? Nothing is more manifest, than that being in good humour, which is benevolence whilst it lasts, is itself the temper of satisfaction and enjoyment.

Suppose then a man sitting down to consider how he might become most easy to himself, and attain the greatest pleasure he could; all that which is his real natural happiness. This can only consist in the enjoyment of those objects, which are by nature adapted to our several faculties. These particular enjoyments make up the sum total of our happiness: and they are supposed to arise from riches, honours, and the gratification of sensual appetites: be it so: yet none profess themselves so completely happy in these enjoyments, but that there is room left in the mind for others, if they were presented to them: nay, these, as much as they engage us, are not thought so high, but that human nature is capable even of greater. Now there have been persons in all ages, who have professed that they found satisfaction in the exercise of charity, in the love of their neighbour, in endeavouring to promote the happiness of all they had to do with, and in the pursuit of what is just and right and good, as the general bent of their mind, and end of their life; and that doing an action of baseness or cruelty, would be as great violence to *their* self, as much breaking in upon their nature, as any external force. Persons of this character would add, if they might be heard, that they consider themselves as acting in the view of an infinite Being, who is in a much higher sense the object of reverence and of love, than all the world besides; and therefore they could have no more enjoyment from a wicked action done under his eye, than the persons to whom they are making their apology could, if all mankind were the spectators of it; and that the satisfaction of approving themselves to his unerring judgment, to whom they thus refer all their actions, is a more continued settled satisfaction than any this world can afford; as also that they have, no less than others, a mind free and open to all the common innocent gratifications of it, such as

they are. And if we go no further, does there appear any absurdity in this? Will any one take upon him to say, that a man cannot find his account in this general course of life, as much as in the most unbounded ambition, and the excesses of pleasure? Or that such a person has not consulted so well for himself, for the satisfaction and peace of his own mind, as the ambitious or dissolute man? And though the consideration, that God himself will in the end justify their taste, and support their cause, is not formally to be insisted upon here; yet thus much comes in, that all enjoyments whatever are much more clear and unmixed from the assurance that they will end well. Is it certain then that there is nothing in these pretensions to happiness? especially when there are not wanting persons, who have supported themselves with satisfactions of this kind in sickness, poverty, disgrace, and in the very pangs of death; whereas it is manifest all other enjoyments fail in these circumstances. This surely looks suspicious of having somewhat in it. Self-love methinks should be alarmed. May she not possibly pass over greater pleasures, than those she is so wholly taken up with?

The short of the matter is no more than this. Happiness consists in the gratification of certain affections, appetites, passions, with objects which are by nature adapted to them. Self-love may indeed set us on work to gratify these: but happiness or enjoyment has no immediate connection with self-love, but arises from such gratification alone. Love of our neighbour is one of those affections. This, considered as a *virtuous principle,* is gratified by a consciousness of *endeavouring* to promote the good of others; but considered as a natural affection, its gratification consists in the actual accomplishment of this endeavour. Now indulgence or gratification of this affection, whether in that consciousness or this accomplishment, has the same respect to interest, as indulgence of any other affection; they equally proceed from or do not proceed from self-love, they equally include or equally exclude this principle. Thus it appears, that *benevolence and the pursuit of public good hath at least as great respect to self-love and the pursuit of private good, as any other particular passions, and their respective pursuits.*

Neither is covetousness, whether as a temper or pursuit, any exception to this. For if by covetousness is meant the desire and pursuit of riches for their own sake, without any regard to, or consideration of, the uses of them; this hath as little to do with self-love, as benevolence hath. But by this word is usually meant, not such madness and total distraction of mind, but immoderate affection to and pursuit of riches as possessions in order to some further end; namely, satisfaction, interest, or good. This therefore is not a particular affection, or particular pursuit, but it is the general principle of self-love, and the general pursuit of our own interest; for which reason, the word *selfish* is by every one appropriated to this temper and pursuit. Now as it is ridiculous to assert, that self-love and the love of our neighbour are the same; so neither is it asserted, that following these different affections hath the same tendency and respect to our own interest. The comparison is not between self-love and the love of our neighbour; between pursuit of our own interest, and the interest of others; but between the several particular affections in human nature towards external objects, as one part of the comparison; and the one particular affection to the good of our neighbour, as the other part of it: and it has been shewn, that all these have the same respect to self-love and private interest.

There is indeed frequently an inconsistence or interfering between self-love or private interest, and the several particular appetites, passions, affections, or the pursuits they lead to. But this competition or interfering is merely accidental; and happens much oftener between pride, revenge, sensual gratifications, and private interest, than between private interest and benevolence. For nothing is more common, than to see men give themselves up to a passion or an affection to their known prejudice and ruin, and in direct contradiction to manifest and real interest, and the loudest calls of self-love: whereas the seeming competitions and interfering, between benevolence and private interest, relate much more to the materials or means of enjoyment, than to enjoyment itself. There is often an interfering in the former, when there is none in the latter. Thus as to riches: so much money as a man gives away, so much less will remain in his possession. Here is a real interfering. But though a man cannot

possibly give without lessening his fortune, yet there are multitudes might give without lessening their own enjoyment; because they may have more than they can turn to any real use or advantage to themselves. Thus, the more thought and time any one employs about the interests and good of others, he must necessarily have less to attend his own; but he may have so ready and large a supply of his own wants, that such thought might be really useless to himself, though of great service and assistance to others.

The general mistake, that there is some greater inconsistence between endeavouring to promote the good of another and self-interest, than between self-interest and pursuing any thing else, seems, as hath already been hinted, to arise from our notions of property; and to be carried on by this property's being supposed to be itself our happiness or good. People are so very much taken up with this one subject, that they seem from it to have formed a general way of thinking, which they apply to other things that they have nothing to do with. Hence, in a confused and slight way, it might well be taken for granted, that another's having no interest in an affection (i.e. his good not being the object of it), renders, as one may speak, the proprietor's interest in it greater; and that if another had an interest in it, this would render his less, or occasion that such affection could not be so friendly to self-love, or conducive to private good, as an affection or pursuit which has not a regard to the good of another. This, I say, might be taken for granted, whilst it was not attended to, that the object of every particular affection is equally somewhat external to ourselves; and whether it be the good of another person, or whether it be any other external thing, makes no alteration with regard to its being one's own affection, and the gratification of it one's own private enjoyment. And so far as it is taken for granted, that barely having the means and materials of enjoyment is what constitutes interest and happiness; that our interest or good consists in possessions themselves, in having the property of riches, houses, lands, gardens, not in the enjoyment of them; so far it will even more strongly be taken for granted, in the way already explained, that an affection's conducing to the good of another, must even necessar-

ily occasion to it conduce less to private good, if not to be positively detrimental to it. For, if property and happiness are one and the same thing, as by increasing the property of another you lessen your own property, so by promoting the happiness of another you must lessen your own happiness. But whatever occasioned the mistake, I hope it has been fully proved to be one; as it has been proved, that there is no peculiar rivalship or competition between self-love and benevolence: that as there may be a competition between these two, so there may also between any particular affection whatever and self-love; that every particular affection, benevolence among the rest, is subservient to self-love by being the instrument of private enjoyment; and that in one respect benevolence contributes more to private interest, i. e. enjoyment or satisfaction, than any other of the particular common affections, as it is in a degree its own gratification.

And to all these things may be added, that religion, from whence arises our strongest obligation to benevolence, is so far from disowning the principle of self-love, that it often addresses itself to that very principle, and always to the mind in that state when reason presides; and there can no access be had to the understanding, but by convincing men, that the course of life we would persuade them to is not contrary to their interest. It may be allowed, without any prejudice to the cause of virtue and religion, that our ideas of happiness and misery are of all our ideas the nearest and most important to us; that they will, nay, if you please, that they ought to prevail over those of order, and beauty, and harmony, and proportion, if there should ever be, as it is impossible there ever should be, any inconsistence between them: though these last too, as expressing the fitness of actions, are real as truth itself. Let it be allowed, though virtue or moral rectitude does indeed consist in affection to and pursuit of what is right and good, as such; yet, that when we sit down in a cool hour, we can neither justify to ourselves this or any other pursuit, till we are convinced that it will be for our happiness, or at least not contrary to it.

Common reason and humanity will have some influence upon mankind, whatever becomes of speculations; but, so far as the interests of virtue depend upon the theory of it being secured from open scorn, so far its

very being in the world depends upon its appearing to have no contrariety to private interest and self-love. The foregoing observations, therefore, it is hoped, may have gained a little ground in favour of the precept before us; the particular explanation of which shall be the subject of the next discourse.

SERMON XII

Upon the Love of Our Neighbor

And if there be any other commandment, it is briefly comprehended in this saying, namely, Thou shalt love thy neighbour as thyself.

—*Romans XIII: 9.*

Having already removed the prejudices against public spirit, or the love of our neighbor, on the side of private interest and self-love, I proceed to the particular explanation of the precept before us, by showing: who is our neighbor; in what sense we are required to love him as ourselves; the influence such love would have upon our behavior in life; and lastly, how this commandment comprehends in it all others.

I. The objects and due extent of this affection will be understood by attending to the nature of it, and to the nature and circumstances of mankind in this world. The love of our neighbor is the same with charity, benevolence, or goodwill: it is an affection to the good and happiness of our fellow creatures. This implies in it a disposition to produce happiness; and this is the simple notion of goodness, which appears so amiable wherever we meet with it. From hence it is easy to see that the perfection of goodness consists in love to the whole universe. This is the perfection of Almighty God.

But as man is so much limited in his capacity, as so small a part of the creation comes under his notice and influence, and as we are not used to consider things in so general a way, it is not to be thought of, that the universe should be the object of benevolence to such creatures as we are. Thus in that precept of our Saviour, "Be ye perfect, even as your Father, which is in heaven, is perfect,"[8] the perfection of the Divine

goodness is proposed to our imitation as it is promiscuous and extends to the evil as well as the good; not as it is absolutely universal, imitation of it in this respect being plainly beyond us. The object is too vast. For this reason moral writers also have substituted a less general object for our benevolence, mankind. But this likewise is an object too general, and very much out of our view. Therefore persons more practical have, instead of mankind, put our country, and made the principle of virtue, of human virtue, to consist in the entire uniform love of our country; and this is what we call a public spirit; which in men of public stations is the character of a patriot. But this is speaking to the upper part of the world. Kingdoms and governments are large; and the sphere of action of far the greatest part of mankind is much narrower than the government they live under; or however, common men do not consider their actions as affecting the whole community of which they are members. There plainly is wanting a less general and nearer object of benevolence for the bulk of men than that of their country. Therefore the Scripture, not being a book of theory and speculation, but a plain rule of life for mankind, has with the utmost possible propriety put the principle of virtue upon the love of our neighbor; which is that part of the universe, that part of mankind, that part of our country, which comes under our immediate notice, acquaintance, and influence, and with which we have to do.

This is plainly the true account or reason why our Saviour places the principle of virtue in the love of our *neighbor;* and the account itself shows who are comprehended under that relation.

II. Let us now consider in what sense we are commanded to love our neighbor *as ourselves.*

This precept, in its first delivery by our Saviour is thus introduced: "Thou shalt love the Lord thy God with all thine heart, with all thy soul, and with all thy strength; and thy neighbor as thyself." These very different manners of expression do not lead our thoughts to the same measure or degree of love, common to both objects, but to one, peculiar to each. Supposing then, which is to be supposed, a distinct meaning and propriety in the words, "as thyself"; the precept we are considering will admit of any of these senses: that we bear the *same kind* of affection to our neighbor as we

do to ourselves; or, that the love we bear to our neighbor should have *some certain proportion or other* to self-love; or, lastly, that it should bear the particular proportion of *equality*, that *it be in the same degree.*

First, the precept may be understood as requiring only that we have the *same kind* of affection to our fellow-creatures as to ourselves: that, as every man has the principle of self-love, which disposes him to avoid misery and consult his own happiness, so we should cultivate the affection of goodwill to our neighbor, and that it should influence us to have the same kind of regard to him. This at least must be commanded; and this will not only prevent our being injurious to him, but will also put us upon promoting his good. There are blessings in life which we share in common with others: peace, plenty, freedom, healthful seasons. But real benevolence to our fellow creatures would give us the notion of a common interest in a stricter sense; for in the degree we love another, his interest, his joys and sorrows, are our own. It is from self-love that we form the notion of private good and consider it as our own; love of our neighbor would teach us thus to appropriate to ourselves his good and welfare, to consider ourselves as having a real share in his happiness. Thus the principle of benevolence would be an advocate within our own breasts, to take care of the interests of our fellow creatures in all the interfering and competitions which cannot but be, from the imperfection of our nature, and the state we are in. It would likewise, in some measure, lessen that interfering, and hinder men from forming so strong a notion of private good, exclusive of the good of others, as we commonly do. Thus, as the private affection makes us in a peculiar manner sensible of humanity, justice or injustice, when exercised toward ourselves, love of our neighbor would give us the same kind of sensibility in his behalf. This would be the greatest security of our uniform obedience to that most equitable rule: "Whatsoever ye would that men should do to you, do ye even so to them."

All this is indeed no more than that we should have a real love to our neighbor; but then, which is to be observed, the words "as thyself" express this in the most distinct manner, and determine the precept to relate to the affection itself. The advantage which this principle of benevolence has over other remote considerations is that it is itself the temper of virtue; and likewise, that it is the chief, nay, the only effectual security of our performing the several offices of kindness we owe to our fellow creatures. When from distant considerations men resolve upon anything to which they have no liking, or perhaps an averseness, they are perpetually finding out evasions and excuses, which need never be wanting if people look for them; and they equivocate with themselves in the plainest cases in the world. This may be in respect to single determinate acts of virtue; but it comes in much more where the obligation is to a general course of behavior, and most of all if it be such as cannot be reduced to fixed determinate rules. This observation may account for the diversity of the expression, in that known passage of the prophet Micah: "to do justly, and to love mercy." A man's heart must be formed to humanity and benevolence, he must *love mercy*, otherwise he will not act mercifully in any settled course of behavior. As consideration of the future sanctions of religion is our only security of persevering in our duty, in cases of great temptation, so to get our heart and temper formed to a love and liking of what is good, is absolutely necessary in order to our behaving rightly in the familiar and daily intercourses amongst mankind.

Secondly, the precept before us may be understood to require that we love our neighbor in some certain *proportion* or other *according as* we love ourselves. And indeed a man's character cannot be determined by the love he bears to his neighbor, considered absolutely; but the proportion which this bears to self-love, whether it be attended to or not, is the chief thing which forms the character and influences the actions. For as the form of the body is a composition of various parts, so likewise our inward structure is not simple or uniform, but a composition of various passions, appetites, affections, together with rationality, including in this last both the discernment of what is right and a disposition to regulate ourselves by it. There is greater variety of parts in what we call a character than there are features in a face; and the morality of that is no more determined by one part than the beauty or deformity of this is by one single feature; each is to be judged of by all the parts or features, not taken singly but together. In the inward frame the various passions,

appetites, affections stand in different respects to each other. The principles in our mind may be contradictory, or checks and allays only, or incentives and assistants to each other. And principles which in their nature have no kind of contrariety of affinity may yet accidentally be each other's allays or incentives.

From hence it comes to pass that though we were able to look into the inward contexture of the heart, and see with the greatest exactness in what degree any one principle is in a particular man, we could not from thence determine how far that principle would go toward forming the character, or what influence it would have upon the actions, unless we could likewise discern what other principles prevailed in him, and see the proportion which that one bears to the others. Thus, though two men should have the affection of compassion in the same degree exactly, yet one may have the principle of resentment, or of ambition, so strong in him as to prevail over that of compassion and prevent its having any influence upon his actions, so that he may deserve the character of an hard or cruel man; whereas the other having compassion in just the same degree only, yet having resentment or ambition in a lower degree, his compassion may prevail over them so as to influence his actions and to denominate his temper compassionate. So that, how strange soever it may appear to people who do not attend to the thing, yet it is quite manifest that, when we say one man is more resenting or compassionate than another, this does not necessarily imply that one has the principle of resentment or of compassion stronger than the other. For if the proportion which resentment or compassion bears to other inward principles is greater in one than in the other, this is itself sufficient to denominate one more resenting or compassionate than the other.

Further, the whole system, as I may speak, of affections (including rationality), which constitute the heart, as this word is used in Scripture and on moral subjects, are each and all of them stronger in some than in others. Now the proportion which the two general affections, benevolence and self-love, bear to each other, according to this interpretation of the text, denominates men's character as to virtue. Suppose then one man to have the principle of benevolence in an higher degree than another, it will not follow from hence that his general temper or character or actions will be more benevolent than the other's. For he may have self-love in such a degree as quite to prevail over benevolence, so that it may have no influence at all upon his actions; whereas benevolence in the other person, though in a lower degree, may yet be the strongest principle in his heart, and strong enough to be the guide of his actions so as to denominate him a good and virtuous man. The case is here as in scales: it is not one weight, considered in itself, which determines whether the scale shall ascend or descend, but this depends upon the proportion which that one weight hath to the other.

It being thus manifest that the influence which benevolence has upon our actions, and how far it goes toward forming our character, is not determined by the degree itself of this principle in our mind, but by the proportion it has to self-love and other principles, a comparison also being made in the texts between self-love and the love of our neighbor; these joint considerations afforded sufficient occasion for treating here of that proportion; it plainly is implied in the precept, though it should be questioned whether it be the exact meaning of the words "as thyself."

Love of our neighbor then must bear some proportion to self-love, and virtue to be sure consists in the due proportion. What this due proportion is, whether as a principle in the mind or as exerted in actions, can be judged of only from our nature and condition in this world. Of the degree in which affections and the principles of action, considered in themselves, prevail, we have no measure; let us then proceed to the course of behavior, the actions they produce.

Both our nature and condition require that each particular man should make particular provision for himself; and the inquiry what proportion benevolence should have to self-love, when brought down to practice, will be what is a competent care and provision for ourselves. And how certain soever it be that each man must determine this for himself, and how ridiculous soever it would be for any to attempt to determine it for another, yet it is to be observed that the proportion is real, and that a competent provision has a bound, and that it cannot be all which we can possibly get and keep within our grasp, without legal injustice.

Mankind almost universally bring in vanity—supplies for what is called a life of pleasure, covetousness, or imaginary notions of superiority over others—to determine this question; but every one who desires to act a proper part in society would do well to consider how far any of them come in to determine it, in the way of moral consideration. All that can be said is, supposing, what, as the world goes, is so much to be supposed that it is scarce to be mentioned, that persons do not neglect what they really owe to themselves; the more of their care and thought, and of their fortune, they employ in doing good to their fellow creatures, the nearer they come up to the law of perfection, "Thou shalt love thy neighbour as thyself."

Thirdly, if the words "as thyself" were to be understood of an equality of affection, it would not be attended with those consequences which perhaps may be thought to follow from it. Suppose a person to have the same settled regard to others as to himself, that in every deliberate scheme or pursuit he took their interest into the account in the same degree as his own, so far as an equality of affection would produce this, yet he would in fact, and ought to be, much more taken up and employed about himself and his own concerns than about others and their interests. For, besides the one common affection toward himself and his neighbor, he would have several other particular affections, passions, appetites, which he could not possibly feel in common both for himself and others; now these sensations themselves very much employ us, and have perhaps as great influence as self-love. So far indeed as self-love and cool reflection upon what is for our interest would set us on work to gain a supply of our own several wants, so far the love of our neighbor would make us do the same for him; but the degree in which we are put upon seeking and making use of the means of gratification, by the feeling of those affections, appetites, and passions, must necessarily be peculiar to ourselves.

That there are particular passions (suppose shame, resentment), which men seem to have and feel in common, both for themselves and others, makes no alteration in respect to those passions and appetites which cannot possibly be thus felt in common. From hence (and perhaps more things of the like kind might be mentioned) it follows that though there were an equality of affection to both, yet regards to ourselves would be more prevalent than attention to the concerns of others.

And from moral considerations it ought to be so, supposing still the equality of affection commanded, because we are in a peculiar manner, as I may speak, intrusted with ourselves, and therefore care of our own interests, as well as of our conduct, particularly belongs to us.

To these things must be added that moral obligations can extend no further than to natural possibilities. Now we have a perception of our own interests, like consciousness of our own existence, which we always carry about with us; and which, in its continuation, kind, and degree, seems impossible to be felt in respect to the interest of others.

From all these things it fully appears that though we were to love our neighbor in the same degree as we love ourselves, so far as this is possible, yet the care of ourselves, of the individual, would not be neglected; the apprehended danger of which seems to be the only objection against understanding the precept in this strict sense.

III. The general temper of mind which the due love of our neighbor would form us to, and the influence it would have upon our behavior in life, is now to be considered.

The temper and behavior of charity is explained at large in that known passage of St. Paul: "Charity suffereth long, and is kind; charity envieth not, doth not behave itself unseemly, seeketh not her own, thinketh no evil, beareth all things, believeth all things, hopeth all things."[9] As to the meaning of the expressions, "seeketh not her own, thinketh no evil, believeth all things," however those expressions may be explained away, this meekness, and in some degree easiness of temper, readiness to forego our right for the sake of peace as well as in the way of compassion, freedom from mistrust, and disposition to believe well of our neighbor—this general temper, I say, accompanies and is plainly the effect of love and goodwill. And though such is the world in which we live, that experience and knowledge of it not only may but must beget in us greater regard to ourselves,

and doubtfulness of the characters of others, than is natural to mankind; yet these ought not to be carried further than the nature and course of things make necessary. It is still true, even in the present state of things, bad as it is, that a real good man had rather be deceived than be suspicious, had rather forego his own right than run the venture of doing even a hard thing. This is the general temper of that charity of which the apostle asserts that if he had it not, giving his "body to be burned would avail him nothing"; and which he says "shall never fail."

The happy influence of this temper extends to every different relation and circumstance in human life. It plainly renders a man better, more to be desired, as to all the respects and relations we can stand in to each other. The benevolent man is disposed to make use of all external advantages in such a manner as shall contribute to the good of others as well as to his own satisfaction. His own satisfaction consists in this. He will be easy and kind to his dependents, compassionate to the poor and distressed, friendly to all with whom he has to do. This includes the good neighbor, parent, master, magistrate; and such a behavior would plainly make dependence, inferiority, and even servitude, easy. So that a good or charitable man of superior rank in wisdom, fortune, authority, is a common blessing to the place he lives in—happiness grows under his influence. This good principle in inferiors would discover itself in paying respect, gratitude, obedience, as due. It were therefore, methinks, one just way of trying one's own character to ask ourselves, Am I in reality a better master or servant, a better friend, a better neighbor, than such and such persons whom, perhaps, I may think not to deserve the character of virtue and religion so much as myself?

And as to the spirit of party, which unhappily prevails amongst mankind, whatever are the distinctions which serve for a supply to it, some or other of which have obtained in all ages and countries: one who is thus friendly to his kind will immediately make due allowances for it, as what cannot but be amongst such creatures as men, in such a world as this. And as wrath and fury and overbearing upon these occasions proceed, as I may speak, from men's feeling only on their own side, so a common feeling, for others as well as

for ourselves, would render us sensible to this truth—which it is strange can have so little influence—that we ourselves differ from others just as much as they do from us. I put the matter in this way, because it can scarce be expected that the generality of men should see that those things which are made the occasions of dissension and fomenting the party spirit are really nothing at all; but it may be expected from all people, how much soever they are in earnest about their respective peculiarities, that humanity and common goodwill to their fellow creatures should moderate and restrain that wretched spirit.

This good temper of charity likewise would prevent strife and enmity arising from other occasions; it would prevent our giving just cause of offense, and our taking it without cause. And in cases of real injury, a good man will make all the allowances which are to be made, and without any attempts of retaliation, he will only consult his own and other men's security for the future, against injustice and wrong.

IV. I proceed to consider, lastly, what is affirmed of the precept now explained, that it comprehends in it all others; that is, that to love our neighbor as ourselves includes in it all virtues.

Now the way in which every maxim of conduct, or general speculative assertion, when it is to be explained at large, should be treated is to show what are the particular truths which were designed to be comprehended under such a general observation, how far it is strictly true; and then the limitations, restrictions, and exceptions, if there be exceptions, with which it is to be understood. But it is only the former of these, namely, how far the assertion in the text holds, and the ground of the preeminence assigned to the precept of it, which in strictness comes into our present consideration.

However, in almost everything that is said, there is somewhat to be understood beyond what is explicitly laid down, and which we of course supply—somewhat, I mean, which would not be commonly called a restriction or limitation. Thus, when benevolence is said to be the sum of virtue, it is not spoken of as a blind propension, but as a principle in reasonable creatures, and so to be directed by their reason; for reason and reflection comes into our notion of a moral agent. And that will lead us to consider distant

consequences as well as the immediate tendency of an action; it will teach us that the care of some persons, suppose children and families, is particularly committed to our charge by Nature and Providence, as also that there are other circumstances, suppose friendship or former obligations, which require that we do good to some, preferably to others. Reason, considered merely as subservient to benevolence, as assisting to produce the greatest good, will teach us to have particular regard to these relations and circumstances; because it is plainly for the good of the world that they should be regarded. And as there are numberless cases in which, notwithstanding appearances, we are not competent judges, whether a particular action will upon the whole do good or harm, reason in the same way will teach us to be cautious how we act in these cases of uncertainty. It will suggest to our consideration which is the safer side, how liable we are to be led wrong by passion and private interest, and what regard is due to laws and the judgment of mankind. All these things must come into consideration were it only in order to determine which way of acting is likely to produce the greatest good. Thus, upon supposition that it were in the strictest sense true, without limitation, that benevolence includes in it all virtues, yet reason must come in as its guide and director in order to attain its own end, the end of benevolence, the greatest public good. Reason then being thus included, let us now consider the truth of the assertion itself.

First, it is manifest that nothing can be of consequence to mankind or any creature, but happiness. This then is all which any person can, in strictness of speaking, be said to have a right to. We can therefore "owe no man anything," but only further and promote his happiness, according to our abilities. And therefore a disposition and endeavor to do good to all with whom we have to do, in the degree and manner which the different relations we stand in to them require, is a discharge of all the obligations we are under to them.

As human nature is not one simple uniform thing, but a composition of various parts, body, spirit, appetites, particular passions, and affections, for each of which reasonable self-love would lead men to have due regard and make suitable provision, so society consists of various parts to which we stand in different respects and relations; and just benevolence would as surely lead us to have due regard to each of these, and behave as the respective relations require. Reasonable goodwill and right behavior toward our fellow creatures are in a manner the same, only that the former expresseth the principle as it is in the mind, the latter, the principle as it were become external, that is, exerted in actions.

And so far as temperance, sobriety, and moderation in sensual pleasures, and the contrary vices, have any respect to our fellow creatures, any influence upon their quiet, welfare, and happiness, as they always have a real and often a near influence upon it, so far it is manifest those virtues may be produced by the love of our neighbor, and that the contrary vices would be prevented by it. Indeed, if men's regard to themselves will not restrain them from excess, it may be thought little probable that their love to others will be sufficient; but the reason is that their love to others is not, any more than their regard to themselves, just and in its due degree. There are however manifest instances of persons kept sober and temperate from regard to their affairs and the welfare of those who depend upon them. And it is obvious to everyone that habitual excess, a dissolute course of life, implies a general neglect of the duties we owe toward our friends, our families, and our country.

From hence it is manifest that the common virtues and the common vices of mankind may be traced up to benevolence, or the want of it. And this entitles the precept, "Thou shalt love thy neighbour as thyself," to the preeminence given to it; and is a justification of the Apostle's assertion that all other commandments are comprehended in it, whatever cautions and restrictions[10] there are, which might require to be considered if we were to state particularly and at length what is virtue and right behavior in mankind. But,

Secondly, it might be added that in a higher and more general way of consideration, leaving out the particular nature of creatures and the particular circumstances in which they are placed, benevolence seems in the strictest sense to include in it all that is good and worthy; all that is good, which we have any distinct particular notion of. We have no clear conception of any positive moral attribute in the Supreme

Being but what may be resolved up into goodness. And if we consider a reasonable creature or moral agent, without regard to the particular relations and circumstances in which he is placed, we cannot conceive anything else to come in toward determining whether he is to be ranked in an higher or lower class of virtuous beings, but the higher or lower degree in which that principle, and what is manifestly connected with it, prevail in him.

That which we more strictly call piety, or the love of God, and which is an essential part of a right temper, some may perhaps imagine no way connected with benevolence; yet surely they must be connected if there be indeed in being an object infinitely good. Human nature is so constituted that every good affection implies the love of itself, that is, becomes the object of a new affection in the same person. Thus to be righteous implies in it the love of righteousness; to be benevolent, the love of benevolence; to be good, the love of goodness, whether this righteousness, benevolence, or goodness be viewed as in our own mind or in another's; and the love of God as being perfectly good is the love of perfect goodness contemplated in a being or person. Thus morality and religion, virtue and piety, will at last necessarily coincide, run up into one and the same point, and love will be in all senses "the end of the commandment."

O Almighty God, inspire us with this divine principle; kill in us all the seeds of envy and ill will; and help us, by cultivating within ourselves the love of our neighbor, to improve in the love of Thee. Thou hast placed us in various kindreds, friendships, and relations, as the school of discipline for our affections; help us, by the due exercise of them, to improve to perfection, till all partial affection be lost in that entire universal one, and Thou, O God, shalt be all in all.

Notes

1. *I Cor.* XII.

2. Suppose a man of learning to be writing a grave book upon *human nature*, and to show in several parts of it that he had an insight into the subject he was considering; amongst other things, the following one would require to be accounted for: the appearance of benevolence or goodwill in men toward each other in the instances of natural relation, and in others (Hobbes, Of *Human Nature,* c. ix. § 7). Cautious of being deceived with outward show, he retires within himself to see exactly what that is in the mind of man from whence this appearance proceeds; and, upon deep reflection, asserts the principle in the mind to be only the love of power, and delight in the exercise of it. Would not everybody think here was a mistake of one word for another; that the philosopher was contemplating and accounting for some other human actions, some other behavior of man to man? And could anyone be thoroughly satisfied that what is commonly called benevolence or goodwill was really the affection meant, but only by being made to understand that this learned person had a general hypothesis to which the appearance of goodwill could no otherwise be reconciled? That what has this appearance is often nothing but ambition; that delight in superiority often (suppose always) mixes itself with benevolence, only makes it more specious to call it ambition than hunger, of the two: but in reality that passion does no more account for the whole appearance of goodwill than this appetite does. Is there not often the appearance of one man's wishing that good to another which he knows himself unable to procure him; and rejoicing in it, though bestowed by a third person? And can love of power anyway possibly come in to account for this desire or delight? Is there not often the appearance of men's distinguishing between two or more persons, preferring one before another, to do good to, in cases where love of power cannot in the least account for the distinction and preference? For this principle can no otherwise distinguish between objects than as it is a greater instance and exertion of power to do good to one rather than to another. Again, suppose goodwill in the mind of man to be nothing but delight in the exercise of power; men might indeed be restrained by distant and accidental considerations; but these restraints being removed, they would have a disposition to, and delight in, mischief as an exercise and proof of power; and this disposition and delight would arise from or be the same principle in the mind, as a disposition to, and delight in, charity. Thus cruelty, as distinct from envy and resentment, would be exactly the same in the mind of man as goodwill—that one tends to the happiness, the other to the misery of our fellow creatures, is, it seems, merely an accidental circumstance, which the mind has not the least regard to. These are the absurdities which even men of capacity run into when they have occasion to belie their nature, and will perversely disclaim that image of God which was originally stamped upon it, the traces of which, however faint, are plainly discernible upon the mind of man.

If any person can in earnest doubt whether there be such a thing as goodwill in one man toward another (for the question is not concerning either the degree or extensiveness of it, but concerning the affection itself), let it be observed that whether man be thus or otherwise constituted, what is the inward frame in this particular, is a mere question of fact or natural history, not provable immediately by reason. It is therefore to be judged of and determined in the same way other facts or matters of natural history are: by appealing to the external senses or inward perceptions respectively, as the matter under consideration is cognizable by one or the other; by arguing from acknowledged facts and actions; for a great number of actions in the same kind, in different circumstances, and respecting different objects, will prove, to a certainty, what principles they do not, and, to the greatest probability, what principles they do proceed from; and lastly, by the testimony of mankind. Now that there is some degree of benevolence amongst men may be as strongly and plainly proved in all these ways, as it could possibly be proved, supposing there was this affection in our nature. And should anyone think fit to assert that resentment in the mind of man was absolutely nothing but reasonable concern for our own safety, the falsity of this, and what is the real nature of that passion, could be shown in no other ways than those in which it may be shown, that there is such a thing in some degree as real goodwill in man toward man. It is sufficient that the seeds of it be implanted in our nature by God. There is, it is owned, much left for us to do upon our own heart and temper; to cultivate, to improve, to call it forth, to exercise it in a steady, uniform manner. This is our work; this is virtue and religion.

3. Everybody makes a distinction between self-love and the several particular passions, appetites, and affections; and yet they are often confounded again. That they are totally different, will be seen by any one who will distinguish between the passions and appetites themselves, and endeavoring after the means of their gratification. Consider the appetite of hunger, and the desire of esteem; these being the occasion both of pleasure and pain, the coolest self-love, as well as the appetites and passions themselves, may put us upon making use of the proper methods of obtaining that pleasure, and avoiding that pain; but the feelings themselves, the pain of hunger and shame, and the delight from esteem, are no more self-love than they are anything in the world. Though a man hated himself, he would as much feel the pain of hunger as he would that of the gout; and it is plainly supposable there may be creatures with self-love in them to the highest degree, who may be quite insensible and indifferent (as men in some cases are) to the contempt

and esteem of those upon whom their happiness does not in some further respects depend. And as self-love and the several particular passions and appetites are in themselves totally different, so that some actions proceed from one, and some from the other, will be manifest to any who will observe the two following very supposable cases. One man rushes upon certain ruin for the gratification of a present desire; nobody will call the principle of this action self-love. Suppose another man to go through some laborious work upon promise of a great reward, without any distinct knowledge what the reward will be; this course of action cannot be ascribed to any particular passion. The former of these actions is plainly to be imputed to some particular passion or affection, the latter as plainly to the general affection or principle of self-love. That there are some particular pursuits or actions concerning which we cannot determine how far they are owing to one, and how far to the other, proceeds from this that the two principles are frequently mixed together, and run up into each other. This distinction is further explained in the eleventh sermon.

4. If any desire to see this distinction and comparison made in a particular instance, the appetite and passion now mentioned may serve for one. Hunger is to be considered as a private appetite; because the end for which it was given us is the preservation of the individual. Desire of esteem is a public passion; because the end for which it was given us is to regulate our behavior toward society. The respect which this has to private good is as remote as the respect that has to public good: and the appetite is no more self-love than the passion is benevolence. The object and end of the former is merely food; the object and end of the latter is merely esteem; but the latter can no more be gratified without contributing to the good of society, than the former can be gratified without contributing to the preservation of the individual.

5. Emulation is merely the desire and hope of equality with, or superiority over, others with whom we compare ourselves. There does not appear to be any other grief in the natural passion, but only that want which is implied in desire. However, this may be so strong as to be the occasion of great grief. To desire the attainment of this equality or superiority by the particular means of others being brought down to our own level, or below it, is, I think, the distinct notion of envy. From whence it is easy to see that the real end, which the natural passion, emulation, and which the unlawful one, envy, aims at, is exactly the same—namely, that equality or superiority and consequently that to do mischief is not the end of envy, but merely the means it makes use of to attain its end....

6. Ephes. ii. 3.

7. Every man in his physical nature is one individual single agent. He has likewise properties and principles, each of which may be considered separately, and without regard to the respects which they have to each other. Neither of these are the nature we are taking a view of. But it is the inward frame of man considered as a *system* or *constitution:* whose several parts are united, not by a physical principle of individuation, but by the respects they have to each other; the chief of which is the subjection which the appetites, passions, and particular affections have to the one supreme principle of reflection or conscience. The system or constitution is formed by and consists in these respects and this subjection. Thus the body is a *system* or *constitution:* so is a tree: so is every machine. Consider all the several parts of a tree without the natural respects they have to each other, and you have not at all the idea of a tree; but add these respects, and this gives you the idea. The body may be impaired by sickness, a tree may decay, a machine be out of order, and yet the system and constitution of them not totally dissolved. There is plainly somewhat which answers to all this in the moral constitution of man. Whoever will consider his own nature, will see that the several appetites, passions, and particular affections, have different respects among themselves. They are restraints upon, and are in a proportion to each other. This proportion is just and perfect, when all those under principles are perfectly coincident with conscience, so far as their nature permits, and in all cases under its absolute and entire direction. The least excess or defect, the least alteration of the due proportions amongst themselves, or of their coincidence with conscience, though not proceeding into action, is some degree of disorder in the moral constitution. But perfection, though plainly intelligible and unsupposable, was never attained by any man. If the higher principle of reflection maintains its place, and as much as it can corrects that disorder, and hinders it from breaking out into action, this is all that can be expected in such a creature as man. And though the appetites and passions have not their exact due proportion to each other; though they often strive for mastery with judgment or reflection: yet, since the superiority of this principle to all others is the chief respect which forms the constitution, so far as this superiority is maintained, the character, the man, is good, worthy, virtuous.

8. *St. Matt.* V: 48.

9. *I Cor.* XIII: 4–7.

10. For instance: as we are not competent judges what is upon the whole for the good of the world, there may be other immediate ends appointed us to pursue, besides that one of doing good or producing happiness. Though the good of the creation be the only end of the Author of it, yet He may have laid us under particular obligations, which we may discern and feel ourselves under, quite distinct from a perception that the observance or violation of them is for the happiness or misery of our fellow creatures. And this is in fact the case. For there are certain dispositions of mind, and certain actions, which are in themselves approved or disapproved by mankind, abstracted from the consideration of their tendency to the happiness or misery of the world; approved or disapproved by reflection, by that principle within, which is the guide of life, the judge of right and wrong. Numberless instances of this kind might be mentioned. There are pieces of treachery which in themselves appear base and detestable to every one. There are actions which perhaps can scarce have any other general name given them than indecencies, which yet are odious and shocking to human nature. There is such a thing as meanness, a little mind; which, as it is quite distinct from incapacity, so it raises a dislike and disapprobation quite different from that contempt which men are too apt to have of mere folly. On the other hand, what we call greatness of mind is the object of another sort of approbation than superior understanding. Fidelity, honor, strict justice are themselves approved in the highest degree, abstracted from the consideration of their tendency. Now, whether it be thought that each of these are connected with benevolence in our nature, and so may be considered as the same thing with it, or whether some of them be thought an inferior kind of virtues and vices, somewhat like natural beauties and deformities, or lastly, plain exceptions to the general rule—thus much however is certain that the things now instanced in, and numberless others, are approved or disapproved by mankind in general, in quite another view than as conducive to the happiness or misery of the world.

Study Questions

1. If nature were different, would morality be different?

2. What is a selfish action?

3. Can your conscience be mistaken?

4. Do morality and self-interest ever conflict?

10

DAVID HUME

David Hume (1711–1776), the influential Scottish philosopher, maintains that morality is based on sentiment, not reason. Reason alone cannot motivate us to act, but morality involves actions and thus falls outside reason's domain. Moral distinctions are determined by feelings of approval and disapproval and are not implied by the results of empirical research. Thus any valid argument that rests only on factual assertions cannot by itself lead to a conclusion that is a value judgment.

A Treatise of Human Nature

BOOK II
OF THE PASSIONS

Part III
Of the Will
and Direct Passions

Section III
Of the Influencing Motives of the Will

Nothing is more usual in philosophy, and even in common life, than to talk of the combat of passion and reason, to give the preference to reason, and assert that men are only so far virtuous as they conform themselves to its dictates. Every rational creature, it is said, is obliged to regulate his actions by reason; and if any other motive or principle challenge the direction of his conduct, he ought to oppose it, till it be entirely subdued, or at least brought to a conformity with that superior principle. On this method of thinking the greatest part of moral philosophy, ancient and modern, seems to be founded; nor is there an ampler field, as well for metaphysical arguments, as popular declamations, than this supposed preëminence of reason above passion. The eternity, invariableness, and divine origin of the former, have been displayed to the best advantage: the blindness, inconstancy, and deceitfulness of the latter, have been as strongly insisted on. In order to show the fallacy of all this philosophy, I shall endeavour to prove *first,* that reason alone can never be a motive to any action of the will; and *secondly,* that it can never oppose passion in the direction of the will.

The understanding exerts itself after two different ways, as it judges from demonstration or probability; as it regards the abstract relations of our ideas, or those relations of objects of which experience only gives us information. I believe it scarce will be asserted, that the first species of reasoning alone is ever the cause of any action. As its proper province is the world of ideas, and as the will always places us in that of realities, demonstration and volition seem upon that account to be totally removed from each other. Mathematics, indeed, are useful in all mechanical operations, and arithmetic in almost

From *A Treatise of Human Nature*, David Hume (1739–1740).

every art and profession: but it is not of themselves they have any influence. Mechanics are the art of regulating the motions of bodies *to some designed end or purpose;* and the reason why we employ arithmetic in fixing the proportions of numbers, is only that we may discover the proportions of their influence and operation. A merchant is desirous of knowing the sum total of his accounts with any person: why? but that he may learn what sum will have the same *effects* in paying his debt, and going to market, as all the particular articles taken together. Abstract or demonstrative reasoning, therefore, never influences any of our actions, but only as it directs our judgment concerning causes and effects; which leads us to the second operation of the understanding.

It is obvious, that when we have the prospect of pain or pleasure from any object, we feel a consequent emotion of aversion or propensity, and are carried to avoid or embrace what will give us this uneasiness or satisfaction. It is also obvious, that this emotion rests not here, but, making us cast our view on every side, comprehends whatever objects are connected with its original one by the relation of cause and effect. Here then reasoning takes place to discover this relation; and according as our reasoning varies, our actions receive a subsequent variation. But it is evident, in this case, that the impulse arises not from reason, but is only directed by it. It is from the prospect of pain or pleasure that the aversion or propensity arises towards any object: and these emotions extend themselves to the causes and effects of that object, as they are pointed out to us by reason and experience. It can never in the least concern us to know, that such objects are causes, and such others effects, if both the causes and effects be indifferent to us. Where the objects themselves do not affect us, their connection can never give them any influence; and it is plain that, as reason is nothing but the discovery of this connection, it cannot be by its means that the objects are able to affect us.

Since reason alone can never produce any action, or give rise to volition, I infer, that the same faculty is as incapable of preventing volition, or of disputing the preference with any passion or emotion. This consequence is necessary. It is impossible reason could have the latter effect of preventing volition, but by giving an impulse in a contrary direction to our passions; and that impulse, had it operated alone, would have been ample to produce volition. Nothing can oppose or retard the impulse of passion, but a contrary impulse; and if this contrary impulse ever arises from reason, that latter faculty must have an original influence on the will, and must be able to cause, as well as hinder, any act of volition. But if reason has no original influence, it is impossible it can withstand any principle which has such an efficacy, or ever keep the mind in suspense a moment. Thus, it appears, that the principle which opposes our passion cannot be the same with reason, and is only called so in an improper sense. We speak not strictly and philosophically, when we talk of the combat of passion and of reason. Reason is, and ought only to be, the slave of the passions, and can never pretend to any other office than to serve and obey them. As this opinion may appear somewhat extraordinary, it may not be improper to confirm it by some other considerations.

A passion is an original existence, or, if you will, modification of existence, and contains not any representative quality, which renders it a copy of any other existence or modification. When I am angry, I am actually possessed with the passion, and in that emotion have no more a reference to any other object, than when I am thirsty, or sick, or more than five feet high. It is impossible, therefore, that this passion can be opposed by, or be contradictory to truth and reason; since this contradiction consists in the disagreement of ideas, considered as copies, with those objects which they represent.

What may at first occur on this head is, that as nothing can be contrary to truth or reason, except what has a reference to it, and as the judgments of our understanding only have this reference, it must follow that passions can be contrary to reason only, so far as they are *accompanied* with some judgment or opinion. According to this principle, which is so obvious and natural, it is only in two senses that any affection can be called unreasonable. First, When a passion, such as hope or fear, grief or joy, despair or security, is founded on the supposition of the existence of objects, which really do not exist. Secondly,

When in exerting any passion in action, we choose means sufficient for the designed end, and deceive ourselves in our judgment of causes and effects. Where a passion is neither founded on false suppositions, nor chooses means insufficient for the end, the understanding can neither justify nor condemn it. It is not contrary to reason to prefer the destruction of the whole world to the scratching of my finger. It is not contrary to reason for me to choose my total ruin, to prevent the least uneasiness of an Indian, or person wholly unknown to me. It is as little contrary to reason to prefer even my own acknowledged lesser good to my greater, and have a more ardent affection for the former than the latter. A trivial good may, from certain circumstances, produce a desire superior to what arises from the greatest and most valuable enjoyment; nor is there anything more extraordinary in this, than in mechanics to see one pound weight raise up a hundred by the advantage of its situation. In short, a passion must be accompanied with some false judgment, in order to its being unreasonable; and even then it is not the passion, properly speaking, which is unreasonable, but the judgment.

The consequences are evident. Since a passion can never, in any sense, be called unreasonable, but when founded on a false supposition, or when it chooses means insufficient for the designed end, it is impossible that reason and passion can ever oppose each other, or dispute for the government of the will and actions. The moment we perceive the falsehood of any supposition, or the insufficiency of any means, our passions yield to our reason without any opposition. I may desire any fruit as of an excellent relish; but whenever you convince me of my mistake, my longing ceases. I may will the performance of certain actions as means of obtaining any desired good; but as my willing of these actions is only secondary, and founded on the supposition that they are causes of the proposed effect; as soon as I discover the falsehood of that supposition, they must become indifferent to me.

It is natural for one, that does not examine objects with a strict philosophic eye, to imagine, that those actions of the mind are entirely the same, which produce not a different sensation, and are not immediately distinguishable to the feeling and perception.

Reason, for instance, exerts itself without producing any sensible emotions; and except in the more sublime disquisitions of philosophy, or in the frivolous subtilties of the schools, scarce ever conveys any pleasure or uneasiness. Hence it proceeds, that every action of the mind which operates with the same calmness and tranquillity, is confounded with reason by all those who judge of things from the first view and appearance. Now it is certain there are certain calm desires and tendencies, which, though they be real passions, produce little emotion in the mind, and are more known by their effects than by the immediate feeling or sensation. These desires are of two kinds; either certain instincts originally implanted in our natures, such as benevolence and resentment, the love of life, and kindness to children; or the general appetite to good, and aversion to evil, considered merely as such. When any of these passions are calm, and cause no disorder in the soul, they are very readily taken for the determinations of reason, and are supposed to proceed from the same faculty with that which judges of truth and falsehood. Their nature and principles have been supposed the same, because their sensations are not evidently different.

Besides these calm passions, which often determine the will, there are certain violent emotions of the same kind, which have likewise a great influence on that faculty. When I receive any injury from another, I often feel a violent passion of resentment, which makes me desire his evil and punishment, independent of all considerations of pleasure and advantage to myself. When I am immediately threatened with any grievous ill, my fears, apprehensions, and aversions rise to a great height, and produce a sensible emotion.

The common error of metaphysicians has lain in ascribing the direction of the will entirely to one of these principles, and supposing the other to have no influence. Men often act knowingly against their interest; for which reason, the view of the greatest possible good does not always influence them. Men often counteract a violent passion in prosecution of their interests and designs; it is not, therefore, the present uneasiness alone which determines them. In general we may observe that both these principles operate on the will; and where they are contrary, that either of them

prevails, according to the *general* character or *present* disposition of the person. What we call strength of mind, implies the prevalence of the calm passions above the violent; though we may easily observe, there is no man so constantly possessed of this virtue as never on any occasion to yield to the solicitations of passion and desire. From these variations of temper proceeds the great difficulty of deciding concerning the actions and resolutions of men, where there is any contrariety of motives and passions.

BOOK III
OF MORALS

Part I
Of Virtue and Vice in General

Section I
Moral Distinctions Not Derived from Reason

There is an inconvenience which attends all abstruse reasoning, that it may silence, without convincing an antagonist, and requires the same intense study to make us sensible of its force, that was at first requisite for its invention. When we leave our closet, and engage in the common affairs of life, its conclusions seem to vanish like the phantoms of the night on the appearance of the morning; and it is difficult for us to retain even that conviction which we had attained with difficulty. This is still more conspicuous in a long chain of reasoning, where we must preserve to the end the evidence of the first propositions, and where we often lose sight of all the most received maxims, either of philosophy or common life. I am not, however, without hopes, that the present system of philosophy will acquire new force as it advances; and that our reasonings concerning *morals* will corroborate whatever has been said concerning the *understanding* and the *passions*. Morality is a subject that interests us above all others; we fancy the peace of society to be at stake in every decision concerning it; and it is evident that this concern must make our speculations appear more real and solid, than where the subject is in a great measure indifferent to us. What affects

us, we conclude, can never be a chimera; and, as our passion is engaged on the one side or the other, we naturally think that the question lies within human comprehension; which, in other cases of this nature, we are apt to entertain some doubt of. Without this advantage, I never should have ventured upon a third volume of such abstruse philosophy, in an age wherein the greatest part of men seem agreed to convert reading into an amusement, and to reject everything that requires any considerable degree of attention to be comprehended.

It has been observed, that nothing is ever present to the mind but its perceptions; and that all the actions of seeing, hearing, judging, loving, hating, and thinking, fall under this denomination. The mind can never exert itself in any action which we may not comprehend under the term of *perception;* and consequently that term is no less applicable to those judgments by which we distinguish moral good and evil, than to every other operation of the mind. To approve of one character, to condemn another, are only so many different perceptions.

Now, as perceptions resolve themselves into two kinds, viz. *impressions* and *ideas,* this distinction gives rise to a question, with which we shall open up our present inquiry concerning morals, *whether it is by means of our* ideas *or* impressions *we distinguish betwixt vice and virtue, and pronounce an action blamable or praiseworthy?* This will immediately cut off all loose discourses and declamations, and reduce us to something precise and exact on the present subject.

Those who affirm that virtue is nothing but a conformity to reason; that there are eternal fitnesses and unfitnesses of things, which are the same to every rational being that considers them; that the immutable measure of right and wrong impose an obligation, not only on human creatures, but also on the Deity himself: all these systems concur in the opinion, that morality, like truth, is discerned merely by ideas, and by their juxtaposition and comparison. In order, therefore, to judge of these systems, we need only consider whether it be possible from reason alone, to distinguish betwixt moral good and evil, or whether there must concur some other principles to enable us to make that distinction.

If morality had naturally no influence on human passions and actions, it were in vain to take such pains to inculcate it; and nothing would be more fruitless than that multitude of rules and precepts with which all moralists abound. Philosophy is commonly divided into *speculative* and *practical;* and as morality is always comprehended under the latter division, it is supposed to influence our passions and actions, and to go beyond the calm and indolent judgments of the understanding. And this is confirmed by common experience, which informs us that men are often governed by their duties, and are deterred from some actions by the opinion of injustice, and impelled to others by that of obligation.

Since morals, therefore, have an influence on the actions and affections, it follows that they cannot be derived from reason; and that because reason alone, as we have already proved, can never have any such influence. Morals excite passions, and produce or prevent actions. Reason of itself is utterly impotent in this particular. The rules of morality, therefore, are not conclusions of our reason.

No one, I believe, will deny the justness of this inference; nor is there any other means of evading it, than by denying that principle on which it is founded. As long as it is allowed, that reason has no influence on our passions and actions, it is in vain to pretend that morality is discovered only by a deduction of reason. An active principle can never be founded on an inactive; and if reason be inactive in itself, it must remain so in all its shapes and appearances, whether it exerts itself in natural or moral subjects, whether it considers the powers of external bodies, or the actions of rational beings.

It would be tedious to repeat all the arguments by which I have proved that reason is perfectly inert, and can never either prevent or produce any action or affection. It will be easy to recollect what has been said upon that subject. I shall only recall on this occasion one of these arguments, which I shall endeavour to render still more conclusive, and more applicable to the present subject.

Reason is the discovery of truth or falsehood. Truth or falsehood consists in an agreement or disagreement either to the *real* relations of ideas, or to *real* existence and matter of fact. Whatever therefore is not susceptible of this agreement or disagreement, is incapable of being true or false, and can never be an object of our reason. Now, it is evident our passions, volitions, and actions, are not susceptible of any such agreement or disagreement; being original facts and realities, complete in themselves, and implying no reference to other passions, volitions, and actions. It is impossible, therefore, they can be pronounced either true or false, and be either contrary or conformable to reason.

This argument is of double advantage to our present purpose. For it proves *directly,* that actions do not derive their merit from a conformity to reason, nor their blame from a contrariety to it; and it proves the same truth more *indirectly,* by showing us, that as reason can never immediately prevent or produce any action by contradicting or approving of it, it cannot be the source of moral good and evil, which are found to have that influence. Actions may be laudable or blamable; but they cannot be reasonable or unreasonable: laudable or blamable, therefore, are not the same with reasonable or unreasonable. The merit and demerit of actions frequently contradict, and sometimes control our natural propensities. But reason has no such influence. Moral distinctions, therefore, are not the offspring of reason. Reason is wholly inactive, and can never be the source of so active a principle as conscience, or a sense of morals.

But perhaps it may be said, that though no will or action can be immediately contradictory to reason, yet we may find such a contradiction in some of the attendants of the actions, that is, in its causes or effects. The action may cause a judgment, or may be *obliquely* caused by one, when the judgment concurs with a passion; and by an abusive way of speaking, which philosophy will scarce allow of, the same contrariety may, upon that account, be ascribed to the action. How far this truth or falsehood may be the source of morals, it will now be proper to consider.

It has been observed that reason, in a strict and philosophical sense, can have an influence on our conduct only after two ways: either when it excites a passion,

by informing us of the existence of something which is a proper object of it; or when it discovers the connection of causes and effects, so as to afford us means of exerting any passion. These are the only kinds of judgment which can accompany our actions, or can be said to produce them in any manner; and it must be allowed, that these judgments may often be false and erroneous. A person may be affected with passion, by supposing a pain or pleasure to lie in an object which has no tendency to produce either of these sensations, or which produces the contrary to what is imagined. A person may also take false measures for the attaining of his end, and may retard, by his foolish conduct, instead of forwarding the execution of any object. These false judgments may be thought to affect the passions and actions, which are connected with them, and may be said to render them unreasonable, in a figurative and improper way of speaking. But though this be acknowledged, it is easy to observe, that these errors are so far from being the source of all immorality, that they are commonly very innocent, and draw no manner of guilt upon the person who is so unfortunate as to fall into them. They extend not beyond a mistake of *fact,* which moralists have not generally supposed criminal, as being perfectly involuntary. I am more to be lamented than blamed, if I am mistaken with regard to the influence of objects in producing pain or pleasure, or if I know not the proper means of satisfying my desires. No one can ever regard such errors as a defect in my moral character. A fruit, for instance, that is really disagreeable, appears to me at a distance, and, through mistake, I fancy it to be pleasant and delicious. Here is one error. I choose certain means of reaching this fruit, which are not proper for my end. Here is a second error; nor is there any third one, which can ever possibly enter into our reasonings concerning actions. I ask, therefore, if a man in this situation, and guilty of these two errors, is to be regarded as vicious and criminal, however unavoidable they might have been? Or if it be possible to imagine that such errors are the sources of all immorality?

And here it may be proper to observe, that if moral distinctions be derived from the truth or falsehood of those judgments, they must take place wherever we form the judgments; nor will there be any difference, whether the question be concerning an apple or a kingdom, or whether the error be avoidable or unavoidable.

For as the very essence of morality is supposed to consist in an agreement or disagreement to reason, the other circumstances are entirely arbitrary, and can never either bestow on any action the character of virtuous or vicious, or deprive it of that character. To which we may add, that this agreement or disagreement, not admitting of degrees, all virtues and vices would of course be equal.

Should it be pretended, that though a mistake of *fact* be not criminal, yet a mistake of *right* often is; and that this may be the source of immorality: I would answer, that it is impossible such a mistake can ever be the original source of immorality, since it supposes a real right and wrong; that is, a real distinction in morals, independent of these judgments. A mistake, therefore, of right, may become a species of immorality; but it is only a secondary one, and is founded on some other antecedent to it.

As to those judgments which are the *effects* of our actions, and which, when false, give occasion to pronounce the actions contrary to truth and reason; we may observe, that our actions never cause any judgment, either true or false, in ourselves, and that it is only on others they have such an influence. It is certain that an action, on many occasions, may give rise to false conclusions in others; and that a person, who, through a window, sees any lewd behaviour of mine with my neighbour's wife, may be so simple as to imagine she is certainly my own. In this respect my action resembles somewhat a lie or falsehood; only with this difference, which is material, that I perform not the action with any intention of giving rise to a false judgment in another, but merely to satisfy my lust and passion. It causes, however, a mistake and false judgment by accident; and the falsehood of its effects may be ascribed, by some odd figurative way of speaking, to the action itself. But still I can see no pretext of reason for asserting, that the tendency to cause such an error is the first spring or original source of all immorality.

Thus, upon the whole, it is impossible that the distinction betwixt moral good and evil can be made by reason; since that distinction has an influence upon our actions, of which reason alone is incapable. Reason and judgment may, indeed, be the mediate cause of an action, by prompting or by directing a passion; but it is not pretended that a judgment of this kind, either in its truth or falsehood, is attended with virtue or vice. And as to the judgments, which are caused by our judgments, they can still less bestow those moral qualities on the actions which are their causes.

But, to be more particular, and to show that those eternal immutable fitnesses and unfitnesses of things cannot be defended by sound philosophy, we may weigh the following considerations.

If the thought and understanding were alone capable of fixing the boundaries of right and wrong, the character of virtuous and vicious either must lie in some relations of objects, or must be a matter of fact which is discovered by our reasoning. This consequence is evident. As the operations of human understanding divide themselves into two kinds, the comparing of ideas, and the inferring of matter of fact, were virtue discovered by the understanding, it must be an object of one of these operations; nor is there any third operation of the understanding which can discover it. There has been an opinion very industriously propagated by certain philosophers, that morality is susceptible of demonstration; and though no one has ever been able to advance a single step in those demonstrations, yet it is taken for granted that this science may be brought to an equal certainty with geometry or algebra. Upon this supposition, vice and virtue must consist in some relations; since it is allowed on all hands, that no matter of fact is capable of being demonstrated. Let us therefore begin with examining this hypothesis, and endeavour, if possible, to fix those moral qualities which have been so long the objects of our fruitless researches; point out distinctly the relations which constitute morality or obligation, that we may know wherein they consist, and after what manner we must judge of them.

If you assert that vice and virtue consist in relations susceptible of certainty and demonstration, you must confine yourself to those *four* relations which alone admit of that degree of evidence; and in that case you run into absurdities from which you will never be able to extricate yourself. For as you make the very essence of morality to lie in the relations, and as there is no one of these relations but what is applicable, not only to an irrational but also to an inanimate object, it follows that even such objects must be susceptible of merit or demerit. *Resemblance, contrariety, degrees in quality,* and *proportions in quantity and number;* all these relations belong as properly to matter as to our actions, passions, and volitions. It is unquestionable, therefore, that morality lies not in any of these relations, nor the sense of it in their discovery.

Should it be asserted, that the sense of morality consists in the discovery of some relation distinct from these, and that our enumeration was not complete when we comprehended all demonstrable relations under four general heads; to this I know not what to reply, till some one be so good as to point out to me this new relation. It is impossible to refute a system which has never yet been explained. In such a manner of fighting in the dark, a man loses his blows in the air, and often places them where the enemy is not present.

I must therefore, on this occasion, rest contented with requiring the two following conditions of any one that would undertake to clear up this system. *First,* as moral good and evil belong only to the actions of the mind, and are derived from our situation with regard to external objects, the relations from which these moral distinctions arise must lie only betwixt internal actions and external objects, and must not be applicable either to internal actions, compared among themselves, or to external objects, when placed in opposition to other external objects. For as morality is supposed to attend certain relations, if these relations could belong to internal actions considered singly, it would follow, that we might be guilty of crimes in ourselves, and independent of our situation with respect to the universe; and in like manner, if these moral relations could be applied to external objects, it would follow that even inanimate beings would be susceptible of moral beauty

and deformity. Now, it seems difficult to imagine that any relation can be discovered betwixt our passions, volitions, and actions, compared to external objects, which relation might not belong either to these passions and volitions, or to these external objects, compared among *themselves.*

But it will be still more difficult to fulfil the *second* condition, requisite to justify this system. According to the principles of those who maintain an abstract rational difference betwixt moral good and evil, and a natural fitness and unfitness of things, it is not only supposed, that these relations, being eternal and immutable, are the same, when considered by every rational creature, but their *effects* are also supposed to be necessarily the same; and it is concluded they have no less, or rather a greater, influence in directing the will of the Deity, than in governing the rational and virtuous of our own species. These two particulars are evidently distinct. It is one thing to know virtue, and another to conform the will to it. In order, therefore, to prove that the measures of right and wrong are eternal laws, *obligatory* on every rational mind, it is not sufficient to show the relations upon which they are founded: we must also point out the connection betwixt the relation and the will; and must prove that this connection is so necessary, that in every well-disposed mind, it must take place and have its influence; though the difference betwixt these minds be in other respects immense and infinite. Now, besides what I have already proved, that even in human nature no relation can ever alone produce any action; besides this, I say, it has been shown, in treating of the understanding, that there is no connection of cause and effect, such as this is supposed to be, which is discoverable otherwise than by experience, and of which we can pretend to have any security by the simple consideration of the objects. All beings in the universe, considered in themselves, appear entirely loose and independent of each other. It is only by experience we learn their influence and connection; and this influence we ought never to extend beyond experience.

Thus it will be impossible to fulfil the *first* condition required to the system of eternal rational measures of right and wrong; because it is impossible to show those relations, upon which such a distinction may be founded: and it is as impossible to fulfil the *second* condition; because we cannot prove *a priori,* that these relations, if they really existed and were perceived, would be universally forcible and obligatory.

But to make these general reflections more clear and convincing, we may illustrate them by some particular instances, wherein this character of moral good or evil is the most universally acknowledged. Of all crimes that human creatures are capable of committing, the most horrid and unnatural is ingratitude, especially when it is committed against parents, and appears in the more flagrant instances of wounds and death. This is acknowledged by all mankind, philosophers as well as the people: the question only arises among philosophers, whether the guilt or moral deformity of this action be discovered by demonstrative reasoning, or be felt by an internal sense, and by means of some sentiment, which the reflecting on such an action naturally occasions. This question will soon be decided against the former opinion, if we can show the same relations in other objects, without the notion of any guilt or iniquity attending them. Reason or science is nothing but the comparing of ideas, and the discovery of their relations; and if the same relations have different characters, it must evidently follow, that those characters are not discovered merely by reason. To put the affair, therefore, to this trial, let us choose any inanimate object, such as an oak or elm; and let us suppose, that, by the dropping of its seed, it produces a sapling below it, which, springing up by degrees, at last overtops and destroys the parent tree: I ask, if, in this instance, there be wanting any relation which is discoverable in parricide or ingratitude? Is not the one tree the cause of the other's existence; and the latter the cause of the destruction of the former, in the same manner as when a child murders his parent? It is not sufficient to reply, that a choice or will is wanting. For in the case of parricide, a will does not give rise to any *different* relations, but is only the cause from which the action is derived; and consequently produces the *same* relations, that in the oak or elm arise

from some other principles. It is a will or choice that determines a man to kill his parent: and they are the laws of matter and motion that determine a sapling to destroy the oak from which it sprung. Here then the same relations have different causes; but still the relations are the same: and as their discovery is not in both cases attended with a notion of immorality, it follows, that that notion does not arise from such a discovery.

But to choose an instance still more resembling; I would fain ask any one, why incest in the human species is criminal, and why the very same action, and the same relations in animals, have not the smallest moral turpitude and deformity? If it be answered, that this action is innocent in animals, because they have not reason sufficient to discover its turpitude; but that man, being endowed with that faculty, which *ought* to restrain him to his duty, the same action instantly becomes criminal to him. Should this be said, I would reply, that this is evidently arguing in a circle. For, before reason can perceive this turpitude, the turpitude must exist; and consequently is independent of the decisions of our reason, and is their object more properly than their effect. According to this system, then, every animal that has sense and appetite and will, that is, every animal must be susceptible of all the same virtues and vices, for which we ascribe praise and blame to human creatures. All the difference is, that our superior reason may serve to discover the vice or virtue, and by that means may augment the blame or praise: but still this discovery supposes a separate being in these moral distinctions, and a being which depends only on the will and appetite, and which, both in thought and reality, may be distinguished from reason. Animals are susceptible of the same relations with respect to each other as the human species, and therefore would also be susceptible of the same morality, if the essence of morality consisted in these relations. Their want of a sufficient degree of reason may hinder them from perceiving the duties and obligations of morality, but can never hinder these duties from existing; since they must antecedently exist, in order to their being perceived. Reason must find them, and can never produce them. This argument deserves

to be weighed, as being, in my opinion, entirely decisive.

Nor does this reasoning only prove, that morality consists not in any relations that are the objects of science; but if examined, will prove with equal certainty, that it consists not in any *matter of fact,* which can be discovered by the understanding. This is the *second* part of our argument; and if it can be made evident, we may conclude that morality is not an object of reason. But can there be any difficulty in proving that vice and virtue are not matters of fact, whose existence we can infer by reason? Take any action allowed to be vicious; wilful murder, for instance. Examine it in all lights, and see if you can find that matter of fact, or real existence, which you call *vice.* In whichever way you take it, you find only certain passions, motives, volitions, and thoughts. There is no other matter of fact in the case. The vice entirely escapes you, as long as you consider the object. You never can find it, till you turn your reflection into your own breast, and find a sentiment of disapprobation, which arises in you, towards this action. Here is a matter of fact; but it is the object of feeling, not of reason. It lies in yourself, not in the object. So that when you pronounce any action or character to be vicious, you mean nothing, but that from the constitution of your nature you have a feeling or sentiment of blame from the contemplation of it. Vice and virtue, therefore, may be compared to sounds, colours, heat, and cold, which, according to modern philosophy, are not qualities in objects, but perceptions in the mind: and this discovery in morals, like that other in physics, is to be regarded as a considerable advancement of the speculative sciences; though, like that too, it has little or no influence on practice. Nothing can be more real, or concern us more, than our own sentiments of pleasure and uneasiness; and if these be favourable to virtue, and unfavourable to vice, no more can be requisite to the regulation of our conduct and behaviour.

I cannot forbear adding to these reasonings an observation, which may, perhaps, be found of some importance. In every system of morality which I have hitherto met with, I have always remarked, that the author proceeds for some time in the ordinary way

of reasoning, and establishes the being of a God, or makes observations concerning human affairs; when of a sudden I am surprised to find, that instead of the usual copulations of propositions, *is,* and *is not,* I meet with no proposition that is not connected with an *ought,* or an *ought not.* This change is imperceptible; but is, however, of the last consequence. For as this *ought,* or *ought not,* expresses some new relation or affirmation, it is necessary that it should be observed and explained; and at the same time that a reason should be given, for what seems altogether inconceivable, how this new relation can be a deduction from others, which are entirely different from it. But as authors do not commonly use this precaution, I shall presume to recommend it to the readers; and am persuaded, that this small attention would subvert all the vulgar systems of morality, and let us see that the distinction of vice and virtue is not founded merely on the relations of objects, nor is perceived by reason.

Section II
Moral Distinctions Derived From a Moral Sense

Thus the course of the argument leads us to conclude, that since vice and virtue are not discoverable merely by reason, or the comparison of ideas, it must be by means of some impression or sentiment they occasion, that we are able to mark the difference betwixt them. Our decisions concerning moral rectitude and depravity are evidently perceptions; and as all perceptions are either impressions or ideas, the exclusion of the one is a convincing argument for the other. Morality, therefore, is more properly felt than judged of; though this feeling or sentiment is commonly so soft and gentle that we are apt to confound it with an idea, according to our common custom of taking all things for the same which have any near resemblance to each other.

The next question is, of what nature are these impressions, and after what manner do they operate upon us? Here we cannot remain long in suspense, but must pronounce the impression arising from virtue to be agreeable, and that proceeding from vice to be uneasy. Every moment's experience

must convince us of this. There is no spectacle so fair and beautiful as a noble and generous action; nor any which gives us more abhorrence than one that is cruel and treacherous. No enjoyment equals the satisfaction we receive from the company of those we love and esteem; as the greatest of all punishments is to be obliged to pass our lives with those we hate or contemn. A very play or romance may afford us instances of this pleasure which virtue conveys to us; and pain, which arises from vice.

Now, since the distinguishing impressions by which moral good or evil is known, are nothing but *particular* pains or pleasures, it follows, that in all inquiries concerning these moral distinctions, it will be sufficient to show the principles which make us feel a satisfaction or uneasiness from the survey of any character, in order to satisfy us why the character is laudable or blamable. An action, or sentiment, or character, is virtuous or vicious; why? because its view causes a pleasure or uneasiness of a particular kind. In giving a reason, therefore, for the pleasure or uneasiness, we sufficiently explain the vice or virtue. To have the sense of virtue, is nothing but to *feel* a satisfaction of a particular kind from the contemplation of a character. The very *feeling* constitutes our praise or admiration. We go no further; nor do we inquire into the cause of the satisfaction. We do not infer a character to be virtuous, because it pleases; but in feeling that it pleases after such a particular manner, we in effect feel that it is virtuous. The case is the same as in our judgments concerning all kinds of beauty, and tastes, and sensations. Our approbation is implied in the immediate pleasure they convey to us.

I have objected to the system which establishes eternal rational measures of right and wrong, that it is impossible to show, in the actions of reasonable creatures, any relations which are not found in external objects; and therefore, if morality always attended these relations, it were possible for inanimate matter to become virtuous or vicious. Now it may, in like manner, be objected to the present system, that if virtue and vice be determined by pleasure and pain, these qualities must, in every case, arise from the sensations; and consequently any object, whether animate or inanimate, rational or

irrational, might become morally good or evil, provided it can excite a satisfaction or uneasiness. But though this objection seems to be the very same, it has by no means the same force in the one case as in the other. For, *first,* it is evident that, under the term *pleasure,* we comprehend sensations, which are very different from each other, and which have only such a distant resemblance as is requisite to make them be expressed by the same abstract term. A good composition of music and a bottle of good wine equally produce pleasure; and, what is more, their goodness is determined merely by the pleasure. But shall we say, upon that account, that the wine is harmonious, or the music of a good flavour? In like manner, an inanimate object, and the character or sentiments of any person, may, both of them, give satisfaction; but, as the satisfaction is different, this keeps our sentiments concerning them from being confounded, and makes us ascribe virtue to the one and not to the other. Nor is every sentiment of pleasure or pain, which arises from characters and actions, of that *peculiar* kind which makes us praise or condemn. The good qualities of an enemy are hurtful to us, but may still command our esteem and respect. It is only when a character is considered in general, without reference to our particular interest, that it causes such a feeling or sentiment as denominates it morally good or evil. It is true, those sentiments from interest and morals are apt to be confounded, and naturally run into one another. It seldom happens that we do not think an enemy vicious, and can distinguish betwixt his opposition to our interest and real villainy or baseness. But this hinders not but that the sentiments are in themselves distinct; and a man of temper and judgment may preserve himself from these illusions. In like manner, though it is certain a musical voice is nothing but one that naturally gives a *particular* kind of pleasure; yet it is difficult for a man to be sensible that the voice of an enemy is agreeable, or to allow it to be musical. But a person of a fine ear, who has the command of himself, can separate these feelings, and give praise to what deserves it.

Secondly, we may call to remembrance the preceding system of the passions, in order to remark a still more considerable difference among our pains and pleasures. Pride and humility, love and hatred, are excited, when there is anything presented to us that both bears a relation to the object of the passion, and produces a separate sensation, related to the sensation of the passion. Now, virtue and vice are attended with these circumstances. They must necessarily be placed either in ourselves or others, and excite either pleasure or uneasiness; and therefore must give rise to one of these four passions, which clearly distinguishes them from the pleasure and pain arising from inanimate objects, that often bear no relation to us; and this is, perhaps, the most considerable effect that virtue and vice have upon the human mind.

It may now be asked, *in general,* concerning this pain or pleasure that distinguishes moral good and evil, *From what principle is it derived, and whence does it arise in the human mind?* To this I reply, *first,* that it is absurd to imagine that, in every particular instance, these sentiments are produced by an *original* quality and *primary* constitution. For as the number of our duties is in a manner infinite, it is impossible that our original instincts should extend to each of them, and from our very first infancy impress on the human mind all that multitude of precepts which are contained in the completest system of ethics. Such a method of proceeding is not conformable to the usual maxims by which nature is conducted, where a few principles produce all that variety we observe in the universe, and everything is carried on in the easiest and most simple manner. It is necessary, therefore, to abridge these primary impulses, and find some more general principles upon which all our notions of morals are founded.

But, in the *second* place, should it be asked, whether we ought to search for these principles in *nature,* or whether we must look for them in some other origin? I would reply, that our answer to this question depends upon the definition of the word Nature, than which there is none more ambiguous and equivocal. If *nature* be opposed to miracles, not only the distinction betwixt vice and virtue is natural, but also every event which has ever happened in the world, *excepting those miracles on which our*

religion is founded. In saying, then, that the sentiments of vice and virtue are natural in this sense, we make no very extraordinary discovery.

But *nature* may also be opposed to rare and unusual; and in this sense of the word, which is the common one, there may often arise disputes concerning what is natural or unnatural; and one may in general affirm, that we are not possessed of any very precise standard by which these disputes can be decided. Frequent and rare depend upon the number of examples we have observed; and as this number may gradually increase or diminish, it will be impossible to fix any exact boundaries betwixt them. We may only affirm on this head, that if ever there was anything which could be called natural in this sense, the sentiments of morality certainly may; since there never was any nation of the world, nor any single person in any nation, who was utterly deprived of them, and who never, in any instance, showed the least approbation or dislike of manners. These sentiments are so rooted in our constitution and temper, that, without entirely confounding the human mind by disease or madness, it is impossible to extirpate and destroy them.

But *nature* may also be opposed to artifice, as well as to what is rare and unusual; and in this sense it may be disputed, whether the notions of virtue be natural or not. We readily forget that the designs, and projects, and views of men are principles as necessary in their operation as heat and cold, moist and dry; but, taking them to be free and entirely our own, it is usual for us to set them in opposition to the other principles of nature. Should it therefore be demanded, whether the sense of virtue be natural or artificial, I am of opinion that it is impossible for me at present to give any precise answer to this question. Perhaps it will appear afterwards that our sense of some virtues is artificial, and that of others natural. The discussion of this question will be more proper, when we enter upon an exact detail of each particular vice and virtue.

Meanwhile, it may not be amiss to observe, from these definitions of *natural* and *unnatural,* that nothing can be more unphilosophical than those systems which assert that virtue is the same with what is natural, and vice with what is unnatural. For, in the first sense of the word, nature, as opposed to miracles, both vice and virtue are equally natural; and, in the second sense, as opposed to what is unusual, perhaps virtue will be found to be the most unnatural. At least it must be owned, that heroic virtue, being as unusual, is as little natural as the most brutal barbarity. As to the third sense of the word, it is certain that both vice and virtue are equally artificial and out of nature. For, however it may be disputed, whether the notion of a merit or demerit in certain actions, be natural or artificial, it is evident that the actions themselves are artificial, and performed with a certain design and intention; otherwise they could never be ranked under any of these denominations. It is impossible, therefore, that the character of natural and unnatural can ever, in any sense, mark the boundaries of vice and virtue.

Thus we are still brought back to our first position, that virtue is distinguished by the pleasure, and vice by the pain, that any action, sentiment, or character, gives us by the mere view and contemplation. This decision is very commodious; because it reduces us to this simple question, *Why any action or sentiment, upon the general view or survey, gives a certain satisfaction or uneasiness,* in order to show the origin of its moral rectitude or depravity, without looking for any incomprehensible relations and qualities, which never did exist in nature, nor even in our imagination, by any clear and distinct conception? I flatter myself I have executed a great part of my present design by a state of the question, which appears to me so free from ambiguity and obscurity.

An Enquiry Concerning the Principles of Morals

SECTION I

Of the General Principles of Morals

Disputes with men, pertinaciously obstinate in their principles, are, of all others, the most irksome; except, perhaps, those with persons, entirely disingenuous, who really do not believe the opinions they defend, but engage in the controversy, from affectation, from a spirit of opposition, or from a desire of showing wit and ingenuity, superior to the rest of mankind. The same blind adherence to their own arguments is to be expected in both; the same contempt of their antagonists; and the same passionate vehemence, in inforcing sophistry and falsehood. And as reasoning is not the source, whence either disputant derives his tenets; it is in vain to expect, that any logic, which speaks not to the affections, will ever engage him to embrace sounder principles.

Those who have denied the reality of moral distinctions, may be ranked among the disingenuous disputants; nor is it conceivable, that any human creature could ever seriously believe, that all characters and actions were alike entitled to the affection and regard of everyone. The difference, which nature has placed between one man and another, is so wide, and this difference is still so much farther widened, by education, example, and habit, that, where the opposite extremes come at once under our apprehension, there is no scepticism so scrupulous, and scarce any assurance so determined, as absolutely to deny all distinction between them. Let a man's insensibility be ever so great, he must often be touched with the images of Right and Wrong; and let his prejudices be ever so obstinate, he must observe, that others are susceptible of like impressions. The only way, therefore, of converting an antagonist of this kind, is to leave him to himself. For, finding that nobody keeps up the controversy with him, it is probable he will, at last, of himself, from mere weariness, come over to the side of common sense and reason.

There has been a controversy started of late, much better worth examination, concerning the general foundation of Morals; whether they be derived from Reason, or from Sentiment; whether we attain the knowledge of them by a chain of argument and induction, or by an immediate feeling and finer internal sense; whether, like all sound judgement of truth and falsehood, they should be the same to every rational intelligent being; or whether, like the perception of beauty and deformity, they be founded entirely on the particular fabric and constitution of the human species.

The ancient philosophers, though they often affirm, that virtue is nothing but conformity to reason, yet, in general, seem to consider morals as deriving their existence from taste and sentiment. On the other hand, our modern enquirers, though they also talk much of the beauty of virtue, and deformity of vice, yet have commonly endeavoured to account for these distinctions by metaphysical reasonings, and by deductions from the most abstract principles of the understanding. Such confusion reigned in these subjects, that an opposition of the greatest consequence could prevail between one system and another, and even in the parts of almost each individual system; and yet nobody, till very lately, was ever sensible of it. The elegant Lord Shaftesbury, who first gave occasion to remark this distinction, and who, in general, adhered to the principles of the ancients, is not, himself, entirely free from the same confusion.

It must be acknowledged, that both sides of the question are susceptible of specious arguments. Moral distinctions, it may be said, are discernible by pure *reason:* else, whence the many disputes that reign in common life, as well as in philosophy, with regard to this subject: the long chain of

From *An Enquiry Concerning the Principles of Morals*, David Hume (1751).

proofs often produced on both sides; the examples cited, the authorities appealed to, the analogies employed, the fallacies detected, the inferences drawn, and the several conclusions adjusted to their proper principles. Truth is disputable; not taste: what exists in the nature of things is the standard of our judgement; what each man feels within himself is the standard of sentiment. Propositions in geometry may be proved, systems in physics may be controverted; but the harmony of verse, the tenderness of passion, the brilliancy of wit, must give immediate pleasure. No man reasons concerning another's beauty; but frequently concerning the justice or injustice of his actions. In every criminal trial the first object of the prisoner is to disprove the facts alleged, and deny the actions imputed to him: the second to prove, that, even if these actions were real, they might be justified, as innocent and lawful. It is confessedly by deductions of the understanding, that the first point is ascertained: how can we suppose that a different faculty of the mind is employed in fixing the other?

On the other hand, those who would resolve all moral determinations into *sentiment,* may endeavour to show, that it is impossible for reason ever to draw conclusions of this nature. To virtue, say they, it belongs to be *amiable,* and vice *odious.* This forms their very nature or essence. But can reason or argumentation distribute these different epithets to any subjects, and pronounce beforehand, that this must produce love, and that hatred? Or what other reason can we ever assign for these affections, but the original fabric and formation of the human mind, which is naturally adapted to receive them?

The end of all moral speculations is to teach us our duty; and, by proper representations of the deformity of vice and beauty of virtue, beget correspondent habits, and engage us to avoid the one, and embrace the other. But is this ever to be expected from inferences and conclusions of the understanding, which of themselves have no hold of the affections nor set in motion the active powers of men? They discover truths: but where the truths which they discover are indifferent, and beget no desire or aversion, they can have no influence on conduct and behaviour. What is honourable, what is fair, what is becoming, what is noble, what is generous, takes possession of the heart, and animates us to embrace and maintain it. What is intelligible, what is evident, what is probable, what is true, procures only the cool assent of the understanding; and gratifying a speculative curiosity, puts an end to our researches.

Extinguish all the warm feelings and prepossessions in favour of virtue, and all disgust or aversion to vice: render men totally indifferent towards these distinctions; and morality is no longer a practical study, nor has any tendency to regulate our lives and actions.

These arguments on each side (and many more might be produced) are so plausible, that I am apt to suspect, they may, the one as well as the other, be solid and satisfactory, and that *reason* and *sentiment* concur in almost all moral determinations and conclusions. The final sentence, it is probable, which pronounces characters and actions amiable or odious, praise-worthy or blameable; that which stamps on them the mark of honour or infamy, approbation or censure; that which renders morality an active principle and constitutes virtue our happiness, and vice our misery: it is probable, I say, that this final sentence depends on some internal sense or feeling, which nature has made universal in the whole species. For what else can have an influence of this nature? But in order to pave the way for such a sentiment, and give a proper discernment of its object, it is often necessary, we find, that much reasoning should precede, that nice distinctions be made, just conclusions drawn, distant comparisons formed, complicated relations examined, and general facts fixed and ascertained. Some species of beauty, especially the natural kinds, on their first appearance, command our affection and approbation; and where they fail of this effect, it is impossible for any reasoning to redress their influence, or adapt them better to our taste and sentiment. But in many orders of beauty, particularly those of the finer arts, it is requisite to employ much reasoning, in order to feel the proper sentiment; and a false relish may frequently be corrected by argument and reflection. There are just grounds to conclude, that moral beauty partakes much of this latter species, and demands the assistance of our intellectual

faculties, in order to give it a suitable influence on the human mind.

But though this question, concerning the general principles of morals, be curious and important, it is needless for us, at present, to employ farther care in our researches concerning it. For if we can be so happy, in the course of this enquiry, as to discover the true origin of morals, it will then easily appear how far either sentiment or reason enters into all determinations of this nature. In order to attain this purpose, we shall endeavour to follow a very simple method: we shall analyse that complication of mental qualities, which form what, in common life, we call Personal Merit: we shall consider every attribute of the mind, which renders a man an object either of esteem and affection, or of hatred and contempt; every habit or sentiment or faculty, which, if ascribed to any person, implies either praise or blame, and may enter into any panegyric or satire of his character and manners. The quick sensibility, which, on this head, is so universal among mankind, gives a philosopher sufficient assurance, that he can never be considerably mistaken in framing the catalogue, or incur any danger of misplacing the objects of his contemplation: he needs only enter into his own breast for a moment, and consider whether or not he should desire to have this or that quality ascribed to him, and whether such or such an imputation would proceed from a friend or an enemy. The very nature of language guides us almost infallibly in forming a judgement of this nature; and as every tongue possesses one set of words which are taken in a good sense, and another in the opposite, the least acquaintance with the idiom suffices, without any reasoning, to direct us in collecting and arranging the estimable or blameable qualities of men. The only object of reasoning is to discover the circumstances on both sides, which are common to these qualities; to observe that particular in which the estimable qualities agree on the one hand, and the blameable on the other; and thence to reach the foundation of ethics, and find those universal principles, from which all censure or approbation is ultimately derived. As this is a question of fact, not of abstract science, we can only expect success, by following the experimental method, and

deducing general maxims from a comparison of particular instances. The other scientific method, where a general abstract principle is first established, and is afterwards branched out into a variety of inferences and conclusions, may be more perfect in itself, but suits less the imperfection of human nature, and is a common source of illusion and mistake in this as well as in other subjects. Men are now cured of their passion for hypotheses and systems in natural philosophy, and will hearken to no arguments but those which are derived from experience. It is full time they should attempt a like reformation in all moral disquisitions; and reject every system of ethics, however subtle or ingenious, which is not founded on fact and observation.

We shall begin our enquiry on this head by the consideration of the social virtues, Benevolence and Justice. The explication of them will probably give us an opening by which the others may be accounted for.

SECTION II

Of Benevolence

Part I

It may be esteemed, perhaps, a superfluous task to prove, that the benevolent or softer affections are estimable; and wherever they appear, engage the approbation and good-will of mankind. The epithets *sociable, good-natured, humane, merciful, grateful, friendly, generous, beneficent,* or their equivalents, are known in all languages, and universally express the highest merit, which *human nature* is capable of attaining. Where these amiable qualities are attended with birth and power and eminent abilities, and display themselves in the good government or useful instruction of mankind, they seem even to raise the possessors of them above the rank of *human nature,* and make them approach in some measure to the divine. Exalted capacity, undaunted courage, prosperous success; these may only expose a hero or politician to the envy and ill-will of the public: but as soon as the praises are added of humane and beneficent;

when instances are displayed of lenity, tenderness or friendship; envy itself is silent, or joins the general voice of approbation and applause.

When Pericles, the great Athenian statesman and general, was on his death-bed, his surrounding friends, deeming him now insensible, began to indulge their sorrow for their expiring patron, by enumerating his great qualities and successes, his conquests and victories, the unusual length of his administration, and his nine trophies erected over the enemies of the republic. *You forget,* cries the dying hero, who had heard all, *you forget the most eminent of my praises, while you dwell so much on those vulgar advantages, in which fortune had a principal share. You have not observed that no citizen has ever yet worne mourning on my account.*

In men of more ordinary talents and capacity, the social virtues become, if possible, still more essentially requisite; there being nothing eminent, in that case, to compensate for the want of them, or preserve the person from our severest hatred, as well as contempt. A high ambition, an elevated courage, is apt, says Cicero, in less perfect characters, to degenerate into a turbulent ferocity. The more social and softer virtues are there chiefly to be regarded. These are always good and amiable.

The principal advantage, which Juvenal discovers in the extensive capacity of the human species, is that it renders our benevolence also more extensive, and gives us larger opportunities of spreading our kindly influence than what are indulged to the inferior creation. It must, indeed, be confessed, that by doing good only, can a man truly enjoy the advantages of being eminent. His exalted station, of itself but the more exposes him to danger and tempest. His sole prerogative is to afford shelter to inferiors, who repose themselves under his cover and protection.

But I forget, that it is not my present business to recommend generosity and benevolence, or to paint, in their true colours, all the genuine charms of the social virtues. These, indeed, sufficiently engage every heart, on the first apprehension of them; and it is difficult to abstain from some sally of panegyric, as often as they occur in discourse or reasoning. But our object here being more the speculative, than

the practical part of morals, it will suffice to remark, (what will readily, I believe, be allowed) that no qualities are more intitled to the general good-will and approbation of mankind than beneficence and humanity, friendship and gratitude, natural affection and public spirit, or whatever proceeds from a tender sympathy with others, and a generous concern for our kind and species. These wherever they appear, seem to transfuse themselves, in a manner, into each beholder, and to call forth, in their own behalf, the same favourable and affectionate sentiments, which they exert on all around.

Part II

We may observe that, in displaying the praises of any humane, beneficent man, there is one circumstance which never fails to be amply insisted on, namely, the happiness and satisfaction, derived to society from his intercourse and good offices. To his parents, we are apt to say, he endears himself by his pious attachment and duteous care still more than by the connexions of nature. His children never feel his authority, but when employed for their advantage. With him, the ties of love are consolidated by beneficence and friendship. The ties of friendship approach, in a fond observance of each obliging office, to those of love and inclination. His domestics and dependants have in him a sure resource; and no longer dread the power of fortune, but so far as she exercises it over him. From him the hungry receive food, the naked clothing, the ignorant and slothful skill and industry. Like the sun, an inferior minister of providence he cheers, invigorates, and sustains the surrounding world.

If confined to private life, the sphere of his activity is narrower; but his influence is all benign and gentle. If exalted into a higher station, mankind and posterity reap the fruit of his labours.

As these topics of praise never fail to be employed, and with success, where we would inspire esteem for any one; may it not thence be concluded, that the utility, resulting from the social virtues, forms, at least, a *part* of their merit, and is one source of that approbation and regard so universally paid to them?

When we recommend even an animal or a plant as *useful* and *beneficial,* we give it an applause and

recommendation suited to its nature. As, on the other hand, reflection on the baneful influence of any of these inferior beings always inspires us with the sentiment of aversion. The eye is pleased with the prospect of corn-fields and loaded vineyards; horses grazing, and flocks pasturing: but flies the view of briars and brambles, affording shelter to wolves and serpents.

A machine, a piece of furniture, a vestment, a house well contrived for use and conveniency, is so far beautiful, and is contemplated with pleasure and approbation. An experienced eye is here sensible to many excellencies, which escape persons ignorant and uninstructed.

Can anything stronger be said in praise of a profession, such as merchandise or manufacture, than to observe the advantages which it procures to society; and is not a monk and inquisitor enraged when we treat his order as useless or pernicious to mankind?

The historian exults in displaying the benefit arising from his labours. The writer of romance alleviates or denies the bad consequences ascribed to his manner of composition.

In general, what praise is implied in the simple epithet *useful!* What reproach in the contrary!

Your Gods, says Cicero, in opposition to the Epicureans, cannot justly claim any worship or adoration, with whatever imaginary perfections you may suppose them endowed. They are totally useless and inactive. Even the Egyptians, whom you so much ridicule, never consecrated any animal but on account of its utility.

The sceptics assert, though absurdly, that the origin of all religious worship was derived from the utility of inanimate objects, as the sun and moon, to the support and well-being of mankind. This is also the common reason assigned by historians, for the deification of eminent heroes and legislators.

To plant a tree, to cultivate a field, to beget children; meritorious acts, according to the religion of Zoroaster.

In all determinations of morality, this circumstance of public utility is ever principally in view; and wherever disputes arise, either in philosophy or common life, concerning the bounds of duty, the question cannot, by any means, be decided with greater certainty, than by ascertaining, on any side, the true interests of mankind. If any false opinion, embraced from appearances, has been found to prevail; as soon as farther experience and sounder reasoning have given us juster notions of human affairs, we retract our first sentiment, and adjust anew the boundaries of moral good and evil.

Giving alms to common beggars is naturally praised; because it seems to carry relief to the distressed and indigent: but when we observe the encouragement thence arising to idleness and debauchery, we regard that species of charity rather as a weakness than a virtue.

Tyrannicide, or the assassination of usurpers and oppressive princes, was highly extolled in ancient times; because it both freed mankind from many of these monsters, and seemed to keep the others in awe, whom the sword or poinard could not reach. But history and experience having since convinced us, that this practice increases the jealousy and cruelty of princes, a Timoleon and a Brutus, though treated with indulgence on account of the prejudices of their times, are now considered as very improper models for imitation.

Liberality in princes is regarded as a mark of beneficence, but when it occurs, that the homely bread of the honest and industrious is often thereby converted into delicious cates for the idle and the prodigal, we soon retract our heedless praises. The regrets of a prince, for having lost a day, were noble and generous: but had he intended to have spent it in acts of generosity to his greedy courtiers, it was better lost than misemployed after that manner.

Luxury, or a refinement on the pleasures and conveniencies of life, had long been supposed the source of every corruption in government, and the immediate cause of faction, sedition, civil wars, and the total loss of liberty. It was, therefore, universally regarded as a vice, and was an object of declamation to all satirists, and severe moralists. Those, who prove, or attempt to prove, that such refinements rather tend to the increase of industry, civility, and arts regulate anew our *moral* as well as *political* sentiments, and represent, as laudable or innocent, what had formerly been regarded as pernicious and blameable.

Upon the whole, then, it seems undeniable, *that* nothing can bestow more merit on any human creature than the sentiment of benevolence in an eminent degree; and *that* a *part,* at least, of its merit arises from its tendency to promote the interests of our species, and bestow happiness on human society. We carry our view into the salutary consequences of such a character and disposition; and whatever has so benign an influence, and forwards so desirable an end, is beheld with complacency and pleasure. The social virtues are never regarded without their beneficial tendencies, nor viewed as barren and unfruitful. The happiness of mankind, the order of society, the harmony of families, the mutual support of friends, are always considered as the result of their gentle dominion over the breasts of men.

How considerable a *part* of their merit we ought to ascribe to their utility, will better appear from future disquisitions, as well as the reason, why this circumstance has such a command over our esteem and approbation.

SECTION III

Of Justice

Part I

That Justice is useful to society, and consequently that *part* of its merit, at least, must arise from that consideration, it would be a superfluous undertaking to prove. That public utility is the *sole* origin of justice, and that reflections on the beneficial consequences of this virtue are the *sole* foundation of its merit; this proposition, being more curious and important, will better deserve our examination and enquiry.

Let us suppose that nature has bestowed on the human race such profuse *abundance* of all *external* conveniencies, that, without any uncertainty in the event, without any care or industry on our part, every individual finds himself fully provided with whatever his most voracious appetites can want, or luxurious imagination wish or desire. His natural beauty, we shall suppose, surpasses all acquired ornaments: the perpetual clemency of the seasons renders useless all clothes or covering: the raw herbage affords him the most delicious fare; the clear fountain, the richest beverage. No laborious occupation required: no tillage: no navigation. Music, poetry, and contemplation form his sole business: conversation, mirth, and friendship his sole amusement.

It seems evident that, in such a happy state, every other social virtue would flourish, and receive tenfold increase; but the cautious, jealous virtue of justice would never once have been dreamed of. For what purpose make a partition of goods, where every one has already more than enough? Why give rise to property, where there cannot possibly be any injury? Why call this object *mine,* when upon the seizing of it by another, I need but stretch out my hand to possess myself of what is equally valuable? Justice, in that case, being totally useless, would be an idle ceremonial, and could never possibly have place in the catalogue of virtues.

We see, even in the present necessitous condition of mankind, that, wherever any benefit is bestowed by nature in an unlimited abundance, we leave it always in common among the whole human race, and make no subdivisions of right and property. Water and air, though the most necessary of all objects, are not challenged as the property of individuals; nor can any man commit injustice by the most lavish use and enjoyment of these blessings. In fertile extensive countries, with few inhabitants, land is regarded on the same footing. And no topic is so much insisted on by those, who defend the liberty of the seas, as the unexhausted use of them in navigation. Were the advantages, procured by navigation, as inexhaustible, these reasoners had never had any adversaries to refute; nor had any claims ever been advanced of a separate, exclusive dominion over the ocean.

It may happen, in some countries, at some periods, that there be established a property in water, none in land; if the latter be in greater abundance than can be used by the inhabitants, and the former be found, with difficulty, and in very small quantities.

Again; suppose, that, though the necessities of human race continue the same as at present, yet the mind is so enlarged, and so replete with friendship and generosity, that every man has the utmost tenderness

for every man, and feels no more concern for his own interest than for that of his fellows; it seems evident, that the use of justice would, in this case, be suspended by such an extensive benevolence, nor would the divisions and barriers of property and obligation have ever been thought of. Why should I bind another, by a deed or promise, to do me any good office, when I know that he is already prompted, by the strongest inclination, to seek my happiness, and would, of himself, perform the desired service; except the hurt, he thereby receives, be greater than the benefit accruing to me? in which case, he knows, that, from my innate humanity and friendship, I should be the first to oppose myself to his imprudent generosity. Why raise land-marks between my neighbour's field and mine, when my heart has made no division between our interests; but shares all his joys and sorrows with the same force and vivacity as if originally my own? Every man, upon this supposition, being a second self to another, would trust all his interests to the discretion of every man; without jealousy, without partition, without distinction. And the whole human race would form only one family; where all would lie in common, and be used freely, without regard to property; but cautiously too, with as entire regard to the necessities of each individual, as if our own interests were most intimately concerned.

In the present disposition of the human heart, it would, perhaps, be difficult to find complete instances of such enlarged affections; but still we may observe, that the case of families approaches towards it; and the stronger the mutual benevolence is among the individuals, the nearer it approaches; till all distinction of property be, in a great measure, lost and confounded among them. Between married persons, the cement of friendship is by the laws supposed so strong as to abolish all division of possessions; and has often, in reality, the force ascribed to it. And it is observable, that, during the ardour of new enthusiasms, when every principle is inflamed into extravagance, the community of goods has frequently been attempted; and nothing but experience of its inconveniences, from the returning or disguised selfishness of men, could make the imprudent fanatics adopt anew the ideas of justice and of separate property. So

true is it, that this virtue derives its existence entirely from its necessary *use* to the intercourse and social state of mankind.

To make this truth more evident, let us reserve the foregoing suppositions; and carrying everything to the opposite extreme, consider what would be the effect of these new situations. Suppose a society to fall into such want of all common necessaries, that the utmost frugality and industry cannot preserve the greater number from perishing, and the whole from extreme misery; it will readily, I believe, be admitted, that the strict laws of justice are suspended, in such a pressing emergence, and give peace to the stronger motives of necessity and self-preservation. Is it any crime, after a shipwreck, to seize whatever means or instrument of safety one can lay hold of, without regard to former limitations of property? Or if a city besieged were perishing with hunger; can we imagine, that men will see any means of preservation before them, and lose their lives, from a scrupulous regard to what, in other situations, would be the rules of equity and justice? The use and tendency of that virtue is to procure happiness and security, by preserving order in society: but where the society is ready to perish from extreme necessity, no greater evil can be dreaded from violence and injustice; and every man may now provide for himself by all the means which prudence can dictate, or humanity permit. The public, even in less urgent necessities, opens granaries, without the consent of proprietors; as justly supposing, that the authority of magistracy may, consistent with equity, extend so far: but were any number of men to assemble, without the tie of laws or civil jurisdiction; would an equal partition of bread in a famine, though affected by power and even violence, be regarded as criminal or injurious?

Suppose likewise, that it should be a virtuous man's fate to fall into the society of ruffians, remote from the protection of laws and government; what conduct must he embrace in that melancholy situation? He sees such a desperate rapaciousness prevail; such a disregard to equity, such contempt of order, such stupid blindness to future consequences, as must immediately have the most tragical conclusion,

and must terminate in destruction to the greater number, and in a total dissolution of society to the rest. He, meanwhile, can have no other expedient than to arm himself, to whomever the sword he seizes, or the buckler, may belong: To make provision of all means of defence and security: And his particular regard to justice being no longer of use to his own safety or that of others, he must consult the dictates of self-preservation alone, without concern for those who no longer merit his care and attention.

When any man, even in political society, renders himself by his crimes, obnoxious to the public, he is punished by the laws in his goods and person; that is, the ordinary rules of justice are, with regard to him, suspended for a moment, and it becomes equitable to inflict on him, for the *benefit* of society, what otherwise he could not suffer without wrong or injury.

The rage and violence of public war; what is it but a suspension of justice among the warring parties, who perceive, that this virtue is now no longer of any *use* or advantage to them? The laws of war, which then succeed to those of equity and justice, are rules calculated for the *advantage* and *utility* of that particular state, in which men are now placed. And were a civilized nation engaged with barbarians, who observed no rules even of war, the former must also suspend their observance of them, where they no longer serve to any purpose; and must render every action or rencounter as bloody and pernicious as possible to the first aggressors.

Thus, the rules of equity or justice depend entirely on the particular state and condition in which men are placed, and owe their origin and existence to that utility, which results to the public from their strict and regular observance. Reverse, in any considerable circumstance, the condition of men: Produce extreme abundance or extreme necessity: Implant in the human breast perfect moderation and humanity, or perfect rapaciousness and malice: By rendering justice totally *useless,* you thereby totally destroy its essence, and suspend its obligation upon mankind.

The common situation of society is a medium amidst all these extremes. We are naturally partial to ourselves, and to our friends; but are capable of learning the advantage resulting from a more equitable conduct. Few enjoyments are given us from the open and liberal hand of nature; but by art, labour, and industry, we can extract them in great abundance. Hence the idea of property becomes necessary in all civil society: Hence justice derives its usefulness to the public: And hence alone arises its merit and moral obligation.

These conclusions are so natural and obvious, that they have not escaped even the poets, in their descriptions of the felicity attending the golden age or the reign of Saturn. The seasons, in that first period of nature, were so temperate, if we credit these agreeable fictions, that there was no necessity for men to provide themselves with clothes and houses, as a security against the violence of heat and cold: The rivers flowed with wine and milk: The oaks yielded honey; and nature spontaneously produced her greatest delicacies. Nor were these the chief advantages of that happy age. Tempests were not alone removed from nature; but those more furious tempests were unknown to human breasts, which now cause such uproar, and engender such confusion. Avarice, ambition, cruelty, selfishness, were never heard of: Cordial affection, compassion, sympathy, were the only movements with which the mind was yet acquainted. Even the punctilious distinction of *mine* and *thine* was banished from among that happy race of mortals, and carried with it the very notion of property and obligation, justice and injustice.

This *poetical* fiction of the *golden age* is, in some respects, of a piece with the *philosophical* fiction of the *state of nature;* only that the former is represented as the most charming and most peaceable condition, which can possibly be imagined; whereas the latter is painted out as a state of mutual war and violence, attended with the most extreme necessity. On the first origin of mankind, we are told, their ignorance and savage nature were so prevalent, that they could give no mutual trust, but must each depend upon himself and his own force or cunning for protection and security. No law was heard of: No rule of justice known: No distinction of property regarded: Power was the only measure of right; and a perpetual war of all against all was the result of men's untamed selfishness and barbarity.

Whether such a condition of human nature could ever exist, or if it did, could continue so long as to merit the appellation of a *state,* may justly be doubted. Men are necessarily born in a family-society, at least; and are trained up by their parents to some rule of conduct and behaviour. But this must be admitted, that, if such a state of mutual war and violence was ever real, the suspension of all laws of justice, from their absolute inutility, is a necessary and infallible consequence.

The more we vary our views of human life, and the newer and more unusual the lights are in which we survey it, the more shall we be convinced, that the origin here assigned for the virtue of justice is real and satisfactory.

Were there a species of creatures intermingled with men, which, though rational, were possessed of such inferior strength, both of body and mind, that they were incapable of all resistance, and could never, upon the highest provocation, make us feel the effects of their resentment; the necessary consequence, I think, is that we should be bound by the laws of humanity to give gentle usage to these creatures, but should not, properly speaking, lie under any restraint of justice with regard to them, nor could they possess any right or property, exclusive of such arbitrary lords. Our intercourse with them could not be called society, which supposes a degree of equality; but absolute command on the one side, and servile obedience on the other. Whatever we covet, they must instantly resign: Our permission is the only tenure, by which they hold their possessions: Our compassion and kindness the only check, by which they curb our lawless will: And as no inconvenience ever results from the exercise of a power, so firmly established in nature, the restraints of justice and property, being totally *useless,* would never have place in so unequal a confederacy.

This is plainly the situation of men, with regard to animals; and how far these may be said to possess reason, I leave it to others to determine. The great superiority of civilized Europeans above barbarous Indians, tempted us to imagine ourselves on the same footing with regard to them, and made us throw off all restraints of justice, and even of humanity, in our treatment of them. In many nations, the female sex are reduced to like slavery, and are rendered incapable of all property, in opposition to their lordly masters. But though the males, when united, have in all countries bodily force sufficient to maintain this severe tyranny, yet such are the insinuation, address, and charms of their fair companions, that women are commonly able to break the confederacy, and share with the other sex in all the rights and privileges of society.

Were the human species so framed by nature as that each individual possessed within himself every faculty, requisite both for his own preservation and for the propagation of his kind: Were all society and intercourse cut off between man and man, by the primary intention of the supreme Creator: It seems evident, that so solitary a being would be as much incapable of justice, as of social discourse and conversation. Where mutual regards and forbearance serve to no manner of purpose, they would never direct the conduct of any reasonable man. The headlong course of the passions would be checked by no reflection on future consequences. And as each man is here supposed to love himself alone, and to depend only on himself and his own activity for safety and happiness, he would, on every occasion, to the utmost of his power, challenge the preference above every other being, to none of which he is bound by any ties, either of nature or of interest.

But suppose the conjunction of the sexes to be established in nature, a family immediately arises; and particular rules being found requisite for its subsistence, these are immediately embraced; though without comprehending the rest of mankind within their prescriptions. Suppose that several families unite together into one society, which is totally disjoined from all others, the rules, which preserve peace and order, enlarge themselves to the utmost extent of that society; but becoming then entirely useless, lose their force when carried one step farther. But again suppose, that several distinct societies maintain a kind of intercourse for mutual convenience and advantage, the boundaries of justice still grow larger, in proportion to the largeness of men's views, and the force of their mutual connexions. History, experience, reason sufficiently instruct us in this natural

progress of human sentiments, and in the gradual enlargement of our regards to justice, in proportion as we become acquainted with the extensive utility of that virtue.

Part II

If we examine the *particular* laws, by which justice is directed, and property determined; we shall still be presented with the same conclusion. The good of mankind is the only object of all these laws and regulations. Not only it is requisite, for the peace and interest of society, that men's possessions should be separated; but the rules, which we follow, in making the separation, are such as can best be contrived to serve farther the interests of society.

We shall suppose that a creature, possessed of reason, but unacquainted with human nature, deliberates with himself what rules of justice or property would best promote public interest, and establish peace and security among mankind: His most obvious thought would be, to assign the largest possessions to the most extensive virtue, and give every one the power of doing good, proportioned to his inclination. In a perfect theocracy, where a being, infinitely intelligent, governs by particular volitions, this rule would certainly have place, and might serve to the wisest purposes: But were mankind to execute such a law; so great is the uncertainty of merit, both from its natural obscurity, and from the self-conceit of each individual, that no determinate rule of conduct would ever result from it; and the total dissolution of society must be the immediate consequence. Fanatics may suppose, *that dominion is founded on grace,* and *that saints alone inherit the earth;* but the civil magistrate very justly puts these sublime theorists on the same footing with common robbers, and teaches them by the severest discipline, that a rule, which, in speculation, may seem the most advantageous to society, may yet be found, in practice, totally pernicious and destructive.

That there were *religious* fanatics of this kind in England, during the civil wars, we learn from history; though it is probable, that the obvious *tendency* of these principles excited such horror in mankind, as soon obliged the dangerous enthusiasts to renounce, or at least conceal their tenets. Perhaps the *levellers,*

who claimed an equal distribution of property, were a kind of *political* fanatics, which arose from the religious species, and more openly avowed their pretensions; as carrying a more plausible appearance, of being practicable in themselves, as well as useful to human society.

It must, indeed, be confessed, that nature is so liberal to mankind, that, were all her presents equally divided among the species, and improved by art and industry, every individual would enjoy all the necessaries, and even most of the comforts of life; nor would ever be liable to any ills, but such as might accidentally arise from the sickly frame and constitution of his body. It must also be confessed, that, wherever we depart from this equality, we rob the poor of more satisfaction than we add to the rich, and that the slight gratification of a frivolous vanity, in one individual, frequently costs more than bread to many families, and even provinces. It may appear withal, that the rule of equality, as it would be highly *useful,* is not altogether *impracticable;* but has taken place, at least in an imperfect degree, in some republics; particularly that of Sparta; where it was attended, it is said, with the most beneficial consequences. Not to mention that the Agrarian laws, so frequently claimed in Rome, and carried into execution in many Greek cities, proceeded, all of them, from a general idea of the utility of this principle.

But historians, and even common sense, may inform us, that however specious these ideas of *perfect* equality may seem, they are really, at bottom, *impracticable;* and were they not so, would be extremely *pernicious* to human society. Render possessions ever so equal, men's different degrees of art, care, and industry will immediately break that equality. Or if you check these virtues, you reduce society to the most extreme indigence; and instead of preventing want and beggary in a few, render it unavoidable to the whole community. The most rigorous inquisition too is requisite to watch every inequality on its first appearance; and the most severe jurisdiction, to punish and redress it. But besides, that so much authority must soon degenerate into tyranny, and be exerted with great partialities; who can possibly be possessed of it, in such a situation as is here supposed?

Perfect quality of possessions, destroying all subordination, weakens extremely the authority of magistracy, and must reduce all power nearly to a level, as well as property.

We may conclude, therefore, that, in order to establish laws for the regulation of property, we must be acquainted with the nature and situation of man; must reject appearances, which may be false, though specious; and must search for those rules, which are, on the whole, most *useful* and *beneficial.* Vulgar sense and slight experience are sufficient for this purpose; where men give not way to too selfish avidity, or too extensive enthusiasm.

Who sees not, for instance, that whatever is produced or improved by a man's art or industry ought, for ever, to be secured to him, in order to give encouragement to such *useful* habits and accomplishments? That the property ought also to descend to children and relations, for the same *useful* purpose? That it may be alienated by consent, in order to beget that commerce and intercourse, which is so *beneficial* to human society? And that all contracts and promises ought carefully to be fulfilled, in order to secure mutual trust and confidence, by which the general *interest* of mankind is so much promoted?

Examine the writers on the laws of nature; and you will always find, that, whatever principles they set out with, they are sure to terminate here at last, and to assign, as the ultimate reason for every rule which they establish, the convenience and necessities of mankind. A concession thus extorted, in opposition to systems, has more authority than if it has been made in prosecution of them.

What other reason, indeed, could writers ever give, why this must be *mine* and that *yours;* since uninstructed nature surely never made any such distinction? The objects which receive those appellations are, of themselves, foreign to us; they are totally disjoined and separated from us; and nothing but the general interests of society can form the connexion.

Sometimes the interests of society may require a rule of justice in a particular case; but may not determine any particular rule, among several, which are all equally beneficial. In that case, the slightest *analogies* are laid hold of, in order to prevent that indifference and ambiguity, which would be the source of perpetual dissension. Thus possession alone, and first possession, is supposed to convey property, where no body else has any preceding claim and pretension. Many of the reasonings of lawyers are of this analogical nature, and depend on very slight connexions of the imagination.

Does any one scruple, in extraordinary cases, to violate all regard to the private property of individuals, and sacrifice to public interest a distinction, which had been established for the sake of that interest? The safety of the people is the supreme law: All other particular laws are subordinate to it, and dependent on it: And if, in the *common* course of things, they be followed and regarded; it is only because the public safety and interest *commonly* demand so equal and impartial an administration.

Sometimes both *utility* and *analogy* fail, and leave the laws of justice in total uncertainty. Thus, it is highly requisite, that prescription or long possession should convey property; but what number of days or months or years should be sufficient for that purpose, it is impossible for reason alone to determine. *Civil laws* here supply the place of the natural *code,* and assign different terms for prescription, according to the different *utilities,* proposed by the legislator. Bills of exchange and promissory notes, by the laws of most countries, prescribe sooner than bonds, and mortgages, and contracts of a more formal nature.

In general we may observe that all questions of property are subordinate to the authority of civil laws, which extend, restrain, modify, and alter the rules of natural justice, according to the particular *convenience* of each community. The laws have, or ought to have, a constant reference to the constitution of government, the manners, the climate, the religion, the commerce, the situation of each society. A late author of genius, as well as learning, has prosecuted this subject at large, and has established, from these principles, a system of political knowledge, which abounds in ingenious and brilliant thoughts, and is not wanting in solidity.

What is a man's property? Anything which it is lawful for him, and for him alone, to use. *But what rule have we, by which we can distinguish these objects? Here we must have recourse to statutes, customs,*

precedents, analogies, and a hundred other circumstances; some of which are constant and inflexible, some variable and arbitrary. But the ultimate point, in which they all professedly terminate, is the interest and happiness of human society. Where this enters not into consideration, nothing can appear more whimsical, unnatural, and even superstitious, than all or most of the laws of justice and of property.

Those who ridicule vulgar superstitions, and expose the folly of particular regards to meats, days, places, postures, apparel, have an easy task; while they consider all the qualities and relations of the objects, and discover no adequate cause for that affection or antipathy, veneration or horror, which have so mighty an influence over a considerable part of mankind. A Syrian would have starved rather than taste pigeon; an Egyptian would not have approached bacon: But if these species of food be examined by the senses of sight, smell, or taste, or scrutinized by the sciences of chemistry, medicine, or physics, no difference is ever found between them and any other species, nor can that precise circumstance be pitched on, which may afford a just foundation for the religious passion. A fowl on Thursday is lawful food; on Friday abominable: Eggs in this house and in this diocese, are permitted during Lent; a hundred paces farther, to eat them is a damnable sin. This earth or building, yesterday was profane; to-day, by the muttering of certain words, it has become holy and sacred. Such reflections as these, in the mouth of a philosopher, one may safely say, are too obvious to have any influence; because they must always, to every man, occur at first sight; and where they prevail not, of themselves, they are surely obstructed by education, prejudice, and passion, not by ignorance or mistake.

It may appear to a careless view, or rather a too abstracted reflection, that there enters a like superstition into all the sentiments of justice; and that, if a man expose its object, or what we call property, to the same scrutiny of sense and science, he will not, by the most accurate enquiry, find any foundation for the difference made by moral sentiment. I may lawfully nourish myself from this tree; but the fruit of another of the same species, ten paces off, it is criminal for me to touch. Had I worn this apparel an hour ago, I had merited the severest punishment; but a man, by pronouncing a few magical syllables, has now rendered it fit for my use and service. Were this house placed in the neighbouring territory, it had been immoral for me to dwell in it; but being built on this side the river, it is subject to a different municipal law, and by its becoming mine I incur no blame or censure. The same species of reasoning it may be thought, which so successfully exposes superstition, is also applicable to justice; nor is it possible, in the one case more than in the other, to point out, in the object, that precise quality or circumstance, which is the foundation of the sentiment.

But there is this material difference between *superstition* and *justice,* that the former is frivolous, useless, and burdensome; the latter is absolutely requisite to the well-being of mankind and existence of society. When we abstract from this circumstance (for it is too apparent ever to be overlooked) it must be confessed, that all regards to right and property, seem entirely without foundation, as much as the grossest and most vulgar superstition. Were the interests of society nowise concerned, it is as unintelligible why another's articulating certain sounds implying consent, should change the nature of my actions with regard to a particular object, as why the reciting of a liturgy by a priest, in a certain habit and posture, should dedicate a heap of brick and timber, and render it, thenceforth and for ever, sacred.

These reflections are far from weakening the obligations of justice, or diminishing anything from the most sacred attention to property. On the contrary, such sentiments must acquire new force from the present reasoning. For what stronger foundation can be desired or conceived for any duty, than to observe, that human society, or even human nature, could not subsist without the establishment of it; and will still arrive at greater degrees of happiness and perfection, the more inviolable the regard is, which is paid to that duty?

The dilemma seems obvious: As justice evidently tends to promote public utility and to support civil society, the sentiment of justice is either derived from our reflecting on that tendency, or like hunger, thirst, and other appetites, resentment, love of life, attachment to offspring, and other passions, arises from a

simple original instinct in the human breast, which nature has implanted for like salutary purposes. If the latter be the case, it follows, that property, which is the object of justice, is also distinguished by a simple original instinct, and is not ascertained by any argument or reflection. But who is there that ever heard of such an instinct? Or is this a subject in which new discoveries can be made? We may as well expect to discover, in the body, new senses, which had before escaped the observation of all mankind.

But farther, though it seems a very simple proposition to say, that nature, by an instinctive sentiment, distinguishes property, yet in reality we shall find, that there are required for that purpose ten thousand different instincts, and these employed about objects of the greatest intricacy and nicest discernment. For when a definition of *property* is required, that relation is found to resolve itself into any possession acquired by occupation, by industry, by prescription, by inheritance, by contract, &c. Can we think that nature, by an original instinct, instructs us in all these methods of acquisition?

These words, too, inheritance and contract, stand for ideas infinitely complicated; and to define them exactly, a hundred volumes of laws, and a thousand volumes of commentators, have not been found sufficient. Does nature, whose instincts in men are all simple, embrace such complicated and artificial objects, and create a rational creature, without trusting anything to the operation of his reason?

But even though all this were admitted, it would not be satisfactory. Positive laws can certainly transfer property. Is it by another original instinct, that we recognize the authority of kings and senates, and mark all the boundaries of their jurisdiction? Judges too, even though their sentence be erroneous and illegal, must be allowed, for the sake of peace and order, to have decisive authority, and ultimately to determine property. Have we original innate ideas of praetors and chancellors and juries? Who sees not, that all these institutions arise merely from the necessities of human society?

All birds of the same species in every age and country, build their nests alike: In this we see the force of instinct. Men, in different times and places, frame their houses differently: Here we perceive the influence of reason and custom. A like inference may be drawn from comparing the instinct of generation and the institution of property.

How great soever the variety of municipal laws, it must be confessed, that their chief out-lines pretty regularly concur; because the purposes, to which they tend, are everywhere exactly similar. In like manner, all houses have a roof and walls, windows and chimneys; though diversified in their shape, figure, and materials. The purposes of the latter, directed to the conveniencies of human life, discover not more plainly their origin from reason and reflection, than do those of the former, which point all to a like end.

I need not mention the variations, which all the rules of property receive from the finer turns and connexions of the imagination, and from the subtilties and abstractions of law-topics and reasonings. There is no possibility of reconciling this observation to the notion of original instincts.

What alone will beget a doubt concerning the theory, on which I insist, is the influence of education and acquired habits, by which we are so accustomed to blame injustice, that we are not, in every instance, conscious of any immediate reflection on the pernicious consequences of it. The views the most familiar to us are apt, for that very reason, to escape us; and what we have very frequently performed from certain motives, we are apt likewise to continue mechanically, without recalling, on every occasion, the reflections, which first determined us. The convenience, or rather necessity, which leads to justice is so universal, and everywhere points so much to the same rules, that the habit takes place in all societies; and it is not without some scrutiny, that we are able to ascertain its true origin. The matter, however, is not so obscure, but that even in common life we have every moment recourse to the principle of public utility, and ask, *What must become of the world, if such practices prevail? How could society subsist under such disorders?* Were the distinction or separation of possessions entirely useless, can any one conceive, that it ever should have obtained in society?

Thus we seem, upon the whole, to have attained a knowledge of the force of that principle here insisted on, and can determine what degree of esteem or moral approbation may result from reflections on public interest and utility. The necessity of justice to

the support of society is the sole foundation of that virtue; and since no moral excellence is more highly esteemed, we may conclude that this circumstance of usefulness has, in general, the strongest energy, and most entire command over our sentiments. It must, therefore, be the source of a considerable part of the merit ascribed to humanity, benevolence, friendship, public spirit, and other social virtues of that stamp; as it is the sole source of the moral approbation paid to fidelity, justice, veracity, integrity, and those other estimable and useful qualities and principles. It is entirely agreeable to the rules of philosophy, and even of common reason; where any principle has been found to have a great force and energy in one instance, to ascribe to it a like energy in all similar instances. This indeed is Newton's chief rule of philosophizing.

SECTION V

Why Utility Pleases

Part I

It seems so natural a thought to ascribe to their utility the praise, which we bestow on the social virtues, that one would expect to meet with this principle everywhere in moral writers, as the chief foundation of their reasoning and enquiry. In common life, we may observe, that the circumstance of utility is always appealed to; nor is it supposed, that a greater eulogy can be given to any man, than to display his usefulness to the public, and enumerate the services, which he has performed to mankind and society. What praise, even of an inanimate form, if the regularity and elegance of its parts destroy not its fitness for any useful purpose! And how satisfactory an apology for any disproportion or seeming deformity, if we can show the necessity of that particular construction for the use intended! A ship appears more beautiful to an artist, or one moderately skilled in navigation, where its prow is wide and swelling beyond its poop, than if it were framed with a precise geometrical regularity, in contradiction to all the laws of mechanics. A building, whose doors and windows were exact squares, would hurt the eye by that very proportion; as ill adapted to

the figure of a human creature, for whose service the fabric was intended. What wonder then, that a man, whose habits and conduct are hurtful to society, and dangerous or pernicious to every one who has an intercourse with him, should, on that account, be an object of disapprobation, and communicate to every spectator the strongest sentiment of disgust and hatred.

But perhaps the difficulty of accounting for these effects of usefulness, or its contrary, has kept philosophers from admitting them into their systems of ethics, and has induced them rather to employ any other principle, in explaining the origin of moral good and evil. But it is no just reason for rejecting any principle, confirmed by experience, that we cannot give a satisfactory account of its origin, nor are able to resolve it into other more general principles. And if we would employ a little thought on the present subject, we need be at no loss to account for the influence of utility, and to deduce it from principles, the most known and avowed in human nature.

From the apparent usefulness of the social virtues, it has readily been inferred by sceptics, both ancient and modern, that all moral distinctions arise from education, and were, at first, invented, and afterwards encouraged, by the art of politicians, in order to render men tractable, and subdue their natural ferocity and selfishness, which incapacitated them for society. This principle, indeed, of precept and education, must so far be owned to have a powerful influence, that it may frequently increase or diminish, beyond their natural standard, the sentiments of approbation or dislike; and may even, in particular instances, create, without any natural principle, a new sentiment of this kind; as is evident in all superstitious practices and observances: But that *all* moral affection or dislike arises from this origin, will never surely be allowed by any judicious enquirer. Had nature made no such distinction, founded on the original constitution of the mind, the words, *honourable* and *shameful, lovely* and *odious, noble* and *despicable,* had never had place in any language; nor could politicians, had they invented these terms, ever have been able to render them intelligible, or make them convey any idea to the audience. So that nothing can be more superficial than this paradox of the sceptics; and it

were well, if, in the abstruser studies of logic and metaphysics, we could as easily obviate the cavils of that sect, as in the practical and more intelligible sciences of politics and morals.

The social virtues must, therefore, be allowed to have a natural beauty and amiableness, which, at first, antecedent to all precept or education, recommends them to the esteem of uninstructed mankind, and engages their affections. And as the public utility of these virtues is the chief circumstance, whence they derive their merit, it follows, that the end, which they have a tendency to promote, must be some way agreeable to us, and take hold of some natural affection. It must please, either from considerations of self-interest, or from more generous motives and regards.

It has often been asserted, that, as every man has a strong connexion with society, and perceives the impossibility of his solitary subsistence, he becomes, on that account, favourable to all those habits or principles, which promote order in society, and insure to him the quiet possession of so inestimable a blessing. As much as we value our own happiness and welfare, as much must we applaud the practice of justice and humanity, by which alone the social confederacy can be maintained, and every man reap the fruits of mutual protection and assistance.

This deduction of morals from self-love, or a regard to private interest, is an obvious thought, and has not arisen wholly from the wanton sallies and sportive assaults of the sceptics. To mention no others, Polybius, one of the gravest and most judicious, as well as most moral writers of antiquity, has assigned this selfish origin to all our sentiments of virtue. But though the solid practical sense of that author, and his aversion to all vain subtilties, render his authority on the present subject very considerable; yet is not this an affair to be decided by authority, and the voice of nature and experience seems plainly to oppose the selfish theory.

We frequently bestow praise on virtuous actions, performed in very distant ages and remote countries; where the utmost subtilty of imagination would not discover any appearance of self-interest, or find any connexion of our present happiness and security with events so widely separated from us.

A generous, a brave, a noble deed, performed by an adversary, commands our approbation; while in its consequences it may be acknowledged prejudicial to our particular interest.

Where private advantage concurs with general affection for virtue, we readily perceive and avow the mixture of these distinct sentiments, which have a very different feeling and influence on the mind. We praise, perhaps, with more alacrity, where the generous humane action contributes to our particular interest: But the topics of praise, which we insist on, are very wide of this circumstance. And we may attempt to bring over others to our sentiments, without endeavouring to convince them, that they reap any advantage from the actions which we recommend to their approbation and applause.

Frame the model of a praiseworthy character, consisting of all the most amiable moral virtues: Give instances, in which these display themselves after an eminent and extraordinary manner: You readily engage the esteem and approbation of all your audience, who never so much as enquire in what age and country the person lived, who possessed these noble qualities: A circumstance, however, of all others, the most material to self-love, or a concern for our own individual happiness.

Once on a time, a statesman, in the shock and contest of parties, prevailed so far as to procure, by his eloquence, the banishment of an able adversary; whom he secretly followed, offering him money for his support during his exile, and soothing him with topics of consolation in his misfortunes. *Alas!* cries the banished statesman, *with what regret must I leave my friends in this city, where even enemies are so generous!* Virtue, though in an enemy, here pleased him: And we also give it the just tribute of praise and approbation; nor do we retract these sentiments, when we hear, that the action passed at Athens, about two thousand years ago, and that the persons' names were Eschines and Demosthenes.

What is that to me? There are few occasions, when this question is not pertinent: And had it that universal, infallible influence supposed, it would turn into ridicule every composition, and almost every

conversation, which contain any praise or censure of men and manners.

It is but a weak subterfuge, when pressed by these facts and arguments, to say, that we transport ourselves, by the force of imagination, into distant ages and countries, and consider the advantage, which we should have reaped from these characters, had we been contemporaries, and had any commerce with the persons. It is not conceivable, how a *real* sentiment or passion can ever arise from a known *imaginary* interest; especially when our *real* interest is still kept in view, and is often acknowledged to be entirely distinct from the imaginary, and even sometimes opposite to it.

A man, brought to the brink of a precipice, cannot look down without trembling; and the sentiment of *imaginary* danger actuates him, in opposition to the opinion and belief of *real* safety. But the imagination is here assisted by the presence of a striking object; and yet prevails not, except it be also aided by novelty, and the unusual appearance of the object. Custom soon reconciles us to heights and precipices, and wears off these false and delusive terrors. The reverse is observable in the estimates which we form of characters and manners; and the more we habituate ourselves to an accurate scrutiny of morals, the more delicate feeling do we acquire of the most minute distinctions between vice and virtue. Such frequent occasion, indeed, have we, in common life, to pronounce all kinds of moral determinations, that no object of this kind can be new or unusual to us; nor could any *false* views or prepossessions maintain their ground against an experience, so common and familiar. Experience being chiefly what forms the associations of ideas, it is impossible that any association could establish and support itself, in direct opposition to that principle.

Usefulness is agreeable, and engages our approbation. This is a matter of fact, confirmed by daily observation. But, *useful? For what?* For somebody's interest, surely. Whose interest then? Not our own only: For our approbation frequently extends farther. It must, therefore, be the interest of those, who are served by the character or action approved of; and these we may conclude, however remote, are not totally indifferent to us. By opening up this principle, we shall discover one great source of moral distinctions.

Part II

Self-love is a principle in human nature of such extensive energy, and the interest of each individual is, in general, so closely connected with that of the community, that those philosophers were excusable, who fancied that all our concern for the public might be resolved into a concern for our own happiness and preservation. They saw every moment, instances of approbation or blame, satisfaction or displeasure towards characters and actions; they denominated the objects of these sentiments, *virtues,* or *vices;* they observed, that the former had a tendency to increase the happiness, and the latter the misery of mankind; they asked, whether it were possible that we could have any general concern for society, or any disinterested resentment of the welfare or injury of others; they found it simpler to consider all these sentiments as modifications of self-love; and they discovered a pretence, at least, for this unity of principle, in that close union of interest, which is so observable between the public and each individual.

But notwithstanding this frequent confusion of interests, it, is easy to attain what natural philosophers, after Lord Bacon, have affected to call the *experimentum crucis,* or that experiment which points out the right way in any doubt or ambiguity. We have found instances, in which private interest was separate from public; in which it was even contrary: And yet we observed the moral sentiment to continue, notwithstanding this disjunction of interests. And wherever these distinct interests sensibly concurred, we always found a sensible increase of the sentiment, and a more warm affection to virtue, and detestation of vice, or what we properly call, *gratitude* and *revenge.* Compelled by these instances, we must renounce the theory, which accounts for every moral sentiment by the principle of self-love. We must adopt a more public affection, and allow, that the interests of society are not, even on their own account, entirely indifferent to us. Usefulness is only a tendency to a certain end; and it is a contradiction in terms, that anything pleases as means to an end, where the end itself no wise affects

us. If usefulness, therefore, be a source of moral senti-ment, and if this usefulness be not always considered with a reference to self; it follows, that everything, which contributes to the happiness of society, recom-mends itself directly to our approbation and good-will. Here is a principle, which accounts, in great part, for the origin of morality: And what need we seek for abstruse and remote systems, when there occurs one so obvious and natural?

Have we any difficulty to comprehend the force of humanity and benevolence? Or to conceive, that the very aspect of happiness, joy, prosperity, gives plea-sure; that of pain, suffering, sorrow, communicates uneasiness? The human countenance, says Horace, borrows smiles or tears from the human counte-nance. Reduce a person to solitude, and he loses all enjoyment, except either of the sensual or speculative kind; and that because the movements of his heart are not forwarded by correspondent movements in his fellow-creatures. The signs of sorrow and mourning, though arbitrary, affect us with melancholy; but the natural symptoms, tears and cries and groans, never fail to infuse compassion and uneasiness. And if the effects of misery touch us in so lively a manner; can we be supposed altogether insensible or indifferent towards its causes; when a malicious or treacherous character and behaviour are presented to us?

We enter, I shall suppose, into a convenient, warm, well-contrived apartment: We necessarily receive a pleasure from its very survey; because it presents us with the pleasing ideas of ease, satisfaction, and enjoyment. The hospitable, good-humoured, humane landlord appears. This circumstance surely must embellish the whole; nor can we easily forbear reflect-ing, with pleasure, on the satisfaction which results to every one from his intercourse and good-offices.

His whole family, by the freedom, ease, confi-dence, and calm enjoyment, diffused over their coun-tenances, sufficiently express their happiness. I have a pleasing sympathy in the prospect of so much joy, and can never consider the source of it, without the most agreeable emotions.

He tells me, that an oppressive and powerful neighbour had attempted to dispossess him of his inheritance, and had long disturbed all his innocent

and social pleasures. I feel an immediate indignation arise in me against such violence and injury.

But it is no wonder, he adds, that a private wrong should proceed from a man, who had enslaved prov-inces, depopulated cities, and made the field and scaffold stream with human blood. I am struck with horror at the prospect of so much misery, and am actuated by the strongest antipathy against its author.

In general, it is certain, that, wherever we go, whatever we reflect on or converse about, everything still presents us with the view of human happiness or misery, and excites in our breast a sympathetic move-ment of pleasure or uneasiness. In our serious occu-pations, in our careless amusements, this principle still exerts its active energy.

A man who enters the theatre, is immediately struck with the view of so great a multitude, par-ticipating of one common amusement; and experi-ences, from their very aspect, a superior sensibility or disposition of being affected with every sentiment, which he shares with his fellow-creatures.

He observes the actors to be animated by the appearance of a full audience, and raised to a degree of enthusiasm, which they cannot command in any arbitrary or calm moment.

Every moment of the theatre, by a skilful poet, is communicated, as it were by magic, to the spec-tators; who weep, tremble, resent, rejoice, and are inflamed with all the variety of passions, which actu-ate the several personages of the drama.

Where any event crosses our wishes, and interrupts the happiness of the favourite characters, we feel a sensible anxiety and concern. But where their suffer-ings proceed from the treachery, cruelty, or tyranny of an enemy, our breasts are affected with the liveli-est resentment against the author of these calamities.

It is here esteemed contrary to the rules of art to represent anything cool and indifferent. A distant friend, or a confident, who has no immediate interest in the catastrophe, ought, if possible, to be avoided by the poet; as communicating a like indifference to the audience, and checking the progress of the passions.

Few species of poetry are more entertaining than *pastoral;* and every one is sensible, that the chief source of its pleasure arises from those images of a

gentle and tender tranquillity, which it represents in its personages, and of which it communicates a like sentiment to the reader. Sannazarius, who transferred the scene to the sea-shore, though he presented the most magnificent object in nature, is confessed to have erred in his choice. The idea of toil, labour, and danger, suffered by the fishermen, is painful; by an unavoidable sympathy, which attends every conception of human happiness or misery.

When I was twenty, says a French poet, Ovid was my favourite: Now I am forty, I declare for Horace. We enter, to be sure, more readily into sentiments, which resemble those we feel every day: But no passion, when well represented, can be entirely indifferent to us; because there is none, of which every man has not, within him, at least the seeds and first principles. It is the business of poetry to bring every affection near to us by lively imagery and representation, and make it look like truth and reality: A certain proof, that, wherever that reality is found, our minds are disposed to be strongly affected by it.

Any recent event or piece of news, by which the fate of states, provinces, or many individuals is affected, is extremely interesting even to those whose welfare is not immediately engaged. Such intelligence is propagated with celerity, heard with avidity, and enquired into with attention and concern. The interest of society appears, on this occasion, to be in some degree the interest of each individual. The imagination is sure to be affected; though the passions excited may not always be so strong and steady as to have great influence on the conduct and behaviour.

The perusal of a history seems a calm entertainment; but would be no entertainment at all, did not our hearts beat with correspondent movements to those which are described by the historians.

Thucydides and Guicciardin support with difficulty our attention; while the former describes the trivial rencounters of the small cities of Greece, and the latter the harmless wars of Pisa. The few persons interested and the small interest fill not the imagination, and engage not the affections. The deep distress of the numerous Athenian army before Syracuse; the danger which so nearly threatens Venice; these excite compassion; these move terror and anxiety.

The indifferent, uninteresting style of Suetonius, equally with the masterly pencil of Tacitus, may convince us of the cruel depravity of Nero or Tiberius: But what a difference of sentiment! While the former coldly relates the facts; and the latter sets before our eyes the venerable figures of a Soranus and a Thrasea, intrepid in their fate, and only moved by the melting sorrows of their friends and kindred. What sympathy then touches every human heart! What indignation against the tyrant, whose causeless fear or unprovoked malice gave rise to such detestable barbarity!

If we bring these subjects nearer: If we remove all suspicion of fiction and deceit: What powerful concern is excited, and how much superior, in many instances, to the narrow attachments of self-love and private interest! Popular sedition, party zeal, a devoted obedience to factious leaders; these are some of the most visible, though less laudable effects of this social sympathy in human nature.

The frivolousness of the subject too, we may observe, is not able to detach us entirely from what carries an image of human sentiment and affection.

When a person stutters, and pronounces with difficulty, we even sympathize with this trivial uneasiness, and suffer for him. And it is a rule in criticism, that every combination of syllables or letters, which gives pain to the organs of speech in the recital, appears also from a species of sympathy harsh and disagreeable to the ear. Nay, when we run over a book with our eye, we are sensible of such unharmonious composition; because we still imagine, that a person recites it to us, and suffers from the pronouniation of these jarring sounds. So delicate is our sympathy!

Easy and unconstrained postures and motions are always beautiful: An air of health and vigour is agreeable: Clothes which warm, without burdening the body; which cover, without imprisoning the limbs, are well-fashioned. In every judgement of beauty, the feelings of the person affected enter into consideration, and communicate to the spectator similar touches of pain or pleasure. What wonder, then, if we can pronounce no judgement concerning the character and conduct of men, without considering the tendencies of their actions, and the happiness or misery which thence

arises to society? What association of ideas would ever operate, were that principle here totally unactive.

If any man from a cold insensibility, or narrow selfishness of temper, is unaffected with the images of human happiness or misery, he must be equally indifferent to the images of vice and virtue: As, on the other hand, it is always found, that a warm concern for the interests of our species is attended with a delicate feeling of all moral distinctions; a strong resentment of injury done to men; a lively approbation of their welfare. In this particular, though great superiority is observable of one man above another; yet none are so entirely indifferent to the interest of their fellow-creatures, as to perceive no distinctions of moral good and evil, in consequences of the different tendencies of actions and principles. How, indeed, can we suppose it possible in any one, who wears a human heart, that if there be subjected to his censure, one character or system of conduct, which is beneficial, and another which is pernicious, to his species or community, he will not so much as give a cool preference to the former, or ascribe to it the smallest merit or regard? Let us suppose such a person ever so selfish; let private interest have ingrossed ever so much his attention; yet in instances, where that is not concerned, he must unavoidably feel *some* propensity to the good of mankind, and make it an object of choice, if everything else be equal. Would any man, who is walking along, tread as willingly on another's gouty toes, whom he has no quarrel with, as on the hard flint and pavement? There is here surely a difference in the case. We surely take into consideration the happiness and misery of others, in weighing the several motives of action, and incline to the former, where no private regards draw us to seek our own promotion or advantage by the injury of our fellow-creatures. And if the principles of humanity are capable, in many instances, of influencing our actions, they must, at all times, have *some* authority over our sentiments, and give us a general approbation of what is useful to society, and blame of what is dangerous or pernicious. The degrees of these sentiments may be the subject of controversy; but the reality of their existence, one should think, must be admitted in every theory or system.

A creature, absolutely malicious and spiteful, were there any such in nature, must be worse than indifferent to the images of vice and virtue. All his sentiments must be inverted, and directly opposite to those, which prevail in the human species. Whatever contributes to the good of mankind, as it crosses the constant bent of his wishes and desires, must produce uneasiness and disapprobation; and on the contrary, whatever is the source of disorder and misery in society, must, for the same reason, be regarded with pleasure and complacency. Timon, who probably from his affected spleen more than any inveterate malice, was denominated the manhater, embraced Alcibiades with great fondness. *Go on my boy!* cried he, *acquire the confidence of the people: You will one day, I foresee, be the cause of great calamities to them.* Could we admit the two principles of the Manicheans, it is an infallible consequence, that their sentiments of human actions, as well as of everything else, must be totally opposite, and that every instance of justice and humanity, from its necessary tendency, must please the one deity and displease the other. All mankind so far resemble the good principle, that, where interest or revenge or envy perverts not our disposition, we are always inclined, from our natural philanthropy, to give the preference to the happiness of society, and consequently to virtue above its opposite. Absolute, unprovoked, disinterested malice has never perhaps place in any human breast; or if it had, must there pervert all the sentiments of morals, as well as the feelings of humanity. If the cruelty of Nero be allowed entirely voluntary, and not rather the effect of constant fear and resentment; it is evident that Tigellinus, preferably to Seneca or Burrhus, must have possessed his steady and uniform approbation.

A statesman or patriot, who serves our own country in our own time, has always a more passionate regard paid to him, than one whose beneficial influence operated on distant ages or remote nations; where the good, resulting from his generous humanity, being less connected with us, seems more obscure, and affects us with a less lively sympathy. We may own the merit to be equally great, though our sentiments are not raised to an equal height, in both cases. The judgement here corrects the inequalities of our

internal emotions and perceptions; in like manner, as it preserves us from error, in the several variations of images, presented to our external senses. The same object, at a double distance, really throws on the eye a picture of but half the bulk; yet we imagine that it appears of the same size in both situations; because we know that on our approach to it, its image would expand on the eye, and that the difference consists not in the object itself, but in our position with regard to it. And, indeed, without such a correction of appearances, both in internal and external sentiment, men could never think or talk steadily on any subject; while their fluctuating situations produce a continual variation on objects, and throw them into such different and contrary lights and positions.

The more we converse with mankind, and the greater social intercourse we maintain, the more shall we be familiarized to these general preferences and distinctions, without which our conversation and discourse could scarcely be rendered intelligible to each other. Every man's interest is peculiar to himself, and the aversions and desires, which result from it, cannot be supposed to affect others in a like degree. General language, therefore, being formed for general use, must be moulded on some more general views, and must affix the epithets of praise or blame, in conformity to sentiments, which arise from the general interests of the community. And if these sentiments, in most men, be not so strong as those, which have a reference to private good; yet still they must make some distinction, even in persons the most depraved and selfish; and must attach the notion of good to a beneficent conduct, and of evil to the contrary. Sympathy, we shall allow, is much fainter than our concern for ourselves, and sympathy with persons remote from us much fainter than that with persons near and contiguous; but for this very reason it is necessary for us, in our calm judgements and discourse concerning the characters of men, to neglect all these differences, and render our sentiments more public and social. Besides, that we ourselves often change our situation in this particular, we every day meet with persons who are in a situation different from us, and who could never converse with us were we to remain constantly in that position and point of view, which is peculiar to ourselves. The intercourse of sentiments, therefore, in society and conversation, makes us form some general unalterable standard, by which we may approve or disapprove of characters and manners. And though the heart takes not part entirely with those general notions, nor regulates all its love and hatred, by the universal abstract differences of vice and virtue, without regard to self, or the persons with whom we are more intimately connected; yet have these moral differences a considerable influence, and being sufficient, at least, for discourse, serve all our purposes in company, in the pulpit, on the theatre, and in the schools.

Thus, in whatever light we take this subject, the merit, ascribed to the social virtues, appears still uniform, and arises chiefly from that regard, which the natural sentiment of benevolence engages us to pay to the interests of mankind and society. If we consider the principles of the human make, such as they appear to daily experience and observation, we must, *a priori,* conclude it impossible for such a creature as man to be totally indifferent to the well or ill-being of his fellow-creatures, and not readily, of himself, to pronounce, where nothing gives him any particular bias, that what promotes their happiness is good, what tends to their misery is evil, without any farther regard or consideration. Here then are the faint rudiments, at least, or outlines, of a *general* distinction between actions; and in proportion as the humanity of the person is supposed to encrease, his connexion with those who are injured or benefited, and his lively conception of their misery or happiness; his consequent censure or approbation acquires proportionable vigour. There is no necessity, that a generous action, barely mentioned in an old history or remote gazette, should communicate any strong feelings of applause and admiration. Virtue, placed at such a distance, is like a fixed star, which, though to the eye of reason it may appear as luminous as the sun in his meridian, is so infinitely removed as to affect the senses, neither with light nor heat. Bring this virtue nearer, by our acquaintance or connexion with the persons, or even by an eloquent recital of the case; our hearts are immediately caught, our sympathy enlivened, and our cool approbation converted into

the warmest sentiments of friendship and regard. These seem necessary and infallible consequences of the general principles of human nature, as discovered in common life and practice.

Again; reverse these views and reasonings: Consider the matter *a posteriori;* and weighing the consequences, enquire if the merit of social virtue be not, in a great measure, derived from the feelings of humanity, with which it affects the spectators. It appears to be matter of fact, that the circumstance of *utility,* in all subjects, is a source of praise and approbation: That it is constantly appealed to in all moral decisions concerning the merit and demerit of actions: That it is the *sole* source of that high regard paid to justice, fidelity, honour, allegiance, and chastity: That it is inseparable from all the other social virtues, humanity, generosity, charity, affability, lenity, mercy, and moderation: And, in a word, that it is a foundation of the chief part of morals, which has a reference to mankind and our fellow-creatures.

It appears also, that, in our general approbation of characters and manners, the useful tendency of the social virtues moves us not by any regards to self-interest, but has an influence much more universal and extensive. It appears that a tendency to public good, and to the promoting of peace, harmony, and order in society, does always, by affecting the benevolent principles of our frame, engage us on the side of the social virtues. And it appears, as an additional confirmation, that these principles of humanity and sympathy enter so deeply into all our sentiments, and have so powerful an influence, as may enable them to excite the strongest censure and applause. The present theory is the simple result of all these inferences, each of which seems founded on uniform experience and observation.

Were it doubtful, whether there were any such principle in our nature as humanity or a concern for others, yet when we see, in numberless instances, that whatever has a tendency to promote the interests of society, is so highly approved of, we ought thence to learn the force of the benevolent principle; since it is impossible for anything to please as means to an end, where the end is totally indifferent. On the other hand, were it doubtful, whether there

were, implanted in our nature, any general principle of moral blame and approbation, yet when we see, in numberless instances, the influence of humanity, we ought thence to conclude, that it is impossible, but that everything which promotes the interest of society must communicate pleasure, and what is pernicious give uneasiness. But when these different reflections and observations concur in establishing the same conclusion, must they not bestow an undisputed evidence upon it?

It is however hoped, that the progress of this argument will bring a farther confirmation of the present theory, by showing the rise of other sentiments of esteem and regard from the same or like principles.

APPENDIX I

Concerning Moral Sentiment

If the foregoing hypothesis be received, it will now be easy for us to determine the question first started, concerning the general principles of morals; and though we postponed the decision of that question, lest it should then involve us in intricate speculations, which are unfit for moral discourses, we may resume it at present, and examine how far either *reason* or *sentiment* enters into all decisions of praise or censure.

One principal foundation of moral praise being supposed to lie in the usefulness of any quality or action, it is evident that *reason* must enter for a considerable share in all decisions of this kind; since nothing but that faculty can instruct us in the tendency of qualities and actions, and point out their beneficial consequences to society and to their possessor. In many cases this is an affair liable to great controversy: doubts may arise; opposite interests may occur; and a preference must be given to one side, from very nice views, and a small overbalance of utility. This is particularly remarkable in questions with regard to justice; as is, indeed, natural to suppose, from that species of utility which attends this virtue. Were every single instance of justice, like that of benevolence, useful to society; this would be a more simple state of the case, and seldom liable to great controversy. But as single instances of justice are often pernicious in

their first and immediate tendency, and as the advantage to society results only from the observance of the general rule, and from the concurrence and combination of several persons in the same equitable conduct; the case here becomes more intricate and involved. The various circumstances of society; the various consequences of any practice; the various interests which may be proposed; these, on many occasions, are doubtful, and subject to great discussion and inquiry. The object of municipal laws is to fix all the questions with regard to justice: the debates of civilians; the reflections of politicians; the precedents of history and public records, are all directed to the same purpose. And in a very accurate *reason* or *judgement* is often requisite, to give the true determination, amidst such intricate doubts arising from obscure or opposite utilities.

But though reason, when fully assisted and improved, be sufficient to instruct us in the pernicious or useful tendency of qualities and actions; it is not alone sufficient to produce any moral blame or approbation. Utility is only a tendency to a certain end; and were the end totally indifferent to us, we should feel the same indifference towards the means. It is requisite a *sentiment* should here display itself, in order to give a preference to the useful above the pernicious tendencies. This sentiment can be no other than a feeling for the happiness of mankind, and a resentment of their misery; since these are the different ends which virtue and vice have a tendency to promote. Here therefore *reason* instructs us in the several tendencies of actions, and *humanity* makes a distinction in favour of those which are useful and beneficial.

This partition between the faculties of understanding and sentiment, in all moral decisions, seems clear from the preceding hypothesis. But I shall suppose that hypothesis false: it will then be requisite to look out for some other theory that may be satisfactory; and I dare venture to affirm that none such will ever be found, so long as we suppose reason to be the sole source of morals. To prove this, it will be proper to weigh the five following considerations.

I. It is easy for a false hypothesis to maintain some appearance of truth, while it keeps wholly in generals, makes use of undefined terms, and employs comparisons, instead of instances. This is particularly remarkable in that philosophy, which ascribes the discernment of all moral distinctions to reason alone, without the concurrence of sentiment. It is impossible that, in any particular instance, this hypothesis can so much as be rendered intelligible, whatever specious figure it may make in general declamations and discourses. Examine the crime of *ingratitude,* for instance; which has place, wherever we observe good-will, expressed and known, together with good-offices performed, on the one side, and a return of ill-will or indifference, with ill-offices or neglect on the other: anatomize all these circumstances, and examine, by your reason alone, in what consists the demerit or blame. You never will come to any issue or conclusion.

Reason judges either of *matter of fact* or of *relations.* Enquire then, *first,* where is that matter of fact which we here call *crime;* point it out; determine the time of its existence; describe its essence or nature; explain the sense or faculty to which it discovers itself. It resides in the mind of the person who is ungrateful. He must, therefore, feel it, and be conscious of it. But nothing is there, except the passion of ill-will or absolute indifference. You cannot say that these, of themselves, always, and in all circumstances, are crimes. No, they are only crimes when directed towards persons who have before expressed and displayed good-will towards us. Consequently, we may infer, that the crime of ingratitude is not any particular individual *fact;* but arises from a complication of circumstances, which, being presented to the spectator, excites the *sentiment* of blame, by the particular structure and fabric of his mind.

This representation, you say, is false. Crime, indeed, consists not in a particular *fact,* of whose reality we are assured by *reason;* but it consists in certain *moral relations,* discovered by reason, in the same manner as we discover by reason the truths of geometry or algebra. But what are the relations, I ask, of which you here talk? In the case stated above, I see first good-will and good-offices in one person; then ill-will and ill-offices in the other. Between these, there is a relation of *contrariety.* Does the crime

consist in that relation? But suppose a person bore me ill-will or did me ill-offices; and I, in return, were indifferent towards him, or did him good-offices. Here is the same relation of *contrariety;* and yet my conduct is often highly laudable. Twist and turn this matter as much as you will, you can never rest the morality on relation; but must have recourse to the decisions of sentiment.

When it is affirmed that two and three are equal to the half of ten, this relation of equality I understand perfectly. I conceive, that if ten be divided into two parts, of which one has as many units as the other; and if any of these parts be compared to two added to three, it will contain as many units as that compound number. But when you draw thence a comparison to moral relations, I own that I am altogether at a loss to understand you. A moral action, a crime, such as ingratitude, is a complicated object. Does the morality consist in the relation of its parts to each other? How? After what manner? Specify the relation: be more particular and explicit in your propositions, and you will easily see their falsehood.

No, say you, the morality consists in the relation of actions to the rule of right; and they are denominated good or ill, according as they agree or disagree with it. What then is this rule of right? In what does it consist? How is it determined? By reason, you say, which examines the moral relations of actions. So that moral relations are determined by the comparison of action to a rule. And that rule is determined by considering the moral relations of objects. Is not this fine reasoning?

All this is metaphysics, you cry. That is enough; there needs nothing more to give a strong presumption of falsehood. Yes, reply I, here are metaphysics surely; but they are all on your side, who advance an abstruse hypothesis, which can never be made intelligible, nor quadrate with any particular instance or illustration. The hypothesis which we embrace is plain. It maintains that morality is determined by sentiment. It defines virtue to be *whatever mental action or quality gives to a spectator the pleasing sentiment of approbation;* and vice the contrary. We then proceed to examine a plain matter of fact, to wit, what actions have this influence. We consider all the circumstances in which these actions agree, and thence

endeavour to extract some general observations with regard to these sentiments. If you call this metaphysics, and find anything abstruse here, you need only conclude that your turn of mind is not suited to the moral sciences.

II. When a man, at any time, deliberates concerning his own conduct (as, whether he had better, in a particular emergence, assist a brother or a benefactor), he must consider these separate relations, with all the circumstances and situations of the persons, in order to determine the superior duty and obligation; and in order to determine the proportion of lines in any triangle, it is necessary to examine the nature of that figure, and the relations which its several parts bear to each other. But notwithstanding this appearing similarity in the two cases, there is, at bottom, an extreme difference between them. A speculative reasoner concerning triangles or circles considers the several known and given relations of the parts of these figures, and thence infers some unknown relation, which is dependent on the former. But in moral deliberations we must be acquainted beforehand with all the objects, and all their relations to each other; and from a comparison of the whole, fix our choice or approbation. No new fact to be ascertained; no new relation to be discovered. All the circumstances of the care are supposed to be laid before us, ere we can fix any sentence of blame or approbation. If any material circumstance be yet unknown or doubtful, we must first employ our inquiry or intellectual faculties to assure us of it; and must suspend for a time all moral decision or sentiment. While we are ignorant whether a man were aggressor or not, how can we determine whether the person who killed him be criminal or innocent? But after every circumstance, every relation is known, the understanding has no further room to operate, nor any object on which it could employ itself. The approbation or blame which then ensues, cannot be the work of the judgement, but of the heart; and is not a speculative proposition or affirmation, but an active feeling or sentiment. In the disquisitions of the understanding, from known circumstances and relations, we infer some new and unknown. In moral decisions, all the circumstances and relations must

be previously known; and the mind, from the contemplation of the whole, feels some new impression of affection or disgust, esteem or contempt, approbation or blame.

Hence the great difference between a mistake of *fact* and one of *right;* and hence the reason why the one is commonly criminal and not the other. When Oedipus killed Laius, he was ignorant of the relation, and from circumstances, innocent and involuntary, formed erroneous opinions concerning the action which he committed. But when Nero killed Agrippina, all the relations between himself and the person, and all the circumstances of the fact, were previously known to him; but the motive of revenge, or fear, or interest, prevailed in his savage heart over the sentiments of duty and humanity. And when we express that detestation against him to which he himself, in a little time, became insensible, it is not that we see any relations, of which he was ignorant; but that, from the rectitude of our disposition, we feel sentiments against which he was hardened from flattery and a long perseverance in the most enormous crimes. In these sentiments then, not in a discovery of relations of any kind, do all moral determinations consist. Before we can pretend to form any decision of this kind, everything must be known and ascertained on the side of the object or action. Nothing remains but to feel, on our part, some sentiment of blame or approbation; whence we pronounce the action criminal or virtuous.

III. This doctrine will become still more evident, if we compare moral beauty with natural, to which in many particulars it bears so near a resemblance. It is on the proportion, relation, and position of parts, that all natural beauty depends; but it would be absurd thence to infer, that the perception of beauty, like that of truth in geometrical problems, consists wholly in the perception of relations, and was performed entirely by the understanding or intellectual faculties. In all the sciences, our mind from the known relations investigates the unknown. But in all decisions of taste or external beauty, all the relations are beforehand obvious to the eye; and we thence proceed to feel a sentiment of complacency or disgust, according to the nature of the object, and disposition of our organs.

Euclid has fully explained all the qualities of the circle; but has not in any proposition said a word of its beauty. The reason is evident. The beauty is not a quality of the circle. It lies not in any part of the line, whose parts are equally distant from a common centre. It is only the effect which that figure produces upon the mind, whose peculiar fabric or structure renders it susceptible of such sentiments. In vain would you look for it in the circle, or seek it, either by your senses or by mathematical reasonings, in all the properties of that figure.

Attend to Palladio and Perrault, while they explain all the parts and proportions of a pillar. They talk of the cornice, and frieze, and base, and entablature, and shaft and architrave; and give the description and position of each of these members. But should you ask the description and position of its beauty, they would readily reply, that the beauty is not in any of the parts or members of a pillar, but results from the whole, when that complicated figure is presented to an intelligent mind, susceptible to those finer sensations. Till such a spectator appear, there is nothing but a figure of such particular dimensions and proportions: from his sentiments alone arise its elegance and beauty.

Again; attend to Cicero, while he paints the crimes of a Verres or a Catiline. You must acknowledge that the moral turpitude results, in the same manner, from the contemplation of the whole, when presented to a being whose organs have such a particular structure and formation. The orator may paint rage, insolence, barbarity on the one side; meekness, suffering, sorrow, innocence on the other. But if you feel no indignation or compassion arise in you from this complication of circumstances, you would in vain ask him, in what consists the crime or villainy, which he so vehemently exclaims against? At what time, or on what subject it first began to exist? And what has a few months afterwards become of it, when every disposition and thought of all the actors is totally altered or annihilated? No satisfactory answer can be given to any of these questions, upon the abstract hypothesis of morals; and we must at last acknowledge, that the crime or immorality is no particular fact or relation, which can be the object of the understanding, but arises entirely from the sentiment

of disapprobation, which, by the structure of human nature, we unavoidably feel on the apprehension of barbarity or treachery.

IV. Inanimate objects may bear to each other all the same relations which we observe in moral agents; though the former can never be the object of love or hatred, nor are consequently susceptible of merit or iniquity. A young tree, which over-tops and destroys its parent, stands in all the same relations with Nero, when he murdered Agrippina; and if morality consisted merely in relations, would no doubt be equally criminal.

V. It appears evident that the ultimate ends of human actions can never, in any case, be accounted for by *reason,* but recommend themselves entirely to the sentiments and affections of mankind, without any dependance on the intellectual faculties. Ask a man *why he uses exercise;* he will answer, *because he desires to keep his health.* If you then enquire, *why he desires health,* he will readily reply, *because sickness is painful.* If you push your enquiries farther, and desire a reason *why he hates pain,* it is impossible he can ever give any. This is an ultimate end, and is never referred to any other object.

Perhaps to your second question, *why he desires health,* he may also reply, that *it is necessary for the exercise of his calling.* If you ask, *why he is anxious on that head,* he will answer, *because he desires to get money.* If you demand *Why? It is the instrument of pleasure,* says he. And beyond this it is an absurdity to ask for a reason. It is impossible there can be a progress *in infinitum;* and that one thing can always be a reason why another is desired. Something must be desirable on its own account, and because of its immediate accord or agreement with human sentiment and affection.

Now as virtue is an end, and is desirable on its own account, without fee or reward, merely for the immediate satisfaction which it conveys; it is requisite that there should be some sentiment which it touches, some internal taste or feeling, or whatever you please to call it, which distinguishes moral good and evil, and which embraces the one and rejects the other.

Thus the distinct boundaries and offices of *reason* and of *taste* are easily ascertained. The former conveys the knowledge of truth and falsehood: the latter gives the sentiment of beauty and deformity, vice and virtue. The one discovers objects as they really stand in nature, without addition or diminution: the other has a productive faculty, and gilding or staining all natural objects with the colours, borrowed from internal sentiment, raises in a manner a new creation. Reason being cool and disengaged, is no motive to action, and directs only the impulse received from appetite or inclination, by showing us the means of attaining happiness or avoiding misery: Taste, as it gives pleasure or pain, and thereby constitutes happiness or misery, becomes a motive to action, and is the first spring or impulse to desire and volition. From circumstances and relations, known or supposed, the former leads us to the discovery of the concealed and unknown: after all circumstances and relations are laid before us, the latter makes us feel from the whole a new sentiment of blame or approbation. The standard of the one, being founded on the nature of things, is eternal and inflexible, even by the will of the Supreme Being: the standard of the other, arising from the internal frame and constitution of animals, is ultimately derived from that Supreme Will, which bestowed on each being its peculiar nature, and arranged the several classes and orders of existence.

Study Questions

1. Can beliefs alone motivate you to act?
2. If human beings were different, would morality be different?
3. Do facts by themselves ever imply values?
4. If human beings agree about basic sentiments, what is the source of moral disagreement?

11

IMMANUEL KANT

Immanuel Kant (1724–1804) was a dominant figure in the history of modern philosophy, making groundbreaking contributions in virtually every area of inquiry. Kant argued that the moral worth of an action is to be judged not by its consequences but by the nature of the maxim or principle that motivated the action. According to Kant, the only correct ones are those that can serve as universal laws because they are applicable without exception to every person at any time. In other words, one should act only on a maxim that can be universalized without contradiction. Kant referred to his supreme moral principle as the "categorical imperative," categorical because it does not depend on anyone's particular desires, and an imperative because it is a command of reason. Kant also claimed that the categorical imperative can be reformulated as follows: So act that you treat humanity, whether in your own person or in any other person, always at the same time as an end, never merely as a means. Actions that violate this imperative are immoral, because a person is using another person only as a means, not treating that individual as an end, a rational being worthy of respect. By acting in this manner an individual becomes what Kant called "a lawgiving member in the kingdom of ends," thus providing a third way of understanding the categorical imperative.

Groundwork for the Metaphysics of Morals

PREFACE

Ancient Greek philosophy was divided into three sciences: *physics, ethics,* and *logic.* This division fits the nature of the subject perfectly and needs no improvement except perhaps to add the principle on which that division rests. By doing this we may be able to guarantee its completeness as well as to determine its necessary subdivisions correctly.

All rational knowledge is either *material* and considers some object or other or *formal,* concerned just with the form of the understanding and the form of reason itself, and with the universal rules of thinking as such, whatever its objects might be. Formal philosophy is called *logic.* Material philosophy, which is concerned with specific objects and their laws, consists of two parts; for those laws are either laws of *nature* or laws of *freedom.* The science of the first is called *physics,* that of the second *ethics.* The former science is also called natural philosophy, the latter moral philosophy.

Logic can have no empirical part, that is, it can have no part in which the universal and necessary laws

of thinking are based on facts taken from experience. Otherwise it would not be logic—that is, it would not be an authoritative set of rules for the understanding or for reason, rules that are valid, and must be shown to be valid, for all thinking. On the other hand, both natural philosophy and moral philosophy can have an empirical part. The reason is that natural philosophy has to formulate nature's laws in so far as nature is an object of experience, while moral philosophy has to define the laws of the human will, to the extent that the will is affected by nature. Laws of nature are laws according to which everything happens; laws of freedom are laws according to which everything ought to happen, although these laws also weigh the conditions under which what ought to happen very often does not happen.

We can call any philosophy that is based on experience *empirical.* We can call it *pure* philosophy if it sets forth its teachings entirely on the basis of a priori principles. When pure philosophy is merely formal, it is called *logic;* but if it is limited to specific objects of the understanding, pure philosophy is then called *metaphysics.*

In this way there arises the idea of a two-fold metaphysics—*a metaphysics of nature* and *a metaphysics of morals.* Thus physics will have an empirical part, but also a rational part; and similarly ethics, although here the empirical part might be given the special title *practical anthropology,* the term *moral philosophy* being properly used to refer just to the rational part.

All professions, handicrafts, and arts have made progress by the division of labour. That is to say, one person can accomplish something most perfectly and easily if he confines himself to a particular job that differs significantly from other jobs in the treatment it requires. Where various tasks are not thus distinguished and divided, where everyone is a jack-of-all-trades, industry remains at a primitive level. It might be worth considering whether pure philosophy, in all its divisions, does not require its own specialist. Perhaps the learned profession as a whole would be better off if a warning were issued—a warning to those who call themselves 'independent thinkers' but who belittle as 'hair-splitters' those who work on the purely rational part of philosophy: For these people are used to marketing a mixture of the empirical and the rational (in various proportions unknown even to themselves, as they pander to the public's taste), but they should be warned against engaging at one and the same time in rational and empirical disciplines, two so different enterprises, involving such different techniques. For each job perhaps requires a special talent and the attempt to combine both in one person produces mere bunglers. Here, however, I ask only whether the nature of science does not require that the empirical part should always be scrupulously separated from the rational one, and that (empirical) physics proper should be prefaced by a metaphysic of nature, while practical anthropology should be prefaced by a metaphysic of morals. Each of these prior sciences must be scrupulously cleansed of everything empirical if we are to know how much pure reason can accomplish in each case and from what sources it can by itself create its own teaching a priori. I leave it an open question whether the latter business is to be conducted by all moralists (whose name is legion) or only by those who feel a calling for the subject.

Since my aim here is directed strictly to moral philosophy, I confine the proposed question to this single point. Is it not a matter of utmost importance to forge for once a pure moral philosophy, completely cleansed of everything that may be only empirical and that really belongs to anthropology? That there must be such a philosophy is already evident if one looks at the common idea of duty and of moral laws. For everyone must admit that a law has to carry with it absolute necessity if it is to be morally valid—valid, that is, as a basis of obligation; and everyone must grant that the commandment, 'Thou shalt not lie' could not hold merely for human beings, as if other rational beings had no obligation to abide by it. So it is with all other genuine moral laws. Consequently, the ground of obligation must here be sought, not in the nature of human beings or in facts about the way the world is, but solely a priori in concepts of pure reason. Every other precept, based on principles of mere experience—even a precept that might in a certain sense be considered

universal—can indeed be called a practical rule, but never a moral law, so far as it rests even slightly (perhaps only in its motive) on empirical grounds.

Thus moral laws and their principles are essentially different from all the rest of practical knowledge, in which there is some empirical element. Furthermore, the whole of moral philosophy is based entirely on the part of it that is non-empirical, i.e., pure. When applied to man, it does not borrow in the slightest from our knowledge of human beings (i.e., from anthropology). Rather, it prescribes to man, as a rational being, laws a priori. These laws certainly require in addition a power of judgement sharpened by experience, partly in order to distinguish the cases to which they apply, partly to obtain for these laws access to the human will and impetus to their practice. For man, affected by so many inclinations, is indeed capable of grasping the idea of a pure practical reason, but it is not so easy for him to render this idea concretely effective in his conduct of life.

A metaphysic of morals is thus indispensably necessary not merely because one wants to investigate and understand the source of practical principles which are present a priori in our reason, but because morality itself remains subjected to all sorts of corruption as long as this guiding thread, this ultimate norm for correct moral judgement, is lacking. For if any action is to be morally good, it is not enough that it should *conform* to the moral law—it must also be done *for the sake of that law*. Where this is not the case, the conformity is just very coincidental and precarious. since the non-moral ground will now and then produce actions that accord with the law, but it will often produce actions that transgress it. But the moral law in its purity and authenticity (and in the field of action it is precisely this that matters most) can be found nowhere else than in a pure philosophy. Pure philosophy (metaphysics) must therefore come first, and without it there can be no moral philosophy at all. A philosophy that mixes these pure principles with empirical ones does not even deserve to be called philosophy (since philosophy is distinguished from common rational knowledge precisely because it treats in separate sciences what the latter apprehends

only in a disordered way). Still less does it deserve to be called moral philosophy, since by this confusion of a priori and empirical principles it spoils the purity of morality itself and works against its own purpose.

It would be a mistake to think that what is here demanded has already been done by the celebrated Wolff in the preparatory study to his moral philosophy—that is, in what he entitles 'Universal Practical Philosophy'—and consequently to think that we do not need to break entirely new ground. Precisely because Wolff's work was supposed to be a universal practical philosophy, it did not take into consideration a special kind of will—a will motivated completely by a priori principles apart from any empirical motives, a pure will, as we might call it. Rather, Wolff's concern was with willing in general, together with all the actions and conditions that belong to volition in this general sense. Because of this it differs from a metaphysic of morals in the same way that general logic differs from transcendental philosophy. General logic sets forth the activities and rules of thinking *in general*, while transcendental philosophy speaks of the special activities and rules of *pure* thinking—that is, of thinking whereby objects are cognized completely a priori. For the metaphysics of morals has to examine the idea and the principles of a possible *pure* will, and not the acts and conditions of human volition generally, which are drawn largely from psychology. The fact that this 'universal practical philosophy' does talk (though quite unjustifiably) of moral laws and duty is no objection to what I am claiming. For the authors of that science remain true to their idea of it in this respect as well: they do not distinguish motives which, as such, are prescribed completely a priori by reason alone and are genuinely moral, from empirical motives which the understanding promotes to general concepts merely by comparison of experiences. On the contrary, without taking into account the difference in their origin they consider motives only as regards to their relative strength or weakness (looking upon all of them as of the same kind) and construct on this basis their concept of *obligation*. This concept is anything but moral; but a concept of that sort is all we can expect from a philosophy

which ignores the question of *origin* and fails to decide whether all possible practical concepts are a priori or only a posteriori.

As a prelude to a metaphysics of morals, which I intend to publish someday, I present this *Groundwork*. Strictly speaking, there is no other foundation for a metaphysics of morals than the critique of *pure practical reason*, just as there is no other foundation for metaphysics than the critique of pure speculative reason, which I have already published. But, in the first place, the former critique is not as indispensable as the latter, since even the most ordinary human intelligence can easily be brought to a high degree of correctness and completeness in moral matters, while reason's theoretical but pure employment is, by contrast, totally dialectical. Secondly, I hold that a critique of practical reason, if it is to be complete, must demonstrate the unity of practical and theoretical reason under a single comprehensive principle, since ultimately there can only be one reason which has to be differentiated solely in its application. However. I found that I could not as yet achieve this completeness without bringing up considerations of quite another sort and confusing the reader. This is why I have used the title *Groundwork for the Metaphysics of Morals* rather than *Critique of Pure Practical Reason.*

But, in the third place, since a metaphysics of morals, in spite of its frightening title, is capable of a high degree of popularity and appeal to ordinary minds, I think it useful to publish this preliminary work on its foundation separately, so as to avoid having to insert the subtleties unavoidable here into the later, more easily understood work.

The present groundwork, however, aims only to seek out and establish *the supreme principle of morality*. This aim constitutes a complete project all by itself and must be kept separate from every other moral investigation. It is true that my claims about this central question, a question so important and yet until now so inadequately debated, would be greatly clarified by seeing the application of that supreme principle to the whole system, and they would be strongly confirmed by the adequacy the principle would manifest throughout. All the same, I had to

forgo this advantage, which in any case would be more flattering to myself than helpful to others. For the convenience of a principle in use and its apparent adequacy do not constitute a secure proof of its correctness. They rather awaken a certain bias against examining and weighing it rigorously and independently of its consequences.

The method I have adopted in this book is, I believe, one which will work best if we proceed analytically from common knowledge to the formulation of its supreme principle and then back again synthetically from an examination of this principle and its origins to the common knowledge in which we find its application. Hence the division turns out to be as follows:

1. Chapter One: Passage from the common rational knowledge of morality to the philosophical.

2. Chapter Two. Transition from popular moral philosophy to a metaphysic of morals.

3. Chapter Three. Final step from a metaphysic of morals to critique of pure practical reason.

CHAPTER ONE

Passage from the Common Rational Knowledge of Morality to the Philosophical

It is impossible to imagine anything at all in the world, or even beyond it, that can be called good without qualification—except a *good will*. Intelligence, wit, judgement, and the other mental talents, whatever we may call them, or courage, decisiveness, and perseverance, are, as qualities of *temperament*, certainly good and desirable in many respects; but they can also be extremely bad and harmful when the will which makes use of these *gifts of nature* and whose specific quality we refer to as *character*, is not good. It is exactly the same with *gifts of fortune*. Power, wealth, honour, even health and that total well-being and contentment with one's condition which we call *'happiness,'* can make a person bold but consequently often reckless as well, unless a good will is present to correct their influence on the mind, thus adjusting the whole principle of one's action to render

it conformable to universal ends. It goes without saying that the sight of a creature enjoying uninterrupted prosperity, but never feeling the slightest pull of a pure and good will, cannot excite approval in a rational and impartial spectator. Consequently, a good will seems to constitute the indispensable condition even of our worthiness to be happy.

Some qualities, even though they are helpful to this good will and can make its task very much easier, nevertheless have no intrinsic unconditional worth. Rather, they presuppose a good will which puts limits on the esteem in which they are rightly held and forbids us to regard them as absolutely good. Moderation in emotions and passions, self-control, and sober reflection are not only good in many respects: they may even seem to constitute part of the inner worth of a person. Yet they are far from being properly described as good without qualification (however unconditionally they were prized by the ancients). For without the principles of a good will those qualities may become exceedingly bad; the passionless composure of a villain makes him not merely more dangerous but also directly more detestable in our eyes than we would have taken him to be without it.

A good will is not good because of its effects or accomplishments, and not because of its adequacy to achieve any proposed end: it is good only by virtue of its willing—that is, it is good in itself. Considered in itself it is to be treasured as incomparably higher than anything it could ever bring about merely in order to satisfy some inclination or, if you like, the sum total of all inclinations. Even if it were to happen that, because of some particularly unfortunate face or the miserly bequest of a step-motherly nature, this will were completely powerless to carry out its aims; if with even its utmost effort it still accomplished nothing, so that only good will itself remained (not, of course, as a mere wish, but as the summoning of every means in our power), even then it would still, like a jewel, glisten in its own right, as something that has its full worth in itself. Its utility or ineffectuality can neither add to nor subtract from this worth. Utility would be merely, as it were, its setting, enabling us to handle it better in our ordinary dealings or to attract to it the attention of those who are not yet experts, but not why we recommend it to experts and determine its worth.

Yet there is something so strange in this idea of the absolute worth of a mere will, all utility being left out of account, that, in spite of all the agreement this idea receives even from common reason, the suspicion must arise that perhaps its hidden basis is merely some high-flown fantasy, and that we may have misunderstood the purpose of nature in appointing reason as ruler of our will. Let us therefore examine this idea from this perspective.

In the natural constitution of an organized being—that is, a being properly equipped for life—we take it as a principle that no instrument for any purpose will be found in that being unless it is also the most appropriate and best adapted for that purpose. Now if nature's real purpose for a being possessed of reason and a will were its *preservation,* its *welfare*, or in a word its *happiness*, then nature would have hit on a very bad arrangement if it assigned the creature's reason the job of carrying out this purpose. For all the actions this creature has to perform with this end in view, and the whole rule of its conduct, would have been disclosed to it far more precisely by instinct; and the end in question could have been attained far more surely by instinct than it ever could be by reason. If, in that case, reason had been given to this favoured creature additionally, its service would have been only to contemplate the fortunate constitution of the creature's nature, to admire it, enjoy it, and be grateful to its beneficent Cause. But reason would not have been given in order that this creature would subject its faculty of desire to such feeble and defective guidance or to meddle incompetently with nature's purpose. In a word, nature would have prevented reason from striking out into a practical use and from presuming, with its feeble insights, to think out for itself a plan for happiness and for the means of attaining it. Nature would herself have taken over not only the choice of ends but also that of means, and would with wise foresight have entrusted both to instinct alone.

And in fact we do find that the more one devotes one's cultivated reason to the enjoyment of life and

happiness, the further away does one get from true contentment. This is why a certain degree of *misology*, i.e., hatred of reason, arises in many people, including those who have been most tempted by this use of reason, if only they are candid enough to admit it. For, according to their calculation of all the benefits they draw—I will not say from the invention of all the arts of common luxury but even from the sciences (which in the final analysis seem to them to be only a luxury of the understanding)—they find that instead of gaining in happiness they have in fact only brought more trouble on their heads. They therefore come to envy, rather than despise, more ordinary people, who are closer to being guided by mere natural instinct and who do not let their reason have much influence on conduct. To this extent we must admit that the judgement of those who seek to moderate—and even to reduce below zero—the boasting glorification of benefits that reason is supposed to provide in the way of happiness and contentment with life, is by no means morose or ungrateful for the kindness of the world's ruler. That judgement rather is based on the idea that our existence has another and much worthier purpose, for which, and not for happiness, our reason is properly intended, an end which, therefore, is the supreme condition to which our private ends must for the most part be subordinated.

For since reason is not sufficiently competent to guide the will safely with regard to its objects and the satisfaction of all our needs (which it in part even multiplies)—a goal to which an implanted natural instinct would have led us much more certainly—and since reason is nevertheless given to us as a practical faculty—that is, as one which is supposed to influence the will; since, finally, reason was absolutely necessary for this purpose, as nature has everywhere distributed her abilities so as to fit the functions they are to perform; reason's true vocation must therefore be to produce a *will* which is *good in itself*, not just *good as a means* to some further end. Such a will must not be the sole and complete good, but it must be the highest good and the condition of all the rest, even of all our longing for happiness. In that case it is entirely compatible with the wisdom of nature that the cultivation of reason, which is required for the

former unconditional purpose, may in many ways, at least in this life, restrict the attainment of the second, conditional purpose—happiness—and indeed that it can even reduce it to less than nothing. Nor does nature here violate its own purpose, for reason, which recognizes as its highest practical vocation the establishment of a good will, is capable only of its own peculiar kind of satisfaction—satisfaction from fulfilling a purpose which reason alone determines, even if this fulfilment damages the ends of inclination.

We must thus develop the concept of a will estimable in itself and good apart from any further aim. This concept is already present in the natural, healthy mind, which requires not so much instruction as merely clarification. It is this concept that always holds the highest place in estimating the total worth of our actions and it constitutes the condition of all the rest. Let us then take up the concept of *duty*, which includes that of a good will, the latter however being here under certain subjective limitations and obstacles. These, so far from hiding a good will or disguising it, rather bring it out by contrast and make it shine forth more brightly....

I will here omit all actions already recognized as opposed to duty, even if they may be useful from this or that perspective; for about these it makes no sense even to ask the question whether they might have been done *out of duty* since they are directly opposed to it. I will also set aside actions that in fact accord with duty, yet for one has no *direct inclination*, but which one performs because impelled to do so by some other inclination. For in such a case it is easy to decide whether the action [which accords with duty] was done *out of duty* or for some self-interested goal. This distinction is far more difficult to perceive when the action accords with duty but the agent has in addition a *direct* inclination to do it. For example, it is certainly in accord with duty that a shopkeeper should not overcharge an inexperienced customer; and, where there is much business, a prudent merchant refrains from doing this and maintains a fixed general price for everybody, so that a child can buy from him just as well as anyone else. People thus get *honest* treatment. But this is not nearly enough to justify our believing that the shopkeeper acted in

this way out of duty or from principles of honesty; his interests required him to act as he did. We cannot assume him to have in addition a direct inclination towards his customers, leading him, as it were out of love, to give no one preferential treatment over another person in the matter of price. Thus the action was done neither out of duty nor from immediate inclination, but solely out of self-interest.

On the other hand, it is a duty to preserve one's life, and every one also has a direct inclination to do it. But for that reason the often-fearful care that most people take for their lives has no intrinsic worth, and the maxim of their action has no moral merit. They do protect their lives *in conformity with duty*, but not *out of duty*. If, by contrast, disappointments and hopeless misery have entirely taken away someone's taste for life; if that wretched person, strong in soul and more angered at fate than fainthearted or cast down, longs for death and still preserves life without loving it—not out of inclination or fear but out of duty—then indeed that person's maxim has moral worth.

It is a duty to help others where one can, and besides this many souls are so compassionately disposed that, without any further motive of vanity or self-interest, they find an inner pleasure in spreading joy around them, taking delight in the contentment of others, so far as they have brought it about. Yet I maintain that, however dutiful and kind an action of this sort may be, it still has no genuinely moral worth. It is on a level with other inclinations—for example, the inclination to pursue honour, which if fortunate enough to aim at something generally useful and consistent with duty, something consequently honourable, deserves praise and encouragement but not esteem. For its maxim lacks the moral merit of such actions done not out of inclination but out of *duty.* Suppose then that the mind of this humanitarian were overclouded by sorrows of his own which extinguished all compassion for the fate of others, but that he still had the power to assist others in distress; suppose though that their adversity no longer stirred him, because he is preoccupied with his own; and now imagine that, though no longer moved by any inclination, he nevertheless tears himself out of this deadly apathy and does the action without any

inclination, solely out of duty. Then for the first time his action has its genuine moral worth. Furthermore, if nature had put little sympathy into this or that person's heart; if he, though an honest man, were cold in temperament and indifferent to the sufferings of others—perhaps because he has the special gifts of patience and fortitude in his own sufferings and he assumes or even demands the same of others; if such a man (who would in truth not be the worst product of nature) were not exactly fashioned by nature to be a humanitarian, would he not still find in himself a source from which he might give himself a worth far higher than that of a good-natured temperament? Assuredly he would. It is precisely in this that the worth of character begins to show—a moral worth, and incomparably the highest—namely, that he does good, not out of inclination, but out of duty.

To secure one's own happiness is a duty (at least indirectly); for discontent with one's condition when pressed by many cares and amidst unsatisfied needs might easily become a *great temptation to transgress one's duties.* But even apart from duty, all human beings already have by their own nature the strongest and deepest inclination towards happiness, because it is precisely in this idea that all the inclinations come together. The prescription for happiness is, however, often so constituted that it greatly interferes with some inclinations, and yet we cannot form a precise conception of the satisfaction of all inclinations as a sum, the conception to which we give the name "happiness". Hence it is not surprising that a single inclination, well defined as to what it promises and as to the time at which it can be satisfied, may outweigh a fluctuating idea; so, for example, a man who suffers from gout, may choose to enjoy whatever he likes and put up with what he must—because according to his calculations he has at least not sacrificed the enjoyment of the present moment to some possibly groundless expectations of happiness allegedly attached to health. But even in this case, if the universal inclination to happiness has failed to determine his will, and if good health, at least for him, did not enter into his calculations, what would remain, as in other cases, is a law—the law that he ought to promote his happiness, not out of inclination, but out

of duty. And only from this law would his conduct begin to have real moral worth.

It is doubtless in this sense that we should understand too the passages from Scripture in which we are commanded to love our neighbour and even our enemy. For love as inclination cannot be commanded; but kindness done out of duty—although no inclination impels us, and even although natural and unconquerable aversion stands in our way—is *practical love*, not *pathological love*. It resides in the will and not in the partiality of feeling, in principles of action and not in melting compassion; and it is this practical love alone that can be commanded.

The second proposition is this: The moral worth of an action done out of duty has its moral worth, not *in the objective* to be reached by that action, but in the maxim in accordance with which the action is decided upon; it depends, therefore, not on actualizing the object of the action, but solely on the *principle of volition* in accordance with which the action was done, without any regard for objects of the faculty of desire. It is clear from our previous discussion that the objectives we may have in acting, and also our actions' effects considered as ends and as what motivates our volition, can give to actions no unconditional or moral worth. Where then can this worth be found if not in the willing of the action's hoped for effect? It can be found nowhere but *in the principle of the will*, irrespective of the ends that can be brought about by such action. For the will stands, so to speak, at the crossroads between its a priori principle, which is formal, and its a posteriori motivation, which is material; and since it must be determined by something, it will have to be determined by the formal principle of volition, since every material principle is ruled out when an action is done out of duty.

The third proposition, which follows from the two preceding, I would express in this way: *Duty is the necessity of an act done out of respect for the law.* While I can certainly have an *inclination* for an object that results from my proposed action, I can never *respect* it, precisely because it is nothing but an effect of a will and not its activity. Similarly I cannot respect any inclination whatsoever, whether it be my own inclination or that of another. At most I can approve of that towards which I feel an inclination, and occasionally I can like the object of somebody else's inclination myself—that is, see it as conducive to my own advantage. But the only thing that could be an object of respect (and thus a commandment) for me is something that is conjoined with my will purely as a ground and never as a consequence, something that does not serve my inclination but overpowers it or at least excludes it entirely from my decision-making—consequently, nothing but the law itself. Now if an action done out of duty is supposed to exclude totally the influence of inclination, and, along with inclination, every object of volition, then nothing remains that could determine the will except objectively *the law* and subjectively *pure respect* for this practical law. What is left therefore is the maxim,[1] to obey this sort of law even when doing so is prejudicial to all my inclinations.

Thus the moral worth of an action depends neither on the result expected from that action nor on any principle of action that has to borrow its motive from this expected result. For all these results (such as one's own pleasurable condition or even the promotion of the happiness of others) could have been brought about by other causes as well. It would not require the will of a rational being to produce them, but it is only in such a will that the highest and unconditional good can be found. That pre-eminent good which we call "moral" consists therefore in nothing but *the idea of the law* in itself, which certainly *is present only in a rational being*—so far as that idea, and not an expected result, is the determining ground of the will. And this pre-eminent good is already present in the person who acts in accordance with this idea; we need not await the result of the action in order to find it.[2]

But what kind of law can it be, the idea of which must determine the will, even without considering the expected result, if that will is to be called good absolutely and without qualification? Since I have robbed the will of every inducement that might arise for it from its obeying any particular law, the only thing remaining that could serve the will as a principle is the universal conformity of actions to law as such. That is, I ought never to act in such a way *that*

I could not also will that my maxim should become a universal law. Here it is the mere conformity to law as such (without presupposing any law prescribing particular actions) that serves the will as its principle, and must so serve it if duty is not to be a totally empty delusion and a chimerical concept. Common human reason, when engaged in making practical judgements, also agrees with this completely and has that principle constantly in view.

Suppose, for example, the question is this: May I, when in distress, make a promise with the intention not to keep it? Here I easily distinguish the different meanings this question can have, whether it is prudent to make a false promise, or whether it is in accord with duty. The first no doubt can often be the case. Of course I see that [even for prudence] it is not enough just to extricate myself from my present predicament by means of this deception; I need to consider whether this lie might give rise to even greater troubles than those from which I am escaping, since, for all my supposed *cunning*, it is not so easy to foresee all the consequences, e.g., the loss of trust may cost me more than all the misfortune I am now trying to avoid. I must consider therefore whether it might be *more* prudent for me to act on a general maxim and make it a habit to issue a promise only when I intend to keep it. But it is soon clear to me that such a maxim is always based solely on fear of consequences. To tell the truth out of duty is something entirely different from telling the truth out of fear of troublesome consequences; for in the first case the concept of the action itself already contains a law for me, while in the second case I must first look around to see how I am likely to be affected by the action. For deviating from the principle of duty is quite certainly bad; but deserting my prudential maxim can often be greatly to my advantage, though it is admittedly safer to stick to it. If, on the other hand, I want to find out most quickly but unerringly the answer to a different question—whether a deceitful promise accords with duty—I must ask myself 'Would I really be content if my maxim (the maxim of getting out of a difficulty by making a false promise) were to hold as a universal law (one valid both for myself and for others)? And could I really say

to myself. 'Let everyone be allowed to make a false promise if they find themselves in difficulties from which there is otherwise no escape'? I immediately see that I can indeed will the lie, but I cannot will a universal law to lie. For with such a law, there would actually be no promising at all, since it would be futile for me to allege my intentions with regard to some future actions to others who would not believe me, or who, if they did so over-hastily, would pay me back in the same coin. Consequently my maxim, as soon as it became a universal law, would necessarily subvert itself.

Thus I need no far-reaching acuteness to know what I have to do in order that my volition can be morally good. Inexperienced in the ways of the world and incapable of anticipating all its actual events, I ask myself only, 'Can you will that your maxim become a universal law?' If not, that maxim must be repudiated, and not because of any impending disadvantage to you or even to others, but because it cannot fit as a principle into a possible universal legislation, and reason forces me to offer my immediate respect to such legislation. As yet I have no *insight* into the grounds of that respect (something the philosopher may investigate), but I do at least understand this much: it is the appreciation of something whose worth far exceeds all the worth of anything favoured by inclination. I understand too that the necessity that I act out of *pure* respect for the practical law is what constitutes duty. To duty every other motive must give way, because it is the condition of a will good *in itself*, whose worth transcends all else.

Considering the moral knowledge of common human reason we have thus arrived at its principle, a principle it admittedly does not think about abstractly in such a universal formulation; but which it really does always have in view and employs as the standard in its judging. It would be easy to show here how common human reason, with this compass in hand, knows very well how to distinguish what is good or evil, consistent or inconsistent with duty, in all cases that present themselves. Without attempting to teach it anything new, one merely has to make reason attend, as Socrates did, to its own principle. Therefore neither science nor philosophy is needed

in order for us to know what one has to do to be honest and good, and even to be wise and virtuous. This is something that we could have suspected from the start: that knowledge of what it is incumbent upon everyone to do, and so also to know, would be attainable by everyone, even the most ordinary human being. Here we cannot help but be impressed when we notice the great advantage that the power of practical judgement has over theoretical judgement, in the minds of ordinary people. In theoretical judgements, if common reason dares to go beyond the laws of experience and the perceptions of the senses, it falls into sheer inconceivabilities and self-contradictions, or at least into a chaos of uncertainty, obscurity, and vacillation. On the practical side, however, the power of judgement first begins to look its best when the ordinary mind excludes all sensuous motives from its practical laws. The ordinary mind then becomes even subtle—perhaps vexing itself with its conscience or with other claims regarding what is to be called "right", or trying to determine honestly for its own instruction the worth of various actions. But what is most important, the common understanding has, in the latter case, as good a chance of hitting the mark as any philosopher has. Indeed its chances are almost better than a philosopher's, since the latter's judgement has no principle different from that of ordinary intelligence, and a philosopher's judgement may easily be confused by a mass of strange and irrelevant considerations and caused to turn from the right path. Would it not be wise therefore to accept the judgement of common reason in moral matters, or to bring in philosophy at most to make the system of morals more complete and comprehensible and to present its rules in formulations more convenient to use (especially in disputation)—but not to lead the common human understanding away from its happy simplicity in matters of action and set it on a new path of inquiry and instruction?

A wonderful thing about innocence—but also something very bad—is that it cannot defend itself very well and is easily led astray. For this reason even wisdom—which otherwise is more a matter of acting than knowing—also needs science, not in order to learn from it, but in order to gain access and

durability for what it prescribes. Human beings feel within themselves a powerful counterweight opposed to all the commandments of duty, which reason portrays as so worthy of esteem: the counterweight of needs and inclinations, whose total satisfaction people sum up under the name 'happiness'. But reason, without promising anything to inclination, dictates its prescriptions relentlessly, thus treating with neglect and contempt those blustering and seemingly legitimate claims (which refuse to be suppressed by any commandment). From this there arises a *natural dialectic*—that is, a tendency to quibble with these strict laws of duty, to cast doubt on their validity or at least on their purity and strictness, and, if possible, to make them conform better to our wishes and inclinations. This means corrupting their very foundations and destroying their dignity—a result that even common practical reason cannot ultimately endorse.

In this way *common human reason* is driven, not by any cognitive need (which never touches it so long as it is content to be mere sound reason), but on practical grounds, driven to leave its own sphere and take a step into the field of *practical philosophy*. There it seeks instruction and precise direction as to the source of its own principle and about the correct function of this principle in contrast with maxims based on need and inclination. It ventures into philosophy so as to escape from the perplexity caused by conflicting claims and so as to avoid the risk of losing all genuine moral principles through the obscurity into which it easily falls. Thus, just as happens in its theoretical use, a *dialectic* arises unnoticed when practical common reason is cultivated, and it is forced to seek help in philosophy. As with the theoretical use of reason, the conflict will be resolved only by a thorough critical examination of our reason.

CHAPTER TWO

Transition from Popular Moral Philosophy to a Metaphysics of Morals

Although we have drawn our previous concept of duty from the common use of our practical reason,

this by no means implies that we have treated it as a concept derived from experience. On the contrary, if we pay attention to our experience of what human beings do and fail to do, we encounter frequent and, I must admit, justified complaints that one cannot in fact point to any sure examples of the disposition to act out of pure duty. Thus we hear the charge that, although many things may be done that are in accord with what duty commands, it still remains doubtful whether those actions are really done out of duty, and doubtful therefore whether they have moral worth. That is why there have always been philosophers who absolutely denied the reality of this disposition in human conduct and ascribed everything we do to more or less refined self-love. But those philosophers have not denied the correctness of the concept of morality. Rather, they have spoken with sincere regret of the frailty and corruption of human nature, noble enough to fake as its rule an Idea so worthy of respect, but at the same time too weak to follow it, so that reason, which should serve as the law-giver to human nature, is used only to serve the interests of our inclinations, either singly or, at most, to maximize their compatibility. It is in fact absolutely impossible to identify by experience, with complete certainty, a single case in which the maxim of an action—an action that accords with duty—was based exclusively on moral reasons and the thought of one's duty. There are cases when the most searching self-examination comes up with nothing but duty as the moral reason that could have been strong enough to move us to this or that good action or to some great sacrifice. But we cannot conclude from this with certainty that the real determining cause of our will was not some secret impulse of self-love, disguising itself as that Idea of duty. So we like to flatter ourselves with the false claim to a nobler motive but in fact we can never, even with the most rigorous self-examination, completely uncover our hidden motivations. For when moral worth is the issue, what counts is not the actions which one sees, but their inner principles, which one does not see.

Furthermore, there is no better way to serve the interests of those who mock all morality as a mere phantom of the brain, an illusion with which, out of vanity, the human imagination puffs itself up, than to concede that concepts of duty must be drawn solely from experience (as people find it only too easy to believe about all other concepts). For by conceding this we prepare an assured victory for those scoffers. Out of charity I am willing to grant that most of our actions are in accord with duty; but if we look more closely at the devising and striving that lies behind them, then everywhere we run into the dear self which is always there; and it is this and not the strict command of duty (which would often require self-denial) that underlies our intentions. One need not be an enemy of virtue but only a dispassionate observer who does not immediately confuse even the liveliest wish for goodness with its reality, to become doubtful at certain moments whether any genuine virtue can really be found in the world. (Such doubts occur particularly as one grows older and experience renders one's power of judgement and observation shrewder and more discerning.) And at that point only one thing can protect us against a complete abandonment of our Ideas of duty, or can preserve in us a well-founded respect for its law: the clear conviction that even if there never were any actions springing from such pure sources, the question at issue here is not whether this or that actually occurs. The question is rather whether reason, by itself and independently of all appearances, commands what ought to be done, actions of which the world has perhaps never until now provided an example—actions whose feasibility might well be doubted by those who rest everything on experience—which are nevertheless commanded inexorably by reason. For example, the duty to be totally sincere in one's friendships can be demanded of everyone even if up to now there may never have existed a totally sincere friend. For this duty, as duty in general, lies prior to all experience in the Idea of a power of reason which determines the will by a priori grounds.

Unless we wish to deny to the concept of morality all truth and all application to a possible object, we must grant that its law is so broad in meaning that it must be valid not merely for human beings, but for all rational beings as such, and valid not merely under contingent conditions and subject to exceptions, but with absolute necessity. It is therefore clear

that no experience could warrant even the possibility of such absolutely certain and necessary laws. For by what right can we make something that is perhaps valid only under the contingent human conditions into an object of unlimited respect and view it as universally prescribed for every rational creature? And how could laws for determining our will be taken as laws for determining the will of rational beings in general—and only on that account laws for determining our will—if these laws were merely empirical and did not have their source completely a priori in pure, but practical, reason?

Nor could one give morality worse advice than by trying to derive it from examples. For every example of morality presented to me must itself first be assessed with moral principles to see whether it deserves to be used as an original example, i.e., as a model. By no means can it have the authority to give us the concept of morality. Even the Holy One of the Gospels must first be compared with our ideal of moral perfection before we can acknowledge Him to be such. Even He says of Himself: 'Why do you call Me (whom you see) good? There is none good (the archetype of the good) but the one God alone (whom you do not see).' But where do we get the concept of God as the highest good? Only from the *Idea* of moral perfection which reason designs a priori and connects inseparably with the concept of a free will. Imitation has no place in moral matters, and examples serve us only for encouragement—that is, they set beyond doubt the feasibility of doing what the law commands and they make perceptible what the law prescribing conduct expresses in more general terms; but examples can never justify our guiding ourselves by examples and setting aside their true origin which resides in reason.

If, then, there is no genuine supreme principle of morality that is not grounded on pure reason alone, independently of all experience, I think it should be unnecessary even to ask whether it is desirable to exhibit these concepts in general (abstractly)—these concepts which, together with their corresponding principles, hold a priori, in so far as knowledge which establishes this is to be distinguished from common knowledge and described as philosophical. But

nowadays it may well be necessary to raise this question. For if we took a vote on which is to be preferred, pure rational knowledge detached from everything empirical—that is to say, a metaphysic of morals—or popular practical philosophy, we can easily guess on which side the majority would stand.

It is certainly most commendable to descend to the level of folk concept once the ascent to the principles of pure reason has been satisfactorily completed. This ascent could be described as first *grounding* moral philosophy on metaphysics and subsequently, when moral philosophy has been established, winning *acceptance* for it by giving it a popular character. But it is utterly absurd to aim at popularity in our first investigation, on which the whole correctness of our principles depends. Not only can such a procedure never lay claim to the extremely rare merit of *truly philosophical popularity*, since it takes no skill to be generally understandable once one renounces all thorough probing: what that popularizing produces is a disgusting mishmash of second-hand observations and half-reasoned principles. Empty-headed people regale themselves with this, because it is something useful in everyday chitchat. More insightful people, on the other hand, are confused by it and avert their eyes, dissatisfied but not knowing how to help themselves. They turn away, but philosophers who see through this deception get little hearing if they urge those moralists to postpone this so-called popularizing for a while until the achievement of some definite insight earns them the right to be popular.

We need only look at essays on morality written in this fashionable style. What we run into is a marvellous medley—now the talk is of the particular vocation of human nature (but along with this also the Idea of a rational nature as such), now they talk of perfection, now of happiness, here moral feeling and there the fear of God; a little of this and a little of that. But it never occurs to anyone to ask whether the principles of morality are to be sought at all in our knowledge of human nature (which we can get only from experience); nor does it occur to them that if this is not so—if these principles are to be found completely a priori and free from empirical elements in concepts of pure reason and absolutely nowhere

else, even to the slightest extent—they had better pursue the latter investigation altogether separately, as pure practical philosophy, or (if one may use a word so much vilified) as a metaphysics[3] of morals. They do not see that this investigation must be completed entirely by itself and that the public, which demands popularity, should be put off until the outcome of this undertaking is at hand.

Nevertheless, such a completely isolated metaphysics of morals, mixed with no anthropology, no theology, no physics or hyperphysics, still less with occult qualities (which one might call 'hypophysical'), is not only an indispensable underlying support for all theoretical and precisely defined knowledge of duties; it is also something to be desired and of the utmost importance for the actual fulfilment of moral precepts. For the pure thought of duty and of the moral law generally, unmixed with any additional empirical inducements, has an influence on the human heart much more powerful than all other motivations[4] that may arise from the field of experience, so much so that reason, conscious of its own dignity, despises these and is able gradually to become their master. The thought of duty and the moral law has this influence through reason alone (and reason first learns from this that by itself it is able to be practical [as well as theoretical]). A mixed moral theory, on the other hand, compounded of motives derived from feeling or inclination and also of rational concepts, must make the mind vacillate between [different] sources of motivation that cannot be brought under any single principle and that can guide us only by sheer accident to the good, and often to the evil.

From what has been said, it is clear that all moral concepts have their seat and origin in reason completely a priori, and this is just as true of the most ordinary human intellect as of the most highly theoretical. Moral principles cannot be abstracted from any empirical, and therefore merely contingent, cognition. Their worthiness to serve as supreme practical principles lies precisely in this purity of their origin. Everything empirical added to them subtracts just that much from their genuine influence and from the unqualified worth of the corresponding actions. It is of the utmost necessity—and not only from a cognitive

point of view, where our concern is exclusively with theory, but it is also of the utmost importance for action, that we derive these concepts and laws from pure reason, enunciating them pure and unmixed, and indeed determine the scope of this whole practical but pure sphere of rational cognition—that is, of this whole faculty of pure practical reason. But in doing this, we must not make its principles depend on the particular nature of human reason—as speculative philosophy allows and even at times requires. Since moral laws must hold for every rational being as such, our principles must instead be derived from the universal concept of a rational being as such. In this way the whole of ethics, which does require anthropology for its *application* to human beings, should at first be expounded independently of this and fully, as pure philosophy, that is, as metaphysics (which is quite possible to do in a totally separate branch of knowledge such as this). We are well aware that without possessing such a metaphysics it is not only futile to try to determine precisely, for purposes of speculative judgement, the moral element of duty in all actions which accord with duty; it is impossible to establish morality on genuine principles even for merely ordinary practical purposes and particularly for moral instruction, if we lack such a metaphysics. Only in this way can we produce pure moral dispositions and engraft them onto the minds of human beings for the sake of the world's highest good.

In this study we must not go merely from common moral judgement (which is here worthy of great respect) to philosophical judgement, as has already been done, but advance by natural steps from a popular philosophy which goes no further than it can grope by means of examples, to metaphysics (which is not restricted by anything empirical, and—since it must survey the totality of this kind of rational knowledge—extends itself even to Ideas, where examples themselves forsake us). We must pursue and portray in detail the faculty of practical reason, from its general ordinances right up to the point where the concept of duty arises from it.

Everything in nature works in accordance with laws. Only a rational being has the power to act in accordance with the idea of laws—that is, in accordance

with principles—and thus has a will. Since reason is required if we are to derive actions from laws, the will is nothing else than practical reason. If reason were inevitably to determine the will, then, in a being of this kind, actions which are recognized as objectively necessary would also be subjectively necessary—that is to say, the will would be a power to choose only that which reason independently of inclination recognizes to be practically necessary, that is, sees to be good. But if reason by itself alone is not sufficient to determine the will; if the will is exposed also to subjective conditions (certain incentives) which do not always harmonize with the objective ones; if, in a word, (as is actually the case with human beings) the will is not of itself completely in accord with reason; then actions which are recognized to be objectively necessary are subjectively contingent, and the determining of such a will in accordance with objective laws is constraint; that is, the relation between objective laws and an incompletely good will can be represented as the determining of a rational being's will by principles that are indeed principles of reason, but principles to which this will by its own nature is not necessarily obedient.

The idea of an objective principle, in so far as it constrains a will, is called a commandment (of reason), and the formulation of this commandment is called an Imperative.

All imperatives are expressed by a 'must'. Thereby they mark a constraint, that is to say, the relation of an objective law of reason to a will that in its subjective constitution is not necessarily determined by this law. Imperatives say that something would be good to do or to leave undone; but they say this to a will that does not always do something simply because it has been informed that it is a good thing to do. Practical good however is something that determines the will by means of what reason presents to it, and therefore not by means of subjective causes but objectively—that is, by reasons that are valid for every rational being as such. The practical good is distinguished from the pleasant, which influences the will solely through the medium of sensation as a result of purely subjective causes, effective only for the senses of this person or that, not as a principle of reason valid for everyone.[5]

A perfectly good will would thus be just as much subject to objective laws (laws of the Good), but it could not for that reason be thought to be constrained to act lawfully, since by its own subjective constitution, it can be moved only by the concept of the Good. Hence no imperatives hold for the divine will or, more generally, for a holy will. The "must" is here out of place, because the "willing" is already of itself necessarily in agreement with the law. For this reason imperatives are only formulas for expressing the relation of objective laws of willing in general to the subjective imperfection of the will of this or that rational being—for example, the human will.

All imperatives command either hypothetically or categorically. Hypothetical imperatives declare a possible action to be practically necessary as a means to the attainment of something else that one wants (or that one may want). A categorical imperative would be one that represented an action as itself objectively necessary, without regard to any further end.

Since every practical law presents a possible action as good and therefore as necessary for a subject whose actions are determined by reason, all imperatives are therefore formulae for determining an action which is necessary according to the principle of a will in some way good. If the action would be good only as a means to something else, the imperative is hypothetical; if the action is thought of as good in itself and therefore as necessary for a will which of itself conforms to reason as its principle, then the imperative is categorical.

An imperative therefore states which of my possible actions would be good. The imperative formulates a practical rule for a will that does not perform an action immediately just because that action is good, partly because the subject does not always know that a good action is good, partly because, even if he did know this, his maxims might still be contrary to the objective principles of practical reason.

A hypothetical imperative thus says only that an action is good for some purpose or other, either possible or actual. In the first case it is a problematic practical principle; in the second case an assertoric practical principle. A categorical imperative, which declares an action to be objectively necessary of itself without reference to any purpose—that is, even

without any further end—ranks as an apodictic practical principle.

What is possible only through the powers of some rational being can also be thought of as a possible purpose of some will. Consequently, if we think of principles of action as stating what is necessary in order to achieve some possible purpose, there are in fact infinitely many principles of action. All sciences have a practical part consisting of projects, which suppose that some end is possible for us, and imperatives, which tell us how that end is to be reached. These imperatives can in general be called imperatives of *skill*. Here there is no question at all as to whether the end is reasonable and good, but only about what one would have to do to attain it. The prescriptions required by a doctor in order to cure a patient and those that a poisoner needs in order to bring about certain death are of equal value so far as each will accomplish its purpose perfectly. Since young people do not know what ends may occur to them in the course of life, parents try to make their children learn *many kinds* of things. They try carefully to teach *skill* in the use of means to *various* desired ends, not knowing with certainty which possible end may in the future become an actual goal adopted by their pupil. Their anxiety in this matter is so great that they commonly neglect to form and correct their children's judgements about the worth of things that they might possibly adopt as ends.

There is, however, *one* end that we may presuppose as actual in all rational beings (so far as they are dependent beings to whom imperatives apply); and thus there is one aim which they not only *might* have, but which we can assume with certainty that they all *do* have by a necessity of nature and that aim is *perfect happiness*. The hypothetical imperative which affirms the practical necessity of an action as a means to the promotion of perfect happiness is an assertoric imperative. We must not characterize it as necessary merely for some uncertain, merely possible purpose, but as necessary for a purpose that we can presuppose a priori and with certainty to be present in everyone because it belongs to the essence of human beings. Now we can call skill in the choice of the means to one's own greatest well-being "prudence"[6] in the narrowest sense of

the word. So the imperative concerning the choice of means to one's own happiness—that is, the precept of prudence—still remains hypothetical; the action is commanded not absolutely but only as a means to a further end.

Finally, there is one imperative which commands a certain line of conduct directly, without assuming or being conditional on any further goal to be reached by that conduct. This imperative is categorical. It is concerned not with the material of the action and its anticipated result, but with its form and with the principle from which the action itself results. And what is essentially good in the action consists in the [agent's] disposition, whatever the result may be. This imperative may be called the imperative of morality.

Volition in accordance with these three kinds of principles is also sharply distinguished by the dissimilarity in how they constrain the will. To make this dissimilarity obvious, I think we would name them most appropriately if we called them rules of skill, counsels of prudence, or commandments (laws) of morality, respectively. For only law carries with it the concept of necessity, an unconditional and objective and therefore universally valid necessity; and commandments are laws that must be obeyed, even against inclination. Counsels do indeed involve necessity, but a necessity valid only under a subjective and contingent condition—namely, depending on whether this or that human being counts this or that as essential to his happiness. As against this, a categorical imperative is limited by no condition and can actually be called a commandment in the strict sense, being absolutely, although practically necessary. We could also call imperatives of the first kind technical (concerned with art), imperatives of the second kind pragmatic[7] (concerned with well-being), and imperatives of the third kind moral (concerned with free conduct as such—that is, with morals).

The question now arises 'How are all these imperatives possible?' This question does not ask how an action commanded by the imperative can be performed, but merely how we can understand the constraining of the will, which imperatives express in setting us a task. How an imperative of skill is possible requires no special discussion. Whoever wills

the end also wills (so far as reason has decisive influence on his actions) the means which are indispensably necessary and in his power. This proposition is analytic as far as willing is concerned. For when I will an object as an effect of my action I already conceive of my causality as an acting cause—that is, the use of means is included in the concept of the end; and the imperative merely extracts the concept of actions necessary to this end from the concept of willing an end. (Of course synthetic propositions are required in determining the means to a proposed end, but these propositions are concerned, not with the ground, the act of will, but with how to actualize the object.) Mathematics teaches, and certainly by synthetic propositions alone, that in order to bisect a line according to a reliable principle I must make two intersecting arcs from each of its extremities. But if I know that the aforesaid effect can be produced only by such an action, then the proposition 'If I fully will the effect, I must also will the action required to produce it' is analytic. For it is one and the same thing to think of something as an effect that is in a certain way possible through me and to think of myself as acting in this same way.

If it were only that easy to provide a definite concept of perfect happiness the imperatives of prudence would coincide entirely with those of skill and would be equally analytic. For then it could be said in this case as in the former case, 'Whoever wills the end, also (necessarily, according to reason) wills the sole means which are in his power.' Unfortunately, however, the concept of perfect happiness is such a vague concept that although everyone wants it, they can never say definitely and self-consistently what it really is that they wish and will. The reason for this is that all the elements that belong to the concept of happiness are empirical—that is, they must be borrowed from experience; but the Idea of perfect happiness requires an absolute whole, a maximum, of well-being in my present and in every future state. Now it is impossible for even the most insightful and most capable but finite being to form here a definite concept of what he really wants. Is it riches that he wants? How much anxiety, envy, and intrigue might he not bring on his own head in this way! Is

it knowledge and insight? This might just give him an eye even sharper in seeing evils at present hidden from him and yet unavoidable, making those evils all the more frightful, or it might add a load of still further needs to the desires which already give him trouble enough. Is it long life? Who will guarantee that it would not be a life of long misery? Is it at least health? How often has not physical infirmity kept someone from excesses into which perfect health would have let him fall!—and so on. In short, he has no principle by which he is able to decide with complete certainty what would make him truly happy, since for this he would require omniscience. Thus we cannot act on definite principles in order to be happy, but only on empirical counsels, for example, of diet, frugality, politeness, reserve, and so on—things which experience shows contribute most to well-being on the average. Hence the imperatives of prudence, strictly speaking, do not command at all—that is, they cannot exhibit actions objectively as practically necessary. They should be taken as pieces of advice (*consilia*), rather than as commandments (*praecepta*), of reason. The problem of determining certainly and universally what action will promote the perfect happiness of a rational being is completely insoluble; and consequently in regard to this there is no imperative possible which in the strictest sense could command us to do what will make us happy, since perfect happiness is an ideal, not of reason, but of imagination—an ideal resting merely on empirical grounds, of which it is vain to expect that they should determine an action by which we could attain the totality of a series of consequences which is in fact infinite. Nevertheless, if we were to assume that the means to happiness could be discovered with certainty, this imperative of prudence would be an analytic practical proposition; for it differs from the imperative of skill only in this—that in the latter the end is merely possible, while in the former the end is given. In spite of this difference, since both command solely the means to something assumed to be willed as an end, the imperative that commands him who wills the end to will the means is in both cases analytic. Thus, the possibility of an imperative of prudence also poses no difficulty.

By contrast, 'How is the imperative of morality possible?' is beyond all doubt the one question in need of solution. For the moral imperative is in no way hypothetical, and consequently the objective necessity, which it affirms, cannot be supported by any presupposition, as was the case with hypothetical imperatives. But we must never forget that it is impossible to settle by any example, i.e., empirically, whether there is any imperative of this kind at all; we should rather worry that all imperatives that seem to be categorical may yet be hypothetical in some hidden way. For example, when it is said, 'You must abstain from making deceitful promises,' one assumes that the necessity for this abstention is not mere advice so as to avoid some further evil—as though the meaning of what was said was, You ought not to make a deceitful promise lest, when it comes to light, you destroy your credit. On the contrary, an action of this kind would have to be considered as bad in itself, and the imperative of the prohibition would be therefore categorical. Even so, no example can show with certainty that the will would be determined here solely by the law without any further motivation, although it may appear to be so; for it is always possible that fear of disgrace, perhaps also hidden dread of other risks, may unconsciously influence the will. Who can prove by experience the non-existence of a cause? For experience shows only that we do not perceive it. In such a case, however, the so-called moral imperative, which as such appears to be categorical and unconditional, would in fact be only a pragmatic prescription calling attention to our own advantage and merely instructing us to take this into account.

We shall thus have to investigate entirely a priori the possibility of a categorical imperative, since here we do not enjoy the advantage of having its reality given in experience so that the discussion of its possibility would be needed merely to explain, and not to establish it. However, we can see the following at least provisionally: that the categorical imperative alone purports to be a practical law, while all the rest may be called principles of the will but not laws; for an action that is necessary merely to achieve some arbitrary purpose can be considered as in itself contingent, and we can always escape from the prescription if we abandon the purpose; whereas an unconditional commandment does not leave it open to the will to do the opposite at its discretion and therefore alone carries with it that necessity which we demand from a law.

In the second place, with this categorical imperative or law of morality the reason for our difficulty (in comprehending its possibility) is a very serious one. We have here a synthetic a priori practical proposition;[8] and since in theoretical knowledge there is so much difficulty in comprehending the possibility of propositions of this kind, we may well assume that the difficulty will be no less in the practical sphere.

The first part of our task is to see whether perhaps the mere concept of a categorical imperative might also give us the formula containing the only proposition that can be a categorical imperative. Showing how such an absolute commandment is possible will still require special and difficult effort, even when we know what the commandment asserts. But we postpone this to the last section.

If I think of a *hypothetical* imperative as such, I do not know beforehand what it will contain—not until I am given its condition. But if I think of a *categorical imperative*, I know right away what it contains. For since this imperative contains, besides the law, only the necessity that the maxim[9] conform to this law, while the law, as we have seen, contains no condition limiting it, there is nothing left over to which the maxim of action should conform except the universality of a law as such; and it is only this conformity that the imperative asserts to be necessary.

There is therefore only one categorical imperative and it is this: 'Act only on that maxim by which you can at the same time will that it should become a universal law.'

Now if all imperatives of duty can be derived from this one imperative as their principle, then even though we leave it unsettled whether what we call duty is or is not an empty concept, we shall still be able to indicate at least what we understand by it and what the concept means.

Because the universality of law according to which effects occur constitutes what is properly called nature in its most general sense (nature as regards its form)—that is, the existence of things so far as this is

determined by universal laws—the universal imperative of duty could also be formulated as follows: 'Act as though the maxim of your action were to become by your will a universal law of nature.'

We shall now enumerate some duties, dividing them in the usual way into duties towards ourselves and duties towards others and into perfect and imperfect duties.[10]

1. A man feels sick of life as the result of a mounting series of misfortunes that has reduced him to hopelessness, but he still possesses enough of his reason to ask himself whether it would not be contrary to his duty to himself to take his own life. Now he tests whether the maxim of his action could really become a universal law of nature. His maxim, however, is: 'I make it my principle out of self-love to shorten my life if its continuance threatens more evil than it promises advantage.' The only further question is whether this principle of self-love can become a universal law of nature. But one sees at once that a nature whose law was that the very same feeling meant to promote life should actually destroy life would contradict itself, and hence would not endure as nature. The maxim therefore could not possibly be a general law of nature and thus it wholly contradicts the supreme principle of all duty.

2. Another finds himself driven by need to borrow money. He knows very well that he will not be able to pay it back, but he sees too that nobody will lend him anything unless he firmly promises to pay it back within a fixed time. He wants to make such a promise, but he still has enough conscience to ask himself, 'Isn't it impermissible and contrary to duty to get out of one's difficulties this way?' Suppose, however, that he did decide to do it. The maxim of his action would run thus: 'When I believe myself short of money, I will borrow money and promise to pay it back, even though I know that this will never be done.' Now this principle of self-love or personal advantage is perhaps quite compatible with my own entire future welfare; only there remains the question 'Is it right?' I therefore transform the unfair demand of self-love into a universal law and frame my question thus: 'How would things stand if my maxim became a universal law?' I then see immediately that this maxim can never qualify as a self-consistent universal law of nature, but must necessarily contradict itself. For the universality of a law that permits anyone who believes himself to be in need to make any promise he pleases with the intention of not keeping it would make promising, and the very purpose one has in promising, itself impossible. For no one would believe he was being promised anything, but would laugh at any such utterance as hollow pretence.

3. A third finds in himself a talent that, with a certain amount of cultivation, could make him a useful man for all sorts of purposes. But he sees himself in comfortable circumstances, and he prefers to give himself up to pleasure rather than to bother about increasing and improving his fortunate natural aptitudes. Yet he asks himself further 'Does my maxim of neglecting my natural gifts, besides agreeing with my taste for amusement, agree also with what is called duty?' He then sees that a nature could indeed endure under such a universal law, even if (like the South Sea Islanders) every man should let his talents rust and should be bent on devoting his life solely to idleness, amusement, procreation—in a word, to enjoyment. Only he cannot possibly *will* that this should become a universal law of nature or should be implanted in us as such a law by a natural instinct. For as a rational being he necessarily wills that all his powers should be developed, since they are after all useful to him and given to him for all sorts of possible purposes.

4. A fourth man, who is himself flourishing but sees others who have to struggle with great hardships (and whom he could easily help) thinks to himself: 'What do I care? Let every one be as happy as Heaven intends or as he can make himself; I won't deprive him of anything; I won't even envy him; but I don't feel like contributing anything to his well-being or to helping him in his distress!' Now admittedly if such an attitude were a universal law of nature, the human race could survive perfectly well and doubtless even better than when everybody chatters about sympathy and good will, and even makes an effort, now and then, to practise them, but, when one can get away with it, swindles, traffics in human rights, or violates them in other ways. But although it is possible that

a universal law of nature in accord with this maxim could exist, it is impossible to *will* that such a principle should hold everywhere as a law of nature. For a will that intended this would be in conflict with itself, since many situations might arise in which the man needs love and sympathy from others, and in which, by such a law of nature generated by his own will, he would rob himself of all hope of the help he wants.

These are some of the many actual duties—or at least of what we take to be actual—whose derivation from the single principle cited above is perspicuous. We must be able to will that a maxim of our action should become a universal law—this is the authoritative model for moral judging of action generally. Some actions are so constituted that we cannot even *conceive* without contradiction that their maxim be a universal law of nature, let alone that we could *will* that it *ought* to become one. In the case of other actions, we do not find this inner impossibility, but it is still impossible to *will* that their maxim should be raised to the universality of a law of nature, because such a will would contradict itself. We see readily that the first kind of action is opposed to strict or narrow duty, the second opposed only to wide (meritorious) duty; Thus all duties—so far as the type of obligation (not the object of its action) is concerned—are fully set out in these examples as dependent on our single principle.

If we now look at ourselves whenever we transgress a duty, we find that we in fact do not intend that our maxim should become a universal law. For this is impossible for us. What we really intend is rather that its opposite should remain a law generally; we only take the liberty of making an *exception* to it, for ourselves or (of course just this once) to satisfy our inclination. Consequently if we weighed it all up from one and the same perspective—that of reason—we should find a contradiction in our own will, the contradiction that a certain principle should be objectively necessary as a universal law and yet subjectively should not hold universally but should admit of exceptions. But there is actually no contradiction here, since we are first considering our action from the perspective of a will wholly in accord with reason, and then considering exactly the same action from the point of view of a will affected by inclination. What we have is rather an opposition (antagonism) of inclination to the precept of reason whereby the universality of the principle (*universalitas*) is transformed into a mere generality (*generalitas*) in order that the practical principle of reason can meet the maxim halfway. This procedure, though unjustifiable in our own impartial judgement, proves nevertheless that we in fact recognize the validity of the categorical imperative and (with all respect to it) merely allow ourselves a few exceptions that are, as we pretend, unimportant and apparently forced upon us.

We have thus at least shown this much—that if duty is a concept that is to have meaning and actual legislative authority for our actions, it can be expressed only in categorical imperatives and not at all in hypothetical ones. At the same time—and this is already a great deal—we have set forth clearly, and defined for every use, the content of the categorical imperative, which must contain the principle of all duty (if there is to be such a thing at all). But we are still not so far advanced as to prove a priori that there actually is an imperative of this kind—that there is a practical law which by itself commands absolutely and without any further motivation, and that it is our duty to follow this law.

If we really intend to arrive at this proof it is extremely important to remember that we should not let ourselves think for a moment that the reality of this principle can be derived from *the particular characteristics of human nature.* For duty has to be a practical, unconditional necessity of action; it must therefore hold for all rational beings (to whom alone an imperative can apply at all), and *only for that reason* a law that holds also for all human wills. Whatever, on the other hand, is derived from the special predisposition of humanity, from certain feelings and propensities, and even, if this were possible, from some special bent peculiar to human reason and not holding necessarily for the will of every rational being—all this can indeed supply a personal maxim, but not a law: it can give us a subjective principle—one on which we have a natural disposition and inclination to act—but not an objective principle on which we should be directed to act even though our every propensity, inclination,

and natural bent were opposed to it. This is so much the case that the sublimity and inner dignity of the commandment is even more manifest in a duty, the fewer subjective causes there are for obeying it and the more there are against it, but without this weakening in the slightest the constraint exercised by the law or diminishing its validity.

Here we see philosophy placed in what is actually a precarious position, a position that is supposed to be firm though it is neither suspended from heaven nor supported by the earth. Here she must show her purity as the sustainer of her own laws—not as the herald of laws that some implanted sense or who knows what guardian-like nature has whispered to her. Such laws, though perhaps always better than nothing, can never furnish us with fundamental principles dictated by reason, principles whose origin must be completely a priori and, because of this, have commanding authority. Such fundamental principles expect nothing from human inclinations but everything from the supremacy of the law and the respect owed it. Without this they condemn human beings to self-contempt and inner disgust.

Everything empirical is thus not only wholly unfit to contribute to the principle of morality; it is highly damaging to the purity of moral practices themselves. For, in morality, the proper worth of an absolutely good will, a worth exalted above all price, lies precisely in the freedom of its principle of action from any influence by contingent reasons that only experience can provide. We cannot warn too strongly or too often against the slack, or indeed vulgar, attitude which searches among empirical motives and laws for the principle; for human reason in its weariness is glad to rest on this cushion, and in a dream of sweet illusions (which allow it to embrace a cloud instead of Juno) to substitute for morality a bastard patched up from limbs of very diverse parentage, looking like anything one wishes to see in it, only not resembling virtue to anyone who has once beheld her in her true form.[11]

Our question then is this: 'Is it a necessary law *for all rational beings* to judge their actions always in accordance with those maxims which they can themselves will that they should serve as universal laws?' If it is a necessary law, it must already be connected (entirely a priori) with the concept of the will of a rational being as such. But in order to discover this connection we must, however reluctantly, venture into metaphysics, although into a region of metaphysics different from that of speculative philosophy, namely, the metaphysics of morals. In a practical philosophy we are not concerned with assuming reasons for what happens, but with acknowledging laws for what ought to happen, even if it may never happen—that is, objective practical laws. And here we have no need to investigate the reasons why anything pleases or displeases, how the pleasure of mere sensation differs from taste, and whether the latter is distinct from general satisfaction of reason. We need not inquire on what the feelings of pleasure and displeasure are based, or how from these feelings there arise desires and inclinations; and how from these, with the co-operation of reason, there arise maxims. For all this belongs to empirical psychology, which would constitute the second part of the study of nature, if we regard the latter as the *philosophy of nature* to the extent to which it rests on *empirical laws*. Here, however, we are discussing objective practical laws, and consequently the relation of a will to itself insofar as it determines itself solely by reason. Everything related to the empirical then falls away of itself; for if *reason all by itself* determines conduct (and the possibility of this is what we now wish to investigate), it must necessarily do so a priori.

We think of the will as a power of determining oneself to act *in conformity with the idea of certain laws*. And such a power can be found only in rational beings. Now, what serves the will as the objective ground of its self-determining is an *end;* and this end, if it is given by reason alone, must be equally valid for all rational beings. On the other hand, something that contains merely the ground of the possibility of an action, where the result of that action is the end, is called a *means*. The subjective ground of desiring is a *driving-spring;* the objective ground of willing is *a motivating reason*. Hence the difference between subjective ends, which depend on driving-springs, and objective ends, which depend on motivating reasons that are valid for every rational being. Practical principles are *formal* if they abstract from all subjective ends; they are *material*, on the other hand, if

they are based on subjective ends and consequently on certain driving-springs. Those ends that a rational being at his own discretion sets for himself as *what he intends to accomplish* through his action (material ends) are in every case only relative; for what gives them worth is only their relation to some subject's particularly constituted faculty of desire. Such worth can therefore provide no universal principles, no principles valid and necessary for all rational beings and for every act of will—that is, it can provide no practical laws. Consequently all these relative ends are only the ground of hypothetical imperatives.

Suppose, however, there were something *whose existence in itself* had an absolute worth, something that, as an end *in itself*, could be a ground of definite laws. Then in it and in it alone, would the ground of a possible categorical imperative, that is, of a practical law, reside.

Now, I say, a human being, and in general every rational being, *does exist* as an end in himself, *not merely as a means* to be used by this or that will as it pleases. In all his actions, whether they are directed to himself or to other rational beings, a human being must always be viewed *at the same time as an end.* All the objects of inclination have only a conditional worth; for if these inclinations and the needs based on them did not exist, their object would be worthless. But inclinations themselves, as sources of needs, are so far from having absolute value to make them desirable for their own sake that it must rather be the universal wish of every rational being to be wholly free of them. Thus the value of any object *that is to be acquired* by our action is always conditional. Beings whose existence depends not on our will but on nature still have only a relative value as means and are therefore called *things*, if they lack reason. Rational beings, on the other hand, are called *persons* because, their nature already marks them out as ends in themselves—that is, as something which ought not to be used *merely* as a means—and consequently imposes restrictions on all choice making (and is an object of respect). Persons, therefore, are not merely subjective ends whose existence as an effect of our actions has a value *for us.* They are *objective ends*—that is, things whose existence is in itself an end, and indeed an end such that

no other end can be substituted for it, no end to which they should serve *merely* as a means. For if this were not so, there would be nothing at all having *absolute value* anywhere. But if all value were conditional, and thus contingent, then no supreme principle could be found for reason at all.

If then there is to be a supreme practical principle and a categorical imperative for the human will, it must be such that it forms an objective principle of the will from the idea of something which is necessarily an end for everyone because *it is an end in itself*, a principle that can therefore serve as a universal practical law. The ground of this principle is: *Rational nature exists as an end in itself.* This is the way in which a human being necessarily conceives his own existence, and it is therefore a *subjective* principle of human actions. But it is also the way in which every other rational being conceives his existence, on the same rational ground which holds also for me;[12] hence it is at the same time an *objective* principle from which, since it is a supreme practical ground, it must be possible to derive all laws of the will. The practical imperative will therefore be the following: *Act in such a way that you treat humanity, whether in your own person or in any other person, always at the same time as an end, never merely as a means.* We will now see whether this can be carried out in practice.

Let us keep to our previous examples.

First, as regards the concept of necessary duty to oneself, the man who contemplates suicide will ask himself whether his action could be compatible with the Idea of humanity as *an end in itself.* If he damages himself in order to escape from a painful situation, he is making use of a person *merely as a means* to maintain a tolerable state of affairs till the end of his life. But a human being is not a thing—not something to be used *merely* as a means: he must always in all his actions be regarded as an end in himself. Hence I cannot dispose of a human being in my own person, by maiming, corrupting, or killing him. (I must here forego a more precise definition of this principle that would forestall any misunderstanding—for example, as to having limbs amputated to save myself or exposing my life to danger in order to preserve it, and so on—this discussion belongs to ethics proper.)

Secondly, as regards necessary or strict duty owed to others, the man who has in mind making a false promise to others will see at once that he is intending to make use of another person *merely as a means* to an end which that person does not share. For the person whom I seek to use for my own purposes by such a promise cannot possibly agree with my way of treating him, and so cannot himself share the end of the action. This incompatibility with the principle of duty to others can be seen more distinctly when we bring in examples of attacks on the freedom and property of others. For then it is manifest that a violator of the rights of human beings intends to use the person of others merely as a means without taking into consideration that, as rational beings, they must always at the same time be valued as ends—that is, treated only as beings who must themselves be able to share in the end of the very same action.[13]

Thirdly, as regards contingent (meritorious) duty to oneself, it is not enough that an action not conflict with humanity in our own person as an end in itself: it must also *harmonize with this end.* Now there are in humanity capacities for greater perfection that form part of nature's purpose for humanity in our own person. To neglect these can perhaps be compatible with the *survival* of humanity as an end in itself, but not with the *promotion* of that end.

Fourthly, as regards meritorious duties to others, the natural end that all human beings seek is their own perfect happiness. Now the human race might indeed exist if everybody contributed nothing to the happiness of others but at the same time refrained from deliberately impairing it. This harmonizing with humanity *as an end in itself* would, however, be merely negative and not positive, unless everyone also endeavours, as far as he can, to further the ends of others. For the ends of any person who is an end in himself must, if this idea is to have its full effect in me, be also, as far as possible, *my* ends.

This principle of humanity, and in general of every rational agent, *as an end in itself* (a principle which is the supreme limiting condition on every person's freedom of action) is not borrowed from experience: first, because it is universal, applying to all rational beings generally, and no experience is sufficient to determine anything about all such beings; secondly, because in this principle we conceive of humanity not as an end that one happens to have (a subjective end)—that is, as an object which people, as a matter of fact, happen to make their end. We conceive of it rather as an objective end—one that, as a law, should constitute the supreme limiting condition on all subjective ends, whatever those ends may be. This principle must therefore spring from pure reason.

That is to say, the ground of every practical legislating lies *objectively in the rule* and in the form of universality that (according to our first principle) makes the rule fit to be a law (and possibly a law of nature); *subjectively*, however, the ground of practical legislating lies in the *end*. But, according to our second principle, the *subject* of all ends is every rational being as an end in itself. From this there follows our third practical principle of the will: the supreme condition of the will's harmony with universal practical reason is the Idea of *the will of every rational being as a will that legislates universal law.*

By this principle all maxims are rejected which are inconsistent with the will's own universal lawgiving. The will is therefore not merely subject to the law, but subject in such a way that it must be considered as also *giving the law to itself* and only for this reason as first of all subject to the law (of which it can regard itself as the author).

Imperatives as formulated above excluded from their legislative authority every admixture of interest as a motivation. They either commanded a conformity of actions to universal law, a conformity analogous to a *natural order*, or they asserted the prerogative of rational beings to be regarded universally as *supreme ends* in themselves. (This followed from the mere fact that these imperatives were conceived as categorical.) But the imperatives were only *assumed* to be categorical because we had to make this assumption if we wished to explain the concept of duty. That there were practical propositions that command categorically could not itself be proved, any more than it can be proved here in this chapter. But one thing might have been done—namely, to show that in willing something just out of duty the renunciation of all interest is the specific mark distinguishing a categorical from

a hypothetical imperative. This is what we are doing in the present third formulation of the principle— namely, in the Idea of the will of every rational being as *a will that legislates universal law.*

For once we think of a will of this kind, it becomes clear that while a will *that is subject to laws* may be bound to this law by some interest, a will that is itself a supreme lawgiver cannot possibly depend on any interest; for such a dependent will would itself require yet another law in order to restrict the interest of self-love by the condition that this interest must be valid as a universal law.

Thus the *principle* that every human will is *a will that enacts universal laws in all its maxims*[14] *would be well adapted* to be a categorical imperative, pro- vided only that this principle is correct in other ways. Because of the Idea of giving universal law, it is *based on no interest*, and consequently, of all pos- sible imperatives it alone can be *unconditional*. Or better still, let us take the converse of this proposi- tion: if there is a categorical imperative (a law that applies to the will of every rational being), it can command us only to act always on the maxim of its will as one which could at the same time look upon itself as giving universal laws. For only then is the practical principle, and the imperative that the will obeys, unconditional, because the imperative cannot be based on any interest.

If we look back on all the previous efforts to dis- cover the principle of morality, it is no wonder that they have all had to fail. One saw that human beings are bound to laws by their duty, but it never occurred to anyone that they are subject only to *laws which they themselves have given* but which are neverthe- less *universal*, and that people are bound only to act in conformity with a will that is their own but that is, according to nature's purpose, a will that gives uni- versal law. For when one thought of human beings merely as subject to a law (whatever it might be), the law had to carry with it some interest, as stimulus or compulsion to obedience, because it did not spring as law from their *own* will: in order to conform to the law, their will had to be compelled by *something else* to act in a certain way. But this strictly necessary consequence meant that all the labour spent in trying

to find a supreme foundation for duty was irrevoca- bly lost. For what one discovered was never duty, but only the necessity of acting from a certain interest. This interest might be one's own or another's. But the resulting imperative was bound to be always a condi- tional one and could not at all serve as a moral com- mandment. I therefore want to call my principle the principle of the *Autonomy* of the will in contrast with all others, which I therefore count as *Heteronomy.*

The concept of every rational being as a being who must regard itself as making universal law by all the maxims of its will, and must seek to judge itself and its actions from this standpoint, leads to a closely connected and very fruitful concept—namely, that of *a kingdom of ends.*

I understand by a 'kingdom' the systematic union of different rational beings under common laws. Now since laws determine ends as regards their universal validity, we can—if we abstract from the personal dif- ferences between rational beings, and also from the content of their private ends—conceive a whole of all ends systematically united (a whole composed of rational beings as ends in themselves and also of the personal ends which each may set for himself); that is, we can conceive of a kingdom of ends which is pos- sible in accordance with the aforesaid principles.

For rational beings all stand under the *law* that each of them should treat himself and all others *never merely as a means* but always *at the same time as an end in himself.* But from this there arises a system- atic union of rational beings through shared objec- tive laws—that is, a kingdom. Since these laws aim precisely at the relation of such beings to one another as ends and means, this kingdom may be called a kingdom of ends (admittedly only an ideal).

A rational being, however, belongs to the king- dom of ends as a *member*, if, while legislating its universal laws, he is also subject to these laws. He belongs to the kingdom as its *head*, if, as legislating, he is not subject to the will of any other being.

A rational being must always regard himself as lawgiving in a kingdom of ends made possible through freedom of the will—whether as member or as head. But he cannot maintain the position of head merely through the maxim of his will, but only if he

is a completely independent being, without needs and with an unlimited power adequate to his will.

Thus morality consists in the relation of all action to just that lawgiving through which a kingdom of ends is made possible. But this lawgiving must be found in every rational being itself and must be capable of arising from the will of that being. The principle of its will is therefore this: never to perform any action except one whose maxim could also be a universal law, and thus to act only on a maxim *through which the will could regard itself at the same time as enacting universal law.* If maxims are not already by their very nature in harmony with this objective principle of rational beings as legislating universal law, the necessity of acting on this principle is called a constraint on the choice of actions, i.e., *duty.* Duty does not apply to the head in a kingdom of ends, but it does apply to every member and to all of them in equal measure.

The practical necessity of acting on this principle— that is, duty—is not based at all on feelings, impulses, and inclinations, but only on the relation of rational beings to one another, a relation in which the will of a rational being must always be regarded as *lawgiving,* because otherwise it could not be thought of as *an end in itself.* Reason thus relates every maxim of a universally legislating will to every other will and also to every action towards oneself: it does so, not because of any further motive or future advantage, but from the Idea of the *dignity* of a rational being who obeys no law other than one which he himself also enacts.

In the kingdom of ends everything has either a *price or a dignity.* Whatever has a price can be replaced by something else as *equivalent.* Whatever by contrast is exalted above all price and so admits of no equivalent has a dignity.

Whatever is relative to universal human inclinations and needs has a *market price.* Whatever, even without presupposing a need, accords with a certain taste— that is, with satisfaction in the mere random play of our mental powers—has an *attachment price.* But that which constitutes the sole condition under which anything can be an end in itself has not mere relative worth, i.e., a price, but an inner worth—i.e., *dignity.*

Now morality is the only condition under which a rational being can be an end in itself; for only through this is it possible to be a lawgiving member in the kingdom of ends. Therefore morality, and humanity so far as it is capable of morality, is the only thing that has dignity. Skill and diligence in work have a market price; wit, lively imagination, and humour have an attachment price but fidelity to promises and benevolence out of basic principles (not out of instinct) have an inner worth. Nature and art alike offer nothing that could replace their lack; for their worth consists not in the effects which result from them, not in the advantage or profit they produce, but in the intentions—that is, in the maxims of the will—which are ready in this way to reveal themselves in action even if they are not favoured by success. Such actions too need no recommendation from any subjective disposition or taste in order to be regarded with immediate favour and approval; they need no direct predilection or feeling for them. They exhibit as an object of immediate respect the will that performs them; since nothing but reason is required in order to *impose* them on the will. Nor is the will to be *coaxed* into them, which would anyhow be a contradiction in the case of duties. This assessment lets us recognize the value of such a mental attitude as dignity and puts it infinitely above all price, with which it cannot be brought into comparison or computation without, as it were, violating its holiness.

And what is it then that justifies a morally good disposition, or virtue, in making such lofty claims? It is nothing less than the *sharing* which it allows to a rational being in *giving universal laws,* which therefore renders him fit to be a member in a possible kingdom of ends. His own nature as an end in himself already marked out this fitness and therefore his status as lawgiver in a kingdom of ends and as free from all laws of nature, obedient only to those laws which he himself prescribes, laws according to which his maxims can participate in the making of universal law (to which he at the same time subjects himself). For nothing can have worth other than that determined for it by the law. But the lawgiving that determines all worth must therefore have a dignity, i.e., an unconditional and incomparable worth. The word *'respect'* is the only suitable expression for the esteem that a rational being must necessarily feel for

such lawgiving. *Autonomy* is thus the basis of the dignity of human nature and of every rational nature.

Our three ways of presenting the principle of morality are basically only so many formulations of precisely the same law, each one of them by itself uniting the other two within it. There is nevertheless a difference among them, which, however, is more subjectively than objectively practical: that is to say, the different formulations aim to bring an Idea of reason closer to intuition (by means of a certain analogy) and thus nearer to feeling. All maxims have:

1. A *form*, which consists in universality; and in this respect the formula of the moral imperative is expressed thus: 'Maxims must be chosen as if they were to hold as universal laws of nature.'

2. A *matter*—that is, an end; and in this respect the formula says: 'A rational being, as by its very nature an end and thus an end in itself, must serve every maxim as the limiting condition restricting the pursuit of all merely relative and arbitrary ends.'

3. A *complete determination* of all maxims by means of the following formula: 'All maxims which stem from autonomous lawgiving are to harmonize with a possible kingdom of ends and with a kingdom of nature.'[15] Progression that takes place here as elsewhere is through the categories of unity, plurality, and totality: *unity* of the form of the will (its universality); *plurality* of its matter (its objects—that is, its ends); and the totality or *all-comprehensiveness* of its system of ends. It is, however, better if in moral *judgement* one proceeds always in accordance with the strict method and takes as one's basic principle the universal formula of the categorical imperative: '*Act on that maxim that can at the same time make itself into a universal law.*' If, however, we wish also to *gain a hearing* for the moral law, it is very useful to bring one and the same action under the three stated formulae and thereby, as far as possible, bring the moral law closer to intuition.

We can now end at the point from which we began—namely, with the concept of an unconditionally good will. *A will* is *absolutely good if* it cannot be evil—that is, if its maxim, when made into a universal law, can never be in conflict with itself. This principle is therefore also its supreme law: 'Act always on that maxim whose universality as a law you can at the same time will.' This is the one principle on which a will can never be in conflict with itself, and such an imperative is categorical. Since the validity of the will, as a universal law for possible actions, is analogous to the universal connection of the existence of things under universal laws, which is the formal aspect of nature in general, we can also express the categorical imperative as follows: '*Act on maxims which can at the same time have as their object [making] themselves into universal laws of nature.*' This then gives us the formula for an absolutely good will.

A rational nature distinguishes itself from others by the fact that it sets itself an end. That end would be the matter for every good will. But in the idea of an absolutely good will, good without any limiting condition (the attaining of this or that end), we must abstract completely from every end that has to be *brought about* (for such an end would make any will only relatively good). Hence the proposed end must here be conceived, not as an end to be produced, *but as a self-sufficient* end. It must therefore be conceived only negatively—that is, as an end which we should never act against, and consequently one which in all our willing we must never value merely as a means, but always at the same time as an end. Now this end can be nothing other than the subject of all possible ends itself, because this subject is also the subject of a will that may be absolutely good; for such a will cannot without contradiction be subordinated to any other object. The principle 'So act in relation to every rational being (both yourself and others) that this being may at the same time count in your maxim as an end in itself' is thus basically the same as the principle 'Act on a maxim which at the same time embodies in itself its own universal validity for every rational being.' For to say that, in using means to any end, I ought to restrict my maxim by the condition that it should also be universally valid as a law for every subject, is just the same as to say this: a subject of ends, i.e., a rational being itself, must be made the foundation of all maxims of action, and must thus be treated never merely as a means, but as the supreme condition restricting the use of all means—that is, always at the same time as an end.

Now from this it unquestionably follows that every rational being, as an end in itself, must be able to regard himself as also the maker of universal law in respect of any law whatever to which he may be subject; for it is precisely the fitness of his maxims to make universal law that marks him out as an end in himself. It follows equally that this dignity (or prerogative) he possesses above all merely natural beings carries with it the necessity of always choosing his maxims from the point of view of himself, but also of every other rational being (which is why they are called persons) as lawgiving beings. It is in this way that a world of rational beings (*mundus intelligibilis*) [intelligible world] is possible as a kingdom of ends—possible, that is, through the giving of their own laws by all persons as its members. Accordingly every rational being must act as if he were always by his maxims a lawgiving member in the universal kingdom of ends. The formal principle of such maxims is 'Act as if your maxims had to serve at the same time as a universal law (for all rational beings).' A kingdom of ends is thus possible only by analogy with a kingdom of nature. A kingdom of ends is possible only through maxims—that is, self-imposed rules—while nature is possible only through laws of efficient causes externally necessitated. In spite of this difference, we give to nature as a whole, even though it is regarded as a machine, the name of a 'kingdom of nature' so far as and because rational beings are its ends. Now a kingdom of ends would actually come into existence through maxims whose rule the categorical imperative prescribes for all rational beings, *if these maxims were universally followed.* Yet even if a rational being were himself to follow such a maxim strictly, he cannot count on everybody else therefore being faithful to the same maxim, nor can he count on the kingdom of nature and its purposive order harmonizing with him, as a fitting member, towards a kingdom of ends made possible through himself, i.e., that the kingdom of nature will favour his expectations of perfect happiness. Nevertheless the law 'Act on the maxims of a universally lawgiving member of a merely possible kingdom of ends' remains in full force, because it commands categorically. And precisely here we encounter the paradox that, without any further end or advantage to be attained by it, the mere dignity of humanity as

rational nature—and consequently respect for a mere Idea—should serve as an inflexible precept for the will; and that it is just this independence from any motivations based on his expectations of perfect happiness that constitutes the sublimity of a maxim and the worthiness of every rational subject to be a lawgiving member in the kingdom of ends; for otherwise he would have to be regarded as subject only to the natural law of his own needs. Even if both the kingdom of nature and the kingdom of ends were imagined to be united under one head and thus the kingdom of ends ceased to be a mere Idea and achieved genuine reality, the Idea would indeed gain additional motivating power by this, but no increase in its inner worth. For, even if this were so, this unique and absolute lawgiver would have to be conceived as judging the worth of rational beings solely by the disinterested behaviour they prescribed to themselves from this Idea alone. The essence of things is not changed by their external relations; and, leaving aside such relations, whatever constitutes by itself the absolute worth of human beings is that by which they must be judged—by everyone whatsoever, even by the Supreme Being. *Morality* is thus the relation of actions to the autonomy of the will—that is, to a possible universal lawgiving by means of its maxims. An action that is compatible with the autonomy of the will is *permitted*; one that does not harmonize with it is *forbidden*. A will whose maxims necessarily agree with the laws of autonomy is a *holy*, absolutely good will. The dependence of a will not absolutely good on the principle of autonomy (that is, moral necessitation) is *obligation*. Obligation can thus not apply to a holy being. The objective necessity of an action out of obligation is called *duty*.

From what has just been said we can now easily explain how it happens that, although the concept of duty includes the idea of a person's subjection to the law, we nevertheless attribute a certain sublimity and *dignity* to the person who fulfils all his duties. For although there is nothing sublime about him just in so far as he is *subject* to the law, there is sublimity to him in his being at the same time its *author* and being subordinated only for this reason to this very same law. We have also shown above how neither fear nor inclination, but only respect for the law, is the motivation that

can give an action moral worth. Our own will, provided it would act only under the condition of being able to give universal law by means of its maxims—this ideal will, which is possible for us, is the proper object of respect. The dignity of humanity consists precisely in this power of giving universal law, though only on condition of also being subject to this same lawgiving.

Autonomy of the Will

AS THE SUPREME PRINCIPLE OF MORALITY

Autonomy of the will is the property the will has of being a law to itself (independently of any property of the objects of volition). Hence the principle of autonomy is 'Never choose except in such a way that the maxims of your choice are also comprehended as universal law in the same act of will.' That this practical rule is an imperative, that is, that the will of every rational being is necessarily bound to the rule as a condition, cannot be proved by a mere analysis of the concepts contained in it, since it is a synthetic proposition. To prove it we would have to go beyond knowledge of objects and to a critique of the subject—that is, to a critique of pure practical reason—since this synthetic proposition, which commands apodictically, must be capable of being known entirely a priori. This task does not belong to the present chapter. However, by mere analysis of the concepts of morality we can quite well show that the above principle of autonomy is the sole principle of ethics. For analysis discloses that the principle of morality must be a categorical imperative, and that the imperative in turn commands nothing neither more nor less than precisely this autonomy of the will.

Heteronomy of the Will

AS THE SOURCE OF ALL SPURIOUS PRINCIPLES OF MORALITY

If the will seeks the law that is to determine it *anywhere else* than in the fitness of its maxims for its own giving of universal law, and if therefore it goes outside itself and seeks this law in a property of any of its objects—the result is always *heteronomy*. In that case the will does not give itself the law; rather, the object gives the law to it, in virtue of its relation to the will. This relation, whether based on inclination or on rational ideas, can give rise only to hypothetical imperatives: 'I ought to do something *because I want something else*'. As against this, the moral, and therefore categorical imperative, says, 'I ought to act thus or thus, even though I did not want anything else.' For example, the first says 'I ought not to lie if I want to maintain my reputation' while the second says 'I ought not to lie even if it would not bring me the slightest disgrace.' The second imperative must therefore leave out of consideration all objects to this extent; that they have no *influence* at all on the will, so that practical reason (the will) may not merely administer some alien interest but may simply manifest its own sovereign authority as the supreme legislation. Thus, for example, the reason why I ought to promote the happiness of others is not because the realization of their happiness concerns me (whether because of direct inclination or on account of some satisfaction gained indirectly through reason,) but simply because a maxim that excludes this cannot be included as a universal law in one and the same act of will.

CLASSIFICATION OF ALL POSSIBLE PRINCIPLES OF MORALITY BASED ON HETERONOMY AS THEIR ASSUMED FOUNDATION

Here, as everywhere else in the pure use of reason—so long as a critique of it is lacking—human reason tries every possible wrong way before it succeeds in finding the only true way.

All the principles that can be adopted from this point of view are either *empirical* or *rational*. Principles of the *first* kind, drawn from the principle of *perfect happiness*, are built on either physical or moral, feeling. Principles of the *second* kind, drawn from the principle of *perfection,* are built either on the rational concept of perfection as a possible effect of our will or on the concept of an independently existing perfection (God's will) as a determining cause of our will.

Empirical principles are never fit to serve as a foundation for moral laws. For the universality with which these laws must hold for all rational beings without exception—the unconditioned practical necessity that they thus impose—is lost if their basis is taken from the *particular constitution of human*

nature or from the accidental circumstances in which it is placed. The principle of *one's own perfect happiness* is, however, the most objectionable, not just because it is false and because its claim that well-being always adjusts itself to well-doing is contradicted by experience; nor merely because it contributes nothing whatever towards establishing morality, since making people happy is quite different from making them good, and making them prudent or clever in seeking their own advantage is quite different from making them virtuous. It is most objectionable because by basing morality on sensuous motives which undermine it and totally destroy its sublimity, since it puts the motives of virtue in the same class as those of vice and teaches us only to become better at calculation, the specific difference between virtue and vice is completely obliterated. On the other hand, moral feeling, this alleged special sense[16] (however shallow be the appeal to it, when people who are unable to *think* hope to help themselves out by *feeling*, even when the question is solely one of universal law, and however little feelings, differing as they naturally do from one another by an infinity of degrees, can supply a uniform measure of good and evil—let alone the fact that one person by his feeling can make no valid judgements at all for others)—moral feeling still remains closer to morality and to its dignity in this respect: it does virtue the honour of ascribing to her *directly* the approval and esteem in which she is held, and does not, as it were, tell her to her face that we are attached to her, not for her beauty, but only for our own advantage.

Among the *rational* or reason-based foundations of morality, the ontological concept of *perfection* is better than the theological concept that derives morality from a divine and supremely perfect will. It is of course empty, indefinite, and consequently useless for discovering in the boundless field of possible reality, the greatest sum which is appropriate to us; and, in trying to distinguish specifically between the reality here in question from every other reality, it inevitably tends to move in a circle and cannot avoid tacitly presupposing the morality it is meant to explain. Still, it is better than the theological concept, which derives morality from an all-perfect, divine

will, not merely because we cannot directly apprehend God's perfection and can only derive it from our own concepts, among which that of morality is pre-eminent; but because, if we do not do this (and to do it would be to give a grossly circular explanation), the concept of God's will that remains for us is made up of such attributes as lust for glory and dominion, bound up with frightful ideas of power and vengefulness—inevitably the foundation for a moral system that would be directly opposed to morality.

Yet if I had to choose between the concept of moral sense and that of perfection in general (both of which at least do not undermine morality, though they are totally unfit to support it as its foundation), I should decide for the latter. For this, since it at least withdraws the decision of this question from sensibility and brings it before the court of pure reason, even though it there decides nothing, does still preserve undistorted the indeterminate Idea (of a will good in itself) for more precise definition.

For the rest I believe I may be excused from a lengthy refutation of all these systems. This is so easy and is presumably so well understood even by those whose office requires them to declare themselves for one or other of these theories (since their audience will not lightly put up with a suspension of judgement) that to spend time on it would be merely superfluous labour. But what is of more interest to us here is to know that these principles never lay down anything but heteronomy as the first basis of morality and must in consequence necessarily fail in their objective.

Whenever an object of the will has to be assumed as prescribing the rule that is to determine the will, the rule is nothing but heteronomy. The imperative is then conditional: '*If* or *because* one wants this object, one ought to act thus or thus'. Consequently this imperative can never command morally, that is, categorically. In whatever way the object determines the will—whether by means of inclination, as in the principle of one's own perfect happiness, or by means of reason directed to objects of our possible volitions generally, as in the principle of perfection—the will in these cases never determines itself *directly* by the thought of an action, but only by the motivation which the anticipated effect of the action exercises

on the will: *'I ought to do something because I want something else'*. And the basis for this imperative must be the assumption of yet another law in my person, whereby I necessarily will this 'something else'—and this law in turn requires an imperative to limit this maxim. Because the idea of an object commensurate to our own powers stimulates in the will of the subject an impulse in accordance with our natural constitution, this impulse belongs to the nature of the subject, whether to sensibility, (i.e., inclinations and taste,) or to understanding and reason, whose operation on an object is accompanied by delight due to the particular constitution of their nature. Strictly speaking, therefore, it is nature that would prescribe the law. This law, as a law of nature, not only must be known and proved by experience and therefore is in itself contingent and consequently unfitted to serve as an apodictic rule of action such as a moral rule must be, but it is *always merely heteronomy of the will*: The will would not prescribe the law to itself, but an alien stimulus would do so through the medium of the subject's own nature which is attuned to receive it.

An absolutely good will, whose principle must be a categorical imperative, will therefore be undetermined with respect to all objects and will contain only the *form* of *willing* in general and that form is autonomy. In other words, the fitness of the maxim of every good will to make itself a universal law is itself the sole law that the will of every rational being spontaneously imposes on itself without requiring any incentive or interest for support.

How such a synthetic practical proposition is possible a priori and why it is necessary—that is a problem whose solution does not lie within the boundaries of the metaphysics of morals; nor have we claimed it to be true or, still less, pretended to have a proof of it in our power. We have merely shown by developing the generally accepted concept of morality that autonomy of the will is unavoidably bound up with it or rather is its very foundation. Whoever therefore takes morality to be something real and not merely an illusory idea that lacks truth, must at the same time admit its principle, which we have presented here. This chapter, consequently, like the first, has been merely analytical. To prove that morality is

not a mere phantom of the brain—a conclusion that follows if the categorical imperative, and with it the autonomy of the will is true and is absolutely necessary as an a priori principle—requires a *possible synthetic use of pure practical reason*. But we cannot venture on this synthetic use of reason without prefacing it by a *critique* of this faculty of reason itself. In our final chapter we outline, sufficiently for our purpose, the main features of such a critique.

CHAPTER THREE

Final Step from a Metaphysics of Morals to a Critique of Pure Practical Reason

The Concept of Freedom Is the Key to Explain Autonomy of the Will

The will is a kind of causality that living beings have so far as they are rational. *Freedom* would then be that property whereby this causality can be active, independently of alien causes *determining* it; just as *natural necessity* is a property characterizing the causality of all non-rational beings—the property of being determined to activity by the influence of alien causes.

The above definition of freedom is *negative* and therefore sterile when it comes to grasping freedom's essence; but a *positive* concept springs from it, which is richer and more fruitful. Since the concept of causality carries with it that of *laws*, implying that because of something we call a cause, something else—namely, its effect—must be posited, so freedom, although it is not a property the will has by virtue of natural laws, is not for that reason totally lawless. Freedom must rather be a causality that accords with immutable laws, though laws of a special kind; for otherwise a free will would be a fiction. Natural necessity, as we have seen, is a heteronomy of efficient causes; for we saw that every effect was only possible according to the law that something else gets the efficient cause to act as a cause. What else then can freedom of will be but autonomy—that is, the property that a will has of being a law to itself? However, the proposition 'Will is in all its actions a

law to itself' expresses only the principle of acting on no other maxim than one that can also have being itself a universal law for its object. But this is precisely the formula of the Categorical Imperative and the principle of morality. Thus a free will and a will under moral laws are one and the same.

Consequently if freedom of the will is presupposed, then morality, together with its principle, follows from this presupposition by mere analysis of its concept. Nevertheless the principle of morality is still a synthetic proposition, namely: An absolutely good will is one whose maxim can always include itself considered as a universal law; for this characteristic of its maxim cannot be discovered by analysis of the concept of an absolutely good will. Such synthetic propositions are however possible only if two cognitions are bound together by their connection with a third in which both of them are to be found. The *positive* concept of freedom supplies this third cognition, which cannot, as is the case with physical causes, be the nature of the sensible world (in the concept of which the concepts of something as a cause in relation to *something else* as effect come together). What this third cognition is, to which freedom directs us and of which we have an Idea a priori, cannot yet be shown here; nor can we as yet make comprehensible the deduction of the concept of freedom from pure practical reason and so the possibility of a categorical imperative. Some further preparation is needed.

1. Freedom Must be Presupposed as a Property of the Will of All Rational Beings

It is not enough to ascribe freedom to our will, on whatever basis, unless we have sufficient reason to attribute the same freedom to all rational beings. For since morality serves as a law for us only insofar as we are *rational beings*, it must be equally valid for all rational beings; and since it must be derived solely from the property of freedom, we need to prove that freedom too is a property of the will of all rational beings. And it is not enough to demonstrate freedom by appeal to certain alleged experiences of human nature (though to demonstrate freedom in this way is in any case absolutely impossible—it can be demonstrated only a priori). Rather, we must prove that freedom belongs

universally to the activity of rational beings endowed with a will. Now I say that every being who cannot act except *under the Idea of freedom* is just for that reason really free—from the standpoint of practice. That is to say, all laws inseparably bound up with freedom are valid for such a being just as if his will could be proved to be free in itself and by means of proofs taken from theoretical philosophy.[17] I maintain too that we must necessarily grant the idea of freedom to every rational being who has a will, since only under that idea can such a being act. For we think of such a being as having a power of reason that is practical, i.e., that has causality in regard to its aims. But it is impossible to conceive of a power of reason that consciously regards its own judgements as directed from outside; for in that case the subject would attribute the determination of his power of judgement to some impulse, not to his reason. Reason must regard itself as the author of its own principles independently of alien influences. It follows that reason, as practical reason, or as the will of a rational being, must regard itself as free. That is to say, the will of a rational being can be a will of its own only under the idea of freedom, and it must therefore—for purposes of action—be attributed to all rational beings.

2. Of the Interest Attached to the Ideas of Morality

We have at last traced the distinct concept of morality back to the Idea of freedom, but we could not demonstrate freedom as something real in human nature nor even in ourselves. We saw only that we must presuppose it if we want to conceive a being as rational and as endowed with consciousness of his causality in regard to actions—that is, as endowed with a will. Thus we find that on precisely the same grounds we must attribute to every being endowed with reason and a will this property of determining himself to action under the Idea of his freedom.

From the presupposition of this Idea there sprang also, as we saw, the consciousness of a law governing action, the law that subjective principles of action—that is, maxims—must always be so chosen that they can also hold as objective principles—that is, universally—and can therefore serve for our own

enactment of universal law. But why should I subject myself to this principle simply as a rational being and in so doing also subject to it every other being endowed with reason? I am willing to admit that no interest *drives* me to do so, since that would not produce a categorical imperative. Yet I must necessarily *take* an interest in it and understand how this happens; for this 'I ought to' is actually an 'I intend to' that would hold necessarily for every rational being—if reason in him were practical without hindrance. For beings like us, who are affected also by the senses—that is, by motives of a different kind—and who do not always act as reason by itself would act, this necessity of action is only an 'ought' and the subjective necessity is distinguished from the objective.

It thus looks as though we have in fact merely presupposed the moral law in our Idea of freedom—that is, presupposed the principle of the autonomy of the will itself—without being able to give an independent proof of its reality and objective necessity. But in that case we would still have gained something quite considerable, since we would at least have formulated the genuine principle more precisely than has been done before. However, we would have made no progress at all with proving the principle's validity and the practical necessity of subjecting ourselves to it. For if someone asks us: Why must the universal validity of our maxim as a law be the condition that restricts our action, and what is the basis of the worth we ascribe to this way of acting—a worth supposedly so great that there cannot be any interest higher than it—and asks how it happens that human beings believe this alone to be the source of their personal worth, in contrast to which the worth of a pleasant or painful condition counts as nothing? To these questions we could give no sufficient answer.

We do indeed find that we can take an interest in a personal characteristic that involves no interest in any condition, but only if that characteristic makes us fit to share in the latter condition in case reason were to determine its distribution. That is to say, the mere fact of deserving to be happy, even without the motive of sharing in this happiness, can by itself interest us. But such a judgement is in fact merely the result of the importance we have already assumed moral laws

to have (when by means of the Idea of freedom we detach ourselves from every empirical interest). But we cannot as yet see why we ought to detach ourselves from such interest—that is, why we ought to regard ourselves as free in our actions and yet bound by certain laws, in order to find solely in our own person a worth that can compensate us for the loss of everything that makes our condition valuable. We do not see how this is possible nor consequently *on what grounds the moral law can be binding*.

We must frankly admit that a kind of circle shows up here, from which there seems to be no escape. We suppose ourselves to be free in the order of efficient causes in order that we may conceive ourselves to be under moral laws in the order of ends; and then we proceed to think of ourselves as subject to moral laws on the ground that we have ascribed freedom of will to ourselves. For freedom and the will's lawgiving of its own laws are both autonomy, and therefore reciprocal concepts. But just for this reason one of them cannot be used to explain the other or to furnish its ground. It can at most be used for the logical purpose of reducing seemingly different ideas of the same object to a single concept (as different fractions of the same value can be reduced to the lowest common terms).

One route, however, still remains open to us. We can inquire whether we do not take one standpoint when, through freedom, we think of ourselves as causes acting a priori, and another standpoint when we contemplate ourselves in the light of our actions as effects that we see before our eyes.

A remark that does not require any subtle reflection and that we may assume even the most ordinary intelligence can make—no doubt in its own way, by some obscure distinction in the power of judgement that it calls 'feeling', is this: all ideas that come to us involuntarily (as do those of the senses) allow us to know objects only as they affect us: what those objects may be in themselves remains unknown. Consequently, ideas of this kind, no matter how strenuously the understanding attempts to exert focus and clarity on them, serve only to give us knowledge of *appearances*, never of *things in themselves*. Once this distinction is drawn (it may be merely by noting the difference between ideas given to us from without,

where we ourselves are passive, and ideas which we produce entirely from ourselves, ideas that therefore manifest our own activity), it follows directly that behind appearances we must admit and assume something else which is not appearance—namely, things in themselves. Since we can never be acquainted with these, but only with the way in which they affect us, we must however resign ourselves to the fact that we can never get any nearer to them and can never know what they are in themselves. This thought must yield a distinction, however rough, between a *sensible world* and the *intelligible world*, the first of which can vary a great deal because of differences in sensibility among different observers, while the second, which is its foundation, always remains the same. Even as regards himself—so far as a human being is acquainted with himself by inner sensation—he has no right to claim to know what he is in himself. For since he does not as it were create himself and since he acquires his concept of himself not a priori but empirically, it is natural that he can get information even about himself only through inner sense and so only through the way his nature appears and the way his consciousness is affected. Beyond this constitution of himself as a subject, compounded of nothing but appearances, he must assume that there is something else that is its foundation—namely, his ego, however it may be constituted in itself. Thus, as far as mere perception and the capacity for receiving sensations are concerned, he must count himself as belonging to the *world of sense*, but as regards whatever pure activity there may be in him (whatever reaches consciousness directly and not by affecting the senses), *he* must count himself as belonging to the *intellectual world.* Of that world, however, he knows nothing more.

A reflective human being must reach a conclusion of this kind about all things that may present themselves to him. Such a conclusion is presumably to be found even in the most common understanding, which, as is well known, is always inclined to look behind the objects of the senses for something further that is invisible and is spontaneously active. But such an understanding goes on to spoil this invisible something by immediately trying to make it into something sensible—that is to say, it wants to make it an object of intuition, so by this procedure the common understanding does not become the least bit wiser.

Now, a human being actually finds in himself a power by which he distinguishes himself from all other things—and even from himself so far as he is affected by objects. That power is *reason*. As pure spontaneity, reason is elevated even above the *understanding* in the following respect: although the latter too is spontaneous activity and is not, like sense, confined to ideas that arise only when we are affected by things (and therefore are passive), it can produce by its own activity only concepts whose sole purpose is *to bring sensuous representations under rules* and so to unite them in one consciousness. Without using sensibility, the understanding would think nothing at all. Reason, on the other hand—in what are called 'Ideas'—shows a spontaneity so pure that it goes far beyond anything sensibility can offer. It manifests its highest function in distinguishing the world of sense from the intelligible world and thereby prescribing limits to the understanding itself.

Because of this a rational being must regard himself, *as an intelligence* (i.e., not from the perspective of his lower powers), as belonging to the world of the understanding rather than the world of sense. Consequently he has two perspectives from which he can consider himself and from which he can acknowledge the laws governing the use of his powers and consequently governing all his actions. He can consider himself *first* so far as he belongs to the world of sense, under laws of nature (heteronomy); and *secondly*—so far as he belongs to the intelligible world—under laws that are not empirical but being independent of nature, are founded on reason alone.

As a rational being, and consequently as a being who belongs to the intelligible world, a human being can never conceive the causality of his own will except under the Idea of freedom; for independence from the determining causes of the sensible world (and this is what reason must always ascribe to itself) is freedom. To the Idea of freedom there is inseparably attached the concept of *autonomy*, but to the latter in turn the universal principle of morality—a principle which ideally is the ground of all the

actions of *rational* beings, just as the law of nature is the ground of all appearances.

We have now removed the suspicion which we raised earlier, namely, that there might be a hidden circle in our reasoning from freedom to autonomy and from autonomy to the moral law, the suspicion that in effect we had perhaps assumed the Idea of freedom only because of the moral law in order later to derive the moral law from freedom; and that we were thus unable to offer any ground at all for the moral law, but had merely begged the question by putting forward a principle which well-meaning souls would gladly concede us, but never as a demonstrable proposition. We see now that when we think of ourselves as free, we transfer ourselves into the world of the understanding as members and we recognize the autonomy of the will together with its consequence, morality; whereas when we think of ourselves as under obligation, we view ourselves as belonging to the world of sense and yet simultaneously to the world of understanding.

3. How Is a Categorical Imperative Possible?

As an intelligence, a rational being counts himself as belonging to the world of the understanding, and simply as an efficient cause belonging to that world, he calls his causality a will. On the other hand, however, he is also conscious of himself as a part of the world of sense, where his actions are encountered as mere appearances of that causality. But we can have no insight into how these actions are possible by means of such a causality, since we have no direct acquaintance with it. Instead, these actions, when viewed as belonging to the world of sense, have to be understood as determined by other appearances—namely, by desires and inclinations. Hence, if I were solely a member of the world of understanding, all my actions would conform perfectly to the principle of the autonomy of a pure will; if I were solely a part of the sensible world, they would have to be taken as conforming completely to the natural law of desires and inclinations, consequently to the heteronomy of nature. (In the first case they would rest on the supreme principle of morality; in the second case on that of

happiness.) But since the *world of understanding contains the ground of the world of sense and therefore also of its laws*, it thus gives laws directly to my will (which belongs entirely to the world of understanding) and must be conceived as thus lawgiving. Therefore, although I regard myself from one point of view as a being that belongs to the world of sense, I shall have to recognize that, as an intelligence, I am subject to the law of the world of understanding—that is, of reason, which contains this law in the Idea of freedom, and thus in the autonomy of the will. I must therefore regard the laws of the world of the understanding as imperatives for me and see the actions that conform to this principle as duties.

And thus categorical imperatives are possible, because the Idea of freedom makes me a member of an intelligible world. If I were only that, then all my actions *would* thereby invariably be in accord with the autonomy of the will. But since I see myself at the same time as a member of the world of sense, my actions *ought* to be in accord with it. This *categorical* 'ought' presents us with a synthetic a priori proposition, since to my will as affected by sensuous desires there is added the Idea of that same will, viewed, however, as a pure will belonging to the world of understanding and active of its own accord—a will which, according to reason, contains the supreme condition of the former, my sensuously affected will. This is similar to the way in which concepts of the understanding, which by themselves signify nothing but lawful form in general, are added to intuitions of the world of sense and so make possible synthetic a priori propositions on which all knowledge of nature is based.

The use of common human reason in matters of conduct confirms the correctness of this deduction. There is no one, not even the most malicious villain, provided only that he is otherwise accustomed to use reason, who, when presented with examples of honesty of purpose, of faithfulness to good maxims, of sympathy, and of general benevolence even when requiring great sacrifice of advantages and comfort, does not wish that he too might have these qualities. He cannot bring this about in himself, only because of his desires and impulses, but at the same time he wishes he could be free from

these burdensome inclinations. By such a wish he proves that with a will free from sensuous impulses he transfers himself in thought into an order of things altogether different from that of his desires in the field of sensibility. For he cannot expect that the fulfillment of this wish would gratify any of his sensuous desires, nor that any of his actual or even conceivable inclinations will be satisfied (since such an expectation would cause the very Idea that elicited the wish to forfeit its excellence). All he can expect is a greater inner worth of his own person. He believes himself to be this better person when he transfers himself to the standpoint of a member of the world of understanding. It is the Idea of freedom that involuntarily constrains him to do this—that is, the Idea of being independent of *determining* causes of the world of sense; and from this standpoint he is conscious of possessing a good will which, on his own admission, constitutes the law for his evil will as a member of the world of sense—a law of whose authority he is conscious even while transgressing it. The moral 'I ought' is thus his own necessary 'I will' as a member of the intelligible world; and he thinks of it as an 'I ought' only insofar as he regards himself at the same time to be a member of the world of sense.

4. The Extreme Limit of Practical Philosophy

All human beings think of themselves as having free will. That is the basis of all the judgements of actions that say they *ought to have been done*, although they *were not done.* But this freedom is not an empirical concept, nor can it be, since it still holds although experience shows the contrary of those requirements that are viewed as necessary under the presupposition of freedom. On the other hand, it is equally necessary that everything that takes place should be inexorably determined in accordance with the laws of nature; and this necessity of nature is likewise not an empirical concept, precisely because it carries with it the concept of necessity and thus the concept of an a priori cognition. This concept of a system of nature is, however, confirmed by experience and must unavoidably be presupposed

if experience—that is, coherent knowledge of sensible objects in accordance with universal laws—is to be possible. Hence, while freedom is only an Idea of Reason whose objective reality is in itself questionable, nature is a *concept of the understanding,* which proves, and must necessarily prove, its reality in examples from experience.

From this there arises a dialectic of reason, since the freedom ascribed to the will seems to contradict the necessity of nature. Although at this parting of the ways reason, for *cognitive* purposes, finds the path of natural necessity much more beaten and serviceable than that of freedom, yet for *purposes of action* the footpath of freedom is the only one on which we can make use of our reason in our conduct. Hence it is as impossible for the subtlest philosophy as it is for the most common human reason to argue freedom away. Philosophy must therefore presuppose that no genuine contradiction will be found between freedom and natural necessity ascribed to the very same human actions, for it cannot give up the concept of nature any more than that of freedom.

All the same, even if we should never be able to grasp how freedom is possible, this seeming contradiction must at least be eradicated convincingly. For if even the thought of freedom contradicts itself or contradicts nature—a concept which is equally necessary—freedom would have to be given up altogether in favour of natural necessity.

It would be impossible to escape from this contradiction if the subject who believes himself free thought of himself *in the same sense,* or *in precisely the same relationship,* when he calls himself free as when he assumes that in the same action he is subject to the law of nature. Hence speculative philosophy has the unavoidable task of showing at least that its illusion about the contradiction rests on our thinking of the human being in one sense and relation when we call him free and in another when we consider him, as a part of nature, to be subject to nature's laws. And philosophy must show not merely that both characteristics *can* very well coexist, but that they must be thought of as *necessarily united* in one and the same subject. For otherwise we could not explain why we should burden reason

with an Idea which—even if it can *without contradiction* be united with another concept that has been adequately justified—entangles us in a perplexity that sorely embarrasses reason in its theoretical use. This duty is imposed on speculative philosophy only in order that it may clear a path for practical philosophy. Thus philosophers have no choice as to whether they will remove the seeming contradiction or leave it untouched; for in the latter case the theory on this topic would be *bonum vacans* [unoccupied property—a good that belongs to no one], of which the fatalist can justifiably take possession and can chase all of morality out of its supposed property, which it has no title to hold.

Nevertheless we cannot yet say that at this point the boundary of practical philosophy begins. For the settlement of this controversy is not part of practical philosophy, which merely requires speculative reason to bring to an end the dissension in which it is entangled on theoretical questions, so that practical reason may have peace and security from external attacks which could contest its right to the ground on which it seeks to build.

The legitimate title to freedom of the will claimed even by common human reason is grounded on the consciousness and the accepted presupposition that reason is independent of purely subjective determining causes which collectively make up all that belongs to sensation and comes under the general name of sensibility. In thus regarding himself as an intelligence, a human being puts himself into another order of things, and into relation with determining causes of quite another sort, when he thinks of himself as an intelligence endowed with a will and consequently with causality, than he does when he perceives himself as a phenomenon (which he actually is as well) in the world of sense, and sees his causality as the result of external determination in accordance with laws of nature. He then soon realizes that both of these can, and indeed must, take place at the same time. For there is not the slightest contradiction in holding that a thing *as an appearance* (as belonging to the world of sense) is subject to certain laws, laws of which it is independent *as a thing* or a being *in itself*. That he

must think and conceive of himself in this twofold way rests, as regards the first way, on the consciousness of himself as an object affected through the senses; as concerns the second way, it rests on the consciousness of himself as an intelligence—that is, as independent of sensible impressions in his use of reason (and so as belonging to the world of understanding).

This is why the human being claims for himself a will that does not allow him to be accountable for anything that belongs merely to his desires and inclinations. Rather, he conceives of actions that can be done only by disregarding all desires and incitements of sense as possible—indeed as necessary—through this will. The causality of such actions lies in him as intelligence and in the laws of effects and actions according to the principles of an intelligible world. Of that world he knows nothing but this—that in that intelligible world, reason alone, and indeed pure reason independent of sensibility, is the source of law; and also that since in that world he is his true self, an intelligence only (while as a human being he is merely an appearance of himself), these laws apply to him directly and categorically. It follows that what desires and impulses (and therefore the whole nature of the sensible world) spur him to do cannot impair the laws of his will as intelligence. Indeed he does not even hold himself responsible for those desires and impulses nor impute them to his true self, that is, to his will, though he does impute to himself the indulgence he would show them if he were to let them influence his maxims to the detriment of the rational laws of his will.

Practical reason does not overstep its limits in the least by *thinking* itself into the world of understanding. It would do so only if it sought to *inspect* [*hineinschauen*] *or feel itself* into that world. That thinking is a merely negative thought—that the world of sense gives reason no laws for determining the will. It is a positive thought only in one point: that that freedom, as a negative characteristic, is combined with a (positive) power as well—a causality of reason we call a will—the power to act so that the principle of our actions accords with the essential character of a rational cause, that is, with the condition that the maxim of these actions have the universal validity of

a law. But if practical reason were also to take from the intelligible world *an object of the will*, that is, a motivating cause of action, it would overstep its limits and pretend to be acquainted with something of which it knows nothing. The concept of a world of understanding is thus only a *standpoint* that reason finds itself constrained to adopt outside of appearances, *in order to think of itself as practical.* If the influences of sensibility were determining for human beings, this would be impossible. It is nevertheless necessary unless the human being is to be denied the consciousness of himself as an intelligence and consequently as a rational and rationally active cause—that is, a cause that is free in its operation. This thought certainly brings on the Idea of another order and another lawgiving than that of the mechanism of nature, which applies to the world of sense. It makes necessary the concept of an intelligible world (that is, the concept of the totality of rational beings as things in themselves) but it makes not the slightest pretence of doing more than to conceive of such a world with respect to its *formal* condition—that is, as conforming to the condition that the maxim of the will should have the universality of a law, and so as conforming to the autonomy of the will, which alone is compatible with its freedom. In contrast with this, all laws determined by reference to an object give us heteronomy, which can be found only in laws of nature and can apply only to the world of sense.

But reason would overstep all its limits if it took it upon itself to *explain how* pure reason can be practical. This would be exactly the same task as explaining *how freedom is possible.*

For we cannot explain anything unless we can bring it under laws whose object can be given in some possible experience. Freedom, however, is a mere Idea: its objective reality can in no way be exhibited according to laws of nature nor, consequently, in any possible experience. And since no example can ever illustrate it even by analogy, we can have no full comprehension or insight into the Idea of freedom. It holds only as a necessary presupposition of reason in a being that believes itself to be conscious of a will—that is, of a power distinct from the mere faculty of desire (a power, namely, of determining

itself to act as intelligence and consequently to act in accordance with laws of reason independently of natural instincts). But where determination by laws of nature comes to an end, all *explanation* comes to an end as well. Nothing remains but *defence*—that is, to repulse the objections of those who pretend to have seen more deeply into the essence of things and therefore boldly declare freedom to be impossible. We can only show them that the contradiction they pretend to have discovered in it consists just in this: in order to make the law of nature apply validly to human actions, they must necessarily consider the human being as an appearance; and now that they are asked to think of him as an intelligence and also as a thing in himself, they persist in looking at him as an appearance in this respect also. In that case, admittedly, to exempt the human being's causality (that is, his will) from all the natural laws of the sensible world, in one and the same subject, would yield a contradiction. But that contradiction would fall away if they were willing to reflect and to admit, as is only fair, that behind appearances there must lie things in themselves as their hidden ground, and that we cannot expect the laws by which things in themselves act to be identical with those laws that govern their appearances.

The subjective impossibility of explaining the freedom of the will is one and the same as the impossibility of locating and making comprehensible an *interest*[18] that a human being can take in moral laws; and yet be does really take such an interest. We call the foundation in us of this interest "moral feeling"— a feeling that has been mistakenly taken by some people to be the standard for our moral judgement. It ought to be regarded rather as the *subjective* effect exercised on our will by the law. It is reason alone that supplies the objective grounds for that law.

In order to will actions that reason by itself prescribes to a rational, yet sensuously affected being as what he ought to do, it is certainly necessary that reason should have a power of *infusing a feeling of pleasure* or a feeling of satisfaction in the fulfilment of duty, and consequently that it should possess a kind of causality by which it can determine sensibility in accordance with rational principles. It is, however, wholly impossible to comprehend—that is, to make

intelligible a priori—how a mere thought containing nothing sensible in itself can bring about a sensation of pleasure or displeasure; for there is here a special kind of causality, and—as with all causality—we are totally unable to determine its character a priori. For any knowledge of such a causality, we must consult experience alone. But experience cannot provide us with a relation of cause and effect except between two objects of experience—whereas here pure reason by means of mere Ideas (which furnish absolutely no objects for experience) has to be the cause of an effect admittedly found in experience. Hence for us human beings it is wholly impossible to explain how and why the *universality of a maxim as a law*—and therefore morality—should interest us. This much only is certain; the law is not valid for us *because it interests us* (for this is heteronomy and makes practical reason dependent on sensibility—that is to say, on an underlying feeling—in which case practical reason could never give us moral laws). The law interests us because it is valid for us as human beings in virtue of having sprung from our will as intelligence and so from our true self. *But what belongs to mere appearance is necessarily subordinated by reason to the character of the thing in itself.*

Thus the question 'How is a categorical imperative possible?' can be answered to this extent: We can supply the sole presupposition under which it is possible—namely, the Idea of freedom—and we can discern the necessity of this presupposition. This is sufficient for the *practical use* of reason—that is, to convince us of the *validity of this imperative*, and so too of the moral law. But human reason will forever lack insight into how this presupposition itself is possible. On the presupposition that the will of an intelligence is free, its *autonomy* follows necessarily as the formal condition under which alone it can be determined. It is not only perfectly *possible* to presuppose such freedom of the will (as speculative philosophy can prove, and without contradicting the principle that natural necessity governs the interconnection of appearances in the world of sense); it is also unconditionally *necessary*, that is, necessary in Idea that a rational being conscious of exercising his causality by means of reason and so of having

a will (which is distinct from desires) should take such freedom as the fundamental condition of all his voluntary actions. But *how* pure reason can be practical by itself without any further motives drawn from some other source; that is, how the bare principle of *the universal validity of all its maxims as laws* (which would certainly be the form of a pure practical reason) can by itself—without any material (or object) of the will in which we might take some prior interest—how pure reason can supply a motive and create an interest which could be called purely *moral*; or, in other words, *how pure reason can be practical*—all human reason is totally incapable of explaining this, and all the pains and labour to seek such an explanation are wasted.

It is precisely the same as if I sought to fathom how freedom itself as the causality of a will is possible. For in doing this I would abandon the philosophical basis of explanation, and I have no other. I could, no doubt, proceed to daydream in the intelligible world, which still remains to me—the world of intelligences; but although I have a well-founded *Idea* of it, I have not the slightest *knowledge* of it and cannot hope to arrive at any by all the efforts of my natural power of reason. My Idea of this intelligible world signifies only a 'something' that remains when I have excluded from the grounds determining my will everything that belongs to the world of sense; its sole purpose is to restrict the principle of motivating causes [*Bewegursachen*] from the field of sensibility, by setting bounds to this field and by showing that it does not encompass absolutely everything within itself, but that there is still more beyond it; yet with this 'more' I have no further acquaintance. All that remains for me of the pure reason that formulates this ideal, after I have excluded all material—that is, all knowledge of objects—from it, is its form: the practical law that maxims should be universally valid, plus the corresponding conception of reason, in its relation to a purely intelligible world, as a possible efficient cause, that is, as a cause determining the will. Here the sensuous motive [*Triebfeder*] must be entirely absent; for this Idea of an intelligible world would itself have to be the motive or that in which reason took a direct interest. But to make this comprehensible is precisely the problem that we cannot solve.

Here then is the supreme limit of all moral inquiry. To define it is of great importance so that reason may not, on the one hand, hunt around in the sensible world, to the detriment of morality, for the supreme motive and for some comprehensible but empirical interest; and so that it will not, on the other hand, impotently flap its wings in the space (for it, an empty space) of transcendent concepts known as 'the intelligible world', flailing without moving from the spot, and thus losing itself among phantoms of the brain. For the rest, the Idea of a pure world of the understanding, as a whole of all intelligences to which we ourselves belong as rational beings (although from another point of view we are also members of the world of sense), remains always as a useful and permitted Idea for the purposes of a reasonable faith though all knowledge ends at its border. It serves to produce in us a lively interest in the moral law by means of the splendid ideal of a universal kingdom of ends in themselves (rational beings), to which we can belong as members only if we are scrupulous to conduct ourselves in accordance with maxims of freedom, as if they were laws of nature.

Concluding Remark

The speculative use of reason *in regard to nature* leads to the absolute necessity of some supreme cause of the *world;* the practical use of reason *with respect to freedom* leads also to absolute necessity, but only to the absolute necessity *of the laws of actions* for a rational being as such. Now it is an essential *principle* for every use of reason to push its knowledge to a consciousness of its *necessity* (for without necessity it would not be rational knowledge). But it is an equally essential *limitation* of this same reason that it cannot have insight into the necessity either of what is or of what happens, or of what ought to happen, unless a *condition* is presupposed under which it is or happens or ought to happen. In this way, however, by continual asking for the condition, reason's satisfaction is merely postponed again and again. Hence reason restlessly seeks the unconditionally necessary and sees itself compelled to assume it without any means of making it comprehensible, though it is happy enough if only it can find a concept compatible with this presupposition. Thus it is no discredit to our deduction of the supreme

principle of morality, but rather a reproach which must be brought against reason as such, that it cannot make comprehensible the absolute necessity of an unconditional practical law (such as the categorical imperative must be). For reason cannot be blamed for its unwillingness to do this by means of a condition—namely, by basing this necessity on some underlying interest—since in that case there would be no moral law, that is, no supreme law of freedom. And thus, while we do not comprehend the practical unconditional necessity of the moral imperative, we do comprehend its *incomprehensibility*. This is all that can fairly be demanded of a philosophy that presses forward in its principles to the very frontier of human reason.

Notes

1. A *maxim* is the subjective principle of volition: an objective principle (that is, one which would also serve subjectively as a practical principle for all rational beings if reason had full control over the faculty of desire) is a practical *law*.

2. It might be objected that instead of clearly resolving the question by means of a concept of reason I have tried to take refuge in an obscure feeling, under the cover of the word *'respect'* [*Achtung*]. However, though respect is a feeling, it is not a feeling that we are caused to *receive* by some (external) influence: rather, it is a feeling that is *self-generated* by a rational concept, and it is therefore different in kind from feelings of the first sort, all of which can be reduced to inclination or fear. What I recognize directly as a law for myself, I recognize with respect, which means nothing more than the consciousness of my will's *submission* to the law, without the mediation of any other influences on my mind. The direct determination of the will by the law, and the awareness of that determination, is called *'respect'* so we should see respect as the *effect* of the law on a person rather than as what *produces* the law. Actually, respect is the thought of something of such worth that it breaches my self-love. It is neither an object of inclination nor an object of fear, though it is somewhat analogous to both. The sole *object* of respect is the [moral] *law*—that law which we impose *on ourselves* and yet recognize as necessary in itself. As a law, we must submit to it without any consulting of self-love; as self-imposed it is nevertheless a consequence of our will. Considered in the first way,

it is analogous to fear: considered in the second way, analogous to inclination. All respect for a person is actually only respect for the law (of righteousness, etc.,) that that person exemplifies. Because we regard the development of our talents as a duty, we see a talented person also as a sort of *example of a law* (to strive to resemble that person), and this is what constitutes our respect. Any moral so-called *interest* consists solely in *respect* for the law.

3. We can, if we wish, distinguish pure moral philosophy (metaphysics) from applied (applied, that is, to human nature—just as pure mathematics is distinguished from applied mathematics and pure logic from applied logic). Using this terminology immediately reminds us that moral principles are not grounded on the peculiarities of human nature, but must be established a priori by themselves, though it must be possible to derive practical rules for human beings from them as well, just as it is for every kind of rational being.

4. I have a letter from the late, distinguished Professor Sulzer, in which he asks me why moral teachings are so ineffective, even though they contain much that is convincing to reason. My answer was delayed because I wanted it to be complete. Yet it is just this: the teachers themselves fail to make their concepts clear, and they over-do their job by looking for all sorts of inducements to moral goodness, spoiling their medicine altogether by their very attempt to make it really powerful. For the most ordinary observation shows that when a righteous act is represented as being done with a steadfast mind in complete disregard of any advantage in this world or another, and even under the greatest temptations of need or enticement, it far surpasses and eclipses any similar act that was affected even in the slightest by an extraneous incentive; it uplifts the soul and arouses the wish that we too could act in this way. Even children of moderate age feel this impression, and one should never present duties to them in any other way. [Editor's note: Johann Georg Sulzer (1720–79) was a prominent aesthetician and so-called 'popular philosopher', important in Berlin intellectual circles. The only extant letter from Sulzer to Kant does not in fact raise the particular question Kant here ascribes to him.]

5. The dependence of the faculty of desire on sensations is called an inclination, and thus an inclination always indicates a *need*. The dependence of a contingently determinable will on principles of reason is called an *interest*. Hence an interest is found only where there is a dependent will which of itself is not always in accord with reason; to God's will we cannot ascribe any interest. But even the human will can *take an interest* in something without therefore *acting out of interest*. The first expression signifies *practical*

interest in the action; the second signifies *pathological* interest in the object of the action. [Ed. note: pathological = a feeling one is *caused* or *made* to have by something outside one's own will.] The first indicates only dependence of the will on principles of reason in themselves; the second its dependence on principles of reason at the service of inclination—that is to say, where reason merely supplies a practical rule for meeting the needs of inclination. In the first case what interests me is the action; in the second case what interests me is the object of the action (so far as this object is pleasant to me). We have seen in Chapter One that in an action done out of duty one must consider not the interest in the object, but the interest in the action itself and its rational principle (namely, the law).

6. The word 'prudence' (*Klugheit*) is used in two senses; in one sense it can be called 'worldly wisdom' (*Weltklugheit*); in a second sense, 'personal wisdom' (*Privatklugheit*). The first is a person's skill in influencing others in order to use them for his own ends. The second is the ability to combine all of these ends to his own lasting advantage. The latter is properly that to which the value of the former can itself be traced; and if a person is prudent in the first sense, but not in the second, we might better say that he is clever and astute, but on the whole imprudent.

7. It seems to me that the proper meaning of the word 'pragmatic' can be defined most accurately in this way. For *sanctions* that do nor properly speaking spring from the law of states as necessary statutes, but arise from *provision* for the general welfare are called pragmatic. We say that a *history* is written pragmatically when it teaches *prudence*—that is, when it instructs the world how to provide for its interests better than, or at least as well as, the world of other times has done.

8. I connect the deed with the will a priori and thus necessarily, without supposing as a condition that there is any inclination for this deed (although I make this connection only objectively—that is to say, under the Idea of a power of reason that would have complete control over all subjective motives). Hence we have here a practical proposition in which the willing of an action is not derived analytically from some other volition already presupposed (for we do not possess any such perfect will); rather, the willing of the action is connected directly with the concept of the will of a rational being [but] as something that is not contained in this concept.

9. A *maxim* is a subjective principle of action and must be distinguished from an *objective principle*—namely, a practical law. The former contains a practical rule determined by reason in accordance with the conditions of the subject (often his ignorance or his inclinations): it is thus a principle

on which the subject *acts*. A law. on the other hand, is an objective principle, valid for every rational being; and it is a principle on which he *ought to act*—that is, an imperative.

10. It should be noted that I reserve the division of duties entirely for a future *Metaphysic of Morals* and that my present division is put forward as an arbitrary one (merely for the purpose of arranging my examples). Further, I understand here by a perfect duty one that allows no exception in the interests of inclination, and so I recognize among *perfect* duties, both outer and inner duties. This runs contrary to the standard usage in the schools, but I do not intend to justify it here, since for my purpose it makes no difference whether this point is conceded or not.

11. To behold virtue in her true form means nothing other than to show morality stripped of any admixture with what is sensuous and of all the inauthentic adornments of reward or self-love. How much she then casts into the shade all else that appears enticing to the inclinations can be readily perceived by anyone willing to exert his reason in the slightest if it is not entirely spoiled for all abstract thinking.

12. This proposition I put forward here as a postulate. The grounds for it will be found in the final chapter.

13. Let no one think that the trivial *'quod tibi non vis fieri,* etc.' could here serve as a guide or principle. For it is merely a derivation from our principle, and subject to various qualifications: it cannot be a universal law since it contains the ground neither of duties to oneself nor of duties of kindness to others (for many a man would gladly consent that others should not benefit him if only he could be excused from showing benevolence to them. Nor, finally, does this rule contain the ground of strict duties owed to others; for the criminal would be able to argue on this basis against the judge who sentences him, and so on.

14. I may be excused from citing examples to illustrate this principle, since those that were already used to illustrate the categorical imperative and its formula can all serve the same purpose here.

15. Teleology considers nature as a kingdom of ends, morality considers a possible kingdom of ends as a kingdom of nature. In the former, the kingdom of ends is a theoretical Idea that aims to explain what exists. In the latter, it is a practical Idea, aiming to bring about that which does not exist but which could actually become real through our conduct.

16. I classify the principle of moral feeling with that of happiness because every empirical principle promises a contribution to our well-being merely from the satisfaction that something leads us to expect—whether this satisfaction occurs directly and without any consideration of advantage or with a view to such advantage. Similarly we must, with Hutcheson, classify the principle of sympathy for the happiness of others with the principle of moral sense which he assumed.

17. I use this approach here because I take it as sufficient for our purpose if all rational beings in their actions presuppose freedom merely *as an Idea.* Thus I avoid having to prove freedom also from a theoretical point of view. For even if this latter problem is left unsettled, the laws that would obligate a being who was really free are equally valid for a being who cannot act except under the Idea of his own freedom. In this way we can escape from the burden that weighs upon the theory.

18. An interest is that by which reason becomes practical—that is, becomes a cause determining the will. Therefore only of a rational being can one say that he takes an interest in something: non-rational creatures feel only sensuous impulses. Reason takes a direct interest in an action only when the universal validity of the maxim of the action is a ground sufficient to determine the will. Only such an interest is pure. If reason can motivate the will only by means of some further object of desire or under the presupposition of some special feeling in the subject, then it takes only an indirect interest in the action; and since reason all by itself, without the help of experience, can discover neither objects of the will nor a special feeling underlying the will, the latter interest would be merely empirical, and not a pure rational interest. The logical interest of reason (interest in furthering its insights) is never direct, but presupposes purposes for its use.

Study Questions

1. According to Kant, why does empirical inquiry not provide a sound basis for morality?

2. Can you imagine circumstances in which lying would be morally acceptable?

3. Can a person be so wicked as not to have moral worth?

4. Does Kant's moral philosophy recognize special duties to relatives or friends?

12

JEREMY BENTHAM

Jeremy Bentham (1748–1822) was a British philosopher and social reformer who founded utilitarianism, the theory that an act is morally right when it maximizes the happiness of the community. By happiness, Bentham meant pleasure and the absence of pain, to be measured quantitatively. In addition to this hedonistic account of value, Bentham also maintained that pain and pleasure are the sole motives behind all human actions, a point he marshalled against rival theories to utilitarianism. Among the reforms Bentham advocated were the abolition of capital punishment, more humane conditions in prisons, and relief programs for the poor.

An Introduction to the Principles of Morals and Legislation

CHAPTER I

Of the Principle of Utility

1. Nature has placed mankind under the governance of two sovereign masters, *pain* and *pleasure*. It is for them alone to point out what we ought to do, as well as to determine what we shall do. On the one hand the standard of right and wrong, on the other the chain of causes and effects, are fastened to their throne. They govern us in all we do, in all we say, in all we think: every effort we can make to throw off our subjection, will serve but to demonstrate and confirm it. In words a man may pretend to abjure their empire: but in reality he will remain subject to it all the while. The *principle of utility* recognises this subjection, and assumes it for the foundation of that system, the object of which is to rear the fabric of felicity by the hands of reason and of law. Systems which attempt to question it, deal in sounds instead of sense, in caprice instead of reason, in darkness instead of light.

But enough of metaphor and declamation: it is not by such means that moral science is to be improved.

2. The principle of utility is the foundation of the present work: it will be proper therefore at the outset to give an explicit and determinate account of what is meant by it. By the principle of utility is meant that principle which approves or disapproves of every action whatsoever, according to the tendency which it appears to have to augment or diminish the happiness of the party whose interest is in question: or, what is the same thing in other words, to promote or to oppose that happiness. I say of every action whatsoever; and therefore not only of every action of a private individual, but of every measure of government.

3. By utility is meant that property in any object, whereby it tends to produce benefit, advantage, pleasure, good, or happiness, (all this in the present case comes to the same thing), or (what comes again to the same thing) to prevent the happening of mischief,

From *An Introduction to the Principles of Morals and Legislation*, Jeremy Bentham (1789).

pain, evil, or unhappiness to the party whose interest is considered: if that party be the community in general, then the happiness of the community: if a particular individual, then the happiness of that individual.

4. The interest of the community is one of the most general expressions that can occur in the phraseology of morals: no wonder that the meaning of it is often lost. When it has a meaning, it is this. The community is a fictitious *body,* composed of the individual persons who are considered as constituting as it were its *members.* The interest of the community then is, what?—the sum of the interests of the several members who compose it.

5. It is in vain to talk of the interest of the community, without understanding what is the interest of the individual. A thing is said to promote the interest, or to be *for* the interest, of an individual, when it tends to add to the sum total of his pleasures: or, what comes to the same thing, to diminish the sum total of his pains.

6. An action then may be said to be conformable to the principle of utility, or, for shortness sake, to utility, (meaning with respect to the community at large) when the tendency it has to augment the happiness of the community is greater than any it has to diminish it.

7. A measure of government (which is but a particular kind of action, performed by a particular person or persons) may be said to be conformable to or dictated by the principle of utility, when in like manner the tendency which it has to augment the happiness of the community is greater than any which it has to diminish it.

8. When an action, or in particular a measure of government, is supposed by a man to be conformable to the principle of utility, it may be convenient, for the purposes of discourse, to imagine a kind of law or dictate, called a law or dictate of utility: and to speak of the action in question, as being conformable to such law or dictate.

9. A man may be said to be a partisan of the principle of utility, when the approbation or disapprobation he annexes to any action, or to any measure, is determined by, and proportioned to the tendency which he conceives it to have to augment or to diminish the happiness of the community: or in other words, to its conformity or unconformity to the laws or dictates of utility.

10. Of an action that is conformable to the principle of utility, one may always say either that it is one that ought to be done, or at least that it is not one that ought not to be done. One may say also, that it is right it should be done; at least that it is not wrong it should be done: that it is a right action; at least that it is not a wrong action. When thus interpreted, the words *ought,* and *right* and *wrong,* and others of that stamp, have a meaning: when otherwise, they have none.

11. Has the rectitude of this principle been ever formally contested? It should seem that it had, by those who have not known what they have been meaning. Is it susceptible of any direct proof? it should seem not: for that which is used to prove every thing else, cannot itself be proved: a chain of proofs must have their commencement somewhere. To give such proof is as impossible as it is needless.

12. Not that there is or ever has been that human creature breathing, however stupid or perverse, who has not on many, perhaps on most occasions of his life, deferred to it. By the natural constitution of the human frame, on most occasions of their lives men in general embrace this principle, without thinking of it: if not for the ordering of their own actions, yet for the trying of their own actions, as well as of those of other men. There have been, at the same time, not many, perhaps, even of the most intelligent, who have been disposed to embrace it purely and without reserve. There are even few who have not taken some occasion or other to quarrel with it, either on account of their not understanding always how to apply it, or on account of some prejudice or other which they were afraid to examine into, or could not bear to part with. For such is the stuff that man is made of: in principle and in practice, in a right track and in a wrong one, the rarest of all human qualities is consistency.

13. When a man attempts to combat the principle of utility, it is with reasons drawn, without his being aware of it, from that very principle itself. His arguments, if they prove any thing, prove not that the principle is *wrong,* but that, according to the applications he supposes to be made of it, it is *misapplied.* Is

it possible for a man to move the earth? Yes; but he must first find out another earth to stand upon.

14. To disprove the propriety of it by arguments is impossible; but, from the causes that have been mentioned, or from some confused or partial view of it, a man may happen to be disposed not to relish it. Where this is the case, if he thinks the settling of his opinions on such a subject worth the trouble, let him take the following steps, and at length, perhaps, he may come to reconcile himself to it.

(1) Let him settle with himself, whether he would wish to discard this principle altogether; if so, let him consider what it is that all his reasonings (in matters of politics especially) can amount to?

(2) If he would, let him settle with himself, whether he would judge and act without any principle, or whether there is any other he would judge and act by?

(3) If there be, let him examine and satisfy himself whether the principle he thinks he has found is really any separate intelligible principle; or whether it be not a mere principle in words, a kind of phrase, which at bottom expresses neither more nor less than the mere averment of his own unfounded sentiments; that is, what in another person he might be apt to call *caprice*?

(4) If he is inclined to think that his own approbation or disapprobation, annexed to the idea of an act, without any regard to its consequences, is a sufficient foundation for him to judge and act upon, let him ask himself whether his sentiment is to be a standard of right and wrong, with respect to every other man, or whether every man's sentiment has the same privilege of being a standard to itself?

(5) In the first case, let him ask himself whether his principle is not despotical, and hostile to all the rest of human race?

(6) In the second case, whether it is not anarchical, and whether at this rate there are not as many different standards of right and wrong as there are men? and whether even to the same man, the same thing, which is right today, may not (without the least change in its nature) be wrong to-morrow? and whether the same thing is not right and wrong in the same place at the same time? and in either case, whether all argument is not at an end? and whether, when two men have said,

'I like this,' and 'I don't like it', they can (upon such a principle) have any thing more to say?

(7) If he should have said to himself, No: for that the sentiment which he proposes as a standard must be grounded on reflection, let him say on what particulars the reflection is to turn? if on particulars having relation to the utility of the act, then let him say whether this is not deserting his own principle, and borrowing assistance from that very one in opposition to which he sets it up: or if not on those particulars, on what other particulars?

(8) If he should be for compounding the matter, and adopting his own principle in part, and the principle of utility in part, let him say how far he will adopt it?

(9) When he has settled with himself where he will stop, then let him ask himself how he justifies to himself the adopting it so far? and why he will not adopt it any farther?

(10) Admitting any other principle than the principle of utility to be a right principle, a principle that it is right for a man to pursue; admitting (what is not true) that the word *right* can have a meaning without reference to utility, let him say whether there is any such thing as a *motive* that a man can have to pursue the dictates of it: if there is, let him say what that motive is, and how it is to be distinguished from those which enforce the dictates of utility: if not, then lastly let him say what it is this other principle can be good for?

CHAPTER II

Of Principles Adverse to That of Utility

1. If the principle of utility be a right principle to be governed by, and that in all cases, it follows from what has been just observed, that whatever principle differs from it in any case must necessarily be a wrong one. To prove any other principle, therefore, to be a wrong one, there needs no more than just to show it to be what it is, a principle of which the dictates are in some point or other different from those of the principle of utility: to state it is to confute it.

2. A principle may be different from that of utility in two ways: 1. By being constantly opposed to it: this is the case with a principle which may be termed the principle of *asceticism.* 2. By being sometimes opposed to it, and sometimes not, as it may happen: this is the case with another, which may be termed the principle of *sympathy* and *antipathy.*

3. By the principle of asceticism I mean that principle, which, like the principle of utility, approves or disapproves of any action, according to the tendency which it appears to have to augment or diminish the happiness of the party whose interest is in question; but in an inverse manner: approving of actions in as far as they tend to diminish his happiness; disapproving of them in as far as they tend to augment it. . . .

9. The principle of asceticism seems originally to have been the reverie of certain hasty speculators, who having perceived, or fancied, that certain pleasures, when reaped in certain circumstances, have, at the long run, been attended with pains more than equivalent to them, took occasion to quarrel with every thing that offered itself under the name of pleasure. Having then got thus far, and having forgot the point which they set out from, they pushed on, and went so much further as to think it meritorious to fall in love with pain. Even this, we see, is at bottom but the principle of utility misapplied.

10. The principle of utility is capable of being consistently pursued; and it is but tautology to say, that the more consistently it is pursued, the better it must ever be for human-kind. The principle of asceticism never was, nor ever can be, consistently pursued by any living creature. Let but one tenth part of the inhabitants of this earth pursue it consistently, and in a day's time they will have turned it into a hell.

11. Among principles adverse to that of utility, that which at this day seems to have most influence in matters of government, is what may be called the principle of sympathy and antipathy. By the principle of sympathy and antipathy, I mean that principle which approves or disapproves of certain actions, not on account of their tending to augment the happiness, nor yet on account of their tending to diminish the happiness of the party whose interest is in question, but merely because a man finds himself

disposed to approve or disapprove of them: holding up that approbation or disapprobation as a sufficient reason for itself, and disclaiming the necessity of looking out for any extrinsic ground. Thus far in the general department of morals: and in the particular department of politics, measuring out the quantum (as well as determining the ground) of punishment, by the degree of the disapprobation.

12. It is manifest, that this is rather a principle in name than in reality: it is not a positive principle of itself, so much as a term employed to signify the negation of all principle. What one expects to find in a principle is something that points out some external consideration, as a means of warranting and guiding the internal sentiments of approbation and disapprobation: this expectation is but ill fulfilled by a proposition, which does neither more nor less than hold up each of those sentiments as a ground and standard for itself.

13. In looking over the catalogue of human actions (says a partisan of this principle) in order to determine which of them are to be marked with the seal of disapprobation, you need but to take counsel of your own feelings: whatever you find in yourself a propensity to condemn, is wrong for that very reason. For the same reason it is also meet for punishment: in what proportion it is adverse to utility, or whether it be adverse to utility at all, is a matter that makes no difference. In that same *proportion* also is it meet for punishment: if you hate much, punish much: if you hate little, punish little: punish as you hate. If you hate not at all, punish not at all: the fine feelings of the soul are not to be overborne and tyrannized by the harsh and rugged dictates of political utility.

14. The various systems that have been formed concerning the standard of right and wrong, may all be reduced to the principle of sympathy and antipathy. One account may serve for all of them. They consist all of them in so many contrivances for avoiding the obligation of appealing to any external standard, and for prevailing upon the reader to accept of the author's sentiment or opinion as a reason and that a sufficient one for itself. The phrases different, but the principle the same.

15. It is manifest, that the dictates of this principle will frequently coincide with those of utility,

though perhaps without intending any such thing. Probably more frequently than not: and hence it is that the business of penal justice is carried on upon that tolerable sort of footing upon which we see it carried on in common at this day. For what more natural or more general ground of hatred to a practice can there be, than the mischievousness of such practice? What all men are exposed to suffer by, all men will be disposed to hate. It is far yet, however, from being a constant ground: for when a man suffers, it is not always that he knows what it is he suffers by. A man may suffer grievously, for instance, by a new tax, without being able to trace up the cause of his sufferings to the injustice of some neighbour, who has eluded the payment of an old one.

16. The principle of sympathy and antipathy is most apt to err on the side of severity. It is for applying punishment in many cases which deserve none: in many cases which deserve some, it is for applying more than they deserve. There is no incident imaginable, be it ever so trivial, and so remote from mischief, from which this principle may not extract a ground of punishment. Any difference in taste: any difference in opinion: upon one subject as well as upon another. No disagreement so trifling which perseverance and altercation will not render serious. Each becomes in the other's eyes an enemy, and, if laws permit, a criminal. This is one of the circumstances by which the human race is distinguished (not much indeed to its advantage) from the brute creation.

17. It is not, however, by any means unexampled for this principle to err on the side of lenity. A near and perceptible mischief moves antipathy. A remote and imperceptible mischief, though not less real, has no effect. Instances in proof of this will occur in numbers in the course of the work. It would be breaking in upon the order of it to give them here.

18. It may be wondered, perhaps, that in all this while no mention has been made of the *theological* principle; meaning that principle which professes to recur for the standard of right and wrong to the will of God. But the case is, this is not in fact a distinct principle. It is never any thing more or less than one or other of the three before-mentioned principles presenting itself under another shape. The *will* of God

here meant cannot be his revealed will, as contained in the sacred writings: for that is a system which nobody ever thinks of recurring to at this time of day, for the details of political administration: and even before it can be applied to the details of private conduct, it is universally allowed, by the most eminent divines of all persuasions, to stand in need of pretty ample interpretations; else to what use are the works of those divines? And for the guidance of these interpretations, it is also allowed, that some other standard must be assumed. The will then which is meant on this occasion, is that which may be called the *presumptive* will: that is to say, that which is presumed to be his will on account of the conformity of its dictates to those of some other principle. What then may be this other principle? it must be one or other of the three mentioned above: for there cannot, as we have seen, be any more. It is plain, therefore, that, setting revelation out of the question, no light can ever be thrown upon the standard of right and wrong, by any thing that can be said upon the question, what is God's will. We may be perfectly sure, indeed, that whatever is right is conformable to the will of God: but so far is that from answering the purpose of showing us what is right, that it is necessary to know first whether a thing is right, in order to know from thence whether it be conformable to the will of God.

19. There are two things which are very apt to be confounded, but which it imports us carefully to distinguish:—the motive or cause, which, by operating on the mind of an individual, is productive of any act: and the ground or reason which warrants a legislator, or other by-stander, in regarding that act with an eye of approbation. When the act happens, in the particular instance in question, to be productive of effects which we approve of, much more if we happen to observe that the same motive may frequently be productive, in other instances, of the like effects, we are apt to transfer our approbation to the motive itself, and to assume, as the just ground for the approbation we bestow on the act, the circumstance of its originating from that motive. It is in this way that the sentiment of antipathy has often been considered as a just ground of action. Antipathy, for instance, in such or such a case, is the cause of an action, which is attended with

good effects: but this does not make it a right ground of action in that case, any more than in any other. Still farther. Not only the effects are good, but the agent sees beforehand that they will be so. This may make the action indeed a perfectly right action: but it does not make antipathy a right ground of action. For the same sentiment of antipathy, if implicitly deferred to, may be, and very frequently is, productive of the very worst effects. Antipathy, therefore, can never be a right ground of action. No more, therefore, can resentment, which, as will be seen more particularly hereafter, is but a modification of antipathy. The only right ground of action, that can possibly subsist, is, after all, the consideration of utility, which, if it is a right principle of action, and of approbation, in any one case, is so in every other. Other principles in abundance, that is, other motives, may be the reasons why such and such an act *has* been done: that is, the reasons or causes of its being done: but it is this alone that can be the reason why it might or ought to have been done. Antipathy or resentment requires always to be regulated, to prevent its doing mischief: to be regulated by what? always by the principle of utility. The principle of utility neither requires nor admits of any other regulator than itself.

CHAPTER III

Of the Four Sanctions or Sources of Pain and Pleasure

1. It has been shown that the happiness of the individuals, of whom a community is composed, that is their pleasures and their security, is the end and the sole end which the legislator ought to have in view: the sole standard, in conformity to which each individual ought, as far as depends upon the legislator, to be *made* to fashion his behaviour. But whether it be this or any thing else that is to be *done,* there is nothing by which a man can ultimately be *made* to do it, but either pain or pleasure. Having taken a general view of these two grand objects (viz. pleasure, and what comes to the same thing, immunity from pain) in the character of *final* causes; it will be necessary to take a view of pleasure and pain itself, in the character of *efficient* causes or means.

2. There are four distinguishable sources from which pleasure and pain are in use to flow: considered separately, they may be termed the *physical,* the *political,* the *moral,* and the *religious:* and inasmuch as the pleasures and pains belonging to each of them are capable of giving a binding force to any law or rule of conduct, they may all of them be termed *sanctions.*

3. If it be in the present life, and from the ordinary course of nature, not purposely modified by the interposition of the will of any human being, nor by any extraordinary interposition of any superior invisible being, that the pleasure or the pain takes place or is expected, it may be said to issue from or to belong to the *physical sanction.*

4. If at the hands of a *particular* person or set of persons in the community, who under names correspondent to that of *judge,* are chosen for the particular purpose of dispensing it, according to the will of the sovereign or supreme ruling power in the state, it may be said to issue from the *political sanction.*

5. If at the hands of such *chance* persons in the community, as the party in question may happen in the course of his life to have concerns with, according to each man's spontaneous disposition, and not according to any settled or concerted rule, it may be said to issue from the *moral* or *popular sanction.*

6. If from the immediate hand of a superior invisible being, either in the present life, or in a future, it may be said to issue from the *religious sanction.*

7. Pleasures or pains which may be expected to issue from the *physical, political,* or *moral* sanctions, must all of them be expected to be experienced, if ever, in the *present* life: those which may be expected to issue from the *religious* sanction, may be expected to be experienced either in the *present* life or in a *future.*

8. Those which can be experienced in the present life, can of course be no others than such as human nature in the course of the present life is susceptible of: and from each of these sources may flow all the pleasures or pains of which, in the course of the present life, human nature is susceptible. With regard to these then (with which alone we have in

this place any concern) those of them which belong to any one of those sanctions, differ not ultimately in kind from those which belong to any one of the other three: the only difference there is among them lies in the circumstances that accompany their production. A suffering which befalls a man in the natural and spontaneous course of things, shall be styled, for instance, a *calamity;* in which case, if it be supposed to befall him through any imprudence of his, it may be styled a punishment issuing from the *physical* sanction. Now this same suffering, if inflicted by the law, will be what is commonly called a *punishment;* if incurred for want of any friendly assistance, which the misconduct, or supposed misconduct, of the sufferer has occasioned to be withholden, a punishment issuing from the *moral* sanction; if through the immediate interposition of a particular providence, a punishment issuing from the *religious* sanction.

9. A man's goods, or his person, are consumed by fire. If this happened to him by what is called an accident, it was a *calamity:* if by reason of his own imprudence (for instance, from his neglecting to put his candle out) it may be styled a punishment of the *physical* sanction: if it happened to him by the sentence of the political magistrate, a punishment belonging to the *political* sanction; that is, what is commonly called a *punishment:* if for want of any assistance which his *neighbour* withheld from him out of some dislike to his *moral* character, a punishment of the *moral* sanction: if by an immediate act of *God's* displeasure, manifested on account of some *sin* committed by him, or through any distraction of mind, occasioned by the dread of such displeasure, a punishment of the *religious* sanction.

10. As to such of the pleasures and pains belonging to the religious sanction, as regard a future life, of what kind these may be we cannot know. These lie not open to our observation. During the present life they are matter only of expectation: and, whether that expectation be derived from natural or revealed religion, the particular kind of pleasure or pain, if it be different from all those which lie open to our observation, is what we can have no idea of. The best ideas we can obtain of such pains and pleasures are altogether unliquidated in point of quality. In what

other respects our ideas of them *may* be liquidated will be considered in another place.

11. Of these four sanctions the physical is altogether, we may observe, the ground-work of the political and the moral: so is it also of the religious, in as far as the latter bears relation to the present life. It is included in each of those other three. This may operate in any case, (that is, any of the pains or pleasures belonging to it may operate) independently of *them:* none of *them* can operate but by means of this. In a word, the powers of nature may operate of themselves; but neither the magistrate, nor men at large, *can* operate, nor is God in the case in question *supposed* to operate, but through the powers of nature.

12. For these four objects, which in their nature have so much in common, it seemed of use to find a common name. It seemed of use, in the first place, for the convenience of giving a name to certain pleasures and pains, for which a name equally characteristic could hardly otherwise have been found: in the second place, for the sake of holding up the efficacy of certain moral forces, the influence of which is apt not to be sufficiently attended to. Does the political sanction exert an influence over the conduct of mankind? The moral, the religious sanctions do so too. In every inch of his career are the operations of the political magistrate liable to be aided or impeded by these two foreign powers: who, one or other of them, or both, are sure to be either his rivals or his allies. Does it happen to him to leave them out in his calculations? he will be sure almost to find himself mistaken in the result. Of all this we shall find abundant proofs in the sequel of this work. It behoves him, therefore, to have them continually before his eyes; and that under such a name as exhibits the relation they bear to his own purposes and designs.

CHAPTER IV

Value of a Lot of Pleasure or Pain, How to Be Measured

1. Pleasures then, and the avoidance of pains, are the *ends* which the legislator has in view: it

behoves him therefore to understand their *value.* Pleasures and pains are the instruments he has to work with: it behoves him therefore to understand their force, which is again, in another point of view their value.

2. To a person considered *by himself,* the value of a pleasure or pain considered *by itself,* will be greater or less, according to the four following circumstances:

1. Its *intensity.*
2. Its *duration.*
3. Its *certainty* or *uncertainty.*
4. Its *propinquity* or *remoteness.*

3. These are the circumstances which are to be considered in estimating a pleasure or a pain considered each of them by itself. But when the value of any pleasure or pain is considered for the purpose of estimating the tendency of any *act* by which it is produced, there are two other circumstances to be taken into the account; these are,

5. Its *fecundity,* or the chance it has of being followed by sensations of the *same* kind: that is, pleasures, if it be a pleasure: pains, if it be a pain.
6. Its *purity,* or the chance it has of *not* being followed by sensations of the *opposite* kind: that is, pains, if it be a pleasure: pleasures, if it be a pain.

These two last, however, are in strictness scarcely to be deemed properties of the pleasure or the pain itself; they are not, therefore, in strictness to be taken into the account of the value of that pleasure or that pain. They are in strictness to be deemed properties only of the act, or other event, by which such pleasure or pain has been produced; and accordingly are only to be taken into the account of the tendency of such act or such event.

4. To a *number* of persons, with reference to each of whom the value of a pleasure or a pain is considered, it will be greater or less, according to seven circumstances: to wit, the six preceding ones; viz.

1. Its *intensity.*
2. Its *duration.*
3. Its *certainty* or *uncertainty.*
4. Its *propinquity* or *remoteness.*
5. Its *fecundity.*
6. Its *purity.*

And one other; to wit;

7. Its *extent;* that is, the number of persons to whom it *extends;* or (in other words) who are affected by it.

5. To take an exact account then of the general tendency of any act, by which the interests of a community are affected, proceed as follows. Begin with any one person of those whose interests seem most immediately to be affected by it: and take an account,

1. Of the value of each distinguishable *pleasure* which appears to be produced by it in the *first* instance.
2. Of the value of each *pain* which appears to be produced by it in the *first* instance.
3. Of the value of each pleasure which appears to be produced by it *after* the first. This constitutes the *fecundity* of the first *pleasure* and the impurity of the first *pain.*
4. Of the value of each *pain* which appears to be produced by it after the first. This constitutes the *fecundity* of the first *pain,* and the *impurity* of the first pleasure.
5. Sum up all the values of all the *pleasures* on the one side, and those of all the *pains* on the other. The balance, if it be on the side of pleasure, will give the *good* tendency of the act upon the whole, with respect to the interests of that *individual* person; if on the side of pain, the *bad* tendency of it upon the whole.
6. Take an account of the *number* of persons whose interests appear to be concerned; and repeat the above process with respect to each. *Sum up* the numbers expressive of the degrees of *good* tendency, which the act has, with

respect to each individual, in regard to whom the tendency of it is *good* upon the whole: do this again with respect to each individual, in regard to whom the tendency of it is *good* upon the whole: do this again with respect to each individual, in regard to whom the tendency of it is *bad* upon the whole. Take the *balance;* which, if on the side of *pleasure,* will give the general *good tendency* of the act, with respect to the total number or community of individuals concerned; if on the side of pain, the general *evil tendency,* with respect to the same community.

6. It is not to be expected that this process should be strictly pursued previously to every moral judgment, or to every legislative or judicial operation. It may, however, be always kept in view: and as near as the process actually pursued on these occasions approaches to it, so near will such process approach to the character of an exact one.

7. The same process is alike applicable to pleasure and pain, in whatever shape they appear: and by whatever denomination they are distinguished: to pleasure, whether it be called *good* (which is properly the cause or instrument of pleasure) or *profit* (which is distant pleasure, or the cause or instrument of distant pleasure,) or *convenience,* to *advantage, benefit, emolument, happiness,* and so forth: to pain, whether it be called *evil,* (which corresponds to *good*) or *mischief,* or *inconvenience,* or *disadvantage,* or *loss,* or *unhappiness,* and so forth.

8. Nor is this a novel and unwarranted, any more than it is a useless theory. In all this there is nothing but what the practice of mankind, wheresoever they have a clear view of their own interest, is perfectly conformable to. An article of property, an estate in land, for instance, is valuable, on what account? On account of the pleasures of all kinds which it enables a man to produce, and what comes to the same thing the pains of all kinds which it enables him to avert. But the value of such an article of property is universally understood to rise or fall according to the length or shortness of the time which a man has in it: the certainty or uncertainty of its coming into possession: and the nearness or remoteness of the time at which, if at all, it is to come into possession. As to the *intensity* of the pleasures which a man may derive from it, this is never thought of, because it depends upon the use which each particular person may come to make of it: which cannot be estimated till the particular pleasures he may come to derive from it, or the particular pains he may come to exclude by means of it, are brought to view. For the same reason, neither does he think of the *fecundity* or *purity* of those pleasures.

Thus much for pleasure and pain, happiness and unhappiness, in *general.* We come now to consider the several particular kinds of pain and pleasure.

Study Questions

1. Is reading philosophy morally wrong because you could be doing more to enhance the happiness of the community?

2. Is friendship good solely because it brings pleasure?

3. Is punishing the innocent right if it maximizes the happiness of the community?

4. Are all pleasures equally valuable?

13

JOHN STUART MILL

John Stuart Mill (1806–1873), born in London, received an intense early education from his father, James Mill, a philosophical and political writer. While pursuing a career in the East India Company, John Stuart Mill published widely in philosophy, political theory, and economics. A strong influence on his thought was Harriet Taylor, whom he met in 1831 and married two decades later following the death of her husband. Mill wrote that she was "the inspirer, and in part the author, of all that is best in my writings." Mill defended utilitarianism, the view that actions are right in proportion as they tend to promote happiness and wrong as they tend to produce the reverse of happiness, each person to be counted equally. By "happiness" Mill meant pleasure and the absence of pain. He grants, however, that some pleasures are more valuable than others, and these higher pleasures are those that would be chosen by knowledgeable judges. In response to the criticism that utilitarians do not adequately recognize claims of justice, Mill replied that the pursuit of justice has clear social utility.

Utilitarianism

CHAPTER I

General Remarks

There are few circumstances among those which make up the present condition of human knowledge more unlike what might have been expected, or more significant of the backward state in which speculation on the most important subjects still lingers, than the little progress which has been made in the decision of the controversy respecting the criterion of right and wrong. From the dawn of philosophy, the question concerning the *summum bonum,* or, what is the same thing, concerning the foundation of morality, has been accounted the main problem in speculative thought, has occupied the most gifted intellects and divided them into sects and schools carrying on a vigorous warfare against one another. And after more than two thousand years the same discussions continue, philosophers are still ranged under the same contending banners, and neither thinkers nor mankind at large seem nearer to being unanimous on the subject than when the youth Socrates listened to the old Protagoras and asserted (if Plato's dialogue be grounded on a real conversation) the theory of utilitarianism against the popular morality of the so-called sophist.

It is true that similar confusion and uncertainty and, in some cases, similar discordance exist respecting the first principles of all the sciences, not excepting that which is deemed the most certain of them—mathematics, without much impairing,

From "Utilitarianism," John Stuart Mill (1861).

generally indeed without impairing at all, the trustworthiness of the conclusions of those sciences. An apparent anomaly, the explanation of which is that the detailed doctrines of a science are not usually deduced from, nor depend for their evidence upon, what are called its first principles. Were it not so, there would be no science more precarious, or whose conclusions were more insufficiently made out, than algebra, which derives none of its certainty from what are commonly taught to learners as its elements, since these, as laid down by some of its most eminent teachers, are as full of fictions as English law, and of mysteries as theology. The truths which are ultimately accepted as the first principles of a science are really the last results of metaphysical analysis practiced on the elementary notions with which the science is conversant; and their relation to the science is not that of foundations to an edifice, but of roots to a tree, which may perform their office equally well though they be never dug down to and exposed to light. But though in science the particular truths precede the general theory, the contrary might be expected to be the case with a practical art, such as morals or legislation. All action is for the sake of some end, and rules of action, it seems natural to suppose, must take their whole character and color from the end to which they are subservient. When we engage in pursuit, a clear and precise conception of what we are pursuing would seem to be the first thing we need, instead of the last we are to look forward to. A test of right and wrong must be the means, one would think, of ascertaining what is right or wrong, and not a consequence of having already ascertained it.

The difficulty is not avoided by having recourse to the popular theory of a natural faculty, a sense of instinct, informing us of right and wrong. For—besides that the existence of such a moral instinct is itself one of the matters in dispute—those believers in it who have any pretensions to philosophy have been obliged to abandon the idea that it discerns what is right or wrong in the particular case in hand, as our other senses discern the sight or sound actually present. Our moral faculty, according to all those of its interpreters who are entitled to the name of thinkers, supplies us only with the general principles of moral judgments; it is a branch of our reason, not of our sensitive faculty, and must be looked to for the abstract doctrines of morality, not for perception of it in the concrete. The intuitive, no less than what may be termed the inductive, school of ethics insists on the necessity of general laws. They both agree that the morality of an individual action is not a question of direct perception, but of the application of a law to an individual case. They recognize also, to a great extent, the same moral laws, but differ as to their evidence and the source from which they derive their authority. According to the one opinion, the principles of morals are evident *a priori,* requiring nothing to command assent except that the meaning of the terms be understood. According to the other doctrine, right and wrong, as well as truth and falsehood, are questions of observation and experience. But both hold equally that morality must be deduced from principles; and the intuitive school affirm as strongly as the inductive that there is a science of morals. Yet they seldom attempt to make out a list of the *a priori* principles which are to serve as the premises of the science; still more rarely do they make any effort to reduce those various principles to one first principle or common ground of obligation. They either assume the ordinary precepts of morals as of *a priori* authority, or they lay down as the common groundwork of those maxims some generality much less obviously authoritative than the maxims themselves, and which has never succeeded in gaining popular acceptance. Yet to support their pretensions there ought either to be some one fundamental principle or law at the root of all morality, or, if there be several, there should be a determinate order of precedence among them; and the one principle, or the rule for deciding between the various principles when they conflict, ought to be self-evident.

To inquire how far the bad effects of this deficiency have been mitigated in practice, or to what extent the moral beliefs of mankind have been vitiated or made uncertain by the absence of any distinct recognition of an ultimate standard, would imply a complete survey and criticism of past and present ethical doctrine. It would, however, be easy to show

that whatever steadiness or consistency these moral beliefs have attained has been mainly due to the tacit influence of a standard not recognized. Although the nonexistence of an acknowledged first principle has made ethics not so much a guide as a consecration of men's actual sentiments, still, as men's sentiments, both of favor and of aversion, are greatly influenced by what they suppose to be the effects of things upon their happiness, the principle of utility, or, as Bentham latterly called it, the greatest happiness principle, has had a large share in forming the moral doctrines even of those who most scornfully reject its authority. Nor is there any school of thought which refuses to admit that the influence of actions on happiness is a most material and even predominant consideration in many of the details of morals, however unwilling to acknowledge it as the fundamental principle of morality and the source of moral obligation. I might go much further and say that to all those *a priori* moralists who deem it necessary to argue at all, utilitarian arguments are indispensable. It is not my present purpose to criticize these thinkers; but I cannot help referring, for illustration, to a systematic treatise by one of the most illustrious of them, the *Metaphysics of Ethics* by Kant. This remarkable man, whose system of thought will long remain one of the landmarks in the history of philosophical speculation, does, in the treatise in question, lay down a universal first principle as the origin and ground of moral obligation; it is this: "So act that the rule on which thou actest would admit of being adopted as a law by all rational beings." But when he begins to deduce from this precept any of the actual duties of morality, he fails, almost grotesquely, to show that there would be any contradiction, any logical (not to say physical) impossibility, in the adoption by all rational beings of the most outrageously immoral rules of conduct. All he shows is that the *consequences* of their universal adoption would be such as no one would choose to incur.

On the present occasion, I shall, without further discussion of the other theories, attempt to contribute something toward the understanding and appreciation of the "utilitarian" or "happiness" theory, and toward such proof as it is susceptible of. It is evident that this cannot be proof in the ordinary and popular meaning of the term. Questions of ultimate ends are not amenable to direct proof. Whatever can be proved to be good must be so by being shown to be a means to something admitted to be good without proof. The medical art is proved to be good by its conducing to health; but how is it possible to prove that health is good? The art of music is good, for the reason, among others, that it produces pleasure; but what proof is it possible to give that pleasure is good? If, then, it is asserted that there is a comprehensive formula, including all things which are in themselves good, and that whatever else is good is not so as an end but as a means, the formula may be accepted or rejected, but is not a subject of what is commonly understood by proof. We are not, however, to infer that its acceptance or rejection must depend on blind impulse or arbitrary choice. There is a larger meaning of the word "proof," in which this question is as amenable to it as any other of the disputed questions of philosophy. The subject is within the cognizance of the rational faculty; and neither does that faculty deal with it solely in the way of intuition. Considerations may be presented capable of determining the intellect either to give or withhold its assent to the doctrine; and this is equivalent to proof.

We shall examine presently of what nature are these considerations; in what manner they apply to the case, and what rational grounds, therefore, can be given for accepting or rejecting the utilitarian formula. But it is a preliminary condition of rational acceptance or rejection that the formula should be correctly understood. I believe that the very imperfect notion ordinarily formed of its meaning is the chief obstacle which impedes its reception, and that, could it be cleared even from only the grosser misconceptions, the question would be greatly simplified and a large proportion of its difficulties removed. Before, therefore, I attempt to enter into the philosophical grounds which can be given for assenting to the utilitarian standard, I shall offer some illustrations of the doctrine itself, with the view of showing more clearly what it is, distinguishing it from what it is not, and disposing of such of the practical objections to it as either originate in, or are closely connected with,

mistaken interpretations of its meaning. Having thus prepared the ground, I shall afterwards endeavor to throw such light as I can call upon the question considered as one of philosophical theory.

CHAPTER II

What Utilitarianism Is

A passing remark is all that needs to be given to the ignorant blunder of supposing that those who stand up for utility as the test of right and wrong use the term in that restricted and merely colloquial sense in which utility is opposed to pleasure. An apology is due to the philosophical opponents of utilitarianism for even the momentary appearance of confounding them with anyone capable of so absurd a misconception; which is the more extraordinary, inasmuch as the contrary accusation, of referring everything to pleasure, and that, too, in its grossest form, is another of the common charges against utilitarianism: and, as has been pointedly remarked by an able writer, the same sort of persons, and often the very same persons, denounce the theory "as impracticably dry when the word 'utility' precedes the word 'pleasure,' and as too practically voluptuous when the word 'pleasure' precedes the word 'utility.'" Those who know anything about the matter are aware that every writer, from Epicurus to Bentham, who maintained the theory of utility meant by it, not something to be contradistinguished from pleasure, but pleasure itself, together with exemption from pain; and instead of opposing the useful to the agreeable or the ornamental, have always declared that the useful means these, among other things. Yet the common herd, including the herd of writers, not only in newspapers and periodicals, but in books of weight and pretension, are perpetually falling into this shallow mistake. Having caught up the word "utilitarian," while knowing nothing whatever about it but its sound, they habitually express by it the rejection or the neglect of pleasure in some of its forms: of beauty, of ornament, or of amusement. Nor is the term thus ignorantly misapplied solely in disparagement, but occasionally in compliment, as though it

implied superiority to frivolity and the mere pleasures of the moment. And this perverted use is the only one in which the word is popularly known, and the one from which the new generation are acquiring their sole notion of its meaning. Those who introduced the word, but who had for many years discontinued it as a distinctive appellation, may well feel themselves called upon to resume it if by doing so they can hope to contribute anything toward rescuing it from this utter degradation.[1]

The creed which accepts as the foundation of morals "utility" or the "greatest happiness principle" holds that actions are right in proportion as they tend to promote happiness; wrong as they tend to produce the reverse of happiness. By happiness is intended pleasure and the absence of pain; by unhappiness, pain and the privation of pleasure. To give a clear view of the moral standard set up by the theory, much more requires to be said; in particular, what things it includes in the ideas of pain and pleasure, and to what extent this is left an open question. But these supplementary explanations do not affect the theory of life on which this theory of morality is grounded—namely, that pleasure and freedom from pain are the only things desirable as ends; and that all desirable things (which are as numerous in the utilitarian as in any other scheme) are desirable either for pleasure inherent in themselves or as means to the promotion of pleasure and the prevention of pain.

Now such a theory of life excites in many minds, and among them in some of the most estimable in feeling and purpose, inveterate dislike. To suppose that life has (as they express it) no higher end than pleasure—no better and nobler object of desire and pursuit—they designate as utterly mean and groveling, as a doctrine worthy only of swine, to whom the followers of Epicurus were, at a very early period, contemptuously likened; and modern holders of the doctrine are occasionally made the subject of equally polite comparisons by its German, French, and English assailants.

When thus attacked, the Epicureans have always answered that it is not they, but their accusers, who represent human nature in a degrading light, since the accusation supposes human beings to be capable

of no pleasures except those of which swine are capable. If this supposition were true, the charge could not be gainsaid, but would then be no longer an imputation; for if the sources of pleasure were precisely the same to human beings and to swine, the rule of life which is good enough for the one would be good enough for the other. The comparison of the Epicurean life to that of beasts is felt as degrading, precisely because a beast's pleasures do not satisfy a human being's conceptions of happiness. Human beings have faculties more elevated than the animal appetites and, when once made conscious of them, do not regard anything as happiness which does not include their gratification. I do not indeed, consider the Epicureans to have been by any means faultless in drawing out their scheme of consequences from the utilitarian principle. To do this in any sufficient manner, many Stoic, as well as Christian, elements require to be included. But there is no known Epicurean theory of life which does not assign to the pleasures of the intellect, of the feelings and imagination, and of the moral sentiments a much higher value as pleasures than to those of mere sensation. It must be admitted, however, that utilitarian writers in general have placed the superiority of mental over bodily pleasures chiefly in the greater permanency, safety, uncostliness, etc., of the former—that is, in their circumstantial advantages rather than in their intrinsic nature. And on all these points utilitarians have fully proved their case; but they might have taken the other and, as it may be called, higher ground with entire consistency. It is quite compatible with the principle of utility to recognize the fact that some kinds of pleasures are more desirable and more valuable than others. It would be absurd that, while in estimating all other things quality is considered as well as quantity, the estimation of pleasure should be supposed to depend on quantity alone.

If I am asked what I mean by difference of quality in pleasures, or what makes one pleasure more valuable than another, merely as a pleasure, except its being greater in amount, there is but one possible answer. Of two pleasures, if there be one to which all or almost all who have experience of both give a decided preference, irrespective of any feeling of moral obligation to prefer it, that is the more desirable pleasure. If one of the two is, by those who are competently acquainted with both, placed so far above the other that they prefer it, even though knowing it to be attended with a greater amount of discontent, and would not resign it for any quantity of the other pleasure which their nature is capable of, we are justified in ascribing to the preferred enjoyment a superiority in quality so far outweighing quantity as to render it, in comparison, of small account.

Now it is an unquestionable fact that those who are equally acquainted with and equally capable of appreciating and enjoying both do give a most marked preference to the manner of existence which employs their higher faculties. Few human creatures would consent to be changed into any of the lower animals for a promise of the fullest allowance of a beast's pleasures; no intelligent human being would consent to be a fool, no instructed person would be an ignoramus, no person of feeling and conscience would be selfish and base, even though they should be persuaded that the fool, the dunce, or the rascal is better satisfied with his lot than they are with theirs. They would not resign what they possess more than he for the most complete satisfaction of all the desires which they have in common with him. If they ever fancy they would, it is only in cases of unhappiness so extreme that to escape from it they would exchange their lot for almost any other, however undesirable in their own eyes. A being of higher faculties requires more to make him happy, is capable probably of more acute suffering, and certainly accessible to it at more points, than one of an inferior type; but in spite of these liabilities, he can never really wish to sink into what he feels to be a lower grade of existence. We may give what explanation we please of this unwillingness; we may attribute it to pride, a name which is given indiscriminately to some of the most and to some of the least estimable feelings of which mankind are capable; we may refer it to the love of liberty and personal independence, an appeal to which was with the Stoics one of the most effective means for the inculcation of it; to the love of power or to the love of excitement, both of which do really enter

into and contribute to it; but its most appropriate appellation is a sense of dignity, which all human beings possess in one form or other, and in some, though by no means in exact, proportion to their higher faculties, and which is so essential a part of the happiness of those in whom it is strong that nothing which conflicts with it could be otherwise than momentarily an object of desire to them. Whoever supposes that this preference takes place at a sacrifice of happiness—that the superior being, in anything like equal circumstances, is not happier than the inferior—confounds the two very different ideas of happiness and content. It is indisputable that the being whose capacities of enjoyment are low has the greatest chance of having them fully satisfied; and a highly endowed being will always feel that any happiness which he can look for, as the world is constituted, is imperfect. But he can learn to bear its imperfections, if they are at all bearable; and they will not make him envy the being who is indeed unconscious of the imperfections, but only because he feels not at all the good which those imperfections qualify. It is better to be a human being dissatisfied than a pig satisfied; better to be Socrates dissatisfied than a fool satisfied. And if the fool, or the pig, are of a different opinion, it is because they only know their own side of the question. The other party to the comparison knows both sides.

 It may be objected that many who are capable of the higher pleasures occasionally, under the influence of temptation, postpone them to the lower. But this is quite compatible with a full appreciation of the intrinsic superiority of the higher. Men often, from infirmity of character, make their election for the nearer good, though they know it to be the less valuable; and this no less when the choice is between two bodily pleasures than when it is between bodily and mental. They pursue sensual indulgences to the injury of health, though perfectly aware that health is the greater good. It may be further objected that many who begin with youthful enthusiasm for everything noble, as they advance in years, sink into indolence and selfishness. But I do not believe that those who undergo this very common change voluntarily choose the lower description of pleasures in preference to the higher. I believe that, before they devote themselves exclusively to the one, they have already become incapable of the other. Capacity for the nobler feelings is in most natures a very tender plant, easily killed, not only by hostile influences, but by mere want of sustenance; and in the majority of young persons it speedily dies away if the occupations to which their position in life has devoted them, and the society into which it has thrown them, are not favorable to keeping that higher capacity in exercise. Men lose their high aspirations as they lose their intellectual tastes, because they have not time or opportunity for indulging them; and they addict themselves to inferior pleasures, not because they deliberately prefer them, but because they are either the only ones to which they have access or the only ones which they are any longer capable of enjoying. It may be questioned whether anyone who has remained equally susceptible to both classes of pleasures ever knowingly and calmly preferred the lower, though many, in all ages, have broken down in an ineffectual attempt to combine both.

From this verdict of the only competent judges, I apprehend there can be no appeal. On a question which is the best worth having of two pleasures, or which of two modes of existence is the most grateful to the feelings, apart from its moral attributes and from its consequences, the judgment of those who are qualified by knowledge of both, or, if they differ, that of the majority among them, must be admitted as final. And there needs be the less hesitation to accept this judgment respecting the quality of pleasures, since there is no other tribunal to be referred to even on the question of quantity. What means are there of determining which is the acutest of two pains, or the intensest of two pleasurable sensations, except the general suffrage of those who are familiar with both? Neither pains nor pleasures are homogeneous, and pain is always heterogeneous with pleasure. What is there to decide whether a particular pleasure is worth purchasing at the cost of a particular pain, except the feelings and judgment of the experienced? When, therefore, those feelings and judgment declare the pleasures derived from the higher faculties to be preferable *in kind,* apart from the question of intensity, to

those of which the animal nature, disjoined from the higher faculties, is susceptible, they are entitled on this subject to the same regard.

I have dwelt on this point as being a necessary part of a perfectly just conception of utility or happiness considered as the directive rule of human conduct. But it is by no means an indispensable condition to the acceptance of the utilitarian standard; for that standard is not the agent's own greatest happiness, but the greatest amount of happiness altogether; and if it may possibly be doubted whether a noble character is always the happier for its nobleness, there can be no doubt that it makes other people happier, and that the world in general is immensely a gainer by it. Utilitarianism, therefore, could only attain its end by the general cultivation of nobleness of character, even if each individual were only benefited by the nobleness of others, and his own, so far as happiness is concerned, were a sheer deduction from the benefit. But the bare enunciation of such an absurdity as this last renders refutation superfluous.

According to the greatest happiness principle, as above explained, the ultimate end, with reference to and for the sake of which all other things are desirable—whether we are considering our own good or that of other people—is an existence exempt as far as possible from pain, and as rich as possible in enjoyments, both in point of quantity and quality; the test of quality and the rule for measuring it against quantity being the preference felt by those who, in their opportunities of experience, to which must be added their habits of self-consciousness and self-observation, are best furnished with the means of comparison. This, being according to the utilitarian opinion the end of human action, is necessarily also the standard of morality, which may accordingly be defined "the rules and precepts for human conduct," by the observance of which an existence such as has been described might be, to the greatest extent possible, secured to all mankind; and not to them only, but, so far as the nature of things admits to, to the whole sentient creation.

Against this doctrine, however, arises another class of objectors who say that happiness, in any form, cannot be the rational purpose of human life and action; because, in the first place, it is unattainable; and they contemptuously ask, What right hast thou to be happy?—a question which Mr. Carlyle clinches by the addition, What right, a short time ago, hadst thou even *to be?* Next they say that men can do *without* happiness; that all noble human beings have felt this, and could not have become noble but by learning the lesson of *Entsagen,* or renunciation; which lesson, thoroughly learned and submitted to, they affirm to be the beginning and necessary condition of all virtue.

The first of these objections would go to the root of the matter were it well founded; for if no happiness is to be had at all by human beings, the attainment of it cannot be the end of morality or of any rational conduct. Though, even in that case, something might still be said for the utilitarian theory, since utility includes not solely the pursuit of happiness, but the prevention or mitigation of unhappiness; and if the former aim be chimerical, there will be all the greater scope and more imperative need for the latter, so long at least as mankind think fit to live and do not take refuge in the simultaneous act of suicide recommended under certain conditions by Novalis. When, however, it is thus positively asserted to be impossible that human life should be happy, the assertion, if not something like a verbal quibble, is at least an exaggeration. If by happiness be meant a continuity of highly pleasurable excitement, it is evident enough that this is impossible. A state of exalted pleasure lasts only moments or in some cases, and with some intermissions, hours or days, and is the occasional brilliant flash of enjoyment, not its permanent and steady flame. Of this the philosophers who have taught that happiness is the end of life were as fully aware as those who taunt them. The happiness which they meant was not a life of rapture, but moments of such, in an existence made up of few and transitory pains, many and various pleasures, with a decided predominance of the active over the passive, and having as the foundation of the whole not to expect more from life than it is capable of bestowing. A life thus composed, to those who have been fortunate enough to obtain it, has always appeared worthy of the name of happiness. And such an existence is

even now the lot of many during some considerable portion of their lives. The present wretched education and wretched social arrangements are the only real hindrance to its being attainable by almost all.

The objectors perhaps may doubt whether human beings, if taught to consider happiness as the end of life, would be satisfied with such a moderate share of it. But great numbers of mankind have been satisfied with much less. The main constituents of a satisfied life appear to be two, either of which by itself is often found sufficient for the purpose: tranquility and excitement. With much tranquility, many find that they can be content with very little pleasure; with much excitement, many can reconcile themselves to a considerable quantity of pain. There is assuredly no inherent impossibility of enabling even the mass of mankind to unite both, since the two are so far from being incompatible that they are in natural alliance, the prolongation of either being a preparation for, and exciting a wish for, the other. It is only those in whom indolence amounts to a vice that do not desire excitement after an interval of response; it is only those in whom the need of excitement is a disease that feel the tranquillity which follows excitement dull and insipid, instead of pleasurable in direct proportion to the excitement which preceded it. When people who are tolerably fortunate in their outward lot do not find in life sufficient enjoyment to make it valuable to them, the cause generally is caring for nobody but themselves. To those who have neither public nor private affections, the excitements of life are much curtailed, and in any case dwindle in value as the time approaches when all selfish interests must be terminated by death; while those who leave after them objects of personal affection, and especially those who have also cultivated a fellow-feeling with the collective interests of mankind, retain as lively an interest in life on the eve of death as in the vigor of youth and health. Next to selfishness, the principal cause which makes life unsatisfactory is want of mental cultivation. A cultivated mind—I do not mean that of a philosopher, but any mind to which the fountains of knowledge have been opened, and which has been taught, in any tolerable degree, to exercise its faculties—finds sources of

inexhaustible interest in all that surrounds it: in the objects of nature, the achievements of art, the imaginations of poetry, the incidents of history, the ways of mankind, past and present, and their prospects in the future. It is possible, indeed, to become indifferent to all this, and that too without having exhausted a thousandth part of it, but only when one has had from the beginning no moral or human interest in these things and has sought in them only the gratification of curiosity.

Now there is absolutely no reason in the nature of things why an amount of mental culture sufficient to give an intelligent interest in these objects of contemplation should not be the inheritance of everyone born in a civilized country. As little is there an inherent necessity that any human being should be a selfish egotist, devoid of every feeling or care but those which center in his own miserable individuality. Something far superior to this is sufficiently common even now, to give ample earnest of what the human species may be made. Genuine private affections and a sincere interest in the public good are possible, though in unequal degrees, to every rightly brought up human being. In a world in which there is so much to interest, so much to enjoy, and so much also to correct and improve, everyone who has this moderate amount of moral and intellectual requisites is capable of an existence which may be called enviable; and unless such a person, through bad laws or subjection to the will of others, is denied the liberty to use the sources of happiness within his reach, he will not fail to find this enviable existence, if he escapes the positive evils of life, the great sources of physical and mental suffering—such as indigence, disease, and the unkindness, worthlessness, or premature loss of objects of affection. The main stress of the problem lies, therefore, in the contest with these calamities from which it is a rare good fortune entirely to escape; which, as things now are, cannot be obviated, and often cannot be in any material degree mitigated. Yet no one whose opinion deserves a moment's consideration can doubt that most of the great positive evils of the world are in themselves removable, and will, if human affairs continue to improve, be in the end reduced within narrow limits. Poverty, in any sense implying suffering,

may be completely extinguished by the wisdom of society combined with the good sense and providence of individuals. Even that most intractable of enemies, disease, may be indefinitely reduced in dimensions by good physical and moral education and proper control of noxious influences, while the progress of science holds out a promise for the future of still more direct conquests over this detestable foe. And every advance in that direction relieves us from some, not only of the chances which cut short our own lives, but, what concerns us still more, which deprive us of those in whom our happiness is wrapt up. As for vicissitudes of fortune and other disappointments connected with wordly circumstances, these are principally the effect either of gross imprudence, of ill-regulated desires, or of bad or imperfect social institutions. All the grand sources, in short, of human suffering are in a great degree, many of them almost entirely, conquerable by human care and effort; and though their removal is grievously slow—though a long succession of generations will perish in the breach before the conquest is completed, and this world becomes all that, if will and knowledge were not wanting, it might easily be made—yet every mind sufficiently intelligent and generous to bear a part, however small and inconspicuous, in the endeavour will draw a noble enjoyment from the contest itself, which he would not for any bribe in the form of selfish indulgence consent to be without.

And this leads to the true estimation of what is said by the objectors concerning the possibility and the obligation of learning to do without happiness. Unquestionably it is possible to do without happiness; it is done involuntarily by nineteen-twentieths of mankind, even in those parts of our present world which are least deep in barbarism; and it often has to be done voluntarily by the hero or the martyr, for the sake of something which he prizes more than his individual happiness. But this something, what is it, unless the happiness of others or some of the requisites of happiness? It is noble to be capable of resigning entirely one's own portion of happiness, or chances of it; but, after all, this self-sacrifice must be for some end, it is not its own end; and if we are told that its end is not happiness but virtue, which

is better than happiness, I ask, would the sacrifice be made if the hero or martyr did not believe that it would earn for others immunity from similar sacrifices? Would it be made if he thought that his renunciation of happiness for himself would produce no fruit for any of his fellow creatures, but to make their lot like his and place them also in the condition of persons who have renounced happiness? All honor to those who can abnegate for themselves the personal enjoyment of life when by such renunciation they contribute worthily to increase the amount of happiness in the world; but he who does it or professes to do it for any other purpose is no more deserving of admiration than the ascetic mounted on his pillar. He may be an inspiriting proof of what men *can* do, but assuredly not an example of what they *should*.

Though it is only in a very imperfect state of the world's arrangements that anyone can best serve the happiness of others by the absolute sacrifice of his own, yet, so long as the world is in that imperfect state, I fully acknowledge that the readiness to make such a sacrifice is the highest virtue which can be found in man. I will add that in this condition of the world, paradoxical as the assertion may be, the conscious ability to do without happiness gives the best prospect of realizing such happiness as is attainable. For nothing except that consciousness can raise a person above the chances of life by making him feel that, let fate and fortune do their worst, they have not power to subdue him; which, once felt, frees him from excess of anxiety concerning the evils of life and enables him, like many a Stoic in the worst times of the Roman Empire, to cultivate in tranquillity the sources of satisfaction accessible to him, without concerning himself about the uncertainty of their duration any more than about their inevitable end.

Meanwhile, let utilitarians never cease to claim the morality of self-devotion as a possession which belongs by as good a right to them as either to the Stoic or to the Transcendentalist. The utilitarian morality does recognize in human beings the power of sacrificing their own greatest good for the good of others. It only refuses to admit that the sacrifice is itself a good. A sacrifice which does not increase

or tend to increase the sum total of happiness, it considers as wasted. The only self-renunciation which it applauds is devotion to the happiness, or to some of the means of happiness, of others, either of mankind collectively or of individuals within the limits imposed by the collective interests of mankind.

I must again repeat what the assailants of utilitarianism seldom have the justice to acknowledge, that the happiness which forms the utilitarian standard of what is right in conduct is not the agent's own happiness but that of all concerned. As between his own happiness and that of others, utilitarianism requires him to be as strictly impartial as a disinterested and benevolent spectator. In the golden rule of Jesus of Nazareth, we read the complete spirit of the ethics of utility. "To do as you would be done by," and "to love your neighbor as yourself," constitute the ideal perfection of utilitarian morality. As the means of making the nearest approach to this ideal, utility would enjoin, first, that laws and social arrangements should place the happiness or (as, speaking practically, it may be called) the interest of every individual as nearly as possible in harmony with the interest of the whole; and, secondly, that education and opinion, which have so vast a power over human character, should so use that power as to establish in the mind of every individual an indissoluble association between his own happiness and the good of the whole, especially between his own happiness and the practice of such modes of conduct, negative and positive, as regard for the universal happiness prescribes; so that not only he may be unable to conceive the possibility of happiness to himself, consistently with conduct opposed to the general good, but also that a direct impulse to promote the general good may be in every individual one of the habitual motives of action, and the sentiments connected therewith may fill a large and prominent place in every human being's sentient existence. If the impugners of the utilitarian morality represented it to their own minds in this its true character, I know not what recommendation possessed by any other morality they could possibly affirm to be wanting to it; what more beautiful or more exalted developments of human nature any other ethical system can be supposed to foster, or what springs of

action, not accessible to the utilitarian, such systems rely on for giving effect to their mandates.

The objectors to utilitarianism cannot always be charged with representing it in a discreditable light. On the contrary, those among them who entertain anything like a just idea of its disinterested character sometimes find fault with its standard as being too high for humanity. They say it is exacting too much to require that people shall always act from the inducement of promoting the general interests of society. But this is to mistake the very meaning of a standard of morals and confound the rule of action with the motive of it. It is the business of ethics to tell us what are our duties, or by what test we may know them; but no system of ethics requires that the sole motive of all we do shall be a feeling of duty; on the contrary, ninety-nine hundredths of all our actions are done from other motives, and rightly so done if the rule of duty does not condemn them. It is the more unjust to utilitarianism that this particular misapprehension should be made a ground of objection to it, inasmuch as utilitarian moralists have gone beyond almost all others in affirming that the motive has nothing to do with the morality of the action, though much with the worth of the agent. He who saves a fellow creature from drowning does what is morally right, whether his motive be duty or the hope of being paid for his trouble; he who betrays the friend that trusts him is guilty of a crime, even if his object be to serve another friend to whom he is under greater obligations.[2] But to speak only of actions done from the motive of duty, and in direct obedience to principle: it is a misapprehension of the utilitarian mode of thought to conceive it as implying that people should fix their minds upon so wide a generality as the world, or society at large. The great majority of good actions are intended not for the benefit of the world, but for that of individuals, of which the good of the world is made up; and the thoughts of the most virtuous man need not on these occasions travel beyond the particular persons concerned, except so far as is necessary to assure himself that in benefiting them he is not violating the rights, that is, the legitimate and authorized expectations, of anyone else. The multiplication of happiness is, according to

the utilitarian ethics, the object of virtue: the occasions on which any person (except one in a thousand) has it in his power to do this on an extended scale—in other words, to be a public benefactor—are but exceptional; and on these occasions alone is he called on to consider public utility; in every other case, private utility, the interest or happiness of some few persons, is all he has to attend to. Those alone the influence of whose actions extends to society in general need concern themselves habitually about so large an object. In the case of abstinences indeed—of things which people forbear to do from moral considerations, though the consequences in the particular case might be beneficial—it would be unworthy of an intelligent agent not to be consciously aware that the action is of a class which, if practiced generally, would be generally injurious, and that this is the ground of the obligation to abstain from it. The amount of regard for the public interest implied in this recognition is no greater than is demanded by every system of morals, for they all enjoin to abstain from whatever is manifestly pernicious to society.

The same considerations dispose of another reproach against the doctrine of utility, founded on a still grosser misconception of the purpose of a standard of morality and of the very meaning of the words "right" and "wrong." It is often affirmed that utilitarianism renders men cold and unsympathizing; that it chills their moral feelings toward individuals; that it makes them regard only the dry and hard consideration of the consequences of actions, not taking into their moral estimate the qualities from which those actions emanate. If the assertion means that they do not allow their judgment respecting the rightness or wrongness of an action to be influenced by their opinion of the qualities of the person who does it, this is a complaint not against utilitarianism, but against any standard of morality at all; for certainly no known ethical standard decides an action to be good or bad because it is done by a good or bad man, still less because done by an amiable, a brave, or a benevolent man, or the contrary. These considerations are relevant, not to the estimation of actions, but of persons; and there is nothing in the utilitarian theory inconsistent with the fact that there are

other things which interest us in persons besides the rightness and wrongness of their actions. The Stoics, indeed, with the paradoxical misuse of language which was part of their system, and by which they strove to raise themselves above all concern about anything but virtue, were fond of saying that he who has that has everything; that he, and only he, is rich, is beautiful, is a king. But no claim of this description is made for the virtuous man by the utilitarian doctrine. Utilitarians are quite aware that there are other desirable possessions and qualities besides virtue, and are perfectly willing to allow to all of them their full worth. They are also aware that a right action does not necessarily indicate a virtuous character, and that actions which are blamable often proceed from qualities entitled to praise. When this is apparent in any particular case, it modifies their estimation, not certainly of the act, but of the agent. I grant that they are, notwithstanding, of opinion that in the long run the best proof of a good character is good actions; and resolutely refuse to consider any mental disposition as good of which the predominant tendency is to produce bad conduct. This makes them unpopular with many people, but it is an unpopularity which they must share with everyone who regards the distinction between right and wrong in a serious light; and the reproach is not one which a conscientious utilitarian need be anxious to repel.

If no more be meant by the objection than that many utilitarians look on the morality of actions, as measured by the utilitarian standards, with too exclusive a regard, and do not lay sufficient stress upon the other beauties of character which go toward making a human being lovable or admirable, this may be admitted. Utilitarians who have cultivated their moral feelings, but not their sympathies, nor their artistic perceptions, do fall into this mistake; and so do all other moralists under the same conditions. What can be said in excuse for other moralists is equally available for them, namely, that, if there is to be any error, it is better that it should be on that side. As a matter of fact, we may affirm that among utilitarians, as among adherents of other systems, there is every imaginable degree of rigidity and of laxity in the application of their standard; some are

even puritanically rigorous, while others are as indulgent as can possibly be desired by sinner or by sentimentalist. But on the whole, a doctrine which brings prominently forward the interest that mankind have in the repression and prevention of conduct which violates the moral law is likely to be inferior to no other in turning the sanctions of opinion against such violations. It is true, the question "What does violate the moral law?" is one on which those who recognize different standards of morality are likely now and then to differ. But difference of opinion on moral questions was not first introduced into the world by utilitarianism, while the doctrine does supply, if not always an easy, at all events a tangible and intelligible, mode of deciding such differences.

It may not be superfluous to notice a few more of the common misapprehensions of utilitarian ethics, even those which are so obvious and gross that it might appear impossible for any person of candor and intelligence to fall into them; since persons, even of considerable mental endowment, often give themselves so little trouble to understand the bearings of any opinion against which they entertain a prejudice, and men are in general so little conscious of this voluntary ignorance as a defect that the vulgarest misunderstandings of ethical doctrines are continually met with in the deliberate writings of persons of the greatest pretensions both to high principle and to philosophy. We not uncommonly hear the doctrine of utility inveighed against a *godless* doctrine. If it be necessary to say anything at all against so mere an assumption, we may say that the question depends upon what idea we have formed of the moral character of the Deity. If it be a true belief that God desires, above all things, the happiness of his creatures, and that this was his purpose in their creation, utility is not only not a godless doctrine, but more profoundly religious than any other. If it be meant that utilitarianism does not recognize the revealed will of God as the supreme law of morals, I answer that a utilitarian who believes in the perfect goodness and wisdom of *God* necessarily believes that whatever God has thought fit to reveal on the subject of morals must fulfill the requirements of utility in a supreme degree. But others besides

utilitarians have been of opinion that the Christian revelation was intended, and is fitted, to inform the hearts and minds of mankind with a spirit which should enable them to find for themselves what is right, and incline them to do it when found, rather than to tell them, except in a very general way, what it is; and that we need a doctrine of ethics, carefully followed out, to *interpret* to us the will of God. Whether this opinion is correct or not, it is superfluous here to discuss; since whatever aid religion, either natural or revealed, can afford to ethical investigation is as open to the utilitarian moralist as to any other. He can use it as the testimony of God to the usefulness or hurtfulness of any given course of action by as good a right as others can use it for the indication of a transcendental law having no connection with usefulness or with happiness.

Again, utility is often summarily stigmatized as an immoral doctrine by giving it the name of "expediency," and taking advantage of the popular use of that term to contrast it with principle. But the expedient, in the sense in which it is opposed to the right, generally means that which is expedient for the particular interest of the agent himself; as when a minister sacrifices the interests of his country to keep himself in place. When it means anything better than this, it means that which is expedient for some immediate object, some temporary purpose, but which violates a rule whose observance is expedient in a much higher degree. The expedient, in this sense, instead of being the same thing with the useful, is a branch of the hurtful. Thus it would often be expedient, for the purpose of getting over some momentary embarrassment, or attaining some object immediately useful to ourselves or others, to tell a lie. But inasmuch as the cultivation in ourselves of a sensitive feeling on the subject of veracity is one of the most useful, and the enfeeblement of that feeling one of the most hurtful, things to which our conduct can be instrumental; and inasmuch as any, even unintentional, deviation from truth does that much toward weakening the trustworthiness of human assertion, which is not only the principal support of all present social well-being, but the insufficiency of which does more than any one thing that can be named to keep back civilization,

virtue, everything on which human happiness on the largest scale depends—we feel that the violation, for a present advantage, of a rule of such transcendent expediency is not expedient, and that he who, for the sake of convenience to himself or to some other individual, does what depends on him to deprive mankind of the good, and inflict upon them the evil, involved in the greater or less reliance which they can place in each other's word, acts the part of one of their worst enemies. Yet that even this rule, sacred as it is, admits of possible exceptions is acknowledged by all moralists; the chief of which is when the withholding of some fact (as of information from a malefactor, or of bad news from a person dangerously ill) would save an individual (especially an individual other than oneself) from great and unmerited evil, and when the withholding can only be effected by denial. But in order that the exception may not extend itself beyond the need, and may have the least possible effect in weakening reliance on veracity, it ought to be recognized and, if possible, its limits defined; and, if the principle of utility is good for anything, it must be good for weighing these conflicting utilities against one another and marking out the region within which one or the other preponderates.

Again, defenders of utility often find themselves called upon to reply to such objections as this—that there is not time, previous to action, for calculating and weighing the effects of any line of conduct on the general happiness. This is exactly as if anyone were to say that it is impossible to guide our conduct by Christianity because there is not time, on every occasion on which anything has to be done, to read through the Old and New Testaments. The answer to the objection is that there has been ample time, namely, the whole past duration of the human species. During all that time mankind have been learning by experience the tendencies of actions; on which experience all the prudence as well as all the morality of life are dependent. People talk as if the commencement of this course of experience had hitherto been put off, and as if, at the moment when some man feels tempted to meddle with the property or life of another, he had to begin considering for the first time whether murder and theft are

injurious to human happiness. Even then I do not think that he would find the question very puzzling; but, at all events, the matter is now done to his hand. It is truly a whimsical supposition that, if mankind were agreed in considering utility to be the test of morality, they would remain without any agreement as to what *is* useful, and would take no measures for having their notions on the subject taught to the young and enforced by law and opinion. There is no difficulty in proving any ethical standard whatever to work ill if we suppose universal idiocy to be conjoined with it; but on any hypothesis short of that, mankind must by this time have acquired positive beliefs as to the effects of some actions on their happiness; and the beliefs which have thus come down are the rules of morality for the multitude, and for the philosopher until he has succeeded in finding better. That philosophers might easily do this, even now, on many subjects; that the received code of ethics is by no means of divine right; and that mankind have still much to learn as to the effects of actions on the general happiness, I admit or rather earnestly maintain. The corollaries from the principle of utility, like the precepts of every practical art, admit of indefinite improvement, and, in a progressive state of the human mind, their improvement is perpetually going on. But to consider the rules of morality as improvable is one thing; to pass over the intermediate generalization entirely and endeavor to test each individual action directly by the first principle is another. It is a strange notion that the acknowledgment of a first principle is inconsistent with the admission of secondary ones. To inform a traveler respecting the place of his ultimate destination is not to forbid the use of landmarks and direction-posts on the way. The proposition that happiness is the end and aim of morality does not mean that no road ought to be laid down to that goal, or that persons going thither should not be advised to take one direction rather than another. Men really ought to leave off talking a kind of nonsense on this subject, which they would neither talk nor listen to on other matters of practical concernment. Nobody argues that the art of navigation is not founded on astronomy because

sailors cannot wait to calculate the Nautical Almanac. Being rational creatures, they go to sea with it ready calculated; and all rational creatures go out upon the sea of life with their minds made up on the common questions of right and wrong, as well as on many of the far more difficult questions of wise and foolish. And this, as long as foresight is a human quality, it is to be presumed they will continue to do. Whatever we adopt as the fundamental principle of morality, we require subordinate principles to apply it by; the impossibility of doing without them, being common to all systems, can afford no argument against any one in particular; but gravely to argue as if no such secondary principles could be had, and as if mankind had remained till now, and always must remain, without drawing any general conclusions from the experience of human life is as high a pitch, I think, as absurdity has ever reached in philosophical controversy.

The remainder of the stock arguments against utilitarianism mostly consist in laying to its charge the common infirmities of human nature, and the general difficulties which embarrass conscientious persons in shaping their course through life. We are told that a utilitarian will be apt to make his own particular case an exception to moral rules, and, when under temptation, will see a utility in the breach of a rule, greater than he will see in its observance. But is utility the only creed which is able to furnish us with excuses for evil-doing and means of cheating our own conscience? They are afforded in abundance by all doctrines which recognize as a fact in morals the existence of conflicting considerations, which all doctrines do that have been believed by sane persons. It is not the fault of any creed, but of the complicated nature of human affairs, that rules of conduct cannot be so framed as to require no exceptions, and that hardly any kind of action can safely be laid down as either always obligatory or always condemnable. There is no ethical creed which does not temper the rigidity of its laws by giving a certain latitude, under the moral responsibility of the agent, for accommodation to peculiarities of circumstances; and under every creed, at the opening thus made, self-deception and dishonest casuistry get in. There exists no moral system under which there do not arise unequivocal cases of conflicting obligation. These are the real difficulties, the knotty points both in the theory of ethics and in the conscientious guidance of personal conduct. They are overcome practically, with greater or with less success, according to the intellect and virtue of the individual; but it can hardly be pretended that anyone will be the less qualified for dealing with them, from possessing an ultimate standard to which conflicting rights and duties can be referred. If utility is the ultimate source of moral obligations, utility may be invoked to decide between them when their demands are incompatible. Though the application of the standard may be difficult, it is better than none at all; while in other systems, the moral laws all claiming independent authority, there is no common umpire entitled to interfere between them; their claims to precedence one over another rest on little better than sophistry, and, unless determined, as they generally are, by the unacknowledged influence of consideration of utility, afford a free scope for the action of personal desires and partialities. We must remember that only in these cases of conflict between secondary principles is it requisite that first principles should be appealed to. There is no case of moral obligation in which some secondary principle is not involved; and if only one, there can seldom be any real doubt which one it is, in the mind of any person by whom the principle itself is recognized.

CHAPTER III

Of the Ultimate Sanction of the Principle of Utility

The question is often asked, and properly so, in regard to any supposed moral standard—What is its sanction? what are the motives to obey? or, more specifically, what is the source of its obligation? whence does it derive its binding force? It is a necessary part of moral philosophy to provide the answer to this question, which, though frequently assuming the shape of an objection to the utilitarian morality, as if it had some special applicability to that

above others, really arises in regard to all standards. It arises, in fact, whenever a person is called on to *adopt* a standard, or refer morality to any basis on which he has not been accustomed to rest it. For the customary morality, that which education and opinion have consecrated, is the only one which presents itself to the mind with the feeling of being *in itself* obligatory; and when a person is asked to believe that this morality *derives* its obligation from some general principle round which custom has not thrown the same halo, the assertion is to him a paradox; the supposed corollaries seem to have a more binding force than the original theorem; the superstructure seems to stand better without than with what is represented as its foundation. He says to himself, I feel that I am bound not to rob or murder, betray or deceive; but why am I bound to promote the general happiness? If my own happiness lies in something else, why may I not give that the preference?

If the view adopted by the utilitarian philosophy of the nature of the moral sense be correct, this difficulty will always present itself until the influences which form moral character have taken the same hold of the principle which they have taken of some of the consequences—until, by the improvement of education, the feeling of unity with our fellow creatures shall be (what it cannot be denied that Christ intended it to be) as deeply rooted in our character, and to our own consciousness as completely a part of our nature, as the horror of crime is in an ordinarily well-brought up young person. In the meantime, however, the difficulty has no peculiar application to the doctrine of utility, but is inherent in every attempt to analyze morality and reduce it to principles; which, unless the principle is already in men's minds invested with as much sacredness as any of its applications, always seems to divest them of a part of their sanctity.

The principle of utility either has, or there is no reason why it might not have, all the sanctions which belong to any other system of morals. Those sanctions are either external or internal. Of the external sanctions it is not necessary to speak at any length. They are the hope of favor and the fear of displeasure from our fellow creatures or from the Ruler of the universe, along with whatever we may have of sympathy or affection for them, or of love and awe of Him, inclining us to do His will independently of selfish consequences. There is evidently no reason why all these motives for observance should not attach themselves to the utilitarian morality as completely and as powerfully as to any other. Indeed, those of them which refer to our fellow creatures are sure to do so, in proportion to the amount of general intelligence; for whether there be any other ground of moral obligation than the general happiness or not, men do desire happiness; and however imperfect may be their own practice, they desire and commend all conduct in others toward themselves by which they think their happiness is promoted. With regard to the religious motive, if men believe, as most profess to do, in the goodness of God, those who think that conduciveness to the general happiness is the essence or even only the criterion of good must necessarily believe that it is also that which God approves. The whole force therefore of external reward and punishment, whether physical or moral, and whether proceeding from God or from our fellow men, together with all that the capacities of human nature admit of disinterested devotion to either, become available to enforce the utilitarian morality, in proportion as that morality is recognized; and the more powerfully, the more the appliances of education and general cultivation are bent to the purpose.

So far as to external sanctions. The internal sanction of duty, whatever our standard of duty may be, is one and the same—a feeling in our own mind; a pain, more or less intense, attendant on violation of duty, which in properly cultivated moral natures rises, in the more serious cases, into shrinking from it as an impossibility. This feeling, when disinterested and connecting itself with the pure idea of duty, and not with some particular form of it, or with any of the merely accessory circumstances, is the essence of conscience; though in that complex phenomenon as it actually exists, the simple fact is in general all encrusted over with collateral associations derived from sympathy, from love, and still more from fear; from all the forms of religious feeling; from the recollections of childhood and of all our

past life; from self-esteem, desire of the esteem of others, and occasionally even self-abasement. This extreme complication is, I apprehend, the origin of the sort of mystical character which, by a tendency of the human mind of which there are many other examples, is apt to be attributed to the idea of moral obligation, and which leads people to believe that the idea cannot possibly attach itself to any other objects than those which, by a supposed mysterious law, are found in our present experience to excite it. Its binding force, however, consists in the existence of a mass of feeling which must be broken through in order to do what violates our standard of right, and which, if we do nevertheless violate that standard, will probably have to be encountered afterwards in the form of remorse. Whatever theory we have of the nature or origin of conscience, this is what essentially constitutes it.

The ultimate sanction, therefore, of all morality (external motives apart) being a subjective feeling in our own minds, I see nothing embarrassing to those whose standard is utility in the question, What is the sanction of that particular standard? We may answer, the same as of all other moral standards—the conscientious feelings of mankind. Undoubtedly this sanction has no binding efficacy on those who do not possess the feelings it appeals to; but neither will these persons be more obedient to any other moral principle than to the utilitarian one. On them morality of any kind has no hold but through the external sanctions. Meanwhile the feelings exist, a fact in human nature, the reality of which, and the great power with which they are capable of acting on those in whom they have been duly cultivated, are proved by experience. No reason has ever been shown why they may not be cultivated to as great intensity in connection with the utilitarian as with any other rule of morals.

There is, I am aware, a disposition to believe that a person who sees in moral obligation a transcendental fact, an objective reality belonging to the province of "things in themselves," is likely to be more obedient to it than one who believes it to be entirely subjective, having its seat in human consciousness only. But whatever a person's opinion may be on this point of ontology, the force he is really urged by is his own subjective feeling, and is exactly measured by its strength. No one's belief that duty is an objective reality is stronger than the belief that God is so; yet the belief in God, apart from the expectation of actual reward and punishment, only operates on conduct through, and in proportion to, the subjective religious feeling. The sanction, so far as it is disinterested, is always in the mind itself; and the motion, therefore, of the transcendental moralists must be that this sanction will not exist *in* the mind unless it is believed to have its root out of the mind; and that if a person is able to say to himself, "That which is restraining me and which is called my conscience is only a feeling in my own mind," he may possibly draw the conclusion that when the feeling ceases the obligation ceases, and that if he find the feeling inconvenient, he may disregard it and endeavor to get rid of it. But is this danger confined to the utilitarian morality? Does the belief that moral obligation has its seat outside the mind make the feeling of it too strong to get rid of? The fact is so far otherwise that all moralists admit and lament the ease with which, in the generality of minds, conscience can be silenced or stifled. The question, "Need I obey my conscience?" is quite as often put to themselves by persons who never heard of the principle of utility as by its adherents. Those whose conscientious feelings are so weak as to allow of their asking this question, if they answer it affirmatively, will not do so because they believe in the transcendental theory, but because of the external sanctions.

It is not necessary, for the present purpose, to decide whether the feeling of duty is innate or implanted. Assuming it to be innate, it is an open question to what objects it naturally attaches itself; for the philosophic supporters of that theory are now agreed that the intuitive perception is of principles of morality and not of the details. If there be anything innate in the matter, I see no reason why the feeling which is innate should not be that of regard to the pleasures and pains of others. If there is any principle of morals which is intuitively obligatory, I should say it must be that. If so, the intuitive ethics would coincide with the utilitarian, and there would

be no further quarrel between them. Even as it is, the intuitive moralists, though they believe that there are other intuitive moral obligations, do already believe this to be one; for they unanimously hold that a large *portion* of morality turns upon the consideration due to the interests of our fellow creatures. Therefore, if the belief in the transcendental origin of moral obligation gives any additional efficacy to the internal sanction, it appears to me that the utilitarian principle has already the benefit of it.

On the other hand, if, as is my own belief, the moral feelings are not innate but acquired, they are not for that reason the less natural. It is natural to man to speak, to reason, to build cities, to cultivate the ground, though these are acquired faculties. The moral feelings are not indeed a part of our nature in the sense of being in any perceptible degree present in all of us; but this, unhappily, is a fact admitted by those who believe the most strenuously in their transcendental origin. Like the other acquired capacities above referred to, the moral faculty, if not a part of our nature, is a natural outgrowth from it; capable, like them, in a certain small degree, of springing up spontaneously; and susceptible of being brought by cultivation to a high degree of development. Unhappily it is also susceptible, by a sufficient use of the external sanctions and of the force of early impressions, of being cultivated in almost any direction, so that there is hardly anything so absurd or so mischievous that it may not, by means of these influences, be made to act on the human mind with all the authority of conscience. To doubt that the same potency might be given by the same means to the principle of utility, even if it had no foundation in human nature, would be flying in the face of all experience.

But moral associations which are wholly of artificial creation, when the intellectual culture goes on, yield by degrees to the dissolving force of analysis; and if the feeling of duty, when associated with utility, would appear equally arbitrary; if there were no leading department of our nature, no powerful class of sentiments, with which that association would harmonize, which would make us feel congenial and incline us not only to foster it in ourselves—if there were not, in short, a natural basis of sentiments for utilitarian morality, it might well happen that this association also, even after it had been implanted by education, might be analyzed away.

But there *is* this basis of powerful natural sentiment; and that it is which, when once the general happiness is recognized as the ethical standard, will constitute the strength of the utilitarian morality. This firm foundation is that of the social feelings of mankind—the desire to be in unity with our fellow creatures, which is already a powerful principle in human nature, and happily one of those which tend to become stronger, even without express inculcation, from the influences of advancing civilization. The social state is at once so natural, so necessary, and so habitual to man, that, except in some unusual circumstances or by an effort of voluntary abstraction, he never conceives himself otherwise than as a member of a body; and this association is riveted more and more, as mankind are further removed from the state of savage independence. Any condition, therefore, which is essential to a state of society becomes more and more an inseparable part of every person's conception of the state of things which he is born into, and which is the destiny of a human being. Now society between human beings, except in the relation of master and slave, is manifestly impossible on any other footing than that of the interests of all are to be consulted. Society between equals can only exist on the understanding that the interests of all are to be regarded equally. And since in all states of civilization, every person, except an absolute monarch, has equals, everyone is obliged to live on these terms with somebody; and in every age some advance is made toward a state in which it will be impossible to live permanently on other terms with anybody. In this way people grow up unable to conceive as possible to them a state of total disregard of other people's interests. They are under a necessity of conceiving themselves as at least abstaining from all the grosser injuries, and (if only for their own protection) living in a state of constant protest against them. They are also familiar with the fact of co-operating with others and proposing to themselves a collective, not an individual, interest as the aim (at least for the time being) of their actions. So long as they are

co-operating, their ends are identified with those of others; there is at least a temporary feeling that the interests of others are their own interests. Not only does all strengthening of social ties, and all healthy growth of society, give to each individual a stronger personal interest in practically consulting the welfare of others, it also leads him to identify his *feelings* more and more with their good, or at least with an even greater degree of practical consideration for it. He comes, as though instinctively, to be conscious of himself as a being who *of course* pays regard to others. The good of others becomes to him a thing naturally and necessarily to be attended to, like any of the physical conditions of our existence. Now, whatever amount of this feeling a person has, he is urged by the strongest motives both of interest and of sympathy to demonstrate it, and to the utmost of his power encourage it in others; and even if he has none of it himself, he is as greatly interested as anyone else that others should have it. Consequently, the smaller germs of the feeling are laid hold of and nourished by the contagion of sympathy and the influences of education; and a complete web of corroborative association is woven round it by the powerful agency of the external sanctions. This mode of conceiving ourselves and human life, as civilization goes on, is felt to be more and more natural. Every step in political improvement renders it more so, by removing the sources of opposition of interest and leveling those inequalities of legal privilege between individuals or classes, owing to which there are large portions of mankind whose happiness it is still practicable to disregard. In an improving state of the human mind, the influences are constantly on the increase which tend to generate in each individual a feeling of unity with all the rest; which, if perfect, would make him never think of, or desire, any beneficial condition for himself in the benefits of which they are not included. If we now suppose this feeling of unity to be taught as a religion, and the whole force of education, of institutions, and of opinion directed, as it once was in the case of religion, to make every person grow up from infancy surrounded on all sides both by the profession and the practice of it, I think that no one who can realize this conception will feel any misgiving about the sufficiency of the ultimate sanction for the happiness morality. To any ethical student who finds the realization difficult, I recommend, as a means of facilitating it, the second of M. Comte's two principal works, the *Traité de politique positive.* I entertain the strongest objections to the system of politics and morals set forth in that treatise, but I think it has superabundantly shown the possibility of giving to the service of humanity, even without the aid of belief in a Providence, both the psychological power and the social efficacy of a religion, making it take hold of human life, and color all thought, feeling, and action in a manner of which the greatest ascendancy ever exercised by any religion may be but a type and foretaste; and of which the danger is, not that it should be insufficient, but that it should be so excessive as to interfere unduly with human freedom and individuality.

Neither is it necessary to the feeling which constitutes the binding force of the utilitarian morality on those who recognize it to wait for those social influences which would make its obligation felt by mankind at large. In the comparatively early state of human advancement in which we now live, a person cannot, indeed, feel that entireness of sympathy with all others which would make any real discordance in the general direction of their conduct in life impossible, but already a person in whom the social feeling is at all developed cannot bring himself to think of the rest of his fellow creatures as struggling rivals with him for the means of happiness, whom he must desire to see defeated in their object in order that he may succeed in his. The deeply rooted conception which every individual even now has of himself as a social being tends to make him feel it one of his natural wants that there should be harmony between his feelings and aims and those of his fellow creatures. If differences of opinion and of mental culture make it impossible for him to share many of their actual feelings—perhaps make him denounce and defy those feelings—he still needs to be conscious that his real aim and theirs do not conflict; that he is not opposing himself to what they really wish for, namely, their own good, but is, on the contrary, promoting it. This feeling in most individuals is much

inferior in strength to their selfish feelings, and is often wanting altogether. But to those who have it, it possesses all the characters of a natural feeling. It does not present itself to their minds as a superstition of education or a law despotically imposed by the power of society, but as an attribute which it would not be well for them to be without. This conviction is the ultimate sanction of the greatest happiness morality. This it is which makes any mind of well-developed feelings work with, and not against, the outward motives to care for others, afforded by what I have called the external sanctions; and, when those sanctions are wanting or act in an opposite direction, constitutes in itself a powerful internal binding force, in proportion to the sensitiveness and thoughtfulness of the character, since few but those whose mind is a moral blank could bear to lay out their course of life on the plan of paying no regard to others except so far as their own private interest compels.

CHAPTER IV

Of What Sort of Proof the Principle of Utility Is Susceptible

It has already been remarked that questions of ultimate ends do not admit of proof, in the ordinary acceptation of the term. To be incapable of proof by reasoning is common to all first principles, to the first premises of our knowledge, as well as to those of our conduct. But the former, being matters of fact, may be the subject of a direct appeal to the faculties which judge of fact—namely, our senses and our internal consciousness. Can an appeal be made to the same faculties on questions of practical ends? Or by what other faculty is cognizance taken of them?

Questions about ends are, in other words, questions about what things are desirable. The utilitarian doctrine is that happiness is desirable, and the only thing desirable, as an end; all other things being only desirable as means to that end. What ought to be required of this doctrine, what conditions is it requisite that the doctrine should fulfill—to make good its claim to be believed?

The only proof capable of being given that an object is visible is that people actually see it. The only proof that a sound is audible is that people hear it; and so of the other sources of our experience. In like manner, I apprehend, the sole evidence it is possible to produce that anything is desirable is that people do actually desire it. If the end which the utilitarian doctrine proposes to itself were not, in theory and in practice, acknowledged to be an end, nothing could ever convince any person that it was so. No reason can be given why the general happiness is desirable, except that each person, so far as he believes it to be attainable, desires his own happiness. This, however, being a fact, we have not only all the proof which the case admits of, but all which it is possible to require, that happiness is a good, that each person's happiness is a good to that person, and the general happiness, therefore, a good to the aggregate of all persons. Happiness has made out its title as *one* of the ends of conduct and, consequently, one of the criteria of morality.

But it has not, by this alone, proved itself to be the sole criterion. To do that, it would seem, by the same rule, necessary to show, not only that people desire happiness, but that they never desire anything else. Now it is palpable that they do desire things which, in common language, are decidedly distinguished from happiness. They desire, for example, virtue and the absence of vice no less really than pleasure and the absence of pain. The desire of virtue is not as universal, but it is as authentic a fact as the desire of happiness. And hence the opponents of the utilitarian standard deem that they have a right to infer that there are other ends of human action besides happiness, and that happiness is not the standard of approbation and disapprobation.

But does the utilitarian doctrine deny that people desire virtue, or maintain that virtue is not a thing to be desired? The very reverse. It maintains not only that virtue is to be desired, but that it is to be desired disinterestedly, for itself. Whatever may be the opinion of utilitarian moralists as to the original conditions by which virtue is made virtue, however they may believe (as they do) that actions and dispositions are only virtuous because they promote

another end than virtue, yet this being granted, and it having been decided, from considerations of this description, what *is* virtuous, they not only place virtue at the very head of the things which are good as means to the ultimate end, but they also recognize as a psychological fact the possibility of its being, to the individual, a good in itself, without looking to any end beyond it; and hold that the mind is not in a right state, not in a state conformable to utility, not in the state most conducive to the general happiness, unless it does love virtue in this manner—as a thing desirable in itself, even although, in the individual instance, it should not produce those other desirable consequences which it tends to produce, and on account of which it is held to be virtue. This opinion is not, in the smallest degree, a departure from the happiness principle. The ingredients of happiness are very various, and each of them is desirable in itself, and not merely when considered as swelling an aggregate. The principle of utility does not mean that any given pleasure, as music, for instance, or any given exemption from pain, as for example health, is to be looked upon as means to a collective something termed happiness, and to be desired on that account. They are desired and desirable in and for themselves; besides being means, they are a part of the end. Virtue, according to the utilitarian doctrine, is not naturally and originally part of the end, but it is capable of becoming so; and in those who live it disinterestedly it has become so, and is desired and cherished, not as a means to happiness, but as a part of their happiness.

To illustrate this further, we may remember that virtue is not the only thing originally a means, and which if it were not a means to anything else would be and remain indifferent, but which by association with what it is a means to comes to be desired for itself, and that too with the utmost intensity. What, for example, shall we say of the love of money? There is nothing originally more desirable about money than about any heap of glittering pebbles. Its worth is solely that of the things which it will buy; the desires for other things than itself, which it is a means of gratifying. Yet the love of money is not only one of the strongest moving forces of human

life, but money is, in many cases, desired in and for itself; the desire to possess it is often stronger than the desire to use it, and goes on increasing when all the desires which point to ends beyond it, to be compassed by it, are falling off. It may, then, be said truly that money is desired not for the sake of an end, but as part of the end. From being a means to happiness, it has come to be itself a principal ingredient of the individual's conception of happiness. The same may be said of the majority of the great objects of human life: power, for example, or fame, except that to each of these there is a certain amount of immediate pleasure annexed, which has at least the semblance of being naturally inherent in them—a thing which cannot be said of money. Still, however, the strongest natural attraction, both of power and of fame, is the immense aid they give to the attainment of our other wishes; and it is the strong association thus generated between them and all our objects of desire which gives to the direct desire of them the intensity it often assumes, so as in some characters to surpass in strength all other desires. In these cases the means have become a part of the end, and a more important part of it than any of the things which they are means to. What was once desired as an instrument for the attainment of happiness has come to be desired for its own sake. In being desired for its own sake it is, however, desired as *part* of happiness. The person is made, or thinks he would be made, happy by its mere possession; and is made unhappy by failure to obtain it. The desire of it is not a different thing from the desire of happiness any more than the love of music or the desire of health. They are included in happiness. They are some of the elements of which the desire of happiness is made up. Happiness is not an abstract idea but a concrete whole; and these are some of its parts. And the utilitarian standard sanctions and approves their being so. Life would be a poor thing, very ill provided with sources of happiness, if there were not this provision of nature by which things originally indifferent, but conducive to, or otherwise associated with, the satisfaction of our primitive desires, become in themselves sources of pleasure more valuable than the primitive pleasures, both in permanency, in the space of human

existence that they are capable of covering, and even in intensity.

Virtue, according to the utilitarian conception, is a good of this description. There was no original desire of it, or motive to it, save its conduciveness to pleasure, and especially to protection from pain. But through the association thus formed it may be felt a good in itself, and desired as such with as great intensity as any other good; and with this difference between it and the love of money, of power, or of fame—that all of these may, and often do, render the individual noxious to the other members of the society to which he belongs, whereas there is nothing which makes him so much a blessing to them as the cultivation of the disinterested love of virtue. And consequently, the utilitarian standard, while it tolerates and approves those other acquired desires, up to the point beyond which they would be more injurious to the general happiness than promotive of it, enjoins and requires the cultivation of the love of virtue up to the greatest strength possible, as being above all things important to the general happiness.

It results from the preceding considerations that there is in reality nothing desired except happiness. Whatever is desired otherwise than as a means to some end beyond itself, and ultimately to happiness, is desired as itself a part of happiness, and is not desired for itself until it has become so. Those who desire virtue for its own sake desire it either because the consciousness of it is a pleasure, or because the consciousness of being without it is a pain, or for both reasons united; as in truth the pleasure and pain seldom exist separately, but almost always together— the same person feeling pleasure in the degree of virtue attained, and pain in not having attained more. If one of these gave him no pleasure, and the other no pain, he would not love or desire virtue, or would desire it only for the other benefits which it might produce to himself or to persons whom he cared for.

We have now, then, an answer to the question, of what sort of proof the principle of utility is susceptible. If the opinion which I have now stated is psychologically true—if human nature is so constituted as to desire nothing which is not either a part of happiness or a means of happiness—we can have no other

proof, and we require no other, that these are the only things desirable. If so, happiness is the sole end of human action, and the promotion of it the test by which to judge of all human conduct; from whence it necessarily follows that it must be the criterion of morality, since a part is included in the whole.

And now to decide whether this is really so, whether mankind do desire nothing for itself but that which is a pleasure to them, or of which the absence is a pain, we have evidently arrived at a question of fact and experience, dependent, like all similar questions, upon evidence. It can only be determined by practiced self-consciousness and self-observation, assisted by observation of others. I believe that these sources of evidence, impartially consulted, will declare that desiring a thing and finding it pleasant, aversion to it and thinking of it as painful, are phenomena entirely inseparable or, rather, two parts of the same phenomenon—in strictness of language, two different modes of naming the same psychological fact; that to think of an object as desirable (unless for the sake of its consequences) and to think of it as pleasant are one and the same thing; and that to desire anything except in proportion as the idea of it is pleasant is a physical and metaphysical impossibility.

So obvious does this appear to me that I expect it will hardly be disputed; and the objection made will be, not that desire can possibly be directed to anything ultimately except pleasure and exemption from pain, but that the will is a different thing from desire; that a person of confirmed virtue or any other person whose purposes are fixed carries out his purposes without any thought of the pleasure he has in contemplating them or expects to derive from their fulfillment, and persists in acting on them, even though these pleasures are much diminished by changes in his character or decay of his passive sensibilities, or are outweighed by the pains which the pursuit of the purposes may bring upon him. All this I fully admit and have stated it elsewhere as positively and emphatically as anyone. Will, the active phenomenon, is a different thing from desire, the state of passive sensibility, and, though originally an offshoot from it, may in time take root and detach itself from the parent stock, so much so that in the

case of a habitual purpose, instead of willing the thing because we desire it, we often desire it only because we will it. This, however, is but an instance of that familiar fact, the power of habit, and is nowise confined to the case of virtuous actions. Many indifferent things which men originally did from a motive of some sort they continue to do from habit. Sometimes this is done unconsciously, the consciousness coming only after the action; at other times with conscious volition, but volition which has become habitual and is put in operation by the force of habit, in opposition perhaps to the deliberate preference, as often happens with those who have contracted habits of vicious or hurtful indulgence. Third and last comes the case in which the habitual act of will in the individual instance is not in contradiction to the general intention prevailing at other times, but in fulfillment of it, as in the case of the person of confirmed virtue and of all who pursue deliberately and consistently any determinate end. The distinction between will and desire thus understood is an authentic and highly important psychological fact; but the fact consists solely in this—that will, like all other parts of our constitution, is amenable to habit, and that we may will from habit what we no longer desire for itself, or desire only because we will it. It is not the less true that will, in the beginning, is entirely produced by desire, including in that term the repelling influence of pain as well as the attractive one of pleasure. Let us take into consideration no longer the person who has a confirmed will to do right, but him in whom that virtuous will is still feeble, conquerable by temptation, and not to be fully relied on; by what means can it be strengthened? How can the will to be virtuous, where it does not exist in sufficient force, be implanted or awakened? Only by making the person *desire* virtue—by making him think of it in a pleasurable light, or of its absence in a painful one. It is by associating the doing right with pleasure, or the wrong with pain, or by eliciting and impressing and bringing home to the person's experience the pleasure naturally involved in the one or the pain in the other, that it is possible to call forth that will to be virtuous which, when confirmed, acts without any thought of either pleasure or pain. Will is the child

of desire, and passes out of the dominion of its parent only to come under that of habit. That which is the result of habit affords no presumption of being intrinsically good; and there would be no reason for wishing that the purpose of virtue should become independent of pleasure and pain were it not that the influence of the pleasurable and painful associations which prompt to virtue is not sufficiently to be depended on for unerring constancy of action until it has acquired the support of habit. Both in feeling and in conduct, habit is the only thing which imparts certainty; and it is because of the importance to others of being able to rely absolutely on one's feelings and conduct, and to oneself of being able to rely on one's own, that the will to do right ought to be cultivated into this habitual independence. In other words, this state of the will is a means to good, not intrinsically a good; and does not contradict the doctrine that nothing is a good to human beings but in so far as it is either itself pleasurable or a means of attaining pleasure or averting pain.

But if this doctrine be true, the principle of utility is proved. Whether it is so or not must now be left to the consideration of the thoughtful reader.

CHAPTER V

On the Connection Between Justice and Utility

In all ages of speculation one of the strongest obstacles to the reception of the doctrine that utility or happiness is the criteria of right and wrong has been drawn from the idea of justice. The powerful sentiment and apparently clear perception which that word recalls with a rapidity and certainty resembling an instinct have seemed to the majority of thinkers to point to an inherent quality in things; to show that the just must have an existence in nature as something absolute, generically distinct from every variety of the expedient and, in idea, opposed to it, though (as is commonly acknowledged) never, in the long run, disjoined from it in fact.

In the case of this, as of our other moral sentiments, there is no necessary connection between the

question of its origin and that of its binding force. That a feeling is bestowed on us by nature does not necessarily legitimate all its promptings. The feeling of justice might be a peculiar instinct, and might yet require, like our other instincts, to be controlled and enlightened by a higher reason. If we have intellectual instincts leading us to judge in a particular way, as well as animal instincts that prompt us to act in a particular way, there is no necessity that the former should be more infallible in their sphere than the latter in theirs; it may as well happen that wrong judgments are occasionally suggested by those, as wrong actions by these. But though it is one thing to believe that we have natural feelings of justice, and another to acknowledge them as an ultimate criterion of conduct, these two opinions are very closely connected in point of fact. Mankind are always predisposed to believe that any subjective feeling, not otherwise accounted for, is a revelation of some objective reality. Our present object is to determine whether the reality to which the feeling of justice corresponds is one which needs any such special revelation, whether the justice or injustice of an action is a thing intrinsically peculiar and distinct from all its other qualities or only a combination of certain of those qualities presented under a peculiar aspect. For the purpose of this inquiry it is practically important to consider whether the feeling itself, of justice and injustice, is *sui generis* like our sensations of color and taste or a derivative feeling formed by a combination of others. And this it is the more essential to examine, as people are in general willing enough to allow that objectively the dictates of justice coincide with a part of the field of general expediency; but inasmuch as the subjective mental feeling of justice is different from that which commonly attaches to simple expediency, and, except in the extreme cases of the latter, is far more imperative in its demands, people find it difficult to see in justice only a particular kind or branch of general utility, and think that its superior binding force requires a totally different origin.

To throw light upon this question, it is necessary to attempt to ascertain what is the distinguishing character of justice, or of injustice; what is the quality, or whether there is any quality, attributed in common to all modes of conduct designated as unjust (for justice, like many other moral attributes, is best defined by its opposite), and distinguishing them from such modes of conduct as are disapproved, but without having that particular epithet of disapprobation applied to them. If in everything which men are accustomed to characterize as just or unjust some one common attribute or collection of attributes is always present, we may judge whether this particular attribute or combination of attributes would be capable of gathering round it a sentiment of that peculiar character and intensity by virtue of the general laws of our emotional constitution, or whether the sentiment is inexplicable and requires to be regarded as a special provision of nature. If we find the former to be the case, we shall, in resolving this question, have resolved also the main problem; if the latter, we shall have to seek for some other mode of investigating it.

To find the common attributes of a variety of objects, it is necessary to begin by surveying the objects themselves in the concrete. Let us therefore advert successively to the various modes of action and arrangements of human affairs which are classed, by universal or widely spread opinion, as just or as unjust. The things well known to excite the sentiments associated with those names are of a very multifarious character. I shall pass them rapidly in review, without studying any particular arrangement.

In the first place, it is mostly considered unjust to deprive anyone of his personal liberty, his property, or any other thing which belongs to him by law. Here, therefore, is one instance of the application of the terms "just" and "unjust" in a perfectly definite sense, namely, that it is just to respect, unjust to violate, the *legal rights* of anyone. But this judgment admits of several exceptions, arising from the other forms in which the notions of justice and injustice present themselves. For example, the person who suffers the deprivation may (as the phrase is) have *forfeited* the rights which he is so deprived of—a case to which we shall return presently. But also—

Secondly, the legal rights of which he is deprived may be rights which *ought* not to have belonged to him; in other words, the law which confers on him

these rights may be a bad law. When it is so or when (which is the same thing for our purpose) it is supposed to be so, opinions will differ as to the justice or injustice of infringing it. Some maintain that no law, however bad, ought to be disobeyed by an individual citizen; that his opposition to it, if shown at all, should only be shown in endeavoring to get it altered by competent authority. This opinion (which condemns many of the most illustrious benefactors of mankind, and would often protect pernicious institutions against the only weapons which, in the state of things existing at the time, have any chance of succeeding against them) is defended by those who hold it on grounds of expediency, principally on that of the importance to the common interest of mankind, of maintaining inviolate the sentiment of submission to law. Other persons, again, hold the directly contrary opinion that any law, judged to be bad, may blamelessly be disobeyed, even though it be not judged to be unjust but only inexpedient, while others would confine the license of disobedience to the case of unjust laws; but, again, some say that all laws which are inexpedient are unjust, since every law imposes some restriction on the natural liberty of mankind, which restriction is an injustice unless legitimated by tending to their good. Among these diversities of opinion it seems to be universally admitted that there may be unjust laws, and that law, consequently, is not the ultimate criterion of justice, but may give to one person a benefit, or impose on another an evil, which justice condemns. When, however, a law is thought to be unjust, it seems always to be regarded as being so in the same way in which a breach of law is unjust, namely, by infringing somebody's right, which, as it cannot in this case be a legal right, receives a different appellation and is called a moral right. We may say, therefore, that a second case of injustice consists in taking or withholding from any person that to which he has a *moral right.*

Thirdly, it is universally considered just that each person should obtain that (whether good or evil) which he *deserves,* and unjust that he should obtain a good or be made to undergo an evil which he does not deserve. This is, perhaps, the clearest and most emphatic form in which the idea of justice is conceived by the general mind. As it involves the notion of desert, the question arises what constitutes desert? Speaking in a general way, a person is understood to deserve good if he does right, evil if he does wrong; and in a more particular sense, to deserve good from those to whom he does or has done good, and evil from those to whom he does or has done evil. The precept of returning good for evil has never been regarded as a case of the fulfillment of justice, but as one in which the claims of justice are waived, in obedience to other considerations.

Fourthly, it is confessedly unjust to *break faith* with anyone: to violate an engagement, either express or implied, or disappoint expectations raised by our own conduct, at least if we have raised those expectations knowingly and voluntarily. Like the other obligations of justice already spoken of, this one is not regarded as absolute, but as capable of being overruled by a stronger obligation of justice on the other side, or by such conduct on the part of the person concerned as is deemed to absolve us from our obligation to him and to constitute a *forfeiture* of the benefit which he has been led to expect.

Fifthly, it is, by universal admission, inconsistent with justice to be *partial*—to show favor or preference to one person over another in matters to which favor and preference do not properly apply. Impartiality, however, does not seem to be regarded as a duty in itself, but rather as instrumental to some other duty; for it is admitted that favor and preference are not always censurable, and, indeed, the cases in which they are condemned are rather the exception than the rule. A person would be more likely to be blamed than applauded for giving his family or friends no superiority in good offices over strangers when he could do so without violating any other duty; and no one thinks it unjust to seek one person in preference to another as a friend, connection, or companion. Impartiality where rights are concerned is of course obligatory, but this is involved in the more general obligation of giving to everyone his right. A tribunal, for example, must be impartial because it is bound to award, without regard to any other consideration, a disputed object to the one of two parties who has the right to it. There are other

cases in which impartiality means being solely influenced by desert, as with those who, in the capacity of judges, preceptors, or parents, administer reward and punishment as such. There are cases, again, in which it means being solely influenced by consideration for the public interest, as in making a selection among candidates for a government employment. Impartiality, in short, as an obligation of justice, may be said to mean being exclusively influenced by the considerations which it is supposed ought to influence the particular case in hand, and resisting solicitation of any motives which prompt to conduct different from what those considerations would dictate.

Nearly allied to the idea of impartiality is that of *equality,* which often enters as a component part both into the conception of justice and into the practice of it, and, in the eyes of many persons, constitutes its essence. But in this, still more than in any other case, the notion of justice varies in different persons, and always conforms in its variations to their notion of utility. Each person maintains that equality is the dictate of justice, except where he thinks that expediency requires inequality. The justice of giving equal protection to the rights of all is maintained by those who support the most outrageous inequality in the rights themselves. Even in slave countries it is theoretically admitted that the rights of the slave, such as they are, ought to be as sacred as those of the master, and that a tribunal which fails to enforce them with equal strictness is wanting in justice; while, at the same time, institutions which leave to the slave scarcely any rights to enforce are not deemed unjust because they are not deemed inexpedient. Those who think that utility requires distinctions of rank do not consider it unjust that riches and social privileges should be unequally dispensed; but those who think this inequality inexpedient think it unjust also. Whoever thinks that government is necessary sees no injustice in as much inequality as is constituted by giving to the magistrate powers not granted to other people. Even among those who hold leveling doctrines, there are differences of opinion about expediency. Some communists consider it unjust that the produce of the labor of the community should be shared on any other principle than that of exact equality; others think it just that those should receive most whose wants are greatest; while others hold that those who work harder, or who produce more, or whose services are more valuable to the community, may justly claim a larger quota in the division of the produce. And the sense of natural justice may be plausibly appealed to in behalf of every one of these opinions.

Among so many diverse applications of the term "justice," which yet is not regarded as ambiguous, it is a matter of some difficulty to seize the mental link which holds them together, and on which the moral sentiment adhering to the term essentially depends. Perhaps, in this embarrassment, some help may be derived from the history of the word, as indicated by its etymology.

In most if not in all languages, the etymology of the word which corresponds to "just" points distinctly to an origin connected with the ordinances of law. *Justum* is a form of *jussum,* that which has been ordered. *Dikaion* comes directly from *dike,* a suit at law. *Recht,* from which came *right* and *righteous,* is synonymous with law. The courts of justice, the administration of justice, are the courts and the administration of law. *La justice,* in French, is the established term for judicature. I am not committing the fallacy, imputed with some show of truth to Horne Tooke, of assuming that a word must still continue to mean what it originally meant. Etymology is slight evidence of what the idea now signified is, but the very best evidence of how it sprang up. There can, I think, be no doubt that the *idée mère,* the primitive element, in the formation of the notion of justice was conformity to law. It constituted the entire idea among the Hebrews, up to the birth of Christianity; as might be expected in the case of a people whose laws attempted to embrace all subjects on which precepts were required, and who believed those laws to be a direct emanation from the Supreme Being. But other nations, and in particular the Greeks and Romans, who knew that their laws had been made originally, and still continued to be made, by men, were not afraid to admit that those men might make bad laws; might do, by law, the same things, and from the same motives, which if done by individuals

without the sanction of law would be called unjust. And hence the sentiment of injustice came to be attached, not to all violations of law, but only to violations of such laws as *ought* to exist, including such as ought to exist but do not, and to laws themselves if supposed to be contrary to what ought to be law. In this manner the idea of law and of its injunctions was still predominant in the notion of justice, even when the laws actually in force ceased to be accepted as the standard of it.

It is true that mankind consider the idea of justice and its obligations as applicable to many things which neither are, nor is it desired that they should be, regulated by law. Nobody desires that laws should interfere with the whole detail of private life; yet everyone allows that in all daily conduct a person may and does show himself to be either just or unjust. But even here, the idea of the breach of what ought to be law still lingers in a modified shape. It would always give us pleasure, and chime in with our feelings of fitness, that acts which we deem unjust should be punished, though we do not always think it expedient that this should be done by the tribunals. We forego that gratification on account of incidental inconveniences. We should be glad to see just conduct enforced and injustice repressed, even in the minutest details, if we were not, with reason, afraid of trusting the magistrate with so unlimited an amount of power over individuals. When we think that a person is bound in justice to do a thing, it is an ordinary form of language to say that he ought to be compelled to do it. We should be gratified to see the obligation enforced by anybody who had the power. If we see that its enforcement by law would be inexpedient, we lament the impossibility, we consider the impunity given to injustice as an evil, and strive to make amends for it by bringing a strong expression of our own and the public disapprobation to bear upon the offender. Thus the idea of legal constraint is still the generating idea of the notion of justice, though undergoing several transformations before that notion as it exists in an advanced state of society becomes complete.

The above is, I think, a true account, as far as it goes, of the origin and progressive growth of the idea of justice. But we must observe that it contains as yet nothing to distinguish that obligation from moral obligation in general. For the truth is that the idea of penal sanction, which is the essence of law, enters not only into the conception of injustice, but into that of any kind of wrong. We do not call anything wrong unless we mean to imply that a person ought to be punished in some way or other for doing it—if not by law, by the opinion of his fellow creatures; if not by opinion, by the reproaches of his own conscience. This seems the real turning point of the distinction between morality and simple expediency. It is a part of the notion of duty in every one of its forms that a person may rightfully be compelled to fulfill it. Duty is a thing which may be *exacted* from a person, as one exacts a debt. Unless we think that it may be exacted from him, we do not call it his duty. Reasons of prudence, or the interest of other people, may militate against actually exacting it, but the person himself, it is clearly understood, would not be entitled to complain. There are other things, on the contrary, which we wish that people should do, which we like or admire them for doing, perhaps dislike or despise them for not doing, but yet admit that they are not bound to do; it is not a case of moral obligation; we do not blame them, that is, we do not think that they are proper objects of punishment. How we come by these ideas of deserving and not deserving punishment will appear, perhaps, in the sequel; but I think there is no doubt that this distinction lies at the bottom of the notions of right and wrong; that we call any conduct wrong, or employ, instead, some other term of dislike or disparagement, according as we think that the person ought, or ought not, to be punished for it; and we say it would be right to do so and so, or merely that it would be desirable or laudable, according as we would wish to see the person whom it concerns compelled, or only persuaded and exhorted, to act in that manner.[3]

This, therefore, being the characteristic difference which marks off, not justice, but morality in general from the remaining provinces of expediency and worthiness, the character is still to be sought which distinguishes justice from other branches of morality. Now it is known that ethical writers divide moral

duties into two classes, denoted by the ill-chosen expressions, duties of perfect and of imperfect obligation; the latter being those in which, though the act is obligatory, the particular occasions of performing it are left to our choice, as in the case of charity or beneficence, which we are indeed bound to practice but not toward any definite person, nor at any prescribed time. In the more precise language of philosophic jurists, duties of perfect obligation are those duties in virtue of which a correlative *right* resides in some person or persons; duties of imperfect obligation are those moral obligations which do not give birth to any right. I think it will be found that this distinction exactly coincides with that which exists between justice and the other obligations of morality. In our survey of the various popular acceptations of justice, the term appeared generally to involve the idea of a personal right—a claim on the part of one or more individuals, like that which the law gives when it confers a proprietary or other legal right. Whether the injustice consists in depriving a person of a possession, or in breaking faith with him, or in treating him worse than he deserves, or worse than other people who have no greater claims—in each case the supposition implies two things: a wrong done, and some assignable person who is wronged. Injustice may also be done by treating a person better than others; but the wrong in this case is to his competitors, who are also assignable persons. It seems to me that this feature in the case—a right in some person, correlative to the moral obligation—constitutes the specific difference between justice and generosity of beneficence. Justice implies something which it is not only right to do, and wrong not to do, but which some individual person can claim from us as his moral right. No one has a moral right to our generosity or beneficence because we are not morally bound to practice those virtues toward any given individual. And it will be found with respect to this as to every correct definition that the instances which seem to conflict with it are those which most confirm it. For if a moralist attempts, as some have done, to make out that mankind generally, though not any given individual, have a right to all the good we can do them, he at once, by that thesis, includes generosity and beneficence

within the category of justice. He is obliged to say that our utmost exertions are *due* to our fellow creatures, thus assimilating them to a debt; or that nothing less can be a sufficient *return* for what society does for us, thus classing the case as one of gratitude; both of which are acknowledged cases of justice, and not of the virtue of beneficence; and whoever does not place the distinction between justice and morality in general, where we have now placed it, will be found to make no distinction between them at all, but to merge all morality in justice.

Having thus endeavored to determine the distinctive elements which enter into the composition of the idea of justice, we are ready to enter on the inquiry whether the feeling which accompanies the idea is attached to it by a special dispensation of nature, or whether it could have grown up, by any known laws, out of the idea itself; and, in particular, whether it can have originated in considerations of general expediency.

I conceive that the sentiment itself does not arise from anything which would commonly or correctly be termed an idea of expediency, but that, though the sentiment does not, whatever is moral in it does.

We have seen that the two essential ingredients in the sentiment of justice are the desire to punish a person who has done harm and the knowledge or belief that there is some definite individual or individuals to whom harm has been done.

Now it appears to me that the desire to punish a person who has done harm to some individual is a spontaneous outgrowth from two sentiments, both in the highest degree natural and which either are or resemble instincts: the impulse of self-defense and the feeling of sympathy.

It is natural to resent and to repel or retaliate any harm done or attempted against ourselves or against those with whom we sympathize. The origin of this sentiment it is not necessary here to discuss. Whether it be an instinct or a result of intelligence, it is, we know, common to all animal nature; for every animal tries to hurt those who have hurt, or who it thinks are about to hurt, itself or its young. Human beings, on this point, only differ from other animals in two particulars. First, in being capable of sympathizing, not solely with their offspring, or, like some of the

more noble animals, with some superior animal who is kind to them, but with all human, and even with all sentient, beings; secondly, in having a more developed intelligence, which gives a wider range to the whole of their sentiments, whether self-regarding or sympathetic. By virtue of his superior intelligence, even apart from his superior range of sympathy, a human being is capable of apprehending a community of interest between himself and the human society of which he forms a part, such that any conduct which threatens the security of the society generally is threatening to his own, and calls forth his instinct (if instinct it be) of self-defense. The same superiority of intelligence, joined to the power of sympathizing with human beings generally, enables him to attach himself to the collective idea of his tribe, his country, or mankind in such a manner that any act hurtful to them raises his instinct of sympathy and urges him to resistance.

The sentiment of justice, in that one of its elements which consists of the desire to punish, is thus, I conceive, the natural feeling of retaliation or vengeance, rendered by intellect and sympathy applicable to those injuries, that is, to those hurts, which wound us through, or in common with, society at large. This sentiment, in itself, has nothing moral in it; what is moral is the exclusive subordination of it to the social sympathies, so as to wait on and obey their call. For the natural feeling would make us resent indiscriminately whatever anyone does that is disagreeable to us; but, when moralized by the social feeling, it only acts in the directions conformable to the general good: just persons resenting a hurt to society, though not otherwise a hurt to themselves, and not resenting a hurt to themselves, however painful, unless it be of the kind which society has a common interest with them in the repression of.

It is no objection against this doctrine to say that, when we feel our sentiment of justice outraged, we are not thinking of society at large or of any collective interest, but only of the individual case. It is common enough, certainly, though the reverse of commendable, to feel resentment merely because we have suffered pain; but a person whose resentment is really a moral feeling, that is, who considers whether an act is blamable before he allows himself to resent it—such a person, though he may not say expressly to himself that he is standing up for the interest of society, certainly does feel that he is asserting a rule which is for the benefit of others as well as for his own. If he is not feeling this, if he is regarding the act solely as it affects him individually, he is not consciously just; he is not concerning himself about the justice of his actions. This is admitted even by anti-utilitarian moralists. When Kant (as before remarked) propounds as the fundamental principle of morals, "So act that thy rule of conduct might be adopted as a law by all rational beings," he virtually acknowledges that the interest of mankind collectively, or at least of mankind indiscriminately, must be in the mind of the agent when conscientiously deciding on the morality of the act. Otherwise he uses words without a meaning; for that a rule even of utter selfishness could not *possibly* be adopted by all rational beings—that there is any insuperable obstacle in the nature of things to its adoption—cannot be even plausibly maintained. To give any meaning to Kant's principle, the sense put upon it must be that we ought to shape our conduct by a rule which all rational beings might adopt *with benefit to their collective interest.*

To recapitulate: the idea of justice supposes two things—a rule of conduct and a sentiment which sanctions the rule. The first must be supposed common to all mankind and intended for their good. The other (the sentiment) is a desire that punishment may be suffered by those who infringe the rule. There is involved, in addition, the conception of some definite person who suffers by the infringement, whose rights (to use the expression appropriated to the case) are violated by it. And the sentiment of justice appears to me to be the animal desire to repel or retaliate a hurt or damage to oneself or to those with whom one sympathizes, widened so as to include all persons, by the human capacity of enlarged sympathy and the human conception of intelligent self-interest. From the latter elements the feeling derives its morality; from the former, its peculiar impressiveness and energy of self-assertion.

I have, throughout, treated the idea of a *right* residing in the injured person and violated by the

injury, not as a separate element in the composition of the idea and sentiment, but as one of the forms in which the other two elements clothe themselves. These elements are a hurt to some assignable person or persons, on the one hand, and a demand for punishment, on the other. An examination of our own minds, I think, will show that these two things include all that we mean when we speak of violation of a right. When we call anything a person's right, we mean that he has a valid claim on society to protect him in the possession of it, either by the force of law or by that of education and opinion. If he has what we consider a sufficient claim, on whatever account, to have something guaranteed to him by society, we say that he has a right to it. If we desire to prove that anything does not belong to him by right, we think this done as soon as it is admitted that society ought not to take measure for securing it to him, but should leave him to chance or to his own exertions. Thus a person is said to have a right to what he can earn in fair professional competition, because society ought not to allow any other person to hinder him from endeavoring to earn in that manner as much as he can. But he has not a right to three hundred a year, though he may happen to be earning it; because society is not called on to provide that he shall earn that sum. On the contrary, if he owns ten thousand pounds three-per-cent stock, he *has* a right to three hundred a year because society has come under an obligation to provide him with an income of that amount.

To have a right, then, is, I conceive, to have something which society ought to defend me in the possession of. If the objector goes on to ask why it ought, I can give him no other reason than general utility. If that expression does not seem to convey a sufficient feeling of the strength of the obligation, nor to account for the peculiar energy of the feeling, it is because there goes to the composition of the sentiment, not a rational only but also an animal element—the thirst for retaliation; and this thirst derives its intensity, as well as its moral justification, from the extraordinarily important and impressive kind of utility which is concerned. The interest involved is that of security, to everyone's feelings the most vital of all interests. All other earthly benefits

are needed by one person, not needed by another; and many of them can, if necessary, be cheerfully foregone or replaced by something else; but security no human being can possibly do without; on it we depend for all our immunity from evil and for the whole value of all and every good, beyond the passing moment, since nothing but the gratification of the instant could be of any worth to us if we could be deprived of everything the next instant by whoever was momentarily stronger than ourselves. Now this most indispensable of all necessaries, after physical nutriment, cannot be had unless the machinery for providing it is kept unintermittedly in active play. Our notion, therefore, of the claim we have on our fellow creatures to join in making safe for us the very groundwork of our existence gathers feelings around it so much more intense than those concerned in any of the more common cases of utility that the difference in degree (as is often the case in psychology) becomes a real difference in kind. The claim assumes that character of absoluteness, that apparent infinity and incommensurability with all other considerations which constitute the distinction between the feeling of right and wrong and that of ordinary expediency and inexpediency. The feelings concerned are so powerful, and we count so positively on finding a responsive feeling in others (all being alike interested) that *ought* and *should* grow into *must,* and recognized indispensability becomes a moral necessity, analogous to physical, and often not inferior to it in binding force.

If the preceding analysis, or something resembling it, be not the correct account of the notion of justice— if justice be totally independent of utility, and be a standard *per se,* which the mind can recognize by simple introspection of itself—it is hard to understand why that internal oracle is so ambiguous, and why so many things appear either just or unjust, according to the light in which they are regarded.

We are continually informed that utility is an uncertain standard, which every different person interprets differently, and that there is no safety but in the immutable, ineffaceable, and unmistakable dictates of justice, which carry their evidence in themselves and are independent of the fluctuations of opinion. One

would suppose from this that on questions of justice there could be no controversy; that, if we take that for our rule, its application to any given case could leave us in as little doubt as a mathematical demonstration. So far is this from being the fact that there is as much difference of opinion, and as much discussion, about what is just as about what is useful to society. Not only have different nations and individuals different notions of justice, but in the mind of one and the same individual, justice is not some one rule, principle, or maxim, but many which do not always coincide in their dictates, and, in choosing between which, he is guided either by some extraneous standard or by his own personal predilections.

For instance, there are some who say that it is unjust to punish anyone for the sake of example to others, that punishment is just only when intended for the good of the sufferer himself. Others maintain the extreme reverse, contending that to punish persons who have attained years of discretion, for their own benefit, is despotism and injustice, since, if the matter at issue is solely their own good, no one has a right to control their own judgment of it; but that they may justly be punished to prevent evil to others, this being the exercise of the legitimate right of self-defense. Mr. Owen, again, affirms that it is unjust to punish at all, for the criminal did not make his own character; his education and the circumstances which surrounded him have made him a criminal, and for these he is not responsible. All these opinions are extremely plausible; and so long as the question is argued as one of justice simply, without going down to the principles which lie under justice and are the source of its authority, I am unable to see how any of these reasoners can be refuted. For in truth every one of the three builds upon rules of justice confessedly true. The first appeals to the acknowledged injustice of singling out an individual and making him a sacrifice, without his consent, for other people's benefit. The second relies on the acknowledged justice of self-defense and the admitted injustice of forcing one person to conform to another's notions of what constitutes his good. The Owenite invokes the admitted principle that it is unjust to punish anyone for what he cannot help. Each is triumphant so long as he is not compelled to take into consideration any other maxims of justice than the one he has selected; but as soon as their several maxims are brought face to face, each disputant seems to have exactly as much to say for himself as the others. No one of them can carry out his own notion of justice without trampling upon another equally binding. These are difficulties; they have always been felt to be such; and many devices have been invented to turn rather than to overcome them. As a refuge from the last of the three, men imagined what they called the freedom of the will—fancying that they could not justify punishing a man whose will is in a thoroughly hateful state unless it be supposed to have come into that state through no influence of anterior circumstances. To escape from the other difficulties, a favorite contrivance has been the fiction of a contract whereby at some unknown period all the members of society engaged to obey the laws and consented to be punished for any disobedience to them, thereby giving to their legislators the right, which it is assumed they would not otherwise have had, of punishing them, either for their own good or for that of society. This happy thought was considered to get rid of the whole difficulty and to legitimate the infliction of punishment, in virtue of another received maxim of justice, *volenti non fit injuria*—that is not unjust which is done with the consent of the person who is supposed to be hurt by it. I need hardly remark that, even if the consent were not a mere fiction, this maxim is not superior in authority to the others which it is brought in to supersede. It is, on the contrary, an instructive specimen of the loose and irregular manner in which supposed principles of justice grow up. This particular one evidently came into use as a help to the coarse exigencies of courts of law, which are sometimes obliged to be content with very uncertain presumptions, on account of the greater evils which would often arise from any attempt on their part to cut finer. But even courts of law are not able to adhere consistently to the maxim, for they allow voluntary engagements to be set aside on the ground of fraud, and sometimes on that of mere mistake or misinformation.

Again, when the legitimacy of inflicting punishment is admitted, how many conflicting conceptions

of justice come to light in discussing the proper apportionment of punishments to offenses. No rule on the subject recommends itself so strongly to the primitive and spontaneous sentiment of justice as the *lex talionis,* an eye for an eye and a tooth for a tooth. Though this principle of the Jewish and of the Mohammedan law has been generally abandoned in Europe as a practical maxim, there is, I suspect, in most minds, a secret hankering after it; and when retribution accidentally falls on an offender in that precise shape, the general feeling of satisfaction evinced bears witness how natural is the sentiment to which this repayment in kind is acceptable. With many, the test of justice in penal infliction is that the punishment should be proportioned to the offense, meaning that it should be exactly measured by the moral guilt of the culprit (whatever be their standard for measuring moral guilt), the consideration what amount of punishment is necessary to deter from the offense having nothing to do with the question of justice, in their estimation; while there are others to whom that consideration is all in all, who maintain that it is not just, at least for man, to inflict on a fellow creature, whatever may be his offenses, any amount of suffering beyond the least that will suffice to prevent him from repeating, and others from imitating, his misconduct.

To take another example from a subject already once referred to. In co-operative industrial association, is it just or not that talent or skill should give a title to superior remuneration? On the negative side of the question it is argued that whoever does the best he can deserves equally well, and ought not in justice to be put in a position of inferiority for no fault of his own; that superior abilities have already advantages more than enough, in the admiration they excite, the personal influence they command, and the internal sources of satisfaction attending them, without adding to these a superior share of the world's goods; and that society is bound in justice rather to make compensation to the less favored for this unmerited inequality of advantages than to aggravate it. On the contrary side it is contended that society receives more from the more efficient laborer; that, his services being more useful, society owes him a larger return for them; that a greater

share of the joint result is actually his work, and not to allow his claim to it is a kind of robbery; that, if he is only to receive as much as others, he can only be justly required to produce as much, and to give a smaller amount of time and exertion, proportioned to his superior efficiency. Who shall decide between these appeals to conflicting principles of justice? Justice has in this case two sides to it, which it is impossible to bring into harmony, and the two disputants have chosen opposite sides; the one looks to what it is just that the individual should receive, the other to what it is just that the community should give. Each, from his own point of view, is unanswerable; and any choice between them, on grounds of justice, must be perfectly arbitrary. Social utility alone can decide the preference.

How many, again, and how irreconcilable are the standards of justice to which reference is made in discussing the repartition of taxation. One opinion is that payment to the state should be in numerical proportion to pecuniary means. Others think that justice dictates what they term graduated taxation—taking a higher percentage from those who have more to spare. In point of natural justice a strong case might be made for disregarding means altogether, and taking the same absolute sum (whenever it could be got) from everyone; as the subscribers to a mess or to a club all pay the same sum for the same privileges, whether they can all equally afford it or not. Since the protection (it might be said) of law and government is afforded to and is equally required by all, there is no injustice in making all buy it at the same price. It is reckoned justice, not injustice, that a dealer should charge to all customers the same price for the same article, not a price varying according to their means of payment. This doctrine, as applied to taxation, finds no advocates because it conflicts so strongly with man's feelings of humanity and of social expediency, but the principle of justice which it invokes is as true and as binding to those which can be appealed to against it. Accordingly it exerts a tacit influence on the line of defense employed for other modes of assessing taxation. People feel obliged to argue that the state does more for the rich man than for the poor, as a justification for its taking more

from them, though this is in reality not true, for the rich would be far better able to protect themselves, in the absence of law or government, than the poor, and indeed would probably be successful in converting the poor into their slaves. Others, again, so far defer to the same conception of justice as to maintain that all should pay an equal capitation tax for the protection of their persons (these being of equal value to all), and an unequal tax for the protection of their property, which is unequal. To this others reply that the all of one man is as valuable to him as the all of another. From these confusions there is no other mode of extrication than the utilitarian.

Is, then, the difference between the just and the expedient a merely imaginary distinction? Have mankind been under a delusion in thinking that justice is a more sacred thing than policy, and that the latter ought only to be listened to after the former has been satisfied? By no means. The exposition we have given of the nature and origin of the sentiment recognizes a real distinction; and no one of those who profess the most sublime contempt for the consequences of actions as an element in their morality attaches more importance to the distinction than I do. While I dispute the pretensions of any theory which sets up an imaginary standard of justice not grounded on utility, I account the justice which is grounded on utility to be the chief part, and incomparably the most sacred and binding part, of all morality. Justice is a name for certain classes of moral rules which concern the essentials of human well-being more nearly, and are therefore of more absolute obligation, than any other rules for the guidance of life; and the notion which we have found to be of the essence of the idea of justice—that of a right residing in an individual—implies and testifies to this more binding obligation.

The moral rules which forbid mankind to hurt one another (in which we must never forget to include a wrongful interference with each other's freedom) are more vital to human well-being than any maxims, however important, which only point out the best mode of managing some department of human affairs. They have also the peculiarity that they are the main element in determining the whole of the social feelings of mankind. It is their observance which alone preserves peace among human beings; if obedience to them were not the rule, and disobedience the exception, everyone would see in everyone else an enemy against whom he must be perpetually guarding himself. What is hardly less important, these are the precepts which mankind have the strongest and the most direct inducements for impressing upon one another. By merely giving to each other prudential instruction or exhortation, they may gain, or think they gain, nothing; in inculcating on each other the duty of positive beneficence, they have an unmistakable interest, but far less in degree; a person may possibly not need the benefits of others, but he always needs that they should not do him hurt. Thus the moralities which protect every individual from being harmed by others, either directly or by being hindered in his freedom of pursuing his own good, are at once those which he himself has most at heart and those which he has the strongest interest in publishing and enforcing by word and deed. It is by a person's observance of these that his fitness to exist as one of the fellowship of human beings is tested and decided; for on that depends his being a nuisance or not to those with whom he is in contact. Now it is these moralities primarily which compose the obligations of justice. The most marked cases of injustice, and those which give the tone to the feeling of repugnance which characterizes the sentiment, are acts of wrongful aggression or wrongful exercise of power over someone; the next are those which consist in wrongfully withholding from him something which is his due—in both cases inflicting on him a positive hurt, either in the form of direct suffering or of the privation of some good which he had reasonable ground, either of a physical or of a social kind, for counting upon.

The same powerful motives which command the observance of these primary moralities enjoin the punishment of those who violate them; and as the impulses of self-defense, of defense of others, and of vengeance are all called forth against such persons, retribution, or evil for evil, becomes closely connected with the sentiment of justice, and is universally included in the idea. Good for good is also one of the dictates of justice; and this, though its social utility is evident, and though it carries with it a natural human feeling, has not at first sight that obvious connection with hurt or

injury which, existing in the most elementary cases of just and unjust, is the source of the characteristic intensity of the sentiment. But the connection, though less obvious, is not less real. He who accepts benefits and denies a return of them when needed inflicts a real hurt by disappointing one of the most natural and reasonable of expectations, and one which he must at least tacitly have encouraged, otherwise the benefits would seldom have been conferred. The important rank, among human evils and wrongs, of the disappointment of expectation is shown in the fact that it constitutes the principal criminality of two such highly immoral acts as a breach of friendship and a breach of promise. Few hurts which human beings can sustain are greater, and none wound more, than when that on which they habitually and with full assurance relied fails them in the hour of need; and few wrongs are greater than this mere withholding of good; none excite more resentment, either in the person suffering or in a sympathizing spectator. The principle, therefore, of giving to each what they deserve, that is, good for good as well as evil for evil, is not only included within the idea of justice as we have defined it, but is a proper object of that intensity of sentiment which places the just human estimation above the simply expedient.

Most of the maxims of justice current in the world, and commonly appealed to in its transactions, are simply instrumental to carrying into effect the principles of justice which we have now spoken of. That a person is only responsible for what he has done voluntarily, or could voluntarily have avoided, that it is unjust to condemn any person unheard; that the punishment ought to be proportioned to the offense, and the like, are maxims intended to prevent the just principle of evil for evil from being perverted to the infliction of evil without that justification. The greater part of these common maxims have come into use from the practice of courts of justice, which have been naturally led to a more complete recognition and elaboration than was likely to suggest itself to others, of the rules necessary to enable them to fulfill their double function—of inflicting punishment when due, and of awarding to each person his right.

That first of judicial virtues, impartiality, is an obligation of justice, partly for the reason last mentioned, as being a necessary condition of the fulfillment of other obligations of justice. But this is not the only source of the exalted rank, among human obligations, of those maxims of equality and impartiality, which, both in popular estimation and in that of the most enlightened, are included among the precepts of justice. In one point of view, they may be considered as corollaries from the principles already laid down. If it is a duty to do to each according to his deserts, returning good for good, as well as repressing evil by evil, it necessarily follows that we should treat all equally well (when no higher duty forbids) who have deserved equally well of *us,* and that society should treat all equally well who have deserved equally well of *it,* that is, who have deserved equally well absolutely. This is the highest abstract standard of social and distributive justice, toward which all institutions and the efforts of all virtuous citizens should be made in the utmost possible degree to converge. But this great moral duty rests upon a still deeper foundation, being a direct emanation from the first principle of morals, and not a mere logical corollary from secondary or derivative doctrines. It is involved in the very meaning of utility, or the greatest happiness principle. That principle is a mere form of words without rational signification unless one person's happiness, supposed equal in degree (with the proper allowance made for kind), is counted for exactly as much as another's. Those conditions being supplied, Bentham's dictum "everybody to count for one, nobody for more than one," might be written under the principle of utility as an explanatory commentary.[4] The equal claim of everybody to happiness, in the estimation of the moralist and of the legislator, involves an equal claim to all the means of happiness except in so far as the inevitable conditions of human life and the general interest in which that of every individual is included set limits to the maxim; and those limits ought to be strictly construed. As every other maxim of justice, so this is by no means applied or held applicable universally; on the contrary, as I have already remarked, it bends to every person's ideas of social expediency. But in whatever case it is deemed applicable at all, it is held to be the dictate of justice. All persons are deemed to have a *right* to equality of treatment, except when some recognized

social expediency requires the reverse. And hence all social inequalities which have ceased to be considered expedient assume the character, not of simple inexpediency, but of injustice, and appear so tyrannical that people are apt to wonder how they ever could have been tolerated—forgetful that they themselves, perhaps, tolerate other inequalities under an equally mistaken notion of expediency, the correction of which would make that which they approve seem quite as monstrous as what they have at last learned to condemn. The entire history of social improvement has been a series of transitions by which one custom or institution after another, from being a supposed primary necessity of social existence, has passed into the rank of a universally stigmatized injustice and tyranny. So it has been with the distinctions of slaves and freemen, nobles and serfs, patricians and plebeians; and so it will be, and in part already is, with the aristocracies of color, race, and sex.

It appears from what has been said that justice is a name for certain moral requirements which, regarded collectively, stand higher in the scale of social utility, and are therefore of more paramount obligation, than any others, though particular cases may occur in which some other social duty is so important as to overrule any one of the general maxims of justice. Thus, to save a life, it may not only be allowable, but a duty, to steal or take by force the necessary food or medicine, or to kidnap and compel to officiate the only qualified medical practitioner. In such cases, as we do not call anything justice which is not a virtue, we usually say, not that justice must give way to some other moral principle, but that what is just in ordinary cases is, by reason of that other principle, not just in the particular case. By this useful accommodation of language, the character of indefeasibility attributed to justice is kept up, and we are saved from the necessity of maintaining that there can be laudable injustice.

The considerations which have not been adduced resolve, I conceive, the only real difficulty in the utilitarian theory of morals. It has always been evident that all cases of justice are also cases of expediency; the difference is in the peculiar sentiment which attaches to the former, as contradistinguished from the latter. If this characteristic sentiment has been

sufficiently accounted for; if there is no necessity to assume for it any peculiarity of origin; if it is simply the natural feeling of resentment, moralized by being made co-extensive with the demands of social good; and if this feeling not only does but ought to exist in all the classes of cases to which the idea of justice corresponds—that idea no longer presents itself as a stumbling block to the utilitarian ethics. Justice remains the appropriate name for certain social utilities which are vastly more important, and therefore more absolute and imperative, than any others are as a class (though not more so than others may be in particular cases); and which, therefore, ought to be, as well as naturally are, guarded by a sentiment, not only different in degree, but also in kind; distinguished from the milder feeling which attaches to the mere idea of promoting human pleasure or convenience at once by the more definite nature of its commands and by the sterner character of its sanctions.

Notes

1. The author of this essay has reason for believing himself to be the first person who brought the word "utilitarian" into use. He did not invent it, but adopted it from a passing expression in Mr. Galt's *Annals of the Parish*. After using it as a designation for several years, he and others abandoned it from a growing dislike to anything resembling a badge or watchword of sectarian distinction. But as a name for one single opinion, not a set of opinions—to denote the recognition of utility as a standard, not any particular way of applying it—the term supplies a want in the language, and offers, in many cases, a convenient mode of avoiding tiresome circumlocutions.

2. An opponent, whose intellectual and moral fairness it is a pleasure to acknowledge (the Rev. J. Llewellyn Davies), has objected to this passage, saying, "Surely the rightness or wrongness of saving a man from drowning does depend very much upon the motive with which it is done. Suppose that a tyrant, when his enemy jumped into the sea to escape from him, saved him from drowning simply in order that he might inflict upon him more exquisite tortures, would it tend to clearness to speak of that rescue as 'a morally right action'? Or suppose again, according to one of the stock illustrations of ethical inquiries, that a man betrayed a trust received from a friend, because the discharge of it would fatally injure that friend himself or

someone belonging to him, would utilitarianism compel one to call the betrayal 'a crime' as much as if it had been done from the meanest motive?"

I submit that he who saves another from drowning in order to kill him by torture afterwards does not differ only in motive from him who does the same thing from duty or benevolence; the act itself is different. The rescue of the man is, in the case supposed, only the necessary first step of an act far more atrocious than leaving him to drown would have been. Had Mr. Davies said, "The rightness or wrongness of saving a man from drowning does depend very much"—not upon the motive, but—"upon the *intention*," no utilitarian would have differed from him. Mr. Davies, by an oversight too common not to be quite venial, has in this case confounded the very different ideas of Motive and Intention. There is no point which utilitarian thinkers (and Bentham preeminently) have taken more pains to illustrate than this. The morality of the action depends entirely upon the intention—that is, upon what the agent *wills to do*. But the motive, that is, the feeling which makes him will so to do, if it makes no difference in the act, makes none in the morality: though it makes a great difference in our moral estimation of the agent, especially if it indicates a good or a bad habitual *disposition*—a bent of character from which useful, or from which hurtful actions are likely to arise.

[This note appeared in the second edition of *Utilitarianism* but not in subsequent ones.]

3. See this point enforced and illustrated by Professor Bain, in an admirable chapter (entitled "The Ethical Emotions, or the Moral Sense"), of the second of the two treatises composing his elaborate and profound work on the Mind.

4. This implication, in the first principle of the utilitarian scheme, of perfect impartiality between persons is regarded by Mr. Herbert Spencer (in his *Social Statics*) as a disproof of the pretensions of utility to be a sufficient guide to right; since (he says) the principle of utility presupposes the anterior principle that everybody has an equal right to happiness. It may be more correctly described as supposing that equal amounts of happiness are equally desirable, whether felt by the same or different persons. This, however, is not a *pre*supposition, not a premise needful to support the principle of utility, but the very principle itself; for what is the principle of utility if it be not that "happiness" and "desirable" are synonymous terms? If there is any anterior principle implied, it can be no other than this, that the truths of arithmetic are applicable to the valuation of happiness, as of all other measurable quantities.

(Mr. Herbert Spencer, in a private communication on the subject of the preceding note, objects to being considered an opponent of utilitarianism and states that he regards happiness as the ultimate end of morality; but deems that end only partially attainable by empirical generalizations from the observed results of conduct, and completely attainable only by deducing, from the laws of life and the conditions of existence, what kinds of action necessarily tend to produce happiness, and what kinds to produce unhappiness. With the exception of the word "necessarily," I have no dissent to express from this doctrine; and (omitting that word) I am not aware that any modern advocate of utilitarianism is of a different opinion. Bentham, certainly, to whom in the Social Statics Mr. Spencer particularly referred, is, least of all writers, chargeable with unwillingness to deduce the effect of actions on happiness from the laws of human nature and the universal conditions of human life. The common charge against him is of relying too exclusively upon such deductions and declining altogether to be bound by the generalizations from specific experience which Mr. Spencer thinks that utilitarians generally confine themselves to. My own opinion (and, as I collect, Mr. Spencer's) is that in ethics, as in all other branches of scientific study, the consilience of the results of both these processes, each corroborating and verifying the other, is requisite to give to any general proposition the kind and degree of evidence which constitutes scientific proof.)

Study Questions

1. Does utilitarianism judge actions by actual or expected consequences?

2. If people knowledgeable about poetry and video games prefer the latter, are they, therefore, more worthwhile?

3. Did Mill believe the principle of utilitarianism can be proven?

4. Does utilitarianism justify the actions of a professor who awards all students high grades in order to enhance happiness?

14

FRIEDRICH NIETZSCHE

Friedrich Nietzsche (1844–1900) was a German philosopher and classical scholar. Because of his unconventional views and aphoristic style of writing, he is regarded as one of the most controversial figures in the history of philosophy. According to Nietzsche, originally the term "good" was associated with nobility and power, but this "master morality" was replaced by "slave morality," which celebrates altruism and self-denial. The guilt (or bad conscience) that drives slave morality should be transcended by a higher form of humanity that will lead toward superior forms of life in a world without God.

On the Genealogy of Morals

A POLEMIC

Preface

2

—My thoughts on the *origin* of our moral prejudices—for such is the subject of this polemic—found their first, spare, provisional expression in the collection of aphorisms entitled *Human, All Too Human: A Book for Free Spirits.* . . .

3

. . . [U]nder what conditions did man invent the value-judgements good and evil? *And what value do they themselves possess?* Have they helped or hindered the progress of mankind? Are they a sign of indigence, of impoverishment, of the degeneration of life? Or do they rather reveal the plenitude, the strength, the will of life, its courage, confidence, and future? . . .

6

This problem of the *value* of compassion and of the morality of compassion (—I am an opponent of the shameful modern weakening of sensibility—) seems at first merely an isolated issue, a freestanding question-mark. But whoever pauses here, whoever *learns* to ask questions here, will undergo the same experience as I—that of a huge new prospect opening up, a vertiginous possibility, as every kind of mistrust, suspicion, and fear leaps forward, and the belief in morality, all morality, falters. Finally, a new demand finds expression. Let us articulate this *new demand:* we stand in need of a *critique* of moral values, *the value of these values itself should first of all be called into question.* This requires a knowledge of the conditions and circumstances of their growth, development, and displacement (morality as consequence, symptom, mask, Tartufferie,[1] illness, misunderstanding: but also morality as cause, cure, stimulant, inhibition, poison); knowledge the like

of which has never before existed nor even been desired. The *value* of these "values" was accepted as given, as fact, as beyond all question. Previously, no one had expressed even the remotest doubt or shown the slightest hesitation in assuming the "good man" to be of greater worth than the "evil man," of greater worth in the sense of his usefulness in promoting the progress of human *existence* (including the future of man). What? And if the opposite were the case? What? What if there existed a symptom of regression in the "good man," likewise a danger, a temptation, a poison, a narcotic, by means of which the present were living *at the expense of the future?* Perhaps more comfortably and less dangerously, but also in less grand style, in a humbler manner? So that none other than morality itself would be the culprit, if the *highest power and splendour* of the human type, in itself a possibility, were never to be reached? So that morality would constitute the danger of dangers?

<div align="center">8</div>

. . . An aphorism, honestly cast and stamped, is still some way from being "deciphered" once it has been read; rather, it is only then that its *interpretation* can begin, and for this an art of interpretation is required. In the third essay of this book I have offered a model for what I mean by "interpretation" in such a case—the essay opens with an aphorism and is itself a commentary upon it. Admittedly, to practise reading as an *art* in this way requires one thing above all, and it is something which today more than ever has been thoroughly unlearnt—a fact which explains why it will be some time before my writings are "readable"—it is something for which one must be practically bovine and certainly *not* a "modern man": that is to say, *rumination.* . . .

<div align="right">*Sils-Maria, Upper Engadine, July 1887*</div>

<div align="center">

FIRST ESSAY

"Good and Evil," "Good and Bad"

2
</div>

. . . [T]he greatest respect to the good spirits who preside over . . . historians of morality! Unfortunately,

there is no doubt that they lack the *historical spirit,* that they have been abandoned by all the good spirits of history! As is the wont of philosophers, they all think in an *essentially* unhistorical manner; there is no doubt about that. The amateurishness of their genealogy of morals comes to light as soon as they have to account for the origin of "good" as concept and judgement. "Originally"—so they decree—"unegoistic actions were acclaimed and described as good by those towards whom they were directed, thus those to whom they were *useful.* The origin of this acclaim was later forgotten and unegoistic actions were simply felt to be good, because they were *habitually* always praised as such—as if they were in themselves something good." It is clear from the outset that all the typical characteristics of the English psychologists'[2] prejudice are already present in this first deduction—here we have "utility," "forgetting," "habit," and finally "error," all as the basis of a value-judgement which has up to now been the pride of civilized man and been accepted as a kind of essential human prerogative. The *goal* here is to humble this pride, devalue this value-judgement: is this goal attained? It seems clear to me that this theory looks in the wrong place for the real origin of the concept "good." The judgement "good" does *not* derive from those to whom "goodness" is shown! Rather, the "good" themselves— that is, the noble, the powerful, the superior, and the high-minded—were the ones who felt themselves and their actions to be good—that is, as of the first rank—and posited them as such, in contrast to everything low, low-minded, common, and plebeian. On the basis of this *pathos of distance,*[3] they first arrogated the right to create values, to coin the names of values. What did utility matter to them? The point of view of utility could not be more alien and inappropriate to such a high-temperature outpouring of the highest value-judgements when engaged in the making and breaking of hierarchies: for here feeling is at the opposite end of the scale from the low temperature presupposed by every prudent calculation and utilitarian estimation—and not only on one occasion, not for an exceptional hour, but over the long term. As I said, the pathos of

nobility and distance, the enduring, dominating, and fundamental overall feeling of a higher ruling kind in relation to a lower kind, to a "below"—*that* is the origin of the opposition between "good" and "bad." (The right of the masters to confer names extends so far that one should allow oneself to grasp the origin of language itself as the expression of the power of the rulers: they say "this *is* such and such," they put their seal on each thing and event with a sound and in the process take possession of it.) It follows from this origin that there is from the outset absolutely *no* necessary connection between the word "good" and "unegoistic" actions, as the superstition of the genealogists of morals would have it. Rather, it is only with the decline of aristocratic value-judgements that this whole opposition between "egoistic" and "unegoistic" comes to impose itself increasingly on the human conscience. To adopt my own terminology, it is the *herd-instinct,* which here finally has its chance to put in a word (and to put itself into *words*). Even then, it is a long time before this instinct dominates to such an extent that the moral value-judgement catches and sticks fast on this opposition (as is, for example, the case in contemporary Europe: today the prejudice which takes "moral," "unegoistic," "*désintéressé*" [4] as synonyms already rules with the power of an "*idée fixe*" and mental illness.)

3

As a second point, however: quite apart from its untenability in historical terms, this hypothesis on the origin of the value-judgement "good" suffers from an inherent psychological contradiction. The acclaim which the unegoistic action receives is supposedly derived from its utility, and this origin has supposedly been *forgotten*—but how is such forgetting even *possible?* Have such actions at some point perhaps ceased to be useful? The opposite is the case: their utility has become rather the daily experience for all time, something which has been continually underlined anew, and, consequently, instead of disappearing from consciousness, instead of becoming forgettable, must have impressed itself on consciousness with ever-greater clarity. How much more reasonable is the opposing theory (which is no more true for all that—),

represented by Herbert Spencer,[5] for example. Spencer postulates that the concept "good" is essentially the same as the concept "useful" or "expedient," so that humanity has summed up and sanctioned precisely its *unforgotten* and *unforgettable* experiences of what is useful and expedient on the one hand and what is harmful and inexpedient on the other in the judgements "good" and "bad." According to this theory, whatever has proven itself useful from time immemorial is good: as a result, it may assert its validity as "of the highest value," as "valuable in itself." This mode of explanation is, as I said, also incorrect, but at least the explanation itself is internally consistent and tenable in terms of its psychology.

4

—What pointed me in the *right* direction was actually the question of what the designations of "good" coined in various languages meant from an etymological perspective.[6] I found that they all led back to the *same transformation of concepts*—that "refined" or "noble" in the sense of social standing is everywhere the fundamental concept, from which "good" in the sense of "having a refined soul," "noble" in the sense of "superior in soul," "privileged in soul" necessarily developed. This development always ran parallel with that other one by means of which "common" or "plebeian" or "low" ultimately slide over into the concept "bad.". . . This seems to me to be a *fundamental* insight with respect to the genealogy of morals. The reason for its coming to light so late is the inhibiting influence exerted in the modern world by the democratic prejudice against all questions of origin. And this prejudice encroaches even on what are apparently the most objective areas of natural science and physiology, which I shall only allude to here. . . .

5

With respect to *our* problem—which might with good reason be described as a *reticent* problem, one which addresses itself with discrimination to a few ears only—it is of no small interest to note that, in those words and roots which designate "good," the main nuance, according to which the noble felt themselves to be men of higher rank, often still shows through.

Admittedly, the most frequent practice is perhaps for those of higher rank to name themselves according to their superiority in matters of power (as "the powerful," "the masters," "those who command"), or according to the most visible sign of this superiority, as, for example, "the wealthy," "the owners" (that is the meaning of *arya*;[7] and similar formulations can be found in Persian and Slavic). But they also do so according to a *typical character trait*: and this is the case which concerns us here. The noble might refer to themselves, for example, as "the truthful": the prime example is the Greek nobility, whose spokesman is the Megarian poet Theognis.[8] The word coined for this purpose—*esthlos*[9]—means according to its root someone who *is,* who has reality, who is real, who is true. Then, with a subjective turn, the true becomes the truthful: in this phase of concept-transformation the word becomes the slogan and motto of the nobility and slides completely over into the meaning "noble," marking it off from the *deceitful* common man, as Theognis takes and represents him—until finally, after the decline of the nobility, the word survives to designate nobility of soul and becomes at the same time ripe and sweet. . . . I believe that I am entitled to interpret the Latin *bonus*[10] as "warrior": provided that I correctly derive *bonus* from the older *duonus* (compare *bellum*[11] = *duellum* = *duenlum,* in which *duonus* seems to me to be included). So *bonus* as a man of conflict, of division (*duo*), as warrior: from this it is clear in what a man's "goodness" consisted in ancient Rome. Our German *gut* [good] itself: should it not mean "the godly" [*den Göttlichen*], the man "of godly race" [*göttlichen Geschlechts*]? And should it not be identical with the Goths [*Goten*], the name of the people (and originally of the nobility)? The grounds for this hypothesis would be out of place here.—

<div align="center">6</div>

To the rule that the political concept of rank always transforms itself into a spiritual concept of rank, it at first constitutes no exception (although it may in turn occasion such exceptions) if the highest caste is at the same time the *priestly* caste, and consequently prefers to designate itself collectively through a predicate which reminds one of its priestly function. It is here, for example, that "pure" and "impure" are first opposed as marks of social station; and here also that a "good" and a "bad" are later developed in a sense which is no longer one of social station. By the way, one should be warned against taking these concepts of "pure" and "impure" too seriously, too broadly, or even symbolically from the outset: rather, all human concepts from earlier times were, to an extent which we can scarcely conceive, initially understood in a crude, clumsy, external, narrow, and frankly, particularly *unsymbolic* way. The "pure" man is from the outset merely a man who washes, who denies himself certain types of food which cause skin complaints, who refrains from sleeping with the unclean women of the lower classes, who abhors blood—and no more, not a great deal more than that! On the other hand, admittedly, the whole constitution of an essentially priestly aristocracy illuminates why it should be here rather than anywhere else that the dangerous internalization and intensification of the value-oppositions could take place at an early stage. In fact, these oppositions have finally torn open chasms between man and man, chasms which would make even an Achilles of spiritual freedom shudder before he leapt. There is from the outset something *unhealthy* in such priestly aristocracies and in the customs which prevail among them, customs which are turned away from action and combine brooding with emotional volatility. The consequence of these customs is the almost unavoidable intestinal sickness and neurasthenia which afflicts priests of all times. But as for what they themselves invented as a cure for their sickliness—are we not bound to say that its after-effects have ultimately proven to be a hundred times more dangerous than the illness which it was intended to relieve? Mankind itself continues to suffer from the after-effects of these naïve priestly cures! Let us think, for example, of certain forms of diet (avoidance of meat), of fasting, of sexual abstinence, of flight "into the desert.". . . And added to that, the whole anti-sensual and enervating metaphysics of the priests, their self-hypnosis in the manner of fakirs and Brahmins . . . and the ultimate, only too understandable general satiety with its radical cure, with *nothingness* (or God—the desire for a *unio mystica* with God is the Buddhist's desire for

nothingness, nirvana—and nothing more!). With the priests, *everything* becomes more dangerous, not only cures and therapies, but also arrogance, revenge, perspicacity, extravagance, love, the desire to dominate, virtue, illness. With some fairness, admittedly, it might also be added that it is only on the basis of this *essentially dangerous* form of human existence, the priestly form, that man has at all developed into an *interesting animal,* that it is only here that the human soul has in a higher sense taken on *depth* and become *evil*—and these have certainly been the two fundamental forms of man's superiority over other animals up to now!

7

—By now it will be clear how easily the priestly mode of evaluation may diverge from the knightly-aristocratic mode and then develop into its opposite. This process receives a particular impetus each time the priest and warrior castes jealously confront each other and are unwilling to strike a compromise. The knightly-aristocratic value-judgements presuppose a powerful physicality, a rich, burgeoning, even overflowing health, as well as all those things which help to preserve it—war, adventure, hunting, dancing, competitive games, and everything which involves strong, free, high-spirited activity. As we have seen, the noble priestly mode of evaluation has different conditions: so much the worse for the priests when it comes to war! Priests are, as is well-known, the *most evil enemies*—but why? Because they are the most powerless. From powerlessness their hatred grows to take on a monstrous and sinister shape, the most cerebral and most poisonous form. The very greatest haters of world-history have always been priests, as have the most ingenious. In comparison with the ingenuity of priestly revenge, all other intelligence scarcely merits consideration. Human history would be a much too stupid affair were it not for the intelligence introduced by the powerless. Let us immediately consider the most important example. Nothing which anyone else has perpetrated against the "noble," the "powerful," the "masters," the "rulers" merits discussion in comparison with the deeds of the *Jews*—the Jews, that priestly people who ultimately knew no other way of exacting satisfaction

from its enemies and conquerors than through a radical transvaluation of their values, through an art of *the most intelligent revenge.* This was only as befitted a priestly people, the people of the most downtrodden priestly vindictiveness. It has been the Jews who have, with terrifying consistency, dared to undertake the reversal of the aristocratic value equation (good = noble = powerful = beautiful = happy = blessed) and have held on to it tenaciously by the teeth of the most unfathomable hatred (the hatred of the powerless). It is they who have declared: "The miserable alone are the good; the poor, the powerless, the low alone are the good. The suffering, the deprived, the sick, the ugly are the only pious ones, the only blessed, for them alone is there salvation. You, on the other hand, the noble and the powerful, you are for all eternity the evil, the cruel, the lascivious, the insatiable, the godless ones. You will be without salvation, accursed and damned to all eternity!" There is no doubt as to *who* inherited this Jewish transvaluation.[12] In relation to the monstrous initiative, disastrous beyond all bounds, which the Jews have taken with this most fundamental of all declarations of war, I remind the reader of the phrase which I arrived at in another context (*Beyond Good and Evil,* §195): that with the Jews *the slave revolt in morals* begins: that revolt which has a two-thousand-year history behind it and which has today dropped out of sight only because it—has succeeded.

8

—But you are finding this hard to follow? You have no eyes for something which took two thousand years to triumph? . . . That comes as no surprise: all things whose *history stretches out far behind them* are difficult to see, to see in their entirety. But *this* is indeed what happened: from the trunk of that tree of revenge and hatred, Jewish hatred—the deepest and most sublime hatred, that is, the kind of hatred which creates ideals and changes the meaning of values, a hatred the like of which has never been on earth—from this tree grew forth something equally incomparable, a *new love,* the deepest and most sublime of all the kinds of love—and from what other trunk could it have grown? . . . But let no one think that it

somehow grew up as the genuine negation of that thirst for revenge, as the antithesis of Jewish hatred! No, the opposite is the case! Love grew forth from this hatred, as its crown, as its triumphant crown, spreading itself ever wider in the purest brightness and fullness of the sun, as a crown which pursued in the lofty realm of light the goals of hatred—victory, spoils, seduction—driven there by the same impulse with which the roots of that hatred sank down ever further and more lasciviously into everything deep and evil. This Jesus of Nazareth, as the gospel of love incarnate, this "redeemer" bringing victory and salvation to the poor, the sick, the sinners—did he not represent the most sinister and irresistible form of the very same temptation, the indirect temptation to accept those self-same *Jewish* values and new versions of the ideal? Has Israel not reached the ultimate goal of its sublime vindictiveness through the detour of this very "redeemer" who appeared to oppose and announce the dissolution of Israel? Is it not characteristic of the secret black art of a truly *great* policy of revenge, of a far-sighted, subterranean revenge which unfolds itself slowly and thinks ahead, that Israel itself was obliged to deny the very instrument of this revenge as a mortal enemy and crucify him before the whole world, so that the "whole world," all the opponents of Israel, might unthinkingly bite on just this very bait? And on the other hand, would it be possible, with the most refined ingenuity, to devise a *more dangerous* bait? To devise something which could even approach the seductive, intoxicating, anaesthetizing, and corrupting power of that symbol of the "holy cross," that horrific paradox of the "crucified God," that mystery of an inconceivably ultimate, most extreme cruelty and self-crucifixion undertaken *for the salvation of mankind*? It is certain at least that *sub hoc signo*[13] Israel's revenge and transvaluation of all values has so far continued to triumph over all other ideals, over all *nobler* ideals. . . .

10

—The slave revolt in morals begins when *ressentiment*[14] itself becomes creative and ordains values: the *ressentiment* of creatures to whom the real reaction, that of the deed, is denied and who find compensation in an imaginary revenge. While all noble morality grows from a triumphant affirmation of itself, slave morality from the outset says no to an "outside," to an "other," to a "non-self": and *this* no is its creative act. The reversal of the evaluating gaze—this *necessary* orientation outwards rather than inwards to the self— belongs characteristically to *ressentiment*. In order to exist at all, slave morality from the outset always needs an opposing, outer world; in physiological terms, it needs external stimuli in order to act—its action is fundamentally reaction. . . .To be incapable of taking one's enemies, accidents, even one's *misdeeds* seriously for long—such is the sign of strong full natures, natures in possession of a surplus of the power to shape, form, and heal, of the power which also enables one to forget (a good example of this in the modern world is Mirabeau,[15] who had no memory for the insults and malicious behaviour directed against him and could not forgive simply because he could not—remember). Such a man with a *single* shrug shakes off much of that which worms and digs its way into others. Here alone is actual "*love* of one's enemy"[16] possible, assuming that such a thing is at all possible on earth. How much respect a noble man has already for his enemy!—and such respect is already a bridge to love. . . . The noble man claims his enemy for himself, as a mark of distinction. He tolerates no other enemy than one in whom nothing is to be despised and a *great deal* is worthy of respect! In contrast, imagine the "enemy" as conceived by the man of *ressentiment*. This is the very place where his deed, his creation is to be found—he has conceived the "evil enemy," the "*evil man*." Moreover, he has conceived him as a fundamental concept, from which he now derives another as an after-image and counterpart, the "good man"—himself!

11

This, then, is the very opposite of what the noble man does—for the latter conceives the fundamental concept "good" spontaneously and in advance—that is, from his own point of view—and only then does he proceed to create for himself an idea of the "bad"! This "bad" of noble origin and that "evil" which issues from the cauldron of insatiable hatred—the former

being a retrospective creation, an incidental, a complementary colour, while the latter is the original, the beginning, the real *deed* in the conception of a slave morality—what a difference there is between these two words "bad" and "evil," in spite of the fact that they both appear to stand in opposition to one and the same concept of "good"! But it is not the *same* concept of "good" which is involved in each case: the question which should be asked is rather: *who* is actually "evil" according to the morality of *ressentiment?* In all strictness, the answer is: *none other* than the "good man" of the other morality, none other than the noble, powerful, dominating man, but only once he has been given a new colour, interpretation, and aspect by the poisonous eye of *ressentiment.* We would be the last to deny that anyone who met these "good men" only as enemies would know them only as *evil enemies,* and that these same men, who are *inter pares* so strictly restrained by custom, respect, usage, gratitude, even more by circumspection and jealousy, and who in their relations with one another prove so inventive in matters of consideration, self-control, tenderness, fidelity, pride, and friendship—these same men behave towards the outside world—where the foreign, the *foreigners,* are to be found—in a manner not much better than predators on the rampage. There they enjoy freedom from all social constraint, in the wilderness they make up for the tension built up over a long period of confinement and enclosure within a peaceful community, they *regress* to the innocence of the predator's conscience, as rejoicing monsters, capable of high spirits as they walk away without qualms from a horrific succession of murder, arson, violence, and torture, as if it were nothing more than a student prank, something new for the poets to sing and celebrate for some time to come. There is no mistaking the predator beneath the surface of all these noble races, the magnificent *blond beast*[17] roaming lecherously in search of booty and victory; the energy of this hidden core needs to be discharged from time to time, the animal must emerge again, must return to the wilderness. . . .

13

—But let us return to our problem: for our discussion of the problem of the *other* origin of "good,"

of good as conceived by the man of *ressentiment,* requires its conclusion.—That lambs bear ill-will towards large birds of prey is hardly strange: but is in itself no reason to blame large birds of prey for making off with little lambs. And if the lambs say among themselves: "These birds of prey are evil; and whoever is as little of a bird of prey as possible, indeed, rather the opposite, a lamb—should he not be said to be good?," then there can be no objection to setting up an ideal like this, even if the birds of prey might look down on it a little contemptuously and perhaps say to themselves: "*We* bear them no ill-will at all, these good lambs—indeed, we love them: there is nothing tastier than a tender lamb." To demand of strength that it should *not* express itself as strength, that it should *not* be a will to overcome, overthrow, dominate, a thirst for enemies and resistance and triumph, makes as little sense as to demand of weakness that it should express itself as strength. A quantum of force is also a quantum of drive, will, action—in fact, it is nothing more than this driving, willing, acting, and it is only through the seduction of language (and through the fundamental errors of reason petrified in it)—language which understands and misunderstands all action as conditioned by an actor, by a "subject"[18]—that it can appear otherwise. Just as the common people distinguish lightning from the flash of light and takes the latter as *doing,* as the effect of a subject which is called lightning, just so popular morality distinguishes strength from expressions of strength, as if behind the strong individual there were an indifferent substratum which was at *liberty* to express or not to express strength. But no such substratum exists; there is no "being" behind doing, acting, becoming; "the doer" is merely a fiction imposed on the doing—the doing itself is everything. Basically, the common people represent the doing twice over, when they make lightning flash—that is a doing doubled by another doing: it posits the same event once as cause and then once again as effect. The natural scientists do not fare any better when they say: "Force moves, force causes," and the like—in spite of all its coldness, its freedom from emotion, our entire science is still subject to the seduction of language and has not shaken itself free

of the monstrous changelings, the "subjects," foisted upon it (the atom[19] is an example of such a changeling, as is the Kantian "thing in itself "[20]). No wonder that the downtrodden and surreptitiously smouldering emotions of revenge and hatred exploit this belief in their own interests and maintain no belief with greater intensity than that *the strong may freely choose* to be weak, and the bird of prey to be lamb—and so they win the right to blame the bird of prey for simply being a bird of prey. . . .

16

Let us conclude. For thousands of years, a fearful struggle has raged on earth between the two opposed value-judgements, "good and bad" and "good and evil"; and as certain as it is that the second value-judgement has long been in the ascendant, there is even now no shortage of places where the outcome of the conflict remains undecided. It might even be said that the conflict has escalated in the interim and so become increasingly profound, more spiritual: so that today there is perhaps no more decisive mark of the "*higher nature,*" of the more spiritual nature, than to be divided against oneself in this sense and to remain a battleground for these oppositions. The symbol for this struggle, written in a script which has remained legible throughout the whole of human history up until now, is called "Rome against Judaea, Judaea against Rome"—so far, there has been no greater event than *this* struggle, *this* questioning, *this* mortal enmity and contradiction. Rome felt the Jew to be something like the incarnation of the unnatural, its monstrous opposite, as it were: in Rome, the Jew "*stood convicted* of hatred towards the whole of mankind":[21] rightly, in so far as one is entitled to associate the salvation and future of mankind with the absolute supremacy of the aristocratic values, the Roman values. How, on the other hand, did the Jews feel towards Rome? A thousand signs give us an indication; but it is sufficient to call to mind once more the Apocalypse according to St John, that most desolate of all the written outbursts which vindictiveness has on its conscience. (By the way, one should not underestimate the deep logic of the Christian instinct which inscribed this book of hatred with the name of the apostle of love, the one to whom it attributed that infatuated and enraptured gospel as his own—: there is a grain of truth in that, however much literary forgery may have been necessary to bring it about.[22]) The Romans were the strong and noble men, stronger and nobler than they had ever been on earth, or even dreamed themselves to be; every vestige left behind by them, every inscription is a delight, as long as one has an inkling of *what* is behind the writing. The Jews conversely were the priestly people of *ressentiment par excellence,* with an innate genius in matters of popular morality: one need only compare those peoples with related gifts, say, the Chinese or the Germans, with the Jews in order to appreciate the difference between first- and fifth-rate. Which of these is in the ascendant at the moment, Rome or Judaea? But there is no room for doubt: consider before whom one bows today in Rome as before the epitome of all the highest values—and not only in Rome, but over almost half the world, wherever man has been tamed or wants to be tamed—before *three Jews,* as one knows, and *one Jewess* (before Jesus of Nazareth, the fisherman Peter, the carpet-maker Paul, and the mother of the aforementioned Jesus, Mary). This is most remarkable: there is no doubt that Rome has been defeated. . . .

17

. . . Anyone who, like my reader, starts to reflect at this point and to pursue his thoughts will find no early end to them—reason enough for me to come to an end, assuming that my *aim* has long since become sufficiently clear, the aim of that dangerous slogan written on the body of my last book: "Beyond Good and Evil.". . . This at the very least does *not* mean "Beyond Good and Bad.". . .

In fact, all tables of commandments, all "Thou shalts" known to history or ethnological research, certainly require *physiological* investigation and interpretation prior to psychological examination. Equally, all await a critique from the medical sciences. The question: what is the *value* of this or that table of commandments and "morality"? should be examined from the most varied perspectives; in particular, the question of its value *to what end?* cannot

be examined too closely. For example, something possessing clear value for the greatest possible survival capacity of a race (or for increasing its powers of adaptation to a certain climate or for the preservation of the greatest number) would not have anything like the same value if what was at issue were the development of a stronger type. The welfare of the greatest number and the welfare of the few represent opposed points of view on value: to hold the former as of intrinsically higher value may be left to the naïveté of English biologists. . . . From now on, *all* disciplines have to prepare the future task of the philosopher: this task being understood as the solution of the *problem of value,* the determination of the *hierarchy of values.*—

SECOND ESSAY

"Guilt," "Bad Conscience," and Related Matters

1

The breeding of an animal which is *entitled to make promises*—is this not the paradoxical task which nature has set itself with respect to man? Is this not the real problem which man not only poses but faces also? The extent to which this problem has been solved must seem all the more surprising to someone who fully appreciates the countervailing force of *forgetfulness.* Forgetfulness is no mere *vis inertiae,*[23] as the superficial believe; it is rather an active—in the strictest sense, positive—inhibiting capacity, responsible for the fact that what we absorb through experience impinges as little on our consciousness during its digestion (what might be called its "psychic assimilation") as does the whole manifold process of our physical nourishment, that of so-called "physical assimilation." The temporary shutting of the doors and windows of consciousness; guaranteed freedom from disturbance by the noise and struggle caused by our underworld of obedient organs as they co-operate with and compete against one another; a little silence, a little *tabula rasa*[24] of consciousness, making room for the new, making room above all

for the superior functions and functionaries—those of governing, anticipating, planning ahead (since our organism is structured as an oligarchy)—such is the use of what I have called active forgetfulness, an active forgetfulness whose function resembles that of a concierge preserving mental order, calm, and decorum. On this basis, one may appreciate immediately to what extent there could be no happiness, no serenity, no hope, no pride, no *present* without forgetfulness. The man in whom this inhibiting apparatus is damaged and out of order may be compared to a dyspeptic (and not only compared)—he is never "through" with anything. Even this necessarily forgetful animal—in whom forgetting is a strength, a form of *robust* health—has now bred for himself a counter-faculty, a memory, by means of which forgetfulness is in certain cases suspended—that is, those which involve promising. This development is not merely the result of a passive inability to rid oneself of an impression once etched on the mind, nor of the incapacity to digest a once-given word with which one is never through, but represents rather an active *will* not to let go, an ongoing willing of what was once willed, a real *memory of the will*: so that between the original "I will," "I shall do," and the actual realization of the will, its *enactment,* a world of new and strange things, circumstances, even other acts of will may safely intervene, without causing this long chain of the will to break. But how much all this presupposes! In order to dispose of the future in advance in this way, how much man must first have learnt to distinguish necessity from accident! To think in terms of causality, to see and anticipate from afar, to posit ends and means with certainty, to be able above all to reckon and calculate! For that to be the case, how much man himself must have become *calculable, regular, necessary,* even to his own mind, so that finally he would be able to vouch for himself *as future,* in the way that someone making a promise does!

2

Such is the long history of the origin of *responsibility.* As we have already grasped, the task of breeding an animal which is entitled to make promises

presupposes as its condition a more immediate task, that of first *making* man to a certain extent necessary, uniform, an equal among equals, regular and consequently calculable. The enormous labour of what I have called the "morality of custom"—the special work of man on himself throughout the longest era of the human race, his whole endeavour *prior to the onset of history,* all this finds its meaning, its great justification—regardless of the degree to which harshness, tyranny, apathy, and idiocy are intrinsic to it—in the following fact: it was by means of the morality of custom and the social strait-jacket that man was really *made* calculable. By way of contrast, let us place ourselves at the other end of this enormous process, at the point where the tree finally bears its fruit, where society and its morality of custom finally reveal the *end* to which they were merely a means: there we find as the ripest fruit on their tree the *sovereign individual,* the individual who resembles no one but himself, who has once again broken away from the morality of custom, the autonomous supramoral individual (since "autonomous" and "moral" are mutually exclusive)—in short, the man with his own independent, enduring will, the man who is *entitled to make promises.* And in him we find a proud consciousness, tense in every muscle, of *what* has finally been achieved here, of what has become incarnate in him—a special consciousness of power and freedom, a feeling of the ultimate completion of man. This liberated man, who is really *entitled* to make promises, this master of *free* will, this sovereign—how should he not be aware of his superiority over everything which cannot promise and vouch for itself? How should he not be aware of how much trust, how much fear, how much respect he arouses— he "*deserves*" all three—and how much mastery over circumstances, over nature, and over all less reliable creatures with less enduring wills is necessarily given into his hands along with this self-mastery? The "free" man—the owner of an enduring, indestructible will—possesses also in this property his *measure of value*: looking out at others from his own vantage-point, he bestows respect or contempt. Necessarily, he respects those who are like him—the strong and reliable (those who are *entitled* to make promises), that is, anyone who promises like a sovereign—seriously,

seldom, slowly—who is sparing with his trust, who *confers distinction* when he trusts, who gives his word as something which can be relied on, because he knows himself strong enough to uphold it even against accidents, even "against fate." Even so, he will have to keep the toe of his boot poised for the cowering dogs who make promises without entitlement, and hold his stick at the ready for the liar who breaks his word the moment he utters it. The proud knowledge of this extraordinary privilege of *responsibility,* the consciousness of this rare freedom, this power over oneself and over fate has sunk down into his innermost depths and has become an instinct, a dominant instinct—what will he call it, this dominant instinct, assuming that he needs a name for it? About that there can be no doubt: this sovereign man calls it his *conscience.*

3

His conscience? It may be surmised in advance that the concept of "conscience"—which we meet here in its highest, almost disconcerting form—is the product of a long history and series of transformations. To be able to vouch for oneself, and to do so with pride, and so to have the *right to affirm oneself*—that is, as I have said, a ripe fruit, but also a *late* fruit. How long this fruit had to hang sharp and bitter on the tree! . . . [T]here is, perhaps, nothing more frightening and more sinister in the whole prehistory of man than his *technique for remembering things.* "Something is branded in, so that it stays in the memory: only that which *hurts* incessantly is remembered"—this is a central proposition of the oldest (and unfortunately also the most enduring) psychology on earth. One may even be tempted to say that something of this horror—by means of which promises were once made all over the earth, and guarantees and undertakings given—something of this *survives* still wherever solemnity, seriousness, secrecy, and sombre colours are found in the life of men and nations: the past, the longest, deepest, harshest past, breathes on us and wells up in us, whenever we become "serious." Things never proceeded without blood, torture, and victims, when man thought it necessary to forge a memory for himself. The most horrifying sacrifices

and offerings (including sacrifice of the first-born), the most repulsive mutilations (castrations, for example), the cruellest rituals of all religious cults (and all religions are at their deepest foundations systems of cruelty)—all these things originate from that instinct which guessed that the most powerful aid to memory was pain. In a certain sense, the whole of asceticism belongs here: a few ideas are to be made inextinguishable, omnipresent, unforgettable, "fixed"—with the aim of hypnotizing the whole nervous system and intellect by means of these "fixed ideas"—and the ascetic procedures and forms of life are the means of freeing these ideas from competition with all other ideas, in order to make them "unforgettable." The worse mankind's memory was, the more frightening its customs appear; the harshness of punishment codes, in particular, gives a measure of how much effort it required to triumph over forgetfulness and to make these ephemeral slaves of emotion and desire mindful of a few primitive requirements of social cohabitation. . . . With the help of such images and procedures one eventually memorizes five or six "I will not's," thus giving one's *promise* in return for the advantages offered by society. And indeed! with the help of this sort of memory, one eventually did come to "see reason"!—Ah, reason, seriousness, mastery over the emotions, the whole murky affair which goes by the name of thought, all these privileges and showpieces of man: what a high price has been paid for them! how much blood and horror is at the bottom of all "good things"!

4

But how then did that other "murky affair," the sense of guilt, the whole matter of "bad conscience," originate? . . . The thought which is nowadays so proper and apparently so natural, so unavoidable, the thought which had to serve as the explanation for how the sense of justice came to exist on earth at all—the thought that "the criminal deserves punishment, because he could have acted otherwise"—is in fact an extremely recent and refined form of human judgement and logic; whoever displaces it on to the origins of human judgement is guilty of tampering crudely with the psychology of mankind in its early stages. Throughout the longest period of human history, punishment was not exacted *because* the trouble-maker was held responsible for his action, that is, it was *not* exacted on the assumption that only the guilty man was to be punished, but rather, just as nowadays parents still punish their children, out of anger at harm done, anger which is then taken out on the person who causes it—albeit held in check and modified by the idea that any damage somehow has an *equivalent* and really can be paid off, even if this is through the *pain* of the culprit. Where has this ancient, deeply rooted, and by now perhaps ineradicable idea, this idea of the equivalence between damage and pain, drawn its strength from? I have already given it away: from the contractual relationship between *creditor* and *debtor,* which is as old as the concept of "legal subjects" itself and which points back in turn to the fundamental forms of buying, selling, exchange, wheeling and dealing.

5

As might be expected from what I have said before, when we consider these contractual relations there is no doubt that the mankind of an earlier age which created or sanctioned them arouses a degree of suspicion and revulsion on our part. For this is where *promises* are made; at issue here is the *making* of a memory for the man who promises; this is where, so one may suspect, hard, cruel, and painful things will be found. In order to instil trust for his promise of repayment, in order to give a guarantee for the seriousness and sacredness of his promise, in order to impress repayment as a duty and obligation sharply upon his own conscience, the debtor contractually pledges to the creditor in the event of non-payment something which he otherwise still "possesses," something over which he still has power—for example, his body or his wife or his freedom or even his life (or, under certain religious conditions, even his salvation, the good of his soul, ultimately even the peace of his grave: as in Egypt, where even in the grave the corpse of the debtor finds no respite from the creditor—and among the Egyptians this peace meant a great deal). In particular, however, the creditor could subject the body of the debtor to

all sorts of humiliation and torture—he could, for example, excise as much flesh as seemed commensurate with the size of the debt. For this purpose, there have existed from the earliest times precise and in part horrifically detailed measurements, *legal* measurements, of the individual limbs and parts of the body. . . . Let us be clear about the logic of this whole form of exchange: it is alien enough. The equivalence is established by the fact that, instead of a direct compensation for the damage done (i.e. instead of money, land, possessions of whatever sort), a sort of *pleasure* is conceded to the creditor as a form of repayment and recompense—the pleasure of being able to vent his power without a second thought on someone who is powerless, the enjoyment "*de faire le mal pour le plaisir de le faire,*"[25] the pleasure of violation. This enjoyment will be prized all the more highly, the lower the creditor stands in the social order, and can easily appear to him as the choicest morsel, even as a foretaste of a higher rank. By means of the "punishment" inflicted on the debtor, the creditor partakes of a *privilege of the masters*: at last, he too has the opportunity to experience the uplifting feeling of being entitled to despise and mistreat someone as "beneath him"—or at least, in cases where the actual power and execution of punishment has already passed to the "authorities," to *see* this person despised and mistreated. So this compensation consists in an entitlement and right to cruelty.—

6

It is in *this* sphere, in legal obligations, then, that the moral conceptual world of "guilt," "conscience," "duty," "sacred duty" originates—its beginning, like the beginning of everything great on earth, has long been steeped in blood. And might one not add that the world has basically never since shaken off a certain odour of blood and torture? (not even with old Kant: the categorical imperative gives off a whiff of cruelty . . .). Likewise, this is where the sinister and by now perhaps inextricable entanglement of the ideas "guilt and pain" was first woven together. To repeat the question: to what extent can suffering compensate for "debt"? To the extent that *inflicting* pain occasions

the greatest pleasure, to the extent that the injured party exchanges for the damage done, together with the displeasure it causes, an extraordinary pleasure which offsets it: the opportunity to *inflict* suffering— an actual *festivity,* something which, as I said, is valued all the more highly the more it contradicts the social standing of the creditor. This is said by way of a hypothesis: for it is difficult to see to the bottom of such subterranean things, quite apart from the fact that it is unpleasant; and anyone who is clumsy and hasty enough to introduce the concept of revenge at this point, has concealed and obscured his view rather than made it clearer (—for revenge itself leads back to the same problem: "How can inflicting pain provide satisfaction?"). . . .

7

Perhaps the possibility might even be entertained that pleasure in cruelty need not actually have died out: considering the extent to which pain hurts more nowadays, all that it had to do was sublimate and refine itself—that is, it had to appear translated into the imagination and the psyche, embellished only with such harmless names as were incapable of arousing the suspicion of even the most delicate hypocritical conscience ("tragic sympathy" is such a name; another is "*les nostalgies de la croix*"[26]). The aspect of suffering which actually causes outrage is not suffering itself, but the meaninglessness of suffering: but neither for the Christian who has interpreted a whole secret machinery of salvation into suffering, nor for the naïve man of earlier times, who knew how to interpret all suffering in relation to those who actually inflict it or view it as a spectacle, did such a *meaningless* suffering actually exist. So that hidden, undiscovered, and unwitnessed suffering could be banished from the world and honestly negated, mankind was at that time virtually forced to invent gods and supernatural beings of all heights and depths—in short, to invent something which can penetrate secrets, see in the dark, and would only with great reluctance pass up an interesting spectacle of pain. With the help of such inventions, life at that time demonstrated its expertise in the trick for which it has always shown an aptitude—that is, self-justification, justifying its "evil.". . .

8

To take up once again the trail of our investigation, the feeling of guilt, of personal responsibility originated, as we have seen, in the earliest and most primordial relationship between men, in the relationship between buyer and seller, debtor and creditor: it is here that one man first encountered another, here that one man first *measured himself* against another. No level of civilization, however rudimentary, has been found where something of this relationship cannot be discerned. Setting prices, estimating values, devising equivalents, making exchanges—this has preoccupied the very earliest thinking of man to such an extent that it, in a certain sense, constitutes *thinking as such*: it is here that the earliest form of astuteness was bred, here likewise, we might suppose, that human pride, man's feeling of superiority over other animals originated. Perhaps our word "man" (*manas*[27]) still reveals something of *this* very perception of the self: man designated himself as the being who estimates values, who evaluates and measures, as *the* "measuring animal.". . . Justice at the earliest stage of its development is the good will which prevails among those of roughly equal power to come to terms with one another, to "come to an understanding" once more through a settlement—and to *force* those who are less powerful to agree a settlement among themselves.—

9

. . . [T]he . . . community stands in the same important fundamental relationship to its members as the creditor does to his debtors. One lives in a community, one enjoys the advantages of a community (oh what advantages! we sometimes underestimate them today), one lives protected, looked after, in peace and trust, without a care for certain forms of harm and hostility to which the man *outside,* the "outlaw" is exposed . . . , since man has pledged and committed himself to the community as regards this harm and hostility. What will happen *if the pledge is broken?* The community, the deceived creditor, will see that it receives payment, in so far as it can, one may count on that. The direct harm caused is the least matter of concern here: leaving that aside, the criminal

is above all someone who "breaks," someone who breaks a contractual commitment, breaks his word[28] *towards the whole community,* in relation to all the goods and amenities of communal life in which he previously shared. The criminal is a debtor who not only fails to repay the advantages and advances offered to him but even attacks his creditors, and for that reason he is from that point on not only, as is just, denied all these goods and advantages—he is also reminded of *what these goods represent.* The fury of the aggrieved creditor, of the community, returns him to the wild and outlaw status from which he was previously protected: it expels him—and now every kind of hostility may be vented on him. On this level of morality, "punishment" is simply the image, the *minus*[29] of normal behaviour towards a hated enemy, who lies prostrate and defenceless, bereft not only of every right and protection, but also of all hope of grace. Punishment is, then, the prerogative of the victor and celebration of the *Vae victis!*[30] in all its ruthlessness and cruelty—which explains how war itself (including the warlike cult of sacrifice) has produced all the *forms* in which punishment appears throughout history.

10

As its power increases, a community no longer takes the misdemeanours of the individual so seriously, because they no longer seem to pose the same revolutionary threat to the existence of the whole as they did previously. . . . Compromise with the fury of the man immediately affected by the misdeed; an effort to localize the case and to obviate further or even general participation and unrest; attempts to find equivalents and to settle the whole business (the *compositio*[31]); above all, the increasingly definite emergence of the will to accept every crime as in some sense capable of being *paid off,* and so, at least to a certain extent, to *isolate* the criminal from his deed—these are the characteristics which become more and more clearly stamped on the later development of the penal code. . . . The humanity of the "creditor" has always increased in proportion to his wealth; ultimately, the *measure* of his wealth becomes how much harm he can sustain without

suffering. It is not impossible to conceive of a society whose *consciousness of power* would allow it the most refined luxury there is—that of allowing those who do it harm to go *unpunished.* "Of what concern are these parasites to me?," it would be entitled to say. "May they live and prosper: I am strong enough to allow that!" The justice which began with: "Everything can be paid off, everything must be paid off," ends with a look the other way as those who are unable to pay are allowed to run free—it ends as every good thing on earth ends, by *cancelling itself out.* This self-cancellation of justice: the beautiful name it goes by is well enough known—*grace*; needless to say, it remains the prerogative of the most powerful man, even better, his domain beyond the law. . . .

11

If it really is the case that the just man remains just even in his dealings with those who do him harm (and not merely cold, measured, foreign, indifferent: being just is always a *positive* mode of behaviour), if the high, clear, objective vision of the just, the *judging* eye, as penetrating as it is mild, is not obscured even under the onslaught of personal injury, humiliation, and suspicion, then that is a piece of perfection and the highest mastery on earth—something which one would not in all wisdom expect to find here, and in which one should not too readily *believe.* There is no doubt that on average just a tiny amount of aggression, malice, and insinuation is sufficient to make even the most honest people see red and to deprive them of an impartial eye. The active, attacking, encroaching man is still a hundred paces closer to justice than his reactive counterpart; to the extent that he has no need to evaluate his object in a false and prejudiced manner as the reactive man does. For this reason, in fact, the aggressive man, the stronger, braver, nobler man has at all times had the *freer* eye, the *better* conscience on his side. Conversely, perhaps it is clear by now on whose conscience the invention of "bad conscience" rests—that of the man of *ressentiment!* . . . Accordingly, "right" and "wrong" exist only from the moment the law is established . . . To talk of right and wrong *as such* is senseless; *in themselves,* injury, violation, exploitation, destruction can of course be nothing "wrong," in so far as life operates *essentially*—that is, in terms of its basic functions—through injury, violation, exploitation, and destruction, and cannot be conceived in any other way. One is forced to admit something even more disturbing: that, from the highest biological point of view, legal conditions may be nothing more than *exceptional states of emergency,* partial restrictions which the will to life in its quest for power provisionally imposes on itself in order to serve its overall goal: the creation of *larger* units of power. A state of law conceived as sovereign and general, not as a means in the struggle between power-complexes, but as a means *against* struggle itself, in the manner of Dühring's[32] communist cliché according to which each will must recognize every other will as equal, would be a principle *hostile to life,* would represent the destruction and dissolution of man, an attack on the future of man, a sign of exhaustion, a secret path towards nothingness.—

12

At this point, let me add another word on the origin and aim of punishment—two problems which are, or at least ought to be, clearly distinguished, but are, unfortunately, more usually conflated. How, then, do the genealogists of morals, in the form in which they have existed until now, proceed in this matter? Naïvely, as they have always proceeded:—they find some "aim" in punishment—revenge or deterrence, for example—then unsuspectingly posit this aim as the origin, as the *causa fiendi*[33] of punishment, and then . . . leave it at that. But the "lawful aim" is the last thing that should be used to investigate the history of the genesis of the law: there is, rather, no more important principle for all types of history than the following one, which it has taken such effort to acquire and furthermore really *should* be acquired by now—and that is, that there is a world of difference between the reason for something coming into existence in the first place and the ultimate use to which it is put, its actual application and integration into a system of goals; that anything which exists, once it has somehow come into being, can be reinterpreted in the service of new intentions, repossessed, repeatedly modified to a new use by a power superior

to it; that everything which happens in the organic world is part of a process of *overpowering, mastering,* and that, in turn, all overpowering and mastering is a reinterpretation, a manipulation, in the course of which the previous "meaning" and "aim" must necessarily be obscured or completely effaced. No matter how well one has understood the *usefulness* of any physiological organ (or, for that matter, legal institution, social custom, political practice, artistic or religious form), one has learnt nothing about its origin in the process. I maintain this view regardless of the discomfort and displeasure it might cause to older ears—since from time immemorial it had been believed that in understanding the ascertainable aims and use of a thing, a form, an institution, one also understood why it had come into existence—thus the eye was understood as made for seeing, the hand as made for grasping. Similarly, punishment had been regarded as having been invented specifically for the purpose of punishing. But all aims, all uses are merely *signs* indicating that a will to power[34] has mastered something less powerful than itself and impressed the meaning of a function upon it in accordance with its own interests. So the entire history of a "thing," an organ, a custom may take the form of an extended chain of signs, of ever-new interpretations and manipulations, whose causes do not themselves necessarily stand in relation to one another, but merely follow and replace one another arbitrarily and according to circumstance. The "development" of a thing, a custom, an organ does not in the least resemble a *progressus*[35] towards a goal, and even less the logical and shortest *progressus,* the most economical in terms of expenditure of force and cost. Rather, this development assumes the form of the succession of the more or less far-reaching, more or less independent processes of over-powering which affect it—including also in each case the resistance marshalled against these processes, the changes of form attempted with a view to defence and reaction, and the results of these successful counteractions. The form is fluid, but the 'meaning' even more so . . . Even within each individual organism the situation is no different: with each essential stage of growth of the whole, the 'meaning'

of the individual organs also changes. Under certain circumstances, the partial destruction or reduction in number of these individual organs (as, for example, through the elimination of connecting members) can be a sign of increasing strength and completion. By this I mean that partial *loss of use,* withering, degeneration, loss of meaning and expediency—in short, death—belongs to the conditions of true *progressus,* and as such always appears in the form of a will and a way to *greater power* and is always implemented at the expense of countless lesser powers. The extent of an "advance" is even *measured* according to the scale of the sacrifice required; the mass of humanity sacrificed to the flourishing of a single *stronger* species of man—now that *would* be progress. . . . I emphasize this central perspective of historical method all the more since it is fundamentally opposed to the prevailing instincts and tastes of the time, which would rather accommodate the absolute arbitrariness, even mechanistic senselessness of all that happens, than the theory of a *will to power* manifesting itself in all things and events. The idiosyncratic democratic prejudice against everything which dominates and wishes to dominate, this modern *misarchism*[36] (to give an ugly name to an ugly development), has gradually disguised itself in the form of intelligence, the greatest intelligence, to the extent that it is now in the process of gradually infiltrating—has now been *allowed* to infiltrate—the most rigorous, and apparently most objective sciences. As far as I can see, it has already succeeded in dominating physiology and the study of life as a whole—to its detriment, as goes without saying—by conjuring away one of its basic concepts, that of essential *activity.* Instead, under pressure from the aforementioned idiosyncratic prejudice, the concept of "adaptation"—a second-order activity, a mere reactivity—has been pushed to the forefront, and even life itself has been defined as an ever-more expedient inner adaptation to external circumstances (Herbert Spencer). But this represents a failure to recognize the essence of life, its *will to power;* this overlooks the priority of the spontaneous, attacking, overcoming, reinterpreting, restructuring and shaping forces, whose action

precedes "adaptation"; this denies even the dominating role of the organism's highest functionaries, in which the vital will manifests itself actively and in its formgiving capacity. Remember what Huxley[37] reproached Spencer with—"administrative nihilism": but what is at issue here is *more* than just "administration."

13

—To return to the subject, to the issue of *punishment,* that is, there are two aspects of the problem to be distinguished: on the one hand, that aspect of punishment which is relatively *enduring*—the custom, the act, the "drama," a certain strict sequence of procedures—and, on the other hand, that aspect which is *fluid*—the meaning, the aim, the expectation which is attached to the execution of such procedures. It is here simply presupposed, *per analogiam,*[38] in accordance with the central perspective of historical method which I have just elaborated, that the procedure itself will be something older, earlier than its use as a means of punishment, and that this use has only been *introduced* or interpreted into the procedure, which, having been in existence for some time, previously had another meaning and use. In short, it is presupposed that things are not as our naïve genealogists of morals and law have previously assumed, thinking as they all do that the procedure was *invented* specifically for the purpose of punishment—just as it was formerly thought that the hand was invented in order to grasp. As for that other element of punishment—the fluid aspect, its "meaning"—in a very late stage of cultural development (as, for example, in contemporary Europe) the concept "punishment" in fact no longer possesses a *single* meaning, but a whole synthesis of "meanings." The whole history of punishment up to this point, the history of its exploitation to the most diverse ends, finally crystallizes in a sort of unity which is difficult to unravel, difficult to analyse, and—a point which must be emphasized—completely *beyond definition.* (Nowadays it is impossible to say *why* people are punished: all concepts in which a whole process is summarized in signs escape definition; only that which is without history can be defined.) In an earlier stage, however, this synthesis of "meanings" seems less tightly bound together and more easily altered; one can still perceive how in each individual case the elements of the synthesis change their value and reorganize themselves accordingly, so that now one, now another element comes to the fore and dominates at the expense of the rest; even how under the right circumstances one element (say, the aim of deterrence) seems to cancel out all the others. In order to give at least an idea of how unsure, how retroactive, how accidental the "meaning" of punishment is, and how one and the same procedure can be used, interpreted, and manipulated according to diametrically opposed intentions, here is the schema which I myself have come up with on the basis of a relatively small and arbitrary sample of material: punishment as a way of rendering harmless, of preventing further damage; punishment as compensation in any form to the victim for the harm done (also in the form of emotional compensation); punishment as the isolation of something which disturbs equilibrium, in order to prevent the disturbance from spreading; punishment as a means of instilling fear of those who determine and exact punishment; punishment as a form of forfeit due in return for the advantages which the criminal previously enjoyed (as, for example, when he is made useful as slave-labour in the mines); punishment as elimination of a degenerate element (in certain circumstances, of a whole branch, as in Chinese law: hence, as a means towards maintaining racial purity or a social type); punishment as festivity, that is, as the violation and humiliation of an enemy finally overcome; punishment as a means of producing a memory, whether for the person on whom the punishment is inflicted—so-called "rehabilitation"—or for those who witness its execution; punishment as the payment of a remuneration stipulated by the power which then protects the wrongdoer from the excesses of revenge; punishment as a form of compromise with the natural condition of revenge, in so far as this state is still maintained by powerful races and claimed as a privilege; punishment as a declaration of war and implementation of a military strategy against an enemy of peace, law, order, authority, who, deemed dangerous to the community and in breach of contract with

regard to its conditions, is combated as a rebel, traitor, and breaker of the peace with the very means offered by war itself.

14

This list is far from exhaustive; punishment is clearly overlaid with all sorts of uses. All the more reason to rule out an *alleged* use, albeit one which is popularly regarded as the most essential—and indeed this is where the faltering belief in punishment nowadays, for a variety of reasons, still finds its strongest support. Punishment is supposed to have the value of awakening the *sense of guilt* in the culprit, it is expected to be the actual *instrumentum*[39] of the psychic reaction which is called "bad conscience," "pangs of conscience." But this is to distort the reality and psychology of the present: and how much more this is the case when it comes to the longest period of human history, its prehistory! Genuine pangs of conscience are especially rare among criminals and prisoners, prisons and jails are far from being the preferred breeding-grounds of this species of gnawing worm—there is agreement on this point among all conscientious observers, who in many cases deliver such a judgement reluctantly enough and against their own wishes. Broadly speaking, punishment hardens and deadens: it concentrates; it intensifies the feeling of alienation; it strengthens resistance. If punishment does happen to sap a man's energy and bring about a wretched prostration and self-abasement, then such a result is certainly even more unpleasant than the average effect of punishment, which is dry and sombre seriousness. But if we bear in mind the *pre*-historical phase of mankind, then we may be quite safe in judging that it is the practice of punishment itself which has most powerfully *hindered* the development of this sense of guilt—at least with respect to the victims on whom the power of punishment is exercised. For let us not underestimate the extent to which the spectacle of the judicial and executive procedures themselves prevent the criminal from feeling his deed, his type of action to be reprehensible *as such*: for he sees exactly the same type of actions performed in the service of justice and as such approved, practised with good conscience:

spying, deception, corruption, entrapment, the whole sly and cunning art of the police and the prosecutor. Not to mention the fundamental theft, assault, insult, imprisonment, torture, murder—practised in this instance as a matter of principle and without mitigating emotional circumstances—which appear in a pronounced manner in the various forms of punishment—all actions now in no way condemned and dismissed *as such* by his judges, but only from a certain perspective and in terms of a certain application. "Bad conscience," this most sinister and most interesting plant of our earthly vegetation, did *not* grow up on this soil—in fact, throughout the longest period of history, those who judge and punish had no consciousness of dealing with a "guilty" man, but rather with someone who causes harm, with an irresponsible piece of fate. And the man himself, on whom punishment subsequently descended, likewise like a piece of fate, experienced in the process no other 'inner suffering' than he might in the event of something unexpected suddenly occurring, of a terrifying natural phenomenon, of an avalanche, against which there is no possibility of defence. . . .

16

At this point, I can no longer avoid giving my own hypothesis as to the origin of "bad conscience" its first, provisional expression: it does not make for easy listening and requires a long period of continuous reflection and consideration, filling waking and sleeping hours. I take bad conscience to be the deep sickness to which man was obliged to succumb under the pressure of that most fundamental of all changes—when he found himself definitively locked in the spell of society and peace. These half-animals who were happily adapted to a life of wilderness, war, nomadism, and adventure were affected in a similar way to the creatures of the sea when they were forced either to adapt to life on land or to perish—in a single stroke, all their instincts were devalued and "suspended." From that moment on they had to walk on their feet and "support themselves," where previously they had been supported by water: a horrific weight bore down on them. The simplest tasks made them feel clumsy, they were without their old guides in this new, unknown world,

the regulating drives with their instinctive certainty—they were reduced, these unfortunate creatures, to thinking, drawing conclusions, calculating, combining causes and effects, to their "consciousness," their most meagre and unreliable organ! I believe that never on earth had there been such a feeling of misery, such leaden discomfort. Nor did the old instincts all of a sudden cease making their demands! Only it was difficult and seldom possible to obey them: for the most part, they had to seek new and, at the same time, subterranean satisfactions for themselves. Every instinct which does not vent itself externally *turns inwards*—this is what I call the *internalization* of man: it is at this point that what is later called the 'soul' first develops in man. The whole inner world, originally stretched thinly as between two membranes, has been extended and expanded, has acquired depth, breadth, and height in proportion as the external venting of human instinct has been *inhibited*. Those fearful bulwarks by means of which the state organization protected itself against the old instincts of freedom—punishment belongs above all to these bulwarks—, caused all the instincts of the wild, free, nomadic man to turn backwards *against man himself*. Hostility, cruelty, pleasure in persecution, in assault, in change, in destruction,—all that turning against the man who possesses such instincts: *such* is the origin of "bad conscience." . . .

17

This hypothesis as to the origin of bad conscience presupposes first that this change was not gradual and voluntary, an organic growth into new conditions, but rather a break, a leap, a compulsion, an irrefutable fate, against which there was no struggle nor even any *ressentiment*. And secondly, that the insertion of a previously unrestrained and unshaped population into a fixed form, just as it began with an act of violence, was only brought to completion through simple acts of violence—that the oldest "state" accordingly emerged and endured as a fearful tyranny, as a crushing and thoughtless machinery, until such a raw material of common people and half-animals was finally not only thoroughly kneaded and malleable but also *formed*. I used the word "state": it goes without saying what I mean by that—some horde or other

of blond predatory animals, a race of conquerors and masters which, itself organized for war and with the strength to organize others, unhesitatingly lays its fearful paws on a population which may be hugely superior in numerical terms but remains shapeless and nomadic. Such is the beginning of the "state" on earth: I think that the sentimental effusion which suggested that it originates in a "contract" has been done away with. He who is capable of giving commands, who is a "master" by nature, who behaves violently in deed and gesture—what are contracts to him! One does not reckon with such beings, they arrive like fate, without motive, reason, consideration, pretext, they arrive like lightning, too fearful, too sudden, too convincing, too "different," even to be hated. Their work is an instinctive creation and impression of form, they are the most involuntary, most unconscious artists there are—wherever they appear, something new quickly grows up, a *living* structure of domination, in which parts and functions are demarcated and articulated, where only that which has first been given a "meaning" with respect to the whole finds a place. The meaning of guilt, responsibility, and consideration is unknown to these born organizers; the fearful egoism of the artist presides in them, with its gaze of bronze and sense of being justified in advance to all eternity in its "work," like the mother in her child. *They* were not the ones among whom "bad conscience" grew up, as goes without saying from the outset—but it would not have grown up *without them,* this ugly weed, it would not exist if, under the force of their hammer-blows, of their artists' violence, a vast quantity of freedom had not been expelled from the world, or at least removed from visibility and, as it were, forcibly made *latent*. This *instinct of freedom* made latent through force—as we have already understood—this instinct of freedom, forced back, trodden down, incarcerated within and ultimately still venting and discharging itself only upon itself: such is *bad conscience* at its origin, that and nothing more.

18

So one should take care not to think any the worse of this entire phenomenon because it is from the outset

ugly and painful. It is basically the same active force as is more impressively at work in the artists of force and organizers who build states. But here, on the inside, on a smaller, meaner scale, in the reverse direction, in the "labyrinth of the breast," to use Goethe's words,[40] it creates for itself a bad conscience and builds negative ideals. It is that very same *instinct of freedom* (in my terminology: the will to power): except that the material on which the form-creating and violating nature of this force vents itself is in this case man himself, the whole of his old animal self—and *not,* as is the case with that greater and more conspicuous phenomenon, the *other* man, *other* men. This secret self-violation, this artistic cruelty, this desire to give a form to the refractory, resistant, suffering material of oneself, to brand oneself with a will, a criticism, a contradiction, a contempt, a No, this sinister labour, both horrific and pleasurable, of a soul voluntarily divided against itself, a soul which makes itself suffer for the pleasure of it, this whole *active* "bad conscience," this actual maternal womb of ideal and imaginative events, has ultimately—as will be clear by now—brought to light much that is new and disturbing in the way of beauty and affirmation, and perhaps even first brought to light beauty *as such.* For what would the meaning of "beautiful" be, if contradiction had not first become conscious of itself, if the ugly had not first said to itself: "I am ugly"? . . .

19

Bad conscience is an illness, there is no doubt about it, but an illness in the same way that pregnancy is an illness. Let us seek the conditions under which this illness has attained its most fearful and most sublime peak—then we will see what actually made its entry into the world at this point. But for that a deep breath is required—and as a first step we must return to an earlier point of view. The private legal relationship between debtor and creditor which we have discussed earlier has been interpreted, in a manner which, when viewed from a historical perspective, strikes one as extremely alien and disturbing, into a relationship where we modern men perhaps have the greatest difficulty in grasping its relevance: that is, into the relationship of the *present generation* to its *forefathers.*

Within the original race-community—we are talking about the very earliest times—the living generation always recognizes a juridical obligation towards the earlier generation, and particularly towards the earliest generation, which founded the race (and this is in no way merely an emotional tie: there may even be grounds to dispute the existence of such a tie as regards the longest period of the history of mankind). Here the conviction prevails that the race only *exists* by virtue of the sacrifice and achievements of the forefathers—and that one is obliged to *repay* them through sacrifice and achievements: a *debt* is recognized, which gnaws incessantly by virtue of the fact that these forefathers, in their continued existence as powerful spirits, never cease to grant the race new advantages and advances in strength. . . . [T]he *fear* of the forefather and of his power, the consciousness of indebtedness towards him necessarily increases in exact proportion as the power of the race itself increases, as the race itself becomes ever-more victorious, independent, respected, feared. And not somehow the other way round! Every step towards the withering of the race, all the arbitrary miseries, all signs of degeneration, of approaching dissolution always rather *reduce* the fear of the spirit of the founder and give rise to an ever-weaker impression of his wisdom, foresight, and powerful presence. If one thinks this crude kind of logic through to its conclusion, then finally the forefathers of the *most powerful* races would have to grow to a monstrous scale in the eyes of an increasingly fearful imagination and retreat into the darkness of what is divinely sinister and inconceivable—ultimately, the forefather is necessarily transfigured into a *god.* Perhaps this is where the gods originate, then—from *fear*!. . . And whoever should deem it necessary to add: "but from piety as well!" would be hard-pressed to justify this as regards the longest period of the history of the human race, the very earliest times. And even more so admittedly as regards the *middle* period, in which the noble races develop themselves—and who as such, in fact, repay their founding fathers, their ancestors (heroes, gods) with interest, in terms of all the qualities which in the meantime have been revealed in themselves, the *noble* qualities. Later we will take another look at the

ennobling and refining of the gods (which is certainly not to be equated with their becoming "holy"). But for the moment let us bring our account of the course of this entire development of the sense of guilt to a provisional conclusion.

20

As history teaches us, the sense of being indebted to the deity by no means came to an end with the decline of the organization of "community" according to kinship. Just as it has inherited the concepts "good and bad" from the nobility of the race (along with its basic psychological propensity to establish hierarchies), mankind has inherited along with the gods of the race and the tribe the burden of its still-outstanding debts and the desire to have them redeemed. . . . The sense of guilt towards the divinity has continued to grow for several thousands of years, and always in the same proportion as the concept and sense of god has grown and risen into the heights. . . . The arrival of the Christian God, as the uttermost example of godliness so far realized on earth, has brought with it the phenomenon of the uttermost sense of guilt. . . .

21

So much briefly by way of a provisional note on the relationship between religious presuppositions and the concepts of "guilt" and "duty." So far, I have deliberately left aside the actual moralization of these concepts (the way these same concepts are pushed back into the conscience; to be more precise, the entanglement of *bad* conscience with the concept of God). . . . The moralization of the concepts guilt and duty, their being pushed back into *bad* conscience, actually represents an attempt to *reverse* the direction of the development just described, or at least to halt its movement. The *goal* now is the pessimistic one of closing off once and for all the prospect of a definitive repayment, the *goal* now is to make the gaze ricochet, recoil inconsolably from an iron impossibility, the *goal* now is to turn those concepts "guilt" and "duty" back—against *whom* then? There can be no doubt: first against the "debtor," in whom from now on bad conscience takes root, eating its way in, spreading

down and out like a polyp, until finally, along with the irredeemability of guilt, the irredeemability of penance, the thought of the impossibility of repayment (of "*eternal* punishment") is conceived. But ultimately these concepts are turned back even against the "creditor," whether one has in mind the *causa prima* of man, the beginning of the human race, its forefather, who is from now on tainted by a curse ("Adam," "original sin," "lack of free will"), or nature, from whose womb man developed and into which from now on the principle of evil is introduced ("demonization of nature"), or existence itself, which survives as *essentially devoid of value* (the nihilistic renunciation of existence, the desire for nothingness or desire for its "opposite," a different way of being, Buddhism and related matters)—until all at once we find ourselves standing in front of the horrific and paradoxical expedient in which tortured humanity has found a temporary relief, that stroke of genius on the part of *Christianity*: God sacrificing himself for the guilt of man, God paying himself off, God as the sole figure who can redeem on man's behalf that which has become irredeemable for man himself—the creditor sacrificing himself for his debtor, out of *love* (are we supposed to believe this?—), out of love for his debtor!

22

Exactly *what* has happened here *underneath* all this will already be clear: the will to self-torture, that downtrodden cruelty of the internalized animal man who has been chased back into himself, of the man locked up in the "state" in order to be tamed, the man who invented bad conscience in order to inflict pain on himself after the *more natural* outlet for this desire to inflict pain was obstructed—this man of bad conscience has assumed control of the religious presupposition in order to carry his self-punishment to the most horrific pitch of harsh intensity. Indebtedness towards *God*: this thought becomes for him an instrument of torture. . . .

24

—I conclude with three question-marks, that much seems clear. "Is an ideal actually being set up or

broken down here?" I may be asked. . . . But have you ever asked yourselves often enough how much the setting up of *every* single ideal on earth has cost? How much reality had to be defamed and denied, how many lies sanctified, how much conscience disturbed, how much "god" sacrificed each time to that end? In order for a shrine to be set up, *another shrine must be broken into pieces*: that is the law—show me the case where it is not so! . . . We modern men, we are the heirs to centuries of the vivisection of conscience and animal self-torture: it is in this that we have our greatest experience, our artistry perhaps, in any case, our refinement, the luxury which vitiates our taste. For all too long man has looked askance at his natural inclinations, with the result that they have ultimately become interwoven with "bad conscience." An attempt at reversal would *in itself* be possible—but who is strong enough to undertake it?—that is, an attempt instead to interweave bad conscience with the *unnatural* inclinations, all those aspirations to the beyond, the absurd, the anti-instinctual, the anti-animal, in short, to what have up to now been regarded as ideals, ideals which are all hostile to life, ideals which defame the world. To whom can one turn today with *such* hopes and demands? The good men are the very people who would oppose it; as would, of course, the comfortable, the reconciled, the vain, the sentimentally effusive, the exhausted men. What is more deeply insulting to them, what isolates us more completely from them than to reveal a glimpse of our self-discipline and self-respect? And again—how accommodating, how kind the whole world shows itself to us, as soon as we behave like everyone else and "let ourselves go" like everyone else! Such a goal would require *different* kinds of spirit than are likely in this period, of all periods: spirits, who, strengthened through wars and victories, have developed a need for conquest, adventure, danger, pain; it would require acclimatization to sharp, high-altitude air, to winter expeditions, to ice and mountains in every sense, it would even require a kind of sublime wickedness, a last, self-assured intellectual malice which belongs to great health, it would require, in short—and which is bad enough—nothing less than

this *great health* itself! . . . Is this still possible even today? But at some time, in a period stronger than this brittle, self-doubting present, he must yet come to us, the *redeemer* of great love and contempt, the creative spirit whose compelling strength allows him no rest in any remote retreat and beyond, a spirit whose seclusion is misunderstood by the common people, as if it were a flight *from* reality—while it is only a further steeping, burrowing, plunging *into* reality, from which he may at some time return to the light, bearing the *redemption* of this reality: its redemption from the curse which the previous ideal has laid upon it. This man of the future, who will redeem us as much from the previous ideal as from *what was bound to grow out of it,* from the great disgust, from the will to nothingness, from nihilism, this midday stroke of the bell, this toll of great decision, which once again liberates the will, which once again gives the earth its goal and man his hope, this Antichristian and Antinihilist, this conqueror of God and of nothingness—*he must come one day.*

25

—But what am I saying here? Enough! Enough! At this point only one thing is fitting, to keep silent: otherwise I would interfere with what only a younger man is at liberty to do, someone "more pregnant with the future," someone stronger than I am—something which only *Zarathustra*[41] is at liberty to do, *Zarathustra the godless.*

THIRD ESSAY

What Is the Meaning of Ascetic Ideals?

Unconcerned, contemptuous, violent—this is how wisdom would have *us* be: she is a woman, she only ever loves a warrior.

—*Thus Spake Zarathustra*[42]

1

What is the meaning of ascetic ideals?—In the case of artists, nothing or too many things; in the case of philosophers and intellectuals, something like an

instinctive sense for the preconditions favourable to higher spirituality; in the case of women, yet *another* seductive charm, a little *morbidezza*[43] in beautiful flesh, the angelic character of a plump and pretty animal; in the case of the deformed and the disgruntled (the *majority* of mortals), an attempt to imagine oneself "too good" for this world, a holy form of dissipation, their principal means in the struggle against chronic pain and boredom; in the case of priests, the distinctive priestly belief, its most effective instrument of power, also the "very highest" licence for power; in the case of saints finally, a pretext for hibernation their *novissima gloriae cupido,*[44] their rest in nothingness ("God"), their form of madness. But *that* the ascetic ideal has meant so many things to man expresses above all the fundamental truth about human will, its *horror vacui:*[45] *it must have a goal—* and it would even will *nothingness* rather than *not* will at all.—Do you follow? . . . Have you been following? . . . "*Certainly not! Sir!*"—Then let us start from the beginning.

2

What is the meaning of ascetic ideals?—Or, to take an individual case on which I am frequently consulted, what does it mean, for example, when an artist like Richard Wagner[46] pays homage to chastity in his old age? In a certain sense, admittedly, he has never done anything else; but only right at the end did he do so in an ascetic sense. What does it mean, this change of "meaning," this radical reversal of meaning?—for it was nothing less than that, and through it Wagner at a single stroke transformed himself directly into his opposite. What does it mean when an artist transforms himself into his opposite in this way? . . .

3

Here admittedly one cannot avoid that other question, the question as to what that manly (oh, so unmanly) "village idiot," that poor devil and country lad Parsifal[47] was to him, Parsifal, whom he finally with such insidious means made Catholic— what? was this Parsifal meant to be taken at all *seriously?* For one might be tempted to suspect, even to wish, the opposite—that Wagner's Parsifal was

meant as a joke, as an epilogue and satyr play,[48] so to speak, with which the tragedian Wagner wanted to take his leave of us, of himself, above all, of *tragedy,* in a fitting and worthy way, that is to say, in an excess of the highest and most mischievous parody of the tragic itself, of the whole horror of earthly seriousness and misery as it has existed from time immemorial, of the *crudest form,* now overcome at last, assumed by the unnatural ascetic ideal. That, as I said, would have been worthy of a great tragedian; he, like all artists, only reaches the peak of his greatness once he is capable of looking *down* on himself and his art—once he is capable of *laughing* at himself. Is Wagner's *Parsifal* his secret superior laughter at himself, the triumph of his achievement of the ultimate, highest artistic freedom, artistic transcendence?

5

—What is the meaning of ascetic ideals, then? In the case of an artist, as we appreciate immediately: they mean *absolutely nothing!* Or so many things as to amount to absolutely nothing! Let us first eliminate the artists. . . . And so we have arrived at the more serious question: what does it mean when the ascetic ideal is acclaimed by a genuine *philosopher,* a real self-reliant spirit like Schopenhauer's,[49] a man and knight with an iron gaze, who has the courage to be himself, who is able to stand alone, and does not wait first for a vanguard, for higher indications? . . . Schopenhauer talks about few things with as much assurance as he does about the effect of aesthetic contemplation: he says of it that it actually counteracts *sexual* "interest," like lupulin and camphor; he never tired of glorifying *this* liberation from the "will" as the great advantage and use of the aesthetic condition. One might even be tempted to enquire whether his fundamental conception of "will and representation," the thought that only "representation" can offer redemption from the "will," did not originate from a generalization of that sexual experience.[50] . . . As long as philosophers have existed on earth, regardless of their location (from India to England, to take the opposite poles of the talent for philosophy), there is no disputing the fact

that they have harboured feelings of irritation and rancour towards sensuality—Schopenhauer is only their most eloquent and, if one has the ears to hear it, also their most exciting and delightful spokesman. Likewise there exists among philosophers a real bias and warmth in favour of the entire ascetic ideal, one should have no illusions about that. Both belong, as I said, to the type; if both are lacking in a philosopher, then he will never be anything more than a "so-called" philosopher—one may be sure of that. What is the *meaning* of this? . . . All animals, including *la bête philosophe*,[51] strive instinctively for an optimum combination of favourable conditions which allow them to expend all their energy and achieve their maximum feeling of power; equally instinctively, and with a fine sense of smell which is "higher than any reason," all animals loathe any kind of trouble-maker or obstacle which either actually obstructs their path to this optimum combination or has the potential to do so (—I am *not* talking here about their path to happiness, but their path to power, to action, to the most powerful action, which is in most cases actually the path to unhappiness). . . . [What] is the meaning of the ascetic ideal for a philosopher? My answer is—as will be clear by now: in beholding the ascetic ideal, the philosopher sees before him the optimum conditions for the highest and boldest spirituality, and smiles—in the process, he does *not* deny "existence," but rather affirms his *own* existence and *nothing but* his own existence, and this perhaps to the extent that he is not far from the sinful wish: *pereat mundus, fiat philosophia, fiat philosophus,* **fiam!**[52]

8

. . . The three splendid slogans of the ascetic ideal are well known: poverty, humility, chastity. Now take a close look at the life of all great, fruitful, inventive spirits—you will always find all three present to some extent. But absolutely *not,* as goes without saying, as if these were "virtues"—what are virtues to this kind of man!—, rather as the most authentic and most natural conditions of their *optimum* existence, their *most beautiful* fruitfulness. In order to achieve this, their domineering

spirituality was very probably forced to bridle an unrestrained and irritable pride or a wilful sensuality, or perhaps struggled to maintain the will to the "desert" against an inclination to the choice and luxurious, not to mention against a profligate generosity of hand and heart. But this domineering spirituality succeeded, being, as it was, the domineering instinct which asserted its demands over all the other instincts,—and it continues to do so; if it did not, it would simply cease to dominate. So there is no question of "virtue" here. . . . Ultimately, they make few enough demands, these philosophers, their motto is: "He who possesses is possessed"—: *not,* as I am obliged to keep repeating, out of virtue, out of a meritorious will to self-sufficiency and simplicity, but rather because their highest master demands this of them, in his wisdom and ruthlessness; their master with his sense for one thing only, accumulating and storing up everything—time, strength, love, interest—only for that. This kind of man dislikes being disturbed by enmities or friendships; he forgets or despises with equal ease. He deems it in bad taste to play the martyr; "to *suffer* for the truth"—he leaves that to the ambitious men and the stage heroes of the spirit and whoever else has the time for it (—the philosophers, on the other hand, are obliged to *do* something for the truth). . . . Let us then explicate the aforementioned case of Schopenhauer in the light of this interpretation: there, the sight of the beautiful obviously operated as a catalytic stimulus to the *principal strength* of his nature (the strength of contemplation and of profound perspicacity); in such a way that the latter then exploded and all at once came to dominate his consciousness. This is not at all to exclude the possibility that the peculiar sweetness and plenitude which characterizes the aesthetic condition might originate in an element of "sensuality" (just as the "idealism" which characterizes sexually mature girls springs from the same source)—sensuality is not cancelled out through the onset of the aesthetic condition, as Schopenhauer believed, but only transfigured and no longer present to consciousness as a sexual stimulus. (I will return to this point of view on another occasion, in connection with the

even more delicate problems of the *physiology of aesthetics,* a field which has so far remained completely untouched and unexplored.)

9

... A serious historical investigation reveals that the link between the ascetic ideal and philosophy is even closer and stronger. ... Philosophy began as all good things do—for a long time it lacked confidence in itself, it looked around constantly to see if someone would come to its aid, even more, it was afraid of everyone who looked its way. Draw up a list of the individual drives and virtues of the philosopher—his drive to doubt, his drive to negate, his drive to wait (his "ephectic"[53] drive), his drive to analyse, his drive to research, to seek, to dare, his drive to compare, to balance, his will to neutrality and objectivity, his will to all *"sine ira et studio"*[54]—: has one even begun to appreciate how, throughout most of their existence, all these drives were in contradiction with the elementary demands of morality and conscience? (not to mention those of *reason* above all, which even Luther liked to call "Mistress Clever, the clever whore"). That a philosopher, *had* he attained consciousness, would necessarily have felt himself to be the embodiment of the *"nitimur in vetitum"*[55]—and consequently took care *not* to "feel himself," *not* to attain consciousness? ... [E]ven if measured according to the criteria of the ancient Greeks, our whole modern being, in so far as it is not weakness but power and consciousness of power, continues to distinguish itself as sheer hubris[56] and godlessness: for throughout most of history it has been the very opposite of the things we honour today which have had conscience on their side and God as their guardian. Today our whole attitude towards nature is one of hubris, our violation of nature with the aid of machines and the thoughtless ingenuity of technicians and engineers. ... [W]e experiment with ourselves in a way which we would never allow ourselves to experiment with any animal, we derive pleasure from our curious dissection of the soul of a living body. What is the "salvation" of the soul to us! We will heal ourselves later: sickness is

instructive, we have no doubt, even more instructive than health. ...

10

... [T]he philosophical spirit has at first always been obliged to disguise and mask itself in the types of the contemplative man *established in earlier times,* that is, as priest, magician, prophet, above all, as a religious man. For a long time, *the ascetic ideal* has served the philosopher as a form in which to manifest himself, as a pre-condition of existence—he was obliged to *represent* it in order to be a philosopher, and he was obliged to *believe* in it in order to be able to represent it. The particular remoteness of the philosophers—with its negation of the world, its hostility to life, its scepticism towards the senses, its freedom from sensuality—which has survived until very recently, and in the process almost gained currency as *the philosophers' attitude* as such—this is above all a consequence of the critical situation in which philosophy first emerged and managed to endure: that is, in so far as throughout most of history philosophy would not have been *at all possible* on earth without an ascetic shell and disguise, without an ascetic self-misunderstanding. To express this clearly in concrete terms: until very recently the ascetic priest has assumed the dark, repulsive form of a caterpillar, the only form in which philosophy was allowed to live, creeping around. Has this really *changed?* Has the bright and dangerous winged creature, the "spirit" which this caterpillar concealed within itself, finally, thanks to a sunnier, warmer, brighter world, really sloughed its cocoon and escaped into the light? Is there enough pride, daring, boldness, self-assurance, enough spiritual will, will to responsibility, *freedom of will* available today for "the philosopher" to be from now on really—*possible* on earth?

11

Only now, once we have the *ascetic priest* in sight, do we begin to approach our problem—what is the meaning of ascetic ideals?—in all seriousness, only now do things begin to get "serious": we find ourselves face to face with none other than the *representative of seriousness* itself. "What is the meaning

of 'in all seriousness?' "—this even more funda-
mental question is by this stage perhaps already
on our lips: a question for physiologists, of course,
but one which we will leave aside for the moment.
This ideal constitutes not only the conviction of the
ascetic priest, but also his will, his power, his inter-
est. His *right* to exist stands and falls with this ideal:
no wonder that we find ourselves confronted with
a fearful opponent—assuming, that is, that we do
oppose this ideal—such an opponent as fights for his
very existence against those who deny the ideal. . . .
The idea at issue in this struggle is the *value* which
the ascetic priests ascribe to our life: they juxtapose
this life (along with what belongs to it, "nature,"
"world," the whole sphere of becoming and the
ephemeral) to a completely different form of exist-
ence, which it opposes and excludes, *unless* it some-
how turns itself against itself, *denies itself.* In which
case, the case of an ascetic life, life functions as a
bridge to that other existence. The ascetic treats life
as a wrong track along which one must retrace one's
steps to the point at which it begins; or as a mistake
which one rectifies through action—indeed, which
one *should* rectify: for he *demands* that one should
follow him, he imposes wherever he can his *own*
evaluation of existence. What does this mean? . . .
For an ascetic life is a contradiction in terms: a par-
ticular kind of *ressentiment* rules there, that of an
unsatisfied instinct and will to power which seeks
not to master some isolated aspect of life but rather
life itself, its deepest, strongest, most fundamental
conditions; an attempt is made to use strength to
dam up the very source of strength; a green and cun-
ning gaze is directed against thriving physiological
growth, especially against its expression, beauty,
joy; while a pleasure is felt and *sought* in failure,
atrophy, pain, accident, ugliness, arbitrary atone-
ments, self-denial, self-flagellation, self-sacrifice.
All this is paradoxical to an extreme: we find our-
selves confronted here with a contradiction which
wills itself as a contradiction, which derives *enjoy-
ment* from this suffering and even becomes increas-
ingly self-assured and triumphant in proportion as
its own pre-condition, the physiological capacity
for life, *diminishes.* "Triumph at the very moment

of ultimate agony": the ascetic ideal has from its
earliest days fought under this superlative sign; in
this seductive enigma, in this image of delight and
suffering, it recognized its brightest light, its salva-
tion, its final victory. *Crux, nux, lux*[57] in the ascetic
ideal they are as one.—

12

. . . But ultimately, and particularly in our capacity
as seekers after knowledge, let us be duly grateful
for such resolute reversals of the usual perspectives
and evaluations, by means of which the spirit has
for all too long raged against itself in an appar-
ently sinful and senseless way: to see differently,
the *desire* to see differently for once in this way
is no small discipline of the intellect and a prepa-
ration for its eventual "objectivity"—this latter
understood not as "disinterested contemplation,"
(which is a non-concept and a nonsense), but as the
capacity to have all the arguments for and against
at one's disposal and to suspend or implement
them at will: so that one can exploit that very *diver-
sity* of perspectives and affective interpretations in
the interests of knowledge. From now on, my dear
philosophers, let us beware of the dangerous old
conceptual fable which posited a "pure, will-less,
painless, timeless knowing subject," let us beware
of the tentacles of such contradictory concepts as
"pure reason," "absolute spirituality," "knowledge
in itself,"—for these always ask us to imagine an
eye which is impossible to imagine, an eye which
supposedly looks out in no particular direction, an
eye which supposedly either restrains or altogether
lacks the active powers of interpretation which
first make seeing into seeing something—for here,
then, a nonsense and non-concept is demanded
of the eye. Perspectival seeing is the *only* kind of
seeing there is, perspectival "knowing" the *only*
kind of "knowing," and the *more* feelings about
a matter which we allow to come to expression,
the *more* eyes, different eyes through which we are
able to view this same matter, the more complete
our "conception" of it, our "objectivity," will be.
But to eliminate the will completely, to suspend the
feeling altogether, even assuming that we could do

so: what? would this not amount to the *castration* of the intellect?

13

But let us return to our problem. It is clear from the outset that such a self-contradiction as the ascetic priest seems to represent, that of "life against life," is, in terms of physiology now rather than psychology, simply nonsense. It can be nothing more than *apparent*; it must be a kind of provisional expression, an interpretation, a formula, a disguise, a psychological misunderstanding of something whose real nature could not be understood and identified for *what it really was*—a mere word, lodged in an old *gap* in human understanding. To contrast this briefly with the actual facts of the matter: *the ascetic ideal is derived from the protective and healing instincts of a degenerating life,* which seeks to preserve itself and fights for existence with any available means; it points to a partial physiological inhibition and fatigue against which those deepest instincts of life which have remained intact struggle incessantly with new means and inventions. The ascetic ideal is such a means: the situation is thus the very opposite of what those who revere this ideal think—in it and through it, life struggles with death and *against* death, the ascetic ideal is a trick played in order to *preserve* life. . . . My point is already clear: this ascetic priest, this apparent enemy of life, this *man of negation*—yes, even he counts among the very great forces which *conserve* and *affirm* life. . . .

15

. . . We must regard the ascetic priest as the predestined saviour, shepherd, and advocate of the sick herd: only then do we begin to understand his tremendous historical mission. The *dominion of the suffering* is his realm, his instinct points him in that direction, there he finds his most authentic art, his mastery, his kind of good fortune. He must himself be sick, he must be fundamentally related to the sick and underprivileged in order to understand them—in order to come to an understanding with them; but he must also be strong, even more a master of himself than of others, with his will to power

virtually unscathed, so that he inspires the trust and fear of the sick, so that he can be for them a support, resistance, aid, compulsion, prison-master, tyrant, god. He has to defend his herd—against whom? Against the healthy, of course, but also against envy of the healthy; he must be the natural opponent *and despiser* of all raw, stormy, unrestrained, hard, violent, predatory health and power. The priest is the prototype of the *more delicate* animal to which contempt comes more easily than hatred. He will be obliged to lead a war against the predators, a war of cunning (of the "spirit") more than violence, as goes without saying—to this end, he may possibly have to develop, or at least *represent,* a new form of the predatory type in himself—a new animal ferocity, in which the polar bear, the supple, cold, and patient tiger, and not least the fox appear bound together in a unity as attractive as it is terrifying. If left with no other choice, he may then emerge among the other kind of predators with bearish seriousness, venerable, wise, cold, deceptively superior, as the vanguard and spokesman of more secret forces, intent on sowing pain, self-division, self-contradiction wherever he can, and only too sure of his skill in mastering *those who suffer* at all times. He brings salves and balsam, there is no doubt; but he needs to wound before he can cure; then, in relieving the pain he has inflicted, *he poisons the wound*—for this is his particular area of expertise, this magician and tamer of predators, in whose circle everything healthy necessarily falls sick and everything sick is tamed. In fact, this strange shepherd defends his sick herd well enough—he defends them against themselves too, against the baseness, spite, malice, and whatever else is particular to all addicts and sick men and which smoulders in the herd itself. . . . If one wanted to sum up the value of the priestly existence as succinctly as possible, one might say straight away: the priest *changes the direction* of *ressentiment.* For every suffering man instinctively seeks a cause for his suffering; more precisely, a doer, more definitely, a *guilty* doer, someone capable of suffering—in short, something living on which he can upon any pretext discharge his feelings either in fact or *in effigie*:[58] for the discharge of feelings

represents the greatest attempt on the part of the suffering man to find relief, *anaesthetic,* his involuntarily desired narcotic against pain of any sort. According to my hypothesis, it is here alone, in a desire to *anaesthetize pain through feeling,* that the real physiological cause of *ressentiment,* of revenge, and related matters is to be found. . . . The suffering are gifted with a horrific readiness and inventiveness in finding pretexts for painful feelings; they even enjoy being suspicious, grumbling over misdeeds and apparent insults, they rummage through the entrails of their past and present in search of dark, questionable stories which allow them to revel in a painful mistrust and to intoxicate themselves on their own malicious poison. . . . "I am suffering: someone must be to blame"—this is how all sickly sheep think. But their shepherd, the ascetic priest, tells them: "Just so, my sheep! someone must be to blame: but you yourself are this someone, you alone are to blame—*you alone are to blame for yourself!*" That is bold enough, false enough: but one thing at least is achieved in the process—through this, as I said, the direction of *ressentiment* is—*changed.*

16

. . . [I]n my view, "spiritual suffering" itself is far from being a fact, but counts only as an interpretation [causal interpretation][59] of sets of facts which have so far resisted precise formulation: as something which continues to float vaguely in the air without any claim to the status of science—really a fat word in place of what is only a question-mark, and a spindly one at that. . . . A stronger man with a better constitution digests his experiences [deeds, misdeeds included], as he digests his meals, even when the food is tough. If he cannot "deal" with an experience, then this kind of indigestion is as much a matter of physiology as the other kind—and is in fact often only one of the consequences of the other kind.—Between ourselves, it is possible to hold such a view and remain the strictest opponent of all materialism.

17

But is he really a *physician,* this ascetic priest? . . . He combats only suffering itself, the listlessness of the suffering man, and *not* their cause, *not* the real sickness—this must be our most fundamental objection to the priestly medication. . . . We ought then to respect the notion of "redemption" in the great religions. But it will not be easy for us to take seriously the way in which these men who are tired of life, too tired even to dream, appreciate *deep sleep*—deep sleep already envisaged mainly as access to the Brahma, as the *attainment of the unio mystica*[60] with God. . . . Nevertheless, here too, as in the case of the notion of "redemption," we should bear in mind that the evaluation expressed here, in however luxurious and exaggerated a manner after the Oriental fashion, is basically no different from that of the clear and cool, Hellenically cool but still suffering Epicurus:[61] the hypnotic feeling of nothingness, the rest of the deepest sleep, *the absence of pain,* in short—the suffering and fundamentally disgruntled hold this as the highest good, as the value of values, they *must* give it a positive value, feel it to be *the* positive as such. (According to the same logic of feeling, nothingness in all pessimistic religions goes by the name of *God.*)

18

More often than this hypnotic dampening of the capacity for pain and of sensibility as a whole—which already presupposes rare strengths, above all, courage, contempt for opinion, "intellectual Stoicism"[62] a different kind of training[63] is tried out against states of depression, one which is in any case easier: *mechanical activity.* There is absolutely no doubt that it brings considerable relief to a life of suffering: this state of affairs is nowadays called, somewhat dishonestly, the "blessing of work." The relief consists in the fact that the interest of the suffering man is completely distracted from his suffering—that nothing enters into consciousness but activity, continual and repeated activity, and thus leaves little room for suffering: for the chamber of human consciousness is *narrow!* An even more highly appreciated means in the struggle against depression is the prescription of a *modest pleasure,* something which is readily attainable and can be made available on a regular basis; this

medication is often used in conjunction with the one just discussed. Pleasure is prescribed as a remedy most frequently in the form of the pleasure of *giving pleasure* (in the form of good deeds, gifts, relief, help, encouragement, consolation, praise, rewarding); in prescribing "love of one's neighbour," the ascetic priest is basically prescribing, albeit in the most careful doses, a stimulus for the strongest, most life-affirming drive—the *will to power.* . . . [T]he *formation of the herd* marks an essential advance and victory in the struggle against depression. With the growth of the community, a new interest is strengthened even in the individual, and often enough raises him above the most personal aspects of his discontent, his aversion from *himself.* . . .

19

. . . [L]et us now turn to the more interesting means, the "guilty" ones. These all involve one thing: some *excess of emotion*—used as the most effective means of anaesthetizing chronic pain and its numbing paralysis. This explains why priests have shown almost inexhaustible ingenuity in exploring the implications of this one question: "*How* is an excess of emotion to be attained?". . . Our intellectuals of today, our "good men," do not tell lies—that much is true; but this does them *not the slightest* credit! The real lie, the genuine, resolute, "honest" lie (on whose value Plato should be consulted) would be something far too severe, too strong for them; it would ask of them what *may not* be asked of them, that they should open their eyes to themselves, that they should know how to distinguish between "true" and "false" with respect to themselves. Only the *dishonest lie*[64] is worthy of them; today, anyone who feels himself to be a "good man" is completely incapable of taking any stance on any matter whatsoever other than one of *dishonest deceit,* deceit which is unfathomable, but innocent, faithful, blue-eyed, and virtuous. These "good men"—they are all now thoroughly moralized, wrecked and ruined to all eternity as far as honesty is concerned: who among them could bear another *truth* about man! Or, in more concrete terms: who among them could bear a *true* biography! . . .

20

. . . *The ascetic ideal employed to stimulate an excess of emotion*—anyone who remembers the preceding essay will already anticipate the essence of what remains to be presented, compressed as it is into these ten words. To tear the human soul loose from its moorings, to immerse it in fear, frost, intense heat, and delight to the point that it breaks free like a bolt of lightning from all the narrowness and pettiness of listlessness, of dullness, of disgruntlement: which paths lead to *this* goal? And which are the most reliable? . . . Fundamentally, every great feeling has this capacity, provided that it is discharged suddenly—wrath, fear, lust, revenge, hope, triumph, despair, cruelty; and the ascetic priest has indeed harnessed for his own designs this *entire* pack of wild dogs, sometimes unleashing this one, sometimes that one, and always to the same end, that is, in order to rouse man from his lethargic sadness, to put to flight, even if only for a time, his dull pain, his miserable hesitation, and always under cover of a religious interpretation and "justification." Each of these excesses of emotion has to be *paid for* afterwards, as goes without saying—each makes the sick man sicker—: and so this kind of remedy for pain is, according to modern criteria, a "guilty" kind. Yet one must, to be fair, insist all the more upon the fact that it is applied in *good conscience,* that the ascetic priest prescribed it in the most profound belief in its usefulness, even its indispensability— and often enough he almost broke himself through the misery which he created. Furthermore, one must insist upon the fact that vehement physiological reactions to such excesses, perhaps even taking the form of mental disturbances, do not ultimately refute the sense of this kind of medication: which, as has been demonstrated earlier, aims not to heal sickness but to combat the listlessness of depression, to alleviate and anaesthetize it. And this goal was indeed attained *by these means.* The masterstroke which the ascetic priest permitted himself in order to play heart-rending and enraptured music of all kinds upon the human soul was—as everyone knows—his exploitation of the *sense of guilt.* The

preceding essay alluded briefly to the origin of this sense of guilt—as a piece of animal psychology, nothing more: there we encountered the feeling of guilt in its raw state, so to speak. Only in the hands of the priest, this real artist in guilty feelings, did it take form—oh what a form! "Sin," for such is the priestly name given to the reinterpretation of animal "bad conscience" (cruelty turned inwards against itself)—has been the greatest event so far in the history of the sick soul: it represents the most dangerous and fateful trick of religious interpretation. Man, suffering from himself in some way, suffering physiologically in any case, like an animal locked in a cage, uncertain as to why and wherefore, desiring reasons—reasons are a relief—desiring means and narcotics, finally consults someone who is also acquainted with hidden things—and behold! he receives a hint, he receives from a magician, from the ascetic priest, the first hint as to the "cause" of his suffering: he is to seek it in *himself,* in some *guilt,* in a piece of the past, he should understand his suffering itself as a *state of punishment....* And by means of this system of procedures the old depression, lethargy, and fatigue was indeed thoroughly *overcome,* life became *very* interesting once again: awake, eternally awake, sleepless, glowing, charred, exhausted and yet not tired—this was what distinguished the man, the "sinner" who had been initiated into *these* mysteries. This great old magician struggling against listlessness, the ascetic priest—he had obviously succeeded, *his* kingdom had come: no longer did one lament pain, one *craved* pain; "*more* pain! *more* pain!," his disciples and initiates have for centuries cried yearningly. Every painful excess of emotion, everything which shattered, overturned, crushed, transported, enraptured, the secret of the torture-chambers, the ingenuity of hell itself—all this from now on lay uncovered, surmised, exploited, all this stood at the disposal of the magician, all this served the end of the victory of his ideal, the ascetic ideal.... "My kingdom is not of *this* world"[65] he said as before; was he really entitled to say this? Goethe asserted that there were only thirty-six tragic situations:[66] from this one could guess, if one did not already know, that Goethe was no ascetic priest. For the ascetic priest—*he* knows more.

21

To indulge in criticism of *this* kind of priestly medication, the "guilty" kind, in its entirety is an idle pastime. Who would wish to maintain that such an excess of emotion as the ascetic priest usually prescribes to his sick men (under the holiest name, as goes without saying, and likewise thoroughly steeped in the holiness of his goal), was ever of actual *benefit* to any of them? We should agree at least as to what is meant by "benefit." If one wishes to suggest that such a system of treatment has *improved* man, I will not dispute that: I would only add what I understand by "improved"—much the same as "tamed," "weakened," "discouraged," "refined," "pampered," "emasculated" (much the same, then, as *damaged*). But when it is administered to the sick, the disgruntled, and the depressed, then such a system always makes the sick man *sicker,* even if it makes him "better"; one should ask the psychiatrists what happens when the torture of repentance, remorse, and cramps of redemption are methodically administered. One should consult history too; wherever the ascetic priest has implemented this treatment of the sick, sickness has always spread and deepened with sinister speed. What has been the constant sign of its "success"? A ruined nervous system in addition to what was otherwise already sick; and that on the largest and on the smallest scale, for the individual as for the masses.... Broadly speaking, the ascetic ideal and its cult of sublime morality, this most ingenious, most unscrupulous, and most dangerous systematization of all the means towards excess of emotion concealed beneath the cloak of holy intentions, has thus carved its fearful and unforgettable inscription into the whole history of mankind; and, unfortunately, into *more* than just its history....

23

The ascetic ideal expresses a will: *where* is the opposing will which expresses an *opposing ideal?* The ascetic ideal has a *goal*—and this goal is sufficiently

universal for all other interests of human existence to seem narrow and petty in comparison; it relentlessly interprets periods, peoples, men in terms of this goal, it allows no other interpretation, no other goal, it reproaches, negates, affirms, confirms exclusively with reference to *its* interpretation (—and has there ever existed a system of interpretation more fully thought through to its end?); it subordinates itself to no other power, it believes rather in its prerogative over all other powers, in its absolute *seniority of rank* with respect to all other powers—it believes that no power can exist on earth without first having had conferred upon it a meaning, a right to existence, a value as an instrument in the service of *its* work, as a path and means to *its* goal, to its *single* goal. Where is the opposition to this closed system of will, goal, and interpretation? Why does no opposition *exist?* Where is the *other* "*single* goal"? But I am told that such opposition does *exist,* that it has not only fought a long and successful campaign against that ideal but has even already overcome it in all important respects: the whole of our modern *science*[67] supposedly bears witness to this fact—this modern science, which, as a genuine philosophy of reality, clearly believes only in itself, clearly possesses the courage to be itself, the will to itself, and has managed well enough up to now without God, the beyond, and the virtues of denial. However, such noisy agitators' chatter has no effect on me: these trumpeters of reality are bad musicians, it is clear from the sound they make that their voices do *not* rise up from the depths, that the abyss of the scientific conscience—for today the scientific conscience is an abyss—does *not* speak through them, that the word "science" in the mouths of such trumpeters is simply an obscenity, an abuse, an example of impudence. The very opposite of what is being asserted here is the truth: science today has simply *no* belief in itself, let alone an ideal *above* it—and where it survives at all as passion, love, glowing intensity, *suffering,* it constitutes not the opposite of the ascetic ideal but rather *its most recent and most refined form.* Does that sound alienating to you?. For there are enough good and modest working folk even among today's scholars, who are content in their little corner and, because they are content

there, sometimes a little presumptuously voice the demand that in general one *should* be content with things today, particularly in science, where so many useful things remain to be done. I do not dispute this; the last thing I would want to do is to spoil the enjoyment which these honest workers take in their craft: for their work gives me pleasure. But the fact that there is disciplined work being done in science and that there are contented workers *fails* to prove that today science as a whole has a goal, a will, an ideal, a passion of great conviction. The opposite, as I said, is the case: where it is not the most recent manifestation of the ascetic ideal—the instances involved here are too few, refined, and exceptional to refute the general case—science today is a *hiding-place* for all kinds of discontent, lack of conviction, gnawing worm, *despectio sui,*[68] bad conscience—it is none other than the *restlessness* which results from lack of ideals, a form of suffering from a *lack* of any great love, from dissatisfaction with an *involuntary* temperance. Oh what does science not conceal today! how much, at least, it is *supposed* to conceal! The diligence of our best scholars, their heedless industry, the smoke rising from their heads by day and night, their mastery of the craft itself—how often the real meaning of all this consists in keeping something hidden from oneself! Science as a means of self-anaesthesis: *are you familiar with that?.* Anyone who keeps the company of scholars has had on occasion the experience of wounding them to the quick with a harmless word, one embitters and alienates one's scholar friends at the very moment of intending to honour them, one throws them into a wild rage simply because one is too insensitive to realize with whom one is actually dealing, with men who *suffer* but refuse to admit as much to themselves, with anaesthetized and insensate men who fear one thing only: *being brought to consciousness.* . . .

24

We "seekers after knowledge" are suspicious of virtually every kind of believer; our mistrust has gradually taught us to infer the opposite of what was previously inferred: wherever the strength of a belief

comes clearly to the fore, we assume a certain weakness in the proof, even a certain *improbability* in what is believed. It is not that we deny that belief "makes one blessed": *this is the very reason* why we deny that belief *proves* anything—a strong belief which "makes one blessed" arouses suspicion of what is believed, it does not establish "truth," it establishes a certain probability—of *illusion*. How do things stand in the present case?—These deniers and outsiders of today, these absolutists in a single respect—in their claim to intellectual hygiene—these hard, severe, abstemious, heroic spirits, who constitute the pride of our age, all these pale atheists, anti-Christians, immoralists, nihilists, these spiritual sceptics, ephectics, *hectic* ones (for this is what they all are in some sense or other); these last idealists of knowledge, these men in whom the intellectual conscience is alone embodied and dwells today—they believe themselves to be as free as possible from the ascetic ideal, these "free, *very* free spirits": and yet, if I may reveal to them what they themselves cannot see—for they are too close to themselves—: this self-same ideal is *their* ideal too, they themselves are perhaps its sole representatives today, they themselves are its most spiritualized product, its most advanced party of warriors and scouts, its most insidious, most delicate, least tangible form of seduction—if I am in anything a solver of enigmas, then let me be so now with *this* proposition! These men are far from *free* spirits: *for they still believe in the truth!*. . . . But what *compels* these men to this absolute will to truth, albeit as its unconscious imperative, is the *belief in the ascetic ideal itself*—make no mistake on this point—it is the belief in a *metaphysical* value, the value of *truth in itself,* as it alone is guaranteed and attested in each ideal (it stands or falls with each ideal). Strictly speaking, there is absolutely no science "without presuppositions," the very idea is inconceivable, paralogical: a philosophy, a "belief" must always exist first in order for science to derive from it a direction, a meaning, a limit, a method, a *right* to existence. . . . [U]p to now the ascetic ideal has *dominated* all philosophy, because truth was posited as being, as God, as the highest instance itself, because it was *not permitted* that truth should be a problem. Is this "permitted" understood?—From the moment when belief in

the God of the ascetic ideal is denied, *a new problem exists*: that of the *value* of truth.—The will to truth requires critique—let us define our own task in this way—the value of truth must for once, by way of experiment, be *called into question.* . . .

25

No! Do not come to me with science when I am looking for the natural antagonist of the ascetic ideal, when I ask: "Where is the opposing will, which expresses its *opposing ideal?*" It is a long time since science has been independent enough for that, it first requires a value-ideal, a value-creating power, in whose service it is *allowed to believe* in itself—it never creates values itself. Its relationship to the ascetic ideal is in itself by no means antagonistic; rather, for the most part, it provides the impetus for the latter's inner development. On closer scrutiny, its contradiction and struggle does not refer at all to the ascetic ideal itself, but only to its outworks, its disguise, its play of masks, to its occasional tendency to become rigid, wooden, and dogmatic—science sets the life within it free once again by denying what is exoteric to it. These two, science and the ascetic ideal, share the same foundation—I have already indicated as much—: that is, the same overestimation of the truth (more accurately: the same belief that the truth is *above* evaluation and criticism). They are, then, *necessarily* allies—so that, if they are to be resisted, they must be resisted and called into question together. A depreciation of the ascetic ideal inevitably entails a depreciation of science: keep your eyes and ears open for occasional indications of this! (*Art,* let me say in advance, for I will at some stage return to this idea at greater length—art, in which the *lie* is sanctified and the *will to deceive* has good conscience on its side, is much more fundamentally opposed to the ascetic ideal than science: Plato, the greatest enemy of art which Europe has so far produced, felt this instinctively. Plato versus Homer: that is the complete, the real antagonism—on one side, the sincerest "man of the beyond," the philosopher who most defames life; on the other, the poet who involuntarily deifies it, the *golden* nature. The artist in the service of the ascetic ideal is therefore the most essential

corruption of the artist possible, and unfortunately one of the most common: for nothing is more venal than an artist.) Even when examined from the point of view of physiology, science rests on the same foundation as the ascetic ideal: both presuppose a certain *impoverishment of life*—a cooling of the feelings, a slowing of the tempo, dialectic in place of instinct, the impression of *seriousness* upon face and gesture (seriousness, the most unmistakable sign of a straining metabolism, of an increasingly arduous struggle for life). . . . Is man perhaps *less in need* of a transcendental solution to his enigmatic existence now that this existence seems more conspicuously random, idle, and dispensable within the *visible* order of things? Is the very self-belittlement of man, his *will* to self-belittlement since Copernicus,[69] not continuing its inexorable progress? Oh, the belief in his worth, uniqueness, irreplaceability in the chain of being is a thing of the past—he has become an animal, an animal in the literal sense, without qualification or reservation, he, who previously believed himself almost a god ("child of God," "demigod"). Since Copernicus, man seems to have been on a steep slope—from now on he rolls faster and faster away from the centre—in what direction? towards nothingness? towards the "*piercing* feeling of his nothingness"? Well now! and is this not the very path which leads directly back—to the *old* ideal?. . . .

26

—Or perhaps modern historiography as a whole displays an attitude which is more certain of life, more certain of the ideal? Its most refined aspiration now is to the status of *mirror*; it rejects all teleology; it no longer has the slightest desire to "prove" anything; it disdains the opportunity of playing the judge and deems this a matter of good taste—it affirms as little as it denies, it ascertains, it "describes." All this is ascetic to a high degree; but it is at the same time and to an even higher degree *nihilistic,* make no mistake! . . .

27

My exclusive concern here has been to indicate that, even in the spiritual sphere, there is still only one kind of enemy who is capable of causing the ascetic ideal real *harm*: those play-actors who act out this ideal—for they arouse suspicion. Otherwise, wherever the spirit is at work today, severe, powerful, and without forgery, it dispenses completely with this ideal—the popular term for this abstinence is "atheism"—*except for its will to truth*. But this will, this *remnant* of the ideal, is, if one is willing to believe me, the strictest, most spiritual formulation of the ideal itself, absolutely esoteric, stripped of all outworks—not so much its remnant, then, as its *core*. Absolute, honest atheism (—and *this* is the only air which we more spiritual men of this age breathe!) is *not* the antithesis of the ideal which it appears to be; it is rather only one of the last phases of its development, one of its ultimate forms and inner consequences—it is an awe-inspiring *catastrophe,* the outcome of a two-thousand-year training in truthfulness, which finally forbids itself the *lie of belief in God.* . . . All great things are the cause of their own destruction, through an act of self-cancellation: the law of life, the law of *necessary* "self-overcoming" which is the essence of life, wills it so—ultimately, the call goes out to the legislator himself: "*patere legem, quam ipse tulisti*"[70] In this way, Christianity *as dogma* was destroyed by its own morality; in this way, Christianity *as morality* must now be destroyed—we are standing on the threshold of *this* very event. After Christian truthfulness has drawn one conclusion after another, it finally draws its *strongest conclusion,* its conclusion *against* itself; this will occur when it asks the question: "*What is the meaning of all will to truth?*". And here again I touch on my problem, on our problem, my *unknown* friends (—for as yet I *know* of no friend): what meaning would *our* whole being possess, if we were not those in whom this will to truth becomes conscious of itself as a *problem?* There is no doubt that from now on morality will be *destroyed* through the coming to consciousness of the will to truth: this is the great drama in a hundred acts which is reserved for Europe over the next two thousand years, the most fearful, most questionable and perhaps also most hopeful of all dramas. . . .

28

If we put aside the ascetic ideal, then man, the *animal* man, has had no meaning up to now. His existence on earth has lacked a goal: "why does man exist at all?"—was a question without an answer; the *will* for man and earth was missing; behind every great human destiny rang the even greater refrain: "In vain!" For the meaning of the ascetic ideal is none other than *this*: that something was missing, that man was surrounded by a gaping *void*—he did not know how to justify, explain, affirm himself, he *suffered* from the problem of his meaning. He suffered in other ways too, he was for the most part a *sickly* animal: his problem, however, was *not* suffering itself, but rather the absence of an answer to his questioning cry: "*Why* do I suffer?" Man, the boldest animal and the one most accustomed to pain, does *not* repudiate suffering as such; he *desires* it, he even seeks it out, provided that he has been shown a *meaning* for it, a *reason* for suffering. The meaninglessness of suffering, and *not* suffering as such, has been the curse which has hung over mankind up to now—*and the ascetic ideal offered mankind a meaning!* As yet, it has been the only meaning; and any meaning is better than no meaning; in every respect, the ascetic ideal has been the best "*faute de mieux*"[71] so far. It *explained* suffering; it seemed to fill the gaping void; the door was closed against all suicidal nihilism. The explanation—there is no doubt—brought new suffering with it, deeper, more internal, more poisonous, gnawing suffering: it brought all suffering under the perspective of *guilt*. But in spite of all this—or thanks to it—man was *saved,* he had a meaning, from now on he was no longer like a leaf in the wind, a plaything of absurdity, of the absence of meaning, from now on he was able to *will* something—it did not matter at first to what end, why, and with what means he exercised his will: *the will itself was saved.* We can no longer conceal from ourselves *what* this willing directed by the ascetic ideal actually expresses in its entirety: this hatred of the human, and even more of the animal, of the material, this revulsion from the senses, from reason itself, this fear of happiness and beauty, this yearning to pass beyond all appearance, change, becoming, death, desire, beyond yearning

itself. All this represents—may we be bold enough to grasp this—a *will to nothingness,* an aversion to life, a rebellion against the most fundamental preconditions of life, but which is and remains none the less a *will*! And, to say once again in conclusion what I said at the beginning: man would rather will *nothingness* than *not* will at all.

Notes

1. *Tartufferie*: hypocrisy, with reference to the play *Tartuffe* (1664) by the French comic dramatist Moliére. The protagonist is a religious hypocrite.
2. *English psychologists*: this is an umbrella term which Nietzsche uses to designate empiricist psychology (Locke), Utilitarian ethics (Mill and Bentham), and the evolutionary theory of development (Darwin), all associated in his view with the science and scholarship of Victorian England.
3. *pathos of distance*: Nietzsche's term for the difference between the noble and the servile, referring both to differences in social status and values.
4. *désintéressé*: French: disinterested. An allusion to the Kantian postulation of disinterested and universal ethical principles.
5. *Herbert Spencer*: (1820–1903), English philosopher, psychologist and sociologist. Anticipating Darwin, Spencer combined evolutionary theory with Utilitarianism in his analysis of ethics. On this basis, that which preserves or is useful to life is deemed good.
6. *etymological perspective*: the etymological investigation of ethical terms is central to Nietzsche's genealogy of morals. Typically, Nietzsche uses etymology to trace the "original" meaning of ethical vocabulary and thus provide "historical" support for his assertion of the priority of noble over slave morality. As a result, Nietzsche's etymologies are often speculative and tendentious.
7. *arya*: Sanscrit for "Aryan."
8. *Theognis*: Greek poet (*c.* 500 BC), the subject of an article written by Nietzsche while still a student.
9. *esthlos*: Greek: good; brave, stout; noble; well-bred; morally good, faithful; fortunate, lucky.
10. *bonus*: Latin: good.
11. *bellum*: Latin: war.
12. *who inherited this Jewish transvaluation*: i.e. Christ and Christianity. It is important to realize the extent to which Nietzsche indiscriminately identifies Platonism,

Judaism, and Christianity as transcendentalizing doctrines which depreciate the actual life. Nietzsche is not anti-Semitic, but anti-idealist, anti-transcendentalist.

13. *sub hoc signo*: Latin: under this sign. Reworking of the motto which the Christian Emperor Constantine I had inscribed on the cross, "*In hoc signo vinces*" ("in this sign you will triumph"). In Nietzsche's version, which changes the prefix and drops the verb of the original, the cross becomes a symbol of submissiveness rather than of future triumph.

14. *ressentiment*: French: resentment. A central concept in Nietzsche's argument, *ressentiment* is the essence of slave morality, a purely reactive mode of feeling which simply negates the active and spontaneous affirmation of values on the part of the nobility.

15. *Mirabeau*: Honoré Gabriel de Riqueti, Comte de Mirabeau (1749–91). French politician and writer, president of the National Assembly in 1791.

16. "*love of one's enemy*": allusion to Matthew 5: 43–4—"Ye have heard that it hath been said, Thou shalt love thy neighbour, and hate thine enemy.—But I say unto you, Love your enemies, bless them that curse you, do good to them that hate you, and pray for them that despitefully use you, and persecute you."

17. *blond beast*: one of Nietzsche's most notoriously misread images, the "blond beast" refers to a predatory animal, probably a lion, metaphorically associated with the ruthless representatives of aristocratic morality. As the development of the passage makes clear, the image carries no specific racial connotations and is not a reference to supposed Aryan supremacy.

18. "*subject*": in grammar, the part of speech of which something is predicated; in epistemology, the ground of knowledge, the knowing subject.

19. *atom*: according to the physicist Ernst Mach (1836–1916), the atom was an ideal mental construct rather than something which really existed.

20. *Kantian "thing in itself"*: reference to Kant's distinction in the *Critique of Pure Reason* between phenomenal appearance (*Erscheinung*) and noumenal essence (*Ding an sich*). According to Kant, the essence or thing in itself is beyond human knowledge, which is limited to phenomenal appearance.

21. *stood convicted . . . mankind*: quotation from Tacitus, *Annals,* xv. 14.

22. *however much literary forgery . . . to bring it about*: allusion to the questionable attribution of the Gospel of St John and the Book of Revelation to the same author.

23. *vis inertiae*: Latin: force of inertia.

24. *tabula rasa*: Latin: blank slate, tablet. Image used by the English empiricist John Locke to describe the mind prior to the imprint of sense impressions.

25. *faire le mal pour le plaisir de le faire*: French: doing evil for the pleasure of it. Quotation from Prosper Mérimée, *Lettres à une inconnue* (1874).

26. *les nostalgies de la croix*: French: nostalgia for the cross.

27. *manas*: Veda Sancrit: consciousness.

28. *the criminal is above all someone who "breaks" . . . breaks his word*: Nietzsche here is punning on the cognate forms of *Verbrecher* (criminal) and brechen (to break).

29. *mimus*: Latin: image, imitation.

30. *Vae victis!*: Latin: Woe to the defeated. Quotation from the Roman historian Livy, *Ab Urbe Condita,* v. xlviii. 9.

31. *compositio*: Latin: comparison; amicable settlement of legal case. Technical term from Roman law.

32. *E. Dühring*: Eugen Karl Dühring (1833–1921), philosopher and political economist. Dühring defended a positivist, mechanistic view of evolution determined by teleological ends.

33. *causa fiendi*: Latin: initial cause, origin. Opposite of *causa finalis,* final cause.

34. *will to power*: a central concept in Nietzsche's work, the immanent principle of domination and appropriation which informs all life, even that which appears to oppose it.

35. *progressus*: Latin: progress, advance.

36. *misarchism*: neologism meaning: hatred of power or mastery (from Greek: *missein,* to hate; *archein,* to rule).

37. *Huxley*: Thomas Henry Huxley (1825–95), English biologist and supporter of Darwin, whose ideas he helped popularize.

38. *per analogiam*: Latin: by analogy.

39. *instrumentum*: Latin: instrument.

40. "*labyrinth of the breast," to use Goethe's words*: quotation from Goethe's poem "To the Moon" (*An den Mond*).

41. *Zarathustra*: central character of *Thus Spake Zarathustra,* Nietzsche's work based on the Persian founder of Zoroastrianism. According to Nietzsche, Zoroaster was the first to introduce dualism (good/evil, immanence/transcendence) into religion, and will thus be the first to overcome them, in the guise of Zarathustra.

42. [Epigraph]: quotation from *Thus Spake Zarathustra,* I: "On Reading and Writing." The figure of truth or wisdom as a woman is common in Nietzsche's later works.

43. *morbidezza*: Italian: softness, sickliness.

44. *novissima gloriae cupido*: Latin: the most recent desire for fame. Allusion to Tacitus, *Histories,* iv. 6.

45. *horror vacui*: Latin: the horror of a vacuum; the dislike of empty space.

46. *Richard Wagner*: (1813–83), German composer.

47. *Parsifal*: eponymous hero of Wagner's opera of 1882, based on Wolfram von Eschenbach's *Parzival* (*c*.1210). Parsifal, having spent his childhood in seclusion in a forest, frees King Amfortas from the spell of diabolic sorcerer Klingsor through the power of compassion.

48. *satyr play*: in ancient Greece, the performance of tragedies at the Dionysian festivals was followed by the performance of a comic satyr play.

49. Schopenhauer: Arthur Schopenhauer (1788–1860), German philosopher. Instrumental in introducing Eastern ideas into the Western philosophical tradition, he held that human desire and will are doomed to frustration and that serenity can be attained only through the self-cancellation of the will. This conviction forms the basis for his ethics.

50. *originate from a generalization of that sexual experience*: without using the term (which he uses elsewhere in a similar context), Nietzsche here sketches out a theory of what Freud was later to call sublimation, the channelling of libidinal energy into cultural activity.

51. *la bête philosophe*: French: the philosophical animal, a pun on the dual meaning of *bête* (animal/stupid).

52. *pereat mundus, fiat philosophia, fiat philosophus, fiam!*: Latin: May the world perish, let there be philosophy, let there be the philosopher, let there be I!

53. *"ephectic"*: hesitating. Ephectics (Greek: the hesitating ones) was the nickname given to the Sceptics, who were perceived as withholding their judgement on whatever issue was under discussion.

54. *"sine ira et studio"*: Latin: with neither anger nor enthusiasm.

55. *"nitimur in vetitum"*: Latin: we strive after what is forbidden. Quotation from Ovid, *Amores,* III. iv. 7.

56. *hubris*: Greek: overweening pride. In tragedy, the flaw which brings about the protagonist's downfall (nemesis).

57. *crux, nux, lux*: Latin: "cross, nut, light."

58. *in effigie*: Latin: in effigy, in the form of an image.

59. [causal interpretation]: these square brackets are Nietzsche's.

60. *unio mystica*: Latin: mystical union.

61. *Epicurus*: Despite his popular association with hedonism, Epicurus's atomism actually led him to advocate imperturbability (the Greek *ataraxie*) as the highest virtue in face of the ephemeral nature of all things.

62. *Stoicism*: doctrine of the Stoics, a school of philosophers founded by Zenon of Kition around 300 BC. Its morality was based on the rational laws of nature, involving the unflinching acceptance of what they produced.

63. *training*: in English in the original.

64. *dishonest lie*: possible allusion to Plato's "noble lie" in *Republic,* 414c.

65. *"My kingdom is not of this world"*: John 18: 36.

66. *Goethe . . . thirty-six tragic situations*: see the *Conversations with Eckermann,* 14 Feb. 1830.

67. *the whole of our modern science*: In the extended discussion of "science" which follows, Nietzsche seems at times to be referring to the natural sciences in general, and at others exclusively to contemporary positivist historiography, which sought to place the discipline of history on a scientific basis. As a result, certain passages are ambiguous.

68. *despectio sui*: contempt for oneself.

69. *Copernicus*: Nicolas Copernicus (1473–1543), astronomer who replaced the earlier geocentric model of the universe with a heliocentric one.

70. *"patere legem, quam ipse tulisti"*: Latin: submit to the law which you yourself have decreed.

71. *"faute de mieux"*: French: for want of something better.

Study Questions

1. Explain in your own words Nietzsche's distinction between slave and master morality.

2. Does master morality have any place for concern about others?

3. If God exists, is master morality pointless?

4. If God does not exist, is slave morality pointless?

15

JOHN DEWEY

John Dewey (1859–1952) was the leading American philosopher of the first half of the twentieth century. He viewed ethical judgments neither as mere expressions of emotion nor revelations of a transcendent order but rather statements of human ideals, emerging from and verifiable in experience. What is desired may not prove desirable, once consideration is given both to the means needed to achieve the ends and the consequences of the ends themselves. Thus valuations can be tested empirically, and doing so systematically is the key to enhancing human welfare.

Theory of Valuation

I. ITS PROBLEMS

A skeptically inclined person viewing the present state of the discussion of valuing and values might find reason for concluding that a great ado is being made about very little, possibly about nothing at all. For the existing state of discussion shows not only that there is a great difference of opinion about the proper theoretical interpretation to be put upon facts, which might be a healthy sign of progress, but also that there is great disagreement as to what the facts are to which theory applies, and indeed whether there are any facts to which a theory of value can apply. For a survey of the current literature of the subject discloses that views on the subject range from the belief, at one extreme, that so-called "values" are but emotional epithets or mere ejaculations, to the belief, at the other extreme, that a priori necessary standardized, rational values are the principles upon which art, science, and morals depend for their validity.

And between these two conceptions lies a number of intermediate views. The same survey will also disclose that discussion of the subject of "values" is profoundly affected by epistemological theories about idealism and realism and by metaphysical theories regarding the "subjective" and the "objective."

Given a situation of this sort, it is not easy to find a starting-point which is not compromised in advance. For what seems on the surface to be a proper starting-point may in fact be simply the conclusion of some prior epistemological or metaphysical theory. Perhaps it is safest to begin by asking how it is that the problem of valuation-theory has come to bulk so largely in recent discussions. Have there been any factors in intellectual history which have produced such marked changes in scientific attitudes and conceptions as to throw the problem into relief?

When one looks at the problem of valuation in this context, one is at once struck by the fact that the sciences of astronomy, physics, chemistry, etc.,

do not contain expressions that by any stretch of the imagination can be regarded as standing for value-facts or conceptions. But, on the other hand, all deliberate, all planned human conduct, personal and collective, seems to be influenced, if not controlled, by estimates of value or worth of ends to be attained. Good sense in practical affairs is generally identified with a sense of relative values. This contrast between natural science and human affairs apparently results in a bifurcation, amounting to a radical split. There seems to be no ground common to the conceptions and methods that are taken for granted in all physical matters and those that appear to be most important in respect to human activities. Since the propositions of the natural sciences concern matters-of-fact and the relations between them, and since such propositions constitute the subject matter acknowledged to possess preeminent scientific standing, the question inevitably arises whether scientific propositions about the direction of human conduct, about any situation into which the idea of *should* enters, are possible; and, if so, of what sort they are and the grounds upon which they rest.

The elimination of value-conceptions from the science of non-human phenomena is, from a historical point of view, comparatively recent. For centuries, until, say, the sixteenth and seventeenth centuries, nature was supposed to be what it is because of the presénce within it of *ends*. In their very capacity as ends they represented complete or *perfect* Being. All natural changes were believed to be striving to actualize these ends as the goals toward which they moved by their own nature. Classic philosophy identified *ens, verum,* and *bonum,* and the identification was taken to be an expression of the constitution of nature as the object of natural science. In such a context there was no call and no place for any *separate* problem of valuation and values, since what are now termed values were taken to be integrally incorporated in the very structure of the world. But when teleological considerations were eliminated from one natural science after another, and finally from the sciences of physiology and biology, the problem of value arose as a separate problem.

If it is asked why it happened that, with the exclusion from nature of conceptions of ends and of striving to attain them, the conception of values did not entirely drop out—as did, for example, that of phlogiston—the answer is suggested by what has been said about the place of conceptions and estimates of value in distinctively human affairs. Human behavior *seems* to be influenced, if not controlled, by considerations such as are expressed in the words "good-bad," "right-wrong," "admirable-hideous," etc. All conduct that is not simply either blindly impulsive or mechanically routine seems to involve valuations. The problem of valuation is thus closely associated with the problem of the structure of the sciences of *human* activities and *human* relations. When the problem of valuation is placed in this context, it begins to be clear that the problem is one of moment. The various and conflicting theories that are entertained about valuation also take on significance. For those who hold that the field of scientifically warranted propositions is exhausted in the field of propositions of physics and chemistry will be led to hold that there are no genuine value-propositions or judgments, no propositions that state (affirm or deny) anything about values capable of support and test by experimental evidence. Others, who accept the distinction between the nonpersonal field and the personal or human field as one of two separate fields of existence, the physical and the mental or psychical, will hold that the elimination of value-categories from the physical field makes it clear that they are located in the mental. A third school employs the fact that value-expressions are not found in the physical sciences as proof that the subject matter of the physical sciences is only partial (sometimes called merely "phenomenal") and hence needs to be supplemented by a "higher" type of subject matter and knowledge in which value-categories are supreme over those of factual existence.

The views just listed are typical but not exhaustive. They are listed not so much to indicate the theme of discussion as to help delimit the central problem about which discussions turn, often, apparently, without being aware of their source; namely, the problem of the possibility of genuine propositions about the direction of human affairs. Were it possible, it would probably be desirable to discuss this problem with a minimum of explicit reference

to value-expressions. For much ambiguity has been imported into discussion of the latter from outside epistemological and psychological sources. Since this mode of approach is not possible under existing circumstances, this introductory section will conclude with some remarks about certain linguistic expressions purporting to designate distinctive value-facts.

1. The expression "value" is used as a verb and a noun, and there is a basic dispute as to which sense is primary. If there are things that are values or that have the property of value apart from connection with any activity, then the verb "to value" is derivative. For in this case an act of apprehension is called valuation simply because of the object it grasps. If, however, the active sense, designated by a verb, is primary, then the noun "value" designates what common speech calls a *valuable*—something that is the object of a certain kind of activity. For example, things which exist independently of being valued, like diamonds or mines and forests, are valuable when they are the objects of certain human activities. There are many nouns designating things not in their primary existence but as the material or objectives (as when something is called a target) of activities. The question whether this holds in the case of a thing (or the property) called value is one of the matters involved in controversy. Take, for example, the following quotations. Value is said to be "best defined as the qualitative content of an apprehending process. . . . It is a given qualitative content present to attention or intuition." This statement would seem to take "value" as primarily a noun, or at least an adjective, designating an object or its intrinsic quality. But when the same author goes on to speak of the process of intuiting and apprehending, he says: "What seems to distinguish the act of valuing from the bare act of intuiting is that the former is qualified, to a noticeable degree, by feeling. . . . It consciously discriminates some specific content. But the act of valuing is also emotional; it is the conscious expression of an interest, a motor-affective attitude." This passage gives the opposite impression of the one previously cited. Nor is the matter made clearer when it is further said that "the value-quality or content of the

experience has been distinguished from the value-act or psychological attitude of which this content is the immediate object"—a position that seems like an attempt to solve a problem by riding two horses going in opposite directions.

Furthermore, when attention is confined to the usage of the verb "to value," we find that common speech exhibits a double usage. For a glance at the dictionary will show that in ordinary speech the words "valuing" and "valuation" are verbally employed to designate both *prizing,* in the sense of holding precious, dear (and various other nearly equivalent activities, like honoring, regarding highly), and *appraising* in the sense of *putting* a value upon, *assigning* value to. This is an activity of rating, an act that involves comparison, as is explicit, for example, in appraisals in money terms of goods and services. The double meaning is significant because there is implicit in it one of the basic issues regarding valuation. For in *prizing,* emphasis falls upon something having definite *personal* reference, which, like all activities of distinctively personal reference, has an aspectual quality called emotional. Valuation as *appraisal,* however, is primarily concerned with a relational property of objects so that an intellectual aspect is uppermost of the same general sort that is found in *estimate* as distinguished from the personal-emotional word *esteem.* That the same verb is employed in both senses suggests the problem upon which schools are divided at the present time. Which of the two references is basic in its implications? Are the two activities separate or are they complementary? In connection with etymological history, it is suggestive (though, of course, in no way conclusive) that "praise," "prize," and "price" are all derived from the same Latin word; that "appreciate" and "appraise" were once used interchangeably; and that "dear" is still used as equivalent both to "precious" and to "costly" in monetary price. While the dual significance of the word as used in ordinary speech raises a problem, the question of linguistic usage is further extended—not to say confused—by the fact that current theories often identify the verb "to value" with "to enjoy" in the sense of receiving pleasure or gratification from something, finding it agreeable; and also with "to enjoy" in the active sense of *concurring* in an activity and its outcome.

2. If we take certain words commonly regarded as value-expressions, we find no agreement in theoretical discussions as to their proper status. There are, for example, those who hold that "good" means *good for,* useful, serviceable, helpful; while "bad" means harmful, detrimental—a conception which contains implicitly a complete theory of valuation. Others hold that a sharp difference exists between good in the sense of "good for" and that which is "good in itself." Again, as just noted, there are those who hold that "pleasant" and "gratifying" are value-expressions of the first rank, while others would not give them standing as primary value-expressions. There is also dispute as to the respective status of 'good" and "right" as value-words.

The conclusion is that verbal usage gives us little help. Indeed, when it is used to give direction to the discussion, it proves confusing. The most that reference to linguistic expressions can do at the outset is to point out certain problems. These problems may be used to delimit the topic under discussion. As far, then, as the terminology of the present discussion is concerned, the word "valuation" will be used, both verbally and as a noun, as the most neutral in its theoretical implications, leaving it to further discussion to determine its connection with *prizing, appraising, enjoying,* etc.

II. VALUE-EXPRESSION AS EJACULATORY

Discussion will begin with consideration of the most extreme of the views which have been advanced. This view affirms that value-expressions cannot be constituents of propositions, that is, of sentences which affirm or deny, because they are purely ejaculatory. Such expressions as "good," "bad," "right," "wrong," "lovely," "hideous," etc., are regarded as of the same nature as interjections; or as phenomena like blushing, smiling, weeping; or/and as stimuli to move others to act in certain ways—much as one says "Gee" to oxen or "Whoa" to a horse. They do not say or state anything, not even about feelings; they merely evince or manifest the latter.

The following quotations represent this view: "If I say to someone, 'You acted wrongly in stealing that money,' I am not *stating* anything more than if I had simply said 'You stole that money.' . . . It is as if I had said 'You stole that money' in a peculiar tone of horror, or written it with the addition of some special exclamation marks. The tone . . . merely serves to show that the expression is attended by certain feelings in the speaker." And again: "Ethical terms do not serve only to express feelings. They are calculated also to arouse feeling and so to stimulate action. . . . Thus the sentence 'It is your duty to tell the truth' may be regarded both as the expression of a certain sort of ethical feeling about truthfulness and as the expression of the command 'Tell the truth.' . . . In the sentence 'It is good to tell the truth' the command has become little more than a suggestion." On what grounds the writer calls the terms and the "feelings" of which he speaks "ethical" does not appear. Nevertheless, applying this adjective to the feelings seems to involve some objective ground for discriminating and identifying them as of a certain kind, a conclusion inconsistent with the position taken. But, ignoring this fact, we pass on to a further illustration: "In saying 'tolerance is a virtue' I should not be making a statement about my own feelings or about anything else. I should simply be evincing my own feelings, which is not at all the same thing as saying that I have them." Hence "it is impossible to dispute about questions of value," for sentences that do not say or state anything whatever cannot, a fortiori, be incompatible with one another. Cases of apparent dispute or of opposed statements are, if they have any meaning at all, reducible to differences regarding the facts of the case—as there might be a dispute whether a man performed the particular action called stealing or lying. Our hope or expectation is that if "we can get an opponent to agree with us about the empirical facts of the case he will adopt the same moral attitude towards them as we do"—though once more it is not evident why the attitude is called "moral" rather than "magical," "belligerent," or any one of thousands of adjectives that might be selected at random.

Discussion will proceed, as has previously been intimated, by analyzing the facts that are appealed to and not by discussing the merits of the theory in the abstract. Let us begin with phenomena that admittedly say nothing, like the first cries of a baby, his first

smiles, or his early cooings, gurglings, and squeals. When it is said that they "express feelings," there is a dangerous ambiguity in the words "feelings" and "express." What is clear in the case of tears or smiles ought to be clear in the case of sounds involuntarily uttered. They are not in themselves expressive. They are constituents of a larger organic condition. They are facts of organic behavior and are *not* in any sense whatever value-expressions. They may, however, be taken by other persons as *signs* of an organic state, and, so taken, *qua* signs or treated as *symptoms,* they evoke certain responsive forms of behavior in these other persons. A baby cries. The mother takes the cry as a sign the baby is hungry or that a pin is pricking it, and so acts to change the organic condition inferred to exist by using the cry as an evidential sign.

Then, as the baby matures, it becomes aware of the connection that exists between a certain cry, the activity evoked, and the consequences produced in response to it. The cry (gesture, posture) is now made *in order* to evoke the activity and in order to experience the consequences of that activity. Just as with respect to the original response there is a difference between the activity that is merely *caused* by the cry as a stimulus (as the cry of a child may awaken a sleeping mother before she is even aware there is a cry) and an activity that is evoked by the cry interpreted as a *sign* or evidence of something, so there is a difference between the original cry—which may properly be called purely ejaculatory—and the cry made on purpose, that is, with the intent to evoke a response that will have certain consequences. The latter cry exists in the medium of language; it is a linguistic sign that not only says something but is intended to say, to convey, to tell.

What is it which is then told or stated? In connection with this question, a fatal ambiguity in the word "feelings" requires notice. For perhaps the view will be propounded that at most all that is communicated is the existence of certain feelings along perhaps with a desire to obtain other feelings in consequence of the activity evoked in another person. But any such view (*a*) goes contrary to the obvious facts with which the account began and (*b*) introduces a totally superfluous not to say empirically unverifiable matter. (*a*) For what we started with was not a feeling but an organic condition of which a cry, or tears, or a smile, or a

blush, is a constituent part. (*b*) The word "feelings" is accordingly either a strictly behavioral term, a name for the total organic state of which the cry or gesture is a part, or it is a word which is introduced entirely gratuitously. The phenomena in question are events in the course of the life of an organic being, not differing from taking food or gaining weight. But just as a gain in weight may be taken as a sign or evidence of proper feeding, so the cry may be taken as a sign or evidence of some special occurrence in organic life.

The phrase "evincing feeling," whether or not "evincing" is taken as a synonym of "expressing," has, then, no business in the report of what takes place. The original activity—crying, smiling, weeping, squealing—is, as we have seen, a part of a larger organic state, so the phrase does not apply to it. When the cry or bodily attitude is purposely made, it is not a feeling that is evinced or expressed. Overt linguistic behavior is undertaken so as to obtain a change in organic conditions—a change to occur as the result of some behavior undertaken by some other person. Take another simple example: A smacking of the lips is or may be part of the original behavioral action called taking food. In one social group the noise made in smacking the lips is treated as a sign of boorishness or of "bad manners." Hence as the young grow in power of muscular control, they are taught to inhibit this activity. In another social group smacking the lips and the accompanying noise are taken as a sign that a guest is properly aware of what the host has provided. Both cases are completely describable in terms of observable modes of behavior and their respective observable consequences.

The serious problem in this connection is why the word "feelings" is introduced in the theoretical account, since it is unnecessary in report of what actually happens. There is but one reasonable answer. The word is brought in from an alleged psychological theory which is couched in mentalistic terms, or in terms of alleged states of an inner consciousness or something of that sort. Now it is irrelevant and unnecessary to ask in connection with events before us whether there are in fact such inner states. For, even if there be such states, they are by description wholly private, accessible only to private inspection. Consequently, even if there were a legitimate introspectionist theory of states of consciousness or of feelings as purely mentalistic, there is

no justification for borrowing from this theory in giving an account of the occurrences under examination. The reference to "feelings" is superfluous and gratuitous, moreover, because the important part of the account given is the use of "value-expressions" to influence the conduct of others by evoking certain responses from them. From the standpoint of an empirical report it is meaningless, since the interpretation is couched in terms of something not open to public inspection and verification. If there are "feelings" of the kind mentioned, there cannot be any assurance that any given word when used by two different persons even refers to the same thing, since the thing is not open to common observation and description.

Confining further consideration, then, to the part of the account that has an empirical meaning, namely, the existence of organic activities which evoke certain responses from others and which are capable of being employed with a view to evoking them, the following statements are warranted: (1) The phenomena in question are *social* phenomena where "social" means simply that there is a form of behavior of the nature of an interaction or transaction between two or more persons. Such an interpersonal activity exists whenever one person—as a mother or nurse—treats a sound made by another person incidentally to a more extensive organic behavior *as a sign,* and responds to it in that capacity instead of reacting to it in its primary existence. The interpersonal activity is even more evident when the item of organic personal behavior in question takes place *for the sake of* evoking a certain kind of response from other persons. If, then, we follow the writer in locating value-expressions where he located them, we are led, after carrying out the required elimination of the ambiguity of "expression" and the irrelevance of "feeling," to the conclusions that value-expressions have to do with or are involved in the behavioral relations of persons to one another. (2) Taken as signs (and, a fortiori, when used as signs) gestures, postures, and words are linguistic symbols. They say something and are of the nature of propositions. Take, for example, the case of a person who assumes the posture appropriate to an ailing person and who utters sounds such as the latter person would ordinarily make. It is then a legitimate subject of inquiry whether the person is genuinely

ailing and incapacitated for work or is malingering. The conclusions obtained as a result of the inquiries undertaken will certainly "evoke" from other persons very different kinds of responsive behavior. The investigation is carried on to determine what is the actual case of things that are empirically observable; it is not about inner "feelings." Physicians have worked out experimental tests that have a high degree of reliability. Every parent and schoolteacher learns to be on guard against the assuming by a child of certain facial "expressions" and bodily attitudes for the purpose of causing, inferences to be drawn which are the source of favor on the part of the adult. In such cases (they could easily be extended to include more complex matters) the propositions that embody the inference are likely to be in error when only a short segment of behavior is observed and are likely to be warranted when they rest upon a prolonged segment or upon a variety of carefully scrutinized data—traits that the propositions in question have in common with all genuine physical propositions. (3) So far the question has not been raised as to whether the propositions that occur in the course of interpersonal behavioral situations are or are not of the nature of valuation-propositions. The conclusions reached are hypothetical. *If* the expressions involved are valuation-expressions, as this particular school takes them to be, *then* it follows (i) that valuation-phenomena are social or interpersonal phenomena and (ii) that they are such as to provide material for propositions about observable events—propositions subject to empirical test and verification or refutation. But so far the hypothesis remains a hypothesis. It raises the question whether the statements which occur with a view to influencing the activity of others, so as to call out from them certain modes of activity having certain consequences, are phenomena falling under the head of valuation.

Take, for example, the case of a person calling "Fire!" or "Help!" There can be no doubt of the intent to influence the conduct of others in order to bring about certain consequences capable of observation and of statement in propositions. The expressions, taken in their observable context, say something of a complex character. When analyzed, what is said is (i) that there exists a situation that will have obnoxious consequences; (ii) that the person uttering the expressions

is unable to cope with the situation; and (iii) that an improved situation is anticipated in case the assistance of others is obtained. All three of these matters are capable of being tested by empirical evidence, since they all refer to things that are observable. The proposition in which the content of the last point (the anticipation) is stated is capable, for example, of being tested by observation of what happens in a particular case. Previous observations may substantiate the conclusion that in any case objectionable consequences are much less likely to happen if the linguistic sign is employed in order to obtain the assistance it is designed to evoke.

Examination shows certain resemblances between these cases and those previously examined which, according to the passage quoted, contain valuation-expressions. The propositions refer directly to an *existing* situation and indirectly to a *future* situation which it is intended and desired to produce. The expressions noted are employed as intermediaries to bring about the desired change from present to future conditions. In the set of illustrative cases that was first examined, certain valuation-words, like "good" and "right," explicitly appear; in the second set there are no *explicit* value-expressions. The cry for aid, however, when taken in connection with its existential context, affirms in effect, although not in so many words, that the situation with reference to which the cry is made is "bad." It is "bad" in the sense that it is objected to, while a future situation which is *better* is anticipated, provided the cry evokes a certain response. The analysis may seem to be unnecessarily detailed. But, unless in each set of examples the existential context is made clear, the verbal expressions that are employed can be made to mean anything or nothing. When the contexts are taken into account, what emerges are propositions assigning a relatively negative value to existing conditions; a comparatively positive value to a prospective set of conditions; and intermediate propositions (which may or may not contain a valuation-expression) intended to evoke activities that will bring about a transformation from one state of affairs to another. There are thus involved (i) aversion to an existing situation and attraction toward a prospective possible situation and (ii) a *specifiable and testable relation between the latter as an end and certain activities as means for accomplishing it.* Two

problems for further discussion are thus set. One of them is the relation of active or behavioral attitudes to what may be called (for the purpose of identification) *liking* and *disliking,* while the other is the relation of valuation to things as means-end.

III. VALUATION AS LIKING AND DISLIKING

That liking and disliking in their connection with valuation are to be considered in terms of observable and identifiable modes of behavior follows from what is stated in the previous section. As behavioral the adjective "affective-motor" is applicable, although care must be taken not to permit the "affective" quality to be interpreted in terms of private "feelings"—an interpretation that nullifies the active and observable element expressed in "motor." For the "motor" takes place in the public and observable world, and, like anything else taking place there, has observable conditions and consequences. When, then, the word "liking" is used as a name for a mode of behavior (not as a name for a private and inaccessible feeling), what sort of activities does it stand for? What is its designatum? This inquiry is forwarded by noting that the words "caring" and "caring for" are, as modes of behavior, closely connected with "liking," and that other substantially equivalent words are "looking out for or after," "cherishing," "being devoted to," "attending to," in the sense of "tending," "ministering to," "fostering"—words that all seem to be variants of what is referred to by "prizing," which, as we saw earlier, is one of the two main significations recognized by the dictionary. When these words are taken in the behavioral sense, or as naming activities that take place so as to maintain or procure certain conditions, it is possible to demarcate what is designated by them from things designated by such an ambiguous word as "enjoy." For the latter word may point to a condition of *receiving* gratification *from* something already in existence, apart from any affective-motor action exerted as a condition of its production or continued existence. Or it may refer to precisely the latter activity, in which case "to enjoy" is a synonym for the

activity of taking delight in an effort, having a certain
overtone of relishing, which "takes pains," as we say,
to perpetuate *the existence of conditions* from which
gratification is received. Enjoying in this active sense
is marked by energy expended to secure the condi-
tions that are the source of the gratification.

The foregoing remarks serve the purpose of get-
ting theory away from a futile task of trying to assign
signification to words in isolation from objects as des-
ignata. We are led instead to evocation of specifiable
existential situations and to observation of what takes
place in them. We are directed to observe whether
energy is put forth to call into existence or to maintain
in existence certain conditions; in ordinary language,
to note whether effort is evoked, whether pains are
taken to bring about the existence of certain conditions
rather than others, the need for expenditure of energy
showing that there exist conditions adverse to what is
wanted. The mother who professes to prize her child
and to enjoy (in the active sense of the word) the child's
companionship but who systematically neglects the
child and does not seek out occasions for being with
the child is deceiving herself; if she makes, in addition,
demonstrative signs of affection—like fondling—only
when others are present, she is presumably trying to
deceive them also. It is by observations of behavior—
which observations (as the last illustration suggests)
may need to be extended over a considerable space-
time—that the existence and description of valuations
have to be determined. Observation of the amount of
energy expended and the length of time over which it
persists enables qualifying adjectives like "slight" and
"great" to be warrantably prefixed to a given valuation.
The direction the energy is observed to take, as toward
and away from, enables grounded discrimination to be
made between "positive" and "negative" valuations. If
there are "feelings" existing in addition, their existence
has nothing to do with any verifiable proposition that
can be made about a valuation.

Because valuations in the sense of prizing and car-
ing for occur only when it is necessary to bring some-
thing into existence which is lacking, or to conserve
in existence something which is menaced by outside
conditions, valuation *involves* desiring. The latter is
to be distinguished from mere wishing in the sense in
which wishes occur in the absence of effort. "If wishes
were horses, beggars would ride." There is something
lacking, and it would be gratifying if it were present,
but there is either no energy expended to bring what is
absent into existence or else, under the given conditions,
no expenditure of effort would bring it into existence—
as when the baby is said to cry for the moon, and when
infantile adults indulge in dreams about how nice every-
thing would be if things were only different. The *desig-
nata* in the cases to which the names "desiring" and
"wishing" are respectively applied are basically differ-
ent. When, accordingly, "valuation" is defined in terms
of desiring, the prerequisite is a treatment of desire in
terms of the existential context in which it arises and
functions. If "valuation" is defined in terms of desire as
something initial and complete in itself, there is noth-
ing by which to discriminate one desire from another
and hence no way in which to measure the worth of
different valuations in comparison with one another.
Desires are desires, and that is all that can be said. Fur-
thermore, desire is then conceived of as *merely* personal
and hence as not capable of being stated in terms of
other objects or events. If, for example, it should hap-
pen to be noted that effort ensues upon desire and that
the effort put forth changes existing conditions, these
considerations would then be looked upon as matters
wholly external to desire—provided, that is, desire is
taken to be original and complete in itself, independent
of an observable contextual situation.

When, however, desires are seen to arise only
within certain existential contexts (namely, those in
which some lack prevents the immediate execution of
an active tendency) and when they are seen to func-
tion in reference to these contexts in such a way as
to make good the existing want, the relation between
desire and *valuation* is found to be such as both to
make possible, and to require, statement in verifiable
propositions. (i) The content and object of desires are
seen to depend upon the particular context in which
they arise, a matter that in turn depends upon the
antecedent state of both personal activity and of sur-
rounding conditions. Desires for food, for example,
will hardly be the same if one has eaten five hours
or five days previously, nor will they be of the same
content in a hovel and a palace or in a nomadic or

agricultural group. (ii) Effort, instead of being something that comes after desire, is seen to be of the very essence of the tension involved in desire. For the latter, instead of being merely personal, is an active relation of the organism to the environment (as is obvious in the case of hunger), a factor that makes the difference between genuine desire and mere wish and fantasy. It follows that valuation in its connection with desire is linked to existential situations and that it differs with differences in its existential context. Since its existence depends upon the situation, its adequacy depends upon its adaptation to the needs and demands imposed by the situation. Since the situation is open to observation, and since the consequences of effort-behavior as observed determine the adaptation, the adequacy of a given desire can be stated in propositions. The propositions are capable of empirical test because the connection that exists between a given desire and the conditions with reference to which it functions are ascertained by means of these observations.

The word "interest" suggests in a forcible way the active connection between personal activity and the conditions that must be taken into account in the theory of valuation. Even in etymology it indicates something in which both a person and surrounding conditions participate in intimate connection with one another. In naming this something that occurs between them it names a transaction. It points to an activity which takes effect through the mediation of external conditions. When we think, for example, of the interest of any particular group, say the bankers' interest, the trade-union interest, or the interest of a political machine, we think not of mere states of mind but of the group as a pressure group having organized channels in which it directs action to obtain and make secure conditions that will produce specified consequences. Similarly in the case of singular persons, when a court recognizes an individual as having an interest in some matter, it recognizes that he has certain claims whose enforcement will affect an existential issue or outcome. Whenever a person has an interest in something, he has a stake in the course of events and in their final issue—a stake which leads him to take action to bring into existence a particular result rather than some other one.

It follows from the facts here adduced that the view which connects valuation (and "values") with desires and interest is but a starting-point. It is indeterminate in its bearing upon the theory of valuation until the nature of interest and desire has been analyzed, and until a method has been established for determining the constituents of desires and interests in their concrete particular occurrence. Practically all the fallacies in the theories that connect valuation with desire result from taking "desire" at large. For example, when it is said (quite correctly) that "values *spring from* the immediate and inexplicable reaction of vital impulse and from the irrational part of our nature," what is actually stated is that vital impulses are a *causal condition* of the existence of desires. When "vital impulse" is given the only interpretation which is empirically verifiable (that of an organic biological tendency), the fact that an "irrational" factor is the causal condition of valuations proves that valuations have their roots *in an existence* which, like any existence *taken in itself,* is *a*-rational. Correctly interpreted, the statement is thus a reminder that organic tendencies are existences which are connected with other existences (the word "irrational" adds nothing to *existence* as such) and hence are observable. But the sentence cited is often interpreted to mean that vital impulses *are* valuations—an interpretation which is incompatible with the view which connects valuations with desires and interests, and which, by parity of logic, would justify the statement that trees are seeds since they "spring from" seeds. Vital impulses are doubtless conditions *sine qua non* for the existence of desires and interests. But the latter include foreseen consequences along with ideas in the form of signs of the measures (involving expenditure of energy) required to bring the ends into existence. When valuation is identified with the activity of desire or interest, its identification with vital impulse is denied. For its identification with the latter would lead to the absurdity of making every organic activity of every kind an act of valuation, since there is none that does not involve some "vital impulse."

The view that "a value is any object of any interest" must also be taken with great caution. On its face it places all interests on exactly the same level. But, when interests are examined in their concrete makeup

in relation to their place in some situation, it is plain that everything depends upon the objects involved in them. This in turn depends upon the care with which the needs of existing situations have been looked into and upon the care with which the ability of a proposed act to satisfy or fulfil just those needs has been examined. That all interests stand on the same footing with respect to their function as valuators is contradicted by observation of even the most ordinary of everyday experiences. It may be said that an interest in burglary and its fruits confers value upon certain objects. But the valuations of the burglar and the policeman are not identical, any more than the interest in the fruits of productive work institutes the same values as does the interest of the burglar in the pursuit of his calling—as is evident in the action of a judge when stolen goods are brought before him for disposition. Since interests occur in definite existential contexts and not at large in a void, and since these contexts are situations within the life-activity of a person or group, interests are so linked with one another that the valuation-capacity of any one is a function of the set to which it belongs. The notion that a value is equally any object of any interest can be maintained only upon a view that completely isolates them from one another—a view that is so removed from readily observed facts that its existence can be explained only as a corollary of the introspectionist psychology which holds that desires and interests are but "feelings" instead of modes of behavior.

IV. PROPOSITIONS OF APPRAISAL

Since desires and interests are activities which take place in the world and which have effects in the world, they are observable in themselves and in connection with their observed effects. It might seem then as if, upon any theory that relates valuation with desire and interest, we had now come within sight of our goal—the discovery of valuation-propositions. Propositions *about* valuations have, indeed, been shown to be possible. But they are valuation-propositions only in the sense in which propositions about potatoes are potato-propositions. They are propositions about matters-of-fact. The fact that these occurrences happen to be

valuations does not make the propositions valuation-propositions in any *distinctive* sense. Nevertheless, the fact that such matter-of-fact propositions can be made is of importance. For, unless they exist, it is doubly absurd to suppose that valuation-propositions in a *distinctive* sense can exist. It has also been shown that the subject matter of personal activities forms no theoretical barrier to institution of matter-of-fact propositions, for the behavior of human beings is open to observation. While there are practical obstacles to the establishment of valid general propositions about such behavior (i.e., about the relations of its constituent acts), its conditions and effects may be investigated. Propositions about valuations made in terms of their conditions and consequences delimit the problem as to existence of valuation-propositions in a *distinctive* sense. Are propositions about existent valuations themselves capable of being appraised, and can the appraisal when made enter into the constitution of further valuations? That a mother prizes or holds dear her child, we have seen, may be determined by observation; and the conditions and effects of different kinds of prizing or caring for may, in theory, be compared and contrasted with one another. In case the final outcome is to show that some kinds of acts of prizing are *better* than others, valuation-acts are themselves evaluated, and the evaluation may modify further direct acts of prizing. If this condition is satisfied, then propositions about valuations that actually take place become the subject matter of valuations in a distinctive sense, that is, a sense that marks them off both from propositions of physics and from historical propositions about what human beings have in fact done.

We are brought thus to the problem of the nature of appraisal or evaluation which, as we saw, is one of the two recognized significations of "valuation." Take such an elementary appraisal proposition as "This plot of ground is worth $200 a front foot." It is different in form from the proposition, "It has a frontage of 200 feet." The latter sentence states a matter of accomplished fact. The former sentence states a rule for determination of an act to be performed, its reference being to the future and not to something already accomplished or done. If stated in the context in which a tax-assessor operates, it states a regulative condition

for levying a tax against the owner; if stated by the owner to a real estate dealer, it sets forth a regulative condition to be observed by the latter in offering the property for sale. The future act or state is not set forth as a prediction of what will happen but as something which *shall* or *should* happen. Thus the proposition may be said to lay down a norm, but "norm" must be understood simply in the sense of a condition *to be* conformed to in definite forms of future action. That rules are all but omnipresent in every mode of human relationship is too obvious to require argument. They are in no way confined to activities to which the name "moral" is applied. Every recurrent form of activity, in the arts and professions, develops rules as to the best way in which to accomplish the ends in view. Such rules are used as criteria or "norms" for judging the value of proposed modes of behavior. The existence of rules for valuation of modes of behavior in different fields as wise or unwise, economical or extravagant, effective or futile, cannot be denied. The problem concerns not their existence as general propositions (since every rule of action is general) but whether they express only custom, convention, tradition, or are capable of stating relations between things as means and other things as consequences, which relations are themselves grounded in empirically ascertained and tested existential relations such as are usually termed those of cause and effect.

In the case of some crafts, arts, and technologies, there can be no doubt which of these alternatives is correct. The medical art, for example, is approaching a state in which many of the rules laid down for a patient by a physician as to what it is *better* for him to do, not merely in the way of medicaments but of diet and habits of life, are based upon experimentally ascertained principles of chemistry and physics. When engineers say that certain materials subjected to certain technical operations are *required* if a bridge capable of supporting certain loads is to be built over the Hudson River at a certain point, their advice does not represent their personal opinions or whims but is backed by acknowledged physical laws. It is commonly believed that such devices as radios and automobiles have been greatly improved (bettered) since they were first invented, and that the betterment in

the relation of means to consequences is due to more adequate scientific knowledge of underlying physical principles. The argument does not demand the belief that the influence of custom and convention is entirely eliminated. It is enough that such cases show that it is possible for rules of appraisal or evaluation to rest upon scientifically warranted physical generalizations and that the ratio of rules of this type to those expressing mere customary habits is on the increase.

In medicine a quack may cite a number of alleged cures as evidential ground for taking the remedies he offers. Only a little examination is needed to show in what definite respects the procedures he recommends differ from those said to be "good" or to be "required" by competent physicians. There is, for example, no analysis of the cases presented as evidence to show that they are actually like the disease for the cure of which the remedy is urged; and there is no analysis to show that the recoveries which are said (rather than proved) to have taken place were in fact due to taking the medicine in question rather than to any one of an indefinite number of other causes. Everything is asserted wholesale with no analytic control of conditions. Furthermore, the first requirement of scientific procedure—namely, full publicity as to materials and processes—is lacking. The sole justification for citing these familiar facts is that their contrast with competent medical practice shows the extent to which the rules of procedure in the latter art have the warrant of tested empirical propositions. Appraisals of courses of action as better and worse, more and less serviceable, are as experimentally justified as are nonvaluative propositions about impersonal subject matter. In advanced engineering technologies propositions that state the *proper* courses of action to be adopted are evidently grounded in generalizations of physical and chemical science; they are often referred to as *applied* science. Nevertheless, propositions which lay down rules for procedures as being fit and good, as distinct from those that are inept and bad, are different in form from the scientific propositions upon which they rest. For they are rules for the use, in and by human activity, of scientific generalizations as means for accomplishing certain desired and intended ends.

Examination of these appraisals discloses that they have to do with things as they sustain to each other the relation of *means* to *ends or consequences.* Wherever there is an appraisal involving a rule as to better or as to needed action, there is an end to be reached: the appraisal is a valuation of things with respect to their serviceability or needfulness. If we take the examples given earlier, it is evident that real estate is appraised for the purpose of levying taxes or fixing a selling price; that medicinal treatments are appraised with reference to the end of effecting recovery of health; that materials and techniques are valued with respect to the building of bridges, radios, motorcars, etc. If a bird builds its nest by what is called pure "instinct," it does not have to appraise materials and processes with respect to their fitness for an end. But if the result—the nest—is contemplated as an object of desire, then either there is the most arbitrary kind of trial-and-error operations or there is consideration of the fitness and usefulness of materials and processes to bring the desired object into existence. And this process of weighing obviously involves comparison of different materials and operations as alternative possible means. In every case, except those of sheer "instinct" and complete trial and error, there are involved observation of actual materials and estimate of their potential force in production of a particular result. There is always some observation of the *outcome attained* in comparison and contrast with that intended, such that the comparison throws light upon the actual fitness of the things employed as means. It thus makes possible a better judgment in the future as to their fitness and usefulness. On the basis of such observations certain modes of conduct are adjudged silly, imprudent, or unwise, and other modes of conduct sensible, prudent, or wise, the discrimination being made upon the basis of the validity of the estimates reached about the relation of things as means to the end or consequence actually reached.

The standing objection raised against this view of valuation is that it applies only to things *as means,* while propositions that are genuine valuations apply to things as *ends.* This point will be shortly considered at length. But it may be noted here that ends are appraised in the same evaluations in which things as means are weighed. For example, an end suggests itself. But, when things are weighed as means toward that end, it

is found that it will take too much time or too great an expenditure of energy to achieve it, or that, if it were attained, it would bring with it certain accompanying inconveniences and the promise of future troubles. It is then appraised and rejected as a "bad" end.

The conclusions reached may be summarized as follows: (1) There are propositions which are not merely about valuations that have actually occurred (about, i.e., prizings, desires, and interests that have taken place in the past) but which describe and define certain things as good, fit, or proper in a definite existential relation: these propositions, moreover, are *generalizations,* since they form rules for the proper use of materials. (2) The existential relation in question is that of means-ends or means-consequences. (3) These propositions in their generalized form may rest upon scientifically warranted empirical propositions and are themselves capable of being tested by observation of results actually attained as compared with those intended.

The objection brought against the view just set forth is that it fails to distinguish between things that are good and right in and of themselves, immediately, intrinsically, and things that are simply good *for* something else. In other words, the latter are useful for attaining the things which have, so it is said, value in and of themselves, since they are prized for their own sake and not as means to something else. This distinction between two different meanings of "good" (and "right") is, it is claimed, so crucial for the whole theory of valuation and values that failure to make the distinction destroys the validity of the conclusions that have been set forth. This objection definitely puts before us for consideration the question of the relations to each other of the categories of *means* and *end.* In terms of the dual meaning of "valuation" already mentioned, the question of the relation of *prizing* and *appraising* to one another is explicitly raised. For, according to the objection, appraising applies only to *means,* while prizing applies to things that are *ends,* so that a difference must be recognized between valuation in its full pregnant sense and evaluation as a secondary and derived affair.

Let the connection between prizing and valuation be admitted and also the connection between desire (and interest) and prizing. The problem as to

the relation between appraisal of things as means and prizing of things as ends then takes the following form: Are desires and interests ("likings," if one prefers that word), which directly effect an institution of end-values, independent of the appraisal of things as means or are they intimately influenced by this appraisal? If a person, for example, finds after due investigation that an immense amount of effort is required to procure the conditions that are the means required for realization of a desire (including perhaps sacrifice of other end-values that might be obtained by the same expenditure of effort), does that fact react to modify his original desire and hence, by definition, his valuation? A survey of what takes place in any deliberate activity provides an affirmative answer to this question. For what is deliberation except weighing of various alternative desires (and hence end-values) in terms of the conditions that are the means of their execution, and which, as means, determine the consequences actually arrived at? There can be no control of the operation of foreseeing consequences (and hence of forming ends-in-view) save in terms of conditions that operate as the causal conditions of their attainment. The proposition in which any object adopted as an end-in-view is statable (or explicitly stated) is *warranted* in just the degree to which existing conditions have been surveyed and appraised in their capacity as means. The sole alternative to this statement is that no deliberation whatsoever occurs, no ends-in-view are formed, but a person acts directly upon whatever impulse happens to present itself.

Any survey of the experiences in which ends-in-view are formed, and in which earlier impulsive tendencies are shaped through deliberation into a *chosen* desire, reveals that the object finally valued as an end to be reached is determined in its concrete makeup by appraisal of existing conditions as means. However, the habit of completely separating the conceptions of ends from that of means is so ingrained because of a long philosophical tradition that further discussion is required.

1. The common assumption that there is a sharp separation between things, on the one hand, as useful or helpful, and, on the other hand, as *intrinsically* good, and hence that there exists a separation between propositions as to what is expedient, prudent, or advisable and what is inherently desirable, does not, in any case, state a *self-evident* truth. The fact that such words as "prudent," "sensible," and "expedient," in the long run, or after survey of all conditions, merge so readily into the word "wise" suggests (though, of course, it does not prove) that ends framed in separation from consideration of things as means are foolish to the point of irrationality.

2. Common sense regards some desires and interests as shortsighted, "blind," and others, in contrast, as enlightened, farsighted. It does not for a moment lump all desires and interests together as having the same status with respect to end-values. Discrimination between their respective shortsightedness and farsightedness is made precisely on the ground of whether the object of a given desire is viewed as, in turn, itself a conditioning means of further consequences. Instead of taking a laudatory view of "immediate" desires and valuations, common sense treats refusal to mediate as the very essence of short-view judgment. For treating the end as *merely* immediate and exclusively final is equivalent to refusal to consider what will happen after and because a particular end is reached.

3. The words "inherent," "intrinsic," and "immediate" are used ambiguously, so that a fallacious conclusion is reached. Any quality or property that actually belongs to any object or event is properly said to be immediate, inherent, or intrinsic. The fallacy consists in interpreting what is designated by these terms as out of relation to anything else and hence as absolute. For example, *means* are by definition relational, mediated, and mediating, since they are intermediate between an existing situation and a situation that is to be brought into existence by their use. But the relational character of the *things* that are employed as means does not prevent the things from having their own immediate qualities. In case the things in question are prized and cared for, then, according to the theory that connects the property of value with prizing, they necessarily have an immediate quality of value. The notion that, when means and instruments are valued, the value-qualities which result are only instrumental is hardly more than a bad pun. There is nothing in the nature of prizing or desiring to prevent their being directed to things which are means, and there is nothing in the nature of means to militate

against their being desired and prized. In empirical fact, the measure of the value a person attaches to a given end is not what he *says* about its preciousness but the care he devotes to obtaining and using the *means* without which it cannot be attained. No case of notable achievement can be cited in any field (save as a matter of sheer accident) in which the persons who brought about the end did not give loving care to the instruments and agencies of its production. The dependence of ends attained upon means employed is such that the statement just made reduces in fact to a tautology. Lack of desire and interest are proved by neglect of, and indifference to, required means. As soon as an attitude of desire and interest has been developed, then, because without full-hearted attention an end which is professedly prized will not be attained, the desire and interest in question automatically attach themselves to whatever other things are seen to be required means of attaining the end.

The considerations that apply to "immediate" apply also to "intrinsic" and "inherent." A quality, including that of value, is inherent if it actually belongs to something, and the question of whether or not it belongs is one of *fact* and not a question that can be decided by dialectical manipulation of the concept of inherency. If one has an ardent desire to obtain certain things as means, then the quality of value belongs to, or inheres in, those things. For the time being, producing or obtaining those means *is* the end-in-view. The notion that only that which is out of relation to everything else can justly be called *inherent* is not only itself absurd but is contradicted by the very theory that connects the value of objects as ends with desire and interest, for this view expressly makes the value of the end-object relational, so that, if the inherent is identified with the nonrelational, there are, according to this view, no inherent values at all. On the other hand, if it is the fact that the quality exists in this case, because that to which it belongs is conditioned by a relation, then the relational character of means cannot be brought forward as evidence that their value is not inherent. The same considerations apply to the terms "intrinsic" and "extrinsic" as applied to value-qualities. Strictly speaking, the phrase "extrinsic value" involves a contradiction in terms. Relational

properties do not lose their intrinsic quality of being just what they are because their coming into being is *caused* by something "extrinsic." The theory that such is the case would terminate logically in the view that there are no intrinsic qualities whatever, since it can be shown that such intrinsic qualities as *red, sweet, hard,* etc., are causally conditioned as to their occurrence. The trouble, once more, is that a dialectic of concepts has taken the place of examination of actual empirical facts. The extreme instance of the view that to be intrinsic is to be out of any relation is found in those writers who hold that, since values *are* intrinsic, they cannot depend upon *any* relation whatever, and certainly not upon a relation to human beings. Hence this school attacks those who connect value-properties with desire and interest on exactly the same ground that the latter equate the distinction between the values of means and ends with the distinction between instrumental and intrinsic values. The views of this extreme nonnaturalistic school may, accordingly, be regarded as a definite exposure of what happens when an analysis of the abstract concept of "intrinsicalness" is substituted for analysis of empirical occurrences.

The more overtly and emphatically the valuation of objects as ends is connected with desire and interest, the more evident it should be that, since desire and interest are ineffectual save as they cooperatively interact with environing conditions, valuation of desire and interest, as means correlated with other means, is the sole condition for valid appraisal of objects as ends. If the lesson were learned that the object of scientific knowledge is *in any case* an ascertained correlation of changes, it would be seen, beyond the possibility of denial, that anything taken *as end* is in its own content or constituents a correlation of the energies, personal and extra-personal, which operate as means. An end as an *actual* consequence, as an existing outcome, is, like any other occurrence which is scientifically analyzed, nothing but the interaction of the conditions that bring it to pass. Hence it follows necessarily that the *idea* of the object of desire and interest, the *end-in-view* as distinct from the end or outcome actually effected, is warranted in the precise degree in which it is formed in terms of these operative conditions.

4. The chief weakness of current theories of valuation which relate the latter to desire and interest is due to failure to make an empirical analysis of concrete desires and interests as they actually exist. When such an analysis is made, certain relevant considerations at once present themselves.

(i) Desires are subject to frustration and interests are subject to defeat. The likelihood of the occurrence of failure in attaining desired ends is in direct ratio to failure to form desire and interest (and the objects they involve) on the basis of conditions that operate either as obstacles (negatively valued) or as positive resources. The difference between reasonable and unreasonable desires and interests is precisely the difference between those which arise casually and are not reconstituted through consideration of the conditions that will actually decide the outcome and those which are formed on the basis of existing liabilities and potential resources. That desires as they first present themselves are the product of a mechanism consisting of native organic tendencies and acquired habits is an undeniable fact. All growth in maturity consists in *not* immediately giving way to such tendencies but in remaking them in their first manifestation through consideration of the consequences they will occasion *if* they are acted upon—an operation which is equivalent to judging or evaluating them as means operating in connection with extra-personal conditions as also means. Theories of valuation which relate it to desire and interest cannot both eat their cake and have it. They cannot continually oscillate between a view of desire and interest that identifies the latter with impulses just as they happen to occur (as products of organic mechanisms) and a view of desire as a modification of a raw impulse through foresight of its outcome; the latter alone being desire, the whole difference between impulse and desire is made by the presence in desire of an end-in-view, of objects *as* foreseen consequences. The foresight will be dependable in the degree in which it is constituted by examination of the conditions that will in fact decide the outcome. If it seems that this point is being hammered in too insistently, it is because the issue at stake is nothing other and nothing less than the possibility of distinctive valuation-propositions. For it

cannot be denied that propositions having evidential warrant and experimental test are possible in the case of evaluation of things as means. Hence it follows that, if these propositions enter into the formation of the interests and desires which are valuations of ends, the latter are thereby constituted the subject matter of authentic empirical affirmations and denials.

(ii) We commonly speak of "learning from experience" and the "maturity" of an individual or a group. What do we mean by such expressions? At the very least, we mean that in the history of individual persons and of the human race there takes place a change from original, comparatively unreflective, impulses and hard-and-fast habits to desires and interests that incorporate the results of critical inquiry. When this process is examined, it is seen to take place chiefly on the basis of careful observation of differences found between desired and proposed ends (ends-*in-view*) and attained ends or actual consequences. Agreement between what is wanted and anticipated and what is actually obtained confirms the selection of conditions which operate as means to the desired end; discrepancies, which are experienced as frustrations and defeats, lead to an inquiry to discover the causes of failure. This inquiry consists of more and more thorough examination of the conditions under which impulses and habits are formed and in which they operate. The result is formation of desires and interests which are what they are through the union of the affective-motor conditions of action with the intellectual or ideational. The latter is there in any case if there is an end-in-view of any sort, no matter how casually formed, while it is adequate in just the degree in which the end is constituted in terms of the conditions of its actualization. For, wherever there is an *end-in-view* of any sort whatever, there is affective-*ideational*-motor activity; or, in terms of the dual meaning of valuation, there is union of prizing and appraising. Observation of results obtained, of *actual* consequences in their agreement with and difference from ends anticipated or held in view, thus provides the conditions by which desires and interests (and hence valuations) are matured and tested. Nothing more contrary to common sense can be imagined than the notion that we are incapable of changing our desires and interests by means of learning what

the consequences of acting upon them are, or, as it is sometimes put, of *indulging* them. It should not be necessary to point in evidence to the spoiled child and the adult who cannot "face reality." Yet, as far as valuation and the theory of values are concerned, any theory which isolates valuation of ends from appraisal of means equates the spoiled child and the irresponsible adult to the mature and sane person.

(iii) Every person in the degree in which he is capable of learning from experience draws a distinction between what is desired and what is desirable whenever he engages in formation and choice of competing desires and interests. There is nothing farfetched or "moralistic" in this statement. The contrast referred to is simply that between the object of a desire as it first presents itself (because of the existing mechanism of impulses and habits) and the object of desire which emerges as a revision of the first-appearing impulse, after the latter is critically judged in reference to the conditions which will decide the actual result. The "desirable," or the object which *should* be desired (valued), does not descend out of the a priori blue nor descend as an imperative from a moral Mount Sinai. It presents itself because past experience has shown that hasty action upon uncriticized desire leads to defeat and possibly to catastrophe. The "desirable" as distinct from the "desired" does not then designate something at large or a priori. It points to the difference between the operation and consequences of unexamined impulses and those of desires and interests that are the product of investigation of conditions and consequences. Social conditions and pressures are part of the conditions that affect the execution of desires. Hence they have to be taken into account in framing ends in terms of available means. But the distinction between the "is" in the sense of the object of a casually emerging desire and the "should be" of a desire framed in relation to actual conditions is a distinction which in any case is bound to offer itself as human beings grow in maturity and part with the childish disposition to "indulge" every impulse as it arises.

Desires and interests are, as we have seen, themselves causal conditions of results. As such they are potential means and have to be appraised as such. This statement is but a restatement of points already made. But it is worth making because it forcibly indicates how far away some of the theoretical views of valuation are from practical common-sense attitudes and beliefs. There is an indefinite number of proverbial sayings which in effect set forth the necessity of not treating desires and interests as final in their first appearance but of treating them as means—that is, of appraising them and forming objects or ends-in-view on the ground of what consequences they will tend to produce in practice. "Look before you leap"; "Act in haste, repent at leisure"; "A stitch in time saves nine"; "When angry count ten"; "Do not put your hand to the plow until the cost has been counted"—are but a few of the many maxims. They are summed up in the old saying, *"Respice finem"*— a saying which marks the difference between simply *having* an end-in-view for which *any* desire suffices, and *looking,* examining, to make sure that the consequences that will actually result are such as will be actually prized and valued when they occur. Only the exigencies of a preconceived theory (in all probability one seriously infected by the conclusions of an uncritically accepted "subjectivistic" psychology) will ignore the concrete differences that are made in the content of "likings" and "prizings," and of desires and interests, by evaluating them in their respective causal capacities when they are taken as means.

V. ENDS AND VALUES

It has been remarked more than once that the source of the trouble with theories which relate value to desire and interest, and then proceed to make a sharp division between prizing and appraisal, between ends and means, is the failure to make an empirical investigation of the actual conditions under which desires and interests arise and function, and in which end-objects, ends-in-view, acquire their actual contents. Such an analysis will now be undertaken.

When we inquire into the actual emergence of desire and its object and the value-property ascribed to the latter (instead of merely manipulating dialectically the general concept of desire), it is as plain as anything can be that desires arise only when "there is

something the matter," when there is some "trouble" in an existing situation. When analyzed, this "something the matter" is found to spring from the fact that there is something lacking, wanting, in the existing situation as it stands, an absence which produces conflict in the elements that do exist. When things are going completely smoothly, desires do not arise, and there is no occasion to project ends-in-view, for "going smoothly" signifies that there is no need for effort and struggle. It suffices to let things take their "natural" course. There is no occasion to investigate what it would be better to have happen in the future, and hence no projection of an end-object.

Now vital impulses and acquired habits often operate without the intervention of an end-in-view or a purpose. When someone finds that his foot has been stepped on, he is likely to react with a push to get rid of the offending element. He does not stop to form a definite desire and set up an end to be reached. A man who has started walking may continue walking from force of an acquired habit without continually interrupting his course of action to inquire what object is to be obtained at the next step. These rudimentary examples are typical of much of human activity. Behavior is often so direct that no desires and ends intervene and no valuations take place. Only the requirements of a preconceived theory will lead to the conclusion that a hungry animal seeks food because it has formed an idea of an end-object to be reached, or because it has evaluated that object in terms of a desire. Organic tensions suffice to keep the animal going until it has found the material that relieves the tension. But if and when *desire* and *an end-in-view* intervene between the occurrence of a vital impulse or a habitual tendency and the execution of an activity, then the impulse or tendency is to some degree modified and transformed: a statement which is purely tautological, since the occurrence of a desire related to an end-in-view *is* a transformation of a prior impulse or routine habit. It is only in such cases that valuation occurs. This fact, as we have seen, is of much greater importance than it might at first sight seem to be in connection with the theory which relates valuation to desire and interest,[1] for it proves that valuation takes place only when there is something the matter;

when there is some trouble to be done away with, some need, lack, or privation to be made good, some conflict of tendencies to be resolved by means of changing existing conditions. This fact in turn proves that there is present an intellectual factor—a factor of inquiry—whenever there is valuation, for the end-in-view is formed and projected as that which, if acted upon, will supply the existing need or lack and resolve the existing conflict. It follows from this that the difference in different desires and their correlative ends-in-view depends upon two things. The first is the adequacy with which inquiry into the lacks and conflicts of the existing situation has been carried on. The second is the adequacy of the inquiry into the likelihood that the particular end-in-view which is set up will, if acted upon, actually fill the existing need, satisfy the requirements constituted by what is needed, and do away with conflict by directing activity so as to institute a unified state of affairs.

The case is empirically and dialectically so simple that it would be extremely difficult to understand why it has become so confused in discussion were it not for the influence of irrelevant theoretical preconceptions drawn in part from introspectionist psychology and in part from metaphysics. Empirically, there are two alternatives. Action may take place with or without an end-in-view. In the latter case, there is overt action with no intermediate valuation; a vital impulse or settled habit reacts directly to some immediate sensory stimulation. In case an end-in-view exists and is valued, or exists in relation to a desire or an interest, the (motor) activity engaged in is, tautologically, mediated by the anticipation of the consequences which *as a foreseen end* enter into the makeup of the desire or interest. Now, as has been so often repeated, things can be anticipated or foreseen *as ends* or outcomes only in terms of the conditions by which they are brought into existence. It is simply impossible to have an end-in-view or to anticipate the consequences of any proposed line of action save upon the basis of some, however slight, consideration of the means by which it can be brought into existence. Otherwise, there is no genuine desire but an idle fantasy, a futile wish. That vital impulses and acquired habits are capable of expending themselves in the channels of

daydreaming and building castles in the air is unfortunately true. But by description the contents of dreams and air castles are *not* ends-in-view, and what makes them fantasies is precisely the fact that they are *not* formed in terms of actual conditions serving as means of their actualization. *Propositions in which things (acts and materials) are appraised as means enter necessarily into desires and interests that determine end-values.* Hence the importance of the inquiries that result in the appraisal of things as means.

The case is so clear that, instead of arguing it directly, it will prove more profitable to consider how it is that there has grown up the belief that there are such things as ends having value apart from valuation of the means by which they are reached.

1. The mentalistic psychology which operates "to reduce" affective-motor activities to mere *feelings* has also operated in the interpretations assigned to *ends-in-view, purposes,* and *aims.* Instead of being treated as anticipations of consequences of the same order as a prediction of future events and, in any case, as depending for their contents and validity upon such predictions, they have been treated as merely mental states; for, when they are so taken (and only then), ends, needs, and satisfactions are affected in a way that distorts the whole theory of valuation. An end, aim, or purpose as a *mental* state *is* independent of the biological and physical means by which it can be realized. The want, lack, or privation which exists wherever there is desire is then interpreted as a mere state of "mind" instead of as something lacking or absent *in the situation*—something that must be supplied if the empirical situation is to be complete. In its latter sense, the needful or required is that which is *existentially necessary* if an end-in-view is to be brought into actual existence. *What* is needed cannot in this case be told by examination of a state of mind but only by examination of actual conditions. With respect to interpretation of "satisfaction" there is an obvious difference between it as a state of mind and as fulfilment of conditions, i.e., as something that meets the conditions imposed by the conjoint potentialities and lacks of the situation in which desire arises and functions. Satisfaction of desire signifies that the lack, characteristic of the situation evoking desire, has been so met that the

means used make sufficient, in the most literal sense, the conditions for accomplishing the end. Because of the subjectivistic interpretation of end, need, and satisfaction, the verbally correct statement that valuation is a *relation* between a personal attitude and extra-personal things—a relation which, moreover, includes a motor (and hence physical) element—is so construed as to involve separation of means and end, of appraisal and prizing. A "value" is then affirmed to be a "feeling"—a feeling which is not, apparently, the feeling of anything but itself. If it were said that a "value" is *felt,* the statement *might* be interpreted to signify that a certain existing relation between a personal motor attitude and extra-personal environing conditions is a matter of direct experience.

2. The shift of ground between valuation as *desire-interest* and as *enjoyment* introduces further confusion in theory. The shift is facilitated because in fact there exist both enjoyments of things directly possessed *without* desire and effort and enjoyments of things that are possessed only *because* of activity put forth to obtain the conditions required to satisfy desire, in the latter case, the enjoyment is in functional relation to desire or interest, and there is no violation of the definition of valuation in terms of desire-interest. But since the same *word,* "enjoyment," is applied also to gratifications that arise quite independently of prior desire and attendant effort, the ground is shifted so that "valuing" is identified with any and every state of enjoyment no matter how it comes about—including gratifications obtained in the most casual and accidental manner, "accidental" in the sense of coming about apart from desire and intent. Take, for example, the gratification of learning that one has been left a fortune by an unknown relative. There is *enjoyment.* But if valuation is defined in terms of desire and interest, there is no valuation, and in so far no "value," the latter coming into being only when there arises some desire as to what shall be done with the money and some question as to formation of an end-in-view. The two kinds of enjoyment are thus not only different but their respective bearings upon the theory of valuation are incompatible with each other, since one is connected with direct possession and the other is conditioned upon prior lack of possession—the very case in which desire enters.

For sake of emphasis, let us repeat the point in a slightly varied illustration. Consider the case of a man gratified by the unexpected receipt of a sum of money, say money picked up while he is walking on the street, an act having nothing to do with his purpose and desire at the moment he is performing it. If values are connected with desire in such a way that the connection is involved in their definition, there is, so far, no valuation. The latter begins when the finder begins to consider *how* he shall prize and care for the money. Shall he prize it, for example, as a means of satisfying certain wants he has previously been unable to satisfy, or shall he prize it as something held in trust until the owner is found? In either case, there is, by definition, an act of valuation. But it is clear that the property of value is attached in the two cases to very different objects. Of course, the uses to which money is put, the ends-in-view which it will serve, are fairly standardized, and in so far the instance just cited is not especially well chosen. But take the case of a child who has found a bright smooth stone. His sense of touch and of sight is gratified. But there is no valuation because no desire and no end-in-view, until the question arises of what shall be done with it; until the child *treasures* what he has accidentally hit upon. The moment he begins to prize and care for it he puts it to some use and thereby employs it as a *means* to some end, and, depending upon his maturity, he estimates or values it *in that relation,* or as means to end.

The confusion that occurs in theory when shift is made from valuation related to desire and interest, to "enjoyment" independent of any relation to desire and interest is facilitated by the fact that attainment of the objectives of desire and interest (of valuation) is itself enjoyed. The nub of the confusion consists in isolating enjoyment from the conditions under which it occurs. Yet the enjoyment that is the consequence of fulfilment of a desire and realization of an interest is what it is because of satisfaction or making good of a need or lack—a satisfaction conditioned by effort directed by the idea of something as an end-in-view. In this sense "enjoyment" involves inherent connection with *lack* of possession; while, in the other sense, the "enjoyment" is that of sheer possession. Lack of possession and possession are tautologically incompatible. Moreover, it is a common experience that the object of desire

when attained is *not* enjoyed, so common that there are proverbial sayings to the effect that enjoyment is in the seeking rather than in the obtaining. It is not necessary to take these sayings literally to be aware that the occurrences in question prove the existence of the difference between value as connected with desire and value as mere enjoyment. Finally, as matter of daily experience, enjoyments provide the primary material of *problems* of valuation. Quite independently of any "moral" issues, people continually ask themselves whether a given enjoyment is worth while or whether the conditions involved in its production are such as to make it a costly indulgence.

Reference was made earlier to the confusion in theory which results when "values" are *defined* in terms of vital impulses. (The ground offered is that the latter are conditions of the existence of values in the sense that they "spring from" vital impulse.) In the text from which the passage was quoted there occurs in close connection the following: "The ideal of rationality is itself as arbitrary, as much dependent upon the needs of a finite organization, as any other ideal." Implicit in this passage are two extraordinary conceptions. One of them is that an ideal is arbitrary if it is causally conditioned by actual existences and is relevant to actual needs of human beings. This conception is extraordinary because naturally it would be supposed that an ideal is arbitrary in the degree in which it is *not* connected with things which exist and is not related to concrete existential requirements. The other astounding conception is that the ideal of rationality is "arbitrary" because it is so conditioned. One would suppose it to be peculiarly true of the ideal of rationality that it is to be judged as to its reasonableness (versus its arbitrariness) on the ground of its function, of what it does, not on the ground of its origin. If rationality as an ideal or generalized end-in-view serves to direct conduct so that things experienced in consequence of conduct so directed are more reasonable in the concrete, nothing more can be asked of it. Both of the implied conceptions are so extraordinary that they can be understood only on the ground of some unexpressed preconceptions. As far as one can judge, these pre-conceptions are (i) that an ideal *ought* to be independent of existence, that is, a priori. The reference to the origin of ideals in vital impulses is in fact an effective criticism of this a priori

view. But it provides a ground for calling ideas arbitrary only if the a priori view is accepted. (ii) The other preconception would seem to be an acceptance of the view that there are or ought to be "ends-in-themselves"; that is to say, ends or ideals that are not also means, which, as we have already seen, is precisely what an ideal is, if it is judged and valued in terms of its function. The sole way of arriving at the conclusion that a generalized end-in-view or ideal is arbitrary because of existential and empirical origin is by first laying down as an ultimate criterion that an end should also *not* be a means. The whole passage and the views of which it is a typical and influential manifestation is redolent of the survival of belief in "ends-in-themselves" as the solely and finally legitimate kind of ends.

VI. THE CONTINUUM
OF ENDS-MEANS

Those who have read and enjoyed Charles Lamb's essay on the origin of roast pork have probably not been conscious that their enjoyment of its absurdity was due to perception of the absurdity of any "end" which is set up apart from the means by which it is to be attained and apart from its own further function as means. Nor is it probable that Lamb himself wrote the story as a deliberate travesty of the theories that make such a separation. Nonetheless, that is the whole point of the tale. The story, it will be remembered, is that roast pork was first enjoyed when a house in which pigs were confined was accidentally burned down. While searching in the ruins, the owners touched the pigs that had been roasted in the fire and scorched their fingers. Impulsively bringing their fingers to their mouths to cool them, they experienced a new taste. Enjoying the taste, they henceforth set themselves to building houses, inclosing pigs in them, and then burning the houses down. Now, if ends-in-view are what they are entirely apart from means, and have their value independently of valuation of means, there is nothing absurd, nothing ridiculous, in this procedure, for the end attained, the *de facto* termination, *was* eating and enjoying roast pork, and that was just the end desired. Only when the end attained

is estimated in terms of the means employed—the building and burning-down of houses in comparison with other available means by which the desired result in view might be attained—is there anything absurd or unreasonable about the method employed.

The story has a direct bearing upon another point, the meaning of "intrinsic." *Enjoyment* of the taste of roast pork may be said to be immediate, although even so the enjoyment would be a somewhat troubled one, for those who have memory, by the thought of the needless cost at which it was obtained. But to pass from immediacy of enjoyment to something called "intrinsic value" is a leap for which there is no ground. The *value* of enjoyment of an object *as* an attained end is a value of something which in being an end, an outcome, stands in relation to the means of which it is the consequence. Hence if the object in question is prized *as* an end or "final" value, it is valued *in this relation* or as mediated. The first time roast pork was enjoyed, it was *not* an end-value, since by description it was not the result of desire, foresight, and intent. Upon subsequent occasions it was, by description, the outcome of prior foresight, desire, and effort, and hence occupied the position of an end-in-view. There are occasions in which previous effort enhances enjoyment of what is attained. But there are also many occasions in which persons find that, when they have attained something as an end, they have paid too high a price in effort and in sacrifice of other ends. In such situations *enjoyment* of the end attained is itself *valued,* for it is not taken in its immediacy but in terms of its cost—a fact fatal to its being regarded as "an end-in-itself," a self-contradictory term in any case.

The story throws a flood of light upon what is usually meant by the maxim "the end justifies the means" and also upon the popular objection to it. Applied in this case, it would mean that the value of the attained end, the eating of roast pork, was such as to warrant the price paid in the means by which it was attained—destruction of dwelling-houses and sacrifice of the values to which they contribute. The conception involved in the maxim that "the end justifies the means" is basically the same as that in the notion of ends-in-themselves; indeed, from a historical point of view, it is the fruit of the latter, for only the conception that certain

things are ends-in-themselves can warrant the belief that the relation of ends-means is unilateral, proceeding exclusively from end to means. When the maxim is compared with empirically ascertained facts, it is equivalent to holding one of two views, both of which are incompatible with the facts. One of the views is that only the specially selected "end" held in view will actually be brought into existence by the means used, something miraculously intervening to prevent the means employed from having their other usual effects; the other (and more probable) view is that, as compared with the importance of the selected and uniquely prized end, other consequences may be completely ignored and brushed aside no matter how intrinsically obnoxious they are. This arbitrary selection of some one part of the attained consequences as *the* end and hence as the warrant of means used (no matter how objectionable are their *other* consequences) is the fruit of holding that *it,* as *the* end, is an end-in-itself, and hence possessed of "value" irrespective of all its existential relations. And this notion is inherent in *every* view that assumes that "ends" can be valued apart from appraisal of the things used as means in attaining them. The sole alternative to the view that *the* end is an arbitrarily selected part of actual consequences which as "the end" then justifies the use of means irrespective of the other consequences they produce, is that desires, ends-in-view, and consequences achieved be valued in turn as means of further consequences. The maxim referred to, under the guise of saying that ends, in the sense of actual consequences, provide the warrant for means employed—a correct position—actually says that some fragment of these actual consequences—a fragment arbitrarily selected because the heart has been set upon it—authorizes the use of means to obtain *it,* without the need of foreseeing and weighing other ends as consequences of the means used. It thus discloses in a striking manner the fallacy involved in the position that ends have value independent of appraisal of means involved and independent of their own further causal efficacy.

We are thus brought back to a point already set forth. In all the physical sciences (using "physical" here as a synonym for *nonhuman*) it is now taken for granted that all "effects" are also "causes," or,

stated more accurately, that nothing happens which is *final* in the sense that it is not part of an ongoing stream of events. If this principle, with the accompanying discrediting of belief in objects that are ends but not means, is employed in dealing with distinctive human phenomena, it necessarily follows that the distinction between ends and means is temporal and relational. Every condition that has to be brought into existence in order to serve as means is, *in that connection,* an object of desire and an end-in-view, while the end actually reached is a means to future ends as well as a test of valuations previously made. Since the end attained is a condition of further existential occurrences, it must be appraised as a potential obstacle and potential resource. If the notion of some objects as ends-in-themselves were abandoned, not merely in words but in all practical implications, human beings would for the first time in history be in a position to frame ends-in-view and form desires on the basis of empirically grounded propositions of the temporal relations of events to one another.

At any given time an adult person in a social group has certain ends which are so standardized by custom that they are taken for granted without examination, so that the only problems arising concern the best means for attaining them. In one group money-making would be such an end; in another group, possession of political power; in another group, advancement of scientific knowledge; in still another group, military prowess, etc. But such ends in any case are (i) more or less blank frameworks where the nominal "end" sets limits within which definite ends will fall, the latter being determined by appraisal of things as means; while (ii) as far as they simply express habits that have become established without critical examination of the relation of means and ends, they do not provide a model for a theory of valuation to follow. If a person moved by an experience of intense cold, which is highly objectionable, should momentarily judge it worth while to get warm by burning his house down, all that saves him from an act determined by a "compulsion neurosis" is the intellectual realization of what other consequences would ensue with the loss of his house. It is not necessarily a sign of insanity (as in the case cited) to isolate some event projected as an end out of the context

of a world of moving changes in which it will in fact take place. But it is at least a sign of immaturity when an individual fails to view his end as also a moving condition of further consequences, thereby treating it as *final* in the sense in which "final" signifies that the course of events has come to a complete stop. Human beings do indulge in such arrests. But to treat them as models for forming a theory of ends is to substitute a manipulation of ideas, abstracted from the contexts in which they arise and function, for the conclusions of observation of concrete facts. It is a sign either of insanity, immaturity, indurated routine, or of a fanaticism that is a mixture of all three.

Generalized ideas of ends and values undoubtedly exist. They exist not only as expressions of habit and as uncritical and probably invalid ideas but also in the same way as valid general ideas arise in any subject. Similar situations recur; desires and interests are carried over from one situation to another and progressively consolidated. A schedule of general ends results, the involved values being "abstract" in the sense of not being directly connected with any particular existing case but not in the sense of independence of all empirically existent cases. As with general ideas in the conduct of any natural science, these general ideas are used as intellectual instrumentalities in judgment of particular cases as the latter arise; they are, in effect, tools that direct and facilitate examination of things in the concrete while they are also developed and tested by the results of their application in these cases. Just as the natural sciences began a course of sure development when the dialectic of concepts ceased to be employed to arrive at conclusions about existential affairs and was employed instead as a means of arriving at a hypothesis fruitfully applicable to particulars, so it will be with the theory of human activities and relations. There is irony in the fact that the very continuity of experienced activities which enables general ideas of value to function as rules for evaluation of particular desires and ends should have become the source of a belief that desires, by the bare fact of their occurrence, confer value upon objects as ends, entirely independent of their contexts in the continuum of activities.

In this connection there is danger that the idea of "finality" be manipulated in a way analogous to the manipulation of the concepts of "immediacy" and "intrinsic" previously remarked upon. A value is *final* in the sense that it represents the conclusion of a process of analytic appraisals of conditions operating in a concrete case, the conditions including impulses and desires on one side and external conditions on the other. Any conclusion reached by an inquiry that is taken to warrant the conclusion is "final" for that case. "Final" here has logical force. The quality or property of value that is correlated with the *last* desire formed in the process of valuation is, tautologically, ultimate for that particular situation. It applies, however, to a specifiable temporal *means-end relation* and not to something which is an end per se. There is a fundamental difference between a final property or quality and the property or quality of finality.

The objection always brought against the view set forth is that, according to it, valuation activities and judgments are involved in a hopeless *regressus ad infinitum*. If, so it is said, there is no end which is not in turn a means, foresight has no place at which it can stop, and no end-in-view can be formed except by the most arbitrary of acts—an act so arbitrary that it mocks the claim of being a genuine valuation-proposition.

This objection brings us back to the conditions under which desires take shape and foreseen consequences are projected as ends to be reached. These conditions are those of need, deficit, and conflict. Apart from a condition of tension between a person and environing conditions there is, as we have seen, no occasion for evocation of desire for something else; there is nothing to induce the formation of an end, much less the formation of one end rather than any other out of the indefinite number of ends theoretically possible. Control of transformation of active tendencies into a desire in which a particular end-in-view is incorporated, is exercised by the needs or privations of an actual situation as its requirements are disclosed to observation. The "value" of different ends that suggest themselves is estimated or measured by the capacity they exhibit to guide action in making good, *satisfying,* in its literal sense, existing lacks. Here is the factor which cuts short the process of foreseeing and weighing ends-in-view in their function as means. Sufficient unto the day is the evil thereof and sufficient also is

the *good* of that which does away with the existing evil. Sufficient because it is the means of instituting a complete situation or an integrated set of conditions.

Two illustrations will be given. A physician has to determine the value of various courses of action and their results in the case of a particular patient. He forms ends-in-view having the value that justifies their adoption, on the ground of what his examination discloses is the "matter" or "trouble" with the patient. He estimates the worth of what he undertakes on the ground of its capacity to produce a condition in which these troubles will not exist, in which, as it is ordinarily put, the patient will be "restored to health." He does not have an idea of health as an absolute end-in-itself, an absolute good by which to determine what to do. On the contrary, he forms his general idea of health as an end and a good (value) for the patient on the ground of what his techniques of examination have shown to be the troubles from which patients suffer and the means by which they are overcome. There is no need to deny that a general and abstract conception of health finally develops. But it is the outcome of a great number of definite, empirical inquiries, not an a priori preconditioning "standard" for carrying on inquiries.

The other illustration is more general. In all inquiry, even the most completely scientific, what is proposed as a conclusion (the end-in-view in that inquiry) is evaluated as to its worth on the ground of its ability to resolve the *problem* presented by the conditions under investigation. There is no a priori standard for determining the value of a proposed solution in concrete cases. A hypothetical possible solution, as an end-in-view, is used as a methodological means to direct further observations and experiments. Either it performs the function of resolution of a problem for the sake of which it is adopted and tried or it does not. Experience has shown that problems for the most part fall into certain recurrent kinds so that there are general principles which, it is believed, proposed solutions must satisfy in a particular case. There thus develops a sort of framework of conditions to be satisfied—a framework of reference which operates in an *empirically* regulative way in given cases. We may even say that it operates as an "a priori" principle, but in exactly the same sense in which rules for the conduct of a

technological art are both empirically antecedent and controlling in a given case of the art. While there is no a priori standard of health with which the actual state of human beings can be compared so as to determine whether they are well or ill, or in what respect they are ill, there have developed, out of past experience, certain criteria which are operatively applicable in new cases as they arise. Ends-in-view are appraised or valued as *good* or *bad* on the ground of their serviceability in the direction of behavior dealing with states of affairs found to be objectionable because of some lack or conflict in them. They are appraised as fit or unfit, proper or improper, *right* or *wrong*, on the ground of their *requiredness* in accomplishing this end.

Considering the all but omnipresence of troubles and "evils" in human experience (evils in the sense of deficiencies, failures, and frustrations), and considering the amount of time that has been spent explaining them away, theories of human activity have been strangely oblivious of the concrete function troubles are capable of exercising when they are taken as *problems* whose conditions and consequences are explored with a view to finding methods of solution. The two instances just cited, the progress of medical art and of scientific inquiry, are most instructive on this point. As long as actual events were supposed to be judged by comparison with some absolute end-value as a standard and norm, no sure progress was made. When standards of health and of satisfaction of conditions of knowledge were conceived in terms of analytic observation of existing conditions, disclosing a trouble statable in a problem, criteria of judging were progressively self-corrective through the very process of use in observation to locate the source of the trouble and to indicate the effective means of dealing with it. These means form the content of the specific end-in-view, not some abstract standard or ideal.

This emphasis upon the function of needs and conflicts as the controlling factor in institution of ends and values does not signify that the latter are themselves negative in content and import. While they are framed with reference to a negative factor, deficit, want, privation, and conflict, their function is positive, and the resolution effected by performance of their function is positive. To attempt to gain an end *directly* is to put

into operation the very conditions that are the source of the experienced trouble, thereby strengthening them and at most changing the outward form in which they manifest themselves. Ends-in-view framed with a negative *reference* (i.e., to some trouble or problem) are means which inhibit the operation of conditions producing the obnoxious result; they enable positive conditions to operate as resources and thereby to effect a result which is, in the highest possible sense, positive in content. The content of the end as an object *held in view* is intellectual or methodological; the content of the attained outcome or the end *as consequence* is existential. It is positive in the degree in which it marks the doing-away of the need and conflict that evoked the *end-in-view*. The negative factor operates as a condition of forming the appropriate *idea* of an end; the idea when acted upon determines a positive outcome.

The attained end or consequence is always an organization of activities, where organization is a coordination of all activities which enter as factors. The *end-in-view* is that particular activity which operates as a coordinating factor of all other subactivities involved. Recognition of the end as a coordination or unified organization of activities, and of the end-in-view as the special activity which is the means of effecting this coordination, does away with any appearance of paradox that seems to be attached to the idea of a temporal continuum of activities in which each successive stage is equally end and means. The *form* of an attained end or consequence is always the same: that of adequate coordination. The content or involved matter of each successive result differs from that of its predecessors; for, while it is a *reinstatement* of a unified ongoing action, after a period of interruption through conflict and need, it is also an *enactment* of a new state of affairs. It has the qualities and properties appropriate to its being the consummatory resolution of a previous state of activity in which there was a peculiar need, desire, and end-in-view. In the continuous temporal process of organizing activities into a coordinated and coordinating unity, a constituent activity is both an end and a means: an end, in so far as it is temporally and relatively a close; a means, in so far as it provides a condition to be taken into account in further activity.

Instead of there being anything strange or paradoxical in the existence of situations in which means are constituents of the very end-objects they have helped to bring into existence, such situations occur whenever behavior succeeds in intelligent projection of ends-in-view that direct activity to resolution of the antecedent trouble. The cases in which ends and means fall apart are the abnormal ones, the ones which deviate from activity which is intelligently conducted. Wherever, for example, there is sheer drudgery, there is separation of the required and necessary means from both the end-in-view and the end attained. Wherever, on the other side, there is a so-called "ideal" which is utopian and a matter of fantasy, the same separation occurs, now from the side of the so-called *end.* Means that do not become constituent elements of the very ends or consequences they produce form what are called "necessary evils," their "necessity" being relative to the existing state of knowledge and art. They are comparable to scaffoldings that had to be later torn down, but which were necessary in erection of buildings until elevators were introduced. The latter remained for use in the building erected and were employed as means of transporting materials that in turn became an integral part of the building. Results or consequences which at one time were necessarily waste products in the production of the particular thing desired were utilized in the light of the development of human experience and intelligence as means for further desired consequences. The generalized ideal and standard of economy-efficiency which operates in every advanced art and technology is equivalent, upon analysis, to the conception of means that are constituents of ends attained and of ends that are usable as means to further ends.

It must also be noted that *activity* and *activities,* as these words are employed in the foregoing account, involve, like any actual behavior, existential materials, as breathing involves air; walking, the earth; buying and selling, commodities; inquiry, things investigated, etc. No human activity operates in a vacuum; it acts in the world and has materials upon which and through which it produces results. On the other hand, no material—air, water, metal, wood, etc.—is *means* save as it is employed in some human activity to accomplish something. When "organization of

activities" is mentioned, it always includes within itself organization of the materials existing in the world in which we live. That organization which is the "final" value for each concrete situation of valuation thus forms part of the existential conditions that have to be taken into account in further formation of desires and interests or valuations. In the degree in which a particular valuation is invalid because of inconsiderate shortsighted investigation of things in their relation of means-end, difficulties are put in the way of subsequent reasonable valuations. To the degree in which desires and interests are formed after critical survey of the conditions which as means determine the actual outcome, the more smoothly continuous become subsequent activities, for consequences attained are then such as are evaluated more readily as means in the continuum of action.

VII. THEORY OF VALUATION AS OUTLINE OF A PROGRAM

Because of the confusion which affects current discussion of the problem of valuation, the analysis undertaken in the present study has been obliged to concern itself to a considerable extent with tracking the confusion to its source. This is necessary in order that empirical inquiry into facts which are taken for granted by common sense may be freed from irrelevant and confusing associations. The more important conclusions may be summarized as follows.

1. Even if "value-expressions" were ejaculatory and such as to influence the conduct of other persons, genuine propositions about such expressions would be possible. We could investigate whether or not they had the effect intended; and further examination would be able to discover the differential conditions of the cases that were successful in obtaining the intended outcome and those that were not. It is useful to discriminate between linguistic expressions which are "emotive" and those which are "scientific." Nevertheless, even if the former said nothing whatever, they would, like other natural events, be capable of becoming the subject matter of "scientific" propositions as a result of an examination of their conditions and effects.

2. Another view connects valuation and value-expressions with desires and interests. Since desire and interest are behavioral phenomena (involving at the very least a "motor" aspect), the valuations they produce are capable of being investigated as to *their* respective conditions and results. Valuations are empirically observable patterns of behavior and may be studied as such. The propositions that result are *about* valuations but are not of themselves value-propositions in any sense marking them off from other matter-of-fact propositions.

3. Value-propositions of the distinctive sort exist whenever things are appraised as to their suitability and serviceability as means, for such propositions are not about things or events that have occurred or that already exist (although they cannot be validly instituted apart from propositions of the kind mentioned in the previous sentence), but are about things *to be* brought into existence. Moreover, while they are logically conditioned upon matter-of-fact predictions, they are more than simple predictions, for the things in question are such as will *not* take place, under the given circumstances, except through the intervention of some personal act. The difference is similar to that between a proposition predicting that in *any* case a certain eclipse will take place and a proposition that the eclipse will be seen or experienced by certain human beings in case the latter intervene to perform certain actions. While valuation-propositions as appraisals of means occur in all arts and technologies and are grounded in strictly physical propositions (as in advanced engineering technologies), nevertheless they are distinct from the latter in that they inherently involve the means-end relationship.

4. Wherever there are desires, there are *ends-in-view,* not simply effects produced as in the case of sheer impulse, appetite, and routine habit. Ends-in-view as anticipated results reacting upon a given desire are *ideational* by definition or tautologically. The involved foresight, forecast or anticipation is warranted, like any other intellectual inferent factor, in the degree in which it is based upon propositions that are conclusions of adequate observational activities. Any given desire is what it is in its actual content or "object" *because* of its ideational constituents. Sheer

impulse or appetite may be described as affective-motor; but any theory that connects valuation with desire and interest by that very fact connects valuation with behavior which is affective-*ideational*-motor. This fact proves the *possibility* of the existence of distinctive valuation-propositions. In view of the role played by ends-in-view in directing the activities that contribute either to the realization or to the frustration of desire, the *necessity* for valuation-propositions is proved if desires are to be intelligent, and purposes are to be other than shortsighted and irrational.

5. The required appraisal of desires and ends-in-view, as means of the activities by which actual results are produced, is dependent upon observation of consequences attained when they are compared and contrasted with the content of ends-in-view. Careless, inconsiderate action is that which foregoes the inquiry that determines the points of agreement and disagreement between the desire actually formed (and hence the valuation actually made) and the things brought into existence by acting upon it. Since desire and valuation of objects proposed as ends are inherently connected, and since desire and ends-in-view need to be appraised as means to ends (an appraisal made on the basis of warranted physical generalizations) the valuation of ends-in-view is tested by consequences that actually ensue. It is verified to the degree in which there is agreement upon results. Failure to agree, in case deviations are carefully observed, is not mere failure but provides the means for improving the formation of later desires and ends-in-view.

The net outcome is (i) that the problem of valuation in general as well as in particular cases concerns things that sustain to one another the relation of means-ends; that (ii) ends are determinable only on the ground of the means that are involved in bringing them about; and that (iii) desires and interests must themselves be evaluated as means in their interaction with external or environing conditions. Ends-in-view, as distinct from ends as accomplished results, themselves function as directive means; or, in ordinary language, as *plans.* Desires, interests, and environing conditions as means are modes of action, and hence are to be conceived in terms of energies which are capable of reduction to homogeneous and comparable terms. Coordination or organizations of energies, proceeding from the two sources of the organism and the environment, are thus both means and attained result or "end" in all cases of valuation, the two kinds of energy being theoretically (if not as yet completely so in practice) capable of statement in terms of physical units.

The conclusions stated do not constitute a complete theory of valuation. They do, however, state the conditions which such a theory must satisfy. An actual theory can be completed only when inquiries into things sustaining the relation of ends-means have been systematically conducted and their results brought to bear upon the formation of desires and ends. For the theory of valuation is itself an intellectual or methodological means and as such can be developed and perfected only in and by use. Since that use does not now exist in any adequate way, the theoretical consideration advanced and conclusions reached outline a program to be undertaken, rather than a complete theory. The undertaking can be carried out only by regulated guidance of the formation of interests and purposes in the concrete. The prime condition of this undertaking (in contrast with the current theory of the relation of valuation to desire and interest) is recognition that desire and interest are not given ready-made at the outset, and a fortiori are not, as they may at first appear, starting-points, original data, or premises of any theory of valuation, for desire always emerges within a prior system of activities or interrelated energies. It arises within a *field* when the field is disrupted or is menaced with disruption, when conflict introduces the tension of need or threatens to introduce it. An interest represents not just a desire but a set of interrelated desires which have been found in experience to produce, because of their connection with one another, a definite order in the processes of continuing behavior.

The test of the existence of a valuation and the nature of the latter is actual behavior as that is subject to observation. Is the existing field of activities (including environing conditions) *accepted,* where "acceptance" consists in effort to maintain it against adverse conditions? Or is it *rejected,* where "rejection" consists of effort to get rid of it and to produce another behavioral field? And in the latter case, what

is the actual field to which, as an end, desire-efforts (or the organization of desire-efforts constituting an interest) are directed? Determination of this field as an objective of behavior determines *what* is valued. Until there is actual or threatened shock and disturbance of a situation, there is a green light to go ahead in immediate act—overt action. There is no need, no desire, and no valuation, just as where there is no doubt, there is no cause of inquiry. Just as the problem which evokes inquiry is related to an empirical situation in which the problem presents itself, so desire and the projection of ends as consequences to be reached are relative to a concrete situation and to its need for transformation. The burden of proof lies, so to speak, on occurrence of conditions that are impeding, obstructive, and that introduce conflict and need. Examination of the situation in respect to the conditions that constitute lack and need and thus serve as positive means for formation of an attainable end or outcome, is the method by which warranted (required and effective) desires and ends-in-view are formed: by which, in short, valuation takes place.

The confusions and mistakes in existing theories, which have produced the need for the previous prolonged analysis, arise very largely from taking desire and interest as original instead of in the contextual situations in which they arise. When they are so taken, they become ultimate in relation to valuation. Being taken, so to speak, at large, there is nothing by which we can empirically check or test them. If desire were of this original nature, if it were independent of the structure and requirements of some concrete empirical situation and hence had no function to perform with reference to an existential situation, then insistence upon the necessity of an ideational or intellectual factor in every desire and the consequent necessity for fulfilment of the empirical conditions of its validity would be as superfluous and irrelevant as critics have said it is. The insistence might then be, what it has been called, a "moral" bias springing from an interest in the "reform" of individuals and society. But since in empirical fact there are no desires and interests apart from some field of activities in which they occur and in which they function, either as poor or as good means, the insistence in question is simply and

wholly in the interest of a correct empirical account of what actually exists as over against what turns out to be, when examined, a dialectical manipulation of *concepts* of desire and interest at large, a procedure which is all that is possible when desire is taken in isolation from its existential context.

It is a common occurrence in the history of theories that an error at one extreme calls out a complementary error at the other extreme. The type of theory just considered isolates desires as sources of valuation from any existential context and hence from any possibility of intellectual control of their contents and objectives. It thereby renders valuation an arbitrary matter. It says in effect that any desire is just as "good" as any other in respect to the value it institutes. Since desires—and their organization into interests—are the sources of human action, this view, if it were systematically acted upon, would produce disordered behavior to the point of complete chaos. The fact that in spite of conflicts, and unnecessary conflicts, there is not complete disorder is proof that actually some degree of intellectual respect for existing conditions and consequences does operate as a control factor in formation of desires and valuations. However, the implications of the theory in the direction of intellectual and practical disorder are such as to evoke a contrary theory, one, however, which has the same fundamental postulate of the isolation of valuation from concrete empirical situations, their potentialities, and their requirements. This is the theory of "ends-in-themselves" as ultimate standards of all valuation—a theory which denies implicitly or explicitly that desires have anything to do with "final values" unless and until they are subjected to the external control of a priori absolute ends as standards and ideals for their valuation. This theory, in its endeavor to escape from the frying pan of disordered valuations, jumps into the fire of absolutism. It confers the simulation of final and complete rational authority upon certain interests of certain persons or groups at the expense of all others: a view which, in turn, because of the consequences it entails, strengthens the notion that no intellectual and empirically reasonable control of desires, and hence of valuations and value-properties, is possible. The seesaw between

theories which by definition are not empirically test-able (since they are a priori) and professed empiri-cal theories that unwittingly substitute conclusions derived from the bare *concept* of desire for the results of observation of desires in the concrete is thus kept up. The astonishing thing about the a priori theory (astonishing if the history of philosophical thought be omitted from the survey) is its complete neglect of the fact that valuations are constant phenomena of human behavior, personal and associated, and arc capable of rectification and development by use of the resources provided by knowledge of physical relations.

VIII. VALUATION AND THE CONDITIONS OF SOCIAL THEORY

We are thus brought to the problem which, as was shown in the opening section of this study, is back of the present interest in the problem of valuation and val-ues, namely, the possibility of genuine and grounded propositions about the purposes, plans, measures, and policies which influence human activity whenever the latter is other than merely impulsive or routine. A theory of valuation *as* theory can only set forth the conditions which a method of formation of desires and interests must observe in concrete situations. The problem of the existence of such a method is all one with the prob-lem of the possibility of genuine propositions which have as their subject matter the intelligent conduct of human activities, whether personal or associated. The view that value in the sense of *good* is inherently con-nected with that which promotes, furthers, assists, a course of activity, and that value in the sense of *right* is inherently connected with that which is needed, required, in the maintenance of a course of activity, is not in itself novel. Indeed, it is suggested by the very etymology of the word *value,* associated as it is with the words "avail," "valor," "valid," and "invalid." What the foregoing discussion has added to the idea is proof that if, and *only* if, valuation is taken in this sense, are empirically grounded propositions about desires and interests as sources of valuations possible—such prop-ositions being grounded in the degree in which they employ scientific physical generalizations as means of forming propositions about activities which are

correlated as ends-means. The resulting general prop-ositions provide rules for valuation of the aims, pur-poses, plans, and policies that direct intelligent human activity. They are not rules in the sense that they enable us to tell directly, or upon bare inspection, the values of given particular ends (a foolish quest that underlies the belief in a priori values as ideals and standards); they are rules of methodic procedure in the conduct of the investigations that determine the respective conditions and consequences of various modes of behavior. It does not purport to solve the problems of valuation in and of itself; it does claim to state con-ditions that inquiry must satisfy if these problems are to be resolved, and to serve in this way as a leading principle in conduct of such inquiries.

I. Valuations exist in fact and are capable of empiri-cal observation so that propositions about them are empirically verifiable. What individuals and groups hold dear or prize and the grounds upon which they prize them are capable, in principle, of ascertainment, no matter how great the *practical* difficulties in the way. But, upon the whole, in the past values have been determined by customs, which are then commended because they favor some special interest, the commen-dation being attended with coercion or exhortation or with a mixture of both. The practical difficulties in the way of scientific inquiry into valuations are great, so great that they are readily mistaken for inherent theo-retical obstacles. Moreover, such knowledge as does exist about valuations is far from organized, to say nothing about its being adequate. The notion that valu-ations do not exist in empirical fact and that therefore value-conceptions have to be imported from a source outside experience is one of the most curious beliefs the mind of man has ever entertained. Human beings are continuously engaged in valuations. The latter supply the primary material for operations of further valuations and for the general theory of valuation.

Knowledge of these valuations does not of itself, as we have seen, provide valuation-propositions; it is rather of the nature of historical and cultural-anthropological knowledge. But such factual knowledge is a *sine qua non* of ability to formulate valuation-propositions. This statement only involves recognition that past experience, when properly analyzed and ordered, is the sole guide we have in future experience. An

individual within the limits of his personal experience revises his desires and purposes as he becomes aware of the consequences they have produced in the past. This knowledge is what enables him to foresee probable consequences of his prospective activities and to direct his conduct accordingly. The ability to form valid propositions about the relation of present desires and purposes to future consequences depends in turn upon ability to analyze these present desires and purposes into their constituent elements. When they are taken in gross, foresight is correspondingly coarse and indefinite. The history of science shows that power of prediction has increased *pari passu* with analysis of gross qualitative events into elementary constituents. Now, in the absence of adequate and organized knowledge of human valuations as occurrences that have taken place, it is a fortiori impossible that there be valid propositions formulating new valuations in terms of consequences of specified causal conditions. On account of the continuity of human activities, personal and associated, the import of present valuations cannot be validly stated until they are placed in the perspective of the past valuation-events with which they are continuous. Without this perception, the future perspective, i.e., the consequences of present and new valuations, is indefinite. In the degree in which existing desires and interests (and hence valuations) can be judged in their connection with past conditions, they are seen in a context which enables them to be revaluated on the ground of evidence capable of observation and empirical test.

Suppose, for example, that it be ascertained that a particular set of current valuations have, as their antecedent historical conditions, the interest of a small group or special class in maintaining certain exclusive privileges and advantages, and that this maintenance has the effect of limiting both the range of the desires of others and their capacity to actualize them. Is it not obvious that this knowledge of conditions and consequences would surely lead to revaluation of the desires and ends that had been assumed to be authoritative sources of valuation? Not that such revaluation would of necessity take effect immediately. But, when valuations that exist at a given time are found to lack the support they have previously been supposed to have, they exist in a context that is highly adverse to their continued maintenance. In the long run the effect is similar to a warier attitude that develops toward certain bodies of water as the result of knowledge that these bodies of water contain disease germs. If, on the other hand, investigation shows that a given set of existing valuations, including the rules for their enforcement, be such as to release individual potentialities of desire and interest, and does so in a way that contributes to mutual reinforcement of the desires and interests of all members of a group, it is impossible for this knowledge not to serve as a bulwark of the particular set of valuations in question, and to induce intensified effort to sustain them in existence.

II. These considerations lead to the central question: What are the conditions that have to be met so that knowledge of past and existing valuations becomes an instrumentality of valuation in formation of new desires and interests—of desires and interests that the test of experience show to be best worth fostering? It is clear upon our view that no abstract theory of valuation can be put side by side, so to speak, with existing valuations as the standard for judging them.

The answer is that improved valuation must grow out of existing valuations, subjected to critical methods of investigation that bring them into systematic relations with one another. Admitting that these valuations are largely and probably, in the main, defective, it might at first sight seem as if the idea that improvement would spring from bringing them into connection with one another is like recommending that one lift himself by his bootstraps. But such an impression arises only because of failure to consider how they actually may be brought into relation with one another, namely, by examination of their respective conditions and consequences. Only by following this path will they be reduced to such homogeneous terms that they are comparable with one another.

This method, in fact, simply carries over to human or social phenomena the methods that have proved successful in dealing with the subject matter of physics and chemistry. In these fields before the rise of modern science there was a mass of facts which were isolated and seemingly independent of one another. Systematic advance dates from the time when conceptions that formed the content of theory were derived from the phenomena themselves and were

then employed as hypotheses for relating together the otherwise separate matters-of-fact. When, for example, ordinary drinking water is operatively regarded as H_2O what has happened is that water is related to an immense number of other phenomena so that inferences and predictions are indefinitely expanded and, at the same time, made subject to empirical tests. In the field of human activities there are at present an immense number of facts of desires and purposes existing in rather complete isolation from one another. But there are no hypotheses of the same empirical order which are capable of relating them to one another so that the resulting propositions will serve as methodic controls of the formation of future desires and purposes, and, thereby, of new valuations. The material is ample. But the means for bringing its constituents into such connections that fruit is borne are lacking. This lack of means for bringing actual valuations into relation with one another is partly the cause and partly the effect of belief in standards and ideals of value that lie outside ("above" is the usual term) actual valuations. It is cause in so far as some method of control of desires and purposes is such an important desideratum that in the absence of an empirical method, *any* conception that seems to satisfy the need is grasped at. It is the effect in that a priori theories, once they are formed and have obtained prestige, serve to conceal the necessity for concrete methods of relating valuations and, by so doing, provide intellectual instruments for placing impulses and desires in a context where the very place they occupy affects their evaluation.

However, the difficulties that stand in the way are, in the main, practical. They are supplied by traditions, customs, and institutions which persist without being subjected to a systematic empirical investigation and which constitute the most influential source of further desires and ends. This is supplemented by a priori theories serving, upon the whole, to "rationalize" these desires and ends so as to give them apparent intellectual status and prestige. Hence it is worth while to note that the same obstacles once existed in the subject matters now ruled by scientific methods. Take, as an outstanding example, the difficulties experienced in getting a hearing for the Copernican astronomy a few centuries ago. Traditional and customary beliefs

which were sanctioned and maintained by powerful institutions regarded the new scientific ideas as a menace. Nevertheless, the methods which yielded propositions verifiable in terms of actual observations and experimental evidence maintained themselves, widened their range, and gained continually in influence.

The propositions which have resulted and which now form the substantial content of physics, of chemistry, and, to a growing extent, of biology, provide the very means by which the change which is required can be introduced into beliefs and ideas purporting to deal with human and social phenomena. Until natural science had attained to something approaching its present estate, a grounded empirical theory of valuation, capable of serving in turn as a method of regulating the production of new valuations, was out of the question. Desires and interests produce consequences only when the activities in which they are expressed take effect in the environment by interacting with physical conditions. As long as there was no adequate knowledge of physical conditions and no well-grounded propositions regarding their relations to one another (no known "laws"), the kind of forecast of the consequences of alternative desires and purposes involved in their evaluation was impossible. When we note how recently—in comparison with the length of time man has existed on earth—the arts and technologies employed in strictly physical affairs have had scientific support, the backward condition of the arts connected with the social and political affairs of men provides no ground for surprise.

Psychological science is now in much the same state in which astronomy, physics, and chemistry were when they first emerged as genuinely experimental sciences, yet without such a science systematic theoretical control of valuation is impossible; for without competent psychological knowledge the force of the human factors which interact with environing nonhuman conditions to produce consequences cannot be estimated. This statement is purely truistic, since knowledge of the human conditions *is* psychological science. For over a century, moreover, the ideas central to what passed for psychological knowledge were such as actually obstructed that foresight of consequences which is required to

control the formation of ends-in-view. For when psychological subject matter was taken to form a psychical or mentalistic realm set over against the physical environment, inquiry, such as it was, was deflected into the metaphysical problem of the possibility of interaction between the mental and the physical and away from the problem central in evaluation, namely, that of discovering the concrete interactions between human behavior and environing conditions which determine the actual consequences of desires and purposes. A grounded theory of the phenomena of human behavior is as much a prerequisite of a theory of valuation as is a theory of the behavior of physical (in the sense of nonhuman) things. The development of a science of the phenomena of living creatures was an unqualified prerequisite of the development of a sound psychology. Until biology supplied the material facts which lie between the nonhuman and the human, the apparent traits of the latter were so different from those of the former that the doctrine of a complete gulf between the two seemed to be the only plausible one. The missing link in the chain of knowledge that terminates in grounded valuation propositions is the biological. As that link is in process of forging, we may expect the time soon to arrive in which the obstacles to development of an empirical theory of valuation will be those of habits and traditions that flow from institutional and class interests rather than from intellectual deficiencies.

Need for a theory of human relations in terms of a sociology which might perhaps instructively be named cultural anthropology is a further condition of the development of a theory of valuation as an effective instrumentality, for human organisms live in a cultural environment. There is no desire and no interest which, in its distinction from raw impulse and strictly organic appetite, is not what it is because of transformation effected in the latter by their interaction with the cultural environment. When current theories are examined which, quite properly, relate valuation with desires and interests, nothing is more striking than their neglect— so extensive as to be systematic—of the role of cultural conditions and institutions in the shaping of desires and ends and thereby of valuations. This neglect is perhaps the most convincing evidence that can be had

of the substitution of dialectical manipulation of the concept of desire for investigation of desires and valuations as concretely existent facts. Furthermore, the notion that an adequate theory of human behavior— including particularly the phenomena of desire and purpose—can be formed by considering individuals apart from the cultural setting in which they live, move, and have their being—a theory which may justly be called metaphysical individualism—has united with the metaphysical belief in a mentalistic realm to keep valuation-phenomena in subjection to unexamined traditions, conventions, and institutionalized customs.[2] The separation alleged to exist between the "world of facts" and the "realm of values" will disappear from human beliefs only as valuation-phenomena are seen to have their immediate source in biological modes of behavior and to owe their concrete content to the influence of cultural conditions.

The hard-and-fast impassable line which is supposed by some to exist between "emotive" and "scientific" language is a reflex of the gap which now exists between the intellectual and the emotional in human relations and activities. The split which exists in present social life between ideas and emotions, especially between ideas that have *scientific* warrant and uncontrolled emotions that dominate practice, the split between the affectional and the cognitive, is probably one of the chief sources of the maladjustments and unendurable strains from which the world is suffering. I doubt if an adequate explanation upon the psychological side of the rise of dictatorships can be found which does not take account of the fact that the strain produced by separation of the intellectual and the emotional is so intolerable that human beings are willing to pay almost any price for the semblance of even its temporary annihilation. We are living in a period in which emotional loyalties and attachments are centered on objects that no longer command that intellectual loyalty which has the sanction of the methods which attain valid conclusions in scientific inquiry, while ideas that have their origin in the rationale of inquiry have not as yet succeeded in acquiring the force that only emotional ardor provides. The *practical* problem that has to be faced is the establishment of cultural conditions that

will support the kinds of behavior in which emotions and ideas, desires and appraisals, are integrated.

If, then, discussion in the earlier sections of this study seems to have placed chief emphasis upon the importance of valid *ideas* in formation of the desires and interests which are the sources of valuation, and to have centered attention chiefly upon the possibility and the necessity of control of this ideational factor by empirically warranted matters-of-fact, it is because the *empirical* (as distinct from a priori) theory of valuation is currently stated in terms of desire as emotional in isolation from the ideational. In fact and in net outcome, the previous discussion does not point in the least to supersession of the emotive by the intellectual. Its only and complete import is the need for their integration in behavior—behavior in which, according to common speech, the head and the heart work together, in which, to use more technical language, prizing and appraising unite in direction of action. That growth of knowledge of the physical—in the sense of the nonpersonal—has limited the range of freedom of human action in relation to such things as light, heat, electricity, etc., is so absurd in view of what has actually taken place that no one holds it. The operation of desire in producing the valuations that influence human action will also be liberated when they, too, are ordered by verifiable propositions regarding matters-of-fact.

The chief *practical* problem with which the present *Encyclopedia* is concerned, the unification of science, may justly be said to centre here, for at the present time the widest gap in knowledge is that which exists between humanistic and non-humanistic subjects. The breach will disappear, the gap be filled, and science be manifest as an operating unity in fact and not merely in idea when the conclusions of impersonal nonhumanistic science are employed in guiding the course of distinctively human behavior, that, namely, which is influenced by emotion and desire in the framing of means and ends; for desire, having ends-in-view, and hence involving valuations, is the characteristic that marks off human from nonhuman behavior. On the other side, the science that is put to distinctively human use is that in which warranted ideas about the nonhuman world are integrated with emotion as human traits. In this integration not only is science itself *a* value (since it is the expression and the fulfilment of a special human desire and interest) but it is the supreme means of the valid determination of all valuations in all aspects of human and social life.

Notes

1. Cf. pp. 217 ff., above.
2. The statement, sometimes made, that metaphysical sentences are "meaningless" usually fails to take account of the fact that culturally speaking they are very far from being devoid of meaning, in the sense of having significant cultural effects. Indeed, they are so far from being meaningless in this respect that there is no short dialectic cut to their elimination, since the latter can be accomplished only by concrete applications of scientific method which modify cultural conditions. The view that sentences having a nonempirical reference are meaningless, is sound in the sense that what they purport or pretend to mean cannot be given intelligibility, and this fact is presumably what is intended by those who hold this view. Interpreted as symptoms or signs of actually existent conditions, they may be and usually are highly significant, and the most effective criticism of them is disclosure of the conditions of which they are evidential.

Study Questions

1. What did Dewey mean by a "theory of valuation"?
2. Do we use empirical testing to assess nonmoral value judgments, such as whether a computer is good?
3. Can we use empirical testing to assess moral value judgments, such as whether an action is good?
4. Can values, whether moral or nonmoral, be judged apart from the needs of a particular situation?

16

ALBERT CAMUS

Albert Camus (1913–1960) was an Algerian-born French novelist, playwright, and philosopher who won the Nobel Prize for Literature in 1957. He maintained that in a world without God the one serious philosophical question is whether life is worth living. While believing that the human condition is absurd, because the universe is indifferent to us, Camus nevertheless rejected the option of suicide and found a model for our existence in the Greek mythological figure of Sisyphus, who was condemned for his misdeeds to the eternal task of rolling a huge stone to the top of a hill, only each time to have it roll down to the bottom again. Such is the nature of our absurd lives, and we need to find joy therein.

The Myth of Sisyphus

AN ABSURD REASONING

Absurdity and Suicide

There is but one truly serious philosophical problem, and that is suicide. Judging whether life is or is not worth living amounts to answering the fundamental question of philosophy. All the rest—whether or not the world has three dimensions, whether the mind has nine or twelve categories—comes afterwards. These are games; one must first answer. And if it is true, as Nietzsche claims, that a philosopher, to deserve our respect, must preach by example, you can appreciate the importance of that reply, for it will precede the definitive act. These are facts the heart can feel; yet they call for careful study before they become clear to the intellect.

If I ask myself how to judge that this question is more urgent than that, I reply that one judges by the actions it entails. I have never seen anyone die for the ontological argument. Galileo, who held a scientific truth of great importance, abjured it with the greatest ease as soon as it endangered his life. In a certain sense, he did right.[1] That truth was not worth the stake. Whether the earth or the sun revolves around the other is a matter of profound indifference. To tell the truth, it is a futile question. On the other hand, I see many people die because they judge that life is not worth living. I see others paradoxically getting killed for the ideas or illusions that give them a reason for living (what is called a reason for living is also an excellent reason for dying). I therefore conclude that the meaning of life is the most urgent of questions. How to answer it? On all essential problems (I mean thereby those that run the risk of leading to death or those that intensify the passion of living) there are probably but two methods of thought: the method of La Palisse and the method of Don Quixote. Solely the balance between evidence

and lyricism can allow us to achieve simultaneously emotion and lucidity. In a subject at once so humble and so heavy with emotion, the learned and classical dialectic must yield, one can see, to a more modest attitude of mind deriving at one and the same time from common sense and understanding.

Suicide has never been dealt with except as a social phenomenon. On the contrary, we are concerned here, at the outset, with the relationship between individual thought and suicide. An act like this is prepared within the silence of the heart, as is a great work of art. The man himself is ignorant of it. One evening he pulls the trigger or jumps. Of an apartment-building manager who had killed himself I was told that he had lost his daughter five years before, that he had changed greatly since, and that that experience had "undermined" him. A more exact word cannot be imagined. Beginning to think is beginning to be undermined. Society has but little connection with such beginnings. The worm is in man's heart. That is where it must be sought. One must follow and understand this fatal game that leads from lucidity in the face of existence to flight from light.

There are many causes for a suicide, and generally the most obvious ones were not the most powerful. Rarely is suicide committed (yet the hypothesis is not excluded) through reflection. What sets off the crisis is almost always unverifiable. Newspapers often speak of "personal sorrows" or of "incurable illness." These explanations are plausible. But one would have to know whether a friend of the desperate man had not that very day addressed him indifferently. He is the guilty one. For that is enough to precipitate all the rancors and all the boredom still in suspension.[2]

But if it is hard to fix the precise instant, the subtle step when the mind opted for death, it is easier to deduce from the act itself the consequences it implies. In a sense, and as in melodrama, killing yourself amounts to confessing. It is confessing that life is too much for you or that you do not understand it. Let's not go too far in such analogies, however, but rather return to everyday words. It is merely confessing that that "is not worth the trouble." Living, naturally, is never easy. You continue making the gestures commanded by existence for many reasons, the first

of which is habit. Dying voluntarily implies that you have recognized, even instinctively, the ridiculous character of that habit, the absence of any profound reason for living, the insane character of that daily agitation, and the uselessness of suffering.

What, then, is that incalculable feeling that deprives the mind of the sleep necessary to life? A world that can be explained even with bad reasons is a familiar world. But, on the other hand, in a universe suddenly divested of illusions and lights, man feels an alien, a stranger. His exile is without remedy since he is deprived of the memory of a lost home or the hope of a promised land. This divorce between man and his life, the actor and his setting, is properly the feeling of absurdity. All healthy men having thought of their own suicide, it can be seen, without further explanation, that there is a direct connection between this feeling and the longing for death. . . .

Absurd Walls

. . . All great deeds and all great thoughts have a ridiculous beginning. Great works are often born on a street corner or in a restaurant's revolving door. So it is with absurdity. The absurd world more than others derives its nobility from that abject birth. In certain situations, replying "nothing" when asked what one is thinking about may be pretense in a man. Those who are loved are well aware of this. But if that reply is sincere, if it symbolizes that odd state of soul in which the void becomes eloquent, in which the chain of daily gestures is broken, in which the heart vainly seeks the link that will connect it again, then it is as it were the first sign of absurdity.

It happens that the stage sets collapse. Rising, streetcar, four hours in the office or the factory, meal, streetcar, four hours of work, meal, sleep, and Monday Tuesday Wednesday Thursday Friday and Saturday according to the same rhythm—this path is easily followed most of the time. But one day the "why" arises and everything begins in that weariness tinged with amazement. "Begins"—this is important. Weariness comes at the end of the acts of a mechanical life, but at the same time it inaugurates the impulse of consciousness. It awakens consciousness and provokes what

follows. What follows is the gradual return into the chain or it is the definitive awakening. At the end of the awakening comes, in time, the consequence: suicide or recovery. In itself weariness has something sickening about it. Here, I must conclude that it is good. For everything begins with consciousness and nothing is worth anything except through it. There is nothing original about these remarks. But they are obvious; that is enough for a while, during a sketchy reconnaissance in the origins of the absurd. Mere "anxiety," as Heidegger says, is at the source of everything.

Likewise and during every day of an unillustrious life, time carries us. But a moment always comes when we have to carry it. We live on the future: "tomorrow," "later on," "when you have made your way," "you will understand when you are old enough." Such irrelevancies are wonderful, for, after all, it's a matter of dying. Yet a day comes when a man notices or says that he is thirty. Thus he asserts his youth. But simultaneously he situates himself in relation to time. He takes his place in it. He admits that he stands at a certain point on a curve that he acknowledges having to travel to its end. He belongs to time, and by the horror that seizes him, he recognizes his worst enemy. Tomorrow, he was longing for tomorrow, whereas everything in him ought to reject it. That revolt of the flesh is the absurd.[3]

A step lower and strangeness creeps in: perceiving that the world is "dense," sensing to what a degree a stone is foreign and irreducible to us, with what intensity nature or a landscape can negate us. At the heart of all beauty lies something inhuman, and these hills, the softness of the sky, the outline of these trees at this very minute lose the illusory meaning with which we had clothed them, henceforth more remote than a lost paradise. The primitive hostility of the world rises up to face us across millennia. For a second we cease to understand it because for centuries we have understood in it solely the images and designs that we had attributed to it beforehand, because henceforth we lack the power to make use of that artifice. The world evades us because it becomes itself again. That stage scenery masked by habit becomes again what it is. It withdraws at a distance from us. Just as there are days when under the familiar face of a woman, we see

as a stranger her we had loved months or years ago, perhaps we shall come even to desire what suddenly leaves us so alone. But the time has not yet come. Just one thing: that denseness and that strangeness of the world is the absurd.

Men, too, secrete the inhuman. At certain moments of lucidity, the mechanical aspect of their gestures, their meaningless pantomime makes silly everything that surrounds them. A man is talking on the telephone behind a glass partition; you cannot hear him, but you see his incomprehensible dumb show: you wonder why he is alive. This discomfort in the face of man's own inhumanity, this incalculable tumble before the image of what we are, this "nausea," as a writer of today calls it, is also the absurd. Likewise the stranger who at certain seconds comes to meet us in a mirror, the familiar and yet alarming brother we encounter in our own photographs is also the absurd. . . .

Absurd Freedom

Now I can broach the notion of suicide. It has already been felt what solution might be given. At this point the problem is reversed. It was previously a question of finding out whether or not life had to have a meaning to be lived. It now becomes clear, on the contrary, that it will be lived all the better if it has no meaning. Living an experience, a particular fate, is accepting it fully. Now, no one will live this fate, knowing it to be absurd, unless he does everything to keep before him that absurd brought to light by consciousness. Negating one of the terms of the opposition on which he lives amounts to escaping it. To abolish conscious revolt is to elude the problem. The theme of permanent revolution is thus carried into individual experience. Living is keeping the absurd alive. Keeping it alive is, above all, contemplating it. Unlike Eurydice, the absurd dies only when we turn away from it. One of the only coherent philosophical positions is thus revolt. It is a constant confrontation between man and his own obscurity. It is an insistence upon an impossible transparency. It challenges the world anew every second. Just as danger provided man the · unique opportunity of seizing awareness, so metaphysical revolt extends awareness to the whole of

experience. It is that constant presence of man in his own eyes. It is not aspiration, for it is devoid of hope. That revolt is the certainty of a crushing fate, without the resignation that ought to accompany it.

This is where it is seen to what a degree absurd experience is remote from suicide. It may be thought that suicide follows revolt—but wrongly. For it does not represent the logical outcome of revolt. It is just the contrary by the consent it presupposes. Suicide, like the leap, is acceptance at its extreme. Everything is over and man returns to his essential history. His future, his unique and dreadful future—he sees and rushes toward it. In its way, suicide settles the absurd. It engulfs the absurd in the same death. But I know that in order to keep alive, the absurd cannot be settled. It escapes suicide to the extent that it is simultaneously awareness and rejection of death. It is, at the extreme limit of the condemned man's last thought, that shoe-lace that despite everything he sees a few yards away, on the very brink of his dizzying fall. The contrary of suicide, in fact, is the man condemned to death.

That revolt gives life its value. Spread out over the whole length of a life, it restores its majesty to that life. To a man devoid of blinders, there is no finer sight than that of the intelligence at grips with a reality that transcends it. The sight of human pride is unequaled. No disparagement is of any use. That discipline that the mind imposes on itself, that will conjured up out of nothing, that face-to-face struggle have something exceptional about them. To impoverish that reality whose inhumanity constitutes man's majesty is tanta-mount to impoverishing him himself. I understand then why the doctrines that explain everything to me also debilitate me at the same time. They relieve me of the weight of my own life, and yet I must carry it alone. At this juncture, I cannot conceive that a skeptical meta-physics can be joined to an ethics of renunciation.

Consciousness and revolt, these rejections are the contrary of renunciation. Everything that is indomi-table and passionate in a human heart quickens them, on the contrary, with its own life. It is essential to die unreconciled and not of one's own free will. Suicide is a repudiation. The absurd man can only drain everything to the bitter end, and deplete himself. The absurd is his extreme tension, which he maintains constantly by solitary effort, for he knows that in that consciousness and in that day-to-day revolt he gives proof of his only truth, which is defiance. This is a first consequence.

If I remain in that prearranged position which con-sists in drawing all the conclusions (and nothing else) involved in a newly discovered notion, I am faced with a second paradox. In order to remain faithful to that method, I have nothing to do with the problem of metaphysical liberty. Knowing whether or not man is free doesn't interest me. I can experi-ence only my own freedom. As to it, I can have no general notions, but merely a few clear insights. The problem of "freedom as such" has no meaning. For it is linked in quite a different way with the problem of God. Knowing whether or not man is free involves knowing whether he can have a master. The absurd-ity peculiar to this problem comes from the fact that the very notion that makes the problem of freedom possible also takes away all its meaning. For in the presence of God there is less a problem of freedom than a problem of evil. You know the alternative: either we are not free and God the all-powerful is responsible for evil. Or we are free and responsible but God is not all-powerful. All the scholastic sub-tleties have neither added anything to nor subtracted anything from the acuteness of this paradox.

This is why I cannot get lost in the glorification or the mere definition of a notion which eludes me and loses its meaning as soon as it goes beyond the frame of reference of my individual experience. I cannot understand what kind of freedom would be given me by a higher being. I have lost the sense of hierarchy. The only conception of freedom I can have is that of the prisoner of the individual in the midst of the State. The only one I know is freedom of thought and action. Now if the absurd cancels all my chances of eternal freedom, it restores and magnifies, on the other hand, my freedom of action. That privation of hope and future means an increase in man's availability.

Before encountering the absurd, the everyday man lives with aims, a concern for the future or for justifica-tion (with regard to whom or what is not the question). He weighs his chances, he counts on "someday," his retirement or the labor of his sons. He still thinks that something in his life can be directed. In truth, he acts as if he were free, even if all the facts make a point of

contradicting that liberty. But after the absurd, everything is upset. That idea that "I am," my way of acting as if everything has a meaning (even if, on occasion, I said that nothing has)—all that is given the lie in vertiginous fashion by the absurdity of a possible death. Thinking of the future, establishing aims for oneself, having preferences—all this presupposes a belief in freedom, even if one occasionally ascertains that one doesn't feel it. But at that moment I am well aware that that higher liberty, that freedom *to be*, which alone can serve as basis for a truth, does not exist. Death is there as the only reality. After death the chips are down. I am not even free, either, to perpetuate myself, but a slave, and, above all, a slave without hope of an eternal revolution, without recourse to contempt. And who without revolution and without contempt can remain a slave? What freedom can exist in the fullest sense without assurance of eternity?

But at the same time the absurd man realizes that hitherto he was bound to that postulate of freedom on the illusion of which he was living. In a certain sense, that hampered him. To the extent to which he imagined a purpose to his life, he adapted himself to the demands of a purpose to be achieved and became the slave of his liberty. Thus I could not act otherwise than as the father (or the engineer or the leader of a nation, or the post-office sub-clerk) that I am preparing to be. I think I can choose to be that rather than something else. I think so unconsciously, to be sure. But at the same time I strengthen my postulate with the beliefs of those around me, with the presumptions of my human environment (others are so sure of being free, and that cheerful mood is so contagious!). However far one may remain from any presumption, moral or social, one is partly influenced by them and even, for the best among them (there are good and bad presumptions), one adapts one's life to them. Thus the absurd man realizes that he was not really free. To speak clearly, to the extent to which I hope, to which I worry about a truth that might be individual to me, about a way of being or creating, to the extent to which I arrange my life and prove thereby that I accept its having a meaning, I create for myself barriers between which I confine my life. I do like so many bureaucrats of the mind and heart who only fill me with disgust and whose only vice, I now see clearly, is to take man's freedom seriously.

The absurd enlightens me on this point: there is no future. Henceforth this is the reason for my inner freedom. I shall use two comparisons here. Mystics, to begin with, find freedom in giving themselves. By losing themselves in their god, by accepting his rules, they become secretly free. In spontaneously accepted slavery they recover a deeper independence. But what does that freedom mean? It may be said, above all, that they *feel* free with regard to themselves, and not so much free as liberated. Likewise, completely turned toward death (taken here as the most obvious absurdity), the absurd man feels released from everything outside that passionate attention crystallizing in him. He enjoys a freedom with regard to common rules. It can be seen at this point that the initial themes of existential philosophy keep their entire value. The return to consciousness, the escape from everyday sleep represent the first steps of absurd freedom. But it is existential *preaching* that is alluded to, and with it that spiritual leap which basically escapes consciousness. In the same way (this is my second comparison) the slaves of antiquity did not belong to themselves. But they knew that freedom which consists in not feeling responsible.[4] Death, too, has patrician hands which, while crushing, also liberate.

Losing oneself in that bottomless certainty, feeling henceforth sufficiently remote from one's own life to increase it and take a broad view of it—this involves the principle of a liberation. Such new independence has a definite time limit, like any freedom of action. It does not write a check on eternity. But it takes the place of the illusions of *freedom*, which all stopped with death. The divine availability of the condemned man before whom the prison doors open in a certain early dawn, that unbelievable disinterestedness with regard to everything except for the pure flame of life—it is clear that death and the absurd are here the principles of the only reasonable freedom: that which a human heart can experience and live. This is a second consequence. The absurd man thus catches sight of a burning and frigid, transparent and limited universe in which nothing is possible but everything is given, and beyond which all is collapse and nothingness. He can then decide to accept such a universe and draw from it his strength, his refusal to hope, and the unyielding evidence of a life without consolation.

But what does life mean in such a universe? Nothing else for the moment but indifference to the future and a desire to use up everything that is given. Belief in the meaning of life always implies a scale of values, a choice, our preferences. Belief in the absurd, according to our definitions, teaches the contrary. But this is worth examining.

Knowing whether or not one can live *without appeal* is all that interests me. I do not want to get out of my depth. This aspect of life being given me, can I adapt myself to it? Now, faced with this particular concern, belief in the absurd is tantamount to substituting the quantity of experiences for the quality. If I convince myself that this life has no other aspect than that of the absurd, if I feel that its whole equilibrium depends on that perpetual opposition between my conscious revolt and the darkness in which it struggles, if I admit that my freedom has no meaning except in relation to its limited fate, then I must say that what counts is not the best living but the most living. It is not up to me to wonder if this is vulgar or revolting, elegant or deplorable. Once and for all, value judgments are discarded here in favor of factual judgments. I have merely to draw the conclusions from what I can see and to risk nothing that is hypothetical. Supposing that living in this way were not honorable, then true propriety would command me to be dishonorable.

The most living; in the broadest sense, that rule means nothing. It calls for definition. It seems to begin with the fact that the notion of quantity has not been sufficiently explored. For it can account for a large share of human experience. A man's rule of conduct and his scale of values have no meaning except through the quantity and variety of experiences he has been in a position to accumulate. Now, the conditions of modern life impose on the majority of men the same quantity of experiences and consequently the same profound experience. To be sure, there must also be taken into consideration the individual's spontaneous contribution, the "given" element in him. But I cannot judge of that, and let me repeat that my rule here is to get along with the immediate evidence. I see, then, that the individual character of a common code of ethics lies not so much in the ideal importance of its basic principles as in the norm of an experience that it is possible to measure. To stretch a point somewhat, the Greeks had the code

of their leisure just as we have the code of our eight-hour day. But already many men among the most tragic cause us to foresee that a longer experience changes this table of values. They make us imagine that adventurer of the everyday who through mere quantity of experiences would break all records (I am purposely using this sports expression) and would thus win his own code of ethics.[5] Yet let's avoid romanticism and just ask ourselves what such an attitude may mean to a man with his mind made up to take up his bet and to observe strictly what he takes to be the rules of the game.

Breaking all the records is first and foremost being faced with the world as often as possible. How can that be done without contradictions and without playing on words? For on the one hand the absurd teaches that all experiences are unimportant, and on the other it urges toward the greatest quantity of experiences. How, then, can one fail to do as so many of those men I was speaking of earlier—choose the form of life that brings us the most possible of that human matter, thereby introducing a scale of values that on the other hand one claims to reject?

But again it is the absurd and its contradictory life that teaches us. For the mistake is thinking that that quantity of experiences depends on the circumstances of our life when it depends solely on us. Here we have to be over-simple. To two men living the same number of years, the world always provides the same sum of experiences. It is up to us to be conscious of them. Being aware of one's life, one's revolt, one's freedom, and to the maximum, is living, and to the maximum. Where lucidity dominates, the scale of values becomes useless. Let's be even more simple. Let us say that the sole obstacle, the sole deficiency to be made good, is constituted by premature death. Thus it is that no depth, no emotion, no passion, and no sacrifice could render equal in the eyes of the absurd man (even if he wished it so) a conscious life of forty years and a lucidity spread over sixty years.[6] Madness and death are his irreparables. Man does not choose. The absurd and the extra life it involves *therefore do not depend on man's will*, but on its contrary, which is death.[7] Weighing words carefully, it is altogether a question of luck. One just has to be able to consent to this. There will never be any substitute for twenty years of life and experience.

By what is an odd inconsistency in such an alert race, the Greeks claimed that those who died young were beloved of the gods. And that is true only if you are willing to believe that entering the ridiculous world of the gods is forever losing the purest of joys, which is feeling, and feeling on this earth. The present and the succession of presents before a constantly conscious soul is the ideal of the absurd man. But the word "ideal" rings false in this connection. It is not even his vocation, but merely the third consequence of his reasoning. Having started from an anguished awareness of the inhuman, the meditation on the absurd returns at the end of its itinerary to the very heart of the passionate flames of human revolt.[8]

Thus I draw from the absurd three consequences, which are my revolt, my freedom, and my passion. By the mere activity of consciousness I transform into a rule of life what was an invitation to death—and I refuse suicide. I know, to be sure, the dull resonance that vibrates throughout these days. Yet I have but a word to say: that it is necessary. When Nietzsche writes: "It clearly seems that the chief thing in heaven and on earth is to *obey* at length and in a single direction: in the long run there results something for which it is worth the trouble of living on this earth as, for example, virtue, art, music, the dance, reason, the mind—something that transfigures, something delicate, mad, or divine," he elucidates the rule of a really distinguished code of ethics. But he also points the way of the absurd man. Obeying the flame is both the easiest and the hardest thing to do. However, it is good for man to judge himself occasionally. He is alone in being able to do so.

"Prayer," says Alain, "is when night descends over thought." "But the mind must meet the night," reply the mystics and the existentials. Yes, indeed, but not that night that is born under closed eyelids and through the mere will of man—dark, impenetrable night that the mind calls up in order to plunge into it. If it must encounter a night, let it be rather that of despair, which remains lucid—polar night, vigil of the mind, whence will arise perhaps that white and virginal brightness which outlines every object in the light of the intelligence. At that degree, equivalence encounters passionate understanding. Then it is no longer even a question

of judging the existential leap. It resumes its place amid the age-old fresco of human attitudes. For the spectator, if he is conscious, that leap is still absurd. In so far as it thinks it solves the paradox, it reinstates it intact. On this score, it is stirring. On this score, everything resumes its place and the absurd world is reborn in all its splendor and diversity.

But it is bad to stop, hard to be satisfied with a single way of seeing, to go without contradiction, perhaps the most subtle of all spiritual forces. The preceding merely defines a way of thinking. But the point is to live.

THE MYTH OF SISYPHUS

The gods had condemned Sisyphus to ceaselessly rolling a rock to the top of a mountain, whence the stone would fall back of its own weight. They had thought with some reason that there is no more dreadful punishment than futile and hopeless labor.

If one believes Homer, Sisyphus was the wisest and most prudent of mortals. According to another tradition, however, he was disposed to practice the profession of highwayman. I see no contradiction in this. Opinions differ as to the reasons why he became the futile laborer of the underworld. To begin with, he is accused of a certain levity in regard to the gods. He stole their secrets. Ægina, the daughter of Æsopus, was carried off by Jupiter. The father was shocked by that disappearance and complained to Sisyphus. He, who knew of the abduction, offered to tell about it on condition that Æsopus would give water to the citadel of Corinth. To the celestial thunderbolts he preferred the benediction of water. He was punished for this in the underworld. Homer tells us also that Sisyphus had put Death in chains. Pluto could not endure the sight of his deserted, silent empire. He dispatched the god of war, who liberated Death from the hands of her conqueror.

It is said also that Sisyphus, being near to death, rashly wanted to test his wife's love. He ordered her to cast his unburied body into the middle of the public square. Sisyphus woke up in the underworld. And there, annoyed by an obedience so contrary to human love, he obtained from Pluto permission to return to earth in order to chastise his wife. But when he had seen again

the face of this world, enjoyed water and sun, warm stones and the sea, he no longer wanted to go back to the infernal darkness. Recalls, signs of anger, warnings were of no avail. Many years more he lived facing the curve of the gulf, the sparkling sea, and the smiles of earth. A decree of the gods was necessary. Mercury came and seized the impudent man by the collar and, snatching him from his joys, led him forcibly back to the underworld, where his rock was ready for him.

You have already grasped that Sisyphus is the absurd hero. He *is*, as much through his passions as through his torture. His scorn of the gods, his hatred of death, and his passion for life won him that unspeakable penalty in which the whole being is exerted toward accomplishing nothing. This is the price that must be paid for the passions of this earth. Nothing is told us about Sisyphus in the underworld. Myths are made for the imagination to breathe life into them. As for this myth, one sees merely the whole effort of a body straining to raise the huge stone, to roll it and push it up a slope a hundred times over; one sees the face screwed up, the cheek tight against the stone, the shoulder bracing the clay-covered mass, the foot wedging it, the fresh start with arms outstretched, the wholly human security of two earth-clotted hands. At the very end of his long effort measured by skyless space and time without depth, the purpose is achieved. Then Sisyphus watches the stone rush down in a few moments toward that lower world whence he will have to push it up again toward the summit. He goes back down to the plain.

It is during that return, that pause, that Sisyphus interests me. A face that toils so close to stones is already stone itself! I see that man going back down with a heavy yet measured step toward the torment of which he will never know the end. That hour like a breathing-space which returns as surely as his suffering, that is the hour of consciousness. At each of those moments when he leaves the heights and gradually sinks toward the lairs of the gods, he is superior to his fate. He is stronger than his rock.

If this myth is tragic, that is because its hero is conscious. Where would his torture be, indeed, if at every step the hope of succeeding upheld him? The workman of today works every day in his life at the same tasks, and this fate is no less absurd. But it is

tragic only at the rare moments when it becomes conscious. Sisyphus, proletarian of the gods, powerless and rebellious, knows the whole extent of his wretched condition: it is what he thinks of during his descent. The lucidity that was to constitute his torture at the same time crowns his victory. There is no fate that cannot be surmounted by scorn.

If the descent is thus sometimes performed in sorrow, it can also take place in joy. This word is not too much. Again I fancy Sisyphus returning toward his rock, and the sorrow was in the beginning. When the images of earth cling too tightly to memory, when the call of happiness becomes too insistent, it happens that melancholy rises in man's heart: this is the rock's victory, this is the rock itself. The boundless grief is too heavy to bear. These are our nights of Gethsemane. But crushing truths perish from being acknowledged. Thus, Œdipus at the outset obeys fate without knowing it. But from the moment he knows, his tragedy begins. Yet at the same moment, blind and desperate, he realizes that the only bond linking him to the world is the cool hand of a girl. Then a tremendous remark rings out: "Despite so many ordeals, my advanced age and the nobility of my soul make me conclude that all is well." Sophocles' Œdipus, like Dostoevsky's Kirilov, thus gives the recipe for the absurd victory. Ancient wisdom confirms modern heroism.

One does not discover the absurd without being tempted to write a manual of happiness. "What! by such narrow ways—?" There is but one world, however. Happiness and the absurd are two sons of the same earth. They are inseparable. It would be a mistake to say that happiness necessarily springs from the absurd discovery. It happens as well that the feeling of the absurd springs from happiness. "I conclude that all is well," says Œdipus, and that remark is sacred. It echoes in the wild and limited universe of man. It teaches that all is not, has not been, exhausted. It drives out of this world a god who had come into it with dissatisfaction and a preference for futile sufferings. It makes of fate a human matter, which must be settled among men.

All Sisyphus' silent joy is contained therein. His fate belongs to him. His rock is his thing. Likewise, the absurd man, when he contemplates his torment, silences all the idols. In the universe suddenly restored to its silence, the myriad wondering little voices of

the earth rise up. Unconscious, secret calls, invitations from all the faces, they are the necessary reverse and price of victory. There is no sun without shadow, and it is essential to know the night. The absurd man says yes and his effort will henceforth be unceasing. If there is a personal fate, there is no higher destiny, or at least there is but one which he concludes is inevitable and despicable. For the rest, he knows himself to be the master of his days. At that subtle moment when man glances backward over his life, Sisyphus returning toward his rock, in that slight pivoting he contemplates that series of unrelated actions which becomes his fate, created by him, combined under his memory's eye and soon sealed by his death. Thus, convinced of the wholly human origin of all that is human, a blind man eager to see who knows that the night has no end, he is still on the go. The rock is still rolling.

I leave Sisyphus at the foot of the mountain! One always finds one's burden again. But Sisyphus teaches the higher fidelity that negates the gods and raises rocks. He too concludes that all is well. This universe henceforth without a master seems to him neither sterile nor futile. Each atom of that stone, each mineral flake of that night-filled mountain, in itself forms a world. The struggle itself toward the heights is enough to fill a man's heart. One must imagine Sisyphus happy.

Notes

1. From the point of view of the relative value of truth. On the other hand, from the point of view of virile behavior, this scholar's fragility may well make us smile.

2. Let us not miss this opportunity to point out the relative character of this essay. Suicide may indeed be related to much more honorable considerations—for example, the political suicides of protest, as they were called, during the Chinese revolution.

3. But not in the proper sense. This is not a definition, but rather an *enumeration* of the feelings that may admit of the absurd. Still, the enumeration finished, the absurd has nevertheless not been exhausted.

4. I am concerned here with a factual comparison, not with an apology of humility. The absurd man is the contrary of the reconciled man.

5. Quantity sometimes constitutes quality. If I can believe the latest restatements of scientific theory, all matter is constituted by centers of energy. Their greater or lesser quantity makes its specificity more or less remarkable. A billion ions and one ion differ not only in quantity but also in quality. It is easy to find an analogy in human experience.

6. Same reflection on a notion as different as the idea of eternal nothingness. It neither adds anything to nor subtracts anything from reality. In psychological experience of nothingness, it is by the consideration of what will happen in two thousand years that our own nothingness truly takes on meaning. In one of its aspects, eternal nothingness is made up precisely of the sum of lives to come which will not be ours.

7. The will is only the agent here: it tends to maintain consciousness. It provides a discipline of life, and that is appreciable.

8. What matters is coherence. We start out here from acceptance of the world. But Oriental thought teaches that one can indulge in the same effort of logic by choosing *against* the world. That is just as legitimate and gives this essay its perspectives and its limits. But when the negation of the world is pursued just as rigorously, one often achieves (in certain Vedantic schools) similar results regarding, for instance, the indifference of works. In a book of great importance, *Le Choix*, Jean Grenier establishes in this way a veritable "philosophy of indifference."

Study Questions

1. If God exists, what meaning can thereby be found in the world?

2. If God doesn't exist, why can't we find meaning in the world?

3. If our lives our meaningless, why extend their duration?

4. Can you imagine Sisyphus happy?

17

JEAN-PAUL SARTRE

Jean-Paul Sartre (1905–1980) was a leading French philosopher, novelist, and dramatist who was offered but declined the 1964 Nobel Prize for Literature. He defended existentialism, the theory that human agents by their thoughts and deeds freely shape themselves. In Sartre's terms our existence (or being) precedes our essence (or nature), and hence we are nothing but what we make of ourselves. At the heart of Sartre's ethical theory is authenticity, the willingness to take responsibility for our choices. Doing so, however, brings with it anguish, forlornness, and despair. For Sartre, an atheist, each of us is alone with no way to avoid the responsibility for making ourselves whatever we become, and all that matters is not what we dream, expect, or hope, but what we actually do.

Existentialism Is a Humanism

What is meant by the term *existentialism?*

Most people who use the word would be rather embarrassed if they had to explain it, since, now that the word is all the rage, even the work of a musician or painter is being called existentialist. A gossip columnist in *Clartés* signs himself *The Existentialist*, so that by this time the word has been so stretched and has taken on so broad a meaning, that it no longer means anything at all. It seems that for want of an advance-guard doctrine analogous to surrealism, the kind of people who are eager for scandal and flurry turn to this philosophy which in other respects does not at all serve their purposes in this sphere.

Actually, it is the least scandalous, the most austere of doctrines. It is intended strictly for specialists and philosophers. Yet it can be defined easily. What complicates matters is that there are two kinds of existentialist; first, those who are Christian, among whom I would include Jaspers and Gabriel Marcel, both Catholic; and on the other hand the atheistic existentialists, among whom I class Heidegger, and then the French existentialists and myself. What they have in common is that they think that existence precedes essence, or, if you prefer, that subjectivity must be the starting point.

Just what does that mean? Let us consider some object that is manufactured, for example, a book or a paper-cutter: here is an object which has been made by an artisan whose inspiration came from a concept. He referred to the concept of what a paper-cutter is and likewise to a known method of production, which is part of the concept, something which is, by and large, a routine. Thus, the paper-cutter is at once an object produced in a certain way and, on the other hand, one having a specific use; and one can not postulate a man who produces a paper-cutter but does not

know what it is used for. Therefore, let us say that, for the paper-cutter, essence—that is, the ensemble of both the production routines and the properties which enable it to be both produced and defined—precedes existence. Thus, the presence of the paper-cutter or book in front of me is determined. Therefore, we have here a technical view of the world whereby it can be said that production precedes existence.

When we conceive God as the Creator, He is generally thought of as a superior sort of artisan. Whatever doctrine we may be considering, whether one like that of Descartes or that of Leibnitz, we always grant that will more or less follows understanding or, at the very least, accompanies it, and that when God creates He knows exactly what He is creating. Thus, the concept of man in the mind of God is comparable to the concept of paper-cutter in the mind of the manufacturer, and, following certain techniques and a conception, God produces man, just as the artisan, following a definition and a technique, makes a paper-cutter. Thus, the individual man is the realization of a certain concept in the divine intelligence.

In the eighteenth century, the atheism of the *philosophes* discarded the idea of God, but not so much for the notion that essence precedes existence. To a certain extent, this idea is found everywhere; we find it in Diderot, in Voltaire, and even in Kant. Man has a human nature; this human nature, which is the concept of the human, is found in all men, which means that each man is a particular example of a universal concept, man. In Kant, the result of this universality is that the wild-man, the natural man, as well as the bourgeois, are circumscribed by the same definition and have the same basic qualities. Thus, here too the essence of man precedes the historical existence that we find in nature.

Atheistic existentialism, which I represent, is more coherent. It states that if God does not exist, there is at least one being in whom existence precedes essence, a being who exists before he can be defined by any concept, and that this being is man, or, as Heidegger says, human reality. What is meant here by saying that existence precedes essence? It means that, first of all, man exists, turns up, appears on the scene, and, only afterwards, defines himself. If man,

as the existentialist conceives him, is indefinable, it is because at first he is nothing. Only afterward will he be something, and he himself will have made what he will be. Thus, there is no human nature, since there is no God to conceive it. Not only is man what he conceives himself to be, but he is also only what he wills himself to be after this thrust toward existence.

Man is nothing else but what he makes of himself. Such is the first principle of existentialism. It is also what is called subjectivity, the name we are labeled with when charges are brought against us. But what do we mean by this, if not that man has a greater dignity than a stone or table? For we mean that man first exists, that is, that man first of all is the being who hurls himself toward a future and who is conscious of imagining himself as being in the future. Man is at the start a plan which is aware of itself, rather than a patch of moss, a piece of garbage, or a cauliflower; nothing exists prior to this plan; there is nothing in heaven; man will be what he will have planned to be. Not what he will want to be. Because by the word "will" we generally mean a conscious decision, which is subsequent to what we have already made of ourselves. I may want to belong to a political party, write a book, get married; but all that is only a manifestation of an earlier, more spontaneous choice that is called "will." But if existence really does precede essence, man is responsible for what he is. Thus, existentialism's first move is to make every man aware of what he is and to make the full responsibility of his existence rest on him. And when we say that a man is responsible for himself, we do not only mean that he is responsible for his own individuality, but that he is responsible for all men.

The word subjectivism has two meanings, and our opponents play on the two. Subjectivism means, on the one hand, that an individual chooses and makes himself; and, on the other, that it is impossible for man to transcend human subjectivity. The second of these is the essential meaning of existentialism. When we say that man chooses his own self, we mean that every one of us does likewise; but we also mean by that that in making this choice he also

chooses all men. In fact, in creating the man that we want to be, there is not a single one of our acts which does not at the same time create an image of man as we think he ought to be. To choose to be this or that is to affirm at the same time the value of what we choose, because we can never choose evil. We always choose the good, and nothing can be good for us without being good for all.

If, on the other hand, existence precedes essence, and if we grant that we exist and fashion our image at one and the same time, the image is valid for everybody and for our whole age. Thus, our responsibility is much greater than we might have supposed, because it involves all mankind. If I am a working-man and choose to join a Christian trade-union rather than be a communist, and if by being a member I want to show that the best thing for man is resignation, that the kingdom of man is not of this world, I am not only involving my own case—I want to be resigned for everyone. As a result, my action has involved all humanity. To take a more individual matter, if I want to marry, to have children; even if this marriage depends solely on my own circumstances or passion or wish, I am involving all humanity in monogamy and not merely myself. Therefore, I am responsible for myself and for everyone else. I am creating a certain image of man of my own choosing. In choosing myself, I choose man.

This helps us understand what the actual content is of such rather grandiloquent words as anguish, forlornness, despair. As you will see, it's all quite simple.

First, what is meant by anguish? The existentialists say at once that man is anguish. What that means is this: the man who involves himself and who realizes that he is not only the person he chooses to be, but also a lawmaker who is, at the same time, choosing all mankind as well as himself, can not help escape the feeling of his total and deep responsibility. Of course, there are many people who are not anxious; but we claim that they are hiding their anxiety, that they are fleeing from it. Certainly, many people believe that when they do something, they themselves are the only ones involved, and when someone says to them, "What if everyone acted that way?" they shrug their shoulders and answer, "Everyone doesn't act that way." But really, one should always ask himself, "What would happen if everybody looked at things that way?" There is no escaping this disturbing thought except by a kind of double-dealing. A man who lies and makes excuses for himself by saying "not everybody does that," is someone with an uneasy conscience, because the act of lying implies that a universal value is conferred upon the lie.

Anguish is evident even when it conceals itself. This is the anguish that Kierkegaard called the anguish of Abraham. You know the story: an angel has ordered Abraham to sacrifice his son; if it really were an angel who has come and said, "You are Abraham, you shall sacrifice your son," everything would be all right. But everyone might first wonder, "Is it really an angel, and am I really Abraham? What proof do I have?"

There was a madwoman who had hallucinations; someone used to speak to her on the telephone and give her orders. Her doctor asked her, "Who is it who talks to you?" She answered, "He says it's God." What proof did she really have that it was God? If an angel comes to me, what proof is there that it's an angel? And if I hear voices, what proof is there that they come from heaven and not from hell, or from the subconscious, or a pathological condition? What proves that they are addressed to me? What proof is there that I have been appointed to impose my choice and my conception of man on humanity? I'll never find any proof or sign to convince me of that. If a voice addresses me, it is always for me to decide that this is the angel's voice; if I consider that such an act is a good one, it is I who will choose to say that it is good rather than bad.

Now, I'm not being singled out as an Abraham, and yet at every moment I'm obliged to perform exemplary acts. For every man, everything happens as if all mankind had its eyes fixed on him and were guiding itself by what he does. And every man ought to say to himself, "Am I really the kind of man who has the right to act in such a way that humanity might guide itself by my actions?" And if he does not say that to himself, he is masking his anguish.

There is no question here of the kind of anguish which would lead to quietism, to inaction. It is a matter of a simple sort of anguish that anybody who has had responsibilities is familiar with. For example, when a military officer takes the responsibility for an attack and sends a certain number of men to death, he chooses to do so, and in the main he alone makes the choice. Doubtless, orders come from above, but they are too broad; he interprets them, and on this interpretation depend the lives of ten or fourteen or twenty men. In making a decision he can not help having a certain anguish. All leaders know this anguish. That doesn't keep them from acting; on the contrary, it is the very condition of their action. For it implies that they envisage a number of possibilities, and when they choose one, they realize that it has value only because it is chosen. We shall see that this kind of anguish, which is the kind that existentialism describes, is explained, in addition, by a direct responsibility to the other men whom it involves. It is not a curtain separating us from action, but is part of action itself.

When we speak of forlornness, a term Heidegger was fond of, we mean only that God does not exist and that we have to face all the consequences of this. The existentialist is strongly opposed to a certain kind of secular ethics which would like to abolish God with the least possible expense. About 1880, some French teachers tried to set up a secular ethics which went something like this: God is a useless and costly hypothesis; we are discarding it; but, meanwhile, in order for there to be an ethics, a society, a civilization, it is essential that certain values be taken seriously and that they be considered as having an *a priori* existence. It must be obligatory, *a priori*, to be honest, not to lie, not to beat your wife, to have children, etc., etc. So we're going to try a little device which will make it possible to show that values exist all the same, inscribed in a heaven of ideas, though otherwise God does not exist. In other words—and this, I believe, is the tendency of everything called reformism in France—nothing will be changed if God does not exist. We shall find ourselves with the same norms of honesty, progress, and humanism, and we shall have made of God an outdated hypothesis which will peacefully die off by itself.

The existentialist, on the contrary, thinks it very distressing that God does not exist, because all possibility of finding values in a heaven of ideas disappears along with Him; there can no longer be an *a priori* Good, since there is no infinite and perfect consciousness to think it. Nowhere is it written that the Good exists, that we must be honest, that we must not lie; because the fact is we are on a plane where there are only men. Dostoevsky said, "If God didn't exist, everything would be possible." That is the very starting point of existentialism. Indeed, everything is permissible if God does not exist, and as a result man is forlorn, because neither within him nor without does he find anything to cling to. He can't start making excuses for himself.

If existence really does precede essence, there is no explaining things away by reference to a fixed and given human nature. In other words, there is no determinism, man is free, man is freedom. On the other hand, if God does not exist, we find no values or commands to turn to which legitimize our conduct. So, in the bright realm of values, we have no excuse behind us, nor justification before us. We are alone, with no excuses.

That is the idea I shall try to convey when I say that man is condemned to be free. Condemned, because he did not create himself, yet, in other respects is free; because, once thrown into the world, he is responsible for everything he does. The existentialist does not believe in the power of passion. He will never agree that a sweeping passion is a ravaging torrent which fatally leads a man to certain acts and is therefore an excuse. He thinks that man is responsible for his passion.

The existentialist does not think that man is going to help himself by finding in the world some omen by which to orient himself. Because he thinks that man will interpret the omen to suit himself. Therefore, he thinks that man, with no support and no aid, is condemned every moment to invent man. Ponge, in a very fine article, has said, "Man is the future of man." That's exactly it. But if it is taken to mean that this future is recorded in heaven, that God sees it, then it is false, because it would really no longer be a future. If it is taken to mean that, whatever a man

may be, there is a future to be forged, a virgin future before him, then this remark is sound. But then we are forlorn.

To give you an example which will enable you to understand forlornness better, I shall cite the case of one of my students who came to see me under the following circumstances: his father was on bad terms with his mother, and, moreover, was inclined to be a collaborationist; his older brother had been killed in the German offensive of 1940, and the young man, with somewhat immature but generous feelings, wanted to avenge him. His mother lived alone with him, very much upset by the half-treason of her husband and the death of her older son; the boy was her only consolation.

The boy was faced with the choice of leaving for England and joining the Free French Forces—that is, leaving his mother behind—or remaining with his mother and helping her to carry on. He was fully aware that the woman lived only for him and that his going-off—and perhaps his death—would plunge her into despair. He was also aware that every act that he did for his mother's sake was a sure thing, in the sense that it was helping her to carry on, whereas every effort he made toward going off and fighting was an uncertain move which might run aground and prove completely useless; for example, on his way to England he might, while passing through Spain, be detained indefinitely in a Spanish camp; he might reach England or Algiers and be stuck in an office at a desk job. As a result, he was faced with two very different kinds of action: one, concrete, immediate, but concerning only one individual; the other concerned an incomparably vaster group, a national collectivity, but for that very reason was dubious, and might be interrupted en route. And, at the same time, he was wavering between two kinds of ethics. On the one hand, an ethics of sympathy, of personal devotion; on the other hand, a broader ethics, but one whose efficacy was more dubious. He had to choose between the two.

Who could help him choose? Christian doctrine? No. Christian doctrine says, "Be charitable, love your neighbor, take the more rugged path, etc., etc." But which is the more rugged path? Whom should he love as a brother? The fighting man or his mother? Which does the greater good, the vague act of fighting in a group, or the concrete one of helping a particular human being to go on living? Who can decide *a priori?* Nobody. No book of ethics can tell him. The Kantian ethics says, "Never treat any person as a means, but as an end." Very well, if I stay with my mother, I'll treat her as an end and not as a means; but by virtue of this very fact, I'm running the risk of treating the people around me who are fighting, as means; and, conversely, if I go to join those who are fighting, I'll be treating them as an end, and, by doing that, I run the risk of treating my mother as a means.

If values are vague, and if they are always too broad for the concrete and specific case that we are considering, the only thing left for us is to trust our instincts. That's what this young man tried to do; and when I saw him, he said, "In the end, feeling is what counts. I ought to choose whichever pushes me in one direction. If I feel that I love my mother enough to sacrifice everything else for her—my desire for vengeance, for action, for adventure—then I'll stay with her. If, on the contrary, I feel that my love for my mother isn't enough, I'll leave."

But how is the value of a feeling determined? What gives his feeling for his mother value? Precisely the fact that he remained with her. I may say that I like so-and-so well enough to sacrifice a certain amount of money for him, but I may say so only if I've done it. I may say "I love my mother well enough to remain with her" if I have remained with her. The only way to determine the value of this affection is, precisely, to perform an act which confirms and defines it. But, since I require this affection to justify my act, I find myself caught in a vicious circle.

On the other hand, Gide has well said that a mock feeling and a true feeling are almost indistinguishable; to decide that I love my mother and will remain with her, or to remain with her by putting on an act, amount somewhat to the same thing. In other words, the feeling is formed by the acts one performs; so, I can not refer to it in order to act upon it. Which means that I can neither seek within myself the true condition which will impel me to act, nor apply

to a system of ethics for concepts which will permit me to act. You will say, "At least, he did go to a teacher for advice." But if you seek advice from a priest, for example, you have chosen this priest; you already knew, more or less, just about what advice he was going to give you. In other words, choosing your adviser is involving yourself. The proof of this is that if you are a Christian, you will say, "Consult a priest." But some priests are collaborating, some are just marking time, some are resisting. Which to choose? If the young man chooses a priest who is resisting or collaborating, he has already decided on the kind of advice he's going to get. Therefore, in coming to see me he knew the answer I was going to give him, and I had only one answer to give: "You're free, choose, that is, invent." No general ethics can show you what is to be done; there are no omens in the world. The Catholics will reply, "But there are." Granted—but, in any case, I myself choose the meaning they have.

When I was a prisoner, I knew a rather remarkable young man who was a Jesuit. He had entered the Jesuit order in the following way: he had had a number of very bad breaks; in childhood, his father died, leaving him in poverty, and he was a scholarship student at a religious institution where he was constantly made to feel that he was being kept out of charity; then, he failed to get any of the honors and distinctions that children like; later on, at about eighteen, he bungled a love affair; finally at twenty-two, he failed in military training, a childish enough matter, but it was the last straw.

This young fellow might well have felt that he had botched everything. It was a sign of something, but of what? He might have taken refuge in bitterness or despair. But he very wisely looked upon all this as a sign that he was not made for secular triumphs, and that only the triumphs of religion, holiness, and faith were open to him. He saw the hand of God in all this, and so he entered the order. Who can help seeing that he alone decided what the sign meant?

Some other interpretation might have been drawn from this series of set-backs; for example, that he might have done better to turn carpenter or revolutionist. Therefore, he is fully responsible for

the interpretation. Forlornness implies that we ourselves choose our being. Forlornness and anguish go together.

As for despair, the term has a very simple meaning. It means that we shall confine ourselves to reckoning only with what depends upon our will, or on the ensemble of probabilities which make our action possible. When we want something, we always have to reckon with probabilities. I may be counting on the arrival of a friend. The friend is coming by rail or street-car; this supposes that the train will arrive on schedule, or that the street-car will not jump the track. I am left in the realm of possibility; but possibilities are to be reckoned with only to the point where my action comports with the ensemble of these possibilities, and no further. The moment the possibilities I am considering are not rigorously involved by my action, I ought to disengage myself from them, because no God, no scheme, can adapt the world and its possibilities to my will. When Descartes said, "Conquer yourself rather than the world," he meant essentially the same thing.

The Marxists to whom I have spoken reply, "You can rely on the support of others in your action, which obviously has certain limits because you're not going to live forever. That means: rely on both what others are doing elsewhere to help you, in China, in Russia, and what they will do later on, after your death, to carry on the action and lead it to its fulfillment, which will be the revolution. You even *have* to rely upon that, otherwise you're immoral." I reply at once that I will always rely on fellow-fighters insofar as these comrades are involved with me in a common struggle, in the unity of a party or a group in which I can more or less make my weight felt; that is, one whose ranks I am in as a fighter and whose movements I am aware of at every moment. In such a situation, relying on the unity and will of the party is exactly like counting on the fact that the train will arrive on time or that the car won't jump the track. But, given that man is free and that there is no human nature for me to depend on, I can not count on men whom I do not know by relying on human goodness or man's concern for the good of society. I don't know what will become of the Russian revolution; I may make an

example of it to the extent that at the present time it is apparent that the proletariat plays a part in Russia that it plays in no other nation. But I can't swear that this will inevitably lead to a triumph of the proletariat. I've got to limit myself to what I see.

Given that men are free and that tomorrow they will freely decide what man will be, I can not be sure that, after my death, fellow-fighters will carry on my work to bring it to its maximum perfection. Tomorrow, after my death, some men may decide to set up Fascism, and the others may be cowardly and muddled enough to let them do it. Fascism will then be the human reality, so much the worse for us.

Actually, things will be as man will have decided they are to be. Does that mean that I should abandon myself to quietism? No. First, I should involve myself; then, act on the old saw, "Nothing ventured, nothing gained." Nor does it mean that I shouldn't belong to a party, but rather that I shall have no illusions and shall do what I can. For example, suppose I ask myself, "Will socialization, as such, ever come about?" I know nothing about it. All I know is that I'm going to do everything in my power to bring it about. Beyond that, I can't count on anything. Quietism is the attitude of people who say, "Let others do what I can't do." The doctrine I am presenting is the very opposite of quietism, since it declares, "There is no reality except in action." Moreover, it goes further, since it adds, "Man is nothing else than his plan; he exists only to the extent that he fulfills himself; he is therefore nothing else than the ensemble of his acts, nothing else than his life."

According to this, we can understand why our doctrine horrifies certain people. Because often the only way they can bear their wretchedness is to think, "Circumstances have been against me. What

I've been and done doesn't show my true worth. To be sure, I've had no great love, no great friendship, but that's because I haven't met a man or woman who was worthy. The books I've written haven't been very good because I haven't had the proper leisure. I haven't had children to devote myself to because I didn't find a man with whom I could have spent my life. So there remains within me, unused and quite viable, a host of propensities, inclinations, possibilities, that one wouldn't guess from the mere series of things I've done."

Now, for the existentialist there is really no love other than one which manifests itself in a person's being in love. There is no genius other than one which is expressed in works of art; the genius of Proust is the sum of Proust's works; the genius of Racine is his series of tragedies. Outside of that, there is nothing. Why say that Racine could have written another tragedy, when he didn't write it? A man is involved in life, leaves his impress on it, and outside of that there is nothing. To be sure, this may seem a harsh thought to someone whose life hasn't been a success. But, on the other hand, it prompts people to understand that reality alone is what counts, that dreams, expectations, and hopes warrant no more than to define a man as a disappointed dream, as miscarried hopes, as vain expectations. In other words, to define him negatively and not positively. However, when we say, "You are nothing else than your life," that does not imply that the artist will be judged solely on the basis of his works of art; a thousand other things will contribute toward summing him up. What we mean is that a man is nothing else than a series of undertakings, that he is the sum, the organization, the ensemble of the relationships which make up these undertakings.

Study Questions

1. Does our existence precede our essence?
2. How did Sartre distinguish between anguish, forlornness, and despair?

3. In the case of the boy faced with joining the Free French Forces or staying with his mother, is only one decision correct?
4. What makes a life successful?

PART II

Modern Ethical Theory

INTRODUCTION

James Rachels

James Rachels (1941–2003) was professor of philosophy at the University of Alabama at Birmingham.

"It is a salutary reflection," wrote John Passmore at the beginning of his *A Hundred Years of Philosophy*, "that had I written this book in 1800 I should probably have dismissed Berkeley and Hume in a few lines, in order to concentrate my attention on Dugald Stewart."[1] As the year 2000 approaches, we will no doubt be flooded with reviews of the past century, and they will contain plenty of misperceptions to amuse future generations. Perhaps history will judge the greatest thinker of the age to have been someone whom today we do not deem worthy of attention.

But even if we cannot be sure what will seem important to future generations, at least we know what has seemed important to us. From our present perspective, the story of what has happened during the last hundred years is clear enough. During the twentieth century, moral philosophers in the English-speaking countries have been preoccupied with two broad questions. The first concerns the objectivity of ethics: Is there any sense in which our moral judgments express truths that are independent of our feelings and conventions? And the second is about substantive moral theory: What is the best way to explain and summarize how we ought to live? As we shall see, these questions are not entirely independent of one another. Nevertheless, they provide a convenient way to organize our subject.

From *Twentieth Century Ethical Theory*, eds. Steven M. Cahn and Joram G. Haber, © 1995. Reprinted by permission of the author.

Our story begins in 1903 with the publication of G. E. Moore's *Principia Ethica,* a book that would become a classic as much for its way of framing issues, its style of argument, and its criticisms of familiar views as for its positive doctrines. Moore, who taught at Cambridge University in England, was revered as a gentle, saintly man. But he began his book with the contentious declaration that previous moral philosophy had been based on a mistake. Earlier philosophers, he said, had gone wrong by failing to be clear about what questions they were asking. The central question is "What is goodness?" We must know what goodness is before we can broach other important matters, such as what things are good, how we know they are good, and how we ought to live.

Like Socrates, Moore wanted a definition of goodness, and not just a verbal definition, but an analysis that would lay bare the essence of the thing. He soon concluded, however, that no such definition was possible. Earlier thinkers had suggested that goodness might be the same as pleasure, or evolutionary progress, or conformity to the will of God. But, Moore said, none of these views will do. They all commit a certain mistake, which he dubbed "the naturalistic fallacy." Moore argued, instead, that "good" is the name of a simple, unanalyzable property. "Good" is like "yellow": We can perceive its presence in things, but we cannot define it by breaking it down into simpler notions.

Moore thought it was obvious that goodness is an objective property of things; for him the only real issue was what sort of property it was. He was the first of a distinguished line of British philosophers, known as the intuitionists, who would defend this view throughout the first half of the century—a line that included, most prominently, H. A. Prichard, W. D. Ross, and A. C. Ewing. What united the intuitionists, despite their differences on many points, was the conviction that good and bad are matters of fact entirely independent of what we think or how we feel. They were English gentlemen who did not see how it could be otherwise. The alternative, as they saw it, was subjectivism, the idea that our evaluative judgments are nothing more than reports of our feelings. Subjectivism, in their view, could not possibly be true. They gave argument after argument against it.

To other philosophers, however, Moore's view seemed incredible. How can goodness be a property of things? We cannot see it or touch it. We cannot detect it with any scientific instrument. To say that we "intuit" goodness with some sort of sixth sense seems like so much occult mumbo jumbo. Hume had made the right point about this sort of view two centuries before:

> Take any action allow'd to be vicious: Willful murder, for instance. Examine it in all lights, and see if you can find that matter of fact, or real existence, which you call *vice.* In whichever way you take it, you find only certain passions, motives, volitions and thoughts. There is no other matter of fact in the case. The vice entirely escapes you, so long as you consider the object. You never can find it, till you turn your reflection into your own breast, and find a sentiment of disapprobation, which arises in you, towards this action.[2]

So Moore's critics did not reject subjectivism. Instead, they embraced it enthusiastically— or, more precisely, they embraced a new, sophisticated version of subjectivism known as emotivism.

Emotivism was the ethical theory favored by the Vienna Circle, a group of scientifically minded thinkers whose ideas would be enormously influential on the subsequent development

of philosophy. The Circle formed in Vienna in the early 1920s; its members included such figures as Rudolf Carnap, Mortiz Schlick, and Kurt Gödel. They believed that any meaningful statement about the world must be expressible in the language of science, and they dismissed religion and metaphysics as mere nonsense. Ethical utterances they allowed might serve the purpose of ventilating feelings and recommending actions. A. J. Ayer popularized these ideas in his 1936 book *Language, Truth and Logic*, but it was the American philosopher Charles Stevenson who gave emotivism its definitive formulation in 1944 in his *Ethics and Language*. Emotivism became the principal alternative to Moorean intuitionism, and soon it eclipsed the older view in influence and popularity.

What made emotivism more sophisticated than earlier versions of subjectivism was its analysis of moral language. The key idea exploited by the emotivists was that *not every utterance is meant to be true or false*. An imperative—"Don't do that!"—is neither true nor false. It does not convey information; rather, it gives an instruction about what is to be done. Similarly, a cheer—"Hurrah"—is not a statement of fact, not even the fact that we like something. It is merely a verbal manifestation of an attitude. According to the emotivists, ethical "statements" are like this. They are not used to state facts; they are, really, disguised imperatives or avowals. Thus, when someone says "Lying is wrong," it is as if he or she had said "Don't lie!" or "Lying—yech."

We can now understand, said the emotivists, why ethical disputes go on endlessly, with neither side being able to convert the other. Ethical disagreement is like disagreeing about the choice of a restaurant: People may agree on all the facts about restaurants and yet disagree about where to eat, because some prefer Chinese food while others like Italian. That's the way ethics is. We may agree fully about the facts and yet disagree profoundly in what we like and what we want to see happen.

During the heyday of emotivism, many philosophers believed that the final truth about ethics had at last been found. But by the early 1950s there was a growing consensus, even among those sympathetic to this approach, that it was a deeply flawed theory. The problem was that emotivism could not adequately account for the place of reason in ethics. It is a point of logic that moral judgments, if they are to be acceptable, must be founded on good reasons. If I tell you that such-and-such action is wrong, you are entitled to ask why it is wrong; and if I have no good reply, you may reject my advice as unfounded. This is what separates moral judgments from mere statements of preference.

But what could the emotivists say about the nature of moral reasoning? Remember that in their view, if I tell you that such-and-such action is wrong, I am not trying to alter your beliefs; I am trying to influence your attitudes. Therefore, if you challenge me to explain why it is wrong, I will want to cite whatever considerations will influence your attitudes in the desired way. The business of giving reasons, therefore, turns out to be nothing more than an exercise in psychological manipulation.

This might strike us as a realistic, if somewhat cynical, view. What is wrong with it? The problem is that if this view is correct, then *any* fact that influences attitudes would count as a reason for the attitude produced. Thus, if the thought that Goldberg is Jewish causes someone to distrust him, then "Goldberg is a Jew" would become a reason in support of the judgment that he is a shady character. Could this possibly be right? Stevenson embraced this consequence of his view without flinching: "Any statement," he said, "about any fact which any speaker considers likely to alter attitudes may be adduced as a reason for or against an

ethical judgment."[3] But in the end, not many would agree with him. This account of reasons proved to be the Achilles' heel of emotivism.

Sometimes philosophy advances because new ideas appear that are unlike anything seen before. But genuinely revolutionary conceptions are rare. More commonly, progress is made as old ideas are rethought and combined in new ways, sidestepping difficulties that previously caused trouble. This happened when the emotivists reformulated the basic idea of Humean subjectivism, rescuing it from the objections of the intuitionists. It happened again when emotivism seemed to be finished. In 1952 R. M. Hare of Oxford University published *The Language of Morals*, in which he recast the basic idea of emotivism in a way that permitted a better account of moral reasoning. Hare's "universal prescriptivism," as he called it, became the most widely debated view in moral philosophy for the next twenty years.

The motivists had been right, Hare argued, in thinking that moral language is prescriptive rather than descriptive. Moral language is typically used to prescribe what is to be done rather than to describe what is the case. But the emotivists erred by overlooking an important logical feature of words such as "right" and "ought." When we use such words to make moral judgments, we implicitly commit ourselves to universal principles. If, for example, we say on a particular occasion that someone ought not to lie, we are committing ourselves to the general principle that lying is wrong. This, in turn, commits us to other judgments on other occasions, when lying is at issue. If we are to be consistent, we may not appeal to a principle at one time that we would not be willing to accept at other times. Hare refers to this logical feature of moral judgment as its "universalizability."

Emotivism had been faulted for implying that "anything goes"—it imposed no rational constraints at all on what could count as a moral reason. The requirement of universalizability, however, imposes severe constraints, because it means that we must apply to ourselves the same principles we use in judging others.

Did universal prescriptivism provide a satisfactory account of moral reasoning? During the 1950s and 1960s many philosophers argued that it was vulnerable to the same kind of objection that had brought down emotivism. What if someone were to insist, for example, that it is wrong to walk around pear trees in the light of the moon? And suppose that person was willing to universalize this, applying the rule to him- or herself and to others equally? Would there be any way, within the limits of universal prescriptivism, to object that this was a silly notion that has nothing to do with morality? The problem was not just that someone might be willing to universalize a bad moral principle. The problem was that *any* sort of "principle" could turn out to be moral. Philippa Foot pressed this sort of objection in some important papers published in the 1950s. If something vital was missing from Stevenson's account, something equally important seemed to be missing from Hare's.

The missing element, in the opinion of many, was the social content of morality. Morality, as John Dewey had insisted, is not just a matter of individuals ventilating their feelings or prescribing what they would like to see happen. It is, rather, a set of social practices that has a purpose—namely, the promotion of the common welfare. In his 1958 book *The Moral Point of View*, Kurt Baier suggested that the moral rules are, by definition, "for the good of everyone alike." Moral reasoning, therefore, is simply a matter of trying to figure out what is best from this perspective. Does it help or harm people to walk around pear trees in the moonlight? If not, then it has nothing to do with morality. Only by viewing morality as

essentially social, Baier argued, can we firmly distinguish good moral reasons from other kinds of reasons and from sheer imposters.

During the 1960s the philosophical journals were filled with articles debating issues connected with these theories. What is the relation between moral judgment and emotion? Is there a logical gap between "is" and "ought"? In what sense, if any, are moral judgments universalizable? Is morality necessarily social, or is an ethics of pure self-interest possible? If morality does impose social duties, why should a rational person bother with it? Then, around 1970, a great deal changed. Philosophers began to think about some entirely different questions.

The preceding account might seem strangely bloodless. It summarizes a main line of moral philosophy for the first seventy years of this century, but there is no reference to the century's great tragedies and struggles. The two world wars, the Great Depression, the rise of communism, the holocaust, and the struggles against colonialism and racism are all missing. Is it possible that a philosophical debate about the nature of good and evil could have been carried on in isolation from such matters? Equally conspicuous by their absence are the human sciences. Can moral philosophy proceed in ignorance of what psychology, sociology, politics, and history teach us? Critics viewing the field from the outside were puzzled by philosophy's lack of engagement. Moral philosophy seemed to have drifted away from the human concerns that gave it life, and the educated public began to look elsewhere for enlightenment about right and wrong.

The philosophers whose work we have been considering were unmoved by such criticism. After all, what was the task of philosophy supposed to be? Were philosophers supposed to be amateur scientists or social commentators? The distinctively philosophical task, they contended, was the logical analysis of concepts—or, as many preferred to put it, the analysis of language. In *Language, Truth and Logic*, perhaps the most widely read book of philosophy during this period, Ayer proclaimed that the philosopher is not concerned with the nature of things: "He is concerned only with the way in which we speak about them. In other words, the propositions of philosophy are not factual, but linguistic in character."[4] Not everyone agreed that philosophy should be limited to linguistic analysis. Nevertheless, many insisted that only works of conceptual analysis were "really" philosophical (this was often said with a disdainful sniff), and from the 1930s to the 1960s it was standard practice for philosophers to express their ideas as theses about language.

The conception of philosophy as logical analysis placed limits on what moral philosophers could do. It was not their business to issue instructions about how people should live. "A philosopher is not a parish priest or Universal Aunt or Citizens' Advice Bureau," said P. H. Nowell-Smith in his book *Ethics*.[5] A moral philosopher might tell you that "good" is the name of an unanalyzable property of things, but it is not his business to tell you what things have that property; or, she might tell you that "Chastity is good" means something like "Hurrah for chastity!"; but it is not her business to join in the cheers either for or against sexual abstinence. Philosophers, it was said, are no more moralists than they are scientists or mathematicians.

Meanwhile, despite all this, philosophers were in fact discussing how we ought to live, at least in an abstract and general way. While the debate continued over moral language and the objectivity of ethics, a somewhat less prominent debate was going on about substantive moral theory. It was mainly a debate about utilitarianism.

In the nineteenth century Jeremy Bentham and John Stuart Mill had argued that all moral duties may be derived from one ultimate principle, which they called the principle of utility. This principle required that we do whatever will have the best overall results for everyone who is affected by our actions—in Bentham's memorable phrase, that we should promote "the greatest happiness for the greatest number." Moore aligned himself with this view when he defined "right" in utilitarian terms: After explaining that "good" was the name of an unanalyzable property, Moore turned to the question "What actions are right?" and his answer was that right actions are the ones that produce the most good.

Utilitarianism seemed to its partisans to be an enlightened ethic that set aside the superstitions and irrationalities of the past. It dismissed as mere "rule worship" the idea that virtue consists in blindly following moral rules, and it grounded morality firmly in the necessities of this world rather than deferring to demands imposed from some supernatural realm. Utilitarianism was a revolutionary ethical outlook that would have enormous influence in law, economics, and philosophy, as well as affecting how ordinary people think.

Soon, however, the theory came under attack. The most influential criticisms were advanced in 1930 by W. D. Ross in his book *The Right and the Good*. Ross pointed out that utilitarianism leads to conclusions about what should be done in particular cases that, on reflection, seem plainly wrong. When you promise someone to do something, for example, you create an obligation that is independent of how much good you might accomplish. Suppose, when the time comes to do it, you realize that breaking your promise would have slightly better consequences than keeping it. The principle of utility would say that you should break the promise. But should you? Doesn't the fact that you promised impose an obligation on you that might outweigh the slight gain in utility? If not, what was the point of promising in the first place? More generally, Ross wrote:

> It [utilitarianism] says, in effect, that the only morally significant relation in which my neighbors stand to me is that of being possible beneficiaries by my action. They do stand in this relation to me, and this relation is morally significant. But they may also stand to me in the relation of promisee to promiser, of creditor to debtor, of wife to husband, of child to parent, of friend to friend, of fellow countryman to fellow countryman, and the like; and each of these relations is the foundation of the *prima facie* duty, which is more or less incumbent on me according to the circumstances of the case.[6]

Ross argued that we have an indefinite number of independent duties that must be balanced against one another when they come into conflict. These include at least the following: (1) duties resting on some previous act of our own, such as the duty to keep our promises and the duty to make restitution for wrongs we have done; (2) the duty of gratitude, to return favors others have done for us; (3) the duty of justice, to distribute goods fairly; (4) the duty of self-improvement, to develop our own talents and abilities; (5) the duty of beneficence, to act so as to benefit others; and (6) the duty of nonmaleficence, not to injure others. The problem with utilitarianism, Ross argued, was that it recognizes only the last two as fundamental duties. But these others are important, too, and they cannot be reduced to (5) and (6).

Many philosophers were persuaded by Ross's criticisms and concluded that utilitarianism could not be right. Others, however, tried to defend the theory. One of the main strategies

of defense was to cast the theory in a new form that would not be vulnerable to Ross's objections. A distinction was drawn between act-utilitarianism and rule-utilitarianism. The former is the idea that the principle of utility is to be applied to each individual action, one by one. So, to determine whether you ought to keep a promise you have made, you would ask whether this particular act of promise keeping would lead to the best possible outcome for everyone concerned. This is the method of classical utilitarianism, and it generated the difficulties that Ross noticed. Rule-utilitarianism, however, suggests a more sophisticated approach. First, the principle of utility is used to select a set of rules that it would be good to follow. We would all be better off, for example, if we were to follow such rules as "Keep your promises," "Tell the truth," "Respect one another's privacy," and so on. Then, to determine whether a particular action is mandatory—such as keeping a particular promise you have made—we refer to this set of rules. The key point is that the principle of utility is not applied directly to particular actions; it is used only to identify the general rules that are to be followed. Rule-utilitarianism, it was said, does not lead to the difficulties Ross noted. Indeed, all of Ross's "*prima facie* duties" could be understood as nothing more than rules that are themselves ultimately validated by appeal to the principle of utility.

As the debate about the best moral theory continued, Ross's theory of *prima facie* duties and utilitarianism were seen as the main alternatives. But both outlooks came under attack from a minority of philosophers who believed that this debate was radically misconceived. Their banner was raised in 1958 by G. E. M. Anscombe when she published an article called "Modern Moral Philosophy" in the British journal *Philosophy*. Anscombe contended that moral philosophers were discussing the wrong subject. They ought not to be discussing moral obligation and right action at all. Those notions, she argued, are tied to a conception of "moral law" that makes no sense apart from a divine lawgiver. Instead, like Aristotle, modern philosophers should scale back their ambitions and turn their attention to the everyday virtues and vices that make us good or bad people. The primary concern of moral philosophy, in other words, should be questions about *character* rather than action. Anscombe called for nothing less than a radical reorientation of the whole subject.

Eventually, "virtue theory" did emerge as a main alternative, and dozens of books and articles were written about moral character and about particular virtues such as courage, honesty, and friendship. But this did not happen right away. Throughout the 1960s philosophical attention remained focused on theories of right action and on issues of conceptual analysis. Virtue theory came into its own only in the 1970s, when the field of moral philosophy changed.

In the early 1970s two things happened that opened the field to an avalanche of new ideas. The first was the advent of the applied ethics movement. Previously the philosophical discussion of how we ought to live had been general and abstract. Now suddenly academic philosophers began to write about such matters as abortion, racial and sexual discrimination, civil disobedience, economic injustice, war, and even the treatment of nonhuman animals. It was a startling about-face for thinkers who, only a few years before, had agreed that "A philosopher is not a parish priest or Universal Aunt or Citizens' Advice Bureau."

The turn toward concrete issues was, in part, a delayed reaction to the failure of emotivism. It wasn't just that emotivism failed; it was the way it failed. Emotivism failed because it could not account for the place of reason in ethics. So in retrospect it seems inevitable that philosophers would turn their attention to the way in which reasons support moral

judgments. And what better way to do this than to study the reasons that might be given in support of particular judgments, in particular moral controversies?

The second thing that happened was the publication of John Rawls's *A Theory of Justice* in 1971. Rarely has a single work had such impact. Rawls, a Harvard professor, had published a series of articles outlining his ideas beginning in the 1950s. But it was not until his book was published that those ideas became the leading topic of debate among moral philosophers. Rawls sought to construct a general theory describing how moral judgments—in particular, judgments about the justice of social institutions—might be made and justified. His theory was a variant of the familiar idea of the social contract.

Rawls proposed that the rules of justice be conceived as whatever rules we would accept in special circumstances called "the original position." The original position is an imaginary situation in which we are negotiating with other people about how the basic institutions of our society are to be structured. But the negotiation takes place under special constraint: Everyone is ignorant of his or her own personal qualities and social position. No one knows whether he or she is male or female, black or white, talented or clumsy, smart or stupid, rich or poor. This influences how the negotiations will go. Because we lack this information, we cannot press for social arrangements that will favor ourselves or people like us. Instead we will be motivated to seek an arrangement in which everyone is as well-off as possible, so that we will have a maximum chance of flourishing regardless of who we turn out to be when the "veil of ignorance" is lifted.

What would be the result of negotiating under such a constraint? Rawls argues that we would agree on two general principles: First, that everyone should have the most extensive liberty compatible with a similar liberty for others; and second, that social or economic inequalities should not be permitted unless they work to everyone's advantage and are attached to positions open to everyone. These are the basic principles of justice: Social institutions are acceptable, from the point of view of justice, only if they satisfy them. These institutions would obviously be egalitarian and democratic.

Future historians might find it difficult to understand why Rawls's book seemed, to philosophers working in the field at the time, such a complete break with the past. True, it was a work of substantive moral theory that had nothing to say about the logic of moral language. But substantive theory had been under discussion, off and on, for the whole century, in the debate over utilitarianism. True, Rawls offered an alternative to both utilitarianism and Ross's theory of *prima facie* duties. But his alternative was a kind of theory, contractarianism, that dates back to the seventeenth century. Rawls himself disclaimed any particular originality. So what was all the fuss about?

Several things might be said about this. First, Rawls was too modest in assessing his own originality. In fact he did something that no one else in this century had done when he constructed a unified, systematic moral theory. Although his view incorporated some older ideas, taken as a whole it was strikingly different from anything that had been seen in a long time. Second, Rawls "changed the subject" of the ongoing philosophical debate by focusing on the notions of justice and rights. When it turned out, in his view, that justice requires social institutions that benefit all people equally, the notion of equality was also brought to center stage. Third, the theory he constructed was rich with implications for all sorts of related matters: the development of the theory involved the elaboration of such notions as autonomy, human life-plans, desert, self-respect, and the basic human goods. A wealth of

topics was opened up for discussion within a systematic context. Philosophers were happy to jump in and talk about them rather than continue with the hoary questions of conceptual analysis that had occupied them for so long.

Finally, Rawls's work was attractive in the way it cast off the disciplinary blinders that other philosophers had worn. He saw connections between his work in ethics and theoretical work in economics, law, and psychology. Because of the way he appropriated material from those areas, thinkers in those fields, who had found little of interest in previous philosophical writing, began to see important connections between their work and moral theory. So *A Theory of Justice* signaled the reuniting of ethical theory with these other subjects, as well as with social and political philosophy of the traditional kind. It provided, for many philosophers, a new paradigm of how ethics might be done.

In the continuing debate about the best substantive moral theory, the main contenders have now become utilitarianism and contractarianism. In the 1980s significant new contributions were made to the development of both sorts of views, with Derek Parfit's *Reasons and Persons* breaking new ground in utilitarian theory and David Gauthier's *Morals by Agreement* offering a powerful contractarian view different in important ways from the theory propounded by Rawls.

Gauthier's contractarianism is more general than Rawls's theory because it is a view about the nature of morality as a whole, rather than being limited to the justice of social institutions. Gauthier's idea is more in line with the classical view of Thomas Hobbes, which sees morality as essentially a scheme of social cooperation established by rational, self-interested people for their mutual benefit. (Each of us is better off living in a society in which murder, theft, and so on are prohibited, and in which people can be relied upon to tell the truth and keep their promises.) Moral principles, then, are nothing more or less than the rules rational people would agree to accept, for their own benefit, provided that others accept them as well.

One of the striking features of this view is the way that it finesses the traditional question about the objectivity of ethics. Contractarianism provides the resources for an elegant solution to this problem. Morality is a rational enterprise. It really is true—independent of what anyone thinks or how anyone feels—that certain goods cannot be obtained without social cooperation and that, therefore, rational self-interested people will be motivated to agree to cooperate with one another to obtain those goods. It is further true that this cooperation will involve accepting rules that constrain behavior. If this is what moral rules are like, then it is easy to explain their rationality and objectivity without resorting to any strange or mystifying conception of "objective values." In this form of contractarianism the two concerns with which we began—the concerns about moral objectivity and about the best substantive theory—seem to have merged.

I have not tried to determine which of these views is best; my only purpose has been to describe, in the most general way possible, the course moral philosophy has taken since Moore. It is easy to describe history from a distance. Hindsight enables us to select from the mass of detail just the thoughts and events we need to make up a coherent narrative. Although this inevitably involves some distortion, the exercise helps to put ideas in perspective. The closer one comes to the present, however, the messier and more confusing things become. Current debates cover a dizzying array of topics. Many of the positions taken in these debates are associated with the theories we have been describing, but some are

connected to other points of view entirely. And meanwhile, some philosophers argue that a systematic moral theory is not even possible.

Some observers might find this situation chaotic and think that in the twenty-four hundred years since Socrates greater progress should have been made. But Derek Parfit's assessment might be more accurate. Secular moral philosophy, as distinct from theological ethics, is not an old subject—it is, on the contrary, a fairly young discipline that has only recently begun to be developed in a rigorous way. The variety of options still being tested may be just a sign of youthful vigor.

Notes

1. John Passmore, *A Hundred Years of Philosophy* (Harmondsworth, Middlesex: Penguin, 1966), 8.

2. David Hume, *A Treatise of Human Nature*, Selby-Bigge edition (Oxford: Oxford University Press, 1888; originally published in 1739), 468–69.

3. C. L. Stevenson, *Ethics and Language* (New Haven: Yale University Press, 1944), 114.

4. A. J. Ayer, *Language Truth and Logic*, 2nd ed. (New York: Dover Books, 1946; first edition published in 1936), 57.

5. P. H. Nowell-Smith, *Ethics* (Baltimore: Penguin Books, 1954), 12.

6. W. D. Ross, *The Right and the Good* (Oxford: Oxford University Press, 1930), 19.

18

G. E. MOORE

George Edward Moore (1873–1958), Professor of Mental Philosophy and Logic at the University of Cambridge, was one of the most influential philosophers of the twentieth century. He argued that goodness, like the color yellow, is simple, and having no parts, indefinable. In other words, goodness is an ultimate quality by reference to which other qualities can be defined. To offer a definition of goodness is to commit what Moore called "the naturalistic fallacy." Whether that so-called fallacy is indeed fallacious became a crucial issue in ethical inquiry.

Principia Ethica

5. ... [H]ow "good" is to be defined, is the most fundamental question in all Ethics. That which is meant by "good" is, in fact, except its converse "bad," the *only* simple object of thought which is peculiar to Ethics. Its definition is, therefore, the most essential point in the definition of Ethics; and moreover a mistake with regard to it entails a far larger number of erroneous ethical judgments than any other. Unless this first question be fully understood, and its true answer clearly recognised, the rest of Ethics is as good as useless from the point of view of systematic knowledge. True ethical judgments, of the two kinds last dealt with, may indeed be made by those who do not know the answer to this question as well as by those who do; and it goes without saying that the two classes of people may lead equally good lives. But it is extremely unlikely that the *most general* ethical judgments will be equally valid, in the absence of a true answer to this question: I shall presently try to shew that the gravest errors have been largely due to beliefs in a false answer. And, in any case, it is impossible that, till the answer to this question be known, any one should know *what is the evidence* for any ethical judgment whatsoever. But the main object of Ethics, as a systematic science, is to give correct *reasons* for thinking that this or that is good; and, unless this question be answered, such reasons cannot be given. Even, therefore, apart from the fact that a false answer leads to false conclusions, the present enquiry is a most necessary and important part of the science of Ethics.

6. What, then, is good? How is good to be defined? Now, it may be thought that this is a verbal question. A definition does indeed often mean the expressing of one word's meaning in other words. But this is not the sort of definition I am asking for. Such a definition can never be of ultimate importance in any study except lexicography. If I wanted that kind of definition I should have to consider in the first place how people generally used the word "good"; but my business is not with its proper usage, as established by custom. I should, indeed, be foolish, if I tried to use

it for something which it did not usually denote: if, for instance, I were to announce that, whenever I used the word "good," I must be understood to be thinking of that object which is usually denoted by the word "table." I shall, therefore, use the word in the sense in which I think it is ordinarily used; but at the same time I am not anxious to discuss whether I am right in thinking that it is so used. My business is solely with that object or idea, which I hold, rightly or wrongly, that the word is generally used to stand for. What I want to discover is the nature of that object or idea, and about this I am extremely anxious to arrive at an agreement.

But, if we understand the question in this sense, my answer to it may seem a very disappointing one. If I am asked "What is good?" my answer is that good is good, and that is the end of the matter. Or if I am asked "How is good to be defined?" my answer is that it cannot be defined, and that is all I have to say about it. But disappointing as these answers may appear, they are of the very last importance. To readers who are familiar with philosophic terminology, I can express their importance by saying that they amount to this: That propositions about the good are all of them synthetic and never analytic; and that is plainly no trivial matter. And the same thing may be expressed more popularly, by saying that, if I am right, then nobody can foist upon us such an axiom as that "Pleasure is the only good" or that "The good is the desired" on the pretence that this is "the very meaning of the word."

7. Let us, then, consider this position. My point is that "good" is a simple notion, just as "yellow" is a simple notion; that, just as you cannot, by any manner of means, explain to any one who does not already know it, what yellow is, so you cannot explain what good is. Definitions of the kind that I was asking for, definitions which describe the real nature of the object or notion denoted by a word, and which do not merely tell us what the word is used to mean, are only possible when the object or notion in question is something complex. You can give a definition of a horse, because a horse has many different properties and qualities, all of which you can enumerate. But when you have enumerated them all,

when you have reduced a horse to his simplest terms, then you can no longer define those terms. They are simply something which you think of or perceive, and to any one who cannot think of or perceive them, you can never, by any definition, make their nature known. It may perhaps be objected to this that we are able to describe to others, objects which they have never seen or thought of. We can, for instance, make a man understand what a chimaera is, although he has never heard of one or seen one. You can tell him that it is an animal with a lioness's head and body, with a goat's head growing from the middle of its back, and with a snake in place of a tail. But here the object which you are describing is a complex object; it is entirely composed of parts, with which we are all perfectly familiar—a snake, a goat, a lioness; and we know, too, the manner in which those parts are to be put together, because we know what is meant by the middle of a lioness's back, and where her tail is wont to grow. And so it is with all objects, not previously known, which we are able to define: they are all complex; all composed of parts, which may themselves, in the first instance, be capable of similar definition, but which must in the end be reducible to simplest parts, which can no longer be defined. But yellow and good, we say, are not complex: they are notions of that simple kind, out of which definitions are composed and with which the power of further defining ceases.

8. When we say, as Webster says, "The definition of horse is 'A hoofed quadruped of the genus Equus,'" we may, in fact, mean three different things. (1) We may mean merely: "When I say 'horse,' you are to understand that I am talking about a hoofed quadruped of the genus Equus." This might be called the arbitrary verbal definition: and I do not mean that good is indefinable in that sense. (2) We may mean, as Webster ought to mean: "When most English people say 'horse,' they mean a hoofed quadruped of the genus Equus." This may be called the verbal definition proper, and I do not say that good is indefinable in this sense either; for it is certainly possible to discover how people use a word: otherwise, we could never have known that "good" may be translated by "gut" in German and by "bon" in French. But (3) we

may, when we define horse, mean something much more important. We may mean that a certain object, which we all of us know, is composed in a certain manner: that it has four legs, a head, a heart, a liver, etc., etc., all of them arranged in definite relations to one another. It is in this sense that I deny good to be definable. I say that it is not composed of any parts, which we can substitute for it in our minds when we are thinking of it. We might think just as clearly and correctly about a horse, if we thought of all its parts and their arrangement instead of thinking of the whole: we could, I say, think how a horse differed from a donkey just as well, just as truly, in this way, as now we do, only not so easily; but there is nothing whatsoever which we could so substitute for good; and that is what I mean, when I say that good is indefinable.

9. But I am afraid I have still not removed the chief difficulty which may prevent acceptance of the proposition that good is indefinable. I do not mean to say that *the* good, that which is good, is thus indefinable; if I did think so, I should not be writing on Ethics, for my main object is to help towards discovering that definition. It is just because I think there will be less risk of error in our search for a definition of "the good," that I am now insisting that *good* is indefinable. I must try to explain the difference between these two. I suppose it may be granted that "good" is an adjective. Well "the good," "that which is good," must therefore be the substantive to which the adjective "good" will apply: it must be the whole of that to which the adjective will apply, and the adjective must *always* truly apply to it. But if it is that to which the adjective will apply, it must be something different from that adjective itself; and the whole of that something different, whatever it is, will be our definition of *the* good. Now it may be that this something will have other adjectives, besides "good," that will apply to it. It may be full of pleasure, for example; it may be intelligent: and if these two adjectives are really part of its definition, then it will certainly be true, that pleasure and intelligence are good. And many people appear to think that, if we say "Pleasure and intelligence are good," or if we say "Only

pleasure and intelligence are good," we are defining "good." Well, I cannot deny that propositions of this nature may sometimes be called definitions; I do not know well enough how the word is generally used to decide upon this point. I only wish it to be understood that that is not what I mean when I say there is no possible definition of good, and that I shall not mean this if I use the word again. I do most fully believe that some true proposition of the form "Intelligence is good and intelligence alone is good" can be found; if none could be found, our definition of *the* good would be impossible. As it is, I believe *the* good to be definable; and yet I still say that good itself is indefinable.

10. "Good," then, if we mean by it that quality which we assert to belong to a thing, when we say that the thing is good, is incapable of any definition, in the most important sense of that word. The most important sense of "definition" is that in which a definition states what are the parts which invariably compose a certain whole; and in this sense "good" has no definition because it is simple and has no parts. It is one of those innumerable objects of thought which are themselves incapable of definition, because they are the ultimate terms by reference to which whatever *is* capable of definition must be defined. That there must be an indefinite number of such terms is obvious, on reflection; since we cannot define anything except by an analysis, which, when carried as far as it will go, refers us to something, which is simply different from anything else, and which by that ultimate difference explains the peculiarity of the whole which we are defining: for every whole contains some parts which are common to other wholes also. There is, therefore, no intrinsic difficulty in the contention that "good" denotes a simple and indefinable quality. There are many other instances of such qualities.

Consider yellow, for example. We may try to define it, by describing its physical equivalent; we may state what kind of light-vibrations must stimulate the normal eye, in order that we may perceive it. But a moment's reflection is sufficient to shew that those light-vibrations are not themselves what we mean by yellow. *They* are not what we perceive.

Indeed we should never have been able to discover their existence, unless we had first been struck by the patent difference of quality between the different colours. The most we can be entitled to say of those vibrations is that they are what corresponds in space to the yellow which we actually perceive.

Yet a mistake of this simple kind has commonly been made about "good." It may be true that all things which are good are *also* something else, just as it is true that all things which are yellow produce a certain kind of vibration in the light. And it is a fact, that Ethics aims at discovering what are those other properties belonging to all things which are good. But far too many philosophers have thought that when they named those other properties they were actually defining good; that these properties, in fact, were simply not "other," but absolutely and entirely the same with goodness. This view I propose to call the "naturalistic fallacy" and of it I shall now endeavour to dispose.

11. Let us consider what it is such philosophers say. And first it is to be noticed that they do not agree among themselves. They not only say that they are right as to what good is, but they endeavour to prove that other people who say that it is something else, are wrong. One, for instance, will affirm that good is pleasure, another, perhaps, that good is that which is desired; and each of these will argue eagerly to prove that the other is wrong. But how is that possible? One of them says that good is nothing but the object of desire, and at the same time tries to prove that it is not pleasure. But from his first assertion, that good just means the object of desire, one of two things must follow as regards his proof:

(1) He may be trying to prove that the object of desire is not pleasure. But, if this be all, where is his Ethics? The position he is maintaining is merely a psychological one. Desire is something which occurs in our minds, and pleasure is something else which so occurs; and our would-be ethical philosopher is merely holding that the latter is not the object of the former. But what has that to do with the question in dispute? His opponent held the ethical proposition that pleasure was the good, and although he should

prove a million times over the psychological proposition that pleasure is not the object of desire, he is no nearer proving his opponent to be wrong. The position is like this. One man says a triangle is a circle: another replies "A triangle is a straight line, and I will prove to you that I am right: *for* " (this is the only argument) "a straight line is not a circle." "That is quite true," the other may reply; "but nevertheless a triangle is a circle, and you have said nothing whatever to prove the contrary. What is proved is that one of us is wrong, for we agree that a triangle cannot be both a straight line and a circle: but which is wrong, there can be no earthly means of proving, since you define triangle as straight line and I define it as circle."—Well, that is one alternative which any naturalistic Ethics has to face; if good is *defined* as something else, it is then impossible either to prove that any other definition is wrong or even to deny such definition.

(2) The other alternative will scarcely be more welcome. It is that the discussion is after all a verbal one. When A says "Good means pleasant" and B says "Good means desired," they may merely wish to assert that most people have used the word for what is pleasant and for what is desired respectively. And this is quite an interesting subject for discussion: only it is not a whit more an ethical discussion than the last was. Nor do I think that any exponent of naturalistic Ethics would be willing to allow that this was all he meant. They are all so anxious to persuade us that what they call the good is what we really ought to do. "Do pray, act so, because the word 'good' is generally used to denote actions of this nature": such, on this view, would be the substance of their teaching. And in so far as they tell us how we ought to act, their teaching is truly ethical, as they mean it to be. But how perfectly absurd is the reason they would give for it! "You are to do this, because most people use a certain word to denote conduct such as this." "You are to say the thing which is not, because most people call it lying." That is an argument just as good!—My dear sirs, what we want to know from you as ethical teachers, is not how people use a word; it is not even, what kind of actions they approve, which the use of this word "good" may certainly imply: what we want to know is simply what *is* good. We may indeed

agree that what most people do think good, is actually so; we shall at all events be glad to know their opinions: but when we say their opinions about what *is* good, we do mean what we say; we do not care whether they call that thing which they mean "horse" or "table" or "chair," "gut" or "bon" or "ἀγαθός"; we want to know what it is that they so call. When they say "Pleasure is good," we cannot believe that they merely mean "Pleasure is pleasure" and nothing more than that.

12. Suppose a man says "I am pleased"; and suppose that is not a lie or a mistake but the truth. Well, if it is true, what does that mean? It means that his mind, a certain definite mind, distinguished by certain definite marks from all others, has at this moment a certain definite feeling called pleasure. "Pleased" *means* nothing but having pleasure, and though we may be more pleased or less pleased, and even, we may admit for the present, have one or another kind of pleasure; yet in so far as it is pleasure we have, whether there be more or less of it, and whether it be of one kind or another, what we have is one definite thing, absolutely indefinable, some one thing that is the same in all the various degrees and in all the various kinds of it that there may be. We may be able to say how it is related to other things: that, for example, it is in the mind, that it causes desire, that we are conscious of it, etc., etc. We can, I say, describe its relations to other things, but define it we can *not*. And if anybody tried to define pleasure for us as being any other natural object; if anybody were to say, for instance, that pleasure *means* the sensation of red, and were to proceed to deduce from that that pleasure is a colour, we should be entitled to laugh at him and to distrust his future statements about pleasure. Well, that would be the same fallacy which I have called the naturalistic fallacy. That "pleased" does not mean "having the sensation of red," or anything else whatever, does not prevent us from understanding what it does mean. It is enough for us to know that "pleased" does mean "having the sensation of pleasure," and though pleasure is absolutely indefinable, though pleasure is pleasure and nothing else whatever, yet we feel no difficulty in saying that

we are pleased. The reason is, of course, that when I say "I am pleased," I do *not* mean that "I" am the same thing as "having pleasure." And similarly no difficulty need be found in my saying that "pleasure is good" and yet not meaning that "pleasure" is the same thing as "good," that pleasure *means* good, and that good *means* pleasure. If I were to imagine that when I said "I am pleased," I meant that I was exactly the same thing as "pleased," I should not indeed call that a naturalistic fallacy, although it would be the same fallacy as I have called naturalistic with reference to Ethics. The reason of this is obvious enough. When a man confuses two natural objects with one another, defining the one by the other, if for instance, he confuses himself, who is one natural object, with "pleased" or with "pleasure" which are others, then there is no reason to call the fallacy naturalistic. But if he confuses "good," which is not in the same sense a natural object, with any natural object whatever, then there is a reason for calling that a naturalistic fallacy; its being made with regard to "good" marks it as something quite specific, and this specific mistake deserves a name because it is so common. As for the reasons why good is not to be considered a natural object, they may be reserved for discussion in another place. But, for the present, it is sufficient to notice this: Even if it were a natural object, that would not alter the nature of the fallacy nor diminish its importance one whit. All that I have said about it would remain quite equally true: only the name which I have called it would not be so appropriate as I think it is. And I do not care about the name: what I do care about is the fallacy. It does not matter what we call it, provided we recognise it when we meet with it. It is to be met with in almost every book on Ethics; and yet it is not recognised: and that is why it is necessary to multiply illustrations of it, and convenient to give it a name. It is a very simple fallacy indeed. When we say that an orange is yellow, we do not think our statement binds us to hold that "orange" means nothing else than "yellow," or that nothing can be yellow but an orange. Supposing the orange is also sweet! Does that bind us to say that "sweet" is exactly the same thing as "yellow," that "sweet" must be defined as "yellow"? And supposing it be

recognised that "yellow" just means "yellow" and nothing else whatever, does that make it any more difficult to hold that oranges are yellow? Most certainly it does not: on the contrary, it would be absolutely meaningless to say that oranges were yellow, unless yellow did in the end mean just "yellow" and nothing else whatever—unless it was absolutely indefinable. We should not get any very clear notion about things, which are yellow—we should not get very far with our science, if we were bound to hold that everything which was yellow, *meant* exactly the same thing as yellow. We should find we had to hold that an orange was exactly the same thing as a stool, a piece of paper, a lemon, anything you like. We could prove any number of absurdities; but should we be the nearer to the truth? Why, then, should it be different with "good"? Why, if good is good and indefinable, should I be held to deny that pleasure is good? Is there any difficulty in holding both to be true at once? On the contrary, there is no meaning in saying that pleasure is good, unless good is something different from pleasure. It is absolutely useless, so far as Ethics is concerned, to prove, as Mr Spencer tries to do, that increase of pleasure coincides with increase of life, unless good *means* something different from either life or pleasure. He might just as well try to prove that an orange is yellow by shewing that it always is wrapped up in paper.

13. In fact, if it is not the case that "good" denotes something simple and indefinable, only two alternatives are possible: either it is a complex, a given whole, about the correct analysis of which there may be disagreement; or else it means nothing at all, and there is no such subject as Ethics. In general, however, ethical philosophers have attempted to define good, without recognising what such an attempt must mean. They actually use arguments which involve one or both of the absurdities considered in § 11. We are, therefore, justified in concluding that the attempt to define good is chiefly due to want of clearness as to the possible nature of definition. There are, in fact, only two serious alternatives to be considered, in order to establish the conclusion that "good" does denote a simple and indefinable notion. It might possibly denote a complex, as "horse" does; or it might have no meaning at all. Neither of these possibilities has, however, been clearly conceived and seriously maintained, as such, by those who presume to define good; and both may be dismissed by a simple appeal to facts.

(1) The hypothesis that disagreement about the meaning of good is disagreement with regard to the correct analysis of a given whole, may be most plainly seen to be incorrect by consideration of the fact that, whatever definition be offered, it may be always asked, with significance, of the complex so defined, whether it is itself good. To take, for instance, one of the more plausible, because one of the more complicated, of such proposed definitions, it may easily be thought, at first sight, that to be good may mean to be that which we desire to desire. Thus if we apply this definition to a particular instance and say "When we think that A is good, we are thinking that A is one of the things which we desire to desire," our proposition may seem quite plausible. But, if we carry the investigation further, and ask ourselves "Is it good to desire to desire A?" it is apparent, on a little reflection, that this question is itself as intelligible, as the original question "Is A good?"—that we are, in fact, now asking for exactly the same information about the desire to desire A, for which we formerly asked with regard to A itself. But it is also apparent that the meaning of this second question cannot be correctly analysed into "Is the desire to desire A one of the things which we desire to desire?": we have not before our minds anything so complicated as the question "Do we desire to desire to desire A?" Moreover any one can easily convince himself by inspection that the predicate of this proposition—"good"—is positively different from the notion of "desiring to desire" which enters into its subject: "That we should desire to desire A is good" is *not* merely equivalent to "That A should be good is good." It may indeed be true that what we desire to desire is always also good; perhaps, even the converse may be true: but it is very doubtful whether this is the case, and the mere fact that we understand very

well what is meant by doubting it, shews clearly that we have two different notions before our minds.

(2) And the same consideration is sufficient to dismiss the hypothesis that "good" has no meaning whatsoever. It is very natural to make the mistake of supposing that what is universally true is of such a nature that its negation would be self-contradictory: the importance which has been assigned to analytic propositions in the history of philosophy shews how easy such a mistake is. And thus it is very easy to conclude that what seems to be a universal ethical principle is in fact an identical proposition; that, if, for example, whatever is called "good" seems to be pleasant, the proposition "Pleasure is the good" does not assert a connection between two different notions, but involves only one, that of pleasure, which is easily recognised as a distinct entity. But whoever will attentively consider with himself what is actually before his mind when he asks the question "Is pleasure (or whatever it may be) after all good?" can easily satisfy himself that he is not merely wondering whether pleasure is pleasant. And if he will try this experiment with each suggested definition in succession, he may become expert enough to recognise that in every case he has before his mind a unique object, with regard to the connection of which with any other object, a distinct question may be asked. Every one does in fact understand the question "Is this good?" When he thinks of it, his state of mind is different from what it would be, were he asked "Is this pleasant, or desired, or approved?" It has a distinct meaning for him, even though he may not recognise in what respect it is distinct. Whenever he thinks of "intrinsic value," or "intrinsic worth," or says that a thing "ought to exist," he has before his mind the unique object—the unique property of things—which I mean by "good." Everybody is constantly aware of this notion, although he may never become aware at all that it is different from other notions of which he is also aware. But, for correct ethical reasoning, it is extremely important that he should become aware of this fact; and, as soon as the nature of the problem is clearly understood, there should be little difficulty in advancing so far in analysis.

Study Questions

1. According to Moore, what is the most fundamental question in ethics?

2. How does Moore answer that fundamental question?

3. According to Moore, what is the naturalistic fallacy?

4. What did Moore mean by "intrinsic value"?

19

H. A. PRICHARD

Harold Arthur Prichard (1871–1947) was White's Professor of Moral Philosophy at the University of Oxford. He maintained that moral philosophy has mistakenly been focused on seeking to answer the question: Why should I be moral? Yet, according to Prichard, even if we could demonstrate that fulfilling our duties is in our interest, doing so would not prove that we *ought* to fulfill them, only that we *want* to fulfill them. His view was that a moral obligation is not the conclusion of an argument but a self-evident truth, apprehended directly by an act of moral thinking.

Does Moral Philosophy Rest on a Mistake?

Probably to most students of Moral Philosophy there comes a time when they feel a vague sense of dissatisfaction with the whole subject. And the sense of dissatisfaction tends to grow rather than to diminish. It is not so much that the positions, and still more the arguments, of particular thinkers seem unconvincing, though this is true. It is rather that the aim of the subject becomes increasingly obscure. "What," it is asked, "are we really going to learn by Moral Philosophy?" "What are books on Moral Philosophy really trying to show, and when their aim is clear, why are they so unconvincing and artificial?" And again: "Why is it so difficult to substitute anything better?" Personally, I have been led by growing dissatisfaction of this kind to wonder whether the reason may not be that the subject, at any rate as usually understood, consists in the attempt to answer an improper question. And in this article I shall venture to contend that the existence of the whole subject, as usually understood, rests on a mistake, and on a mistake parallel to that on which rests, as I think, the subject usually called the Theory of Knowledge.

If we reflect on our own mental history or on the history of the subject, we feel no doubt about the nature of the demand which originates the subject. Any one who, stimulated by education, has come to feel the force of the various obligations in life, at some time or other comes to feel the irksomeness of carrying them out, and to recognize the sacrifice of interest involved; and, if thoughtful, he inevitably puts to himself the question: "Is there really a reason why I should act in the ways in which hitherto I have thought I ought to act? May I not have been all the time under an illusion in so thinking? Should not I really be justified in simply trying to have a good time?" Yet, like Glaucon, feeling that somehow he ought after all to act in these ways, he asks for a *proof* that this feeling is justified. In other words, he asks "*Why* should I do these things?," and his and other people's moral philosophizing is an attempt to supply the answer, i.e. to supply by a process of reflection a proof of the truth of what he and they have prior to reflection believed immediately or

H. A. Prichard, "Does Moral Philosophy Rest on a Mistake?," *Mind* 21 (1912). Reprinted with the permission of Oxford University Press.

without proof. This frame of mind seems to present a close parallel to the frame of mind which originates the Theory of Knowledge. Just as the recognition that the doing of our duty often vitally interferes with the satisfaction of our inclinations leads us to wonder whether we really ought to do what we usually call our duty, so the recognition that we and others are liable to mistakes in knowledge generally leads us, as it did Descartes, to wonder whether hitherto we may not have been always mistaken. And just as we try to find a proof, based on the general consideration of action and of human life, that we ought to act in the ways usually called moral, so we, like Descartes, propose by a process of reflection on our thinking to find a test of knowledge, i.e. a principle by applying which we can show that a certain condition of mind was really knowledge, a condition which *ex hypothesi* existed independently of the process of reflection.

Now, how has the moral question been answered? So far as I can see, the answers all fall, and fall from the necessities of the case, into one of two species. *Either* they state that we ought to do so and so, because, as we see when we fully apprehend the facts, doing so will be for our good, i.e. really, as I would rather say, for our advantage, or, better still, for our happiness; *or* they state that we ought to do so and so, because something realized either in or by the action is good. In other words, the reason "why" is stated in terms either of the agent's happiness or of the goodness of something involved in the action.

To see the prevalence of the former species of answer, we have only to consider the history of Moral Philosophy. To take obvious instances, Plato, Hutcheson, Paley, Mill, each in his own way seeks at bottom to convince the individual that he ought to act in so-called moral ways by showing that to do so will really be for his happiness. Plato is perhaps the most significant instance, because of all philosophers he is the one to whom we are least willing to ascribe a mistake on such matters, and a mistake on his part would be evidence of the deep-rootedness of the tendency to make it. To show that Plato really justifies morality by its profitableness, it is only necessary to point out (1) that the very formulation of the thesis to be met,

viz. that justice is a ἀλλόπριου ἀγαθὺν [someone else's good] implies that any refutation must consist in showing that justice is οἰκεῖον ἀγαθὺν [one's own good], i.e., really, as the context shows, one's own advantage, and (2) that the term λυσιτελεῖν [to be profitable] supplies the key not only to the problem but also to its solution.

The tendency to justify acting on moral rules in this way is natural. For if, as often happens, we put to ourselves the question "Why should we do so and so?," we are satisfied by being convinced either that the doing so will lead to something which we want (e.g. that taking certain medicine will heal our disease), or that the doing so itself, as we see when we appreciate its nature, is something that we want or should like, e.g. playing golf. The formulation of the question implies a state of unwillingness or indifference towards the action, and we are brought into a condition of willingness by the answer. And this process seems to be precisely what we desire when we ask, e.g., "Why should we keep our engagements to our own loss?"; for it is just the fact that the keeping of our engagements runs counter to the satisfaction of our desires which produced the question.

The answer is, of course, not an answer, for it fails to convince us that we ought to keep our engagements; even if successful on its own lines, it only makes us *want* to keep them. And Kant was really only pointing out this fact when he distinguished hypothetical and categorical imperatives, even though he obscured the nature of the fact by wrongly describing his so-called "hypothetical imperatives" as imperatives. But if this answer be no answer, what other can be offered? Only, it seems, an answer which bases the obligation to do something on the *goodness* either of something to which the act leads or of the act itself. Suppose, when wondering whether we really ought to act in the ways usually called moral, we are told as a means of resolving our doubt that those acts are right which produce happiness. We at once ask: "Whose happiness?" If we are told "Our own happiness," then, though we shall lose our hesitation to act in these ways, we shall not recover our sense that we ought to do so. But how can this result be avoided? Apparently, only by being

told one of two things: *either* that anyone's happiness is a thing good in itself, and that *therefore* we ought to do whatever will produce it, *or* that working for happiness is itself good, and that the intrinsic goodness of such an action is the reason why we ought to do it. The advantage of this appeal to the goodness of something consists in the fact that it avoids reference to desire, and, instead, refers to something impersonal and objective. In this way it seems possible to avoid the resolution of obligation into inclination. But just for this reason it is of the essence of the answer, that to be effective it must neither include nor involve the view that the apprehension of the goodness of anything necessarily arouses the desire for it. Otherwise the answer resolves itself into a form of the former answer by substituting desire or inclination for the sense of obligation, and in this way it loses what seems its special advantage.

Now it seems to me that both forms of this answer break down, though each for a different reason.

Consider the first form. It is what may be called Utilitarianism in the generic sense, in which what is good is not limited to pleasure. It takes its stand upon the distinction between something which is not itself an action, but which can be produced by an action, and the action which will produce it, and contends that if something which is not an action is good, then we *ought* to undertake the action which will, directly or indirectly, originate it.[1]

But this argument, if it is to restore the sense of obligation to act, must presuppose an intermediate link, viz. the further thesis that what is good ought to be.[2] The necessity of this link is obvious. An "ought," if it is to be derived at all, can only be derived from another "ought." Moreover, this link tacitly presupposes another, viz. that the apprehension that something good which is not an action ought to be involves just the feeling of imperativeness or obligation which is to be aroused by the thought of the action which will originate it. Otherwise the argument will not lead us to feel the obligation to produce it by the action. And, surely, both this link and its implication are false.[3] The word "ought" refers to actions and to actions alone. The proper language is never "So and so ought to be," but "I ought to do so

and so." Even if we are sometimes moved to say that the world or something in it is not what it ought to be, what we really mean is that God or some human being has not made something what he ought to have made it. And it is merely stating another side of this fact to urge that we can only feel the imperativeness upon us of something which is in our power; for it is actions and actions alone which, directly at least, are in our power.

Perhaps, however, the best way to see the failure of this view is to see its failure to correspond to our actual moral convictions. Suppose we ask ourselves whether our sense that we ought to pay our debts or to tell the truth arises from our recognition that in doing so we should be originating something good, e.g. material comfort in A or true belief in B, i.e. suppose we ask ourselves whether it is this aspect of the action which leads to our recognition that we ought to do it. We at once and without hesitation answer "No." Again, if we take as our illustration our sense that we ought to act justly as between two parties, we have, if possible, even less hesitation in giving a similar answer; for the balance of resulting good may be, and often is, not on the side of justice.

At best it can only be maintained that there is this element of truth in the Utilitarian view, that unless we recognize that something which an act will originate is good, we should not recognize that we ought to do the action. Unless we thought knowledge a good thing, it may be urged, we should not think that we ought to tell the truth; unless we thought pain a bad thing, we should not think the infliction of it, without special reason, wrong. But this is not to imply that the badness of error is the reason why it is wrong to lie, or the badness of pain the reason why we ought not to inflict it without special cause.[4]

It is, I think, just because this form of the view is so plainly at variance with our moral consciousness that we are driven to adopt the other form of the view, viz. that the act is good in itself and that its intrinsic goodness is the reason why it ought to be done. It is this form which has always made the most serious appeal; for the goodness of the act itself seems more closely related to the obligation to do it than of its mere consequences or results, and therefore, if

obligation is to be based on the goodness of something, it would seem that this goodness should be that of the act itself. Moreover, the view gains plausibility from the fact that moral actions are most conspicuously those to which the term "intrinsically good" is applicable.

Nevertheless this view, though perhaps less superficial, is equally untenable. For it leads to precisely the dilemma which faces everyone who tries to solve the problem raised by Kant's theory of the good will. To see this, we need only consider the nature of the acts to which we apply the term "intrinsically good."

There is, of course, no doubt that we approve and even admire certain actions, and also that we should describe them as good, and as good in themselves. But it is, I think, equally unquestionable that our approval and our use of the term "good" is always in respect of the motive and refers to actions which have been actually done and of which we think we know the motive. Further, the actions of which we approve and which we should describe as intrinsically good are of two and only two kinds. They are either actions in which the agent did what he did because he thought he ought to do it, or actions of which the motive was a desire prompted by some good emotion, such as gratitude, affection, family feeling, or public spirit, the most prominent of such desires in books on Moral Philosophy being that ascribed to what is vaguely called benevolence. For the sake of simplicity I omit the case of actions done partly from some such desire and partly from a sense of duty; for even if all good actions are done from a combination of these motives, the argument will not be affected. The dilemma is this. If the motive in respect of which we think an action good is the sense of obligation, then so far from the sense that we ought to do it being derived from our apprehension of its goodness, our apprehension of its goodness will presuppose the sense that we ought to do it. In other words, in this case the recognition that the act is good will plainly *presuppose* the recognition that the act is right, whereas the view under consideration is that the recognition of the goodness of the act *gives rise* to the recognition of its rightness. On the other hand, if the motive in respect of which we think an

action good is some intrinsically good desire, such as the desire to help a friend, the recognition of the goodness of the act will equally fail to give rise to the sense of obligation to do it. For we cannot feel that we ought to do that the doing of which is *ex hypothesi* prompted solely by the desire to do it.[5]

The fallacy underlying the view is that while to base the rightness of an act upon its intrinsic goodness implies that the goodness in question is that of the motive, in reality the rightness or wrongness of an act has nothing to do with any question of motives at all. For, as any instance will show, the rightness of an action concerns an action not in the fuller sense of the term in which we include the motive in the action, but in the narrower and commoner sense in which we distinguish an action from its motive and mean by an action merely the conscious origination of something, an origination which on different occasions or in different people may be prompted by different motives. The question "Ought I to pay my bills?" really means simply "Ought I to bring about my tradesmen's possession of what by my previous acts I explicitly or implicitly promised them?" There is, and can be, no question of whether I ought to pay my debts from a particular motive. No doubt we know that if we pay our bills we shall pay them with a motive, but in considering whether we ought to pay them we inevitably think of the act in abstraction from the motive. Even if we knew what our motive would be if we did the act, we should not be any nearer an answer to the question.

Moreover, if we eventually pay our bills from fear of the county court, we shall still have done *what* we ought, even though we shall not have done it *as* we ought. The attempt to bring in the motive involves a mistake similar to that involved in supposing that we can will to will. To feel that I ought to pay my bills is to be *moved towards* paying them. But what I can be moved towards must always be an action and not an action in which I am moved in a particular way, i.e. an action from a particular motive; otherwise I should be moved towards being moved, which is impossible. Yet the view under consideration involves this impossibility, for it really resolves the sense that I ought to do so and so, into the sense that I ought to be moved to do it in a particular way.[6]

So far my contentions have been mainly negative, but they form, I think, a useful, if not a necessary, introduction to what I take to be the truth. This I will now endeavor to state, first formulating what, as I think, is the real nature of our apprehension or appreciation of moral obligations, and then applying the result to elucidate the question of the existence of Moral Philosophy.

The sense of obligation to do, or of the rightness of, an action of a particular kind is absolutely underivative or immediate. The rightness of an action consists in its being the origination of something of a certain kind A in a situation of a certain kind, a situation consisting in a certain relation B of the agent to others or to his own nature. To appreciate its rightness two preliminaries may be necessary. We may have to follow out the consequences of the proposed action more fully than we have hitherto done, in order to realize that in the action we should originate A. Thus we may not appreciate the wrongness of telling a certain story until we realize that we should thereby be hurting the feelings of one of our audience. Again, we may have to take into account the relation B involved in the situation, which we had hitherto failed to notice. For instance, we may not appreciate the obligation to give X a present, until we remember that he has done us an act of kindness. But, given that by a process which is, of course, merely a process of general and not of moral thinking we come to recognize that the proposed act is one by which we shall originate A in a relation B, then we appreciate the obligation immediately or directly, the appreciation being an activity of *moral* thinking. We recognize, for instance, that this performance of a service to X, who has done us a service, just in virtue of its being the performance of a service to one who has rendered a service to the would-be agent, ought to be done by us. This apprehension is immediate, in precisely the sense in which a mathematical apprehension is immediate, e.g. the apprehension that this three-sided figure, in virtue of its being three-sided, must have three angles. Both apprehensions are immediate in the sense that in both insight into the nature of the subject leads us to recognize its possession of the predicate; and it is only stating this fact from the other side to say that in both cases the fact apprehended is self-evident.

The plausibility of the view that obligations are not self-evident but need proof lies in the fact that an act which is referred to as an obligation may be incompletely stated, what I have called the preliminaries to appreciating the obligation being incomplete. If, e.g., we refer to the act of repaying X by a present merely as giving X a present, it appears, and indeed is, necessary to give a reason. In other words, wherever a moral act is regarded in this incomplete way the question "*Why* should I do it?" is perfectly legitimate. This fact suggests, but suggests wrongly, that even if the nature of the act is completely stated, it is still necessary to give a reason, or, in other words, to supply a proof.

The relations involved in obligations of various kinds are, of course, very different. The relation in certain cases is a relation to others due to a past act of theirs or ours. The obligation to repay a benefit involves a relation due to a past act of the benefactor. The obligation to repay a benefit involves a relation due to a past act of ours in which we have either said or implied that we would make a certain return for something which we have asked for and received. On the other hand, the obligation to speak the truth implies no such definite act; it involves a relation consisting in the fact that others are trusting us to speak the truth, a relation the apprehension of which gives rise to the sense that communication of the truth is something owing by us to them. Again, the obligation not to hurt the feelings of another involves no special relation of us to that other, i.e. no relation other than that involved in our both being men, and men in one and the same world. Moreover, it seems that the relation involved in an obligation need not be a relation to another at all. Thus we should admit that there is an obligation to overcome our natural timidity or greediness, and that this involves no relations to others. Still there is a relation involved, viz. a relation to our own disposition. It is simply because we can and because others cannot directly modify our disposition that it is our business to improve it, and that it is not theirs, or, at least, not theirs to the same extent.

The negative side of all this is, of course, that we do not come to appreciate an obligation by an *argument*, i.e. by a process of nonmoral thinking, and

that, in particular, we do not do so by an argument of which a premise is the ethical but not moral activity of appreciating the goodness either of the act or of a consequence of the act; i.e. that our sense of the rightness of an act is not a conclusion from our appreciation of the goodness either of it or of anything else.

It will probably be urged that on this view our various obligations form, like Aristotle's categories, an unrelated chaos in which it is impossible to acquiesce. For, according to it, the obligation to repay a benefit, or to pay a debt, or to keep a promise, presupposes a previous act of another; whereas the obligation to speak the truth or not to harm another does not; and, again, the obligation to remove our timidity involves no relations to others at all. Yet, at any rate, an effective *argumentum ad hominem* is at hand in the fact that the various qualities which we recognize as good are equally unrelated; e.g. courage, humility, and interest in knowledge. If, as is plainly the case, ἀγαθά differ η ἀγαθά [Goods differ *qua* goods], why should not obligations equally differ *qua* their obligatoriness? Moreover, if this were not so there could in the end be only one obligation, which is palpably contrary to fact.[7]

Certain observations will help to make the view clearer.

In the first place, it may seem that the view, being—as it is—avowedly put forward in opposition to the view that what is right is derived from what is good, must itself involve the opposite of this, viz. the Kantian position that what is good is based upon what is right, i.e. that an act, if it be good, is good because it is right. But this is not so. For, on the view put forward, the rightness of a right action lies solely in the origination in which the act consists, whereas the intrinsic goodness of an action lies solely in its motive; and this implies that a morally good action is morally good not simply because it is a right action but because it is a right action done because it is right, i.e. from a sense of obligation. And this implication, it may be remarked incidentally, seems plainly true.

In the second place, the view involves that when, or rather so far as, we act from a sense of obligation, we have no purpose or end. By a "purpose" or "end" we really mean something the existence of which we

desire, and desire of the existence of which leads us to act. Usually our purpose is something which the act will originate, as when we turn round in order to look at a picture. But it may be the action itself, i.e. the origination of something, as when we hit a golf ball into a hole or kill someone out of revenge.[8] Now if by a purpose we mean something the existence of which we desire and desire for which leads us to act, then plainly, so far as we act from a sense of obligation, we have no purpose, consisting either in the action or in anything which it will produce. This is so obvious that is scarcely seems worth pointing out. But I do so for two reasons. (1) If we fail to scrutinize the meaning of the terms "end" and "purpose," we are apt to assume uncritically that all deliberate action, i.e. action proper, must have a purpose; we then become puzzled both when we look for the purpose of an action done from a sense of obligation, and also when we try to apply to such an action the distinction of means and end, the truth all the time being that since there is no end, there is no means either. (2) The attempt to base the sense of obligation on the recognition of the goodness of something is really an attempt to find a purpose in a moral action in the shape of something good which, as good, we want. And the expectation that the goodness of something underlies an obligation disappears as soon as we cease to look for a purpose.

The thesis, however, that, so far as we act from a sense of obligation, we have no purpose must not be misunderstood. It must not be taken either to mean or to imply that so far as we so act we have no *motive*. No doubt in ordinary speech the words "motive" and "purpose" are usually treated as correlatives, "motive" standing for the desire which induces us to act, and "purpose" standing for the object of this desire. But this is only because, when we are looking for the motive of the action, say, of some crime, we are usually presupposing that the act in question is prompted by a desire and not by the sense of obligation. At bottom, however, we mean by a motive what moves us to act; a sense of obligation does sometimes move us to act; and in our ordinary consciousness we should not hesitate to allow that the action we were considering might have had as its motive a

sense of obligation. Desire and the sense of obligation are coordinate forms or species of motive.

In the third place, if the view put forward be right, we must sharply distinguish morality and virtue as independent, though related, species of goodness, neither being an aspect of something of which the other is an aspect, nor again a form or species of the other, nor again something deducible from the other; and we must at the same time allow that it is possible to do the same act either virtuously or morally or in both ways at once. And surely this is true. An act, to be virtuous, must, as Aristotle saw, be done willingly or with pleasure; as such it is just not done from a sense of obligation but from some desire which is intrinsically good, as arising from some intrinsically good emotion. Thus, in an act of generosity the motive is the desire to help another arising from sympathy with that other; in an act which is courageous and no more, i.e. in an act which is not at the same time an act of public spirit or family affection or the like, we prevent ourselves from being dominated by a feeling of terror, desiring to do so from a sense of shame at being terrified. The goodness of such an act is different from the goodness of an act to which we apply the term moral in the strict and narrow sense, viz. an act done from a sense of obligation. Its goodness lies in the intrinsic goodness of the emotion and of the consequent desire under which we act, the goodness of this motive being different from the goodness of the moral motive proper, viz. the sense of duty or obligation. Nevertheless, at any rate in certain cases, an act can be done either virtuously or morally or in both ways at once. It is possible to repay a benefit either from desire to repay it, or from the feeling that we ought to do so, or from both motives combined. A doctor may tend his patients either from a desire arising out of interest in his patients or in the exercise of skill, or from a sense of duty, or from a desire and a sense of duty combined. Further, although we recognize that in each case the act possesses an intrinsic goodness, we regard that action as the best in which both motives are combined; in other words, we regard as the really best man the man in whom virtue and morality are united.

It may be objected that the distinction between the two kinds of motive is untenable, on the ground that the *desire* to repay a benefit, for example, is only the manifestation of that which manifests itself as the *sense of obligation* to repay whenever we think of something in the action which is other than the repayment and which we should not like, such as the loss or pain involved. Yet the distinction can, I think, easily be shown to be tenable. For, in the analogous case of revenge, the desire to return the injury and the sense that we ought not to do so, leading, as they do, in opposite directions, are plainly distinct; and the obviousness of the distinction here seems to remove any difficulty in admitting the existence of a parallel distinction between the desire to return a benefit and the sense that we ought to return it.[9]

Further, the view implies that an obligation can no more be based on or derived from a virtue than a virtue can be derived from an obligation, in which latter case a virtue would consist in carrying out an obligation. And the implication is surely true and important. Take the case of courage. It is untrue to urge that, since courage is a virtue, we ought to act courageously. It is and must be untrue, because, as we see in the end, to feel an obligation to act courageously would involve a contradiction. For, as I have urged before, we can only feel an obligation to *act;* we cannot feel an obligation to *act from a certain desire*, in this case the desire to conquer one's feelings of terror arising from the sense of shame which they arouse. Moreover, if the sense of obligation to act in a particular way leads to an action, the action will be an action done from a sense of obligation, and therefore not, if the above analysis of virtue be right, an act of courage.

The mistake of supposing that there can be an obligation to act courageously seems to arise from two causes. In the first place, there is often an obligation to do that which involves the conquering or controlling of our fear in the doing of it, e.g. the obligation to walk along the side of a precipice to fetch a doctor for a member of our family. Here the acting on the obligation is externally, though only externally, the same as an act of courage proper. In the second place there is an obligation to acquire courage, i.e. to do such things as will enable us afterwards to act courageously, and this may be mistaken for an obligation to act courageously. The same considerations

can, of course, be applied, *mutatis mutandis*, to the other virtues.

The fact, if it be a fact, that virtue is no basis for morality will explain what otherwise it is difficult to account for, viz. the extreme sense of dissatisfaction produced by a close reading of Aristotle's *Ethics*. Why is the *Ethics* so disappointing? Not, I think, because it really answers two radically different questions as if they were one: (1) "What is the happy life?" (2) "What is the virtuous life?" It is, rather, because Aristotle does not do what we as moral philosophers want him to do, viz. to convince us that we really ought to do what in our nonreflective consciousness we have hitherto believed we ought to do, or if not, to tell us what, if any, are the other things which we really ought to do, and to prove to us that he is right. Now, if what I have just been contending is true, a systematic account of the virtuous character cannot possibly satisfy this demand. At best it can only make clear to us the details of one of our obligations, viz. the obligation to make ourselves better men; but the achievement of this does not help us to discover what we ought to do in life as a whole, and why; to think that it did would be to think that our only business in life was self-improvement. Hence it is not surprising that Aristotle's account of the good man strikes us as almost wholly of academic value, with little relation to our real demand, which is formulated in Plato's words: οὐ γὰρ περὶ τοῦἐπιτυχόντος, ὁ λογος ἀλλὰ περὶ τοῦ ὄντινα τρόπον χρὴ ζῆν [for no light matter is at stake, nothing less than the rule of human life].

I am not, of course, *criticizing* Aristotle for failing to satisfy this demand, except so far as here and there he leads us to think that he intends to satisfy it. For my main contention is that the demand cannot be satisfied, and cannot be satisfied because it is illegitimate. Thus we are brought to the question: "Is there really such a thing as Moral Philosophy, and, if there is, in what sense?"

We should first consider the parallel case—as it appears to be—of the Theory of Knowledge. As I urged before, at some time or other in the history of all of us, if we are thoughtful, the frequency of our own and of others' mistakes is bound to lead to the reflection that possibly we and others have *always* been mistaken in consequence of some radical defect of our faculties. In consequence, certain things which previously we should have said without hesitation that we *knew*, as e.g. that $4 \times 7 = 28$, become subject to doubt; we become able only to say that we thought we knew these things. We inevitably go on to look for some general procedure by which we can ascertain that a given condition of mind is really one of knowledge. And this involves the search for a criterion of knowledge, i.e. for a principle by applying which we can settle that a given state of mind is really knowledge. The search for this criterion and the application of it, when found, is what is called the Theory of Knowledge. The search implies that instead of its being the fact that the knowledge that A is B is obtained directly by consideration of the nature of A and B, the knowledge that A is B, in the full or complete sense, can only be obtained by first knowing that A is B, and then knowing that we knew it by applying a criterion, such as Descartes's principle that what we clearly and distinctly conceive is true.

Now it is easy to show that the doubt whether A is B, based on this speculative or general ground, could, if genuine, never be set at rest. For if, in order really to know that A is B, we must first know that we knew it, then really, to know that we knew it, we must first know that we knew that we knew it. But—what is more important—it is also easy to show that this doubt is not a genuine doubt but rests on a confusion the exposure of which removes the doubt. For when we *say* we doubt whether our previous condition was one of knowledge, what we *mean*, if we mean anything at all, is that we doubt whether our previous *belief* was *true*, a belief which we should express as the *thinking* that A is B. For in order to doubt whether our previous condition was one of knowledge, we have to think of it not as knowledge but as only belief, and our only question can be "Was this belief true?" But as soon as we see that we are thinking of our previous condition as only one of belief, we see that what we are now doubting is not what we first *said* we were doubting, viz. whether a previous condition of knowledge was really knowledge. Hence, to remove the doubt, it is only necessary to appreciate

the real nature of our consciousness in apprehending, e.g. that $7 \times 4 = 28$, and thereby see that it was no mere condition of believing but a condition of knowing, and then to notice that in our subsequent doubt what we are really doubting is not whether this consciousness was really knowledge, but whether a consciousness of another kind, viz. a belief that $7 \times 4 = 28$, was true. We thereby see that though a doubt based on speculative grounds is possible, it is not a doubt concerning what we believed the doubt concerned, and that a doubt concerning this latter is impossible.

Two results follow. In the first place, if, as is usually the case, we mean by the "Theory of Knowledge" the knowledge which supplies the answer to the question "Is what we have hitherto thought knowledge really knowledge?," there is and can be no such thing, and the supposition that there can is simply due to a confusion. There can be no answer to an illegitimate question, except that the question is illegitimate. Nevertheless the question is one which we continue to put until we realize the inevitable immediacy of knowledge. And it is positive knowledge that knowledge is immediate and neither can be, nor needs to be, improved or vindicated by the further knowledge that it was knowledge. This positive knowledge sets at rest the inevitable doubt, and, so far as by the "Theory of Knowledge" is meant this knowledge, then even though this knowledge be the knowledge that there is no Theory of Knowledge in the former sense, to that extent the Theory of Knowledge exists.

In the second place, suppose we come genuinely to doubt whether, e.g., $7 \times 4 = 28$ owing to a genuine doubt whether we were right in believing yesterday that $7 \times 4 = 28$, a doubt which can in fact only arise if we have lost our hold of, i.e. no longer remember, the real nature of our consciousness of yesterday, and so think of it as consisting in believing. Plainly, the only remedy is to do the sum again. Or, to put the matter generally, if we do come to doubt whether it is true that A is B, as we once thought, the remedy lies not in any process of reflection but in such a reconsideration of the nature of A and B as leads to the knowledge that A is B.

With these considerations in mind, consider the parallel which, as it seems to me, is presented—though with certain differences—by Moral Philosophy. The sense that we ought to do certain things arises in our unreflective consciousness, being an activity of moral thinking occasioned by the various situations in which we find ourselves. At this stage our attitude to these obligations is one of unquestioning confidence. But inevitably the appreciation of the degree to which the execution of these obligations is contrary to our interest raises the doubt whether after all these obligations are really obligatory, i.e. whether our sense that we ought not to do certain things is not illusion. We then want to have it *proved* to us that we ought to do so, i.e. to be convinced of this by a process which, as an argument, is different in kind from our original and unreflective appreciation of it. This demand is, as I have argued, illegitimate.

Hence, in the first place, if, as is almost universally the case, by Moral Philosophy is meant the knowledge which would satisfy this demand, there is no such knowledge, and all attempts to attain it are doomed to failure because they rest on a mistake, the mistake of supposing the possibility of proving what can only be apprehended directly by an act of moral thinking. Nevertheless the demand, though illegitimate, is inevitable until we have carried the process of reflection far enough to realize the self-evidence of our obligations, i.e. the immediacy of our apprehension of them. This realization of their self-evidence is positive knowledge, and so far, and so far only, as the term Moral Philosophy is confined to this knowledge and to the knowledge of the parallel immediacy of the apprehension of the goodness of the various virtues and of good dispositions generally, is there such a thing as Moral Philosophy. But since this knowledge may allay doubts which often affect the whole conduct of life, it is, though not extensive, important, and even vitally important.

In the second place, suppose we come genuinely to doubt whether we ought, for example, to pay our debts, owing to a genuine doubt whether our previous conviction that we ought to do so is true, a doubt which can, in fact, only arise if we fail to remember the real nature of what we now call our past conviction. The only remedy lies in actually getting into a situation which occasions the obligation, or—if our imagination be strong enough—in imagining ourselves in

that situation, and then letting our moral capacities of thinking do their work. Or, to put the matter generally, if we do doubt whether there is really an obligation to originate A in a situation B, the remedy lies not in any process of general thinking, but in getting face to face with a particular instance of the situation B, and then directly appreciating the obligation to originate A in that situation.

Notes

1. Cf. Dr. Rashdall's *Theory of Good and Evil*, I, 138.

2. Dr. Rashdall, if I understand him rightly, supplies this link (cf. ibid., 135–36).

3. When we speak of anything, e.g., of some emotion or of some quality of a human being, as good, we never dream in our ordinary consciousness of going on to say that therefore it ought to be.

4. It may be noted that if the badness of pain were the reason why we ought not to inflict pain on another, it would equally be a reason why we ought not to inflict pain on ourselves: yet, though we should allow the wanton infliction of pain on ourselves to be foolish, we should not think of describing it as wrong.

5. It is, I think, on this latter horn of the dilemma that Martineau's view falls; cf. *Types of Ethical Theory*, Part II, Book I.

6. It is of course not denied here that an action done for a particular motive may be *good;* it is only denied that the *rightness* of an action depends on its being done with a particular motive.

7. Two other objections may be anticipated: (1) that obligations cannot be self-evident, since many actions regarded as obligations by some are not so regarded by others, and (2) that if obligations are self-evident, the problem of how we ought to act in the presence of conflicting obligations is insoluble.

To the first I should reply:

(a) That the appreciation of an obligation is, of course, only possible for a developed moral being, and that different degrees of development are possible.

(b) That the failure to recognize some particular obligation is usually due to the fact that, owing to a lack of thoughtfulness, what I have called the preliminaries to this recognition are incomplete.

(c) That the view put forward is consistent with the admission that, owing to a lack of thoughtfulness, even the best men are blind to many of their obligations, and that in the end our obligations are seen to be co-extensive with almost the whole of our life.

To the second objection I should reply that obligation admits of degrees, and that where obligations conflict, the decision of what we ought to do turns not on the question "Which of the alternative courses of action will originate the greater good?" but on the question "Which is the greater obligation?"

8. It is no objection to urge that an action cannot be its own purpose, since the purpose of something cannot be the thing itself. For, speaking strictly, the purpose is not the *action's* purpose but *our* purpose, and there is no contradiction in holding that our purpose in acting may be the action.

9. This sharp distinction of virtue and morality as coordinate and independent forms of goodness will explain a fact which otherwise it is difficult to account for. If we turn from books on Moral Philosophy to any vivid account of human life and action such as we find in Shakespeare, nothing strikes us more than the comparative remoteness of the discussions of Moral Philosophy from the facts of actual life. Is not this largely because, while Moral Philosophy has, quite rightly, concentrated its attention on the fact of obligation, in the case of many of those whom we admire most and whose lives are of the greatest interest, the sense of obligation, though it may be an important, is not a dominating factor in their lives?

Study Questions

1. What is the mistake to which Prichard referred in the title of his article?

2. What did Prichard mean by "an act of moral thinking"?

3. Could two people engage in an act of moral thinking and nevertheless disagree about what ought to be done?

4. Did Prichard's position specify any particular moral duties?

20

A. J. AYER

Alfred Jules Ayer (1910–1989) was Wykeham Professor of Logic at the University of Oxford. He argued that because ethical judgments are not empirically verifiable, they are neither true nor false but, instead, express the emotions of the speaker. To assert, for example, that murder is wrong is to express a negative attitude toward murder. This ethical theory, which became widely known as "emotivism," led to extensive discussion of what role, if any, reason plays in ethical inquiry.

Language, Truth, and Logic

There is still one objection to be met before we can claim to have justified our view that all synthetic propositions are empirical hypotheses. This objection is based on the common supposition that our speculative knowledge is of two distinct kinds—that which relates to questions of empirical fact, and that which relates to questions of value. It will be said that "statements of value" are genuine synthetic propositions, but that they cannot with any show of justice be represented as hypotheses, which are used to predict the course of our sensations; and, accordingly, that the existence of ethics and æsthetics as branches of speculative knowledge presents an insuperable objection to our radical empiricist thesis.

In face of this objection, it is our business to give an account of "judgments of value" which is both satisfactory in itself and consistent with our general empiricist principles. We shall set ourselves to show that in so far as statements of value are significant, they are ordinary "scientific" statements; and that in so far as they are not scientific, they are not in the literal sense significant, but are simply expressions of emotion which can be neither true nor false. In maintaining this view, we may confine ourselves for the present to the case of ethical statements. What is said about them will be found to apply, *mutatis mutandis*, to the case of æsthetic statements also.

The ordinary system of ethics, as elaborated in the works of ethical philosophers, is very far from being a homogeneous whole. Not only is it apt to contain pieces of metaphysics, and analyses of non-ethical concepts: its actual ethical contents are themselves of very different kinds. We may divide them, indeed, into four main classes. There are, first of all, propositions which express definitions of ethical terms, or judgments about the legitimacy or possibility of certain definitions. Secondly, there are propositions describing the phenomena of moral experience, and their causes. Thirdly, there are exhortations to moral virtue. And, lastly, there are actual ethical judgments. It is unfortunately the case that the distinction between these four classes, plain as it is, is commonly

ignored by ethical philosophers; with the result that it is often very difficult to tell from their works what it is that they are seeking to discover or prove.

In fact, it is easy to see that only the first of our four classes, namely that which comprises the propositions relating to the definitions of ethical terms, can be said to constitute ethical philosophy. The propositions which describe the phenomena of moral experience, and their causes, must be assigned to the science of psychology, or sociology. The exhortations to moral virtue are not propositions at all, but ejaculations or commands which are designed to provoke the reader to action of a certain sort. Accordingly, they do not belong to any branch of philosophy or science. As for the expressions of ethical judgments, we have not yet determined how they should be classified. But inasmuch as they are certainly neither definitions nor comments upon definitions, nor quotations, we may say decisively that they do not belong to ethical philosophy. A strictly philosophical treatise on ethics should therefore make no ethical pronouncements. But it should, by giving an analysis of ethical terms, show what is the category to which all such pronouncements belong. And this is what we are now about to do.

A question which is often discussed by ethical philosophers is whether it is possible to find definitions which would reduce all ethical terms to one or two fundamental terms. But this question, though it undeniably belongs to ethical philosophy, is not relevant to our present enquiry. We are not now concerned to discover which term, within the sphere of ethical terms, is to be taken as fundamental; whether, for example, "good" can be defined in terms of "right" or "right" in terms of "good," or both in terms of "value." What we are interested in is the possibility of reducing the whole sphere of ethical terms to non-ethical terms. We are enquiring whether statements of ethical value can be translated into statements of empirical fact.

That they can be so translated is the contention of those ethical philosophers who are commonly called subjectivists, and of those who are known as utilitarians. For the utilitarian defines the rightness of actions, and the goodness of ends, in terms of the pleasure, or happiness, or satisfaction, to which they give rise; the subjectivist, in terms of the feelings of

approval which a certain person, or group of people, has towards them. Each of these types of definition makes moral judgments into a sub-class of psychological or sociological judgments; and for this reason they are very attractive to us. For, if either was correct, it would follow that ethical assertions were not generically different from the factual assertions which are ordinarily contrasted with them; and the account which we have already given of empirical hypotheses would apply to them also.

Nevertheless we shall not adopt either a subjectivist or a utilitarian analysis of ethical terms. We reject the subjectivist view that to call an action right, or a thing good, is to say that it is generally approved of, because it is not self-contradictory to assert that some actions which are generally approved of are not right, or that some things which are generally approved of are not good. And we reject the alternative subjectivist view that a man who asserts that a certain action is right, or that a certain thing is good, is saying that he himself approves of it, on the ground that a man who confessed that he sometimes approved of what was bad or wrong would not be contradicting himself. And a similar argument is fatal to utilitarianism. We cannot agree that to call an action right is to say that of all the actions possible in the circumstances it would cause, or be likely to cause, the greatest happiness, or the greatest balance of pleasure over pain, or the greatest balance of satisfied over unsatisfied desire, because we find that it is not self-contradictory to say that it is sometimes wrong to perform the action which would actually or probably cause the greatest happiness, or the greatest balance of pleasure over pain, or of satisfied over unsatisfied desire. And since it is not self-contradictory to say that some pleasant things are not good, or that some bad things are desired, it cannot be the case that the sentence "x is good" is equivalent to "x is pleasant," or to "x is desired." And to every other variant of utilitarianism with which I am acquainted the same objection can be made. And therefore we should, I think, conclude that the validity of ethical judgments is not determined by the felicific tendencies of actions, any more than by the nature of people's feelings; but that it must be regarded as "absolute" or "intrinsic," and not empirically calculable.

If we say this, we are not, of course, denying that it is possible to invent a language in which all ethical symbols are definable in non-ethical terms, or even that it is desirable to invent such a language and adopt it in place of our own; what we are denying is that the suggested reduction of ethical to non-ethical statements is consistent with the conventions of our actual language. That is, we reject utilitarianism and subjectivism, not as proposals to replace our existing ethical notions by new ones, but as analyses of our existing ethical notions. Our contention is simply that, in our language, sentences which contain normative ethical symbols are not equivalent to sentences which express psychological propositions, or indeed empirical propositions of any kind.

It is advisable here to make it plain that it is only normative ethical symbols, and not descriptive ethical symbols, that are held by us to be indefinable in factual terms. There is a danger of confusing these two types of symbols, because they are commonly constituted by signs of the same sensible form. Thus a complex sign of the form "*x* is wrong" may constitute a sentence which expresses a moral judgment concerning a certain type of conduct, or it may constitute a sentence which states that a certain type of conduct is repugnant to the moral sense of a particular society. In the latter case, the symbol "wrong" is a descriptive ethical symbol, and the sentence in which it occurs expresses an ordinary sociological proposition; in the former case, the symbol "wrong" is a normative ethical symbol, and the sentence in which it occurs does not, we maintain, express an empirical proposition at all. It is only with normative ethics that we are at present concerned; so that whenever ethical symbols are used in the course of this argument without qualification, they are always to be interpreted as symbols of the normative type.

In admitting that normative ethical concepts are irreducible to empirical concepts, we seem to be leaving the way clear for the "absolutist" view of ethics—that is, the view that statements of value are not controlled by observation, as ordinary empirical propositions are, but only by a mysterious "intellectual intuition." A feature of this theory, which is seldom recognized by its advocates, is that it makes statements of value unverifiable. For it is notorious that what seems intuitively certain to one person may seem doubtful, or even false, to another. So that unless it is possible to provide some criterion by which one may decide between conflicting intuitions, a mere appeal to intuition is worthless as a test of a proposition's validity. But in the case of moral judgments, no such criterion can be given. Some moralists claim to settle the matter by saying that they "know" that their own moral judgments are correct. But such an assertion is of purely psychological interest, and has not the slightest tendency to prove the validity of any moral judgment. For dissentient moralists may equally well "know" that their ethical views are correct. And, as far as subjective certainty goes, there will be nothing to choose between them. When such differences of opinion arise in connection with an ordinary empirical proposition, one may attempt to resolve them by referring to, or actually carrying out, some relevant empirical test. But with regard to ethical statements, there is, on the "absolutist" or "intuitionist" theory, no relevant empirical test. We are therefore justified in saying that on this theory ethical statements are held to be unverifiable. They are, of course, also held to be genuine synthetic propositions.

Considering the use which we have made of the principle that a synthetic proposition is significant only if it is empirically verifiable, it is clear that the acceptance of an "absolutist" theory of ethics would undermine the whole of our main argument. And as we have already rejected the "naturalistic" theories which are commonly supposed to provide the only alternative to "absolutism" in ethics, we seem to have reached a difficult position. We shall meet the difficulty by showing that the correct treatment of ethical statements is afforded by a third theory, which is wholly compatible with our radical empiricism.

We begin by admitting that the fundamental ethical concepts are unanalyzable, inasmuch as there is no criterion by which one can test the validity of the judgments in which they occur. So far we are in agreement with the absolutists. But, unlike the absolutists, we are able to give an explanation of this fact about ethical concepts. We say that the reason why they are unanalyzable is that they are mere

pseudo-concepts. The presence of an ethical symbol in a proposition adds nothing to its factual content. Thus if I say to someone, "You acted wrongly in stealing that money," I am not stating anything more than if I had simply said, "You stole that money." In adding that this action is wrong I am not making any further statement about it. I am simply evincing my moral disapproval of it. It is as if I had said, "You stole that money," in a peculiar tone of horror, or written it with the addition of some special exclamation marks. The tone, or the exclamation marks, adds nothing to the literal meaning of the sentence. It merely serves to show that the expression of it is attended by certain feelings in the speaker.

If now I generalize my previous statement and say, "Stealing money is wrong," I produce a sentence which has no factual meaning—that is, expresses no proposition which can be either true or false. It is as if I had written "Stealing money!!"—where the shape and thickness of the exclamation marks show, by a suitable convention, that a special sort of moral disapproval is the feeling which is being expressed. It is clear that there is nothing said here which can be true or false. Another man may disagree with me about the wrongness of stealing, in the sense that he may not have the same feelings about stealing as I have, and he may quarrel with me on account of my moral sentiments. But he cannot, strictly speaking, contradict me. For in saying that a certain type of action is right or wrong, I am not making any factual statement, not even a statement about my own state of mind. I am merely expressing certain moral sentiments. And the man who is ostensibly contradicting me is merely expressing his moral sentiments. So that there is plainly no sense in asking which of us is the right. For neither of us is asserting a genuine proposition.

What we have just been saying about the symbol "wrong" applies to all normative ethical symbols. Sometimes they occur in sentences which record ordinary empirical facts besides expressing ethical feeling about those facts: sometimes they occur in sentences which simply express ethical feeling about a certain type of action, or situation, without making any statement of fact. But in every case in which one would commonly be said to be making an ethical judgment,

the function of the relevant ethical word is purely "emotive." It is used to express feeling about certain objects, but not to make any assertion about them.

It is worth mentioning that ethical terms do not serve only to express feeling. They are calculated also to arouse feeling, and so to stimulate action. Indeed some of them are used in such a way as to give the sentences in which they occur the effect of commands. Thus the sentence "It is your duty to tell the truth" may be regarded both as the expression of a certain sort of ethical feeling about truthfulness and as the expression of the command "Tell the truth." The sentence "You ought to tell the truth" also involves the command "Tell the truth," but here the tone of the command is less emphatic. In the sentence "It is good to tell the truth" the command has become little more than a suggestion. And thus the "meaning" of the word "good," in its ethical usage, is differentiated from that of the word "duty" or the word "ought." In fact we may define the meaning of the various ethical words in terms both of the different feelings they are ordinarily taken to express, and also the different responses which they are calculated to provoke.

We can now see why it is impossible to find a criterion for determining the validity of ethical judgments. It is not because they have an "absolute" validity which is mysteriously independent of ordinary sense-experience, but because they have no objective validity whatsoever. If a sentence makes no statement at all, there is obviously no sense in asking whether what it says is true or false. And we have seen that sentences which simply express moral judgments do not say anything. They are pure expression of feeling and as such do not come under the category of truth and falsehood. They are unverifiable for the same reason as a cry of pain or a word of command is unverifiable—because they do not express genuine propositions.

Thus, although our theory of ethics might fairly be said to be radically subjectivist, it differs in a very important respect from the orthodox subjectivist theory. For the orthodox subjectivist does not deny, as we do, that the sentences of a moralizer express genuine propositions. All he denies is that they express propositions of a unique non-empirical character. His own view is that they express propositions about the

speaker's feelings. If this were so, ethical judgments clearly would be capable of being true or false. They would be true if the speaker had the relevant feelings, and false if he had not. And this is a matter which is, in principle, empirically verifiable. Furthermore they could be significantly contradicted. For if I say, "Tolerance is a virtue," and someone answers, "You don't approve of it," he would, on the ordinary subjectivist theory, be contradicting me. On our theory, he would not be contradicting me, because, in saying that tolerance was a virtue, I should not be making any statement about my own feelings or about anything else. I should simply be evincing my feelings, which is not at all the same thing as saying that I have them.

The distinction between the expression of feeling and the assertion of feeling is complicated by the fact that the assertion that one has a certain feeling often accompanies the expression of that feeling, and is then, indeed, a factor in the expression of that feeling. Thus I may simultaneously express boredom and say that I am bored, and in that case my utterance of the words, "I am bored," is one of the circumstances which make it true to say that I am expressing or evincing boredom. But I can express boredom without actually saying that I am bored. I can express it by my tone and gestures, while making a statement about something wholly unconnected with it, or by an ejaculation, or without uttering any words at all. So that even if the assertion that one has a certain feeling always involves the expression of that feeling, the expression of a feeling assuredly does not always involve the assertion that one has it. And this is the important point to grasp in considering the distinction between our theory and the ordinary subjectivist theory. For whereas the subjectivist holds that ethical statements actually assert the existence of certain feelings, we hold that ethical statements are expressions and excitants of feeling which do not necessarily involve any assertions.

We have already remarked that the main objection to the ordinary subjectivist theory is that the validity of ethical judgments is not determined by the nature of their author's feelings. And this is an objection which our theory escapes. For it does not imply that the existence of any feelings is a necessary and sufficient condition of the validity of an ethical judgment. It implies, on the contrary, that ethical judgments have no validity.

There is, however, a celebrated argument against subjectivist theories which our theory does not escape. It has been pointed out by Moore that if ethical statements were simply statements about the speaker's feelings, it would be impossible to argue about questions of value. To take a typical example: if a man said that thrift was a virtue, and another replied that it was a vice, they would not, on this theory, be disputing with one another. One would be saying that he approved of thrift, and the other that *he* didn't; and there is no reason why both these statements should not be true. Now Moore held it to be obvious that we do dispute about questions of value, and accordingly concluded that the particular form of subjectivism which he was discussing was false.

It is plain that the conclusion that it is impossible to dispute about questions of value follows from our theory also. For as we hold that such sentences as "Thrift is a virtue" and "Thrift is a vice" do not express propositions at all, we clearly cannot hold that they express incompatible propositions. We must therefore admit that if Moore's argument really refutes the ordinary subjectivist theory, it also refutes ours. But, in fact, we deny that it does refute even the ordinary subjectivist theory. For we hold that one really never does dispute about questions of value.

This may seem, at first sight, to be a very paradoxical assertion. For we certainly do engage in disputes which are ordinarily regarded as disputes about questions of value. But, in all such cases, we find, if we consider the matter closely, that the dispute is not really about a question of value, but about a question of fact. When someone disagrees with us about the moral value of a certain action or type of action, we do admittedly resort to argument in order to win him over to our way of thinking. But we do not attempt to show by our arguments that he has the "wrong" ethical feeling towards a situation whose nature he has correctly apprehended. What we attempt to show is that he is mistaken about the facts of the case. We argue that he has misconceived the agent's motive: or that he has misjudged the effects of the action, or its probable effects in view of the agent's knowledge; or that he has failed to take into account the special circumstances in which the agent was placed. Or else we employ more general arguments about the effects which actions of a

certain type tend to produce, or the qualities which are usually manifested in their performance. We do this in the hope that we have only to get our opponent to agree with us about the nature of the empirical facts for him to adopt the same moral attitude towards them as we do. And as the people with whom we argue have generally received the same moral education as ourselves, and live in the same social order, our expectation is usually justified. But if our opponent happens to have undergone a different process of moral "conditioning" from ourselves, so that, even when he acknowledges all the facts, he still disagrees with us about the moral value of the actions under discussion, then we abandon the attempt to convince him by argument. We say that it is impossible to argue with him because he has a distorted or undeveloped moral sense; which signifies merely that he employs a different set of values from our own. We feel that our own system of values is superior, and therefore speak in such derogatory terms of his. But we cannot bring forward any arguments to show that our system is superior. For our judgment that it is so is itself a judgment of value, and accordingly outside the scope of argument. It is because argument fails us when we come to deal with pure questions of value, as distinct from questions of fact, that we finally resort to mere abuse.

In short, we find that argument is possible on moral questions only if some system of values is presupposed. If our opponent concurs with us in expressing moral disapproval of all actions of a given type t, then we may get him to condemn a particular action A, bringing forward arguments to show that A is of type t. For the question whether A does or does not belong to that type is a plain question of fact. Given that a man has certain moral principles, we argue that he must, in order to be consistent, react morally to certain things in a certain way. What we do not and cannot argue about is the validity of these moral principles. We merely praise or condemn them in the light of our own feelings.

If anyone doubts the accuracy of this account of moral disputes, let him try to construct even an imaginary argument on a question of value which does not reduce itself to an argument about a question of logic or about an empirical matter of fact. I am confident that he will not succeed in producing a single example. And if that is the case, he must allow that

its involving the impossibility of purely ethical arguments is not, as Moore thought, a ground of objection to our theory, but rather a point in favor of it.

Having upheld our theory against the only criticism which appeared to threaten it, we may now use it to define the nature of all ethical enquiries. We find that ethical philosophy consists simply in saying that ethical concepts are pseudo-concepts and therefore unanalyzable. The further task of describing the different feelings that the different ethical terms are used to express, and the different reactions that they customarily provoke, is a task for the psychologist. There cannot be such a thing as ethical science, if by ethical science one means the elaboration of a "true" system of morals. For we have seen that, as ethical judgments are mere expressions of feeling, there can be no way of determining the validity of any ethical system, and, indeed, no sense in asking whether any such system is true. All that one may legitimately enquire in this connection is, What are the moral habits of a given person or group of people, and what causes them to have precisely those habits and feelings? And this enquiry falls wholly within the scope of the existing social sciences.

It appears, then, that ethics, as a branch of knowledge, is nothing more than a department of psychology and sociology. And in case anyone thinks that we are overlooking the existence of casuistry, we may remark that casuistry is not a science, but is a purely analytical investigation of the structure of a given moral system. In other words, it is an exercise in formal logic.

When one comes to pursue the psychological enquiries which constitute ethical science, one is immediately enabled to account for the Kantian and hedonistic theories of morals. For one finds that one of the chief causes of moral behavior is fear, both conscious and unconscious, of a god's displeasure, and fear of the enmity of society. And this, indeed, is the reason why moral precepts present themselves to some people as "categorical" commands. And one finds, also, that the moral code of a society is partly determined by the beliefs of that society concerning the conditions of its own happiness—or, in other words, that a society tends to encourage or discourage a given type of conduct by the use of moral sanctions according as it appears to promote or detract from the contentment of the society as a whole. And this

is the reason why altruism is recommended in most moral codes and egotism condemned. It is from the observation of this connection between morality and happiness that hedonistic or eudæmonistic theories of morals ultimately spring, just as the moral theory of Kant is based on the fact, previously explained, that moral precepts have for some people the force of inexorable commands. As each of these theories ignores the fact which lies at the root of the other, both may be criticized as being one-sided; but this is not the main objection to either of them. Their essential defect is that they treat propositions which refer to the causes and attributes of our ethical feelings as if they were definitions of ethical concepts. And thus they fail to recognize that ethical concepts are pseudoconcepts and consequently indefinable. . . .

Study Questions

1. According to emotivism, do those who say stealing is wrong thereby say that they disapprove of stealing?
2. According to Ayer, why are moral judgments unanalyzable?
3. According to Ayer, is argument over moral issues possible?
4. Can emotivists believe your moral judgments are wrong?

21

C. L. STEVENSON

Charles Leslie Stevenson (1908–1979) was Professor of Philosophy at the University of Michigan. He argued that the purpose of a value judgment (whether moral or nonmoral) is not primarily to state a belief but to express approval or disapproval, seeking to influence the feelings of others. Stevenson claimed that disagreements about value, while often having a factual component, are fundamentally disagreements in attitude, each individual seeking to persuade others to share an interest.

The Emotive Meaning of Ethical Terms

I

Ethical questions first arise in the form "Is so and so good?", or "Is this alternative better than that?" These questions are difficult partly because we don't quite know what we are seeking. We are asking, "Is there a needle in that haystack?" without even knowing just what a needle is. So the first thing to do is to examine the questions themselves. We must try to make them clearer, either by defining the terms in

From *Mind*, vol. 46 (1937). Reprinted by permission of Oxford University Press.

which they are expressed, or by any other method that is available.

The present paper is concerned wholly with this preliminary step of making ethical questions clear. In order to help answer the question "Is X good?" we must *substitute* for it a question which is free from ambiguity and confusion.

It is obvious that in substituting a clearer question we must not introduce some utterly different kind of question. It won't do (to take an extreme instance of a prevalent fallacy) to substitute for "Is X good?" the question "Is X pink with yellow trimmings?" and then point out how easy the question really is. This would beg the original question, not help answer it. On the other hand, we must not expect the substituted question to be strictly "identical" with the original one. The original question may embody hypostatization, anthropomorphism, vagueness, and all the other ills to which our ordinary discourse is subject. If our substituted question is to be clearer, it must remove these ills. The questions will be identical only in the sense that a child is identical with the man he later becomes. Hence we must not demand that the substitution strike us, on immediate introspection, as making no change in meaning.

Just how, then, must the substituted question be related to the original? Let us assume (inaccurately) that it must result from replacing "good" by some set of terms which define it. The question then resolves itself to this: How must the defined meaning of "good" be related to its original meaning?

I answer that it must be *relevant*. A defined meaning will be called "relevant" to the original meaning under these circumstances: Those who have understood the definition must be able to say all that they then want to say by using the term in the defined way. They must never have occasion to use the term in the old, unclear sense. (If a person did have to go on using the word in the old sense, then to this extent his meaning would not be clarified, and the philosophical task would not be completed.) It frequently happens that a word is used so confusedly and ambiguously that we must give it *several* defined meanings, rather than one. In this case only the whole set of defined meanings will be called

"relevant," and any one of them will be called "partially relevant." This is not a rigorous treatment of *relevance*, by any means; but it will serve for the present purposes.

Let us now turn to our particular task—that of giving a relevant definition of "good." Let us first examine some of the ways in which others have attempted to do this.

The word "good" has often been defined in terms of *approval*, or similar psychological attitudes. We may take as typical examples: "good" means *desired by me* (Hobbes); and "good" means *approved by most people* (Hume, in effect). It will be convenient to refer to definitions of this sort as "interest theories," following Mr. R. B. Perry, although neither "interest" nor "theory" is used in the most usual way.

Are definitions of this sort relevant?

It is idle to deny their *partial* relevance. The most superficial inquiry will reveal that "good" is exceedingly ambiguous. To maintain that "good" is *never* used in Hobbes's sense, and never in Hume's, is only to manifest an insensitivity to the complexities of language. We must recognize, perhaps, not only these senses, but a variety of similar ones, differing both with regard to the kind of interest in question, and with regard to the people who are said to have the interest.

But this is a minor matter. The essential question is not whether interest theories are *partially* relevant, but whether they are *wholly* relevant. This is the only point for intelligent dispute. Briefly: Granted that some senses of "good" may relevantly be defined in terms of interest, is there some *other* sense which is *not* relevantly so defined? We must give this question careful attention. For it is quite possible that when philosophers (and many others) have found the question "Is X good?" so difficult, they have been grasping for this *other* sense of "good," and not any sense relevantly defined in terms of interest. If we insist on defining "good" in terms of interest, and answer the question when thus interpreted, we may be begging *their* question entirely. Of course this *other* sense of "good" may not exist, or it may be a complete confusion; but that is what we must discover.

Now many have maintained that interest theories are *far* from being completely relevant. They have

argued that such theories neglect the very sense of "good" which is most vital. And certainly, their arguments are not without plausibility.

Only . . . what *is* this "vital" sense of "good"? The answers have been so vague, and so beset with difficulties, that one can scarcely determine.

There are certain requirements, however, with which this "vital" sense has been expected to comply—requirements which appeal strongly to our common sense. It will be helpful to summarize these, showing how they exclude the interest theories:

In the first place, we must be able sensibly to *disagree* about whether something is "good." This condition rules out Hobbes's definition. For consider the following argument: "This is good." "That isn't so; it's not good." As translated by Hobbes, this becomes: "I desire this." "That isn't so, for *I* don't." The speakers are not contradicting one another, and think they are, only because of an elementary confusion in the use of pronouns. The definition, "good" means *desired by my community*, is also excluded, for how could people from different communities disagree?[1]

In the second place, "goodness" must have, so to speak, a magnetism. A person who recognizes X to be "good" must *ipso facto* acquire a stronger tendency to act in its favour than he otherwise would have had. This rules out the Humean type of definition. For according to Hume, to recognize that something is "good" is simply to recognize that the majority approve of it. Clearly, a man may see that the majority approve of X without having, himself, a stronger tendency to favour it. This requirement excludes any attempt to define "good" in terms of the interest of people *other* than the speaker.[2]

In the third place, the "goodness" of anything must not be verifiable solely by use of the scientific method. "Ethics must not be psychology." This restriction rules out all of the traditional interest theories, without exception. It is so sweeping a restriction that we must examine its plausibility. What are the methodological implications of interest theories which are here rejected?

According to Hobbes's definition, a person can prove his ethical judgments, with finality, by showing that he is not making an introspective error about his desires. According to Hume's definition, one may prove ethical judgments (roughly speaking) by taking a vote. *This* use of the empirical method, at any rate, seems highly remote from what we usually accept as proof, and reflects on the complete relevance of the definitions which imply it.

But aren't there more complicated interest theories which are immune from such methodological implications? No, for the same factors appear; they are only put off for a while. Consider, for example, the definition: "X is good" means *most people would approve of X if they knew its nature and consequences*. How, according to this definition, could we prove that a certain X was good? We should first have to find out, empirically, just what X was like, and what its consequences would be. To this extent the empirical method, as required by the definition, seems beyond intelligent objection. But what remains? We should next have to discover whether most people would approve of the sort of thing we had discovered X to be. This couldn't be determined by popular vote—but only because it would be too difficult to explain to the voters, beforehand, what the nature and consequences of X really were. Apart from this, voting would be a pertinent method. We are again reduced to counting noses, as a *perfectly final* appeal.

Now we need not scorn voting entirely. A man who rejected interest theories as irrelevant might readily make the following statement: "If I believed that X would be approved by the majority, when they knew all about it, I should be strongly *led* to say that X was good." But he would continue: "*Need* I say that X was good, under the circumstances? Wouldn't my acceptance of the alleged 'final proof' result simply from my being democratic? What about the more aristocratic people? They would simply say that the approval of most people, even when they knew all about the object of their approval, simply had nothing to do with the goodness of anything, and they would probably add a few remarks about the low state of people's interests." It would indeed seem, from these considerations, that the definition we have been considering has presupposed democratic ideals from the

start; it has dressed up democratic propaganda in the guise of a definition.

The omnipotence of the empirical method, as implied by interest theories and others, may be shown unacceptable in a somewhat different way. Mr. G. E. Moore's familiar objection about the open question is chiefly pertinent in this regard. No matter what set of scientifically knowable properties a thing may have (says Moore, in effect), you will find, on careful introspection, that it is an open question to ask whether anything having these properties is *good*. It is difficult to believe that this recurrent question is a totally confused one, or that it seems open only because of the ambiguity of "good." Rather, we must be using some sense of "good" which is not definable, relevantly, in terms of anything scientifically knowable. That is, the scientific method is not sufficient for ethics.[3]

These, then, are the requirements with which the "vital" sense of "good" is expected to comply: (1) goodness must be a topic for intelligent disagreement; (2) it must be "magnetic"; and (3) it must not be discoverable solely through the scientific method.

II

Let us now turn to my own analysis of ethical judgments. First let me present my position dogmatically, showing to what extent I vary from tradition.

I believe that the three requirements, given above, are perfectly sensible; that there is some *one* sense of "good" which satisfies all three requirements; and that no traditional interest theory satisfies them all. But this does not imply that "good" must be explained in terms of a Platonic Idea, or of a Categorical Imperative, or of an unique, unanalyzable property. On the contrary, the three requirements can be met by a *kind* of interest theory. *But we must give up a presupposition which all the traditional interest theories have made.*

Traditional interest theories hold that ethical statements are *descriptive* of the existing state of interests— that they simply *give information* about interests. (More accurately, ethical judgments are said to describe what the state of interests is, was, or will be, or to indicate what the state of interests *would* be under specified circumstances.) It is this emphasis on description, on information, which leads to their incomplete relevance. Doubtless there is always *some* elements of description in ethical judgments, but this is by no means all. Their major use is not to indicate facts, but to *create an influence*. Instead of merely describing people's interests, they *change* or *intensify* them. They *recommend* an interest in an object, rather than state that the interest already exists.

For instance: When you tell a man that he oughtn't to steal, your object isn't merely to let him know that people disapprove of stealing. You are attempting, rather, to get *him* to disapprove of it. Your ethical judgment has a quasi-imperative force which, operating through suggestion, and intensified by your tone of voice, readily permits you to begin to *influence*, to *modify*, his interests. If in the end you do not succeed in getting *him* to disapprove of stealing, you will feel that you've failed to convince him that stealing is wrong. You will continue to feel this, even though he fully acknowledges that you disapprove of it, and that almost everyone else does. When you point out to him the consequences of his actions— consequences which you suspect he already disapproves of—these *reasons* which support your ethical judgment are simply a means of facilitating your influence. If you think you can change his interests by making vivid to him how others will disapprove of him, you will do so; otherwise not. So the consideration about other people's interest is just an additional means you may employ, in order to move him, and is not a part of the ethical judgment itself. Your ethical judgment doesn't merely describe interests to him, it directs his very interests. The difference between the traditional interest theories and my view is like the difference between describing a desert and irrigating it.

Another example: A munition maker declares that war is a good thing. If he merely meant that he approved of it, he would not have to insist so strongly, nor grow so excited in his argument. People would be quite easily convinced that he approved of it. If he

merely meant that most people approved of war, or that most people would approve of it if they knew the consequences, he would have to yield his point if it were proved that this wasn't so. But he wouldn't do this, nor does consistency require it. He is not *describing* the state of people's approval; he is trying to *change* it by his influence. If he found that few people approved of war, he might insist all the more strongly that it was good, for there would be more changing to be done.

This example illustrates how "good" may be used for what most of us would call bad purposes. Such cases are as pertinent as any others. I am not indicating the *good* way of using "good." I am not influencing people, but am describing the way this influence sometimes goes on. If the reader wishes to say that the munition maker's influence is bad—that is, if the reader wishes to awaken people's disapproval of the man, and to make him disapprove of his own actions—I should at another time be willing to join in this undertaking. But this is not the present concern. I am not using ethical terms, but am indicating how they *are* used. The munition maker, in his use of "good," illustrates the persuasive character of the word just as well as does the unselfish man who, eager to encourage in each of us a desire for the happiness of all, contends that the supreme good is peace.

Thus ethical terms are *instruments* used in the complicated interplay and readjustment of human interests. This can be seen plainly from more general observations. People from widely separated communities have different moral attitudes. Why? To a great extent because they have been subject to different social influences. Now clearly this influence doesn't operate through sticks and stones alone; words play a great part. People praise one another, to encourage certain inclinations, and blame one another, to discourage others. Those of forceful personalities issue commands which weaker people, for complicated instinctive reasons, find it difficult to disobey, quite apart from fears of consequences. Further influence is brought to bear by writers and orators. Thus social influence is exerted, to an enormous extent, by means that have nothing to do with physical force or material reward. The ethical terms facilitate such influence. Being suited for use in *suggestion*, they

are a means by which men's attitudes may be led this way or that. The reason, then, that we find a greater similarity in the moral attitudes of one community than in those of different communities is largely this: ethical judgments propagate themselves. One man says "This is good"; this may influence the approval of another person, who then makes the same ethical judgment, which in turn influences another person, and so on. In the end, by a process of mutual influence, people take up more or less the same attitudes. Between people of widely separated communities, of course, the influence is less strong; hence different communities have different attitudes.

These remarks will serve to give a general idea of my point of view. We must now go into more detail. There are several questions which must be answered: How does an ethical sentence acquire its power of influencing people—why is it suited to suggestion? Again, what has this influence to do with the *meaning* of ethical terms? And finally, do these considerations really lead us to a sense of "good" which meets the requirements mentioned in the preceding section?

Let us deal first with the question about *meaning*. This is far from an easy question, so we must enter into a preliminary inquiry about meaning in general. Although a seeming digression, this will prove indispensable.

III

Broadly speaking, there are two different *purposes* which lead us to use language. On the one hand we use words (as in science) to record, clarify, and communicate *beliefs*. On the other hand we use words to give vent to our feelings (interjections), or to create moods (poetry), or to incite people to actions or attitudes (oratory).

The first use of words I shall call "descriptive"; the second, "dynamic." Note that the distinction depends solely upon the *purpose* of the *speaker*.

When a person says "Hydrogen is the lightest known gas," his purpose *may* be simply to lead the hearer to believe this, or to believe that the speaker believes it. In that case the words are used

descriptively. When a person cuts himself and says "Damn," his purpose is not ordinarily to record, clarify, or communicate any belief. The word is used dynamically. The two ways of using words, however, are by no means mutually exclusive. This is obvious from the fact that our purposes are often complex. Thus when one says "I want you to close the door," part of his purpose, ordinarily, is to lead the hearer to believe that he has this want. To that extent the words are used descriptively. But the major part of one's purpose is to lead the hearer to *satisfy* the want. To that extent the words are used dynamically.

It very frequently happens that the same sentence may have a dynamic use on one occasion, and may not have a dynamic use on another; and that it may have different dynamic uses on different occasions. For instance: A man says to a visiting neighbour, "I am loaded down with work." His purpose may be to let the neighbour know how life is going with him. This would *not* be a dynamic use of words. He may make the remark, however, in order to drop a hint. This *would* be dynamic usage (as well as descriptive). Again, he may make the remark to arouse the neighbour's sympathy. This would be a *different* dynamic usage from that of hinting.

Or again, when we say to a man, "Of course you won't make those mistakes any more," we *may* simply be making a prediction. But we are more likely to be using "suggestion," in order to encourage him and hence *keep* him from making mistakes. The first use would be descriptive; the second, mainly dynamic.

From these examples it will be clear that we can't determine whether words are used dynamically or not, merely by reading the dictionary—even assuming that everyone is faithful to dictionary meanings. Indeed, to know whether a person is using a word dynamically, we must note his tone of voice, his gestures, the general circumstances under which he is speaking, and so on.

We must now proceed to an important question: What has the dynamic use of words to do with their *meaning*? One thing is clear—we must not define "meaning" in a way that would make meaning vary with dynamic usage. If we did, we should have no use for the term. All that we could say about such "meaning"

would be that it is very complicated, and subject to constant change. So we must certainly distinguish between the dynamic use of words and their meaning.

It doesn't follow, however, that we must define "meaning" in some psychological fashion. We must simply restrict the psychological field. Instead of identifying meaning with *all* the psychological causes and effects that attend a word's utterance, we must identify it with those that it has a *tendency* (causal property, dispositional property) to be connected with. The tendency must be of a particular kind, moreover. It must exist for all who speak the language; it must be persistent; and must be realizable more or less independently of determinate circumstances attending the word's utterance. There will be further restrictions dealing with the interrelation of words in different contexts. Moreover, we must include, under the psychological responses which the words tend to produce, not only immediately introspectable experiences, but *dispositions* to react in a given way with appropriate stimuli. I hope to go into these matters in a subsequent paper. Suffice it now to say that I think "meaning" may be thus defined in a way to include "propositional" meaning as an important kind. Now a word may *tend* to have causal relations which in fact it sometimes doesn't; and it may sometimes have causal relations which it *doesn't tend* to have. And since the tendency of words which constitutes their meaning must be of a particular kind, and may include, as responses, dispositions to reactions, of which any of *several* immediate experiences may be a sign, then there is nothing surprising in the fact that words have a permanent meaning, in spite of the fact that the immediately introspectable experiences which attend their usage are so highly varied.

When "meaning" is defined in this way, meaning will not include dynamic use. For although words are sometimes accompanied by dynamic purposes, they do not *tend* to be accompanied by them in the way above mentioned. *E.g.*, there is no tendency realizable independently of the determinate circumstances under which the words are uttered.

There will be a kind of meaning, however, in the sense above defined, which has an intimate relation to dynamic usage. I refer to "emotive" meaning (in

a sense roughly like that employed by Ogden and Richards).[4] The emotive meaning of a word is a tendency of a word, arising through the history of its usage, to produce (result from) *affective* responses in people. It is the immediate aura of feeling which hovers about a word. Such tendencies to produce affective responses cling to words very tenaciously. It would be difficult, for instance to express merriment by using the interjection "alas." Because of the persistence of such affective tendencies (among other reasons) it becomes feasible to classify them as "meanings."

Just *what* is the relation between emotive meaning and the dynamic use of words? Let us take an example. Suppose that a man is talking with a group of people which includes Miss Jones, aged 59. He refers to her, without thinking, as an "old maid." Now even if his purposes are perfectly innocent—even if he is using the words purely descriptively—Miss Jones won't think so. She will think he is encouraging the others to have contempt for her, and will draw in her skirts, defensively. The man might have done better if instead of saying "old maid" he had said "elderly spinster." The latter words could have been put to the same descriptive use, and would not so readily have caused suspicions about the dynamic use.

"Old maid" and "elderly spinster" differ, to be sure, only in emotive meaning. From the example it will be clear that certain words, because of their emotive meaning, are suited to a certain kind of dynamic use—so well suited, in fact, that the hearer is likely to be misled when we use them in any other way. The more pronounced a word's emotive meaning is, the less likely people are to use it purely descriptively. Some words are suited to encourage people, some to discourage them, some to quiet them, and so on.

Even in these cases, of course, the dynamic purposes are not to be identified with any sort of meaning; for the emotive meaning accompanies a word much more persistently than do the dynamic purposes. But there is an important contingent relation between emotive meaning and dynamic purpose: the former assists the latter. Hence if we define emotively laden terms in a way that neglects their emotive meaning, we are likely to be confusing. *We lead people to think that the terms defined are used dynamically less often than they are.*

IV

Let us now apply these remarks in defining "good." This word may be used morally or non-morally. I shall deal with the non-moral usage almost entirely, but only because it is simpler. The main points of the analysis will apply equally well to either usage.

As a preliminary definition, let us take an inaccurate approximation. It may be more misleading than helpful, but will do to begin with. Roughly, then, the sentence "X is good" means *We like X.* ("We" includes the hearer or hearers.)

At first glance this definition sounds absurd. If used, we should expect to find the following sort of conversation: A. "This is good." B. "But I *don't* like it. What led you to believe that I did?" The unnaturalness of B's reply, judged by ordinary word-usage, would seem to cast doubt on the relevance of my definition.

B's unnaturalness, however, lies simply in this: he is assuming that "We like it" (as would occur implicitly in the use of "good") is being used descriptively. This won't do. When "We like it" is to take the place of "This is good," the former sentence must be used not purely descriptively, but dynamically. More specifically, it must be used to promote a very subtle (and for the non-moral sense in question, a very easily resisted) kind of *suggestion.* To the extent that "we" refers to the hearer, it must have the dynamic use, essential to suggestion, of leading the hearer to *make* true what is said, rather than merely to believe it. And to the extent that "we" refers to the speaker, the sentence must have not only the descriptive use of indicating belief about the speaker's interest, but the quasi-interjectory, dynamic function of giving direct expression to the interest. (This immediate expression of feelings assists in the process of suggestion. It is difficult to disapprove in the face of another's enthusiasm.)

For an example of a case where "We like this" is used in the dynamic way that "This is good" is used, consider the case of a mother who says to her several children. "One thing is certain, *we all like to be neat.*" If she really believed this, she wouldn't bother to say so. But she is not using the words descriptively. She is *encouraging* the children to like neatness. By telling

them that they like neatness, she will lead them to *make* her statement true, so to speak. If, instead of saying "We all like to be neat" in this way, she had said "It's a good thing to be neat," the effect would have been approximately the same.

But these remarks are still misleading. Even when "We like it" is used for suggestion, it isn't quite like "This is good." The latter is more subtle. With such a sentence as "This is a good book," for example, it would be practically impossible to use instead "We like this book." When the latter is used, it must be accompanied by so exaggerated an intonation, to prevent its becoming confused with a descriptive statement, that the force of suggestion becomes stronger, and ludicrously more overt, than when "good" is used.

The definition is inadequate, further, in that the definiens has been restricted to dynamic usage. Having said that dynamic usage was different from meaning, I should not have to mention it in giving the *meaning* of "good."

It is in connection with this last point that we must return to emotive meaning. The word "good" has a pleasing emotive meaning which fits it especially for the dynamic use of suggesting favourable interest. But the sentence "We like it" has no such emotive meaning. Hence my definition has neglected emotive meaning entirely. Now to neglect emotive meaning is likely to lead to endless confusions, as we shall presently see; so I have sought to make up for the inadequacy of the definition by letting the restriction about dynamic usage take the place of emotive meaning. What I should do, of course, is to find a definiens whose emotive meaning, like that of "good," simply does *lead* to dynamic usage.

Why didn't I do this? I answer that it isn't possible, if the definition is to afford us increased clarity. No two words, in the first place, have quite the same emotive meaning. The most we can hope for is a rough approximation. But if we seek for such an approximation for "good," we shall find nothing more than synonyms, such as "desirable" or "valuable"; and these are profitless because they do not clear up the connection between "good" and favourable interest. If we reject such synonyms, in favour of nonethical terms, we shall be highly misleading. For instance: "This is good" has something like the

meaning of "I *do* like this; do so as well." But this is certainly not accurate. For the imperative makes an appeal to the conscious efforts of the hearer. Of course he can't like something just by trying. He must be led to like it through suggestion. Hence an ethical sentence differs from an imperative in that it enables one to make changes in a much more subtle, less fully conscious way. Note that the ethical sentence centres the hearer's attention not on his interests, but on the object of interest, and thereby facilitates suggestion. Because of its subtlety, moreover, an ethical sentence readily permits counter-suggestion, and leads to the give and take situation which is so characteristic of arguments about values.

Strictly speaking, then, it is impossible to define "good" in terms of favourable interest if emotive meaning is not to be distorted. Yet it is possible to say that "This is good" is *about* the favourable interest of the speaker and the hearer or hearers, and that it has a pleasing emotive meaning which fits the words for use in suggestion. This is a rough description of meaning, not a definition. But it serves the same clarifying function that a definition ordinarily does; and that, after all, is enough.

A word must be added about the moral use of "good." This differs from the above in that it is about a different kind of interest. Instead of being about what the hearer and speaker *like*, it is about a stronger sort of approval. When a person *likes* something, he is pleased when it prospers, and disappointed when it doesn't. When a person *morally approves* of something, he experiences a rich feeling of security when it prospers, and is indignant, or "shocked" when it doesn't. These are rough and inaccurate examples of the many factors which one would have to mention in distinguishing the two kinds of interest. In the moral usage, as well as in the non-moral, "good" has an emotive meaning which adapts it to suggestion.

And now, are these considerations of any importance? Why do I stress emotive meanings in this fashion? Does the omission of them really lead people into errors? I think, indeed, that the errors resulting from such omissions are enormous. In order to see this, however, we must return to the restrictions, mentioned in section I, with which the "vital" sense of "good" has been expected to comply.

V

The first restriction, it will be remembered, had to do with disagreement. Now there is clearly some sense in which people disagree on ethical points; but we must not rashly assume that all disagreement is modelled after the sort that occurs in the natural sciences. We must distinguish between "disagreement in belief" (typical of the sciences) and "disagreement in interest." Disagreement in belief occurs when A believes *p* and B disbelieves it. Disagreement in interest occurs when A has a favourable interest in X, when B has an unfavourable one in it, and when neither is content to let the other's interest remain unchanged.

Let me give an example of disagreement in interest. A. "Let's go to a cinema to-night." B. "I don't want to do that. Let's go to the symphony." A continues to insist on the cinema, B on the symphony. This is disagreement in a perfectly conventional sense. They can't agree on where they want to go, and each is trying to redirect the other's interest. (Note that imperatives are used in the example.)

It is disagreement in *interest* which takes places in ethics. When C says "This is good," and D says "No, it's bad," we have a case of suggestion and counter-suggestion. Each man is trying to redirect the other's interest. There obviously need be no domineering, since each may be willing to give ear to the other's influence; but each is trying to move the other none the less. It is in this sense that they disagree. Those who argue that certain interest theories make no provision for disagreement have been misled, I believe, simply because the traditional theories, in leaving out emotive meaning, give the impression that ethical judgments are used descriptively only; and of course when judgments are used purely descriptively, the only disagreement that can arise is disagreement *in belief*. Such disagreement may be disagreement in belief *about* interests; but this is not the same as disagreement *in* interest. My definition doesn't provide for disagreement in belief about interests, any more than does Hobbes's; but that is no matter, for there is no reason to believe, at least on common-sense grounds, that this kind of disagreement exists. There is only disagreement *in* interest. (We shall see in a moment

that disagreement in interest does not remove ethics from sober argument—that this kind of disagreement may often be resolved through empirical means.)

The second restriction, about "magnetism," or the connection between goodness and actions, requires only a word. This rules out *only* those interest theories which do *not* include the interest of the speaker, in defining "good." My account does include the speaker's interest; hence is immune.

The third restriction, about the empirical method, may be met in a way that springs naturally from the above account of disagreement. Let us put the question in this way: When two people disagree over an ethical matter, can they completely resolve the disagreement through empirical considerations, assuming that each applies the empirical method exhaustively, consistently, and without error?

I answer that sometimes they can, and sometimes they cannot; and that at any rate, even when they can, the relation between empirical knowledge and ethical judgments is quite different from the one which traditional interest theories seem to imply.

This can best be seen from an analogy. Let's return to the example where A and B couldn't agree on a cinema or a symphony. The example differed from an ethical argument in that imperatives were used, rather than ethical judgments; but was analogous to the extent that each person was endeavouring to modify the other's interest. Now how would these people argue the case, assuming that they were too intelligent just to shout at one another?

Clearly, they would give "reasons" to support their imperatives. A might say, "But you know, Garbo is at the Bijou." His hope is that B, who admires Garbo, will acquire a desire to go to the cinema when he knows what play will be there. B may counter, "But Toscanini is guest conductor to-night, in an all-Beethoven programme." And so on. Each supports his imperative ("*Let's* do so and so") by reasons which may be empirically established.

To generalize from this: disagreement in interest may be rooted in disagreement in belief. That is to say, people who disagree in interest would often cease to do so if they knew the precise nature and consequences of the object of their interest. To this extent disagreement

in interest may be resolved by securing agreement in belief, which in turn may be secured empirically.

This generalization holds for ethics. If A and B, instead of using imperatives, had said, respectively, "It would be *better* to go to the cinema," and "It would be better to go to the symphony," the reasons which they would advance would be roughly the same. They would each give a more thorough account of the object of interest, with the purpose of completing the redirection of interest which was begun by the suggestive force of the ethical sentence. On the whole, of course, the suggestive force of the ethical statement merely exerts enough pressure to start such trains of reasons, since the reasons are much more essential in resolving disagreement in interest than the persuasive effect of the ethical judgment itself.

Thus the empirical method is relevant to ethics simply because our knowledge of the world is a determining factor to our interests. But note that empirical facts are not inductive grounds from which the ethical judgment problematically follows. (This is what traditional interest theories imply.) If someone said "Close the door," and added the reason "We'll catch cold," the latter would scarcely be called an inductive ground of the former. Now imperatives are related to the reasons which support them in the same way that ethical judgments are related to reasons.

Is the empirical method *sufficient* for attaining ethical agreement? Clearly not. For empirical knowledge resolves disagreement in interest only to the extent that such disagreement is rooted in disagreement in belief. Not all disagreement in interest is of this sort. For instance: A is of a sympathetic nature, and B isn't. They are arguing about whether a public dole would be good. Suppose that they discovered all the consequences of the dole. Isn't it possible, even so, that A will say that it's good, and B that it's bad? The disagreement in interest may arise not from limited factual knowledge, but simply from A's sympathy and B's coldness. Or again, suppose, in the above argument, that A was poor and unemployed, and that B was rich. Here again the disagreement might not be due to different factual knowledge. It would be due to the different social positions of the men, together with their predominant self-interest.

When ethical disagreement is not rooted in disagreement in belief, is there *any* method by which it may be settled? If one means by "method" a *rational* method, then there is no method. But in any case there is a "way." Let's consider the above example, again, where disagreement was due to A's sympathy and B's coldness. Must they end by saying, "Well, it's just a matter of our having different temperaments"? Not necessarily. A, for instance, may try to *change* the temperament of his opponent. He may pour out his enthusiasms in such a moving way—present the sufferings of the poor with such appeal—that he will lead his opponent to see life through different eyes. He may build up, by the contagion of his feelings, an influence which will modify B's temperament, and create in him a sympathy for the poor which didn't previously exist. This is often the only way to obtain ethical agreement, if there is any way at all. It is persuasive, not empirical or rational; but that is no reason for neglecting it. There is no reason to scorn it, either, for it is only by such means that our personalities are able to grow, through our contact with others.

The point I wish to stress, however, is simply that the empirical method is instrumental to ethical agreement only to the extent that disagreement in interest is rooted in disagreement in belief. There is little reason to believe that all disagreement is of this sort. Hence the empirical method is not sufficient for ethics. In any case, ethics is not psychology, since psychology doesn't endeavour to *direct* our interests; it discovers facts about the ways in which interests are or can be directed, but that's quite another matter.

To summarize this section: my analysis of ethical judgments meets the three requirements for the "vital" sense of "good" that were mentioned in section I. The traditional interest theories fail to meet these requirements simply because they neglect emotive meaning. This neglect leads them to neglect dynamic usage, and the sort of disagreement that results from such usage, together with the method of resolving the disagreement. I may add that my analysis answers Moore's objection about the open question. Whatever scientifically knowable properties a thing may have, it *is* always open to question whether a thing having these (enumerated) qualities is good. For to ask whether it

is good is to ask for *influence*. And whatever I may know about an object, I can still ask, quite pertinently, to be influenced with regard to my interest in it.

VI

And now, have I really pointed out the "vital" sense of "good"?

I suppose that many still will say "No," claiming that I have simply failed to set down *enough* requirements which this sense must meet, and that my analysis, like all others given in terms of interest, is a way of begging the issue. They will say: "When we ask 'Is X good?' we don't want mere influence, mere advice. We decidedly don't want to be influenced through persuasion, nor are we fully content when the influence is supported by a wide scientific knowledge of X. The answer to our question will, of course, modify our interests. But this is only because an unique sort of *truth* will be revealed to us—a truth which must be apprehended *a priori*. We want our interests to be guided by this truth, and by nothing else. To substitute for such a truth mere emotive meaning and suggestion is to conceal from us the very object of our search."

I can only answer that I do not understand. What is this truth to be *about?* For I recollect no Platonic Idea, nor do I know what to *try* to recollect. I find no indefinable property, nor do I know what to look for. And the "self-evident" deliverances of reason, which so many philosophers have claimed, seem, on examination, to be deliverances of their respective reasons only (if of anyone's) and not of mine.

I strongly suspect, indeed, that any sense of "good" which is expected both to unite itself in synthetic *a priori* fashion with other concepts, and to influence interests as well, is really a great confusion. I extract from this meaning the power of influence alone, which I find the only intelligible part. If the rest is confusion, however, then it certainly deserves more than the shrug of one's shoulders. What I should like to do is to *account* for the confusion—to examine the psychological needs which have given rise to it, and to show how these needs may be satisfied in another way. This is *the* problem, if confusion is to be stopped at its source. But it is an enormous problem, and my reflections on it, which are at present worked out only roughly, must be reserved until some later time.

I may add that if "X is good" is essentially a vehicle for suggestion, it is scarcely a statement which philosophers, any more than many other men, are called upon to make. To the extent that ethics predicates the ethical terms of anything, rather than explains their meaning, it ceases to be a reflective study. Ethical statements are social instruments. They are used in a cooperative enterprise in which we are mutually adjusting ourselves to the interests of others. Philosophers have a part in this, as do all men, but not the major part.

Notes

1. See G. E. Moore's *Philosophical Studies*, pp. 332–334.

2. See G. C. Field's *Moral Theory*, pp. 52, 56–57.

3. See G. E. Moore's *Principia Ethica*, chap i. I am simply trying to preserve the spirit of Moore's objection, and not the exact form of it.

4. See *The Meaning of Meaning*, by C. K. Ogden and I. A. Richards. On p. 125, second edition, there is a passage on ethics which was the source of the ideas embodied in this paper.

Study Questions

1. How do disagreements in belief differ from disagreements in attitude?

2. Can science ever help resolve a nonmoral value disagreement?

3. Can science ever help resolve a moral disagreement?

4. How did Stevenson respond to the claim that moral truths are self-evident?

22

R. M. HARE

Richard M. Hare (1919–2002) was White's Professor of Moral Philosophy at the University of Oxford. He argued that moral judgments are prescriptive and universal. They are prescriptive because they direct rather than describe action, and universal because they apply to all relevantly similar cases. While the facts alone do not imply any moral conclusion, we may revise our moral views once we realize that they apply to all others, including ourselves. Whether this test is sufficient to eliminate objectionable moral principles is a challenge Hare addressed by considering instances of fanaticism.

Freedom and Reason

6.3. I will now try to exhibit the bare bones of the theory of moral reasoning that I wish to advocate by considering a very simple (indeed over-simplified) example. As we shall see, even this very simple case generates the most baffling complexities; and so we may be pardoned for not attempting anything more difficult to start with.

The example is adapted from a well-known parable.[1] A owes money to B, and B owes money to C, and it is the law that creditors may exact their debts by putting their debtors into prison. B asks himself, "Can I say that I ought to take this measure against A in order to make him pay?" He is no doubt *inclined* to do this, or *wants* to do it. Therefore, if there were no question of universalizing his prescriptions, he would assent readily to the *singular* prescription "let me put A into prison" (4.3). But when he seeks to turn this prescription into a moral judgement, and say, "I *ought* to put A into prison because he will not pay me what he owes," he reflects that this would

involve accepting the principle "Anyone who is in my position ought to put his debtor into prison if he does not pay." But then he reflects that C is in the same position of unpaid creditor with regard to himself (B), and that the cases are otherwise identical; and that if anyone in this position ought to put his debtors into prison, then so ought C to put him (B) into prison. And to accept the moral prescription "C ought to put me into prison" would commit him (since, as we have seen, he must be using the word "ought" prescriptively) to accepting the singular prescription "Let C put me into prison"; and this he is not ready to accept. But if he is not, then neither can he accept the original judgement that he (B) ought to put A into prison for debt. Notice that the whole of this argument would break down if "ought" were not being used both universalizably *and prescriptively;* for if it were not being used prescriptively, the step from "C ought to put me into prison" to "Let C put me into prison" would not be valid.

From *Freedom and Reason* by R. M. Hare (1963). Reprinted by permission of Oxford University Press.

The structure and ingredients of this argument must now be examined. We must first notice an analogy between it and the Popperian theory of scientific method. What has happened is that a provisional or suggested moral principle has been rejected because one of its particular consequences proved unacceptable. But an important difference between the two kinds of reasoning must also be noted; it is what we should expect, given that the data of scientific observation are recorded in descriptive statements, whereas we are here dealing with prescriptions. What knocks out a suggested hypothesis, on Popper's theory, is a singular statement of fact: the hypothesis has the consequences that p; but not-p. Here the logic is just the same, except that in place of the observation-statements "p" and "not-p" we have the singular *prescriptions* "Let C put B into prison for debt" and its contradictory. Nevertheless, given that B is disposed to reject the first of these prescriptions, the argument against him is just as cogent as in the scientific case.

We may carry the parallel further. Just as science, seriously pursued, is the search for hypotheses and the testing of them by the attempt to falsify their particular consequences, so morals, as a serious endeavour, consists in the search for principles and the testing of them against particular cases. Any rational activity has its discipline, and this is the discipline of moral thought: to test the moral principles that suggest themselves to us by following out their consequences and seeing whether we can accept *them*.

No argument, however, starts from nothing. We must therefore ask what we have to have before moral arguments of the sort of which I have given a simple example can proceed. The first requisite is that the facts of the case should be given; for all moral discussion is about some particular set of facts, whether actual or supposed. Secondly we have the logical framework provided by the meaning of the word "ought" (i.e. prescriptivity and universalizability, both of which we saw to be necessary). Because moral judgements have to be universalizable, B cannot say that he ought to put A into prison for debt without committing himself to the view that C, who

is *ex hypothesi* in the same position *vis-à-vis* himself, ought to put *him* into prison; and because moral judgements are prescriptive, this would be, in effect, prescribing to C to put him into prison; and this he is unwilling to do, since he has a strong inclination not to go to prison. This inclination gives us the third necessary ingredient in the argument: if B were a completely apathetic person, who literally did not mind what happened to himself or to anybody else, the argument would not touch him. The three necessary ingredients which we have noticed, then, are (1) facts; (2) logic; (3) inclinations. These ingredients enable us, not indeed to arrive at an evaluative conclusion, but to *reject* an evaluative proposition. We shall see later that these are not, in all cases, the only necessary ingredients.

6.4. In the example which we have been using, the position was deliberately made simpler by supposing that B actually stood to some other person in exactly the same relation as A does to him. Such cases are unlikely to arise in practice. But it is not necessary for the force of the argument that B should *in fact* stand in this relation to anyone; it is sufficient that he should consider hypothetically such a case, and see what would be the consequences in it of those moral principles between whose acceptance and rejection he has to decide. Here we have an important point of difference from the parallel scientific argument, in that the crucial case which leads to rejection of the principle can itself be a supposed, not an observed, one. That hypothetical cases will do as well as actual ones is important, since it enables us to guard against a possible misinterpretation of the argument which I have outlined. It might be thought that what moves B is the *fear* that C will actually do to him as he does to A—as happens in the gospel parable. But this fear is not only irrelevant to the moral argument; it does not even provide a particularly strong non-moral motive unless the circumstances are somewhat exceptional. C may, after all, not find out what B has done to A; or C's moral principles may be different from B's, and independent of them, so that what moral principle B accepts makes no difference to the moral principles on which C acts.

Even, therefore, if C did not exist, it would be no answer to the argument for B to say "But in my case there is no fear that anybody will ever be in a position to do to me what I am proposing to do to A." For the argument does not rest on any such fear. All that is essential to it is that B should disregard the fact that he plays the particular role in the situation which he does, without disregarding the inclinations which people have in situations of this sort. In other words, he must be prepared to give weight to A's inclinations and interests as if they were his own. This is what turns selfish prudential reasoning into moral reasoning. It is much easier, psychologically, for B to do this if he is actually placed in a situation like A's *vis-à-vis* somebody else; but this is not necessary, provided that he has sufficient imagination to envisage what it is like to be A. For our first example, a case was deliberately chosen in which little imagination was necessary; but in most normal cases a certain power of imagination and readiness to use it is a fourth necessary ingredient in moral arguments, alongside those already mentioned, viz. logic (in the shape of universalizability and prescriptivity), the facts, and the inclinations of interests of the people concerned.

It must be pointed out that the absence of even one of these ingredients may render the rest ineffective. For example, impartiality by itself is not enough. If, in becoming impartial, B became also completely dispassionate and apathetic, and moved as little by other people's interests as by his own, then, as we have seen, there would be nothing to make him accept or reject one moral principle rather than another. That is why those who, like Adam Smith and Professor Kneale, advocate what have been called "Ideal Observer Theories" of ethics, sometimes postulate as their imaginary ideal observer not merely an impartial spectator, but an impartially *sympathetic* spectator.[2] To take another example, if the person who faces the moral decision has no imagination, then even the fact that someone can do the very same thing to him may pass him by. If, again, he lacks the readiness to universalize, then the vivid imagination of the sufferings which he is inflicting on others may only spur

him on to intensify them, to increase his own vindictive enjoyment. And if he is ignorant of the material facts (for example about what is likely to happen to a person if one takes out a writ against him), then there is nothing to tie the moral argument to particular choices.

6.5. The best way of testing the argument which we have outlined will be to consider various ways in which somebody in B's position might seek to escape from it. There are indeed a number of such ways; and all of them may be successful, at a price. It is important to understand what the price is in each case. We may classify these manœuvres which are open to B into two kinds. There are first of all the moves which depend on his using the moral words in a different way from that on which the argument relied. We saw that for the success of the argument it was necessary that "ought" should be used universalizably and prescriptively. If B uses it in a way that is either not prescriptive or not universalizable, then he can escape the force of the argument, at the cost of resigning from the kind of discussion that we thought we were having with him. We shall discuss these two possibilities separately. Secondly, there are moves which can still be made by B, even though he is using the moral words in the same way as we are. We shall examine three different sub-classes of these.

Before dealing with what I shall call the *verbal* manœuvres in detail, it may be helpful to make a general remark. Suppose that we are having a simple mathematical argument with somebody, and he admits, for example, that there are five eggs in this basket, and six in the other, but maintains that there are a dozen eggs in the two baskets taken together; and suppose that this is because he is using the expression "a dozen" to mean "eleven." It is obvious that we cannot compel him logically to admit that there are not a dozen eggs, in *his* sense of "dozen." But it is equally obvious that this should not disturb us. For such a man only appears to be dissenting from us. His dissent is only apparent, because the proposition which his words express is actually consistent with the conclusion which we wish to draw; he *says* "There are a dozen eggs"; but he *means*

what we should express by saying "There are eleven eggs"; and this we are not disputing. It is important to remember that in the moral case also the dissent may be only apparent, if the words are being used in different ways, and that it is no defect in a method of argument if it does not make it possible to prove a conclusion to a person when he is using words in such a way that the conclusion does not follow.

It must be pointed out, further (since this is a common source of confusion), that in this argument nothing whatever hangs upon our *actual* use of words in common speech, any more than it does in the arithmetical case. That we use the sound "dozen" to express the meaning that we customarily do use it to express is of no consequence for the argument about the eggs; and the same may be said of the sound "ought." There is, however, something which I, at any rate, customarily express by the sound "ought," whose character is correctly described by saying that it is a universalizable prescription. I hope that what I customarily express by the sound "ought" is the same as what most people customarily express by it; but if I am mistaken in this assumption, I shall still have given a correct account, so far as I am able, of that which I express by this sound.[3] Nevertheless, this account will interest other people mainly in so far as my hope that they understand the same thing as I do by "ought" is fulfilled; and since I am moderately sure that this is indeed the case with many people, I hope that I may be of use to them in elucidating the logical properties of the concept which they thus express.

At this point, however, it is of the utmost importance to stress that the fact that two people express the same thing by "ought" does not entail that they share the same moral opinions. For the formal, logical properties of the word "ought" (those which are determined by its *meaning*) are only one of the four factors (listed earlier) whose combination governs a man's moral opinion on a given matter. Thus ethics, the study of the logical properties of the moral words, remains morally neutral (its conclusions neither are substantial moral judgements, nor entail them, even in conjunction with factual premisses);

its bearing upon moral questions lies in this, that it makes logically impossible certain combinations of moral and other prescriptions. Two people who are using the word "ought" in the same way may yet disagree about what ought to be done in a certain situation, either because they differ about the facts, or because one or other of them lacks imagination, or because their different inclinations make one reject some singular prescription which the other can accept. For all that, ethics (i.e. the logic of moral language) is an immensely powerful engine for producing moral agreement; for if two people are willing to use the moral word "ought," and to use it in the same way (viz. the way that I have been describing), the other possible sources of moral disagreement are all eliminable. People's inclinations about most of the important matters in life tend to be the same (very few people, for example, like being starved or run over by motor-cars); and, even when they are not, there is a way of generalizing the argument, to be described in the next chapter, which enables us to make allowance for differences in inclinations. The facts are often, given sufficient patience, ascertainable. Imagination can be cultivated. If these three factors are looked after, as they can be, agreement on the use of "ought" is the only other necessary condition for producing moral agreement, at any rate in typical cases. And, if I am not mistaken, this agreement in use is already there in the discourse of anybody with whom we are at all likely to find ourselves arguing; all that is needed is to think clearly, and so make it evident.

After this methodological digression, let us consider what is to be done with the man who professes to be using "ought" in some different way from that which I have described—because he is not using it prescriptively, or not universalizably. For the reasons that I have given, if he takes either of these courses, he is no longer in substantial moral disagreement with us. Our apparent moral disagreement is really only verbal; for although, as we shall see shortly, there may be a residuum of substantial disagreement, this cannot be moral. It cannot even be an evaluative disagreement . . .

Let us take first the man who is using the word "ought" prescriptively, but not universalizably. He can say that he ought to put his debtor into prison, although he is not prepared to agree that his creditor ought to put *him* into prison. We, on the other hand, since we are not prepared to admit that our creditors in these circumstances ought to put us into prison, cannot say that we ought to put our debtors into prison. So there is an appearance of substantial moral disagreement, which is intensified by the fact that, since we are both using the word "ought" prescriptively, our respective views will lead to different particular actions. Different *singular* prescriptions about what to do are (since both our judgements are prescriptive) derivable from what we are respectively saying. But this is not enough to constitute a moral disagreement. For there to be a moral disagreement, or even an evaluative one of any kind, we must differ, not only about what *is* to be done in some particular case, but about some universal principle concerning what *ought* to be done in cases of a certain sort; and since B is (on the hypothesis considered) advocating no such universal principle, he is saying nothing with which we can be in moral or evaluative disagreement. Considered purely as prescriptions, indeed, our two views are in substantial disagreement; but the moral, evaluative (i.e. the *universal* prescriptive) disagreement is only verbal, because, when the expression of B's view is understood as he means it, the view turns out not to be a view about the morality of the action at all. So B, by this manœuvre, can go on prescribing to himself to put A into prison, but has to abandon the claim that he is justifying the action morally, as we understand the word "morally." One may, of course, use any word as one pleases, at a price. But he can no longer claim to be giving that sort of justification of his action for which, as I think, the common expression is "moral justification."

I need not deal at length with the second way in which B might be differing from us in his use of "ought," viz. by not using it prescriptively. If he were not using it prescriptively, it will be remembered, he could assent to the singular prescription "Let not C put me into prison for debt," and yet assent also to the non-prescriptive moral judgement "C ought to put me into prison for debt." And so his disinclination to be put into prison for debt by C would furnish no obstacle to his saying that he (B) ought to put A into prison for debt. And thus he could carry out his own inclination to put A into prison with apparent moral justification. The justification would be, however, only apparent. For if B is using the word "ought" non-prescriptively, then "I ought to put A into prison for debt" does not entail the singular prescription "Let me put A into prison for debt"; the "moral" judgement becomes quite irrelevant to the choice of what to do. There would also be the same lack of substantial moral disagreement as we noticed in the preceding case. B would not be disagreeing with us other than verbally, so far as the moral question is concerned (though there might be points of *factual* disagreement between us, arising from the *descriptive* meaning of our judgements). The "moral" disagreement could be only verbal, because whereas we should be dissenting from the universalizable prescription "B ought to put A into prison for debt," *this* would not be what B was expressing, though the words he would be using would be the same. For B would not, by these words, be expressing a prescription at all.

6.6. So much for the ways (of which my list may well be incomplete) in which B can escape from our argument by using the word "ought" in a different way from us. The remaining ways of escape are open to him even if he is using "ought" in the same way as we are, viz. to express a universalizable prescription.

We must first consider that class of escape-routes whose distinguishing feature is that B, while using the moral words in the same way as we are, refuses to make positive moral judgements at all in certain cases. There are two main variations of this manœuvre. B may either say that it is indifferent, morally, whether he imprisons A or not; or he may refuse to make any moral judgement at all, even one of indifference, about the case. It will be obvious that if he adopts either of these moves, he can evade the argument as so far set out. For that argument only forced him to *reject* the moral judgement "I ought to

imprison A for debt." It did not force him to assent to any moral judgement; in particular, he remained free to assent, either to the judgement that he ought not to imprison A for debt (which is the one that we want him to accept) or to the judgement that it is neither the case that he ought, nor the case that he ought not (that it is, in short, indifferent); and he remained free, also, to say "I am just not making any moral judgements at all about this case."

We have not yet, however, exhausted the arguments generated by the demand for universalizability, provided that the moral words are being used in a way which allows this demand. For it is evident that these manœuvres could, in principle, be practised in any case whatever in which the morality of an act is in question. And this enables us to place B in a dilemma. Either he practises this manœuvre in *every* situation in which he is faced with a moral decision; or else he practises it only *sometimes*. The first alternative, however, has to be sub-divided; for "every situation" might mean "every situation in which he himself has to face a moral decision regarding one of his own actions," or it might mean "every situation in which a moral question arises for him, whether about his own actions or about somebody else's." So there are three courses that he can adopt: (1) He either refrains altogether from making moral judgements, or makes none except judgements of indifference (that is to say, he either observes a complete moral silence, or says "Nothing matters morally"; either of these two positions might be called a sort of amoralism); (2) He makes moral judgements in the normal way about other people's actions, but adopts one or other of the kinds of amoralism, just mentioned, with regard to his own; (3) He expresses moral indifference, or will make no moral judgement at all, with regard to *some* of his own actions and those of other people, but makes moral judgements in the normal way about others.

Now it will be obvious that in the first case there is nothing that we can do, and that this should not disturb us. Just as one cannot win a game of chess against an opponent who will not make any moves— and just as one cannot argue mathematically with a person who will not commit himself to any mathematical statements—so moral argument is impossible with a man who will make no moral judgements at all, or—which for practical purposes comes to the same thing—makes only judgements of indifference. Such a person is not entering the arena of moral dispute, and therefore it is impossible to contest with him. He is compelled also—and this is important—to abjure the protection of morality for his own interests.

In the other two cases, however, we have an argument left. If a man is prepared to make positive moral judgements about other people's actions, but not about his own, or if he is prepared to make them about some of his own decisions, but not about others, then we can ask him on what principle he makes the distinction between these various cases. This is a particular application of the demand for universalizability. He will still have left to him the ways of escape from this demand which are available in all its applications, and which we shall consider later. But there is no way of escape which is available in this application, but not in others. He must either produce (or at least admit the existence of) some principle which makes him hold different moral opinions about apparently similar cases, or else admit that the judgements he is making are not moral ones. But in the latter case, he is in the same position, in the present dispute, as the man who will not make any moral judgements at all; he has resigned from the contest.

In the particular example which we have been considering, we supposed that the cases of B and of C, his own creditor, were identical. The demand for universalization therefore compels B to make the same moral judgement, whatever it is, about both cases. He has therefore, unless he is going to give up the claim to be arguing morally, either to say that neither he nor C ought to exercise their legal rights to imprison their debtors; or that both ought (a possibility to which we shall recur in the next section); or that it is indifferent whether they do. But the last alternative leaves it open to B and C to do what they like in the matter; and we may suppose that, though

B himself would like to have this freedom, he will be unwilling to allow it to *C*. It is as unlikely that he will *permit C* to put him (*B*) into prison as that he will *prescribe* it (10.5). We may say, therefore, that while move (1), described above, constitutes an abandonment of the dispute, moves (2) and (3) really add nothing new to it.

6.7. We must next consider a way of escape which may seem much more respectable than those which I have so far mentioned. Let us suppose that *B* is a firm believer in the rights of property and the sanctity of contracts. In this case he may say roundly that debtors ought to be imprisoned by their creditors whoever they are, and that, specifically, *C* ought to imprison him (*B*), and he (*B*) ought to imprison *A*. And he may, unlike the superficially similar person described earlier, be meaning by "ought" just what we usually mean by it—i.e. he may be using the word prescriptively, realizing that in saying that *C* ought to put him into prison, he is prescribing that *C* put him in prison. *B*, in this case, is perfectly ready to go to prison for his principles, in order that the sanctity of contracts may be enforced, In real life, *B* would be much more likely to take this line if the situation in which he himself played the role of debtor were not actual but only hypothetical; but this, as we saw earlier, ought not to make any difference to the argument.

We are not yet, however, in a position to deal with this escape-route. All we can do is to say why we cannot now deal with it, and leave this loose end to be picked up later. *B*, if he is sincere in holding the principle about the sanctity of contracts (or any other universal moral principle which has the same effect in this particular case), may have two sorts of grounds for it. He may hold it on utilitarian grounds, thinking that, unless contracts are rigorously enforced, the results will be so disastrous as to outweigh any benefits that *A*, or *B* himself, may get from being let off. This could, in certain circumstances, be a good argument. But we cannot tell whether it is, until we have generalized the type of moral argument which has been set out in this chapter, to cover cases in which

the interests of more than two parties are involved. As we saw, it is only the interests of *A* and *B* that come into the argument as so far considered (the interests of the third party, *C*, do not need separate consideration, since *C* was introduced only in order to show *B*, if necessary fictionally, a situation in which the roles were reversed; therefore *C*'s interests, being a mere replica of *B*'s, will vanish, as a separate factor, once the *A/B* situation, and the moral judgements made on it, are universalized). But if utilitarian grounds of the sort suggested are to be adduced, they will bring with them a reference to all the other people whose interests would be harmed by laxity in the enforcement of contracts. This escape-route, therefore, if this is its basis, introduces considerations which cannot be assessed until we have generalized our form of argument to cover "multilateral" moral situations. At present, it can only be said that if *B* can show that leniency in the enforcement of contracts would really have the results he claims for the community at large, he might be justified in taking the severer course. This will be apparent after we have considered in some detail an example (that of the judge and the criminal) which brings out these considerations even more clearly.

On the other hand, *B* might have a quite different, non-utilitarian kind of reason for adhering to his principle. He might be moved, not by any weight which he might attach to the interests of other people, but by the thought that to enforce contracts of this sort is necessary in order to conform to some moral or other *ideal* that he has espoused. Such ideals might be of various sorts. He might be moved, for example, by an ideal of abstract justice, of the *fiat justitia, ruat caelum* variety. We have to distinguish such an ideal of justice, which pays no regard to people's interests, from that which is concerned merely to do justice *between* people's interests. It is very important, if considerations of justice are introduced into a moral argument, to know of which sort they are. Justice of the second kind can perhaps be accommodated within a moral view which it is not misleading to call utilitarian (7.4). But this is not

true of an ideal of the first kind. It is characteristic of this sort of non-utilitarian ideals that, when they are introduced into moral arguments, they render ineffective the appeal to universalized self-interest which is the foundation of the argument that we have been considering. This is because the person who has whole-heartedly espoused such an ideal (we shall call him the "fanatic") does not mind if people's interests—even his own—are harmed in the pursuit of it.

It need not be justice which provides the basis of such an escape-route as we are considering. Any moral ideal would do, provided that it were pursued regardless of other people's interests. For example, B might be a believer in the survival of the fittest, and think that, in order to promote this, he (and everyone else) ought to pursue their own interests by all means in their power and regardless of everyone else's interests. This ideal might lead him, in this particular case, to put A in prison, and he might agree that C ought to do the same to him, if he were not clever enough to avoid this fate. He might think that universal obedience to such a principle would maximize the production of supermen and so make the world a better place. If these were his grounds, it is possible that we might argue with him factually, showing that the universal observance of the principle would not have the results he claimed. But we might be defeated in this factual argument if he had an ideal which made him call the world "a better place" when the jungle law prevailed; he could then agree to our factual statements, but still maintain that the condition of the world described by us as resulting from the observance of his principle would be better than its present condition. In this case, the argument might take two courses. If we could get him to imagine himself in the position of the weak, who went to the wall in such a state of the world, we might bring him to realize that to hold his principle involved prescribing that things should be done to him, in hypothetical situations, which he could not sincerely prescribe. If so, then the argument would be on the rails again, and could proceed on lines which we have already

sketched. But he might stick to his principle and say "If I were weak, then I ought to go to the wall." If he did this, he would be putting himself beyond the reach of what we shall call "golden-rule" or "utilitarian" arguments by becoming what we shall call a "fanatic." Since a great part of the rest of this book will be concerned with people who take this sort of line, it is unnecessary to pursue their case further at this point.

6.8. The remaining manœuvre that B might seek to practise is probably the commonest. It is certainly the one which is most frequently brought up in philosophical controversies on this topic. This consists in a fresh appeal to the facts—i.e. in asserting that there are in fact morally relevant differences between his case and that of others. In the example which we have been considering, we have artificially ruled out this way of escape by assuming that the case of B and C is exactly similar to that of A and B; from this it follows a *fortiori* that there are no morally relevant differences. Since the B/C case may be a hypothetical one, this condition of exact similarity can always be fulfilled, and therefore this manœuvre is based on a misconception of the type of argument against which it is directed. Nevertheless it may be useful, since this objection is so commonly raised, to deal with it at this point, although nothing further will be added thereby to what has been said already.

It may be claimed that no two actual cases would ever be exactly similar; there would always be some differences, and B might allege that some of these were morally relevant. He might allege, for example, that, whereas his family would starve if C put him into prison, this would not be the case if he put A into prison, because A's family would be looked after by A's relatives. If such a difference existed, there might be nothing logically disreputable in calling it morally relevant, and such arguments are in fact often put forward and accepted.

The difficulty, however, lies in drawing the line between those arguments of this sort which are legitimate, and those which are not. Suppose that

B alleges that the fact that A has a hooked nose or a black skin entitles him, B, to put him in prison, but that C ought not to do the same thing to him, B, because his nose is straight and his skin white. Is this an argument of equal logical respectability? Can I say that the fact that I have a mole in a particular place on my chin entitles me to further my own interests at others' expense, but that they are forbidden to do this by the fact that they lack this mark of natural pre-eminence?

The answer to this manœuvre is implicit in what has been said already about the relevance, in moral arguments, of hypothetical as well as of actual cases. The fact that no two actual cases are ever identical has no bearing on the problem. For all we have to do is to imagine an identical case in which the roles are reversed. Suppose that my mole disappears, and that my neighbour grows one in the very same spot on his chin. Or, to use our other example, what does B say about a hypothetical case in which he has a black skin or a hooked nose, and A and C are both straight-nosed and white-skinned (9.4; 11.7)? Since this is the same argument, in essentials, as we used at the very beginning, it need not be repeated here. B is in fact faced with a dilemma. Either the property of his own case, which he claims to be morally relevant, is a properly universal property (i.e. one describable without reference to individuals), or it is not. If it is a universal property, then, because of the meaning of the word "universal," it is a property which might be possessed by another case in which he played a different role (though in fact it may not be); and we can therefore ask him to ignore the fact that it is he himself who plays the role which he does in this case. This will force him to count as morally relevant only those properties which he is prepared to allow to be relevant even when the other people have them. And this rules out all the attractive kinds of special pleading. On the other hand, if the property in question is not a properly universal one, then he has not met the demand for universalizability, and cannot claim to be putting forward a moral argument at all.

6.9. It is necessary, in order to avoid misunderstanding, to add two notes to the foregoing discussion. The misunderstanding arises through a too literal interpretation of the common forms of expression—which constantly recur in arguments of this type—"How would you like it if . . .?" and "Do as you would be done by." Though I shall later, for convenience, refer to the type of arguments here discussed as "golden-rule" arguments, we must not be misled by these forms of expression.

First of all, we shall make the nature of the argument clearer if, when we are asking B to imagine himself in the position of his victim, we phrase our question, never in the form "What *would* you say, or feel, or think, or how *would* you like it, if you were he?", but always in the form "What *do* you say (*in propria persona*) about a hypothetical case in which you are in your victim's position?" The importance of this way of phrasing the question is that, if the question were put in the first way, B might reply "Well, of course, if anybody did this to me I should resent it very much and make all sorts of adverse moral judgements about the act; but this has absolutely no bearing on the validity of the moral opinion which I am *now* expressing." To involve him in contradiction, we have to show that he *now* holds an opinion about the hypothetical case which is inconsistent with his opinion about the actual case.

The second thing which has to be noticed is that the argument, as set out, does not involve any sort of deduction of a moral judgement, or even of the negation of a moral judgement, from a factual statement about people's inclinations, interests, &c. We are not saying to B "You are as a matter of fact averse to this being done to you in a hypothetical case; and from this it follows logically that you ought to do it to another." Such a deduction would be a breach of Hume's Law ("No 'ought' from an 'is'"), to which I have repeatedly declared my adherence (*LM* 2.5). The point is, rather, that because of his aversion to its being done to him in the hypothetical case, he cannot accept the singular *prescription* that in the hypothetical case it should

be done to him; and this, because of the logic of "ought," precludes him from accepting the moral judgement that he ought to do likewise to another in the actual case. It is not a question of a factual statement about a person's inclinations being inconsistent with a moral judgement; rather, his inclinations being what they are, he cannot assent sincerely to a certain singular prescription, and if he cannot do this, he cannot assent to a certain universal prescription which entails it, when conjoined with factual statements about the circumstances whose truth he admits. Because of this entailment, if he assented to the factual statements and to the universal prescription, but refused (as he must, his inclinations being what they are) to assent to the singular prescription, he would be guilty of a logical inconsistency.

If it be asked what the relation is between his aversion to being put in prison in the hypothetical case, and his inability to accept the hypothetical singular prescription that if he were in such a situation he should be put into prison, it would seem that the relation is not unlike that between a belief that the cat is on the mat, and an inability to accept the proposition that the cat is not on the mat. Further attention to this parallel will perhaps make the position clearer. Suppose that somebody advances the hypothesis that cats never sit on mats, and that we refute him by pointing to a cat on a mat. The logic of our refutation proceeds in two stages. Of these, the second is: "Here is a cat sitting on a mat, so it is not the case that cats never sit on mats." This is a piece of logical deduction; and to it, in the moral case, corresponds the step from "Let this not be done to me" to "It is not the case that I ought to do it to another in similar circumstances." But in both cases there is a first stage whose nature is more obscure, and different in the two cases, though there is an analogy between them.

In the "cat" case, it is logically possible for a man to look straight at the cat on the mat, and yet believe that there is no cat on the mat. But if a person with normal eyesight and no psychological aberrations does this, we say that he does not understand the meaning of the words, "The cat is on the mat." And even if he does not have normal eyesight, or suffers from some psychological aberration (such a phobia of cats, say, that he just *cannot* admit to himself that he is face to face with one), yet, if we can convince him that everyone else can see a cat there, he will have to admit that there *is* a cat there, or be accused of misusing the language.

If, on the other hand, a man says "But I *want* to be put in prison, if ever I am in that situation," we can, indeed, get as far as accusing him of having eccentric desires; but we cannot, when we have proved to him that nobody else has such a desire, face him with the choice of either saying, with the rest, "Let this not be done to me," or else being open to the accusation of not understanding what he is saying. For it is not an incorrect use of words to want eccentric things. Logic does not prevent me wanting to be put in a gas chamber if a Jew. It is perhaps true that I logically cannot want for its own sake an experience which I think of as *unpleasant;* for to say that I think of it as unpleasant may be logically inconsistent with saying that I want it for its own sake. If this is so, it is because "unpleasant" is a prescriptive expression. But "to be put in prison" and "to be put in a gas chamber if a Jew," are not prescriptive expressions; and therefore these things can be wanted without offence to logic. It is, indeed, in the logical possibility of wanting *anything* (neutrally described) that the "freedom" which is alluded to in my title essentially consists. And it is this, as we shall see, that lets by the person whom I shall call the "fanatic."

There is not, then, a complete analogy between the man who says "There is no cat on the mat" when there is, and the man who wants things which others do not. But there is a partial analogy, which, having noticed this difference, we may be able to isolate. The analogy is between two relations: the relations between, in both cases, the "mental state" of these men and what they say. If I believe that there is a cat on the mat I cannot sincerely say that there is not; and, if I want not to be put into prison more than I want anything else, I cannot sincerely say "Let me

be put into prison." When, therefore, I said above "His inclinations being what they are, he cannot assent sincerely to a certain singular prescription," I was making an analytic statement (although the "cannot" is not a logical "cannot"); for if he were to assent sincerely to the prescription, that would entail *ex vi terminorum* that his inclinations had changed—in the very same way that it is analytically true that, if the other man were to say sincerely that there was a cat on the mat, when before he had sincerely denied this, he must have changed his belief.

If, however, instead of writing "His inclinations being what they are, he cannot . . .," we leave out the first clause and write simply "He cannot . . .," the statement is no longer analytic; we are making a statement about his psychology which might be false. For it is logically possible for inclinations to change; hence it is possible for a man to come sincerely to hold an ideal which requires that he himself should be sent to a gas chamber if a Jew. That is the price we have to pay for our freedom. But, as we shall see, in order for reason to have a place in morals it is not necessary for us to close this way of escape by means of a logical barrier; it is sufficient that, men and the world being what they are, we can be very

sure that hardly anybody is going to take it with his eyes open. And when we are arguing with one of the vast majority who are not going to take it, the reply that somebody else *might* take it does not help his case against us. In this respect, all moral arguments are *ad hominem*.[4]

Notes

1. Matthew xviii. 23.
2. It will be plain that there are affinities, though there are also differences, between this type of theory and my own. . . . Since for many Christians God occupies the role of "ideal observer," the moral judgements which they make may be expected to coincide with those arrived at by the method of reasoning which I am advocating.
3. Cf. Moore, *Principia Ethica*, p. 6.
4. The above discussion may help to atone for what is confused or even wrong in *LM [Language of Morals]* 3.3 (p. 42). The remarks there about the possibility or impossibility of accepting certain moral principles gave the impression of creating an impasse; I can, however, plead that in *LM* 4.4 (p. 69) there appeared a hint of the way out which is developed in this book.

Study Questions

1. What did Hare mean by a "prescription"?
2. What did Hare mean by "universalizing a prescription"?
3. According to Hare, what role do facts play in a moral dispute?
4. Explain and assess Hare's response to the case of the individual he called a "fanatic."

23

J. J. C. SMART

John Jamieson Carswell Smart (1920–2012) was Professor of Philosophy at the Australian National University. The views he termed "extreme utilitarianism" and "restricted utilitarianism" are now commonly referred to as "act utilitarianism" and "rule utilitarianism." According to act utilitarianism, each individual action should be evaluated by considering the consequences of its being performed on one particular occasion. According to rule utilitarianism, however, each individual action should be viewed as exemplifying a moral rule, and then that rule should be evaluated by considering the consequences of always acting in accord with it. Smart claimed that rule utilitarianism ultimately collapses into act utilitarianism, a claim that has been the subject of extensive discussion.

Extreme and Restricted Utilitarianism

I

Utilitarianism is the doctrine that the rightness of actions is to be judged by their consequences. What do we mean by "actions" here? Do we mean particular actions or do we mean classes of actions? According to which way we interpret the word "actions" we get two different theories, both of which merit the appellation "utilitarian."

(1) If by "actions" we mean particular individual actions we get the sort of doctrine held by Bentham, Sidgwick, and Moore. According to this doctrine we test individual actions by their consequences, and general rules, like "keep promises," are mere rules of thumb which we use only to avoid the necessity of estimating the probable consequences of our actions at every step. The rightness or wrongness of keeping a promise on a particular occasion depends only on the goodness or badness of the consequences of keeping or of breaking the promise on that particular occasion. Of course part of the consequences of breaking the promise, and a part to which the extreme utilitarian will normally ascribe decisive importance, will be the weakening of faith in the institution of promising. However, if the goodness of the consequences of breaking the rule is *in toto* greater than the goodness of the consequences of keeping it, then we must break the rule, irrespective of whether the goodness of the consequences of *everybody's* obeying the rule is or is not greater than the consequences of *everybody's* breaking it. To put it shortly, rules do not matter, save *per accidens* as rules of thumb and as *de facto* social institutions with which the utilitarian has to

From *The Philosophical Quarterly* 6 (1956), by permission of the journal.

reckon when estimating consequences. I shall call this doctrine "extreme utilitarianism."

(2) A more modest form of utilitarianism has recently become fashionable. The doctrine is to be found in Toulmin's book *The Place of Reason in Ethics*, in Nowell-Smith's *Ethics* (though I think Nowell-Smith has qualms), in John Austin's *Lectures on Jurisprudence* (Lecture II), and even in J. S. Mill, if Urmson's interpretation of him is correct (*Philosophical Quarterly*, Vol. 3, pp. 33–39, 1953). Part of its charm is that it appears to resolve the dispute in moral philosophy between intuitionists and utilitarians in a way which is very neat. The above philosophers hold, or seem to hold, that moral rules are more than rules of thumb. In general the rightness of an action is *not* to be tested by evaluating its consequences but only by considering whether or not it falls under a certain rule. Whether the rule is to be considered an acceptable moral rule, is, however, to be decided by considering the consequences of adopting the rule. Broadly, then, actions are to be tested by rules and rules by consequences. The only cases in which we must test an individual action directly by its consequences are (*a*) when the action comes under two different rules, one of which enjoins it and one of which forbids it, and (*b*) when there is no rule whatever that governs the given ease. I shall call this doctrine "restricted utilitarianism."

It should be noticed that the distinction I am making cuts across, and is quite different from, the distinction commonly made between hedonistic and ideal utilitarianism. Bentham was an extreme hedonistic utilitarian and Moore an extreme ideal utilitarian, and Toulmin (perhaps) could be classified as a restricted ideal utilitarian. A hedonistic utilitarian holds that the goodness of the consequences of an action is a function only of its pleasurableness and an ideal utilitarian, like Moore, holds that pleasurableness is not even a necessary condition of goodness. Mill seems, if we are to take his remarks about higher and lower pleasures seriously, to be neither a pure hedonistic nor a pure ideal utilitarian. He seems to hold that pleasurableness is a necessary condition for goodness, but that goodness is a function of other qualities of mind as well. Perhaps we can call him a quasi-ideal utilitarian.

When we say that a state of mind is good I take it that we are expressing some sort of *rational preference*. When we say that it is pleasurable I take it that we are saying that it is enjoyable, and when we say that something is a higher pleasure I take it that we are saying that it is more truly, or more deeply, enjoyable. I am doubtful whether "more deeply enjoyable" does not just mean, "more enjoyable, even though not more enjoyable on a first look," and so I am doubtful whether quasi-ideal utilitarianism, and possibly ideal utilitarianism too, would not collapse into hedonistic utilitarianism on a closer scrutiny of the logic of words like "preference," "pleasure," "enjoy," "deeply enjoy," and so on. However, it is beside the point of the present paper to go into these questions. I am here concerned only with the issue between extreme and restricted utilitarianism and am ready to concede that both forms of utilitarianism can be either hedonistic or non-hedonistic.

The issue between extreme and restricted utilitarianism can be illustrated by considering the remark "But suppose everyone did the same." (Cf. A. K. Stout's article in *The Australasian Journal of Philosophy*, Vol. 32, pp. 1–29.) Stout distinguishes two forms of the universalisation principle, the causal form and the hypothetical form. To say that you ought not to do an action A because it would have bad results if everyone (or many people) did action A may be merely to point out that while the action A would otherwise be the optimific one, nevertheless when you take into account that doing A will probably cause other people to do A too, you can see that A is not, on a broad view, really optimific. If this causal influence could be avoided (as may happen in the ease of a secret desert island promise) then we would disregard the universalisation principle. This is the causal form of the principle. A person who accepted the universalisation principle in its hypothetical form would be one who was concerned only with what would happen *if* everyone did the action A: he would be totally unconcerned with the question of whether in fact everyone would do the action A. That is, he might say that it would be wrong not to vote because it would have bad results if everyone took this attitude, and he would be totally unmoved by arguments purporting to

show that my refusing to vote has no effect whatever on other people's propensity to vote. Making use of Stout's distinction, we can say that an extreme utilitarian would apply the universalisation principle in the causal form, while a restricted utilitarian would apply it in the hypothetical form.

How are we to decide the issue between extreme and restricted utilitarianism? I wish to repudiate at the outset that milk and water approach which describes itself sometimes as "investigating what is implicit in the common moral consciousness" and sometimes as "investigating how people ordinarily talk about morality." We have only to read the newspaper correspondence about capital punishment or about what should be done with Formosa to realise that the common moral consciousness is in part made up of superstitious elements, of morally bad elements, and of logically confused elements. I address myself to good hearted and benevolent people and so I hope that if we rid ourselves of the logical confusion the superstitious and morally bad elements will largely fall away. For even among good hearted and benevolent people it is possible to find superstitious and morally bad reasons for moral beliefs. These superstitious and morally bad reasons hide behind the protective screen of logical confusion. With people who are not logically confused but who are openly superstitious or morally bad I can of course do nothing. That is, our ultimate pro-attitudes may be different. Nevertheless I propose to rely on *my own* moral consciousness and to appeal to *your* moral consciousness and to forget about what people ordinarily say. "The obligation to obey a rule," says Nowell-Smith (*Ethics,* p. 239), "does not, *in the opinion of ordinary men,*" (my italics), "rest on the beneficial consequences of obeying it in a particular case." What does this prove? Surely it is more than likely that ordinary men are confused here. Philosophers should be able to examine the question more rationally.

II

For an extreme utilitarian moral rules are rules of thumb. In practice the extreme utilitarian will mostly guide his conduct by appealing to the rules ("do not lie," "do not break promises," etc.) of common sense morality. This is not because there is anything sacrosanct in the rules themselves but because he can argue that probably he will most often act in an extreme utilitarian way if he does not think as a utilitarian. For one thing, actions have frequently to be done in a hurry. Imagine a man seeing a person drowning. He jumps in and rescues him. There is no time to reason the matter out, but always this will be the course of action which an extreme utilitarian would recommend if he did reason the matter out. If, however, the man drowning had been drowning in a river near Berchtesgaden in 1938, and if he had had the well known black forelock and moustache of Adolf Hitler, an extreme utilitarian would, if he had time, work out the probability of the man's being the villainous dictator, and if the probability were high enough he would, on extreme utilitarian grounds, leave him to drown. The rescuer, however, has not time. He trusts to his instincts and dives in and rescues the man. And this trusting to instincts and to moral rules can be justified on extreme utilitarian grounds. Furthermore, an extreme utilitarian who knew that the drowning man was Hitler would nevertheless praise the rescuer, not condemn him. For by praising the man he is strengthening a courageous and benevolent disposition of mind, and in general this disposition has great positive utility. (Next time, perhaps, it will be Winston Churchill that the man saves!) We must never forget that an extreme utilitarian may praise actions which he knows to be wrong. Saving Hitler was wrong, but it was a member of a class of actions which are generally right, and the motive to do actions of this class is in general an optimific one. In considering questions of praise and blame it is not the expediency of the praised or blamed action that is at issue, but the expediency of the praise. It can be expedient to praise an inexpedient action and inexpedient to praise an expedient one.

Lack of time is not the only reason why an extreme utilitarian may, on extreme utilitarian principles, trust to rules of common sense morality. He knows that in particular cases where his own interests are involved his calculations are likely to be biased in

his own favour. Suppose that he is unhappily married and is deciding whether to get divorced. He will in all probability greatly exaggerate his own unhappiness (and possibly his wife's) and greatly underestimate the harm done to his children by the break up of the family. He will probably also underestimate the likely harm done by the weakening of the general faith in marriage vows. So probably he will come to the correct extreme utilitarian conclusion if he does not in this instance think as an extreme utilitarian but trusts to common sense morality.

There are many more and subtle points that could be made in connection with the relation between extreme utilitarianism and the morality of common sense. All those that I have just made and many more will be found in Book IV Chapters 3–5 of Sidgwick's *Methods of Ethics*. I think that this book is the best book ever written on ethics, and that these chapters are the best chapters of the book. As they occur so near the end of a very long book they are unduly neglected. I refer the reader, then, to Sidgwick for the classical exposition of the relation between (extreme) utilitarianism and the morality of common sense. One further point raised by Sidgwick in this connection is whether an (extreme) utilitarian ought on (extreme) utilitarian principles, to propagate (extreme) utilitarianism among the public. As most people are not very philosophical and not good at empirical calculations, it is probable that they will most often act in an extreme utilitarian way if they do not try to think as extreme utilitarians. We have seen how easy it would be to misapply the extreme utilitarian criterion in the case of divorce. Sidgwick seems to think it quite probable that an extreme utilitarian should not propagate his doctrine too widely. However, the great danger to humanity comes nowadays on the plane of public morality—not private morality. There is a greater danger to humanity from the hydrogen bomb than from an increase of the divorce rate, regrettable though that might be, and there seems no doubt that extreme utilitarianism makes for good sense in international relations. When France walked out of the United Nations because she did not wish Morocco discussed, she said that she was within her rights because Morocco and Algiers are

part of her metropolitan territory and nothing to do with U.N. This was clearly a legalistic if not superstitious argument. We should not be concerned with the so-called "rights" of France or any other country but with whether the cause of humanity would best be served by discussing Morocco in U.N. (I am not saying that the answer to this is "Yes." There are good grounds for supposing that more harm than good would come by such a discussion.) I myself have no hesitation in saying that on extreme utilitarian principles we ought to propagate extreme utilitarianism as widely as possible. But Sidgwick had respectable reasons for suspecting the opposite.

The extreme utilitarian, then, regards moral rules as rules of thumb and as sociological facts that have to be taken into account when deciding what to do, just as facts of any other sort have to be taken into account. But in themselves they do not justify any action.

III

The restricted utilitarian regards moral rules as more than rules of thumb for short-circuiting calculations of consequences. Generally, he argues, consequences are not relevant at all when we are deciding what to do in a particular case. In general, they are relevant only to deciding what rules are good reasons for acting in a certain way in particular cases. This doctrine is possibly a good account of how the modern unreflective twentieth century Englishman often thinks about morality, but surely it is monstrous as an account of how it is most rational to think about morality. Suppose that there is a rule R and that in 99% of cases the best possible results are obtained by acting in accordance with R. Then clearly R is a useful rule of thumb; if we have not time or are not impartial enough to assess the consequences of an action it is an extremely good bet that the thing to do is to act in accordance with R. But is it not monstrous to suppose that if we *have* worked out the consequences and if we have perfect faith in the impartiality of our calculations, and if we *know* that in this instance to break R will have better results than to keep it, we should nevertheless obey the rule? Is it

not to erect R into a sort of idol if we keep it when breaking it will prevent, say, some avoidable misery? Is not this a form of superstitions rule-worship (easily explicable psychologically) and not the rational thought of a philosopher?

The point may be made more clearly if we consider Mill's comparison of moral rules to the tables in the nautical almanack. (*Utilitarianism, Everyman* Edition, pp. 22–23). This comparison of Mill's is adduced by Urmson as evidence that Mill was a restricted utilitarian, but I do not think that it will bear this interpretation at all. (Though I quite agree with Urmson that many other things said by Mill are in harmony with restricted rather than extreme utilitarianism. Probably Mill had never thought very much about the distinction and was arguing for utilitarianism, restricted or extreme, against other and quite non-utilitarian forms of moral argument.) Mill says: "Nobody argues that the art of navigation is not founded on astronomy, because sailors cannot wait to calculate the Nautical Almanack. Being rational creatures, they go out upon the sea of life with their minds made up on the common questions of right and wrong, as well as on many of the far more difficult questions of wise and foolish. . . . Whatever we adopt as the fundamental principle of morality, we require subordinate principles to apply it by." Notice that this is, as it stands, only an argument for subordinate principles as rules of thumb. The example of the nautical almanack is misleading because the information given in the almanack is in all cases the same as the information one would get if one made a long and laborious calculation from the original astronomical data on which the almanack is founded. Suppose, however, that astronomy were different. Suppose that the behaviour of the sun, moon and planets was very nearly as it is now, but that on rare occasions there were peculiar irregularities and discontinuities, so that the almanack gave us rules of the form "in 99% of cases where the observations are such and such you can deduce that your position is so and so." Furthermore, let us suppose that there were methods which enabled us, by direct and laborious calculation from the original astronomical data, not using the rough and ready tables of the almanack, to get our correct position in 100% of cases. Seafarers

might use the almanack because they never had time for the long calculations and they were content with a 99% chance of success in calculating their positions. Would it not be absurd, however, if they *did* make the direct calculation, and finding that it disagreed with the almanack calculation, nevertheless they ignored it and stuck to the almanack conclusion? Of course the case would be altered if there were a high enough probability of making slips in the direct calculation: then we might stick to the almanack result, liable to error though we knew it to be, simply because the direct calculation would be open to error for a different reason, the fallibility of the computer. This would be analogous to the case of the extreme utilitarian who abides by the conventional rule against the dictates of his utilitarian calculations simply because he thinks that his calculations are probably affected by personal bias. But if the navigator were sure of his direct calculations would he not be foolish to abide by his almanack? I conclude, then, that if we change our suppositions about astronomy and the almanack (to which there are no exceptions) to bring the case into line with that of morality (to whose rules there are exceptions), Mill's example loses its appearance of supporting the restricted form of utilitarianism. Let me say once more that I am not here concerned with how ordinary men think about morality but with how they ought to think. We could quite well imagine a race of sailors who acquired a superstitious reverence for their almanack, even though it was only right in 99% of cases, and who indignantly threw overboard any man who mentioned the possibility of a direct calculation. But would this behaviour of the sailors be rational?

Let us consider a much discussed sort of case in which the extreme utilitarian might go against the conventional moral rule. I have promised to a friend, dying on a desert island from which I am subsequently rescued, that I will see that his fortune (over which I have contol) is given to a jockey club. However, when I am rescued I decide that it would be better to give the money to a hospital, which can do more good with it. It may be argued that I am wrong to give the money to the hospital. But why? (*a*) The hospital can do more good with the money

than the jockey club can. (*b*) The present case is unlike most cases of promising in that no one except me knows about the promise. In breaking the promise I am doing so with complete secrecy and am doing nothing to weaken the general faith in promises. That is, a factor, which would normally keep the extreme utilitarian from promise breaking even in otherwise unoptimific cases, does not at present operate. (*c*) There is no doubt a slight weakening in my own character as an habitual promise keeper, and moreover psychological tensions will be set up in me every time I am asked what the man made me promise him to do. For clearly I shall have to say that he made me promise to give the money to the hospital, and, since I am an habitual truth teller, this will go very much against the grain with me. Indeed I am pretty sure that in practice I myself would keep the promise. But we are not discussing what my moral habits would probably make me do; we are discussing what I ought to do. Moreover, we must not forget that even if it would be most rational of me to give the money to the hospital it would also be most rational of you to punish or condemn me if you did, most improbably, find out the truth (e.g. by finding a note washed ashore in a bottle). Furthermore, I would agree that though it was most rational of me to give the money to the hospital it would be most rational of you to condemn me for it. We revert again to Sidgwick's distinction between the utility of the action and the utility of the praise of it.

Many such issues are discussed by A. K. Stout in the article to which I have already referred. I do not wish to go over the same ground again, especially as I think that Stout's arguments support my own point of view. It will be useful, however, to consider one other example that he gives. Suppose that during hot weather there is an edict that no water must be used for watering gardens. I have a garden and I reason that most people are sure to obey the edict, and that as the amount of water that I use will be by itself negligible no harm will be done if I use the water secretly. So I do use the water, thus producing some lovely flowers which give happiness to various people. Still, you may say, though the action was perhaps optimific, it was unfair and wrong.

There are several matters to consider. Certainly my action should be condemned. We revert once more to Sidgwick's distinction. A right action may be rationally condemned. Furthermore, this sort of offence is normally found out. If I have a wonderful garden when everybody else's is dry and brown there is only one explanation. So if I water my garden I am weakening my respect for law and order, and as this leads to bad results an extreme utilitarian would agree that I was wrong to water the garden. Suppose now that the case is altered and that I can keep the thing secret: there is a secluded part of the garden where I grow flowers which I give away anonymously to a home for old ladies. Are you still so sure that I did the wrong thing by watering my garden? However, this is still a weaker case than that of the hospital and the jockey club. There will be tensions set up within myself: my secret knowledge that I have broken the rule will make it hard for me to exhort others to keep the rule. These psychological ill effects in myself may be not inconsiderable: directly and indirectly they may lead to harm which is at least of the same order as the happiness that the old ladies get from the flowers. You can see that on an extreme utilitarian view there are two sides to the question.

So far I have been considering the duty of an extreme utilitarian in a predominantly non-utilitarian society. The case is altered if we consider the extreme utilitarian who lives in a society every member, or most members, of which can be expected to reason as he does. Should he water his flowers now? (Granting, what is doubtful, that in the case already considered he would have been right to water his flowers.) Clearly not. For what is rational for him will be rational for others. Hence by a *reductio ad absurdum* argument we see that it would be rational for none. Even without the edict, no one would water their flowers in a drought. (At least if the chance of doing so secretly were equal to all.) Notice that in this sort of case the extreme utilitarian in an extreme utilitarian society does not need edicts to keep him in order. In order to see better what is at issue let us consider a simplified situation which can be treated schematically in a quasi-mathematical fashion. Suppose that there is a country, peopled by extreme utilitarians, in which there are no traffic rules.

Suppose that four extreme utilitarians are converging in cars on to a cross-roads, so that, unless they do something about it, they will simultaneously crash. Suppose also that each has an urgent appointment (to catch a train, say) and that the delay of a few seconds in stopping to avoid a crash is likely to cost him or other people fairly dear. Let us temporarily espouse the fiction that goodness and badness can be measured quantitatively and try to treat our situation as though it were part of a theory of games. We must consider the following possibilities. If A goes on and B, C and D stop no harm is done and humanity gains m points. If A goes on and B goes on and C and D stop there is a crash and humanity loses $2n$ points (n points of pain, death, or inconvenience to each driver). If three drivers do not stop $3n$ points are lost and if none stop $4n$ points are lost. If all stop no points are gained and none lost. Quite clearly the best consequences are got by one of the drivers going on and the other three stopping. As, however, no driver can be sure that the other three will all stop each will play safe and stop. Suppose, then, that all drivers get into the habit of stopping in such a situation. The existence of this habit alters the situation. Suppose that p is the probability that a driver in the habit of stopping will continue to do so. Then it will be rational for one of the drivers to try a bluff and go on if $m > 3n (1-p)$. Since p cannot be very near to unity (or our hypothesis that one of them tries a bluff would be a most unlikely one) and as m is likely to be infinitesimal compared with n (the advantages of catching a train are negligible compared with the advantages of avoiding a crash), each driver will still probably play safe.

What is needed to illuminate the basis of ethics is some sort of theory of games of the above sort.[1] Whether it could be worked out in a non-trivial manner, I do not know. Von Neumann's theory of games will not help us because it is concerned with what we might call "egoistic" games (each player tries to got as much as possible for himself, usually at the expense of the others) whereas we are concerned with what might be called "beneficent" games. Each extreme utilitarian is, so to speak, trying to gain as many points as possible for humanity as a whole, not for himself alone.

I now pass on to a type of case which may be thought to be the trump card of restricted utilitarianism. Consider the rule of the road. It may be said that since all that matters is that everyone should do the same it is indifferent which rule we have, "go on the left hand side" or "go on the right hand side." Hence the only *reason* for going on the left hand side in British countries is that this is the rule. Here the rule does seem to be a reason, in itself, for acting in a certain way. I wish to argue against this; the rule in itself is not a reason for our actions. We would be perfectly justified in going on the right hand side if (*a*) we knew that the rule was to go on the left hand side, and (*b*) we were in a country peopled by super-anarchists who always on principle did the opposite of what they were told. This shows that the rule does not give us a reason for acting so much as an indication of the probable actions of others, which helps us to find out what would be our own most rational course of action. If we are in a country not peopled by anarchists, but by non-anarchist extreme utilitarians, we expect, other things being equal, that they will keep rules laid down for them. Knowledge of the rule enables us to predict their behaviour and to harmonise our own actions with theirs. The rule "keep to the left hand side," then, is not a logical *reason* for action but an anthropological *datum* for planning actions.

I conclude that in every case if there is a rule R the keeping of which is in general optimific, but such that in a special sort of circumstances the optimific behaviour is to break R, then in these circumstances we should break R. Of course we must consider all the less obvious effects of breaking R, such as reducing people's faith in the moral order, before coming to the conclusion that to break R is right: in fact we shall rarely come to such a conclusion. Moral rules, on the extreme utilitarian view, are rules of thumb only, but they are not bad rules of thumb. But if we *do* come to the conclusion that we should break the rule and if we have weighed in the balance our own fallibility and liability to personal bias, what good reason remains for keeping the rule? I can understand "it is optimific" as a reason for action, but why should "it is a member of a class of actions which are usually

optimific" or "it is a member of a class of actions which as a class are more optimific than any alternative general class" be a good reason? You might as well say that a person ought to be picked to play for Australia just because all his brothers have been, or that the Australian team should be composed entirely of the Harvey family because this would be better than composing it entirely of some other family. The extreme utilitarian does not appeal to artificial feelings, but only to our feelings of benevolence, and what better feelings can there be to appeal to? Admittedly we can have a pro-attitude to anything, even to rules, but such artificially begotten pro-attitudes smack of superstition. Let us get down to realities, human happiness and misery, and make these the objects of our pro-attitudes and anti-attitudes.

The restricted utilitarian might say that he is talking only of *morality,* not of such things as rules of the road. I am not sure how far this objection, if valid, would affect my argument, but in any case I would reply that as a philosopher I conceive of ethics as the study of how it would be *most rational* to act. If my opponent wishes to restrict the word "morality" to a narrower use he can have the word. The fundamental question is the question of rationality of action *in general.* Similarly if the restricted utilitarian were to appeal to ordinary usage and say "it might be most rational to leave Hitler to drown but it would surely not be *wrong* to rescue him," I should again let him have the words "right" and "wrong" and should stick to "rational" and "irrational." We already saw that it would be rational to praise Hitler's rescuer, even though it would have been most rational not to have rescued Hitler. In ordinary language, no doubt, "right" and "wrong" have not only the meaning "most rational to do" and "not most rational to do"

but also have the meaning "praiseworthy" and "not praiseworthy." Usually to the utility of an action corresponds utility of praise of it, but as we saw, this is not always so. Moral language could thus do with tidying up, for example by reserving "right" for "most rational" and "good" as an epithet of praise for the motive from which the action sprang. It would be more becoming in a philosopher to try to iron out illogicalities in moral language and to make suggestions for its reform than to use it as a court of appeal whereby to perpetuate confusions.

One last defence of restricted utilitarianism might be as follows. "Act optimifically" might be regarded as itself one of the rules of our system (though it would be odd to say that this rule was justified by its optimificality). According to Toulmin (*The Place of Reason in Ethics,* pp. 146–8) if "keep promises," say, conflicts with another rule we are allowed to argue the case on its merits, as if we were extreme utilitarians. If "act optimifically" is itself one of our rules then there will always be a conflict of rules whenever to keep a rule is not itself optimific. If this is so, restricted utilitarianism collapses into extreme utilitarianism. And no one could read Toulmin's book or Urmson's article on Mill without thinking that Toulmin and Urmson are of the opinion that they have thought of a doctrine which does *not* collapse into extreme utilitarianism, but which is, on the contrary, an improvement on it.

Note

1. At the time of writing this article I had not yet seen Professor R. B. Braithwaite's lecture, *Theory of Games as a Tool for the Moral Philosopher* (C.U.P., 1955).

Study Questions

1. Explain in your own words the difference between act utilitarianism and rule utilitarianism.

2. What are rules of thumb?

3. Do rule utilitarians consider their rules to be rules of thumb?

4. Do you agree with Smart that rule utilitarianism ultimately collapses into act utilitarianism?

24

BERNARD WILLIAMS

Bernard Williams (1929–2003), born in England, was Professor of Philosophy at the University of California Berkeley. He argued that utilitarianism presents an improverished view of our moral lives, reducing agents to mere instruments for maximizing overall happiness and overlooking the importance of the agents' own projects and sense of self. In other words, in judging an action we need to take account of the identity and integrity of the agent. Williams believed that some actions, whatever their consequences, lie beyond what any particular individual can be expected to do.

A Critique of Utilitarianism

THE STRUCTURE OF CONSEQUENTIALISM

No one can hold that everything, of whatever category, that has value, has it in virtue of its consequences. If that were so, one would just go on for ever, and there would be an obviously hopeless regress. That regress would be hopeless even if one takes the view, which is not an absurd view, that although men set themselves ends and work towards them, it is very often not really the supposed end, but the effort towards it on which they set value—that they travel, not really in order to arrive (for as soon as they have arrived they set out for somewhere else), but rather they choose somewhere to arrive, in order to travel. Even on that view, not everything would have consequential value; what would have non-consequential value would in fact be travelling, even though people had to think of travelling as having the consequential value, and something else—the destination—the non-consequential value.

If not everything that has value has it in virtue of consequences, then presumably there are some types of thing which have non-consequential value, and also some particular things that have such value because they are instances of those types. Let us say, using a traditional term, that anything that has that sort of value, has *intrinsic* value.[1] I take it to be the central idea of consequentialism that the only kind of thing that has intrinsic value is states of affairs, and that anything else that has value has it because it conduces to some intrinsically valuable state of affairs.

How much, however, does this say? Does it succeed in distinguishing consequentialism from anything else? The trouble is that the term "state of affairs" seems altogether too permissive to exclude anything: may not the obtaining of absolutely anything be represented formally as a state of affairs? A Kantian view of morality, for instance, is usually

thought to be opposed to consequentialism, if any is; at the very least, if someone were going to show that Kantianism collapsed into consequentialism, it should be the product of a long and unobvious argument, and not just happen at the drop of a definition. But on the present account it looks as though Kantianism can be made instantly into a kind of consequentialism—a kind which identifies the states of affairs that have intrinsic value (or at least intrinsic moral value) as those that consist of actions being performed for duty's sake.[2] We need something more to our specification if it is to be the specification of anything distinctly consequentialist.

The point of saying that consequentialism ascribes intrinsic value to states of affairs is rather to *contrast* states of affairs with other candidates for having such value: in particular, perhaps, actions. A distinctive mark of consequentialism might rather be this, that it regards the value of actions as always consequential (or, as we may more generally say, derivative), and not intrinsic. The value of actions would then lie in their causal properties, of producing valuable states of affairs; or if they did not derive their value in this simple way, they would derive it in some more roundabout way, as for instance by being expressive of some motive, or in accordance with some rule, whose operation in society conduced to desirable states of affairs. (The lengths to which such indirect derivations can be taken without wrecking the point of consequentialism is something we shall be considering later.)

To insist that what has intrinsic value are states of affairs and not actions seems to come near an important feature of consequentialism. Yet it may be that we have still not hit exactly what we want, and that the restriction is now too severe. Surely *some* actions, compatibly with consequentialism, might have intrinsic value? This is a question which has a special interest for utilitarianism, that is to say, the form of consequentialism concerned particularly with happiness. Traditionally utilitarians have tended to regard happiness or, again, pleasure, as experiences or sensations which were related to actions and activity as effect to cause; and, granted that view, utilitarianism will indeed see the value of all action

as derivative, intrinsic value being reserved for the experiences of happiness. But that view of the relations between action and either pleasure or happiness is widely recognized to be inadequate. To say that a man finds certain actions or activity pleasant, or that they make him happy, or that he finds his happiness in them, is certainly not always to say that they induce certain sensations in him, and in the case of happiness, it is doubtful whether that is ever what is meant. Rather it means such things (among others) as that he enjoys doing these things for their own sake. It would trivialize the discussion of utilitarianism to tie it by definition to inadequate conceptions of happiness or pleasure, and we must be able to recognize as versions of utilitarianism those which, as most modern versions do, take as central some notion such as *satisfaction*, and connect that criterially with such matters as the activities which a man will freely choose to engage in. But the activities which a man engages in for their own sake are activities in which he finds intrinsic value. So any specification of consequentialism which logically debars action or activity from having intrinsic value will be too restrictive even to admit the central case, utilitarianism, so soon as that takes on a more sophisticated and adequate conception of its basic value of happiness.

So far then, we seem to have one specification of consequentialism which is too generous to exclude anything, and another one which is too restrictive to admit even the central case. These difficulties arise from either admitting without question actions among desirable states of affairs, or blankly excluding all actions from the state of affairs category. This suggests that we shall do better by looking at the interrelations between states of affairs and actions.

It will be helpful, in doing this, to introduce the notion of the *right* action for an agent in given circumstances. I take it that in any form of direct consequentialism, and certainly in act-utilitarianism, the notion of the right action in given circumstances is a maximizing notion[3]: the right action is that which out of the actions available to the agent brings about or represents the highest degree of whatever it is the system in question regards as intrinsically valuable—in the central case, utilitarianism, this is of course

happiness. In this argument, I shall confine myself to direct consequentialism, for which "right action" is unqualifiedly a maximizing notion.

The notion of the right action as that which, of the possible alternatives, maximizes the good (where this embraces, in unfavourable circumstances, minimizing the bad), is an objective notion in this sense, that it is perfectly possible for an agent to be ignorant or mistaken, and non-culpably ignorant or mistaken, about what is the right action in the circumstances. Thus the assessment by others of whether the agent did, in this sense, do the right thing, is not bounded by the agent's state of knowledge at the time, and the claim that he did the wrong thing is compatible with recognizing that he did as well as anyone in his state of knowledge could have done.[4] It might be suggested that, contrary to this, we have already imported the subjective conditions of action in speaking of the best of the actions *available to him:* if he is ignorant or misinformed, then the actions which might seem to us available to him were not in any real sense available. But this would be an exaggeration; the notion of availability imports some, but not all, kinds of subjective condition. Over and above the question of actions which, granted his situation and powers, were physically not available to him, we might perhaps add that a course of action was not really available to an agent if his historical, cultural or psychological situation was such that it could not possibly occur to him. But it is scarcely reasonable to extend the notion of unavailability to actions which merely did not occur to him; and surely absurd to extend it to actions which did occur to him, but where he was misinformed about their consequences.

If then an agent does the right thing, he does the best of the alternatives available to him (where that, again, embraces the least bad: we shall omit this rider from now on). Standardly, the action will be right in virtue of its causal properties, of maximally conducing to good states of affairs. Sometimes, however, the relation of the action to the good state of affairs may not be that of cause to effect—the good state of affairs may be constituted, or partly constituted, by the agent's doing that act (as when under

utilitarianism he just enjoys doing it, and there is no project available to him more productive of happiness for him or anyone else).

Although this may be so under consequentialism, there seems to be an important difference between this situation and a situation of an action's being right for some non-consequentialist reason, as for instance under a Kantian morality. This difference might be brought out intuitively by saying that for the consequentialist, even a situation of this kind in which the action itself possesses intrinsic value is one in which the rightness of the act is derived from the goodness of a certain state of affairs—the act is right *because* the state of affairs which consists in its being done is better than any other state of affairs accessible to the agent; whereas for the non-consequentialist it is sometimes, at least, the other way round, and a state of affairs which is better than the alternatives is so because it consists of the right act being done. This intuitive description of the difference has something in it, but it needs to be made more precise.

We can take a step towards making it more precise, perhaps, in the following way. Suppose S is some particular concrete situation. Consider the statement, made about some particular agent

(1) In S, he did the right thing in doing A.

For consequentialists, (1) implies a statement of the form

(2) The state of affairs P is better than any other state of affairs accessible to him; where a state of affairs being "accessible" to an agent means that it is a state of affairs which is the consequence of, or is constituted by, his doing an act available to him (for that, see above); and P is a state of affairs accessible to him only in virtue of his doing A.[5]

Now in the exceptional case where it is just his doing A which carries the intrinsic value, we get for (2)

(3) The state of affairs which consists in his doing A is better than any other state of affairs accessible to him.

It was just the possibility of this sort of case which raised the difficulty of not being able to distinguish between a sophisticated consequentialism and non-consequentialism. The question thus is: if (3) is what we get for consequentialism in this sort of case, is it what a non-consequentialist would regard as implied by (1)? If so, we still cannot tell the difference between them. But the answer in fact seems to be "no."

There are two reasons for this. One reason is that a non-consequentialist, though he must inevitably be able to attach a sense to (1), does not have to be able to attach a sense to (3) at all, while the consequentialist, of course, attaches a sense to (1) only because he attaches a sense to (3). Although the non-consequentialist is concerned with right actions—such as the carrying out of promises—he may have no general way of comparing states of affairs from a moral point of view at all. Indeed, we shall see later and in greater depth than these schematic arguments allow, that the emphasis on the necessary comparability of situations is a peculiar feature of consequentialism in general, and of utilitarianism in particular.

A different kind of reason emerges if we suppose that the non-consequentialist does admit, in general, comparison between states of affairs. Thus, we might suppose that some non-consequentialist would consider it a better state of things in which more, rather than fewer, people kept their promises, and kept them for non-consequentialist reasons. Yet consistently with that he could accept, in a particular case, all of the following: that X would do the right thing only if he kept his promise; that keeping his promise would involve (or consist in) doing A; that several other people would, as a matter of fact, keep their promises (and for the right reasons) if and only if X did not do A. There are all sorts of situations in which this sort of thing would be true: thus it might be the case that an effect of X's doing A would be to provide some inducement to these others which would lead them to break promises which otherwise they would have kept. Thus a non-consequentialist can hold both that it is a better state of affairs in which more people keep their promises, and that the right thing for X to do is something which brings it about that fewer promises are kept. Moreover, it is very obvious what

view of things goes with holding that. It is one in which, even though from some abstract point of view one state of affairs is better than another, it does not follow that a given agent should regard it as his business to bring it about, even though it is open to him to do so. More than that, it might be that he could not properly regard it as his business. If the goodness of the world were to consist in people's fulfilling their obligations, it would by no means follow that one of my obligations was to bring it about that other people kept their obligations.

Of course, no sane person could really believe that the goodness of the world just consisted in people keeping their obligations. But that is just an example, to illustrate the point that under non-consequentialism (3) does not, as one might expect, follow from (1). Thus even allowing some actions to have intrinsic value, we can still distinguish consequentialism. A consequentialist view, then, is one in which a statement of the form (2) follows from a statement of the form (1). A non-consequentialist view is one in which this is not so—not even when the (2) statement takes the special form of (3).

This is not at all to say that the alternative to consequentialism is that one has to accept that there are some actions which one should always do, or again some which one should never do, *whatever the consequences:* this is a much stronger position than any involved, as I have defined the issues, in the denial of consequentialism. All that is involved, on the present account, in the denial of consequentialism, is that with respect to some type of action, there are some situations in which that would be the right thing to do, even though the state of affairs produced by one's doing that would be worse than some other state of affairs accessible to one. The claim that there is a type of action which is right *whatever the consequences* can be put by saying that with respect to some type of action, assumed as being adequately specified, then *whatever* the situation may (otherwise) be, that will be the right thing to do, *whatever* other state of affairs might be accessible to one, however much better it might be than the state of affairs produced by one's doing this action.

If that somewhat Moorean formulation has not hopelessly concealed the point, it will be seen that

this second position—the *whatever the consequences* position—is very much stronger than the first, the mere rejection of consequentialism. It is perfectly consistent, and it might be thought a mark of sense, to believe, while not being a consequentialist, that there was no type of action which satisfied this second condition: that if an adequate (and non-question-begging) specification of a type of action has been given in advance, it is always possible to think of some situation in which the consequences of doing the action so specified would be so awful that it would be right to do something else.

Of course, one might think that there just *were* some types of action which satisfied this condition; though it seems to me obscure how one could have much faith in a list of such actions unless one supposed that it had supernatural warrant. Alternatively, one might think that while logically there was a difference between the two positions, in social and psychological fact they came to much the same thing, since so soon (it might be claimed) as people give up thinking in terms of certain things being right or wrong whatever the consequences, they turn to thinking in purely consequential terms. This might be offered as a very general proposition about human thought, or (more plausibly) as a sociological proposition about certain situations of social change, in which utilitarianism (in particular) looks the only coherent alternative to a dilapidated set of values. At the level of language, it is worth noting that the use of the word "*absolute*" mirrors, and perhaps also assists, this association: the claim that no type of action is "absolutely right"—leaving aside the sense in which it means that the rightness of anything depends on the value-system of a society (the confused doctrine of relativism)—can mean either that no type of action is right-whatever-its-consequences, or, alternatively, that "it all depends on the consequences," that is, in each case the decision whether an action is right is determined by its consequences.

A particular sort of psychological connexion—or in an old-fashioned use of the term, a "moral" connexion—between the two positions might be found in this. If people do not regard certain things as "absolutely out," then they are prepared

to start thinking about extreme situations in which what would otherwise be out might, exceptionally, be justified. They will, if they are to get clear about what they believe, be prepared to compare different extreme situations and ask what action would be justified in them. But once they have got used to that, their inhibitions about thinking of everything in consequential terms disappear: the difference between the extreme situations and the less extreme, presents itself no longer as a difference between the exceptional and the usual, but between the greater and the less—and the consequential thoughts one was prepared to deploy in the greater it may seem quite irrational not to deploy in the less. *A fortiori*, someone might say: but he would have already had to complete this process to see it as a case of *a fortiori*.

One could regard this process of adaptation to consequentialism, moreover, not merely as a blank piece of psychological association, but as concealing a more elaborate structure of thought. One might have the idea that the *unthinkable* was itself a moral category; and in more than one way. It would be a feature of a man's moral outlook that he regarded certain courses of action as unthinkable, in the sense that he would not entertain the idea of doing them: and the witness to that might, in many cases, be that they simply would not come into his head. Entertaining certain alternatives, regarding them indeed as *alternatives*, is itself something that he regards as dishonourable or morally absurd. But, further, he might equally find it unacceptable to consider what to do in certain conceivable situations. Logically, or indeed empirically conceivable they may be, but they are not to him morally conceivable, meaning by that that their occurrence as situations presenting him with a choice would represent not a special problem in his moral world, but something that lay beyond its limits. For him, there are certain situations so monstrous that the idea that the processes of moral rationality could yield an answer in them is insane: they are situations which so transcend in enormity the human business of moral deliberation that from a moral point of view it cannot matter any more what happens. Equally, for him, to spend time thinking what one would decide if one were in such a situation is also insane, if not merely frivolous.

For such a man, and indeed for anyone who is prepared to take him seriously, the demand, in Herman Kahn's words, to *think the unthinkable* is not an unquestionable demand of rationality, set against a cowardly or inert refusal to follow out one's moral thoughts. Rationality he sees as a demand not merely on him, but on the situations in, and about, which he has to think; unless the environment reveals minimum sanity, it is insanity to carry the decorum of sanity into it. Consequentialist rationality, however, and in particular utilitarian rationality, has no such limitations: making the best of a bad job is one of its maxims, and it will have something to say even on the difference between massacring seven million, and massacring seven million and one.

There are other important questions about the idea of the morally unthinkable, which we cannot pursue here. Here we have been concerned with the role it might play in someone's connecting, by more than a mistake, the idea that there was nothing which was right whatever the consequences, and the different idea that everything depends on consequences. While someone might, in this way or another, move from one of those ideas to the other, it is very important that the two ideas are different: especially important in a world where we have lost traditional reasons for resisting the first idea, but have more than enough reasons for fearing the second.

NEGATIVE RESPONSIBILITY: AND TWO EXAMPLES

Although I have defined a state of affairs being *accessible* to an agent in terms of the actions which are *available* to him,[6] nevertheless it is the former notion which is really more important for consequentialism. Consequentialism is basically indifferent to whether a state of affairs consists in what I do, or is produced by what I do, where that notion is itself wide enough to include, for instance, situations in which other people do things which I have made them do, or allowed them to do, or encouraged them to do, or given them a chance to do. All that consequentialism is interested in is the idea of these

doings being *consequences* of what I do, and that is a relation broad enough to include the relations just mentioned, and many others.

Just what the relation is, is a different question, and at least as obscure as the nature of its relative, cause and effect. It is not a question I shall try to pursue; I will rely on cases where I suppose that any consequentialist would be bound to regard the situations in question as consequences of what the agent does. There are cases where the supposed consequences stand in a rather remote relation to the action, which are sometimes difficult to assess from a practical point of view, but which raise no very interesting question for the present enquiry. The more interesting points about consequentialism lie rather elsewhere. There are certain situations in which the causation of the situation, the relation it has to what I do, is in no way remote or problematic in itself, and entirely justifies the claim that the situation is a consequence of what I do: for instance, it is quite clear, or reasonably clear, that if I do a certain thing, this situation will come about, and if I do not, it will not. So from a consequentialist point of view it goes into the calculation of consequences along with any other state of affairs accessible to me. Yet from some, at least, non-consequentialist points of view, there is a vital difference between some such situations and others: namely, that in some a vital link in the production of the eventual outcome is provided by *someone else's* doing something. But for consequentialism, all causal connexions are on the same level, and it makes no difference, so far as that goes, whether the causation of a given state of affairs lies through another agent, or not.

Correspondingly, there is no relevant difference which consists *just* in one state of affairs being brought about by me, without intervention of other agents, and another being brought about through the invervention of other agents; although some genuinely causal differences involving a difference of value may correspond to that (as when, for instance, the other agents derive pleasure or pain from the transaction), that kind of difference will already be included in the specification of the state of affairs to be produced. Granted that the states of

affairs have been adequately described in causally and evaluatively relevant terms, it makes no further comprehensible difference who produces them. It is because consequentialism attaches value ultimately to states of affairs, and its concern is with what states of affairs the world contains, that it essentially involves the notion of *negative responsibility:* that if I am ever responsible for anything, then I must be just as much responsible for things that I allow or fail to prevent, as I am for things that I myself, in the more everyday restricted sense, bring about.[7] Those things also must enter my deliberations, as a responsible moral agent, on the same footing. What matters is what states of affairs the world contains, and so what matters with respect to a given action is what comes about if it is done, and what comes about if it is not done, and those are questions not intrinsically affected by the nature of the causal linkage, in particular by whether the outcome is partly produced by other agents.

The strong doctrine of negative responsibility flows directly from consequentialism's assignment of ultimate value to states of affairs. Looked at from another point of view, it can be seen also as a special application of something that is favoured in many moral outlooks not themselves consequentialist— something which, indeed, some thinkers have been disposed to regard as the essence of morality itself: a principle of impartiality. Such a principle will claim that there can be no relevant difference from a moral point of view which consists just in the fact, not further explicable in general terms, that benefits or harms accrue to one person rather than to another—"it's me" can never in itself be a morally comprehensible reason.[8] This principle, familiar with regard to the reception of harms and benefits, we can see consequentialism as extending to their production: from the moral point of view, there is no comprehensible difference which consists just in my bringing about a certain outcome rather than someone else's producing it. That the doctrine of negative responsibility represents in this way the extreme of impartiality, and abstracts from the identity of the agent, leaving just a locus of causal intervention in

the world—that fact is not merely a surface paradox. It helps to explain why consequentialism can seem to some to express a more serious attitude than non-consequentialist views, why part of its appeal is to a certain kind of high-mindedness. Indeed, that is part of what is wrong with it.

For a lot of the time so far we have been operating at an exceedingly abstract level. This has been necessary in order to get clearer in general terms about the differences between consequentialist and other outlooks, an aim which is important if we want to know what features of them lead to what results for our thought. Now, however, let us look more concretely at two examples, to see what utilitarianism might say about them, what we might say about utilitarianism and, most importantly of all, what would be implied by certain ways of thinking about the situations. The examples are inevitably schematized, and they are open to the objection that they beg as many questions as they illuminate. There are two ways in particular in which examples in moral philosophy tend to beg important questions. One is that, as presented, they arbitrarily cut off and restrict the range of alternative courses of action—this objection might particularly be made against the first of my two examples. The second is that they inevitably present one with the situation as a going concern, and cut off questions about how the agent got into it, and correspondingly about moral considerations which might flow from that: this objection might perhaps specially arise with regard to the second of my two situations. These difficulties, however, just have to be accepted, and if anyone finds these examples cripplingly defective in this sort of respect, then he must in his own thought rework them in richer and less question-begging form. If he feels that no presentation of any imagined situation can ever be other than misleading in morality, and that there can never be any substitute for the concrete experienced complexity of actual moral situations, then this discussion, with him, must certainly grind to a halt: but then one may legitimately wonder whether every discussion with him about conduct will not grind to a halt, including any discussion about the

actual situations, since discussion about how one would think and feel about situations somewhat different from the actual (that is to say, situations to that extent imaginary) plays an important role in discussion of the actual.

(1) George, who has just taken his Ph.D. in chemistry, finds it extremely difficult to get a job. He is not very robust in health, which cuts down the number of jobs he might be able to do satisfactorily. His wife has to go out to work to keep them, which itself causes a great deal of strain, since they have small children and there are severe problems about looking after them. The results of all this, especially on the children, are damaging. An older chemist, who knows about this situation, says that he can get George a decently paid job in a certain laboratory, which pursues research into chemical and biological warfare. George says that he cannot accept this, since he is opposed to chemical and biological warfare. The older man replies that he is not too keen on it himself, come to that, but after all George's refusal is not going to make the job or the laboratory go away; what is more, he happens to know that if George refuses the job, it will certainly go to a contemporary of George's who is not inhibited by any such scruples and is likely if appointed to push along the research with greater zeal than George would. Indeed, it is not merely concern for George and his family, but (to speak frankly and in confidence) some alarm about this other man's excess of zeal, which has led the older man to offer to use his influence to get George the job . . . George's wife, to whom he is deeply attached, has views (the details of which need not concern us) from which it follows that at least there is nothing particularly wrong with research into CBW. What should he do?

(2) Jim finds himself in the central square of a small South American town. Tied up against the wall are a row of twenty Indians, most terrified, a few defiant, in front of them several armed men in uniform. A heavy man in a sweat-stained khaki shirt turns out to be the captain in charge and, after a good deal of questioning of Jim which establishes that he got there by accident while on a botanical expedition, explains that the Indians are a random group of the inhabitants who, after recent acts of protest against the government, are just about to be killed to remind other possible protestors of the advantages of not protesting. However, since Jim is an honoured visitor from another land, the captain is happy to offer him a guest's privilege of killing one of the Indians himself. If Jim accepts, then as a special mark of the occasion, the other Indians will be let off. Of course, if Jim refuses, then there is no special occasion, and Pedro here will do what he was about to do when Jim arrived, and kill them all. Jim, with some desperate recollection of schoolboy fiction, wonders whether if he got hold of a gun, he could hold the captain, Pedro and the rest of the soldiers to threat, but it is quite clear from the set-up that nothing of that kind is going to work: any attempt at that sort of thing will mean that all the Indians will be killed, and himself. The men against the wall, and the other villagers, understand the situation, and are obviously begging him to accept. What should he do?

To these dilemmas, it seems to me that utilitarianism replies, in the first case, that George should accept the job, and in the second, that Jim should kill the Indian. Not only does utilitarianism give these answers but, if the situations are essentially as described and there are no further special factors, it regards them, it seems to me, as *obviously* the right answers. But many of us would certainly wonder whether, in (1), that could possibly be the right answer at all; and in the case of (2), even one who came to think that perhaps that was the answer, might well wonder whether it was obviously the answer. Nor is it just a question of the rightness or obviousness of these answers. It is also a question of what sort of considerations come into finding the answer. A feature of utilitarianism is that it cuts out a kind of consideration which for some others makes a difference to what they feel about such cases: a consideration involving the idea, as we might first and very simply put it, that each of us is specially responsible for what *he* does, rather than for what other people do. This is an idea closely connected with the value of integrity. It is often suspected that utilitarianism,

at least in its direct forms, makes integrity as a value more or less unintelligible. I shall try to show that this suspicion is correct. Of course, even if that is correct, it would not necessarily follow that we should reject utilitarianism; perhaps, as utilitarians sometimes suggest, we should just forget about integrity, in favour of such things as a concern for the general good. However, if I am right, we cannot merely do that, since the reason why utilitarianism cannot understand integrity is that it cannot coherently describe the relations between a man's projects and his actions.

TWO KINDS OF REMOTE EFFECT

A lot of what we have to say about this question will be about the relations between my projects and other people's projects. But before we get on to that, we should first ask whether we are assuming too hastily what the utilitarian answers to the dilemmas will be. In terms of more direct effect of the possible decisions, there does not indeed seem much doubt about the answer in either case; but it might be said that in terms of more remote or less evident effects counterweights might be found to enter the utilitarian scales. Thus the effect on George of a decision to take the job might be invoked, or its effect on others who might know of his decision. The possibility of there being more beneficent labours in the future from which he might be barred or disqualified, might be mentioned; and so forth. Such effects—in particular, possible effects on the agent's character, and effects on the public at large—are often invoked by utilitarian writers dealing with problems about lying or promise-breaking, and some similar considerations might be invoked here.

There is one very general remark that is worth making about arguments of this sort. The certainty that attaches to these hypotheses about possible effects is usually pretty low; in some cases, indeed, the hypothesis invoked is so implausible that it would scarcely pass if it were not being used to deliver the respectable moral answer, as in the standard fantasy that one of the effects of one's telling a particular lie is to weaken the disposition of the world at large to tell the truth. The demands on the certainty or probability of these beliefs as beliefs about particular actions are much milder than they would be on beliefs favouring the unconventional course. It may be said that this is as it should be, since the presumption must be in favour of the conventional course: but that scarcely seems a *utilitarian* answer, unless utilitarianism has already taken off in the direction of not applying the consequences to the particular act at all.

Leaving aside that very general point, I want to consider now two types of effect that are often invoked by utilitarians, and which might be invoked in connexion with these imaginary cases. The attitude or tone involved in invoking these effects may sometimes seem peculiar; but that sort of peculiarity soon becomes familiar in utilitarian discussions, and indeed it can be something of an achievement to retain a sense of it.

First, there is the psychological effect on the agent. Our descriptions of these situations have not so far taken account of how George or Jim will be after they have taken the one course or the other; and it might be said that if they take the course which seemed at first the utilitarian one, the effects on them will be in fact bad enough and extensive enough to cancel out the initial utilitarian advantages of that course. Now there is one version of this effect in which, for a utilitarian, some confusion must be involved, namely that in which the agent feels bad, his subsequent conduct and relations are crippled and so on, *because he thinks that he has done the wrong thing*—for if the balance of outcomes was as it appeared to be *before* invoking this effect, then he has not (from the utilitarian point of view) done the wrong thing. So that version of the effect, for a rational and utilitarian agent, could not possibly make any difference to the assessment of right and wrong. However, perhaps he is not a thoroughly rational agent, and is disposed to have bad feelings, whichever he decided to do. Now such feelings, which are from a strictly utilitarian point of view irrational—nothing, a utilitarian can point out, is advanced by having them—cannot, consistently, have any great weight in a utilitarian calculation. I shall consider in a moment an argument to

suggest that they should have no weight at all in it. But short of that, the utilitarian could reasonably say that such feelings should not be encouraged, even if we accept their existence, and that to give them a lot of weight is to encourage them. Or, at the very best, even if they are straightforwardly and without any discount to be put into the calculation, their weight must be small: they are after all (and at best) one man's feelings.

That consideration might seem to have particular force in Jim's case. In George's case, his feelings represent a larger proportion of what is to be weighed, and are more commensurate in character with other items in the calculation. In Jim's case, however, his feelings might seem to be of very little weight compared with other things that are at stake. There is a powerful and recognizable appeal that can be made on this point: as that a refusal by Jim to do what he has been invited to do would be a kind of self-indulgent squeamishness. That is an appeal which can be made by other than utilitarians—indeed, there are some uses of it which cannot be consistently made by utilitarians, as when it essentially involves the idea that there is something dishonourable about such self-indulgence. But in some versions it is a familiar, and it must be said a powerful, weapon of utilitarianism. One must be clear, though, about what it can and cannot accomplish. The most it can do, so far as I can see, is to invite one to consider how seriously, and for what reasons, one feels that what one is invited to do is (in these circumstances) wrong, and in particular, to consider that question from the utilitarian point of view. When the agent is not seeing the situation from a utilitarian point of view, the appeal cannot force him to do so; and if he does come round to seeing it from a utilitarian point of view, there is virtually nothing left for the appeal to do. If he does not see it from a utilitarian point of view, he will not see his resistance to the invitation, and the unpleasant feelings he associates with accepting it, *just* as disagreeable experiences of his; they figure rather as emotional expressions of a thought that to accept would be wrong. He may be asked, as by the appeal, to consider whether he is right, and indeed whether he is fully serious, in

thinking that. But the assertion of the appeal, that he is being self-indulgently squeamish, will not itself answer that question, or even help to answer it, since it essentially tells him to regard his feelings just as unpleasant experiences of his, and he cannot, by doing that, answer the question they pose when they are precisely not so regarded, but are regarded as indications[9] of what he thinks is right and wrong. If he does come round fully to the utilitarian point of view then of course he will regard these feelings just as unpleasant experiences of his. And once Jim—at least—has come to see them in that light, there is nothing left for the appeal to do, since *of course* his feelings, so regarded, are of virtually no weight at all in relation to the other things at stake. The "squeamishness" appeal is not an argument which adds in a hitherto neglected consideration. Rather, it is an invitation to consider the situation, and one's own feelings, from a utilitarian point of view.

The reason why the squeamishness appeal can be very unsettling, and one can be unnerved by the suggestion of self-indulgence in going against utilitarian considerations, is not that we are utilitarians who are uncertain what utilitarian value to attach to our moral feelings, but that we are partially at least not utilitarians, and cannot regard our moral feelings merely as objects of utilitarian value. Because our moral relation to the world is partly given by such feelings, and by a sense of what we can or cannot "live with," to come to regard those feelings from a purely utilitarian point of view, that is to say, as happenings outside one's moral self, is to lose a sense of one's moral identity; to lose, in the most literal way, one's integrity. At this point utilitarianism alienates one from one's moral feelings; we shall see a little later how, more basically, it alienates one from one's actions as well.

If, then, one is really going to regard one's feelings from a strictly utilitarian point of view, Jim should give very little weight at all to his; it seems almost indecent, in fact, once one has taken that point of view, to suppose that he should give any at all. In George's case one might feel that things were slightly different. It is interesting, though, that one reason why one might think that—namely that one

person principally affected is his wife—is very dubiously available to a utilitarian. George's wife has some reason to be interested in George's integrity and his sense of it; the Indians, quite properly, have no interest in Jim's. But it is not at all clear how utilitarianism would describe that difference.

There is an argument, and a strong one, that a strict utilitarian should give not merely small extra weight, in calculations of right and wrong, to feelings of this kind, but that he should give absolutely no weight to them at all. This is based on the point, which we have already seen, that if a course of action is, before taking these sorts of feelings into account, utilitarianly preferable, then bad feelings about that kind of action will be from a utilitarian point of view irrational. Now it might be thought that even if that is so, it would not mean that in a utilitarian calculation such feelings should not be taken into account; it is after all a well-known boast of utilitarianism that it is a realistic outlook which seeks the best in the world as it is, and takes any form of happiness or unhappiness into account. While a utilitarian will no doubt seek to diminish the incidence of feelings which are utilitarianly irrational—or at least of disagreeable feelings which are so—he might be expected to take them into account while they exist. This is without doubt classical utilitarian doctrine, but there is good reason to think that utilitarianism cannot stick to it without embracing results which are startlingly unacceptable and perhaps self-defeating.

Suppose that there is in a certain society a racial minority. Considering merely the ordinary interests of the other citizens, as opposed to their sentiments, this minority does no particular harm; we may suppose that it does not confer any very great benefits either. Its presence is in those terms neutral or mildly beneficial. However, the other citizens have such prejudices that they find the sight of this group, even the knowledge of its presence, very disagreeable. Proposals are made for removing in some way this minority. If we assume various quite plausible things (as that programmes to change the majority sentiment are likely to be protracted and ineffective) then even

if the removal would be unpleasant for the minority, a utilitarian calculation might well end up favouring this step, especially if the minority were a rather small minority and the majority were very severely prejudiced, that is to say, were made very severely uncomfortable by the presence of the minority.

A utilitarian might find that conclusion embarrassing; and not merely because of its nature, but because of the grounds on which it is reached. While a utilitarian might be expected to take into account certain other sorts of consequences of the prejudice, as that a majority prejudice is likely to be displayed in conduct disagreeable to the minority, and so forth, he might be made to wonder whether the unpleasant experiences of the prejudiced people should be allowed, *merely as such*, to count. If he does count them, merely as such, then he has once more separated himself from a body of ordinary moral thought which he might have hoped to accommodate; he may also have started on the path of defeating his own view of things. For one feature of these sentiments is that they are from the utilitarian point of view itself irrational, and a thoroughly utilitarian person would either not have them, or if he found that he did tend to have them, would himself seek to discount them. Since the sentiments in question are such that a rational utilitarian would discount them in himself, it is reasonable to suppose that he should discount them in his calculations about society; it does seem quite unreasonable for him to give just as much weight to feelings—considered just in themselves, one must recall, as experiences of those that have them—which are essentially based on views which are from a utilitarian point of view irrational, as to those which accord with utilitarian principles. Granted this idea, it seems reasonable for him to rejoin a body of moral thought in other respects congenial to him, and discount those sentiments, just considered in themselves, totally, on the principle that no pains or discomforts are to count in the utilitarian sum which their subjects have just because they hold views which are by utilitarian standards irrational. But if he accepts that, then in the cases we are at

present considering no extra weight at all can be put in for bad feelings of George or Jim about their choices, if those choices are, leaving out those feelings, on the first round utilitarianly rational.

The psychological effect on the agent was the first of two general effects considered by utilitarians, which had to be discussed. The second is in general a more substantial item, but it need not take so long, since it is both clearer and has little application to the present cases. This is the *precedent effect*. As Burke rightly emphasized, this effect can be important: that one morally *can* do what someone has actually done, is a psychologically effective principle, if not a deontically valid one. For the effect to operate, obviously some conditions must hold on the publicity of the act and on such things as the status of the agent (such considerations weighed importantly with Sir Thomas More); what these may be will vary evidently with circumstances.

In order for the precedent effect to make a difference to a utilitarian calculation, it must be based upon a confusion. For suppose that there is an act which would be the best in the circumstances, except that doing it will encourage by precedent other people to do things which will not be the best things to do. Then the situation of those other people must be relevantly different from that of the original agent; if it were not, then in doing the same as what would be the best course for the original agent, they would necessarily do the best thing themselves. But if the situations are in this way relevantly different, it must be a confused perception which takes the first situation, and the agent's course in it, as an adequate precedent for the second.

However, the fact that the precedent effect, if it really makes a difference, is in this sense based on a confusion, does not mean that it is not perfectly real, nor that it is to be discounted: social effects are by their nature confused in this sort of way. What it does emphasize is that calculations of the precedent effect have got to be realistic, involving considerations of how people are actually likely to be influenced. In the present examples, however, it is very implausible to think that the precedent effect could be invoked to

make any difference to the calculation. Jim's case is extraordinary enough, and it is hard to imagine who the recipients of the effect might be supposed to be; while George is not in a sufficiently public situation or role for the question to arise in that form, and in any case one might suppose that the motivations of others on such an issue were quite likely to be fixed one way or another already.

No appeal, then, to these other effects is going to make a difference to what the utilitarian will decide about our examples. Let us now look more closely at the structure of those decisions.

INTEGRITY

The situations have in common that if the agent does not do a certain disagreeable thing, someone else will, and in Jim's situation at least the result, the state of affairs after the other man has acted, if he does, will be worse than after Jim has acted, if Jim does. The same, on a smaller scale, is true of George's case. I have already suggested that it is inherent in consequentialism that it offers a strong doctrine of negative responsibility: if I know that if I do X, O_1 will eventuate, and if I refrain from doing X, O_2 will, and that O_2 is worse than O_1, then I am responsible for O_2 if I refrain voluntarily from doing X. "You could have prevented it," as will be said, and truly, to Jim, if he refuses, by the relatives of the other Indians. (I shall leave the important question, which is to the side of the present issue, of the obligations, if any, that nest round the word "know": how far does one, under utilitarianism, have to research into the possibilities of maximally beneficent action, including prevention?)

In the present cases, the situation of O_2 includes another agent bringing about results worse than O_1. So far as O_2 has been identified up to this point— merely as the worse outcome which will eventuate if I refrain from doing X—we might equally have said that what that other brings about is O_2; but that would be to underdescribe the situation. For what occurs if Jim refrains from action is not solely twenty Indians

dead, but *Pedro's killing twenty Indians*, and that is not a result which Pedro brings about, though the death of the Indians is. We can say: what one does is not included in the outcome of what one does, while what another does can be included in the outcome of what one does. For that to be so, as the terms are now being used, only a very weak condition has to be satisfied: for Pedro's killing the Indians to be the outcome of Jim's refusal, it only has to be causally true that if Jim had not refused, Pedro would not have done it.

That may be enough for us to speak, in some sense, of Jim's responsibility for that outcome, if it occurs; but it is certainly not enough, it is worth noticing, for us to speak of Jim's *making* those things happen. For granted this way of their coming about, he could have made them happen only by making Pedro shoot, and there is no acceptable sense in which his refusal makes Pedro shoot. If the captain had said on Jim's refusal, "you leave me with no alternative," he would have been lying, like most who use that phrase. While the deaths, and the killing, may be the outcome of Jim's refusal, it is misleading to think, in such a case, of Jim having an *effect* on the world through the medium (as it happens) of Pedro's acts; for this is to leave Pedro out of the picture in his essential role of one who has intentions and projects, projects for realizing which Jim's refusal would leave an opportunity. Instead of thinking in terms of supposed effects of Jim's projects on Pedro, it is more revealing to think in terms of the effects of Pedro's projects on Jim's decision. This is the direction from which I want to criticize the notion of negative responsibility.

There are of course other ways in which this notion can be criticized. Many have hoped to discredit it by insisting on the basic moral relevance of the distinction between action and inaction, between intervening and letting things take their course. The distinction is certainly of great moral significance, and indeed it is not easy to think of any moral outlook which could get along without making some use of it. But it is unclear, both in itself and in its moral applications, and the unclarities are of a kind which precisely cause it to give way when, in very difficult cases, weight has to be put on it. There is much to be said in this area, but I doubt whether the sort of dilemma we are considering is going to be resolved by a simple use of this distinction. Again, the issue of negative responsibility can be pressed on the question of how limits are to be placed on one's apparently boundless obligation, implied by utilitarianism, to improve the world. Some answers are needed to that, too—and answers which stop short of relapsing into the bad faith of supposing that one's responsibilities could be adequately characterized just by appeal to one's roles.[10] But, once again, while that is a real question, it cannot be brought to bear directly on the present kind of case, since it is hard to think of anyone supposing that in Jim's case it would be an adequate response for him to say that it was none of his business.

What projects does a utilitarian agent have? As a utilitarian, he has the general project of bringing about maximally desirable outcomes; how he is to do this at any given moment is a question of what causal levers, so to speak, are at that moment within reach. The desirable outcomes, however, do not just consist of agents carrying out *that* project; there must be other more basic or lower-order projects which he and other agents have, and the desirable outcomes are going to consist, in part, of the maximally harmonious realization of those projects ("in part," because one component of a utilitarianly desirable outcome may be the occurrence of agreeable experiences which are not the satisfaction of anybody's projects). Unless there were first-order projects, the general utilitarian project would have nothing to work on, and would be vacuous. What do the more basic or lower-order projects comprise? Many will be the obvious kinds of desires for things for oneself, one's family, one's friends, including basic necessities of life, and in more relaxed circumstances, objects of taste. Or there may be pursuits and interests of an intellectual, cultural or creative character. I introduce those as a separate class not because the objects of them lie in a separate class, and provide—as some utilitarians, in their churchy way, are fond of saying—"higher" pleasures. I introduce them separately because the

agent's identification with them may be of a different order. It does not have to be: cultural and aesthetic interests just belong, for many, along with any other taste; but some people's commitment to these kinds of interests just is at once more thoroughgoing and serious than their pursuit of various objects of taste, while it is more individual and permeated with character than the desire for the necessities of life.

Beyond these, someone may have projects connected with his support of some cause: Zionism, for instance, or the abolition of chemical and biological warfare. Or there may be projects which flow from some more general disposition towards human conduct and character, such as a hatred of injustice, or of cruelty, or of killing.

It may be said that this last sort of disposition and its associated project do not count as (logically) "lower-order" relative to the higher-order project of maximizing desirable outcomes; rather, it may be said, it is itself a "higher-order" project. The vital question is not, however, how it is to be classified, but whether it and similar projects are to count among the projects whose satisfaction is to be included in the maximizing sum, and, correspondingly, as contributing to the agent's happiness. If the utilitarian says "no" to that, then he is almost certainly committed to a version of utilitarianism as absurdly superficial and shallow as Benthamite versions have often been accused of being. For this project will be discounted, presumably, on the ground that it involves, in the specification of its object, the mention of other people's happiness or interests: thus it is the kind of project which (unlike the pursuit of food for myself) presupposes a reference to other people's projects. But that criterion would eliminate any desire at all which was not blankly and in the most straightforward sense egoistic.[11] Thus we should be reduced to frankly egoistic first-order projects, and—for all essential purposes—the one second-order utilitarian project of maximally satisfying first-order projects. Utilitarianism has a tendency to slide in this direction, and to leave a vast hole in the range of human desires, between egoistic inclinations and necessities at one end, and impersonally benevolent happiness-management at

the other. But the utilitarianism which has to leave this hole is the most primitive form, which offers a quite rudimentary account of desire. Modern versions of the theory are supposed to be neutral with regard to what sorts of things make people happy or what their projects are. Utilitarianism would do well then to acknowledge the evident fact that among the things that make people happy is not only making other people happy, but being taken up or involved in any of a vast range of projects, or—if we waive the evangelical and moralizing associations of the word—commitments. One can be committed to such things as a person, a cause, an institution, a career, one's own genius, or the pursuit of danger.

Now none of these is itself the *pursuit of happiness:* by an exceedingly ancient platitude, it is not at all clear that there could be anything which was just that, or at least anything that had the slightest chance of being successful. Happiness, rather, requires being involved in, or at least content with, something else.[12] It is not impossible for utilitarianism to accept that point: it does not have to be saddled with a naïve and absurd philosophy of mind about the relation between desire and happiness. What it does have to say is that if such commitments are worth while, then pursuing the projects that flow from them, and realizing some of those projects, will make the person for whom they are worth while, happy. It may be that to claim that is still wrong: it may well be that a commitment can make sense to a man (can make sense to his life) without his supposing that it will make him *happy*.[13] But that is not the present point; let us grant to utilitarianism that all worthwhile human projects must conduce, one way or another, to happiness. The point is that even if that is true, it does not follow, nor could it possibly be true, that those projects are themselves projects of pursuing happiness. One has to believe in, or at least want, or quite minimally, be content with, other things, for there to be anywhere that happiness can come from.

Utilitarianism, then, should be willing to agree that its general aim of maximizing happiness does not imply that what everyone is doing is just pursuing happiness. On the contrary, people have to be pursuing other things. What those other things may

be, utilitarianism, sticking to its professed empirical stance, should be prepared just to find out. No doubt some possible projects it will want to discourage, on the grounds that their being pursued involves a negative balance of happiness to others: though even there, the unblinking accountant's eye of the strict utilitarian will have something to put in the positive column, the satisfactions of the destructive agent. Beyond that, there will be a vast variety of generally beneficent or at least harmless projects; and some no doubt, will take the form not just of tastes or fancies, but of what I have called "commitments." It may even be that the utilitarian researcher will find that many of those with commitments, who have really identified themselves with objects outside themselves, who are thoroughly involved with other persons, or institutions, or activities or causes, are actually happier than those whose projects and wants are not like that. If so, that is an important piece of utilitarian empirical lore.

When I say "happier" here, I have in mind the sort of consideration which any utilitarian would be committed to accepting: as for instance that such people are less likely to have a break-down or commit suicide. Of course that is not all that is actually involved, but the point in this argument is to use to the maximum degree utilitarian notions, in order to locate a breaking point in utilitarian thought. In appealing to this strictly utilitarian notion, I am being more consistent with utilitarianism than Smart is. In his struggles with the problem of the brain-electrode man, Smart (p. 22) commends the idea that "happy" is a partly evaluative term, in the sense that we call "happiness" those kinds of satisfaction which, as things are, we approve of. But *by what standard* is this surplus element of approval supposed, from a utilitarian point of view, to be allocated? There is no source for it, on a strictly utilitarian view, except further degrees of satisfaction, but there are none of those available, or the problem would not arise. Nor does it help to appeal to the fact that we dislike in prospect things which we like when we get there, for from a utilitarian point of view it would seem that the original dislike

was merely irrational or based on an error. Smart's argument at this point seems to be embarrassed by a well-known utilitarian uneasiness, which comes from a feeling that it is not respectable to ignore the "deep," while, not having anywhere left in human life to locate it.[14]

Let us now go back to the agent as utilitarian, and his higher-order project of maximizing desirable outcomes. At this level, he is committed only to that: what the outcome will actually consist of will depend entirely on the facts, on what persons with what projects and what potential satisfactions there are within calculable reach of the causal levers near which he finds himself. His own substantial projects and commitments come into it, but only as one lot among others—they potentially provide one set of satisfactions among those which he may be able to assist from where he happens to be. He is the agent of the satisfaction system who happens to be at a particular point at a particular time: in Jim's case, our man in South America. His own decisions as a utilitarian agent are a function of all the satisfactions which he can affect from where he is: and this means that the projects of others, to an indeterminately great extent, determine his decision.

This may be so either positively or negatively. It will be so positively if agents within the causal field of his decision have projects which are at any rate harmless, and so should be assisted. It will equally be so, but negatively, if there is an agent within the causal field whose projects are harmful, and have to be frustrated to maximize desirable outcomes. So it is with Jim and the soldier Pedro. On the utilitarian view, the undesirable projects of other people as much determine, in this negative way, one's decisions as the desirable ones do positively: if those people were not there, or had different projects, the causal nexus would be different, and it is the actual state of the causal nexus which determines the decision. The determination to an indefinite degree of my decisions by other people's projects is just another aspect of my unlimited responsibility to act for the best in a causal framework formed to a considerable extent by their projects.

The decision so determined is, for utilitarianism, the right decision. But what if it conflicts with some project of mine? This, the utilitarian will say, has already been dealt with: the satisfaction to you of fulfilling your project, and any satisfactions to others of your so doing, have already been through the calculating device and have been found inadequate. Now in the case of many sorts of projects, that is a perfectly reasonable sort of answer. But in the case of projects of the sort I have called "commitments," those with which one is more deeply and extensively involved and identified, this cannot just by itself be an adequate answer, and there may be no adequate answer at all. For, to take the extreme sort of case, how can a man, as a utilitarian agent, come to regard as one satisfaction among others, and a dispensable one, a project or attitude round which he has built his life, just because someone else's projects have so structured the causal scene that that is how the utilitarian sum comes out?

The point here is not, as utilitarians may hasten to say, that if the project or attitude is that central to his life, then to abandon it will be very disagreeable to him and great loss of utility will be involved. I have already argued in [the previous] section that it is not like that; on the contrary, once he is prepared to look at it like that, the argument in any serious case is over anyway. The point is that he is identified with his actions as flowing from projects and attitudes which in some cases he takes seriously at the deepest level, as what his life is about (or, in some cases, this section of his life—seriousness is not necessarily the same as persistence). It is absurd to demand of such a man, when the sums come in from the utility network which the projects of others have in part determined, that he should just step aside from his own project and decision and acknowledge the decision which utilitarian calculation requires. It is to alienate him in a real sense from his actions and the source of his action in his own convictions. It is to make him into a channel between the input of everyone's projects, including his own, and an output of optimific decision; but this is to neglect the extent to which *his*

actions and *his* decisions have to be seen as the actions and decisions which flow from the projects and attitudes with which he is most closely identified. It is thus, in the most literal sense, an attack on his integrity.[15]

These sorts of considerations do not in themselves give solutions to practical dilemmas such as those provided by our examples; but I hope they help to provide other ways of thinking about them. In fact, it is not hard to see that in George's case, viewed from this perspective, the utilitarian solution would be wrong. Jim's case is different, and harder. But if (as I suppose) the utilitarian is probably right in this case, that is not to be found out just by asking the utilitarian's questions. Discussions of it—and I am not going to try to carry it further here—will have to take seriously the distinction between my killing someone, and its coming about because of what I do that someone else kills them: a distinction based, not so much on the distinction between action and inaction, as on the distinction between my projects and someone else's projects. At least it will have to start by taking that seriously, as utilitarianism does not; but then it will have to build out from there by asking why that distinction seems to have less, or a different, force in this case than it has in George's. One question here would be how far one's powerful objection to killing people just is, in fact, an application of a powerful objection to their being killed. Another dimension of that is the issue of how much it matters that the people at risk are actual, and there, as opposed to hypothetical, or future, or merely elsewhere.[16]

Notes

1. The terminology of things "being valuable," "having intrinsic value," etc., is not meant to beg any questions in general value-theory. Non-cognitive theories, such as Smart's, should be able to recognize the distinctions made here. [Williams is referring to Smart's essay, which is in the same volume as his.]

2. A point noted by Smart, p. 13.

3. Cf. Smart's definition, p. 45.

4. In Smart's terminology, the "rational thing": pp. 46–7.

5. "Only" here may seem a bit strong: but I take it that it is not an unreasonable demand on an account of his doing *the* right thing in S that his action is uniquely singled out from the alternatives. A further detail: one should strictly say, not that (1) implies a statement of the form (2), but that (1) implies *that there is* a true statement of that form.

6. See last section. . . .

7. This is a fairly modest sense of "responsibility," introduced merely by one's ability to reflect on, and decide, what one ought to do. This presumably escapes Smart's ban on the notion of "the responsibility" as "a piece of metaphysical nonsense"—his remarks seem to be concerned solely with situations of inter-personal blame.

8. There is a tendency in some writers to suggest that it is not a comprehensible reason at all. But this, I suspect, is due to the overwhelming importance those writers ascribe to the moral point of view.

9. On the non-cognitivist meta-ethic in terms of which Smart presents his utilitarianism, the term "indications" here would represent an understatement.

10. For some remarks bearing on this, see *Morality*, the section on "Goodness and roles," and Cohen's article there cited.

11. On the subject of egoistic and non-egoistic desires, see "Egoism and altruism," in *Problems of the Self* (Cambridge University Press, London, 1973).

12. This does not imply that there is no such thing as the project of pursuing pleasure. Some writers who have correctly resisted the view that all desires are desires for pleasure, have given an account of pleasure so thoroughly adverbial as to leave it quite unclear how there could be a distinctively hedonist way of life at all. Some room has to be left for that, though there are important difficulties both in defining it and living it. Thus (particularly in the case of the very rich) it often has highly ritual aspects, apparently part of a strategy to counter boredom.

13. For some remarks on this possibility, see *Morality* section on "What is morality about?" [*Morality: An Introduction to Ethics* (Harper and Row, New York, 1972).]

14. One of many resemblances in spirit between utilitarianism and high-minded evangelical Christianity.

15. Interestingly related to these notions is the Socratic idea that courage is a virtue particularly connected with keeping a clear sense of what one regards as most important. They also centrally raise questions about the value of pride. Humility, as something beyond the real demand of correct self-appraisal, was specially a Christian virtue because it involved subservience to God. In a secular context it can only represent subservience to other men and their projects.

16. For a more general discussion of this issue see Charles Fried, *An Anatomy of Values* (Harvard University Press, Cambridge, Mass., 1970), Part Three.

Study Questions

1. What did Williams mean by "integrity"?

2. Why did Williams believe that utilitarianism cannot allow for the value of integrity?

3. Is integrity a value that should be adhered to in all circumstances?

4. In the case of Jim, what should he do?

25

W. D. ROSS

William David Ross (1877–1971) was Deputy White's Professor of Moral Philosophy at the University of Oxford. He argued that neither utilitarianism nor Kantianism captures the special relationships we may have with others, such as gratitude to a benefactor. These give rise to prima facie duties, those we ought to do unless they are outweighed by conflicting prima facie duties. How to take them all into account is a matter of judgment in particular cases. Ross maintained that prima facie duties are self-evident, known by intuition just like logical or mathematical truths.

The Right and the Good

The real point at issue between hedonism and utilitarianism on the one hand and their opponents on the other is not whether "right" means "productive of so and so"; for it cannot with any plausibility be maintained that it does. The point at issue is that to which we now pass, viz. whether there is any general character which makes right acts right, and if so, what it is. Among the main historical attempts to state a single characteristic of all right actions which is the foundation of their rightness are those made by egoism and utilitarianism. But I do not propose to discuss these, not because the subject is unimportant, but because it has been dealt with so often and so well already, and because there has come to be so much agreement among moral philosophers that neither of these theories is satisfactory. A much more attractive theory has been put forward by Professor Moore: that what makes actions right is that they are productive of more *good* than could have been produced by any other action open to the agent.[1]

This theory is in fact the culmination of all the attempts to base rightness on productivity of some sort of result. The first form this attempt takes is the attempt to base rightness on conduciveness to the advantage or pleasure of the agent. This theory comes to grief over the fact, which stares us in the face, that a great part of duty consists in an observance of the rights and a furtherance of the interests of others, whatever the cost to ourselves may be. Plato and others may be right in holding that a regard for the rights of others never in the long run involves a loss of happiness for the agent, that "the just life profits a man." But this, even if true, is irrelevant to the rightness of the act. As soon as a man does an action *because* he thinks he will promote his own interests thereby, he is acting not from a sense of its rightness but from self-interest.

To the egoistic theory hedonistic utilitarianism supplies a much-needed amendment. It points out correctly that the fact that a certain pleasure will be

From *The Right and the Good* by W. D. Ross (1930). Reprinted by permission of Oxford University Press.

enjoyed by the agent is no reason why he *ought* to bring it into being rather than an equal or greater pleasure to be enjoyed by another, though, human nature being what it is, it makes it not unlikely that he *will* try to bring it into being. But hedonistic utilitarianism in its turn needs a correction. On reflection it seems clear that pleasure is not the only thing in life that we think good in itself, that for instance we think the possession of a good character, or an intelligent understanding of the world, as good or better. A great advance is made by the substitution of "productive of the greatest good" for "productive of the greatest pleasure."

Not only is this theory more attractive than hedonistic utilitarianism, but its logical relation to that theory is such that the latter could not be true unless *it* were true, while it might be true though hedonistic utilitarianism were not. It is in fact one of the logical bases of hedonistic utilitarianism. For the view that what produces the maximum pleasure is right has for its bases the views (1) that what produces the maximum good is right, and (2) that pleasure is the only thing good in itself. If they were not assuming that what produces the maximum *good* is right, the utilitarians' attempt to show that pleasure is the only thing good in itself, which is in fact the point they take most pains to establish, would have been quite irrelevant to their attempt to prove that only what produces the maximum *pleasure* is right. If, therefore, it can be shown that productivity of the maximum good is not what makes all right actions right, we shall *a fortiori* have refuted hedonistic utilitarianism.

When a plain man fulfils a promise because he thinks he ought to do so, it seems clear that he does so with no thought of its total consequences, still less with any opinion that these are likely to be the best possible. He thinks in fact much more of the past than of the future. What makes him think it right to act in a certain way is the fact that he has promised to do so—that and, usually, nothing more. That his act will produce the best possible consequences is not his reason for calling it right. What lends colour to the theory we are examining, then, is not the actions (which form probably a great majority of our

actions) in which some such reflection as "I have promised" is the only reason we give ourselves for thinking a certain action right, but the exceptional cases in which the consequences of fulfilling a promise (for instance) would be so disastrous to others that we judge it right not to do so. It must of course be admitted that such cases exist. If I have promised to meet a friend at a particular time for some trivial purpose, I should certainly think myself justified in breaking my engagement if by doing so I could prevent a serious accident or bring relief to the victims of one. And the supporters of the view we are examining hold that my thinking so is due to my thinking that I shall bring more good into existence by the one action than by the other. A different account may, however, be given of the matter, an account which will, I believe, show itself to be the true one. It may be said that besides the duty of fulfilling promises I have and recognize a duty of relieving distress,[2] and that when I think it right to do the latter at the cost of not doing the former, it is not because I think I shall produce more good thereby but because I think it the duty which is in the circumstances more of a duty. This account surely corresponds much more closely with what we really think in such a situation. If, so far as I can see, I could bring equal amounts of good into being by fulfilling my promise and by helping some one to whom I had made no promise, I should not hesitate to regard the former as my duty. Yet on the view that what is right is right because it is productive of the most good I should not so regard it.

There are two theories, each in its way simple, that offer a solution of such cases of conscience. One is the view of Kant, that there are certain duties of perfect obligation, such as those of fulfilling promises, of paying debts, of telling the truth, which admit of no exception whatever in favour of duties of imperfect obligation, such as that of relieving distress. The other is the view of, for instance, Professor Moore and Dr. Rashdall, that there is only the duty of producing good, and that all "conflicts of duties" should be resolved by asking "by which action will most good be produced?" But it is more important that our theory fit the facts than that it be simple, and the

account we have given above corresponds (it seems to me) better than either of the simpler theories with what we really think, viz. that normally promise-keeping, for example, should come before benevolence, but that when and only when the good to be produced by the benevolent act is very great and the promise comparatively trivial, the act of benevolence becomes our duty.

In fact the theory of "ideal utilitarianism," if I may for brevity refer so to the theory of Professor Moore, seems to simplify unduly our relations to our fellows. It says, in effect, that the only morally significant relation in which my neighbours stand to me is that of being possible beneficiaries by my action.[3] They do stand in this relation to me, and this relation is morally significant. But they may also stand to me in the relation of promisee to promiser, of creditor to debtor, of wife to husband, of child to parent, of friend to friend, of fellow countryman to fellow countryman, and the like; and each of these relations is the foundation of a *prima facie* duty, which is more or less incumbent on me according to the circumstances of the case. When I am in a situation, as perhaps I always am, in which more than one of these *prima facie* duties is incumbent on me, what I have to do is to study the situation as fully as I can until I form the considered opinion (it is never more) that in the circumstances one of them is more incumbent than any other; then I am bound to think that to do this *prima facie* duty is my duty *sans phrase* in the situation.

I suggest "*prima facie* duty" or "conditional duty" as a brief way of referring to the characteristic (quite distinct from that of being a duty proper) which an act has, in virtue of being of a certain kind (e.g. the keeping of a promise), of being an act which would be a duty proper if it were not at the same time of another kind which is morally significant. Whether an act is a duty proper or actual duty depends on *all* the morally significant kinds it is an instance of. The phrase "*prima facie* duty" must be apologized for, since (1) it suggests that what we are speaking of is a certain kind of duty, whereas it is in fact not a duty, but something related in a special way to duty.

Strictly speaking, we want not a phrase in which duty is qualified by an adjective, but a separate noun. (2) "*Prima*" *facie* suggests that one is speaking only of an appearance which a moral situation presents at first sight, and which may turn out to be illusory; whereas what I am speaking of is an objective fact involved in the nature of the situation, or more strictly in an element of its nature, though not, as duty proper does, arising from its *whole* nature. I can, however, think of no term which fully meets the case. "Claim" has been suggested by Professor Prichard. The word "claim" has the advantage of being quite a familiar one in this connexion, and it seems to cover much of the ground. It would be quite natural to say, "a person to whom I have made a promise has a claim on me," and also, "a person whose distress I could relieve (at the cost of breaking the promise) has a claim on me." But (1) while "claim" is appropriate from *their* point of view, we want a word to express the corresponding fact from the agent's point of view—the fact of his being subject to claims that can be made against him; and ordinary language provides us with no such correlative to "claim." And (2) (what is more important) "claim" seems inevitably to suggest two persons, one of whom might make a claim on the other; and while this covers the ground of social duty, it is inappropriate in the case of that important part of duty which is the duty of cultivating a certain kind of character in oneself. It would be artificial, I think, and at any rate metaphorical, to say that one's character has a claim on oneself.

There is nothing arbitary about these *prima facie* duties. Each rests on a definite circumstance which cannot seriously be held to be without moral significance. Of *prima facie* duties I suggest, without claiming completeness or finality for it, the following division.[4]

(1) Some duties rest on previous acts of my own. These duties seem to include two kinds, (*a*) those resting on a promise or what may fairly be called an implicit promise, such as the implicit undertaking not to tell lies which seems to be implied in the act of entering into conversation (at any rate by civilized men), or of writing books that purport to be history

and not fiction. These may be called the duties of fidelity. (*b*) Those resting on a previous wrongful act. These may be called the duties of reparation. (2) Some rest on previous acts of other men, i.e. services done by them to me. These may be loosely described as the duties of gratitude. (3) Some rest on the fact or possibility of a distribution of pleasure or happiness (or of the means thereto) which is not in accordance with the merit of the persons concerned; in such cases there arises a duty to upset or prevent such a distribution. These are the duties of justice. (4) Some rest on the mere fact that there are other beings in the world whose condition we can make better in respect of virtue, or of intelligence, or of pleasure. These are the duties of beneficence. (5) Some rest on the fact that we can improve our own condition in respect of virtue or of intelligence. These are the duties of self-improvement. (6) I think that we should distinguish from (4) the duties that may be summed up under the title of "not injuring others." No doubt to injure others is incidentally to fail to do them good; but it seems to me clear that non-maleficence is apprehended as a duty distinct from that of beneficence, and as a duty of a more stringent character. It will be noticed that this alone among the types of duty has been stated in a negative way. An attempt might no doubt be made to state this duty, like the others, in a positive way. It might be said that it is really the duty to prevent ourselves from acting either from an inclination to harm others or from an inclination to seek our own pleasure, in doing which we should incidentally harm them. But on reflection it seems clear that the primary duty here is the duty not to harm others, this being a duty whether or not we have an inclination that if followed would lead to our harming them; and that when we have such an inclination the primary duty not to harm others gives rise to a consequential duty to resist the inclination. The recognition of this duty of non-maleficence is the first step on the way to the recognition of the duty of beneficence; and that accounts for the prominence of the commands "thou shalt not kill," "thou shalt not commit adultery," "thou shalt not steal," "thou shalt not bear false witness," in so early a code as the Decalogue. But even when we have come to recognize the duty of beneficence, it appears to me that the duty of non-maleficence is recognized as a distinct one, and as *prima facie* more binding. We should not in general consider it justifiable to kill one person in order to keep another alive, or to steal from one in order to give alms to another.

The essential defect of the "ideal utilitarian" theory is that it ignores, or at least does not do full justice to, the highly personal character of duty. If the only duty is to produce the maximum of good, the question who is to have the good—whether it is myself, or my benefactor, or a person to whom I have made a promise to confer that good on him, or a mere fellow man to whom I stand in no such special relation—should make no difference to my having a duty to produce that good. But we are all in fact sure that it makes a vast difference.

One or two other comments must be made on this provisional list of the divisions of duty. (1) The nomenclature is not strictly correct. For by "fidelity" or "gratitude" we mean, strictly, certain states of motivation; and, as I have urged, it is not our duty to have certain motives, but to do certain acts. By "fidelity," for instance, is meant, strictly, the disposition to fulfil promises and implicit promises *because we have made them*. We have no general word to cover the actual fulfilment of promises and implicit promises *irrespective of motive;* and I use "fidelity," loosely but perhaps conveniently, to fill this gap. So too I use "gratitude" for the returning of services, irrespective of motive. The term "justice" is not so much confined, in ordinary usage, to a certain state of motivation, for we should often talk of a man as acting justly even when we did not think his motive was the wish to do what was just simply for the sake of doing so. Less apology is therefore needed for our use of "justice" in this sense. And I have used the word "beneficence" rather than "benevolence," in order to emphasize the fact that it is our duty to do certain things, and not to do them from certain motives.

(2) If the objection be made, that this catalogue of the main types of duty is an unsystematic one resting on no logical principle, it may be replied, first, that it makes no claim to being ultimate. It is a *prima facie* classification of the duties which

reflection on our moral convictions seems actually to reveal. And if these convictions are, as I would claim that they are, of the nature of knowledge, and if I have not misstated them, the list will be a list of authentic conditional duties, correct as far as it goes though not necessarily complete. The list of *goods* put forward by the rival theory is reached by exactly the same method—the only sound one in the circumstances—viz. that of direct reflection on what we really think. Loyalty to the facts is worth more than a symmetrical architectonic or a hastily reached simplicity. If further reflection discovers a perfect logical basis for this or for a better classification, so much the better.

(3) It may, again, be objected that our theory that there are these various and often conflicting types of *prima facie* duty leaves us with no principle upon which to discern what is our actual duty in particular circumstances. But this objection is not one which the rival theory is in a position to bring forward. For when we have to choose between the production of two heterogeneous goods, say knowledge and pleasure, the "ideal utilitarian" theory can only fall back on an opinion, for which no logical basis can be offered, that one of the goods is the greater; and this is no better than a similar opinion that one of two duties is the more urgent. And again, when we consider the infinite variety of the effects of our actions in the way of pleasure, it must surely be admitted that the claim which *hedonism* sometimes makes, that it offers a readily applicable criterion of right conduct, is quite illusory.

I am unwilling, however, to content myself with an *argumentum ad hominem*, and I would contend that in principle there is no reason to anticipate that every act that is our duty is so for one and the same reason. Why should two sets of circumstances, or one set of circumstances, *not* possess different characteristics, any one of which makes a certain act our *prima facie* duty? When I ask what it is that makes me in certain cases sure that I have a *prima facie* duty to do so and so, I find that it lies in the fact that I have made a promise; when I ask the same question in another case, I find the answer lies in the fact that I have done a wrong. And if on reflection I find (as

I think I do) that neither of these reasons is reducible to the other, I must not on any *a priori* ground assume that such a reduction is possible.

An attempt may be made to arrange in a more systematic way the main types of duty which we have indicated. In the first place it seems self-evident that if there are things that are intrinsically good, it is *prima facie* a duty to bring them into existence rather than not to do so, and to bring as much of them into existence as possible. It will be argued in our fifth chapter that there are three main things that are intrinsically good—virtue, knowledge, and, with certain limitations, pleasure. And since a given virtuous disposition, for instance, is equally good whether it is realized in myself or in another, it seems to be my duty to bring it into existence whether in myself or in another. So too with a given piece of knowledge.

The case of pleasure is difficult; for while we clearly recognize a duty to produce pleasure for others, it is by no means so clear that we recognize a duty to produce pleasure for ourselves. This appears to arise from the following facts. The thought of an act as our duty is one that presupposes a certain amount of reflection about the act; and for that reason does not normally arise in connexion with acts towards which we are already impelled by another strong impulse. So far, the cause of our thinking of the promotion of our own pleasure as a duty is analogous to the cause which usually prevents a highly sympathetic person from thinking of the promotion of the pleasure of others as a duty. He is impelled so strongly by direct interest in the well-being of others towards promoting their pleasure that he does not stop to ask whether it is his duty to promote it; and we are all impelled so strongly towards the promotion of our own pleasure that we do not stop to ask whether it is a duty or not. But there is a further reason why even when we stop to think about the matter it does not usually present itself as a duty: viz. that, since the performance of most of our duties involves the giving up of some pleasure that we desire, the doing of duty and the getting of pleasure for ourselves come by a natural association of ideas to be thought of as incompatible things. This association

of ideas is in the main salutary in its operation, since it puts a check on what but for it would be much too strong, the tendency to pursue one's own pleasure without thought of other considerations. Yet if pleasure is good, it seems in the long run clear that it is right to get it for ourselves as well as to produce it for others, when this does not involve the failure to discharge some more stringent *prima facie* duty. The question is a very difficult one, but it seems that this conclusion can be denied only on one or other of three grounds: (1) that pleasure is not *prima facie* good (i.e. good when it is neither the actualization of a bad disposition nor undeserved), (2) that there is no *prima facie* duty to produce as much that is good as we can, or (3) that though there is a *prima facie* duty to produce other things that are good, there is no *prima facie* duty to produce pleasure which will be enjoyed by ourselves. I give reasons later for not accepting the first contention. The second hardly admits of argument but seems to me plainly false. The third seems plausible only if we hold that an act that is pleasant or brings pleasure to ourselves must for that reason not be a duty; and this would lead to paradoxical consequences, such as that if a man enjoys giving pleasure to others or working for their moral improvement, it cannot be his duty to do so. Yet it seems to be a very stubborn fact, that in our ordinary consciousness we are not aware of a duty to get pleasure for ourselves; and by way of partial explanation of this I may add that though, as I think, one's own pleasure is a good and there is a duty to produce it, it is only if we *think* of our own pleasure not as simply our own pleasure, but as an objective good, something that an impartial spectator would approve, that we can think of the getting it as a duty; and we do not habitually think of it in this way.

If these contentions are right, what we have called the duty of beneficence and the duty of self-improvement rest on the same ground. No different principles of duty are involved in the two cases. If we feel a special responsibility for improving our own character rather than that of others, it is not because a special principle is involved, but because we are aware that the one is more under our control than the other. It was on this ground that Kant

expressed the practical law of duty in the form "seek to make yourself good and other people happy." He was so persuaded of the internality of virtue that he regarded any attempt by one person to produce virtue in another as bound to produce, at most, only a counterfeit of virtue, the doing of externally right acts not from the true principle of virtuous action but out of regard to another person. It must be admitted that one man cannot compel another to be virtuous; compulsory virtue would just not be virtue. But experience clearly shows that Kant overshoots the mark when he contends that one man cannot do anything to *promote* virtue in another, to bring such influences to bear upon him that his own response to them is more likely to be virtuous than his response to other influences would have been. And our duty to do this is not different in kind from our duty to improve our own characters.

It is equally clear, and clear at an earlier stage of moral development, that if there are things that are bad in themselves we ought, *prima facie*, not to bring them upon others; and on this fact rests the duty of non-maleficence.

The duty of justice is particularly complicated, and the word is used to cover things which are really very different—things such as the payment of debts, the reparation of injuries done by oneself to another, and the bringing about of a distribution of happiness between other people in proportion to merit. I use the word to denote only the last of these three. In the fifth chapter I shall try to show that besides the three (comparatively) simple goods, virtue, knowledge, and pleasure, there is a more complex good, not reducible to these, consisting in the proportionment of happiness to virtue. The bringing of this about is a duty which we owe to all men alike, though it may be reinforced by special responsibilities that we have undertaken to particular men. This, therefore, with beneficence and self-improvement, comes under the general principle that we should produce as much good as possible, though the good here involved is different in kind from any other.

But besides this general obligation, there are special obligations. These may arise, in the first place, incidentally, from acts which were not essentially

meant to create such an obligation, but which nevertheless create it. From the nature of the case such acts may be of two kinds—the infliction of injuries on others, and the acceptance of benefits from them. It seems clear that these put us under a special obligation to other men, and that only these acts can do so incidentally. From these arise the twin duties of reparation and gratitude.

And finally there are special obligations arising from acts the very intention of which, when they were done, was to put us under such an obligation. The name for such acts is "promises"; the name is wide enough if we are willing to include under it implicit promises, i.e. modes of behaviour in which without explicit verbal promise we intentionally create an expectation that we can be counted on to behave in a certain way in the interest of another person.

These seem to be, in principle, all the ways in which *prima facie* duties arise. In actual experience they are compounded together in highly complex ways. Thus, for example, the duty of obeying the laws of one's country arises partly (as Socrates contends in the *Crito*) from the duty of gratitude for the benefits one has received from it; partly from the implicit promise to obey which seems to be involved in permanent residence in a country whose laws we know we are *expected* to obey, and still more clearly involved when we ourselves invoke the protection of its laws (this is the truth underlying the doctrine of the social contract); and partly (if we are fortunate in our country) from the fact that its laws are potent instruments for the general good.

Or again, the sense of a general obligation to bring about (so far as we can) a just apportionment of happiness to merit is often greatly reinforced by the fact that many of the existing injustices are due to a social and economic system which we have, not indeed created, but taken part in and assented to; the duty of justice is then reinforced by the duty of reparation.

It is necessary to say something by way of clearing up the relation between *prima facie* duties and the actual or absolute duty to do one particular act in particular circumstances. If, as almost all moralists except Kant are agreed, and as most plain men think, it is sometimes right to tell a lie or to break a promise, it must be maintained that there is a difference between *prima facie* duty and actual or absolute duty. When we think ourselves justified in breaking, and indeed morally obliged to break, a promise in order to relieve some one's distress, we do not for a moment cease to recognize a *prima facie* duty to keep our promise, and this leads us to feel, not indeed shame or repentance, but certainly compunction, for behaving as we do; we recognize, further, that it is our duty to make up somehow to the promisee for the breaking of the promise. We have to distinguish from the characteristic of being our duty that of tending to be our duty. Any act that we do contains various elements in virtue of which it falls under various categories. In virtue of being the breaking of a promise, for instance, it tends to be wrong; in virtue of being an instance of relieving distress it tends to be right. Tendency to be one's duty may be called a parti-resultant attribute, i.e. one which belongs to an act in virtue of some one component in its nature. *Being* one's duty is a toti-resultant attribute, one which belongs to an act in virtue of its whole nature and of nothing less than this. This distinction between parti-resultant and toti-resultant attributes is one which we shall meet in another context also.

Another instance of the same distinction may be found in the operation of natural laws. *Qua* subject to the force of gravitation towards some other body, each body tends to move in a particular direction with a particular velocity; but its actual movement depends on *all* the forces to which it is subject. It is only by recognizing this distinction that we can preserve the absoluteness of laws of nature, and only by recognizing a corresponding distinction that we can preserve the absoluteness of the general principles of morality. But an important difference between the two cases must be pointed out. When we say that in virtue of gravitation a body tends to move in a certain way, we are referring to a causal influence actually exercised on it by another body or other bodies. When we say that in virtue of being deliberately untrue a certain remark tends to be wrong, we are referring to no causal relation, to no relation that involves succession in time, but to such a relation as

connects the various attributes of a mathematical figure. And if the word "tendency" is thought to suggest too much a causal relation, it is better to talk of certain types of act as being *prima facie* right or wrong (or of different persons as having different and possibly conflicting claims upon us), than of their tending to be right or wrong.

Something should be said of the relation between our apprehension of the *prima facie* rightness of certain types of act and our mental attitude towards particular acts. It is proper to use the word "apprehension" in the former case and not in the latter. That an act, *qua* fulfilling a promise, or *qua* effecting a just distribution of good, or *qua* returning services rendered, or *qua* promoting the good of others, or *qua* promoting the virtue or insight of the agent, is *prima facie* right, is self-evident; not in the sense that it is evident from the beginning of our lives, or as soon as we attend to the proposition for the first time, but in the sense that when we have reached sufficient mental maturity and have given sufficient attention to the proposition it is evident without any need of proof, or of evidence beyond itself. It is self-evident just as a mathematical axiom, or the validity of a form of inference, is evident. The moral order expressed in these propositions is just as much part of the fundamental nature of the universe (and, we may add, of any possible universe in which there were moral agents at all) as is the spatial or numerical structure expressed in the axioms of geometry or arithmetic. In our confidence that these propositions are true there is involved the same trust in our reason that is involved in our confidence in mathematics; and we should have no justification for trusting it in the latter sphere and distrusting it in the former. In both cases we are dealing with propositions that cannot be proved, but that just as certainly need no proof.

Some of these general principles of *prima facie* duty may appear to be open to criticism. It may be thought, for example, that the principle of returning good for good is a falling off from the Christian principle, generally and rightly recognized as expressing the highest morality, of returning good for evil. To this it may be replied that I do not suggest that there is a principle commanding us to return good for good and forbidding us to return good for evil, and that I do suggest that there is a positive duty to seek the good of all men. What I maintain is that an act in which good is returned for good is recognized as *specially* binding on us just because it is of that character, and that *ceteris paribus* any one would think it his duty to help his benefactors rather than his enemies, if he could not do both; just as it is generally recognized that *ceteris paribus* we should pay our debts rather than give our money in charity, when we cannot do both. A benefactor is not only a man, calling for our effort on his behalf on that ground, but also our benefactor, calling for our *special* effort on *that* ground.

Our judgements about our actual duty in concrete situations have none of the certainty that attaches to our recognition of the general principles of duty. A statement is certain, i.e. is an expression of knowledge, only in one or other of two cases: when it is either self-evident, or a valid conclusion from self-evident premisses. And our judgements about our particular duties have neither of these characters. (1) They are not self-evident. Where a possible act is seen to have two characteristics, in virtue of one of which it is *prima facie* right, and in virtue of the other *prima facie* wrong, we are (I think) well aware that we are not certain whether we ought or ought not to do it; that whether we do it or not, we are taking a moral risk. We come in the long run, after consideration, to think one duty more pressing than the other, but we do not feel certain that it is so. And though we do not always recognize that a possible act has two such characteristics, and though there *may* be cases in which it has not, we are never certain that any particular possible act has not, and therefore never certain that it is right, nor certain that it is wrong. For, to go no further in the analysis, it is enough to point out that any particular act will in all probability in the course of time contribute to the bringing about of good or of evil for many human beings, and thus have a *prima facie* rightness or wrongness of which we know nothing. (2) Again, our judgements about our particular duties are not logical conclusions from self-evident premisses. The only possible premisses would be the general principles stating their *prima facie* rightness or wrongness *qua* having the different characteristics

they do have; and even if we could (as we cannot) apprehend the extent to which an act will tend on the one hand, for example, to bring about advantages for our benefactors, and on the other hand to bring about disadvantages for fellow men who are not our benefactors, there is no principle by which we can draw the conclusion that it is on the whole right or on the whole wrong. In this respect the judgement as to the rightness of a particular act is just like the judgement as to the beauty of a particular natural object or work of art. A poem is, for instance, in respect of certain qualities beautiful and in respect of certain others not beautiful; and our judgement as to the degree of beauty it possesses on the whole is never reached by logical reasoning from the apprehension of its particular beauties or particular defects. Both in this and in the moral case we have more or less probable opinions which are not logically justified conclusions from the general principles that are recognized as self-evident.

There is therefore much truth in the description of the right act as a fortunate act. If we cannot be certain that it is right, it is our good fortune if the act we do is the right act. This consideration does not, however, make the doing of our duty a mere matter of chance. There is a parallel here between the doing of duty and the doing of what will be to our personal advantage. We never *know* what act will in the long run be to our advantage. Yet it is certain that we are more likely in general to secure our advantage if we estimate to the best of our ability the probable tendencies of our actions in this respect, than if we act on caprice. And similarly we are more likely to do our duty if we reflect to the best of our ability on the *prima facie* rightness or wrongness of various possible acts in virtue of the characteristics we perceive them to have, than if we act without reflection. With this greater likelihood we must be content.

Many people would be inclined to say that the right act for me is not that whose general nature I have been describing, viz. that which if I were omniscient I should see to be my duty, but that which on all the evidence available to me I should think to be my duty. But suppose that from the state of partial knowledge in which I think act *A* to be my duty, I could pass to a state of perfect knowledge in which I saw act *B* to be my duty should I not say "act *B* was the right act for me to do"? I should no doubt add "though I am not to be blamed for doing act *A*." But in adding this am I not passing from the question "what is right" to the question "what is morally good"? At the same time I am not making the *full* passage from the one notion to the other; for in order that the act should be morally good, or an act I am not to be blamed for doing, it must not merely be the act which it is reasonable for me to think my duty; it must also be done for that reason, or from some other morally good motive. Thus the conception of the right act as the act which it is reasonable for me to think my duty is an unsatisfactory compromise between the true notion of the right act and the notion of the morally good action.

The general principles of duty are obviously not self-evident from the beginning of our lives. How do they come to be so? The answer is, that they come to be self-evident to us just as mathematical axioms do. We find by experience that this couple of matches and that couple make four matches, that this couple of balls on a wire and that couple make four balls; and by reflection on these and similar discoveries we come to see that it is of the nature of two and two to make four. In a precisely similar way, we see the *prima facie* rightness of an act which would be the fulfilment of a particular promise, and of another which would be the fulfilment of another promise, and when we have reached sufficient maturity to think in general terms, we apprehend *prima facie* rightness to belong to the nature of any fulfilment of promise. What comes first in time is the apprehension of the self-evident *prima facie* rightness of an individual act of a particular type. From this we come by reflection to apprehend the self-evident general principle of *prima facie* duty. From this, too, perhaps along with the apprehension of the self-evident *prima facie* rightness of the same act in virtue of its having another characteristic as well, and perhaps in spite of the apprehension of its *prima facie* wrongness in virtue of its having some third characteristic, we come to believe something not self-evident at all, but an object of probable opinion,

viz. that this particular act is (not *prima facie* but) actually right.

In this respect there is an important difference between rightness and mathematical properties. A triangle which is isosceles necessarily has two of its angles equal, whatever other characteristics the triangle may have—whatever, for instance, be its area, or the size of its third angle. The equality of the two angles is a parti-resultant attribute. And the same is true of all mathematical attributes. It is true, I may add, of *prima facie* rightness. But no act is ever, in virtue of falling under some general description, necessarily actually right; its rightness depends on its whole nature[5] and not on any element in it. The reason is that no mathematical object (no figure, for instance, or angle) ever has two characteristics that tend to give it opposite resultant characteristics, while moral acts often (as every one knows) and indeed always (as on reflection we must admit) have different characteristics that tend to make them at the same time *prima facie* right and *prima facie* wrong; there is probably no act, for instance, which does good to any one without doing harm to some one else, and *vice versa*.

Notes

1. I take the theory which, as I have tried to show, seems to be put forward in *Ethics* rather than the earlier and less plausible theory put forward in *Principia Ethica*.

2. These are not strictly speaking duties, but things that tend to be our duty, or *prima facie* duties.

3. Some will think it, apart from other considerations, a sufficient refutation of this view to point out that I also stand in that relation to myself, so that for this view the distinction of oneself from others is morally insignificant.

4. I should make it plain at this stage that I am *assuming* the correctness of some of our main convictions as to *prima facie* duties, or, more strictly, am claiming that we *know* them to be true. To me it seems as self-evident as anything could be, that to make a promise, for instance, is to create a moral claim on us in someone else. Many readers will perhaps say that they do *not* know this to be true. If so, I certainly cannot prove it to them; I can only ask them to reflect again, in the hope that they will ultimately agree that they also know it to be true. The main moral convictions of the plain man seem to me to be, not opinions which it is for philosophy to prove or disprove, but knowledge from the start; and in my own case I seem to find little difficulty in distinguishing these essential convictions from other moral convictions which I also have, which are merely fallible opinions based on an imperfect study of the working for good or evil of certain institutions or types of action.

5. To avoid complicating unduly the statement of the general view I am putting forward, I have here rather overstated it. Any act is the origination of a great variety of things many of which make no difference to its rightness or wrongness. But there are always many elements in its nature (i.e. in what it is the origination of) that make a difference to its rightness or wrongness, and no element in its nature can be dismissed without consideration as indifferent.

Study Questions

1. According to Ross, what is a prima facie duty?

2. Does Ross believe you are ever justified in telling a lie?

3. How do we decide if a duty is self-evident?

4. Might a self-evident claim be mistaken?

26

JOHN RAWLS

John Rawls (1921–2002) was professor of philosophy at Harvard University. He proposed that justice was the social arrangement that would be chosen by the members of society if they did not know either their individual places in that society or their own personal characteristics, such as race, gender, or class. Rawls claimed that in "the original position" in which all are behind "a veil of ignorance," the parties would choose two fundamental principles: first, equality of rights and liberties for all; and second, the arrangement of social and economic inequalities so that both are (a) to the greatest benefit of the least advantaged, "the difference principle," and (b) attached to positions and offices open to all, a condition that has not received the extensive attention given to the difference principle. Rawls argued against utilitarianism on the grounds that its principle of maximizing happiness for the greatest number allows individual concerns to be sacrificed to social preferences.

A Theory of Justice

3. THE MAIN IDEA
OF THE THEORY OF JUSTICE

My aim is to present a conception of justice which generalizes and carries to a higher level of abstraction the familiar theory of the social contract as found, say, in Locke, Rousseau, and Kant.[1] In order to do this we are not to think of the original contract as one to enter a particular society or to set up a particular form of government. Rather, the guiding idea is that the principles of justice for the basic structure of society are the object of the original agreement. They are the principles that free and rational persons concerned to further their own interests would accept in an initial position of equality as defining the fundamental terms of their association. These principles are to regulate all further agreements; they specify the kinds of social cooperation that can be entered into and the forms of government that can be established. This way of regarding the principles of justice I shall call justice as fairness.

Thus we are to imagine that those who engage in social cooperation choose together, in one joint act, the principles which are to assign basic rights and duties and to determine the division of social benefits. Men are to decide in advance how they are to regulate their claims against one another and what is to be the foundation charter of their society. Just as each person must decide by rational reflection what constitutes his good, that is, the system of ends which it is rational for him to pursue, so a group of persons must decide once and for all what is to count among them as just

and unjust. The choice which rational men would make in this hypothetical situation of equal liberty, assuming for the present that this choice problem has a solution, determines the principles of justice.

In justice as fairness the original position of equality corresponds to the state of nature in the traditional theory of the social contract. This original position is not, of course, thought of as an actual historical state of affairs, much less as a primitive condition of culture. It is understood as a purely hypothetical situation characterized so as to lead to a certain conception of justice.[2] Among the essential features of this situation is that no one knows his place in society, his class position or social status, nor does any one know his fortune in the distribution of natural assets and abilities, his intelligence, strength, and the like. I shall even assume that the parties do not know their conceptions of the good or their special psychological propensities. The principles of justice are chosen behind a veil of ignorance. This ensures that no one is advantaged or disadvantaged in the choice of principles by the outcome of natural chance or the contingency of social circumstances. Since all are similarly situated and no one is able to design principles to favor his particular condition, the principles of justice are the result of a fair agreement or bargain. For given the circumstances of the original position, the symmetry of everyone's relations to each other, this initial situation is fair between individuals as moral persons, that is, as rational beings with their own ends and capable, I shall assume, of a sense of justice. The original position is, one might say, the appropriate initial status quo, and thus the fundamental agreements reached in it are fair. This explains the propriety of the name "justice as fairness": it conveys the idea that the principles of justice are agreed to in an initial situation that is fair. The name does not mean that the concepts of justice and fairness are the same, any more than the phrase "poetry as metaphor" means that the concepts of poetry and metaphor are the same.

Justice as fairness begins, as I have said, with one of the most general of all choices which persons might make together, namely, with the choice of the first principles of a conception of justice which is to regulate all subsequent criticism and reform of institutions. Then, having chosen a conception of justice, we can suppose that they are to choose a constitution and a legislature to enact laws, and so on, all in accordance with the principles of justice initially agreed upon. Our social situation is just if it is such that by this sequence of hypothetical agreements we would have contracted into the general system of rules which defines it. Moreover, assuming that the original position does determine a set of principles (that is, that a particular conception of justice would be chosen), it will then be true that whenever social institutions satisfy these principles those engaged in them can say to one another that they are cooperating on terms to which they would agree if they were free and equal persons whose relations with respect to one another were fair. They could all view their arrangements as meeting the stipulations which they would acknowledge in an initial situation that embodies widely accepted and reasonable constraints on the choice of principles. The general recognition of this fact would provide the basis for a public acceptance of the corresponding principles of justice. No society can, of course, be a scheme of cooperation which men enter voluntarily in a literal sense; each person finds himself placed at birth in some particular position in some particular society, and the nature of this position materially affects his life prospects. Yet a society satisfying the principles of justice as fairness comes as close as a society can to being a voluntary scheme, for it meets the principles which free and equal persons would assent to under circumstances that are fair. In this sense its members are autonomous and the obligations they recognize self-imposed.

One feature of justice as fairness is to think of the parties in the initial situation as rational and mutually disinterested. This does not mean that the parties are egoists, that is, individuals with only certain kinds of interests, say in wealth, prestige, and domination. But they are conceived as not taking an interest in one another's interests. They are to presume that even their spiritual aims may be opposed, in the way that the aims of those of different religions may be opposed. Moreover, the concept of rationality must be interpreted as far as possible in the narrow sense,

standard in economic theory, of taking the most effective means to given ends. I shall modify this concept to some extent, as explained later, but one must try to avoid introducing into it any controversial ethical elements. The initial situation must be characterized by stipulations that are widely accepted.

In working out the conception of justice as fairness one main task clearly is to determine which principles of justice would be chosen in the original position. To do this we must describe this situation in some detail and formulate with care the problem of choice which it presents. These matters I shall take up in the immediately succeeding chapters. It may be observed, however, that once the principles of justice are thought of as arising from an original agreement in a situation of equality, it is an open question whether the principle of utility would be acknowledged. Off-hand it hardly seems likely that persons who view themselves as equals, entitled to press their claims upon one another, would agree to a principle which may require lesser life prospects for some simply for the sake of a greater sum of advantages enjoyed by others. Since each desires to protect his interests, his capacity to advance his conception of the good, no one has a reason to acquiesce in an enduring loss for himself in order to bring about a greater net balance of satisfaction. In the absence of strong and lasting benevolent impulses, a rational man would not accept a basic structure merely because it maximized the algebraic sum of advantages irrespective of its permanent effects on his own basic rights and interests. Thus it seems that the principle of utility is incompatible with the conception of social cooperation among equals for mutual advantage. It appears to be inconsistent with the idea of reciprocity implicit in the notion of a well-ordered society. Or, at any rate, so I shall argue.

I shall maintain instead that the persons in the initial situation would choose two rather different principles: the first requires equality in the assignment of basic rights and duties, while the second holds that social and economic inequalities, for example inequalities of wealth and authority, are just only if they result in compensating benefits for everyone, and in particular for the least advantaged members of society. These principles rule out justifying institutions on the grounds that the hardships of some are offset by a greater good in the aggregate. It may be expedient but it is not just that some should have less in order that others may prosper. But there is no injustice in the greater benefits earned by a few provided that the situation of persons not so fortunate is thereby improved. The intuitive idea is that since everyone's well-being depends upon a scheme of cooperation without which no one could have a satisfactory life, the division of advantages should be such as to draw forth the willing cooperation of everyone taking part in it, including those less well situated. The two principles mentioned seem to be a fair basis on which those better endowed, or more fortunate in their social position, neither of which we can be said to deserve, could expect the willing cooperation of others when some workable scheme is a necessary condition of the welfare of all.[3] Once we decide to look for a conception of justice that prevents the use of the accidents of natural endowment and the contingencies of social circumstance as counters in a quest for political and economic advantage, we are led to these principles. They express the result of leaving aside those aspects of the social world that seem arbitrary from a moral point of view.

The problem of the choice of principles, however, is extremely difficult. I do not expect the answer I shall suggest to be convincing to everyone. It is, therefore, worth noting from the outset that justice as fairness, like other contract views, consists of two parts: (1) an interpretation of the initial situation and of the problem of choice posed there, and (2) a set of principles which, it is argued, would be agreed to. One may accept the first part of the theory (or some variant thereof), but not the other, and conversely. The concept of the initial contractual situation may seem reasonable although the particular principles proposed are rejected. To be sure, I want to maintain that the most appropriate conception of this situation does lead to principles of justice contrary to utilitarianism and perfectionism, and therefore that the contract doctrine provides an alternative to these views. Still, one may dispute this contention even though one grants that the contractarian method is a useful

way of studying ethical theories and of setting forth their underlying assumptions.

Justice as fairness is an example of what I have called a contract theory. Now there may be an objection to the term "contract" and related expressions, but I think it will serve reasonably well. Many words have misleading connotations which at first are likely to confuse. The terms "utility" and "utilitarianism" are surely no exception. They too have unfortunate suggestions which hostile critics have been willing to exploit; yet they are clear enough for those prepared to study utilitarian doctrine. The same should be true of the term "contract" applied to moral theories. As I have mentioned, to understand it one has to keep in mind that it implies a certain level of abstraction. In particular, the content of the relevant agreement is not to enter a given society or to adopt a given form of government, but to accept certain moral principles. Moreover, the undertakings referred to are purely hypothetical: a contract view holds that certain principles would be accepted in a well-defined initial situation.

The merit of the contract terminology is that it conveys the idea that principles of justice may be conceived as principles that would be chosen by rational persons, and that in this way conceptions of justice may be explained and justified. The theory of justice is a part, perhaps the most significant part, of the theory of rational choice. Furthermore, principles of justice deal with conflicting claims upon the advantages won by social cooperation; they apply to the relations among several persons or groups. The word "contract" suggests this plurality as well as the condition that the appropriate division of advantages must be in accordance with principles acceptable to all parties. The condition of publicity for principles of justice is also connoted by the contract phraseology. Thus, if these principles are the outcome of an agreement, citizens have a knowledge of the principles that others follow. It is characteristic of contract theories to stress the public nature of political principles. Finally there is the long tradition of the contract doctrine. Expressing the tie with this line of thought helps to define ideas and accords with natural piety. There are then several advantages in the use of the term "contract." With due precautions taken, it should not be misleading. . . .

4. THE ORIGINAL POSITION AND JUSTIFICATION

I have said that the original position is the appropriate initial status quo which insures that the fundamental agreements reached in it are fair. This fact yields the name "justice as fairness." It is clear, then, that I want to say that one conception of justice is more reasonable than another, or justifiable with respect to it, if rational persons in the initial situation would choose its principles over those of the other for the role of justice. Conceptions of justice are to be ranked by their acceptability to persons so circumstanced. Understood in this way the question of justification is settled by working out a problem of deliberation: we have to ascertain which principles it would be rational to adopt given the contractual situation. This connects the theory of justice with the theory of rational choice.

If this view of the problem of justification is to succeed, we must, of course, describe in some detail the nature of this choice problem. A problem of rational decision has a definite answer only if we know the beliefs and interests of the parties, their relations with respect to one another, the alternatives between which they are to choose, the procedure whereby they make up their minds, and so on. As the circumstances are presented in different ways, correspondingly different principles are accepted. The concept of the original position, as I shall refer to it, is that of the most philosophically favored interpretation of this initial choice situation for the purposes of a theory of justice.

But how are we to decide what is the most favored interpretation? I assume, for one thing, that there is a broad measure of agreement that principles of justice should be chosen under certain conditions. To justify a particular description of the initial situation one shows that it incorporates these commonly shared presumptions. One argues from widely accepted but weak premises to more specific conclusions. Each of the presumptions should itself be natural and plausible; some of them may seem innocuous or even trivial. The aim of the contract approach is to establish that taken together they impose significant bounds on

acceptable principles of justice. The ideal outcome would be that these conditions determine a unique set of principles; but I shall be satisfied if they suffice to rank the main traditional conceptions of social justice.

One should not be misled, then, by the somewhat unusual conditions which characterize the original position. The idea here is simply to make vivid to ourselves the restrictions that it seems reasonable to impose on arguments for principles of justice, and therefore on these principles themselves. Thus it seems reasonable and generally acceptable that no one should be advantaged or disadvantaged by natural fortune or social circumstances in the choice of principles. It also seems widely agreed that it should be impossible to tailor principles to the circumstances of one's own case. We should insure further that particular inclinations and aspirations, and persons' conceptions of their good do not affect the principles adopted. The aim is to rule out those principles that it would be rational to propose for acceptance, however little the chance of success, only if one knew certain things that are irrelevant from the standpoint of justice. For example, if a man knew that he was wealthy, he might find it rational to advance the principle that various taxes for welfare measures be counted unjust; if he knew that he was poor, he would most likely propose the contrary principle. To represent the desired restrictions one imagines a situation in which everyone is deprived of this sort of information. One excludes the knowledge of those contingencies which sets men at odds and allows them to be guided by their prejudices. In this manner the veil of ignorance is arrived at in a natural way. This concept should cause no difficulty if we keep in mind the constraints on arguments that it is meant to express. At any time we can enter the original position, so to speak, simply by following a certain procedure, namely, by arguing for principles of justice in accordance with these restrictions.

It seems reasonable to suppose that the parties in the original position are equal. That is, all have the same rights in the procedure for choosing principles; each can make proposals, submit reasons for their acceptance, and so on. Obviously the purpose of these conditions is to represent equality between human beings as moral persons, as creatures having a conception of their good and capable of a sense of justice. The basis of equality is taken to be similarity in these two respects. Systems of ends are not ranked in value; and each man is presumed to have the requisite ability to understand and to act upon whatever principles are adopted. Together with the veil of ignorance, these conditions define the principles of justice as those which rational persons concerned to advance their interests would consent to as equals when none are known to be advantaged or disadvantaged by social and natural contingencies.

There is, however, another side to justifying a particular description of the original position. This is to see if the principles which would be chosen match our considered convictions of justice or extend them in an acceptable way. We can note whether applying these principles would lead us to make the same judgments about the basic structure of society which we now make intuitively and in which we have the greatest confidence; or whether, in cases where our present judgments are in doubt and given with hesitation, these principles offer a resolution which we can affirm on reflection. There are questions which we feel sure must be answered in a certain way. For example, we are confident that religious intolerance and racial discrimination are unjust. We think that we have examined these things with care and have reached what we believe is an impartial judgment not likely to be distorted by an excessive attention to our own interests. These convictions are provisional fixed points which we presume any conception of justice must fit. But we have much less assurance as to what is the correct distribution of wealth and authority. Here we may be looking for a way to remove our doubts. We can check an interpretation of the initial situation, then, by the capacity of its principles to accommodate our firmest convictions and to provide guidance where guidance is needed.

In searching for the most favored description of this situation we work from both ends. We begin by describing it so that it represents generally shared and preferably weak conditions. We then see if these conditions are strong enough to yield a significant

set of principles. If not, we look for further premises equally reasonable. But if so, and these principles match our considered convictions of justice, then so far well and good. But presumably there will be discrepancies. In this case we have a choice. We can either modify the account of the initial situation or we can revise our existing judgments, for even the judgments we take provisionally as fixed points are liable to revision. By going back and forth, sometimes altering the conditions of the contractual circumstances, at others withdrawing our judgments and conforming them to principle, I assume that eventually we shall find a description of the initial situation that both expresses reasonable conditions and yields principles which match our considered judgments duly pruned and adjusted. This state of affairs I refer to as reflective equilibrium.[4] It is an equilibrium because at last our principles and judgments coincide; and it is reflective since we know to what principles our judgments conform and the premises of their derivation. At the moment everything is in order. But this equilibrium is not necessarily stable. It is liable to be upset by further examination of the conditions which should be imposed on the contractual situation and by particular cases which may lead us to revise our judgments. Yet for the time being we have done what we can to render coherent and to justify our convictions of social justice. We have reached a conception of the original position.

I shall not, of course, actually work through this process. Still, we may think of the interpretation of the original position that I shall present as the result of such a hypothetical course of reflection. It represents the attempt to accommodate within one scheme both reasonable philosophical conditions on principles as well as our considered judgments of justice. In arriving at the favored interpretation of the initial situation there is no point at which an appeal is made to self-evidence in the traditional sense either of general conceptions or particular convictions. I do not claim for the principles of justice proposed that they are necessary truths or derivable from such truths. A conception of justice cannot be deduced from self-evident premises or conditions on principles; instead, its justification is a matter of the mutual support of many considerations, of everything fitting together into one coherent view.

A final comment. We shall want to say that certain principles of justice are justified because they would be agreed to in an initial situation of equality. I have emphasized that this original position is purely hypothetical. It is natural to ask why, if this agreement is never actually entered into, we should take any interest in these principles, moral or otherwise. The answer is that the conditions embodied in the description of the original position are ones that we do in fact accept. Or if we do not, then perhaps we can be persuaded to do so by philosophical reflection. Each aspect of the contractual situation can be given supporting grounds. Thus what we shall do is to collect together into one conception a number of conditions on principles that we are ready upon due consideration to recognize as reasonable. These constraints express what we are prepared to regard as limits on fair terms of social cooperation. One way to look at the idea of the original position, therefore, is to see it as an expository device which sums up the meaning of these conditions and helps us to extract their consequences. On the other hand, this conception is also an intuitive notion that suggests its own elaboration, so that led on by it we are drawn to define more clearly the standpoint from which we can best interpret moral relationships. We need a conception that enables us to envision our objective from afar: the intuitive notion of the original position is to do this for us.[5]

5. CLASSICAL UTILITARIANISM

There are many forms of utilitarianism, and the development of the theory has continued in recent years. I shall not survey these forms here, nor take account of the numerous refinements found in contemporary discussions. My aim is to work out a theory of justice that represents an alternative to utilitarian thought generally and so to all of these different versions of it. I believe that the contrast between the contract view and utilitarianism remains essentially the same in all these cases. Therefore I shall compare justice as fairness with familiar variants of intuitionism, perfectionism,

and utilitarianism in order to bring out the underlying differences in the simplest way. With this end in mind, the kind of utilitarianism I shall describe here is the strict classical doctrine which receives perhaps its clearest and most accessible formulation in Sidgwick. The main idea is that society is rightly ordered, and therefore just, when its major institutions are arranged so as to achieve the greatest net balance of satisfaction summed over all the individuals belonging to it.[6]

We may note first that there is, indeed, a way of thinking of society which makes it easy to suppose that the most rational conception of justice is utilitarian. For consider: each man in realizing his own interests is certainly free to balance his own losses against his own gains. We may impose a sacrifice on ourselves now for the sake of a greater advantage later. A person quite properly acts, at least when others are not affected, to achieve his own greatest good, to advance his rational ends as far as possible. Now why should not a society act on precisely the same principle applied to the group and therefore regard that which is rational for one man as right for an association of men? Just as the well-being of a person is constructed from the series of satisfactions that are experienced at different moments in the course of his life, so in very much the same way the well-being of society is to be constructed from the fulfillment of the systems of desires of the many individuals who belong to it. Since the principle for an individual is to advance as far as possible his own welfare, his own system of desires, the principle for society is to advance as far as possible the welfare of the group, to realize to the greatest extent the comprehensive system of desire arrived at from the desires of its members. Just as an individual balances present and future gains against present and future losses, so a society may balance satisfactions and dissatisfactions between different individuals. And so by these reflections one reaches the principle of utility in a natural way: a society is properly arranged when its institutions maximize the net balance of satisfaction. The principle of choice for an association of men is interpreted as an extension of the principle of choice for one man. Social justice is the principle of rational prudence applied to an aggregative conception of the welfare of the group.[7]

This idea is made all the more attractive by a further consideration. The two main concepts of ethics are those of the right and the good; the concept of a morally worthy person is, I believe, derived from them. The structure of an ethical theory is, then, largely determined by how it defines and connects these two basic notions. Now it seems that the simplest way of relating them is taken by teleological theories: the good is defined independently from the right, and then the right is defined as that which maximizes the good.[8] More precisely, those institutions and acts are right which of the available alternatives produce the most good, or at least as much good as any of the other institutions and acts open as real possibilities (a rider needed when the maximal class is not a singleton). Teleological theories have a deep intuitive appeal since they seem to embody the idea of rationality. It is natural to think that rationality is maximizing something and that in morals it must be maximizing the good. Indeed, it is tempting to suppose that it is self-evident that things should be arranged so as to lead to the most good.

It is essential to keep in mind that in a teleological theory the good is defined independently from the right. This means two things. First, the theory accounts for our considered judgments as to which things are good (our judgments of value) as a separate class of judgments intuitively distinguishable by common sense, and then proposes the hypothesis that the right is maximizing the good as already specified. Second, the theory enables one to judge the goodness of things without referring to what is right. For example, if pleasure is said to be the sole good, then presumably pleasures can be recognized and ranked in value by criteria that do not presuppose any standards of right, or what we would normally think of as such. Whereas if the distribution of goods is also counted as a good, perhaps a higher order one, and the theory directs us to produce the most good (including the good of distribution among others), we no longer have a teleological view in the classical sense. The problem of distribution falls under the concept of right as one intuitively understands it, and so the theory lacks an independent definition of the good. The clarity and simplicity of classical

teleological theories derives largely from the fact that they factor our moral judgments into two classes, the one being characterized separately while the other is then connected with it by a maximizing principle.

Teleological doctrines differ, pretty clearly, according to how the conception of the good is specified. If it is taken as the realization of human excellence in the various forms of culture, we have what may be called perfectionism. This notion is found in Aristotle and Nietzsche, among others. If the good is defined as pleasure, we have hedonism; if as happiness, eudaimonism, and so on. I shall understand the principle of utility in its classical form as defining the good as the satisfaction of desire, or perhaps better, as the satisfaction of rational desire. This accords with the view in all essentials and provides, I believe, a fair interpretation of it. The appropriate terms of social cooperation are settled by whatever in the circumstances will achieve the greatest sum of satisfaction of the rational desires of individuals. It is impossible to deny the initial plausibility and attractiveness of this conception.

The striking feature of the utilitarian view of justice is that it does not matter, except indirectly, how this sum of satisfactions is distributed among individuals any more than it matters, except indirectly, how one man distributes his satisfactions over time. The correct distribution in either case is that which yields the maximum fulfillment. Society must allocate its means of satisfaction whatever these are, rights and duties, opportunities and privileges, and various forms of wealth, so as to achieve this maximum if it can. But in itself no distribution of satisfaction is better than another except that the more equal distribution is to be preferred to break ties.[9] It is true that certain common sense precepts of justice, particularly those which concern the protection of liberties and rights, or which express the claims of desert, seem to contradict this contention. But from a utilitarian standpoint the explanation of these precepts and of their seemingly stringent character is that they are those precepts which experience shows should be strictly respected and departed from only under exceptional circumstances if the sum of advantages is to be maximized.[10] Yet, as with all other precepts,

those of justice are derivative from the one end of attaining the greatest balance of satisfaction. Thus there is no reason in principle why the greater gains of some should not compensate for the lesser losses of others; or more importantly, why the violation of the liberty of a few might not be made right by the greater good shared by many. It simply happens that under most conditions, at least in a reasonably advanced stage of civilization, the greatest sum of advantages is not attained in this way. No doubt the strictness of common sense precepts of justice has a certain usefulness in limiting men's propensities to injustice and to socially injurious actions, but the utilitarian believes that to affirm this strictness as a first principle of morals is a mistake. For just as it is rational for one man to maximize the fulfillment of his system of desires, it is right for a society to maximize the net balance of satisfaction taken over all of its members.

The most natural way, then, of arriving at utilitarianism (although not, of course, the only way of doing so) is to adopt for society as a whole the principle of rational choice for one man. Once this is recognized, the place of the impartial spectator and the emphasis on sympathy in the history of utilitarian thought is readily understood. For it is by the conception of the impartial spectator and the use of sympathetic identification in guiding our imagination that the principle for one man is applied to society. It is this spectator who is conceived as carrying out the required organization of the desires of all persons into one coherent system of desire; it is by this construction that many persons are fused into one. Endowed with ideal powers of sympathy and imagination, the impartial spectator is the perfectly rational individual who identifies with and experiences the desires of others as if these desires were his own. In this way he ascertains the intensity of these desires and assigns them their appropriate weight in the one system of desire the satisfaction of which the ideal legislator then tries to maximize by adjusting the rules of the social system. On this conception of society separate individuals are thought of as so many different lines along which rights and duties are to be assigned and scarce means of satisfaction allocated in accordance with rules so as to give the greatest fulfillment of

wants. The nature of the decision made by the ideal legislator is not, therefore, materially different from that of an entrepreneur deciding how to maximize his profit by producing this or that commodity, or that of a consumer deciding how to maximize his satisfaction by the purchase of this or that collection of goods. In each case there is a single person whose system of desires determines the best allocation of limited means. The correct decision is essentially a question of efficient administration. This view of social cooperation is the consequence of extending to society the principle of choice for one man, and then, to make this extension work, conflating all persons into one through the imaginative acts of the impartial sympathetic spectator. Utilitarianism does not take seriously the distinction between persons. . . .

11. TWO PRINCIPLES OF JUSTICE

I shall now state in a provisional form the two principles of justice that I believe would be agreed to in the original position. The first formulation of these principles is tentative. As we go on I shall consider several formulations and approximate step by step the final statement to be given much later. I believe that doing this allows the exposition to proceed in a natural way.

The first statement of the two principles reads as follows.

First: each person is to have an equal right to the most extensive scheme of equal basic liberties compatible with a similar scheme of liberties for others.

Second: social and economic inequalities are to be arranged so that they are both (a) reasonably expected to be to everyone's advantage, and (b) attached to positions and offices open to all. . . .

These principles primarily apply, as I have said, to the basic structure of society and govern the assignment of rights and duties and regulate the distribution of social and economic advantages. Their formulation presupposes that, for the purposes of a theory of justice, the social structure may be viewed as having two more or less distinct parts, the first principle applying to the one, the second principle to the other. Thus we distinguish between the aspects of the social system that define and secure the equal basic liberties and the aspects that specify and establish social and economic inequalities. Now it is essential to observe that the basic liberties are given by a list of such liberties. Important among these are political liberty (the right to vote and to hold public office) and freedom of speech and assembly; liberty of conscience and freedom of thought; freedom of the person, which includes freedom from psychological oppression and physical assault and dismemberment (integrity of the person); the right to hold personal property and freedom from arbitrary arrest and seizure as defined by the concept of the rule of law. These liberties are to be equal by the first principle.

The second principle applies, in the first approximation, to the distribution of income and wealth and to the design of organizations that make use of differences in authority and responsibility. While the distribution of wealth and income need not be equal, it must be to everyone's advantage, and at the same time, positions of authority and responsibility must be accessible to all. One applies the second principle by holding positions open, and then, subject to this constraint, arranges social and economic inequalities so that everyone benefits.

These principles are to be arranged in a serial order with the first principle prior to the second. This ordering means that infringements of the basic equal liberties protected by the first principle cannot be justified, or compensated for, by greater social and economic advantages. These liberties have a central range of application within which they can be limited and compromised only when they conflict with other basic liberties. Since they may be limited when they clash with one another, none of these liberties is absolute; but however they are adjusted to form one system, this system is to be the same for all. It is difficult, and perhaps impossible, to give a complete specification of these liberties independently from the particular circumstances—social, economic, and technological— of a given society. The hypothesis is that the general form of such a list could be devised with sufficient exactness to sustain this conception of justice. Of course, liberties not on the list, for example, the right to own certain kinds of property (e.g., means of

production) and freedom of contract as understood by the doctrine of laissez-faire are not basic; and so they are not protected by the priority of the first principle. Finally, in regard to the second principle, the distribution of wealth and income, and positions of authority and responsibility, are to be consistent with both the basic liberties and equality of opportunity.

The two principles are rather specific in their content, and their acceptance rests on certain assumptions that I must eventually try to explain and justify. For the present, it should be observed that these principles are a special case of a more general conception of justice that can be expressed as follows.

> All social values—liberty and opportunity, income and wealth, and the social bases of self-respect—are to be distributed equally unless an unequal distribution of any, or all, of these values is to everyone's advantage.

Injustice, then, is simply inequalities that are not to the benefit of all. Of course, this conception is extremely vague and requires interpretation.

As a first step, suppose that the basic structure of society distributes certain primary goods, that is, things that every rational man is presumed to want. These goods normally have a use whatever a person's rational plan of life. For simplicity, assume that the chief primary goods at the disposition of society are rights, liberties, and opportunities, and income and wealth. (Later on in Part Three the primary good of self-respect has a central place.) These are the social primary goods. Other primary goods such as health and vigor, intelligence and imagination, are natural goods; although their possession is influenced by the basic structure, they are not so directly under its control. Imagine, then, a hypothetical initial arrangement in which all the social primary goods are equally distributed: everyone has similar rights and duties, and income and wealth are evenly shared. This state of affairs provides a benchmark for judging improvements. If certain inequalities of wealth and differences in authority would make everyone better off than in this hypothetical starting situation, then they accord with the general conception.

Now it is possible, at least theoretically, that by giving up some of their fundamental liberties men are sufficiently compensated by the resulting social and economic gains. The general conception of justice imposes no restrictions on what sort of inequalities are permissible; it only requires that everyone's position be improved. We need not suppose anything so drastic as consenting to a condition of slavery. Imagine instead that people seem willing to forego certain political rights when the economic returns are significant. It is this kind of exchange which the two principles rule out; being arranged in serial order they do not permit exchanges between basic liberties and economic and social gains except under extenuating circumstances. . . .

The fact that the two principles apply to institutions has certain consequences. First of all, the rights and basic liberties referred to by these principles are those which are defined by the public rules of the basic structure. Whether men are free is determined by the rights and duties established by the major institutions of society. Liberty is a certain pattern of social forms. The first principle simply requires that certain sorts of rules, those defining basic liberties, apply to everyone equally and that they allow the most extensive liberty compatible with a like liberty for all. The only reason for circumscribing basic liberties and making them less extensive is that otherwise they would interfere with one another.

Further, when principles mention persons, or require that everyone gain from an inequality, the reference is to representative persons holding the various social positions, or offices established by the basic structure. Thus in applying the second principle I assume that it is possible to assign an expectation of well-being to representative individuals holding these positions. This expectation indicates their life prospects as viewed from their social station. In general, the expectations of representative persons depend upon the distribution of rights and duties throughout the basic structure. Expectations are connected: by raising the prospects of the representative man in one position we presumably increase or decrease the prospects of representative men in other positions. Since it applies to institutional forms, the second principle

(or rather the first part of it) refers to the expectations of representative individuals. As I shall discuss below, neither principle applies to distributions of particular goods to particular individuals who may be identified by their proper names. The situation where someone is considering how to allocate certain commodities to needy persons who are known to him is not within the scope of the principles. They are meant to regulate basic institutional arrangements. We must not assume that there is much similarity from the standpoint of justice between an administrative allotment of goods to specific persons and the appropriate design of society. Our common sense intuitions for the former may be a poor guide to the latter.

Now the second principle insists that each person benefit from permissible inequalities in the basic structure. This means that it must be reasonable for each relevant representative man defined by this structure, when he views it as a going concern, to prefer his prospects with the inequality to his prospects without it. One is not allowed to justify differences in income or in positions of authority and responsibility on the ground that the disadvantages of those in one position are outweighed by the greater advantages of those in another. Much less can infringements of liberty be counterbalanced in this way. It is obvious, however, that there are indefinitely many ways in which all may be advantaged when the initial arrangement of equality is taken as a benchmark. How then are we to choose among these possibilities? The principles must be specified so that they yield a determinate conclusion. . . .

society. The intuitive idea is that the social order is not to establish and secure the more attractive prospects of those better off unless doing so is to the advantage of those less fortunate. . . .

To illustrate the difference principle, consider the distribution of income among social classes. Let us suppose that the various income groups correlate with representative individuals by reference to whose expectations we can judge the distribution. Now those starting out as members of the entrepreneurial class in a property-owning democracy, say, have a better prospect than those who begin in the class of unskilled laborers. It seems likely that this will be true even when the social injustices which now exist are removed. What, then, can possibly justify this kind of initial inequality in life prospects? According to the difference principle, it is justifiable only if the difference in expectation is to the advantage of the representative man who is worse off, in this case the representative unskilled worker. The inequality in expectation is permissible only if lowering it would make the working class even more worse off. Supposedly, given the rider in the second principle concerning open positions, and the principle of liberty generally, the greater expectations allowed to entrepreneurs encourages them to do things which raise the prospects of the laboring class. Their better prospects act as incentives so that the economic process is more efficient, innovation proceeds at a faster pace, and so on. I shall not consider how far these things are true. The point is that something of this kind must be argued if these inequalities are to satisfy by the difference principle. . . .

13. DEMOCRATIC EQUALITY AND THE DIFFERENCE PRINCIPLE

The democratic interpretation . . . is arrived at by combining the principle of fair equality of opportunity with the difference principle. . . . Assuming the framework of institutions required by equal liberty and fair equality of opportunity, the higher expectations of those better situated are just if and only if they work as part of a scheme which improves the expectations of the least advantaged members of

17. THE TENDENCY TO EQUALITY

I wish to conclude this discussion of the two principles by explaining the sense in which they express an egalitarian conception of justice. Also I should like to forestall the objection to the principle of fair opportunity that it leads to a meritocratic society. In order to prepare the way for doing this, I note several aspects of the conception of justice that I have set out.

First we may observe that the difference principle gives some weight to the considerations singled

out by the principle of redress. This is the principle that undeserved inequalities call for redress; and since inequalities of birth and natural endowment are undeserved, these inequalities are to be somehow compensated for.[11] Thus the principle holds that in order to treat all persons equally, to provide genuine equality of opportunity, society must give more attention to those with fewer native assets and to those born into the less favorable social positions. The idea is to redress the bias of contingencies in the direction of equality. In pursuit of this principle greater resources might be spent on the education of the less rather than the more intelligent, at least over a certain time of life, say the earlier years of school.

Now the principle of redress has not to my knowledge been proposed as the sole criterion of justice, as the single aim of the social order. It is plausible as most such principles are only as a prima facie principle, one that is to be weighed in the balance with others. For example, we are to weigh it against the principle to improve the average standard of life, or to advance the common good.[12] But whatever other principles we hold, the claims of redress are to be taken into account. It is thought to represent one of the elements in our conception of justice. Now the difference principle is not of course the principle of redress. It does not require society to try to even out handicaps as if all were expected to compete on a fair basis in the same race. But the difference principle would allocate resources in education, say, so as to improve the long-term expectation of the least favored. If this end is attained by giving more attention to the better endowed, it is permissible; otherwise not. And in making this decision, the value of education should not be assessed solely in terms of economic efficiency and social welfare. Equally if not more important is the role of education in enabling a person to enjoy the culture of his society and to take part in its affairs, and in this way to provide for each individual a secure sense of his own worth.

Thus although the difference principle is not the same as that of redress, it does achieve some of the intent of the latter principle. It transforms the aims of the basic structure so that the total scheme of institutions no longer emphasizes social efficiency and technocratic values. The difference principle represents, in effect, an agreement to regard the distribution of natural talents as in some respects a common asset and to share in the greater social and economic benefits made possible by the complementarities of this distribution. Those who have been favored by nature, whoever they are, may gain from their good fortune only on terms that improve the situation of those who have lost out. The naturally advantaged are not to gain merely because they are more gifted, but only to cover the costs of training and education and for using their endowments in ways that help the less fortunate as well. No one deserves his greater natural capacity nor merits a more favorable starting place in society. But, of course, this is no reason to ignore, much less to eliminate these distinctions. Instead, the basic structure can be arranged so that these contingencies work for the good of the least fortunate. Thus we are led to the difference principle if we wish to set up the social system so that no one gains or loses from his arbitrary place in the distribution of natural assets or his initial position in society without giving or receiving compensating advantages in return.

In view of these remarks we may reject the contention that the ordering of institutions is always defective because the distribution of natural talents and the contingencies of social circumstance are unjust, and this injustice must inevitably carry over to human arrangements. Occasionally this reflection is offered as an excuse for ignoring injustice, as if the refusal to acquiesce in injustice is on a par with being unable to accept death. The natural distribution is neither just nor unjust; nor is it unjust that persons are born into society at some particular position. These are simply natural facts. What is just and unjust is the way that institutions deal with these facts. Aristocratic and caste societies are unjust because they make these contingencies the ascriptive basis for belonging to more or less enclosed and privileged social classes. The basic structure of these societies incorporates the arbitrariness found in nature. But there is no necessity for men to resign themselves to these contingencies. The social system is not an unchangeable order beyond human control

but a pattern of human action. In justice as fairness men agree to avail themselves of the accidents of nature and social circumstance only when doing so is for the common benefit. The two principles are a fair way of meeting the arbitrariness of fortune; and while no doubt imperfect in other ways, the institutions which satisfy these principles are just.

A further point is that the difference principle expresses a conception of reciprocity. It is a principle of mutual benefit. At first sight, however, it may appear unfairly biased towards the least favored. To consider this question in an intuitive way, suppose for simplicity that there are only two groups in society, one noticeably more fortunate than the other. Subject to the usual constraints (defined by the priority of the first principle and fair equality of opportunity), society could maximize the expectations of either group but not both, since we can maximize with respect to only one aim at a time. It seems clear that society should not do the best it can for those initially more advantaged; so if we reject the difference principle, we must prefer maximizing some weighted mean of the two expectations. But if we give any weight to the more fortunate, we are valuing for their own sake the gains to those already more favored by natural and social contingencies. No one had an antecedent claim to be benefited in this way, and so to maximize a weighted mean is, so to speak, to favor the more fortunate twice over. Thus the more advantaged, when they view the matter from a general perspective, recognize that the well-being of each depends on a scheme of social cooperation without which no one could have a satisfactory life; they recognize also that they can expect the willing cooperation of all only if the terms of the scheme are reasonable. So they regard themselves as already compensated, as it were, by the advantages to which no one (including themselves) had a prior claim. They forego the idea of maximizing a weighted mean and regard the difference principle as a fair basis for regulating the basic structure.

One may object that those better situated deserve the greater advantages they could acquire for themselves under other schemes of cooperation whether or not these advantages are gained in ways that benefit others. Now it is true that given a just system of cooperation as a framework of public rules, and the expectations set up by it, those who, with the prospect of improving their condition, have done what the system announces it will reward are entitled to have their expectations met. In this sense the more fortunate have title to their better situation; their claims are legitimate expectations established by social institutions and the community is obligated to fulfill them. But this sense of desert is that of entitlement. It presupposes the existence of an ongoing cooperative scheme and is irrelevant to the question whether this scheme itself is to be designed in accordance with the difference principle or some other criterion.

Thus it is incorrect that individuals with greater natural endowments and the superior character that has made their development possible have a right to a cooperative scheme that enables them to obtain even further benefits in ways that do not contribute to the advantages of others. We do not deserve our place in the distribution of native endowments, any more than we deserve our initial starting place in society. That we deserve the superior character that enables us to make the effort to cultivate our abilities is also problematic; for such character depends in good part upon fortunate family and social circumstances in early life for which we can claim no credit. The notion of desert does not apply here. To be sure, the more advantaged have a right to their natural assets, as does everyone else; this right is covered by the first principle under the basic liberty protecting the integrity of the person. And so the more advantaged are entitled to whatever they can acquire in accordance with the rules of a fair system of social cooperation. Our problem is how this scheme, the basic structure of society, is to be designed. From a suitably general standpoint, the difference principle appears acceptable to both the more advantaged and the less advantaged individual. Of course, none of this is strictly speaking an argument for the principle, since in a contract theory arguments are made from the point of view of the original position. But these intuitive considerations help to clarify the principle and the sense in which it is egalitarian. . . .

24. THE VEIL OF IGNORANCE

The idea of the original position is to set up a fair procedure so that any principles agreed to will be just. The aim is to use the notion of pure procedural justice as a basis of theory. Somehow we must nullify the effects of specific contingencies which put men at odds and tempt them to exploit social and natural circumstances to their own advantage. Now in order to do this I assume that the parties are situated behind a veil of ignorance. They do not know how the various alternatives will affect their own particular case and they are obliged to evaluate principles solely on the basis of general considerations.[13]

It is assumed, then, that the parties do not know certain kinds of particular facts. First of all, no one knows his place in society, his class position or social status; nor does he know his fortune in the distribution of natural assets and abilities, his intelligence and strength, and the like. Nor, again, does anyone know his conception of the good, the particulars of his rational plan of life, or even the special features of his psychology such as his aversion to risk or liability to optimism or pessimism. More than this, I assume that the parties do not know the particular circumstances of their own society. That is, they do not know its economic or political situation, or the level of civilization and culture it has been able to achieve. The persons in the original position have no information as to which generation they belong. These broader restrictions on knowledge are appropriate in part because questions of social justice arise between generations as well as within them, for example, the question of the appropriate rate of capital saving and of the conservation of natural resources and the environment of nature. There is also, theoretically anyway, the question of a reasonable genetic policy. In these cases too, in order to carry through the idea of the original position, the parties must not know the contingencies that set them in opposition. They must choose principles the consequences of which they are prepared to live with whatever generation they turn out to belong to.

As far as possible, then, the only particular facts which the parties know is that their society is subject to

the circumstances of justice and whatever this implies. It is taken for granted, however, that they know the general facts about human society. They understand political affairs and the principles of economic theory; they know the basis of social organization and the laws of human psychology. Indeed, the parties are presumed to know whatever general facts affect the choice of the principles of justice. There are no limitations on general information, that is, on general laws and theories, since conceptions of justice must be adjusted to the characteristics of the systems of social cooperation which they are to regulate, and there is no reason to rule out these facts. It is, for example, a consideration against a conception of justice that, in view of the laws of moral psychology, men would not acquire a desire to act upon it even when the institutions of their society satisfied it. For in this case there would be difficulty in securing the stability of social cooperation. An important feature of a conception of justice is that it should generate its own support. Its principles should be such that when they are embodied in the basic structure of society men tend to acquire the corresponding sense of justice and develop a desire to act in accordance with its principles. In this case a conception of justice is stable. This kind of general information is admissible in the original position.

The notion of the veil of ignorance raises several difficulties. Some may object that the exclusion of nearly all particular information makes it difficult to grasp what is meant by the original position. Thus it may be helpful to observe that one or more persons can at any time enter this position, or perhaps better, simulate the deliberations of this hypothetical situation, simply by reasoning in accordance with the appropriate restrictions. In arguing for a conception of justice we must be sure that it is among the permitted alternatives and satisfies the stipulated formal constraints. No considerations can be advanced in its favor unless they would be rational ones for us to urge were we to lack the kind of knowledge that is excluded. The evaluation of principles must proceed in terms of the general consequences of their public recognition and universal application, it being assumed that they will be complied with by everyone. To say that a certain conception of justice would

be chosen in the original position is equivalent to saying that rational deliberation satisfying certain conditions and restrictions would reach a certain conclusion. If necessary, the argument to this result could be set out more formally. I shall, however, speak throughout in terms of the notion of the original position. It is more economical and suggestive, and brings out certain essential features that otherwise one might easily overlook.

These remarks show that the original position is not to be thought of as a general assembly which includes at one moment everyone who will live at some time or, much less, as an assembly of everyone who could live at some time. It is not a gathering of all actual or possible persons. If we conceived of the original position in either of these ways, the conception would cease to be a natural guide to intuition and would lack a clear sense. In any case, the original position must be interpreted so that one can at any time adopt its perspective. It must make no difference when one takes up this viewpoint, or who does so: the restrictions must be such that the same principles are always chosen. The veil of ignorance is a key condition in meeting this requirement. It insures not only that the information available is relevant, but that it is at all times the same.

It may be protested that the condition of the veil of ignorance is irrational. Surely, some may object, principles should be chosen in the light of all the knowledge available. There are various replies to this contention. Here I shall sketch those which emphasize the simplifications that need to be made if one is to have any theory at all. (Those based on the Kantian interpretation of the original position are given later.) To begin with, it is clear that since the differences among the parties are unknown to them, and everyone is equally rational and similarly situated, each is convinced by the same arguments. Therefore, we can view the agreement in the original position from the standpoint of one person selected at random. If anyone after due reflection prefers a conception of justice to another, then they all do, and a unanimous agreement can be reached. We can, to make the circumstances more vivid, imagine that the parties are required to communicate with each other through a referee as intermediary, and that he is to announce which alternatives have been suggested and the reasons offered in their support. He forbids the attempt to form coalitions, and he informs the parties when they have come to an understanding. But such a referee is actually superfluous, assuming that the deliberations of the parties must be similar.

Thus there follows the very important consequence that the parties have no basis for bargaining in the usual sense. No one knows his situation in society nor his natural assets, and therefore no one is in a position to tailor principles to his advantage. We might imagine that one of the contractees threatens to hold out unless the others agree to principles favorable to him. But how does he know which principles are especially in his interests? The same holds for the formation of coalitions: if a group were to decide to band together to the disadvantage of the others, they would not know how to favor themselves in the choice of principles. Even if they could get everyone to agree to their proposal, they would have no assurance that it was to their advantage, since they cannot identify themselves either by name or description. The one case where this conclusion fails is that of saving. Since the persons in the original position know that they are contemporaries (taking the present time of entry interpretation), they can favor their generation by refusing to make any sacrifices at all for their successors; they simply acknowledge the principle that no one has a duty to save for posterity. Previous generations have saved or they have not; there is nothing the parties can now do to affect that. So in this instance the veil of ignorance fails to secure the desired result. Therefore, to handle the question of justice between generations, I modify the motivation assumption and add a further constraint. . . . With these adjustments, no generation is able to formulate principles especially designed to advance its own cause and some significant limits on savings principles can be derived. . . . Whatever a person's temporal position, each is forced to choose for all.[14]

The restrictions on particular information in the original position are, then, of fundamental importance. Without them we would not be able to work out any definite theory of justice at all. We would

have to be content with a vague formula stating that justice is what would be agreed to without being able to say much, if anything, about the substance of the agreement itself. The formal constraints of the concept of right, those applying to principles directly; are not sufficient for our purpose. The veil of ignorance makes possible a unanimous choice of a particular conception of justice. Without these limitations on knowledge the bargaining problem of the original position would be hopelessly complicated. Even if theoretically a solution were to exist, we would not, at present anyway, be able to determine it. . . .

26. THE REASONING LEADING TO THE TWO PRINCIPLES OF JUSTICE

. . . It seems from these remarks that the two principles are at least a plausible conception of justice. The question, though, is how one is to argue for them more systematically. Now there are several things to do. One can work out their consequences for institutions and note their implications for fundamental social policy. In this way they are tested by a comparison with our considered judgments of justice. . . . But one can also try to find arguments in their favor that are decisive from the standpoint of the original position. In order to see how this might be done, it is useful as a heuristic device to think of the two principles as the maximin solution to the problem of social justice. There is a relation between the two principles and the maximin rule for choice under uncertainty.[15] This is evident from the fact that the two principles are those a person would choose for the design of a society in which his enemy is to assign him his place. The maximin rule tells us to rank alternatives by their worst possible outcomes: we are to adopt the alternative the worst outcome of which is superior to the worst outcomes of the others.[16] The persons in the original position do not, of course, assume that their initial place in society is decided by a malevolent opponent. As I note below, they should not reason from false premises. The veil of ignorance does not violate this idea, since an absence of information is not misinformation. But that the two principles of justice would be chosen if the

parties were forced to protect themselves against such a contingency explains the sense in which this conception is the maximin solution. And this analogy suggests that if the original position has been described so that it is rational for the parties to adopt the conservative attitude expressed by this rule, a conclusive argument can indeed be constructed for these principles. Clearly the maximin rule is not, in general, a suitable guide for choices under uncertainty. But it holds only in situations marked by certain special features. My aim, then, is to show that a good case can be made for the two principles based on the fact that the original position has these features to a very high degree.

Now there appear to be three chief features of situations that give plausibility to this unusual rule.[17] First, since the rule takes no account of the likelihoods of the possible circumstances, there must be some reason for sharply discounting estimates of these probabilities. Offhand, the most natural rule of choice would seem to be to compute the expectation of monetary gain for each decision and then to adopt the course of action with the highest prospect. . . . Thus it must be, for example, that the situation is one in which a knowledge of likelihoods is impossible, or at best extremely insecure. In this case it is unreasonable not to be skeptical of probabilistic calculations unless there is no other way out, particularly if the decision is a fundamental one that needs to be justified to others.

The second feature that suggests the maximin rule is the following: the person choosing has a conception of the good such that he cares very little, if anything, for what he might gain above the minimum stipend that he can, in fact, be sure of by following the maximin rule. It is not worthwhile for him to take a chance for the sake of a further advantage, especially when it may turn out that he loses much that is important to him. This last provision brings in the third feature, namely, that the rejected alternatives have outcomes that one can hardly accept. The situation involves grave risks. Of course these features work most effectively in combination. The paradigm situation for following the maximin rule is when all three features are realized to the highest degree.

Let us review briefly the nature of the original position with these three special features in mind. To begin

with, the veil of ignorance excludes all knowledge of likelihoods. The parties have no basis for determining the probable nature of their society, or their place in it. Thus they have no basis for probability calculations. They must also take into account the fact that their choice of principles should seem reasonable to others, in particular their descendants, whose rights will be deeply affected by it. These considerations are strengthened by the fact that the parties know very little about the possible states of society. Not only are they unable to conjecture the likelihoods of the various possible circumstances, they cannot say much about what the possible circumstances are, much less enumerate them and foresee the outcome of each alternative available. Those deciding are much more in the dark than illustrations by numerical tables suggest. It is for this reason that I have spoken only of a relation to the maximin rule.

Several kinds of arguments for the two principles of justice illustrate the second feature. Thus, if we can maintain that these principles provide a workable theory of social justice, and that they are compatible with reasonable demands of efficiency, then this conception guarantees a satisfactory minimum. There may be, on reflection, little reason for trying to do better. Thus much of the argument . . . is to show, by their application to some main questions of social justice, that the two principles are a satisfactory conception. These details have a philosophical purpose. Moreover, this line of thought is practically decisive if we can establish the priority of liberty. For this priority implies that the persons in the original position have no desire to try for greater gains at the expense of the basic equal liberties. The minimum assured by the two principles in lexical order is not one that the parties wish to jeopardize for the sake of greater economic and social advantages.

Finally, the third feature holds if we can assume that other conceptions of justice may lead to institutions that the parties would find intolerable. For example, it has sometimes been held that under some conditions the utility principle (in either form) justifies, if not slavery or serfdom, at any rate serious infractions of liberty for the sake of greater social benefits. We need not consider here the truth of this claim. For the

moment, this contention is only to illustrate the way in which conceptions of justice may allow for outcomes which the parties may not be able to accept. And having the ready alternative of the two principles of justice which secure a satisfactory minimum, it seems unwise, if not irrational, for them to take a chance that these conditions are not realized. . . .

40. THE KANTIAN INTERPRETATION OF JUSTICE AS FAIRNESS

For the most part I have considered the content of the principle of equal liberty and the meaning of the priority of the rights that it defines. It seems appropriate at this point to note that there is a Kantian interpretation of the conception of justice from which this principle derives. This interpretation is based upon Kant's notion of autonomy. It is a mistake, I believe, to emphasize the place of generality and universality in Kant's ethics. That moral principles are general and universal is hardly new with him; and as we have seen these conditions do not in any case take us very far. It is impossible to construct a moral theory on so slender a basis, and therefore to limit the discussion of Kant's doctrine to these notions is to reduce it to triviality. The real force of his view lies elsewhere.[18]

For one thing, he begins with the idea that moral principles are the object of rational choice. They define the moral law that men can rationally will to govern their conduct in an ethical commonwealth. Moral philosophy becomes the study of the conception and outcome of a suitably defined rational decision. This idea has immediate consequences. For once we think of moral principles as legislation for a kingdom of ends, it is clear that these principles must not only be acceptable to all but public as well. Finally Kant supposes that this moral legislation is to be agreed to under conditions that characterize men as free and equal rational beings. The description of the original position is an attempt to interpret this conception. I do not wish to argue here for this interpretation on the basis of Kant's text. Certainly some will want to read him differently. Perhaps the

remarks to follow are best taken as suggestions for relating justice as fairness to the high point of the contractarian tradition in Kant and Rousseau.

Kant held, I believe, that a person is acting autonomously when the principles of his action are chosen by him as the most adequate possible expression of his nature as a free and equal rational being. The principles he acts upon are not adopted because of his social position or natural endowments, or in view of the particular kind of society in which he lives or the specific things that he happens to want. To act on such principles is to act heteronomously. Now the veil of ignorance deprives the persons in the original position of the knowledge that would enable them to choose heteronomous principles. The parties arrive at their choice together as free and equal rational persons knowing only that those circumstances obtain which give rise to the need for principles of justice.

To be sure, the argument for these principles does add in various ways to Kant's conception. For example, it adds the feature that the principles chosen are to apply to the basic structure of society; and premises characterizing this structure are used in deriving the principles of justice. But I believe that this and other additions are natural enough and remain fairly close to Kant's doctrine, at least when all of his ethical writings are viewed together. Assuming, then, that the reasoning in favor of the principles of justice is correct, we can say that when persons act on these principles they are acting in accordance with principles that they would choose as rational and independent persons in an original position of equality. The principles of their actions do not depend upon social or natural contingencies, nor do they reflect the bias of the particulars of their plan of life or the aspirations that motivate them. By acting from these principles persons express their nature as free and equal rational beings subject to the general conditions of human life. For to express one's nature as a being of a particular kind is to act on the principles that would be chosen if this nature were the decisive determining element. Of course, the choice of the parties in the original position is subject to the restrictions of that situation. But when we knowingly act on the principles of justice in the ordinary course of events, we deliberately assume the limitations of the original position. One reason for doing this, for persons who can do so and want to, is to give expression to one's nature.

The principles of justice are also analogous to categorical imperatives. For by a categorical imperative Kant understands a principle of conduct that applies to a person in virtue of his nature as a free and equal rational being. The validity of the principle does not presuppose that one has a particular desire or aim. Whereas a hypothetical imperative by contrast does assume this: it directs us to take certain steps as effective means to achieve a specific end. Whether the desire is for a particular thing, or whether it is for something more general, such as certain kinds of agreeable feelings or pleasures, the corresponding imperative is hypothetical. Its applicability depends upon one's having an aim which one need not have as a condition of being a rational human individual. The argument for the two principles of justice does not assume that the parties have particular ends, but only that they desire certain primary goods. These are things that it is rational to want whatever else one wants. Thus given human nature, wanting them is part of being rational; and while each is presumed to have some conception of the good, nothing is known about his final ends. The preference for primary goods is derived, then, from only the most general assumptions about rationality and the conditions of human life. To act from the principles of justice is to act from categorical imperatives in the sense that they apply to us whatever in particular our aims are. This simply reflects the fact that no such contingencies appear as premises in their derivation.

We may note also that the motivational assumption of mutual disinterest parallels Kant's notion of autonomy, and gives another reason for this condition. So far this assumption has been used to characterize the circumstances of justice and to provide a clear conception to guide the reasoning of the parties. We have also seen that the concept of benevolence, being a second-order notion, would not work out well. Now we can add that the assumption of mutual disinterest is to allow for freedom in the choice of a system of final ends.[19] Liberty in adopting a conception of the good is limited only by principles that are deduced from a doctrine which imposes no prior constraints on these conceptions. Presuming mutual

disinterest in the original position carries out this idea. We postulate that the parties have opposing claims in a suitably general sense. If their ends were restricted in some specific way, this would appear at the outset as an arbitrary restriction on freedom. Moreover, if the parties were conceived as altruists, or as pursuing certain kinds of pleasures, then the principles chosen would apply, as far as the argument would have shown, only to persons whose freedom was restricted to choices compatible with altruism or hedonism. As the argument now runs, the principles of justice cover all persons with rational plans of life, whatever their content, and these principles represent the appropriate restrictions on freedom. Thus it is possible to say that the constraints on conceptions of the good are the result of an interpretation of the contractual situation that puts no prior limitations on what men may desire. There are a variety of reasons, then, for the motivational premise of mutual disinterest. This premise is not only a matter of realism about the circumstances of justice or a way to make the theory manageable. It also connects up with the Kantian idea of autonomy.

There is, however, a difficulty that should be clarified. It is well expressed by Sidgwick.[20] He remarks that nothing in Kant's ethics is more striking than the idea that a man realizes his true self when he acts from the moral law, whereas if he permits his actions to be determined by sensuous desires or contingent aims, he becomes subject to the law of nature. Yet in Sidgwick's opinion this idea comes to naught. It seems to him that on Kant's view the lives of the saint and the scoundrel are equally the outcome of a free choice (on the part of the noumenal self) and equally the subject of causal laws (as a phenomenal self). Kant never explains why the scoundrel does not express in a bad life his characteristic and freely chosen selfhood in the same way that a saint expresses his characteristic and freely chosen selfhood in a good one. Sidgwick's objection is decisive, I think, as long as one assumes, as Kant's exposition may seem to allow, both that the noumenal self can choose any consistent set of principles and that acting from such principles, whatever they are, is sufficient to express one's choice as that of a free and equal rational being. Kant's reply must be that though acting on any consistent set of principles could be the outcome of a decision on the part of the noumenal self, not all such action by the phenomenal self expresses this decision as that of a free and equal rational being. Thus if a person realizes his true self by expressing it in his actions, and if he desires above all else to realize this self, then he will choose to act from principles that manifest his nature as a free and equal rational being. The missing part of the argument concerns the concept of expression. Kant did not show that acting from the moral law expresses our nature in identifiable ways that acting from contrary principles does not.

This defect is made good, I believe, by the conception of the original position. The essential point is that we need an argument showing which principles, if any, free and equal rational persons would choose and these principles must be applicable in practice. A definite answer to this question is required to meet Sidgwick's objection. My suggestion is that we think of the original position as in important ways similar to the point of view from which noumenal selves see the world. The parties qua noumenal selves have complete freedom to choose whatever principles they wish; but they also have a desire to express their nature as rational and equal members of the intelligible realm with precisely this liberty to choose, that is, as beings who can look at the world in this way and express this perspective in their life as members of society. They must decide, then, which principles when consciously followed and acted upon in everyday life will best manifest this freedom in their community, most fully reveal their independence from natural contingencies and social accident. Now if the argument of the contract doctrine is correct, these principles are indeed those defining the moral law, or more exactly, the principles of justice for institutions and individuals. The description of the original position resembles the point of view of noumenal selves, of what it means to be a free and equal rational being. Our nature as such beings is displayed when we act from the principles we would choose when this nature is reflected in the conditions determining the choice. Thus men exhibit their freedom, their independence from the contingencies of nature and society, by acting in ways they would acknowledge in the original position.

Properly understood, then, the desire to act justly derives in part from the desire to express most fully what we are or can be, namely free and equal rational

beings with a liberty to choose. It is for this reason, I believe, that Kant speaks of the failure to act on the moral law as giving rise to shame and not to feelings of guilt. And this is appropriate, since for him acting unjustly is acting in a manner that fails to express our nature as a free and equal rational being. Such actions therefore strike at our self-respect, our sense of our own worth, and the experience of this loss is shame. We have acted as though we belonged to a lower order, as though we were a creature whose first principles are decided by natural contingencies. Those who think of Kant's moral doctrine as one of law and guilt badly misunderstand him. Kant's main aim is to deepen and to justify Rousseau's idea that liberty is acting in accordance with a law that we give to ourselves. And this leads not to a morality of austere command but to an ethic of mutual respect and self-esteem.[21]

The original position may be viewed, then, as a procedural interpretation of Kant's conception of autonomy and the categorical imperative within the framework of an empirical theory. The principles regulative of the kingdom of ends are those that would be chosen in this position, and the description of this situation enables us to explain the sense in which acting from these principles expresses our nature as free and equal rational persons. No longer are these notions purely transcendent and lacking explicable connections with human conduct, for the procedural conception of the original position allows us to make these ties. Of course, I have departed from Kant's views in several respects. I cannot discuss these matters here; but two points should be noted. The person's choice as a noumenal self I have assumed to be a collective one. The force of the self's being equal is that the principles chosen must be acceptable to other selves. Since all are similarly free and rational, each must have an equal say in adopting the public principles of the ethical commonwealth. This means that as noumenal selves, everyone is to consent to these principles. Unless the scoundrel's principles would be agreed to, they cannot express this free choice, however much a single self might be of a mind to adopt them. . . .

Secondly, I have assumed all along that the parties know that they are subject to the conditions of human life. Being in the circumstances of justice, they are situated in the world with other men who likewise face limitations of moderate scarcity and competing claims. Human freedom is to be regulated by principles chosen in the light of these natural restrictions. Thus justice as fairness is a theory of human justice and among its premises are the elementary facts about persons and their place in nature. The freedom of pure intelligences not subject to these constraints (God and the angels) are outside the range of the theory. Kant may have meant his doctrine to apply to all rational beings as such and therefore that men's social situation in the world is to have no role in determining the first principles of justice. If so, this is another difference between justice as fairness and Kant's theory.

But the Kantian interpretation is not intended as an interpretation of Kant's actual doctrine but rather of justice as fairness. Kant's view is marked by a number of deep dualisms, in particular, the dualism between the necessary and the contingent, form and content, reason and desire, and noumena and phenomena. To abandon these dualisms as he understood them is, for many, to abandon what is distinctive in his theory. I believe otherwise. His moral conception has a characteristic structure that is more clearly discernible when these dualisms are not taken in the sense he gave them but recast and their moral force reformulated with the scope of an empirical theory. What I have called the Kantian interpretation indicates how this can be done.

Notes

1. As the text suggests, I shall regard Locke's *Second Treatise of Government*, Rousseau's *The Social Contract*, and Kant's ethical works beginning with *The Foundations of the Metaphysics of Morals* as definitive of the contract tradition. For all of its greatness, Hobbes's *Leviathan* raises special problems. A general historical survey is provided by J. W. Gough, *The Social Contract*, 2nd ed. (Oxford, The Clarendon Press, 1957), and Otto Gierke, *Natural Law and the Theory of Society*, trans. with an introduction by Ernest Barker (Cambridge, The University Press, 1934). A presentation of the contract view as primarily an ethical theory is to be found in G. R. Grice, *The Grounds of Moral Judgment* (Cambridge, The University Press, 1967). . . .

2. Kant is clear that the original agreement is hypothetical. See *The Metaphysics of Morals*, pt. I (*Rechtslehre*), especially §§47, 52; and pt. II of the essay "Concerning the Common Saying: This May Be True in Theory but It Does Not Apply in Practice," in *Kant's Political Writings*, ed. Hans Reiss and trans. by H. B. Nisbet (Cambridge, The University Press, 1970), pp. 73–87. See Georges Vlachos, *La Pensée politique de Kant* (Paris, Presses Universitaires de France, 1962), pp. 326–335; and J. G. Murphy, *Kant: The Philosophy of Right* (London, Macmillan. 1970), pp. 109–112, 133–136, for a further discussion.

3. For the formulation of this intuitive idea I am indebted to Allan Gibbard.

4. The process of mutual adjustment of principles and considered judgments is not peculiar to moral philosophy. See Nelson Goodman, *Fact, Fiction, and Forecast* (Cambridge, Mass., Harvard University Press, 1955), pp. 65–68, for parallel remarks concerning the justification of the principles of deductive and inductive inference.

5. Henri Poincaré remarks: "Il nous faut une faculté qui nous fasse voir le but de loin, et, cette faculté, c'est l'intuition." *La Valeur de la science* (Paris, Flammarion, 1909), p. 27.

6. I shall take Henry Sidgwick's *The Methods of Ethics*, 7th ed. (London, 1907), as summarizing the development of utilitarian moral theory. Book III of his *Principles of Political Economy* (London, 1883) applies this doctrine to questions of economic and social justice, and is a precursor of A. C. Pigou, *The Economics of Welfare* (London, Macmillan, 1920). Sidgwick's *Outlines of the History of Ethics*, 5th ed. (London, 1902), contains a brief history of the utilitarian tradition. We may follow him in assuming, somewhat arbitrarily, that it begins with Shaftesbury's *An Inquiry Concerning Virtue and Merit* (1711) and Hutcheson's *An Inquiry Concerning Moral Good and Evil* (1725). Hutcheson seems to have been the first to state clearly the principle of utility. He says in *Inquiry*, sec. 111, §8, that "that action is best, which procures the greatest happiness for the greatest numbers; and that, worst, which, in like manner, occasions misery." Other major eighteenth century works are Hume's *A Treatise of Human Nature* (1739), and *An Enquiry Concerning the Principles of Morals* (1751); Adam Smith's *A Theory of the Moral Sentiments* (1759); and Bentham's *The Principles of Morals and Legislation* (1789). To these we must add the writings of J. S. Mill represented by *Utilitarianism* (1863) and F. Y. Edgeworth's *Mathematical Psychics* (London, 1888).

The discussion of utilitarianism has taken a different turn in recent years by focusing on what we may call the coordination problem and related questions of publicity. This development stems from the essays of R. F. Harrod, "Utilitarianism Revised," *Mind*, vol. 45 (1936); J. D. Mabbott, "Punishment," *Mind*, vol. 48 (1939); Jonathan Harrison, "Utilitarianism, Universalisation, and Our Duty to Be Just," *Proceedings of the Aristotelian Society*, vol. 53 (1952–53): and J. O. Urmson, "The Interpretation of the Philosophy of J. S. Mill," *Philosophical Quarterly*, vol. 3 (1953). See also J. J. C. Smart, "Extreme and Restricted Utilitarianism," *Philosophical Quarterly*, vol. 6 (1956), and his *An Outline of a System of Utilitarian Ethics* (Cambridge, The University Press, 1961). For an account of these matters, see David Lyons, *Forms and Limits of Utilitarianism* (Oxford, The Clarendon Press, 1965); and Allan Gibbard, "Utilitarianisms and Coordination" (dissertation, Harvard University, 1971). The problems raised by these works, as important as they are, I shall leave aside as not bearing directly on the more elementary question of distribution which I wish to discuss.

Finally, we should note here the essays of J. C. Harsanyi, in particular, "Cardinal Utility in Welfare Economics and in the Theory of Risk-Taking," *Journal of Political Economy*, 1953, and "Cardinal Welfare, Individualistic Ethics, and Interpersonal Comparisons of Utility," *Journal of Political Economy*, 1955; and R. B. Brandt, "Some Merits of One Form of Rule-Utilitarianism." *University of Colorado Studies* (Boulder, Colorado, 1967). . . .

7. On this point see also D. P. Gauthier, *Practical Reasoning* (Oxford, Clarendon Press, 1963), pp. 126f. The text elaborates the suggestion found in "Constitutional Liberty and the Concept of Justice," *Nomos VI: Justice*, ed. C. J. Friedrich and J. W. Chapman (New York, Atherton Press, 1963), pp. 124f, which in turn is related to the idea of justice as a higher-order administrative decision. See "Justice as Fairness," *Philosophical Review*, 1958, pp. 185–187. For references to utilitarians who explicitly affirm this extension, see §30, note 37. That the principle of social integration is distinct from the principle of personal integration is stated by R. B. Perry, *General Theory of Value* (New York, Longmans, Green, and Company, 1926), pp. 674–677. He attributes the error of overlooking this fact to Emile Durkheim and others with similar views. Perry's conception of social integration is that brought about by a shared and dominant benevolent purpose. . . .

8. Here I adopt W. K. Frankena's definition of teleological theories in *Ethics* (Englewood Cliffs, N. J., Prentice Hall, Inc., 1963), p. 13.

9. On this point see Sidgwick, *The Methods of Ethics*, pp. 416f.

10. See J. S. Mill, *Utilitarianism*, ch. V, last two pars.

11. See Herbert Spiegelberg, "A Defense of Human Equality," *Philosophical Review*, vol. 53 (1944), pp. 101, 113–123; and D. D. Raphael, "Justice and Liberty," *Proceedings of the Aristotelian Society*, vol. 51 (1950–1951), pp. 187f.

12. See, for example, Spiegelberg, pp. 120f.

13. The veil of ignorance is so natural a condition that something like it must have occurred to many. The formulation in the text is implicit, I believe, in Kant's doctrine of the categorical imperative, both in the way this procedural criterion is defined and the use Kant makes of it. Thus when Kant tells us to test our maxim by considering what would be the case were it a universal law of nature, he must suppose that we do not know our place within this imagined system of nature. See, for example, his discussion of the topic of practical judgment in *The Critique of Practical Reason*, Academy Edition, vol. 5, pp. 68–72. A similar restriction on information is found in J. C. Harsanyi, "Cardinal Utility in Welfare Economics and in the Theory of Risk-taking," *Journal of Political Economy*, vol. 61 (1953). However, other aspects of Harsanyi's view are quite different, and he uses the restriction to develop a utilitarian theory. . . .

14. Rousseau, *The Social Contract*, bk. II, ch. IV, par. 5

15. An accessible discussion of this and other rules of choice under uncertainty can be found in W. J. Baumol, *Economic Theory and Operations Analysis*. 2nd ed. (Englewood Cliffs, N. J., Prentice-Hall Inc., 1965), ch. 24. Baumol gives a geometric interpretation of these rules . . . to illustrate the difference principle. See pp. 558–562. See also R. D. Luce and Howard Raiffa, *Games and Decisions* (New York, John Wiley and Sons, Inc., 1957), ch. XIII, for a fuller account.

16. Consider the gain-and-loss table below. It represents the gains and losses for a situation which is not a game of strategy. There is no one playing against the person making the decision; instead he is faced with several possible circumstances which may or may not obtain. Which circumstances happen to exist does not depend upon what the person choosing decides or whether he announces his moves in advance. The numbers in the table are monetary values (in hundreds of dollars) in comparison with some initial situation. The gain (g) depends upon the individual's decision (d) and the circumstances (c). Thus $g = f(d, c)$. Assuming that there are three possible decisions and three possible circumstances, we might have this gain-and-loss table.

Decisions	Circumstances		
	c1	c2	c3
d_1	−7	8	12
d_2	−8	7	14
d_3	5	6	8

The maximin rule requires that we make the third decision. For in this case the worst that can happen is that one gains five hundred dollars, which is better than the worst for the other actions. If we adopt one of these we may lose either eight or seven hundred dollars. Thus, the choice of d_3 maximizes $f(d, c)$ for that value of c, which for a given d, minimizes f. The term "maximin" means the *maximum minimorum;* and the rule directs our attention to the worst that can happen under any proposed course of action, and to decide in the light of that.

17. Here I borrow from William Fellner, *Probability and Profit* (Homewood, Ill., R. D. Irwin, Inc., 1965), pp. 140–142, where these features are noted.

18. Especially to be avoided is the idea that Kant's doctrine provides at best only the general, or formal, elements for a utilitarian or indeed for any other moral conception. This idea is found in Sidgwick, *The Methods of Ethics*, 7th ed. (London, Macmillan, 1907), pp. xvii and xx of the preface; and in F. H. Bradley, *Ethical Studies*, 2nd ed. (Oxford, Clarendon Press, 1927), Essay IV; and goes back at least to Hegel. One must not lose sight of the full scope of his view and take the later works into consideration. Unfortunately, there is no commentary on Kant's moral theory as a whole; perhaps it would prove impossible to write. But the standard works of H. J. Paton, *The Categorical Imperative* (Chicago, University of Chicago Press, 1948), and L. W. Beck, *A Commentary on Kant's Critique of Practical Reason* (Chicago, University of Chicago Press, 1960), and others need to be further complemented by studies of the other writings. See here M. J. Gregor's *Laws of Freedom* (Oxford, Basil Blackwell, 1963), an account of *The Metaphysics of Morals*, and J. G. Murphy's brief *Kant: The Philosophy of Right* (London, Macmillan, 1970). Beyond this, *The Critique of Judgment, Religion within the Limits of Reason*, and the political writings cannot be neglected without distorting his doctrine. For the last, see *Kant's Political Writings*, ed. Hans Reiss and trans. H. B. Nisbet (Cambridge, The University Press, 1970).

19. For this point I am indebted to Charles Fried.

20. See *The Methods of Ethics*, Appendix, "The Kantian Conception of Free Will" (reprinted from *Mind*, vol. 13, 1888), pp. 511–516, esp. p. 516.

21. See B. A. O. Williams, "The Idea of Equality," in *Philosophy, Politics and Society*, Second Series, ed. Peter Laslett and W. G. Runciman (Oxford, Basil Blackwell, 1962), pp. 115f. For confirmation of this interpretation, see Kant's remarks on moral education in *The Critique of Practical Reason*, pt. II. See also Beck, *A Commentary on Kant's Critique of Practical Reason*, pp. 233–236.

Study Questions

1. Explain in your own words what Rawls meant by claiming that the difference principle would be chosen in the original position by those behind a veil of ignorance.

2. What principles would you choose if you were in the original position?

3. If the principles you would choose are different from those Rawls proposed, how could we decide whose view, if either, is correct?

4. Are the two principles of Rawls shown to be just by being chosen in the original position, or are they chosen in the original position because they are just?

27

DAVID GAUTHIER

David Gauthier, born in Canada, is Professor Emeritus of Philosophy at the University of Pittsburgh. He defends the view that morality is based on each individual's pursuing long-term self-interest. Morality is to be identified with the constraints rational persons would agree upon when choosing the terms of their interactions. This view, now known as "contractarianism," thus views morality as cooperation among people for their mutual benefit, and ethics can thereby be justified without any need to appeal to independent-standing moral values.

Why Contractarianism?

I

As the will to truth thus gains self-consciousness—there can be no doubt of that—morality will gradually *perish* now: this is the great spectacle in a hundred acts reserved for the next two centuries in Europe—the most terrible, most questionable, and perhaps also the most hopeful of all spectacles.
—*Nietzsche*[1]

Morality faces a foundational crisis. Contractarianism offers the only plausible resolution of this crisis.

These two propositions state my theme. What follows is elaboration.

Nietzsche may have been the first, but he has not been alone, in recognizing the crisis to which I refer. Consider these recent statements. "The hypothesis which I wish to advance is that in the actual world which we inhabit the language of morality is in . . . [a] state of grave disorder . . . we have—very largely, if not entirely—lost our comprehension, both theoretical and practical, of morality" (Alasdair MacIntyre).[2] "The resources of most modern moral philosophy are not well adjusted to the modern world" (Bernard Williams).[3] "There are no objective values. . . . [But] the main tradition of European moral philosophy includes the contrary claim" (J. L. Mackie).[4] "Moral hypotheses do not help explain why people observe what they observe. So ethics is problematic and nihilism must be taken seriously. . . . An extreme version of nihilism holds that morality is simply an illusion. . . . In this version, we should abandon morality, just as an atheist abandons religion after he has decided that religious facts cannot help explain observations" (Gilbert Harman).[5]

I choose these statements to point to features of the crisis that morality faces. They suggest that moral language fits a world view that we have abandoned—a view of the world as purposively ordered. Without this view, we no longer truly understand the moral claims we continue to make. They suggest that there is a lack of fit between what morality presupposes—objective values that help explain our behavior, and the psychological states—desires and beliefs—that, given our present world view, actually provide the best explanation. This lack of fit threatens to undermine the very idea of a morality as more than an anthropological curiosity. But how could this be? How could morality *perish?*

II

To proceed, I must offer a minimal characterization of the morality that faces a foundational crisis. And this is the morality of justified constraint. From the standpoint of the agent, moral considerations present themselves as constraining his choices and actions, in ways independent of his desires, aims, and interests. Later, I shall add to this characterization, but for the moment it will suffice. For it reveals clearly what is in question—the ground of constraint. This ground seems absent from our present world view. And so we ask, what reason can a person have for recognizing and accepting a constraint that is independent of his desires and interests? He may agree that such a constraint would be *morally* justified; he would have a reason for accepting it *if* he had a reason for accepting morality. But what justifies paying attention to morality, rather than dismissing it as an appendage of outworn beliefs? We ask, and seem to find no answer. But before proceeding, we should consider three objections.

The first is to query the idea of constraint. Why should morality be seen as constraining our choices and actions? Why should we not rather say that the moral person chooses most freely, because she chooses in the light of a true conception of herself, rather than in the light of the false conceptions that so often predominate? Why should we not link morality with self-understanding? Plato and Hume might be enlisted to support this view, but Hume would be at best a partial ally, for his representation of "virtue in all her genuine and most engaging charms, . . . talk[ing] not of useless austerities and rigors, suffering and self-denial," but rather making "her votaries . . . , during every instant of their existence, if possible, cheerful and happy," is rather overcast by his admission that "in the case of justice, . . . a man, taking things in a certain light, may often seem to be a loser by his integrity."[6] Plato, to be sure, goes further, insisting that only the just man has a healthy soul, but heroic as Socrates' defense of justice may be, we are all too apt to judge that Glaucon and Adeimantus have been charmed rather than reasoned into agreement, and that the unjust man has not been shown necessarily to be the loser.[7] I do not, in any event, intend to pursue this direction of thought. Morality, as we, heirs to the Christian and Kantian traditions, conceive it, constrains the pursuits to which even our reflective desires would lead us. And this is not simply or entirely a constraint on self-interest; the

affections that morality curbs include the social ones of favoritism and partiality, to say nothing of cruelty.

The second objection to the view that moral constraint is insufficiently grounded is to query the claim that it operates independently of, rather than through, our desires, interests, and affections. Morality, some may say, concerns the well-being of all persons, or perhaps of all sentient creatures.[8] And one may then argue, either with Hume, that morality arises in and from our sympathetic identification with our fellows, or that it lies directly in well-being, and that our affections tend to be disposed favorably toward it. But, of course, not all of our affections. And so our sympathetic feelings come into characteristic opposition to other feelings, in relation to which they function as a constraint.

This is a very crude characterization, but it will suffice for the present argument. This view grants that morality, as we understand it, is without purely *rational* foundations, but reminds us that we are not therefore unconcerned about the well-being of our fellows. Morality is founded on the widespread, sympathetic, other-directed concerns that most of us have, and these concerns do curb self-interest, and also the favoritism and partiality with which we often treat others. Nevertheless, if morality depends for its practical relevance and motivational efficacity entirely on our sympathetic feelings, it has no title to the prescriptive grip with which it has been invested in the Christian and Kantian views to which I have referred, and which indeed Glaucon and Adeimantus demanded that Socrates defend to them in the case of justice. For to be reminded that some of the time we do care about our fellows and are willing to curb other desires in order to exhibit that care tells us nothing that can guide us in those cases in which, on the face of it, we do not care, or do not care enough— nothing that will defend the demands that morality makes on us in the hard cases. That not all situations in which concern for others combats self-concern are hard cases is true, but morality, as we ordinarily understand it, speaks to the hard cases, whereas its Humean or naturalistic replacement does not.

These remarks apply to the most sustained recent positive attempt to create a moral theory—that of John Rawls. For the attempt to describe our moral capacity, or more particularly, for Rawls, our sense of justice, in terms of principles, plausible in the light of our more general psychological theory, and coherent with "our considered judgments in reflective equilibrium,"[9] will not yield any answer to why, in those cases in which we have no, or insufficient, interest in being just, we should nevertheless follow the principles. John Harsanyi, whose moral theory is in some respects a utilitarian variant of Rawls' contractarian construction, recognizes this explicitly: "All we can prove by rational arguments is that anybody who wants to serve our common human interests in a rational manner must obey these commands."[10] But although morality may offer itself in the service of our common human interests, it does not offer itself only to those who want to serve them.

Morality is a constraint that, as Kant recognized, must not be supposed to depend solely on our feelings. And so we may not appeal to feelings to answer the question of its foundation. But the third objection is to dismiss this question directly, rejecting the very idea of a foundational crisis. Nothing justifies morality, for morality needs no justification. We find ourselves, in morality as elsewhere, in mediis rebus. We make, accept and reject, justify and criticize moral judgments. The concern of moral theory is to systematize that practice, and so to give us a deeper understanding of what moral justification is. But there are no extramoral foundations for moral justification, any more than there are extraepistemic foundations for epistemic judgments. In morals as in science, foundationalism is a bankrupt project.

Fortunately, I do not have to defend *normative* foundationalism. One problem with accepting moral justification as part of our ongoing practice is that, as I have suggested, we no longer accept the world view on which it depends. But perhaps a more immediately pressing problem is that we have, ready to hand, an alternative mode for justifying our choices and actions. In its more austere and, in my view, more defensible form, this is to show that choices and actions maximize the agent's expected utility, where utility is a measure of considered preference. In its less austere version, this is to show that choices and actions satisfy, not a subjectively defined

requirement such as utility, but meet the agent's objective interests. Since I do not believe that we have objective interests, I shall ignore this latter. But it will not matter. For the idea is clear; we have a mode of justification that does not require the introduction of moral considerations.[11]

Let me call this alternative nonmoral mode of justification, neutrally, deliberative justification. Now moral and deliberative justification are directed at the same objects—our choices and actions. What if they conflict? And what do we say to the person who offers a deliberative justification of his choices and actions and refuses to offer any other? We can say, of course, that his behavior lacks *moral* justification, but this seems to lack any hold, unless he chooses to enter the moral framework. And such entry, he may insist, lacks any deliberative justification, at least for him.

If morality perishes, the justificatory enterprise, in relation to choice and action, does not perish with it. Rather, one mode of justification perishes, a mode that, it may seem, now hangs unsupported. But not only unsupported, for it is difficult to deny that deliberative justification is more clearly basic, that it cannot be avoided insofar as we are rational agents, so that if moral justification conflicts with it, morality seems not only unsupported but opposed by what is rationally more fundamental.

Deliberative justification relates to our deep sense of self. What distinguishes human beings from other animals, and provides the basis for rationality, is the capacity for semantic representation. You can, as your dog on the whole cannot, represent a state of affairs to yourself, and consider in particular whether or not it is the case, and whether or not you would want it to be the case. You can represent to yourself the contents of your beliefs, and your desires or preferences. But in representing them, you bring them into relation with one another. You represent to yourself that the Blue Jays will win the World Series, and that a National League team will win the World Series, and that the Blue Jays are not a National League team. And in recognizing a conflict among those beliefs, you find rationality thrust upon you. Note that the first two beliefs could be replaced by preferences, with the same effect.

Since in representing our preferences we become aware of conflict among them, the step from representation to choice becomes complicated. We must, somehow, bring our conflicting desires and preferences into some sort of coherence. And there is only one plausible candidate for a principle of coherence—a maximizing principle. We order our preferences, in relation to decision and action, so that we may choose in a way that maximizes our expectation of preference fulfillment. And in so doing, we show ourselves to be rational agents, engaged in deliberation and deliberative justification. There is simply nothing else for practical rationality to be.

The foundational crisis of morality thus cannot be avoided by pointing to the existence of a practice of justification within the moral framework, and denying that any extramoral foundation is relevant. For an extramoral mode of justification is already present, existing not side by side with moral justification, but in a manner tied to the way in which we unify our beliefs and preferences and so acquire our deep sense of self. We need not suppose that this deliberative justification is itself to be understood foundationally. All that we need suppose is that moral justification does not plausibly survive conflict with it.

III

In explaining why we may not dismiss the idea of a foundational crisis in morality as resulting from a misplaced appeal to a philosophically discredited or suspect idea of foundationalism, I have begun to expose the character and dimensions of the crisis. I have claimed that morality faces an alternative, conflicting, deeper mode of justification, related to our deep sense of self, that applies to the entire realm of choice and action, and that evaluates each *action* in terms of the reflectively held concerns of its *agent*. The relevance of the agent's concerns to practical justification does not seem to me in doubt. The relevance of anything else, except insofar as it bears on the agent's concerns, does seem to me very much in doubt. If the agent's reflectively endorsed concerns, his preferences, desires, and aims, are, with his considered beliefs, constitutive of his self-conception, then I can see no remotely plausible way of arguing from their relevance to that of anything

else that is not similarly related to his sense of self. And, indeed, I can see no way of introducing anything as relevant to practical justification except through the agent's self-conception. My assertion of this practical individualism is not a conclusive argument, but the burden of proof is surely on those who would maintain a contrary position. Let them provide the arguments—if they can.

Deliberative justification does not refute morality. Indeed, it does not offer morality the courtesy of a refutation. It ignores morality, and seemingly replaces it. It preempts the arena of justification, apparently leaving morality no room to gain purchase. Let me offer a controversial comparison. Religion faces—indeed, has faced—a comparable foundational crisis. Religion demands the worship of a divine being who purposively orders the universe. But it has confronted an alternative mode of explanation. Although the emergence of a cosmological theory based on efficient, rather than teleological, causation provided warning of what was to come, the supplanting of teleology in biology by the success of evolutionary theory in providing a mode of explanation that accounted in efficient-causal terms for the *appearance* of a purposive order among living beings, may seem to toll the death knell for religion as an intellectually respectable enterprise. But evolutionary biology and, more generally, modern science do not refute religion. Rather they ignore it, replacing its explanations by ontologically simpler ones. Religion, understood as affirming the justifiable worship of a divine being, may be unable to survive its foundational crisis. Can morality, understood as affirming justifiable constraints on choice independent of the agent's concerns, survive?

There would seem to be three ways for morality to escape religion's apparent fate. One would be to find, for moral facts or moral properties, an explanatory role that would entrench them prior to any consideration of justification.[12] One could then argue that any mode of justification that ignored moral considerations would be ontologically defective. I mention this possibility only to put it to one side. No doubt there are persons who accept moral constraints on their choices and actions, and it would not be possible to explain those choices and actions were we to ignore

this. But our explanation of their behavior need not commit us to their view. Here the comparison with religion should be straightforward and uncontroversial. We could not explain many of the practices of the religious without reference to their beliefs. But to characterize what a religious person is doing as, say, an act of worship, does not commit us to supposing that an object of worship actually exists, though it does commit us to supposing that she believes such an object to exist. Similarly, to characterize what a moral agent is doing as, say, fulfilling a duty does not commit us to supposing that there are any duties, though it does commit us to supposing that he believes that there are duties. The skeptic who accepts neither can treat the apparent role of morality in explanation as similar to that of religion. Of course, I do not consider that the parallel can be ultimately sustained, since I agree with the religious skeptic but not with the moral skeptic. But to establish an explanatory role for morality, one must first demonstrate its justificatory credentials. One may not assume that it has a prior explanatory role.

The second way would be to reinterpret the idea of justification, showing that, more fully understood, deliberative justification is incomplete, and must be supplemented in a way that makes room for morality. There is a long tradition in moral philosophy, deriving primarily from Kant, that is committed to this enterprise. This is not the occasion to embark on a critique of what, in the hope again of achieving a neutral characterization, I shall call universalistic justification. But critique may be out of place. The success of deliberative justification may suffice. For theoretical claims about its incompleteness seem to fail before the simple practical recognition that it works. Of course, on the face of it, deliberative justification does not work to provide a place for morality. But to suppose that it must, if it is to be fully adequate or complete as a mode of justification, would be to assume what is in question, whether moral justification is defensible.

If, independent of one's actual desires, and aims, there were objective values, and if, independent of one's actual purposes, one were part of an objectively purposive order, then we might have reason to insist on the inadequacy of the deliberative framework. An

objectively purposive order would introduce considerations relevant to practical justification that did not depend on the agent's self-conception. But the supplanting of teleology in our physical and biological explanations closes this possibility, as it closes the possibility of religious explanation.

I turn then to the third way of resolving morality's foundational crisis. The first step is to embrace deliberative justification, and recognize that morality's place must be found within, and not outside, its framework. Now this will immediately raise two problems. First of all, it will seem that the attempt to establish any constraint on choice and action, within the framework of a deliberation that aims at the maximal fulfillment of the agent's considered preferences, must prove impossible. But even if this be doubted, it will seem that the attempt to establish a constraint *independent of the agent's preferences*, within such a framework, verges on lunacy. Nevertheless, this is precisely the task accepted by my third way. And, unlike its predecessors, I believe that it can be successful; indeed, I believe that my recent book, *Morals by Agreement*, shows how it can succeed.[13]

I shall not rehearse at length an argument that is now familiar to at least some readers, and, in any event, can be found in that book. But let me sketch briefly those features of deliberative rationality that enable it to constrain maximizing choice. The key idea is that in many situations, if each person chooses what, given the choices of the others, would maximize her expected utility, then the outcome will be mutually disadvantageous in comparison with some alternative—everyone could do better.[14] Equilibrium, which obtains when each person's action is a best response to the others' actions, is incompatible with (Pareto-)optimality, which obtains when no one could do better without someone else doing worse. Given the ubiquity of such situations, each person can see the benefit, to herself, of participating with her fellows in practices requiring each to refrain from the direct endeavor to maximize her own utility, when such mutual restraint is mutually advantageous. No one, of course, can have reason to accept any unilateral constraint on her maximizing behavior; each benefits from, and only from, the constraint

accepted by her fellows. But if one benefits more from a constraint on others than one loses by being constrained oneself, one may have reason to accept a practice requiring everyone, including oneself, to exhibit such a constraint. We may represent such a practice as capable of gaining unanimous agreement among rational persons who were choosing the terms on which they would interact with each other. And this agreement is the basis of morality.

Consider a simple example of a moral practice that would command rational agreement. Suppose each of us were to assist her fellows only when either she could expect to benefit herself from giving assistance, or she took a direct interest in their well-being. Then, in many situations, persons would not give assistance to others, even though the benefit to the recipient would greatly exceed the cost to the giver, because there would be no provision for the giver to share in the benefit. Everyone would then expect to do better were each to give assistance to her fellows, regardless of her own benefit or interest, whenever the cost of assisting was low and the benefit of receiving assistance considerable. Each would thereby accept a constraint on the direct pursuit of her own concerns, not unilaterally, but given a like acceptance by others. Reflection leads us to recognize that those who belong to groups whose members adhere to such a practice of mutual assistance enjoy benefits in interaction that are denied to others. We may then represent such a practice as rationally acceptable to everyone.

This rationale for agreed constraint makes no reference to the content of anyone's preferences. The argument depends simply on the *structure* of interaction, on the way in which each person's endeavor to fulfill her own preferences affects the fulfillment of everyone else. Thus, each person's reason to accept a mutually constraining practice is independent of her particular desires, aims and interests, although not, of course, of the fact that she has such concerns. The idea of a purely rational agent, moved to act by reason alone, is not, I think, an intelligible one. Morality is not to be understood as a constraint arising from reason alone on the fulfillment of nonrational preferences. Rather, a rational agent is one who acts to achieve the

maximal fulfillment of her preferences, and morality is a constraint on the manner in which she acts, arising from the effects of interaction with other agents.

Hobbes's Foole now makes his familiar entry onto the scene, to insist that however rational it may be for a person to agree with her fellows to practices that hold out the promise of mutual advantage, yet it is rational to follow such practices only when so doing directly conduces to her maximal preference fulfillment.[15] But then such practices impose no real constraint. The effect of agreeing to or accepting them can only be to change the expected payoffs of her possible choices, making it rational for her to choose what in the absence of the practice would not be utility maximizing. The practices would offer only true prudence, not true morality.

The Foole is guilty of a twofold error. First, he fails to understand that real acceptance of such moral practices as assisting one's fellows, or keeping one's promises, or telling the truth is possible only among those who are disposed to comply with them. If my disposition to comply extends only so far as my interests or concerns at the time of performance, then you will be the real fool if you interact with me in ways that demand a more rigorous compliance. If, for example, it is rational to keep promises only when so doing is directly utility maximizing, then among persons whose rationality is common knowledge, only promises that require such limited compliance will be made. And opportunities for mutual advantage will be thereby forgone.

Consider this example of the way in which promises facilitate mutual benefit. Jones and Smith have adjacent farms. Although neighbors, and not hostile, they are also not friends, so that neither gets satisfaction from assisting the other. Nevertheless, they recognize that, if they harvest their crops together, each does better than if each harvests alone. Next week, Jone's crop will be ready for harvesting; a fortnight hence, Smith's crop will be ready. The harvest in, Jones is retiring, selling his farm, and moving to Florida, where he is unlikely to encounter Smith or other members of their community. Jones would like to promise Smith that, if Smith helps him harvest next week, he will help Smith harvest in a fortnight.

But Jones and Smith both know that in a fortnight, helping Smith would be a pure cost to Jones. Even if Smith helps him, he has nothing to gain by returning the assistance, since neither care for Smith nor, in the circumstances, concern for his own reputation, moves him. Hence, if Jones and Smith know that Jones acts straightforwardly to maximize the fulfillment of his preferences, they know that he will not help Smith. Smith, therefore, will not help Jones even if Jones pretends to promise assistance in return. Nevertheless, Jones would do better could he make and keep such a promise—and so would Smith.

The Foole's second error, following on his first, should be clear; he fails to recognize that in plausible circumstances, persons who are genuinely disposed to a more rigorous compliance with moral practices that would follow from their interests at the time of performance can expect to do better than those who are not so disposed. For the former, constrained maximizers as I call them, will be welcome partners in mutually advantageous cooperation, in which each relies on the voluntary adherence of the others, from which the latter, straightforward maximizers, will be excluded. Constrained maximizers may thus expect more favorable opportunities than their fellows. Although in assisting their fellows, keeping their promises, and complying with other moral practices, they forgo preference fulfillment that they might obtain, yet they do better overall than those who always maximize expected utility, because of their superior opportunities.

In identifying morality with those constraints that would obtain agreement among rational persons who were choosing their terms of interaction, I am engaged in rational reconstruction. I do not suppose that we have actually agreed to existent moral practices and principles. Nor do I suppose that all existent moral practices would secure our agreement, were the question to be raised. Not all existent moral practices need be justifiable—need be ones with which we ought willingly to comply. Indeed, I do not even suppose that the practices with which we ought willingly to comply need be those that would secure our present agreement. I suppose that justifiable moral practices are those that would secure our agreement

ex ante, in an appropriate premoral situation. They are those to which we should have agreed as constituting the terms of our future interaction, had we been, per impossible, in a position to decide those terms. Hypothetical agreement thus provides a test of the justifiability of our existent moral practices.

IV

Many questions could be raised about this account, but here I want to consider only one. I have claimed that moral practices are rational, even though they constrain each person's attempt to maximize her own utility, insofar as they would be the objects of unanimous ex ante ageement. But to refute the Foole, I must defend not only the rationality of agreement, but also that of compliance, and the defense of compliance threatens to preempt the case for agreement, so that my title should be "Why Constraint?" and not "Why Contractarianism?" It is rational to dispose oneself to accept certain constraints on direct maximization in choosing and acting, if and only if so disposing oneself maximizes one's expected utility. What then is the relevance of agreement, and especially of hypothetical agreement? Why should it be rational to dispose oneself to accept only those constraints that would be the object of mutual agreement in an appropriate premoral situation, rather than those constraints that are found in our existent moral practices? Surely it is acceptance of the latter that makes a person welcome in interaction with his fellows. For compliance with existing morality will be what they expect, and take into account in choosing partners with whom to cooperate.

I began with a challenge to morality—how can it be rational for us to accept its constraints? It may now seem that what I have shown is that it is indeed rational for us to accept constraints, but to accept them whether or not they might be plausibly considered moral. Morality, it may seem, has nothing to do with my argument; what I have shown is that it is rational to be disposed to comply with whatever constraints are generally accepted and expected, regardless of their nature. But this is not my view.

To show the relevance of agreement to the justification of constraints, let us assume an ongoing society in which individuals more or less acknowledge and comply with a given set of practices that constrain their choices in relation to what they would be did they take only their desires, aims, and interests directly into account. Suppose that a disposition to conform to these existing practices is prima facie advantageous, since persons who are not so disposed may expect to be excluded from desirable opportunities by their fellows. However, the practices themselves have, or at least need have, no basis in agreement. And they need satisfy no intuitive standard of fairness or impartiality, characteristics that we may suppose relevant to the identification of the practices with those of a genuine morality. Although we may speak of the practices as constituting the morality of the society in question, we need not consider them morally justified or acceptable. They are simply practices constraining individual behavior in a way that each finds rational to accept.

Suppose now that our persons, as rational maximizers of individual utility, come to reflect on the practices constituting their morality. They will, of course, assess the practices in relation to their own utility, but with the awareness that their fellows will be doing the same. And one question that must arise is: Why these practices? For they will recognize that the set of actual moral practices is not the only possible set of constraining practices that would yield mutually advantageous, optimal outcomes. They will recognize the possibility of alternative moral orders. At this point it will not be enough to say that, as a matter of fact, each person can expect to benefit from a disposition to comply with existing practices. For persons will also ask themselves: Can I benefit more, not from simply abandoning any morality, and recognizing no constraint, but from a partial rejection of existing constraints in favor of an alternative set? Once this question is asked, the situation is transformed; the existing moral order must be assessed, not only against simple noncompliance, but also against what we may call alternative compliance.

To make this assessment, each will compare her prospects under the existing practices with those

she would anticipate from a set that, in the existing circumstances, she would expect to result from bargaining with her fellows. If her prospects would be improved by such negotiation, then she will have a real, although not necessarily sufficient, incentive to demand a change in the established moral order. More generally, if there are persons whose prospects would be improved by renegotiation, then the existing order will be recognizably unstable. No doubt those whose prospects would be worsened by renegotiation will have a clear incentive to resist, to appeal to the status quo. But their appeal will be a weak one, especially among persons who are not taken in by spurious ideological considerations, but focus on individual utility maximization. Thus, although in the real world, we begin with an existing set of moral practices as constraints on our maximizing behavior, yet we are led by reflection to the idea of an amended set that would obtain the agreement of everyone, and this amended set has, and will be recognized to have, a stability lacking in existing morality.

The reflective capacity of rational agents leads them from the given to the agreed, from existing practices and principles requiring constraint to those that would receive each person's assent. The same reflective capacity, I claim, leads from those practices that would be agreed to, in existing social circumstances, to those that would receive ex ante agreement, premoral and presocial. As the status quo proves unstable when it comes into conflict with what would be agreed to, so what would be agreed to proves unstable when it comes into conflict with what would have been agreed to in an appropriate presocial context. For as existing practices must seem arbitrary insofar as they do not correspond to what a rational person would agree to, so what such a person would agree to in existing circumstances must seem arbitrary in relation to what she would accept in a presocial condition.

What a rational person would agree to in existing circumstances depends in large part on her negotiating position vis-à-vis her fellows. But her negotiating position is significantly affected by the existing social institutions, and so by the currently accepted moral practices embodied in those institutions. Thus, although agreement may well yield

practices differing from those embodied in existing social institutions, yet it will be influenced by those practices, which are not themselves the product of rational agreement. And this must call the rationality of the agreed practices into question. The arbitrariness of existing practices must infect any agreement whose terms are significantly affected by them. Although rational agreement is in itself a source of stability, yet this stability is undermined by the arbitrariness of the circumstances in which it takes place. To escape this arbitrariness, rational persons will revert from actual to hypothetical agreement, considering what practices they would have agreed to from an initial position not structured by existing institutions and the practices they embody.

The content of a hypothetical agreement is determined by an appeal to the equal rationality of persons. Rational persons will voluntarily accept an agreement only insofar as they perceive it to be equally advantageous to each. To be sure, each would be happy to accept an agreement more advantageous to herself than to her fellows, but since no one will accept an agreement perceived to be less advantageous, agents whose rationality is a matter of common knowledge will recognize the futility of aiming at or holding out for more, and minimize their bargaining costs by coordinating at the point of equal advantage. Now the extent of advantage is determined in a twofold way. First, there is advantage internal to an agreement. In this respect, the expectation of equal advantage is assured by procedural fairness. The step from existing moral practices to those resulting from actual agreement takes rational persons to a procedurally fair situation, in which each perceives the agreed practices to be ones that it is equally rational for all to accept, given the circumstances in which agreement is reached. But those circumstances themselves may be called into question insofar as they are perceived to be arbitrary— the result, in part, of compliance with constraining practices that do not themselves ensure the expectation of equal advantage, and so do not reflect the equal rationality of the complying parties. To neutralize this arbitrary element, moral practices to be fully acceptable must be conceived as constituting a

possible outcome of a hypothetical agreement under circumstances that are unaffected by social institutions that themselves lack full acceptability. Equal rationality demands consideration of external circumstances as well as internal procedures.

But what is the practical import of this argument? It would be absurd to claim that mere acquaintance with it, or even acceptance of it, will lead to the replacement of existing moral practices by those that would secure presocial agreement. It would be irrational for anyone to give up the benefits of the existing moral order simply because he comes to realize that it affords him more than he could expect from pure rational agreement with his fellows. And it would be irrational for anyone to accept a long-term utility loss by refusing to comply with the existing moral order, simply because she comes to realize that such compliance affords her less than she could expect from pure rational agreement. Nevertheless, these realizations do transform, or perhaps bring to the surface, the character of the relationships between persons that are maintained by the existing constraints, so that some of these relationships come to be recognized as coercive. These realizations constitute the elimination of false consciousness, and they result from a process of rational reflection that brings persons into what, in my theory, is the parallel of Jürgen Habermas's ideal speech situation.[16] Without an argument to defend themselves in open dialogue with their fellows, those who are more than equally advantaged can hope to maintain their privileged position only if they can coerce their fellows into accepting it. And this, of course, may be possible. But coercion is not agreement, and it lacks any inherent stability.

Stability plays a key role in linking compliance to agreement. Aware of the benefits to be gained from constraining practices, rational persons will seek those that invite stable compliance. Now compliance is stable if it arises from agreement among persons each of whom considers both that the terms of agreement are sufficiently favorable to herself that it is rational for her to accept them, and that they are not so favorable to others that it would be rational for them to accept terms less favorable to them and more

favorable to herself. An agreement affording equally favorable terms to all thus invites, as no other can, stable compliance.

V

In defending the claim that moral practices, to obtain the stable voluntary compliance of rational individuals, must be the objects of an appropriate hypothetical agreement, I have added to the initial minimal characterization of morality. Not only does morality constrain our choices and actions, but it does so in an impartial way, reflecting the equal rationality of the persons subject to constraint. Although it is no part of my argument to show that the requirements of contractarian morality will satisfy the Rawlsian test of cohering with our considered judgments in reflective equilibrium, yet it would be misleading to treat rationally agreed constraints on direct utility maximization as constituting a morality at all, rather than as replacing morality, were there no fit between their content and our pretheoretical moral views. The fit lies, I suggest, in the impartiality required for hypothetical agreement.

The foundational crisis of morality is thus resolved by exhibiting the rationality of our compliance with mutual, rationally agreed constraints on the pursuit of our desires, aims, and interests. Although bereft of a basis in objective values or an objectively purposive order, and confronted by a more fundamental mode of justification, morality survives by incorporating itself into that mode. Moral considerations have the same status, and the same role in explaining behavior, as the other reasons acknowledged by a rational deliberator. We are left with a unified account of justification, in which an agent's choices and actions are evaluated in relation to his preferences—to the concerns that are constitutive of his sense of self. But since morality binds the agent independently of the particular content of his preferences, it has the prescriptive grip with which the Christian and Kantian views have invested it.

In incorporating morality into deliberative justification, we recognize a new dimension to the agent's

self-conception. For morality requires that a person have the capacity to commit himself, to enter into agreement with his fellows secure in the awareness that he can and will carry out his part of the agreement without regard to many of those considerations that normally and justifiably would enter into his future deliberations. And this is more than the capacity to bring one's desires and interests together with one's beliefs into a single coherent whole. Although this latter unifying capacity must extend its attention to past and future, the unification it achieves may itself be restricted to that extended present within which a person judges and decides. But in committing oneself to future action in accordance with one's agreement, one must fix at least a subset of one's desires and beliefs to hold in that future. The self that agrees and the self that complies must be one. "Man himself must first of all have become *calculable, regular, necessary*, even in his own image of himself, if he is to be able to stand security for *his own future*, which is what one who promises does!"[17]

In developing *"the right to make promises,"*[18] we human beings have found a contractarian bulwark against the perishing of morality.

Notes

1. *On the Genealogy of Morals*, trans. by Walter Kaufmann and R. J. Hollingdale (New York: Random House, 1967), third essay, sec. 27, p. 161.

2. *After Virtue* (Notre Dame, IN: University of Notre Dame Press, 1981), p. 2.

3. *Ethics and the Limits of Philosophy* (Cambridge, MA: Harvard University Press, 1985), p. 197.

4. *Ethics: Inventing Right and Wrong* (Harmondsworth: Penguin, 1977), pp. 15, 30.

5. *The Nature of Morality* (New York: Oxford University Press, 1977), p. 11.

6. David Hume, *An Enquiry Concerning the Principles of Morals*, 1751, sec. IX, pt. II.

7. See Plato, *Republic*, esp. books II and IV.

8. Some would extend morality to the nonsentient, but sympathetic as I am to the rights of trolley cars and steam locomotives, I propose to leave this view quite out of consideration.

9. John Rawls, *A Theory of Justice* (Cambridge, MA: Harvard University Press, 1971), p. 51.

10. John C. Harsanyi, "Morality and the Theory of Rational Behaviour," in *Utilitarianism and Beyond*, edited by Amartya Sen and Bernard Williams (Cambridge: Cambridge University Press, 1982), p. 62.

11. To be sure, if we think of morality as expressed in certain of our affections and/or interests, it will incorporate moral considerations to the extent that they actually are present in our preferences. But this would be to embrace the naturalism that I have put to one side as inadequate.

12. This would meet the challenge to morality found in my previous quotation from Gilbert Harman.

13. See David Gauthier, *Morals by Agreement* (Oxford: Oxford University Press, 1986), especially chaps. V and VI.

14. The now-classic example of this type of situation is the Prisoner's Dilemma; see *Morals by Agreement*, pp. 79–80. More generally, such situations may be said, in economists' parlance, to exhibit market failure. See, for example, "Market Contractarianism" in Jules Coleman, *Markets, Morals, and the Law* (Cambridge: Cambridge University Press, 1988), chap. 10.

15. See Hobbes, *Leviathan*, London, 1651, chap. 15.

16. See Raymond Geuss, *The Idea of a Critical Theory: Habermas and the Frankfurt School* (Cambridge: Cambridge University Press, 1981), p. 65ff.

17. Nietzsche, *On the Genealogy of Morals*, trans. by Walter Kaufmann and R. J. Hollingdale (New York: Random House, 1967), second essay, sec. 1, p. 58.

18. Ibid., p. 57.

Study Questions

1. According to Gauthier, how does morality face a foundational crisis?

2. Does contractarianism provide a means to avoid this foundational crisis?

3. Can you provide a realistic case in which acting morally is not in your long-term self-interest?

4. If you could provide such a case, would it undermine Gauthier's theory?

28

T. M. SCANLON

Whereas contractarianism holds that rational self-interest can provide a basis for morality, contractualism maintains that rationality requires respect for persons, thereby providing a foundation for cooperation among equals. Thomas Scanlon, Professor of Philosophy at Harvard University, offers a defense of contractualism, maintaining that an act is wrong if it would be disallowed by a set of principles that no one could reasonably reject as the basis of informed, general agreement. In short, wrong acts are acts that cannot be justified to all others. Scanlon claims that this moral theory offers a more persuasive account of the foundations of moral reasoning than does any version of utilitarianism.

Contractualism and Utilitarianism

Utilitarianism occupies a central place in the moral philosophy of our time. It is not the view which most people hold; certainly there are very few who would claim to be act utilitarians. But for a much wider range of people it is the view towards which they find themselves pressed when they try to give a theoretical account of their moral beliefs. Within moral philosophy it represents a position one must struggle against if one wishes to avoid it. This is so in spite of the fact that the implications of act utilitarianism are wildly at variance with firmly held moral convictions, while rule utilitarianism, the most common alternative formulation, strikes most people as an unstable compromise.

The wide appeal of utilitarianism is due, I think, to philosophical considerations of a more or less sophisticated kind which pull us in a quite different direction than our first order moral beliefs. In particular,

utilitarianism derives much of its appeal from alleged difficulties about the foundations of rival views. What a successful alternative to utilitarianism must do, first and foremost, is to sap this source of strength by providing a clear account of the foundations of non-utilitarian moral reasoning. In what follows I will first describe the problem in more detail by setting out the questions which a philosophical account of the foundations of morality must answer. I will then put forward a version of contractualism which, I will argue, offers a better set of responses to these questions than that supplied by straightforward versions of utilitarianism. Finally I will explain why contractualism, as I understand it, does not lead back to some utilitarian formula as its normative outcome.

Contractualism has been proposed as the alternative to utilitarianism before, notably by John Rawls in *A Theory of Justice* (Rawls 1971). Despite the

T. M. Scanlon, "Contractualism and Utilitarianism," pp. 103–29 from Amartya Sen and Bernard Williams (eds.), *Utilitarianism and Beyond*. Cambridge: Cambridge University Press, 1982, © 1982 by Maison des Sciences de l'Homme and Cambridge University Press, reproduced with permission.

wide discussion which this book has received, however, I think that the appeal of contractualism as a foundational view has been underrated. In particular, it has not been sufficiently appreciated that contractualism offers a particularly plausible account of moral motivation. The version of contractualism that I shall present differs from Rawls' in a number of respects. In particular, it makes no use, or only a different and more limited kind of use, of his notion of choice from behind a veil of ignorance. One result of this difference is to make the contrast between contractualism and utilitarianism stand out more clearly.

I

There is such a subject as moral philosophy for much the same reason that there is such a subject as the philosophy of mathematics. In moral judgements, as in mathematical ones, we have a set of putatively objective beliefs in which we are inclined to invest a certain degree of confidence and importance. Yet on reflection it is not at all obvious what, if anything, these judgements can be about, in virtue of which some can be said to be correct or defensible and others not. This question of subject matter, or the grounds of truth, is the first philosophical question about both morality and mathematics. Second, in both morality and mathematics it seems to be possible to discover the truth simply by thinking or reasoning about it. Experience and observation may be helpful, but observation in the normal sense is not the standard means of discovery in either subject. So, given any positive answer to the first question—any specification of the subject matter or ground of truth in mathematics or morality—we need some compatible epistemology explaining how it is possible to discover the facts about this subject matter through something like the means we seem to use.

Given this similarity in the questions giving rise to moral philosophy and to the philosophy of mathematics, it is not surprising that the answers commonly given fall into similar general types. If we were to interview students in a freshman mathematics course many of them would, I think, declare themselves for some kind of conventionalism. They would hold that mathematics proceeds from definitions and principles that are either arbitrary or instrumentally justified, and that mathematical reasoning consists in perceiving what follows from these definitions and principles. A few others, perhaps, would be realists or platonists according to whom mathematical truths are a special kind of non-empirical fact that we can perceive through some form of intuition. Others might be naturalists who hold that mathematics, properly understood, is just the most abstract empirial science. Finally there are, though perhaps not in an average freshman course, those who hold that there are no mathematical facts in the world "outside of us," but that the truths of mathematics are objective truths about the mental constructions of which we are capable. Kant held that pure mathematics was a realm of objective mind-dependent truths, and Brouwer's mathematical Intuitionism is another theory of this type (with the important difference that it offers grounds for the warranted assertability of mathematical judgements rather than for their truth in the classical sense). All of these positions have natural correlates in moral philosophy. Intuitionism of the sort espoused by W. D. Ross is perhaps the closest analogue to mathematical platonism, and Kant's theory is the most familiar version of the thesis that morality is a sphere of objective, mind-dependent truths.

All of the views I have mentioned (with some qualification in the case of conventionalism) give positive (i.e. non-sceptical) answers to the first philosophical question about mathematics. Each identifies some objective, or at least intersubjective, ground of truth for mathematical judgements. Outright scepticism and subjective versions of mind-dependence (analogues of emotivism or prescriptivism) are less appealing as philosophies of mathematics than as moral philosophies. This is so in part simply because of the greater degree of intersubjective agreement in mathematical judgement. But it is also due to the difference in the further questions that philosophical accounts of the two fields must answer.

Neither mathematics nor morality can be taken to describe a realm of facts existing in isolation from the rest of reality. Each is supposed to be connected with other things. Mathematical judgements give rise to predictions about those realms to which mathematics

is applied. This connection is something that a philosophical account of mathematical truth must explain, but the fact that we can observe and learn from the correctness of such predictions also gives support to our belief in objective mathematical truth. In the case of morality the main connection is, or is generally supposed to be, with the will. Given any candidate for the role of subject matter of morality we must explain why anyone should care about it, and the need to answer this question of motivation has given strong support to subjectivist views.

But what must an adequate philosophical theory of morality say about moral motivation? It need not, I think, show that the moral truth gives anyone who knows it a reason to act which appeals to that person's present desires or to the advancement of his or her interests. I find it entirely intelligible that moral requirement might correctly apply to a person even though that person had no reason of either of these kinds for complying with it. Whether moral requirements give those to whom they apply reasons for compliance of some third kind is a disputed question which I shall set aside. But what an adequate moral philosophy must do, I think, is to make clearer to us the nature of the reasons that morality does provide, at least to those who are concerned with it. A philosophical theory of morality must offer an account of these reasons that is, on the one hand, compatible with its account of moral truth and moral reasoning and, on the other, supported by a plausible analysis of moral experience. A satisfactory moral philosophy will not leave concern with morality as a simple special preference, like a fetish or a special taste, which some people just happen to have. It must make it understandable why moral reasons are ones that people can take seriously, and why they strike those who are moved by them as reasons of a special stringency and inescapability.

There is also a further question whether susceptibility to such reasons is compatible with a person's good or whether it is, as Nietzsche argued, a psychological disaster for the person who has it. If one is to defend morality one must show that it is not disastrous in this way, but I will not pursue this second motivational question here. I mention it only to distinguish it from the first question, which is my present concern.

The task of giving a philosophical explanation of the subject matter of morality differs both from the task of analysing the meaning of moral terms and from that of finding the most coherent formulation of our first order moral beliefs. A maximally coherent ordering of our first order moral beliefs could provide us with a valuable kind of explanation: it would make clear how various, apparently disparate moral notions, precepts and judgements are related to one another, thus indicating to what degree conflicts between them are fundamental and to what degree, on the other hand, they can be resolved or explained away. But philosophical inquiry into the subject matter of morality takes a more external view. It seeks to explain what kind of truths moral truths are by describing them in relation to other things in the world and in relation to our particular concerns. An explanation of how we can come to know the truth about morality must be based on such an external explanation of the kind of things moral truths are rather than on a list of particular moral truths, even a maximally coherent list. This seems to be true as well about explanations of how moral beliefs can give one a reason to act.[1]

Coherence among our first-order moral beliefs—what Rawls has called narrow reflective equilibrium[2]—seems unsatisfying[3] as an account of moral truth or as an account of the basis of justification in ethics just because, taken by itself, a maximally coherent account of our moral beliefs need not provide us with what I have called a philosophical explanation of the subject matter of morality. However internally coherent our moral beliefs may be rendered, the nagging doubt may remain that there is nothing to them at all. They may be merely a set of socially inculcated reactions, mutually consistent perhaps but not judgements of a kind which can properly be said to be correct or incorrect. A philosophical theory of the nature of morality can contribute to our confidence in our first order moral beliefs chiefly by allaying these natural doubts about the subject. Insofar as it includes an account of moral epistemology, such a theory may guide us towards new forms of moral argument, but it need not do this. Moral argument of more or less the kind we have been familiar with may remain as the only form of

justification in ethics. But whether or not it leads to revision in our modes of justification, what a good philosophical theory should do is to give us a clearer understanding of what the best forms of moral argument amount to and what kind of truth it is that they can be a way of arriving at. (Much the same can be said, I believe, about the contribution which philosophy of mathematics makes to our confidence in particular mathematical judgements and particular forms of mathematical reasoning.)

Like any thesis about morality, a philosophical account of the subject matter of morality must have some connection with the meaning of moral terms: it must be plausible to claim that the subject matter described is in fact what these terms refer to at least in much of their normal use. But the current meaning of moral terms is the product of many different moral beliefs held by past and present speakers of the language, and this meaning is surely compatible with a variety of moral views and with a variety of views about the nature of morality. After all, moral terms are used to express many different views of these kinds, and people who express these views are not using moral terms incorrectly, even though what some of them say must be mistaken. Like a first-order moral judgement, a philosophical characterisation of the subject matter of morality is a substantive claim about morality, albeit a claim of a different kind.

While a philosophical characterisation of morality makes a kind of claim that differs from a first-order moral judgement, this does not mean that a philosophical theory of morality will be neutral between competing normative doctrines. The adoption of a philosophical thesis about the nature of morality will almost always have some effect on the plausibility of particular moral claims, but philosophical theories of morality vary widely in the extent and directness of their normative implications. At one extreme is intuitionism, understood as the philosophical thesis that morality is concerned with certain non-natural properties. Rightness, for example, is held by Ross[4] to be the property of "fittingness" or "moral suitability." Intuitionism holds that we can identify occurrences of these properties, and that we can recognise as self-evident certain general truths about them, but that they

cannot be further analysed or explained in terms of other notions. So understood, intuitionism is in principle compatible with a wide variety of normative positions. One could, for example, be an intuitionistic utilitarian or an intuitionistic believer in moral rights, depending on the general truths about the property of moral rightness which one took to be self-evident.

The other extreme is represented by philosophical utilitarianism. The term "utilitarianism" is generally used to refer to a family of specific normative doctrines—doctrines which might be held on the basis of a number of different philosophical theses about the nature of morality. In this sense of the term one might, for example, be a utilitarian on intuitionist or on contractualist grounds. Bur what I will call "philosophical utilitarianism" is a particular philosophical thesis about the subject matter of morality, namely the thesis that the only fundamental moral facts are facts about individual well-being.[5] I believe that this thesis has a great deal of plausibility for many people, and that, while some people are utilitarians for other reasons, it is the attractiveness of philosophical utilitarianism which accounts for the widespread influence of utilitarian principles.

It seems evident to people that there is such a thing as individuals' being made better or worse off. Such facts have an obvious motivational force; it is quite understandable that people should be moved by them in much the way that they are supposed to be moved by moral considerations. Further, these facts are clearly relevant to morality as we now understand it. Claims about individual well-being are one class of valid starting points for moral argument. But many people find it much harder to see how there could be any other, independent starting points. Substantive moral requirements independent of individual well-being strike people as intuitionist in an objectionable sense. They would represent "moral facts" of a kind it would be difficult to explain. There is no problem about recognising it as a fact that a certain act is, say, an instance of lying or of promise breaking. And a utilitarian can acknowledge that such facts as these often have (derivative) moral significance: they are morally significant because of their consequences for individual well-being. The problems, and the charge of "intuitionism,"

arise when it is claimed that such acts are wrong in a sense that is not reducible to the fact that they decrease individual well-being. How could this independent property of moral wrongness be understood in a way that would give it the kind of importance and motivational force which moral considerations have been taken to have? If one accepts the idea that there are no moral properties having this kind of intrinsic significance, then philosophical utilitarianism may seem to be the only tenable account of morality. And once philosophical utilitarianism is accepted, some form of normative utilitarianism seems to be forced on us as the correct first-order moral theory. Utilitarianism thus has, for many people, something like the status which Hilbert's Formalism and Brouwer's Intuitionism have for their believers. It is a view which seems to be forced on us by the need to give a philosophically defensible account of the subject. But it leaves us with a hard choice: we can either abandon many of our previous first-order beliefs or try to salvage them by showing that they can be obtained as derived truths or explained away as useful and harmless fictions.

It may seem that the appeal of philosophical utilitarianism as I have described it is spurious, since this theory must amount either to a form of intuitionism (differing from others only in that it involves just one appeal to intuition) or else to definitional naturalism of a kind refuted by Moore and others long ago. But I do not think that the doctrine can be disposed of so easily. Philosophical utilitarianism is a philosophical thesis about the nature of morality. As such, it is on a par with intuitionism or with the form of contractualism which I will defend later in this paper. None of these theses need claim to be true as a matter of definition; if one of them is true it does not follow that a person who denies it is misusing the words "right," "wrong" and "ought." Nor are all these theses forms of intuitionism, if intuitionism is understood as the view that moral facts concern special non-natural properties, which we can apprehend by intuitive insight but which do not need or admit of any further analysis. Both contractualism and philosophical utilitarianism are specifically incompatible with this claim. Like other philosophical theses about the nature of morality (including, I would say, intuitionism itself), contractualism and philosophical utilitarianism are to be appraised on the basis of their

success in giving an account of moral belief, moral argument and moral motivation that is compatible with our general beliefs about the world: our beliefs about what kinds of things there are in the world, what kinds of observation and reasoning we are capable of, and what kinds of reasons we have for action. A judgement as to which account of the nature of morality (or of mathematics) is most plausible in this general sense is just that: a judgement of overall plausibility. It is not usefully described as an insight into concepts or as a special intuitive insight of some other kind.

If philosophical utilitarianism is accepted then some form of utilitarianism appears to be forced upon us as a normative doctrine, but further argument is required to determine which form we should accept. If all that counts morally is the well-being of individuals, no one of whom is singled out as counting for more than the others, and if all that matters in the case of each individual is the degree to which his or her well-being is affected, then it would seem to follow that the basis of moral appraisal is the goal of maximising the *sum*[6] of individual well-being. Whether this standard is to be applied to the criticism of individual actions, or to the selection of rules or policies, or to the inculcation of habits and dispositions to act is a further question, as is the question of how "well-being" itself is to be understood. Thus the hypothesis that much of the appeal of utilitarianism as a normative doctrine derives from the attractiveness of philosophical utilitarianism explains how people can be convinced that some form of utilitarianism must be correct while yet being quite uncertain as to which form it is, whether it is "direct" or "act" utilitarianism or some form of indirect "rule" or "motive" utilitarianism. What these views have in common, despite their differing normative consequences, is the identification of the same class of fundamental moral facts.

II

If what I have said about the appeal of utilitarianism is correct, then what a rival theory must do is to provide an alternative to philosophical utilitarianism as a conception of the subject matter of morality. This is what the theory which I shall call contractualism

seeks to do. Even if it succeeds in this, however, and is judged superior to philosophical utilitarianism as an account of the nature of morality, normative utilitarianism will not have been refuted. The possibility will remain that normative utilitarianism can be established on other grounds, for example as the normative outcome of contractualism itself. But one direct and, I think, influential argument for normative utilitarianism will have been set aside.

To give an example of what I mean by contractualism, a contractualist account of the nature of moral wrongness might be stated as follows.

> An act is wrong if its performance under the circumstances would be disallowed by any system of rules for the general regulation of behaviour which no one could reasonably reject as a basis for informed, unforced general agreement.

This is intended as a characterisation of the kind of property which moral wrongness is. Like philosophical utilitarianism, it will have normative consequences, but it is not my present purpose to explore these in detail. As a contractualist account of one moral notion, what I have set out here is only an approximation, which may need to be modified considerably. Here I can offer a few remarks by way of clarification.

The idea of "informed agreement" is meant to exclude agreement based on superstition or false belief about the consequences of actions, even if these beliefs are ones which it would be reasonable for the person in question to have. The intended force of the qualification "reasonably," on the other hand, is to exclude rejections that would be unreasonable *given* the aim of finding principles which could be the basis of informed, unforced general agreement. Given this aim, it would be unreasonable, for example, to reject a principle because it imposed a burden on you when every alternative principle would impose much greater burdens on others. I will have more to say about grounds for rejection later in the paper.

The requirement that the hypothetical agreement which is the subject of moral argument be unforced is meant not only to rule out coercion, but also to exclude being forced to accept an agreement by being in a weak bargaining position, for example because others are able to hold out longer and hence to insist on better terms. Moral argument abstracts from such considerations. The only relevant pressure for agreement comes from the desire to find and agree on principles which no one who had this desire could reasonably reject. According to contractualism, moral argument concerns the possibility of agreement among persons who are all moved by this desire, and moved by it to the same degree. But this counter-factual assumption characterises only the agreement with which morality is concerned, not the world to which moral principles are to apply. Those who are concerned with morality look for principles for application to their imperfect world which they could not reasonably reject, and which others in this world, who are not now moved by the desire for agreement, could not reasonably reject should they come to be so moved.[7]

The contractualist account of moral wrongness refers to principles "which no one could reasonably reject" rather than to principles "which everyone could reasonably accept" for the following reason.[8] Consider a principle under which some people will suffer severe hardships, and suppose that these hardships are avoidable. That is, there are alternative principles under which no one would have to bear comparable burdens. It might happen, however, that the people on whom these hardships fall are particularly self-sacrificing, and are willing to accept these burdens for the sake of what they see as the greater good of all. We would not say, I think, that it would be unreasonable of them to do this. On the other hand, it might not be unreasonable for them to refuse these burdens, and, hence, not unreasonable for someone to reject a principle requiring him to bear them. If this rejection would be reasonable, then the principle imposing these burdens is put in doubt, despite the fact that some particularly self-sacrificing people could (reasonably) accept it. Thus it is the reasonableness of rejecting a principle, rather than the reasonableness of accepting it, on which moral argument turns.

It seems likely that many non-equivalent sets of principles will pass the test of non-rejectability. This is suggested, for example, by the fact that there are many different ways of defining important duties, no one of which is more or less "rejectable" than the others. There are, for example, many different systems

of agreement-making and many different ways of assigning responsibility to care for others. It does not follow, however, that any action allowed by at least one of these sets of principles cannot be morally wrong according to contractualism. If it is important for us to have *some* duty of a given kind (some duty of fidelity to agreements, or some duty of mutual aid) of which there are many morally acceptable forms, then one of these forms needs to be established by convention. In a setting in which one of these forms *is* conventionally established, acts disallowed by it will be wrong in the sense of the definition given. For, given the need for such conventions, one thing that could not be generally agreed to would be a set of principles allowing one to disregard conventionally established (and morally acceptable) definitions of important duties. This dependence on convention introduces a degree of cultural relativity into contractualist morality. In addition, what a person can reasonably reject will depend on the aims and conditions that are important in his life, and these will also depend on the society in which he lives. The definition given above allows for variation of both of these kinds by making the wrongness of an action depend on the circumstances in which it is performed.

The partial statement of contractualism which I have given has the abstract character appropriate in an account of the subject matter of morality. On its face, it involves no specific claim as to which principles could be agreed to or even whether there is a unique set of principles which could be the basis of agreement. One way, though not the only way, for a contractualist to arrive at substantive moral claims would be to give a technical definition of the relevant notion of agreement, e.g. by specifying the conditions under which agreement is to be reached, the parties to this agreement and the criteria of reasonableness to be employed. Different contractualists have done this in different ways. What must be claimed for such a definition is that (under the circumstances in which it is to apply) what it describes is indeed the kind of unforced, reasonable agreement at which moral argument aims. But contractualism can also be understood as an informal description of the subject matter of morality on the basis of which

ordinary forms of moral reasoning can be understood and appraised without proceeding via a technical notion of agreement.

Who is to be included in the general agreement to which contractualism refers? The scope of morality is a difficult question of substantive morality, but a philosophical theory of the nature of morality should provide some basis for answering it. What an adequate theory should do is to provide a framework within which what seem to be relevant arguments for and against particular interpretations of the moral boundary can be carried out. It is often thought that contractualism can provide no plausible basis for an answer to this question. Critics charge either that contractualism provides no answer at all, because it must begin with some set of contracting parries taken as given, or that contractualism suggests an answer which is obviously too restrictive, since a contract requires parties who are able to make and keep agreements and who are each able to offer the others some benefit in return for their cooperation. Neither of these objections applies to the version of contractualism that I am defending. The general specification of the scope of morality which it implies seems to me to be this: morality applies to a being if the notion of justification to a being of that kind makes sense. What is required in order for this to be the case? Here I can only suggest some necessary conditions. The first is that the being have a good, that is, that there be a clear sense in which things can be said to go better or worse for that being. This gives partial sense to the idea of what it would be reasonable for a trustee to accept on the being's behalf. It would be reasonable for a trustee to accept at least those things that are good, or not bad, for the being in question. Using this idea of trusteeship we can extend the notion of acceptance to apply to beings that are incapable of literally agreeing to anything. But this minimal notion of trusteeship is too weak to provide a basis for morality, according to contractualism. Contractualist morality relies on notions of what it would be reasonable to accept, or reasonable to reject, which are essentially comparative. Whether it would be unreasonable for me to reject a certain principle, given the aim of finding principles which no one with this aim could

reasonably reject, depends not only on how much actions allowed by that principle might hurt me in absolute terms but also on how that potential loss compares with other potential losses to others under this principle and alternatives to it. Thus, in order for a being to stand in moral relations with us it is not enough that it have a good, it is also necessary that its good be sufficiently similar to our own to provide a basis for some system of comparability. Only on the basis of such a system can we give the proper kind of sense to the notion of what a trustee could reasonably reject on a being's behalf.

But the range of possible trusteeship is broader than that of morality. One could act as a trustee for a tomato plant, a forest or an ant colony, and such entities are not included in morality. Perhaps this can be explained by appeal to the requirement of comparability: while these entities have a good, it is not comparable to our own in a way that provides a basis for moral argument. Beyond this, however, there is in these cases insufficient foothold for the notion of justification *to* a being. One further minimum requirement for this notion is that the being constitute a point of view; that is, that there be such a thing as what it is like to be that being, such a thing as what the world seems like to it. Without this, we do not stand in a relation to the being that makes even hypothetical justification *to it* appropriate.

On the basis of what I have said so far contractualism can explain why the capacity to feel pain should have seemed to many to count in favour of moral status: a being which has this capacity seems also to satisfy the three conditions I have just mentioned as necessary for the idea of justification to it to make sense. If a being can feel pain, then it constitutes a centre of consciousness to which justification can be addressed. Feeling pain is a clear way in which the being can be worse off; having its pain alleviated a way in which it can be benefited; and these are forms of weal and woe which seem directly comparable to our own.

It is not clear that the three conditions I have listed as necessary are also sufficient for the idea of justification to a being to make sense. Whether they are, and, if they are not, what more may be required, are difficult and disputed questions. Some would restrict the moral sphere to those to whom justifications could in principle be communicated, or to those who can actually agree to something, or to those who have the capacity to understand moral argument. Contractualism as I have stated it does not settle these issues at once. All I claim is that it provides a basis for argument about them which is at least as plausible as that offered by rival accounts of the nature of morality. These proposed restrictions on the scope of morality are naturally understood as debatable claims about the conditions under which the relevant notion of justification makes sense, and the arguments commonly offered for and against them can also be plausibly understood on this basis.

Some other possible restrictions on the scope of morality are more evidently rejectable. Morality might be restricted to those who have the capacity to observe its constraints, or to those who are able to confer some reciprocal benefit on other participants. But it is extremely implausible to suppose that the beings excluded by these requirements fall entirely outside the protection of morality. Contractualism as I have formulated it[9] can explain why this is so: the absence of these capacities alone does nothing to undermine the possibility of justification to a being. What it may do in some cases, however, is to alter the justifications which are relevant. I suggest that whatever importance the capacities for deliberative control and reciprocal benefit may have is as factors altering the duties which beings have and the duties others have towards them, not as conditions whose absence suspends the moral framework altogether.

III

I have so far said little about the normative content of contractualism. For all I have said, the act utilitarian formula might turn out to be a theorem of contractualism. I do not think that this is the case, but my main thesis is that whatever the normative implications of contractualism may be it still has distinctive content as a philosophical thesis about the nature of morality. This content—the difference, for example, between being a utilitarian because the utilitarian formula is the basis of general agreement and being

a utilitarian on other grounds—is shown most clearly in the answer that a contractualist gives to the first motivational question.

Philosophical utilitarianism is a plausible view partly because the facts which it identifies as fundamental to morality—facts about individual well-being—have obvious motivational force. Moral facts can motivate us, on this view, because of our sympathetic identification with the good of others. But as we move from philosophical utilitarianism to a specific utilitarian formula as the standard of right action, the form of motivation that utilitarianism appeals to becomes more abstract. If classical utilitarianism is the correct normative doctrine then the natural source of moral motivation will be a tendency to be moved by changes in aggregate well-being, however these may be composed. We must be moved in the same way by an aggregate gain of the same magnitude whether it is obtained by relieving the acute suffering of a few people or by bringing tiny benefits to a vast number, perhaps at the expense of moderate discomfort for a few. This is very different from sympathy of the familiar kind toward particular individuals, but a utilitarian may argue that this more abstract desire is what natural sympathy becomes when it is corrected by rational reflection. This desire has the same content as sympathy—it is a concern for the good of others—but it is not partial or selective in its choice of objects.

Leaving aside the psychological plausibility of this even-handed sympathy, how good a candidate is it for the role of moral motivation? Certainly sympathy of the usual kind is one of the many motives that can sometimes impel one to do the right thing. It may be the dominant motive, for example, when I run to the aid of a suffering child. But when I feel convinced by Peter Singer's article[10] on famine, and find myself crushed by the recognition of what seems a clear moral requirement, there is something else at work. In addition to the thought of how much good I could do for people in drought-stricken lands, I am overwhelmed by the further, seemingly distinct thought that it would be wrong for me to fail to aid them when I could do so at so little cost to myself. A utilitarian may respond that his account of moral motivation cannot be faulted for not capturing this aspect of moral experience, since it is just a reflection of our non-utilitarian moral upbringing. Moreover, it must be groundless. For what kind of fact could this supposed further fact of moral wrongness be, and how could it give us a further special reason for acting? The question for contractualism, then, is whether it can provide a satisfactory answer to this challenge.

According to contractualism, the source of motivation that is directly triggered by the belief that an action is wrong is the desire to be able to justify one's actions to others on grounds they could not reasonably[11] reject. I find this an extremely plausible account of moral motivation—a better account of at least my moral experience than the natural utilitarian alternative—and it seems to me to constitute a strong point for the contractualist view. We all might like to be in actual agreement with the people around us, but the desire which contractualism identifies as basic to morality does not lead us simply to conform to the standards accepted by others whatever these may be. The desire to be able to justify one's actions to others on grounds they could not reasonably reject will be satisfied when we know that there is adequate justification for our action even though others in fact refuse to accept it (perhaps because they have no interest in finding principles which we and others could not reasonably reject). Similarly, a person moved by this desire will not be satisfied by the fact that others accept a justification for his action if he regards this justification as spurious.

One rough test of whether you regard a justification as sufficient is whether you would accept that justification if you were in another person's position. This connection between the idea of "changing places" and the motivation which underlies morality explains the frequent occurrence of "Golden Rule" arguments within different systems of morality and in the teachings of various religions. But the thought experiment of changing places is only a rough guide; the fundamental question is what would it be unreasonable to reject as a basis for informed, unforced, general agreement. As Kant observed,[12] our different individual points of view, taken as they are, may

in general by simply irreconcilable. "Judgemental harmony" requires the construction of a genuinely interpersonal form of justification which is nonetheless something that each individual could agree to. From this interpersonal standpoint, a certain amount of how things look from another person's point of view, like a certain amount of how they look from my own, will be counted as bias.

I am not claiming that the desire to be able to justify one's actions to others on grounds they could not reasonably reject is universal or "natural." "Moral education" seems to me plausibly understood as a process of cultivating this desire and shaping it, largely by learning what justifications others are in fact willing to accept, by finding which ones you yourself find acceptable as you confront them from a variety of perspectives, and by appraising your own and others' acceptance or rejection of these justifications in the light of greater experience.

In fact it seems to me that the desire to be able to justify one's actions (and institutions) on grounds one takes to be acceptable is quite strong in most people. People are willing to go to considerable lengths, involving quite heavy sacrifices, in order to avoid admitting the unjustifiability of their actions and institutions. The notorious insufficiency of moral motivation as a way of getting people to do the right thing is not due to simple weakness of the underlying motive, but rather to the fact that it is easily deflected by self-interest and self-deception.

It could reasonably be objected here that the source of motivation I have described is not tied exclusively to the contractualist notion of moral truth. The account of moral motivation which I have offered refers to the idea of a justification which it would be unreasonable to reject, and this idea is potentially broader than the contractualist notion of agreement. For let M be some non-contractualist account of moral truth. According to M, we may suppose, the wrongness of an action is simply a moral characteristic of that action in virtue of which it ought not to be done. An act which has this characteristic, according to M, has it quite independently of any tendency of informed persons to come to agreement about it. However, since informed persons are

presumably in a position to recognise the wrongness of a type of action, it would seem to follow that if an action is wrong then such persons would agree that it is not to be performed. Similarly, if an act is not morally wrong, and there is adequate moral justification to perform it, then there will presumably be a moral justification for it which an informed person would be unreasonable to reject. Thus, even if M, and not contractualism, is the correct account of moral truth, the desire to be able to justify my actions to others on grounds they could not reasonably reject could still serve as a basis for moral motivation.

What this shows is that the appeal of contractualism, like that of utilitarianism, rests in part on a qualified scepticism. A non-contractualist theory of morality can make use of the source of motivation to which contractualism appeals. But a moral argument will trigger this source of motivation only in virtue of being a good justification for acting in a certain way, a justification which others would be unreasonable not to accept. So a non-contractualist theory must claim that there are moral properties which have justificatory force quite independent of their recognition in any ideal agreement. These would represent what John Mackie has called instances of intrinsic "to-be-doneness" and "not-to-be-doneness."[13] Part of contractualism's appeal rests on the view that, as Mackie puts it, it is puzzling how there could be such properties "in the world." By contrast, contractualism seeks to explain the justificatory status of moral properties, as well as their motivational force, in terms of the notion of reasonable agreement. In some cases the moral properties are themselves to be understood in terms of this notion. This is so, for example, in the case of the property of moral wrongness, considered above. But there are also right- and wrong-making properties which are themselves independent of the contractualist notion of agreement. I take the property of being an act of killing for the pleasure of doing so to be a wrong-making property of this kind. Such properties are wrong-making because it would be reasonable to reject any set of principles which permitted the acts they characterise. Thus, while there are morally relevant properties "in the world" which are independent of the contractualist notion of

agreement, these do not constitute instances of intrinsic "to-be-doneness" and "not-to-be-doneness:" their moral relevance—their force in justifications as well as their link with motivation—is to be explained on contractualist grounds.

In particular, contractualism can account for the apparent moral significance of facts about individual well-being, which utilitarianism takes to be fundamental. Individual well-being will be morally significant, according to contractualism, not because it is intrinsically valuable or because promoting it is self-evidently a right-making characteristic, but simply because an individual could reasonably reject a form of argument that gave his well-being no weight. This claim of moral significance is, however, only approximate, since it is a further difficult question exactly how "well-being" is to be understood and in what ways we are required to take account of the well-being of others in deciding what to do. It does not follow from this claim, for example, that a given desire will always and everywhere have the same weight in determining the rightness of an action that would promote its satisfaction, a weight proportional to its strength or "intensity." The right-making force of a person's desires is specified by what might be called a conception of morally legitimate interests. Such a conception is a product of moral argument; it is not given, as the notion of individual well-being may be, simply by the idea of what it is rational for an individual to desire. Not everything for which I have a rational desire will be something in which others need concede me to have a legitimate interest which they undertake to weigh in deciding what to do. The range of things which may be objects of my rational desires is very wide indeed, and the range of claims which others could not reasonably refuse to recognise will almost certainly be narrower than this. There will be a tendency for interests to conform to rational desire—for those conditions making it rational to desire something also to establish a legitimate interest in it—but the two will not always coincide.

One effect of contractualism, then, is to break down the sharp distinction, which arguments for utilitarianism appeal to, between the status of individual well-being and that of other moral notions. A framework of moral argument is required to define our legitimate interests and to account for their moral force. This same contractualist framework can also account for the force of other moral notions such as rights, individual responsibility and procedural fairness.

IV

It seems unlikely that act utilitarianism will be a theorem of the version of contractualism which I have described. The positive moral significance of individual interests is a direct reflection of the contractualist requirement that actions be defensible to each person on grounds he could not reasonably reject. But it is a long step from here to the conclusion that each individual must agree to deliberate always from the point of view of maximum aggregate benefit and to accept justifications appealing to this consideration alone. It is quite possible that, according to contractualism, *some* moral questions may be properly settled by appeal to maximum aggregate well-being, even though this is not the sole or ultimate standard of justification.

What seems less improbable is that contractualism should turn out to coincide with some form of "two-level" utilitarianism. I cannot fully assess this possibility here. Contractualism does share with these theories the important features that the defense of individual actions must proceed via a defense of principles that would allow those acts. But contractualism differs from *some* forms of two level utilitarianism in an important way. The role of principles in contractualism is fundamental; they do not enter merely as devices for the promotion of acts that are right according to some other standard. Since it does not establish two potentially conflicting forms of moral reasoning, contractualism avoids the instability which often plagues rule utilitarianism.

The fundamental question here, however, is whether the principles to which contractualism leads

must be ones whose general adoption (either ideally or under some more realistic conditions) would promote maximum aggregate well-being. It has seemed to many that this must be the case. To indicate why I do not agree I will consider one of the best known arguments for this conclusion and explain why I do not think it is successful. This will also provide an opportunity to examine the relation between the version of contractualism I have advocated here and the version set forth by Rawls.

The argument I will consider, which is familiar from the writings of Harsanyi[14] and others, proceeds via an interpretation of the contractualist notion of acceptance and leads to the principle of maximum average utility. To think of a principle as a candidate for unanimous agreement I must think of it not merely as acceptable to *me* (perhaps in virtue of my particular position, my tastes, etc.) but as acceptable[15] to others as well. To be relevant, my judgement that the principle is acceptable must be impartial. What does this mean? To judge impartially that a principle is acceptable is one might say, to judge that it is one which you would have reason to accept no matter who you were. That is, and here is the interpretation, to judge that it is a principle which it would be rational to accept if you did not know which person's position you occupied and believed that you had an equal chance of being in any of these positions. ("Being in a person's position" is here understood to mean being in his objective circumstances and evaluating these from the perspective of his tastes and preferences.) But, it is claimed, the principle which it would be rational to prefer under these circumstances—the one which would offer the chooser greatest expected utility—would be that principle under which the average utility of the affected parties would be highest.

This argument might be questioned at a number of points, but what concerns me at present is the interpretation of impartiality. The argument can be broken down into three stages. The first of these is the idea that moral principles must be impartially acceptable. The second is the idea of choosing principles in ignorance of one's position (including one's tastes, preferences, etc.). The third is the idea of rational choice

under the assumption that one has an equal chance of occupying anyone's position. Let me leave aside for the moment the move from stage two to stage three, and concentrate on the first step, from stage one to stage two. There is a way of making something like this step which is, I think, quite valid, but it does not yield the conclusion needed by the argument. If I believe that a certain principle, P, could not reasonably be rejected as a basis for informed, unforced general agreement, then I must believe not only that it is something which it would be reasonable for me to accept but something which it would be reasonable for others to accept as well, insofar as we are all seeking a ground for general agreement. Accordingly, I must believe that I would have reason to accept P no matter which social position I were to occupy (though, for reasons mentioned above, I may not believe that I *would* agree to P if I were in some of these positions). Now it may be thought that no sense can be attached to the notion of choosing or agreeing to a principle in ignorance of one's social position, especially when this includes ignorance of one's tastes, preferences, etc. But there is at least a minimal sense that might be attached to this notion. If it would be reasonable for everyone to choose or agree to P, then my knowledge that I have reason to do so need not depend on my knowledge of my particular position, tastes, preferences, etc. So, insofar as it makes any sense at all to speak of choosing or agreeing to something in the absence of this knowledge, it could be said that I have reason to choose or agree to those things which everyone has reason to choose or agree to (assuming, again, the aim of finding principles on which all could agree). And indeed, this same reasoning can carry us through to a version of stage three. For if I judge P to be a principle which everyone has reason to agree to, then it could be said that I would have reason to agree to it if I thought that I had an equal chance of being anybody, or indeed, if I assign any other set of probabilities to being one or another of the people in question.

But it is clear that this is not the conclusion at which the original argument aimed. That conclusion concerned what it would be rational for a self-interested

person to choose or agree to under the assumption of ignorance or equal probability of being anyone. The conclusion we have reached appeals to a different notion: the idea of what it would be unreasonable for people to reject given that they are seeking a basis for general agreement. The direction of explanation in the two arguments is quite different. The original argument sought to explain the notion of impartial acceptability of an ethical principle by appealing to the notion of rational self-interested choice under special conditions, a notion which appears to be a clearer one. My revised argument explains how *a* sense might be attached to the idea of choice or agreement in ignorance of one's position given some idea of what it would be unreasonable for someone to reject as a basis for general agreement. This indicates a problem for my version of contractualism: it may be charged with failure to explain the central notion on which it relies. Here I would reply that my version of contractualism does not seek to explain this notion. It only tries to describe it clearly and to show how other features of morality can be understood in terms of it. In particular, it does not try to explain this notion by reducing it to the idea of what would maximise a person's self-interested expectations if he were choosing from a position of ignorance or under the assumption of equal probability of being anyone.

The initial plausibility of the move from stage one to stage two of the original argument rests on a subtle transition from one of these notions to the other. To believe that a principle is morally correct one must believe that it is one which all could reasonably agree to and none could reasonably reject. But my belief that this is the case may often be distorted by a tendency to take its advantage to me more seriously than its possible costs to others. For this reason, the idea of "putting myself in another's place" is a useful corrective device. The same can be said for the thought experiment of asking what I could agree to in ignorance of my true position. But both of these thought experiments are devices for considering more accurately the question of what *everyone* could reasonably agree to or what no one could reasonably reject. That is, they involve the pattern of reasoning exhibited in my revised form

of the three-stage argument, not that of the argument as originally given. The question, what would maximise the expectations of a single self-interested person choosing in ignorance of his true position, is a quite different question. This can be seen by considering the possibility that the distribution with the highest average utility, call it *A*, might involve extremely low utility levels for some people, levels much lower than the minimum anyone would enjoy under a more equal distribution.

Suppose that *A* is a principle which it would be rational for a self-interested chooser with an equal chance of being in anyone's position to select. Does it follow that no one could reasonably reject *A*? It seems evident that this does not follow.[16] Suppose that the situation of those who would fare worst under *A*, call them the Losers, is extremely bad, and that there is an alternative to *A*, call it *E*, under which no one's situation would be nearly as bad as this. Prima facie, the losers would seem to have a reasonable ground for complaint against *A*. Their objection may be rebutted, by appeal to the sacrifices that would be imposed on some other individual by the selection of *E* rather than *A*. But the mere fact that *A* yields higher average utility, which might be due to the fact that many people do very slightly better under *A* than under *E* while a very few do much worse, does not settle the matter.

Under contractualism, when we consider a principle our attention is naturally directed first to those who would do worst under it. This is because if anyone has reasonable grounds for objecting to the principle it is *likely* to be them. It does not follow, however, that contractualism always requires us to select the principle under which the expectations of the worse off are highest. The reasonableness of the Losers' objection to *A* is not established simply by the fact that they are worse off under *A* and no-one would be this badly off under *E*. The force of their complaint depends also on the fact that their position under *A* is, in absolute terms, very bad, and would be significantly better under *E*. This complaint must be weighed against those of individuals who would do worse under *E*. The question to be asked is, is it unreasonable for someone to refuse to put up with

the Losers' situation under A in order that someone else should be able to enjoy the benefits which he would have to give up under E? As the supposed situation of the Loser under A becomes better, or his gain under E smaller in relation to the sacrifices required to produce it, his case is weakened.

One noteworthy feature of contractualist argument as I have presented it so far is that it is non-aggregative: what are compared are individual gains, losses and levels of welfare. How aggregative considerations can enter into contractualist argument is a further question too large to be entered into here.

I have been criticising an argument for Average Utilitarianism that is generally associated with Harsanyi, and my objections to this argument (leaving aside the last remarks about maximin) have an obvious similarity to objections raised by Rawls.[17] But the objections I have raised apply as well against some features of Rawls' own argument. Rawls accepts the first step of the argument I have described. That is, he believes that the correct principles of justice are those which "rational persons concerned to advance their interests" would accept under the conditions defined by his Original Position, where they would be ignorant of their own particular talents, their conception of the good, and the social position (or generation) into which they were born. It is the second step of the argument which Rawls rejects, i.e. the claim that it would be rational for persons so situated to choose those principles which would offer them greatest expected utility under the assumption that they have an equal chance of being anyone in the society in question. I believe, however, that a mistake has already been made once the first step is taken.

This can be brought out by considering an ambiguity in the idea of acceptance by persons "concerned to advance their interests." On one reading, this is an essential ingredient in contractual argument; on another it is avoidable and, I think, mistaken. On the first reading, the interests in question are simply those of the members of society to whom the principles of justice are to apply (and by whom those principles must ultimately be accepted). The fact that they have interests which may conflict, and which they are concerned to advance, is what gives

substance to questions of justice. On the second reading, the concern "to advance their interests" that is in question is a concern of the parties to Rawls' Original Position, and it is this concern which determines, in the first instance,[18] what principles of justice they will adopt. Unanimous agreement among these parties, each motivated to do as well for himself as he can, is to be achieved by depriving them of any information that could give them reason to choose differently from one another. From behind the veil of ignorance, what offers the best prospects for one will offer the best prospects for all, since no-one can tell what would benefit him in particular. Thus the choice of principles can be made, Rawls says, from the point of view of a single rational individual behind the veil of ignorance.

Whatever rules of rational choice this single individual, concerned to advance his own interests as best he can, is said to employ, this reduction of the problem to the case of a single person's self-interested choice should arouse our suspicion. As I indicated in criticising Harsanyi, it is important to ask whether this single individual is held to accept a principle because he judges that it is one he could not reasonably reject whatever position he turns out to occupy, or whether, on the contrary, it is supposed to be acceptable to a person in any social position because it would be the rational choice for a single self-interested person behind the veil of ignorance. I have argued above that the argument for average utilitarianism involves a covert transition from the first pattern of reasoning to the second. Rawls' argument also appears to be of this second form; his defence of his two principles of justice relies, at least initially, on claims about what it would be rational for a person, concerned to advance his own interests, to choose behind a veil of ignorance. I would claim, however, that the plausibility of Rawls' arguments favouring his two principles over the principle of average utility is preserved, and in some cases enhanced, when they are interpreted as instances of the first form of contractualist argument.

Some of these arguments are of an informal moral character. I have already mentioned his remark about the unacceptability of imposing lower expectations on some for the sake of the higher expectations of

others. More specifically, he says of the parties to the Original Position that they are concerned "to choose principles the consequences of which they are prepared to live with whatever generation they turn out to belong to"[19] or, presumably, whatever their social position turns out to be. This is a clear statement of the first form of contractualist argument. Somewhat later he remarks, in favour of the two principles, that they "are those a person would choose for the design of a society in which his enemy is to assign him a place"[20] Rawls goes on to dismiss this remark, saying that the parties "should not reason from false premises,"[21] but it is worth asking why it seemed a plausible thing to say in the first place. The reason, I take it, is this. In a contractualist argument of the first form, the object of which is to find principles acceptable to each person, assignment by a malevolent opponent is a thought experiment which has a heuristic role like that of a veil of ignorance: it is a way of testing whether one really does judge a principle to be acceptable from all points of view or whether, on the contrary, one is failing to take seriously its effect on people in social positions other than one's own.

But these are all informal remarks, and it is fair to suppose that Rawls' argument, like the argument for average utility, is intended to move from the informal contractualist idea of principles "acceptable to all" to the idea of rational choice behind a veil of ignorance, an idea which is, he hopes, more precise and more capable of yielding definite results. Let me turn then to his more formal arguments for the choice of the Difference Principle by the parties to the Original Position. Rawls cites three features of the decision faced by parties to the Original Position which, he claims, make it rational for them to use the maximin rule and, therefore, to select his Difference Principle as a principle of justice. These are (1) the absence of any objective basis for estimating probabilities, (2) the fact that some principles could have consequences for them which "they could hardly accept" while (3) it is possible for them (by following maximin) to ensure themselves of a minimum prospect, advances above which, in comparison, matter very little.[22] The first of these features is slightly puzzling, and I leave it aside. It seems clear, however, that the other considerations

mentioned have at least as much force in an informal contractualist argument about what all could reasonably agree to as they do in determining the rational choice of a single person concerned to advance his interests. They express the strength of the objection that the "losers" might have to a scheme that maximised average utility at their expense, as compared with the counter-objections that others might have to a more egalitarian arrangement.

In addition to this argument about rational choice, Rawls invokes among "the main grounds for the two principles" other considerations which, as he says, use the concept of contract to a greater extent.[23] The parties to the Original Position, Rawls says, can agree to principles of justice only if they think that this agreement is one that they will actually be able to live up to. It is, he claims, more plausible to believe this of his two principles than of the principle of average utility, under which the sacrifices demanded ("the strains of commitment") could be much higher. A second, related claim is that the two principles of justice have greater psychological stability than the principle of average utility. It is more plausible to believe, Rawls claims, that in a society in which they were fulfilled people would continue to accept them and to be motivated to act in accordance with them. Continuing acceptance of the principle of average utility, on the other hand, would require an exceptional degree of identification with the good of the whole on the part of those from who sacrifices were demanded.

These remarks can be understood as claims about the "stability" (in a quite practical sense) of a society founded on Rawls' two principles of justice. But they can also be seen as an attempt to show that a principle arrived at via the second form of contractualist reasoning will also satisfy the requirements of the first form, i.e. that it is something no one could reasonably reject. The question "Is the acceptance of this principle an agreement you could actually live up to?" is, like the idea of assignment by one's worst enemy, a thought experiment through which we can use our own reactions to test our judgement that certain principles are ones that no one could reasonably reject. General principles of human psychology can also be invoked to this same end.

Rawls' final argument is that the adoption of his two principles gives public support to the self-respect of individual members of society, and "give a stronger and more characteristic interpretation of Kant's idea"[24] that people must be treated as ends, not merely as means to the greater collective good. But, whatever difference there may be here between Rawls' two principles of justice and the principle of average utility, there is at least as sharp a contrast between the two patterns of contractualist reasoning distinguished above. The connection with self-respect, and with the Kantian formula, is preserved by the requirement that principles of justice be ones which no member of the society could reasonably reject. This connection is weakened when we shift to the idea of a choice which advances the interests of a single rational individual for whom the various individual lives in a society are just so many different possibilities. This is so whatever decision rule this rational chooser is said to employ. The argument from maximin seems to preserve this connection because it reproduces as a claim about rational choice what is, in slightly different terms, an appealing moral argument.

The "choice situation" that is fundamental to contractualism as I have described it is obtained by beginning with "mutually disinterested" individuals with full knowledge of their situations and adding to this (not, as is sometimes suggested, benevolence but) a desire on each of their parts to find principles which none could reasonably reject insofar as they too have this desire. Rawls several times considers such an idea in passing.[25] He rejects it in favour of his own idea of mutually disinterested choice from behind a veil of ignorance on the ground that only the latter enables us to reach definite results: "if in choosing principles we required unanimity even where there is full information, only a few rather obvious cases could be decided."[26] I believe that this supposed advantage is questionable. Perhaps this is because my expectations for moral argument are more modest than Rawls'. However, as I have argued, almost all of Rawls' own arguments have at least as much force when they are interpreted as arguments within the form of contractualism which I have been proposing. One possible exception is the

argument from maximin. If the Difference Principle were taken to be generally applicable to decisions of public policy, then the second form of contractualist reasoning through which it is derived would have more far reaching implications than the looser form of argument by comparison of losses, which I have employed. But these wider applications of the principle are not always plausible, and I do not think that Rawls intends it to be applied so widely. His intention is that the Difference Principle should be applied only to major inequalities generated by the basic institutions of a society, and this limitation is a reflection of the special conditions under which he holds maximin to be the appropriate basis for rational choice: some choices have outcomes one could hardly accept, while gains above the minimum one can assure one's self matter very little, and so on. It follows, then, that in applying the Difference Principle—in identifying the limits of its applicability—we must fall back on the informal comparison of losses which is central to the form of contractualism I have described.

V

I have described this version of contractualism only in outline. Much more needs to be said to clarify its central notions and to work out its normative implications. I hope that I have said enough to indicate its appeal as a philosophical theory of morality and as an account of moral motivation. I have put forward contractualism as an alternative to utilitarianism, but the characteristic feature of the doctrine can be brought out by contrasting it with a somewhat different view.

It is sometimes said[27] that morality is a device for our mutual protection. According to contractualism, this view is partly true but in an important way incomplete. Our concern to protect our central interests will have an important effect on what we could reasonably agree to. It will thus have an important effect on the content of morality if contractualism is correct. To the degree that this morality is observed, these interests will gain from it. If we had no desire

to be able to justify our actions to others on grounds they could reasonably accept, the hope of gaining this protection would give us reason to try to instil this desire in others, perhaps through mass hypnosis or conditioning, even if this also meant acquiring it ourselves. But given that we have this desire already, our concern with morality is less instrumental.

The contrast might be put as follows. On one view, concern with protection is fundamental, and general agreement becomes relevant as a means or a necessary condition for securing this protection. On the other, contractualist view, the desire for protection is an important factor determining the content of morality because it determines what can reasonably be agreed to. But the idea of general agreement does not arise as a means of securing protection. It is, in a more fundamental sense, what morality is about.

Bibliography

Brandt, R. B., 1979, *A Theory of the Good and the Right*, Oxford: Oxford University Press.

Daniels, Norman, 1979, "Wide Reflective Equilibrium and Theory Acceptance in Ethics," *Journal of Philosophy*, 76, pp. 256–82.

Harsanyi, John C., 1953, "Cardinal Utility in Welfare Economics and in the Theory of Risk-Taking," *Journal of Political Economy*, 61, pp. 434–5. Reprinted in Harsanyi 1976.

———, 1955, "Cardinal Welfare, Individualistic Ethics, and Interpersonal Comparisons of Utility," *Journal of Political Economy*, 63, pp. 309–21. Reprinted in Harsanyi 1976.

———, 1976, *Essays in Ethics, Social Behaviour, and Scientific Explanation*, Dordrecht: Reidel.

Kant, Immanuel, 1785, *Grundlegung zur Metaphysik der Sitten*, translated by H. J. Paton as *The Moral Law*, London: Hutchinson, 1948.

Mackie, J. L., 1977, *Ethics: Inventing Right and Wrong*, Harmondsworth: Pelican.

Nagel, Thomas, 1979, *Mortal Questions*, Cambridge: Cambridge University Press.

Parfit, D., 1976, "On Doing the Best for Our Children," in *Ethics and Population*, edited by M. Bayles, Cambridge, Mass.: Schenkman Publishing Company Inc., pp. 100–15.

Rawls, John, 1971, *A Theory of Justice*, Cambridge, Mass.: Harvard University Press.

———, 1974–5, "The Independence of Moral Theory," *Proceedings and Addresses of the American Philosophical Association,* 47.

Ross, Sir W. D., 1939, *Foundations of Ethics*, Oxford: Oxford University Press.

Singer, Peter, 1972, "Famine, Affluence and Morality," *Philosophy and Public Affairs*, 1, pp. 229–43.

———, 1974, "Sidgwick and Reflective Equilibrium," *The Monist*, 58, pp. 490–517.

Warnock, G. J., 1971, *The Object of Morality*, London: Methuen & Co.

Notes

1. Though here the ties between the nature of morality and its content are more important. It is not clear that an account of the nature of morality which left its content *entirely* open could be the basis for a plausible account of moral motivation.

2. See Rawls 1974–5, p. 8; and Daniels 1979 pp. 257–8. How closely the process of what I am calling philosophical explanation will coincide with the search for "wide reflective equilibrium" as this is understood by Rawls and by Daniels is a further question which I cannot take up here.

3. For expression of this dissatisfaction see Singer 1974 and Brandt 1979, pp. 16–21.

4. Ross 1939 pp. 52–4, 315.

5. For purposes of this discussion I leave open the important questions of which individuals are to count and how "well-being" is to be understood. Philosophical utilitarianism will retain the appeal I am concerned with under many different answers to these questions.

6. "Average Utilitarianism" is most plausibly arrived at through quite a different form of argument, one more akin to contractualism. I discuss one such argument in section IV below.

7. Here I am indebted to Gilbert Harman for comments which have helped me to clarify my statement of contractualism.

8. A point I owe to Derek Parfit.

9. On this view (as contrasted with some others in which the notion of a contract is employed) what is fundamental to morality is the desire for reasonable agreement, not the pursuit of mutual advantage. See section V below.

It should be clear that this version of contractualism can account for the moral standing of future persons who will be better or worse off as a result of what we do now. It is less clear how it can deal with the problem presented by future people who would not have been born but for actions of ours which also made the conditions in which they live worse. Do such people have reason to reject principles allowing these actions to be performed? This difficult problem, which I cannot explore here, is raised by Derek Parfit in Parfit 1976.

10. Singer 1972.

11. Reasonably, that is, given the desire to find principles which others similarly motivated could not reasonably reject.

12. Kant 1785, section 2, footnote 14.

13. Mackie 1977, p. 42.

14. See Harsanyi 1955, sec. IV. He is there discussing an argument which he presented earlier in Harsanyi 1953.

15. In discussing Harsanyi and Rawls I will generally follow them in speaking of the acceptability of principles rather than their unrejectability. The difference between these, pointed out above, is important only within the version of contractualism I am presenting; accordingly. I will speak of rejectability only when I am contrasting my own version with theirs.

16. The discussion which follows has much in common with the contrast between majority principles and unanimity principles drawn by Thomas Nagel in "Equality," Chapter 8 of Nagel 1979. I am indebted to Nagel's discussion of this idea.

17. For example, the intuitive argument against utilitarianism on page 14 of Rawls 1971 and his repeated remark that we cannot expect some people to accept lower standards of life for the sake of the higher expectations of others.

18. Though they must then check to see that the principles they have chosen will be stable, not produce intolerable strains of commitment, and so on. As I argue below, these further considerations can be interpreted in a way that brings Rawls' theory closer to the version of contractualism presented here.

19. Rawls 1971, p. 137.

20. Rawls 1971, p. 152.

21. Rawls 1971, p. 153.

22. Rawls 1971, p. 154.

23. Rawls 1971, sec. 29, pp. 175ff.

24. Rawls 1971, p. 183.

25. E.g. Rawls 1971, pp. 141, 148, although these passages may not clearly distinguish between this alternative and an assumption of benevolence.

26. Rawls 1971, p. 141.

27. In different ways by G. J. Warnock in Warnock 1971, and by J. L. Mackie in Mackie 1977. See also Richard Brandt's remarks on justification in Chapter X of Brandt 1979.

Study Questions

1. In what ways, if any, does Scanlon's version of contractualism differ from rule utilitarianism?

2. According to Scanlon, who is included in the general agreement to which contractualism refers?

3. What test is available to determine whether everyone could reasonably accept a particular moral rule?

4. According to Scanlon, is morality best understood as a device for our mutual protection?

29

JOEL FEINBERG

Joel Feinberg (1926–2004) was Professor of Philosophy at the University of Arizona. He examined the nature and importance of moral rights by having us consider an imaginary place without any. There no one makes any claims to receive their due. According to Feinberg, making claims against those who morally should recognize them is not only appropriate but also a source of self-respect as well as respect for others. In short, claiming our rights gives a sense to the notion of personal dignity.

The Nature and Value of Rights

1

I would like to begin by conducting a thought experiment. Try to imagine Nowheresville—a world very much like our own except that no one, or hardly any one (the qualification is not important), has *rights*. If this flaw makes Nowheresville too ugly to hold very long in contemplation, we can make it as pretty as we wish in other moral respects. We can, for example, make the human beings in it as attractive and virtuous as possible without taxing our conceptions of the limits of human nature. In particular, let the virtues of moral sensibility flourish. Fill this imagined world with as much benevolence, compassion, sympathy, and pity as it will conveniently hold without strain. Now we can imagine men helping one another from compassionate motives merely, quite as much or even more than they do in our actual world from a variety of more complicated motives.

This picture, pleasant as it is in some respects, would hardly have satisfied Immanuel Kant. Benevolently motivated actions do good, Kant admitted, and therefore are better, *ceteris paribus*, than malevolently motivated actions; but no action can have supreme kind of worth—what Kant called "moral worth"—unless its whole motivating power derives from the thought that it is *required by duty*. Accordingly, let us try to make Nowheresville more appealing to Kant by introducing the idea of duty into it, and letting the sense of duty be a sufficient motive for many beneficent and honorable actions. But doesn't this bring our original thought experiment to an abortive conclusion? If duties are permitted entry into Nowheresville, are not rights necessarily smuggled in along with them?

The question is well-asked, and requires here a brief digression so that we might consider the so-called "doctrine of the logical correlativity of rights and duties." This is the doctrine that (i) all duties entail other people's rights and (ii) all rights entail other people's duties. Only the first part of the doctrine, the alleged entailment from duties to rights, need concern us here. Is this part of the doctrine

From *Journal of Value Inquiry*, vol. 4 (1970), pp. 245–257. Reprinted by permission of Kluwer Academic publishers.

correct? It should not be surprising that my answer is: "In a sense yes and in a sense no." Etymologically, the word "duty" is associated with actions that are *due* someone else, the payments of debts *to* creditors, the keeping of agreements with promisees, the payment of club dues, or legal fees, or tariff levies to appropriate authorities or their representatives. In this original sense of "duty," all duties are correlated with the rights of those *to* whom the duty is owed. On the other hand, there seem to be numerous classes of duties, both of a legal and non-legal kind, that are *not* logically correlated with the rights of other persons. This seems to be a consequence of the fact that the word "duty" has come to be used for *any* action understood to be *required*, whether by the rights of others, or by law, or by higher authority, or by conscience, or whatever. When the notion of requirement is in clear focus it is likely to seem the only element in the idea of duty that is essential, and the other component notion—that a duty is something *due* someone else—drops off. Thus, in this widespread but derivative usage, "duty" tends to be used for any action we feel we *must* (for whatever reason) do. It comes, in short, to be a term of moral modality merely; and it is no wonder that the first thesis of the logical correlativity doctrine often fails.

Let us then introduce duties into Nowheresville, but only in the sense of actions that are, or are believed to be, morally mandatory, but not in the older sense of actions that are due others and can be claimed by others as their right. Nowheresville now can have duties of the sort imposed by positive law. A legal duty is not something we are implored or advised to do merely; it is something the law, or an authority under the law, *requires* us to do whether we want to or not, under pain of penalty. When traffic lights turn red, however, there is no determinate person who can plausibly be said to claim our stopping as his due, so that the motorist owes it to *him* to stop, in the way a debtor owes it to his creditor to pay. In our own actual world, of course, we sometimes owe it to our *fellow motorists* to stop; but that kind of right-correlated duty does not exist in Nowheresville. There, motorists "owe" obedience to the Law, but they owe nothing to one another. When

they collide, no matter who is at fault, no one is morally accountable to anyone else, and no one has any sound grievance or "right to complain."

When we leave legal contexts to consider moral obligations and other extra-legal duties, a greater variety of duties-without-correlative-rights present themselves. Duties of charity, for example, require us to contribute to one or another of a large number of eligible recipients, no one of whom can claim our contribution from us as his due. Charitable contributions are more like gratuitous services, favors, and gifts than like repayments of debts or reparations; and yet we do have duties to be charitable. Many persons, moreover, in our actual world believe that they are required by their own consciences to do more than that "duty" that *can* be demanded of them by their prospective beneficiaries. I have quoted elsewhere the citation from H. B. Acton of a character in a Malraux novel who "gave all his supply of poison to his fellow prisoners to enable them by suicide to escape the burning alive which was to be their fate and his." This man, Acton adds, "probably did not think that [the others] had more of a right to the poison than he had, though he thought it his duty to give it to them."[1] I am sure that there are many actual examples, less dramatically heroic than this fictitious one, of persons who believe, rightly or wrongly, that they *must do* something (hence the word "duty") for another person in excess of what that person can appropriately demand of him (hence the absence of "right").

Now the digression is over and we can return to Nowheresville and summarize what we have put in it thus far. We now find spontaneous benevolence in somewhat larger degree than in our actual world, and also the acknowledged existence of duties of obedience, duties of charity, and duties imposed by exacting private consciences, and also, let us suppose, a degree of conscientiousness in respect to those duties somewhat in excess of what is to be found in our actual world. I doubt that Kant would be fully satisfied with Nowheresville even now that duty and respect for law and authority have been added to it; but I feel certain that he would regard their addition at least as an improvement. I will now introduce two

further moral practices into Nowheresville that will make that world very little more appealing to Kant, but will make it appear more familiar to us. These are the practices connected with the notions of *personal desert* and what I call a *sovereign monopoly of rights*.

When a person is said to deserve something good from us what is meant in part is that there would be a certain propriety in our giving that good thing to him in virtue of the kind of person he is, perhaps, or more likely, in virtue of some specific thing he has done. The propriety involved here is a much weaker kind than that which derives from our having promised him the good thing or from his having qualified for it by satisfying the well-advertised conditions of some public rule. In the latter case he could be said not merely to deserve the good thing but also to have a *right* to it, that is to be in a position to demand it as his due; and of course we will not have that sort of thing in Nowheresville. That weaker kind of propriety which is mere desert is simply a kind of *fittingness* between one party's character or action and another party's favorable response, much like that between humor and laughter, or good performance and applause.

The following seems to be the origin of the idea of deserving good or bad treatment from others: A master or lord was under no obligation to reward his servant for especially good service; still a master might naturally feel that there would be a special fittingness in giving a gratuitous reward as a grateful response to the good service (or conversely imposing a penalty for bad service). Such an act while surely fitting and proper was entirely supererogatory. The fitting response in turn from the rewarded servant should be gratitude. If the deserved reward had not been given him he should have had no complaint, since he only *deserved* the reward, as opposed to having a *right* to it, or a ground for claiming it as his due.

The idea of desert has evolved a good bit away from its beginnings by now, but nevertheless, it seems clearly to be one of those words J. L. Austin said "never entirely forget their pasts."[2] Today servants qualify for their wages by doing their agreed upon chores, no more and no less. If their wages are

not forthcoming, their contractual rights have been violated and they can make legal claim to the money that is their due. If they do less than they agreed to do, however, their employers may "dock" them, by paying them proportionately less than the agreed upon fee. This is all a matter of right. But if the servant does a splendid job, above and beyond his minimal contractual duties, the employer is under no further obligation to reward him, for this was not agreed upon, even tacitly, in advance. The additional service was all the servant's idea and done entirely on his own. Nevertheless, the morally sensitive employer may feel that it would be exceptionally appropriate for him to respond, freely on *his* own, to the servant's meritorious services, with a reward. The employee cannot demand it as his due, but he will happily accept it, with gratitude, as a fitting response to his desert.

In our age of organized labor, even this picture is now archaic; for almost every kind of exchange of service is governed by hard bargained contracts so that even bonuses can sometimes be demanded as a matter of right, and nothing is given for nothing on either side of the bargaining table. And perhaps that is a good thing; for consider an anachronistic instance of the earlier kind of practice that survives, at least as a matter of form, in the quaint old practice of "tipping." The tip was originally conceived as a reward that has to be earned by "zealous service." It is not something to be taken for granted as a standard response to *any* service. That is to say that its payment is a "*gratuity*," not a discharge of obligation, but something given apart from, or in addition to, anything the recipient can expect as a matter of right. That is what tipping originally meant at any rate, and tips are still referred to as "gratuities" in the tax forms. But try to explain all that to a New York cab driver! If he has *earned* his gratuity, by God, he has it coming, and there had better be sufficient acknowledgement of his desert or he'll give you a piece of his mind! I'm not generally prone to defend New York cab drivers, but they do have a point here. There is the making of a paradox in the queerly unstable concept of an "earned gratuity." One can understand how "desert" in the weak sense of "propriety" or "mere

fittingness" tends to generate a stronger sense in which desert is itself the ground for a claim of right.

In Nowheresville, nevertheless, we will have only the original weak kind of desert. Indeed, it will be impossible to keep this idea out if we allow such practices as teachers grading students, judges awarding prizes, and servants serving benevolent but class-conscious masters. Nowheresville is a reasonably good world in many ways, and its teachers, judges, and masters will generally try to give students, contestants, and servants the grades, prizes, and rewards they deserve. For this the recipients will be grateful; but they will never think to complain, or even feel aggrieved, when expected responses to desert fail. The masters, judges, and teachers don't *have* to do good things, after all, for *anyone*. One should be happy that they *ever* treat us well, and not grumble over their occasional lapses. Their hoped for responses, after all, are *gratuities*, and there is no wrong in the omission of what is merely gratuitous. Such is the response of persons who have no concept of *rights*, even persons who are proud of their own deserts.[3]

Surely, one might ask, rights have to come in somewhere, if we are to have even moderately complex forms of social organization. Without rules that confer rights and impose obligations, how can we have ownership of property, bargains and deals, promises and contracts, appointments and loans, marriages and partnerships? Very well, let us introduce all of these social and economic practices into Nowheresville, but *with one big twist*. With them I should like to introduce the curious notion of a "sovereign right-monopoly." You will recall that the subjects in Hobbes's *Leviathan* had no rights whatever against their sovereign. He could do as he liked with them, even gratuitously harm them, but this gave them no valid grievance against him. The sovereign, to be sure, had a certain duty to treat his subjects well, but this duty was owed not to the subjects directly, but to God, just as we might have a duty to a person to treat his property well, but of course no duty to the property itself but only to its owner. Thus, while the sovereign was quite capable of *harming* his subjects, he could commit no wrong against them that they

could complain about, since they had no prior claims against his conduct. The only party *wronged* by the sovereign's mistreatment of his subjects was God, the supreme lawmaker. Thus, in repenting cruelty to his subjects, the sovereign might say to God, as David did after killing Uriah, "to Thee only have I sinned."[4]

Even in the *Leviathan*, however, ordinary people had ordinary rights *against one another*. They played roles, occupied offices, made agreements, and signed contracts. In a genuine "sovereign right monopoly," as I shall be using that phrase, they will do all those things too, and thus incur genuine obligations toward one another; but the obligations (here is the twist) will not be owed directly *to* promisees, creditors, parents, and the like, but rather to God alone, or to the members of some elite, or to a single sovereign under God. Hence, the rights correlative to the obligations that derive from these transactions are all owned by some "outside" authority.

As far as I know, no philosopher has ever suggested that even our role and contract obligations (in this, our actual world) are all owed directly to a divine intermediary; but some theologians have approached such extreme moral occasionalism. I have in mind the familiar phrase in certain widely distributed religious tracts that "it takes three to marry," which suggests that marital vows are not made between bride and groom directly but between each spouse and God, so that if one breaks his vow, the other cannot rightly complain of being wronged, since only God could have claimed performance of the marital duties as his *own* due; and hence God alone had a claim-right violated by nonperformance. If John breaks his vow to God, he might then properly repent in the words of David: "To Thee only have I sinned."

In our actual world, very few spouses conceive of their mutual obligations in this way; but their small children, at a certain stage in their moral upbringing, are likely to feel precisely this way toward *their* mutual obligations. If Billy kicks Bobby and is punished by Daddy, he may come to feel contrition for his naughtiness induced by his painful estrangement from the loved parent. He may then be happy to make amends and sincere apology *to Daddy;* but

when Daddy insists that he apologize to his wronged brother, that is another story. A direct apology to Billy would be a tacit recognition of Billy's status as a right-holder against him, some one he can wrong as well as harm, and someone to whom he is directly accountable for his wrongs. This is a status Bobby will happily accord Daddy; but it would imply a respect for Billy that he does not presently feel, so he bitterly resents according it to him. On the "three-to-marry" model, the relations between each spouse and God would be like those between Bobby and Daddy; respect for the other spouse as an independent claimant would not even be necessary; and where present, of course, never sufficient.

The advocates of the "three to marry" model who conceive it either as a description of our actual institution of marriage or a recommendation of what marriage ought to be, may wish to escape this embarrassment by granting rights to spouses in capacities other than as promisees. They may wish to say, for example, that when John promises God that he will be faithful to Mary, a right is thus conferred not only on God as promisee but also on Mary herself as third-party beneficiary, just as when John contracts with an insurance company and names Mary as his intended beneficiary, she has a right to the accumulated funds after John's death, even though the insurance company made no promise to her. But this seems to be an unnecessarily cumbersome complication contributing nothing to our understanding of the marriage bond. The life insurance transaction is necessarily a three-party relation, involving occupants of three distinct offices, no two of whom alone could do the whole job. The transaction, after all, is defined as the purchase by the customer (first office) from the vendor (second office) of protection for a beneficiary (third office) against the customer's untimely death. Marriage, on the other hand, in this our actual world, appears to be a binary relation between a husband and wife, and even though third parties such as children, neighbors, psychiatrists, and priests may sometimes be helpful and even causally necessary for the survival of the relation, they are not logically necessary to our *conception* of the relation, and indeed many married couples do

quite well without them. Still, I am not now purporting to describe our actual world, but rather trying to contrast it with a counterpart world of the imagination. In *that* world, it takes three to make almost *any* moral relation and all rights are owned by God or some sovereign under God.

There will, of course, be delegated authorities in the imaginary world, empowered to give commands to their underlings and to punish them for their disobedience. But the commands are all given in the name of the right-monopoly who in turn are the only persons to whom obligations are owed. Hence, even intermediate superiors do not have claim-rights against their subordinates but only legal *powers* to create obligations in the subordinates *to* the monopolistic right-holders, and also the legal *privilege* to impose penalties in the name of that monopoly.

2

So much for the imaginary "world without rights." If some of the moral concepts and practices I have allowed into that world do not sit well with one another, no matter. Imagine Nowheresville with all of these practices if you can, or with any harmonious subset of them, if you prefer. The important thing is not what I've let into it, but what I have kept out. The remainder of this paper will be devoted to an analysis of what precisely a world is missing when it does not contain rights and why that absence is morally important.

The most conspicuous difference, I think, between the Nowheresvillians and ourselves has something to do with the activity of *claiming*. Nowheresvillians, even when they are discriminated against invidiously, or left without the things they need, or otherwise badly treated, do not think to leap to their feet and make righteous demands against one another, though they may not hesitate to resort to force and trickery to get what they want. They have no notion of rights, so they do not have a notion of what is their due; hence they do not claim before they take. The conceptual linkage between

personal rights and claiming has long been noticed by legal writers and is reflected in the standard usage in which "claim-rights" are distinguished from the mere liberties, immunities, and powers, also sometimes called "rights," with which they are easily confused. When a person has a legal claim-right to X, it must be the case (i) that he is at liberty in respect to X, i.e., that he has no duty to refrain from or relinquish X, and also (ii) that his liberty is the ground of other people's *duties* to grant him X or not to interfere with him in respect to X. Thus, in the sense of claim-rights, it is true by definition that rights logically entail other people's duties. The paradigmatic examples of such rights are the creditor's right to be paid a debt by his debtor, and the landowner's right not to be interfered with by anyone in the exclusive occupancy of his land. The creditor's right against his debtor, for example, and the debtor's duty to his creditor, are precisely the same relation seen from two different vantage points, as inextricably linked as the two sides of the same coin.

And yet, this is not quite an accurate account of the matter, for it fails to do justice to the way claim-rights are somehow prior to, or more basic than, the duties with which they are necessarily correlated. If Nip has a claim-right against Tuck, it is because of this fact that Tuck has a duty to Nip. It is only because something from Tuck is *due* Nip (directional element) that there is something Tuck *must do* (modal element). This is a relation, moreover, in which Tuck is bound and Nip is free. Nip not only *has* a right, but he can choose whether or not to exercise it, whether to claim it, whether to register complaints upon its infringement, even whether to release Tuck from his duty, and forget the whole thing. If the personal claim-right is also backed up by criminal sanctions, however, Tuck may yet have a duty of obedience to the law from which no one, not even Nip, may release him. He would even have such duties if he lived in Nowheresville; but duties subject to acts of claiming, duties derivative from and contingent upon the personal rights of others, are unknown and undreamed of in Nowheresville.

Many philosophical writers have simply identified rights with claims. The dictionaries tend to define "claims," in turn, as "assertions of right," a dizzying piece of circularity that led one philosopher to complain—"We go in search of rights and are directed to claims, and then back again to rights in bureaucratic futility."[5] What then is the relation between a claim and a right?

As we shall see, a right *is* a kind of claim, and a claim is "an assertion of right," so that a formal definition of either notion in terms of the other will not get us very far. Thus if a "formal definition" of the usual philosophical sort is what we are after, the game is over before it has begun, and we can say that the concept of a right is a "simple, undefinable, unanalysable primitive." Here as elsewhere in philosophy this will have the effect of making the commonplace seem unnecessarily mysterious. We would be better advised, I think, not to attempt a formal definition of either "right" or "claim," but rather to use the idea of a claim in informal elucidation of the idea of a right. This is made possible by the fact that *claiming* is an elaborate sort of rule-governed *activity*. A claim is that which is claimed, the object of the act of claiming. There is, after all, a verb "to claim," but no verb "to right." If we concentrate on the whole activity of claiming, which is public, familiar, and open to our observation, rather than on its upshot alone, we may learn more about the generic nature of rights than we could ever hope to learn from a formal definition, even if one were possible. Moreover, certain facts about rights more easily, if not solely, expressible in the language of claims and claiming are essential to a full understanding not only of what rights are, but also why they are so vitally important.

Let us begin then by distinguishing between: (i) making claim to . . . , (ii) claiming that . . . , and (iii) having a claim. One sort of thing we may be doing when we claim is to *make claim to something*. This is "to petition or seek by virtue of supposed right; to demand as due." Sometimes this is done by an acknowledged right-holder when he serves notice that he now wants turned over to him that which has already been acknowledged to be his, something borrowed, say, or improperly taken from him. This is often done by turning in a chit, a receipt, an I.O.U., a check, an insurance policy, or a deed, that is, a *title*

to something currently in the possession of someone else. On other occasions, making claim is making application for titles or rights themselves, as when a mining prospector stakes a claim to mineral rights, or a householder to a tract of land in the public domain, or an inventor to his patent rights. In the one kind of case, to make claim is to exercize rights one already has by presenting title; in the other kind of case it is to apply for the title itself, by showing that one has satisfied the conditions specified by a rule for the ownership of title and therefore that one can demand it as one's due.

Generally speaking, only the person who has a title or who has qualified for it, or someone speaking in his name, can make claim to something as a matter of right. It is an important fact about rights (or claims), then, that they can be claimed only by those who have them. Anyone can claim, of course, *that* this umbrella is yours, but only you or your representative can actually claim the umbrella. If Smith owes Jones five dollars, only Jones can claim the five dollars as his own, though any bystander can *claim that* it belongs to Jones. One important difference then between *making legal claim to* and *claiming that* is that the former is a legal performance with direct legal consequences whereas the latter is often a mere piece of descriptive commentary with no legal force. Legally speaking, *making claim to* can itself make things happen. This sense of "claiming," then, might well be called "the performative sense." The legal power to claim (performatively) one's right or the things to which one has a right seems to be essential to the very notion of a right. A right to which one could not make claim (i.e. not even for recognition) would be a very "imperfect" right indeed!

Claiming that one has a right (what we can call "propositional claiming" as opposed to "performative claiming") is another sort of thing one can do with language, but it is not the sort of doing that characteristically has legal consequences. To claim that one has rights is to make an assertion that one has them, and to make it in such a manner as to demand or insist that they be recognized. In this sense of "claim" many things in addition to rights can be claimed, that is, many other kinds of

proposition can be asserted in the claiming way. I can claim, for example, that you, he, or she has certain rights, or that Julius Caesar once had certain rights; or I can claim that certain statements are true, or that I have certain skills, or accomplishments, or virtually anything at all. I can claim that the earth is flat. What is essential to *claiming that* is the manner of assertion. One can assert without even caring very much whether any one is listening, but part of the point of propositional claiming is to *make sure* people listen. When I claim to others that I know something, for example, I am not merely asserting it, but rather "obtruding my putative knowledge upon their attention, demanding that it be recognized, that appropriate notice be taken of it by those concerned . . ."[6] Not every truth is properly assertable, much less claimable, in every context. To claim that something is the case in circumstances that justify no more than calm assertion is to behave like a boor. (This kind of boorishness, I might add, is probably less common in Nowheresville.) But not to claim in the appropriate circumstances that one has a right is to be spiritless or foolish. A list of "appropriate circumstances" would include occasions when one is challenged, when one's possession is denied, or seems insufficiently acknowledged or appreciated; and of course even in these circumstances, the claiming should be done only with an appropriate degree of vehemence.

Even if there are conceivable circumstances in which one would admit rights diffidently, there is no doubt that their characteristic use and that for which they are distinctively well suited, is to be claimed, demanded, affirmed, insisted upon. They are especially sturdy objects to "stand upon," a most useful sort of moral furniture. Having rights, of course, makes claiming possible; but it is claiming that gives rights their special moral significance. This feature of rights is connected in a way with the customary rhetoric about what it is to be a human being. Having rights enables us to "stand up like men," to look others in the eye, and to feel in some fundamental way the equal of anyone. To think of oneself as the holder of rights is not to be unduly but properly proud, to have that minimal self-respect that is

necessary to be worthy of the love and esteem of others. Indeed, respect for persons (this is an intriguing idea) may simply be respect for their rights, so that there cannot be the one without the other; and what is called "human dignity" may simply be the recognizable capacity to assert claims. To respect a person then, or to think of him as possessed of human dignity, simply *is* to think of him as a potential maker of claims. Not all of this can be packed into a definition of "rights;" but these are *facts* about the possession of rights that argue well their supreme moral importance. More than anything else I am going to say, these facts explain what is wrong with Nowheresville.

We come now to the third interesting employment of the claiming vocabulary, that involving not the verb "to claim" but the substantive "a claim." What is it to *have a claim* and how is this related to rights? I would like to suggest that *having a claim consists in being in a position to claim, that is, to make claim to* or *claim that*. If this suggestion is correct it shows the primacy of the verbal over the nominative forms. It links claims to a kind of activity and obviates the temptation to think of claims as *things*, on the model of coins, pencils, and other material possessions which we can carry in our hip pockets. To be sure, we often make or establish our claims by presenting titles, and these typically have the form of receipts, tickets, certificates, and other pieces of paper or parchment. The title, however, is not the same thing as the claim; rather it is the evidence that establishes the claim as valid. On this analysis, one might have a claim without ever claiming that to which one is entitled, or without even knowing that one has the claim; for one might simply be ignorant of the fact that one is in a position to claim; or one might be unwilling to exploit that position for one reason or another, including fear that the legal machinery is broken down or corrupt and will not enforce one's claim despite its validity.

Nearly all writers maintain that there is some intimate connection between having a claim and having a right. Some identify right and claim without qualification; some define "right" as justified or justifiable claim, others as recognized claim, still others as valid claim. My own preference is for the latter definition.

Some writers, however, reject the identification of rights with valid claims on the ground that all claims as such are valid, so that the expression "valid claim" is redundant. These writers, therefore, would identify rights with claims *simpliciter*. But this is a very simple confusion. All claims, to be sure, are *put forward* as justified, whether they are justified in fact or not. A claim conceded even by its maker to have no validity is not a claim at all, but a mere demand. The highwayman, for example, *demands* his victim's money; but he hardly makes claim to it as rightfully his own.

But it does not follow from this sound point that it is redundant to qualify claims as justified (or as I prefer, valid) in the definition of a right; for it remains true that not all claims put forward as valid really are valid; and only the valid ones can be acknowledged as rights.

If having a valid claim is not redundant, i.e., if it is not redundant to pronounce *another's* claim valid, there must be such a thing as having a claim that is not valid. What would this be like? One might accumulate just enough evidence to argue with relevance and cogency that one has a right (or ought to be granted a right), although one's case might not be overwhelmingly conclusive. In such a case, one might have strong enough argument to be entitled to a hearing and given fair consideration. When one is in this position, it might be said that one "has a claim" that deserves to be weighed carefully. Nevertheless, the balance of reasons may turn out to militate against recognition of the claim, so that the claim, which one admittedly had, and perhaps still does, is not a valid claim or right. "Having a claim" in this sense is an expression very much like the legal phrase "having a *prima facie* case." A plaintiff establishes a *prima facie* case for the defendant's liability when he establishes grounds that will be sufficient for liability unless outweighed by reasons of a different sort that may be offered by the defendant. Similarly, in the criminal law, a grand jury returns an indictment when it thinks that the prosecution has sufficient evidence to be taken seriously and given a fair hearing, whatever countervailing reasons may eventually be offered on the other side. That initial evidence, serious but not conclusive, is

also sometimes called a *prima facie* case. In a parallel "*prima facie* sense" of "claim," having a claim to X is not (yet) the same as having a right to X, but is rather having a case of at least minimal plausibility that one has a right to X, a case that does establish a right, not to X, but to fair hearing and consideration. Claims, so conceived, differ in degree: some are stronger than others. Rights, on the other hand, do not differ in degree: no one right is more of a right than another.[7]

Another reason for not identifying rights with claims *simply* is that there is a well-established usage in international law that makes a theoretically interesting distinction between claims and rights. Statesmen are sometimes led to speak of "claims" when they are concerned with the natural needs of deprived human beings in conditions of scarcity. Young orphans *need* good upbringings, balanced diets, education, and technical training everywhere in the world; but unfortunately there are many places where these goods are in such short supply that it is impossible to provision all who need them. If we persist, nevertheless, in speaking of these needs as constituting rights and not merely claims, we are committed to the conception of a right which is an entitlement *to* some good, but not a valid claim *against* any particular individual; for in conditions of scarcity there may be no determinate individuals who can plausibly be said to have a duty to provide the missing goods to those in need. J. E. S. Fawcett therefore prefers to keep the distinction between claims and rights firmly in mind. "Claims," he writes, "are needs and demands in movement, and there is a continuous transformation, as a society advances [toward greater abundance] of economic and social claims into civil and political rights . . . and not all countries or all claims are by any means at the same stage in the process."[8] The manifesto writers on the other side who seem to identify needs, or at least basic needs, with what they call "human rights," are more properly described, I think, as urging upon the world community the moral principle that *all* basic human needs ought to be recognized as *claims* (in the

customary *prima facie* sense) worthy of sympathy and serious consideration right now, even though, in many cases, they cannot yet plausibly be treated as *valid* claims, that is, as grounds of any other people's duties. This way of talking avoids the anomaly of ascribing to all human beings now, even those in pre-industrial societies, such "economic and social rights" as "periodic holidays with pay."[9]

Still, for all of that, I have a certain sympathy with the manifesto writers, and I am even willing to speak of a special "manifesto sense" of "right," in which a right need not be correlated with another's duty. Natural needs are real claims if only upon hypothetical future beings not yet in existence. I accept the moral principle that to have an unfulfilled need is to have a kind of claim against the world, even if against no one in particular. A natural need for some good as such, like a natural desert, is always a reason in support of a claim to that good. A person in need, then, is always "in a position" to make a claim, even when there is no one in the corresponding position to do anything about it. Such claims, based on need alone, are "permanent possibilities of rights," the natural seed from which rights grow. When manifesto writers speak of them as if already actual rights, they are easily forgiven, for this is but a powerful way of expressing the conviction that they ought to be recognized by states here and now as potential rights and consequently as determinants of *present* aspirations and guides to *present* policies. That usage, I think, is a valid exercise of rhetorical licence.

I prefer to characterize rights as valid claims rather than justified ones, because I suspect that justification is rather too broad a qualification. "Validity," as I understand it, is justification of a peculiar and narrow kind, namely justification within a system of rules. A man has a legal right when the official recognition of his claim (as valid) is called for by the governing rules. This definition, of course, hardly applies to moral rights, but that is not because the genus of which moral rights are a species is something other than *claims*. A man has a moral right when he has a claim the recognition of which is called for—not

(necessarily) by legal rules—but by moral principles, or the principles of an enlightened conscience.

There is one final kind of attack on the generic identification of rights with claims, and it has been launched with great spirit in a recent article by H. J. McCloskey, who holds that rights are not essentially claims at all, but rather entitlements. The springboard of his argument is his insistence that rights in their essential character are always *rights to*, not *rights against*:

> My right to life is not a right against anyone. It is my right and by virtue of it, it is normally permissible for me to sustain my life in the face of obstacles. It does give rise to rights against others *in the sense* that others have or may come to have duties to refrain from killing me, but it is essentially a right of mine, not an infinite list of claims, hypothetical and actual, against an infinite number of actual, potential, and as yet nonexistent human beings . . . Similarly, the right of the tennis club member to play on the club courts is a right to play, not a right against some vague group of potential or possible obstructors.[10]

The argument seems to be that since rights are essentially rights *to*, whereas claims are essentially claims *against*, rights cannot be claims, though they can be grounds for claims. The argument is doubly defective though. First of all, contrary to McCloskey, rights (at least legal claim-rights) *are* held *against* others. McCloskey admits this in the case of *in personam* rights (what he calls "special rights") but denies it in the case of *in rem* rights (which he calls "general rights"):

> Special rights are sometimes against specific individuals or institutions—e.g. rights created by promises, contracts, etc. . . . but these differ from . . . characteristic . . . general rights where the right is simply a right to . . .[11]

As far as I can tell, the only reason McCloskey gives for denying that *in rem* rights are against others is that those against whom they would have to hold make up an enormously multitudinous and "vague" group, including hypothetical people not yet even in existence. Many others have found this a paradoxical consequence of the notion of *in rem* rights, but I see nothing troublesome in it. If a general rule gives me a right of noninterference in a certain respect against everybody, then there are literally hundreds of millions of people who have a duty toward me in that respect; and if the same general rule gives the same right to everyone else, then it imposes on me literally hundreds of millions of duties—or duties towards hundreds of millions of people. I see nothing paradoxical about this, however. The duties, after all, are negative; and I can discharge all of them at a stroke simply by minding my own business. And if all human beings make up one moral community and there are hundreds of millions of human beings, we should expect there to be hundreds of millions of moral relations holding between them.

McCloskey's other premise is even more obviously defective. There is no good reason to think that all *claims* are "essentially" *against*, rather than *to*. Indeed most of the discussion of claims above has been of claims *to*, and as we have seen, the law finds it useful to recognize claims *to* (or "mere claims") that are not yet qualified to be claims *against*, or rights (except in a "manifesto sense" of "rights").

Whether we are speaking of claims or rights, however, we must notice that they seem to have two dimensions, as indicated by the prepositions "to" and "against," and it is quite natural to wonder whether either of these dimensions is somehow more fundamental or essential than the other. All rights seem to merge *entitlements to* do, have, omit, or be something with *claims against* others to act or refrain from acting in certain ways. In some statements of rights the entitlement is perfectly determinate (e.g. *to* play tennis) and the claim vague (e.g. *against* "some vague group of potential or possible obstructors"); but in other cases the object of the claim is clear and determinate (e.g. *against* one's parents), and the entitlement general and indeterminate (e.g. to be given a proper upbringing.) If we mean by "entitlement" that *to* which one has a right and by "claim" something directed at those *against*

whom the right holds (as McCloskey apparently does), then we can say that all claim-rights necessarily involve both, though in individual cases the one element or the other may be in sharper focus.

In brief conclusion: To have a right is to have a claim against someone whose recognition as valid is called for by some set of governing rules or moral principles. To have a *claim* in turn, is to have a case meriting consideration, that is, to have reasons or grounds that put one in a position to engage in performative and propositional claiming. The activity of claiming, finally, as much as any other thing, makes for self-respect and respect for others, gives a sense to the notion of personal dignity, and distinguishes this otherwise morally flawed world from the even worse world of Nowheresville.

Notes

1. H. B. Acton, "Symposium on 'Rights,'" *Proceedings of the Aristotelian Society*, Supplementary Volume 24 (1950), pp. 107–8.

2. J. L. Austin, "A Plea for Excuses," *Proceedings of the Aristotelian Society*, vol. 57 (1956–57).

3. For a fuller discussion of the concept of personal desert see my "Justice and Personal Desert," *Nomos VI,*

Justice, ed. by C. J. Friedrich and J. Chapman. (New York: Atherton Press, 1963), pp. 69–97.

4. II Sam. 11. Cited with approval by Thomas Hobbes in *The Leviathan*, Part II, Chap. 21.

5. H. B. Acton, Op. cit.

6. This is the important difference between rights and mere claims. It is analogous to the difference between *evidence* of guilt (subject to degrees of cogency) and conviction of guilt (which is all or nothing). One can "have evidence" that is not conclusive just as one can "have a claim" that is not valid. "Prima-facieness" is built into the sense of "claim," but the notion of a "prima-facie right" makes little sense. On the latter point, see A. I. Melden, *Rights and Right Conduct* (Oxford: Basil Blackwell, 1959), pp. 18–20, and Herbert Morris, "Persons and Punishment," *The Monist*, Vol. 52 (1968), pp. 498–9.

7. J. E. S. Fawcett, "The International Protection of Human Rights," in *Political Theory and the Rights of Man*, ed. by D. D. Raphael (Bloomington: Indiana University Press, 1967), p. 125.

8. Ibid., p. 128.

9. As declared in Article 24 of *The Universal Declaration of Human Rights* adopted on December 10, 1948, by the General Assembly of the United Nations.

10. H. J. McCloskey, "Rights," *Philosophical Quarterly*, Vol. 15 (1965), p. 118.

11. Loc. cit.

Study Questions

1. Is Nowheresville a realistic example?

2. Do rights always imply duties?

3. Is your ability to make claims the source of your human dignity?

4. What rights do you possess?

30

BARBARA HERMAN

Barbara Herman is Professor of Philosophy and also of Law at the University of California, Los Angeles. She explores the Kantian doctrine that the moral worth of an action requires that it be done from the motive of duty. In her view, an act has moral worth only if it is required by duty and has as its primary motive the motive of duty. Other motives may be present but may not move the agent to act, because if they do, then whether the agent is acting morally is merely a matter of luck.

On the Value of Acting from the Motive of Duty

It has quite reasonably been a source of frustration to sympathetic readers that Kant seems to claim that a dutiful action can have moral worth only if it is done from the motive of duty alone. The apparent consequence of this view—that an action cannot have moral worth if there is supporting inclination or desire present—is, at the least, troubling in that it judges a grudging or resentfully performed dutiful act morally preferable to a similar act done from affection or with pleasure. To many, sympathetic or not, it has in addition seemed contrary to ordinary judgment to withhold the accolade of moral worth from actions done from "good" motives other than the motive of duty. These concerns cut deeply, challenging the intuitive basis in ordinary moral knowledge that is essential to Kant's argument.

There are strategies that might be employed to disperse the problem of moral worth. One might note that the discussion of moral worth is brief and unique to the *Groundwork of the Metaphysics of Morals* where it plays a bridging role between the announcement of the unconditioned goodness of the good will and the Categorical Imperative as its principle. Kant may not have accorded moral worth the doctrinal importance we give it and so was not attentive to the kinds of cases that concern us. We might then amend his account. While it is indeed important to locate moral worth in the full argument of the *Groundwork*, Kant seems careful enough about the cases and quite clear about his conclusion: an act has moral worth if and only if it is done from the motive of duty.

Alternatively, one might accept this conclusion but seek to give it diminished importance within the general Kantian argument. It is because one takes the doctrine of moral worth to contain Kant's central claim about the moral goodness of persons that restriction of moral worth to actions done from the motive of duty seems so objectionable. Kant has much to say elsewhere—especially in *The Doctrine of Virtue* and *Religion Within the Limits of Reason Alone*—about virtue and the moral disposition that supports caution about the scope of the doctrine

of moral worth. But one cannot, I think, avoid the importance of the idea that *one way* of acting—from one motive—is given moral preeminence. So even if Kant has an account of moral virtue that makes room for other motives and traits, if the virtuous disposition represents a good will, then it (its virtue) will be expressed in actions done from the motive of duty.

It is best to take a direct approach to the doctrine of moral worth: we need to understand the moral question that Kant thought required "dutiful action done from the motive of duty" as an answer. Both sympathetic and hostile critics of the doctrine take the question to be obvious: What motive (or motives) distinguish the actions of the good moral agent from those of the agent whose actions are merely morally correct? If the dour "the motive of duty alone" is Kant's response to *this* question, it is not surprising that it has provoked harsh reactions.[1] If, however, the question is not the one Kant asked, then these reactions may not be in order. Since we proceed against the grain of traditional interpretation, we will do well to go slowly.

I

Kant introduces the concept of moral worth in the *Groundwork* as part of the opening account of the good will. The paragraphs that precede its introduction present the two basic facts about the good will: it is unqualifiedly good (and the only thing that is), and it is good only because of its willing, not because of its success in producing effects. With this characterization of the good will, what is needed, Kant says, is "to elucidate the concept of a will estimable in itself and good apart from any further end."[2] That is, we need to see what good willing looks like. Kant proceeds by taking up

> the concept of duty, which includes that of a good will, exposed, however, to certain subjective limitations and obstacles. These so far from hiding a good will or disguising it, rather bring it out by contrast and make it shine forth more brightly. (G397)

What follows is the discussion of moral worth and the examples of "acting for the sake of duty."

The way the examples are set up suggests that they are offered as cases in which good willing is perspicuous, rather than as the only kinds of cases in which good willing is present or can be known. If this is correct, and it is good willing in an action that "moral worth" honors, we need to see exactly what the "subjective limitations and obstacles" reveal about good willing (and so about moral worth) before we can generalize to correct conditions of attribution of moral worth.

Staying with Kant's presentation: the key to good willing is to be found in an examination of the motive someone has in performing a dutiful act *for the sake of duty*. Kant seems to think that what is special about this motive is revealed by contrasting it to other motives that, in at least some circumstances, can also lead to dutiful actions. He proceeds by looking at examples of two kinds of action that are "according to duty" but are not performed from the motive of duty, and so are said not to have moral worth: (1) dutiful actions done because they serve the agent's self-interest (the shopkeeper example) and (2) dutiful actions that are just what the agent wants to do—those for which he is said to have an "immediate inclination" or interest (the sympathy, self-preservation, and happiness examples).

The crucial question, obviously, is: *why* is it not possible that these nonmoral motives give dutiful actions moral worth? We will look at the two most famous of Kant's examples to see whether they provide a clue to what Kant thinks is of value in the actions he says have moral worth.

The shopkeeper example. We want to see whether this example makes clear what significant moral difference there is between doing a dutiful action (treating people honestly, giving inexperienced customers the correct change) from the motive of self-interest (or profit) and doing the same action from the motive of duty. One may say: when you do a dutiful action from duty, you do it because it is what duty requires; when you do it from self-interest, you do it for some other reason. This is hardly wrong. But it is uninformative about *why* doing an action "because it is what duty requires" is of any moral importance.

The details of the example are instructive. The dutiful action is not to overcharge inexperienced customers. When there is considerable competition, Kant points out, it is good business not to overcharge, and so the sensible shopkeeper's business interests *require* him to act honestly in such circumstances. The message is plain: while it is *always* morally correct to serve people honestly (we can assume this for the example), acting from an interest in making a profit will require honest actions in only *some* circumstances—there may be times when honesty is not the best policy.

It seems, then, that the moral fault with the profit motive is that it is unreliable. When it leads to dutiful actions, it does so for circumstantial reasons. The businessman's interest in the dutiful action is controlled by (Kant says: mediated by) his interest in his business, and whether he acts well or not depends on the paths that circumstances open for the pursuit of his business goals. This example suggests the need for a motive that will guarantee that the right action will be done. But the sympathy example suggests that this is only part of the story.

The sympathy example.[3] Here is a person who would help others from an *immediate* inclination: he helps others because that is what he wants to do; helping others is not the means to some further end he has. In Kant's words, "there are many spirits of so sympathetic a temper that, *without any further motive of vanity or self-interest*, they find an inner pleasure in spreading happiness around them" (G398, emphasis added). Now if, following the shopkeeper example, the issue here is the reliability of the motive (wanting to help others), we have a problem. In the shopkeeper example it seemed plausible to argue that the interest in profit was inadequate as a moral motive[4] because the likelihood of such a motive producing morally correct action was dependent on contingent and changeable circumstances. But here, where the right action is given as helping another, and that is just what the person has an immediate inclination to do, there can be no complaint that this motive will lead to other sorts of action in changed circumstances. But if the motive of sympathy yields right actions, why isn't it judged to be a motive producing actions with moral worth?

Kant says that such an action,

> however right and amiable it might be, has still no genuinely moral worth. It stands on the same footing as [action from] the other inclinations—for example, the inclination for honor, which if fortunate to hit on something beneficial and right and consequently honorable, deserves praise and encouragement, but not esteem; for its maxim lacks moral content, namely, the performance of such actions, not from inclination, but *from duty*. (G398)

The inclination for honor is criticized in two ways: it is described as only "fortunate" to hit on something right; and the maxim of the action it prompts is said to lack moral content. Is the motive of sympathy only fortunate when it hits on a right action? Doesn't it necessarily prompt a person to help others? Suppose I see someone struggling, late at night, with a heavy burden at the backdoor of the Museum of Fine Arts. Because of my sympathetic temper I feel the immediate inclination to help him out. We need not pursue the example to see its point: the class of actions that follows from the inclination to help others is not a subset of the class of right or dutiful actions.

In acting from immediate inclination, the agent is not concerned with whether his action is morally correct or required. That is why he acts no differently, and in a sense no better, when he saves a drowning child than when he helps the art thief. Of course we are happier to see the child saved, and indeed might well prefer to live in a community of sympathetic persons to most others, but the issue remains. The man of sympathetic temper, while concerned with others, is indifferent to morality. In Kant's language, the maxim of his action—the subjective principle on which the agent acts—has no moral content. If we suppose that the *only* motive the agent has is the desire to help others, then we are imagining someone who would not be concerned with or deterred by the fact that his action is morally wrong. And, correspondingly, the moral rightness of an action is no part of what brings him to act.

On this reading of the sympathy example it would seem that Kant did not reject such emotions as moral motives because they could not be steady

and strong, or because they were essentially partial.[5] Even if, for example, sympathy could be strengthened to the force of habit, and trained (as Hume suggests) toward impartial response, it would still generate morally correct actions only by accident. For while sympathy can give an interest in an action that is (as it happens) right, it cannot give an interest in its being right.[6]

I said of the shopkeeper example that the person's motive was to make a profit, and so his hitting upon a right action was also, in this way, a matter of luck. The economic circumstances that happened to prevail required honest actions as the necessary means to business ends. So in this example, too, the denial of moral worth to an action is intended to mark the absence of interest in the morality of the action: that the shopkeeper's action was morally correct and required was not a matter of concern to him.

This suggests a more general thesis. Even if social institutions were arranged to guarantee that profit and honesty went together (through penalties, social sanctions, and so on), the performance of honest actions, so motivated, would still be no more than "fortunate": that is, dependent on external and contingent circumstances. Maximizing the number of honest transactions is not what moral worth looks to. And a concern with moral worth will not encourage the social manipulation of circumstances so that people just find themselves doing what is right.

What can we conclude? This reading of the two examples does not (and is not intended to) give us an account of what moral worth is or a clear idea of the conditions for its correct attribution. It does suggest why Kant thought that there was something the matter with a dutiful action performed from a nonmoral motive: nonmoral motives may well lead to dutiful actions, and may do this with any degree of regularity desired. The problem is that the dutiful actions are the product of a fortuitous alignment of motives and circumstances. People who act according to duty from such motives may nonetheless remain morally indifferent.

Taking the limits of nonmoral motives as a guide, we can introduce a minimal claim. For a motive to be a moral motive, it must provide the agent with an interest in the moral rightness of his actions. And when

we say that an action has moral worth, we mean to indicate (at the very least) that the agent acted dutifully from an interest in the rightness of his action: an interest that therefore makes its being a right action the nonaccidental effect of the agent's concern.

II

If we now see why a dutiful action does not have moral worth when done from a nonmoral motive alone, what can we say of the dutiful actions that *are* done from the motive of duty where the agent *also* has nonmoral interests in the action? This is the problem of the overdetermination of dutiful action.

The overdetermination of actions is a general phenomenon. It is quite common for us to have more than one motive for what we do, and even more than one motive that by itself would be sufficient to produce a particular action. Although Kant never explicitly discusses overdetermined moral cases, where an action is done from the motive of duty and from some other nonmoral motive, there is a tradition of reading Kant—especially the sympathy example—as holding that the mere presence of the nonmoral motive signifies a lack of moral worth. On this reading, the value that moral worth marks depends on the motive of duty acting alone.

The key text is in the second stage of the sympathy example. In the first stage of the example, Kant considers a man of sympathetic temper who does what is right (he helps others where he can) because he finds "an inner satisfaction in spreading joy and rejoice[s] in the contentment which (he has] made possible" (G398). As we have seen, Kant says that while such an action is "dutiful and amiable," it has no moral worth. In the second stage, Kant imagines "this friend of man" so overcome by sorrow that he is no longer moved by the needs of others. Kant continues:

> Suppose that, when no longer moved by any inclination, he tears himself out of this deadly insensibility and does the action without any inclination for the sake of duty alone; then for the first time his action has its genuine moral worth. *(G398)*

As one commentator responds: "Surely the most obvious way of generalizing from this remark yields the doctrine that only when one acts from duty alone—'without *any* inclination'—does his act have moral worth."[7] If one accepts this generalization—and it is traditional to do so—then one is faced either with the grim interpretation of moral worth or with the need to revise the doctrine to include cooperating nonmoral motives in a less stringent requirement. Although I think the generalization drawn from the passage is neither obvious nor necessary, there is insight to be gained from the difficulties that come with trying to accommodate it.

An instructive example is Richard Henson's attempt to take the sting out of the doctrine of moral worth by diminishing the significance of the *Groundwork* view. Drawing on the account of duties of virtue in the later *Metaphysics of Morals*, Henson argues that Kant can be seen as having another and benign conception of moral worth—he calls it the "fitness-report" model—according to which a dutiful act would have moral worth "provided that respect for duty was present and would have sufficed by itself [to produce the dutiful act], even though (as it happened) other motives were also present and might themselves have sufficed."[8] This is the model that is to do the basic work of crediting moral agents for doing the right thing in the right way. By contrast, Henson suggests we understand the *Groundwork's* conception of moral worth on the analogue of praise acknowledging victory against great odds (say, powerful desires tempting one away from duty), calling it, appropriately, the "battle-citation" model. If the conditions of action include supporting inclinations, and especially if the inclinations are sufficient by themselves to produce the dutiful act, then there is no great victory and no reason for praise. And, as Henson remarks, in honoring a person who has struggled morally and won, "we mean of course to encourage others who find themselves in comparable straits: but we emphatically do not mean to encourage anyone to try to *bring about* such situations"[9] which this sort of praise is appropriate. It need not be a fault if one never earns a battle citation for one's dutiful actions.[10]

The two-model approach to moral worth leaves Kant acquitted of the damaging charge that he believes it morally desirable not to want to do the action you morally ought to do. And each of the models of moral worth captures a natural form of moral praise. But the success of the two-model strategy depends on the adequacy of either model to capture the moral point of Kant's account of moral worth: that a right or dutiful action is performed is the non-accidental effect of the agent's moral concern.

According to the fitness-report model, overdetermined actions can have moral worth so long as the motive of duty is *sufficient by itself* to produce the dutiful action. But what it means for the moral motive to be "sufficient by itself" is unclear. It could mean sufficient if alone—that is, cooperating motives would not be required to bring about the dutiful action. Or it might be a stronger condition: if at the time of the action the agent had some conflicting motives, the moral motive was capable of bringing about the dutiful action without the aid of cooperating motives. Neither of these quite natural interpretations will support a satisfactory account of moral worth. It is instructive to see why they cannot.

Overdetermination involves cooperation between moral and nonmoral motives. Knowing this much does not reveal the conditions of cooperation. For the most part, two motives will cooperate to produce the same action only by accident.[11] As circumstances change, we may expect the actions the two motives require to be different and, at times, incompatible. But then, on either reading of sufficient moral motive, an agent judged morally fit might not have a moral motive capable of producing a required action "by itself" if his *presently* cooperating nonmoral motives were, instead, in conflict with the moral motive.[12] That is, an agent with a sufficient moral motive could, in different circumstances, act contrary to duty, from the *same* configuration of moral and nonmoral motives that in felicitous circumstances led him to act morally.

Consider a shopkeeper whose honest actions are overdetermined. On the fitness model, a shopkeeper with a sufficient moral motive will perform honest actions even if the profit motive is absent. But the fact that the moral motive was sufficient by itself in the overdetermined case does not imply that he

would perform honest actions when the profit motive clearly indicated that he should *not* act honestly. What does this tell us? Looking at the possible outcome of the original configuration of motives in altered circumstances introduces the suspicion that it might have been an accident that the agent acted as duty required in the *first* case: the explanation of his dutiful action might have been the absence of conflict with the profit motive. In what sense, then, was the shopkeeper morally fit? Surety to say that an action had moral worth we need to know that it was no accident that the agent acted as duty required.

There are two paths that can be taken here. (1) If the moral motive would have prevailed in altered circumstances (where the presently cooperating nonmoral motive instead indicated some other, incompatible, course of action), then the success of the moral motive in the case at hand was not dependent on the accident of circumstances that produced cooperation rather than conflict. This suggests a move to a greater-strength interpretation of sufficiency. While such a move solves the problem with the fitness model, it would pose a serious difficulty to an argument like Henson's for two models of moral worth.

On a greater-strength interpretation of the fitness model, an action can have moral worth only if the moral motive is strong enough to prevail over the other inclinations—without concern for whether they in fact cooperate or conflict. Henson's battle-citation model of moral worth differs only in that the moral motive has had to prevail. We do give different praise to the man who we know would be courageous than we do to the man who is (though why we do is a matter of some puzzlement), but there is no difference in the structure and strength of the two men's motives. Henson is right to point out that it is not morally desirable to be in circumstances where the moral motive has to win out, and so we are under no moral requirement to put ourselves in situations where we will earn such praise. But it is hardly plausible to see *this* difference in praise as marking a distinct notion of moral worth—since there is no difference in moral motive or the configuration of motives in the two cases. The only difference is in the circumstantial accident of cooperation or opposition of the nonmoral motives in the presence of an overpowering moral motive. A greater-strength interpretation of sufficiency would then undermine the claim that there were *two* notions of moral worth in Kant, and leave us with just the battle-citation model's powerful moral motive.

There are more substantive questions raised by a shift to a greater-strength interpretation of sufficiency, however. It is not at all clear that we should require of the moral motive that it be stronger or be able to prevail in altered circumstances in order to attribute moral worth to a given action. Even if circumstances tomorrow are such that the alignment of moral and nonmoral motives breaks down, and the dutiful action is as a result not done, it is surely possible that the dutiful action that *is* done today, when the motives are aligned, has moral worth. (In much the same way, succumbing to temptation only *raises* a question about motives in past cases.) Moral worth is not equivalent to moral virtue.

The problem is this: the experiment of imagining altered circumstances while holding fixed a given configuration of moral and nonmoral motives suggests that a dutiful action's being performed may be an accident of circumstances even with the presence of a sufficient moral motive (in Henson's original sense). While it seems reasonable to credit an action with moral worth only if its performance does not depend on an accident of circumstances, it seems equally reasonable to allow that failure in different circumstances does not require denial of moral worth to the original performance. With strength its only variable, the sufficiency account cannot satisfy both reasonable requirements.

(2) Both conditions could be met by a configuration of moral and nonmoral motives such that in acting dutifully it is the moral motive itself on which the agent acted. When this configuration holds, it would be no accident that the dutiful action was done, since it was just the agent's concern to act as duty required that determined his acting as he did. In different circumstances, if the configuration remains the same, the agent will again act dutifully. If he does not, it can only be from a different configuration of motives—one in which he is acting from some motive other than the motive of duty. But this failure

to act dutifully would provide no reason to discredit the dutiful action in the original case. Thus the difficulties that emerge with the notion of sufficiency support a literal reading of Kant's requirement that dutiful actions be done *from* the motive of duty: the presence of a moral motive sufficient to produce the dutiful action does not show that the interest that in fact determined the action was a moral one.[13]

Support for this third alternative to strength and fitness can be found in the *Critique of Practical Reason* (92–93),[14] where Kant denies any necessary opposition between moral and nonmoral motives, including the "principle of happiness." What is required is that where there is a question of duty, we "take no account" of the claims of happiness; we are not required to renounce them. For an action to have moral worth, the nonmoral motives (which are empirical and therefore belong to the principle of happiness, not the moral law) "must be separated from the supreme practical principle and never be incorporated with it *as a condition*" (emphasis added). It seems natural to conclude that when an action has moral worth nonmoral motives may be present, but they may not be what moves the agent to act. But it is not obvious how a motive could be present and yet not operative. To make sense of the third alternative, we need to complicate our understanding of motives in Kant's theory of action.

From the perspective of a familiar empiricist account of motives, the third alternative is unintelligible. It is easy to see why. If one takes motives to be desires, and desires are a kind of cause, when a motive is present it should have an effect (direct or indirect) on choice or action.[15] In line with this, one would suppose that cooperating motives add force in a given direction of action, and conflicting motives interfere with or even cancel each other (at the extreme). A prudential or a moral motive would be just another kind of desire, distinguished, presumably, by its object. What moves an agent to act is the resultant of these vector-like forces.[16] On such an account of motives, it will seem that the only way to satisfy the moral-worth requirement—that acting from the motive of duty not be an accident—is to require that the outcome of the agent's present configuration of motives be invariant through changes in circumstances. The implausibility

of the latter requirement then counts against the former one. We plainly cannot use this kind of account of motives to make sense of Kant's view.

The key to understanding Kant is in the idea that moral worth does not turn on the presence or absence of inclination supporting an action, but on its inclusion in the agent's maxim *as* a determining ground of action: as a motive. Kantian motives are neither desires nor causes. An agent's motives reflect his *reasons* for acting. An agent may take the presence of a desire to give him a reason for action as he may also find reasons in his passions, principles, or practical interests. All of these, in themselves, are "incentives" (*Triebfedern*), not motives, to action. It is the mark of a rational agent that incentives determine the will only as they are taken up into an agent's maxim. Indeed, it is only when an agent has a maxim that we can talk about his motive.[17]

The man of sympathetic temper responds to suffering *and* takes that response to give him a reason to help. Only then does he act from the motive of sympathy. An action that is done from the motive of duty is performed because the agent finds it to be the right thing to do and takes its rightness or requiredness as his reason for acting. He acts from the motive of duty with a maxim that has moral content.

On this view of motives, an agent could act from more than one motive in more than one way. It may be that neither of two incentives alone gives the agent sufficient reason to act (assuming a "favorable balance of reasons" principle). Then the agent may act from a combined motive. Or an agent may have incentives that provide two independent sufficient reasons for an action. Clearly no dutiful action from a combined motive could have moral worth. The harder question is whether there is anything wrong with taking both moral and nonmoral incentives into one's maxim as independently sufficient motives. Since a dutiful action has moral worth because the agent takes the fact that an action is morally required to be his reason for action—it is morality that guides his will—the presence of a nonmoral motive in his maxim is disqualifying.[18]

What we should now say about the preferred (third) alternative is this: when an action has moral worth, nonmoral *incentives* may be present, but they

may not be the agent's motives in acting. If the agent acts from the motive of duty, he acts because he takes the fact that the action is morally required to be the ground of choice. It does not follow from this that the action's moral worth is compromised by the presence of nonmoral feelings or interests, so long as they are not taken by the agent as grounds of choice: as motives. Thus one can say both that an agent's doing the right thing is nonaccidental because he acted from the motive of duty *and* admit that he might not have acted from this motive in altered circumstances. Strictly speaking, the doctrine of moral worth can accept the overdetermination of action with respect to *incentives*, not motives.

One might still object that, on this account of moral worth, it remains a matter of luck or accident that an agent acted in a morally worthy way. The strength of competing inclinations, the presence of circumstances that evoke competition, the strength of the moral motive itself may be affected by chance. The effect of chance, however, is on *who* is able to act in a morally worthy way. It poses a distributive problem that belongs to the theory of moral virtue and not to moral worth. It is *actions* and not agents that are credited with moral worth.[19] And although it may be a matter of luck *whose* actions have moral worth, what moral worth expresses is the relation of a motive to an action (through its maxim). When an agent does act dutifully from the motive of duty, when his maxim of action has moral content, it is not a matter of luck that the *action* has moral worth.[20]

III

The scope of the motive of duty is not restricted to morally worthy actions. It applies as well to actions that are merely correct or permissible: actions whose maxims satisfy the conditions set by the Categorical Imperative. Since it is possible to act in accordance with duty, but not from duty, it is obviously possible to have a morally correct action and only a nonmoral motive for acting on it. But for an action not required by duty, what can the moral motive add when the maxim already passes the Categorical Imperative's tests?

Our discussion of why *dutiful* actions should be done from the motive of duty suggests an answer: in acting from the motive of duty, the agent sets himself to abide by the moral assessment of his proposed actions. Suppose you have something you want (for whatever reason) to do. What the motive of duty provides is a commitment to do what you want only if the maxim of your action is judged morally satisfactory.[21] If it does pass the test, you are free to act, and the motive of duty as well as your original motive are satisfied. The difference introduced by the motive of duty is that one would *not* have acted on the original (nonmoral) motive had the maxim of action it prompted been morally unsatisfactory (failed the Categorical Imperative tests).

This aspect of the motive of duty fits a general pattern of motives that do not themselves have an object (in the ordinary way), but rather set limits to the ways (and whether) *other motives* may be acted upon. For example, a concern for economy is a motive that, by itself, does not normally lead one to do anything. It leads one to consider whether something that is wanted for other reasons is also a good value. That is, the motive to economy does not have a role to play unless another motive to action is already present. Then it says to act as you plan to only if what you would do is economical (as well as whatever else it is). If there is conflict between my desire for something and my more general concern for economy, that does not indicate what I will do: motives like that for economy may be easily (and sometimes appropriately) set aside for the satisfaction of other desires. (We often experience this as a kind of quasi-moral guilt; sometimes it is a release from inhibition.)

Following Kant, let us say that such motives provide *limiting conditions* on what may be done from other motives (usually primary, or initiating, motives).[22] Cooperation is then seen as the case in which the limiting condition sanctions acting on the primary motive; it does not merely, and independently, push along with it. Similarly, conflict does not consist in opposing tugs, but in the action suiting the primary motive failing to satisfy the limiting condition. What, in the end, will be done does involve an issue of strength. But the strength metaphor alone masks the complexity of the interaction.

When the motive of duty functions as a limiting condition, there is no lessening of the agent's moral commitment if he acts from the motive of duty *and* nonmoral motives, so long as the motive of duty is effective: its satisfaction is decisive in the agent's going on with his proposed action. Rather than posing a moral obstacle, the nonmoral motive is in most cases necessary if the motive of duty (as a limiting condition) is to have an object of interest. As Kant sees it, moral deliberation characteristically begins with a nonmoral interest or motive that prompts consideration of an appropriate course of action.[23] Ordinary moral life is embedded in desires for ordinary things, desires that lead to different kinds of action in different circumstances. My need for money may send me to the bank, to work, or to a deceitful promise, depending on the situation in which I must act to meet my need. Whether I will be tempted to act in a morally impermissible way will likewise depend on contingent and variable circumstances. If we follow Kant, it is what happens next that is the crucial moment for the moral agent. Once I am aware of what I want to do, I must consider whether it is morally permissible. If I have an effective motive of duty, I will act only when I determine that it is. I then act in the presence of more than one motive, satisfying both my nonmoral desire *and* the motive of duty. This is the normal state of affairs for someone with a sincere interest in doing what is right.[24]

Although as a limiting condition the motive of duty can enter only when there is a proposed course of action based on another motive, it is unlike many other motives that impose limiting conditions since it can, by itself, move an agent to act. The clearest case of this is, of course, in morally worthy actions. There are also certain kinds of action that cannot be done at all unless done from the motive of duty (as a primary motive). For example, not every act of bringing aid is a beneficent act. It is beneficent only if the agent conceives of what he is doing as an instance of what *any* moral agent is required to do when he can help another, and acts to help for that reason. For Kant, only the motive of duty could prompt someone to act on a maxim with such content—for no other motive responds to a conception of action that regards the agent himself impersonally or is impartial in its application.

The motive of duty cannot, by itself (as a primary motive), prompt merely permissible actions, for it is by definition a matter of moral indifference whether they are performed. (We might say, with Kant, that the maxims of permissible actions have no moral content.) The role of the motive of duty here can only be in the background, as an effective limiting condition, requiring that the agent not act contrary to duty. If the agent loses interest in his proposed course of action, the motive of duty can have nothing to say about what he should do until another course of action is proposed (other things morally equal). In other words, permissible actions cannot be done "from the motive of duty." Therefore merely permissible actions, even when they are performed on the condition that they are permissible (that is, even when the motive of duty is effective as a limiting condition in them), cannot have moral worth.[25]

For an action to be a *candidate* for moral worth, it must make a moral difference whether it is performed. (Only then is it even possible for the action to be done from the motive of duty.) For an action to *have* moral worth, moral considerations must determine how the agent conceives of his action (he understands his action to be what morality requires), and this conception of his action must then determine what he does. (It is when this condition is satisfied that a maxim of action has moral content.[26] That is, an action has moral worth if it is required by duty and has as its primary motive the motive of duty. The motive of duty need not reflect the only interest the agent has in the action (or its effect); it must, however, be the interest that determines the agent's acting as he did.

Earlier we noted that the discussion of moral worth was introduced by Kant to illuminate the nature of good willing (good of itself, without regard to any further end). Now we can see why good willing is found in actions that have moral worth: in them, the agent need not be concerned with anything other than the morality of what he does in order to have sufficient motive to act. If the maxim of an action is an expression of an agent's will in acting, to say that

the maxim of a dutiful action done from the motive of duty has moral content is to say of the agent's will that it is ultimately determined by "that preeminent good which we call moral" (G401).

It is clear that the role of the motive of duty is considerably more extensive than the illustrative examples in the *Groundwork* might lead one to believe. This is especially important in providing some idea of the moral cast given to ordinary action in the theory. Although we should never act contrary to duty, the function of the motive of duty is not to press constantly for *more* dutiful actions, or to get us to see the most trivial actions as occasions for virtue: rather it is to keep us free of the effects of temptations in ordinary situations that can suggest morally prohibited courses of action. It is only in its function as a primary motive that one acts *from* the motive of duty at all, and only those actions that are required (by the Categorical Imperative) *can* have the motive of duty as a primary motive. As a limiting condition, the motive of duty can be present in (or satisfied by) an action, and yet that action have no moral import. Thus we can preserve the sense in which, for Kant, the motive of duty is ubiquitous—governing all our actions—without having to accept the view that all of our actions must be seen as matters of duty.

IV

At this point we need to return to the *Groundwork*'s sympathy example to see how our account of moral worth and the moral motive fares interpretively. That is, we want, in its terms, an analysis of the value of acting with moral worth that satisfactorily explains Kant's apparent insistence that only the action done from the motive of duty alone has moral worth.

Earlier I suggested that the problem with the natural motive of sympathy is that the interest it gives an agent in his action is not a moral interest. The man of sympathetic temper is one whose helpful actions, however steady and genuinely beneficial, are motivated by his natural response to the plight of others. He acts because he is moved by others' distress. As such there is no moral component in his conception

of what he does. Therefore nothing in what motivates him would prevent his acting in a morally impermissible way if that were helpful to others, and it is to be regarded as a bit of good luck that he happens to have the inclination to act as morality requires.[27] What is missing is an effective and motivating moral interest in his action: the source of the action is not the moral motive itself (he is not acting beneficently), nor is he committed to refraining from helpful actions that are not permissible. That is to say, his action neither has moral worth nor indicates an attitude of virtue.

If the moral motive *is* effective and motivating, it would seem that the presence of a nonmoral inclination should have no effect on the action's moral worth. That is, even if the moral motive expresses but *one* kind of interest the agent has in the helpful action, so long as it is the moral motive the agent acts on, the action should have moral worth. Indeed, what is morally valuable in actions judged to have moral worth seems prominently displayed in cases of this type: the dutiful act is chosen without concern for its satisfying other incentives the agent may have.

What, then, can we make of Kant's supposed insistence that only when there is no natural inclination to help can the helping action have moral worth? The key to the sympathy example is found in attending to the fact that it describes the moral situation of the *same man* in two different circumstances: the "friend of man," no longer moved by the needs of others, is the man of sympathetic temper with whom the discussion begins. Straightaway we should ask why Kant would think *this* change of circumstances for *this* man is revelatory. At the least, the emphasis on an individual should make us cautious about how we generalize from the case.

Let us follow Kant. The first part of the sympathy example looks at the helping act of the man of sympathetic temper. We concluded that there is good reason to find moral fault in the dutiful action done from inclination alone. Kant says that this action has no moral worth. In the second part of the example, we are to suppose that things change for the man, and his natural concern for others becomes ineffective. We need not imagine that his character changes—he is still a man of sympathetic temper; changed circumstances

have called forth other, more powerful inclinations, which have made him unable to feel for others or disinclined to concern himself on their behalf. Looking to inclination *alone* for motivation, then, he cannot act to help. Kant supposes that he does act in the face of this "deadly insensibility," from the motive of duty. That such an action is judged to have moral worth is in no way problematic. What has seemed unwarranted is the claim that in acting "without any inclination—then for the first time the action has its genuine moral worth." And it would be if it were an instance of the generalization "only when there is no inclination to a dutiful action can it have moral worth." We come to a quite different conclusion, however, if we see the passage as a set of remarks about one (kind of) person, a man of sympathetic temper who normally helps others because he is stirred by their need but sometimes, when his feelings are dimmed, helps them because that is what duty requires. Of *him* it is then said: only when the inclination to help others is not available does *his* helping action have moral worth. For of him it was true that when he had the inclination he did not act from the motive of duty. This does not imply that no dutiful action can have moral worth if there is cooperating inclination. Nor does it imply that a sympathetic man could not act from the motive of duty when his sympathy was aroused. The account is of a kind of temperament we are tempted to value morally, designed to show how even dutiful actions done from apparently attractive motives might yet be morally wanting.

We should expect confirmation of this interpretation in the other examples Kant offers in this section, and it will be worth reminding ourselves of their detail to see it.[28] Immediately after the shopkeeper example, which describes an action "done neither from duty nor from immediate inclination," Kant considers the duty of self-preservation:

> to preserve one's life is a duty, and besides this everyone has also an immediate inclination to do so. But on account of this the often anxious precautions taken by the greater part of mankind for this purpose have no inner worth, and the maxim of their action is without moral content. They do protect their lives in conformity with duty, but not from the motive of duty. When on the contrary, disappointments and hopeless misery have quite taken away the taste for life; when a wretched man, strong in soul and more angered at his fate than fainthearted or cast down, longs for death and still preserves his life without loving it—not from inclination or fear but from duty; then indeed his maxim has a moral content. (G397–398)

I think that one reads this as *obviously* supporting the "no-inclination" generalization only by ignoring what Kant seems to be taking elaborate pains to say: most of the time people act to preserve their lives with no regard to its being a duty (and often with no regard to morality at all), simply because they have an inclination to self-preservation. This seems true enough. *If* it is a duty to preserve one's life, then Kant would surely be right in saying that most self-preserving acts have no moral worth. Here, as before, we could point to a lack of interest in the morality of such actions. There is a willingness, from the point of view of the inclination to self-preservation, to act in a morally impermissible way; and with the absence of such inclination, "when disappointments and hopeless misery have quite taken away the taste for life," no reason remains to preserve the life no longer cared about. The conclusion is that actions motivated by the inclination to self-preservation alone have no moral worth. And since, as a matter of fact, most self-preserving actions come from this source, "the often anxious precautions taken by the greater part of mankind for this purpose have no inner worth."

Now the contrast. We imagine a person who normally acts to preserve his life because he wants to keep living. Circumstances change, his "taste for life," is gone; death appears as a more attractive alternative to continued life.[29] If inclination were all that now prompted his actions, what once led him to self-preserving actions would now lead him to act contrary to duty. He then acts to preserve his life from the motive of duty; *that* self-preserving action has moral worth. The conclusion: for most of us, most of the time, self-preserving actions stem from inclination alone and have no moral worth. Sometimes, some people, when they have no inclination to preserve their lives, may yet do so from the motive of duty. For such a person, only then, and for the first time, would his self-preserving action have moral

worth. Nothing in this account speaks against the possibility of an action with more than one incentive having moral worth. As with the sympathy example, what is being examined is the dutiful act done from immediate inclination *alone*. The point of the discussion is to reveal what is added, morally, when a person acts from the motive of duty. It is easier to see what is added when all inclination is taken away.[30]

We can see this structure of argument again in Kant's discussion of the indirect duty we have to promote our happiness. He begins with the observation that the motive for most of the actions that conform to this duty is the ordinary desire to be happy ("the universal inclination towards happiness"). Such actions, plainly, have no moral worth. As with the sympathy and self-preservation examples, the argument looks at the actions of a particular man (in this case someone suffering from gout), whose altered circumstances direct an inclination that ordinarily conforms to duty away from it. The gout sufferer is in the odd situation where he cannot act according to the (indirect) duty to promote his own happiness unless he acts from the motive of duty. This is so because the inclination toward happiness *in him*, in his special circumstances, is distracted by present pleasure, when, for the sake of happiness, he ought to abstain and seek good *health*. If he follows inclination, *in these circumstances*, he will act contrary to duty, although ordinarily he would not. (Pleasure and happiness frequently coincide.) Kant concludes that when the gout sufferer acts to promote his happiness from the motive of duty (choosing health over pleasure), "for the first time his conduct has a real moral worth." Here again the example directs us to refrain from giving moral value to inclination, however likely it is to promote dutiful actions, because of the accidental nature of the connection between *any* inclination and duty. When the inclination alone prompts a morally correct action, there is no moral worth because, in Kant's terms, there is no moral content or interest in the volition (maxim). Nothing in the example forces the reading that it is the mere *presence* of the inclination that is responsible for the denial of moral worth. The moral failure is seen when, in the absence of the motive of duty, and so of a moral interest in the action, circumstances may be such that inclination alone gives the agent no reason to do the dutiful action. Indeed, in acting from inclination alone, the agent *never had* a reason to do what morality required.

What can be said in summary about these three examples? They concern men motivated to dutiful actions by different kinds of inclination.[31] Exactly what normally motivates their acting according to duty leads them to act impermissibly when changed circumstances direct the inclination to something other than a dutiful action. It is said of *these* men that their dutiful actions have moral worth only when, in the altered circumstances (where inclination does not in fact support a dutiful action), they nonetheless act, from the motive of duty alone. Then, for the first time, they show a moral interest in their action. For it is only then that they act from the motive of duty at all. If there is any obvious generalization to be taken from these cases, it has to do with the moral inadequacy of nonmoral motives.

If an agent does not have an independently effective and motivating moral interest in an action, although he may act as duty requires, there remains a dependence on nonmoral interests that compromises his ability to act morally. One need not be indifferent to the possible satisfactions that a dutiful action may produce. It is just that the presence of such possibilities should not be the ground of the agent's commitment to acting morally. Overdetermined actions *can* have moral worth so long as the moral motive is the determining ground of action—the motive on which the agent acts. Morality is not to be merely one of the things, among others, in which we have an interest.

When someone acts from an effective and primary moral motive, it could well be said that such a person is morally fit. But the nature of this fitness includes more than the presence of a moral motive sufficient to produce a dutiful action. It expresses a kind of independence from circumstances and need, such that in acting from the motive of duty, we are, as Kant saw it, free.

Notes

1. And the reactions have been extremely harsh: from the mockery of Schiller's verse, to the dismissive arguments of philosophers responsive to the virtues, to the angry contempt of contemporary philosophical feminists.

It has seemed incredible that Kant could have held such a view *and* claimed authority for it in ordinary moral knowledge.

2. *Groundwork of the Metaphysics of Morals*, p. 397; Hereafter cited G with page numbers from the Prussian Academy edition.

3. I consider here only the first part of the sympathy example, since it most clearly addresses the question of the moral value of the moral motive. The reading of the whole example comes after this question is resolved, and we have a clearer sense of what it is for an action to have moral worth (see section IV).

4. "The moral motive" and "the motive of duty" I use interchangeably. In asking whether something could be *a* moral motive I am asking whether it could be a motive that gives an action moral worth.

5. A sharply argued version of this criticism can be found in Bernard Williams, "Morality and the Emotions," in *Problems of the Self* (Cambridge: Cambridge University Press, 1973), pp. 226–228.

6. Whether *any* emotion could give an agent a moral interest in an action is a question that must look first to an account of the emotions (of what it is to say of a motive that it is an emotion). For Kant, the answer is clearly no; he holds that no emotion or inclination can make the moral law the determining ground of the will, since they determine the will according to the principle of happiness. See *Critique of Practical Reason* (hereafter cited KpV) 92–93 and G401n.

7. Richard Henson, "What Kant Might Have Said: Moral Worth and the Overdetermination of Dutiful Action," *Philosophical Review* 88 (1979), 45.

8. Ibid., p. 48. The original version of this chapter was written in response to Henson's essay.

9. Ibid., p. 50.

10. The battle-citation metaphor suggests powerful, serious, difficult-to-control conflict. But the metaphor exaggerates the case. Dutiful action from a moral motive in the face of temptation is an ordinary and natural part of moral life. Indeed, the introduction of such conflict would be a necessary part of a moral education if its occurrence were not inevitable.

11. Part of the task of moral education is to shape a person's character so that the alignment of moral and nonmoral motives can be depended upon.

12. The weaker version may not yield a dutiful action in the presence of any conflicting motive. The stronger version takes care of only motives that in fact conflict with the moral motive at the time of the action. It is not set up to deal with motives that *might have* produced conflict.

13. Henson acknowledges such an account as an alternative to his fitness and battle-citation models of moral worth, but rejects it because he believes there are no adequate criteria for deciding the factual question of which of a number of motives an agent actually acted on (p. 44). By itself this is a weak argument. We often need to insist that although we had a motive we did not act on it. Unless this were so, there would be little room for moral insincerity.

14. See also G400–401 and *Theory and Practice* 278–279.

15. Holly Smith, canvassing this way of understanding moral worth, remarks, "Since I find problems in understanding the idea of a desire that exists but has no connection with the agent's choice, even though it is a desire to perform or to avoid performance of actions available for choice, I shall not discuss this suggestion." See "Moral Worth and Moral Credit," *Ethics* 101 (1991), 290–291n. Interestingly, she finds no issue in couching a claim about motives in the language of desires. A similar objection to the idea of motives not acted on can be found in Paul Benson, "Moral Worth," *Philosophical Studies* 51 (1987), 365–382.

16. This is of course a crude version of the empiricist view. In particular, it leaves out the complexity of structure that comes with second-order desires. Nevertheless, something very much like the crude version is at work in the critical debate about Kant's doctrine of moral worth.

17. Evidence for this account of motives can be found throughout Kant's practical philosophy. It is perhaps most clearly laid out in the introduction to the *Metaphysics of Morals*.

18. I take the conjunction of motives in one maxim to imply a principle that makes each the condition of acting on the other. More puzzling is the disjunctive motive, "Do the right thing because it is right *or* because it promotes some nonmoral good." Here as well the motive of duty would not be the determining ground of the will, not because of some condition but because the principle is one of indifference.

19. This may not seem so clear, for the moral worth of an action is said to be in its maxim (G399): the expression [in rule form] of an agent's volition (what the agent is moved to do and for what reason). Thus there is a sense in which moral worth *is* about agents—it is about their willings. The point of saying that it is actions that are credited with moral worth is to highlight the relationship between *an* action and *its* motive (via the action's maxim), which is where moral worth resides (and not in the permanent structure of an agent's motives: that is the matter of virtue—see DV46). The opposite view is argued in Keith Simmons, "Kant on Moral Worth," *History of Philosophy Quarterly* 6 (1989), 85–100.

20. Here I disagree with Thomas Sorrell, "Kant's Good Will," *Kant-Studien* 78 (1987), 87–101, who argues that if moral worth signifies good willing, and the good will is a will that can never be bad, an action cannot have moral worth unless it is done from a good will. This erases the distinction between moral worth and virtue that I would draw. I see no reason why good willing cannot be present in a will that is not altogether good. We do not always give moral concerns priority—and so our will is not good—but sometimes we do.

21. Motives other than duty can appear to produce this result: someone might believe that the road to salvation lies in satisfying the Categorical Imperative. The only difference here is in the motive: the end (satisfying the Categorical Imperative), and so the actions taken, will be the same. That is, the difference is in the nature of the agent's attachment to his end. In the one case, Kant could argue, it is the realization through the Categorical Imperative of the agent's dignity as a rational being; in the other, the attachment to the Categorical Imperative depends on a desire to be saved. Giving up the idea of an afterlife might require that such a person remotivate his attachment to morality. The attachment to the Categorical Imperative that comes from the motive of duty does not depend on the maintenance of such extramoral beliefs (although such beliefs may be needed to reinforce moral commitment).

22. A primary motive is one that can, by itself, produce action. Limiting conditions may also be directed at other limiting conditions—lexically, or in some other structure (with or without conflict among them). Insofar as a motive functions as a limiting condition, all it can require is that the actions prompted by *other* motives satisfy its condition. The problem of disjunctive motives does not occur here because the moral motive is the condition of acting on the nonmoral motive.

23. This is clear in the way he presents instances of moral deliberation. For example: "[A person] finds himself driven to borrow money because of need. He well knows that he will not be able to pay it back; but he sees too that he will get no loan unless he gives a firm promise to pay it back...He is inclined to make such a promise; but he still has enough conscience to ask 'Is it not unlawful and contrary to duty to get out of difficulties in this way?'" (G422).

24. Such actions can be described as overdetermined in the sense that they satisfy more than one motive. They are not overdetermined in Henson's sense, where each motive must be sufficient by itself to produce the action.

25. One might want to say that, in permitting myself to act only when and because my maxim satisfies the Categorical Imperative, I *am* doing an action that has moral worth, since it is done from the motive of duty. But it is the permitting and not the action permitted that would have moral worth. (In permitting myself another glass of wine I am not acting on the same motive I will be acting on when I drink it.) Since it is not clear to me how there can be a *duty* to act on maxims that satisfy the Categorical Imperative (the Categorical Imperative tells you what your duty is), I would rather treat the permitting as acting on the moral motive in its limiting condition function, thereby indicating an attitude of virtue rather than moral worth.

26. Thus a dutiful action performed on the condition that it is permissible (that is, from the motive of duty as a limiting condition only), will not have moral worth, even if it is no accident of circumstances that the dutiful action is done. Its not being an accident is only a necessary condition for moral worth. In the case of a perfect duty, for example, only those maxims of inclination that include the required action will be permissible (G401n). So an agent with a policy of never acting impermissibly will (nonaccidentally) act as perfect duty requires. When inclination and duty coincide, however, he may act with no other conception of his action than as a permissible means of satisfying inclination. That is, he may act dutifully, with no sense that his action is required, from a maxim that has no moral content.

27. One might, of course, cultivate an inclination because of its recognized moral utility. In *Doctrine of Virtue* (hereafter cited DV) 456 Kant distinguishes between what we might call "natural" and "moral" sympathy: the latter appears to be the moral motive making use of our natural propensity to care about the welfare of others to promote "active and rational benevolence." The message for us is in the clear subordination of the natural to the moral motive. We are not morally better off without natural sympathy.

28. It is unfortunate that such exclusive attention has been lavished on the sympathy example for it is difficult to see its point given the obvious attractiveness of the kind of person it criticizes. The striking similarity of detail in the self-preservation and happiness examples is easily overlooked once one is convinced that Kant has made the argument "if inclination, no moral worth" in the sympathy case.

29. There is surprising subtlety in this example. Why, one might wonder, does Kant insist on someone "strong in soul" and angered by his fate, rather than someone depressed or weak? Is it that a weaker person might turn to morality as a comfort? Or perhaps he is interested in cases where the choice against morality seems strongest, most rational. The resolution of this does not affect the larger interpretive question. The presence and the quality of the detail do suggest a kind of concern with a particular case that should quickly warn one off easy and large generalizations.

30. Beck notes that when Kant discusses the use of examples in *Second Critique* 92–93 he compares himself to a chemist separating a compound (of motives) into its elements: Kant's purpose in using cases that present conflict between moral and nonmoral motives is merely to precipitate the motive of duty, and not to present conflict as a condition for moral worth. Sec Lewis W. Beck, *A Commentary on Kant's Critique of Practical Reason* (Chicago: University of Chicago Press, 1960), p. 120n.

31. Each of the examples deals with a different category of inclination: the inclination to self-preservation is an instinct; a sympathetic temper is a natural (to human beings) disposition; the desire for happiness is based on an empirically determined Idea.

Study Questions

1. If you visit a friend in the hospital in hope of being financially rewarded, are you acting morally?

2. If you visit a friend in the hospital because of concern for your friend, are you acting morally?

3. If you visit a friend in the hospital not to relieve your friend's distress but because you believe you have a duty to visit, are you acting morally?

4. If you visit a friend in the hospital both to relieve your friend's distress and because you believe you have a duty to visit, are you acting morally?

31

PHILIPPA FOOT

Philippa Foot (1920–2010), born in England, became Professor of Philosophy at the University of California, Los Angeles. She argued against the Kantian claim that moral imperatives must be categorical rather than hypothetical. Just as rules of etiquette do not have binding force and can be disregarded without violating rationality, the same is true of moral rules, although in both cases failure to adhere to widely accepted guidelines can undermine a person's ability to work with others and achieve common goals. In other words, a moral person cares about suffering and injustice, but not out of duty, which is only an illusion.

Morality as a System of Hypothetical Imperatives

There are many difficulties and obscurities in Kant's moral philosophy, and few contemporary moralists will try to defend it all; many, for instance, agree in rejecting Kant's derivation of duties from the mere

From *Philosophical Review* 71 (1972).

form of law expressed in terms of a universally legislative will. Nevertheless, it is generally supposed, even by those who would not dream of calling themselves his followers, that Kant established one thing beyond doubt—namely, the necessity of distinguishing moral judgments from hypothetical imperatives. That moral judgments cannot be hypothetical imperatives has come to seem an unquestionable truth. It will be argued here that it is not.

In discussing so thoroughly Kantian a notion as that of the hypothetical imperative, one naturally begins by asking what Kant himself meant by a hypothetical imperative, and it may be useful to say a little about the idea of an imperative as this appears in Kant's works. In writing about imperatives Kant seems to be thinking at least as much of statements about what ought to be or should be done, as of injunctions expressed in the imperative mood. He even describes as an imperative the assertion that it would be "good to do or refrain from doing something"[1] and explains that for a will that "does not always do something simply because it is presented to it as a good thing to do" this has the force of a command of reason. We may therefore think of Kant's imperatives as statements to the effect that something ought to be done or that it would be good to do it.

The distinction between hypothetical imperatives and categorical imperatives, which plays so important a part in Kant's ethics, appears in characteristic form in the following passages from the *Foundations of the Metaphysics of Morals*:

> All imperatives command either hypothetically or categorically. The former present the practical necessity of a possible action as a means to achieving something else which one desires (or which one may possibly desire). The categorical imperative would be one which presented an action as of itself objectively necessary, without regard to any other end.[2]
>
> If the action is good only as a means to something else, the imperative is hypothetical; but if it is thought of as good in itself, and hence as necessary in a will which of itself conforms to reason as the principle of this will, the imperative is categorical.[3]

The hypothetical imperative, as Kant defines it, "says only that the action is good to some purpose" and the purpose, he explains, may be possible or actual. Among imperatives related to actual purposes Kant mentions rules of prudence, since he believes that all men necessarily desire their own happiness. Without committing ourselves to this view it will be useful to follow Kant in classing together as "hypothetical imperatives" those telling a man what he ought to do because (or if) he wants something and those telling him what he ought to do on grounds of self-interest. Common opinion agrees with Kant in insisting that a moral man must accept a rule of duty whatever his interests or desires.[4]

Having given a rough description of the class of Kantian hypothetical imperatives it may be useful to point to the heterogeneity within it. Sometimes what a man should do depends on his passing inclination, as when he wants his coffee hot and should warm the jug. Sometimes it depends on some long-term project, when the feelings and inclinations of the moment are irrelevant. If one wants to be a respectable philosopher one should get up in the mornings and do some work, though just at that moment when one should do it the thought of being a respectable philosopher leaves one cold. It is true nevertheless to say of one, at that moment, that one wants to be a respectable philosopher,[5] and this can be the foundation of a desire-dependent hypothetical imperative. The term "desire" as used in the original account of the hypothetical imperative was meant as a grammatically convenient substitute for "want," and was not meant to carry any implication of inclination rather than long-term aim or project. Even the word "project," taken strictly, introduces undesirable restrictions. If someone is devoted to his family or his country or to any cause, there are certain things he wants, which may then be the basis of hypothetical imperatives, without either inclinations or projects being quite what is in question. Hypothetical imperatives should already be appearing as extremely diverse; a further important distinction is between those that concern an individual and those that concern a group. The desires on which a hypothetical imperative is dependent may be those of one

man, or may be taken for granted as belonging to a number of people, engaged in some common project or sharing common aims.

Is Kant right to say that moral judgments are categorical, not hypothetical, imperatives? It may seem that he is, for we find in our language two different uses of words such as "should" and "ought," apparently corresponding to Kant's hypothetical and categorical imperatives, and we find moral judgments on the "categorical" side. Suppose, for instance, we have advised a traveler that he should take a certain train, believing him to be journeying to his home. If we find that he has decided to go elsewhere, we will most likely have to take back what we said: the "should" will now be unsupported and in need of support. Similarly, we must be prepared to withdraw our statement about what he should do if we find that the right relation does not hold between the action and the end—that it is either no way of getting what he wants (or doing what he wants to do) or not the most eligible among possible means. The use of "should" and "ought" in moral contexts is, however, quite different. When we say that a man should do something and intend a moral judgment we do not have to back up what we say by considerations about his interests or his desires; if no such connection can be found the "should" need not be withdrawn. It follows that the agent cannot rebut an assertion about what, morally speaking, he should do by showing that the action is not ancillary to his interests or desires. Without such a connection the "should" does not stand unsupported and in need of support; the support that *it* requires is of another kind.[6]

There is, then, one clear difference between moral judgments and the class of "hypothetical imperatives" so far discussed. In the latter "should" is used "hypothetically," in the sense defined, and if Kant were merely drawing attention to this piece of linguistic usage his point would be easily proved. But obviously Kant meant more than this; in describing moral judgments as non-hypothetical—that is, categorical imperatives—he is ascribing to them a special dignity and necessity which this usage cannot give. Modern philosophers follow Kant in talking, for example, about the "unconditional requirement" expressed in moral judgments. These tell us what

we have to do whatever our interests or desires, and by their inescapability they are distinguished from hypothetical imperatives.

The problem is to find proof for this further feature of moral judgments. If anyone fails to see the gap that has to be filled it will be useful to point out to him that we find "should" used non-hypothetically in some non-moral statements to which no one attributes the special dignity and necessity conveyed by the description "categorical imperative." For instance, we find this non-hypothetical use of "should" in sentences enunciating rules of etiquette, as, for example, that an invitation in the third person should be answered in the third person, where the rule does not *fail to apply* to someone who has his own good reasons for ignoring this piece of nonsense, or who simply does not care about what, from the point of view of etiquette, he should do. Similarly, there is a non-hypothetical use of "should" in contexts where something like a club rule is in question. The club secretary who has told a member that he should not bring ladies into the smoking room does not say, "Sorry, I was mistaken" when informed that this member is resigning tomorrow and cares nothing about his reputation in the club. Lacking a connection with the agent's desires or interests, this "should" does not stand "unsupported and in need of support"; it requires only the backing of the rule. The use of "should" is therefore "non-hypothetical" in the sense defined.

It follows that if a hypothetical use of "should" gives a hypothetical imperative, and a non-hypothetical use of "should" a categorical imperative, then "should" statements based on rules of etiquette, or rules of a club, are categorical imperatives. Since this would not be accepted by defenders of the categorical imperative in ethics, who would insist that these other "should" statements give hypothetical imperatives, they must be using this expression in some other sense. We must therefore ask what they mean when they say that "You should answer . . . in the third person" is a hypothetical imperative. Very roughly the idea seems to be that one may reasonably ask why anyone should bother about what should*e* (should from the point of view of etiquette) be done, and that such considerations deserve no notice unless reason is shown. So

although people give as their reason for doing some-thing the fact that it is required by etiquette, we do not take this consideration as *in itself giving us reason to act*. Considerations of etiquette do not have any auto-matic reason-giving force, and a man might be right if he denied that he had reason to do "what's done."

This seems to take us to the heart of the matter, for, by contrast, it is supposed that moral considera-tions necessarily give reasons for acting to any man. The difficulty is, of course, to defend this proposition which is more often repeated than explained. Unless it is said, implausibly, that all "should" or "ought" statements give reasons for acting, which leaves the old problem of assigning a special categorical status to moral judgment, we must be told what it is that makes the moral "should" relevantly different from the "shoulds" appearing in normative statements of other kinds.[7] Attempts have sometimes been made to show that some kind of irrationality is involved in ignoring the "should" of morality: in saying "Immoral—so what?" as one says "Not *comme il faut*—so what?" But as far as I can see these have all rested on some illegitimate assumption, as, for instance, of think-ing that the amoral man, who agrees that some piece of conduct is immoral but takes no notice of that, is inconsistently disregarding a rule of conduct that he has accepted; or again of thinking it inconsistent to desire that others will not do to one what one proposes to do to them. The fact is that the man who rejects morality because he sees no reason to obey its rules can be convicted of villainy but not of inconsistency. Nor will his action necessarily be irrational. Irrational actions are those in which a man in some way defeats his own purposes, doing what is calculated to be dis-advantageous or to frustrate his ends. Immorality does not *necessarily* involve any such thing.

It is obvious that the normative character of moral judgment does not guarantee its reason-giving force. Moral judgments are normative, but so are judgments of manners, statements of club rules, and many oth-ers. Why should the first provide reasons for acting as the others do not? In every case it is because there is a background of teaching that the non-hypothetical "should" can be used. The behavior is required, not simply recommended, but the question remains as to why we should do what we are required to do. It is true that moral rules are often enforced much more strictly than the rules of etiquette, and our reluctance to press the non-hypothetical "should" of etiquette may be one reason why we think of the rules of eti-quette as hypothetical imperatives. But are we then to say that there is nothing behind the idea that moral judgments are categorical imperatives but the relative stringency of our moral teaching? I believe that this may have more to do with the matter than the defend-ers of the categorical imperative would like to admit. For if we look at the kind of thing that is said in its defense we may find ourselves puzzled about what the words can even mean unless we connect them with the feelings that this stringent teaching implants. People talk, for instance, about the "binding force" of morality, but it is not clear what this means if not that we *feel* ourselves unable to escape. Indeed the "ines-capability" of moral requirements is often cited when they are being contrasted with hypothetical impera-tives. No one, it is said, escapes the requirements of ethics by having or not having particular interests or desires. Taken in one way this only reiterates the contrast between the "should" of morality and the hypothetical "should," and once more places moral-ity alongside of etiquette. Both are inescapable in that behavior does not cease to offend against either morality or etiquette because the agent is indifferent to their purposes and to the disapproval he will incur by flouting them. But morality is supposed to be ines-capable in some special way and this may turn out to be merely the reflection of the way morality is taught. Of course, we must try other ways of expressing the fugitive thought. It may be said, for instance, that moral judgments have a kind of necessity since they tell us what we "must do" or "have to do" whatever our interests and desires. The sense of this is, again, obscure. Sometimes when we use such expressions we are referring to physical or mental compulsion. (A man has to go along if he is pulled by strong men, and he has to give in if tortured beyond endurance.) But it is only in the absence of such conditions that moral judgments apply. Another and more common sense of the words is found in sentences such as "I caught a bad cold and had to stay in bed" where a penalty for

acting otherwise is in the offing. The necessity of acting morally is not, however, supposed to depend on such penalties. Another range of examples, not necessarily having to do with penalties, is found where there is an unquestioned acceptance of some project or role, as when a nurse tells us that she has to make her rounds at a certain time, or we say that we have to run for a certain train.[8] But these too are irrelevant in the present context, since the acceptance condition can always be revoked.

No doubt it will be suggested that it is in some other sense of the words "have to" or "must" that one has to or must do what morality demands. But why should one insist that there must be such a sense when it proves so difficult to say what it is? Suppose that what we take for a puzzling thought were really no thought at all but only the reflection of our *feelings* about morality? Perhaps it makes no sense to say that we "have to" submit to the moral law, or that morality is "inescapable" in some special way. For just as one may feel as if one is falling without believing that one is moving downward, so one may feel as if one has to do what is morally required without believing oneself to be under physical or psychological compulsion, or about to incur a penalty if one does not comply. No one thinks that if the word "falling" is used in a statement reporting one's sensations it must be used in a special sense. But this kind of mistake may be involved in looking for the special sense in which one "has to" do what morality demands. There is no difficulty about the idea that we feel we *have to* behave morally, and given the psychological conditions of the learning of moral behavior it is natural that we should have such feelings. What we cannot do is quote them in support of the doctrine of the categorical imperative. It seems, then, that in so far as it is backed up by statements to the effect that the moral *is* inescapable, or that we *do* have to do what is morally required of us, it is uncertain whether the doctrine of the categorical imperative even makes sense.

The conclusion we should draw is that moral judgments have no better claim to be categorical imperatives than do statements about matters of etiquette. People may indeed follow either morality or etiquette without asking why they should do so, but

equally well they may not. They may ask for reasons and may reasonably refuse to follow either if reasons are not to be found.

It will be said that this way of viewing moral considerations must be totally destructive of morality, because no one could ever act morally unless he accepted such considerations as in themselves sufficient reason for action. Actions that are truly moral must be done "for their own sake," "because they are right," and not for some ulterior purpose. This argument we must examine with care, for the doctrine of the categorical imperative has owed much to its persuasion.

Is there anything to be said for the thesis that a truly moral man acts "out of respect for the moral law" or that he does what is morally right because it is morally right? That such propositions are not prima facie absurd depends on the fact that moral judgment concerns itself with a man's reasons for acting as well as with what he does. Law and etiquette require only that certain things are done or left undone, but no one is counted as charitable if he gives alms "for the praise of men," and one who is honest only because it pays him to be honest does not have the virtue of honesty. This kind of consideration was crucial in shaping Kant's moral philosophy. He many times contrasts acting out of respect for the moral law with acting from an ulterior motive, and what is more from one that is self-interested. In the early *Lectures on Ethics* he gave the principle of truth-telling under a system of hypothetical imperatives as that of not lying *if it harms one* to lie. In the *Metaphysics of Morals* he says that ethics cannot start from the ends which a man may propose to himself, since these are all "selfish."[9] In the *Critique of Practical Reason* he argues explicitly that when acting not out of respect for the moral law but "on a material maxim" men do what they do for the sake of pleasure or happiness.

> All material practical principles are, as such, of one and the same kind and belong under the general principle of self love or one's own happiness.[10]

Kant, in fact, was a psychological hedonist in respect of all actions except those done for the sake of the

moral law, and this faulty theory of human nature was one of the things preventing him from seeing that moral virtue might be compatible with the rejection of the categorical imperative.

If we put this theory of human action aside, and allow as ends the things that seem to be ends, the picture changes. It will surely be allowed that quite apart from thoughts of duty a man may care about the suffering of others, having a sense of identification with them, and wanting to help if he can. Of course he must want not the reputation of charity, nor even a gratifying role helping others, but, quite simply, their good. If this is what he does care about, then he will be attached to the end proper to the virtue of charity and a comparison with someone acting from an ulterior motive (even a respectable ulterior motive) is out of place. Nor will the conformity of his action to the rule of charity be merely contingent. Honest action may happen to further a man's career; charitable actions do not *happen* to further the good of others.

Can a man accepting only hypothetical imperatives possess other virtues besides that of charity? Could he be just or honest? This problem is more complex because there is no one end related to such virtues as the good of others is related to charity. But what reason could there be for refusing to call a man a just man if he acted justly because he loved truth and liberty, and wanted every man to be treated with a certain minimum respect? And why should the truly honest man not follow honesty for the sake of the good that honest dealing brings to men? Of course, the usual difficulties can be raised about the rare case in which no good is foreseen from an individual act of honesty. But it is not evident that a man's desires could not give him reason to act honestly even here. He wants to live openly and in good faith with his neighbors; it is not all the same to him to lie and conceal.

If one wants to know whether there could be a truly moral man who accepted moral principles as hypothetical rules of conduct, as many people accept rules of etiquette as hypothetical rules of conduct, one must consider the right kind of example. A man who demanded that morality should be brought under the heading of self-interest would not be a good candidate, nor would anyone who was ready to be charitable or honest only so long as he felt inclined. A cause such as justice makes strenuous demands, but this is not peculiar to morality, and men are prepared to toil to achieve many ends not endorsed by morality. That they are prepared to fight so hard for moral ends—for example, for liberty and justice—depends on the fact that these are the kinds of ends that arouse devotion. To sacrifice a great deal for the sake of etiquette one would need to be under the spell of the emphatic "ought*e*." One could hardly be devoted to behaving *comme il faut*.

In spite of all that has been urged in favor of the hypothetical imperative in ethics, I am sure that many people will be unconvinced and will argue that one element essential to moral virtue is still missing. This missing feature is the recognition of a *duty* to adopt those ends which we have attributed to the moral man. We have said that he *does* care about others, and about causes such as liberty and justice; that it is on this account that he will accept a system of morality. But what if he never cared about such things, or what if he ceased to care? Is it not the case that he *ought* to care? This is exactly what Kant would say, for though at times he sounds as if he thought that morality is not concerned with ends, at others he insists that the adoption of ends such as the happiness of others is itself dictated by morality.[11] How is this proposition to be regarded by one who rejects all talk about the binding force of the moral law? He will agree that a moral man has moral ends and cannot be indifferent to matters such as suffering and injustice. Further, he will recognize in the statement that one *ought* to care about these things a correct application of the non-hypothetical moral "ought" by which society is apt to voice its demands. He will not, however, take the fact that he ought to have certain ends as in itself reason to adopt them. If he himself is a moral man then he cares about such things, but not "because he ought." If he is an amoral man he may deny that he has any reason to trouble his head over this or any other moral demand. Of course he may be mistaken, and his life as well as others' lives may be most sadly spoiled by his selfishness. But this is not what is urged by those who think they can close the matter by an emphatic use of "ought." My argument

is that they are relying on an illusion, as if trying to give the moral "ought" a magic force.[12]

This conclusion may, as I said, appear dangerous and subversive of morality. We are apt to panic at the thought that we ourselves, or other people, might stop caring about the things we do care about, and we feel that the categorical imperative gives us some control over the situation. But it is interesting that the people of Leningrad were not similarly struck by the thought that only the *contingent* fact that other citizens shared their loyalty and devotion to the city stood between them and the Germans during the terrible years of the siege. Perhaps we should be less troubled than we are by fear of defection from the moral cause; perhaps we should even have less reason to fear it if people thought of themselves as volunteers banded together to fight for liberty and justice and against inhumanity and oppression. It is often felt, even if obscurely, that there is an element of deception in the official line about morality. And while some have been persuaded by talk about the authority of the moral law, others have turned away with a sense of distrust.

Notes

1. *Foundations of the Metaphysics of Morals*, Sec. II, trans. by L. W. Beck.

2. Ibid.

3. Ibid.

4. According to the position sketched here we have three forms of the hypothetical imperative: "If you want *x* you should do *y*," "Because you want *x* you should do *y*," and "Because *x* is in your interest you should do *y*." For Kant the third would automatically be covered by the second.

5. To say that at that moment one wants to be a respectable philosopher would be another matter. Such a statement requires a special connection between the desire and the moment.

6. I am here going back on something I said in an earlier article ("Moral Beliefs," *Proceedings of the Aristotelian Society, 1958–1959*) where I thought it necessary to show that virtue must benefit the agent. I believe the rest of the article can stand.

7. To say that moral considerations are *called* reasons is blatantly to ignore the problem.

8. I am grateful to Rogers Albritton for drawing my attention to this interesting use of expressions such as "have to" or "must."

9. Pt. II, Introduction, sec. II.

10. Immanuel Kant, *Critique of Practical Reason*, trans. by L. W. Beck, p. 133.

11. See, e.g., *The Metaphysics of Morals*, pt. II, sec. 30.

12. See G. E. M. Anscombe, "Modern Moral Philosophy," *Philosophy* (1958). My view is different from Miss Anscombe's, but I have learned from her.

Study Questions

1. Explain in your own words the difference between a hypothetical and a categorical imperative.

2. Do moral rules bind us in ways that rules of etiquette do not?

3. If you don't have a duty to tell the truth, might you still have a good reason to do so?

4. Do you agree with Foot that a person who rejects morality can be convicted of villainy but not of inconsistency?

32

CHRISTINE KORSGAARD

Christine Korsgaard is Professor of Philosophy at Harvard University. She aims to allay doubts that reason can guide choice and action. The typical source of such doubts is the requirement that practical reasons must have motivational force. Korsgaard maintains, however, that when a reason fails to motivate, we can infer either that one lacks such a reason or that the agent is irrational. Given this latter possibility, an agent's lack of motivation alone does not imply skepticism concerning practical reason.

Skepticism About Practical Reason

The Kantian approach to moral philosophy is to try to show that ethics is based on practical reason: that is, that our ethical judgments can be explained in terms of rational standards that apply directly to conduct or to deliberation. Part of the appeal of this approach lies in the way that it avoids certain sources of skepticism that some other approaches meet with inevitably. If ethically good action is simply rational action, we do not need to postulate special ethical properties in the world or faculties in the mind, in order to provide ethics with a foundation. But the Kantian approach gives rise to its own specific of skepticism, skepticism about practical reason.

By *skepticism about practical reason*, I mean doubts about the extent to which human action is or could possibly be directed by reason. One form that such skepticism takes is doubt about the bearing of rational considerations on the activities of deliberation and choice; doubts, that is to say, about whether "formal" principles have any content and can give substantive guidance to choice and action. An example of

this would be the common doubt about whether the contradiction tests associated with the first formulation of the categorical imperative succeed in ruling out anything. I will refer to this as *content skepticism*. A second form taken by skepticism about practical reason is doubt about the scope of reason as a motive. I will call this *motivational skepticism*. In this paper my main concern is with motivational skepticism and with the question whether it is justified. Some people think that motivational considerations alone provide grounds for skepticism about the project of founding ethics on practical reason. I will argue, against this view, that motivational skepticism must always be based on content skepticism. I will not address the question of whether or not content skepticism is justified. I want only to establish the fact that motivational skepticism has no independent force.

Skepticism about practical reason gets its classical formulation in the well-known passages in the *Treatise of Human Nature* that lead Hume to the conclusion

that "Reason is, and ought only to be the slave of the passions, and can never pretend to any other office than to serve and obey them."[1] According to these passages, as they are usually understood, the role of reason in action is limited to the discernment of the means to our ends. Reason can teach us how to satisfy our desires or passions, but it cannot tell us whether those desires or passions are themselves "rational," that is, there is no sense in which desires or passions are rational or irrational. Our ends are picked out, so to speak, by our desires, and these ultimately determine what we do. Normative standards applying to conduct may come from other sources (such as a moral sense), but the only standard that comes from reason is that of effectiveness in the choice of means.

The limitation of practical reason to an instrumental role does not only prevent reason from determining ends; it even prevents reason from ranking them, except with respect to their conduciveness to some other end. Even the view that those choices and actions which are conducive to our over-all self-interest are rationally to be preferred to self-destructive ones is undermined by the instrumental limitation. Self-interest itself has no rational *authority* over even the most whimsical desires. As Hume says:

> 'Tis not contrary to reason to prefer the destruction of the whole world to the scratching of my finger. 'Tis not contrary to reason for me to chuse my total ruin, to prevent the least uneasiness of an *Indian* or person wholly unknown to me. 'Tis as little contrary to reason to prefer even my own acknowledg'd lesser good to my greater, and have a more ardent affection for the former than the latter. (*Treatise*, p. 416)

Under the influence of self-interest [or of "a general appetite to good, and aversion to evil, consider'd merely as such" (p. 417)] we may rank our ends, according to the amount of good that each represents for us, and determine which are, as Hume puts it, our "greatest and most valuable enjoyments" (p. 416). But the self-interest that would make us favor the greater good need not itself be a stronger desire, or a stronger reason, than the desire for the lesser good, or than any of our more particular desires. Reason by itself neither selects nor ranks our ends.

Hume poses his argument as an argument against "the greatest part of moral philosophy, ancient and modern" (p. 413). Moral philosophers, Hume says, have claimed that we ought to regulate our conduct by reason, and either suppress our passions or bring them into conformity with it; but he is going to show the fallacy of all this by showing, first, that reason alone can never provide a motive to any action, and, second, that reason can never oppose passion in the direction of the will. His argument for the first point goes this way: all reasoning is concerned either with abstract relations of ideas or with relations of objects, especially causal relations, which we learn about from experience. Abstract relations of ideas are the subject of logic and mathematics, and no one supposes that those by themselves give rise to any motives. They yield no conclusions about action. We are sometimes moved by the perception of causal relations, but only when there is a pre-existing motive in the case. As Hume puts it, if there is "the prospect of pleasure or pain from some object," we are concerned with its causes and effects. The argument that reason cannot oppose a passion in the direction of the will depends on, and in fact springs directly from, the argument that reason by itself cannot give rise to a motive. It is simply that reason *could* oppose a passion only if it could give rise to an *opposing motive*.

What is important to notice in this discussion is the relation between Hume's views about the possible content of principles of reason bearing on action and the scope of its motivational efficacy. The answer to the question what sorts of operation, procedure, or judgment of reason exist is presupposed in these passages. In the first part of the argument Hume goes through what by this point in the *Treatise* is a *settled* list of the types of rational judgment. The argument is a sort of process of elimination: there are rational judgments concerning logical and mathematical relations; there are empirical connections such as cause and effect: Hume looks at each of these in turn in order to see under what circumstances it might be thought to have a bearing on decision and action. In other words, Hume's arguments against a more extensive practical employment of reason depend upon Hume's own views about what reason is—that is, about what

sorts of operation and judgment are "rational." His motivational skepticism (skepticism about the scope of reason as a motive) is entirely dependent upon his content skepticism (skepticism about what reason has to *say* about choice and action).

Yet Hume's arguments may give the impression of doing something much stronger: of placing independent constraints, based solely on motivational considerations, on what might count as a principle of practical reason. Hume seems to say simply that all reasoning that has a motivational influence must start from a passion, that being the only possible source of motivation. and must proceed to the means to satisfy that passion, that being the only operation of reason that transmits motivational force. Yet these are separate points: they can be doubted, and challenged, separately. One could disagree with Hume about his list of the types of rational judgment, operation, or possible deliberation, and yet still agree with the basic point about the source of motivation: that all rational motivation must ultimately spring from some nonrational source, such as passion. At least one contemporary philosopher, Bernard Williams, has taken something like Hume's argument to have this kind of independent force, and has so argued in his essay "Internal and External Reason,"[2] which I will take up later in this paper.

The Kantian must go further, and disagree with Hume on both counts, since the Kantian supposes that there are operations of practical reason which yield conclusions about actions and which do not involve discerning relations between passions (or any pre-existing sources of motivation) and those actions. What gives rise to the difficulty about this further possibility is the question of how such operations could yield conclusions that can motivate us.

II

The problem can best be stated in some terms provided by certain recent discussions in moral philosophy. W. D. Falk, William Frankena, and Thomas Nagel, among others, have distinguished between two kinds of moral theories, which are called "internalist" and "externalist."[3] An *internalist* theory is a theory according to which the knowledge (or the truth or the acceptance) of a moral judgment implies the existence of a motive (not necessarily overriding) for acting on that judgment. If I judge that some action is right, it is implied that I have, and acknowledge, some motive or reason for performing that action. It is part of the sense of the judgment that a motive is present: if someone agrees that an action is right, but cannot see any motive or reason for doing it, we must suppose, according to these views, that she does not quite know what she means when she agrees that the action is right. On an *externalist* theory, by contrast, such a conjunction of moral comprehension and total unmotivatedness is perfectly possible: knowledge is one thing and motivation another.

Examples of unquestionably external theories are not easy to find. As Falk points out (pp. 125–26), the simplest example would be a view according to which the motives for moral action come from something wholly separate from a grasp of the correctness of the judgments—say, an interest in obeying divine commands. In philosophical ethics the best example is John Stuart Mill (see Nagel pp. 8–9), who firmly separates the question of the proof of the principle of utility from the question of its "sanctions." The reason why the principle of utility is true and the motive we might have for acting on it are not the same: the theoretical proof of its truth is contained in chapter IV of *Utilitarianism*, but the motives must be acquired in a utilitarian upbringing. It is Mill's view that *any* moral principle would have to be motivated by education and training and that "there is hardly anything so absurd or so mischievous" that it cannot be so motivated.[4] The "ultimate sanction" of the principle of utility is *not* that it can be proved, but that it is in accordance with our natural social feelings. Even to some who, like Mill himself, realize that the motives are acquired, "It does not present itself . . . as a superstition of education or a law despotically imposed by the power of society, but as an attribute which it would not be well for them to be without" (Mill p. 36). The modern intuitionists, such as W. D. Ross and H. A. Prichard,

seem also to have been externalists, but of a rather minimal kind. They believed that there was a distinctively moral motive, a sense of right or desire to do one's duty. This motive is triggered by the news that something is your duty, and only by that news, but it is still separate from the rational intuition that constitutes the understanding of your duty. It would be possible to have that intuition and not be motivated by it.[5] The reason why the act is right and the motive you have for doing it are separate items, although it is nevertheless the case that the motive for doing it is "because it is right." This falls just short of the internalist position, which is that the reason why the act is right is the reason, and the motive, for doing it: it is a practical reason. Intuitionism is a form of rationalist ethics, but intuitionists do not believe in practical reason, properly speaking. They believe there is a branch of theoretical reason that is specifically concerned with morals, by which human beings can be motivated because of a special psychological mechanism: a desire to do one's duty. One can see the oddity of this if one considers what the analogue would be in the case of theoretical reasoning. It is as if human beings could not be convinced by arguments acknowledged to be sound without the intervention of a special psychological mechanism: a belief that the conclusions of sound arguments are true.

By contrast, an internalist believes that the reasons why an action is right and the reasons why you do it are the same. The reason that the action is right is both the reason and the motive for doing it. Nagel gives as one example of this the theory of Hobbes: the reason for the action's rightness and your motive for doing it are both that it is in your interest. The literature on this subject splits, however, on the question of whether the Kantian position is internalist or not. Falk, for instance, characterizes the difference between internalism and externalism as one of whether the moral command arises from a source outside the agent (like God or society) or from within. If the difference is described this way, Kant's attempt to derive morality from autonomy makes him a paradigmatic internalist (see Falk, p. 125, 129). On the other hand, some have believed that Kant's view that the moral command is indifferent to our desires, needs, and interests—that it is categorical—makes him a paradigmatic externalist.[6] Since Kant himself took the categorical character of the imperative and autonomy of the moral motive to be necessarily connected, this is a surprising difference of opinion. I will come back to Kant in Section VII.

This kind of reflection about the motivational force of ethical judgments has been brought to bear by Bernard Williams on the motivational force of reason claims generally. In "Internal and External Reasons" Williams argues that there are two kinds of reason claims, or two ways of making reason claims. Suppose I say that some person P has a reason to do action A. If I intend this to imply that the person P has a motive to do the action A, the claim is of an internal reason, if not, the claim is of an external reason. Williams is concerned to argue that only internal reasons really exist. He points out (pp. 106–7) that, since an external-reason claim does not imply the existence of a motive, it cannot be used to explain anyone's action: that is, we cannot say that the person P did the action A because of reason R; for R does not provide P with a motive for doing A, and *that* is what we need to explain P's doing A: a motive. Nagel points out that if acknowledgment of a reason claim did not include acknowledgment of a motive, someone presented with a reason for action could ask: Why do what I have a reason to do? (p. 9; see also Falk, pp. 121–22). Nagel's argument makes from the agent's perspective the same point that Williams makes from the explainer's perspective, namely, that unless reasons are motives, they cannot prompt or explain actions. And, unless reasons are motives, we cannot be said to be practically rational.

Thus, it seems to be a requirement on practical reasons, that they be capable of motivating us. This is where the difficulty arises about reasons that do not, like means/end reasons, draw on an obvious motivational source. So long as there is doubt about whether a given consideration is able to motivate a rational person, there is doubt about whether that consideration has the force of a practical *reason*. The consideration that such and such action is a means to getting what you want has a clear motivational source; so no one doubts that this is a reason. Practical-reason

claims, if they are really to present us with reasons for action, must be capable of motivating rational persons. I will call this the *internalism requirement*.

III

In this section I want to talk about how the internalism requirement functions—or, more precisely, malfunctions—in skeptical arguments. Hume winds up his argument by putting the whole thing in a quite general form. Reason is the faculty that judges of truth and falsehood, and it can judge our ideas to be true or false because they represent other things. But a passion is an original existence or modification of existence, not a copy of anything: it cannot be true or false, and therefore it cannot in itself be reasonable or unreasonable. Passions can be unreasonable, then, only if they are accompanied by judgments, and there are two cases of this kind. One is when the passion is founded on the supposition of the existence of objects that do not exist. You are outraged at the mocking things you heard me say about you, but I was talking about somebody else. You are terrified by the burglars you hear whispering in the living room, but in fact you left the radio on. It is of course only in an extended sense that Hume can think of these as cases where a passion is irrational. Judgments of irrationality, whether of belief or action, are, strictly speaking, relative to the subject's beliefs. Conclusions drawn from mistaken premises are not *irrational*.[7] The case of passions based on false beliefs seems to be of this sort.

The second kind of case in which Hume says that the passion might be called unreasonable is "... when, in exerting any passion in action, we chuse means insufficient for the design'd end, and deceive ourselves in our judgment of causes and effects" (*Treatise*, p. 416). This is in itself an ambiguous remark. Hume might, and in fact does, mean simply that we base our action on a false belief about causal relations. So this is no more genuinely a case of irrationality than the other. Relative to the (false) causal belief, the action is not irrational. But it is important that there is something else one

might mean in this case, which is that, knowing the truth about the relevant causal relations in the case, we might nevertheless choose means insufficient to our end or fail to choose obviously sufficient and readily available means to the end. This would be what I will call *true irrationality*, by which I mean a failure to respond appropriately to an available reason.

If the only possibility Hume means to be putting forward here is the possibility of action based on false belief about causes and effects, we get a curious result. Neither of the cases that Hume considers is a case of true irrationality: relative to their beliefs, people *never* act irrationally. Hume indeed says this: "... the moment we perceive the falsehood of any supposition, or the insufficiency of any means, our passions yield to our reason without any opposition" (*Treatise*, p. 416). But it looks as if a theory of means/end rationality ought to allow for at least one form of true irrationality, namely, failure to be motivated by the consideration that the action is the means to your end. Even the skeptic about practical reason admits that human beings can be motivated by the consideration that a given action is a means to a desired end. But it is not enough, to explain this fact, that human beings can engage in causal reasoning. It is perfectly possible to imagine a sort of being who could engage in causal reasoning and who could therefore, engage in reasoning that would point out the means to her ends, but who was not motivated by it.

Kant, in a passage early in the *Foundations*, imagines a human being in just such a condition of being able to reason, so to speak, theoretically but not practically. He is talking about what the world would have been like if nature had had our happiness as her end. Our actions would have been controlled entirely by instincts designed to secure our happiness, and: "... if, over and above this, reason should have been granted to the favored creature, it would have served only to let it contemplate the happy constitution of its nature."[8] The favored creature is portrayed as able to see that his actions are rational in the sense that they promote the means to his end (happiness): but he is not motivated by their reasonableness: he acts from instinct. Reason allows him to admire the rational

appropriateness of what he does, but this is not what gets him to do it—he has the sort of attitude toward all his behavior that we in fact might have toward the involuntary well-functioning of our bodies.

Being motivated by the consideration that an action is a means to a desirable end is something beyond merely reflecting on that fact. The motive force attached to the end must be transmitted to the means in order for this to be a consideration that sets the human body in motion—and only if this is a consideration that sets the human body in motion can we say that reason has an influence on action. A practically rational person is not merely capable of performing certain rational mental operations, but capable also of transmitting motive force, so to speak, along the paths laid out by those operations. Otherwise even means/end reasoning will not meet the internalism requirement.

But the internalism requirement does not imply that nothing can interfere with this motivational transmission. And generally, this is something there seems to be no reason to believe: there seem to be plenty of things that could interfere with the motivational influence of a given rational consideration. Rage, passion, depression, distraction, grief, physical or mental illness: all these things could cause us to act irrationally, that is, to fail to be motivationally responsive to the rational considerations available to us.[9] The necessity, or the compellingness, of rational considerations lies in those considerations themselves, not in us: that is, we will not necessarily be motivated by them. Or rather, to put the point more properly and not to foreclose any metaphysical possibilities, their necessity may lie in the fact that, when they do move us—either in the realm of conviction or in that of motivation—they move us with the force of necessity. But it will still not be the case that they necessarily move us. So a person may be irrational, not merely by failing to observe rational connections—say, failing to see that the sufficient means are at hand—but also by being "willfully" blind to them, or even by being indifferent to them when they are pointed out.[10]

In this respect practical reason is no different from theoretical reason. Many things might cause me to fail to be convinced by a good argument. For me to be a theoretically rational person is not merely for me to be capable of performing logical and inductive operations, but for me to be appropriately *convinced* by them: my conviction in the premises must carry through, so to speak, to a conviction in the conclusion. Thus, the internalism requirement for theoretical reasons is that they be capable of convincing us—insofar as we are rational. It is quite possible for me to be able to perform these operations without generating any conviction, as a sort of game, say, and then I would not be a rational person.

Aristotle describes the novice in scientific studies as being able to repeat the argument, but without the sort of conviction that it will have for him later, when he fully understands it. In order for a theoretical argument or a practical deliberation to have the status of reason, it must of course be capable of motivating or convincing a rational person, but it does not follow that it must at all times be capable of motivating or convincing any given individual. It may follow from the supposition that we are rational persons and the supposition that a given argument or deliberation is rational that, if we are not convinced or motivated, there must be some explanation of that failure. But there is no reason at all to believe that such an explanation will always show that we had mistaken reasons, which, if true, would have been good reasons. Many things can interfere with the functioning of the rational operations in a human body. Thus there is no reason to deny that human beings might be practically irrational in the sense that Hume considers impossible: that, even with the truth at our disposal, we might from one cause or another fail to be interested in the means our ends.

IV

My speculation is that skepticism about practical reason is sometimes based on a false impression of what the internalism requirement requires. It does not require that rational considerations always succeed in motivating us. All it requires is that rational considerations succeed in motivating us insofar as we are

rational. One can admit the possibility of true irrationality and yet still believe that all practical reasoning is instrumental. But once this kind of irrationality is allowed in the means/end case, some of the grounds for skepticism about more ambitious forms of practical reasoning will seem less compelling. The case of prudence or self-interest will show what I have in mind. I have already mentioned Hume's account of this matter: he thinks that there is "a general appetite to good, and aversion to evil" and that a person will act prudently insofar as this calm and general passion remains dominant over particular passions. It is under the influence of this end that we weigh one possible satisfaction against another, trying to determine which conduces to our greater good. But if this general desire for the good does not remain predominant, not only the motive, but the reason, for doing what will conduce to one's greater good, disappears. For Hume says it is not contrary to reason to prefer an acknowledged lesser good to a greater.

Suppose, then, that you are confronted with a choice and, though informed that one option will lead to your greater good, you take the other. If true irrationality is excluded, and you fail to take the means to some end, this is evidence either that you don't really have this end or that it is not the most important thing to you. Thus, in this imagined case, where you do not choose your greater good, this is evidence either that you do not care about your greater good or that you do not care about it as much as you do about this particular lesser good. On the other hand, if you do respond to the news that one option leads to your greater good, then we have evidence that you do care about your greater good. This makes it seem as if your greater good is an end you might care about or not, and rationality is relative to what you care about. But, once we admit that one might from some other cause fail to be responsive to a rational consideration, there is no special reason to accept this analysis of the case. I do not mean that there is a reason to reject it, either, of course; my point is that whether you accept it depends on whether you *already* accept the limitation to means/end rationality. If you do, you will say that the case where the lesser good was chosen was a case where there was a stronger desire for it,

and so a stronger reason; if you do not, and you think it *is* reasonable to choose the greater good (because prudence has rational authority), you will say that this is a case of true irrationality. The point is that the motivational analysis of the case *depends* upon your views of the content of rational principles of action, not the reverse. The fact that one might or might not be motivated to choose a certain course of action by the consideration that it leads to the greater good does not by itself show that the greater good is just one end among others, without special rational authority, something that some people care about and some people do not. Take the parallel case. The fact that one might or might not be motivated to choose a certain course of action by the consideration that it is the best available means to one's end does not show that taking the means to one's ends is just one end among others, an end some people care about and some people do not. In both cases, what we have is the fact that people are sometimes motivated by considerations of this sort, and that we all think in the latter case and some think in the former case that it is rational to be so motivated.

The argument about whether prudence or the greater good has any special rational authority—about whether it is a rational consideration—will have to be carried out on another plane: it will have to be made in terms of a more metaphysical argument about just what reason does, what its scope is, and what sorts of operation, procedure, and judgment are rational. This argument will usually consist in an attempt to arrive at a general notion of reason by discovering features or characteristics that theoretical and practical reason share; such characteristic features as universality, sufficiency, timelessness, impersonality, or authority will be appealed to.[11] What the argument in favor of prudence would be will vary from theory to theory; here, the point is this: the fact that someone might fail to be motivated by the consideration that something will serve her greater good cannot by itself throw any doubt on the argument, whatever it is, that preferring the greater good is rational. If someone were not convinced by the logical operation of conjunction, and so could not reason with conviction from "*A*" and

from "*B*" to "*A* and *B*," we would not be eager to conclude that conjunction was just a theory that some people believe and some people do not. Conjunction is not a theory to believe or disbelieve, but a principle of reasoning. Not everything that drives us to conclusions is a theory. Not everything that drives us to action need be a desired end (see Nagel, pp. 20–22).

V

An interesting result of admitting the possibility of true irrationality is that it follows that it will not always be possible to argue someone into rational behavior. If people are acting irrationally only because they do not know about the relevant means/end connection, they may respond properly to argument: point the connection out to them, and their behavior will be modified accordingly. In such a person the motivational path, so to speak, from end to means is open. A person in whom this path is, from some cause, blocked or nonfunctioning may not respond to argument, even if this person understands the argument in a theoretical way. Aristotle thinks of the incontinent person as being in a condition of this sort: this happens to people in fits of passion or rage, and the condition is actually physiological.[12] Now this is important; for it is sometimes thought, on the basis of the internalism requirement, that if there is a reason to do something it must be possible to argue someone into doing it: anyone who understands the argument will straightaway act. (The conclusion of a practical syllogism is an action.) Frankena, for example, argues against an internalist construal of the moral "ought" on the grounds that even after full reflection we do not always do what is right (p. 71). But if there is a gap between understanding a reason and being motivated by it, then internalism does not imply that people can always be argued into reasonable conduct. The reason motivates someone who is capable of being motivated by the perception of a rational connection. Rationality is a condition that human beings are capable of, but it is not a condition that we are always in.

It is for this reason that some ethical theories centered on the idea of practical reason are best thought of as establishing ideals of character. A person with a good character will be, on such a view, one who responds to the available reasons in an appropriate way, one whose motivational structure is organized for rational receptivity, so that reasons motivate in accord with their proper force and necessity. It is not an accident that the two major philosophers in our tradition who thought of ethics in terms of practical reason—Aristotle and Kant—were also the two most concerned with the methods of moral education. Human beings must be taught, or habituated, to listen to reason: we are, as Kant says, imperfectly rational.

In fact, the argument of the last section can be recast in terms of virtues. Suppose that it is irrational not to prefer the greater good: this need have nothing at all to do with having the greater good *among* your desired ends. It is of course true that some people are more steadily motivated by considerations of what conduces to their greater good than others: call such a person *the prudent person*. The fact that the prudent is more strongly motivated by reasons of greater good need not be taken to show that he has stronger reasons for attending to his greater good. (People have varying theoretical virtues too.[13]) We may, indeed say that the prudent person "cares more" about his greater good, but that is just another way of saying that he responds more strongly to these kinds of consideration, that he has the virtue of prudence. It need not be taken to imply that his greater good is a more heavily weighted end with him and that, therefore, it really does matter more to him that he achieve his greater good than it does to another person, an imprudent person, that he achieve his. It makes more sense to say that this other person ignores reasons that he has. Again, take the parallel: some people respond much more readily and definitely to the consideration that something is an effective means to their end. We might call such a person a *determined* or *resolute* person. Presumably no one feels like saying that the determined or resolute person has a stronger reason for taking the means to her ends than anyone

else does. We all have just the same reason for taking the means to our ends. The fact that people are motivated differently by the reasons they have does not show that they have different reasons. It may show that some have virtues that others lack. On a practical-reason theory, the possibility of rationality sets a standard for character; but that standard will not always be met. But this is not by itself a reason for skepticism about the scope of the deliberative guidance that reason *can* provide. This is a reason for skepticism only about the extent to which that guidance will ever be taken advantage of.

VI

Nevertheless, the fact that a practical reason must be capable of motivating us might still seem to put a limitation on the scope of practical reason: it might be thought that it is a subjective matter which considerations can motivate a given individual and that, therefore, all judgments of practical reason must be conditional in form. In Hume's argument, this kind of limitation is captured in the claim that motivation must originate in a passion. In the means/end case, we are able to be motivated by the consideration that action *A* will promote purpose *P* because, and only if, we have a pre-existing motivational impulse (a passion) attached to purpose *P*. As Hume says, a relation between two things will not have any motivational impact on us unless one of the two things has such impact. This does not limit practical reason to the means/end variety, but it might seem to impose a limitation of this sort: practical-reason claims must be reached by something that is recognizably a rational deliberative process from interests and motives one already has. This position is advocated by Bernard Williams in "Internal and External Reasons." Williams, as I have mentioned, argues that only internal reasons exist; but he takes this to have a strong Humean implication. Williams takes it that internal reasons are by definition relative to something that he calls the agent's "subjective motivational set": this follows from the fact that they can motivate. The contents of this set are left

open, but one kind of thing it will obviously contain is the agent's desires and passions. Internal reasons are reasons reached by deliberation from the subjective motivational set: they can motivate us because of their connection to that set. Means/end deliberation, where the end is in the set and the means are what we arrive at by the motivating deliberation, is the most characteristic, but not the only, source of reasons for action. Williams calls the means/end view the "sub-Humean model," and he says this:

> The sub-Humean model supposes that φ-ing [where φ-ing is some action we have a reason for doing] has to be related to some element in [the subjective motivational set] as causal means to end (unless perhaps it is straightforwardly the carrying out of a desire which is itself that element in [the subjective motivational set].) But this is only one case . . . there are much wider possibilities for deliberation, such as: thinking how the satisfaction of elements in [the subjective motivational set] can be combined, e.g. by time-ordering; where there is some irresoluble conflict among the elements of [the subjective motivational set,] considering which one attaches most weight to . . .; or again, finding constitutive solutions, such as deciding what would make for an entertaining evening, granted that one wants entertainment (pp. 104–5).[14]

Anything reached by a process of deliberation from the subjective motivational set may be something for which there is an internal reason, one that can motivate. External reasons, by contrast, exist regardless of what is in one's subjective motivational set. In this case, Williams points out, there must be some rational process, not springing from the subjective motivational set and therefore not relative to it, which could bring you to acknowledge something to be a reason and at the same time to be motivated by it. Reason must be able to produce an entirely new motive, the thing that Hume said could not be done.

Thus, Williams takes up one part of the skeptic's argument: that a piece of practical reasoning must start from something that is capable of motivating you; and drops the other, that the only kind of reasoning is means/end. One might suppose that this

limits the operations or judgments of practical reason to those functions which are natural extensions or expansions of the means/end variety, and the things Williams mentions in this passage, such as making a plan to satisfy the various elements in the set, or constitutive reasoning, are generally thought to be of that sort. But in fact this is not Williams's view, nor is it necessitated by his argument, as he points out.

> The processes of deliberation can have all sorts of effect on [the subjective motivational set], and this is a fact which a theory of internal reasons should very happy to accommodate. So also it should be more liberal than some theorists have been about the possible elements in the [subjective motivational set]. I have discussed [the subjective motivational set] primarily in terms of desires, and this term can be used, formally, for all elements in [the subjective motivational set]. But this terminology may make one forget that [the subjective motivational set] can contain such things as dispositions of evaluation, patterns of emotional reaction, personal loyalties, and various projects, as they may be abstractly called, embodying commitments of the agent (p. 105).

Williams can accommodate the case of someone's acting for reasons of principle, and in this case the form the deliberation will take is that of applying the principle or of seeing that the principle applies to the case at hand. The advocate of the view that all deliberation is strictly of the means/ends variety may claim to assimilate this case by the formal device of saying that the agent must have a desire to act on this principle, but this will not change the important fact, which is that the reasoning in this case will involve the application of the principle, which is not the same as means/end reasoning.[15]

In this kind of case, Williams's point will be that in order for the principle to provide reasons for a given agent, acceptance of the principle must constitute part of the agent's subjective motivational set. If the principle is not accepted by the agent, its dictates are not reasons for her. Reasons are relativized to the set. If this is true, it looks at first as if all practical reasons will be relative to the individual, because they are conditioned by what is in the subjective motivational set. Reasons that apply to you regardless of what is in your subjective motivational set will not exist.

This argument, however, having been cut loose from Hume's very definite ideas about what sort of rational operations and processes exist, has a very unclear bearing on claims about pure practical reason. If one accepts the internalism requirement, it follows that pure practical reason will exist if and only if we are capable of being motivated by the conclusions of the operations of pure practical reason as such. Something in us must make us capable of being motivated by them, and this something will be part of the subjective motivational set. Williams seems to think that this is a reason for doubting that pure practical reasons exist, whereas what seems to follow from the internalism requirement is this: if we can be motivated by considerations stemming from pure practical reason, then that capacity belongs to the subjective motivational set of every rational being. One cannot argue that the subjective motivational set contains only ends or desires; for that would be true only if all reasoning were of the means/end variety or its natural extensions. What sorts of items can be found in the set does not limit, but rather depends on, what kinds of reasoning are possible. Nor can one assume that the subjective motivational set consists only of individual or idiosyncratic elements; for that is to close off without argument the possibility that reason could yield conclusions that every rational being must acknowledge and be capable of being motivated by. As long as it is left open what kinds of rational operations yield conclusions about what to do and what to pursue, it must be left open whether we are capable of being motivated by them.

Consider the question of how an agent comes to accept a principle: to have it in her subjective motivational set. If we say that the agent comes to accept the principle through reasoning—through having been convinced that the principle admits of some ultimate justification—then there are grounds for saying that this principle is in the subjective motivational set of

every rational person: for all rational persons could be brought to see that they have reason to act in the way required by the principle, and this is all that the internalism requirement requires. Now this is of course not Williams's view: he believes that the principles are acquired by education, training, and so forth, and that they do not admit of any ultimate justification.[16] There are two important points to make about this.

First, consider the case of the reflective agent who, after being raised to live by a certain principle, comes to question it. Some doubt, temptation, or argument has made her consider eliminating the principle from her subjective motivational set. Now what will she think? The principle does not, we are supposing, admit of an ultimate justification, so she will not find that. But this does not necessarily mean that she will reject the principle. She may, on reflection, find that she thinks it better (where this will be relative to what other things are in her motivational set) that people should have and act on such a principle, that it is in some rough way a good idea—perhaps not the only but an excellent basis for community living, and so forth—and so she may retain it and even proceed to educate those under her influence to adopt it. The odd thing to notice is that this is almost exactly the sort of description Mill gives of the reflective utilitarian who, on realizing that his capacity to be motivated by the principle of utility is an acquirement of education, is not sorry. But Mill's position, as I mentioned earlier, is often taken to be the best example of an *externalist* ethical position.

More immediately to the point, what this kind of case shows is that for Williams, as for Hume, the motivational skepticism depends on what I have called the "content skepticism." Williams's argument does not show that if there were unconditional principles of reason applying to action we could not be motivated by them. He only thinks that there are none. But Williams's argument, like Hume's, gives the appearance of going the other way around: it looks as if the motivational point—the internalism requirement—is supposed to have some force in limiting what might count as a principle of practical reason. Whereas in fact, the real source of the skepticism is a doubt about

the existence of principles of action whose content shows them to be ultimately justified.

VII

The internalism requirement is correct, but there is probably no moral theory that it excludes. I do not think that it even excludes utilitarianism or intuitionism, although it calls for a reformulation of the associated views about the influence of ethical reasoning or motivation. The force of the internalism requirement is psychological: what it does is not to refute ethical theories, but to make a psychological demand on them.

This is in fact how philosophers advocating a connection between morality and practical reason have thought of the matter. From considerations concerning the necessity that reasons be internal and capable of motivating us which are almost identical to Williams's, Nagel, in the opening sections of *The Possibility of Altruism*, argues that investigations into practical reason will yield discoveries about our motivational capacities. Granting that reasons must be capable of motivating us, he thinks that if we then are able to show the existence of reasons, we will have shown something capable of motivating us. In Nagel's eyes, the internalism requirement leads not to a limitation on practical reason, but to a rather surprising increase in the power of moral philosophy: it can teach us about human motivational capacities; it can teach us psychology.[17]

As Nagel points out, this approach also characterizes the moral philosophy of Kant. By the end of the Second Section of the *Foundations*, there is in *one* sense no doubt that Kant has done what he set out to do: he has shown us what sort of demand pure reason would make on action. Working from the ideas that reasons in general (either theoretical or practical) must be universal, that reason seeks the unconditioned, and that its binding force must derive from autonomy, he has shown us what a law of pure reason applying to action would look like. But until it has been shown that we can be motivated to act according to the categorical imperative,

it has not been completely shown that the categori-
cal imperative really exists—that there really is a
law of pure practical reason. And this is because
of the internalism requirement. The question how
the imperative is possible is equated to that of
"how the constraint of the will, which the impera-
tive expresses in the problem, can be conceived"
(Beck, p. 34; Acad., p. 417). Thus, what remains
for proof by a "deduction" is that we are capable
of being motivated by this law of reason: that we
have an autonomous will. In the Third Section of
the *Foundations*, Kant does try to argue that we can
be motivated by the categorical imperative, appeal-
ing to the pure spontaneity of reason as evidence
for our intelligible nature and so for an autonomous
will (Beck, pp. 70–71; Acad., p. 452). In the *Cri-
tique of Practical Reason*,[18] however, Kant turns his
strategy around. He argues that we know that we
are capable of being motivated by the categorical
imperative and therefore that we know (in a practi-
cal sense) that we have an autonomous will. Again,
explorations into practical reason reveal our nature.
It is important, however, that although in the *Cri-
tique of Practical Reason* Kant does not try to argue
that pure reason can be a motive, he has detailed
things to say about *how* it can be a motive—about
how it functions as an incentive in combatting other
incentives.[19] Something is still owed to the internal-
ism requirement: namely, to show what psychologi-
cal conclusions the moral theory implies.

It may be that we are immune to motivation by
pure practical reason. But, for that matter, it may be
that we are immune to motivation by means/ends
connections. Perhaps our awareness of these in cases
where we seem to act on them is epiphenomenal.
In fact we are quite sure that we are not immune to
the reasons springing from means/ends connections;
and Kant maintained that, if we thought about it,
we would see that we are not immune to the laws of
pure practical reason: that we know we can do what
we ought. But there is no guarantee of this; for our
knowledge of our motives is limited. The conclusion
is that, if we are rational, we will act as the categori-
cal imperative directs. But we are not necessarily
rational.

VIII

I have not attempted to show in this paper that there
is such a thing as pure practical reason, or that rea-
son has in any way a more extensive bearing on
conduct than empiricism has standardly credited
it with. What I have attempted to show is that this
question is open in a particular way: that motiva-
tional considerations do not provide any reason, in
advance of specific proposals, for skepticism about
practical reason. If a philosopher can show us that
something that is recognizably a law of reason has
bearing on conduct, there is no special reason to
doubt that human beings might be motivated by
that consideration. The fact that the law might not
govern conduct, even when someone understood it,
is no reason for skepticism: the necessity is in the
law, and not in us.

To the extent that skepticism about pure prac-
tical reason is based on the strange idea that an
acknowledged reason can never fail to motivate,
there is no reason to accept it. It is based on some
sort of a misunderstanding, and I have suggested a
misunderstanding of the internalism requirement
as a possible account. To the extent that skepticism
about pure practical reason is based on the idea that
no process or operation of reason yielding uncon-
ditional conclusions about action can be found, it
depends on—and is not a reason for believing—the
thesis that no process or operation of reason yield-
ing unconditional conclusions about action can be
found. To the extent that skepticism about pure prac-
tical reason is based on the requirement that reasons
be capable of motivating us, the correct response
is that if someone discovers what are recognizably
reasons bearing on conduct and those reasons fail to
motivate us, that only shows the limits of our ration-
ality. Motivational skepticism about practical reason
depends on, and cannot be the basis for, skepticism
about the possible content of rational requirements.
The extent to which people are actually moved by
rational considerations, either in their conduct or in
their credence, is beyond the purview of philosophy.
Philosophy can at most tell us what it would be like
to be rational.

Notes

1. David Hume, *Treatise of Human Nature*, L. A. Selby-Bigge, ed. (London: Oxford University Press, 1888), p. 415. Page references to the *Treatise* will be to this edition.

2. This paper was originally published in Ross Harrison, ed., *Rational Action* (New York: Cambridge University Press, 1980), and is reprinted in Williams, *Moral Luck* (New York: Cambridge University Press, 1981), pp. 101–13. Page references to Williams are to this article, as it appears in *Moral Luck*.

3. Actually, Falk and Frankena speak of internalist and externalist senses of 'ought.' See Falk, "'Ought' and Motivation," *Proceedings of the Aristotelian Society* (1947–48). Frankena's discussion, "Obligation and Motivation in Recent Moral Philosophy," was originally published in A. I. Melden, ed. *Essays in Moral Philosophy* (Seattle: University of Washington Press, 1958), and is reprinted in *Perspectives on Morality: Essays of William K. Frankena*, Kenneth E. Goodpaster, ed. (Notre Dame, Ind.: University of Notre Dame Press, 1976), pp. 49–73 (page references are to this volume). Nagel's discussion is in *The Possibility of Altruism* (New York: Oxford University Press, 1970), Pt. I.

4. *Utilitarianism*, in Samuel Gorovitz, ed., *Utilitarianism with Critical Essays* (Indianapolis: Bobbs-Merrill, 1971), p. 34.

5. See Prichard, "Duty and Interest," in *Duty and Interest* (London: Oxford University Press, 1928). Falk's original use of the distinction between internal and external senses of ought in "'Ought' and Motivation" is in an argument responding to Prichard's paper.

6. See Frankena, op. cit., p. 63 for a discussion of this surprising view.

7. I am ignoring here the more complicated case in which the passion in question is parent to the false beliefs. In my examples, for instance, there might be cases such as these: irritation at me predisposes you to think my insults are aimed at you; terror of being alone in the house makes you more likely to mistake the radio for a burglar. Hume does discuss this phenomenon (*Treatise* 120). Here, we might say that the judgment is irrational, not merely false, and that its irrationality infects the passions and actions based on the judgment. If Hume's theory allows him to say that the judgment is irrational, he will be able to say that some passions and actions are truly irrational, and not merely mistaken, although he does not do this.

8. Immanuel Kant, *Foundations of the Metaphysics of Morals*, Lewis White Beck, trans. (New York: Library of Liberal Arts, 1959), p. 11; Prussian Academy Edition [hereafter cited as "Acad."], p. 395.

9. "Available to us" is vague, for there is a range of cases in which one might be uncertain whether or not to say that a reason was available to us. For instance there are (1) cases in which we don't know about the reason, (2) cases in which we couldn't possibly know about the reason, (3) cases in which we deceive ourselves about the reason, (4) cases in which some physical or psychological condition makes us unable to see the reason, and (5) cases in which some physical or psychological condition makes us fail to respond to the reason, even though in some sense we look it right in the eye. Now no one will want to say that reason claims involving reasons people do not know about are therefore external, but as we move down the list there will be a progressive uneasiness about whether the claim is becoming external. For toward the end of the list we will come to claim that someone is psychologically incapable of responding to the reason, and yet that it is internal: capable of motivating a rational person. I do not think there is a problem about any of these cases; for all that is necessary for the reason claim to be internal is that we can say that, if a person did know and *if nothing were interfering with her rationality*, she would respond accordingly. This does not trivialize the limitation to internal reasons as long as the notion of a psychological condition that interferes with rationality is not trivially defined.

10. I have in mind such phenomena as self-deception, rationalization, and the various forms of weakness of will. Some of these apply to theoretical as well as practical reason, and for the former we can add the various forms of intellectual resistance or ideology (though "willful" is not a good way to characterize these). For some reason, people find the second thing that I mention—being indifferent to a reason that is pointed out to you—harder to imagine in a theoretical than in a practical case. To simply shrug in the face of the acknowledged reason seems to some to be possible in practice in a way that it is not in theory. I think part of the problem is that we can push what the practically paralyzed person accepts over into the realm of theory: he *believes* "that he ought to do such-and-such," although he is not moved to; whereas there seems to be nowhere further back (except maybe to a suspense of judgment) to push what the theoretically paralyzed person accepts. It may also be that the problem arises because we

do not give enough weight to the difference between being convinced by an argument and being left without anything to say by it, or it may be just that what paralysis *is* is less visible in the case of belief than in the case of action.

11. Universality and sufficiency are appealed to by Kant; timelessness and impersonality by Nagel; and authority by Joseph Butler.

12. *Nicomachean Ethics*, V11.3, 1147b5–10.

13. The comparisons I have been drawing between theoretical and practical reason now suggest that there should also be something like an ideal of good theoretical character: a receptivity to theoretical reasons. The vision of someone free of all ideology and intellectual resistance might be such an ideal.

14. Williams uses the designation "*S*" for "subjective motivational set," but I have put back the original phrase wherever it occurs; hence the brackets.

15. It is true that the application of a principle may be so simple or immediate that it will be a matter of judgment or perception rather than deliberation. In such a case there will be some who want to deny that practical reason has been used. On the other hand, the reasoning involved in applying a principle may be quite complicated (as in the case of the contradiction tests under the categorical imperative), and so be such that anyone should be willing to call it reasoning. If the fact that you hold the principle gives motivational force to either the insight or the deliberative argument to the effect that this case falls under the principle, then the result is a practical reason.

16. Williams himself remarks that the "onus of proof about what is to count as a 'purely rational process'. . . properly belongs with the critic who wants to oppose Hume's general conclusion and to make a lot out of external reason statements" (108). Although I think he is quite right in saying that the burden of proof about what is to count as a purely rational process—about *content*—belongs to Hume's opponents, I am arguing that there is no reason to suppose that if this burden is successfully picked up the reasons will be external.

17. Op. cit., p. 13. Nagel calls this a "rebellion against the priority of psychology" (p. 11) and accordingly distinguishes two kinds of internalism: one that takes the psychological facts as given and supposes that we must somehow derive ethics from them in order to achieve an internalist theory, and one that supposes that metaphysical investigations—investigations into what it is to be a rational person—will have psychological conclusions. Hobbes would be an example of the first kind and Kant of the second.

18. See esp. pp. 30 and 43–51 in the translation by Lewis White Beck (New York: Library of Liberal Arts, 1956) and pp. 30 and 41–50 in the Prussian Academy Edition.

19. In chapter III of the Analytic of the *Critique of Practical Reason*, where Kant's project is "not . . . to show a priori why the moral law supplies an incentive but rather what it effects (or better, must effect) in the mind, in so far as it is an incentive" (Beck, p. 17; Acad., p. 72).

Study Questions

1. What is "practical reason"?

2. Explain in your own words the difference between an internalist and an externalist theory.

3. What does Korsgaard mean by "true irrationality"?

4. Could immorality ever be rational?

33

THOMAS NAGEL

Thomas Nagel is Professor of Philosophy and also of Law at New York University. He examines the extent to which factors beyond our control enter into the moral evaluation of our actions. He emphasizes that although we believe our moral assessments are not dependent on luck, in a variety of cases chance plays a significant role in how we are judged. Whether, for example, a driver's negligence results in a deadly accident or merely a dented fire hydrant is beyond the driver's control, yet affects the extent of the driver's moral and legal responsibility. Nagel concludes that the problem of moral luck has no entirely satisfactory solution.

Moral Luck

Kant believed that good or bad luck should influence neither our moral judgment of a person and his actions, nor his moral assessment of himself.

> The good will is not good because of what it effects or accomplishes or because of its adequacy to achieve some proposed end; it is good only because of its willing, i.e., it is good of itself. And, regarded for itself, it is to be esteemed incomparably higher than anything which could be brought about by it in favor of any inclination or even of the sum total of all inclinations. Even if it should happen that, by a particularly unfortunate fate or by the niggardly provision of a stepmotherly nature, this will should be wholly lacking in power to accomplish its purpose, and if even the greatest effort should not avail it to achieve anything of its end, and if there remained only the good will (not as a mere wish but as the summoning of all the means in our power), it would sparkle like a jewel in its own right, as something that had its full worth in itself. Usefulness or fruitlessness can neither diminish nor augment this worth.[1]

He would presumably have said the same about a bad will: whether it accomplishes its evil purposes is morally irrelevant. And a course of action that would be condemned if it had a bad outcome cannot be vindicated if by luck it turns out well. There cannot be moral risk. This view seems to be wrong, but it arises in response to a fundamental problem about moral responsibility to which we possess no satisfactory solution.

The problem develops out of the ordinary conditions of moral judgment. Prior to reflection it is intuitively plausible that people cannot be morally assessed for what is not their fault, or for what is due to factors beyond their control. Such judgment is different from the evaluation of something as a good or bad thing, or state of affairs. The latter may be present in addition to moral judgment, but when we blame someone for his actions we are not merely saying it is bad that they happened, or bad that he exists: we are judging *him*, saying he is bad, which is different from his being a bad thing.

This kind of judgment takes only a certain kind of object. Without being able to explain exactly why, we feel that the appropriateness of moral assessment is easily undermined by the discovery that the act or attribute, no matter how good or bad, is not under the person's control. While other evaluations remain, this one seems to lose its footing. So a clear absence of control produced by involuntary movement, physical force, or ignorance of the circumstances, excuses what is done from moral judgment. But what we do depends in many more ways than these on what is not under our control—what is not produced by a good or a bad will, in Kant's phrase. And external influences in this broader range are not usually thought to excuse what is done from moral judgment, positive or negative.

Let me give a few examples, beginning with the type of case Kant has in mind. Whether we succeed or fail in what we try to do nearly always depends to some extent on factors beyond our control. This is true of murder, altruism, revolution, the sacrifice of certain interests for the sake of others—almost any morally important act. What has been done, and what is morally judged, is partly determined by external factors. However jewel-like the good will may be in its own right, there is a morally significant difference between rescuing someone from a burning building and dropping him from a twelfth-story window while trying to rescue him. Similarly, there is a morally significant difference between reckless driving and manslaughter. But whether a reckless driver hits a pedestrian depends on the presence of the pedestrian at the point where he recklessly passes a red light. What we do is also limited by the opportunities and choices with which we are faced, and these are largely determined by factors beyond our control. Someone who was an officer in a concentration camp might have led a quiet and harmless life if the Nazis had never come to power in Germany. And someone who led a quiet and harmless life in Argentina might have become an officer in a concentration camp if he had not left Germany for business reasons in 1930.

I shall say more later about these and other examples. I introduce them here to illustrate a general point. Where a significant aspect of what someone does depends on factors beyond his control, yet we continue to treat him in that respect as an object of moral judgment, it can be called moral luck. Such luck can be good or bad. And the problem posed by this phenomenon, which led Kant to deny its possibility, is that the broad range of external influences here identified seems on close examination to undermine moral assessment as surely as does the narrower range of familiar excusing conditions. If the condition of control is consistently applied, it threatens to erode most of the moral assessments we find it natural to make. The things for which people are morally judged are determined in more ways than we at first realize by what is beyond their control. And when the seemingly natural requirement of fault or responsibility is applied in light of these facts, it leaves few pre-reflective moral judgments intact. Ultimately, nothing or almost nothing about what a person does seems to be under his control.

Why not conclude, then, that the condition of control is false—that it is an initially plausible hypothesis refuted by clear counter-examples? One could in that case look instead for a more refined condition which picked out the *kinds* of lack of control that really undermine certain moral judgments, without yielding the unacceptable conclusion derived from the broader condition, that most or all ordinary moral judgments are illegitimate.

What rules out this escape is that we are dealing not with a theoretical conjecture but with a philosophical problem. The condition of control does not suggest itself merely as a generalization from certain clear cases. It seems *correct* in the further cases to which it is extended beyond the original set. When we undermine moral assessment by considering new ways in which control is absent, we are not just discovering what *would* follow given the general hypothesis, but are actually being persuaded that in itself the absence of control is relevant in these cases too. The erosion of moral judgment emerges not as the absurd consequence of an over-simple theory, but as a natural consequence of the ordinary idea of moral assessment, when it is applied in view of a more complete and precise

account of the facts. It would therefore be a mistake to argue from the unacceptability of the conclusions to the need for a different account of the conditions of moral responsibility. The view that moral luck is paradoxical is not a *mistake*, ethical or logical, but a perception of one of the ways in which the intuitively acceptable conditions of moral judgment threaten to undermine it all.

It resembles the situation in another area of philosophy, the theory of knowledge. There too conditions which seem perfectly natural, and which grow out of the ordinary procedures for challenging and defending claims to knowledge, threaten to undermine all such claims if consistently applied. Most skeptical arguments have this quality: they do not depend on the imposition of arbitrarily stringent standards of knowledge, arrived at by misunderstanding, but appear to grow inevitably from the consistent application of ordinary standards.[2] There is a substantive parallel as well, for epistemological skepticism arises from consideration of the respects in which our beliefs and their relation to reality depend on factors beyond our control. External and internal causes produce our beliefs. We may subject these processes to scrutiny in an effort to avoid error, but our conclusions at this next level also result, in part, from influences which we do not control directly. The same will be true no matter how far we carry the investigation. Our beliefs are always, ultimately, due to factors outside our control, and the impossibility of encompassing those factors without being at the mercy of others leads us to doubt whether we know anything. It looks as though, if any of our beliefs are true, it is pure biological luck rather than knowledge.

Moral luck is like this because while there are various respects in which the natural objects of moral assessment are out of our control or influenced by what is out of our control, we cannot reflect on these facts without losing our grip on the judgments.

There are roughly four ways in which the natural objects of moral assessment are disturbingly subject to luck. One is the phenomenon of constitutive luck—the kind of person you are, where this is not just a question of what you deliberately do, but of your inclinations, capacities, and temperament. Another category is luck in one's circumstances—the kind of problems and situations one faces. The other two have to do with the causes and effects of action: luck in how one is determined by antecedent circumstances, and luck in the way one's actions and projects turn out. All of them present a common problem. They are all opposed by the idea that one cannot be more culpable or estimable for anything than one is for that fraction of it which is under one's control. It seems irrational to take or dispense credit or blame for matters over which a person has no control, or for their influence on results over which he has partial control. Such things may create the conditions for action, but action can be judged only to the extent that it goes beyond these conditions and does not just result from them.

Let us first consider luck, good and bad, in the way things turn out. Kant, in the above-quoted passage, has one example of this in mind, but the category covers a wide range. It includes the truck driver who accidentally runs over a child, the artist who abandons his wife and five children to devote himself to painting,[3] and other cases in which the possibilities of success and failure are even greater. The driver, if he is entirely without fault, will feel terrible about his role in the event, but will not have to reproach himself. Therefore this example of agent-regret[4] is not yet a case of *moral* bad luck. However, if the driver was guilty of even a minor degree of negligence—failing to have his brakes checked recently, for example—then if that negligence contributes to the death of the child, he will not merely feel terrible. He will blame himself for the death. And what makes this an example of moral luck is that he would have to blame himself only slightly for the negligence itself if no situation arose which required him to brake suddenly and violently to avoid hitting a child. Yet the *negligence* is the same in both cases, and the driver has no control over whether a child will run into his path.

The same is true at higher levels of negligence. If someone has had too much to drink and his car swerves on to the sidewalk, he can count himself morally lucky if there are no pedestrians in its path.

If there were, he would be to blame for their deaths, and would probably be prosecuted for manslaughter. But if he hurts no one, although his recklessness is exactly the same, he is guilty of a far less serious legal offense and will certainly reproach himself and be reproached by others much less severely. To take another legal example, the penalty for attempted murder is less than that for successful murder—however similar the intentions and motives of the assailant may be in the two cases. His degree of culpability can depend, it would seem, on whether the victim happened to be wearing a bullet-proof vest, or whether a bird flew into the path of the bullet—matters beyond his control.

Finally, there are cases of decision under uncertainty—common in public and in private life. Anna Karenina goes off with Vronsky, Gauguin leaves his family, Chamberlain signs the Munich agreement, the Decembrists persuade the troops under their command to revolt against the czar, the American colonies declare their independence from Britain, you introduce two people in an attempt at match-making. It is tempting in all such cases to feel that some decision must be possible, in the light of what is known at the time, which will make reproach unsuitable no matter how things turn out. But this is not true; when someone acts in such ways he takes his life, or his moral position, into his hands, because how things turn out determines what he has done. It is possible *also* to assess the decision from the point of view of what could be known at the time, but this is not the end of the story. If the Decembrists had succeeded in overthrowing Nicholas I in 1825 and establishing a constitutional regime, they would be heroes. As it is, not only did they fail and pay for it, but they bore some responsibility for the terrible punishments meted out to the troops who had been persuaded to follow them. If the American Revolution had been a bloody failure resulting in greater repression, then Jefferson, Franklin and Washington would still have made a noble attempt, and might not even have regretted it on their way to the scaffold, but they would also have had to blame themselves for what they had helped to bring on their compatriots. (Perhaps peaceful efforts at reform would

eventually have succeeded.) If Hitler had not overrun Europe and exterminated millions, but instead had died of a heart attack after occupying the Sudetenland, Chamberlain's action at Munich would still have utterly betrayed the Czechs, but it would not be the great moral disaster that has made his name a household word.[5]

In many cases of difficult choice the outcome cannot be foreseen with certainty. One kind of assessment of the choice is possible in advance, but another kind must await the outcome, because the outcome determines what has been done. The same degree of culpability or estimability in intention, motive, or concern is compatible with a wide range of judgments, positive or negative, depending on what happened beyond the point of decision. The *mens rea* which could have existed in the absence of any consequences does not exhaust the grounds of moral judgment. Actual results influence culpability or esteem in a large class of unquestionably ethical cases ranging from negligence through political choice.

That these are genuine moral judgments rather than expressions of temporary attitude is evident from the fact that one can say *in advance* how the moral verdict will depend on the results. If one negligently leaves the bath running with the baby in it, one will realize, as one bounds up the stairs toward the bathroom, that if the baby has drowned one has done something awful, whereas if it has not one has merely been careless. Someone who launches a violent revolution against an authoritarian regime knows that if he fails he will be responsible for much suffering that is in vain, but if he succeeds he will be justified by the outcome. I do not mean that *any* action can be retroactively justified by history. Certain things are so bad in themselves, or so risky, that no results can make them all right. Nevertheless, when moral judgment does depend on the outcome, it is objective and timeless and not dependent on a change of standpoint produced by success or failure. The judgment after the fact follows from an hypothetical judgment that can be made beforehand, and it can be made as easily by someone else as by the agent.

From the point of view which makes responsibility dependent on control, all this seems absurd. How is it possible to be more or less culpable depending on whether a child gets into the path of one's car, or a bird into the path of one's bullet? Perhaps it is true that what is done depends on more than the agent's state of mind or intention. The problem then is, why is it not irrational to base moral assessment on what people do, in this broad sense? It amounts to holding them responsible for the contributions of fate as well as for their own—provided they have made some contribution to begin with. If we look at cases of negligence or attempt, the pattern seems to be that overall culpability corresponds to the product of mental or intentional fault and the seriousness of the outcome. Cases of decision under uncertainty are less easily explained in this way, for it seems that the overall judgment can even shift from positive to negative depending on the outcome. But here too it seems rational to subtract the effects of occurrences subsequent to the choice, that were merely possible at the time, and concentrate moral assessment on the actual decision in light of the probabilities. If the object of moral judgment is the *person*, then to hold him accountable for what he has done in the broader sense is akin to strict liability, which may have its legal uses but seems irrational as a moral position.

The result of such a line of thought is to pare down each act to its morally essential core, an inner act of pure will assessed by motive and intention. Adam Smith advocates such a position in *The Theory of Moral Sentiments*, but notes that it runs contrary to our actual judgments.

But how well soever we may seem to be persuaded of the truth of this equitable maxim, when we consider it after this manner, in abstract, yet when we come to particular cases, the actual consequences which happen to proceed from any action, have a very great effect upon our sentiments concerning its merit or demerit, and almost always either enhance or diminish our sense of both. Scarce, in any one instance, perhaps, will our sentiments be found, after examination, to be entirely regulated by this rule, which we all acknowledge ought entirely to regulate them.[6]

Joel Feinberg points out further that restricting the domain of moral responsibility to the inner world will not immunize it to luck. Factors beyond the agent's control, like a coughing fit, can interfere with his decisions as surely as they can with the path of a bullet from his gun.[7] Nevertheless the tendency to cut down the scope of moral assessment is pervasive, and does not limit itself to the influence of effects. It attempts to isolate the will from the other direction, so to speak, by separating out constitutive luck. Let us consider that next.

Kant was particularly insistent on the moral irrelevance of qualities of temperament and personality that are not under the control of the will. Such qualities as sympathy or coldness might provide the background against which obedience to moral requirements is more or less difficult, but they could not be objects of moral assessment themselves, and might well interfere with confident assessment of its proper object—the determination of the will by the motive of duty. This rules out moral judgment of many of the virtues and vices, which are states of character that influence choice but are certainly not exhausted by dispositions to act deliberately in certain ways. A person may be greedy, envious, cowardly, cold, ungenerous, unkind, vain, or conceited, but *behave* perfectly by a monumental effort of will. To possess these vices is to be unable to help having certain feelings under certain circumstances, and to have strong spontaneous impulses to act badly. Even if one controls the impulses, one still has the vice. An envious person hates the greater success of others. He can be morally condemned as envious even if he congratulates them cordially and does nothing to denigrate or spoil their success. Conceit, likewise, need not be displayed. It is fully present in someone who cannot help dwelling with secret satisfaction on the superiority of his own achievements, talents, beauty, intelligence, or virtue. To some extent such a quality may be the product of earlier choices; to some extent it may be amenable to change by current actions. But it is largely a matter of constitutive bad fortune. Yet people are morally condemned for such qualities, and esteemed for others equally beyond control of the will: they are assessed for what they are *like*.

To Kant this seems incoherent because virtue is enjoined on everyone and therefore must in principle be possible for everyone. It may be easier for some than for others, but it must be possible to achieve it by making the right choices, against whatever temperamental background.[8] One may want to have a generous spirit, or regret not having one, but it makes no sense to condemn oneself or anyone else for a quality which is not within the control of the will. Condemnation implies that you should not be like that, not that it is unfortunate that you are.

Nevertheless, Kant's conclusion remains intuitively unacceptable. We may be persuaded that these moral judgments are irrational, but they reappear involuntarily as soon as the argument is over. This is the pattern throughout the subject.

The third category to consider is luck in one's circumstances, and I shall mention it briefly. The things we are called upon to do, the moral tests we face, are importantly determined by factors beyond our control. It may be true of someone that in a dangerous situation he would behave in a cowardly or heroic fashion, but if the situation never arises, he will never have the chance to distinguish or disgrace himself in this way, and his moral record will be different.[9]

A conspicuous example of this is political. Ordinary citizens of Nazi Germany had an opportunity to behave heroically by opposing the regime. They also had an opportunity to behave badly, and most of them are culpable for having failed this test. But it is a test to which the citizens of other countries were not subjected, with the result that even if they, or some of them, would have behaved as badly as the Germans in like circumstances, they simply did not and therefore are not similarly culpable. Here again one is morally at the mercy of fate, and it may seem irrational upon reflection, but our ordinary moral attitudes would be unrecognizable without it. We judge people for what they actually do or fail to do, not just for what they would have done if circumstances had been different.[10]

This form of moral determination by the actual is also paradoxical, but we can begin to see how deep in the concept of responsibility the paradox is embedded. A person can be morally responsible only for what he does; but what he does results from a great deal that he does not do; therefore he is not morally responsible for what he is and is not responsible for. (This is not a contradiction, but it is a paradox.)

It should be obvious that there is a connection between these problems about responsibility and control and an even more familiar problem, that of freedom of the will. That is the last type of moral luck I want to take up, though I can do no more within the scope of this essay than indicate its connection with the other types.

If one cannot be responsible for consequences of one's acts due to factors beyond one's control, or for antecedents of one's acts that are properties of temperament not subject to one's will, or for the circumstances that pose one's moral choices, then how can one be responsible even for the stripped-down acts of the will itself, if *they* are the product of antecedent circumstances outside of the will's control?

The area of genuine agency, and therefore of legitimate moral judgment, seems to shrink under this scrutiny to an extensionless point. Everything seems to result from the combined influence of factors, antecedent and posterior to action, that are not within the agent's control. Since he cannot be responsible for them, he cannot be responsible for their results—though it may remain possible to take up the aesthetic or other evaluative analogues of the moral attitudes that are thus displaced.

It is also possible, of course, to brazen it out and refuse to accept the results, which indeed seem unacceptable as soon as we stop thinking about the arguments. Admittedly, if certain surrounding circumstances had been different, then no unfortunate consequences would have followed from a wicked intention, and no seriously culpable act would have been performed; but since the circumstances were *not* different, and the agent *in fact* succeeded in perpetrating a particularly cruel murder, *that* is what he did, and that is what he is responsible for. Similarly, we may admit that if certain antecedent

circumstances had been different, the agent would never have developed into the sort of person who would do such a thing; but since he *did* develop (as the inevitable result of those antecedent circumstances) into the sort of swine he is, and into the person who committed such a murder, *that* is what he is blameable for. In both cases one is responsible for what one actually does—even if what one actually does depends in important ways on what is not within one's control. This compatibilist account of our moral judgments would leave room for the ordinary conditions of responsibility—the absence of coercion, ignorance, or involuntary movement—as part of the determination of what someone has done; but it is understood not to exclude the influence of a great deal that he has not done.[11]

The only thing wrong with this solution is its failure to explain how skeptical problems arise. For they arise not from the imposition of an arbitrary external requirement, but from the nature of moral judgment itself. Something in the ordinary idea of what someone does must explain how it can seem necessary to subtract from it anything that merely happens—even though the ultimate consequence of such subtraction is that nothing remains. And something in the ordinary idea of knowledge must explain why it seems to be undermined by any influences on belief not within the control of the subject—so that knowledge seems impossible without an impossible foundation in autonomous reason. But let us leave epistemology aside and concentrate on action, character, and moral assessment.

The problem arises, I believe, because the self which acts and is the object of moral judgment is threatened with dissolution by the absorption of its acts and impulses into the class of events. Moral judgment of a person is judgment not of what happens to him, but of him. It does not say merely that a certain event or state of affairs is fortunate or unfortunate or even terrible. It is not an evaluation of a state of the world, or of an individual as part of the world. We are not thinking just that it would be better if he were different, or did not exist, or had not done some of the things he has done. We are judging *him*, rather than his existence or characteristics.

The effect of concentrating on the influence of what is not under his control is to make this responsible self seem to disappear, swallowed up by the order of mere events.

What, however, do we have in mind that a person must *be* to be the object of these moral attitudes? While the concept of agency is easily undermined, it is very difficult to give it a positive characterization. That is familiar from the literature on Free Will.

I believe that in a sense the problem has no solution, because something in the idea of agency is incompatible with actions being events, or people being things. But as the external determinants of what someone has done are gradually exposed, in their effect on consequences, character, and choice itself, it becomes gradually clear that actions are events and people things. Eventually nothing remains which can be ascribed to the responsible self, and we are left with nothing but a portion of the larger sequence of events, which can be deplored or celebrated, but not blamed or praised.

Though I cannot define the idea of the active self that is thus undermined, it is possible to say something about its sources. There is a close connection between our feelings about ourselves and our feelings about others. Guilt and indignation, shame and contempt, pride and admiration are internal and external sides of the same moral attitudes. We are unable to view ourselves simply as portions of the world, and from inside we have a rough idea of the boundary between what is us and what is not, what we do and what happens to us, what is our personality and what is an accidental handicap. We apply the same essentially internal conception of the self to others. About ourselves we feel pride, shame, guilt, remorse—and agent-regret. We do not regard our actions and our characters merely as fortunate or unfortunate episodes—though they may also be that. We cannot *simply* take an external evaluative view of ourselves—of what we most essentially are and what we do. And this remains true even when we have seen that we are not responsible for our own existence, or our nature, or the choices we have to make, or the circumstances that give our acts the consequences they have. Those acts remain

ours and we remain ourselves, despite the persuasiveness of the reasons that seem to argue us out of existence.

It is this internal view that we extend to others in moral judgment—when we judge *them* rather than their desirability or utility. We extend to others the refusal to limit ourselves to external evaluation, and we accord to them selves like our own. But in both cases this comes up against the brutal inclusion of humans and everything about them in a world from which they cannot be separated and of which they are nothing but contents. The external view forces itself on us at the same time that we resist it. One way this occurs is through the gradual erosion of what we do by the subtraction of what happens.[12]

The inclusion of consequences in the conception of what we have done is an acknowledgment that we are parts of the world, but the paradoxical character of moral luck which emerges from this acknowledgment shows that we are unable to operate with such a view, for it leaves us with no one to be. The same thing is revealed in the appearance that determinism obliterates responsibility. Once we see an aspect of what we or someone else does as something that happens, we lose our grip on the idea that it has been done and that we can judge the doer and not just the happening. This explains why the absence of determinism is no more hospitable to the concept of agency than is its presence—a point that has been noticed often. Either way the act is viewed externally, as part of the course of events.

The problem of moral luck cannot be understood without an account of the internal conception of agency and its special connection with the moral attitudes as opposed to other types of value. I do not have such an account. The degree to which the problem has a solution can be determined only by seeing whether in some degree the incompatibility between this conception and the various ways in which we do not control what we do is only apparent. I have nothing to offer on that topic either. But it is not enough to say merely that our basic moral attitudes toward ourselves and others are determined by what is actual; for they are also threatened by the sources of that actuality, and by the external view of action which forces itself on us when we see how everything we do belongs to a world that we have not created.

Notes

1. *Foundations of the Metaphysics of Morals*, first section, third paragraph.

2. See Thompson Clark, "The Legacy of Skepticism," *Journal of Philosophy*. LXIX, no. 20 (November 9, 1972), 754–69.

3. Such a case, modelled on the life of Gauguin, is discussed by Bernard Williams in "Moral Luck," *Proceedings of the Aristotelian Society*, supplementary vol. L (1976), 115–35 (to which the original version of this essay was a reply). He points out that though success or failure cannot be predicted in advance, Gauguin's most basic retrospective feelings about the decision will be determined by the development of his talent. My disagreement with Williams is that his account fails to explain why such retrospective attitudes can be called moral. If success does not permit Gauguin to justify himself to others, but still determines his most basic feelings, that shows only that his most basic feelings need not be moral. It does not show that morality is subject to luck. If the retrospective judgment were moral, it would imply the truth of a hypothetical judgment made in advance, of the form "If I leave my family and become a great painter, I will be justified by success; if I don't become a great painter, the act will be unforgivable."

4. Williams' term (ibid.).

5. For a fascinating but morally repellent discussion of the topic of justification by history, see Maurice Merleau-Ponty, *Humanisme et Terreur* (Paris: Gallimard, 1947), translated as *Humanism and Terror* (Boston: Beacon, 1969).

6. Pt. II, sect. 3, Introduction, para. 5.

7. "Problematic Responsibility in Law and Morals," in Joel Feinberg, *Doing and Deserving* (Princeton: Princeton University Press, 1970).

8. "If nature has put little sympathy in the heart of a man, and if he, though an honest man, is by temperament

cold and indifferent to the sufferings of others, perhaps because he is provided with special gifts of patience and fortitude and expects or even requires that others should have the same—and such a man would certainly not be the meanest product of nature—would not he find in himself a source from which to give himself a far higher worth than he could have got by having a good-natured temperament?" (*Foundations of the Metaphysics of Morals*, first section, eleventh paragraph).

9. Cf. Thomas Gray, "Elegy Written in a Country Churchyard":

> *Some mute inglorious Milton here may rest,*
> *Some Cromwell, guiltless of his country's blood.*

An unusual example of circumstantial moral luck is provided by the kind of moral dilemma with which someone can be faced through no fault of his own, but which leaves him with nothing to do which is not wrong. See . . . Bernard Williams, "Ethical Consistency," *Proceedings of the Aristotelian Society*, supplementary vol. XXXIX (1965), reprinted in *Problems of the Self* (Cambridge: Cambridge University Press, 1973), pp. 166–86.

10. Circumstantial luck can extend to aspects of the situation other than individual behavior. For example, during the Vietnam War even U.S. citizens who had opposed their country's actions vigorously from the start often felt compromised by its crimes. Here they were not even responsible; there was probably nothing they could do to stop what was happening, so the feeling of being implicated may seem unintelligible. But it is nearly impossible to view the crimes of one's own country in the same way that one views the crimes of another country, no matter how equal one's lack of power to stop them in the two cases. One *is* a citizen of one of them, and has a connection with its actions (even if only through taxes that cannot be withheld)—that one does not have with the other's. This makes it possible to be ashamed of one's country, and to feel a victim of moral bad luck that one was an American in the 1960s.

11. The corresponding position in epistemology would be that knowledge consists of true beliefs formed in certain ways, and that it does not require all aspects of the process to be under the knower's control, actually or potentially. Both the correctness of these beliefs and the process by which they are arrived at would therefore be importantly subject to luck. The Nobel Prize is not awarded to people who turn out to be wrong, no matter how brilliant their reasoning.

12. See P. F. Strawson's discussion of the conflict between the objective attitude and personal reactive attitudes in "Freedom and Resentment," *Proceedings of the British Academy*, 1962, reprinted in *Studies in the Philosophy of Thought and Action*, ed. P. F. Strawson (London: Oxford University Press, 1968), and in P. F. Strawson, *Freedom and Resentment and Other Essays* (London: Methuen, 1974).

Study Questions

1. What is "moral luck"?

2. According to Nagel, in what four ways are moral assessments subject to luck?

3. In judging yourself, do you give major roles both to good and bad luck?

4. Does moral luck undermine any notion of moral responsibility?

34

SUSAN WOLF

Susan Wolf is Professor of Philosophy at the University of North Carolina at Chapel Hill. She challenges the view that the best life is that of the moral saint, a person whose every action is as good as possible. Such an individual would necessarily sacrifice other ideals, such as academic, artistic, or athletic excellence, whose pursuit would be incompatible with maximum devotion to morality. Wolf concludes, then, that moral goodness should not serve as a comprehensive guide to conduct.

Moral Saints

I don't know whether there are any moral saints. But if there are, I am glad that neither I nor those about whom I care most are among them. By *moral saint* I mean a person whose every action is as morally good as possible, a person, that is, who is as morally worthy as can be. Though I shall in a moment acknowledge the variety of types of person that might be thought to satisfy this description, it seems to me that none of these types serve as unequivocally compelling personal ideals. In other words, I believe that moral perfection, in the sense of moral saintliness, does not constitute a model of personal well-being toward which it would be particularly rational or good or desirable for a human being to strive.

Outside the context of moral discussion, this will strike many as an obvious point. But, within that context, the point, if it be granted, will be granted with some discomfort. For within that context it is generally assumed that one ought to be as morally good as possible and that what limits there are to morality's hold on us are set by features of human nature of which we ought not to be proud. If, as I believe, the ideals that are derivable from common sense and philosophically popular moral theories do not support these assumptions, then something has to change. Either we must change our moral theories in ways that will make them yield more palatable ideals, or, as I shall argue, we must change our conception of what is involved in affirming a moral theory.

In this paper, I wish to examine the notion of a moral saint, first, to understand what a moral saint would be like and why such a being would be unattractive, and, second, to raise some questions about the significance of this paradoxical figure for moral philosophy. I shall look first at the model(s) of moral sainthood that might be extrapolated from the morality or moralities of common sense. Then I shall consider what relations these have to conclusions that can be drawn from utilitarian and Kantian moral theories. Finally, I shall speculate on the implications of these considerations for moral philosophy.

Susan Wolf, "Moral Saints," *The Journal of Philosophy*, vol. 79, no. 8 (August 1982), pp. 419–439. Reprinted with the permission of the author and *The Journal of Philosophy*.

MORAL SAINTS
AND COMMON SENSE

Consider first what, pretheoretically, would count for us—contemporary members of Western culture—as a moral saint. A necessary condition of moral sainthood would be that one's life be dominated by a commitment to improving the welfare of others or of society as a whole. As to what role this commitment must play in the individual's motivational system, two contrasting accounts suggest themselves to me which might equally be thought to qualify a person for moral sainthood.

First, a moral saint might be someone whose concern for others plays the role that is played in most of our lives by more selfish, or at any rate, less morally worthy concerns. For the moral saint, the promotion of the welfare of others might play the role that is played for most of us by the enjoyment of material comforts, the opportunity to engage in the intellectual and physical activities of our choice, and the love, respect, and companionship of people whom we love, respect, and enjoy. The happiness of the moral saint, then, would truly lie in the happiness of others, and so he would devote himself to others gladly, and with a whole and open heart.

On the other hand, a moral saint might be someone for whom the basic ingredients of happiness are not unlike those of most of the rest of us. What makes him a moral saint is rather that he pays little or no attention to his own happiness in light of the overriding importance he gives to the wider concerns of morality. In other words, this person sacrifices his own interests to the interests of others, and feels the sacrifice as such.

Roughly, these two models may be distinguished according to whether one thinks of the moral saint as being a saint out of love or one thinks of the moral saint as being a saint out of duty (or some other intellectual appreciation and recognition of moral principles). We may refer to the first model as the model of the Loving Saint; to the second, as the model of the Rational Saint.

The two models differ considerably with respect to the qualities of the motives of the individuals who conform to them. But this difference would have limited effect on the saints' respective public personalities. The shared content of what these individuals are motivated to be—namely, as morally good as possible—would play the dominant role in the determination of their characters. Of course, just as a variety of large-scale projects, from tending the sick to political campaigning, may be equally and maximally morally worthy, so a variety of characters are compatible with the ideal of moral sainthood. One moral saint may be more or less jovial, more or less garrulous, more or less athletic than another. But, above all, a moral saint must have and cultivate those qualities which are apt to allow him to treat others as justly and kindly as possible. He will have the standard moral virtues to a nonstandard degree. He will be patient, considerate, even-tempered, hospitable, charitable in thought as well as in deed. He will be very reluctant to make negative judgments of other people. He will be careful not to favor some people over others on the basis of properties they could not help but have.

Perhaps what I have already said is enough to make some people begin to regard the absence of moral saints in their lives as a blessing. For there comes a point in the listing of virtues that a moral saint is likely to have where one might naturally begin to wonder whether the moral saint isn't, after all, too good—if not too good for his own good, at least too good for his own well-being. For the moral virtues, given that they are, by hypothesis, *all* present in the same individual, and to an extreme degree, are apt to crowd out the nonmoral virtues, as well as many of the interests and personal characteristics that we generally think contribute to a healthy, well-rounded, richly developed character.

In other words, if the moral saint is devoting all his time to feeding the hungry or healing the sick or raising money for Oxfam, then necessarily he is not reading Victorian novels, playing the oboe, or improving his backhand. Although no one of the interests or tastes in the category containing these latter activities could be claimed to be a necessary element in a life well lived, a life in which *none* of these possible aspects of character are developed may seem to be a life strangely barren.

The reasons why a moral saint cannot, in general, encourage the discovery and development of significant nonmoral interests and skills are not logical but practical reasons. There are, in addition, a class of nonmoral characteristics that a moral saint cannot encourage in himself for reasons that are not just practical. There is a more substantial tension between having any of these qualities unashamedly and being a moral saint. These qualities might be described as going against the moral grain. For example, a cynical or sarcastic wit, or a sense of humor that appreciates this kind of wit in others, requires that one take an attitude of resignation and pessimism towards the flaws and vices to be found in the world. A moral saint, on the other hand, has reason to take an attitude in opposition to this—he should try to look for the best in people, give them the benefit of the doubt as long as possible, try to improve regrettable situations as long as there is any hope of success. This suggests that, although a moral saint might well enjoy a good episode of *Father Knows Best*, he may not in good conscience be able to laugh at a Marx Brothers movie or enjoy a play by George Bernard Shaw.

An interest in something like gourmet cooking will be, for different reasons, difficult for a moral saint to rest easy with. For it seems to me that no plausible argument can justify the use of human resources involved in producing a *paté de canard en crois* against possible alternative beneficent ends to which these resources might be put. If there is a justification for the institution of haute cuisine, it is one which rests on the decision *not* to justify every activity against morally beneficial alternatives, and this is a decision a moral saint will never make. Presumably, an interest in high fashion or interior design will fare much the same, as will, very possibly, a cultivation of the finer arts as well.

A moral saint will have to be very, very nice. It is important that he not be offensive. The worry is that, as a result, he will have to be dull-witted or humorless or bland.

This worry is confirmed when we consider what sorts of characters, taken and refined both from life and from fiction, typically form our ideals. One would hope they would be figures who are morally good—and by this I mean more than just not morally bad—but one would hope, too, that they are not *just* morally good, but talented or accomplished or attractive in nonmoral ways as well. We may make ideals out of athletes, scholars, artists—more frivolously, out of cowboys, private eyes, and rock stars. We may strive for Katharine Hepburn's grace, Paul Newman's "cool"; we are attracted to the high-spirited passionate nature of Natasha Rostov; we admire the keen perceptiveness of Lambert Strether. Though there is certainly nothing immoral about the ideal characters or traits I have in mind, they cannot be superimposed upon the ideal of a moral saint. For although it is a part of many of these ideals that the characters set high, and not merely acceptable moral standards for themselves, it is also essential to their power and attractiveness that the moral strengths go, so to speak, alongside of specific, independently admirable, nonmoral ground projects and dominant personal traits.

When one does finally turn one's eyes toward lives that are dominated by explicitly moral commitments, moreover, one finds oneself relieved at the discovery of idiosyncrasies or eccentricities not quite in line with the picture of moral perfection. One prefers the blunt, tactless, and opinionated Betsy Trotwood to the unfailingly kind and patient Agnes Copperfield; one prefers the mischievousness and the sense of irony in Chesterton's Father Brown to the innocence and undiscriminating love of St. Francis.

It seems that, as we look in our ideals for people who achieve nonmoral varieties of personal excellence in conjunction with or colored by some version of high moral tone, we look in our paragons of moral excellence for people whose moral achievements occur in conjunction with or colored by some interests or traits that have low moral tone. In other words, there seems to be a limit to how much morality we can stand.

One might suspect that the essence of the problem is simply that there is a limit to how much of *any* single value, or any single type of value, we can stand. Our objection then would not be specific to a life in which one's dominant concern is morality, but would apply to any life that can be so completely characterized by an extraordinarily dominant

concern. The objection in that case would reduce to the recognition that such a life is incompatible with well-roundedness. If that were the objection, one could fairly reply that well-roundedness is no more supreme a virtue than the totality of moral virtues embodied by the ideal it is being used to criticize. But I think this misidentifies the objection. For the way in which a concern for morality may dominate a life, or, more to the point, the way in which it may dominate an ideal of life, is not easily imagined by analogy to the dominance an aspiration to become an Olympic swimmer or a concert pianist might have.

A person who is passionately committed to one of these latter concerns might decide that her attachment to it is strong enough to be worth the sacrifice of her ability to maintain and pursue a significant portion of what else life might offer which a proper devotion to her dominant passion would require. But a desire to be as morally good as possible is not likely to take the form of one desire among others which, because of its peculiar psychological strength, requires one to forego the pursuit of other weaker and separately less demanding desires. Rather, the desire to be as morally good as possible is apt to have the character not just of a stronger but of a higher desire, which does not merely successfully compete with one's other desires but which rather subsumes or demeans them. The sacrifice of other interests for the interest in morality then, will have the character, not of a choice, but of an imperative.

Moreover, there is something odd about the idea of morality itself, or moral goodness, serving as the object of a dominant passion in the way that a more concrete and specific vision of a goal (even a concrete *moral* goal) might be imagined to serve. Morality itself does not seem to be a suitable object of passion. Thus, when one reflects, for example, on the Loving Saint easily and gladly giving up his fishing trip or his stereo or his hot fudge sundae at the drop of the moral hat, one is apt to wonder not at how much he loves morality, but at how little he loves these other things. One thinks that, if he can give these up so easily, he does not know what it is to truly love them. There seems, in other words, to be a kind of joy which the Loving Saint, either by

nature or by practice, is incapable of experiencing. The Rational Saint, on the other hand, might retain strong non-moral and concrete desires—(he simply denies himself the opportunity to act on them). But this is no less troubling. The Loving Saint one might suspect of missing a piece of perceptual machinery, of being blind to some of what the world has to offer. The Rational Saint, who sees it but foregoes it, one suspects of having a different problem—a pathological fear of damnation, perhaps, or an extreme form of self-hatred that interferes with his ability to enjoy the enjoyable in life.

In other words, the ideal of a life of moral sainthood disturbs not simply because it is an ideal of a life in which morality unduly dominates. The normal person's direct and specific desires for objects, activities, and events that conflict with the attainment of moral perfection are not simply sacrificed but removed, suppressed, or subsumed. The way in which morality, unlike other possible goals, is apt to dominate is particularly disturbing, for it seems to require either the lack or the denial of the existence of an identifiable, personal self.

This distinctively troubling feature is not, I think, absolutely unique to the ideal of the moral saint, as I have been using that phrase. It is shared by the conception of the pure aesthete, by a certain kind of religious ideal, and, somewhat paradoxically, by the model of the thorough-going, self-conscious egoist. It is not a coincidence that the ways of comprehending the world of which these ideals are the extreme embodiments are sometimes described as "moralities" themselves. At any rate, they compete with what we ordinarily mean by "morality." Nor is it a coincidence that these ideals are naturally described as fanatical. But it is easy to see that these other types of perfection cannot serve as satisfactory personal ideals; for the realization of these ideals would be straightforwardly immoral. It may come as a surprise to some that there may in addition be such a thing as a *moral* fanatic.

Some will object that I am being unfair to "common-sense morality"—that it does not really require a moral saint to be either a disgusting goody-goody or an obsessive ascetic. Admittedly, there is

no logical inconsistency between having any of the personal characteristics I have mentioned and being a moral saint. It is not morally wrong to notice the faults and shortcomings of others or to recognize and appreciate nonmoral talents and skills. Nor is it immoral to be an avid Celtics fan or to have a passion for caviar or to be an excellent cellist. With enough imagination, we can always contrive a suitable history and set of circumstances that will embrace such characteristics in one or another specific fictional story of a perfect moral saint.

If one turned onto the path of moral sainthood relatively late in life, one may have already developed interests that can be turned to moral purposes. It may be that a good golf game is just what is needed to secure that big donation to Oxfam. Perhaps the cultivation of one's exceptional artistic talent will turn out to be the way one can make one's greatest contribution to society. Furthermore, one might stumble upon joys and skills in the very service of morality. If, because the children are short a ninth player for the team, one's generous offer to serve reveals a natural fielding arm or if one's part in the campaign against nuclear power requires accepting a lobbyist's invitation to lunch at Le Lion d'Or, there is no moral gain in denying the satisfaction one gets from these activities. The moral saint, then, may, by happy accident, find himself with nonmoral virtues on which he can capitalize morally or which make psychological demands to which he has no choice but to attend. The point is that, for a moral saint, the existence of these interests and skills can be given at best the status of happy accidents—they cannot be encouraged for their own sakes as distinct, independent aspects of the realization of human good.

It must be remembered that from the fact that there is a tension between having any of these qualities and being a moral saint it does not follow that having any of these qualities is immoral. For it is not part of common-sense morality that one ought to be a moral saint. Still, if someone just happened to want to be a moral saint, he or she would not have or encourage these qualities, and on the basis of our common-sense values, this counts as a reason *not* to want to be a moral saint.

One might still wonder what kind of reason this is, and what kind of conclusion this properly allows us to draw. For the fact that the models of moral saints are unattractive does not necessarily mean that they are unsuitable ideals. Perhaps they are unattractive because they make us feel uncomfortable—they highlight our own weaknesses, vices, and flaws. If so, the fault lies not in the characters of the saints, but in those of our unsaintly selves.

To be sure, some of the reasons behind the disaffection we feel for the model of moral sainthood have to do with a reluctance to criticize ourselves and a reluctance to committing ourselves to trying to give up activities and interests that we heartily enjoy. These considerations might provide an *excuse* for the fact that we are not moral saints, but they do not provide a basis for criticizing sainthood as a possible ideal. Since these considerations rely on an appeal to the egoistic, hedonistic side of our natures, to use them as a basis for criticizing the ideal of the moral saint would be at best to beg the question and at worst to glorify features of ourselves that ought to be condemned.

The fact that the moral saint would be without qualities which we have and which, indeed, we like to have, does not in itself provide reason to condemn the ideal of the moral saint. The fact that some of these qualities are good qualities, however, and that they are qualities we *ought* to like, does provide reason to discourage this ideal and to offer other ideals in its place. In other words, some of the qualities the moral saint necessarily lacks are virtues, albeit nonmoral virtues, in the unsaintly characters who have them. The feats of Groucho Marx, Reggie Jackson, and the head chef at Lutèce are impressive accomplishments that it is not only permissible but positively appropriate to recognize as such. In general, the admiration of and striving toward achieving any of a great variety of forms of personal excellence are character traits it is valuable and desirable for people to have. In advocating the development of these varieties of excellence, we advocate nonmoral reasons for acting, and in thinking that it is good for a person to strive for an ideal that gives a substantial role to the interests and values that correspond to these virtues,

we implicitly acknowledge the goodness of ideals incompatible with that of the moral saint. Finally, if we think that it is *as* good, or even better for a person to strive for one of these ideals than it is for him or her to strive for and realize the ideal of the moral saint, we express a conviction that it is good not to be a moral saint.

MORAL SAINTS AND MORAL THEORIES

I have tried so far to paint a picture—or, rather, two pictures—of what a moral saint might be like, drawing on what I take to be the attitudes and beliefs about morality prevalent in contemporary, common-sense thought. To my suggestion that common-sense morality generates conceptions of moral saints that are unattractive or otherwise unacceptable, it is open to someone to reply, "so much the worse for common-sense morality." After all, it is often claimed that the goal of moral philosophy is to correct and improve upon common-sense morality, and I have as yet given no attention to the question of what conceptions of moral sainthood, if any, are generated from the leading moral theories of our time.

A quick, breezy reading of utilitarian and Kantian writings will suggest the images, respectively, of the Loving Saint and the Rational Saint. A utilitarian, with his emphasis on happiness, will certainly prefer the Loving Saint to the Rational one, since the Loving Saint will himself be a happier person than the Rational Saint. A Kantian, with his emphasis on reason, on the other hand, will find at least as much to praise in the latter as in the former. Still, both models, drawn as they are from common sense, appeal to an impure mixture of utilitarian and Kantian intuitions. A more careful examination of these moral theories raises questions about whether either model of moral sainthood would really be advocated by a believer in the explicit doctrines associated with either of these views.

Certainly, the utilitarian in no way denies the value of self-realization. He in no way disparages the development of interests, talents, and other personally attractive traits that I have claimed the moral saint would be without. Indeed, since just these features enhance the happiness both of the individuals who possess them and of those with whom they associate, the ability to promote these features both in oneself and in others will have considerable positive weight in utilitarian calculations.

This implies that the utilitarian would not support moral sainthood as a universal ideal. A world in which everyone, or even a large number of people, achieved moral sainthood—even a world in which they *strove* to achieve it—would probably contain less happiness than a world in which people realized a diversity of ideals involving a variety of personal and perfectionist values. More pragmatic considerations also suggest that, if the utilitarian wants to influence more people to achieve more good, then he would do better to encourage them to pursue happiness-producing goals that are more attractive and more within a normal person's reach.

These considerations still leave open, however, the question of what kind of an ideal the committed utilitarian should privately aspire to himself. Utilitarianism requires him to want to achieve the greatest general happiness, and this would seem to commit him to the ideal of the moral saint.

One might try to use the claims I made earlier as a basis for an argument that a utilitarian should choose to give up utilitarianism. If, as I have said, a moral saint would be a less happy person both to be and to be around than many other possible ideals, perhaps one could create more total happiness by not trying too hard to promote the total happiness. But this argument is simply unconvincing in light of the empirical circumstances of our world. The gain in happiness that would accrue to oneself and one's neighbors by a more well-rounded, richer life than that of the moral saint would be pathetically small in comparison to the amount by which one could increase the general happiness if one devoted oneself explicitly to the care of the sick, the downtrodden, the starving, and the homeless. Of course, there may be psychological limits to the extent to which a person can devote himself to such things without going crazy. But the utilitarian's individual limitations

would not thereby become a positive feature of his personal ideals.

The unattractiveness of the moral saint, then, ought not rationally convince the utilitarian to abandon his utilitarianism. It may, however, convince him to take efforts not to wear his saintly moral aspirations on his sleeve. If it is not too difficult, the utilitarian will try not to make those around him uncomfortable. He will not want to appear "holier than thou"; he will not want to inhibit others' ability to enjoy themselves. In practice, this might make the perfect utilitarian a less nauseating companion than the moral saint I earlier portrayed. But insofar as this kind of reasoning produces a more bearable public personality, it is at the cost of giving him a personality that must be evaluated as hypocritical and condescending when his private thoughts and attitudes are taken into account.

Still, the criticisms I have raised against the saint of common-sense morality should make some difference to the utilitarian's conception of an ideal which neither requires him to abandon his utilitarian principles nor forces him to fake an interest he does not have or a judgment he does not make. For it may be that a limited and carefully monitored allotment of time and energy to be devoted to the pursuit of some nonmoral interests or to the development of some nonmoral talents would make a person a better contributor to the general welfare than he would be if he allowed himself no indulgences of this sort. The enjoyment of such activities in no way compromises a commitment to utilitarian principles as long as the involvement with these activities is conditioned by a willingness to give them up whenever it is recognized that they cease to be in the general interest.

This will go some way in mitigating the picture of the loving saint that an understanding of utilitarianism will on first impression suggest. But I think it will not go very far. For the limitations on time and energy will have to be rather severe, and the need to monitor will restrict not only the extent but also the quality of one's attachment to these interests and traits. They are only weak and somewhat peculiar sorts of passions to which one can consciously remain so conditionally committed. Moreover, the

way in which the utilitarian can enjoy these "extra-curricular" aspects of his life is simply not the way in which these aspects are to be enjoyed insofar as they figure into our less saintly ideals.

The problem is not exactly that the utilitarian values these aspects of his life only as a means to an end, for the enjoyment he and others get from these aspects are not a means to, but a part of, the general happiness. Nonetheless, he values these things only because of and insofar as they *are* a part of the general happiness. He values them, as it were, under the description "a contribution to the general happiness." This is to be contrasted with the various ways in which these aspects of life may be valued by nonutilitarians. A person might love literature because of the insights into human nature literature affords. Another might love the cultivation of roses because roses are things of great beauty and delicacy. It may be true that these features of the respective activities also explain why these activities are happiness-producing. But, to the nonutilitarian, this may not be to the point. For if one values these activities in these more direct ways, one may not be willing to exchange them for others that produce an equal, or even a greater amount of happiness. From that point of view, it is not because they produce happiness that these activities are valuable; it is because these activities are valuable in more direct and specific ways that they produce happiness.

To adopt a phrase of Bernard Williams', the utilitarian's manner of valuing the not explicitly moral aspects of his life "provides (him) with one thought too many."[1] The requirement that the utilitarian have this thought—periodically, at least—is indicative of not only a weakness but a shallowness in his appreciation of the aspects in question. Thus, the ideals toward which a utilitarian could acceptably strive would remain too close to the model of the common-sense moral saint to escape the criticisms of that model which I earlier suggested. Whether a Kantian would be similarly committed to so restrictive and unattractive a range of possible ideals is a somewhat more difficult question.

The Kantian believes that being morally worthy consists in always acting from maxims that one

could will to be universal law and doing this not out of any pathological desire but out of reverence for the moral law as such. Or, to take a different formulation of the categorical imperative, the Kantian believes that moral action consists in treating other persons always as ends and never as means only. Presumably, and according to Kant himself, the Kantian thereby commits himself to some degree of benevolence as well as to the rules of fair play. But we surely would not will that *every* person become a moral saint, and treating others as ends hardly requires bending over backwards to protect and promote their interests. On one interpretation of Kantian doctrine, then, moral perfection would be achieved simply by unerring obedience to a limited set of side-constraints. On this interpretation, Kantian theory simply does not yield an ideal conception of a person of any fullness comparable to that of the moral saints I have so far been portraying.

On the other hand, Kant does say explicitly that we have a duty of benevolence, a duty not only to allow others to pursue their ends, but to take up their ends as our own. In addition, we have positive duties to ourselves, duties to increase our natural as well as our moral perfection. These duties are unlimited in the degree to which they *may* dominate a life. If action in accordance with and motivated by the thought of these duties is considered virtuous, it is natural to assume that the more one performs such actions, the more virtuous one is. Moreover, of virtue in general Kant says, "it is an ideal which is unattainable while yet our duty is constantly to approximate to it."[2] On this interpretation, then, the Kantian moral saint, like the other moral saints I have been considering, is dominated by the motivation to be moral.

Which of these interpretations of Kant one prefers will depend on the interpretation and the importance one gives to the role of the imperfect duties in Kant's over-all system. Rather than choose between them here, I shall consider each briefly in turn.

On the second interpretation of Kant, the Kantian moral saint is, not surprisingly, subject to many of the same objections I have been raising against other versions of moral sainthood. Though the Kantian saint may differ from the utilitarian saint as to *which*

actions he is bound to perform and which he is bound to refrain from performing, I suspect that the range of activities acceptable to the Kantian saint will remain objectionably restrictive. Moreover, the manner in which the Kantian saint must think about and justify the activities he pursues and the character traits he develops will strike us, as it did with the utilitarian saint, as containing "one thought too many." As the utilitarian could value his activities and character traits only insofar as they fell under the description of "contributions to the general happiness," the Kantian would have to value his activities and character traits insofar as they were manifestations of respect for the moral law. If the development of our powers to achieve physical, intellectual, or artistic excellence, or the activities directed toward making others happy are to have any moral worth, they must arise from a reverence for the dignity that members of our species have as a result of being endowed with pure practical reason. This is a good and noble motivation, to be sure. But it is hardly what one expects to be dominantly behind a person's aspirations to dance as well as Fred Astaire, to paint as well as Picasso, or to solve some outstanding problem in abstract algebra, and it is hardly what one hopes to find lying dominantly behind a father's action on behalf of his son or a lover's on behalf of her beloved.

Since the basic problem with any of the models of moral sainthood we have been considering is that they are dominated by a single, all-important value under which all other possible values must be subsumed, it may seem that the alternative interpretation of Kant, as providing a stringent but finite set of obligations and constraints, might provide a more acceptable morality. According to this interpretation of Kant, one is as morally good as can be so long as one devotes some limited portion of one's energies toward altruism and the maintenance of one's physical and spiritual health, and otherwise pursues one's independently motivated interests and values in such a way as to avoid overstepping certain bounds. Certainly, if it be a requirement of an acceptable moral theory that perfect obedience to its laws and maximal devotion to its interests and concerns be something we can wholeheartedly strive for in ourselves and

wish for in those around us, it will count in favor of this brand of Kantianism that its commands can be fulfilled without swallowing up the perfect moral agent's entire personality.

Even this more limited understanding of morality, if its connection to Kant's views is to be taken at all seriously, is not likely to give an unqualified seal of approval to the nonmorally directed ideals I have been advocating. For Kant is explicit about what he calls "duties of apathy and self-mastery" (69/70)—duties to ensure that our passions are never so strong as to interfere with calm, practical deliberation, or so deep as to wrest control from the more disinterested, rational part of ourselves. The tight and self-conscious rein we are thus obliged to keep on our commitments to specific individuals and causes will doubtless restrict our value in these things, assigning them a necessarily attenuated place.

A more interesting objection to this brand of Kantianism, however, comes when we consider the implications of placing the kind of upper bound on moral worthiness which seemed to count in favor of this conception of morality. For to put such a limit on one's capacity to be moral is effectively to deny, not just the moral necessity, but the moral goodness of a devotion to benevolence and the maintenance of justice that passes beyond a certain, required point. It is to deny the possibility of going morally above and beyond the call of a restricted set of duties. Despite my claim that all-consuming moral saintliness is not a particularly healthy and desirable ideal, it seems perverse to insist that, were moral saints to exist, they would not, in their way, be remarkably noble and admirable figures. Despite my conviction that it is as rational and as good for a person to take Katharine Hepburn or Jane Austen as her role model instead of Mother Theresa, it would be absurd to deny that Mother Theresa is a morally better person.

I can think of two ways of viewing morality as having an upper bound. First, we can think that altruism and impartiality are indeed positive moral interests, but that they are moral only if the degree to which these interests are actively pursued remains within certain fixed limits. Second, we can think that these positive interests are only incidentally related

to morality and that the essence of morality lies elsewhere, in, say, an implicit social contract or in the recognition of our own dignified rationality. According to the first conception of morality, there is a cut-off line to the amount of altruism or to the extent of devotion to justice and fairness that is worthy of moral praise. But to draw this line earlier than the line that brings the altruist in question into a worse-off position than all those to whom he devotes himself seems unacceptably artificial and gratuitous. According to the second conception, these positive interests are not essentially related to morality at all. But then we are unable to regard a more affectionate and generous expression of good will toward others as a natural and reasonable extension of morality, and we encourage a cold and unduly self-centered approach to the development and evaluation of our motivations and concerns.

A moral theory that does not contain the seeds of an all-consuming ideal of moral sainthood thus seems to place false and unnatural limits on our opportunity to do moral good and our potential to deserve moral praise. Yet the main thrust of the arguments of this paper has been leading to the conclusion that, when such ideals are present, they are not ideals to which it is particularly reasonable or healthy or desirable for human beings to aspire. These claims, taken together, have the appearance of a dilemma from which there is no obvious escape. In a moment, I shall argue that, despite appearances, these claims should not be understood as constituting a dilemma. But, before I do, let me briefly describe another path which those who are convinced by my above remarks may feel inclined to take.

If the above remarks are understood to be implicitly critical of the views on the content of morality which seem most popular today, an alternative that naturally suggests itself is that we revise our views about the content of morality. More specifically, my remarks may be taken to support a more Aristotelian, or even a more Nietzschean, approach to moral philosophy. Such a change in approach involves substantially broadening or replacing our contemporary intuitions about which character traits constitute moral virtues and vices and which interests

constitute moral interests. If, for example, we include personal bearing, or creativity, or sense of style, as features that contribute to one's *moral* personality, then we can create moral ideals which are incompatible with and probably more attractive than the Kantian and utilitarian ideals I have discussed. Given such an alteration of our conception of morality, the figures with which I have been concerned above might, far from being considered to be moral saints, be seen as morally inferior to other more appealing or more interesting models of individuals.

This approach seems unlikely to succeed, if for no other reason, because it is doubtful that any single, or even any reasonably small number of substantial personal ideals could capture the full range of possible ways of realizing human potential or achieving human good which deserve encouragement and praise. Even if we could provide a sufficiently broad characterization of the range of positive ways for human beings to live, however, I think there are strong reasons not to want to incorporate such a characterization more centrally into the framework of morality itself. For, in claiming that a character trait or activity is morally good, one claims that there is a certain kind of reason for developing that trait or engaging in that activity. Yet, lying behind our criticism of more conventional conceptions of moral sainthood, there seems to be a recognition that among the immensely valuable traits and activities that a human life might positively embrace are some of which we hope that, if a person does embrace them, he does so *not* for moral reasons. In other words, no matter how flexible we make the guide to conduct which we choose to label "morality," no matter how rich we make the life in which perfect obedience to this guide would result, we will have reason to hope that a person does not wholly rule and direct his life by the abstract and impersonal consideration that such a life would be morally good.

Once it is recognized that morality itself should not serve as a comprehensive guide to conduct, moreover, we can see reasons to retain the admittedly vague contemporary intuitions about what the classification of moral and nonmoral virtues, interests, and the like should be. That is, there seem to

be important differences between the aspects of a person's life which are currently considered appropriate objects of moral evaluation and the aspects that might be included under the altered conception of morality we are now considering, which the latter approach would tend wrongly to blur or to neglect. Moral evaluation now is focused primarily on features of a person's life over which that person has control; it is largely restricted to aspects of his life which are likely to have considerable effect on other people. These restrictions seem as they should be. Even if responsible people could reach agreement as to what constituted good taste or a healthy degree of well-roundedness, for example, it seems wrong to insist that everyone try to achieve these things or to blame someone who fails or refuses to conform.

If we are not to respond to the unattractiveness of the moral ideals that contemporary theories yield either by offering alternative theories with more palatable ideals or by understanding these theories in such a way as to prevent them from yielding ideals at all, how, then, are we to respond? Simply, I think, by admitting that moral ideals do not, and need not, make the best personal ideals. Earlier, I mentioned one of the consequences of regarding as a test of an adequate moral theory that perfect obedience to its laws and maximal devotion to its interests be something we can wholeheartedly strive for in ourselves and wish for in those around us. Drawing out the consequences somewhat further should, I think, make us more doubtful of the proposed test than of the theories which, on this test, would fail. Given the empirical circumstances, of our world, it seems to be an ethical fact that we have unlimited potential to be morally good, and endless opportunity to promote moral interests. But this is not incompatible with the not-so-ethical fact that we have sound, compelling, and not particularly selfish reasons to choose not to devote ourselves univocally to realizing this potential or to taking up this opportunity.

Thus, in one sense at least, I am not really criticizing either Kantianism or utilitarianism. Insofar as the point of view I am offering bears directly on recent work in moral philosophy, in fact, it bears on critics of these theories who, in a spirit not unlike the

spirit of most of this paper, point out that the perfect utilitarian would be flawed in this way or the perfect Kantian flawed in that.[3] The assumption lying behind these claims, implicitly or explicitly, has been that the recognition of these flaws shows us something wrong with utilitarianism as opposed to Kantianism, or something wrong with Kantianism as opposed to utilitarianism, or something wrong with both of these theories as opposed to some nameless third alternative. The claims of this paper suggest, however, that this assumption is unwarranted. The flaws of a perfect master of a moral theory need not reflect flaws in the intramoral content of the theory itself.

MORAL SAINTS AND MORAL PHILOSOPHY

In pointing out the regrettable features and the necessary absence of some desirable features in a moral saint, I have not meant to condemn the moral saint or the person who aspires to become one. Rather, I have meant to insist that the ideal of moral sainthood should not be held as a standard against which any other ideal must be judged or justified, and that the posture we take in response to the recognition that our lives are not as morally good as they might be need not be defensive.[4] It is misleading to insist that one is *permitted* to live a life in which the goals, relationships, activities, and interests that one pursues are not maximally morally good. For our lives are not so comprehensively subject to the requirement that we apply for permission, and our nonmoral reasons for the goals we set ourselves are not excuses, but may rather be positive, good reasons which do not exist *despite* any reasons that might threaten to outweigh them. In other words, a person may be *perfectly wonderful* without being *perfectly moral*.

Recognizing this requires a perspective which contemporary moral philosophy has generally ignored. This perspective yields judgments of a type that is neither moral nor egoistic. Like moral judgments, judgments about what it would be good for a person to be are made from a point of view outside the limits set by the values, interests, and desires that the person might actually have. And, like moral judgments, these judgments claim for themselves a kind of objectivity or a grounding in a perspective which any rational and perceptive being can take up. Unlike moral judgments, however, the good with which these judgments are concerned is not the good of anyone or any group other than the individual himself.

Nonetheless, it would be equally misleading to say that these judgments are made for the sake of the individual himself. For these judgments are not concerned with what kind of life it is in a person's interest to lead, but with what kind of interests it would be good for a person to have, and it need not be in a person's interest that he acquire or maintain objectively good interests. Indeed, the model of the Loving Saint, whose interests are identified with the interests of morality, is a model of a person for whom the dictates of rational self-interest and the dictates of morality coincide. Yet, I have urged that we have reason not to aspire to this ideal and that some of us would have reason to be sorry if our children aspired to and achieved it.

The moral point of view, we might say, is the point of view one takes up insofar as one takes the recognition of the fact that one is just one person among others equally real and deserving of the good things in life as a fact with practical consequences, a fact the recognition of which demands expression in one's actions and in the form of one's practical deliberations. Competing moral theories offer alternative answers to the question of what the most correct or the best way to express this fact is. In doing so, they offer alternative ways to evaluate and to compare the variety of actions, states of affairs, and so on that appear good and bad to agents from other, nonmoral points of view. But it seems that alternative interpretations of the moral point of view do not exhaust the ways in which our actions, characters, and their consequences can be comprehensively and objectively evaluated. Let us call the point of view from which we consider what kinds of lives are good lives, and what kinds of persons it would be good for ourselves and others to be, *the point of view of individual perfection*.

Since either point of view provides a way of comprehensively evaluating a person's life, each point of view takes account of, and, in a sense, subsumes the other. From the moral point of view, the perfection of an individual life will have some, but limited, value—for each individual remains, after all, just one person among others. From the perfectionist point of view, the moral worth of an individual's relation to his world will likewise have some, but limited, value—for, as I have argued, the (perfectionist) goodness of an individual's life does not vary proportionally with the degree to which it exemplifies moral goodness.

It may not be the case that the perfectionist point of view is like the moral point of view in being a point of view we are ever *obliged* to take up and express in our actions. Nonetheless, it provides us with reasons that are independent of moral reasons for wanting ourselves and others to develop our characters and live our lives in certain ways. When we take up this point of view and ask how much it would be good for an individual to act from the moral point of view, we do not find an obvious answer.[5]

The considerations of this paper suggest, at any rate, that the answer is not "as much as possible." This has implications both for the continued development of moral theories and for the development of metamoral views and for our conception of moral philosophy more generally. From the moral point of view, we have reasons to want people to live lives that seem good from outside that point of view. If, as I have argued, this means that we have reason to want people to live lives that are not morally perfect then any plausible moral theory must make use of some conception of supererogation.[6]

If moral philosophers are to address themselves at the most basic level to the question of how people should live, however, they must do more than adjust the content of their moral theories in ways that leave room for the affirmation of nonmoral values. They must examine explicitly the range and nature of these nonmoral values and, in light of this examination, they must ask how the acceptance of a moral theory is to be understood and acted upon. For the claims of this paper do not so much conflict with the content of any particular currently popular moral theory

as they call into question a metamoral assumption that implicitly surrounds discussions of moral theory more generally. Specifically, they call into question the assumption that it is always better to be morally better.

The role morality plays in the development of our characters and the shape of our practical deliberations need be neither that of a universal medium into which all other values must be translated nor that of an ever-present filter through which all other values must pass. This is not to say that moral value should not be an important, even the most important, kind of value we attend to in evaluating and improving ourselves and our world. It is to say that our values cannot be fully comprehended on the model of a hierarchical system with morality at the top.

The philosophical temperament will naturally incline, at this point, toward asking, "What, then, *is* at the top—or, if there is no top, how *are* we to decide when and how much to be moral?" In other words, there is a temptation to seek a metamoral—though not, in the standard sense, metaethical—theory that will give us principles, or, at least, informal directives on the basis of which we can develop and evaluate more comprehensive personal ideals. Perhaps a theory that distinguishes among the various roles a person is expected to play within a life—as professional, as citizen, as friend, and so on—might give us some rules that would offer us, if nothing else, a better framework in which to think about and discuss these questions. I am pessimistic, however, about the chances of such a theory to yield substantial and satisfying results. For I do not see how a metamoral theory could be constructed which would not be subject to considerations parallel to those which seem inherently to limit the appropriateness of regarding moral theories as ultimate comprehensive guides for action.

This suggests that, at some point, both in our philosophizing and in our lives, we must be willing to raise normative questions from a perspective that is unattached to a commitment to any particular well-ordered system of values. It must be admitted that, in doing so, we run the risk of finding normative answers that diverge from the answers given by

whatever moral theory one accepts. This, I take it, is the grain of truth in G. E. Moore's "open question" argument. In the background of this paper, then, there lurks a commitment to what seems to me to be a healthy form of intuitionism. It is a form of intuitionism which is not intended to take the place of more rigorous, systematically developed, moral theories—rather, it is intended to put these more rigorous and systematic moral theories in their place.

Notes

1. "Persons, Character and Morality" in Amelie Rorty, ed., *The Identities of Persons* (Berkeley: Univ. of California Press, 1976), p. 214.

2. Immanuel Kant, *The Doctrine of Virtue*, Mary J. Gregor, trans. (New York: Harper & Row, 1964), p. 71.

3. See, e.g., Williams, *op. cit.* and J. J. C. Smart and Bernard Williams, *Utilitarianism: For and Against* (New York: Cambridge, 1973). Also, Michael Stocker, "The Schizophrenia of Modern Ethical Theories," *Journal of Philosophy*, LXXIII, 14 (Aug. 12, 1976): 453–466.

4. George Orwell makes a similar point in "Reflections on Gandhi," in *A Collection of Essays by George Orwell* (New York: Harcourt Brace Jovanovich, 1945, p. 176: "sainthood is . . . a thing that human beings must avoid . . . It is too readily assumed that . . . the ordinary man only rejects it because it is too difficult, in other words, that the average human being is a failed saint. It is doubtful whether this is true. Many people genuinely do not wish to be saints, and it is probable that some who achieve or aspire to sainthood have never felt much temptation to be human beings."

5. A similar view, which has strongly influenced mine, is expressed by Thomas Nagel in "The Fragmentation of Value," in *Mortal Questions* (New York: Cambridge, 1979), pp. 128–141. Nagel focuses on the difficulties such apparently incommensurable points of view create for specific, isolable practical decisions that must be made both by individuals and by societies. In focusing on the way in which these points of view figure into the development of individual personal ideals, the questions with which I am concerned are more likely to lurk in the background of any individual's life.

6. The variety of forms that a conception of supererogation might take, however, has not generally been noticed. Moral theories that make use of this notion typically do so by identifying some specific set of principles as universal moral requirements and supplement this list with a further set of directives which it is morally praiseworthy but not required for an agent to follow. [See, e.g., Charles Fried, *Right and Wrong* (Cambridge, Mass.: Harvard, 1979).] But it is possible that the ability to live a morally blameless life cannot be so easily or definitely secured as this type of theory would suggest. The fact that there are some situations in which an agent is morally required to do something and other situations in which it would be good but not required for an agent to do something does not imply that there are specific principles such that, in any situation, an agent is required to act in accordance with these principles and other specific principles such that, in any situation, it would be good but not required for an agent to act in accordance with those principles.

Study Questions

1. How does Wolf distinguish the "Loving Saint" and the "Rational Saint"?

2. Does the desire to be as morally good as possible conflict with the desire to be an outstanding scholar, musician, or athlete?

3. Would you admire a moral saint?

4. Would you want to be a moral saint?

35

G. E. M. ANSCOMBE

G. E. M. Anscombe (1919–2001) held a Chair of Philosophy at the University of Cambridge. The article reprinted here has been highly influential. It argues that given widespread lack of belief in a divine lawgiver we should abandon the concept of moral obligation and replace it by an ethics of virtue, thus shifting attention from correctness of actions to qualities of character. Whether Anscombe preferred a return to a theologically grounded ethics, were it feasible, remains a matter open to interpretation.

Modern Moral Philosophy

I will begin by stating three theses which I present in this paper. The first is that it is not profitable for us at present to do moral philosophy; that should be laid aside at any rate until we have an adequate philosophy of psychology, in which we are conspicuously lacking. The second is that the concepts of obligation, and duty—*moral* obligation and *moral* duty, that is to say—and of what is *morally* right and wrong, and of the *moral* sense of "ought," ought to be jettisoned if this is psychologically possible; because they are survivals, or derivatives from survivals, from an earlier conception of ethics which no longer generally survives, and are only harmful without it. My third thesis is that the differences between the well-known English writers on moral philosophy from Sidgwick to the present day are of little importance.

Anyone who has read Aristotle's *Ethics* and has also read modern moral philosophy must have been struck by the great contrasts between them. The concepts which are prominent among the moderns seem to be lacking, or at any rate buried or far in the background, in Aristotle. Most noticeably, the term "moral" itself, which we have by direct inheritance from Aristotle, just doesn't seem to fit, in its modern sense, into an account of Aristotelian ethics. Aristotle distinguishes virtues as moral and intellectual. Have some of what he calls "intellectual" virtues what *we* should call a "moral" aspect? It would seem so; the criterion is presumably that a failure in an "intellectual" virtue—like that of having good judgment in calculating how to bring about something useful, say in municipal government—may be *blameworthy*. But—it may reasonably be asked—cannot *any* failure be made a matter of blame or reproach? Any derogatory criticism, say of the workmanship of a product or the design of a machine, can be called blame or reproach. So we want to put in the word "morally" again: sometimes such a failure may be

Elizabeth Anscombe, "Modern Moral Philosophy," *Philosophy* 33, No. 124 (January 1958). Copyright © 1958 The Royal Institute of Philosophy. Reprinted with the permission of Cambridge University Press.

morally blameworthy, sometimes not. Now has Aristotle got this idea of *moral* blame, as opposed to any other? If he has, why isn't it more central? There are some mistakes, he says, which are causes, not of involuntariness in actions but of scoundrelism, and for which a man is blamed. Does this mean that there is a *moral* obligation not to make certain intellectual mistakes? Why doesn't he discuss obligation in general, and this obligation in particular? If someone professes to be expounding Aristotle and talks in a modern fashion about "moral" such-and-such he must be very imperceptive if he does not constantly feel like someone whose jaws have somehow got out of alignment: the teeth don't come together in a proper bite.

We cannot, then, look to Aristotle for any elucidation of the modern way of talking about "moral" goodness, obligation, etc. And all the best-known writers on ethics in modern times, from Butler to Mill, appear to me to have faults as thinkers on the subject which make it impossible to hope for any direct light on it from them. I will state these objections with the brevity which their character makes possible.

Butler exalts conscience, but appears ignorant that a man's conscience may tell him to do the vilest things.

Hume defines "truth" in such a way as to exclude ethical judgments from it, and professes that he has proved that they are so excluded. He also implicitly defines "passion" in such a way that aiming at anything is having a passion. His objection to passing from "is" to "ought" would apply equally to passing from "is" to "owes" or from "is" to "needs." (However, because of the historical situation, he has a point here, which I shall return to.)

Kant introduces the idea of "legislating for oneself," which is as absurd as if in these days, when majority votes command great respect, one were to call each reflective decision a man made a *vote* resulting in a majority, which as a matter of proportion is overwhelming, for it is always 1-0. The concept of legislation requires superior power in the legislator. His own rigoristic convictions on the subject of lying were so intense that it never occurred to

him that a lie could be relevantly described as anything but just a lie (e.g. as "a lie in such-and-such circumstances"). His rule about universalizable maxims is useless without stipulations as to what shall count as a relevant description of an action with a view to constructing a maxim about it.

Bentham and Mill do not notice the difficulty of the concept "pleasure." They are often said to have gone wrong through committing the "naturalistic fallacy"; but this charge does not impress me, because I do not find accounts of it coherent. But the other point—about pleasure—seems to me a fatal objection from the very outset. The ancients found this concept pretty baffling. It reduced Aristotle to sheer babble about "the bloom on the cheek of youth" because, for good reasons, he wanted to make it out both identical with and different from the pleasurable activity. Generations of modern philosophers found this concept quite unperplexing, and it reappeared in the literature as a problematic one only a year or two ago when Ryle wrote about it. The reason is simple: since Locke, pleasure was taken to be some sort of internal impression. But it was superficial, if that was the right account of it, to make it the point of actions. One might adapt something Wittgenstein said about "meaning" and say "Pleasure cannot be an internal impression, for no internal impression could have the consequences of pleasure."

Mill also, like Kant, fails to realize the necessity for stipulation as to relevant descriptions, if his theory is to have content. It did not occur to him that acts of murder and theft could be otherwise described. He holds that where a proposed action is of such a kind as to fall under some one principle established on grounds of utility, one must go by that; where it falls under none or several, the several suggesting contrary views of the action, the thing to do is to calculate particular consequences. But pretty well any action can be so described as to make it fall under a variety of principles of utility (as I shall say for short) if it falls under any.

I will now return to Hume. The features of Hume's philosophy which I have mentioned, like many other features of it, would incline me to think that Hume was a mere—brilliant—sophist; and his procedures

are certainly sophistical. But I am forced, not to reverse, but to add to, this judgment by a peculiarity of Hume's philosophizing: namely that although he reaches his conclusions—with which he is in love—by sophistical methods, his considerations constantly open up very deep and important problems. It is often the case that in the act of exhibiting the sophistry one finds oneself noticing matters which deserve a lot of exploring: the obvious stands in need of investigation as a result of the points that Hume pretends to have made. In this, he is unlike, say, Butler. It was already well known that conscience could dictate vile actions; for Butler to have written disregarding this does not open up any new topics for us. But with Hume it is otherwise: hence he is a very profound and great philosopher, in spite of his sophistry. For example:

Suppose that I say to my grocer "Truth consists in *either* relations of ideas, as that 20s. = £1, *or* matters of fact, as that I ordered potatoes, you supplied them, and you sent me a bill. So it doesn't apply to such a proposition as that I *owe* you such-and-such a sum."

Now if one makes this comparison, it comes to light that the relation of the facts mentioned to the description "X owes Y so much money" is an interesting one, which I will call that of being "brute relative to" that description. Further, the "brute" facts mentioned here themselves have descriptions relatively to which *other* facts are "brute"—as, e.g., *he had potatoes carted to my house* and *they were left there* are brute facts relative to "he supplied me with potatoes." And the fact *X owes Y money* is in turn "brute" relative to other descriptions—e.g. "X is solvent." Now the relation of "relative bruteness" is a complicated one. To mention a few points: if xyz is a set of facts brute relative to a description A, then xyz is a set out of a range some set among which holds if A holds; but the holding of some set among these does not necessarily entail A because exceptional circumstances can always make a difference; and what are exceptional circumstances relatively to A can generally only be explained by giving a few diverse examples, and *no* theoretically adequate provision can be made for exceptional circumstances, since a further special context can theoretically always be imagined that would reinterpret any special context. Further, though in normal circumstances, xyz would be a justification for A, that is not to say that A just comes to the same as "xyz"; and also there is apt to be an institutional context which gives its point to the description A, of which institution A is of course not itself a description. (E.g. the statement that I give someone a shilling is not a description of the institution of money or of the currency of this country.) Thus, though it would be ludicrous to pretend that there can be no such thing as a transition from, e.g., "is" to "owes," the character of the transition is in fact rather interesting and comes to light as a result of reflecting on Hume's arguments.[1]

That I owe the grocer such-and-such a sum would be one of a set of facts which would be "brute" in relation to the description "I am a bilker." "Bilking" is of course a species of "dishonesty" or "injustice." (Naturally the consideration will not have any effect on my actions unless I want to commit or avoid acts of injustice.)

So far, in spite of their strong associations, I conceive "bilking," "injustice" and "dishonesty" in a merely "factual" way. That I can do this for "bilking" is obvious enough; "justice" I have no idea how to define, except that its sphere is that of actions which relate to someone else, but "injustice," its defect, can for the moment be offered as a generic name covering various species. E.g.: "bilking," "theft" (which is relative to whatever property institutions exist), "slander," "adultery," "punishment of the innocent."

In present-day philosophy an explanation is required how an unjust man is a bad man, or an unjust action a bad one; to give such an explanation belongs to ethics; but it cannot even be begun until we are equipped with a sound philosophy of psychology. For the proof that an unjust man is a bad man would require a positive account of justice as a "virtue." This part of the subject-matter of ethics is, however, completely closed to us until we have an account of what *type of characteristic* a virtue is—a problem, not of ethics, but of conceptual analysis—and how it relates to the actions in which it is instanced: a matter which I think Aristotle did not succeed in really making clear. For this we certainly need an account

at least of what a human action is at all, and how its description as "doing such-and-such" is affected by its motive and by the intention or intentions in it; and for this an account of such concepts is required.

The terms "should" or "ought" or "needs" relate to good and bad: e.g. machinery needs oil, or should or ought to be oiled, in that running without oil is bad for it, or it runs badly without oil. According to this conception, of course, "should" and "ought" are not used in a special "moral" sense when one says that a man should not bilk. (In Aristotle's sense of the term "moral" [ἠθικός], they are being used in connection with a *moral* subject-matter: namely that of human passions and [non-technical] actions.) But they have now acquired a special so-called "moral" sense—i.e. a sense in which they imply some absolute verdict (like one of guilty/not guilty on a man) on what is described in the "ought" sentences used in certain types of context: not merely the contexts that *Aristotle* would call "moral"—passions and actions—but also some of the contexts that he would call "intellectual."

The ordinary (and quite indispensable) terms "should," "needs," "ought," "must"—acquired this special sense by being equated in the relevant contexts with "is obliged," or "is bound," or "is required to," in the sense in which one can be obliged or bound by law, or something can be required by law.

How did this come about? The answer is in history: between Aristotle and us came Christianity, with its *law* conception of ethics. For Christianity derived its ethical notions from the Torah. (One might be inclined to think that a law conception of ethics could arise only among people who accepted an allegedly divine positive law; that this is not so is shown by the example of the Stoics, who also thought that whatever was involved in conformity to human virtues was required by divine law.)

In consequence of the dominance of Christianity for many centuries, the concepts of being bound, permitted, or excused became deeply embedded in our language and thought. The Greek word "ἁμαρτάνειν," the aptest to be turned to that use, acquired the sense "sin," from having meant "mistake," "missing the mark," "going wrong." The Latin *peccatum* which

roughly corresponded to ἁμάρτημα was even apter for the sense "sin," because it was already associated with "culpa"—"guilt"—a juridical notion. The blanket term "illicit," "unlawful," meaning much the same as our blanket term "wrong," explains itself. It is interesting that Aristotle did not have such a blanket term. He has blanket terms for wickedness—"villain," "scoundrel"; but of course a man is not a villain or a scoundrel by the performance of one bad action, or a few bad actions. And he has terms like "disgraceful," "impious"; and specific terms signifying defect of the relevant virtue, like "unjust"; but no term corresponding to "illicit." The extension of this term (i.e. the range of its application) could be indicated in his terminology only by a quite lengthy sentence: that is "illicit" which, whether it is a thought or a consented-to passion or an action or an omission in thought or action, is something contrary to one of the virtues the lack of which shows a man to be bad *qua* man. That formulation would yield a concept coextensive with the concept "illicit."

To have a *law* conception of ethics is to hold that what is needed for conformity with the virtues failure in which is the mark of being bad *qua* man (and not merely, say, *qua* craftsman or logician)—that what is needed for *this*, is required by divine law. Naturally it is not possible to have such a conception unless you believe in God as a law-giver; like Jews, Stoics, and Christians. But if such a conception is dominant for many centuries, and then is given up, it is a natural result that the concepts of "obligation," of being bound or required as by a law, should remain though they had lost their root; and if the word "ought" has become invested in certain contexts with the sense of "obligation," it too will remain to be spoken with a special emphasis and a special feeling in these contexts.

It is as if the notion "criminal" were to remain when criminal law and criminal courts had been abolished and forgotten. A Hume discovering this situation might conclude that there was a special sentiment, expressed by "criminal," which alone gave the word its sense. So Hume discovered the situation in which the notion "obligation" survived, and the notion "ought" was invested with that peculiar force having which it is said to be used in a "moral" sense,

but in which the belief in divine law had long since been abandoned: for it was substantially given up among Protestants at the time of the Reformation.[2] The situation, if I am right, was the interesting one of the survival of a concept outside the framework of thought that made it a really intelligible one.

When Hume produced his famous remarks about the transition from "is" to "ought," he was, then, bringing together several quite different points. One I have tried to bring out by my remarks on the transition from "is" to "owes" and on the relative "bruteness" of facts. It would be possible to bring out a different point by enquiring about the transition from "is" to "needs"; from the characteristics of an organism to the environment that it needs, for example. To say that it needs that environment is not to say, e.g., that you want it to have that environment, but that it won't flourish unless it has it. Certainly, it all depends whether you *want* it to flourish! as Hume would say. But what "all depends" on whether you want it to flourish is whether the fact that it needs that environment, or won't flourish without it, has the slightest influence on your actions, Now *that* such-and-such "ought" to be or "is needed" is supposed to have an influence on your actions: from which it seemed natural to infer that to judge that it "ought to be" was in fact to grant what you judged "ought to be" influence on your actions. And no amount of truth as to what *is* the case could possibly have a logical claim to have influence on your actions. (It is not judgment as such that sets us in motion; but our judgment on how to get or do something we *want*.) Hence it *must* be impossible to infer "needs" or "ought to be" from "is." But in the case of a plant, let us say, the inference from "is" to "needs" is certainly not in the least dubious. It is interesting and worth examining; but not at all fishy. Its interest is similar to the interest of the relation between brute and less brute facts: these relations have been very little considered. And while you can contrast "what it needs" with "what it's got"—like contrasting *de facto* and *de iure*—that does not make its needing this environment less of a "truth."

Certainly in the case of what the plant needs, the thought of a need will only affect action if you want the plant to flourish. Here, then, there is no necessary connection between what you can judge the plant "needs" and what you want. But there is some sort of necessary connection between what you think *you* need, and what you want. The connection is a complicated one; it is possible *not* to want something that you judge you need. But, e.g., it is not possible never to want *anything* that you judge you need. This, however, is not a fact about the meaning of the word "to need," but about the phenomenon of *wanting*. Hume's reasoning, we might say, in effect, leads one to think it must be about the word "to need," or "to be good for."

Thus we find two problems already wrapped up in the remark about a transition from "is" to "ought"; now supposing that we had clarified the "relative bruteness" of facts on the one hand, and the notions involved in "needing," and "flourishing" on the other—there would *still* remain a third point. For, following Hume, someone might say: Perhaps you have made out your point about a transition from "is" to "owes" and from "is" to "needs": but only at the cost of showing "owes" and "needs" sentences to express a *kind* of truths, a *kind* of facts. And it remains impossible to infer "*morally ought*" from "is" sentences.

This comment, it seems to me, would be correct. This word "ought," having become a word of mere mesmeric force, could not, in the character of having that force, be inferred from anything whatever. It may be objected that it could be inferred from other "morally ought" sentences: but that cannot be true. The appearance that this is so is produced by the fact that we say "All men are φ" and "Socrates is a man" implies "Socrates is φ." But here "φ" is a dummy predicate. We mean that if you substitute a real predicate for "φ" the implication is valid. A real predicate is required; not just a word containing no intelligible thought: a word retaining the suggestion of force, and apt to have a strong psychological effect, but which no longer signifies a real concept at all.

For its suggestion is one of a *verdict* on my action, according as it agrees or disagrees with the description in the "ought" sentence. And where one does not think there is a judge or a law, the notion of a

verdict may retain its psychological effect, but not its meaning. Now imagine that just this word "verdict" *were* so used—with a characteristically solemn emphasis—as to retain its atmosphere but not its meaning, and someone were to say: "For a *verdict*, after all, you need a law and a judge." The reply might be made: "Not at all, for if there were a law and a judge who gave a verdict, the question for us would be whether accepting that verdict is something that there is a *Verdict* on." This is an analogue of an argument which is so frequently referred to as decisive: If someone does have a divine law conception of ethics, all the same, he has to agree that he has to have a judgment that he *ought* (morally ought) to obey the divine law; so his ethic is in exactly the same position as any other: he merely has a "practical major premise"[3]: "Divine law ought to be obeyed" where someone else has, e.g., "The greatest happiness principle ought to be employed in all decisions."

I should judge that Hume and our present-day ethicists had done a considerable service by showing that no content could be found in the notion "morally ought"; if it were not that the latter philosophers try to find an alternative (very fishy) content and to retain the psychological force of the term. It would be most reasonable to drop it. It has no reasonable sense outside a law conception of ethics; they are not going to maintain such a conception; and you can do ethics without it, as is shown by the example of Aristotle. It would be a great improvement if, instead of "morally wrong," one always named a genus such as "untruthful," "unchaste," "unjust." We should no longer ask whether doing something was "wrong," passing directly from some description of an action to this notion; we should ask whether, e.g., it was unjust; and the answer would sometimes be clear at once.

I now come to the epoch in modern English moral philosophy marked by Sidgwick. There is a startling change that seems to have taken place between Mill and Moore. Mill assumes, as we saw, that there is no question of calculating the particular consequences of an action such as murder or theft; and we saw too that his position was stupid, because it is not at all clear how an action *can* fall under just one principle of utility. In Moore and in subsequent academic moralists of England we find it taken to be pretty obvious that "the right action" is the action which produces the best possible consequences (reckoning among consequences the intrinsic values ascribed to certain kinds of act by some "Objectivists"[4]). Now it follows from this that a man does well, subjectively speaking, if he acts for the best in the particular circumstances according to his judgment of the total consequences of this particular action. I say that this follows, not that any philosopher has said precisely that. For discussion of these questions can of course get extremely complicated: e.g. it can be doubted whether "such-and-such is the right action" is a satisfactory formulation, on the grounds that things have to exist to have predicates—so perhaps the best formulation is "I am obliged"; or again, a philosopher may deny that "right" is a "descriptive" term, and then take a roundabout route through linguistic analysis to reach a view which comes to the same thing as "the right action is the one productive of the best consequences" (e.g. the view that you frame your "principles" to effect the end you choose to pursue, the connection between "choice" and "best" being supposedly such that choosing reflectively means that you choose how to act so as to produce the best consequences); further, the roles of what are called "moral principles" and of the "motive of duty" have to be described; the differences between "good" and "morally good" and "right" need to be explored, the special characteristics of "ought" sentences investigated. Such discussions generate an appearance of significant diversity of views where what is really significant is an overall similarity. The overall similarity is made clear if you consider that every one of the best known English academic moral philosophers has put out a philosophy according to which, e.g., it is not possible to hold that it cannot be right to kill the innocent as a means to any end whatsoever and that someone who thinks otherwise is in error. (I have to mention both points; because Mr. Hare, for example, while teaching a philosophy which would encourage a person to judge that killing the innocent would be what he "ought" to choose for over-riding purposes would also teach, I think, that if a man chooses to make avoiding killing the

innocent for any purpose his "supreme practical principle," he cannot be impugned for error: that just is his "principle." But with that qualification, I think it can be seen that the point I have mentioned holds good of every single English academic moral philosopher since Sidgwick.) Now this is a significant thing: for it means that all these philosophies are quite incompatible with the Hebrew-Christian ethic. For it has been characteristic of that ethic to teach that there are certain things forbidden whatever *consequences* threaten, such as choosing to kill the innocent for any purpose, however good; vicarious punishment; treachery (by which I mean obtaining a man's confidence in a grave matter by promises of trustworthy friendship and then betraying him to his enemies); idolatry; sodomy; adultery; making a false profession of faith. The prohibition of certain things simply in virtue of their description as such-and-such identifiable kinds of action, regardless of any further consequences, is certainly not the whole of the Hebrew-Christian ethic; but it is a noteworthy feature of it; and if every academic philosopher since Sidgwick has written in such a way as to exclude this ethic, it would argue a certain provinciality of mind not to see this incompatibility as the most important fact about these philosophers, and the differences between them as somewhat trifling by comparison.

It is noticeable that none of these philosophers displays any consciousness that there is such an ethic, which he is contradicting: it is pretty well taken for obvious among them all that a prohibition such as that on murder does not operate in face of some consequences. But of course the strictness of the prohibition has as its point *that you are not to be tempted by fear or hope of consequences.*

If you notice the transition from Mill to Moore, you will suspect that it was made somewhere by someone; Sidgwick will come to mind as a likely name; and you will in fact find it going on, almost casually, in him. He is rather a dull author; and the important things in him occur in asides and footnotes and small bits of argument which are not concerned with his grand classification of the "methods of ethics." A divine law theory of ethics is reduced to an insignificant variety by a footnote telling us that

"the best theologians" (God knows whom he meant) tell us that God is to be obeyed in his capacity of a *moral* being. ἢ φορτικος ὁ ἔπαινος one seems to hear Aristotle saying: "Isn't the praise vulgar?"[5]— But Sidgwick *is* vulgar in that kind of way: he thinks, for example, that humility consists in underestimating your own merits—i.e. in a species of untruthfulness; and that the ground for having laws against blasphemy was that it was offensive to believers; and that to go accurately into the virtue of purity is to offend against its canons, a thing he reproves "medieval theologians" for not realizing.

From the point of view of the present enquiry, the most important thing about Sidgwick was his definition of intention. He defines intention in such a way that one must be said to intend any foreseen consequences of one's voluntary action. This definition is obviously incorrect, and I dare say that no one would be found to defend it now. He uses it to put forward an ethical thesis which would now be accepted by many people: the thesis that it does not make any difference to a man's responsibility for something that he foresaw, that he felt no desire for it, either as an end or as a means to an end. Using the language of intention more correctly, and avoiding Sidgwick's faulty conception, we may state the thesis thus: it does not make any difference to a man's responsibility for an effect of his action which he can foresee, that he does not intend it. Now this sounds rather edifying; it is I think quite characteristic of very bad degenerations of thought on such questions that they sound edifying. We can see what it amounts to by considering an example. Let us suppose that a man has a responsibility for the maintenance of some child. Therefore deliberately to withdraw support from it is a bad sort of thing for him to do. It would be bad for him to withdraw its maintenance because he didn't want to maintain it any longer; *and* also bad for him to withdraw it because by doing so he would, let us say, compel someone else to do something. (We may suppose for the sake of argument that compelling that person to do that thing is in itself quite admirable.) But now he has to choose between doing something disgraceful and going to prison; if he goes to prison, it will follow that he withdraws

support from the child. By Sidgwick's doctrine, there is no difference in his responsibility for ceasing to maintain the child, between the case where he does it for its own sake or as a means to some other purpose, and when it happens as a foreseen and unavoidable consequence of his going to prison rather than do something disgraceful. It follows that he must weigh up the relative badness of withdrawing support from the child and of doing the disgraceful thing; and it may easily be that the disgraceful thing is in fact a less vicious action than intentionally withdrawing support from the child would be; if then the fact that withdrawing support from the child is a side effect of his going to prison does not make any difference to his responsibility, this consideration will incline him to do the disgraceful thing; which can still be pretty bad. And of course, once he has started to look at the matter in this light, the only reasonable thing for him to consider will be the consequences and not the intrinsic badness of this or that action. So that, given that he judges reasonably that no *great* harm will come of it, he can do a much more disgraceful thing than deliberately withdrawing support from the child. And if his calculations turn out in fact wrong, it will appear that he was not responsible for the consequences, because he did not foresee them. For in fact Sidgwick's thesis leads to its being quite impossible to estimate the badness of an action except in the light of *expected* consequences. But if so, then *you* must estimate the badness in the light of the consequences *you* expect; and so it will follow that you can exculpate yourself from the *actual* consequences of the most disgraceful actions, so long as you can make out a case for not having foreseen them. Whereas I should contend that a man is responsible for the bad consequences of his bad actions, but gets no credit for the good ones; and contrariwise is not responsible for the bad consequences of good actions.

The denial of *any* distinction between foreseen and intended consequences, as far as responsibility is concerned, was not made by Sidgwick in developing any one "method of ethics"; he made this important move on behalf of everybody and just on its own account; and I think it plausible to suggest that *this* move on the part of Sidgwick explains the difference between old-fashioned Utilitarianism and that *consequentialism*, as I name it, which marks him and every English academic moral philosopher since him. By it, the kind of consideration which would formerly have been regarded as a temptation, the kind of consideration urged upon men by wives and flattering friends, was given a status by moral philosophers in their theories.

It is a necessary feature of consequentialism that it is a shallow philosophy. For there are always borderline cases in ethics. Now if you are either an Aristotelian, or a believer in divine law, you will deal with a borderline case by considering whether doing such-and-such in such-and-such circumstances is, say, murder, or is an act of injustice; and according as you decide it is or it isn't, you judge it to be a thing to do or not. This would be the method of casuistry; and while it may lead you to stretch a point on the circumference, it will not permit you to destroy the center. But if you are a consequentialist, the question "What is it right to do in such-and-such circumstances?" is a stupid one to raise. The casuist raises such a question only to ask "Would it be *permissible* to do so-and-so?" or "Would it be permissible *not* to do so-and-so?" Only if it would *not* be permissible *not* to do so-and-so could he say "*This* would be *the* thing to do."[6] Otherwise, though he may speak *against* some action, he cannot prescribe any—for in an *actual* case, the circumstances (beyond the ones imagined) might suggest all sorts of possibilities, and you can't know in advance what the possibilities are going to be. Now the consequentialist has no footing on which to say "This would be permissible, this not"; because by his own hypothesis, it is the consequences that are to decide, and he has no business to pretend that he can lay it down what possible twists a man could give doing this or that; the most he can say is: a man must not *bring about* this or that; he has no right to say he will, in an actual case, bring about such-and-such unless he does so-and-so. Further, the consequentialist, in order to be imagining borderline cases at all, has of course to assume some sort of law or standard according to which this is a borderline case. Where then does he get the standard from? In practice the answer invariably is: from the standards

current in his society or his circle. And it has in fact been the mark of all these philosophers that they have been extremely conventional; they have nothing in them by which to revolt against the conventional standards of their sort of people; it is impossible that they should be profound. But the chance that a whole range of conventional standards will be decent is small.—Finally, the point of considering hypothetical situations, perhaps very improbable ones, *seems* to be to elicit from yourself or someone else a hypothetical decision to do something of a bad kind. I don't doubt this has the effect of predisposing people—who will never get into the situations for which they have made hypothetical choices—to consent to similar bad actions, or to praise and flatter those who do them, so long as their crowd does so too, when the desperate circumstances imagined don't hold at all.

Those who recognize the origins of the notions of "obligation" and of the emphatic, "moral," *ought*, in the divine law conception of ethics, but who reject the notion of a divine legislator, sometimes look about for the possibility of retaining a law conception without a divine legislator. This search, I think, has some interest in it. Perhaps the first thing that suggests itself is the "norms" of a society. But just as one cannot be impressed by Butler when one reflects what conscience can tell people to do, so, I think, one cannot be impressed by this idea if one reflects what the "norms" of a society can be like. That legislation can be "for oneself" I reject as absurd; whatever you do "for yourself" may be admirable; but is not legislating. Once one sees this, one may say: I have to frame my own rules, and these are the best I can frame, and I shall go by them until I know something better: as a man might say "I shall go by the customs of my ancestors." Whether this leads to good or evil will depend on the *content* of the rules or of the customs of one's ancestors. If one is lucky it will lead to good. Such an attitude would be hopeful in this at any rate: it seems to have in it some Socratic doubt where, from having to fall back on such expedients, it should be clear that Socratic doubt is good; in fact rather generally it must be good for anyone to think "Perhaps in some way I can't see, I may be on a bad path, perhaps I am hopelessly wrong in some

essential way".—The search for "norms" might lead someone to look for laws of nature, as if the universe were a legislator; but in the present day this is not likely to lead to good results; it might lead one to eat the weaker according to the laws of nature, but would hardly lead anyone nowadays to notions of justice; the pre-Socratic feeling about justice as comparable to the balance or harmony which kept things going is very remote to us.

There is another possibility here: "obligation" may be contractual. Just as we look at the law to find out what a man subject to it is required by it to do, so we look at a contract to find out what the man who has made it is required by it to do. Thinkers, admittedly remote from us, might have the idea of a *foedus rerum*, of the universe not as a legislator but as the embodiment of a contract. Then if you could find out what the contract was, you would learn your obligations under it. Now, you cannot be under a law unless it has been promulgated to you; and the thinkers who believed in "natural divine law" held that it was promulgated to every grown man in his knowledge of good and evil. Similarly you cannot be in a contract without having contracted, i.e. given signs of entering upon the contract. Just possibly, it might be argued that the use of language which one makes in the ordinary conduct of life amounts in some sense to giving the signs of entering into various contracts. If anyone had this theory, we should want to see it worked out. I suspect that it would be largely formal; it might be possible to construct a system embodying the law (whose status might be compared to that of "laws" of logic): "what's sauce for the goose is sauce for the gander," but hardly one descending to such particularities as the prohibition on murder or sodomy. Also, while it is clear that you can be subject to a law that you do not acknowledge and have not thought of as law, it does not seem reasonable to say that you can enter upon a contract without knowing that you are doing so; such ignorance is usually held to be destructive of the nature of a contract.

It might remain to look for "norms" in human virtues: just as *man* has so many teeth, which is certainly not the average number of teeth men have, but is the number of teeth for the species, so perhaps

the species *man*, regarded not just biologically, but from the point of view of the activity of thought and choice in regard to the various departments of life—powers and faculties and use of things needed—"has" such-and-such virtues: and this "man" with the complete set of virtues is the "norm," as "man" with, e.g., a complete set of teeth is a norm. But in *this* sense "norm" has ceased to be roughly equivalent to "law." In *this* sense the notion of a "norm" brings us nearer to an Aristotelian than a law conception of ethics. There is, I think, no harm in that; but if someone looked in this direction to give "norm" a sense, then he ought to recognize what has happened to the notion "norm," which he wanted to mean "law—without bringing God in"—it has ceased to mean "law" at all; and *so* the notions of "moral obligation," "the moral ought," and "duty" are best put on the Index, if he can manage it.

But meanwhile—is it not clear that there are several concepts that need investigating simply as part of the philosophy of psychology and,—as I should recommend—*banishing ethics totally* from our minds? Namely—to begin with: "action," "intention," "pleasure," "wanting." More will probably turn up if we start with these. Eventually it might be possible to advance to considering the concept "virtue"; with which, I suppose, we should be beginning some sort of a study of ethics.

I will end by describing the advantages of using the word "ought" in a non-emphatic fashion, and not in a special "moral" sense; of discarding the term "wrong" in a "moral" sense, and using such notions as "unjust."

It is possible, if one is allowed to proceed just by giving examples, to distinguish between the intrinsically unjust, and what is unjust given the circumstances. To arrange to get a man judicially punished for something which it can be clearly seen he has not done is intrinsically unjust. This might be done, of course, and often has been done, in all sorts of ways; by suborning false witnesses, by a rule of law by which something is "deemed" to be the case which is admittedly not the case as a matter of fact, and by open insolence on the part of the judges and powerful people when they more or less openly say: "A fig for

the fact that you did not do it; we mean to sentence you for it all the same." What is unjust given, e.g., normal circumstances is to deprive people of their ostensible property without legal procedure, not to pay debts, not to keep contracts, and a host of other things of the kind. Now, the circumstances can clearly make a great deal of difference in estimating the justice or injustice of such procedures as these; and these circumstances may *sometimes* include expected consequences; for example, a man's claim to a bit of property can become a nullity when its seizure and use can avert some obvious disaster: as, e.g., if you could use a machine of his to produce an explosion in which it would be destroyed, but by means of which you could divert a flood or make a gap which a fire could not jump. Now this certainly does not mean that what would ordinarily be an act of injustice, but is not intrinsically unjust, can always be rendered just by a reasonable calculation of better consequences; far from it; but the problems that would be raised in an attempt to draw a boundary line (or boundary area) here are obviously complicated. And while there are certainly some general remarks which ought to be made here, and some boundaries that can be drawn, the decision on particular cases would for the most part be determined κατόν όρθον λόγον "according to what's reasonable."—E.g. that *such-and-such* a delay of payment of a *such-and-such* debt to a person *so* circumstanced, on the part of a person *so* circumstanced, would or would not be unjust, is really only to be decided "according to what's reasonable"; and for this there can *in principle* be no canon other than giving a few examples. That is to say, while it is because of a big gap in philosophy that we can give no general account of the concept of virtue and of the concept of justice, but have to proceed using the concepts, only by giving examples; still there is an area where it is not because of any gap, but is in principle the case, that there is no account except by way of examples: and that is where the canon is "what's reasonable": which of course is *not* a canon.

That is all I wish to say about what is just in some circumstances, unjust in others; and about the way in which expected consequences can play a part in determining what is just. Returning to my example

of the intrinsically unjust: if a procedure *is* one of judicially punishing a man for what he is clearly understood not to have done, there can be absolutely no argument about the description of this as unjust. No circumstances, and no expected consequences, which do *not* modify the description of the procedure as one of judicially punishing a man for what he is known not to have done can modify the description of it as unjust. Someone who attempted to dispute this would only be pretending not to know what "unjust" means: for this is a paradigm case of injustice.

And here we see the superiority of the term "unjust" over the terms "morally right" and "morally wrong." For in the context of English moral philosophy since Sidgwick it appears legitimate to discuss whether it *might* be "morally right" in some circumstances to adopt that procedure; but it cannot be argued that the procedure would in any circumstances be just.

Now I am not able to do the philosophy involved—and I think that no one in the present situation of English philosophy *can* do the philosophy involved—but it is clear that a good man is a just man; and a just man is a man who habitually refuses to commit or participate in any unjust actions for fear of any consequences, or to obtain any advantage, for himself or anyone else. Perhaps no one will disagree. But, it will be said, what *is* unjust is sometimes determined by expected consequences; and certainly that is true. But there are cases where it is not: now if someone says, "I agree, but all this wants a lot of explaining," then he is right, and, what is more, the situation at present is that we can't do the explaining; we lack the philosophic equipment. But if someone really thinks, *in advance*,[7] that it is open to question whether such an action as procuring the judicial execution of the innocent should be quite excluded from consideration—I do not want to argue with him; he shows a corrupt mind.

In such cases our moral philosophers seek to impose a dilemma upon us. "If we have a case where the term 'unjust' applies purely in virtue of a factual description, can't one raise the question whether one sometimes conceivably ought to do

injustice? If 'what is unjust' is determined by consideration of whether it is *right* to do so-and-so in such-and-such circumstances, then the question whether it is 'right' to commit injustice can't arise, just because 'wrong' has been built into the definition of injustice. But if we have a case where the description 'unjust' applies purely in virtue of the facts, without bringing 'wrong' in, then the question can arise whether one 'ought' perhaps to commit an injustice, whether it might not be 'right' to? And of course 'ought' and 'right' are being used in their *moral* senses here. Now either you must decide what is 'morally right' in the light of certain *other* 'principles,' or you make a 'principle' about *this* and decide that an injustice is never 'right'; but even if you do the latter you are going beyond the facts; you are making a decision that you will not, or that it is wrong to, commit injustice. But in either case, *if* the term 'unjust' is determined simply by the facts, it is not the term 'unjust' that determines that the term 'wrong' applies, but a decision that injustice is *wrong*, together with the diagnosis of the 'factual' description as entailing injustice. But the man who makes an absolute decision that injustice is 'wrong' has no footing on which to criticize someone who does *not* make that decision as judging falsely."

In this argument "wrong" of course is explained as meaning "morally wrong," and all the atmosphere of the term is retained while its substance is guaranteed quite null. Now let us remember that "morally wrong" is the term which is the heir of the notion "illicit," or "what there is an obligation *not* to do"; which belongs in a divine law theory of ethics. Here it really does add something to the description "unjust" to say there is an obligation not to do it; for what obliges is the divine law—as rules oblige in a game. So if the divine law obliges not to commit injustice by forbidding injustice, it really does add something to the description "unjust" to say there is an obligation not to do it. And it is because "morally wrong" is the heir of this concept, but an heir that is cut off from the family of concepts from which it sprang, that "morally wrong" *both* goes beyond the mere factual description "unjust" *and* seems to have

no discernible content except a certain compelling force, which I should call purely psychological. And such is the force of the term that philosophers actually suppose that the divine law notion can be dismissed as making no essential difference even if it is held—*because* they think that a "practical principle" running "I *ought* (i.e. am morally obliged) to obey divine laws" is required for the man who believes in divine laws. But actually this notion of obligation is a notion which only operates in the context of law. And I should be inclined to congratulate the present-day moral philosophers on depriving "morally ought" of its now delusive appearance of content, if only they did not manifest a detestable desire to retain the atmosphere of the term.

It may be possible, if we are resolute, to discard the notion "morally ought," and simply return to the ordinary "ought," which, we ought to notice, is such an extremely frequent term of human language that it is difficult to imagine getting on without it. Now if we do return to it, can't it reasonably be asked whether one might ever need to commit injustice, or whether it won't be the best thing to do? Of course it can. And the answers will be various. One man—a philosopher—may say that since justice is a virtue, and injustice a vice, and virtues and vices are built up by the performances of the action in which they are instanced, an act of injustice will tend to make a man bad; and essentially the flourishing of a man *qua* man consists in his being good (e.g. in virtues); but for any X to which such terms apply, X needs what makes it flourish, so a man needs, or ought to perform, only virtuous actions; and even if, as it must be admitted may happen, he flourishes less, or not at all, in inessentials, by avoiding injustice, his life is spoiled in essentials by not avoiding injustice— so he still needs to perform only just actions. That is roughly how Plato and Aristotle talk; but it can be seen that philosophically there is a huge gap, at present unfillable as far as we are concerned, which needs to be filled by an account of human nature, human action, the type of characteristic a virtue is, and above all of human "flourishing." And it is the last concept that appears the most doubtful. For it is

a bit much to swallow that a man in pain and hunger and poor and friendless is "flourishing," as Aristotle himself admitted. Further, someone might say that one at least needed to stay alive to "flourish." Another man unimpressed by all that will say in a hard case "What we need is such-and-such, which we won't get without doing this (which is unjust)— so this is what we ought to do." Another man, who does not follow the rather elaborate reasoning of the philosophers, simply says "I know it is in any case a disgraceful thing to say that one had better commit this unjust action." The man who believes in divine laws will say perhaps "It is forbidden, and however it looks, it cannot be to anyone's profit to commit injustice"; he like the Greek philosophers can think in terms of "flourishing." If he is a Stoic, he is apt to have a decidedly strained notion of what "flourishing consists" in; if he is a Jew or Christian, he need not have any very distinct notion: the way it will profit him to abstain from injustice is something that he leaves it to God to determine, himself only saying "It can't do me any good to go against his law." (But he also hopes for a great reward in a new life later on, e.g. at the coming of Messiah; but in this he is relying on special promises.)

It is left to modern moral philosophy—the moral philosophy of all the well-known English ethicists since Sidgwick—to construct systems according to which the man who says "We need such-and-such, and will only get it this way" *may* be a virtuous character: that is to say, it is left open to debate whether such a procedure as the judicial punishment of the innocent may not in some circumstances be the "right" one to adopt; and though the present Oxford moral philosophers would accord a man *permission* to "make it his principle" not to do such a thing, they teach a philosophy according to which the particular consequences of such an action *could* "morally" be taken into account by a man who was debating what to do; and if they were such as to conflict with his "ends," it might be a step in his moral education to frame a moral principle under which he "managed" (to use Mr. Nowell-Smith's phrase[8]) to bring the action; or it might be a new "decision of principle,"

making which was an advance in the formation of his moral thinking (to adopt Mr. Hare's conception), to decide: in such-and-such circumstances one ought to procure the judicial condemnation of the innocent. And that is my complaint.

Notes

1. The above two paragraphs are an abstract of a paper "On Brute Facts," *Analysis*, 18, 3 (1958).

2. They did not deny the existence of divine law; but their most characteristic doctrine was that it was given, not to be obeyed, but to show man's incapacity to obey it, even by grace; and this applied not merely to the ramified prescriptions of the Torah, but to the requirements of "natural divine law." Cf. in this connection the decree of Trent against the teaching that Christ was only to be trusted in as mediator, not obeyed as legislator.

3. As it is absurdly called. Since major premise = premise containing the term which is predicate in the conclusion, it is a solecism to speak of it in the connection with practical reasoning.

4. Oxford Objectivists of course distinguish between "consequences" and "intrinsic values" and so produce a misleading appearance of not being "consequentialists." But they do not hold—and Ross explicitly denies—that the gravity of, e.g., procuring the condemnation of the innocent is such that it cannot be outweighed by, e.g., national interest. Hence their distinction is of no importance.

5. E. N. 1178b16.

6. Necessarily a rare case: for the positive precepts, e.g. "Honor your parents," hardly ever prescribe, and seldom even necessitate, any particular action.

7. If he thinks it in the concrete situation, he is of course merely a normally tempted human being. In discussion when this paper was read, as was perhaps to be expected, this case was produced: a government is required to have an innocent man tried, sentenced and executed under threat of a "hydrogen bomb war." It would seem strange to me to have much hope of so averting a war threatened by such men as made this demand. But the most important thing about the way in which cases like this are invented in discussions, is the assumption that only two courses are open: here, compliance and open defiance. No one can say in advance of such a situation what the possibilities are going to be—e.g. that there is none of stalling by a feigned willingness to comply, accompanied by a skillfully arranged "escape" of the victim.

8. *Ethics*, p. 308.

Study Questions

1. Against whom was Anscombe arguing?

2. How would the existence of God affect the concept of moral obligation?

3. Are moral decisions always based on rules?

4. When you make a moral decision, do you ask yourself "What should I do?" or "What sort of person should I be?"

36

JULIA ANNAS

Julia Annas is Professor of Philosophy at the University of Arizona. She argues that we should not expect an ethical theory to provide the right answer to every moral problem. Instead, learning to be moral is akin to mastering a practical skill, such as building or playing music, that we learn by emulating people whose understanding is more advanced than ours. Eventually we develop virtuous dispositions, doing the right thing after having learned how to think for ourselves about the moral concepts.

Being Virtuous and Doing the Right Thing

One common objection to virtue ethics is that it is "not applicable"; it is, allegedly, a theory which is too vague for us to apply it to the actual world. There is a quick response to this: we do apply it all the time, for we take people to be brave or cowardly, generous or mean. This is, of course, not what the objectors have in mind: they mean that it is not applicable in the special sense, familiar to moral philosophers, of being too vague to be capable of *telling us what to do*. But here again there is a quick response: someone whose ethical thinking is in terms of the virtues can tell people (perhaps his children) what to do: they should do what's kind, avoid mean actions, and not be dishonest.[1]

This is unlikely to satisfy the objectors. Among the objections brought at this point, two have been prominent: since we pick up our understanding of virtue terms from our family and social contexts, and our culture in general, virtue ethics will tend to be parochial in a way unsuitable for ethical thinking. Further, the recommendations of virtue ethics will be too vague to resolve ethical disagreement, which, again, ethical thinking ought to be able to do.

Before meeting these points on the level of theory, I think it is interesting to point out that, if you get on the Web and go to www.virtuesproject.com, you will find the Virtues Project, an organization which specializes in moral education and conflict resolution, which has been particularly successful in the First Nations areas of western Canada and in Maori areas of New Zealand. It does this by using the language of the virtues, which they have found to be the most effective inter-cultural ethical language. The website features a list of fifty-two virtues which the project has found to be character traits respected in seven world spiritual traditions. The Virtues Project is unaffected by ethical philosophy; it uses the language of educational psychology. It is also not hard to find many respects in which it is strikingly under-theorized; it treats the virtues on a very elementary level. Despite all this, it strikes me as worthy of reflection that the Virtues Project has for some years and in

From *Proceedings and Addresses of the American Philosophical Association* 78 (2004), pp. 61–75. Reprinted by permission of the American Philosophical Association.

many countries actually been successfully using the virtues to resolve conflicts in schools and intercultural situations, while some philosophers have been deeming from their armchairs that thinking in terms of the virtues is ethnocentric and can't resolve disagreements. It also strikes me as worthy of reflection that, for all that on the theoretical level consequentialism is often praised as a practical, problem-solving theory, it has, as far as I know, no similar facts on the ground; no teachers (again, as far as I know) are successfully teaching children and actually resolving conflicts in intercultural situations using the language of consequences.

Still, doubt remains at the level of theory. We do learn to apply virtue terms in our own social and cultural contexts. And recommendations to be honest, or brave, are on the face of them somewhat unspecific. Ethical theories, in the tradition in which they have developed in the twentieth century, have raised a certain expectation about ethical theory: that it will apply to everyone in the same way, and that it will do so by telling people what to do in a fairly specific manner. This expectation cannot, I think, just be rejected; it has to be met on its own terms before we are entitled to proceed without it.

When we ask, before getting to theory, what we or other people should do, it is unlikely that we will appeal to principles or methods of deciding which are pulled out of thin air. We are most likely to appeal to the rules, conventions, and ideals of our social and cultural context. For what other source has given us directives as to what to do, and how to live, which are likely to have any authority with us? One way of putting this point is that by the time we get to reflecting about ethical matters at all, we are not blank slates; we already have firm views about right and wrong ways to act, worthy and unworthy ways to be.

As we get to reflecting about the principles and ideals we have acquired, we come to see that there is much in them that is due merely to convention. Worse, some aspects of our moral outlook, when we think about them, appear to be due merely to prejudice. Few of us grow up thinking that our moral education has been entirely adequate; we need to think how to do better.[2] How do we do this?

Ethical theories that have been orthodox among philosophers in the twentieth century have typically thought that what we do is to take the directives that we find in our unreflective ethical thought, and refine them so that they do one thing clearly and specifically, namely direct us. We look at the rules in everyday ethical discourse, notice that they are vague and may conflict, and try to refine them so that conflict is ruled out. Or we follow Sidgwick in looking for principles behind everyday ethical rules—principles which do not suffer from the flexibility of those everyday rules. This general direction of thought can be reasonably summed up in the claim that as we move to the level of explicit ethical theory we search for a *decision procedure* which will tell us what to do.

The term "decision procedure" has had a bad press in some quarters, so it is worth stressing that it does not itself import the idea of a mechanical, algorithmic procedure. The idea is simply that as we get to the level of moral theory, we discover a better moral methodology than the one we have been using, a methodology which will deliver an organized and systematic way of telling us what is the right thing to do.

(It is sometimes suggested that there is a parallel here to the development of a more sophisticated scientific methodology from everyday naïve views of the world. But this is surely a mistake, on two grounds. Firstly, the idea of "scientific method" is scarcely a help here. There are far more divergences between the ways different sciences develop than between different moral theories. And secondly, the purpose of science, insofar as it can be said to have a purpose, is theoretical understanding, which is precisely the wrong analogue for ethical theory insofar as that is taken to be practical, and hence focused on particular people and actions.)

If we need a decision procedure, a systematic and theorizable way of telling us what to do, then it will seem reasonable to think of the major aim of moral theory as being that of producing a *theory of right action*. This will be a theory which will produce, and defend theoretically, some decision procedure for telling us what to do, where "telling us what to do" means: giving specific instructions for how to act

which are applicable to everyone in the same way. Consequentialism is standardly the clearest example of this kind of theory. It isolates one simple principle behind the directives of our everyday ethical discourse, and then tells us how to formulate this principle and apply it to tell us, systematically and specifically, what to do. This task is simple in principle, although difficult and technical in practice.[3]

This is very like the kind of help we seek in areas of our lives where we have theoretically simple but practically complex decisions to make. This model of a theory of right action, on this way of looking at ethics, is rather like the model often provided in these technical areas, for example by a technical manual. For example, a computer manual does the technical work for us and makes clear to us the theoretically simple grounds of the decisions we need to make when we use the computer. The common model of a theory of right action, as we meet it explicitly in many introductions to moral theory, and implicitly in the work of many moral theorists, can be called the *technical manual model.*

I have found that some people think that comparison to a technical manual is in some way a dismissive or reductive way of thinking of a theory of right action. I am not sure why this should be so, especially since the model embodies an important, and in many ways attractive, feature of this way of thinking of a theory of right action. It is *egalitarian*—it is, in principle, equally available to anyone. It is not, of course, available to everyone equally just as they are, any more than a technical manual is. However, this difference is standardly taken, surely correctly, as a difference merely in education, where this is training in technical matters which are, we suppose, equally accessible to all who have the opportunity. Similarly, applying the theory will on this account be available equally to all who take the trouble to master the decision procedure. Thus, what a theory of this type offers is something which is in principle available to anyone; inequities in its possession will be due to social contingencies rather than to the characters of the people concerned. It is this egalitarianism, I think, which helps to give this model continued appeal in the face of difficulties.

There are some obvious problems with this model. Two of them have been stressed by Rosalind Hursthouse.[4] Firstly, given the point that the understanding required is technical, and that mastering this kind of information is notoriously something which some people can do at a very young age, it would follow that there could (and predictably would) be clever teenagers who had mastered the relevant theory of right action, and thus would be, since the technical manual model is a model of moral theory, reliable and sound sources of moral advice and direction. But of course as soon as we pose this suggestion we can see how absurd it is. We do not go to clever teenagers for advice on what to do or how to live, because we realize that the technical cleverness they often do have may, because of their comparative lack of experience, be accompanied by naïvete and credulity, rendering their advice shaky at best. We could call this the objection from the idiot savant: the young person with technically brilliant understanding may be a moral idiot.[5]

Secondly, if the theory of right action is to have this kind of form, then it would be possible in principle for someone to be brilliant at it, and to offer outstanding moral advice, while having a character and values that were morally detestable. After all, it is a supposed advantage of this model that the moral understanding it offers is available to all regardless of their moral character. So, I could in principle go to someone for moral advice, and take it, regardless of the fact that her character was marked by, for example, great cruelty and sadism. As long as this was unconnected to her theory of right action, there would be no reason for this to bother me. Indeed, I might be intrigued by the interesting complexity of her character. "I hate the way you torture kittens," I might say, "but I appreciate the excellence of your theory of right action. What a good job it is unconnected to your character and values—for I will do what your theory of right action tells me to do, though of course I would be horrified at the thought of my being in the least like you." I take it that this is deeply absurd, and indicates that divorcing right action from character is problematic. We could call this the objection from the loathsome advisor.

Some may object that this example is a travesty, but if so the reasons are going to be interesting. The objection has to be some variant on the thought that people with horrible characters are just not going to come up with excellent theories of right action; so we will not be faced by the loathsome advisor. But is this just a massive and fortunate accident? That is not very plausible. And if not, it will suggest the idea that such a theory is not in fact accessible to anyone with the required technical ability, but might involve character and its development. But one of the advantages of this kind of theory of right action was that it was supposed to be available to anyone, regardless of character, who could be taught the necessary technical skills.

However, strong as these two objections are, I think that there is a more important one. It emerges from the discomfort that I, at any rate, feel when faced by the common idea that what we need from a moral theory is to be "told what to do." Do I really want to be told what to do? I have a moral problem: Should I do this action? I get the answer, Yes (or alternatively the answer, No). Or I recount my problem and get told to do, or not do, action A. I have been told what to do, but is this what I want from a moral theory? It is certainly the kind of answer I want when I have a technical problem; I consult the manual, and get a specific and decisive answer, Yes, do that, or No, don't do it; or I recount my problem and get told the steps to follow to put it right. But in the moral case this gives us what the theory was supposed to be so good at, and yet clearly something is missing.

Perhaps this is so far an insufficiently charitable interpretation of what a theory of right action is supposed to do. Perhaps so far I am leaving out something else the theory gives us, namely, the justification for doing (or not doing) the action it tells us to do. So a theory of right action won't just tell us what to do; it will tell us what to do and give reasons why this is the right answer. After all, it's a *theory*: it will show us why the answer is correct, in terms of the way that the considerations relevant in this situation are processed by the theory (which will differ, of course, as the theories differ).

This does not remove the discomfort, however. Theories of right action are supposed to be practical, to give us specific directions. Since it is taken to be a fault in such a theory to be vague or unspecific, the desired result has to be, precisely, my being told what to do here and now, Yes or No. Reasons to back this up and enlarge my understanding of why the answer is Yes, on this occasion, rather than No, do not remove this feature. So the original discomfort remains: Do we really want a moral theory to tell us what to do? Aren't we losing an important sense in which we should be making our *own* decisions? Suppose I later come to think that what I did was actually the wrong thing to do. In a technical case I think that either I got the manual wrong, or the manual was wrong. And this is unproblematic; there is no soul-searching to be done as to why *I* made the wrong decision. But in the moral case there is surely something problematic in the thought that either I got the theory wrong or the theory was wrong, but there is no worry as to *my* making the wrong decision.

The idea that we want a theory of right action which tells anybody (with the right technical skills) what to do seems so far to leave out something important about the making of moral decisions. My moral decisions are *mine* in that I am responsible for them, but in a further way as well. They reveal something about me such that I can be praised or blamed for them in a way that cannot be shifted to the theory I was following. This is so even when it is true that the theory was correct, I was following the theory correctly, and the point of my following the theory was to be told what to do.

This point can be put vividly. Suppose (unrealistically!) someone always does what his mother tells him to do. He always follows her orders; if he fails to do so he feels guilt, regret, and so on. We take this to be immature, a case of arrested development; at his age, we say, he should be making his own decisions. Now, why should this picture become all right when we replace Mom by a decision procedure? Presumably, a decision procedure, supported by a theory of right action, can be expected to be correct more often, and more reliably, than Mom can; but how could this remove the worry?

Once again we may be told that this is an uncharitable way to be interpreting a theory of right action and people who think we need one. The idea, it will be claimed, is not that I ask the theory to tell me what to do in the way I consult the technical manual. Rather, the theory is supposed to be something I internalize, a way of thinking which, when I adopt it, enables me to have the correct criteria for moral decisions. So the theory does not strictly tell me what to do; it gives me the criteria for doing it myself. The theory of right action is supposed to be like a technical manual in specificity, and in being accessible to all with the technical skills, but unlike it in that I am supposed to internalize it to come to my own decisions.

But again this does not meet the fundamental point. Granted that the theory does not literally tell me what to do, it still gives me the criteria for coming to the right decision. But if the theory is practical and specific, in the way stressed so far, what it is doing, in doing this, is enabling me to tell myself what to do. And furthermore, my acceptance that this is, in fact, the right thing to do comes entirely from my acceptance of, and internalization of, the theory of right action. So whether the theory is pictured as outside me, like a manual, or inside me, like a set of directions as to how to think, it is still telling me what to do. The point remains: what I should be doing is interpreting the theory correctly. If we bothered to internalize technical manuals, like car or computer manuals, it would be somewhat similar.

So we can see that the idea of a decision procedure backed by a theory of right action, as that has been assumed in much moral philosophy, runs into serious problems. And apart from these we can feel the force of a more general dissatisfaction. Informally, this can be put as the query whether we do in fact think of the moral life this way, as our going round all the time telling one another what to do. Is the moral life really this endless busybodying? Further, what on this model do we make of our concern for our own moral lives? It looks as though it has to come from the thought that amidst all this telling other people what to do, we from time to time, if only out of fairness, tell ourselves what to do too. And this definitely gets the concern wrong.

Virtue ethics has, for much of the period of its recent revival, been taken to offer an appealing alternative to this anxious and obsessive picture of the moral life. It is an alternative in which issues of the best life to live, a good person to be and a good character to have are important along with doing the right thing. It is by now clear that the nature of this shift from focus on right action to concern with being a good person is complex, and diverse accounts of it have been given. I will first give a common account of what virtue ethics is alleged to hold about right action and the virtuous person. Bringing out what is wrong with this account will point us in the direction of a better alternative.

A common view is that, by way of an alternative to the egalitarian, technical manual model of a theory of right action, virtue ethics offers a theory of right action that starts from some version of the following:

An action is right if and only if it is what a virtuous person would do, adding *"reliably* (or *characteristically)"* or the like since virtue is a matter of character. There are many ways of interpreting this schema.[6] I am concerned only with people who take it to provide a criterion of right action. What I take to be the common view holds that the virtuous person must be identified independently of their performance of right actions. Otherwise, we would not have an account of right action which was *explanatory.* If we define right action as what the virtuous person would do, but it turns out that the virtuous person is even in part defined in turn by the doing of right action, the claim goes, we have a circle, and so no explanation.

So construed, the account has been attacked by well-known objections. Firstly, how are we to identify the virtuous person? We can, of course, point to actual examples of alleged virtuous people. "Fred and Jane are the virtuous people around here," we are supposed to say, "so do what they do." But there is an obvious response to this: our account will be parochial, for people in other places or cultures might not think Fred and Jane virtuous.

Secondly, we can avoid this objection by saying that unfortunately there are no virtuous people, at least not around here; virtue is an ideal, so that we cannot point to any *actual* virtuous people (though

figures like Socrates and Gandhi may give us some inkling). This might be all right from some points of view, but is unfortunate if we want to give an account of right action in terms of the virtuous person, since the account will now be vague, and it will not be obvious how it is supposed to apply to particular circumstances.

Thirdly, we are taken to recognize clear cases where there would be agreement on what was the right thing to do, but this is patently not what the virtuous person would (reliably or characteristically) do. A familiar example is this: I have behaved badly: What would be the right thing to do in the circumstances? It is no good appealing to what the virtuous person would do, since the virtuous person wouldn't have behaved badly in the first place.[7] Recently, Robert Johnson has added to the list.[8] The right thing to do, he claims, might be for me to improve my character (by controlling myself more); or to organize my life so that I am forced to do the right thing when my own motivation is insufficient; or to ask for guidance in an area where I know I am faulty. But none of these actions can be plausibly taken to be what the virtuous person does, reliably or as a matter of character. For the virtuous person does not need to improve; does not need to strategize to make up for absent motivation; does not need to ask for guidance where she is faulty.

We can't, I think, see how these objections can be met until we look at a more adequate alternative account of virtue and right action. And before doing this I shall raise what I take to be a further, more fundamental objection to this standard view. Suppose that we *can* define the virtuous person in a way satisfactorily independent from performance of right action. We then define right action in terms of what the virtuous person, so understood, would (reliably, or whatever) do. Whatever we have or haven't done, we haven't produced an *alternative* to the kind of theory of right action that has been so problematic all along. At most we have put a loop in it. Instead of trying to produce a theory of right action with the form of a technical manual, we have called up the figure of the technical expert—as when one has a computer problem and calls in tech support. The expert might use a manual herself, in which case we have merely postponed the application of the manual to tell us what to do. But even if the expert is supposed not to use a manual herself, but to have an understanding of right and wrong action which cannot be codified in a manual, we are still, on this model, *using* the expert to tell us what to do, in exactly the way we used the manual, namely, to tell us what to do.

We find, then, that bringing in the virtuous person in this way does not help with the deepest problem we found with theories of right action. Appeal to the virtuous person certainly helps with some of the problems, for at least we will not be getting our theory of right action from a precocious teenager, or somebody with loathsome values. But the deepest problem remains intact, indeed is worse if anything. We still have a theory of right action which tells us what to do. All that has changed is the criterion for locating the right thing to do. It is still the case that what we have to do is to get the theory right; our decisions are the decisions that come from applying the theory correctly, as anybody could in principle do. Hence, this kind of appeal to the virtuous person still doesn't let the character of the person deciding make any difference; for, whether we appeal to Fred and Jane or to the ideal virtuous person, we are still applying the theory in a way that anybody might have done, regardless of character.

So far, then, we have not found a real alternative to the problematic role of a theory of right action, understood as importing a decision procedure. If we assume that the virtuous person must be defined independently of right action, then importing the virtuous person into our theory of right action does no good at all.

A lot of people see this as an impasse. What, after all, is the alternative supposed to be? If we bring the virtuous person into our definition of right action, haven't we just given up on the prospect of a noncircular account of right action?

Obviously, we do not want an account in which being virtuous and doing the right thing are trivially defined in terms of each other. But we might, I suggest, try an alternative: producing a developmental account, in which we give an account of being virtuous and doing the right thing in a way which involves

a developmental process. If so, we would have a theory involving not two items but three: the virtuous person, right action, and the relevant developmental process.

This prospect becomes more attractive if we can find an analogous example which is convincing in its own right and also indicates that we can think of virtue in this way. And this is what we find if we look at the classical tradition of virtue ethics, which points us to a model which was fundamental in thinking of virtue for many centuries. It emerges most dramatically when we notice that Aristotle urges us to think of becoming virtuous on the lines of learning to be a builder.[9] This passage is well-known and we have to remind ourselves that, in terms of what modern theories require, it is outrageous in its mundanity. Learning to be moral is like acquiring a *practical skill?* But yes, this is the point of the analogy. A practical skill is a useful model for the intellectual structure of a virtue in several ways: it is, of course, practical, it is undergirded by general understanding of the relevant field, and, most important, it is an area where there is a process of *learning,* of passage from the state of being a learner to the state of being an expert.

This is a large topic, on which a lot has been written, and here I am just bringing out points relevant to our understanding of virtue and action. The beginning builder has to learn by picking a role model and copying what she does, repeating her actions, Gradually, he learns to build better, that is, to engage in the practical activity in a way which is less dependent on the examples of others and expresses more understanding of his own. He progresses from piecemeal and derivative understanding of building to a more unified and explanatory understanding of his own. His actions may at this point differ from those of his role model precisely because he is a better builder. This is because he is learning, and learning contains the notion of aspiration to improve.

We can see how this leads to an improvement in both activity and understanding if we take an example from the performance arts. Suppose I aim to be an expert piano player, and take Alfred Brendel as my role model. Clearly I am making a mistake if I think that I will learn to "play like Alfred Brendel" if

I listen obsessively to his recordings, copy his mannerisms, play only pieces he performs. The development from learner to expert essentially involves acquiring *your own* understanding of the field you are learning. The learner depends on the expert to learn in the first place, but the goal of learning is to have your own understanding of what you have learned from the expert. The expert in a practical field aims not to produce clone-like disciples who will mimic what she does, but pupils who will go on to become experts themselves, which they can do only if they acquire their own understanding of the subject. The person who succeeds in playing like Alfred Brendel ends up performing in a way which sounds rather different.

It is these points about practical skill which make it a good model for thinking of virtue. This in no way implies, it should be stressed, that virtue is going to be in all ways like a skill—clearly, in some ways it is quite different. Nor does it imply that this story is all there is to an account of the development of virtue. I have just emphasized the initial point, that we start as learners dependent on models and progress to acquire our own understanding. There remains much further story to tell.[10] However, the importance of the movement from learner to expert in a practical skill is important for understanding the initial development of virtue. Let us recall the story at the start of this Address: we grow up in a particular social and cultural context and acquire corresponding beliefs, principles, and ideals, along with conceptions of the virtues as those are practised and thought of in our society. We then reach a point where we realize that our moral upbringing has left us with much that is merely conventional, or wrong. Many moral theories react at this point, as was noted, by trying to systematize the rules and principles of everyday thought, with the aim of producing a decision procedure to be used by anyone.

Here is the point of decisive difference with virtue ethics—at least virtue ethics as I take it to be defensible. For instead of trying to force our everyday moral thoughts into a system of a one-size-fits-all kind, virtue ethics tells us to look elsewhere—at what happens when we try to become a builder or a

pianist. The moral beliefs we have taken over from others are just the beginning stage. It is up to us to put in the work needed to develop into someone who has more understanding. Virtue ethics assumes that this is something that we will all tend to do. Other factors may prevent this becoming effective, but it is a rare person who if unaffected by other factors grows up morally in a purely passive and dependent way, never reflecting on the moral beliefs they have grown up with or wondering whether what they were told to do was a complete guide to right action.

What should we do, then, at the stage when we realize the merely conventional status of many of our moral beliefs? In the spirit of other theories, but in a different way, virtue ethics tries to improve our understanding in a way which will lead to our acting in better ways. But virtue ethics regards it as misguided to try to produce a theory-based decision procedure for anyone at any stage to use. This would be like trying to improve building by insisting that all builders learn from the same books. These might be helpful, but they don't produce expert builders; it is people who have to make themselves into expert builders. Similarly, each of us has to do the work in our own case, aiming to become a virtuous person with understanding and not just derivative copying of others. No manual will do it for us.

If we take this developmental model seriously, we can see that it is important to differentiate the initial, uncritical grasp of virtue from the kind of understanding that the developed virtuous person has. We all start with some conventional grasp of virtue that we pick up as we grow up from parents, teachers, and so on. It is up to us to recognize at this point that we are *learners,* and so to aspire to improve. To the extent that we do, we are on the way to becoming more fully virtuous. What form will this improvement take? A number of accounts have been defended here. The fully virtuous person, analogous to the practical expert, may have developed an uncodifiable ability to discern morally relevant features of situations. Or he may have developed practical wisdom which develops from, but goes beyond, that

of his role models.[11] Or he may have developed a grasp of rules and principles such that he can apply them intelligently and with insight.[12] I take it that the term "virtue ethics" picks out a cluster of theories,[13] so that these and others are options within virtue ethics, and decision between them is not needed here. One thing, however, is true of all of them: becoming more fully virtuous requires each of us to think for ourselves, hard and critically, about the moral concepts, especially those of the virtues, that we have picked up from our surroundings.

How does this help us with the issue of being virtuous and doing the right thing? The learner starts by doing what he is taught is the right thing to do, copying the actions which in his society are conventionally marked off as the kinds of thing that, for example, a brave person does. As he progresses in virtue, he does these things as a virtuous person does them, with understanding, and also gets better at doing the right thing. He acts bravely with greater understanding of what bravery requires, for example, and does the right thing as the truly brave person would do it—from the right reasons, as a result of having the right disposition, and so on.

It is generally true that brave people in our society, for example, do certain actions, which can be independently specified. But most people in our society are only at the beginning, learner stage of virtue. They do the right thing for people at that stage. It is what bravery requires of them, demanded by society's rules, exemplified in people who are role models of bravery. When the completely virtuous brave person does the right thing it is not because it is required of him by the conventional account of bravery, but as a result of his own reflective understanding of bravery and its requirements, and his development of the appropriate disposition.

So if we return to the schema

An action is right if and only if it is what a virtuous person would (reliably, characteristically) do.

we can see that it can be applied in two quite different kinds of way. The beginner does the right thing in the following way: it is what bravery requires, it is the

right, not the wrong thing to do; it is praised, emulated and so on. The fully virtuous person also does the right thing; in this case it is the right thing done for the all the right reasons and from a disposition that has developed virtuously in both its intellectual and affective aspects, based on fully developed understanding of all relevant ethical factors.[14] These are obviously very different ways of being the right thing to do. We cannot, of course, give an account of doing the right thing as the virtuous person would do it, without reference to the virtuous person. So we cannot come up with independent characterizations of the virtuous person and the right thing to do if we take into account not merely the beginner in virtue but also the fully virtuous person. And if we omit the latter from our account of virtue, we are failing to notice a crucial point: the fully virtuous person is the ideal that the beginner in virtue is aspiring to be.

We can now see why we cannot give a satisfactory virtue ethical account of right action if we insist on independent characterizations of the virtuous person and the right thing to do; such an account (whatever else can be said for and against it) will capture only the learner, the person whose virtue is limited to doing the conventionally right thing. But the learner does not exhaust our conception of virtue; we also need to take account of the expert. And we will not get the point even of what the learner is doing if we take him to be merely doing the conventional thing, failing to notice that he is also aspiring to do better, and thus to get closer to an ideal. So we can also now see why rejecting independent characterization of the virtuous person and right action is far from landing us with a trivially circular account.

Someone might say that, if we are going to distinguish the way the beginner does the right thing from the way the fully virtuous person does the right thing, then what the theory should say is that the right thing to do just is what the fully virtuous person would do, and the beginning virtuous person is not doing the right thing. This would be a rigorist approach, like that of consequentialists who hold that the right thing to do is what the ideal calculator of consequences would do, so that we ordinary people, however admirable our intentions, character, and so on, almost

never do the right thing. This way of looking at things, however, has to hold that some of us are worthy of praise, emulation, and so on, even though we are not doing the right thing; and this is at least awkward. It is also difficult to make sense of moral education and improvement on this view; someone becoming brave, for example, would still never be doing the right thing until they became completely virtuous. It is worth noticing here that the Stoics were rigorists about virtue, holding that only the completely virtuous have virtue, while we are all vicious and base—but even they held that the nonvirtuous, as well as the virtuous, can do the right thing, though only the virtuous do the right thing in the fully virtuous way.[15]

Another response might be to suggest that we have two senses of "right" here. But this is surely implausible, for the same kind of reason that it is implausible that we would have different senses of "right" when the apprentice carpenter and the skilled carpenter both fix the shelves in the right way.

We can see, then, why the familiar schema cannot produce a decision procedure for virtue ethics if we take into account the point that virtue involves aspiring to an ideal; any account that could produce a decision procedure would be stuck at the level of the learner, helpless to deal with our ethical aspirations.

So, if I am wondering what the right thing is to do, and approach the virtuous person's characteristic actions for guidance as to what that is, there are two important factors. Firstly, to what extent is the person I look to an expert or a mere learner? How virtuous are they, really? If they are a mere learner then their actions may be right, but only through doing what they were told without deep understanding. Only if they have developed the right kind of understanding will their examples be good ones from which I can learn. And secondly, to what extent am I an expert or a mere learner? How virtuous am I, really? If I am a mere learner then I may not have chosen the right model, and even if I have, I may not be emulating the right aspect of it.

If we bear these two factors in mind we see that and why the virtuous person cannot provide an all-purpose decision procedure that I can apply regardless of my character to find out what the right thing

is for me to do. Even if I try to go through the virtuous person to find the right thing to do, the merits of my decision will depend not just on the goodness of my model but the degree of my own virtuous development in discerning what in it to emulate.

Some people regard this result as a disaster, for it loses the one attractive aspect of the technical manual model, namely, its egalitarianism. We no longer have a decision procedure for working out the right thing to do in a way which is available to everyone. However, I have worked to undermine the thought that a decision procedure is what we want. And the result here is, I claim, supported by our everyday ethical discourse. We do recognize that the worth of the advice and direction we get from other people depends on their degree of moral development. We don't emulate, or get advice from, airheads, or untrustworthy people. When we take moral advice we assess its source; we know that the character of the person we go to will be shown in the advice we get. It would be bizarre for me to say that I will do what John tells me to do, though I thoroughly despise John. And we do take my actions to show something about my character, not just my ability to understand a theory.

What of the three common objections to virtue ethics I mentioned earlier? We can see, briefly, that and why they lose their force once we recognize that virtue involves a progress from the beginner to the fully virtuous.

How do we identify the virtuous people? We do so in the way that we identify good builders and pianists—that is, in a way which is initially hostage to our own lack of expertise. At first we just have to accept their credentials; as we improve in the relevant area we might end up by challenging them.

What of the unhelpful vagueness of the ideally virtuous person? This need not matter if it is not the ideally virtuous person we are appealing to for guidance in how we are to act. We start with teachers and role models who are braver, more generous, and so on than we are, but we do not need, or expect, them to be already completely virtuous for the process to get going.

What of the clear cases of right action which are not actions which a virtuous person would characteristically do? Again, we need to distinguish between what the ordinarily virtuous person, the learner, would do, and what the fully virtuous person would do. The person who is at the stage of learning to be virtuous and still aspiring to do better might quite well do the wrong thing and have to apologize. He might well try to improve his character, organize his life to help his improvement along, and need guidance from a person who is in the relevant respect better. These are all normal actions characteristic of someone who is developing a virtuous disposition, given ordinary facts about human weaknesses. Fully virtuous person would never need to do such things; but we are not fully virtuous people, though hopefully we are trying to improve.

We have seen, then, how virtue ethics is applicable. It is not a theory which tells us what to do; we have seen that we neither have nor should want any such thing. Rather, it guides us by improving the practical reasoning with which we act. It directs us, as we are wondering what to do, toward emulating people who are braver, more generous and generally better than we are, and does so in a way which recognizes the constraints put on this by the level of our development as well as that of the people we emulate. This result will be disappointing only to those who think that acting well can be reduced to the results of a formula applied across the board with no further moral effort. Virtue ethics does better, I have suggested, because it has a built-in recognition of the point that the moral life is not static; it is always developing. When it comes to working out the right thing to do, we cannot shift the work to a theory, however excellent, because we, unlike the theories, are always learning, and so we are always aspiring to do better.

Notes

1. This is what Rosalind Hursthouse calls thinking in terms of the "v-rules"; see her *On Virtue Ethics* (New York: Oxford University Press, 1999).

2. It is sometimes suggested that this happens only in relatively open societies, whose members are exposed to different ways of life and encouraged to think for themselves about them; in relatively closed and traditional

societies this is unlikely to happen. I think that this makes an unwarranted inference from the fact that in traditional societies ethically more reflective thought may be repressed (sometimes harshly) to the claim that in such societies people are satisfied with unreflective thought. History strongly suggests otherwise.

3. There are theories which do not make this kind of demand, or which make it in their simpler versions but reject it in their more sophisticated versions. While I do not have the scope to develop the point here, I think that virtue ethics will converge with these theories, rather than provide an alternative to them. However, in my experience the need for a decision procedure is often assumed to be a requirement on a respectable moral theory. Cf. Mark Timmons, *Moral Theory* (Lanham: Rowman and Littlefield, 2002), 3: "The main practical aim of a moral theory is to discover a decision procedure that can be used to guide correct moral reasoning about matters of moral concern." Successfully meeting this demand is thus necessary for virtue ethics to be recognized as even a contender for being a type of moral theory.

4. In much of her work, but particularly in *On Virtue Ethics.*

5. Followers of the *Fox Trot* daily cartoon can think of this point as the Jason Fox point.

6. Hursthouse has made extensive use of this schema, but not to produce a decision procedure, something she rightly takes virtue ethics not to do.

7. This common example is found in Gilbert Harman, "Moral Philosophy Meets Social Psychology," *Proceedings of the Aristotelian Society,* New Series (2000): 223–36; and John Doris, "Persons, Situations and Virtue Ethics," Nous 32.4 (1998): 504–30.

8. Robert N. Johnson, "Virtue and Right," in *Ethics* 113.4 (July 2003): 810–34.

9. *Nicomachean Ethics* II 1.

10. The analogy with building is relevant to the initial stage of moving from acquiring a conventional understanding of virtue to coming to have your own understanding of that virtue. Most versions of virtue ethics will also move on to further stages. The practice of the several virtues is not compartmentalized; reflection on the ways in which they interrelate generally leads to some form of unification of the virtues via the exercise of the practical reasoning displayed in them. Further, people both within a culture and between cultures will learn to respect one another's reasoning insofar as they recognize the practice of the virtues in different contexts and across cultural boundaries.

11. This, the Aristotelian model, is the most familiar, which is why I have used it as illustration in the present Address.

12. This would be required by religious versions of virtue ethics, in which the content of the virtuous person's reasonings would be initially given by religiously sanctioned rules (such as Mosaic law) which are not open to rejection or revision, but do demand intelligent interpretation to be correctly applied.

13. In a way precisely paralleled by consequentialism and deontology.

14. This is a gesture at what full virtue might require; different theories have different accounts here.

15. The distinction drawn here, between doing the right thing as the beginner (the learner) does it and doing the right thing as the fully virtuous person (the expert) does it, maps well onto the Stoic distinction between a *kathekon,* a right action which anyone can perform, and a *katorthoma,* a right action performed by a virtuous person. (For the Stoics, however, this would be limited to the sage or ideally virtuous person, nobody else being virtuous.)

Study Questions

1. What does Annas mean by the "technical manual model" of a theory of right action?

2. Could a person not be virtuous yet be an effective teacher of virtue?

3. Are teachers of ethics likely to be more ethical than others?

4. If you take someone to be a virtuous person whom others do not recognize as such, how might the disagreement be resolved?

37

VIRGINIA HELD

Virginia Held is Professor Emerita of Philosophy at Hunter College and the Graduate Center of the City University of New York. She examines how feminist philosophers are modifying moral concepts and theories that are believed to have been constructed from a male perspective. Held urges embracing emotion as providing at least a partial basis for morality, reconceptualizing the ways in which every human life is entwined with personal and social components, and rethinking the concept of the self to take account of family relations, friendships, group ties, and neighborhood concerns.

Feminist Transformations of Moral Theory

The history of philosophy, including the history of ethics, has been constructed from male points of view, and has been built on assumptions and concepts that are by no means gender-neutral.[1] Feminists characteristically begin with different concerns and give different emphases to the issues we consider than do non-feminist approaches. And, as Lorraine Code expresses it, "starting points and focal points shape the impact of theoretical discussion."[2] Within philosophy, feminists often start with, and focus on, quite different issues than those found in standard philosophy and ethics, however "standard" is understood. Far from providing mere additional insights which can be incorporated into traditional theory, feminist explorations often require radical transformations of existing fields of inquiry and theory.[3] From a feminist point of view, moral theory along with almost all theory will have to be transformed to take adequate account of the experience of women.

I shall in this paper begin with a brief examination of how various fundamental aspects of the history of ethics have not been gender-neutral. And I shall discuss three issues where feminist rethinking is transforming moral concepts and theories.

THE HISTORY OF ETHICS

Consider the ideals embodied in the phrase "the man of reason." As Genevieve Lloyd has told the story, what has been taken to characterize the man of reason may have changed from historical period to historical period, but in each, the character ideal of the man of reason has been constructed in conjunction with a rejection of whatever has been taken to be characteristic of the feminine. "Rationality," Lloyd writes, "has been conceived as transcendence of the 'feminine,' and the 'feminine' itself has been partly constituted by its occurrence within this structure."[4]

This has of course fundamentally affected the history of philosophy and of ethics. The split between reason and emotion is one of the most familiar of

From *Philosophy and Phenomenological Research*, Fall 1990 (Supplement), pp. 321–344. Reprinted by permission.

philosophical conceptions. And the advocacy of reason "controlling" unruly emotion, of rationality guiding responsible human action against the blindness of passion, has a long and highly influential history, almost as familiar to non-philosophers as to philosophers. We should certainly now be alert to the ways in which reason has been associated with male endeavor, emotion with female weakness, and the ways in which this is of course not an accidental association. As Lloyd writes, "From the beginnings of philosophical thought, femaleness was symbolically associated with what Reason supposedly left behind—the dark powers of the earth goddesses, immersion in unknown forces associated with mysterious female powers. The early Greeks saw women's capacity to conceive as connecting them with the fertility of Nature. As Plato later expressed the thought, women 'imitate the earth.'"[5]

Reason, in asserting its claims and winning its status in human history, was thought to have to conquer the female forces of Unreason. Reason and clarity of thought were early associated with maleness, and as Lloyd notes, "what had to be shed in developing culturally prized rationality was, from the start, symbolically associated with femaleness."[6] In later Greek philosophical thought, the form/matter distinction was articulated, and with a similar hierarchical and gendered association. Maleness was aligned with active, determinate, and defining form; femaleness with mere passive, indeterminate, and inferior matter. Plato, in the *Timaeus*, compared the defining aspect of form with the father, and indefinite matter with the mother; Aristotle also compared the form/matter distinction with the male/female distinction. To quote Lloyd again, "This comparison . . . meant that the very nature of knowledge was implicitly associated with the extrusion of what was symbolically associated with the feminine."[7]

The associations, between Reason, form, knowledge, and maleness, have persisted in various guises, and have permeated what has been thought to be moral knowledge as well as what has been thought to be scientific knowledge, and what has been thought to be the practice of morality. The associations between the philosophical concepts and gender

cannot be merely dropped, and the concepts retained regardless of gender, because gender has been built into them in such a way that without it, they will have to be different concepts. As feminists repeatedly show, if the concept of "human" were built on what we think about "woman" rather than what we think about "man," it would be a very different concept. Ethics, thus, has not been a search for universal, or truly human guidance, but a gender-biased enterprise.

Other distinctions and associations have supplemented and reinforced the identification of reason with maleness, and of the irrational with the female; on this and other grounds "man" has been associated with the human, "woman" with the natural. Prominent among distinctions reinforcing the latter view has been that between the public and the private, because of the way they have been interpreted. Again, these provide as familiar and entrenched a framework as do reason and emotion, and they have been as influential for non-philosophers as for philosophers. It has been supposed that in the public realm, man transcends his animal nature and creates human history. As citizen, he creates government and law; as warrior, he protects society by his willingness to risk death; and as artist or philosopher, he overcomes his human mortality. Here, in the public realm, morality should guide human decision. In the household, in contrast, it has been supposed that women merely "reproduce" life as natural, biological matter. Within the household, the "natural" needs of man for food and shelter are served, and new instances of the biological creature that man is are brought into being. But what is distinctively human, and what transcends any given level of development to create human progress, are thought to occur elsewhere.

This contrast was made highly explicit in Aristotle's conceptions of polis and household; it has continued to affect the basic assumptions of a remarkably broad swath of thought ever since. In ancient Athens, women were confined to the household; the public sphere was literally a male domain. In more recent history, though women have been permitted to venture into public space, the associations of the public, historically male sphere with the

distinctively human, and of the household, historically a female sphere, with the merely natural and repetitious, have persisted. These associations have deeply affected moral theory, which has often supposed the transcendent, public domain to be relevant to the foundations of morality in ways that the natural behavior of women in the household could not be. To take some recent and representative examples, David Heyd, in his discussion of supererogation, dismisses a mother's sacrifice for her child as an example of the supererogatory because it belongs, in his view, to "the sphere of natural relationships and instinctive feelings (which lie outside morality)."[8] J. O. Urmson had earlier taken a similar position. In his discussion of supererogation, Urmson said, "Let us be clear that we are not now considering cases of natural affection, such as the sacrifice made by a mother for her child; such cases may be said with some justice not to fall under the concept of morality. . . ."[9] And in a recent article called "Distrusting Economics," Alan Ryan argues persuasively about the questionableness of economics and other branches of the social sciences built on the assumption that human beings are rational, self-interested calculators; he discusses various examples of non self-interested behavior, such as of men in wartime, which show the assumption to be false, but nowhere in the article is there any mention of the activity of mothering, which would seem to be a fertile locus for doubts about the usual picture of rational man.[10] Although Ryan does not provide the kind of explicit reason offered by Heyd and Urmson for omitting the context of mothering from consideration as relevant to his discussion, it is difficult to understand the omission without a comparable assumption being implicit here, as it so often is elsewhere. Without feminist insistence on the relevance for morality of the experience in mothering, this context is largely ignored by moral theorists. And yet, from a gender-neutral point of view, how can this vast and fundamental domain of human experience possibly be imagined to lie "outside morality"?

The result of the public/private distinction, as usually formulated, has been to privilege the points of view of men in the public domains of state and law, and later in the marketplace, and to discount the experience of women. Mothering has been conceptualized as a primarily biological activity, even when performed by humans, and virtually no moral theory in the history of ethics has taken mothering, as experienced by women, seriously as a source of moral insight, until feminists in recent years have begun to.[11] Women have been seen as emotional rather than as rational beings, and thus as incapable of full moral personhood. Women's behavior has been interpreted as either "natural" and driven by instinct, and thus as irrelevant to morality and to the construction of moral principles, or it has been interpreted as, at best, in need of instruction and supervision by males better able to know what morality requires and better able to live up to its demands.

The Hobbesian conception of reason is very different from the Platonic or Aristotelian conceptions before it, and from the conceptions of Rousseau or Kant or Hegel later; all have in common that they ignore and disparage the experience and reality of women. Consider Hobbes's account of man in the state of nature contracting with other men to establish society. These men hypothetically come into existence fully formed and independent of one another, and decide on entering or staying outside of civil society. As Christine Di Stefano writes, "What we find in Hobbes's account of human nature and political order is a vital concern with the survival of a self conceived in masculine terms. . . . This masculine dimension of Hobbes's atomistic egoism is powerfully underscored in his state of nature, which is effectively built on the foundation of denied maternity."[12] In *The Citizen*, where Hobbes gave his first systematic exposition of the state of nature, he asks us to "consider men as if but even now sprung out of the earth, and suddenly, like mushrooms, come to full maturity, without all kinds of engagement with each other."[13] As Di Stefano says, it is a most incredible and problematic feature of Hobbes's state of nature that the men in it "are not born of, much less nurtured by, women, or anyone else."[14] To abstract from the complex web of human reality an abstract man for rational perusal, Hobbes has, Di Stefano continues, "expunged human reproduction and early nurturance, two of the most basic and typically female-identified

features of distinctively human life, from his account of basic human nature. Such a strategy ensures that he can present a thoroughly atomistic subject. . . ."[15] From the point of view of women's experience, such a subject or self is unbelievable and misleading, even as a theoretical construct. The Leviathan, Di Stefano writes, "is effectively comprised of a body politic of orphans who have reared themselves, whose desires are situated within and reflect nothing but independently generated movement. . . . These essential elements are natural human beings conceived along masculine lines."[16]

Rousseau, and Kant, and Hegel, paid homage to the emotional power, the aesthetic sensibility, and the familial concerns, respectively, of women. But since in their views morality must be based on rational principle, and women were incapable of full rationality, or a degree or kind of rationality comparable to that of men, women were deemed, in the view of these moralists, to be inherently wanting in morality. For Rousseau, women must be trained from childhood to submit to the will of men lest their sexual power lead both men and women to disaster. For Kant, women were thought incapable of achieving full moral personhood, and women lose all charm if they try to behave like men by engaging in rational pursuits. For Hegel, women's moral concern for their families could be admirable in its proper place, but is a threat to the more universal aims to which men, as members of the state, should aspire.[17]

These images, of the feminine as what must be overcome if knowledge and morality are to be achieved, of female experience as naturally irrelevant to morality, and of women as inherently deficient moral creatures, are built into the history of ethics. Feminists examine these images, and see that they are not the incidental or merely idiosyncratic suppositions of a few philosophers whose views on many topics depart far from the ordinary anyway. Such views are the nearly uniform reflection in philosophical and ethical theory of patriarchal attitudes pervasive throughout human history. Or they are exaggerations even of ordinary male experience, which exaggerations then reinforce rather than temper other patriarchal conceptions and institutions. They distort the actual experience and aspirations of many men as well as of women. Annette Baier recently speculated about why it is that moral philosophy has so seriously overlooked the trust between human beings that in her view is an utterly central aspect of moral life. She noted that "the great moral theorists in our tradition not only are all men, they are mostly men who had minimal adult dealings with (and so were then minimally influenced by) women."[18] They were for the most part "clerics, misogynists, and puritan bachelors," and thus it is not surprising that they focus their philosophical attention "so single-mindedly on cool, distanced relations between more or less free and equal adult strangers. . . ."[19]

As feminists, we deplore the patriarchal attitudes that so much of philosophy and moral theory reflect. But we recognize that the problem is more serious even than changing those attitudes. For moral theory as so far developed is incapable of correcting itself without an almost total transformation. It cannot simply absorb the gender that has been "left behind," even if both genders would want it to. To continue to build morality on rational principles opposed to the emotions and to include women among the rational will leave no one to reflect the promptings of the heart, which promptings can be moral rather than merely instinctive. To simply bring women into the public and male domain of the polis will leave no one to speak for the household. Its values have been hitherto unrecognized, but they are often moral values. Or to continue to seek contractual restraints on the pursuits of self-interest by atomistic individuals, and to have women join men in devotion to these pursuits, will leave no one involved in the nurturance of children and cultivation of social relations, which nurturance and cultivation can be of greatest moral import.

There are very good reasons for women not to want simply to be accorded entry as equals into the enterprise of morality as so far developed. In a recent survey of types of feminist moral theory, Kathryn Morgan notes that "many women who engage in philosophical reflection are acutely aware of the masculine nature of the profession and tradition, and feel their own moral concerns as women silenced

or trivialized in virtually all the official settings that define the practice."[20] Women should clearly not agree, as the price of admission to the masculine realm of traditional morality, to abandon our own moral concerns as women.

And so we are groping to shape new moral theory. Understandably, we do not yet have fully worked out feminist moral theories to offer. But we can suggest some directions our project of developing such theories is taking. As Kathryn Morgan points out, there is not likely to be a "star" feminist moral theorist on the order of a Rawls or Nozick: "There will be no individual singled out for two reasons. One reason is that vital moral and theoretical conversations are taking place on a large dialectical scale as the feminist community struggles to develop a feminist ethic. The second reason is that this community of feminist theoreticians is calling into question the very model of the individualized autonomous self presupposed by a star-centered male-dominated tradition. . . . We experience it as a common labour, a common task."[21]

The dialogues that are enabling feminist approaches to moral theory to develop are proceeding. As Alison Jaggar makes clear in her useful overview of them, there is no unitary view of ethics that can be identified as "feminist ethics." Feminist approaches to ethics share a commitment to "rethinking ethics with a view to correcting whatever forms of male bias it may contain."[22] While those who develop these approaches are "united by a shared project, they diverge widely in their views as to how this project is to be accomplished."[23]

Not all feminists, by any means, agree that there are distinctive feminist virtues or values. Some are especially skeptical of the attempt to give positive value to such traditional "feminine virtues" as a willingness to nurture, or an affinity with caring, or reluctance to seek independence. They see this approach as playing into the hands of those who would confine women to traditional roles.[24] Other feminists are skeptical of all claims about women as such, emphasizing that women are divided by class and race and sexual orientation in ways that make any conclusions drawn from "women's experience" dubious.[25]

Still, it is possible, I think, to discern various important focal points evident in current feminist attempts to transform ethics into a theoretical and practical activity that could be acceptable from a feminist point of view. In the glimpse I have presented of bias in the history of ethics, I focused on what, from a feminist point of view, are three of its most questionable aspects: 1) the split between reason and emotion and the devaluation of emotion; 2) the public/private distinction and the relegation of the private to the natural; and 3) the concept of the self as constructed from a male point of view. In the remainder of this article, I shall consider further how some feminists are exploring these topics. We are showing how their previous treatment has been distorted, and we are trying to reenvision the realities and recommendations with which these aspects of moral theorizing do and should try to deal.

I. REASON AND EMOTION

In the area of moral theory in the modern era, the priority accorded to reason has taken two major forms. A) On the one hand has been the Kantian, or Kantian-inspired search for very general, abstract, deontological, universal moral principles by which rational beings should be guided. Kant's Categorical Imperative is a foremost example: it suggests that all moral problems can be handled by applying an impartial, pure, rational principle to particular cases. It requires that we try to see what the general features of the problem before us are, and that we apply an abstract principle, or rules derivable from it, to this problem. On this view, this procedure should be adequate for all moral decisions. We should thus be able to act as reason recommends, and resist yielding to emotional inclinations and desires in conflict with our rational wills.

B) On the other hand, the priority accorded to reason in the modern era has taken a Utilitarian form. The Utilitarian approach, reflected in rational choice theory, recognizes that persons have desires and interests, and suggests rules of rational choice for maximizing the satisfaction of these. While some

philosophers in this tradition espouse egoism, especially of an intelligent and long-term kind, many do not. They begin, however, with assumptions that what are morally relevant are gains and losses of utility to theoretically isolatable individuals, and that the outcome at which morality should aim is the maximization of the utility of individuals. Rational calculation about such an outcome will, in this view, provide moral recommendations to guide all our choices. As with the Kantian approach, the Utilitarian approach relies on abstract general principles or rules to be applied to particular cases. And it holds that although emotion is, in fact, the source of our desires for certain objectives, the task of morality should be to instruct us on how to pursue those objectives most rationally. Emotional attitudes toward moral issues themselves interfere with rationality and should be disregarded. Among the questions Utilitarians can ask can be questions about which emotions to cultivate, and which desires to try to change, but these questions are to be handled in the terms of rational calculation, not of what our feelings suggest.

Although the conceptions of what the judgments of morality should be based on, and of how reason should guide moral decision, are different in Kantian and in Utilitarian approaches, both share a reliance on a highly abstract, universal principle as the appropriate source of moral guidance, and both share the view that moral problems are to be solved by the application of such an abstract principle to particular cases. Both share an admiration for the rules of reason to be appealed to in moral contexts, and both denigrate emotional responses to moral issues.

Many feminist philosophers have questioned whether the reliance on abstract rules, rather than the adoption of more context-respectful approaches, can possibly be adequate for dealing with moral problems, especially as women experience them.[26] Though Kantians may hold that complex rules can be elaborated for specific contexts, there is nevertheless an assumption in this approach that the more abstract the reasoning applied to a moral problem, the more satisfactory. And Utilitarians suppose that one highly abstract principle, the Principle of Utility, can be applied to every moral problem no matter what the context.

A genuinely universal or gender-neutral moral theory would be one which would take account of the experience and concerns of women as fully as it would take account of the experience and concerns of men. When we focus on the experience of women, however, we seem to be able to see a set of moral concerns becoming salient that differs from those of traditional or standard moral theory. Women's experience of moral problems seems to lead us to be especially concerned with actual relationships between embodied persons, and with what these relationships seem to require. Women are often inclined to attend to rather than to dismiss the particularities of the context in which a moral problem arises. And we often pay attention to feelings of empathy and caring to suggest what we ought to do rather than relying as fully as possible on abstract rules of reason.

Margaret Walker, for instance, contrasts feminist moral "understanding" with traditional moral "knowledge." She sees the components of the former as involving "attention, contextual and narrative appreciation, and communication in the event of moral deliberation."[27] This alternative moral epistemology holds that "the adequacy of moral understanding decreases as its form approaches generality through abstraction."[28]

The work of psychologists such as Carol Gilligan and others has led to a clarification of what may be thought of as tendencies among women to approach moral issues differently. Rather than interpreting moral problems in terms of what could be handled by applying abstract rules of justice to particular cases, many of the women studied by Gilligan tended to be more concerned with preserving actual human relationships, and with expressing care for those for whom they felt responsible. Their moral reasoning was typically more embedded in a context of particular others than was the reasoning of a comparable group of men.[29] One should not equate tendencies women in fact display with feminist views, since the former may well be the result of the sexist, oppressive conditions in which women's lives have been lived. But many feminists see our own consciously considered experience as lending confirmation to the

view that what has come to be called "an ethic of care" needs to be developed. Some think it should supersede "the ethic of justice" of traditional or standard moral theory. Others think it should be integrated with the ethic of justice and rules.

In any case, feminist philosophers are in the process of reevaluating the place of emotion in morality in at least two respects. First, many think morality requires the development of the moral emotions, in contrast to moral theories emphasizing the primacy of reason. As Annette Baier notes, the rationalism typical of traditional moral theory will be challenged when we pay attention to the role of parent. "It might be important," she writes, "for father figures to have rational control over their violent urges to beat to death the children whose screams enrage them, but more than control of such nasty passions seems needed in the mother or primary parent, or parent-substitute, by most psychological theories. They need to love their children, not just to control their irritation."[30] So the emphasis in many traditional theories on rational control over the emotions, "rather than on cultivating desirable forms of emotion,"[31] is challenged by feminist approaches to ethics.

Secondly, emotion will be respected rather than dismissed by many feminist moral philosophers in the process of gaining moral understanding. The experience and practice out of which feminist moral theory can be expected to be developed will include embodied feeling as well as thought. In a recent overview of a vast amount of writing, Kathryn Morgan states that "feminist theorists begin ethical theorizing with embodied, gendered subjects who have particular histories, particular communities, particular allegiances, and particular visions of human flourishing. The starting point involves valorizing what has frequently been most mistrusted and despised in the western philosophical tradition. . . ."[32] Among the elements being reevaluated are feminine emotions. The "care" of the alternative feminist approach to morality appreciates rather than rejects emotion. The caring relationships important to feminist morality cannot be understood in terms of abstract rules or moral reasoning. And the "weighing" so often

needed between the conflicting claims of some relationships and others cannot be settled by deduction or rational calculation. A feminist ethic will not just acknowledge emotion, as do Utilitarians, as giving us the objectives toward which moral rationality can direct us. It will embrace emotion as providing at least a partial basis for morality itself, and for moral understanding.

Annette Baier stresses the centrality of trust for an adequate morality.[33] Achieving and maintaining trusting, caring, relationships is quite different from acting in accord with rational principles, or satisfying the individual desires of either self or other. Caring, empathy, feeling with others, being sensitive to each other's feelings, all may be better guides to what morality requires in actual contexts than may abstract rules of reason, or rational calculation, or at least they may be necessary components of an adequate morality.

The fear that a feminist ethic will be a relativistic "situation ethic" is misplaced. Some feelings can be as widely shared as are rational beliefs, and feminists do not see their views as reducible to "just another attitude."[34] In her discussion of the differences between feminist medical ethics and non-feminist medical ethics, Susan Sherwin gives an example of how feminists reject the mere case by case approach that has come to predominate in nonfeminist medical ethics. The latter also rejects the excessive reliance on abstract rules characteristic of standard ethics, and in this way resembles feminist ethics. But the very focus on cases in isolation from one another deprives this approach from attending to general features in the institutions and practices of medicine that, among other faults, systematically contribute to the oppression of women.[35] The difference of approach can be seen in the treatment of issues in the new reproductive technologies, where feminists consider how the new technologies may further decrease the control of women over reproduction.

This difference might be thought to be one of substance rather than of method, but Sherwin shows the implications for method also. With respect to

reproductive technologies one can see especially clearly the deficiencies of the case by case approach: what needs to be considered is not only choice in the purely individualistic interpretation of the case by case approach, but control at a more general level and how it affects the structure of gender in society. Thus, a feminist perspective does not always counsel attention to specific case vs. appeal to general considerations, as some sort of methodological rule. But the general considerations are often not the purely abstract ones of traditional and standard moral theory, they are the general features and judgments to be made about cases in actual (which means, so far, patriarchal) societies. A feminist evaluation of a moral problem should never omit the political elements involved; and it is likely to recognize that political issues cannot be dealt with adequately in purely abstract terms any more than can moral issues.

The liberal tradition in social and moral philosophy argues that in pluralistic society and even more clearly in a pluralistic world, we cannot agree on our visions of the good life, on what is the best kind of life for humans, but we can hope to agree on the minimal conditions for justice, for coexistence within a framework allowing us to pursue our visions of the good life.[36] Many feminists contend that the commitment to justice needed for agreement *in actual conditions* on even minimal requirements of justice is as likely to demand relational feelings as a rational recognition of abstract principles. Human beings can and do care, and are capable of caring far more than at present, about the sufferings of children quite distant from them, about the prospects for future generations, and about the well-being of the globe. The liberal tradition's mutually disinterested rational individualists would seem unlikely to care enough to take the actions needed to achieve moral decency at a global level, or environmental sanity for decades hence, as they would seem unable to represent caring relationships within the family and among friends. As Annette Baier puts it, "A moral theory, it can plausibly be claimed, cannot regard concern for new and future persons as an optional charity left for those

with a taste for it. If the morality the theory endorses is to sustain itself, it must provide for its own continuers, not just take out a loan on a carefully encouraged maternal instinct or on the enthusiasm of a self-selected group of environmentalists, who make it their business or hobby to be concerned with what we are doing to mother earth."[37]

The possibilities as well as the problems (and we are well aware of some of them) in a feminist reenvisioning of emotion and reason need to be further developed, but we can already see that the views of nonfeminist moral theory are unsatisfactory.

II. THE PUBLIC AND THE PRIVATE

The second questionable aspect of the history of ethics on which I focused was its conception of the distinction between the public and the private. As with the split between reason and emotion, feminists are showing how gender-bias has distorted previous conceptions of these spheres, and we are trying to offer more appropriate understandings of "private" morality and "public" life.

Part of what feminists have criticized has been the way the distinction has been accompanied by a supposition that what occurs in the household occurs as if on an island beyond politics, whereas the personal is highly affected by the political power beyond, from legislation about abortion to the greater earning power of men, to the interconnected division of labor by gender both within and beyond the household, to the lack of adequate social protection for women against domestic violence.[38] Of course we recognize that the family is not identical to the state, and we need concepts for thinking about the private or personal, and the public or political. But they will have to be very different from the traditional concepts.

Feminists have also criticized deeper assumptions about what is distinctively human and what is "natural" in the public and private aspects of human life, and what is meant by "natural" in connection with women.[39] Consider the associations that have

traditionally been built up: the public realm is seen as the distinctively human realm in which man transcends his animal nature, while the private realm of the household is seen as the natural region in which women merely reproduce the species.[40] These associations are extraordinarily pervasive in standard concepts and theories, in art and thought and cultural ideals, and especially in politics.

Dominant patterns of thought have seen women as primarily mothers, and mothering as the performance of a primarily biological function. Then it has been supposed that while engaging in political life is a specifically human activity, women are engaged in an activity which is not specifically human. Women accordingly have been thought to be closer to nature than men,[41] to be enmeshed in a biological function involving processes more like those in which other animals are involved than like the rational discussion of the citizen in the polis, or the glorious battles of noble soldiers, or the trading and rational contracting of "economic man." The total or relative exclusion of women from the domain of public life has then been seen as either inevitable or appropriate.

The view that women are more determined by biology than are men is still extraordinarily prevalent. It is as questionable from a feminist perspective as many other traditional misinterpretations of women's experience. Human mothering is an extremely different activity from the mothering engaged in by other animals. The work and speech of men is recognized as very different from what might be thought of as the "work" and "speech" of other animals. Human mothering is fully as different from animal mothering. Of course all human beings are animal as well as human. But to whatever extent it is appropriate to recognize a difference between "man" and other animals, so would it be appropriate to recognize a comparable difference between "woman" and other animals, and between the activities—including mothering—engaged in by women and the behavior of other animals.

Human mothering shapes language and culture, it forms human social personhood, it develops

morality. Animal behavior can be highly impressive and complex, but it does not have built into it any of the consciously chosen aims of morality. In creating human social persons, human mothering is different in kind from merely propagating a species. And human mothering can be fully as creative an activity as those activities traditionally thought of as distinctively human, because to create *new* persons, and new types of *persons*, can surely be as creative as to make new objects, products, or institutions. *Human* mothering is no more "natural" or "primarily biological" than is any other human activity.

Consider nursing an infant, often thought of as the epitome of a biological process with which mothering is associated and women are identified. There is no reason to think of human nursing as any more simply biological than there is to think of, say, a businessmen's lunch this way. Eating is a biological process, but what and how and with whom we eat are thoroughly cultural. Whether and how long and with whom a woman nurses an infant, are also human, cultural matters. If men transcend the natural by conquering new territory and trading with their neighbors and making deals over lunch to do so, women can transcend the natural by choosing not to nurse their children when they could, or choosing to nurse them when their culture tells them not to, or singing songs to their infants as they nurse, or nursing in restaurants to overcome the prejudices against doing so, or thinking human thoughts as they nurse, and so forth. Human culture surrounds and characterizes the activity of nursing as it does the activities of eating, or governing, or writing, or thinking.

We are continually being presented with images of the humanly new and creative as occurring in the public realm of the polis, or the realms of marketplace or of art and science outside the household. The very term "reproduction" suggests mere repetition, the "natural" bringing into existence of repeated instances of the same human animal. But human reproduction is not repetition.[42] This is not to suggest that bringing up children in the interstices of patriarchal society, in society structured by institutions supporting male dominance, can achieve the

potential of transformation latent in the activity of human mothering. But the activity of creating new social persons and new kinds of persons is potentially the most transformative human activity of all. And it suggests that morality should concern itself first of all with this activity, with what its norms and practices ought to be, and with how the institutions and arrangements throughout society and the world ought to be structured to facilitate the right kinds of development of the best kinds of new persons. The flourishing of children ought to be at the very center of moral and social and political and economic and legal thought, rather than, as at present, at the periphery, if attended to at all.

Revised conceptions of public and private have significant implications for our conceptions of human beings and relationships between them. Some feminists suggest that instead of seeing human relationships in terms of the impersonal ones of the "public" sphere, as standard political and moral theory has so often done, we might consider seeing human relationships in terms of those experienced in the sphere of the "private," or of what these relationships could be imagined to be like in post-patriarchal society.[43] The traditional approach is illustrated by those who generalize, to other regions of human life than the economic, assumptions about "economic man" in contractual relations with other men. It sees such impersonal, contractual relations as paradigmatic, even, on some views, for moral theory. Many feminists, in contrast, consider the realm of what has been misconstrued as the "private" as offering guidance to what human beings and their relationships should be like even in regions beyond those of family and friendship. Sara Ruddick looks at the implications of the practice of mothering for the conduct of peace politics.[44] Marilyn Friedman and Lorraine Code consider friendship, especially as women understand it, as a possible model for human relationships.[45] Others see society as non-contractual rather than as contractual.

Clearly, a reconceptualization is needed of the ways in which every human life is entwined with personal and with social components. Feminist theorists are contributing imaginative work to this project.

III. THE CONCEPT OF SELF

Let me turn now to the third aspect of the history of ethics which I discussed and which feminists are reenvisioning: the concept of self. One of the most important emphases in a feminist approach to morality is the recognition that more attention must be paid to the domain between, on the one hand, the self as ego, as self-interested individual, and, on the other hand, the universal, everyone, others in general.[46] Traditionally, ethics has dealt with these poles of individual self and universal all. Usually, it has called for impartiality against the partiality of the egoistic self; sometimes it has defended egoism against claims for a universal perspective. But most standard moral theory has hardly noticed as morally significant the intermediate realm of family relations and relations of friendship, of group ties and neighborhood concerns, especially from the point of view of women. When it has noticed this intermediate realm it has often seen its attachments as threatening to the aspirations of the Man of Reason, or as subversive of "true" morality. In seeing the problems of ethics as problems of reconciling the interests of the self with what would be right or best for "everyone," standard ethics has neglected the moral aspects of the concern and sympathy which people actually feel for particular others, and what moral experience in this intermediate realm suggests for an adequate morality.

The region of "particular others" is a distinct domain, where what can be seen to be artificial and problematic are the very egoistic "self" and the universal "all others" of standard moral theory. In the domain of particular others, the self is already constituted to an important degree by relations with others, and these relations may be much more salient and significant than the interests of any individual self in isolation.[47] The "others" in the picture, however, are not the "all others," or "everyone," of traditional moral theory; they are not what a universal point of view or a view from nowhere could provide.[48] They are, characteristically, actual flesh and blood other human beings for whom we have actual feelings and with whom we have real ties.

From the point of view of much feminist theory, the individualistic assumptions of liberal theory and of most standard moral theory are suspect. Even if we would be freed from the debilitating aspects of dominating male power to "be ourselves" and to pursue our own interests, we would, as persons, still have ties to other persons, and we would at least in part be constituted by such ties. Such ties would be part of what we inherently are. We are, for instance, the daughter or son of given parents, or the mother or father of given children, and we carry with us at least some ties to the racial or ethnic or national group within which we developed into the persons we are.

If we look, for instance, at the realities of the relation between mothering person (who can be female or male) and child, we can see that what we value in the relation cannot be broken down into individual gains and losses for the individual members in the relation. Nor can it be understood in universalistic terms. Self-development apart from the relation may be much less important than the satisfactory development of the relation. What matters may often be the health and growth of and the development of the relation-and-its-members in ways that cannot be understood in the individualistic terms of standard moral theories designed to maximize the satisfaction of self-interest. The universalistic terms of moral theories grounded in what would be right for "all rational beings" or "everyone" cannot handle, either, what has moral value in the relation between mothering person and child.

Feminism is of course not the only locus of criticism of the individualistic and abstractly universalistic features of liberalism and of standard moral theory. Marxists and communitarians also see the self as constituted by its social relations. But in their usual form, Marxist and communitarian criticisms pay no more attention than liberalism and standard moral theory to the experience of women, to the context of mothering, or to friendship as women experience it.[49] Some recent nonfeminist criticisms, such as offered by Bernard Williams, of the impartiality required by standard moral theory, stress how a person's identity may be formed by personal projects in ways that do not satisfy universal norms, yet ought to be admired. Such views still interpret morality from the point of view of an individual and his project, not a social relationship such as that between mothering person and child. And recent nonfeminist criticisms in terms of traditional communities and their moral practices, as seen for instance in the work of Stuart Hampshire and Alasdair MacIntyre, often take traditional gender roles as given, or provide no basis for a radical critique of them.[50] There is no substitute, then, for feminist exploration of the area between ego and universal, as women experience this area, or for the development of a refocused concept of relational self that could be acceptable from a feminist point of view.

Relationships can be evaluated as trusting or mistrustful, mutually considerate or selfish, harmonious or stressful, and so forth. Where trust and consideration are appropriate, which is not always, we can find ways to foster them. But understanding and evaluating relationships, and encouraging them to be what they can be at their best, require us to look at relationships between actual persons, and to see what both standard moral theories and their nonfeminist critics often miss. To be adequate, moral theories must pay attention to the neglected realm of particular others in the actual relationships and actual contexts of women's experience. In doing so, problems of individual self-interest vs. universal rules may recede to a region more like background, out-of-focus insolubility or relative unimportance. The salient problems may then be seen to be how we ought best to guide or to maintain or to reshape the relationships, both close and more distant, that we have, or might have, with actual other human beings. Particular others can be actual children in need in distant continents, or the anticipated children of generations not yet even close to being born. But they are not "all rational beings" or "the greatest number," and the self that is in relationships with particular others and is composed to a significant degree by such relations is not a self whose ego must be pitted against abstract, universal claims. Developing the needed guidance for maintaining and reshaping relationships presents enormous problems, but a first step is to recognize how traditional and nonfeminist

moral theory of both an individualistic and communitarian kind falls short in providing it.

The concept of the relational self which is evolving within feminist thought is leading to interesting inquiry in many fields. An example is the work being done at the Stone Center at Wellesley College.[51] Psychologists there have posited a self-in-relation theory and are conducting empirical inquiries to try to establish how the female self develops. They are working with a theory that a female relational self develops through a mutually empathetic mother-daughter bond.

The work has been influenced by Jean Baker Miller's re-evaluation of women's psychological qualities as strengths rather than weaknesses. In her book *Toward a New Psychology of Women*, published in 1976, Miller identified women's "great desire for affiliation" as one such strength.[52] Nancy Chodorow's *The Reproduction of Mothering*, published in 1978, has also had a significant influence on the work done at the Stone Center, as it has on much feminist inquiry.[53] Chodorow argued that a female affiliative self is reproduced by a structure of parenting in which mothers are the primary caretakers, and sons and daughters develop differently in relation to a parent of the same sex, or a parent of different sex, as primary caretaker. Daughters develop a sense of self by identifying themselves with the mother; they come to define themselves as connected to or in relation with others. Sons, in contrast, develop a sense of self by differentiating themselves from the mother; they come to define themselves as separate from or unconnected to others. An implication often drawn from Chodorow's work is that parenting should be shared equally by fathers and mothers so that children of either sex can develop with caretakers of both same and different sex.

In 1982, Carol Gilligan, building on both Miller and Chodorow, offered her view of the "different voice" with which girls and women express their understanding of moral problems.[54] Like Miller and Chodorow, Gilligan valued tendencies found especially in women to affiliate with others and to interpret their moral responsibilities in terms of their relationships with others. In all, the valuing of autonomy and individual independence over care and concern for relationships, was seen as an expression of male bias. The Stone Center has tried to elaborate and to study a feminist conception of the relational self. In a series of Working Papers, researchers and clinicians have explored the implications of this conception for various issues in women's psychology (e.g. power, anger, work inhibitions, violence, eating patterns) and for therapy.

The self as conceptualized in these studies is seen as having both a need for recognition and a need to understand the other, and these needs are seen as compatible. They are created in the context of mother-child interaction, and are satisfied in a mutually empathetic relationship. This does not require a loss of self, but a relationship of mutuality in which self and other both express intersubjectivity. Both give and take in a way that not only contributes to the satisfaction of their needs as individuals, but also affirms the "larger relational unit" they compose.[55] Maintaining this larger relational unit then becomes a goal, and maturity is seen not in terms of individual autonomy but in terms of competence in creating and sustaining relations of empathy and mutual intersubjectivity.

The Stone Center psychologists contend that the goal of mutuality is rarely achieved in adult male-female relationships because of the traditional gender system. The gender system leads men to seek autonomy and power over others, and to undervalue the caring and relational connectedness that is expected of women. Women rarely receive the nurturing and empathetic support they provide. Accordingly, these psychologists look to the interaction that occurs in mother-daughter relationships as the best source of insight into the promotion of the healthy, relational self. This research provides an example of exploration into a refocused, feminist conception of the self, and into empirical questions about its development and implications.

In a quite different field, that of legal theory, a refocused concept of self is leading to reexaminations of such concepts as property and autonomy and the role these have played in political theory and in constitutional law. For instance, the legal theorist Jennifer Nedelsky questions the imagery that is

dominant in constitutional law and in our conceptions of property: the imagery of a bounded self, a self contained within boundaries and having rights to property within a wall allowing it to exclude others and to exclude government. The boundary metaphor, she argues, obscures and distorts our thinking about human relationships and what is valuable in them. "The boundedness of selves," Nedelsky writes, "may seem to be a self-evident truth, but I think it is a wrong-headed and destructive way of conceiving of the human creatures law and government are created for."[56] In the domain of the self's relation to the state, the central problem, she argues, is not "maintaining a sphere into which the state cannot penetrate, but fostering autonomy when people are already within the sphere of state control or responsibility."[57] What we can from a feminist perspective think of as the male "separative self" seems on an endless quest for security behind such walls of protection as those of property. Property focuses the quest for security "in ways that are paradigmatic of the efforts of separative selves to protect themselves through boundaries. . . ."[58] But of course property is a social construction, not a thing; it requires the involvement of the state to define what it is and to defend it. What will provide what it seeks to offer will not be boundaries and exclusions, but constructive relationships.

In an article on autonomy, Nedelsky examines the deficiencies in the concept of self with which so much of our political and legal thinking about autonomy has been developed. She well recognizes that of course feminists are centrally concerned with freedom and autonomy, with enabling women to live our own lives. But we need a language with which to express these concerns which will also reflect "the equally important feminist precept that any good theorizing will start with people in their social contexts. And the notion of social context must take seriously its constitutive quality; social context cannot simply mean that individuals will, of course, encounter one another."[59] The problem, then, is how to combine the claim of the constitutiveness of social relations with the value of self-determination. Liberalism has

been the source of our language of freedom and self-determination, but it lacks the ability to express comprehension of "the reality we know: the centrality of relationships in constituting the self."[60]

In developing a new conception of autonomy that avoids positing self-sufficient and thus highly artificial individuals, Nedelsky points out first that "the capacity to find one's own law can develop only in the context of relations with others (both intimate and more broadly social) that nurture this capacity, and second, that the 'content' of one's own law is comprehensible only with reference to shared social norms, values, and concepts."[61] She sees the traditional liberal view of the self as implying that the most perfectly autonomous man is the most perfectly isolated, and finds this pathological.

Instead of developing autonomy through images of walls around one's property, as does the Western liberal tradition and as does U.S. constitutional law, Nedelsky suggests that "the most promising model, symbol, or metaphor for autonomy is not property, but childrearing. There we have encapsulated the emergence of autonomy through relationship with others. . . . Interdependence [is] a constant component of autonomy."[62] And she goes on to examine how law and bureaucracies can foster autonomy within relationships between citizen and government. This does not entail extrapolating from intimate relations to largescale ones; rather, the insights gained from experience with the context of childrearing allow us to recognize the relational aspects of autonomy. In work such as Nedelsky's we can see how feminist reconceptualizations of the self can lead to the rethinking of fundamental concepts even in terrains such as law, thought by many to be quite distant from such disturbances.

To argue for a view of the self as relational does not mean that women need to remain enmeshed in the ties by which they are constituted. In recent decades, especially, women have been breaking free of relationships with parents, with the communities in which they grew up, and with men, relationships in which they defined themselves through the traditional and often stifling expectations of others.[63] These quests

for self have often involved wrenching instability and painful insecurity. But the quest has been for a new and more satisfactory relational self, not for the self-sufficient individual of liberal theory. Many might share the concerns expressed by Alison Jaggar that disconnecting ourselves from particular others, as ideals of individual autonomy seem to presuppose we should, might make us *in*capable of morality, rather than capable of it, if, as so many feminists think, "an ineliminable part of morality consists in responding emotionally to particular others."[64]

I have examined three topics on which feminist philosophers and feminists in other fields are thinking anew about where we should start and how we should focus our attention in ethics. Feminist reconceptualizations and recommendations concerning the relation between reason and emotion, the distinction between public and private, and the concept of the self, are providing insights deeply challenging to standard moral theory. The implications of this work are that we need an almost total reconstruction of social and political and economic and legal theory in all their traditional forms as well as a reconstruction of moral theory and practice at more comprehensive, or fundamental, levels.

Notes

1. See e.g. Cheshire Calhoun, "Justice, Care, Gender Bias," *The Journal of Philosophy* 85 (September, 1988): 451–63.

2. Lorraine Code, "Second Persons," in *Science, Morality and Feminist Theory*, ed. Marsha Hanen and Kai Nielsen (Calgary: University of Calgary Press, 1987), p. 360.

3. See e.g. *Revolutions in Knowledge: Feminism in the Social Sciences*, ed. Sue Rosenberg Zalk and Janice Gordon-Kelter (Boulder: Westview Press, forthcoming).

4. Genevieve Lloyd, *The Man of Reason: 'Male' and 'Female' in Western Philosophy* (Minneapolis: University of Minnesota Press, 1984), p. 104.

5. Ibid., p. 2.

6. Ibid., p. 3.

7. Ibid., p. 4. For a feminist view of how reason and emotion in the search for knowledge might be reevaluated, see Alison M. Jaggar, "Love and Knowledge:

Emotion in Feminist Epistemology," *Inquiry* 32 (June, 1989): 151–76.

8. David Heyd, *Supererogation: Its Status in Ethical Theory* (New York: Cambridge University Press, 1982), p. 134.

9. J. O. Urmson, "Saints and Heroes," in *Essays in Moral Philosophy*, ed. A. I. Melden (Seattle: University of Washington Press, 1958), p. 202. I am indebted to Marcia Baron for pointing out this and the previous example in her "Kantian Ethics and Supererogation," *The Journal of Philosophy* 84 (May, 1987): 237–62.

10. Alan Ryan, "Distrusting Economics," *New York Review of Books* (May 18, 1989): 25–27. For a different treatment, see *Beyond Self-Interest*, ed. Jane Mansbridge (Chicago: University of Chicago Press, 1990).

11. See especially *Mothering: Essays in Feminist Theory*, ed. Joyce Trebilcot (Totowa, New Jersey: Rowman and Allanheld, 1984); and Sara Ruddick, *Maternal Thinking: Toward a Politics of Peace* (Boston: Beacon Press, 1989).

12. Christine Di Stefano, "Masculinity as Ideology in Political Theory: Hobbesian Man Considered," *Women's Studies International Forum* (Special Issue: *Hypatia*), Vol. 6, No. 6 (1983): 633–44, p. 637.

13. Thomas Hobbes, *The Citizen: Philosophical Rudiments Concerning Government and Society*, ed. B. Gert (Garden City, New York: Doubleday, 1972 (1651)), p. 205.

14. Di Stefano, op. cit., p. 638.

15. Ibid.

16. Ibid., p. 639.

17. For examples of relevant passages, see *Philosophy of Woman: Classical to Current Concepts*, ed. Mary Mahowald (Indianapolis: Hackett, 1978); and *Visions of Women*, ed. Linda Bell (Clifton, New Jersey: Humana, 1985). For discussion, see Susan Moller Okin, *Women in Western Political Thought* (Princeton, New Jersey: Princeton University Press, 1979); and Lorenne Clark and Lynda Lange, eds., *The Sexism of Social and Political Theory* (Toronto: University of Toronto Press, 1979).

18. Annette Baier, "Trust and Anti-Trust," *Ethics* 96 (1986): 231–60, pp. 247–48.

19. Ibid.

20. Kathryn Pauly Morgan, "Strangers in a Strange Land: Feminists Visit Relativists" in *Perspectives on Relativism*, ed. D. Odegaard and Carole Stewart (Toronto: Agathon Press, 1990).

21. Kathryn Morgan, "Women and Moral Madness," in *Science, Morality and Feminist Theory*, ed. Hanen and Nielsen, p. 223.

22. Alison M. Jaggar, "Feminist Ethics: Some Issues For The Nineties," *Journal of Social Philosophy* 20 (Spring/Fall 1989), p. 91.

23. Ibid.

24. One well-argued statement of this position is Barbara Houston, "Rescuing Womanly Virtues: Some Dangers of Moral Reclamation," in *Science, Morality and Feminist Theory*, ed. Hanen and Nielsen.

25. See e.g. Elizabeth V. Spelman, *Inessential Woman: Problems of Exclusion in Feminist Thought* (Boston: Beacon Press, 1988). See also Sarah Lucia Hoagland, *Lesbian Ethics: Toward New Value* (Palo Alto, California: Institute of Lesbian Studies, 1989); and Katie Geneva Cannon, *Black Womanist Ethics* (Atlanta, Georgia: Scholars Press, 1988).

26. For an approach to social and political as well as moral issues that attempts to be context-respectful, see Virginia Held, *Rights and Goods: Justifying Social Action* (Chicago: University of Chicago Press, 1989).

27. Margaret Urban Walker, "Moral Understandings: Alternative 'Epistemology' for a Feminist Ethics," *Hypatia* 4 (Summer, 1989): 15–28, p. 19.

28. Ibid., p. 20. See also Iris Marion Young, "Impartiality and the Civic Public. Some Implications of Feminist Critiques of Moral and Political Theory," in Seyla Benhabib and Drucilla Cornell, *Feminism as Critique* (Minneapolis: University of Minnesota Press, 1987).

29. See especially Carol Gilligan, *In a Different Voice: Psychological Theory and Women's Development* (Cambridge, Massachusetts: Harvard University Press, 1988); and Eva Feder Kittay and Diana T. Meyers, eds., *Women and Moral Theory* (Totowa, New Jersey: Rowman and Allanheld, 1987).

30. Annette Baier, "The Need for More Than Justice," in *Science, Morality and Feminist Theory*, ed. Hanen and Nielsen, p. 55.

31. Ibid.

32. Kathryn Pauly Morgan, "Strangers in a Strange Land . . .," p. 2.

33. Annette Baier, "Trust and Anti-Trust."

34. See especially Kathryn Pauly Morgan, "Strangers in a Strange Land. . . ."

35. Susan Sherwin, "Feminist and Medical Ethics: Two Different Approaches to Contextual Ethics," *Hypatia* 4 (Summer, 1989): 57–72.

36. See especially the work of John Rawls and Ronald Dworkin; see also Charles Larmore, *Patterns of Moral Complexity* (Cambridge: Cambridge University Press, 1987).

37. Annette Baier, "The Need for More Than Justice," pp. 53–54.

38. See e.g. Linda Nicholson, *Gender and History: The Limits of Social Theory in the Age of the Family* (New York: Columbia University Press, 1986); and Jean Bethke Elshtain, *Public Man, Private Woman* (Princeton, New Jersey: Princeton University Press, 1981). See also Carole Pateman, *The Sexual Contract* (Stanford, California: Stanford University Press, 1988).

39. See e.g. Susan Moller Okin, *Women in Western Political Thought*. See also Alison M. Jaggar, *Feminist Politics and Human Nature* (Totowa, New Jersey: Rowman and Allanheld, 1983).

40. So entrenched is this way of thinking that it was even reflected in Simone de Beauvoir's pathbreaking feminist text *The Second Sex*, published in 1949. Here, as elsewhere, feminists have had to transcend our own early searches for our own perspectives.

41. See e.g. Sherry B. Ortner, "Is Female to Male as Nature is to Culture?" in *Woman, Culture, and Society*, ed. Michelle Z. Rosaldo and Louise Lamphere (Stanford: Stanford University Press, 1974).

42. For further discussion and an examination of surrounding associations, see Virginia Held, "Birth and Death," in *Ethics* 99 (January 1989): 362–88.

43. See e.g., Virginia Held, "Non-contractual Society: A Feminist View," in *Science, Morality and Feminist Theory*, eds. Hanen and Nielson.

44. Sara Ruddick, *Maternal Thinking*.

45. See Marilyn Friedman, "Feminism and Modern Friendship: Dislocating the Community," *Ethics* 99 (January 1989): 275–90; and Lorraine Code, "Second Persons."

46. See Virginia Held, "Feminism and Moral Theory," in *Women and Moral Theory*, eds. Kittay and Meyers.

47. See Seyla Benhabib, "The Generalized and the Concrete Other: The Kohlberg-Gilligan Controversy and Moral Theory," in *Women and Moral Theory*, ed. Kittay and Meyers. See also Caroline Whitbeck, "Feminist Ontology: A Different Reality," in *Beyond Domination*, ed. Carol Gould (Totowa, New Jersey: Rowman and Allanheld, 1983).

48. See Thomas Nagel, *The View from Nowhere* (New York: Oxford University Press, 1986). For a feminist critique, see Susan Bordo, "Feminism, Postmodernism, and Gender-Skepticism," in *Feminism/Postmodernism*, ed. Linda Nicholson (New York: Routledge, 1989).

49. On Marxist theory, see e.g. *Women and Revolution*, ed. Lydia Sargent (Boston: South End Press, 1981); Alison Jaggar, *Feminist Politics and Human Nature;* and

Ann Ferguson, *Blood at the Root: Motherhood, Sexuality and Male Dominance* (London: Pandora, 1989). On communitarian theory, see Marilyn Friedman, "Feminism and Modern Friendship . . .," and also her paper "The Social Self and the Partiality Debates," presented at the Society for Women in Philosophy meeting in New Orleans, April 1990.

50. Bernard Williams, *Moral Luck* (Cambridge: Cambridge University Press, 1981); *Public and Private Morality*, ed. Stuart Hampshire (Cambridge: Cambridge University Press, 1978); Alasdair MacIntyre, *After Virtue: A Study in Moral Theory* (Notre Dame, Indiana: University of Notre Dame Press, 1981). For discussion see Susan Moller Okin, *Justice, Gender, and the Family* (New York: Basic Books, 1989).

51. On the Stone Center concept of the self see especially Jean Baker Miller, "The Development of Women's Sense of Self," Wellesley, Massachusetts: Stone Center Working Paper No. 12; Janet Surrey, "The 'Self-in-Relation': A Theory of Women's Development" (Wellesley, Massachusetts: Stone Center Working Paper No. 13); and Judith Jordan, "The Meaning of Mutuality" (Wellesley, Massachusetts: Stone Center Working Paper No. 23). For a feminist but critical view of this work, see Marcia Westkott, "Female Relationality and the Idealized Self," *American Journal of Psychoanalysis* 49 (September, 1989): 239–50.

52. Jean Baker Miller, *Toward a New Psychology of Women* (Boston: Beacon Press, 1976).

53. Nancy Chodrow, *The Reproduction of Mothering: Psychoanalysis and the Sociology of Gender* (Berkeley: University of California Press, 1978).

54. Carol Gilligan, *In a Different Voice.*

55. J. V. Jordan, "The Meaning of Mutuality," p. 2.

56. Jennifer Nedelsky, "Law, Boundaries, and the Bounded Self," *Representations* 30 (Spring, 1990): 162–89, at 167.

57. Ibid., p. 169.

58. Ibid., p. 181.

59. Jennifer Nedelsky, "Reconceiving Autonomy: Sources, Thoughts and Possibilities," *Yale Journal of Law and Feminism* 1 (Spring, 1989): 7–36, p. 9. See also Diana T. Meyers, *Self, Society, and Personal Choice* (New York: Columbia University Press, 1989).

60. Ibid.

61. Ibid., p. 11.

62. Ibid., p. 12. See also Mari J. Matsuda, "Liberal Jurisprudence and Abstracted Visions of Human Nature," *New Mexico Law Review* 16 (Fall, 1986): 613–30.

63. See e.g. *Women's Ways of Knowing: The Development of Self, Voice, and Mind*, by Mary Field Belenky, Blyth McVicker Clinchy, Nancy Rule Goldberger, and Jill Mattuck Tarule (New York: Basic Books, 1986).

64. Alison Jaggar, "Feminist Ethics: Some Issues for the Nineties," p. 11.

Study Questions

1. According to Held, how has gender bias distorted our concept of the distinction between the public and the private?

2. Why does Held refer to the "mothering person" rather than the "fathering person"?

3. What does Held mean by "the relational self"?

4. Do you recognize distinctive feminist virtues or values?

38

GILBERT HARMAN

Gilbert Harman is Professor of Philosophy at Princeton University. He argues that moral beliefs are incapable of the sort of empirical confirmation characteristic of scientific beliefs. This asymmetry suggests moral nihilism, the absence of moral facts, moral truths, and moral knowledge. Harman believes, however, that just as nonmoral evaluations, such as "a good watch" or "a good teacher," can rest on facts about the world, so moral evaluations may do so also. Yet for Harman specifying such facts remains problematic.

The Nature of Morality

ETHICS AND OBSERVATION

1. The Basic Issue

Can moral principles be tested and confirmed in the way scientific principles can? Consider the principle that, if you are given a choice between five people alive and one dead or five people dead and one alive, you should always choose to have five people alive and one dead rather than the other way round. We can easily imagine examples that appear to confirm this principle. Here is one:

> You are a doctor in a hospital's emergency room when six accident victims are brought in. All six are in danger of dying but one is much worse off than the others. You can just barely save that person if you devote all of your resources to him and let the others die. Alternatively, you can save the other five if you are willing to ignore the most seriously injured person.

It would seem that in this case you, the doctor, would be right to save the five and let the other person die. So this example, taken by itself, confirms the principle under consideration. Next, consider the following case.

> You have five patients in the hospital who are dying, each in need of a separate organ. One needs a kidney, another a lung, a third a heart, and so forth. You can save all five if you take a single healthy person and remove his heart, lungs, kidneys, and so forth, to distribute to these five patients. Just such a healthy person is in Room 306. He is in the hospital for routine tests. Having seen his test results, you know that he is perfectly healthy and of the right tissue compatability. If you do nothing, he will survive without incident; the other patients will die, however. The other five patients can be saved only if the person in Room 306 is cut up and his organs distributed. In that case, there would be one dead but five saved.

The principle in question tells us that you should cut up the patient in Room 306. But in this case, surely you must not sacrifice this innocent bystander, even to save the five other patients. Here a moral

principle has been tested and disconfirmed in what may seem to be a surprising way.

This, of course, was a "thought experiment." We did not really compare a hypothesis with the world. We compared an explicit principle with our feelings about certain imagined examples. In the same way, a physicist performs thought experiments in order to compare explicit hypotheses with his "sense" of what should happen in certain situations, a "sense" that he has acquired as a result of his long working familiarity with current theory. But scientific hypotheses can also be tested in real experiments, out in the world.

Can moral principles be tested in the same way, out in the world? You can observe someone do something, but can you ever perceive the rightness or wrongness of what he does? If you round a corner and see a group of young hoodlums pour gasoline on a cat and ignite it, you do not need to *conclude* that what they are doing is wrong; you do not need to figure anything out; you can *see* that it is wrong. But is your reaction due to the actual wrongness of what you see or is it simply a reflection of your moral "sense," a "sense" that you have acquired perhaps as a result of your moral upbringing?

2. Observation

The issue is complicated. There are no pure observations. Observations are always "theory laden." What you perceive depends to some extent on the theory you hold, consciously or unconsciously. You see some children pour gasoline on a cat and ignite it. To really see that, you have to possess a great deal of knowledge, know about a considerable number of objects, know about people: that people pass through the life stages infant, baby, child, adolescent, adult. You must know what flesh and blood animals are, and in particular, cats. You must have some idea of life. You must know what gasoline is, what burning is, and much more. In one sense, what you "see" is a pattern of light on your retina, a shifting array of splotches, although even that is theory, and you could never adequately describe what you see in that sense. In another sense, you see what you do because of the theories you hold. Change those theories and you

would see something else, given the same pattern of light.

Similarly, if you hold a moral view, whether it is held consciously or unconsciously, you will be able to perceive rightness or wrongness, goodness or badness, justice or injustice. There is no difference in this respect between moral propositions and other theoretical propositions. If there is a difference, it must be found elsewhere.

Observation depends on theory because perception involves forming a belief as a fairly direct result of observing something; you can form a belief only if you understand the relevant concepts and a concept is what it is by virtue of its role in some theory or system of beliefs. To recognize a child as a child is to employ, consciously or unconsciously, a concept that is defined by its place in a framework of the stages of human life. Similarly, burning is an empty concept apart from its theoretical connections to the concepts of heat, destruction, smoke, and fire.

Moral concepts—Right and Wrong, Good and Bad, Justice and Injustice—also have a place in your theory or system of beliefs and are the concepts they are because of their context. If we say that observation has occurred whenever an opinion is a direct result of perception, we must allow that there is moral observation, because such an opinion can be a moral opinion as easily as any other sort. In this sense, observation may be used to confirm or disconfirm moral theories. The observational opinions that, in this sense, you find yourself with can be in either agreement or conflict with your consciously explicit moral principles. When they are in conflict, you must choose between your explicit theory and observation. In ethics, as in science, you sometimes opt for theory, and say that you made an error in observation or were biased or whatever, or you sometimes opt for observation, and modify your theory.

In other words, in both science and ethics, general principles are invoked to explain particular cases and, therefore, in both science and ethics, the general principles you accept can be tested by appealing to particular judgments that certain things are right or wrong, just or unjust, and so forth; and these judgments are analogous to direct perceptual judgments about facts.

3. Observational Evidence

Nevertheless, observation plays a role in science that it does not seem to play in ethics. The difference is that you need to make assumptions about certain physical facts to explain the occurrence of the observations that support a scientific theory, but you do not seem to need to make assumptions about any moral facts to explain the occurrence of the so-called moral observations I have been talking about. In the moral case, it would seem that you need only make assumptions about the psychology or moral sensibility of the person making the moral observation. In the scientific case, theory is tested against the world.

The point is subtle but important. Consider a physicist making an observation to test a scientific theory. Seeing a vapor trail in a cloud chamber, he thinks, "There goes a proton." Let us suppose that this is an observation in the relevant sense, namely, an immediate judgment made in response to the situation without any conscious reasoning having taken place. Let us also suppose that this observation confirms his theory, a theory that helps give meaning to the very term "proton" as it occurs in his observational judgment. Such a confirmation rests on inferring an explanation. He can count his making the observation as confirming evidence for his theory only to the extent that it is reasonable to explain his making the observation by assuming that, not only is he in a certain psychological "set," given the theory he accepts and his beliefs about the experimental apparatus, but furthermore, there really was a proton going through the cloud chamber, causing the vapor trail, which he saw as a proton. (This is evidence for the theory to the extent that the theory can explain the proton's being there better than competing theories can.) But, if his having made that observation could have been equally well explained by his psychological set alone, without the need for any assumption about a proton, then the observation would not have been evidence for the existence of that proton and therefore would not have been evidence for the theory. His making the observation supports the theory only because, in order to explain his making the observation, it is reasonable to assume something about the

world over and above the assumptions made about the observer's psychology. In particular, it is reasonable to assume that there was a proton going through the cloud chamber, causing the vapor trail.

Compare this case with one in which you make a moral judgment immediately and without conscious reasoning, say, that the children are wrong to set the cat on fire or that the doctor would be wrong to cut up one healthy patient to save five dying patients. In order to explain your making the first of these judgments, it would be reasonable to assume, perhaps, that the children really are pouring gasoline on a cat and you are seeing them do it. But, in neither case is there any obvious reason to assume anything about "moral facts," such as that it really is wrong to set the cat on fire or to cut up the patient in Room 306. Indeed, an assumption about moral facts would seem to be totally irrelevant to the explanation of your making the judgment you make. It would seem that all we need assume is that you have certain more or less well articulated moral principles that are reflected in the judgments you make, based on your moral sensibility. It seems to be completely irrelevant to our explanation whether your intuitive immediate judgment is true or false.

The observation of an event can provide observational evidence for or against a scientific theory in the sense that the truth of that observation can be relevant to a reasonable explanation of why that observation was made. A moral observation does not seem, in the same sense, to be observational evidence for or against any moral theory, since the truth or falsity of the moral observation seems to be completely irrelevant to any reasonable explanation of why that observation was made. The fact that an observation of an event was made at the time it was made is evidence not only about the observer but also about the physical facts. The fact that you made a particular moral observation when you did does not seem to be evidence about moral facts, only evidence about you and your moral sensibility. Facts about protons can affect what you observe, since a proton passing through the cloud chamber can cause a vapor trail that reflects light to your eye in a way that, given your scientific training and psychological set, leads you to

judge that what you see is a proton. But there does not seem to be any way in which the actual rightness or wrongness of a given situation can have any effect on your perceptual apparatus. In this respect, ethics seems to differ from science.

In considering whether moral principles can help explain observations, it is therefore important to note an ambiguity in the word "observation." You see the children set the cat on fire and immediately think, "That's wrong." In one sense, your observation is that what the children are doing is wrong. In another sense, your observation is your thinking that thought. Moral observations might explain observations in the first sense but not in the second sense. Certain moral principles might help to explain why it was *wrong* of the children to set the cat on fire, but moral principles seem to be of no help in explaining *your thinking* that that is wrong. In the first sense of "observation," moral principles can be tested by observation—"That this act is wrong is evidence that causing unnecessary suffering is wrong." But in the second sense of "observation," moral principles cannot clearly be tested by observation, since they do not appear to help explain observations in this second sense of "observation." Moral principles do not seem to help explain your observing what you observe.

Of course, if you are already given the moral principle that it is wrong to cause unnecessary suffering, you can take your seeing the children setting the cat on fire as observational evidence that they are doing something wrong. Similarly, you can suppose that your seeing the vapor trail is observational evidence that a proton is going through the cloud chamber, if you are given the relevant physical theory. But there is an important apparent difference between the two cases. In the scientific case, your making that observation is itself evidence for the physical theory because the physical theory explains the proton, which explains the trail, which explains your observation. In the moral case, your making your observation does not seem to be evidence for the relevant moral principle because that principle does not seem to help explain your observation. The explanatory chain from principle to observation seems to be broken in morality. The moral principle may "explain" why it is wrong for the children to set the cat on fire. But the wrongness of that act does not appear to help explain the act, which you observe, itself. The explanatory chain appears to be broken in such a way that neither the moral principle nor the wrongness of the act can help explain why you observe what you observe.

A qualification may seem to be needed here. Perhaps the children perversely set the cat on fire simply "because it is wrong." Here it may seem at first that the actual wrongness of the act does help explain why they do it and therefore indirectly helps explain why you observe what you observe just as a physical theory, by explaining why the proton is producing a vapor trail, indirectly helps explain why the observer observes what he observes. But on reflection we must agree that this is probably an illusion. What explains the children's act is not clearly the actual wrongness of the act but, rather, their belief that the act is wrong. The actual rightness or wrongness of their act seems to have nothing to do with why they do it.

Observational evidence plays a part in science it does not appear to play in ethics, because scientific principles can be justified ultimately by their role in explaining observations, in the second sense of observation—by their explanatory role. Apparently, moral principles cannot be justified in the same way. It appears to be true that there can be no explanatory chain between moral principles and particular observings in the way that there can be such a chain between scientific principles and particular observings. Conceived as an explanatory theory, morality, unlike science, seems to be cut off from observation.

Not that every legitimate scientific hypothesis is susceptible to direct observational testing. Certain hypotheses about "black holes" in space cannot be directly tested, for example, because no signal is emitted from within a black hole. The connection with observation in such a case is indirect. And there are many similar examples. Nevertheless, seen in the large, there is the apparent difference between science and ethics we have noted. The scientific realm is accessible to observation in a way the moral realm is not.

4. Ethics and Mathematics

Perhaps ethics is to be compared, not with physics, but with mathematics. Perhaps such a moral principle as "You ought to keep your promises" is confirmed or disconfirmed in the way (whatever it is) in which such a mathematical principle as "$5 + 7 = 12$" is. Observation does not seem to play the role in mathematics it plays in physics. We do not and cannot perceive numbers, for example, since we cannot be in causal contact with them. We do not even understand what it would be like to be in causal contact with the number 12, say. Relations among numbers cannot have any more of an effect on our perceptual apparatus than moral facts can.

Observation, however, *is* relevant to mathematics. In explaining the observations that support a physical theory, scientists typically appeal to mathematical principles. On the other hand, one never seems to need to appeal in this way to moral principles. Since an observation is evidence for what best explains it, and since mathematics often figures in the explanations of scientific observations, there is indirect observational evidence for mathematics. There does not seem to be observational evidence, even indirectly, for basic moral principles. In explaining why certain observations have been made, we never seem to use purely moral assumptions. In this respect, then, ethics appears to differ not only from physics but also from mathematics.

In what follows, we will be considering a number of possible responses to the apparent fact that ethics is cut off from observational testing in a way that science is not. Some of these responses claim that there is a distinction of this sort between science and ethics and try to say what its implications are. Others deny that there is a distinction of this sort between science and ethics and argue that ethics is not really exempt from observational testing in the way it appears to be.

NIHILISM AND NATURALISM

1. Moral Nihilism

We have seen that observational evidence plays a role in science and mathematics it does not seem to play in ethics. Moral hypotheses do not help explain why people observe what they observe. So ethics is problematic and nihilism must be taken seriously. Nihilism is the doctrine that there are no moral facts, no moral truths, and no moral knowledge. This doctrine can account for why reference to moral facts does not seem to help explain observations, on the grounds that what does not exist cannot explain anything.

An extreme version of nihilism holds that morality is simply an illusion: nothing is ever right or wrong, just or unjust, good or bad. In this version, we should abandon morality, just as an atheist abandons religion after he has decided that religious facts cannot help explain observations. Some extreme nihilists have even suggested that morality is merely a superstitious remnant of religion.

Such extreme nihilism is hard to accept. It implies that there are no moral constraints—that everything is permitted. As Dostoevsky observes, it implies that there is nothing wrong with murdering your father. It also implies that slavery is not unjust and that Hitler's extermination camps were not immoral. These are not easy conclusions to accept.

This, of course, does not refute extreme nihilism. Nihilism does not purport to reflect our ordinary views; and the fact that it is difficult to believe does not mean that it must be false. At one time in the history of the world people had difficulty in believing that the earth was round; nevertheless the earth was round. A truly religious person could not easily come to believe that God does not exist; that is no argument against atheism. Extreme nihilism is a possible view and it deserves to be taken seriously.

On the other hand, it is also worth pointing out that extreme nihilism is not an automatic consequence of the point that moral facts apparently cannot help explain observations. Although this is grounds for nihilism, there are more moderate versions of nihilism. Not all versions imply that morality is a delusion and that moral judgments are to be abandoned the way an atheist abandons religious judgments. Thus, a more moderate nihilism holds that the purpose of moral judgments is not to describe the world but to express our moral feelings or to serve as imperatives we address to ourselves and to others. In this view,

morality is not undermined by its apparent failure to explain observations, because to expect moral judgments to be of help in explaining observations is to be confused about the function of morality. It is as if you were to expect to explain observations by exclaiming, "Alas!" or by commanding, "Close the door!"

Moderate nihilism is easier to accept than extreme nihilism. It allows us to keep morality and continue to make moral judgments. It does not imply that there is nothing wrong with murdering your father, owning slaves, or setting up extermination camps. Because we disapprove of these activities, we can, according to moderate nihilism, legitimately express our disapproval by saying that they are wrong.

Moderate nihilism, nevertheless, still conflicts with common sense, even if the conflict is less blatant. To assert, as even moderate nihilists assert, that there are no moral facts, no moral truths, and no moral knowledge is to assert something that runs counter to much that we ordinarily think and say. If someone suggests that it was wrong of members of the Oregon Taxpayers Union to have kidnapped Sally Jones in order to get at her father, Austin P. Jones, and you agree, you will express your agreement by saying, "That's *true!*" Similarly, in deciding what to do on a particular occasion, you say such things as this, "I *know* that I should not break my promise to Herbert, but I really would like to go to the beach today." We ordinarily do speak of moral judgments as true or false; and we talk as if we knew certain moral truths but not others.

Nihilism, then, extreme or moderate, is in conflict with ordinary ways of talking and thinking. Although such a conflict does not refute a theory, we must ask whether we can accommodate the point about ethics and observation without having to give up our ordinary views and endorsing some form of nihilism.

2. Reductions

Our previous discussion suggests the following argument for moral nihilism:

> Moral hypotheses never help explain why we observe anything. So we have no evidence for our moral opinions.

The argument depends upon this assumption:

> We can have evidence for hypotheses of a certain sort only if such hypotheses sometimes help explain why we observe what we observe.

But that assumption is too strong. Hypotheses about the average American citizen never help explain why we observe anything about a particular American, but we can obtain evidence for such hypotheses by obtaining evidence for hypotheses about American citizens. The reason is that facts about the average American citizen are definable in terms of facts about American citizens. Facts of the first sort are constructed out of and therefore reducible to facts of the second sort. Even if assumptions about moral facts do not directly help explain observations, it may be that moral facts can be reduced to other sorts of facts and that assumptions about these facts do help explain observations. In that case, there could be evidence for assumptions about moral facts.

To take another example, we might be able to account for color perception without making the supposition that objects actually have colors. For we might be able to explain how objects whose surfaces have certain physical characteristics will reflect light of a particular wave length; this light then strikes the retina of an observer's eye, affecting him in a way that might be described by an adequate neurophysiological psychology. That is, we might be able to explain perception of color entirely in terms of the physical characteristics of the objects perceived and the properties of light together with an account of the perceptual apparatus of the observer. This would not prove that there are no facts about colors; it would only show that facts about colors are not additional facts, over and above physical and psychological facts. If we could explain color perception in this way, we would conclude that facts about color are somehow reducible to facts about the physical characteristics of perceived objects, facts about light, and facts about the psychology and perceptual apparatus of perceivers. We might consider whether moral facts are in a similar way constructible out

of or reducible to certain other facts that can help explain our observations.

3. Ethical Naturalism: Functionalism

This is certainly a plausible suggestion for certain nonmoral evaluative facts. Consider, for example, what is involved in something's being a good thing of its kind, a good knife, a good watch, or a good heart. Associated with these kinds of things are certain functions. A knife is something that is used for cutting; a watch is used to keep time; a heart is that organ that pumps the blood. Furthermore, something is a good thing of the relevant kind to the extent that it adequately fulfills its proper function. A good knife cuts well; a good watch keeps accurate time; a good heart pumps blood at the right pressure without faltering. Let us use the letter "K" to stand for a kind of thing. Then, for these cases, a good K is a K that adequately fulfills its function. It is a factual question whether or not something is a good K because it is a factual question whether or not K's have that function and a factual question whether or not this given something adequately fulfills that function.

Moreover, a K ought to fulfill its function. If it does not do so, something has gone wrong. Therefore, it is a factual question whether a given K of this sort is as it ought to be and does what it ought to do, and it is a factual question whether anything is wrong with a K of this sort. A knife ought to be sharp, so that it will cut well. There is something wrong with a heart that fails to pump blood without faltering.

There are, of course, two somewhat different cases here, artifacts, such as watches and knives, and parts of natural systems, such as hearts. The functions of artifacts are determined by their makers and users. The functions of parts of natural systems are determined by their roles in sustaining those systems. In either case, though, it is a factual question what the relevant function of a K is.

Let us next consider a somewhat different range of cases: a good meal, a good swim, a good time. We might stretch a point and say that meals, swims, and times have functions or purposes; but it would be more accurate to say that they can answer to certain interests. We judge that particular meals, swims, or times are good inasmuch as they answer to the relevant interests. Where different sets of interests are relevant, we get ambiguity: "a good meal" may mean a nourishing meal or a tasty meal.

With this range of cases, "ought" and "wrong" are used as before. A good meal ought to be balanced (or tasty). There is something wrong with a steak that is not tender and juicy.

More complex cases involve roles that a person can have in one way or another: a good farmer, a good soldier, a good teacher, a good citizen, a good thief. A person is evaluated in terms of functions, roles, and various interests in a way that is hard to specify. Here too the words "ought" and "wrong" are relevant as before. During battle, we say, a soldier ought to obey his superior officers without question. It is wrong for a teacher to play favorites. A thief ought to wear gloves.

Some kinds of things are not associated with functions, purposes, or sets of interests; for example, rocks per se are not. Therefore, it does not make sense to ask apart from a specific context whether something is a good rock. We can answer such a question only in relation to interests that we might have in possible uses of the rock. For example, it might be a good rock to use as a paperweight; but, if it is to be used as a doorstop, maybe it ought to be heavier.

The relevant evaluative judgments are factual. The facts are natural facts though somewhat complex facts. We judge that something is good or bad, that it is right or wrong, that it ought or ought not to have certain characteristics or do certain things, relative to a cluster of interests, roles and functions. We can abbreviate this by saying that something X is good to the extent that it adequately answers to the relevant interests. To specify those interests is to specify what X is good as. Similarly, a person P ought to do D if and only if P's doing D would answer to the relevant interests.

This analysis is a realistic one for many cases and it suggests how evaluative facts might be constructed out of observable facts even when the evaluative facts themselves do not figure in explanations of observations. That my watch is a good one may not explain anything about my observations of it; but

that it keeps fairly accurate time does help to explain its continual agreement with the announcements of the time on the radio and perhaps the goodness of my watch consists in facts of this sort.

But a problem manifests itself when this sort of analysis is applied in ethics. Consider the case in which you are a doctor who either can save five patients by cutting up the healthy patient in Room 306 and distributing his organs to the other patients or can do nothing and let the five other patients die. The problem is that in either case you would be satisfying certain interests and not others. The interests of the five dying patients conflict with the interests of the healthy patient in Room 306. The moral question is what you ought to do, taking all interests into account. As we saw earlier, our intuitive judgment is that you ought not to sacrifice the one patient in Room 306 to save the five other patients. Is this a factual judgment? If we suppose that it is a fact that you ought not to sacrifice the patient in Room 306, how is that fact related to facts that can help explain observations? It is not at all obvious how we can extend our analysis to cover this sort of case.

Actually, the problem is not peculiar to ethics. Is a heavy, waterproof, shockproof watch that can withstand a considerable amount of pressure a better or worse watch than a lighter, graceful, delicate watch without those features? Is one teacher better or worse than a second if the first teacher makes students unhappy while teaching them more?

To some extent, our difficulty in these cases lies in the vagueness of our standards for watches and teachers. Often we can resolve the vagueness by specifying relevant interests. The heavy watch is a better watch for deep-sea diving. The lighter watch is better for social occasions, out of the water. In the case of evaluating teachers, we must decide what we want from teachers—perhaps that their students should learn a certain minimal amount and, given that they learn at least that much, that they not be made miserable. But even given further specifications of our interests in watches and teachers in this way, there may be no fact of the matter as to which watch or teacher is better—not because these are not factual questions but because of vagueness

of standards. Factual questions are still factual even when they cannot be answered because of vagueness. (Is a door open or shut if it is slightly ajar?) Furthermore, even in cases where we feel intuitively that one watch or teacher is clearly better, we may not be able to specify very clearly the interests, functions, and roles with reference to which one is better, as a watch or teacher, than the other. Still, it may well be a fact that one is better—a fact constructed in a way that we can only vaguely specify from facts of a sort that can help explain observations.

Similarly, it *may* be that moral facts, such as the fact that you ought not to sacrifice the healthy patient in Room 306 to save the five other patients, can be constructed in some way or other out of facts of a sort that can explain observations, even though we can only vaguely indicate relevant roles, interests, and functions.

That would vindicate ethical naturalism, which is the doctrine that moral facts are facts of nature. Naturalism as a general view is the sensible thesis that *all* facts are facts of nature. Of course, one can accept naturalism in general without being committed to ethical naturalism, since one can instead be a nihilist and deny that there are any moral facts at all, just as one might deny that there are any religious facts. Naturalists must be either ethical nihilists or ethical naturalists. The question is how do we decide between ethical nihilism and ethical naturalism, and there is no simple answer. If an analysis of moral facts as facts about functions, roles, and interests could be made plausible, that would be a powerful argument for ethical naturalism. But the relevant functions, roles, and interests can at best be only vaguely indicated, so the proposed analysis is difficult to evaluate. Nihilism remains a possibility.

4. The Open Question Argument

On the other hand, general arguments against ethical naturalism, and for nihilism, are also inconclusive. For example, moderate nihilists argue that naturalists misconstrue the function of moral judgments, which is not to describe the facts (they say) but rather to express the speaker's approval or disapproval. Therefore, moderate

nihilists say that ethical naturalism involves a "natural-istic fallacy." But as we shall see, the evaluation of this moderate nihilist position is also quite complex.

An ethical naturalist holds that there are moral facts and that these can be "reduced" to natural facts of a sort that might explain observations in the way that facts about color might be reduced to facts about physical characteristics of objects, the properties of light, and the perceptual apparatus of an observer. I have alluded to one way in which an ethical natural-ist might attempt such a reduction by appealing to functions, roles, and interests. There are also other ways; he might, for example, try to develop an "ideal observer" theory of moral facts by analogy with the suggested theory of color facts. . . . And other kinds of ethical naturalism are also possible. Now, some moderate nihilists believe that there is a perfectly general argument that can be used once and for all to show that any version of ethical naturalism must fail. This is the so-called "open question argument." Any naturalistic reduction in ethics would have the form, "P ought to do D if and only if P's doing D has char-acteristics C," in which the characteristics C are natu-ralistic characteristics of a sort that can help explain observations. Given any such proposed naturalistic reduction, defenders of the open question argument maintain that the following question remains open.

> I agree that for P to do D would be for P to do some-thing that is C, but ought P to do D?

This remains an open question, moderate nihil-ists say, because describing an act is not the same as endorsing it. No matter how you describe it, you have so far not endorsed it and, therefore, have not yet said whether it ought to be done, according to moderate nihilists. Therefore, the displayed question is (they assert) an open question in a way that the fol-lowing question is not.

> I agree that P ought to do D, but ought P to do D?

This question is obviously foolish. Given that some-thing ought to be done, it cannot be an open ques-tion whether it ought to be done. And since the first question is an open question but the second is not, we are to conclude that the natural characteristic of being an act that is C cannot be equated with the moral char-acteristic of being an act that ought to be done.

One problem with this argument is that it has to be shown that the first question is always open. An ethical nihilist is simply begging the question if he only says, in arguing against ethical naturalism, that describing an act as having certain natural characteristics cannot amount to endorsing the act in the sense of saying that it ought to be done. It is not obvious, for example, that the following question is open in the relevant sense.

> I agree that, if P does D, P will satisfy the relevant interests, but ought P to do D?

Of course, one part of the problem here is that the "relevant interests" are not specified in a precise nat-uralistic way. Nevertheless, it is not obvious that, if they are so specified, the question is open.

More important, perhaps, is the fact that as it stands the open question argument is invalid. An analogous argument could be used on someone who was igno-rant of the chemical composition of water to "prove" to him that water is not H_2O. This person will agree that it is not an open question whether water is water but it is an open question, at least for him, whether water is H_2O. Since this argument would not show that water is not H_2O, the open question argument in ethics cannot be used as it stands to show that for an act to be an act that ought to be done is not for it to have some natural characteristic C.

The open question argument is often put forward as a refutation, not of ethical naturalism in general, but of a more particular version, which we might call definitional naturalism. Definitional natural-ists assume that moral judgments are definitionally equivalent to natural judgments. The open question argument then should show that the proposed defini-tions must be incorrect.

There are, however, various kinds of definitions and the open question argument is not relevant to most of them. For example, a scientist defines water as H_2O and, as we have seen, the open question argu-ment applied to this definition does not refute it.

Presumably the open question argument is aimed at someone who claims that a naturalistic definition captures the meaning of a moral term in the sense that moral judgments as we ordinarily use them are synonymous with judgments that describe natural facts. If it really is an open question whether an act that is C is an act that ought to be done—an open question even to someone who knows the meanings of "C" and "ought to be done," how can "C" and "ought to be done" be synonymous? It must be shown, not just assumed, however, that the relevant question is always open, no matter what the natural characteristics C.

5. Redefinitional Naturalism

Another kind of definitional naturalism in ethics is actually not a version of ethical naturalism at all. In this view, our moral terminology is so vague, unclear, and confused that we would do well to replace it with better and more precise terminology. For example, someone who was developing the theory that you ought to do what answers to the relevant interests might argue that our view about the example involving the patient in Room 306 shows that our moral views are incoherent. He might go on to suggest that we replace our present notions with clearer concepts, for example, defining "ought" so that an act ought to be done if and only if it would maximize the satisfaction of interests. By this utilitarian criterion, you ought to cut up the patient in Room 306 in order to save the other patients. It is true that the proposed definition does not capture the ordinary meaning of "ought," since, when we judge intuitively that you ought to protect the healthy patient in Room 306, we are definitely not judging that this would maximize the satisfaction of interests—indeed we see that it would not. But a definition need not capture what we ordinarily mean. We can define our terms however we like, as long as we are willing to use these terms in accordance with our definitions. The suggested definition is relatively clear and precise. What is a better definition?

This line of argument is intelligible and not absurd, although it is also not without its own difficulties. It must be shown and not just assumed that ordinary moral notions are confused. This is a debatable claim.

The fact that there is no obvious way to define ordinary moral terminology in a precise way does not show that there is anything wrong with that terminology. Not every term can be defined; it may be that moral terminology cannot be reduced to any simpler terminology.

Furthermore, there is a risk in this line of argument in that someone who takes this line may cheat, using "ought" sometimes as he has defined it and at other times in its ordinary sense. The best way to avoid this problem would be to dispense altogether with moral terminology in favor of utilitarian terminology and, instead of talking about what people ought to do, talk instead about what would satisfy the most interests. But that would be to give up any pretense of ethical naturalism and reveal that you have adopted extreme nihilism. It would involve denying that there are moral facts in the ordinary sense of "moral" and would ask us to abandon morality in the ordinary sense of "morality," just as a general naturalist abandons religion in the ordinary sense of "religion."

6. Why Ethics Is Problematic

Although we are in no position to assume that nihilism, extreme or moderate, is correct, we are now in a position to see more clearly the way in which ethics is problematic. Our starting point in this chapter was that moral judgments do not seem to help explain observations. This led us to wonder whether there are moral facts, moral truths, and moral knowledge. We saw that there could be moral facts if these facts were reducible in some way or other to other facts of a sort that might help explain observations. For we noticed that there are facts about the average American citizen, even though such facts do not themselves help explain observations, because such facts are reducible to facts about American citizens that can help explain observations. Similarly, we noticed that we would not decide that there are no facts about colors even if we were able to explain color perception without appealing to facts about colors; we would instead suppose that facts about colors are reducible to facts about the physical surfaces of objects, the properties of light, and the neurophysiological psychology of observers. So, we concluded that we did

not have to accept ethical nihilism simply because moral facts do not seem to help explain observations; instead we might hope for a naturalistic reduction of moral facts.

With this in mind, we considered the possibility that moral facts might be reduced to facts about interests, roles, and functions. We concluded that, if they were to be, the reduction would have to be complex, vague, and difficult to specify. Ethics remains problematic.

It is true that the reduction of facts about colors is also complex, vague, and difficult (probably impossible) to specify. But there is an important difference between facts about colors and moral facts. Even if we come to be able to explain color perception by appeal to the physical characteristics of surfaces, the properties of light, and the neurophysiological psychology of observers, we will still *sometimes* refer to the actual colors of objects in explaining color perception, if only for the sake of simplicity. For example, we will explain that something looks green because it is yellow and the light is blue. It may be that the reference to the actual color of the object in an explanation of this sort can be replaced with talk about the physical characteristics of the surface. But that would greatly complicate what is a simple and easily understood explanation. That is why, even after we come to be able to give explanations without referring to the actual colors of objects, we will still assume that objects have actual colors and that therefore facts about the actual colors of objects are somehow reducible to facts about physical characteristics of surfaces and so forth, even though we will (probably) not be able to specify the reduction in any but the vaguest way. We will continue to believe that objects have colors because we will continue to refer to the actual colors of objects in the explanations that we will in practice give. A similar point does not seem to hold for moral facts. There does not ever seem to be, even in practice, any point to explaining someone's moral observations by appeal to what is actually right or wrong, just or unjust, good or bad. It always seems to be more accurate to explain moral observations by citing facts about moral views, moral sensibility. So, the reasons we have for supposing that there are facts about colors do not correspond to reasons for thinking that there are moral facts.

It is true that facts about the average American citizen never seem to help explain observations, even in practice. In this respect such facts are like moral facts. But there is this difference. We can give a *precise* reduction of facts about the average American citizen; we cannot for moral facts. We are willing to think that there are facts about the average American citizen because we can explicitly define these facts in terms of facts that are of a sort that can help to explain observations. The trouble with alleged moral facts is that, as far as we can see at present, there is no simple and precise way to define them in terms of natural facts.

We are willing to suppose that there are facts about color, despite our not knowing precisely how to reduce them, because in practice we assume that there are such facts in many of our explanations of color perception, even if in theory this assumption is dispensable. We are willing to suppose that there are facts about the average American citizen, despite our never using such an assumption to explain observations, because we can precisely reduce these facts to facts of a sort that can help explain observations. Since moral facts seem to be neither precisely reducible nor useful even in practice in our explanations of observations, it remains problematic whether we have any reason to suppose that there are any moral facts.

Study Questions

1. According to Harman, why can't moral claims be tested in the same way as scientific claims?

2. Is nihilism in conflict with ordinary ways of thinking?

3. Is the claim that a person is honest more complex, vague, and difficult to specify than the claim that a person is healthy?

4. Does the open question argument refute ethical naturalism?

39

NICHOLAS L. STURGEON

Nicholas L. Sturgeon is Professor Emeritus of Philosophy at Cornell University. He argues, against the view of Gilbert Harman, that moral facts play a role in our explanations of behavior. Sturgeon claims that the principal test of whether moral facts are relevant in a particular situation is whether, if they had been different, the conclusion would have been the same. If not, then the moral facts matter, and in that case according to Sturgeon the position defended by Harman would have been shown to be mistaken.

Moral Explanations

There is one argument for moral skepticism that I respect even though I remain unconvinced. It has sometimes been called the argument from moral diversity or relativity, but that is somewhat misleading, for the problem arises not from the diversity of moral views, but from the apparent difficulty of *settling* moral disagreements, or even of knowing what would be required to settle them, a difficulty thought to be noticeably greater than any found in settling disagreements that arise in, for example, the sciences. This provides an argument for moral skepticism because one obviously possible explanation of our difficulty in settling moral disagreements is that they are really unsettleable, that there is no way of justifying one rather than another competing view on these issues; and a possible further explanation for the unsettleability of moral disagreements, in turn, is moral nihilism, the view that on these issues there just is no fact of the matter, that the impossibility of discovering and establishing moral truths is due to there not being any.

I am, as I say, unconvinced: partly because I think this argument exaggerates the difficulty we actually find in settling moral disagreements, partly because there are alternative explanations to be considered for the difficulty we do find. Under the latter heading, for example, it certainly matters to what extent moral disagreements depend on disagreements about other questions which, however, disputed they may be, are nevertheless regarded as having objective answers: questions such as which, if any, religion is true, which account of human psychology, which theory of human society. And it also matters to what extent consideration of moral questions is in practice skewed by distorting factors such as personal interest and social ideology. These are large issues. Although it is possible to say some useful things to put them in perspective,[1] it appears impossible to settle them quickly or in any a priori way. Consideration of them is likely to have to be piecemeal and, in the short run at least, frustratingly indecisive.

Reprinted from *Morality, Reason and Truth*, eds. David Copp and David Zimmerman (Rowman & Allanheld, 1984), by permission of Rowman & Littlefield Publishers, Inc.

These large issues are not my topic here. But I mention them, and the difficulty of settling them, to show why it is natural that moral skeptics have hoped to find some quicker way of establishing their thesis. I doubt that any exist, but some have of course been proposed. Verificationist attacks on ethics should no doubt be seen in this light, and J. L. Mackie's recent "argument from queerness" is a clear instance.[2] The quicker response on which I shall concentrate, however, is neither of these, but instead an argument by Gilbert Harman designed to bring out the "basic problem" about morality, which in his view is "its apparent immunity from observational testing" and "the seeming irrelevance of observational evidence."[3] The argument is that reference to moral facts appears unnecessary for the *explanation* of our moral observations and beliefs.

Harman's view, I should say at once, is not in the end a skeptical one, and he does not view the argument I shall discuss as a decisive defense of moral skepticism or moral nihilism. Someone else might easily so regard it, however. For Harman himself regards it as creating a strong *prima facie* case for skepticism and nihilism, strong enough to justify calling it "the problem with ethics."[4] And he believes it shows that the only recourse for someone who wishes to avoid moral skepticism is to find defensible reductive definitions for ethical terms; so skepticism would be the obvious conclusion to draw for anyone who doubted the possibility of such definitions. I believe, however, that Harman is mistaken on both counts. I shall show that his argument for skepticism either rests on claims that most people would find quite implausible (and so cannot be what constitutes, for *them*, the problem with ethics); or else becomes just the application to ethics of a familiar *general* skeptical strategy, one which, if it works for ethics, will work equally well for unobservable theoretical entities, or for other minds, or for an external world (and so, again, can hardly be what constitutes the distinctive problem with *ethics*). I have argued elsewhere,[5] moreover, that one can in any case be a moral realist, and indeed an ethical naturalist, without believing that we are now or ever will be in possession of reductive naturalistic definitions for ethical terms.

I. THE PROBLEM WITH ETHICS

Moral theories are often tested in thought experiments, against imagined examples; and, as Harman notes, trained researchers often test scientific theories in the same way. The problem, though, is that scientific theories can also be tested against the world, by observations or real experiments; and, Harman asks, "can moral principles be tested in the same way, out in the world?"

This would not be a very interesting or impressive challenge, of course, if it were merely a resurrection of standard verificationist worries about whether moral assertions and theories have any testable empirical implications, implications statable in some relatively austere "observational" vocabulary. One problem with that form of the challenge, as Harman points out, is that there are no "pure" observations, and in consequence no purely observational vocabulary either. But there is also a deeper problem that Harman does not mention, one that remains even if we shelve worries about "pure" observations and, at least for the sake of argument, grant the verificationist his observational language, pretty much as it was usually conceived: that is, as lacking at the very least any obviously theoretical terminology from any recognized science, and of course as lacking any moral terminology. For then the difficulty is that moral principles fare just as well (or just as badly) against the verificationist challenge as do typical scientific principles. For it is by now a familiar point about scientific principles—principles such as Newton's law of universal gravitation or Darwin's theory of evolution—that they are entirely devoid of empirical implications when considered in isolation.[6] We do of course base observational predictions on such theories and so test them against experience, but that is because we do *not* consider them in isolation. For we can derive these predictions only by relying at the same time on a large background of additional assumptions, many of which are equally theoretical and equally incapable of being tested in isolation.

A less familiar point, because less often spelled out, is that the relation of moral principles to observation is similar in *both* these respects. Candidate

moral principles—for example, that an action is wrong just in case there is something else the agent could have done that would have produced a greater balance of pleasure over pain—lack empirical implications when considered in isolation. But it is easy to derive empirical consequences from them, and thus to test them against experience, if we allow ourselves, as we do in the scientific case, to rely on a background of other assumptions of comparable status. Thus, if we conjoin the act-utilitarian principle I just cited with the further view, also untestable in isolation, that it is always wrong deliberately to kill a human being, we can deduce from these two premises together the consequence that deliberately killing a human being always produces a lesser balance of pleasure over pain than some available alternative act; and this claim is one any positivist would have conceded we know, in principle at least, how to test. If we found it to be false, moreover, then we would be forced by this empirical test to abandon at least one of the moral claims from which we derived it.

It might be thought a worrisome feature of this example, however, and a further opening for skepticism, that there could be controversy about which moral premise to abandon, and that we have not explained how our empirical test can provide an answer to *this* question. And this may be a problem. It should be a familiar problem, however, because the Duhemian commentary includes a precisely corresponding point about the scientific case: that if we are at all cautious in characterizing what we observe, then the requirement that our theories merely be *consistent* with observation is a very weak one. There are always many, perhaps indefinitely many, different mutually inconsistent ways to adjust our views to meet this constraint. Of course, in practice we are often confident of how to do it: if you are a freshman chemistry student, you do not conclude from your failure to obtain the predicted value in an experiment that it is all over for the atomic theory of gases. And the decision can be equally easy, one should note, in a moral case. Consider two examples. From the surprising moral thesis that Adolf Hitler was a morally admirable person, together with a modest piece of

moral theory to the effect that no morally admirable person would, for example, instigate and oversee the degradation and death of millions of persons, one can derive the testable consequence that Hitler did not do this. But he did, so we must give up one of our premises; and the choice of which to abandon is neither difficult nor controversial.

Or, to take a less monumental example, contrived around one of Harman's own, suppose you have been thinking yourself lucky enough to live in a neighborhood in which no one would do anything wrong, at least not in public; and that the modest piece of theory you accept, this time, is that malicious cruelty, just for the hell of it, is wrong. Then, as in Harman's example, "you round a corner and see a group of young hoodlums pour gasoline on a cat and ignite it." At this point, either your confidence in the neighborhood or your principle about cruelty has got to give way. But the choice is easy, if dispiriting, so easy as hardly to require thought. As Harman says, "You do not need to *conclude* that what they are doing is wrong; you do not need to figure anything out; you can *see* that it is wrong" (p. 4). But a skeptic can still wonder whether this practical confidence, or this "seeing," rests in either sort of case on anything more than deeply ingrained conventions of thought—respect for scientific experts, say, and for certain moral traditions—as opposed to anything answerable to the facts of the matter, any reliable strategy for getting it right about the world.

Now, Harman's challenge is interesting partly because it does not rest on these verificationist doubts about whether moral beliefs have observational implications, but even more because what it does rest on is a partial answer to the kind of general skepticism to which, as we have seen, reflection on the verificationist picture can lead. Many of our beliefs are justified, in Harman's view, by their providing or helping to provide a reasonable *explanation* of our observing what we do. It would be consistent with your failure, as a beginning student, to obtain the experimental result predicted by the gas laws, that the laws are mistaken. But a better explanation, in light of your inexperience and the general success experts have had in confirming and applying these

laws, is that you made some mistake in running the experiment. So our scientific beliefs can be justified by their explanatory role; and so too, in Harman's view, can mathematical beliefs and many common-sense beliefs about the world.

Not so, however, moral beliefs: they appear to have no such explanatory role. That is "the problem with ethics." Harman spells out his version of this contrast:

> You need to make assumptions about certain physical facts to explain the occurrence of the observations that support a scientific theory, but you do not seem to need to make assumptions about any moral facts to explain the occurrence of the so-called moral observations I have been talking about. In the moral case, it would seem that you need only make assumptions about the psychology or moral sensibility of the person making the moral observation. (p. 6)

More precisely, and applied to his own example, it might be reasonable, in order to explain your judging that the hoodlums are wrong to set the cat on fire, to assume "that the children really are pouring gasoline on a cat and you are seeing them do it." But there is no

> obvious reason to assume anything about "moral facts," such as that it is really wrong to set the cat on fire. . . . Indeed, an assumption about moral facts would seem to be totally irrelevant to the explanation of your making the judgment you make. It would seem that all we need assume is that you have certain more or less well articulated moral principles that are reflected in the judgments you make, based on your moral sensibility. (p. 7)

And Harman thinks that if we accept this conclusion, suitably generalized, then, subject to one possible qualification concerning reduction that I have discussed elsewhere,[7] we must conclude that moral theories cannot be tested against the world as scientific theories can, and that we have no reason to believe that moral facts are part of the order of nature or that there is any moral knowledge (pp. 23, 35).

My own view is that Harman is quite wrong, not in thinking that the explanatory role of our beliefs is important to their justification, but in thinking that moral beliefs play no such role.[8] I shall have to say something about the initial plausibility of Harman's thesis as applied to his own example, but part of my reason for dissenting should be apparent from the other example I just gave. We find it easy (and so does Harman [p. 108]) to conclude from the evidence not just that Hitler was not morally admirable, but that he was morally depraved. But isn't it plausible that Hitler's moral depravity—the fact of his really having been morally depraved—forms part of a reasonable explanation of why we believe he was depraved? I think so, and I shall argue concerning this and other examples that moral beliefs very commonly play the explanatory role Harman denies them. Before I can press my case, however, I need to clear up several preliminary points about just what Harman is claiming and just how his argument is intended to work.

II. OBSERVATION AND EXPLANATION

(1) For there are several ways in which Harman's argument invites misunderstanding. One results from his focusing at the start on the question of whether there can be moral *observations*.[9] But this question turns out to be a side issue, in no way central to his argument that moral principles cannot be tested against the world. There are a couple of reasons for this, of which the more important[10] by far is that Harman does not really require of moral facts, if belief in them is to be justified, that they figure in the explanation of moral observations. It would be enough, on the one hand, if they were needed for the explanation of moral beliefs that are not in any interesting sense observations. For example, Harman thinks belief in moral facts would be vindicated if they were needed to explain our drawing the moral conclusions we do when we reflect on hypothetical cases, but I think there is no illumination in calling these conclusions observations.[11] It would also be enough, on the other hand, if moral facts were needed for the

explanation of what were clearly observations, but not moral observations. Harman thinks mathematical beliefs are justified, but he does not suggest that there are mathematical observations; it is rather that appeal to mathematical truths helps to explain why we make the physical observations we do (p. 10). Moral beliefs would surely be justified, too, if they played such a role, whether or not there are any moral observations.

So the claim is that moral facts are not needed to explain our having any of the moral beliefs we do, whether or not those beliefs are observations, and are equally unneeded to explain any of the observations we make, whether or not those observations are moral. In fact, Harman's view appears to be that moral facts aren't needed to explain anything at all: though it would perhaps be question-begging for him to begin with this strong a claim, since he grants that if there were any moral facts, then appeal to other moral facts—more general ones, for example—might be needed to explain *them* (p. 8). But he is certainly claiming, at the very least, that moral facts aren't needed to explain any nonmoral facts we have any reason to believe in.

(2) Other possible misunderstandings concern what is meant in asking whether reference to moral facts is *needed* to explain moral beliefs. One warning about this question I have dealt with in my discussion of reduction elsewhere;[12] but another, about what Harman is clearly *not* asking, and about what sort of answer I can attempt to defend to the question he is asking, I can spell out here. For Harman's question is clearly not just whether there is *an* explanation of our moral beliefs that does not mention moral facts. Almost surely there is. Equally surely, however, there is *an* explanation of our commonsense non-moral beliefs that does not mention an external world: one which cites only our sensory experience, for example, together with whatever needs to be said about our psychology to explain why with that history of experience we would form just the beliefs we do. Harman means to be asking a question that will lead to skepticism about moral facts, but not to skepticism about the existence of material bodies or about well-established scientific theories of the world.

Harman illustrates the kind of question he is asking, and the kind of answer he is seeking, with an example from physics that it will be useful to keep in mind. A physicist sees a vapor trail in a cloud chamber and thinks, "There goes a proton." What explains his thinking this? Partly, of course, his psychological set, which largely depends on his beliefs about the apparatus and all the theory he has learned; but partly also, perhaps, the hypothesis that "there really was a proton going through the cloud chamber, causing the vapor trail, which he saw as a proton." We will *not* need this latter assumption, however, "if his having made that observation could have been equally well explained by his psychological set alone, without the need for any assumption about a proton" (p. 6).[13] So for reference to moral facts to be *needed* in the explanation of our beliefs and observations, is for this reference to be required for an explanation that is somehow *better* than competing explanations. Correspondingly, reference to moral facts will be unnecessary to an explanation, in Harman's view, not just because we can find some explanation that does not appeal to them, but because *no* explanation that appeals to them is any better than some competing explanation that does not.

Now, fine discriminations among competing explanations of almost anything are likely to be difficult, controversial, and provisional. Fortunately, however, my discussion of Harman's argument will not require any fine discriminations. This is because Harman's thesis, as we have seen, is *not* that moral explanations lose out by a small margin; nor is it that moral explanations, though sometimes initially promising, always turn out on further examination to be inferior to nonmoral ones. It is, rather, that reference to moral facts always looks, right from the start, to be "completely irrelevant" to the explanation of any of our observations and beliefs. And my argument will be that this is mistaken: that many moral explanations appear to be good explanations, or components in good explanations, that are not obviously undermined by anything else that we know.

My suspicion, in fact, is that moral facts are needed in the sense explained, that they will turn out to belong in our best overall explanatory picture of the world, even in the long run, but I shall not attempt to establish that here. Indeed, it should be clear why I could not pretend to do so. For I have explicitly put to one side the issue (which I regard as incapable in any case of quick resolution) of whether and to what extent actual moral disagreements can be settled satisfactorily; but I assume it would count as a defect in any sort of explanation to rely on claims about which rational agreement proved unattainable. So I concede that it *could* turn out, for anything I say here, that moral explanations are all defective and should be discarded. What I shall try to show is merely that many moral explanations look reasonable enough to be in the running; and, more specifically, that nothing Harman says provides any reason for thinking they are not. This claim is surely strong enough (and controversial enough) to be worth defending.

(3) It is implicit in this statement of my project, but worth noting separately, that I take Harman to be proposing an *independent* skeptical argument—independent not merely of the argument from the difficulty of settling disputed moral questions, but also of other standard arguments for moral skepticism. Otherwise his argument is not worth separate discussion. For *any* of these more familiar skeptical arguments will of course imply that moral explanations are defective, on the reasonable assumption that it would be a defect in any explanation to rely on claims as doubtful as these arguments attempt to show all moral claims to be. But if *that* is why there is a problem with moral explanations, one should surely just cite the relevant skeptical argument, rather than this derivative difficulty about moral explanations, as the basic "problem with ethics," and it is that argument we should discuss. So I take Harman's interesting suggestion to be that there is a *different* difficulty that remains even if we put other arguments for moral skepticism aside and *assume*, for the sake of argument, that there are moral facts (for example, that what the children in his example are doing is really wrong): namely, that these assumed facts *still* seem to play no explanatory role.

This understanding of Harman's thesis crucially affects my argumentative strategy in a way to which I should alert the reader in advance. For it should be clear that assessment of this thesis not merely permits, but *requires*, that we provisionally assume the existence of moral facts. I can see no way of evaluating the claim that *even if* we assumed the existence of moral facts they would still appear explanatorily irrelevant, without assuming the existence of some, to see how they would look. So I do freely assume this in each of the examples I discuss in the next section. (I have tried to choose plausible examples, moreover, moral facts most of us would be inclined to believe in if we did believe in moral facts, since those are the easiest to think about; but the precise examples don't matter, and anyone who would prefer others should feel free to substitute her own.) I grant, furthermore, that if Harman were right about the outcome of this thought experiment—that even after we assumed these facts they still looked irrelevant to the explanation of our moral beliefs and other nonmoral facts—then we might conclude with him that there were, after all, no such facts. But I claim he is wrong: that once we have provisionally assumed the existence of moral facts they *do* appear relevant, by perfectly ordinary standards, to the explanation of moral beliefs and of a good deal else besides. Does this prove that there *are* such facts? Well of course it helps support that view, but here I carefully make no claim to have shown so much. What I *show* is that any remaining reservations about the existence of moral facts must be based on those *other* skeptical arguments, of which Harman's argument is independent. In short, there may still be a "problem with ethics," but it has *nothing* special to do with moral explanations.

III. MORAL EXPLANATIONS

Now that I have explained how I understand Harman's thesis, I turn to my arguments against it. I shall first add to my example of Hitler's moral character several more in which it seems plausible to cite moral facts as part of an explanation of nonmoral facts, and

in particular of people's forming the moral opinions they do. I shall then argue that Harman gives us no plausible reason to reject or ignore these explanations; I shall claim, in fact, that the same is true for his own example of the children igniting the cat. I shall conclude, finally, by attempting to diagnose the source of the disagreement between Harman and me on these issues.

My Hitler example suggests a whole range of extremely common cases that appear not to have occurred to Harman, cases in which we cite someone's moral character as part of an explanation of his or her deeds, and in which that whole story is then available as a plausible further explanation of someone's arriving at a correct assessment of that moral character. Take just one other example. Bernard DeVoto, in *The Year of Decision: 1846*, describes the efforts of American emigrants already in California to rescue another party of emigrants, the Donner Party, trapped by snows in the High Sierras, once their plight became known. At a meeting in Yerba Buena (now San Francisco), the relief efforts were put under the direction of a recent arrival, Passed Midshipman Selim Woodworth, described by a previous acquaintance as "a great busybody and ambitious of taking a command among the emigrants."[14] But Woodworth not only failed to lead rescue parties into the mountains himself, where other rescuers were counting on him (leaving children to be picked up by him, for example), but had to be "shamed, threatened and bullied" even into organizing the efforts of others willing to take the risk; he spent time arranging comforts for himself in camp, preening himself on the importance of his position; and as a predictable result of his cowardice and his exercises in vainglory, many died who might have been saved, including four known still to be alive when he turned back for the last time in mid-March.

DeVoto concludes: "Passed Midshipman Woodworth was just no damned good" (1942, p. 442). I cite this case partly because it has so clearly the structure of an inference to a reasonable explanation. One can think of competing explanations, but the evidence points against them. It isn't, for example, that Woodworth was a basically decent person who

simply proved too weak when thrust into a situation that placed heroic demands on him. He volunteered, he put no serious effort even into tasks that required no heroism, and it seems clear that concern for his own position and reputation played a much larger role in his motivation than did any concern for the people he was expected to save. If DeVoto is right about this evidence, moreover, it seems reasonable that part of the explanation of his believing that Woodworth was no damned good is just that Woodworth *was* no damned good.

DeVoto writes of course with more moral intensity (and with more of a flourish) than academic historians usually permit themselves, but it would be difficult to find a serious work of biography, for example, in which actions are not explained by appeal to moral character: sometimes by appeal to specific virtues and vices, but often enough also by appeal to a more general assessment. A different question, and perhaps a more difficult one, concerns the sort of example on which Harman concentrates, the explanation of judgments of right and wrong. Here again he appears just to have overlooked explanations in terms of moral character: a judge's thinking that it would be wrong to sentence a particular offender to the maximum prison term the law allows, for example, may be due in part to her decency and fairmindedness, which I take to be moral properties if any are. But do moral features of the action or institution being judged ever play an explanatory role? Here is an example in which they appear to. An interesting historical question is why vigorous and reasonably widespread moral opposition to slavery arose for the first time in the eighteenth and nineteenth centuries, even though slavery was a very old institution; and why this opposition arose primarily in Britain, France, and in French- and English-speaking North America, even though slavery existed throughout the New World.[15] There is a standard answer to this question. It is that chattel slavery in British and French America, and then in the United States, was much *worse* than previous forms of slavery, and much worse than slavery in Latin America. This is, I should add, a controversial explanation. But as is often the case with historical explanations, its

proponents do not claim it is the whole story, and many of its opponents grant that there may be some truth in these comparisons, and that they may after all form a small part of a larger explanation.[16] This latter concession is all I require for my example. Equally good for my purpose would be the more limited thesis which explains the growth of antislavery sentiment in the United States, between the Revolution and the Civil War, in part by saying that slavery in the United States became a more oppressive institution during that time. The appeal in these standard explanations is straightforwardly to moral facts.

What is supposed to be wrong with all these explanations? Harman says that assumptions about moral facts seem "completely irrelevant" in explaining moral observations and moral beliefs (p. 7), but on its more natural reading that claim seems pretty obviously mistaken about these examples. For it is natural to think that if a particular assumption is completely irrelevant to the explanation of a certain fact, then that fact would have obtained, and we could have explained it just as well, even if the assumption had been false.[17] But I do not believe that Hitler would have done all he did if he had not been morally depraved, nor, on the assumption that he was not depraved, can I think of any plausible explanation for his doing those things. Nor is it plausible that we would all have believed he was morally depraved even if he hadn't been. Granted, there is a tendency for writers who do not attach much weight to fascism as a social movement to want to blame its evils on a single maniacal leader, so perhaps some of them would have painted Hitler as a moral monster even if he had not been one. But this is only a tendency, and one for which many people know how to discount, so I doubt that our moral belief really is overdetermined in this way. Nor, similarly, do I believe that Woodworth's actions were overdetermined, so that he would have done just as he did even if he had been a more admirable person. I suppose one could have doubts about DeVoto's objectivity and reliability; it is obvious he dislikes Woodworth, so perhaps he would have thought him a moral loss and convinced his readers of this no matter what the man was really like. But it is more plausible that the dislike is mostly based on the same evidence that supports DeVoto's moral view of him, and that very different evidence, at any rate, would have produced a different verdict. If so, then Woodworth's moral character is part of the explanation of DeVoto's belief about his moral character.

It is more plausible of course that serious moral opposition to slavery would have emerged in Britain, France, and the United States even if slavery hadn't been worse in the modern period than before, and worse in the United States than in Latin America, and that the American antislavery movement would have grown even if slavery had not become more oppressive as the nineteenth century progressed. But that is because these moral facts are offered as at best a partial explanation of these developments in moral opinion. And if they really *are* part of the explanation, as seems plausible, then it is also plausible that whatever effect they produced was not entirely overdetermined; that, for example, the growth of the antislavery movement in the United States would at least have been somewhat slower if slavery had been and remained less bad an institution. Here again it hardly seems "completely irrelevant" to the explanation whether or not these moral facts obtained.

It is more puzzling, I grant, to consider Harman's own example in which you see the children igniting a cat and react immediately with the thought that this is wrong. Is it true, as Harman claims, that the assumption that the children are really doing something wrong is "totally irrelevant" to any reasonable explanation of your making that judgment? Would you, for example, have reacted in just the same way, with the thought that the action is wrong, even if what they were doing *hadn't* been wrong, and could we explain your reaction equally well on this assumption? Now, there is more than one way to understand this counterfactual question, and I shall return below to a reading of it that might appear favorable to Harman's view. What I wish to point out for now is merely that there is a natural way of taking it, parallel to the way in which I have been understanding similar counterfactual questions about my own examples, on which the answer to it has to be simply: it depends. For to answer the question, I take it,[18] we

must consider a situation in which what the children are doing is not wrong, but which is otherwise as much like the actual situation as possible, and then decide what your reaction would be in that situation. But since what makes their action wrong, what its wrongness *consists* in, is presumably something like its being an act of gratuitous cruelty (or, perhaps we should add, of intense cruelty, and to a helpless victim), to imagine them not doing something wrong we are going to have to imagine their action different in this respect. More cautiously and more generally, if what they are actually doing is wrong, and if moral properties are, as many writers have held, supervenient on natural ones,[19] then in order to imagine them not doing something wrong we are going to have to suppose their action different from the actual one in some of its natural features as well. So our question becomes: Even if the children had been doing something else, something just different enough not to be wrong, would you have taken them even so to be doing something wrong?

Surely there is no one answer to this question. It depends on a lot about you, including your moral views and how good you are at seeing at a glance what some children are doing. It probably depends also on a debatable moral issue; namely, just *how* different the children's action would have to be in order not to be wrong. (Is unkindness to animals, for example, also wrong?) I believe we can see how, in a case in which the answer was clearly affirmative, we might be tempted to agree with Harman that the wrongness of the action was no part of the explanation of your reaction. For suppose you are like this. You hate children. What you especially hate, moreover, is the sight of children enjoying themselves; so much so that whenever you see children having fun, you immediately assume they are up to no good. The more they seem to be enjoying themselves, furthermore, the readier you are to fasten on any pretext for thinking them engaged in real wickedness. Then it is true that even if the children had been engaged in some robust but innocent fun, you would have thought they were doing something wrong; and Harman is perhaps right[20] about you that the actual wrongness of the action you see is irrelevant to your

thinking it wrong. This is because your reaction is due to a feature of the action that coincides only very accidentally with the ones that make it wrong.[21] But, of course, and fortunately, many people aren't like this (nor does Harman argue that they are). It isn't true of them, in general, that if the children had been doing something similar, although different enough not to be wrong, they would still have thought the children were doing something wrong. And it isn't true either, therefore, that the wrongness of the action is irrelevant to the explanation of why they think it wrong.

Now, one might have the sense from my discussion of all these examples, but perhaps especially from my discussion of this last one, Harman's own, that I have perversely been refusing to understand his claim about the explanatory irrelevance of moral facts in the way he intends. And perhaps I have not been understanding it as he wishes. In any case, I agree, I have certainly not been understanding the crucial counterfactual question, of whether we would have drawn the same moral conclusion even if the moral facts had been different, in the way he must intend. But I am not being perverse. I believe, as I have said, that my way of taking the question is the more natural one. And, more importantly: although there is, I grant, a reading of that question on which it will always yield the answer Harman wants— namely, that a difference in the moral facts would *not* have made a difference in our judgment—I do not believe this reading can support his argument. I must now explain why.

It will help if I contrast my general approach with his. I am approaching questions about the justification of belief in the spirit of what Quine has called "epistemology naturalized."[22] I take this to mean that we have in general no a priori way of knowing which strategies for forming and refining our beliefs are likely to take us closer to the truth. The only way we have of proceeding is to assume the approximate truth of what seems to us the best overall theory we already have of what we are like and what the world is like, and to decide in the light of *that* what strategies of research and reasoning are likely to be reliable in producing a more nearly true overall theory. One result of

applying these procedures, in turn, is likely to be the refinement or perhaps even the abandonment of parts of the tentative theory with which we began.

I take Harman's approach, too, to be an instance of this one. He says we are justified in believing in those facts that we need to assume to explain why we observe what we do. But he does not think that our knowledge of this principle about justification is a priori. Furthermore, as he knows, we cannot decide whether one explanation is better than another without relying on beliefs we already have about the world. Is it really a better explanation of the vapor trail the physicist sees in the cloud chamber to suppose that a proton caused it, as Harman suggests in his example, rather than some other charged particle? Would there, for example, have been no vapor trail in the absence of that proton? There is obviously no hope of answering such questions without assuming at least the approximate truth of some quite far-reaching microphysical theory, and our knowledge of such theories is not a priori.

But my approach differs from Harman's in one crucial way. For among the beliefs in which I have enough confidence to rely on in evaluating explanations, at least at the outset, are some moral beliefs. And I have been relying on them in the following way.[23] Harman's thesis implies that the supposed moral fact of Hitler's being morally depraved is irrelevant to the explanation of Hitler's doing what he did. (For we may suppose that if it explains his doing what he did, it also helps explain, at greater remove, Harman's belief and mine in his moral depravity.) To assess this claim, we need to conceive a situation in which Hitler was *not* morally depraved and consider the question whether in that situation he would still have done what he did. My answer is that he would not, and this answer relies on a (not very controversial) moral view: that in any world at all like the actual one, only a morally depraved person could have initiated a world war, ordered the "final solution," and done any number of other things Hitler did. That is why I believe that, if Hitler hadn't been morally depraved, he wouldn't have done those things, and hence that the fact of his moral depravity is relevant to an explanation of what he did.

Harman, however, cannot want us to rely on any such moral views in answering this counterfactual question. This comes out most clearly if we return to his example of the children igniting the cat. He claims that the wrongness of this act is irrelevant to an explanation of your thinking it wrong, that you would have *thought* it wrong even if it wasn't. My reply was that in order for the action not to be wrong it would have had to lack the feature of deliberate, intense, pointless cruelty, and that if it had differed in this way you might very well *not* have thought it wrong. I also suggested a more cautious version of this reply: that since the action is in fact wrong, and since moral properties supervene on more basic natural ones, it would have had to be different in *some* further natural respect in order not to be wrong; and that we do not know whether if it had so differed you would still have thought it wrong. Both of these replies, again, rely on moral views, the latter merely on the view that there is *something* about the natural features of the action in Harman's example that makes it wrong, the former on a more specific view as to which of these features do this.

But Harman, it is fairly clear, intends for us *not* to rely on any such moral views in evaluating his counterfactual claim. His claim is not that if the action had not been one of deliberate cruelty (or had otherwise differed in whatever way would be required to remove its wrongness), you would still have thought it wrong. It is, instead, that if the action were one of deliberate, pointless cruelty, but this *did not make it wrong*, you would still have thought it was wrong. And to return to the example of Hitler's moral character, the counterfactual claim that Harman will need in order to defend a comparable conclusion about that case is not that if Hitler had been, for example, humane and fairminded, free of nationalistic pride and racial hatred, he would still have done exactly as he did. It is, rather, that if Hitler's psychology, and anything else about his situation that could strike us as morally relevant, had been exactly as it in fact was, but this had *not constituted moral depravity*, he would still have done exactly what he did.

Now the antecedents of these two conditionals are puzzling. For one thing, both are, I believe,

necessarily false. I am fairly confident, for example, that Hitler really was morally depraved;[24] and since I also accept the view that moral features supervene on more basic natural properties,[25] I take this to imply that there is no possible world in which Hitler has just the personality he in fact did, in just the situation he was in, but is not morally depraved. Any attempt to describe such a situation, moreover, will surely run up against the limits of our moral concepts—what Harman calls our "moral sensibility"—and this is no accident. For what Harman is asking us to do, in general, is to consider cases in which absolutely *everything* about the nonmoral facts that could seem morally relevant to us, in light of whatever moral theory we accept and of the concepts required for understanding that theory, is held fixed, but in which the moral judgment that our theory yields about the case is nevertheless mistaken. So it is hardly surprising that, using that theory and those concepts, we should find it difficult to conceive in any detail what such a situation would be like. It is especially not surprising when the cases in question are as paradigmatic in light of the moral outlook we in fact have as is Harman's example or is, even more so, mine of Hitler's moral character. The only way we could be wrong about this latter case (assuming we have the nonmoral facts right) would be for our whole theory to be hopelessly wrong, so radically mistaken that there could be no hope of straightening it out through adjustments from within.

But I do not believe we should conclude, as we might be tempted to,[26] that we therefore know a priori that this is not so, or that we cannot understand these conditionals that are crucial to Harman's argument. Rather, now that we have seen how we have to understand them, we should grant that they are true: that if our moral theory were somehow hopelessly mistaken, but all the nonmoral facts remained exactly as they in fact are, then, since we do *accept* that moral theory, we would still draw exactly the moral conclusions we in fact do. But we should deny that any skeptical conclusion follows from this. In particular, we should deny that it follows that moral facts play no role in explaining our moral judgments.

For consider what follows from the parallel claim about microphysics, in particular about Harman's example in which a physicist concludes from his observation of a vapor trail in a cloud chamber, and from the microphysical theory he accepts, that a free proton has passed through the chamber. The parallel claim, notice, is *not* just that if the proton had not been there the physicist would still have thought it was. This claim is implausible, for we may assume that the physicist's theory is generally correct, and it follows from that theory that if there hadn't been a proton there, then there wouldn't have been a vapor trail. But in a perfectly similar way it is implausible that if Hitler hadn't been morally depraved we would still have thought he was: for we may assume that our moral theory also is at least roughly correct, and it follows from the most central features of that theory that if Hitler hadn't been morally depraved, he wouldn't have done what he did. The *parallel* claim about the microphysical example is, instead, that if there hadn't been a proton there, but there *had* been a vapor trail, the physicist would still have concluded that a proton was present. More precisely, to maintain a perfect parallel with Harman's claims about the moral cases, the antecedent must specify that although no proton is present, absolutely *all* the non-microphysical facts that the physicist, in light of his theory, might take to be relevant to the question of whether or not a proton is present, are exactly as in the actual case. (These macrophysical facts, as we may for convenience call them, surely include everything one would normally think of as an observable fact.) Of course, we shall be unable to imagine this without imagining that the physicist's theory is pretty badly mistaken;[27] but I believe we should grant that, *if* the physicist's theory were somehow this badly mistaken, but all the macrophysical facts (including all the observable facts) were held fixed, then the physicist, since he does accept that theory, would still draw all the same conclusions that he actually does. That is, this conditional claim, like Harman's parallel claim about the moral cases, is true.

But no skeptical conclusions follow; nor can Harman, since he does not intend to be a skeptic about physics, think that they do. It does not follow, in

the first place, that we have any reason to think the physicist's theory *is* generally mistaken. Nor does it follow, furthermore, that the hypothesis that a proton really did pass through the cloud chamber is not part of a good explanation of the vapor trail, and hence of the physicist's thinking this has happened. This looks like a reasonable explanation, of course, only on the assumption that the physicist's theory is at least roughly true, for it is this theory that tells us, for example, what happens when charged particles pass through a supersaturated atmosphere, what other causes (if any) there might be for a similar phenomenon, and so on. But, as I say, we have not been provided with any reason for not trusting the theory to this extent.

Similarly, I conclude, we should draw no skeptical conclusions from Harman's claims about the moral cases. It is true that if our moral theory were seriously mistaken, but we still believed it, and the nonmoral facts were held fixed, we would still make just the moral judgments we do. But *this* fact by itself provides us with no reason for thinking that our moral theory *is* generally mistaken. Nor, again, does it imply that the fact of Hitler's really having been morally depraved forms no part of a good explanation of his doing what he did and hence, at greater remove, of our thinking him depraved. This explanation will appear reasonable, of course, only on the assumption that our accepted moral theory is at least roughly correct, for it is this theory that assures us that only a depraved person could have thought, felt, and acted as Hitler did. But, as I say, Harman's argument has provided us with no reason for not trusting our moral views to this extent, and hence with no reason for doubting that it is sometimes moral facts that explain our moral judgments.

I conclude with three comments about my argument.

(1) I have tried to show that Harman's claim— that we would have held the particular moral beliefs we do even if those beliefs were untrue—admits of two readings, one of which makes it implausible, and the other of which reduces it to an application of a general skeptical strategy, a strategy which could as

easily be used to produce doubt about microphysical as about moral facts. The general strategy is this. Consider any conclusion C we arrive at by relying both on some distinguishable "theory" T and on some body of evidence not being challenged, and ask whether we would have believed C even if it had been false. The plausible answer, *if* we are allowed to rely on T, will often be no: for if C had been false, then (according to T) the evidence would have had to be different, and in that case we wouldn't have believed C. (I have illustrated the plausibility of this sort of reply for all my moral examples, as well as for the microphysical one.) But the skeptic of course intends us *not* to rely on T in this way, and so rephrases the question: Would we have believed C even if it were false *but* all the evidence had been exactly as it in fact was? Now the answer has to be yes; and the skeptic concludes that C is doubtful. (It should be obvious how to extend this strategy to belief in other minds, or in an external world.) I am of course not convinced: I do not think answers to the rephrased question show anything interesting about what we know or justifiably believe. But it is enough for my purposes here that no such *general* skeptical strategy could pretend to reveal any problems peculiar to belief in *moral* facts.

(2) My conclusion about Harman's argument, although it is not exactly the same as, is nevertheless similar to and very much in the spirit of the Duhemian point I invoked earlier against verificationism. There the question was whether typical moral assertions have testable implications, and the answer was that they do, so long as you include additional moral assumptions of the right sort among the background theories on which you rely in evaluating these assertions. Harman's more important question is whether we should ever regard moral facts as relevant to the explanation of nonmoral facts, and in particular of our having the moral beliefs we do. But the answer, again, is that we should, so long as we are willing to hold the right sorts of *other* moral assumptions fixed in answering counterfactual questions. Neither answer shows morality to be on any shakier ground than, say, physics, for typical

microphysical hypotheses, too, have testable implications, and appear relevant to explanations, only if we are willing to assume at least the approximate truth of an elaborate microphysical theory and to hold this assumption fixed in answering counterfactual questions.

(3) Of course, this picture of how explanations depend on background theories, and moral explanations in particular on moral background theories, does show why someone already tempted toward moral skepticism on other grounds (such as those I mentioned at the beginning of this essay) might find Harman's claim about moral explanations plausible. To the extent that you already have pervasive doubts about moral theories, you will also find moral facts nonexplanatory. So I grant that Harman has located a natural symptom of moral skepticism; but I am sure he has neither traced this skepticism to its roots nor provided any independent argument for it. His claim (p. 22) that we do not *in fact* cite moral facts in explanation of moral beliefs and observations cannot provide such an argument, for that claim is false. So, too, is the claim that assumptions about moral facts seem irrelevant to such explanations, for many do not. The claim that we *should* not rely on such assumptions because they *are* irrelevant, on the other hand, unless it is supported by some independent argument for moral skepticism, will just be question-begging: for the principal test of whether they are relevant, in any situation in which it appears they might be, is a counterfactual question about what would have happened if the moral fact had not obtained, and how we answer that question depends precisely upon whether we *do* rely on moral assumptions in answering it.

My own view I stated at the outset: that the only argument for moral skepticism with any independent weight is the argument from the difficulty of settling disputed moral questions. I have shown that anyone who finds Harman's claim about moral explanations plausible must already have been tempted toward skepticism by some other considerations, and I suspect that the other considerations will typically be the ones I sketched. So that is where discussion should

focus. I also suggested that those considerations may provide less support for moral skepticism than is sometimes supposed, but I must reserve a thorough defense of that thesis for another occasion.

Notes

1. As, for example, in Alan Gewirth, "Positive 'Ethics' and Normative 'Science,'" *The Philosophical Review* 69 (1960), pp. 311–330, in which there are some useful remarks about the first of them.

2. J. L. Mackie, *Ethics: Inventing Right and Wrong* (Harmondsworth, England: Penguin, 1977), pp. 38–42.

3. Gilbert Harman, *The Nature of Morality: An Introduction to Ethics* (New York: Oxford University Press, 1977), pp. vii, viii. Parenthetical page references are to this work.

4. Harman's title for the entire first section of his book.

5. In the longer article of which this is an abridgement.

6. This point is generally credited to Pierre Duhem; see *The Aim and Structure of Physical Theory*, trans. Philip P. Wiener (Princeton, NJ: Princeton University Press, 1954). It is a prominent theme in the influential writings of W. V. O. Quine. For an especially clear application of it, see Hilary Putnam, "The 'Corroboration' of Theories," in *Mathematics, Matter and Method: Philosophical Papers, Volume I*, second ed. (Cambridge: Cambridge University Press, 1977), pp. 250–269.

7. See note 5.

8. Harman is careful always to say only that moral beliefs *appear* to play no such role, and since he eventually concludes that there *are* moral facts (p. 132), this caution may be more than stylistic. I shall argue that this more cautious claim, too, is mistaken (indeed, that is my central thesis). But to avoid issues about Harman's intent, I shall simply mean by "Harman's argument" the skeptical argument of his first two chapters, whether or not he means to endorse all of it. This argument surely deserves discussion in its own right in either case, especially since Harman never explains what is wrong with it.

9. He asks: "Can moral principles be tested in the same way [as scientific hypotheses can], out in the world? You can observe someone do something, but can you ever perceive the rightness or wrongness of what he does?" (p. 4).

10. The other is that Harman appears to use "observe" (and "perceive" and "see") in a surprising way. One

would normally take observing (or perceiving, or seeing) something to involve *knowing* it was the case. But Harman apparently takes an observation to be *any* opinion arrived at as "a direct result of perception" (p. 5) or, at any rate (see next footnote), "immediately and without conscious reasoning" (p. 7). This means that observations need not even be true, much less known to be true. A consequence is that the existence of moral observations, in Harman's sense, would not be sufficient to show that there is moral knowledge, although this *would* be sufficient if "observe" were being used in a more standard sense. What I argue in the text is that the existence of moral observations (in either Harman's or the standard sense) is not *necessary* for showing that there is moral knowledge, either.

11. This sort of case does not meet Harman's characterization of an observation as an opinion that is "a direct result of perception" (p. 5), but he is surely right that moral facts would be as well vindicated if they were needed to explain our drawing conclusions about hypothetical cases as they would be if they were needed to explain observations in the narrower sense. To be sure, Harman is still confining his attention to cases in which we draw the moral conclusion from our thought experiment "immediately and without conscious reasoning" (p. 7), and it is no doubt the existence of such cases that gives purchase to talk of a "moral sense." But this feature, again, can hardly matter to the argument: would belief in moral facts be less justified if they were needed only to explain the instances in which we draw the moral conclusion *slowly?* Nor can it make any difference for that matter whether the case we are reflecting on is hypothetical: so my example in which we, quickly or slowly, draw a moral conclusion about Hitler from what we know of him, is surely relevant.

12. In the longer paper from which this one is abridged. The salient point is that there are two very *different* reasons one might have for thinking that no reference to moral facts is needed in the explanation of moral beliefs. One—Harman's reason, and my target in this essay—is that no moral explanations even *seem* plausible, that reference to moral facts always strikes us as "completely irrelevant" to the explanation of moral beliefs. This claim, if true, would tend to support moral skepticism. The other, which might appeal to a "reductive" naturalist in ethics, is that any moral explanations that *do* seem plausible can be paraphrased without explanatory loss in entirely nonmoral terms. I doubt this view, too, and I argue in the longer version of this paper that

no ethical naturalist need hold it. But anyone tempted by it should note that it is anyway no version of moral skepticism: for what it says is that we know so *much* about ethics that we are always able to say, in entirely nonmoral terms, exactly which natural properties the moral terms in any plausible moral explanations refer to—that's why the moral expressions are dispensable. These two reasons should not be confused with one another.

13. It is surprising that Harman does not mention the obvious intermediate possibility, which would occur to any instrumentalist: to cite the physicist's psychological set *and* the vapor trail, but say nothing about protons or other unobservables. It is *this* explanation, as I emphasize below, that is most closely parallel to an explanation of beliefs about an external world in terms of sensory experience and psychological makeup, or of moral beliefs in terms of nonmoral facts together with our "moral sensibility."

14. Bernard DeVoto, *The Year of Decision: 1846* (Boston: Houghton Mifflin, 1942), p. 426; a quotation from the notebooks of Francis Parkman. The account of the entire rescue effort is on pp. 424–444.

15. What is being explained, of course, is not just why people came to think slavery wrong, but why people who were not themselves slaves or in danger of being enslaved came to think it so seriously wrong as to be intolerable. There is a much larger and longer history of people who thought it wrong but tolerable and an even longer one of people who appear not to have gotten past the thought that the world would be a better place without it. See David Brion Davis, *The Problem of Slavery in Western Culture* (Ithaca, NY: Cornell University Press, 1966).

16. For a version of what I am calling the standard view of slavery in the Americas, see Frank Tannenbaum, *Slave and Citizen* (New York: Alfred A. Knopf, 1947). For an argument against both halves of the standard view, see Davis, *The Problem of Slavery*, esp. pp. 60–61, 223–225, 262–263.

17. This counterfactual test requires qualification to be exactly right, but none of the plausible qualification matters to my examples. See the longer version of this paper.

18. Following, informally, Stalnaker and Lewis on counterfactuals. See Robert Stalnaker, "A Theory of Conditionals," in Nicholas Rescher, ed., *Studies in Logical Theory*, APQ Monograph No. 2. (Oxford: Basil Blackwell, 1968); and David Lewis, *Counterfactuals* (Cambridge, MA: Harvard University Press, 1973).

19. What would be generally granted is just that *if* there are moral properties they supervene on natural properties. But, remember, we are assuming for the sake of argument that there are.

I think moral properties *are* natural properties; and from this view it of course follows trivially that they supervene on natural properties: that, necessarily, nothing could differ in its moral properties without differing in some natural respect. But I also accept the more interesting thesis usually intended by the claim about supervenience—that there are more basic natural features such that, necessarily, once they are fixed, so are the moral properties. (In supervening on more basic natural facts of some sort, moral facts are like *most* natural facts. Social facts like unemployment, for example, supervene on complex histories of many individuals and their relations; and facts about the existence and properties of macroscopic physical objects—colliding billiard balls, say—clearly supervene on the microphysical constitution of the situations that include them.)

20. Not *certainly* right, because there is still the possibility that your reaction is to some extent overdetermined, and is to be explained partly by your sympathy for the cat and your dislike of cruelty, as well as by your hatred for children (although this last alone would have been sufficient to produce it).

We could of course rule out this possibility by making you an even less attractive character, indifferent to the suffering of animals and not offended by cruelty. But it may then be hard to imagine that such a person (whom I shall cease calling "you") could retain enough of a grip on moral thought for us to be willing to say he thought the action *wrong*, as opposed to saying that he merely pretended to do so. This difficulty is perhaps not insuperable, but it is revealing. Harman says that the actual wrongness of the action is "completely irrelevent" to the explanation of the observer's reaction. Notice that what is in fact true, however, is that it is *very hard* to imagine someone who reacts in the way Harman describes, but whose reaction is *not* due, at least in part, to the actual wrongness of the action.

21. Perhaps deliberate cruelty is worse the more one enjoys it (a standard counterexample to hedonism). If so, the fact that the children are enjoying themselves makes their action worse, but presumably isn't what makes it wrong to begin with.

22. W. V. O. Quine, "Epistemology Naturalized," in *Ontological Relativity and Other Essays* (New York:

Columbia University Press, 1969), pp. 69-90. In the same volume, see also "Natural Kinds," pp. 114–138.

23. Harman of course allows us to assume the moral facts whose explanatory relevance is being assessed: that Hitler was depraved, or that what the children in his example are doing is wrong. But I have been assuming something more—something about what depravity *is*, and about what *makes* the children's action wrong. (At a minimum, in the more cautions version of my argument, I have been assuming that *something* about its more basic features makes it wrong, so that it could not have differed in its moral quality without differing in those other features as well.)

24. And anyway, remember, this is the sort of fact Harman allows us to assume in order to see whether, if we assume it, it will look explanatory.

25. It is about here that I have several times encountered the objection: but surely *supervenient* properties aren't needed to explain anything. It is a little hard, however, to see just what this objection is supposed to come to. If it includes endorsement of the conditional I here attribute to Harman, then I believe the remainder of my discussion is an adequate reply to it. If it is the claim that, because moral properties are supervenient, we can always exploit the insights in any moral explanations, however plausible, without resort to moral *language*, then I have already dealt with it in my discussion of reductionism (see note 10, above): the claim is probably false, but even if it is true it is no support for Harman's view, which is not that moral explanations are plausible but reducible, but that they are totally implausible. And doubts about the causal efficacy of supervenient facts seem misplaced in any case, as attention to my earlier examples (note 17) illustrates. High unemployment causes widespread hardship, and can also bring down the rate of inflation. The masses and velocities of two colliding billiard balls causally influence the subsequent trajectories of the two balls. There is no doubt some sense in which these facts are causally efficacious *in virtue of* the way they supervene on—that is, are constituted out of, or causally realized by—more basic facts, but this hardly shows them *inefficacious*. (Nor does Harman appear to think it does: for his *favored* explanation of your moral belief about the burning cat, recall, appeals to psychological facts [about your moral sensibility], a biological fact [that it's a cat], and macrophysical facts [that it's on fire]—supervenient facts all, on his physicalist view and mine.) If anyone

does hold to a general suspicion of causation by supervenient facts and properties, however, as Jaegwon Kim appears to (see "Causality, Identity, and Supervenience in the Mind-Body Problem," *Midwest Studies in Philosophy* 4 [1979], pp. 31–49), it is enough to note that this suspicion cannot diagnose any special difficulty with *moral* explanations, any distinctive "problem with ethics." The "problem," arguably, will be with every discipline but fundamental physics.

26. And as I take it Philippa Foot, for example, is still prepared to do, at least about paradigmatic cases. See her *Moral Relativism* (Lawrence: The University of Kansas, 1978).

27. If we imagine the physicist *regularly* mistaken in this way, moreover, we will have to imagine his theory not just mistaken but hopelessly so. And we can easily reproduce the other notable feature of Harman's claims about the moral cases, that what we are imagining is *necessarily* false, if we suppose that one of the physicist's (or better, chemist's) conclusions is about the microstructure of some common substance, such as water. For I agree with Saul Kripke that whatever microstructure water has is essential to it, that it has this structure in every possible world in which it exists (Saul Kripke, *Naming and Necessity* [Cambridge, MA: Harvard University Press, 1980]). If we are right (as we have every reason to suppose) in thinking that water is actually H_2O, therefore, the conditional, "If water were not H_2O, but all the observable, macrophysical facts were just as they actually are, chemists would still have come to *think* it was H_2O," has a necessarily false antecedent; just as, if we are right (as we also have good reason to suppose) in thinking that Hitler was actually morally depraved, the conditional, "If Hitler were just as he was in all natural respects, but not morally depraved, we would still have *thought* he was depraved," has a necessarily false antecedent. Of course, I am not suggesting that in either case our knowledge that the antecedent is false is a priori.

These counterfactuals, because of their impossible antecedents, will have to be interpreted over worlds that are (at best) only "epistemically" possible; and, as Richard Boyd has pointed out to me, this helps to explain why anyone who accepts a causal theory of knowledge (or any theory according to which the justification of our belief depends on what explains our holding them) will find their truth irrelevant to the question of how much we know, either in chemistry or in morals. For although there certainly are counterfactuals that are relevant to questions about what causes what (and, hence, about what explains what), these have to be counterfactuals about real possibilities, not merely epistemic ones.

Study Questions

1. What are moral facts?
2. If you hold moral beliefs, do you necessarily accept moral facts?
3. What are moral explanations?
4. If you take part in a moral disagreement, do you thereby appeal to a moral explanation?

40

J. L. MACKIE

J. L. Mackie (1917–1981) was an Australian philosopher who was elected a fellow at University College, Oxford. He argued that making moral judgments presumes a standard of right and wrong independent of anyone's feelings. But no such standard exists. Hence ethics has no foundation and is based on a misunderstanding. People believe they are apprehending moral values in the world, but such strange entities do not exist, and even if they did, we would lack any special faculty that would enable us to perceive them.

Ethics: Inventing Right and Wrong

THE SUBJECTIVITY OF VALUES

1. Moral Scepticism

There are no objective values. This is a bald statement of the thesis of this chapter, but before arguing for it I shall try to clarify and restrict it in ways that may meet some objections and prevent some misunderstanding.

The statement of this thesis is liable to provoke one of three very different reactions. Some will think it not merely false but pernicious; they will see it as a threat to morality and to everything else that is worthwhile, and they will find the presenting of such a thesis in what purports to be a book on ethics paradoxical or even outrageous. Others will regard it as a trivial truth, almost too obvious to be worth mentioning, and certainly too plain to be worth much argument. Others again will say that it is meaningless or empty, that no real issue is raised by the question whether values are or are not part of the fabric of the world. But, precisely because there can be these three different reactions, much more needs to be said.

The claim that values are not objective, are not part of the fabric of the world, is meant to include not only moral goodness, which might be most naturally equated with moral value, but also other things that could be more loosely called moral values or disvalues—rightness and wrongness, duty, obligation, an action's being rotten and contemptible, and so on. It also includes non-moral values, notably aesthetic ones, beauty and various kinds of artistic merit. I shall not discuss these explicitly, but clearly much the same considerations apply to aesthetic and to moral values, and there would be at least some initial implausibility in a view that gave the one a different status from the other.

Since it is with moral values that I am primarily concerned, the view I am adopting may be called moral scepticism. But this name is likely to be misunderstood: "moral scepticism" might also be used as

From *Ethics: Inventing Right and Wrong* by J. L. Mackie (Harmondsworth: Penguin, 1977). Reprinted by permission of the publisher.

a name for either of two first order views, or perhaps for an incoherent mixture of the two. A moral sceptic might be the sort of person who says "All this talk of morality is tripe," who rejects morality and will take no notice of it. Such a person may be literally rejecting all moral judgements: he is more likely to be making moral judgements of his own, expressing a positive moral condemnation of all that conventionally passes for morality: or he may be confusing these two logically incompatible views, and saying that he rejects all morality, while he is in fact rejecting only a particular morality that is current in the society in which he has grown up. But I am not at present concerned with the merits or faults of such a position. These are first order moral views, positive or negative: the person who adopts either of them is taking a certain practical, normative, stand. By contrast, what I am discussing is a second order view, a view about the status of moral values and the nature of moral valuing, about where and how they fit into the world. These first and second order views are not merely distinct but completely independent: one could be a second order moral sceptic without being a first order one, or again the other way round. A man could hold strong moral views, and indeed ones whose content was thoroughly conventional, while believing that they were simply attitudes and policies with regard to conduct that he and other people held. Conversely, a man could reject all established morality while believing it to be an objective truth that it was evil or corrupt.

With another sort of misunderstanding moral scepticism would seem not so much pernicious as absurd. How could anyone deny that there is a difference between a kind action and a cruel one, or that a coward and a brave man behave differently in the face of danger? Of course, this is undeniable, but it is not to the point. The kinds of behaviour to which moral values and disvalues are ascribed are indeed part of the furniture of the world, and so are the natural, descriptive, differences between them, but not, perhaps, their differences in value. It is a hard fact that cruel actions differ from kind ones, and hence that we can learn, as in fact we all do, to distinguish them fairly well in practice, and to use the words "cruel" and "kind" with fairly clear descriptive

meanings: but is it an equally hard fact that actions which are cruel in such a descriptive sense are to be condemned? The present issue is with regard to the objectivity specifically of value, not with regard to the objectivity of those natural, factual, differences on the basis of which differing values are assigned.

2. Subjectivism

Another name often used, as an alternative to "moral scepticism," for the view I am discussing is "subjectivism," But this too has more than one meaning, Moral subjectivism too could be a first order, normative, view, namely that everyone really ought to do whatever he thinks he should. This plainly is a (systematic) first order view, on examination it soon ceases to be plausible, but that is beside the point, for it is quite independent of the second order thesis at present under consideration. What is more confusing is that different second order views compete for the name "subjectivism." Several of these are doctrines about the meaning of moral terms and moral statements. What is often called moral subjectivism is the doctrine that, for example, "This action is right" *means* "I approve of this action," or more generally that moral judgements are equivalent to reports of the speaker's own feelings or attitudes. But the view I am now discussing is to be distinguished in two vital respects from any such doctrine as this. First, what I have called moral scepticism is a negative doctrine, not a positive one: it says what there isn't, not what there is. It says that there do not exist entities or relations of a certain kind, objective values or requirements, which many people have believed to exist. Of course, the moral sceptic cannot leave it at that. If his position is to be at all plausible, he must give some account of how other people have fallen into what he regards as an error, and this account will have to include some positive suggestions about how values fail to be objective, about what has been mistaken for, or has led to false beliefs about, objective values. But this will be a development of this theory, not its core: its core is the negation. Secondly, what I have called moral scepticism is an ontological thesis, not a linguistic or conceptual one. It is not, like

the other doctrine often called moral subjectivism, a view about the meanings of moral statements. Again, no doubt, if it is to be at all plausible, it will have to give some account of their meanings, and I shall say something about this in Section 7 of this chapter and again [later in *Ethics: Inventing Right and Wrong*]. But this too will be a development of the theory, not its core.

It is true that those who have accepted the moral subjectivism which is the doctrine that moral judgements are equivalent to reports of the speaker's own feelings or attitudes have usually presupposed what I am calling moral scepticism. It is because they have assumed that there are no objective values that they have looked elsewhere for an analysis of what moral statements might mean, and have settled upon subjective reports. Indeed, if all our moral statements were such subjective reports, it would follow that, at least so far as we are aware, there are no objective moral values. If we were aware of them, we would say something about them, In this sense this sort of subjectivism entails moral scepticism. But the converse entailment does not hold. The denial that there are objective values does not commit one to any particular view about what moral statements mean, and certainly not to the view that they are equivalent to subjective reports. No doubt if moral values are not objective they are in some very broad sense subjective, and for this reason I would accept "moral subjectivism" as an alternative name to "moral scepticism." But subjectivism in this broad sense must be distinguished from the specific doctrine about meaning referred to above. Neither name is altogether satisfactory: we simply have to guard against the (different) misinterpretations which each may suggest. . . .

7. The Claim to Objectivity

If I have succeeded in specifying precisely enough the moral values whose objectivity I am denying, my thesis may now seem to be trivially true. Of course, some will say, valuing, preferring, choosing, recommending, rejecting, condemning, and so on, are human activities, and there is no need to look for values that are prior to and logically independent of all such activities. There may be widespread agreement in valuing, and particular value-judgements are not in general arbitrary or isolated: they typically cohere with others, or can be criticized if they do not, reasons can be given for them, and so on: but if all that the subjectivist is maintaining is that desires, ends, purposes, and the like figure somewhere in the system of reasons, and that no ends or purposes are objective as opposed to being merely intersubjective, then this may be conceded without much fuss.

But I do not think that this should be conceded so easily. As I have said, the main tradition of European moral philosophy includes the contrary claim, that there are objective values of just the sort I have denied. I have referred already to Plato, Kant, and Sidgwick. Kant in particular holds that the categorical imperative is not only categorical and imperative but objectively so: though a rational being gives the moral law to himself, the law that he thus makes is determinate and necessary. Aristotle begins the *Nicomachean Ethics* by saying that the good is that at which all things aim, and that ethics is part of a science which he calls "politics," whose goal is not knowledge but practice: yet he does not doubt that there can be *knowledge* of what is the good for man, nor, once he has identified this as well-being or happiness, *eudaimonia,* that it can be known, rationally determined, in what happiness consists; and it is plain that he thinks that this happiness is intrinsically desirable, not good simply because it is desired. The rationalist Samuel Clarke holds that

> these eternal and necessary differences of things make it *fit and reasonable* for creatures so to act . . . even separate from the consideration of these rules being the *positive will* or *command of God*; and also antecedent to any respect or regard, expectation or apprehension, of any *particular private and personal advantage or disadvantage, reward or punishment*, either present or future. . . .

Even the sentimentalist Hutcheson defines moral goodness as "some quality apprehended in actions, which procures approbation . . . ," while saying that the moral sense by which we perceive virtue and

vice has been given to us (by the Author of nature) to direct our actions. Hume indeed was on the other side, but he is still a witness to the dominance of the objectivist tradition, since he claims that when we "see that the distinction of vice and virtue is not founded merely on the relations of objects, nor is perceiv'd by reason," this "wou'd subvert all the vulgar systems of morality." And Richard Price insists that right and wrong are "real characters of actions," not "qualities of our minds," and are perceived by the understanding; he criticizes the notion of moral sense on the ground that it would make virtue an affair of taste, and moral right and wrong "nothing in the objects themselves"; he rejects Hutcheson's view because (perhaps mistakenly) he sees it as collapsing into Hume's.

But this objectivism about values is not only a feature of the philosophical tradition. It has also a firm basis in ordinary thought, and even in the meanings of moral terms. No doubt it was an extravagance for Moore to say that "good" is the name of a nonnatural quality, but it would not be so far wrong to say that in moral contexts it is used as if it were the name of a supposed non-natural quality, where the description "nonnatural" leaves room for the peculiar evaluative, prescriptive, intrinsically action-guiding aspects of this supposed quality. This point can be illustrated by reflection on the conflicts and swings of opinion in recent years between noncognitivist and naturalist views about the central, basic, meanings of ethical terms. If we reject the view that it is the function of such terms to introduce objective values into discourse about conduct and choices of action, there seem to be two main alternative types of account. One (which has importantly different subdivisions) is that they conventionally express either attitudes which the speaker purports to adopt towards whatever it is that he characterizes morally, or prescriptions or recommendations, subject perhaps to the logical constraint of universalizability. Different views of this type share the central thesis that ethical terms have, at least partly and primarily, some sort of non-cognitive, non-descriptive, meaning. Views of the other type hold that they are descriptive in meaning, but descriptive of natural features, partly

of such features as everyone, even the non-cognitivist, would recognize as distinguishing kind actions from cruel ones, courage from cowardice, politeness from rudeness, and so on, and partly (though these two overlap) of relations between the actions and some human wants, satisfactions, and the like. I believe that views of both these types capture part of the truth. Each approach can account for the fact that moral judgements are action-guiding or practical. Yet each gains much of its plausibility from the felt inadequacy of the other. It is a very natural reaction to any non-cognitive analysis of ethical terms to protest that there is more to ethics than this, something more external to the maker of moral judgements, more authoritative over both him and those of or to whom he speaks, and this reaction is likely to persist even when full allowance has been made for the logical, formal, constraints of full-blooded prescriptivity and universalizability. Ethics, we are inclined to believe, is more a matter of knowledge and less a matter of decision than any non-cognitive analysis allows. And of course naturalism satisfies this demand. It will not be a matter of choice or decision whether an action is cruel or unjust or imprudent or whether it is likely to produce more distress than pleasure. But in satisfying this demand, it introduces a converse deficiency. On a naturalist analysis, moral judgements can be practical, but their practicality is wholly relative to desires or possible satisfactions of the person or persons whose actions are to be guided; but moral judgements seem to say more than this. This view leaves out the categorical quality of moral requirements. In fact both naturalist and noncognitive analyses leave out the apparent authority of ethics, the one by excluding the categorically imperative aspect, the other the claim to objective validity or truth. The ordinary user of moral language means to say something about whatever it is that he characterizes morally, for example a possible action, as it is in itself, or would be if it were realized, and not about, or even simply expressive of, his, or anyone else's, attitude or relation to it. But the something he wants to say is not purely descriptive, certainly not inert, but something that involves a call for action or for the refraining from action, and one that is absolute, not

contingent upon any desire or preference or policy or choice, his own or anyone else's. Someone in a state of moral perplexity, wondering whether it would be wrong for him to engage, say, in research related to bacteriological warfare, wants to arrive at some judgment about this concrete case, his doing this work at this time in these actual circumstances; his relevant characteristics will be part of the subject of the judgment, but no relation between him and the proposed action will be part of the predicate. The question is not, for example, whether he really wants to do this work, whether it will satisfy or dissatisfy him, whether he will in the long run have a pro-attitude towards it, or even whether this is an action of a sort that he can happily and sincerely recommend in all relevantly similar cases. Nor is he even wondering just whether to recommend such action in all relevantly similar cases. He wants to know whether this course of action would be wrong in itself. Something like this is the everyday objectivist concept of which talk about non-natural qualities is a philosopher's reconstruction.

The prevalence of this tendency to objectify values—and not only moral ones—is confirmed by a pattern of thinking that we find in existentialists and those influenced by them. The denial of objective values can carry with it an extreme emotional reaction, a feeling that nothing matters at all, that life has lost its purpose. Of course this does not follow; the lack of objective values is not a good reason for abandoning subjective concern or for ceasing to want anything. But the abandonment of a belief in objective values can cause, at least temporarily, a decay of subjective concern and sense of purpose. That it does so is evidence that the people in whom this reaction occurs have been tending to objectify their concerns and purposes, have been giving them a fictitious external authority. A claim to objectivity has been so strongly associated with their subjective concerns and purposes that the collapse of the former seems to undermine the latter as well.

This view, that conceptual analysis would reveal a claim to objectivity, is sometimes dramatically confirmed by philosophers who are officially on the other side. Bertrand Russell, for example, says that "ethical propositions should be expressed in the optative mood, not in the indicative"; he defends himself effectively against the charge of inconsistency in both holding ultimate ethical valuations to be subjective and expressing emphatic opinions on ethical questions. Yet at the end he admits:

> Certainly there *seems* to be something more. Suppose, for example, that some one were to advocate the introduction of bullfighting in this country. In opposing the proposal, I should *feel*, not only that I was expressing my desires, but that my desires in the matter are *right*, whatever that may mean. As a matter of argument, I can, I think, show that I am not guilty of any logical inconsistency in holding to the above interpretation of ethics and at the same time expressing strong ethical preferences. But in feeling I am not satisfied.

But he concludes, reasonably enough, with the remark: "I can only say that, while my own opinions as to ethics do not satisfy me, other people's satisfy me still less."

I conclude, then, that ordinary moral judgements include a claim to objectivity, an assumption that there are objective values in just the sense in which I am concerned to deny this. And I do not think it is going too far to say that this assumption has been incorporated in the basic, conventional, meanings of moral terms. Any analysis of the meanings of moral terms which omits this claim to objective, intrinsic, prescriptivity is to that extent incomplete; and this is true of any non-cognitive analysis, any naturalist one, and any combination of the two.

If second order ethics were confined, then, to linguistic and conceptual analysis, it ought to conclude that moral values at least are objective: that they are so is part of what our ordinary moral statements mean: the traditional moral concepts of the ordinary man as well as of the main line of western philosophers are concepts of objective value. But it is precisely for this reason that linguistic and conceptual analysis is not enough. The claim to objectivity, however ingrained in our language and thought, is not self-validating. It can and should be questioned. But the denial of objective values will have to be put forward

not as the result of an analytic approach, but as an "error theory," a theory that although most people in making moral judgements implicitly claim, among other things, to be pointing to something objectively prescriptive, these claims are all false. It is this that makes the name "moral scepticism" appropriate.

But since this is an error theory, since it goes against assumptions ingrained in our thought and built into some of the ways in which language is used, since it conflicts with what is sometimes called common sense, it needs very solid support. It is not something we can accept lightly or casually and then quietly pass on. If we are to adopt this view, we must argue explicitly for it. Traditionally it has been supported by arguments of two main kinds, which I shall call the argument from relativity and the argument from queerness, but these can, as I shall show, be supplemented in several ways.

8. *The Argument from Relativity*

The argument from relativity has as its premiss the well-known variation in moral codes from one society to another and from one period to another, and also the differences in moral belief between different groups and classes within a complex community. Such variation is in itself merely a truth of descriptive morality, a fact of anthropology which entails neither first order nor second order ethical views. Yet it may indirectly support second order subjectivism: radical differences between first order moral judgements make it difficult to treat those judgements as apprehensions of objective truths. But it is not the mere occurrence of disagreements that tells against the objectivity of values. Disagreement on questions in history or biology or cosmology does not show that there are no objective issues in these fields for investigation to disagree about. But such scientific disagreement results from speculative inferences or explanatory hypotheses based on inadequate evidence, and it is hardly plausible to interpret moral disagreement in the same way. Disagreement about moral codes seems to reflect people's adherence to and participation in different ways of life. The causal connection seems to be mainly that way round: it

is that people approve of monogamy because they participate in a monogamous way of life rather than that they participate in a monogamous way of life because they approve of monogamy. Of course, the standards may be an idealization of the way of life from which they arise: the monogamy in which people participate may be less complete, less rigid, than that of which it leads them to approve. This is not to say that moral judgements are purely conventional. Of course there have been and are moral heretics and moral reformers, people who have turned against the established rules and practices of their own communities for moral reasons, and often for moral reasons that we would endorse. But this can usually be understood as the extension, in ways which, though new and unconventional, seemed to them to be required for consistency, of rules to which they already adhered as arising out of an existing way of life. In short, the argument from relativity has some force simply because the actual variations in the moral codes are more readily explained by the hypothesis that they reflect ways of life than by the hypothesis that they express perceptions, most of them seriously inadequate and badly distorted, of objective values.

But there is a well-known counter to this argument from relativity, namely to say that the items for which objective validity is in the first place to be claimed are not specific moral rules or codes but very general basic principles which are recognized at least implicitly to some extent in all society—such principles as provide the foundations of what Sidgwick has called different methods of ethics, the principle of universalizability, perhaps, or the rule that one ought to conform to the specific rules of any way of life in which one takes part, from which one profits, and on which one relies, or some utilitarian principle of doing what tends, or seems likely, to promote the general happiness. It is easy to show that such general principles, married with differing concrete circumstances, different existing social patterns or different preferences, will beget different specific moral rules, and there is some plausibility in the claim that the specific rules thus generated will vary from community to community or from group to group in close agreement with the actual variations in accepted codes.

The argument from relativity can be only partly countered in this way. To take this line the moral objectivist has to say that it is only in these principles that the objective moral character attaches immediately to its descriptively specified ground or subject: other moral judgements are objectively valid or true, but only derivatively and contingently—if things had been otherwise, quite different sorts of actions would have been right. And despite the prominence in recent philosophical ethics of universalization, utilitarian principles, and the like, these are very far from constituting the whole of what is actually affirmed as basic in ordinary moral thought. Much of this is concerned rather with what Hare calls "ideals" or, less kindly, "fanaticism." That is, people judge that some things are good or right, and others are bad or wrong, not because—or at any rate not only because—they exemplify some general principle for which widespread implicit acceptance could be claimed, but because something about those things arouses certain responses immediately in them, though they would arouse radically and irresolvably different responses in others. "Moral sense" or "intuition" is an initially more plausible description of what supplies many of our basic moral judgements than "reason." With regard to all these starting points of moral thinking the argument from relativity remains in full force.

9. The Argument from Queerness

Even more important, however, and certainly more generally applicable, is the argument from queerness. This has two parts, one metaphysical, the other epistemological. If there were objective values, then they would be entities or qualities or relations of a very strange sort, utterly different from anything else in the universe. Correspondingly, if we were aware of them, it would have to be by some special faculty of moral perception or intuition, utterly different from our ordinary ways of knowing everything else. These points were recognized by Moore when he spoke of non-natural qualities, and by the intuitionists in their talk about a "faculty of moral intuition." Intuitionism has long been out of favour, and it is indeed easy to point out its implausibilities. What is

not so often stressed, but is more important, is that the central thesis of intuitionism is one to which any objectivist view of values is in the end committed: intuitionism merely makes unpalatably plain what other forms of objectivism wrap up. Of course the suggestion that moral judgements are made or moral problems solved by just sitting down and having an ethical intuition is a travesty of actual moral thinking. But, however complex the real process, it will require (if it is to yield authoritatively prescriptive conclusions) some input of this distinctive sort, either premisses or forms of argument or both. When we ask the awkward question, how we can be aware of this authoritative prescriptivity, of the truth of these distinctively ethical premisses or of the cogency of this distinctively ethical pattern of reasoning, none of our ordinary accounts of sensory perception or introspection or the framing and confirming of explanatory hypotheses or inference or logical construction or conceptual analysis, or any combination of these, will provide a satisfactory answer; "a special sort of intuition" is a lame answer, but it is the one to which the clearheaded objectivist is compelled to resort.

Indeed, the best move for the moral objectivist is not to evade this issue, but to look for companions in guilt. For example, Richard Price argues that it is not moral knowledge alone that such an empiricism as those of Locke and Hume is unable to account for, but also our knowledge and even our ideas of essence, number, identity, diversity, solidity, inertia, substance, the necessary existence and infinite extension of time and space, necessity and possibility in general, power, and causation. If the understanding, which Price defines as the faculty within us that discerns truth, is also a source of new simple ideas of so many other sorts, may it not also be a power of immediately perceiving right and wrong, which yet are real characters of actions?

This is an important counter to the argument from queerness. The only adequate reply to it would be to show how, on empiricist foundations, we can construct an account of the ideas and beliefs and knowledge that we have of all these matters. I cannot even begin to do that here, though I have undertaken some parts of the task elsewhere. I can only state

my belief that satisfactory accounts of most of these can be given in empirical terms. If some supposed metaphysical necessities or essences resist such treatment, then they too should be included, along with objective values, among the targets of the argument from queerness.

This queerness does not consist simply in the fact that ethical statements are "unverifiable." Although logical positivism with its verifiability theory of descriptive meaning gave an impetus to non-cognitive accounts of ethics, it is not only logical positivists but also empiricists of a much more liberal sort who should find objective values hard to accommodate. Indeed, I would not only reject the verifiability principle but also deny the conclusion commonly drawn from it, that moral judgements lack descriptive meaning. The assertion that there are objective values or intrinsically prescriptive entities or features of some kind, which ordinary moral judgements presuppose, is, I hold, not meaningless but false.

Plato's Forms give a dramatic picture of what objective values would have to be. The Form of the Good is such that knowledge of it provides the knower with both a direction and an overriding motive; something's being good both tells the person who knows this to pursue it and makes him pursue it. An objective good would be sought by anyone who was acquainted with it, not because of any contingent fact that this person, or every person, is so constituted that he desires this end, but just because the end has to-be-pursuedness somehow built into it. Similarly, if there were objective principles of right and wrong, any wrong (possible) course of action would have not-to-be-doneness somehow built into it. Or we should have something like Clarke's necessary relations of fitness between situations and actions, so that a situation would have a demand for such-and-such an action somehow built into it.

The need for an argument of this sort can be brought out by reflection on Hume's argument that "reason"—in which at this stage he includes all sorts of knowing as well as reasoning—can never be an "influencing motive of the will." Someone might object that Hume has argued unfairly from the lack of influencing power (not contingent upon desires) in ordinary objects of knowledge and ordinary reasoning, and might maintain that values differ from natural objects precisely in their power, when known, automatically to influence the will. To this Hume could, and would need to, reply that this objection involves the postulating of value-entities or value-features of quite a different order from anything else with which we are acquainted, and of a corresponding faculty with which to detect them. That is, he would have to supplement his explicit argument with what I have called the argument from queerness.

Another way of bringing out this queerness is to ask, about anything that is supposed to have some objective moral quality, how this is linked with its natural features. What is the connection between the natural fact that an action is a piece of deliberate cruelty—say, causing pain just for fun—and the moral fact that it is wrong? It cannot be an entailment, a logical or semantic necessity. Yet it is not merely that the two features occur together. The wrongness must somehow be "consequential" or "supervenient"; it is wrong because it is a piece of deliberate cruelty. But just what *in the world* is signified by this "because"? And how do we know the relation that it signifies, if this is something more than such actions being socially condemned, and condemned by us too, perhaps through our having absorbed attitudes from our social environment? It is not even sufficient to postulate a faculty which "sees" the wrongness: something must be postulated which can see at once the natural features that constitute the cruelty, and the wrongness, and the mysterious consequential link between the two. Alternatively, the intuition required might be the perception that wrongness is a higher order property belonging to certain natural properties; but what is this belonging of properties to other properties, and how can we discern it? How much simpler and more comprehensible the situation would be if we could replace the moral quality with some sort of subjective response which could be causally related to the detection of the natural features on which the supposed quality is said to be consequential.

It may be thought that the argument from queerness is given an unfair start if we thus relate it to what are admittedly among the wilder products of

philosophical fancy—Platonic Forms, non-natural qualities, self-evident relations of fitness, faculties of intuition, and the like. Is it equally forceful if applied to the terms in which everyday moral judgements are more likely to be expressed—though still, as has been argued in Section 7, with a claim to objectivity—"you must do this," "you can't do that," "obligation," "unjust," "rotten," "disgraceful," "mean," or talk about good reasons for or against possible actions? Admittedly not; but that is because the objective prescriptivity, the element a claim for whose authoritativeness is embedded in ordinary moral thought and language, is not yet isolated in these forms of speech, but is presented along with relations to desires and feelings, reasoning about the means to desired ends, interpersonal demands, the injustice which consists in the violation of what are in the context the accepted standards of merit, the psychological constituents of meanness, and so on. There is nothing queer about any of these, and under cover of them the claim for moral authority may pass unnoticed. But if I am right in arguing that it is ordinarily there, and is therefore very likely to be incorporated almost automatically in philosophical accounts of ethics which systematize our ordinary thought even in such apparently innocent terms as these, it needs to be examined, and for this purpose it needs to be isolated and exposed as it is by the less cautious philosophical reconstructions.

10. Patterns of Objectification

Considerations of these kinds suggest that it is in the end less paradoxical to reject than to retain the common-sense belief in the objectivity of moral values, provided that we can explain how this belief, if it is false, has become established and is so resistant to criticisms. This proviso is not difficult to satisfy.

On a subjectivist view, the supposedly objective values will be based in fact upon attitudes which the person has who takes himself to be recognizing and responding to those values. If we admit what Hume calls the mind's "propensity to spread itself on external objects," we can understand the supposed objectivity of moral qualities as arising from what we can call the projection or objectification of moral attitudes. This would be analogous to what is called the "pathetic fallacy," the tendency to read our feelings into their objects. If a fungus, say, fills us with disgust, we may be inclined to ascribe to the fungus itself a non-natural quality of foulness. But in moral contexts there is more than this propensity at work. Moral attitudes themselves are at least partly social in origin: socially established—and socially necessary—patterns of behaviour put pressure on individuals, and each individual tends to internalize these pressures and to join in requiring these patterns of behaviour of himself and of others. The attitudes that are objectified into moral values have indeed an external source, though not the one assigned to them by the belief in their absolute authority. Moreover, there are motives that would support objectification. We need morality to regulate interpersonal relations, to control some of the ways in which people behave towards one another, often in opposition to contrary inclinations. We therefore want our moral judgements to be authoritative for other agents as well as for ourselves: objective validity would give them the authority required. Aesthetic values are logically in the same position as moral ones; much the same metaphysical and epistemological considerations apply to them. But aesthetic values are less strongly objectified than moral ones; their subjective status, and an "error theory" with regard to such claims to objectivity as are incorporated in aesthetic judgements, will be more readily accepted, just because the motives for their objectification are less compelling.

But it would be misleading to think of the objectification of moral values as primarily the projection of feelings, as in the pathetic fallacy. More important are wants and demands. As Hobbes says, "whatsoever is the object of any man's Appetite or Desire, that is it, which he for his part calleth *Good*"; and certainly both the adjective "good" and the noun "goods" are used in non-moral contexts of things because they are such as to satisfy desires. We get the notion of something's being objectively good, or having intrinsic value, by reversing the direction of dependence here, by making the desire depend upon the goodness, instead of the goodness on the desire.

And this is aided by the fact that the desired thing will indeed have features that make it desired, that enable it to arouse a desire or that make it such as to satisfy some desire that is already there. It is fairly easy to confuse the way in which a thing's desirability is indeed objective with its having in our sense objective value. The fact that the word "good" serves as one of our main moral terms is a trace of this pattern of objectification.

Similarly related uses of words are covered by the distinction between hypothetical and categorical imperatives. The statement that someone "ought to" or, more strongly, "must" do such-and-such may be backed up explicitly or implicitly by reference to what he wants or to what his purposes and objects are. Again, there may be a reference to the purposes of someone else, perhaps the speaker: "You must do this"—"Why?"—"Because I want such-and-such." The moral categorical imperative which could be expressed in the same words can be seen as resulting from the suppression of the conditional clause in a hypothetical imperative without its being replaced by any such reference to the speaker's wants. The action in question is still required in something like the way in which it would be if it were appropriately related to a want, but it is no longer admitted that there is any contingent want upon which its being required depends. Again this move can be understood when we remember that at least our central and basic moral judgements represent social demands, where the source of the demand is indeterminate and diffuse. Whose demands or wants are in question, the agent's, or the speaker's, or those of an indefinite multitude of other people? All of these in a way, but there are advantages in not specifying them precisely. The speaker is expressing demands which he makes as a member of a community, which he has developed in and by participation in a joint way of life; also, what is required of this particular agent would be required of any other in a relevantly similar situation; but the agent too is expected to have internalized the relevant demands, to act as if the ends for which the action is required were his own. By suppressing any explicit reference to demands and making the imperatives categorical we

facilitate conceptual moves from one such demand relation to another. The moral uses of such words as "must" and "ought" and "should," all of which are used also to express hypothetical imperatives, are traces of this pattern of objectification.

It may be objected that this explanation links normative ethics too closely with descriptive morality, with the mores or socially enforced patterns of behaviour that anthropologists record. But it can hardly be denied that moral thinking starts from the enforcement of social codes. Of course it is not confined to that. But even when moral judgements are detached from the mores of any actual society they are liable to be framed with reference to an ideal community of moral agents, such as Kant's kingdom of ends, which but for the need to give God a special place in it would have been better called a commonwealth of ends.

Another way of explaining the objectification of moral values is to say that ethics is a system of law from which the legislator has been removed. This might have been derived either from the positive law of a state or from a supposed system of divine law. There can be no doubt that some features of modern European moral concepts are traceable to the theological ethics of Christianity. The stress on quasi-imperative notions, on what ought to be done or on what is wrong in a sense that is close to that of "forbidden," are surely relics of divine commands. Admittedly, the central ethical concepts for Plato and Aristotle also are in a broad sense prescriptive or intrinsically action-guiding, but in concentrating rather on "good" than on "ought" they show that their moral thought is an objectification of the desired and the satisfying rather than of the commanded. Elizabeth Anscombe has argued that modern, non-Aristotelian, concepts of *moral* obligation, *moral* duty, of what is *morally* right and wrong, and of the *moral* sense of "ought" are survivals outside the framework of thought that made them really intelligible, namely the belief in divine law. She infers that "ought" has "become a word of mere mesmeric force," with only a "delusive appearance of content," and that we would do better to discard such terms and concepts altogether, and go back to Aristotelian ones.

There is much to be said for this view. But while we can explain some distinctive features of modern moral philosophy in this way, it would be a mistake to see the whole problem of the claim to objective prescriptivity as merely local and unnecessary, as a post-operative complication of a society from which a dominant system of theistic belief has recently been rather hastily excised. As Cudworth and Clarke and Price, for example, show, even those who still admit divine commands, or the positive law of God, may believe moral values to have an independent objective but still action-guiding authority. Responding to Plato's *Euthyphro* dilemma, they believe that God commands what he commands because it is in itself good or right, not that it is good or right merely because and in that he commands it. Otherwise God himself could not be called good. Price asks, "What can be more preposterous, than to make the Deity nothing but will; and to exalt this on the ruins of all his attributes?" The apparent objectivity of moral value is a widespread phenomenon which has more than one source: the persistence of a belief in something like divine law when the belief in the divine legislator has faded out is only one factor among others. There are several different patterns of objectification, all of which have left characteristic traces in our actual moral concepts and moral language. . . .

12. Conclusion

I have maintained that there is a real issue about the status of values, including moral values. Moral scepticism, the denial of objective moral values, is not to be confused with any one of several first order normative views, or with any linguistic or conceptual analysis. Indeed, ordinary moral judgements involve a claim to objectivity which both non-cognitive and naturalist analyses fail to capture. Moral scepticism must, therefore, take the form of an error theory, admitting that a belief in objective values is built into ordinary moral thought and language, but holding that this ingrained belief is false. As such, it needs arguments to support it against "common sense." But solid arguments can be found. The considerations that favour moral scepticism are: first, the relativity or variability of some important starting points of moral thinking and their apparent dependence on actual ways of life; secondly, the metaphysical peculiarity of the supposed objective values, in that they would have to be intrinsically action-guiding and motivating; thirdly, the problem of how such values could be consequential or supervenient upon natural features; fourthly, the corresponding epistemological difficulty of accounting for our knowledge of value entities or features and of their links with the features on which they would be consequential; fifthly, the possibility of explaining, in terms of several different patterns of objectification, traces of which remain in moral language and moral concepts, how even if there were no such objective values people not only might have come to suppose that there are but also might persist firmly in that belief. These five points sum up the case for moral scepticism; but of almost equal importance are the preliminary removal of misunderstandings that often prevent this thesis from being considered fairly and explicitly, and the isolation of those items about which the moral sceptic is sceptical from many associated qualities and relations whose objective status is not in dispute.

Study Questions

1. Why did Mackie label his view an "error theory"?
2. To recognize objective values, do you need a special faculty of moral perception?
3. Does the variation in moral codes from one society to another provide evidence in favor of Mackie's view?
4. Is Mackie's theory supposed to apply to nonmoral value judgments?

41

JOHN McDOWELL

In his classic 1690 work *An Essay Concerning Human Understanding*, John Locke draws a distinction between an object's primary and secondary qualities. The primary qualities are those inseparable from an object, such as its solidity, size, or velocity. The secondary qualities are powers in an object to produce sensations in us, for example, color, taste, and odor. Thus the solid brown table I see in front of me is in itself solid but only perceived as brown. John McDowell, Professor of Philosophy at the University of Pittsburgh, uses his own version of Locke's distinction to argue against J. L. Mackie that values are not primary qualities, existing independently, but secondary qualities, disposed to present themselves in particular ways to our sensibility.

Values and Secondary Qualities

1. J. L. Mackie insists that ordinary evaluative thought presents itself as a matter of sensitivity to aspects of the world.[1] And this phenomenological thesis seems correct. When one or another variety of philosophical non-cognitivism claims to capture the truth about what the experience of value is like, or (in a familiar surrogate for phenomenology[2]) about what we mean by our evaluative language, the claim is never based on careful attention to the lived character of evaluative thought or discourse. The idea is, rather, that the very concept of the cognitive or factual rules out the possibility of an undiluted representation of how things are, enjoying, nevertheless, the internal relation to "attitudes" or the will that would be needed for it to count as evaluative.[3] On this view the phenomenology of value would involve a mere incoherence, if it were as Mackie says—a possibility that then tends (naturally enough) not to be so

much as entertained. But, as Mackie sees, there is no satisfactory justification for supposing that the factual is, by definition, attitudinatively and motivationally neutral. This clears away the only obstacle to accepting his phenomenological claim; and the upshot is that non-cognitivism must offer to correct the phenomenology of value, rather than to give an account of it.[4]

In Mackie's view the correction is called for. In this paper I want to suggest that he attributes an unmerited plausibility to this thesis, by giving a false picture of what one is committed to if one resists it.

2. Given that Mackie is right about the phenomenology of value, an attempt to accept the appearances makes it virtually irresistible to appeal to a perceptual model. Now Mackie holds that the model must be perceptual awareness of *primary* qualities (see *HMT*, pp. 32, 60–61, 73–74). And this makes

it comparatively easy to argue that the appearances are misleading. For it seems impossible—at least on reflection—to take seriously the idea of something that is like a primary quality in being simply *there*, independently of human sensibility, but is nevertheless intrinsically (not conditionally on contingencies about human sensibility) such as to elicit some "attitude" or state of will from someone who becomes aware of it. Moreover, the primary-quality model turns the epistemology of value into mere mystification. The perceptual model is no more than a model: perception, strictly so called, does not mirror the role of reason in evaluative thinking, which seems to require us to regard the apprehension of value as an intellectual rather than a merely sensory matter. But if we are to take account of this, while preserving the model's picture of values as brutely and absolutely *there*, it seems that we need to postulate a faculty— "intuition"—about which all that can be said is that it makes us aware of objective rational connections: the model itself ensures that there is nothing helpful to say about how such a faculty might work, or why its deliverances might deserve to count as knowledge.

But why is it supposed that the model must be awareness of primary qualities rather than secondary qualities? The answer is that Mackie, following Locke, takes secondary-quality perception, as conceived by a pre-philosophical consciousness, to involve a projective error: one analogous to the error he finds in ordinary evaluative thought. He holds that we are prone to conceive secondary-quality experience in a way that would be appropriate for experience of primary qualities. So a pre-philosophical secondary-quality model for awareness of value would in effect be, after all, a primary-quality model. And to accept a philosophically corrected secondary-quality model for the awareness of value would be simply to give up trying to go along with the appearances.

I believe, however, that this conception of secondary-quality experience is seriously mistaken.

3. A secondary quality is a property the ascription of which to an object is not adequately understood except as true, if it is true, in virtue of the object's disposition to present a certain sort of perceptual appearance: specifically, an appearance characterizable by using a word for the property itself to say how the object perceptually appears. Thus an object's being red is understood as obtaining in virtue of the object's being such as (in certain circumstances) to look, precisely, red.

This account of secondary qualities is faithful to one key Lockean doctrine, namely the identification of secondary qualities with "powers to produce various sensations in us."[5] (The phrase "perceptual appearance," with its gloss, goes beyond Locke's unspecific "sensations," but harmlessly; it serves simply to restrict our attention, as Locke's word may not, to properties that are in a certain obvious sense perceptible.[6])

I have written of what property-ascriptions are understood to be true in virtue of, rather than of what they are true in virtue of. No doubt it is true that a given thing is red in virtue of some microscopic textural property of its surface; but a predication understood only in such terms—not in terms of how the object would look—would not be an ascription of the secondary quality of redness.[7]

Secondary-quality experience present itself as perceptual awareness of properties genuinely possessed by the objects that confront one. And there is no general obstacle to taking that appearance at face value.[8] An object's being such as to look red is independent of its actually looking red to anyone on any particular occasion; so, notwithstanding the conceptual connection between being red and being experienced as red, an experience of something as red can count as a case of being presented with a property that is there anyway—there independently of the experience itself.[9] And there is no evident ground for accusing the appearance of being misleading. What would one expect it to be like to experience something's being such as to look red, if not to experience the thing in question (in the right circumstances) as looking, precisely, red?

On Mackie's account, by contrast, to take experiencing something as red at face value, as a nonmisleading awareness of a property that really confronts one, is to attribute to the object a property which is "thoroughly objective" (*PFL*, p. 18), in the sense that it does not need to be understood

in terms of experiences that the object is disposed to give rise to; but which nevertheless resembles redness as it figures in our experience—this to ensure that the phenomenal character of the experience need not stand accused of misleadingness, as it would if the "thoroughly objective" property of which it constituted an awareness were conceived as a microscopic textural basis for the object's disposition to look red. This use of the notion of resemblance corresponds to one key element in Locke's exposition of the concept of a primary quality.[10] In these Lockean terms Mackie's view amounts to accusing a naive perceptual consciousness of taking secondary qualities for primary qualities (see *PFL*, p. 16).

According to Mackie, this conception of primary qualities that resemble colours as we see them is coherent; that nothing is characterized by such qualities is established by merely empirical argument (see *PFL*, pp. 17–20). But is the idea coherent? This would require two things: first, that colours figure in perceptual experience neutrally, so to speak, rather than as essentially phenomenal qualities of objects, qualities that could not be adequately conceived except in terms of how their possessors would look; and, second, that we command a concept of resemblance that would enable us to construct notions of possible primary qualities out of the idea of resemblance to such neutral elements of experience. The first of these requirements is quite dubious. (I shall return to this.) But even if we try to let it pass, the second requirement seems impossible. Starting with, say, redness as it (putatively neutrally) figures in our experience, we are asked to form the notion of a feature of objects which resembles that, but which is adequately conceivable otherwise than in terms of how its possessors would look (since if it were adequately conceivable only in those terms it would simply be secondary). But the second part of these instructions leaves it wholly mysterious what to make of the first: it precludes the required resemblance being in phenomenal respects, but it is quite unclear what other sense we could make of the notion of resemblance to redness as it figures in our experience. (If we find no other, we have failed to let the first requirement pass; redness as it figures in our experience proves stubbornly phenomenal.)[11] I have indicated how we can make error-free sense of the thought that colours are authentic objects of perceptual awareness; in face of that, it seems a gratuitous slur on perceptual "common sense" to accuse it of this wildly problematic understanding of itself.

Why is Mackie resolved, nevertheless, to convict "common sense" of error? Secondary qualities are qualities not adequately conceivable except in terms of certain subjective states, and thus subjective themselves in a sense that that characterization defines. In the natural contrast, a primary quality would be objective in the sense that what it is for something to have it can be adequately understood otherwise than in terms of dispositions to give rise to subjective states. Now this contrast between objective and subjective is not a contrast between veridical and illusory experience. But it is easily confused with a different contrast, in which to call a putative object of awareness "objective" is to say that it is there to be experienced, as opposed to being a mere figment of the subjective state that purports to be an experience of it. If secondary qualities were subjective in the sense that naturally contrasts with this, naive consciousness would indeed be wrong about them, and we would need something like Mackie's Lockean picture of the error it commits. What is acceptable, though, is only that secondary qualities are subjective in the first sense, and it would be simply wrong to suppose that this gives any support to the idea that they are subjective in the second.[12]

More specifically, Mackie seems insufficiently whole-hearted in an insight of his about perceptual experiences. In the case of "realistic" depiction, it makes sense to think of veridicality as a matter of resemblance between aspects of a picture and aspects of what it depicts.[13] Mackie's insight is that the best hope of a philosophically hygienic interpretation for Locke's talk of "ideas," in a perceptual context, is in terms of "intentional objects": that is, aspects of representational content—aspects of how things seem to one in the enjoyment of a perceptual experience. (See *PFL*, pp. 47–50.) Now it is an illusion to suppose, as Mackie does, that this warrants thinking of

the relation between a quality and an "idea" of it on the model of the relation between a property of a picture's subject and an aspect of the picture. Explaining "ideas" as "intentional objects" should direct our attention to the relation between how things are and how an experience represents them as being—in fact identity, not resemblance, if the representation is veridical.[14] Mackie's Lockean appeal to resemblance fits something quite different: a relation borne to aspects of how things are by intrinsic aspects of a bearer of representational content—not how things are represented to be, but features of an item that does the representing, with particular aspects of its content carried by particular aspects of what it is intrinsically (non-representationally) like.[15] Perceptual experiences have representational content; but nothing in Mackie's defense of the "intentional objects" gloss on "ideas" would force us to suppose that they have it in that sort of way.[16]

The temptation to which Mackie succumbs, to suppose that intrinsic features of experience function as vehicles for particular aspects of representational content, is indifferent to any distinction between primary and secondary qualities in the representational significance that these features supposedly carry. What it is for a colour to figure in experience and what it is for a shape to figure in experience would be alike, on this view, in so far as both are a matter of an experience's having a certain intrinsic feature. If one wants, within this framework, to preserve Locke's intuition that primary-quality experience is distinctive in potentially disclosing the objective properties of things, one will be naturally led to Locke's use of the notion of resemblance. But no notion of resemblance could get us from an essentially experiential state of affairs to the concept of a feature of objects intelligible otherwise than in terms of how its possessors would strike us. (A version of this point told against Mackie's idea of possible primary qualities answering to "colours as we see them"; it tells equally against the Lockean conception of shapes.)

If one gives up the Lockean use of resemblance, but retains the idea that primary and secondary qualities are experientially on a par, one will be led to suppose that the properties attributed to objects in

the "manifest image" are all equally phenomenal—intelligible, that is, only in terms of how their possessors are disposed to appear. Properties that are objective, in the contrasting sense, can then figure only in the "scientific image."[17] On these lines one altogether loses hold of Locke's intuition that primary qualities are distinctive in being both objective and perceptible.[18]

If we want to preserve the intuition, as I believe we should, then we need to exorcize the idea that what it is for a quality to figure in experience is for an experience to have a certain intrinsic feature: in fact I believe that we need to reject these supposed vehicles of content altogether. Then we can say that colours and shapes figure in experience, not as the representational significance carried by features that are—being intrinsic features of experience—indifferently subjective (which makes it hard to see how a difference in respect of objectivity could show up in their representational significance); but simply as properties that objects are represented as having, distinctively phenomenal in the one case and not so in the other. (Without the supposed intrinsic features, we should be immune to the illusion that experiences cannot represent objects as having properties that are not phenomenal—properties that are adequately conceivable otherwise than in terms of dispositions to produce suitable experiences.[19]) What Locke unfelicitously tried to yoke together, with his picture of real resemblances of our "ideas," can now divide into two notions that we must insist on keeping separate: first, the possible veridicality of experience (the objectivity of its object, in the second of the two senses I distinguished), in respect of which primary and secondary qualities are on all fours; and, second, the not essentially phenomenal character of some properties that experience represents objects as having (their objectivity in the first sense), which marks off the primary perceptible qualities from the secondary ones.

In order to deny that a quality's figuring in experience consists in an experience's having a certain intrinsic feature, we do not need to reject the intrinsic features altogether; it would suffice to insist that a quality's figuring in experience consists in an experience's having a certain intrinsic feature *together with*

the quality's being the representational significance carried by that feature. But I do not believe that this yields a position in which acceptance of the supposed vehicles of content coheres with a satisfactory account of perception. This position would have it that the fact that an experience represents things as being one way rather than another is strictly additional to the experience's intrinsic nature, and so extrinsic to the experience itself (it seems natural to say "read into it"). There is a phenomenological falsification here. (This brings out a third role for Locke's resemblance, namely to obviate the threat of such a falsification by constituting a sort of intrinsic representationality: Locke's "ideas" carry the representational significance they do by virtue of what they are like, and this can be glossed both as "how they are intrinsically" and as "what they resemble.") In any case, given that we cannot project ourselves from features of experience to nonphenomenal properties of objects by means of an appeal to resemblance, it is doubtful that the metaphor of representational significance being "read into" intrinsic features can be spelled out in such a way as to avoid the second horn of our dilemma. How could representational significance be "read into" intrinsic features of experience in such a way that what was signified did not need to be understood in terms of them? How could a not intrinsically representational feature of experience become imbued with objective significance in such a way that an experience could count, by virtue of having that feature, as a direct awareness of a not essentially phenomenal property of objects?[20]

How things strike someone as being is, in a clear sense, a subjective matter: there is no conceiving it in abstraction from the subject of the experience. Now a motive for insisting on the supposed vehicles of aspects of content might lie in an aspiration, familiar in philosophy, to bring subjectivity within the compass of a fundamentally objective conception of reality.[21] If aspects of content are not carried by elements in an intrinsic structure, their subjectivity is irreducible. By contrast, one might hope to objectivize any "essential subjectivity" that needs to be attributed to not intrinsically representational features of experience, by exploiting a picture involving special

access on a subject's part to something conceived in a broadly objective way—its presence in the world not conceived as constituted by the subject's special access to it.[22] Given this move, it becomes natural to suppose that the phenomenal character of the "manifest image" can be explained in terms of a certain familiar picture: one in which a confronted "external" reality, conceived as having only an objective nature, is processed through a structured "subjectivity," conceived in this objectivistic manner. This picture seems to capture the essence of Mackie's approach to the secondary qualities.[23] What I have tried to suggest is that the picture is suspect in threatening to cut us off from the *primary* (not essentially phenomenal) qualities of the objects that we perceive: either (with the appeal to resemblance) making it impossible, after all, to keep an essentially phenomenal character out of our conception of the qualities in question, or else making them merely hypothetical, not accessible to perception. If we are to achieve a satisfactory understanding of experience's openness to objective reality, we must put a more radical construction on experience's essential subjectivity. And this removes an insidious obstacle—one whose foundation is summarily captured in Mackie's idea that it is not simply wrong to count "colours as we see them" as items in our minds (see the diagram at *PFL*, p. 17)—that stands in the way of understanding how secondary-quality experience can be awareness, with nothing misleading about its phenomenal character, of properties genuinely possessed by elements in a not exclusively phenomenal reality.

4. The empirical ground that Mackie thinks we have for not postulating "thoroughly objective features which resemble our ideas of secondary qualities" (*PFL*, pp. 18–19) is that attributing such features to objects is surplus to the requirements of explaining our experience of secondary qualities (see *PFL*, pp. 17–18). If it would be incoherent to attribute such features to objects, as I believe, this empirical argument falls away as unnecessary. But it is worth considering how an argument from explanatory superfluity might fare against the less extravagant construal I have suggested for the thought that secondary qualities genuinely characterize objects: not because the

question is difficult or contentious, but because of the light it casts on how an explanatory test for reality—which is commonly thought to undermine the claims of values—should be applied.

A "*virtus dormitiva*" objection would tell against the idea that one might mount a satisfying explanation of an object's looking red on its being such as to look red. The weight of the explanation would fall through the disposition to its structural ground.[24] Still, however optimistic we are about the prospects for explaining colour experience on the basis of surface textures,[25] it would be obviously wrong to suppose that someone who gave such an explanation could in consistency deny that the object was such as to look red. The right explanatory test is not whether something pulls its own weight in the favoured explanation (it may fail to do so without thereby being explained away), but whether the explainer can consistently deny its reality.[26]

Given Mackie's view about secondary qualities, the thought that values fail an explanatory test for reality is implicit in a parallel that he commonly draws between them (see, for instance, *HMT*, pp. 51–52; *E*, pp. 19–20). It is nearer the surface in his "argument from queerness" (*E*, pp. 95–98 in this volume), and explicit in his citing "patterns of objectification" to explain the distinctive phenomenology of value experience (*E*, pp. 98–100 in this volume).[27] Now it is, if anything, even more obvious with values than with essentially phenomenal qualities that they cannot be credited with causal efficacy: values would not pull their weight in any explanation of value experience even remotely analogous to the standard explanations of primary-quality experience. But reflection on the case of secondary qualities has already opened a gap between that admission and any concession that values are not genuine aspects of reality. And the point is reinforced by a crucial disanalogy between values and secondary qualities. To press the analogy is to stress that evaluative "attitudes," or states of will, are like (say) colour experience in being unintelligible except as modifications of a sensibility like ours. The idea of value experience involves taking admiration, say, to represent its object as having a property which (although there in

the object) is essentially subjective in much the same way as the property that an object is represented as having by an experience of redness—that is, understood adequately only in terms of the appropriate modification of human (or similar) sensibility. The disanalogy, now, is that a virtue (say) is conceived to be not merely such as to elicit the appropriate "attitude" (as a colour is merely such as to cause the appropriate experiences), but rather such as to *merit* it. And this makes it doubtful whether merely causal explanations of value experience are relevant to the explanatory test, even to the extent that the question to ask is whether someone could consistently give such explanations while denying that the values involved are real. It looks as if we should be raising that question about explanations of a different kind.

For simplicity's sake, I shall elaborate this point in connection with something that is not a value, though it shares the crucial feature: namely danger or the fearful. On the face of it, this might seem a promising subject for a projectivist treatment (a treatment that appeals to what Hume called the mind's "propensity to spread itself on external objects").[28] At any rate the response that, according to such a treatment, is projected into the world can be characterized, without phenomenological falsification, otherwise than in terms of seeming to find the supposed product of projection already there.[29] And it would be obviously grotesque to fancy that a case of fear might be explained as the upshot of a mechanical (or perhaps para-mechanical) process initiated by an instance of "objective fearfulness." But if what we are engaged in is an "attempt to understand ourselves,"[30] then merely causal explanations of responses like fear will not be satisfying anyway.[31] What we want here is a style of explanation that makes sense of what is explained (in so far as sense can be made of it). This means that a technique for giving satisfying explanations of cases of fear—which would perhaps amount to a satisfactory explanatory theory of danger, though the label is possibly too grand—must allow for the possibility of criticism; we make sense of fear by seeing it as a response to objects that *merit* such a response, or as the intelligibly defective product of a propensity towards responses that would be intelligible in

that way.[32] For an object to merit fear just is for it to be fearful. So explanations of fear that manifest our capacity to understand ourselves in this region of our lives will simply not cohere with the claim that reality contains nothing in the way of fearfulness.[33] Any such claim would undermine the intelligibility that the explanations confer on our responses.

The shared crucial feature suggests that this disarming of a supposed explanatory argument for unreality should carry over to the case of values. There is, of course, a striking disanalogy in the contentiousness that is typical of values; but I think it would be a mistake to suppose that this spoils the point. In so far as we succeed in achieving the sort of understanding of our responses that is in question, we do so on the basis of preparedness to attribute, to at least some possible objects of the responses, properties that would validate the responses. What the disanalogy makes especially clear is that the explanations that preclude our denying the reality of the special properties that are putatively discernible from some (broadly) evaluative point of view are themselves constructed from that point of view. (We already had this in the case of the fearful, but the point is brought home when the validation of the responses is controversial.) However, the critical dimension of the explanations that we want means that there is no question of just any actual response pulling itself up by its own bootstraps into counting as an undistorted perception of the relevant special aspect of reality.[34] Indeed, awareness that values are contentious tells against an unreflective contentment with the current state of one's critical outlook, and in favour of a readiness to suppose that there may be something to be learned from people with whom one's first inclination is to disagree. The aspiration to understand oneself is an aspiration to change one's responses, if that is necessary for them to become intelligible otherwise than as defective. But although a sensible person will never be confident that his evaluative outlook is incapable of improvement, that need not stop him supposing, of some of his evaluative responses, that their objects really do merit them. He will be able to back up this supposition with explanations that show how the responses are well-placed; the

explanations will share the contentiousness of the values whose reality they certify, but that should not stop him accepting the explanations any more than (what nobody thinks) it should stop him endorsing the values.[35] There is perhaps an air of bootstrapping about this. But if we restrict ourselves to explanations from a more external standpoint, at which values are not in our field of view, we deprive ourselves of a kind of intelligibility that we aspire to; and projectivists have given no reason whatever to suppose that there would be anything better about whatever different kind of self-understanding the restriction would permit.

5. It will be obvious how these considerations undermine the damaging effect of the primary-quality model. Shifting to a secondary-quality analogy renders irrelevant any worry about how something that is brutely *there* could nevertheless stand in an internal relation to some exercise of human sensibility. Values are not brutely there—not there independently of our sensibility—any more than colours are: though, as with colours, this does not stop us supposing that they are there independently of any particular apparent experience of them. As for the epistemology of value, the epistemology of danger is a good model. (Fearfulness is not a secondary quality, although the model is available only after the primary-quality model has been dislodged. A secondary-quality analogy for value experience gives out at certain points, no less than the primary-quality analogy that Mackie attacks.) To drop the primary-quality model in this case is to give up the idea that fearfulness itself, were it real, would need to be intelligible from a standpoint independent of the propensity to fear; the same must go for the relations of rational consequentiality in which fearfulness stands to more straightforward properties of things.[36] Explanations of fear of the sort I envisaged would not only establish, from a different standpoint, that some of its objects are really fearful, but also make plain, case by case, what it is about them that makes them so; this should leave it quite unmysterious how a fear response rationally grounded in awareness (unproblematic, at least for present purposes) of these "fearful-making characteristics" can be counted as being, or yielding,

knowledge that one is confronted by an instance of real fearfulness.[37]

Simon Blackburn has written, on behalf of a projectivist sentimentalism in ethics, that "we profit . . . by realizing that a training of the feelings rather than a cultivation of a mysterious ability to spot the immutable fitnesses of things is the foundation of how to live."[38] This picture of what an opponent of projectivism must hold is of a piece with Mackie's primary-quality model; it simply fails to fit the position I have described.[39] Perhaps with Aristotle's notion of practical wisdom in mind, one might ask why a training of the feelings (as long as the notion of feeling is comprehensive enough) cannot *be* the cultivation of an ability—utterly unmysterious just because of its connections with feelings—to spot (if you like) the fitnesses of things; even "immutable" may be all right, so long as it is not understood (as I take it Blackburn intends) to suggest a "platonistic" conception of the fitnesses of things, which would reimport the characteristic ideas of the primary quality model.[40]

Mackie's response to this suggestion used to be, in effect, that it simply conceded his point.[41] Can a projectivist claim that the position I have outlined is at best a notational variant, perhaps an inferior notational variant, of his own position?

It would be inferior if, in eschewing the projectivist metaphysical framework, it obscured some important truth. But what truth would this be? It will not do at this point to answer "The truth of projectivism." I have disarmed the explanatory argument for the projectivist's thin conception of genuine reality. What remains is rhetoric expressing what amounts to a now unargued primary-quality model for genuine reality.[42] The picture that this suggests for value experience—objective (value-free) reality processed through a moulded subjectivity—is no less questionable than the picture of secondary-quality experience on which, in Mackie at any rate, it is explicitly modelled. In fact I should be inclined to argue that it is projectivism that is inferior. Deprived of the specious explanatory argument, projectivism has nothing to sustain its thin conception of reality (that on to which the projections are effected) but a contentiously

substantial version of the correspondence theory of truth, with the associated picture of genuinely true judgment as something to which the judger makes no contribution at all.[43]

I do not want to argue this now. The point I want to make is that even if projectivism were not actually worse, metaphysically speaking, than the alternative I have described, it would be wrong to regard the issue between them as nothing but a question of metaphysical preference.[44] In the projectivist picture, having one's ethical or aesthetic responses rationally suited to their objects would be a matter of having the relevant processing mechanism functioning acceptably. Now projectivism can of course perfectly well accommodate the idea of assessing one's processing mechanism. But it pictures the mechanism as something that one can contemplate as an object in itself. It would be appropriate to say "something one can step back from," were it not for the fact that one needs to use the mechanism itself in assessing it; at any rate one is supposed to be able to step back from any naively realistic acceptance of the values that the first-level employment of the mechanism has one attribute to items in the world. How, then, are we to understand this pictured availability of the processing mechanism as an object for contemplation, separated off from the world of value? Is there any alternative to thinking of it as capable of being captured, at least in theory, by a set of principles for superimposing values on to a value-free reality? The upshot is that the search for an evaluative outlook that one can endorse as rational becomes, virtually irresistibly, a search for such a set of principles: a search for a *theory* of beauty or goodness. One comes to count "intuitions" respectable only in so far as they can be validated by an approximation to that ideal.[45] (This is the shape that the attempt to objectivize subjectivity takes here.) I have a hunch that such efforts are misguided; not that we should rest content with an "anything goes" irrationalism, but that we need a conception of rationality in evaluation that will cohere with the possibility that particular cases may stubbornly resist capture in any general net. Such a conception is straightforwardly available within

the alternative to projectivism that I have described. I allowed that being able to explain cases of fear in the right way might amount to having a theory of danger, but there is no need to generalize that feature of the case; the explanatory capacity that certifies the special objects of an evaluative outlook as real, and certifies its responses to them as rational, would need to be exactly as creative and case-specific as the capacity to discern those objects itself. (It would be the same capacity: the picture of "stepping back" does not fit here.)[46] I take it that my hunch poses a question of moral and aesthetic taste, which—like other questions of taste—should be capable of being argued about. The trouble with projectivism is that it threatens to bypass that argument, on the basis of a metaphysical picture whose purported justification falls well short of making it compulsory. We should not let the question seem to be settled by what stands revealed, in the absence of compelling argument, as a prejudice claiming the honour due to metaphysical good taste.

Notes

1. See *E*, pp. 31–35. I shall also abbreviate references to the following other books by Mackie: *Problems from Locke* (Clarendon Press, Oxford, 1976: hereafter *PFL*); and *Hume's Moral Theory* (London: Routledge & Kegan Paul, 1980; hereafter *HMT*).

2. An inferior surrogate: it leads us to exaggerate the extent to which expressions of our sensitivity to values are signalled by the use of a special vocabulary. See my "Aesthetic Value, Objectivity, and the Fabric of the World," in Eva Schaper, ed., *Pleasure, Preference, and Value* (Cambridge: Cambridge University Press, 1983), pp. 1–16, at pp. 1–2.

3. I am trying here to soften a sharpness of focus that Mackie introduces by stressing the notion of prescriptivity. Mackie's singleness of vision here has the perhaps unfortunate effect of discouraging a distinction such as David Wiggins has drawn between "valuations" and "directives or deliberative (or practical) judgments" (see "Truth, Invention, and the Meaning of Life," *Proceedings of the British Academy* 62 (1976): 331–78, at pp. 338–39). My topic here is really the former of these. (It may be that the distinction does not matter in the way that Wiggins suggests: see note 35 below.)

4. I do not believe that the "quasi-realism" that Simon Blackburn has elaborated is a real alternative to this. (See p. 358 of his "Truth, Realism, and the Regulation of Theory," in Peter A. French, Theodore E. Uehling, Jr., and Howard Wettstein, eds., *Midwest Studies in Philosophy V: Studies in Epistemology* [Minneapolis: University of Minnesota Press, 1980, pp. 353–71.]) In so far as the quasi-realist holds that the values, in his thought and speech about which he imitates the practices supposedly characteristic of realism, are *really* products of projecting "attitudes" into the world, he must have a conception of genuine reality—that which the values lack and the things on to which they are projected have. And the phenomenological claim ought to be that *that* is what the appearances entice us to attribute to values.

5. *An Essay concerning Human Understanding*, II.viii.10.

6. Being stung by a nettle is an actualization of a power in the nettle that conforms to Locke's description, but it seems wrong to regard it as a perception of that power; the experience lacks an intrinsically representational character which that would require. (It is implausible that looking red is intelligible independently of being red; combined with the account of secondary qualities that I am giving, this sets up a circle. But it is quite unclear that we ought to have the sort of analytic or definitional aspirations that would make the circle problematic. See Colin McGinn, *The Subjective View* ([Oxford: Clarendon Press, 1983], pp. 6–8.)

7. See McGinn, op. cit., pp. 12–14.

8. Of course there is room for the concept of illusion, not only because the senses can malfunction but also because of the need for a modifier like my "(in certain circumstances)," in an account of what it is for something to have a secondary quality. (The latter has no counterpart with primary qualities.)

9. See the discussion of (one interpretation of the notion of) objectivity at pp. 77–78 of Gareth Evans, "Things Without the Mind," in Zak van Straaten, ed., *Philosophical Subjects: Essays Presented to P. F. Strawson* (Oxford: Clarendon Press, 1980), pp. 76–116. Throughout the present section I am heavily indebted to this most important paper.

10. See *Essay*, II.viii. 15.

11. Cf. pp. 56–7 of P. F Strawson, "Perception and Its Objects," in G. F. Macdonald, ed., *Perception and Identity: Essays Presented to A. J. Ayer* (London: Macmillan, 1979), pp. 41–60.

12. This is a different way of formulating a point made by McGinn, op. cit. p. 121. Mackie's phrase "the fabric of

the world" belongs with the second sense of "objective," but I think his arguments really address only the first. *Pace* p. 103 of A. W. Price, "Varieties of Objectivity and Values," *Proceedings of the Aristotelian Society* 82 (1982–83): 103–19, I do not think the phrase can be passed over as unhelpful, in favour of what the arguments do succeed in establishing, without missing something that Mackie wanted to say. (A gloss on "objective" as "there to be experienced" does not figure in Price's inventory, p. 104. It seems to be the obvious response to his challenge at pp. 118–19.)

13. I do not say it is correct: skepticism about this is very much in point. (See Nelson Goodman, *Languages of Art* [London: Oxford University Press, 1969], chap. I.)

14. When resemblance is in play, it functions as a palliative to lack of veridicality, not as what veridicality consists in.

15. Intrinsic features of experience, functioning as vehicles for aspects of content, seem to be taken for granted in Mackie's discussion of Molyneux's problem (*PFL*, pp. 28–32). The slide from talk of content to talk that fits only bearers of content seems to happen also in Mackie's discussion of truth, in *Truth, Probability, and Paradox* (Oxford: Clarendon Press, 1973), with the idea that a formulation like "A true statement is one such that the way things are is the way it represents things as being" makes truth consist in a relation of correspondence (rather than identity) between how things are and how things are represented as being; pp. 56–57 come too late to undo the damage done by the earlier talk of "comparison," e.g., at pp. 50, 51. (A subject matter for the talk that fits bearers is unproblematically available in this case; but Mackie does not mean to be discussing truth as a property of sentences or utterances.)

16. Indeed, this goes against the spirit of a passage about the word "content" at *PFL*, p. 48. Mackie's failure to profit by his insight emerges particularly strikingly in his remarkable claim (*PFL*, p. 50) that the "intentional object" conception of the content of experience yields an account of perception that is within the target area of "the stock objections against an argument from an effect to a supposed cause of a type which is never directly observed." (Part of the trouble here is a misconception of direct realism as a surely forlorn attempt to make perceptual knowledge unproblematic: *PFL*, p. 43.)

17. The phrases "manifest image" and "scientific image" are due to Wilfrid Sellars; see "Philosophy and the Scientific Image of Man," in *Science, Perception and Reality* (London: Routledge & Kegan Paul, 1963).

18. This is the position of Strawson, op. cit. (and see also his "Reply to Evans" in van Straaten, ed., op. cit.,

pp. 273–82). I am suggesting a diagnosis, to back up McGinn's complaint, op. cit., p. 124n.

19. Notice Strawson's sleight of hand with phrases like "shapes-as-seen," at p. 280 of "Reply to Evans." Strawson's understanding of what Evans is trying to say fails altogether to accommodate Evans's remark ("Things Without the Mind," p. 96) that "to deny that . . . primary properties are *sensory* is not at all to deny that they are *sensible* or *observable*." Shapes as seen are *shapes*—that is, non-sensory properties; it is one thing to deny, as Evans does, that experience can furnish us with the concepts of such properties, but quite another to deny that experience can disclose instantiations of them to us.

20. Features of physiologically specified states are not to the point here. Such features are not apparent in experience; whereas the supposed features that I am concerned with would have to be aspects of what experience is like for us, in order to function intelligibly as carriers for aspects of the content that experience presents to us. There may be an inclination to ask why it should be any harder for a feature of experience to acquire an objective significance than it is for a word to do so. But the case of language affords no counterpart to the fact that the objective significance in the case we are concerned with is a matter of how things (e.g.) *look* to be; the special problem is how to stop that "look" having the effect that a supposed intrinsic feature of experience get taken up into its own representational significance, thus ensuring that the significance is phenomenal and not primary.

21. See Thomas Nagel, "Subjective and Objective," in *Mortal Questions* (Cambridge: Cambridge University Press, 1979), pp. 196–213.

22. Cf. Bernard Williams, *Descartes: The Project of Pure Enquiry* (Harmondsworth: Penguin, 1978), p. 295.

23. Although McGinn, op. cit., is not taken in by the idea that "external" reality has only objective characteristics, I am not sure that he sufficiently avoids the picture that underlies that idea: see pp. 106–9. (This connects with a suspicion that at pp. 9–10 he partly succumbs to a temptation to objectivize the subjective properties of objects that he countenances: it is not as clear as he seems to suppose that, say, redness can be, so to speak, abstracted from the way things strike *us* by an appeal to relativity. His worry at pp. 132–36, that secondary quality experience may after all be phenomenologically misleading, seems to betray the influence of the idea of content-bearing intrinsic features of experience.)

24. See McGinn, op. cit., p. 14.

25. There are difficulties over how complete such explanations could aspire to be: see Price, op. cit.,

pp. 114–15, and my "Aesthetic Value, Objectivity, and the Fabric of the World," op. cit., pp. 10–12.

26. Cf. pp. 206–8, especially p. 208, of David Wiggins, "What Would Be a Substantial Theory of Truth?" in van Straaten, ed., op. cit., pp. 189–221. The test of whether the explanations in question are consistent with rejecting the item in contention is something that Wiggins once mooted, in the course of a continuing attempt to improve that formulation: I am indebted to discussion with him.

27. See also Simon Blackburn, "Rule-Following and Moral Realism," in Steven Holtzman and Christopher Leich, eds., *Wittgenstein: To Follow a Rule* (London: Routledge & Kegan Paul, 1981), pp. 163–87; and the first chapter of Gilbert Harman, *The Nature of Morality* (New York: Oxford University Press, 1977).

28. *A Treatise of Human Nature*, I.iii.14. "Projectivist" is Blackburn's useful label: see "Rule-Following and Moral Realism," op. cit., and "Opinions and Chances," in D. H. Mellor, ed., *Prospects for Pragmatism* (Cambridge: Cambridge University Press, 1980), pp. 175–96.

29. At pp. 180–81 of "Opinions and Chances," Blackburn suggests that a projectivist need not mind whether or not this is so; but I think he trades on a slide between "can . . . only be understood in terms of" and "our best vocabulary for identifying" (which allows that there may be an admittedly inferior alternative).

30. The phrase is from p. 165 of Blackburn, "Rule-Following and Moral Realism."

31. I do not mean that satisfying explanations will not be causal. But they will not be *merely* causal.

32. I am assuming that we are not in the presence of a theory according to which no responses of the kind in question *could* be well-placed. That would have a quite unintended effect. (See *E*, p. 16.) Notice that it will not meet my point to suggest that calling a response "well-placed" is to be understood only quasi-realistically. Explanatory indispensability is supposed to be the test for the *genuine* reality supposedly lacked by what warrants only quasi-realistic treatment.

33. Cf. Blackburn, "Rule-Following and Moral Realism," op. cit., p. 164.

34. This will be so even in a case in which there are no materials for constructing standards of criticism except actual responses: something that is not so with fearfulness, although given a not implausible holism it will be so with values.

35. I can see no reason why we should not regard the contentiousness as ineliminable. The effect of this would be to detach the explanatory test of reality from a requirement of convergence (cf. the passage by Wiggins

cited in note 26 above). As far as I can see, this separation would be a good thing. It would enable resistance to projectivism to free itself, with a good conscience, of some unnecessary worries about relativism. It might also discourage a misconception of the appeal to Wittgenstein that comes naturally to such a position. (Blackburn, "Rule-Following and Moral Realism," pp. 170–74, reads into my "Non-cognitivism and Rule-Following," in Holtzman and Leich, eds., op. cit., pp. 141–62, an interpretation of Wittgenstein as, in effect, making truth a matter of consensus, and has no difficulty in arguing that this will not make room for hard cases: but the interpretation is not mine.) With the requirement of convergence dropped, or at least radically relativized to a point of view, the question of the claim to truth of directives may come closer to the question of the truth status of evaluations than Wiggins suggests, at least in "Truth, Invention, and the Meaning of Life," op. cit.

36. Mackie's question (*E*, p. 41) "Just what *in the world* is signified by this 'because'?" involves a tendentious notion of "the world."

37. See Price, op. cit., pp. 106–7, 115.

38. "Rule-Following and Moral Realism," p. 186.

39. Blackburn's realist evades the explanatory burdens that sentimentalism discharges, by making the world rich (cf. p. 181) and then picturing it as simply setting its print on us. Cf. *E*, p. 22: "If there were something in the fabric of the world that validated certain kinds of concern, then it would be possible to acquire these merely by finding something out, by letting one's thinking be controlled by how things were." This saddles an opponent of projectivism with a picture of awareness of value as an exercise of pure receptivity, preventing him from deriving any profit from an analogy with secondary-quality perception.

40. On "platonism," see my "Non-Cognitivism and Rule-Following," op. cit., at pp. 156–57. On Aristotle, see M. F. Burnyeat, "Aristotle on Learning To Be Good," in Amelie O. Rorty, ed., *Essays on Aristotle's Ethics* (Berkeley: University of California Press, Los Angeles, London, 1980), pp. 69–92.

41. Price, op. cit. p. 107, cites Mackie's response to one of my contributions to the 1978 seminar (see Acknowledgment above).

42. We must not let the confusion between the two notions of objectivity distinguished in Sec. 3 above seem to support this conception of reality.

43. Blackburn uses the correspondence theorist's pictures for rhetorical effect, but he is properly skeptical about

whether this sort of realism makes sense (see "Truth, Realism, and the Regulation of Theory, op. cit."). His idea is that the explanatory argument makes a counterpart to its metaphysical favouritism safely available to a projectivist about values in particular. Deprived of the explanatory argument, this projectivism should simply wither away. (See "Rule-Following and Moral Realism," p. 165. Of course I am not saying that the thin conception of reality that Blackburn's projectivism needs is unattainable, in the sense of being unformulable. What we lack is reasons of a respectable kind to recognize it as a complete conception of *reality*.)

44. Something like this seems to be suggested by Price, op. cit., pp. 107–8.

45. It is hard to see how a rational *inventing* of values could take a more piecemeal form.

46. Why do I suggest that a particularistic conception of evaluative rationality is unavailable to a projectivist? (See Blackburn, "Rule-Following and Moral Realism," pp. 167–70.) In the terms of that discussion, the point is that (with no good explanatory argument for his metaphysical favouritism) a projectivist has no alternative to being "a *real* realist" about the world on which he thinks values are superimposed. He cannot stop this from generating a quite un-Wittgensteinian picture of what is *really* going on in the same way would be; which means that *he* cannot appeal to Wittgenstein in order to avert, as Blackburn puts it, "the threat which shapelessness poses to a respectable notion of consistency" (p. 169). So, at any rate, I meant to argue in my "Non-Cognitivism and Rule-Following," to which Blackburn's paper is a reply. Blackburn thinks his projectivism is untouched by the argument, because he thinks he can sustain its metaphysical favouritism without appealing to "*real* realism," on the basis of the explanatory argument. But I have argued that this is an illusion. (At p. 181, Blackburn writes: "Of course, it is true that our reactions are 'simply felt' and, in a sense, not rationally explicable." He thinks he can comfortably say this because our conception of reason will go along with the quasi-realist truth that his projectivism confers on some evaluations. But how can one restrain the metaphysical favouritism that a projectivist must show from generating some such thought as "This is not *real* reason"? If that is allowed to happen, a remark like the one I have quoted will merely threaten—like an ordinary nihilism—to dislodge us from our ethical and aesthetic convictions.)

Study Questions

1. Explain in your own words the distinction between primary and secondary qualities.

2. In what ways are values akin to colors?

3. In what ways are values not akin to colors?

4. Are values genuine aspects of reality?

42

WALTER SINNOTT-ARMSTRONG

Moral intuitionism maintains that ethical judgments are known to be true or false not by empirical evidence but by a special faculty of intuition. Walter Sinnot-Armstrong, Professor of Philosophy at Duke University, maintains that recent research in psychology, brain science, and biology undermines moral intuitionism. After all, our moral intuitions may be partial, controversial, emotional, subject to illusion, or explicable by dubious sources, and thus do not by themselves provide a firm basis for justifying moral beliefs.

Moral Intuitionism Meets Empirical Psychology

> . . . if this be all, where is his ethics? The position he is maintaining is merely a psychological one.
>
> (Moore 1903: § 11, 11)[1]

G. E. Moore's diatribe against the naturalistic fallacy in 1903 set the stage for most of twentieth-century moral philosophy. The main protagonists over the next sixty years were intuitionists and emotivists, both of whom were convinced by Moore that empirical science is irrelevant to moral philosophy and common moral beliefs. Even in the 1970s and 1980s, when a wider array of moral theories entered the scene and applied ethics became popular, few moral philosophers paid much attention to developments in biology and psychology.

This isolation must end. Moral philosophers cannot continue to ignore developments in psychology, brain science, and biology. Of course, philosophers need to be careful when they draw lessons from empirical research. As Moore and his followers argued, we should not jump straight from descriptive premises in psychology or biology to positive moral conclusions or normative conclusions in moral epistemology. That would be a fallacy.[2] Nonetheless, psychology can still affect moral philosophy in indirect ways. That is what I want to illustrate here. I will trace an indirect path from empirical premises to a normative conclusion in moral epistemology. In particular, I will argue that some recent research in psychology and brain science undermines moral intuitionism.

1. WHAT IS MORAL INTUITIONISM?

Some philosophers define moral intuitionism as the structural view that there are many moral values or requirements with no systematic unification or ranking. Other philosophers see moral intuitionism as the metaphysical view that moral properties are non-natural. Neither of these views concerns me here. I mention them only to set them aside.

The kind of moral intuitionism that is my target here is a position in moral epistemology, which is general epistemology applied to moral beliefs. The

deepest challenge in moral epistemology, as in general epistemology, is raised by a skeptical regress argument: Someone is justified in believing something only if the believer has a reason that is expressible in an inference with premises that the believer is already justified in believing. This requires a chain of inferences that must continue infinitely, close into a circle, or stop arbitrarily. Academic skeptics reject all three options and conclude that there is no way for anyone to be justified in believing anything. The same regress arises for moral beliefs (cf. Sinnott-Armstrong 1996: 9–14; 2002a).

The simplest way to stop this regress is simply to stop. If a believer can work back to a premise that the believer is justified in believing without being able to infer that premise from anything else, then there is no new premise to justify, so the regress goes no further. That is how foundationalists stop the regress in general epistemology. Moral intuitionists apply foundationalism to moral beliefs as a way to stop the skeptical regress regarding moral beliefs.

The motivation behind moral intuitionism is not always to stop the skeptical regress,[3] but that use of moral intuitionism is common and is what concerns us here, so we can use it to decide among possible definitions of moral intuitionism. What we need to define is the weakest version of moral intuitionism that is strong enough to solve the regress problem that would lead to moral skepticism. Here it is:

Moral intuitionism is the claim that some people are adequately epistemically justified in holding some moral beliefs independently of whether those people are able to infer those moral beliefs from any other beliefs.[4]

Several features of this definition are worth highlighting.

So defined, moral intuitionism is not about knowledge. It is about justified belief. This makes it normative. Psychologists sometimes define intuitionism as a descriptive claim about the nature and origins of moral beliefs (see Haidt 2001). Such descriptive claims are not intended to stop the skeptical regress; so they do not concern me here.

More specifically, the defining claim of moral intuitionism is about what is *epistemically* justified because moral skeptics win if the only justification for holding moral beliefs is that those belief states have beneficial practical effects. Similarly, moral skeptics win if some moral beliefs are inadequately justified but none is *adequately* justified, that is, justified strongly enough that the believer ought to believe it as opposed to denying it or suspending belief.[5] Accordingly, I will henceforth use "justified" as shorthand for "adequately epistemically justified."

To say that moral believers are justified independently of an inferential ability is just to say that they would be justified even if they lacked that ability, that is, even if they were not able to infer those beliefs from any other beliefs. This independence claim can hold even when moral believers are able to infer those moral beliefs from other beliefs as long as they do not need that inferential ability to be justified.[6] This notion of need will become prominent later.

I infer a belief when I go through a reasoning process of which the belief is the (or a) conclusion and other beliefs are premises. A believer is able to draw such an inference when the believer has enough information to go through a reasoning process that results in this belief if he had enough incentive and time to do so. This ability does not require self-consciousness or reflection about the beliefs or abilities. All that is needed, other than general intelligence, is for the requisite information to be encoded appropriately in the believer's brain at the time of belief.[7]

Some moral intuitionists claim only that certain moral beliefs are justified independently of any actual inference. However, that weak moral intuitionism is not enough to stop the skeptical regress. Even if whether certain moral beliefs are justified does not depend on any actual inference, it still might depend on the believer's ability to infer them from other beliefs. The ability to draw an inference cannot make a belief justified if beliefs in the inference's premises are not themselves justified. This requirement is enough to restart a skeptical regress. Thus, to meet the skeptical challenge, moral intuitionists must make the strong claim that some moral believers are adequately epistemically justified in

holding some moral beliefs independently of any ability to infer the moral belief from any other belief.[8] So that's what they claim.

Although this claim is strong, it has many defenders. Rational intuitionists see basic moral beliefs as analogous to beliefs in mathematical axioms, which are taken to be justified independently of inference. Moral sense theorists assimilate particular moral beliefs to perceptual beliefs, which are supposed to be justified independently of inference. More recently, reliabilists hold that any belief is justified if it results from a reliable process, regardless of whether that process has anything to do with any inference. I group these views together under my broad definition of moral intuitionism because my arguments will apply to them all.

Under my definition, there are at least two ways to deny moral intuitionism. Moral intuitionists claim that some moral believers would be justified even if they did not have any ability to infer their moral beliefs from any other beliefs. Some opponents object that moral beliefs always depend on some inference or inferential ability. However, the evidence (cf. Haidt 2001) strongly suggests that people often have moral beliefs that do not result from any actual inference. It is harder to tell whether any moral beliefs are independent of any ability to infer. Nonetheless, I will grant for the sake of argument that some moral beliefs are spontaneous in the sense that they are independent of any inference or inferential ability.

Other opponents of moral intuitionism deny that moral believers are ever justified in holding such spontaneous moral beliefs if they lack certain inferential abilities. This conclusion follows if inferential abilities are always needed for a moral believer to be justified. That is what I will try to show.

2. WHEN IS CONFIRMATION NEEDED?

We cannot answer this question directly. If a moral intuitionist baldly asserts that we do not need inferential abilities to back up our spontaneous moral beliefs, then this assertion begs the question. Similarly, if a critic of moral intuitionism baldly asserts that we do need inferential abilities to back up our spontaneous moral beliefs, then this assertion also begs the question. Neither side can win so easily. We need a less direct method.

One alternative uses analogies to non-moral beliefs. This path is fraught with peril, but it might be the only way to go. What this approach does is appeal to non-moral cases to develop principles of epistemic need and then later apply those principles back to moral beliefs. Let's try it.

I will formulate my principles in terms of when confirmation is needed, but they do not claim that the believer needs to go through any process of confirming the belief. The point, instead, is only that some confirmation needs to be available at least implicitly as information stored somehow in the believer that gives the believer an ability to infer the belief from some other beliefs.[9] The question is when some such confirmation is needed in non-moral cases.

Suppose that I listen to my daughter in a piano competition. I judge that she played great and her rival was mediocre. Am I justified in trusting my judgment? Not if all I can say is, "Her performance sounded better to me." I am too biased for such immediate reactions alone to count as evidence. I still might be justified, if I am able to specify laudable features of her performance, or if I know that others agree, but some confirmation seems needed. Generalizing,

> Principle 1: confirmation is needed for a believer to be justified when the believer is partial.

This principle also applies to direct perceptual judgments, such as when I believe that my daughter played middle C at just the right time in the midst of her piece. This partly explains why we prefer umpires, referees, and judges not to be parents of competitors. Even reliabilists can admit this principle because partiality often creates unreliability.

Second, imagine that each of us adds a column of figures, and I get one sum, but you get a different sum. Maybe I would be justified in believing that I am right if you were my child and I was helping you

with your homework. However, if you are just as good at arithmetic as I am, then, when we get different answers, we need to check again to find out who made a mistake before either of us can be justified in believing that his or her answer is the correct one. We owe each other that much epistemic respect. The best explanation of this natural reaction seems to be

> Principle 2: confirmation is needed for a believer to be justified when people disagree with no independent reason to prefer one belief or believer to the other.

This principle also applies when the person on the sidewalk looks like Tom Cruise to me but not to you. If I have no reason to believe that I am better than you at this identification, then I am not justified in believing that your belief is incorrect or that mine is correct.

A third principle concerns emotions. When people get very angry, for example, they tend to overlook relevant facts. They often do not notice excuses or apologies by the person who made them angry. We should not generalize to all emotions, but we can still endorse something like this:

> Principle 3: confirmation is needed for a believer to be justified when the believer is emotional in a way that clouds judgment.

This explains why jurors are dismissed from a case that would make them too emotional. This principle applies even if their emotions do not bias them towards either side, so it is distinct from Principle 1, regarding partiality.

Next consider illusions. At least three kinds are relevant here. First, some illusions are due to context. Objects look larger when they are next to smaller objects, and they look smaller when they are next to larger objects. Since our estimates of their sizes are affected by their surroundings, we are not justified in trusting our estimates until we check their sizes in other circumstances or by other methods.

A second group of illusions arises from generalizations. For example, an oval that is shaded on top looks concave, but an oval that is shaded on the bottom looks convex. The explanation seems to be that our cognitive apparatus evolved in circumstances where the light usually came from above, which would produce a shadow on the top of a concave oval (such as a cave opening) and on the bottom of a convex oval (such as an egg). Since we often overextend generalizations like this, we are not justified in trusting beliefs that depend on such generalizations until we check to determine whether our circumstances are exceptional.

The third kind of illusion involves heuristics, which are quick and simple decision procedures. In a passage with a thousand words, how many seven-letter words have the form "_ _ _ _ in _"? How many seven-letter words have the form "_ _ _ _ ing"? Most people estimate more words have the latter form, although that is impossible, since every word of the form "_ _ _ _ ing" also has the form "_ _ _ in _." Why do people make this simple mistake? They seem to test how likely something is by trying to imagine examples and guessing high if they easily think of lots of examples. This is called the availability heuristic (Kahneman *et al.* 1982). Most people easily produce words that end in "ing," but they have more trouble coming up with words that end in "in _" because they do not think of putting "g" in the last place. In cases like this, the availability heuristic is misleading. Accordingly, they do not seem adequately epistemically justified in trusting beliefs based on such heuristics until they check on whether they are in circumstances where the heuristics work.

This quick survey of three common kinds of illusion suggests

> Principle 4: confirmation is needed for a believer to be justified when the circumstances are conducive to illusion.

This principle would apply as well to many other kinds of illusions.

A fifth and final principle considers the source of a belief. If you believe that George Washington never told a lie, and if this belief comes from a legend

spread by Washington's allies to gain power, then you are not justified in believing the legend, though it still might be true. Even if you believe only that Washington was unusually honest, this belief might be a lingering effect of this childhood story, and then its origin makes this belief need confirmation. The point can be generalized into something like

> Principle 5: confirmation is needed for a believer to be justified when the belief arises from an unreliable or disreputable source.

This principle also explains why we do not view people as justified in beliefs based only on prejudice and stereotypes.

These five principles, although distinct, complement each other. When a belief is partial, controversial, emotional, subject to illusion, and explicable by dubious sources, then all of these principles apply. In such cases, they work together to make it even clearer that confirmation is needed for justified belief. Even if not all of these principles apply, the more that do apply, the clearer it will be that there is more need for more confirmation. We might think of this as a sixth principle.

I do not claim that these principles are precise or that my list is complete.[10] What I do claim is that these principles or some close relatives seem plausible to most people and are assumed in our shared epistemic practices. I also claim that they make sense because they pick out features that are correlated with reliability and other epistemic values.

Most importantly, I claim that these principles apply in all areas of belief. My illustrations include beliefs about arithmetic, language, history, identity, value, sound, size, and shape, but the same principles apply in scientific research, religion, and so on. The main question here is whether they apply to moral beliefs. Admittedly, morality might be a special case where these principles do not apply. However, unless someone can point to a relevant difference between these other areas and moral beliefs, it seems only fair to apply these same standards to moral beliefs when asking whether moral beliefs are justified. So that's what I will do.

3. WHEN ARE MORAL BELIEFS JUSTIFIED?

Some of these principles can be applied only with the help of empirical research. Others are easier to apply. Let's start with the easy ones.

Partiality

Principle 1 says that partiality adds a need for confirmation. But what is partiality? A judge is often called partial when the judge's self-interest is affected by the outcome of the case. However, if the judge's self-interest does not influence the judge's decision, so the judge would have made the same decision if the judge's self-interest had not been involved, then it is natural to say that the judge's decision is not partial, even if the judge is partial. Analogously, believers can be called partial whenever their beliefs affect their self-interest either directly or indirectly (by affecting the interests of people whom they care about). Beliefs are then partial only when the believer's self-interest influences whether the believer holds that belief. Thus, a partial believer can hold an impartial belief (or can hold it impartially) if the believer has an interest in holding the belief, but that interest does not influence whether the believer holds that belief.

Partiality of a belief can't be all that triggers Principle 1. To see why, recall the examples that motivated Principle 1. Because I am biased in favor of my daughter, even after watching her play in the piano competition, I need confirmation to be justified in believing that my daughter played better than her rival. Maybe my interest in her victory did not influence my assessment, but the danger of such influence is enough to create a need for confirmation. Admittedly, if I can rule out such influence, then I can be justified in believing that my daughter played better, but the only way to rule out such influence involves independent confirmation. Thus, confirmation seems needed when the believer is partial, even if the believer is not actually influenced by that partiality, so the belief is not partial. Since confirmation is also needed when the belief is partial, Principle 1 requires

confirmation when either the believer or the belief is partial.

To apply this principle to moral beliefs, we need to determine whether moral beliefs affect our self-interest either directly or indirectly. The answer seems clear: Moral beliefs affect us all. It can be very expensive to believe that we are morally required to help the needy, but it can be even more expensive if others do not believe that they are morally required to help us when we are in need. It can also cost a lot to believe that we have to tell the truth or to keep a promise. And all of us know or should know that, if killing, stealing, lying, cheating, and promise-breaking were generally seen as morally permitted, then we would be more likely to get hurt by others doing such acts. Life would be more "solitary, poor, nasty, brutish, and short," as Hobbes put it. Moreover, if an individual did not see such acts as immoral, then he or she would be more likely to do them and then to be punished in various ways—"if not by law, by the opinion of his fellow creatures," as Mill said. Special interests also arise in special cases: Women and men know or should know that, if abortion is not seen as morally permissible, then they, their friends, or their daughters will be more likely to suffer more. Moral beliefs about affirmative action affect the interests of the preferred groups and also the non-preferred groups. And so on. Indeed, on many views, what makes an issue moral in nature is that interests are significantly affected by the judged actions. Since moral beliefs about actions affect those actions, our moral beliefs themselves affect our interests at least indirectly. Finally, social groups often form around and then solidify moral beliefs (cf. Chen and Tetlock *et al.* as discussed in Haidt 2001). People who believe that homosexuality is immoral find it harder to get along with homosexuals and easier to get along with homophobes. Conversely, people who believe that homosexuality is not immoral find it harder to get along with homophobes and easier to get along with homosexuals. Some might try to fake moral beliefs in order to get along, but few of us are good enough actors, and those who believe that homosexuality is immoral usually also believe that they ought not to pretend otherwise in order to get along with homosexuals. Thus, our moral beliefs affect our social options as well as our actions.

Many moral beliefs might seem to have no effect on us. If I believe that it was immoral for Brutus to stab Caesar, this moral belief by itself will not change my social options or rule out any acts that I could do today. Still, given universalizability, my judgment of Brutus seems to depend on a principle that does apply in other cases where my self-interest is involved more directly. Arguments from analogy also might force me to take a moral stand that affects my interests. Thus, any moral belief can affect my self-interest indirectly.

Because our moral beliefs affect our self-interest so often in so many ways at least indirectly, we cannot be justified in assuming that any of us is ever fully impartial as a moral believer. Even if our self-interest is not involved in some exceptional case, we still need a reason to believe that our self-interest is not affected in that case, since we know or should know that such effects are very common and often hidden. The facts that partiality is so common in this area and so difficult to detect in ourselves are what create a need for confirmation of all moral beliefs, according to Principle 1.

Disagreement

Principle 2 says that disagreement creates a need for confirmation. Many people seem to think that this principle is easy to apply to moral beliefs because moral disagreement is pervasive. In their view, people from different cultures, time periods, social classes, and genders disagree about a wide variety of particular moral judgments and general moral principles.

Actually, the extent of moral disagreement is not obvious. One reason is that people who seem to disagree are often judging different actions or using different concepts. Also, many apparently moral disagreements are really factual, since those who seem to disagree morally would agree in their moral judgments if they agreed about the facts.

Still, straightening out concepts and non-moral facts seems unlikely to resolve all apparently moral disagreements. One reason is that people often express

different moral beliefs about hypothetical cases where all of the facts are stipulated, so these moral believers seem to accept the same non-moral facts. Admittedly, descriptions of these situations usually leave out important facts, and moral believers might interpret the hypothetical cases in light of different background beliefs. But there still seem to be lots of cases where all relevant non-moral facts are agreed upon without leading to agreement in moral belief.

This claim is supported by a study in which Jana Schaich Borg and I surveyed fifty-two undergraduates at Dartmouth College, using thirty-six scenarios, including the well-known side-track and fat-man trolley cases. In both cases, five people tied to a track will be killed by a runaway trolley if you do nothing, and the only way to save the five is to kill one other person.[11] In the side-track version, you can save the five only by pulling a lever to divert the trolley onto a side-track where it will run over one victim. In the fat-man variation, you can save the five only by pushing a fat man in front of the trolley so that his body will stop the trolley before it hits the five. In two rounds, 35 percent then 43 percent of our subjects said that it would be wrong to divert the trolley onto the side-track. When the same scenario was described with more vivid language, 61 percent then 45 percent judged diversion wrong in the two rounds. In contrast, 76 percent in the first round then 88 percent in the second round judged it wrong to push the fat man. (Interestingly, there were still 35 percent in the first round and 18 percent in the second round who said that they would push the fat man.) These percentages did not change much with more vivid language. Thus, we found significant disagreement about the very cases that philosophers often cite to support their theories.[12]

There is, admittedly, more agreement about other cases: Would it be wrong to push the fat man in front of the trolley just because you are angry at him for beating you at golf when killing him will not save or help anyone else? I hope and expect that 100 percent would answer, "Yes." But what would that show? The universality of moral beliefs about cases like this one could hardly be used to justify any moral theory or any controversial moral belief.[13] Such cases cannot get moral intuitionists all that they seem to want.[14]

Moral intuitionists might respond that all they claim is that *some* moral beliefs are non-inferentially justified. One case seems enough to establish that claim. However, the fact that there is so much disagreement in other cases affects the epistemology of cases where there is no disagreement. Compare a box with one hundred thermometers. We know that many of them don't work, but we are not sure how many. If we pick one thermometer arbitrarily from the box, and it reads 77 degrees, then we are not justified in believing that the temperature really is 77 degrees, even if we were in fact lucky enough to pick a thermometer that works. Of course, if we confirm that this thermometer works, such as by testing it against other thermometers, then we can use it to form justified beliefs, but cannot be justified in trusting it before we confirm that it works.[15] Similarly, if we know that many moral intuitions are unreliable because others hold conflicting intuitions, then we are not justified in trusting a particular moral intuition without some reason to believe that it is one of the reliable ones. If we know that everyone agrees with that particular moral intuition, then we might have reason to trust it. But that is just because the known agreement provides confirmation, so it does not undermine the point that some confirmation is needed, as Principle 2 claims.

Emotion

Next consider Principle 3, which says that emotions that cloud judgment create a need for confirmation. It is hard to tell whether this principle applies to moral beliefs. Philosophers and others have argued for millennia about whether moral beliefs are based on emotion or on reason. They also argue about which emotions, if any, cloud judgment. How can we resolve these debates? Luckily, some recent empirical studies suggest an answer.

Haidt and his group have been accumulating an impressive body of behavioral evidence for what they call the social intuitionist model:

> This model suggests that moral judgment is much like aesthetic judgment: we see an action or hear a story and we have an instant feeling of approval or

disapproval. These feelings are best thought of as affect-laden intuitions, as they appear suddenly and effortlessly in consciousness, with an affective valence (good or bad), but without any feeling of having gone through any steps of searching, weighing evidence or inferring a conclusion. (Greene and Haidt 2002: 517)[16]

Haidt's behavioral evidence dovetails nicely with independent brain studies. Moll's group found that brain tissue associated with emotions becomes more activated when subjects think about simple sentences with moral content (e.g. "They hung an innocent") than when they think about similar sentences without moral content (e.g. "Stones are made of water") (Moll *et al.* 2001) or disgusting non-moral sentences (e.g. "He licked the dirty toilet") (Moll *et al.* 2002*a*).[17] Similar results were found with pictures in place of sentences (Moll *et al.* 2002*b*).

Studies by Joshua Greene and his colleagues are even more fascinating because they distinguish kinds of moral beliefs (2001).[18] Greene's group scanned brains of subjects while they considered what was appropriate in three kinds of dilemmas: non-moral dilemmas, personal moral dilemmas, and impersonal moral dilemmas. A moral dilemma is personal if and only if one of its options is likely to cause serious harm to a particular person other than by deflecting an existing threat onto a different party (Greene and Haidt 2002: 519). A standard personal moral dilemma is the fat-man trolley case. A paradigm impersonal moral dilemma is the side-track trolley case. These different moral cases stimulated different parts of the brain. While considering appropriate action in impersonal dilemmas, subjects showed significant activation in brain areas associated with working memory but no significant activation in areas associated with emotion. In contrast, while considering appropriate action in personal dilemmas, subjects showed significant activation in brain areas associated with emotion and under-activation (below the resting baseline) in areas associated with working memory. It is not obvious what to make of these results. Brain scientists do not know how to interpret under-activation in general. Nonetheless, one natural speculation is

this: When asked about pushing the fat man, subjects react, "That's so horrible that I can't even think about it." Emotions stop subjects from considering the many factors in these examples. If this interpretation is correct, then many pervasive and fundamental moral beliefs result from emotions that cloud judgment.[19]

Some moral intuitionists might argue that there is no need to consider anything else when the proposed action is the intentional killing of an innocent fat man. It might even be counterproductive to consider additional factors, since they might lead one away from the correct belief. Such responses, however, assume that it is morally wrong to push the fat man, so they beg the question here. When asking whether a moral belief is justified, we should not assume that the only relevant factors are those that would be relevant if the belief were true. Ridiculous moral beliefs could be defended if that method worked.

Still, moral intuitionism is hardly refuted by these experiments because Greene's results must be replicated and interpreted much more carefully. (Some initial replication can be found in Greene 2004.) All I can say now is that such brain studies seem to provide some evidence that many moral judgments result from emotions that cloud judgment.

Additional evidence comes from Wheatley and Haidt (2005). They gave participants the post-hypnotic suggestion that they would feel a pang of disgust whenever they saw either the word "take" or the word "often." Participants were later asked to make moral judgments about six stories designed to elicit mild to moderate disgust. When a story contained the word that elicited disgust in a participant, that participant was more likely to express stronger moral condemnation of acts in the story. Moral judgments were then affected by elements of the story that could not determine the accuracy or acceptability of those moral judgments. In that sense, emotions clouded their judgment. Because independently caused emotions can distort moral beliefs in such ways, moral believers need confirmation in order to be justified in holding their moral beliefs.

Illusions

To apply Principle 4 to moral beliefs, we again need empirical research, but this time in cognitive science rather than brain science. I mentioned three kinds of illusions that should be considered separately.

The first kind of illusion occurs when appearances and beliefs depend on context. An interesting recent example comes from Peter Unger, who found that the order in which options are presented affects beliefs about whether a given option is morally wrong. He also claims that people's moral beliefs about a certain option depend on whether that option is presented as part of a pair or, instead, as part of a series that includes additional options intermediate between the original pair (Unger 1996: 88–94).[20] Since order and intermediate options are not morally relevant factors that could affect the moral wrongness of the judged option, the fact that moral beliefs are affected by these factors shows that moral beliefs are unreliable in such cases. That is why confirmation is needed. One still might confirm one's moral belief by reconsidering the issue in several contexts over time to see whether one's moral belief remains stable, but that is just a way of seeking confirmation, so it does not undermine my point that confirmation is needed.

The second kind of illusion arises from overgeneralization. Such illusions also affect moral beliefs. Jonathan Baron even argues that all "nonconsequentialist principles arise from overgeneralizing rules that are consistent with consequentialism in a limited set of cases" (1994: 1). But one need not accept consequentialism in order to admit that many people condemn defensible lying, harming, and love-making because they apply generalizations to exceptional cases. We probably disagree about which moral beliefs are overgeneralizations, but we should agree that many people overgeneralize in ways that create illusions of moral wrongness. In any such case, the moral believer could argue that this case is not an exception to the generalization, but, as before, that is just a way of seeking confirmation, so it does not undermine my point that this kind of illusion creates a need for confirmation.

Heuristics, which are quick and simple decision procedures, also create illusions in morality. One reason is that many moral beliefs depend on consequences and probabilities, for which we often lack adequate evidence, and then we have to guess these probabilities. Such guesses are notoriously distorted by the availability heuristic, the representative heuristic, and so on.[21] Even when moral beliefs do not depend on probability assessments, moral beliefs are affected by the so-called "I agree with people I like" heuristic (cf. Chaiken and Lord, Ross, and Lepper as discussed by Haidt 2001). When people whom we like express moral beliefs, we tend to go along and form the same belief. When people whom we dislike oppose our moral beliefs, we tend to hold on to them in spite of contrary arguments. This heuristic often works fine, but it fails in enough cases to create a need for confirmation.

In addition to these three kinds of illusions, moral beliefs also seem subject to framing effects, which were explored by Kahneman and Tversky (1979). In one famous experiment, they asked some subjects this question:

> Imagine that the U.S. is preparing for an outbreak of an unusual Asian disease which is expected to kill 600 people. Two alternative programs to fight the disease, A and B, have been proposed. Assume that the exact scientific estimates of the consequences of the programs are as follows: If program A is adopted, 200 people will be saved. If program B is adopted, there is a 1/3 probability that 600 people will be saved, and a 2/3 probability that no people will be saved. Which program would you choose?

The same story was told to a second group of subjects, but these subjects had to choose between these programs:

> If program C is adopted, 400 people will die. If program D is adopted, there is a 1/3 probability that nobody will die and a 2/3 probability that 600 will die.

It should be obvious that programs A and C are equivalent, as are programs B and D. However, most subjects who chose between A and B favored A, but

most subjects who chose between C and D favored D. More generally, subjects were risk averse when results were described in positive terms (such as "lives saved") but risk seeking when results were described in negative terms (such as "lives lost" or "people who die").

The question in this experiment was about choices rather than moral wrongness. Still, the subjects were not told how the policies affect them personally, so their choices seem to result from beliefs about which program is morally right or wrong. If so, the subjects had different moral beliefs about programs A and C and about programs B and D. The only difference within each pair is how the programs are framed or described. Thus, descriptions seem to affect moral beliefs. Descriptions cannot affect what is really morally right or wrong. Hence, these results suggest that such moral beliefs are unreliable.

Moral intuitionists could claim that moral intuitions are still reliable when subjects have consistent beliefs after considering all relevant descriptions. But then moral believers would need to know that their beliefs are consistent and that they are aware of all relevant descriptions before they could be justified in holding moral beliefs. Framing effects distort moral beliefs in so many cases that moral believers need confirmation for any particular moral belief.

To see how deeply this point cuts, consider Warren Quinn's argument for the traditional doctrine of doing and allowing, which claims that stronger moral justification is needed for killing than for letting die. In support of this general doctrine, Quinn appeals to moral intuitions of specific cases:

> In Rescue I, we can save either five people in danger of drowning at one place or a single person in danger of drowning somewhere else. We cannot save all six. In Rescue II, we can save the five only by driving over and thereby killing someone who (for as unspecified reason) is trapped on the road. If we do not undertake the rescue, the trapped person can later be freed. (1993: 152)

Most people judge that saving the five is morally wrong in Rescue II but not in Rescue I. Why do they react this way? Quinn assumes that these different intuitions result from the difference between killing and letting die or, more generally, doing and allowing harm. However, Tamara Horowitz uses a different distinction (between gains and losses) and a different theory (prospect theory) to develop an alternative explanation of Quinn's moral intuitions:

> In deciding whether to kill the person or leave the person alone, one thinks of the person's being alive as the status quo and chooses this as the neutral outcome. Killing the person is regarded as a negative deviation. . . . But in deciding to save a person who would otherwise die, the person being dead is the status quo and is selected as the neutral outcome. So saving the person is a positive deviation. . . . (1998: 153)

The point is that we tend to reject options that cause definite negative deviations from the status quo. That explains why subjects rejected program C but did not reject program A in the Asian disease case (despite the equivalence between those programs). It also explains why we think that it is morally wrong to "kill" in Rescue II but is not morally wrong to "not save" in Rescue I, since killing causes a definite negative deviation from the status quo. This explanation clearly hinges on what is taken to be the status quo, which in turn depends on how the options are described. Quinn's story about Rescue I describes the people as already "in danger of drowning," whereas the trapped person in Rescue II can "later be freed" if not for our "killing" him. These descriptions affect our choice of the neutral starting point. As in the Asian disease cases, our choice of the neutral starting point then affects our moral intuitions. Horowitz adds, "I do not see why anyone would think the distinction [that explains our reactions to Quinn's rescue cases] is morally significant, but perhaps there is some argument I have not thought of. If the distinction is not morally significant, then Quinn's thought experiments do not support one moral theory over against another" (1998: 155).

Admittedly, Horowitz's explanation does not imply that Quinn's moral intuitions are false or incoherent, as in the Asian disease case. It does not even establish that his moral intuitions are arbitrary. As

Mark van Roojen says, "Nothing in the example shows anything wrong with treating losses from a neutral baseline differently from gains. Such reasoning might well be appropriate where framing proceeds in a reasonable manner" (1999).[22] Nonetheless, the framing also "might well" *not* be reasonable, so the epistemological dilemma remains: If there is no reason to choose one baseline over the other, then our moral intuitions seem arbitrary and unjustified. If there is a reason to choose one baseline over the other, then either we have access to that reason or we do not. If we have access to the reason, then we are able to draw an inference from that reason to justify our moral belief. If we do not have access to that reason, then we do not seem justified in our moral belief. Because framing effects so often lead to incoherence and error, we cannot be justified in trusting a moral intuition that relies on framing effects unless we at least can be aware that this intuition is one where the baseline is reasonable. So Horowitz's explanation creates serious trouble for moral intuitionism whenever framing effects could explain our moral intuitions.

The doctrine of doing and allowing is not an isolated case. It affects many prominent issues and is strongly believed by many philosophers and common people, who do not seem to be able to infer it from any other beliefs. If moral intuitions are unjustified in this case, doubts should arise about a wide range of other moral intuitions as well.

Origins

Some previous principles look at origins of individual moral beliefs, but Principle 5 considers the social origins of shared moral beliefs. The two issues are related insofar as many of our moral beliefs result from training and social interaction.

Specifically, Principle 5 claims that problematic social origins create a need for confirmation. To apply this principle, we need to ask whether moral beliefs have problematic social origins. The social origins of moral beliefs might be problematic in two ways. First, moral beliefs might be caused by factors that are unrelated with the truth of those beliefs.

Second, the origins of moral beliefs might be immoral according to those moral beliefs. I will focus on the latter case.

Are the origins of our moral intuitions immoral by their own lights? Friedrich Nietzsche suggests as much when he argues that Christian morality results from slaves cleverly overcoming their superiors by re-evaluating values. Insofar as Christian morality condemns such subterfuge and self-promotion, Christian morality condemns its own origins, if Nietzsche is correct (Nietzsche 1966).[23] Similarly, Michel Foucault argues at length that moral beliefs express or result from social power relations. Yet these moral beliefs themselves seem to condemn the very kind of power that leads to these beliefs. But I don't want to rely on Nietzsche or Foucault, at least not in this context, so I will consider Gilbert Harman's explanation of the common moral belief that harming someone is much worse than failing to helping someone in need:

> whereas everyone would benefit equally from a conventional practice of trying not to harm each other, some people would benefit considerably more than others from a convention to help those who needed help. The rich and powerful do not need much help and are often in the best position to give it; so, if a strong principle of mutual aid were adopted, they would gain little and lose a great deal, because they would end up doing most of the helping and would receive little in return. On the other hand, the poor and the weak might refuse to agree to a principle of non-interference or non-injury unless they also reached some agreement on mutual aid. We would therefore expect a compromise [that] would involve a strong principle of non-injury and a weaker principle of mutual aid—which is just what we now have. (1977: 110; cf. Scheffler 1982: 113)

Remember also that rich and powerful people have always controlled the church, the media, and culture, which in turn affect most people's moral beliefs. In this context, Harman's claim is that the self-interest of the rich and powerful in making everyone believe that harming is worse than failing to help can explain why so many people believe that harming is worse than failing to help. But our moral beliefs also

seem to condemn such self-serving indoctrination by the rich and powerful, since morality is supposed to consider everyone's interests equally. Thus, if Harman is correct, morality condemns its own origins, as Nietzsche and Foucault claimed.

The point is not that such moral views are internally inconsistent, self-condemning, or even self-defeating. The point is only that there are grounds for doubt when beliefs come from disreputable sources. Defenders of such moral beliefs must admit that the sources of their beliefs are disreputable if Harman's explanation is accurate. Then they need additional support for their beliefs beyond the mere fact that those beliefs seem correct to them.

These speculations about the origins of moral beliefs are mere armchair psychology. Perhaps more support could be obtained from the literature on sociobiology or evolutionary psychology. Still, these explanations are likely to remain very controversial. Luckily, I don't need to prove them here. I claim only that these undermining accounts are live possibilities. They seem plausible to many people and have not been refuted.

That would not be enough if I were arguing for the falsehood of a certain moral belief, such as Christian morality (from Nietzsche) or the prevalence of non-injury over mutual aid (from Harman). However, I am not drawing any substantive moral conclusion. To do so would commit a genetic fallacy, but my argument is different. My point lies in moral epistemology, and I reach it indirectly. If these disreputable origins are live possibilities, then moral believers need some independent confirmation that their beliefs are not distorted by such disreputable origins. This need for independent confirmation then undermines moral intuitionism.

Togetherness

Don't forget that Principles 1–5 complement each other. If I am right, moral beliefs are partial, controversial, emotional, subject to illusion, and explicable by dubious sources, so all of the principles apply. However, even if not all but only several of them apply, these principles still work together to make it

clear that confirmation is needed for justified moral belief. That undermines moral intuitionism. It also shows how empirical research can be indirectly relevant to normative moral epistemology.

4. OBJECTIONS

None of my arguments is conclusive, so opponents can object at several points. Here I cannot respond to every objection or to any objection thoroughly. But I will quickly run through the most formidable objections.

Confirmation

One common objection is that, even if some confirmation is needed, that does not show that any inference is needed. If we can confirm color beliefs just by looking again in different light, perhaps we can confirm moral beliefs simply by reflecting on the moral issue again in a different mood without involving any substantive moral principle from which we infer our moral belief.

I grant that confirmation does not require an actual inference. To avoid the skeptical regress, however, moral intuitionists must deny more than the need for an actual inference. They must deny the need for any ability to infer the moral belief. It is hard to see how you could confirm a moral belief without gaining information that makes you able to draw some kind of inference to the moral belief. Even if you just think about the moral issue several times in different moods, after such rethinking you have all the information you need for a simple inference like this:

> I hold this moral belief after reflecting on the issue several times in different moods.
>
> If I hold a moral belief after reflecting on the issue several times in different moods, then it is usually true.
>
> So, probably, this moral belief is true.

Admittedly, this inference is not a deductive proof. Nor does it infer the moral belief from a more

general substantive moral principle. But no specific kind of inference is needed. Any kind of inference can lead to a skeptical regress, so moral intuitionists have to deny dependence on any kind of inference or ability to infer. And an ability to draw the above kind of inference is needed, since, if the moral believer does not believe its premises (or something like them), then it is hard to see why the moral believer is justified in holding the moral belief.

At this point, externalists (including reliabilists) sometimes accuse me of confusing whether a belief is justified with whether the believer knows that it is justified. I plead innocent. I do not assume that justified believers must know or be justified in believing (or even be able to know or be justified in believing) that they are justified. I claim only that justified moral believers must be able to infer their moral beliefs from something. Some externalists still deny this, but their denial is implausible, as I have argued elsewhere (Sinnott-Armstrong 2002b). Besides, most externalists are mainly concerned about non-moral beliefs, including perceptual beliefs. Principles 1–5 do not apply to perceptual beliefs in the same way as to moral beliefs. Most perceptual beliefs are not partial, controversial, emotional, or explicable by dubious sources. Perceptual illusions are common, but they are normally easier to detect than moral illusions, and they do not affect anything as widespread and fundamental as the doctrine of doing and allowing. Consequently, externalism and reliabilism might work for perceptual beliefs even if, as I have argued, moral beliefs need confirmation of a kind that requires an inferential ability.[24]

Children

This response leads to another objection. It might seem too strict to require an inferential ability because then young children cannot have justified moral beliefs, since they cannot formulate the needed inferences.

I love children. I grant that they can have justified beliefs in other areas, such as beliefs about food and toys. However, it is not as clear that very young children (say, 1–3 years old) can be justified in holding

moral beliefs. After all, young children often base their normative beliefs on fear of punishment. If someone believes that stealing is wrong just because he believes that he is likely to get punished if he steals, then it is not even clear that the belief is a moral belief. It might be purely prudential. Instead of fear, the basis for some young children's moral beliefs might be deference to authorities (or peers). But if children accept their parents' word that an act is wrong without any idea of what makes that act wrong, then these children might not believe that the act is wrong *morally,* since they might not believe that there is any specifically moral reason not to do the act. Moreover, authorities can make someone justified only if she is justified in trusting those authorities. Maybe young children are justified in trusting their parents, for example. But then they can infer:

> My parents are trustworthy.
> My parents tell me that I shouldn't pull my sister's hair.
> Therefore, I shouldn't pull my sister's hair.

If a young child is not able to draw any inference like this, then this child does not seem justified (even if her parents are trustworthy and even if her belief is true). Those who think otherwise are too soft on their kids.

Ignorance

Another objection claims that, if a moral believer could not know that moral beliefs are subject to controversy, partiality, illusion, and so on, then that moral believer does not need to guard against these problems by getting confirmation. Children and some adults (such as isolated medieval peasants) might have no way of discovering such problems for moral beliefs. They certainly lack access to the psychological research that I cited. So maybe these moral believers do not need confirmation for their moral beliefs.

This objection confuses two claims. To call a believer unjustified is often to criticize that believer. Such criticism seems misplaced when the believer is not responsible for any epistemic failures. Believers

are not responsible when they have no way of knowing that their beliefs are problematic. Thus, if children and medieval peasants cannot know that moral beliefs are problematic, it seems odd to call them unjustified.

In contrast, to say that a believer is not justified is not to criticize the believer. It is only to withhold the praise of calling the believer justified. There is nothing unfair about withholding praise when a believer is not responsible. Thus, even if children and medieval peasants are not responsible for their epistemic failures, that does not undermine my claim that they are not justified in their moral beliefs.

Moreover, even if children and medieval peasants were justified in their moral beliefs, that would not save moral intuitionists or my readers from the need for confirmation. Moral intuitionists and my readers are neither children nor medieval peasants. They are modern educated adults. Modern educated adults can know that moral beliefs are problematic in the ways that I outlined (at least if they have read this far). So my readers and other modern adults need confirmation for moral beliefs, regardless of what you think about other people.

Moral intuitionists might seem to avoid this point if they claim only that some moral believers are justified. However, moral intuitionists always include themselves among those who are justified. Similarly, I assume that my readers want to know whether they themselves are justified moral believers. If it turns out that the only moral believers who are justified without confirmation are children, medieval peasants, and others who are ignorant of the empirical research in this paper, then it is not so great to be justified.

Defeasibility

Some moral intuitionists accuse me of forgetting that a moral believer can be defeasibly justified without being adequately justified. Again, I plead innocent.

To say that a moral believer is defeasibly justified is to say that the believer would be justified in the absence of any defeater. Defeaters come in two kinds. An overriding defeater of a belief provides a reason to believe that the belief is false. For example, if one

newspaper predicts rain tomorrow, but a more reliable newspaper predicts clear skies, then the latter prediction overrides the former, even if I still have some reason to believe the former. In contrast, an undermining defeater takes the force out of a reason without providing any reason to believe the opposite. If I find out that the newspaper that predicts rain based its prediction on a crystal ball, then this new information keeps the prediction from making me justified in believing that it will rain, but the new information does not make me justified in believing that it will *not* rain, since a crystal ball is just as likely to lead to a true prediction. When my justification is undermined completely in this way, I have no reason left for believing that it will rain or that it will not rain.

The factors in Principles 1–5 cannot be overriding defeaters, since they do not provide any reason to believe the moral belief is false. Even when moral beliefs are partial, controversial, emotional, subject to illusion, and due to disreputable sources, that does not show that those beliefs are false. Thus, the factors in Principles 1–5 seem to be undermining defeaters. That suggests that we have no reason to trust our spontaneous moral beliefs before confirmation. Admittedly, some defeaters might not completely undermine a justification. They might leave some weaker reason that makes believers partially justified. However, the manifold underminers in Principles 1–5 add up, so that it is hard to see why there is any reason left to hold spontaneous moral beliefs without confirmation.

Moreover, I am not just talking about *possible* underminers. I argued in section 3 that the underminers in Principles 1–5 actually exist for many moral beliefs. Actual moral believers are partial and emotional. They actually do disagree often. Cultures actually are disreputable in ways that affect moral beliefs. There is even empirical evidence for actual widespread illusions in morality.

Moral intuitionists can still say that spontaneous moral believers are prima facie justified if that means only that they would be adequately justified if their moral beliefs were not undermined by the factors in Principles 1–5. This counterfactual claim is compatible with their actually not being justified at all, but only appearing to be justified. They might

have no real reason for belief but only the misleading appearance of a reason (as with the newspaper's rain prediction based on a crystal ball). In contrast, to call a believer pro tanto justified is to indicate some actual positive epistemic force that is not cancelled or undermined even if it is overridden. If the factors in Principles 1–5 are underminers, as I argued, then spontaneous moral believers are not even pro tanto justified. At most they misleadingly appear to be justified when they are not really justified at all.

Besides, even if moral intuitions were pro tanto justified independently of any inferential ability, this status would not make them adequately justified. As I said, skeptics win if no moral belief is adequately justified. So moral intuitionists cannot rest easy with the claim that moral intuitions are merely pro tanto justified.

Some

Many opponents object that, even if Principles 1–5 apply to some moral beliefs, they do not apply to all moral beliefs. As I admitted, some moral beliefs are not controversial. For example, almost everyone (except moral nihilists) agrees that it is morally wrong to push the fat man in front of the trolley just because you are angry with him for beating you in a game. Such cases also do not seem due to context, heuristics, overgeneralization, or framing effects. Still, such moral believers are partial and emotional (as Greene's experiments suggested). So Principles 1 and 3 do seem to create a need for confirmation even in such clear cases.

Furthermore, if very many moral beliefs need confirmation, the others cannot be immune from this need. To see why, compare a country with lots of barn façades that look just like real barns when viewed from the road (Goldman 1976). If someone looks only from the road, then he is not justified in believing that what he sees is a real barn, at least if he should know about the barn façades. The barn facades are analogous to situations that produce distorted moral beliefs. Since such distortions are so common, morality is a land of fake barns. In such areas, confirmation is needed for each justified belief, even for those beliefs formed in front of real barns.

Analogously, confirmation is needed for each spontaneous moral belief, even when the common distorting factors are absent. We need to get off the road and look closer. At least when we should know that moral beliefs in general are so often subject to distortion, we cannot be justified in trusting any moral belief until we confirm that it is an exception to the rule that most moral beliefs are problematic. So moral intuitionists cannot claim that any moral believers are justified without confirmation.

This point can be presented as a dilemma: If a moral believer is an educated modern adult, then she should know that many moral beliefs are problematic in the ways indicated by Principles 1–5. She either knows or does not know that her moral belief is an exception to the trend. If she does not know this, she should accept a significant probability that her belief is problematic. Then she cannot be justified without confirmation. Alternatively, if she does know that her moral belief is exceptionally reliable, then she has enough information to draw an inference like this: My moral belief is exceptionally reliable. Exceptionally reliable beliefs are probably true. Therefore, my belief is (probably) true. If this moral believer does not have the information in these premises, then it is hard to see why we should call her justified. So, either way, moral intuitionism fails.

Skepticism

A common objection is that my argument leads to general skepticism, since every inference has premises, so the demand for an inference cannot always be met. However, my argument does not generalize so easily. If my belief that a pen is in front of me is not subject to disagreement or illusions and has no disreputable sources, and if I am neither partial nor emotional about pens, then I might be justified in holding that non-moral belief without being able to support it with any inference. Thus, my argument against moral intuitionism does not lead to general skepticism.

My argument still might seem to lead to moral skepticism. If so, and if moral skepticism is unacceptable, then something must be wrong with my argument. However, my argument does not by itself

lead to moral skepticism. My thesis is not that spontaneous moral beliefs are not justified, but only that they are not justified non-inferentially because they need confirmation. Such confirmation still might be possible somehow. Even if moral intuitionism is rejected, there are other non-skeptical methods in moral epistemology, including coherentism, contractarianism, contractualism, contextualism, and naturalism (Sinnott-Armstrong 1996: 31–41). Moral skepticism arises only after all of these other approaches fall. So my argument does not by itself support moral skepticism.

Besides, even if these other approaches also fail, so my argument plays a role in a larger argument for moral skepticism, that does not show that anything is wrong with my argument, unless one assumes that moral skepticism is unacceptable. Why assume that? I accept a limited Pyrrhonian version of moral skepticism. So I, at least, will not be dismayed if my argument takes one step in that direction.[25]

Anyway, my goal here has not been to argue for moral skepticism. My goal has been to argue against moral intuitionism. More generally, I tried to show one way in which empirical research in psychology and brain science might be relevant to normative moral epistemology. If I succeeded in that enterprise, I will happily leave moral skepticism for another occasion.

Notes

1. Here Moore was discussing the claim that the object of desire is not pleasure, but his charge against naturalism extended much further.

2. Although some such arguments are formally valid. See my 2000: 159–74. I add the qualification "positive" because "Bettie and Madeleine are dead" might entail "It is not the case that Bettie ought to marry Madeleine."

3. As George Pappas reminded me, part of foundationalism can be separated from the denial of skepticism. Foundationalists can be skeptics if foundationalism claims only that a believer is justified in a belief only if the belief is either non-inferentially justified or inferable from non-inferentially justified beliefs. Non-skeptical foundationalists merely add that some beliefs are justified. Analogously, moral intuitionism could be seen as a claim about the structure of justification separate from any denial of skepticism.

Nonetheless, I will define moral intuitionism to include the denial of moral skepticism because almost all actual moral intuitionists do deny skepticism and because I am concerned with whether moral intuitionism can succeed as a response to skepticism.

4. Although I define moral intuitionism in terms of "some" believers and "some" moral beliefs, all actual moral intuitionists claim that a significant group of believers and beliefs can be justified non-inferentially. It also might seem odd that a theory counts as moral intuitionism on my definition if it holds that some beliefs based on testimony are justified independently of any inference or inferential ability. However, my arguments will apply to such views, so I see no pressing need to complicate my definition so as to avoid these problems.

5. I will discuss pro tanto justifiedness in responses to objections below. For more detail on kinds of justifiedness, see my 2002*b*: 17–25.

6. Compare Ross 1930: 29: "without any need of proof." (Since not all inferences are proofs, and Ross does not mention abilities, he might not deny the need for an inferential ability.) Contrast Moore (1903: 77), who sees moral intuitions as unprovable. Moore's stronger claim is not needed to stop the skeptical regress. Notice also that opponents of moral intuitionism, who claim that an inferential ability is *necessary*, do not have to claim that any inferential ability is *sufficient* to make any moral belief justified. At least the moral belief must also be *based on* the inferential ability. Other necessary conditions might also have to be met. Opponents of moral intuitionism can hold that an inferential ability is needed without specifying what, if anything, else is needed and, so, without specifying what is sufficient for justified moral belief.

7. The relevant notion of ability, then, is not the same as when I am able to become justified in believing that there are ten coins in my pocket because I could take them out of my pocket and count them. To have an ability of the relevant kind, I must be able to infer the belief from other beliefs that I already have without gaining any new information. I hope that it is also clear that, when I write about needing "an inferential ability", I am not referring to a general ability to draw just any old inference, or any inference of a certain form. What is at issue is the ability to infer the specific moral belief from other beliefs.

8. The stronger claim is also needed for moral intuitionism to contrast with its traditional opponent, moral coherentism, since coherentists do not claim that believers must actually draw inferences in order to be justified.

9. Confirmation need not always be evidence, since I want confirmation to include defeater defeaters, that is,

reasons to discount what would otherwise keep a belief from being justified.

10. One additional principle might claim that confirmation is needed when errors are costly. This principle applies to moral beliefs insofar as moral errors are costly.

11. These cases originate from Foot 1967. If such cases seem unrealistic, see the real case at www.cnn.com/2003/US/West/06/21/train.derail.ap/index.html.

12. For more evidence of disagreement, see Haidt *et al.* 1993.

13. Compare Descarte's "I think," which is nowhere near enough to ground science. Notice also that I am talking about actual moral beliefs, not possible moral beliefs. There might be an infinite number of possible moral beliefs that would garner agreement from everyone who understands them. However, there still might be a high rate of disagreement among the actual moral beliefs that people bother to form. That is what matters when we ask whether our actual moral beliefs are justified.

14. Some intuitionists might claim agreement on qualified general principles, such as that it is morally wrong to kill anyone in a protected class without an adequate reason. Of course, those who accept this formula still disagree about which class is protected and which reasons are adequate. Similarly, although many people (today!) agree that all moral agents deserve respect, different people count different acts as violating that rule by showing disrespect. It is not clear whether to count agreement on such indeterminate formulas as real moral agreement. See Snare 1980.

15. According to Bayesians, if the temperature feels to us as if it is about 70 degrees, so we start with that assumption, then the fact that this thermometer reads 77 degrees should make us move our estimate towards 77 degrees. How much our estimate should increase depends on our prior assumption about how many thermometers work. This might make it seem as if the thermometer reading can lead to justified belief. However, if our initial estimates (about temperature and the percentage of working thermometers) are unjustified, then I doubt that one reading can ground justified belief. Besides, many of us do not form any of the initial estimates that are needed to start Bayesian reasoning.

16. See also Haidt 2001. Of course, many other judgments cause emotional reactions "suddenly and effortlessly." But Haidt argues that emotions drive or constitute moral judgments rather than being effects of those judgments.

17. It would be interesting to test reactions to negations, such as "They did not hang an innocent" and "He did not lick the dirty toilet."

18. This article also reports timing studies that confirm the different roles of emotion in different moral beliefs.

19. Philosophers should notice that what Greene calls "personal dilemmas" include most proposed counterexamples to consequentialism. If those intuitions are unjustified, then Greene's study might help consequentialists defend their moral theory, even if other intuitions are not affected.

20. Unfortunately, Unger does not describe the method or precise results of his informal survey, so there is room for more careful empirical work to test his claims. Some philosophical support comes from moral paradoxes, which often arise through the mechanisms that Unger describes. One example is the mere addition paradox of Parfit 1984, in which B seems worse than A when the two are compared directly, but it seems not worse than A when Parfit interjects A+ and Divided B as options intermediate between A and B.

21. Kahneman *et al.* 1982. Lackcy 1986: 634, suggests how such heuristics might explain conflicting moral intuitions about nuclear deterrence.

22. Van Roojen might admit that Horowitz's argument undermines moral intuitionism, since he defends a method of reflective equilibrium that is coherentist rather than foundationalist.

23. I am not, of course, endorsing Nietzsche's speculations.

24. I do not claim that moral judgments are the only ones that need confirmation according to Principles 1–5. Several of these principles also apply to beliefs about what is prudent, rational, wise, and beautiful.

25. See Sinnott–Armstrong 2006. My version of Pyrrhonism denies that any particular contrast class is the relevant one in the sense that believers need to rule out all alternatives in that class in order to be justified without qualification. That view might seem to conflict with my claim here that moral beliefs need inferential confirmation. However, there might be no need to rule out any particular contrast class, even if there is a need to give evidence of a certain kind.

References

Baron, J. (1994). "Nonconsequentialist Decisions." *Behavioral and Brain Sciences,* 17: 1–42.

Foot, Philippa (1967). "The Problem of Abortion and the Doctrine of Double Effect." *Oxford Review,* 5: 5–15.

Goldman, A. (1976). "Discrimination and Perceptual Knowledge." *Journal of Philosophy,* 73: 771–91.

Greene, J., et al. (2001). "An fMRI Investigation of Emotional Engagement in Moral Judgment." *Science,* 293: 2105–8.

——— and Haidt, J. (2002). "How (and Where) does Moral Judgment Work?" *Trends in Cognitive Science,* 6: 517–23.

——— et al. (2004). "The Neural Bases of Cognitive Conflict and Control in Moral Judgment." *Neuron,* 44: 389–400.

Haidt, J. (2001). "The Emotional Dog and its Rational Tail: A Social Intuitionist Approach to Moral Judgment." *Psychological Review,* 108: 814–34.

——— et al. (1993). "Affect, Culture, and Morality, or is it Wrong to Eat Your Dog?" *Journal of Personality and Social Psychology,* 65: 613–28.

Harman, G. (1977). *The Nature of Morality.* New York: Oxford University Press.

Horowitz, T. (1998). "Philosophical Intuitions and Psychological Theory." In M. DePaul and W. Ramsey (eds.), *Rethinking Intuition: The Psychology of Intuition and its Role in Philosophical Inquiry.* Lanham, Md.: Rowman & Littlefield.

Kahneman, D., Slovic, P., and Tversky, A. (eds.) (1982). *Judgment under Uncertainty: Heuristics and Biases.* Cambridge: Cambridge University Press.

——— and Tversky, A. (1979). "Prospect Theory: An Analysis of Decision under Risk." *Econometrica,* 47/2: 263–92.

Lackey, D. (1986). "Taking Risk Seriously." *Journal of Philosophy,* 83: 633–40.

Moll, J., et al. (2001). "Frontopolar and Anterior Temporal Cortex Activation in a Moral Judgment Task: Preliminary Functional MRI results in Normal Subjects." *Arq. Neuropsiquiatr,* 59: 657–64.

——— et al. (2002*a*). "Functional Networks in Emotional Moral and Nonmoral Social Judgments." *Neuroimage,* 16: 696–703.

——— et al. (2002*b*). "The Neural Correlates of Moral Sensitivity: A Functional Magnetic Resonance Imaging Investigation of Basic and Moral Emotions." *Journal of Neuroscience,* 22: 2730–6.

Moore, G. E. (1903). *Principia Ethica.* Cambridge: Cambridge University Press.

Nietzsche, F. (1966). *Genealogy of Morals.* In *Basic Writings of Nietzsche,* ed. and trans. W. Kaufmann. New York: Random House.

Parfit, D. (1984). *Reasons and Persons.* Oxford: Clarendon Press.

Quinn, W. (1993). "Actions, Intentions, and Consequences: The Doctrine of Doing and Allowing," repr. in *Morality and Action.* New York: Cambridge University Press.

Ross, W. D. (1930). *The Right and the Good.* Oxford: Oxford University Press.

Scheffler, S. (1982). *The Rejection of Consequentialism.* Oxford: Clarendon Press.

Sinnott-Armstrong, W. (1996). "Moral Skepticism and Justification." In W. Sinnott-Armstrong and M. Timmons (eds.), *Moral Knowledge?* New York: Oxford University Press.

——— (2000). "From "Is" to "Ought" in Moral Epistemology." *Argumentation,* 14: 159–74.

——— (2002*a*). "Moral Skepticism," in Edward N. Zalta (ed.), *The Stanford Encyclopedia of Philosophy* (Summer 2002 edn.), http://plato.stanford.edu/archives/sum2002/entries/skepticism-moral/.

——— (2002*b*). "Moral Relativity and Intuitionism." *Philosophical Issues,* Realism and Relativism, 12: 305–28.

——— (2006). *Moral Skepticism.* New York: Oxford University Press.

Snare, F. (1980). "The Diversity of Morals." *Mind,* 89: 353–69.

Unger, P. (1996). *Living High and Letting Die.* New York: Oxford University Press.

van Roojen, M. (1999). "Reflective Moral Equilibrium and Psychological Theory." *Ethics,* 109: 846–57.

Wheatley, T., and Haidt, J. (2005). "The Wisdom of Repugnance: Hypnotically-Induced Disgust Makes Moral Judgments More Severe" (unpublished manuscript, University of Virginia).

Study Questions

1. Have you ever abandoned your intuition when others disagree with you?

2. Do you believe that the order in which questions are asked may affect the answers given?

3. Have you ever found that your intuition about a person's character turns out to be mistaken?

4. Is your intuition dependable?

43

MARY MIDGLEY

Some claim that the search for universal answers to moral questions is futile because morality differs from one culture to another. This view, sometimes referred to as "cultural relativism," maintains that while we can seek understanding of a particular culture's moral system, we have no basis for judging it, for morality is only a matter of custom. Mary Midgley, who was Senior Lecturer in Philosophy at Newcastle University in England, argues against cultural relativism, maintaining that moral reasoning requires the possibility of judging the practices of other cultures.

Trying Out One's New Sword

All of us are, more or less, in trouble today about trying to understand cultures strange to us. We hear constantly of alien customs. We see changes in our lifetime which would have astonished our parents. I want to discuss here one very short way of dealing with this difficulty, a drastic way which many people now theoretically favour. It consists in simply denying that we can ever understand any culture except our own well enough to make judgements about it. Those who recommend this hold that the world is sharply divided into separate societies, sealed units, each with its own system of thought. They feel that the respect and tolerance due from one system to another forbids us ever to take up a critical position to any other culture. Moral judgement, they suggest, is a kind of coinage valid only in its country of origin.

I shall call this position "moral isolationism." I shall suggest that it is certainly not forced upon us, and indeed that it makes no sense at all. People usually take it up because they think it is a respectful attitude to other cultures. In fact, however, it is not respectful. Nobody can respect what is entirely unintelligible to them. To respect someone, we have to know enough about him to make a *favourable* judgement, however general and tentative. And we do understand people in other cultures to this extent. Otherwise a great mass of our most valuable thinking would be paralysed.

To show this, I shall take a remote example, because we shall probably find it easier to think calmly about it than we should with a contemporary one, such as female circumcision in Africa or the Chinese Cultural Revolution. The principles involved will still be the same. My example is this. There is, it seems, a verb in classical Japanese which means "to try out one's new sword on a chance wayfarer." (The word is *tsujigiri*, literally "crossroads-cut.") A samurai sword had to be tried out because, if it was to work properly, it had to slice through someone at a single blow, from the shoulder to the opposite flank.

From Mary Midgley, *Heart and Mind: The Varieties of Moral Experience*. Routledge, 2003. Reprinted by permission of Taylor & Francis.

Otherwise, the warrior bungled his stroke. This could injure his honour, offend his ancestors, and even let down his emperor. So tests were needed, and wayfarers had to be expended. Any wayfarer would do—provided, of course, that he was not another Samurai. Scientists will recognize a familiar problem about the rights of experimental subjects.

Now when we hear of a custom like this, we may well reflect that we simply do not understand it; and therefore are not qualified to criticize it at all, because we are not members of that culture. But we are not members of any other culture either, except our own. So we extend the principle to cover all extraneous cultures, and we seem therefore to be moral isolationists. But this is, as we shall see, an impossible position. Let us ask what it would involve.

We must ask first: Does the isolating barrier work both ways? Are people in other cultures equally unable to criticize *us*? This question struck me sharply when I read a remark in *The Guardian* by an anthropologist about a South American Indian who had been taken into a Brazilian town for an operation, which saved his life. When he came back to his village, he made several highly critical remarks about the white Brazilians' way of life. They may very well have been justified. But the interesting point was that the anthropologist called these remarks "a damning indictment of Western civilization." Now the Indian had been in that town about two weeks. Was he in a position to deliver a damning indictment? Would we ourselves be qualified to deliver such an indictment on the Samurai, provided we could spend two weeks in ancient Japan? What do we really think about this?

My own impression is that we believe that outsiders can, in principle, deliver perfectly good indictments—only, it usually takes more than two weeks to make them damning. Understanding has degrees. It is not a slapdash yes-or-no matter. Intelligent outsiders can progress in it, and in some ways will be at an advantage over the locals. But if this is so, it must clearly apply to ourselves as much as anybody else.

Our next question is this: Does the isolating barrier between cultures block praise as well as blame? If I want to say that the Samurai culture has many virtues, or to praise the South American Indians, am I prevented from doing *that* by my outside status? Now, we certainly do need to praise other societies in this way. But it is hardly possible that we could praise them effectively if we could not, in principle, criticize them. Our praise would be worthless if it rested on no definite grounds, if it did not flow from some understanding. Certainly we may need to praise things which we do not *fully* understand. We say "there's something very good here, but I can't quite make out what it is yet." This happens when we want to learn from strangers. And we can learn from strangers. But to do this we have to distinguish between those strangers who are worth learning from and those who are not. Can we then judge which is which?

This brings us to our third question: What is involved in judging? Now plainly there is no question here of sitting on a bench in a red robe and sentencing people. Judging simply means forming an opinion, and expressing it if it is called for. Is there anything wrong about this? Naturally, we ought to avoid forming—and expressing—*crude* opinions, like that of a simpleminded missionary, who might dismiss the whole Samurai culture as entirely bad, because non-Christian. But this is a different objection. The trouble with crude opinions is that they are crude, whoever forms them, not that they are formed by the wrong people.

Anthropologists, after all, are outsiders quite as much as missionaries. Moral isolationism forbids us to form *any* opinions on these matters. Its ground for doing so is that we don't understand them. But there is much that we don't understand in our own culture too. This brings us to our last question: If we can't judge other cultures, can we really judge our own? Our efforts to do so will be much damaged if we are really deprived of our opinions about other societies, because these provide the range of comparison, the spectrum of alternatives against which we set what we want to understand. We would have to stop using the mirror which anthropology so helpfully holds up to us.

In short, moral isolationism would lay down a general ban on moral reasoning. Essentially, this is

the programme of immoralism, and it carries a distressing logical difficulty. Immoralists like Nietzsche are actually just a rather specialized sect of moralists. They can no more afford to put moralizing out of business than smugglers can afford to abolish customs regulations. The power of moral judgement is, in fact, not a luxury, not a perverse indulgence of the self-righteous. It is a necessity. When we judge something to be bad or good, better or worse than something else, we are taking it as an example to aim at or avoid. Without opinions of this sort, we would have no framework of comparison for our own policy, no chance of profiting by other people's insights or mistakes. In this vacuum, we could form no judgements on our own actions.

Now it would be odd if *Homo sapiens* had really got himself into a position as bad as this—a position where his main evolutionary asset, his brain, was so little use to him. None of us is going to accept this sceptical diagnosis. We cannot do so, because our involvement in moral isolationism does not flow from apathy, but from a rather acute concern about human hypocrisy and other forms of wickedness. But we polarize that concern around a few selected moral truths. We are rightly angry with those who despise, oppress or steamroll other cultures. We think that doing these things is actually *wrong*. But this is itself a moral judgement. We could not condemn oppression and insolence if we thought that all our condemnations were just a trivial local quirk of our own culture. We could still less do it if we tried to stop judging altogether.

Real moral scepticism, in fact, could lead only to inaction, to our losing all interest in moral questions, most of all in those which concern other societies. When we discuss these things, it becomes instantly clear how far we are from doing this.

Suppose, for instance, that I criticize the bisecting Samurai, that I say his behaviour is brutal. What will usually happen next is that someone will protest, will say that I have no right to make criticisms like that of another culture. But it is most unlikely that he will use this move to end the discussion of the subject. Instead, he will justify the Samurai. He will try to fill in the background, to make me understand the custom, by explaining the exalted ideals of discipline and devotion which produced it. He will probably talk of the lower value which the ancient Japanese placed on individual life generally. He may well suggest that this is a healthier attitude than our own obsession with security. He may add, too, that the wayfarers did not seriously mind being bisected, that in principle they accepted the whole arrangement.

Now an objector who talks like this is implying that it *is* possible to understand alien customs. That is just what he is trying to make me do. And he implies, too, that if I do succeed in understanding them, I shall do something better than giving up judging them. He expects me to change my present judgement to a truer one—namely, one that is favourable. And the standards I must use to do this cannot just be Samurai standards. They have to be ones current in my own culture. Ideals like discipline and devotion will not move anybody unless he himself accepts them. As it happens, neither discipline nor devotion is very popular in the West at present. Anyone who appeals to them may well have so do some more arguing to make *them* acceptable, before he can use them to explain the Samurai. But if he does succeed here, he will have persuaded us, not just that there was something to be said for them in ancient Japan, but that there would be here as well.

Isolating barriers simply cannot arise here. If we accept something as a serious moral truth about one culture, we can't refuse to apply it—in however different an outward form—to other cultures as well, wherever circumstance admit it. If we refuse to do this, we just are not taking the other culture seriously.

This becomes clear if we look at the last argument used by my objector—that of justification by consent of the victim. It is suggested that sudden bisection is quite in order, *provided* that it takes place between consenting adults. I cannot now discuss how conclusive this justification is. What I am pointing out is simply that it can only work if we believe that *consent* can make such a transaction respectable—and this is a thoroughly modern and Western idea. It would probably never occur to a Samurai: if it did, it would surprise him very much. It is *our* standard.

In applying it, too, we are likely to make another typically Western demand. We shall ask for good factual evidence that the wayfarers actually do have this rather surprising taste—that they are really willing to be bisected. In applying Western standards in this way, we are not being confused or irrelevant. We are asking the questions which arise *from where we stand,* questions which we can see the sense of. We do this because asking questions which you can't see the sense of is humbug. Certainly we can extend our questioning by imaginative effort. We can come to understand other societies better. By doing so, we may make their questions our own, or we may see that they are really forms of the questions which we are asking already. This is not impossible. It is just very hard work. The obstacles which often prevent it are simply those of ordinary ignorance, laziness and prejudice.

If there were really an isolating barrier, of course, our own culture could never have been formed. It is no sealed box, but a fertile jungle of different influences—Greek, Jewish, Roman, Norse, Celtic and so forth, into which further influences are still pouring—American, Indian, Japanese, Jamaican, you name it. The moral isolationist's picture of separate, unmixable cultures is quite unreal. People who talk about British history usually stress the value of this fertilizing mix, no doubt rightly. But this is not just an odd fact about Britain. Except for the very smallest and most remote, all cultures are formed out of many streams. All have the problem of digesting and assimilating things which, at the start, they do not understand. All have the choice of learning something from this challenge, or, alternatively, of refusing to learn, and fighting it mindlessly instead.

This universal predicament has been obscured by the fact that anthropologists used to concentrate largely on very small and remote cultures, which did not seem to have this problem. These tiny societies, which had often forgotten their own history, made neat, self-contained subjects for study.

No doubt it was valuable to emphasize their remoteness, their extreme strangeness, their independence of our cultural tradition. This emphasis was, I think, the root of moral isolationism. But, as the tribal studies themselves showed, even there the anthropologists were able to interpret what they saw and make judgements—often favourable—about the tribesmen. And the tribesmen, too, were quite equal to making judgements about the anthropologists—and about the tourists and Coca-Cola salesmen who followed them. Both sets of judgements, no doubt, were somewhat hasty, both have been refined in the light of further experience. A similar transaction between us and the Samurai might take even longer. But that is no reason at all for deeming it impossible. Morally as well as physically, there is only one world, and we all have to live in it.

Study Questions

1. What does Midgley mean by "moral isolationism"?

2. Are those opposed to our judging other cultures equally opposed to other cultures judging ours?

3. Do those who live in a culture necessarily understand it better than those who don't live in that culture?

4. If criticisms of other cultures are always inappropriate, can praise of other cultures ever be appropriate?

44

JAMES RACHELS

According to psychological egoism, all human behavior is motivated only by self-interest. According to ethical egoism, even if we could act in the interest of others, we ought not do so but should be concerned only with ourselves. James Rachels (1941–2003), who was Professor of Philosophy at the University of Alabama at Birmingham, examined psychological and ethical egoism, concluding that neither is acceptable. He emphasized that selfishness should not be confused with self-interest, that actions may be done from neither self-interest nor other-regarding motives, and that a concern for one's own welfare is not incompatible with concern for the welfare of others.

Egoism and Moral Skepticism

1. Our ordinary thinking about morality is full of assumptions that we almost never question. We assume, for example, that we have an obligation to consider the welfare of other people when we decide what actions to perform or what rules to obey; we think that we must refrain from acting in ways harmful to others, and that we must respect their rights and interests as well as our own. We also assume that people are in fact capable of being motivated by such considerations, that is, that people are not wholly selfish and that they do sometimes act in the interests of others.

Both of these assumptions have come under attack by moral sceptics, as long ago as by Glaucon in Book II of Plato's *Republic*. Glaucon recalls the legend of Gyges, a shepherd who was said to have found a magic ring in a fissure opened by an earthquake. The ring would make its wearer invisible and thus would enable him to go anywhere and do anything undetected. Gyges used the power of the ring to gain entry to the Royal Palace, where he seduced the Queen, murdered the King, and subsequently seized the throne. Now Glaucon asks us to imagine that there are two such rings, one given to a man of virtue and one given to a rogue. The rogue, of course, will use his ring unscrupulously and do anything necessary to increase his own wealth and power. He will recognize no moral constraints on his conduct, and, since the cloak of invisibility will protect him from discovery, he can do anything he pleases without fear of reprisal. So, there will be no end to the mischief he will do. But how will the so-called virtuous man behave? Glaucon suggests that he will behave no better than the rogue: "No one, it is commonly believed, would have such iron strength of mind as to stand fast in doing right or keep his hands off other men's goods, when he could go to the market-place and fearlessly help himself to anything he wanted, enter houses and sleep with any woman he chose, set prisoners free and kill men at his pleasure, and in a word go about among men with the powers of a god. He would behave no better than the other; both would take the same course."[1] Moreover, why

shouldn't he? Once he is freed from the fear of reprisal, why shouldn't a man simply do what he pleases, or what he thinks is best for himself? What reason is there for him to continue being "moral" when it is clearly not to his own advantage to do so?

These sceptical views suggested by Glaucon have come to be known as *psychological egoism* and *ethical egoism,* respectively. Psychological egoism is the view that all men are selfish in everything that they do, that is, that the only motive from which anyone ever acts is self-interest. On this view, even when men are acting in ways apparently calculated to benefit others, they are actually motivated by the belief that acting in this way is to their own advantage, and if they did not believe this, they would not be doing that action. Ethical egoism is, by contrast, a normative view about how men *ought* to act. It is the view that, regardless of how men do in fact behave, they have no obligation to do anything except what is in their own interests. According to ethical egoists, a person is always justified in doing whatever is in his own interests, regardless of the effect on others.

Clearly, if either of these views is correct, then "the moral institution of life" (to use Butler's well-turned phrase) is very different than what we normally think. The majority of mankind is grossly deceived about what is, or ought to be, the case, where morals are concerned.

2. Psychological egoism seems to fly in the face of the facts. We are tempted to say, "Of course people act unselfishly all the time. For example, Smith gives up a trip to the country, which he would have enjoyed very much, in order to stay behind and help a friend with his studies, which is a miserable way to pass the time. This is a perfectly clear case of unselfish behavior, and if the psychological egoist thinks that such cases do not occur, then he is just mistaken." Given such obvious instances of "unselfish behavior," what reply can the egoist make? There are two general arguments by which he might try to show that all actions, including those such as the one just outlined, are in fact motivated by self-interest. Let us examine these in turn:

a. The first argument goes as follows: If we describe one person's action as selfish, and another person's action as unselfish, we are overlooking the crucial fact that in both cases, assuming that the action is done voluntarily, *the agent is merely doing what he most wants to do.* If Smith stays behind to help his friend, that only shows that he wanted to help his friend more than he wanted to go to the country. And why should he be praised for his "unselfishness" when he is only doing what he most wants to do? So, since Smith is only doing what he wants to do, he cannot be said to be acting unselfishly.

This argument is so bad that it would not deserve to be taken seriously except for the fact that so many otherwise intelligent people have been taken in by it. First, the argument rests on the premise that people never voluntarily do anything except what they want to do. But this is patently false; there are at least two classes of actions that are exceptions to this generalization. One is the set of actions which we may not want to do, but which we do anyway as a means to an end which we want to achieve, for example, going to the dentist in order to stop a toothache, or going to work every day in order to be able to draw our pay at the end of the month. These cases may be regarded as consistent with the spirit of the egoist argument, however, since the ends mentioned are wanted by the agent. But the other set of actions are those which we do, not because we want to, nor even because there is an end which we want to achieve, but because we feel ourselves *under an obligation* to do them. For example, someone may do something because he has promised to do it, and thus feels obligated, even though he does not want to do it. It is sometimes suggested that in such cases we do the action because, after all, we want to keep our promises; so, even here, we are doing what we want. However, this dodge will not work: if I have promised to do something, and if I do not want to do it, then it is simply false to say that I want to keep my promise. In such cases we feel a conflict precisely because we do *not* want to do what we feel obligated to do. It is reasonable to think that Smith's action falls roughly into this second category: he might stay behind, not because he wants to, but because he feels that this friend needs help.

But suppose we were to concede, for the sake of the argument, that all voluntary action is motivated by the agent's wants, or at least that Smith is so motivated. Even if this were granted, it would not follow

that Smith is acting selfishly or from self-interest. For if Smith wants to do something that will help his friend, even when it means forgoing his own enjoyments, that is precisely what makes him *un*selfish. What else could unselfishness be, if not wanting to help others? Another way to put the same point is to say that it is the *object* of a want that determines whether it is selfish or not. The mere fact that I am acting on *my* wants does not mean that I am acting selfishly; that depends on *what it is* that I want. If I want only my own good, and care nothing for others, then I am selfish; but if I also want other people to be well-off and happy, and if I act on *that* desire, then my action is not selfish. So much for this argument.

b. The second argument for psychological egoism is this: Since so-called unselfish actions always produce a sense of self-satisfaction in the agent,[2] and since this sense of satisfaction is a pleasant state of consciousness, it follows that the point of the action is really to achieve a pleasant state of consciousness, rather than to bring about any good for others. Therefore, the action is "unselfish" only at a superficial level of analysis. Smith will feel much better with himself for having stayed to help his friend—if he had gone to the country, he would have felt terrible about it—and that is the real point of the action. According to a well-known story, this argument was once expressed by Abraham Lincoln:

> Mr. Lincoln once remarked to a fellow-passenger on an old-time mud-coach that all men were prompted by selfishness in doing good. His fellow-passenger was antagonizing this position when they were passing over a corduroy bridge that spanned a slough. As they crossed this bridge they espied an old razor-backed sow on the bank making a terrible noise because her pigs had got into the slough and were in danger of drowning. As the old coach began to climb the hill. Mr. Lincoln called out, "Driver, can't you stop just a moment?" Then Mr. Lincoln jumped out, ran back, and lifted the little pigs out of the mud and water and placed them on the bank. When he returned, his companion remarked: "Now, Abe, where does selfishness come in on this little episode?" "Why, bless your soul, Ed, that was the very essence of selfishness. I should have had no peace of mind all day had I gone on and left that suffering old sow worrying over those pigs. I did it to get peace of mind, don't you see?"[3]

This argument suffers from defects similar to the previous one. Why should we think that merely because someone derives satisfaction from helping others this makes him selfish? Isn't the unselfish man precisely the one who *does* derive satisfaction from helping others, while the selfish man does not? If Lincoln "got peace of mind" from rescuing the piglets, does this show him to be selfish, or, on the contrary, doesn't it show him to be compassionate and good-hearted? (If a man were truly selfish, why should it bother his conscience that *others* suffer—much less pigs?) Similarly, it is nothing more than shabby sophistry to say, because Smith takes satisfaction in helping his friend, that he is behaving selfishly. If we say this rapidly, while thinking about something else, perhaps it will sound all right; but if we speak slowly, and pay attention to what we are saying, it sounds plain silly.

Moreover, suppose we ask *why* Smith derives satisfaction from helping his friend. The answer will be, it is because Smith cares for him and wants him to succeed. If Smith did not have these concerns, then he would take no pleasure in assisting him; and these concerns, as we have already seen, are the marks of unselfishness, not selfishness. To put the point more generally: if we have a positive attitude toward the attainment of some goal, then we may derive satisfaction from attaining that goal. But the *object* of our attitude is *the attainment of that goal*; and we must want to attain the goal *before* we can find any satisfaction in it. We do not, in other words, desire some sort of "pleasurable consciousness" and then try to figure out how to achieve it; rather, we desire all sorts of different things—money, a new fishing boat, to be a better chess player, to get a promotion in our work, etc.—and because we desire these things, we derive satisfaction from attaining them. And so, if someone desires the welfare and happiness of another person, he will derive satisfaction from that; but this does not mean that this satisfaction is the object of his desire, or that he is in any way selfish on account of it.

It is a measure of the weakness of psychological egoism that these insupportable arguments are the ones most often advanced in its favor. Why, then, should anyone ever have thought it a true view? Perhaps because of a desire for theoretical simplicity: In thinking about human conduct, it would be nice if there were some simple formula that would unite the

diverse phenomena of human behavior under a single explanatory principle, just as simple formulae in physics bring together a great many apparently different phenomena. And since it is obvious that self-regard is an overwhelmingly important factor in motivation, it is only natural to wonder whether all motivation might not be explained in these terms. But the answer is clearly No; while a great many human actions are motivated entirely or in part by self-interest, only by a deliberate distortion of the facts can we say that all conduct is so motivated. This will be clear, I think, if we correct three confusions which are commonplace. The exposure of these confusions will remove the last traces of plausibility from the psychological egoist thesis.

The first is the confusion of selfishness with self-interest. The two are clearly not the same. If I see a physician when I am feeling poorly, I am acting in my own interest but no one would think of calling me "selfish" on account of it. Similarly, brushing my teeth, working hard at my job, and obeying the law are all in my self-interest but none of these are examples of selfish conduct. This is because selfish behavior is behavior that ignores the interests of others, in circumstances in which their interests ought not to be ignored. This concept has a definite evaluative flavor; to call someone "selfish" is not just to describe his action but to condemn it. Thus, you would not call me selfish for eating a normal meal in normal circumstances (although it may surely be in my self-interest); but you would call me selfish for hoarding food while others about are starving.

The second confusion is the assumption that every action is done *either* from self-interest or from other-regarding motives. Thus, the egoist concludes that if there is no such thing as genuine altruism then all actions must be done from self-interest. But this is certainly a false dichotomy. The man who continues to smoke cigarettes, even after learning about the connection between smoking and cancer, is surely not acting from self-interest, not even by his own standards—self-interest would dictate that he quit smoking at once—and he is not acting altruistically either. He *is,* no doubt, smoking for the pleasure of it, but all that this shows is that undisciplined pleasure-seeking and acting from self-interest are very different. This is what led Butler to remark that "the thing to be

lamented is, not that men have so great regard to their own good or interest in the present world, for they have not enough."[4]

The last two paragraphs show (*a*) that it is false that all actions are selfish, and (*b*) that it is false that all actions are done out of self-interest. And it should be noted that these two points can be made, and were, without any appeal to putative examples of altruism.

The third confusion is the common but false assumption that a concern for one's own welfare is incompatible with any genuine concern for the welfare of others. Thus, since it is obvious that everyone (or very nearly everyone) does desire his own well-being, it might be thought that no one can really be concerned with others. But again, this is false. There is no inconsistency in desiring that everyone, including oneself *and* others, be well-off and happy. To be sure, it may happen on occasion that our own interests conflict with the interests of others, and in these cases we will have to make hard choices. But even in these cases we might sometimes opt for the interests of others, especially when the others involved are our family or friends. But more importantly, not all cases are like this: sometimes we are able to promote the welfare of others when our own interests are not involved at all. In these cases not even the strongest self-regard need prevent us from acting considerately toward others.

Once these confusions are cleared away, it seems to me obvious enough that there is no reason whatever to accept psychological egoism. On the contrary, if we simply observe people's behavior with an open mind, we may find that a great deal of it is motivated by self-regard, but by no means all of it; and that there is no reason to deny that "the moral institution of life" can include a place for the virtue of beneficence.[5]

3. The ethical egoist would say at this point, "Of course it is possible for people to act altruistically, and perhaps many people do act that way—but there is no reason why they *should* do so. A person is under no obligation to do anything except what is in his own interests."[6] This is really quite a radical doctrine. Suppose I have an urge to set fire to some public building (say, a department store) just for the fascination of watching the spectacular blaze: according to this view, the fact that several people might be burned to death provides no reason

whatever why I should not do it. After all, this only concerns *their* welfare, not my own, and according to the ethical egoist the only person I need think of is myself.

Some might deny that ethical egoism has any such monstrous consequences. They would point out that it is really to my own advantage not to set the fire—for, if I do that I may be caught and put into prison (unlike Gyges, I have no magic ring for protection). Moreover, even if I could avoid being caught it is still to my advantage to respect the rights and interests of others, for it is to my advantage to live in a society in which people's rights and interests are respected. Only in such a society can I live a happy and secure life, so, in acting kindly toward others, I would merely be doing my part to create and maintain the sort of society which it is to my advantage to have.[7] Therefore, it is said, the egoist would not be such a bad man; he would be as kindly and considerate as anyone else, because he would see that it is to his own advantage to be kindly and considerate.

This is a seductive line of thought, but it seems to me mistaken. Certainly it is to everyone's advantage (including the egoist's) to preserve a stable society where people's interests are generally protected. But there is no reason for the egoist to think that merely because *he* will not honor the rules of the social game, decent society will collapse. For the vast majority of people are not egoists, and there is no reason to think that they will be converted by his example—especially if he is discreet and does not unduly flaunt his style of life. What this line of reasoning shows is not that the egoist himself must act benevolently, but that he must encourage *others* to do so. He must take care to conceal from public view his own self-centered method of decision making, and urge others to act on precepts very different from those on which he is willing to act.

The rational egoist, then, cannot advocate that egoism be universally adopted by everyone. For he wants a world in which his own interests are maximized; and if other people adopted the egoistic policy of pursuing their own interests to the exclusion of his interests, as he pursues his interests to the exclusion of theirs, then such a world would be impossible. So he himself will be an egoist, but he will want others to be altruists.

This brings us to what is perhaps the most popular "refutation" of ethical egoism current among philosophical writers—the argument that ethical egoism is at bottom inconsistent because it cannot be universalized.[8] The argument goes like this:

To say that any action or policy of action is *right* (or that it *ought* to be adopted) entails that it is right for *anyone* in the same sort of circumstances. I cannot, for example, say that it is right for me to lie to you, and yet object when you lie to me (provided, of course, that the circumstances are the same). I cannot hold that it is all right for me to drink your beer and then complain when you drink mine. This is just the requirement that we be consistent in our evaluations; it is a requirement of logic. Now it is said that ethical egoism cannot meet this requirement because, as we have already seen, the egoist would not want others to act in the same way that he acts. Moreover, suppose he *did* advocate the universal adoption of egoistic policies: he would be saying to Peter, "You ought to pursue your own interests even if it means destroying Paul"; and he would be saying to Paul, "You ought to pursue your own interests even if it means destroying Peter." The attitudes expressed in these two recommendations seem clearly inconsistent—he is urging the advancement of Peter's interest at one moment, and countenancing their defeat at the next. Therefore, the argument goes, there is no way to maintain the doctrine of ethical egoism as a consistent view about how we ought to act. We will fall into inconsistency whenever we try.

What are we to make of this argument? Are we to conclude that ethical egoism has been refuted? Such a conclusion, I think, would be unwarranted; for I think that we can show, contrary to this argument, how ethical egoism can be maintained consistently. We need only to interpret the egoist's position in a sympathetic way: we should say that he has in mind a certain kind of world which he would prefer over all others; it would be a world in which his own interests were maximized, regardless of the effects on the other people. The egoist's primary policy of action, then, would be to act in such a way as to bring about, as nearly as possible, this sort of world. Regardless of however morally reprehensible we might find it, there is nothing *inconsistent* in someone's adopting this as

his ideal and acting in a way calculated to bring it about. And if someone did adopt this as his ideal, then he would not advocate universal egoism; as we have already seen, he would want other people to be altruists. So, if he advocates any principles of conduct for the general public, they will be altruistic principles. This could not be inconsistent; on the contrary, it would be perfectly consistent with his goal of creating a world in which his own interests are maximized. To be sure, he would have to be deceitful; in order to secure the good will of others, and a favorable hearing for his exhortations to altruism, he would have to pretend that he was himself prepared to accept altruistic principles. But again, that would be all right; from the egoist's point of view, this would merely be a matter of adopting the necessary means to the achievement of his goal—and while we might not approve of this, there is nothing inconsistent about it. Again, it might be said, "He advocates one thing, but does another. Surely *that's* inconsistent." But it is not; for what he advocates and what he does are both calculated as means to an end (the *same* end, we might note); and as such, he is doing what is rationally required in each case. Therefore, contrary to the previous argument, there is nothing inconsistent in the ethical egoist's view. He cannot be refuted by the claim that he contradicts himself.

Is there, then, no way to refine the ethical egoist? If by "refute" we mean show that he has made some *logical* error, the answer is that there is not. However, there is something more that can be said. The egoist challenge to our ordinary moral convictions amounts to a demand for an explanation of why we should adopt certain policies of action, namely, policies in which the good of others is given importance. We can give an answer to this demand, albeit an indirect one. The reason one ought not to do actions that would hurt other people is other people would be hurt. The reason one ought to do actions that would benefit other people is other people would be benefited. This may at first seem like a piece of philosophical sleight-of-hand, but it is not. The point is that the welfare of human beings is something that most of us value *for its own sake,* and not merely for the sake of something else. Therefore, when *further* reasons are demanded for valuing the welfare of

human beings, we cannot point to anything further to satisfy this demand. It is not that we have no reason for pursuing these policies, but that our reason *is* that these policies are for the good of human beings.

So if we are asked, "Why shouldn't I set fire to this department store?" one answer would be, "Because if you do, people may be burned to death." This is a complete, sufficient reason which does not require qualification or supplementation of any sort. If someone seriously wants to know why this action shouldn't be done, that's the reason. If we are pressed further and asked the sceptical question, "But why shouldn't I do actions that will harm others?" we may not know what to say—but this is because the questioner has included in his question the very answer we would like to give: "Why shouldn't you do actions that will harm others? Because, doing those actions would harm others."

The egoist, no doubt, will not be happy with this. He will protest that *we* may accept this as a reason, but *he* does not. And here the argument stops: there are limits to what can be accomplished by argument, and if the egoist really doesn't care about other people—if he honestly doesn't care whether they are helped or hurt by his actions—then we have reached those limits. If we want to persuade him to act decently toward his fellow humans, we will have to make our appeal to such other attitudes as he does possess, by threats, bribes, or other cajolery. That is all that we can do.

Though some may find this situation distressing (we would like to be able to show that the egoist is just *wrong*), it holds no embarrassment for common morality. What we have come up against is simply a fundamental requirement of rational action, namely, that the existence of reasons for action always depends on the prior existence of certain attitudes in the agent. For example, the fact that a certain course of action would make the agent a lot of money is a reason for doing it only if the agent wants to make money; the fact that practicing at chess makes one a better player is a reason for practicing only if one wants to be a better player; and so on. Similarly, the fact that a certain action would help the agent is a reason for doing the action only if the agent cares about his own welfare, and the fact that an action would help others is a reason for doing it only if the agent cares about others.

In this respect ethical egoism and what we might call ethical altruism are in exactly the same fix: both require that the agent *care* about himself, or about other people, before they can get started.

So a nonegoist will accept "It would harm another person" as a reason not to do an action simply because he cares about what happens to that other person. When the egoist says that he does *not* accept that as a reason, he is saying something quite extraordinary. He is saying that he has no affection for friends or family, that he never feels pity or compassion, that he is the sort of person who can look on scenes of human misery with complete indifference, so long as he is not the one suffering. Genuine egoists, people who really don't care at all about anyone other than themselves, are rare. It is important to keep this in mind when thinking about ethical egoism; it is easy to forget just how fundamental to human psychological makeup the feeling of sympathy is. Indeed, a man without any sympathy at all would scarcely be recognizable as a man; and that is what makes ethical egoism such a disturbing doctrine in the first place.

4. There are, of course, many different ways in which the sceptic might challenge the assumptions underlying our moral practice. In this essay I have discussed only two of them, the two put forward by Glaucon in the passage that I cited from Plato's *Republic*. It is important that the assumptions underlying our moral practice should not be confused with particular judgments made within that practice. To defend one is not to defend the other. We may assume—quite properly, if my analysis has been correct—that the virtue of beneficence does, and indeed should, occupy an important place in "the moral institution of life"; and yet we may make constant and miserable errors when it comes to judging when and in what ways this virtue is to be exercised. Even worse, we may often be able to make accurate moral judgments, and know what we ought to do, but not do it. For these ills, philosophy alone is not the cure.

Notes

1. *The Republic of Plato,* translated by E. M. Cornford (Oxford, 1941), p. 45.

2. Or, as it is sometimes said, "It gives him a clear conscience," or "He couldn't sleep at night if he had done otherwise," or "He would have been ashamed of himself for not doing it," and so on.

3. Frank C. Sharp, *Ethics* (New York, 1928), pp. 74–75. Quoted from the Springfield (IL) *Monitor* in the *Outlook,* vol. 56, p. 1059.

4. *The Works of Joseph Butler,* edited by W. E. Gladstone (Oxford, 1896). vol. II, p. 26. It should be noted that most of the points I am making against psychological egoism were first made by Joseph Butler. Butler made all the important points; all that is left for us is to remember them.

5. The capacity for altruistic behavior is not unique to human beings. Some interesting experiments with rhesus monkeys have shown that these animals will refrain from operating a device for securing food if this causes other animals to suffer pain. See Jules H. Masserman, Stanley Wechkin, and William Terris. "'Altruistic' Behavior in Rhesus Monkeys," *American Journal of Psychiatry,* vol. 121 (1964), pp. 584–85.

6. I take this to be the view of Ayn Rand, insofar as I understand her confused doctrine.

7. Cf. Thomas Hobbes, *Leviathan* (London, 1651), chap. 17.

8. See, for example, Brian Medlin, "Ultimate Principles and Ethical Egoism," *Australasian Journal of Philosophy,* vol. 35 (1957), pp. 111–18; and D. H. Monro, *Empiricism and Ethics* (Cambridge, 1967), chap. 16.

Study Questions

1. Explain in your own words the distinction between psychological egoism and ethical egoism.

2. If you do what you want to do, are you being selfish?

3. Is a concern for yourself incompatible with a concern for others?

4. Is an ethical egoist self-defeating in urging everyone to act egoistically?

PART III

Contemporary Moral Problems

INTRODUCTION

Peter Singer

Peter Singer is Ira W. DeCamp Professor of Bioethics at Princeton University.

To an observer of moral philosophy in the twentieth century, the most striking development of the past twenty years would not be any advance in our theoretical understanding of the subject, nor would it be the acceptance of any particular ideas about right and wrong. It would, rather, be the revival of an entire department of the subject: applied ethics.

I use the term "revival" because applied ethics is not new to philosophy. . . . From Plato onwards moral philosophers have confronted practical questions, including suicide, the exposure of infants, the treatment of women, and the proper behaviour of public officials. . . . Christian philosophers like Augustine and Aquinas examined with great care such matters as when a war was just, whether it could ever be right to tell a lie, and if a Christian woman did wrong to commit suicide in order to save herself from rape. Hobbes, with the English Civil War freshly in mind, had an urgent practical purpose in writing about the moral basis of obedience to the sovereign. Practical concerns continued with Hume and then with the British utilitarians. Bentham's reforming zeal ranged over an incredible variety of topics, and Mill . . . wrote celebrated essays on liberty and on the subjection of women.

Despite this long tradition, for most of the present century moral philosophers kept aloof from practical ethics—a fact that becomes all the more remarkable if we consider the traumatic events through which most of them lived. . . .

Instead of taking up practical issues, moral philosophers limited themselves to the study of the nature of morality, or (in the heyday of linguistic philosophy) to the study of the meaning of moral judgements. This came to be known as "meta-ethics"—a term which signified that they were not actually *taking part* in ethics, but were engaged in a higher-level study *about* ethics. Normative ethics, the study of general theories about what is good and bad, right and wrong, was considered an important part of ethics until the 1930s. Then it too was relegated to a secondary concern, except for occasional discussions of utilitarianism and the different forms it might take.

Ordinary people—and no doubt students beginning their study of the subject— sometimes still harboured the illusion that moral philosophy could be of some use in deciding what we ought to do. Leading philosophers like A. J. Ayer soon put them right: "It is silly, as well as presumptuous, for any one type of philosopher to pose as the champion of virtue. And it is also one reason why many people find moral philosophy an unsatisfactory subject. For they mistakenly look to the moral philosopher for guidance."[1] C. D. Broad went to the trouble of offering reasons for the received wisdom: "It is no part of the professional business of moral philosophers to tell people what they ought or ought not to do. . . . Moral philosophers, as such, have no special information not available to the general public about what is right and what is wrong; nor have they any call to undertake those hortatory functions which are so adequately performed by clergymen, politicians, leader-writers [editorialists]. . . ."[2]

It may in part have been doubts about the adequacy of those to whom Broad refers which induced moral philosophers to take up practical questions; someone had to be able to do better than the clergy, politicians, and leader-writers! More importantly, those who nodded assent to views like Ayer's and Broad's had not stopped to ask whether moral philosophers could, without merely preaching, make an effective contribution to ethical dilemmas. Does expertise in moral philosophy equip one to clarify the muddy waters of popular moral debates? Does a knowledge of normative ethical theories make it possible to apply such theories to real ethical problems? Can such an application lead to more defensible positions on these questions? The possibility of an affirmative answer to such questions began to be widely recognized only during the 1960s, when first the American civil rights movement, and then the Vietnam war and the rise of student activism began to draw philosophers into discussions of moral issues: equality, justice, war, and civil disobedience. Philosophers who entered these debates as concerned citizens gradually realized that they were discussing ethical questions which were part of the philosophical tradition in which they had been educated. The skills they had acquired in studying and teaching philosophy were suddenly highly relevant. . . .

The broader community has willingly accepted the relevance and value of contributions by philosophers to practical issues—perhaps they too have not been entirely satisfied with the performance of the clergy, politicians, and leader-writers. This acceptance is particularly noticeable in bioethics, where new developments in medicine and the biological sciences throw up ethical questions which have few precedents. Thus it was no surprise when the British Government appointed a philosopher, Mary Warnock, to chair its Committee of Inquiry into Human Fertilisation and Embryology.[3] In several countries philosophers sit on ethics committees in universities, passing judgement on research involving human or animal experimentation, and in some hospitals they are members of committees which

advise on such matters as the withdrawal of treatment from comatose patients. In the Australian state of Victoria, there is now even a legislative requirement that medical experiments involving human embryos must be approved by a committee which includes, among other members, "a person holding a qualification in the study of philosophy."

Applied ethics has become part of the teaching of most philosophy departments in English-speaking universities, taking its place alongside meta-ethics and normative ethics. The climate of political radicalism and student activism from which applied ethics gained so much initial impetus has gone; but applied ethics continues to thrive. This should cause no surprise; it is testimony to the perennial importance of the issues discussed, and to the need for them to be discussed with the greatest possible clarity and rigour. Against the long history of philosophical involvement in practical ethical issues, it is the neglect of applied ethics in the earlier years of this century which should be regarded as surprising.

Notes

1. A. J. Ayer, "The Analysis of Moral Judgements" in *Philosophical Essays* (London, 1959), p. 246.

2. C. D. Broad, *Ethics and the History of Philosophy* (London, 1952), p. 244.

3. See the *Report of the Committee of Inquiry into Human Fertilisation and Embryology* (London, 1984).

45

JUDITH JARVIS THOMSON

Consider the argument that because a fetus is an innocent human being, and killing an innocent human being is always wrong, therefore abortion is always wrong. Some would respond by denying that the earliest embryo is a human person, but putting that issue aside, is killing an innocent human being always wrong? In an article that has given rise to much discussion, Judith Jarvis Thomson, Professor Emerita at the Massachusetts Institute of Technology, argues that while people have a right not to be killed unjustly, they do not have an unqualified right to life. Hence even if the human fetus is a person, abortion may remain morally permissible.

A Defense of Abortion

Most opposition to abortion relies on the premise that the fetus is a human being, a person, from the moment of conception. The premise is argued for, but, as I think, not well. Take, for example, the most common argument. We are asked to notice that the development of a human being from conception through birth into childhood is continuous; then it is said that to draw a line, to choose a point in this development and say "before this point the thing is not a person, after this point it is a person" is to make an arbitrary choice, a choice for which in the nature of things no good reason can be given. It is concluded that the fetus is, or anyway that we had better say it is, a person from the moment of conception. But this conclusion does not follow. Similar things might be said about the development of an acorn into an oak tree, and it does not follow that acorns are oak trees, or that we had better say they are. Arguments of this form are sometimes called "slippery slope arguments"—the phrase is perhaps self-explanatory—and it is dismaying that

opponents of abortion rely on them so heavily and uncritically.

I am inclined to agree, however, that the prospects for "drawing a line" in the development of the fetus look dim. I am inclined to think also that we shall probably have to agree that the fetus has already become a human person well before birth. Indeed, it comes as a surprise when one first learns how early in its life it begins to acquire human characteristics. By the tenth week, for example, it already has a face, arms and legs, fingers and toes; it has internal organs, and brain activity is detectable.[1] On the other hand, I think that the premise is false, that the fetus is not a person from the moment of conception. A newly fertilized ovum, a newly implanted clump of cells, is no more a person than an acorn is an oak tree. But I shall not discuss any of this. For it seems to me to be of great interest to ask what happens if, for the sake of argument, we allow the premise. How, precisely, are we supposed to get from there to the conclusion that abortion is morally

impermissible? Opponents of abortion commonly spend most of their time establishing that the fetus is a person, and hardly any time explaining the step from there to the impermissibility of abortion. Perhaps they think the step too simple and obvious to require much comment. Or perhaps instead they are simply being economical in argument. Many of those who defend abortion rely on the premise that the fetus is not a person, but only a bit of tissue that will become a person at birth; and why pay out more arguments than you have to? Whatever the explanation, I suggest that the step they take is neither easy nor obvious, that it calls for closer examination than it is commonly given, and that when we do give it this closer examination we shall feel inclined to reject it.

I propose, then, that we grant that the fetus is a person from the moment of conception. How does the argument go from here? Something like this, I take it. Every person has a right to life. So the fetus has a right to life. No doubt the mother has a right to decide what shall happen in and to her body; everyone would grant that. But surely a person's right to life is stronger and more stringent than the mother's right to decide what happens in and to her body, and so outweighs it. So the fetus may not be killed; an abortion may not be performed.

It sounds plausible. But now let me ask you to imagine this. You wake up in the morning and find yourself back to back in bed with an unconscious violinist. A famous unconscious violinist. He has been found to have a fatal kidney ailment, and the Society of Music Lovers has canvassed all the available medical records and found that you alone have the right blood type to help. They have therefore kidnapped you, and last night the violinist's circulatory system was plugged into yours, so that your kidneys can be used to extract poisons from his blood as well as your own. The director of the hospital now tells you, "Look, we're sorry the Society of Music Lovers did this to you—we would never have permitted it if we had known. But still, they did it, and the violinist now is plugged into you. To unplug you would be to kill him. But never mind, it's only for nine months. By then he will have recovered from his ailment, and can safely be unplugged from you." Is it morally incumbent on you to accede to this situation? No doubt it would be very nice of you if you did, a great kindness. But do you *have* to accede to it? What if it were not nine months, but nine years? Or longer still? What if the director of the hospital says, "Tough luck, I agree, but you've now got to stay in bed, with the violinist plugged into you, for the rest of your life. Because remember this. All persons have a right to life, and violinists are persons. Granted you have a right to decide what happens in and to your body, but a person's right to life outweighs your right to decide what happens in and to your body. So you cannot ever be unplugged from him." I imagine you would regard this as outrageous, which suggests that something really is wrong with the plausible-sounding argument I mentioned a moment ago.

In this case, of course, you were kidnapped; you didn't volunteer for the operation that plugged the violinist into your kidneys. Can those who oppose abortion on the ground I mentioned make an exception for a pregnancy due to rape? Certainly. They can say that persons have a right to life only if they didn't come into existence because of rape; or they can say that all persons have a right to life, but that some have less of a right to life than others, in particular, that those who came into existence because of rape have less. But these statements have a rather unpleasant sound. Surely the question of whether you have a right to life at all, or how much of it you have, shouldn't turn on the question of whether or not you are the product of a rape. And in fact the people who oppose abortion on the ground I mentioned do not make this distinction, and hence do not make an exception in case of rape.

Nor do they make an exception for a case in which the mother has to spend the nine months of her pregnancy in bed. They would agree that would be a great pity, and hard on the mother; but all the same, all persons have a right to life, the fetus is a person, and so on. I suspect, in fact, that they would not make an exception for a case in which, miraculously enough, the pregnancy went on for nine years, or even the rest of the mother's life.

Some won't even make an exception for a case in which continuation of the pregnancy is likely to shorten the mother's life; they regard abortion as impermissible even to save the mother's life. Such

cases are nowadays very rare, and many opponents of abortion do not accept this extreme view. All the same, it is a good place to begin: a number of points of interest come out in respect to it.

1. Let us call the view that abortion is impermissible even to save the mother's life "the extreme view." I want to suggest first that it does not issue from the argument I mentioned earlier without the addition of some fairly powerful premises. Suppose a woman has become pregnant, and now learns that she has a cardiac condition such that she will die if she carries the baby to term. What may be done for her? The fetus, being a person, has a right to life, but as the mother is a person too, so has she a right to life. Presumably they have an equal right to life. How is it supposed to come out that an abortion may not be performed? If mother and child have an equal right to life, shouldn't we perhaps flip a coin? Or should we add to the mother's right to life her right to decide what happens in and to her body, which everybody seems to be ready to grant—the sum of her rights now outweighing the fetus' right to life?

The most familiar argument here is the following. We are told that performing the abortion would be directly killing[2] the child, whereas doing nothing would not be killing the mother, but only letting her die. Moreover, in killing the child, one would be killing an innocent person, for the child has committed no crime, and is not aiming at his mother's death. And then there are a variety of ways in which this might be continued. (1) But as directly killing an innocent person is always and absolutely impermissible, an abortion may not be performed. Or, (2) as directly killing an innocent person is murder, and murder is always and absolutely impermissible, an abortion may not be performed.[3] Or, (3) as one's duty to refrain from directly killing an innocent person is more stringent than one's duty to keep a person from dying, an abortion may not be performed. Or, (4) if one's only options are directly killing an innocent person or letting a person die, one must prefer letting the person die, and thus an abortion may not be performed.[4]

Some people seem to have thought that these are not further premises which must be added if the conclusion is to be reached, but that they follow from the very fact that an innocent person has a right to life.[5] But this seems to me to be a mistake, and perhaps the simplest way to show this is to bring out that while we must certainly grant that innocent persons have a right to life, the theses in (1) through (4) are all false. Take (2), for example. If directly killing an innocent person is murder, and thus is impermissible, then the mother's directly killing the innocent person inside her is murder, and thus is impermissible. But it cannot seriously be thought to be murder if the mother performs an abortion on herself to save her life. It cannot seriously be said that she *must* refrain, that she *must* sit passively by and wait for her death. Let us look again at the case of you and the violinist. There you are, in bed with the violinist, and the director of the hospital says to you, "It's all most distressing, and I deeply sympathize, but you see this is putting an additional strain on your kidneys, and you'll be dead within the month. But you *have* to stay where you are all the same. Because unplugging you would be directly killing an innocent violinist, and that's murder, and that's impermissible." If anything in the world is true, it is that you do not commit murder, you do not do what is impermissible, if you reach around to your back and unplug yourself from that violinist to save your life.

The main focus of attention in writings on abortion has been on what a third party may or may not do in answer to a request from a woman for an abortion. This is in a way understandable. Things being as they are, there isn't much a woman can safely do to abort herself. So the question asked is what a third party may do, and what the mother may do, if it is mentioned at all, is deduced, almost as an afterthought, from what it is concluded that third parties may do. But it seems to me that to treat the matter in this way is to refuse to grant to the mother that very status of person which is so firmly insisted on for the fetus. For we cannot simply read off what a person may do from what a third party may do. Suppose you find yourself trapped in a tiny house with a growing child. I mean a very tiny house, and a rapidly growing child—you are already up against the wall of the house and in a few minutes you'll be crushed to death. The child on the other hand won't

be crushed to death; if nothing is done to stop him from growing he'll be hurt, but in the end he'll simply burst open the house and walk out a free man. Now I could well understand it if a bystander were to say, "There's nothing we can do for you. We cannot choose between your life and his, we cannot be the ones to decide who is to live, we cannot intervene." But it cannot be concluded that you too can do nothing, that you cannot attack it to save your life. However innocent the child may be, you do not have to wait passively while it crushes you to death. Perhaps a pregnant woman is vaguely felt to have the status of house, to which we don't allow the right of self-defense. But if the woman houses the child, it should be remembered that she is a person who houses it.

I should perhaps stop to say explicitly that I am not claiming that people have a right to do anything whatever to save their lives. I think, rather, that there are drastic limits to the right of self-defense. If someone threatens you with death unless you torture someone else to death, I think you have not the right, even to save your life, to do so. But the case under consideration here is very different. In our case there are only two people involved, one whose life is threatened, and one who threatens it. Both are innocent: the one who is threatened is not threatened because of any fault, the one who threatens does not threaten because of any fault. For this reason we may feel that we bystanders cannot intervene. But the person threatened can.

In sum, a woman surely can defend her life against the threat to it posed by the unborn child, even if doing so involves its death. And this shows not merely that the theses in (1) through (4) are false; it shows also that the extreme view of abortion is false, and so we need not canvass any other possible ways of arriving at it from the argument I mentioned at the outset.

2. The extreme view could of course be weakened to say that while abortion is permissible to save the mother's life, it may not be performed by a third party, but only by the mother herself. But this cannot be right either. For what we have to keep in mind is that the mother and the unborn child are not like two tenants in a small house which has, by an unfortunate

mistake, been rented to both: the mother *owns* the house. The fact that she does adds to the offensiveness of deducing that the mother can do nothing from the supposition that third parties can do nothing. But it does more than this: it casts a bright light on the supposition that third parties can do nothing. Certainly it lets us see that a third party who says "I cannot choose between you" is fooling himself if he thinks this is impartiality. If Jones has found and fastened on a certain coat, which he needs to keep him from freezing, but which Smith also needs to keep him from freezing, then it is not impartiality that says "I cannot choose between you" when Smith owns the coat. Women have said again and again "This body is *my* body!" and they have reason to feel angry, reason to feel that it has been like shouting into the wind. Smith, after all, is hardly likely to bless us if we say to him, "Of course it's your coat, anybody would grant that it is. But no one may choose between you and Jones who is to have it."

We should really ask what it is that says "no one may choose" in the face of the fact that the body that houses the child is the mother's body. It may be simply a failure to appreciate this fact. But it may be something more interesting, namely the sense that one has a right to refuse to lay hands on people, even where it would be just and fair to do so, even where justice seems to require that somebody do so. Thus justice might call for somebody to get Smith's coat back from Jones, and yet you have a right to refuse to be the one to lay hands on Jones, a right to refuse to do physical violence to him. This, I think, must be granted. But then what should be said is not "no one may choose," but only "*I* cannot choose," and indeed not even this, but "*I* will not *act*," leaving it open that somebody else can or should, and in particular that anyone in a position of authority, with the job of securing people's rights, both can and should. So this is no difficulty. I have not been arguing that any given third party must accede to the mother's request that he perform an abortion to save her life, but only that he may.

I suppose that in some views of human life the mother's body is only on loan to her, the loan not being one which gives her any prior claim to it. One

who held this view might well think it impartiality to say "I cannot choose." But I shall simply ignore this possibility. My own view is that if a human being has any just, prior claim to anything at all, he has a just, prior claim to his own body. And perhaps this needn't be argued for here anyway, since, as I mentioned, the arguments against abortion we are looking at do grant that the woman has a right to decide what happens in and to her body.

But although they do grant it, I have tried to show that they do not take seriously what is done in granting it. I suggest the same thing will reappear even more clearly when we turn away from cases in which the mother's life is at stake, and attend, as I propose we now do, to the vastly more common cases in which a woman wants an abortion for some less weighty reason than preserving her own life.

3. Where the mother's life is not at stake, the argument I mentioned at the outset seems to have a much stronger pull. "Everyone has a right to life, so the unborn person has a right to life." And isn't the child's right to life weightier than anything other than the mother's own right to life, which she might put forward as ground for an abortion?

This argument treats the right to life as if it were unproblematic. It is not, and this seems to me to be precisely the source of the mistake.

For we should now, at long last, ask what it comes to, to have a right to life. In some views having a right to life includes having a right to be given at least the bare minimum one needs for continued life. But suppose that what in fact *is* the bare minimum a man needs for continued life is something he has no right at all to be given? If I am sick unto death, and the only thing that will save my life is the touch of Henry Fonda's cool hand on my fevered brow, then all the same, I have no right to be given the touch of Henry Fonda's cool hand on my fevered brow. It would be frightfully nice of him to fly in from the West Coast to provide it. It would be less nice, though no doubt well meant, if my friends flew out to the West Coast and carried Henry Fonda back with them. But I have no right at all against anybody that he should do this for me. Or again, to return to the story I told earlier, the fact that for

continued life that violinist needs the continued use of your kidneys does not establish that he has a right to be given the continued use of your kidneys. He certainly has no right against you that *you* should give him continued use of your kidneys. For nobody has any right to use our kidneys unless you give him such a right; and nobody has the right against you that you shall give him this right—if you do allow him to go on using your kidneys, this is a kindness on your part, and not something he can claim from you as his due. Nor has he any right against anybody else that *they* should give him continued use of your kidneys. Certainly he had no right against the Society of Music Lovers that they should plug him into you in the first place. And if you now start to unplug yourself, having learned that you will otherwise have to spend nine years in bed with him, there is nobody in the world who must try to prevent you, in order to see to it that he is given something he has a right to be given.

Some people are rather stricter about the right to life. In their view, it does not include the right to be given anything, but amounts to, and only to, the right not to be killed by anybody. But here a related difficulty arises. If everybody is to refrain from killing that violinist, then everybody must refrain from doing a great many different sorts of things. Everybody must refrain from slitting his throat, everybody must refrain from shooting him—and everybody must refrain from unplugging you from him. But does he have a right against everybody that they shall refrain from unplugging you from him? To refrain from doing this is to allow him to continue to use your kidneys. It could be argued that he has a right against us that *we* should allow him to continue to use your kidneys. That is, while he had no right against us that we should give him the use of your kidneys, it might be argued that he anyway has a right against us that we shall not now intervene and deprive him of the use of your kidneys. I shall come back to third-party interventions later. But certainly the violinist has no right against you that *you* shall allow him to continue to use your kidneys. As I said, if you do allow him to use them, it is a kindness on your part, and not something you owe him.

The difficulty I point to here is not peculiar to the right to life. It reappears in connection with all the other natural rights; and it is something which an adequate account of rights must deal with. For present purposes it is enough just to draw attention to it. But I would stress that I am not arguing that people do not have a right to life—quite to the contrary, it seems to me that the primary control we must place on the acceptability of an account of rights is that it should turn out in that account to be a truth that all persons have a right to life. I am arguing only that having a right to life does not guarantee having either a right to be given the use of or a right to be allowed continued use of another person's body—even if one needs it for life itself. So the right to life will not serve the opponents of abortion in the very simple and clear way in which they seem to have thought it would.

4. There is another way to bring out the difficulty. In the most ordinary sort of case, to deprive someone of what he has a right to is to treat him unjustly. Suppose a boy and his small brother are jointly given a box of chocolates for Christmas. If the older boy takes the box and refuses to give his brother any of the chocolates, he is unjust to him, for the brother has been given a right to half of them. But suppose that, having learned that otherwise it means nine years in bed with that violinist, you unplug yourself from him. You surely are not being unjust to him, for you gave him no right to use your kidneys, and no one else can have given him any such right. But we have to notice that in unplugging yourself, you are killing him; and violinists, like everybody else, have a right to life, and thus in the view we were considering just now, the right not to be killed. So here you do what he supposedly has a right you shall not do, but you do not act unjustly to him in doing it.

The emendation which may be made at this point is this: the right to life consists not in the right not to be killed, but rather in the right not to be killed unjustly. This runs a risk of circularity, but never mind: it would enable us to square the fact that the violinist has a right to life with the fact that you do not act unjustly toward him in unplugging yourself, thereby killing him. For if you do not kill him unjustly, you do not violate his right to life, and so it is no wonder you do him no injustice.

But if this emendation is accepted, the gap in the argument against abortion stares us plainly in the face: it is by no means enough to show that the fetus is a person, and to remind us that all persons have a right to life—we need to be shown also that killing the fetus violates its right to life, i.e., that abortion is unjust killing. And is it?

I suppose we may take it as a datum that in a case of pregnancy due to rape the mother has not given the unborn person a right to the use of her body for food and shelter. Indeed, in what pregnancy could it be supposed that the mother has given the unborn person such a right? It is not as if there were unborn persons drifting about the world, to whom a woman who wants a child says "I invite you in."

But it might be argued that there are other ways one can have acquired a right to the use of another person's body than by having been invited to use it by that person. Suppose a woman voluntarily indulges in intercourse, knowing of the chance it will issue in pregnancy, and then she does become pregnant; is she not in part responsible for the presence, in fact the very existence, of the unborn person inside her? No doubt she did not invite it in. But doesn't her partial responsibility for its being there itself give it a right to the use of her body?[6] If so, then her aborting it would be more like the boy's taking away the chocolates, and less like your unplugging yourself from the violinist—doing so would be depriving it of what it does have a right to, and thus would be doing it an injustice.

And then, too, it might be asked whether or not she can kill it even to save her own life: If she voluntarily called it into existence, how can she now kill it, even in self-defense?

The first thing to be said about this is that it is something new. Opponents of abortion have been so concerned to make out the independence of the fetus, in order to establish that it has a right to life, just as its mother does, that they have tended to overlook the possible support they might gain from making out that the fetus is *dependent* on the mother, in order to establish that she has a special kind of responsibility for it, a responsibility that gives it rights against her which

are not possessed by any independent person—such as an ailing violinist who is a stranger to her.

On the other hand, this argument would give the unborn person a right to its mother's body only if her pregnancy resulted from a voluntary act, undertaken in full knowledge of the chance a pregnancy might result from it. It would leave out entirely the unborn person whose existence is due to rape. Pending the availability of some further argument, then, we would be left with the conclusion that unborn persons whose existence is due to rape have no right to the use of their mothers' bodies, and thus that aborting them is not depriving them of anything they have a right to and hence is not unjust killing.

And we should also notice that it is not at all plain that this argument really does go even as far as it purports to. For there are cases and cases, and the details make a difference. If the room is stuffy, and I therefore open a window to air it, and a burglar climbs in, it would be absurd to say, "Ah, now he can stay, she's given him a right to the use of her house—for she is partially responsible for his presence there, having voluntarily done what enabled him to get in, in full knowledge that there are such things as burglars, and that burglars burgle." It would be still more absurd to say this if I had had bars installed outside my windows, precisely to prevent burglars from getting in, and a burglar got in only because of a defect in the bars. It remains equally absurd if we imagine it is not a burglar who climbs in, but an innocent person who blunders or falls in. Again, suppose it were like this: people-seeds drift about in the air like pollen, and if you open your windows, one may drift in and take root in your carpets or upholstery. You don't want children, so you fix up your windows with fine mesh screens, the very best you can buy. As can happen, however, and on very, very rare occasions does happen, one of the screens is defective; and a seed drifts in and takes root. Does the person-plant who now develops have a right to the use of your house? Surely not—despite the fact that you voluntarily opened your windows, you knowingly kept carpets and upholstered furniture, and you knew that screens were sometimes defective. Someone may argue that you are responsible for its rooting, that it does have a

right to your house, because after all you *could* have lived out your life with bare floors and furniture, or with sealed windows and doors. But this won't do— for by the same token anyone can avoid a pregnancy due to rape by having a hysterectomy, or anyway by never leaving home without a (reliable!) army.

It seems to me that the argument we are looking at can establish at most that there are *some* cases in which the unborn person has a right to the use of its mother's body, and therefore *some* cases in which abortion is unjust killing. There is room for much discussion and argument as to precisely which, if any. But I think we should sidestep this issue and leave it open, for at any rate the argument certainly does not establish that all abortion is unjust killing.

5. There is room for yet another argument here, however. We surely must all grant that there may be cases in which it would be morally indecent to detach a person from your body at the cost of his life. Suppose you learn that what the violinist needs is not nine years of your life, but only one hour: all you need do to save his life is to spend one hour in that bed with him. Suppose also that letting him use your kidneys for that one hour would not affect your health in the slightest. Admittedly you were kidnapped. Admittedly you did not give anyone permission to plug him into you. Nevertheless it seems to me plain you *ought* to allow him to use your kidneys for that hour—it would be indecent to refuse.

Again, suppose pregnancy lasted only an hour, and constituted no threat to life or health. And suppose that a woman becomes pregnant as a result of rape. Admittedly she did not voluntarily do anything to bring about the existence of a child. Admittedly she did nothing at all which would give the unborn person a right to the use of her body. All the same it might well be said, as in the newly emended violinist story, that she *ought* to allow it to remain for that hour—that it would be indecent of her to refuse.

Now some people are inclined to use the term "right" in such a way that it follows from the fact that you ought to allow a person to use your body for the hour he needs, that he has a right to use your body for the hour he needs, even though he has not been given that right by any person or act. They may say

that it follows also that if you refuse, you act unjustly toward him. This use of the term is perhaps so common that it cannot be called wrong; nevertheless it seems to me to be an unfortunate loosening of what we would do better to keep a tight rein on. Suppose that box of chocolates I mentioned earlier had not been given to both boys jointly, but was given only to the older boy. There he sits, stolidly eating his way through the box, his small brother watching enviously. Here we are likely to say "You ought not to be so mean. You ought to give your brother some of those chocolates." My own view is that it just does not follow from the truth of this that the brother has any right to any of the chocolates. If the boy refuses to give his brother any, he is greedy, stingy, callous—but not unjust. I suppose that the people I have in mind will say it does follow that the brother has a right to some of the chocolates, and thus that the boy does act unjustly if he refuses to give his brother any. But the effect of saying this is to obscure what we should keep distinct, namely the difference between the boy's refusal in this case and the boy's refusal in the earlier case, in which the box was given to both boys jointly, and in which the small brother thus had what was from any point of view clear title to half.

A further objection to so using the term "right" that from the fact that A ought to do a thing for B, it follows that B has a right against A that A do it for him, is that it is going to make the question of whether or not a man has a right to a thing turn on how easy it is to provide him with it; and this seems not merely unfortunate, but morally unacceptable. Take the case of Henry Fonda again. I said earlier that I had no right to the touch of his cool hand on my fevered brow, even though I needed it to save my life. I said it would be frightfully nice of him to fly in from the West Coast to provide me with it, but that I had no right against him that he should do so. But suppose he isn't on the West Coast. Suppose he has only to walk across the room, place a hand briefly on my brow—and lo, my life is saved. Then surely he ought to do it, it would be indecent to refuse. Is it to be said "Ah, well, it follows that in this case she has a right to the touch of his hand on her brow, and so it would be an injustice in him to refuse"? So that I have a right

to it when it is easy for him to provide it, though no right when it's hard? It's rather a shocking idea that anyone's rights should fade away and disappear as it gets harder and harder to accord them to him.

So my own view is that even though you ought to let the violinist use your kidneys for the one hour he needs, we should not conclude that he has a right to do so—we should say that if you refuse, you are, like the boy who owns all the chocolates and will give none away, self-centered and callous, indecent in fact, but not unjust. And similarly, that even supposing a case in which a woman pregnant due to rape ought to allow the unborn person to use her body for the hour he needs, we should not conclude that he has a right to do so; we should conclude that she is self-centered, callous, indecent, but not unjust, if she refuses. The complaints are no less grave; they are just different. However, there is no need to insist on this point. If anyone does wish to deduce "he has a right" from "you ought," then all the same he must surely grant that there are cases in which it is not morally required of you that you allow that violinist to use your kidneys, and in which he does not have a right to use them, and in which you do not do him an injustice if you refuse. And so also for mother and unborn child. Except in such cases as the unborn person has a right to demand it—and we were leaving open the possibility that there may be such cases—nobody is morally *required* to make large sacrifices, of health, of all other interests and concerns, of all other duties and commitments, for nine years, or even for nine months, in order to keep another person alive.

6. We have in fact to distinguish between two kinds of Samaritan: the Good Samaritan and what we might call the Minimally Decent Samaritan. The story of the Good Samaritan, you will remember, goes like this:

> A certain man went down from Jerusalem to Jericho, and fell among thieves, which stripped him of his raiment, and wounded him, and departed, leaving him half dead.
>
> And by chance there came down a certain priest that way; and when he saw him, he passed by on the other side.

And likewise a Levite, when he was at the place, came and looked on him, and passed by on the other side.

But a certain Samaritan, as he journeyed, came where he was; and when he saw him he had compassion on him.

And went to him, and bound up his wounds, pouring in oil and wine, and set him on his own beast, and brought him to an inn, and took care of him.

And on the morrow, when he departed, he took out two pence, and gave them to the host, and said unto him, "Take care of him; and whatsoever thou spendest more, when I come again, I will repay thee." (Luke 10:30–35)

The Good Samaritan went out of his way, at some cost to himself, to help one in need of it. We are not told what the options were, that is, whether or not the priest and the Levite could have helped by doing less than the Good Samaritan did, but assuming they could have, then the fact they did nothing at all shows they were not even Minimally Decent Samaritans, not because they were not Samaritans, but because they were not even minimally decent.

These things are a matter of degree, of course, but there is a difference, and it comes out perhaps most clearly in the story of Kitty Genovese, who, as you will remember, was murdered while thirty-eight people watched or listened, and did nothing at all to help her. A Good Samaritan would have rushed out to give direct assistance against the murderer. Or perhaps we had better allow that it would have been a Splendid Samaritan who did this, on the ground that it would have involved a risk of death for himself. But the thirty-eight not only did not do this, they did not even trouble to pick up a phone to call the police. Minimally Decent Samaritanism would call for doing at least that, and their not having done it was monstrous.

After telling the story of the Good Samaritan, Jesus said "Go, and do thou likewise." Perhaps he meant that we are morally required to act as the Good Samaritan did. Perhaps he was urging people to do more than is morally required of them. At all events it seems plain that it was not morally required of any of the thirty-eight that he rush out to give direct assistance at the risk of his own life, and that it is not

morally required of anyone that he give long stretches of his life—nine years or nine months—to sustaining the life of a person who has no special right (we were leaving open the possibility of this) to demand it.

Indeed, with one rather striking class of exceptions, no one in any country in the world is *legally* required to do anywhere near as much as this for anyone else. The class of exceptions is obvious. My main concern here is not the state of the law in respect to abortion, but it is worth drawing attention to the fact that in no state in this country is any man compelled by law to be even a Minimally Decent Samaritan to any person; there is no law under which charges could be brought against the thirty-eight who stood by while Kitty Genovese died. By contrast, in most states in this country women are compelled by law to be not merely Minimally Decent Samaritans, but Good Samaritans to unborn persons inside them. This doesn't by itself settle anything one way or the other, because it may well be argued that there should be laws in this country—as there are in many European countries—compelling at least Minimally Decent Samaritanism.[7] But it does show that there is a gross injustice in the existing state of the law. And it shows also that the groups currently working against liberalization of abortion laws, in fact working toward having it declared unconstitutional for a state to permit abortion, had better start working for the adoption of Good Samaritan laws generally, or earn the charge that they are acting in bad faith.

I should think, myself, that Minimally Decent Samaritan laws would be one thing, Good Samaritan laws quite another, and in fact highly improper. But we are not here concerned with the law. What we should ask is not whether anybody should be compelled by law to be a Good Samaritan, but whether we must accede to a situation in which somebody is being compelled—by nature, perhaps—to be a Good Samaritan. We have, in other words, to look now at third-party interventions. I have been arguing that no person is morally required to make large sacrifices to sustain the life of another who has no right to demand them, and this even where the sacrifices do not include life itself; we are not morally required to be Good Samaritans or anyway Very Good Samaritans to one another. But what if a man cannot extricate himself from such a situation? What if

he appeals to us to extricate him? It seems to me plain that there are cases in which we can, cases in which a Good Samaritan would extricate him. There you are, you were kidnapped, and nine years in bed with that violinist lie ahead of you. You have your own life to lead. You are sorry, but you simply cannot see giving up so much of your life to the sustaining of his. You cannot extricate yourself, and ask us to do so. I should have thought that—in light of his having no right to the use of your body—it was obvious that we do not have to accede to your being forced to give up so much. We can do what you ask. There is no injustice to the violinist in our doing so.

7. Following the lead of the opponents of abortion, I have throughout been speaking of the fetus merely as a person, and what I have been asking is whether or not the argument we began with, which proceeds only from the fetus' being a person, really does establish its conclusion. I have argued that it does not.

But of course there are arguments and arguments, and it may be said that I have simply fastened on the wrong one. It may be said that what is important is not merely the fact that the fetus is a person, but that it is a person for whom the woman has a special kind of responsibility issuing from the fact that she is its mother. And it might be argued that all my analogies are therefore irrelevant—for you do not have that special kind of responsibility for that violinist, Henry Fonda does not have that special kind of responsibility for me. And our attention might be drawn to the fact that men and women both *are* compelled by law to provide support for their children.

I have in effect dealt (briefly) with this argument in section 4 above; but a (still briefer) recapitulation now may be in order. Surely we do not have any such "special responsibility" for a person unless we have assumed it, explicitly or implicitly. If a set of parents do not try to prevent pregnancy, do not obtain an abortion, and then at the time of birth of the child do not put it out for adoption, but rather take it home with them, then they have assumed responsibility for it, they have given it rights, and they cannot *now* withdraw support from it at the cost of its life because they now find it difficult to go on providing for it. But if they have taken all reasonable precautions against having

a child, they do not simply by virtue of their biological relationship to the child who comes into existence have a special responsibility for it. They may wish to assume responsibility for it, or they may not wish to. And I am suggesting that if assuming responsibility for it would require large sacrifices, then they may refuse. A Good Samaritan would not refuse—or anyway, a Splendid Samaritan, if the sacrifices that had to be made were enormous. But then so would a Good Samaritan assume responsibility for that violinist; so would Henry Fonda, if he is a Good Samaritan, fly in from the West Coast and assume responsibility for me.

8. My argument will be found unsatisfactory on two counts by many of those who want to regard abortion as morally permissible. First, while I do argue that abortion is not impermissible, I do not argue that it is always permissible. There may well be cases in which carrying the child to term requires only Minimally Decent Samaritanism of the mother, and this is a standard we must not fall below. I am inclined to think it a merit of my account precisely that it does *not* give a general yes or a general no. It allows for and supports our sense that, for example, a sick and desperately frightened fourteen-year-old schoolgirl, pregnant due to rape, may *of course* choose abortion, and that any law which rules this out is an insane law. And it also allows for and supports our sense that in other cases resort to abortion is even positively indecent. It would be indecent in the woman to request an abortion, and indecent in a doctor to perform it, if she is in her seventh month, and wants the abortion just to avoid the nuisance of postponing a trip abroad. The very fact that the arguments I have been drawing attention to treat all cases of abortion, or even all cases of abortion in which the mother's life is not at stake, as morally on a par ought to have made them suspect at the outset.

Secondly, while I am arguing for the permissibility of abortion in some cases, I am not arguing for the right to secure the death of the unborn child. It is easy to confuse these two things in that up to a certain point in the life of the fetus it is not able to survive outside the mother's body; hence removing it from her body guarantees its death. But they are importantly different. I have argued that you are not morally required to spend nine months in bed, sustaining the life of that violinist;

but to say this is by no means to say that if, when you unplug yourself, there is a miracle and he survives, you then have a right to turn round and slit his throat. You may detach yourself even if this costs him his life; you have no right to be guaranteed his death, by some other means, if unplugging yourself does not kill him. There are some people who will feel dissatisfied by this feature of my argument. A woman may be utterly devastated by the thought of a child, a bit of herself, put out for adoption and never seen or heard of again. She may therefore want not merely that the child be detached from her, but more, that it die. Some opponents of abortion are inclined to regard this as beneath contempt—thereby showing insensitivity to what is surely a powerful source of despair. All the same, I agree that the desire for the child's death is not one which anybody may gratify, should it turn out to be possible to detach the child alive.

At this place, however, it should be remembered that we have only been pretending throughout that the fetus is a human being from the moment of conception. A very early abortion is surely not the killing of a person, and so is not dealt with by anything I have said here.

Notes

1. Daniel Callahan, *Abortion: Law, Choice and Morality* (New York, 1970), p. 373. This book gives a fascinating survey of the available information on abortion. The Jewish tradition is surveyed in David M. Feldman, *Birth Control in Jewish Law* (New York, 1968), Part 5, the Catholic tradition in John T. Noonan, Jr., "An Almost Absolute Value in History," in *The Morality of Abortion*, ed. John T. Noonan, Jr. (Cambridge, Mass., 1970).

2. The term "direct" in the arguments I refer to is a technical one. Roughly, what is meant by "direct killing" is either killing as an end in itself, or killing as a means to some end, for example, the end of saving someone else's life. See note 5, below, for an example of its use.

3. Cf. *Encyclical Letter of Pope Pius XI on Christian Marriage*, St. Paul Editions (Boston, n.d.), p. 32: "however much we may pity the mother whose health and even life is gravely imperiled in the performance of the duty allotted to her by nature, nevertheless what could ever be a sufficient reason for excusing in any way the direct murder of the innocent? This is precisely what we are dealing with here." Noonan (*The Morality of Abortion*, p. 43) reads this as follows: "What cause can ever avail to excuse in any way the direct killing of the innocent? For it is a question of that."

4. The thesis in (4) is in an interesting way weaker than those in (1), (2), and (3): they rule out abortion even in cases in which both mother *and* child will die if the abortion is not performed. By contrast, one who held the view expressed in (4) could consistently say that one needn't prefer letting two persons die to killing one.

5. Cf. the following passage from Pius XII, *Address to the Italian Catholic Society of Midwives*: "The baby in the maternal breast has the right to life immediately from God.—Hence there is no man, no human authority, no science, no medical, eugenic, social, economic or moral 'indication' which can establish or grant a valid juridical ground for a direct deliberate disposition of an innocent human life, that is a disposition which looks to its destruction either as an end or as a means to another end perhaps in itself not illicit.—The baby, still not born, is a man in the same degree and for the same reason as the mother" (quoted in Noonan, *The Morality of Abortion*, p. 45).

6. The need for a discussion of this argument was brought home to me by members of the Society for Ethical and Legal Philosophy, to whom this paper was originally presented.

7. For a discussion of the difficulties involved, and a survey of the European experience with such laws, see *The Good Samaritan and the Law*, ed. James M. Ratcliffe (New York, 1966).

Study Questions

1. What are the main points Thomson seeks to make by the example of the unconscious violinist?

2. Does the morality of aborting a fetus depend on the conditions surrounding its conception?

3. Explain in your own words the distinction Thomson draws between the Good Samaritan and the Minimally Decent Samaritan.

4. If the abortion controversy is described as a debate between those who believe in a right to life and those who affirm a woman's right to choose, on which side is Thomson?

46

MARY ANNE WARREN

Mary Anne Warren (1942–2010) was a Professor of Philosophy at San Francisco State University. She argued that among the characteristics central to personhood are the capacity to experience pain and pleasure, feel happy or sad, solve relatively complex problems, communicate messages on many possible topics, have a concept of oneself as a member of a social group, and regulate one's own action through moral principles. Warren maintained that a fetus, lacking these characteristics, is not a person, and hence women's rights override whatever right to life a fetus may possess.

On the Moral and Legal Status of Abortion

For our purposes, abortion may be defined as the act a woman performs in deliberately terminating her pregnancy before it comes to term, or in allowing another person to terminate it. Abortion usually entails the death of a fetus.[1] Nevertheless, I will argue that it is morally permissible, and should be neither legally prohibited nor made needlessly difficult to obtain, e.g., by obstructive legal regulations.[2]

Some philosophers have argued that the moral status of abortion cannot be resolved by rational means.[3] If this is so then liberty should prevail; for it is not a proper function of the law to enforce prohibitions upon personal behavior that cannot clearly be shown to be morally objectionable, and seriously so. But the advocates of prohibition believe that their position is objectively correct, and not merely a result of religious beliefs or personal prejudices. They argue that the humanity of the fetus is a matter of scientific fact, and that abortion is therefore the moral equivalent of murder, and must be prohibited in all or most cases. (Some

would make an exception when the woman's life is in danger, or when the pregnancy is due to rape or incest; others would prohibit abortion even in these cases.)

In response, advocates of a right to choose abortion point to the terrible consequences of prohibiting it, especially while contraception is still unreliable, and is financially beyond the reach of much of the world's population. Worldwide, hundreds of thousands of women die each year from illegal abortions, and many more suffer from complications that may leave them injured or infertile. Women who are poor, under-age, disabled, or otherwise vulnerable, suffer most from the absence of safe and legal abortion. Advocates of choice also argue that to deny a woman access to abortion is to deprive her of the right to control her own body—a right so fundamental that without it other rights are often all but meaningless.

These arguments do not convince abortion opponents. The tragic consequences of prohibition leave them unmoved, because they regard the deliberate

killing of fetuses as even more tragic. Nor do appeals to the right to control one's own body impress them, since they deny that this right includes the right to destroy a fetus. We cannot hope to persuade those who equate abortion with murder that they are mistaken, unless we can refute the standard anti-abortion argument: that because fetuses are human beings, they have a right to life equal to that of any other human being. Unfortunately, confusion has prevailed with respect to the two important questions which that argument raises: (1) Is a human fetus really a human being at all stages of prenatal development? and (2) If so, what (if anything) follows about the moral and legal status of abortion?

John Noonan says that "the fundamental question in the long history of abortion is: How do you determine the humanity of a being?"[4] His anti-abortion argument is essentially that of the Roman Catholic Church. In his words:

> It is wrong to kill humans, however poor, weak, defenseless, and lacking in opportunity to develop their potential they may be. It is therefore morally wrong to kill Biafrans. Similarly, it is morally wrong to kill embryos.[5]

Noonan bases his claim that fetuses are human beings from the time of conception upon what he calls the theologians' criterion of humanity: that whoever is conceived of human beings is a human being. But although he argues at length for the appropriateness of this criterion of humanity, he does not question the assumption that if a fetus is a human being then abortion is almost always immoral.[6]

Judith Thomson has questioned this assumption. She argues that, even if we grant the anti-abortionist the claim that a fetus is a human being with the same right to life as any other human being, we can still demonstrate that women are not morally obliged to complete every unwanted pregnancy.[7] Her argument is worth examining, because if it is sound it may enable us to establish the moral permissibility of abortion without having to decide just what makes an entity a human being, or what entitles it to full moral rights. This would represent a considerable gain in the power and simplicity of the pro-choice position.

Even if Thomson's argument does not hold up, her essential insight—that it requires *argument* to show that if fetuses are human beings then abortion is murder—is a valuable one. The assumption that she attacks is invidious, for it requires that in our deliberations about the ethics of abortion we must ignore almost entirely the needs of the pregnant woman and other persons for whom she is responsible. This will not do; determining what moral rights a fetus has is only one step in determining the moral status of abortion. The next step is finding a just solution to conflicts between whatever rights the fetus has, and the rights and responsibilities of the woman who is unwillingly pregnant.

My own inquiry will also have two stages. In Section I, I consider whether abortion can be shown to be morally permissible even on the assumption that a fetus is a human being with a strong right to life. I argue that this cannot be established, except in special cases. Consequently, we cannot avoid facing the question of whether or not a fetus has the same right to life as any human being.

In Section II, I propose an answer to this question, namely, that a fetus is not a member of the moral community—the set of beings with full and equal moral rights. The reason that a fetus is not a member of the moral community is that it is not yet a person, nor is it enough like a person in the morally relevant respects to be regarded the equal of those human beings who are persons. I argue that it is personhood, and not genetic humanity, which is the fundamental basis for membership in the moral community. A fetus, especially in the early stages of its development, satisfies none of the criteria of personhood. Consequently, it makes no sense to grant it moral rights strong enough to override the woman's moral rights to liberty, bodily integrity, and sometimes life itself. Unlike an infant who has already been born, a fetus cannot be granted full and equal moral rights without severely threatening the rights and well-being of women. Nor, as we will see, is a fetus's *potential* personhood a threat to the moral permissibility of abortion, since merely potential persons do not have a moral right to become actual—or none that is strong enough to override the fundamental moral rights of actual persons.

I

Judith Thomson argues that, even if a fetus has a right to life, abortion is often morally permissible. Her argument is based upon an imaginative analogy. She asks you to picture yourself waking up one day, in bed with a famous violinist, who is a stranger to you. Imagine that you have been kidnapped, and your bloodstream connected to that of the violinist, who has an ailment that will kill him unless he is permitted to share your kidneys for nine months. No one else can save him, since you alone have the right type of blood. Consequently, the Society of Music Lovers has arranged for you to be kidnapped and hooked up. If you unhook yourself, he will die. But if you remain in bed with him, then after nine months he will be cured and able to survive without further assistance from you.

Now, Thomson asks, what are your obligations in this situation? To be consistent, the anti-abortionist must say that you are obliged to stay in bed with the violinist: for violinists are human beings, and all human beings have a right to life.[8] But this is outrageous; thus, there must be something very wrong with the same argument when it is applied to abortion. It would be extremely generous of you to agree to stay in bed with the violinist; but it is absurd to suggest that your refusal to do so would be the moral equivalent of murder. The violinist's right to life does not oblige you to do whatever is required to keep him alive; still less does it justify anyone else in forcing you to do so. A law which required you to stay in bed with the violinist would be an unjust law, since unwilling persons ought not to be required to be Extremely Good Samaritans, i.e., to make enormous personal sacrifices for the sake of other individuals towards whom they have no special prior obligation.

Thomson concludes that we can grant the anti-abortionist his claim that a fetus is a human being with a right to life, and still hold that a pregnant woman is morally entitled to refuse to be an Extremely Good Samaritan toward the fetus. For there is a great gap between the claim that a human being has a right to life, and the claim that other human beings are morally obligated to do whatever is necessary to keep him alive. One has no duty to keep another human being alive *at great personal cost*, unless one has somehow contracted a special obligation toward that individual; and a woman who is pregnant may have done nothing that morally obliges her to make the burdensome personal sacrifices necessary to preserve the life of the fetus.

This argument is plausible, and in the case of pregnancy due to rape it is probably conclusive. Difficulties arise, however, when we attempt to specify the larger range of cases in which abortion can be justified on the basis of this argument. Thomson considers it a virtue of her argument that it does not imply that abortion is *always* morally permissible. It would, she says, be indecent for a woman in her seventh month of pregnancy to have an abortion in order to embark on a trip to Europe. On the other hand, the violinist analogy shows that, "a sick and desperately frightened fourteen-year-old schoolgirl, pregnant due to rape, may *of course* choose abortion, and that any law which rules this out is an insane law."[9] So far, so good; but what are we to say about the woman who becomes pregnant not through rape but because she and her partner did not use available forms of contraception, or because their attempts at contraception failed? What about a woman who becomes pregnant intentionally, but then re-evaluates the wisdom of having a child? In such cases, the violinist analogy is considerably less useful to advocates of the right to choose abortion.

It is perhaps only when a woman's pregnancy is due to rape, or some other form of coercion, that the situation is sufficiently analogous to the violinist case for our moral intuitions to transfer convincingly from the one case to the other. One difference between a pregnancy caused by rape and most unwanted pregnancies is that only in the former case is it perfectly clear that the woman is in no way responsible for her predicament. In the other cases, she *might* have been able to avoid becoming pregnant, e.g., by taking birth control pills (more faithfully), or insisting upon the use of high-quality condoms, or even avoiding heterosexual intercourse altogether throughout her fertile years. In contrast, if you are suddenly kidnapped by strange music lovers and hooked up to a

sick violinist, then you are in no way responsible for your situation, which you could not have foreseen or prevented. And responsibility does seem to matter here. If a person behaves in a way which she could have avoided, and which she knows might bring into existence a human being who will depend upon her for survival, then it is not entirely clear that if and when that happens she may rightly refuse to do what she must in order to keep that human being alive.

This argument shows that the violinist analogy provides a persuasive defense of a woman's right to choose abortion only in cases where she is in no way morally responsible for her own pregnancy. In all other cases, the assumption that a fetus has a strong right to life makes it necessary to look carefully at the particular circumstances in order to determine the extent of the woman's responsibility, and hence the extent of her obligation. This outcome is unsatisfactory to advocates of the right to choose abortion, because it suggests that the decision should not be left in the woman's own hands, but should be supervised by other persons, who will inquire into the most intimate aspects of her personal life in order to determine whether or not she is entitled to choose abortion.

A supporter of the violinist analogy might reply that it is absurd to suggest that forgetting her pill one day might be sufficient to morally oblige a woman to complete an unwanted pregnancy. And indeed it is absurd to suggest this. As we will see, a woman's moral right to choose abortion does not depend upon the extent to which she might be thought to be morally responsible for her own pregnancy. But once we allow the assumption that a fetus has a strong right to life, we cannot avoid taking this absurd suggestion seriously. On this assumption, it is a vexing question whether and when abortion is morally justifiable. The violinist analogy can at best show that aborting a pregnancy is a deeply tragic act, though one that is sometimes morally justified.

My conviction is that an abortion is not always this deeply tragic, because a fetus is not yet a person, and therefore does not yet have a strong moral right to life. Although the truth of this conviction may not be self-evident, it does, I believe, follow

from some highly plausible claims about the appropriate grounds for ascribing moral rights. It is worth examining these grounds, since this has not been adequately done before.

<div align="center">

II

</div>

The question we must answer in order to determine the moral status of abortion is: How are we to define the moral community, the set of beings with full and equal moral rights? What sort of entity has the inalienable moral rights to life, liberty, and the pursuit of happiness? Thomas Jefferson attributed these rights to all *men*, and he may have intended to attribute them *only* to men. Perhaps he ought to have attributed them to all human beings. If so, then we arrive, first, at Noonan's problem of defining what makes an entity a human being, and second, at the question which Noonan does not consider: What reason is there for identifying the moral community with the set of all human beings, in whatever way we have chosen to define that term?

On the Definition of "Human"

The term "human being" has two distinct, but not often distinguished, senses. This results in a slide of meaning, which serves to conceal the fallacy in the traditional argument that, since (1) it is wrong to kill innocent human beings, and (2) fetuses are innocent human beings, therefore (3) it is wrong to kill fetuses. For if "human being" is used in the same sense in both (1) and (2), then whichever of the two senses is meant, one of these premises is question-begging. And if it is used in different senses then the conclusion does not follow.

Thus, (1) is a generally accepted moral truth,[10] and one that does not beg the question about abortion, only if "human being" is used to mean something like "a full-fledged member of the moral community, who is also a member of the human species." I will call this the *moral* sense of "human being." It is not to be confused with what I will call the *genetic* sense, i.e., the sense in which any individual entity

that belongs to the human species is a human being, regardless of whether or not it is rightly considered to be an equal member of the moral community. Premise (1) avoids begging the question only if the moral sense is intended; while premise (2) avoids it only if what is intended is the genetic sense.

Noonan argues for the classification of fetuses with human beings by pointing, first, to the presence of the human genome in the cell nuclei of the human conceptus from conception onwards; and secondly, to the potential capacity for rational thought.[11] But what he needs to show, in order to support his version of the traditional anti-abortion argument, is that fetuses are human beings in the moral sense—the sense in which all human beings have full and equal moral rights. In the absence of any argument showing that whatever is genetically human is also morally human—and he gives none—nothing more than genetic humanity can be demonstrated by the presence of human chromosomes in the fetus's cell nuclei. And, as we will see, the strictly potential capacity for rational thought can at most show that the fetus may later *become* human in the moral sense.

Defining the Moral Community

Is genetic humanity sufficient for moral humanity? There are good reasons for not defining the moral community in this way. I would suggest that the moral community consists, in the first instance, of all *persons*, rather than all genetically human entities.[12] It is persons who invent moral rights, and who are (sometimes) capable of respecting them. It does not follow from this that only persons can have moral rights. However, persons are wise not to ascribe to entities that clearly are not persons moral rights that cannot in practice be respected without severely undercutting the fundamental moral rights of those who clearly are.

What characteristics entitle an entity to be considered a person? This is not the place to attempt a complete analysis of the concept of personhood; but we do not need such an analysis to explain why a fetus is not a person. All we need is an approximate list of the most basic criteria of personhood. In searching

for these criteria, it is useful to look beyond the set of people with whom we are acquainted, all of whom are human. Imagine, then, a space traveler who lands on a new planet, and encounters organisms unlike any she has ever seen or heard of. If she wants to behave morally toward these organisms, she has somehow to determine whether they are people and thus have full moral rights, or whether they are things that she need not feel guilty about treating, for instance, as a source of food.

How should she go about making this determination? If she has some anthropological background, she might look for signs of religion, art, and the manufacturing of tools, weapons, or shelters, since these cultural traits have frequently been used to distinguish our human ancestors from prehuman beings, in what seems to be closer to the moral than the genetic sense of "human being." She would be right to take the presence of such traits as evidence that the extraterrestrials were persons. It would, however, be anthropocentric of her to take the absence of these traits as proof that they were not, since they could be people who have progressed beyond, or who have never needed, these particular cultural traits.

I suggest that among the characteristics which are central to the concept of personhood are the following:

1. *sentience*—the capacity to have conscious experiences, usually including the capacity to experience pain and pleasure;
2. *emotionality*—the capacity to feel happy, sad, angry, loving, etc.;
3. *reason*—the capacity to solve new and relatively complex problems;
4. *the capacity to communicate*, by whatever means, messages of an indefinite variety of types; that is, not just with an indefinite number of possible contents, but on indefinitely many possible topics;
5. *self-awareness*—having a concept of oneself, as an individual and/or as a member of a social group; and finally
6. *moral agency*—the capacity to regulate one's own actions through moral principles or ideals.

It is difficult to produce precise definitions of these traits, let alone to specify universally valid behavioral indications that these traits are present. But let us assume that our explorer knows approximately what these six characteristics mean, and that she is able to observe whether or not the extraterrestrials possess these mental and behavioral capacities. How should she use her findings to decide whether or not they are persons?

An entity need not have *all* of these attributes to be a person. And perhaps none of them is absolutely necessary. For instance, the absence of emotion would not disqualify a being that was person-like in all other ways. Think, for instance, of two of the *Star Trek* characters, Mr Spock (who is half human and half alien), and Data (who is an android). Both are depicted as lacking the capacity to feel emotion; yet both are sentient, reasoning, communicative, self-aware moral agents, and unquestionably persons. Some people are unemotional; some cannot communicate well; some lack self-awareness; and some are not moral agents. It should not surprise us that many people do not meet all of the criteria of personhood. Criteria for the applicability of complex concepts are often like this: none may be logically necessary, but the more criteria that are satisfied, the more confident we are that the concept is applicable. Conversely, the fewer criteria are satisfied, the less plausible it is to hold that the concept applies. And if none of the relevant criteria are met, then we may be confident that it does not.

Thus, to demonstrate that a fetus is not a person, all I need to claim is that an entity that has *none* of these six characteristics is not a person. Sentience is the most basic mental capacity, and the one that may have the best claim to being a necessary (though not sufficient) condition for personhood. Sentience can establish a claim to moral considerability, since sentient beings can be harmed in ways that matter to them; for instance, they can be caused to feel pain, or deprived of the continuation of a life that is pleasant to them. It is unlikely that an entirely insentient organism could develop the other mental and behavioral capacities that are characteristic of persons. Consequently, it is odd to claim that an entity that is not sentient, and that has never been sentient, is nevertheless a person. Persons who have permanently and irreparably lost all capacity for sentience, but who remain biologically alive, arguably still have strong moral rights by virtue of what they have been in the past. But small fetuses, which have not yet begun to have experiences, are not persons yet and do not have the rights that persons do.

The presumption that all persons have full and equal basic moral rights may be part of the very concept of a person. If this is so, then the concept of a person is in part a moral one; once we have admitted that X is a person, we have implicitly committed ourselves to recognizing X's right to be treated as a member of the moral community.[13] The claim that X is a *human being* may also be voiced as an appeal to treat X decently; but this is usually either because "human being" is used in the moral sense, or because of a confusion between genetic and moral humanity.

If (1)–(6) are the primary criteria of personhood, then genetic humanity is neither necessary nor sufficient for personhood. Some genetically human entities are not persons, and there may be persons who belong to other species. A man or woman whose consciousness has been permanently obliterated but who remains biologically alive is a human entity who may no longer be a person; and some unfortunate humans, who have never had any sensory or cognitive capacities at all, may not be people either. Similarly, an early fetus is a human entity which is not yet a person. It is not even minimally sentient, let alone capable of emotion, reason, sophisticated communication, self-awareness, or moral agency.[14] Thus, while it may be greatly valued as a future child, it does not yet have the claim to moral consideration that it may come to have later.

Moral agency matters to moral status, because it is moral agents who invent moral rights, and who can be obliged to respect them. Human beings have become moral agents from social necessity. Most social animals exist well enough, with no evident notion of a moral right. But human beings need moral rights, because we are not only highly social, but also sufficiently clever and self-interested to be

capable of undermining our societies through violence and duplicity. For human persons, moral rights are essential for peaceful and mutually beneficial social life. So long as some moral agents are denied basic rights, peaceful existence is difficult, since moral agents justly resent being treated as something less. If animals of some terrestrial species are found to be persons, or if alien persons come from other worlds, or if human beings someday invent machines whose mental and behavioral capacities make them persons, then we will be morally obliged to respect the moral rights of these nonhuman persons—at least to the extent that they are willing and able to respect ours in turn.

Although only those persons who are moral agents can participate directly in the shaping and enforcement of moral rights, they need not and usually do not ascribe moral rights only to themselves and other moral agents. Human beings are social creatures who naturally care for small children, and other members of the social community who are not currently capable of moral agency. Moreover, we are all vulnerable to the temporary or permanent loss of the mental capacities necessary for moral agency. Thus, we have self-interested as well as altruistic reasons for extending basic moral rights to infants and other sentient human beings who have already been born, but who currently lack some of these other mental capacities. These human beings, despite their current disabilities, are persons and members of the moral community.

But in extending moral rights to beings (human or otherwise) that have few or none of the morally significant characteristics of persons, we need to be careful not to burden human moral agents with obligations that they cannot possibly fulfill, except at unacceptably great cost to their own well-being and that of those they care about. Women often cannot complete unwanted pregnancies, except at intolerable mental, physical, and economic cost to themselves and their families. And heterosexual intercourse is too important a part of the social lives of most men and women to be reserved for times when pregnancy is an acceptable outcome. Furthermore, the world cannot afford the continued rapid population growth which is the inevitable consequence of prohibiting abortion, so long as contraception is neither very reliable nor available to everyone. If fetuses were persons, then they would have rights that must be respected, even at great social or personal cost. But given that early fetuses, at least, are unlike persons in the morally relevant respects, it is unreasonable to insist that they be accorded exactly the same moral and legal status.

Fetal Development and the Right to Life

Two questions arise regarding the application of these suggestions to the moral status of the fetus. First, if indeed fetuses are not yet persons, then might they nevertheless have strong moral rights based upon the degree to which they *resemble* persons? Secondly, to what extent, if any, does a fetus's potential to *become* a person imply that we ought to accord to it some of the same moral rights? Each of these questions requires comment.

It is reasonable to suggest that the more like a person something is—the more it appears to meet at least some of the criteria of personhood—the stronger is the case for according it a right to life, and perhaps the stronger its right to life is. That being the case, perhaps the fetus gradually gains a stronger right to life as it develops. We should take seriously the suggestion that, just as "the human individual develops biologically in a continuous fashion

the rights of a human person . . . develop in the same way."[15]

A seven-month fetus can apparently feel pain, and can respond to such stimuli as light and sound. Thus, it may have a rudimentary form of consciousness. Nevertheless, it is probably not as conscious, or as capable of emotion, as even a very young infant is; and it has as yet little or no capacity for reason, sophisticated intentional communication, or self-awareness. In these respects, even a late-term fetus is arguably less like a person than are many nonhuman animals. Many animals (e.g., large-brained mammals such as

elephants, cetaceans, or apes) are not only sentient, but clearly possessed of a degree of reason, and perhaps even of self-awareness. Thus, on the basis of its resemblance to a person, even a late-term fetus can have no more right to life than do these animals.

Animals may, indeed, plausibly be held to have some moral rights, and perhaps rather strong ones.[16] But it is impossible in practice to accord full and equal moral rights to all animals. When an animal poses a serious threat to the life or well-being of a person, we do not, as a rule, greatly blame the person for killing it; and there are good reasons for this species-based discrimination. Animals, however intelligent in their own domains, are generally not beings with whom we can reason; we cannot persuade mice not to invade our dwellings or consume our food. That is why their rights are necessarily weaker than those of a being who can understand and respect the rights of other beings.

But the probable sentience of late-term fetuses is not the only argument in favor of treating late abortion as a morally more serious matter than early abortion. Many—perhaps most—people are repulsed by the thought of needlessly aborting a late-term fetus. The late-term fetus has features which cause it to arouse in us almost the same powerful protective instinct as does a small infant.

This response needs to be taken seriously. If it were impossible to perform abortions early in pregnancy, then we might have to tolerate the mental and physical trauma that would be occasioned by the routine resort to late abortion. But where early abortion is safe, legal, and readily available to all women, it is not unreasonable to expect most women who wish to end a pregnancy to do so prior to the third trimester. Most women strongly prefer early to late abortion, because it is far less physically painful and emotionally traumatic. Other things being equal, it is better for all concerned that pregnancies that are not to be completed should be ended as early as possible. Few women would consider ending a pregnancy in the seventh month in order to take a trip to Europe. If, however, a woman's own life or health is at stake, or if the fetus has been found to be so severely abnormal as to be unlikely to survive or to have a life worth living, then late abortion may be the morally best

choice. For even a late-term fetus is not a person yet, and its rights must yield to those of the woman whenever it is impossible for both to be respected.

Potential Personhood and the Right to Life

We have seen that a presentient fetus does not yet resemble a person in ways which support the claim that it has strong moral rights. But what about its *potential*, the fact that if nurtured and allowed to develop it may eventually become a person? Doesn't that potential give it at least some right to life? The fact that something is a potential person may be a reason for not destroying it; but we need not conclude from this that potential people have a strong right to life. It may be that the feeling that it is better not to destroy a potential person is largely due to the fact that potential people are felt to be an invaluable resource, not to be lightly squandered. If every speck of dust were a potential person, we would be less apt to suppose that all potential persons have a right to become actual.

We do not need to insist that a potential person has no right to life whatever. There may be something immoral, and not just imprudent, about wantonly destroying potential people, when doing so isn't necessary. But even if a potential person does have some right to life, that right could not outweigh the right of a woman to obtain an abortion; for the basic moral rights of an actual person outweigh the rights of a merely potential person, whenever the two conflict. Since this may not be immediately obvious in the case of a human fetus, let us look at another case.

Suppose that our space explorer falls into the hands of an extraterrestrial civilization, whose scientists decide to create a few thousand new human beings by killing her and using some of her cells to create clones. We may imagine that each of these newly created women will have all of the original woman's abilities, skills, knowledge, and so on, and will also have an individual self-concept; in short, that each of them will be a bona fide (though not genetically unique) person. Imagine, further, that our explorer knows all of this, and knows that these people will

be treated kindly and fairly. I maintain that in such a situation she would have the right to escape if she could, thus depriving all of these potential people of their potential lives. For her right to life outweighs all of theirs put together, even though they are all genetically human, and have a high probability of becoming people, if only she refrains from acting.

Indeed, I think that our space traveler would have a right to escape even if it were not her life which the aliens planned to take, but only a year of her freedom, or only a day. She would not be obliged to stay, even if she had been captured because of her own lack of caution—or even if she had done so deliberately, knowing the possible consequences. Regardless of why she was captured, she is not obliged to remain in captivity for *any* period of time in order to permit merely potential people to become actual people. By the same token, a woman's rights to liberty and the control of her own body outweigh whatever right to life a fetus may have merely by virtue of its potential personhood.

The Objection from Infanticide

One objection to my argument is that it appears to justify not only abortion, but also infanticide. A newborn infant is not much more personlike than a nine-month fetus, and thus it might appear that if late-term abortion is sometimes justified, then infanticide must also sometimes be justified. Yet most people believe that infanticide is a form of murder, and virtually never justified.

This objection is less telling than it may seem. There are many reasons why infanticide is more difficult to justify than abortion, even though neither fetuses nor newborn infants are clearly persons. In this period of history, the deliberate killing of newborns is virtually never justified. This is in part because newborns are so close to being persons that to kill them requires a very strong moral justification—as does the killing of dolphins, chimpanzees, and other highly person-like creatures. It is certainly wrong to kill such beings for the sake of convenience, or financial profit, or "sport." Only the most vital human needs, such as the need to defend one's own life and physical integrity, can provide a plausible justification for killing such beings.

In the case of an infant, there is no such vital need, since in the contemporary world there are usually other people who are eager to provide a good home for an infant whose own parents are unable or unwilling to care for it. Many people wait years for the opportunity to adopt a child, and some are unable to do so, even though there is every reason to believe that they would be good parents. The needless destruction of a viable infant not only deprives a sentient human being of life, but also deprives other persons of a source of great satisfaction, perhaps severely impoverishing *their* lives.

Even if an infant is unadoptable (e.g., because of some severe physical disability), it is still wrong to kill it. For most of us value the lives of infants, and would greatly prefer to pay taxes to support foster care and state institutions for disabled children, rather than to allow them to be killed or abandoned. So long as most people feel this way, and so long as it is possible to provide care for infants who are unwanted, or who have special needs that their parents cannot meet without assistance, it is wrong to let any infant die who has a chance of living a reasonably good life.

If these arguments show that infanticide is wrong, at least in today's world, then why don't they also show that late-term abortion is always wrong? After all, third-trimester fetuses are almost as personlike as infants, and many people value them and would prefer that they be preserved. As a potential source of pleasure to some family, a fetus is just as valuable as an infant. But there is an important difference between these two cases: once the infant is born, its continued life cannot pose any serious threat to the woman's life or health, since she is free to put it up for adoption or to place it in foster care. While she might, in rare cases, prefer that the child die rather than being raised by others, such a preference would not establish a right on her part.

In contrast, a pregnant woman's right to protect her own life and health outweighs other people's desire that the fetus be preserved—just as, when a person's life or health is threatened by an animal, and when the threat cannot be removed without killing the animal, that person's right to self-defense outweighs the desires of those who would prefer that

the animal not be killed. Thus, while the moment of birth may mark no sharp discontinuity in the degree to which an infant resembles a person, it does mark the end of the mother's right to determine its fate. Indeed, if a late abortion can be safely performed without harming the fetus, the mother has in most cases no right to insist upon its death, for the same reason that she has no right to insist that a viable infant be killed or allowed to die.

It remains true that, on my view, neither abortion nor the killing of newborns is obviously a form of murder. Perhaps our legal system is correct in its classification of infanticide as murder, since no other legal category adequately expresses the force of our disapproval of this action. But some moral distinction remains, and it has important consequences. When a society cannot possibly care for all of the children who are born, without endangering the survival of adults and older children, allowing some infants to die may be the best of a bad set of options. Throughout history, most societies—from those that lived by gathering and hunting to the highly civilized Chinese, Japanese, Greeks, and Romans—have permitted infanticide under such unfortunate circumstances, regarding it as a necessary evil. It shows a lack of understanding to condemn these societies as morally benighted for this reason alone, since in the absence of safe and effective means of contraception and abortion, parents must sometimes have had no morally better options.

CONCLUSION

I have argued that fetuses are neither persons nor members of the moral community. Furthermore, neither a fetus's resemblance to a person, nor its potential for becoming a person, provides an adequate basis for the claim that it has a full and equal right to life. At the same time, there are medical as well as moral reasons for preferring early to late abortion when the pregnancy is unwanted.

Women, unlike fetuses, are undeniably persons and members of the human moral community. If unwanted or medically dangerous pregnancies never occurred, then it might be possible to respect women's basic moral rights, while at the same time extending the same basic rights to fetuses. But in the real world such pregnancies do occur—often despite the woman's best efforts to prevent them. Even if the perfect contraceptive were universally available, the continued occurrence of rape and incest would make access to abortion a vital human need. Because women are persons, and fetuses are not, women's rights to life, liberty, and physical integrity morally override whatever right to life it may be appropriate to ascribe to a fetus. Consequently, laws that deny women the right to obtain abortions, or that make safe early abortions difficult or impossible for some women to obtain, are an unjustified violation of basic moral and constitutional rights.

Notes

1. Strictly speaking, a human conceptus does not become a fetus until the primary organ systems have formed, at about six to eight weeks gestational age. However, for simplicity I shall refer to the conceptus as a fetus at every stage of its prenatal development.

2. The views defended in this article are set forth in greater depth in my book *Moral Status*, Oxford University Press, 2000.

3. For example, Roger Wertheimer argues, in "Understanding the Abortion Argument," *Philosophy and Public Affairs* 1 (Fall, 1971), that the moral status of abortion is not a question of fact, but only of how one responds to the facts.

4. John Noonan, "Abortion and the Catholic Church: A Summary History," *Natural Law Forum* 12 (1967): p. 125.

5. John Noonan, "Deciding Who is Human," *Natural Law Forum* 13 (1968): 134.

6. Noonan deviates from the current position of the Roman Catholic Church in that he thinks that abortion is morally permissible when it is the only way of saving the woman's life. See "An Almost Absolute Value in History," in *Contemporary Issues in Bioethics*, edited by Tom L. Beauchamp and LeRoy Walters (Belmont, California: Wadsworth, 1994), p. 283.

7. Judith Jarvis Thomson, "A Defense of Abortion," *Philosophy and Public Affairs* 11 (Fall, 1971): 173–8.

8. Ibid., p. 174.

9. Ibid., p. 187.

10. The principle that it is always wrong to kill innocent human beings may be in need of other modifications, e.g., that it may be permissible to kill innocent human

beings in order to save a larger number of equally innocent human beings; but we may ignore these complications here.

11. Noonan, "Deciding Who is Human," p. 135.

12. From here on, I will use "human" to mean "genetically human," since the moral sense of the term seems closely connected to, and perhaps derived from, the assumption that genetic humanity is both necessary and sufficient for membership in the moral community.

13. Alan Gewirth defends a similar claim, in *Reason and Morality* (Chicago: University of Chicago Press, 1978).

14. Fetal sentience is impossible prior to the development of neurological connections between the sense organs and the brain, and between the various parts of the brain involved in the processing of conscious experience. This stage of neurological development is currently thought to occur at some point in the late second or early third trimester.

15. Thomas L. Hayes, "A Biological View," *Commonweal*, 85 (March 17, 1967): 677–8; cited by Daniel Callahan, in *Abortion: Law, Choice, and Morality* (London: Macmillan, 1970).

16. See, for instance, Tom Regan, *The Case for Animal Rights* (Berkeley: University of California Press, 1983).

Study Questions

1. What characteristics entitle an entity to be considered a person?

2. What lessons does Warren draw from Thomson's case of the unconscious violinist?

3. According to Warren, who belongs to the moral community?

4. Is infanticide more difficult to justify than late-term abortion?

47

DON MARQUIS

Don Marquis, Professor of Philosophy at the University of Kansas, argues that, with rare exceptions, abortion is immoral. Marquis does not base his argument on the claim that the fetus is a person but rather on the view that an aborted fetus loses the future goods of consciousness, such as the completion of projects, the pursuit of goals, aesthetic enjoyment, friendships, intellectual pursuits, and physical pleasures of various sorts. In short, premature death deprives individuals of a future of value.

An Argument That Abortion Is Wrong

The purpose of this essay is to set out an argument for the claim that abortion, except perhaps in rare instances, is seriously wrong. One reason for these exceptions is to eliminate from consideration cases whose ethical analysis should be controversial and detailed for clear-headed opponents of abortion. Such cases include

abortion after rape and abortion during the first fourteen days after conception when there is an argument that the fetus is not definitely an individual. Another reason for making these exceptions is to allow for those cases in which the permissibility of abortion is compatible with the argument of this essay. Such cases include abortion when continuation of a pregnancy endangers a woman's life and abortion when the fetus is anencephalic. When I speak of the wrongness of abortion in this essay, a reader should presume the above qualifications. I mean by an abortion an action intended to bring about the death of a fetus for the sake of the woman who carries it. (Thus, as is standard on the literature on this subject, I eliminate spontaneous abortions from consideration.) I mean by a fetus a developing human being from the time of conception to the time of birth. (Thus, as is standard, I call embryos and zygotes, fetuses.)

The argument of this essay will establish that abortion is wrong for the same reason as killing a reader of this essay is wrong. I shall just assume, rather than establish, that killing you is seriously wrong. I shall make no attempt to offer a complete ethics of killing. Finally, I shall make no attempt to resolve some very fundamental and difficult general philosophical issues into which this analysis of the ethics of abortion might lead.

WHY THE DEBATE OVER ABORTION SEEMS INTRACTABLE

Symmetries that emerge from the analysis of the major arguments on either side of the abortion debate may explain why the abortion debate seems intractable. Consider the following standard anti-abortion argument: Fetuses are both human and alive. Humans have the right to life. Therefore, fetuses have the right to life. Of course, women have the right to control their own bodies, but the right to life overrides the right of a woman to control her own body. Therefore, abortion is wrong.

Thomson's View

Judith Thomson (1971) has argued that even if one grants (for the sake of argument only) that fetuses have the right to life, this argument fails. Thomson invites you to imagine that you have been connected while sleeping, bloodstream to bloodstream, to a famous violinist. The violinist, who suffers from a rare blood disease, will die if disconnected. Thomson argues that you surely have the right to disconnect yourself. She appeals to our intuition that having to lie in bed with a violinist for an indefinite period is too much for morality to demand. She supports this claim by noting that the body being used is *your* body, not the violinist's body. She distinguishes the right to life, which the violinist clearly has, from the right to use someone else's body when necessary to preserve one's life, which it is not at all obvious the violinist has. Because the case of pregnancy is like the case of the violinist, one is no more morally obligated to remain attached to a fetus than to remain attached to the violinist.

It is widely conceded that one can generate from Thomson's vivid case the conclusion that abortion is morally permissible when a pregnancy is due to rape (Warren, 1973, p. 49; and Steinbock, 1992, p. 79). But this is hardly a general right to abortion. Do Thomson's more general theses generate a more general right to an abortion? Thomson draws our attention to the fact that in a pregnancy, although a fetus uses a woman's body as a life-support system, a pregnant woman does not use a fetus's body as a life-support system. However, an opponent of abortion might draw our attention to the fact that in an abortion the life that is lost is the fetus's, not the woman's. This symmetry seems to leave us with a stand-off.

Thomson points out that a fetus's right to life does not entail its right to use someone else's body to preserve its life. However, an opponent of abortion might point out that a woman's right to use her own body does not entail her right to end someone else's life in order to do what she wants with her body. In reply, one might argue that a pregnant woman's right to control her own body doesn't come to much if it is wrong for her to take any action that ends the life of the fetus within her. However, an opponent of abortion can argue that the fetus's right to life doesn't come to much if a pregnant woman can end it when she chooses. The consequence of all of these symmetries seems to be a

stand-off. But if we have the stand-off, then one might argue that we are left with a conflict of rights: a fetal right to life versus the right of a woman to control her own body. One might then argue that the right to life seems to be a stronger right than the right to control one's own body in the case of abortion because the loss of one's life is a greater loss than the loss of the right to control one's own body in one respect for nine months. Therefore, the right to life overrides the right to control one's own body and abortion is wrong. Considerations like these have suggested to both opponents of abortion and supporters of choice that a Thomsonian strategy for defending a general right to abortion will not succeed (Tooley, 1972; Warren, 1973; and Steinbock, 1992). In fairness, one must note that Thomson did not intend her strategy to generate a general moral permissibility of abortion.

Do Fetuses Have the Right to Life?

The above considerations suggest that whether abortion is morally permissible boils down to the question of whether fetuses have the right to life. An argument that fetuses either have or lack the right to life must be based upon some general criterion for having or lacking the right to life. Opponents of abortion, on the one hand, look around for the broadest possible plausible criterion, so that fetuses will fall under it. This explains why classic arguments against abortion appeal to the criterion of being human (Noonan, 1970; Beckwith, 1993). This criterion appears plausible: The claim that all humans, whatever their race, gender, religion or *age*, have the right to life seems evident enough. In addition, because the fetuses we are concerned with do not, after all, belong to another species, they are clearly human. Thus, the syllogism that generates the conclusion that fetuses have the right to life is apparently sound.

On the other hand, those who believe abortion is morally permissible wish to find a narrow, but plausible, criterion for possession of the right to life so that fetuses will fall outside of it. This explains, in part, why the standard pro-choice arguments in the philosophical literature appeal to the criterion of being a person (Feinberg, 1986; Tooley, 1972; Warren,

1973; Benn, 1973; Engelhardt, 1986). This criterion appears plausible: The claim that only persons have the right to life seems evident enough. Furthermore, because fetuses neither are rational nor possess the capacity to communicate in complex ways nor possess a concept of self that continues through time, no fetus is a person. Thus, the syllogism needed to generate the conclusion that no fetus possesses the right to life is apparently sound. Given that no fetus possesses the right to life, a woman's right to control her own body easily generates the general right to abortion. The existence of two apparently defensible syllogisms which support contrary conclusions helps to explain why partisans on both sides of the abortion dispute often regard their opponents as either morally depraved or mentally deficient.

Which syllogism should we reject? The anti-abortion syllogism is usually attacked by attacking its major premise: the claim that whatever is biologically human has the right to life. This premise is subject to scope problems because the class of the biologically human includes too much: human cancer-cell cultures are biologically human, but they do not have the right to life. Moreover, this premise also is subject to moral-relevance problems: the connection between the biological and the moral is merely assumed. It is hard to think of a good *argument* for such a connection. If one wishes to consider the category of "human" a moral category, as some people find it plausible to do in other contexts, then one is left with no way of showing that the fetus is fully human without begging the question. Thus, the classic anti-abortion argument appears subject to fatal difficulties.

These difficulties with the classic anti-abortion argument are well known and thought by many to be conclusive. The symmetrical difficulties with the classic pro-choice syllogism are not as well recognized. The pro-choice syllogism can be attacked by attacking its major premise: Only persons have the right to life. This premise is subject to scope problems because the class of persons includes too little: infants, the severely retarded, and some of the mentally ill seem to fall outside the class of persons as the supporter of choice understands the concept. The premise is also subject to moral-relevance problems:

Being a person is understood by the pro-choicer as having certain psychological attributes. If the pro-choicer questions the connection between the biological and the moral, the opponent of abortion can question the connection between the psychological and the moral. If one wishes to consider "person" a moral category, as is often done, then one is left with no way of showing that the fetus is not a person without begging the question.

Pro-choicers appear to have resources for dealing with their difficulties that opponents of abortion lack. Consider their moral-relevance problem. A pro-choicer might argue that morality rests on contractual foundations and that only those who have the psychological attributes of persons are capable of entering into the moral contract and, as a consequence, being a member of the moral community. (This is essentially Engelhardt's [1986] view.) The great advantage of this contractarian approach to morality is that it seems far more plausible than any approach the anti-abortionist can provide. The great disadvantage of this contractarian approach to morality is that it adds to our earlier scope problems by leaving it unclear how we can have the duty not to inflict pain and suffering on animals.

Contractarians have tried to deal with their scope problems by arguing that duties to some individuals who are not persons can be justified even though those individuals are not contracting members of the moral community. For example, Kant argued that, although we do not have direct duties to animals, we "must practice kindness towards animals, for he who is cruel to animals becomes hard also in his dealings with men" (Kant, 1963, p. 240). Feinberg argues that infanticide is wrong, not because infants have the right to life, but because our society's protection of infants has social utility. If we do not treat infants with tenderness and consideration, then when they are persons they will be worse off and we will be worse off also (Feinberg, 1986, p. 271).

These moves only stave off the difficulties with the pro-choice view; they do not resolve them. Consider Kant's account of our obligations to animals. Kantians certainly know the difference between persons and animals. Therefore, no true Kantian would

treat persons as she would treat animals. Thus, Kant's defense of our duties to animals fails to show that Kantians have a duty not to be cruel to animals. Consider Feinberg's attempt to show that infanticide is wrong even though no infant is a person. All Feinberg really shows is that it is a good idea to treat with care and consideration the infants we intend to keep. That is quite compatible with killing the infants we intend to discard. This point can be supported by an analogy with which any pro-choicer will agree. There are plainly good reasons to treat with care and consideration the fetuses we intend to keep. This is quite compatible with aborting those fetuses we intend to discard. Thus, Feinberg's account of the wrongness of infanticide is inadequate.

Accordingly, we can see that a contractarian defense of the pro-choice personhood syllogism fails. The problem arises because the contractarian cannot account for our duties to individuals who are not persons, whether these individuals are animals or infants. Because the pro-choicer wishes to adopt a narrow criterion for the right to life so that fetuses will not be included, the scope of her major premise is too narrow. Her problem is the opposite of the problem the classic opponent of abortion faces.

The argument of this section has attempted to establish, albeit briefly, that the classic anti-abortion argument and the pro-choice argument favored by most philosophers both face problems that are mirror images of one another. A stand-off results. The abortion debate requires a different strategy.

THE "FUTURE LIKE OURS" ACCOUNT OF THE WRONGNESS OF KILLING

Why do the standard arguments in the abortion debate fail to resolve the issue? The general principles to which partisans in the debate appeal are either truisms most persons would affirm in the absence of much reflection, or very general moral theories. All are subject to major problems. A different approach is needed.

Opponents of abortion claim that abortion is wrong because abortion involves killing someone

like us, a human being who just happens to be very young. Supporters of choice claim that ending the life of a fetus is not in the same moral category as ending the life of an adult human being. Surely this controversy cannot be resolved in the absence of an account of what it is about killing us that makes killing us wrong. On the one hand, if we know what property we possess that makes killing us wrong, then we can ask whether fetuses have the same property. On the other hand, suppose that we do not know what it is about us that makes killing us wrong. If this is so, we do not understand even easy cases in which killing is wrong. Surely, we will not understand the ethics of killing fetuses, for if we do not understand easy cases, then we will not understand hard cases. Both pro-choicer and anti-abortionist agree that it is obvious that it is wrong to kill us. Thus, a discussion of what it is about us that makes killing us not only wrong, but seriously wrong, seems to be the right place to begin a discussion of the abortion issue.

Who is primarily wronged by a killing? The wrong of killing is not primarily explained in terms of the loss to the family and friends of the victim. Perhaps the victim is a hermit. Perhaps one's friends find it easy to make new friends. The wrong of killing is not primarily explained in terms of the brutalization of the killer. The great wrong to the victim explains the brutalization, not the other way around. The wrongness of killing us is understood in terms of what killing does to us. Killing us imposes on us the misfortune of premature death. That misfortune underlies the wrongness.

Premature death is a misfortune because when one is dead, one has been deprived of life. This misfortune can be more precisely specified. Premature death cannot deprive me of my past life. That part of my life is already gone. If I die tomorrow or if I live thirty more years my past life will be no different. It has occurred on either alternative. Rather than my past, my death deprives me of my future, of the life that I would have lived if I had lived out my natural life span.

The loss of a future biological life does not explain the misfortune of death. Compare two scenarios: In the former I now fall into a coma from which I do not recover until my death in thirty years. In the latter I die now. The latter scenario does not seem to describe a greater misfortune than the former.

The loss of our future conscious life is what underlies the misfortune of premature death. Not any future conscious life qualifies, however. Suppose that I am terminally ill with cancer. Suppose also that pain and suffering would dominate my future conscious life. If so, then death would not be a misfortune for me.

Thus, the misfortune of premature death consists of the loss to us of the future goods of consciousness. What are these goods? Much can be said about this issue, but a simple answer will do for the purposes of this essay. The goods of life are whatever we get out of life. The goods of life are those items toward which we take a "pro" attitude. They are completed projects of which we are proud, the pursuit of our goals, aesthetic enjoyments, friendships, intellectual pursuits, and physical pleasures of various sorts. The goods of life are what makes life worth living. In general, what makes life worth living for one person will not be the same as what makes life worth living for another. Nevertheless, the list of goods in each of our lives will overlap. The lists are usually different in different stages of our lives.

What makes the goods of my future good for me? One possible, but wrong, answer is my desire for those goods now. This answer does not account for those aspects of my future life that I now believe I will later value, but about which I am wrong. Neither does it account for those aspects of my future that I will come to value, but which I don't value now. What is valuable to the young may not be valuable to the middle-aged. What is valuable to the middle-aged may not be valuable to the old. Some of life's values for the elderly are best appreciated by the elderly. Thus it is wrong to say that the value of my future to me is just what I value now. What makes my future valuable to me are those aspects of my future that I will (or would) value when I will (or would) experience them, whether I value them now or not.

It follows that a person can believe that she will have a valuable future and be wrong. Furthermore,

a person can believe that he will not have a valuable future and also be wrong. This is confirmed by our attitude toward many of the suicidal. We attempt to save the lives of the suicidal and to convince them that they have made an error in judgment. This does not mean that the future of an individual obtains value from the value that others confer on it. It means that, in some cases, others can make a clearer judgment of the value of a person's future *to that person* than the person herself. This often happens when one's judgment concerning the value of one's own future is clouded by personal tragedy. (Compare the views of McInerney, 1990, and Shirley, 1995.)

Thus, what is sufficient to make killing us wrong, in general, is that it causes premature death. Premature death is a misfortune. Premature death is a misfortune, in general, because it deprives an individual of a future of value. An individual's future will be valuable to that individual if that individual will come, or would come, to value it. We know that killing us is wrong. What makes killing us wrong, in general, is that it deprives us of a future of value. Thus, killing someone is wrong, in general, when it deprives her of a future like ours. I shall call this "an FLO."

ARGUMENTS IN FAVOR OF THE FLO THEORY

At least four arguments support this FLO account of the wrongness of killing.

The Considered Judgment Argument

The FLO account of the wrongness of killing is correct because it fits with our considered judgment concerning the nature of the misfortune of death. The analysis of the previous section is an exposition of the nature of this considered judgment. This judgment can be confirmed. If one were to ask individuals with AIDS or with incurable cancer about the nature of their misfortune, I believe that they would say or imply that their impending loss of an FLO makes their premature death a misfortune. If they would not, then the FLO account would plainly be wrong.

The Worst of Crimes Argument

The FLO account of the wrongness of killing is correct because it explains why we believe that killing is one of the worst of crimes. My being killed deprives me of more than does my being robbed or beaten or harmed in some other way because my being killed deprives me of all of the value of my future, not merely part of it. This explains why we make the penalty for murder greater than the penalty for other crimes.

As a corollary the FLO account of the wrongness of killing also explains why killing an adult human being is justified only in the most extreme circumstances, only in circumstances in which the loss of life to an individual is outweighed by a worse outcome if that life is not taken. Thus, we are willing to justify killing in self-defense, killing in order to save one's own life, because one's loss if one does not kill in that situation is so very great. We justify killing in a just war for similar reasons. We believe that capital punishment would be justified if, by having such an institution, fewer premature deaths would occur. The FLO account of the wrongness of killing does not entail that killing is always wrong. Nevertheless, the FLO account explains both why killing is one of the worst of crimes and, as a corollary, why the exceptions to the wrongness of killing are so very rare. A correct theory of the wrongness of killing should have these features.

The Appeal to Cases Argument

The FLO account of the wrongness of killing is correct because it yields the correct answers in many life-and-death cases that arise in medicine and have interested philosophers.

Consider medicine first. Most people believe that it is not wrong deliberately to end the life of a person who is permanently unconscious. Thus we believe that it is not wrong to remove a feeding tube or a ventilator from a permanently comatose patient, knowing that such a removal will cause death. The FLO account of the wrongness of killing explains why this is so. A patient who is permanently unconscious

cannot have a future that she would come to value, whatever her values. Therefore, according to the FLO theory of the wrongness of killing, death could not, *ceteris paribus*, be a misfortune to her. Therefore, removing the feeding tube or ventilator does not wrong her.

By contrast, almost all people believe that it is wrong, *ceteris paribus*, to withdraw medical treatment from patients who are temporarily unconscious. The FLO account of the wrongness of killing also explains why this is so. Furthermore, these two unconsciousness cases explain why the FLO account of the wrongness of killing does not include present consciousness as a necessary condition for the wrongness of killing.

Consider now the issue of the morality of legalizing active euthanasia. Proponents of active euthanasia argue that if a patient faces a future of intractable pain and wants to die, then, *ceteris paribus*, it would not be wrong for a physician to give him medicine that she knows would result in his death. This view is so universally accepted that even the strongest *opponents* of active euthanasia hold it. The official Vatican view (Sacred Congregation, 1980) is that it is permissible for a physician to administer to a patient morphine sufficient (although no more than sufficient) to control his pain even if she foresees that the morphine will result in his death. Notice how nicely the FLO account of the wrongness of killing explains this unanimity of opinion. A patient known to be in severe intractable pain is presumed to have a future without positive value. Accordingly, death would not be a misfortune for him and an action that would (foreseeably) end his life would not be wrong.

Contrast this with the standard emergency medical treatment of the suicidal. Even though the suicidal have indicated that they want to die, medical personnel will act to save their lives. This supports the view that it is not the mere *desire* to enjoy an FLO which is crucial to our understanding of the wrongness of killing. *Having* an FLO is what is crucial to the account, although one would, of course, want to make an exception in the case of fully autonomous people who refuse life-saving medical treatment. Opponents of abortion can, of course, be willing to make an exception for fully autonomous fetuses who refuse life support.

The FLO theory of the wrongness of killing also deals correctly with issues that have concerned philosophers. It implies that it would be wrong to kill (peaceful) persons from outer space who come to visit our planet even though they are biologically utterly unlike us. Presumably, if they are persons, then they will have futures that are sufficiently like ours so that it would be wrong to kill them. The FLO account of the wrongness of killing shares this feature with the personhood views of the supporters of choice. Classical opponents of abortion who locate the wrongness of abortion somehow in the biological humanity of a fetus cannot explain this.

The FLO account does not entail that there is another species of animals whose members ought not to be killed. Neither does it entail that it is permissible to kill any non-human animal. On the one hand, a supporter of animals' rights might argue that since some non-human animals have a future of value, it is wrong to kill them also, or at least it is wrong to kill them without a far better reason than we usually have for killing non-human animals. On the other hand, one might argue that the futures of non-human animals are not sufficiently like ours for the FLO account to entail that it is wrong to kill them. Since the FLO account does not specify which properties a future of another individual must possess so that killing that individual is wrong, the FLO account is indeterminate with respect to this issue. The fact that the FLO account of the wrongness of killing does not give a determinate answer to this question is not a flaw in the theory. A sound ethical account should yield the right answers in the obvious cases; it should not be required to resolve every disputed question.

A major respect in which the FLO account is superior to accounts that appeal to the concept of person is the explanation the FLO account provides of the wrongness of killing infants. There was a class of infants who had futures that included a class of events that were identical to the futures of the readers of this essay. Thus, reader, the FLO account

explains why it was as wrong to kill you when you were an infant as it is to kill you now. This account can be generalized to almost all infants. Notice that the wrongness of killing infants can be explained in the absence of an account of what makes the future of an individual sufficiently valuable so that it is wrong to kill that individual. The absence of such an account explains why the FLO account is indeterminate with respect to the wrongness of killing non-human animals.

If the FLO account is the correct theory of the wrongness of killing, then because abortion involves killing fetuses and fetuses have FLOs for exactly the same reasons that infants have FLOs, abortion is presumptively seriously immoral. This inference lays the necessary groundwork for a fourth argument in favor of the FLO account that shows that abortion is wrong.

The Analogy with Animals Argument

Why do we believe it is wrong to cause animals suffering? We believe that, in our own case and in the case of other adults and children, suffering is a misfortune. It would be as morally arbitrary to refuse to acknowledge that animal suffering is wrong as it would be to refuse to acknowledge that the suffering of persons of another race is wrong. It is, on reflection, suffering that is a misfortune, not the suffering of white males or the suffering of humans. Therefore, infliction of suffering is presumptively wrong no matter on whom it is inflicted and whether it is inflicted on persons or nonpersons. Arbitrary restrictions on the wrongness of suffering count as racism or speciesism. Not only is this argument convincing on its own, but it is the only way of justifying the wrongness of animal cruelty. Cruelty toward animals is clearly wrong. (This famous argument is due to Singer, 1979.)

The FLO account of the wrongness of abortion is analogous. We believe that, in our own case and the cases of other adults and children, the loss of a future of value is a misfortune. It would be as morally arbitrary to refuse to acknowledge that the loss of a future of value to a fetus is wrong as to refuse to acknowledge that the loss of a future of value to Jews (to take a relevant twentieth-century example) is wrong. It is, on reflection, the loss of a future of value that is a misfortune; not the loss of a future of value to adults or loss of a future of value to non-Jews. To deprive someone of a future of value is wrong no matter on whom the deprivation is inflicted and no matter whether the deprivation is inflicted on persons or nonpersons. Arbitrary restrictions on the wrongness of this deprivation count as racism, genocide or ageism. Therefore, abortion is wrong. This argument that abortion is wrong should be convincing because it has the same form as the argument for the claim that causing pain and suffering to non-human animals is wrong. Since the latter argument is convincing, the former argument should be also. Thus, an analogy with animals supports the thesis that abortion is wrong.

REPLIES TO OBJECTIONS

The four arguments in the previous section establish that abortion is, except in rare cases, seriously immoral. Not surprisingly, there are objections to this view. There are replies to the four most important objections to the FLO argument for the immorality of abortion.

The Potentiality Objection

The FLO account of the wrongness of abortion is a potentiality argument. To claim that a fetus *has* an FLO is to claim that a fetus now has the potential to be in a state of a certain kind in the future. It is not to claim that all ordinary fetuses *will* have FLOs. Fetuses who are aborted, of course, will not. To say that a standard fetus has an FLO is to say that a standard fetus either will have or would have a life it will or would value. To say that a standard fetus would have a life it would value is to say that it will have a life it will value if it does not die prematurely. The truth of this conditional is based upon the nature of fetuses (including the fact that they naturally age) and this nature concerns their potential.

Some appeals to potentiality in the abortion debate rest on unsound inferences. For example, one may try to generate an argument against abortion by arguing that because persons have the right to life, potential persons also have the right to life. Such an argument is plainly invalid as it stands. The premise one needs to add to make it valid would have to be something like: "If Xs have the right to Y, then potential Xs have the right to Y." This premise is plainly false. Potential presidents don't have the rights of the presidency; potential voters don't have the right to vote.

In the FLO argument potentiality is not used in order to bridge the gap between adults and fetuses as is done in the argument in the above paragraph. The FLO theory of the wrongness of killing adults is based upon the adult's potentiality to have a future of value. Potentiality is in the argument from the very beginning. Thus, the plainly false premise is not required. Accordingly, the use of potentiality in the FLO theory is not a sign of an illegitimate inference.

The Argument from Interests

A second objection to the FLO account of the immorality of abortion involves arguing that even though fetuses have FLOs, nonsentient fetuses do not meet the minimum conditions for having any moral standing at all because they lack interests. Steinbock (1992, p. 5) has presented this argument clearly:

> Beings that have moral status must be capable of caring about what is done to them. They must be capable of being made, if only in a rudimentary sense, happy or miserable, comfortable or distressed. Whatever reasons we may have for preserving or protecting nonsentient beings, these reasons do not refer to their own interests. For without conscious awareness, beings cannot have interests. Without interests, they cannot have a welfare of their own. Without a welfare of their own, nothing can be done for their sake. Hence, they lack moral standing or status.

Medical researchers have argued that fetuses do not become sentient until after 22 weeks of gestation

(Steinbock, 1992, p. 50). If they are correct, and if Steinbock's argument is sound, then we have both an objection to the FLO account of the wrongness of abortion and a basis for a view on abortion minimally acceptable to most supporters of choice.

Steinbock's conclusion conflicts with our settled moral beliefs. Temporarily unconscious human beings are nonsentient, yet no one believes that they lack either interests or moral standing. Accordingly, neither conscious awareness nor the capacity for conscious awareness is a necessary condition for having interests.

The counter-example of the temporarily unconscious human being shows that there is something internally wrong with Steinbock's argument. The difficulty stems from an ambiguity. One cannot *take* an interest in something without being capable of caring about what is done to it. However, something can be *in* someone's interest without that individual being capable of caring about it, or about anything. Thus, life support can be *in* the interests of a temporarily unconscious patient even though the temporarily unconscious patient is incapable of *taking* an interest in that life support. If this can be so for the temporarily unconscious patient, then it is hard to see why it cannot be so for the temporarily unconscious (that is, nonsentient) fetus who requires placental life support. Thus the objection based on interests fails.

The Problem of Equality

The FLO account of the wrongness of killing seems to imply that the degree of wrongness associated with each killing varies inversely with the victim's age. Thus, the FLO account of the wrongness of killing seems to suggest that it is far worse to kill a five-year-old than an 89-year-old because the former is deprived of far more than the latter. However, we believe that all persons have an equal right to life. Thus, it appears that the FLO account of the wrongness of killing entails an obviously false view (Paske, 1994).

However, the FLO account of the wrongness of killing does not, strictly speaking, imply that it

is worse to kill younger people than older people. The FLO account provides an explanation of the wrongness of killing that is sufficient to account for the serious presumptive wrongness of killing. It does not follow that killings cannot be wrong in other ways. For example, one might hold, as does Feldman (1992, p. 184), that in addition to the wrongness of killing that has its basis in the future life of which the victim is deprived, killing an individual is also made wrong by the admirability of an individual's past behavior. Now the amount of admirability will presumably vary directly with age, whereas the amount of deprivation will vary inversely with age. This tends to equalize the wrongness of murder.

However, even if, *ceteris paribus*, it is worse to kill younger persons than older persons, there are good reasons for adopting a doctrine of the legal equality of murder. Suppose that we tried to estimate the seriousness of a crime of murder by appraising the value of the FLO of which the victim had been deprived. How would one go about doing this? In the first place, one would be confronted by the old problem of interpersonal comparisons of utility. In the second place, estimation of the value of a future would involve putting oneself, not into the shoes of the victim at the time she was killed, but rather into the shoes the victim would have worn had the victim survived, and then estimating from that perspective the worth of that person's future. This task seems difficult, if not impossible. Accordingly, there are reasons to adopt a convention that murders are equally wrong.

Furthermore, the FLO theory, in a way, explains why we do adopt the doctrine of the legal equality of murder. The FLO theory explains why we regard murder as one of the worst of crimes, since depriving someone of a future like ours deprives her of more than depriving her of anything else. This gives us a reason for making the punishment for murder very harsh, as harsh as is compatible with civilized society. One should not make the punishment for younger victims harsher than that. Thus, the doctrine of the equal legal right to life does not seem to be incompatible with the FLO theory.

The Contraception Objection

The strongest objection to the FLO argument for the immorality of abortion is based on the claim that, because contraception results in one less FLO, the FLO argument entails that contraception, indeed, abstention from sex when conception is possible, is immoral. Because neither contraception nor abstention from sex when conception is possible is immoral, the FLO account is flawed.

There is a cogent reply to this objection. If the argument of the early part of this essay is correct, then the central issue concerning the morality of abortion is the problem of whether fetuses are individuals who are members of the class of individuals whom it is seriously presumptively wrong to kill. The properties of being human and alive, of being a person, and of having an FLO are criteria that participants in the abortion debate have offered to mark off the relevant class of individuals. The central claim of this essay is that having an FLO marks off the relevant class of individuals. A defender of the FLO view could, therefore, reply that since, at the time of contraception, there is no individual to have an FLO, the FLO account does not entail that contraception is wrong. The wrong of killing is primarily a wrong to the individual who is killed; at the time of contraception there is no individual to be wronged.

However, someone who presses the contraception objection might have an answer to this reply. She might say that the sperm and egg are the individuals deprived of an FLO at the time of contraception. Thus, there are individuals whom contraception deprives of an FLO and if depriving an individual of an FLO is what makes killing wrong, then the FLO theory entails that contraception is wrong.

There is also a reply to this move. In the case of abortion, an objectively determinate individual is the subject of harm caused by the loss of an FLO. This individual is a fetus. In the case of contraception, there are far more candidates (see Norcross, 1990). Let us consider some possible candidates in order of the increasing number of individuals harmed:

(1) The single harmed individual might be the combination of the particular sperm and the particular egg that would have united to form a zygote if contraception had not been used. (2) The two harmed individuals might be the particular sperm itself, and, in addition, the ovum itself that would have physically combined to form the zygote. (This is modeled on the double homicide of two persons who would otherwise in a short time fuse. (1) is modeled on harm to a single entity some of whose parts are not physically contiguous, such as a university.) (3) The many harmed individuals might be the millions of *combinations* of sperm and the released ovum whose (small) chance of having an FLO were reduced by the successful contraception. (4) The even larger class of harmed individuals (larger by one) might be the class consisting of all of the individual sperm in an ejaculate and, in addition, the individual ovum released at the time of the successful contraception. (1) through (4) are all candidates for being the subject(s) of harm in the case of successful contraception or abstinence from sex. Which should be chosen? Should we hold a lottery? There seems to be no non-arbitrarily determinate subject of harm in the case of successful contraception. But if there is no such subject of harm, then no determinate thing was harmed. If no determinate thing was harmed, then (in the case of contraception) no wrong has been done. Thus, the FLO account of the wrongness of abortion does not entail that contraception is wrong.

CONCLUSION

This essay contains an argument for the view that, except in unusual circumstances, abortion is seriously wrong. Deprivation of an FLO explains why killing adults and children is wrong. Abortion deprives fetuses of FLOs. Therefore, abortion is wrong. This argument is based on an account of the wrongness of killing that is a result of our considered judgment of the nature of the misfortune of premature death. It accounts for why we regard killing as one of the worst of crimes. It is superior to alternative accounts of the wrongness of killing that are intended to provide insight into the ethics of abortion. This account of the wrongness of killing is supported by the way it handles cases in which our moral judgments are settled. This account has an analogue in the most plausible account of the wrongness of causing animals to suffer. This account makes no appeal to religion. Therefore, the FLO account shows that abortion, except in rare instances, is seriously wrong.

References

Beckwith, F. J., *Politically Correct Death: Answering Arguments for Abortion Rights* (Grand Rapids, Michigan: Baker Books, 1993).

Benn, S. I., "Abortion, Infanticide, and Respect for Persons," *The Problem of Abortion*, ed. J. Feinberg (Belmont, California: Wadsworth, 1973), pp. 92–104.

Engelhardt, Jr, H. T., *The Foundations of Bioethics* (New York: Oxford University Press, 1986).

Feinberg, J., "Abortion," *Matters of Life and Death: New Introductory Essays in Moral Philosophy*, ed. T. Regan (New York: Random House, 1986).

Feldman, F., *Confrontations with the Reaper: A Philosophical Study of the Nature and Value of Death* (New York: Oxford University Press, 1992).

Kant, I., *Lectures on Ethics*, trans. L. Infeld (New York: Harper, 1963).

Marquis, D. B., "A Future like Ours and the Concept of Person: a Reply to Mcinerney and Paske," *The Abortion Controversy: A Reader*, ed. L. P. Pojman and F. J. Beckwith (Boston: Jones and Bartlett, 1994). pp. 354–68.

———, "Fetuses, Futures and Values: a Reply to Shirley," *Southwest Philosophy Review* 11 (1995): 263–5.

———, "Why Abortion Is Immoral," *Journal of Philosophy* 86 (1989): 183–202.

McInerney, P., "Does a Fetus Already Have a Future like Ours?," *Journal of Philosophy* 87 (1990): 264–8.

Noonan, J., "An Almost Absolute Value in History," in *The Morality of Abortion*, ed. J. Noonan (Cambridge, MA: Harvard University Press, 1970).

Norcross, A., "Killing, Abortion, and Contraception: a Reply to Marquis," *Journal of Philosophy* 87 (1990): 268–77.

Paske, G., "Abortion and the Neo-natal Right to Life: a Critique of Marquis's Futurist Argument," *The Abortion Controversy: A Reader*, ed. L. P. Pojman and F. J. Beckwith (Boston: Jones and Bartlett, 1994), pp. 343–53.

Sacred Congregation for the Propagation of the Faith, *Declaration on Euthanasia* (Vatican City, 1980).

Shirley, E. S., "Marquis' Argument Against Abortion: a Critique," *Southwest Philosophy Review* 11 (1995): 79–89.

Singer, P., "Not for Humans Only: the Place of Nonhumans in Environmental Issues," *Ethics and Problems of the 21st Century*, ed. K. E. Goodpaster and K. M. Sayre (South Bend: Notre Dame University Press, 1979).

Steinbock, B., *Life Before Birth: The Moral and Legal Status of Embryos and Fetuses* (New York: Oxford University Press, 1992).

Thomson, J. J., "A Defense of Abortion," *Philosophy and Public Affairs* 1 (1971): 47–66.

Tooley, M., "Abortion and Infanticide," *Philosophy and Public Affairs* 2 (1972): 37–65.

Warren, M. A., "On the Moral and Legal Status of Abortion," *Monist* 57 (1973): 43–61.

Study Questions

1. Is the loss of one's future as devastating for a fetus as for a child?

2. Does Marquis's argument that abortion is immoral depend on religious considerations?

3. Does Marquis's position imply that using contraception is wrong?

4. According to Marquis, in what circumstances is abortion not wrong?

48

ROSALIND HURSTHOUSE

Rosalind Hursthouse is Professor of Philosophy at the University of Auckland in New Zealand. She responds to criticisms of virtue theory by demonstrating how it can be applied to the issue of abortion. She argues that the deep emotions that surround parenthood and family relationships indicate that pregnancy and its termination are serious matters. Accordingly, treating them trivially demonstrates the vices of callousness and light-mindedness. She maintains that even in cases in which abortion is right, it will probably cause some evil.

Virtue Theory and Abortion

The sort of ethical theory derived from Aristotle, variously described as virtue ethics, virtue-based ethics, or neo-Aristotelianism, is becoming better known, and is now quite widely recognized as at least a possible rival to deontological and utilitarian theories. With recognition has come criticism, of varying quality. In this article I shall discuss nine separate criticisms that I have frequently encountered, most of which seem to me to betray an inadequate grasp either of the structure of virtue theory or of what would be involved in thinking about a real moral issue in its terms. In the first half I aim particularly to secure an understanding that will reveal that many of these criticisms are simply misplaced, and to articulate what I take to be the major criticism of virtue theory. I reject this criticism, but do not claim that it is necessarily misplaced. In the second half I aim to deepen that understanding and highlight the issues raised by the criticisms by illustrating what the theory looks like when it is applied to a particular issue, in this case, abortion.

VIRTUE THEORY

Virtue theory can be laid out in a framework that reveals clearly some of the essential similarities and differences between it and some versions of deontological and utilitarian theories. I begin with a rough sketch of familiar versions of the latter two sorts of theory, not, of course, with the intention of suggesting that they exhaust the field, but on the assumption that their very familiarity will provide a helpful contrast with virtue theory. Suppose a deontological theory has basically the following framework. We begin with a premise providing a specification of right action:

P.1. An action is right iff it is in accordance with a moral rule or principle.

This is a purely formal specification, forging a link between the concepts of *right action* and *moral rule*, and gives one no guidance until one knows what a

From *Philosophy & Public Affairs*, 20 (1991), by permission of Blackwell Publishing Ltd.

moral rule is. So the next thing the theory needs is a premise about that:

P.2. A moral rule is one that . . .

Historically, an acceptable completion of P.2 would have been

(i) is laid on us by God

or

(ii) is required by natural law.

In secular versions (not, of course, unconnected to God's being pure reason, and the universality of natural law) we get such completions as

(iii) is laid on us by reason

or

(iv) is required by rationality

or

(v) would command universal rational acceptance

or

(vi) would be the object of choice of all rational beings

and so on. Such a specification forges a second conceptual link, between the concepts of *moral rule* and *rationality*.

We have here the skeleton of a familiar version of a deontological theory, a skeleton that reveals that what is essential to any such version is the links between *right action, moral rule*, and *rationality*. That these form the basic structure can be seen particularly vividly if we lay out the familiar act-utilitarianism in such a way as to bring out the contrasts.

Act-utilitarianism begins with a premise that provides a specification of right action:

P.1. An action is right iff it promotes the best consequences.

It thereby forges the link between the concepts of *right action* and *consequences*. It goes on to specify what the best consequences are in its second premise:

P.2. The best consequences are those in which happiness is maximized.

It thereby forges the link between *consequences* and *happiness*.

Now let us consider what a skeletal virtue theory looks like. It begins with a specification of right action:

P.1. An action is right iff it is what a virtuous agent would do in the circumstances.[1]

This, like the first premises of the other two sorts of theory, is a purely formal principle, giving one no guidance as to what to do, that forges the conceptual link between *right action* and *virtuous agent*. Like the other theories, it must, of course, go on to specify what the latter is. The first step toward this may appear quite trivial, but is needed to correct a prevailing tendency among many critics to define the virtuous agent as one who is disposed to act in accordance with a deontologist's moral rules.

P.1a. A virtuous agent is one who acts virtuously, that is, one who has and exercises the virtues.

This subsidiary premise lays bare the fact that virtue theory aims to provide a nontrivial specification of the virtuous agent *via* a nontrivial specification of the virtues, which is given in its second premise:

P.2. A virtue is a character trait a human being needs to flourish or live well.

This premise forges a conceptual link between *virtue* and *flourishing* (or *living well* or *eudaimonia*). And, just as deontology, in theory, then goes on to argue that each favored rule meets its specification,

so virtue ethics, in theory, goes on to argue that each favored character trait meets its.

These are the bare bones of virtue theory. Following are five brief comments directed to some misconceived criticisms that should be cleared out of the way.

First, the theory does not have a peculiar weakness or problem in virtue of the fact that it involves the concept of *eudaimonia* (a standard criticism being that this concept is hopelessly obscure). Now no virtue theorist will pretend that the concept of human flourishing is an easy one to grasp. I will not even claim here (though I would elsewhere) that it is no more obscure than the concepts of *rationality* and *happiness*, since, if our vocabulary were more limited, we might, *faute de mieux*, call it (human) *rational happiness*, and thereby reveal that it has at least some of the difficulties of both. But virtue theory has never, so far as I know, been dismissed on the grounds of the *comparative* obscurity of this central concept; rather, the popular view is that it has a problem with this which deontology and utilitarianism in no way share. This, I think, is clearly false. Both *rationality* and *happiness*, as they figure in their respective theories, are rich and difficult concepts—hence all the disputes about the various tests for a rule's being an object of rational choice, and the disputes, dating back to Mill's introduction of the higher and lower pleasures, about what constitutes happiness.

Second, the theory is not trivially circular; it does not specify right action in terms of the virtuous agent and then immediately specify the virtuous agent in terms of right action. Rather, it specifies her in terms of the virtues, and then specifies these, not merely as dispositions to right action, but as the character traits (which are dispositions to feel and react as well as act in certain ways) required for *eudaimonia*.[2]

Third, it does answer the question "What should I do?" as well as the question "What sort of person should I be?" (That is, it is not, as one of the catchphrases has it, concerned only with Being and not with Doing.)

Fourth, the theory does, to a certain extent, answer this question by coming up with rules or principles (contrary to the common claim that it does not come up with any rules or principles). Every virtue generates a positive instruction (act justly, kindly, courageously, honestly, etc.) and every vice a prohibition (do not act unjustly, cruelly, like a coward, dishonestly, etc.). So trying to decide what to do within the framework of virtue theory is not, as some people seem to imagine, necessarily a matter of taking one's favored candidate for a virtuous person and asking oneself, "What would they do in these circumstances?" (as if the raped fifteen-year-old girl might be supposed to say to herself, "Now would Socrates have an abortion if he were in my circumstances?" and as if someone who had never known or heard of anyone very virtuous were going to be left, according to the theory, with no way to decide what to do at all). The agent may instead ask herself, "If I were to do such and such now, would I be acting justly or unjustly (or neither), kindly or unkindly [and so on]?" I shall consider below the problem created by cases in which such a question apparently does not yield an answer to "What should I do?" (because, say, the alternatives are being unkind or being unjust); here my claim is only that it sometimes does—the agent may employ her concepts of the virtues and vices directly, rather than imagining what some hypothetical exemplar would do.

Fifth (a point that is implicit but should be made explicit), virtue theory is not committed to any sort of reductionism involving defining all of our moral concepts in terms of the virtuous agent. On the contrary, it relies on a lot of very significant moral concepts. Charity or benevolence, for instance, is the virtue whose concern is the *good* of others; that concept of *good* is related to the concept of *evil* or *harm*, and they are both related to the concepts of the *worthwhile*, the *advantageous*, and the *pleasant*. If I have the wrong conception of what is worthwhile and advantageous and pleasant, then I shall have the wrong conception of what is good for, and harmful to, myself and others, and, even with the best will in the world, will lack the virtue of charity, which involves getting all this right. (This point will be illustrated at some length in the second half of this article; I mention it here only in support of

the fact that no virtue theorist who takes her inspiration from Aristotle would even contemplate aiming at reductionism.)[3]

Let me now, with equal brevity, run through two more standard criticisms of virtue theory (the sixth and seventh of my nine) to show that, though not entirely misplaced, they do not highlight problems peculiar to that theory but, rather, problems that are shared by familiar versions of deontology.

One common criticism is that we do not know which character traits are the virtues, or that this is open to much dispute, or particularly subject to the threat of moral skepticism or "pluralism"[4] or cultural relativism. But the parallel roles played by the second premises of both deontological and virtue theories reveal the way in which both sorts of theory share this problem. It is at the stage at which one tries to get the right conclusions to drop out of the bottom of one's theory that, *theoretically*, all the work has to be done. Rule deontologists know that they want to get "don't kill," "keep promises," "cherish your children," and so on as the rules that meet their specification, whatever it may be. They also know that any of these can be disputed, that some philosopher may claim, of any one of them, that it is reasonable to reject it, and that at least people claim that there has been, for each rule, some culture that rejected it. Similarly, the virtue theorists know that they want to get justice, charity, fidelity, courage, and so on as the character traits needed for *eudaimonia;* and they also know that any of these can be disputed, that some philosopher will say of any one of them that it is reasonable to reject it as a virtue, and that there is said to be, for each character trait, some culture that has thus rejected it.

This is a problem for both theories, and the virtue theorist certainly does not find it any harder to argue against moral skepticism, "pluralism," or cultural relativism than the deontologist. Each theory has to stick out its neck and say, in some cases, "This person/these people/other cultures are (or would be) in error," and find some grounds for saying this.

Another criticism (the seventh) often made is that virtue ethics has unresolvable conflict built into it. "It is common knowledge," it is said, "that the requirements of the virtues can conflict; charity may prompt me to end the frightful suffering of the person in my care by killing him, but justice bids me to stay my hand. To tell my brother that his wife is being unfaithful to him would be honest and loyal, but it would be kinder to keep quiet about it. So which should I do? In such cases, virtue ethics has nothing helpful to say." (This is one version of the problem, mentioned above, that considering whether a proposed action falls under a virtue or vice term does not always yield an answer to "What should I do?")

The obvious reply to this criticism is that rule deontology notoriously suffers from the same problem, arising not only from the fact that its rules can apparently conflict, but also from the fact that, at first blush, it appears that one and the same rule (e.g., preserve life) can yield contrary instructions in a particular case.[5] As before, I agree that this is a problem for virtue theory, but deny that it is a problem peculiar to it.

Finally, I want to articulate, and reject, what I take to be the major criticism of virtue theory. Perhaps because it is *the* major criticism, the reflection of a very general sort of disquiet about the theory, it is hard to state clearly—especially for someone who does not accept it—but it goes something like this.[6] My interlocutor says:

> Virtue theory can't *get* us anywhere in real moral issues because it's bound to be all assertion and no argument. You admit that the best it can come up with in the way of action-guiding rules are the ones that rely on the virtue and vice concepts, such as "act charitably," "don't act cruelly," and so on; and, as if that weren't bad enough, you admit that these virtue concepts, such as charity, presuppose concepts such as the *good*, and the *worthwhile*, and so on. But that means that any virtue theorist who writes about real moral issues must rely on her audience's agreeing with her application of all these concepts, and hence accepting all the premises in which those applications are enshrined. But some other virtue theorist might take different premises about these matters, and come up with very different conclusions, and, within the terms of the theory, there is no way to distinguish between the two. While there is agreement,

virtue theory can repeat conventional wisdom, preserve the status quo, but it can't get us anywhere in the way that a normative ethical theory is supposed to, namely, by providing rational grounds for acceptance of its practical conclusions.

My strategy will be to split this criticism into two: one (the eighth) addressed to the virtue theorist's employment of the virtue and vice concepts enshrined in her rules—act charitably, honestly, and so on—and the other (the ninth) addressed to her employment of concepts such as that of the *worthwhile*. Each objection, I shall maintain, implicitly appeals to a certain *condition of adequacy* on a normative moral theory, and in each case, I shall claim, the condition of adequacy, once made explicit, is utterly implausible.

It is true that when she discusses real moral issues, the virtue theorist has to assert that certain actions are honest, dishonest, or neither; charitable, uncharitable, or neither. And it is true that this is often a very difficult matter to decide; her rules are not always easy to apply. But this counts as a criticism of the theory only if we assume, as a condition of adequacy, that any adequate action-guiding theory must make the difficult business of knowing what to do if one is to act well easy, that it must provide clear guidance about what ought and ought not to be done which any reasonably clever adolescent could follow if she chose. But such a condition of adequacy is implausible. Acting rightly *is* difficult, and *does* call for much moral wisdom, and the relevant condition of adequacy, which virtue theory meets, is that it should have built into it an explanation of a truth expressed by Aristotle,[7] namely, that moral knowledge—unlike mathematical knowledge—cannot be acquired merely by attending lectures and is not characteristically to be found in people too young to have had much experience of life. There are youthful mathematical geniuses, but rarely, if ever, youthful moral geniuses, and this tells us something significant about the sort of knowledge that moral knowledge is. Virtue ethics builds this in straight off precisely by couching its rules in terms whose application may indeed call for the most delicate and sensitive judgment.

Here we may discern a slightly different version of the problem that there are cases in which applying the virtue and vice terms does not yield an answer to "What should I do?" Suppose someone "youthful in character," as Aristotle puts it, having applied the relevant terms, finds herself landed with what is, unbeknownst to her, a case not of real but of apparent conflict, arising from a misapplication of those terms. Then she will not be able to decide what to do unless she knows of a virtuous agent to look to for guidance. But her quandary is (*ex hypothesi*) the result of her lack of wisdom, and just what virtue theory expects. Someone hesitating over whether to reveal a hurtful truth, for example, thinking it would be kind but dishonest or unjust to lie, may need to realize, with respect to these particular circumstances, not that kindness is more (or less) important than honesty or justice, and not that honesty or justice sometimes requires one to act unkindly or cruelly, but that one does people no kindness by concealing this sort of truth from them, hurtful as it may be. This is the *type* of thing (I use it only as an example) that people with moral wisdom know about, involving the correct application of *kind*, and that people without such wisdom find difficult.

What about the virtue theorist's reliance on concepts such as that of the *worthwhile?* If such reliance is to count as a fault in the theory, what condition of adequacy is implicitly in play? It must be that any good normative theory should provide answers to questions about real moral issues whose truth is in no way determined by truths about what is worthwhile, or what really matters in human life. Now although people are initially inclined to reject out of hand the claim that the practical conclusions of a normative moral theory have to be based on premises about what is truly worthwhile, the alternative, once it is made explicit, may look even more unacceptable. Consider what the condition of adequacy entails. If truths about what is worthwhile (or truly good, or serious, or about what matters in human life) do *not* have to be appealed to in order to answer questions about real moral issues, then I might sensibly seek guidance about what I ought to do from someone who had declared in advance that she knew nothing

about such matters, or from someone who said that, although she had opinions about them, these were quite likely to be wrong but that this did not matter, because they would play no determining role in the advice she gave me.

I should emphasize that we are talking about real moral issues and real guidance; I want to know whether I should have an abortion, take my mother off the life-support machine, leave academic life and become a doctor in the Third World, give up my job with the firm that is using animals in its experiments, tell my father he has cancer. Would I go to someone who says she has *no* views about what is worthwhile in life? Or to someone who says that, as a matter of fact, she tends to think that the only thing that matters is having a good time, but has a normative theory that is consistent both with this view and with my own rather more puritanical one, which will yield the guidance I need?

I take it as a premise that this is absurd. The relevant condition of adequacy should be that the practical conclusions of a good normative theory *must* be in part determined by premises about what is worthwhile, important, and so on. Thus I reject this "major criticism" of virtue theory, that it cannot get us anywhere in the way that a normative moral theory is supposed to. According to my response, a normative theory that any clever adolescent can apply, or that reaches practical conclusions that are in no way determined by premises about what is truly worthwhile, serious, and so on, is guaranteed to be an inadequate theory.

Although I reject this criticism, I have not argued that it is misplaced and that it necessarily manifests a failure to understand what virtue theory is. My rejection is based on premises about what an adequate normative theory must be like—what sorts of concepts it must contain, and what sort of account it must give of moral knowledge—and thereby claims, implicitly, that the "major criticism" manifests a failure to understand what an *adequate normative theory* is. But, as a matter of fact, I think the criticism is often made by people who have no idea of what virtue theory looks like when applied to a real moral issue; they drastically underestimate the variety of

ways in which the virtue and vice concepts, and the others, such as that of the *worthwhile*, figure in such discussion.

As promised, I now turn to an illustration of such discussion, applying virtue theory to abortion. Before I embark on this tendentious business, I should remind the reader of the aim of this discussion. I am not, in this article, trying to solve the problem of abortion; I am illustrating how virtue theory directs one to think about it. It might indeed be said that thinking about the problem in this way "solves" it by *dis*solving it, insofar as it leads one to the conclusion that there is no single right answer, but a variety of particular answers, and in what follows I am certainly trying to make that conclusion seem plausible. But, that granted, it should still be said that I am not trying to "solve the problems" in the practical sense of telling people that they should, or should not, do this or that if they are pregnant and contemplating abortion in these or those particular circumstances.

I do not assume, or expect, that all of my readers will agree with everything I am about to say. On the contrary, given the plausible assumption that some are morally wiser than I am, and some less so, the theory has built into it that we are bound to disagree on some points. For instance, we may well disagree about the particular application of some of the virtue and vice terms; and we may disagree about what is worthwhile or serious, worthless or trivial. But my aim is to make clear how these concepts figure in a discussion conducted in terms of virtue theory. What is at issue is whether these concepts are indeed the ones that should come in, that is, whether virtue theory should be criticized for employing them. The problem of abortion highlights this issue dramatically since virtue theory quite transforms the discussion of it.

ABORTION

As everyone knows, the morality of abortion is commonly discussed in relation to just two considerations: first, and predominantly, the status of the fetus

and whether or not it is the sort of thing that may or may not be innocuously or justifiably killed; and second, and less predominantly (when, that is, the discussion concerns the *morality* of abortion rather than the question of permissible legislation in a just society), women's rights. If one thinks within this familiar framework, one may well be puzzled about what virtue theory, as such, could contribute. Some people assume the discussion will be conducted solely in terms of what the virtuous agent would or would not do (cf. the third, fourth, and fifth criticisms above). Others assume that only justice, or at most justice and charity,[8] will be applied to the issue, generating a discussion very similar to Judith Jarvis Thomson's.[9]

Now if this is the way the virtue theorist's discussion of abortion is imagined to be, no wonder people think little of it. It seems obvious in advance that in any such discussion there must be either a great deal of extremely tendentious application of the virtue terms *just, charitable*, and so on or a lot of rhetorical appeal to "this is what only the virtuous agent knows." But these are caricatures; they fail to appreciate the way in which virtue theory quite transforms the discussion of abortion by dismissing the two familiar dominating considerations as, in a way, fundamentally irrelevant. In what way or ways, I hope to make both clear and plausible.

Let us first consider women's rights. Let me emphasize again that we are discussing the *morality* of abortion, not the rights and wrongs of laws prohibiting or permitting it. If we suppose that women do have a moral right to do as they choose with their own bodies, or, more particularly, to terminate their pregnancies, then it may well follow that a *law* forbidding abortion would be unjust. Indeed, even if they have no such right, such a law might be, as things stand at the moment, unjust, or impractical, or inhumane: on this issue I have nothing to say in this article. But, putting all questions about the justice or injustice of laws to one side, and supposing only that women have such a moral right, *nothing* follows from this supposition about the morality of abortion, according to virtue theory, once it is noted (quite generally, not with particular reference to abortion) that in exercising a moral right I can do something cruel,

or callous, or selfish, light-minded, self-righteous, stupid, inconsiderate, disloyal, dishonest—that is, act viciously.[10] Love and friendship do not survive their parties' constantly insisting on their rights, nor do people live well when they think that getting what they have a right to is of preeminent importance; they harm others, and they harm themselves. So whether women have a moral right to terminate their pregnancies is irrelevant within virtue theory, for it is irrelevant to the question "In having an abortion in these circumstances, would the agent be acting virtuously or viciously or neither?"

What about the consideration of the status of the fetus—what can virtue theory say about that? One might say that this issue is not in the province of *any* moral theory; it is a metaphysical question, and an extremely difficult one at that. Must virtue theory then wait upon metaphysics to come up with the answer?

At first sight it might seem so. For virtue is said to involve knowledge, and part of this knowledge consists in having the *right* attitude to things. "Right" here does not just mean "morally right" or "proper" or "nice" in the modern sense; it means "accurate, true." One cannot have the right or correct attitude to something if the attitude is based on or involves false beliefs. And this suggests that if the status of the fetus is relevant to the rightness or wrongness of abortion, its status must be known, as a truth, to the fully wise and virtuous person.

But the sort of wisdom that the fully virtuous person has is not supposed to be recondite; it does not call for fancy philosophical sophistication, and it does not depend upon, let alone wait upon, the discoveries of academic philosophers.[11] And this entails the following, rather startling, conclusion: that the status of the fetus—that issue over which so much ink has been spilt—is, according to virtue theory, simply not relevant to the rightness or wrongness of abortion (within, that is, a secular morality).

Or rather, since that is clearly too radical a conclusion, it is in a sense relevant, but only in the sense that the familiar biological facts are relevant. By "the familiar biological facts" I mean the facts that most human societies are and have been familiar

with—that, standardly (but not invariably), pregnancy occurs as the result of sexual intercourse, that it lasts about nine months, during which time the fetus grows and develops, that standardly it terminates in the birth of a living baby, and that this is how we all come to be.

It might be thought that this distinction—between the familiar biological facts and the status of the fetus—is a distinction without a difference. But this is not so. To attach relevance to the status of the fetus, in the sense in which virtue theory claims it is not relevant, is to be gripped by the conviction that we must go beyond the familiar biological facts, deriving some sort of conclusion from them, such as that the fetus has rights, or is not a person, or something similar. It is also to believe that this exhausts the relevance of the familiar biological facts, that all they are relevant to is the status of the fetus and whether or not it is the sort of thing that may or may not be killed.

These convictions, I suspect, are rooted in the desire to solve the problem of abortion by getting it to fall under some general rule such as "You ought not to kill anything with the right to life but may kill anything else." But they have resulted in what should surely strike any nonphilosopher as a most bizarre aspect of nearly all the current philosophical literature on abortion, namely, that, far from treating abortion as a unique moral problem, markedly unlike any other, nearly everything written on the status of the fetus and its bearing on the abortion issue would be consistent with the human reproductive facts' (to say nothing of family life) being totally different from what they are. Imagine that you are an alien extraterrestrial anthropologist who does not know that the human race is roughly 50 percent female and 50 percent male, or that our only (natural) form of reproduction involves heterosexual intercourse, viviparous birth, and the female's (and only the female's) being pregnant for nine months, or that females are capable of childbearing from late childhood to late middle age, or that childbearing is painful, dangerous, and emotionally charged—do you think you would pick up these facts from the hundreds of articles written on the status of the fetus? I am quite sure you would

not. And that, I think, shows that the current philosophical literature on abortion has got badly out of touch with reality.

Now if we are using virtue theory, our first question is not "What do the familiar biological facts show—what can be derived from them about the status of the fetus?" but "How do these facts figure in the practical reasoning, actions and passions, thoughts and reactions, of the virtuous and the nonvirtuous? What is the mark of having the right attitude to these facts and what manifests having the wrong attitude to them?" This immediately makes essentially relevant not only all the facts about human reproduction I mentioned above, but a whole range of facts about our emotions in relation to them as well. I mean such facts as that human parents, both male and female, tend to care passionately about their offspring, and that family relationships are among the deepest and strongest in our lives—and, significantly, among the longest-lasting.

These facts make it obvious that pregnancy is not just one among many other physical conditions; and hence that anyone who genuinely believes that an abortion is comparable to a haircut or an appendectomy is mistaken.[12] The fact that the premature termination of a pregnancy is, in some sense, the cutting off of a new human life, and thereby, like the procreation of a new human life, connects with all our thoughts about human life and death, parenthood, and family relationships, must make it a serious matter. To disregard this fact about it, to think of abortion as nothing but the killing of something that does not matter, or as nothing but the exercise of some right or rights one has, or as the incidental means to some desirable state of affairs, is to do something callous and light-minded, the sort of thing that no virtuous and wise person would do. It is to have the wrong attitude not only to fetuses, but more generally to human life and death, parenthood, and family relationships.

Although I say that the facts make this obvious, I know that this is one of my tendentious points. In partial support of it I note that even the most dedicated proponents of the view that deliberate abortion is just like an appendectomy or haircut rarely hold the

same view of spontaneous abortion, that is, miscarriage. It is not so tendentious of me to claim that to react to people's grief over miscarriage by saying, or even thinking, "What a fuss about nothing!" would be callous and light-minded, whereas to try to laugh someone out of grief over an appendectomy scar or a botched haircut would not be. It is hard to give this point due prominence within act-centered theories, for the inconsistency is an inconsistency in attitude about the seriousness of loss of life, not in beliefs about which acts are right or wrong. Moreover, an act-centered theorist may say, "Well, there is nothing wrong with *thinking* 'What a fuss about nothing!' as long as you do not say it and hurt the person who is grieving. And besides, we cannot be held responsible for our thoughts, only for the intentional actions they give rise to." But the character traits that virtue theory emphasizes are not simply dispositions to intentional actions, but a seamless disposition to certain actions and passions, thoughts and reactions.

To say that the cutting off of a human life is always a matter of some seriousness, at any stage, is not to deny the relevance of gradual fetal development. Notwithstanding the well-worn point that clear boundary lines cannot be drawn, our emotions and attitudes regarding the fetus do change as it develops, and again when it is born, and indeed further as the baby grows. Abortion for shallow reasons in the later stages is much more shocking than abortion for the same reasons in the early stages in a way that matches the fact that deep grief over miscarriage in the later stages is more appropriate than it is over miscarriage in the earlier stages (when, that is, the grief is solely about the loss of *this* child, not about, as might be the case, the loss of one's only hope of having a child or of having one's husband's child). Imagine (or recall) a woman who already has children; she had not intended to have more, but finds herself unexpectedly pregnant. Though contrary to her plans, the pregnancy, once established as a fact, is welcomed—and then she loses the embryo almost immediately. If this were bemoaned as a tragedy, it would, I think, be a misapplication of the concept of what is tragic. But it may still properly be mourned as a loss. The grief is expressed in such terms as "I shall

always wonder how she or he would have turned out" or "When I look at the others, I shall think, 'How different their lives would have been if this other one had been part of them.'" It would, I take it, be callous and light-minded to say, or think, "Well, she has already *got* four children; what's the problem?"; it would be neither, nor arrogantly intrusive in the case of a close friend, to try to correct prolonged mourning by saying, "I know it's sad, but it's not a tragedy; rejoice in the ones you have." The application of *tragic* becomes more appropriate as the fetus grows, for the mere fact that one has lived with it for longer, conscious of its existence, makes a difference. To shrug off an early abortion is understandable just because it is very hard to be fully conscious of the fetus's existence in the early stages and hence hard to appreciate that an early abortion is the destruction of life. It is particularly hard for the young and inexperienced to appreciate this, because appreciation of it usually comes only with experience.

I do not mean "with the experience of having an abortion" (though that may be part of it) but, quite generally, "with the experience of life." Many women who have borne children contrast their later pregnancies with their first successful one, saying that in the later ones they were conscious of a new life growing in them from very early on. And, more generally, as one reaches the age at which the next generation is coming up close behind one, the counterfactuals "If I, or she, had had an abortion, Alice, or Bob, would not have been born" acquire a significant application, which casts a new light on the conditionals "If I or Alice have an abortion then some Caroline or Bill will not be born."

The fact that pregnancy is not just one among many physical conditions does not mean that one can never regard it in that light without manifesting a vice. When women are in very poor physical health, or worn out from childbearing, or forced to do very physically demanding jobs, then they cannot be described as self-indulgent, callous, irresponsible, or light-minded if they seek abortions mainly with a view to avoiding pregnancy as the physical condition that it is. To go through with a pregnancy when one is utterly exhausted, or when one's job consists of crawling along tunnels hauling coal, as many women

in the nineteenth century were obliged to do, is perhaps heroic, but people who do not achieve heroism are not necessarily vicious. That they can view the pregnancy only as eight months of misery, followed by hours if not days of agony and exhaustion, and abortion only as the blessed escape from this prospect, is entirely understandable and does not manifest any lack of serious respect for human life or a shallow attitude to motherhood. What it does show is that something is terribly amiss in the conditions of their lives, which make it so hard to recognize pregnancy and childbearing as the good that they can be.

In relation to this last point I should draw attention to the way in which virtue theory has a sort of built-in indexicality. Philosophers arguing against anything remotely resembling a belief in the sanctity of life (which the above claims clearly embody) frequently appeal to the existence of other communities in which abortion and infanticide are practiced. We should not automatically assume that it is impossible that some other communities could be morally inferior to our own; maybe some are, or have been, precisely insofar as their members are, typically, callous or light-minded or unjust. But in communities in which life is a great deal tougher for everyone than it is in ours, having the right attitude to human life and death, parenthood, and family relationships might well manifest itself in ways that are unlike ours. When it is essential to survival that most members of the community fend for themselves at a very young age or work during most of their waking hours, selective abortion or infanticide might be practiced either as a form of genuine euthanasia or for the sake of the community and not, I think, be thought callous or light-minded. But this does not make everything all right; as before, it shows that there is something amiss with the conditions of their lives, which are making it impossible for them to live really well.[13]

The foregoing discussion, insofar as it emphasizes the right attitude to human life and death, parallels to a certain extent those standard discussions of abortion that concentrate on it solely as an issue of killing. But it does not, as those discussions do, gloss over the fact, emphasized by those who discuss the morality of abortion in terms of women's rights, that

abortion, wildly unlike any other form of killing, is the termination of a pregnancy, which is a condition of a woman's body and results in *her* having a child if it is not aborted. This fact is given due recognition not by appeal to women's rights but by emphasizing the relevance of the familiar biological and psychological facts and their connection with having the right attitude to parenthood and family relationships. But it may well be thought that failing to bring in women's rights still leaves some important aspects of the problem of abortion untouched.

Speaking in terms of women's rights, people sometimes say things like, "Well, it's her life you're talking about too, you know; she's got a right to her own life, her own happiness." And the discussion stops there. But in the context of virtue theory, given that we are particularly concerned with what constitutes a good human life, with what true happiness or *eudaimonia* is, this is no place to stop. We go on to ask, "And is this life of hers a good one? Is she living well?"

If we are to go on to talk about good human lives, in the context of abortion, we have to bring in our thoughts about the value of love and family life, and our proper emotional development through a natural life cycle. The familiar facts support the view that parenthood in general, and motherhood and child-bearing in particular, are intrinsically worthwhile, are among the things that can be correctly thought to be partially constitutive of a flourishing human life.[14] If this is right, then a woman who opts for not being a mother (at all, or again, or now) by opting for abortion may thereby be manifesting a flawed grasp of what her life should be, and be about—a grasp that is childish, or grossly materialistic, or short-sighted, or shallow.

I said "*may* thereby": this *need* not be so. Consider, for instance, a woman who has already had several children and fears that to have another will seriously affect her capacity to be a good mother to the ones she has—she does not show a lack of appreciation of the intrinsic value of being a parent by opting for abortion. Nor does a woman who has been a good mother and is approaching the age at which she may be looking forward to being a good grandmother. Nor does a woman who discovers that her pregnancy may well kill her, and opts for abortion and adoption. Nor, necessarily,

does a woman who has decided to lead a life centered around some other worthwhile activity or activities with which motherhood would compete.

People who are childless by choice are sometimes described as "irresponsible," or "selfish," or "refusing to grow up," or "not knowing what life is about." But one can hold that having children is intrinsically worthwhile without endorsing this, for we are, after all, in the happy position of there being more worthwhile things to do than can be fitted into one lifetime. Parenthood, and motherhood in particular, even if granted to be intrinsically worthwhile, undoubtedly take up a lot of one's adult life, leaving no room for some other worthwhile pursuits. But some women who choose abortion rather than have their first child, and some men who encourage their partners to choose abortion, are not avoiding parenthood for the sake of other worthwhile pursuits, but for the worthless one of "having a good time," or for the pursuit of some false vision of the ideals of freedom or self-realization. And some others who say "I am not ready for parenthood yet" are making some sort of mistake about the extent to which one can manipulate the circumstances of one's life so as to make it fulfill some dream that one has. Perhaps one's dream is to have two perfect children, a girl and a boy, within a perfect marriage, in financially secure circumstances, with an interesting job of one's own. But to care too much about that dream, to demand of life that it give it to one and act accordingly, may be both greedy and foolish, and is to run the risk of missing out on happiness entirely. Not only may fate make the dream impossible, or destroy it, but one's own attachment to it may make it impossible. Good marriages, and the most promising children, can be destroyed by just one adult's excessive demand for perfection.

Once again, this is not to deny that girls may quite properly say "I am not ready for motherhood yet," especially in our society, and, far from manifesting irresponsibility or light-mindedness, show an appropriate modesty or humility, or a fearfulness that does not amount to cowardice. However, even when the decision to have an abortion is the right decision—one that does not itself fall under a vice-related term and thereby one that the perfectly virtuous could recommend—it does not follow that there is no sense

in which having the abortion is wrong, or guilt inappropriate. For, by virtue of the fact that a human life has been cut short, some evil has probably been brought about,[15] and that circumstances make the decision to bring about some evil the right decision will be a ground for guilt if getting into those circumstances in the first place itself manifested a flaw in character.

What "gets one into those circumstances" in the case of abortion is, except in the case of rape, one's sexual activity and one's choices, or the lack of them, about one's sexual partner and about contraception. The virtuous woman (which here of course does not mean simply "chaste woman" but "woman with the virtues") has such character traits as strength, independence, resoluteness, decisiveness, self-confidence, responsibility, serious-mindedness, and self-determination—and no one, I think, could deny that many women become pregnant in circumstances in which they cannot welcome or cannot face the thought of having *this* child precisely because they lack one or some of these character traits. So even in the cases where the decision to have an abortion is the right one, it can still be the reflection of a moral failing—not because the decision itself is weak or cowardly or irresolute or irresponsible or light-minded, but because lack of the requisite opposite of these failings landed one in the circumstances in the first place. Hence the common universalized claim that guilt and remorse are never appropriate emotions about an abortion is denied. They may be appropriate, and appropriately inculcated, even when the decision was the right one.

Another motivation for bringing women's rights into the discussion may be to attempt to correct the implication, carried by the killing-centered approach, that insofar as abortion is wrong, it is a wrong that only women do, or at least (given the preponderance of male doctors) that only women instigate. I do not myself believe that we can thus escape the fact that nature bears harder on women than it does on men,[16] but virtue theory can certainly correct many of the injustices that the emphasis on women's rights is rightly concerned about. With very little amendment, everything that has been said above applies to boys and men too. Although the abortion decision is, in a natural sense, the woman's decision, proper to her, boys and

men are often party to it, for well or ill, and even when they are not, they are bound to have been party to the circumstances that brought it up. No less than girls and women, boys and men can, in their actions, manifest self-centeredness, callousness, and light-mindeness about life and parenthood in relation to abortion. They can be self-centered or courageous about the possibility of disability in their offspring; they need to reflect on their sexual activity and their choices, or the lack of them, about their sexual partner and contraception; they need to grow up and take responsibility for their own actions and life in relation to fatherhood. If it is true, as I maintain, that insofar as motherhood is intrinsically worthwhile, being a mother is an important purpose in women's lives, being a father (rather than a mere generator) is an important purpose in men's lives as well, and it is adolescent of men to turn a blind eye to this and pretend that they have many more important things to do.

CONCLUSION

Much more might be said, but I shall end the actual discussion of the problem of abortion here, and conclude by highlighting what I take to be its significant features. These hark back to many of the criticisms of virtue theory discussed earlier.

The discussion does not proceed simply by our trying to answer the question "Would a perfectly virtuous agent ever have an abortion and, if so, when?"; virtue theory is not limited to considering "Would Socrates have had an abortion if he were a raped, pregnant fifteen-year-old?" nor automatically stumped when we are considering circumstances into which no virtuous agent would have got herself. Instead, much of the discussion proceeds in the virtue- and vice-related terms whose application, in several cases, yields practical conclusions (cf. the third and fourth criticisms above). These terms are difficult to apply correctly, and anyone might challenge my application of any one of them. So, for example, I have claimed that some abortions, done for certain reasons, would be callous or light-minded; that others might indicate an appropriate modesty or humility; that others would reflect a greedy and foolish attitude to what one could

expect out of life. Any of these examples may be disputed, but what is at issue is, should these difficult terms be there, or should the discussion be couched in terms that all clever adolescents can apply correctly? (Cf. the first half of the "major objection" above.)

Proceeding as it does in the virtue- and vice-related terms, the discussion thereby, inevitably, also contains claims about what is worthwhile, serious and important, good and evil, in our lives. So, for example, I claimed that parenthood is intrinsically worthwhile, and that having a good time was a worthless end (in life, not on individual occasions); that losing a fetus is always a serious matter (albeit not a tragedy in itself in the first trimester) whereas acquiring an appendectomy scar is a trivial one; that (human) death is an evil. Once again, these are difficult matters, and anyone might challenge any one of my claims. But what is at issue is, as before, should those difficult claims be there or can one reach practical conclusions about real moral issues that are in no way determined by premises about such matters? (Cf. the fifth criticism, and the second half of the "major criticism.")

The discussion also thereby, inevitably, contains claims about what life is like (e.g., my claim that love and friendship do not survive their parties' constantly insisting on their rights; or the claim that to demand perfection of life is to run the risk of missing out on happiness entirely). What is at issue is, should those disputable claims be there, or is our knowledge (or are our false opinions) about what life is like irrelevant to our understanding of real moral issues? (Cf. both halves of the "major criticism.")

Naturally, my own view is that all these concepts should be there in any discussion of real moral issues and that virtue theory, which uses all of them, is the right theory to apply to them. I do not pretend to have shown this. I realize that proponents of rival theories may say that, now that they have understood how virtue theory uses the range of concepts it draws on, they are more convinced than ever that such concepts should not figure in an adequate normative theory, because they are sectarian, or vague, or too particular, or improperly anthropocentric, and reinstate what I called the "major criticism." Or, finding many of the details of the discussion appropriate, they may agree that many, perhaps even all, of the concepts should

figure, but argue that virtue theory gives an inaccurate account of the way the concepts fit together (and indeed of the concepts themselves) and that another theory provides a better account; that would be interesting to see. Moreover, I admitted that there were at least two problems for virtue theory: that it has to argue against moral skepticism, "pluralism," and cultural relativism, and that it has to find something to say about conflicting requirements of different virtues. Proponents of rival theories might argue that their favored theory provides better solutions to these problems than virtue theory can. Indeed, they might criticize virtue theory for finding problems here at all. Anyone who argued for at least one of moral skepticism, "pluralism," or cultural relativism could presumably do so (provided their favored theory does not find a similar problem); and a utilitarian might say that benevolence is the only virtue and hence that virtue theory errs when it discusses even apparent conflicts between the requirements of benevolence and some other character trait such as honesty.

Defending virtue theory against all possible, or even likely, criticisms of it would be a lifelong task. As I said at the outset, in this article I aimed to defend the theory against some criticisms which I thought arose from an inadequate understanding of it, and to improve that understanding. If I have succeeded, we may hope for more comprehending criticisms of virtue theory than have appeared hitherto.

Notes

1. It should be noted that this premise intentionally allows for the possibility that two virtuous agents, faced with the same choice in the same circumstances, may act differently. For example, one might opt for taking her father off the life-support machine and the other for leaving her father on it. The theory requires that neither agent thinks that what the other does is wrong (see note 4 below), but it explicitly allows that no action is uniquely right in such a case—both are right. It also intentionally allows for the possibility that in some circumstances—those into which no virtuous agent could have got herself—no action is right. I explore this premise at greater length in "Applying Virtue Ethics," forthcoming in a *festchrift* for Philippa Foot.

2. There is, of course, the further question of whether the theory eventually describes a larger circle and winds up relying on the concept of right action in its interpretation of *eudaimonia*. In denying that the theory is trivially circular, I do not pretend to answer this intricate question. It is certainly true that virtue theory does not claim that the correct conception of *eudaimonia* can be got from "an independent 'value-free' investigation of human nature" (John McDowell, "The Role of *Eudaimonia* in Aristotle's Ethics," in *Essays on Aristotle's Ethics*, ed. Amelie Rorty [Berkeley and Los Angeles: University of California Press, 1980]). The sort of training that is required for acquiring the correct conception no doubt involves being taught from early on such things as "Decent people do this sort of thing, not that" and "To do such and such is the mark of a depraved character" (cf. *Nicomachean Ethics* 1110a22). But whether this counts as relying on the concept of right (or wrong) action seems to me very unclear and requiring much discussion.

3. Cf. Bernard Williams' point in *Ethics and the Limits of Philosophy* (London: William Collins, 1985) that we need an enriched ethical vocabulary, not a cut-down one.

4. I put *pluralism* in scare quotes to serve as a warning that virtue theory is not incompatible with all forms of it. It allows for "competing conceptions" of *eudaimonia* and the worthwhile, for instance, in the sense that it allows for a plurality of flourishing lives—the theory need not follow Aristotle in specifying the life of contemplation as the only one that truly constitutes *eudaimonia* (if he does). But the conceptions "compete" only in the sense that, within a single flourishing life, not everything worthwhile can be fitted in; the theory does not allow that two people with a correct conception of *eudaimonia* can disagree over whether the way the other is living constitutes flourishing. Moreover, the theory is committed to the strong thesis that the same set of character traits is needed for *any* flourishing life; it will not allow that, for instance, soldiers need courage but wives and mothers do not, or that judges need justice but can live well despite lacking kindness. (This obviously is related to the point made in note 1 above.) For an interesting discussion of pluralism (different interpretations thereof) and virtue theory, see Douglas B. Rasmussen, "Liberalism and Natural End Ethics," *American Philosophical Quarterly* 27 (1990): 153–61.

5. E.g., in Williams' Jim and Pedro case in J. J. C. Smart and Bernard Williams, *Utilitarianism: For and Against* (London: Cambridge University Press, 1973).

6. Intimations of this criticism constantly come up in discussion; the clearest statement of it I have found is by Onora O'Neill, in her review of Stephen Clark's *The Moral*

Status of Animals, in *Journal of Philosophy* 77 (1980): 440–46. For a response I am much in sympathy with, see Cora Diamond, "Anything But Argument?" *Philosophical Investigations* 5 (1982): 23–41.

7. Aristotle, *Nicomachean Ethics* 1142a12–16.

8. It seems likely that some people have been misled by Foot's discussion of euthanasia (through no fault of hers) into thinking that a virtue theorist's discussion of terminating human life will be conducted exclusively in terms of justice and charity (and the corresponding vice terms) (Philippa Foot, "Euthanasia," *Philosophy & Public Affairs* 6, no. 2 [Winter 1977]: 85–112). But the act-category *euthanasia* is a very special one, at least as defined in her article, since such an act must be done "for the sake of the one who is to die." Building a virtuous motivation into the specification of the act in this way immediately rules out the application of many other vice terms.

9. Judith Jarvis Thomson, "A Defense of Abortion," *Philosophy & Public Affairs* 1, no. 1 (Fall 1971): 47–66. One could indeed regard this article as proto-virtue theory (no doubt to the surprise of the author) if the concepts of callousness and kindness were allowed more weight.

10. One possible qualification: if one ties the concept of justice very closely to rights, then if women do have a moral right to terminate their pregnancies it *may* follow that in doing so they do not act unjustly. (Cf. Thomson, "A Defense of Abortion.") But it is debatable whether even that much follows.

11. This is an assumption of virtue theory, and I do not attempt to defend it here. An adequate discussion of it would require a separate article, since, although most moral philosophers would be chary of claiming that intellectual sophistication is a necessary condition of moral wisdom or virtue, most of us, from Plato onward, tend to write as if this were so. Sorting out which claims about moral knowledge are committed to this kind of elitism and which can, albeit with difficulty, be reconciled with the idea that moral knowledge can be acquired by anyone who really wants it would be a major task.

12. Mary Anne Warren, in "On the Moral and Legal Status of Abortion," *Monist* 57 (1973), sec. 1, says of the opponents of restrictive laws governing abortion that "their conviction (for the most part) is that abortion is not a *morally* serious and extremely unfortunate, even though sometimes justified, act, comparable to killing in self-defense or to letting the violinist die, but rather is closer to being a *morally neutral* act, like cutting one's hair" (italics mine). I would like to think that no one *genuinely* believes this. But certainly in discussion, particularly when arguing against restrictive laws or the suggestion that remorse over abortion might be appropriate, I have found that some people *say* they believe it (and often cite Warren's article, albeit inaccurately, despite its age). Those who allow that it is morally serious, and far from morally neutral, have to argue against restrictive laws, or the appropriateness of remorse, on a very different ground from that laid down by the premise "The fetus is just part of the woman's body (and she has a right to determine what happens to her body and should not feel guilt about anything she does to it)."

13. For another example of the way in which "tough conditions" can make a difference to what is involved in having the right attitude to human life and death and family relationships, see the concluding sentences of Foot's "Euthanasia."

14. I take this as a premise here, but argue for it in some detail in my *Beginning Lives* (Oxford: Basil Blackwell, 1987). In this connection I also discuss adoption and the sense in which it may be regarded as "second best," and the difficult question of whether the good of parenthood may properly be sought, or indeed bought, by surrogacy.

15. I say "some evil has probably been brought about" on the ground that (human) life is (usually) a good and hence (human) death usually an evil. The exceptions would be (*a*) where death is actually a good or a benefit, because the baby that would come to be if the life were not cut short would be better off dead than alive, and (*b*) where death, though not a good, is not an evil either, because the life that would be led (e.g., in a state of permanent coma) would not be a good. (See Foot, "Euthanasia.")

16. I discuss this point at greater length in *Beginning Lives*.

Study Questions

1. According to Hursthouse, do women's rights have anything to do with the morality of abortion?

2. According to Hursthouse, is the status of the fetus relevant to the rightness or wrongness of abortion?

3. Can a correct moral decision result in some evil?

4. In what distinctive ways, if any, does virtue ethics approach moral issues?

49

JAMES RACHELS

The American Medical Association takes the position that while at a patient's request a physician may withhold extraordinary means of prolonging the patient's life, a physician may not take steps, even if requested by the patient, to terminate that life intentionally. James Rachels (1941–2003), who was Professor of Philosophy at the University of Alabama at Birmingham, argued that killing is not in itself any worse than letting die, and therefore no moral difference between active and passive euthanasia is defensible.

Active and Passive Euthanasia

The distinction between active and passive euthanasia is thought to be crucial for medical ethics. The idea is that it is permissible, at least in some cases, to withhold treatment and allow a patient to die, but it is never permissible to take any direct action designed to kill the patient. This doctrine seems to be accepted by most doctors, and it is endorsed in a statement adopted by the House of Delegates of the American Medical Association on December 4, 1973:

> The intentional termination of the life of one human being by another—mercy killing—is contrary to that for which the medical profession stands and is contrary to the policy of the American Medical Association.
>
> The cessation of the employment of extraordinary means to prolong the life of the body when there is irrefutable evidence that biological death is imminent is the decision of the patient and/or his immediate family. The advice and judgment of the physician should be freely available to the patient and/or his immediate family.

However, a strong case can be made against this doctrine. In what follows I will set out some of the relevant arguments, and urge doctors to reconsider their views on this matter.

To begin with a familiar type of situation, a patient who is dying of incurable cancer of the throat is in terrible pain, which can no longer be satisfactorily alleviated. He is certain to die within a few days, even if present treatment is continued, but he does not want to go on living for those days since the pain is unbearable. So he asks the doctor for an end to it, and his family joins in the request.

Suppose the doctor agrees to withhold treatment, as the conventional doctrine says he may. The justification for his doing so is that the patient is in terrible agony, and since he is going to die anyway, it would be wrong to prolong his suffering needlessly. But now notice this. If one simply withholds treatment, it may take the patient longer to die, and so he may suffer more than he would if more direct action were taken and a lethal injection given. This fact provides strong

reason for thinking that, once the initial decision not to prolong his agony has been made, active euthanasia is actually preferable to passive euthanasia, rather than the reverse. To say otherwise is to endorse the option that leads to more suffering rather than less, and is contrary to the humanitarian impulse that prompts the decision not to prolong his life in the first place.

Part of my point is that the process of being "allowed to die" can be relatively slow and painful, whereas being given a lethal injection is relatively quick and painless. Let me give a different sort of example. In the United States about one in 600 babies is born with Down's syndrome. Most of these babies are otherwise healthy—that is, with only the usual pediatric care, they will proceed to an otherwise normal infancy. Some, however, are born with congenital defects such as intestinal obstructions that require operations if they are to live. Sometimes, the parents and the doctor will decide not to operate, and let the infant die. Anthony Shaw describes what happens then:

> . . . When surgery is denied [the doctor] must try to keep the infant from suffering while natural forces sap the baby's life away. As a surgeon whose natural inclination is to use the scalpel to fight off death, standing by and watching a salvageable baby die is the most emotionally exhausting experience I know. It is easy at a conference, in a theoretical discussion, to decide that such infants should be allowed to die. It is altogether different to stand by in the nursery and watch as dehydration and infection wither a tiny being over hours and days. This is a terrible ordeal for me and the hospital staff—much more so than for the parents who never set foot in the nursery.[1]

I can understand why some people are opposed to all euthanasia, and insist that such infants must be allowed to live. I think I can also understand why other people favor destroying these babies quickly and painlessly. But why should anyone favor letting "dehydration and infection wither a tiny being over hours and days?" The doctrine that says that a baby may be allowed to dehydrate and wither, but may not be given an injection that would end its life without suffering, seems so patently cruel as to require no further refutation. The

strong language is not intended to offend, but only to put the point in the clearest possible way.

My second argument is that the conventional doctrine leads to decisions concerning life and death made on irrelevant grounds.

Consider again the case of the infants with Down's syndrome who need operations for congenital defects unrelated to the syndrome to live. Sometimes, there is no operation, and the baby dies, but when there is no such defect, the baby lives on. Now, an operation such as that to remove an intestinal obstruction is not prohibitively difficult. The reason why such operations are not performed in these cases is, clearly, that the child has Down's syndrome and the parents and doctor judge that because of that fact it is better for the child to die.

But notice that this situation is absurd, no matter what view one takes of the lives and potentials of such babies. If the life of such an infant is worth preserving, what does it matter if it needs a simple operation? Or, if one thinks it better that such a baby should not live on, what difference does it make that it happens to have an unobstructed intestinal tract? In either case, the matter of life and death is being decided on irrelevant grounds. It is the Down's syndrome, and not the intestines, that is the issue. The matter should be decided, if at all, on that basis, and not be allowed to depend on the essentially irrelevant question of whether the intestinal tract is blocked.

What makes this situation possible, of course, is the idea that when there is an intestinal blockage, one can "let the baby die," but when there is no such defect there is nothing that can be done, for one must not "kill" it. The fact that this idea leads to such results as deciding life or death on irrelevant grounds is another good reason why the doctrine should be rejected.

One reason why so many people think that there is an important moral difference between active and passive euthanasia is that they think killing someone is morally worse than letting someone die. But is it? Is killing, in itself, worse than letting die? To investigate this issue, two cases may be considered that are exactly alike except that one involves killing whereas the other involves letting someone die. Then, it can be asked whether this difference makes any difference to the moral assessments. It is important

that the cases be exactly alike, except for this one difference, since otherwise one cannot be confident that it is this difference and not some other that accounts for any variation in the assessments of the two cases. So, let us consider this pair of cases:

In the first, Smith stands to gain a large inheritance if anything should happen to his six-year-old cousin. One evening while the child is taking his bath, Smith sneaks into the bathroom and drowns the child, and then arranges things so that it will look like an accident.

In the second, Jones also stands to gain if anything should happen to his six-year-old cousin. Like Smith, Jones sneaks in planning to drown the child in his bath. However, just as he enters the bathroom Jones sees the child slip and hit his head, and fall face down in the water. Jones is delighted; he stands by, ready to push the child's head back under if it is necessary, but it is not necessary. With only a little thrashing about, the child drowns all by himself, "accidentally," as Jones watches and does nothing.

Now Smith killed the child, whereas Jones "merely" let the child die. That is the only difference between them. Did either man behave better, from a moral point of view? If the difference between killing and letting die were in itself a morally important matter, one should say that Jones's behavior was less reprehensible than Smith's. But does one really want to say that? I think not. In the first place, both men acted from the same motive, personal gain, and both had exactly the same end in view when they acted. It may be inferred from Smith's conduct that he is a bad man, although that judgment may be withdrawn or modified if certain further facts are learned about him—for example, that he is mentally deranged. But would not the very same thing be inferred about Jones from his conduct? And would not the same further considerations also be relevant to any modification of this judgment? Moreover, suppose Jones pleaded, in his own defense, "After all, I didn't do anything except just stand there and watch the child drown. I didn't kill him; I only let him die." Again, if letting die were in itself less bad than killing, this defense should have at least some weight. But it does not. Such a "defense" can only be regarded as a grotesque perversion of moral reasoning. Morally speaking, it is no defense at all.

Now, it may be pointed out, quite properly, that the cases of euthanasia with which doctors are concerned are not like this at all. They do not involve personal gain or the destruction of normal healthy children. Doctors are concerned only with cases in which the patient's life is of no further use to him, or in which the patient's life has become or will soon become a terrible burden. However, the point is the same in these cases: the bare difference between killing and letting die does not, in itself, make a moral difference. If a doctor lets a patient die, for humane reasons, he is in the same moral position as if he had given the patient a lethal injection for humane reasons. If his decision was wrong—if, for example, the patient's illness was in fact curable—the decision would be equally regrettable no matter which method was used to carry it out. And if the doctor's decision was the right one, the method used is not in itself important.

The AMA policy statement isolates the crucial issue very well; the crucial issue is "the intentional termination of the life of one human being by another." But after identifying this issue, and forbidding "mercy killing," the statement goes on to deny that the cessation of treatment is the intentional termination of a life. This is where the mistake comes in, for what is the cessation of treatment, in these circumstances, if it is not "the intentional termination of the life of one human being by another?" Of course it is exactly that, and if it were not, there would be no point to it.

Many people will find this judgment hard to accept. One reason, I think, is that it is very easy to conflate the question of whether killing is, in itself, worse than letting die, with the very different question of whether most actual cases of killing are more reprehensible than most actual cases of letting die. Most actual cases of killing are clearly terrible (think, for example, of all the murders reported in the newspapers), and one hears of such cases every day. On the other hand, one hardly ever hears of a case of letting die, except for the actions of doctors who are motivated by humanitarian reasons. So one learns to think of killing in a much worse light than of letting die. But this does not mean that there is something about killing that makes it in itself worse than letting die, for it is not the bare difference between killing and letting die that makes the difference in

these cases. Rather, the other factors—the murderer's motive of personal gain, for example, contrasted with the doctor's humanitarian motivation—account for different reactions to the different cases.

I have argued that killing is not in itself any worse than letting die; if my contention is right, it follows that active euthanasia is not any worse than passive euthanasia. What arguments can be given on the other side? The most common, I believe, is the following:

"The important difference between active and passive euthanasia is that, in passive euthanasia, the doctor does not do anything to bring about the patient's death. The doctor does nothing, and the patient dies of whatever ills already afflict him. In active euthanasia, however, the doctor does something to bring about the patient's death: he kills him. The doctor who gives the patient with cancer a lethal injection has himself caused his patient's death; whereas if he merely ceases treatment, the cancer is the cause of the death."

A number of points need to be made here. The first is that it is not exactly correct to say that in passive euthanasia the doctor does nothing, for he does do one thing that is very important: he lets the patient die. "Letting someone die" is certainly different, in some respects, from other types of action—mainly in that it is a kind of action that one may perform by way of not performing certain other actions. For example, one may let a patient die by way of not giving medication, just as one may insult someone by way of not shaking his hand. But for any purpose of moral assessment, it is a type of action nonetheless. The decision to let a patient die is subject to moral appraisal in the same way that a decision to kill him would be subject to moral appraisal: it may be assessed as wise or unwise, compassionate or sadistic, right or wrong. If a doctor deliberately let a patient die who was suffering from a routinely curable illness, the doctor would certainly be to blame for what he had done, just as he would be to blame if he had needlessly killed the patient. Charges against him would then be appropriate. If so, it would be no defense at all for him to insist that he didn't "do anything." He would have done something very serious indeed, for he let his patient die.

Fixing the cause of death may be very important from a legal point of view, for it may determine whether criminal charges are brought against the doctor. But I do not think that this notion can be used to show a moral difference between active and passive euthanasia. The reason why it is considered bad to be the cause of someone's death is that death is regarded as a great evil—and so it is. However, if it has been decided that euthanasia—even passive euthanasia—is desirable in a given case, it has also been decided that in this instance death is no greater an evil than the patient's continued existence. And if this is true, the usual reason for not wanting to be the cause of someone's death simply does not apply.

Finally, doctors may think that all of this is only of academic interest—the sort of thing that philosophers may worry about but that has no practical bearing on their own work. After all, doctors must be concerned about the legal consequences of what they do, and active euthanasia is clearly forbidden by the law. But even so, doctors should also be concerned with the fact that the law is forcing upon them a moral doctrine that may well be indefensible, and has a considerable effect on their practices. Of course, most doctors are not now in the position of being coerced in this matter, for they do not regard themselves as merely going along with what the law requires. Rather, in statements such as the AMA policy statement that I have quoted, they are endorsing this doctrine as a central point of medical ethics. In that statement, active euthanasia is condemned not merely as illegal but as "contrary to that for which the medical profession stands," whereas passive euthanasia is approved. However, the preceding considerations suggest that there is really no moral difference between the two, considered in themselves (there may be important moral differences in some cases in their *consequences*, but, as I pointed out, these differences may make active euthanasia, and not passive euthanasia, the morally preferable option). So, whereas doctors may have to discriminate between active and passive euthanasia to satisfy the law, they should not do any more than that. In particular, they should not give the distinction any added authority and weight by writing it into official statements of medical ethics.

Note

1. Shaw, A: 'Doctor, Do We Have a Choice?' *The New York Times Magazine*, January 30, 1972, p. 54.

Study Questions

1. According to Rachels, in passive euthanasia does the physician do anything?

2. According to Rachels, under what circumstances is active euthanasia morally preferable to passive euthanasia?

3. Is someone who allows another person to drown morally guilty of killing the person?

4. Should the punishment be the same whether you drown someone or allow someone to drown?

50

PHILIPPA FOOT

Philippa Foot (1920–2010), was Professor of Philosophy at the University of California at Los Angeles, defended the distinction between killing and letting die on the grounds that only the former case involves an "agent of harm," that is, an originator of a sequence that causes an unfortunate result rather than merely an observer of a sequence who doesn't interfere with it. She concludes by considering the implications for the morality of abortion of the distinction between killing and letting die.

Killing and Letting Die

Is there a morally relevant distinction between killing and allowing to die? Many philosophers say that there is not, and further insist that there is no other closely related difference, as for instance that which divides act from omission, whichever plays a part in determining the moral character of an action. James Rachels has argued this case in his well-known article on active and passive euthanasia, Michael Tooley has argued it in in his writings on abortion, and Jonathan Bennett argued it in the Tanner Lectures given in Oxford in 1980.[1] I believe that these people are mistaken, and this is what I shall try to show in this essay. I shall first consider the question in abstraction from any particular practical moral problem, and then I shall examine the implications my thesis may have concerning the issue of abortion.

The question with which we are concerned has been dramatically posed by asking whether we are as equally to blame for allowing people in Third World countries to starve to death as we would be for killing them by sending poisoned food? In each case it is true that if we acted differently—by sending good food or by not sending poisoned food—those who are going to die because we do not send the good food or do send the poisoned food would not die after all. Our agency plays a part in what happens whichever way they die. Philosophers such as Rachels, Tooley, and Bennett consider this to be all that matters in determining our guilt or innocence.

From *Abortion and Legal Perspectives*, eds. Jay L. Garfield and Patricia Hennessey, Copyright © 2004 by the University of Massachusetts Press and published by the University of Massachusetts Press.

Or rather they say that although related things are morally relevant, such as our reasons for acting as we do and the cost of acting otherwise, these are only contingently related to the distinction between doing and allowing. If we hold *them* steady and vary only the way in which our agency enters into the matter, no moral differences will be found. It is of no significance, they say, whether we kill others or let them die, or whether they die by our act or our omission. Whereas these latter differences may at first seem to affect the morality of action, we shall always find on further enquiry that some other difference—such as a difference of motive or cost—has crept in.

Now this, on the face of it, is extremely implausible. We are not inclined to think that it would be no worse to murder to get money for some comfort such as a nice winter coat than it is to keep the money back before sending a donation to Oxfam or Care. We do not think that we might just as well be called murderers for one as for the other. And there are a host of other examples which seem to make the same point. We may have to allow one person to die if saving him would mean that we could not save five others, as for instance when a drug is in short supply and he needs five times as much as each of them, but that does not mean that we could carve up one patient to get "spare parts" for five.

These moral intuitions stand clearly before us, but I do not think it would be right to conclude from the fact that these examples all seem to hang on the contrast between killing and allowing to die that this is precisely the distinction that is important from the moral point of view. For example, having someone killed is not strictly *killing* him, but seems just the same morally speaking; and on the other hand, turning off a respirator might be called killing, although it seems morally indistinguishable from allowing to die. Nor does it seem that the difference between "act" and "omission" is quite what we want, in that a respirator that had to be turned on each morning would not change the moral problems that arise with the ones we have now. Perhaps there is no locution in the language which exactly serves our purposes and we should therefore invent our own vocabulary. Let us mark the distinction we are after by saying that one person may or may not be "the agent" of harm that befalls someone else.

When is one person "the agent" in this special sense of someone else's death, or of some harm other than death that befalls him? This idea can easily be described in a general way. If there are difficulties when it comes to detail, some of these ideas may be best left unsolved, for there may be an area of indefiniteness reflecting the uncertainty that belongs to our moral judgments in some complex and perhaps infrequently encountered situations. The idea of agency, in the sense that we want, seems to be composed of two subsidiary ideas. First, we think of particular effects as the result of particular sequences, as when a certain fatal sequence leads to someone's death. This idea is implied in coroners' verdicts telling us what someone died of, and this concept is not made suspect by the fact that it is sometimes impossible to pick out a single fatal sequence—as in the lawyers' example of the man journeying into the desert who had two enemies, one of whom bored a hole in his water barrel while another filled it with brine. Suppose such complications absent. Then we can pick our the fatal sequence and go on to ask who initiated it. If the subject died by poisoning and it was I who put the poison into his drink, then I am the agent of his death; likewise if I shot him and he died of a bullet wound. Of course there are problems about fatal sequences which would have been harmless but for special circumstances, and those which although threatening would have run out harmlessly but for something that somebody did. But we can easily understand the idea that a death comes about through our agency if we send someone poisoned food or cut him up for spare parts, but not (ordinarily) if we fail to save him when he is threatened by accident or disease. Our examples are not problem cases from *this* point of view.

Nor is it difficult to find more examples to drive our original point home, and show that it is sometimes permissible to allow a certain harm to befall someone, although it would have been wrong to bring this harm on him by one's own agency, i.e., by originating or sustaining the sequence which brings the harm. Let us consider, for instance, a pair of cases which I shall call Rescue I and Rescue II. In the first Rescue story we are hurrying in our jeep to save some people—let there be five of them—who are imminently threatened by the ocean tide. We

have not a moment to spare, so when we hear of a single person who also needs rescuing from some other disaster we say regretfully that we cannot rescue him, but must leave him to die. To most of us this seems clear, and I shall take it as clear, ignoring John Taurek's interesting if surprising argument against the obligation to save the greater number when we can.[2] This is Rescue I and with it I contrast Rescue II. In this second story we are again hurrying to the place where the tide is coming in in order to rescue the party of people, but this time it is relevant that the road is narrow and rocky. In this version the lone individual is trapped (do not ask me how) on the path. If we are to rescue the five we would have to drive over him. But can we do so? If we stop he will be all right eventually: he is in no danger unless from us. But of course all five of the others will be drowned. As in the first story our choice is between a course of action which will leave one man dead and five alive at the end of the day and a course of action which will have the opposite result. And yet we surely feel that in one case we can rescue the five men and in the other we cannot. We can allow someone to die of whatever disaster threatens him if the cost of saving him is failing to save five; we cannot, however, drive over *him* in order to get to *them*. We cannot originate a fatal sequence, although we can allow one to run its course. Similarly, in the pair of examples mentioned earlier, we find a contrast between on the one hand refusing to give to one man the whole supply of a scarce drug, because we can use portions of it to save five, and on the other, cutting him up for spare parts. And we notice that we may not originate a fatal sequence even if the resulting death is in no sense our object. We could not knowingly subject one person to deadly fumes in the process of manufacturing some substance that would save many, even if the poisoning were a mere side effect of the process that saved lives.

Considering these examples, it is hard to resist the conclusion that it makes all the difference whether those who are going to die if we act in a certain way will die as a result of a sequence that we originate or one that we allow to continue, it being of course something that did not *start* by our agency. So let us ask how this could be? If the distinction—which is roughly that between killing and allowing to die— *is* morally relevant, because it sometimes makes the difference between what is right and what is wrong, how does this work? After all, it cannot be a magical difference, and it does not satisfy anyone to hear that what we have is just an ultimate moral fact. Moreover, those who deny the relevance can point to cases in which it seems to make no difference to the goodness or badness of an action having a certain result, as, for example, that some innocent person dies, whether due to a sequence we originate or because of one we merely allow. And if the way the result comes about *sometimes* makes no difference, how can it ever do so? If it sometimes makes an action bad that harm came to someone else as a result of a sequence we *originated*, must this not always contribute some element of badness? How can a consideration be a reason for saying that an action is bad in one place without being at least a reason for saying the same elsewhere?

Let us address these questions. As to the route by which considerations of agency enter the process of moral judgment, it seems to be through its connection with different types of rights. For there are rights to noninterference, which form one class of rights; and there are also rights to goods or services, which are different. And corresponding to these two types of rights are, on the one hand, the duty not to interfere, called a "negative duty," and on the other the duty to provide the goods or services, called a "positive duty." These rights may in certain circumstances be overridden, and this can in principle happen to rights of either kind. So, for instance, in the matter of property rights, others have in ordinary circumstances a duty not to interfere with our property, though in exceptional circumstances the right is overridden, as in Elizabeth Anscombe's example of destroying someone's house to stop the spread of fire.[3] And a right to goods or services depending, for example, on a promise will quite often be overridden in the same kind of case. There is, however, no guarantee that the special circumstances that allow one kind of right to be overridden will always allow the overriding of the other. Typically, it takes more to

justify an interference than to justify the withholding of goods or services; and it is, of course, possible to think that nothing whatsoever will justify, for example, the infliction of torture or the deliberate killing of the innocent. It is not hard to find how all this connects with the morality of killing and allowing to die—and in general with harm which an agent allows to happen and harm coming about through his agency, in my special sense having to do with originating or sustaining harmful sequences. For the violation of a right to noninterference consists in interference, which implies breaking into an existing sequence and initiating a new one. It is not usually possible, for instance, to violate that right to noninterference, which is at least part of what is meant by "the right to life" by failing to save someone from death. So if, in any circumstances, the right to noninterference is the only right that exists, or if it is the only right special circumstances have not overridden, then it may not be permissible to initiate a fatal sequence, but it *may* be permissible to withhold aid.

The question now is whether we ever find cases in which the right to noninterference exists and is not overridden, but where the right to goods or services either does not exist or *is* here overridden. The answer is, of course, that this is quite a common case. It often happens that whereas someone's rights stand in the way of our interference, we owe him no *service* in relation to that which he would lose if we interfered. We may not deprive him of his property, though we do not have to help him secure his hold on it, in spite of the fact that the balance of good and evil in the outcome (counting his loss or gain and the cost to us) will be the same regardless of how they come about. Similarly, where the issue is one of life and death, it is often impermissible to kill someone— although special circumstances having to do with the good of others make it permissible, or even required, that we do not spend the time or resources needed to save his life, as for instance, in the story of Rescue I, or in that of the scarce drug.

It seems clear, therefore, that there are circumstances in which it makes all the difference, morally speaking, whether a given balance of good and evil came about through our agency (in our sense), or whether it was rather something we had the ability to prevent but, for good reasons, did not prevent. Of course, we often have a strict duty to prevent harm to others, or to ameliorate their condition. And even where they do not, strictly speaking, have a *right* to our goods or services, we should often be failing (and sometimes grossly failing) in charity if we did not help them. But, to reiterate, it may be right to allow one person to die in order to save five, although it would not be right to kill him to bring the same good to them.

How is it, then, that anyone has ever denied this conclusion, so sympathetic to our everyday moral intuitions and apparently so well grounded in a very generally recognized distinction between different types of rights? We must now turn to an argument first *given*, by James Rachels, and more or less followed by others who think as he does. Rachels told a gruesome story of a child drowned in a bathtub in two different ways: in one case someone pushed the child's head under water, and in the other he found the child drowning and did not pull him out. Rachels says that we should judge one way of acting as bad as the other, so we have an example in which killing is as bad as allowing to die. But how, he asks, can the distinction ever be relevant if it is not relevant here?[4]

Based on what has been said earlier, the answer to Rachels should be obvious. The reason why it is, in ordinary circumstances, "no worse" to leave a child drowning in a bathtub than to push it under, is that both charity and the special duty of care that we owe to children give us a positive obligation to save them, and we have no particular reason to say that it is "less bad" to fail in this than it is to be in dereliction of the negative duty by being the agent of harm. The level of badness is, we may suppose, the same, but because a different kind of bad action has been done, there is no reason to suppose that the two ways of acting will always give the same result. In other circumstances one might be worse than the other, or only one might be bad. And this last result is exactly what we find in circumstances that allow a positive but not a negative duty to be overridden. Thus, it could be right to leave someone to die by the roadside in the story of Rescue I, though wrong to

run over him in the story of Rescue II; and it could be right to act correspondingly in the cases of the scarce drug and the "spare parts."

Let me now consider an objection to the thesis I have been defending. It may be said that I shall have difficulty explaining a certain range of examples in which it seems permissible, and even obligatory, to make an intervention which jeopardizes people not already in danger in order to save others who are. The following case has been discussed. Suppose a runaway trolley is heading toward a track on which five people are standing, and that there is someone who can possibly switch the points, thereby diverting the trolley onto a track on which there is only one person. It seems that he should do this, just as a pilot whose plane is going to crash has a duty to steer, if he can, toward a less crowded street than the one he sees below. But the railway man then puts the one man newly in danger, instead of allowing the five to be killed. Why does not the one man's right to noninterference stand in his way, as one person's right to noninterference impeded the manufacture of poisonous fumes when this was necessary to save five?

The answer seems to be that this is a special case, in that we have here the *diverting* of a fatal sequence and not the starting of a new one. So we could not start a flood to stop a fire, even when the fire would kill more than the flood, but we could divert a flood to an area in which fewer people would be drowned.

A second and much more important difficulty involves cases in which it seems that the distinction between agency and allowing is inexplicably irrelevant. Why, I shall be asked, is it not morally permissible to allow someone to die deliberately in order to use his body for a medical procedure that would save many lives? It might be suggested that the distinction between agency and allowing is relevant when what is allowed to happen is itself aimed at. Yet this is not quite right, because there are cases in which it does make a difference whether one originates a sequence or only allows it to continue, although the allowing is with deliberate intent. Thus, for instance, it may not be permissible to deprive someone of a possession which only harms him, but it may be reasonable to refuse to get it back for him if it is already

slipping from his grasp.[5] And it is arguable that nonvoluntary passive euthanasia is sometimes justifiable although nonvoluntary active euthanasia is not. What these examples have in common is that *harm* is not in question, which suggests that the "direct," i.e., deliberate, intention of *evil* is what makes it morally objectionable to allow the beggar to die. When this element is present it is impossible to justify an action by indicating that no *origination* of evil is involved. But this special case leaves no doubt about the relevance of distinguishing between originating an evil and allowing it to occur. It was never suggested that there will *always and everywhere* be a difference of permissibility between the two.

Having defended the moral relevance of the distinction which roughly corresponds to the contrast between killing and allowing to die, I shall now ask how it affects the argument between those who oppose and those who support abortion. The answer seems to be that this entirely depends on how the argument is supposed to go. The most usual defense of abortion lies in the distinction between the destruction of a fetus and the destruction of a human person, and neither side in *this* debate will have reason to refer to the distinction between being the agent of an evil and allowing it to come about. But this is not the only defense of abortion which is current at the present time. In an influential and widely read article, Judith Jarvis Thomson has suggested an argument for allowing abortion which depends on denying what I have been at pains to maintain.[6]

Thomson suggests that abortion can be justified, at least in certain cases, without the need to deny that the fetus has the moral rights of a human person. For, she says, no person has an absolute right to the use of another's body, even to save his life, and so the fetus, whatever its status, has no right to the use of the mother's body. *Her* rights override *its* rights, and justify her in removing it if it seriously encumbers her life. To persuade us to agree with her she invents an example, which is supposed to give a parallel, in which someone dangerously ill is kept alive by being hooked up to the body of another person, without that person's consent. It is obvious, she says, that the person whose body was thus being used would have

no obligation to continue in that situation, suffering immobility or other serious inconvenience, for any length of time. We should not think of him as a murderer if he detached himself, and we ought to think of a pregnant woman as having the same right to rid herself of an unwanted pregnancy.

Thomson's whole case depends on this analogy. It is, however, faulty if what I have said earlier is correct. According to my thesis, the two cases must be treated quite differently because one involves the initiation of a fatal sequence and the other the refusal to save a life. It is true that someone who extricated himself from a situation in which his body was being used in the way a respirator or a kidney machine is used could, indeed, be said to kill the other person in detaching himself. But this only shows, once more, that the use of "kill" is not important: what matters is that the fatal sequence resulting in death is not initiated but is rather allowed to take its course. And although charity or duties of care could have dictated that the help be given, it seems perfectly reasonable to treat this as a case in which such presumptions are overridden by other rights—those belonging to the person whose body would be used. The case of abortion is of course completely different. The fetus is not in jeopardy because it is in its mother's womb; it is merely dependent on her in the way children are dependent on their parents for food. An abortion, therefore, originates the sequence which ends in the death of the fetus, and the destruction comes about "through the agency" of the mother who seeks the abortion. If the fetus has the moral status of a human person then her action is, at best, likened to that of killing for spare parts or in Rescue II; conversely, the act of someone who refused to let his body be used to save the life of the sick man in Thomson's story belongs with the scarce drug decision, or that of Rescue I.

It appears, therefore, that Thomson's argument is not valid, and that we are thrown back to the old debate about the moral status of the fetus, which stands as the crucial issue in determing whether abortion is justified.

Notes

1. James Rachels, "Active and Passive Euthanasia," *New England Journal of Medicine*, 292 (January 9, 1975), 78–80; this volume, chapter 5: Michael Tooley, "Abortion and Infanticide," *Philosophy and Public Affairs*, 2, no. 1 (Fall 1972), 37–65; Jonathan Bennett, "Morality and Consequences," in *The Tanner Lectures on Human Values*, II, ed. Sterling McMurrin (Cambridge: Cambridge University Press, 1981), pp. 47–16.

2. John Taurek, "Should the Numbers Count?" *Philosophy and Public Affairs*, no. 4 (Summer 1977): 293–316.

3. G. E. M. Anscombe, "Modern Moral Philosophy," *Philosophy*, 33 (1958): 1–19.

4. Rachels, "Active and Passive Euthanasia."

5. Cf. Philippa Foot, "Killing, Letting Die, and Euthanasia: A Reply to Holly Smith Goldman," *Analysis*, 41, no. 4 (June 1981).

6. Judith Jarvis Thomson, "A Defense of Abortion," *Philosophy and Public Affairs*, 1 (1971), 44.

Study Questions

1. What is meant by an "agent of harm"?
2. Explain in your own words the distinction between a "negative duty" and a "positive duty."
3. Do you agree with Foot's analysis of the cases Rescue I and Rescue II?
4. What does Foot's view of the distinction between killing and letting die imply about Thomson's example of the unconscious violinist?

51

PETER SINGER

What obligations do we have toward those around the globe who are suffering from a lack of food, shelter, or medical care? Does morality permit us to purchase luxuries for ourselves, our families, and our friends instead of providing needed resources to other people who are suffering in unfortunate circumstances? Peter Singer, Ira W. DeCamp Professor of Bioethics at Princeton University, argues that if we can prevent something bad without thereby sacrificing anything of comparable moral worth, we ought to do so. In short, while some view contributing to relief funds as an act of charity, Singer considers such a donation as a moral duty.

Famine, Affluence, and Morality

As I write this, in November 1971, people are dying in East Bengal from lack of food, shelter, and medical care. The suffering and death that are occurring there now are not inevitable, not unavoidable in any fatalistic sense of the term. Constant poverty, a cyclone, and a civil war have turned at least nine million people into destitute refugees; nevertheless, it is not beyond the capacity of the richer nations to give enough assistance to reduce any further suffering to very small proportions. The decisions and actions of human beings can prevent this kind of suffering. Unfortunately, human beings have not made the necessary decisions. At the individual level, people have, with very few exceptions, not responded to the situation in any significant way. Generally speaking, people have not given large sums to relief funds; they have not written to their parliamentary representatives demanding increased government assistance; they have not demonstrated in the streets, held symbolic

fasts, or done anything else directed toward providing the refugees with the means to satisfy their essential needs. At the governmental level, no government has given the sort of massive aid that would enable the refugees to survive for more than a few days. Britain, for instance, has given rather more than most countries. It has, to date, given £14,750,000. For comparative purposes, Britain's share of the nonrecoverable development costs of the Anglo-French Concorde project is already in excess of £275,000,000, and on present estimates will reach £440,000,000. The implication is that the British government values a supersonic transport more than thirty times as highly as it values the lives of the nine million refugees. Australia is another country which, on a per capita basis, is well up in the "aid to Bengal" table. Australia's aid, however, amounts to less than one-twelfth of the cost of Sydney's new opera house. The total amount given, from all sources, now stands at about

Peter Singer, "Famine, Affluence, and Morality," *Philosophy & Public Affairs*, vol. 1, no. 3 (1972). Reprinted by permission of Blackwell Publishing Ltd.

£65,000,000. The estimated cost of keeping the refugees alive for one year is £464,000,000. Most of the refugees have now been in the camps for more than six months. The World Bank has said that India needs a minimum of £300,000,000 in assistance from other countries before the end of the year. It seems obvious that assistance on this scale will not be forthcoming. India will be forced to choose between letting the refugees starve or diverting funds from her own development program, which will mean that more of her own people will starve in the future.[1]

These are the essential facts about the present situation in Bengal. So far as it concerns us here, there is nothing unique about this situation except its magnitude. The Bengal emergency is just the latest and most acute of a series of major emergencies in various parts of the world, arising both from natural and from man-made causes. There are also many parts of the world in which people die from malnutrition and lack of food independent of any special emergency. I take Bengal as my example only because it is the present concern, and because the size of the problem has ensured that it has been given adequate publicity. Neither individuals nor governments can claim to be unaware of what is happening there.

What are the moral implications of a situation like this? In what follows, I shall argue that the way people in relatively affluent countries react to a situation like that in Bengal cannot be justified; indeed, the whole way we look at moral issues—our moral conceptual scheme—needs to be altered, and with it, the way of life that has come to be taken for granted in our society.

In arguing for this conclusion I will not, of course, claim to be morally neutral. I shall, however, try to argue for the moral position that I take, so that anyone who accepts certain assumptions, to be made explicit, will, I hope, accept my conclusion.

I begin with the assumption that suffering and death from lack of food, shelter, and medical care are bad. I think most people will agree about this, although one may reach the same view by different routes. I shall not argue for this view. People can hold all sorts of eccentric positions, and perhaps from some of them it would not follow that death by starvation is in itself bad. It is difficult, perhaps

impossible, to refute such positions, and so for brevity I will henceforth take this assumption as accepted. Those who disagree need read no further.

My next point is this: if it is in our power to prevent something bad from happening, without thereby sacrificing anything of comparable moral importance, we ought, morally, to do it. By "without sacrificing anything of comparable moral importance" I mean without causing anything else comparably bad to happen, or doing something that is wrong in itself, or failing to promote some moral good, comparable in significance to the bad thing that we can prevent. This principle seems almost as uncontroversial as the last one. It requires us only to prevent what is bad, and not to promote what is good, and it requires this of us only when we can do it without sacrificing anything that is, from the moral point of view, comparably important. I could even, as far as the application of my argument to the Bengal emergency is concerned, qualify the point so as to make it: if it is in our power to prevent something very bad from happening, without thereby sacrificing anything morally significant, we ought, morally, to do it. An application of this principle would be as follows: if I am walking past a shallow pond and see a child drowning in it, I ought to wade in and pull the child out. This will mean getting my clothes muddy, but this is insignificant, while the death of the child would presumably be a very bad thing.

The uncontroversial appearance of the principle just stated is deceptive. If it were acted upon, even in its qualified form, our lives, our society, and our world would be fundamentally changed. For the principle takes, firstly, no account of proximity or distance. It makes no moral difference whether the person I can help is a neighbor's child ten yards from me or a Bengali whose name I shall never know, ten thousand miles away. Secondly, the principle makes no distinction between cases in which I am the only person who could possibly do anything and cases in which I am just one among millions in the same position.

I do not think I need to say much in defense of the refusal to take proximity and distance into account. The fact that a person is physically near to us, so that we have personal contact with him, may make it

more likely that we *shall* assist him, but this does not show that we *ought* to help him rather than another who happens to be further away. If we accept any principle of impartiality, universalizability, equality, or whatever, we cannot discriminate against someone merely because he is far away from us (or we are far away from him). Admittedly, it is possible that we are in a better position to judge what needs to be done to help a person near to us than one far away, and perhaps also to provide the assistance we judge to be necessary. If this were the case, it would be a reason for helping those near to us first. This may once have been a justification for being more concerned with the poor in one's own town than with famine victims in India. Unfortunately for those who like to keep their moral responsibilities limited, instant communication and swift transportation have changed the situation. From the moral point of view, the development of the world into a "global village" has made an important, though still unrecognized, difference to our moral situation. Expert observers and supervisors, sent out by famine relief organizations or permanently stationed in famine-prone areas, can direct our aid to a refugee in Bengal almost as effectively as we could get it to someone in our own block. There would seem, therefore, to be no possible justification for discriminating on geographical grounds.

There may be a greater need to defend the second implication of my principle—that the fact that there are millions of other people in the same position, in respect to the Bengali refugees, as I am, does not make the situation significantly different from a situation in which I am the only person who can prevent something very bad from occurring. Again, of course, I admit that there is a psychological difference between the cases; one feels less guilty about doing nothing if one can point to others, similarly placed, who have also done nothing. Yet this can make no real difference to our moral obligations.[2] Should I consider that I am less obliged to pull the drowning child out of the pond if on looking around I see other people, no further away than I am, who have also noticed the child but are doing nothing? One has only to ask this question to see the absurdity of the view that numbers lessen

obligation. It is a view that is an ideal excuse for inactivity; unfortunately most of the major evils—poverty, overpopulation, pollution—are problems in which everyone is almost equally involved.

The view that numbers do make a difference can be made plausible if stated in this way: if everyone in circumstances like mine gave £5 to the Bengal Relief Fund, there would be enough to provide food, shelter, and medical care for the refugees; there is no reason why I should give more than anyone else in the same circumstances as I am; therefore I have no obligation to give more than £5. Each premise in this argument is true, and the argument looks sound. It may convince us, unless we notice that it is based on a hypothetical premise, although the conclusion is not stated hypothetically. The argument would be sound if the conclusion were: if everyone in circumstances like mine were to give £5, I would have no obligation to give more than £5. If the conclusion were so stated, however, it would be obvious that the argument has no bearing on a situation in which it is not the case that everyone else gives £5. This, of course, is the actual situation. It is more or less certain that not everyone in circumstances like mine will give £5. So there will not be enough to provide the needed food, shelter, and medical care. Therefore by giving more than £5 I will prevent more suffering than I would if I gave just £5.

It might be thought that this argument has an absurd consequence. Since the situation appears to be that very few people are likely to give substantial amounts, it follows that I and everyone else in similar circumstances ought to give as much as possible, that is, at least up to the point at which by giving more one would begin to cause serious suffering for oneself and one's dependents—perhaps even beyond this point to the point of marginal utility, at which by giving more one would cause oneself and one's dependents as much suffering as one would prevent in Bengal. If everyone does this, however, there will be more than can be used for the benefit of the refugees, and some of the sacrifice will have been unnecessary. Thus, if everyone does what he ought to do, the result will not be as good as it would be if everyone did a little less than he ought to do, or if only some do all that they ought to do.

The paradox here arises only if we assume that the actions in question—sending money to the relief funds—are performed more or less simultaneously, and are also unexpected. For if it is to be expected that everyone is going to contribute something, then clearly each is not obliged to give as much as he would have been obliged to had others not been giving too. And if everyone is not acting more or less simultaneously, then those giving later will know how much more is needed, and will have no obligation to give more than is necessary to reach this amount. To say this is not to deny the principle that people in the same circumstances have the same obligations, but to point out that the fact that others have given, or may be expected to give, is a relevant circumstance: those giving after it has become known that many others are giving and those giving before are not in the same circumstances. So the seemingly absurd consequence of the principle I have put forward can occur only if people are in error about the actual circumstances—that is, if they think they are giving when others are not, but in fact they are giving when others are. The result of everyone doing what he really ought to do cannot be worse than the result of everyone doing less than he ought to do, although the result of everyone doing what he reasonably believes he ought to do could be.

If my argument so far has been sound, neither our distance from a preventable evil nor the number of other people who, in respect to that evil, are in the same situation as we are, lessens our obligation to mitigate or prevent that evil. I shall therefore take as established the principle I asserted earlier. As I have already said, I need to assert it only in its qualified form: if it is in our power to prevent something very bad from happening, without thereby sacrificing anything else morally significant, we ought, morally, to do it.

The outcome of this argument is that our traditional moral categories are upset. The traditional distinction between duty and charity cannot be drawn, or at least, not in the place we normally draw it. Giving money to the Bengal Relief Fund is regarded as an act of charity in our society. The bodies which collect money are known as "charities." These organizations see themselves in this way—if you send them a check, you will be thanked for your "generosity." Because giving money is regarded as an act of charity, it is not thought that there is anything wrong with not giving. The charitable man may be praised, but the man who is not charitable is not condemned. People do not feel in any way ashamed or guilty about spending money on new clothes or a new car instead of giving it to famine relief. (Indeed, the alternative does not occur to them.) This way of looking at the matter cannot be justified. When we buy new clothes not to keep ourselves warm but to look "well-dressed" we are not providing for any important need. We would not be sacrificing anything significant if we were to continue to wear our old clothes, and give the money to famine relief. By doing so, we would be preventing another person from starving. It follows from what I have said earlier that we ought to give money away, rather than spend it on clothes which we do not need to keep us warm. To do so is not charitable, or generous. Nor is it the kind of act which philosophers and theologians have called "supererogatory"—an act which it would be good to do, but not wrong not to do. On the contrary, we ought to give the money away, and it is wrong not to do so.

I am not maintaining that there are no acts which are charitable, or that there are no acts which it would be good to do but not wrong not to do. It may be possible to redraw the distinction between duty and charity in some other place. All I am arguing here is that the present way of drawing the distinction, which makes it an act of charity for a man living at the level of affluence which most people in the "developed nations" enjoy to give money to save someone else from starvation, cannot be supported. It is beyond the scope of my argument to consider whether the distinction should be redrawn or abolished altogether. There would be many other possible ways of drawing the distinction—for instance, one might decide that it is good to make other people as happy as possible, but not wrong not to do so.

Despite the limited nature of the revision in our moral conceptual scheme which I am proposing, the revision would, given the extent of both affluence and famine in the world today, have radical implications. These implications may lead to further objections, distinct from those I have already considered. I shall discuss two of these.

One objection to the position I have taken might be simply that it is too drastic a revision of our moral scheme. People do not ordinarily judge in the way I have suggested they should. Most people reserve their moral condemnation for those who violate some moral norm, such as the norm against taking another person's property. They do not condemn those who indulge in luxury instead of giving to famine relief. But given that I did not set out to present a morally neutral description of the way people make moral judgments, the way people do in fact judge has nothing to do with the validity of my conclusion. My conclusion follows from the principle which I advanced earlier, and unless that principle is rejected, or the arguments shown to be unsound, I think the conclusion must stand, however strange it appears.

It might, nevertheless, be interesting to consider why our society, and most other societies, do judge differently from the way I have suggested they should. In a well-known article, J. O. Urmson suggests that the imperatives of duty, which tell us what we must do, as distinct from what it would be good to do but not wrong not to do, function so as to prohibit behavior that is intolerable if men are to live together in society.[3] This may explain the origin and continued existence of the present division between acts of duty and acts of charity. Moral attitudes are shaped by the needs of society, and no doubt society needs people who will observe the rules that make social existence tolerable. From the point of view of a particular society, it is essential to prevent violations of norms against killing, stealing, and so on. It is quite inessential, however, to help people outside one's own society.

If this is an explanation of our common distinction between duty and supererogation, however, it is not a justification of it. The moral point of view requires us to look beyond the interests of our own society. Previously, as I have already mentioned, this may hardly have been feasible, but it is quite feasible now. From the moral point of view, the prevention of the starvation of millions of people outside our society must be considered at least as pressing as the upholding of property norms within our society.

It has been argued by some writers, among them Sidgwick and Urmson, that we need to have a basic moral code which is not too far beyond the capacities of the ordinary man, for otherwise there will be a general breakdown of compliance with the moral code. Crudely stated, this argument suggests that if we tell people that they ought to refrain from murder and give everything they do not really need to famine relief, they will do neither, whereas if we tell them that they ought to refrain from murder and that it is good to give to famine relief but not wrong not to do so, they will at least refrain from murder. The issue here is: Where should we draw the line between conduct that is required and conduct that is good although not required, so as to get the best possible result? This would seem to be an empirical question, although a very difficult one. One objection to the Sidgwick-Urmson line of argument is that it takes insufficient account of the effect that moral standards can have on the decisions we make. Given a society in which a wealthy man who gives five percent of his income to famine relief is regarded as most generous, it is not surprising that a proposal that we all ought to give away half our incomes will be thought to be absurdly unrealistic. In a society which held that no man should have more than enough while others have less than they need, such a proposal might seem narrow-minded. What it is possible for a man to do and what he is likely to do are both, I think, very greatly influenced by what people around him are doing and expecting him to do. In any case, the possibility that by spreading the idea that we ought to be doing very much more than we are to relieve famine we shall bring about a general breakdown of moral behavior seems remote. If the stakes are an end to widespread starvation, it is worth the risk. Finally, it should be emphasized that these considerations are relevant only to the issue of what we should require from others, and not to what we ourselves ought to do.

The second objection to my attack on the present distinction between duty and charity is one which has from time to time been made against utilitarianism. It follows from some forms of utilitarian theory that we all ought, morally, to be working full time to increase the balance of happiness over misery. The position I have taken here would not lead to this conclusion in all circumstances, for if there were no

bad occurrences that we could prevent without sacrificing something of comparable moral importance, my argument would have no application. Given the present conditions in many parts of the world, however, it does follow from my argument that we ought, morally, to be working full time to relieve great suffering of the sort that occurs as a result of famine or other disasters. Of course, mitigating circumstances can be adduced—for instance, that if we wear ourselves out through overwork, we shall be less effective than we would otherwise have been. Nevertheless, when all considerations of this sort have been taken into account, the conclusion remains: we ought to be preventing as much suffering as we can without sacrificing something else of comparable moral importance. This conclusion is one which we may be reluctant to face. I cannot see, though, why it should be regarded as a criticism of the position for which I have argued, rather than a criticism of our ordinary standards of behavior. Since most people are self-interested to some degree, very few of us are likely to do everything that we ought to do. It would, however, hardly be honest to take this as evidence that it is not the case that we ought to do it.

It may still be thought that my conclusions are so wildly out of line with what everyone else thinks and has always thought that there must be something wrong with the argument somewhere. In order to show that my conclusions, while certainly contrary to contemporary Western moral standards, would not have seemed so extraordinary at other times and in other places, I would like to quote a passage from a writer not normally thought of as a way-out radical, Thomas Aquinas. Now, according to the natural order instituted by divine providence, material goods are provided for the satisfaction of human needs. Therefore the division and appropriation of property, which proceeds from human law, must not hinder the satisfaction of man's necessity from such goods. Equally, whatever a man has in superabundance is owed, of natural right, to the poor for their sustenance. So Ambrosius says, and it is also to be found in the *Decretum Gratiani:* "The bread which you withhold belongs to the hungry; the clothing you shut away, to the naked; and the money you bury in the earth is the redemption and freedom of the penniless."[4]

I now want to consider a number of points, more practical than philosophical, which are relevant to the application of the moral conclusion we have reached. These points challenge not the idea that we ought to be doing all we can to prevent starvation, but the idea that giving away a great deal of money is the best means to this end.

It is sometimes said that overseas aid should be a government responsibility, and that therefore one ought not to give to privately run charities. Giving privately, it is said, allows the government and the noncontributing members of society to escape their responsibilities.

This argument seems to assume that the more people there are who give to privately organized famine relief funds, the less likely it is that the government will take over full responsibility for such aid. This assumption is unsupported, and does not strike me as at all plausible. The opposite view—that if no one gives voluntarily, a government will assume that its citizens are uninterested in famine relief and would not wish to be forced into giving aid—seems more plausible. In any case, unless there were a definite probability that by refusing to give one would be helping to bring about massive government assistance, people who do refuse to make voluntary contributions are refusing to prevent a certain amount of suffering without being able to point to any tangible beneficial consequence of their refusal. So the onus of showing how their refusal will bring about government action is on those who refuse to give.

I do not, of course, want to dispute the contention that governments of affluent nations should be giving many times the amount of genuine, no-strings-attached aid that they are giving now. I agree, too, that giving privately is not enough, and that we ought to be campaigning actively for entirely new standards for both public and private contributions to famine relief. Indeed, I would sympathize with someone who thought that campaigning was more important than giving oneself, although I doubt whether preaching what one does not practice would be very effective. Unfortunately, for many people the idea that "it's the government's responsibility" is a reason for not giving which does not appear to entail any political action either.

Another, more serious reason for not giving to famine relief funds is that until there is effective population control, relieving famine merely postpones starvation. If we save the Bengal refugees now, others, perhaps the children of these refugees, will face starvation in a few years' time. In support of this, one may cite the now well-known facts about the population explosion and the relatively limited scope for expanded production.

This point, like the previous one, is an argument against relieving suffering that is happening now, because of a belief about what might happen in the future; it is unlike the previous point in that very good evidence can be adduced in support of this belief about the future. I will not go into the evidence here. I accept that the earth cannot support indefinitely a population rising at the present rate. This certainly poses a problem for anyone who thinks it important to prevent famine. Again, however, one could accept the argument without drawing the conclusion that it absolves one from any obligation to do anything to prevent famine. The conclusion that should be drawn is that the best means of preventing famine, in the long run, is population control. It would then follow from the position reached earlier that one ought to be doing all one can to promote population control (unless one held that all forms of population control were wrong in themselves, or would have significantly bad consequences). Since there are organizations working specifically for population control, one would then support them rather than more orthodox methods of preventing famine.

A third point raised by the conclusion reached earlier relates to the question of just how much we all ought to be giving away. One possibility, which has already been mentioned, is that we ought to give until we reach the level of marginal utility— that is, the level at which, by giving more, I would cause as much suffering to myself or my dependents as I would relieve by my gift. This would mean, of course, that one would reduce oneself to very near the material circumstances of a Bengali refugee. It will be recalled that earlier I put forward both a strong and a moderate version of the principle of preventing bad occurrences. The strong version, which required us to prevent bad things from happening unless in doing so we would be sacrificing something of comparable

moral significance, does seem to require reducing ourselves to the level of marginal utility. I should also say that the strong version seems to me to be the correct one. I proposed the more moderate version—that we should prevent bad occurrences unless, to do so, we had to sacrifice something morally significant— only in order to show that even on this surely undeniable principle a great change in our way of life is required. On the more moderate principle, it may not follow that we ought to reduce ourselves to the level of marginal utility, for one might hold that to reduce oneself and one's family to this level is to cause something significantly bad to happen. Whether this is so I shall not discuss, since, as I have said, I can see no good reason for holding the moderate version of the principle rather than the strong version. Even if we accepted the principle only in its moderate form, however, it should be clear that we would have to give away enough to ensure that the consumer society, dependent as it is on people spending on trivia rather than giving to famine relief, would slow down and perhaps disappear entirely. There are several reasons why this would be desirable in itself. The value and necessity of economic growth are now being questioned not only by conservationists, but by economists as well.[5] There is no doubt, too, that the consumer society has had a distorting effect on the goals and purposes of its members. Yet looking at the matter purely from the point of view of overseas aid, there must be a limit to the extent to which we should deliberately slow down our economy; for it might be the case that if we gave away, say, forty percent of our Gross National Product, we would slow down the economy so much that in absolute terms we would be giving less than if we gave twenty-five percent of the much larger GNP that we would have if we limited our contribution to this smaller percentage.

I mention this only as an indication of the sort of factor that one would have to take into account in working out an ideal. Since Western societies generally consider one percent of the GNP an acceptable level for overseas aid, the matter is entirely academic. Nor does it affect the question of how much an individual should give in a society in which very few are giving substantial amounts.

It is sometimes said, though less often now than it used to be, that philosophers have no special role to play in public affairs, since most public issues depend primarily on an assessment of facts. On questions of fact, it is said, philosophers as such have no special expertise, and so it has been possible to engage in philosophy without committing oneself to any position on major public issues. No doubt there are some issues of social policy and foreign policy about which it can truly be said that a really expert assessment of the facts is required before taking sides or acting, but the issue of famine is surely not one of these. The facts about the existence of suffering are beyond dispute. Nor, I think, is it disputed that we can do something about it, either through orthodox methods of famine relief or through population control or both. This is therefore an issue on which philosophers are competent to take a position. The issue is one which faces everyone who has more money than he needs to support himself and his dependents, or who is in a position to take some sort of political action. These categories must include practically every teacher and student of philosophy in the universities of the Western world. If philosophy is to deal with matters that are relevant to both teachers and students, this is an issue that philosophers should discuss.

Discussion, though, is not enough. What is the point of relating philosophy to public (and personal) affairs if we do not take our conclusions seriously? In this instance, taking our conclusion seriously means acting upon it. The philosopher will not find it any easier than anyone else to alter his attitudes and way of life to the extent that, if I am right, is involved in doing everything that we ought to be doing. At the very least, though, one can make a start. The philosopher who does so will have to sacrifice some of the benefits of the consumer society, but he can find compensation in the satisfaction of a way of life in which theory and practice, if not yet in harmony, are at least coming together.

Notes

1. There was also a third possibility: that India would go to war to enable the refugees to return to their lands. Since I wrote this paper, India has taken this way out. The situation is no longer that described above, but this does not affect my argument, as the next paragraph indicates.

2. In view of the special sense philosophers often give to the term, I should say that I use "obligation" simply as the abstract noun derived from "ought," so that "I have an obligation to" means no more, and no less, than "I ought to." This usage is in accordance with the definition of "ought" given by the *Shorter Oxford English Dictionary:* "the general verb to express duty or obligation." I do not think any issue of substance hangs on the way the term is used; sentences in which I use "obligation" would all be rewritten, although somewhat clumsily, as sentences in which a clause containing "ought" replaces the term "obligation."

3. J. O. Urmson, "Saints and Heroes," in *Essays in Moral Philosophy*, ed. Abraham I. Melden (Seattle and London, 1958), p. 214. For a related but significantly different view see also Henry Sidgwick, *The Methods of Ethics*, 7th edn. (London, 1907), pp. 220–221, 492–493.

4. *Summa Theologica*, II-II, Question 66, Article 7, in *Aquinas, Selected Political Writings*, ed. A. P. d'Entreves, trans. J. G. Dawson (Oxford, 1948), p. 171.

5. See, for instance, John Kenneth Galbraith, *The New Industrial State* (Boston, 1967); and E. J. Mishan, *The Costs of Economic Growth* (London, 1967).

Study Questions

1. If you can prevent something bad from happening at a comparatively small cost to yourself, are you obligated to do so?

2. Is your obligation to save a drowning child affected by how often you are called on to offer such help?

3. Are you acting immorally by paying college tuition for your own children while other children have no opportunity for any schooling at all?

4. Do we have a moral obligation to try to alleviate extreme poverty in our own country before attempting to do so in other countries?

52

JOHN ARTHUR

John Arthur (1946–2007) was Professor of Philosophy at Binghamton University of the State University of New York. He argued that an ideal moral code should rest on realistic assumptions about human beings and our life in this world. Among these practicalities is that people are motivated to work by earning an income, and unless they can keep a large part of what they earn, they will not work as hard, resulting in a reduction in the society's overall well-being. Arthur concluded, therefore, that while we have a duty to help those in need, we are not morally required to make large sacrifices of our own or our family's financial resources in order to aid distant strangers.

Famine Relief and the Ideal Moral Code

What do those of us who are relatively affluent owe, from a moral standpoint, to those who are hungry and sick and who may die without assistance?[1] In a provocative and important article "Famine, Affluence, and Morality" Peter Singer defends what he terms an "uncontroversial" moral principle, that we ought to prevent evil whenever we can do so without sacrificing something of comparable moral significance. In doing so, he argues there is a duty to provide aid whenever others are in greater need and will suffer without our help.[2] Other philosophers, relying on the principle that all human life is of equal value, have reached similar conclusions.[3] My first concern, then, is to assess such arguments on their own terms, asking whether these arguments do, in fact, establish a duty to give aid. I will argue, in response, that our moral "intuitions" include not only the commitments they emphasize but also entitlements, which suggests that people who deserve or have rights to their earnings may be allowed to keep them.

But the fact that our social moral code includes entitlements is not a complete answer, for it is possible that contemporary moral attitudes are mistaken and our accepted code is defective. So, in the final sections I ask whether a moral reformer might reasonably claim that an "ideal" moral code would reject entitlements, arguing that in fact it would not.

A DUTY TO PREVENT EVIL?

What do we intuitively believe, on the basis of our accepted moral views, about helping people in desperate need? Some have argued that the ideal of treating people equally requires that we do much more to aid each other than is usually supposed. Richard Watson, for example, emphasizes what he calls the "principle of equity." Since "all human life is of equal value," and since difference in treatment should be "based on freely chosen actions and not

accidents of birth or environment," he thinks that we have "equal rights to the necessities of life."[4] To distribute food unequally assumes that some lives are worth more than others, an assumption that, he says, we do not accept. Watson believes, in fact, that we put such importance on the "equity principle" that it should not be violated even if unequal distribution is the only way for anybody to survive. (Leaving aside for the moment whether or not he is correct about our code, it seems to me that if it really did require us to commit mass suicide rather than allow inequality in wealth, we would want to abandon it for a more suitable set of moral rules. But more on that later.)

Begin with the premise: Is Watson correct that all life is of equal value? Did Adolf Hitler and Martin Luther King, for example, lead equally valuable lives? Clearly one did far more good, the other far more harm; who would deny that while King fought for people's rights, Hitler violated them on a massive scale? Nor are moral virtues like courage, kindness, and trustworthiness equally distributed among people. So there are many important senses in which people are not, in fact, morally equal: Some lives are more valuable to others, and some people are just, generous, and courageous, whereas others are unjust, cheap, and cowardly.

Yet, all the same, the ideal of equality is often thought to be a cornerstone of morality and justice. But what does it mean to say all people are "equal"? It seems to me that we might have in mind one of two things. First is an idea that Thomas Jefferson expressed in the Declaration of Independence. "All men are created equal" meant, for him, that no man is the moral inferior of another, that, in other words, there are certain rights that all men share equally, including life and liberty. We are entitled in many areas to pursue our own lives without interference from others, just as no person is the natural slave of another. But, as Jefferson also knew, equality in that sense does not require equal distribution of the necessities of life, only that we not interfere with one another, allowing instead every person the liberty to pursue his own affairs, so long as he does not violate the rights of others.

Some people, however, have something different in mind when they speak of human equality. To develop this second idea, we turn to Singer's argument in "Famine, Affluence, and Morality." In that essay, Singer argues that two general moral principles are widely accepted and then that those principles imply an obligation to eliminate starvation.

The first of the two principles he thinks we accept is simply that "suffering and death from lack of food, shelter, and medical care are bad." Some may be inclined to think that the mere existence of such an evil in itself places an obligation on others, but that is, of course, the problem that Singer addresses. I take it that he is not begging the question in this obvious way and will *argue* from the existence of evil to the obligation of others to eliminate it. But how, exactly, does he establish this? The second principle, he thinks, shows the connection, but it is here that I wish to raise some questions. This second principle, which I call the "greater moral evil principle," states that:

> If it is in our power to prevent something bad from happening, without thereby sacrificing anything of comparable moral importance, we ought, morally, to do it.[5]

In other words, people are entitled to keep their earnings only if there is no way for them to prevent a greater evil by giving them away. Providing others with food, clothing, and housing is generally of more importance than buying luxuries, so the greater moral evil principle now requires substantial redistribution of wealth.

Certainly few of us live by that principle, although, as Singer emphasizes, that hardly means that we are justified in behaving as we do. We often fail to live up to our own standards. Why does Singer think our shared morality requires that we follow the greater moral evil principle? What argument does he give for it?

He begins with an analogy. Suppose you came across a child drowning in a shallow pond. Certainly we feel it would be wrong for you not to help. Even if saving a child meant you would dirty your clothes, we would emphasize that those clothes are not of comparable significance to the child's life. The greater moral evil principle thus seems a natural way of capturing why we think it would be wrong not to help.

e argument for the greater moral evil princi- limited to Singer's claim that it explains our feelings about the drowning child or that it appears "uncontroversial." Moral equality also enters the picture, in the following way.[6] In addition to the Jeffersonian idea that we share certain rights equally, most of us are also attracted to another conception of equality, namely, that like amounts of suffering (or happiness) are of equal significance, no matter who is experiencing them. I cannot reasonably say that, while my pain is no more severe than yours, I am somehow special and that it's therefore more important, objectively speaking, that mine be alleviated. Impartiality requires us to admit the opposite—that no one has a unique status that warrants such special consideration.

But if we fail to give money to famine relief and instead purchase a new car when the old one will do, or buy fancy clothes for a friend when his or her old ones are perfectly good, are we not assuming that the relatively minor enjoyment we or our friends may get is as important as another person's life? And that, it seems, is a form of prejudice; we are acting as if people were not equal in the sense that their interests deserve equal consideration. We are giving special consideration to ourselves or to our group, rather as a racist does. Equal consideration of interests thus leads naturally to the greater moral evil principle.

ENTITLEMENTS

Equal consideration seems to require that we prevent harm to others if in doing so we do not sacrifice anything of comparable moral importance. But there is also another side to the coin, which Singer ignores. This idea can be expressed rather awkwardly by the notion of entitlements, by which I have in mind the thought that having either a right or justly deserving something can also be important as we think about our obligations to others. A few examples will show what I mean.

One way we can help others is by giving away body parts. While your life may be shortened by the loss of a kidney or less enjoyable if lived with only one eye, those cases are probably not comparable to the loss experienced by a person who will die without a kidney transplant or who is totally blind. Or perhaps, using Judith Thomson's analogy, somebody needs to remain hooked up to you for an extended period of time while awaiting a transplant.[7] It seems clear, however, that our code does not *require* such heroism; you are entitled to your second eye and kidney and to control who uses your body, and that entitlement blocks the inference from the fact that you could prevent harm to the conclusion that you ought to let others have or use your body.

We express these ideas in terms of rights; it's your body, you have a right to it, and that weighs against whatever duty you have to help. To give up your right to your kidney for a stranger is more than is required; it's heroic—unless, of course, you have freely agreed to let the person use your body, which brings us to the next point.

There are two types of rights, negative and positive. Negative rights are rights against interference by others. The right to life, for example, is a right not to be killed by others; the right against assault is a right not to suffer physical harm from others. The right to one's body, the right to property, the right to privacy, and the right to exercise religious freedom are also negative, requiring only that people leave others alone and not interfere. Positive rights, however, are rights to receive some benefit. By contracting to pay wages, employers acquire the duty to pay the employees who work for them; if the employer backs out of the deal, the employees' positive right to receive a paycheck is violated.

Negative rights also differ from positive rights in that the former are natural or human, in the sense that they depend on what you are, not what you've done. All persons, we assume, have the right to life. If lower animals lack negative moral rights to life or liberty, it is because there is a relevant difference between them and us. But the positive rights you may have are not natural in that sense; they arise because others have promised, agreed, or contracted to do something, just as you may have an obligation to let them use your property or even your body if you have so agreed. The right not to be killed does not depend on anything you or anybody else has done, but the right to be paid a wage makes sense only on the basis of prior agreements.

None of that is to say that rights, whether negative or positive, are beyond controversy. Rights come in a variety of shapes and sizes, and people often disagree about both their shape and their size. And while some rights are part of our generally shared moral code and widely accepted, others are controversial and hotly disputed.

Normally, then, a duty to help a stranger in need is based not on a *right* the person has but, instead, on the general duty all people have to aid those in need (as Singer's drowning child illustrates). A genuine right to be aided requires something more, such as a contract or promise to accept responsibility for the child. Consider, for example a babysitter who agrees to watch out for someone else's children but instead allows a child to drown. We would think that under the circumstances the parent whose child has drowned would in fact be doubly wronged. First, like everybody else, the person who agreed to watch the child should not have cruelly or thoughtlessly let it drown. But it's also the case that here, unlike Singer's example, we can also say there are rights at stake; promises were made that imposed special obligations on the babysitter. Other bystanders also act wrongly by cruelly ignoring the child, but the babysitter violates rights as well.

I am not suggesting that rights are all we need to take into account. Moral rights are one—but only one—factor to be weighed; we also have other obligations that should be considered. This view, like the greater moral evil principle, is an oversimplification. In reality, our moral code expects us to help people in need *as well as* to respect negative and positive rights. But it also seems clear that, besides being asked by our moral code to respect the rights of others, we are entitled, at least sometimes, to invoke our own rights as justification for what we do. It is not as if we promised to help, or are in any way responsible for the person's situation. Our social moral code teaches that although passing by a drowning child whom we can easily save is wrong, we need not ignore our own rights and give away our savings to help distant strangers solely on the basis of the greater moral evil principle.

A second form of entitlement involves just deserts: the idea that sometimes people deserve to keep what they have acquired. To see its role in our moral code, imagine an industrious farmer who manages through hard work to produce a surplus of food for the winter while a lazy neighbor spends the summer relaxing. Must our industrious farmer give the surplus away because without it that neighbor, who refused to work, will suffer? Under certain circumstances we might say because of the greater moral evil principle the farmer should help, but not necessarily. What this shows is that once again we have more than one factor to weigh. Besides, the evil that could be prevented, we (and the hard-working farmer, too) should also consider the fact that one person earned the food, through hard work. And while it might be the case that just desert is outweighed by the greater need of a neighbor, being outweighed is in any case not the same as weighing nothing!

Sometimes just desert can be negative in the sense of unwanted, as well as something regarded as a good. The fact that the Nazi war criminals did what they did means they deserve punishment: We have a good reason to send them to jail, on the basis of just desert. Other considerations, for example, the fact that nobody will be deterred or that the criminal is old and harmless, may weigh against punishment, and we may even decide not to pursue the case for that reason. But, again, that does not mean that deserving to be punished is irrelevant, just that we've decided for other reasons to ignore desert in this case. But again I repeat: A principle's being outweighed is not the same as its having no importance.

Our social moral code thus honors both the greater moral evil principle and entitlements. The former emphasizes equality, claiming that from an objective point of view all comparable suffering, whomever its victim, is equally significant. It encourages us to take an impartial look at all the various effects of our actions and is therefore forward-looking. When we consider entitlements, however, our attention is directed to the past. Whether we have rights to money, property, or even our body depends on how we came to possess them. If money was stolen, for example, then the thief has no right to it. Or perhaps a person has promised to trade something; this would again (under normal circumstances) mean

loss of entitlement. Like rights, just desert is also backward-looking, emphasizing past effort or past transgressions that now warrant responses such as reward, gratitude, or punishment.

I am suggesting, then, that, expressing both equality and entitlements, our social moral code pulls in different directions. How, then, are we to determine when one principle is more important? Unless we are moral relativists, the mere fact that equality and entitlements are both part of our moral code does not in itself justify a person's reliance on them, any more than the fact that our moral code once condemned racial mixing while condoning sexual discrimination and slavery should convince us that those principles are justified. We all assume (I trust) that the more enlightened moral code—the one we now subscribe to—is better in part just because it condemns discrimination and slavery. Because we know that the rules that define acceptable behavior are continually changing, and sometimes changing for the better, we must allow for the replacement of inferior principles with more reasonable guidelines.

Viewed in that light, the issue posed by Singer's argument is really whether we should reform our current social moral code and reject entitlements, at least insofar as they conflict with the greater moral evil principle. What could justify our practice of evaluating actions by looking backward to rights and just desert instead of only to their consequences? To pursue these questions, we need to look more closely at how we might justify the moral rules and principles that constitute a society's moral code; we will then be able to ask whether, although entitlements are part of our current code, we would improve that code—bring it closer to an ideal code—if they were not included.

THE CONCEPT OF A SOCIAL MORAL CODE

So I suggest that we first say something more about the nature and purpose of social moral codes in general; then we will turn to entitlements. We can begin with the obvious: A moral code is a system of principles, rules, and other standards that guide people's conduct.[8] As such, it has characteristics in common with other systems of rules and standards, such as the rules of organizations. Social clubs, sports leagues, corporations, bureaucracies, professional associations, even *The* Organization all have standards that govern the behavior of members.

Such rules function in various ways, imposing different sanctions depending on the nature of the organization. Violation of a university's code of conduct leads to one sort of punishment, while different types of sanctions are typically imposed by a social club or by the American Bar Association.

Some standards of conduct are not limited to members of a specific organization but instead apply more broadly, and it is to those that we now turn. Law, for example, is a social practice rather than an organization. So are etiquette and customs. All these codes apply broadly, not just to members of an organization who have chosen to join. It will be most helpful in our thinking about the nature of a moral code to compare it with these other social practices, along a variety of dimensions.

As we noted with organizations, here too the form sanctions take varies among the different types of codes.[9] While in our legal system transgressions are punished by fines, jail, or even execution, informal sanctions of praise, criticism, and ostracism encourage conformity to the standards of morality and etiquette. Besides the type of sanctions, a second difference among these codes is that while violation of a moral principle is always a serious affair, this need not be so for legal rules or the norms of etiquette and custom. Many of us think it unimportant whether a fork is on the left side of a plate or the right, or whether an outmoded and widely ignored Sunday closing law is violated. But violation of a moral principle is not ignored or thought trivial; indeed, the fact that a moral principle has lost its importance is often indicated by its "demotion" to mere custom.

A third contrast, in addition to differences in sanctions and in importance, is that, unlike morality, custom, and etiquette, legal systems include, besides criminal and civil rules, other "constitutional" rules governing how those laws are to be created, modified, and eliminated.[10] Under the U.S. Constitution,

for instance, if Congress acts to change the tax laws, then as of the date stated in the statute the rules are changed.[11] Moral rules, etiquette, and customs also change, of course, but they do so without benefit of any agreed procedure identifying who or how the changes occur or when they take effect.

So far, then, we've noted that different codes and standards of behavior can vary widely, along a number of dimensions. Some apply narrowly, only to members of a specific organization, while others extend broadly. And while all codes include rules or other standards to guide conduct, the sanctions that are imposed by different codes differ widely, as do the ways rules for change and the importance assigned to violations of the different codes.

The final point I want to make about rules generally, before looking specifically at morality, is that all standards serve a purpose, although what that purpose is will again vary with the organization or practice in question. Rules that govern games, for example, are often changed, either informally among players or by a governing organization like the National Football League. This is done in order to more effectively achieve the goals of the game, although the goals often vary and are sometimes open to dispute. Sometimes, for example, rules may be changed to improve safety (e.g., car design in auto racing) or even to make the sport more exciting but less safe. Other times rules might be changed to accommodate younger players, such as abolishing the walk in kids' baseball. Similar points can be made about organizations, as, for example, when a corporation changes its standards for how many hours people work or a university changes the deadline for dropping a class.

Like the rules that govern games and organizations, legal and moral rules and principles also change in ways that serve their purposes either better or worse. But here enters one final, important point—because there can be deep disagreement about the purpose of such practices, there can also be disagreement about the rules themselves, including when there should be exceptions, what exactly they require, and the circumstances under which they can be ignored. Such a dispute about rules can rest on deeper, sometimes hidden disagreements about the purposes of the organization, just as differences between fundamentalists and liberals over religious rules and principles can also uncover disagreements about the purposes of religious practices.

Turning to morality, first consider a traditional rule such as the one prohibiting homosexual behavior. Assuming people could agree that the rule serves no useful purpose but instead only increases the burden of guilt, shame, and social rejection borne by a significant portion of society, then it seems that people would have good reason to alter their rules about sexual conduct and no longer condemn homosexuality. But people who see morality as serving another purpose, for instance, encouraging behavior that is compatible with God's will or with "natural" law, might oppose such a change. Or suppose, less controversially, that rules against killing and lying help us to accomplish what we want from a moral code. In that case, we have good reason to include those rules in our "ideal" moral code.

My suggestion, then, is that there is a connection between what we ought to do and how well a code serves its purposes. If a rule serves well the goals of a moral code, then we have reason to obey it. But if, on the other hand, a rule is useless, or if it frustrates the purposes of morality, we have reason neither to support it, teach it, nor to follow it (assuming, as I said, we agree what the purpose of a social moral code is).

This suggests, then, the following conception of a right action: Any action is right if and only if it conforms with an ideal moral code for the society in which we are living. We will say more about this shortly, but most basically we must consider what, exactly, an *ideal* moral code is. In order to answer that, we must first ask ourselves the purpose that we hope to accomplish by creating, teaching, and enforcing a moral code for society.

THE IDEAL SOCIAL MORAL CODE

One possibility, already suggested, is that morality's purpose depends on God—that morality serves to encourage people to act in accord with God's will. But I want to suggest, and very briefly defend,

another view, namely, that the ideal moral code is the one that, when recognized and taught by members of society, would have the best consequences. By best consequences, I mean that it would most effectively promote the collective well-being of those living under it.[12] (It's worth noting right off, however, that a religious person need not reject this out of hand but instead might reason that the general well-being is also what God would wish for creation.)

In pursuing this idea, it is helpful to return to the comparison between legal and moral standards. Clearly, both morality and law serve to *discourage* some of the same types of behavior—killing, robbing, and beating—while they both also *encourage* other acts, such as repaying debts, keeping important agreements, and providing for one's children. The reason for rules that discourage acts like killing and beating seems clear enough, for imagine the disastrous consequences for human life absent such moral and legal rules. This idea is further substantiated when we think about how children are taught that it is wrong to hit a baby brother or sister. Parents typically explain such rules in terms of their purpose, emphasizing that it hurts and can harm others when we hit them. At root, then, it seems at least plausible to suppose that these rules of morality and law function to keep people from causing unjustified harm to each other. A world in which people were allowed to kill and assault each other without fear of legal or moral sanctions would be far more miserable than a world in which such behavior is discouraged. Concern for general welfare explains how we learn moral standards as children and why we support them as adults.

In addition to justifying rules that prevent harmful behavior, the other rules I mentioned that encourage different types of behavior can also be justified by their social consequences. Our own well-being, as well as that of our friends, family, and indeed, society as a whole, depends on people's generally keeping promises and fulfilling agreements. Without laws and moral rules to encourage such behavior, the institutions of promising and contracting would likely be unsustainable, and with their passing would be lost all the useful consequences that flow from our ability to bind ourselves and others by promising and contracting.

Moral rules thus promote our own welfare by discouraging acts of violence and by creating and maintaining social conventions like promising and paying debts. They also perform the same service for our family, friends, and, indeed, all of us. A life wholly without legal and moral codes would be in danger of deteriorating into what Thomas Hobbes long ago feared: a state of nature in which life is solitary, poor, nasty, brutish, and short.

Many may find these thoughts fairly uncontroversial, thinking it obvious that moral codes are justified by their good consequences. But what more might be said to those who remain skeptical? One suggestion, from David Hume, emphasizes the importance of sentiment and feeling in human actions. It is, said Hume, only on the basis of feelings and sentiment that people can be moved to act at all, so that the key to understanding morality is that human nature is marked not only by self-interest but also by a sentimental attachment to the well-being of others. We take pleasure, Hume thinks, in the thought that others are happy, as well as in our own happiness. This can be seen, he reasoned, from the fact that we

> frequently bestow praise on virtuous actions, performed in very distant ages and remote countries; where the utmost subtlety of imagination would not discover any appearance of self-interest, or find any connexion with our present happiness and security with events so widely separated from us.[13]

Hume might have added that there is evidence that sympathy and concern for others' well-being are a natural part of our biological heritage, as well as an outgrowth of common sense. Some biologists, for example, think that many animals, particularly higher ones, take an interest in the welfare of other members of their species because such altruistic attitudes enable the species to survive better.[14] Others emphasize the inevitability of acquiring such sentiments through learning, arguing that feelings of benevolence originate naturally, via classical conditioning. We first develop negative associations

with our own pain behavior (we associate screaming and writhing with our own pain), and this negative attitude is then generalized to the pain behavior of anybody.[15]

But whatever the reason behind sympathy, Hume concludes from this that we must renounce any moral theory

> which accounts for every moral sentiment by the principle of self-love. We must adopt a more public affection, and allow, that the interests of society are not, even on their own account, indifferent to us.[16]

Moral approval and condemnation, Hume is claiming, rest finally on sentiments rather than reason, but such sentiments extend beyond our own happiness to encompass the whole of humanity. Given such universal, sympathetic feelings for the well-being of others, he concludes, it is natural to understand a social moral code in terms of its utility or consequences on everybody's well-being.

But suppose that not everybody shares these sympathetic attitudes toward others. It might seem that such a person would therefore have reason to reject the idea that the ideal moral code is the one with the best overall consequences. Instead, such an egoist might say that the truly best code would be the one that maximizes *his own* welfare, even if others are not benefited at all. Caring for nobody else, he might regard as "ideal" a code that gives him absolute power over the lives and property of others, for example. How, then, should such a person be responded to by somebody who, like me, thinks that the ideal code is the one that would have the best consequences for everybody and not just one individual?

One possibility, of course, is to acknowledge that such a person has a mistaken view of morality precisely because the ideal code would benefit not only one person but to admit that such a person cannot be reasoned with, let alone refuted. But while that may seem right, it would of course leave the egoist unpersuaded and without any reason to behave in accord with the ideal moral code. Yet why should we care if we cannot convince such a person that the ideal code would be one that has the best consequences

for everybody? Some people may remain unmoved by moral considerations, but maybe that should not concern those of us who are.

But, that said, it's instructive that we still do, in fact, have available a response to our imaginary egoist, one based on the social nature of a social moral code. Suppose we were to ask the rational egoist concerned only to promote his own well-being to consider whether it really would be rational for him to publicly support the moral code benefiting only himself. How, we might ask, would he expect others to react to the idea that society should recognize and teach a code that serves only his interest? The answer seems clear: Any egoists who spent time supporting such a code, defending it in public, and trying to have it adopted by others would not in fact be acting rationally. For that reason, even the egoist who cares only about his own well-being would be driven toward a conception of the ideal moral code (understood, for him, in the egoistic way as the one it is in his self-interest to recognize and encourage others to adopt) that is not only acceptable from the perspective of a single person but that could be supported by others as well. But that means, in turn, that even our egoist's conception of the ideal moral code begins to look more like the one that other people with more normal, sympathetic feelings would find ideal, namely, the one that would have the best consequences for everybody. A social moral code must be one that can function in the world, which means it must be able to win general public support.

This line of thought, emphasizing the practical side of the ideal moral code, brings us finally to the issue with which we began: Would an ideal moral code (which I will now assume is the one that would have the best consequences generally, not just for one person) include principles that respect rights and just deserts, or would it, as Singer suggested, reject them completely in favor of the greater moral evil principle? The answer, I will argue, rests on the fact that an ideal moral code must not only be one that can hope to win public support but must be practical and workable in other important ways as well. The ideal code is one that works for people as they are, or at least can be encouraged to become.

ARE RIGHTS PART
OF THE IDEAL CODE?

What we want to know is whether rights (and also just desert) would be included in the ideal code, understood as the one that, in the real world, would have the best consequences. Initially, it may seem they would not, since it appears that the best consequences could be realized by substituting the greater moral evil principle for entitlements, requiring people to prevent something bad whenever the cost to them is less significant than the benefit to another. This is true because, unlike entitlements, the greater moral evil principle more clearly and directly expresses the consequentialism I have been defending.

But would such a single moral principle, recognized by society as its ideal, really have the best consequences? I suggest that the ideal code would not in fact ignore rights, for two reasons, each based on the fact that the ideal moral code must rest on realistic, accurate assumptions about human beings and our life in this world.

The first takes us back to the discussion of self-love and altruism. Although I did suggest, following Hume, that we ought not ignore people's altruistic side, it is also important that a social moral code not assume people are more altruistic than they are. Rules that would work only for angels are not the ideal ones for a society of human beings. While we do care about others' well-being, especially those we love, we also care very deeply about ourselves. It would therefore be quite difficult to get people to accept a code that requires that they give away their savings or duplicate organs to a stranger simply because doing so would avoid even more evil, as would be required by the greater moral evil rule if not balanced by entitlements. Many people simply wouldn't do as that rule required; they care too deeply about their own lives and welfare, as well as the welfare of loved ones.

Indeed, were the moral code to attempt to require such saintliness despite these problems, three results would likely follow. First, because many would not live up to the rules, despite having been taught they should, feelings of guilt would increase. Second, such a code would encourage conflict between those who met what they thought of as their moral obligations and those who did not. Such a situation is in contrast, of course, to one in which people who give generously and selflessly are thought of as heroes who have gone beyond what is morally required; in that event, unlike instances in which people don't live up to society's demands of them, the normal response is to praise them for exceeding the moral minimum. And, third, a realistic code that doesn't demand more than people can be expected to do might actually result in more giving than a code that ignores rights in favor of the greater moral evil rule. Think about how parents try to influence how their children spend their money. Perhaps the children will buy less candy if they are allowed to do so occasionally but are also praised for spending on other things than they would if the purchase of candy were prohibited. We cannot assume that making what is now a charitable act into a requirement will always encourage such behavior. In summary, impractical rules would not only create guilt and social conflict, neither of which is compatible with the ideal code, but would also tend to encourage the opposite of the desired result. By giving people the right to keep their property yet praising those who do not exercise the right but help others instead, we have struck a good balance.

My second point is that an ideal moral code must not assume that people are more objective, informed, and unbiased than they are. People often tend, we know, to rationalize when their interests are at stake— a fact that has many implications for the sorts of principles we would include in an ideal, welfare maximizing code. For example, we might at first be tempted to discourage slavish conformity to counter-productive rules, teaching people to break promises whenever doing so would have the best consequences. But again practicality enters: An ideal code would not be blind to people's tendency to give special weight to their own welfare or to their inability always to be objective in tracing the effects of different actions even when they want to be. So, while an ideal code would not teach that promises must never be broken no matter what the consequences, we also would not want to encourage breaking promises whenever people convince themselves that doing so would produce less evil.

Similar considerations apply to property. Imagine a situation in which a person contemplates preventing an evil to herself or himself by taking something from a large store where it won't be missed. Such theft could easily be rationalized by the greater moral evil principle on grounds that stealing prevents something bad from happening (to the person who decides to steal) without sacrificing anything of comparable moral significance (the store won't miss the goods). So, although a particular act of theft may sometimes be welfare maximizing, it does not follow that a *principle* like Singer's is part of an ideal code. To recognize and teach that theft is right whenever the robber is preventing greater evil, even to himself, would work only if people were far more objective, less liable to self-deception, and more knowledgeable about the long-term consequences than they are. So here again, including rights that block such conclusions in our moral code serves a useful role, discouraging the tendency to rationalize our behavior by underestimating the harm we may cause to others or exaggerating the benefits that may accrue to ourselves.

IS JUST DESERT PART OF THE IDEAL MORAL CODE?

Similar practical considerations argue for including desert as well as rights in the ideal moral code. The case of the farmers, recall, was meant to illustrate that our current social moral code encourages the attitude that people who work hard deserve to be rewarded, just as people who behave badly deserve to be punished. Most of us feel that while it would be nice of the hard worker to help out a lazy neighbor, the worker also has reason—based on his past effort—to refuse. But, as I have stressed, it's still an open question whether an ideal code would allow such "selfishness."

But as with rights, here again we must be careful that our conception of an ideal code is realistic and practical and does not assume people are more altruistic, informed, or objective than they are. To see why this is relevant to the principle of just desert, we should first notice that for many people, at least, working and earning a living is not their favorite activity. People would often prefer to spend time doing something else, but they know they must work if they and their family hope to have a decent life. Indeed, if humans generally are to live well, then goods and services must be produced and made available for wide use, which means that (I argue) incentives to work are an important factor in motivating people.

One such incentive, of course, is income. A moral code can encourage hard work by allowing people to keep a large part of what they earn, by respecting both rights and the principle of just desert. "I worked hard for it, so I can keep it" is a familiar thought that expresses this attitude.

But suppose we eliminated the notion of deserving what we work for from our code and asked people to follow the greater moral evil rule instead. What might happen? There are three possibilities. First, they might continue to produce as before, only this time motivated by the desire, derived from their social moral code, to prevent whatever evil they could, as long as the cost to them of doing so was not greater evil. But this seems to me quite unrealistic: While people are not egoists, neither are they that saintly and altruistic.

Given that, one of two other outcomes could be expected. Perhaps people would stop working as hard, feeling that it is no longer worth the effort to help strangers rather than themselves or their family since they are morally required to give away all but what they can use without imposing a greater evil on anybody else. Suppose, to make it vivid, that the tax system enforces the greater moral evil rule, taking away all income that could be used to prevent a greater evil's befalling somebody else. The result would be less work done, less total production of useful commodities, and therefore a general reduction in people's well-being. The other possibility is that people would simply fail to live up to the standards of society's moral code (having replaced desert with the greater moral evil rule), leading to widespread feelings of guilt and resentment by those (few?) who did behave as the code commands. In either case, I am suggesting, replacing the principle of just desert with the greater moral evil principle would actually worsen the situation. Like rights, the principle of just desert is also part of an ideal code.

CONCLUSION

The first sections of this paper attempted to show that our moral code is a bit self-contradictory. It seems to pull us in opposite directions, sometimes toward helping people who are in need and other times toward the view that rights and desert justify keeping things we have even if greater evil could be avoided were we to give away our extra eye or our savings account. This apparent inconsistency led us to a further question: Is the emphasis on rights and desert really defensible, or should we try to resolve the tension in our own code by rejecting entitlements in favor of the greater moral evil rule? In the last sections I have considered this question, focusing on the idea that we should understand the ideal moral code as the one that, if acknowledged and taught, would have the overall best consequences. Having suggested why it might seem sensible to conceive the ideal code this way, as the one that would produce the best consequences, I concluded by showing that an ideal code would not reject entitlements in favor of the greater moral evil rule. Concern that our moral code encourage effort and not fail because it unrealistically assumes people are more altruistic, informed, or objective than they are means that our rules giving people rights to their possessions and encouraging distribution according to desert are part of an ideal moral code. The ideal moral code would therefore not teach people to try to seek the best consequences in each individual case, insisting they give entitlements no weight whatsoever. But neither have I argued, nor do I believe, that an ideal moral code would allow people to overlook those in desperate need by making entitlements absolute, any more than it would ignore entitlements in favor of the greater moral evil rule discussed earlier.

But where would it draw the line? It's hard to know, of course, but the following seems to me to be a sensible stab at an answer. Concerns of the sort I have outlined argue strongly against expecting too much of people's selflessness or ability to make objective and informed decisions. A more modest proposal would require people to help strangers when there is no substantial cost to themselves, that is, when what they are sacrificing would not mean *significant* reduction in their own or

their family's level of happiness. Since most people's savings accounts and nearly everybody's second kidney are not insignificant, entitlements would in those cases outweigh another's need. But if what is at stake is truly trivial, as dirtying one's clothes would normally be, then an ideal moral code would not allow rights to override the greater evil that can be prevented.

Another point is that, again mindful of the need to be realistic in what it expects of people, an ideal code might also distinguish between cases in which the evil is directly present to a person (as in the drowning child) and cases involving distant people. The reason, of course, is again practical: People are more likely to help people with whom they have direct contact and when they can see immediately the evil they will prevent than they are to help strangers. So while such a distinction may seem morally arbitrary, viewed from the perspective of an ideal moral code it seems to make good sense.

Despite our code's unclear and sometimes self-contradictory posture, it seems to me that these conclusions are not that different from our current moral attitudes; an ideal moral code thus might not be a great deal different from our own. We tend to fault selfish people who give little or nothing to charity and expect those with more to give more. Yet we do not ask people to make large sacrifices of their own or their family's well-being in order to aid distant strangers. Singer's arguments do remind us, however, that entitlements are not absolute and that we all have some duty to help. But the greater moral evil rule expresses only part of the story and is not needed to make that point.[17]

Notes

1. © 1996 by John Arthur. This paper refines and extends some of the arguments in an earlier paper of mine, "Equality, Entitlements, and the Distribution of Income." Reprinted by permission of the author.

2. Peter Singer, "Famine, Affluence, and Morality," *Philosophy & Public Affairs* 1, No. 3 (1972): 229–243.

3. For example, Richard Watson, "Reason and Morality in a World of Limited Food," in William Aiken and Hugh LaFollette, eds., *World Hunger and Moral Obligation* (Englewood Cliffs, N.J.: Prentice-Hall, 1977).

4. Ibid., pp. 117–118.

5. Singer also offers a "weak" version of this principle that, it seems to me, is *too* weak. It requires giving aid only if the gift is of *no* moral significance to the giver. But since even minor embarrassment or small amounts of unhappiness are not completely without moral importance, this weak principle would imply no obligation to aid, even to the drowning child.

6. See, for example, Singer's "Postscript" to "Famine, Affluence, and Morality" in Aiken and LaFollette, ibid., p. 36.

7. Judith Jarvis Thomson, "A Defense of Abortion," *Philosophy & Public Affairs* 1, No. 1 (1971).

8. Ronald Dworkin argues that there are important differences between principles and rules: while rules apply in an "all or nothing" fashion and have specific exceptions, principles are not either-or but instead have "weight" that must be considered in light of competing principles. Both of these can also be distinguished from moral ideals, which guide people toward the best, most valuable life. For purposes of this essay, however, these distinctions are not important; I do assume, however, that standards can compete, as Dworkin's analogy with the "weight" of principles suggests.

9. This discussion follows H. L. A. Hart, *The Concept of Law*, 2d ed. (Oxford: Oxford University Press, 1995).

10. But Ronald Dworkin has argued that legal interpretation is partly moral and normative, making this claim more difficult to make in that context. See, for example, *Law's Empire* (Cambridge: Harvard University Press, 1986), chap. 2 and 7.

11. Assuming, of course, the courts do not hold the law unconstitutional.

12. I leave aside here just how we can best understand "well-being" except to note that it should include whatever states of affairs have intrinsic value, however that is understood.

13. David Hume, *An Enquiry Concerning the Principles of Morals*, sect. V, part I, 175.

14. Stephen Jay Gould, "So Cleverly Kind an Animal" in *Ever Since Darwin* (New York: W. W. Norton Co., 1977).

15. Richard B. Brandt, *A Theory of the Good and the Right* (New York: Oxford University Press, 1979).

16. Hume, *An Enquiry*, sect. V, part II, 178.

17. One final qualification is worth emphasizing. The subject of this essay has been the ideal moral code that we should adopt for our *private*, nonpolitical relations, not the character of a just constitution and tax structure. It is therefore possible to argue that while the ideal moral code correctly captures the personal duties we owe to everybody, including foreigners and strangers, a just political order requires more extensive help to fellow citizens with whom we share the basic institutions of society. Many reasons could be given for making such a distinction, including the fact that it may be more practical to expect people to provide welfare when undertaken collectively, by government, than to do so on their own in the form of private charity enforced only by morality's informal sanctions. People may also be more inclined to look to the needs of people near home, who share a common national identity and history. Nor, finally, should we conclude that political justice must be understood in the same, utilitarian way that I have been defending here. While understanding private morality in terms of an ideal moral code that has the best overall consequences, we might nevertheless conceive of political relationships and social justice in terms of the social contract, asking which constitutional arrangements could win universal consent. (The major proponent of this view of course is John Rawls, *A Theory of Justice* [Cambridge: Harvard University Press, 1971].) It is therefore possible that justice is both philosophically distinct and also more demanding than is the ideal social moral code. Tax provisions securing a minimum income and fair equality of opportunity, for example, may be owed to other citizens on grounds of social justice (though many of the points I made earlier would apply in both contexts, including especially the need to provide incentives.) That Rawlsean approach to political justice seems to me quite consistent with the idea that we need not, as private citizens, give away our savings merely because we can prevent evil to another human being who would benefit more from them.

Study Questions

1. If you knew that you would give most of the money you earn to distant strangers, would you work as hard?

2. Does Arthur disparage the importance of making charitable donations?

3. How might residents of a poor country respond to Arthur?

4. How might he reply to them?

53

ELLIOTT SOBER

Should species and ecosystems be preserved for reasons beyond their value as resources for human use? Environmentalists believe so, but what compelling argument can they offer in support of their view? Elliott Sober, Professor of Philosophy at the University of Wisconsin–Madison, maintains that environmental values are analogous to aesthetic ones. Species and ecosystems, like works of art, are prized for their rarity and fittingness in a context. Indeed, Sober asserts that if a striking rock formation were found next to the ruins of a Greek temple, he would see no relevant difference in their value.

Philosophical Problems for Environmentalism

INTRODUCTION

A number of philosophers have recognized that the environmental movement, whatever its practical political effectiveness, faces considerable theoretical difficulties in justification.[1] It has been recognized that traditional moral theories do not provide natural underpinnings for policy objectives and this has led some to skepticism about the claims of environmentalists, and others to the view that a revolutionary reassessment of ethical norms is needed. In this chapter, I will try to summarize the difficulties that confront a philosophical defense of environmentalism. I also will suggest a way of making sense of some environmental concerns that does not require the wholesale jettisoning of certain familiar moral judgments.

Preserving an endangered species or ecosystem poses no special conceptual problem when the instrumental value of that species or ecosystem is known. When we have reason to think that some natural object represents a resource to us, we obviously ought to take that fact into account in deciding what to do. A variety of potential uses may be under discussion, including food supply, medical applications, recreational use, and so on. As with any complex decision, it may be difficult even to agree on how to compare the competing values that may be involved. Willingness to pay in dollars is a familiar least common denominator, although it poses a number of problems. But here we have nothing that is specifically a problem for environmentalism.

The problem for environmentalism stems from the idea that species and ecosystems ought to be preserved for reasons additional to their known value as resources for human use. The feeling is that even when we cannot say what nutritional, medicinal, or recreational benefit the preservation provides, there still is a value in preservation. It is the search for a rationale for this feeling that constitutes the main conceptual problem for environmentalism.

The problem is especially difficult in view of the holistic (as opposed to individualistic) character of the things being assigned value. Put simply, what is special about environmentalism is that it values the preservation of species, communities, or ecosystems, rather than the individual organisms of which they are composed. "Animal liberationists" have urged that we should take the suffering of sentient animals into account in ethical deliberation.[2] Such beasts are not mere things to be used as cruelly as we like no matter how trivial the benefit we derive. But in "widening the ethical circle," we are simply including in the community more individual organisms whose costs and benefits we compare. Animal liberationists are extending an old and familiar ethical doctrine—namely, utilitarianism—to take account of the welfare of other individuals. Although the practical consequences of this point of view may be revolutionary, the theoretical perspective is not at all novel. If suffering is bad, then it is bad for any individual who suffers.[3] Animal liberationists merely remind us of the consequences of familiar principles.

But trees, mountains, and salt marshes do not suffer. They do not experience pleasure and pain, because, evidently, they do not have experiences at all. The same is true of species. Granted, individual organisms may have mental states; but the species—taken to be a population of organisms connected by certain sorts of interactions (preeminently, that of exchanging genetic material in reproduction)—does not. Or put more carefully, we might say that the only sense in which species have experiences is that their member organisms do: the attribution at the population level, if true, is true simply in virtue of its being true at the individual level. Here is a case where reductionism is correct.

So perhaps it is true in this reductive sense that some species experience pain. But the values that environmentalists attach to preserving species do not reduce to any value of preserving organisms. It is in this sense that environmentalists espouse a holistic value system. Environmentalists care about entities that by no stretch of the imagination have experiences (e.g., mountains). What is more, their position does not force them to care if individual organisms suffer pain, so long as the

species is preserved. Steel traps may outrage an animal liberationist because of the suffering they inflict, but an environmentalist aiming just at the preservation of a balanced ecosystem might see here no cause for complaint. Similarly, environmentalists think that the distinction between wild and domesticated organisms is important, in that it is the preservation of "natural" (i.e., not created by the "artificial interference" of human beings) objects that matters, whereas animal liberationists see the main problem in terms of the suffering of any organism—domesticated or not. And finally, environmentalists and animal liberationists diverge on what might be called the $n + m$ question. If two species—say blue and sperm whales—have roughly comparable capacities for experiencing pain, an animal liberationist might tend to think of the preservation of a sperm whale as wholly on an ethical par with the preservation of a blue whale. The fact that one organism is part of an endangered species while the other is not does not make the rare individual more intrinsically important. But for an environmentalist, this holistic property—membership in an endangered species—makes all the difference in the world: a world with n sperm and m blue whales is far better than a world with $n + m$ sperm and 0 blue whales. Here we have a stark contrast between an ethic in which it is the life situation of individuals that matters, and an ethic in which the stability and diversity of populations of individuals are what matter.[4]

Both animal liberationists and environmentalists wish to broaden our ethical horizons—to make us realize that it is not just human welfare that counts. But they do this in very different, often conflicting, ways. It is no accident that at the level of practical politics the two points of view increasingly find themselves at loggerheads. This practical conflict is the expression of a deep theoretical divide.

THE IGNORANCE ARGUMENT

"Although we might not now know what use a particular endangered species might be to us, allowing it to go extinct forever closes off the possibility of discovering and exploiting a future use." According to this point of view, our ignorance of value is turned

into a reason for action. The scenario envisaged in this environmentalist argument is not without precedent; who could have guessed that penicillin would be good for something other than turning out cheese? But there is a fatal defect in such arguments, which we might summarize with the phrase *out of nothing, nothing comes:* rational decisions require assumptions about what is true and what is valuable (in decision-theoretic jargon, the inputs must be probabilities and utilities). If you are completely ignorant of values, then you are incapable of making a rational decision, either for or against preserving some species. The fact that you do not know the value of a species, by itself, cannot count as a reason for wanting one thing rather than another to happen to it.

And there are so many species. How many geese that lay golden eggs are there apt to be in that number? It is hard to assign probabilities and utilities precisely here, but an analogy will perhaps reveal the problem confronting this environmentalist argument. Most of us willingly fly on airplanes, when safer (but less convenient) alternative forms of transportation are available. Is this rational? Suppose it were argued that there is a small probability that the next flight you take will crash. This would be very bad for you. Is it not crazy for you to risk this, given that the only gain to you is that you can reduce your travel time by a few hours (by not going by train, say)? Those of us who not only fly, but congratulate ourselves for being rational in doing so, reject this argument. We are prepared to accept a small chance of a great disaster in return for the high probability of a rather modest benefit. If this is rational, no wonder that we might consistently be willing to allow a species to go extinct in order to build a hydroelectric plant.

That the argument from ignorance is no argument at all can be seen from another angle. If we literally do not know what consequences the extinction of this or that species may bring, then we should take seriously the possibility that the extinction may be beneficial as well as the possibility that it may be deleterious. It may sound deep to insist that we preserve endangered species precisely because we do not know why they are valuable. But ignorance on a scale like this cannot provide the basis for any rational action.

Rather than invoke some unspecified future benefit, an environmentalist may argue that the species in question plays a crucial role in stabilizing the ecosystem of which it is a part. This will undoubtedly be true for carefully chosen species and ecosystems, but one should not generalize this argument into a global claim to the effect that *every* species is crucial to a balanced ecosystem. Although ecologists used to agree that the complexity of an ecosystem stabilizes it, this hypothesis has been subject to a number of criticisms and qualifications, both from a theoretical and an empirical perspective.[5] And for certain kinds of species (those which occupy a rather small area and whose normal population is small) we can argue that extinction would probably not disrupt the community. However fragile the biosphere may be, the extreme view that everything is crucial is almost certainly not true.

But, of course, environmentalists are often concerned by the fact that extinctions are occurring now at a rate much higher than in earlier times. It is mass extinction that threatens the biosphere, they say, and this claim avoids the spurious assertion that communities are so fragile that even one extinction will cause a crash. However, if the point is to avoid a mass extinction of species, how does this provide a rationale for preserving a species of the kind just described, of which we rationally believe that its passing will not destabilize the ecosystem? And, more generally, if mass extinction is known to be a danger to us, how does this translate into a value for preserving any particular species? Notice that we have now passed beyond the confines of the argument from ignorance; we are taking as a premise the idea that mass extinction would be a catastrophe (since it would destroy the ecosystem on which we depend). But how should that premise affect our valuing the California condor, the blue whale, or the snail darter?

THE SLIPPERY SLOPE ARGUMENT

Environmentalists sometimes find themselves asked to explain why each species matters so much to them, when there are, after all, so many. We may know of special reasons for valuing particular species, but how can we justify thinking that each and every species is

important? "Each extinction impoverishes the biosphere" is often the answer given, but it really fails to resolve the issue. Granted, each extinction impoverishes, but it only impoverishes a little bit. So if it is the *wholesale* impoverishment of the biosphere that matters, one would apparently have to concede that each extinction matters a little, but only a little. But environmentalists may be loathe to concede this, for if they concede that each species matters only a little, they seem to be inviting the wholesale impoverishment that would be an unambiguous disaster. So they dig in their heels and insist that each species matters a lot. But to take this line, one must find some other rationale than the idea that mass extinction would be a great harm. Some of these alternative rationales we will examine later. For now, let us take a closer look at the train of thought involved here.

Slippery slopes are curious things: if you take even one step onto them, you inevitably slide all the way to the bottom. So if you want to avoid finding yourself at the bottom, you must avoid stepping onto them at all. To mix metaphors, stepping onto a slippery slope is to invite being nickeled and dimed to death.

Slippery slope arguments have played a powerful role in a number of recent ethical debates. One often hears people defend the legitimacy of abortions by arguing that since it is permissible to abort a single-celled fertilized egg, it must be permissible to abort a foetus of any age, since there is no place to draw the line from 0 to 9 months. Antiabortionists, on the other hand, sometimes argue in the other direction: since infanticide of newborns is not permissible, abortion at any earlier time is also not allowed, since there is no place to draw the line. Although these two arguments reach opposite conclusions about the permissibility of abortions, they agree on the following idea: since there is no principled place to draw the line on the continuum from newly fertilized egg to foetus gone to term, one must treat all these cases in the same way. Either abortion is always permitted or it never is, since there is no place to draw the line. Both sides run their favorite slippery slope arguments, but try to precipitate slides in opposite directions.

Starting with 10 million extant species, and valuing overall diversity, the environmentalist does not want

to grant that each species matters only a little. For having granted this, commercial expansion and other causes will reduce the tally to 9,999,999. And then the argument is repeated, with each species valued only a little, and diversity declines another notch. And so we are well on our way to a considerably impoverished biosphere, a little at a time. Better to reject the starting premise—namely, that each species matters only a little—so that the slippery slope can be avoided.

Slippery slopes should hold no terror for environmentalists, because it is often a mistake to demand that a line be drawn. Let me illustrate by an example. What is the difference between being bald and not? Presumably, the difference concerns the number of hairs you have on your head. But what is the precise number of hairs marking the boundary between baldness and not being bald? There is no such number. Yet, it would be a fallacy to conclude that there is no difference between baldness and hairiness. The fact that you cannot draw a line does not force you to say that the two alleged categories collapse into one. In the abortion case, this means that even if there is no precise point in foetal development that involves some discontinuous, qualitative change, one is still not obliged to think of newly fertilized eggs and foetuses gone to term as morally on a par. Since the biological differences are ones of degree, not kind, one may want to adopt the position that the moral differences are likewise matters of degree. This may lead to the view that a woman should have a better reason for having an abortion, the more developed her foetus is. Of course, this position does not logically follow from the idea that there is no place to draw the line; my point is just that differences in degree do not demolish the possibility of there being real moral differences.

In the environmental case, if one places a value on diversity, then each species becomes more valuable as the overall diversity declines. If we begin with 10 million species, each may matter little, but as extinctions continue, the remaining ones matter more and more. According to this outlook, a better and better reason would be demanded for allowing yet another species to go extinct. Perhaps certain sorts of economic development would justify the extinction of a species at one time. But granting this does not oblige one to

conclude that the same sort of decision would have to be made further down the road. This means that one can value diversity without being obliged to take the somewhat exaggerated position that each species, no matter how many there are, is terribly precious in virtue of its contribution to that diversity.

Yet, one can understand that environmentalists might be reluctant to concede this point. They may fear that if one now allows that most species contribute only a little to overall diversity, one will set in motion a political process that cannot correct itself later. The worry is that even when the overall diversity has been drastically reduced, our ecological sensitivities will have been so coarsened that we will no longer be in a position to realize (or to implement policies fostering) the preciousness of what is left. This fear may be quite justified, but it is important to realize that it does not conflict with what was argued above. The political utility of making an argument should not be confused with the argument's soundness.

The fact that you are on a slippery slope, by itself, does not tell you whether you are near the beginning, in the middle, or at the end. If species diversity is a matter of degree, where do we currently find ourselves—on the verge of catastrophe, well on our way in that direction, or at some distance from a global crash? Environmentalists often urge that we are fast approaching a precipice; if we are, then the reduction in diversity that every succeeding extinction engenders should be all we need to justify species preservation.

Sometimes, however, environmentalists advance a kind of argument not predicated on the idea of fast approaching doom. The goal is to show that there is something wrong with allowing a species to go extinct (or with causing it to go extinct), even if overall diversity is not affected much. I now turn to one argument of this kind.

APPEALS TO WHAT IS NATURAL

I noted earlier that environmentalists and animal liberationists disagree over the significance of the distinction between wild and domesticated animals. Since both types of organisms can experience pain,

animal liberationists will think of each as meriting ethical consideration. But environmentalists will typically not put wild and domesticated organisms on a par. Environmentalists typically are interested in preserving what is natural, be it a species living in the wild or a wilderness ecosystem. If a kind of domesticated chicken were threatened with extinction, I doubt that environmental groups would be up in arms. And if certain unique types of human environments—say urban slums in the United States—were "endangered," it is similarly unlikely that environmentalists would view this process as a deplorable impoverishment of the biosphere.

The environmentalist's lack of concern for humanly created organisms and environments may be practical rather than principled. It may be that at the level of values, no such bifurcation is legitimate, but that from the point of view of practical political action, it makes sense to put one's energies into saving items that exist in the wild. This subject has not been discussed much in the literature, so it is hard to tell. But I sense that the distinction between wild and domesticated has a certain theoretical importance to many environmentalists. They perhaps think that the difference is that we created domesticated organisms which would otherwise not exist, and so are entitled to use them solely for our own interests. But we did not create wild organisms and environments, so it is the height of presumption to expropriate them for our benefit. A more fitting posture would be one of "stewardship": we have come on the scene and found a treasure not of our making. Given this, we ought to preserve this treasure in its natural state.

I do not wish to contest the appropriateness of "stewardship." It is the dichotomy between artificial (domesticated) and natural (wild) that strikes me as wrong-headed. I want to suggest that to the degree that "natural" means anything biologically, it means very little ethically. And, conversely, to the degree that "natural" is understood as a normative concept, it has very little to do with biology.

Environmentalists often express regret that we human beings find it so hard to remember that we are part of nature—one species among many others—rather than something standing outside of nature.

I will not consider here whether this attitude is cause for complaint; the important point is that seeing us as part of nature rules out the environmentalist's use of the distinction between artificial-domesticated and natural-wild described above. *If we are part of nature, then everything we do is part of nature, and is natural in that primary sense.* When we domesticate organisms and bring them into a state of dependence on us, this is simply an example of one species exerting a selection pressure on another. If one calls this "unnatural," one might just as well say the same of parasitism or symbiosis (compare human domestication of animals and plants and "slave-making" in the social insects).

The concept of naturalness is subject to the same abuses as the concept of normalcy. *Normal* can mean *usual* or it can mean *desirable.* Although only the total pessimist will think that the two concepts are mutually exclusive, it is generally recognized that the mere fact that something is common does not by itself count as a reason for thinking that it is desirable. This distinction is quite familiar now in popular discussions of mental health, for example. Yet, when it comes to environmental issues, the concept of naturalness continues to live a double life. The destruction of wilderness areas by increased industrialization is bad because it is unnatural. And it is unnatural because it involves transforming a natural into an artificial habitat. Or one might hear that although extinction is a natural process, the kind of mass extinction currently being precipitated by our species is unprecedented, and so is unnatural. Environmentalists should look elsewhere for a defense of their policies, lest conservation simply become a variant of uncritical conservatism in which the axiom "Whatever is, is right" is modified to read "Whatever is (before human beings come on the scene), is right."

This conflation of the biological with the normative sense of "natural" sometimes comes to the fore when environmentalists attack animal liberationists for naive do-goodism. Callicott writes:

> . . . the value commitments of the humane movement seem at bottom to betray a world-denying or rather a life-loathing philosophy. The natural world as actually constituted is one in which one being lives at the expense of others. Each organism, in

Darwin's metaphor, struggles to maintain its own organic integrity. . . . To live is to be anxious about life, to feel pain and pleasure in a fitting mixture, and sooner or later to die. That is the way the system works. *If nature as a whole is good, then pain and death are also good.* Environmental ethics in general require people to play fair in the natural system. The neo-Benthamites have in a sense taken the uncourageous approach. People have attempted to exempt themselves from the life death reciprocities of natural processes and from ecological limitations in the name of a prophylactic ethic of maximizing rewards (pleasure) and minimizing unwelcome information (pain). To be fair, the humane moralists seem to suggest that we should attempt to project the same values into the nonhuman animal world and to widen the charmed circle—no matter that it would be biologically unrealistic to do so or biologically ruinous if, per impossible, such an environmental ethic were implemented.

> There is another approach. Rather than imposing our alienation from nature and natural processes and cycles of life on other animals, we human beings could reaffirm our participation in nature by accepting life as it is given without a sugar coating. . . .[6]

On the same page, Callicott quotes with approval Shepard's remark that "the humanitarian's projection onto nature of illegal murder and the rights of civilized people to safety not only misses the point but is exactly contrary to fundamental ecological reality: the structure of nature is a sequence of killings."[7]

Thinking that what is found in nature is beyond ethical defect has not always been popular. Darwin wrote:

> . . . That there is much suffering in the world no one disputes.

> Some have attempted to explain this in reference to man by imagining that it serves for his moral improvement. But the number of men in the world is as nothing compared with that of all other sentient beings, and these often suffer greatly without any moral improvement. A being so powerful and so full of knowledge as a God who could create the universe, is to our finite minds omnipotent

and omniscient, and it revolts our understanding to suppose that his benevolence is not unbounded, for what advantage can there be in the sufferings of millions of the lower animals throughout almost endless time? This very old argument from the existence of suffering against the existence of an intelligent first cause seems to me a strong one; whereas, as just remarked, the presence of much suffering agrees well with the view that all organic beings have been developed through variation and natural selection.[8]

Darwin apparently viewed the quantity of pain found in nature as a melancholy and sobering consequence of the struggle for existence. But once we adopt the Panglossian attitude that this is the best of all possible worlds ("there is just the right amount of pain," etc.), a failure to identify what is natural with what is good can only seem "world-denying," "life-loathing," "in a sense uncourageous," and "contrary to fundamental ecological reality."

Earlier in his essay, Callicott expresses distress that animal liberationists fail to draw a sharp distinction "between the very different plights (and rights) of wild and domestic animals."[9] Domestic animals are creations of man, he says. "They are living artifacts, but artifacts nevertheless. . . . There is thus something profoundly incoherent (and insensitive as well) in the complaint of some animal liberationists that the 'natural behavior' of chickens and bobby calves is cruelly frustrated on factory farms. It would make almost as much sense to speak of the natural behavior of tables and chairs."[10] Here again we see teleology playing a decisive role: wild organisms do not have the natural function of serving human ends, but domesticated animals do. Cheetahs in zoos are crimes against what is natural; veal calves in boxes are not.

The idea of "natural tendency" played a decisive role in pre-Darwinian biological thinking. Aristotle's entire science—both his physics and his biology—is articulated in terms of specifying the natural tendencies of kinds of objects and the interfering forces that can prevent an object from achieving its intended state. Heavy objects in the sublunar sphere have location at the center of the earth as their natural state; each tends to go there, but is prevented from

doing so. Organisms likewise are conceptualized in terms of this natural state model:

> . . . [for] any living thing that has reached its normal development and which is unmutilated, and whose mode of generation is not spontaneous, the most natural act is the production of another like itself, an animal producing an animal, a plant a plant. . . .[11]

But many interfering forces are possible, and in fact the occurrence of "monsters" is anything but uncommon. According to Aristotle, mules (sterile hybrids) count as deviations from the natural state. In fact, females are monsters as well, since the natural tendency of sexual reproduction is for the offspring to perfectly resemble the father, who, according to Aristotle, provides the "genetic instructions" (to put the idea anachronistically) while the female provides only the matter.

What has happened to the natural state model in modern science? In physics, the idea of describing what a class of objects will do in the absence of "interference" lives on: Newton specified this "zero-force state" as rest or uniform motion, and in general relativity, this state is understood in terms of motion along geodesics. But one of the most profound achievements of Darwinian biology has been the jettisoning of this kind of model. It isn't just that Aristotle was wrong in his detailed claims about mules and women; the whole structure of the natural state model has been discarded. Population biology is not conceptualized in terms of positing some characteristic that all members of a species would have in common, were interfering forces absent. Variation is not thought of as a deflection from the natural state of uniformity. Rather, variation is taken to be a fundamental property in its own right. Nor, at the level of individual biology, does the natural state model find an application. Developmental theory is not articulated by specifying a natural tendency and a set of interfering forces. The main conceptual tool for describing the various developmental pathways open to a genotype is the norm of reaction. The norm of reaction of a genotype within a range of environments will describe what phenotype the genotype

will produce in a given environment. Thus, the norm of reaction for a corn plant genotype might describe how its height is influenced by the amount of moisture in the soil. The norm of reaction is entirely silent on which phenotype is the "natural" one. The idea that a corn plant might have some "natural height," which can be, augmented or diminished by "interfering forces" is entirely alien to post-Darwinian biology.

The fact that the concepts of natural state and interfering force have lapsed from biological thought does not prevent environmentalists from inventing them anew. Perhaps these concepts can be provided with some sort of normative content; after all, the normative idea of "human rights" may make sense even if it is not a theoretical underpinning of any empirical science. But environmentalists should not assume that they can rely on some previously articulated scientific conception of "natural."

APPEALS TO NEEDS AND INTERESTS

The version of utilitarianism considered earlier (according to which something merits ethical consideration if it can experience pleasure and/or pain) leaves the environmentalist in the lurch. But there is an alternative to Bentham's hedonistic utilitarianism that has been thought by some to be a foundation for environmentalism. Preference utilitarianism says that an object's having interests, needs, or preferences gives it ethical status. This doctrine is at the core of Stone's affirmative answer to the title question of his book *Should Trees Have Standing?*[12] "Natural objects can communicate their wants (needs) to us, and in ways that are not terribly ambiguous. . . . The lawn tells me that it wants water by a certain dryness of the blades and soil—immediately obvious to the touch—the appearance of bald spots, yellowing, and a lack of springiness after being walked on." And if plants can do this, presumably so can mountain ranges, and endangered species. Preference utilitarianism may thereby seem to grant intrinsic ethical importance to precisely the sorts of objects about which environmentalists have expressed concern.

The problems with this perspective have been detailed by Sagoff.[13] If one does not require of an object that it have a mind for it to have wants or needs, what is required for the possession of these ethically relevant properties? Suppose one says that an object needs something if it will cease to exist if it does not get it. Then species, plants, and mountain ranges have needs, but only in the sense that automobiles, garbage dumps, and buildings do too. If everything has needs, the advice to take needs into account in ethical deliberation is empty, unless it is supplemented by some technique for weighting and comparing the needs of different objects. A corporation will go bankrupt unless a highway is built. But the swamp will cease to exist if the highway is built. Perhaps one should take into account all relevant needs, but the question is how to do this in the event that needs conflict.

Although the concept of need can be provided with a permissive, all-inclusive definition, it is less easy to see how to do this with the concept of want. Why think that a mountain range "wants" to retain its unspoiled appearance, rather than house a new amusement park?[14] Needs are not at issue here, since in either case, the mountain continues to exist. One might be tempted to think that natural objects like mountains and species have "natural tendencies," and that the concept of want should be liberalized so as to mean that natural objects "want" to persist in their natural states. This Aristotelian view, as I argued in the previous section, simply makes no sense. Granted, a commercially undeveloped mountain will persist in this state, unless it is commercially developed. But it is equally true that a commercially untouched hill will become commercially developed, unless something causes this not to happen. I see no hope for extending the concept of wants to the full range of objects valued by environmentalists.

The same problems emerge when we try to apply the concepts of needs and wants to species. A species may need various resources, in the sense that these are necessary for its continued existence. But what do species want? Do they want to remain stable in numbers, neither growing nor shrinking? Or since most species have gone extinct, perhaps what species really want is to go extinct, and it is human

meddlesomeness that frustrates this natural tendency? Preference utilitarianism is no more likely than hedonistic utilitarianism to secure autonomous ethical status for endangered species.

Ehrenfeld describes a related distortion that has been inflicted on the diversity/stability hypothesis in theoretical ecology.[15] If it were true that increasing the diversity of an ecosystem causes it to be more stable, this might encourage the Aristotelian idea that ecosystems have a natural tendency to increase their diversity. The full realization of this tendency—the natural state that is the goal of ecosystems—is the "climax" or "mature" community. Extinction diminishes diversity, so it frustrates ecosystems from attaining their goal. Since the hypothesis that diversity causes stability is now considered controversial (to say the least), this line of thinking will not be very tempting. But even if the diversity/stability hypothesis were true, it would not permit the environmentalist to conclude that ecosystems have an interest in retaining their diversity.

Darwinism has not banished the idea that parts of the natural world are goal-directed systems, but has furnished this idea with a natural mechanism. We properly conceive of organisms (or genes, sometimes) as being in the business of maximizing their chances of survival and reproduction. We describe characteristics as adaptations—as devices that exist for the furtherance of these ends. Natural selection makes this perspective intelligible. But Darwinism is a profoundly individualistic doctrine. Darwinism rejects the idea that species, communities, and ecosystems have adaptations that exist for their own benefit. These higher-level entities are not conceptualized as goal-directed systems; what properties of organization they possess are viewed as artifacts of processes operating at lower levels of organization. An environmentalism based on the idea that the ecosystem is directed toward stability and diversity must find its foundation elsewhere.

GRANTING WHOLES AUTONOMOUS VALUE

A number of environmentalists have asserted that environmental values cannot be grounded in values based on regard for individual welfare. Aldo Leopold wrote in *A Sand County Almanac* that "a thing is right when it tends to preserve the integrity, stability, and beauty of the biotic community. It is wrong when it tends otherwise."[16] Callicott develops this idea at some length, and ascribes to ethical environmentalism the view that "the preciousness of individual deer, *as of any other specimen*, is inversely proportional to the population of the species."[17] In his *Desert Solitaire*, Edward Abbey notes that he would sooner shoot a man than a snake.[18] And Garrett Hardin asserts that human beings injured in wilderness areas ought not to be rescued: making great and spectacular efforts to save the life of an individual "makes sense only when there is a shortage of people. I have not lately heard that there is a shortage of people."[19] The point of view suggested by these quotations is quite clear. It isn't that preserving the integrity of ecosystems has autonomous value, to be taken into account just as the quite distinct value of individual human welfare is. Rather, the idea is that the only value is the holistic one of maintaining ecological balance and diversity. Here we have a view that is just as monolithic as the most single-minded individualism; the difference is that the unit of value is thought to exist at a higher level of organization.

It is hard to know what to say to someone who would save a mosquito, just because it is rare, rather than a human being, if there were a choice. In ethics, as in any other subject, rationally persuading another person requires the existence of shared assumptions. If this monolithic environmentalist view is based on the notion that ecosystems have needs and interests, and that these take total precedence over the rights and interests of individual human beings, then the discussion of the previous sections is relevant. And even supposing that these higher-level entities have needs and wants, what reason is there to suppose that these matter and that the wants and needs of individuals matter not at all? But if this source of defense is jettisoned, and it is merely asserted that only ecosystems have value, with no substantive defense being offered, one must begin by requesting an argument: *why* is ecosystem stability and diversity the only value?

Some environmentalists have seen the individualist bias of utilitarianism as being harmful in ways additional to its impact on our perception of ecological values. Thus, Callicott writes:

> On the level of social organization, the interests of society may not always coincide with the sum of the interests of its parts. Discipline, sacrifice, and individual restraint are often necessary in the social sphere to maintain social integrity as within the bodily organism. A society, indeed, is particularly vulnerable to disintegration when its members become preoccupied totally with their own particular interest, and ignore those distinct and independent interests of the community as a whole. One example, unfortunately, our own society, is altogether too close at hand to be examined with strict academic detachment. The United States seems to pursue uncritically a social policy of reductive utilitarianism, aimed at promoting the happiness of all its members severally. Each special interest accordingly clamors more loudly to be satisfied while the community as a whole becomes noticeably more and more infirm economically, environmentally, and politically.[20]

Callicott apparently sees the emergence of individualism and alienation from nature as two aspects of the same process. He values "the symbiotic relationship of Stone Age man to the natural environment" and regrets that "civilization has insulated and alienated us from the rigors and challenges of the natural environment. The hidden agenda of the humane ethic," he says, "is the imposition of the antinatural prophylactic ethos of comfort and soft pleasure on an even wider scale. The land ethic, on the other hand, requires a shrinkage, if at all possible, of the domestic sphere; it rejoices in a recrudescence of the wilderness and a renaissance of tribal cultural experience."[21]

Callicott is right that "strict academic detachment" is difficult here. The reader will have to decide whether the United States currently suffers from too much or too little regard "for the happiness of all its members severally" and whether we should feel nostalgia or pity in contemplating what the Stone Age experience of nature was like.

THE DEMARCATION PROBLEM

Perhaps the most fundamental theoretical problem confronting an environmentalist who wishes to claim that species and ecosystems have autonomous value is what I will call the *problem of demarcation*. Every ethical theory must provide principles that describe which objects matter for their own sakes and which do not. Besides marking the boundary between these two classes by enumerating a set of ethically relevant properties, an ethical theory must say why the properties named, rather than others, are the ones that count. Thus, for example, hedonistic utilitarianism cites the capacity to experience pleasure and/or pain as the decisive criterion; preference utilitarianism cites the having of preferences (or wants, or interests) as the decisive property. And a Kantian ethical theory will include an individual in the ethical community only if it is capable of rational reflection and autonomy. Not that justifying these various proposed solutions to the demarcation problem is easy; indeed, since this issue is so fundamental, it will be very difficult to justify one proposal as opposed to another. Still, a substantive ethical theory is obliged to try.

Environmentalists, wishing to avoid the allegedly distorting perspective of individualism, frequently want to claim autonomous value for wholes. This may take the form of a monolithic doctrine according to which the only thing that matters is the stability of the ecosystem. Or it may embody a pluralistic outlook according to which ecosystem stability and species preservation have an importance additional to the welfare of individual organisms. But an environmentalist theory shares with all ethical theories an interest in not saying that everything has autonomous value. The reason this position is proscribed is that it makes the adjudication of ethical conflict very difficult indeed. (In addition, it is radically implausible, but we can set that objection to one side.)

Environmentalists, as we have seen, may think of natural objects, like mountains, species, and ecosystems, as mattering for their own sake, but of artificial objects, like highway systems and domesticated animals, as having only instrumental value. If a mountain and a highway are both made of rock, it seems unlikely

that the difference between them arises from the fact that mountains have wants, interests, and preferences, but highway systems do not. But perhaps the place to look for the relevant difference is not in their present physical composition, but in the historical fact of how each came into existence. Mountains were created by natural processes, whereas highways are humanly constructed. But once we realize that organisms construct their environments in nature, this contrast begins to cloud. Organisms do not passively reside in an environment whose properties are independently determined. Organisms transform their environments by physically interacting with them. An anthill is an artifact just as a highway is. Granted, a difference obtains at the level of whether conscious deliberation played a role, but can one take seriously the view that artifacts produced by conscious planning are thereby *less* valuable than ones that arise without the intervention of mentality.[22] As we have noted before, although environmentalists often accuse their critics of failing to think in a biologically realistic way, their use of the distinction between "natural" and "artificial" is just the sort of idea that stands in need of a more realistic biological perspective.

My suspicion is that the distinction between natural and artificial is not the crucial one. On the contrary, certain features of environmental concerns imply that natural objects are exactly on a par with certain artificial ones. Here the intended comparison is not between mountains and highways, but between mountains and works of art. My goal in what follows is not to sketch a substantive conception of what determines the value of objects in these two domains, but to motivate an analogy.

For both natural objects and works of art, our values extend beyond the concerns we have for experiencing pleasure. Most of us value seeing an original painting more than we value seeing a copy, even when we could not tell the difference. When we experience works of art, often what we value is not just the kinds of experiences we have, but, in addition, the connections we usually have with certain real objects. Routley and Routley have made an analogous point about valuing the wilderness experience: a "wilderness experience machine" that caused certain sorts of hallucinations would be no substitute for actually going into the

wild.[23] Nor is this fact about our valuation limited to such aesthetic and environmentalist contexts. We love various people in our lives. If a molecule-for-molecule replica of a beloved person were created, you would not love that individual, but would continue to love the individual to whom you actually were historically related. Here again, our attachments are to objects and people as they really are, and not just to the experiences that they facilitate.

Another parallel between environmentalist concerns and aesthetic values concerns the issue of context. Although environmentalists often stress the importance of preserving endangered species, they would not be completely satisfied if an endangered species were preserved by putting a number of specimens in a zoo or in a humanly constructed preserve. What is taken to be important is preserving the species in its natural habitat. This leads to the more holistic position that preserving ecosystems, and not simply preserving certain member species, is of primary importance. Aesthetic concerns often lead in the same direction. It was not merely saving a fresco or an altar piece that motivated art historians after the most recent flood in Florence. Rather, they wanted to save these works of art in their original ("natural") settings. Not just the painting, but the church that housed it; not just the church, but the city itself. The idea of objects residing in a "fitting" environment plays a powerful role in both domains.

Environmentalism and aesthetics both see value in rarity. Of two whales, why should one be more worthy of aid than another, just because one belongs to an endangered species? Here we have the $n + m$ question mentioned in [the introduction to this selection]. As an ethical concern, rarity is difficult to understand. Perhaps this is because our ethical ideas concerning justice and equity (note the word) are saturated with individualism. But in the context of aesthetics, the concept of rarity is far from alien. A work of art may have enhanced value simply because there are very few other works by the same artist, or from the same historical period, or in the same style. It isn't that the price of the item may go up with rarity; I am talking about aesthetic value, not monetary worth. Viewed as valuable aesthetic objects, rare organisms may be valuable because they are rare.

A disanalogy may suggest itself. It may be objected that works of art are of instrumental value only, but that species and ecosystems have intrinsic value. Perhaps it is true, as claimed before, that our attachment to works of art, to nature, and to our loved ones extends beyond the experiences they allow us to have. But it may be argued that what is valuable in the aesthetic case is always the relation of a valuer to a valued object.[24] When we experience a work of art, the value is not simply in the experience, but in the composite fact that we and the work of art are related in certain ways. This immediately suggests that if there were no valuers in the world, nothing would have value, since such relational facts could no longer obtain. So, to adapt Routley and Routley's "last man argument," it would seem that if an ecological crisis precipitated a collapse of the world system, the last human being (whom we may assume for the purposes of this example to be the last valuer) could set about destroying all works of art, and there would be nothing wrong in this.[25] That is, if aesthetic objects are valuable only in so far as valuers can stand in certain relations to them, then when valuers disappear, so does the possibility of aesthetic value. This would deny, in one sense, that aesthetic objects are intrinsically valuable: it isn't they, in themselves, but rather the relational facts that they are part of, that are valuable.

In contrast, it has been claimed that the "last man" would be wrong to destroy natural objects such as mountains, salt marshes, and species. (So as to avoid confusing the issue by bringing in the welfare of individual organisms, Routley and Routley imagine that destruction and mass extinctions can be caused painlessly, so that there would be nothing wrong about this undertaking from the point of view of the nonhuman organisms involved.) If the last man ought to preserve these natural objects, then these objects appear to have a kind of autonomous value; their value would extend beyond their possible relations to valuers. If all this were true, we would have here a contrast between aesthetic and natural objects, one that implies that natural objects are more valuable than works of art.

Routley and Routley advance the last man argument as if it were decisive in showing that environmental objects such as mountains and salt marshes

have autonomous value. I find the example more puzzling than decisive. But, in the present context, we do not have to decide whether Routley and Routley are right. We only have to decide whether this imagined situation brings out any relevant difference between aesthetic and environmental values. Were the last man to look up on a certain hillside, he would see a striking rock formation next to the ruins of a Greek temple. Long ago the temple was built from some of the very rocks that still stud the slope. Both promontory and temple have a history, and both have been transformed by the biotic and the abiotic environments. I myself find it impossible to advise the last man that the peak matters more than the temple. I do not see a relevant difference. Environmentalists, if they hold that the solution to the problem of demarcation is to be found in the distinction between natural and artificial, will have to find such a distinction. But if environmental values are aesthetic, no difference need be discovered.

Environmentalists may be reluctant to classify their concern as aesthetic. Perhaps they will feel that aesthetic concerns are frivolous. Perhaps they will feel that the aesthetic regard for artifacts that has been made possible by culture is antithetical to a proper regard for wilderness. But such contrasts are illusory. Concern for environmental values does not require a stripping away of the perspective afforded by civilization; to value the wild, one does not have to "become wild" oneself (whatever that may mean). Rather, it is the material comforts of civilization that make possible a serious concern for both aesthetic and environmental values. These are concerns that can become pressing in developed nations in part because the populations of those countries now enjoy a certain substantial level of prosperity. It would be the height of condescension to expect a nation experiencing hunger and chronic disease to be inordinately concerned with the autonomous value of ecosystems or with creating and preserving works of art. Such values are not frivolous, but they can become important to us only after certain fundamental human needs are satisfied. Instead of radically jettisoning individualist ethics, environmentalists may find a more hospitable home for their values in a category of value that has existed all along.

Notes

1. Mark Sagoff, "On Preserving the Natural Environment," *Yale Law Review* 84 (1974): 205–38; J. Baird Callicott, "Animal Liberation: A Triangular Affair," *Environmental Ethics* 2 (1980): 311–38; and Bryan Norton, "Environmental Ethics and Nonhuman Rights," *Environmental Ethics* 4 (1982): 17–36.

2. Peter Singer, *Animal Liberation* (New York: Random House, 1975), has elaborated a position of this sort.

3. Occasionally, it has been argued that utilitarianism is not just *insufficient* to justify the principles of environmentalism, but is actually mistaken in holding that pain is intrinsically bad. Callicott writes: "I herewith declare in all soberness that I see nothing wrong with pain. It is a marvelous method, honed by the evolutionary process, of conveying important organic information. I think it was the late Alan Watts who somewhere remarks that upon being asked if he did not think there was too much pain in the world replied, 'No, I think there's just enough'" ("A Triangular Affair," p. 333). Setting to one side the remark attributed to Watts, I should point out that pain can be intrinsically bad and still have some good consequences. The point of calling pain intrinsically bad is to say that one essential aspect of experiencing it is negative.

4. A parallel with a quite different moral problem will perhaps make it clearer how the environmentalist's holism conflicts with some fundamental ethical ideas. When we consider the rights of individuals to receive compensation for harm, we generally expect that the individuals compensated must be one and the same as the individuals harmed. This expectation runs counter to the way an affirmative action program might be set up, if individuals were to receive compensation simply for being members of groups that have suffered certain kinds of discrimination, whether or not they themselves were victims of discrimination. I do not raise this example to suggest that a holistic conception according to which groups have entitlements is beyond consideration. Rather, my point is to exhibit a case in which a rather common ethical idea is individualistic rather than holistic.

5. David Ehrenfeld, "The Conservation of Non-Resources," *American Scientist* 64 (1976): 648–56. For a theoretical discussion see Robert M. May, *Stability and Complexity in Model Ecosystems* (Princeton: Princeton University Press, 1973).

6. Callicott, "A Triangular Affair," pp. 333–34 (my emphasis).

7. Paul Shepard, "Animal Rights and Human Rites," *North American Review* (Winter 1974): 35–41.

8. Charles Darwin, *The Autobiography of Charles Darwin* (London: Collins, 1876, 1958), p. 90.

9. Callicott, "A Triangular Affair," p. 330.

10. Callicott, "A Triangular Affair," p. 330.

11. Aristotle, *De Anima*, 415a26.

12. Christopher Stone, *Should Trees Have Standing?* (Los Altos, Calif.: William Kaufmann, 1972), p. 24.

13. Sagoff, "Natural Environment," pp. 220–24.

14. The example is Sagoff's, "Natural Environment," pp. 220–24.

15. Ehrenfeld, "The Conservation of Non-Resources," pp. 651–52.

16. Aldo Leopold, *A Sand County Almanac* (New York: Oxford University Press, 1949), pp. 224–25.

17. Callicott, "A Triangular Affair," p. 326 (emphasis mine).

18. Edward Abbey, *Desert Solitaire* (New York: Ballantine Books, 1968), p. 20.

19. Garrett Hardin, "The Economics of Wilderness," *Natural History* 78 (1969): 176.

20. Callicott, "A Triangular Affair," p. 323.

21. Callicott, "A Triangular Affair," p. 335.

22. Here we would have an inversion, not just a rejection, of a familiar Marxian doctrine—the labor theory of value.

23. Richard Routley and Val Routley, "Human Chauvinism and Environmental Ethics," *Environmental Philosophy, Monograph Series 2*, edited by D. S. Mannison, M. A. McRobbie, and R. Routley (Philosophy Department, Australian National University, 1980) p. 154.

24. Donald H. Regan, "Duties of Preservation," *The Preservation of Species*, ed. B. Norton (Princeton: Princeton University Press, 1986), pp. 195–220.

25. Routley and Routley, "Human Chauvinism," pp. 121–22.

Study Questions

1. What does Sober mean by "a holistic value system"?

2. What different meanings can be given to the term "natural"?

3. According to Sober, what is "the demarcation problem"?

4. In what ways, if any, is the extinction of a species akin to the destruction of a work of art?

54

HENRY SHUE

Is torture ever justifiable? This question is here considered by Henry Shue, Professor of Politics and International Relations at the University of Oxford. He distinguishes between "interrogational torture," torture to obtain information, and "terroristic torture," torture to intimidate people other than the victim. Shue argues that in both cases torture is morally unacceptable, because it violates the prohibition against assault upon the defenseless. He acknowledges imaginable circumstances in which interrogational torture would be justified but maintains that these rare cases do not warrant relaxing legal prohibitions against it.

Torture

But no one dies in the right place
Or in the right hour
And everyone dies sooner than his time
And before he reaches home.

—*Reza Baraheni*

Whatever one might have to say about torture, there appear to be moral reasons for not saying it. Obviously I am not persuaded by these reasons, but they deserve some mention. Mostly, they add up to a sort of Pandora's Box objection: if practically everyone is opposed to all torture, why bring it up, start people thinking about it, and risk weakening the inhibitions against what is clearly a terrible business?

Torture is indeed contrary to every relevant international law, including the laws of war. No other practice except slavery is so universally and unanimously condemned in law and human convention. Yet, unlike slavery, which is still most definitely practiced but affects relatively few people, torture is widespread and growing. According to Amnesty International, scores of governments are now using

some torture—including governments which are widely viewed as fairly civilized—and a number of governments are heavily dependent upon torture for their very survival.[1]

So, to cut discussion of this objection short, Pandora's Box is open. Although virtually everyone continues ritualistically to condemn all torture publicly, the deep conviction, as reflected in actual policy, is in many cases not behind the strong language. In addition, partial justifications for some of the torture continue to circulate.[2]

One of the general contentions that keeps coming to the surface is: since killing is worse than torture, and killing is sometimes permitted, especially in war, we ought sometimes to permit torture, especially when the situation consists of a protracted, if undeclared, war between a government and its enemies. I shall try first to show the weakness of this argument. To establish that one argument for permitting some torture is unsuccessful is, of course, not to establish that no torture is to be permitted. But in the

Henry Shue, "Torture," *Philosophy & Public Affairs,* vol. 7, no. 2, 1978. Reprinted by permission of Blackwell Publishing Ltd.

remainder of the essay I shall also try to show, far more interestingly, that a comparison between some types of killing in combat and some types of torture actually provides an insight into an important respect in which much torture is morally worse. This respect is the degree of satisfaction of the primitive moral prohibition against assault upon the defenseless. Comprehending how torture violates this prohibition helps to explain—and justify—the peculiar disgust which torture normally arouses.

The general idea of the defense of at least some torture can be explained more fully, using "just-combat killing" to refer to killing done in accord with all relevant requirements for the conduct of warfare.[3] The defense has two stages.

A Since (1) *just-combat killing is total destruc-*
 tion of a person,
 (2) *torture is—usually—only*
 partial destruction or temporary
 incapacitation of a person, and
 (3) *the total destruction of a person*
 is a greater harm than the partial
 destruction of a person is,
 then (4) *just-combat killing is a greater*
 harm than torture usually is;
B since (4) *just-combat killing is a greater*
 harm than torture usually is, and
 (5) *just-combat killing is sometimes*
 morally permissible,
 then (6) *torture is sometimes morally*
 permissible.

To state the argument one step at a time is to reveal its main weakness. Stage B tacitly assumes that if a greater harm is sometimes permissible, then a lesser harm is too, at least sometimes. The mistake is to assume that the only consideration relevant to moral permissibility is the amount of harm done. Even if one grants that killing someone in combat is doing him or her a greater harm than torturing him or her (Stage A), it by no means follows that there could not be a justification for the greater harm that was not applicable to the lesser harm. Specifically, it would matter if some killing could satisfy other

moral constraints (besides the constraint of minimizing harm) which no torture could satisfy.[4]

A defender of at least some torture could, however, readily modify the last step of the argument to deal with the point that one cannot simply weigh amounts of "harm" against each other but must consider other relevant standards as well by adding a final qualification:

(6') torture is sometimes morally permissible,
provided that it meets whichever standards are
satisfied by just-combat killing.

If we do not challenge the judgment that just-combat killing is a greater harm than torture usually is, the question to raise is: Can torture meet the standards satisfied by just-combat killing? If so, that might be one reason in favor of allowing such torture. If not, torture will have been reaffirmed to be an activity of an extremely low moral order.

ASSAULT UPON THE DEFENSELESS

The laws of war include an elaborate, and for the most part long-established, code for what might be described as the proper conduct of the killing of other people. Like most codes, the laws of war have been constructed piecemeal and different bits of the code serve different functions.[5] It would almost certainly be impossible to specify any one unifying purpose served by the laws of warfare as a whole. Surely major portions of the law serve to keep warfare within one sort of principle of efficiency by requiring that the minimum destruction necessary to the attainment of legitimate objectives be used.

However, not all the basic principles incorporated in the laws of war could be justified as serving the purpose of minimizing destruction. One of the most basic principles for the conduct of war (*jus in bello*) rests on the distinction between combatants and noncombatants and requires that insofar as possible, violence not be directed at noncombatants.[6] Now, obviously, there are some conceptual difficulties in trying to separate combatants and noncombatants in some guerrilla warfare and even sometimes in modern conventional

warfare among industrial societies. This difficulty is a two-edged sword; it can be used to argue that it is increasingly impossible for war to be fought justly as readily as it can be used to argue that the distinction between combatants and noncombatants is obsolete. In any case, I do not now want to defend or criticize the principle of avoiding attack upon noncombatants but to isolate one of the more general moral principles this specific principle of warfare serves.

It might be thought to serve, for example, a sort of efficiency principle in that it helps to minimize human casualties and suffering. Normally, the armed forces of the opposing nations constitute only a fraction of the respective total populations. If the casualties can be restricted to these official fighters, perhaps total casualties and suffering will be smaller than they would be if human targets were unrestricted.

But this justification for the principle of not attacking noncombatants does not ring true. Unless one is determined a priori to explain everything in terms of minimizing numbers of casualties, there is little reason to believe that this principle actually functions primarily to restrict the number of casualties rather than, as its own terms suggest, the *types* of casualties.[7] A more convincing suggestion about the best justification which could be given is that the principle goes some way toward keeping combat humane, by protecting those who are assumed to be incapable of defending themselves. The principle of warfare is an instance of a more general moral principle which prohibits assaults upon the defenseless.[8]

Nonpacifists who have refined the international code for the conduct of warfare have not necessarily viewed the killing involved in war as in itself any less terrible than pacifists view it. One fundamental function of the distinction between combatants and noncombatants is to try to make a terrible combat fair, and the killing involved can seem morally tolerable to nonpacifists in large part because it is the outcome of what is conceived as a fair procedure. To the extent that the distinction between combatants and noncombatants is observed, those who are killed will be those who were directly engaged in trying to kill their killers. The fairness may be perceived to lie in this fact: that those who are killed had a reasonable chance to survive by killing instead. It was kill or be killed for both parties, and each had his or her opportunity to survive. No doubt the opportunities may not have been anywhere near equal—it would be impossible to restrict wars to equally matched opponents. But at least none of the parties to the combat were defenseless.

Now this obviously invokes a simplified, if not romanticized, portrait of warfare. And at least some aspects of the laws of warfare can legitimately be criticized for relying too heavily for their justification on a core notion that modern warfare retains aspects of a knightly joust, or a duel, which have long since vanished, if ever they were present. But the point now is not to attack or defend the efficacy of the principle of warfare that combat is more acceptable morally if restricted to official combatants, but to notice one of its moral bases, which, I am suggesting, is that it allows for a "fair fight" by means of protecting the utterly defenseless from assault. The resulting picture of war—accurate or not—is not of victim and perpetrator (or, of mutual victims) but of a winner and a loser, each of whom might have enjoyed, or suffered, the fate of the other. Of course, the satisfaction of the requirement of providing for a "fair fight" would not by itself make a conflict morally acceptable overall. An unprovoked and otherwise unjustified invasion does not become morally acceptable just because attacks upon noncombatants, use of prohibited weapons, and so on are avoided.

At least part of the peculiar disgust which torture evokes may be derived from its apparent failure to satisfy even this weak constraint of being a "fair fight." The supreme reason, of course, is that torture begins only after the fight is—for the victim—finished. Only losers are tortured. A "fair fight" may even in fact already have occurred and led to the capture of the person who is to be tortured. But now that the torture victim has exhausted all means of defense and is powerless before the victors, a fresh assault begins. The surrender is followed by new attacks upon the defeated by the now unrestrained conquerors. In this respect torture is indeed not analogous to the killing in battle of a healthy and well-armed foe; it is a cruel assault upon the defenseless. In combat the other person one kills is still a threat when killed and is killed in part for the

sake of one's own survival. The torturer inflicts pain and damage upon another person who, by virtue of now being within his or her power, is no longer a threat and is entirely at the torturer's mercy.

It is in this respect of violating the prohibition against assault upon the defenseless, then, that the manner in which torture is conducted is morally more reprehensible than the manner in which killing would occur if the laws of war were honored. In this respect torture sinks below even the well-regulated mutual slaughter of a justly fought war.

TORTURE WITHIN CONSTRAINTS?

But is all torture indeed an assault upon the defenseless? For, it could be argued in support of some torture that in many cases there is something beyond the initial surrender which the torturer wants from the victim and that in such cases the victim could comply and provide the torturer with whatever is wanted. To refuse to comply with the further demand would then be to maintain a second line of defense. The victim would, in a sense, not have surrendered—at least not fully surrendered—but instead only retreated. The victim is not, on this view, utterly helpless in the face of unrestrainable assault as long as he or she holds in reserve an act of compliance which would satisfy the torturer and bring the torture to an end.

It might be proposed, then, that there could be at least one type of morally less unacceptable torture. Obviously the torture victim must remain defenseless in the literal sense, because it cannot be expected that his or her captors would provide means of defense against themselves. But an alternative to a capability for a literal defense is an effective capability for surrender, that is, a form of surrender which will in fact bring an end to attacks. In the case of torture the relevant form of surrender might seem to be a compliance with the wishes of the torturer that provides an escape from further torture.

Accordingly, the constraint on the torture that would, on this view, make it less objectionable would be this: the victim of torture must have available an act of compliance which, if performed, will end the torture. In other words, the purpose of the torture must be known to the victim, the purpose must be the performance of some action within the victim's power to perform, and the victim's performance of the desired action must produce the permanent cessation of the torture. I shall refer to torture that provides for such an act of compliance as torture that satisfies the constraint of possible compliance. As soon becomes clear, it makes a great difference what kind of act is presented as the act of compliance. And a person with an iron will, a great sense of honor, or an overwhelming commitment to a cause may choose not to accept voluntarily cessation of the torture on the terms offered. But the basic point would be merely that there should be some terms understood so that the victim retains one last portion of control over his or her fate. Escape is not defense, but it is a manner of protecting oneself. A practice of torture that allows for escape through compliance might seem immune to the charge of engaging in assault upon the defenseless. Such is the proposal.

One type of contemporary torture, however, is clearly incapable of satisfying the constraint of possible compliance. The extraction of information from the victim, which perhaps—whatever the deepest motivations of torturers may have been—has historically been a dominant explicit purpose of torture is now, in world practice, overshadowed by the goal of the intimidation of people other than the victim.[9] Torture is in many countries used primarily to intimidate potential opponents of the government from actively expressing their opposition in any form considered objectionable by the regime. Prohibited forms of expression range, among various regimes, from participation in terroristic guerrilla movements to the publication of accurate news accounts. The extent of the suffering inflicted upon the victims of the torture is proportioned, not according to the responses of the victim, but according to the expected impact of news of the torture upon other people over whom the torture victim normally has no control. The function of general intimidation of others, or deterrence of dissent, is radically different from the function of extracting specific information under the control of the victim of torture, in respects which are central to the assessment of such torture. This is naturally not

to deny that any given instance of torture may serve, to varying degrees, both purposes—and, indeed, other purposes still.

Terroristic torture, as we may call this dominant type, cannot satisfy the constraint of possible compliance, because its purpose (intimidation of persons other than the victim of the torture) cannot be accomplished and may not even be capable of being influenced by the victim of the torture. The victim's suffering—indeed, the victim—is being used entirely as a means to an end over which the victim has no control. Terroristic torture is a pure case—the purest possible case—of the violation of the Kantian principle that no person may be used *only* as a means. The victim is simply a site at which great pain occurs so that others may know about it and be frightened by the prospect. The torturers have no particular reason not to make the suffering as great and as extended as possible. Quite possibly the more terrible the torture, the more intimidating it will be—this is certainly likely to be believed to be so.

Accordingly, one ought to expect extensions into the sorts of "experimentation" and other barbarities documented recently in the cases of, for example, the Pinochet government in Chile and the Amin government in Uganda.[10] Terroristic torturers have no particular reason not to carry the torture through to the murder of the victim, provided the victim's family or friends can be expected to spread the word about the price of any conduct compatible with disloyalty. Therefore, terroristic torture clearly cannot satisfy even the extremely mild constraint of providing for the possibility of compliance by its victim.[11]

The degree of need for assaults upon the defenseless initially appears to be quite different in the case of torture for the purpose of extracting information, which we may call *interrogational torture.*[12] This type of torture needs separate examination because, however condemnable we ought in the end to consider it overall, its purpose of gaining information appears to be consistent with the observation of some constraint on the part of any torturer genuinely pursuing that purpose alone. Interrogational torture does have a built-in end-point: when the information has been obtained, the torture has accomplished its purpose and need not be continued. Thus, satisfaction of the constraint of possible compliance seems to be quite compatible with the explicit end of interrogational torture, which could be terminated upon the victim's compliance in providing the information sought. In a fairly obvious fashion the torturer could consider himself or herself to have completed the assigned task—or probably more hopefully, any superiors who were supervising the process at some emotional distance could consider the task to be finished and put a stop to it. A pure case of interrogational torture, then, appears able to satisfy the constraint of possible compliance, since it offers an escape, in the form of providing the information wanted by the torturers, which affords some protection against further assault.

Two kinds of difficulties arise for the suggestion that even largely interrogational torture could escape the charge that it includes assaults upon the defenseless. It is hardly necessary to point out that very few actual instances of torture are likely to fall entirely within the category of interrogational torture. Torture intended primarily to obtain information is by no means always in practice held to some minimum necessary amount. To the extent that the torturer's motivation is sadistic or otherwise brutal, he or she will be strongly inclined to exceed any rational calculations about what is sufficient for the stated purpose. In view of the strength and nature of a torturer's likely passions—of, for example, hate and self-hate, disgust and self-disgust, horror and fascination, subservience toward superiors and aggression toward victims—no constraint is to be counted upon in practice.

Still, it is of at least theoretical interest to ask whether torturers with a genuine will to do so could conduct interrogational torture in a manner which would satisfy the constraint of possible compliance. In order to tell, it is essential to grasp specifically what compliance would normally involve. Almost all torture is "political" in the sense that it is inflicted by the government in power upon people who are, seem to be, or might be opposed to the government. Some torture is also inflicted by opponents of a government upon people who are, seem to be, or might be supporting the government. Possible victims of torture fall into three broad categories: the ready collaborator, the innocent bystander, and the dedicated enemy.

First, the torturers may happen upon someone who is involved with the other side but is not dedicated to such a degree that cooperation with the torturers would, from the victim's perspective, constitute a betrayal of anything highly valued. For such a person a betrayal of cause and allies might indeed serve as a form of genuine escape.

The second possibility is the capture of someone who is passive toward both sides and essentially uninvolved. If such a bystander should happen to know the relevant information—which is very unlikely—and to be willing to provide it, no torture would be called for. But what if the victim would be perfectly willing to provide the information sought in order to escape the torture but does not have the information? Systems of torture are notoriously incompetent. The usual situation is captured with icy accuracy by the reputed informal motto of the Saigon police, "If they are not guilty, beat them until they are."[13] The victims of torture need an escape not only from beatings for what they know but also from beatings for what they do not know. In short, the victim has no convincing way of demonstrating that he or she cannot comply, even when compliance is impossible. (Compare the reputed dunking test for witches: if the woman sank, she was an ordinary mortal.)

Even a torturer who would be willing to stop after learning all that could be learned, which is nothing at all if the "wrong" person is being tortured, would have difficulty discriminating among pleas. Any keeping of the tacit bargain to stop when compliance has been as complete as possible would likely be undercut by uncertainty about when the fullest possible compliance had occurred. The difficulty of demonstrating that one had collaborated as much as one could might in fact haunt the collaborator as well as the innocent, especially if his or her collaboration had struck the torturers as being of little real value.

Finally, when the torturers succeed in torturing someone genuinely committed to the other side, compliance means, in a word, betrayal; betrayal of one's ideals and one's comrades. The possibility of betrayal cannot be counted as an escape. Undoubtedly some ideals are vicious and some friends are partners in crime—this can be true of either the government, the opposition, or both. Nevertheless, a betrayal is no escape for a dedicated member of either a government or its opposition, who cannot collaborate without denying his or her highest values.[14]

For any genuine escape must be something better than settling for the lesser of two evils. One can always try to minimize one's losses—even in dilemmas from which there is no real escape. But if accepting the lesser of two evils always counted as an escape, there would be no situations from which there was no escape, except perhaps those in which all alternatives happened to be equally evil. On such a loose notion of escape, all conscripts would become volunteers, since they could always desert. And all assaults containing any alternatives would then be acceptable. An alternative which is legitimately to count as an escape must not only be preferable but also itself satisfy some minimum standard of moral acceptability. A denial of one's self does not count.

Therefore, on the whole, the apparent possibility of escape through compliance tends to melt away upon examination. The ready collaborator and the innocent bystander have some hope of an acceptable escape, but only provided that the torturers both (a) are persuaded that the victim has kept his or her part of the bargain by telling all there is to tell and (b) choose to keep their side of the bargain in a situation in which agreements cannot be enforced upon them and they have nothing to lose by continuing the torture if they please. If one is treated as if one is a dedicated enemy, as seems likely to be the standard procedure, the fact that one actually belongs in another category has no effect. On the other hand, the dedicated enemies of the torturers, who presumably tend to know more and consequently are the primary intended targets of the torture, are provided with nothing which can be considered an escape and can only protect themselves, as torture victims always have, by pretending to be collaborators or innocents, and thereby imperiling the members of these two categories.

MORALLY PERMISSIBLE TORTURE?

Still, it must reluctantly be admitted that the avoidance of assaults upon the defenseless is not the only, or even

in all cases an overriding, moral consideration. And, therefore, even if terroristic and interrogational torture, each in its own way, is bound to involve attacks upon people unable to defend themselves or to escape, it is still not utterly inconceivable that instances of one or the other type of torture might sometimes, all things considered, be justified. Consequently, we must sketch the elements of an overall assessment of these two types of torture, beginning again with the dominant contemporary form: terroristic.

Anyone who thought an overall justification could be given for an episode of terroristic torture would at the least have to provide a clear statement of necessary conditions, all of which would have to be satisfied before any actions so extraordinarily cruel as terroristic torture could be morally acceptable. If the torture were actually to be justified, the conditions would, of course, have to be met in fact. An attempt to specify the necessary conditions for a morally permissible episode of terroristic torture might include conditions such as the following. A first necessary condition would be that the purpose actually being sought through the torture would need to be not only morally good but supremely important, and examples of such purposes would have to be selected by criteria of moral importance which would themselves need to be justified. Second, terroristic torture would presumably have to be the least harmful means of accomplishing the supremely important goal. Given how very harmful terroristic torture is, this could rarely be the case. And it would be unlikely unless the period of use of the torture in the society was limited in an enforceable manner. Third, it would have to be absolutely clear for what purpose the terroristic torture was being used, what would constitute achievement of that purpose, and thus, when the torture would end. The torture could not become a standard practice of government for an indefinite duration. And so on.

But is there any supremely important end to which terroristic torture could be the least harmful means? Could terroristic torture be employed for a brief interlude and then outlawed? Consider what would be involved in answering the latter question. A government could, it might seem, terrorize until the terror had accomplished its purpose and then suspend the

terror. There are few, if any, clear cases of a regime's voluntarily renouncing terror after having created, through terror, a situation in which terror was no longer needed. And there is considerable evidence of the improbability of this sequence. Terroristic torture tends to become, according to Amnesty International, "administrative practice": a routine procedure institutionalized into the method of governing.[15] Some bureaus collect taxes, other bureaus conduct torture. First a suspect is arrested, next he or she is tortured. Torture gains the momentum of an ingrained element of a standard operating procedure.

Several factors appear to point in the direction of permanence. From the perspective of the victims, even where the population does not initially feel exploited, terror is very unsuitable to the generation of loyalty. This would add to the difficulty of any transition away from reliance on terror. Where the population does feel exploited even before the torture begins, the sense of outrage (which is certainly rationally justified toward the choice of victims, as we have seen) could often prove stronger than the fear of suffering. Tragically, any unlikelihood that the terroristic torture would "work" would almost guarantee that it would continue to be used. From the perspective of the torturers, it is rare for any entrenched bureau to choose to eliminate itself rather than to try to prove its essential value and the need for its own expansion. This is especially likely if the members of the operation are either thoroughly cynical or thoroughly sincere in their conviction that they are protecting "national security" or some other value taken to be supremely important. The greater burden of proof rests, I would think, on anyone who believes that controllable terroristic torture is possible.

Rousseau says at one point that pure democracy is a system of government suitable only for angels—ordinary mortals cannot handle it. If Rousseau's assumption is that principles for human beings cannot ignore the limits of the capacity of human beings, he is surely right. (This would mean that political philosophy often cannot be entirely nonempirical.) As devilish as terroristic torture is, in a sense it too may be a technique only for angels: perhaps only angels could use it within the only constraints which would make it permissible and, then, lay it aside. The partial

list of criteria for the acceptable use of terroristic torture sketched above, in combination with strong evidence of the uncontrollability of terroristic torture, would come as close to a reductio ad absurdum as one could hope to produce in political philosophy. Observance of merely the constraints listed would require a degree of self-control and self-restraint, individual and bureaucratic, which might turn out to be saintly. If so, terroristic torture would have been shown to be justifiable only if it could be kept within constraints within which it could almost certainly not be kept.

But if the final objection against terroristic torture turned out to be empirical evidence that it is probably uncontrollable, would not the philosophical arguments themselves turn out to have been irrelevant? Why bother to show that terroristic torture assaults the defenseless, if in the end the case against it is going to rest on an empirical hypothesis about the improbability of keeping such torture within reasonable bounds?

The thesis about assault upon the defenseless matters, even though it is not in itself conclusive, because the uncontrollability thesis could only be probable and would also not be conclusive in itself. It could not be shown to be certain that terroristic torture will become entrenched, will be used for minor purposes, will be used when actually not necessary, and so on. And we sometimes go ahead and allow practices which might get out of hand. The relevance of showing the extent of the assault upon defenseless people is to establish how much is at stake if the practice is allowed and then runs amok. If the evidence for uncontrollability were strong, that fact plus the demonstration of extreme cruelty would constitute a decisive case against terroristic torture. It would, then, never be justified.

Much of what can be said about terroristic torture can also be said about instances involving interrogational torture. This is the case primarily because in practice there are evidently few pure cases of interrogational torture.[16] An instance of torture which is to any significant degree terroristic in purpose ought to be treated as terroristic. But if we keep in mind how far we are departing from most actual practice, we may, as before, consider instances in which the *sole* purpose of torture is to extract certain information and therefore the torturer is willing to stop as

soon as he or she is sure that the victim has provided all the information which the victim has.

As argued in the preceding section, interrogational torture would in practice be difficult to make into less of an assault upon the defenseless. The supposed possibility of escape through compliance turns out to depend upon the keeping of a bargain which is entirely unenforceable within the torture situation and upon the making of discriminations among victims that would usually be difficult to make until after they no longer mattered. In fact, since any sensible willing collaborator will cooperate in a hurry, only the committed and the innocent are likely to be severely tortured. More important, in the case of someone being tortured because of profoundly held convictions, the "escape" would normally be a violation of integrity.

As with terroristic torture, any complete argument for permitting instances of interrogational torture would have to include a full specification of all necessary conditions of a permissible instance, such as its serving a supremely important purpose (with criteria of importance), its being the least harmful means to that goal, its having a clearly defined and reachable endpoint, and so on. This would not be a simple matter. Also as in the case of terroristic torture, a considerable danger exists that whatever necessary conditions were specified, any practice of torture once set in motion would gain enough momentum to burst any bonds and become a standard operating procedure. Torture is the ultimate shortcut. If it were ever permitted under any conditions, the temptation to use it increasingly would be very strong.

Nevertheless, it cannot be denied that there are imaginable cases in which the harm that could be prevented by a rare instance of pure interrogational torture would be so enormous as to outweigh the cruelty of the torture itself and, possibly, the enormous potential harm which would result if what was intended to be a rare instance was actually the breaching of the dam which would lead to a torrent of torture. There is a standard philosopher's example which someone always invokes: suppose a fanatic, perfectly willing to die rather than collaborate in the thwarting of his own scheme, has set a hidden nuclear device to explode in the heart of Paris. There is no time to evacuate the innocent people or even the movable art treasures—the

only hope of preventing tragedy is to torture the perpetrator, find the device, and deactivate it.

I can see no way to deny the permissibility of torture in a case *just like this*. To allow the destruction of much of a great city and many of its people would be almost as wicked as purposely to destroy it, as the Nazis did to London and Warsaw, and the Allies did to Dresden and Tokyo, during World War II. But there is a saying in jurisprudence that hard cases make bad law, and there might well be one in philosophy that artificial cases make bad ethics. If the example is made sufficiently extraordinary, the conclusion that the torture is permissible is secure. But one cannot easily draw conclusions for ordinary cases from extraordinary ones, and as the situations described become more likely, the conclusion that the torture is permissible becomes more debatable.

Notice how unlike the circumstances of an actual choice about torture the philosopher's example is. The proposed victim of our torture is not someone we suspect of planting the device: he *is* the perpetrator. He is not some pitiful psychotic making one last play for attention: he *did* plant the device. The wiring is not backwards, the mechanism is not jammed: the device *will* destroy the city if not deactivated.

Much more important from the perspective of whether general conclusions applicable to ordinary cases can be drawn are the background conditions that tend to be assumed. The torture will not be conducted in the basement of a small-town jail in the provinces by local thugs popping pills; the prime minister and chief justice are being kept informed; and a priest and a doctor are present. The victim will not be raped or forced to eat excrement and will not collapse with a heart attack or become deranged before talking; while avoiding irreparable damage, the antiseptic pain will carefully be increased only up to the point at which the necessary information is divulged, and the doctor will then immediately administer an antibiotic and a tranquilizer. The torture is purely interrogational.[17]

Most important, such incidents do not continue to happen. There are not so many people with grievances against this government that the torture is becoming necessary more often, and in the smaller cities, and for slightly lesser threats, and with a little less care, and so on. Any judgment that torture could be sanctioned in an isolated case without seriously weakening existing inhibitions against the more general use of torture rests on empirical hypotheses about the psychology and politics of torture. There *is* considerable evidence of all torture's metastatic tendency. If there is also evidence that interrogational torture can sometimes be used with the surgical precision which imagined justifiable cases always assume, such rare uses would have to be considered.

Does the possibility that torture might be justifiable in some of the rarefied situations which can be imagined provide any reason to consider relaxing the legal prohibitions against it? Absolutely not. The distance between the situations which must be concocted in order to have a plausible case of morally permissible torture and the situations which actually occur is, if anything, further reason why the existing prohibitions against torture should remain and should be strengthened by making torture an international crime. An act of torture ought to remain illegal so that anyone who sincerely believes such an act to be the least available evil is placed in the position of needing to justify his or her act morally in order to defend himself or herself legally. The torturer should be in roughly the same position as someone who commits civil disobedience. Anyone who thinks an act of torture is justified should have no alternative but to convince a group of peers in a public trial that all necessary conditions for a morally permissible act were indeed satisfied. If it is reasonable to put someone through torture, it is reasonable to put someone else through a careful explanation of why. If the situation approximates those in the imaginary examples in which torture seems possible to justify, a judge can surely be expected to suspend the sentence. Meanwhile, there is little need to be concerned about possible injustice to justified torturers and great need to find means to restrain totally unjustified torture.

Notes

1. See Amnesty International, *Report on Torture* (New York: Farrar, Straus and Giroux, 1975), pp. 21–33.

2. I primarily have in mind conversations which cannot be cited, but for a written source see Roger Trinquier, *La*

Guerre Moderne (Paris: La Table Ronde, 1961), pp. 39, 42, 187–191. Consider the following: "Et c'est tricher que d'admettre sereinement que l'artillerie ou l'aviation peuvent bombarder des villages où se trouvent des femmes et des enfants qui seront inutilement massacrés, alors que le plus souvent les ennemis visés auront pu s'enfuir, et refuser que des spécialistes en interrogeant un terroriste permettent de se saisir des vrais coupables et d'épargner les innocents" (p. 42).

3. By "just combat" I mean warfare which satisfies what has traditionally been called *jus in bello*, the law governing how war may be fought once underway, rather than *jus ad bellum*, the law governing when war may be undertaken.

4. Obviously one could also challenge other elements of the argument—most notably, perhaps, premise (3). Torture is usually humiliating and degrading—the pain is normally experienced naked and amidst filth. But while killing destroys life, it need not destroy dignity. Which is worse, an honorable death or a degraded existence? While I am not unsympathetic with this line of attack, I do not want to try to use it. It suffers from being an attempt somehow just to intuit the relative degrees of evil attached respectively to death and degradation. Such judgments should probably be the outcome, rather than the starting point, of an argument. The rest of the essay bears directly on them.

5. See James T. Johnson, *Ideology, Reason, and the Limitation of War: Religious and Secular Concepts 1200–1740* (Princeton: Princeton University Press, 1975). Johnson stresses the largely religious origins of *jus ad bellum* and the largely secular origins of *jus in bello*.

6. For the current law, see Geneva Convention Relative to the Protection of Civilian Persons in Time of War, 12 August 1949 [1955], 6 U.S.T. 3516; T.I.A.S. No. 3365; 75 U.N.T.S. 287. Also see United States, Department of the Army, *The Law of Land Warfare*, Field Manual 27–10 (Washington: Government Printing Office, 1956), Chap. 5, "Civilian Persons"; and United States, Department of the Air Force, *International Law—The Conduct of Armed Conflict and Air Operations*, Air Force Pamphlet 110–31 (Washington: Government Printing Office, 1976), Chap. 3, "Combatants, Noncombatants and Civilians." This Convention was to be revised at a Geneva Conference in 1977; of considerable interest are the recommendations for greater protection of civilians advanced in Subcomm. on International Organizations of the House Comm. on Foreign Affairs, 93d Cong., 2d Sess. (1974), *Human Rights in the World Community: A Call for U.S. Leadership*, p. 38.

For the history, see Johnson, especially pp. 32–33 and 42–46, although I am interested here in the justification which could be given for the principle today, not the original justification (insofar as it was different).

The prohibition against attack upon noncombatants is considered by some authorities to be fundamental. See, for example, Jean Pictet, *The Principles of International Humanitarian Law* (Geneva: International Committee of the Red Cross, 1966), p. 53: "This general immunity of the civilian population has not been clearly defined in positive law, but it remains, in spite of many distortions, the basis of the laws of war." It is often assumed by others that the exigencies of a stable form of mutual assured destruction (MAD) make unavoidable the targeting of a nuclear deterrent on the enemy's civilian population and that therefore priority on avoidance of civilian casualties is impossible in nuclear war. For a persuasive contrary view, see Bruce M. Russett, "Assured Destruction of What? A Counter-combatant Alternative to Nuclear MADness," *Public Policy* 22 (1974): 121–138.

7. This judgment is supported by Stockholm International Peace Research Institute, *The Law of War and Dubious Weapons* (Stockholm: Almqvist & Wiksell, 1976), p. 9: "The prohibition on deliberately attacking the civilian population as such is not based exclusively on the principle of avoiding unnecessary suffering."

8. To defend the bombing of cities in World War II on the ground that *total* casualties (combatant and noncombatant) were thereby reduced is to miss, or ignore, the point.

9. See Amnesty International, 69.

10. See United Nations, General Assembly, Report of the Economic and Social Council, *Protection of Human Rights in Chile* (UN Document A/31/253, 8 October 1976, 31st Session), p. 97; and *Uganda and Human Rights: Reports to the UN Commission on Human Rights* (Geneva: International Commission of Jurists, 1977), p. 118.

11. A further source of arbitrariness is the fact that there is, in addition, no natural limit on the "appropriate" targets of terroristic torture, since the victim does not need to possess any specific information, or to have done anything in particular, except possibly to have acted "suspiciously." Even the latter is not necessary if the judgment is made, as it apparently was by the Nazis, that random terror will be the most effective.

It has been suggested that there might be a category of "deserved" terroristic torture, conducted only after a fair trial had established the guilt of the torture victim for some heinous crime. A fair procedure for determining who is to be tortured would transform the torture into a form of deterrent punishment—doubtless a cruel and unusual one.

Such torture would stand only with a general deterrent theory of punishment according to which *who* is punished depends upon guilt, but *how much* he or she is punished depends upon supposed deterrent effects. I would think that any finding that terroristic torture could be fitted within a deterrent theory of punishment (provided the torture was preceded by a fair trial) could cut either way and would be at least as plausible a reason for rejecting the general theory as it would be for accepting the particular case of terroristic torture. But I will not pursue this because I am not aware of any current practice of reserving torture as the sentence for people after they are convicted by a trial with the usual safeguards. Torture customarily precedes any semblance of a trial. One can, of course, imagine various sorts of torture other than the two common kinds discussed here.

12. These two categories of torture are not intended to be, and are not, exhaustive. See previous note.

13. Amnesty International, 166.

14. Defenders of privilege customarily portray themselves as defenders of civilization against the vilest barbarians. Self-deception sometimes further smooths the way to treating whoever are the current enemies as beneath contempt and certainly unworthy of equal respect as human beings. Consequently, I am reluctant to concede, even as a limiting case, that there are probably rare individuals so wicked as to lack integrity, or anyway to lack any integrity worthy of respect. But, what sort of integrity could one have violated by torturing Hitler?

Any very slight qualification here must not, however, be taken as a flinging wide open of the doors. To be beyond the pale in the relevant respect must involve far more than simply serving values which the torturers find abhorrent. Otherwise, license has been granted simply to torture whoever are one's greatest enemies—the only victims very many torturers would want in any case. Unfortunately, I cannot see a way to delimit those who are genuinely beyond the pale which does not beg for abuse.

15. I am assuming the unrestrained character of terroristic torture as it is actually practiced. Besides the general study by Amnesty International cited above and below, Amnesty International regularly issues studies of individual countries. Of particular interest, perhaps, is: *Report on Allegations of Torture in Brazil*, 3d ed. (London: Amnesty International Publications, 1976). The Committee on International Relations of the United States House of Representatives has published during 1975–1977 extensive hearings on torture in dozens of countries. And other nongovernmental organizations, such as the International Commission of Jurists and the International League for Human Rights, have published careful accounts of the nature of the torture practiced in various particular countries. I believe that the category of terroristic torture used in this article is an accurate reflection of a very high proportion of the actual cases of contemporary torture. It would be tedious to document this here, but see, for example, Amnesty International, pp. 21, 26, 103, 199.

Nevertheless, it can be granted that terroristic torture is not necessarily unrestrained. It is conceivable for torture to fail to be constrained by the responses of its victim but to be subject to other constraints: to use brutality of only a certain degree, to conduct torture of unlimited (or limited) brutality but for only a limited time, to select victims who "deserve" it (compare note 11), etc. I have not discussed such a category of "constrained terroristic torture" because I believe it to be empty—for very good psychological and political reasons. On the methodological question here, see the concluding paragraphs of this article.

16. Amnesty International, pp. 24–25, 114–242.

17. For a realistic account of the effects of torture, see *Evidence of Torture: Studies by the Amnesty International Danish Medical Group* (London: Amnesty International Publications, 1977). Note in particular: "Undoubtedly the worst sequelae of torture were psychological and neurological" (p. 12). For suggestions about medical ethics for physicians attending persons being tortured, see "Declaration of Tokyo: Guidelines for Medical Doctors Concerning Torture," in United Nations, General Assembly, Note by the Secretary-General, *Torture and other Cruel, Inhuman or Degrading Treatment or Punishment in relation to Detention and Imprisonment* (UN Document A/31/234, 6 October 1976, 31st Session), Annex II.

Study Questions

1. How does Shue distinguish between "terroristic torture" and "interrogational torture"?

2. According to Shue, might torture ever be justifiable?

3. Might moral considerations ever require illegal actions?

4. Do artificial cases make bad ethics?

55

DANIEL J. HILL

In the previous reading Henry Shue maintains that in imaginable cases the harm that could be prevented by a rare instance of pure interrogational torture would be so enormous as to outweigh the cruelty of the torture itself. However, Daniel J. Hill, Lecturer in Philosophy at the University of Liverpool, disagrees. He argues that such torture, and more generally, interrogational coercion is never morally permissible. He does, however, believe that acting in self-defense or defense of others is justifiable.

Ticking Bombs, Torture, and the Analogy with Self-Defense

1. INTRODUCTION

One reads in the press that the agents of many countries, and, indeed, many private individuals, engage in torture to coerce others into performing certain actions, frequently the divulging of information ("interrogational torture"). Sometimes this is undertaken for a good end, such as the saving of lives by the disarming of a ticking time-bomb, or the rescue of a kidnap victim. It will be argued in this paper that such torture and, more generally, interrogational coercion are never morally permissible. This will be a specific application of a general moral principle that will be proposed:

(P) It is never permissible intentionally to inflict severe pain or severe harm on someone unwilling, unless the pain/harm is intended (i) for their benefit, or (ii) as a punishment, or (iii) as part of the pursuit of a legitimate war, or (iv) to prevent the individual from causing severe pain or severe harm to innocents.[1]

Disagreement with this absolute rejection of interrogational torture could come from several directions. Act utilitarians would assert that it is fairly easy to imagine circumstances in which the ends would justify the means of torture: if it were known that many would be killed or suffer extreme pain as a result of a bomb's exploding it would surely be for the greatest happiness of the greatest number that one inflict some not-too-extreme pain on a single individual with the knowledge of the whereabouts of the bomb—provided, of course, that one knew there to be no danger of setting a precedent that would lead to abuses that would outweigh the happiness of the lives saved and pain averted. The key word here is "imagine"; many of those that assert that it is possible to *imagine* circumstances in which torture would be justified also assert that *in real life* such circumstances will never obtain.[2] It should further be noted that many suggest that our intuitions concerning imaginary cases are not reliable.[3] This point will not be argued against here, however (even though the argument of

this paper depends heavily on intuitions), since those opposed to the thesis of this paper—i.e., those that argue that interrogational torture *is* sometimes permissible—defend their position on the basis of intuition, so this is not a disputed point in this context.

On the other hand, some deontologists may object that principle (P) does not, despite its intended purpose, rule out interrogational torture, for interrogational torture is indeed intended to "prevent the individual from causing severe pain or severe harm to innocents." More generally, some deontologists argue that it is permissible to inflict severe pain or severe harm in self-defense or in defense of another, and that cases of interrogational torture are analogous to these in the relevant moral respects.[4] The bulk of this paper will be devoted to resisting these objections and arguments, and, therefore, to arguing that (P) does indeed absolutely prohibit interrogational torture. Because of the close connection between the objection to (P) and the analogy from self-defense this paper will often simply say "in self-defense" rather than "to prevent the individual from causing severe pain or severe harm to innocents"; nevertheless it is the longer formulation that represents the precise position of this paper. This paper will deal only with cases of severe pain/harm, and will also use "torture" interchangeably with "inflict severe pain or severe harm," because the admitted differences in meaning between these two are not in view in this paper. The paper will also ignore, as not relevant to the project in hand, the differences in meaning between "torture" and "coerce."

2. THE INTENTION TO CAUSE PAIN

Let us consider a couple of examples that might be cited to support the analogy between self-defense and interrogational torture.

> Defense Case: A police officer spots a known terrorist about to detonate a bomb, which, if it goes off, will illicitly inflict serious harm and serious pain on many innocents.[5] The officer fires a Taser at the terrorist, intending to cause no serious lasting harm but so much pain that the terrorist will be paralyzed and unable to detonate the bomb.[6]

Most deontologists (and consequentialists) would agree here that it is morally permissible for the police officer to Taser the terrorist in self-defense or defense of others. So far so good, but let us now consider the supposedly analogous case from the world of interrogation.

> Interrogation Case: A known terrorist is in the captivity of the security services of a certain country. He is known to have planted somewhere a ticking bomb, which, if it goes off, will illicitly inflict serious harm and serious pain on many innocents. The security services know that he knows where the bomb is, but he is refusing to divulge its whereabouts. In order to get him to talk they give him electric shocks, intending to cause no serious lasting harm but so much pain that he will say where the bomb is.[7]

The contention of this paper will be that the analogy between Defense and Interrogation is superficial. In fact, it will be contended that there is a fundamental difference between the two. There is a way, admittedly, in which they are similar: each case is a case of intent that pain/harm will be caused—in Defense the terrorist is trying there and then to cause severe pain and severe harm, and in Interrogation the terrorist is deliberately not cooperating in order that the earlier causal chain that he set in motion may reach the terminus he desires. There is also, however, a way in which they are different: Interrogation is not a case of aggression, unlike Defense. In Defense the terrorist is *doing* something—he is attempting to inflict severe pain or severe harm—and force is being used to prevent him from causing a tragedy to happen. In Interrogation, by contrast, the terrorist is powerless, in the custody of the security services, and is not *doing* anything—he has *already* set in motion a causal chain threatening a tragedy, and force is being used to cause him to perform the positive action of causing a tragedy not to happen.[8] It will be argued that this distinction is of crucial moral significance.

It is tempting to say that the reason why it is not permissible in Interrogation to inflict pain on the terrorist to get him to talk is that in this case one would be treating him as a mere means. This may well be correct, but this paper will not pursue that line as it is not wholly clear whether cases of self-defense count as treating aggressors as mere means. There will now be adumbrated a case to illustrate this point and to refute another possible objection.

The next possible objection to be considered states that the difference between Defense and Interrogation is merely that in Defense the terrorist is not being caused to perform any action, whereas in Interrogation he is. To show that this is too simple, an example of a *permissible* case in which one *does cause* the terrorist to perform an action will now be presented. This case is a slight variation on Defense above:

Reflex Case: A police officer spots a known terrorist about to detonate a bomb, which, if it goes off, will illicitly inflict serious harm and serious pain on many innocents. The officer sprays the terrorist with a pepper spray, intending to cause no serious lasting harm but so much pain in his eyes that he will instinctively start rubbing his eyes in an effort to relieve the pain, and so won't be able to press the detonator.

Is it permissible to cause the terrorist this pain in order to cause him to rub his eyes and thereby not be able to detonate the bomb? Intuitively, it is, even though here the terrorist is being prevented from detonating the bomb by being caused to perform an action, unlike in Defense in which the terrorist had been prevented from performing an action (the action of detonation) without being caused to *do* anything.

Is the terrorist being used as a mere means in Reflex? This is not clear, and so this paper will not press the line that this is why it is impermissible to inflict pain in Defense.

3. CAUSING A CONSCIOUS ACTION

It might yet be pressed, however, that Reflex was not analogous to Interrogation, because the action was a mere reflex action rather than a consciously chosen one. Once more this does not seem a sound objection. For one thing, it might well be that when in great pain some individuals would "break" and instinctively shout out the answers to questions without consciously choosing to do so. But in any case Reflex can itself be adapted, as is demonstrated by the following case:

Holding Case: A police officer spots a known terrorist about to detonate a bomb, which, if it goes off, will illicitly inflict serious harm and serious pain on many innocents. The detonator button needs to be held down for ten seconds for the bomb to go off. The only way the terrorist can be prevented from holding down the detonator button for ten seconds is if he is caused such pain that he will choose to take his finger off the detonator button in order to get the pain to stop. The officer shoots the terrorist in the foot, intending to cause no serious lasting harm but so much pain that he will make a conscious decision to stop priming the bomb and turn his attention to nursing his foot.[9]

Intuitively, in Holding the police officer is justified in inflicting pain on the terrorist in order to cause him to choose not to detonate the bomb by choosing to take his finger off the detonation button.

Compare this with the following case:

Withholding Case: A police officer spots a known terrorist about to detonate a bomb, which, if it goes off, will illicitly inflict serious harm and serious pain on many innocents. The detonator button needs to be in the down position for ten seconds for the bomb to go off. The device works in such a way, however, that once pressed the button will remain depressed unless pulled up by someone with the terrorist's fingerprint. The only way the detonator button can be prevented from remaining depressed for ten seconds is if the terrorist is caused such pain that he will choose to pull the detonator button up in order to get the pain to stop. The officer shoots the terrorist in the foot, telling the terrorist that he can expect more pain in the other foot unless he pulls up the detonator button.[10]

Withholding and Holding are superficially very similar, but there is one crucial difference: in Holding

the terrorist is prevented from performing an action (holding the button down) and in Withholding the terrorist is not preventing from doing anything— instead he is (just) caused to perform an action, the action of pulling the button up.[11] It would seem that this makes a moral difference. Intuitively, it is not permissible to inflict pain in Withholding in order to compel the terrorist to pull the button up, but intuitively it *is* permissible (as previously stated) for pain to be inflicted in Holding in order that the terrorist might be prevented from pushing the button down.

4. A POSSIBLE REPLY: LOSS OF HUMAN RIGHTS

It might be replied that it is permissible for pain to be inflicted on the terrorist in Withholding and similar cases because the terrorist is guilty of attempting a terrorist atrocity and, as a result of this, has lost his right not to have pain inflicted on him, just as those guilty of crimes lose their right to freedom for a certain time.[12] This means, so the objection goes, that it is morally permissible for pain to be inflicted on him in order that he might be compelled to pull up the detonator button.

It is curious that, while most of those that advance this argument believe that the removal of freedom is a standard punishment for the guilty, relatively few of them believe that the infliction of pain is a standard punishment for the guilty. Yet the removal of freedom is inflicted as a punishment precisely because (at least on a deontological understanding) it is judged that the guilty party has lost the right to freedom; why then do not the proponents of the objection suggest the infliction of pain as a routine punishment? Furthermore, even the proponents of this objection would still think it morally unacceptable if terrorists were tortured for fun, or if the torturers continued to torture even after the terrorists had aborted the ticking bomb. Of course, it could be replied that the terrorists have lost the right against the infliction of less than a certain amount of pain, such as the amount of pain that they themselves were prepared to inflict. This, however, is in marked

contrast to the "I'll do whatever it takes to break you" attitude that is usually associated with the torture of terrorist suspects. It also does not accommodate the intuition accepted by proponents of the objection that it is morally obligatory to try to prevent the torture from passing the minimum level necessary to get the terrorist to abort the tragedy. Finally, the supposition that all terrorists lose their right not to have pain inflicted on them has the counter-intuitive consequence of legitimizing the infliction of pain in the following example:

> Fellow Case: A terrorist from a large terrorist organization has just been captured. The terrorist has planted a ticking bomb somewhere and it is imperative that its whereabouts be discovered. The terrorist refuses to talk, however. Also in custody is one of his fellow terrorists, from the same terrorist organization, who was captured some time ago, and does not know the whereabouts of the ticking bomb, nor was he involved in this particular attack. The psychologist suggests that the quickest way to get the information out of the newly captured terrorist would be to torture his fellow terrorist in front of him. He says that since both are terrorists, both have lost their right not to have pain inflicted on them.

Surely the psychiatrist would be wrong to suggest the torturing of the fellow, uninvolved, terrorist to get the newly captured one to talk, despite the fact that the fellow terrorist is himself guilty of serious terrorist offences. This seems to show that committing a terrorist outrage does not remove one's right not to be tortured, i.e., to have serious pain or serious harm inflicted on one without one's consent when it is not for one's benefit.

5. ANOTHER POSSIBLE REPLY: STILL CAUSING THE ATROCITY

It might be responded that the terrorist in Interrogation and Withholding and similar cases *is* still performing an evil action, viz., the causation of the terrorist atrocity, and that, therefore, the torturer *is*

preventing the terrorist from performing an action, and so there is, after all, a similarity with Defense and Holding and similar cases. Miller (2006) puts it thus:

> [T]he terrorist is in the process of completing his (jointly undertaken) action of murdering thousands of innocent people. He has already undertaken his individual actions of, say, transporting and arming the nuclear device; he has performed these individual actions (in the context of other individual actions performed by the other members of the terrorist cell) in order to realise the end (shared by the other members of the cell) of murdering thousands of Londoners. In refusing to disclose the location of the device the terrorist is preventing the police from preventing him from completing his (joint) action of murdering thousands of innocent people.

Sussman (2005, p. 16) also defends this line:

> Consider again the captured terrorist who we know to have planted a powerful bomb in some crowded civilian area. Although the terrorist is in our power, he refuses to reveal the bomb's location, hoping to strike one last blow against us by allowing a train of events that he has set in motion to come to its intended conclusion. In one sense, the terrorist is indeed defenseless. We can do anything we like to him, and there is nothing he can do to resist or shield himself against us. But such helplessness means neither that the terrorist has ceased to engage in hostilities against us, nor that he is no longer an active military threat. His placing of the bomb was the beginning of an attack on us; his silence, although not any kind of further overt act, is nevertheless voluntary behavior undertaken for the sake of bringing that act to completion. His continued silence thus might well be considered a part of his attack, understood as a temporally extended action.

This raises the big metaphysical question of when one completes an action, (a) when its effects come about, or (b) when one finishes the *basic* actions (i.e., the bodily movements[13]) that ultimately lead

to the effects. Intuitively, only (b) is tenable, as if (a) were correct one would continue performing lots of actions long after one's death. Admittedly, (b) does have the counter-intuitive consequence that a killer kills the victim before the victim dies, but this is less counter-intuitive than the view that one might kill someone after one's death.[14] It follows from (b) that facts about one's actions are "soft facts,"[15] i.e., facts that obtain at least partly in virtue of later events, so, for example, A's killing B on Monday obtains partly in virtue of B's dying on the following Wednesday, as well as partly in virtue of A's leaving slow-acting poison in B's glass on Monday, and B's drinking the poison on Tuesday. It follows, further, that the torturer in Interrogation and Withholding etc. is not preventing the terrorist from performing an action of terror but preventing him from *having performed* an action of terror, and this difference between such cases as Interrogation and Withholding on the one hand, and Defense and Holding on the other hand, seems to make the difference between the licensing of the intentional infliction of severe pain or severe harm in Defense and Holding, but not in Interrogation and Withholding.

6. ANOTHER POSSIBLE REPLY: PREVENTION OF NON-COOPERATION

It might be responded that the terrorist that refuses to abort the bomb or refuses to divulge its whereabouts still uncontroversially intends to perform a different morally evil action, viz., refusing to co-operate with the authorities, and that it is morally permissible to inflict severe pain or severe harm on him to prevent him from fulfilling this intention. The first part of this is quite correct, but not every morally evil action licenses the infliction of severe pain, even in self-defense, as should be made clear by the following example:

> Non-cooperation Case: Suppose the terrorist has been killed but his wife has been detained alive. She didn't know that her husband was a terrorist,

but she does know where he's been spending a lot of time lately. She won't, however, say where until a lawyer skilled in the law of her native land and religion arrives to witness her statement. There is no time to wait for this lawyer, however, but the psychologist suggests that if she were tortured she'd divulge the information in a couple of minutes.

Surely it is not morally permissible to torture the terrorist's innocent wife in Non-cooperation. A historically important case of innocent motives behind non-cooperation is that of the "seal of confession": if a terrorist confesses to a Roman Catholic priest the priest is not allowed to reveal the location of the ticking bomb to the authorities. And we might imagine that even those that are not Roman Catholic priests could promise not to reveal what someone was about to tell them and regard themselves, rightly or wrongly, as absolutely bound by their promise. It would surely be unacceptable to torture them to get the information out of them.[16] This would seem to show that the infliction of pain in Withholding and the like cannot be defended on the grounds that it is designed to prevent the terrorist committing the evil of non-cooperation.

Finally, it may be argued that, although the terrorist in cases of torture such as Withholding and the like doesn't have the intention to perform an action evil enough to justify the infliction of pain to prevent him from performing this action, he does have another intention, which *is* evil enough to warrant torture: he intends that the planned atrocity should happen after all, and this is why he refuses to co-operate. But clearly the fact that he has this intention does not license him to be tortured; there are many terrorist sympathizers throughout the world that have this evil intention, and yet it would be wrong to inflict pain on them unless it were to prevent them from performing an evil action themselves. It may be objected that the terrorist and the sympathizers do not have the *intention* that the atrocity occur; they merely have the *desire* that it occur. It is unclear that this is correct, but if it is permissible to speak of the terrorist's having the intention surely it is also permissible to speak of the sympathizers' having it, at least if they intend to aid and abet it in a certain minor way such as by funding it or praying for its success. It is implausible to maintain that funding a terrorist atrocity is an offence that licenses torture; surely it is even less plausible to maintain that praying for the success of a terrorist atrocity is an offence that licenses torture.

7. POSITIVE AND NEGATIVE DUTIES

What is the basis of this moral difference between preventing someone from performing an action that will cause a tragedy and causing someone to cause a tragedy not to occur? It is an instance of the distinction between our duties to perform certain acts of causation on the one hand, our "positive" duties, and our duties not to perform certain different acts of causation on the other hand, our "negative" duties. Although both the distinction itself and its moral significance have been much attacked in the literature, they do seem to have intuitive support:[17]

> Drowning Case: Suppose A's father and spouse have been deliberately pushed by B into a lake and are drowning: A can rescue one, but only one, of them. A chooses to swim past his father to save his spouse.

Intuitively, in Drowning, A has not caused the death of his father; that was caused by B. And intuitively there is a moral difference between A's choosing to refrain from saving his father in order to save his spouse on the one hand, and the deliberate pushing in by B of A's father on the other hand. Even if A's action of refraining from saving his father is morally bad, it surely isn't as morally bad as that of B. Finally, intuitively there is a distinction between the negative duty not deliberately to push the unwilling non-swimmer into a lake—a duty flouted by B—and the positive duty to save one's father from drowning if one can—a duty not satisfied by A, who could have saved his father, but saved his spouse instead.

It seems permissible, then, in some circumstances to inflict pain to force people to comply with their negative duties, but it does not seem permissible

to inflict pain in order to force people to comply with their positive duties, even extremely important positive duties, such as the duty to avert an atrocity that the people in question have set in motion. In this sense negative duties are more important than positive duties, and the infliction of pain to force someone to comply with a positive duty would *itself* be a breach of a negative duty. On the other hand, failure to inflict pain to enforce a positive duty would not itself be a breach of a positive duty, though failure to inflict pain to enforce a negative duty in certain circumstances *would* be a breach of a positive duty: if a police officer refuses to shoot a terrorist in the foot when that is the only way to prevent him from detonating a devastating bomb then he or she is in breach of his or her duty to defend innocent citizens. On the other hand, as has been argued, the officer's duty to defend innocent citizens does not extend to a duty to shoot a captured terrorist in the foot to force him to divulge the whereabouts of a ticking bomb, as this would be a breach of a negative duty.

One can see that it is not the case that positive duties should be enforced by the infliction of pain by considering the following case:

> Expert Case: A ticking bomb has been located, and the only person that can defuse it is a retired bomb-disposal expert. He, however, doesn't want to come to defuse the bomb because he doesn't want to leave the bedside of his dying wife.

It would clearly be wrong on the deontological scheme to torture the bomb-disposal expert in Expert to get him to defuse the bomb, even if he has a duty to help. Moreover, intuitively it would still be wrong to torture him even if he was "on duty" and not retired, but was being insubordinate.

8. CONCLUSION

It appears that what underlies the cases that have been discussed in this paper is the principle mentioned earlier:

> (P) It is never permissible intentionally to inflict severe pain or severe harm on someone unwilling, unless the pain/harm is intended (i) for their benefit, or (ii) as a punishment, or (iii) as part of the pursuit of a legitimate war, or (iv) to prevent the individual from causing severe pain or severe harm to innocents.

(P) implies that it is impermissible to act in standard torture cases (such as Interrogation). It does not imply that it is impermissible to act in standard cases of self-defense and defense of others (such as Defense). This is as it should be, for it is intuitively permissible to inflict severe pain or severe harm in Defense and similar cases to prevent the aggressor from causing severe pain or severe harm to innocents, but intuitively impermissible to inflict severe pain or severe harm in cases such as Interrogation and standard torture cases.

In this paper it has been argued that there is no inconsistency in giving different moral opinions on the different cases: Defense and similar cases on the one hand, and Interrogation and similar cases on the other hand. An attempt has been made to identify the relevant difference in these cases: the fact that in Defense and similar cases pain is being inflicted in order to enforce a negative duty, i.e., to prevent the individual from causing severe pain or severe harm to innocents, whereas in Interrogation and similar cases it is not. It has been conceded that it is not true that it is never permissible to inflict severe pain or severe harm with the intention of causing the aggressor to perform an action—some cases of the infliction of pain in self-defense are counter-examples. A suggestion has been made that it was permissible for a police officer to inflict pain to cause a terrorist to choose to perform the action of nursing his foot (thereby preventing him from holding down the detonator button) in Holding. But it was maintained that this was permissible only as a means to the intended end of enforcing a negative duty, i.e., preventing that same person from causing severe pain or severe harm to innocents. It follows that the common practice of torture cannot successfully be justified on grounds of a supposed

similarity to self-defense, for, in the common practice, as opposed to cases of self-defense, pain is not being inflicted in order to enforce a negative duty, but rather to enforce a positive one.

Notes

1. Note that "innocents" here has a technical meaning, intended to exclude material or formal aggressors. It is not intended in a kind of theological sense to exclude all that have ever done wrong. Of course, it is not being suggested that if one of the conditions mentioned (the pain or harm is intended for the individual's benefit, as a punishment, as part of the pursuit of a legitimate war, or to prevent the individual from causing severe pain or harm to innocents) is present that automatically makes the action permissible. Rather, it is being asserted that if none of the conditions mentioned is present that automatically makes the action impermissible.

2. Cf. Davis 2005, p. 174 and Shue 1978, pp. 141–142.

3. Cf. Davis 2005, p. 172.

4. Cf. Kershnar 2005, pp. 228–234.

5. The innocents may or may not include the police officer. Since the police officer is charged by the state with the defense of others, this makes no difference.

6. A Taser is a kind of gun that fires projectiles that administer an electric shock.

7. Note that the political elements of terrorism are not essential to the examples. The examples could be reworked to feature kidnappers instead of terrorists.

8. This point will be defended later.

9. This case is analogous to the case of the fat man's sitting on an innocent discussed in Sussman 2005 (pp. 16–17).

10. This case was suggested by Dr James Heather. Dr Heather intended this example as a *reductio ad absurdum* of the view of this paper, however. The reader may judge for him- or herself whether he was right.

11. Of course, in causing him to pull the button up one is thereby preventing him from performing incompatible actions, but this is not to the point, as these preventions are not part of the plan to stop the terrorist outrage.

12. Cf. Kershnar 2005, pp. 228–234.

13. The terms "basic action" and "non-basic action" are due to Danto 1963. Davidson 1971 identifies these with bodily movements.

14. An anonymous referee proposed the following objection in defense of the view that one can perform actions after one's death: "Now, if Stonewall Jackson, the general, ceased to exist when he died, how is it possible to remember his exploits? Surely, they were done by a being of whom it is still possible to predicate them truthfully or untruthfully (unlike the present King of France)." Against this, surely it is possible to remember the general's exploits and the general himself, and to make true statements about them, because they once existed. Memory is a present mental state whose object is in the past. One cannot remember things that never happened, but one can remember things that no longer obtain. (Indeed, it's even possible to see things that no longer exist, as when one looks up at the night sky and sees a far-off star that has exploded since it sent out its light.) But the fact that one can now remember the general as he was then doesn't imply that the general is *now* doing something. The view here defended is, of course, philosophically controversial: it supposes that the past in some sense exists. The view also supposes that the future in some sense exists: it is possible for *A* to kill *B* today even if *B* doesn't die till tomorrow. It would take too long to defend these views in detail here; suffice it to say that an argument that torture is permissible that rests on the philosophical view that the future or past does not exist looks self-defeating: *ex hypothesi* the terrorist's setting of the ticking bomb is in the past and the bomb's detonation is in the (potential) future.

15. For a detailed definition and discussion of "hard facts" and "soft facts" see Hill 2005, p. 95. The terms seem to have been introduced into the literature by Pike 1966.

16. There have been prosecutions in the past of Roman Catholic priests for not revealing information told to them under the seal of confession. The most famous concerned that early act of terrorism, the Gunpowder Plot see http://www.newadvent.org/cathen/13649b.htm, accessed on 7 June 2006.

17. The distinction seems first to have been brought to prominence in contemporary moral philosophy by Foot 1967. It is criticized in, e.g., Glover 1977 (p. 97).

References

Danto, Arthur. 1963. "What We Can Do," *Journal of Philosophy*, vol. 60, pp. 434–445.

Davidson, Donald. 1971. "Agency," in *Agent, Action, and Reason*, ed. R. Binkley, R. Bronaugh, and A. Marras. Toronto: University of Toronto Press.

Davis, Michael. 2005. "The Moral Justification of Torture and Other Cruel, Inhuman, or Degrading Treatment,"

International Journal of Applied Philosophy, vol. 19, no. 2, pp. 161–178; http://www.pdcnet.org/pdf/ijap 192-Davis.pdf, accessed on 19 June 2007.

Foot, Philippa. 1967. "The Problem of Abortion and the Doctrine of Double Effect," *Oxford Review*, vol. 5, pp. 5–15.

Glover, Jonathan. 1977. *Causing Death and Saving Lives.* London: Penguin.

Hill, Daniel J. 2005. *Divinity and Maximal Greatness.* London: Routledge.

Kershnar, Stephen. 2005. "For Interrogational Torture," *International Journal of Applied Philosophy*, vol. 19, no. 2, pp. 223–241; http://www.pdcnet.org/pdf/ijap192-Kershnar.pdf, accessed on 16 June 2007.

Miller, Seumas. 2006. "Torture," in *The Stanford Encyclopedia of Philosophy* (Spring 2006 Edition), ed. Edward N. Zalta; http://plato.stanford.edu/archives/spr2006/entries/torture/, accessed on 15 July 2006.

Pike, Nelson. 1966. "Of God and Freedom: A Rejoinder," *The Philosophical Review,* vol. 74, pp. 27–46.

Shue, Henry. 1978. "Torture," *Philosophy & Public Affairs,* vol. 7, pp. 124–143.

Sussman, David. 2005. "What's Wrong with Torture?" *Philosophy & Public Affairs,* vol. 33, no. 1, pp. 1–33.

Study Questions

1. Do you agree with Hill that utilitarians could easily imagine circumstances in which the ends would justify the means of torture?

2. Would those who subscribe to Kant's moral theory also be able to imagine circumstances in which torture might be justified?

3. What arguments does Hill offer to differentiate the Defense Case from the Interrogation Case?

4. How does Hill use the distinction between positive and negative duties to reach his conclusion regarding the morality of torture?

56

JUDITH JARVIS THOMSON

Judith Jarvis Thomson, Professor Emerita at the Massachusetts Institute of Technology, considers the moral complexities of a hypothetical case that has become well-known as the "trolley problem." It concerns the morality of turning a trolley from a track where it would run down five workmen onto a spur of track where it would run down only one. Is it permissible to turn the trolley? Is it permissible not to turn the trolley? Thomson, appealing to the concept of rights, concludes that you may, but need not, turn the trolley.

The Trolley Problem

I.

Some years ago Philippa Foot drew attention to an extraordinarily interesting problem.[1] Suppose you are the driver of a trolley. The trolley rounds a bend, and there come into view ahead five track workmen, who have been repairing the track. The track goes through a bit of a valley at that point, and the sides are steep, so you must stop the trolley if you are to avoid running the five men down. You step on the brakes, but alas they don't work. Now you suddenly see a spur of track leading off to the right. You can turn the trolley onto it, and thus save the five men on the straight track ahead. Unfortunately, Mrs. Foot has arranged that there is one track workman on that spur of track. He can no more get off the track in time than the five can, so you will kill him if you turn the trolley onto him. Is it morally permissible for you to turn the trolley?

Everybody to whom I have put this hypothetical case says, Yes, it is.[2] Some people say something stronger than that it is morally *permissible* for you to turn the trolley: They say that morally speaking, you must turn it—that morality requires you to do so. Others do not agree that morality requires you to turn the trolley, and even feel a certain discomfort at the idea of turning it. But everybody says that it is true, at a minimum, that you *may* turn it—that it would not be morally wrong for you to do so.

Now consider a second hypothetical case. This time you are to imagine yourself to be a surgeon, a truly great surgeon. Among other things you do, you transplant organs, and you are such a great surgeon that the organs you transplant always take. At the moment you have five patients who need organs. Two need one lung each, two need a kidney each, and the fifth needs a heart. If they do not get those organs today, they will all die; if you find organs for them today, you can transplant the organs and they will all live. But where to find the lungs, the kidneys, and the heart? The time is almost up when a report is brought to you that a young man who has

From *The Yale Law Journal, 94* (1985) by permission of The Yale Law Journal and Fred. B. Rothman & Company. Minor alterations in some footnotes have been made for the sake of uniformity and accessibility.

just come into your clinic for his yearly check-up has exactly the right blood-type, and is in excellent health. Lo, you have a possible donor. All you need do is cut him up and distribute *his* parts among the five who need them. You ask, but he says, "Sorry. I deeply sympathize, but no." Would it be morally permissible for you to operate anyway? Everybody to whom I have put this second hypothetical case says, No, it would not be morally permissible for you to proceed.

Here then is Mrs. Foot's problem: *Why* is it that the trolley driver may turn his trolley, though the surgeon may not remove the young man's lungs, kidneys, and heart?[3] In both cases, one will die if the agent acts, but five will live who would otherwise die—a net saving of four lives. What difference in the other facts of these cases explains the moral difference between them? I fancy that the theorists of tort and criminal law will find this problem as interesting as the moral theorist does.

II.

Mrs. Foot's own solution to the problem she drew attention to is simple, straightforward, and very attractive. She would say: Look, the surgeon's choice is between operating, in which case he kills one, and not operating, in which case he lets five die; and killing is surely worse than letting die[4]—indeed, so much worse that we can even say

(1) *Killing one is worse than letting five die.*

So the surgeon must refrain from operating. By contrast, the trolley driver's choice is between turning the trolley, in which case he kills one, and not turning the trolley, in which case he does not *let five die,* he positively *kills* them. Now surely we can say

(II) *Killing five is worse than killing one.*

But then that is why the trolley driver may turn his trolley: He would be doing what is worse if he fails to turn it, since if he fails to turn it he kills five.

I do think that that is an attractive account of the matter. It seems to me that if the surgeon fails to operate, he does not kill his five patients who need parts; he merely lets them die. By contrast, if the driver fails to turn his trolley, he does not merely let the five track workmen die; he drives his trolley into them, and thereby kills them.

But there is good reason to think that this problem is not so easily solved as that.

Let us begin by looking at a case that is in some ways like Mrs. Foot's story of the trolley driver. I will call her case *Trolley Driver;* let us now consider a case I will call *Bystander at the Switch.* In that case you have been strolling by the trolley track, and you can see the situation at a glance: The driver saw the five on the track ahead, he stamped on the brakes, the brakes failed, so he fainted. What to do? Well, here is the switch, which you can throw, thereby turning the trolley yourself. Of course you will kill one if you do. But I should think you may turn it all the same.[5]

Some people may feel a difference between these two cases. In the first place, the trolley driver is, after all, captain of the trolley. He is charged by the trolley company with responsibility for the safely of his passengers and anyone else who might be harmed by the trolley he drives. The bystander at the switch, on the other hand, is a private person who just happens to be there.

Second, the driver would be driving a trolley into the five if he does not turn it, and the bystander would not—the bystander will do the five no harm at all if he does not throw the switch.

I think it right to feel these differences between the cases.

Nevertheless, my own feeling is that an ordinary person, a mere bystander, may intervene in such a case. If you see something, a trolley, a boulder, an avalanche, heading towards five, and you can deflect it onto one, it really does seem that—other things being equal—it would be permissible for you to *take* charge, *take* responsibility, and deflect the thing, whoever you may be. Of course you run a moral risk if you do, for it might be that, unbeknownst to you, other things are not equal. It might be, that is, that there is some relevant difference between the five

on the one hand, and the one on the other, which would make it morally preferable that the five be hit by the trolley than that the one be hit by it. That would be so if, for example, the five are not track workmen at all, but Mafia members in workmen's clothing, and they have tied the one workman to the right-hand track in the hope that you would turn the trolley onto him. I won't canvass all the many kinds of possibilities, for in fact the moral risk is the same whether you are the trolley driver, or a bystander at the switch.

Moreover, second, we might well wish to ask ourselves what exactly is the difference between what the driver would be doing if he failed to turn the trolley and what the bystander would be doing if he failed to throw the switch. As I said, the driver would be driving a trolley into the five; but what exactly would his driving the trolley into the five consist in? Why, just sitting there, doing nothing! If the driver does just sit there, doing nothing, then that will have been how come he drove his trolley into the five.

I do not mean to make much of that fact about what the driver's driving his trolley into the five would consist in, for it seems to me to be right to say that if he does not turn the trolley, he does drive his trolley into them, and does thereby kill them. (Though this does seem to me to be right, it is not easy to say exactly what makes it so.) By contrast, if the bystander does not throw the switch, he drives no trolley into anybody, and he kills nobody.

But as I said, my own feeling is that the bystander *may* intervene. Perhaps it will seem to some even less clear that morality requires him to turn the trolley than that morality requires the driver to turn the trolley; perhaps some will feel even more discomfort at the idea of the bystander's turning the trolley than at the idea of the driver's turning the trolley. All the same, I shall take it that he *may*.

If he may, there is serious trouble for Mrs. Foot's thesis (I). It is plain that if the bystander throws the switch, he causes the trolley to hit the one, and thus he kills the one. It is equally plain that if the bystander does not throw the switch, he does not cause the trolley to hit the five, he does not kill the five, he merely fails to save them—he lets them die.

His choice therefore is between throwing the switch, in which case he kills one, and not throwing the switch, in which case he lets five die. If thesis (I) were true, it would follow that the bystander may not throw the switch, and that I am taking to be false.

III.

I have been arguing that

(I) Killing one is worse than letting five die

is false, and a fortiori that it cannot be appealed to to explain why the surgeon may not operate in the case I shall call *Transplant*.

I think it pays to take note of something interesting which comes out when we pay close attention to

(II) Killing five is worse than killing one.

For let us ask ourselves how we would feel about *Transplant* if we made a certain addition to it. In telling you that story, I did not tell you why the surgeon's patients are in need of parts. Let us imagine that the history of their ailments is as follows. The surgeon was badly overworked last fall—some of his assistants in the clinic were out sick, and the surgeon had to take over their duties dispensing drugs. While feeling particularly tired one day, he became careless, and made the terrible mistake of dispensing chemical X to five of the day's patients. Now chemical X works differently in different people. In some it causes lung failure, in others kidney failure, in others heart failure. So these five patients who now need parts need them because of the surgeon's carelessness. Indeed, if he does not get them the parts they need, so that they die, he will have killed them. Does that make a moral difference? That is, does the fact that he will have killed the five if he does nothing make it permissible for him to cut the young man up and distribute his parts to the five who need them?

We could imagine it to have been worse. Suppose what had happened was this: The surgeon was badly

overextended last fall, he had known he was named a beneficiary in his five patients' wills, and it swept over him one day to give them chemical X to kill them. Now he repents, and would save them if he could. If he does not save them, he will positively have murdered them. Does *that* fact make it permissible for him to cut the young man up and distribute his parts to the five who need them?

I should think plainly not. The surgeon must not operate on the young man. If he can find no other way of saving his five patients, he will *now* have to let them die—despite the fact that if he now lets them die, he will have killed them.

We tend to forget that some killings themselves include lettings die, and do include them where the act by which the agent kills takes time to cause death—time in which the agent can intervene but does not.

In face of these possibilities, the question arises what we should think of thesis (II), since it *looks* as if it tells us that the surgeon ought to operate, and thus that he may permissibly do so, since if he operates he kills only one instead of five.

There are two ways in which we can go here. First, we can say: (II) does tell us that the surgeon ought to operate, and that shows it is false. Second, we can say: (II) does not tell us that the surgeon ought to operate, and it is true.

For my own part, I prefer the second. If Alfred kills five and Bert kills only one, then questions of motive apart, and other things being equal, what Alfred did *is* worse than what Bert did. If the surgeon does not operate, so that he kills five, then it will later be true that he did something worse than he would have done if he had operated, killing only one—especially if his killing of the five was murder, committed out of a desire for money, and his killing of the one would have been, though misguided and wrongful, nevertheless a well-intentioned effort to save five lives. Taking this line would, of course, require saying that assessments of which acts are worse than which other acts do not by themselves settle the question what it is permissible for an agent to do.

But it might be said that we ought to by-pass (II), for perhaps what Mrs. Foot would have offered us as an explanation of why the driver may turn the trolley in *Trolley Driver* is not (II) itself, but something more complex, such as

(II') If a person is faced with a choice between doing something here and now *to five, by the doing of which he will kill them, and doing something else* here and now *to one, by the doing of which he will kill only the one, then (other things being equal) he ought to choose the second alternative rather than the first.*

We may presumably take (II') to tell us that the driver ought to, and hence permissibly may, turn the trolley in *Trolley Driver,* for we may presumably view the driver as confronted with a choice between here and now driving his trolley into five, and here and now driving his trolley into one. And at the same time, (II') tells us nothing at all about what the surgeon ought to do in *Transplant,* for he is not confronted with such a choice. If the surgeon operates, he does do something by the doing of which he will kill only one; but if the surgeon does not operate, he does not do something by the doing of which he kills five; he merely fails to do something by the doing of which he would make it be the case that he has not killed five.

I have no objection to this shift in attention from (II) to (II'). But we should not overlook an interesting question that lurks here. As it might be put: *Why* should the present tense matter so much? Why should a person prefer killing one to killing five if the alternatives are wholly in front of him, but not (or anyway, not in every case) where one of them is partly behind him? I shall come back to this question briefly later.

Meanwhile, however, even if (II') can be appealed to in order to explain why the trolley driver may turn his trolley, that would leave it entirely open why the bystander at the switch may turn *his* trolley. For he does not drive a trolley into each of five if he refrains from turning the trolley; he merely lets the trolley drive into each of them.

So I suggest we set *Trolley Driver* aside for the time being. What I shall be concerned with is a first cousin of Mrs. Foot's problem, viz.: Why is it that the bystander may turn his trolley, though the surgeon

may not remove the young man's lungs, kidneys, and heart? Since *I* find it particularly puzzling that the bystander may turn his trolley, I am inclined to call this The Trolley Problem. Those who find it particularly puzzling that the surgeon may not operate are cordially invited to call it The Transplant Problem instead.

IV.

It should be clear, I think, that "kill" and "let die" are too blunt to be useful tools for the solving of this problem. We ought to be looking within killings and savings for the ways in which the agents would be carrying them out.

It would be no surprise. I think, if a Kantian idea occurred to us at this point, Kant said: "Act so that you treat humanity, whether in your own person or in that of another, always as an end and never as a means only." It is striking, after all, that the surgeon who proceeds in *Transplant* treats the young man he cuts up "as a means only": He literally uses the young man's body to save his five, and does so without the young man's consent. And perhaps we may say that the agent in *Bystander at the Switch* does not use his victim to save his five, or (more generally) treat his victim as a means only, and that that is why he (unlike the surgeon) may proceed.

But what exactly is it to treat a person as a means only, or to use a person? And why exactly is it wrong to do this? These questions do not have obvious answers.[6]

Suppose an agent is confronted with a choice between doing nothing, in which case five die, or engaging in a certain course of action, in which case the five live, but one dies. Then perhaps we can say: If the agent chooses to engage in the course of action, then he uses the one to save the five only if, had the one gone out of existence just before the agent started, the agent would have been unable to save the five. That is true of the surgeon in *Transplant*. He needs the young man if he is to save his five; if the young man goes wholly out of existence just before the surgeon starts to operate, then the surgeon cannot

save his five. By contrast, the agent in *Bystander at the Switch* does not need the one track workman on the right-hand track if he is to save his five; if the one track workman goes wholly out of existence before the bystander starts to turn the trolley, then the bystander *can* all the same save his five. So here, anyway is a striking difference between the cases.

It does seem to me right to think that solving this problem requires attending to the means by which the agent would be saving his five if he proceeded. But I am inclined to think that this is an overly simple way of taking account of the agent's means.

One reason for thinking so[7] comes out as follows. You have been thinking of the tracks in *Bystander at the Switch* as not merely diverging, but continuing to diverge, as in the following picture:

Consider now what I shall call "the loop variant" on this case, in which the tracks do not continue lo diverge—they circle back, as in the following picture:

Let us now imagine that the five on the straight track are thin, but thick enough so that although all five will be killed if the trolley goes straight, the bodies of the five will stop it, and it will therefore not reach the one. On the other hand, the one on the right-hand track is fat, so fat that his body will by itself stop the trolley, and the trolley will therefore not reach

the five. May the agent turn the trolley? Some people feel more discomfort at the idea of turning the trolley in the loop variant than in the original *Bystander at the Switch*. But we cannot really suppose that the presence or absence of that extra bit of track makes a major moral difference as to what an agent may do in these cases, and it really does seem right to think (despite the discomfort) that the agent may proceed.

On the other hand, we should notice that the agent here needs the one (fat) track workman on the right-hand track if he is to save his five. If the one goes wholly out of existence just before the agent starts to turn the trolley, then the agent cannot save his five[8]— just as the surgeon in *Transplant* cannot save his five if the young man goes wholly out of existence just before the surgeon starts to operate.

Indeed, I should think that there is no plausible account of what is involved in, or what is necessary for, the application of the notions "treating a person as a means only," or "using one to save five," under which the surgeon would be doing this whereas the agent in this variant of *Bystander at the Switch* would not be. If that is right, then appeals to these notions cannot do the work being required of them here.

V.

Suppose the bystander at the switch proceeds: He throws the switch, thereby turning the trolley onto the right-hand track, thereby causing the one to be hit by the trolley, thereby killing him—but saving the five on the straight track. There are two facts about what he does which seem to me to explain the moral difference between what he does and what the agent in *Transplant* would be doing if *he* proceeded. In the first place, the bystander saves his five by making something that threatens them instead threaten one. Second, the bystander does not do that by means which themselves constitute an infringement of any right of the one's.

As is plain, then, my hypothesis as to the source of the moral difference between the cases makes appeal to the concept of a right. My own feeling is that solving this problem requires making appeal to that concept—or to some other concept that does the

same kind of work.[9] Indeed, I think it is one of the many reasons why this problem is of such interest to moral theory that it does force us to appeal to that concept; and by the same token, that we learn something from it about that concept.

Let us begin with an idea, held by many friends of rights, which Ronald Dworkin expressed crisply in a metaphor from bridge: Rights "trump" utilities.[10] That is, if one would infringe a right in or by acting, then it is not sufficient justification for acting that one would thereby maximize utility. It seems to me that something like this must be correct.

Consideration of this idea suggests the possibility of a very simple solution to the problem. That is, it might be said (i) The reason why the surgeon may not proceed in *Transplant* is that if he proceeds, he maximizes utility, for he brings about a net saving of four lives, but in so doing he would infringe a right of the young man's.

Which right? Well, we might say: The right the young man has against the surgeon that the surgeon not kill him—thus a right in the cluster of rights that the young man has in having a right to life.

Solving this problem requires being able to explain also why the bystander may proceed in *Bystander at the Switch*. So it might be said (ii) The reason why the bystander may proceed is that if he proceeds, he maximizes utility, for he brings about a net saving of four lives, and in so doing he does *not* infringe any right of the one track workman's.

But I see no way—certainly there is no easy way—of establishing that these ideas are true.

Is it clear that the bystander would infringe no right of the one track workman's if he turned the trolley? Suppose there weren't anybody on the straight track, and the bystander turned the trolley onto the right-hand track, thereby killing the one, but not saving anybody, since nobody was at risk, and thus nobody needed saving. Wouldn't that infringe a right of the one workman's, a right in the cluster of rights that he has in having a right to life?

So should we suppose that the fact that there are five track workmen on the straight track who are in need of saving makes the one lack that right—which he would have had if that had not been a fact?

But then why doesn't the fact that the surgeon has five patients who are in need of saving make the young man also lack that right?

I think some people would say there is good (excellent, conclusive) reason for thinking that the one track workman lacks the right (given there are five on the straight track) lying in the fact that (given there are five on the straight track) it is morally permissible to turn the trolley onto him. But if your reason for thinking the one lacks the right is that it is permissible to turn the trolley onto him, then you can hardly go on to explain its being permissible to turn the trolley onto him by appeal to the fact that he lacks the right. It pays to stress this point: If you want to say, as (ii) does, that the bystander may proceed because he maximizes utility and infringes no right, then you need an independent account of what makes it be the case that he infringes no right—independent, that is, of its being the case that he may proceed.

There is *some* room for maneuver here. Any plausible theory of rights must make room for the possibility of waiving a right, and within that category, for the possibility of failing to have a right by virtue of assumption of risk; and it might be argued that that is what is involved here, i.e., that track workmen know of the risks of the job, and consent to run them when signing on for it.

But that is not really an attractive way of dealing with this difficulty. Track workmen certainly do not explicitly consent to being run down with trolleys when doing so will save five who are on some other track—certainly they are not asked to consent to this at the time of signing on for the job. And I doubt that they consciously assume the risk of it at that or any other time. And in any case, what if the six people involved had not been track workmen? What if they had been young children? What if they had been people who had been shoved out of helicopters? Wouldn't it all the same be permissible to turn the trolley?

So it is not clear what (independent) reason could be given for thinking that the bystander will infringe no right of the one's if he throws the switch.

I think, moreover, that there is *some* reason to think that the bystander will infringe a right of the one if he

throws the switch, even though it is permissible for him to do so. What I have in mind issues simply from the fact that if the bystander throws the switch, then he does what will kill the one. Suppose the bystander proceeds, and that the one is now dead. The bystander's motives were, of course, excellent—he acted with a view to saving five. But the one did not volunteer his life so that the five might live; the bystander volunteered it for him. The bystander made him pay with his life for the bystander's saving of the five. This consideration seems to me to lend some weight to the idea that the bystander did do him a wrong—a wrong it was morally permissible to do him, since five were saved, but a wrong *to him* all the same.

Consider again that lingering feeling of discomfort (which, as I said, some people do feel) about what the bystander does if he turns the trolley. No doubt it is permissible to turn the trolley, but still . . . but still. . . . People who feel this discomfort also think that, although it is permissible to turn the trolley, it is not morally required to do so. My own view is that they are right to feel and think these things. We would be able to explain why this is so if we supposed that if the bystander turns the trolley, then he does do the one track workman a wrong—if we supposed, in particular, that he infringes a right of the one track workman's which is in that cluster of rights which the workman has in having a right to life.[11]

I do not for a moment take myself to have established that (ii) is false. I have wished only to draw attention to the difficulty that lies ahead of a person who thinks (ii) true, and also to suggest that there is some reason to think that the bystander would infringe a right of the one's if he proceeded, and thus some reason to think that (ii) is false. It can easily be seen that if there is some reason to think the bystander would infringe a right of the one's, then there is also some reason to think that (i) is false—since if the bystander does infringe a right of the one's if he proceeds, and may nevertheless proceed, then it cannot be the fact that the surgeon infringes a right of the young man's if *he* proceeds which makes it impermissible for *him* to do so.

Perhaps a friend of (i) and (ii) can establish that they are true. I propose that, just in case he can't, we

do well to see if there isn't some other way of solving this problem than by appeal to them. In particular, I propose we grant that both the bystander and the surgeon would infringe a right of their ones, a right in the cluster of rights that the ones' have in having a right to life, and that we look for some *other* difference between the cases which could be appealed to to explain the moral difference between them.

Notice that accepting this proposal does not commit us to rejecting the idea expressed in that crisp metaphor of Dworkin's. We can still say that rights trump utilities—if we can find a further feature of what the bystander does if he turns the trolley (beyond the fact that he maximizes utility) which itself trumps the right, and thus makes it permissible to proceed.

VI.

As I said, my own feeling is that the trolley problem can be solved only by appeal to the concept of a right—but not by appeal to it in as simple a way as that discussed in the preceding section. What we were attending to in the preceding section was only the fact that the agents would be killing and saving if they proceeded; what we should be attending to is the means by which they would kill and save.[12] (It is very tempting, because so much simpler, to regard a human act as a solid nugget, without internal structure, and to try to trace its moral value to the shape of its surface, as it were. The trolley problem seems to me to bring home that that will not do.)

I said earlier that there seem to me to be two crucial facts about what the bystander does if he proceeds in *Bystander at the Switch.* In the first place, he saves his five by making something that threatens them instead threaten the one. And second, he does not do that by means which themselves constitute infringements of any right of the one's.

Let us begin with the first.

If the surgeon proceeds in *Transplant,* he plainly does not save his five by making something that threatens them instead threaten one. It is organ failure that threatens his five, and it is not *that* which he makes threaten the young man if he proceeds.

Consider another of Mrs. Foot's cases, which I shall call *Hospital.*

Suppose [Mrs. Foot says] that there are five patients in a hospital whose lives could be saved by the manufacture of a certain gas, but that this will inevitably release lethal fumes into the room of another patient whom for some reason we are unable to move.[13]

Surely it would not be permissible for us to manufacture the gas.

In *Transplant* and *Hospital,* the five at risk are at risk from their ailments, and this might be thought to make a difference. Let us by-pass it. In a variant on *Hospital*—which I shall call *Hospital'*—all six patients are convalescing. The five at risk are at risk, not from their ailments, but from the ceiling of their room, which is about to fall on them. We can prevent this by pumping on a ceiling-support-mechanism: but doing so will inevitably release lethal fumes into the room of the sixth. Here too it is plain we may not proceed.

Contrast a case in which lethal fumes are being released by the heating system in the basement of a building next door to the hospital. They are headed towards the room of five. We can deflect them towards the room of one. Would that be permissible? I should think it would be—the case seems to be in all relevant respects like *Bystander at the Switch.*

In *Bystander at the Switch,* something threatens five, and if the agent proceeds, he saves the five by making that very thing threaten the one instead of the five. That is not true of the agents in *Hospital'* or *Hospital* or *Transplant.* In *Hospital',* for example, what threatens the five is the ceiling, and the agent does not save them by making *it* threaten the one, he saves them by doing what will make something wholly different (some lethal fumes) threaten the one.

Why is this difference morally important? Other things being equal, to kill a man is to infringe his right to life, and we are therefore morally barred from killing. It is not enough to justify killing a person that if we do so, five others will be saved: To say that if we do so, five others will be saved is merely to say that utility will be maximized if we proceed, and

that is not by itself sufficient to justify proceeding. Rights trump utilities. So if that is all that can be said in defense of killing a person, then killing that person is not permissible.

But that five others will be saved is not all that can be said in defense of killing in *Bystander at the Switch*. The bystander who proceeds does not merely minimize the number of deaths which get caused: He minimizes the number of deaths which get caused by something that already threatens people, and that will cause deaths whatever the bystander does.

The bystander who proceeds does not make something be a threat to people which would otherwise not be a threat to anyone; he makes be a threat to fewer what is already a threat to more. We might speak here of a "distributive exemption," which permits arranging that something that will do harm anyway shall be better distributed than it otherwise would be—shall (in *Bystander at the Switch*) do harm to fewer rather than more. Not just any distributive intervention is permissible: It is not in general morally open to us to make one die to save five. But other things being equal, it is not morally required of us that we let a burden descend out of the blue onto five when we can make it instead descend onto one.

I do not find it clear why there should be an exemption for, and only for, making a burden which is descending onto five descend, instead, onto one. That there is seems to me very plausible, however. On the one hand, the agent who acts under this exemption makes be a threat to one something that is *already* a threat to more, and thus something that will do harm *whatever* he does; on the other hand, the exemption seems to allow those acts which intuition tells us are clearly permissible, and to rule out those acts which intuition tells us are clearly impermissible.

VII.

More precisely, it is not morally required of us that we let a burden descend out of the blue onto five when we can make it instead descend onto one *if* we can make it descend onto the one by means which do not themselves constitute infringements of rights of the one.

Consider a case—which I shall call *Fat Man*—in which you are standing on a footbridge over the trolley track. You can see a trolley hurtling down the track, out of control. You turn around to see where the trolley is headed, and there are five workmen on the track where it exits from under the footbridge. What to do? Being an expert on trolleys, you know of one certain way to stop an out-of-control trolley: Drop a really heavy weight in its path. But where to find one? It just so happens that standing next to you on the footbridge is a fat man, a really fat man. He is leaning over the railing, watching the trolley; all you have to do is to give him a little shove, and over the railing he will go, onto the track in the path of the trolley. Would it be permissible for you to do this? Everybody to whom I have put this case says it would not be. But why?

Suppose the agent proceeds. He shoves the fat man, thereby toppling him off the footbridge into the path of the trolley, thereby causing him to be hit by the trolley, thereby killing him—but saving the five on the straight track. Then it is true of this agent, as it is true of the agent in *Bystander at the Switch,* that he saves his five by making something which threatens them instead threaten one.

But *this* agent does so by means which themselves constitute an infringement of a right of the one's. For shoving a person is infringing a right of his. So also is toppling a person off a footbridge.

I should stress that doing these things is infringing a person's rights even if doing them does not cause his death—even if doing them causes him no harm at all. As I shall put it, shoving a person, toppling a person off a footbridge, are *themselves* infringements of rights of his. A theory of rights ought to give an account of what makes it be the case that doing either of these things is itself an infringement of a right of his. But I think we may take it to be a datum that it is, the job which confronts the theorist of rights being, not to establish that it is, but rather to explain why it is.

Consider by contrast the agent in *Bystander at the Switch*. He too, if he proceeds, saves five by making something that threatens them instead threaten one. But the means he takes to make that be the case are these: Turn the trolley onto the right-hand track. And

turning the trolley onto the right-hand track is not *itself* an infringement of a right of anybody's. The agent would do the one no wrong at all if he turned the trolley onto the right-hand track, and by some miracle the trolley did not hit him.

We might of course have imagined it not necessary to shove the fat man. We might have imagined that all you need do to get the trolley to threaten him instead of the five is to wobble the handrail, for the handrail is low, and he is leaning on it, and wobbling it will cause him to fall over and off. Wobbling the handrail would be impermissible, I should think—no less so than shoving. But then there is room for an objection to the idea that the contrast I point to will help explain the moral differences among these cases. For it might be said that if you wobble the handrail, thereby getting the trolley to threaten the one instead of the five, then the means you take to get this to be the case are just these: Wobble the handrail. But doing that is not *itself* an infringement of a right of anybody's. You would do the fat man no wrong at all if you wobbled the handrail and no harm came to him in consequence of your doing so. In this respect, then, your situation seems to be exactly like that of the agent in *Bystander at the Switch*. Just as the means he would be taking to make the trolley threaten one instead of five would not constitute an infringement of a right, so also would the means you would be taking to make the trolley threaten one instead of five not constitute an infringement of a right.

What I had in mind, however, is a rather tighter notion of "means" than shows itself in this objection. By hypothesis, wobbling the handrail will cause the fat man to topple onto the track in the path of the trolley, and thus will cause the trolley to threaten him instead of the five. But the trolley will not threaten him instead of the five unless wobbling the handrail does cause him to topple. Getting the trolley to threaten the fat man instead of the five *requires* getting him into its path. You get the trolley to threaten him instead of them by wobbling the handrail only if, and only because, by wobbling the handrail you topple him into the path of the trolley.

What I had in mind, then, is a notion of "means" which comes out as follows. Suppose you get a trolley

to threaten one instead of five by wobbling a handrail. The means you take to get the trolley to threaten the one instead of the five include wobbling the handrail, *and* all those further things that you have to succeed in doing by wobbling the handrail if the trolley is to threaten the one instead of the five.

So the means by which the agent in *Fat Man* gets the trolley to threaten one instead of five include toppling the fat man off the footbridge; and doing that is itself an infringement of a right of the fat man's. By contrast, the means by which the agent in *Bystander at the Switch* gets the trolley to threaten one instead of five include no more than getting the trolley off the straight track onto the right-hand track; and doing that is not itself an infringement of a right of anybody's.

VIII.

It is arguable, however, that what is relevant is not that toppling the fat man off the footbridge is itself an infringement of *a* right of the fat man's but rather that toppling him off the footbridge is itself an infringement of a particularly stringent right of his.

What I have in mind comes out in yet another variant on *Bystander at the Switch*. Here the bystander must cross (without permission) a patch of land that belongs to the one in order to get to the switch; thus in order to get the trolley to threaten the one instead of five, the bystander must infringe a right of the one's. May he proceed?

Or again, in order to get the switch thrown, the bystander must use a sharply pointed tool, and the only available sharply pointed tool is a nailfile that belongs to the one; here too the bystander must infringe a right of the one's in order to get the trolley to threaten the one instead of five. May he proceed?

For my own part, I do not find it obvious that he may. (Remember what the bystander will be doing to the one by throwing that switch.) But others tell me they think it clear the bystander may proceed in such a case. If they are right—and I guess we should agree that they are—then that must surely be because the rights which the bystander would have to

infringe here are minor, trivial, non-stringent—property rights of no great importance. By contrast, the right to not be toppled off a footbridge onto a trolley track is on any view a stringent right. We shall therefore have to recognize that what is at work in these cases is a matter of degree: If the agent must infringe a stringent right of the one's in order to get something that threatens five to threaten the one (as in *Fat Man*), then he may not proceed, whereas if the agent need infringe no right of the one's (as in *Bystander at the Switch*), or only a more or less trivial right of the one's (as in these variants on *Bystander at the Switch*), in order to get something that threatens five to threaten the one, then he may proceed.

Where what is at work is a matter of degree, it should be no surprise that there are borderline cases, on which people disagree. I confess to having been greatly surprised, however, at the fact of disagreement on the following variant on *Bystander at the Switch:*

> The five on the straight track are regular track workmen. The right-hand track is a dead end, unused in ten years. The Mayor, representing the City, has set out picnic tables on it, and invited the convalescents at the nearby City Hospital to have their meals there, guaranteeing them that no trolleys will ever, for any reason, be turned onto that track. The one on the right-hand track is a convalescent having his lunch there; it would never have occurred to him to do so if the Mayor had not issued his invitation and guarantee. The Mayor was out for a walk; he now stands by the switch.[14]

For the Mayor to get the trolley to threaten the one instead of the five, he must turn the trolley onto the right-hand track; but the one has a right against the Mayor that he not turn the trolley onto the right-hand track—a right generated by an official promise, which was then relied on by the one. (Contrast the original *Bystander at the Switch,* in which the one had no such right.) My own feeling is that it is plain the Mayor may not proceed. To my great surprise, I find that some people think he may. I conclude they think the right less stringent than I do.

In any case, that distributive exemption that I spoke of earlier is very conservative. It permits intervention into the world to get an object that already threatens death to those many to instead threaten death to these few, but only by acts that are not themselves gross impingements on the few. That is, the intervenor must not use means that infringe stringent rights of the few in order to get his distributive intention carried out.

It could of course be argued that the fact that the bystander of the original *Bystander at the Switch* makes threaten the one what already threatens the five, and does so by means that do not themselves constitute infringements of any right of the one's (not even a trivial right of the one's), shows that the bystander in that case infringes no right of the one's at all. That is, it could be argued that we have here that independent ground for saying that the bystander does not infringe the one's right to life which I said would be needed by a friend of (ii).[15] But I see nothing to be gained by taking this line, for I see nothing to be gained by supposing it never permissible to infringe a right; and something is lost by taking this line, namely the possibility of viewing the bystander as doing the one a wrong if he proceeds—albeit a wrong it is permissible to do him.

IX.

What counts as *"an* object which threatens death"? What marks one threat off from another? I have no doubt that ingenious people can construct cases in which we shall be unclear whether to say that if the agent proceeds, he makes threaten the one the very same thing as already threatens the five.

Moreover, which are the interventions in which the agent gets a thing that threatens five to instead threaten one by means that themselves constitute infringements of stringent rights of the one's? I have no doubt that ingenious people can construct cases in which we shall all be unclear whether to say that the agent's means do constitute infringements of stringent rights—and cases also in which we shall be unclear whether to say the agent's means constitute infringements of any rights at all.

But it is surely a mistake to look for precision in the concepts brought to bear to solve this problem: There isn't any to be had. It would be enough if cases

in which it seems to us unclear whether to say "same threat," or unclear whether to say "non-right-infring-ing-means," also seemed to us to be cases in which it is unclear whether the agent may or may not pro-ceed; and if also coming to see a case as one to which these expressions do (or do not) apply involves com-ing to see the case as one in which the agent may (or may not) proceed.

X.

If these ideas are correct, then we have a handle on anyway some of the troublesome cases in which people make threats. Suppose a villain says to us "I will cause a ceiling to fall on five unless you send lethal fumes into the room of one." Most of us think it would not be permissible for us to accede to this threat. Why? We may think of the villain as part of the world around the people involved, a part which is going to drop a burden on the five if we do not act. On this way of thinking of him, nothing *yet* threatens the five (certainly no ceiling as yet threatens them) and a fortiori we cannot save the five by making what (already) threatens them instead threaten the one. Alternatively, we may think of the villain as himself a threat to the five. But sending the fumes in is not making *him* be a threat to the one instead of to the five. The hypothesis I proposed, then, yields what it should: We may not accede.

That is because the hypothesis I proposed says nothing at all about the source of the threat to the five. Whether the threat to the five is, or is caused by, a human being or anything else, it is not per-missible to do what will kill one to save the five except by making what threatens the five itself threaten the one.

By contrast, it seems to me very plausible to think that if a villain has started a trolley towards five, we may deflect the trolley towards one—other things being equal, of course. If a trolley is headed towards five, and we can deflect it towards one, we *may,* no matter who or what caused it to head towards the five.

I think that these considerations help us in dealing with a question I drew attention to earlier. Suppose a

villain says to us "I will cause a ceiling to fall on five unless you send lethal fumes into the room of one." If we refuse, so that he does what he threatens to do, then he surely does something very much worse than we would be doing if we acceded to his threat and sent the fumes in. If we accede, we do something misguided and wrongful, but not nearly as bad as what he does if we refuse.

It should be stressed: The fact that he will do something worse if we do not send the fumes in does not entail that we ought to send them in, or even that it is permissible for us to do so.

How after all could that entail that we may send the fumes in? The fact that we would be saving five lives by sending the fumes in does not itself make it permissible for us to do so. (Rights trump utilities.) How could adding that the taker of those five lives would be doing what is worse than we would tip the balance? If we may not infringe a right of the one in order to save the five lives, it cannot possibly be thought that we may infringe the right of that one in order, not merely to save the five lives, but to make the villain's moral record better than it otherwise would be.

For my own part, I think that considerations of motives apart, and other things being equal, it does no harm to say that

(II) Killing five is worse than killing one

is, after all, true. *Of course* we shall then have to say that assessments of which acts are worse than which do not by themselves settle the question of what is permissible for a person to do. For we shall have to say that, despite the truth of (II), it is not the case that we are required to kill one in order that another person shall not kill five, or even that it is everywhere permissible for us to do this.

What is of interest is that what holds inter-per-sonally also holds intra-personally. I said earlier that we might imagine the surgeon of *Transplant* to have caused the ailments of his five patients. Let us imag-ine the worst: He gave them chemical X precisely in order to cause their deaths, in order to inherit from them. Now he repents. But the fact that he would

be saving five lives by operating on the one does not itself make it permissible for him to operate on the one. (Rights trump utilities.) And if he may not infringe a right of the one in order to save the five lives, it cannot possibly be thought that he may infringe the right of that one in order, not merely to save the five lives, but to make his own moral record better than it otherwise would be.

Another way to put the point is this: Assessments of which acts are worse than which have to be directly relevant to the agent's circumstances if they are to have a bearing on what he may do. If A threatens to kill five unless B kills one, then although killing five is worse than killing one, these are not the alternatives open to B. The alternatives open to B are: Kill one, thereby forestalling the deaths of five (and making A's moral record better than it otherwise would be), or let it be the case that A kills five. And the supposition that it would be worse for B to choose to kill the one is entirely compatible with the supposition that killing five is worse than killing one. Again, the alternatives open to the surgeon are: Operate on the one, thereby saving five (and making the surgeon's own moral record better than it otherwise would be), or let it be the case that he himself will have killed the five. And the supposition that it would be worse for the surgeon to choose to operate is entirely compatible with the supposition that killing five is worse than killing one.

On the other hand, suppose a second surgeon is faced with a choice between here and now giving chemical X to five, thereby killing them, and operating on, and thereby killing, only one. (It taxes the imagination to invent such a second surgeon, but let that pass. And compare *Trolley Driver.*) Then, other things being equal, it does seem he may choose to operate on the one. Some people would say something stronger, namely that he is required to make this choice. Perhaps they would say that

(II′) If a person is faced with a choice between doing something here and now *to five, by the doing of which he will kill them, and doing something else* here and now *to one, by the doing of which he will kill only the one, then (other things being equal) he*

ought to choose the second alternative rather than the first

is a quite general moral truth. Whether or not the second surgeon is morally required to make this choice (and thus whether or not (II′) is a general moral truth), it does seem to be the case that he may. But this did seem puzzling. As I put it: Why should the present tense matter so much?

It is plausible to think that the present tense matters because the question for the agent at the time of acting is about the present, viz., "What may I here and now do?," and because that question is the same as the question "Which of the alternatives here and now open to me may I choose?" The alternatives now open to the second surgeon are: kill five or kill one. If killing five is worse than killing one, then perhaps he ought to, but at any rate he may, kill the one.

Notes

1. See Philippa Foot, "The Problem of Abortion and the Doctrine of the Double Effect," in *Virtues and Vices, and Other Essays in Moral Philosophy* (Berkeley and Los Angeles: University of California Press,1978), p. 19.

2. I think it possible (though by no means certain) that John Taurek would say, "No, it is not permissible to (all simply) turn the trolley; what you ought to do is flip a coin." See John Taurek, "Should the Numbers Count?" *Philosophy & Public Affairs, 6* (1977), p. 293. (But he is there concerned with a different kind of case, namely that in which what is in question is not whether we may do what harms one to avoid harming five, but whether we may or ought to choose to save five in preference to saving one.) For criticism of Taurek's article, see Derek Parfit, "Innumerate Ethics." *Philosophy & Public Affairs 7* (1978), p. 285.

3. I doubt that anyone would say, with any hope of getting agreement from others, that the surgeon ought to flip a coin. So even if you think that the trolley driver ought to flip a coin, there would remain, for you, an analogue of Mrs. Foot's problem, namely: Why ought the trolley driver flip a coin, whereas the surgeon may not?

4. Mrs. Foot speaks more generally of causing injury and failing to provide aid, and her reason for thinking that the former is worse than the latter is that the negative duty

to refrain from causing injury is stricter than the positive duty to provide aid. See Philippa Foot, *supra* note 1, pp. 27–29.

5. A similar case (intended to make a point similar to the one that I shall be making) is discussed in N. Ann Davis, "The Priority of Avoiding Harm," in Bonnie Steinbock, ed., *Killing and Letting Die* (Englewood Cliffs. NJ: Prentice Hall, 1980). pp. 172, 194–195.

6. For a sensitive discussion of some of the difficulties, see N. Ann Davis, "Using Persons and Common Sense," *Ethics 94* (1984), p. 94. Among other things she argues (I think rightly) that the Kantian idea is not to be identified with the common-sense concept of "using a person." Id., p. 402.

7. For a second reason to think so, see *infra* note 13.

8. It is also true that if the five go wholly out of existence just before the agent starts to turn the trolley, then the one will die whatever the agent does. Should we say, then, that the agent uses one to save five if he acts, *and* uses five to save one, if he does not act? No: What follows *"and"* is false. If the agent does not act, he uses nobody. (I doubt that it can even be said that if he does not act, he lets them *be used.* For what is the active for which this is passive? Who or what would be using them if he does not act?)

9. I strongly suspect that giving an account of what makes it wrong to *use* a person, see supra text accompanying notes 6–8, would also require appeal to the concept of a right.

10. Ronald Dworkin. *Taking Rights Seriously* (Cambridge: Harvard University Press, 1977), p. ix.

11. Many of the examples discussed by Bernard Williams and Ruth Marcus plainly call for this kind of treatment. See Bernard Williams. "Ethical Consistency,"

in *Problems of the Self* (Cambridge: Cambridge University Press. 1973), p. 166; Ruth Barcan Marcus. "Moral Dilemmas and Consistency," in *The Journal of Philosophy 77* (1980), p. 121.

12. It may he worth stressing that what I suggest calls for attention is not (as some construals of "double effect" would have it) whether the agent's killing of the one is his means to something, and not (as other construals of "double effect" would have it) whether the death of the one is the agent's means to something, but rather what are the means by which the agent both kills and saves. For a discussion of "the doctrine of double effect," see Philippa Foot, supra note 1.

13. Id., p. 29. As Mrs. Foot says, we do not *use* the one if we proceed in *Hospital.* Yet the impermissibility of proceeding in *Hospital* seems to have a common source with the impermissibility of operating in *Transplant,* in which the surgeon *would* be using the one whose parts he takes for the five who need them. This is my second reason for thinking that an appeal to the fact that the surgeon would be using his victim is an over-simple way of taking account of the means he would be employing for the saving of his five. Sec supra note 7.

14. Notice that in this case too the agent does not use the one if he proceeds. (This case, along with a number of other cases I have been discussing, comes from Judith Jarvis Thomson, "Killing, Letting Die, and the Trolley Problem," *Monist 59* (1976), pp. 204–217. Mrs. Thomson seems to me to have been blundering around in the dark in that paper, but the student of this problem may possibly find some of the cases she discusses useful.)

15. See supra text accompanying notes 9–11.

Study Questions

1. Do you believe that turning the trolley in "Bystander at the Switch" is morally permissible?

2. Do you believe that not turning the trolley in "Bystander at the Switch" is morally permissible?

3. In what crucial ways, if any, does the case Thomson calls "Fat Man" differ from "Bystander at the Switch"?

4. What does Thomson mean by "rights trump utilities"?

57

JUDITH JARVIS THOMSON

More than two decades after publishing the previous article, Judith Jarvis Thomson returned to the problem. Influenced by the work of a doctoral student, she considers a case in which you have the option not only of killing one to save five but also killing yourself to save five. Thomson's conclusion is that if you wouldn't kill yourself to save five, then you shouldn't kill anyone else to save five. She then wonders why so many people think it obvious that turning the trolley is permissible.

Turning the Trolley

I

The trolley problem is by now thoroughly familiar, but it pays to begin with a description of its origins.

In "The Problem of Abortion and the Doctrine of the Double Effect," Philippa Foot described a variety of hypothetical cases, in some of which we regard it as permissible for the agent to act, in others of which we regard it as impermissible for the agent to act, and she asked the good question what explains the differences among our verdicts about them.[1] Her aim was to assess whether the Doctrine of Double Effect provides a plausible answer. She concluded that it doesn't, and went on to offer an answer of her own. It is her own answer that will interest us.

Here are two of her hypothetical cases. In the first, which I will call Judge's Two Options, a crime has been committed, and some rioters have taken five innocent people hostage; they will kill the five unless the judge arranges for the trial, followed by the execution, of the culprit. The real culprit is unknown, however. So the judge has only two options:

Judge's Two Options: he can
(i) let the rioters kill the five hostages, or
(ii) frame an innocent person for the crime, and have him executed.

Most people would say that the judge must not choose option (ii).

In the second case, which I will call Driver's Two Options, the driver of a runaway tram has only the following two options:

Driver's Two Options; he can
(i) continue onto the track ahead, on which five men are working, thereby killing the five, or
(ii) steer onto a spur of track off to the right on which only one man is working, thereby killing the one.

Most people would say that the driver may choose option (ii).

What explains the difference between our verdicts about what the agents may do in these two cases? After all, in both cases, the agents must choose between five deaths and one death.

Foot suggested that the difference is explainable by appeal to two principles. "There is worked into our moral system a distinction between what we owe to people in the form of aid and what we owe to them in the way of non-interference." She suggested that we call what we owe to people in the form of aid our positive duties, and what we owe to people in the way of non-interference our negative duties. She then invited us to accept that negative duties are weightier than positive duties. Markedly weightier. So much so that, as I will express her first principle:

Letting Five Die Vs. Killing One Principle: A must let five die if saving them requires killing B.

That explains why the judge must not choose option (ii).

Things are otherwise in Driver's Two Options. The driver doesn't face a choice between letting five die and killing one, so the first principle is irrelevant to his case. So Foot appealed to a second principle, namely

Killing Five Vs. Killing One Principle: A must not kill five if he can instead kill one.

Given this principle, the driver must choose option (ii), and, a fortiori, he may choose it. So that explains why the driver may choose option (ii). So we now have an explanation of the difference between our verdicts in the two cases.

Her proposal is very attractive. The ideas about negative and positive duties expressed in the two principles are not new, but they are intuitively very plausible, and Foot shows that given those two principles, we have a satisfying explanation of the differences among our verdicts in all of the cases she drew attention to. I should perhaps add that the principles she appeals to are intended merely as *ceteris*

paribus principles, since further information about the six potential victims might make a difference in our views about what the agent may do. For example, finding out that one or more of the six potential victims is at fault for the coming about of the situation they now face might well make such a difference. What she had in mind is just that *other things being equal* the agent must or must not choose such and such an option. It will perhaps be useful, however, if I make explicit the assumption I make throughout that no one of the six in any of the cases we consider is at fault.

But are those two principles true? A doubt might be raised about the second principle.[2] I will ignore it, however. I will assume that the second principle is satisfactory, and focus instead on a doubt that was in fact raised about the first.

In an article provoked by Foot's. I suggested that we should take our eyes off the driver; we should eliminate him.[3] (Make him have dropped dead of a heart attack.) Then let us imagine the situation to be as in the case I will call Bystander's Two Options. A bystander happens to be standing by the track, next to a switch that can be used to turn the tram off the straight track, on which five men are working, onto a spur of track to the right on which only one man is working. The bystander therefore has only two options:

Bystander's Two Options: he can
(i) do nothing, letting five die, or
(ii) throw the switch to the right, killing one.

Most people say that he may choose option (ii).

If the bystander may choose option (ii) in Bystander's Two Options, however, then Foot's first principle won't do. For if the *Letting Five Die Vs. Killing One Principle* is true, then the bystander must not choose option (ii)—for if he chooses option (ii), he kills one, whereas if he chooses option (i), he merely lets five die.

But if the *Letting Five Die Vs. Killing One Principle* is not true, then it cannot be appealed to to explain why the judge must not choose option (ii) in Judge's Two Options.

Perhaps there is some other answer to the question why the judge must not choose option (ii) in Judge's Two Options? An answer resting on the role of a judge in a legal system? No doubt there is. So let us bypass that case. Consider a case I called Fat Man. In this ease a fat man and I happen to be on a footbridge over the track. I have two options;

Fat man: I can
(i) do nothing, letting five die, or
(ii) shove the Fat man off the footbridge down onto the track, thereby killing him, but also, since he's very big, stopping the tram and saving the five.

Most people would say that I must not choose option (ii)—just as they would say that the judge must not choose option (ii) in Judge's Two Options. Yet I am not a judge, and no facts about the role of a judge in a legal system could be appealed to to explain why I must not choose option (ii).

Indeed, Foot might have presented us at the outset, not with Judge's Two Options and Driver's Two Options, but with Fat Man and Driver's Two Options, and asked why I must not choose option (ii) in Fat Man, whereas the driver may choose option (ii) in Driver's Two Options. Let us call that Philippa Foot's problem. We might well have been tempted to answer, as Foot would have answered, that the *Letting Five Die Vs. Killing One Principle* explains why I must not choose option (ii) in Fat Man, whereas the *Killing Five Vs. Killing One Principle* explains why the driver may choose option (ii) in Driver's Two Options.

But of course that answer won't do if the *Letting Five Die Vs. Killing One Principle* is false. So Philippa Foot's problem remains with us.

What is of interest is that we also have a second, different, problem before us. As I said, most people say that the bystander may choose option (ii) in Bystander's Two Options. In both Fat Man and Bystander's Two Options, the agent can choose option (i), letting the five die; in both, the agent who chooses option (ii) kills one. Why is it impermissible for the agent in Fat Man to choose option (ii), but

permissible for the agent in Bystander's Two Options to choose option (ii)? Nothing we have in hand even begins to explain this second difference.

Moreover, it is not in the least easy to see what might explain it. Since trams are trolleys on this side of the Atlantic, I called this "the trolley problem." (Besides, that is more euphonious than "the tram problem.")

It spawned a substantial literature. Unfortunately, nobody produced a solution that anyone else thought satisfactory, and the trolley problem therefore also remains with us.

<h2 style="text-align:center">II</h2>

A few years ago, an MIT graduate student. Alexander Friedman, devoted a chapter of his thesis to a discussion of the most interesting solutions to the trolley problem on offer in the literature.[4] He did a very good job: he showed clearly that none of them worked. What was especially interesting, though, was what he concluded. He said: the reason why no adequate solution has been found is that something went wrong at the outset. He said: it just isn't true that the bystander may choose option (ii) in Bystander's Two Options!

Friedman didn't offer an independent argument to that effect. He drew his conclusion from two premises. First, there is the fact, which, as I say, he showed clearly, that none of the most interesting solutions on offer worked. We shouldn't take that fact lightly. It is, of course, consistent with there actually being a solution to the trolley problem that nobody has been clever enough to find it. But we should be troubled by the fact that so many people have tried, for so many years—well over a quarter of a century by now—and come up wanting. Friedman's second premise was that it just is intuitively plausible that negative duties really are weightier than positive duties. Thus, in particular, that the *Letting Five Die Vs. Killing One Principle* is true. And if it is true, then of course the bystander must not, after all, choose option (ii) in Bystander's Two Options.

Friedman therefore said that we should see the (so-called) trolley problem "for what it really is—a very intriguing, provocative, and eye-opening non-problem."

Well, there's an unsettling idea! But if you mull over Friedman's unsettling idea for a while, then perhaps it can come to seem worth taking very seriously. So let us mull over it.

III

Here is a case that I will call Bystander's Three Options. The switch available to this bystander can be thrown in two ways. If he throws it to the right, then the trolley will turn onto the spur of track to the right, thereby killing one workman. If he throws it to the left, then the trolley will turn onto the spur of track to the left. The bystander himself stands on that left-hand spur of track, and will himself be killed if the trolley turns onto it. Or, of course, he can do nothing, letting five workmen die. In sum.

Bystander's Three Options: he can
(i) do nothing, letting five die, or
(ii) throw the switch to the right, killing one, or
(iii) throw the switch to the left, killing himself.

What is your reaction to the bystander's having the following thought? "Hmm. I want to save those five workmen. I can do that by choosing option (iii), that is by throwing the switch to the left, saving the five but killing myself. I'd prefer not dying today, however, even for the sake of saving five. So I'll choose option (ii), saving the five but killing the one on the right-hand track instead."

I hope you will agree that choosing (ii) would be unacceptable on the bystander's part. If he *can* throw the switch to the left and turn the trolley onto himself, how dare he throw the switch to the right and turn the trolley onto the one workman? The bystander doesn't feel like dying today, even for the sake of saving five, but we can assume, and so let us assume, that the one workman also doesn't feel like dying today, even if the bystander would thereby save five.

Let us get a little clearer about why this bystander must not choose option (ii). He wants to save the five on the straight track ahead. That would be good for them, and his saving them would be a good deed on

his part. But his doing that good deed would have a cost: his life or the life of the one workman on the right-hand track. What the bystander does if he turns the trolley onto the one workman is to make the one workman pay the cost of his good deed because he doesn't feel like paying it himself.

Compare the following possibility. I am asked for a donation to Oxfam. I want to send them some money. I am able to send money of my own, but I don't feel like it. So I steal some from someone else and send *that* money to Oxfam. That is pretty bad. But if the bystander proceeds to turn the trolley onto the one on the right-hand track in Bystander's Three Options, then what he does is markedly worse, because the cost in Bystander's Three Options isn't money, it is life.

In sum, if A wants to do a certain good deed, and can pay what doing it would cost, then—other things being equal—A may do that good deed only if A pays the cost himself. In particular, here is a third *ceteris paribus* principle:

Third Principle: A must not kill B to save five if he can instead kill himself to save the five.

So the bystander in Bystander's Three Options must not kill the one workman on the right-hand track in furtherance of his good deed of saving the five since he can instead save the five by killing himself. Thus he must not choose option (ii).

On the other hand, morality doesn't require him to choose option (iii). If A wants to do a certain good deed, and discovers that the only permissible means he has of doing the good deed is killing himself, then he may refrain from doing the good deed. In particular, here is a fourth *ceteris paribus* principle:

Fourth Principle: A may let five die if the only permissible means he has of saving them is killing himself.

So the bystander in Bystander's Three Options may choose option (i).

Let us now return to Bystander's Two Options. We may imagine that the bystander in this case can see the trolley headed for the five workmen, and wants to

save them. He thinks: "Does this switch allow for me to choose option (iii), in which I turn the trolley onto myself? If it does, then I must not choose option (ii), in which I turn the trolley onto the one workman on the right-hand track, for as the *Third Principle* says, I must prefer killing myself to killing him. But I don't want to kill myself, and if truth be told, I wouldn't if I could. So if the switch does allow for me to choose option (iii), then I have to forgo my good deed of saving the five: I have to choose option (i)—thus I have to let the five die. As, of course, the *Fourth Principle* says I may."

As you can imagine, he therefore examines the switch *very* carefully. Lo, he discovers that the switch doesn't allow him to choose option (iii). "What luck," he thinks, "I can't turn the trolley onto myself. So it's perfectly all right for me to choose option (ii)!" His thought is that since he can't himself pay the cost of his good deed, it is perfectly all right for him to make the workman on the right-hand track pay it—despite the fact that he wouldn't himself pay it if he could.

I put it to you that that thought won't do. Since he wouldn't himself pay the cost of his good deed if he could pay it, there is no way in which he can decently regard himself as entitled to make someone else pay it.

Of how many of us is it true that if we could permissibly save five only by killing ourselves, then we would? Doing so would be altruism, for as the *Fourth Principle* says, nobody is required to do so, and doing so would therefore be altruism; moreover, doing so would be doing something for others at a major cost to oneself, and doing so would therefore be major altruism. Very few of us would. Then very few of us could decently regard ourselves as entitled to choose option (ii) if we were in the bystander's situation in Bystander's Two Options.

IV

Very well, suppose that the bystander in Bystander's Two Options is among the very few major altruists who would choose option (iii) if it were available to them. Should we agree that *he* anyway can decently regard himself as entitled to choose option (ii)?

I stop to mention my impression that altruism that rises to this level is not morally attractive. Quite to the contrary. A willingness to give up one's life *simply* on learning that five others will live if and only if one dies is a sign of a serious moral defect in a person. "They're my children," "They're my friends," "They stand for things that matter to me," "They're young, whereas I haven't much longer to live," "I've committed myself to doing what I can for them": these and their ilk would make sacrificing one's life to save five morally intelligible. Consider, by contrast, the man who learns that five strangers will live if and only if they get the organs they need, and that his are the only ones that are available in time, and who therefore straightway volunteers. No reputable surgeon would perform the operation, and no hospital would allow it to be performed under its auspices. I would certainly not feel proud of my children if I learned that they value their own lives as little as that man values his.

Perhaps you disagree. I therefore do not rely on that idea. It remains the case that the altruistic bystander is not entitled to assume that the one workman is equally altruistic, and would therefore consent to the bystander's choosing option (ii). Altruism is by hypothesis not morally required of us.

Suppose, then, that the bystander knows that the one workman would not consent, and indeed is not morally required to consent, to his choosing option (ii). The bystander has a permissible alternative, namely choosing option (i)—that is, letting the five die. I think it very plausible therefore that there is no way in which he can justify to himself or to anyone else his choosing option (ii), and thus that he cannot decently regard himself as entitled to choose it.

V

If those arguments succeed, then Friedman was right:

Letting Five Die Vs. Killing One Principle: A must let five die if saving them requires killing B

is safe against the objection I made to it in drawing attention to Bystander's Two Options, since the

bystander may not in fact proceed in that case. And if so, two consequences follow. First, Bystander's Two Options is no threat to solving Philippa Foot's problem as she would have done. She *can* explain the difference between our verdicts about the agents in Fat Man and Driver's Two Options as she would have done—that is, she *can* say that the *Letting Five Die Vs. Killing One Principle* explains why I may not proceed in Fat Man, whereas the

> *Killing Five Vs. Killing One Principle.* A must not kill five if he can instead kill one

explains why the driver may proceed in Driver's Two Options. Second, as Friedman said, the (so-called) trolley problem is a nonproblem. The bystander in Bystander's Two Options is no more free to turn the trolley than I am to shove the fat man off the footbridge into the path of the trolley; a fortiori, there is no difference between our verdict about the agent in Fat Man and our (now corrected) verdict about the agent in Bystander's Two Options to *be* explained.

But even if the (so-called) trolley problem is therefore in one way a nonproblem, it is therefore in another way a real problem, for if the bystander must not turn the trolley in Bystander's Two Options, then we need to ask why so many people who are presented with that case think it obvious that he may. I will make a suggestion about why they do.

There is a question that we need to answer first, however.

VI

What I have in mind is this. I have suggested that consideration of Bystander's Three Options brings out that there is trouble for the idea that the bystander may turn the trolley in Bystander's Two Options. What has to be asked is whether consideration of an analogous case, namely Driver's Three Options, brings out that there is analogous trouble for the idea that the driver may turn the trolley in Driver's Two Options. If it does, then something must be wrong with my arguments in the preceding sections. Let us see why.

By way of reminder, here is Driver's Two Options again.

Driver's Two Options: he can
(i) continue onto the track ahead, on which five men are working, thereby killing the five, or
(ii) steer onto a spur of track off to the right on which only one man is working, thereby killing the one.

Most people would say that the driver may choose option (ii). What would make that true? According to the *Killing Five Vs. Killing One Principle,* the driver must choose option (ii). I said in Section I that a doubt might be raised about that principle, but I also said that I would ignore it—thus that I would assume the principle is true. Very well then, the driver must choose option (ii). It follows that he may.

Here, now, is Driver's Three Options:

Driver's Three Options: he can
(i) continue onto the track ahead, on which five men are working, thereby killing the five, or
(ii) steer onto a spur of track off to the right on which only one man is working, thereby killing the one, or
(iii) steer onto a spur of track off to the left, which ends in a stone wall, thereby killing himself.

If consideration of this case makes trouble for the idea that the driver in Driver's Two Options may choose option (ii), then, as I said, something must be wrong with my argument in the preceding sections.

Before attending to the question whether it does, we should take note of an objection that some people make when presented with these cases. If the bystanders in Bystander's Two Options and Bystander's Three Options choose option (i), then they on any view don't kill the five; they merely let the five die. But the people I refer to object that that is also true of the drivers in these cases. After all, choosing option (i) in these cases isn't *steering* onto the track ahead. The drivers merely continue onto the track ahead. We may assume that they don't turn the steering wheel.

Indeed, we may assume that they take their hands entirely off the steering wheels—letting the trolleys continue onto the tracks ahead, where *they* (the trolleys) will kill the five.

It really won't do, however, if we can also assume that the drivers themselves started their trolleys, and were steering them up to the time at which the brakes failed—so let us assume it. Suppose Alfred takes out his car and drives toward a restaurant where he expects to meet his friends. He suddenly sees five people on the street ahead of him, but his brakes fail: he cannot stop his car, he can only continue onto the street ahead or steer to the right (killing one) or steer to the left (killing himself). If he doesn't steer to one or the other side, if he simply takes his hands off the wheel, he runs the five down and kills them. He cannot at all plausibly insist that he merely lets them die. So similarly for the trolley drivers. Let us therefore return to them.

In Section III, I argued that if the bystander in Bystander's Two Options is not a major altruist, and, in particular, would not choose option (iii) if he could, then he cannot decently regard himself as entitled to choose option (ii). Here is a reminder of that argument. The bystander in Bystander's Three Options can choose option (iii)—that is, he can kill himself—and

> *Third Principle:* A must not kill B to save five it he can instead kill himself to save the five

therefore yields that he must not choose option (ii). He isn't required to choose option (iii), for choosing option (iii) would be major altruism, and he therefore may instead choose option (i). But he must not choose option (ii). I then went on to say that if the bystander in Bystander's Two Options is not a major altruist, and in particular, would not choose option (iii) if it were available to him, then he cannot decently regard himself as entitled to choose option (ii).

Does that argument have an analogue for the driver in Driver's Two Options? Well, should we accept yet another *ceteris paribus* principle? Namely

> *Variant Third Principle:* A must not kill B to avoid killing five if he can instead kill himself to avoid killing the five.

If so, then since the driver in Driver's Three Options can choose option (iii)—he can kill himself—he must not choose option (ii). Are we to go on to say that if the driver in Driver's Two Options would not choose option (iii) if it were available to him, then he cannot decently regard himself as entitled to choose option (ii)? Can that be right—given that the *Killing Five Vs. Killing One Principle* yields that the driver in Driver's Two Options must choose option (ii)?

Should we accept the *Variant Third Principle?* One thing that might incline us to accept it should he set aside. We might be moved to accept it because we are moved by the fact that it is trolley drivers, and track workmen, whom we are concerned with here. Perhaps we think of a trolley driver as charged, as part of his duties, with seeing to the safety of the men who are working on the tracks. If we do, then perhaps we will think it true that since the driver in Driver's Three Options can choose option (iii)—he can kill himself—he must not choose option (ii). And the quite general *Variant Third Principle* may strike us as true for that reason.

But we should prescind from the possibility that the agents in the cases we are considering have special duties towards the other parties—special in that they are duties beyond those that any (private) human beings have towards any other (private) human beings. So let us return to Alfred. I invited you to imagine that he took out his car to drive toward a restaurant where he expects to meet his friends. He suddenly sees five people on the street ahead of him, but his brakes fail: he cannot stop his car, he can only continue onto the street ahead, or steer to the right (killing one), or steer to the left (killing himself). I said that if he doesn't steer to one or the other side, if he simply takes his hands off the wheel, then he kills the five. If the *Variant Third Principle* is true, then he must steer to the left, killing himself. Should we agree?

There is reason to believe that we should. Alfred is driving the car; *he* is the threat to people. He will kill five if he does nothing, and it is not morally optional for him to do nothing: he must not kill the five. But since he will kill the five if he does nothing, *he* must be the one to pay the cost of his avoiding

killing them. And if the cost is a life, then so be it: he is the one who must pay it.

(This rationale for saying that Alfred must pay the cost in this case is clearly very different from the rationale for saying that the bystander in Bystander's Three Options must pay the cost of saving the five if he is to save them. The difference lies in the fact that it is morally optional for the bystander, but not Alfred, to do nothing: the bystander may decline to do the good deed he would like to do, whereas Alfred must not kill five.)

On the other hand, there is the fact that Alfred is not at fault for the situation in which he now finds himself. Admittedly, it is not morally optional for him to do nothing, but why does he have to kill himself? Somebody has to pay the cost of his avoiding killing the five, but why him? Wouldn't it be fair in him to flip a coin? Is it mere high-mindedness that lies behind the thought that he had better kill himself?

(By contrast, the bystander in Bystander's Three Options must not flip a coin. It is not fair in him to impose a 0.5 risk of death on a person in order to do what it is morally optional for him to not do.)

On balance, I am more moved by the former consideration than by the latter, and thus prefer the idea that though Alfred is without fault, he must kill himself. (After all, the one on the right is also without fault.) And in sum, that we should accept the *Variant Third Principle*.

But I leave it open.[5] What matters, anyway, is what conclusion should be drawn about the driver in Driver's Two Options, whether or not the *Variant Third Principle* is true. Or, to avoid possible interference due to the thought that trolley drivers have special duties to track workmen, what conclusion should be drawn about Alfred, if it turns out that he cannot after all steer his car to the left, killing himself. Thus if it turns out that he has only the following two options: continue straight (killing five), or steer to the right (killing one). Suppose now that it is true of him that if he had the third alternative of steering to the left (killing himself), he wouldn't choose it. Suppose he wouldn't even flip a coin. Can he decently regard himself as entitled to steer to the right?

It is unjust in him that he would not only not steer to the left, but not flip a coin, if the option of steering to the left were available to him. That remains the case whatever he does. But his not steering to the right would itself be unjust, for his only alternative to steering to the right is killing five. If he knows that those are his only two options, then he cannot decently regard himself as entitled to *not* steer to the right.

Both of those facts mark Alfred off from the non-altruistic bystander in Bystander's Two Options. It is not the case that it is unjust in the bystander that he would not only not throw the switch to the left, killing himself, but not flip a coin as to whether or not to do so, if the option of throwing the switch to the left were available to him. And it is not the case that his not throwing the switch to the right would itself be unjust. For it is morally open to him to do nothing.

This difference between Alfred and the bystander is obviously due to the fact that whereas Alfred kills five if he does nothing, the bystander instead lets five die. Thus it is due to the very difference in weight between positive and negative duties that Foot said we should bring to bear on the cases she drew attention to, and that Friedman said was so plausible. I find myself strongly inclined to think they were right.

I add a proviso, though. I am sure it could go without saying, but it won't: it is one thing to say there is a difference in weight between positive and negative duties, and quite another to say what the source of that difference is. I know of no thoroughly convincing account of its source, and regard the need for one as among the most pressing in all of moral theory.

VII

We should return now to the question I set aside earlier, namely why so many people who are presented with Bystander's Two Options think it obvious that the bystander may turn the trolley.

Friedman suggested that they think this for two reasons, first because of "the subconscious pull of utilitarianism," and second because the bystander's turning the trolley would not be as strikingly abhorrent as the agent's acting in some of the other hypothetical cases described in the literature, such as Fat Man and another case that I will get to shortly.

Friedman's first reason is over-strong. As we know, a number of psychologists have recently been collecting data on people's reactions to cases of the kind we are looking at. Ninety-three percent of the seniors at South Regional High School in Dayton, Ohio, say that the bystander may turn the trolley in Bystander's Two Options! (Actually, I just invented that statistic, but it's in the right ballpark.) I doubt that those students were pulled, consciously or subconsciously, by anything as sophisticated as utilitarianism.

It is surely right, however, to think that the psychologists' informants are moved by the fact that more people will live if the bystander turns the trolley than if he doesn't. A utilitarian would of course be moved by that fact; but so also would many others.[6]

Friedman's second reason is not so much a reason as a restatement of what has to be explained. Consider Fat Man again. It would be strikingly abhorrent for me to shove the fat man off the footbridge down onto the track, thereby killing him, even though more people will live if I do than if I don't. Consider a case often called Transplant. I am a surgeon, and can save my five patients who are in need of organs only by cutting up one healthy bystander—a bystander who has not volunteered—and distributing his organs among the five. Here too it would be strikingly abhorrent for me to proceed. Even more so, in fact. By contrast, it does not strike people generally as abhorrent for the bystander to turn the trolley. However, that difference cannot be thought to explain why people think that the bystander may proceed whereas the agents in Fat Man and Transplant may not. Rather it is what has to *be* explained.

Perhaps the explanation is not deep but right up at the surface?

In those three hypothetical cases, more will live if the agent proceeds than if he or she does not. Yet it isn't open to any of the agents to arrange, by magic, as it were, that there be just that difference, namely that more live. The agents have to *do* something to bring that outcome about. By what means are they to bring it about? Here are the only means by which I can bring it about in Fat Man: move the one into the path of the trolley currently headed toward the five. Here are the only means by which I can bring it about in Transplant: carve the one up and distribute his organs to the five who need them.

There is a wild efflorescence of hypothetical cases in this literature, and much strenuous theorizing about the differences among them. My impression is that when one backs off from all those cases— and one has to back off, lest one get bemused by the details, some of them thoroughly weird—what seems to vary is at heart this: how drastic an assault on the one the agent has to make in order to bring about, thereby, that the five live. The more drastic the means, the more strikingly abhorrent the agent's proceeding. That, I suspect, may be due to the fact that the more drastic the means, the more striking it is that the agent who proceeds infringes a negative duty to the one.

By contrast, if the bystander proceeds, then here are the means by which he brings about that more live: merely turn the trolley.

Some early attempts to explain why the bystander may proceed appealed to that fact about his means. Alas they didn't succeed, since by turning the trolley, the bystander will kill the one, and thus will infringe a negative duty to the one; and there is no good reason to think that that fact about his means makes his infringing the negative duty count any the less heavily against his proceeding. No matter. We are not asking here why the bystander *may* turn the trolley. What we are asking is only why it seems to so many people that he may. The answer, then, may simply lie in our being overly impressed by the fact that if he proceeds, he will bring about that more live by merely turning a trolley.

Notes

1. Foot's article was first published in the *Oxford Review* in 1967: it is reprinted in her collection *Virtues and Vices* (Oxford: Basil Blackwell, 1978).

2. Modeled on John Taurek's doubt about the moral relevance of the numbers in cases where what is in question is distributing a benefit.

3. "Killing, Letting Die, and the Trolley Problem." *The Monist* 59 (1976): 204–17. In that article, the driver was eliminated in favor of a passenger. The case I will call Bystander's Two Options—in which the driver is eliminated in favor of a bystander—comes from my second article provoked by Foot's, namely "The Trolley Problem," *The Yale Law Journal* 94 (1985): 1393–415. Those two articles, along with Foot's and several others on the topic, were helpfully reprinted and discussed, *Ethics: Problems and Principles,* ed. John Martin Fischer and Mark Ravizza (Orlando. Fla.: Harcourt Brace Jovanovich, 1992).

4. A. W. Friedman. *Minimizing Harm: Three Problems in Moral Theory.* Unpublished doctoral dissertation, Department of Linguistics and Philosophy, Massachusetts Institute of Technology (2002).

5. The view one holds on this matter has a bearing on the views one can consistently hold on other issues in moral theory, on the moral limits to self-defense in particular.

6. My own account of how facts of that kind figure in support of a conclusion about what a person ought to do appears in *Normativity* (Chicago: Open Court Publishing, 2008).

Study Questions

1. Is your judgment affected by which role in the story you imagine yourself playing?

2. Would your judgment be different if turning the trolley saved the lives of thousands of people?

3. Do you agree that you should not make someone else pay a cost if in the same circumstances you yourself would not be willing to pay it?

4. According to Thomson, why is the trolley problem in one way a non-problem?

58

THOMAS NAGEL

Is death an evil? If so, why? Thomas Nagel explores these questions. He believes we are all fortunate to have been born, and we all find desirable in life certain states, conditions, or types of activity. The trouble, however, is that life familiarizes us with the goods of which death deprives us. Death is thus an abrupt cancellation of indefinitely extensive possible goods. For that reason, Nagel concludes that a bad end may be in store for all of us.

Death

If death is the unequivocal and permanent end of our existence, the question arises whether it is a bad thing to die.

There is conspicuous disagreement about the matter: some people think death is dreadful; others have no objection to death *per se*, though they hope their own will be neither premature nor painful. Those in the former category tend to think those in the latter are blind to the obvious, while the latter suppose the former to be prey to some sort of confusion. On the one hand it can be said that life is all we have and the loss of it is the greatest loss we can sustain. On the other hand it may be objected that death deprives this supposed loss of its subject, and that if we realize that death is not an unimaginable condition of the persisting person, but a mere blank, we will see that it can have no value whatever, positive or negative.

Since I want to leave aside the question whether we are, or might be, immortal in some form, I shall simply use the word "death" and its cognates in this discussion to mean *permanent* death, unsupplemented by any form of conscious survival. I want to ask whether death is in itself an evil; and how great an evil, and of what kind, it might be. The question should be of interest even to those who believe in some form of immortality, for one's attitude toward immortality must depend in part on one's attitude toward death.

If death is an evil at all, it cannot be because of its positive features, but only because of what it deprives us of. I shall try to deal with the difficulties surrounding the natural view that death is an evil because it brings to an end all the goods that life contains. We need not give an account of these goods here, except to observe that some of them, like perception, desire, activity, and thought, are so general as to be constitutive of human life. They are widely regarded as formidable benefits in themselves, despite the fact that they are conditions of misery as well as of happiness, and that a sufficient quantity of more particular evils can perhaps outweigh them. That is what is meant, I think, by the allegation that it is good simply to be alive, even if one is undergoing terrible experiences. The situation is roughly this: There are elements which, if added to one's experience, make life better; there are other elements which, if added to one's experience, make life worse. But what remains when these are set aside is

Reprinted from *Noûs*, IV (1970). Reprinted by permission of Blackwell Publishing.

not merely *neutral*: it is emphatically positive. Therefore life is worth living even when the bad elements of experience are plentiful, and the good ones too meager to outweigh the bad ones on their own. The additional positive weight is supplied by experience itself, rather than by any of its contents.

I shall not discuss the value that one person's life or death may have for others, or its objective value, but only the value it has for the person who is its subject. That seems to me the primary case, and the case which presents the greatest difficulties. Let me add only two observations. First, the value of life and its contents does not attach to mere organic survival: almost everyone would be indifferent (other things equal) between immediate death and immediate coma followed by death twenty years later without reawakening. And second, like most goods, this can be multiplied by time: more is better than less. The added quantities need not be temporally continuous (though continuity has its social advantages). People are attracted to the possibility of long-term suspended animation or freezing, followed by the resumption of conscious life, because they can regard it from within simply as a *continuation* of their present life. If these techniques are ever perfected, what from outside appeared as a dormant interval of three hundred years could be experienced by the subject as nothing more than a sharp discontinuity in the character of his experiences. I do not deny, of course, that this has its own disadvantages. Family and friends may have died in the meantime; the language may have changed; the comforts of social, geographical, and cultural familiarity would be lacking. Nevertheless these inconveniences would not obliterate the basic advantage of continued, though discontinuous, existence.

If we turn from what is good about life to what is bad about death, the case is completely different. Essentially, though there may be problems about their specification, what we find desirable in life are certain states, conditions, or types of activity. It is *being* alive, *doing* certain things, having certain experiences, that we consider good. But if death is an evil, it is the *loss of life*, rather than the state of being dead, or nonexistent, or unconscious, that is objectionable.[1] This asymmetry is important. If it is good to be alive, that advantage can be attributed to a person at each point of his life. It is a good of which Bach had more than

Schubert, simply because he lived longer. Death, however, is not an evil of which Shakespeare has so far received a larger portion than Proust. If death is a disadvantage, it is not easy to say when a man suffers it.

There are two other indications that we do not object to death merely because it involves long periods of nonexistence. First, as has been mentioned, most of us would not regard the *temporary* suspension of life, even for substantial intervals, as in itself a misfortune. If it ever happens that people can be frozen without reduction of the conscious lifespan, it will be inappropriate to pity those who are temporarily out of circulation. Second, none of us existed before we were born (or conceived), but few regard that as a misfortune. I shall have more to say about this later.

The point that death is not regarded as an unfortunate *state* enables us to refute a curious but very common suggestion about the origin of the fear of death. It is often said that those who object to death have made the mistake of trying to imagine what it is like to *be* dead. It is alleged that the failure to realize that this task is logically impossible (for the banal reason that there is nothing to imagine) leads to the conviction that death is a mysterious and therefore terrifying prospective *state*. But this diagnosis is evidently false, for it is just as impossible to imagine being totally unconscious as to imagine being dead (though it is easy enough to imagine oneself, from the outside, in either of those conditions). Yet people who are averse to death are not usually averse to unconsciousness (so long as it does not entail a substantial cut in the total duration of waking life).

If we are to make sense of the view that to die is bad, it must be on the ground that life is a good and death is the corresponding deprivation or loss, bad not because of any positive features but because of the desirability of what it removes. We must now turn to the serious difficulties which this hypothesis raises, difficulties about loss and privation in general, and about death in particular.

Essentially, there are three types of problem. First, doubt may be raised whether *anything* can be bad for a man without being positively unpleasant to him: specifically, it may be doubted that there are any evils which consist merely in the deprivation or absence of possible goods, and which do not depend on someone's *minding*

that deprivation. Second, there are special difficulties, in the case of death, about how the supposed misfortune is to be assigned to a subject at all. There is doubt both as to *who* its subject is, and as to *when* he undergoes it. So long as a person exists, he has not yet died, and once he has died, he no longer exists; so there seems to be no time when death, if it is a misfortune, can be ascribed to its unfortunate subject. The third type of difficulty concerns the asymmetry, mentioned above, between our attitudes to posthumous and prenatal nonexistence. How can the former be bad if the latter is not?

It should be recognized that if these are valid objections to counting death as an evil, they will apply to many other supposed evils as well. The first type of objection is expressed in general form by the common remark that what you don't know can't hurt you. It means that even if a man is betrayed by his friends, ridiculed behind his back, and despised by people who treat him politely to his face, none of it can be counted as a misfortune for him so long as he does not suffer as a result. It means that a man is not injured if his wishes are ignored by the executor of his will, or if, after his death, the belief becomes current that all the literary works on which his fame rests were really written by his brother, who died in Mexico at the age of 28. It seems to me worth asking what assumptions about good and evil lead to these drastic restrictions.

All the questions have something to do with time. There certainly are goods and evils of a simple kind (including some pleasures and pains) which a person possesses at a given time simply in virtue of his condition at that time. But this is not true of all the things we regard as good or bad for a man. Often we need to know his history to tell whether something is a misfortune or not; this applies to ills like deterioration, deprivation, and damage. Sometimes his experiential *state* is relatively unimportant—as in the case of a man who wastes his life in the cheerful pursuit of a method of communicating with asparagus plants. Someone who holds that all goods and evils must be temporally assignable states of the person may of course try to bring difficult cases into line by pointing to the pleasure or pain that more complicated goods and evils cause. Loss, betrayal, deception, and ridicule are on this view bad because people suffer when they learn of them. But it should be asked how our ideas of human

value would have to be constituted to accommodate these cases directly instead. One advantage of such an account might be that it would enable us to explain *why* the discovery of these misfortunes causes suffering—in a way that makes it reasonable. For the natural view is that the discovery of betrayal makes us unhappy because it is bad to be betrayed—not that betrayal is bad because its discovery makes us unhappy.

It therefore seems to me worth exploring the position that most good and ill fortune has as its subject a person identified by his history and his possibilities, rather than merely by his categorical state of the moment—and that while this subject can be exactly located in a sequence of places and times, the same is not necessarily true of the goods and ills that befall him.[2]

These ideas can be illustrated by an example of deprivation whose severity approaches that of death. Suppose an intelligent person receives a brain injury that reduces him to the mental condition of a contented infant, and that such desires as remain to him can be satisfied by a custodian, so that he is free from care. Such a development would be widely regarded as a severe misfortune, not only for his friends and relations, or for society, but also, and primarily, for the person himself. This does not mean that a contented infant is unfortunate. The intelligent adult who has been *reduced* to this condition is the subject of the misfortune. He is the one we pity, though of course he does not mind his condition—there is some doubt, in fact, whether he can be said to exist any longer.

The view that such a man has suffered a misfortune is open to the same objections which have been raised in regard to death. He does not mind his condition. It is in fact the same condition he was in at the age of three months, except that he is bigger. If we did not pity him then, why pity him now; in any case, who is there to pity? The intelligent adult has disappeared, and for a creature like the one before us, happiness consists in a full stomach and a dry diaper.

If these objections are invalid, it must be because they rest on a mistaken assumption about the temporal relation between the subject of a misfortune and the circumstances which constitute it. If, instead of concentrating exclusively on the oversized baby before us, we consider the person he was, and the person he *could* be now, then his reduction to this state and

the cancellation of his natural adult development constitute a perfectly intelligible catastrophe.

This case should convince us that it is arbitrary to restrict the goods and evils that can befall a man to nonrelational properties ascribable to him at particular times. As it stands, that restriction excludes not only such cases of gross degeneration, but also a good deal of what is important about success and failure, and other features of a life that have the character of processes. I believe we can go further, however. There are goods and evils which are irreducibly relational; they are features of the relations between a person, with spatial and temporal boundaries of the usual sort, and circumstances which may not coincide with him either in space or in time. A man's life includes much that does not take place within the boundaries of his body and his mind, and what happens to him can include much that does not take place within the boundaries of his life. These boundaries are commonly crossed by the misfortunes of being deceived, or despised, or betrayed. (If this is correct, there is a simple account of what is wrong with breaking a deathbed promise. It is an injury to the dead man. For certain purposes it is possible to regard time as just another type of distance.). The case of mental degeneration shows us an evil that depends on a contrast between the reality and the possible alternatives. A man is the subject of good and evil as much because he has hopes which may or may not be fulfilled, or possibilities which may or may not be realized, as because of his capacity to suffer and enjoy. If death is an evil, it must be accounted for in these terms, and the impossibility of locating it within life should not trouble us.

When a man dies we are left with his corpse, and while a corpse can suffer the kind of mishap that may occur to an article of furniture, it is not a suitable object for pity. The man, however, is. He has lost his life, and if he had not died, he would have continued to live it, and to possess whatever good there is in living. If we apply to death the account suggested for the case of dementia, we shall say that although the spatial and temporal locations of the individual who suffered the loss are clear enough, the misfortune itself cannot be so easily located. One must be content just to state that his life is over and there will never be any more of it. That *fact*, rather than his past or present

condition, constitutes his misfortune, if it is one. Nevertheless if there is a loss, someone must suffer it, and *he* must have existence and specific spatial and temporal location even if the loss itself does not. The fact that Beethoven had no children may have been a cause of regret to him, or a sad thing for the world, but it cannot be described as a misfortune for the children that he never had. All of us, I believe, are fortunate to have been born. But unless good and ill can be assigned to an embryo, or even to an unconnected pair of gametes, it cannot be said that not to be born is a misfortune. (That is a factor to be considered in deciding whether abortion and contraception are akin to murder.)

This approach also provides a solution to the problem of temporal asymmetry, pointed out by Lucretius. He observed that no one finds it disturbing to contemplate the eternity preceding his own birth, and he took this to show that it must be irrational to fear death, since death is simply the mirror image of the prior abyss. That is not true, however, and the difference between the two explains why it is reasonable to regard them differently. It is true that both the time before a man's birth and the time after his death are times when he does not exist. But the time after his death is time of which his death deprives him. It is time in which, had he not died then, he would be alive. Therefore any death entails the loss of *some* life that its victim would have led had he not died at that or any earlier point. We know perfectly well what it would be for him to have had it instead of losing it, and there is no difficulty in identifying the loser.

But we cannot say that the time prior to a man's birth is time in which he would have lived had he been born not then but earlier. For aside from the brief margin permitted by premature labor, he *could* not have been born earlier: anyone born substantially earlier than he was would have been someone else. Therefore the time prior to his birth is not time in which his subsequent birth prevents him from living. His birth, when it occurs, does not entail the loss to him of any life whatever.

The direction of time is crucial in assigning possibilities to people or other individuals. Distinct possible lives of a single person can diverge from a common beginning, but they cannot converge to a common conclusion from diverse beginnings. (The latter would

represent not a set of different possible lives of one individual, but a set of distinct possible individuals, whose lives have identical conclusions.) Given an identifiable individual, countless possibilities for his continued existence are imaginable, and we can clearly conceive of what it would be for him to go on existing indefinitely. However inevitable it is that this will not come about, its possibility is still that of the continuation of a good for him, if life is the good we take it to be.[3]

We are left, therefore, with the question whether the nonrealization of this possibility is in every case a misfortune, or whether it depends on what can naturally be hoped for. This seems to me the most serious difficulty with the view that death is always an evil. Even if we can dispose of the objections against admitting misfortune that is not experienced, or cannot be assigned to a definite time in the person's life, we still have to set some limits on *how* possible a possibility must be for its nonrealization to be a misfortune (or good fortune, should the possibility be a bad one). The death of Keats at 24 is generally regarded as tragic; that of Tolstoy at 82 is not. Although they will both be dead for ever, Keats' death deprived him of many years of life which were allowed to Tolstoy; so in a clear sense Keats' loss was greater (though not in the sense standardly employed in mathematical comparison between infinite quantities). However, this does not prove that Tolstoy's loss was insignificant. Perhaps we record an objection only to evils which are gratuitously added to the inevitable; the fact that it is worse to die at 24 than at 82 does not imply that it is not a terrible thing to die at 82, or even at 806. The question is whether we can regard as a misfortune any limitation, like mortality, that is normal to the species. Blindness or near-blindness is not a misfortune for a mole, nor would it be for a man, if that were the natural condition of the human race.

The trouble is that life familiarizes us with the goods of which death deprives us. We are already able to appreciate them, as a mole is not able to appreciate vision. If we put aside doubts about their status as goods and grant that their quantity is in part a function of their duration, the question remains whether death, no matter when it occurs, can be said to deprive its victim of what is in the relevant sense a possible continuation of life.

The situation is an ambiguous one. Observed from without, human beings obviously have a natural lifespan and cannot live much longer than a hundred years. A man's sense of his own experience, on the other hand, does not embody this idea of a natural limit. His existence defines for him an essentially open-ended possible future, containing the usual mixture of goods and evils that he has found so tolerable in the past. Having been gratuitously introduced to the world by a collection of natural, historical, and social accidents, he finds himself the subject of a *life*, with an indeterminate and not essentially limited future. Viewed in this way, death, no matter how inevitable, is an abrupt cancellation of indefinitely extensive possible goods. Normality seems to have nothing to do with it, for the fact that we will all inevitably die in a few score years cannot by itself imply that it would not be good to live longer. Suppose that we were all inevitably going to die in *agony*—physical agony lasting six months. Would inevitability make *that* prospect any less unpleasant? And why should it be different for a deprivation? If the normal lifespan were a thousand years, death at 80 would be a tragedy. As things are, it may just be a more widespread tragedy. If there is no limit to the amount of life that it would be good to have, then it may be that a bad end is in store for us all.

Notes

1. It is sometimes suggested that what we really mind is the process of *dying*. But I should not really object to dying if it were not followed by death.

2. It is certainly not true in general of the things that can be said of him. For example, Abraham Lincoln was taller than Louis XIV. But when?

3. I confess to being troubled by the above argument, on the ground that it is too sophisticated to explain the simple difference between our attitudes to prenatal and posthumous nonexistence. For this reason I suspect that something essential is omitted from the account of the badness of death by an analysis which treats it as a deprivation of possibilities. My suspicion is supported by the following suggestion of Robert Nozick. We could imagine discovering that people developed from individual spores

that had existed indefinitely far in advance of their birth. In this fantasy, birth never occurs naturally more than a hundred years before the permanent end of the spore's existence. But then we discover a way to trigger the premature hatching of these spores, and people are born who have thousands of years of active life before them. Given such a situation, it would be possible to imagine *oneself* having come into existence thousands of years previously. If we put aside the question whether this would really be the same person, even given the identity of the spore, then the consequence appears to be that a person's birth at a given time *could* deprive him of many earlier years of possible life. Now while it would be cause for regret that one had been deprived of all those possible years of life by being born too late, the feeling would differ from that which many people have about death. I conclude that something about the future *prospect* of permanent nothingness is not captured by the analysis in terms of denied possibilities. If so, then Lucretius' argument still awaits an answer. I suspect that it requires a general treatment of the difference between past and future in our attitudes toward our own lives. Our attitudes toward past and future pain are very different, for example. Derek Parfit's unpublished writings on this topic have revealed its difficulty to me.

Study Questions

1. If death is not an evil for a person who dies, is death, therefore, not an evil for anyone?

2. Do you agree with Nagel that a man who devotes himself to cheerful pursuit of a method of communicating with asparagus plants has wasted his life?

3. Just as you are unconcerned whether you lived at any time before you were born, should you be equally unconcerned whether you will live at any time after you die?

4. Are we all fortunate to have been, even those whose lives are filled with misery?

59

RICHARD TAYLOR

Richard Taylor (1919–2003) was Professor of Philosophy at the University of Rochester. He discussed the case of Sisyphus who, according to Greek myth, was condemned for his misdeeds to the eternal task of rolling a huge stone to the top of a hill, only each time to have it roll down to the bottom again. Taylor asks whether the life of Sisyphus is meaningless and argues that the answer depends on whether Sisyphus has a desire to roll stones up hills. If he does, then he has found meaning in life, for his activities match his wishes. Thus, according to Taylor, the meaning of life is not bestowed from without but comes from within us.

The Meaning of Life

The question whether life has any meaning is difficult to interpret, and the more you concentrate your critical faculty on it the more it seems to elude you, or to evaporate as any intelligible question. You want to turn it aside, as a source of embarrassment, as something that, if it cannot be abolished, should at least be decently covered. And yet I think any reflective person recognizes that the question it raises is important, and that it ought to have a significant answer.

If the idea of meaningfulness is difficult to grasp in this context, so that we are unsure what sort of thing would amount to answering the question, the idea of meaninglessness is perhaps less so. If, then, we can bring before our minds a clear image of meaningless existence, then perhaps we can take a step toward coping with our original question by seeing to what extent our lives, as we actually find them, resemble that image, and draw such lessons as we are able to from the comparison.

MEANINGLESS EXISTENCE

A perfect image of meaninglessness, of the kind we are seeking, is found in the ancient myth of Sisyphus. Sisyphus, it will be remembered, betrayed divine secrets to mortals, and for this he was condemned by the gods to roll a stone to the top of a hill, the stone then immediately to roll back down, again to be pushed to the top by Sisyphus, to roll down once more, and so on again and again, *forever*. Now in this we have the picture of meaningless, pointless toil, of a meaningless existence that is absolutely *never* redeemed. It is not even redeemed by a death that, if it were to accomplish nothing more, would at least bring this idiotic cycle to a close. If we were invited to imagine Sisyphus struggling for a while and accomplishing nothing, perhaps eventually falling from exhaustion, so that we might suppose him then eventually turning to something having some sort of promise, then the meaninglessness of that chapter of his life would not be so stark. It would be a dark and dreadful dream, from which he eventually awakens to sunlight and reality. But he does not awaken, for there is nothing for him to awaken to. His repetitive toil is his life and reality, and it goes on forever, and it is without any meaning whatever. Nothing ever comes of what he is doing, except simply, more of the same. Not by one step, nor by a thousand, nor by ten thousand does he even expiate by the smallest token the sin against the gods that led him into this fate. Nothing comes of it, nothing at all.

This ancient myth has always enchanted people, for countless meanings can be read into it. Some of the ancients apparently thought it symbolized the perpetual rising and setting of the sun, and others the repetitious crashing of the waves upon the shore. Probably the commonest interpretation is that it symbolizes our eternal struggle and unquenchable spirit, our determination always to try once more in the face of overwhelming discouragement. This interpretation is further supported by that version of the myth according to which Sisyphus was commanded to roll the stone *over* the hill, so that it would finally roll down the other side, but was never quite able to make it.

I am not concerned with rendering or defending any interpretation of this myth, however. I have cited it only for the one element it does unmistakably contain, namely, that of a repetitious, cyclic activity that never comes to anything. We could contrive other images of this that would serve just as well, and no myth-makers are needed to supply the materials of it. Thus, we can imagine two persons transporting a stone—or even a precious gem, it does not matter—back and forth, relay style. One carries it to a near or distant point where it is received by the other; it is returned to its starting point, there to be recovered by the first, and the process is repeated over and over. Except in this relay nothing counts as winning, and nothing brings the contest to any close, each step only leads to a repetition of itself. Or we can imagine two groups of prisoners, one of them engaged in digging a prodigious hole in the ground that is no sooner finished than it is filled in again by the other group, the latter then digging a new hole that is at once filled in by the first group, and so on and on endlessly.

Now what stands out in all such pictures as oppressive and dejecting is not that the beings who enact these roles suffer any torture or pain, for it need not be assumed that they do. Nor is it that their labors are great, for they are no greater than the labors commonly undertaken by most people most of the time. According to the original myth, the stone is so large that Sisyphus never quite gets it to the top and must groan under every step, so that his enormous labor is all for nought. But this is not what appalls. It is not that his great struggle comes to nothing, but that his existence itself is without meaning. Even if we suppose, for example, that the stone is but a pebble that can be carried effortlessly, or that the holes dug by the prisoners are but small ones, not the slightest meaning is introduced into their lives. The stone that Sisyphus moves to the top of the hill, whether we think of it as large or small, still rolls back every time, and the process is repeated forever. Nothing comes of it, and the work is simply pointless. That is the element of the myth that I wish to capture.

Again, it is not the fact that the labors of Sisyphus continue forever that deprives them of meaning. It is, rather, the implication of this: that they come to nothing. The image would not be changed by our supposing him to push a different stone up every time, each to roll down again. But if we supposed that these stones, instead of rolling back to their places as if they had never been moved, were assembled at the top of the hill and there incorporated, say, in a beautiful and enduring temple, then the aspect of meaninglessness would disappear. His labors would then have a point, something would come of them all, and although one could perhaps still say it was not worth it, one could not say that the life of Sisyphus was devoid of meaning altogether. Meaningfulness would at least have made an appearance, and we could see what it was.

That point will need remembering. But in the meantime, let us note another way in which the image of meaninglessness can be altered by making only a very slight change. Let us suppose that the gods, while condemning Sisyphus to the fate just described, at the same time, as an afterthought, waxed perversely merciful by implanting in him a strange and irrational impulse; namely, a compulsive impulse to roll stones. We may if we like, to make this more graphic, suppose they accomplish this by implanting in him some substance that has this effect on his character and drives. I call this perverse, because from our point of view there is clearly no reason why anyone should have a persistent and insatiable desire to do something so pointless as that. Nevertheless, suppose that is Sisyphus' condition. He has but one obsession, which is to roll stones, and it is an obsession that is only for the moment appeased by his rolling them— he no sooner gets a stone rolled to the top of the hill than he is restless to roll up another.

Now it can be seen why this little afterthought of the gods, which I called perverse, was also in fact merciful. For they have by this device managed to give Sisyphus precisely what he wants—by making him want precisely what they inflict on him. However it may appear to us, Sisyphus' fate now does not appear to him as a condemnation, but the very reverse. His one desire in life is to roll stones, and he is absolutely guaranteed its endless fulfillment. Where otherwise he might profoundly have wished surcease, and even welcomed the quiet of death to release him from endless boredom and meaninglessness, his life is now filled with mission and meaning, and he seems to himself to have been given an entry to heaven. Nor need he even fear death, for the gods have promised him an endless opportunity to indulge his single purpose, without concern or frustration. He will be able to roll stones *forever*.

What we need to mark most carefully at this point is that the picture with which we began has not really been changed in the least by adding this supposition. Exactly the same things happen as before. The only change is in Sisyphus' view of them. The picture before was the image of meaningless activity and existence. It was created precisely to be an image of that. It has not lost that meaninglessness, it has now gained not the least shred of meaningfulness. The stones still roll back as before, each phase of Sisyphus' life still exactly resembles all the others, the task is never completed, nothing comes of it, no temple ever begins to rise, and all this cycle of the same pointless thing over and over goes on forever in this picture as in the other. The *only* thing that has happened is this: Sisyphus has

been reconciled to it, and indeed more, he has been led to embrace it. Not, however, by reason or persuasion, but by nothing more rational than the potency of a new substance in his veins.

THE MEANINGLESSNESS OF LIFE

I believe the foregoing provides a fairly clear content to the idea of meaninglessness and, through it, some hint of what meaningfulness, in this sense might be. Meaninglessness is essentially endless pointlessness, and meaningfulness is therefore the opposite. Activity, and even long, drawn out and repetitive activity, has a meaning if it has some significant culmination, some more or less lasting end that can be considered to have been the direction and purpose of the activity. But the descriptions so far also provide something else; namely, the suggestion of how an existence that is objectively meaningless, in this sense, can nevertheless acquire a meaning for him whose existence it is.

Now let us ask: Which of these pictures does life in fact resemble? And let us not begin with our own lives, for here both our prejudices and wishes are great, but with the life in general that we share with the rest of creation. We shall find, I think, that it all has a certain pattern, and that this pattern is by now easily recognized.

We can begin anywhere, only saving human existence for our last consideration. We can, for example, begin with any animal. It does not matter where we begin, because the result is going to be exactly the same.

Thus, for example, there are caves in New Zealand, deep and dark, whose floors are quiet pools and whose walls and ceilings are covered with soft light. As you gaze in wonder in the stillness of these caves it seems that the Creator has reproduced there in microcosm the heavens themselves, until you scarcely remember the enclosing presence of the walls. As you look more closely, however, the scene is explained. Each dot of light identifies an ugly worm, whose luminous tail is meant to attract insects from the surrounding darkness. As from time to time one of these insects draws near it becomes entangled in a sticky thread lowered by the worm, and is eaten. This goes on month after month, the blind worm lying there in the barren stillness waiting to entrap an occasional bit of nourishment that will only sustain it to another bit of nourishment until. . . . Until what? What great thing awaits all this long and repetitive effort and makes it worthwhile? Really nothing. The larva just transforms itself finally to a tiny winged adult that lacks even mouth parts to feed and lives only a day or two. These adults, as soon as they have mated and laid eggs, are themselves caught in the threads and are devoured by the cannibalist worms, often without having ventured into the day, the only point to their existence having now been fulfilled. This has been going on for millions of years, and to no end other than that the same meaningless cycle may continue for another millions of years.

All living things present essentially the same spectacle. The larva of a certain cicada burrows in the darkness of the earth for seventeen years, through season after season, to emerge finally into the daylight for a brief flight, lay its eggs, and die—this all to repeat itself during the next seventeen years, and so on to eternity. We have already noted, in another connection, the struggles of fish, made only that others may do the same after them and that this cycle, having no other point than itself, may never cease. Some birds span an entire side of the globe each year and then return, only to insure that others may follow the same incredibly long path again and again. One is led to wonder what the point of it all is, with what great triumph this ceaseless effort, repeating itself through millions of years, might finally culminate, and why it should go on and on for so long, accomplishing nothing, getting nowhere. But then you realize that there is no point to it at all, that it really culminates in nothing, that each of these cycles, so filled with toil, is to be followed only by more of the same. The point of any living thing's life is, evidently, nothing but life itself.

This life of the world thus presents itself to our eyes as a vast machine, feeding on itself, running on and on forever to nothing. And we are part of that life. To be sure, we are not just the same, but the differences are not so great as we like to think; many are merely invented, and none really cancels the kind of

meaninglessness that we found in Sisyphus and that we find all around, wherever anything lives. We are conscious of our activity. Our goals, whether in any significant sense we choose them or not, are things of which we are at least partly aware and can therefore in some sense appraise. More significantly, perhaps, we have a history, as other animals do not, such that each generation does not precisely resemble all those before. Still, if we can in imagination disengage our wills from our lives and disregard the deep interest we all have in our own existence, we shall find that they do not so little resemble the existence of Sisyphus. We toil after goals, most of them—indeed every single one of them—of transitory significance and, having gained one of them, we immediately set forth for the next, as if that one had never been, with this next one being essentially more of the same. Look at a busy street any day, and observe the throng going hither and thither. To what? Some office or shop, where the same things will be done today as were done yesterday, and are done now so they may be repeated tomorrow. And if we think that, unlike Sisyphus, these labors do have a point, that they culminate in something lasting and, independently of our own deep interests in them, very worthwhile, then we simply have not considered the thing closely enough. Most such effort is directed only to the establishment and perpetuation of home and family; that is, to the begetting of others who will follow in our steps to do more of the same. Everyone's life thus resembles one of Sisyphus's climbs to the summit of his hill, and each day of it one of his steps; the difference is that whereas Sisyphus himself returns to push the stone up again, we leave this to our children. We at one point imagined that the labors of Sisyphus finally culminated in the creation of a temple, but for this to make any difference it had to be a temple that would at least endure, adding beauty to the world for the remainder of time. Our achievements, even though they are often beautiful, are mostly bubbles; and those that do last, like the sand-swept pyramids, soon become mere curiosities while around them the rest of human-kind continues its perpetual toting of rocks, only to see them roll down. Nations are built upon the bones of their founders and pioneers, but

only to decay and crumble before long, their rubble then becoming the foundation for others directed to exactly the same fate. The picture of Sisyphus is the picture of existence of the individual man, great or unknown, of nations, of the human race, and of the very life of the world.

On a country road one sometimes comes upon the ruined hulks of a house and once extensive buildings, all in collapse and spread over with weeds. A curious eye can in imagination reconstruct from what is left a once warm and thriving life, filled with purpose. There was the hearth, where a family once talked, sang, and made plans; there were the rooms, where people loved, and babes were born to a rejoicing mother; there are the musty remains of a sofa, infested with bugs, once bought at a dear price to enhance an ever-growing comfort, beauty, and warmth. Every small piece of junk fills the mind with what once, not long ago, was utterly real, with children's voices, plans made, and enterprises embarked upon. That is how these stones of Sisyphus were rolled up, and that is how they became incorporated into a beautiful temple, and that temple is what now lies before you. Meanwhile other buildings, institutions, nations, and civilizations spring up all around, only to share the same fate before long. And if the question "What for?" is now asked, the answer is clear: so that just this may go on forever.

The two pictures—of Sisyphus and of our own lives, if we look at them from a distance—are in outline the same and convey to the mind the same image. It is not surprising, then, that we invent ways of denying it, our religions proclaiming a heaven that does not crumble, their hymnals and prayer books declaring a significance to life of which our eyes provide no hint whatever.[1] Even our philosophies portray some permanent and lasting good at which all may aim, from the changeless forms invented by Plato to the beatific vision of St. Thomas and the ideals of permanence contrived by the moderns. When these fail to convince, then earthly ideals such as universal justice and brotherhood are conjured up to take their places and give meaning to our seemingly endless pilgrimage, some final state that will be ushered in when the last obstacle is removed and the last stone pushed to the hilltop.

No one believes, of course, that any such state will be final, or even wants it to be in case it means that human existence would then cease to be a struggle; but in the meantime such ideas serve a very real need.

THE MEANING OF LIFE

We noted that Sisyphus' existence would have meaning if there were some point to his labors, if his efforts ever culminated in something that was not just an occasion for fresh labors of the same kind. But that is precisely the meaning it lacks. And human existence resembles his in that respect. We do achieve things—we scale our towers and raise our stones to the hilltops—but every such accomplishment fades, providing only an occasion for renewed labors of the same kind.

But here we need to note something else that has been mentioned, but its significance not explored, and that is the state of mind and feeling with which such labors are undertaken. We noted that if Sisyphus had a keen and unappeasable desire to be doing just what he found himself doing, then, although his life would in no way be changed, it would nevertheless have a meaning for him. It would be an irrational one, no doubt, because the desire itself would be only the product of the substance in his veins, and not any that reason could discover, but a meaning nevertheless.

And would it not, in fact, be a meaning incomparably better than the other? For let us examine again the first kind of meaning it could have. Let us suppose that, without having any interest in rolling stones, as such, and finding this, in fact, a galling toil, Sisyphus did nevertheless have a deep interest in raising a temple, one that would be beautiful and lasting. And let us suppose he succeeded in this, that after ages of dreadful toil, all directed at this final result, he did at last complete his temple, such that now he could say his work was done, and he could rest and forever enjoy the result. Now what? What picture now presents itself to our minds? It is precisely the picture of infinite boredom! Of Sisyphus doing nothing ever again, but contemplating what he has already wrought and can no longer add anything to, and contemplating it for an eternity! Now in this picture we have a meaning for Sisyphus' existence, a point for his prodigious labor, because we have put it there; yet, at the same time, that which is really worthwhile seems to have slipped away entirely. Where before we were presented with the nightmare of eternal and pointless activity, we are now confronted with the hell of its eternal absence.

Our second picture, then, wherein we imagined Sisyphus to have had inflicted on him the irrational desire to be doing just what he found himself doing, should not have been dismissed so abruptly. The meaning that picture lacked was no meaning that he or anyone could crave, and the strange meaning it had was perhaps just what we were seeking.

At this point, then, we can reintroduce what has been until now, it is hoped, resolutely pushed aside in an effort to view our lives and human existence with objectivity; namely, our own wills, our deep interest in what we find ourselves doing. If we do this we find that our lives do indeed still resemble that of Sisyphus, but that the meaningfulness they thus lack is precisely the meaningfulness of infinite boredom. At the same time, the strange meaningfulness they possess is that of the inner compulsion to be doing just what we were put here to do, and to go on doing it forever. This is the nearest we may hope to get to heaven, but the redeeming side of that fact is that we do thereby avoid a genuine hell.

If the builders of a great and flourishing ancient civilization could somehow return now to see archaeologists unearthing the trivial remnants of what they had once accomplished with such effort—see the fragments of pots and vases, a few broken statues, and such tokens of another age and greatness—they could indeed ask themselves what the point of it all was, if this is all it finally came to. Yet, it did not seem so to them then, for it was just the building, and not what was finally built, that gave their life meaning. Similarly, if the builders of the ruined home and farm that I described a short while ago could be brought back to see what is left, they would have the same feelings. What we construct in our imaginations as we look over these decayed and rusting pieces would reconstruct itself in their very memories, and certainly with unspeakable sadness. The piece of a sled

at our feet would revive in them a warm Christmas. And what rich memories would there be in the broken crib? And the weed-covered remains of a fence would reproduce the scene of a great herd of livestock, so laboriously built up over so many years. What was it all worth, if this is the final result? Yet, again, it did not seem so to them through those many years of struggle and toil, and they did not imagine they were building a Gibraltar. The things to which they bent their backs day after day, realizing one by one their ephemeral plans, were precisely the things in which their wills were deeply involved, precisely the things in which their interests lay, and there was no need then to ask questions. There is no more need of them now—the day was sufficient to itself, and so was the life.

This is surely the way to look at all of life—at one's own life, and each day and moment it contains; of the life of a nation; of the species; of the life of the world; and of everything that breathes. Even the glow worms I described, whose cycles of existence over the millions of years seem so pointless when looked at by us, will seem entirely different to us if we can somehow try to view their existence from within. Their endless activity, which gets nowhere, is just what it is their will to pursue. This is its whole justification and meaning. Nor would it be any salvation to the birds who span the globe every year, back and forth, to have a home made for them in a cage with plenty of food and protection, so that they would not have to migrate anymore. It would be their condemnation, for it is the doing that counts for them, and not what they hope to win by it. Flying these prodigious distances, never ending, is what it is in their veins to do, exactly as it was in Sisyphus's veins to roll stones, without end, after the gods had waxed merciful and implanted this in him.

You no sooner drew your first breath than you responded to the will that was in you to live. You no more ask whether it will be worthwhile, or whether anything of significance will come of it, than the worms and the birds. The point of living is simply to be living, in the manner that it is your nature to be living. You go through life building your castles, each of these beginning to fade into time as the next is begun; yet it would be no salvation to rest from all this. It would be a condemnation, and one that would in no way be redeemed were you able to gaze upon the things you have done, even if these were beautiful and absolutely permanent, as they never are. What counts is that you should be able to begin a new task, a new castle, a new bubble. It counts only because it is there to be done and you have the will to do it. The same will be the life of your children, and of theirs; and if the philosopher is apt to see in this a pattern similar to the unending cycles of the existence of Sisyphus, and to despair, then it is indeed because the meaning and point he is seeking is not there—but mercifully so. The meaning of life is from within us, it is not bestowed from without, and it far exceeds in both its beauty and permanence any heaven of which men have ever dreamed or yearned for.

Note

1. A popular Christian hymn, sung often at funerals and typical of many hymns, expresses this thought:

Swift to its close ebbs out life's little day;
Earth's joys grow dim, its glories pass away;
Change and decay in all around I see:
O thou who changest not, abide with me.

Study Questions

1. Can a life be enjoyed yet meaningless?
2. Can a life be immoral yet meaningful?
3. Can you be mistaken about finding meaning in an activity?

4. Can an activity you find boring give meaning to your life?